THE 2023 GOOD BEER GUIDE

50TH EDITION

MANAGING EDITOR
Emma Haines

EDITORS
Ione Brown, Katie Button, Claire-Michelle Taverner-Pearson

PROJECT ASSISTANCE
Stewart Campbell

SALES & MARKETING
Toby Langdon

CAMRA BOOKS

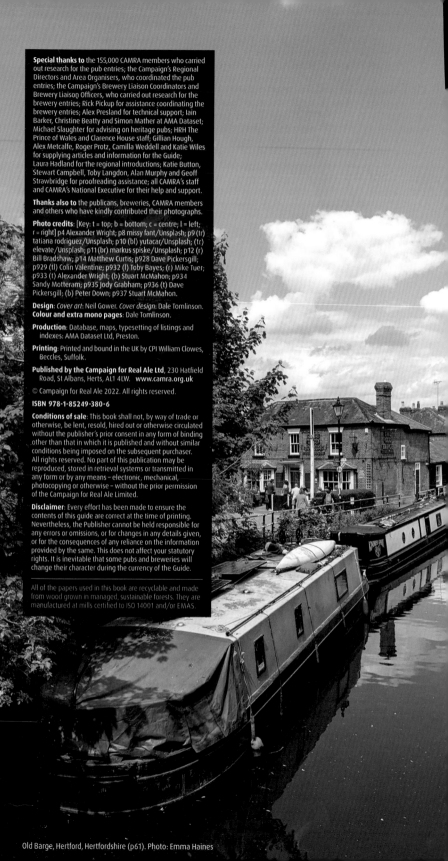

Special thanks to the 155,000 CAMRA members who carried out research for the pub entries; the Campaign's Regional Directors and Area Organisers, who coordinated the pub entries; the Campaign's Brewery Liaison Coordinators and Brewery Liaison Officers, who carried out research for the brewery entries; Rick Pickup for assistance coordinating the brewery entries; Alex Presland for technical support; Iain Barker, Christine Beatty and Simon Mather at AMA Dataset; Michael Slaughter for advising on heritage pubs; HRH The Prince of Wales and Clarence House staff; Gillian Hough, Alex Metcalfe, Roger Protz, Camilla Weddell and Katie Wiles for supplying articles and information for the Guide; Laura Hadland for the regional introductions; Katie Button, Stewart Campbell, Toby Langdon, Alan Murphy and Geoff Strawbridge for proofreading assistance; all CAMRA's staff and CAMRA's National Executive for their help and support.

Thanks also to the publicans, breweries, CAMRA members and others who have kindly contributed their photographs.

Photo credits: [Key: t = top; b = bottom; c = centre; l = left; r = right] p4 Alexander Wright; p8 missy fant/Unsplash; p9 (tr) tatiana rodriguez/Unsplash; p10 (bl) yutacar/Unsplash; (tr) elevate/Unsplash; p11 (br) markus spiske/Unsplash; p12 (r) Bill Bradshaw; p14 Matthew Curtis; p928 Dave Pickersgill; p929 (tl) Colin Valentine; p932 (l) Toby Bayes; (r) Mike Tuer; p933 (t) Alexander Wright; (b) Stuart McMahon; p934 Sandy Motteram; p935 Jody Grabham; p936 (t) Dave Pickersgill; (b) Peter Down; p937 Stuart McMahon.

Design: *Cover art*: Neil Gower. *Cover design*: Dale Tomlinson. **Colour and extra mono pages**: Dale Tomlinson.

Production: Database, maps, typesetting of listings and indexes: AMA Dataset Ltd, Preston.

Printing: Printed and bound in the UK by CPI William Clowes, Beccles, Suffolk.

Published by the Campaign for Real Ale Ltd, 230 Hatfield Road, St Albans, Herts, AL1 4LW. **www.camra.org.uk**

Old Barge, Hertford, Hertfordshire (p61). Photo: Emma Haines

CONTENTS

ABOUT THE GOOD BEER GUIDE

Your Guide to the best pubs and beer in the UK turns 50.
Cheers to 50 years of great beer!

For five decades, *The Good Beer Guide* has been a comprehensive guide to the UK's breweries, their ales and the best outlets to find them in around the country.

There may be other pub guides out there, but this book is different. Where other guides might have a small editorial board pulling together entries, *The Good Beer Guide* has a huge volunteer team, based around the country, all regularly using their local pubs, trying out the beers on offer and recommending the best of them to other beer- and pub-lovers.

We strive hard to ensure that all areas of the country are covered. Each county or region has a listing allocation based on a scientific calculation of its population, number of licensed premises and levels of tourism. As a result, the Guide's reach is unparalleled.

The Good Beer Guide is also proudly independent. Inclusion in this book is dependent on merit, not on payment. No pubs or breweries paid to be in this book.

VOLUNTEER INVOLVEMENT

CAMRA has more than 160,000 members across more than 200 branches around the UK. It's within these branches that entries are democratically selected. All members are invited to rate beers served to them via the National Beer Scoring System (see p938). These scores are used by branches to identify pubs consistently serving the best real ale. Not only is the quality of the cask beer monitored, but also factors that could affect the range on offer and the overall standard of the pub, such as change of ownership or management.

While the core purpose of the Guide is to seek out quality real ale, it also considers other things such as history, architecture, food, family and disabled facilities, gardens, and special events (such as beer festivals). The pub listings you find in these pages paint a full picture of what you can expect before you embark on a trip to visit them.

The listings are checked many times before publication, to ensure they are accurate and up to date.

BREWERY LISTINGS

The Good Beer Guide includes a comprehensive listing of the more than 1,800 breweries currently operating in the UK – not just those producing real ale – and their core cask-conditioned beers available.

Each one is appointed a local CAMRA volunteer as soon as they come on stream. These volunteer officers regularly keep in touch with the brewery to stay abreast of what's being brewed, and developments that may be taking place.

A REGIONAL GUIDE

This year, for the first time, the Guide features pub and brewery listings together, by county within regions, making it easier for you to find local beers and where to drink them, plus information about the breweries that produce them. Each region has an introduction by award-winning beer writer Laura Hadland, author of *50 Years of CAMRA*.

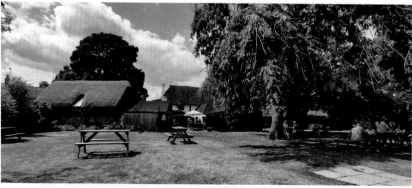

Local CAMRA Pub of the Year, Bell, Waltham St Lawrence, Berkshire (p163)

I am so pleased to be able to contribute to this foreword, celebrating a very special fiftieth edition of CAMRA's *Good Beer Guide.*

Pubs are interwoven in the very fabric of British history, and they are still a much-loved and vital asset of local communities up and down the country. Over twenty years ago, I helped to establish Pub is The Hub which brings rural needs and licensees together to inspire local initiatives, so I do know that Pubs can be an incredible force for good. I was not at all surprised, therefore, to hear that Pub Aid figures show they raise more than £100m a year for charity and offer support worth £40m to grassroots sports.

The U.K. has a rich history born inside pubs. The Freemason Arms in Covent Garden is where the FA first met to agree the universal rules for modern football in 1863. The Eagle in Cambridge is known as the place where Francis Crick and James Watson announced the discovery of the structure of DNA and The Dove, Hammersmith, is where the words for *Rule Britannia* were penned!

I am also keenly aware of the important role that pubs, their landlords and staff played during the pandemic. Despite repeated lockdowns, closures and restrictions, we saw some shining examples of pubs going above and beyond their normal capacity to help their local area. From serving free school meals for children, to selling necessities and supplies for residents and trying to counter loneliness through virtual events, quizzes and groups, pubs truly have been at the heart of their communities, even when they were not able to operate as a business.

When our pubs were allowed to reopen, many rejoiced to be able to meet friends and family once again down at their local and connect with their own community.

Pubs and breweries are still facing huge challenges after the pandemic, but I am delighted to see the work of CAMRA carrying on, as evidenced by this Guide.

This book provides an insight into the rich tapestry of U.K. pub culture, and a keepsake for years to come as we look to the next fifty years. If we want to support and protect the pubs of tomorrow, I can only urge you to use this Guide to visit the very best pubs the nation has to offer today.

CHEERS TO 50 YEARS OF GREAT BEER!

There's so much to celebrate as we mark the 50th edition of *The Good Beer Guide*. Following two years of mandatory closures and changing restrictions, pubs and social clubs are open again and we are back in business here at CAMRA.

It was an absolute delight to bring the Great British Beer Festival back to its home at Olympia, London. Despite building work and renovations taking place and uncertainty over the pandemic, our volunteers were committed to putting on the best show possible. And what an event it was – featuring the very best cask and craft beer, cider, perries, wines and gins from across the UK and abroad. There was every excuse in the book to put the event on hold, but I am so proud of our working group for not only bringing our flagship festival back but going above and beyond all expectations. From launching a new homebrew competition to hosting beer writers, rugby players and exclusive giveaways on the ground, it really was an event to be remembered.

UNITED WE STAND

In fact, we've been working hard from branch to national level to bring back the CAMRAderie that makes being a member so special. Our local festival programme re-started, marking the return of hundreds of local festivals across the UK. Our branches have been bringing back branch magazines, awards, and of course,

in-person meetings and social events, helping members get the most out of volunteering. In fact, we estimate that our volunteers donate around 610,000 hours to CAMRA each year!

Tune in to CAMRA's popular podcast

Our popular podcast *Pubs. Pints. People.* has been shining a spotlight on some of this local activity each month, and I was particularly struck by an interview with Edgar Halton, Membership Secretary at the South Devon branch. Edgar said:

> "*The challenge is that everything in life is habit. When a habit is broken – such as when COVID happened – we must work hard to get our members back into getting involved in CAMRA. We don't want them to sit back – we want them active, taking part in CAMRA and having fun.*"

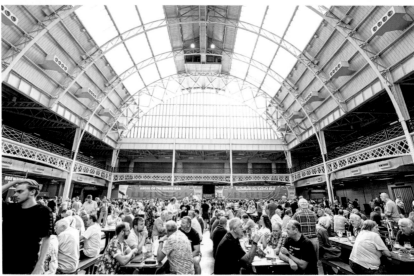

The Great British Beer Festival made a triumphant return to London in 2022

To me, that has been the supreme challenge of the past year and ultimately the biggest cause for celebration, as we've seen so many great examples of CAMRA branches and festivals coming back to life.

And it's not just a return to 'business as usual' that we should be raising a glass to. There's a huge amount to celebrate across the Campaign.

CAMPAIGNING SUCCESS

Our national campaigning efforts have continued to go from strength to strength, with the Government introducing a new draught duty rate for beer and cider served in the on-trade, which has been a long-standing CAMRA policy that we won against all odds. This is a more intelligent way to tax alcohol, as it recognises the community and environmental benefits of drinking on draught, in pubs.

We also saw the introduction of a statutory Pubs Code with a Guest Beer Right for tied tenants in Scotland, giving them legal protections that are in some respects enhanced from those under the Code in England and Wales.

The Government announced a sliding scale of duty for small cider producers, to help them compete against the global producers that dominate the UK cider market.

And finally, brewers and cider makers in Northern Ireland can finally sell their products online and direct to consumers in their own country – something that was impossible just a year ago.

CAMRA Books have won a number of awards this year

In many cases, these campaigns were achieved in the face of outright opposition from big business and powerful lobbying groups who do not understand the power of volunteers, consumers, and grassroots campaigning. It is clear that CAMRA's voice still carries great weight and there is huge power in a collective consumer voice.

AWARD-WINNING RESOURCES

We must also raise a glass to CAMRA Books, which has become a truly award-winning publication team, with several accolades and commendations to its latest titles including:

- *50 Years of CAMRA* was voted the Best Beer Book in the World at the Gourmand Awards
- *A Year in Beer* won Best Drinks Book of 2021 from the Guild of Food Writers and Best Drinks Book at the Fortnum & Mason's Awards
- *Modern British Cider* received a commendation at the Gourmand Awards
- *Beer by Design* received the Best Beer Writer award for Pete Brown at the British Guild of Beer Writers in 2021
- *Modern British Beer* was voted Best Beer Book by Ferment magazine in 2021 and nominated by Jaega Wise in her shortlist of best drinks books of 2021 for BBC Radio 4 Food Programme

Of course, our books are not the only award-winning resources to help people discover more about their favourite drink. Our Learn & Discover content has exploded over lockdown, featuring a huge range of freely available articles, video and audio guides. These cover everything from the history of the 'colour bar' in pubs to the importance of saving cask beer. The project won Best Corporate Communications in the British Guild of Beer Writers Awards – an amazing feat for a relatively novel addition to the Campaign.

KEEPING UP THE GOOD WORK

There's so much to celebrate – and of course, a huge amount of work still to do. We are now undertaking a review of Inclusivity, Diversity & Equality across the organisation, and assessing our environmental impact as a campaign. We cannot rest on our laurels. Yet despite the challenges ahead, and the pressures that continue to plague the industry in the wake of the pandemic, I am confident that CAMRA will continue its important role in representing the consumer, spreading the good word about beer and cider, and of course, having fun!

Nik Antona, *National Chairman*

CAMRA'S BEER STYLES

We are very lucky in the UK to enjoy a rich variety of traditional beer styles developed by brewers over the past few hundred years. The number of brewers brewing international recipes and experimenting with new styles means that there are ever more beers to choose from. Such a wide range of styles, names and variations can be a little overwhelming, so CAMRA have cut through the jargon and have come up with 12 beer style categories to help you navigate the choices at the bar.

Over the next few pages, we take you through the beer style categories, with advice on some of the flavour profiles you can expect, but first here are a few commonly used expressions and terms for describing how beer smells, tastes and feels as you drink it.

Nose: the aroma. Gently swirl the beer to release the aroma. You will detect malt: grainy and biscuity, often likened to crackers or Ovaltine. When darker malts are used, the nose will have powerful hints of chocolate, coffee, nuts, vanilla, liquorice, molasses and such dried fruit as raisins and sultanas. Hops add superb aromas of resins, herbs, spices, fresh-mown grass, and tart citrus fruit – lemon and orange are typical, with intense tropical or grapefruit notes from some American varieties.

Palate: the appeal in the mouth (mouthfeel). The tongue can detect sweetness, bitterness and saltiness as the beer passes over it. The rich flavours of malt will come to the fore but hop bitterness will also make a substantial impact. The tongue will also pick out the natural saltiness from the brewing water and fruit from darker malts, yeast, and hops. Citrus notes often have a major impact on the palate.

Finish: the aftertaste, as the beer goes over the tongue and down the throat. The finish is often radically different from the nose. The aroma may be dominated by malt, whereas hop flavours and bitterness can govern the finish.

There are many different beer styles to choose from in the UK

1. Milds
up to and including 4% ABV

Look: There are two types of mild; light/pale milds, and dark milds. Milds can be dark brown to black to pale amber or even gold.

Taste: Light drinking and not very hoppy. Pale milds are lightly hopped and may have a light fruitiness and sweet taste with a little butterscotch/toffee. Dark milds are frequently sweet with a light bitterness with malt and roasted notes of chocolate, coffee, and liquorice.

Scottish 60 shillings or Scottish light beer also fits into this category and can be dark brown to black in colour with flavours of malt with butterscotch/toffee notes.

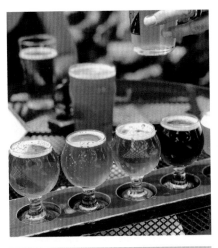

2. Session Bitters
up to and including 4.3% ABV

Look: Amber to dark brown in colour.

Taste: Bitterness can range from light to strong. These are 'traditional bitters' with a thin to average body, a malt character with noticeable hops; typically earthy, spicy, and peppery but may also be floral or piny. Fruitiness, sometimes citrus, can be present.

3. Premium Bitters
4.4%–6.4% ABV

Look: Usually amber to dark brown in colour.

Taste: Premium bitters are traditionally stronger bitters with an average to thick body. They have medium to strong malt flavour with noticeable hops; typically earthy, spicy, and peppery, but can also be floral, piny, or citrus. Fruitiness may be medium to strong.

Stronger bitters may have estery notes such as pear drops, and the bitterness may range from medium to strong.

4. Session Pale, Blond and Golden Ales
up to and including 4.3% ABV

Look: Pale ales are dark gold to amber in colour. Blond ales are straw to golden in colour.

Taste: These are refreshing, light-drinking beers. Malt flavours are light in character, with hop flavours more noticeable and varying from earthy or spicy to citrus and tropical.

Pale ales can be fruitier than a session bitter. Malt is minimal with low to moderate fruit flavours. Hops again may vary but will not have a strong citrus character. Golden ales have pronounced fruity, citrus hop notes and may have strong bitterness.

5. Premium Pale, Blond and Golden Ales: 4.4%–6.4% ABV

Look: Pale ales are dark gold to amber. Blond and golden ales are straw to gold in colour.

Taste: These beers are refreshing but fuller-bodied than the session varieties. Malt is light to medium in character and not dominant. Fruit can vary from minimal to strong and is often citrus or tropical. Hops are noticeable and vary from earthy and spicy to citrus.

6. British & New World IPAs
5.5% ABV and above

Look: British IPAs are usually amber to pale brown. New World IPAs are straw to pale brown. Black IPAs are typically dark brown or black.

Taste: These are strong, hoppy beers. The finish is long and complex.

British IPAs often have a biscuit malt aroma and peppery, spicy, earthy, piny, or floral hop notes. New World IPAs are noticeably fruitier with citrus, tropical or white wine flavours. The malt tends to make less of an impact. Black IPAs have a lighter roasted character which complements rather than dominating the hops and fruit in the flavour profile.

7. Brown & Red Ales, Old Ales & Strong Milds: up to 6.4% ABV

Look: Darker in colour, from deep red to dark brown.

Taste: These beers tend to have malty notes.

Brown ales have malt to the fore, often with roasted, smoky, or nut-like flavours. Hops are sometimes evident, and they may have a moderately bitter or dry finish. Fruity flavours such as raisins or sultanas may be present. American brown ales tend to be much fruitier, sometimes with pronounced bittering.

Red ales have malt to the fore, often with roast or nutty flavours. Rye may be present, creating a balanced tartness. American red ales are fruitier and hoppier. Strong milds and unaged old ales have a light to rich malt character, sometimes with caramel and fruit notes such as raisins and sultanas.

8. Session Stouts and Porters
up to and including 4.9% ABV

Look: Dark ruby to jet black.

Taste: Stouts are typically black and less hopped than porters. Their flavour and aroma results from the roasted grain malts, for example chocolate, caramel, and coffee notes. They have minimal hop and fruit notes. There are several different types of stout brewed, each with a slightly different flavour profile. These include dry stouts, oyster stouts, oatmeal stouts and milk stouts.

Porters also have roasted notes of coffee or chocolate but are balanced by a hoppy character.

9. Strong Stouts and Porters
5% ABV and above

Look: Dark ruby to jet black.

Taste: Grain, burnt fruit, fresh leather, espresso coffee, bitter chocolate, molasses, and liquorice notes. Warming alcohol is often noticeable due to the high alcohol content. These are stronger, dry versions of the session varieties, usually with a smoother, fuller mouthfeel. Flavours range from sweet to dry but with a rich, full body.

Imperial stouts and Baltic (or Imperial) porters are deep and complex with roast grain, burnt fruit and fresh leather notes.

10. Barley Wines and Strong Ales
6.5% ABV and above

Look: Pale gold, amber, ruby to black.

Taste: Strong beer used to be produced to allow it to be kept, particularly to provide beer when it was too warm to brew. Many of the beers in this category are still aged before selling, leading to wine-like notes. They are rich, complex, and full-bodied with noticeable alcohol, but may vary from dry to sweet. Bitterness may be medium to strong.

11. Speciality Beers
differently produced

Look: Varies

Taste: Differently produced speciality beers are those brewed with non-standard ingredients or techniques, as opposed to flavoured speciality beers, which have flavour added. Non-conventional ingredients and techniques are only limited by the brewer's imagination. They can include styles such as Pilsners, Vienna lagers, Märzen, dark lagers and Kölsch, wheat beers, sours, saisons, wood-aged and smoked beers.

12. Speciality Beers: flavoured

Look: Varies.

Taste: Flavoured speciality beers are beers with a flavour added. They can be similar to other styles in that any beer style can be adapted by a flavour addition to become a speciality beer. They include fruit beers or beers brewed with herbs, spices, or other culinary ingredients. The latter can include ginger, coriander, mint, elderflower, or ingredients such as honey, coffee, chocolate, vanilla or fortified wines and spirits.

The character of a base beer will influence the final taste of a fruit beer but the wide range of fruit available to brewers means that tastes can vary from sour (typical of lemons and some cherries), to bitter (such as bergamot), through to sweet (such as mango or strawberry).

To help you find your favourite beers more easily we now include beer style information next to each beer listed in the brewery section of the Guide. Please see the inside rear cover for more information, or the CAMRA website **www.camra.org.uk/learn-discover**

APPLES AND PEARS

Since 1975 CAMRA has recognised that real cider and perry, as traditional drinks, were under threat and was committed to campaigning to support them. CAMRA began to inform consumer choice, encourage producers to continue making real cider and perry, and raise consumer awareness. The world of cider and perry has evolved so much over almost 50 years, but CAMRA still has a central role in lobbying and campaigning for 'Real Cider and Perry #NotFromConcentrate'.

WHAT IS REAL CIDER & PERRY?

CAMRA defines real Cider or Perry as being fermented from the whole juice of fresh pressed apples or pears without the use of concentrated or chaptalised juices.

Real cider and perry are cold pressed, requiring no additional heating. Apples or pears are washed, milled, pressed, and left to ferment – that's it.

WHERE TO DRINK CIDER AND PERRY

In *The Good Beer Guide* 2023, we have included a symbol (🍎) to indicate where premises sell at least one real cider and perry, so you can seek out and try some.

CAMRA has listed over 400 producers of real cider and perry in the UK for consumers and licensees to support and choose from. Our live map is constantly evolving and can be accessed at **producers.camra.org.uk** or through the CAMRA website.

MODERN BRITISH CIDER

In 2021 CAMRA published *Modern British Cider* by Gabe Cook, celebrating the resurgence of artisanal craft cider and perry making, including styles, approaches and traditions.

Cook says: "I hold that now is the most exciting time for cider in the last 400 years, since the 17th-century 'ciderists' were advocating cider as one of the finest drinks made on these shores."

CIDER & PERRY CAMPAIGNING

Traditional orchards are vital because of their biodiversity, so they have been designated as 'priority habitats' by Government since 2007.

Traditional orchards are vital because of their biodiversity

Yet orchards continue to be grubbed up across the UK at an alarming rate.

CAMRA has lobbied the Government, asking for the minimum freshly pressed juice content for all ciders to be raised from 35% to at least 50%. The higher the juice content of the cider or perry you choose, the more UK orchards are supported!

It's also great news that our campaigning to see small producers retain vital tax support has been a success, with Government not only continuing the 'farmgate' exemption but making positive changes that will help cider and perry makers grow their businesses.

CAMRA continues to campaign to secure the long-term future of real cider and perry by increasing their quality, availability and popularity. This requires encouraging and supporting more makers to aspire to make high-quality and delicious drinks.

To find out more about real cider and perry please visit **www.camra.org.uk/learn-discover**

PROUD TO SUPPORT THE GOOD BEER GUIDE

While CAMRA celebrates 50 years of campaigning, Cask Marque, the sponsors of the Good Beer Guide, have been champions of cask beer quality for 25 years. We celebrate together.

Unlike other beers, cask needs the skill of the cellar manager to serve a great pint. How do we support beer quality:

- We have training programmes for bar staff and cellar managers to improve their skill base.
- Make 22,000 unannounced visits to pubs each year undertaken by 60 qualified brewers or technical services personnel.
- Promote cask ale through the CaskFinder app.
- Champion cask ale through Cask Ale Week and an annual industry seminar.
- Support CAMRA in their objectives.

Look out for ✅ on pubs listed in the Guide for those that hold the Cask Marque award.

CASK MARQUE'S FOCUS GOING FORWARD

Cellar inspections

Until now we have checked beer in the glass for temperature, appearance, aroma and taste. All cask beers on sale must pass the inspection to gain the Cask Marque award. We inspect each pub twice a year and any consumer complaint leads to a review of the pub's award.

Going forward we will be checking pub cellars against an 11 point check list and issuing a star rating similar to that of the Food Hygiene rating which we all value. Remember – the kitchen is to food what the cellar is to beer. In future pubs will need a minimum of 4* or 5* to become accredited. This will raise standards even further as well as increase the profitability of the pub; better beer quality means more sales and increased yields. It will also highlight

extra staff training needs which we can satisfy with our current training programme. Watch out for the stickers proudly displayed:

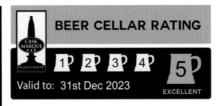

BEER CELLAR RATING

1ᴾ 2ᴾ 3ᴾ 4ᴾ 5ᴾ EXCELLENT

Valid to: 31st Dec 2023

Caskfinder App

Our app, which is free to download, is already used 68,000 times a month to find Cask Marque pubs. It has been downloaded over a quarter of a million times. What does the app deliver:

- It enables you to find your nearest Cask Marque pub with directions.
- Has the World's Biggest Ale Trail. Visit pubs and win prizes.
- Tasting notes on 11,000 beers and details of the brewers.
- The ability to learn more about beers you are drinking by scanning the pump clip using the CaskFinder App.

We will be introducing smaller, regional ale trails linked to prizes. Record your visit to the pub by scanning the QR code on the Cask Marque certificate displayed in the pub. Currently these are scanned 3,250 times a week by customers who have visited a Cask Marque pub for their first time.

Why not join the club and also receive monthly newsletters on Cask Marque activity. Simply scan the QR code.

Look out for the Cask Marque logo to find your perfect pint. To download the CaskFinder App go to **cask-marque.co.uk/cask-finder**. Google Play or the App Store

DRINK GREENER!

CAMRA's Campaigns Officer, Cam Weddell, briefs us on how CAMRA formed an Environmental Working Group to examine how we can change for the better.

This edition marks 50 years of *The Good Beer Guide,* and in that time the world has changed as much as the Guide itself. As the Guide has grown, so has the scope of CAMRA's campaigning, with new challenges for volunteers and staff to meet head on. Indeed, one of the best parts of my job is never quite being able to predict what opportunities the day will bring.

As a millennial I have an obvious stake in the future of the planet, so when the National Executive agreed to form an Environmental Working Group – or EWG – to investigate how 'green' issues cut across CAMRA's activities, I jumped at the chance to be a staff liaison for the project.

WHAT CAN WE DO?

A call was put out for volunteer members of the Group, and the team was assembled. Some were passionate CAMRA stalwarts with years of campaigning expertise and experience; others had never volunteered before and shared invaluable skills and insights from their professional lives.

While it might not seem like an obvious subject for a consumer organisation of pub and beer lovers to campaign on, our initial discussions revealed countless ways the environment touched every part of CAMRA and the licensed trade. The scale of the task at hand quickly became apparent, and we were faced with a simple question –

What can we do about it?

It's often the case in CAMRA that simple questions come with complicated answers. Environmental campaigning can be fraught with ideological and politicised debate, overwhelming statistics, and a nagging sense of guilt that not all your lightbulbs are energy efficient. However, the reality is that many of these issues are practical problems, with equally practical solutions.

BUSINESS RATES LEGISLATION

One of the first areas identified was Business Rates legislation, which was up for Government review during the EWG's six-month remit. Business Rates are a tax usually based on the value of the building a business occupies. The value of a pub is calculated in a slightly different way, which means that they pay a disproportionately high amount of tax, and campaigning to make this system fairer is one of CAMRA's longstanding goals. However, there is a second issue with this legislation. Calculation of a building's value currently includes technology like solar panels, heat recovery systems, and some types of battery bank, meaning that any business that installs this technology will be hit with a higher tax bill for doing so. In response to this, CAMRA has called for this technology to be exempt from Business Rates calculations – a simple change that would make it easier for businesses to invest in innovative energy generation and storage.

Should plastic pint pots, such as those used at festivals, be included in the ban on single use plastics?

LOCALE

CAMRA's LocAle accreditation, which promotes pubs that serve at least one local ale, has been running since 2007, comes with the idea of 'beer miles'. Stocking locally produced beer has a huge range of benefits for consumers and the trade: pub-goers get to enjoy distinctive local beer styles, it improves consumer choice, and supports brewers with increased sales, which in turn creates more local jobs, and increases the resilience of the local economy with more money being generated and spent in the area. With the EWG, CAMRA was able to take a deep dive into the other benefits of localism and measure the environmental impact of consumer choices at the bar. Thousands of pubs already hold the LocAle accreditation and we've since created new materials to help the scheme grow even bigger and encourage more consumers to support local brewers and pubs – I certainly can't think of a more enjoyable way to save the planet!

Reduce your beer miles by drinking local ales

ENVIRONMENTAL BENEFITS

By its very nature, a cask beer comes with a host of environmental benefits, not least that the casks themselves can remain in the supply chain over hundreds of uses. We put out a call for pubs and brewers to tell us about their oldest cask and found some that were still going strong after 30 years. Cask forms the ultimate circular economy with almost every part of the supply chain – from grain to glass – being reused countless times. As a further benefit, much of this equipment is made from material that can be fully recycled at the end of its lifespan.

NEW RELATIONSHIPS

Relationships with Government departments were strengthened as we spoke to them about new issues. We worked with the Department for Environment, Food and Rural Affairs (DEFRA) for the first time to discuss the upcoming Deposit Return Scheme, labelling requirements for cider, and the issue of cider's 'minimum juice content' – the amount of real juice a product must contain to be taxed as cider, which gave us an opportunity to highlight the role orchards play in biodiversity.

GREEN CHAMPIONS

The EWG examined a multitude of different campaigning areas. We created the 'Drink Greener' logo as a simple visual way to draw together the disparate areas of CAMRA's work that these issues affect.

EWG wrapped up its work in early 2022, and its recommendation to add a Green Champion to each strategic committee was taken up, to help ensure that a focus on these issues will be embedded in all CAMRA's future campaigning. The report that EWG produced also contains extensive data and recommendations to guide our future work. We'll be producing consumer guidance, new content for CAMRA's Learn & Discover platform, highlighting the benefits of community hop-growing projects and community orchards, and working with partners in the trade to campaign for legislative changes that will support the industry in embracing the solutions to our changing environment.

We can't be sure what the next 50 years will bring, but I'm optimistic that the 100th edition of the Guide will be published in a world where we can all 'Drink Greener'.

Cam Weddell is CAMRA's Campaigns Officer. Before joining the Campaigns Team, Cam spent 10 years in hospitality, doing everything from bar work in a traditional real ale pub to a management role in a 250-seater carvery. She is passionate about all things pub!

KEY MAP

The Guide is divided into 14 geographical regions. Within each region individual chapters cover the county or authority areas indicated on the map below. Each county area is listed alphabetically within the region, with pub listings first, followed by brewery listings. Numerous changes to administrative boundaries mean that some county areas are approximate only. Please see the contents list on p3 for a full breakdown of regions and areas.

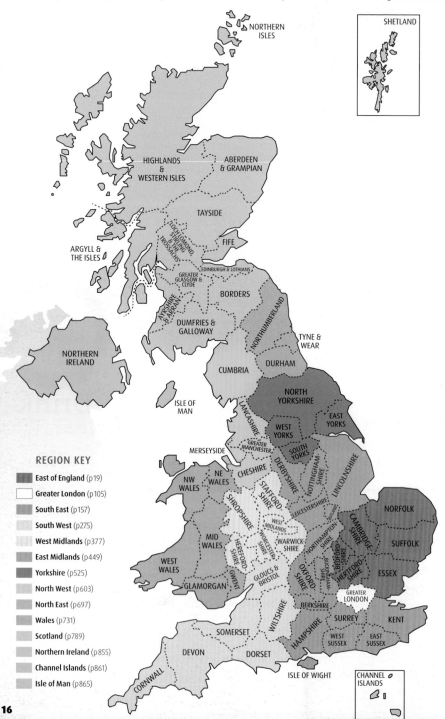

SHETLAND

NORTHERN ISLES

HIGHLANDS & WESTERN ISLES

ABERDEEN & GRAMPIAN

TAYSIDE

ARGYLL & THE ISLES

LOCH LOMOND, STIRLING & THE TROSSACHS

FIFE

EDINBURGH & LOTHIANS

GREATER GLASGOW & CLYDE

BORDERS

AYRSHIRE & ARRAN

DUMFRIES & GALLOWAY

NORTHUMBERLAND

TYNE & WEAR

NORTHERN IRELAND

CUMBRIA

DURHAM

ISLE OF MAN

NORTH YORKSHIRE

LANCASHIRE

WEST YORKS

EAST YORKS

MERSEYSIDE

GREATER MANCHESTER

SOUTH YORKS

NE WALES

NW WALES

CHESHIRE

DERBYSHIRE

NOTTINGHAMSHIRE

LINCOLNSHIRE

SHROPSHIRE

STAFFORDSHIRE

WEST MIDLANDS

LEICESTERSHIRE

RUTLAND

NORFOLK

MID WALES

HEREFORDSHIRE

WORCESTERSHIRE

WARWICKSHIRE

NORTHAMPTONSHIRE

CAMBRIDGESHIRE

SUFFOLK

WEST WALES

GWENT

GLOUCS & BRISTOL

OXFORDSHIRE

BUCKINGHAMSHIRE

HERTFORDSHIRE

ESSEX

GLAMORGAN

BERKSHIRE

GREATER LONDON

WILTSHIRE

SURREY

KENT

SOMERSET

HAMPSHIRE

WEST SUSSEX

EAST SUSSEX

DEVON

DORSET

ISLE OF WIGHT

CHANNEL ISLANDS

CORNWALL

REGION KEY

- East of England (p19)
- Greater London (p105)
- South East (p157)
- South West (p275)
- West Midlands (p377)
- East Midlands (p449)
- Yorkshire (p525)
- North West (p603)
- North East (p697)
- Wales (p731)
- Scotland (p789)
- Northern Ireland (p855)
- Channel Islands (p861)
- Isle of Man (p865)

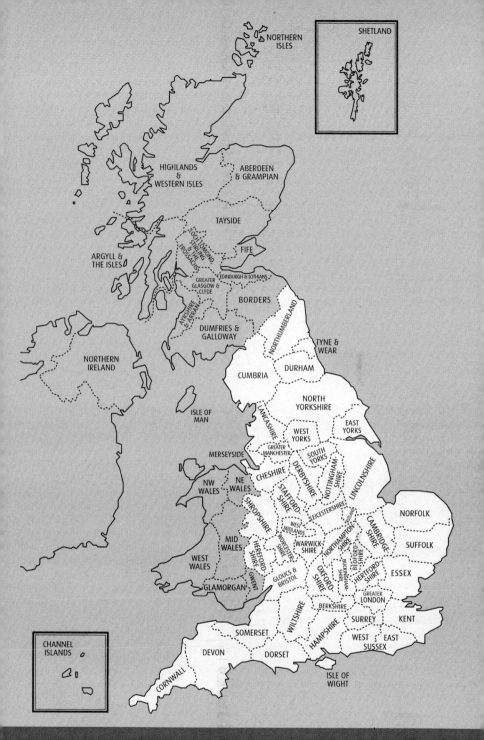

NORTHERN
ISLES

SHETLAND

HIGHLANDS
&
WESTERN ISLES

ABERDEEN
& GRAMPIAN

TAYSIDE

LOCH LOMOND,
STIRLING
& THE
TROSSACHS

FIFE

ARGYLL &
THE ISLES

EDINBURGH & LOTHIANS

GREATER
GLASGOW &
CLYDE

AYRSHIRE
& ARRAN

BORDERS

NORTHERN
IRELAND

DUMFRIES &
GALLOWAY

NORTHUMBERLAND

TYNE &
WEAR

ISLE OF
MAN

CUMBRIA

DURHAM

NORTH
YORKSHIRE

LANCASHIRE

EAST
YORKS

MERSEYSIDE

WEST
YORKS

GREATER
MANCHESTER

SOUTH
YORKS

NW
WALES

NE
WALES

CHESHIRE

DERBYSHIRE

NOTTINGHAM-
SHIRE

LINCOLNSHIRE

SHROPSHIRE

STAFFORD-
SHIRE

LEICESTERSHIRE

RUTLAND

NORFOLK

MID
WALES

HEREFORD-
SHIRE

WEST
MIDLANDS

WORCESTER-
SHIRE

WARWICK-
SHIRE

NORTHAMPTON-
SHIRE

BEDFORD-
SHIRE

CAMBRIDGE-
SHIRE

SUFFOLK

WEST
WALES

GWENT

GLOUCS &
BRISTOL

OXFORD-
SHIRE

BUCKINGHAMSHIRE

HERTFORD-
SHIRE

GREATER
LONDON

ESSEX

GLAMORGAN

WILTSHIRE

BERKSHIRE

SURREY

KENT

SOMERSET

HAMPSHIRE

WEST
SUSSEX

EAST
SUSSEX

DEVON

DORSET

CHANNEL
ISLANDS

CORNWALL

ISLE OF
WIGHT

England

East of England

The East is home to a diverse range of attractions, including the Roman heritage of Colchester and the celebrated wetland bird sanctuary at Minsmere in Suffolk. Nature lovers will also enjoy a visit to Holkham National Nature Reserve, known for its wintering wildfowl.

For the beer tourist, Norwich is a popular choice. Norwich City of Ale was the UK's first beer week, founded in 2011 to promote the city's huge array of excellent pubs (more than 10 per square mile, apparently) as well as the fine malting barley grown in the county. The Red Lion in Preston, Hertfordshire, is also an important stop for the beer pilgrim. It was the first pub in the UK to come under community ownership. It was bought from Whitbread and reopened by Preston's villagers in March 1983.

Tours are offered by breweries both large and small in the region. Visit famous names like Adnams, Greene King or Woodforde's to see the brewers in action, and make a note to visit Elgood's Brewery in Cambridgeshire during the high season. Its historic North Brink Brewery was built in 1795 and the company is now remarkable for being the only brewer in the region that uses a pair of open cooling trays, "coolship trays" to make a Lambic style of beer spontaneously fermented from the wild yeasts of the area.

The East has an important place in the history of beer festivals. The very first public CAMRA festival was held on 30th March 1974 at St Alban's Market Hall. The inaugural Cambridge Beer Festival also took place in 1974. It was the first festival to be run in line with pub licensing hours over several days – the biggest event that the nascent CAMRA had then organised.

The festival, then held at Cambridge Corn Exchange, provided the template for practically every beer festival that was to follow – including the Great British Beer Festival. Cambridge is justifiably proud to hold one of the longest-running and largest regional festivals in the country.

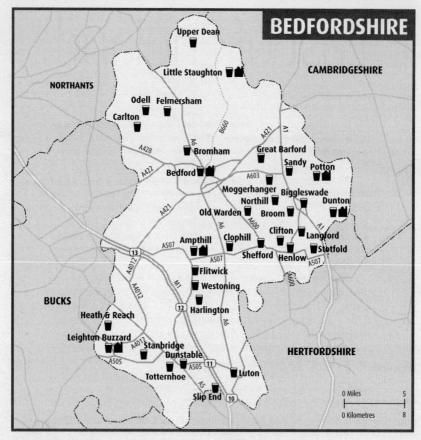

BEDFORDSHIRE

Ampthill

Albion

36 Dunstable Street, MK45 2JT

☎ 07920 875382

Everards Beacon Hill, Sunchaser, Tiger; 3 changing beers (sourced nationally; often Everards) Ⓗ

A proper, narrow-fronted Victorian pub with one large bar and several handpumps serving three regular and two varying ales from Everards plus a changing guest. Craft keg beer is also available on tap. There is a meeting room and a secluded patio garden towards the rear. A varied selection of local clubs and groups is supported. ♿🕮🐾❀

Bedford

Castle Ⓛ

17 Newnham Street, MK40 3JR

☎ (01234) 353295 ⊕ castlebedford.co.uk

Courage Directors; Eagle IPA; Young's London Original, London Special; 2 changing beers (sourced nationally) Ⓗ

Lively town pub with a pleasant walled patio garden, five minutes from the town centre and convenient for the Bedford Blues rugby ground. Lunches and light evening meals are served. Current guest beers with tasting notes are listed on the website and social media. A guesthouse behind the pub provides five en-suite bedrooms. Open mic features on a Monday evening. A former local CAMRA Pub of the Year. ♿🕮🍴🍺♿🅿🛏❀🏳

Devonshire Arms Ⓛ ✔

32 Dudley Street, MK40 3TB (1 mile E of town centre, S of A4280)

☎ (01234) 301170 ⊕ devonshirearmsbedford.co.uk

Courage Directors; 5 changing beers (sourced nationally; often Adnams, Brewpoint, Marston's) Ⓗ

Pleasant late-Victorian pub in a residential area, a Wells house for 123 years. The front bar has bare floorboards and an open fire, while there is a separate rear bar. The garden has a gazebo for smokers and a non-smoking paved area covered by a marquee in winter. Beer and cider festivals are held twice a year. A range of wines is sold by the glass or bottle. Local CAMRA Pub of the Year 2020-21, Town Pub of the Year 2022. Q♿🕮❀♣🖵(4)❀🏳

Pilgrim's Progress ✔

42 Midland Road, MK40 1QB

☎ (01234) 363751

Eagle IPA; Greene King Abbot; Ruddles Best Bitter; Sharp's Doom Bar; 6 changing beers (sourced nationally) Ⓗ

Originally a furniture shop, this building was converted to a pub before becoming a hotel. The bar has five distinct areas plus a small mezzanine. This gives access to the upper (non-smoking) outside area, with a garden below. Suspended trombones mark Glenn Miller's time in Bedford. This venue is just off the pedestrianised shopping area that separates it from the other town-centre pubs. It attracts a wide range of ages and is a good place from which to watch the world go by. ♿🕮🍴🍺♿≢🖵🏳

Three Cups L

45 Newnham Street, MK40 3JR (200yds S of A4280 near rugby ground)

☎ (01234) 352153

Greene King IPA; Morland Old Speckled Hen; 5 changing beers (sourced nationally; often Kelchner) H

Comfortable inn dating from the 1770s, now a Greene King Local Hero pub offering Kelchner and other microbrewery beers plus Saxby's cider. Old wood panelling helps retain some of the pub's original character. An attractive garden offers extra seating under cover plus a large-screen terrestrial TV for major sporting events. Five minutes from the town centre and close to Bedford Blues rugby ground. ⬤⬤⬤P⬤⬤

Wellington Arms L

40-42 Wellington Street, MK40 2JX (N of town centre)

☎ (01234) 308033

3 Brewers of St Albans Shefford Bitter; 10 changing beers (sourced nationally) H

The Welly has been a key part of Bedford's real ale scene for over 20 years. Banks & Taylor's beers (now brewed elsewhere) still feature in the wide selection available, which includes a mild and a stout. The well-stocked fridge offers a range of Belgian and other beers. The walls are decorated with a range of pumpclips and other breweriania. The courtyard provides an attractive outside area. ⬤⬤

Biggleswade

Wheatsheaf ⬤

5 Lawrence Road, SG18 0LS

☎ (01767) 222220

Fuller's London Pride; Greene King IPA H

A traditional, single-bar backstreet pub built in 1873. The landlord is renowned for the quality of his ales and has been in charge of the premises for many years. Darts and dominoes teams are supported and there are two screens for showing live sports events of all kinds, with the emphasis on horse racing. An attractive garden at the rear is a popular location for families in the summer. A meat raffle is held on Sundays. ⬤⬤⬤⬤⬤(73,188)⬤⬤

Bromham

Swan ⬤

Bridge End, MK43 8LS

☎ (01234) 823284

Greene King IPA, Abbot; 3 changing beers (sourced nationally) H

Comfortable village inn with oak beams near the Ouse Valley Way footpath and Bromham Mill museum and art gallery. The building has been an inn since 1798 and retains many old features, despite recent refurbishment incorporating a through lounge bar. The pub hosts poker on Monday, a quiz night on Tuesday and live music every other weekend. A classic pub menu with Sunday roasts is offered in the bar and restaurant. ⬤⬤⬤⬤P⬤(41)⬤⬤

Broom

Cock ★ ⬤

23 High Street, SG18 9NA

☎ (01767) 314411 ⬤ thecockatbroom.co.uk

Greene King Abbot; 3 changing beers (sourced nationally; often St Austell, Tring, Woodforde's) G

Delightful Grade II-listed pub recognised by CAMRA as having a nationally importanthistoric pub interior. It is known as 'the pub with no bar' as service is direct to the

top of the cellar steps. Outside is a popular beer garden. Inside, along with several cosy drinking areas including two snugs, is a games room featuring darts, cribbage and a Northants skittles table. The restaurant serves home-cooked food. Camping is available with access to toilets and cold water, and there are three apartments in adjacent cottages. Local CAMRA Rural Pub of the Year 2022. Q⬤⬤⬤⬤⬤⬤⬤P⬤(200,3)⬤⬤

Carlton

Fox ⬤ L

High Street, MK43 7LA (off Turvey Rd, S of village centre)

☎ (01234) 720235 ⬤ thefoxatcarlton.pub

Eagle IPA; Fuller's London Pride; 2 changing beers (sourced regionally) H

A charming thatched community pub with a warm welcome and an attractive garden popular with families. Guest beers are often from local microbreweries. Good-value, home-cooked lunches are served daily (no food Mon) and evening meals Tuesday to Saturday. There is a regular quiz on Thursday evening. Spring and summer bank holiday beer festivals are held using an outbuilding as an additional bar, and there is a one-day gin festival in June. Local CAMRA Pub of the Year 2022. Q⬤⬤⬤⬤⬤⬤P⬤(25) ⬤⬤

Clifton

Admiral

1 Broad Street, SG17 5RJ

☎ (01462) 811069

5 changing beers (sourced nationally; often Brains, Harvey's) H

Friendly pub dating back to 1867 with a wood-burning stove. It serves five real ales, one real cider (summer only) and usually bottled craft beers. Seafaring-themed pictures and memorabilia decorate the interior, and board games and darts are available. Monthly pub quizzes and live music events are run, as well as an annual beer festival. Sport is regularly shown on an unobtrusive TV screen. Food offerings include midweek bangers & mash and burger nights, fish & chips Fridays, and breakfast and roasts on Sundays. ⬤⬤⬤⬤⬤(9A,9B) ⬤⬤

Clophill

Stone Jug

10 Back Street, MK45 4BY (500yds off A6 at N end of village) TL083381

☎ (01525) 860526 ⬤ stonejug.co.uk

Shepherd Neame Spitfire; Wainwright; 3 changing beers (sourced nationally) H

Originally three 16th-century cottages, this popular village local has an L-shaped bar serving two drinking areas and a family/function room. Excellent home-made lunches are available Tuesday to Saturday. Guest beers are often from local microbreweries. Picnic benches at the front and a rear patio garden offer outdoor drinking

REAL ALE BREWERIES

Brewhouse & Kitchen ⬤ Bedford
Brewpoint ⬤ Bedford
Crown ⬤ Little Staughton
Eagle Bedford
Kelchner Ampthill
Leighton Buzzard Leighton Buzzard
March Hare ⬤ Dunton (NEW)
Potton Potton

spaces in fine weather. Parking can be difficult at busy times. A good refreshment stop for the nearby Greensand Ridge Walk and a former local CAMRA Pub of the Year. Q❄☕◐♿P🚲(44,81)✿

Dunstable

Gary Cooper 🄻 ✓
Grove Park, Court Drive, LU5 4GP
☎ (01582) 471452
Greene King Abbot; Ruddles Best Bitter; Sharp's Doom Bar; 7 changing beers 🄷
A large, modern Wetherspoon bar serving a selection of up to seven guest ales, often local. The usual range of JDW craft beer is also well stocked. Situated in Grove Park leisure area, the pub has a patio overlooking the Grove House Gardens, with many bus routes stopping outside. It gets busy on Friday and Saturday nights. Hollywood star Gary Cooper attended the local grammar school from 1910-1913. ❄◐♿🚲🛜

Globe 🄻
43 Winfield Street, LU6 1LS
☎ (01582) 512300
4 changing beers 🄷
Popular beer destination and community local where the handpumps serve a good range of four ever-changing microbrewery beers, a real cider and a perry. A range of Belgian beers is also available. Bare boards, barstools, breweriana and a famous plank at the end of the bar create a traditional town pub atmosphere buzzing with conversation. Dog (and people) friendly. A former county and local CAMRA Pub of the Year. Q❄♿♣(70)✿

Victoria 🄻
69 West Street, LU6 1ST
☎ (01582) 662682
House beer (by Tring); 3 changing beers (sourced nationally) 🄷
The Victoria is a popular town-centre pub near the police station on West Street. It usually offers three varying ales from microbreweries plus a house beer from the local Tring Brewery. Darts, dominoes and crib are popular as well as televised sports in the bar. A separate function room is available next to the rear courtyard. ☕♣🚲

Dunton

March Hare 🍷 🄻
34 High Street, SG18 8RN
☎ (01767) 600258 ⊕ themarchharedunton.co.uk
6 changing beers (sourced nationally; often Digfield, Nene Valley, Papworth) 🄷
Charming, recently refurbished village pub that is at the heart of the local community. The landlord takes pride in serving up to six ales in superb condition and opened an on-site brewery in 2022. Apple Cottage Cider is always available. Quiz evenings, charity events and local clubs are regularly hosted. The pub's beer festivals are eagerly anticipated and showcase a variety of ales; the winter dark beer festival is a highlight. Opening hours can vary. Local CAMRA County Pub of the Year 2022. Q❄☕♣●🍴🚲(188,189)✿🛜

Felmersham

Sun 🄻
Grange Road, MK43 7EU
☎ (01234) 781355 ⊕ thesunfelmersham.com
Eagle IPA; 2 changing beers (sourced regionally) 🄷
Pretty, thatched community pub with a family-friendly rear garden, convenient for visits to the historic parish

church and a nature reserve just across the river. Guest beers are often from local microbreweries. The creative food menu includes rotisserie-cooked chicken, hand-cut chips and seasonal ingredients from local producers. There is also a monthly food and drink theme night. The refurbished dining room can accommodate up to 40. Local CAMRA Cider Pub of the Year and Lockdown Hero 2020. ❄☕◐♣●P🚲(50)✿🛜

Flitwick

Crown ✓
Station Road, MK45 1LA
☎ (01525) 713737 ⊕ crownflitwick.co.uk
4 changing beers (sourced nationally) 🄷
Large and thriving two-bar pub whose tenants are keen on their real ales: four changing beers and a craft keg brew are usually available. The front bar has TV, jukebox, pool and darts. Table tennis can also be played. Saturday music nights are popular. There is a large garden with patio and children's play area. Pub food is served at lunchtime, with Sunday lunch a favourite; pizza is available in the evenings. ❄☕◐♿🍴➡♣●P🚲(2,200)✿🛜

Great Barford

Anchor Inn 🄻 ✓
High Street, MK44 3LF (by river, 1 mile S of village centre) TL134517
☎ (01234) 870364 ⊕ anchorinngreatbarford.co.uk
Eagle IPA; Young's London Original; 4 changing beers (sourced nationally) 🄷
Busy inn next to the church, overlooking a medieval bridge across the River Great Ouse. At least two guest beers are usually available from an extensive range offered by the pub company. Good home-cooked food is served in the bar and restaurant, backed up by a fine selection of wines. The pub is popular with river users in the summer. Occasional themed food nights are held, mainly during the winter months. Q❄☕◐P🚲(27)🛜

Harlington

Old Sun
34 Sundon Road, LU5 6LS
☎ (01525) 874000
Adnams Ghost Ship; St Austell Tribute; Timothy Taylor Landlord; Wainwright 🄷
Two regular ales and two guests are served in this traditional half-timbered pub near the railway station. The pub dates back to 1785; the building to the 1740s. There are two bars, both featuring sports TVs, plus a side room. The pub also has outdoor seating plus a children's play area. It hosts beer festivals on bank holidays in May and August. Q❄☕➡P🚲(X42)✿🛜

Heath & Reach

Axe & Compass 🄻
Leighton Road, LU7 0AA
☎ (01525) 237394 ⊕ theaxeandcompass.pub
2 changing beers (sourced nationally) 🄷
Village community pub that has been a free house since 2014. The older front bar, with its low beams, is a lounge and dining area. The rear public bar has gaming machines, pool table and a TV screen. The large garden includes a children's play area. Regularly appearing guest beers are mostly from local breweries such as Tring, Vale and Leighton Buzzard. Accommodation is available in a separate lodge. ❄☕🛏◐♣●P🚲(150)✿🛜

Henlow

Engineers Arms 🅛 ⊘
68 High Street, SG16 6AA
☎ (01462) 812284 ⊕ engineersarms.co.uk
10 changing beers (sourced nationally; often Cotleigh, Grainstore, Tring) Ⓗ
Multi-award winning pub that has enjoyed 27 consecutive years in the Guide under the same landlord. It serves 10 continually changing beers plus perries and real ciders, typically Sandford Orchards and Seacider. The front bar is quiet; the rest of the pub shows TV sport and features interesting sporting memorabilia. Attractions include poker, quiz and board game nights, plus karaoke and live bands. There are also pub outings, tap takeovers and a renowned beer festival. CAMRA County Pub and Cider Pub of the Year on several occasions.
Q ১ ⌂ ⊛ ▲ ♣ ➌ ➤ (9B,74) ❀ ☏

Old Transporter Ale House 🅛
300 Hitchin Road, SG16 6DP
☎ (01462) 817410 ⊕ theoldtransporter.co.uk
4 changing beers (sourced nationally; often Potbelly, Tring) Ⓖ
Single-room beer house near RAF Henlow with transport-themed decoration and a welcoming atmosphere. The drinking area has recently been extended with a marquee. Real ale is served direct from barrels set up behind the bar. A choice of snacks is available. The pub is home to a darts team and has a widescreen TV for sporting events. Live music, quizzes, raffles and mini beer festivals feature occasionally. ১ ♣ ➤ (9B,74) ❀ ☏

Langford

Plough
77 Church Street, SG18 9QA
☎ (01462) 701701
Greene King IPA; Timothy Taylor Landlord; 1 changing beer (often Wadworth) Ⓗ
The last pub in the village, it was fully refurbished in spring 2022 and attracts locals and visitors alike. The licensee's cellarmanship has elevated two of his previous pubs into the Guide. Three ales are sometimes supplemented by a polypin on the bar. The pub supports pool, darts and pétanque teams and hosts many local clubs and societies. The large garden is popular, as are the regular quiz nights and occasional live music events.
১ ⊛ ♣ ➌ ➤ (74) ❀ ☏

Leighton Buzzard

Bald Buzzard Micropub 🅛
6 Hockliffe Street, LU7 1HJ
☎ 07484 896131
3 changing beers (sourced nationally) Ⓖ
Popular micropub that opened in 2015 and offers the discerning drinker a superb range of ales and ciders. It has a bespoke chiller room and a seating layout that encourages conversation. Four KeyKeg dispensers serve a changing selection of keg and cask beers not normally found locally. Four ciders are also available alongside many bottled and canned craft ales.
১ ⊛ ⌂ ♣ ➌ ➤ (70,150) ❀

Black Lion 🍸
20 High Street, LU7 1EA
☎ (01525) 853725 ⊕ blacklionlb.com
Draught Bass; Nethergate Suffolk County Best Bitter; Oakham Bishops Farewell; 5 changing beers (sourced nationally) Ⓗ
Traditional alehouse with 17th-century origins featuring exposed beams, wooden floors and an open fire. Eight handpumps dispense beers from the likes of North Cotswold, Slater's and Purity, including four keg brews. Eight changing real ciders are also available, along with an impressive menu of bottled and canned continental and British beers. There is a separate gin bar and a large paved garden. Bar snacks are served and bring-your-own lunches are welcome. Local CAMRA Pub of the Year 2015-2022. Q ১ ⊛ ♣ ➌ ➤ (70,150) ❀

Leighton Buzzard Brewing Company Brewery Tap 🅛
Unit 31, Harmill Industrial Estate, Grovebury Road, LU7 4FF (2nd left from Grovebury Rd)
☎ 07538 903753 ⊕ leightonbuzzardbrewing.co.uk
5 changing beers (sourced locally; often Leighton Buzzard) Ⓖ
The brewery tap of the Leighton Buzzard Brewing Co. It serves a range of the brewery's beers, dispensed from casks in the cool room and in bottles to drink on the premises or take home. Guest ales are also available alongside a range of real ciders. Attractions include live music, local food offerings and monthly comedy nights on Wednesdays between March and December (check website for details). ১ ⌂ ♣ ➌ P ➌ ➤ (D1) ❀ ☏

Swan Hotel ⊘
50 High Street, LU7 1EA
☎ (01525) 380170
Greene King Abbot; Ruddles Best Bitter; Sharp's Doom Bar; 4 changing beers (sourced nationally) Ⓗ
Dating from the 17th century, this former coaching inn renovated by Wetherspoon is a High Street landmark. With good-value food and 39 guest rooms, the Swan is bustling for much of the week. One long bar provides friendly service to two rooms, a conservatory and a courtyard. Guest beers may come from local microbreweries and real cider is available in summer. Families are welcome until 11pm. Events include biannual beer festivals. Q ১ ⊛ ⊛ ➌ ◑ ⌂ ➌ ➤ (70,150) ☏

White Horse
9 New Road, Linslade, LU7 2LS
☎ (01525) 635739 ⊕ whitehorsebandb.co.uk
Fuller's London Pride; 3 changing beers (sourced nationally) Ⓗ
A genuine back-street free house close to the Grand Union Canal and Leighton Buzzard railway station. The L-shaped bar features several sports TV screens. There is a small courtyard to the rear and a small public car park across the road. Guest beers are often from Sharp's, St Austell and Tring. An interesting and varied selection of bottled and canned beers is also offered. Accommodation comprises seven rooms in a converted stable block. ১ ⇔ ⌂ ⇚ ♣ ➌ ➤ ☏

Little Staughton

Crown 🅛
Green End, MK44 2BU (at N end of village on road to Pertenhall)
☎ (01234) 376260 ⊕ thecrownstaughton.com
Crown Pale, The Beer With No Name Ⓗ
A modern pub built in the 1970s after the original thatched building burnt down. The pub sits back from the road behind the car park, with a large garden to the right. The main bar is L-shaped with a wood-burning stove – the fireplace is the only remaining part of the original building. A small room to the right is used for dining and functions. The pub has its own microbrewery.
১ ⊛ ◑ ♣ P ➌ (28,29) ☏

Luton

Black Horse 🅛
23 Hastings Street, LU1 5BE
3 changing beers (sourced nationally; often Leighton Buzzard, Oakham, Tring) 🅗
Characterful back-street pub near Luton town centre. Popular with music fans, it hosts DJ nights and features live bands on Saturday nights. It is handily located for ale-loving Luton Town football fans, being one of the closest pubs to the Kenilworth Road ground. There is a large covered outside seating area for smokers.
🕭❀≋♣⬤P🖩❀

Bricklayers Arms
16-18 High Town Road, LU2 0DD
☎ (01582) 611017
6 changing beers (sourced nationally; often Oakham) 🅗
Quirky pub in High Town that has been run by the same landlady for over 30 years. It has TVs in both bars and hosts a popular Monday night quiz. Six handpumps serve a variety of guest beers from breweries nationwide, including a choice of light, amber and usually a mild ale. Draft Belgian beers and two real ciders are also available. Popular with Luton Town fans on match days.
❀≋♣⬤❀🛜

Globe ✅
26 Union Street, LU1 3AN
☎ (01582) 482259
3 changing beers (sourced nationally) 🅗
Popular, homely street-corner local, just off the town centre. The L-shaped single bar offers three constantly changing ales from regional breweries and micros. Beer festivals feature regularly. Good-value food is served at lunchtime on weekends. Sport is shown on TV. There is an enclosed patio area to the rear of the small car park.
🕭❀🕭♿≋♣P❀🛜

Great Northern
63 Bute Street, LU1 2EY
☎ (01582) 729311
St Austell Tribute 🅗
This may be the smallest pub in Luton. Its name was changed in the 1860s when the Great Northern Railway was built right on its doorstep. It still retains green Victorian wall tiles and a table featuring quirky brass pint glass holders at each corner. Sports are shown on TV. There is a smoking area at the rear. ≋♣🖩❀🛜

White House 🅛 ✅
1 Bridge Street, LU2 2NB
☎ (01582) 454608
Greene King Abbot; Ruddles Best Bitter; Sharp's Doom Bar; 6 changing beers (sourced nationally) 🅗
A large two-bar town-centre Wetherspoon with the usual keenly priced food and drinks. It offers six different guest ales split across the two separate bars, with local beers often from Kelchner, Tring or Vale breweries. This is a bright and clean pub in the Galaxy Centre, conveniently located for several bus routes. Q🕭❀🕭♿≋🖩🛜

Moggerhanger

Guinea 🅛 ✅
Bedford Road, MK44 3RG
☎ (01767) 640388 ⊕ guineamoggerhanger.co.uk
Brewpoint Origin Pale Ale, DNA Amber Ale; Eagle IPA; 1 changing beer (sourced regionally; often Marston's) 🅗
Large 18th-century village pub with beamed ceilings and a front garden, in a prominent position at the heart of the

village. Beyond the main bar's drinking area are two sections for diners. Hood skittles and darts are played in the games bar. A quiz is held on Thursday. Freshly prepared food is available daily (not Sun eve). There are car parks to the side and rear.
Q🕭❀🕭♿♣P🖩(188,72)❀

Northill

Crown Inn ✅
2 Ickwell Road, SG18 9AA
☎ (01767) 627337 ⊕ crownnorthill.co.uk
Greene King IPA, Abbot 🅗
Pub-restaurant tucked away between the church and village pond, a stone's throw from the Greensand Ridge Walk. The main bar and adjoining snug are traditional and welcoming, with antique bay windows, low beams, flagstones and a copper-topped counter. The restaurant has a more contemporary and elegant feel. Freshly-prepared food is served throughout the pub, which can host functions for up to 60. Outside are a sunny patio and a large garden with children's play area.
🕭❀🕭P🖩(74)❀

Odell

Bell
81 High Street, MK43 7AS
☎ (01234) 910850 ⊕ thebellinodell.co.uk
Greene King IPA, Abbot; Ruddles Best Bitter; 3 changing beers (sourced nationally) 🅗
Handsome thatched village pub with a large garden near the River Great Ouse. With the Harrold-Odell Country Park just down the lane, this is a popular stop for walkers. Sympathetic refurbishment and a series of linked but distinct seating areas help retain a traditional pub atmosphere. Good-value, quality food includes a Sunday roast, steak & chips night Monday and pie & chips night Tuesday. Brunch is served in the mornings; tea and cakes are available all day. Q🕭❀🕭P🖩(25,26)❀🛜

Old Warden

Hare & Hounds 🅛
The Village, SG18 9HQ
☎ (01767) 627225 ⊕ hareandhoundsoldwarden.com
Brewpoint DNA Amber Ale; Eagle IPA; 2 changing beers (sourced regionally; often Brewpoint) 🅗
Popular pub-restaurant in a charming thatched village. The car park entrance leads to the main bar, with dining rooms beyond. The second bar and cosy rooms hark back to village times past. Good-quality meals include light-bite lunchtime options, evening meals with daily specials and a traditional roast on Sunday. The pub hosts a spring bank holiday beer and music festival. Shuttleworth, with its aircraft and vehicle collection plus Swiss Garden, is a one mile walk away. Q🕭❀🕭P❀🛜

Potton

Rising Sun 🅛 ✅
11 Everton Road, SG19 2PA
☎ (01767) 260231 ⊕ risingsunpotton.co.uk
Brewpoint DNA Amber Ale; St Austell Tribute; 5 changing beers (sourced nationally; often Black Sheep, Ossett, Rooster's) 🅗
Spacious pub, parts of which date back to the 16th century. It has various comfortable areas for eating, drinking or chatting, including an upstairs function room with outdoor terrace. Ales include three or four from Marston's plus several from distant or smaller local breweries, such as Rocket Ales or Grafham Brewing.

Good-value food is served. Live music features occasionally, including during the beer festival.
♿🏠🍴🍺🅰️Ꮲ🚃(72) ♣ 🛜

Sandy

Sir William Peel
39 High Street, SG19 1AG
☎ (01767) 680607 ⊕ sirwilliampeel.wixsite.com/sirwilliampeel
Batemans XB; 3 changing beers (sourced nationally; often Oakham) Ⓗ
A welcoming traditional hostelry that was created in 1838 when two cottages were combined. It has a prime position opposite the church and is well used by visitors and locals. The U-shaped bar and outside area have ample seating. Four real ales are kept in excellent condition, and served alongside an extensive cider range including Cotswold, Gwatkin, Hecks and Saxby's. There are good transport links by bus and train. CAMRA County Cider Pub of the Year 2022. ♿🏠🍴➰🍺●Ꮲ🚃(72,73)♣🛜

Shefford

Brewery Tap Ⓛ
14 Northbridge Street, SG17 5DH
☎ (01462) 628448
3 Brewers of St Albans Dragon Slayer, Shefford Bitter; 4 changing beers (sourced nationally) Ⓗ
The Tap is primarily a drinkers' pub offering two B&T beers and up to four guest ales. The open-plan bar area has two distinct sections with wood panelling, decorated with breweriana. A smaller family area to the rear offers more tables. Sandwiches, toasties and other light lunches are available. Attractions include a monthly quiz, live music and occasional charity fundraising events. The large rear garden has seating and is heated on cool evenings. Car park access is through an archway beside the pub. ♿🏠🍴●Ꮲ🚃♣🛜

Slip End

Rising Sun Ⓛ
1-3 Front Street, LU1 4BP
☎ (01582) 731384 ⊕ therisingsunslipend.co.uk
3 changing beers (sourced nationally; often Farr) Ⓗ
Comfortable two-bar village local that dates back to the mid-19th century. It is now run by the nearby Wheathampstead brewery Farr Brew following a complete refurbishment. Two rotating ales from Farr are served alongside a range of the brewery's bottles and a changing guest beer. Quizzes, DJs and live music feature regularly. ♿🏠●Ꮲ🚃(46,231)♣🛜

Stanbridge

Five Bells
Station Road, LU7 9JF
☎ (01525) 210224 ⊕ fivebellsstanbridge.co.uk
Fuller's London Pride; Gale's Seafarers Ale, HSB; 1 changing beer Ⓗ
A Fuller's-owned country pub set in extensive and attractive grounds, with wooden floors, a real fire, cosy snug and 'mind-your-head' low beams. A separate 80-seater restaurant in the 18th-century wing can be used for weddings and other functions. Three regular Fuller's/Gale's beers are served, with an occasional guest from the Fuller's portfolio. The pub is named after the nearby church which once had five bells – but now has six.
♿🏠🍴🚹●Ꮲ🚃(70) ♣ 🛜

Stotfold

Crown
39 The Green, SG5 4AL
☎ (01462) 731061
Greene King IPA Ⓗ, Abbot Ⓖ; 2 changing beers (sourced regionally; often Adnams) Ⓗ
Community orientated, open-plan pub with three sections – a main bar, a snug seating area displaying historical local photos, and a small annexe with dart board plus a pool table catering for the pub's several pool teams. Three screens show a variety of sports with football the most enthusiastically followed. Occasional live bands and discos supplement the popular jukebox. Outside is a patio with tables and benches.
♿🏠♣Ꮲ🚃(97) ♣ 🛜

Totternhoe

Cross Keys
Castle Hill Road, LU6 2DA
☎ (01525) 220434
Greene King IPA; 1 changing beer (sourced nationally; often Timothy Taylor) Ⓗ
Attractive thatched Grade II-listed building that dates from 1433 and is a great place to relax and unwind. It has a glorious damson orchard and offers wide views over Ivinghoe Beacon and the Vale of Aylesbury. Guest beers rotate weekly from a list chosen by the locals. Basket meals and barbecues are served in the garden in the warmer months. Dogs are welcome in the public bar.
Q♿🏠🍴●Ꮲ🚃(43,61) ♣

Old Farm Inn
16 Church Road, LU6 1RE
☎ (01582) 674053
Dark Star Hophead; Fuller's London Pride; Gale's HSB; 1 changing beer (sourced nationally) Ⓗ
Charming village pub in the conservation area of Church End, featuring two inglenooks. Dogs are welcome in the front bar. Tasty home-cooked food is served including popular Sunday roasts (no food Sun eve or all day Mon). A quiz is held on alternate Thursdays. Beer festivals take place in May and August. There is a child-friendly garden.
♿🏠🍴🚹●Ꮲ🚃(61) ♣ 🛜

Upper Dean

Three Compasses ✅
High Street, PE28 0NE (S of village on road to Melchbourne)
☎ (01234) 708346 ⊕ thethreecompasses.co.uk
Greene King IPA; St Austell Tribute; Timothy Taylor Landlord Ⓗ
Attractive thatched and partly boarded inn on the southern edge of the village. The main bar is to the left of the entrance with a games area behind. There is a small lounge bar on the right which is used mainly for dining. A large garden is to the rear. The owners have created a popular rural venue for food and drink since reopening the pub several years ago. Local CAMRA Most Improved Pub 2019. ♿🏠🍴●Ꮲ🚃(28)♣🛜

Westoning

Chequers
Park Road, MK45 5LA
☎ (01525) 712967 ⊕ thechequerswestoning.co.uk
Otter Bitter; Purity Pure UBU; 1 changing beer (sourced nationally) Ⓗ
Attractive thatched pub in the heart of the village, dating from the 17th century. Its several drinking and dining

areas offer two regular ales plus an occasional guest that may be from a local brewery. Good food is served to a high standard, including breakfast at weekends. An in-house cork & bottle shop sells wine plus bottled beers from local breweries. Outside is a large enclosed patio with heating. ⏻🕳🍴🚻♿♠P🚪🐾☀📶

Breweries

A-B InBev

Porter Tun House, 500 Capability Green, Luton, Bedfordshire, LU1 3LS
☎ (01582) 391166 ⊕ inbev.com

No real ale.

Brewhouse & Kitchen SIBA

🍴 115 High Street, Bedford, MK40 1NU
☎ (01234) 342931 ⊕ brewhouseandkitchen.com

Part of the Brewhouse & Kitchen chain, producing its own range of beers. Carry outs and brewery experience days are offered.

Brewpoint

Cut Throat Lane, Bedford, MK41 7FY
☎ (01234) 244444 ⊕ brewpoint.co.uk

☺Brewpoint was launched in 2020 by Wells & Co, which has brewed in Bedford since 1876. The Brewpoint complex also houses the company head office and features conference and meeting rooms, a brewery shop and a taproom/restaurant, plus beer garden. Beers are also brewed for the Charles Wells and John Bull brands, but not all are cask-conditioned. ⏷📻♦

Origin Pale Ale (ABV 3.7%) BLOND
Legacy Golden Ale (ABV 4.1%) GOLD
DNA Amber Ale (ABV 4.3%)

Crown

🍴 Crown, Green End, Little Staughton, Bedfordshire, MK44 2BU
☎ (01234) 376260 ⊕ thecrownstaughton.com

Brewing began in 2017 in a building behind the Crown public house in Little Staughton. The brewery is owned and run by the landlord of the Crown with the beers only being produced for the pub and local events. ♦

Eagle

Havelock Street, Bedford, MK40 4LU
☎ (01234) 272766 ⊕ eaglebrewery.co.uk

☺Founded in 1876 and remained with the Wells Family until 2017, when the brewery and its brands were acquired by Marston's, and renamed Eagle Brewery. It has brewed Young's beers since 2007, after the closure of the Ram Brewery, and the popular Bedfordshire Ale, Eagle IPA. It forges strong links with the local area. Part of Carlsberg Marston's Brewing Co. ⏷📻♦

IPA (ABV 3.6%) PALE
Refreshing, amber, session ale with pronounced citrus hop aroma and palate, faint malt in the mouth, and a lasting dry, bitter finish.

Brewed under the Courage brand name:
Best Bitter (ABV 4%) BITTER
Directors (ABV 4.8%) BITTER

Brewed under the Young's brand name:
London Original (ABV 3.7%) BITTER

Light amber bitter with sweet malt and a hint of citrus hops that linger into a slightly dry, bitter finish.
London Special (ABV 4.5%) BITTER
Pale brown in colour, this rounded premium bitter has citrus throughout plus some slight creamy toffee, which balances the bitterness that grows in the aftertaste.

Kelchner SIBA

Unit D, The Sidings, Station Road, Ampthill, Bedfordshire, MK45 2QY ☎ 07508 305754
✉ kelchnerbrewery@gmail.com

Kelchner began brewing began in 2018. Beers tend to be themed on local features and Luton Town FC. The brewery is keen to support various local community organisations. ⏷📻 LIVE

Half Nelson (ABV 3.8%) GOLD
James Blonde (ABV 3.9%) BLOND
Local is Lekker (ABV 3.9%) GOLD
Ampthill Gold (ABV 4.1%) GOLD
Hat Trick (ABV 4.1%) GOLD
Masquerade (ABV 4.3%) RED
Full Nelson (ABV 4.5%) GOLD
IPA (ABV 4.5%) PALE
Parklife (ABV 4.5%) BITTER
After Dark (ABV 4.8%) PALE
Ammetelle (ABV 5%) STOUT

Leighton Buzzard SIBA

Unit 31, Harmill Industrial Estate, Grovebury Road, Leighton Buzzard, Bedfordshire, LU7 4FF
☎ (01525) 839153 ☎ 07538 903753
⊕ leightonbuzzardbrewing.co.uk

The first brewery to operate in Leighton Buzzard for more than 100 years. Established in 2014, the brewery changed hands in 2019. ⏷📻♦

Golden Buzzard (ABV 4.1%) GOLD
Bavarian Dragon (ABV 4.2%) GOLD
Best Buzzard (ABV 4.3%) BITTER
Vimy Bomber (ABV 4.3%) BITTER
Restoration Ale (ABV 4.6%) BITTER

March Hare (NEW)

🍴 March Hare, 34 High Street, Dunton, Bedfordshire, SG18 8RN
☎ (01767) 318121

Brewing commenced in 2022. Head brewer John is an award-winning homebrewer and has been brewing since he was 15. Beer styles include traditional bitters, stouts, porters, milds and golden ales with occasional specials recreated from historic recipes. ♦

Potton

Unit 3, 8 Market Square, Potton, Bedfordshire, SG19 2NP ☎ 07789 680049
⊕ pottonbrewingcompany.com

⊠ Potton Brewing Company was founded in 2017 in order to return brewing to the community after the previous local brewery shut down a few years before. The brewery uses a 2.5-barrel plant, brewing 1-2 times a week. It has a strong social ethic and gives 1p from every pint sold to charity. All bottled beers are unfined and suitable for vegans. 📻V

Holly Pup (ABV 3.8%) MILD
Transmitter (ABV 4%) GOLD
Village Recycler (ABV 4.3%) BITTER
Crow (ABV 4.5%) STOUT
Sunny Days (ABV 4.8%) PALE

LⓒCAlₑ

Many entries in the Guide refer to pubs' support for CAMRA's LocAle scheme. The ⬛ symbol is used where a pub has LocAle accreditation. The aim of the scheme is to get publicans to stock at least one cask beer that comes from a local brewery, usually no more than 30 miles away.

The aim is a simple one: to cut down on 'beer miles'. Research by CAMRA shows that food and drink transport accounts for 25 per cent of all HGV vehicle miles in Britain. Taking into account the miles that ingredients have travelled on top of distribution journeys, an imported lager produced by a multi-national brewery could have notched up more than 24,000 'beer miles' by the time it reaches a pub.

Supporters of LocAle point out that £10 spent on locally-supplied goods generates £25 for the local economy. Keeping trade local helps enterprises, creates more economic activity and jobs, and makes other services more viable. The scheme also generates consumer support for local breweries.

Support for LocAle has grown at a rapid pace since it was created in 2007. It's been embraced by pubs and CAMRA branches throughout England and has now crossed the borders into Scotland and Wales.

For more information, see camra.org.uk/locale

What is CAMRA LocAle?

- An initiative that promotes pubs which sell locally-brewed real ale

- The scheme builds on a growing consumer demand for quality local produce and an increased awareness of 'green' issues

Everyone benefits from local pubs stocking locally brewed real ale...

- Public houses, as stocking local real ales can increase pub visits

- Consumers, who enjoy greater beer choice and locally brewed beer

- Local brewers, who gain from increased sales and get better feedback from consumers

- The local economy, because more money is spent and retained in the local economy

- The environment, due to fewer 'beer miles' resulting in less road congestion and pollution

- Tourism, due to an increased sense of local identity and pride – let's celebrate what makes our locality different

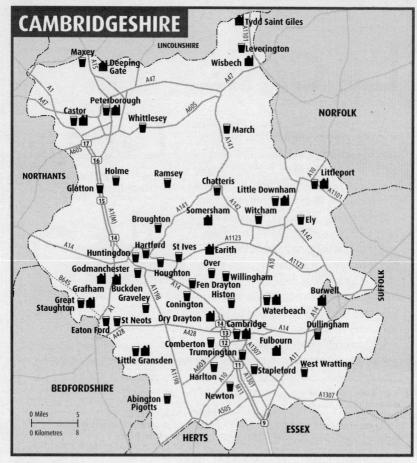

CAMBRIDGESHIRE

Abington Pigotts

Pig & Abbot

High Street, SG8 0SD (off A505 through Litlington)
☎ (01763) 853515 ⊕ pigandabbot.co.uk
Adnams Southwold Bitter; Fuller's London Pride; 2 changing beers (often Mighty Oak, Woodforde's) Ⓗ
Located in a surprisingly remote part of the south Cambridgeshire countryside, this Queen Anne-period pub offers a warm welcome. The interior has exposed oak beams and real fires including a wood-burning stove in a large inglenook. A comfortable restaurant offers home-made traditional pub food and specialises in fresh fish & chips, steak & kidney puddings and pies. Two guest beers are stocked, often from Burton Bridge, Humpty Dumpty, Mighty Oak, Timothy Taylor or Woodforde's. A former local CAMRA Pub of the Year. Q⏃❀◐♦♣P❀

Broughton

Crown Inn

Bridge Road, PE28 3AY
☎ (01487) 824428 ⊕ thecrowninnrestaurant.co.uk
Digfield Fools Nook, Barnwell Bitter Ⓗ
An idyllic 19th-century inn opposite the village church. The decor is modern with scrubbed pine tables and a stone floor. Four handpumps serve two real ales – usually from small regional breweries – and two ciders. Excellent food from seasonally changing menus attracts diners

from a wide area. The pub can be busy at weekends – diners should reserve a table. Outside is a large beer garden where a beer festival is held each May.
Q⏃❀◐▯P❀🕏

Cambridge

Calverley's Brewery Tap Ⓛ

23A Hooper Street, CB1 2NZ
☎ 07769 537342 ⊕ calverleys.com
Calverley's Porter Ⓖ
Close to Mill Road, the brewery was established in a former stable in 2013. It is open for on-sales on Tuesday to Friday evenings and all day Saturday. It offers a wide selection of live beer from keg, cans and bottles, and occasionally cask beer. Real ciders from the local Simon's Ciders are also available. A newly constructed taproom provides more seating and frees up space in the brewery, allowing for a wider beer range. Pizzas are delivered from a nearby restaurant. Q⏃▯♿🐾❀

Cambridge Blue

85-87 Gwydir Street, CB1 2LG
☎ (01223) 471680 ⊕ cambridge.pub/the-blue
Nene Valley Manhattan Project Ⓗ**; Tring Citra Session** Ⓖ**; 12 changing beers** Ⓗ/Ⓖ
Ever-popular side-street pub close to Mill Road. A large rear extension leads to the garden, with a heated marquee in winter. Breweriana and pumpclips provide

much of the decoration. Up to 14 ales from microbreweries nationwide are dispensed by handpump or by gravity, usually including gluten-free beer. Up to seven real ciders and perries and a large selection of international bottled beers are also kept. The main beer festival is held in June. A selection of burgers and sides is available daily. ♿❄️🕒🚲🍴🍽️🐾☕🛜

Champion of the Thames

68 King Street, CB1 1LN

☎ (01223) 351464 ⊕ thechampionofthethames.com

Greene King IPA, Abbot; 3 changing beers Ⓗ

Small, two-room, city-centre pub with a welcoming atmosphere. The champion oarsman of the name is commemorated in the etched windows. Wood-panelled with wooden floors, fixed benches and a part-glazed partition between the rooms, the pub is identified by CAMRA as having a regionally important historic interior. The chatter of customers predominates. Greene King Beer Pub of the Year 2022. ❄️🍴🍽️🐾☕🛜

Devonshire Arms Ⓛ

1 Devonshire Road, CB1 2BH

☎ (01223) 316610

8 changing beers (sourced nationally; often Milton) Ⓗ

Milton Brewery's first Cambridge pub. Just off Mill Road, it attracts a mix of characters for beer, food and a chat. Deceptively large inside, with tall front windows and a high ceiling with fans, outside it has small patio areas front and back. Five Milton cask ales are served, usually including at least one dark beer, with a further three guests from other micros. There are also bottled and keg beers, including Moravka unpasteurised lager, and two ciders. ♿❄️🕒🚃≈🍴🍽️🐾☕🛜

Earl of Beaconsfield

133 Mill Road, CB1 3AA

☎ (01223) 410703

4 changing beers (sourced nationally) Ⓗ

This busy urban corner local in the Romsey town area of Cambridge has an Irish feel, and hosts occasional Irish music nights, weekly blues jams and open mic nights. Music themed decoration adorns the walls. There is an enclosed beer garden at the rear, which leads on to a bar billiard room. ♿❄️🕒≈🍴🍽️☕🛜

Elm Tree

16A Orchard Street, CB1 1JT

☎ (01223) 322553 ⊕ elmtreecambridge.co.uk

Brewpoint Origin Pale Ale, DNA Amber Ale; 5 changing beers (sourced nationally) Ⓗ

Back-street pub close to Parker's Piece, owned by Charles Wells' Brewpoint. The short bar is near the entrance, with seating around and beyond. The decor includes breweriana, quirky bric-a-brac, photos and Belgian flags. There are seven handpumps, with two for Charles Wells beers, the rest offering a choice of guest ales and a real cider or perry. Complementing these is a menu of around 40 bottled Belgian beers. Regular live music features. ♿🍴🍽️🐾☕🛜

Free Press

7 Prospect Row, CB1 1DU

☎ (01223) 368337 ⊕ freepresscambridge.com

Greene King IPA, Abbot; Timothy Taylor Landlord; 3 changing beers Ⓗ

Friendly, intimate pub serving high-quality food and great beer. Greene King-tied, the rare XX Mild was its best seller until regular production ceased. A pub since 1834, the building just survived the 1970s Kite area redevelopment. Identified by CAMRA as having a regionally important historic pub interior, only the tiny snug is original – the rest is a loving reconstruction. There

is a walled garden at the rear. Named after a Temperance movement newspaper that lasted for just one edition. ♿❄️🕒🍴🚲🐾☕🛜

Geldart

1 Ainsworth Street, CB1 2PF (Mill Road area)

☎ (01223) 314264 ⊕ the-geldart.co.uk

Adnams Ghost Ship; Oakham Citra; St Austell Bad Habit; 3 changing beers (sourced nationally) Ⓗ

Large two-bar back-street corner pub with an enclosed patio garden behind. It is decorated throughout with film and music memorabilia, including musical instruments as handpumps and menus on 12-inch vinyl. Don't miss the glass piano. The pub has a good reputation for its food and beers, with a dining area to the right of the entrance and a bar area to the left. Six ales and a wide selection of malt whiskies and rums are available. The changing guest beers are from small breweries nationwide and always include a dark one. Frequent live music is hosted. ♿❄️🕒🐾☕🛜

Haymakers Ⓛ

54 High Street, CB4 1NG

☎ (01223) 311077

Milton Pegasus; 7 changing beers (often Milton) Ⓗ

Milton Brewery's second of three Cambridge pubs, popular with locals and employees from the nearby science park. There are drinking areas either side of the door, plus a snug. Dark wood and warm colours abound. A good-sized beer garden is behind, as well as the largest pub cycle park in Cambridge. Eight real ales, including one dark and three guests, are on offer, plus three real ciders or perries and Moravka unpasteurised lager. Local CAMRA Pub of the Year 2021. ♿❄️🕒🍴🚲🐾☕🛜

Maypole Ⓛ

20A Portugal Place, CB5 8AF

☎ (01223) 352999 ⊕ maypolefreehouse.co.uk

16 changing beers Ⓗ

The Maypole has been in the capable hands of the Castiglione family since 1982, initially as tenants, latterly as owners. Showcasing quality beers won the landlord the branch's first Real Ale Champion award. Up to 16 ever-changing beers are served, more during festivals, including LocAles, with micros predominating. The keg beers are often of interest. It has a busy front bar and a

REAL ALE BREWERIES

Bowler's Deeping Gate
Burwell Burwell
Calverley's Cambridge
Cambridge 🍺 Cambridge
Castor Castor
Downham Isle ⚓ Littleport
Draycott Buckden
Elgood's Wisbech
Grafham Grafham
IVO Somersham
Lord Conrad's Dry Drayton
Mile Tree Peterborough
Milton ⚓ Waterbeach
Moonshine Fulbourn
Oakham Peterborough
Papworth Earith
Pastore ⚓ Waterbeach
Rocket Great Staughton
Son of Sid 🍺 Little Gransden (brewing suspended)
Three Blind Mice Little Downham
Turpin's Burwell
Tydd Steam Tydd Saint Giles
Xtreme Peterborough

quieter back bar downstairs, a function room upstairs and a large covered patio outside. Food focuses on home-cooked Italian dishes and English pub classics. ✿◖❶▣🖵✦

Queen Edith � L
Wulfstan Way, CB1 8QN
☎ (01223) 318536
Milton Pegasus; 7 changing beers (often Milton) Ⓗ
The first new-build pub in Cambridge for around 30 years, after the demolition of a pub of the same name at the rear of the site, and the third Milton Brewery establishment in the city. The style is mock Georgian inside and out. The bigger bar to the left of the entrance has large windows on two sides and a wood-burning stove. The second bar has wooden booths down one side. Regular and changing Milton ales are sold plus guests. Local CAMRA Pub of the Year 2022.
Q🕭✿◖❶♿♣P🖵✦🛜

Royal Standard L
292 Mill Road, CB1 3NL
☎ (01223) 569065 ⊕ cambridge.pub/royal-standard
4 changing beers Ⓗ
The Royal Standard reopened in 2015 after a period of non-pub use, covering around half the area of the original Victorian inn, but with a well-designed indoor space and a small patio garden outside. Bottled beers and changing keg beers are frequently from Belgium, but there are plenty of British options as well, including locally and regionally brewed cask ales. Locally produced real cider is also on offer, and a wide selection of gins. Greek food is available every day, also to take away.
✿◖❶♿🌡🖵(Citi2) ✦🛜

Castor

Prince of Wales Feathers L
38 Peterborough Road, PE5 7AL
☎ (01733) 380222 ⊕ princeofwalesfeathers.co.uk
Adnams Broadside; Castor Hopping Toad; Woodforde's Wherry Ⓗ; **3 changing beers** Ⓗ/Ⓖ
This village corner pub is about 300 years old and built of stone with stained-glass windows. Originally a boot and shoe shop, it has one main bar area, divided into two by the fireplace. There are two smaller rooms for pool and darts – dominoes and crib are also played. Outside are two patios. Four real ales are usually served. Entertainment includes Sky Sports, plus live music every Saturday. Away football fans visiting Peterborough are assured a warm welcome. 🕭✿◖❶♣✦🌡🖵✦🛜

Chatteris

Cross Keys Hotel
12-16 Market Hill, PE16 6BA
☎ (01354) 693036 ⊕ crosskeyschatteris.com
3 changing beers (sourced regionally; often Adnams, Lacons, Woodforde's) Ⓗ
A comfortable and unspoilt freehold pub, restaurant and hotel, opposite the church in the heart of the town. Three real ales, mostly from small breweries, are served in the wood-panelled bar. This listed 16th-century coaching inn is packed full of history, with collections of medieval weaponry, paintings, china, tapestries and clocks. Resident ghosts are said to include a dog. A quiz night is held on the last Sunday of the month. There is a small garden. Q🕭✿◖❶♿♣🖵(33)🛜

Comberton

Three Horseshoes
22 South Street, CB23 7DZ

☎ (01223) 262252
2 changing beers Ⓗ
Hanging baskets adorn this red-roofed village pub. Popular with local clubs and societies, historical photographs of the village and its sports players adorn the walls. The long, low-ceilinged main bar has a cosy alcove at one end and a small raised area at the other, with a games room off to the left. The brick-fronted bar takes up much of the central section. Home-cooked food is tasty and filling. An extensive garden features children's play equipment. 🕭✿◖❶♣P🖵(18)✦🛜

Conington

White Swan
Elsworth Road, CB23 4LN
☎ (01954) 267251 ⊕ thewhiteswanconington.co.uk
Adnams Southwold Bitter, Ghost Ship Ⓖ; **1 changing beer** Ⓗ
Sturdy 19th-century brick building fronted by an impressive sward for outside drinking. The main bar has a tiled floor and a brick fireplace occupied by a fine cast-iron stove. Extended into the former cellar, the regular real ales are now served by gravity from behind the low, accessible bar. Owned by Conington Pub Co, it has been run free of tie since it was sold by Greene King in 2013.
Q🕭✿◖❶♣P✦🛜

Dullingham

Boot
18 Brinkley Road, CB8 9UW
☎ (01638) 507327 ⊕ thebootdullingham.co.uk
Adnams Southwold Bitter; 3 changing beers (sourced regionally) Ⓖ
Traditional village inn, rescued by a regular after it faced closure in 2000. It is now a welcoming community local, with several darts, crib and pétanque teams, and is home to the village cricket team and a veterans' football team. Ales are served direct from the cask in the cellar. Lunchtime food is available, and fish & chips on Wednesday evening. It hosts live music nights and at least one beer festival. Children are welcome until 8pm. Around a mile from Dulllingham railway station.
🕭✿◖❶♣P✦

Eaton Ford

Barley Mow ✅
27 Crosshall Road, PE19 7AB
☎ (01480) 474435
Greene King IPA, Abbot; 2 changing beers (often St Austell, Timothy Taylor) Ⓗ
Simple one-bar community pub with a wide variety of activities focused on the regulars, plus live music events and seasonal celebrations. The decor is a mix of plaster, brick and wood panelling, and a long service counter dominates the centre of the bar. Images of past pub social events adorn the walls. There is a garden room and a large beer garden with an extensive children's play area. The two changing beers are not normally from the Greene King range. 🕭✿◖❶♣P🖵(X5)✦🛜

Ely

Drayman's Son ♙ L
29A Forehill, CB7 4AA
☎ (01353) 662920
12 changing beers (sourced nationally; often Three Blind Mice) Ⓖ
Small, welcoming micropub in former shop premises, nostalgically themed with old railway and enamel signs.

Drinks are generally delivered to your table. Twelve ales are usually available: six on gravity, five KeyKeg and a craft lager on keg, mostly sourced from Three Blind Mice and microbreweries. A large range of ciders is also offered, many sourced locally. The cellar is in a temperature-controlled back room. Local CAMRA Pub of the Year and Cider Pub of the Year 2022. ⑤♿●🍴🖵🐾❀🛜

Minster Tavern ✓

Minster Place, CB7 4EL
☎ (01353) 668492
5 changing beers (sourced nationally) Ⓗ
The Minster Tavern is a traditional old pub opposite the west tower of the impressive Ely Cathedral and just a stone's throw from the main High Street shops. Recently refurbished, it is the oldest pub in Ely and claims to be 'just a little bit haunted'. Tuesday is quiz night. Most major sports are screened. ⑤♿🅿🦽❀🛜

Fen Drayton

Three Tuns

High Street, CB24 4SJ
☎ (01954) 230242 ⊕ threetunsfendrayton.co.uk
Morland Old Speckled Hen; Woodforde's Wherry; 2 changing beers Ⓗ
Originally the village Guild Hall, this superb thatched building dates back to the 15th century. The front entrance leads to the bar area with a stone floor and inglenook fireplace. There are dining areas on both sides. The Hunter's Lodge has recently been added at the rear for drinking and dining. Its windowed panels open onto the beer garden. Locally sourced food is served, with a good reputation for quality and price. The pub was purchased from Greene King in 2019 and renovated by a village resident, and is now run by former licensees. ⑤🅿🖵🐾❀🛜

Glatton

Addison Arms Ⓛ

Sawtry Road, PE28 5RZ
☎ (01487) 830410 ⊕ addison-arms.co.uk
Digfield Fools Nook; Greene King Abbot; house beer (by Digfield) Ⓗ
Grade II-listed pub built at the start of the 18th century and named after playwright and politician Joseph Addison (co-founder of The Spectator), who was a relative of the first landlord. The pub offers at least three real ales including the house beer, Addison Ale (Digfield Shacklebush). Food prepared from fresh locally sourced supplies is popular. A thriving Sunday night quiz is hosted. The large beer garden is busy in the summer. Q⑤♿🅿🦽🖵(904)❀🛜

Godmanchester

Comrades Club

58 Cambridge Street, PE29 2AY
☎ (01480) 453991 ⊕ comradesclubgodmanchester.co.uk
Sharp's Doom Bar; 2 changing beers (sourced nationally) Ⓗ
The Comrades Club (Working Men's & Social Club), which started life in 1920 for the Comrades of the Great War, is a respected and established part of the Godmanchester community and provides members, their families and visitors with excellent facilities and entertainment. It stocks local beers as well as some old favourites. Bar bingo, cash bingo and bar karaoke feature throughout the week (open to members and non-members). 🦽🅿

Exhibition

3-5 London Road, PE29 2HZ (on corner of London Rd and Earning St)
☎ (01480) 459134 ⊕ theexhibitiongodmanchester.com
2 changing beers (sourced regionally) Ⓗ
Spacious two-bar pub with a lively community bar and a large dining room where high quality food is served. Outside is a large family-friendly garden. Two changing ales are usually available, one of which is typically a bitter from Yorkshire. The popular Sunday roast is served from lunchtime until early evening. Q⑤♿🅽🅿🖵🐾❀

Graveley

Three Horseshoes

23 High Street, PE19 6PL
☎ (01480) 700320 ⊕ thethreehorseshoesgraveley.co.uk
2 changing beers (sourced regionally) Ⓗ
A late addition to the village, the pub was built in the early 20th century after the other village pubs closed or burnt down. WWII Graveley Airbase was used by bomber squadrons until 1946. The pub is now well established following a change of management and refurbishment in recent years. Two changing real ales are available from regional or microbreweries. Quality food is served featuring local ingredients, with a popular carvery on Sunday lunchtime. A meat raffle is held on Sunday evening, followed by quiz night. Q⑤♿🅽🦽🅿🛜

Great Staughton

White Hart

56 The Highway, PE19 5DA (on B645)
☎ (01480) 861131
Batemans XB, XXXB; 1 changing beer Ⓗ
Passing through the narrow entrance of this fine small former coaching inn, dating back to 1630, takes you back to the days of horse-drawn coaches. The building has been extended and altered, but still warrants a Grade II listing. It has a main bar, a small pool room at the front and a restaurant at the rear. Outside is a courtyard and garden for fine weather. Traditional pub food is served Thursday to Sunday. Q⑤♿🅽🅿❀🛜

Harlton

Hare & Hounds

60 High Street, CB23 1ES
☎ (01223) 264698 ⊕ hareandhoundsharlton.co.uk
3 changing beers Ⓗ
Thatched 18th-century country inn with a single bar with half-timbered walls, a beamed ceiling and a big fireplace. The large garden has views over the countryside, plus children's amusements and a pétanque pitch. The pub has been owned by a community interest company since 2017. Three changing beers come from local, regional and national breweries. Cider and perry also may be locally produced. Home-cooked food has a strong reputation, especially Sunday lunch. Quiz night is Sunday, bridge on Tuesday and cribbage on Thursday. Local CAMRA Cider Pub of the Year 2022. Q⑤♿🅽🦽🅿🖵(75)❀🛜

Hartford

King of the Belgians Ⓛ

27 Main Street, PE29 1XU (on the old village high street)
☎ (01480) 52030 ⊕ kingofthebelgians.com
4 changing beers (sourced locally; often Digfield, Elgood's, Nene Valley) Ⓗ

A 16th-century pub at the heart of the community and actively supporting local charities. It hosts a beer festival in May and another in late August. An ever-changing selection of four real ales, ciders and good-value food is available every day. The public bar is characterised by its low oak beams and a copper-topped bar, and there is a peaceful separate dining area. Entertainment includes regular quizzes, games nights and an open mic night on the first Monday of each month. Local CAMRA Cider Pub of the Year 2022. Q ☺ ♿ ♣ ◑ ♣ ♠ P ⬚ ☀ ?

Histon

King William IV

8 Church Street, CB24 9EP

☎ (01223) 233930 ⊕ kingbillhiston.co.uk

Buntingford 92 Squadron; Fuller's London Pride; Sharp's Doom Bar; St Austell Tribute; 1 changing beer (sourced regionally) ⊞

Characterful family-run free house, known locally as the King Bill. The L-shaped lounge comprises an old front section with exposed timbers, a brick-built open fire at one end and a wood-burner at the other end. The four regular ales are from St Austell, Sharp's, Fuller's and Buntingford, complemented by a changing guest. Food is not currently served but food trucks visit Wednesday to Saturday. ☺ ♿ ♣ P ⬚ ☀ ?

Red Lion ⓛ ⊘

27 High Street, CB24 9JD

☎ (01223) 564437 ⊕ theredlionhiston.co.uk

Adnams Southwold Bitter; Barsham BOB; Oakham Citra ⊞

Two-bar free house adorned with a wonderful collection of breweriana and historical photographs. The nine handpumps are in the right-hand bar which is quieter and child-free. Two beer festivals are held each year: the Easter aperitif and the main event in September, with proceeds going to local charities. The left-hand bar is family and dog friendly. There is a large beer garden and accommodation at the rear of the premises, as well as a pizza shed. ☺ ♿ ◑ ♿ ♣ P ⬚ ☀ ?

Holme

Admiral Wells ⓛ

41 Station Road, PE7 3PH (jct B660 and Yaxley Rd)

☎ (01487) 831214 ⊕ admiralwells.co.uk

Adnams Southwold Bitter, Ghost Ship; Digfield Fools Nook; Woodforde's Nelson's ⊞

Officially the lowest-level pub in the UK. This Victorian inn was named after one of Nelson's pallbearers, William Wells. It has two bar/lounge areas in a contemporary style, a conservatory and a function room at the rear. Outside there is a beer garden at the front, a large car park to the side, a marquee with a bar in summer, and a children's play area. Four ales are served, including one from the local Digfield brewery. Quiz night is Tuesday. Q ☺ ♿ ◑ ♣ ♠ P ⬚ ☀ ?

Houghton

Three Horseshoes

St Ives Road, PE28 2BE (off A1123)

☎ (01480) 462410 ⊕ threehorseshoesinnhoughton.co.uk

Greene King IPA; Oakham JHB; Sharp's Doom Bar; 1 changing beer ⒢

Characterful Grade II-listed 17th-century building in a picturesque village, popular with locals as well as walkers and cyclists. The lane opposite leads to the river and the historic Houghton Mill. There are two bar areas and plenty of space for diners. The real ales, always

including one from a local brewery, are served by gravity dispense from a taproom behind the bar. Home-cooked food is available daily (not Mon and Tue in winter months). Q ☺ ♿ ♠ ◑ ♠ ▲ ♠ P ⬚ (904) ☀ ?

Huntingdon

Falcon ⓛ

Market Hill, PE29 3NR

☎ (01480) 457416 ⊕ falconhuntingdon.co.uk

Marston's Old Empire; Potbelly Best; Wychwood Hobgoblin Gold; 8 changing beers ⊞

An established venue steeped in local history. This former coaching inn used to be Oliver Cromwell's recruiting station and the gates from the market square were once the entrance to Huntingdon prison. Choose from an ever-changing selection of up to 12 beers, many from Northamptonshire breweries. Good-value food is available every day. A CAMRA award winner for its mild and dark ales. Q ☺ ♿ ◑ ♠ ♣ ♠ ⬚ ☀ ?

Old Bridge Hotel ⓛ ⊘

1 High Street, PE29 3TQ (at S end of High St on ring road, by river)

☎ (01480) 424300 ⊕ huntsbridge.com

3 changing beers (sourced locally; often Adnams, Lacons, Nene Valley) ⊞

An ivy-clad hotel in what was a private bank in the 18th century, at the southern end of the High Street with a prominent position on the bank of the River Great Ouse. Enjoy imaginative and high-quality food in the Terrace Restaurant, the covered patio and the garden area, or simply relax with a drink in the bar or lounge. The award-winning Old Bridge Wine Shop offers wine tasting. The bus station is a short walk away. Q ☺ ♿ ♠ ◑ ◑ ♿ P ⬚ ☀ ?

Leverington

Rising Sun Inn ⓛ

Dowgate Road, PE13 5DH

☎ (01945) 583754

Elgood's Cambridge Bitter; 2 changing beers ⊞

Comfortably furnished pub dating back to at least 1872 with two main rooms – a bar and restaurant – and an enclosed garden. The bar retains the feel of a true village local, with a warming stove at the far end. Cambridge Bitter and two changing guest beers are available. Well known for good-quality food, the restaurant hosts regular themed nights – Wednesday is steak night. Dogs and children are welcome. Closing time may be early if there is no trade. A former CAMRA branch Gold Award winner. Q ♿ ◑ ♣ P ⬚ (50) ☀ ?

Little Downham

Plough

106 Main Street, CB6 2SX (W end of village)

☎ (01353) 698297

2 changing beers (sourced regionally) ⊞

An early Victorian Grade II-listed pub, well preserved in character and charm. At least two cask ales are usually available, generally from Cambridgeshire and East Anglia. Excellent home-cooked Thai cuisine is served, to eat in or take away. The pub supports traditional pub games and has a good community spirit. Children are welcome until 9pm. ☺ ♿ ◑ ♣ P ⬚ (125)

Little Gransden

Chequers ⓛ

71 Main Road, SG19 3DW

☎ (01767) 677348 ⊕ chequersgransden.co.uk

Lacons Legacy; 4 changing beers (sourced locally) ⊞
Village pub owned and run by the same family for over 70 years and in this Guide for 28 years. The unspoilt middle bar, with its wooden benches, roaring fire and collection of decoy birds gathering on the beam over the bar, is a favourite spot to pick up on local gossip. The Chequers' Son of Sid brewhouse supplies the pub and local beer festivals. Home-made pizza is available on Friday night (booking essential). A winner of numerous CAMRA awards and a national Pub of the Year finalist. Q❀♪⋏♦P☰♬❀♀

Littleport

Crown
34 Main Street, CB6 1PJ
☎ (01353) 862700
Batemans XB; Greene King IPA; 1 changing beer ⊞
Situated on the corner of Main Street and Crown Lane, in the heart of Littleport old town, the Crown Inn was in existence well before 1700 when it brewed its own beer from water brought up from the Great Ouse. A central door brings you directly to the main bar in front of you, with rooms on either side. There is usually at least one cask ale available. You will also find a jukebox and a pool table. Weekly live entertainment includes bands and discos. ☎❀♿P☰(9)♀

March

Rose & Crown 𝕃
41 St Peters Road, PE15 9NA
☎ (01354) 652077
St Austell Trelawny; 4 changing beers (often Adnams, St Austell, Tydd Steam) ⊞
Traditional community pub, over 150 years old, with two carpeted rooms, low beamed ceilings and a real fire in the main bar. Ale lovers willing to make the walk away from the town centre will receive a warm welcome. Five real ales are usually on offer from mainly small breweries, with at least one St Austell beer among the range. A mini beer festival is held at Easter time. A large selection of gins and single malts is also available. Good-quality food is served lunchtimes and evenings. Quiz night is Thursday. Q❀◑P☰♀

Ship Inn 𝕃
1 Nene Parade, PE15 8TD
☎ (01354) 607878
Woodforde's Wherry; 3 changing beers (often Church End, Lacons, Tydd Steam) ⊞
This thatched Grade II-listed riverside pub, built in 1680, has extensive moorings. It reopened as a free house in 2010, following a major refit. The unusual carved beams are said to have 'fallen off a barge' during the building of Ely Cathedral. A quaint wobbly floor and wall lead to the toilets and a small games room. Friendly and welcoming, the Ship is a Guide regular and winner of a CAMRA Gold Award. Q☎❀♣♦☰❀♀

Maxey

Blue Bell 𝕃
39 High Street, PE6 9EE
☎ (01778) 348182
Abbeydale Absolution; Fuller's London Pride, ESB; Oakham Bishops Farewell; 5 changing beers (sourced regionally; often Grainstore, Oakham, Woodforde's) ⊞
Originally a limestone barn, the building was converted many years ago and reflects the rural setting in which it is found. Paraphernalia of country life adorn the stone

walls and shelves of the two-roomed interior. Nine handpumps dispense a range of quality ales from large and small breweries far and wide. The pub is a popular meeting place for groups including birdwatchers and golfers. A former local CAMRA Pub of the Year and Gold Award winner. Q❀♣P☰(22,413)❀♀

Newton

Queen's Head ★
Fowlmere Road, CB22 7PG
☎ (01223) 870436 ⊕ queensheadnewton.co.uk
Adnams Southwold Bitter; 2 changing beers (sourced regionally) Ⓖ
Change comes gradually to this village local, one of a handful of pubs to have appeared in every edition of this Guide. Beers from brewers other than Adnams are now available from the stillage directly behind the bar. Regular Sunday lunches, a monthly Saturday supper club and Wednesday night food vans have been added to the soup and sandwiches on offer. Otherwise, little has changed since 1974. In fact, a list of landlords displayed in the public bar has only 18 entries since 1729. Q❀◑♣♦P☰(31)❀♀

Over

Admiral Vernon ✅
31 High Street, CB24 5NB
☎ (01954) 232357 ⊕ admiral-vernonover.square.site
Adnams Ghost Ship; 4 changing beers (often Brewpoint) ⊞
A Victorian pub in the village centre. Drinking areas form an 'L' around the wood-panelled bar. The larger area to the right leads to a rear patio and beer garden. Good-value food is freshly produced, locally sourced where possible, with daily specials and a Sunday roast. Adnams Ghost Ship and two seasonal beers from Charles Wells' Brewpoint brewery are regulars. Two guest ales are also available. ☎❀◑♣P☰❀♀

Peterborough

Bumble Inn
46 Westgate, PE1 1RE
⊕ thebimbleinn.wordpress.com
5 changing beers (sourced regionally; often Box Steam, Marble, Six ° North) ⊞
This micropub opened in 2016 in a former chemist's shop. Minimalist in style, it has five handpumps dispensing quality ales from far and wide, so expect the unusual from regional and local brewers. Taster paddles of three thirds are available, as are two craft keg beers, two ciders and rare bottled and canned beers. A small selection of wines and spirits, tea, coffee and soft drinks are also on offer. A former local CAMRA Pub of the Year. ⇌♦☰♀

Charters 𝕃
Town Bridge, PE1 1FP (down steps at Town Bridge)
☎ (01733) 315700 ⊕ charters-bar.com
Oakham JHB, Inferno, Citra, Bishops Farewell; 4 changing beers (often Nene Valley) ⊞/Ⓖ
This converted Dutch grain barge from circa 1907 sits on the River Nene near the city centre. An oriental restaurant is on the upper deck and food is also served in the bar. Up to 12 beers are on offer plus cider. The large garden with a marquee, bar and landing stage for boats is popular in summer. Live music plays most weekends, outside the pub in summer. It gets busy when Peterborough football club are playing at home. Close to the Nene Valley Railway. ☎❀◑♣♦P☰❀♀

Coalheavers Arms L

5 Park Street, Woodston, PE2 9BH
☎ (01733) 565664
Greene King IPA; house beer (by Morland); 6 changing beers (sourced locally; often Hop Back, Lacons, Zest) Ⓗ
This one-roomed back-street community pub dates back to the 1850s. It was the only Peterborough pub to be bombed in World War II. Greene King IPA is served alongside up to six mostly local guest ales plus cider and craft beer. Well-attended beer festivals are held twice a year, and the large garden is popular in the summer with families. The pub can be busy on football match days.
Q ᗡ ✿ ♣ ♠ P ♬ ✿ ☂

Draper's Arms L

29-31 Cowgate, PE1 1LZ
☎ (01733) 847570
Brewsters Hophead; Grainstore Ten Fifty; Greene King Abbot; Ruddles Best Bitter; Sharp's Doom Bar; Titanic Plum Porter; 5 changing beers (often Brewsters, Grainstore, Newby Wyke) Ⓗ
A converted draper's shop, built in 1899 and one of two Wetherspoon pubs in the city, now with a roof terrace. The beer range, with many from local microbreweries, is dispensed through 12 handpumps. The interior is broken up with dividers and intimate wood-panelled spaces. Food is served all day and regular beer and cider festivals are held throughout the year. Quiz night is Wednesday. A regular top 10 real ale pub within the company chain. Close to bus and railway stations. Q ᗡ ✿ ⓘ ◗ ♿ ⇌ ♠ ♬ ☂

Fletton Ex-Service & Working Men's Club

243A High Street, Fletton, PE2 9EH
☎ (01733) 341326
5 changing beers (often Box Steam, Digfield, Tydd Steam) Ⓗ
Large, multi-roomed members' club, now with five handpumps offering ever-changing guest beers in a range of styles including golden, amber, dark, stout and porter. Regular beer festivals provide even more choice. Cask ales are reduced in price on Friday and Saturday afternoons. Entertainment includes live music, bingo and quizzes, plus Sky Sports on two large screens. Pool, darts and snooker are played. Show a CAMRA membership card for entry. A CAMRA Gold Award winner.
ᗡ ✿ ⓘ ♿ ♣ ♠ (5) ☂

Frothblowers L

78 Storrington Way, Werrington, PE4 6QP
☎ 07756 066503 ⊕ frothblowers.site
7 changing beers (sourced regionally; often Digfield, Hopshackle, Tydd Steam) Ⓗ
This micropub is easily accessed by bus from the city centre. It has five handpumps and more beers available in the cellar, as well as at least 25 ciders and bottled beers. Alcohol-free beers are also available. A hub of the local community, activities include tap takeovers, acoustic music sessions, bus tours, a summer cycling club, knitting club, monthly grub club and cider festivals. A repeat winner of CAMRA branch and county Pub of the Year. Cash only. ᗡ ✿ ⓘ ♿ ♣ ♠ P ♬ ♠ (1) ✿

Hand & Heart ★ L

12 Highbury Street, PE1 3BE
☎ (01733) 564653
6 changing beers (sourced regionally; often Brewster's, Rockingham, Tydd Steam) Ⓗ /Ⓖ
Rebuilt in 1938, this Art Deco-style community local is a CAMRA Heritage Pub of Britain. A drinking corridor connects the rear room to the main public bar, with its

war memorial and real fire. Traditional pub games are played. Six handpumped ales are served, with more from the cellar. The range is eclectic and forever changing. Real cider is available in bottle and box. Beer festivals with live music are held in the large garden. A Guide regular for over 10 years and a former CAMRA branch and county Pub of the Year. Q ᗡ ✿ ♣ ♠ ♬ (1,62) ✿ ☂

Ostrich Inn ♥ L

17 North Street, PE1 2RA
☎ 07307 195560 ⊕ ostrichinnpeterborough.com
5 changing beers (sourced regionally; often Nene Valley, Thornbridge, Tiny Rebel) Ⓗ
The Ostrich reopened in 2009 following refurbishment, with its original name restored. The single-room interior has a U-shaped bar offering up to five regularly changing real ales, many from local breweries, alongside craft keg and KeyKeg lines. A large gin selection is also available. Live music plays up to four evenings most weeks, often weekends. The small enclosed patio is a suntrap. Popular when Peterborough football club are playing at home. Local CAMRA City Pub of the Year 2022.
ᗡ ✿ ♿ ⇌ ♣ ♠ ♬ ✿

Palmerston Arms L

82 Oundle Road, PE2 9PA
☎ (01733) 565865
Batemans Gold, XXXB Ⓗ/Ⓖ; **Castle Rock Harvest Pale; 9 changing beers (sourced regionally; often Lacons, Ossett, St Austell)** Ⓖ
Popular 400-year-old listed stone-built locals' pub. Owned by Batemans, three of its beers are rotated alongside nine or more other real ales, including some from Oakham Ales and Nene Valley. Traditional cider, perry and an extensive range of malt whiskies are also available. The majority of beers are served straight from the cellar, which can be seen through a large glass screen. Rolls and a variety of snacks tempt customers. Philosophy nights feature on occasion. Busy on football match days. ✿ ♣ ♠ ♬ (1,24) ✿ ☂

Ploughman L

1 Staniland Way, Werrington, PE4 6NA
☎ (01733) 327696
6 changing beers (sourced regionally; often Blue Monkey, Castor, Tiny Rebel) Ⓗ
This thriving community free house serves up to six real ales including regular LocAles and unusual beers from far and wide, alongside a large selection of ciders, craft beers and over 50 gins. With two separate bars, the pub is well established on the local entertainment scene, and features live music every weekend. It hosts a popular beer festival in July. An outstanding fundraiser for local charities, the Ploughman is a former local CAMRA Pub of the Year. ᗡ ✿ ♠ ♠ P ♬ (1,22)

Wonky Donkey L

102C High Street, Fletton, PE2 8DR
☎ 07919 470635
Dancing Duck Abduction; 4 changing beers (sourced locally; often Digfield, Mile Tree, Tydd Steam) Ⓗ/Ⓖ
Housed in two rooms of a former florist's, this is Peterborough's latest micropub, situated in a previously pub-free area. It usually offers five beers, many straight from the cask, mostly LocAles, and also stocks a large range of ciders, wines and gins, along with quality bottled lagers. Themed evenings include pop-up food nights. The pub regularly brews house specials with local brewery Mile Tree. A local CAMRA Gold Award recipient in 2021. ᗡ ♿ ♣ ♠ ♬ (5) ✿

Woolpack ✓

29 North Street, Stanground, PE2 8HR (in old part of village by River Nene)

☎ (01733) 753544 ⊕ thewoolpack.pub

Black Sheep Best Bitter; Timothy Taylor Landlord; 2 changing beers (sourced regionally; often Ossett, Tydd Steam) Ⓗ

Originally constructed in 1711, a medieval wall remains in the garden and the old barn used to be the village mortuary (last used in the 1850s). The covered beer garden is used for live music and leads to the old River Nene, with boat moorings available. The L-shaped bar has TV and a dartboard, and is adorned with old photos and prints. Quiz night is Tuesday. Two guest beers are usually on tap. The pub is on the city Green Wheel route. A former local CAMRA Pub of the Year.

Q ☎ ❀ ◑ ♣ ☺ ✿ 🐾 ♠ 📶

Yard of Ale

72 Oundle Road, PE2 9PA

☎ (01733) 348000 ⊕ theyardofalepub.co.uk

Sharp's Doom Bar; house beer (by Digfield); 4 changing beers (often Rooster's, Woodforde's) Ⓗ

Built on land that was part of the nearby Palmerston Arms stable yard, this 120-year-old pub was refurbished and reopened in early 2017. Decorated in shades of grey with a warm wooden bar and surround, the large open-plan single room is divided into four distinct areas by the central supporting structure. Entertainment includes sports TV, darts and pool, plus live music most weekends. Outside is a large beer garden with a pizza oven for the summer. A former CAMRA branch LocAle Pub of the Year.

☎ ❀ ♣ ☺ 📶 (1) 📶

Ramsey

Angel

76 High Street, PE26 1BS

☎ (01487) 711968

Adnams Ghost Ship; Greene King Abbot; 2 changing beers (often Lacons, Tydd Steam) Ⓗ

This traditional brick-built two-room pub was refurbished in 2019. Entry to the main bar area is via the rear car park and beer garden. Here you will find plenty of seating, two dartboards, a jukebox and a pool table. The lounge can also be accessed from the main road. Friendly staff and locals help provide a great venue to enjoy a drink or two, with a LocAle always available, usually from Tydd Steam. Rolls are available from the bar at weekends.

☎ ❀ ♣ 📶 (31) 🐾 📶

St Ives

Nelson's Head Ⓛ

Merryland, PE27 5ED

☎ (01480) 494454 ⊕ nelsonsheadstives.pub

Greene King IPA, Abbot; Oakham JHB; 2 changing beers (sourced regionally; often Grainstore, Nethergate) Ⓗ

Popular pub in a picturesque narrow street in the town centre. It offers three regular beers and two changing guests, often from local breweries. Traditional pub food is served at lunchtimes. On Sunday afternoon live bands perform and the pub gets extremely busy. A former CAMRA branch LocAle Pub of the Year. ❀ ◑ 📶 🐾 📶

St Neots

Ale Taster 🍺

25 Russell Street, PE19 1BA

☎ (01480) 581368

6 changing beers (sourced regionally) Ⓖ

A small back-street pub in the style of a micropub. It features up to three changing ales served from a stillage behind the bar, and up to nine real ciders and perries. The owners source the beers and ciders from local producers as much as possible, and are happy to chat about their beers. Three large fridges display a wide selection of bottled beers from around the world. The pub encourages conversation, with quiet background music and no electronic machines. Traditional bar games are played. Q ☎ ❀ ♣ ☺ 📶 (905) 🐾

Olde Sun Ⓛ

11 Huntingdon Street, PE19 1BL

☎ (01480) 216863

Adnams Ghost Ship; Woodforde's Wherry; 2 changing beers (often Adnams, Elgood's, Woodforde's) Ⓗ

Traditional low-beamed town-centre pub with two large inglenook fireplaces, three bar areas and a secluded patio. The jukebox is zoned, allowing quiet areas for conversation. Shove-ha'penny and bar billiards are played. Five constantly changing guest beers come from various regional breweries including Adnams, Elgood's, Marston's, Thwaites and Woodforde's. A mild and other dark beers are usually among the range. A former local CAMRA Mild/Dark Ales Pub of the Year. ❀ ♣ 📶 (905) 🐾

Pig 'n' Falcon Ⓛ

9 New Street, PE19 1AE

☎ 07951 785678 ⊕ pignfalcon.co.uk

Greene King IPA Ⓗ**, Abbot** Ⓖ**; Potbelly Best** Ⓗ**; 5 changing beers (sourced locally; often Potbelly, Three Blind Mice)** Ⓖ

This busy town-centre free house has up to six real ales and five real ciders, focusing on microbreweries and unusual beers including milds, porters and stouts. It also offers a good range of bottled ciders, UK and foreign bottled beers including Trappist ales. Live blues and rock nights are hosted Wednesday to Sunday. Outside is a large, imaginatively created, covered and heated beer garden. Three Blind Mice beers are real ale served in KeyKegs. ☎ ❀ ☺ 📶 (905) 🐾

Stapleford

Three Horseshoes

2 Church Street, CB22 5DS

☎ (01223) 503402 ⊕ threehorseshoes-pub.co.uk

Adnams Southwold Bitter; 4 changing beers Ⓗ

Friendly village inn on the southern fringe of Cambridge, popular with the local community and visitors from surrounding villages. It has three areas – the main bar, a small room to the left, and a large room to the right. There is a sheltered beer garden with a barbecue at the back. A variety of food is available, with the accent on traditional Cypriot and Greek dishes. Local CAMRA Rural Pub of the Year 2022. ☎ ❀ ◑ ➔ (Shelford) 📶 (7) 🐾

Trumpington

Lord Byron Inn Ⓛ

22 Church Lane, CB2 9LA

☎ (01223) 845102 ⊕ lordbyroninn.co.uk

3 changing beers (sourced locally) Ⓗ

Large 17th-century inn on the edge of Cambridge with a large well-kept garden. Floors on different levels, a low-beamed ceiling, wood panelling on the walls and comfortable seating give the main bar area plenty of character. Regular real ales are primarily from local brewers, including Turpin's, Milton, Oakham and Tring. Real ciders are from Simon's Cider. The pub has a new accommodation block built in keeping with the original building. ☎ ❀ ✦ ◑ ☺ 📶 📶

Waterbeach

Sun Inn ✅
Chapel Street, CB25 9HR
☎ (01223) 861254
3 changing beers Ⓗ

Traditional pub overlooking the village green. The small, cosy lounge is dominated by a huge fireplace, while the simply appointed public bar, with its woodblock floor, is always lively. There is a small meeting room and a function room upstairs where regular gigs are hosted. An annual beer and music festival is held over the early May bank holiday weekend. The list of changing guest beers is interesting, including local ales and often a dark beer.
⅏❀⏨♿♣♠🚭🚍(9)🕸️

West Wratting

Chestnut Tree
1 Mill Road, CB21 5LT
☎ (01223) 290384
Greene King IPA; 3 changing beers Ⓗ

Impressive two-bar Victorian-style pub, with modern extensions creating a roomy interior. The lounge to the right is mainly set out for dining. To the left is a comfortably furnished public bar with a pool table. This friendly pub hosts darts, pool and pétanque teams, and has a small lending library. It has been free of tie since the present owners bought it in 2012. The three changing beers are mainly from micros, often local. A former local CAMRA Pub of the Year and winner of a Lockdown Community Award. Q🚃❀⏨♣🚍(19)🕸️

Whittlesey

Boat Inn Ⓛ
2 Ramsey Road, PE7 1DR
☎ (01733) 202488 ⊕ quinnboatinn.wordpress.com
4 changing beers (sourced regionally) Ⓗ/Ⓖ

This corner pub has two rooms – a public bar with sports TV and a cosy lounge. A large number of traditional ciders and perries supplement the real ales, some of which are served direct from the cask. A whisky club is hosted on the second Friday of the month and there are regular trips to tasting events. Outside is a pétanque terrain which is used by dancers at the Straw Bear Festival in January each year, when there is also an outside bar. There is a large car park to the rear.
🚃❀✉♿♣🚍(31)🕸️

Willingham

Bank Micropub
9 High Street, CB24 5ES
☎ (01954) 200045 ⊕ thebankmicropub.co.uk
4 changing beers Ⓖ

Formerly a village bank, this single-room micropub has a short bar rescued from a closed Cambridge pub. The walls are decorated with photos of local interest. A wide range of beers is available direct from the cask and from keg and KeyKeg. There is also a fridge well stocked with cans. Ciders are still and kegged. The Bank offers a warm welcome and the casual visitor is certain to be included in local conversation. Q♣🚍🚍🕸️

Witcham

White Horse
7 Silver Street, CB6 2LF (1 mile from A142 jct)
☎ (01353) 777999
2 changing beers (sourced regionally; often Grainstore, Rocket Ales, Wolf) Ⓗ

Popular family-friendly village pub with a constantly changing selection of real ales, mostly from East Anglia. It has a main bar, dining area and pool table area. Witcham village is famous for hosting the annual world pea-shooting championship, usually on the second weekend in July. The pub sign is unique, depicting the current world champion in battle dress astride a white horse, with pea shooter held aloft. Q🚃❀⏨♣🚍🕸️

Breweries

Bowler's SIBA
84 Lincoln Road, Deeping Gate, Peterborough, Cambridgeshire, PE6 9BB ☎ 07480 064147
⊕ bowlers.beer

Established in 2019, Bowler's began brewing bottled ales in 2020. The name comes from the owner's surnames, Bowyer and Gowler.

Brown Derby (ABV 4.8%) BLOND
Trusty Steed (ABV 5.2%) IPA

BrewBoard SIBA
Unit B3. Button End Industrial Estate, Harston, Cambridgeshire, CB22 7GX
☎ (01223) 872131 ⊕ brewboard.co.uk

Founded in 2017. Now brewing with 150-hectolitre plant. No real ale. ‼️🍺◆

Burwell
Burwell, Cambridgeshire, CB25 0HQ ☎ 07788 311908
⊕ burwellbrewery.com

⊠ Richard Dolphin and Paul Belton established Burwell Brewery in 2019 in a purpose-built timber brewery at the bottom of Richard's garden. The plant, recently upgraded to 2.5-barrels, together with three conditioning tanks, produces beer for cask, bottle and bag-in-box. ‼️◆

Beer Fuggled Best Bitter (ABV 4%) BITTER
Priory Wood Rauch (ABV 4%) BROWN
Judy's Hole Chocolate Porter (ABV 4.5%) PORTER
Burwell Sunshine Pale Ale (ABV 5%) PALE
Margaret's Field American IPA (ABV 5%) PALE
Moulin D'Etienne Wit Bier (ABV 5%) SPECIALITY
Stefans' Mù¥hle Weiss Bier (ABV 5%) SPECIALITY
Double Beer Fuggled Special Bitter (ABV 5.5%) BITTER
Absolutely Beer Fuggled Extra Special Bitter (ABV 6.5%) STRONG

Calverley's SIBA
23a Hooper Street, Cambridge, CB1 2NZ
☎ (01223) 312370 ☎ 07769 537342
⊕ calverleys.com

⊚ Brewery started 2013 by brothers Sam and Tom Calverley. It is located in a converted stable yard close to the city centre. The brewery is open to the public for on and off-sales (Thursday-Saturday). A large proportion of production is sold on-site, and local pubs are also supplied. Most beers are keg (various styles), but the brewery remains committed to cask ale and its porter is usually available. ‼️🍺

Porter (ABV 5.1%) PORTER

Cambridge
🍺 **1 King Street, Cambridge, CB1 1LH**
☎ (01223) 858155 ⊕ thecambridgebrewhouse.com

⊠ Brewing began in 2013 at the on-site microbrewery in the Cambridge Brew House. ♦

Castor SIBA

Castor, Cambridgeshire, PE5 7AX
☎ (01733) 380337 ⊕ castorales.co.uk

This three-barrel brewery, established in 2009, is located in a specially converted outhouse in the garden of the founder brewer. Several local outlets feature the beers as well as many national beer festivals. ‼♦

Roman Gold (ABV 3.7%) GOLD
Hopping Toad (ABV 4.1%) GOLD
Roman Mosaic (ABV 4.2%) GOLD

Downham Isle

19 Main Street, Littleport, Cambridgeshire, CB6 1PH
☎ (01353) 699695 ☎ 07732 927479
⊕ downhamislebrewery.co.uk

Downham Isle Brewery opened 2016 in Little Downham, in the north eastern Cambridgeshire fens. Brewing real and craft ales, the customer base spans the Isle of Ely, Cambridge and Dusseldorf! Artisan, small batch brewing methods are used. The brewery moved to premises in Littleport in 2021. Normally four core ales are brewed, both cask and bottled-conditioned. New beers, including specialist niche beers, and seasonal beers are planned during the currency of this Guide. ‼ 🍺♦ LIVE ✦

Cobblers Revival (ABV 3.5%) PALE
Main Street Citra (ABV 3.5%) IPA
Goose Ely (ABV 3.7%) PALE
Duneham Ale (ABV 4.8%) BITTER

Draycott

Low Farm, 30 Mill Road, Buckden, Cambridgeshire, PE19 5SS
☎ (01480) 812404 ☎ 07740 374710
⊕ draycottbrewery.co.uk

⊠ The brewery was set up by Jon and Jane Draycott in 2009, and is located in an old farm complex where they live. Focus is on bottle-conditioned beers which are available in a one-pint, traditionally-shaped bottle. Four regular beers are available, along with a cask beer brewed for the Grafham Trout pub, or to order. A seasonal ale made with local, wild hops is also produced. LIVE

Grafham Trout Bitter (ABV 3.8%) BITTER

Elgood's SIBA

North Brink Brewery, Wisbech, Cambridgeshire, PE13 1LW
☎ (01945) 583160 ⊕ elgoods-brewery.co.uk

⊠ The North Brink brewery was established in 1795. Owned by the Elgood family since 1878, the fifth generation are now involved in running the business. Elgood's has approximately 30 tied pubs within a 50-mile radius of the brewery and a substantial free trade. Lambic style beers are produced using the brewery's old open cooling trays as fermenting vessels. Off-sales are available all year round from the shop in the brewery office when the visitor centre is closed. ‼ 🍺♦

Black Dog (ABV 3.6%) MILD
Black-red mild with liquorice and chocolate. Dry roasty finish.
Cambridge Bitter (ABV 3.8%) BITTER
Fruit and malt on the nose with increasing hops and balancing malt on the palate. Dry finish.

Blackberry Porter (ABV 4.5%) SPECIALITY
Plum Porter (ABV 4.5%) SPECIALITY

Grafham

30 Breach Road, Grafham, Huntingdon, Cambridgeshire, PE28 0BA ☎ 07590 836241
⊕ grafhambrewing.co

Grafham Brewing Co is a 1.8-barrel brewery that began commercial production in 2019.

Hodders Panama (ABV 4.8%) PALE

IVO SIBA

10 Church Street, Somersham, Cambridgeshire, PE28 3EG ☎ 07823 400369 ⊕ ivobrewery.co.uk

Established in 2020, IVO Brewery is run by two friends and neighbours, Charlie Abbott and Jason Jones, both successful homebrewers. Every beer is naturally fined and vegan-friendly. Despite being a small brewery, a core range is brewed with occasional and on-demand specials. The core range varies from a Kolsh-style lager to porters. V

Car Park Cuddle (ABV 3.8%) PALE
No Man (ABV 4.5%) STOUT
She Keeps It Nice (ABV 4.5%) PALE
Evening Brown (ABV 5%) BROWN
Heavy On The Chips (ABV 6%) PORTER

Jesus College

Jesus College, Cambridge, CB5 8BL

In-house brewery for Jesus College at the University of Cambridge. Beers are produced for college use only and are not available to the general public.

Lord Conrad's

Unit 21, Dry Drayton Industrial Estate, Scotland Road, Dry Drayton, Cambridge, Cambridgeshire, CB23 8AT
☎ 07736 739700 ⊕ lordconradsbrewery.co.uk

⊠ Lord Conrad's was established in 2007 and moved to Dry Drayton in 2011, using a 2.5-barrel plant. One permanent outlet is supplied, the Black Horse, Dry Drayton, along with other local free houses and beer festivals. The brewery adheres strongly to green principles, using low energy systems, recycled materials and local ingredients. ‼ 🍺

Zulu Dawn (ABV 3.5%) PALE
Hedgerow Hop (ABV 3.7%) BITTER
Her Majes Tea (ABV 3.8%) SPECIALITY
Lickety Split (ABV 3.8%) BROWN
Tangerine Dream (ABV 3.8%) SPECIALITY
Spiffing Wheeze (ABV 3.9%) PALE
Big Bad Wolf (ABV 4%) PALE
Conkerwood (ABV 4%) PORTER
Fools Gold (ABV 4%) PALE
Gubbins (ABV 4%) BITTER
Lobster Licker (ABV 4.2%) RED
Slap N'Tickle (ABV 4.3%) BLOND
Zulu (ABV 4.5%) BITTER
Horny Goat (ABV 4.8%) SPECIALITY
Pheasant's Rise (ABV 5%) BITTER
Stubble Burner (ABV 5%) BLOND

Mile Tree SIBA

29 Alfric Square, Woodston, Peterborough, Cambridgeshire, PE2 7JP ☎ 07858 930363
⊕ miletreebrewery.co.uk

⊠ Mile Tree was established in 2012 at the Secret Garden Touring Park in Wisbech, and moved to Peterborough in 2018. Beer is brewed on a five-barrel plant. It serves the local area and beer festivals. ♦LIVE

Meadowgold (ABV 3.8%) GOLD
Mosaica (ABV 4.2%) GOLD
Larksong (ABV 4.5%) BITTER
Wildwood (ABV 4.9%) GOLD
Porter (ABV 5.2%) PORTER
Winter Ale (ABV 6%) OLD

Milton SIBA

Pegasus House, Pembroke Avenue, Waterbeach, Cambridgeshire, CB25 9PY
☎ (01223) 862067 ⊕ miltonbrewery.co.uk

⊠ The brewery has grown steadily since it was founded in 1999, moving to larger premises in the village of Waterbeach in 2012. It now operates three pubs in Cambridge through a sister company. In 2016 a separate brand, Beach Brewery, was created to market unpasteurised and unfiltered keg beers. Since 2021 the brewery has an outdoor taproom, open on a seasonal basis. ♧♦

Minotaur (ABV 3.3%) MILD
A dark ruby mild with liquorice and raisin fruit throughout. Light dry finish.
Dionysus (ABV 3.6%) BITTER
Yellow bitter with good balance of biscuity malt and citrus hop. Some malt and hops linger on long dry aftertaste.
Justinian (ABV 3.9%) BITTER
Straw-coloured bitter with pink grapefruit hop character and light malt sweetness. Very dry finish.
Pegasus (ABV 4.1%) BITTER
Malty, amber, medium-bodied bitter with faint hops. Bittersweet aftertaste.
Sparta (ABV 4.3%) BITTER
A yellow/gold bitter with floral hops, kiwi fruit and balancing malt softness which fades to leave a long, dry finish.
Minerva (ABV 4.6%) GOLD
Nero (ABV 5%) STOUT
A complex black beer comprising a blend of milk chocolate, raisins and liquorice. Roast malt and fruit completes the experience.
Cyclops (ABV 5.3%) BITTER
Marcus Aurelius (ABV 7.5%) STOUT
A powerful black brew brimming with raisins and liquorice. Big, balanced finish.

Moonshine

Hill Farm, Shelford Road, Fulbourn, Cambridge, Cambridgeshire, CB21 5EQ ☎ 07906 066794

Office: 28 Radegund Road, Cambridge, CB1 3RS
⊕ moonshinebrewery.co.uk

⊠ Established in 2004, the brewery produces up to 20 barrels a week. Locally-produced ingredients are used, including water from the brewery's own well, and barley grown on the farm where the brewery is based. CAMRA beer festivals are supplied throughout the country, with 30 local outlets supplied direct. ♦LIVE

Trumpington Tipple (ABV 3.6%) BITTER
Cambridge Pale Ale (ABV 3.8%) PALE
Shelford Crier (ABV 3.8%) BITTER
Harvest Moon Mild (ABV 3.9%) MILD
Heavenly Matter (ABV 4.1%) GOLD
Cambridge Best Bitter (ABV 4.2%) BITTER
Nightwatch Porter (ABV 4.5%) PORTER
Black Hole Stout (ABV 5%) STOUT

Cellarman's Stout (ABV 6%) STOUT
Chocolate Orange Stout (ABV 6.7%) SPECIALITY

Oakham SIBA

2 Maxwell Road, Woodston, Peterborough, Cambridgeshire, PE2 7JB
☎ (01733) 370500 ⊕ oakhamales.com

⊠ The brewery was established in 1993 in Oakham, Rutland, and moved to Peterborough in 1998. The brewery's main production site is a 75-barrel plant. Around 350 outlets are supplied and four pubs are owned. ♧ ☞ ♦LIVE

JHB (ABV 3.8%) GOLD
Hoppy, yellow golden ale with bags of citrus hop. An underlying sweet maltiness ebbs away as the citrus hop prevails.
Inferno (ABV 4%) GOLD
The citrus hop character of this straw-coloured brew begins on the nose and builds in intensity on the palate. Clean, dry, citrus finish.
Citra (ABV 4.2%) GOLD
Robust golden ale with explosive grapefruit and lemony hop. A scattering of sweet malt provides contrast to the hop bitterness.
Bishops Farewell (ABV 4.6%) GOLD
Powerfully citrusy, the hops and fruit on the aroma of this golden/yellow beer become bittersweet on the palate. Zesty citrus aftertaste.
Green Devil (ABV 6%) GOLD
Powerful, premium golden ale with soaring citrus hop deepening in the mouth progressing into an unrelenting, dry, hoppy finish.

Papworth SIBA

24 Earith Business Park, Meadow Drove, Earith, Cambridgeshire, PE28 3QF
☎ (01487) 842442 ☎ 07835 845797
⊕ papworthbrewery.com

Brewing began in 2014 in Papworth Everard. The brewery moved to new premises in Earith in 2017 and acquired an 11-barrel plant, significantly increasing its production. A brewery tap and bottle shop, the Crystal Ship, opened in 2020 and can be found at Unit 32, Earith Business Park. ♧ ☞

Mild Thing (ABV 3.5%) MILD
Mad Jack (ABV 3.8%) BITTER
The Whitfield Citrabolt (ABV 3.8%) GOLD
Whispering Grass (ABV 3.8%) BITTER
Fen Skater (ABV 4%) PALE
Crystal Ship (ABV 4.2%) BITTER
Half Nelson (ABV 4.2%) PALE
Old Riverport Stout (ABV 4.5%) STOUT
Red Kite (ABV 4.7%) BITTER
Robin Goodfellow (ABV 5.4%) BITTER
Pass the Porter (ABV 5.5%) PORTER
Koura (ABV 5.7%) SPECIALITY

Pastore

Unit 2, Convent Drive, Waterbeach, CB25 9QT
⊕ pastorebrewing.com

⊠ Founded in 2019, Pastore Brewing & Blending specialise in mixed-fermentation sour and wild ales. Pastore (Pas-tor-ray) is Italian for shepherd, in honour of the brewer's Italian family. It ties rustic, wild brewing with a modern, semi-urban setting, making new-age fresh, fruited weisses, as well as barrel-aged old saisons.
♧ ☞ ♦LIVE V♦

Rocket

The Orchard, Garden Farm, The Town, Great
Staughton, Cambridgeshire, PE19 5BE
☎ (01733) 390828 ☎ 07747 617527
✉ mikeblakesley@virginmedia.com

Originally using spare capacity at King's Cliffe Brewery
(qv), Rocket Ales relocated to its own site in 2017.

Atlas IPA (ABV 5.8%) IPA

Son of Sid

🍺 Chequers, 71 Main Road, Little Gransden,
Cambridgeshire, SG19 3DW
☎ (01767) 677348 ⊕ sonofsid.co.uk

⊠ Son of Sid was established in 2007. The three-barrel
plant is situated in a room at the back of the pub and can
be viewed from a window in the lounge bar. It is named
after the father of the current landlord, who ran the pub
for 42 years. His son has carried the business on as a
family-run enterprise. Beer is sold in the pub and at local
beer festivals. Brewing is currently suspended. !! ➤LIVE

Three Blind Mice

Unit W10, Black Bank Business Park, Black Bank
Road, Little Downham, Cambridgeshire, CB6 2UA
☎ (01353) 864438 ☎ 07912 875825
✉ mice@threeblindmicebrewery.com

Award-winning, seven-barrel brewery, established in
2014. The name comes from the three owners/brewers,
who reckoned they didn't have a clue what they were
doing when they first started brewing. Beer is supplied
regularly to the Drayman's Son micropub, Ely, plus other
outlets in Ely, Cambridgeshire and further afield. Beers
are also canned and the brewery has been
experimenting with different lagered beers. ♦

Lonely Snake (ABV 3.5%) GOLD
Old Brown Mouse (ABV 4.2%) BITTER
Juice Rocket (ABV 4.5%) PALE
Hazy pale ale with citrus hop aroma supported by sweet
malt in the mouth. Sweet fruity finish with mellow hop.
Milk Worm (ABV 5.3%) PORTER
Rocket Nun (ABV 5.5%) IPA

Turpin's

Unit 31, Reach Road, Burwell, Cambridgeshire,
CB25 0GH
☎ (01223) 833883 ⊕ turpinsbrewery.co.uk

⊠ Turpin's is a vibrant, modern brewery that moved
from Pampisford to Burwell, near Cambridge in early
2022. Established in 2015 and brewing a wide variety of
beers. ♦

Dragon's Den (ABV 3.9%) GOLD
Mozart (ABV 3.9%) GOLD
Single Hop Range (ABV 3.9%) GOLD
Mango Milkshake Pale Ale (ABV 4.3%) PALE
Meditation (ABV 4.3%) PALE
Cambridge Black (ABV 4.6%) STOUT

NAPA (ABV 5%) PALE
Celebration (ABV 5.5%) SPECIALITY

Tydd Steam SIBA

Manor Barn, Kirkgate, Tydd Saint Giles,
Cambridgeshire, PE13 5NE
☎ (01945) 871020 ☎ 07932 726552
⊕ tyddsteam.co.uk

⊠ Established in 2007 in a converted agricultural barn,
the brewery is named after two farm steam engines. A
15-barrel plant was installed in 2011. Around 70 outlets
are supplied direct. !! ♦LIVE

Barn Ale (ABV 3.9%) BITTER
A golden bitter that has good biscuity malt aroma and
flavour, balanced by spicy hops. Long, dry, fairly
astringent finish.
Scoundrel (ABV 4%) BITTER
A dry, pale amber bitter with a gentle malty and hoppy
aroma, plenty of hop bitterness with fruity hints in the
taste and a persistent dry aftertaste.
Piston Bob (ABV 4.6%) BITTER
Amber bitter with malt and faint hop aroma, a malty
flavour balanced by hops and fruit then a dry finish.

Wylde Sky SIBA

Unit 8a, The Grip, Hadstock Road, Linton,
Cambridgeshire, CB21 4XN
☎ (01223) 778350 ⊕ wyldeskybrewing.com

⊠ Established in 2018, the brewery has a purpose-built,
10-barrel plant, brewing small batches of innovative
beers in a range of styles from around the world. All
beers are unfined, unfiltered and unpasteurised. A
number of outlets are supplied in the area and an on-site
taproom is open Thursday-Sunday (some seasonal
variations.) !! ➤♦∅

Xtreme

Unit 21/22, Alfric Square, Peterborough,
Cambridgeshire, PE2 7JP ☎ 07825 680932
⊕ xtremeales.com

⊠ The Hunt brothers took over Xtreme Ales in 2020. The
core range of ales is retained, along with some of the
popular seasonals, but a number of new brews have also
been added. Bumbling Brewery beers are also brewed
for the Bumble Inn micropub, Peterborough. !! ♦

PiXie APA (ABV 3.7%) PALE
Xplorer Pale Ale (ABV 4.1%) PALE
Pigeon Ale (ABV 4.3%) PALE
Red FoX (ABV 4.5%) RED
OatiX Stout (ABV 4.6%) STOUT
GalaXy IPA (ABV 5%) IPA
Triple Hop Xtra-IPA (ABV 5%) GOLD
Xtreme Special Bitter (ABV 5%) BITTER
Xporter (ABV 6%) PORTER
SaXquatch (ABV 8.6%) OLD

A quart a day keeps the doctor away

A judicious labourer would probably always have some ale in his house, and have small
beer for the general drink. There is no reason why he should not keep Christmas as well
as the farmer; and when he is mowing, reaping, or is at any other hard work, a quart, or
three pints, of really good fat ale a-day is by no means too much.
William Cobbett, Cottage Economy, 1822

Andrewsfield

Millibar ⬡

Stebbing Airfield, New Pasture Lane, CM6 3TH
(accessed by a track beside the runway, nr Stebbing Green) TL689248
☎ 07923 981900 ⊕ andrewsfield.com/andrewsfield-millibar
Bishop Nick Ridley's Rite ⊞
The manager of the bar at this local flying school is keen on local supply and has installed Ridley's Rite from Bishop Nick Brewery as his sole ale. There is also a range of Bishop Nick bottled beers. Home-cooked food is served daily. The training airfield is a small grass strip dominated by single-engine Cessna aircraft, a Mustang III and B17 Meteor IIIs, and trial flying lessons are available. The public are welcome in the bar and it stays open until 11pm if there are customers. It regularly plays host to local gatherings and club activities. Q❄❀⊕ℚ℗🐾🛜

Ballards Gore

Shepherd & Dog

Gore Road, SS4 2DA (between Rochford and Paglesham)
☎ (01702) 258658 ⊕ theshepherdanddogstambridge.co.uk
6 changing beers (sourced locally; often George's) ⊞
A traditional country pub with beams throughout and a real fire. A regular winner of local CAMRA awards. It is L-shaped, with the bar at the front offering six real ales,

plus a range of real ciders. Towards the back is the restaurant, serving home-cooked food made using local produce. There is outside seating at the front and in the family-friendly beer garden to the rear, as well as an outside bar. Regular music events are popular.
❄❀◀▶⊕P🚲(60)🐾

Belchamp Otten

Red Lion ⬡

Fowes Lane, CO10 7BQ (on a very small single-track lane, signed by duck pond) TL799415
☎ (01787) 278301 ⊕ ottenredlion.co.uk
Adnams Southwold Bitter; 2 changing beers (sourced nationally) ⊞
Lovely local inn, hidden away in the smallest of the Belchamps. The owner and his friendly labrador provide a warm welcome. The pub does not currently serve food, but has delivery arrangements with local takeaway restaurants. It has darts and a pool table, and there is an open fire in winter. Occasional events are run. There are excellent views, good walks and cycle rides from here.
❄❀♣P🐾🛜

Belchamp St Paul

Half Moon ✅

Cole Green, CO10 7DP TL792423

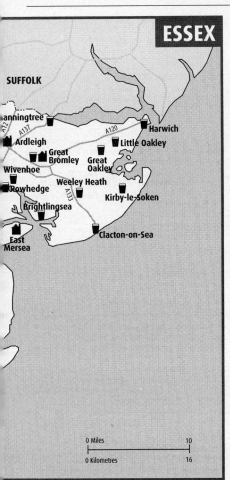

ESSEX

SUFFOLK

anningtree
Ardleigh
Great Bromley
Wivenhoe
Rowhedge
Brightlingsea
East Mersea

Harwich
Little Oakley
Great Oakley
Weeley Heath
Kirby-le-Soken
Clacton-on-Sea

0 Miles 10
0 Kilometres 16

friendly. A collection of tankards hangs from the ceiling. There is a cosy and attractive courtyard garden. ✤❍◐ㅇ➸P🖵(100) 📶

Railway

1 High Street, CM12 9BE
☎ (01277) 652173 ⊕ therailwaybillericay.co.uk
Dark Star Hophead; Wibblers Dengie IPA; 3 changing beers (sourced nationally) Ⓗ
Friendly pub with a welcoming atmosphere, which earns its tag line: Number 1 in the High Street. It has served over 800 different real ales and won several local CAMRA awards. Guest beers are updated on social media. Regular events include a quiz, live music and charity days. This community-oriented venue has a beer garden outside, and an open fire indoors during winter. Traditional bar games include shove-ha'penny with real ha'pennies. ➸✤ㅇ➸♣P🖵❀📶

Birchanger

Birchanger Sports & Social Club

229 Birchanger Lane, CM23 5QJ
☎ (01279) 813441 ⊕ birchangerclub.com
Eagle IPA; 3 changing beers (sourced nationally) Ⓗ
A friendly local social club where CAMRA members are welcome as guests. Many matches and events take place here, so it can get very busy. Beers change frequently as the turnover is high. The club has football, cricket, bowls, darts, crib and snooker teams, and hosts regular quizzes, plus bingo and bottle draws. It has won the local CAMRA Club of the Year award on several occasions. ➸✤❍◐ㅇ♣P🖵(7,7A) 📶

Boreham

Queen's Head 🍷

Church Road, CM3 3EG
☎ (01245) 467298
4 changing beers (sourced nationally) Ⓗ
In the same family for over 20 years, this friendly pub, dating from the 16th century, is just past the church, tucked away behind houses. There are two contrasting

☎ (01787) 277402 ⊕ halfmoonbelchamp.co.uk
3 changing beers (sourced nationally) Ⓗ
Beautiful, friendly, thatched pub dating from about 1685, situated opposite the village green. Three real ales are available with guest beers changing regularly, and often supplied by local breweries. This rural venue is popular with locals and has an excellent choice of freshly-made and locally-sourced bar and restaurant meals (no food Sun eve or Mon). In the past, it provided one of the locations for the first Lovejoy TV series, and has original wooden beams and low ceilings in places.
Q➸✤❍◐ㅇ♣P📶

Billericay

Coach & Horses Ⓛ

36 Chapel Street, CM12 9LU
☎ (01277) 622873 ⊕ thecoachandhorses.org
Adnams Broadside; Mighty Oak Maldon Gold; Oakham Citra; Wibblers Dengie IPA; 1 changing beer (sourced nationally) Ⓗ
Close to the High Street, this welcoming pub with an inviting atmosphere has appeared in the Guide for over 20 years. Five ales are served, with one always from Oakham. The pub is part of the Oakademy, the brewery's accreditation scheme. Good-quality home-made food is available selected lunchtimes and evenings, with a curry night on Wednesday. The bar service is efficient and

bars: one with bench seating, where darts, dominoes and crib are played; the other for dining. Home-cooked food is served Wednesday to Sunday. In the warmer months the garden is a lovely place to sit, and you can enjoy drinks and food at one of the picnic benches, in view of the village church. Beer festivals are held over the bank holiday weekends of Easter and August. Local CAMRA Pub of the Year 2022.
♿🌳🍴♣♠P🚌(40,71A) 😺🛜

Braintree

King William IV 🅛

114 London Road, CM77 7PU
☎ (01376) 567755 ● kingwilliamiv.co.uk
4 changing beers (sourced nationally) 🅖
Friendly free house serving a changing range of real ales, usually featuring Essex microbreweries, with at least one from the Moody Goose Brewery, located in the grounds of the pub. It also serves a changing range of boxed cider from popular producers, not all real. There is a main bar and a small back bar with a dartboard. A large patio area with picnic tables and extensive gardens host beer festivals and other events. This is a traditional drinking pub that does not offer cooked meals. Q🌳♣♠P🚌😺🛜

Brentwood

Rising Sun ✅

144 Ongar Road, CM15 9DJ (on A128, at Western Rd jct)
☎ (01277) 227400
Greene King IPA; Sharp's Atlantic; Timothy Taylor Landlord; 2 changing beers (sourced nationally) 🅗
Superb community local with five real ales, extensively refurbished and extended in spring 2020. A charity quiz is held on Monday evening. There are frequent darts matches in the public bar and occasional chess evenings. Five handpumps in the saloon bar dispense three regular ales plus two guests. Outside is a covered, heated smokers' area, a new garden and a patio.
♿🌳♣P🚌(21,71) 😺🛜

Victoria Arms

50 Ongar Road, CM15 9AX (on A128)
☎ (01277) 201187
Adnams Ghost Ship; Crouch Vale Brewers Gold; Harvey's Sussex Best Bitter; 3 changing beers (sourced nationally) 🅗
Pleasant and comfortable Gray & Sons pub with a friendly atmosphere. Unusually for the area, there is normally a Harvey's beer on tap, as well as Ghost Ship and three changing ales. There are several TV screens which mostly show sports matches, and an outside smoking area. Cribbage and other card games are played. Local CAMRA Pub of the Year 2021. 🌳♦♣P🚌(498,21)

Brightlingsea

Railway Tavern 🅛

58 Station Road, CO7 0DT
● alesattherails.co.uk
Crouch Vale Essex Boys Best Bitter; 2 changing beers (sourced nationally) 🅗
Refurbished over the last few years, the pub has gained a new bar area and covered garden area, with the existing bars and toilets much improved, all while maintaining the traditional local ambience. Since changing hands in 2018, the ales here have remained in excellent condition. The annual cider and perry festival in early May resumed in 2022 after a pandemic-enforced interlude. Local CAMRA Pub of the Year 2020.
Q♿🌳😺🚌(62)😺

Broads Green

Walnut Tree ★ 🅛 ✅

CM3 1DT
☎ (01245) 360222
Bishop Nick Ridley's Rite; Timothy Taylor Landlord; 1 changing beer (sourced nationally) 🅖
This red-brick Victorian pub overlooking the green, previously a dairy, has a CAMRA recognised interior of outstanding historic interest. The front door opens into what was the bottle and jug, but is now a small snug. To the left is a wood-panelled public bar, little-changed since it was built in 1888. To the right is a slightly more modern saloon bar. Outside there is seating at the front, a children's play area and a large garden. No food is served – the landlord preferring to concentrate on his beers and maintaining a traditional atmosphere.
Q♿🌳🅰♣♠P😺🛜

Broxted

Prince of Wales 🅛 ✅

Brick End, CM6 2BJ
☎ (01279) 850256 ● princeofwalesbroxted.co.uk
Greene King IPA; 5 changing beers (sourced nationally) 🅗
This former Charrington pub has been transformed into a welcoming community venue after the current landlords took over more than 10 years ago. It has a comfortable split-level bar, an adjoining room with two wood-burners, and a conservatory seating up to 50. Generous portions of food, mostly made using locally-sourced produce, will satisfy the most demanding appetite. A small garden is to the rear. Up to five guest beers are sold, with LocAle from Bishop Nick. ♿🌳🍴P🚌(6)😺🛜

Bures Hamlet

Eight Bells 🅛

6 Colchester Road, CO8 5AE
☎ (01787) 227354
Greene King IPA, Abbot; 4 changing beers (sourced nationally) 🅗
A real gem, this is a traditional village local with a longstanding landlord in his 42nd year here. Three distinct areas are served by a large bar. Good value home-made food is available seven days a week, with a roast on Sunday. There is a large outdoor drinking area. The pub is a short walk from the station and is popular with walkers and cyclists due to the lovely locality.
Q♿🌳🍴&🚆(Bures) P🚌(83,754)😺🛜

Burnham-on-Crouch

New Welcome Sailor

Station Road, CM0 8HF
☎ (01621) 784778
Mighty Oak Maldon Gold; Wibblers Dengie IPA, Crafty Stoat 🅗
A welcoming and friendly street-corner local owned by Grays. It hosts regular live music and karaoke events. There is an attractive outside seating area and rear patio garden, and a separate function room. Several TVs show live sport and the pub is home to darts and pool teams. A weekly meat raffle is held in aid of local charities.
♿🌳🍴♣P🚌(31B,31X)😺🛜

Queen's Head

26 Providence, CM0 8JU
☎ (01621) 784825
Dark Star Hophead; Wibblers Dengie IPA; 2 changing beers (sourced nationally) 🅗

A true locals' pub just off the High Street, owned by Gray & Sons. It is frequently busy, with a good and varied range of beers and ciders. The basic no-frills interior is warmed in winter by a log-burning stove, and the pool table is a popular feature. A small sheltered garden to the rear provides a delightful outside space, with a heated smoking area. Beer festivals are hosted. Burnham-on-Crouch railway station is 15 minutes' walk away. Q❀♣🖵🖵(31X)❀🐾🛜

Chappel

Swan Inn 🅛
The Street, CO6 2DD
☎ (01787) 222353 ∰ swaninn-chappel.com
3 changing beers (sourced nationally) 🅗
Grade II-listed building near the striking viaduct of the local train line. The pub has a very large garden, with an alfresco terrace and a heated marquee. Very good food is served every day, with breakfast available at the weekend. Beers vary but regularly come from Colchester Brewery a short distance away. There is a mini crazy golf course in the garden. The pub is a short walk from Chappel station. ❀◑➤≠(Chappel & Wakes Colne)P🖵

Chelmsford

Ale House 🅛
24-26 Viaduct Road, CM1 1TS
☎ (01245) 260535 ∰ the-ale-house-chelmsford.co.uk
9 changing beers (sourced nationally) 🅗
A unique bar, located under the arches of Chelmsford railway station, with one of the widest ranges of continuously changing beers in Essex, always including dark and stronger beers, plus eight craft keg beers and 12 real ciders. There are also imported beers on tap and a wide range of bottled beers from around the world. No food is served, but customers are welcome to bring their own. Quizzes are held on the last Sunday of each month and there are regular beer festivals.
🍺♿❀🐾≠♣🖵🐾🛜

Hop Beer Shop 🅛
173 Moulsham Street, CM2 0LD
☎ (01245) 353570 ∰ thehopbeershop.co.uk
4 changing beers (sourced nationally) 🅖
Essex's first micropub. Four ales are served by gravity, with local breweries always represented, as well as interesting beers from around the country. A stout or porter and a golden beer are usually available. There are also craft keg beers, around 100 bottled beers from local and international breweries, and bottled cider (not all real), which may be drunk here or purchased to take home. Local CAMRA Pub of the Year 2016 and 2017 and Cider Pub of the Year 2018-2020. Q🐾🖵(42,100)🐾🛜

Orange Tree 🅛
6 Lower Anchor Street, CM2 0AS
☎ (01245) 262664 ∰ the-ot.com
Mighty Oak Oscar Wilde; house beer (by Chelmsford); 7 changing beers (sourced nationally; often Colchester) 🅗
One of the best real ale pubs in Chelmsford and local CAMRA Pub of the Year in 2020. It is a place for conversation and meeting friends, with separate public and saloon bars. A great range of real ales is on tap, always including something dark, plus craft keg beers. There is also a changing range of boxed cider from popular producers, not all real. Food is served at lunchtimes, including a roast on Sunday.
🍺❀◑♿♣🖵P🖵(42,100)🐾🛜

Original Plough ✔
28 Duke Street, CM1 1HY
☎ (01245) 250145 ∰ theoriginalploughchelmsford.co.uk
Fuller's London Pride; Sharp's Doom Bar; St Austell Tribute; 3 changing beers (sourced nationally) 🅗
Newly refurbished and conveniently located close to both railway and bus stations, this pub is now one of Mitchells & Butlers Oak Tree brand. Six handpulls are available to serve beers. An open-plan pub with several distinct areas, there are historical local prints throughout, and large screens showing news and sporting events. Good-value pub food is available all day, starting with breakfast, with various meal and drink deals, and a 20% student discount Monday-Thursday on selected food and drink. 🍺❀◑♿≠P🖵🛜

Queen's Head 🅛
30 Lower Anchor Street, CM2 0AS
☎ (01245) 265181
Crouch Vale Essex Boys Best Bitter, Brewers Gold; 5 changing beers (sourced nationally) 🅗
Crouch Vale Brewery's first pub in the city, this venue sells three of its beers permanently, with four guests, which may include a Crouch Vale seasonal and always include a dark beer. This Victorian L-shaped pub has bare board flooring and comfortable bench seating. Two fires make it cosy in winter. A popular local, it can be busy when there is a match at the nearby county cricket ground. ❀♣P🖵(42,100)🐾🛜

Railway Tavern 🅛
63 Duke Street, CM1 1LW
☎ (01245) 280679
Greene King Abbot; Red Fox IPA; 5 changing beers (sourced nationally) 🅗
A Tardis-like corner pub, right outside Chelmsford station. Not surprisingly, a railway theme dominates. The interior is long and narrow, with banks of handpumps at opposite ends of the central bar counter. Craft beers and over 50 different gins are also available. There is a small, enclosed garden where you can listen to the station announcements and marvel at the ever-changing mural. The pub may stay open later on Sundays in the summer. Local CAMRA Pub of the Year 2018. ❀◑≠♣🖵🐾🛜

Ship 🅛
18 Broomfield Road, CM1 1SW
☎ (01245) 265961 ∰ theshipchelmsford.co.uk
Greene King IPA, Abbot; 5 changing beers (sourced nationally; often Bishop Nick) 🅗
Traditional medium-sized pub with a comfortable interior and some outside seating in front. The decor is nautical, with dark-brown panelling, portholes, masts, rope, rigging and other maritime artefacts. A wide range of food is offered, including daily specials. There is a jukebox and occasional live music. Sport is shown on the TV. Close to rail and bus stations, with a public car park at the rear. 🍴◑≠🖵🛜

Chrishall

Red Cow
11 High Street, SG8 8RN (N of B1039) TL446393
☎ (01763) 838792 ∰ theredcow.com
Adnams Southwold Bitter; Woodforde's Wherry; 2 changing beers (sourced nationally) 🅗
Thatched 14th-century inn in a small village near the Cambridgeshire/Hertfordshire borders with a tiled bar and restaurant separated by original open timbering. Situated on the Icknield Way, this is a popular stop-off for ramblers. The pub has a good reputation for food, and guest beers are usually from East Anglia. High quality

accommodation is available in the renovated barn alongside. The pub provides the village with essential supplies from a permanent shop established in the car park. One corner of the bar has a small tuck shop.
Q ⑤ ✿ ⛵ ◖ P ♿ 🐾 📶

Clacton-on-Sea

Old Lifeboat House

39 Marine Parade East, CO15 6AD
☎ (01255) 476799
Greene King Abbot; St Austell Proper Job; 3 changing beers (sourced nationally; often Colchester, Greene King, St Austell) 🅷
A favourite with locals, this family-run pub usually has up to five ales available, regularly including local beers from Colchester, Mauldons and Mighty Oak, as well as numerous ciders and perries. A regular in this Guide for more than a decade, it is a former local CAMRA Pub of the Year and Cider Pub of the Year. Food is available Wednesday evening, and occasionally at other times, though hours vary so check first. Two darts teams play on Monday or Thursday. ⑤ ✿ ◖ ≼ ♣ ● 🚰 📶

Colchester

Ale House L

82 Butt Road, CO3 3DA
☎ (01206) 573464 ⊕ thealehousecolchester.co.uk
10 changing beers (sourced nationally) 🅷
A genuine free house just outside the town centre. A wide range of ales is dispensed via handpump and also on gravity, including one dark beer. Real cider is served from the fridge. Regular quiz and folk nights are held. Darts, bar billiards and TV sport are available. The pub has won many local CAMRA awards under the friendly landlady. There is a large walled garden at the rear which was a saviour during the pandemic.
✿ ≼ (Town) ♣ ● 🚰 (S6,S7) 📶

British Grenadier

67 Military Road, CO1 2AP
☎ 07832 215118
4 changing beers (sourced nationally) 🅷
This welcoming local, run by a knowledgeable publican, has featured in the Guide for over 15 years. A traditional Victorian two-bar pub, it has a pool table in the small rear bar and a dartboard in the main bar, heated by an open fire in the winter months. A changing range of local, regional and nationally sourced beers and ciders is served via handpump.
⑤ ✿ ◖ ≼ (Town) ♣ ● 🚰 (S1,S9) 🐾 📶

Fat Cat L

65 Butt Road, CO3 3BZ (nr police station)
☎ (01206) 577990 ⊕ fatcatcolchester.co.uk
Bishop Nick Heresy; Crouch Vale Brewers Gold; Fat Cat Tom Cat, Honey Ale; Hop Back Summer Lightning; 4 changing beers (sourced nationally) 🅶
A popular single bar, split-level establishment just outside the town centre, with the town's smallest pub garden. A good choice of quality ales is sold on gravity dispense from a central tap room. There is also a good selection of Belgian beers and cider. A recent refurbishment has given the pub an upstairs area with a balcony. Home-cooked brunch and pub grub is served all week, and roasts on Sunday. A regular quiz is held on a Sunday. ⑤ ✿ ◖ ≼ (Town) ♣ 🚰 (S6,S7) 🐾 📶

Magnet

134 North Station Road, CO1 1UZ
☎ 07707 399131 ⊕ themagnetpub.co.uk

3 changing beers (sourced nationally) 🅷
Newly renovated micropub on the site of the old Norfolk pub, close to Colchester (North) station. Its name honours the achievements of William Gilberd. Totally independent, three changing ales are on offer, alongside an unusual selection of keg, and a full range of Essex spirits. The pub has a functional layout with a relaxed vibe, and benefits from a suntrap, westerly-facing courtyard area. ⑤ ✿ ≼ ♣ ● P 🚰 🐾 📶

New Inn L

36 Chapel Street South, CO2 7AX
☎ (01206) 522422 ⊕ theoldnewinnpub.co.uk
6 changing beers (sourced nationally) 🅷
With a quiet, comfortable and cosy saloon bar, an open fire and a stripped-back public bar featuring music, TV sports and friendly conversation, this is definitely a venue of two halves. There are up to six real ales and four real ciders on offer. Traditional pub food is served Wednesday to Saturday lunchtimes and evenings, with a traditional roast lunch on Sunday. Numerous board games can be found in the saloon bar. A free-to-hire function room for groups is available.
Q ⑤ ✿ ◖ ♿ ≼ (Town) ♣ ● P 🚰 (S6,S7) 🐾 📶

Odd One Out L

28 Mersea Road, CO2 7ET
☎ 07976 985083
Colchester Metropolis, Number One; 5 changing beers (sourced nationally) 🅷
The multi award-winning Odd One Out features two bars and a back room for customers to enjoy. It offers at least two beers from Colchester Brewery and a range of changing guest ales over seven handpumps, as well as a varied range of ciders. There is a large, landscaped rear garden allowing for a quiet pint outdoors in warmer months, with open fires providing warmth in winter. Check Facebook for regular evening quizzes, impromptu music sessions and barbecues.
Q ⑤ ✿ ≼ (Town) ● 🚰 (8,S8) 🐾 📶

Purple Dog L

42 Eld Lane, CO1 1LS
☎ (01206) 564995 ⊕ thepurpledogpub.co.uk
Adnams Ghost Ship; Fuller's London Pride; 4 changing beers (sourced regionally) 🅷
One of the oldest inns in Colchester, dating back to 1647, this corner pub in the town centre features an outdoor drinking area, and wooden beams internally. Six handpumps provide mainly regional beers, alongside the usual town-centre pub offerings. An extensive menu, complemented by changing special dishes, is available daily. The pub hosts regular music events (DJs with occasional bands) and a monthly quiz night.
⑤ ✿ ◖ ≼ (Town) 🚰 📶

Three Wise Monkeys L

60 High Street, CO1 1DN
☎ (01206) 543014 ⊕ threewisemonkeyscolchester.com
Colchester Metropolis, Number One; Greene King Yardbird; 3 changing beers (sourced nationally) 🅷
Large single-bar public house in a prominent place on the High Street that offers a large range of cask and keg beers, as well as a downstairs gin bar. The top floor hosts music most weekends. The restaurant menu has a smokehouse focus. Regular special events are held, including comedy nights, live music, open mic, quiz nights, and food and drink tastings.
✿ ◖ ♿ ≼ (Town) 🚰 ● 📶

Victoria Inn L

10 North Station Road, CO1 1RB
☎ (01206) 514510 ⊕ victoriainncolchester.co.uk

5 changing beers (sourced nationally) Ⓗ
Multi award-winning pub and current local CAMRA Cider Pub of the Year. It has three distinct seating aras, a quiet area with sofas, a traditional pub area with low tables and a real fire in winter, and a lively rear bar. Two regular beers from Colchester Brewery, and three other constantly changing beers sourced nationally are on offer. Six to nine real ciders are available most of the time. A pleasant courtyard-style area outside is a suntrap in summer. There is live music every other Sunday evening, often held outside in summer. The pub is dog friendly. ✿≉♣♠🚪🚍🐾🐶🛜

Coopersale

Garnon Bushes ✓

13 Coopersale Common, CM16 7QS
☎ (01992) 560211 ● garnonbushespub.com
Courage Best Bitter; Timothy Taylor Landlord; 1 changing beer (sourced nationally) Ⓗ
Situated on the edge of Epping Forest and on the Essex Way, this pub has flagged floors and low beams, and dates back to the 17th century. It was fully refurbished in 2013, and redecorated during lockdown. It is near to the Epping Ongar Steam Railway and is very popular with dog walkers. The menu is varied and there is pleasant outdoor seating. The Mozzino Scooter Club meets there and there is space for a pre-booked overnight stop with a campervan. 🛝✿🕙🛏🚍P🚫

Debden

Plough Ⓛ

High Street, CB11 3LE
☎ (01799) 541899 ● theploughatdebden.co.uk
3 changing beers (sourced nationally) Ⓗ
The sole remaining pub in the village, now revitalised by a young, energetic couple. It has a restaurant and garden, and offers a warm and friendly welcome. An interesting and varied range of local beers is available, alongside an extensive food menu. The pub is an important social centre for this village and the surrounding area, and it is a good base for walkers and cyclists. A monthly quiz night is normally held on the third Wednesday. Q🛝✿🕙🛏P🚍(6,313)

Duton Hill

Three Horseshoes Ⓛ

CM6 2DX (1 mile W of B184) TL606268
☎ (01371) 870681 ● the-shoes.co.uk
Mighty Oak Maldon Gold; 2 changing beers (sourced nationally) Ⓗ
Outstanding village local with a garden, wildlife pond, and terrace overlooking the Chelmer Valley and farmland. The landlord often hosts a weekend of open-air theatre in July. A millennium beacon in the garden, breweriana, and a remarkable collection of Butlin's memorabilia are features. A beer festival is usually held on the late spring bank holiday in the Duton Hill Den. Look for the pub sign depicting a famous painting, Our Blacksmith, by former local resident Sir George Clausen. Local and parish newspapers are available.
🛝✿🕙♣P🚍(313)🐶

Epping

Forest Gate Inn Ⓛ

111 Bell Common, CM16 4DZ (turn off main road opp Bell Hotel)
☎ (01992) 572312 ● forestgateinnepping.co.uk

Adnams Southwold Bitter, Broadside; Bishop Nick Ridley's Rite Ⓗ; **1 changing beer** Ⓗ/Ⓖ
On the edge of Epping Forest, in a 17th-century building with low ceilings and flag floors, this pub has been run by the same family for 50 years. It is popular with locals, walkers and their dogs. Hot pub meals and soups are available in the bar, as well as in Haywards Restaurant next door, which also offers B&B accommodation. There is a large grassed seating area. The town centre and the London Underground station are around a mile away.
Q🛝✿🛏🚪🕙P🚍🐶🛜

Finchingfield

Finchingfield Lion Ⓛ

6 Church Hill, CM7 4NN (on B1053, opp Guildhall)
☎ (01371) 810400 ● thefinchingfieldlion.co.uk
4 changing beers (sourced locally) Ⓗ
Fifteenth-century coaching inn set just up the hill from the pond in this famously picturesque village. A friendly local with a warm atmosphere, it is popular with cyclists, walkers, locals and families. There is a heavily beamed bar area with an open fire, a separate restaurant, function room, and a garden for better weather. Four beers are usually available from various local breweries including Mauldons, Green Jack and Wibblers. The food menu features only pizzas with old favourites and some interesting variations. Q🛝✿🕙♣P🚍🐶🛜

Fobbing

White Lion ✓

1 Lion Hill, SS17 9JR (nr B1420)
☎ (01375) 673281 ● thewhitelionfobbing.com
Greene King IPA; Sharp's Atlantic; St Austell Tribute; Wadworth 6X Ⓗ
Attractive hilltop pub in a 15th-century building that was originally used as a chandlery, making sails for ships that used the nearby wharf. It was licensed to sell alcohol in 1605. This traditional village local has home-cooked food and a large beer garden which includes a small bar. The famous author Daniel Defoe and the Peasants' Revolt leader Jack Straw reputedly frequented the pub.
✿🕙P🚍(11,374)🐶🛜

Galleywood

Horse & Groom

The Common, CM2 8PL
☎ (01245) 261653
Greene King IPA; Sharp's Doom Bar; 3 changing beers (sourced nationally) Ⓗ
Traditional pub, tucked away on Galleywood Common overlooking the old racecourse, making it a popular stop-off for walkers. It has one quiet bar and one with a TV. Home-cooked meals are available. Many photos of Old Chelmsford, in particular the old racecourse, adorn the walls, as well as a 1908 map of Essex. Various car and biker clubs meet here, and barbecues often feature. There is a winter beer festival and occasional live music. Q✿🕙🚗♣P🚍(42,100)🐶🛜

Goldhanger

Chequers ✓

11 Church Street, CM9 8AS
☎ (01621) 788203 ● thechequersgoldhanger.co.uk
Adnams Ghost Ship, Broadside; Sharp's Atlantic; St Austell Proper Job; Timothy Taylor Landlord; 2 changing beers (sourced nationally) Ⓗ
Characterful village inn which has several timbered rooms, including a snug, and a games room with a bar

billiards table. There is an extensive menu offering quality locally-sourced food. The rear courtyard is a suntrap in the summer and open fires in the two bars provide a warm welcome in winter. There are excellent walks nearby along the River Blackwater. Q❄️�️◐▶♣️🅿️🚆(95) 🌸🛜

Grays

Theobald Arms 🍷

141 Argent Street, RM17 6HR (5-7 mins' walk from Grays rail and bus stations, down Kings Walk)
☎ (01375) 372253 🌐 theosarms.co.uk
4 changing beers (sourced nationally) Ⓗ

Genuine, traditional pub with a public bar that has an unusual hexagonal pool table. The changing selection of four guest beers features local independent breweries, and a range of British bottled beers is also stocked. Regular summer beer festivals are held in the old stables and on the rear enclosed patio. Lunchtime meals are served Monday to Friday. Darts and cards are played. Local CAMRA Pub of the Year 2022. 🏮◐�$⇌♣️🅿️🚆

Wharf

Wharf Road South, RM17 6SZ (S of A126)
TQ6085077578
☎ (01375) 374633 🌐 thewharfgrays.co.uk
Adnams Ghost Ship; Sharp's Doom Bar; 3 changing beers (sourced regionally) Ⓗ

Grade II-listed, wood-panelled riverside pub below the River Thames wall, in a new housing development. It reopened under new ownership in 2021 after renovation. Hot food is available every day, and a Sunday carvery. Regular weekly events include a quiz on Monday evening, Tuesday jam session, Wednesday board games and card games, a DJ or live music on Friday, and Saturday open mic. ❄️🏮◐▶♿️🅿️🚆🌸🛜

White Hart Ⓛ ✅

Kings Walk, RM17 6HR (5-7 mins' walk from Grays rail & bus stations, down Kings Walk)
☎ (01375) 373319 🌐 whitehartgrays.co.uk
Dartmoor Legend; 4 changing beers (sourced nationally) Ⓗ

Traditional local just outside the town centre, which has been rejuvenated since it was taken over in 2006. The regular beers are supplemented by four guests (one dark) and a selection of over 30 bottled Belgian beers. Good-value meals are served weekday lunchtimes. There is a meeting/function room and a large, secluded beer garden. Live music features on Saturday. An extensive collection of old-fashioned soft toys is displayed on the historic bar-back. The pub supports pool and darts teams, and sport is screened. Local CAMRA Pub of the Year 2019 and 2020. 🏮♣️🍴◐�$⇌♣️🅿️🚆🌸🛜

Great Baddow

Chelmsford Brew Co Taproom

Brewery Fields, Church Street, CM2 7LE
☎ (01245) 476267 🌐 chelmsfordbrewco.co.uk
2 changing beers (sourced nationally; often Chelmsford)

Located on a small industrial estate in the Great Baddow area of Chelmsford, the Taproom is part of the Chelmsford Brew Co brewery, just behind the brewery shop. With comfortable seating and several benches, the layout lends itself to good conversation and a pleasant atmosphere. A selection of the brewery's own beers is always available, supplemented by the occasional guest beer in cask. Q❄️🌸🅿️🛜

Great Bardfield

Bell Inn Ⓛ

Dunmow Road, CM7 4SA
☎ (01371) 239165
1 changing beer (often Bishop Nick) Ⓗ

A friendly local with a warm welcome. Inside, it has a beamed main bar and restaurant area with an open fire; and a separate public bar with TV and darts. There is also a pool table. Outside is a patio area. Good-value, locally-sourced food is available. The pub is linked to the Great Bardfield Artists, and is a refreshment stop on the Dunwich Dynamo cycle trip. Closing time may vary, but if the outside lights are on, the pub is open. ❄️🏮◐▶♣️🅿️🚆🌸🛜

Great Bromley

Cross Inn

Ardleigh Road, CO7 7TL
☎ (01206) 621772 🌐 greatbromleycross.pub
2 changing beers (sourced nationally) Ⓗ

Saved by the community in 2016 after much campaigning, fund-raising and a share offer, this pub – formerly the home of Frank Goddard, a British heavyweight boxing champion – now also hosts the post office, a coffee shop, and a library on Wednesday morning. Since reopening, the interior (including cellar and kitchen) has been refurbished and the toilets extended and twinned, with disabled access by radar key 24 hours per day. A remote country inn, this absolute gem is well worth a visit. Hours vary, so check before travelling. 🏮♿️🅿️🚆(77A,105)🌸

Great Dunmow

Boars Head

37 High Street, CM6 1AB
☎ (01371) 873630
Adnams Southwold Bitter; Fuller's London Pride; 1 changing beer (sourced nationally) Ⓗ

A 400-year-old traditional town-centre pub, also accessible from the main public car park. This is a timber-framed lathe and plaster building, with beamed low ceilings and three large-screen TVs for sport. Live music is performed on Saturday evenings throughout most of the year. A large decking area at the rear includes covered seating for smokers. No food is served – the focus is on social drinking. 🏮🅿️🚆(X30,133)🛜

Great Oakley

Maybush Inn 🍷 Ⓛ

Farm Road, CO12 5AL
☎ (01255) 880123 🌐 maybushinn.co.uk
Courage Directors; house beer (by Eagle); 1 changing beer (sourced nationally) Ⓗ

An extremely welcoming and friendly village local, this community-owned pub has been a regular Guide entry in recent years. Its ales are kept in excellent condition, and it was voted local CAMRA Pub of the Year 2022. Various activities such as quizzes, bingo, crib and music are hosted every week, enjoyed and supported by the community. A quiet beer garden has been recently added. A beer festival is held each February to mark the anniversary of the pub's opening. Q❄️🏮◐▶♣️🌸🚆(102,104) 🌸🛜

Halstead

White Hart Inn Ⓛ

15 High Street, CO9 2AA

☎ (01787) 475657 ● whitehartinnhalstead.co.uk
4 changing beers (sourced nationally) Ⓗ
The White Hart is one of the oldest coaching inns in Essex. The pub is a medieval hall believed to have been built in the 13th century. It has its own brewery and gin distillery in the old stables; the distillery produces London dry and hop gins. Ales include those from its own brewery as well as local and national beers. Comfortable en-suite bedrooms and traditional home-cooked food, including Sunday roasts, are on offer. ❀⇆◑Ⓟ🖵(88)❀ 🖰

Harwich

Alma Inn Ⓛ ✅
25 Kings Head Street, CO12 3EE
☎ (01255) 318681 ● almaharwich.co.uk
Adnams Southwold Bitter, Broadside; 4 changing beers (sourced regionally) Ⓗ
This fascinating medieval building has been a pub since 1859 and is the embodiment of an ancient inn – providing excellent food, drink and accommodation, although with a distinctly modern twist. Core ales from Adnams are complemented by ever-changing guests, including local brews from Harwich Town Brewery. Take a seat in the main bar to be among the comings and goings, with plenty of history and artefacts to look at; or hide away in one of the plentiful nooks and crannies. ⮞❀⇆◑⮲(Town) ●🖵❀ 🖰

New Bell Inn Ⓛ
Outpart Eastward, CO12 3EN
☎ (01255) 503545 ● thenewbell.co.uk
Greene King IPA; Mighty Oak Oscar Wilde; 2 changing beers (sourced regionally) Ⓗ
This historic 18th-century inn gives a nod to its history before you enter, with a blue plaque on the wall marking the nearby burning of a martyr. The pub has always been a community favourite, with many local groups using it to meet. A regular mild from Mighty Oak, which is much-loved by the locals, is complemented by a changing guest real ale and cider line-up. There is a small car park and a secret walled garden for sunny weekends and summer evenings. Q⮞❀◑⮲(Town)♣●Ⓟ🖵❀ 🖰

Hazel End

Three Horseshoes
CM23 1HB
☎ (01279) 813429 ● threehorseshoeshazelend.co.uk
Adnams Southwold Bitter; Sharp's Doom Bar; 1 changing beer (sourced locally) Ⓗ
A friendly pub opposite the cricket green at Hazel End, with low ceilings, black wooden beams and two wood-burning stoves. It has been completely renovated – and a large extension has created more space to both eat and drink comfortably. Food offerings include an impressive fish menu. This is a good example of a once run-down premises transformed into a thriving, successful establishment. ❀◑ⒶⓅ❀

Helions Bumpstead

Three Horseshoes
Water Lane, CB9 7AL
☎ (01440) 730088 ● helionscommunitypub.co.uk
Adnams Southwold Bitter; 3 changing beers (sourced regionally) Ⓗ
Village pub brought back to life by the Helions Bumpstead Community Benefit Society and reopened in December 2021 having been closed for four years. Now managed by experienced local licensees, the pub is run on community principles with community events held. A

mobile post office, refill provisions van, and a fruit and veg stall visit the car park on Thursday morning. The pub is gaining a reputation for its restaurant. Q⮞❀◑♿♣Ⓟ🖵(59) ❀

High Roding

Black Lion Ⓛ
3 The Street, CM6 1NT (on the B184 Dunmow to Ongar road)
☎ (01371) 872847 ● theblacklionhighroding.co.uk
4 changing beers (sourced locally; often Colchester, Hadham, New River) Ⓗ
A striking half-timbered, 14th-century building, formerly a coaching inn on the London to Norwich road. It has low ceilings, oak beams and a huge fire in winter. The restaurant serves good locally sourced food, with a popular roast on Sunday. There is a TV in the end bar, usually showing rugby on Saturday. Outside is a pleasant courtyard garden. The pub runs tasting evenings throughout the year. Q⮞❀◑♿Ⓟ🖵(17,18)❀

Horndon-on-the-Hill

Bell Inn
High Road, SS17 8LD (nr centre of village, almost opp the Woolmarket and Orsett Rd)
☎ (01375) 642463 ● bell-inn.co.uk
Crouch Vale Brewers Gold; 3 changing beers (sourced nationally) Ⓗ
Popular 15th-century coaching inn, where beamed bars feature wood panelling and carvings, run by the same family since 1938. Note the hot cross bun collection; a bun has been added every Good Friday for more than 100 years. One regular beer is on the bar, plus three guests, including ales from Essex breweries. The award-winning restaurant is open daily, lunchtimes and evenings (booking advisable). Gourmet nights are held – see website for details. Accommodation is available in 27 bedrooms. Q⮞❀⇆◑♿Ⓟ🖵(11)❀ 🖰

Kirby-le-Soken

Ship
35 Walton Road, CO13 0DT
☎ (01255) 679149 ● theshipkirbylesoken.co.uk
Adnams Southwold Bitter, Ghost Ship, Broadside; 3 changing beers (sourced nationally) Ⓗ
This busy free house has a large beer garden to the rear with a marquee used for various events throughout the year, including an annual beer festival. An outside seating area to the front is also popular in fine weather. For cider lovers, trays of three third-pints are available to help you choose a favourite. A wide selection of food is offered in the restaurant. Well-behaved dogs are welcome. Local CAMRA Pub of the Year in 2021 and a former local CAMRA Cider Pub of the Year. Q⮞❀◑♣●Ⓟ🖵(98,98A) ❀ 🖰

Lamarsh

Lamarsh Lion
Bures Road, CO8 5EP (1 ¼ miles NW of Bures) TL892355
☎ (01787) 227007 ● lamarshlion.co.uk
4 changing beers (sourced nationally) Ⓗ
The rural runner-up in the local CAMRA branch Pub of the Year 2022 competition, this popular 14th-century community pub continues to go from strength to strength. Boasting both Constable and Gainsborough as former customers, whose paintings represented outstanding views of the Stour Valley, it showcases several social events, including music, in its beautifully

renovated interior. There is a varied daily menu which includes specials. Cyclists, ramblers and dogs are all welcome. Q✤✿❀✉❍◖♦♿▲♣P❀❀🔊

Langley Lower Green

Bull

Park Lane, CB11 4SB TL437345
☎ (01279) 777307 ⊕ thebullpub.co.uk
Adnams Southwold Bitter; Bishop Nick Heresy; 2 changing beers (sourced regionally) Ⓗ
Classic Victorian village local with original cast-iron lattice windows, in a tiny isolated hamlet close to both Hertfordshire and Cambridgeshire. The pub has a band of local regulars. There is an aquarium in the lounge bar. Occasional quiz nights are held. An annual beer festival takes place in September. Parties can pre-book food at times when it is normally unavailable, and regular food vans are available at weekends. ✤✿❀♣P❀❀🔊

Layer Breton

Hare & Hounds

Crayes Green, CO2 0PN
☎ (01206) 330459 ⊕ thehareandhound.co.uk
Red Fox Coggeshall Gold; 3 changing beers (sourced nationally) Ⓗ
Attractive country pub with a single bar, and a room for dining and functions. There is also a garden room which can host bands and other functions. It has a large garden, with camping available onsite. Three mini beer festivals are held each year, including on St George's Day. A post office is available on Tuesday and Thursday mornings. Quiz night is on the first Wednesday of the month. This pub has won numerous awards.
✤✿❀✉❍◖♦♿♣P❍(50A,92) ❀🔊

Layer-de-la-Haye

Donkey & Buskins Ⓛ

Layer Road, CO2 0HU
☎ (01206) 734774 ⊕ donkeyandbuskins.co.uk
Greene King IPA; 2 changing beers (sourced nationally) Ⓗ
Built circa 1840, this hostelry, run by the same family since 1985, is now an aspiring fresh food gastro-pub supporting local produce suppliers. Up to five ales are available from local and national brewers. It has a bar and three restaurant rooms, a large beer garden off the main road, surrounded by woodland, and a large car park. Q✤✿❀✉❍◖♦P❍(50)❀🔊

Leigh-on-Sea

Leigh On Sea Brewery Tap Ⓛ

35 Progress Road, SS9 5PR (on an industrial estate, behind an industrial unit, reached by a signposted gravel and concrete path to the right of the building)
☎ (01702) 817255 ⊕ leighonseabrewery.co.uk
8 changing beers (sourced locally; often Leigh on Sea) Ⓗ
A wide range of the brewery's beers are served through two cask and six KeyKeg lines, including one-off specials brewed on the pilot kit. The decor features exposed brickwork, tall tables, and a bar top of cockleshells. International rugby and other sporting events are shown on TV. Regular music events and food pop-ups take place. Open Thursday to Saturday, and Sunday in summer – hours can change so check the website or social media. ✿♣❍(25,20) ❀🔊

Mayflower Ⓛ

5-6 High Street, Old Leigh, SS9 2EN (at far end of Old Leigh from railway station, behind chip shop)
☎ (01702) 478535 ⊕ mayfloweroldleigh.com
Crouch Vale Brewers Gold; George's Cockleboats; St Austell Proper Job; 3 changing beers (sourced regionally) Ⓗ
Popular pub selling six beers and one cider, including some from local breweries. It has been the local CAMRA Pub of the Year three times in the past. Food is mainly fish & chips from the attached restaurant. One wall lists the names of all who sailed on the Mayflower. Dogs are welcome, and there is a pleasant seating area at the back with views of the estuary. ✤✿❀◖♦♿➤P❍(26)❀🔊

Little Oakley

Olde Cherry Tree

Clacton Road, CO12 5JH
☎ (01255) 886483
Adnams Southwold Bitter Ⓗ**; 1 changing beer (sourced nationally; often Mighty Oak, Woodforde's, Adnams)** Ⓗ/Ⓖ
Back in the Guide after a period of absence, this welcoming country inn is on the outskirts of Little Oakley, and has views from the front towards the Naze and the North Sea. Real ciders from the cellar often outnumber real ales on the handpumps. Handily located on the bus routes between Clacton and Harwich and between Colchester and Harwich via Manningtree.
✤✿❍◖♦♣P❍❀🔊

Little Thurrock

Traitors' Gate Ⓛ

40-42 Broadway, RM17 6EW (on A126)
☎ (01375) 372628 ⊕ traitorsgatepub.wordpress.com
Greene King Abbot; 3 changing beers (sourced regionally) Ⓗ
Taken over by the current operator in 2013, this hostelry has established a reputation for music, with live bands on Fridays and open mic sessions on Saturdays. The quieter, traditional end is to the right of the front bar. It has four handpumps, with three dispensing a rotating selection of guest beers. The small chalkboards above the bar list current and forthcoming beers. Real ales are discounted at various times through the week. The pub is not easy to find due to the lack of external signage.
✤✿❀♿♣(66,66A) ❀

Little Totham

Swan

School Road, CM9 8LB
☎ (01621) 331713 ⊕ theswanlittletotham.com
Crouch Vale Brewers Gold; Mighty Oak Captain Bob; St Austell Tribute; 3 changing beers (sourced nationally; often Adnams, Woodforde's) Ⓖ
A cosy three-roomed cottage-style pub, with a separate restaurant area and snug. There is a good log fire in the inglenook fireplace in winter. Beers are served direct from the cask from the chilled cellar. Locally sourced food is available at lunchtime. Children and dogs are welcome in the enclosed front and large rear gardens. An annual beer festival is held over two weeks in June, ending on Father's Day. Q✤✿❀✿♿♣P❍❀🔊

Littley Green

Compasses Ⓛ

CM3 1BU

☎ (01245) 362308 ⊕ compasseslittleygreen.co.uk
Bishop Nick Ridley's Rite; Crouch Vale Essex Boys Best Bitter; 3 changing beers (sourced nationally) Ⓖ
Formerly Ridley's brewery tap, this is a picturesque Victorian country pub in a quiet hamlet. The wood-panelled bar has benches around the walls and a tiled floor. Beers are drawn directly from casks. A changing range of boxed cider is also on offer from popular producers, not all real. Renowned filled huffers (giant baps) are available lunchtime and evening, plus other traditional dishes. There are seats and tables outside and in the large gardens. Regular beer festivals are held. Accommodation comprises five high-quality rooms. Local CAMRA Cider Pub of the Year 2022.
Q⏚🏠🛏🕪♣🐾P❤🅿♿🐾🕪

Loughton

Victoria Tavern ⊘
165 Smarts Lane, IG10 4BP
☎ (020) 8508 1779 ⊕ thevictoriatavern.co.uk
Adnams Southwold Bitter; Greene King IPA; Sharp's Doom Bar; Timothy Taylor Landlord; 2 changing beers Ⓗ
This old-fashioned, traditional pub prides itself on real ale and inclusive conversation. It lies between Loughton and Epping Forest and is a 10-15 minute walk from Loughton tube station. The pub is used by locals and walkers and has a pleasant gated garden – well-behaved dogs are welcome. It serves generous portions of fresh home-cooked seasonal food. There is no TV or fruit machines – just good ale, good food and good company.
Q⏚🐾🕪P🖾🐾🕪

Maldon

Mighty Oak Tap Room
10 High Street, CM9 5PJ
☎ (01621) 853892 ⊕ micropubmaldon.uk
Mighty Oak Oscar Wilde, Captain Bob, Maldon Gold, Kings; 2 changing beers (sourced locally) Ⓖ
Mighty Oak brewery's taproom is housed in a 500-year-old beamed building, and showcases its award-winning range of beers, served direct from the cask. The friendly atmosphere in the comfortable downstairs bar, with bench seating and free of music, encourages conversation. There is a quiet and relaxing reading room upstairs, furnished with leather sofas and chairs. Cheeseboards and locally-produced pork pies are available. Ciders are mainly from Celtic Marches. Unplugged acoustic music sessions feature every Sunday afternoon. Q⏚🐾♿♣🐾🖾🐾🕪

Queen Victoria
Spital Road, CM9 6ED
☎ (01621) 852923 ⊕ queenvictoriamaldon.co.uk
Adnams Southwold Bitter; Greene King Abbot; Mighty Oak Captain Bob; 3 changing beers (sourced nationally); often Dartmoor, Elgood's, Skinner's) Ⓗ
A warm and friendly welcome awaits at this convivial Gray's pub, with four well-kept ales from local and regional breweries and up to three guest beers and three real ciders. Extensive food menus offer locally-sourced home-cooked meals, with vegetarian and vegan options (booking recommended). Families are welcome throughout and dogs in the beer garden and public bar. Seasonal events are joyfully celebrated, together with beer festivals, darts, dominoes and bar skittles. Local CAMRA branch Pub of the Year 2020.
⏚🐾🕪♣🐾🖾🐾🕪

Rose & Crown ⊘
109 High Street, CM9 5EP
☎ (01621) 852255
Greene King Abbot; Ruddles Best Bitter; Sharp's Doom Bar; 3 changing beers (sourced nationally) Ⓗ
This 16th-century pub was acquired and substantially refurbished by Wetherspoon in 2015. Food is served all day. There are two beer festivals a year, in March/April and October. Children accompanying adults are welcome until 9pm, and families usually prefer that room that is apart from the main bar area. Mind your head on the way to the toilets upstairs (the accessible toilet is downstairs). Q⏚🐾🕪🖾🐾🕪

Manningtree

Red Lion
42 South Street, CO11 1BG
☎ (01206) 391880 ⊕ redlionmanningtree.co.uk
Adnams Southwold Bitter; 2 changing beers (sourced regionally; often Colchester, Mighty Oak, Woodforde's) Ⓗ
The Red Lion has seen many changes since its 1603 origins. More recently these have included the improvement of the customer space available, modernisation of the toilets, and the addition of a small function room; all while maintaining the quality of the ales, and a high level of service from the friendly staff. Popular events, including Oktoberfest and live music, take place in the large function room upstairs. The pub has a pizza restaurant to the rear, and is takeaway friendly. ⏚🐾♣🐾🖾🐾🕪

Monk Street

Farmhouse Inn Ⓛ
Thaxted, CM6 2NR (off B184, 2 miles S of Thaxted)
TL614288
☎ (01371) 830864 ⊕ farmhouseinn.org
Greene King IPA; 2 changing beers (sourced locally) Ⓗ
Built in the 16th century, this former Dunmow Brewery establishment has been enlarged to incorporate a restaurant and accommodation; the bar is in the original part of the building. The quiet hamlet here overlooks the Chelmer Valley, two miles from historic Thaxted. A disused well in the garden supplied Monk Street with water during World War II. There is a rear patio, front garden and a top field. ⏚🐾🛏🕪P🖾(313)🐾🕪

Newport

Coach & Horses ⊘
Cambridge Road, CB11 3TR
☎ (01799) 540292
Adnams Southwold Bitter; Fuller's London Pride; 1 changing beer (sourced nationally) Ⓗ
A former coaching inn on the main road through Newport, located on the north side of the village. This modernised pub has exposed beams and a warm and welcoming atmosphere, and can be used for functions. There is an excellent kitchen serving great locally sourced food, used in both traditional British and continental dishes. The large garden is suitable for families, with ample seating. Q⏚🐾🕪P🖾🐾🕪

Old Harlow

Crown Ⓛ ⊘
40 Market Street, CM17 0AQ
☎ (01279) 414422

Greene King IPA; 4 changing beers (sourced locally) ⊞

This 16th-century building was formerly a coaching inn and the smaller part was a grocer's shop. When work was undertaken to remove the connecting wall between the two, a 17th-century floral wall painting was discovered, which has been preserved in a side room. The large garden is popular in summer, and the pub is a favourite meeting place for locals. There are occasional acoustic afternoons, and live music on Saturday night. Traditional pub food is served, with vegan options. ⏱❀◖&≷(Harlow Mill) ♬🖵❀🛜

Pleshey

Leather Bottle 🅛
The Street, CM3 1HG
☎ (01245) 237291
3 changing beers (sourced nationally) ⊞
Grade II-listed village pub with two rooms. To the right is the older part of the building (single-storied and believed to date back to the 15th century) with tables, chairs and a cushioned bench along one wall. On the left is another room which is part of a later two-storey house, and houses the bar, an open fire and more chairs and tables. There is a substantial food menu. ⏱❀◖&P🖵(10)🛜

Rayleigh

Crafty Casks
33 Eastwood Road, SS6 7JD
☎ (01268) 779516
4 changing beers (sourced locally) ⊞
A modern micropub with a constantly rotating line-up of real ales, usually sourced from local breweries, as well as craft beer, wine, spirits, cider, cocktails and prosecco. The bar has up to 25 taps in use serving four real ales, up to eight ciders and 13 keg beers – with Tiny Rebel often featured, as well as a strong dark beer. Regular events include live music. The pub is on a street corner, just off Rayleigh High Street. ≷🖵(1,9)

Rowhedge

Olde Albion ♉
High Street, CO5 7ES
☎ (01206) 728972
4 changing beers (sourced nationally) ⊞
This local CAMRA Pub of the Year 2022 is a free house on the waterfront, playing a substantial role in village life. A fire is a welcome addition in colder months, while in warmer weather there are tables and chairs on the greensward overlooking the River Colne. The pub serves an interesting range of changing ales, sourced nationally from various breweries. A cheeseboard is usually provided on Sunday. Occasional live music events are also hosted. ❀♣🖵(S9)❀🛜

Roydon

New Inn ✔
90 High Street, CM19 5EE
☎ (01279) 792225 ⊕ thenewinnroydon.co.uk
Adnams Broadside; Greene King IPA; Sharp's Doom Bar; 1 changing beer (sourced nationally) ⊞
The New Inn was built in the 18th century in the charming village of Roydon and retains many period features. It is a short walk from the station and the River Stort Navigation, and welcomes many walkers and boaters as well as a local clientele. It was nominated for 2020 Parliamentary Pub of the Year by the local MP. There is a large garden with children's play area. The pub

runs a beer festival each September, barbecues on fine Friday evenings, and a Wednesday seniors' lunch. ❀◖≷P❀🛜

Saffron Walden

King's Arms 🅛
10 Market Hill, CB10 1HQ
☎ (01799) 522768 ⊕ thekingsarmssaffronwalden.co.uk
Adnams Southwold Bitter; Otter Bitter; Timothy Taylor Landlord; 2 changing beers (sourced nationally) ⊞
Venerable wooden-beamed, multi-roomed pub, just off the market square (market days are Tuesday and Saturday). It has welcoming log fires in cold weather and a pleasant patio for alfresco dining and drinking. A mild or dark beer is sometimes available in winter. There is live music at weekends, acoustic music on Thursday, and a monthly quiz. Food is served at lunchtimes. Q⏱❀◖🖵❀🛜

Old English Gentleman ✔
11 Gold Street, CB10 1EJ (E of B184/B1052 jct)
☎ (01799) 523595 ⊕ oldenglishgentleman.com
Woodforde's Wherry; 2 changing beers (sourced regionally) ⊞
An 18th-century town-centre pub with log fires and a welcoming atmosphere. It serves a selection of guest ales, and the extensive menu of bar food and sandwiches changes regularly. Traditional roasts and chef's specials are available on Sunday in the bar or dining area. A variety of works of art is displayed. There is a heated patio at the rear and a wood-burning stove too. It can be busy on Saffron Walden's Tuesday and Saturday market days. ⏱❀◖🖵❀🛜

Railway Arms ♉ 🅛 ✔
Station Road, CB11 3HQ (300yds SE of war memorial)
☎ (01799) 619660 ⊕ railwayarms.co.uk
5 changing beers (sourced locally) ⊞
Victorian street-corner local, opposite the former Saffron Walden railway station which closed in 1964 as part of the Beeching cuts. Community owned by over 500 shareholders, there has been significant renovation inside and out, much of it undertaken by volunteers. There is plenty of outside seating and tables in the garden and courtyard. Completely free of tie, it serves a range of beer styles exclusively from local breweries, normally including a dark ale, craft beers and a number of real ciders. Runner-up in CAMRA's National Pub Saving Award in 2022, and local CAMRA Pub of the Year 2022. ⏱❀●P🖵

South Benfleet

South Benfleet Social Club 🅛
8 Vicarage Hill, SS7 1PB (on B1006 High Rd)
☎ (01268) 206159
3 changing beers ⊞/🅖
A popular social club that is a huge asset to the community. Two beer festivals are held in May and December, and a good range of beer and cider is always available to be enjoyed. Games include pool and poker; with quiz nights, sport on TV and live music at weekends all adding to the ambience. CAMRA members and Guide holders are always welcome. Regional CAMRA Club of the Year and a multiple local CAMRA Club of the Year winner. ⏱❀◖&≷(Benfleet)♣●P🖵❀🛜

South Woodham Ferrers

Tap Room 19

19 Haltwhistle Road, CM3 5ZA
☎ (01245) 322744 ⊕ crouchvale.co.uk/tap-room-19
Crouch Vale Blackwater Mild, Essex Boys Best Bitter, Brewers Gold, Yakima Gold; 2 changing beers (sourced locally; often Crouch Vale) Ⓖ

Tucked away on the town's Western Industrial Estate in front of the Crouch Vale brewery, Tap Room 19 is about 10 minutes' walk through side streets from the railway station. It is simply furnished with understated decor, and there is a small outdoor seating area to the front. A welcome real ale oasis in a town with few others, beers are served from a taproom visible through windows at the rear of the bar. Up to four ciders are also on offer.
Q❀≷♣♠P❑🚲(36) 😾 🛜

Southend-on-Sea

Mawson's Ⓛ

781 Southchurch Road, SS1 2PP (on A13)
☎ (01702) 601781 ⊕ mawsonsmicro.com
George's Wallasea Wench, Cockleboats; 4 changing beers (sourced nationally) Ⓗ

This converted shop was Southend's first micropub and has up to six cask ales, with at least two from the local George's Brewery. Also on offer are six real ciders, three craft keg pumps, two draught German pilsners, and two draught ciders, one of which is Rocquette of Guernsey. Set in the Southchurch village area, the bar has a large gallery of Laurel and Hardy pictures. Quiet music adds to the buzz of conversation, with occasional live music and quiz nights held. ぎよ≷(East)♠🚲❑(1,14)😾🛜

Olde Trout Tavern

56 London Road, SS1 1NX (opp Sainsbury's)
☎ (01702) 337000
House beer (by Wantsum); 3 changing beers (sourced nationally) Ⓗ

Modern town-centre ale bar with an eclectic mix of breweriana, signs and numerous clocks adorning the walls. It is within walking distance of Southend High Street and both mainline railway stations. Hot food and snacks are available at lunchtime. Up to three changing ales are served, along with house beer Trout Ale from Wantsum Brewery, and one cider. There is a fortnightly quiz night on Sunday, and a function room upstairs.
◑≷(Victoria)♣❑🛜

Southminster

Station Arms 🍺

39 Station Road, CM0 7EW
☎ (01621) 772225 ⊕ thestationarms.co.uk
Adnams Southwold Bitter; 4 changing beers (sourced regionally; often Bishop Nick, George's, Mighty Oak) Ⓗ

A traditional Essex weatherboarded pub that has featured in this Guide for 31 consecutive years. It is a welcoming and thriving community local. The comfortable bare-boarded bar, with its open log fire, is decorated with railway and brewery memorabilia. An attractive courtyard is popular in fine weather, and a barn with a wood-burning stove provides shelter if required. Live blues and folk music is hosted monthly. Various charity events take place during the year including a conker competition. Local CAMRA Pub of the Year 2022.
Q❀≷♣❑

Wibblers Brewery Taproom & Kitchen

Goldsands Road, CM0 7JW
☎ (01621) 772044 ⊕ wibblers.co.uk/taproomkitchen
Wibblers Dengie IPA, Beneath The Embers Ⓗ; **6 changing beers (sourced locally; often Wibblers)** Ⓗ/Ⓖ

The taproom is attached to the beautiful award-winning restored medieval tithe barn that houses Wibblers Brewery. It features a dining area with an extensive menu of excellent home-cooked food using mostly local produce. The bar is attractively furnished and, weather permitting, you can sit outside in the countryside. The brewery and taproom host open days and various other events throughout the year, including televised rugby and themed food evenings. Southminster railway station is only five minutes' walk away.
Q🐾❀🕙よ≷♠P❑(31X) 😾 🛜

Springfield

Endeavour Ⓛ

351 Springfield Road, CM2 6AW
☎ (01245) 257717
Mighty Oak Captain Bob; 5 changing beers (sourced nationally) Ⓗ

Cosy and friendly community pub, not far from the city centre in the popular Springfield Road area. Three rooms offer a welcoming atmosphere in which to enjoy a selection of regularly changing casks ales. Home-cooked meals are served Thursday, Friday and Saturday. The pub hosts mini beer festivals, tap takeovers and regular charity events. There is a suntrap garden and the pub is dog friendly. ❀◑♣❑😾🛜

Stanford-le-Hope

Rising Sun Ⓛ

Church Hill, SS17 0EU (opp church and nr A1014)
☎ (01375) 671097
5 changing beers (sourced nationally) Ⓗ

Much improved, two-bar, traditional town pub in the shadow of the church. The five guest beers are mainly from independent breweries, including LocAles, and up to three ciders or perries are stocked. There is regular monthly live music. Beer festivals are held three times a year (spring, summer and winter) with the summer festival taking place in the pub's large rear garden. The back bar is available for private functions.
❀≷♣♠P❑😾🛜

Stansted Mountfitchet

Rose & Crown Ⓛ

31 Bentfield Green, CM24 8HX (½ mile W of B1383)
TL505256
☎ (01279) 812107 ⊕ roseandcrownstansted.co.uk
2 changing beers (sourced regionally) Ⓗ

Family-run Victorian pub on the edge of a large village with the welcoming atmosphere of a local. This free house has been modernised to provide one large bar and a snug at the side. Outside is a covered drinking area and garden. Home-cooked food is served at the weekend and there are occasional food trucks. A large variety of gins is stocked. There is an interesting jukebox in the main bar. ぎ❀◑P❑(7,7A)😾🛜

Stanway

Live & Let Live Ⓛ

12 Millers Lane, CO3 0PS (in a small lane 100yds from London Rd, W of Colchester)

☎ (01206) 574071 ⊕ theliveandletlive.co.uk
4 changing beers (sourced nationally) Ⓗ
A traditional, welcoming local that continues to delight, with a homely saloon bar and a public bar. The publicans regularly support local breweries and take great pride in the condition and quality of their real ales. The beers are competitively priced, as is the traditional home-cooked food, served most lunchtimes and evenings. The pub is renowned for its beer, sausage and pie festivals. Local CAMRA Town Pub of the Year in 2022.
Q🍴🐕🌙🍂🐾P🚃🐾🛜

Steeple Bumpstead

Fox & Hounds Ⓛ
3 Chapel Street, CB9 7DQ
☎ (01440) 731810 ⊕ foxinsteeple.co.uk
Greene King IPA; 4 changing beers (sourced nationally) Ⓗ
A 17th-century coaching inn in a picturesque village on the Essex/Suffolk border, featuring an open fire in the main bar, a rear courtyard garden and further seating at the front. On Wednesday evening a complimentary cheeseboard is offered, with reduced-price real ale and wine all evening. Live bands perform and quiz nights take place throughout the year. The outside barn has been converted into a games room. Q🍴🐕🌙🍂🚃(18)🐾🛜

Stow Maries

Prince of Wales
Woodham Road, CM3 6SA
☎ (01621) 828971 ⊕ prince-stowmaries.net
6 changing beers (sourced nationally) Ⓗ
This classic weatherboarded pub boasts several characterful drinking areas, with open fires and an old bread oven. The extensive garden and courtyards provide plenty of options for alfresco drinking. Good food is available, made with local produce where possible. Many special events are held including Burns Night, a firework display on the last Saturday in October, and live music. A free comedy night with top West End acts takes place monthly, as well as a larger festival every year.
Q🍴🐕🌙🍴🍷🚃(593)🐾🛜

Thaxted

Maypole ✅
31 Mill End, CM6 2LT
☎ (01371) 831599 ⊕ maypolethaxted.com
Eagle IPA; Timothy Taylor Landlord; 3 changing beers (sourced locally) Ⓗ
A warm welcome awaits at this tastefully redecorated pub. The current landlords took over in 2020 and are keen to support community activities. Regular musical events and quizzes are held, as well as occasional beer festivals. Home-cooked food is available every day except Tuesday. The pub sits back from the main road and has a rear car park and an attractive garden with comfortable seating. 🍴🌙🍷P🚃(6,312)🐾🛜

Waltham Abbey

Woodbine Inn 🍷 Ⓛ ✅
Honey Lane, EN9 3QT
☎ (01992) 713050 ⊕ thewoodbine.co.uk
Adnams Ghost Ship Ⓗ**; Bishop Nick Divine** Ⓗ**/**Ⓖ**; Mighty Oak Oscar Wilde** Ⓖ**, Captain Bob** Ⓗ**; 4 changing beers (sourced locally)** Ⓗ**/**Ⓖ
National finalist for Cider Pub of the Year in 2019, this multi CAMRA award-winning pub is situated in Epping Forest and close to junction 26 of the M25. The pub

concentrates on real ales and small-producer ciders – featuring over 40 of the latter, and producing London Glider cider on site. Food is home-made, with local sausages, ham and steak as specialities. Dogs are welcome in the main bar, and bar billiards is played. The Ale Sampling Society and Comedy Club meet monthly.
🍴🍷🍂🐾P🚃(66,66A)🐾

Weeley Heath

White Hart
Clacton Road, CO16 9ED (on B1441, 1 mile from Weeley station) TM153208
☎ (01255) 830384
2 changing beers (sourced nationally; often Greene King, Mauldons, Woodforde's) Ⓗ
A regular Guide entry for over two decades with landlords Mark and Sally at the helm, this community focused free house has a real ale club and hosts pool and darts teams. A great pub for sports fans, both Sky TV and BT Sport are screened. Occasional music and quiz evenings are held. There is a garden and a covered patio for smokers. A three-times winner of local CAMRA Pub of the Year and two-times local CAMRA Cider Pub of the Year. 🌙▲🍂🐾P🚃🛜

Westcliff-on-Sea

Cricketers
228 London Road, SS0 7JG (on A13 London Rd)
☎ (01702) 345053 ⊕ thecricketersbarandfood.co.uk
5 changing beers (sourced regionally) Ⓗ
A Gray & Sons establishment with well-kept beer, not far from Southend town centre. A music venue adjoins the pub so it can get busy on music nights. There is a weekly quiz on Monday and Sunday music sessions with R&B, blues and jazz. The five real ales usually include one dark beer, and over 70 different gins are available. Meals are served lunchtimes and evenings from a varied menu.
🍴🌙🍷♿🍴🚃🐾🛜

Mile & a Third 🍷
67 Hamlet Court Road, SS0 7EU
☎ (01702) 902120 ⊕ mileandathird.com
2 changing beers (sourced nationally) Ⓖ
Run by two beer managers from the Rochford beer festival, this is an L-shaped former shop, the front being the bottle shop while the bar is on the side. There are also four trees inside. Two real ales are served on gravity, plus eight keg lines, and three bag-in-box real ciders. The bottle shop's three fridges are stocked with bottles and cans from national and international brewers. All ales and ciders are £3 a pint on Wednesday and Thursday. Music is mainly played on vinyl. Local CAMRA Pub of the Year 2020-2022. 🍴🐕♿🍂🍴🚃🐾🛜

West Road Tap
2 West Road, SS0 9DA
☎ (01702) 330647 ⊕ westroadtap.com
3 changing beers (sourced nationally) Ⓖ
This two-level micropub and bottle shop is located near the Palace Theatre in Westcliff. The main bar, upstairs, serves up to three nationally sourced cask ales and six KeyKeg beers. The downstairs bar, The Bunker, houses six taps. Both bars have an extensive fridge selection of craft beers in bottles and cans to drink in or take home. Two real ciders in boxes are available. Children are welcome until 7pm. A former local CAMRA Pub of the Year. Q🍴🌙🍴🐾(1,27)🐾

Widddington

Widddington

Widddington

Fleur de Lys L ✓
High Street, CB11 3SG TL538316
☎ (01799) 543280 ⊕ thefleurdelys.co.uk
Timothy Taylor Landlord; Woodforde's Wherry; 2 changing beers (sourced nationally) ⊞
A welcoming 400-year-old village local boasting a large open fireplace, beams and an attractive garden. Improvement works, including a bar extension and new toilets, were completed in 2021. This was the first pub to be saved from closure by the local branch of CAMRA after the branch's formation. Quality meals are offered, made with fresh local ingredients. The source of the River Cam, and Prior's Hall Barn, an English Heritage site, are both nearby. A range of real ciders is available.
७֍ⓘ◑Ⓖ♣❀Pꟼ(301)❀

Witham

Battesford Court L ✓
100-102 Newland Street, CM8 1AH
☎ (01376) 504080
Greene King Abbot; Ruddles Best Bitter; Sharp's Doom Bar; 5 changing beers (sourced nationally) ⊞
A large Wetherspoon conversion of a former hotel of the same name. The 16th-century building was previously the courthouse of the manor of Battesford. The interior features wood panelling and oak beams and is divided into distinct areas, including a family space. Up to five regional beers are served, including something local, usually from Bishop Nick or Wibblers, plus up to two ciders and perries, usually from Westons and Gwynt y Ddraig. The standard Wetherspoon food offering is available. Q֍ⓘ◑Ⓖꟼ(38,71)�413

Woolpack Inn L ✓
7 Church Street, CM8 2JP
☎ (01376) 511195
Greene King IPA ⊞; Witham No Name Ⓖ; 3 changing beers (sourced nationally) ⊞/Ⓖ
A traditional local pub, and the only regular outlet for the Witham Brewery, which is now based in Coggeshall. Set in the conservation area, the building probably dates from the 15th century. It has two rooms with low wooden beams, and a real log fire during the winter. Up to three guest ales are served, usually from the local area. Most of the beers are served under gravity. Note the extensive collection of glass soda syphon bottles.
≠♣ꟼ(40)❀413

Wivenhoe

Black Buoy
Black Buoy Hill, CO7 9BS
☎ 07561 494100 ⊕ blackbuoy.co.uk
Colchester Number One; 5 changing beers (sourced nationally) ⊞
Local CAMRA Pub of the Year 2020, the Black Buoy is a popular and welcoming community-owned venue. There is a small public bar at the front for drinkers, and other areas for drinking and dining, with a range of traditional home-cooked food available every day. Regular quiz nights take place throughout the year. Beer festivals are held in May and August in the pleasant outdoor area and garden. Q७֍❀⛵ⓘ◑Ⓖ≠♣Pꟼ(S1)❀413

Horse & Groom ✓
55 The Cross, CO7 9QL
☎ (01206) 824928 ⊕ handgwivenhoe.co.uk
Adnams Southwold Bitter, Ghost Ship, Broadside; 3 changing beers (sourced nationally) ⊞

A real locals' two-bar pub with a large garden to the rear. Children and dogs are always welcome and the garden has a small play area. Adnams beers are available as well as a range of guests. Quality home-cooked lunches are served Monday to Saturday, and roasts on the first Sunday of each month. Q७֍❀ⓘ◑Ⓖ♣❀Pꟼ(S1,74)❀413

Woodham Mortimer

Hurdlemakers Arms
Post Office Road, CM9 6ST
☎ (01245) 225169 ⊕ hurdlemakersarms.co.uk
5 changing beers (sourced locally; often George's, Mighty Oak, Wibblers) ⊞
A Gray's house, this 400-year-old former farmhouse seamlessly blends restaurant with pub. Good food and beer are both available here. One area is dedicated to diners while drinkers are catered for in a smaller bar. There is a huge beer garden ideal for families, with a play area and shady trees. Barbecues are held on summer weekends and a popular beer festival during the last week of June. Functions are catered for in a marquee or Mortimer's Barn. Q७֍❀ⓘ◑Ⓖ♣❀Pꟼ❀413

Writtle

Wheatsheaf L
70 The Green, CM1 3DU
☎ (01245) 420672 ⊕ thewheatsheafwrittle.co.uk
Adnams Southwold Bitter, Broadside; Wibblers Dengie IPA ⊞; 2 changing beers (sourced nationally) Ⓖ
Traditional village pub built in 1813, with a small public bar, an equally compact lounge, and a covered patio by the road. It is a long-time favourite of the local CAMRA branch. The atmosphere is generally quiet, with the TV switched on only for occasional sporting events. Good home-cooked pub food is served Tuesday to Saturday lunchtimes. Note the old Gray's sign in the public bar.
Q◑♣Pꟼ

Breweries

Billericay SIBA
Essex Beer Shop, 54c Chapel Street, Billericay, Essex, CM12 9LS
☎ (01277) 500121 ☎ 07788 373129
⊕ billericaybrewing.co.uk

With numerous regular beers and local distribution outlets, Billericay Brewing opened at its present site in 2014, using a 4.5-barrel plant. It has an adjacent, very popular, micropub and well-stocked beer shop.
‼🛒♦LIVE⏺

Zeppelin (ABV 3.8%) BITTER
Blonde (ABV 4%) GOLD
Dickie (ABV 4.2%) BITTER
Vanilla Woods (ABV 4.2%) SPECIALITY
Woody's Wag (ABV 4.2%) PORTER
Rhythm Stick (ABV 4.8%) BITTER
Sex & Drugs & Rock & Roll (ABV 5%) PALE
Chapel Street Porter (ABV 5.9%) PORTER
Chilli Porter (ABV 5.9%) SPECIALITY
Mayflower Gold (ABV 6.5%) IPA

Bishop Nick SIBA
33 East Street, Braintree, Essex, CM7 3JJ
☎ (01376) 349605 ⊕ bishopnick.com

⊗ Bishop Nick was launched in 2011 by Nelion Ridley, a member of the family that started Ridley's brewery near Chelmsford in 1842. In 2013 a new brewery was established in Braintree using a 20-barrel plant. ☕◆LIVE

Ridley's Rite (ABV 3.6%) BITTER
Heresy (ABV 4%) GOLD
1555 (ABV 4.3%) BITTER
Devout (ABV 4.5%) STOUT
Martyr (ABV 5%) PALE
Divine (ABV 5.1%) BITTER

Black Box (NEW) SIBA

18 Aviation Way, Southend on Sea, Essex, SS2 6UN
☎ 07471 733719 ⊕ blackboxbrewery.co.uk

⊗ A new brewery and taproom on the airport industrial estate, with an aircraft theme. ◆

Ground Speed (ABV 3.8%) PALE
Landing Gear (ABV 3.8%) BITTER
Golden Wings (ABV 4%) GOLD
First Class (ABV 4.4%) PALE
Auto Pilot (ABV 5%) BITTER

Brentwood SIBA

Calcott Hall Farm, Ongar Road, Pilgrims Hatch, Essex, CM15 9HS
☎ (01277) 200483 ⊕ brentwoodbrewing.co.uk

⊗ Since its launch in 2006 Brentwood has steadily increased its capacity and distribution, relocating to a new purpose-built brewery unit in 2013 with a visitor centre. Seasonal and special beers are also available including more unusual beer styles under the Elephant School brand name. ‼☕◆LIVE◆

IPA (ABV 3.7%) PALE
Marvellous Maple Mild (ABV 3.7%) SPECIALITY
Brentwood Legacy (ABV 4%) PALE
Best (ABV 4.2%) BITTER
Gold (ABV 4.3%) GOLD
Hope & Glory (ABV 4.5%) BITTER
Lumberjack (ABV 5.2%) BITTER
Chockwork Orange (ABV 6.5%) SPECIALITY

Brewed under the Elephant School brand name:
Mallophant (ABV 4.1%) STOUT
Cheru Kol (ABV 4.5%) SPECIALITY
Sombrero (ABV 4.5%) SPECIALITY

Chelmsford

2 Brewery Fields, Church Street, Great Baddow, Chelmsford, Essex, CM2 7LE
☎ (01245) 476267 ⊕ chelmsfordbrewco.co.uk

Chelmsford Brew Co, established in 2017, is a family-owned brewery located in Great Baddow, near the former Baddow Brewery. A brewery shop and taproom is open Thursday-Saturday, and online orders are delivered free-of-charge to locations within 10 miles. ☕◆

Blueshack Bitter (ABV 3.8%) BITTER
Cool Bay (ABV 3.9%) PALE
Port Jackson (ABV 4%) PORTER

Colchester SIBA

Viaduct Brewhouse, Unit 16, Wakes Hall Business Centre, Wakes Colne, Essex, CO6 2DY
☎ (01787) 829422 ⊕ colchesterbrewery.com

⊗ Set up in 2012 by three friends, Tom Knox, Roger Clark and Andy Bone, using the double drop process. Popular during the early 20th century this process requires additional brewing vessels in a two-tier system resulting in clean beer with pronounced flavours. ‼☕◆LIVE

AKA Pale (ABV 3.7%) PALE
Metropolis (ABV 3.9%) GOLD
Jack Spitty's Smuggler's Ale (ABV 4%) BITTER
Number One (ABV 4.1%) BITTER
Sweeney Todd (ABV 4.2%) BITTER
Brazilian Coffee & Vanilla Porter (ABV 4.6%) SPECIALITY
Cat's Whiskers (ABV 4.8%) STOUT
Old King Coel London Porter (ABV 5%) PORTER

Courtyard SIBA

Gosfield Cottage, The Street, Gosfield, CO9 1TP
☎ (01787) 475993 ☎ 07710 230662
⊕ courtyardbrewery.co.uk

Courtyard Brewery uses a six-barrel plant designed to perfectly fit into a 19th century coach house in the north Essex village of Gosfield. It is run by two brewers passionate about producing ales traditionally, but with a 21st century twist. ◆

IPA (ABV 3.8%) PALE
Gold (ABV 4.1%) GOLD
Dark (ABV 5%) PORTER

Crouch Vale SIBA

23 Haltwhistle Road, South Woodham Ferrers, Essex, CM3 5ZA
☎ (01245) 322744 ⊕ crouchvale.co.uk

⊗ Founded in 1981 by two CAMRA enthusiasts, Crouch Vale is well established as a major player in Essex brewing, having moved to larger premises in 2006. It supplies to various outlets as well as beer festivals throughout the region. A taproom (Tap Room 19) is on-site. One tied house, the Queen's Head in Chelmsford is owned. ‼☕◆LIVE◆

Blackwater Mild (ABV 3.7%) MILD
Malty, fruity and full with a deep-ruby colour and a dry roast character.
Essex Boys Best Bitter (ABV 3.8%) BITTER
Brewers Gold (ABV 4%) PALE
Golden pale ale with striking citrus hop alongside biscuity malt supported by a sweet fruitiness.
Yakima Gold (ABV 4.2%) GOLD
Amarillo (ABV 5%) GOLD

Dominion

c/o Red Fox Brewery, Upp Hall Farm, Salmons Lane, Coggeshall, Essex, CO6 1RY
☎ (01376) 563123

Office: Queen Street Brewhouse, Colchester, CO1 2PG
✉ andy@dominionbrewerycompany.com

⊗ Dominion Brewery was established in 2012 by Andy Skene. He was renting the premises and Pitfield brand names from the founder of Pitfield, Martin Kemp. In 2018 Dominion Brewery moved and is now using spare capacity at Red Fox Brewery (qv). LIVE

Pitfield Shoreditch Stout (ABV 4%) STOUT
Woodbine Racer (ABV 4.2%) GOLD
A Mild With No Name (ABV 5.5%) MILD
Woodbine Racer Turbo (ABV 6.2%) BITTER
Yukon Gold (ABV 9.7%) BARLEY
Mad Trappiste (ABV 10%) SPECIALITY

Brewed for Billericay Brewery:
A Mild With No Name (ABV 5.5%) MILD

Fable

Essex ⊕ fablebrewery.com

A cuckoo brewery specialising in vegan beers. Brewing is currently suspended. **V**

Fallen Angel

Unit 21c, Reeds Farm Estate, Roxwell Road, Writtle, Essex, CM1 3ST
☎ (01245) 767220 ☎ 07572 614067
⊕ fallenangel-brewery.co.uk

Formerly known as the Broxbourne Brewery, the name changed to Fallen Angel in 2017. Brewing began in 2013 using a 12-barrel plant. A 15-barrel plant has been in operation since the brewery's move from Hertfordshire to Essex in 2015.

Ginger Beer (ABV 4%) SPECIALITY
Cowgirl Gold (ABV 4.2%) GOLD
Angry Ox Bitter (ABV 4.8%) BITTER
Fire in the Hole (ABV 4.9%) SPECIALITY
Black Death (ABV 5.2%) SPECIALITY

George's SIBA

Common Road, Great Wakering, Essex, SS3 0AG
☎ (01702) 826755 ☎ 07771 871255
⊕ georgesbrewery.com

⊗ George's Brewery and Hop Monster Brewing Company (qv) are owned by the same brewer, using the same plant. George's concentrates on traditional styles and Hop Monster on the more unusual. ‼☛♦LIVE

Wallasea Wench (ABV 3.6%) BITTER
Wakering Gold (ABV 3.8%) GOLD
8-bit Bitter (ABV 4%) BITTER
Cockleboats (ABV 4%) BITTER
Empire (ABV 4%) BITTER
Figaro (ABV 4%) PALE
George's Best (ABV 4%) BITTER
Banshee Porter (ABV 4.4%) SPECIALITY
Broadsword (ABV 4.7%) BITTER
Excalibur (ABV 5.4%) GOLD
Merry Gentlemen (ABV 6%) OLD
Excalibur Reserve (ABV 7.2%) STRONG

Brewed under the Hop Monster Brewery name:
Rakau (ABV 4.2%) GOLD
Snake Oil Stout (ABV 5%)

Harwich Town

c/o Unit 1, Upp Hall Farm, Salmons Lane, Coggeshall, Essex, CO6 1RY ☎ 07723 607917
⊕ harwichtown.co.uk

Founded in 2007 with a five-barrel plant in premises next to Harwich Town Railway Station. In 2018 it moved out of its original home and became a cuckoo brewery, using spare capacity at Red Fox Brewery (qv). The owner/brewer, a former customs officer, names the beers after local characters and landmarks. Local pubs and beer festivals are supplied, with reciprocal trading with other breweries. It organises the Harwich Redoubt Beer Festival in a Napoleonic fort in July each year. ♦LIVE

EPA Centenary (ABV 3.8%) PALE
Leading Lights (ABV 3.8%) BITTER
Bathside Battery Bitter (ABV 4.2%) GOLD
Stone Pier (ABV 4.3%) GOLD

JackRabbit

Prettyfields, Dead Lane, Ardleigh, Essex, CO7 7PF
☎ 07506 596597 ⊕ jackrabbitbrewing.co.uk

JackRabbit Brewing Co was founded in 2019 by three craft beer lovers. New and special releases all year round. ☛

Leigh on Sea SIBA

35 Progress Road, Leigh on Sea, Essex, SS9 5PR
☎ (01702) 817255 ⊕ leighonseabrewery.co.uk

⊗ Established in 2017 to produce vegan-friendly beer, which is unfiltered, unpasteurised and unfined (except for Renown). Initially brewing on a one-barrel kit, it rapidly progressed to a 10-barrel plant. Many of the names of the beers are based on Leigh's maritime heritage, which is also reflected in the branding, by a local artist and graphic designer. The brewery has its own taproom, and has now opened a pub, Legra Tap & Kitchen. ‼☛♦V✦

Legra Pale (ABV 3.8%) PALE
McFadden Mild (ABV 3.8%) MILD
Boys of England (ABV 3.9%) BITTER
Brhubarb (ABV 3.9%) SPECIALITY
Kursaal Gold (ABV 3.9%) GOLD
Renown (ABV 4%) STOUT
Six Little Ships (ABV 4.2%) BITTER
Two Tree Island Red (ABV 4.5%) RED
Crowstone (ABV 5.5%) BITTER
Cockle Row Spit (ABV 5.6%) BITTER
Old Leigh Ale (ABV 5.7%) OLD
SS9 (ABV 9%) STOUT

Mersea Island

Rewsalls Lane, East Mersea, Essex, CO5 8SX ☎ 07970 070399 ⊕ merseabrewery.co.uk

⊗ The brewery was established at Mersea Island Vineyard in 2005. It supplies several local pubs on a guest beer basis as well as beer festivals. It holds its own festival of Essex-produced ales over the four-day Easter weekend. The Cork 'n' Cap off sales and gift shop opened in 2020. ☛LIVE

Mersea Mud (ABV 3.8%) MILD
Yo Boy! (ABV 3.8%) BITTER
Gold (ABV 4.4%) SPECIALITY
Skippers (ABV 4.8%) BITTER
Oyster Stout (ABV 5%) STOUT

Mighty Oak

14b West Station Yard, Spital Road, Maldon, Essex, CM9 6TW
☎ (01621) 843713 ⊕ mightyoakbrewing.co.uk

⊗ Mighty Oak was formed in 1996 and has expanded considerably following a move to Maldon in 2001. Current capacity is 8,000 brewers barrels per year, following the acquisition of two adjacent buildings and an enlarged plant. Some 450 outlets are supplied. A popular free, festive beer tasting day takes place each year in early December (date is published October on the website). ‼☛♦LIVE

Oscar Wilde (ABV 3.7%) MILD
Roasty dark mild with suggestions of forest fruits and dark chocolate. A sweet taste yields to a more bitter finish.
Captain Bob (ABV 3.8%) BITTER
Maldon Gold (ABV 3.8%) GOLD
Pale golden ale with a sharp citrus note moderated by honey and biscuity malt.
Jake The Snake (ABV 4%) PALE
Old Man And The Sea (ABV 4.1%) STOUT
Gorgeous George (ABV 4.2%) BITTER
Kings (ABV 4.2%) GOLD

Cascade IPA (ABV 6.2%) GOLD

Moody Goose

▤ King William IV, 114 London Road, Braintree, Essex, CM77 7PU ☎ 07595 911046
⊕ moodygoosebrewery.co.uk

A three-barrel brewery, brewing approximately 15 times a year. The beers are currently only available in the King William IV, where the brewery is located, and select beer festivals.

Neolithic

Bradwell, CM0 7PS ⊕ neolithicbrew.co.uk

Nanobrewery established in 2019 using a one-barrel plant, producing mainly bottled beers.

Other Monkey

c/o Three Wise Monkeys, 60 High Street, Colchester, Essex, CO1 1DN
☎ (01206) 543014 ⊕ othermonkeybrewing.com

⊗ Other Monkey is located in the basement of the Three Wise Monkeys pub. The brewery and pub are separately owned, but beer is only brewed for the Three Wise Monkeys and two other outlets in Colchester.

Pale Ale (ABV 4.4%) PALE

Posh Boys

Riverside House, 8 Lower Southend Road, Wickford, SS11 8BB ☎ 07474 594379 ⊕ poshboysbrewery.com

⊗ Posh Boys is a small, independent craft brewery in Essex, set up by two friends. Operating on a part-time basis producing beers in smaller quantities. Beers are available in the taproom, local pubs and occasionally at festivals. ◆

The Blind Butler (ABV 4%) BITTER
The Blonde Maid (ABV 4%) BLOND
Room No. 6 (ABV 4.1%) BLOND
The Bowlers Hat (ABV 4.5%) BITTER
The Coachman (ABV 4.5%) BITTER
The Night Porter (ABV 4.5%) PORTER

Pumphouse Community

Green Man Barn, Church Lane, Toppesfield, Essex, CO9 4DR ☎ 07786 861009
⊕ pumphousebrewery.co.uk

⊗ Pumphouse is a community-owned brewery. Established in 2015 it uses a two-barrel plant and specialises in session beers with occasional one-off, experimental brews. Pubs, clubs, special events and festivals are supplied within a 10-mile radius as well as its Green Man tap outlet. !! ▤ ◆LIVE

Allied Amber (ABV 3.8%)
St Margaret's Ale (ABV 3.8%) PALE

Red Fox

The Chicken Sheds, Upp Hall Farm, Salmons Lane, Coggeshall, Essex, CO6 1RY
☎ (01376) 563123 ⊕ redfoxbrewery.co.uk

Red Fox began brewing in 2008 and has continued to expand in line with increasing demand. Brewery experience days are available and contract brewing services are offered. !! ▤ ◆LIVE

Mild (ABV 3.6%) MILD
IPA (ABV 3.7%) BITTER

Bitter (ABV 3.8%) BITTER
Hunter's Gold (ABV 3.9%) GOLD
Best Bitter (ABV 4%) BITTER
Coggeshall Gold (ABV 4%) GOLD
Black Fox Porter (ABV 4.8%) PORTER
Wily Ol' Fox (ABV 5.2%) PALE

Redchurch

15-16 Mead Park Industrial Estate, Harlow, Essex, CM20 2SE
☎ (01279) 626895 ☎ 07836 762173
⊕ redchurch.beer

⊗ Established in 2011 using an eight-barrel plant in railway arches at Bethnal Green. In 2016 most of the production moved to Harlow, leaving only the taproom on-site. It was purchased by new management in 2019, who closed that taproom. The current range (ten core beers, seasonal, and the Urban Farmhouse range of sours) are available only in keg and bottles. The taproom also hosts some events some evenings (website for details/ tickets). !! ▤ ◆ ⦿

St Botolphs

8 Gladwin Road, Colchester, Essex, CO2 7HS
☎ (01206) 511835 ✉ info@stbotolphsbrewery.co.uk

Brewing began in 2014. Its Belgian-style bottled beers can be found in pubs, farm shops, specialist beer shops, markets and food festivals in Essex and Suffolk.

Shalford SIBA

Office: PO Box 10411, Braintree, Essex, CM7 5WP
☎ (01371) 850925 ☎ 07749 658512
⊕ shalfordbrewery.co.uk

Shalford began brewing in 2007 on a five-barrel plant at Hyde Farm in the Pant Valley in Essex. More than 50 outlets are supplied direct. ◆LIVE

1319 Mild (ABV 3.7%) MILD
Barnfield Pale Ale (ABV 3.8%) PALE
Pale-coloured but full-flavoured. Traditional pale ale. Malt persists throughout, with bitterness becoming more dominant towards the end.
Braintree Market Ale (ABV 4%) BITTER
Levelly Gold (ABV 4%) GOLD
Stoneley Bitter (ABV 4.2%) BITTER
Dark amber session beer whose vivid hop character is supported by a juicy, malty body. A dry finish makes this beer very drinkable.
Hyde Bitter (ABV 4.7%) BITTER
Stronger version of Barnfield, with a similar but more assertive character.
Levelly Black (ABV 4.8%) STOUT
Rotten End (ABV 6.5%) STRONG

Sticklegs

Primrose Farm, Hall Road, Great Bromley, Essex, CO7 7TR ☎ 07971 138038
✉ waterhouse.philip@btinternet.com

⊗ Sticklegs was established in 2008 at the Cross Inn, Great Bromley. The brewery expanded and relocated to Elmstead Market, where it continued to grow. In 2016 it moved to Primrose Farm. The brewery is owned and run by Phil Reeve and his wife Linda, the brewster.

Stour Gold (ABV 3.8%) GOLD
Bar'King (ABV 4%) BITTER

Watson's

Old Heath, Colchester, Essex, CO1 2HD ☎ 07804 641267 ⊕ watsonsbrewery.co.uk

⊠ Small batch, home brewery set up in 2016 using a 100-litre brew plant. Local pubs, festivals and bottle shops are supplied with one-off beers.

White Hart

▤ **White Hart Hotel & Restaurant, 15 High Street, Halstead, Essex, CO9 2AP**
☎ (01787) 475657 ⊕ whitehartbrewery.co.uk

⊠ Brewing began in 2017 in old stables at the back of the White Hart. Both the brewery and pub are owned by father and son, Charles and Hugo Townsend. Beers are available in the pub and at local beer festivals.

Wibblers SIBA

Goldsands Road, Southminster, Essex, CM0 7JW
☎ (01621) 772044 ⊕ wibblers.com

⊠ Wibblers was established in 2007 and expanded to a 20-barrel plant in 2009. In 2016 the brewery moved to new premises in Southminster with a taproom. In 2018 the taproom was expanded four-fold, along with capacity. Craft beers and ciders are now produced, as well as seasonal specials. Wibblers supply numerous outlets through East Anglia, London and Kent in addition to exporting to mainland Europe. ‼ ☰ ♦ LIVE ✦

Dengie IPA (ABV 3.6%) PALE
Apprentice (ABV 3.9%) BITTER
Dengie Dark (ABV 4%) MILD
Dengie Gold (ABV 4%) GOLD
Hop Black (ABV 4%) BITTER
Beneath The Embers (ABV 4.7%) PALE
Crafty Stout (ABV 5.3%) STOUT

Witham

c/o The Chicken Sheds, Upp Hall Farm, Salmons Lane, Coggeshall, Essex, CO6 1RY
☎ (01376) 563123 ☎ 07824 698235
⊠ glennackerman15@gmail.com

Brewing started in 2012, using a 0.5-barrel plant at the Woolpack Inn, Witham. In 2015 it began using spare capacity at the Red Fox Brewery. The beer continues to be available at the Woolpack, Witham.

Scruffy (ABV 3.9%) MILD
Witham Gold (ABV 4.1%) GOLD
No Name (ABV 4.3%) BITTER
Capt. Keebles Ramming Speed (ABV 5%) BITTER

Victoria Arms, Brentwood (Photo: Alan Barker)

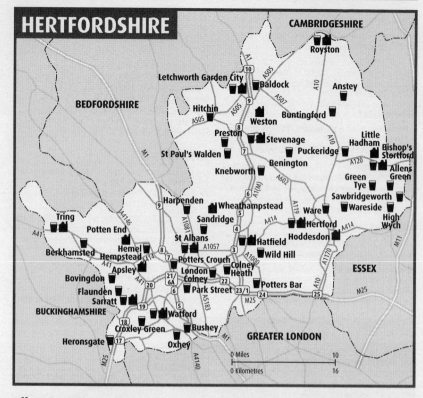

HERTFORDSHIRE

Allens Green

Queen's Head 🅛
CM21 0LS TL455170
☎ (01279) 723393
Fuller's London Pride; Mighty Oak Maldon Gold; 2 changing beers (sourced locally) 🅖
Popular village inn that reopened following the efforts of a group of locals. It is worth seeking out for its constantly changing range of four beers. Hot snacks are available except at very busy times. A frequent winner of local CAMRA Pub of the Year over the past decade and a former regional Cider Pub of the Year. Q❀&♠P❀🕏

Anstey

Blind Fiddler
SG9 0BW (in village)
☎ (01763) 848000 ⊕ theblindfiddler.co.uk
3 changing beers (sourced nationally) 🅗
Named after the local legend of Fiddler George, who disappeared while exploring the tunnel under Anstey Castle, the Blind Fiddler has been opened out into one large bar area with a separate restaurant. Regular beers come from Buntingford and Fuller's. Entertainment includes monthly quiz nights and live music. Pétanque, played in the garden, is popular, and there is a rare bar billiards table. ❀❀♣P❀🕏

Baldock

Orange Tree 🅛 ✅
Norton Road, SG7 5AW
☎ (01462) 892341
Greene King IPA, Abbot; Tring Mansion Mild; 9 changing beers (sourced nationally) 🅗

This 300-year-old, multi-roomed pub is home to more than 10 local clubs and societies. It serves nine guest ales, all from small breweries and changed every weekend, alongside five local real ciders. There is also a large selection of malt whiskies and bottled beers. Good home-cooked food is available. The pub hosts a quiz on Tuesday and folk music on Wednesday.
❀❀◑&➤♣♠P➾❀🕏

Benington

Lordship Arms
42 Whempstead Road, SG2 7BX
☎ (01438) 869665 ⊕ lordshiparms.com
Black Sheep Best Bitter; Crouch Vale Brewers Gold; Timothy Taylor Landlord; 6 changing beers (sourced nationally) 🅗
Under the same ownership since 1993, this pub has won numerous awards over the years including local CAMRA Pub of the Year 2021. Its single bar is decorated with telephone memorabilia. The garden features floral displays to be enjoyed in summer. Snacks are served at lunchtime, and curries are popular on Wednesday evening. A classic car gathering takes place on the third Tuesday of the month from April to September. Sunday hours vary in winter – call to check. Q❀◑♠P➾🕏

Berkhamsted

Crown 🅛 ✅
145 High Street, HP4 3HH
☎ (01442) 863993
Greene King IPA, Abbot; 4 changing beers (sourced locally; often Tring, Vale, Windsor & Eton) 🅗
Family-friendly Wetherspoon pub in an impressive building that dates back to 1743. Its cosy front snug leads

to a narrow, neatly decorated interior. There is a historic coaching arch beyond the small but perfectly formed beer garden. Local ale is always on offer alongside craft beer on draught keg and in bottles, and occasionally real cider from the box. Food is served all day.
&⍟◑&⚂♿🚃(500) ☍

George Inn ✓
261 High Street, HP4 1AB
☎ (01442) 874159 ⊕ thegeorgeberkhamstedpub.co.uk
Wadworth 6X; 3 changing beers (sourced nationally; often Tring) Ⓗ
Welcoming pub on the High Street serving three well-kept handpulled ales. Its single room features a central island bar, tables with high stools, and bench window seating. The covered courtyard has a small bar and cast-iron furniture. Behind that is a sloping garden with more table seating. Families and dogs are welcome.
&⍟⚌&⚂♿🚃(500,501) ♣ ☍

Rising Sun Ⓛ
1 Canal Side, George Street, HP4 2EG (at lock 55 on Grand Union Canal, from station follow canal towards Hemel Hempstead)
☎ (01442) 864913
Tring Drop Bar Pale Ale; house beer (by Tring); 3 changing beers (sourced nationally; often Butcombe, Tring) Ⓗ
The Riser is a thriving canalside pub with plenty of outdoor space. It is a favourite of local hikers, dog walkers and cyclists. Five well-kept real ales are served alongside up to 20 real ciders. Popular events include quiz nights, folk music and a cheese club plus quarterly beer and cider festivals. Bar snacks such as pork pies and nachos are available, as well as the pub's renowned ploughman's. A multiple CAMRA award winner.
&⍟⚌♣♿🚃(500,501) ♣

Bishop's Stortford

Bishop's Stortford Sports Trust Ⓛ
Cricketfield Lane, CM23 2TD
☎ (01279) 654463 ⊕ bssportstrust.co.uk
6 changing beers (sourced locally; often New River, Hadham, Mauldons) Ⓗ
Everyone is welcome at this pub within a club – no membership required. Beer quality is driven by high turnover from the thirsty sports-playing members. Conversation flourishes in the comfortable seating area; the TV sports screens are usually muted. Outside drinking in summer comes with an attractive view. The venue is easily reached from town via Chantry Road: turn left at the end to see the grounds on the right. A recent local CAMRA Club of Year. &⍟&P

Star Ⓛ ✓
7 Bridge Street, CM23 2JU
☎ (01279) 654211
5 changing beers (sourced regionally) Ⓗ
A 17th-century town-centre pub catering for all ages. It is busy on Friday and Saturday evenings with a young crowd, but normally attracts a mixed clientele. Tuesday is quiz night. A quiet pint can be enjoyed on other evenings and at lunchtimes. Beers from regional and local breweries are offered on a changing basis. Reasonably priced traditional pub food is freshly prepared throughout the day. ⍟◑⚌♦🚃☍

Bovingdon

Bell Ⓛ ✓
79 High Street, HP3 0HP

☎ (01442) 832800 ⊕ bellbovingdon.co.uk
Tring Side Pocket for a Toad; 3 changing beers (sourced nationally; often Timothy Taylor, Tring, Young's) Ⓗ
Friendly local featuring a wooden-beamed bar, on two levels, plus a snug with dartboard. It serves up to three guest real ales from local breweries, alongside Inch's craft keg cider. Good food is available from both the bar and rear restaurant. The pub hosts a popular monthly charity quiz. There are log fires in winter. Outside are a patio and smoking area to the side plus a small rear car park. &⍟◑♣P🚃(1,352)♣☍

Buntingford

Crown
17 High Street, SG9 9AB
☎ (01763) 271422
Hadham Gold; 2 changing beers (sourced nationally) Ⓗ
Town-centre pub with a large front bar, a cosy back bar and a function room. Outside it has a covered patio plus a secluded garden with pétanque piste. The pub serves fish & chips on Friday evenings and hosts an acoustic music night on the third Monday of the month. The pub is identified by CAMRA as having a regionally important historic interior. Q&⍟◑♣🚃(386,331)♣

Bushey

Swan
25 Park Road, WD23 3EE
☎ (020) 8950 2256
Black Sheep Best Bitter; Greene King Abbot; Timothy Taylor Landlord; Young's Bitter Ⓗ
Traditional gem of a Victorian pub with a single bar and two open fires, just off the high street. Its original jug-and-bottle window has been retained; old photos and sporting mementos adorn the walls. Hot snacks including toasties and pies are available at all times. The pub hosts a book club, and offers entertainment including darts, board games and shut the box. Access to the Ladies is via the garden. ⍟♣🚃(142,258)♣☍

Colney Heath

Crooked Billet Ⓛ
88 High Street, AL4 0NP
☎ (01727) 822128 ⊕ thecrookedbilletpub.com
Sharp's Doom Bar; Tring Side Pocket for a Toad; Young's London Special Ⓗ

REAL ALE BREWERIES
3 Brewers of St Albans ✦ Hatfield
Belgian Brewer, The ✦ Bishop's Stortford
Bowtie Watford
Buntingford Royston
Crossover Blendery Weston (NEW)
Farr ✦ Wheathampstead
Garden City ▤ Letchworth Garden City
Hadham ✦ Little Hadham
Lock 81 Watford (brewing suspended)
Mad Squirrel ✦ Potten End
McMullen Hertford
New River Hoddesdon
Oxhey Village Watford
Paradigm Sarratt
Pope's Yard Apsley
Six Hills ✦ Stevenage
Tring Tring
White Hart Tap ▤ St Albans (brewing suspended)

Popular and friendly cottage-style village pub dating back over 200 years. A genuine free house, it stocks three beers from national and regional breweries and micros. A wide selection of good-value, home-made food is served lunchtimes plus Friday and Saturday evenings. Summer barbecues and Saturday events are held occasionally. This is a favourite stop-off for walkers on the many local footpaths. Families are welcome in the bar until 9pm and in the large garden, where there is play equipment. ⑤✿◑♣P❋(304)✦

Croxley Green

Sportsman Ⓛ

2 Scots Hill, WD3 3AD (at A412 jct with the Green)
☎ (01923) 443360
Oakham JHB; Sharp's Doom Bar; 5 changing beers (sourced nationally; often New River, Paradigm, Vale) Ⓗ
A family-run community pub with friendly, welcoming service, providing a traditional pub atmosphere in a modern context. It serves up to six ever-changing guest ales, mostly from smaller breweries both local and further afield. Two craft keg beers are sourced from the local Paradigm Brewery. The dartboard and pool table are in frequent use. A rear patio offers comfortable outdoor seating. Croxley tube station is a short walk away. ⑤✿♣P❒➟(321,103)

Flaunden

Green Dragon ✔

Flaunden Hill, HP3 0PP (in village close to church)
TL015008
☎ (01442) 832020 ⊕ greendragonflaunden.co.uk
Rebellion IPA; 4 changing beers (sourced nationally; often Timothy Taylor, Tring, Young's) Ⓗ
This 17th-century pub reopened in 2020 under new ownership following a sympathetic refurbishment, with a new function room and extended garden. In addition to the historic taproom, which has been carefully preserved (and has been identified by CAMRA as a nationally important historic pub interior), there are two areas with wooden beams, exposed bricks and open fires. The food range includes pizza cooked in a wood-fired oven, a trattoria menu and Sunday roast. ⑤✿◑&P❋➟

Green Tye

Prince of Wales Ⓛ

SG10 6JP (Green Tye is well signposted but, as there are many country turnings, sat nav is recommended)
TL444184
☎ (01279) 842139 ⊕ thepow.co.uk
Abbeydale Moonshine; Hadham Gold; Wadworth Henry's IPA; 1 changing beer (sourced locally) Ⓗ
A traditional and friendly village local, whether you are a walker, cyclist, dog owner or just plain thirsty. Food includes sandwiches and great-value pub grub. There is a small garden for fine weather. Well-established beer festivals in May and September feature a barbecue and entertainment. Q⑤✿&P❋➟

Harpenden

Carpenters Arms

14 Cravells Road, AL5 1BD (bottom of Cravells Rd by car park)
☎ (01582) 460311
Adnams Southwold Bitter; Courage Best Bitter; Greene King Abbot; 2 changing beers (sourced nationally) Ⓗ

Landlord Tony has been running Harpenden's smallest pub since 2006, offering five real ales including two changing guests. It is popular with all sections of the community, and their dogs. The cosy interior is comfortably furnished, with an open fire warming the bar in cold weather. The spacious, secluded patio is a suntrap in summer. BT and terrestrial sport are shown on TV, with rugby union internationals especially popular. Live music is hosted occasionally. Q✿P❒❋➟

Cross Keys Ⓛ ✔

39 High Street, AL5 2SD (opp war memorial)
☎ (01582) 763989
Rebellion IPA; Timothy Taylor Landlord; Tring Side Pocket for a Toad Ⓗ
A warm welcome awaits you at this two-bar pub, a regular entry in the Guide. It has retained its traditional charm with a rare fine pewter bar top, flagstone floors and an oak-beamed ceiling. Customers can enjoy a pint in the large secluded garden in spring and summer, or in front of the public bar's fire in autumn and winter. Q⑤✿◑⇌♣❒❋➟

Harpenden Arms

188 High Street, AL5 2TR (corner of High St and Station Rd)
☎ (01582) 461113 ⊕ harpenden-arms.co.uk
Dark Star Hophead; Fuller's London Pride, ESB; 2 changing beers (sourced regionally) Ⓗ
A Victorian era former railway hotel, on the High Street near the station overlooking Harpenden Common. It features creatively designed main drinking and dining areas on the ground floor, with a secluded snug. Upstairs is a more formal dining room that also caters for private functions. Two guest beers are served alongside ales from the Fuller's range. Live music plays on Friday. ◑&⇌❒❋➟

Hatfield

Horse & Groom

21 Park Street, AL9 5AT
☎ (01707) 264765 ⊕ horseandgroom-oldhatfield.com
Greene King Abbot; 5 changing beers (sourced nationally) Ⓗ
In the heart of Old Hatfield, this Grade II-listed building is thought to house a priest hole. It serves up to six real ales and hosts beer festivals during the year. Tuesday is sausage & mash night - purchase an ale for a free portion. Thai food is served on Friday evening. Numerous buses run from the station and the car park behind the nearby Great Northern pub, accessed via an alleyway. Q⑤✿◑&♣❒P❒❋➟

Hemel Hempstead

Full House ♥ Ⓛ ✔

128 Marlowes, HP1 1EZ
☎ (01442) 265512
Greene King IPA, Abbot; Sharp's Doom Bar; house beer (by Tring); 5 changing beers (sourced nationally; often Tring, Vale) Ⓗ
Spacious pub with extensive seating and a decor reminiscent of its past as a cinema and bingo hall. It attracts drinkers with consistent beer quality and a wide range of changing ales, many of them local. There are also eight craft beers on keg. Ciders available from the box include a rotating fruity choice. Beer festivals are hosted in spring and autumn. Q⑤✿◑&●❒➟

Monks Inn ⑃

31-32 The Square, HP1 1EP
☎ 07786 365225 ⊕ monksinn.uk
9 changing beers (sourced nationally; often Neptune, Titanic, Windsor & Eton) ⑁/Ⓖ
Town-centre micropub that has enhanced the local beer scene since opening in 2018. It has something for everyone: six real ales on handpump and three on gravity in a comprehensive range of styles, plus six real ciders and four craft keg beers. The small interior, converted from an old betting shop, is complemented by gazebos outside. Customers are welcome to bring in food from local eateries. Q➳✿♠➡☐➡🐾

Heronsgate

Land of Liberty, Peace & Plenty ♈ ⑃

Long Lane, WD3 5BS (M25 jct 17, head W away from Rickmansworth, ¾ mile on right) TQ023949
☎ (01923) 282226 ⊕ landoflibertypub.com
8 changing beers (sourced nationally; often Tring, XT, Abbeydale) ⑁
Welcoming pub just off the M25, popular with walkers, cyclists, locals and real ale enthusiasts. It has historic connections to the Chartists, who had a short-lived rural community nearby. Up to eight microbrewery beers are offered in a range of styles and strengths. Real cider, perry and a selection of malt whiskies are also served. The pub hosts beer festivals, tastings and charity events throughout the year. Bar snacks are available all day. There is a large outside pavilion for families.
✿♣♠P☐➡(R2) 🐾🐾

Hertford

Black Horse ⑃ ✅

29-31 West Street, SG13 8EZ
☎ (01992) 583630 ⊕ theblackhorse.biz
6 changing beers (sourced nationally) ⑁
A community-focused, timbered free house, dating from 1642 and situated in one of Hertford's most attractive streets, near the start of the Cole Green Way. It serves six real ales from around Britain, including one from Hertfordshire. The menu features home-made curries, pies, game and daily specials. The well-kept garden has a separate children's area and a summer pizza oven. The pub has its own RFU-affiliated rugby team and is handy for Hertford Town FC supporters. ➳✿➊❶♣♠➡🐾🐾

Great Eastern Tavern

29 Railway Place, SG13 7BS
☎ (01992) 582048
McMullen AK Original Mild, IPA; 1 changing beer (sourced locally) ⑁
Popular and buoyant traditional back-street McMullen local with two contrasting bars bedecked with pictures and artefacts. There is live TV sport and interesting rock and blues piped music. The pub hosts a folk club on the first Thursday of the month and a quiz on the first Sunday. Sandwiches are available at lunchtimes. A chilli challenge is held every February. Outside are two small gardens – the larger, to the rear, is paved and adorned with a stunning array of plants.
➳✿❀(East) ♣➡(395,310) 🐾🐾

Hertford Club

Lombard House, Bull Plain, SG14 1DT
☎ (01992) 421422 ⊕ hertford.club
3 changing beers (sourced nationally) ⑁
Dating from the 15th century with later additions, Lombard House, on the River Lea, was built as an English hall house and is one of the oldest buildings in Hertford.

It has been the home of this private members' club since 1897. CAMRA members are welcome and may be signed in on production of a membership card. You will find two or three changing beers and real cider, which in fine weather can be enjoyed in the delightful walled garden and riverside terrace. Home-cooked food is served at lunchtimes and on Friday evenings.
➳✿❶❀(East) ♣♠➡➡🐾

Old Barge ✅

2 The Folly, SG14 1QD (ask for Folly Island and you'll find the Old Barge)
☎ (01992) 581871 ⊕ theoldbarge.com
Marston's 61 Deep; 2 changing beers (sourced nationally) ⑁
A free house on Folly Island, pleasantly situated canalside on the River Lea, offering a selection of ales – often including a dark brew – and a range of ciders and perries. Locally sourced home-cooked food is served all day with roasts on Sundays. There is a music quiz on the last Thursday of the month. The Spring Fling music festival takes place on the second May bank holiday Monday. Look out for the annual duck race on Easter Monday. ➳✿❶❀(East)♣♠➡🐾

Old Cross Tavern ⑃

8 St Andrew Street, SG14 1JA
☎ (01992) 583133 ⊕ oldcrosstavern.com
Timothy Taylor Landlord; 5 changing beers (sourced nationally) ⑁
Superb town free house offering a friendly welcome. It serves up to six real ales from brewers large and small, usually including a dark beer of some distinction, plus a fine choice of Belgian bottle-conditioned brews. Two beer festivals are held each year, one over a spring bank holiday weekend and the other in October. There is no TV or music here, just good old-fashioned conversation. Home-made pork pies and Scotch eggs are available.
Q❀(North) ♣➡(395) 🐾

High Wych

Rising Sun

High Wych Road, CM21 0HZ
☎ (01279) 724099
4 changing beers (often Oakham, Woodforde's) Ⓖ
Friendly village local, popular with locals and walkers. It has never used handpumps; the range of four or five beers is served on gravity, from breweries including Tring, Adnams and Oakham. The refurbished building retains its original character with a stone floor, attractive fireplace and wood panelling. The pub holds an annual vegetable competition. Parking is in the village hall car park opposite. Q✿♣P➡(347)🐾

Hitchin

BB's Bar

Bridge Street, SG5 2DE (near town centre via Sun St from Market Place and via Queen St from station)
☎ (01462) 656084
Fuller's London Pride; Oakham JHB, Citra, Bishops Farewell; 1 changing beer (sourced nationally) ⑁
There is a friendly pub atmosphere at this sports and music bar, named after blues legend BB King. The beer range usually includes two Oakham ales plus two others. The cask taps are on a separate bar counter in the front room, separate from the main counter. An additional rear room opens at busy times and can be hired for private functions. ✿🐾

Half Moon ♟ ⅃

57 Queen Street, SG4 9TZ (on B656 at roundabout jct with Bridge St and Park St, ½ mile off A602, near market)
☎ (01462) 453010 ⊕ thehalfmoonhitchin.com
Young's Bitter; Adnams Southwold Bitter; 8 changing beers (sourced nationally) ⊞
Welcoming one-bar pub near the market, dating from the 18th century. It serves two house ales and eight ever-changing guests from breweries near and far, ensuring a variety of beer styles is always available alongside a selection of traditional ciders. Bar snacks are normally offered. Popular attractions include regular quiz and music nights plus two annual beer festivals. Local CAMRA Pub of the Year and Cider Pub of the Year 2022. ⎈✿◑♣P➈❀ 🛜

Victoria

1 Ickleford Road, SG5 1TJ (NE of town centre via Bancroft towards station)
☎ (01462) 432682 ⊕ thevictoriahitchin.com
Greene King IPA, Abbot; 4 changing beers (sourced nationally) ⊞
This popular and busy pub dates from 1865. It hosts a range of events from quiz nights and live music to comedy and cabaret, as well as an annual beer and cider festival and the Vic Fest music festival. Two regular Greene King beers are served alongside two guests. Good-value, home-cooked food is offered every day, including regular pie nights and Sunday roasts. The historic barn is available for community use and live events. ⎈✿◑&⇌(Hitchin)♣🖳🛜

Knebworth

Lytton Arms

Park Lane, SG3 6QB
☎ (01438) 812312 ⊕ thelyttonarms.co.uk
Abbeydale Daily Bread; Woodforde's Wherry; 5 changing beers (sourced nationally; often Brancaster) ⊞
A 19th-century pub adjacent to the Knebworth House estate. It was built for the Hawkes and Co brewery of Bishop's Stortford, whose original logo is visible in the pub sign's ironwork. Four house beers are served alongside a changing selection from regional breweries and micros. Good home-cooked food is available every day. Live music features on Friday evening. The garden has an attractive decked patio. ⎈✿◑♣P🖳(44,45)❀

Station

1 Station Approach, SG3 6AT
☎ (01438) 579504 ⊕ stationpubknebworth.com
Shepherd Neame Spitfire; 3 changing beers (sourced nationally) ⊞
An attractively refurbished pub next to the railway station. Now owned by the local parish council, it was reopened after a lengthy campaign that saved it from residential development. Four cask ales are served, covering a range of styles, and delicious food is available every day. ⎈✿◑⇌P❀🛜

Letchworth Garden City

Garden City Brewery & Bar ⅃

22 The Wynd, SG6 3EN
☎ 07939 401359 ⊕ gardencitybrewery.co.uk
8 changing beers (sourced nationally) Ⓖ
An award-winning, family-run brew-bar in a converted café on a charming pedestrianised street. All ales are on gravity: usually four of the brewery's own, only available here, and four guests. There is also a large selection of local and UK-wide ciders. Locally produced bar snacks are

on offer. The paved beer garden has a weatherproof awning. The bar has a regular events programme. It is a short walk from the station, with parking adjacent and a playground opposite. Q⎈✿&⇌➈P🖳❀🛜

London Colney

Bull ⅃

Barnet Road, AL2 1QU
☎ (01727) 823160 ⊕ thebullpublondoncolney.co.uk
St Austell Tribute; Timothy Taylor Landlord; 2 changing beers (sourced nationally) ⊞
A lovely 17th-century timbered building near the River Colne, offering a range of real ales. It has a cosy lounge featuring an original fireplace, and a large public bar with dartboard and TV. Evening events include live music sessions. Good-value home-made meals are served Monday to Saturday lunchtimes and evenings, with breakfast on Saturday and a roast on Sunday. Outside is a children's play area. ✿◑♣P🖳❀🛜

Oxhey

Railway Arms ✅

1 Aldenham Road, WD19 4AB
☎ 07976 647569 ⊕ railwayarmsbushey.com
Greene King IPA, Abbot; 2 changing beers (sourced nationally; often Tring) ⊞
Friendly and welcoming Victorian pub opposite Bushey station. Its interior features railway memorabilia, befitting its name. Historically it was used as a masons' meeting house, as indicated by the coat of arms on the side of the pub. It is now a multi-screen TV sports venue with a wide variety shown, including Gaelic football. The public bar features a pool table and signed Watford FC shirts. ⎈✿⇌(Bushey)⊖(Bushey)♣P🖳❀🛜

Park Street

Overdraught

86 Park Street, AL2 2JR
☎ (01727) 768221
Greene King IPA; 1 changing beer (sourced nationally) ⊞
Traditional family-run pub on the old Roman road Watling Street, first mentioned in 1689 documents as White Horse Farm. Its split-level bar features beams, brass and a listed fireplace, and displays sporting photographs on the walls. Meals use locally sourced produce and are served Tuesday to Saturday evenings and every lunchtime, including a Sunday roast. Tuesday is poker night. The newly built annexe has a pool table. Outside is a large garden. ⎈✿◑&⇌♣P🖳(652,655)❀🛜

Potters Bar

Admiral Byng ✅

186-192 Darkes Lane, EN6 1AF (corner of Byng Drive)
☎ (01707) 645484
Greene King Abbot; Ruddles Best Bitter; Sharp's Doom Bar; 8 changing beers (sourced nationally) ⊞
Friendly community Wetherspoon pub with a display of two model sailing ships and other memorabilia celebrating the exploits and death of Admiral Byng, who was executed for 'failing to do his utmost' to save Minorca from falling to the French in 1756. (The family estate is nearby.) It offers a good choice of real cider. In summer the pub's frontage is opened onto the street, with additional seating provided. ⎈✿◑&⇌♣🖳(84,610)🛜

Potters Crouch

Holly Bush

Bedmond Lane, Potters Crouch, AL2 3NN (off B5183 at jct of Potters Crouch Ln and Ragged Hall Ln or off A4147) TL116052

☎ (01727) 851792 ∰ thehollybushpub.co.uk

Fuller's London Pride, ESB; Gale's Seafarers Ale ⊞

Charming wisteria-covered 17th-century pub in pleasant rural surroundings. It is attractively furnished throughout with large oak tables and period chairs. The atmosphere in the three drinking areas is convivial and conversational, with no jukebox, slot machine or TV to disturb guests. The food menu is not extensive but is of high quality. Children are welcome. The garden is ideal in summer. Q🕿🛏🍴🛜🅿🍽

Preston

Red Lion Ⓛ

The Green, SG4 7UD (find Preston, the green is at the crossroads, there's the pub!)

☎ (01462) 459585 ∰ theredlionpreston.co.uk

Timothy Taylor Landlord; 4 changing beers (sourced nationally) ⊞

This attractive free house on the village green was the first community-owned pub in Britain. It offers a variety of beers, many from small breweries. Fresh home-made meals are served, often featuring locally sourced ingredients (no food Sun eve and Mon). The pub hosts the village cricket teams. It has been voted local CAMRA Pub of the Year numerous times in recent years, and received a CAMRA 50th anniversary golden award in 2021. Q🕿🛏🍴🍽🅿🚐(88)🐾🛜

Puckeridge

White Hart Ⓛ

Braughing Road, SG11 1RR

☎ (01920) 821309

McMullen AK Original Mild, Country Bitter; 1 changing beer (sourced nationally) ⊞

A 14th-century pub that was named after the emblem of Richard II. Its numerous rooms include a dining room with a huge fireplace – ask about the story of the beam above it. The large garden features a children's play area. A thatched gazebo is built around a tree in the car park. Breakfast is served on Saturday.

🛏🍴🅿🚐(386,331)🐾🛜

Royston

Manor House ✓

14 Melbourn Street, SG8 7BZ

☎ (01763) 250160

Greene King Abbot; Ruddles Best Bitter; Sharp's Doom Bar; 3 changing beers (sourced nationally) ⊞

A Wetherspoon pub that is full of personality, and features local art pieces that add to its character. The Grade II-listed former town house dates from the early 18th century; the block on the left was added late in the 19th century. Decorative iron railings at the front were removed during World War II. Royston Manor House was the name adopted in 1948 for what later became known as the Manor House Club. 🛏🍴🍽🚐(331)🛜

St Albans

Garibaldi ✓

61 Albert Street, AL1 1RT

☎ (01727) 894745 ∰ garibaldistalbans.co.uk

Fuller's Oliver's Island, London Pride, ESB; Gale's HSB; 1 changing beer (sourced nationally) ⊞

A fine example of a back-street local, in the heart of Sopwell near the cathedral. The landlord is a past winner of the Fuller's Master Cellarman award, and serves an extensive range of the brewery's ales. Food includes artisan pizza (on request Tue to Sat) and home-cooked roasts on Sunday, with excellent service provided by friendly bar staff. This is a genuine community pub that hosts music, darts nights, bingo and an annual charity quiz, and supports numerous good causes. 🛏🍴🛜(Abbey)🍽🐾🛜

Great Northern Ⓛ ✓

172 London Road, AL1 1PQ

☎ (01727) 730867 ∰ greatnorthernpub.co.uk

4 changing beers (sourced nationally) ⊞

A lively free house, this independent pub has been modernised and features a pumpclip wall. It serves four regularly changing cask ales and a wide selection of UK and international craft keg beers, bottles and cans. The menu of locally sourced modern European food is available Wednesday to Sunday lunchtimes and Tuesday to Saturday evenings. Tuesday is quiz night. The pub hosts tap takeovers and restaurant pop-ups throughout the year and beer festivals in summer. 🛏🍴🛜(City)🍽🐾🛜

Lower Red Lion Ⓛ

34-36 Fishpool Street, AL3 4RX

☎ (01727) 855669 ∰ thelowerredlion.co.uk

Tring Side Pocket for a Toad; 4 changing beers (sourced nationally) ⊞

Classic Grade II-listed pub in a conservation area in one of St Albans' most picturesque streets. Both bars have plenty of character and history. The Lower Red was an early champion of CAMRA's values in the real ale revival movement and continues to stock quality real ales, ciders and perries. Home-cooked food is served lunchtimes and weekday evenings. A function room serves as an additional dining area on Sunday. B&B accommodation is available in seven letting rooms. 🛏🍴🅿🐾🛜

Mermaid

98 Hatfield Road, AL1 3RL

☎ (01727) 845700

Oakham Citra; 5 changing beers (sourced nationally) ⊞

Welcoming community pub with a diverse clientele, a short walk from the city centre and railway station. It serves an interesting and regularly changing choice of ales, usually including a stout or porter, plus ciders and bottled foreign beers. Live music is hosted on Sunday evenings. Beer festivals are held on the May Day and August bank holiday weekends, and a cider festival over the spring bank holiday. Outside is an impressive covered garden. Winner of several local CAMRA awards. 🛏🍴(City)🍽🐾🛜

Portland Arms

63 Portland Street, AL3 4RA

☎ (01727) 851463 ∰ portlandarmsstalbans.com

Fuller's London Pride, ESB; Gale's Seafarers Ale; 2 changing beers (sourced nationally) ⊞

Welcoming traditional local tucked away in a residential area, a short stroll from the city centre and the Roman history in Verulamium Museum. The pub has a warm and cosy feel, thanks to its open fire, wood panelling and pictures of historic St Albans on the walls. It hosts a variety of live music, quizzes and entertainment nights. Q🛏🍴🛜(Abbey)🍽🐾🛜

Robin Hood ✓

126 Victoria Street, AL1 3TG
☎ (01727) 856459 ⊕ robin-hood-st-albans.co.uk
**Harvey's Sussex Best Bitter; 2 changing beers
(sourced nationally)** Ⓗ
A friendly single-bar community pub handy for St Albans
City station and popular with homeward-bound
commuters. Real cider or perry is always available to
complement the rotating ales, which are served in
excellent condition. Board games, table skittles and a
traditional jukebox provide entertainment, and a
secluded rear garden offers summer enjoyment. Live folk
music plays on Wednesday evenings. Local CAMRA Pub
of the Year 2021. ✿✿✿≈(City)♣●🅿️✿✿

Six Bells Ⓛ ✓

16-18 St Michael's Street, AL3 4SH
☎ (01727) 856945 ⊕ the-six-bells.com
**Oakham JHB; Timothy Taylor Landlord; Tring
Ridgeway; Vale Gravitas; 2 changing beers (sourced
nationally)** Ⓗ
Characterful 16th-century pub in the attractive St
Michael's village, a short walk from the city centre and
cathedral, and close to Verulamium Park and Museum. It
serves four regular beers and two changing guests,
except when hosting occasional brewery takeovers. Real
cider is often available in summer. The home-cooked
food is excellent. There is a pleasant patio outside.
Notably dog friendly. ✿✿✿♣●🅿️✿✿

White Hart Tap Ⓛ

4 Keyfield Terrace, AL1 1QJ
☎ (01727) 860974 ⊕ whiteharttap.co.uk
**Timothy Taylor Boltmaker, Landlord; Tring Side
Pocket for a Toad; St Austell Tribute; 2 changing beers
(sourced nationally)** Ⓗ
One-bar back-street local serving two beers free of tie,
often from microbreweries. Good-value, home-cooked
food is served lunchtimes and Monday to Saturday
evenings, with roasts on Sunday (booking
recommended) and themed food nights every so often.
Quiz night is Wednesday; other attractions include
summer barbecues and occasional beer festivals. There is
a heated, covered smoking area outside and a public car
park opposite. ✿✿✿≈(City)♣●🍴🖵✿✿

St Paul's Walden

Strathmore Arms Ⓛ

London Road, SG4 8BT TL193222
☎ (01438) 871654 ⊕ thestrathmorearms.co.uk
**Tring Side Pocket for a Toad; 4 changing beers
(sourced nationally)** Ⓗ
This pub on the Bowes-Lyon estate has been serving
drinkers since 1882. It has a separate snug. A constantly
changing list of guest beers is offered, some from lesser
known breweries. Unusual bottled ales are also sold
alongside real ciders and perries. The pub has been a
Guide regular since 1981 and displays a full collection
going back to 1976. Attractions include occasional
gourmet food nights (booking essential) and regular
Wednesday pizza & pasta evenings.
Q✿✿✿🅰️♣🅿️✿✿

Sandridge

Green Man

31 High Street, AL4 9DD
☎ (01727) 854845 ⊕ greenmansandridge.co.uk
**Greene King Abbot; Sharp's Atlantic; Tring Side Pocket
for a Toad** Ⓖ

Village community pub that extends a warm welcome to
beer and cider drinkers alike. All ales are served direct
from the cask. Traditional home-cooked food is available
lunchtimes, and pizza is served Thursday to Saturday
evenings. Monday is quiz night. The pub has a heated
rear patio and a garden with a small aviary. Dogs are
welcome in the conservatory. Q✿✿✿♣●🅿️✿✿

Rose & Crown Ⓛ

24 High Street, AL4 9DA
☎ (01727) 859739 ⊕ roseandcrownpubsandridge.co.uk
**Tring Ridgeway; Young's London Special; 1 changing
beer (sourced nationally)** Ⓗ
A 17th-century inn in the centre of Sandridge, on the
doorstep of Heartwood Forest. Its traditional oak beams
and inglenook fireplace are tastefully complemented by
ample seating and dining areas. To the rear are a large
car park and a garden where barbecues are regularly
held. A separate function room is available for hire.
Q✿✿✿♣🅿️✿✿

Sarratt

Boot ✓

The Green, WD3 6BL
☎ (01923) 262247 ⊕ thebootsarratt.com
**Fuller's London Pride; St Austell Tribute; 1 changing
beer (sourced regionally; often Paradigm)** Ⓗ
Food-oriented pub opposite the green in the heart of the
village. It has several bar areas including the main bar's
separate rear dining space, which can be hired for
functions. Food can be ordered throughout the pub from
both the bar menu and restaurant. The large garden
features children's play areas and a marquee. There is
patio seating in front of the pub, and a large car park.
✿✿✿🅿️(352)✿✿

Sawbridgeworth

Bull

89 Cambridge Road, CM21 9BX
☎ (01279) 722777
Hadham Oddy Ⓗ
Welcoming 18th-century, Grade II-listed coaching inn
that was derelict when bought by its current owners, the
licensees. Staff and customers now provide a friendly
welcome. The pub features open fires, wooden beams
and sparkling brass. The sole beer on offer was chosen by
the customers and is always well kept. Sports screens are
unobtrusive and often have the sound turned off.
Outdoor seating areas provide limited space.
Q✿✿✿🅿️✿

George IV

Knight Street, CM21 9AT
☎ (01279) 723527
McMullen AK Original Mild, Country Bitter, IPA Ⓗ
Traditional two-bar pub near the town centre and railway
station. Darts teams, bellringers and the local beer group
meet in this friendly, community-led pub, and charity
quizzes are held frequently. Food is not served but the
landlady is happy for drinkers to bring their own, with a
nearby baker's a popular choice. Outside is a pleasant
paved garden. Q✿✿✿≈🖵(509,510)✿

Stevenage

Broken Seal

29B High Street, SG1 3AU (entrance on Basils Rd just off
N end of High St)
☎ 07973 673040 ⊕ sixhillsbrewing.co.uk
3 changing beers (sourced nationally) Ⓖ

Stevenage's first brewpub opened in 2019 as the taproom for Six Hills Brewing, previously Bog Brew Brewery. The firm's beers are brewed on site and usually served via KeyKeg; guest ales usually include two or three cask brews. Seating is available in the bar and brewery. There is a large range of bottled and canned beers to drink in or take away. Q✿&●ᑯ

Chequers
164 High Street, SG1 3LL
☎ (01438) 488692
Greene King IPA; 8 changing beers (sourced nationally) Ⓗ
Friendly locals' pub between the old and new towns. Its interior features an interesting old map of Stevenage; outside is a refurbished beer garden. The pub hosts book and bike clubs, and runs teams for scrabble and ladies' darts. On Wednesday there is quiz night plus the Cask Club, offering discounted cask ale, craft beer and craft cider. Q✿✿《》&≉●P♥

Dun Cow
Letchmore Road, SG1 3PP
☎ (01438) 313268
Greene King IPA; St Austell Proper Job; Timothy Taylor Boltmaker Ⓗ
A friendly locals' pub dating back to the 18th century, in a residential area roughly half a mile from the old town. It has an attractive wood-panelled snug and a larger public bar with pool table and TV. Three regular cask beers are served alongside two guests.
✿✿&♣P♥♥

Tring

King's Arms Ⓛ
King Street, HP23 6BE (corner of Queen St and King St)
SP921111
☎ (01442) 823318 ● kingsarmstring.co.uk
Tring Moongazing; 4 changing beers (sourced nationally; often Oakham, Vale, XT) Ⓗ
Family-run town-centre free house that champions local ale and serves great food. Grade II listed, it has been a community hub for more than 100 years. Its traditional and welcoming interior features two real fires. Dining options range from traditional bar snacks to impressive cuisine served in the recently renovated Coach House function room, next to a large heated patio with canopies. Q✿✿✿《》♣●ᑯ(500,501)♥

Ware

Crooked Billet ◉
140 Musley Hill, SG12 7NL (via New Rd from High St)
☎ (01920) 462516
4 changing beers (sourced nationally) Ⓗ
Friendly gem of a traditional community pub, well worth the short walk up New Road and Musley Hill from the town centre. Its two small bars feature TV sport and darts. It serves a varying range of two or three ales, often including a mild, porter or stout at weekends. Outside are tables to the front and rear. ✿✿&♣●ᑯ(395)♥

Wareside

Chequers Ⓛ
Ware Road, SG12 7QY (on B1004)
☎ (01920) 467010 ● chequerswareside.com
Timothy Taylor Landlord; house beer (by Hadham); 1 changing beer (sourced regionally) Ⓗ
A rural free house dating from the 15th century, the Chequers was originally a coaching inn and has three

distinct bars plus a restaurant. The house IPA is exclusively brewed for the pub by the local Hadham Brewery. Three rotating beers are sourced mostly from local brewers with some from further afield. All food is home-made, with numerous vegetarian and vegan options. Walkers and cyclists are welcome, making this a good base for a ramble. There are no games machines, no music... and no swearing allowed!
Q✿《》&♣●Pᑯ(M3,M4) ♥

Watford

Wellington Arms Ⓛ
2 Woodford Road, WD17 1PA
☎ (01923) 220739
Fuller's London Pride; 2 changing beers (sourced locally; often Tring) Ⓗ
Modernised street-corner free house, near Watford Junction station and a short walk from the town centre, that has been run by the same family for over 30 years. Traditional British food is available weekdays, and occasionally at weekends before Watford FC home games. Sporting events are shown on TV screens around the pub. There are 12 letting rooms available.
✿✿✿《》≉(Junction) ❸(Junction) ♣Pᑯ♥

West Herts Sports Club Ⓛ
8 Park Avenue, WD18 7HP (S of A412, near town hall)
☎ (01923) 229239 ● westhertssportsclub.co.uk
Tring Side Pocket for a Toad; Young's Bitter; 3 changing beers (sourced nationally) Ⓗ
The clubhouse is being redeveloped and it is expected that the bar will be in a new first-floor extension by the time this Guide is published. The bar will have a balcony extension with views over the playing fields. Show a CAMRA membership card or a copy of this Guide to gain entry up to four times a year. It can get very busy on Watford FC match days. ✿✿❸♣Pᑯ♥

Wild Hill

Woodman ♈
45 Wildhill Road, AL9 6EA (between A1000 and B158)
TL264068
☎ (01707) 642618 ● thewoodman.uk
Greene King IPA, Abbot; 4 changing beers (sourced nationally) Ⓗ
Friendly and unpretentious rural village pub that is very community oriented. It is a staunch supporter of real ale, serving up to six beers including four guests. Lined oversized glasses are available on request. Good pub grub is served lunchtimes (no food Sun). Look for God's Waiting Room – a good spot for a cosy drink. The large garden is ideal in summer. Multiple winner of local and county CAMRA Pub of the Year awards. ✿✿♣●P♥

Breweries

3 Brewers of St Albans SIBA

The Potato Shed, Symonds Hyde Farm, Symonds Hyde Lane, Hatfield, Hertfordshire, AL10 9BB
☎ (01707) 271636 ☎ 07941 854615
● 3brewers.co.uk

⊠ Launched in 2013, the 3 Brewers operates on a farm, using its own borehole's fresh water. Beers are supplied to a large number of local venues. Bottled beer is sold direct to the public, and it has its own taproom (open every weekend during spring/summer, and Saturdays in winter). A mezzanine level with extra seating was added

in 2021. Regular events are held and it is available to hire. ♨ 🍴 ♪

Golden English Ale (ABV 3.8%) GOLD
Copper (ABV 3.9%) BITTER
Classic English Ale (ABV 4%) BITTER
Blonde (ABV 4.2%) BLOND
IPA (ABV 4.6%) PALE
Special English Ale (ABV 4.8%) BITTER

Contract brewed for B&T Brewery:
Shefford Bitter (ABV 3.8%) BITTER
Pale brown beer with a light hop aroma and a hoppy taste leading to a bitter finish.
Dragon Slayer (ABV 4.5%) GOLD
Golden beer with a malt and hop flavour and a bitter finish. More malty and less hoppy than is usual for this style.

Baron (NEW)

Great Hormead, Hertfordshire, SG9 0PB ☎ 07936 357617 ⊕ baronbrewing.co.uk

Launched in 2021, Baron Brewing is run by Jack Baron. The focus is on modern styles including heavily-hopped pale ales and IPAs along with lagers and table beers. The 1,000-litre brewhouse allows experimentation and an ever-changing range of beers to be brewed. Currently beer is distributed in can and keg only but there are plans for cask in the future along with a taproom and brewery experience days.

Belgian Brewer, The

Unit 11, The Links Business Centre, Raynham Road, Bishop's Stortford, Hertfordshire, CM23 5NZ ☎ (01279) 507515 ⊕ thebelgianbrewer.co.uk

Situated just outside Bishop's Stortford town centre, The Belgian Brewer is a small brewery and taproom. Established in 2018, it produces Belgian-style beers brewed to traditional Belgian methods using family recipes. Currently producing under 5,000 litres per month, demand is increasing week by week, especially for its speciality fruit beers. ♨ 🍴 ♦ LIVE ♪

Bowtie

78 Church Road, Watford, Hertfordshire, WD17 4PU ⊕ bowtiebrewers.co.uk

A 0.25-barrel nanobrewery founded in 2018, in a specially-designed brewshed. Commercial brewing began in 2019, offering three ranges of small batch beers; traditional, craft and speciality. Beers are mostly available in bottles but cask-conditioned beer is occasionally produced. LIVE

Buntingford

Greys Brewhouse, Therfield Road, Royston, Hertfordshire, SG8 9NW ☎ (01763) 250749 ☎ 07851 743799 ⊕ buntingfordbrewery.com

⊗ Brewing commenced on the current site in 2005 and has expanded to a capacity of around 60 barrels per week. Regular beers are brewed alongside seasonal/ occasional brews, and various themed specials. An on-site well supplies water, and all liquid waste is treated in a reed bed. The brewery is located on a conservation farm, and there is a wide variety of bird life visible from the doors of the brewhouse, often including rare and endangered species. ♦

Twitchell (ABV 3.8%) BITTER
Single Hop varieties (ABV 4%) GOLD

Hurricane (ABV 4.3%) BITTER
Polar Star (ABV 4.4%) GOLD

Creative Juices

Woodoaks Farm, Denham Way, Maple Cross, Hertfordshire, WD3 9XQ ☎ (01923) 771779 ⊕ creativejuicesbrewingcompany.com

A craft brewery, taproom and beer garden that opened in 2019 in a renovated dairy building on a farm in Hertfordshire. Beers are unfiltered and unpasteurised and are either kegged or canned. No cask ale is produced. ♦

Crossover Blendery (NEW)

Lannock Manor Farm, Hitchin Road, Weston, Hertfordshire, SG4 7EE ✉ beer@crossoverblendery.co.uk

A small blendery operation producing 100% spontaneously fermented beers aged in traditional vessels such as oak barrels. The aim is to source ingredients as close to the blendery as possible, working with farmers and growers directly, and promoting their produce through the beers.

Farr Brew SIBA

Unit 7, The Courtyard, Samuels Farm, Coleman Green Lane, Wheathampstead, Hertfordshire, AL4 8ER ☎ 07967 998820 ⊕ farrbrew.com

⊗ Farr Brew began brewing in 2014, expanding in 2016 with a new 10-barrel facility. Ecological and environmental concerns are at the forefront of everything Farr Brew creates. Community engagement includes hop-growing and most recently the launch of a home brewers competition. The brewery now runs six pubs around Hertfordshire: The Reading Rooms, Wheathampstead; The Rising Sun, Slip End; The Red Cow, Harpenden; The Eight Bells, Old Hatfield; The Elephant & Castle, Amwell; and most recently The Bull, Whitwell. ♨ 🍴 ♦ ♦

Our Greatest Golden (ABV 4.1%) GOLD
Our Best Bitter (ABV 4.2%) BITTER
Our Most Perfect Pale (ABV 4.2%) PALE
Pride Pale (ABV 4.2%) PALE
Farr Afield (ABV 4.3%) BITTER
Black Listed IPA (ABV 4.5%) PALE
Farr & Away (ABV 4.5%) PALE
Farr Apart (ABV 4.8%) PALE
Rusty Stag (ABV 4.8%) BITTER
Fresh Start (ABV 4.9%) PALE
1492 (ABV 5%) IPA
Porter (ABV 5%) PORTER

Garden City

🏠 **22 The Wynd, Letchworth Garden City, Hertfordshire, SG6 3EN** ☎ 07932 739558 ⊕ gardencitybrewery.co.uk

⊗ A brewbar established in 2016 using a 2.5-barrel plant, serving a selection of its own ales plus guests on gravity.

Hadham SIBA

Unit 6c, Hadham Industrial Estate, Church End, Little Hadham, Hertfordshire, SG11 2DY ☎ (01279) 771916 ☎ 07770 766376 ⊕ hadhambrewery.co.uk

⊗ Founded in 2015, the 10-barrel brewery uses its own spring water. Outlets are supplied within a 30 mile radius

of the brewery. There is an on-site shop and taproom.
‼ ✧

Gold (ABV 3.7%) GOLD
Oddy (ABV 3.9%) BITTER
First (ABV 4%) BITTER

Lock 81

Unit 21, Wenta Business Centre, Colne Way, Watford, WD24 7ND ⊕ lock81brewery.co.uk

Named after the Batchworth lock on the Grand Union Canal at Rickmansworth. Brewing is currently suspended while plans are in place to expand production through gypsy/contract brewing.

McMullen SIBA IFBB

26 Old Cross, Hertford, SG14 1RD
☎ (01992) 584911 ⊕ mcmullens.co.uk

⊛McMullen, Hertfordshire's oldest, independent brewery, was founded in 1827. Its famous brew, AK, is traceable back to the 19th century. The 'Authentic Heritage' tag promotes its core beers. Additional seasonal ales are produced throughout the year, sometimes produced under the Rivertown Brewing name. A microbrewery supplements the main plant. Almost all 125 tied pubs, spread across South-East England, serve cask beer. ‼ ♦

AK Original Mild (ABV 3.7%) MILD
A pleasant mix of malt and hops leads to a distinctive, dry aftertaste.
Country Bitter (ABV 4.3%) BITTER
A full-bodied beer with a well-balanced mix of malt, hops and fruit throughout.
IPA (ABV 4.8%) PALE

Mad Squirrel SIBA

Unit 18, Boxted Farm, Berkhamsted Road, Potten End, Hertfordshire, HP1 2SG
☎ (01442) 256970 ⊕ madsquirrelbrew.co.uk

⊗ Brewing began in 2010 on the outskirts of Hemel Hempstead. Since 2017 it has used a custom brew kit from the US, using water from an on-site borehole at Potten End. The brewery maintains an innovative outlook, introducing many specialised craft beers while maintaining a range of more traditional cask ales and beers. Output is distributed to venues throughout London and the South-East, including its own ever-increasing chain of Tap & Bottle shops. ‼ ♦ ✧

Hopfest (ABV 3.8%) GOLD
Mister Squirrel (ABV 4%) BITTER
Resolution (ABV 4.2%) GOLD
London Porter (ABV 5%) PORTER

New River SIBA

Unit 47, Hoddesdon Industrial Centre, Pindar Road, Hoddesdon, Hertfordshire, EN11 0FF
☎ (01992) 446200 ⊕ newriverbrewery.co.uk

⊗ New River commenced brewing in 2015 on the banks of the New River in Hoddesdon, using a new 10-barrel plant. Many of its beer names are themed around the river. Its core range of ales is complemented by seasonal beers and one-off specials. ♦

London Tap (ABV 3.8%) PALE
Twin Spring (ABV 4%) GOLD
Riverbed Red (ABV 4.2%) BITTER
Blind Poet (ABV 4.5%) PORTER
Five Inch Drop (ABV 4.6%) PALE

Isle Of Rye Pale Ale (ABV 5.2%) PALE

Oxhey Village

14 Maxwell Rise, Watford, WD19 4DX ☎ 07470 422842 ✉ shaun@ruthandshaun.co.uk

Oxhey Village Brewery is a nanobrewery set up by five drinking companions, which began commercial brewing in 2019. Currently producing real ale in cask and craft beer in keg for a few local pubs and clubs. Additionally, small batches are available on request for events and beer festivals.

OVB Session (ABV 3.8%) BITTER

Paradigm

4d Green End Farm, 93a Church Lane, Sarratt, Hertfordshire, WD3 6HH
☎ (01923) 291215 ⊕ paradigmbrewery.com

⊗ Founded by two friends, Neil Hodges and Rob Atkinson, Paradigm went into production in 2015. Its five-barrel plant is located in an industrial unit on a farm in Sarratt village, Hertfordshire. One-off beers are also brewed to complement the core range. The brewery and beer names are based on corporate jargon and buzzwords. ‼ ♦ LIVE

Fake News (ABV 3.8%) PALE
Seven 'C's (ABV 3.8%) PALE
Touchpoint (ABV 3.9%) PALE
Holistic (ABV 4%) GOLD
Heads Up (ABV 4.1%) PALE
Win-Win (ABV 4.2%) BITTER
Levelling-Up (ABV 4.3%) PALE
Synergy (ABV 4.3%) BITTER
Black Friday (ABV 6%) MILD

Pope's Yard

Cutter Room, Frogmore Mill, Apsley, Hertfordshire, HP3 9RY
☎ (01442) 767790 ⊕ popesyard.co.uk

Pope's Yard began commercial brewing in 2012 using a one-barrel plant. Two expansions since then, and two relocations, means it now operates a five-barrel plant for production and a one-barrel pilot plant. LIVE

Lacerta US (ABV 3.9%) PALE
Luminaire (ABV 3.9%) PALE
Quartermaster (ABV 4.4%) BITTER
Club Hammer Stout (ABV 5.5%) STOUT

Six Hills SIBA

Rear of 29b High Street, Stevenage, Hertfordshire, SG1 3BG ☎ 07973 673040 ⊕ sixhillsbrewing.com

⊗ Previously known as Bog Brew, Six Hills Brewing was established in 2017 and renamed in 2021. Beers are available at local beer festivals, freehouses, the online shop and the brewery tap located next door to the brewery. It has expanded from a two-barrel plant to 2,500 litres per month capacity. There are several regular beers as well as seasonal specials. All beers are unfined and vegan. The taproom holds regular events throughout the year. ‼ ▤ LIVE V ✧

Running With the Big Dog (ABV 4.7%) PALE

Tring SIBA

Dunsley Farm, London Road, Tring, Hertfordshire, HP23 6HA
☎ (01442) 890721 ⊕ tringbrewery.co.uk

Founded in 1992, Tring Brewery revived the traditional art of brewing in the market town of Tring, which had been without a brewery for more than 50 years. It moved to its present site in 2010. It brews more than 130 barrels a week, producing an extensive core range of beers augmented by monthly and seasonal specials, most taking their names from local myths and legends. 💷🚂♦LIVE

Side Pocket for a Toad (ABV 3.6%) BITTER
Brock Bitter (ABV 3.7%) BITTER
Mansion Mild (ABV 3.7%) MILD
Citra Session (ABV 3.9%) PALE
Drop Bar Pale Ale (ABV 4%) PALE
Ridgeway (ABV 4%) BITTER
Moongazing (ABV 4.2%) BITTER
Pale Four (ABV 4.6%) GOLD
Tea Kettle Stout (ABV 4.7%) STOUT
Colley's Dog (ABV 5.2%) BITTER
Death or Glory (ABV 7.2%) BARLEY

Two Bob

Correspondence: 10 Abbots Close, Datchworth, Hertfordshire, SG3 6TA ☎ 07966 159643
✉ twobobbrewco@gmail.com

Two Bob Brewing Co is a nanobrewery in North East Hertfordshire producing small batch hand crafted ales using traditional methods and natural ingredients.

Porter (ABV 4.2%) PORTER
Gold (ABV 4.3%) GOLD
EPA (ABV 4.6%) PALE

White Hart Tap

🏠 White Hart Tap, 4 Keyfield Terrace, St Albans, Hertfordshire, AL1 1QJ
☎ (01727) 860974 ⊕ whiteharttap.co.uk

Brewing began in 2015. Beers are only available in the pub. Brewing is currently suspended.

Lytton Arms, Knebworth (Photo: Emma Haines)

East of England Real Heritage Pubs

Paul Ainsworth and Michael Slaughter

This guide will lead you to nearly 100 pubs throughout the East of England that retain interior features of real historical significance. They range from rural 'time-warp' pubs to old coaching inns and include some unsung pub interiors from the inter-war and post-war periods.

Fully updated and illustrated with high-quality photographs throughout; discover the variety of historic pub interiors in the East of England, while informative articles explain their significance. It champions the need to celebrate, understand and protect the genuine pub heritage we have left with every pub described, highlighting its special historic features.

RRP: £8.99 **ISBN**: 978-1-85249-381-3

For this and other books on beer and pubs, visit CAMRA's online bookshop at **shop1.camra.org.uk** or call 01727 867201.

Discounts are available for CAMRA members.

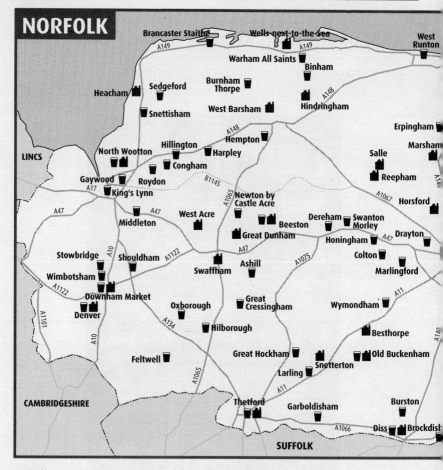

NORFOLK

Ashill

White Hart Free House 🍷 🗓 ✅

Church Street, IP25 7AW (100yds from St Nicholas' Church)

☎ (01760) 622190 ⊕ ashillwhitehart.co.uk

4 changing beers (sourced regionally) 🖽

Voted local CAMRA Pub of the Year for 2022 despite only reopening in October 2020, this free house has a warm and friendly atmosphere, with a great choice of draught beers and home-cooked food. The pub is a hub for the local community as well as a good place for visitors to stay to enjoy the local area. There is now an EV charger available for those with electric vehicles. ❀🛏🍴▸🚻P✿

Banningham

Crown Inn 🗓 ✅

Colby Road, NR11 7DY (N of B1145, 1 mile E of A140)

☎ (01263) 733534 ⊕ banninghamcrown.co.uk

Adnams Ghost Ship; Greene King IPA, Abbot; 4 changing beers (sourced nationally) 🖽

Traditional 17th-century village pub. The bar has some original woodwork, giving it a warm atmosphere which is enhanced in winter by a log fire. There are three permanent ales and up to four guests from regional and microbreweries, as well as an artisan cider from a local producer. Popular for serving fine cuisine using local produce, the main restaurant is open to the kitchen. The patio, garden and barbecue areas are ideal for summer alfresco dining. Check the website for regular events, annual music festival and winter opening times. Q❀🛏🍴&♣P✿🕏

Beeston

Ploughshare ✅

The Street, PE32 2NF

☎ (01328) 598995 ⊕ beestonploughshare.com

Beeston Worth the Wait; 3 changing beers (sourced nationally; often Beeston) 🖽

This popular community-owned pub reopened in 2019 after extensive refurbishment. It has a comfortable bar with an inglenook fireplace and a log-burner, and a separate dining room with a small area off the bar that doubles as a café during the day. Additionally, there is another room off the end of the bar that houses a small shop providing day-to-day essentials. One Beeston beer is always available, and traditional English meals are served in the bar and dining room. Outside are a large patio and car park. Q🛏❀🍴▸AP✿🕏

Binham

Chequers Inn 🗓

Front Street, NR21 0AL

☎ (01328) 830297 ⊕ binhamchequersinn.co.uk

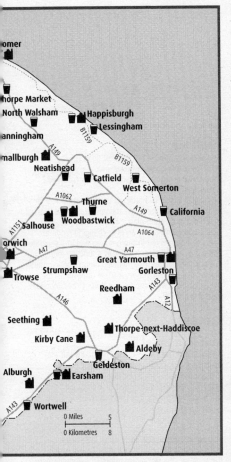

Brockdish

Old King's Head

50 The Street, IP21 4JY

☎ (01379) 668843 ⊕ kingsheadbrockdish.co.uk

Adnams Southwold Bitter, Broadside; Wolf Golden Jackal Ⓗ

A beamed 16th-century community pub with a friendly atmosphere. It reopened in 2015 with the addition of a coffee shop which serves delicious homemade cakes, and bread at weekends. There is a bar with family-friendly seating, and a standing bar with a wood-burner, both serving imaginative Italian food. Locally sourced meats and ingredients are used where possible. Gluten-free meals and cakes are also available. Regular music events are held, usually on a Thursday. A gin club adds to the mix with 150 gins. Local artists display their work in the bars and gallery. ⌂❀◑♿♣P🚌(581)❀

Burnham Thorpe

Lord Nelson

Walsingham Road, PE31 8HN (off B1355)

☎ (01328) 738241

Changing beers (sourced regionally) Ⓗ

A 17th-century inn in the village where Nelson was born and the first pub to be named in his honour after the

4 changing beers (sourced locally; often Adnams, Moon Gazer, Woodforde's) Ⓗ

A traditional brick-and-flint village pub, the Chequers is hugely popular with both locals and visitors. It is a friendly establishment with strong support from the surrounding community. One of the guest beers is from Moon Gazer, others are regional but often from Norfolk. The food offering is good wholesome fare at reasonable prices. The pub has a large garden to the rear.
Q⌂❀◑♿♣P🚌(46)❀🐾🛜

Brancaster Staithe

Jolly Sailors Ⓛ

Main Road, PE31 8BJ

☎ (01485) 210314 ⊕ jollysailorsbrancaster.co.uk

Brancaster Best; Woodforde's Wherry; 2 changing beers (sourced nationally) Ⓗ

A cosy inn with several small drinking areas and two dining rooms, convenient for the Norfolk coast path and Brancaster Staithe harbour. It has a garden and play area, and an ice cream hut; families and dogs are welcome. Brancaster beers are produced by the local Beeston brewery to the pub's recipes, and at least one is always on the bar. Food offerings include local seafood and stone-baked pizza. A beer and music festival is held every June, and a cider festival in September. Coasthopper buses stop outside.
Q⌂❀◑♿♣P🚌🐾🛜

REAL ALE BREWERIES

All Day ✦ Salle
Ampersand ✦ Diss
Barsham West Barsham
Beeston Beeston
Birdhouse Downham Market
Blimey! Norwich
Boudicca Horsford
Bull of the Woods Kirby Cane
Chalk Hill 🍺 Norwich
Dancing Men 🍺 Happisburgh
Drenchfoot Thetford
Duration West Acre
Elmtree Snetterton
Fat Cat 🍺 Norwich
Fengate Marsham
Fox 🍺 Heacham
Golden Triangle Norwich
Grain Alburgh
Humpty Dumpty Reedham
Lacons Great Yarmouth
Lynn North Wootton
Malt Coast Wells-next-to-the-Sea
Moon Gazer Hindringham
Mr Winter's Norwich
Opa Hay's Aldeby
Panther Reepham
People's Thorpe-next-Haddiscoe
Poppyland Cromer
Redwell ✦ Norwich: Trowse
S&P Horsford
St Andrews 🍺 Norwich
Steam Shed Swaffham (NEW)
Stumptail Great Dunham
Tindall Seething
Tipple's Salhouse
Tombstone 🍺 Great Yarmouth
Two Rivers Denver
Wagtail Old Buckenham
Waveney 🍺 Earsham
Why Not Norwich
Wildcraft Smallburgh
Wolf Besthorpe
Woodforde's Woodbastwick

battle of the Nile (Abu Qir). It reopened in 2021 after a five-year closure and is now owned by the Holkham Estate and run by Woodforde's Brewery. The interior has been totally remodelled, but the original room with the settles survives. Beer is now served from the adjoining bar. There is a large dining area and an extensive garden. All the beers are from Woodforde's. Q ⑤ ⑱ ⑪ ⅙ P ♣ ☏

Burston

Crown Inn
Mill Road, IP22 5TW (by crossroads in middle of village, on green)
☎ (01379) 741257 ⊕ burstoncrown.com
Adnams Southwold Bitter Ⓗ/Ⓖ; **Greene King Abbot; 4 changing beers (sourced regionally; often Adnams)** Ⓗ
Attractive 16th-century Grade II-listed pub featuring exposed beams, deep sofas, newspapers, and a log fire blazing in the inglenook fireplace. There are two bars, one with a pool table and darts. Boules is played in the garden in summer. A small restaurant serves a mixed cuisine of locally sourced freshly cooked food (no food Sun eve or Mon); booking is advisable. There is regular live music on Thursday evenings, and music and other entertainments are staged regularly throughout the year, including a beer festival. Q ⑤ ⑱ ⑪ ♣ P ♣ ☏

California

California Tavern
California Road, NR29 3QW
☎ (01493) 730340 ⊕ californiatavern.co.uk
Woodforde's Wherry; 3 changing beers (sourced nationally) Ⓗ
A spacious pub that has been under the same ownership for 30 years. It boasts a large dog-friendly bar area, with separate dining area. The pub is popular with visitors when the local holiday parks are open, and has a strong local following off-season. A Sunday carvery is served, and there is live music at the weekends during the summer. Just a short stroll from a fantastic beach, the pub also has a large child-friendly garden, and ample car parking. ⑤ ⑱ ⑪ ♣ P ⊒ ☼ ☏

Catfield

Crown Inn Ⓛ
The Street, NR29 5AA (in centre of village, S of A149, E of Stalham)
☎ (01692) 580128 ⊕ catfieldcrown.co.uk
Greene King IPA; 3 changing beers (sourced locally) Ⓗ
This 300-year-old village inn is a welcoming local that is also an oasis for Broads holidaymakers. Ales are usually sourced from local breweries, together with unusual imports from the West Country. Food includes home-made pub offerings, with local ingredients used where possible. There is a separate function/dining room, a secluded rear garden for the summer, and a real fire in winter. Two self-catering holiday cottages are available to book. An annual beer festival is held in the summer, usually in July. Q ⑤ ⑱ ⑪ ♣ P ⊒ (10,6) ☼ ☏

Colton

Norfolk Lurcher Ⓛ
High House Farm Lane, NR9 5DG (2 miles S of A47 Norwich southern bypass)
☎ (01603) 880794 ⊕ the-norfolklurcher.com
Beeston Worth the Wait; 1 changing beer (sourced nationally) Ⓗ

Welcoming, family-owned and run country pub that is in the heart of the Norfolk countryside yet only a short drive from Norwich. It serves one beer from Beeston Brewery, plus one other at peak times, and also stocks 60 single malts. Large, comfortable bar areas are complemented by the excellent restaurant serving locally produced food. The extensive beer garden is popular on warmer days, and there are eight en-suite bedrooms.
Q ⑤ ⑱ ⑪ ⅙ Å P ⊒ (4) ☼ ☏

Congham

Anvil Inn
St Andrews Lane, PE32 1DU (off B1153)
☎ (01485) 600625 ⊕ anvilcongham.co.uk
Greene King Abbot; 2 changing beers (sourced nationally) Ⓗ
Although the pub is a little off the beaten track, it is worth seeking out for its great home-made food. The bar is set in a large open-plan area and has three handpumps showcasing an ever-changing range of beers. Food is served in the bar area and in a separate restaurant, which also doubles as a function room. Regular pub quizzes, charity bingo nights and live music make this a popular venue. A small campsite at the rear of the pub is a welcome new feature. Closed Mondays.
⑤ ⑱ ⑪ ⅙ Å P ☏

Cromer

Red Lion Hotel Ⓛ
Brook Street, NR27 9HD (E of church, on cliff top)
☎ (01263) 514964 ⊕ redlion-cromer.co.uk
7 changing beers (sourced locally) Ⓗ
Splendidly situated with views of Cromer pier and the sea, the 19th-century Red Lion has retained many original features including panelling, a Victorian tiled floor and open wood fires. The work of local artists decorates the walls of the two bar areas. Up to six guest ales are usually served, often from local breweries such as Mr Winter's and Green Jack. Beer festivals are held in the summer. The restaurant offers an extensive menu, including breakfast. Accommodation is also available.
Q ⑤ ⑱ ⑪ ⅙ Å ⇌ P ⊒ (CH1,X44) ☼ ☏

White Horse ✔
24 West Street, NR27 9DS
☎ (01263) 512275 ⊕ cromerwhitehorse.co.uk
3 changing beers (sourced nationally; often Adnams, Greene King, Sharp's) Ⓗ
A 16th-century coaching inn, sympathetically modernised, which offers B&B facilities so is ideal for exploring this part of the beautiful north Norfolk coast. The interior has two bars, one of which is a games room, with pool, darts and a large TV screen for live sport. There is also a heated patio garden at the rear. A range of three real ales is available. Accommodation is in six bedrooms. A locals' pub that is welcoming to visitors.
⑤ ⑱ ⑪ ⇌ ♣ P ⊒ ☼

Denver

Blackstone Engine Bar Ⓛ
95 Sluice Road, PE38 0DZ
☎ 07518 099868
Two Rivers Miners Mild, Hares Hopping, Kiwi Kick, Happy Hopper, Denver Diamond, Porters Pride; 3 changing beers (sourced locally) Ⓗ
The bar is located in the old workshop of the Denver Mill complex. The mighty Blackstone diesel engine that powered the mill is still in its original engine house and remains in working condition. A fine selection of cider is

available, and the bar is a previous winner of local CAMRA Cider Pub of the Year. No food is served here, but there is a reciprocal agreement with the café next door for those who want to take beer into the café, or food into the bar. Q✿P

Dereham

Cock

28 Norwich Street, NR19 1BX

☎ (01362) 693393 ⊕ the-cock.co.uk

4 changing beers (sourced nationally) Ⓗ

This cosy pub has a front bar area with low beams and a large inglenook fireplace – complete with wood-burner – which opens into a larger bar area with soft furnishings. To the rear is another room with additional seating and a dartboard. Outside to the rear is an attractive courtyard area with several tables and chairs. There is a separate room available to hire for functions. Four changing beers from local and national breweries are served alongside a range of snacks such as rolls, pork pies and pasties. There is live music every Sunday afternoon.

Q✿☺✐&≉♣P☎✿⏰

Diss

Saracen's Head Hotel ✔

75 Mount Street, IP22 4QQ (at N end of town, next to church)

☎ (01379) 652853 ⊕ saracensheaddiss.co.uk

Adnams Ghost Ship; Woodforde's Wherry Ⓗ

A fine old hotel in the centre of this market town – this pub was originally the hall of the Weavers Guild and a legacy of the prosperous past of Diss which, in medieval times, was an important commercial woollen centre. Well-kept beers and good, home-cooked food are served. The interior of this two-roomed hostelry features lots of original beams and mullioned windows.

Q✿☺✐⏰♣✿P☎

Downham Market

Crown Hotel

12 Bridge Street, PE38 9DH

☎ (01366) 382322 ⊕ crowncoachinginn.com

Greene King IPA, Abbot; 2 changing beers (sourced nationally) Ⓗ

An unspoilt 16th-century coaching inn at the heart of the town. Entering through a room with a lovely staircase brings you to the bar with a beamed ceiling, panelled walls and large fireplaces. A good selection of ales is served. There is a restaurant, plenty of outside seating, and a separate function room that caters for parties and weddings. Accommodation is provided in 18 rooms, including family suites. Q✿✐⏰≉P☎⏰

Whalebone Ⓛ ✔

58 Bridge Street, PE38 9DJ

☎ (01366) 381600

Adnams Ghost Ship; Greene King Abbot; Ruddles Best Bitter; Sharp's Doom Bar; 3 changing beers (sourced nationally) Ⓗ

This Grade II-listed building, formerly the White Hart, is now part of the Wetherspoon chain. The pub has been extensively modified but retains the original façade. A large bar area leads to the gardens at the rear and side. On the walls, heritage displays include whaling, drainage of the Fens, Horatio Nelson and replica whalebones. Look out for the unique carpet. There are regular beer and cider festivals plus occasional tap takeovers. Wheelchair access is available throughout. ☺✿⏰≉♣P☎⏰

Drayton

Bob Carter Centre Ⓛ

School Road, NR8 6DW

☎ (01603) 867102 ⊕ bobcartercentre.co.uk

6 changing beers (sourced nationally) Ⓗ

A sports and social club near the centre of Drayton. The large single bar has plenty of comfortable seating. Up to five real ales are available at all times, including two from Greene King and three from smaller local breweries. Home-cooked food is served in the restaurant. The club was local CAMRA Club of the Year 2019 and is very supportive of CAMRA aims.

⏰P☎(29,29A) ⏰

Earsham

Queen's Head Ⓛ

Station Road, NR35 2TS (W of Bungay)

☎ (01986) 892623

Waveney East Coast Mild, Lightweight; 2 changing beers (often Nene Valley, Three Blind Mice) Ⓗ

Situated on the Norfolk-Suffolk border, near Bungay, this busy 17th-century brewpub has a large front garden overlooking the village green. The main bar has a flagstone floor, wooden beams and a large fireplace with a roaring fire in winter. It is home to the Waveney Brewing Co. There is a separate dining area serving food at lunchtimes (not Mon and Tue). The landlord has owned the pub since 1998. Four ales and at least one real cider are usually available. A previous local CAMRA Pub of the Year. Q☺✿⏰&♣✿P☎(580)✿⏰

Erpingham

Spread Eagle Ⓛ

Eagle Rd, NR11 7QA (signposted off A140)

☎ (01263) 761938

Adnams Ghost Ship; Lacons Encore; Woodforde's Wherry; 3 changing beers (sourced locally; often Grain, Lacons, Timothy Taylor) Ⓗ

A traditional, tastefully-refurbished, village-centre pub with a welcoming atmosphere. The main bar has two distinct areas, both with log stoves. The three East Anglian regular ales are complemented by three varying guests. A large function room, with TV and stove, overlooks the courtyard. There is a beer garden for warmer days. High-quality caterers provide food most Wednesdays and Saturdays, but check availability before travelling. Regular music evenings and events are held, and there is a summer beer festival.

Q✿✐&♣P☎(18,18A) ✿⏰

Feltwell

Wellington Ⓛ

27-29 High Street, IP26 4AF

☎ (01842) 828224 ⊕ feltwellington.co.uk

3 changing beers (sourced nationally) Ⓗ

The Wellington reopened after extensive refurbishment in 2014. There is a cosy lounge bar with a separate games room featuring pool and darts, and a 36-seat restaurant to the rear. One real cider is always on handpump. There is plenty of interesting memorabilia relating to the pub's namesake WWII bomber. The pub is heavily involved with the local community, and participates in the Meet Up Mondays initiative: on alternate weeks there are free movie screenings to provide a way for people to meet. ☺✿⏰&♣✿P☎

Garboldisham

Fox Inn L
The Street, IP22 2RZ
☎ (01953) 688538 ⊕ garboldishamfox.co.uk
6 changing beers (sourced locally; often Boudicca, Cliff Quay, Elmtree) H
A 17th-century coaching inn near Bressingham Gardens and Banham Zoo with a welcoming community feel. Bought by the local community, it reopened in 2016 as a community pub, and renovation work is ongoing. The pub serves ales from breweries such as Adnams, Walls, Blimey, Norfolk Brewhouse and Wolf. Food including pizza and souvlaki is available Saturday evening from various street-food vendors. Sunday roasts are served and local ice cream is sold in tubs. Rumour has it that one of the pub ghosts is a black labrador. Q❀⛅&♣P♥🕸🌳

Gaywood

White Horse
9 Wootton Road, PE30 4EZ
☎ 07776 061934
Timothy Taylor Landlord; 1 changing beer (sourced nationally) H
This popular local pub is located near the Gaywood Clock Tower on the outskirts of King's Lynn. There is an open-plan one-roomed bar, with a number of TVs showing various sporting events, and also a large sheltered seating and smoking area at the rear. Two beers are always available, generally from breweries from around the country. ❀♣P🖵🌳

Geldeston

Locks Inn L
Locks Lane, NR34 0HS (800yds along track from Station Rd)
☎ (01508) 830033 ⊕ thelocksinn.com
6 changing beers (sourced regionally; often Lacons, People's, Wolf) H
The Locks Inn, community owned with over 1,400 shareholders, is on the River Waveney, at the end of a long track off Station Road in Geldeston. It has large gardens and overnight moorings for boats. The original small main bar has low ceiling beams and a clay floor, and is still lit by candlelight at night. On either side of the main bar are a restaurant and a function room. Regular community events and beer festivals are held. Q❀⛅◑&▲♣P🖽🌳

Gorleston

Dock Tavern L
Dock Tavern Lane, NR31 6PY (opp N side of Morrisons)
☎ (01493) 442255 ⊕ thedocktavern.com
Adnams Broadside; 3 changing beers (sourced nationally) H
As its name suggests, the Dock Tavern is close to the river, and not far from the main shopping area. This warm and welcoming pub has been subject to flood damage many times and the various flood levels can be seen by the front door. The outside drinking area at the front has views of the river and docks. There is live music most weekends, and curry and quiz nights monthly, plus an annual charity music day. ⛅◑&♣●🖵🌳🌡

New Entertainer L
80 Pier Plain, NR31 6PG
☎ (01493) 300022

Greene King IPA; 8 changing beers (sourced nationally; often Green Jack, St Austell, Woodforde's) H
This traditional pub with a unusual curved frontage including original Lacons windows, has an interesting design and layout, and has been recently refurbished. A varied choice of beers are always on offer, including up to eight guest ales, often locally brewed. The customers are as widely varied as the beers. Pool, darts and sports TV are available, along with a monthly quiz. This free house is well worth seeking out. Please note that the main entrance is on Back Pier Plain. ❀♣🖵🌡🌳🌡

Oddfellows Arms L
43 Cliff Hill, NR31 6DG
☎ 07876 545982 ⊕ oddiesgy.co.uk
3 changing beers (sourced regionally) H
Cosy two-bar local pub on Cliff Hill, a short distance from the harbour. Music and jam sessions are held on Fridays, especially in summer. There are always at least three beers on offer, often from Norfolk breweries. There is a west-facing outdoor seating area, and limited parking at the rear. The pub also stocks various bottled and canned craft ales from around the world. ⛅&P🌡🌳

Great Cressingham

Olde Windmill Inn
Water End, IP25 6NN (off A1065 S of Swaffham)
☎ (01760) 756232 ⊕ oldewindmillinn.co.uk
Adnams Southwold Bitter, Broadside; Greene King IPA; 2 changing beers (sourced nationally) H
Family run for three generations, the Windmill is a large rural pub and hotel, with a cosy feel despite its size. It offers a rolling range of beers, mostly supplied by Purity, including house beer Windy Miller. Real cider is also available. A popular food menu has something for everyone. The dining areas vary in size from a large conservatory to smaller, intimate rooms. Modern hotel accommodation is in separate buildings behind the pub. Q⛅🛏◑◐&▲♣P🌡

Great Hockham

Eagle L ✓
Harling Road, IP24 1NP
☎ (01953) 498893 ⊕ hockhameagle.com
Black Sheep Best Bitter; Fuller's ESB; Greene King IPA; Morland Old Speckled Hen; Timothy Taylor Landlord; 2 changing beers (sourced nationally) H
In 2022 the landlord celebrated 13 years at this large family-friendly pub, set in a picturesque village close to Thetford Forest. The main bar is separated from a games area by an open fire. Five real ales are available on handpump. Outdoor seating is provided at the front of the pub. Quiz and bingo nights are held on alternate Wednesdays, both preceded by fish and chips. Numerous other events are held regularly, and the pub is home to three pool teams and a darts team. ⛅◑&♣P🌡

Great Yarmouth

Blackfriars Tavern L
94 Blackfriars Road, NR30 3BZ
☎ (01493) 331651
6 changing beers (sourced locally; often Barsham, Fat Cat, Mr Winter's) H
Traditional village-style pub set in an urban conservation area, adjacent to both the best-preserved sections of the town wall and artwork by graffiti artist Banksy. Most of the ever-changing real ales and real ciders are from Norfolk breweries, with occasional CAMRA award-

winning guests from further afield. Recently refurbished, and run by an enthusiastic CAMRA member, the pub welcomes families, dogs and cyclists. It has two separate bars, with traditional games on each table. Outside are two planted courtyards. ✆🕮♣🍺P🗐🚌(10)🕮🛜

King's Arms 🅛
229 Northgate Street, NR30 1BG
☎ (01493) 843736 ⊕ thekingsarmsgreatyarmouth.co.uk
Adnams Broadside; Woodforde's Wherry; 1 changing beer (sourced locally; often Humpty Dumpty, Tombstone) 🅗
Single-room pub that has been divided into drinking areas, including a comfortable seating space with real fire at one end. The friendly bar staff, landlord and landlady provide a warm welcome. Adnams Broadside and Woodforde's Wherry are complemented by a more local offering. The pub has a large well-kept garden, ideal for summer drinking and dining. It holds regular events, with live music at the weekends, and an annual August bank holiday beer festival featuring Norfolk ales and ciders. ✆🕮🍺♣🚻P🗐🕮🛜

Mariners 🅛
69 Howard Street South, NR30 1LN (between Palmers and Star Hotel)
☎ (01493) 331164
Greene King Abbot; 7 changing beers (sourced nationally; often Green Jack, Oakham, Skinner's) 🅗
Traditional two-bar flint-walled pub close to the town centre. Despite appearances, the building only dates from the 1950s and is a good example of the local architecture. The pub features up to eight ales including many offerings rarely seen locally, and also stocks a small selection of continental beers. The decor has a maritime theme with photographs of various ships on the wood-pannelled walls. A real fire welcomes you in the cold winter months. ✆🕮🚻♣🍺P🗐🚌(1,1A)🕮🛜

Red Herring 🅛
24-25 Havelock Road, NR30 3HQ (off St Peters Rd)
☎ 07876 644742
4 changing beers (sourced nationally; often Lacons, Mauldons, Mighty Oak) 🅗
The Red Herring gets its name from the fish that were smoked nearby in the now-closed smoke houses. Four changing beers are on offer. The Herring has a dartboard and pool table, and hosts a pool and a darts team. The pub is close to the impressive medieval walls and the award-winning Time & Tide museum. A regular entry in this Guide due to the long-serving landlord's passion for serving well-kept ales in a relaxing pub environment. Q🕮♣🗐🚌

Tombstone Saloon Bar 🍷 🅛
6 George Street, NR30 1HR (on NE corner of Hall Quay)
☎ 07584 504444 ⊕ tombstonebrewery.co.uk
10 changing beers (sourced regionally; often Green Jack, Milestone, Moon Gazer) 🅖
Small Wild West-themed bar with a brewery to the rear. Tombstone ales feature permanently along with interesting guest ales sourced regionally. The range of ciders always include selections from CAMRA-approved producers. Frequent bus services stop outside, and the bar is a short walk from Great Yarmouth Market Place. An annual Easter beer festival is held. A regular entry in this Guide and winner of numerous CAMRA awards, most recently both the local Pub and Cider Pub of the Year 2022. ✆≅♣🗐🚌🕮🛜

Troll Cart ⊘
7 Regent Road, NR30 2AF (adjacent to Market Gates bus station)

☎ (01493) 332932
Greene King Abbot; Ruddles Best Bitter; Sharp's Doom Bar; 6 changing beers (sourced nationally; often Green Jack, Wolf, Woodforde's) 🅗
Opened in 1996, unlike most Wetherspoon pubs this was not a conversion of an existing building but a new-build project. There is one bar, with various seating areas, which has a comfortable and welcoming feel. The usual JDW menu and facilities are on offer. It reopened in 2018 after a complete refurbishment and the addition of a garden area, along with conversion of upper floors to a hotel. Guest beers, sometimes local, supplement the core ales. ✆🕮≅🍴🍺♣🚌🛜

Happisburgh

Hill House 🅛
The Hill, NR12 0PW (off B1159, behind church)
☎ (01692) 650004
6 changing beers (sourced nationally; often Lacons) 🅗
A Grade II-listed, 16th-century former coaching inn set in a village close to the coast. Sir Arthur Conan Doyle stayed here in 1903 and the on-site brewery is named after a Sherlock Holmes story, the Dancing Men. Up to six real ales are served, with two brewed on-site and others sourced from East Anglia, plus at least one real cider. A noteworthy beer festival is held around the summer solstice, offering 120 real ales and ciders, with another festival in September. Opening times are more limited in winter months. Q✆🕮🍴⚲♣🍺P🚌(34)🕮

Harpley

Rose & Crown
Nethergate Street, PE31 6TW (just off A148 King's Lynn to Fakenham road)
☎ (01485) 521807 ⊕ roseandcrownharpley.co.uk
Woodforde's Wherry; 4 changing beers (sourced nationally) 🅗
This attractive 17th-century pub features open bar areas with a stylish and comfortable feel and has log fires in winter. Outside is an enclosed beer garden for summer drinking. There is an extensive menu serving excellent food, including one of the best Sunday roasts around. Guest ales are from local breweries. The unspoilt village provides pleasant walks and is close to Houghton Hall. A former local CAMRA Pub of the Year. Q✆🕮🍴P🚌(X29) 🕮🛜

Hempton

Bell
24 The Green, NR21 7LG
☎ (01328) 864579 ⊕ hemptonbell.co.uk
Greene King Abbot; Sharp's Doom Bar; Woodforde's Wherry; 1 changing beer (sourced regionally) 🅗
A popular family-run village pub with a relaxed, friendly atmosphere. It retains a two-bar layout little altered since the early 1970s. Pub games, including dominoes, cribbage and poker dice, are popular – you will be welcome to get involved. Changing guest beers are from micros or independent breweries. Open mic folk sessions take place on the second Tuesday of the month and regular quizzes are held. Q✆🕮⚲♣P🕮🛜

Hilborough

Swan
Brandon Road, IP26 5BW
☎ (01760) 756380 ⊕ hilboroughswan.co.uk
4 changing beers (sourced nationally) 🅗

A smart 17th-century building on the A1065 south of Swaffham. It opens early for breakfast every day (except Sun) and good-value food is served throughout the day. On a Sunday a carvery is offered. There are up to four beers on the bar, mostly from local breweries. Outside there is a pleasant seating area and a tent (no smoking permitted). Q❀✤❶◑♣P☺

Hillington

Ffolkes
Lynn Road, PE31 6BJ (on A148)
☎ (01485) 600210 ⊕ ffolkes.org.uk
Adnams Ghost Ship; Moon Gazer Jigfoot; 1 changing beer (sourced nationally) ⊞
This family-run 300-year-old former coaching inn was extensively refurbished in 2017. Located just six miles from King's Lynn and three miles from the Royal Sandringham Estate, it provides a perfect base for exploring north Norfolk. The Ffolkes has 25 bedrooms, an outdoor adventure play area and an indoor games room. There is an extensive menu, and popular street food events are now a fixture. There are always several real ales to choose from. ♿❀✤❶◑♣P☺🐾

Honingham

Buck ℒ
29 The Street, NR9 5BL
☎ (01603) 880393 ⊕ thehoninghambuck.co.uk
Lacons Encore, Legacy; 1 changing beer (sourced nationally) ⊞
Dating back to 1789, this traditional one-bar village pub has a separate restaurant area with an emphasis on serving home-cooked food. An excellent menu of unusual dishes is freshly cooked to order. The Buck has served Lacon's real ales since it was bought by the brewery in 2015. Slate floors, oak beams, a large fireplace and period furniture enhance the image of a country pub. There is a large garden with plenty of seating, and accommodation in eight en-suite rooms. Q♿❀✤❶◑&♣P🛏(4)☺🐾

King's Lynn

Ferry Lane Social Club
Ferry Lane, PE30 1HN (off King St)
☎ (01553) 772239 ⊕ ferrylanesocialclub.co.uk
5 changing beers (sourced nationally) ⒼG
The local CAMRA Club of the Year for 2020 and 2022 is at the end of a lane next to the departure point for the West Lynn Ferry. The bar looks out over the river and there is a balcony where you can sit and enjoy the views. Five beers are on offer from breweries near and afar, along with local cider from Sandringham. There is occasional live music in the bar at weekends. CAMRA members and visitors using this Guide are welcome, with a limit on number of visits before being asked to join. ◑≠♥

Live & Let Live ℒ
18 Windsor Road, PE30 5PL (off London Rd near Catholic church)
☎ (01553) 764990
5 changing beers (sourced nationally) ⊞
This popular two-bar locals' pub has a small cosy lounge and a larger bar with a TV. Five beers are available, including a mild (rare for the locality). Cider drinkers have a choice of ciders, normally including something from a local producer. Live music is sometimes played in the public bar. Local CAMRA Cider Pub of the Year 2020-2022. ♥☺

Wenn's Chop & Ale House ℒ
9 Saturday Market Place, PE30 5DQ
☎ (01553) 772077 ⊕ thewenns.co.uk
4 changing beers (sourced regionally) ⊞
After an extensive renovation in 2020, Wenn's reverted to its former name. The remodelled interior has a number of separate rooms and there are also tables outside on the edge of Saturday Market Place. Beers are from local breweries and, despite its name, the menu offers traditional pub food and does not major on chops. There is pay parking opposite and round the corner. Highly rated accommodation is available. Q♿✤❶&≠♣🛏☺🐾

Larling

Angel
NR16 2QU (1 mile SW from Snetterton racetrack, just off A11)
☎ (01953) 717963 ⊕ angel-larling.co.uk
Adnams Southwold Bitter; 4 changing beers (sourced nationally) ⊞
Five real ales plus a real cider are on handpump here, always including a mild. Over 100 whiskies are stocked, as well as 50 gins. The lounge and bar have real open fires, and there is a dining room which serves home-made fare in generous portions. A friendly atmosphere is enjoyed by locals, visitors, campers and rallyists who use the Angel's campsite. A popular long-running beer festival in August showcases over 80 real ales with live music. Local CAMRA Pub of the Year 2021. Q♿❀✤❶◑&▲♣P🛏

Lessingham

Star Inn ℒ
Star Hill, NR12 0DN (just off B1159, corner of High Rd and Star Hill)
☎ (01692) 580510
Lacons Encore; 2 changing beers (sourced nationally) ⒼG
A traditional country pub with a friendly atmosphere and a log fire in winter. Three ales, including two guests, are served from the cask, as are up to three real ciders. The Star is popular for quality meals with carefully sourced ingredients served in decent portions. Food may be enjoyed in the bar, a separate restaurant, or the spacious beer garden. Two en-suite double B&B rooms make this an excellent base to explore the local coast which has excellent sunsets in summer. Q❀✤❶◑♣♥P🛏(34)☺🐾

Marlingford

Marlingford Bell ℒ
Bawburgh Road, NR9 5HX
☎ (01603) 880263 ⊕ thebellatmarlingford.co.uk
4 changing beers (sourced locally) ⊞
This extended country village pub has a refurbished front bar with a wood-burning stove making it nice and cosy in winter. There are no regular beers: the changing ales – one dispensed on gravity – come from Lacons, Winter's, Woodforde's, and occasionally other small Norfolk breweries. The large function and restaurant room with a separate bar at the rear opens on to a large garden. Quality, locally sourced food is made on the premises, and excellent bar menu dishes are served on biodegradable trays. Sunday roasts are popular (booking advised). Q♿❀◑&▲P☺🐾

Middleton

Gate

Hill Road, Fair Green, PE32 1RW (N of A47, follow Fair Green signs)

☎ (01553) 840518 🌐 thegatefairgreen.co.uk

Greene King Abbot; Woodforde's Wherry; 1 changing beer (sourced nationally) Ⓗ

Although there is a pleasant dining room, this friendly family-run pub just off the A47 is still at heart a village local. The bar and semi-separate area with a jukebox and TV screen are used mainly by those who just want a drink. Food features seasonal produce and ingredients sourced from local suppliers. The pretty garden is popular in summer. Note that the pub is closed on Mondays and Tuesdays. Q✿♿🕙🏃♣P🐾

Neatishead

White Horse Ⓛ

The Street, NR12 8AD

☎ (01692) 630828 🌐 thewhitehorseinnneatishead.com

Woodforde's Wherry; 6 changing beers (sourced nationally) Ⓗ

Traditional Broadland village-centre pub with three separate drinking areas and a log fire in the main bar in winter. Six of the seven cask ales on offer are mainly sourced from microbreweries across the UK, and up to seven craft keg beers are available. Reasonably-priced meals are home-prepared using local produce. There is a comfortable split-level restaurant overlooking a courtyard, with a small beer garden at the rear. Spring and autumn beer festivals are held. Moorings are a short walk away. Q✿🕙&🏃♣P🚬(3)🐾🗢

Newton by Castle Acre

George & Dragon

Swaffham Road, PE32 2BX (on A1065)

☎ (01760) 755623 🌐 georgeatnewton.com

Adnams Ghost Ship; Woodforde's Wherry; 2 changing beers (sourced nationally) Ⓗ

The pub reopened in 2018 after a major refurbishment. With a wooden floor, exposed beams, comfortable seats and the walls lined with old books it has something of the air of a gentleman's club. The interesting menu offers vegan options alongside other imaginative dishes. There is a play area for children at the rear, and the Pig Shed Motel at the back caters for those who wish to stay. ✿✿🚬🕙P🐾🗢

North Walsham

Hop In Ⓛ

2 Market Street, NR28 9BZ

☎ 07714 688386 🌐 thehopin.co.uk

6 changing beers (sourced nationally) Ⓖ

Situated in a former taxi office just around the corner from the marketplace, and owned and run by keen CAMRA members, this was Norfolk's first micropub. Six changing ales are served on gravity dispense alongside real cider, and there is usually one dark beer available. In keeping with the micropub philosophy, there is no Wi-Fi, music or games machines, just good conversation. There is a small seating area downstairs and more upstairs, plus a patio area outside. Q✿🗢🚬🚬

North Wootton

Red Cat Hotel

Station Road, PE30 3QH (Station Rd is opp church of All Saints, where Nursery Ln joins Manor Rd)

☎ (01553) 631244 🌐 redcathotel.com

Adnams Southwold Bitter; 1 changing beer (sourced nationally) Ⓗ

Built in 1898 and constructed in local gingerbread carrstone, this traditional village local offers two real ales. Nicely decorated and in a quiet location close to the Wash marshes, it has attractive gardens for summer drinks. Ask about the history of the namesake red cat – if you can believe it. The pub is near National Cycle Route 1, the Sandringham Estate, and the west Norfolk coast. Q✿✿P🚬(3)🐾🗢

Norwich

Alexandra Tavern

16 Stafford Street, NR2 3BB (on corner of Stafford St and Gladstone St, off Dereham Rd)

☎ (01603) 627772 🌐 alexandratavern.co.uk

5 changing beers (sourced locally) Ⓗ

Popular, bustling and friendly, this pub, sited just outside the city centre, is a real gem. The interior is brightly decorated, with the walls featuring pictures and articles of a nautical nature. The bar serves up to five changing beers from local breweries, and two real ciders. Food is served daily, with a good variety, including a soup menu. There is a dartboard and plenty of board games to choose from. Children are welcome until early evening. Q✿✿🕙&♣🍴🚬🐾🗢

Artichoke

1 Magdalen Road, NR3 4LW

☎ (01603) 662807 🌐 artichokepub.com

8 changing beers (sourced nationally; often Golden Triangle) Ⓗ

A 1930s flint building, originally decorated in the Brewers' Tudor style. The two circular bars have cone-shaped roofs, which give the pub its name. It retains the original Young's, Crawshay & Young's windows, parquet flooring and a long solid wood bar. Bought and significantly but sensitively refurbished by the owner of Golden Triangle Brewery in 2018, the bar now has eight handpumps offering two or three Golden Triangle beers, and a great selection of craft ales. There is outdoor seating in front and part-covered seating at the side. ✿🕙&♣🍴🐾🗢

Beehive Ⓛ

30 Leopold Road, NR4 7PJ (between Unthank and Newmarket roads)

☎ (01603) 451628 🌐 beehivepubnorwich.co.uk

Green Jack Golden Best; 5 changing beers (sourced nationally; often Oakham) Ⓗ

A friendly two-bar local with knowledgeable staff, featuring a comfortable lounge bar with sofas. A beer festival is held in late June with around 25 ales and ciders. The popular beer garden is used all year round and holds charity barbecues during the summer months. There is a function room upstairs (available to hire) with a pool table. The pub has a fortnightly quiz on Wednesdays, and a book swap library was established in 2021. Q✿✿♣🍴P🐾🗢

Bell Hotel ✓

5 Orford Hill, NR1 3QB

☎ (01603) 630017

Greene King Abbot; Sharp's Doom Bar; Woodforde's Wherry; 14 changing beers (sourced nationally) Ⓗ

Large two-bar city centre pub set over three floors serving traditional real ales and food, all at reasonable prices. The building is said to date from 1485 and at one time was one of the city's leading coaching inns. The ground floor bar has a tree-shaded terrace outside with plenty of seating and views along Castle Meadow and

Orford Place. The pub served as the home to the US Women's Army Air Corp during WWII, and there is memorabilia throughout celebrating this. ⛵☕🍴♿🚃🐾🛜

Brewery Tap 🅛

98-100 Lawson Road, NR3 4LF
☎ (01603) 413153 🌐 fatcattap.co.uk
Fat Cat Norwich Bitter, Honey Ale ⑭**; Oakham Bishops Farewell** ⑥**; 15 changing beers (sourced nationally)** ⑭/⑥
Home of the Fat Cat Brewery with beers from Fat Cat, Fyne Ales, Arbor, Marble and Totally Brewed featured amongst a huge range of real ales, ciders and quality keg beers from across the country. Live music on Sundays complements a variety of events including tap takeovers, themed beer evenings, and beer launches. Loaded chips and other snacks are available. There are occasional themed beer festivals, including one in autumn. There is plenty of outside seating at front and rear (mostly covered at rear). Q☕🍴♿♣🚶♦P🚃(11,12)🐾🛜

Coach & Horses

82 Thorpe Road, NR1 1BA
☎ (01603) 477077 🌐 thecoachthorperoad.co.uk
Chalk Hill Tap Bitter, CHB, Dreadnought, Gold; 3 changing beers (sourced nationally) ⑭
Close to the station, this coaching inn, with its iconic balcony, is the home of the Chalk Hill Brewery, and serves its full range of beers. Tours of the brewery are available by appointment. Excellent-value food is served along with Sandford cider. Sport, especially rugby, is shown on big screens, and the large fire is welcome in winter. Not far from the football ground, it gets busy before matches. There is plenty of outside covered seating at the front. 🍴🍷♿🚃♦P🚃🐾🛜

Coach & Horses

51 Bethel Street, NR2 1NR
☎ (01603) 618522 🌐 thecoachandhorsesbethelstreet.co.uk
6 changing beers (sourced regionally) ⑭
Historic city-centre local near the Theatre Royal, the Forum and City Hall. It has a bright, welcoming bar with several separate seating areas including in cosy alcoves. A Greene King house, it offers a good selection of beer styles from local breweries in a range that changes regularly. Food is based on an English tapas theme, which works well. Try some celeb spotting too, or a game of bar billiards. ⛵🍴♣🐾🛜

Cottage

9 Silver Road, NR3 4TB
☎ (01603) 464461 🌐 norwichcottage.com
6 changing beers (sourced nationally) ⑭
A large single-room pub with a lovely enclosed patio garden at the rear. Independently owned since 2019, it has been refurbished to a very high standard, with solid oak flooring, wood paneling, exposed brickwork and a copper bar-top. Six handpumps offer a range of ales including one locally-sourced beer, and there is a selection of quality spirits and craft beers. Sunday roasts are served and there is an excellent burgers and tapas menu every evening except Monday. 🍴🍷♿♣🚶🚃🐾🛜

Duke of Wellington 🅛

91-93 Waterloo Road, NR3 1EG
☎ (01603) 441182 🌐 dukeofwellingtonnorwich.co.uk
Fuller's London Pride ⑭**; Oakham JHB, Bishops Farewell** ⑥**; Wolf Golden Jackal** ⑭**, Wolf in Sheep's Clothing; 8 changing beers (sourced nationally)** ⑥
Friendly pub with a changing range of guest ales to complement the permanent beers, the majority of which are served on gravity from a taproom behind the bar. The attractive award-winning enclosed rear garden/patio

area accommodates a beer festival in late August plus regular barbecues held at weekends in summer. Other events include monthly quiz evenings. Customers can bring their own food or sample the filling and inexpensive pies and sausage rolls. 🍷♿♣🚶P🚃🐾🛜

Fat Cat 🅛

49 West End Street, NR2 4NA
☎ (01603) 624364 🌐 fatcatpub.co.uk
Crouch Vale Yakima Gold; Fat Cat Norwich Bitter ⑭**, Marmalade; Greene King Abbot; Oakham Bishops Farewell, Green Devil** ⑥**; 12 changing beers (sourced nationally)** ⑭/⑥
Comfortable traditional street-corner pub, the outside barely hinting at its outstanding and extensive range of ales sourced from all over the UK. Beers from the Fat Cat range are served, plus real ciders and perries. Food is limited to pork pies. The interior is tiled, and has plenty of seating in two areas each side of the bar, and in a small room at the rear. A superb example of what a real ale outlet should be, with excellent, friendly service. A two-time CAMRA National Pub of the Year. Q🍷♦🚃🐾🛜

Fat Cat & Canary 🅛

101 Thorpe Road, NR1 1TR
☎ (01603) 436925
Fat Cat Norwich Bitter, Honey Ale; 6 changing beers (sourced regionally) ⑭
Sister pub to the original Fat Cat, about a mile and a half from the centre of the city. It serves most of the Fat Cat Brewery's ales and guests from around the UK, together with continental beers and real ciders. Home-made rolls are available and there are regular pop-up food vendors. There is a small TV to the rear of the main bar. Outside are a large car park and outdoor terraces to the front and rear, the latter being heated. The pub can be busy on Norwich City match days. ⛵🍴🍷♿♦P🚃🐾🛜

Golden Star

57 Colegate, NR3 1DD
☎ (01603) 632447 🌐 goldenstarnorwich.co.uk
Greene King IPA, Abbot; 2 changing beers (sourced nationally) ⑭
A welcoming and relaxing pub with a main bar area, and a second room to the left of the bar which hosts the recently-restored bar billiards table, and occasional live music sessions. A quiz is held on Sunday evenings. An excellent specials menu is served daily, which includes locally sourced meat. A wide selection of music is played, but unobtrusively. There is a small patio at the rear, and tables outside the front in summer. 🍴🍷♣🚃🐾🛜

Jubilee 🅛

26 St Leonards Road, NR1 4BL
☎ (01603) 618734
4 changing beers (sourced regionally) ⑭
Attractive Victorian corner pub offering a warm welcome. There are two bars, a comfortable conservatory, and an enclosed patio garden. Many of the well-kept ales and craft beers are local. This popular venue, within easy reach of the city centre, is at the heart of the community and caters for all tastes: from sports fans to those who enjoy local history talks. There are regular Sunday roasts and occasional pop-up street-food fairs, and customers are welcome to bring in takeaway food. ⛵🍴🚃♣🐾🛜

King's Arms

22 Hall Road, NR1 3HQ
☎ (01603) 477888 🌐 kingsarmsnorwich.co.uk
Batemans Gold (Also known as Yella Belly Gold); 10 changing beers (sourced nationally; often Tindall) ⑭

A friendly Batemans house just south of the city, serving a wide range of guest ales to complement the Batemans beers – usually including a stout or porter and a mild. Between three (in winter) and six (in summer) real ciders are also stocked. Customers can bring their own food from various nearby takeaways, with plates and condiments provided. Monthly quiz nights, poker evenings and live music take place. The pub is a recipient of many Batemans cellar-keeping and floral display awards. It gets busy on football match days. ♿️🏠🛒🚃🚌(39,40) 🌠🏵️📶

King's Head 🍻 Ⓛ

42 Magdalen Street, NR3 1JE
☎ (01603) 620468 🌐 kingsheadnorwich.com
8 changing beers (sourced regionally) Ⓗ
A traditional-style two-bar pub which offers no keg beer, but up to eight quality real ales, mostly from local breweries, plus two ciders. A dark beer is usually available. No food is served except snacks, pork pies and pickled eggs, but customers can bring or order in their own, with plates and cutlery supplied. Bar billiards is well supported, with two teams in the local league. The pub supports fundraising for the On the Ball charity. Local CAMRA Pub of the Year 2022. Q♿️🏠🌠🏵️🍴🚃🛒🌠📶

Leopard Ⓛ

98-100 Bull Close Road, NR3 1NQ
☎ (01603) 631111 🌐 theleopardpub.co.uk
6 changing beers (sourced regionally) Ⓗ
Welcoming single-bar corner local with a variety of changing ales on handpump, including Mr Winter's, Green Jack and Nene Valley, plus a selection of cans. The pub has a clean and bright bar area which gives a spacious feel, a pleasant and quiet enclosed courtyard garden at the rear, and seating at the front in summer. Acoustic music is played on Sunday afternoons. A pop-up pizza restaurant is available from 5-9.30pm on Saturdays. 🌠♿️🌠🚃🚌(50,50A) 🌠📶

Lollards Pit Ⓛ

69-71 Riverside Road, NR1 1SR
☎ (01603) 624675 🌐 lollardspit.com
Woodforde's Wherry; 5 changing beers (sourced nationally) Ⓗ
An attractive 17th-century inn, one of the first sited outside the city walls, built on the site of Lollards Pit – a place of execution for heretics for over 200 years. The pub is close to the river and yacht station moorings, and has a large patio garden at the rear. Guest ales are mostly from local breweries, with some interesting offerings from further afield. Snacks include local pork pies and sausage rolls, and the pub hosts local community groups, weekly quiz and bingo nights, and weekend parties. ♿️🏠🌠🌠🍴🚃🌠📶

Malt & Mardle

163 Magdalen Street, NR3 1NF
🌐 maltandmardle.co.uk
2 changing beers (sourced locally) Ⓗ
Norwich's first self-designated micropub, seating about 20 people in a single room, and serving two ales and two KeyKeg beers. The Malt & Mardle was converted from retail use in 2021 by three friends, who now run it. The ales are served on gravity and there is a small bar at the front. Note that the pub is closed Monday to Wednesday and operates on restricted hours when open. 'Mardle' is a Norfolk word for a relaxed conversation. Q🌠🍴🚃(11B,501) 🌠📶

Murderers

2-8 Timber Hill, NR1 3LB
☎ (01603) 621447 🌐 themurderers.co.uk

Wolf Edith Cavell; 9 changing beers (sourced nationally) Ⓗ
A busy city-centre pub that appeals to all sections of the public, with up to 10 real ales, including two permanent beers, one of which is the house Murderer's Ale (brewed by Wolf). Beer festivals are held in summer and autumn, with over 50 beers available, including many from local brewers. The upper area has a large-screen TV, making it a popular venue for viewing sporting events. There is a bar available for private hire, and a much-used outside terrace. A traditional British menu is served in generous portions. 🌠🍴🌠🚃🌠📶

Plasterers Arms Ⓛ

43 Cowgate, NR3 1SZ
☎ (01603) 440992 🌐 theplasterersarms.co.uk
5 changing beers (sourced nationally) Ⓗ
This is a friendly corner local with a range of ales from around the country, specialising in new and exciting breweries. A variety of craft keg beers is also available, alongside a great range of bottled and canned brews. The pub offers tap takeovers, sport (with a big screen for more important events), excellent pizzas, and breakfast at weekends. It also hosts a Fem.Ale Festival celebrating great women in the brewing industry. 🌠🍴🌠🌠🌠📶

Plough

58 St Benedict Street, NR2 4AR
☎ (01603) 661384 🌐 grainpubs.co.uk
5 changing beers (sourced nationally) Ⓗ
A popular pub in one of the city's oldest areas, close to the Norwich Arts Centre. One of two Grain Brewery-owned outlets, it sells five ales, usually all from the brewery. The two-bar interior is fairly small, with wooden chairs and tables, and has an open fire in winter. The large Mediterranean-style courtyard garden is a fine place to spend a summer's evening. Grain lager and craft beers are also served and there are barbecues in the summer. 🌠🌠🚃🌠📶

Red Lion

50 Eaton Street, NR4 7LD
☎ (01603) 454787 🌐 redlion-eaton.co.uk
Adnams Southwold Bitter, Broadside; 2 changing beers (sourced nationally) Ⓗ
Smart, welcoming 17th-century pub and restaurant near Norwich. Architectural features include Dutch gables, beams, panelled walls and inglenook fireplaces. At least one of the changing beers is sourced from a local brewery. The restaurant offers a varied lunch and dinner menu using local produce. The convenient location south of Norwich means that the six en-suite bedrooms are ideal for visitors wanting easy access to the city centre by car or bus. Q🌠🛏️🌠🌠🚃(123,11A)📶

Reindeer

10 Dereham Road, NR2 4AY
☎ 07534 944242
4 changing beers (sourced nationally) Ⓗ
Large, long one-roomed pub serving three or four real ales, run by well-known Norwich landlady Lou Wilding. There is a focus on live music, with bands on Friday and Saturday nights and Sunday afternoons, plus folk music on Wednesdays. Check Facebook for details of upcoming performers. The pub also has a jukebox and pool table, and an enclosed patio garden at the rear. No under-18s after 7pm. 🌠🌠🌠🚃🌠📶

Ribs of Beef Ⓛ ✅

24 Wensum Street, NR3 1HY
☎ (01603) 619517 🌐 ribsofbeef.co.uk

Adnams Ghost Ship; Oakham Citra; Wolf Golden Jackal; Woodforde's Wherry; 5 changing beers (sourced nationally) ⊞
Traditional pub overlooking the River Wensum. A row of nine handpumps dispenses four regular ales, supplemented by a selection from quality microbreweries. A variety of craft cans are also stocked. Food is provided by pop-up kitchen The Recipe. The atmosphere is relaxed and friendly, with a room downstairs, a small riverside terrace with several tables outside at the rear, and a few street tables to the front. There is a regular Monday quiz, live music on most Sunday evenings and sporting fixtures on TV. ✿◖❂❄♥☎

Rose Inn

235 Queens Road, NR1 3AE
☎ (01603) 623942 ⊕ therosepubanddeli.co.uk
4 changing beers (sourced nationally) ⊞
Popular pub close to Carrow Road, the home of Norwich City FC. The owner's passion for beer shows in the selection of five regularly changing real ales and six craft ales from some of the most exciting breweries around the country, plus several real ciders. Occasional beer, cider and gin festivals and tap takeovers are held. A range of excellent stone-baked pizzas are available during the food hours. A bar billiards table, board games, regular quizzes, live music and a deli serving local produce add to the appeal. ✿♫◖❁♣▲♥☎❄♥

Rosebery

94 Rosebery Road, NR3 3AB
⊕ theroseberypubnorwich.co.uk
6 changing beers (sourced regionally) ⊞
A popular Victorian corner pub with large bright windows and high ceilings, which has been stylishly refurbished in modern tones. There is seating outside at the front and in a pleasant part-covered beer garden at the rear. Up to six real ales are available, mostly sourced from local brewers, plus several real ciders. Food is served daily and the pub offers an excellent Sunday roast. There is a popular quiz night on Tuesdays. B&B accommodation is available. ✿♫◖♣♠P❄♥

Trafford Arms Ⓛ ✓

61 Grove Road, NR1 3RL
☎ (01603) 628466 ⊕ traffordarms.co.uk
Adnams Ghost Ship; Lacons Encore; 8 changing beers (sourced regionally; often Barsham, Mr Winter's, Woodforde's) ⊞
Close to the city centre, this friendly local has a strong community feel and is open all day every day. The pub offers a changing guest beer list including offerings from Lacons, Oakham and Moon Gazer, and often including a dark ale. High-quality pub food is sold and there are special themed food evenings and Sunday roasts. The February beer festival is a major attraction, as is the quiz on the last Sunday of the month. ✿◖P☎(38,39)❄♥

Vine Ⓛ

7 Dove Street, NR2 1DE
☎ (01603) 627362 ⊕ vinethai.co.uk
Fat Cat Tom Cat; Oakham JHB; 2 changing beers (sourced nationally) ⊞
Norwich's smallest pub, just off the marketplace, the Vine serves up to four quality ales, mostly from local breweries, plus traditional Thai cuisine in an award-winning combination. It has been in the same hands for over 10 years. The restaurant is upstairs, although customers often eat downstairs in the bar area. Functions are catered for, outside normal opening hours, on demand. A beer festival is held during the City of Ale festival. Extra tables and chairs are set outside in the pedestrianised street. Q✿◖♥❄

Walnut Tree Shades

Old Post Office Court, NR2 1NG
☎ (01603) 622910 ⊕ thewalnuttreeshades.com
4 changing beers (sourced regionally) ⊞
One of Norwich's hidden gems, dating back to the 1800s, the Walnut is well known for its live music, jukebox and traditional feel. Set just off Gentleman's Walk, this is a welcoming pub with a traditional feel, and the best in local rock, blues and rock 'n' roll at weekends, plus comedy, a quiz or musical bingo during the week. The pub also supports cribbage and has a pool table and a dartboard. Food is served all week and is a good selection of traditional fare, using locally sourced ingredients where possible. ✿◖☎

White Lion

73 Oak Street, NR3 3AQ
☎ (01603) 632333
7 changing beers (sourced nationally) ⊞
A changing range of real ales from local breweries is on sale here – beers often include ones from Mr Winter's, Shortts, Bull of the Woods and Nene Valley, among others. Eight to 10 ciders are also available, and usually at least one perry. The traditional interior is split into three rooms, with a front and back bar, and a room to the side with further seating and a bar billiards table. Food is varied and excellent value, made using traditional local produce, with daily specials. Norfolk Cider Pub of the Year 2022. Q✿◖♣♠☎❄♥

Wig & Pen Ⓛ

6 St Martin at Palace Plain, NR3 1RN
☎ (01603) 625891 ⊕ thewigandpen.co.uk
Humpty Dumpty Little Sharpie; 3 changing beers (sourced nationally) ⊞
Pretty, beamed 17th-century free house with a spacious patio, immediately opposite the Bishop's Palace, and with an impressive view of Norwich Cathedral spire. Five ales are always available, usually including two local beers. The small back room can be used for meetings. Good-quality food is served lunchtimes and evenings. The pub is a short walk from Tombland, where there are bus stands for several bus routes, and is an ideal start or end place for a walk along the river or in the Cathedral Close. Q✿◖◖♣♠P❄♥

Old Buckenham

Ox & Plough

The Green, NR17 1RN (in centre of village, overlooking green)
☎ (01953) 860970
Oakham JHB; Sharp's Doom Bar; Timothy Taylor Landlord; 3 changing beers (often Greene King, Ossett) ⊞
A family-friendly community pub with a garden at the front overlooking one of the largest village greens in England. At the centre of village life, it has two open-plan drinking areas, one of which is quiet, without TV or electronic game machines. A member of Oakham Academy, the pub serves various changing Oakham ales from up to five handpumps. Oakham Green Devil is a regular keg offering. Food is bar snacks only. ◖✿♣♠P❄♥

Oxborough

Bedingfeld Arms

Stoke Ferry Road, PE33 9PS
☎ (01366) 328300 ⊕ bedingfeldarms.co.uk
Adnams Broadside; Woodforde's Wherry; 1 changing beer (sourced nationally) ⊞

A historic independent free house, refurbished throughout, providing consistently high-quality beers, meals, service and accommodation. The main central room with the bar and comfortable seating is popular for chat, coffee and cakes. There are two separate public dining rooms in smart country style and a private dining room. A patio area built from local wood leads to the large garden with outdoor seating. The pub is by the village green and part-ruined church, and Oxborough Hall (National Trust) is adjacent. Q★☆❀➔◑&P❀?

Roydon

Union Jack
30 Station Road, PE32 1AW (off A148)
☎ 07771 660439
Tydd Steam Piston Bob; 3 changing beers (sourced nationally) Ⓗ
Popular with locals, this traditional village pub has twice been local CAMRA Pub of the Year. The current landlord celebrated 20 years at the pub in 2022. Four handpumps dispense one regular and three changing ales. The pub supports weekly darts, crib and dominoes, and hosts occasional food nights, live music each month and regular bingo and quizzes. Beer festivals are held over the Easter and August bank holidays, usually featuring local breweries. There is outdoor seating at the front. Q❀A♣●P♫(48)❀?

Sedgeford

King William IV
Heacham Road, PE36 5LU (off B1454)
☎ (01485) 571765 ● thekingwilliamsedgeford.co.uk
Adnams Ghost Ship; Greene King Abbot; Woodforde's Wherry Ⓗ
A large well-appointed village inn, known by the locals as the King Willie. Although renowned for quality locally produced food, it retains a pub atmosphere that attracts local drinkers. There are two bars and a restaurant divided into four areas. The large garden at the rear has a superb outdoor covered drinking and dining area. Dogs are welcome in the bars. Nine luxury rooms are available for overnight stays. Q★☆❀➔◑P❀

Shouldham

King's Arms Ⓛ
The Green, PE33 0BY
☎ (01366) 347410 ● kingsarmsshouldham.co.uk
2 changing beers (sourced nationally) Ⓖ
The King's Arms has been named local CAMRA Pub of the Year four times in the last six years. This is a community-owned business which also includes a café. The beer is served in lined glasses straight from the cask, and two or three options are usually available. Cider is also often on offer. Many community activities take place, from poetry evenings and live music to quiz nights. Details are chalked up on a noticeboard. ★❀◑●P🖥❀?

Snettisham

Rose & Crown
Old Church Road, PE31 7LX (off B1440)
☎ (01485) 541382 ● roseandcrownsnettisham.co.uk
Adnams Broadside; Marston's Pedigree; Woodforde's Wherry; 2 changing beers (sourced nationally) Ⓗ
The old front bar of this multi award-winning pub has been progressively added to, creating a more modern area mainly used by those enjoying the highly regarded food. The pub is popular for dining, so you may need to book a table. Breakfast is served every day before the

bar opens. There is a garden and play area for children, and accommodation is offered.
Q★☆❀➔◑&♣P🖥(10,11)❀?

Stowbridge

Heron
The Causeway, PE34 3PP (between River Ouse and Relief Channel)
☎ (01366) 384040 ● theheronstowbridge.com
Theakston Best Bitter; 1 changing beer (sourced nationally) Ⓗ
A friendly and welcoming pub located on the stretch of land between the Great Ouse and the Relief Channel. Converted from a farmhouse, the bar has a long lounge for drinking and dining, faux beams, and is crammed full of interesting artifacts. Adjacent moorings are available on the Relief Channel. The menu offers wide variety and generous proportions at reasonable prices. There is ample seating by the moorings, and five caravan pitches are available. Q★☆❀➔◑A♣P

Strumpshaw

Shoulder of Mutton Ⓛ
9 Norwich Road, NR13 4NT (on Brundall-Lingwood road)
☎ (01603) 926530 ● themuttonstrumpshaw.co.uk
Adnams Ghost Ship; Sharp's Doom Bar; 3 changing beers (sourced nationally) Ⓗ
Traditional village pub with a friendly welcome. The two main bar areas share a log-burner, and the separate dining room has a heated marquee extension. Ales are from regional and microbreweries, Moon Gazer Hare Today is the house beer, and there are three local ciders. Meals are freshly prepared from local produce with seafood and home-made pies prominent. The rear patios overlook the courtyard with pétanque court.
❀◑&A⇌(Brundall)♣●P🖥(15A)❀?

Swanton Morley

Darbys
1 Elsing Road, NR20 4NY
☎ (01362) 637346 ● darbyspub.co.uk
3 changing beers (sourced nationally) Ⓖ
This pub was originally a row of cottages which were converted into a public house around 30 years ago. There is one long bar plus a dining area, a function room upstairs and an additional coffee bar. Outside, a covered patio area leads to a large garden with enclosed children's play area. To the side is a car park. Up to three changing ales are served by gravity from the the cellar, nationally and locally sourced. An annual beer festival is held in the autumn. Q★☆❀◑&A♣●P🖥(4)❀?

Thetford

Black Horse Ⓛ
64 Magdalen Street, IP24 2BP
☎ (01842) 762717
Adnams Southwold Bitter; Greene King IPA; Woodforde's Wherry; 2 changing beers (sourced nationally) Ⓗ
A good no-nonsense town pub offering a varying range of ales on five handpumps. It holds a popular annual St George's Day beer festival. The food is home-made and good both in quality and value – desserts are a feature. Food is served in a small but pleasant eating area, which now benefits from the addition of a marquee for outside dining. Look for the changing murals on the end wall.
❀◑&P

Thorpe Market

Gunton Arms L ✓

Cromer Road, NR11 8TZ (signposted on W of A149 Cromer-North Walsham road SE of Thorpe Market; look for hanging sign, lit at night)

☎ (01263) 832010 🌐 theguntonarms.co.uk

Lacons Falcon Ale, Legacy; Woodforde's Wherry; 1 changing beer (sourced nationally) ⊞

A fine country inn with magical vistas of Gunton Park and the deer herd. The decor, comfortable furnishings and log fire in winter create a warm country house atmosphere. There are three regular East Anglian ales and one guest from further afield. First-class cuisine is served in three restaurants, and several dishes are cooked on the open range in the vaulted Elk Room. In summer, a large beer garden provides alfresco dining and space for a food and music festival. There are 16 luxurious rooms and suites. ❀✇◖❀⊕♣P🖵(4)❀🤍🛜

Suffield Arms

Station Road, NR11 8UE (signposted on main road S of Thorpe Market; head E on Station Rd)

☎ (01263) 586858 🌐 suffieldarms.com

Grain ThreeOneSix; Lacons Encore, Falcon Ale; Woodforde's Wherry; 1 changing beer (sourced locally) ⊞

A rural pub tastefully redesigned and refurbished, featuring a large front bar with pub games and a log fire. Four regular ales are served alongside one guest, plus a high-quality bar menu. There is also a tapas restaurant bar, with an area off its entrance and a secluded nook at the far end. A comfortable cocktail lounge is upstairs, and there is outside seating overlooking the gardens. Gunton station is a minute's walk away, making this a perfect trip out from Norwich. Q❀❀◖❀⊕♣A⇌(Gunton)P🤍🛜

Thurne

Lion Inn L

The Street, NR29 3AP (at end of Thurne Dyke, off A149 via Mill Ln and Repps Rd)

☎ (01692) 671806 🌐 thelionatthurne.com

6 changing beers (sourced regionally; often Adnams, Fat Cat, Mr Winter's) Ⓖ

A country pub in a remote village near the River Ant, at the end of Thurne Dyke. It has a large garden, and plenty of moorings are available nearby for passing Broads cruisers. Meals made from locally sourced produce are served in the restaurant or bar area. There are four changing real ales on handpump, plus two brewed locally under the Pell & Co badge. The pub also serves real ciders and has 14 kegs taps for craft offerings. A former local CAMRA Pub of the Year. Q❀❀❀◖❀♣P🤍🛜

Warham All Saints

Three Horseshoes

The Street, NR23 1NL (2 miles SE of Wells)

☎ (01328) 710547 🌐 warhamhorseshoes.co.uk

Woodforde's Wherry Ⓖ**; 3 changing beers (sourced nationally)** ⊞

A traditional brick and flint village pub with a unique serving hatch, and log fires in winter. The beer range includes one permanent ale and up to three guests. A local cider is also usually available. Meals are prepared with local ingredients where possible. There is a separate dining room and a barn provides a games room – preserving the tranquillity of the pub itself. The garden is perfect for alfresco dining and has its own bar in summer. Accommodation is in six excellent en-suite rooms. Q❀❀✇◖❀A♣♣P🤍🛜

West Runton

Village Inn

Water Lane, NR27 9QP

☎ (01263) 838000 🌐 villageinnwestrunton.co.uk

4 changing beers (sourced locally; often Adnams, Moon Gazer) ⊞

A large inn, just a short distance from the station and the beach, set in pleasant gardens in the centre of this quiet coastal village. Up to five well-kept and mostly local ales are stocked and rotated. Excellent home-cooked meals can be enjoyed in the dining areas or outside, where there is plenty of seating in the flint-walled garden. In the 1970s rock bands such as Deep Purple played secret gigs at the Pavilion which was at the rear of the pub (sadly now demolished). Q❀❀❀◖A⇌P🖵❀🤍🛜

West Somerton

Lion L

Horsey Road, NR29 4DP (jct of B1159/B1152, 400yds from Staithe)

☎ (01493) 393861 🌐 thelionsomerton.co.uk

Woodforde's Wherry; 2 changing beers (sourced nationally; often Wolf, Woodforde's) ⊞

Warm, cosy, traditional village pub with two bars and a separate dining area. Good-value locally sourced food is served, and there are regular themed food evenings. The friendly owners and staff make this pub an excellent choice, with B&B accommodation for those wishing to make it their base when visiting the grey seal colony or windpump in Horsey, or the nearby Staithe. The pub has a strong community feel with a loyal local following, and is well worth seeking out. Q❀❀❀✇◖♣♣P🖵(1,1A)❀🤍🛜

Wimbotsham

Chequers ✓

7 Church Road, PE34 3QG

☎ (01366) 386768 🌐 thechequerswimbotsham.co.uk

Greene King IPA, Abbot; Woodforde's Wherry; 2 changing beers (sourced nationally) ⊞

A traditional family-run English pub dating back to the mid-17th century overlooking the picturesque village green. There is a large bar and dining area popular with locals. An extensive home-cooked food menu is offered every day (except Sun eve). Live music is hosted, and the pub has a separate function room and car park to the rear. A paved area at the front is pleasant on summer days. ❀◖❀P🛜

Woodbastwick

Fur & Feather Inn ✓

Slad Lane, NR13 6HQ

☎ (01603) 720003

Woodforde's Wherry, Nelson's, Nog; 4 changing beers (sourced locally) Ⓖ

The Fur & Feather is Woodforde's brewery tap, serving all of its ales on gravity. The pub was converted from a row of thatched farmers' cottages, and is set in a delightful country location in pleasant gardens with plenty of seating and a large pond. The restaurant serves food every day, plus afternoon teas, and the shop not only stocks Woodforde's beers and merchandise but also various products such as jam, chutney, gin and coffee. Brewery tours can be arranged. ✒❀❀◖❀P🤍🛜

Wortwell

Bell ✓

52 Low Road, IP20 0HH
☎ (01986) 788025 ⊕ wortwellbell.pub
Adnams Southwold Bitter; Otter Bitter; 3 changing beers Ⓗ

A 17th-century coaching inn with two bars and an open fire. The enthusiastic hosts, whose family were historically linked to the licensed trade, reopened the pub in 2015. Their efforts have rejuvenated this community local to its former glory with regular village events held, and the addition of a small shop and a borrowing library based at the pub and open during pub hours. There is a regular beer festival. Up to 10 ciders are stocked in summer, reduced to two or three in winter months. ⏱❀◑▲♣☝P♖(580)❀🐾

Wymondham

Feathers

13 Town Green, NR18 0PN
☎ (01953) 605675
Adnams Southwold Bitter, Ghost Ship; Fuller's London Pride; St Austell Tribute; 1 changing beer (sourced nationally) Ⓗ

Local community free house run by the same family for many decades, a short walk from the Market Cross, Wymondham Abbey and the Mid-Norfolk Railway terminus. The L-shaped interior has an open-plan main bar and seating, with cosy alcoves and bar access to the side. Good-value meals are served. The patio garden has a large covered seating area and serving hatch for garden customers. In winter months Adnams Tally Ho (on gravity) is the second changing beer. Town Green car park is behind the pub. ⏱❀◑➤♣☝(6)🐾

Breweries

All Day

Salle Moor Farm, Wood Dalling Road, Salle, Norfolk, NR10 4SB
☎ (01603) 327656 ☎ 07825 604887
⊕ alldaybrewing.co.uk

⊗ Housed in a centuries old barn, the brewery has its own hop yard and an adjoining organic orchard. Many of the beers are barrel-aged, or sours, or involve fruit grown at the brewery. They are available in the taproom and kitchen, along with vegan food, pizza, real cider, and raw kombucha. Home of the the Norfolk Hop Festival. ‼ ▦ ♦ LIVE ◈

Ampersand SIBA

27-31 Sawmills Road, Diss, Norfolk, IP22 4GG
☎ (01379) 643944 ☎ 07791 086689
⊕ ampersandbrew.co

A small batch brewery established in 2017. Originally based on a family farm in South Norfolk, it relocated to Diss in 2021. ▦◈

μIPA (ABV 2.9%) PALE
Bidon (ABV 3.9%) BITTER
The Cap Bitter (ABV 3.9%) BITTER
On the Wing (ABV 4.7%) PALE
Cocow (ABV 4.8%) SPECIALITY
Camphillisner (ABV 4.9%) SPECIALITY
Pulpit Pale (ABV 5%) PALE

Barsham SIBA

Estate Office, West Barsham, Fakenham, Norfolk, NR21 9NR
☎ (01328) 864459 ☎ 07760 551056
⊕ barshambrewery.co.uk

⊗ Barsham Brewery was purchased by the present brewers in 2017. Maris Otter is grown on-site and a private bore hole supplies water for the brewery. ▤LIVE

Oaks (ABV 3.6%) BITTER
Norfolk Topper (ABV 3.8%) BITTER
Lemon and grapefruit hoppiness mixes with almond bitterness to loom over an underlying maltiness. Grainy with a short, drying finish.
Pilgrims Ale (ABV 4%) BLOND
B.O.B (ABV 4.3%) BITTER
Tawny-hued with a rich, sweet maltiness that complements the toffee and red fruit baseline. Long-lasting, complex, bittersweet finish.
Stout Robin (ABV 4.6%) STOUT
A rich, creamy, caramel roastiness permeates aroma and taste. Vanilla jostles with Oxo for recognition in a soft, creamy melange.
Golden Close IPA (ABV 5%) PALE

Beeston SIBA

Fransham Road Farm, Beeston, PE32 2LZ
☎ (01328) 700844 ☎ 07768 742763
⊕ beestonbrewery.co.uk

⊗ The brewery was established in 2006 in an old farm building using a five-barrel plant. Brewing water comes from a dedicated borehole and raw ingredients are sourced locally whenever possible. ‼ ♦ LIVE

The Squirrels Nuts (ABV 3.5%) MILD
Cherry, chocolate and vanilla aroma. A malt and cherry sweetness comes to the fore but quickly fades. Short finish.
Worth the Wait (ABV 4.2%) BITTER
Hoppy throughout with a growing dryness. Complex and grainy with fruit notes, malt and understated bitterness.
Stirling (ABV 4.5%) BITTER
The Dry Road (ABV 4.8%) BITTER
Village Life (ABV 4.8%) BITTER
Copper-coloured with a nutty character. Malty throughout, a bittersweet background gives depth. Strong toffee apple finish.
On the Huh (ABV 5%) BITTER
A fruity raisin aroma. A bittersweet maltiness jousts with caramel and roast. A dry hoppiness adds to a strong finale.
Old Stoatwobbler (ABV 6%) STOUT

Contract brewed for Brancaster:
Brancaster Best (ABV 3.8%) BITTER
Malthouse Bitter (ABV 4.2%) BITTER

Birdhouse

Revell Road, Downham Market, Norfolk, PE38 9SE
☎ 07858 628183 ⊕ birdhousebrewery.co.uk

⊗ Birdhouse Brewery, a picobrewery, was established in 2019 by Paul Bird. It produces 150 bottle-conditioned beers per batch, making it one of the smallest breweries in the country. It produces a range of nine beers. Available in shops, local markets and online. ♦

Blimey!

Branksome House, 166 St Clements Hill, Norwich, NR3 1RS

☎ (01603) 449298 ☎ 07775 788299
✉ adriankbryan@googlemail.com

⊗ Brewing began in 2017.

Son of Pale Face (ABV 4%) GOLD
Eleven APA (ABV 4.5%) PALE
Solid orange citrus notes dominate aroma and taste. Full-bodied and robust with malt adding balance. Short, bittersweet finish
TEN DDH APA Cryo (ABV 4.5%) PALE
The Pale Face (ABV 4.5%) GOLD
Thirteen (ABV 4.5%) GOLD
First Born IPA (ABV 5.2%) PALE

Boudicca

c/o S&P Brewery, The Homestead, Brewery Lane, Horsford, NR10 3GL ☎ 07864 321733

Office: 34 Clabon Road, Norwich, NR3 4HF
⊕ boudiccabrewing.co.uk

⊗ Established in 2015, Boudicca Brewery was based on a North Norfolk estate until 2020. S&P (qv) are currently brewing its beers under contract until a new home is located. It is an award-winning, independent brewery exclusively producing vegan beers, supplied to free trade outlets across East Anglia, including cafés, delicatessens and off-licences. ‼♦LIVE V

Bull of the Woods

Brook Farm, Kirby Cane, Bungay, Norfolk, NR35 2PJ
☎ (01508) 518080 ☎ 07833 702658
⊕ bullofthewoods.co.uk

⊗ Production began in 2017. Run by two brothers, the brewery is situated in the old milling barn on a family farm, which also houses the brewery shop. The brothers took a break from their tree surgery business to pursue their love of brewing real ale and the brewery continues to expand its range of eclectic styles and seasonal favourites. Brewery merchandise is available and a taproom is planned. ☒♦LIVE

Rock Steady (ABV 3.8%) BITTER
Traditional malt and hop signature with the added complexity of walnut and quinine flowing through. Long, increasingly bitter finish.
Golden Road (ABV 4%) GOLD
Hacienda (ABV 4%) PALE
Woodstock (ABV 4.2%) IPA
Vapour Trail (ABV 4.3%) PALE
Well-balanced with grapefruit and mandarin complementing a hoppy bittersweet base. Floral notes quickly fade in a long, drying finish.
Inca Gold (ABV 4.4%) GOLD
Pulsating lemon presence in aroma and taste looms over a balanced malt and hop foundation. A crisp, dry finish develops.
Twisted Wheel (ABV 4.5%) BITTER
Strong marmalade notes with sweet, malty support slowly fade behind a crisp, well-defined bitterness. Short, peppery ending.
Banjo Hill (ABV 5%) IPA
Shine a Light IPA (ABV 6.4%) IPA
Hop, apricot and toffee underpin a full-bodied complex character. Bittersweet notes highlight a growing peppery dryness.

Chalk Hill

⊟ Rosary Road, Norwich, NR1 4DA
☎ (01603) 477077 ⊕ thecoachthorperoad.co.uk

⊗ Chalk Hill began production in 1993 on a 15-barrel plant. It supplies local pubs and festivals. A small plant is used to brew experimental beers, which if popular become part of the regular range. ‼♦

Dancing Men

⊟ Hill House Inn, The Hill, Happisburgh, Norfolk, NR12 0PW
☎ (01692) 650004 ☎ 07818 038768
⊕ hillhouseinn.co.uk

⊗ Brewing began in 2014 at the 16th century Hill House Inn on Happisburgh's fast-eroding clifftop. The microbrewery is named in honour of the Sir Arthur Conan Doyle Sherlock Holmes story, after he visited the pub in 1903. The five-barrel plant was acquired from Bees Brewery after its partial destruction in 2013. New recipes have been crafted using exclusive hops and barley including locally-grown Norfolk varieties. ‼♦

Drenchfoot

Office: 65 Vicarage Road, Thetford, Norfolk, IP24 2LW
⊕ drenchfoot.co.uk

Drenchfoot is the result of a homebrew hobby gone wrong. Registered in 2019 it produces around 100 litres a week in a garden shed, supplying a growing number of pubs in and around Thetford. Pre-ordered polypins and bottles are available for sale direct to the public.

Dragon Slayer (ABV 3.6%) BITTER
Bigus Dickus (ABV 4.4%) PALE
Don't Panic (ABV 5%) IPA
To Pee or not to Pee (ABV 5.8%) IPA

Duration SIBA

Abbey Farm, River Road, West Acre, Norfolk, PE32 1UA
☎ (01760) 755436 ⊕ durationbeer.com

Duration brews beers that reflect the rich agricultural landscape around them. Situated at the historic West Acre Priory it produces fresh beers, wild and blended farm-style ales. Beers are available bottle-conditioned, in cans and keg. Its taproom is open Friday and Saturday afternoons. ‼☒♦LIVE

Elmtree SIBA

Unit 10, Oakwood Industrial Estate, Harling Road, Snetterton, NR16 2JU
☎ (01953) 887065 ⊕ elmtreebeers.co.uk

⊗ Established in 2007, Elmtree brews on a six-barrel plant. More than 120 free trade outlets are supplied directly. The brewery specialises in high quality ales made with the best ingredients. Some of the strongest beers are only available in bottled-conditioned form. Bespoke beers for individual pubs are also brewed. ‼☒♦LIVE

Burston's Cuckoo (ABV 3.8%) GOLD
Gentle malt airs. Biscuity sweet beginning with delicate lime hints. Full-bodied, short, sweet finish.
Bitter (ABV 4.2%) BITTER
Traditional malt and hop nose. Solid and well-balanced with a bittersweet, hoppy maltiness throughout. Flowing crisp hoppy ending.
Norfolk's 80 Shilling Ale (ABV 4.5%) BITTER
Mixed fruit nose introduces a sweet fruity bitter with a bitter counterbalance. Short, drying finish.
Dark Horse Stout (ABV 5%) STOUT
Solid coffee and malt aroma. A cornucopia of vanilla, dark chocolate, and roast with a sweet foundation. Long, strong finale.

Golden Pale Ale (ABV 5%) PALE
Sweet fruity aroma with hints of honey. Even handed mix of lemon and crisp hoppiness with a defined bittering finale.

Nightlight Mild (ABV 5.7%) MILD
A heavy mix of liquorice, roast and malt infuses aroma and first taste. A sweet spiciness slowly develops.

Fat Cat

🍴 98-100 Lawson Road, Norwich, NR3 4LF
☎ (01603) 624364 ⊕ fatcatbrewery.co.uk

⊠ Established in 2005 by the mini pub chain's founder, the brewery is based at the Fat Cat Brewery Tap in Norwich. Beers can be sampled in the other pubs in the Fat Cat chain. ‼◆LIVE

Norwich Bitter (ABV 3.8%) BITTER
Grapefruit on the nose. A strong hoppy bitterness with underlying maltiness adds depth and complexity. Softly drying finale.

Tabby (ABV 4%) BITTER

Tom Cat (ABV 4.1%) GOLD
A crisp citrus character with lemon, lime and orange in aroma and taste. Bitterness grows as cut grass hoppiness fades.

Boysen the Hood (ABV 4.6%) SPECIALITY
Sweet chocolate and cherry notes flow over a mix of roast and milky smoothness. Bitterness develops in a long finale.

Milk Stout (ABV 4.6%) STOUT

Incredible Pale Ale (ABV 5.2%) PALE

Marmalade (ABV 5.5%) BITTER
Orange and malt pervades both aroma and taste. A full-bodied mix of balanced flavours. A bittersweet finish with hoppiness.

Lockdown IPA (ABV 5.7%) IPA

Fengate

23 Fengate, Marsham, Norfolk, NR10 5PT
☎ (01263) 479953 ☎ 07884 960697
✉ fengatebrewery@gmail.com

⊠ Fengate Brewery was established in 2019. Head brewer and owner Alistair brews a selection of traditional ales with a mix of new beer styles. Beers can be found in pubs and bottle shops in the surrounding area. ➤◆

California Common Ale (ABV 4.7%) SPECIALITY

Jamadhar (ABV 5.5%) IPA

Fox

🍴 22 Station Road, Heacham, Norfolk, PE31 7EX
☎ (01485) 570345 ⊕ foxbrewery.co.uk

⊠ Based on an old cottage adjacent to the Fox & Hounds pub, Fox Brewery was established in 2002 and now supplies around 30 outlets as well as the pub. All the beers are brewed using malt from Crisps in Great Ryburgh. A hop garden next to the brewery, trialled during 2009, has been enlarged. ‼➤◆LIVE

Heacham Gold (ABV 3.9%) GOLD

Red Knocker (ABV 3.9%) BITTER

Hop Across the Pond (ABV 4.2%) PALE

Cerberus Stout (ABV 4.5%) STOUT

Nelson's Blood (ABV 4.7%) SPECIALITY

Grizzly Bear (ABV 4.8%) SPECIALITY

IPA (ABV 5.2%) PALE

Golden Triangle SIBA

Unit 9, Industrial Estate, Watton Road, Norwich, NR9 4BG

☎ (01603) 757763 ☎ 07976 281132
⊕ goldentriangle.co.uk

⊠ Golden Triangle, named after an area of Norwich, has been brewing modern, hop-forward ales on a 10-barrel plant since 2011. The brewery continues to add new beers to its range. Beers are mainly found in pubs across Norwich. The Artichoke, Norwich, purchased by owner and brewer Kevin Tweedy in 2018, is the brewery tap. ◆

Mosaic City (ABV 3.8%) GOLD
Full-bodied lemon citrus character throughout. Hops provide depth throughout. A subtle, malty bitterness quickly fades.

Simcoe City (ABV 3.8%) BITTER
Peach and lemon nose. A full-bodied and fruity sweet malt beginning. A notable bitter edge to the finish.

Citropolis (ABV 3.9%) GOLD

Equinoxity (ABV 3.9%) PALE
Understated melange of hop, pineapple and lemon throughout. Gentle malt airs arrive in a short, sweet finish.

Grain SIBA

South Farm, Tunbeck Road, Alburgh, Norfolk, IP20 0BS
☎ (01986) 788884 ⊕ grainbrewery.co.uk

⊠ Grain Brewery was launched in 2006 by Geoff Wright and Phil Halls in a converted dairy in the Waveney Valley. It upgraded to an 18-barrel plant in 2012. Two pubs are owned: the Plough, Norwich, and the Spread Eagle, Ipswich. ‼➤◆LIVE

Oak (ABV 3.8%) BITTER
Good balance of malt, toffee and bittersweet fruitiness. Caramel in initial taste fades as biscuit and bitterness dominate the aftertaste.

ThreeOneSix (ABV 3.9%) GOLD
Hop and grapefruit dominate throughout as an underlying bitterness slowly stifles a delicate malty echo. Crisp and well defined.

Best Bitter (ABV 4.2%) BITTER
Brazil nut and malt introduce this well-balanced, complex bitter. Bittersweet caramel notes flourish before a gently tapering malty finish.

Slate (ABV 6%) PORTER
Roast and dark fruits dominate throughout. Caramel and sweet malt add complexity and balance. Full-bodied with a short finish.

Lignum Vitae (ABV 6.5%) STRONG
Orange, toffee and banana on the nose and first taste. A smooth, digestive sweetness adds depth as bitterness slowly grows.

Humpty Dumpty SIBA

Church Road, Reedham, Norfolk, NR13 3TZ
☎ (01493) 701818 ☎ 07843 248865
⊕ humptydumptybrewery.co.uk

⊠ Established in 1998, this 11-barrel, award-winning brewery continues to grow and expand its range of beers, including a new Norfolk Broads Brewing series of occasional one-off brews. ‼➤◆LIVE

Little Sharpie (ABV 3.8%) PALE
Complex and smooth with a crisp bitterness underpinning a buttery biscuit follow through. Lemon hoppiness in a long, drying finish.

Branch Line Bitter (ABV 3.9%) BITTER

Lemon and Ginger (ABV 4%) SPECIALITY

Swallowtail (ABV 4%) PALE
Full-bodied marmalade and biscuit aroma with matching beginning. Grainy texture is enhanced by solid bitter notes flowing onward.

Broadland Sunrise (ABV 4.2%) BITTER

Red Mill (ABV 4.3%) BITTER
Full-bodied, robust and fruity. Coffee, dark fruits and caramel vie for dominance against a malty, bitter base. Powerful rich ending.

Reedcutter (ABV 4.4%) GOLD
A sweet, malty beer; golden-hued with a gentle malt background. Smooth and full-bodied with a quick, gentle finish.

Cheltenham Flyer (ABV 4.6%) BITTER
A full-flavoured golden, earthy bitter with a long, grainy finish. A strong hop bitterness dominates throughout. Little evidence of malt.

EAPA (East Anglian Pale Ale) (ABV 4.6%) PALE
Amber gold with an orange marmalade nose. A bittersweet caramel beginning slowly dries out as malty nuances fade away.

Railway Sleeper (ABV 5%) OLD
A rich Christmas pudding aroma introduces this delightfully fruity brew. Malt, sultanas and raisins dominate a bittersweet backdrop. Full-bodied, smooth finish.

Lacons SIBA

The Courtyard, Main Cross Road, Great Yarmouth, Norfolk, NR30 3NZ
☎ (01493) 850578

Office: Cooke Road, Lowestoft, NR33 7NA
⊕ lacons.co.uk

⊠ Lacons Brewery has a rich history dating back to 1760, but was closed by Whitbread in the 1960s. It relaunched in 2013 and the Falcon Brewery is now nestled in a Courtyard in Great Yarmouth. Beers are available across East Anglia and use the original Lacons yeast Strand. A range of monthly special heritage beers is also produced. ‼ ☞ ◆LIVE

Encore (ABV 3.8%) PALE
A solid hop backbone with strong citrus support. Sweetness subsides as a crisp dryness emerges in the long, strong finale.

Legacy (ABV 4.4%) GOLD
Grapefruit and lemon nose and first taste where a crisp bitterness is also encountered. Some malt in a bitter finish.

Audit (ABV 8%) BARLEY
Honey, orange marmalade and maltiness define this full-bodied ale. Damson, toffee and a refreshing bitterness sharpens the palate.

Lynn

5 Hayfield Road, North Wootton, Norfolk, PE30 3PR
☎ 07706 187894 ⊕ lynnbrewery.co.uk

Lynn Brewery is an independent, family-owned brewery based in King's Lynn, making small-batch, hand-bottled craft beer. It is passionately local; the grain used comes from a local malting group and all beers are inspired by and named after the people and places of Lynn.

Malt Coast

Branthill Farm, Wells-next-to-the-Sea, Norfolk, NR23 1SB ☎ 07881 378900 ⊕ maltcoast.com

Brewing began in 2016. It grows its own barley on the farm. ‼ ☞

Moon Gazer SIBA

Moon Gazer Barn, Harvest Lane, Hindringham, Fakenham, Norfolk, NR21 0PW
☎ (01328) 878495 ⊕ moongazerale.co.uk

⊠ Brewing began in 2012 using a 10-barrel plant. The brewery is owned and run by Rachel and David Holliday. Chalk-filtered water is used from the brewery's own well. ‼◆

Jumper (ABV 3.9%) BITTER
Gentle hop character with supporting sweet malt and bitterness. Caramel swirls in and out as a dry edge develops.

Pintail (ABV 3.9%) PALE
Crisp lemon hoppiness flows through this well-balanced, longlasting brew. Bitterness and light malty sweetness float in the background.

Jigfoot (ABV 4%) PALE
Orange peel and honey nose. Marmalade intro bolstered by well-defined bitterness. Initial sweetness fades into a sharp astringent bitterness.

Nibbler (ABV 4%) MILD
Roasty dark fruit nose flows through into the first taste. Increasing malt and caramel. Smooth grainy mouthfeel. Short, bitter finish.

Bouchart (ABV 4.9%) MILD
Savoury, smoky bacon character throughout. Bittersweet dark chocolate nuances give depth. A smooth and creamy finish with hints of blackcurrant.

White Face (ABV 5%) PALE
Full-bodied with a rich tropical fruit aroma. Oranges the taste, mixing well with a piquant hoppy bitterness.

Mr Winter's

8 Keelan Close, Norwich, NR6 6QZ
☎ (01603) 787820 ⊕ mrwintersbeers.co.uk

⊠ Winter's was established in 2001 by David Winter, who had previous award-winning success as a brewer for both Woodforde's and Chalk Hill breweries. Winter's ales has won many awards, with David now passing his brewing knowledge to his son, Mark, now a multi award-winning brewer in his own right. The brewery rebranded as Mr Winter's in 2020; operating at 5-15 barrels. Some existing beers have been discontinued or renamed, and new brews commenced. ☞◆LIVE

Fusioneer (ABV 3.6%) MILD
Roast and dried fruit in both aroma and taste. Caramel, hazelnut and arrowroot add to a complex mix of flavours.

Twin Parallel (ABV 3.8%) PALE

Evolution APA (ABV 4%) GOLD
Clementine on the nose is followed by lemon and grapefruit in the body. Hoppy bitterness develops in a full-bodied finish.

Quantum Gold (ABV 4.1%) GOLD
Just a hint of hops in the aroma. The initial taste combines a dry bitterness with a fruity apple buttress. The finish slowly subsides into a long, dry bitterness.

Tranquility (ABV 4.2%) BITTER
Sulphurous hoppy nose. Balanced hoppiness throughout with cereal and bitter orange providing contrast. Short ending with a bitter signature.

Rorschach (ABV 4.5%) STOUT
A dark brown stout that has a smooth mouthfeel with a grainy edge. Roast dominates throughout but is balanced by a mix of malt, a bittersweet fruitiness and an increasingly nutty finish.

Vanilla Latte (ABV 4.6%) SPECIALITY
Full on mix of coffee, vanilla and lactose with a smooth, malty base. Continues to a long, coffee crème ending.

Twisted Ladder (ABV 5%) PALE

Citrus Kiss IPA (ABV 6%) IPA
Strong citrus base with hop and malt in the background. Lemon and grapefruit continue as a bittersweet background provides depth.

Opa Hay's

Glencot, Wood Lane, Aldeby, Norfolk, NR34 0DA
☎ (01502) 679144 ☎ 07916 282729
✉ arnthengel@hotmail.co.uk

Opa Hay's began brewing in 2008. It is a small, family-run brewery, taking its name from the brewer's great grandfather. Only traditional brewing methods are used, with ingredients that are, where possible, sourced locally. ◆LIVE

Samuel Engels Meister Pils (SEMP) (ABV 4.8%) SPECIALITY
Liquid Bread (ABV 5.2%) SPECIALITY
Bavarian Breakfast Beer (ABV 5.4%) SPECIALITY

Panther

Unit 1, Collers Way, Reepham, Norfolk, NR10 4SW
☎ 07766 558215 ⊕ pantherbrewery.co.uk

⊗ Panther began brewing in 2010 on an industrial estate near the old railway station, formerly the home of Reepham Brewery. ‼ ☰ ◆LIVE

Mild Panther (ABV 3.3%) MILD
Smooth, sweet base with contrasting dry cobnut notes and a gentle roastiness. Short, clean finish with biscuit airs.
Ginger Panther (ABV 3.7%) SPECIALITY
Refreshingly clean, ginger wheat beer with a distinct fiery kick. It contains all the ingredients of a Thai Curry.
Golden Panther (ABV 3.7%) GOLD
Refreshing orange and malt notes flow through this well-balanced, easy-drinking bitter. Hops and a soft bitterness add depth.
Honey Panther (ABV 4%) SPECIALITY
A gentle flowing brew with honey and malt throughout. Amber-coloured with a tapering bittersweet finale.
Red Panther (ABV 4.1%) RED
A distinctly malty nose with a nutty, bittersweet beginning. Rye, plum and caramel appear before a full-bodied hoppiness emerges.
American Pale Ale (ABV 4.4%) BLOND
Zesty lemon and hop character with a gentle sweet counterpoint. Light grapefruit notes bolster a short crisp finish.
Black Panther (ABV 4.5%) PORTER
Vanilla, rum and raisin throughout. Strong supporting mix of caramel, malt and robust roastiness. Mellow and complex finish slowly sweetens.
Beast of the East (ABV 5.5%) IPA
A hoppy resinous bouquet with hints of sweetness. Earthy, peppery beginning with a hoppy backdrop. Long, drying, bitter citrus finish.

Pell & Co

🍺 **White Horse Inn, The Street, Neatishead, Norfolk, NR12 8AD**
☎ (01692) 630828
⊕ thewhitehorseinnneatishead.com

⊗ Formerly known as Neatishead Brewery, production began in 2015 at the White Horse Inn. The brew kit can be viewed through glass from the restaurant. Beer is only available in the White Horse and the owner's other pub, the Lion, Thurne. A range of semi-regular beers is brewed with at least one ever-changing ale. The range is currently being contract brewed by an unknown brewery.

People's

Mill House, Mill Lane, Thorpe-Next-Haddiscoe, Norwich, Norfolk, NR14 6PA
☎ (01508) 548706 ✉ peoplesbrewery@mail.com

⊗ A one-barrel brewery associated with the Queen's Head pub in Thurlton, which takes most of its draught output. Bottled beers are also available at Thurlton Community Shop.

Northdown Bitter (ABV 3.8%) BITTER
Raveningham Bitter (ABV 3.9%) BITTER
Thurlton Gold (ABV 4.2%) PALE
Norfolk Cascade (ABV 4.5%) GOLD
Northern Brewers (ABV 4.6%) BITTER

Poppyland

46 West Street, Cromer, Norfolk, NR27 9DS
☎ (01263) 515214 ☎ 07802 160558
⊕ poppylandbrewery.com

Established in 2012, the 2.5-barrel brewery specialises in unusual and innovative brews mainly using Norfolk malt. Foraged saisons a speciality. Beers are on sale at the brewery and at numerous specialist beer shops across East Anglia. Cask ales are available in some Norfolk and Norwich pubs. ☰LIVE

Bert's Dark Mild (ABV 4.1%) MILD
East Coast IPA (ABV 5.4%) PALE
Sweet Chestnut Ale (ABV 6.7%) SPECIALITY
Rich, multi-dimensional base with malt and caramel alongside blackcurrant and eucalyptus. Nuttiness and gentle sourness in a complex, sweet finish.

Redwell

Under the Arches, Bracondale, Trowse Millgate, Norwich, NR1 2EF
☎ (01603) 904990 ⊕ redwellbrewing.com

⊗ Redwell was started in 2013 by a group of beer lovers, tracing their beery influences from around the world. It is now under new ownership, and its Polish head brewer is Marcel Liput. The brews are certified vegan, audited gluten-free, and are unfined and unfiltered. ‼ ☰ GF V ✦

S&P

Homestead, Brewery Lane, Horsford, Norfolk, NR10 3AN ☎ 07884 455425 ⊕ spbrewery.co.uk

⊗ Production commenced in 2013 using a 10-barrel plant constructed upon land once owned by prominent Norfolk brewers Steward & Patteson (1800-1965), hence the name. Locally-produced malts are used, as is water from the brewery's own borehole. ‼

Topaz Blonde (ABV 3.7%) BLOND
Tilt (ABV 3.8%) GOLD
Barrack Street Bitter (ABV 4%) BITTER
Blackberry Porter (ABV 4%) SPECIALITY
First Light (ABV 4.1%) GOLD
Dennis (ABV 4.2%) BITTER
Fruit and malt, with some caramel, dominate aroma and taste. Full-bodied throughout with an increasingly bitter tail.
Eve's Drop (ABV 4.3%) BITTER
Darkest Hour (ABV 4.4%) STOUT
Deep, dark roast notes dominate this singularly dry stout. Sweet biscuit notes fade in an increasingly bitter chocolate finish.
Beano (ABV 4.5%) STOUT
NASHA IPA (ABV 5%) PALE
Strong banana and grapefruit character throughout. A good balance of malt and hop with a bittersweet background. Rich and filling.

Contract brewed for Boudicca Brewery:

Queen of Hops (ABV 3.7%) PALE
A definitive grapefruit hoppiness dominates throughout. A backdrop of ginger and gentle grassiness appears before a growing dryness gains ascendancy.

Three Tails (ABV 3.9%) BITTER
A bitter backbone dominates throughout. Malt, grapefruit and pepper in the first taste fades as a dry bitterness slowly grows.

Golden Torc (ABV 4.3%) GOLD
Malty bouquet with a hint of grassy hop. Biscuity beginning with a growing zesty citrus background appears. Clean grapefruit finish.

The Red Queen (ABV 4.5%) RED
Malt, dark fruits and caramel in nose and taste. Sweetness counters a growing hoppiness. Rye adds contrast and depth.

Spiral Stout (ABV 4.6%) STOUT
Burnt toast on the nose and black malt in the taste defines this traditional black and dry stout. Strong finish.

Prasto's Porter (ABV 5.2%) PORTER
Smooth and dark with molasses, malt and sweetness in aroma and taste. A roast toffee edge with a drying finish.

St Andrews

41 Saint Andrews Street, Norwich, NR2 4TP
☎ (01603) 305995 ☎ 07976 652410
⊕ standrewsbrewhouse.com

⊠ A city centre brewpub opened in 2015 in the premises formerly occupied by Delaney's Irish Bar. ⁋◆

Steam Shed (NEW)

The Old Train Shed, Station Street, Swaffham, Norfolk, PE37 7HP ☎ 07813 005424

Production began in 2021 and currently the beer is only available in bottles and at Holt farmers' market. Expansion is planned. LIVE

Stumptail

North Street, Great Dunham, Kings Lynn, Norfolk, PE32 2LR
☎ (01328) 701042 ✉ stumptail@btinternet.com

⊠ Stumptail began commercial homebrewing in 2011 using a 100-litre plant. Bottle-conditioned beers are produced with cask-conditioned versions brewed to order, all to bespoke recipes. Most parts of Norfolk can be supplied. LIVE

Tindall

Toad Lane, Seething, Norwich, Norfolk, NR35 2EQ
☎ 07703 379116 ✉ info@tindallales.com

⊠ Tindall Ales began brewing in 1998. It was originally based in Ditchingham but moved to its current location in 2001. Mike is passionate about brewing a new generation of cask beer using the finest local ingredients, whenever possible, and live yeast. ⁋🛒◆

Best Bitter (ABV 3.7%) BITTER
Mild (ABV 3.7%) MILD
Soft malty, dark fruit bouquet. Balanced, with fig roll, roast and a crisp, bitterness leading to a strong, savoury finish.

Liberator (ABV 3.8%) PALE
Golden-hued with a grapefruit and lemon hoppiness that floats over a subtle maltiness. A bittersweet finish with citrus notes.

Alltime (ABV 4%) BITTER
Seething Pint (ABV 4.3%) BITTER

Tipple's

Unit 3, The Mill, Wood Green, Salhouse, Norfolk, NR13 6NY
☎ (01603) 721310 ⊕ tipplesbrewery.com

⊠ Tipples was established in 2004 on a six-barrel brew plant. In addition to a full range of cask ales, an extensive range of bottled beers is produced, which can be found in some farmers markets and supermarkets in Norfolk. Bottled beers can now be ordered direct from the brewery for delivery or collection. 🛒◆LIVE

Bowline (ABV 3.8%) BITTER
Sundown (ABV 3.9%) BITTER
Berries and malt introduce this smooth, creamy bitter. Bitterness gives depth to the fruity malt core as it slowly sweetens.

Redhead (ABV 4.2%) BITTER
Malt and hops in both nose and palate. Toffee in the initial taste gives way to an increasing bitterness.

Malten Copper (ABV 4.4%) BITTER
Moonrocket (ABV 5%) BITTER
A complex, golden brew. Malt, hop bitterness and a fruity sweetness swirl around in an ever-changing kaleidoscope of flavours.

Tombstone

6 George Street, Great Yarmouth, Norfolk, NR30 4HU ☎ 07584 504444
⊕ tombstonebrewery.co.uk

⊠ Established in 2013, the brewery is run by former homebrewer Paul Hodgson. The original brewery backed onto the town cemetery, inspiring the name, but it has now relocated to the rear of its brewery tap, the Tombstone Saloon. Around 30 outlets are supplied around Norwich. 🛒◆

Ale (ABV 3.7%) GOLD
Banana toffee aroma. Piquant, bitter, hoppy beginning softened by a biscuity maltiness. Dry, bitter finish.

Amarillo (ABV 3.8%) BITTER
Arizona (ABV 3.9%) BITTER
Malt and lemon nose. Initial lemongrass and sweet biscuit beginning quickly fades. Sweet, watery finish enhanced by malt.

Texas Jack (ABV 4%) BITTER
Toffee apple and vanilla aroma. Caramel leads the smooth complex mix of flavours. A bittersweet fruitiness continues to the end.

Regulators (ABV 4.1%) GOLD
Gunslinger (ABV 4.3%) BITTER
Lone Rider (ABV 4.3%) OLD
Stagecoach (ABV 4.4%) OLD
A rich caramel and treacle aroma. Malt, roast and caramel dominate a hoppy bittersweeet foundation. Short, increasingly dry finish.

Cherokee (ABV 4.5%) BITTER
Malty nose with plum and cherry. Initial mix of biscuit and roasty bitterness gently changes to a slightly spicy maltiness.

Santa Fe (ABV 5%) BITTER
Big Nose Kate (ABV 5.2%) BITTER
6 Shooter (ABV 6.6%) IPA

Brewed for Brunning & Price pub Co:
Blackfoot (ABV 4.8%) PORTER

Two Rivers SIBA

2 Sluice Bank, Denver, Downham Market, Norfolk, PE38 0EQ
☎ (01366) 858365 ☎ 07518 099868
⊕ denverbrewery.co.uk

⊠ Established in 2012, bottled-conditioned ales have been available since then, with cask ales being produced since 2013. The brewery now has six established production ales and one seasonal ale. Experimental brews are also available on an ad-hoc basis. The brewery also brews three regular house ales for the Wellington at Feltwell and will brew bottled or cask ale on commission. The Blackstone (micropub) and beer gardens at Denver Windmill is the breweries' popular brewery tap. ‼ ⮐ ♦ LIVE

Miners Mild (ABV 3.1%) MILD
Hares Hopping (ABV 4.1%) BITTER
Kiwi Kick (ABV 4.1%) GOLD
Denver Diamond (ABV 4.4%) BITTER
Captain Manby (ABV 5%) BITTER
Porters Pride (ABV 5%) PORTER
Windmill Wheat (ABV 5%) SPECIALITY
Norfolk Stoat (ABV 5.8%) STOUT

Wagtail

New Barn Farm, Wilby Warrens, Old Buckenham, Norfolk, NR17 1PF
☎ (01953) 887133
✉ wagtailbrewery@btinternet.com

Wagtail Brewery went into full-time production in 2006. All beers are only available bottle-conditioned. This is a chemical-free brewery. No chemicals are on-site and all cleaning is done with hot water and 'elbow grease'. LIVE

Waveney

🍺 Queen's Head, Station Road, Earsham, Norfolk, NR35 2TS
☎ (01986) 892623 ✉ lyndahamps@aol.com

⊠ Established at the Queen's Head in 2004, the five-barrel brewery produces three beers, regularly available at the pub along with other free trade outlets. ♦

Why Not

95 Gordon Avenue, Norwich, Norfolk, NR7 0DR
☎ (01603) 300786 ⊕ thewhynotbrewery.co.uk

Why Not began brewing in 2005 on a 1.5-barrel plant located to the rear of the house of proprietor Colin Emms. In 2006 the brewery was extensively upgraded, doubling in capacity. In 2011 the brewery was moved to a new location in Thorpe St Andrew. LIVE

Wildcraft SIBA

Church Farm, Smallburgh, Norfolk, NR12 9NB
☎ (01603) 278054 ☎ 07584 308850
⊕ wildcraftbrewery.co.uk

⊠ Wildcraft was set up in 2016 and uses as much foraged and locally-sourced ingredients as possible to produce its beers. Its continuing success resulted in a move in 2022 to much larger premises in the village of Smallburgh. ‼ ⮐

Wild Eye PA (ABV 3.8%) PALE
Wild Norfolk (ABV 4.2%) PALE
Strong cut grass and citrus hop aroma. Full-bodied with lemon, sweet biscuit and a dry bitterness. Increasingly astringent finish.
Wild Bill Hiccup (ABV 4.5%) BITTER
Wild Summer (ABV 4.5%) PALE
Wild Stallion (ABV 5%) STOUT

Wolf SIBA

Decoy Farm, Old Norwich Road, Besthorpe, Attleborough, Norfolk, NR17 2LA
☎ (01953) 457775 ⊕ wolfbrewery.com

⊠ The brewery was founded in 1995 on a 20-barrel plant, which was upgraded to a 25-barrel plant in 2006. It moved to its current site in 2013. More than 300 outlets are supplied. ⮐ ♦

Edith Cavell (ABV 3.7%) GOLD
Hoppy, peppery nose flows into taste. Malt, caramel and bitterness give depth and complexity. Crisp finish with a hoppy edge.
Golden Jackal (ABV 3.7%) GOLD
Gentle lemon citrus aroma. A balanced mix of malt and hop with a crisp bitter tang. Burgeoning bitter swansong.
Wolf in Sheep's Clothing (ABV 3.7%) MILD
Strong, fruity nose with roast. A strong caramel beginning with a bitter roast counterpoint. Gently tapering finish. Increasing raspberry sweetness.
Lavender Honey (ABV 3.8%) SPECIALITY
Malty caramel aroma leads into a bittersweet beginning with background honey notes. A long drying finish.
Battle of Britain (ABV 3.9%) BITTER
Wolf Ale (ABV 3.9%) BITTER
Copper-coloured with a smooth mix of biscuit and hop. A growing grainy bitterness gives contrast to the long finale.
Lupus Lupus (ABV 4.2%) PALE
Hoppy throughout with malt and lemon. Increasing bitterness overcomes the initial sweetness although the beer is easy-drinking and balanced.
Sirius Dog Star (ABV 4.4%) RED
Rich tapestry of malt, roast and caramel with interwoven hop hints. Sweetness and bitterness provide a light but growing undercurrent.
Sly Wolf (ABV 4.4%) BLOND
Straw Dog (ABV 4.5%) SPECIALITY
Delicately-flavoured with a fruity character. A redcurrant aroma gives way to marmalade and hops. A strong increasingly bitter finale.
Mad Wolf (ABV 4.7%) RED
Well-rounded, malty foundation with chocolate and chestnut support. A bittersweet hoppiness provides depth and balance. Full-bodied and lasting.
Granny Wouldn't Like It (ABV 4.8%) BITTER
Complex, with a malty bouquet. Increasing bitterness is softened by malt as a gentle, fruity sweetness adds depth.
Woild Moild (ABV 4.8%) MILD
Heavy and complex with malt, vine fruit, bitterness and roast notes vying for dominance. Increasingly dry finish.

Contract brewed for City of Cambridge Brewery:
Boathouse (ABV 3.7%) BITTER
Hobson's Choice (ABV 4.2%) GOLD
Atom Splitter (ABV 4.5%) GOLD
Parkers Piece (ABV 5%) BITTER

Woodforde's SIBA

Broadland Brewery, Woodbastwick, Norfolk, NR13 6SW
☎ (01603) 720353 ⊕ woodfordes.co.uk

⊠ Founded in 1981 by two members of the Homebrewers' Society, Woodforde's is named after Parson Woodforde, the 18th century Norfolk diarist with a penchant for real ale. In 1989 the brewery moved to its current home at Woodbastwick. It has its own boreholes and brews using locally-grown Maris Otter. Further investment has increased the capacity and the brewery tap (Fur & Feather) is located next door to the brewery, with three further pubs taken on in 2021. ‼ ⮐ ♦ LIVE

Wherry (ABV 3.8%) BITTER
A sweet biscuit base with strawberry and a contrasting hoppy bitterness. Long and well-balanced with a noticeable citrusy encore.

Reedlighter (ABV 4%) PALE
Well-balanced hop and grapefruit backbone with a sweet biscuity undercurrent. Full-bodied with a pronounced bittersweet ending.

Bure Gold (ABV 4.3%) GOLD
Singularly citrus throughout with a succinct hop garland. Sweet biscuit floats in the background over a bitter footing.

Nelson's (ABV 4.5%) BITTER
Malt, hop and vine fruits dominate this full-bodied, well-balanced brew. Caramel and bitterness add depth and contrast.

Volt (ABV 4.5%) PALE
Rollicking mix of lemon, lime, hop and biscuit. Slightly astringent resinous notes add crispness and character at the end.

Nog (ABV 4.6%) OLD
Echoes of Pontefract cake dominate. A plummy sweetness is aided by a dry bitterness and a hint of caramel.

Jubilee, Norwich (Photo: Ian Stamp)

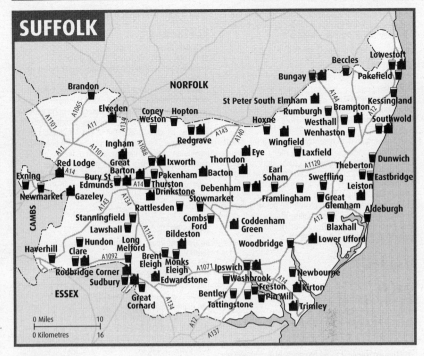

SUFFOLK

Aldeburgh

White Hart 🅛

222 High Street, IP15 5AJ (next to fish & chip shop)
☎ (01728) 453205 ⊕ whitehartaldeburgh.co.uk

Adnams Southwold Bitter, Ghost Ship, Broadside; 3 changing beers (often Adnams) 🅗

Friendly traditional single bar, formerly used as a public reading room, with a real fire in winter. Only a few yards from the beach, it features plenty of nautical memorabilia. Families are welcome to use the garden in the summer months, with a covered barbecue and wood-fired pizza oven often in use Easter to mid-September. Customers can buy fish & chips from the famous chippy next door and eat them in the garden while enjoying a drink from the bar. Live music features on occasion. 🅑🌸♣🅟🐾🛜

Beccles

Butchers Arms 🍷 🅛

51 London Road, NR34 9YT
☎ (01502) 712243 ⊕ mypub.org.uk

6 changing beers (sourced locally; often Barsham, Beccles, Woodforde's) 🅗

Situated a 10-minute walk from the town centre, this friendly pub serves up to six real ales, mainly from local breweries. Live jazz and other live music, frequent quiz nights and other community events are hosted. The interior, formerly with separate lounge and public bars, is now open plan. The bar and real fire remain, with a dartboard and pool tables in an extension. The rear garden has been refreshed and there is a patio with seating at the front. Local CAMRA Pub of the Year 2022. 🌸🅘♣🅟🐾🛜

Caxton Club 🅛

Gaol Lane, NR34 9SJ
☎ (01502) 712829

4 changing beers (sourced nationally; often Greene King, Mauldons, Parkway) 🅗

Spacious club conveniently situated a short walk from the train and bus stations and close to the town centre. It has a central bar, TV and darts room, and snooker room. There is also a large function room, available to hire, where occasional music events are held. Four ever-changing real ales are offered. All members and guests receive a warm welcome (a small charge is made to cover entertainment on Saturday evening). Assistance dogs only are allowed. 🅑🌸🅘♿♣🅟🐾🛜

Ingate 🅛

108 Grove Road, NR34 9RE
☎ 07585 121583 ⊕ theingatefreehouse.co.uk

3 changing beers (sourced regionally; often Green Jack, Lacons) 🅗

Privately owned two-bar free house serving the local community, a short walk from the town centre and train station. The back bar, furnished with tables, bar stools and sofas, serves three real ales on handpump. The front bar has a dartboard and pool tables – the pub's teams play in local leagues. Live sports are shown on large screens. There is a large covered seating area in the former car park at the side. 🌸🅘♿♣🅟🐾🛜

Bentley

Case is Altered 🅛 ✅

Capel Road, IP9 2DW
☎ (01473) 805575 ⊕ thecasepubbentley.co.uk

Adnams Southwold Bitter; 3 changing beers (sourced locally) 🅗

Owned and run by the local community, the pub has a single bar serving two drinking areas, a restaurant area with a wood-burning stove, and a pretty beer garden with plenty of seating. Various music evenings and themed food nights are hosted but there is no TV. Traditional pub games are played including darts, cards and dominoes. A quiz is held on the last Saturday of the

month. Local artists' work is on display. Some of the produce used in the kitchen is grown at home by the locals themselves. ➤☆❂◑ऀ♣₽🖵❀☕🌐

Blaxhall

Ship 🅛

School Road, IP12 2DY
☎ (01728) 688316 ⊕ blaxhallshipinn.co.uk
Adnams Southwold Bitter; Woodforde's Wherry; 3 changing beers Ⓗ
A cosy two-roomed 16th-century inn with a reputation for traditional singing in the bar. The menu offers a wide choice of home-made dishes and daily specials using locally sourced ingredients. Live entertainment includes folk music, local bands and story telling, and the pub hosts a Folk East stage during the festival weekend. Letting chalets are available beside the pub and there is camping at the nearby village hall by arrangement. Open all day but book for breakfast (from 10.30am) in summer. ➤☆❂◑ऀ♣₽🖵❀☕🌐

Brandon

Ram ❂

High Street, IP27 0AX
☎ (01842) 810275 ⊕ ramhotel.co.uk
Greene King Abbot; 6 changing beers (sourced nationally) Ⓗ
Said to be one of the oldest surviving buildings in town, this attractive Grade II-listed inn dates back 500 years in parts. A wonderful log fire greets you as you enter this friendly, family-run and -owned free house. It hosts regular club nights for the Iceni Car Club, Classic Vehicle Club, Model Engineering Club, Brandon Speakers Club and the Champions Poker League. ➤☆❂◑Å⇌♣₽🖵(86)

Brent Eleigh

Cock ★ 🅛

Lavenham Road, CO10 9PB
☎ (01787) 247371
Adnams Southwold Bitter; Greene King Abbot; 2 changing beers (sourced locally; often Bishop Nick, Mauldons) Ⓗ
An unspoilt gem, well worthy of its recognition by CAMRA as having a nationally important historic pub interior. With just two small bars, conversation with the regulars is assured. The public bar has a main table deeply etched with shove-ha'penny grooves and a settle with a 'pinch penny' cut into it. The snug bar is ideal for families. Home-cooked food service does not intrude on the classic pub ambience. Q☆❂◑♣₽❀🌐

Bungay

Green Dragon 🅛

29 Broad Street, NR35 1EF
☎ (01986) 892681 ⊕ greendragonbungay.co.uk
Green Dragon Chaucer Ale, Gold, Bridge Street Bitter, Strong Mild; 1 changing beer (sourced locally; often Green Dragon) Ⓗ
Originally called the Horse & Groom, the pub is on the edge of town and is home to the Green Dragon Brewery. Ales are brewed in outbuildings next to the car park at the rear of the property. This spacious pub has a public bar and a separate lounge area with a side room where families are welcome, leading to an enclosed garden surrounded by a hop hedge. A range of KeyKegs and canned craft ales is also available. ➤☆❂◑Å♣₽🖵❀☕🌐

Bury St Edmunds

Beerhouse 🅛

1 Tayfen Road, IP32 6BH
☎ (01284) 766415 ⊕ burybeerhouse.co.uk
Brewshed Best Bitter; 7 changing beers (sourced nationally) Ⓗ
Traditional beer house in an unusual semicircular Victorian building (previously called the Ipswich Arms), handy for the railway station, and refurbished with a modern feel. It serves its own beers from the Brewshed Brewery, which is located out of town and also supplies the company's four other local pubs. Seven beer engines provide an ever-changing selection of well-kept real ales. Three real ciders are also stocked. Regular beer festivals and an annual cider festival are hosted. Major sporting events are shown on a big screen. There is an open fire for the winter. ➤☆❂⇌♣₽🖵❀🌐

Dove ♟ 🅛

68 Hospital Road, IP33 3JU (5 mins' walk from town centre)
☎ (01284) 702787 ⊕ thedovepub.co.uk
Woodforde's Wherry Ⓗ**; changing beers** Ⓗ/Ⓖ
This early-Victorian back-street free house is just five minutes' walk from the town centre. It has six handpumps, plus jugged ales brought up direct from the cellar, and the staff are knowledgeable about the ever-changing choice of local ales. A selection of real ciders is also available. Truly traditional and basic, the Dove is just how pubs used to be – no lager, TVs, pool or gaming machines. A two-times winner of CAMRA Regional Pub of the Year and current local Pub of the Year. Q☆♣₽🖵❀

Nutshell ★ ✓

17 The Traverse, IP33 1BJ
☎ (01284) 764867 ⊕ thenutshellpub.co.uk
Greene King IPA, Abbot Ⓗ
The Nutshell is among Britain's smallest pubs, with an interior measuring only 15ft by 7ft, and is listed in the Guinness Book of Records. The main drinking area is crowded if more than six people are in it. The Grade II-listed building dates from the mid-19th century and is a popular tourist attraction in the town. Good-quality Greene King Abbot and IPA are regularly available. There is a function room upstairs. Q🖵

Oakes Barn Ⓛ ✓

St Andrews Street South, IP33 3PH (opp Waitrose car park)
☎ (01284) 761592 ⊕ oakesbarn.com
Oakham JHB; Woodforde's Wherry; 4 changing beers (sourced nationally) Ⓗ
A real ale free house and social hub near the town centre with some period features and historic links to the medieval town. Six real ales are always on the bar, including one dark beer alongside craft cider. Home-made food comprises lunchtime specials and snacks served all day, plus a monthly Sunday lunch. There is a covered smoking area outside and an open courtyard with seating. Regular events are held in the bar, and an upstairs function room is available to hire.
🚌🕮❍⚂♣🖵🐾🛜

Old Cannon Brewery Ⓛ

86 Cannon Street, IP33 1JR
☎ (01284) 768769 ⊕ oldcannonbrewery.co.uk
Adnams Southwold Bitter, Old Cannon Best Bitter, Gunner's Daughter; 3 changing beers (sourced nationally; often Old Cannon, Mauldons, Timothy Taylor) Ⓗ
This excellent brewpub is on the site of the original Cannon Brewery. Both the brewpub and stable block date from the mid-19th century and are Grade II-listed. Now in private hands, this is a true free house. The beers are brewed on-site and tours of the microbrewery are available (book ahead). Brewing in two copper vessels in the bar usually takes place on Monday and Wednesday. Good-quality food is served and comfortable accommodation is available. 🕮🛏❍≈🖵🐾🛜

Rose & Crown ✓

48 Whiting Street, IP33 1NP (on corner of Whiting St and Westgate)
☎ (01284) 361336
Greene King IPA, Abbot; 4 changing beers (sourced nationally; often Nethergate, Theakston, Timothy Taylor) Ⓗ
In sight of Greene King's Westgate Brewery, this is a traditional pub with two bars and a separate off-sales hatch. A Grade II-listed building within a conservation area of the town, it has been identified by CAMRA as having a nationally important historic pub interior. Good-value wholesome food is served lunchtimes Monday to Saturday. One mild beer is always on handpump.
Q🕮❍♣🖵🛜

Clare

Globe

10 Callis Street, CO10 8PX
☎ (01787) 278122
Young's London Original; 3 changing beers (sourced nationally) Ⓗ
A phoenix risen from the ashes, the Globe reopened in 2013 after a two-year closure. Serving one well-kept

regular beer and up to three changing guests, it is now a thriving local where beer and conversation dominate. Live music plays every other Saturday night and afternoon sessions every other Sunday. There is a separate pool room at the rear and a garden for summer drinking. No food is served. Q🚌❀✿🖵🐾🛜

Combs Ford

Gladstone Arms Ⓛ

2 Combs Road, IP14 2AP
☎ (01449) 771608 ⊕ gladstonearms.co.uk
Adnams Southwold Bitter, Broadside; Crouch Vale Brewers Gold; Fuller's London Pride; Sharp's Doom Bar; Woodforde's Wherry Ⓗ**; 4 changing beers** Ⓗ/Ⓖ
A large open-plan pub serving consistently good beer. The owners also run the Dove Street Inn in Ipswich. The two pubs offer a similar beer range, with 12-14 ales, including house beers brewed in Ipswich, and a wide range of craft lagers, ciders and specialist foreign beers. Good-value snacks and meals are served, with vegetarian options. There are board games, sports TV and regular live music. A beer festival features over the Easter weekend. At the rear is the riverside garden. Q🚌❀❍⚂♣🖵(87,88)🐾🛜

Coney Weston

Swan ✓

Thetford Road, IP31 1DN
☎ (01359) 221900 ⊕ swaninnconeyweston.com
Adnams Broadside; Greene King IPA; Wychwood Hobgoblin Ruby; 1 changing beer (often Adnams, Sharp's) Ⓗ
The current building is about a century old, though there has been an inn on this site for many hundreds of years – the original building burned down. A changing range of popular ales is served such as Draught Bass, Doom Bar and Hobgoblin. A full menu of traditional pub food is available. Regular events are hosted for charity, and the pub has its own bowls club. The site is a camping and caravan stopover, and coaches are also welcome by arrangement. Q🚌❍⚂♣🖵(338)🐾

Debenham

Woolpack Ⓛ

49 High Street, IP14 6QN
☎ (01728) 860516
Earl Soham Victoria Bitter Ⓗ**, Sir Roger's Porter** Ⓖ**; Fuller's London Pride; 1 changing beer (often Earl Soham)** Ⓗ
Small one-bar wooden-floored pub with steps up from the road. Until recent years it was licensed as a beer house. Horse brasses, village photographs and miniature bottles decorate the bar area. Two TVs show terrestrial sport. Keenly priced home-cooked food is served. The pub is home to a darts team and hosts occasional live music, karaoke and quiz nights. There is a splendid view of the church from the patio – bell ringers meet here after practice on Tuesday. 🚌🕮❍♣🐾🛜

Dunwich

Ship

St James Street, IP17 3DT
☎ (01728) 648219 ⊕ shipatdunwich.co.uk
Adnams Southwold Bitter; 3 changing beers Ⓗ
Once a haunt of smugglers, the Ship is now an excellent place to eat, drink, relax and get away from it all. It has comfortable, traditionally furnished rooms, some with views across the sea or nearby salt marshes, and a small

public bar with simple wooden furniture and a wood-burner. Draught beers are sourced from local brewers and bottled local cider is available. An extensive food menu is served. The enormous garden boasts fruit trees including a 300-year-old fig. The beach is just a short walk away. ♿🏠🛏️🍴◖🅿🐾🛜

Earl Soham

Victoria 🅛
The Street, IP13 7RL
☎ (01728) 685758
Earl Soham Victoria Bitter; 2 changing beers (often Cliff Quay, Earl Soham) 🅷
A former traditional beer house that despite refurbishment has changed little over the years, with two small bars separated by a large fireplace with wood-burner. A varied home-cooked menu with daily specials is offered lunchtimes and evenings. The pub gets busy at weekends, when even a seat in the garden can be hard to find. Dogs and children are welcome. The Gents toilet remains outside. The Earl Soham Brewery was originally behind the pub. Q♿🏠◖🍴♣🅿🐾🛜

Eastbridge

Eel's Foot 🅛
Leiston Road, IP16 4SN (close to entrance to Minsmere nature reserve)
☎ (01728) 830154 ⊕ theeelsfootinn.co.uk
Adnams Southwold Bitter, Ghost Ship, Broadside; 2 changing beers (often Adnams) 🅷
Adjacent to the famous Minsmere nature reserve where avocets and otters are local success stories, the pub is popular with ramblers and birdwatchers. It has a good reputation for locally sourced home-cooked food, with an extended and refurbished restaurant area leading out to a large terraced seating space for alfresco drinking and dining on summer days. Further improvements include an enlarged outdoor play area for children and en-suite accommodation. Traditional music sessions feature on Thursday evenings and live bands monthly.
Q♿🏠🛏️🍴◖♿♣🅿🐾🛜

Exning

White Horse ✅
23 Church Street, CB8 7EH
☎ (01638) 577323 ⊕ whitehorseexning.co.uk
3 changing beers 🅷
Mentioned in the Domesday Book and a pub for 300 years, this fine free house has been run by the same family since 1935. Still retaining much original character, it comprises a public bar, cosy lounge and separate restaurant. At least 10 changing real ales are rotated each week, plus cider on draught, and a good choice of home-cooked food is served. A private room is available to hire. Q🏠◖♣🅿(11)🐾

Framlingham

Station Hotel 🅛
Station Road, IP13 9EE
☎ (01728) 723455 ⊕ thestationframlingham.com
Earl Soham Gannet Mild, Victoria Bitter, Brandeston Gold; 1 changing beer (often Earl Soham) 🅷
Cosy two-bar pub set in a former station buffet (the branch line closed in 1963). Beers and a guest cider are dispensed from a set of Edwardian German silver handpumps. The pub has a long-standing reputation for good food, made with locally sourced ingredients and prepared on the premises – the ever-changing menu is displayed on chalkboards. On Sundays, brunch and beers are available. The garden bar has a wood-fired pizza oven. Children and dogs welcome. Q♿🏠◖🍴♣🅿🐾🛜

Freston

Boot
Freston Hill, IP9 1AB
☎ (01473) 780722 ⊕ thefrestonboot.co.uk
6 changing beers 🅷
After standing derelict for many years, this pub reopened in 2018 following a complete refurbishment. It now offers a comfortable bar area plus various extensions that provide additional space for an excellent kitchen and restaurant. The bar serves a changing selection of real ales and craft beers. Outside, the site has been relandscaped and much improved with new car parking, garden seating areas, a duck pond and a large allotment that provides some of the vegetables for the kitchen. ♿🏠◖♿♣🅿🐾🛜

Great Cornard

Brook Inn
241 Bures Road, CO10 0JQ
☎ 07759 960051
5 changing beers (sourced nationally) 🅷
Welcoming locals' country pub near the Suffolk/Essex border, with a beer garden and a good-sized car park. Formerly owned by Greene King, it is now independent and offers a good range of up to five real ales on handpump. There are two bars, one with low-key TV for sports events. Bar billiards and pool are played, with teams in local leagues. An open-mic music session is held on the third Sunday of each month.
♿🏠♿♣🅿🐾🛜

Great Glemham

Crown 🅛
The Street, IP17 2DA
☎ (01728) 663693 ⊕ thecrowninnglemham.co.uk
6 changing beers (sourced locally) 🅷
Furnished to a high standard, this multi-roomed pub has wood-burners, traditionally tiled floors and many lovely seating areas. Up to six beers are on offer during the busy summer months and at least four during quieter periods. Acoustic music sessions feature regularly. The pub hosts a local community lunch once a month and caters for private parties. All food is cooked on the premises, from bar snacks to an à la carte menu.
♿🏠◖♣🅿🐾🛜

Haverhill

Royal Exchange ✅
69 High Street, CB9 8AH
☎ (01440) 702155
Greene King IPA; Nethergate Suffolk County Best Bitter; 3 changing beers (sourced nationally; often Nethergate) 🅷
Friendly town-centre local in a classic street-corner location. The Greene King-managed house has had the full refurbishment treatment, with scrubbed floors and traditional furniture. It can be boisterous with sports fans watching the five TVs – glasses are available for those wishing to watch in 3D. A swift turnover on the beer helps sustain its high quality. There is a large public car park behind the Arts Centre opposite. ♿♿♣🅿🐾

Hopton

Vine 🅛

High Street, IP22 2QX
☎ (01953) 688581
Adnams Southwold Bitter; Greene King IPA, Abbot; Timothy Taylor Landlord; 5 changing beers (sourced locally; often Colchester, Lacons, Mauldons) 🄷
On the main road near the church, this village local has been revitalised since it was taken over by the current landlord in 2013. Nine ales including a selection of local and regional guests are offered at reasonable prices, alongside a variety of ciders. This welcoming pub, popular with locals and visitors, is a regular winner of local CAMRA Pub of the Year. 🌣🏵♣♠🚶🅿🚆(100)🏵🐾🛜

Hoxne

Swan Inn of Hoxne

Low Street, IP21 5AS
☎ (01379) 668275 🌐 theswaninnofhoxne.co.uk
Adnams Southwold Bitter, Ghost Ship, Broadside; Timothy Taylor Landlord 🄶
The Swan reopened in 2016 after temporary closure and is once again a thriving village local. The 15th-century building has a colourful history – it claims to be both the former home of the Bishop of Norwich and later a brothel. There is a large open fire in the main bar and a wood-burner in the adjacent bar. The restaurant serves excellent home-cooked food, with an emphasis on local produce. To the rear is a large garden. An annual beer festival features in August. Buskers' night is Thursday. 🌣🏵🌖👌♣🚶🐾🛜

Hundon

Rose & Crown

20 North Street, CO10 8ED (in centre of village)
☎ (01440) 786261 🌐 hundon-village.co.uk/ roseandcrown.html
Sharp's Doom Bar; 3 changing beers (sourced nationally; often Fuller's, Mauldons, St Austell) 🄷
A traditional country pub comprising two bars with open fires. Home-cooked food is available Thursday to Sunday, with the Sunday lunchtime roasts ever-popular. The deceptively large beer garden has a patio for alfresco dining leading to a lawned area with a stage. The outside bar is used for weddings, parties, an annual community music festival over the August bank holiday and other events. The morris men gathering on St George's Day is enjoyed by all. A proud former winner of local CAMRA Community Pub of the Year. 🌣🏵🌖👌♣🐾🛜

Ipswich

Arcade Street Tavern

Arcade Street, IP1 1EX (behind Corn Exchange)
☎ (01473) 805454 🌐 arcadetavern.co.uk
2 changing beers (sourced regionally) 🄷
A stylish and popular multi-roomed café bar with a traditional wooden interior and an emphasis on craft and imported beers. Two handpumps dispense a variety of ever-changing local real ales. The bar regularly hosts street food traders on Friday evenings. There is a heated seating area outside and two function rooms, one used for product launches and tasting evenings. Artisan coffee is available. The bar can be busy on match days. 🏵🚆🛜

Briarbank 🅛

70 Fore Street, IP4 1LB
☎ (01473) 284000 🌐 briarbank.org

Briarbank Perpendicular, Old Spiteful; 3 changing beers (sourced locally; often Briarbank) 🄷
A smart and modern first-floor drinking bar that opened in 2013 in a former bank above a small brewery. Many house beers are also available as craft ales and in bottles. A large outside seating area includes a marquee that provides additional space as weather permits. Live music – usually jazz – features twice monthly, either in the bar or outside. TVs show various sporting events – including international rugby, Formula 1, tennis and golf. Easter and summer beer festivals are hosted. 🏵🌖🅿🚆🛜

Dove Street Inn 🅛 ✅

76 St Helen's Street, IP4 2LA
☎ (01473) 211270 🌐 dovestreetinn.co.uk
Adnams Broadside; Crouch Vale Brewers Gold; Fuller's London Pride; Greene King Abbot; Ruddles County 🄷**; changing beers (often Dove Street)** 🄷/🄶
Popular inn with a wide selection of ales, continental beers and ciders. Some beers are brewed in the pub's own microbrewery. Home-cooked food and bar snacks are served at all times. Sports TV is shown in the conservatory. Well-behaved dogs and children are welcome. A sister pub to the Gladstone Arms in Combs Ford, there is also a nearby gin bar and accommodation. Last admission is 10.45pm. 🌣🏵🛏🌖👌♣🚶(66)🐾🛜

Fat Cat

288 Spring Road, IP4 5NL
☎ (01473) 726524 🌐 fatcatipswich.co.uk
Adnams Southwold Bitter 🄷**; Woodforde's Wherry; 14 changing beers** 🄶
The owner recently celebrated 25 years at this splendid pub – often voted the best pub in town by local CAMRA members. The small, multi-roomed drinking bar is free from background music and games machines. Up to 14 beers and five ciders are served from the taproom. Bar snacks include Scotch eggs and pasties cooked on the premises. An airy conservatory behind the main bar leads to the pretty garden, providing extra space on sunny afternoons. A quiz is held monthly. No under-16s. Q🏵🌖🚆🐾🛜

Lord Nelson

81 Fore Street, IP4 1JZ
☎ (01473) 407510 🌐 thenelsonipswich.co.uk
Adnams Southwold Bitter, Ghost Ship 🄶**; 3 changing beers (often Adnams)** 🄷
Cosy, timber-framed building dating from the 17th century, just a short walk from the historic waterfront. An unusual gravity dispense system incorporates old wooden casks to good effect and guarantees temperature-controlled real ales. Freshly prepared food is served including daily specials. A small enclosed patio area to the rear is popular throughout the year. The pub attracts a diverse cientele including tourists and students. Families and dogs are welcome. Quiz nights are held twice a month. A sister pub to the Red Lion in Manningtree and the Marlborough in Dedham. 🌣🏵🌖👌♣🐾🛜

Spread Eagle 🅛

1-3 Fore Street, IP4 1JW
☎ (01473) 421858
Grain ThreeOneSix, Best Bitter, Redwood, Slate, Lignum Vitae; 1 changing beer (often Grain) 🄷
This distinctive Grade II-listed building is the sole survivor of four pubs that once dominated this busy road junction. The historic building was restored to a high standard a few years ago by Grain. It offers up to six real ales from Grain on handpump, plus a selection of local craft beers and imported beers. Various events are hosted including occasional music sessions, regular quiz nights and the

annual Octoberfest. There is a secluded seating area outside. On Tuesday evenings it is candle-lit throughout. Locally roasted coffee is served. Q✿❄🚲🅿🐾🛜

Thomas Wolsey

9-13 St Peters Street, IP1 1XF (300yds from bus station)
☎ (01473) 210055
Adnams Ghost Ship; Crouch Vale Brewers Gold; Woodforde's Wherry; 1 changing beer 🅗

A large lounge bar set in a historic Grade II-listed building. It has a patio area to the side and two nicely furnished function rooms upstairs, used for a wide variety of events including story-telling nights, charity quizzes and various meetings. Craft ales are available, plus over 25 bottled beers and 40 quality wines. Games are played including darts. Home supporters only on football match days. ✿❄♣🚲🛜

Ixworth

Greyhound ✔

49 High Street, IP31 2HJ
☎ (01359) 230887
Greene King IPA, Abbot; 3 changing beers (sourced nationally) 🅗

Situated on the village's attractive high street, this welcoming traditional inn has three bars, one a lovely central snug. The heart of the building dates back to Tudor times. Good-value lunches and early evening meals are served in the restaurant, including a good-value daily special. Dominoes, crib, darts and pool are played in leagues and for charity fundraising. Dogs and children are welcome. Q🛏✿🕙▲♣🅿🚌(304,338)🐾

Kessingland

Sailors Home 🅛

302 Church Road, NR33 7SB
☎ (01502) 740245 🌐 sailorshome.co.uk
Green Jack Golden Best, Gone Fishing ESB; 5 changing beers (sourced locally; often Green Jack, Lacons, Wolf) 🅖

Situated on the sea front, with coastal views, the pub is popular in summer with holidaymakers from nearby caravan parks and guest houses. There is a covered seating area outside at the front. The interior has a mock-Tudor design with four adjoining rooms – one for diners serving value-for-money food, a large central bar area with a TV screen, a games room and a side room. Up to seven ales are served on gravity plus a regularly changing real cider. 🛏✿🕙▲♣🅿🚌(99)🐾🛜

Lawshall

Swan 🅛

The Street, IP29 4QA
☎ (01284) 828477 🌐 swaninnlawshall.com
5 changing beers (sourced nationally; often Adnams, Colchester, Woodforde's) 🅗

Set in the heart of rural Suffolk, the Swan is a classic Suffolk country pub. The beautiful 18th-century thatched building with a low-beamed bar and an inglenook fireplace has been lovingly restored and is crammed full of period features. On the menu you will find all the traditional pub classics and a few extra culinary delights. The large garden encourages children to play. Q🛏✿🕙♣🅿🐾🛜

Laxfield

King's Head (Low House) ★ 🅛

Gorams Mill Lane, IP13 8DW (walk through pretty churchyard and exit via lower street gate, pub is on your right)
☎ (01986) 798395 🌐 lowhouselaxfield.com
Green Jack Golden Best; Shortts Skiffle; Timothy Taylor Landlord; 3 changing beers (sourced locally; often Shortts) 🅖

The local CAMRA branch's newest Community Pub. Also known as the Low House, and bought from Adnams in 2018, this timeless thatched building is a classic pub, always worth a visit. The main room features high-back settles around a small fireplace, with the beers served on gravity from a small taproom to the rear. The separate dining room offers an interesting menu of locally sourced food, including roast lunch on Sunday. There is an enclosed garden and patio to the rear. Accommodation is available in an outbuilding. 🛏✿🛌♣🅿🐾🐾

Long Melford

Crown Inn

Hall Street, CO10 9JL
☎ (01787) 377666 🌐 thecrownhotelmelford.co.uk
Adnams Southwold Bitter, Ghost Ship; 2 changing beers (sourced nationally) 🅗

A busy family-run free house and cosy hotel set in the centre of this popular village. Two regular ales and two changing guests, together with real cider, are on handpump. A high-quality home-cooked food menu is served in the spacious bar and separate restaurant. There is a large, attractive patio garden for summer dining and drinking. Eleven comfortable bedrooms are available for those wishing to stay and explore this picturesque area. Q🛏✿🕙▲🚶♿🅿🐾🛜

Nethergate Brewery Tap 🅛

Rodbridge Corner, CO10 9HJ
☎ (01787) 377087 🌐 nethergate.co.uk
8 changing beers (sourced locally; often Nethergate) 🅗

Nethergate Brewery was founded in 1986 in Clare. This custom-built visitor centre and taproom opened in 2017 and is the third location the brewery has operated from. The taproom has a bar offering a range of Nethergate ales on draught, and a shop selling bottled beers, wines and spirits. There is a window to view the brewery and tours can be booked. The members' club hosts regular events including beer festivals. Q🐾🅿🛜

Lowestoft

Norman Warrior 🅛

Fir Lane, NR32 2RB
☎ (01502) 561982 🌐 thenormanwarrior.co.uk
4 changing beers (sourced nationally; often Greene King, Lacons, Wolf) 🅗

Large estate pub situated between the town centre and Oulton Broad North, with ample parking. It comprises a public bar where pool and darts are played and a comfortable lounge leading to a spacious restaurant serving reasonably priced home-cooked food daily. Outside is a large refurbished garden and terrace where a beer and cider festival featuring live music is held annually over the August bank holiday weekend. A popular quiz takes place weekly. 🛏✿🕙♣🅿🚌(102)🐾🛜

Stanford Arms 🅛

Stanford Street, NR32 2DD
☎ (01502) 574505 🌐 stanfordarmslowestoft.co.uk

7 changing beers (sourced nationally; often Mr Winter's, Nene Valley, Three Blind Mice) ⒣

This free house is a short walk from Lowestoft train and bus stations. The open-plan L-shaped bar is decorated with a fine collection of beer trays adorning the walls. To the rear is a refurbished courtyard garden with a wood-fired pizza oven. The pub offers an exceptional range of beers including real ales sourced from all over the UK and bottled and canned beers from around Europe. There is live music most weekends. TV screens show major sporting events. ⌚⊛⬤♦⎕❀🐾

Triangle Tavern ⓛ

29 St Peters Street, NR32 1QA

☎ (01502) 582711 ⊕ green-jack.com

Green Jack Golden Best, Trawlerboys Best Bitter, Lurcher Stout, Gone Fishing ESB, Ripper Tripel; 2 changing beers (sourced locally; often Crouch Vale, Green Jack) ⒣/Ⓖ

The flagship for local brewery Green Jack, this popular community town hostelry was originally two pubs, but is now one. The cosy front bar has wood-panelled surrounds and benches, giving the feel of a front parlour, and hosts live music on Friday nights. A corridor leads to an open-plan back bar with pool table. Both bars are decorated with brewery awards and memorabilia, and are dog friendly. Customers are welcome to bring in their own food. ⌚⊛≈♣⬤⎕❀

Monks Eleigh

Swan

The Street, IP7 7AU

☎ (01449) 744544 ⊕ swaninnmonkseleigh.co.uk

Greene King Abbot; Mighty Oak Oscar Wilde; 2 changing beers (sourced regionally) ⒣

A welcoming, traditional country pub in the heart of Suffolk. Food and drink come from small and artisan producers, bringing a range of Suffolk ingredients to the table and bar, including cask ales on handpump. The restaurant area has a large inglenook fireplace and there is a smaller real fire in the bar area. Events include comedy and quiz nights. Closed Monday but available to hire. ⊛⬤⎕(111)❀

Newbourne

Fox Inn ✅

The Street, IP12 4NY

☎ (01473) 736307

Adnams Southwold Bitter; 3 changing beers ⒣

This picturesque timber-framed, two-bar village local is becoming increasingly popular, not just with ramblers and cyclists, but also with discerning diners. The refurbished kitchen offers a wide range of locally sourced home-cooked food, with daily specials plus vegetarian and gluten-free options. The restaurant has been extended in sympathy with the existing building. Outside, the large garden has a pond and a shed with an old skittle alley – the only one in Suffolk. Q⌚⊛⬤♿♣⎕(179)❀🔊

Newmarket

Golden Lion ✅

44 High Street, CB8 8LB

☎ (01638) 672040

Adnams Ghost Ship; Greene King Abbot; 7 changing beers ⒣

A large, bustling, 18th-century Wetherspoon on the main street. The name is thought to have come from King Henry I, who was known as the Lion of Justice.

Knowledgeable and efficient staff serve up to seven real ales at any one time, including up to four guest ales. Real cider is also available. The pub is popular with the local horse-racing community. Children are welcome until 9pm in the family area. ⌚⊛⬤♿≈⬤P⎕🔊

Pakefield

Oddfellows ⓛ

6 Nightingale Road, NR33 7AU

☎ (01502) 538415

House beer (by Green Jack); 4 changing beers (sourced locally; often Green Jack, Lacons, Woodforde's) ⒣

Popular inn close to Pakefield's cliffs and coastal path, and just a stone's throw from the sea. A small and cosy pub, it has three open-plan areas including one for diners, with wood flooring and panelling throughout. The walls are festooned with pictures of old Pakefield, and sporting events are shown on TV screens. Up to five ales are available from local breweries and, in summer, a beer festival is hosted on the village green opposite. ⌚⊛⬤⎕❀🔊

Pakenham

Fox ⓛ

The Street, IP31 2JU

☎ (01359) 230194 ⊕ pakenhamfox.co.uk

Mighty Oak Kings; 3 changing beers (sourced locally; often Elmtree, Shortts, Star Wing) ⒣

Traditional 18th-century pub in a picturesque village, beautifully restored with a handcrafted central bar. A free house, the Fox serves four well-chosen ales from local breweries and two real ciders on draught. The chef prepares lunches Wednesday to Sunday and evening meals Wednesday, Thursday and Saturday using local ingredients. Friday is home-made pizza night. Every second Tuesday is quiz night. The spacious beer garden, smokers' shelter and pétanque pitch overlook a wildflower meadow. Q⌚⊛⬤♿♣⬤P⎕(304,338)❀🔊

Pin Mill

Butt & Oyster ✅

Pin Mill Road, IP9 1JW

☎ (01473) 780764

Adnams Southwold Bitter, Ghost Ship, Broadside; 1 changing beer (often Adnams) Ⓖ

Dating from the 17th century, this riverside pub enjoys a famous setting, with magnificent views from the main bar and patio of the Orwell with its local quay and historic coastal barges. Inside, it has three separate rooms connected via a flagstoned corridor. High-backed settles and a wood-burner in the main room add to the old-world charm on cold winter days. The patio at the front is often used by diners during busy sessions. Breakfast is served weekends only.

Q⌚⊛⬤♿♣P⎕(97,202)❀🔊

Rattlesden

Five Bells ⓛ

High Street, IP30 0RA

☎ (01449) 737373

3 changing beers (sourced locally; often Earl Soham, Elgood's, Woodforde's) ⒣

Set on the high road through a picturesque village, this is a fine traditional Suffolk drinking house – sadly few of its kind still survive. Three well-chosen ales on the bar usually come direct from the breweries, often including a mild. The cosy single-room interior has a games area on

a lower level and there is occasional live music. Pub games include shut-the-box and shove-ha'penny, plus pétanque in the garden in summer. Q✿♣🚐🌟

Redgrave

Cross Keys 🄻

The Street, IP22 1RW
☎ (01379) 779822 ⊕ crosskeysredgrave.co.uk
Earl Soham Victoria Bitter; 3 changing beers (sourced locally) Ⓗ
The building dates from the late 16th or early 17th century, with later extensions and refronting. It was bought by the community and reopened in 2018, run by a mix of paid staff and volunteers. Earl Soham Bitter is the regular beer, plus three changing ales. Numerous events are held – see social media for details. Check food service times ahead of your visit as they may vary.
🚶✿🕪&♣P🚐(304) 🌟🛜

Star Wing Tap Room 🄻

Hall Farm, Church Road, IP22 1RJ
☎ (01379) 890586 ⊕ starwingbrewery.com
Star Wing Dawn on the Border, Gospel Oak, Spire Light, Red at Night, Four Acre Arcadia, Stain Glass Blue; 1 changing beer Ⓗ
The Tap Room opened in 2019 and has developed a reputation as an excellent place to enjoy Star Wing beers and guests. Based in an old sawmill, the bar retains many original features and also has an on-site bakery. As well as the core range of six Star Wing craft ales on tap, the bar offers a range of drinks from local suppliers including Finningham-based Betty's Gin and Harleston cider, based in Palgrave. There is also a fine keg wall.
✿&P🌟🛜

Rumburgh

Buck 🄻

Mill Road, IP19 0NT
☎ (01986) 785257 ⊕ rumburghbuck.co.uk
Adnams Southwold Bitter; 4 changing beers (sourced regionally; often Earl Soham, Lacons, Mighty Oak) Ⓗ
Originally, this pub and the parish church were part of a Benedictine priory. The inn was extended some years ago and now has two dining areas, a public bar and games room retained around the historic core. The original bar is timber-framed with a flagstone floor. Full of character and at the heart of village life, the pub hosts folk music evenings and is home to the Old Glory Molly Dancers. Good-quality meals are served featuring locally sourced produce. Q🚶✿🕪👤♣P🌟🛜

Southwold

Lord Nelson 🄻 ✅

42 East Street, IP18 6EJ
☎ (01502) 722079 ⊕ thelordnelsonsouthwold.co.uk
Adnams Southwold Bitter, Ghost Ship, Mosaic, Broadside Ⓗ
A regular entry in the Guide, this pub is situated close to the Sailors' Reading Room Museum and enjoys coastal views from the nearby cliff-top promenade. A busy and lively pub, it is popular with locals and visitors alike. It has a central bar offering the full range of Adnams beers. The walls are adorned with naval memorabilia and photos of old Southwold. Children are welcome in the side room and courtyard patio to the rear.
🚶✿🕪👤🚐🌟🛜

Stanningfield

Red House

Bury Road, IP29 4RR
☎ (01284) 828330 ⊕ theredhousesuffolk.co.uk
Greene King IPA; 2 changing beers Ⓗ
Red brick in construction and displaying the red dress uniform of the Suffolk Regiment on its sign, the Red House is a family-run free house at the heart of the village. Good-value lunches and early evening meals are all home cooked. The pub supports darts, cribbage and bar billiards teams and hosts regular entertainment nights. There is a lovely garden at the rear. Car and bicycle parking are available.
🚶✿🕪♣P🚐(750,753) 🌟🛜

Stowmarket

Royal William 🄻

53 Union Street East, IP14 1HP
☎ (01449) 674553
Greene King IPA; 10 changing beers Ⓖ
An end-of-terrace back-street bar tucked away down a narrow side street, a short walk from the town centre and railway station. Ales are dispensed on gravity from the cellar behind the bar, with up to 10 beers and five ciders. There is a games room, home to dominoes, darts and crib matches, and a smoking area outside. Sport is shown on TV and traditional music hosted monthly. Home-made bar snacks are often available. A winner of many local CAMRA awards. 🚶✿🕪&♣🚆🚐🌟🛜

Walnut

39 Violet Hill Road, IP14 1NE
☎ (01449) 401 6769 ⊕ the-walnut.square.site
6 changing beers Ⓗ
Refurbished by the landlord and landlady in early 2019, this much-improved back-street venue offers an ever-changing selection of real ales on handpump, along with ciders and craft beers listed on a large blackboard. The beer menu regularly features some unusual choices for the area. Good-value snacks are available. The pub holds regular quiz and vinyl nights. There are two beer gardens, with children welcome until 8pm. Local CAMRA Pub of the Year 2020. 🚶✿&≠🍴🚐🌟🛜

Sudbury

Brewery Tap 🄻

21-23 East Street, CO10 2TP (200yds from market place)
☎ (01787) 370876 ⊕ thebrewerytapsudbury.co.uk
Mauldons Moletrap Bitter, Suffolk Pride, Black Adder Ⓗ**; 7 changing beers (sourced nationally)** Ⓗ/Ⓖ
The Mauldons Brewery tap is a haven for ale lovers. A good selection of the brewery's beers is always stocked, complemented by a range of national and locally sourced ales, up to 10 at any one time, on both handpump and gravity. Hearty snacks are served at lunchtimes including pies and sandwiches. Beer festivals are held in April and October, and quiz, music and comedy nights are regular attractions in a traditional pub where conversation dominates. Q✿🕪&≠🍴🚐🌟

Swefling

White Horse 🍷 🄻

Low Road, IP17 2BB
☎ (01728) 664178 ⊕ swefllingwhitehorse.co.uk
3 changing beers Ⓖ
A cosy two-room pub, warmed by a wood-burner and wood-fired range. Beers from local brewers are

dispensed on gravity, served through a taproom door. Cider is also available, as well as Fairtrade, organic and locally produced bottled beers. Pub games include bar billiards, darts, crib and board games, and live music features twice a month. Horse and trap rides may be available in summer. A former CAMRA East Anglian Pub of the Year with a garden and an award-winning campsite. Q♿❄🛏🏕️🅰♣♠🅿🐾🛜

Tattingstone

Wheatsheaf 🄻
Church Road, IP9 2LY
☎ (01473) 805470 ⊕ wheatsheaftattingstone.com
3 changing beers (sourced locally) 🄶
Recently refurbished and extended country pub, on the outskirts of this small village divided by the Alton Water Park reservoir. There is a large garden to the side – home to an annual charity music and beer festival plus a beetroot competition in June. An ever-changing beer selection includes many from local brewers. Live music and quiz nights are always popular, as are themed food evenings and Sunday roasts. The pub hosts local cribbage league matches and caters for private parties. ♿❄🏕️🅰♣🅿(94,96) 🐾🛜

Theberton

Lion 🄻
The Street, IP16 4RU
☎ (01728) 830185 ⊕ thebertonlion.co.uk
Woodforde's Wherry; 2 changing beers (sourced locally) 🄷
Lively and large village bar with patio seating outside at the front, various seating areas inside and a central fireplace. Many pictures of the area decorate the walls. The local beer club meets in the bar to enjoy the varied beer range. Real ciders in bottle (BiB) are now available all year round including Giggler and Thistly Cross Traditional. The outdoor toilets have been retained. Two en-suite log cabins are available to let. Opening hours may vary depending on the time of year. ♿❄🛏🍴♿♣♠🅿🐾🛜

Thurston

Fox & Hounds
Barton Road, IP31 3QT
☎ (01359) 232228 ⊕ thurstonfoxandhounds.co.uk
Greene King IPA; 5 changing beers (sourced nationally; often Cliff Quay, Green Jack, Tring) 🄷
A listed building, this popular local sits in the middle of the village a short walk from the railway station. Good home-cooked food is served in a separate dining area within the public bar, and there is a bar for pool and darts. The pub holds regular quiz nights and bingo, and live music on bank holidays and special occasions. It has its own golf society. A previous winner of local CAMRA awards. ♿❄🛏🍴🅰⇌🅿🐾🛜

Washbrook

Brook Inn
Back Lane, IP8 3HR
☎ (01473) 730531 ⊕ thebrookinnwashbrook.co.uk
Adnams Southwold Bitter; 2 changing beers 🄷
A spacious village pub that was purchased by a group of local residents in 2015. The public bar still retains a traditional pub atmosphere, with a separate large and comfortable restaurant area for families. The menu offers good, tasty food with plenty of gluten-free and vegetarian options. Real ales include Adnams Southwold

Bitter and Ghost Ship, along with guests, which change frequently. The outside seating area includes a children's play area. ♿❄🛏🅿🖳(96,95)🐾

Wenhaston

Star Inn 🄻
Hall Road, IP19 9HF
☎ (01502) 478240 ⊕ wenhastonstar.co.uk
Green Jack Golden Best; 5 changing beers (sourced regionally; often Colchester, Green Jack, Wolf) 🄷
Situated on the outskirts of the village with fine views of the Blyth Valley, this pub is popular with walkers and cyclists – dogs and muddy boots are welcome. The interior comprises three small public rooms overlooking a large lawn and garden. The front bar is a gem with old enamel advertising signs and an open fire on cold evenings. Good home-cooked food is served featuring locally sourced produce. Two beer festivals are held in May and August. Q♿❄🛏🅰♣♠🅿🖳(99A)🐾🛜

Westhall

Racehorse Inn 🄻
Mill Common, IP19 8RQ
☎ (01502) 575665 ⊕ westhallpub.com
Green Jack Golden Best; 2 changing beers (sourced locally; often Ampersand, Green Jack, Lacons) 🄷
Village pub deep in rural Suffolk. This free house is community owned and has a central bar with three interlinked rooms. Three beers and one cider are usually available. The pub is well supported by locals, with a community lunch on Wednesday plus various food options most weekends. Open mic night is the last Friday of the month and there is live screening of sporting events. At the rear there is a large garden and covered seating area. Q♿❄♿🅰♣♠🅿🖳(524)🐾🛜

Woodbridge

Angel 🄻
2 Theatre Street, IP12 4NE
☎ (01394) 382660 ⊕ theangelwoodbridge.co.uk
Adnams Southwold Bitter; 5 changing beers 🄷
A lively and traditional two-bar drinking pub with beams and tiled floors. The regularly changing range of real ales is complemented by a massive selection of gins, with gin tasting sessions by arrangement. There is seating outside and a former stables to the rear. No regular meals are served but there is a wood-fired oven in the garden for pizza. Open mic is hosted on the second and fourth Wednesday of the month plus a DJ every Saturday evening and more live music. ♿❄⇌♣♠🅿🐾🛜

Cherry Tree
73 Cumberland Street, IP12 4AG
☎ (01394) 384627 ⊕ thecherrytreepub.co.uk
Adnams Southwold Bitter, Ghost Ship, Broadside; 1 changing beer (often Adnams) 🄷
A deceptively spacious family-friendly lounge bar/diner with a central servery and several distinct cosy seating areas. The kitchen provides popular home-cooked food all day, every day, starting with breakfast, including vegetarian and gluten-free options. Board games and cards are available and a quiz is held on Thursday evening. The large garden has children's play equipment. Accommodation is in a converted barn. ♿❄🛏🍴⇌♣🅿🐾🛜

Breweries

Adnams SIBA

Sole Bay Brewery, East Green, Southwold, Suffolk, IP18 6JW
☎ (01502) 727200 ⊕ adnams.co.uk

⊗ Established in 1872 and still based in Southwold, Suffolk. More than 35 pubs are owned around East Anglia, with national distribution. Beers are from a 300-barrel plant within the confines of the present site. ⏸🍺♦

Southwold Bitter (ABV 3.7%) BITTER
Aromas of toffee apple, caramel and sulphur. Taste is a complex mix of malt toffee and roast bitterness with hops. Malty bitter and apple flavours linger into the aftertaste.
Mosaic (ABV 4.1%) BITTER
Tropical fruit nose, intensely fruity flavour with complex hop characteristics, which linger in the aftertaste.
Ghost Ship (ABV 4.5%) PALE
Vibrant compote of orange and oily hoppiness underpinned by a biscuity sweetness. Great balance and easy drinking.
Broadside (ABV 4.7%) RED
Rich, malty aroma with blackberries and dried fruit. Rich and full flavours of malt and fruit, with roast and caramel notes and subtle hops. Well-balanced, long-lasting aftertaste.

Artefact SIBA

Bridge Farm, Bury Road, Ixworth, Suffolk, IP31 2HX
⊕ artefactbrewing.co.uk

Artefact Brewing is a nanobrewery established in 2020. The brainchild of husband-and-wife team James and Kat Lawson-Philips, it operates from a cleverly converted shipping container in the village of Ixworth. Committed to a classic range using local and seasonal hops, the brewery also experiments and collaborates to produce new and interesting beers.

Dark Mild (ABV 3.2%) MILD
Session Pale Ale (ABV 3.8%) PALE
English Pale Ale (ABV 4.8%) PALE
Ixworth Blonde (ABV 4.8%) GOLD
Amber Haze IPA (ABV 6.2%) IPA

Beccles

The Studios, London Road, Beccles, Brampton, Suffolk, NR34 8DQ ☎ 07815 519576
⊕ becclesbrewco.co.uk

⊗ The brewery has been in production since 2019 and is now run by one of the original owners with the assistance of family and friends. It has a production run three times a week, with a 700-litre capacity. Six beers are regularly produced and can be found in local pubs. The beers are also available in bottle and mini-keg from the brewery and at the local Friday market in Beccles Town Centre. 🍺

Uncle Albert's (ABV 3%) MILD
Hodgkins Hop (ABV 3.6%) GOLD
Neil, Neil Orange Peel (ABV 4.2%) PALE
Paint The Town Red (ABV 4.5%) RED
Boney's Island (ABV 4.6%) STOUT
Nelson's Tree (ABV 4.8%) BITTER

Biochemist

19 Boundary Road, Red Lodge, IP28 8JQ ☎ 07821 540237 ⊕ biochemistbrewery.com

Established in 2020, Biochemist is a 100-litre nanobrewery producing unfiltered, unfined beer for sale at local markets and local delivery. Small batches of seasonal, dry ciders also produced.

Brewshed

Place Farm, Ingham, Suffolk, IP31 1NQ
☎ (01284) 848066 ⊕ brewshedbrewery.co.uk

⊗ Brewshed began brewing in 2011 using a five-barrel plant in buildings located behind the Beerhouse (one of its outlets). It's now located in the nearby village of Ingham, using a 12-barrel plant, resulting in greater capacity and a more modern beer range with two-three seasonal beers usually available, plus a number of unusual keg beers. It supplies its own five pubs plus a limited free trade. ♦

Pale (ABV 3.9%) PALE
Kveik IPA (ABV 4.2%) PALE
Best Bitter (ABV 4.3%) BITTER
American Blonde (ABV 5.5%) BLOND

Briarbank SIBA

🍴 **70 Fore Street, Ipswich, Suffolk, IP4 1LB**
☎ (01473) 284000 ⊕ briarbank.org

The Briarbank Brewing Company was established in 2013, and is situated on the site of the old Lloyds Bank on Fore Street, Ipswich. The brewery is a two-barrel plant, and the bar above offers a core range of beers – including some speciality ales. ⏸🍺♦

Bruha

Unit 4, Progress Way, Eye, Suffolk, IP23 7HU
☎ (01379) 882230 ⊕ bruhabrewing.co.uk

Originally known as Station 119, the brewery changed name in 2020 to Bruha Brewing. Established in 2014, it graduated to the current brewery and taproom premises in Eye, Suffolk, in 2017. In 2018 a 12-barrel brewhouse was installed. All the beers are unfiltered and have an emphasis on East Anglian malt. LIVE 🍴

Session Pale (ABV 3.9%) PALE

Burnt Mill

Badley, Ipswich, Suffolk, IP6 8RS ☎ 07791 961974
⊕ burntmillbrewery.com

This farm brewery was created by Charles O'Reilly in 2016 and is set in a former grain shed. In 2017 Sophie de Ronde joined the brewing team as Head Brewer. All beers brewed to date have been unfiltered and are available in both KeyKeg and 440ml cans.

Cabin

44 Brooksfield, Bildeston, Suffolk, IP7 7EJ ☎ 07990 845855 ⊕ cabinbrewery.co.uk

Owner and brewer Chris Smith has been brewing since 2013, with Cabin Ales available commercially since 2015. Demand soon outgrew the original plant and a new two-barrel kit was designed and installed in 2018.

Autumn Leaf (ABV 3.8%) BITTER
Chesn't (ABV 3.9%) BROWN
Gold Rush (ABV 4%) PALE
Mark's Gold (ABV 4%) PALE
Red Nek (ABV 4.3%) RED
Mary Celeste (ABV 4.5%) PALE
INNspiration (ABV 5%) PALE

Calvors SIBA

Home Farm, Coddenham Green, Suffolk, IP6 9UN
☎ (01449) 711055 ⊕ calvorsbrewery.com

Calvors Brewery was established in 2008 and brews three craft lagers, as well as cask-conditioned beers.

Lodestar Festival Ale (ABV 3.8%) GOLD
Smooth Hoperator (ABV 4%) PALE

Cliff Quay

Unit 1, Meadow Works, Kenton Road, Debenham, Suffolk, IP14 6RT
☎ (01728) 861213 ⊕ cliffquay.co.uk

⊠ Cliff Quay was established in 2008 by Jeremy Moss and John Bjornson (owner of Earl Soham Brewery) in part of the historic Tolly Cobbold brewery, Ipswich. In 2012 the brewery relocated to Debenham, a small, picturesque market town, due to redevelopment of the Cliff Quay brewery site. It now operates alongside Earl Soham brewery, with shared production, offices and distribution facilities. !! ▼ ◆

Bitter (ABV 3.4%) BITTER
Pleasantly drinkable, well-balanced, malty, sweet bitter with a hint of caramel, followed by a sweet/malty aftertaste. Good flavour for such a low gravity beer.
Anchor Bitter (ABV 4%) BITTER
Black Jack Porter (ABV 4.2%) SPECIALITY
Unusual dark porter with a strong aniseed aroma and rich liquorice and aniseed flavours, reminiscent of old-fashioned sweets. The aftertaste is long and increasingly sweet.
Tolly Roger (ABV 4.2%) BITTER
Well-balanced, highly-drinkable, mid-gold summer beer with a bittersweet hoppiness, some biscuity flavours and hints of summer fruit.
Tumble Home (ABV 4.7%) BITTER
Aroma of marzipan and dried fruit. Flavour reminiscent of Amaretto, leading to a short, bitter, slightly spicy aftertaste.
Sea Dog (ABV 5.5%) GOLD
Dreadnought (ABV 6.5%) STRONG

Dove Street SIBA

82 St Helens Street, Ipswich, Suffolk, IP4 2LB
☎ (01473) 211270 ☎ 07880 707077
⊕ dovestreetbrewery.co.uk

⊠ Dove Street began brewing in 2011 using a 2.5-barrel plant in a garage opposite the Dove Street Inn. The pub, its sister pub and beer festivals are supplied. !!

Underwood Mild (ABV 3.2%) MILD
Gladstone Guzzler (ABV 3.6%) BLOND
Citra (ABV 3.9%) GOLD
Incredible Taste Fantastic Clarity (ABV 4%) GOLD
Dove Elder (ABV 4.1%) SPECIALITY
Apples & Pears (ABV 4.2%) PALE
Ed Porter (ABV 4.5%) PORTER
Thirsty Walker (ABV 4.6%) BITTER

Drinkstone

Rattlesden Road, Drinkstone, Suffolk, IP30 9TL
☎ 07592 072140 ✉ drinkstoneales@gmail.com

Drinkstone Ales is a 100-litre, part-time nanobrewery owned by Colin Field, and based in his converted garage. It commenced brewing in 2021, supplying local outlets and festivals. It concentrates on traditional cask ale using only English malt and hops.

Bitter (ABV 3.8%) BITTER

Road Apple Strong (ABV 5.2%)

Earl Soham SIBA

Meadow Works, Cross Green, Debenham, Suffolk, IP14 6RP
☎ (01728) 861213 ⊕ earlsohambrewery.co.uk

⊠ Earl Soham was set up behind the Victoria pub in 1984 and continued there until 2001 when the brewery relocated, moving again in 2013 to Debenham. Around 30 outlets are supplied and two pubs are owned. !! ▼ ◆ LIVE

Gannet Mild (ABV 3.3%) MILD
A beautifully-balanced mild, sweet and fruity flavour with a lingering, coffee aftertaste.
Victoria Bitter (ABV 3.6%) BITTER
A light, fruity, amber session beer with a clean taste and a long, lingering hoppy aftertaste.
Elizabeth Ale (ABV 4%) BITTER
Sir Roger's Porter (ABV 4.2%) PORTER
Roast/coffee aroma and berry fruit introduce a full-bodied porter with roast/coffee flavours. Dry roast finish.
Albert Ale (ABV 4.4%) BITTER
Brandeston Gold (ABV 4.5%) GOLD
Popular beer brewed with local ingredients. Lovely sharp clean flavour, malty/hoppy and heavily laden with citrus fruit. Malty finish.

Green Dragon

🏠 Green Dragon, 29 Broad Street, Bungay, Suffolk, NR35 1EF
☎ (01986) 892681 ⊕ greendragonbungay.co.uk

⊠ The Green Dragon is Bungay's busiest pub and oldest existing brewery, established in 1991 by brothers Robert and William Pickard. In 1994 the plant was expanded and moved to a converted barn. The doubling of capacity allowed the production of a larger range of ales. !! ◆

Green Jack SIBA

Argyle Place, Love Road, Lowestoft, Suffolk, NR32 2NZ
☎ (01502) 562863 ☎ 07902 219459
⊕ green-jack.com

⊠ After 10 years at Oulton Broad, Green Jack moved to the Triangle Tavern, Lowestoft in 2003 and then to a nearby 35-barrel plant in 2009. One pub is owned and more than 150 outlets supplied. !! ◆ LIVE

Golden Best (ABV 3.8%) GOLD
Nightingale (ABV 4%) BITTER
LGM1 (ABV 4.2%) PALE
Orange Wheat Beer (ABV 4.2%) SPECIALITY
Marmalade aroma with a hint of hops, leading to a well-balanced blend of sweetness, hops and citrus with a malt background. Mixed fruit flavours in the aftertaste.
Trawlerboys Best Bitter (ABV 4.6%) BITTER
Tawny premium bitter with sweet malt gently balanced by caramel and fruit, and a gentle lingering hop bitterness providing contrast.
Lurcher Stout (ABV 4.8%) STOUT
Impressive creamy stout with spirited roast malt supported by a satisfying mix of hops and caramel. Lingering, roast bitter finish.
Red Herring (ABV 5%) SPECIALITY
Gone Fishing ESB (ABV 5.5%) BITTER
Mahseer IPA (ABV 5.8%) IPA
Pale amber brew with well-defined citrus hop, a background balance of malty sweetness and a lingering bitter-sweet finale.
Ripper (ABV 8.5%) BARLEY

Baltic Trader Export Stout (ABV 10.5%) STOUT

Greene King

Westgate Brewery, Westgate Street, Bury St Edmunds, Suffolk, IP33 1QT
☎ (01284) 763222

Office: Abbot House, Westgate Street, Bury St Edmunds, IP33 1QT ⊕ greeneking.co.uk

⊗ Greene King has been brewing in the market town of Bury St Edmunds since 1799. It brews its beers using water drawn from artesian chalk wells below its brewhouse, as well as local East Anglian malt. Beers are also brewed under various brand names. ‼☎♦LIVE

IPA (ABV 3.6%) BITTER
Hop-infused fruit cake aromas. Complex flavours of malt, caramel and hop with both sweetness and bitterness. A lingering mellow aftertaste with blackberries.
London Glory (ABV 4%) BITTER
Yardbird (ABV 4%) PALE
St Edmunds (ABV 4.2%) GOLD
Abbot (ABV 5%) BITTER
Mouth-filling, premium bitter with sweet malt, caramel and redcurrant. Underpinning hop bitterness holds up well in a malty fruity finish.

Brewed for Taylor Walker:
1730 (ABV 4%) BITTER

Brewed under the Hardys & Hansons brand name:
Bitter (ABV 3.9%) BITTER
Olde Trip (ABV 4.3%) BITTER

Brewed under the Morland brand name:
Original Bitter (ABV 4%) BITTER
Old Golden Hen (ABV 4.1%) GOLD
Old Speckled Hen (ABV 4.5%) BITTER
Light-bodied, ruby-brown, premium bitter with caramel, fruit and malt, touches of background hops and a developing, gentle dryness.

Brewed under the Ruddles brand name:
Best Bitter (ABV 3.7%) BITTER
An amber/brown beer, strong on bitterness but with some initial sweetness, fruit and subtle, distinctive Bramling Cross hop. Dryness lingers in the aftertaste.

Humber Doucy SIBA

St Edmunds Garage, Broad Road, Bacton, Suffolk, IP14 4HP
☎ (01449) 780151 ⊕ humberdoucybrew.co

Producing fresh, vegan-friendly beers from the heart of Suffolk, Humber Doucy started brewing in 2019 in an old MOT garage in Bacton, with a brewery shop located down the road within the Jeffries of Bacton Subaru Dealership. Beers are available nationwide and in pubs, shops and restaurants across East Anglia in bottles, cask and keg. ☎V

King Slayer (ABV 3.6%) BITTER
Friday Street (ABV 4%) PALE
Pale Ale (ABV 4.4%) PALE
Nettle & Elderflower Saison (ABV 4.5%) SPECIALITY
Porter (ABV 5%) PORTER

Iceni

The Walled Garden, Elveden Courtyard, London Road, Elveden, Suffolk, IP24 3TQ
☎ (01842) 878922 ☎ 07949 488113

Office: 70 Risbygate Street, Bury St Edmunds, IP33 3AZ ✉ icenibrewe@aol.com

The Iceni Brewery is owned by Brendan Moore, who set it up in 1995. In 2020 a micropub, the Magic Hammer, opened. ♦LIVE

Fine Soft Day (ABV 4%) BITTER
Golden-hued with toffee notes throughout. A creamy, lightly-hopped backdrop softly sinks into a pleasant sweetness.

Krafty Braumeister SIBA

Unit 4a, Eastlands Industrial Estate, Leiston, Suffolk, IP16 4LL ☎ 07508 435893 ⊕ kraftybraumeister.co.uk

Krafty Braumeister was established in 2018 and produces historic German beer styles, matured naturally in bottles and kegs.

Little Earth Project

Mill Green, Edwardstone, Sudbury, Suffolk, CO10 5PX
☎ (01787) 211118 ⊕ littleearthproject.com

Mill Green Brewery started in 2008, becoming Little Earth Project in 2016. Built on an old stable site, using local wood, reclaimed bricks, sheep wool and lime plaster. It has its own borehole, brewing liquor is heated using bio and solar power, and its 3,000-litre storage is heated by solar panels, and a wood boiler. It creates innovative beers and sours. Most use local ingredients, and age in old wine barrels. About half is KeyKeg, the rest is bottled, with some cask available.

Mauldons SIBA

13 Church Field Road, Sudbury, Suffolk, CO10 2YA
☎ (01787) 311055 ⊕ mauldons.co.uk

Mauldons started brewing in Sudbury in 1795, was taken over by Greene King in the 1960s, and reopened by the Sims family in 2000. A new 30-barrel plant and brewery were built. After 19 years they retired and sold to local farming-based company, Heathpatch. It is planned that its barley and hops will be used in production. A new website was launched in 2020 (bottled and draught beer available online). Three pubs are owned, and over 200 outlets supplied. ‼☎♦LIVE♦

Pale Ale (ABV 3.6%) BITTER
Moletrap Bitter (ABV 3.8%) BITTER
Plum and toffee on the nose. A good balance of malt, hops and fruit, leading to an increasingly bitter aftertaste.
Ploughmans (ABV 3.9%) GOLD
Silver Adder (ABV 4.2%) BITTER
Light fruity aroma, dry hoppiness and citrus fruit with rich honey in the taste, and a long fruity sweet aftertaste. Refreshing and well-balanced.
225 (ABV 4.5%) PALE
Blackberry Porter (ABV 4.8%) SPECIALITY
Cherry Porter (ABV 4.8%) SPECIALITY
Suffolk Pride (ABV 4.8%) BITTER
A full-bodied, copper-coloured beer. A bubblegum nose leads to a spicy taste, with mild astringency in the aftertaste.
Black Adder (ABV 5.3%) STOUT
Malty, roasty aroma leads to a well-balanced, full-bodied beer, malty with roast and dark soft fruit overtones.

Mr Bees

Units D, Searsons Farm, Cordys Lane, Trimley, Suffolk, IP11 0UD ☎ 07503 773630 ⊕ mrbeesbrewery.co.uk

Mr Bees is based on the beautiful Suffolk Coast. All beers contain honey direct from the brewery's own beehives. All malted barley used comes from Suffolk and only English hops are used. Around 30 local outlets are supplied.

Best Bee-R (ABV 4%) BITTER
Beelightful (ABV 4.3%) BITTER
Black Bee (ABV 4.5%) STOUT

Munson's

Chequers, The Green Gazeley, Newmarket, Suffolk, CB8 8RF
☎ (01638) 551511 ⊕ munsons.co.uk

Microbrewery at the Chequers in Gazeley, specialising in small-batch hoppy IPAs and Belgian-style beers.

Nethergate SIBA

The Brewery, Rodbridge Corner, Long Melford, Suffolk, CO10 9HJ
☎ (01787) 377087 ⊕ nethergate.co.uk

Nethergate was formed in 1986 in Clare, Suffolk and moved to its current site in 2017. It produces both traditional recipes and more modern beers and has recently added craft lager and low alcohol beer to its range. The establishment of a borehole means all the water comes directly from the chalk bed. In 2021 a still was added and local craft gins are now produced. Nethergate have now opened a shop in nearby Bury St Edmunds. ‼♦

Melford Mild (ABV 3.7%) MILD
Venture (ABV 3.7%) GOLD
Umbel Ale (ABV 3.8%) SPECIALITY
Pleasant, easy-drinking bitter, infused with coriander, which dominates.
Suffolk County Best Bitter (ABV 4%) BITTER
Dark bitter with roast grain tones off-setting biscuity malt and powerful hoppy, bitter notes.
Stour Valley Gold (ABV 4.2%) GOLD
Augustinian Ale (ABV 4.5%) BITTER
A pale, refreshing, complex premium bitter. A fruity aroma leads to a bittersweet flavour and aftertaste with a predominance of citrus tones.
Old Growler (ABV 5%) PORTER
Robust, dark brown porter with appealing bittersweet meld of roast malt, hop and caramel; sustained finish with developing hop bitterness.
Umbel Magna (ABV 5%) SPECIALITY
Old Growler flavoured with coriander. The spice is less dominant than in Umbel Ale, with some of the weight and body of the beer coming through.

Old Cannon

86 Cannon Street, Bury St Edmunds, Suffolk, IP33 1JR
☎ (01284) 768769 ⊕ oldcannonbrewery.co.uk

The St Edmunds Head pub opened in 1845 with its own brewery. Brewing ceased in 1917, and Greene King closed the pub in 1995. It reopened in 1999 as the Old Cannon Brewery, complete with a unique state-of-the-art brewery housed in the bar area. Other pubs in the chain are also supplied. At least six beers available at any one time. ‼♦

Old Chimneys

Office: Old Chimneys, The Street, Market Weston, Suffolk, IP22 2NZ
☎ (01359) 221411 ⊕ oldchimneysbrewery.com

Old Chimneys was established in 1995, moving to a converted farm building in 2001. In 2019 Alan Thomson ceased brewing at Market Weston to concentrate on collaborative brewing projects with other breweries. ‼♦LIVE

Old Felixstowe

30 Falkenham Road, Kirton, Ipswich, Suffolk, IP10 0NW ☎ 07889 238784 ⊕ tofbc.co.uk

Brewing began in 2018 in an outhouse in Old Felixstowe. Following a move to Kirton, the brewery was upgraded to a two-barrel plant in 2020. Five core beers are produced, with seasonal specials. Beer is mostly available bottle-conditioned, but cask beers are provided to a handful of local pubs when capacity allows. Beers can be found at most local farmers markets and a selection of food and drink festivals. Free local delivery is also available.

Roughacre

Clare Hall Barns, Clare, Cambridgeshire, CO10 8PJ
☎ (01799) 585956 ⊕ roughacre.com

Established in 2018 by a passionate home brewer in Castle Camps, East Cambs. The brewery moved to Clare in West Suffolk in 2021. The brewery is run by a two-person team and now has a taproom and shop. It brews high quality, fine ales of character which range from classic amber ales and golden IPA, to Belgian-style Abbey Ale, and a dark coffee porter. The beers are now available in several local pubs. ‼♦LIVE♦

The Saintly One (ABV 1.5%) BITTER
Cavendish Red (ABV 3.8%) MILD
Alliance TPA (Transatlantic Pale Ale) (ABV 4.2%) PALE
Ashdon Amber (ABV 4.4%) BITTER
Nighthawker Coffee Porter (ABV 4.6%) SPECIALITY
All Saints Old English Ale (ABV 4.8%) BITTER
Abbey Gold (ABV 5.2%) SPECIALITY
Mosquito IPA (ABV 5.2%) PALE
ESB (ABV 5.4%) SPECIALITY
Saffron Sun (ABV 5.4%) SPECIALITY

St Judes

2 Cardigan Street, Ipswich, Suffolk, IP1 3PF
☎ (01473) 413334 ☎ 07879 360879
⊕ stjudestavern.com

The 10-barrel brewery produces beer for the St Judes Brewery Tavern in Ipswich. It can also be found at some local festivals.

St Peter's SIBA

St Peter's Hall, St Peter South Elmham, Suffolk, NR35 1NQ
☎ (01986) 782322 ⊕ stpetersbrewery.co.uk

The brewery, built in 1996, is housed in traditional former agricultural buildings adjacent to moated, medieval St Peters Hall, dating from 1280. Brewing makes use of the water from an on-site bore hole combined with locally malted barley. Beer is distributed nationally across the UK and exported to more than 40 countries worldwide. ‼♦♦

Best Bitter (ABV 4.1%) BITTER
A complex but well-balanced hoppy brew. A gentle hop nose introduces a singular hoppiness with supporting malt notes and underlying bitterness. Other flavours fade to leave a long, dry, hoppy finish.
Ruby Red (ABV 4.3%) BITTER
Gold Dust (ABV 4.5%) GOLD
Plum Porter (ABV 4.6%) SPECIALITY
Citrus (ABV 4.7%) PALE
Fudge as well as grapefruit on the nose. A refreshing fruit flavour, with hints of grapefruit peel in the aftertaste.

Shortts SIBA

Shortts Farm, Thorndon, Eye, Suffolk, IP23 7LS
☎ 07900 268100 ⊕ shorttsfarmbrewery.com

An award-winning brewery established in 2012 by Matt Hammond on what has been the family farm for over a century. Ales are produced using carefully selected ingredients to create both traditional and more complex contemporary flavours. The beer names are based around a musical theme and can be found throughout East Anglia. LIVE

The Cure (ABV 3.6%) BITTER
Strummer (ABV 3.8%) BITTER
Two Tone (ABV 3.8%) MILD
Blondie (ABV 4%) PALE
Rockabilly (ABV 4.3%) PALE
Skiffle (ABV 4.5%) BITTER
Black Volt (ABV 4.8%) STOUT
Indie (ABV 4.8%) PALE
Darkside (ABV 5%) PORTER
Powerful porter with inviting roast malt and hop aroma then a booming roasty taste with biscuity, caramel sweetness and hops.

Star Wing

Unit 6, Hall Farm, Church Road, Redgrave, Suffolk, IP22 1RJ
☎ (01379) 890586 ⊕ starwingbrewery.com

Brewing began in 2017 after converting an old sawmill into a brewery. Half an acre of hops have been planted with plans to grow more. Part of the sawmill has been converted into a taproom, which opened in 2019. Around 75 outlets are supplied direct. ☒ ♦

Dawn on the Border (ABV 3.6%) PALE
Electric Trail (ABV 3.7%) PALE
Gospel Oak (ABV 3.8%) BITTER
Spire Light (ABV 4.2%) GOLD
Into the Woods (ABV 4.5%) PALE
Red at Night (ABV 4.5%) RED
Pesky Pilgrim (ABV 4.7%) BITTER
Four Acre Arcadia (ABV 5%) PALE
Stain Glass Blue (ABV 5.4%) PORTER

Stow Fen

Fenview, Flixton Road, Bungay, Suffolk, NR35 1PD
☎ 07775 279181 ✉ stowfenbrewingco@gmail.com

☒ Stow Fen Brewing Co Ltd was established in 2020 by Paul Holland and Philip Gilham, the head brewer. Malts are from Branthill Farms in Wells-next-the-Sea, and all hops are from the UK. At present beers are all sold directly from the brewery.

Broad Water Gold (ABV 4.2%) GOLD
Angels Way Amber (ABV 4.4%) BITTER
Stock Bridge Best (ABV 4.6%) BITTER
Twisted Oak IPA (ABV 5%) IPA
Wolds ESB (ABV 5.8%) BITTER
Mouldings Porter (ABV 6.5%) PORTER

Turnstone

The Old Post Office, Vicarage Road, Wingfield, Suffolk, IP21 5RB ☎ 07807 262662
✉ turnstoneales@outlook.com

☒ Turnstone Ales is a small, home-based brewery set up in 2014 in Kent, which has now relocated to Suffolk. Beers are available from local farmers markets, including Framlingham, and local shops selling bottled local beers. LIVE

Uffa

⬛ **White Lion Inn, Lower Street, Lower Ufford, Suffolk, IP13 6DW**
☎ (01394) 460770 ⊕ uffabrewery.co.uk

Uffa began brewing in 2011 using a 2.5-barrel plant. It is situated next to the White Lion pub in a converted coach house. ♦

Watts & Co

Gardeners Road, Debenham, Suffolk, IP14 6RX
☎ 07764 906886 ⊕ watts.fm

Watts and Co was established in 2015 and brew a range of traditional and modern beers from its tiny brewhouse in the heart of Suffolk. Each brew produces just 300 pints, with a range of traditional and modern beers, all handcrafted.

Weird Sisters

24 Timworth Heath Cottages, Great Barton, Suffolk, IP31 2QH ☎ 07827 923923

☒ A nanobrewery established by a father and three daughters (the weird sisters) in 2018. The brewery has one core beer and mainly produces seasonal beers to mark the eight seasonal festivals of the wheel of the year. Beers can be found at festivals, morris dancing events and in specialist beer shops.

Slaphead (ABV 6.7%) IPA

Nethergate Brewery, Rodbridge Corner (Photo: Peter Phillips)

Greater London

London has an excellent public transport network that makes it easy to explore different areas. Besides the more well-known tourist attractions, consider spending some time touring the River Thames and the rivers and canals that feed into it. There are plenty of pubs, old and new, to enjoy along the way. Don't pass up the opportunity to taste a proper London Porter!

The micropub scene is strong, with half of CAMRA's Greater London Pub of the Year winners in 2022 being micros. Seek them out across the city; Greenwich's River Ale House and One Inn the Wood in Petts Wood are two excellent examples.

Sambrook's Heritage Centre, the old Young's Ram Brewery at Wandsworth and Fuller's Griffin Brewery at Chiswick are great options for discovering the story of London's brewing history. See history being made with a tour of the Five Points Brewing Company in Hackney. It has received numerous awards for its beers, including being named The Brewers Journal Brewery of the Year in 2021.

The beer scene in London has truly exploded in recent years. There were just a handful of breweries 20 years ago, and now the region is home to well over a hundred. New brewers tend to start up in affordable areas of the capital in proximity to other breweries to maximise trade. This creates concentrations of microbreweries with taphouses and real ale pubs offering locally brewed beers. Look to areas like Blackhorse Lane, Walthamstow or the Bermondsey Beer Mile. Not far from Walthamstow, ORA Brewing is an exciting Italian-run brewery crafting modern styles. If experimental craft brewing is your thing, you might also like to head south of the river to Battersea and visit the renowned Mondo Brewing Company.

CAMRA's first London beer festival was the 1975 Covent Garden Beer Exhibition. Since then, a huge number of festivals of all sizes have been organised in the city. All CAMRA beer festivals are special because they are run by volunteers. Besides the Great British Beer Festival, now held at Olympia, look out for the Ealing festival which takes place in vast marquees on Walpole Park and Pig's Ear, held in the Round Chapel, Lower Clapton, which is perhaps the most atmospheric indoor event.

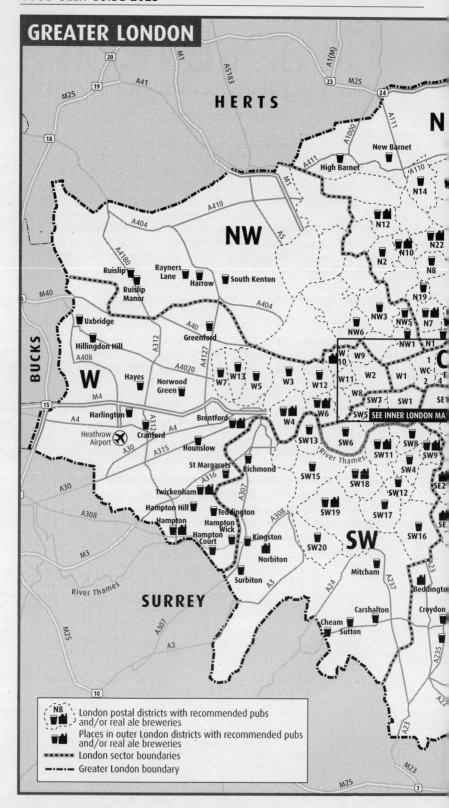

GREATER LONDON

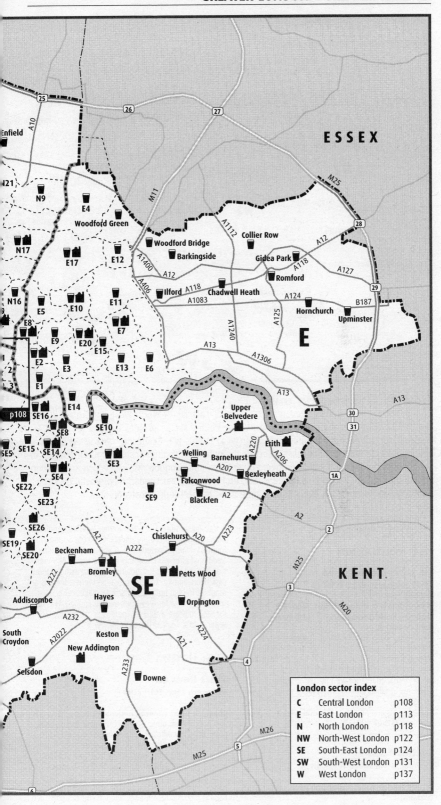

Enfield

N9

E4

Woodford Green

N17

E17

E12

Woodford Bridge

Barkingside

Collier Row

Gidea Park

Romford

N16

E5

E10

E11

Ilford

Chadwell Heath

Hornchurch

Upminster

E8

E9

E20

E15

E7

E2

E3

E13

E6

E1

E14

E

SE16

Upper Belvedere

SE8

SE10

Erith

SE15

SE14

Welling

Barnehurst

SE5

SE4

SE3

Bexleyheath

Falconwood

SE22

SE9

Blackfen

SE23

SE26

Chislehurst

SE19

SE20

Beckenham

Bromley

Petts Wood

SE

Addiscombe

Hayes

Orpington

South Croydon

Keston

New Addington

Selsdon

Downe

E S S E X

K E N T

M25

M11

M26

p108

London sector index		
C	Central London	p108
E	East London	p113
N	North London	p118
NW	North-West London	p122
SE	South-East London	p124
SW	South-West London	p131
W	West London	p137

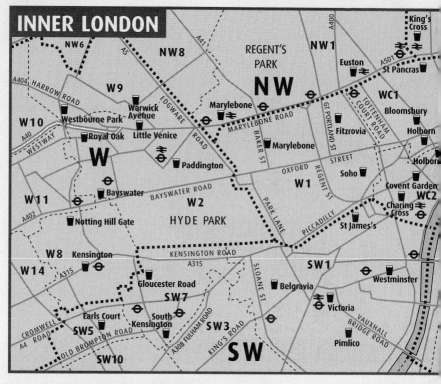

How to find London pubs

Greater London is divided into seven sectors: Central, East, North, North-West, South-East, South-West and West, reflecting postal boundaries. The Central sector includes the City (EC1 to EC4) and Holborn, Covent Garden and the Strand (WC1/2) plus W1, where pubs are listed in postal district order. In each of the other six sectors the pubs with London postcodes are listed first in postal district order (E1, E2 etc), followed by those in outer London districts, which are listed in alphabetical order (Barking, Chadwell Heath, etc) – see Greater London map. Postal district numbers can be found on every street name plate in the London postcode area.

CENTRAL LONDON

EC1: Farringdon

Sir John Oldcastle ✓

29-35 Farringdon Road, EC1M 3JF
☎ (020) 7242 1013
Greene King IPA, Abbot; Sharp's Doom Bar; 3 changing beers (often Adnams, Flack Manor, Harviestoun) Ⓗ

This Wetherspoon pub is named after the Sir John Oldcastle Tavern, which stood in the former grounds of Sir John's nearby mansion. He is thought to have been the model for Shakespeare's character, Falstaff. The pub has an L-shaped interior with plenty of seating in the usual mix of tables and booths. It has a range of regular and guest ales available. There are various interesting framed prints and photos of the local area around the premises. Q❄◑≢♿🚇♿🛜

Sutton Arms Ⓛ

16 Great Sutton Street, EC1V 0DH
☎ (020) 7253 2462 ⊕ suttonarms.co.uk
Fuller's London Pride; 2 changing beers (often Ilkley, Oakham) Ⓗ

A free house since 1991, this former Whitbread pub is named after 17th-century plutocrat Thomas Sutton who founded nearby Charterhouse. If you are looking for a traditional after-work bar, this is it – a corner pub with side bar and upstairs function room. Along with the three cask beers and KeyKeg from local breweries, there is a range of foreign bottled beers. A tap takeover is sometimes held for breweries outside London. Pies and sausage rolls are available. There is some outside seating. ❄❅◑♿≢♿(Barbican)♠🚇♿🛜

EC1: Hatton Garden

Craft Beer Co

82 Leather Lane, EC1N 7TR
☎ (020) 7404 7049
Changing beers (sourced nationally) Ⓗ

This popular pub offers several cask ales, 20 keg lines, more than 100 different bottled beers and two ciders. Two handpumps dispense the specially brewed house ale while others offer guest beers from independent microbreweries. Downstairs it has stools and tables around the walls, and plenty of standing room. There is more seating upstairs and a small standing area outside. Food is pies and Scotch eggs, though you can order in a

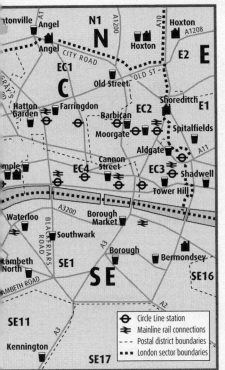

Circle Line station
Mainline rail connections
--- Postal district boundaries
▪▪▪ London sector boundaries

EC1: Old Street

Artillery Arms 🅛

102 Bunhill Row, EC1Y 8ND

☎ (020) 7253 4683 ⊕ artillery-arms.co.uk

Fuller's London Pride, ESB; Gale's Seafarers Ale; 1 changing beer (often Dark Star, Fuller's, Gale's) Ⓗ

Named after the nearby headquarters of the Honourable Artillery Company, close to the dissenters' burial ground of Bunhill Fields and near the Barbican, the Artillery Arms is a relaxed and comfortable single-room pub with a central bar and extra seating upstairs. It has a bare wooden floor throughout and some interesting stained glass. On the wall are military prints and a framed collection of cigarette cards. ◧≠⊖♠🖾🐾❀

Old Fountain 🅛

3 Baldwin Street, EC1V 9NU

☎ (020) 7253 2970 ⊕ oldfountain.co.uk

3 changing beers (sourced regionally) Ⓗ

A privately-owned free house with a single bar on two levels, and a fish tank gracing the upper area. It is popular with workers from nearby Silicon Roundabout. You can relax upstairs on the roof garden with its two large parasols and heating. The extensive beer range comes mainly from local breweries, featuring new brews and many local bottled beers. ℧❀◧≠⊖♠🖾🐾❀🛜

EC2: Barbican

Wood Street

53 Fore Street, EC2Y 5EJ

☎ (020) 7256 6990 ⊕ woodstreetbar.co.uk

3 changing beers (often Ringwood, Tiny Rebel, Twickenham) Ⓗ

Situated at the south edge of the Barbican complex, this is a hidden gem. The main bar is wood panelled with booths and tables. The rear windows give a good view of the Barbican's lake. There is a downstairs bar with two dartboards, two pool tables and a poker room. A varied food menu is available. As well as the rotating beers, a real cider is usually on handpump. All areas are available for private hire. ℧◧≠⊖(Moorgate)♠🖾🐾❀🛜

EC2: Moorgate

Globe 🅛 ✔

83 Moorgate, EC2M 6SA

☎ (020) 7374 2915

Fuller's London Pride; St Austell Nicholson's Pale Ale; Sharp's Doom Bar; 6 changing beers (often Northern Monk, Timothy Taylor, Titanic) Ⓗ

This large, multi-room M&B Nicholson's pub is a stone's throw from Moorgate tube. An interesting glass-topped table is located in the spacious main bar, displaying barley, hops and yeast in separate sections. Walk through to the adjoining Keats Bar where the poet was known to write. Upstairs are a large dining room and separate lounge bar with pool table. A ramp is available for wheelchair access. Toilets are downstairs. ◧&≠⊖🖾❀🛜

EC3: Aldgate

Craft Beer Co

29-31 Mitre Street, EC3A 5BU

☎ (020) 7929 5112

Changing beers (sourced nationally) Ⓗ

A city pub with a craft feel: wooden floorboards and bare brick walls that are furnished with mirrors from Bass and Burton breweries. There are high tables and stools in the upstairs bar, and more seating downstairs. Eighteen keg

takeaway. Interesting features of the Grade II-listed building include a glass ceiling and chandelier and a large Bass mirror. ℧❀≠(Farringdon) ⊖(Chancery Lane/Farringdon) 🖾❀🛜

Inn of Court 🅛

18 Holborn, EC1N 2LE

☎ (020) 7405 7077 ⊕ innofcourt.co.uk

Dark Star Hophead; Fuller's London Pride, ESB; 4 changing beers (often Fuller's, Oxford) Ⓗ

An ornate Fuller's Ale & Pie House near Chancery Lane tube station. The main, wood-panelled bar has leather seating throughout. There are two raised areas, one of which, called the Dock, has three framed historical newspapers and details of notable criminals. There are many artefacts from the legal profession, including judges' wigs and gowns. Toilets are downstairs, along with a basement function room. ℧❀◧≠(Farringdon) ⊖(Chancery Lane/Farringdon) 🖾❀🛜

Olde Mitre ★ 🅛

1 Ely Court, Ely Place, EC1N 6SJ

☎ (020) 7405 4751 ⊕ yeoldemitreholborn.co.uk

Fuller's London Pride; 5 changing beers (often East London, Sambrook's, Windsor & Eton) Ⓗ

This ancient pub is located down an alley off Hatton Garden and can be hard to find the first time. The current building dates from the 18th century and has a nationally important historic pub interior, with two bars and an upstairs function room, reached by a narrow staircase. There is often a beer from the wood: check the website for details. Snacks such as toasties and sausage rolls are available.

Q❀≠(City Thameslink) ⊖(Chancery Lane/Farringdon) ♠🖾🛜

lines include cider, and a range of bottled beers is available. Scotch eggs are offered as bar snacks. Toilets are downstairs. The pub is available for private hire at weekends.
◑▸≋(Fenchurch St) ⊖(Aldgate/Aldgate East) ♿🍴🐾🐾📶

Hoop & Grapes ✅

47 Aldgate High Street, EC3N 1AL

☎ (020) 7481 4583

St Austell Nicholson's Pale Ale; Sharp's Doom Bar; 5 changing beers (often Northern Monk, Timothy Taylor, Titanic) Ⓗ

There has been an inn on this site since the 13th century. The Great Fire of London stopped about 50 yards away, leaving this a rare example of a timbered building in London. Originally the Hop & Grapes as it sold beer and wine, it was renamed in 1920. The Grade II*-listed building is bent by time and the front leans outwards. Renovated in 1983 and now an M&B Nicholson's outlet, it has an extensive food offering.
🥂◑▸≋(Fenchurch St) ⊖(Aldgate/Aldgate E) 🚊🐾📶

EC3: Tower Hill

Hung Drawn & Quartered Ⓛ

26-27 Great Tower Street, EC3R 5AQ

☎ (020) 7626 6123 ⊕ hung-drawn-and-quartered.co.uk

Dark Star Hophead; Fuller's Oliver's Island, London Pride; 2 changing beers Ⓗ

Just a short walk from the Tower of London, famously a site of execution, this Fuller's Ale & Pie House is housed in a Grade II-listed building dating from 1914. The interior area is quite compact, with a high ceiling and extensive wood panelling. Popular with both city workers and tourists, it is particularly busy on Thursdays, Friday evenings and Saturdays.
🥂◑ਠ≋(Fenchurch St) ⊖(Tower Gateway/Tower Hill) 🚊🐾📶

EC4: Cannon Street

Pelt Trader

Arch 3, Dowgate Hill, EC4N 6AP

☎ (020) 7160 0253 ⊕ pelttrader.com

3 changing beers (often Five Points, Redemption) Ⓐ

A bar since 2013, nestled under an archway beneath Cannon Street station, this independent venue offers three cask ales, mainly from microbreweries, and a cider on cask. Up to 14 keg taps showcase a variety of modern craft beer and cider. Decorative mirrors and pictures portray pelt traders, and a canoe hangs from the ceiling. Pizzas are available. The pub is family and dog-friendly but can get busy with the City trade in the evenings.
🥂🍴◑≋⊖🚊🐾📶

Sir John Hawkshaw ✅

Cannon Street Railway Station, EC4N 6AP

☎ (020) 3206 1004

Greene King IPA, Abbot; Sharp's Doom Bar; 3 changing beers (sourced nationally) Ⓗ

Named after one of the co-designers of the original station building that opened in 1866, this is a modern, quite small Wetherspoon pub next to Platform 1. There is an outside seating area but no smoking as it is still within the station; customers use the toilets by Platform 7. The cellar can be viewed through a large glass window.
Q🥂◑ਠ≋⊖♿🚊📶

EC4: Temple

Old Bank of England

194 Fleet Street, EC4A 2LT

☎ (020) 7430 2255

McMullen AK Original Mild, Country Bitter; 1 changing beer (often McMullen) Ⓗ

A Grade II-listed building belonging to the Bank of England until 1975 and then the Bristol & West Building Society. After a period as a Fuller's pub, its lease reverted in 2019 to owner McMullens, who refurbished it in early 2020. The ornate high ceiling and the gallery beneath it now contrast with a modern metalwork island bar. There

REAL ALE BREWERIES

Affinity ◆ SW9: Brixton
Anspach & Hobday ◆ Beddington
Battersea ◆ SW11: Battersea Power Station
Beerblefish ◆ E17: Walthamstow
Bexley ◆ Erith
Block 🍴 N1: Hoxton
Boxcar ◆ E2: Bethnal Green
Brewhouse & Kitchen 🍴 E2: Hoxton
Brewhouse & Kitchen 🍴 EC1: Angel
Brewhouse & Kitchen 🍴 N5: Highbury
Brick ◆ SE8: Deptford
Brixton ◆ SW9: Loughborough Junction
Brockley ◆ SE4: Brockley / SE12: Hither Green
Broken Drum Upper Belvedere
Bullfinch ◆ SE24: Herne Hill
Canopy ◆ SE24: Herne Hill
Clarkshaws ◆ SW9: Loughborough Junction
Cronx New Addington
Ealing ◆ Brentford
Essex Street 🍴 WC2: Temple
Fearless Nomad 🍴 Brentford
Five Points ◆ E8: London Fields
Forest Road ◆ SE14: South Bermondsey
Fuller's ◆ W4: Chiswick
Gipsy Hill ◆ SE27: West Norwood
Goodness ◆ N22: Wood Green

Goose Island 🍴 E1: Shoreditch
Hammerton ◆ N7: Barnsbury
Kernel ◆ SE16: Bermondsey
London Beer Factory SE27: West Norwood
London Beer Lab ◆ SW9: Loughborough Junction
London Brewing ◆ N12: North Finchley
Macintosh W6: Stamford Brook
Marlix Petts Wood
Muswell Hillbilly ◆ N10: Muswell Hill
Mutineers Bromley
One Mile End ◆ N17: Tottenham
Park ◆ Norbiton
Portobello W10: North Kensington
Pretty Decent ◆ E7: Forest Gate
Redemption ◆ N17: Tottenham
Sambrook's ◆ SW18: Wandsworth
Signal ◆ Beddington
Signature ◆ E17: Walthamstow
Southey ◆ SE20: Penge
Southwark ◆ SE1: Bermondsey
Spartan ◆ SE16: South Bermondsey
Tap East 🍴 E20: Stratford Westfield
Tiny Vessel Hampton
Twickenham ◆ Twickenham
Up The Creek 🍴 SE10: Greenwich
Wild Card ◆ E17: Walthamstow
Wimbledon ◆ SW19: Colliers Wood
Zerodegrees 🍴 ◆ SE3: Blackheath

are two function areas but the whole pub may sometimes be booked, so do check first before any special visit. ♿🕮🌂◐≅(City Thameslink)⊖🚌🐾🛜

WC1: Bloomsbury

Swan 🅛 ✅
7 Cosmo Place, WC1N 3AP
☎ (020) 7837 6223
Greene King IPA; Hammerton N1; Theakston Old Peculier; Timothy Taylor Landlord; 2 changing beers (often Greene King, St Austell) 🄷
Popular, lively family-oriented venue among the tourist hotels on Southampton Row, close to Great Ormond Street Children's Hospital. It has a single long room and tables at the front on a pedestrian passage. Six handpumps offer three to four regular real ales (Hammerton Penton Stout might alternate with Theakston Old Peculier) and up to three guests, many from London breweries. An extensive menu of pub grub and snacks is served all day. A large-screen TV shows live sports events. Q♿🕮🌂◐&⊖(Russell Sq)🚌🐾🛜

WC1: Holborn

Craft Beer Co
168 High Holborn, WC1V 7AA
☎ (020) 7240 0431
Kent Pale; changing beers (sourced nationally) 🄷
Though in the ancient parish of St Giles, whose church featured in several of Hogarth's etchings including Gin Lane, this pub on the north-eastern edge of Covent Garden has a modern resonance. Over two levels, the sixth Craft Beer Co outlet would be more at home in Beer Street, with its many handpumps dispensing a changing range of ales from across the UK. There are frequent tap takeovers and Meet the Brewer events.
🌂⊖(Covent Garden/Holborn) 🚌

WC1: St Pancras

McGlynn's
1-5 Whidbourne Street, WC1H 8ET
☎ (020) 7916 9816 ⊕ mcglynnsfreehouse.com
Southwark Bankside Blonde, Mayflower; 2 changing beers (often Southwark) 🄷
A pleasant pub, located in a quiet side street, and one you might not expect to sell real ale, though it now has up to four regular beers, usually from Southwark Brewery. The pub almost feels trapped in a welcoming time warp with its eclectic selection of bric-a-brac, old Courage mirrors and unusual upright lighting on the bar. There is limited outside seating but plenty indoors as the pub is larger than it appears from the outside.
🌂◐≅⊖(King's Cross St Pancras)♣🚌

Queen's Head 🍷 🅛
66 Acton Street, WC1X 9NB
☎ (020) 7713 5772 ⊕ queensheadlondon.com
Redemption Trinity; 2 changing beers (sourced nationally) 🄷
Narrow, late-Georgian premises off Gray's Inn Road, with a single bar, a smoking patio at the rear and benches in front. The piano is used for jazz and blues on Thursdays and late Sunday afternoons. One handpump serves cider, with three more real ciders and a range of other draught and bottled beers in stock. Sharing snack platters are on offer at this comfortable pub frequented by locals and the occasional tourist. Local CAMRA Pub of the Year 2022.
🌂◐≅⊖(King's Cross St Pancras) 🍴🚌🛜

Skinners Arms
114 Judd Street, WC1H 9NT
☎ (020) 7837 6521 ⊕ skinnersarmslondon.com
Greene King IPA, Abbot; 4 changing beers (often St Austell, Timothy Taylor) 🄷
Named after the City livery company and standing on a street named after one of its past masters, this traditional corner pub has in effect been converted to one bar, despite the signs on the doors and in the stained glass. A raised seating area is on the left as you enter and the previously separate room at the back is now a large alcove with more seating. A couple of the guest beers will often come from smaller breweries.
🌂◐≅⊖(King's Cross St Pancras) 🚌

WC2: Charing Cross

Harp 🅛
47 Chandos Place, WC2N 4HS
☎ (020) 7836 0291 ⊕ harpcoventgarden.com
Dark Star American Pale Ale, Hophead; Fuller's London Pride; Harvey's Sussex Best Bitter; 5 changing beers (sourced nationally) 🄷
Small friendly Fuller's pub that became a haven for beer choice and was CAMRA National Pub of the Year in 2010 in its previous incarnation as a free house run by the late, legendary Binnie Walsh. Ciders and perries complement the fine beer range. The narrow bar is adorned with mirrors and portraits. There is no intrusive music or TV and a cosy upstairs room provides a refuge from the throng. Q◐≅⊖🚌🛜

Lemon Tree ✅
4 Bedfordbury, WC2N 4BP
☎ (020) 7831 1391 ⊕ lemontreecoventgarden.com
Harvey's Sussex Best Bitter; St Austell Tribute; 3 changing beers (often Adnams, Portobello) 🄷
A one-bar pub next to the stage door of the Coliseum that is a favourite among locals, musicians and theatregoers. The Thai restaurant upstairs doubles as a function room. Look out for the pub entrance, slightly set back. In the choice of guest beers there is an emphasis on London brews, by popular demand. It is operated by All Our Bars, a small chain based in Edenbridge.
◐≅⊖🛜

Ship & Shovell
1-3 Craven Passage, WC2N 5PH
☎ (020) 7839 1311 ⊕ shipandshovell.co.uk
Hall & Woodhouse Badger Best Bitter, Fursty Ferret, Tanglefoot; 1 changing beer (often Hall & Woodhouse) 🄷
Attractive, welcoming pub almost underneath Charing Cross station, perhaps uniquely (for London, at least), divided into two separate halves, facing each other across Craven Passage alleyway between Villiers Street and Craven Street. Acquired by Hall & Woodhouse in 1997, it commemorates Admiral Sir Cloudesley Shovell, the grounding of whose fleet off the Scilly Isles in 1707 drowned him and 2,000 men. That catastrophe is believed to have inspired the Admiralty to offer the Longitude Prize for an accurate nautical timepiece.
Q♿🕮🌂◐≅⊖🚌🐾🛜

WC2: Covent Garden

Lamb & Flag ★
33 Rose Street, WC2E 9EB
☎ (020) 7497 9504 ⊕ lambandflagcoventgarden.co.uk
Dark Star Hophead; Fuller's Oliver's Island, London Pride, ESB; Gale's Seafarers Ale; 2 changing beers (sourced nationally) 🄷

Owned by Fuller's since 2013, this Grade II-listed pub remains pleasant and traditional, with neither muzak nor games machines. Tucked away up Rose Street from Garrick Street, it has a regionally important historic interior with two dark wood-panelled rooms, the rear one with an attractive fireplace and a connecting passage from the main bar on the ground floor. Please note that the upstairs bar and restaurant has table service only. Charles Dickens and Karl Marx were both regulars.

🌭🕭🕮🗏≉⊖(Covent Garden/Leicester Sq)🚃🏵🛜

WC2: Holborn

Shakespeare's Head ✪
Africa House, 64-68 Kingsway, WC2B 6BG
☎ (020) 7404 8846
Greene King IPA, Abbot; Sharp's Doom Bar; 6 changing beers (often Twickenham, Windsor & Eaton) 🅷

Large Wetherspoon bank conversion from 1998, named after a famous pub in the locality until the demolition of Wych Street over 100 years ago. It is usually busy with shoppers, tourists, local office workers and, during term time, students from the nearby London School of Economics. It is a convenient place for a couple of pints after your cultural sojourn at the nearby Sir John Soane's Museum. Q🌭🕭🕮🗏⊖🚃🛜

WC2: Temple

Devereux
20 Devereux Court, WC2R 3JJ
☎ (020) 7583 4530 🌐 thedevereux.co.uk
Fuller's London Pride; 3 changing beers (often Adnams, St Austell, Timothy Taylor) 🅷

An attractive Grade II-listed pub built in 1844; part of the site was once the Grecian Coffee House. The comfortable lounge with wood panelling has a bar with five handpumps. Prints on the walls show local places of interest and historic figures, the judges and wigs reflecting proximity to the law courts. Upstairs is a restaurant available for hire.

🌭🕭🕮≉(City Thameslink)⊖🍴🚃🛜

Edgar Wallace
40 Essex Street, WC2R 3JF
☎ (020) 7353 3120
3 changing beers (often Redemption, St Austell, Southwark) 🅷

Just off Fleet Street near the Royal Courts of Justice, this is a real gem of a one-room pub, with additional seating upstairs. The comfortable downstairs room, its walls and ceiling covered with beer mats and old advertising signs, has a fine wooden bar offering a range of rotating ales. This quiet pub allows no music, laptops, mobiles and so on. Good-value food is served all day, except Friday evenings. Q🌭🕭🕮⊖🚃🏵

W1: Fitzrovia

Stag's Head 🄻
102 New Cavendish Street, W1W 6XW
☎ (020) 7580 8313
Fuller's London Pride; 1 changing beer (often Tring) 🅷

A smart, oak-panelled pub which CAMRA has identified as having an historic interior of regional importance, offering a friendly welcome to regulars and visitors alike. Rebuilt in the late 1930s by brewers William Younger, it has a marvellous Art Deco exterior, sporting a curved corner profile. Vertical drinking is assisted by unusual

peninsular shelf projections to the bar and elsewhere. Three large TV screens are not overly intrusive. Sun lovers and smokers can relax on shaded benches outside. Traditional pub food is served at lunchtimes (hours extended on Sun). 🌭🕭🕮⊖(Great Portland St)🚃

W1: Marylebone

Barley Mow ★
8 Dorset Street, W1U 6QW
☎ (020) 7487 4773 🌐 barleymowlondon.co.uk
Fuller's London Pride; Sharp's Doom Bar; 4 changing beers (sourced nationally) 🅷

Dating from 1791, the pub is one of the oldest to survive in the area, Grade II listed and identified by CAMRA as having a nationally important historic interior, comprising the main bar and a small snug. Original matchboard panelling now displays prints of 18th-century Marylebone. Most notably, the pub retains two small drinking compartments fronting the main bar counter. Both bars, with their partly bare wood, partly carpeted floors, are furnished with upholstered pews, benches and stools. Discreetly positioned screens and an eclectic selection of background music complete the ambience.

🌭🕭🕮🗏⊖(Baker St)🍴🚃🛜

Golden Eagle
59 Marylebone Lane, W1U 2NY
☎ (020) 7935 3228
Fuller's London Pride; St Austell Tribute; 2 changing beers (often Elgood's, Otter, Twickenham) 🅷

First licensed in 1842 and rebuilt in 1890, this single-bar pub is traditional in every way: small and cosy, with smart decor, a fine etched bar-back mirror and leaded windows. The historic interior is recognised by CAMRA as being of regional importance. Landlady Gina Vernon and her family celebrated 30 years here in 2021. Piano singalongs on Tuesday and Thursday evenings maintain the timeless atmosphere. Real ales are quality, not quantity. The pub has received local CAMRA awards several times. 🗏⊖(Bond St)🚃

Jackalope
43 Weymouth Mews, W1G 7EQ
☎ (020) 3455 2871 🌐 jackalopelondon.com
4 changing beers (often Adnams, Five Points, Redemption) 🅷

One of Marylebone's two remaining mews pubs, built in 1777 and Grade II listed, with a regionally important historic interior. The mirrors underneath the dividing beam allowed coachmen to observe when their passengers wanted to depart. Owned by Bloomsbury Leisure, operators of the Euston Tap, it has London's first Xiao Mian noodle kitchen downstairs, specialising in ramen dishes. A Jackalope is a cross between a jackrabbit and an antelope, a mythical creature of North American folklore.

🌭🕮⊖(Great Portland St/Regent's Park)🚃🏵🛜

W1: Soho

Dog & Duck ★ ✪
18 Bateman Street, W1D 3AJ
☎ (020) 7494 0697
St Austell Nicholson's Pale Ale; Sharp's Doom Bar; 5 changing beers (often St Austell, Sharp's) 🅷

In the heart of Soho, this Grade II-listed M&B Nicholson's outlet, built in 1897, has a nationally important historic pub interior. An elaborate mosaic depicts dogs and ducks, and wonderful advertising mirrors adorn the walls. The upstairs Orwell Bar can be hired for functions. The pub is small and so popular, especially with media

people, that it is not just smokers who have to drink outside. The bar extends towards the Frith Street door. ◖❶⊖(Tottenham Court Rd) 🚌🛜

Lyric Ⓛ
37 Great Windmill Street, W1D 7LT
☎ (020) 7434 0604 ⊕ lyricsoho.co.uk
Harvey's Sussex Best Bitter; 8 changing beers (often Siren, Southwark) Ⓗ
A small, independently owned bar just off Shaftesbury Avenue, bay-fronted with a tiled, panelled interior, popular with local trade. Once two adjacent taverns, the Windmill and the Ham, it merged in the mid-18th century to form the Windmill & Ham, renamed in 1890 and rebuilt 16 years later. Alongside other draught beers, including London specialities, the cask ales come from a wide range of mainly small breweries nationwide, including Big Smoke. ♿◖❶⊖(Piccadilly Circus)🚌🌸🛜

Old Coffee House
49 Beak Street, W1F 9SF
☎ (020) 7437 2197
3 changing beers (sourced locally) Ⓗ
A large but cosy pub, close to the buzz of Carnaby Street. First licensed as the Silver Street Coffee House, it was rebuilt in 1894 and is Grade II listed. The long bar and dark panelling are adorned with Watneys Red Barrel signage, brewery mirrors and sundry prints, posters, pictures and brassware. At lunchtimes you will find reasonably priced good-sized portions of pub grub. ♿❄◖❶⊖(Piccadilly Circus) 🚌🌸

Queen's Head Ⓛ ✅
15 Denman Street, W1D 7HN
☎ (020) 7437 1540 ⊕ queensheadpiccadilly.com
Fuller's London Pride; Sambrook's Wandle; 3 changing beers (often Dark Star, Gun, Sambrook's) Ⓗ
A rare West End free house with plenty of vertical drinking space below and a restaurant upstairs. The traditional feel is enhanced by an attractive bar-back and wall mirroring downstairs and an unusual leather-fronted bar in the restaurant. With its real ales, good-value pies and other pub food, including snacks and cheeseboards at the bar, this is a popular pub both before and after theatre visits. ♿⊖(Piccadilly Circus)🚌🌸🛜

EAST LONDON
E1: Shadwell

Sir Sydney Smith
22 Dock Street, E1 8JP
☎ (020) 7481 1766 ⊕ sirsydneysmith.co.uk
2 changing beers (often Greene King, Ruddles) Ⓗ
Named after a British admiral from the Napoleonic wars, this traditional and comfortable pub is a short walk from St Katherine's Dock, and not far from Wilton's Music Hall. It has a main bar and a back bar with bare brick walls, a wooden floor throughout and a dartboard. Burgers and pizzas are available. There are tables outside on the pavement. ♿◖≠(Fenchurch St) ⊖(Shadwell/Tower Gateway/Tower Hill) ♣🚌🌸

E1: Spitalfields

Pride of Spitalfields Ⓛ
3 Heneage Street, E1 5LJ
☎ (020) 7247 8933
Crouch Vale Brewers Gold; Fuller's London Pride, ESB; Sharp's Doom Bar; 1 changing beer (often Five Points) Ⓗ

This back-street local is just off Brick Lane on a cobbled side street. A very traditional pub, it is fairly small and can get quite busy in the evenings with standing room only. It has an excellent atmosphere and there is a piano which customers sometimes play. Food is available weekday lunchtimes. The landlady has been here for a number of years and there is always a warm welcome. ♿◖❶(Aldgate East/Shoreditch High St) 🚌🌸

E1: Wapping

Prospect of Whitby ✅
57 Wapping Wall, E1W 3SH
☎ (020) 7481 1095
Greene King IPA, Abbot; 4 changing beers (sourced nationally) Ⓗ
Grade II-listed Thames-side pub named after a coal boat. The current building is a 1777 rebuild of a 16th century one all but destroyed by fire. The interior has a flagstone floor and an unusual pewter bar top supported by wooden barrels. There are a further three rooms upstairs and a riverside beer garden. Popular with locals and tourists, it is often busy. The pub claims connections with Samuel Pepys and Charles Dickens. ♿❄◖❶♿🚌(100,D3) 🌸🛜

Town of Ramsgate Ⓛ
62 Wapping High Street, E1W 2PN
☎ (020) 7481 8000 ⊕ townoframsgate.pub
Black Sheep Best Bitter; Fuller's London Pride; Harvey's Sussex Best Bitter; Shepherd Neame Whitstable Bay Pale Ale; Young's London Original Ⓗ
The name of this Grade II-listed pub relates to fishermen from Ramsgate who sold their catches here to avoid taxation at Billingsgate fish market. The interior is long and narrow, and comfortably furnished. Outside at the rear is a riverside patio. The cellars were reputedly used for housing press-ganged sailors and convicts awaiting transportation to Australia. Food is served all day, with a short break between lunch and dinner service on weekdays. Children are welcome until 7.30pm. A quiz is held on Monday evenings. ♿❄◖❶⊖🚌(100,D3)🌸🛜

E2: Bethnal Green

Camel Ⓛ ✅
277 Globe Road, E2 0JD
☎ 07305 470811
Sambrook's Wandle; 2 changing beers (often Adnams, Five Points, St Austell) Ⓗ
Small corner pub of a type becoming rare in London, boasting a noteworthy tiled exterior. Run by an enthusiastic and welcoming landlady, the atmosphere is convivial. Space inside is limited, but there are tables and chairs on the front pavement and a beer garden at the rear. The menu consists mostly of speciality pies and mash alongside burgers. Sport is occasionally shown on TV. A dark beer is usually available in winter. ♿❄◖❶⊖🚌🌸🛜

King's Arms
11A Buckfast Street, E2 6EY
☎ (020) 7729 2627 ⊕ thekingsarmspub.com
3 changing beers (often Five Points, Howling Hops, Siren) Ⓗ
A stylish back-street local serving four cask ales regularly, with five at the weekend. There are also a dozen keg beers and a large range of bottles and two ciders. There are no pumpclips; the beer menu is on the tables and on the wall. The food offering is Scotch eggs and tortillas with cheese or meat. There is some seating outside. ♿❄♿⊖(Bethnal Green/Shoreditch High St) 🚌🌸🛜

E3: Bow

Eleanor Arms
460 Old Ford Road, E3 5JP
☎ (020) 8980 6992 ⊕ eleanorarms.co.uk
Shepherd Neame Master Brew, Whitstable Bay Pale Ale; 2 changing beers (often Shepherd Neame) Ⓗ
There has been a pub on this site since 1879, convenient for Victoria Park, canal users and the London Stadium. Traditional in style, it combines 1930s wood panelling with some interesting artwork and music-related decor. On Sunday evening it becomes the Old Ford Jazz Club and usually hosts a jam session. There is a beer garden to the rear. Traditional pub games are available, including shove ha'penny and shut the box. ⓢ⛄&♣➡(8)🎵

Lord Tredegar
50 Lichfield Road, E3 5AL
☎ (020) 8983 0130 ⊕ thelordtredegar.co.uk
3 changing beers (often Northern Whisper, One Mile End, Shepherd Neame) Ⓗ
A terraced pub that is larger within than the exterior suggests. The front bar and two smaller rooms on either side all have bare floorboards and comfortable furnishings. At the back is a large conservatory with an open kitchen, and the garden. There are two impressive fireplaces that are still in use. Food is served in the evening, and all day at weekends. Wheelchair users can access the pub via a ramp but the toilets are downstairs. ⓢ⛄◑⊖(Mile End) ♠➡🐾🎵

E4: Chingford

King's Head Ⓛ ✪
2B Kings Head Hill, E4 7EA
☎ (020) 8529 6283
Brains Rev James Original; Fuller's London Pride; Morland Old Speckled Hen; St Austell Tribute; Sharp's Doom Bar; 4 changing beers (often Bishop Nick, New River, Timothy Taylor) Ⓗ
Now a Stonegate Classic Inns branded establishment, this North Chingford pub is popular with diners. It is spacious with lots of seating areas and also outside seating for warmer days. As well as offering the largest range of real ales in Chingford, it also has one handpump, branded as Doom Bark, that provides free water for dogs! Quiz nights are every Wednesday and Sunday. See the website for other events. ⓢ⛄◑&P➡🐾🎵

E4: Highams Park

Stag & Lantern
11-12 The Broadway, E4 9LQ
☎ (020) 7998 8930 ⊕ thestagandlantern.co.uk
3 changing beers (sourced nationally) Ⓗ
A welcoming and inclusive community-focused micropub, converted from shops in 2020. The inside is fairly small with stools made from beer casks. There is also seating outside in front of the premises. Takeaway beer is available. Plans for the future include beer festivals, tasting events, and Meet the Brewer showcases. See the website for updates. ⊖➡🐾

E5: Clapton

Anchor & Hope Ⓛ ✪
15 High Hill Ferry, E5 9HG (800yds N of Lea Bridge Rd, along river path)
☎ (020) 8806 1730 ⊕ anchor-and-hope-clapton.co.uk
Fuller's London Pride, ESB; 1 changing beer (often Fuller's) Ⓗ

One of Fuller's smallest pubs, on the bank of the River Lea and dating from about 1850. Externally refurbished, it has one wood-panelled bar, and a bar at the front with a wood fire. Drinkers include wildlife enthusiasts and bird watchers, boaters and locals. It is worth seeking out the barbecues in summer. A 2017 film, Anchor & Hope, includes the landlord as an extra. Traditional music is played fortnightly on Wednesday, also live music on Saturday. ⓢ⛄◑♣P➡(393)🐾🎵

Crooked Billet Ⓛ
84 Upper Clapton Road, E5 9JP
☎ (020) 3058 1166 ⊕ e5crookedbillet.co.uk
4 changing beers (often Five Points, Redemption, Southwark) Ⓗ
Spacious, often busy, one-bar pub with wood-panelled walls, bare floorboards and ample seating at wooden tables and chairs. The large garden with its own (keg) bar, ping-pong table and heated booths, is popular all year. A wide variety of food is served Monday to Thursday evenings and all day Friday to Sunday. The majority of beers, both cask and keg, are from London breweries. Children are welcome until 7.30pm. ⓢ⛄◑◐♣➡🐾🎵

E6: East Ham

Miller's Well ✪
419-421 Barking Road, E6 2JX
☎ (020) 8471 8404
Greene King Abbot; Ruddles Best Bitter; Sharp's Doom Bar; 3 changing beers Ⓗ
Converted from shops, this Wetherspoon pub has a wide range of seating and tables including six booths. Outside at the rear are seven picnic benches. A large collection of military shields is located in the glass-ceilinged area where Remembrance Sunday meetings are held. Many framed posters depict historical events and characters, including a tribute to 1966 World Cup hat-trick goal scoring Sir Geoff Hurst. The pub is completely wheelchair accessible and assistance dogs are admitted. Toilets are upstairs. Qⓢ⛄◑&⊖➡🎵

E6: Upton Park

Boleyn Tavern ★
1 Barking Road, E6 1PW
☎ (020) 8472 2182 ⊕ boleyntavern.co.uk
4 changing beers (often Five Points, Shepherd Neame) Ⓗ
The former local to West Ham United football club's Boleyn ground, it closed after the team moved to the London Stadium but reopened in 2021 following a spectacular £1.5m restoration by Remarkable Pubs of the nationally important historic interior. Hand-crafted wooden screens with acid-etched cut glass have been recreated to restore the original seven-bar layout. The highlight is a massive coloured skylight in the rear dining area. The Grade II-listed building is floodlit at night, making it visible from a distance. ⓢ⛄◑&⊖➡🎵

E7: Forest Gate

Hudson Bay ✪
1-5 Upton Lane, E7 9PA
☎ (020) 8471 7702
Greene King Abbot; Ruddles Best Bitter; Sharp's Doom Bar; 2 changing beers (sourced nationally) Ⓗ
A Wetherspoon pub popular with locals. Sir John Pelly, a leading local landowner in the late 18th and 19th centuries, was Governor of the Hudson Bay Company. The unfussy interior has a mixture of high and low

wooden tables as well as booths for groups of four. A rear walled garden doubles as a smoking area. Quiet TVs show rolling news and occasional sporting events. Food is available until late every day. Q❄✿⏰☕️♿🍽☂🏳

E8: Hackney

Cock Tavern ⓛ
315 Mare Street, E8 1EJ
🌐 thecocktavern.co.uk
8 changing beers (sourced locally; often Howling Hops) Ⓗ
A bustling, friendly town-centre single-roomed pub with a small beer garden. There has been a pub called the Cock Tavern in Hackney since the 1650s. This one was built by Truman's in the 1930s. Eight handpumps dispense a changing selection of ales, and another eight handpumps dispense ciders. A wide KeyKeg selection is also available. Food can be ordered in from outside. Local CAMRA Cider Pub of the Year 2022.
❄✿⏰➖(Downs) ⊖(Central/Downs) 🍴🏳✿🏳

Five Points Brewery Taproom ⓛ
61 Mare Street, E8 4RG
☎ (020) 8533 7746 🌐 fivepointsbrewing.co.uk
2 changing beers (often Five Points)
Based at the warehouse on Mare Street, this taproom has a vibrant atmosphere, with seating downstairs and on the mezzanine level, as well as outside in the yard in the summer. One or two casks from Five Points and a wide range of keg beers are available, together with some guest beers and ACE pizzas. You can also pre-book a brewery tour. ❄⏰♿⊖(Cambridge Heath)🏳🏳

Hackney Tap
354 Mare Street, E8 1HR
☎ (020) 3026 4373 🌐 hackneytap.com
4 changing beers (often Five Points, Hammerton, Rooster's) Ⓗ
This interesting building has been a town hall, a bank and a bookmaker's. Original features are still in place: the panelling on the bar is from when it was a bank, and if you look up at the building on the outside you will see the logos from previous incarnations. As well as the variety of changing cask beers, up to 20 keg choices are on offer, plus gyoza dumplings. Plenty of outside seating is available. ❄✿⏰➖(Downs)⊖(Central/Downs)🏳🏳

Pembury Tavern ⓛ
90 Amhurst Road, E8 1JH
☎ (020) 8986 8597 🌐 pemburytavern.co.uk
Five Points Pale, Railway Porter; 3 changing beers (sourced nationally; often Five Points) Ⓗ
A large corner pub with a friendly vibe, run by Five Points Brewery. The spacious interior is comfortably furnished, with hard wood floors. As well as the handpumps, there are also 16 keg lines. Pizzas are available every day except Tuesday, including vegetarian and vegan options. The pub is famous locally for its bar billiards table. There is a quiz night on a Monday and occasional comedy nights – check the website for upcoming events.
❄⏰♿➖(Downs) ⊖(Central/Downs) ♣🍴🏳✿🏳

E9: Homerton

Chesham Arms
15 Mehetabel Road, E9 6DU
☎ (020) 8986 6717 🌐 cheshamarms.com
4 changing beers (sourced nationally) Ⓗ
A lovely and friendly traditional back-street local that was saved from closure. It now sits at the heart of the community, with book swaps and occasional singalongs

at the piano. The cosy atmosphere inside is enhanced by two real fires. There is a large and attractive garden at the back. Four changing ales and one cider are on offer in winter; three and two respectively in the summer. Pizzas are available for delivery from Yard Sale Pizzas.
❄✿⏰➖⊖(Hackney Central) ♣🍴🏳✿🏳

E10: Leyton

Coach & Horses
391 High Road, E10 5NA
☎ (020) 8281 3398 🌐 thecoachleyton.com
Mighty Oak Captain Bob; 5 changing beers (often East London, Purity, Sharp's) Ⓗ
A recently refurbished pub with a horseshoe bar. Some beers from London breweries are among those on the handpumps and 20 keg fonts. There is ample seating in the two rooms and rear beer garden. Monday is quiz night; Dungeons & Dragons games and Escape Room adventures are also played here (book ahead). The menu includes speciality burgers, steak & Guinness and vegetarian pies, and Sunday roasts. The pub gets busy on Leyton Orient match days. ❄✿⏰⊖🍴🏳✿🏳

Leyton Orient Supporters Club ⓛ
Breyer Group Stadium, Oliver Road, E10 5NF
☎ (020) 8988 8288 🌐 orientsupporters.org
Mighty Oak Oscar Wilde Ⓖ; **10 changing beers** Ⓗ
Multi award-winning club, previously a CAMRA national finalist, and current local CAMRA Club of the Year 2022. It is open on home match days (not during the matches) and for England football fixtures but also hosts four brewery tap takeovers every year. It can get extremely busy but the volunteer staff are very efficient. On match days CAMRA members may need to show their membership card, but other events are open to all.
Q❄✿⊖🍴🏳

E11: Leytonstone

North Star ⓛ
24 Browning Road, E11 3AR
☎ 07747 010013 🌐 thenorthstarpub.co.uk
East London Foundation Bitter; Oakham JHB; 4 changing beers (often Harvey's, Timothy Taylor) Ⓗ
A warm and welcoming atmosphere is guaranteed in this historic traditional glass-fronted pub in the Leytonstone Village Conservation Area. A varied selection of cask, keg and other drinks is dispensed in the smaller saloon bar and can be ordered from the public bar hatch. There is ample seating in the public bar, and outside in front and in the walled garden at the rear. Food is traditional Thai and stone-baked pizza. The pub is closed on Monday in winter. ❄✿⏰⊖♣🏳✿

Northcote Arms ⓛ
110 Grove Green Road, E11 4EL
☎ (020) 8518 7516 🌐 northcotee11.com
2 changing beers (often East London, Redemption, Signature) Ⓗ
Traditional local pub with a strong community ethos. The regionally important historic interior comprises five separate areas, comfortably furnished and served from a horseshoe bar. There are two gardens to the rear. Entertainment includes drag queens every Sunday evening as well as regular discos, singalongs, music bingo and live music. Burgers or hot dogs, with vegan options, are available all week except Monday. Additional cask ales are on offer on days of Leyton Orient home games. ❄✿⏰⊖(Leyton)♣🍴🏳✿🏳

Walnut Tree ✅

857-861 High Road, E11 1HH
☎ (020) 8539 2526
Adnams Ghost Ship; Greene King IPA, Abbot; Ruddles Best Bitter; Sharp's Doom Bar; 8 changing beers (often East London, Sambrook's) Ⓗ

A typically recognisable Wetherspoon pub from the outside, comprising a large single floor with two levels. The upper level is available free of charge for meetings or parties. The bar, located on the left, dispenses the usual range of regular and guest beers from the 12 handpumps. A garden and smoking area is accessed to the right on entry. Q🦽🕮🕯🚹&⊖(Leytonstone/High Rd) ●🚲🛜

E11: Wanstead

George Ⓛ ✅

159 High Street, E11 2RL
☎ (020) 8989 2921
Fuller's London Pride; Greene King IPA, Abbot; Sharp's Doom Bar; 8 changing beers (often East London, Sambrook's, Southwark) Ⓗ

A glass-fronted three-storey Victorian pub, originally the George & Dragon and then the George Hotel before Wetherspoon's acquisition in 1992. Spacious inside, it is spread over two levels but all the handpumps are on the main bar downstairs. Pictures of famous Georges adorn the walls. A car park and smoking area is at the rear. Three real ale festivals are held every year. Q🦽🕮🕯🚹&⊖🚲🛜

E12: Manor Park

Golden Fleece ✅

166 Capel Road, E12 5DB
☎ (020) 8478 0024
Greene King IPA, Abbot; Timothy Taylor Landlord; 3 changing beers (often Castle Rock, Greene King) Ⓗ

A busy pub in the summer, its large garden is popular with families. The recently refurbished interior has a comfortable atmosphere. Food is served all week. Georgina, the manager, is welcoming and supports community groups. The pub screens sporting events and has regular entertainment including karaoke on the third Saturday and a singer on the last Saturday of the month, and also a jamming session for local musicians on alternate Friday evenings. 🦽🕮🕯🚹&●♣🚲🐾🛜

E13: Plaistow

Black Lion ✅

59-61 High Street, E13 0AD
☎ (020) 8472 2351 ⊕ blacklionplaistow.co.uk
6 changing beers (sourced nationally; often Mighty Oak) Ⓗ

Former coaching inn, rebuilt in 1747, with a split-level main bar and small back bar, both with beams and wood panelling. The back bar has its own door or can be accessed from the other bar via the serving area. The cobbled courtyard gives access to converted stables and outbuildings that house a function room, available for hire, and a local boxing club. A menu of homemade pub food is offered. The pub has had the same landlord for more than 35 years. 🦽🕮🕯🚹●♣🚲🛜

E14: Crossharbour

Pepper Saint Ontiod ✅

21 Pepper Street, E14 9RP
☎ (020) 7987 5205 ⊕ peppersaintontiod.com

2 changing beers (often Volden) Ⓗ

Named from its location in Pepper Street on the Isle of Dogs, this modern dockside pub is part of the Antic chain and is done up in its typical retro and somewhat quirky style, with displays of old cameras and ceramics. Enjoy waterfront seating outside, great views from the large windows inside and large upstairs rooms with TV, pool, darts and table football as well as a number of board games. 🦽🕮🕯🚹&●≠🚲🐾🛜

E15: Stratford

Goldengrove Ⓛ ✅

146-148 The Grove, E15 1NS
☎ (020) 8519 0750
Fuller's London Pride; Greene King IPA, Abbot Ⓗ**; Ruddles Best Bitter** Ⓗ**/**Ⓖ**; Sharp's Doom Bar; 5 changing beers (often Hackney)** Ⓗ

An early Wetherspoon pub, converted from a clothes shop 30 years ago. It takes its name from the poem Spring and Fall by Gerard Manley Hopkins who was born in Stratford in 1844. There is plenty of seating inside and in the sizeable beer garden behind the pub. It can be very busy here, especially if West Ham are playing at home. Q🦽🕮🕯🚹&≠⊖(Maryland/Stratford)🚲🛜

E17: Blackhorse Lane

Beerblefish Brewing Taproom Ⓛ

Unit 2A-4, Uplands Business Park, E17 5QJ
☎ 07594 383195 ⊕ beerblefish.co.uk/taproom
4 changing beers (often Beerblefish) Ⓖ

A taproom in a former factory premises where you will be warmly welcomed. The beers are all brewed on the premises and some are to old recipes and may contain unusual natural adjuncts. For amusement, in addition to board games, there is a shuffleboard, pool table with bias and a piano. Games night is Wednesday from 6pm but drop in for a drink anyway. 🦽🕮&⊖(Blackhorse Rd) ●P🚲(158,W15)🐾🛜

E17: Walthamstow

Olde Rose & Crown 🍷 Ⓛ ✅

53-55 Hoe Street, E17 4SA
☎ (020) 8509 3880 ⊕ yeolderoseandcrowntheatrepub.co.uk
4 changing beers (sourced nationally; often East London) Ⓗ

A spacious, welcoming community pub that, being free of tie, can surprise with the beers on offer. A theatre upstairs hosts regular events and a function room is downstairs. In the bar the second Wednesday of the month is 78rpm record night. Live bands may feature on other nights. Catering is split between two franchises with roasts Sunday lunchtimes and hot delights on other evenings. Local CAMRA Pub of the Year 2022. 🦽🕮🕯●(Central) ♣●🐾🛜

E20: Stratford Westfield

Tap East Ⓛ

7 International Square, Montfichet Road, E20 1EE
☎ (020) 8555 4467 ⊕ tapeast.co.uk
6 changing beers (sourced nationally; often Tap East) Ⓗ

This brewpub is in the Great Eastern Market area at the north end of the Westfield shopping centre, close to Waitrose and opposite the entrance to Stratford International station. The brewery is visible to drinkers and passers-by alike. With up to three house beers and three guests, plus a vast range of international bottled beers, it is packed solid when West Ham are playing at

home, but otherwise a relaxing escape from the shops. Card payments only.
♿🍴♿🚆♿(Stratford/Stratford Intl) ♣🍺P🚉📶

Barkingside

New Fairlop Oak ✅

Fencepiece Road, Fulwell Cross, IG6 2JP (on A123)
☎ (020) 8500 2217
Greene King Abbot; Ruddles Best Bitter; Sharp's Doom Bar; 7 changing beers (sourced nationally) Ⓗ

A Wetherspoon pub that puts customers and real ale first, with six handpulled guest beers waiting for eager patrons ready to quench their thirst. It is named after an oak tree that was replanted in 1909; the original was one of Britain's largest trees and is thought to have been named by Queen Anne on a 1704 visit to the Fairlop Fair. A popular weekly quiz is held on Wednesdays.
♿🍴🍺♿♿(Fairlop) P🚉📶

Chadwell Heath

Eva Hart ✅

1128 High Road, RM6 4AH (on A118)
☎ (020) 8597 1069
Greene King Abbot; Ruddles Best Bitter; Sharp's Doom Bar; 8 changing beers (often Adnams, Fuller's) Ⓗ

Large and comfortable split-level Wetherspoon pub divided into several distinct drinking areas. The building dates from 1892 and used to be the local police station. It is named after a local musical personality who was one of the longest-living survivors of the 1912 Titanic disaster; photographs and memorabilia are on display around the pub. Alcoholic drinks are served from 9am, food all day. Toilets (except accessible) are upstairs. Muted TVs show subtitles. Q♿🍴🍺♿♿P🚉📶

Collier Row

Colley Rowe Inn ✅

54-56 Collier Row Road, RM5 3PA (on B174)
☎ (01708) 760633
Greene King Abbot; Ruddles Best Bitter; Sharp's Doom Bar; 3 changing beers (sourced nationally) Ⓗ

Converted by Wetherspoon from two shops, the pub is close to six bus routes, giving easy access to and from Romford. It has a changing selection of guest ales and is often lively around the bar, but there are quieter alcoves at the rear. Alcoholic drinks are served from 9am. Food is served all day, every day and steak night is particularly popular. ♿🍴♿🚉📶

Gidea Park

Gidea Park Micropub

236 Main Road, RM2 5HA (on A118)
☎ (01708) 397290
Wibblers Apprentice Ⓗ**; 6 changing beers (sourced nationally)** Ⓖ

Havering Borough and East London's second micropub, opened in 2017 after winning a planning appeal for the change of use. Five to eight real ales from microbreweries are served (in all legal measures) from casks in the ground-floor cellar, also real ciders, wines and gins. There are high and low tables and chairs, unusual spider lighting and an ever-growing display of pumpclips from beers sold here. Mobile phones should be switched to silent. Local CAMRA Pub of the Year 2020.
Q♿🍴♿♿🍺🚉(174,498)🐾📶

Ship ✅

93 Main Road, RM2 5EL (on A118)
☎ (01708) 741571 🌐 theshipgideapark.co.uk
Greene King IPA; Sharp's Doom Bar; Timothy Taylor Landlord; 1 changing beer (sourced nationally) Ⓗ

More than 250 years old, this family-run Grade II-listed split-level pub has extensive dark-wood panelling, timber beams and huge fireplaces. The building is largely unchanged and has low ceilings in places – so duck or grouse! A quiz night is held on Thursday and live music is hosted on Saturday. Q♿🍴♿🍺P🚉(174,498)🐾📶

Hornchurch

Hop Inn 🍺

122 North Street, RM11 1SU (at jct with Seymour Place)
☎ 07888 622532 🌐 hopinnhornchurch.co.uk
4 changing beers (sourced nationally) Ⓖ

Havering Borough's third micropub, opened in 2019. Up to five cask ales are served from the cooled cabinets behind the bar, together with KeyKeg beers, real ciders and perries, and an impressive selection of other drinks including gins and malt whiskies. No babies or children under 18 are admitted, and mobile phones should be silent. Greater London CAMRA Pub of the Year and Cider award winner for 2021 and 2022.
Q♿(Emerson Park)🍺P🚰🐾

J.J. Moon's

48-52 High Street, RM12 4UN (on A124)
☎ (01708) 478410
Greene King Abbot; Ruddles Best Bitter; Sharp's Doom Bar; 8 changing beers (sourced nationally) Ⓗ

A busy Wetherspoon pub, opened in 1993 and popular with all age groups, featuring a good variety of ales with an emphasis on breweries from London and the South East. Watercolour paintings of local scenes provide the main decoration, with the usual historical information panels to the rear. Families are welcome until 6pm, and alcoholic drinks are served from 9am. Silent TVs show subtitles. Q♿🍴♿♿(Emerson Park)🚉📶

Ilford

Jono's ✅

37 Cranbrook Road, IG1 4PA (on A123)
☎ (020) 8514 6676
Castle Rock Harvest Pale; St Austell Tribute Ⓗ

Just one minute's walk from the station, Jono's is a converted shop with an unusual style. The front of the bar is in dark wood and the rear is half-timbered with a patch of thatch over the seating. Largescreen TVs show sports fixtures and there is live music on Friday and Saturday evenings. Friendly and efficient staff look after the beer; the owner intends to restore the second handpump when trading conditions permit. ♿🚉📶

Romford

Moon & Stars ✅

99-103 South Street, RM1 1NX
☎ (01708) 730117
Greene King Abbot; Ruddles Best Bitter; Sharp's Doom Bar; 3 changing beers (sourced nationally) Ⓗ

Reopened with a new roof terrace and lift after a £1.1 million refurbishment, this Wetherspoon pub has a raised rear area where children are welcome. Food is served all day. Wall panels display local history and an assortment of books fills the shelves. Close to Romford station and buses, it is busy on Thursday and Friday evenings. Toilets (except accessible) are upstairs. ♿🍴♿♿🚆♿🚉📶

Upminster

Upminster TapRoom 🅛

1B Sunnyside Gardens, RM14 3DT (off St Mary's Lane)
☎ 07841 676225
Dark Star Hophead; 6 changing beers (sourced locally) 🅖
Upminster and East London's first micropub, opened in a converted office in 2015 as a snack bar selling real ale before obtaining change of use on appeal. Garlands of hops adorn the walls. The ales are served straight from casks in the cool cellar visible from the bar. Walk or use public transport to get here, and silence mobile phones or pay a fee for charity. Previous local CAMRA Pub of the Year. Closed Monday. Q🕭🎄🍴♿≢⊖●🛋🚆🐾

Woodford Bridge

Crown & Crooked Billet ✅

13 Cross Road, IG8 8BN (off B173)
☎ (020) 8502 9192
Fuller's London Pride; Sharp's Doom Bar; 3 changing beers (sourced nationally) 🅗
Spacious multi-room pub overlooking the village green, church spire and duckpond complete with a large weeping willow tree. Recently refurbished, the pub is clean and stylish, with wooden beams and a conservatory, as well as plenty of outdoor seating. Altogether, this has all the makings of a pleasant venue in which to enjoy drinks and meals from an inviting menu. 🕭🎄🍴♿🅿🚆(275,W14)🐾🛜

Woodford Green

Cricketers 🅛

299-301 High Road Woodford Green, IG8 9HQ (on A1199)
☎ (020) 8504 2734
McMullen AK Original Mild, Country Bitter; 1 changing beer (sourced locally) 🅗
Warm and friendly, and serving good value food, this two-bar local has a dartboard in the public bar and plaques in the saloon for all 18 first-class cricket counties, together with photographs of former MP Sir Winston Churchill. His statue stands on the green almost opposite. There are tables on the front patio and a covered smoking area with seats at the rear. Boules is sometimes played on a pitch at the back.
Q🎄🍴♿♣🅿🚆(179,W13) 🐾🛜

NORTH LONDON
N1: Angel

Angel 🅛 ✅

3-5 Islington High Street, N1 9LQ
☎ (020) 7837 2218
Greene King IPA, Abbot; Sharp's Doom Bar; 6 changing beers (often By The Horns, Windsor & Eton) 🅗
A large, modern, open-plan Wetherspoon conversion with some booths towards the back giving slightly more privacy. The adjacent tower was a part of the Angel, one of the first talkie cinemas, which was sadly mostly demolished. With the long-gone Philharmonic Hall (subsequently Grand Theatre), this was always a centre of popular entertainment. Its classic columns and caryatids can apparently be seen in the Museum of London. 🕭🎄🍴♿⊖🚆🛜

N1: Hoxton

Wenlock Arms 🅛

26 Wenlock Road, N1 7TA
☎ (020) 7608 3406 ● wenlockarms.com
Mighty Oak Oscar Wilde; 7 changing beers (sourced nationally) 🅗
Free house saved from closure by a vigorous local campaign. It features beers from small and medium-sized breweries across the UK, usually including a mild and subject to regular change. With one traditional cider, and a small snacks menu of toasties, Pieminister pies, baked Camembert and vegan sausage rolls, this is a truly welcoming street-corner local with an international reputation. Occasionally it serves beer from the in-house Block Brewery in the cellar.
🎄🍴♿≢⊖(Old St) ♣●🚆🐾🛜

N1: King's Cross

Parcel Yard

King's Cross Railway Station, Euston Road, N1C 4AH
☎ (020) 7713 7258 ● parcelyard.co.uk
Dark Star Hophead; Fuller's Oliver's Island, London Pride, ESB 🅗
A large pub, upstairs at the rear of the concourse, converted from the former station parcel office. It is used by local workers and commuters, and to host meetings. As well as bars on two levels, there are semi-private rooms converted from offices (available to book) and an indoor balcony. The decor is minimal and features rescued furniture. No music is played. Food, starting with breakfast, is served throughout the day. Wheelchair access is by lift.
🕭🎄🍴♿⊖(King's Cross St Pancras) ♣🚆🛜

N1: Newington Green

Lady Mildmay 🅛

92 Mildmay Park, N1 4PR
☎ (020) 7241 6238 ● ladymildmay.com
Five Points Best; 2 changing beers (often Five Points, Redemption) 🅗
A large corner bar facing Newington Green, refurbished in 2015 when ownership moved to the current operator. That internal redecoration brought back the pub's original features. With its open kitchen, cosy fireplaces, sofas to lounge on and large windows to watch the world go by, this pleasant place to visit. The beers listed may change. Five Points Best is close to being a regular, and others come mostly from London breweries.
🎄🍴♿⊖(Canonbury) ●🚆🐾🛜

N1: Pentonville

King Charles I

55-57 Northdown Street, N1 9BL
☎ (020) 7837 7758
3 changing beers (often Hammerton, Southwark) 🅗
The regionally important historic 1930s interior of this Georgian building is small and cosy, containing knick-knacks and homely artefacts, warmed by real fires in the winter. Food can be ordered at the bar or, during the day, from the Blue River café opposite. Live blues, folk and indie music can be impromptu or planned. Since 2015 the pub has been community-owned, with a 20-year lease shared by local residents and regulars.
🎄≢⊖(King's Cross St Pancras) ●🚆🐾🛜

N2: East Finchley

Bald Faced Stag ✓

69 High Road, N2 8AB

☎ (020) 8442 1201 ⊕ thebaldfacedstagn2.co.uk

Greene King IPA; house beer (by Greene King); 2 changing beers (often Redemption, St Austell, Windsor & Eton) Ⓗ

A short walk from the underground station, this large and busy open-plan pub has a three-sided bar offering a friendly welcome, and a spacious restaurant at the rear. The decked garden surrounds an historic sycamore tree. There is a Monday night quiz, occasional live music and a DJ from 9pm on Friday and Saturday. Note that disabled access is through the rear car park. Children are admitted until 8.30pm. Stag Session is the GK house beer.

ᖰ֎◖ᵶ�ðⓅ⊟ᵱᵽ

N5: Canonbury

Snooty Fox Ⓛ

75 Grosvenor Avenue, N5 2NN

☎ (020) 7354 9532 ⊕ snootyfoxlondon.co.uk

Otter Ale; 3 changing beers (sourced nationally) Ⓗ

A vibrant community establishment with 1960s icons depicted throughout, serving up to four real ales. The airy bar features a 45rpm jukebox. A function room accommodates local groups and private dining, and outside there is a pleasant patio with seating. The kitchen serves quality modern British food and an excellent Sunday roast. A former local CAMRA Pub of the Year. ֎◖ðᐱ

N5: Highbury

Brewhouse & Kitchen Ⓛ ✓

2A Corsica Street, N5 1JJ

☎ (020) 7226 1026

Brewhouse & Kitchen Goalscorer, Tramshed, Astronomer, Romford Pele Ⓗ

The former tramshed at Highbury Corner, refurbished and reopened with an in-house brewery. The Brewhouse & Kitchen chain continues to expand, opening new outlets across the UK, but this location offers a lovely outdoor space at the front, a large interior to accommodate private parties, brewing classes in its academy and plenty of room to enjoy some pub classics with a delicious twist. On Arsenal home match days it is open only to season ticket holders.

ᖰ֎◖ᵶðᵶⴱ(Highbury & Islington) ⊟ᵱᵽ

N7: Holloway

Coronet Ⓛ ✓

338-346 Holloway Road, N7 6NJ

☎ (020) 7609 5014

Fuller's London Pride; Greene King IPA, Abbot; Ruddles Best Bitter; Sharp's Doom Bar; 6 changing beers (sourced nationally) Ⓗ

Impressive Wetherspoon conversion of the Savoy cinema, which was designed by William Glen and showed its last film in 1983. The pub displays large prints of movie stars and former local entertainers, with an old projector the centrepiece of a raised dais towards the rear. Sometimes there are single-brewery festivals. Expect plastic glasses and higher prices when Arsenal are playing at home. Tables are on the pavement, some under cover. Qᖰ֎◖ᵶðⴱ(Holloway Rd)⊟ᵽ

Lamb Ⓛ

54 Holloway Road, N7 8JL

☎ (020) 7619 9187 ⊕ thelambn7.co.uk

3 changing beers (often Five Points, Signature, Three Sods) Ⓗ

Highbury Brewery's tap, taken over by Taylor Walker in 1912, later becoming the Flounder & Firkin before the demise of that chain. Three cask beers rotate, typically a best bitter and a pale ale alongside an amber, rye beer or porter from Redemption, Howling Hops, Five Points, Signature and many more local breweries. The beautiful interior has handsome wood panelling and skylights; the façade parades its painstakingly stripped back original green tiles. Live music is a speciality.

֎ᵶðᵶⴱ(Highbury & Islington) ⊟ⴱᵽ

N8: Hornsey

Toll Gate Ⓛ ✓

26-30 Turnpike Lane, N8 0PS

☎ (020) 8889 9085

Greene King IPA, Abbot; Sharp's Doom Bar; 5 changing beers Ⓗ

Large early Wetherspoon pub first opened in 1989, with a central bar and an outside seating area in front. Up to five guest beers come from small breweries, the local ales varying regularly. Very much a local community pub, it can be busy and loud on weekend evenings. Meals are available daily. It takes its name from the toll gate erected in 1765 where High Road meets Green Lanes, which was dismantled soon after the system of turnpikes (private roads) was abolished in 1872.

ᖰ֎◖ᵶðᵶⴱ(Turnpike Lane) ⊟ᵽ

N9: Lower Edmonton

Beehive ✓

24 Little Bury Street, N9 9JZ

☎ (020) 8360 4358 ⊕ thebeehivebhp.co.uk

Greene King IPA; 3 changing beers (often Beerblefish, Mighty Oak, Vale) Ⓗ

Tucked away in semi-detached suburbia, this imposing pub, rebuilt in 1929, has a keen landlord who is rightly proud of the ales he serves and keeps them in good condition. The bar has a games area at one end, a dining area at the other and attracts a good mix of local customers. The garden houses an interesting selection of animals including pigs, goats, ducks and also an iguana only visible from the Gents. A wide selection of food is on offer, including popular Sunday lunches.

ᖰ֎◖ᵶᵽ⊟(329,W8) ⴱᵽ

Rising Sun ✓

240 Winchester Road, N9 9EF

☎ (020) 8807 1512

Dark Star Hophead; 2 changing beers (often Adnams, St Austell, Vale) Ⓗ

A spacious, traditional, back-street local with a cosy bar on one side and, on the other, a larger games room where pool and darts can be played. Darts league matches take place every week: men on Monday, women on Tuesday. For outside drinking there is an enclosed area to the side of the pub and additional pavement seating at the front. ᖰ֎ᵽᵽ⊟ⴱᵽ

N10: Muswell Hill

Mossy Well ✓

258 Muswell Hill Broadway, N10 3SH

☎ (020) 8444 2914

Greene King IPA, Abbot; Sharp's Doom Bar; 8 changing beers (often Redemption, Theakston) Ⓗ

A former Express Dairies tearoom and milk depot but a pub since 1984, reopened by Wetherspoon in 2015. Its name derives from the etymology of Muswell. Many

internal features reflect its milky history. It is spacious inside, with a mezzanine floor and outdoor drinking areas at both front and back. Despite the size, it can be packed. Q♿☀🅿♿🚆🚲🛈

N12: North Finchley

Bohemia 🅛
762-764 High Road, N12 9QH
☎ (020) 8446 0294 🌐 thebohemia.co.uk
London Brewing London Lush, Beer Street, 100 Oysters Stout, Hasty DDH Pale Ale, Tapped 🅷
A lively brewpub on two levels, with additional outside seating. The front area has large sofas to sit in comfort. The London Brewing Company brewery is visible at the back. Ten handpumps offer five of the brewery's cask ales plus five real ciders. A wide keg selection is also on offer. Pinball, table tennis, table football and a selection of board games can be played. The pub hosts a monthly comedy night. ♿☀🅘♿🚇(Woodside Park)♣♠🚆♿🛈

Elephant Inn
283 Ballards Lane, N12 8NR
☎ (020) 8343 6110 🌐 elephantinnfinchley.co.uk
Fuller's London Pride, ESB; 2 changing beers (often Dark Star, Fuller's) 🅷
Formerly the Moss Hall Tavern, this corner pub has a regionally important historic interior. Three distinct areas round a U-shaped bar cater equally for televised sports, socialising and quiet relaxation. A large patio at the front is covered by a wooden pergola and there is also a secluded rear courtyard. Food from the Thai restaurant upstairs can be served in any of the drinking areas. ♿☀🅘♿🚇(West Finchley)♣🚆♿🛈

N14: Southgate

New Crown ✅
80-84 Chase Side, N14 5PH
☎ (020) 8882 8758
Greene King Abbot; Ruddles Best Bitter; Sharp's Doom Bar; 5 changing beers (often Redemption, Twickenham, Windsor & Eton) 🅷
There was an Old Crown on Chase Side until its demolition in the 1960s, hence the name. This large, well-established Wetherspoon pub is convenient for the tube, and four bus routes stop outside. Converted from a Sainsbury's store more than 20 years ago, it has a single open-plan seating area. Up to five guest ales come from breweries across the country, but with an emphasis on London beers whenever possible. Q♿☀🅘♿🚆🛈

N16: Stoke Newington

Rochester Castle ✅
143-145 Stoke Newington High Street, N16 0NY
☎ (020) 7249 6016
Greene King IPA; Sharp's Doom Bar; 6 changing beers (sourced nationally) 🅷
A Grade II-listed building with an impressive frontage featuring some fine tiling and a large skylight at the back. This is a welcome outlet for cask beer and is now Wetherspoon's longest-trading venue. The pub dates originally from 1702 as the Green Dragon, was subsequently demolished and rebuilt by Richard Payne from Rochester (hence the name), although it was briefly the Tanners Hall in the 1980s. Among other features, note the four tiled wall fixtures, one for each season. ♿☀🅘🚆🛈

N17: Tottenham

Antwerp Arms 🅛
168-170 Church Road, N17 8AS (500yds along Church Rd from Tottenham Sports Centre bus stop)
☎ (020) 8216 9289 🌐 antwerparms.co.uk
Redemption Pale Ale, Hopspur; 2 changing beers (often Redemption) 🅷
Tucked away in the historic and atmospheric Bruce Castle Park area, this Georgian building with beer garden is Tottenham's oldest working pub, serving the neighbourhood since 1822. Facing demolition in 2013, it was saved by the local community and CAMRA campaigners. Now owned as a community collective, it is in effect a permanent outlet for Redemption Brewery beers. Food is served at limited times, so do check the Antwerp's website. Local CAMRA Pub of the Year 2020. ☀🅘🚇(White Hart Lane)♣🚆♿🛈

N19: Upper Holloway

Landseer Arms 🅛
37 Landseer Road, N19 4JU
☎ (020) 7281 2569 🌐 landseerarms.com
Hammerton N1; 4 changing beers (often One Mile End, Twickenham) 🅷
A Victorian pub, quite different from most of the places on nearby Holloway Road, and one that has been through many incarnations, eventually renamed after the artist whose works included the Trafalgar Square lions and the painting Monarch of the Glen. The spacious interior includes a conservatory-style area on the other side of the bar, sometimes used for dining. There is plenty of pavement seating, with heaters and retractable awnings. ♿☀🅘♿♣🚆♿🛈

Shaftesbury Tavern 🅛
534 Hornsey Road, N19 3QN
☎ (020) 7272 7950 🌐 theshaftesburytavern.co.uk
Gale's Seafarers Ale; 2 changing beers (often Five Points, Shepherd Neame) 🅷
A nice old venue, now operated by Remarkable Pubs and comprehensively restored since a 2014 refurbishment, with the former pool room turned into the restaurant area under a fine skylight. The historic interior is identified by CAMRA as of regional importance. Outside at the front there is seating on the terrace. Food comes from a predominantly Thai menu (not Sun), with some classics such as fish & chips and Sunday roasts. Quiz night is Tuesday. ♿☀🅘♿(Crouch Hill)🚆♿🛈

St John's Tavern
91 Junction Road, N19 5QU
☎ (020) 7272 1587 🌐 stjohnstavern.com
Fuller's London Pride; 2 changing beers (sourced nationally) 🅷
Another piece of the real ale renaissance taking place in this part of London. Although the emphasis here is undeniably on food (hams hanging in the food preparation area are visible from the bar), this gastro-pub can have up to five real ales on at any one time and has room for those who just want to relax with a drink. The overall impression is one of space, helped by a large bar area and high ceilings. ☀🅘🚇(Archway)♣🚆🛈

N21: Winchmore Hill

Little Green Dragon 🍸
928 Green Lanes, N21 2AD
☎ (020) 8351 3530 🌐 littlegreendragonenfield.com
5 changing beers (often Beerblefish, Goodness, Wantsum) 🅖

This micropub is a former CAMRA Greater London Pub of the Year and has been the local winner for five consecutive years. Meet the Brewer events are often held as well as regular music nights. Eclectic seating including a church pew, bus seats and padded kegs contribute to the friendly community atmosphere, with pavement seating or a small courtyard at the back for alfresco drinking. No excuses for missing your bus – electronic live times are displayed. Q🟠🛇☆≉♣♿🍴🚲(125,329) ☻🛜

N22: Wood Green

Prince
1 Finsbury Road, N22 8PA
☎ (020) 8888 6698 ⊕ theprincen22.co.uk
4 changing beers (often Five Points, Goodness, Hammerton) Ⓗ
A handsome two-roomed venue occupying a prominent corner site, opposite the pleasant Finsbury Gardens and the New River Path, brought back to life in 2016. Up to four cask ales and nine keg beers come from small breweries across the UK and are listed on the website as they change regularly. Snacks are served weekday lunchtimes, and Japanese dishes in the evenings and all day at weekends. ☆🕽≉(Alexandra Palace)⊖🚲

Westbury
57 Westbury Avenue, N22 6SA
☎ (020) 8889 2059 ⊕ westburyn22.co.uk
Timothy Taylor Landlord; 5 changing beers (often Goodness, Hammerton, Redemption) Ⓗ
Large, impressive corner pub taken over in 2014 by London Village Inns and extensively renovated as a pub and kitchen with lots of space, big windows throughout and heated outside seating. The wide range of beers includes a number from London breweries such as Hammerton and Redemption. Quiz night is Tuesday and there is live music on a Saturday. Payment by card only. 🟠☆🕽♿⊖(Turnpike Lane) ♿🚲🛜

Enfield

Old Wheatsheaf
3 Windmill Hill, EN2 6SE
☎ (020) 8367 4167 ⊕ oldwheatsheaf.co.uk
Big Smoke Solaris Session Pale Ale, Underworld; 4 changing beers (often Goodness, Mad Squirrel, Tiny Rebel) Ⓗ
Sited opposite Enfield Chase station and well served by buses, the pub was reopened by Big Smoke Brewery after a complete renovation in June 2021, and is a welcome addition to the area. Its regionally important historic interior retains two separate bars with beautiful original features. There is also a function room and the large garden is suitable for all weathers and hosts the occasional beer festival. The kitchen is small but offers pub classics and daily specials. 🟠☆🕽≉(Chase) ⊖(Town) ♿🚲☻🛜

Wonder 𝕃
1 Batley Road, EN2 0JG
☎ (020) 8363 0202
McMullen AK Original Mild, IPA; 1 changing beer (often McMullen) Ⓗ
An old-fashioned two-bar local with a regionally important historic interior. The seasonal offer might be one of McMullen's Rivertown beers. The large public bar has a real fire, a dartboard and a honky tonk piano for Sunday afternoons. Bands play some Friday and/or Saturday evenings. Some tables host board games such as backgammon, draughts and snakes and ladders. There

is also a quiet lounge with a fruit machine. The car park has become an outside seating area.
Q🟠☆🕽♿≉(Gordon Hill) ♣🚲(191,W8) ☻🛜

High Barnet

Lord Nelson ✔
14 West End Lane, EN5 2SA
☎ (020) 8449 7249
Young's London Original, Special London Ale; 1 changing beer (often Timothy Taylor, Young's) Ⓗ
A friendly and comfortable one-bar locals' pub hidden away off Wood Street. Full of bric-a-brac, it has a fabulous collection of novelty salt and pepper pots donated by customers returning from holiday. A guest beer may be available from the Marston's list. Fresh sandwiches are available all day while stock lasts. Tuesday night alternates between bingo and a quiz. Dogs are very welcome provided they are on leads and off chairs. The pub often closes early on Thursday.
☆🕽♣🚲☻🛜

Olde Mitre Inne
58 High Street, EN5 5SJ
☎ (020) 8449 5701
Greene King IPA, Abbot; Timothy Taylor Landlord; house beer (by Greene King); 4 changing beers (often Greene King, Tring, Twickenham) Ⓗ
There has been a pub here since 1553 and this Grade II-listed building oozes character and charm. Barnet's oldest coaching inn, it has beams, exposed brickwork, wood panelling, open fires and friendly, efficient, well-trained staff. Walking through three separate drinking areas in the original building, you come to the converted old stables, maintaining the style. The large courtyard has a retractable roof and a brick-built chiminea. Families are welcome. 🟠☆🕽⊖♣🚲☻🛜

Olde Monken Holt ✔
193 High Street, EN5 5SU
☎ (020) 3674 3145
Greene King IPA, Abbot; Timothy Taylor Landlord Ⓗ
At the northern end of the High Street, close to the site of the 1471 Battle of Barnet, this traditional Greene King tenanted pub dates from 1863. Popular and dog-friendly, it has a recently refurbished beer garden at the back and additional seating at the front. There are many TVs at the rear showing sport or news. 🟠☆♣🚲(399)☻🛜

New Barnet

Builders Arms ✔
3 Albert Road, EN4 9SH
☎ (020) 8216 5678 ⊕ buildersarmsnewbarnet.co.uk
Greene King IPA, Abbot; 1 changing beer (often Greene King, Timothy Taylor) Ⓗ
This traditional, two-bar pub tucked away in a side street off East Barnet Road has been a popular real ale outlet since the 1970s. The quiet saloon bar is tastefully decorated with old pictures of Barnet hanging on the walls. The public bar shows sporting events on television. To the rear is a garden room with eclectic furniture, where regular live music events are held. This can also be booked for private functions. Q🟠☆🕽≉♣🚲☻🛜

Railway Bell ✔
13 East Barnet Road, EN4 8RR
☎ (020) 8449 1369
Courage Directors; Greene King Abbot; Ruddles Best Bitter; Sharp's Doom Bar; 6 changing beers (often East London, Oakham, Twickenham) Ⓗ

There has been a hostelry on this site since the late 19th century. Photographs and information about railways and the local area adorn the walls. It has a large conservatory giving it a bright and spacious feel, and outside are a generous patio and garden with a no-smoking area where you can watch the trains go by. There is a suggestion box for future guest ales. A Wetherspoon establishment, it has been in 25 editions of this Guide since 1977. Q✿❄◐♿❄●🚃❄🛜

NORTH-WEST LONDON
NW1: Camden Town

Camden Road Arms
102-106 Camden Road, NW1 9EA
☎ (020) 7485 4530
3 changing beers (often Siren) Ⓗ
Previously the Eagle, Rosie O'Grady's, Mac Bar and Grand Union, this huge pub was massively improved by the Draft House group in 2017 and twice since then by BrewDog. It has a horseshoe-shaped bar, eclectic lighting and comfortable seating – including armchairs, settees and semi-private booths. A board lists the various beers available; often one cask ale can be on offer at a bargain price until sold out.
✿❄◐♿♿❄(Camden Rd/Town) 🚃❀🛜

Golden Lion Ⓛ
88 Royal College Street, NW1 0TH
☎ (020) 3915 3852 ⊕ goldenlioncamden.com
Dark Star Hophead; Fuller's London Pride; Sambrook's Junction Ⓗ
A lovely and popular community pub, saved from closure in 2013; the licensee and the local community, supported by Camden Council, waged a long campaign to prevent its conversion into flats. This came to its final and excellent conclusion with the sitting tenant buying the building, which he now leases out. Tasteful decor complements the regionally important historic interior features, notably the mirrored bar-back. A real back-street community boozer.
✿❄◐♿♿❄(Camden Rd) ♣🚃❀🛜

Tapping the Admiral Ⓛ
77 Castle Road, NW1 8SU
☎ (020) 7267 6118 ⊕ tappingtheadmiral.com
House beer (by Brakspear); 7 changing beers (sourced regionally) Ⓗ
A lively and enjoyable community venue where friendly, knowledgeable staff offer a warm welcome. Guest ales come mainly from local breweries. Great British food includes speciality home-made pies. Outside at the back is a well-designed, heated and covered beer garden. There is a popular Wednesday quiz and live traditional music on Thursday evening. Look out for monthly tap takeovers, pop-up events, and also the pub's cat, Nelson.
Q✿❄◐♿♿❄(Kentish Town West) ♠🚃❀🛜

NW1: Euston

Doric Arch Ⓛ
Euston Station Colonnade, 1 Eversholt Street, NW1 2DN
☎ (020) 7383 3359 ⊕ doric-arch.co.uk
Dark Star Hophead; Fuller's Oliver's Island, London Pride, ESB; 3 changing beers (sourced nationally) Ⓗ
Right next to Euston station, celebrating the arch wantonly demolished as part of its 'development', the pub is up a flight of stairs, with large picture windows affording a bird's eye view of the busy urban world below. It is used extensively by commuters, aided by the train times screen. Excellent staff are helpful and informative about the ales, including up to three guest beers. Railway memorabilia adorns the walls. Toilets are at basement level. ✿❄◐♿❄●(Euston/Euston Sq)🚃❀🛜

Euston Tap
West & East Lodges, 190 Euston Road, NW1 2EF
☎ (020) 3137 8837 ⊕ eustontap.com
7 changing beers (often Five Points, Hammerton, Redemption) Ⓟ
Fronting the main station building, these impressive Grade II-listed Portland stone lodges, separated by a bus lane, are relics from the original 1830s station. The beers, mostly from smaller breweries, are pumped up to taps behind the bar. The small ground-floor spaces are augmented by seating, and toilets, up the wrought iron spiral staircases, and large heated drinking areas outside. The East Lodge opens later in the afternoon and in April 2022 reverted back to being The Cider Tap.
✿❄●(Euston/Euston Sq) ♦🚃❀🛜

Exmouth Arms
1 Starcross Street, NW1 2HR
☎ (020) 7387 5440
Titanic Plum Porter; 4 changing beers (often Sambrook's, Signature, Southwark) Ⓗ
Adjacent to the HS2 works, this lively venue has a boutique hostel on the upper floors and an open-plan kitchen offering burgers and tapas from Burger Craft. The interior has large picture windows and comfortable seating – booths by the windows, high tables and benches – around a large L-shaped bar fronted by mosaic tiles. Local cask beers appear regularly, alongside a good range of keg, bottled and canned beers. Breakfasts are served. Outside there is plentiful bench seating.
✿❄◐♿❄●(Euston/Euston Sq) ♦🚃❀🛜

Royal George Ⓛ ✅
8-14 Eversholt Street, NW1 1DG
☎ (020) 7387 2431
Greene King IPA, Abbot; 4 changing beers (often Greene King, Portobello, Southwark) Ⓗ
Directly opposite Euston station, this large pub was built in 1939 and named after a flagship vessel for the Royal Navy in the 1800s. It is Grade II listed and arranged as interconnecting areas facing the three street frontages, with a central bar. One side has an unusual fireplace with marquetry work on the surrounds. Local London beers are augmented by regional guests or Greene King seasonal beers. Its many TV screens often show different sporting events. ✿❄◐♿❄●(Euston/Euston Sq)🚃❀🛜

NW1: Marylebone

Globe
47 Lisson Grove, NW1 6UB
☎ 07920 827391 ⊕ theglobemarylebone.co.uk
2 changing beers (often Hammerton, Redemption, Timothy Taylor) Ⓗ
Traditional, street-corner locals' pub very close to Marylebone station. There is some outside seating on the street. A sign proclaims 'Craft Beer' and most of the keg offerings are from London breweries including Beavertown, Hammerton and Camden. There is a consistently good KeyKeg range. The food here is Indian, including starters, wraps, mixed platters and curries. Weekend opening hours may vary if a private function is being hosted. ✿❄◐♿❄●(Baker St/Marylebone)♠🚃🛜

NW3: Hampstead

Magdala Ⓛ
2A South Hill Park, NW3 2SB

☎ (020) 7433 8322 ⏺ themagdala.co.uk
Big Smoke Solaris Session Pale Ale; Five Points Best; Harvey's Sussex Best Bitter; 4 changing beers (often By The Horns, Hammerton, Southwark) Ⓗ
Reopened as an independent pub after a long period under threat of permanent closure, the regionally important historic interior of this typical Charrington inter-war rebuild, with its wood panelling and green stained glass, has undergone careful restoration. Named after Lord Napier of Magdala and dating back to 1885, it was outside this pub that Ruth Ellis, the last woman hanged in England, shot her lover to death on Easter Sunday 1955, though alleged bullet marks on the façade are not authentic. Q❀⏺❷⊖(Hampstead Heath)🚌❀

Old White Bear
1 Well Road, NW3 1LJ
☎ (020) 4553 0602 ⏺ theoldwhitebearhampstead.co.uk
Dark Star Hophead; Fuller's London Pride; Leeds Midnight Bell; Timothy Taylor Landlord Ⓗ
Now run by Northern Union Pubs, owned by the team behind Leeds Brewery, this pub had been closed for nearly eight years until saved after another prolonged campaign by locals and CAMRA alike. The interior will be familiar to returning customers. The bar remains in a central position, with bar stools in front available for drinkers. The side rooms both have fireplaces, large wooden bench-style tables and banquette seating. A parquet floor extends throughout. ❶⊖🚌

Spaniards Inn ✅
Spaniards Road, NW3 7JJ
☎ (020) 8731 8406 ⏺ thespaniardshampstead.co.uk
Timothy Taylor Landlord; 2 changing beers (often Oakham, St Austell) Ⓗ
A large, rambling inn with one bar and several rooms, some featuring wooden beams and low ceilings, making for a cosy atmosphere. The building dates back to 1585, although it may not originally have been a pub. It is popular with walkers from the heath and so weekends can be extremely busy and booking is recommended for meals. Open for breakfast, it serves alcoholic drinks from noon. There is a large garden at the back.
Q❀❀⏺❶P🚌(210,H3)❀❈

NW5: Kentish Town

Grafton Ⓛ ✅
20 Prince of Wales Road, NW5 3LG
☎ (020) 7482 4466 ⏺ thegraftonnw5.co.uk
3 changing beers (often Timothy Taylor) Ⓗ
Popular award-winning pub with beautiful Victorian features, which combines a traditional feel with many contemporary touches. The spacious, partly tiled ground-floor horseshoe bar offers ample seating. There is also an upstairs bar/function room (no real ale) and an elegant covered roof garden. The pub specialises in local cask beers, and knowledgeable and friendly bar staff are happy to advise you. Quiz night is alternate Tuesdays; Thursday and Sunday evenings feature music in the lounge, as well as a piano and board games.
❀❀⏺❀⊖(Kentish Town/Kentish Town West) 🚌❀❈

Lion & Unicorn Ⓛ
42 Gaisford Street, NW5 2ED
☎ (020) 7267 2304 ⏺ thelionandunicornnw5.co.uk
Young's London Original, London Special; 1 changing beer (often Redemption) Ⓗ
This popular community venue is a great favourite, with its genuine homely feel, open fire and comfortable seating. Run by friendly management and staff as a Geronimo-branded gastro-pub, its cask ale range

features several breweries from the area. Front and back gardens have both won local and regional awards. A quiz is held on Sunday. Comedy nights are hosted on occasion. Upstairs is the Giant Olive Theatre company – details of productions are available on the theatre's website. ❀❀⏺❶⏺❀⊖🚌❀❈

Pineapple Ⓛ
51 Leverton Street, NW5 2NX
☎ (020) 7284 4631 ⏺ thepineapplepubnw5.com
House beer (by Marston's); 3 changing beers (sourced nationally) Ⓗ
An authentic and friendly community venue, saved from closure by the locals. It is Grade II listed and with a regionally important historic interior, notable for its mirrors and splendid bar-back. The front bar, with comfortable seating around tables, leads through to an informal conservatory overlooking the patio garden. The menu is Thai kitchen cuisine. Some of the beers come from across London and the range changes regularly as the pub is free of tie. Q❀❀⏺❶⊖🚌❀❈

Southampton Arms
139 Highgate Road, NW5 1LE
⏺ thesouthamptonarms.co.uk
8 changing beers (sourced nationally) Ⓗ
The pub does what it says on the sign outside: Ale, Cider, Meat. Fourteen handpumps on and behind the bar serve almost equal numbers of ciders and different beers from microbreweries across the UK. Snacks include pork pies, roast pork baps, cheese and meat baps, plus veggie options. Music is played on vinyl only and the piano is in regular use. At the back is a secluded patio. Local CAMRA Cider Pub of the Year 2022.
❀❶⏺❀⊖(Gospel Oak/Kentish Town)❀🚌

NW6: Kilburn Park

Carlton Tavern 🍸
33 Carlton Vale, NW6 5EU
☎ (020) 7625 4760 ⏺ carltontavern.co.uk
House beer (by Anspach & Hobday); 3 changing beers (often Big Smoke, Five Points, London Brewing) Ⓗ
A site now famous nationally, it made headlines after the pub was demolished illegally and Westminster Council forced the developer to rebuild it brick by brick, working from its original plans. Much was salvaged from the wreckage of the old building, including tiles, bricks and the original bar and fireplaces, and some of the decorative ceilings were also rescued. Outside is a garden/patio area also used for dining in summer. Local CAMRA Pub of the Year 2022. ❀❀⏺❶⊖🚌❀❈

Harrow

Castle ★
30 West Street, HA1 3EF
☎ (020) 8422 3155 ⏺ castle-harrow.co.uk
Dark Star Hophead; Fuller's London Pride, ESB; 1 changing beer (often Dark Star, Gale's, Wimbledon) Ⓗ
A lively and friendly Fuller's house in the heart of historic Harrow-on-the-Hill. Built in 1901 and Grade II listed, it has a nationally important historic interior. Food is served all day; reservations are recommended for Sunday lunchtimes. Three real coal fires help to keep the pub warm and cosy in the colder months, and a secluded beer garden is popular during the summer. Local CAMRA Pub of the Year 2022. ❀❀⏺❀🚌(258,H17)❀❈

Rayners Lane

Village Inn ✔

402-408 Rayners Lane, HA5 5DY
☎ (020) 8868 8551
Greene King IPA, Abbot; Sharp's Doom Bar; Twickenham Naked Ladies; 4 changing beers (sourced nationally) ⊞

A split-level, double-fronted shop conversion. The rear of the pub, accessed down a few steps, sports the traditional Wetherspoon booths, with a row of tables down the centre. A terraced area behind has a variety of large potted plants among the picnic tables. The front pavement has a few tables and chairs for that alfresco moment. There is a good range of customers who mingle quite happily together. Alcoholic drinks are served from 9am. Q ⑤ ❀ ⓘ & ⊖ ♣ ⬛ ♠

Ruislip

Hop & Vine

18 High Street, HA4 7AN
3 changing beers (sourced nationally) Ⓖ

A micropub converted from a café, with seating at low tables with chairs and benches. The small bar counter in the right-hand corner dispenses real ales, keg beers and ciders from a temperature-controlled cellar room behind it. Bottled and canned beers, wines and spirits are also sold. Snacks are enhanced by cheeseboard and charcuterie board options. The real ale choice increases to four or five at weekends, often with table service.
Q ❀ & ⊖ ♣ ⬛ ♠ ❀

Woodman ✔

Breakspear Road, HA4 7SE
☎ (01895) 635763 ⊕ thewoodmanruislip.com
Fuller's London Pride; Rebellion IPA; Timothy Taylor Landlord; 1 changing beer (often Tring) ⊞

A cheerful and welcoming two-bar local, close to Ruislip Lido and woods, recognised by CAMRA as having a nationally important historic interior. The cosy lounge bar is open plan with a dartboard and games machine. The public bar is friendly and comfortable. The pub was a finalist in the Great British Pub awards and national finalist in the Stonegate Group Pub Partners Pub of the Year in 2021. Q ⑤ ❀ ⓘ & P ⬛ (331) ❀ ♠

Ruislip Manor

J.J. Moon's ✔

12 Victoria Road, HA4 0AA
☎ (01895) 622373
Courage Directors; Greene King Abbot; Ruddles Best Bitter; Sharp's Doom Bar; Vale Gravitas; 7 changing beers (often Twickenham) ⊞

A large Wetherspoon pub conveniently opposite the tube station. It is popular and often busy in the evening and at weekends. Food and beer alike are of good value. As well as the usual promotions, the pub hosts a weekly cellar dash and holds an annual Battle of the Brewery. At the rear is an elevated section, leading to a small garden patio, while the front has a partitioned-off smoking area on the street. Local CAMRA Pub of the Year 2022.
Q ⑤ ❀ ⓘ & ⊖ ⬛ ♠

South Kenton

Windermere ★ ✔

Windermere Avenue, HA9 8QT
☎ (020) 3632 0020
⊕ windermerepub-com.stackstaging.com

Fuller's London Pride; 1 changing beer (often Greene King) ⊞

Built in 1939 and next to South Kenton station, the Windermere has a nationally important historic interior. It is a genuine community pub with three bars, although the public bar is now used only for functions. The saloon and lounge retain many original features, including the large inner porches, bar counters, back fittings, wall panelling and fireplaces. A quiz is held on alternate Thursdays and there is sometimes live entertainment.
⑤ ❀ & ⊖ ♣ P ⬛ (223) ♠

SOUTH-EAST LONDON
SE1: Bermondsey

Simon the Tanner Ⓛ

231 Long Lane, SE1 4PR
☎ (020) 7357 8740 ⊕ simonthetanner.co.uk
3 changing beers (often Bristol Beer Factory, Brockley, Redemption) ⊞

In a quiet road off busy Bermondsey Street, the Simon is a mid-terrace, modestly sized Grade II-listed pub. A former Shepherd Neame outlet, it is now a free house. The three regularly changing real ales are from small breweries, and there is often also real cider. Pizza is available daily apart from Sunday when the focus is on roasts. A quiz is held on a Tuesday. Children are welcome until early evening. ⑤ ⓘ ♣ ⬛ ♠ ❀ ♠

SE1: Borough

King's Arms

65 Newcomen Street, SE1 1YT
☎ (020) 7407 1132 ⊕ kingsarmsborough.co.uk
Harvey's Sussex Best Bitter; Purity Mad Goose; Timothy Taylor Landlord; 1 changing beer (often Five Points, Twickenham, Wantsum) ⊞

A Grade II-listed single-room pub, with a traditional and comfortable interior, situated just off the busy Borough High Street. The striking plaque above the entrance originally adorned the old London Bridge. Five cask beers are usually available and traditional, mainly British, meals are served lunchtimes daily and evenings Monday-Saturday. A first-floor function room is available for hire. ⑤ ❀ ⓘ ⇌ (London Bridge) ⊖ ⬛

Libertine ✔

125 Great Suffolk Street, SE1 1PQ
☎ (020) 7378 7877 ⊕ thelibertine.co.uk
Dark Star Hophead; Harvey's Sussex Best Bitter; 1 changing beer (sourced regionally) ⊞

Originally a Whitbread house, this lively and spacious street-corner pub is popular with a mix of workers, locals and students. Pizza is the speciality on the food menu (served Mon-Sat, pub is closed Sundays). Regular live music or DJ sessions are hosted and a quiz is held on Tuesday. Major sporting events are shown and there is a dartboard in the front corner on a raised oche.
ⓘ ⇌ (Elephant & Castle) ⊖ ♣ ⬛ ❀ ♠

Lord Clyde

27 Clennam Street, SE1 1ER
☎ (020) 7407 5643
Fuller's London Pride; Sharp's Doom Bar; Timothy Taylor Landlord; 2 changing beers (often Adnams, Portobello, Sambrook's) ⊞

A gem of a street-corner pub that has changed little since it was rebuilt in 1913, including beautiful Truman's Brewery exterior tilework. It has been identified by CAMRA as having a regionally important historic pub interior with its traditional decor, comfortable seating and curtains over the doors. In addition to the main bar is

a side room with its own serving hatch. Run by three generations of the same family until 2020. ◖❶⇄(London Bridge) ❸♣🚆🌼🛜

Royal Oak ✓

44 Tabard Street, SE1 4JU

☎ (020) 7357 7173 ⊕ royaloaklondon.co.uk

Harvey's Dark Mild, Sussex Best Bitter; house beer (by Harvey's); 2 changing beers (often Harvey's) Ⓗ

A charming back-to-basics drinkers' pub separated into two sections by the bar counter and an off-sales hatch. This was the first London tied house of Sussex-based Harvey's Brewery and is renowned for friendly and attentive service. The ales include seasonal brews, a mild, which is unusual for London, and several additional Harvey's bottled beers. The pub is something of a local institution with regulars coming from miles around to spend time here. ᐅ🌼◖❶⇄(London Bridge)❸🚆🌼🛜

Ship

68 Borough Road, SE1 1DX

☎ (020) 7403 7059 ⊕ shipborough.co.uk

Fuller's London Pride, ESB; 1 changing beer (often Gale's) Ⓗ

Situated midway between Borough and the Elephant & Castle, this is a great example of a pub that combines good beer, good food, sport and music. As part of the local Victorian landscape, the pub is long and narrow with the bar running along most of its length and larger seating areas at the front and rear. The food menu has a Caribbean theme. 🌼◖❶⇄(Elephant & Castle)❸🚆🛜

SE1: Borough Market

Market Porter

9 Stoney Street, SE1 9AA

☎ (020) 7407 2495 ⊕ themarketporter.co.uk

Harvey's Sussex Best Bitter; 3 changing beers (sourced nationally) Ⓗ

This classic, rustic market pub next to the famous Borough Market has a licence to open from 6am to 8.30am during the week, to accommodate the market workers from whom it gets its name. Adorning the walls, a vast array of pumpclips reflects the huge number of beers offered over the years. Popular with locals and visitors alike, it can get busy, with drinkers spilling out onto the street. An upstairs restaurant serves lunches. ᐅ◖❶♿⇄❸(London Bridge)🚆🛜

Old King's Head

King's Head Yard, 45-49 Borough High Street, SE1 1NA

☎ (020) 7407 1550 ⊕ theoldkingshead.uk.com

Harvey's Sussex Best Bitter; St Austell Proper Job; 2 changing beers (often Southwark) Ⓗ

A traditional hostelry down a narrow, cobbled lane off Borough High Street. Stained-glass windows hint at a bygone era and the pictures adorning the walls tell the story of a pub, and an area, that has a rich history. The layout inside is simple, with an L-shaped bar in one corner usually offering four cask ales on handpump. The clientele is a mix of tourists, office workers and visitors to the nearby Borough Market. ◖♿⇄❸(London Bridge)🚆🛜

Rake

14 Winchester Walk, SE1 9AG

☎ (020) 7407 0557

2 changing beers (sourced nationally) Ⓗ

On the edge of Borough Market, this small pub prides itself on offering a high-quality, varied beer selection, and over the years has become a real global destination for beer aficionados and brewers. The ever-changing

cask ales are complemented by a comprehensive range of bottled beers, mainly from North America and Europe, plus a small range of wines and spirits. Beer festivals, brewery tap takeovers and other themed beer selections all feature. Q🌼♿⇄❸(London Bridge)🚆🛜

SE1: Lambeth North

Hercules

2 Kennington Road, SE1 7BL

☎ (020) 7920 9092 ⊕ thehercules.co.uk

Dark Star Hophead; Fuller's London Pride; 2 changing beers (sourced nationally) Ⓗ

Having operated as a variety of restaurants over the preceding years, the Hercules reverted back to a pub in 2019 under the ownership of Fuller's. The decor is contemporary, including exposed brickwork and large, modern chandeliers. There are bars on both the ground and first floors, the former serving cask beer and the latter featuring a large shuffleboard table. A separate meeting room is also available. Food is served all day. 🌼◖⇄(Waterloo) ❸♣🚆

SE1: Southwark

Ring

72 Blackfriars Road, SE1 8HA

☎ (020) 7620 0811 ⊕ theringbarlondon.co.uk

Sharp's Doom Bar; 3 changing beers (often East London, Saltaire, Southwark) Ⓗ

A pleasant bar named after the boxing arena that stood opposite the pub during the early part of the 20th century, with boxers calling in for a drink before and after bouts. It has a gym and a ring upstairs, and pictures of the rich local boxing history adorn the walls of the bar. There is extra outdoor seating on the pavement. Major sporting events on terrestrial TV are shown. ᐅ◖⇄(Waterloo/Waterloo East)❸🚆🛜

SE1: Waterloo

King's Arms Ⓛ

25 Roupell Street, SE1 8TB

☎ (020) 7207 0784 ⊕ thekingsarmslondon.co.uk

Adnams Southwold Bitter; house beer (by Sharp's); 8 changing beers (sourced nationally) Ⓗ

Tucked away in a back street, this popular pub, busy in the early evenings, is worth seeking out. It has been identified by CAMRA as having a regionally important historic pub interior. Two small rooms are separated by a central bar and drinking is also allowed on the front pavement. The real ales usually include two or more from London breweries and at least one dark beer. Thai food is served in the public bar and rear conservatory. ᐅ◖⇄(Waterloo/Waterloo East)❸🚆🌼🛜

Waterloo Tap

Arch 147, Sutton Walk, SE1 7ES

☎ (020) 3455 7436 ⊕ waterlootap.com

3 changing beers (often East London, Siren) Ⓐ

This fairly compact, modern sister pub to the Euston Tap is in a railway arch close to Waterloo station and a short stroll from the South Bank, making it handy for visitors to the BFI IMAX and Royal Festival Hall complex. The cask ales are all dispensed from taps mounted on the copper bar-back. Additional outdoor seating is available under the cover of the railway arch. ᐅ🌼♿⇄❸🚆🌼🛜

SE3: Blackheath

Hare & Billet ✓

1A Eliot Cottages, Hare & Billet Road, SE3 0QJ

☎ (020) 8852 2352 ⊕ hareandbillet.com
Greene King IPA; house beer (by Greene King); 4 changing beers (often Five Points, Sambrook's, Twickenham) Ⓗ

An inn of this name has existed on the site since at least 1732, though the current building dates from the 19th century. The decor is faux Victorian in a contemporary style, with stripped natural-finish wood cladding and bare floorboards. Up to six real ales are on offer. Plastic glasses may be used in the summer for outdoor drinking, with views over the heath's open expanse. The pub overlooks the Hare and Billet Pond with its abundance of avian wildlife. ᏕᏬ♿≁♣⊜☐(380)❀🍴♿

SE4: Brockley

Brockley Barge ✓
184 Brockley Road, SE4 2RR
☎ (020) 8694 7690
Greene King IPA, Abbot; Sharp's Doom Bar; 4 changing beers (often Portobello, Sambrook's, Twickenham) Ⓗ

A former Courage house, now part of the Wetherspoon chain, a stone's throw from the railway station. This is a popular, thriving hub with a clientele reflecting the vibrant local area. The premises is laid out in a semi-horseshoe shape with a variety of seating spaces and all facilities on the same level. A small courtyard to the south side is well used in the summer. The name recalls the former Croydon Canal, where the railway line now runs. Q ᏕᏬ♿≁⊜☐♿

SE4: Crofton Park

London Beer Dispensary
389 Brockley Road, SE4 2PH
☎ (020) 8694 6962
4 changing beers (often Siren, Southey) Ⓗ

This former wine bar is one of the handful of Beer Dispensary outlets run by Penge-based Southey Brewery. The beers were previously gravity dispensed but the counter now sports a set of handpumps, one of which serves cider. Alongside a Southey beer are two changing guest beers, usually from microbreweries. The bar is popular with families; children are welcome until the evening. Food is available from Wednesday to Sunday and includes vegetarian and vegan options, with meal deals often available. ᏕᏬ♿≁☐❀♿

SE5: Camberwell

Stormbird
25 Camberwell Church Street, SE5 8TR
☎ (020) 7708 4460
3 changing beers (often East London, Howling Hops, Siren) Ⓗ

The sister pub to the Hermit's Cave across the road, offering a slightly more contemporary feel and attracting a mixed but generally younger crowd. There is a huge array of beers of all types on the bar, including four changing cask ales and an extensive bottled and canned beer selection. The choice encompasses brews from the UK, continental Europe and the US. Draught beers are available in third-pint measures. ❀≁⊜(Denmark Hill) ☐♿

Sun of Camberwell ✓
61-63 Coldharbour Lane, SE5 9NS
☎ (020) 7737 5861 ⊕ suncamberwell.com
Timothy Taylor Landlord; Volden Session Ale; 4 changing beers (often Wye Valley) Ⓗ

Spacious and friendly pub operated by Antic. The tasteful decoration includes retro items such as suitcases, a radio and interesting pictures that add to the pleasant atmosphere. Children and dogs are welcome. Up to six cask beers include one or two from the in-house Volden brewery. Quality meals are available all day and the large floor space with plentiful tables makes for comfortable dining. ᏕᏬ♿🍴(Denmark Hill/Loughborough Jct) ⊖(Denmark Hill) ☐❀♿

SE5: Denmark Hill

Fox on the Hill ✓
149 Denmark Hill, SE5 8EH
☎ (020) 7738 4756
Greene King Abbot; Ruddles Best Bitter; Sharp's Doom Bar; 4 changing beers (often Southwark, Twickenham, Windsor & Eton) Ⓗ

An attractive and imposing brick-built Wetherspoon pub opposite Ruskin Park. A series of rooms, with quiet alcoves and screened booths, surrounds a central bar area. Framed prints celebrate the numerous historic figures and notable thinkers who lived nearby, often lending their names to the streets. A lawn at the front affords views across to central London and there are large gardens to the rear. The pub is particularly popular when Dulwich Hamlet FC is playing at home. ᏕᏬ♿≁⊖☐♿

SE8: Deptford

Dog & Bell Ⓛ ✓
116 Prince Street, SE8 3JD
☎ (020) 8692 5664
Fuller's London Pride; 4 changing beers (often Clarkshaws, Dent, Old Dairy) Ⓗ

A Guide stalwart for over 30 years, this welcoming traditional pub is down a side street a short stroll from the centre of Deptford. Complementing the real ales is a selection of Belgian bottled beers, malt whiskies and simple, tasty meals. A lively bar and a real fire in winter attract a wide clientele including locals, cyclists and those strolling along the nearby Thames Path. Regular beer festivals are often themed around the UK patron saints' days. ᏕᏬ♿≁♣☐❀♿

SE9: Eltham

Long Pond Ⓛ
110 Westmount Road, SE9 1UT
☎ (020) 8331 6767 ⊕ thelongpond.co.uk
House beer (by Tonbridge); 4 changing beers (often Goody, Musket, Tonbridge) Ⓖ

A micropub situated in a former plumbers' merchants in a neighbourhood previously lacking a pub, named after the pond in nearby Eltham Park North. Mainly Kentish ales are served from a chilled stillage room. Dudda's Tun cider or perry is also available, along with wine, several gins, malt whiskies and limited bar snacks. Seating is mainly high benches and tables, though the rear snug features low tables and chairs. Children and dogs are not admitted. Card payment only. Q♿≁♿☐(B16)

Park Tavern
45 Passey Place, SE9 5DA
☎ (020) 8850 3216 ⊕ parktaverneltham.co.uk
6 changing beers (sourced nationally) Ⓗ

A free house since 2022, this traditional Victorian pub retains the original Truman's Brewery tiled frontage and signage. The compact interior has an L-shaped bar with stylish lamps and chandeliers. Etched windows feature

elegant drapes, and decorative plates and pictures line the walls. Light background music is played. There is a well-kept, heated rear garden and further seating to the front and side. Alongside the range of real ales is an impressive selection of craft beers and lagers, whiskies and wines. Q✿⚙🅰️⬤🚆🍴🌼

Rusty Bucket

11 Court Yard, SE9 5PR
☎ 07776 145990 ⊕ therustybucket.pub
2 changing beers (often Harvey's, Kent, Siren) G
Opened along micropub lines in 2018, the pub retains the original frontage of the redeveloped Crown. Inside, the walls are half-panelled and brightly painted. The place is run by a couple of friends who are enthusiastic and knowledgeable about beers. The cask ales and some real ciders are dispensed from a walk-in chilled cellar cupboard. A large range of keg draught, bottled and canned beers is on offer. Live music sessions are held on Sunday. Card payment only. ⬤🍴🚆♣️🔔🍴🌼🛜

SE10: East Greenwich

River Ale House 🍸

131 Woolwich Road, SE10 0RJ
☎ 07963 127595 ⊕ theriveralehouse.com
7 changing beers (often Canterbury Ales, East London, Kent) H/G
A converted shop unit encompassing two rooms with a rustic feel and a ramp between them. Real ales and ciders are dispensed from a chilled room behind the bar counter. Wines and spirits are also available. Pizzas are delivered in partnership with a nearby supplier. This friendly, family-run house has become a part of the local community and has also developed a wider following. Local CAMRA Pub of the Year and Cider Pub of the Year 2022. Q⬤🚆(Westcombe Park)♣️🔔🚆🌼🛜

SE10: Greenwich

Morden Arms

1 Brand Street, SE10 8SP
☎ (020) 8858 2189
Sharp's Doom Bar; 3 changing beers (often Brockley, Truman's) H
An ex-Courage corner house, now an independent pub with a strong emphasis on live music most weekends. Unpretentious, with no external pub sign or name even, this is one of a dying breed of back-street boozers in the area. It has a clientele of locals and music lovers. Cribbage night is Monday. The beer range is mainly from London breweries, with guest ales from further afield appearing occasionally. Cash payment only. ⬤✿🚆♠️🔔🚆🌼🛜

Plume of Feathers ✅

19 Park Vista, SE10 9LZ
☎ (020) 8858 1661 ⊕ plumeoffeathers-greenwich.co.uk
Harvey's Sussex Best Bitter; 2 changing beers (often Brockley, Southwark, Wantsum) H
With parts dating from 1691, this cosy and quiet pub sits opposite the northern wall of Greenwich Park, close to the National Maritime Museum. The maritime association is reflected inside with numerous interesting historical paintings and memorabilia. Outside is a pleasant garden area. Meals are served daily in both the bar and the separate rear restaurant; afternoon tea can be booked for a minimum of eight people. The pub has a football team, the Plume Rockets, and a golf society. ⬤✿🌙🚆(Maze Hill) ⊖(Cutty Sark)🚆🌼🛜

SE11: Kennington

Mansion House

48 Kennington Park Road, SE11 4RS
☎ (020) 7582 5599 ⊕ oakalondon.com
Oakham JHB, Inferno, Citra, Bishops Farewell; 1 changing beer (often Oakham) H
Oakham Ales' flagship pub in London is styled Oaka at the Mansion House and was previously a cocktail lounge and piano bar. The interior is modern with an oriental flavour, an appropriate setting for enjoying the pan-Asian meals served by attentive staff. During the summer, the front glass doors open out onto an outside seating area. One guest or seasonal Oakham beer often complements the permanent range. ⬤🌙♿🚆(Elephant & Castle)🚆🌼🛜

Old Red Lion ★

42 Kennington Park Road, SE11 4RS
☎ (020) 7735 4312 ⊕ theoldredlion.uk
Portobello Westway Pale Ale; 2 changing beers (sourced locally) H
This Grade II-listed twin-bar venue, now run by Portobello Brewery, retains plenty of character and is a fine example of the Brewers' Tudor style, having been rebuilt by Charrington circa 1929. Identified by CAMRA as having a regionally important historic interior, it has many original features including exposed wooden beams, fireplaces and low doors connecting the bars. Often there is background music playing. ⬤✿🌙🚆(Elephant & Castle)🚆🌼🛜

SE14: New Cross

Royal Albert

460 New Cross Road, SE14 6TJ
☎ (020) 8692 3737 ⊕ royalalbertpub.co.uk
3 changing beers (often Five Points, Portobello, Southwark) H
Now run by Portobello Brewery, this Grade II-listed Victorian inn retains the original etched-glass windows and bar-back. The spacious interior is furnished with wood panelling, ornate lamps and a mix of seating including Chesterfield sofas. The open kitchen at the rear serves a selection of distinctive and enticing dishes. Monday is quiz night and there is a superb live jazz session on Sunday evening. ⬤✿🌙🚆⊖🚆🌼🛜

SE15: Nunhead

Beer Shop London

40 Nunhead Green, SE15 3QF
☎ (020) 7732 5555 ⊕ thebeershoplondon.co.uk
2 changing beers (often Anspach & Hobday, Moor Beer, Squawk) G
A former corner shop, haberdashery and, latterly, a recording studio, this is now a small, friendly micropub. Knowledgeable staff serve a changing selection of real ales direct from the cask, along with an extensive range of bottled beers, plus wine, spirits and soft drinks. Boxed cider, from various producers, is also on offer, as are snacks. Events such as Meet the Brewer evenings are hosted on occasion. Opening hours may shorten in January and February. Card payment only. ⬤✿♿🚆🔔🚆(78,P12)🌼🛜

SE16: Rotherhithe

Mayflower

117 Rotherhithe Street, SE16 4NF
☎ (020) 7237 4088 ⊕ mayflowerpub.co.uk

House beer (by Greene King); 5 changing beers (often Bexley, St Austell) Ⓗ
This nautical-themed pub celebrates the Mayflower's historic journey taking the Pilgrim Fathers to New England. Those with a family connection may sign the Mayflower Descendants Book. The interior is in the style of a 17th-century tavern and at the rear is a wooden jetty over the River Thames. This is a popular place for tourists and the only pub licensed to sell UK and US postage stamps. The house beer is the appropriately named Scurvy Ale. ⊛◑➌⬤➍🚌(381,C10)

SE19: Crystal Palace

Westow House
79 Westow Hill, SE19 1TX
☎ (020) 8670 0654 ⊕ westowhouse.co.uk
Portobello Westway Pale Ale; 2 changing beers (often Arbor, Marble) Ⓗ
Large Victorian corner hostelry, now operated by Portobello Brewing, bordering the edge of the Crystal Palace triangle and with a varied clientele. The vintage shabby-chic furnishings provide a warm ambience and there is a spacious, partly covered, outdoor seating area at the front. Three cask ales are complemented by two changing draught, often real, ciders. A weekly quiz is hosted each Tuesday. Boutique bedroom accommodation is available on the upper floors. ➤⊛🛌◑⇄⬤♣🚌❀🛜

SE22: East Dulwich

East Dulwich Tavern ✅
1 Lordship Lane, SE22 8EW
☎ (020) 8693 1316 ⊕ eastdulwichtavern.com
3 changing beers (often Sambrook's, Twickenham, Volden) Ⓗ
An imposing building in a prominent corner position and operated by the Antic pub company. The spacious interior, with a mix of vintage and recycled decor, is classic boozer, but in tune with the times and alive with customers. The kitchen menu is varied and of good quality. Previously a hotel, the upper storeys are now offices, although the first-floor Masonic hall, known as the Lodge, with its own bar is available for hire and also hosts jazz concerts. ➤⊛◑♿⇄♣🚌❀🛜

SE23: Forest Hill

Blythe Hill Tavern ★
319 Stanstead Road, SE23 1JB
☎ (020) 8690 5176 ⊕ blythehilltavern.org.uk
Dark Star Hophead; Harvey's Sussex Best Bitter; Sharp's Doom Bar; 1 changing beer (often Adnams, Brockley, St Austell) Ⓗ
A multiple award-winning suburban pub with a long-standing licensee. This friendly Victorian local, now Grade II listed, has an unusual three-bar layout, identified by CAMRA as a nationally important historic pub interior. Four cask beers are usually available and up to 13 ciders, many of them real. In two of the bars TV screens show sporting events, especially horse racing. Live traditional Irish music is played on Thursday evening. The pretty rear garden includes a children's play area. Q➤⊛❀⇄(Catford/Catford Bridge)♣🚌❀🛜

Capitol Ⓛ ✅
11-21 London Road, SE23 3TW
☎ (020) 8291 8920
Greene King Abbot; Ruddles Best Bitter; 5 changing beers (often Southwark, Twickenham, Windsor & Eton) Ⓗ

This 1920s Grade II-listed former cinema, now a Wetherspoon outlet, retains its grandeur. Behind the imposing Art Deco frontage is a spacious open-plan drinking area on three levels with a long, impressive bar along the rear wall where the screen was previously located. While at the bar, visitors should be sure to turn around and look up at the old seating circle, tours of which are occasionally run. There is also an outside area with picnic benches. ➤⊛◑♿⬤♣🚌🛜

Addiscombe

Claret & Ale
5 Bingham Corner, Lower Addiscombe Road, CRO 7AA
☎ (020) 8656 7452
Palmers IPA, Tally Ho!; 4 changing beers (sourced nationally) Ⓗ
This small, privately owned and friendly free house, which has regularly been local CAMRA Pub of the Year, is making its 35th appearance in the Guide. It is a community pub where conversation is king, although sports are shown on silent screens. The changing beers often include another from Palmers; others are mainly from microbreweries all over the UK. A board opposite the bar indicates beers that are on and in the cellar. ♿🚷🚌🐾❀

Barnehurst

Bird & Barrel Ⓛ
100 Barnehurst Road, DA7 6HG
House beer (by Bexley); 2 changing beers (sourced nationally; often Bexley) Ⓗ
A micropub opened in 2018 in a former tropical fish emporium. Owned by Cliff and Jane of Bexley Brewery, it is in effect the brewery tap. A small one-roomer with a handful of standard-height tables, it has a covered, secluded beer garden at the back. House beer Hills & Holes commemorates the old name of the lane serving the station nearby. Three keg beers plus wines and spirits are also available. Last orders are 30 minutes before closing time. Q➤⊛♣🚌❀🛜

Beckenham

Bricklayers Arms
237 High Street, BR3 1BN
☎ (020) 8402 0007 ⊕ bricklayersarms.co
St Austell Proper Job, Tribute; Young's London Special; 1 changing beer (sourced nationally) Ⓗ
Traditional high-street pub providing a friendly welcome to a clientele of all ages. There is an open log fire in winter and a covered outdoor seating area with heaters and even a TV screen. The changing guest ales often reflect customers' recommendations. Occasional beer festivals are held. Live music is popular; both local and visiting bands play here. Live sports fixtures are also shown. Sunday hours apply on most bank holidays. ➤⊛⇄(Junction/Clock House)🚆(Junction)♣⬤🚌❀🛜

Bexleyheath

Furze Wren ✅
6 Market Place, Broadway Square, DA6 7DY
☎ (020) 8298 2590
Greene King Abbot; Ruddles Best Bitter; Sharp's Doom Bar; 7 changing beers (often Brains, Courage, Ringwood) Ⓗ
Spacious Wetherspoon establishment named after a local bird better known as the Dartford Warbler. The pub is at the heart of the shopping area, with buses serving every route through town, and attracts a wide clientele. Plenty

of seating and large windows make it a great place to eat, drink and people-watch. Local history panels are displayed around the walls. Alcoholic drinks are served from 9am. No new admittance after 11pm.
Q❄☻☀◑&♣⊒❖

Kentish Belle

8 Pickford Lane, DA7 4QW
☎ (020) 3417 2050 ⊕ thekentishbelle.com
7 changing beers (often Arbor, No Frills Joe, Thornbridge) Ⓗ
Bexleyheath's first micropub, next to the station, has solid walnut furniture and a distinctly Art Deco feel. William Morris wallpaper is a nod to the artist who lived at the Red House, just under a mile away. Outdoor seating is provided during the summer. Regular events include tap takeovers, quiz nights and mini-festivals. Various unusual beers, plus real cider and perry, are served by gravity from a chilled cellar room. A former Greater London CAMRA Cider Pub of the Year.
Q❄≉♣●P⊒❖☀

Long Haul 🍺

149 Long Lane, DA7 5AE
☎ 07753 617874 ⊕ thelonghaul.co.uk
3 changing beers Ⓖ
Opened in August 2020 in what had been a tattoo parlour in the local shopping area in Long Lane, this micropub is handy for the nearby Indian restaurant. Inside is the bar counter towards the back, bench seating and standard tables. Usually there is also seating on the forecourt. Predominantly Kentish real ales and ciders are served from a rear chilled cellar room. Last orders are 30 minutes before closing time. Local CAMRA Pub of the Year 2022. Q❄●⊒(301,401)❖

Robin Hood & Little John Ⓛ

78 Lion Road, DA6 8PF
☎ (020) 8303 1128 ⊕ robinhoodbexleyheath.co.uk
Adnams Southwold Bitter; Bexley Bexley's Own Beer; Fuller's London Pride; Harvey's Sussex Best Bitter; Shepherd Neame Whitstable Bay Pale Ale; 3 changing beers (often Bexley, Shepherd Neame, Westerham) Ⓗ
A back-street local dating from the 1830s when it was surrounded by fields. Real ales come mostly from independent breweries, including Bexley. It has a good reputation for its home-cooked food at lunchtimes (no food Sun) with Italian specials. Dining tables are made from old Singer sewing machines. A frequent local CAMRA Pub of the Year and regional winner three times, Ray and Katerina have been running it for 42 years. Over-21s only. Q❄◑⊒(B13)❖

Blackfen

Broken Drum Ⓛ

308 Westwood Lane, DA15 9PT
☎ 07803 131678 ⊕ thebrokendrum.co.uk
3 changing beers (sourced nationally) Ⓖ
A micropub named after an inn from Terry Pratchett's Discworld series. Seating comprises bay window settles and a variety of tables and chairs, with more out on the pavement for fair-weather drinking (until 8pm). With Cheesy Thursday the first Thursday of each month, occasional quizzes and excursions, this is a real community pub. It has won awards from both CAMRA and the Society for the Preservation of Beers from the Wood. Q❄♣●P⊒(51,132)❖☀

Hangar

37 The Oval, DA15 9ER
☎ (020) 8300 6909 ⊕ hangarmicropub.com

5 changing beers (often Iron Pier, Wantsum, Westerham) Ⓖ
Bexley borough's ninth micropub, this is a one-room former carpet shop with wall-mounted benches or stools at high tables, some outdoor seating in the summer and an open patio 'cabin' to the rear. Real ales are served from a cooled cellar room; keg beers, craft lagers, wines and gins are also available. Large windows give a relaxing view over the greenery of the Oval. Midsummer events have been staged. Last orders are called 30 minutes before closing time. ❄●⊒(51,B13)❖

Bromley

Partridge

194 High Street, BR1 1HE
☎ (020) 8464 7656 ⊕ partridgebromley.co.uk
Dark Star Hophead; Fuller's London Pride, ESB; Gale's HSB; 2 changing beers (often Butcombe, Fuller's) Ⓗ
Grade II-listed former NatWest bank, now a spacious Fuller's Ale & Pie house, retaining many original features including the high ceilings and chandeliers. There are two snug rooms off the long main bar, plus a small back patio. An upmarket food menu is offered, including vegetarian choices. Located by the Market Square, the pub is popular with shoppers and theatregoers for the nearby Churchill Theatre, as well as those drawn by its live music on Saturday evenings.
Q❄☻☀◑&≉(North/South)⊒❖☀

Red Lion ✅

10 North Road, BR1 3LG
☎ (020) 8460 2691 ⊕ redlionbromley.co.uk
Greene King IPA, Abbot; Harvey's Sussex Best Bitter; 1 changing beer (often Black Sheep, Jennings, Oakham) Ⓗ
A traditional, well kept hostelry in the quiet back streets just north of Bromley town centre, the Red Lion is well worth seeking out. Now in its 26th consecutive year in the Guide, this is the only pub in the borough to have featured in every edition since the local branch was formed in 2011. It retains many original features, including tiling. An extensive library of books dominates one wall, while a real fire adds warmth in winter.
Q☀◑≉(North)♣⊒

Star & Garter

227 High Street, BR1 1NZ
⊕ starandgarterbromley.com
7 changing beers (often Bristol Beer Factory, Fyne, Siren) Ⓗ
A late 19th-century Grade II-listed pub, reopened in 2016 after more than two years' closure and offering real ale for the first time. The building has been completely refurbished and boasts eight handpumps, one of which frequently dispenses real cider. Real ales are usually from outside the mainstream, with local and regional microbreweries strongly represented. Customers are welcome to order in food from nearby takeaways. Local CAMRA Pub of the Year 2018-2020.
Q❄&≉(North/South)●⊒❖☀

Chislehurst

Cockpit

4 Royal Parade, BR7 6NR
☎ (07946 100018) ⊕ thecockpitchislehurst.co.uk
House beer (by BritHop); 5 changing beers (sourced nationally) Ⓗ
Opened in December 2020 during the Covid crisis, this micropub was able to operate more normally in 2021 as lockdown eased. A choice of real ales is available from

small breweries around the country. The premises are shared with a florist and provide plenty of seating inside as well as more benches at the front. The pub name comes from the ancient cockpit situated nearby on Chislehurst Common. Q ⏱☕👥🚃♿

Croydon

Dog & Bull ✔
24 Surrey Street, CRO 1RG
☎ (020) 3971 5747 ⊕ dogandbullcroydon.co.uk
Young's London Original, London Special; 2 changing beers (sourced nationally) Ⓗ
With origins back in the 16th century, this Grade II-listed pub has an island bar and stained-glass windows. It is a favourite with local traders as well as visitors to the Surrey Street market. The large garden, an unexpected find in central Croydon, has been brought up to date with booths equipped with TV, large awnings and a bar and barbecue in the summer. The upstairs room is now a restaurant area.
⏱☕◑♿🚋(East/West) 🅿(George St/Reeves Corner) ⊖(West) 🚃♿🛜

George Ⓛ ✔
17-21 George Street, CRO 1LA
☎ (020) 8649 9077
Greene King IPA, Abbot; Sharp's Doom Bar; Thornbridge Jaipur IPA; 11 changing beers (often Oakham, Surrey Hills) Ⓗ
A converted shop, this town-centre pub is named after a former Croydon coaching inn, the George & Dragon. The raised rear bar, with a ramp for access, is lined with booths and has six handpumps often showcasing beers from breweries such as Surrey Hills, Oakham and Thornbridge. The front bar offers a wider mix of beers, including real ales from local breweries and the Wetherspoon national range. The pub also hosts occasional tap takeovers.
⏱◑♿🚋(East/West) 🅿(George St/Reeves Corner) ⊖(West) 🚃🛜

Green Dragon Ⓛ ✔
58 High Street, CRO 1NA
☎ (020) 8667 0684
8 changing beers Ⓗ
A converted bank with a modern twist, the pub boasts a large range of cask ales and other changing draught beers from local and national breweries. The food menu includes vegetarian and vegan dishes. Located between the historic Surrey Street market and the south Croydon restaurant quarter, the pub appeals to drinkers of all ages. An upstairs function room hosts weekly events such as quizzes, poker and open mic nights, and is also available for hire.
⏱◑♿🚋(East/West) 🅿(George St/Reeves Corner) ⊖(West) ♣🚃🛜

Oval Tavern ✔
131 Oval Road, CRO 6BR
☎ (020) 8686 6023 ⊕ theovaltavern.co.uk
4 changing beers (often St Austell) Ⓗ
Back-street family-friendly pub with a good reputation for live music, including jam sessions, acoustic acts and the occasional DJ. A quiz is held on Wednesday. Tasty home-made food is served, including pub favourites and vegetarian and vegan dishes. There is a large garden and barbecue area to the rear. Half-timbering creates an interesting interior decor with a rural atmosphere. The pub continues to improve and promote its range of cask ales, mainly from national brewers.
⏱☕◑🚋🅿(East) ♣🚃♿🛜

Royal Standard
1 Sheldon Street, CRO 1SS
☎ (020) 8680 3106 ⊕ royalstandardcroydon.co.uk
Fuller's London Pride, ESB; Gale's HSB; 1 changing beer (often Dark Star) Ⓗ
A street-corner local dwarfed by the adjacent Croydon flyover and multi-storey car park. This quiet retreat just south of the town centre offers a single bar with four different drinking areas, each with its own character. A small secluded garden area is across the road. Football and rugby are often shown on the TV with the sound turned down. ☕👥🅿(Church St/George St)♣🚃🚃♿

Spreadeagle
39-41 Katharine Street, CRO 1NX
☎ (020) 8781 1135 ⊕ spreadeaglecroydon.co.uk
Fuller's London Pride, ESB; Gale's HSB; 3 changing beers Ⓗ
Large street-corner pub built in 1893 as a bank. The spacious interior boasts wood panelling, high ceilings, glass mirrors and an imposing staircase leading up to two function rooms, one occasionally used as a 50-seater theatre/cinema. As well as cask ale from six handpumps, a good range of other draught and bottled beers is on offer. The pub has Fuller's Master Cellarman accreditation. Quiz night is Sunday.
👥◑♿🚋(East/West) 🅿(George St/Reeves Corner) ⊖(West) 🚃🛜

Downe

Queen's Head Ⓛ ✔
25 High Street, BR6 7US TQ432616
☎ (01689) 852145 ⊕ queensheaddowne.com
Harvey's Sussex Best Bitter; 3 changing beers (often Bexley, Northdown, Westerham) Ⓗ
Attractive, traditional venue with open fireplaces, dating from 1565 and named following a visit to Downe by Queen Elizabeth I. It may have enjoyed the patronage of Charles Darwin who lived locally at Down House. A daily food menu including home-made pies and specials is served in several dining areas. Though in the centre of this historic country village, the pub is less than 20 minutes by bus from Bromley or Orpington. It is popular with walkers all year round. ⏱☕◑♣🅿🚃(146,R8)♿🛜

Falconwood

Bolthole
12 Falconwood Parade, DA16 2PL
☎ 07464 365898 ⊕ bolthole-micropub.co.uk
3 changing beers (often Harvey's, Kent) Ⓗ
A delightful micropub opened in 2019 in a shop parade in the Falconwood Green area. It is furnished with high tables, wall-mounted benches and high stools, and has seating outside in the summer. Real ales are dispensed by two handpumps, and sometimes by gravity from a chilled cellar room. There is a strict over-21s admission policy, and last orders is 30 minutes before closing time. 🚃(B16)♿

Hayes

Real Ale Way Ⓛ
55 Station Approach, BR2 7EB
☎ 07446 897885
House beer (by Tonbridge); 9 changing beers (often Larkins, Mad Cat, Whitstable) Ⓖ
Opened in 2018, this family-owned micropub offers a welcome choice for local drinkers and rail commuters alike. It overlooks the entrance to Hayes station, and numerous bus routes stop outside. Up to nine Kentish

real ales are served from a cold room. The Kent theme extends to the wines and spirits, as well as to the bar snacks. The premises, once a bank and more recently an accountancy office, is quite large by micropub standards. Q⊛❄♿☺♻❀

Keston

Greyhound ✅
Commonside, BR2 6BP TQ413646
☎ (01689) 856338 ⊕ greyhound.pub
Sharp's Doom Bar; Timothy Taylor Landlord; 4 changing beers (sourced nationally) ⊞
A popular local with an enthusiastic and welcoming landlord. It overlooks the common and is on walking routes, including the London Outer Orbital Path, but is also easily accessed by bus from Bromley. The pub is at the heart of village life with a crowded calendar of events, detailed in the local newsletter. A beer festival is held during the Easter weekend when up to 15 less well-known beers can be enjoyed.
Q🎴⊛◐♣♿P🚌(146,246)❀🛜

Orpington

Orpington Liberal Club ⎣
7 Station Road, BR6 0RZ
☎ (01689) 820882 ⊕ orpingtonliberalclub.co.uk
5 changing beers (sourced nationally) ⊞
A friendly club with over 200 different cask ales every year, mainly from smaller breweries, in a range of beer styles. Real cider and bottled lower-alcohol and gluten-free beers are also available. Two real ale festivals are held each year. The club is a hub of the community, hosting many events in its spacious hall and supporting local charities. Regularly voted local CAMRA Club of the Year and a national finalist in 2020. A CAMRA/NULC card is required for entry. Q🎴⊛❄♣♿P🚪🚌❀🛜

Petts Wood

One Inn the Wood ▼ ⎣
209 Petts Wood Road, BR5 1LA
☎ 07799 535982 ⊕ oneinnthewood.co.uk
House beer (by Tonbridge); 4 changing beers (often Kent, Ramsgate, Tonbridge) ⒢
The first micropub in the area, opened in a former wine bar near the station in 2014 and winner of several CAMRA awards. Seating is on benches, with a large woodland backdrop dominating the left-hand wall. Beer is served from a glass-fronted cool room. Wine, gin and soft drinks are also sold, together with a range of mainly locally produced snacks. Families and dogs are welcome. Local CAMRA Pub of the Year for 2022. Q🎴❄♿🚌❀

Selsdon

Golden Ark
186 Addington Road, CR2 8LB
☎ (020) 8651 0700 ⊕ thegoldenark.co.uk
4 changing beers (sourced locally) ⊞
Croydon's first micropub, situated in Selsdon's main street, and offering a full range of alcoholic drinks. Bottled and canned beers and cider are also available for off-sales. Boards detailing current beers are hung on the ceiling beam above the corner bar. The bar and some of the wooden tabletops have been artistically finished and artworks adorn the walls. The pub has won local CAMRA awards and has strong links with the local community.
Q🎴♿♣♿🚌❀🛜

South Croydon

Crown & Sceptre
32 Junction Road, CR2 6RB
☎ (020) 8688 8037 ⊕ crownandsceptresouthcroydon.co.uk
Dark Star Hophead; Fuller's London Pride, ESB; 2 changing beers (often Fuller's, Gale's) ⊞
A quiet, traditional side-street pub, with its name etched into one of the front windows. The single bar has been extended towards a patio at the rear and the walls carry pictures of local scenes and an impressive brewery mirror. A cabinet of trophies attests to the local golfing society's successes. The food leans towards pizza, although other dishes are available.
🎴⊛◐♿❄♣P🚌❀🛜

Welling

Door Hinge ⎣
11 Welling High Street, DA16 1TR
☎ 07743 294909 ⊕ thedoorhinge.co.uk
3 changing beers (often Kent, Mighty Oak, Old Dairy) ⒢
A breath of fresh air on the local pub scene and handy for the football ground, London's first permanent micropub opened in 2013 in part of a former electrical wholesaler's. There are usually at least three beers, dispensed by gravity from a glass-fronted cold room. The cosy bar encourages conversation among previous strangers and there is an even smaller quiet room to the rear. Cider comes from various sources. Q♦🚪🚌❀

SOUTH-WEST LONDON
SW1: Belgravia

Antelope
22-24 Eaton Terrace, SW1W 8EZ
☎ (020) 7824 8512 ⊕ antelope-eaton-terrace.co.uk
Fuller's Oliver's Island, London Pride, ESB; Gale's Seafarers Ale; 1 changing beer (sourced nationally) ⊞
Dating back to 1827, this Fuller's venue was more recently an M&B Nicholson's pub until 2005. Original preserved features include etched-glass windows, a side room used as a snug and the central bar. The upstairs bar and side room can be hired for functions. This is an upmarket house and the clientele consists mainly of local professionals. The pub plays cricket matches against the Churchill Arms in Notting Hill. Q🎴◐⊖(Sloane Sq)🚌🛜

Star Tavern
6 Belgrave Mews West, SW1X 8HT
☎ (020) 7235 3019 ⊕ star-tavern-belgravia.co.uk
Fuller's London Pride, ESB; 3 changing beers (often Butcombe, Dark Star, Wimbledon) ⊞
Down a mews, near embassies and rich in the history of the powerful and famous, this is rumoured to be where the Great Train Robbery was planned. A popular Fuller's pub where local residents, business people and embassy staff rub shoulders with casual visitors, it has featured in all 50 editions of this Guide. Beers from the wood may be served here on an occasional basis. There is an upstairs function room.
🎴◐⊖(Hyde Park Corner/Knightsbridge)♣🚌❀🛜

SW1: Pimlico

Cask Pub & Kitchen
6 Charlwood Street, SW1V 2EE
☎ (020) 7630 7225 ⊕ caskpubandkitchen.com
Changing beers (sourced nationally) ⊞
Formerly the Pimlico Tram, the Cask was converted to a beer destination 11 years ago by owners who have since

also found renown for the Craft Beer Co chain. Ten handpumps serve an ever-changing selection of real ales from many microbreweries, and a vast range of bottled beers from the UK and around the world complements some unusual draught choices. Burgers feature on the weekday menu, with roasts on Sundays until late afternoon. A former local CAMRA Pub of the Year. ⑤❀◖●≠(Victoria) ⊖🖨❀🛜

SW1: St James's

Red Lion ★
2 Duke of York Street, SW1Y 6JP
☎ (020) 7321 0782 🌐 redlionmayfair.co.uk
Fuller's Oliver's Island, London Pride, ESB; Gales Seafarers Ale; 2 changing beers (often Fuller's) Ⓗ
Close to the upmarket shops in Jermyn Street, this is a deservedly celebrated little gem, worth visiting just for its nationally important historic pub interior and, in particular, its spectacular Victorian etched and cut mirrors and glass. The Grade II-listed building dates from 1821 and was given a new frontage in 1871. With little space inside, visitors often spill out onto the pavement. Beware of the precipitous steps down to the toilets. Food is served lunchtimes only.
⑤◖●(Green Park/Piccadilly Circus) 🖨❀🛜

SW1: Victoria

Willow Walk Ⓛ ⊘
25 Wilton Road, SW1V 1LW
☎ (020) 7828 2953
Greene King IPA; Sharp's Doom Bar; 6 changing beers (often East London, Portobello, Windsor & Eton) Ⓗ
Ground-floor Wetherspoon pub converted from a Woolworths in 1999, extending from opposite the eastern side entrance to Victoria station back to Vauxhall Bridge Road, with entrances on both streets. Some wood panelling, a fairly low ceiling and subdued lighting create a warm atmosphere. Friendly and attentive staff look after a mixed clientele including families. Some London-brewed guest beers are usually available. Alcoholic drinks are served from 9am. Q⑤◖●&≠⊖🖨🛜

SW1: Westminster

Buckingham Arms
62 Petty France, SW1H 9EU
☎ (020) 7222 3386 🌐 buckinghamarms.com
Young's London Original, London Special; 3 changing beers (often Young's) Ⓗ
Said to have once been a hat shop, the Bell opened here in the 1720s and was renamed the Black Horse in the 1740s. Rebuilt in 1898, renamed again in 1901 and substantially renovated in recent years, it has appeared in all 50 editions of this Guide and was a winner of a CAMRA Golden Award in 2021. A mix of modern and traditional seats and tables draws civil servants, visitors and the occasional MP. Open on Sundays from the end of March through the summer. ⑤◖●(St James's Park)🖨

Speaker ⊘
46 Great Peter Street, SW1P 2HA
☎ (020) 7222 4589
Timothy Taylor Landlord; 4 changing beers (often Hammerton, London Brewing, Sambrook's) Ⓗ
A friendly pine-panelled one-bar local decorated with parliamentary caricatures. Dating from 1729 or earlier, the Castle, renamed the Elephant & Castle around 1800 and the Speaker from 1999, was part of the Devil's Acre, a notorious slum next to the world's first public gas works. Local residents, office workers and the occasional

MP all now enjoy an attractive range of beers and the hot bagels. Upstairs is a function room. No music, TV or children. ⊖(St James's Park)🖨🛜

SW4: Clapham

Abbeville ⊘
67-69 Abbeville Road, SW4 9JW
☎ (020) 8675 2201 🌐 theabbeville.co.uk
Harvey's Sussex Best Bitter; Sambrook's Wandle; Timothy Taylor Landlord Ⓗ
A cosy Three Cheers gastro-pub, halfway down a bus-free residential road running parallel behind Clapham Common South Side. Separate drinking areas occupy different levels in front of and around two small side bars, with tables also outside. Mostly half-panelled, with cream walls decorated with old prints, it caters for a mixed, mainly younger, clientele and welcomes families and pets. Small functions are bookable. Sports may be shown on a big screen by request. ⑤❀◖●(South)🖨🛜

King & Co
100 Clapham Park Road, SW4 7BZ
☎ (020) 7498 1971 🌐 thekingandco.uk
3 changing beers (often Adnams, Portobello) Ⓗ
Innovative pub offering an enterprising and changing range of beers from microbreweries throughout the UK plus real ciders from smaller producers. The single bar is basically furnished, with current beer offerings (cask and keg) displayed on a large board. The kitchen is taken over for six-week periods by varying street food specialists. There are tables outside on the heated front terrace. ⑤❀◖●(Common)●🖨❀🛜

SW5: Earls Court

King's Head
17 Hogarth Place, SW5 0QT
☎ (020) 7373 5239 🌐 kingsheadearlscourt.co.uk
Fuller's Oliver's Island, London Pride; 2 changing beers (often Fuller's) Ⓗ
A comfortable, friendly corner pub with a modernised interior, hidden away off the busy Earls Court Road; the building is a 1937 rebuild of the oldest (circa 17th century) licensed premises in the area. Seating is a mixture of high stools around tall tables, dining tables and settees. Three Fuller's cask ales are supplemented by a guest, usually from another local brewery. On Monday evening there is a quiz. Alcoholic drinks are served from 11am. ⑤◖&≠(West Brompton)⊖🖨❀🛜

SW6: Fulham

Lillie Langtry ⊘
19 Lillie Road, SW6 1UE
☎ (020) 3637 6690 🌐 thelillielangtry.co.uk
4 changing beers (sourced locally) Ⓗ
Fulham's oldest surviving 19th-century pub, built in 1835 as the Lillie Arms and named after owner Sir John Scott Lillie. It was originally a watering hole for canal workers and bargees on the nearby Kensington Canal – later to become the West London Railway. In 1979 it was renamed after the famous actress and socialite who reputedly entertained many noblemen including Bertie, Prince of Wales. Real ales were introduced with the extensive 2016 refurbishment by Hippo Inns.
❀◖&≠⊖(West Brompton) 🖨❀🛜

SW6: Parsons Green

White Horse Ⓛ ⊘
1-3 Parsons Green, SW6 4UL

☎ (020) 7736 2115 ⊕ whitehorsesw6.com
6 changing beers (sourced nationally) Ⓗ
Destination Mitchells & Butlers pub that normally boasts
five guest beers on handpump and an international
selection of bottled beers. Regular beer and food
matching events take place as well as beer festivals; the
Old Ale Festival in late November has run for 37 years,
with a stillage in the Coach House, normally reserved for
dining. The pub can get busy when Chelsea FC are
playing at home but upstairs there is room to escape the
crowds. Q❀☆◑♿⊖🚍(22,424)❀🗢

SW7: Gloucester Road

Queen's Arms

30 Queen's Gate Mews, SW7 5QL
☎ (020) 7823 9293 ⊕ thequeensarmskensington.co.uk
**St Austell Proper Job; Sharp's Doom Bar; Timothy
Taylor Landlord; 5 changing beers (sourced
nationally)** Ⓗ
Lovely corner mews pub, discreetly tucked away off
Queen's Gate, well worth seeking out for its real ales and
large range of interesting draught and bottled beers,
malt whiskies and other spirits. Note the unusual curved
doors. The L-shaped room has wooden floors and
panelling. The clientele reflects the location: affluent
locals, students from Imperial College and musicians
from, and visitors to, the nearby Royal Albert Hall. It is
wise to reserve a table. ◑♿⊖🚍❀🗢

SW7: South Kensington

Anglesea Arms ⊘

15 Selwood Terrace, SW7 3QG
☎ (020) 7373 7960 ⊕ angleseaarms.com
**Greene King IPA; 2 changing beers (often Timothy
Taylor)** Ⓗ
A real ale stalwart from CAMRA's early years. Built in
1827, it was a Meux tied house for more than a century.
Now a Grade II-listed Greene King Metropolitan pub, it
has the air of a country inn, with outside seating and an
interior featuring a diverse collection of mirrors, prints,
photographs and paintings. Apart from the range of real
ales, the menu offers a variety of food at reasonable
prices for the area. Q❀☆◑⊖🚍❀🗢

SW8: South Lambeth

Fentiman Arms

64 Fentiman Road, SW8 1LA
☎ (020) 7793 9796 ⊕ thefentimanarms.co.uk
**St Austell Proper Job; Young's London Original,
London Special; 1 changing beer (often
Sambrook's)** Ⓗ
On the border of South Lambeth and Kennington, and
within easy reach of the Oval cricket ground, this
elegant, 19th-century end-of-terrace building has been
impressively refurbished as a comfortable, popular
dining pub where drinkers are also welcome. There is a
front terrace and, at the back, an enclosed, split-level
garden patio, heated in winter, with a Burger Shack and
views over the adjacent, post-war estate. Decor includes
Penguin paperback covers in the back room.
❀☆◑⊖(Oval)🚍❀🗢

Priory Arms Ⓛ

83 Lansdowne Way, SW8 2PB
☎ (020) 7622 1884 ⊕ theprioryarms.com
**3 changing beers (often Anspach & Hobday, DEYA,
Kent)** Ⓗ
Long-established free house with a modernised, split-
level interior, attracting a youngish clientele.

Microbreweries are well supported and there is a good
choice of ciders, foreign and craft keg beers as well as
tasty food. The pub has an upstairs function room and
hosts occasional beer festivals. Board games are
available and at the front is a small patio for smoking and
outdoor drinking. Children are allowed inside until early
evening. ❀◑⊖(Stockwell)●🚍

SW9: Brixton

Craft Beer Co

11-13 Brixton Station Road, SW9 8PA
☎ (020) 7274 8383
Changing beers (sourced nationally) Ⓗ
Close to Brixton market, this small modern pub has a
retro feel with hints of an American diner. Downstairs
has red high stools and an industrial vibe while upstairs
are bright blue bench seats, a tumbling blocks parquet
floor, neon signs and enamel brewery advertisements
from Belgium and France. London microbreweries are
well represented among the draught and bottled beers,
as are Belgian Trappists and Lambic. A snack menu is
available, including pork pies. The pub gets busy when
concerts are on at nearby O2 Academy.
❀☆♿⇌⊖🚍❀🗢

SW11: Battersea Power Station

Battersea Brewery Tap Room Ⓛ

12-14 Arches Lane, SW11 8AB
☎ (020) 8161 2366 ⊕ batterseabrew.co.uk
2 changing beers (often Battersea, Hogs Back) Ⓗ
A must for the cask ale drinker visiting the Power Station
complex, this taproom is located in a railway arch
adjacent to its brewery. The decor on the ground and
mezzanine floors has a suitably industrial feel with bare
brick, exposed pipework and copper-topped tables. Food
is limited to bar snacks such as chicken wings and
toasties. In fine weather bench seating outside provides
a good vantage point on Arches Lane, home to
restaurants, a cinema and a theatre.
❀☆◑♿⇌(Park)⊖●🚍❀🗢

SW11: Clapham Junction

Eagle Ale House ♈ Ⓛ

104 Chatham Road, SW11 6HG
☎ (020) 7228 2328
**Changing beers (often Downton, East London, Surrey
Hills)** Ⓗ
A charming, cosy local, just off the busy Northcote Road.
The Eagle is a bastion for microbrewery cask and KeyKeg
beers from near and far. One handpump is kept for
ciders, and bottle coolers now offer continental classics
including several Lambics. The garden benefits from a
large heated shelter. Several TV screens come to life for
major sporting events, especially rugby. Occasionally
there is live music. Local CAMRA Pub of the Year again in
2022. Cash payment preferred. ❀🚍(319,G1)❀🗢

SW12: Balham

Balham Bowls Club ⊘

7-9 Ramsden Rd, SW12 8QX
☎ (020) 8673 4700 ⊕ balhambowlsclub.com
**Volden Session Ale; 3 changing beers (often By The
Horns, Sambrook's, Twickenham)** Ⓗ
Converted to a pub by Antic in 2006, this former club just
off Balham High Road retains a traditional feel but is now
more popular with young people. The multi-roomed
historic interior, which is of regional importance, features
wood panelling decorated with emblematic military

shields and sporting paraphernalia. Guest beers may be from Volden but are typically from other London microbreweries. Live music entertains on Friday evenings. ㅎ❀◑)≢⊖◻▨❀ᶠ

SW13: Barnes

Red Lion

2 Castelnau, SW13 9RU
☎ (020) 8748 2984 ⊕ red-lion-barnes.co.uk
Fuller's London Pride, ESB; 3 changing beers (often Dark Star, Gale's) Ⓗ
Large Victorian landmark establishment at the Wetland Centre entrance, comprising a front bar area and a spacious rear dining room with a mosaic domed ceiling light and impressive fireplace. Outside is a covered patio, a large artificial grass garden, play area, two four-seater heated cabins and a bar in summer. Dogs are welcome inside at all times, children under 10 before 6pm. Occasional beers come from Wimbledon and Park breweries. The pub has a Fuller's Master Cellarman award. Q ㅎ❀◑&◻P▨❀ᶠ

SW15: Putney

Bricklayer's Arms

32 Waterman Street, SW15 1DD
☎ (020) 8246 5544 ⊕ bricklayers-arms.co.uk
Timothy Taylor Boltmaker, Knowle Spring, Landlord; 7 changing beers (often By The Horns, Five Points, Portobello) Ⓗ
The oldest pub in Putney, dating from 1826, the Bricklayer's Arms is a rolling mini beer festival with up to nine changing guest beers, often with several from the same brewery. It is a family-run, community local. Shove-ha'penny and bar skittles are played and the pub runs a cricket team. Fulham FC supporters tend to reduce the beer range after home matches. Opening hours vary in the winter. ㅎ❀≢⊖(Bridge)♣▨❀ᶠ

Telegraph Ⓛ

Putney Heath, SW15 3TU
☎ (020) 8194 2808
House beer (by St Austell); 7 changing beers (often Adnams, Twickenham, Wimbledon) Ⓗ
Impressive destination pub on the edge of Putney Heath, offering dining on two floors but also a wide choice for the ale and cider drinker. The smart decor includes many prints and old London Underground posters as well as vintage maps and photographs. One striking feature is the square gallery on the first floor affording a view of the ground floor below. There is an extensive outdoor drinking area to enjoy in fine weather. ㅎ❀◑&♣◻P▨❀ᶠ

SW16: Streatham

Railway Ⓛ ✓

2 Greyhound Lane, SW16 5SD
☎ (020) 8769 9448 ⊕ therailwaysw16.co.uk
Sambrook's Wandle; 3 changing beers (often Portobello, Southwark, Three Sods) Ⓗ
Showcasing beers from London microbreweries, both cask and bottled, this is a busy two-bar community pub close to Streatham Common station. The back bar, available for hire, is open in the afternoon as a popular tearoom. There is outside seating at the front and in the spacious rear enclosure. It hosts a quiz on Tuesdays, music nights and a popular comedy night on the last Sunday of the month. Local CAMRA Pub of the Year 2019 and 2021. ㅎ❀◑&≢(Common)▨(60,118)❀ᶠ

SW17: Tooting

Antelope ✓

76 Mitcham Road, SW17 9NG
☎ (020) 8672 3888 ⊕ theantelopepub.com
Sambrook's Wandle; Thornbridge Jaipur IPA; Volden Session Ale, Pale Ale; 3 changing beers (often Twickenham, Wimbledon) Ⓗ
A large, lively community pub in Tooting's bustling town centre, the Antelope has an historic interior of regional importance, decorated in the shabby-chic style typical of its operators, Antic. The main bar area, retaining some Barclay's signage, leads back to dining tables and the spacious Rankin Room used to show big-screen sports events. Seating in the large back yard is part-covered and heated in winter. Sundays feature popular roasts and folk music from 3pm. Children are welcome until mid-evening. ㅎ❀◑&⊖(Broadway)▨❀ᶠ

J.J. Moon's ✓

56A Tooting High Street, SW17 0RN
☎ (020) 8672 0426
Greene King Abbot; Ruddles Best Bitter; 3 changing beers (often Twickenham, Windsor & Eton) Ⓗ
Long, narrow Wetherspoon pub opposite the tube station and handy for the area's many South Asian restaurants. The wood-panelled interior features photos of Edwardian Tooting. There are two large TV screens for sport but the sound is usually turned down. This is a vibrant community pub – move to the rear for a quieter drink. Open at 9am for breakfast. ㅎ◑&⊖(Broadway)▨ᶠ

SW18: Earlsfield

Country House ✓

2-4 Groton Road, SW18 4EP
☎ (020) 8870 3204
Sharp's Doom Bar; Timothy Taylor Landlord; 2 changing beers (sourced locally) Ⓗ
In an area where many pubs are focusing on food, this remains a traditional back-street boozer. It still has three separate rooms and an historic interior of regional importance. Outdoor seating is provided in a small yard to the side that claims to be Earlsfield's smallest pub garden. The pub is traditionally known as the Fog, supposedly because homeward-bound rail commuters said they had been delayed by the atmospheric condition rather than being detained in this friendly establishment. ㅎ❀≢♣▨❀ᶠ

SW18: Wandsworth

Cat's Back

86-88 Point Pleasant, SW18 1PP
☎ (020) 3441 2232 ⊕ thecatsback.co.uk
Harvey's IPA, Old Ale, Sussex Best Bitter; 1 changing beer (often Harvey's) Ⓗ
As befits a pub owned by one of Britain's most traditional breweries, the Cat's Back has the feel of a back-street local despite being in an area dominated by new riverside residential developments. The upstairs room has recently been remodelled. Outdoors is a single bench on the pavement in front and a back garden with tables and chairs. In winter a real fire adds to the cosy atmosphere. ㅎ❀◑&▨❀ᶠ

Roundhouse Ⓛ ✓

2 North Side, Wandsworth Common, SW18 2SS
☎ (020) 7326 8580 ⊕ theroundhousewandsworth.com
3 changing beers (often Portobello, Sambrook's) Ⓗ
Cresting the top of Battersea Rise, the curved exterior of this popular pub draws you in. Once you have crossed the mosaic bearing its former name, the Freemasons, and

entered through the impressive Victorian door lobby, you will find a light and airy modern interior decorated with vintage travel posters. Past the open-plan kitchen there is a raised dining area. Outdoor seating is available in front of the pub. ⮠🍴🕩⊜⊖(Clapham Jct)🖵🐾🛜

Sambrook's Brewery Tap

40 Ram Street, SW18 1UD
☎ (020) 7228 0598 ⊕ sambrooksbrewery.co.uk
Sambrook's Wandle, Junction; 2 changing beers (often Sambrook's) Ⓗ
Opened in July 2021 within the historic site of the former Young's Ram Brewery, the taproom has outside seating in Bubbling Well Square and two inside bars, downstairs and upstairs, each with tall tables and stools as well as comfortable bench seating. Both bars have great views of large fermenting and conditioning tanks. On-site pizzas are provided by Crust Bros. The old Young's Brewery coppers now form the centrepiece of a heritage centre and museum. ⮠🍴🕩&🕿(Town)🖵🐾🛜

SW19: Colliers Wood

Wimbledon Brewery Tap Ⓛ

Unit 8, College Fields Business Centre, 19 Prince Georges Road, SW19 2PT
☎ (020) 3674 9786 ⊕ wimbledonbrewery.com
Wimbledon Common Pale Ale; 1 changing beer (often Wimbledon) Ⓖ
The tap room for Wimbledon Brewery, the front space outside has tables and benches, some in a covered area with heating available. Inside seating is mainly upstairs overlooking the brewing processes. Note the large metal representation of the company logo at the bar. Opening hours are limited: check the website, which also has details of events including comedy nights and brewery tours. Wimbledon keg, bottled and canned beers are available for purchase, with the shop usually open for off-sales Monday to Saturday daytime.
⮠🍴🕩&⊖(Colliers Wood) 🅿🖵(152,200) 🐾

SW19: South Wimbledon

Sultan

78 Norman Road, SW19 1BT
☎ (020) 8544 9323
Hop Back GFB, Citra, Taiphoon, Entire Stout, Summer Lightning; 2 changing beers (often Downton, Hop Back) Ⓗ
Hop Back's only London tied house, an attractive two-bar 1950s brick building, identified by CAMRA as having a regionally important historic interior. Mostly carpeted, it has dark-wood walls, large tables with chairs, some fixed seating, settees in the conservatory and benches in the patio and outside. Two handpumps in the saloon bar dispense ciders. Three-day beer festivals are held usually in April or May and in September. The pub opens earlier on bank holiday Mondays. Card payment only.
⮠🍴&🕿(Haydons Rd) ⊖(Colliers Wood/South Wimbledon) ♣🖵🐾🛜

SW19: Wimbledon

Hand in Hand Ⓛ

7 Crooked Billet, SW19 4RQ
☎ (020) 8946 5720 ⊕ thehandinhandwimbledon.co.uk
Courage Directors; St Austell Proper Job; Young's London Original, London Special Ⓗ**; 3 changing beers (often Adnams, Twickenham)** Ⓗ/Ⓖ
Popular, dog-friendly ale house on the edge of Wimbledon Common with separate drinking areas and a variety of seating. At least three guest beers are usually

sold, increasingly from local breweries. Children are welcome in the family room. This is a great place to eat, inside or on the front patio, with beer included in several recipes. There is poker on Monday, a quiz on Tuesday and occasional beer tastings and cellar tours.
Q⮠🍴🕩&🖵🐾(200) 🐾🛜

Wibbas Down Inn Ⓛ ✓

6-12 Gladstone Road, SW19 1QT
☎ (020) 8540 6788
Greene King IPA, Abbot; Oakham JHB; Sharp's Doom Bar; 14 changing beers Ⓗ
An enormous two-bar Wetherspoon pub stretching from Gladstone Road to Russell Road, unusual in that it was converted in 1995 from a Tesco supermarket. It is a favourite haunt for drinkers owing to its low prices and the back bar being well placed to serve the Wimbledon Theatre across the road. The guest beers change frequently and many are sourced from local breweries. Up to 50 beers are available at the frequent festivals. Food and coffee are served all day.
Q⮠🍴🕩&🕿🖵🖵🛜

SW20: Raynes Park

Cavern

100 Coombe Lane, SW20 0AY
☎ (020) 8946 7980 ⊕ thecavernfreehouse.co.uk
Sharp's Doom Bar; Wimbledon Common Pale Ale; 1 changing beer (often Wimbledon) Ⓗ
Opened in 1991 but with a 1960s rock'n'roll atmosphere successfully created by many photographs and records, matched by the landlord's record selection and regular live music sessions. The floor is tiled but with carpeted seating areas in the corners. An original Gilbert Scott red telephone kiosk stands next to the door. The pub does not serve food but customers are welcome to bring in their own. 🕩🕿♣🖵

Carshalton

Cryer Arts Centre Ⓛ

39 High Street, SM5 3BB
☎ (020) 8773 9390 ⊕ cryerarts.co.uk
Surrey Hills Shere Drop; 2 changing beers (sourced nationally) Ⓗ
Formerly the Charles Cryer Theatre, the Cryer Arts Centre now combines arts events with the Spotlight Bar and Restaurant. A changing selection of cask ales is available on three handpumps, supplemented by a range of bottled and KeyKeg beers. An extra bar on the mezzanine floor is open when the theatre is in use and a room with its own small bar is available for hire. 🕿🖵🛜

Hope 🍴 Ⓛ

48 West Street, SM5 2PR
☎ (020) 8240 1255 ⊕ hopecarshalton.co.uk
Downton New Forest Ale; Windsor & Eton Knight of the Garter; 5 changing beers Ⓗ
A traditional pub in the heart of the Carshalton Conservation Area, owned by its regulars and winner of many awards. Seven handpumps dispense cask ale in a variety of styles, and up to four real ciders and a range of craft keg beers are served. Third-pint measures are available and a good range of bottled beer is stocked. A permanent marquee is available for private functions and regular beer festivals. Children are not allowed in the pub. Q🍴🕩&🕿♣🖵P🖵🐾🛜

Railway Tavern ✓

47 North Street, SM5 2HG
☎ 07710 476437 ⊕ railwaytaverncarshalton.co.uk

Fuller's London Pride; 2 changing beers (often Dark Star) ⊞

Street-corner community local in Carshalton village with hanging baskets and window boxes beneath the fine etched windows. Inside are a small U-shaped drinking area around a central bar and a comfortable side area. As well as various items of railwayana, the walls display certificates and awards to mark achievements and qualifications of the pub and its staff. The landlord is a Fuller's Master Cellarman. ⏴❄&♣🚌♣⟊

Cheam

Railway
32 Station Way, SM3 8SQ
☎ (020) 8395 5393
Courage Best Bitter; Timothy Taylor Landlord; 2 changing beers (sourced nationally) ⊞
A small traditional pub conveniently close to Cheam station and a local landmark for over 150 years. An ambience of warmth and charm dominates and the pub provides a home to several community groups. The two regular beers are supplemented by up to three changing ales from a range of breweries. Well-behaved dogs are welcome. Rugby and horse racing are screened and there are regular quiz nights and occasional live music evenings. ❄♣🚌🐾⟊

Kingston

Albion 🛈
45 Fairfield Road, KT1 2PY
☎ (020) 8541 1691 ⊕ thealbionkingston.com
Big Smoke Solaris Session Pale Ale, Underworld; Harvey's Sussex Best Bitter; 7 changing beers ⊞
Part of a chain that includes the Big Smoke Brewery, ales come from small breweries nationwide and there are up to five changing ciders. Varnished wooden floors and comfortable wood-panelled seating areas extend back to a rear patio garden with heaters, a gin distillery and a glazed garden room which is available for hire. Music is from an extensive collection of vinyl LPs. Home-cooked food is served all day. Board games are available and quiz night is Sunday. A former local CAMRA Pub of the Year. ⏴❄◑&❄🚌♣🐾⟊

Willoughby Arms 🛈
47 Willoughby Road, KT2 6LN
☎ (020) 8546 4236 ⊕ thewilloughbyarms.com
7 changing beers (often Harvey's, Surrey Hills, Twickenham) ⊞
Friendly Victorian back-street premises, with a games and TV sports bar, a quieter lounge area and a soundproofed function room upstairs. Free of tie, it serves beers from smaller breweries and cider from Celtic Marches. Pizzas are cooked to order. The spacious garden includes beach huts and a covered, heated and lit smoking area with a large TV screen. Quiz night is Sunday. Beer festivals are held to celebrate St George's day and Halloween. Local CAMRA Pub of the Year 2020-2021. Q⏴❄&♣🚌(371,K5)🐾⟊

Wych Elm 🍷 🛈 ✅
93 Elm Road, KT2 6HT
☎ (020) 8546 3271 ⊕ thewychelmkingston.co.uk
Dark Star Hophead; Fuller's London Pride, ESB; 2 changing beers (often Dark Star) ⊞
Run by independent operators, this traditional local in the heart of north Kingston offers great food and friendly service. Guest ales supplied by Fuller's often include one from another brewery – a Master Cellarman takes care of the beers. There is a secluded garden and log-burners in

winter. Some major sporting events are shown and parties and celebrations can be hosted. Charity quizzes, piano and wine evenings are also held. Local CAMRA Pub of the Year 2022. Q⏴❄◑🚌(K5)🐾⟊

Mitcham

Windmill
40 Commonside West, CR4 4HA
☎ (020) 8685 0333
Young's London Original; 1 changing beer (often Courage, Sharp's, Shepherd Neame) ⊞
A warm, friendly, independent free house facing the common, with stained-glass windmills in attractive bow windows. This is very much a community pub, with terrestrial TV for sports highlights, a dartboard and occasional live music. There is sometimes a second guest beer. To the side is a spacious, heated and covered patio with plenty of seating for smokers. Outside is a convenient bus stop. ⏴❄&♣🚌

Richmond

Mitre
20 St Mary's Grove, TW9 1UY
☎ (020) 8940 1336 ⊕ themitretw9.co.uk
Timothy Taylor Landlord; 6 changing beers (often Bristol Beer Factory, Ilkley, Oakham) ⊞
A traditional community free house off Sheen Road, originally built as a coach house in 1865 as part of the Church Estates; church mitres feature in the leaded stained-glass windows. It has a decked area at the front and covered patio at the rear. Cask beers rotate from independent brewers outside the M25, with three handpumps dedicated to cider or perry. Toasted sandwiches are available, also Neapolitan style pizzas to eat in or take away Wednesday to Sunday. ⏴❄◑❄(North Sheen) ⊖♣P🚌🐾

Roebuck
130 Richmond Hill, TW10 6RN
☎ (020) 8948 2329
Greene King IPA, Abbot; 3 changing beers (often Exeter, Oakham, Wimbledon) ⊞
Close to Richmond Park, this 280-year-old pub, rebuilt in 1741, commands the world-famous view as painted by Turner – the only view to be protected by Act of Parliament. Inside are a number of comfortable secluded areas and upstairs is a function room and bar for hire. Guest beers are on constant rotation and Weston's Old Rosie is a regular cider. Patrons can also use the outside terrace across the road. Dogs on leads are welcome. ⏴◑&🚌(371)🐾⟊

Surbiton

Antelope 🛈
87 Maple Road, KT6 4AW
☎ (020) 8399 5565 ⊕ theantelope.co.uk
Big Smoke Solaris Session Pale Ale; 9 changing beers (sourced nationally) ⊞
The original pub home of the Big Smoke Brewery, with other locally brewed beers also available. Five changing ciders are also usually sold. The spacious split-level interior has a real fire in winter and behind is a covered, heated and lit courtyard. The old brewhouse serves as a dining or function room. Home-cooked food includes Sunday roasts. Popular with locals and commuters, the pub can be particularly busy evenings and weekends. A former local CAMRA Pub of the Year. ⏴❄◑❄♣🚌🐾⟊

Coronation Hall Ⓛ ✔

St Marks Hill, KT6 4LQ
☎ (020) 8390 6164
Greene King Abbot; Ruddles County; Sharp's Doom Bar; 9 changing beers (sourced nationally) 🅷
Across the road from Surbiton station, this Wetherspoon pub occupies a 1911 building that has previously served as a music hall, cinema, bingo hall and nudist club. The decor is a mix of movie stars, film artefacts, the coronation of George V and the planets. Guest beers change regularly, many from local microbreweries. Occasionally the pub hosts local beer festivals. Wheelchair access is via a side entrance. Children are welcome until 9pm. Q🌑◖❀⇋�🛜

Lamb Ⓛ

73 Brighton Road, KT6 5NF
☎ (020) 8390 9229 ⊕ lambsurbiton.co.uk
Hop Back Summer Lightning; Surrey Hills Shere Drop; 2 changing beers (sourced nationally) 🅷
This small, family-run free house hosts many community events, especially those bringing people together through creativity. Live music often plays. Built in 1850 and formerly comprising four separate rooms and a small brewery, it retains the original horseshoe-shaped bar. Changing beers are usually from a microbrewery, sometimes local. Visiting local caterers provide food in the evenings Thursday to Sunday. Children are welcome before 7.30pm. To the rear is an extensive covered outdoor area. 🌑❀⇋🚕🛜

Prince of Wales Ⓛ

117 Ewell Road, KT6 6AL
☎ (020) 8296 0265 ⊕ princeofwalessurbiton.co.uk
Dark Star Hophead; Fuller's London Pride; Gale's HSB; 1 changing beer (often Fuller's) 🅷
The open-plan interior of this Victorian pub has a modern edge to it, with a varnished wood floor and blue patterned tiles around the bar. The walls are a mixture of low wood panelling, glazed tiles and exposed brickwork covered with pictures of local scenes. A stove fire adds to the ambience. The seating is a mix of high and low chairs. A smaller extension to the rear leads out to the large garden. 🌑◖❀⇋🚕

Sutton

Little Windsor ✔

13 Greyhound Road, SM1 4BY
☎ (020) 8643 2574 ⊕ thelittlewindsor.co.uk 🅷
Fuller's London Pride, ESB; 1 changing beer (often Dark Star) 🅷
A small back-street corner local in the New Town area, east of Sutton town centre. The pub is popular with nearby residents, especially in the evenings and at weekends, and sport is usually shown on TV. The L-shaped bar leads to a heated covered terrace and a garden on two levels. Children are welcome until 9pm. 🌑❀◖⇋🚕🛜

WEST LONDON
W2: Bayswater

Champion ✔

1 Wellington Terrace, W2 4LW
☎ (020) 7792 4527 ⊕ thechampionpub.co.uk
Adnams Ghost Ship; 4 changing beers (often By The Horns, Dark Star, Oakham) 🅷
The nearest pub to Kensington Palace, opposite the security-protected road on the northern side of Kensington Gardens. Built in 1838 and Grade II listed, it

was refurbished in 2004 and spruced up since then by owner Mitchells & Butlers. In warm weather the front windows are often opened into the bar, where there is a mix of tables and chairs and standing space. A plush basement area leads through to a sunken beer garden, with patio heaters lit in cold weather.
🌑❀◖&⊖(Notting Hill Gate/Queensway) 🚕❀🛜

W2: Little Venice

Bridge House ✔

13 Westbourne Terrace Road, W2 6NG
☎ (020) 7266 4326 ⊕ thebridgehouselittlevenice.co.uk
Sharp's Doom Bar; Timothy Taylor Landlord; 1 changing beer (often Purity, St Austell, Thornbridge) 🅷
Dating from 1848, this pub beside the canal is now a lounge-style bar, ideal for a quiet afternoon drink. There is a good solid bar counter, wooden floor and panelling, with old mirrors (Bass, and HD Rawlings' High Class Mineral Waters) above the fireplace. A chandelier, pastel-painted walls, high and standard tables and chairs, and low easy chairs complete the setting. There is an extensive food menu for lunch and dinner.
Q🌑❀◖⇋(Paddington) ⊖(Warwick Ave) 🚕❀🛜

W2: Paddington

Mad Bishop & Bear

Upper Level, The Lawn, Paddington Station Concourse, W2 1HB
☎ (020) 7402 2441 ⊕ madbishopandbear.co.uk
Dark Star Hophead; Fuller's London Pride, ESB; 5 changing beers (often Tiny Rebel, Wild Beer, Wimbledon) 🅷
Above the shopping complex just behind the station concourse, the modern pub interior features one long bar, railway memorabilia and train information on screens. The raised areas can be hired for events and there are café-style seats outside. It can be quiet, even in the rush hour, but the bar could close early if football crowds are passing through. 🌑❀◖&⇋⊖🚕❀🛜

Victoria ★

10A Strathearn Place, W2 2NH
☎ (020) 7724 1191 ⊕ victoriapaddington.co.uk
Fuller's Oliver's Island 🅷/🅿, **London Pride, ESB; 3 changing beers (often Dark Star, Thornbridge, Tiny Rebel)** 🅷
There is plenty to admire in this Grade II-listed mid-Victorian inn, popular with tourists and locals alike. The nationally important historic interior includes ornately gilded mirrors above a crescent-shaped bar, painted tiles in wall niches and numerous portraits of Queen Victoria. The walls display cartoons, paperweights and a Silver Jubilee plate. Upstairs, via a spiral staircase, the Library and the Theatre Bar provide extra space. Tuesday is quiz night. Several times a local CAMRA award runner-up.
Q🌑❀◖⇋⊖(Lancaster Gate/Paddington) 🚕❀🛜

W2: Royal Oak

Cow

89 Westbourne Park Road, W2 5QH
☎ (020) 7221 0021 ⊕ thecowlondon.com
2 changing beers (often Fuller's, St Austell, Timothy Taylor) 🅷
Built in 1858 as the Railway Tavern, which it remained until 1992 when renamed, possibly in reference to cattle driven on the hoof to Smithfield Market. The pub is owned by the Conran family and is famous for its house-speciality oysters and seafood menu generally. There is

an unpretentious smallish ground-floor bar with a good real ale reputation, and a first-floor restaurant.
❀❍➊✆(Royal Oak/Westbourne Park) ▯

W3: Acton

Red Lion & Pineapple ✓
281 High Street, W3 9BP
☎ (020) 8896 2248
Greene King IPA, Abbot; Sharp's Doom Bar; 5 changing beers (often East London, Oakham, Twickenham) ⊞
A Wetherspoon pub at the top of Acton Hill, formerly owned by Fuller's. Two pubs here were combined in 1906, hence the name. The larger room is home to the circular bar, surrounded by red and black tiles. The windows are large, with etched and stained tops, and the walls are decorated with historical photographs of Acton. The smaller room is mainly used by diners and families. The rear patio was recently refurbished. Alcoholic drinks are served from 9am.
❍❀❀❍➊✆(Town) ▯ ♠

W4: Chiswick

Steam Packet
85 Strand on the Green, W4 3PU
☎ (020) 3994 8140
House beer (by St Austell); 2 changing beers (often Adnams, Gorgeous, Twickenham) ⊞
The high-quality furnishings in this pub include a unique brass handrail with mermaid fixings around the bar. A cosy area beyond the bar gives more privacy. The upper deck has additional dining/drinking space with a balcony overlooking the river. The name comes from the steam launches that used to dock at Kew Pier opposite as part of the regular steam packet service up the river. The Thames Path footpath is close by.
❀❍➊≈(Kew Bridge) ▯ ❀ ♠

W4: Turnham Green

Tabard 🅛 ✓
2 Bath Road, W4 1LW
☎ (020) 8994 3492
Greene King IPA; 5 changing beers (often St Austell, Timothy Taylor, Twickenham) ⊞
Built in 1880 as part of the Bedford Park estate, the first London garden suburb, this Grade II*-listed pub has a regionally important historic interior. Features include the replica swing sign (the original was painted by TM Rooke), interior tiling by William de Morgan and Walter Crane, and Arts and Crafts mirrors and pictures. There are four distinct drinking areas and two bars. The dining area usually has live music on Saturday evening and a quiz on Wednesday. ❀❍❀❍➊➊❀❀♠

W5: Ealing

Questors Grapevine Bar 🅛 ✓
12 Mattock Lane, W5 5BQ
☎ (020) 8567 0011 ⊕ questors.org.uk/grapevine
Fuller's London Pride; 2 changing beers ⊞
A friendly theatre club bar near the centre of Ealing and Walpole Park, run by enthusiastic volunteers. CAMRA members and Questors theatre ticket holders are also welcome. Guest beers include some from local breweries. Beer festivals are held twice-yearly and there are malt whisky tastings. Some books and the odd board game are available. A former local and national CAMRA Club of the Year. ❍❀❀❀➋≈➊✆(Broadway)♣P▯❀♠

Sir Michael Balcon ✓
46-47 The Mall, W5 3TJ
☎ (020) 8799 2850
Greene King IPA, Abbot; Sharp's Doom Bar; 4 changing beers (sourced nationally) ⊞
Located on the Uxbridge Road east of Ealing town centre, this pub became a Wetherspoon venue in 2008, converted from Bryant's furniture shop. It is named after the legendary producer of Ealing comedies including The Ladykillers and The Lavender Hill Mob, whose life and films form the basis of many of the wall displays. Split level, there is a raised area at the rear and a glass-covered area at the front for smokers. Alcoholic drinks are sold from 9am. ❍❀❀❍➋➋≈✆(Broadway)▯♠

W6: Hammersmith

Dove
19 Upper Mall, W6 9TA
☎ (020) 8748 9474 ⊕ dovehammersmith.co.uk
Fuller's London Pride, ESB; 2 changing beers (often Dark Star, Fuller's) ⊞
A Grade II-listed pub dating from the 1740s with a regionally important historic interior. With an outside seating area overlooking the Thames, it is often crowded in summer. The likes of Dylan Thomas, Ernest Hemingway and Alec Guinness enjoyed a pint or two here. Down off the main bar area, a tiny public bar holds the Guinness world record for the smallest bar area. The food service can be slow at busy times but is usually worth the wait. ❀❀❍➊➊≈(Ravenscourt Park)▯❀♠

Plough & Harrow 🅛 ✓
120-124 King Street, W6 0QU
☎ (020) 8735 6020
Greene King IPA, Abbot; Sharp's Doom Bar; 7 changing beers ⊞
On the site of an inn established in 1419, and more recently a Rolls-Royce showroom, this light and airy Wetherspoon pub dates from 2002. It has a mixture of stone and carpeted floors and a long metal-topped bar. Many of the guest beers come from microbreweries. There are a number of tables outside at the front and at the side. Alcoholic drinks are served from 9am. ❍❀❀❍➋➊➋✆(Hammersmith/Ravenscourt Park) ▯ ♠

Prince of Wales Townhouse
73 Dalling Road, W6 0JD
☎ (020) 8563 1713 ⊕ princeofwales-townhouse.co.uk
Big Smoke Solaris Session Pale Ale, Underworld; 3 changing beers (often Big Smoke, Harvey's, Laine) ⊞
Just a little outside the centre of Hammersmith, this pub now belongs to the Big Smoke chain. Up to five ciders and 20 keg lines complement the cask beers. It has a spacious, light and airy bar, and outside a covered and heated garden featuring open-sided huts. The food menu starts early with breakfast and features pub favourites, sharers and more upmarket dishes from lunchtime until late evening. Alcoholic drinks are served from 11am. ❀❀❍➊➋✆(Ravenscourt Park) ♣▯❀♠

William Morris 🅛 ✓
2-4 King Street, W6 0QA
☎ (020) 8741 7175
Greene King Abbot; Ruddles Best Bitter; Sharp's Doom Bar; 7 changing beers (sourced nationally) ⊞
Close to Hammersmith's two underground stations and Lyric Theatre, and not far from the Apollo music venue, this large, popular Wetherspoon pub is named after the Arts and Crafts designer who had a home nearby. A modern pub with entrances on both King Street and the pedestrianised Lyric Square, on which there is terrace

seating, it stretches in an L shape, with the bar in the middle. Frequently changing interesting ales, often from smaller breweries, are usually on offer. ♿❀◐❶&⊖🚌🛇

W7: Hanwell

Fox

Green Lane, W7 2PJ
☎ (020) 8567 0060 ⊕ thefoxpub.co.uk
Fuller's London Pride; St Austell Proper Job; Timothy Taylor Landlord; 2 changing beers (sourced nationally) Ⓗ
Wonderful free house in the welcoming multicultural town of Hanwell, as popular with walkers, cyclists and other nearby canal users as it is with locals. A good range of beers is complemented by excellent, inexpensive food, including the sought-after Sunday lunch (booking recommended). The pub runs beer festivals at Easter and in the autumn. Thursday is quiz night. Local CAMRA Pub of the Year on many occasions. ♿❀◐❶&🚍(195,E8)❀🛇

Grosvenor

127 Oaklands Road, W7 2DT
☎ (020) 8840 0007
4 changing beers (often Ealing, Five Points, Timothy Taylor) Ⓗ
A traditional Edwardian back street local identified by CAMRA as having a regionally important historic interior, it was refurbished in 2014 without losing its features and charm. Inside is a main bar and a dining room area. Food is served daily. The cask and bottle-conditioned beer selections are complemented by a wide range of other locally produced beers. Family-friendly, it has a pleasant atmosphere and promotes local events. Jazz night is the second Tuesday of every month and there is an open mic night on the fourth Tuesday. A former local CAMRA Pub of the Year. ♿❀◐❶&♣🚌❀🛇

Viaduct ✓

221 Uxbridge Road, W7 3TD
☎ (020) 8567 5866 ⊕ viaduct-hanwell.co.uk
Dark Star Hophead; Fuller's London Pride, ESB; Gale's Seafarers Ⓗ
A friendly Fuller's pub that is much larger on the inside than it appears from the outside. There is a separate function room which is available for hire when it is not being used for the Friday comedy nights. The pub was renamed around 1838 after the Wharncliffe Viaduct behind it, famous as the first viaduct to carry a commercial electric telegraph. Ealing Hospital is also close by. Q♿❀◐❶&⊖🚌🛇

W8: Kensington

Elephant & Castle ✓

40 Holland Street, W8 4LT
☎ (020) 7937 6382
Fuller's London Pride; St Austell Nicholson's Pale Ale; Sharp's Doom Bar; 3 changing beers (sourced nationally) Ⓗ
Tucked away north-east of Kensington Town Hall, this busy, cosy, wood-panelled M&B Nicholson's pub was first licensed in 1865 as a beer house in what were originally two adjacent houses. It has a regionally important historic interior: note the fine Charrington's bar-back. With its rural feel, it is a welcome refuge from the hurly-burly of Kensington High Street. Guest beers come from a wide range of breweries. Food, especially pies and sausages, is served all day except 4-5pm. ♿❀◐❶⊖(High St Kensington)🚌❀🛇

Scarsdale Tavern

23A Edwardes Square, W8 6HE
☎ (020) 7937 1811 ⊕ scarsdaletavern.co.uk
Fuller's London Pride; Gale's Seafarers Ale; 2 changing beers (often Fuller's) Ⓗ
On a secluded square off Kensington High Street, this upmarket 1867 pub was reportedly a haunt of the late Diana, Princess of Wales. Behind the half-frosted windows lies an L-shaped dark wood bar with an ornate etched mirrored back. Elegantly framed paintings on the walls include a reproduction of David's striking Napoleon Crossing the Alps. The front patio has tables and heating. The pub is claimed to be the local used in the 1970s TV crime series The Professionals. ❀◐❶≷(Kensington Olympia) ⊖(High St Kensington/Kensington Olympia) 🚌🛇

W8: Notting Hill Gate

Churchill Arms

119 Kensington Church Street, W8 7LN
☎ (020) 7727 4242 ⊕ churchillarmskensington.co.uk
Fuller's Oliver's Island, London Pride, ESB; 2 changing beers (often Fuller's) Ⓗ
A multi award-winning, deservedly popular pub with a regionally important historic interior including snob screens, now rare. Churchillian and Irish memorabilia are among the bric-a-brac suspended from the panelled ceiling. The Thai restaurant in the conservatory was one of the first in a London pub. Outside, at busy times, drinkers stand on the pavement below numerous hanging flower baskets; at Christmas, the tree decorations are something to behold. Q❀◐❶⊖🚌❀🛇

Windsor Castle ★ ✓

114 Campden Hill Road, W8 7AR
☎ (020) 7243 8797 ⊕ thewindsorcastlekensington.co.uk
Marston's Pedigree; Timothy Taylor Landlord; 4 changing beers (sourced nationally) Ⓗ
A back-street, Grade II-listed pub dating from 1830 and identified by CAMRA as having a nationally important historic interior. Sited on a corner, it contrasts an old-world rural feel with a modern upmarket service and menu style. The bar room is divided into four drinking areas separated by partitions that date from a 1933 refurbishment. The four rotating beers may include some interesting offerings. The beer garden to the rear boasts its own bar. Q♿❀◐❶⊖🚌❀🛇

W9: Warwick Avenue

Prince Alfred ★

5A Formosa Street, W9 1EE
☎ (020) 7286 3287 ⊕ theprincealfred.com
Young's London Original, London Special; 1 changing beer (often St Austell) Ⓗ
A mid-Victorian pub, now Grade II* listed, with a nationally important historic interior dating from 1896 when many London pubs had small drinking compartments. The ornate bar-back draws the eye up to a highly decorated ceiling. Together with the intricate carving on the partitions, these impart a rococo feel to the place. The passageway and bar area to the side sport some delightful wall tiling and floor mosaics as well as a fireplace. Beyond is the open kitchen and Formosa Dining Room restaurant. ♿❀◐❶&🚌❀🛇

Warwick Castle ✓

6 Warwick Place, W9 2PX
☎ (020) 7266 0921 ⊕ warwickcastlemaidavale.com
Greene King IPA; house beer (by Hardys & Hansons); 2 changing beers (often Timothy Taylor) Ⓗ

With a dark green frontage blending with the rest of the terrace, this 1846 pub, featured in a 1927 painting by artist and illustrator Edward Ardizzone, is recognised by CAMRA as having a regionally important historic interior. Note the leaded windows with varied shades of coloured glass inserts. An interesting food menu offers a variety of dishes, including pub classics and roasts on Sundays. The clientele reflects the broad social mix of the area. ⌂❀❍⊖⊟❀

W9: Westbourne Park

Union Tavern Ⓛ
45 Woodfield Road, W9 2BA
☎ (020) 7286 1886 ⊕ union-tavern.co.uk
Dark Star Hophead; Fuller's London Pride; 2 changing beers (often Five Points) Ⓗ
Following a takeover by Fuller's, this is now a part-tied beer house offering craft keg beers and cask ales produced within 30 miles and, with just one brewery exception, in London. The mainly young crowd enjoys various music nights and a Meet the Brewer event on the first Tuesday of the month. Good-value food is another attraction, with traditional Sunday lunches served. The canalside terrace comes into its own on a warm, sunny day. ⌂❀❍⊖⊟❀⚲

W12: Shepherds Bush

Central Bar ✅
Unit 1, West 12 Centre, Shepherds Bush Green, W12 8PH
☎ (020) 8746 4290
Greene King IPA, Abbot; changing beers (sourced nationally) Ⓗ
A Wetherspoon pub opened in 2002 on the upper floor of a new shopping centre. Access from the ground floor is via escalator or lift and through a wide entrance into a long bar area with large windows to the side overlooking the Green. it is named after the Central London Railway (or Tuppenny Tube), now the Central Line, which reached Shepherds Bush in 1900 when the Prince of Wales (later Edward VII) opened the station opposite.
Q⌂❍⇌⊖(Shepherds Bush/Market) ⊟⚲

W13: West Ealing

Owl & the Pussycat ⟡ Ⓛ
106 Northfield Avenue, W13 9RT
⊕ markopaulo.co.uk
6 changing beers (often Ealing) Ⓗ
Until recently also a microbrewery, this pub has retained the atmosphere of the former bookshop in which it is located. Avid readers can browse through the beer-related books and magazines. The owners now brew all the beers at Ealing Brewing in Brentford. The ciders are often from Oliver's. In this small, friendly environment, conversation is all-important. Local CAMRA Pub of the Year and Cider Pub of the Year for 2022.
Q⊖(Northfields) ♣❀⊟(E2,E3) ⚲

Brentford

Black Dog Beer House
17 Albany Road, TW8 0NF
☎ (020) 8568 5688 ⊕ blackdogbeerhouse.co.uk
5 changing beers (often Ramsbury, Windsor & Eton, Wye Valley) Ⓗ
This landmark building, a former Royal Brewery (Brentford) pub dating back to at least 1861, has become a neighbourhood favourite after reopening in 2018. The light, open, L-shaped room has plenty of seating, no TV

screens, music from classic vinyl LPs and an eclectic food menu. The real ales, ciders, and beers on 14 keg taps, are listed on chalkboards. Dogs are welcome, though sadly the eponymous hound lives elsewhere. Local CAMRA Pub of the Year 2020. ❀❍⇌♣❀⊟❀⚲

Express Tavern ★
56 Kew Bridge Road, TW8 0EW
☎ (020) 8560 8484 ⊕ expresstavern.co.uk
Big Smoke Solaris Session Pale Ale; Draught Bass; Harvey's Sussex Best Bitter; 7 changing beers (often Bristol Beer Factory, Rudgate, Thornbridge) Ⓗ
A local landmark since the 1800s, with a regionally important historic pub interior and still featuring illuminated external Bass signage – Draught Bass remains a fixture on the bar. The small Chiswick Bar offers 10 ales on handpump; the saloon/lounge bar has up to five handpumps for ciders and perries alongside 10 craft keg taps. Behind is a heated conservatory with TV screens. Outside is a spacious beer garden. Music is played from vinyl LPs.
⌂❀❍⇖⇌(Kew Bridge) ♣⊟❀⚲

Cranford

Queen's Head ★
123 High Street, TW5 9PB
☎ (020) 8897 0022 ⊕ queens-head-cranford.co.uk
Fuller's London Pride, ESB; 2 changing beers (often Adnams, St Austell) Ⓗ
Close to Heathrow Airport, this was among the first pubs bought by Fuller's Brewery. Built in 1604 and rebuilt in the 1930s, it has a nationally important historic interior, retaining its wooden beams, fireplaces, solid oak doors and wood panelling. Many photographs of old Cranford adorn the walls, together with other bric-a-brac around the bar. There are two main bars and a large barn-style restaurant/function room. ⌂❀❍♣⊟⚲

Greenford

Black Horse
425 Oldfield Lane North, UB6 0AS
☎ (020) 8578 1384 ⊕ blackhorsegreenford.co.uk
Fuller's London Pride, ESB; house beer (by Dark Star) Ⓗ
Large old split-level pub, tastefully extended and refurbished, very convenient for public transport. A landscaped garden overlooks the scenic Grand Union Canal; boaters mooring outside and towpath walkers and cyclists are frequent visitors. Beer deliveries were once by barge. Friday and Saturday nights offer live music, Thursday nights a quiz. Function space is free to hire for group bookings. Sports are shown on a large screen in the lounge bar and a smaller one downstairs.
⌂❀❍⇖⊖♣⊟(92,395) ❀⚲

Hampton

Jolly Coopers ⟡
16 High Street, TW12 2SJ
☎ (020) 8979 3384 ⊕ squiffysrestaurant.co.uk
Exeter Avocet; Hop Back Summer Lightning; Portobello Star; 2 changing beers (often Ascot, Park) Ⓗ
A traditional community pub with a proud heritage. A splendid wall panel lists all the landlords from 1726 to the present incumbent who took over in 1986. The small horseshoe bar has five handpumps always in use. Guest beers are usually from local breweries. The walls are adorned with water jugs, pictures and local memorabilia. There is a dining room and covered patio. Squiffy's

restaurant serves excellent tapas and traditional food; booking is essential for Sunday lunches.
&🕏◑&⇌♣🅿🐾🗲

Hampton Court

Mute Swan
3 Palace Gate, Hampton Court Road, KT8 9BN
☎ (020) 8941 5959 ● muteswan.co.uk
House beer (by St Austell); 3 changing beers (often Ilkley, Surrey Hills, Twickenham) Ⓗ
This popular Brunning & Price pub opposite the palace gates draws locals and tourists alike. The main feature as you enter is the wrought iron spiral staircase up to a dining area (also accessible via stairs). Food is also served downstairs. Cask beers change frequently, with a cider on handpump during the summer months. There is a log fire in the winter and no distracting TV screens. Seating and tables are also provided outside. No prams are allowed inside. Q◑⇌♣🅿🐾🗲

Hampton Hill

Roebuck
72 Hampton Road, TW12 1JN
☎ (020) 8255 8133 ● roebuck-hamptonhill.co.uk
St Austell Tribute; Young's London Original; 2 changing beers (often Triple fff, Wantsum, Windsor & Eton) Ⓗ
Comfortable single-bar Victorian pub with partitioned seating areas, owned by an inveterate collector – obvious from the decor. Look beyond the wickerwork Harley-Davidson, fishing rods, flying boats and miniature steam locomotive for the growing collections of smaller items such as military honours, blowlamps and carpentry tools. The small garden has a gazebo for smokers and there is a garden room, available for hire, for cooler evenings. The real fire never goes out in winter. 🐾⇌(Fulwell)🚌🗲

Hampton Wick

Foresters Arms
45 High Street, KT1 4DG
☎ (020) 8943 5379 ● the-foresters.com
Sharp's Doom Bar; 2 changing beers (often Surrey Hills, Twickenham) Ⓗ
Small traditional neighbourhood pub/restaurant and hotel that has a reputation for good food. A range of interesting bottled beers complements the local cask ales. The decor incorporates a real fireplace, leather sofas and dark woodwork. The pub is part-carpeted with a wooden floor in the centre bar area; there is also a small cosy side room. Outside seating is provided on the front corner pavement and to the side. Quiz night is every other Monday. &🕏🖾◑⇌♣●🐾🗲

Harlington

White Hart
158 High Street, UB3 5DP
☎ (020) 8759 9608 ● whitehartharlington.co.uk
Fuller's London Pride, ESB; 1 changing beer (often Dark Star, Fuller's, Gale's) Ⓗ
Large, Grade II-listed Fuller's pub standing proud at the north end of the village. It was refurbished in 2009 to improve facilities and create an open feel, enjoyed by regulars and visitors from the nearby Heathrow Airport. The bar provides access to an open-plan space with soft seating, leading to an area favoured by diners. Local history is the theme of the wall displays. Quiz night is Thursday. Fuller's or Gale's seasonal ales are sometimes on the bar. &🕏◑&🅿🚌🐾🗲

Hayes

Botwell Inn ✓
25-29 Coldharbour Lane, UB3 3EB
☎ (020) 8848 3112
Greene King Abbot; Ruddles Best Bitter; Sharp's Doom Bar; 3 changing beers (often Adnams, Hogs Back, Windsor & Eton) Ⓗ
Named after the hamlet of Botwell, now the location of Hayes town centre, this large Wetherspoon pub with several areas for dining and drinking opened in 2000 following a shop conversion from furnishers S Moore & Son. There is a fenced paved area to the front and a patio at the rear with large market-type parasols with heaters. Several beer festivals are held annually.
Q&🕏◑&⇌Ө(Hayes & Harlington)🚌🗲

Hillingdon Hill

Red Lion Hotel
Royal Lane, UB8 3QP
☎ (01895) 236860 ● redlionhotelhillingdon.co.uk
Fuller's London Pride, ESB Ⓗ
A Grade II-listed pub more than 400 years old (refronted in 1800) with wood panelling, very low ceilings and exposed beams. Part of the London Wall is claimed to be visible in the car park and it is believed that Charles I stayed here in 1646. The third handpump is often used to showcase other Fuller's ales such as Jack Frost, Gale's Seafarers or HSB. Q&🕏🖾◑&🅿🚌🐾🗲

Hounslow

Moon under Water ✓
84-88 Staines Road, TW3 3LF
☎ (020) 8572 7506
Greene King Abbot; Ruddles Best Bitter; Sharp's Doom Bar; 6 changing beers (often Hook Norton, Ramsgate, Salopian) Ⓗ
Licensed from 9am, this is a 1991 Wetherspoon shop conversion still in original style, displaying many local history panels and photographs. A real ale oasis for beer lovers from the town and surrounding areas, it has been in this Guide for 21 consecutive years. Up to six guest beers come from across the country, with more at festival times when 11 handpumps are put to work. The regular cider is usually Westons Old Rosie. Families are welcome during the day. Q&🕏◑&Ө(Central)🚌🗲

Norwood Green

Plough
Tentelow Lane, UB2 4LG
☎ (020) 8574 7473 ● ploughinnnorwoodgreen.co.uk
Fuller's London Pride; Twickenham Naked Ladies; 1 changing beer (often Fuller's, Harvey's, St Austell) Ⓗ
Dating back to circa 1650, this Grade II-listed building is Fuller's oldest tied house. With low, exposed beams, two real fires and a superb landlord who takes pride in both friendly service and a well-kept range of real ales and ciders, it offers traditional roasts alongside other dishes every day. Musicians entertain from time to time inside the pub as well as in the garden during the summer. There is patio seating at the front.
&🕏◑&♣●(120)🐾🗲

St Margarets

Crown
174 Richmond Road, TW1 2NH
☎ (020) 8892 5896 ● crowntwickenham.co.uk

Harvey's Sussex Best Bitter; Surrey Hills Shere Drop; Young's London Original ⊞
A large pub dating from about 1730 and Grade II listed, with a substantial refurbishment enhancing the Georgian heritage of the original building. The Victorian hall at the back has been opened up for dining and the courtyard garden attractively remodelled. Inside are various seating areas and three fireplaces, one in the bar area with a real fire. Several windows and doors are original. Food is served throughout the day. ▭☺◑◒≒P▭☺☎

Turk's Head
28 Winchester Road, TW1 1LF
☎ (020) 8892 1972 ⊕ turksheadtwickenham.co.uk
Dark Star Hophead; Fuller's London Pride, ESB; 2 changing beers (often Fuller's, Twickenham) ⊞
A genuine local corner pub, built in 1902. Beatles fans visit to see the location for a scene from A Hard Day's Night and where Ringo played darts. The Bearcat Comedy Club takes place on Saturday night in the Winchester Hall, except in summer, and there is regular live music. The Jazz Sanctuary operates every other Thursday and the pub takes part in London's Festival of Jazz. ▭☺◑⅙≒▭(110,H37)☺☎

Teddington

Masons Arms
41 Walpole Road, TW11 8PJ
☎ (020) 8977 6521 ⊕ the-masons-arms.co.uk
Hop Back Summer Lightning; Sambrook's Junction; Vale Best IPA; 1 changing beer (often Gorgeous, Portobello, Twisted Wheel) ⊞
A friendly back-street community free house built in 1860, this is a beer drinkers' haven, with bottles, cans, pictures and pub memorabilia on display. Carpeting and comfortable seating create a cosy atmosphere. There is a log-burning stove, a dartboard and a secluded rear patio. Music evenings include a bring-your-own vinyl night on the third Tuesday of the month. The guest beer, sourced from a wide range of independent brewers, changes frequently. A former local CAMRA Pub of the Year. ☺⅙≒♣●▭▭

Twickenham

Rifleman
7 Fourth Cross Road, TW2 5EL
☎ (020) 8255 0205
Harvey's Sussex Best Bitter; Twickenham Red Sky, Naked Ladies; 3 changing beers (often Hook Norton, Otter, Twickenham) ⊞
A traditional late-Victorian pub whose name commemorates rifleman Frank Edwards, a local resident, who dribbled a football across No Man's Land towards the German trenches in WWI. A Twickenham Fine Ales house since 2019 and very much a community hub, it has a small beer garden and front patio, board games, TV sport and an open mic evening on Thursday. Twickenham Stadium and Harlequins rugby clubs are a short walk away. Several bus routes are close. Q☺≒(Strawberry Hill) ♣P▭☺☎

White Swan ✓
Riverside, TW1 3DN
☎ (020) 8744 2951 ⊕ whiteswantwickenham.co.uk
Otter Bitter; Twickenham Naked Ladies; 2 changing beers (often Gale's, Twickenham, West Berkshire) ⊞
A Grade II-listed building and award-winning traditional pub, built around 1690. Entry is via steps up to the first floor, where the bar has real fires and walls covered with rugby and other memorabilia. A small veranda/balcony

and a triclinium (a three-sided room with window seats) afford views of the river and Eel Pie Island. Directly opposite is a larger riverside beer garden, tides permitting, right on the water's edge. Q☺☺◑≒▭☺☎

Uxbridge

General Eliott
1 St Johns Road, UB8 2UR
☎ (01895) 237385 ⊕ generaleliottuxbridge.co.uk
Fuller's London Pride; St Austell Tribute; 1 changing beer (often Black Sheep, Butcombe, Otter) ⊞
One of six pubs in the country named after the teetotaller who defended Gibraltar from the Spanish in the late 18th century, this attractive, comfortable canalside pub dating from 1820 has a warm and friendly atmosphere. It was totally refurbished prior to lockdown, including a new covered seating area next to the canal. There is a Tuesday quiz, Wednesday karaoke, live music on Saturday and an open mic night on the last Thursday of the month. ☺☺◑≒P▭(3)☺☎

Good Yarn ✓
132 High Street, UB8 1JX
☎ (01895) 239852
Greene King Abbot; Ruddles Best Bitter; Sharp's Doom Bar; 4 changing beers (sourced nationally) ⊞
Opened in 1994 in the former Pearson's menswear shop in the town centre, this is a typical Wetherspoon pub, apart from its narrow frontage. It has a long bar, the raised far end of which is surrounded with shelves of old books. The front section boasts vintage framed advertisements for local businesses on the walls, and old photographs can be found throughout. Alcoholic drinks are served from 9am. Q☺◑⅙●▭☎

Breweries

40FT SIBA
Bootyard, Abbot Street, Dalston, E8 3DP
☎ (020) 8126 6892

Office: The Printhouse, 18-20 Ashwin Street, Dalston, E8 3DL ⊕ 40ftbrewery.com
This six-barrel microbrewery was established in 2015 in two 20ft shipping containers. It has since expanded to a total of 150ft. Beers are produced for its taproom as well as pubs, bars, restaurants and off-licences. Output is nearly all keg and can. ◆

Affinity
Grosvenor Arms, 17 Sidney Road, Brixton, SW9 0TP
☎ 07904 391807 ⊕ affinitybrewco.com
Established in 2016 in a container in Tottenham Hale and expanded in 2017 to the Bermondsey Beer Mile, 2020 saw the brewery start afresh in the basement of the Grosvenor Arms. Run as a separate business, cask, keg and canned beers are available in the pub and now quite widely. ◆
Grosvenor Gold (ABV 3.8%) GOLD

Anomaly
Glebe Gardens, Old Malden, KT3 5RU ☎ 07903 623993 ⊕ anomalybrewing.co.uk
Founded in 2017, beers started to appear at the end of 2018 brewed on a 100-litre home kit. Most production is available in bottles and cans but cask is sometimes

available for pubs and at beer festivals. Old Belgian, French and English styles are the regular range.

Anspach & Hobday SIBA

Unit 11, Valley Point Industrial Estate, Beddington Farm Road, Beddington, CR0 4WP
☎ (020) 3302 9669 ⊕ anspachandhobday.com

⊗ Anspach & Hobday began brewing in 2014. In 2020 it moved to Croydon with its existing seven-barrel kit and a canning line. An increase was planned during 2022 with the acqustion of the Moncada Brewery kit. Its original railway arch site (on the Bermondsey Beer Mile) is now the home of its barrel-aged and sour beers. The brewery also has a bar, the Pigeon, Camberwell. ‼🍺LIVE◆

The Ordinary Bitter (ABV 3.7%) BITTER
Flavours of spicy and resinous hop overlaid with biscuit malt. A subtle bitterness and sweet malt emerge in the aftertaste.

The Patersbier (ABV 4.1%) SPECIALITY

The Smoked Brown (ABV 5.5%) SPECIALITY
Smoke, chocolate orange and caramel on nose and palate creates a well-balanced, dark-brown beer with roasted malt and earthy hops.

The IPA (ABV 6%) IPA
Easy-drinking, hoppy, gold-coloured IPA with lemons, grapefruit and spicy peppercorns overlaid by biscuit. Sweet, biscuity, dry, bitter finish.

The Porter (ABV 6.7%) PORTER
Roasted coffee notes throughout with caramel, dark fruit and hops in the flavour and lingering finish which is slightly dry.

Battersea

12-14 Arches Lane, Battersea Power Station, Nine Elms, SW11 8AB
☎ (020) 8161 2366 ⊕ batterseabrew.co.uk

Opening in 2018, the brewery consists of two railway arches, one for the brewery and one for the taproom. A changing range of beers is produced in cask and keg available at the taproom and in pubs run by the brewery owners, the Mosaic Pub Company. ◆

Beavertown

Units 17 & 18, Lockwood Industrial Park, Mill Mead Road, Tottenham Hale, N17 9QP
☎ (020) 8525 9884

Tottenham Hotspurs Stadium: 748 High Road, Tottenham, N17 0AP

Ponders End: Unit 7, Ponders End Industrial Estate, 102 East Dock Lees Lane, Ponders End, EN3 7SR
⊕ beavertownbrewery.co.uk

⊗ Beavertown, established in 2012, opened its Tottenham Hale site 2014. After selling a stake to Heineken in 2018, further investment saw the opening of 'Beaverworld' in Ponders End in 2020 (a ten-fold production increase). Tottenham Hale is being used to expand the Tempus Project (barrel-ageing). An on-site brewery and bar opened in the newly-built Tottenham Hotspur's football ground in 2019 (access to ticket holders only). This beer is also available in the Corner Pin, opened opposite the stadium in 2021. The Tottenham Hale taproom is open at weekends. In September 2022 Heineken bought the remaining shares in the company. No real ale. 🍺◆GF◆

Beerblefish SIBA

Unit 2A-4, Uplands Business Park, Blackhorse Lane, Walthamstow, E17 5QJ ☎ 07594 383195
⊕ beerblefish.co.uk

Starting at UBrew in Bermondsey in 2015, the Edmonton site began production in 2016. A move to Walthamstow occurred in 2021, to a site three times larger. It has a homely taproom. Capacity increased by subsequently buying the former Brew By Numbers kit. A series of hoppy pale ales and a range of Victorian heritage ales are available in cask, keg and bottles. LIVE◆

Hoppy Little Fish (ABV 3.5%) PALE
Refreshing pale ale with fruity, perfumed hoppy aroma and lingering, dry, bitter finish. Pineapple, lemon and biscuit on the palate.

Hackney TNT (ABV 4%) RED

Edmonton Best Bitter (ABV 4.3%) BITTER
Amber-coloured, smooth, traditional bitter. Pears and citrus fruits overlay caramelised fudge. Spicy hops on the dryish bitter finish.

Pan Galactic Pale (ABV 4.6%) PALE
Amber, full-bodied beer with fruity tangerine notes with sweet biscuit. Aftertaste starts soft becoming bitter and dry. Floral, biscuity nose.

Blackbeerble Stout (ABV 5.2%) STOUT

1853 ESB (ABV 5.3%) BITTER
Sweet caramel flavour aroma and flavour with marmalade and a gentle, developing spicy hoppiness becoming slightly bitter in the aftertaste.

1820 Porter (ABV 6.6%) PORTER
Aromas of brett, roast and black treacle, which are also in the sweet, caramelised fruity flavour. Spicy, dry, bitter finish.

1892 IPA (ABV 6.9%) IPA
Full-bodied with apricot, honey, caramelised orange and Brett. Strong, spicy, hoppy bitterness builds in the finish. Brett and marmalade aroma.

Belleville

Unit 36, Jaggard Way, Wandsworth Common, SW12 8SG
☎ (020) 8675 4768 ⊕ bellevillebrewing.co.uk

Belleville began brewing in 2012. It was set up by a group of parents from a local primary school, after the success of the (now) head brewer's efforts at homebrewing for a beer festival at the school. It specialises in American-style beers, with a core range and quarterly seasonals, available in keg and can. The taproom is a few units along from the brewery and offers the core range and current seasonals plus occasional guest beers. No real ale. ‼◆◆

Bexley SIBA

Unit 18, Manford Industrial Estate, Manor Road, Erith, DA8 2AJ
☎ (01322) 337368 ⊕ bexleybrewery.co.uk

Bexley Brewery was founded in 2014. Brewers Cliff and Jane Murphy produce regular, seasonal and experimental brews. Formerly also selling own-brand beer mustard, exotic products now feature beer soap, to which Bursted session contributes. The Bird & Barrel in Barnehurst, opened in 2018, replaced the taproom as the main source of the beers locally as well as stalls at local farmers' markets. ‼🍺◆◆

Bursted Session Bitter (ABV 3.8%) BITTER
Hills & Holes Kent Pale (ABV 3.8%) PALE
Golden Acre (ABV 4%) GOLD

Smooth, golden ale with citrus aroma. Flavour is of grapefruit, hops and a strong bitterness, continuing in the dry-fruity finish.

Bexley's Own Beer (ABV 4.2%) BITTER
Pale brown beer with a balance of fudge, floral hop, stone fruit and some bitterness growing in the dry finish.

Redhouse Premium (ABV 4.2%) BITTER
Copper-coloured bitter with roast and sweet orange marmalade. Dry finish with a touch of chocolate in finish and aroma.

Anchor Bay IPA (ABV 4.8%) PALE
Spike Island Stout (ABV 5.3%) STOUT

Bianca Road

83-84 Enid Street, Bermondsey, SE16 3RA
☎ (020) 3221 1001 ⊕ biancaroad.com

After starting in 2016 in Peckham, the brewery moved to a bigger site in 2017, and again in 2019 to two arches along the Bermondsey Beer Mile which double up as the taproom. Output is mostly keg and cans. No real ale. ◆

Block

🏠 Wenlock Arms, 26 Wenlock Road, Hoxton, N1 7TA
☎ (020) 7608 3406 ⊕ wenlockarms.com

⊗ Block is based in the cellar of the award-winning Wenlock Arms. Launched at the end of 2016, the beer is available at the pub in cask and keg formats. Specials are available for local beer festivals.

Bohem

Unit 5, Littleline House, 41-43 West Road, Tottenham, N17 0RE
☎ (020) 8617 8350 ☎ 07455 502976
⊕ bohembrewery.com

Traditional Bohemian lagers brewed by Czech expats in North London. The brewery moved to larger premises in 2018. Beers are supplied to local outlets, including the taproom near Bowes Park station. A second outlet was added in 2020, Bohemia House, West Hampstead, replacing the former Czech club. No real ale. 🍺◆

Boxcar

Unit 1, Birkbeck Street, Bethnal Green, E2 6JY
⊕ boxcarbrewery.co.uk

After being located in Homerton for two years, Boxcar moved to Bethnal Green in 2019 opening a larger brewery and taproom. An ever-changing range of hoppy beers in keg and cans forms the majority of production, with cask available, usually the popular Dark Mild. ◆

Dark Mild (ABV 3.6%) MILD
Chocolate, hazelnuts and dark fruit on nose and taste where toasty malt is prominent. Sweetness reduces with an increased roastiness.

Br3wery

253 Beckenham Road, Beckenham, BR3 4RP
⊕ br3wery.com

Established in 2019 producing bottle-conditioned beers at the nanobrewery. Bigger batches of beer were later brewed at Birmingham Brewery. The bottle shop opened in 2021 with the on-site brewery starting production soon after with an ever-changing range of styles. No real ale. ◆

Brew By Numbers

79 Enid Street, Bermondsey, SE16 3RA

☎ (020) 7237 9794
Greenwich site: Morden Wharf, Morden Wharf Road, North Greenwich, SE10 0NU ⊕ bbno.co

Established in 2012, Brew By Numbers produces a wide range of styles with differing ingredients leading to its eponymous numbering system although this was simplified a few years ago. A new brewery was installed in 2021 at a new site in North Greenwich doubling as a taproom with the original arch retaining a pilot plant and a presence on the Bermondsey Beer Mile. 🍺LIVE ◆

Brewhouse & Kitchen SIBA

🏠 5 Torrens Street, Angel, EC1V 1NQ
☎ (020) 7837 9421 ⊕ brewhouseandkitchen.com

Brewing began in 2014 in the open plan brewery at the rear of the pub, the ground floor of the landmark office building by the Angel junction. Four cask beers are brewed to the chain's formula, named after local icons including former resident Charlie Chaplin.

Brewhouse & Kitchen SIBA

🏠 2a Corsica Street, Highbury, N5 1JJ
☎ (020) 7226 1026 ⊕ brewhouseandkitchen.com

Brewing began in 2015 in the open plan brewery at the rear of the pub, a former tramshed. Four cask beers are brewed to the chain's formula, named after local icons including the nearby Arsenal FC. ◆

Brewhouse & Kitchen SIBA

🏠 397-400 Geffrye Street, Hoxton, E2 8HZ
☎ (020) 3861 8920 ⊕ brewhouseandkitchen.com

Brewing began in 2018 in one of the arches under Hoxton Overground station. Four cask ales are brewed to the chain's formula, named after local icons including former land owner Sir Humphrey Starkey. It is opposite the relaunched Museum of the Home.

Brick SIBA

Units 13-14, Deptford Trading Estate, Blackhorse Road, Deptford, SE8 5HY
☎ (020) 3903 9441 ⊕ brickbrewery.co.uk

Established by owner and former homebrewer Ian Stewart in 2013. Due to continued expansion, the brewing operation relocated from Peckham to larger premises in nearby Deptford in 2017. The original Peckham railway arch site is retained as an expanded taproom. Beside the Foundation beers, frequent one-off and collaboration brews are produced, including a range of sours. 🍺◆◆

Peckham Pale (ABV 4.5%) GOLD
Well-balanced, refreshing, hazy, amber/gold-coloured beer with tropical fruits and sweet orange. Bready malt notes lead to a bitter finish.

Blackhorse (ABV 4.9%) STOUT
Smooth stout with sweet chocolate aroma. Dark bitter chocolate, sweet toffee and dark orange marmalade flavours. Lingering dry roastiness.

Extra Special Bitter (ABV 5.2%) BITTER
Ruby brown beer. Roasty chocolate notes throughout overlaid with raisins, toffee and marmalade. Dry, roasty bitter finish with spicy hops.

Brixton

Arches 547 & 548, Brixton Station Road, Loughborough Junction, SW9 8PF
☎ (020) 3609 8880

Loughborough Junction: Units 1&2, Dylan Road Estate, Dylan Road, Milkwood Road, Loughborough Junction, SE24 0HL ⊕ brixtonbrewery.com

The brewery opened in 2013 in central Brixton with beer names and branding reflecting the local area. An investment by Heineken in 2017 enabled expansion into a nearby industrial unit. As of 2021 Brixton is now owned outright by Heineken. The original arch is used for seasonal and experimental brews. The adjacent arch houses the taproom. The bulk of production is in KeyKeg, cans and bottles. ‼️🍴◆LIVE ♦

Reliance Pale Ale (ABV 4.2%) PALE
Tropical notes and a little malt are noticeable in this refreshing, amber-coloured beer. A gentle bitterness grows on drinking.

Brockley SIBA

31 Harcourt Road, Brockley, SE4 2AJ
☎ (020) 8691 4380 ☎ 07814 584338

Hither Green: Unit 28, Chiltonian Industrial Estate, Manor Road, Hither Green, SE12 0TX
⊕ brockleybrewery.co.uk

The original SE4 brewery has been trading since 2013 and now focuses on core cask ales, single-batch specials and Brewschool. In 2019, a new 20-barrel brewery was opened on the former site of the Chiltonian Biscuit factory in Hither Green. The brewery concentrates on brewing cask beers and supplying outlets across SE London. The whole range is vegan and available at the taprooms on both sites. 🚚◆V♦

Pale Ale (ABV 4.1%) BITTER
Hints of citrus and lychee notes with a sweetness and spicy hops in the flavour and the bitterish finish.
Red Ale (ABV 4.8%) RED
Smoky aroma on this well-balanced sweet, fruity, American-style red ale, with growing spice overlaid with dry-roasted bitter character.

Broken Drum

Heron Hill, Upper Belvedere, DA17 5ER ☎ 07803 131678 ⊕ thebrokendrum.co.uk

Homebrewer that started trial brewing for the Broken Drum micropub in Blackfen, before going commercial in 2018. Brewed in small batches for the micropub and local beer festivals. All output is in cask.

Bullfinch

Arches 886 & 887, Rosendale Road, Herne Hill, SE24 9EH ☎ 07795 546630
⊕ thebullfinchbrewery.co.uk

Bullfinch began brewing in 2014 sharing with Anspach & Hobday in Bermondsey but opened in Herne Hill in 2016 using a 2.5-barrel plant. Production is mainly keg but cask and bottle-conditioned beers are available in the taproom, at its Bull & Finch bar in Gipsy Hill (which now has its own kit, the So What Brewery) and increasingly in local pubs. ‼️🚚LIVE ♦

Swift (ABV 4%) BLOND
Dark Side of the Moon (ABV 4.5%) PORTER
Chocolate and vanilla on the nose, fading to a bitterness. Chocolate, roast, black cherries and liquorice flavours. Light, dry finish.

Camden Town

Unit 1, Navigation Park, Morson Road, Ponders End, EN3 4TJ

Kentish Town: Arches 55-65, Wilkin Street Mews, Kentish Town, NW5 3NN ☎ (020) 7485 1671
⊕ camdentownbrewery.com

⊗ Bought by A-B InBev in 2016. A modern, automated brewhouse situated in railway arches underneath Kentish Town West railway station with an on-site brewery tap. A second brewery in Ponders End opened in 2017, and is the main production site, with a large taproom open for special events. No real ale. ‼️♦

Canopy

Arch 1127, Bath Factory Estate, 41 Norwood Road, Herne Hill, SE24 9AJ
☎ (020) 8671 9496 ☎ 07792 463386
⊕ canopybeer.com

⊗ Canopy started brewing in a railway arch in Herne Hill in late 2014, with the taproom following in 2015 (open every day apart from Monday). Mostly available in keg and cans, cask does get out into pubs around south London. The taproom is the best place to get the widest range, including regular specials. ‼️LIVE ♦

Sunray Pale Ale (ABV 4.2%) GOLD
Floral, fruity, hoppy aroma. Flavour is citrusy with floral hops and sweet biscuit character. Bitterness and dryness builds on drinking. Smooth mouthfeel.
Snapper (ABV 4.8%) GOLD
Refreshing, smooth, yellow beer. Mango, lemon and green pine notes lead to a dry, bitter aftertaste with hints of tobacco/smokiness.
Full Moon Porter (ABV 5%) PORTER
Strong malt aroma with raisins, figs, dark vintage marmalade and coffee. Roasted flavour with dark treacly, dark chocolate sweetness.

Clarkshaws

Arch 497, Ridgway Road, Loughborough Junction, SW9 7EX ☎ 07989 402687 ⊕ clarkshaws.co.uk

Established 2013, Clarkshaws is a small brewery focusing on using UK ingredients for its core beers, and reducing beer miles. The beers are suitable for vegetarians and are accredited by the Vegetarian Society. All beers are unfined and may be hazy. A small taproom operates on the premises for most of the year (check before travelling). ♦

Gorgon's Alive (ABV 4%) BITTER
Unfined, golden-coloured beer with spicy hops throughout. The flavour has hints of orange and peach with a dry bitterness.
Phoenix Rising (ABV 4%) BITTER
Tawny beer with a creamy toffee nose. Bananas, pineapple, hops and caramel flavours. Dryish, short, fruity, biscuit finish.
Strange Brew No. 1 (ABV 4%) GOLD
Easy-drinking, yellow-coloured beer. Flavour is of peppery hops, tropical fruits and biscuit sweetness with a trace of bitterness.
Four Freedoms (ABV 4.3%) PALE
Coldharbour Hell Yeah Lager (ABV 5.3%) SPECIALITY
Hops and mango notes that are also present on the flavour with some butterscotch. Dryish palate.
Hellhound IPA (ABV 5.5%) IPA
Spiced and citrus notes in this unfined amber beer with a bitterness in the flavour and finish, which is dry.

Concrete Island

Pavilion Terrace, Wood Lane, Shepherd's Bush, W12 0HT ⊕ concreteislandbrewery.co.uk

Established as Small Beer Brewing in 2016 and rebranded as Concrete Island Brewery in 2020. Run from a private flat in West London and with a brewlength of just 25 litres, it is probably the smallest commercial brewery in the country. Unpasteurised, unfiltered beers are available in bottles.

Crate

▤ White Building, Unit 7, Queens Yard, White Post Lane, Hackney Wick, E9 5EN ☎ 07547 695841 ⊕ cratebrewery.com

Created as a brewpub and pizzeria in 2012, expansion later saw a move to the Brew Shed across the yard. Falling into administration in mid-2020, the Brew Shed was bought by Trumans, and Crate retreated back to the brewpub. The range of seven beers is available on keg and in bottles and cans. Beers are temporarily being brewed at Purity whilst the brew kit in the bar is refurbished. No real ale. ◢

Cronx SIBA

Unit 6, Vulcan Business Centre, Vulcan Way, New Addington, CR0 9UG ☎ (020) 3475 8848 ⊕ thecronx.com

Croydon-based microbrewery, opened in 2012, brewing a range of award-winning beers in cask, keg, bottles, cans and mini-kegs. ◆LIVE

Standard (ABV 3.8%) BITTER
Easy-drinking, brown bitter with sweetish fudge and spicy hoppiness notes throughout. Malty bitter finish with a dryness that remains.

Kotchin (ABV 3.9%) SPECIALITY
Grapefruity beer with pleasant hoppy notes. A little sweetness is balanced by a crisp, bitter finish that grows on drinking.

Nektar (ABV 4.5%) PALE
Full-bodied, dark gold pale ale. Peach with citrus, sweet biscuit and floral hops, gently fade in the lingering bitter finish.

Pop Up! (ABV 5%) PALE
Smooth, amber APA with strong tropical and grapefruit throughout. Hoppy and bitter on the palate and dry finish.

Entire (ABV 5.2%) PORTER
Dark brown porter with chocolate roast in the aroma, flavour and finish. Fruit character is of caramelised raisins and plums.

Deviant & Dandy SIBA

Arches 184 & 185, Nursery Road, Hackney, E9 6PB ⊕ deviantanddandy.com

Initially cuckoo-brewed at Enfield Brewery for the Off Broadway bar in London Fields, Deviant & Dandy started brewing at its current premises in 2018. Beer is available in bars and bottle shops and at the on-site taproom, open at the weekend. No real ale. ◢

Distortion

647 Portslade Road, Battersea, SW8 3DH ☎ 07557 307452 ⊕ distortionbrewing.co.uk

⊗ Starting in the founder's garage in south London, the brewery was installed in a railway arch in 2020. The keg range is sold directly from serving tanks in the taproom (open Thursday-Sunday). No real ale. ◢

Dog's Grandad

Arch 550, Brixton Station Road, Brixton, SW9 8PF ⊕ dogsgrandadbrewery.co.uk

Opened early 2021. The range of beers is available in keg at the taproom (open Wednesday-Sunday), some local bars, in cans from the website and bottle shops. No real ale. ◢

Dragonfly

▤ George & Dragon, 183 High Street, Acton, W3 9DJ ☎ (020) 8992 3712 ⊕ georgeanddragonacton.co.uk

⊗ Dragonfly began brewing in 2014 with a Chinese-built, vertically-stacked brewing kit, installed in the back bar of the George & Dragon. After a short time in 2019 being run by Portobello, the kit is currently unused (brewing is currently suspended).

Drop Project SIBA

Unit 8, Willow Business Centre, 17 Willow Lane, Mitcham, CR4 4NX ⊕ drop-project.co.uk

Drop Project began brewing at Missing Link (qv) in Sussex with brewing commencing at the Mitcham site in 2021. Beers are mostly available in can but also keg including regular collaboration brews with other breweries and groups. Cask is being trialled in 2022. ◢

Ealing

Unit 2, The Ham, Brentford, TW8 8EX ☎ (020) 8568 9906 ⊕ ealingbrewing.com

⊗ Opening in 2019, Ealing brews a wide variety of ever-changing styles including European beers and lagers. The current beers are available at the Owl & the Pussycat, Northfields. Cask is popular but beers also appear in keg and bottle-conditioned. ▶LIVE ◢

TW8 (ABV 5.8%) BITTER
Tawny beer with caramel malty nose. Caramel sweetness is over earthy, herbal bitterness, and with a light fruity background.

East London SIBA

Unit 45, Fairways Business Centre, Lammas Road, Leyton, E10 7QB ☎ (020) 8539 0805 ⊕ eastlondonbrewing.com

East London Brewing Company is an award-winning, 25-barrel brewery established in 2011 by Stu and Claire. The brewery brews a core range of regular beers available for cask, keg, bottles and can. Regular specials are made, including an annual green-hopped beer each September, in collaboration with Walthamstow Beer (a collective of small-batch hop growers). ◆LIVE

Pale Ale (ABV 4%) PALE
Amber beer with spicy hops, bitter lemon, tropical fruits and biscuit that are there in the dry aftertaste. Hoppy aroma.

Foundation Bitter (ABV 4.2%) BITTER
Dark amber bitter with nutty sweet toffee and caramelised orange. Earthy, hoppy finish is balanced by a sweetness that lingers.

Nightwatchman (ABV 4.5%) BROWN
Dark ruby-brown complex beer. Peach, caramelised fruit, toffee balanced by bitter, nutty and roasted malt flavours. Dry aftertaste.

Cowcatcher American Pale Ale (ABV 4.8%) PALE
Smooth pale ale. Sweet biscuit and hoppy, citrusy notes on nose and palate. Long, dry finish of earthy bitter hops.

Jamboree (ABV 4.8%) BLOND

Hazy, blond beer with a lemon-sherbet nose. Slightly bitter with malt, orange and berries. Lasting bitter, dry, citrus, hoppy aftertaste.

Quadrant Oatmeal Stout (ABV 5.8%) STOUT
Flavours of creamy chocolate and Christmas cake with an oat dryness, continuing into a long, sweet spiced fruitcake bitterish aftertaste.

East Side

Unit 5b, Elms Industrial Estate, Church Road, Harold Wood, RM3 0HU
☎ (020) 3355 1197 ☎ 07749 125264
⊕ theeastsidebrewery.co.uk

The brewery was installed in early 2020, with opening delayed until 2021. The two beers are available in keg at the on-site taproom and in bottles and cans from its website. No real ale. ✦

Essex Street

▤ **Temple Brew House, 46 Essex Street, Temple, WC2R 3JF**
☎ (020) 7936 2536 ⊕ templebrewhouse.com/brewery

☺Opened in 2014 within the Temple Brew House pub (one of the group of brewpubs run by the City Pub Company). Beers are neither filtered nor pasteurised. Also supplies some other City Pub Co pubs in London.
⊪✦

Exale SIBA

Unit 2C, Uplands Business Park, Blackhorse Lane, Walthamstow, E17 5QJ ⊕ exalebrewing.com

Originally started as Hale Brewery in Tottenham in 2017. Expansion in 2019 saw a new brewery in Walthamstow and a new name. Most famous for Krankie, the Iron Brew Sour. The core range and collaborations are available in keg and cans. Its taproom, open Thursday to Sunday, is one of the destinations on the Blackhorse Beer Mile. No real ale. ⊫✦

Fearless Nomad

▤ **Black Dog Beer House, 17 Albany Road, Brentford, TW8 0NF**
☎ (020) 8568 5688 ⊕ blackdogbeerhouse.co.uk/fearless-nomad

The Fearless Nomad Brewery is owned by Pete Brew who previously helped to set up the Big Smoke Brewery. Established in 2020, it is a small one-barrel brew plant producing a variety of different beers served in the Black Dog Beer House. There are plans to increase brewing capacity, distribute to other venues and introduce a canned range.

Five Points SIBA

61 Mare Street, London Fields, Hackney, E8 4RG
☎ (020) 8533 7746 ⊕ fivepointsbrewing.co.uk

Five Points commenced brewing in 2013 in Hackney Downs. 2018 saw successful crowdfunding which helped buy the Pembury Tavern. In 2020, the brewery moved into the existing warehouse facility in Mare Street. A second round of crowdfunding, in 2021, helped fund the addition of a taproom at Mare Street. Commitment to quality cask ale extends to a care scheme for stockists.
⊪LIVE✦

Micro Pale (ABV 2.7%) GOLD
XPA (ABV 4%) GOLD

Easy-drinking golden ale with grapefruit, biscuit and tropical fruit in aroma and flavour, fading to a spicy, hoppy bitterness.

Best (ABV 4.1%) BITTER
Balanced bitter with earthy and sweet caramel aromas. Dry, roasty nutty flavours overlaid with caramelised orange. Spicy, hoppy, bitter finish.

Pale (ABV 4.4%) PALE
Well-balanced pale ale with biscuit, lemon/grapefruit and tropical notes on nose and palate. Initial floral hops become spicy and bitter.

Railway Porter (ABV 4.8%) PORTER
Smoky, black porter with raisins, dark chocolate, plums and touch of marmalade. Lasting finish is bitter roasty dry and lingering.

Flat Iron Square (NEW)

▤ **45 Southwark Street, Borough Market, SE1 9HP**
⊕ flatironsquare.co.uk

This brewpub opened in 2021. Owned by Lagunitas (Heineken), exclusive beers are brewed for the site and possibly some of the Lagunitas range as well.

Forest Road SIBA

Unit 1a, Elizabeth Industrial Estate, Juno Way, South Bermondsey, SE14 5RW
☎ (020) 7249 7033 ⊕ forestroad.co.uk

Homebrewing started in Forest Road, E8 in 2015, going commercial at the start of 2016 by brewing at Van Eecke in Belgium. Then followed by beers being brewed at C'84 (Great Yorkshire). A brewery imported from San Francisco was installed at Deptford during 2021. The beer range is now replicated here with cask sometimes being available in local pubs. The on-site Emerald City taproom is open at weekends. ✦

Fourpure

22 Bermondsey Trading Estate, Rotherhithe New Road, South Bermondsey, SE16 3LL
☎ (020) 3744 2141 ⊕ fourpure.com

Fourpure began brewing in 2013. Beers are available in cans and kegs, unfiltered, unpasteurised and unfined. In 2018 the brewery was bought by Lion of Australia, part of Kirin of Japan. The brewery was sold in 2022 to Odyssey Inns Ltd. A substantial taproom opened along from the brewery in 2019, becoming a popular start (or end!) on the Bermondsey Beer Mile. No real ale. ⊫LIVE✦

Friendship Adventure SIBA

Unit G1, Coldharbour Works, 245a Coldharbour Lane, Loughborough Junction, SW9 8RR
⊕ friendship-adventure.com

Friendship Adventure began cuckoo brewing at a range of breweries, most recently Signal (qv). Its new brewery at Loughborough Junction opened in 2021 with an on-site taproom selling its range of keg beers. Canned beers are also available. No real ale. ✦

Fuller's

Griffin Brewery, Chiswick Lane South, Chiswick, W4 2QB
☎ (020) 8996 2400 ⊕ fullersbrewery.co.uk

⊗ The Griffin brewery has stood for more than 360 years with the Fuller's name coming from the partnership formed in 1845. Gale's of Horndean was bought in 2005 and closed a year later, the beers are now brewed at Chiswick. Dark Star of Sussex was bought in 2018 and

brewing continues there. Fuller's sold its brewing interests to Asahi in 2019 but kept its pubs and hotels. ‼ ☲ ♦ LIVE ✦

Oliver's Island (ABV 3.8%) GOLD
Well-balanced golden ale with fruity aroma and flavour. Gentle bitter hoppiness balances a sweet, malty character flavour and short finish.

London Pride (ABV 4.1%) BITTER
Well-balanced smooth bitter with orange citrus fruit, malt and hops in aroma and flavour lingering into a slightly bitter aftertaste.

Bengal Lancer (ABV 5%) PALE
Rich, creamy, well-balanced, pale brown IPA with a gold hue. Hops with a dryish bitterness harmonise with the fruit and malty sweetness that linger into the aftertaste.

ESB (ABV 5.5%) BITTER
Orange marmalade with hops, caramelised toffee and some raisin are all present in this warming, multifaceted strong brown bitter. Long, bitter, malty, dry finish.

Brewed under the Gale's brand name:

Seafarers Ale (ABV 3.6%) BITTER
A pale brown bitter, predominantly malty, with a refreshing balance of fruit and hops that lingers into the aftertaste where a dry bitterness unfolds.

HSB (ABV 4.8%) BITTER
Dates and dried fruit with some spicy hops in the nose adding to the caramelised orange and treacle in the flavour of this smooth brown beer. Malty throughout with a bittersweet finish.

German Kraft

Mercato Metropolitano, 42 Newington Causeway, Borough, SE1 6DR

Mayfair: Mercato Metropolitano, 13a North Audley Street, Mayfair, W1K 6ZA.

Dalston: Kraft Dalston, 130a Kingsland High Street, Dalston, E8 2LQ ⊕ **germankraftbeer.com**

Opening in 2017, to start with, beer was imported from its German brewery in Bavaria, Steinbach. In early 2018 the brewery officially opened and beers were replicated on-site. The core range and seasonals reflect traditional German styles including lagering for four weeks. Further breweries have opened in Mayfair and Dalston. No real ale. ✦

Gipsy Hill SIBA

Unit 8, Hamilton Road Industrial Estate, 160 Hamilton Road, West Norwood, SE27 9SF
☎ **(020) 8761 9061** ⊕ **gipsyhillbrew.com**

Gipsy Hill opened in 2014 at the same time and on the same site as London Beer Factory. It has since expanded into adjacent units and the taproom moved across the yard. A core range of four is supplemented by regular specials, available in keg and cans. Cask is occasionally produced but on a limited edition basis. It has also brewed some barrel-aged beers. ♦ LIVE ✦

Goodness SIBA

5a, Clarendon Yards, Coburg Road, Wood Green, N22 6TZ ☎ **07398 760051** ⊕ **thegoodnessbrew.co**

⊗ A community-focused microbrewery with taproom and event space since 2019. The range consists of six core beers and various one-offs. All are unfiltered and vegan-friendly which are variously available as cask, keg or can. Cask Wood Green Hopping is brewed annually with local hops from Harringey. V✦

Yes! Session IPA (ABV 4.5%) SPECIALITY

Gold, smooth rye beer. Impactful flavours of citrus, mango, perfumed hops and sweet biscuit. Finish starts bitter with a growing dryness.

Goose Island

☷ **222 Shoreditch High Street, Shoreditch, E1 6PJ**
☎ **(020) 3657 6555** ⊕ **gooseislandshoreditch.com**

The Chicago-based Goose Island brewery opened its London brewpub in 2018. The on-site kit brews a range of continually changing beers only available at the pub, including a bourbon barrel-aged barley wine. A changing real ale from the range is usually available.

Gorgeous

c/o 64 New Cavendish Street, Marylebone, W1G 8TB
☎ **07714 649988** ⊕ **gorgeousbrewery.com**

⊗ Formerly the home of London Brewing, Gorgeous inherited the brewing kit on the purchase of the Bull in Highgate, N6 in 2017. At the beginning of 2018 a newly-built brewhouse at the rear of the pub came on stream, however the brewery is currently in storage until a new location is found with beers contract brewed elsewhere in the meantime. LIVE ✦

Gravity Well

Arch 142, Tilbury Road, Leyton, E10 6RE ☎ **07833 226373** ⊕ **gravitywellbrewing.co.uk**

The brewery was installed during 2018 in a railway arch under the Gospel Oak to Barking Overground line. A bigger taproom opened in 2020 along the line by Leyton Midland Station. The range of pale ales, sours and stouts (including double and imperial versions) is available in keg and cans.

Greywood

Sandford Avenue, Wood Green, N22 5EJ
⊕ **greywoodbrewery.co.uk**

⊙ Commercial brewing began in 2020. Its one beer, the Longest Road, is named after the nearby Green Lanes, and was available at the Westbury in Wood Green. Brewing is currently suspended.

Hackney SIBA

Unit 10, Lockwood Way, Blackhorse Lane, Walthamstow, E17 5RB
☎ **(020) 3489 9595** ⊕ **hackneybrewery.co.uk**

⊗ Founded in 2011, Hackney was the oldest brewery in the area. Expansion in 2021 saw a new brewery started from scratch in Walthamstow close to the other Blackhorse Lane breweries. The core range is available on keg and in cans supplemented by regular specials. Cask is being trialled in 2022. LIVE ✦

Hackney Church SIBA

Arches 16 & 17, Bohemia Place, Hackney, E8 1DU
☎ **(020) 3795 8295** ⊕ **hackneychurchbrew.co**

Formerly known as St John at Hackney Brewery. Comprising two railway arches, the brewery is in one, the other being the taproom. Available only from the taproom for quality control, beers come from kegs or the tanks above the bar or in bottles or cans for take away. All profits are used by the trust for worthy, church-based projects at St John at Hackney. No real ale. ✦

Hammerton SIBA

Units 8 & 9, Roman Way Industrial Estate, 149 Roman Way, Barnsbury, N7 8XH
☎ (020) 3302 5880 ⊕ hammertonbrewery.co.uk

Hammerton began brewing in London in 1868, but ceased in the 1950s, and was later demolished. In 2014, a member of the Hammerton family resurrected the name and opened a new brewery in Barnsbury. Expanded in 2019 after crowdfunding, the taproom is open more regularly, now complementing its nearby bar, the House of Hammerton. **LIVE** ⬦

Bitter (ABV 4%) BITTER
N1 (ABV 4.1%) PALE
Biscuity sweet pale ale balanced by grapefruit and a building bitterness. Finish has a peppery character and is slightly dry.
Life on Mars (ABV 4.6%) RED
Ruby ale with roast, toffee and fruit aroma. Peppery hops, nutty roasty flavour with dark bitter marmalade. Dry, lingering finish.
N7 (ABV 5.2%) PALE
Full-bodied pale ale. Sweet honey with marmalade, earthy hops and a hint of apricot. Spicy, sweet finish overlaid dry bitterness.
Penton Oatmeal Stout (ABV 5.3%) STOUT
Sweet treacle and dark chocolate on the nose and rich palate. Developing dry, bitter finish that lingers long and sweet.

Howling Hops SIBA

▤ **Unit 9a, Queen's Yard, White Post Lane, Hackney Wick, E9 5EN**
☎ (020) 3583 8262 ⊕ howlinghops.co.uk

⊗ Brewing began in 2012 at the Cock Tavern in Hackney, later opening a new brewery and Tank Bar in 2015 at Hackney Wick. Beers are now widely available and cover many styles from a standard range to taproom specials; hoppy styles being the favourite. Cask beer is occasionally available. ⬦

Husk SIBA

Unit 58a, Waterfront Studios Business Centre, North Woolwich Road, West Silvertown, E16 2AA
☎ (020) 7474 3827 ⊕ huskbrewing.com

Brewing in West Silvertown, along from the Royal Docks, since 2015. The first brewery in the area, now has its taproom and newly-opened kitchen open every Thursday to Saturday. Beers are available in keg and cans, with eye-catching clip and label designs based on local landmarks. Cask beer is available on request. **LIVE** ⬦

Ignition

44a Sydenham Road, Sydenham, SE26 5QF
⊕ ignition.beer

Ignition is a not-for-profit South London brewery, which employs and trains people with learning disabilities to brew beer. An onsite taproom was opened in 2018, providing the staff with customer-facing experience. **LIVE** ⬦

Inkspot

Rookery Barn, The Rookery, 40 Streatham Common South, Streatham, SW16 3BX
☎ (020) 8679 7322 ☎ 07747 607803
⊕ theinkspotbrewery.com

Started in 2012 as Perfect Blend after a bar in Streatham, the brewery changed its name to Inkspot a few years later. Originally cuckoo brewing, brewing began at its own premises in the middle of Streatham Common in 2018. Its Art & Craft bottle shops are the best places to find the beers along with when the brewery taproom is open for 'shutters up' events. No real ale. ⬦

Jawbone

Unit C, 1 Strawberry Vale, Twickenham, TW1 4RY
⊕ jawbonebrewing.com

Brewing commenced in 2020. Beer was initially available in cans, keg is now available. The range of beers is available at the BrewDock taproom (open Thursday to Saturday) located next to a working boatyard by the River Thames. ⬦

Jeffersons

Brew Shed, 84 Verdun Road, Barnes, SW13 9AX
☎ 07960 597311 ⊕ jeffersonsbrewery.co.uk

Brewing began in 2017 at this family-run nanobrewery. Most output is in cans, which are sold online, at markets and (along with kegs) in pubs and beer festivals. A core range and around 20 seasonal or special brews are produced per year, continuing experimentation with yeast strains. Brewing is currently suspended.

Jiddlers Tipple

Office: Hornsey Park Road, Wood Green, N8 0JY
☎ 07966 527902 ⊕ jiddlerstipple.com

Started in 2019 at home with the intention of setting up a brewery in the area. Output has scaled up with brewing first at Birmingham Brewery and more recently at By The Horns Brewery.

Kentish Town

Ingestre Road, Kentish Town, NW5 1UF
⊕ kentishtownbrewery.com

Fleet Lager has been brewed at home in small batches with larger batches and other beers brewed at various London breweries. Brewing suspended in 2019 allowing the brewer to take a sabbatical in Australia, with brewing to start again on his return. No real ale.

Kernel SIBA

Arch 11, Dockley Road Industrial Estate, Dockley Road, Bermondsey, SE16 3SF
☎ (020) 7231 4516

Office: 1 Spa Business Park, Spa Road, Bermondsey, SE16 4QT ⊕ thekernelbrewery.com

Kernel was established in 2009 by Evin O'Riordain and moved to larger premises in 2012 to keep up with demand. The brewery produces bottle-conditioned and keg beers, and has won many awards for its wide, ever-changing range. A new taproom, a few arches along, opened in 2020, and in 2022 it started to sell a different Kernel cask beer each week. ▤**LIVE** ⬦

Little Creatures

▤ **1 Lewis Cubitt Walk, Kings Cross, N1C 4DL**
☎ (020) 8161 4446 ⊕ littlecreatures.co.uk

This US-style brewpub opened in 2019 under Little Creatures of Fremantle, Australia but ultimately Lion of Kirin Group ownership. A couple of changing keg house beers are available from tanks behind the bar under the Regents Canal name, along with imported Little Creatures beers. Close to the rejuvinated Coal Drops Yard development. No real ale.

London Beer Factory

Units 4 & 6, Hamilton Road Industrial Estate, 160 Hamilton Road, West Norwood, SE27 9SF
☎ (020) 8670 7054 ⊕ thelondonbeerfactory.com

London Beer Factory started brewing in 2014 using a 20-barrel plant on the same estate and at the same time as Gipsy Hill. It also runs the Barrel Project along the Bermondsey Beer Mile, showcasing its range, and providing an impressive display of barrels used for aging beer.

London Beer Lab SIBA

Arch 283, Belinda Road, Loughborough Junction, Brixton, SW9 7DT
☎ (020) 8396 6517

Brixton: Arch 41, Railway Arches, Nursery Road, Brixton, London, SW9 8BP ⊕ londonbeerlab.com

Opened in Brixton in 2013 as a bottle shop and homebrew supplies outlet, also offering brewing workshops and tastings. Commercial brewing began in Loughborough Junction in 2015 for larger batches with the shop focusing on small batch production and collaborations, available downstairs at the 14-line taproom. 🍴✦

Session IPA (ABV 4.2%) GOLD
Tip Top Citra (ABV 5%) PALE
Amber beer with citrus nose and flavour with some biscuity sweetness. The pithy bitter astringency builds in the bitter finish.

London Brewing SIBA

Bohemia, 762-764 High Road, North Finchley, N12 9QH
☎ (020) 8446 0294 ⊕ londonbrewing.com

⊠ London Brewing Co began brewing in 2011 at the Bull in Highgate. In 2014 it acquired its second pub, the Bohemia in North Finchley. Brewing began there in 2015 in a new 6.5-barrel, publicly-visible brewhouse, becoming its sole location when the Bull was sold in 2016. The brewery endeavours to increase the range of cask ales. Beer is now widely available through pub chains and the free trade. ✦✦

London Lush (ABV 3.8%) BITTER
A pale, hoppy bitter with a good balance of hop and malt and a little fruit. The finish is dry but with some lingering hoppiness.

Beer Street (ABV 4%) BITTER
Well-balanced, coppery brown best bitter with the hoppy bitterness underpinned by the caramelised malt character. Fruit is present throughout.

Hasty DDH Pale Ale (ABV 5%) PALE
Highly aromatic, citrus, dry-hopped beer with an extremely bitter, cloying, earthy aftertaste.

Long Arm

Long Arm, 20-26 Worship Street, Shoreditch, EC2A 2DX
☎ (020) 3873 4065 ⊕ longarmpub.co.uk

Opened in 2017, this brewery took over all Long Arm beers when brewing at the Ealing Park Tavern stopped. Beers are served onsite from tanks and in keg in other pubs in the ETM chain, the brewery's owners. No real ale. ✦

Macintosh

Stamford Brook Road, Stamford Brook, W6 0XH
⊕ macintoshales.com

Garage-based, 250-litre brewery, which went commercial in 2019, brewing once a week and gypsy brewing for larger batches. Beers are available in cask, keg and bottle around North and East London.

Best Bitter (ABV 4.6%) BITTER

Mad Yank SIBA

Alandale Drive, Northwood Hills, HA5 3UP
⊕ madyank.com

Brewing is done on a small, home plant, after plans to install a larger plant elsewhere fell through, and it is still searching for the right location. Mostly bottled output, with keg from time to time, often available at the Beer Asylum in Pinner.

Magic Spells

c/o 24 Rigg Approach, Leyton, E10 7QN
☎ (020) 3475 1781 ⊕ magicspellsbrewery.co.uk

Magic Spells is owned and operated by Hare Wines. The onsite brewery was removed during 2021, with the beers now being brewed at an unknown brewery. Beer is available bottled.

Mammoth

Units DG02 3&4, Hackney Bridge, East Bay Lane, Hackney Wick, E15 2SJ ☎ 07970 927272
⊕ mammothbeer.com

Mammoth began brewing in 2021 and is located in a canal-side Hackney Bridge development for local enterprises. Sometimes available in keg at the site's Hangar Bar and the Rosemary Branch pub in Islington, it is being seen more widely in London and is available in cans. No real ale.

Marlix

Berger Close, Petts Wood, BR5 1HR ⊕ marlix.co.uk

⊠ Longtime friends Mark and Alex built a sizable garden shed to contain the brewery, after brewing beer together for the past 20 years, going commercial in 2020. Beers are available in cask, keg and bottles, with names based on the TV show The Young Ones. The range can be found in local micropubs and clubs. ✦

TPP (The People's Poet) (ABV 3.5%) BITTER
Kebab & Calculator (ABV 4.2%) PALE
SPG (ABV 4.2%) SPECIALITY
Shut Up (ABV 4.7%) STOUT

Mash Paddle (NEW)

92 Enid Street, Bermondsey, SE16 3RA
⊕ mashpaddlebrewery.com

Mash Paddle opened in 2022 in a railway arch along the Bermondsey beer mile as an incubator for startup brewers. A collection of small brewing kits allows customers to brew their own beers using supplied ingredients and tapping into the expert guidance onsite. Its own beers are also available from the taproom, open at weekends. No real ale.

Meantime

Units 4&5, Lawrence Trading Estate, Blackwall Lane, East Greenwich, SE10 0AR

☎ (020) 8293 1111

Office: **Norman House, 110-114 Norman Road, Greenwich, SE10 9EH** ⊕ meantimebrewing.com

⊗ Founded in 2000, Meantime brews a wide range of continental-style beers. In 2010 the brewery relocated to larger premises in Greenwich. Taken over by SABMiller in 2015, and now owned by Asahi UK. ‼ 🍴 ♦ LIVE ✦

Mellors

Trundleys Road, Deptford, SE8
⊕ mellorsbrewing.co.uk

After a short time in Suffolk, brewing on a larger kit, Mellors has returned to London, based at the brewer's house in Deptford. ✦

Mikkeller

🍴 **37-39 Exmouth Market, Clerkenwell, EC1R 4QL**
☎ (020) 3940 4991 ⊕ mikkellerbrewpublondon.com

Mikkeller of Denmark's second bar in London (sister pub to Mikkeller Shoreditch) in collaboration with Rick Astley. It opened during 2020. Regular new beers appear in the brewpub and in bottle, but a core range of favourites is emerging. A changing cask beer from the range has started to appear on the bar during 2022.

Mondo SIBA

86-92 Stewarts Road, South Lambeth, SW8 4UG
☎ (020) 7720 0782 ⊕ mondobeer.com

⊗ Mondo began brewing in 2015. The on-site taproom (open Wednesday-Saturday) which has 15 taps, showcases the wide range of beer styles brewed throughout the year. The core, seasonal and occasional beers available in can and keg are found on the website and in the taproom. ‼ ✦

Muswell Hillbilly

4 Avenue Mews, Muswell Hill, N10 3NP ☎ 07919 567164 ⊕ muswellhillbillybrewers.co.uk

⊗ Originally homebrewers, premises were acquired in Muswell Hill in 2017. Beers are brewed in small batches incorporating locally-grown hops and named after the local area. Following the successful launch of the taproom in 2018 the brewery moved into a nearby unit in 2020, using the 500-litre brew kit formerly used by Hale, now Exale. ‼ 🍴 ✦

Tetherdown Wheat Saison (ABV 5.1%) SPECIALITY
Cloudy beer with smooth mouthfeel. Lemon sherbet and lemon notes throughout with a little malty sweetness and a gentle bitterness.
IPA (ABV 5.5%) IPA
Sweet, cloudy, fruity New World IPA with a mixture of American and UK hops, which are noticeable throughout. Smooth mouthfeel.

Mutineers

London Lane, Bromley, BR1 4HE ⊕ mutineers.beer

Established in 2018, Mutineers brews in small batches using a 100-litre brew kit. Beers can be found locally and at beer festivals in cask and bottles.

Redacted (ABV 3.8%) BROWN
Black Flag (ABV 4.5%) STOUT
Sky Pirate (ABV 4.8%) GOLD

Neckstamper SIBA

Unit 3, Cromwell Industrial Estate, Staffa Road, Leyton, E10 7QZ
☎ (020) 7018 1760 ☎ 07968 150075
⊕ neckstamper.com

Neckstamper began brewing in 2016 using a 10-barrel plant. No real ale. Beers are available in keg and cans at the taproom, and locally. ✦

Oddly

St John's Avenue, Friern Barnet, N11 3BX
✉ hello@oddlybeer.com

⊗ Originally founded on an island in the Thames at Hampton, it moved to be one of the three breweries in the Tottenham Brewery location during 2019 until later in the year. Since then it has been brewing at home and using spare capacity at other breweries such as Muswell Hillbilly. ♦

Old Fountain

🍴 **Old Fountain, 3 Baldwin Street, EC1V 9NU**
☎ (020) 7253 2970 ⊕ oldfountain.co.uk

Brewing on-site since 2016 has been sporadic and is currently suspended awaiting appointment of a new brewer. Its keg Fountain Pils is brewed by Bavo Brewery in Belgium.

Old Street

Unit 1, Queens Yard, White Post Lane, Hackney Wick, E9 5EN
☎ (020) 8525 9731 ⊕ oldstreet.beer

Brewing began in 2013 at the Queen's Head pub in King's Cross. In 2018, the brewery moved to a railway arch near Bethnal Green underground station, with an on-site taproom. A second brewing site and on-site taproom was installed in Queens Yard, Hackney Wick in 2020. The Bethnal Green site was closed in late 2021. No real ale. ✦

One Mile End SIBA

Unit 2, Compass West Estate, 33 West Road, Tottenham, N17 0XL
☎ (020) 7998 0610

Whitechapel: The White Hart, 1-3 Mile End Road, Whitechapel, E1 4TP (brewing suspended)
⊕ onemileend.com

⊗ One Mile End took over the former premises of the Redemption Brewery using a 12.5-barrel plant, brewing up to four times a week. A three-barrel plant is also occasionally in operation at the White Hart in Whitechapel, its original home. Beer is available in cask, keg and cans. ‼ 🍴 ✦

Salvation! (ABV 4.4%) GOLD
Citrus and tropical fruits are balanced by digestive biscuits in this easy-drinking golden ale. A spicy, hoppy bitterness grows.
Juicy 4pm (ABV 4.9%) BLOND
Smooth, hazy pale with strong citrus and mango flavours and a little biscuit becoming more hoppy and bitter on drinking.
Snakecharmer (ABV 5.7%) IPA
Lightly citrus-tangy and toasty-malty nose. Smooth, slightly syrupy texture and a light malty sweetness under firm and almost bone-dry bitterness.

ORA

Unit 16a, Rosebery Industrial Estate, Rosebery Avenue, Tottenham, N17 9SR ☎ 07703 563559 ⊕ orabeer.com

Originally split between Italy and cuckoo brewing at Ubrew, ORA took over Brewheadz in Tottenham in 2019. A variety of hop-forward beers are brewed complemented with styles incorporating classic Italian ingredients such as lemons, balsamic vinegar and vanilla. No real ale. ✦

Orbit SIBA

Arches 225 & 228, Fielding Street, Walworth, SE17 3HD
☎ (020) 7703 9092 ⊕ orbitbeers.com

Established in 2014 in a railway arch in Walworth, Orbit produces keg and bottled beers, focusing on traditional styles, especially continental European styles, supplemented by White Label specials. The design work and beer names relate to the founder's love of vinyl records. Cask is sometimes available in the new taproom in another railway arch across the street. LIVE ✦

Parakeet City

Meadvale Road, Pitshanger, W5 1NT
⊕ parakeetcitybrewing.com

Brewing began in 2020, based in Pitshanger, north of central Ealing. The name comes from the birdlife now inhabiting London's parks. The original Session IPA has been joined by a weaker Table Beer, both available in cans. No real ale.

Park SIBA

Unit 7, Hampden Road, Norbiton, KT1 3HG
☎ (020) 8541 1887

Office: 38 St Georges Road, Kingston upon Thames, KT2 6DN ⊕ theparkbrewery.com

⊗ Founded in 2014, naming its beers after sites in nearby Richmond Park, Park moved to larger premises in 2018. A wide variety of beers is now produced (mostly in cans). Some pubs, particularly around New Malden and Norbiton, offer a cask version. The beers are unfined and sometimes experimental in their range of hops. ‼◆LIVE ✦

Killcat Pale (ABV 3.7%) BITTER
Unfined, golden bitter with grapefruit throughout. Subtle malt and strong, hoppy, bitter notes in the flavour and short, dry finish.
Amelia (ABV 4.2%) PALE
Gallows Gold (ABV 4.5%) GOLD
Tropical fruit, orange and hop notes dominate. Malt is restrained with a gentle biscuit presence and growing bitterness. Well-balanced.
Spankers IPA (ABV 6%) IPA
An amber-coloured, hoppy, citrus, dry golden ale with a similar finish and a touch of dry bitterness.

Partizan

34 Raymouth Road, Bermondsey, SE16 2DB
☎ (020) 8127 5053 ⊕ partizanbrewing.co.uk

Started in 2012, using an ex-Kernel kit in an early taproom on the Bermondsey Beer Mile. Expanded in 2017 by moving to an arch around the corner. The extensive range (available in keg, bottles and some cans), includes hop-forward pales and IPAs, stouts and experimental saisons. No real ale. ▤◆✦

Perivale

Horsenden Farm, Horsenden Lane North, Perivale, UB6 7PQ ☎ 07850 176177 ⊕ perivale.beer

Established in 2019, the brewery is based at a farm looked after by the Friends of Horsenden Hill. As well as other events, monthly taproom openings are hosted, selling beers using hops grown on the farm, and other local foraged ingredients, available in keg and bottles. No real ale. ✦

Pillars SIBA

Unit 2, Ravenswood Industrial Estate, Shernhall Street, Walthamstow, E17 9HQ
☎ (020) 8521 5552 ⊕ pillarsbrewery.com

Brewing began in 2016 as an exclusively keg lager brewery. The range has been expanded over the years but still sticks to its lager roots. 2021 saw the introduction of 330ml stubby bottles. As well as the taproom, it runs the Untraditional Pub in the Crate development in Walthamstow. No real ale. ✦

Pinnora SIBA

Unit 2, rear of Jubilee Parade, Marsh Road, Pinner, HA5 1BB
☎ (0845) 744 2337 ⊕ pinnorabrewing.com

Family-run, craft brewery based in North West London. Refurbishment took place in 2021. The short four-hectolitre brew length means brewing focuses on seasonal beers and an evolving series of craft beers from its brew lab. This includes the official beer of the Chelsea Pensioners, released on Remembrance Sunday 2021. No real ale.

Portobello SIBA

Unit 6, Mitre Bridge Industrial Estate, Mitre Way, North Kensington, W10 6AU
☎ (020) 8969 2269 ⊕ portobellobrewing.com

⊗ Established in 2012, Portobello has since expanded into an adjacent unit and has a 7,500-hl capacity. The range of beers is available in cask with a similar range in keg, all widely available around London. The management of some pubs has recently been taken on, increasing the number to 22. ◆

Westway Pale Ale (ABV 3.8%) PALE
Pale ale with bitter orange and a touch of honey. Spicy, bitter, slightly dry finish. Aromas of fresh citrus and sweet tropical notes.
VPA (ABV 4%) PALE
Refreshing yellow best bitter with citrus fruit throughout and a little peppery hop and biscuit notes. Bitterness builds on drinking.
Star (ABV 4.3%) BITTER
Caramel toffee character throughout. Orange and apricot fruits in the flavour and notes of orange on nose. Spicy, dry, bitter finish.
Market Porter (ABV 4.6%) SPECIALITY
Rye porter with sweet chocolate and unripe plums on the palate. Finish which is of dry, dark chocolate and a little fruit.
APA (ABV 5%) PALE
Full-bodied, straw-coloured, strong ale. The honey sweetness and soft citrus fruit balanced by bitter hops. Dry aftertaste.
Stiff Lip IPA (ABV 5%) PALE
Caramelised citrus, earthy hops and sweet honey notes. Apricot and mango flavours. Finish is sweet increasingly spicy. Aromas of sulphur malt and orange.

Contract brewed for Thames Ditton Brewery:
Henry's Alt (ABV 4.5%) BITTER
Screaming Queen (ABV 5%) IPA

Pressure Drop SIBA

Unit 6, Lockwood Industrial Park, Mill Mead Road, Tottenham Hale, N17 9QP
☎ (020) 8801 0616 ⊕ pressuredropbrewing.co.uk

Run by three partners who were homebrewers but began commercial brewing in 2013, using a five-barrel plant and a small pilot kit. Moving to Tottenham in 2017, the original location is now a bar called the Experiment, operated with Verdant. Beers are mostly sold in KeyKeg and cans, cask versions are produced occasionally for beer festivals. LIVE ✦

Pretty Decent SIBA

Arch 338, Sheridan Road, Forest Gate, E7 9EF
☎ (020) 8638 6603 ⊕ prettydecentbeer.co

Brewing began in 2017 in a railway arch in Forest Gate, recently expanding into the adjacent arch. Production is mostly keg and cans in a wide range of styles. This recently expanded to include milk stouts and sours (changing weekly), and included an alcohol-free option. On demand cask beer is available for local pubs and festivals. A portion of profits is donated to charities such as Pump Aid, a water project in Africa, as well as many local charities. ‼ 🍴 ✦ LIVE ✦

Redemption SIBA

Unit 16, Compass West Industrial Estate, 33 West Road, Tottenham, N17 0XL
☎ (020) 8885 5227 ⊕ redemptionbrewing.co.uk

⊗ Redemption began brewing in 2010 on a 12-barrel plant. In 2016 it moved into a larger unit with a 30-barrel plant. Most of the beer is supplied in cask to pubs in north and central London and to beer festivals. Keg, cans and bottles are also available, some being found in North London supermarket chains. The taproom is open before matches at the Tottenham Hotspur stadium. ‼ 🍴 ✦ LIVE ✦

Trinity (ABV 3%) GOLD
Thirst-quenching golden ale with strong hops and flavours of lemon and grapefruit. Dry bitterness is balanced by sweet biscuit.

Pale Ale (ABV 3.8%) PALE
Well-balanced amber bitter with peppery hops and citrus throughout. Sweet toffee and fruit fades in the slightly dry, bitter finish.

Rock the Kazbek (ABV 4%) BLOND
Blonde beer with honey, citrus and earthy hops. Gentle dry bitterness in the lingering aftertaste where the hops become spicier.

Hopspur (ABV 4.5%) BITTER
Nicely-balanced, dark amber premium bitter. Smooth with spicy hops, caramelised toffee, orange marmalade. Dry, bitter finish.

Urban Dusk (ABV 4.6%) BITTER
Malt and earthy/spicy hops in the aroma, giving a bitter taste, that quickly fades to give a lingering sweet if astringent finish.

Fellowship Porter (ABV 5.1%) PORTER
Sultanas and damsons overlaid with dark chocolate and black treacle. Roast, liquorice aromas. Dry roasty finish with notes of pepper.

Big Chief (ABV 5.5%) IPA
Grassy and lemon character is balanced with earthy bitter hops on the palate and spicy finish. Aromas of malt lemon and earthy hops.

Roundwood Project (NEW)

Unit 24, Excelsior Studios, 17-21 Sunbeam Road, North Acton, NW10 6JP ☎ 07815 784704
⊕ theroundwoodproject.com

Brewing began in 2022 selling bottled beers. The site is sometimes open for special events. No real ale.

St Mary's

St Mary the Virgin, Elsworthy Road, Primrose Hill, NW3 3DJ
☎ (020) 7722 3238 ⊕ stmarysbrewery.co.uk

Based in the church crypt, this nanobrewery produces small-batch bottled beers sold at the adjacent farmers' market and on its website in aid of the church's youth projects. Larger batches may be produced elsewhere. The first pint was blessed by the Bishop of Edmonton and the names have an ecclesiastical theme. LIVE

Sambrook's SIBA

1 Bellwether Lane, The Ram Quarter, Wandsworth, SW18 1UR
☎ (020) 7228 0598 ⊕ sambrooksbrewery.co.uk

⊗ Sambrook's was founded in 2008 and supplies its award-winning ales throughout London. The range of beers is traditional in style and available in all formats but cask is the key focus. A move in 2021 saw a new brewery built in the redeveloped Youngs Brewery complex in central Wandsworth, including the private Ram Brewery. This ensures centuries of continuous brewing on the site has been maintained. ‼ 🍴 ✦ LIVE ✦

Wandle (ABV 3.8%) BITTER
A malty, hoppy beer with good bitterness. Some sweetness and lime and pear notes. Malty finish with supporting hops and bitterness.

American Red (ABV 4.2%) BITTER
Fruity red beer with some chocolate notes in the palate. A developing dark chocolate on the spicy hoppy, dry finish.

Pumphouse Pale (ABV 4.2%) PALE
Refreshing golden beer. Citrus aroma becoming more pronounced on the palate with spicy hops, digestives and hints of vanilla.

APA (ABV 4.5%) PALE
A light-coloured, refreshing, smooth beer with hints of malt and fruit in the flavour.

Junction (ABV 4.5%) BITTER
Caramelised citrus, toffee, sultanas and hints of roast throughout. Aroma is roasty, slightly sweet. Dry, spicy, bitter finish.

Powerhouse Porter (ABV 4.9%) PORTER
Dark brown porter with a pleasant roasted malt nose. Coffee, sweet milk chocolate, currants, spice with an underlying roasty bitterness.

Short Stack

🍺 **Cock Tavern, 315 Mare Street, Hackney, E8 1EJ**
⊕ howlinghops.co.uk

Brewing began in 2018 on kit previously used by Howling Hops and Maregade. Its name reflects the limited headroom in the cellar of The Cock Tavern, where it is situated. Same owner as Howling Hops, which moved to Queens Yard, Hackney Wick. Brewing is currently suspended.

Signal SIBA

8 Stirling Way, Beddington Farm Road, Beddington, CR0 4XN

☎ (020) 8684 6111 ⊕ signalbeerco.com

Starting in 2016, Signal's lager was the staple product in keg and cans. 2018 saw a change, and a range of cask ale is now produced along with an increased variety of keg. Available at the taproom, its Cloud Nine bar at the O2 Arena in North Greenwich, and around South London. ‼◆

Absolutely Fuggled (ABV 4%) BITTER
Yellow-coloured, easy-drinking bitter with earthy hops and orangey fruit on the sweetish nose and biscuit flavour becoming bitter.

Sticky Hoppy Pudding (ABV 4.3%) SPECIALITY
Pale brown beer with a smooth mouthfeel. Distinct caramel and biscuit aroma and flavour with a little hop and fruit.

Signature SIBA

Unit 15, Uplands Business Park, Blackhorse Lane, Walthamstow, E17 5QJ
☎ (020) 7684 4664 ⊕ signaturebrew.co.uk

Starting off cuckoo brewing in 2011, crowdfunding saw brewing start in Leyton in 2015 followed by a move to Walthamstow in 2019. Aside from the core range, specials are brewed in collaboration with music artists. These are available in the on-site taproom, now selling cask, and its bars in Walthamstow and Haggerston. ◆LIVE◆

Roadie All-Night IPA (ABV 4.3%) GOLD
Grapefruit and honey malt on nose and flavour with apricot on the palate. Fruit fades in the sweetish finish becoming dry and spicy.

Backstage IPA (ABV 5.6%) IPA
Amber, unfined IPA with fruity hops and a bitterness, overlaid with some banana and biscuity malty notes. Lingering dry finish.

Nightliner Coffee Porter (ABV 5.7%) SPECIALITY

Small Beer SIBA

70-72 Verney Road, South Bermondsey, SE16 3DH
☎ (020) 7096 2353 ⊕ theoriginalsmallbeer.com

Small Beer Brewery was set up in 2017 as the world's first to specialise exclusively in the production of low strength beers (1.0-2.7% ABV). The core range of five beers is widely available in keg and 350ml stubby bottles.

So What (NEW)

🍴 Bull & Finch, 126 Gipsy Hill, SE19 1PL
⊕ thebullandfinch.square.site

A nanobrewery was installed in the Bull & Finch in early 2022, a bar run by the Bullfinch brewery of Herne Hill. The existing So What beer has been brewed by Bullfinch.

Solvay Society

Arch 224, Dyers Hall Railway Arches, Madeira Road, Leytonstone, E11 4AF ☎ 07999 554667
⊕ solvaysociety.com

Solvay Society started in Walthamstow in 2014, transferring to Islington in 2015 before taking on the former Ha'penny Brewery kit in Aldborough Hatch in 2016. After crowdfunding it moved next to its taproom in Leytonstone in 2021. Beers, modern Belgian in style, are available in keg, bottles and cans. No real ale. LIVE◆

Southey

21 Southey Street, Penge, SE20 7JD
⊕ southeybrewing.co.uk

⊗ Southey took over the Late Knights brewery in 2017 in an old warehouse that has been an abattoir and a candle factory. The unfined beers are available in the three Beer Dispensary bars and the onsite taproom which is open Wednesday-Sunday. ◆◆

Pale (ABV 3.8%) BITTER
A fairly bitter, hoppy citrus beer balanced with some sweetness. A subtle aroma of citrus fruit and spices. Dry taste and aftertaste.

Session IPA (ABV 4.2%) GOLD
Best Bitter (ABV 4.5%) BITTER
Oatmeal Stout (ABV 5.5%) STOUT
Smooth, rich stout with expresso coffee, dark chocolate and roasted malt in the flavour. Sweet honey notes in the aftertaste.

Southwark SIBA

46 Druid Street, Bermondsey, SE1 2EZ
☎ (020) 3302 4190 ⊕ southwarkbrewing.co.uk

⊗ Southwark opened in 2014 as the first cask venue on the emerging Bermondsey Beer Mile. The range of beers is very traditional (including a 5% beer with an ever-changing hop), and is complemented by a small keg range. 🍺◆LIVE◆

Bankside Blonde (ABV 3.8%) BLOND
Refreshing golden ale with grapefruit aroma and bittersweet grapefruit flavour fading in the dry lingering finish with some peppery hops.

Routemaster Red (ABV 3.8%) RED
Lemon, honey and hints of farmyard. Spicy character develops then a dry, slightly hoppy bitter flavour with fruit notes also in the aroma.

London Pale Ale (ABV 4%) PALE
Lime and melon, caramelised biscuit on the palate and aroma. Citrus and fruit finish. Dry, fruity and spicy bitter aftertaste.

Potters' Fields Porter (ABV 4%) PORTER
Raisins, prunes, caramel, cocoa and bitter chocolate in the flavour fading in the dry roast bitter aftertaste. Roasty, caramel nose.

Mayflower (ABV 4.2%) GOLD
Pale amber with soft malty and fruity-hoppy nose, white grape, lychee and citrus. Flavour is malty with fruity hop character.

Bermondsey Best (ABV 4.4%) BITTER
Balanced best bitter. Nutty and caramelised fruit with a pithy citrus character completed by a toffee sweetness. Spicy, dry finish.

Single Hop (ABV 5%) GOLD
Harvard (ABV 5.5%) IPA
Honey sweetness throughout. Hops, sweet orange and grapefruit marmalade becoming bitter and dry.

Spartan

Arch 8, Almond Road, South Bermondsey, SE16 3LR
⊕ spartanbrewery.com

Spartan began brewing at UBrew in 2017, before moving in 2018 to premises on the Bermondsey Beer Mile vacated by Partizan Brewery. Beer is available in its on-site taproom and an increasing number of other outlets. Cask is a big part of the output having been introduced in 2019. 🍺◆

Fog of War (ABV 2.8%) GOLD

Unfined, refreshing golden beer with a hoppy citrus aroma. Flavour is dry, hoppy bitter with orange notes. Dry, bitter finish.

Son of Zeus (ABV 3.6%) MILD
River Styx (ABV 3.7%) PORTER
Malty aroma and taste. Notes of chocolate and Horlicks on the palate. Sweetness builds in the finish.

Hoplite (ABV 3.8%) BLOND
Elysian Fields (ABV 4.1%) BITTER
Aromas of vintage marmalade. Apricot and sultanas on the palate with honey sweetness that moves into a short, bittersweet finish.

Swords & Sandals (ABV 4.6%) GOLD
Golden ale with powerful citrus flavours combining with pithy and piney notes overlaid with a hoppy bitterness, by sweet biscuit.

Phalanx (ABV 5%) MILD
Pole March (ABV 5.5%) IPA

Tankleys

Correspondence: Beech Avenue, Sidcup, DA15 8NH
☎ 07901 333273 ⊕ tankleysbrewery.com

Tankleys is a cuckoo brewery based in Sidcup with a licence to brew at Beerblefish in Walthamstow. Its Australian brewer brews styles from modern takes on traditional through to avant garde, the Hawaiian Pizza Beer being particularly notable. Available in bottles, and cask locally and at beer festivals.

Golden Ale (ABV 4.5%) BITTER

Tap East SIBA

⊟ Great Eastern Market, 7 International Square, Montfichet Road, Stratford Westfield, E20 1EE
☎ (020) 8555 4467 ⊕ tapeast.co.uk

⊠ Tap East is located in Westfield Stratford City Shopping Centre, opposite the entrance to Stratford International Station. Brewing began in 2011 using a 2.5-barrel plant. One-off and collaborative beers with other breweries are also produced. Beers are available on-site or at Utobeer cage in Borough Market. ☒♦

Tiny Vessel

Unit 505, Platts Eyot, Hampton, TW12 2HF ☎ 07888 730210 ⊕ tinyvessel.co.uk

⊠ Tiny Vessel is a 1.5-barrel brewery established in 2016 on Platts Eyot, an island on the River Thames near Hampton. All beers are unfiltered and unfined, mostly available bottled or in keg, although at least one beer is usually available on cask in the Northumberland Arms, Brentford. LIVE

Dark Matter (ABV 4.5%) PORTER
Black porter, malty with chocolate and coffee notes. Malty finish with supporting hops and bitterness. Roasted, dry, bitter finish.

Truman's

c/o 1 Priestley Way, Walthamstow, E17 6AL
☎ (020) 8533 3575 ⊕ trumansbeer.co.uk

Once a glorious name in the history of British brewing – at one time the greatest output of any brewery in the world! Originally operating from 1666 to 1989, it was reborn in 2013. Beer is contract brewed. ♦LIVE ♦

Twickenham SIBA

Unit 6, 18 Mereway Road, Twickenham, TW2 6RG
☎ (020) 8241 1825 ⊕ twickenham-fine-ales.co.uk

⊠ Established in 2004, Twickenham Fine Ales is London's oldest, independent, standalone brewery. Operating a 25-barrel plant, the styles are traditional with a modern twist and output is predominantly cask. It opens on match days for the rugby fans going to the nearby stadium. ‼☒♦◆

Grandstand Bitter (ABV 3.8%) BITTER
Amber bitter with apricot and touch of orange fruits. Floral hops become spicier and bitter, balanced by a biscuity sweetness throughout.

Red Sky (ABV 4.1%) RED
Naked Ladies (ABV 4.4%) BLOND
Biscuit, stone fruit, pine and citrus, aromas and flavours. Bitter palate with a long-lasting slightly astringent bitter finish.

Two Tribes

Unit 4, Tileyard Studios, Tileyard Road, Barnsbury, N7 9AH
☎ (020) 3955 6782 ⊕ twotribes.co.uk

Brewing started in the old King's Brewery in Horsham in 2015, moving to the new London brewery north of King's Cross in 2018. It brews both on-site, and using third parties. The name is based on the idea of collaboration. Beers are sold around London, Horsham and Leeds as well as in its new taproom (adjacent) which offers outside drinking in shipping containers with camp fires and 'live-fire' food, plus music events. No real ale. ☒◆

Up The Creek

⊟ Up The Creek Comedy Club, 302 Creek Road, Greenwich, SE10 9SW
☎ (020) 8858 4581 ⊕ up-the-creek-brewery.co.uk

Up The Creek began brewing in 2018 (as Greenwich Brewery) using a three-barrel plant and is situated in the front part of the bar area of the Up the Creek Comedy Club. The beers are available in the bar and the range was updated in 2021 on the appointment of a new brewer. Please note, entrance may be restricted to ticket holders for some events. LIVE

Urban Alchemy

York Road, New Barnet, EN5 1LJ ☎ 07894 452263
⊕ urban-alchemy-brewing.co.uk

⊠ Urban Alchemy started brewing commercially in 2019 and was established by a group of friends with years of brewing experience between them. A bespoke three-barrel plant is used. Beers are supplied to local pubs and beer festivals but are likely to be KeyKeg, whilst Cask is occasionally produced. All beers are suitable for vegans. Bottle-conditioned beers are available for delivery. LIVE V

Villages

21-22 Resolution Way, Deptford, SE8 4NT
☎ (020) 3489 1143 ⊕ villagesbrewery.com

Established in 2016 by brothers Archie and Louis Village. Predominantly keg and canned beers although some cask may be available. ☒♦

Volden SIBA

77 Malham Road, Forest Hill, SE23 1AH
☎ (020) 8684 4492 ⊕ volden.co.uk

⊠ Volden produce cask beer for the Antic Pub Collective pubs. Originally taking over the Clarence & Fredericks brewery in Croydon in 2015, a new brewery was installed in Forest Hill in 2020 which is still to be commissioned so beer is brewed elsewhere. The two

core beers are supplemented by seasonally-named specials along with a clutch of football-focused pales. Brewing is currently suspended. ♦

Werewolf SIBA

Arch 87, Randolph Street, Camden Town, NW1 0SR
⊕ werewolfbeer.com

First cuckoo brewed in 2020 at Little Creatures, Kings Cross, followed at the end of the year on a nanobrewery in the basement of the Rose & Crown in Kentish Town. Brewing started in a railway arch in Camden Town in early 2022. No real ale.

Wild Card SIBA

Unit 2, Lockwood Way, Blackhorse Lane, Walthamstow, E17 5RB
☎ (020) 8935 5560 ⊕ wildcardbrewery.co.uk

⊠ Wild Card began brewing in 2013, initially using spare capacity at several breweries in and around London. After brewing at its Ravenswood site, production moved to its Lockwood site in 2018 along with increasing the capacity of the brewery. Both sites remain popular taprooms at the weekend. Real ale was re-introduced in 2021. 🍺♦

Best (ABV 4.2%) BITTER
Amber brown bitter. Sweet, with caramel toffee and notes of orange and sultanas. Spicy, dry finish with a gentle bitterness.
Pale (ABV 4.3%) GOLD
Peach and citrus on the nose. Grainy mouthfeel, taste is slightly sweet, with pineapple, citrus and earthiness. Finish is dry and bitter.

Wimbledon SIBA

Unit 8, College Fields Business Centre, 19 Prince Georges Road, Colliers Wood, SW19 2PT
☎ (020) 3674 9786 ⊕ wimbledonbrewery.com

⊠ Set up by Mark Gordon after a 23 year career in the City, Wimbledon began production in 2015, with former Young's and Fuller's brewer Derek Prentice at the helm of a brand new, 30-barrel plant. The brewery expanded in 2017 with two new 60-barrel fermenters, and further

expanded in 2018 with an additional 60-barrel fermenter. Some beers are inspired by the original Wimbledon Brewery, destroyed by fire in 1889. Keg and canned beers are unfiltered and conditioned. ‼🍺♦LIVE♦

Common Pale Ale (ABV 3.7%) BITTER
A hoppy bitter beer, with supporting malt and citrus notes with a balanced finish.
Copper Leaf Ale (ABV 4%) RED
Caramelised toffee, roast, raisins and citrus is complemented by a dry, spicy bitterness with a slightly dry, spicy finish.
SW19 (ABV 4%) BLOND
A strong hop presence, with hints of lemon and pineapple, balanced by malt flavours. A dry aftertaste developed.

Workshy (NEW)

Cardigan Road, Richmond, TW10 6BW
⊕ workshybrewing.co.uk

Workshy started using the facilities at UBrew in 2018 and brewed elsewhere when UBrew closed in 2019. The home kit was upgraded during 2021 and the beers now come from there. Available locally in keg and wider afield in cans. No real ale.

Wrong Side of the Tracks

South Park Crescent, Catford, SE6 1JW ☎ 07493 499494 ⊕ wrongsideofthetracks.beer

A small-scale home brewer selling bottled beers commercially to local bottle shops and from its webshop with delivery to the local area. Brewing is currently suspended.

Zerodegrees SIBA

🏠 **29-31 Montpelier Vale, Blackheath, SE3 0TJ**
☎ (020) 8852 5619 ⊕ zerodegrees.co.uk

A chain of four brewpubs, the first began brewing in 2000 in Blackheath, London. Each incorporates a computer-controlled, German plant producing unfiltered and unfined ales and lagers. All beers use natural ingredients, are suitable for vegetarians, and are served from tanks using air pressure (not CO2). ♦♦

Prince of Wales Townhouse, W6: Hammersmith (Photo: Jim Linwood / Flickr CC BY 2.0)

South East

The South East offers a charming selection of memorable activities, not least a visit to Britain's oldest brewery, Shepherd Neame in Faversham, Kent. Walk the Ridgeway along the North Wessex Downs and Chilterns, and enjoy an ancient landscape crowned with the incredible chalk hill figure, the White Horse of Uffington. Or make the most of modern technology to take the solar-powered Electra narrowboat along the Grand Union Canal in Milton Keynes.

You could do worse than stop for a pint and a bite to eat at the Bell Inn at Aldworth. Set high on the Berkshire Downs, this picturesque venue is the only Grade II-listed public house in Berkshire. Named CAMRA National Pub of the Year in 1990 and 2019, it has been run by the Macaulay family for 250 years. Another must-visit is the Butcher's Arms in Herne. Founded by Martyn Hillier in 2005 it was the UK's first micropub.

The urban landscapes of the region are also a heady mixture of old and new. Oxford's dreaming spires are home to the Teardrop nanopub and bottle shop by Church Hanbrewery, while just a short drive away you can visit the historic Hook Norton Brewery. Founded in 1849, it is one of the oldest independent breweries in the country. They still use shire horses and dray to deliver their beer to local hostelries, and brewery tours, as well as a brewery museum, are available on site.

This region has a strong tradition of innovation and quality. Sample a wide range for yourself at the Reading Beer & Cider Festival. It is held in the spring and is one of the largest real ale festivals in the country as well as the home of the National Cider & Perry Championships. Harvey's of Lewes has a proud heritage, and its Imperial Extra Double Stout was named the Champion Bottled Beer in CAMRA's 2022 competition. Also worth a visit, the Loddon Brewery, north of Reading, was one of the first microbreweries to be founded following the introduction of Progressive Beer Duty in 2002.

Siren Craft Brew in Berkshire is one of the most exciting modern breweries in the UK, winning Supreme Champion Beer of Britain in 2018 with Broken Dream. If you want to know how nitrogen dosers, hop cannons and spinbots can add a unique flavour to your beer-drinking experience, this is the brewery for you.

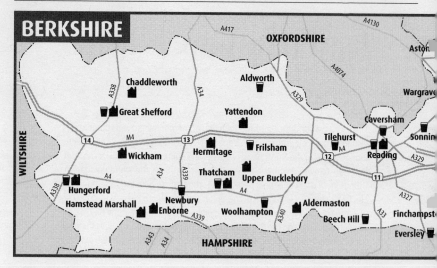

Aldworth

Bell Inn ★ Ⓛ

Bell Lane, RG8 9SE (250yds off B4009)
☎ (01635) 578272
Arkell's 3B; Indigenous Baldrick; Rebellion Roasted Nuts; 3 changing beers (sourced locally; often Delphic) Ⓗ
This is a pub in the true sense – welcoming, inclusive and sociable. A long-standing Guide entry, it has been recognised by CAMRA as having a nationally important historic pub interior. The hatch servery greets you as you enter. Expect to share tables with locals and visitors alike, all happy to join in the conversation. Three of the six handpumps showcase small breweries within a 25-mile radius, including the on-premise microbrewery. Filled rolls and puddings are available lunchtimes only. A repeat winner of CAMRA National Pub of the Year.
Q ☺ ♿ ◑ ♣ ♠ P ♥

Aston

Flower Pot

Ferry Lane, RG9 3DG SU7841984213
☎ (01491) 574721
Brakspear Gravity; Ringwood Boondoggle; 2 changing beers Ⓗ
Charming rural inn set in the heart of the village, close to the River Thames with beautiful views of the countryside. The large, popular garden is a picture in summer, providing a welcoming place to enjoy food and well-kept beers. In the public bar and restaurant you will find an eclectic display of aquatic taxidermy. Licensees Tony and Pat have been here over 30 years and are Brakspear's longest-serving tenants in a single pub.
Q ☺ ❀ 🛏 ◑ ♣ ♠ P 🚏 ♥ 🛜

Beech Hill

Elm Tree

Beech Hill Road, RG7 2AZ SU6950364118
☎ (0118) 988 3505 ⊕ theelmtreebeechhill.co.uk
Ringwood Boondoggle; Timothy Taylor Landlord Ⓗ
Part pub, part restaurant, the Elm Tree is popular both with locals and visitors from further afield. Diners come to this gastropub to enjoy quality food, but drinkers are equally welcome at the bars. The cosy interior features some lovely murals, a small collection of bells and a real

fire. Elaborate decking outside includes palm trees and mood lighting, with spectacular countryside views. The pub may close early on Sunday if quiet. ☺ ❀ ◑ ♦ ♿ P ♥ 🛜

Binfield

Victoria Arms 🍷

Terrace Road North, RG42 5JA (100yds S of jct with Tilehurst Lane)
☎ (01344) 483856 ⊕ victoriaarmsbinfield.co.uk
Dark Star Hophead; Fuller's London Pride, ESB; 1 changing beer (sourced locally; often Elusive, Rebellion, Stardust) Ⓗ
This lively Fuller's local with a single bar warmed by a real fire in winter has a wall and beams covered with a collection of old beer bottles. The spacious terraced garden, reached down a set of side steps, is pleasant in summer and has a large heated marquee. Traditional food is available, with a popular roast on Sunday until early evening. The pub is dog friendly and can get busy on occasion. Local CAMRA Pub of the Year 2022.
☺ ❀ ◑ ♦ P 🚏 (150,151) ♥ 🛜

Bracknell

Newtown Pippin Ⓛ

Ralphs Ride, Harmans Water, RG12 9LR
☎ (01344) 426298 ⊕ thenewtownpippin.com
Rebellion IPA; 2 changing beers (sourced locally; often Hogs Back, St Austell, Twickenham) Ⓗ
This family-focused pub is a well-deserved new entry in the Guide, thanks to new licensees who have reinvigorated real ale sales by offering a wide range of high-quality local beers. The interior has been extensively refurbished to provide two pleasant bars with a new focus on food. The pub has become a true asset to the community with weekly quiz nights and music events. ☺ ❀ ◑ ≠ (Martins Heron) ♠ P 🚏 (156) ♥

Old Manor Ⓛ ✅

Grenville Place, RG12 1BP (at College roundabout jct with Church Rd)
☎ (01344) 304490
Greene King Abbot; Ruddles Best Bitter; Sharp's Doom Bar; 5 changing beers (sourced nationally; often Loddon, Rebellion, Windsor & Eton) Ⓗ
A Wetherspoon pub in a genuinely old building which has deservedly been in the Guide for more than 20 years

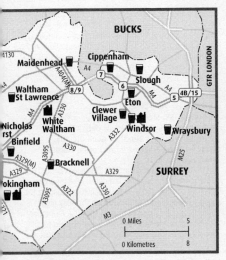

Occasional live music and two sports TVs provide entertainment. The nearby public car park is free.
Q❀♣♦P�%(5) ☻ ♣

Clewer Village

Swan 🅛
9 Mill Lane, SL4 5JG
☎ 07458 300026 ⊕ theswanwindsor.co.uk
Windsor & Eton Guardsman; 2 changing beers (sourced nationally; often Windsor & Eton) 🅗
Just 15 minutes' walk from Windsor town centre, this 18th-century village free house has been renovated following closure of over three years. Purchased as a community interest company, it has become the hub of the village and now provides coffee mornings, cribbage, quiz nights, a cycle hub, occasional music and a book club. Renovations are almost finished, with a new kitchen offering freshly cooked food.
Q❧❀%(71,702) ☻ ♣

Eton

George Inn 🅛 ✅
77 High Street, SL4 6AF
☎ (01753) 861797 ⊕ georgeinn-eton.co.uk
Windsor & Eton Knight of the Garter, Windsor Knot, Guardsman, Conqueror; 2 changing beers (sourced locally; often Windsor & Eton) 🅗
Windsor & Eton Brewery's first pub is popular with tourists and locals alike. It offers six of the brewery's beers, the range subject to change when special or seasonal ales become available. Wooden floors and lighting supplied by carriage lamps and candles help to create a warm, comfortable ambience. Breakfast is served every day. The Hop House, a separate building in the beer garden, is available for private functions. Accommodation is in eight en-suite rooms.
Q❧❀⇌①●≢(Windsor & Eton Riverside) ➎(10) ☻ ♣

Eversley

Tally Ho 🅛
Fleet Hill, RG27 0RR (on A327 jct with B3348)
☎ (0118) 973 2134
House beer (by St Austell); 4 changing beers (sourced regionally; often Andwell, Frome, Hogs Back) 🅗

and is something of an oasis in the town centre. It has a variety of drinking areas. Knowledgeable and friendly staff serve an ever-changing range of guest beers and the pub welcomes suggestions for new beers.
❧❀①&≢P%(4,53) ♣

Caversham

Fox & Hounds 🅛
51 Gosbrook Road, RG4 8BN
☎ 07915 540926 ⊕ thefoxcaversham.com
6 changing beers (often Oakham, Siren, Wild Weather) 🅗
This is a popular and lively community hub, offering six changing beers and eight craft keg lines from local and independent breweries, plus up to four ciders and perries and a good selection of cans and bottles. Extensive outside areas are covered and heated. A blue plaque commemorates the day in 1960 when John Lennon and Paul McCartney performed a gig here as the Nerk Twins.
❧❀①♣♦P%☻ ♣

Griffin 🅛 ✅
10/12 Church Road, RG4 7AD
☎ (0118) 947 5018
Greene King IPA, Abbot; 3 changing beers (often Loddon, Rebellion) 🅗
There has been a pub on this site since the 1800s (when eels were fished in the nearby River Thames and brought here to be sold). The current building dates from 1916 and offers good food and ale, with numerous specials on the chalkboards and regular themed produce weeks. The spacious interior and heated rear patio garden provide plenty of choice for a quiet drink or a big family meal. There is usually a LocAle at the bar. ❧❀①&♦P%☻ ♣

Cippenham

Barleycorn 🅛
151 Lower Cippenham Lane, SL1 5DS
☎ (01628) 603115
6 changing beers (sourced nationally) 🅗
Refurbished traditional single-bar pub that caters well for a strong local following. Six guest beers always include one from Rebellion plus a strong ale. The rest are from both national and local breweries, along with a regularly changing real cider plus a choice of fruit ciders. A large collection of bottles and jugs features around the walls.

REAL ALE BREWERIES

Bond Brews Wokingham
Bucklebury Upper Bucklebury
Butts Great Shefford
Delphic Thatcham
Double-Barrelled ◆ Reading
Elusive ◆ Finchampstead
FutureState Reading (NEW)
Hermitage Hermitage
Indigenous Chaddleworth
INNformal Hungerford
Outhouse ◆ Wokingham
Renegade ◆ Yattendon
Saviour ▤ Hamstead Marshall
Siren ◆ Finchampstead
Stardust ◆ White Waltham
Swamp Bog Enborne
Two Cocks Enborne
Wickham ▤ Wickham
Wild Weather Aldermaston
Windsor & Eton ◆ Windsor
Zerodegrees ▤ ◆ Reading (brewing suspended)

A free house with extensive gardens and large car parks on the border of Berkshire and Hampshire. It has a well-regarded restaurant and is popular for food at weekends and during holiday periods. The bar serves up to four real ales from local and regional breweries and one local real cider. Families with children and dogs are warmly welcomed, with plenty of space to roam the gardens and woods around the pub on the edge of the river. Q❄🌞◑👦🚲●P🚬(92)❀🐾🛜

Frilsham

Pot Kiln 🛱

Chapel Lane, RG18 0XX (on road between Yattendon and Bucklebury) SU552731

☎ (01635) 201366 🌐 potkiln.org

Indigenous Chinwag, Tickety-Boo; house beer (by West Berkshire); 1 changing beer (sourced locally; often Indigenous) 🖻

This well-established country inn is a delightful gem and a top destination for lovers of excellent food – game is a speciality – and wine. Great beer, primarily sourced from Indigenous Brewery, and delicious bar meals are served from the timeless front bar. Although hidden away, deep in the West Berkshire countryside, the pub sits in an idyllic and sunny position overlooking fields. Passing walkers and horse riders often stop by for refreshment. On summer weekends a popular Country Kitchen operates in the extensive garden. Q🌞🛏◑👦🐾🛜

Great Shefford

Great Shefford 🛱

Newbury Road, RG17 7DS

☎ (01488) 648462 🌐 thegreatshefford.com

6 changing beers (sourced nationally; often Indigenous, Otter) 🖻

Adjacent to the River Lambourn, this large, friendly pub has both a restaurant and lounge where food is available, as well as a long bar for those who are just drinking. Outside, there is plenty of seating including a large terrace complete with canopy. Up to six cask ales are on offer including at least one from a local brewery. Situated between Hungerford and Wantage, the pub is popular with walkers and cyclists. 🌞❄◑👦P🚬🐾🛜

Hungerford

John o' Gaunt 🛱 ✅

21 Bridge Street, RG17 0EG (30yds N of canal bridge)

☎ (01488) 683535 🌐 john-o-gaunt-hungerford.co.uk

House beer (by INNformal); 7 changing beers (sourced regionally; often INNformal, Oakham) 🖻

A 16th-century listed town centre free house and brew pub. There are eight handpumps for ale, four for beers from the pub's own brewery, INNformal. The range changes constantly and is complemented by a large selection of real ciders and bottled beers from around the world. Quality locally sourced food is available lunchtimes and evenings, all day at weekends. Outside, there are heated tiki tents and a garden area with seating, complete with a bar and kitchen serving street food. Q🌞❄◑⇌♣●P🚬🐾🛜

Maidenhead

Bear 🛱 ✅

8-10 High Street, SL6 1QJ

☎ (01628) 763030

Greene King IPA, Abbot; Sharp's Doom Bar; 3 changing beers (sourced nationally) 🖻

A short walk from the town hall, this former coaching inn became a Wetherspoon house in 2009 and has an open-plan bar with several different seating areas, including a licensed outside space at the front. There is additional seating on the upper floor. The 10 handpumps dispense up to six guest ales, many from local breweries. Ciders are also available. 🌞❄◑👦⇌🚬🐾🛜

Craufurd Arms 🛱

15 Gringer Hill, SL6 7LY

☎ (01628) 675410 🌐 craufurdarms.com

Rebellion IPA; West Berkshire Good Old Boy; 2 changing beers (sourced locally; often Stardust, Windsor & Eton) 🖻

This pint-sized local was the 50th community owned pub in the country. The building, just outside the town centre, dates back to the 1800s. It hosts activities including live music, cribbage, darts and a quiz on Thursday night. Three TV screens show Sky and BT Sports. A former local CAMRA Pub of the Year, the pub is well known for its friendly atmosphere and fine selection of local real and craft ales. 🌞❄⇌(Furze Platt)♣P🚬(5,8)🐾🛜

Maiden's Head 🛱

34 High Street, SL6 1QE

☎ (01628) 784786 🌐 themaidenshead.co.uk

4 changing beers (often Rebellion, Stardust, Windsor & Eton) 🖻

Large single-room high street pub, with separate seating areas. It offers four constantly rotating guest ales, with an emphasis on local breweries, plus keg craft beers (two American), as well as a range of world bottled beers. Food includes locally sourced beef burgers and filled wraps. Outside, there is a beer garden at the back. Terrestrial TV shows some events and live music is hosted at the weekend. Dogs are welcome outside. 🌞❄◑👦⇌♣🚬🐾🛜

North Star 🛱

91 Westborough Road, SL6 4AP

☎ (01628) 622711

Timothy Taylor Landlord; 2 changing beers (sourced locally; often New Wharf) 🖻

A very friendly traditional back-street pub with two bars – a busy public bar with TV and darts, and a lovely quiet lounge. The North Star is an Asset of Community Value (ACV) and CAMRA accredited for serving consistently well-kept real ales, including a LocAle. Darts and cribbage are played. There is a quiz every other Thursday evening and occasional live bands are hosted. Outside, there is a patio area to the front. Q❄🌞♣🚬(5)🐾🛜

Newbury

Bowler's Arms

Enborne Street, Wash Common, RG14 6TW (between Enborne Lodge Lane and Wheatlands Lane)

☎ (01635) 47658 🌐 thebowlersarms.co.uk

Fuller's London Pride; St Austell Tribute; Timothy Taylor Landlord 🖻

Located within the recently built Falkland Cricket Club pavilion, the bar is light with tall windows overlooking the tree-lined ground. The spacious, contemporary interior contains well-spaced tables and a cricket themed wall. Pool is played and sporting events can be viewed on several screens. Outside, the sheltered terrace has black rattan furniture and wide views. This community asset enjoys an elevated setting on Newbury's southern outskirts, with country footpaths nearby. The menu includes sausages, burgers, pasta, curry and salads. ❄🌞◑👦P🚬🛜

Catherine Wheel Ⓛ

35 Cheap Street, RG14 5DB

☎ (01635) 569897 ● thecatherinewheel.com

6 changing beers (sourced regionally; often Loddon, Sherfield Village, Wild Weather) Ⓗ

Run by the current landlord since its refurbishment in 2014, this town-centre pub serves a changing selection of beers from six handpumps on the main bar plus additional cask ales on stillage in the courtyard. It also offers a large range of craft and continental beers, local and national ciders and artisan gins. The food menu is based around Pieminister pies. A former winner of local CAMRA Pub of the Year and four times Cider Pub of the Year. ⏰🕭🌢◗≈♣🕭🐾⛱🗢❄🖵🞋

Cow & Cask Ⓛ

1 Inches Yard, Market Street, RG14 5DP (SE of pedestrian crossing at corner of Market St and Bartholomew St)

☎ 07517 658071

3 changing beers (sourced regionally; often Indigenous, Loddon, XT) Ⓖ

Berkshire's first micropub is a small and friendly establishment where conversation flourishes. Three to four regionally sourced ales are available on stillage, often from Indigenous, Loddon and XT breweries. A large blackboard lists the range of drinks available and the current total of different beers served since opening in 2014. There are several tables outside for use in fine weather. Close to Newbury's railway station and cinema. Q≈♣🕭🖵(2) ❄

King Charles Tavern

54 Cheap Street, RG14 5BX

☎ (01635) 36695 ● kctavern.com

House beer (by Greene King); 7 changing beers (sourced nationally; often Greene King, Oakham, Vale) Ⓗ

This smart town centre pub has recently undergone a stylish internal renovation. It has retained its range of, and reputation for, well-kept beers, served from a central bar directly above the cellar. A house ale is always available alongside up to seven changing cask ales, sourced nationally. Hot and cold bar snacks are served throughout the week, as well as a popular roast on Sunday. A former local CAMRA Pub of the Year. ⏰🕭🌢◗≈🖵🞋❄🗢

Lion Ⓨ ◉

39 West Street, RG14 1BD

☎ (01635) 528468 ● thelionatnewbury.co.uk

Wadworth 6X, Horizon; 5 changing beers (sourced nationally; often Oakham, Rudgate, Tiny Rebel) Ⓗ

The father-and-son team have transformed this friendly, traditional back street local into a real ale destination pub. In addition to Wadworth 6X and Horizon, up to four guest beers, sourced nationally, are served, often from Oakham, Tiny Rebel and Rudgate breweries. Real cider is occasionally available. Tex-Mex food is served until evening. Sport is shown on several TV screens. A popular quiz night is held on Thursday. Local CAMRA Pub of the Year winner. ⏰🕭🌢◗≈♣❄🗢

Lock, Stock & Barrel

104 Northbrook Street, RG14 1AA (alleyway 20yds NW of the canal bridge)

☎ (01635) 580550 ● lockstockandbarrelnewbury.co.uk

Fuller's London Pride; 4 changing beers (sourced regionally; often Dark Star, Fuller's) Ⓗ

Located adjacent to the Kennet and Avon Canal, close to the town centre, with a contemporary interior. Canal-side and roof terrace seating provides views across the lock basin to St Nicolas Church (blankets provided). There is

regular live music and a pub quiz, with families welcome until 9pm. Beers are selected from the Fuller's range including Gale's and Dark Star. Traditional pub food is freshly cooked to order. ⏰🕭🌢◗❄≈🖵🐾❄🗢

Reading

Alehouse Ⓛ

2 Broad Street, RG1 2BH

☎ (0118) 950 8119

9 changing beers (sourced locally) Ⓗ

Popular town-centre drinking establishment that always leaves an impression on visitors with its quirky wooden fixtures and reclaimed wooden floor. As a champion of microbreweries, both local and further afield, rare and unusual ales and beer styles are frequently found on the handpumps. A selection of real ciders, perries and mead is also available. Often busy around the bar area, those wishing for a more peaceful drink can take advantage of the secluded snugs at the back of the pub. ⏰≈🕭🔸♣🞋🖵❄

Allied Arms Ⓛ

57 St Mary's Butts, RG1 2LG

☎ (0118) 958 3323 ● allied-arms.co.uk

Loddon Hullabaloo; 4 changing beers Ⓗ

A town-centre pub dating from around 1828, with two cosy bars entered through the side passage, not the front door. An enhanced range of up to 10 ales is available every weekend. The large walled garden is a popular refuge from the chaos of the town, with patio heaters for colder nights. A wide and interesting selection of music is available on the jukebox. The pub hosts a regular charity quiz. ⏰🕭≈🔸◗🖵🐾❄🗢

Greyfriar Ⓛ

53 Greyfriars Road, RG1 1PA

☎ (0118) 958 0560 ● thegreyfriarreading.co.uk

4 changing beers (often Elusive, Siren, Stardust) Ⓗ

A traditional yet modern-looking pub with eight handpumps and 14 keg lines, offering an impressive choice of ales from local independent breweries. Bottled and canned beers also come from countrywide and foreign suppliers. Tap takeovers and meet the brewer events are held on occasion. The pub also offers a permanent selection of more than 40 gins. A quiz night is held every other Monday. Convenient for the railway station and popular for an after-work pint. ⏰◗≈🔸♣🖵❄🗢

Moderation

213 Caversham Road, RG1 8BB

☎ (0118) 375 0767 ● themodreading.com

Sharp's Doom Bar; Timothy Taylor Landlord; 2 changing beers (sourced nationally) Ⓗ

A smart pub popular with local residents and office workers. Décor in the airy interior is a fusion of east meets west, with comfy sofas and wooden tables. There is a large decked garden and smoking area to the rear, plus roadside tables at the front. Food is a mixture of English and Thai cuisines, with regular offers including steak night and two-for-one on main courses on Monday. Quiz night is Sunday. ⏰🕭🌢◗≈♣🖵🗢

Nag's Head Ⓛ

5 Russell Street, RG1 7XD

☎ 07765 880137 ● thenagsheadreading.co.uk

12 changing beers Ⓗ

With a wide range of real ales, real cider and perry always on offer, visitors are sure to find something to their taste here. There is also a craft beer wall, with vessel and dispense indicated on the adjacent blackboard. A selection of board games is available for

those wanting to while away a few sociable hours. The pub gets busy on Reading FC match days. A regular in CAMRA's National Pub of the Year awards.
ᗌ❀◖◗≉(West) ⊖♣♨➡❀᚛

Park House (University of Reading) ⅃

Park House, Whiteknights Campus, RG6 6UR
☎ (0118) 378 5098
1 changing beer (often Rebellion, Siren, Titanic) Ⓗ
The university's old senior common room is open to the general public. Five ales, mostly LocAle, in an array of styles are usually available. The bar is popular with the more mature university community and can get busy in the early evening. The large outdoor seating area is perfect for a quiet drink in the evening sun. Visitors' vehicles are allowed on campus after 5pm Monday to Friday and all day at the weekend – however a regular bus service drops off inside the campus. Ring ahead to check opening times. Payment is card only.
Q ᗌ❀◖◗க♣➡(21,21A) ❀᚛

Retreat

8 St John's Street, RG1 4EH
☎ (0118) 376 9159 ⊕ theretreat.pub
Harvey's Sussex Best Bitter; 4 changing beers (often Butcombe, Sharp's) Ⓗ
This well-loved back-street boozer has been recently refurbished. A good range of real ales is squeezed onto the small bar – the landlord tends to concentrate on well-known regional brands, however there is a good range of more eclectic choices available in bottles, including continental beers, as well as a number of ciders. Locally renowned for regular live music and local events.
Q ᗌ◖◗க♣➡

Three Guineas

Station Approach, RG1 1LY
☎ (0118) 957 2743 ⊕ three-guineas.co.uk
Fuller's Oliver's Island, London Pride, ESB; Gale's Seafarers Ale; 4 changing beers (often Butcombe, Windsor & Eton) Ⓗ
Designed by Isambard Kingdom Brunel, the Three Guineas is a Grade II-listed pub in the old ticket hall of Reading railway station. Thoroughly refurbished by Fuller's a few years ago to a high standard, it features ornate tiling, old railway memorabilia and a selection of classic clocks. There is a large outdoor seating area at the front but this does not have direct access to the station platforms. ᗌ❀◖◗க≉⊖♨❀᚛

Weather Station ⅃

19 Eldon Terrace, RG1 4DX
☎ (0118) 958 3750 ⊕ wildweatherales.com/taproom
1 changing beer (often Wild Weather)
The former Eldon Arms was unexpectedly reopened in 2019 combining a dual role as a tap for the Wild Weather Brewery and a back-street pub, 10 minutes' walk from the centre of town. While majoring on KeyKeg craft beers from the UK and overseas, there are always a couple of Wild Weather real ales on offer. The unashamedly modern decor features various cartoon art prints. Payment is by card only. ᗌ❀♣♨❀᚛

St Nicholas Hurst

Wheelwrights Arms ✅

Davis Way, RG10 0TR (off B3030 opp entrance to Dinton Pastures)
☎ (0118) 934 4100 ⊕ thewheelwrightsarms.co.uk

Wadworth Henry's IPA, Horizon, 6X, Swordfish; 2 changing beers (sourced nationally; often Wadworth) Ⓗ
This former wheelwright's premises branched out into selling beer when the railways arrived in the 1850s. It now provides refreshment to locals, ramblers, dog walkers, cyclists and those out to enjoy the nearby Dinton Pastures nature reserve. The L-shaped bar has a cosy olde-worlde charm and leads to a more formal restaurant serving classic pub favourites and roasts on Sunday. Families with children are welcome until 8.30pm. There is covered and heated seating outside.
ᗌ❀◖◗க♨(128,129) ❀᚛

Slough

Moon & Spoon ⅃ ✅

86 High Street, SL1 1EL
☎ (01753) 531650
Greene King Abbot; Ruddles Best Bitter; Sharp's Doom Bar; 4 changing beers Ⓗ
This Wetherspoon establishment has 12 handpumps offering three regulars beers accompanied by up to four constantly changing guest ales, always including one from a local brewery. A couple of ciders are also usually available, often Old Rosie and Black Dragon. The usual Wetherspoon all-day food menu is served. At the entrance is an eye-catching sculpture made of 1,148 spoons. The rear has a cosy feel with separate seating areas and an interesting ceiling light. ᗌ◖◗க≉♨(8,2)᚛

Sonning

Bull Inn

High Street, RG4 6UP (next to St Andrew's Church)
☎ (0118) 969 3901 ⊕ bullinnsonning.co.uk
Fuller's London Pride; Gale's HSB; 2 changing beers (sourced nationally; often Butcombe, Dark Star, Fuller's) Ⓗ
Full of character, this delightful 16th-century pub is leased to Fuller's by the adjacent church. Most of the interior is set for dining, but there is a separate Village Bar drinking area, also used as a function room. The regular beers and changing guests are mainly from the Fuller's range. An excellent selection of quality food, from snacks to fine dining, is available seven days a week. A good stop-off for those taking a walk alongside the Thames. Q ᗌ❀⇌◖◗P♨❀᚛

Thatcham

Wheatsheaf Inn

15 Chapel Street, RG18 4JP
☎ (01635) 876715
House beer (by Delphic); 1 changing beer (often Bond Brews, Flack Manor) Ⓗ
The Wheat Sheaf, as it was originally known, has been an inn since 1814. Rebuilt in 1927, this traditional pub has a single bar with two seating areas and a third a games room' with a pool table and dartboard. To one side is the 'book corner' (an informal library) with a comfy chair. Two TVs show major sporting events. On the first Friday of the month, the pub hosts a modern soul/Motown vinyl music evening. At the rear, the neat south-facing garden has a well-maintained lawn and several benches.
ᗌ❀⇌க♣P♨❀᚛

Tilehurst

Fox & Hounds

116 City Road, RG31 5SB
☎ (0118) 942 2982 ⊕ thefoxandhoundstilehurst.co.uk

2 changing beers Ⓗ/Ⓖ

This popular low-beamed village pub is in a bit of a backwater on the edge of Tilehurst close to open fields and Sulham Woods. Originally an end-of-terrace cottage, it now has a large open conservatory at the rear. A wood-burning stove, installed in a recently uncovered bricked-in fireplace during recent renovations, adds to the atmosphere. ⛲🐕♿♣♥Ⓟ🚲(33)🛜

Royal Oak

69 Westwood Glen, RG31 5NW

☎ (0118) 327 3712

3 changing beers Ⓗ

Encroaching suburbia has now enveloped this once-remote, hill-top drovers' inn, which remains a jumble of rooms on different levels. The higher lounge exhibits a recently discovered fireplace, while the lower public bar has games facilities and angling memorabilia. In clement weather enjoy the prize-winning garden at this quirky and entirely wet-led pub. ⛲🐕♣Ⓟ🚲(33)🐾🛜

Waltham St Lawrence

Bell 🍷 Ⓛ

The Street, RG10 0JJ

☎ (0118) 934 1788 ⊕ thebellwalthamstlawrence.co.uk

Loddon Hoppit; 4 changing beers (often Butts, Loose Cannon, Stardust) Ⓗ

A classic half-timbered 15th-century pub bequeathed to the village in 1608 by Sir Ralph Newbury. It serves as both the village local and a quality restaurant, producing exceptionally good food from fresh, seasonal ingredients and promoting real ales from small, independent breweries. Up to eight ciders and perries are served from the cellar. You will find log fires in the winter and a good-sized beer garden for sunny summer days. Q⛲🐕🌜♣🚲(4A)🐾🛜

Wargrave

Wargrave & District Snooker Club

Woodclyffe Hostel, Church Street, RG10 8EP

⊕ wargravesnooker.co.uk

2 changing beers Ⓗ

The club opens weekday evenings only and shares the building with the local library. The regularly changing beers reflect members' recommendations, with two on in the winter months and one in the summer. The TV's default is off, though the Six Nations Rugby and World Cup are exceptions. Show this Guide or CAMRA membership card for entry (£3 fee to use the snooker tables). Local CAMRA Club of the Year winner for several years. ≢♣Ⓟ🚲(850)🐾

Windsor

A Hoppy Place 🍷 Ⓛ

11 St Leonard's Road, SL4 3BN

☎ (01753) 206802 ⊕ ahoppyplace.co.uk

2 changing beers (sourced locally; often Stardust) Ⓟ

Windsor's first micropub, winner of local CAMRA Pub of the Year in 2021 and 2022, and SIBA Best UK Craft Beer Retailer 2021. It offers two casks, 11 keg lines and five fridges full of bottled and canned beers, with a focus on local and international brews. The fridges are arranged by beer style, with another fridge for cider. The pub has a canning machine to can cask and keg beer for takeaway while you wait. 🐕≢(Windsor & Eton Central)♣♥🚲🐾🛜

Acre ✅

Donnelly House, Victoria Street, SL4 1EN

☎ (01753) 841083 ⊕ theacrewindsor.com

3 changing beers (sourced nationally) Ⓗ

Converted some years ago from the Liberal Club, this is now a successful community free house. The name refers to the adjacent Bachelors Acre. Three rotating real ales are on offer. The pub is a significant live music venue at weekends, with occasional karaoke nights also hosted. Sports fans are also well catered for, with three screens showing live sport and excellent facilities for darts. The well-equipped cellar bar can be hired as a function room. Parking is available in the multi-storey car park across the road. 🐕≢(Windsor & Eton Central)♣🚲(8,2)🛜

Carpenters Arms ✅

4 Market Street, SL4 1PB

☎ (01753) 863739

St Austell Nicholson's Pale Ale; Sharp's Doom Bar; 4 changing beers (sourced nationally) Ⓗ

Situated on a narrow cobbled street close to the castle, this excellent Nicholson's pub has been voted local CAMRA Pub of the Year several times. The elegantly decorated interior is on three levels, the lowest of which is reputed to house a passageway to the castle. Ashby's Brewery tiles are on the floor by the entrance, a reminder of the pub's former owners. The two regular beers are supplemented by four interesting guests, often including something dark. 🐕🌜≢(Windsor & Eton Central)🚲🛜

Corner House Ⓛ

22 Sheet Street, SL4 1BG

☎ (01753) 862031 ⊕ thecornerhousepub.co.uk

Big Smoke Solaris Session Pale Ale; 9 changing beers (sourced nationally) Ⓗ

This Grade II-listed building was completely refurbished in a traditional style by new owners in 2017 and designated an ale and cider house. Fifteen handpumps serve nine regularly changing real ales plus five ciders. There are also 10 keg lines. Diners are well catered for too with a good selection of traditional pub food. The pub's vinyl collection supplies the background music. There is a large function room upstairs and a small, partly covered roof terrace. 🌜🌜≢(Windsor & Eton Central)♥🚲🐾🛜

Windsor & Eton Unit Four Brewery Tap Ⓛ

4 Vansittart Estate, Duke Street, SL4 1SE

☎ (01753) 392495 ⊕ webrew.co.uk/brewery-tap

Windsor & Eton Knight of the Garter, Windsor Knot, Guardsman, Conqueror; 4 changing beers (sourced regionally; often Windsor & Eton) Ⓗ

The Windsor & Eton brewery opened its on-site shop and taproom in 2016. In 2019, a bigger and better taproom was launched. Unit Four features eight handpumps dispensing six of the brewery's beers plus two guests. In addition there are 22 keg lines for Uprising beers and guests. There is also an interesting range of cans and bottles. The decor is modern, relaxing, and includes a mezzanine floor and stage for events. Brewery tours are available. 🐕🌜♿≢(Windsor & Eton Central)Ⓟ🚲

Windsor Trooper ✅

97 St Leonards Road, SL4 3BZ

☎ (01753) 670122 ⊕ thewindsortrooper.com

Adnams Southwold Bitter; Oakham Citra; 3 changing beers (sourced regionally) Ⓗ

Popular pub within walking distance of Windsor town centre. It has been pleasantly refurbished in a traditional style with a collection of original brewery mirrors. Five cask beers are available plus nine traditional ciders. There is a large room at the rear that also serves as a function room and venue for Thursday night live music. Outside is a sizeable beer garden. Accommodation is

available in nine en-suite rooms. Local CAMRA Cider Pub of the Year 2022.

🏠🛏🍴◑🍺(Windsor & Eton Central) ●🚗🚌☕🎵📶

Wokingham

Crispin ⓛ

45 Denmark Street, RG40 2AY (opp Denmark St car park)

☎ (0118) 978 0309

Hogs Back TEA; 4 changing beers (sourced regionally; often Bond Brews, Rebellion, Siren) Ⓗ

This independent real ale and cider pub has recently been awarded local CAMRA Pub of the Year. Four or five real ales are usually available plus still ciders from Westons and Lilley's. There is no kitchen but you can bring your own food or order a takeaway. A large garden (for the middle of Wokingham) has a smokers' gazebo and Aunt Sally pitch. There are seasonal beer festivals and live music. 🏠🍴♣🔥🚗🚌(4,X4)☕🎵📶

Elusive Brewing Tap Room ⓛ

Unit 5, Marino Way, Hogwood Industrial Estate, Finchampstead, RG40 4RF

☎ (0118) 973 2153 ● elusivebrewing.com/tap-room

Elusive Microball, Level Up, Oregon Trail, Spellbinder; 8 changing beers (sourced locally) Ⓗ

Small innovative brewery tap room on an industrial estate, open Friday and Saturday, showcasing eight of Elusive Brewing's own beers served from KeyKeg and one from handpump. The beer range varies, with occasional guests and collaboration brews. Retro computer games are available to play for free, and covered tables are provided outside in front of the tap room during warmer months. A good selection of the brewery's own beers and guest beers in cans and growler fills is available to take away. Q🏠🚲🏠P🚌☕🎵📶

Outhouse Brewery ⓛ

Unit 4, Southgate House, Alexandra Court, RG40 2SL

● theouthousebrewery.com

4 changing beers (sourced locally; often Outhouse Wokingham)

This bijou venue houses both a nanobrewery and a local community bar. Beers are served from a tap wall, with those in KeyKeg clearly labelled on the beer list blackboard. The premises falls within the site of the old Headington & Son brewery which was sold in 1921, 100 years before this brewery opened. Headington memorabilia can be seen above the bar. Closed on Monday and Tuesday. Snacks are available. 🏠🚲🚌🚗(4,X4)☕📶

Queen's Head ⓛ ✅

23 The Terrace, RG40 1BP

☎ (0118) 978 1221

Greene King Abbot; Loddon Ferryman's Gold; house beer (by Hardys & Hansons); 1 changing beer (sourced locally; often Windsor & Eton) Ⓗ

Listed 15th-century cruck-framed inn nestling in a terrace close to the station. The characterful, cosy single bar has low ceilings, timber floors and a log fire. A Greene King Local Hero pub, local ales are available alongside the brewery regulars. Beer paddles with three third-pints can provide a selection to sample. The rear patio and garden are pleasant in summer, with seating on the terrace popular on summer evenings. Local CAMRA Pub of the Year 2021. 🏠🏠🚲♣🚗🚌(4,X4)☕📶

Ship Inn

104 Peach Street, RG40 1XH (jct with London Rd, on entrance to one-way system)

☎ (0118) 978 0389 ● shipwokingham.co.uk

Fuller's Oliver's Island, London Pride, ESB; 1 changing beer (sourced locally; often Fuller's) Ⓗ

A large, popular Fuller's establishment on the south corner of Wokingham's ring road, with three bars plus a spacious outside area that has been extended in recent years. The pub is especially busy at weekends and when live sports events are screened. Good food is served lunchtimes and evenings. This recent local CAMRA Pub of the Year has a strong community focus and offers tea, coffee and chat for senior citizens in the morning. 🏠🏠◑🚗🚌(4,X4)☕📶

Woolhampton

Rowbarge ⓛ

Station Road, RG7 5SH

☎ (0118) 971 2213

House beer (by St Austell); 5 changing beers (sourced regionally; often Delphic, Loddon, Stonehenge) Ⓗ

Built as a cottage in 1815, the building later became a pub and has since been extended to provide further kitchen and dining areas. Now operated by Brunning & Price, the Rowbarge's large beer garden overlooks the Kennet and Avon Canal and includes a barbecue area and pizza oven. The well-kept local ales turn over rapidly. Midgham railway station is five minutes' walk, providing the swing bridge and level crossing allow passage. Q🏠🏠◑🚲🚌(Midgham)♣●P🚌☕📶

Wraysbury

Perseverance ✅

2 High Street, TW19 5DB

☎ (01784) 482375 ● thepercy.co.uk

Otter Ale; 2 changing beers Ⓗ

Comfortable pub with several seating areas. The larger front room has a piano and a large inglenook fireplace with a real log fire. Another seating area with an open fire leads to the rear dining section, which has well-stocked bookshelves. The rear garden is delightful. Two guest ales are always varied and from some of the more interesting breweries, both LocAle and around the country. Regular beer festivals are held. Quiz night is Thursday and live music features on Sunday afternoon. Q🏠🏠◑♣●P🚌(305)☕📶

Breweries

Bond Brews

Units 3 & 4, South Barns, Gardeners Green Farm, Heathlands Road, Wokingham, Berkshire, RG40 3AS

☎ (01344) 775450 ● bondbrews.co.uk

⊠ An award-winning brewery, Bond Brews was established in 2015 using a six-barrel plant and produces a range of cask-conditioned and bottle-conditioned beers. Deliveries are made to pubs within a 30-mile radius and retail purchases are available from the brewery shop and also online since 2020. Brewery tours and experience days are available by arrangement with the brewer. ‼🍺◆LIVE

Goldi-hops (ABV 3.9%) PALE
A golden-coloured, session pale ale with a fruit and hop aroma. Bramble and apple flavours lead to a lingering fruity, dry bitter aftertaste.

Best of British (ABV 4%) BITTER
A tawny-coloured, session bitter with malt, hops and fruit aroma. Dried fruit, earthy and caramel flavours lead to a sweet, nutty aftertaste.

Bengal Tiger (ABV 4.3%) PALE

A golden-coloured, session pale ale with a hoppy, fruity aroma. Initial fruity flavour leads to an earthy bitterness and a long, dry, bitter finish.

Railway Porter (ABV 4.5%) PORTER
A brown-coloured session porter with roast malt and fruit aroma. Bitter and hoppy flavour with an earthy, peppery, bitter chocolate aftertaste.

Bucklebury SIBA

Broad Lane, Upper Bucklebury, Berkshire, RG7 6QJ
☎ 07834 044468 ✉ info@buckleburybrewers.co.uk

A small-scale brewery which started production in 2020 using two 150-litre fermenting vessels. All the beers are unfiltered and unpasteurised. Beer in pressurised kegs is supplied to the Cottage Inn in the village, and bottled beers are supplied to local shops within a 10-15 mile radius of the brewery. LIVE

Butts

Northfield Farm, Wantage Road, Great Shefford, Berkshire, RG17 7BY
☎ (01488) 648133 ⊕ buttsbrewery.com

⊠ The brewery was set up in a converted barn in 1994. In 2002 the owners took the decision to become dedicated to organic production; all the beers brewed use organic malted barley and organic hops, and are certified by the Soil Association. ☎♦LIVE

Jester (ABV 3.5%) BITTER
A pale brown session bitter with a hoppy aroma and a hint of fruit. The taste balances malt, hops, fruit and bitterness with a hoppy aftertaste.

Traditional (ABV 4%) BITTER
Pale brown session bitter with citrus hop aroma and flavours. A long, dry aftertaste is dominated by fruity hops.

Barbus Barbus (ABV 4.6%) GOLD
Premium golden ale with fruity hop aroma and hint of malt. Hops dominate the taste and aftertaste followed by some fruitiness and bitterness,

Golden Brown (ABV 5%) BITTER

Delphic

26 The Martins, Thatcham, Berkshire, RG19 4FD
☎ 07595 386568 ⊕ delphicbrewing.com

Thatcham's first craft brewery, established in 2019 by head brewer Tom Broadbank. It is a 2.5-barrel plant providing regular and seasonal beers to local pubs and clubs. Bottles and cans are available too, through well-established, off-sales outlets in Berkshire as well as the online shop. ♦

Level Crossing (ABV 4.2%) BITTER
World's End (ABV 4.6%) PALE
Daydream Believer (ABV 5.4%) SPECIALITY

Dolphin SIBA

Woodley, Reading, Berkshire, RG5 4TL ☎ 07979 753391 ⊕ dolphinbrewery.co.uk

A 130-litre brewery operating on a small scale from the garage of one of the brewers' parents. It produces bottled beers and occasional KeyKeg. It specialises in niche styles; sours, gose, saison and porters.

Double-Barrelled SIBA

Unit 20, Stadium Way, Tilehurst, Reading, Berkshire, RG30 6BX
☎ (0118) 942 8390 ⊕ doublebarrelled.co.uk

Brewing began in 2018 on a 15-barrel plant. The beer range is wide, concentrating on pale ales, IPAs and a lager, but also includes seasonal fruited sours and stouts. Barrel-aged beers will be available in 2023. The majority of beers are only brewed once, with regular collaborations. The ever-popular taproom/shop opened in 2019. ♨☎♦

Elusive SIBA

Units 3-5, Marino Way, Hogwood Lane Industrial Estate, Finchampstead, Berkshire, RG40 4RF
⊕ elusivebrewing.com

Award-winning Elusive Brewing is a five-barrel brewery, established in 2016. With a fermenting capacity of 41 barrels, it produces a diverse range of unfiltered and unpasteurised cask, KeyKeg and canned beers. It continues many brewery collaborations and tap take-overs. The taproom sells beers from the Elusive range and other breweries, plus related merchandise. It has flat screens on which people can play retro computer games and includes a covered outdoor area. ☎♦♦

Microball (ABV 3.7%) MILD
Level Up (ABV 5%) RED
Morrisman (ABV 5%) SPECIALITY
Oregon Trail (ABV 5.8%) IPA
Spellbinder (ABV 6%) SPECIALITY

FutureState (NEW)

Earley, Reading, RG6 5XF ⊕ futurestatebrew.com

A nanobrewery being run from the owner's domestic garage, producing a wide variety of beers and participating in many collaborative brews. It registered for commercial activity in 2020.

Hermitage

Heathwaite, Slanting Hill, Hermitage, Berkshire, RG18 9QG
☎ (01635) 200907 ☎ 07980 019484
⊕ hermitagebrewery.co.uk

⊠ Established in 2013 by semi-retired, food science lecturer, Richard Marshall. After many years as a keen home brewer, the opportunity arose to go commercial on a very small scale. The 0.5-barrel brewery produces bottle-conditioned, traditional beers and some casks. Volumes vary, but is about 200 bottles per week. A range of seven 'core' beers and four seasonal beers are sold to local shops and pubs, and festivals. LIVE

Indigenous

Peacock Cottage, Main Street, Chaddleworth, Berkshire, RG20 7EH
☎ (01488) 505060 ⊕ indigenousbrewery.co.uk

⊠ An occasional and informal microbrewer for many years, Kevin Brady established Indigenous in 2014, increasing production using a 2.5-barrel plant. Availability is restricted to local pubs, shops and an increasing number of regional beer festivals. ♨☎♦LIVE

Baldrick (ABV 3.4%) MILD
Chinwag (ABV 4%) BITTER
Forager's Gold (ABV 4%) GOLD
Summer Solstice (ABV 4.1%) PALE
Billy No Mates (ABV 4.2%) PALE
Frisky Mare (ABV 4.2%) GOLD
Silly Moo (ABV 4.2%) STOUT
Tickety-Boo (ABV 4.2%) GOLD
Monocle (ABV 4.5%) STOUT
Nutcracker (ABV 4.5%) OLD

Old Cadger (ABV 4.5%) BITTER
Moonstruck (ABV 4.8%) PORTER
Dark brown session porter with malt, chocolate and coffee aromas. Full mouthfeel of hops, caramel and fruit with a bitter finish.
Nosey Parker (ABV 5.5%) MILD
Strong ruby mild with a malt and toffee note aroma. Malt dominates the taste with a balanced malt and hop aftertaste.
AMMO Belle (ABV 5.6%) IPA
Amber new world IPA with fruit, hops and malt on the nose followed by some bitterness in the taste. Malty aftertaste joined by a fruity hoppiness.
Double Warp (ABV 5.8%) STOUT
Dark brown strong stout with malt aroma and coffee notes. Roasted, sweet, malt flavour finishes with a balanced aftertaste.

INNformal

14 Charnham Street, Hungerford, Berkshire, RG17 0ES
⊕ john-o-gaunt-hungerford.co.uk

⊠ The INNformal brewery was established in 2015 and moved to Hungerford in 2019 when it expanded to a four-barrel plant. A selection of the beers can always be found at its affiliated pub the John O'Gaunt Inn in Hungerford. ‼◆

Inn Session (ABV 3.5%) PALE
Inn House Bitter (ABV 4.1%) BITTER
Inn Deep (ABV 5%) STOUT
Black Pepper Porter (ABV 6%) PORTER
Inn Alcatraz (ABV 6%) IPA
Alice Inn Wonderland (ABV 7.1%) STRONG

New Wharf SIBA

Hyde Farm, Marlow Road, Maidenhead, Berkshire, SL6 6PQ
☎ (01628) 634535 ⊕ newwharfbrewing.co.uk

A 20-barrel brewery, which was set up in 2017. After a pause in 2019-2020, it restarted brewing in 2021 with an updated core range of two keg beers plus a pilsner and with intentions to expand and add seasonal beers to the range.

Outhouse

4 Southgate House, Alexandra Court, Denmark Street, Wokingham, Berkshire, RG40 2SL
⊕ theouthousebrewery.com

⊠ A new nanobrewery, established in 2021, using a 300-litre (1.8-barrel) plant, situated within the onsite taproom. This is the first brewery in Wokingham town centre since the Wellington Brewery (Headington's) closed in 1928. Beers are supplied in KeyKegs, are unfiltered and unpasteurised and can be purchased from the taproom. ⦿LIVE◆

Phantom

Unit 3, Meadow Road, Reading, Berkshire, RG1 8LB
⊕ phantombrew.com

A 12-barrel KeyKeg brewery founded in 2020 and situated on the outskirts of Reading Town centre. It produces a range of different styles including hop-heavy pale ales, fruit sours and stouts. ‼◆

Renegade

The Old Dairy, Frilsham Farm, Yattendon, Berkshire, RG18 0XT
☎ (01635) 767090

⊠ Formerly known as West Berkshire and under new ownership since late 2021, the brewery rebranded to Renegade in 2022. Originally established in 1995, it moved to new, purpose-built premises in 2018 (its fourth expansion). Capacity was increased tenfold to 50,000 hectolitres. The state-of-the-art brewing plant is located in a former dairy farm building, covering 68,000 sq ft. The site includes a shop, taproom and kitchen. ‼☞◆⌂

Mister Chubb's (ABV 3.4%) BITTER
A drinkable, balanced, session bitter. A malty caramel note dominates aroma and taste and is accompanied by a nutty bittersweetness and a hoppy aftertaste.
Maggs' Mild (ABV 3.5%) MILD
Silky, full-bodied, dark mild with a creamy head. Roast malt aroma is joined in the taste by caramel, sweetness and mild, fruity hoppiness. Aftertaste of roast malt with balancing bitterness.
Good Old Boy (ABV 4%) BITTER
Tawny-coloured session bitter with malty aroma, then a balanced flavour with hops and fruit, leading to a long, dry, bitter aftertaste.
Gold Star (ABV 4.1%) GOLD
Maharaja IPA (ABV 5.1%) PALE

Saviour

▤ **White Hart Inn, Hamstead Marshall, Berkshire, RG20 0HW**
☎ (01488) 657545 ⊕ saviourwhitehart.co.uk/saviour-ales

Brewing began in 2019 on a four-barrel plant in an outbuilding in the grounds of the White Hart. Beers are only available at the pub.

Siren SIBA

Unit 1, Hogwood Lane Industrial Estate, Weller Drive, Finchampstead, Berkshire, RG40 4QZ
☎ (0118) 973 0929

Office: Siren Tap Yard, Unit 18, Marino Way, Finchampstead, Berkshire, RG40 4RF
⊕ sirencraftbrew.com

⊠ Established in 2013, this is a state-of-the-art, 40-barrel craft brewery, which produces 70-100 unique beers every year. Beers are produced in cask, keg, KeyKeg, bottles, and cans and distributed throughout the UK and Europe. The tap yard serves freshly-brewed beers and holds almost monthly special events. In 2021, Siren purchased its first country pub nearby in Shinfield. It has plans for further expansion as well as continuing to increase brewing capacity and making further use of new ingredients and brewing technologies. ‼☞◆⌂

Yu Lu (ABV 3.6%) SPECIALITY
Memento (ABV 3.8%) BITTER
Lumina (ABV 4.2%) PALE
Broken Dream Breakfast Stout (ABV 6.5%) SPECIALITY

Stardust SIBA

Unit 5, Howe Lane Farm Estate, Howe Lane, White Waltham, Berkshire, SL6 3JP
☎ (01628) 947325 ⊕ stardustbrewery.co.uk

⊠ An independent, family-owned and run brewery. Stardust was established in 2016. Located in a unit on a small farm estate, brewing takes place on a six-barrel plant. There is a brewery shop and taproom on-site and an online shop offering local and national delivery. ‼☞◆⌂

Easy Pale Citra (ABV 3.8%) PALE

English Bitter (ABV 4%) BITTER
Just Stout (ABV 4.2%) STOUT
Optic (ABV 4.2%) GOLD
Roast Note (ABV 4.3%) BITTER
Saaz Pilsner (ABV 4.5%) SPECIALITY
PK3 (ABV 5.6%) IPA

Swamp Bog

Church Lane, Enborne, Berkshire, RG20 0HB
⊕ swampbogbrewery.com

⊗ Under the same ownership and sharing the same kit as Two Cocks brewery (qv) this microbrewery, based on the edge of Hampshire/Berkshire, specialises in long-lost craft beer recipes from a time before brewing giants existed. The passion is for taste, not profit; low volume rather than mass production.

Bottom Biter (ABV 3.6%) BITTER
Edge Hopper (ABV 4.2%) GOLD
Pixie Pee (ABV 5%) PALE
The Ferryman's Brew (ABV 5%) SPECIALITY

Two Cocks

Church Lane, Enborne, Berkshire, RG20 0HB
☎ (01635) 37777 ⊕ twococksbrewery.com

⊗ Under the same ownership and sharing the same kit as Swamp Bog brewery (qv), Two Cocks was established in 2011, after wild hops were found growing in the farm's hedgerows. A 180-feet deep borehole supplies water for the brewery. During the English Civil War, the first Battle of Newbury (1643) was fought on the surrounding land and most of the beer names refer to it in some way.

'Diamond Lil' (ABV 3.2%) GOLD
1643 Cavalier (ABV 3.8%) GOLD
1643 Leveller (ABV 3.8%) BITTER
1643 Musket Bitter (ABV 3.8%) BITTER
1643 Roundhead (ABV 4.2%) BITTER
1643 Puritan (ABV 4.5%) STOUT
1643 Viscount (ABV 5.6%) BITTER

Wickham

🍺 Five Bells, Baydon Road, Wickham, Berkshire, RG20 8HH
☎ (01488) 657300 ⊕ fivebellswickham.co.uk

A brewpub which started in 2020, on the same site and using the kit as previously used by INNformal brewery, which moved to Hungerford in 2019. The brewhouse was built by the previous owners behind the Five Bells in 2015. A borehole in the pub garden supplies water for the 2.5-barrel plant and 0.5-barrel test kit.

Wild Weather SIBA

Unit 19, Easter Park, Benyon Road, Silchester, Aldermaston, Berkshire, RG7 2PQ
☎ (0118) 970 1837 ⊕ wildweatherales.com

⊗ Established in 2012, this 12-barrel plant brews a vast array of beer styles. Many of the beers are one-off or collaborations and are distributed throughout the UK in cask, keykeg and cans. The Weather Station tap opened in 2019 and is located in central Reading. ⊞🍺♦

King Street Pale (ABV 4.2%) PALE
Shepherd's Warning (ABV 5.6%) IPA

Windsor & Eton SIBA

Unit 1, Vansittart Estate, Duke Street, Windsor, Berkshire, SL4 1SE
☎ (01753) 854075 ⊕ webrew.co.uk

⊗ Founded in 2010 by ex-Courage brewers, Windsor & Eton Brewery produces over 5,000 barrels per year —mainly for the pubs of London and Thames Valley from its 18-barrel Burton-fabricated brewing plant. It has a Royal Warrant and strong sustainability credentials. In 2021 it opened a new taproom, featuring up to 22 different draft beers, and Young's last working dray, which is used as a stage when not delivering beer around Windsor. Beers are also produced under the Uprising brand name. ⊞🍺♦LIVE♦

Knight of the Garter (ABV 3.8%) GOLD
Session golden ale with a citrusy hop aroma, joined by some sweetness in the taste, followed by bitterness in the finish.
Windsor Knot (ABV 4%) BITTER
Guardsman (ABV 4.2%) BITTER
Eton Boatman (ABV 4.3%) GOLD
Session golden ale with tropical fruit and citrus hop aroma, continuing into the taste with some sweetness and subtle bitter finish.
Father Thames (ABV 4.8%) BITTER
Conqueror (ABV 5%) PALE
Dark brown ale with an aroma of dark malts and citrus hops. Malt dominates the taste with citrus and spice. Dry, malty finish.

Zerodegrees SIBA

🍺 9 Bridge Street, Reading, Berkshire, RG1 2LR
☎ (0118) 959 7959 ⊕ zerodegrees.co.uk

A chain of four brewpubs, the first began brewing in 2000 in Blackheath, London. Each incorporates a computer-controlled, German plant producing unfiltered and unfined ales and lagers. All beers use natural ingredients, are suitable for vegetarians, and are served from tanks using air pressure (not CO2). Brewing is currently suspended. 🍺♦

A short history of the Good Beer Guide

The Good Beer Guide was first published in 1972 and was just 18 pages long. Rather than a printed and bound edition, it was just a collection of sheets of paper stapled together and posted out to CAMRA members. The first printed edition was published in 1974 and contained a comment on Watney's brewery that was considered libellous, causing the first print run to be pulped and the description for the brewery to be revised. There are a few copies of the first print run out there but they change hands for a fair amount of money.

There has been an edition of the Guide printed annually since 1974, meaning it is now in its 50th year. The longest serving editor was Roger Protz, who edited the Guide from 1978-1983 and 2000-2018. It has grown from 96 pages in 1974 to 944 pages for this edition, with 4,500 pubs listed and nearly 1,900 breweries.

BUCKINGHAMSHIRE

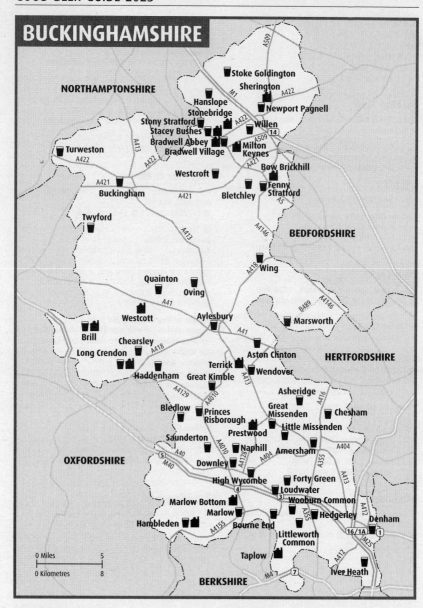

NORTHAMPTONSHIRE

Stoke Goldington
Sherington
Hanslope
Stonebridge
Newport Pagnell
Stony Stratford
Stacey Bushes
Willen
Bradwell Abbey
Milton
Bradwell Village
Keynes
Turweston
Westcroft
Bow Brickhill
Fenny
Buckingham
Bletchley
Stratford
Twyford

BEDFORDSHIRE

Wing
Quainton
Oving
Westcott
Aylesbury
Marsworth
Brill
Chearsley
Long Crendon
Aston Clinton
HERTFORDSHIRE
Terrick
Wendover
Haddenham
Great Kimble
Asheridge
Bledlow
Great
Chesham
Princes
Missenden
Risborough
Little Missenden
Prestwood
Saunderton
Naphill
Amersham
OXFORDSHIRE
Downley
High Wycombe
Forty Green
Marlow Bottom
Loudwater
Wooburn Common
Marlow
Hedgerley
Hambleden
Bourne End
Denham
Littleworth
Common
Taplow
Iver Heath

BERKSHIRE

0 Miles 5
0 Kilometres 8

Amersham

Elephant & Castle ✓

97 High Street, HP7 0DT
☎ (01494) 721049
Sharp's Doom Bar; 2 changing beers (sourced
nationally) Ⓗ
Originally a butcher's shop, this 17th-century Grade II-
listed building has been a pub since 1861. Tables
surround the centrally located bar; a wood-burning stove
adds to the warm welcome. To the rear is an extensive
covered seating area with dining tables. This extends to a
glazed section with views of the garden, which features
a grassy area plus side cubicles and seating under
parasols. ☕✿⊕▯🚪(1)🐾🐾🛜

Asheridge

Blue Ball

Asheridge Road, HP5 2UX
☎ (01494) 758263
Adnams Ghost Ship; Fuller's London Pride; Sharp's
Doom Bar; Tring Side Pocket for a Toad Ⓗ
Rural family pub in a hamlet two miles north-west of
Chesham, dating from the late 17th century. It is warmed
by two wood-burning stoves, one at each end of the
main bar area. The L-shaped bar's four handpumps
dispense well-kept beers. A restaurant serves good food
at lunchtime. The extensive garden has seating and a
heated enclosure giving fine views over the adjacent
valley. ☕✿⊕🍴♣🅿🐾🛜

Aston Clinton

Oak

119 Green End Street, HP22 5EU
☎ (01296) 630466 ⊕ oakastonclinton.co.uk
Fuller's London Pride; 1 changing beer (often Fuller's) Ⓗ

A handsome 500-year-old pub whose large and pleasant L-shaped bar has a wooden floor and plenty of seating. A tiled area to the left is like a traditional public bar – full of local characters and chit-chat. The other sections are low-beamed and comfortable. Outside is an extensive beer garden with attractive leafy trees in season.
✿❶&P🚍(500,61)❀🐾🛜

Aylesbury

Hop Pole Inn Ⓨ Ⓛ

83 Bicester Road, HP19 9AZ (near Gatehouse Industrial Area)
☎ (01296) 482129
10 changing beers Ⓗ

Well worth a short stroll out of the town centre, this temple of beer regularly sports nine cask ales including three or four guests alongside the Vale Brewery beers. There is also a good range of bottled beers, mostly from Belgium. The pub hosts a long-running quiz on Tuesday and a ukulele night on the second and fourth Wednesday each month. Live music features occasionally at the weekend. Regular beer festivals are held. ✿❶●🚍❀🐾🛜

King's Head Ⓛ

Market Square, HP20 2RW
☎ (01296) 718812 ⊕ kingsheadaylesbury.co.uk
Chiltern Pale Ale, Beechwood Bitter; 2 changing beers Ⓗ

This is the oldest courtyard inn in England, complete with cobbles. Converted stables occupy one side and host a grocery shop. The magnificent building is owned by the National Trust; the bar and shop are run by the Chiltern Brewery. The bar has up to four Chiltern ales, with two often changing, and a guest beer – often a stout or porter in winter. A cider is also usually available. There is plenty of outside seating. Beer festivals are held periodically. Closed Monday and Tuesday. Q🛞✿❶&≈●🚍❀🛜

Bledlow

Lions of Bledlow Ⓛ

Church End, HP27 9PE (from M40 jct 6 go through Chinnor to Bledlow on B4009, take second left turn through village on B4009, pub is signposted)
☎ (01844) 343345 ⊕ thelionsofbledlow.co.uk
4 changing beers (sourced locally; often Tring, Wadworth) Ⓗ

A charming 16th-century free house at the foot of the Chilterns, between Icknield Way and the Chinnor and Princes Risborough Railway, popular with ramblers, cyclists and dog walkers. Its four handpumps serve a rotating selection of local, regional and national beers. The interior, with its dark oak beams and quarry tiles, has been a location for ITV's Midsomer Murders detective series on several occasions. Q🛞✿❶&P🚍❀🛜

Bourne End

KEG – Craft Beer Tasting Bar

12 Oakfield Road, SL8 5QN
☎ (01628) 529369 ⊕ kegcraftbeer.co.uk
2 changing beers Ⓗ

Small and welcoming micropub that goes from strength to strength, just off the main road through the village.

Named KEG after its owner Kim E Georgiou, it serves two cask ales and seven craft keg beers. The bar is full of bric-a-brac, and plays music from the proprietor's eclectic vinyl collection. There is limited seating outside and a car park nearby. ≈●🚍(36)❀🛜

Brill

Pointer Ⓛ ✔

27 Church Street, HP18 9RT
☎ (01844) 238339 ⊕ thepointerbrill.co.uk
Vale Best IPA; house beer (by XT); 2 changing beers Ⓗ

More than merely a destination eatery, this free house has become a destination alehouse too, thanks to the skilled cellarwoman. Its four handpumps offer a reliable choice, often featuring a stout or porter plus another guest beer. An open-walled kitchen serves wonderful locally sourced food to a separate vaulted dining room. The pub supports the Brill beer festival in August.
Q🛞✿❶●♣🚍❀🛜

Buckingham

King's Head Coffee & Gin Bar ✔

7 Market Hill, MK18 1JX
☎ (01280) 812442 ⊕ thekingsheadcoffeebar.com
Hornes Triple Goat Pale Ale; 1 changing beer (often Brains, Purity, Wadworth) Ⓗ

In the centre of Buckingham, this is a pleasant and comfortable pub with a hidden-away, sunny courtyard garden. As well as two real ales from the SIBA list and Old Rosie cider, it is a coffee, gin and cocktail bar with a buy-one get-one-free cocktail menu throughout the day. Its range of food menus from breakfast to evening offer a very wide range, with gluten-free and vegan needs catered for. 🛞✿❶🚍(X60,X5)❀🛜

Mitre

2 Mitre Street, MK18 1DW
☎ (01280) 813080 ⊕ themitrepub.co.uk
Five Points Pale; 4 changing beers (sourced nationally; often Arbor, Lister's, Oakham) Ⓗ

Buckingham's oldest pub is a stone-built free house dating from the 17th century. Its cosy and friendly atmosphere is enhanced by an open fire. In winter its five handpumps offer interesting changing beers, regularly including local brews. In summer one ale is replaced by a still cider. Large-screen TVs show major events. Live music is played once or twice a month. Parking is on the street. Local CAMRA Pub of the Year 2022. 🛞✿♣P🚍❀🛜

Woolpack ✔

57 Well Street, MK18 1EP
☎ (01280) 817972 ⊕ thewoolpackbuckingham.com

REAL ALE BREWERIES

Blackened Sun ✦ Milton Keynes: Stacey Bushes
Boobytrap ✦ Westcott (NEW)
Brewhouse & Kitchen 🍺 Milton Keynes: Central
Bucks Star Milton Keynes: Stonebridge
Chiltern ✦ Terrick
Concrete Cow Milton Keynes: Bradwell Abbey
Hopping Mad Sherington
Hornes Milton Keynes: Bow Brickhill
Malt ✦ Prestwood
moogBREW ✦ Taplow
Old Luxters Hambleden
Rebellion ✦ Marlow Bottom
Vale Brill
XT ✦ Long Crendon

St Austell Tribute; Sharp's Doom Bar; 2 changing beers (sourced nationally; often Hornes, Otter) ⊞
A short walk from the town centre, this busy, nicely modernised pub retains many old features. It has a separate function room with its own bar, and a large riverside garden with a covered and heated patio. Four handpumps serve two regular and two guest ales, joined in summer by a box cider that is often Old Rosie. Food is freshly cooked, with local produce used where possible. Children are welcome until early evening. The garden has treats and water for dogs. Parking nearby can be difficult. Q ⏰ ✿ ◑ ◗ ♣ ♿ (X60,X5) ❀

Chearsley

Bell
Church Lane, HP18 0DJ
☎ (01844) 208077 ⊕ thebellchearsley.co.uk
Fuller's London Pride; Gale's Seafarers Ale; 2 changing beers ⊞
Attractive thatched pub on the edge of the village green, often featuring in Midsomer Murders. A Fuller's house, it is pleasant on sunny summer days and cool winter evenings alike. Its ales are well kept, all coming from the Fuller's stable. This pub is also renowned for its good wholesome food. Q ✿ ◑ ◗ P ♿ (110)

Chesham

Trekkers Bar & Bottleshop Ⓛ
2 High Street, HP5 1EP
☎ 07943 711501 ⊕ trekkersbars.co.uk
2 changing beers (sourced nationally; often Chiltern, Rebellion, Tring) Ⓐ
Micropub in a former barbershop, its name reflecting the pub's popularity with thirsty walkers. It serves two cask ales, one normally local and the other from an interesting brewery further afield. There are also eight keg beers on tap, plus traditional ciders, sparkling wines and gin. The fridge and shelves offer further national and international takeaway beer options. The friendly staff are always happy to offer a recommendation if the choice becomes too much. ✿ ⊖ ♣ ♿ (1)

Denham

Falcon Inn ✔
Village Road, UB9 5BE
☎ (01895) 832125 ⊕ falcondenham.com
Harviestoun Bitter & Twisted; St Austell Proper Job; Timothy Taylor Landlord; 1 changing beer (sourced regionally; often Adnams, St Austell) ⊞
Small one-bar pub in Denham Village conservation area, overlooking the village green. The building dates from the 18th century and has a smart interior, accessed from the road via interesting old steps. Good food is served lunchtimes and evenings, with bar snacks supplementing the restaurant menu. To the rear is a lovely sunny garden. Parking can be difficult but there is easy access on foot from nearby Denham station. High-quality accommodation is offered. Q ✿ ≠ ◑ ◗ ≈ ♿ ❀ 🎵

Green Man Ⓛ
Village Road, UB9 5BH
☎ (01895) 832760 ⊕ greenmandenham.co.uk
Rebellion IPA, Smuggler; Sharp's Doom Bar; 1 changing beer (sourced regionally) ⊞
A friendly free-of-tie inn that has been sympathetically refurbished. Its front bar has beams, a real fire and flagged floors, opening out into a large conservatory and well-tended beer garden and patio, both with covered seating areas. The pub has a tempting food menu and is

popular with diners, families and drinkers. Historic Denham is a picturesque rural village, a pleasant stroll from the Colne Valley Country Park Visitor Centre. ⏰ ✿ ◑ ◗ ≠ ♣ ♿ ❀ 🎵

Downley

De Spencer Arms
The Common, HP13 5YQ (across common from village on flint track beyond end of Plomer Green Lane)
☎ (01494) 535317 ⊕ ledespencers.co.uk
Dark Star American Pale Ale; Fuller's London Pride; 2 changing beers (sourced nationally) ⊞
A busy, friendly local on the edge of Downley Common, offering a warm welcome to all including walkers, cyclists, children and dogs. Its garden is a lovely place to sit in summer. The surrounding Area of Outstanding Natural Beauty offers many walks. There is car parking to the rear. ⏰ ✿ ◑ ◗ ♣ P ♿ ❀ 🎵

Forty Green

Royal Standard of England Ⓛ
Forty Green Road, HP9 1XT
☎ (01494) 673382 ⊕ theoldestpub.com
Chiltern Pale Ale; Rebellion IPA; Windsor & Eton Knight of the Garter; 2 changing beers (sourced locally) ⊞
This centuries-old hostelry with its fascinating history and claims to be the oldest freehouse in England is well worth a detour. A barrel-shaped wooden partition wall leads to rooms containing log fires or cast-iron stoves. The architecture and furniture are rustic; hops hang from the bar areas. Craft breweries supply the bottled ales; food is of exemplary standard. Bekonscot Model Village and Beaconsfield railway station are within a couple of miles. The area is a walkers' paradise. Q ✿ ◑ ◗ ♣ P

Great Kimble

Swan Ⓛ
Lower Icknield Way, HP17 9TR
☎ (01844) 275288
Tring Side Pocket for a Toad, Moongazing ⊞
A family-owned free house that dates back to the 18th century. It adjoins the children's playground on the green of this village at the foot of the Chiltern hills, in excellent hiking, cycling and horse riding country. The recently refurbished rear garden houses a barbecue and wood-fired pizza oven – Sunday lunchtime is popular. Opening times and the ales available can vary, especially in winter. ⏰ ✿ ≠ ◑ ◗ ♿ ≈ (Little Kimble) ♣ P ♿ (300) ❀ 🎵

Great Missenden

George Ale House
94 High Street, HP16 0BG
☎ (01494) 865185
Harvey's Sussex Best Bitter; 3 changing beers (sourced nationally) ⊞
A traditional adult-only, dog-friendly pub with a great atmosphere. It has three seating areas, some with comfy sofas and real fires. Four real ales are served from breweries far and wide, alongside craft keg beer, real cider, gin and wine. Bar snacks are available. The pub hosts regular music nights featuring guitars, banjos and an accordion. Local CAMRA Pub of the Year 2021 runner-up. Q ✿ ≈ ♣ ♿ P ❀

Haddenham

Rising Sun L ✅
9 Thame Road, HP17 8EN
☎ (01844) 291744 ⊕ risingsunhaddenham.co.uk
XT Four; 5 changing beers (sourced locally) Ⓗ
This bustling village pub boasts six real ales on handpump, with favourites from XT Brewing as well as unusual Animal Brewing Co creations, plus a changing selection of guest ales, craft beers and ciders. With a landscaped garden and treats on tap for canine companions, this family and pooch friendly pub seamlessly blends the best of old and new. Local CAMRA Pub of the Year 2019. Q❀🏖🛱♿(Haddenham & Thame Parkway) ♣🚌(280) 🐾🛜

Hambleden

Stag & Huntsman L
RG9 6RP
☎ (01491) 571227 ⊕ thestagandhuntsman.com
3 changing beers (sourced locally; often Rebellion) Ⓗ
There is an old-fashioned charm about this historic restored pub in its unspoilt village setting in the Chilterns, midway between Marlow and Henley and just up from the River Thames. It serves four hand-drawn real ales, with Rebellion's IPA a regular alongside a variety of changing local brews. Until 1820 the pub was reportedly called the Dog & Badger – now the name of a pub in nearby Medmenham. Q🏖❀🛋🕦♿P🐾🛜

Hanslope

Cock Inn
35 High Street, MK19 7LQ
☎ (01908) 510553 ⊕ cock-inn.co.uk
Greene King IPA; 1 changing beer (sourced regionally; often Vale) Ⓗ
Popular local whose large single room is used for both drinking and dining. It serves one regular ale alongside a local guest, usually from Vale Brewery. The pleasantly decorated rectangular bar has a real fire at one end and a TV showing BT Sport at the other, with plenty of tables and chairs in between. A new kitchen offers good-quality lunchtime and evening meals. The pub hosts live music and themed events including a fancy-dress party at Halloween. 🏖❀🕦♿P🚌🐾🛜

Hedgerley

White Horse L
Village Lane, SL2 3UY (in old village, near church)
☎ (01753) 643225 ⊕ thewhitehorsehedgerley.co.uk
Rebellion IPA; 7 changing beers (often Mighty Oak, Oakham) Ⓖ
Local CAMRA Pub of the Year on numerous occasions, this village local serves an impressive range of real ales. New breweries often feature, as well as favourite beers from Oakham and Mighty Oak. Two craft ales and three real ciders/perries are also available. This classic pub has a well-tended garden with a heated and covered patio. It hosts regular beer festivals, the largest of which is over the Whitsun weekend and a must for real ale enthusiasts. Q🏖❀🕦♣♿P🐾🛜

High Wycombe

Belle Vue ✅
45 Gordon Road, HP13 6EQ
☎ (01494) 524728 ⊕ thebv.pub
Adnams Ghost Ship; 2 changing beers Ⓗ
Welcoming pub that is a regular in this Guide, situated just outside the town centre near the railway station on Gordon Road. It serves a fine range of beers, with real cider also available. An open fire contributes to a warm atmosphere in winter. Live music is hosted regularly. The pub walls normally display artwork that is for sale. ❀🏖♣♿🚌🐾🛜

Chiltern Taps L
120-123 Oxford Road, HP11 2DN
☎ (01494) 917080 ⊕ craft-pubs.co.uk/chilterntaps
Rebellion IPA; Sharp's Doom Bar; St Austell Tribute; 1 changing beer (sourced regionally) Ⓗ
A bright and airy sports bar, conveniently located near the bus station and Eden Shopping Centre. It serves an interesting selection of real ales and keg beers. The upper floor is dedicated to sport, featuring a pool table and 12 TV screens. Food offerings include freshly made pizzas and tapas. 🏖🕦♿🛱🚌🛜

Rose & Crown ✅
Desborough Road, HP11 2PR
☎ (01494) 571578
4 changing beers Ⓗ
This pub next to the Eden Shopping Centre has steadily built up its real ale offering and now has an extensive range. It is a comfortable establishment in an area consisting mainly of small businesses. The pub holds quizzes, discos and charity events, and hosts live bands and karaoke once a month. Many sporting events are shown on two large-screen TVs. Snacks are served, and Sunday roasts to order. The bus station is nearby. ❀♣♿🚌🐾🛜

Iver Heath

Black Horse
95 Slough Road, SL0 0DH
☎ (01753) 652631 ⊕ theblackhorseiverheath.co.uk
Hall & Woodhouse Badger Best Bitter; 1 changing beer (sourced regionally) Ⓗ
Refurbished by Hall & Woodhouse, this large pub/diner has a country-house feel with oak panelling and shelves packed with interesting books. The separate drinking area has comfortable leather armchairs. A green oak timber conservatory restaurant opens onto a patio and garden. Meals and snacks, including vegetarian options, are served all day. The Uxbridge to Slough bus stops outside (last bus approximately 8pm).
Q🏖❀🕦♿P🚌(3) 🐾🛜

Little Missenden

Crown Inn
HP7 0RD (off A413, between Amersham and Gt Missenden)
☎ (01494) 862571 ⊕ thecrownlittlemissenden.co.uk
Harvey's Sussex Best Bitter; 3 changing beers (sourced nationally; often Oakham, Otter, Timothy Taylor) Ⓗ
This lovely old local has been in the same family for almost a hundred years. Former Watford footballer Trevor How and his wife took over in 1993. The village inn sits in an acre of beautiful countryside, with a patio at the back where children are welcome. Inside you will find a traditional adults-only pub with stone and wood floors, and in winter an open fire. Good pub grub is served at lunchtimes. Three double en-suite rooms are available. Q🏖❀🛋🕦♣P🚌(55) 🐾🛜

Littleworth Common

Blackwood Arms 🅛

Common Lane, SL1 8PP SU937863
☎ (01753) 645672 🌐 theblackwoodarms.co.uk
Brakspear Gravity, Oxford Gold; Stardust Easy Pale Citra; 1 changing beer 🅗
A delightful Victorian country pub that was restored to life after a long period of closure. Close to Burnham Beeches nature reserve, it is popular with walkers and diners. The pub is warmed by a roaring log fire in winter. For summer there is a large and attractive garden with plenty of seating, some of it covered and heated. Dogs and horses are welcome – treats and hay can be provided. Closed on Monday. Q ➄ ❀ ◑ ♣ P ✿ 🖤

Long Crendon

Eight Bells 🅛

51 High Street, HP18 9AL
☎ (01844) 208244 🌐 8bellspub.com
Chiltern Fudgel; 2 changing beers (sourced locally; often Chiltern, XT) 🅗
Charming and characterful village pub with a glorious beer garden. It is renowned for slaking the thirst of ale enthusiasts. Fudgel ale from Chiltern Brewery is a permanent fixture on handpump alongside guest beers from across the country. Food features local produce. The local morris dancers perform here, and the pub hosts beer festivals over Easter weekend and August bank holiday. Q ➄ ❀ ◑ ♣ ♣ P 🚆 (110) ✿ 🖤

Loudwater

General Havelock

114 Kingsmead Road, HP11 1HZ
☎ (01494) 520391 🌐 generalhavelock.co.uk
Fuller's London Pride, ESB; Gale's Seafarers Ale; 3 changing beers 🅗
Originally farm buildings before being converted to a pub, the General Havelock was purchased by Fuller's in 1986 and has been run by the same family ever since. Its decor is an eclectic mix of antiques and bric-a-brac. Six ales are available at all times, mostly from Fuller's and including some guest brews. TVs are brought out for England football matches and some other events. There is an open fire in winter and the garden is a peaceful haven in summer. ➄ ❀ ◑ ♣ P 🚆 (35) ✿ 🖤

Marlow

Royal British Legion 🅛 ✅

Station Approach, SL7 1NT (50yds from Marlow train station)
☎ (01628) 486659 🌐 rblmarlow.co.uk
6 changing beers 🅗
A friendly Royal British Legion club that serves a wide range of cask ales. It is a private members' club that welcomes guests – show a copy of this Guide or a CAMRA membership card for entry. Various events are held including jazz and music nights, and two beer festivals a year. This popular venue next to the railway station is a regular winner of regional CAMRA Club of the Year. ❀ ⅙ ≈ ♣ ♠ P 🚆 🖤

Marsworth

Red Lion

90 Vicarage Road, HP23 4LU (opp church)
☎ (01296) 668366 🌐 redlionmarsworth.co.uk

Fuller's London Pride; Harvey's Sussex Best Bitter; Tring Side Pocket for a Toad; 3 changing beers (sourced locally) 🅗
Genuine 17th-century village pub close to the Grand Union Canal. A central bar serves three areas: an upstairs lounge bar with comfortable sofas, a small snug and a public bar with an open fire. The handpumps dispense six well-kept beers, some from local breweries; the kitchen serves generous portions of home-cooked food. At the rear are a beautiful well-kept garden and a smoking refuge. ➄ ❀ ◑ ♣ P 🚆 (164) ✿ 🖤

Milton Keynes: Bletchley

Captain Ridley's Shooting Party ✅

183 Queensway, MK2 2ED
☎ (01908) 621020
Greene King Abbot; Ruddles Best Bitter; Sharp's Doom Bar; 4 changing beers (sourced nationally; often Adnams, Hornes, Tring) 🅗
A Wetherspoon outlet that commemorates Bletchley Park, the headquarters of Britain's famous World War II codebreakers, with pictures, artefacts and features. The pub name was used by MI5 agents secretly checking the location's suitability. The ground floor comprises one large bar with seating throughout. A dozen handpumps serve three regular ales and four guests. There is seating in front of the pub and a large patio garden at the rear. ➄ ❀ ◑ ⅙ ≈ P 🚆 (5,6) 🖤

Milton Keynes: Bradwell Village

Victoria Inn

Vicarage Road, MK13 9AQ
☎ (01908) 312769
4 changing beers (sourced regionally; often Grainstore, Hornes, Vale) 🅗
A traditional, recently refurbished 17th-century stone-built pub whose exposed beams and low ceilings provide a comfortable and relaxed atmosphere. The bar's four handpumps serve regional beers. A split-level room on the left has tables, chairs and an open fire; the room on the right hosts a pool table and dartboard. There is seating on the paved terrace at the front. Q ➄ ♣ 🚆 (33,33A) ✿ 🖤

Milton Keynes: Fenny Stratford

Chequers 🅛

48 Watling Street, MK2 2BY
☎ (01908) 990718
Vale Red Kite, Gravitas; 2 changing beers (sourced locally; often Vale) 🅗
Small, traditional public house with exposed beams and brickwork. Its focus is on beer from the Vale Brewery, though its four handpumps often feature a guest ale. Entrance is up several steep steps at the front or through a low rear door down a step. To the rear are a neat courtyard garden furnished with wooden tables and a small car park. The pub welcomes away supporters on match days. Closed Monday and Tuesday. Q ❀ ◑ ≈ P 🚆 (18,X31) 🖤

Milton Keynes: Stacey Bushes

Blackened Sun Brewery Tap 🅛

Unit 3, Heathfield, MK12 6HP
☎ (01908) 990242 🌐 blackenedsunbrewing.co.uk
Blackened Sun Hedone, Luna Saison 🅟; 4 changing beers (sourced locally; often Blackened Sun) 🅚
The Blackened Sun microbrewery's taproom is on an unpretentious trading estate, and has long tables, stools

and bench seating. Six taps serve the micro's beers, sometimes including a collaboration brew. All are real ales – naturally conditioned, unfined, unpasteurised and unfiltered. Most are vegan and many are brewed with Belgian yeasts. Bottled house and guest beers are also available, to drink or take away, and growlers can be refilled. Under-18s are welcome before 8pm accompanied by an adult. Winner of several local CAMRA awards. Q✤P╗🖵(6)🐾

Milton Keynes: Stony Stratford

Stony Stratford Conservative Club
77 High Street, MK11 1AY
☎ (01908) 567105 ⊕ stonyconclub.co.uk
Brains Rev James Original; Vale Pale Ale; 2 changing beers (often Brains, Phipps NBC, Vale) Ⓗ
Private members' club that admits card-carrying CAMRA members as guests. It offers up to four cask-conditioned ales from Carlsberg's lists. The lounge/restaurant is open to the public noon-2pm, when food is served. The club hosts regular members' activities, and occasionally events open to the public. The car park is restricted to members and their guests; parking outside can be difficult. ♿✤🕐❺♣P╗🖵(6,X60)🐾🖥

Milton Keynes: Westcroft

Nut & Squirrel
1 Barnsdale Drive, MK4 4DD
☎ (01908) 340031
Black Sheep Twilighter Pale Ale; 3 changing beers (sourced nationally; often Fuller's, Purity, St Austell) Ⓗ
Modern open-plan pub with nooks and crannies that give a traditional multi-room feel. Five handpumps serve the house ale and three cask beers from the Ember Inns list. Several craft beers and Old Rosie cider are also on tap. The separate restaurant's menu includes vegetarian and vegan choices plus a weekend brunch. The pub is just outside the Westcroft shopping centre and opposite Howe Park Wood. ♿✤🕐❺P╗(3,8)🐾🖥

Milton Keynes: Willen

Ship Ashore
Granville Square, MK15 9JL
☎ (01908) 694360
Black Sheep Twilighter Pale Ale; 4 changing beers (sourced nationally; often Brains, Fuller's, St Austell) Ⓗ
Drinkers and diners are equally welcome at this smart pub on a residential estate near Willen Lake and its recreational facilities. It has one large bar, with pillars and low walls helping to give an intimate feel. The pub serves Twilighter, the house beer from Black Sheep, plus a changing selection of four real ales, all at reduced prices on Monday and Thursday. Food is available all day and includes a vegetarian/vegan menu. The pub hosts a weekly quiz. Outside are a small garden and ample free parking. ✤🕐❺╗(1)🐾🖥

Naphill

Wheel ✓
100 Main Road, HP14 4QA
☎ (01494) 562210 ⊕ thewheelnaphill.com
Greene King Abbot; 3 changing beers Ⓗ
Friendly local with a large garden, opposite the village hall. It has two bar areas plus a rear section that is used for dining. One regular beer is served alongside three changing brews. The pub is a regular in this Guide. Dogs

and muddy boots are welcome. Worth a visit if you are in the area walking or visiting friends or family.
✤🕐♣P╗🐾🖥

Newport Pagnell

Cannon
50 High Street, MK16 8AQ
☎ (01908) 211495
Banks's Amber Ale; Ringwood Fortyniner; 2 changing beers (often Courage, Marston's, Wychwood) Ⓗ
A busy, family-run free house in the town centre, in a building that dates from the early 19th century. Despite being located at 'Cannon Corner' – named after an artillery piece reputedly left after the Civil War – the pub became the Cannon as recently as 1953, though the former-brewery of that name behind the pub dates back further. The single L-shaped bar's four handpumps serve beers from Marston's lists. A function room is accessed from the rear where there is a patio with a bar for busy times, plus a heated smoking area. ✤P╗🐾

Rose & Crown
Silver Street, MK16 0EG
☎ (01908) 611685
⊕ theroseandcrownnewportpagnell.co.uk
Brewpoint Origin Pale Ale, DNA Amber Ale; Courage Directors; 1 changing beer (sourced regionally; often Brewpoint, Courage, Eagle) Ⓗ
Two-bar pub in a quiet area, a short walk from the High Street. It has been nicely refurbished by new tenants, with grey panelling, exposed brickwork and wood beams. The central bar is straight ahead as you enter, with tables and chairs on either side and armchairs around a log-burner. Four handpumps dispense beers from the Brewpoint family, including Courage and Eagle. The popular back bar has a dartboard and high tables. Q✤🕐♣P╗🐾🖥

Oving

Black Boy Ⓛ
Church Lane, HP22 4HN
☎ (01296) 641258 ⊕ theblackboyoving.co.uk
XT Four; 3 changing beers (sourced locally; often Chiltern, Leighton Buzzard, XT) Ⓗ
Delightful 17th-century inn with a roaring fire in winter. Summer visits are also a treat, with wonderful views across the local countryside from the huge beer garden. An archway divides the restaurant from the bar opposite. The drinking areas have wooden beams and flagstone floors. This cosy pub is a pleasure to visit, offering good food and a great atmosphere. ♿✤🕐♣P🐾🖥

Princes Risborough

Bird in Hand Ⓛ ✓
47 Station Road, HP27 9DE
☎ (01844) 345602 ⊕ birdinhandprincesrisborough.co.uk
Chiltern Beechwood Bitter; Thame Hoppiness; 2 changing beers Ⓗ
Thriving community local in a residential area near the station. It has a compact L-shaped bar, supplemented by a beer garden and outside drinking area. There is an excellent choice of real ales on handpump. The pub hosts events including quizzes and live music. Regular street food pop-ups visit at weekends. Parking can be tricky nearby. ✤≉♣🍽╗(300)🐾🖥

Quainton

George & Dragon 🅛
32 The Green, HP22 4AR
☎ (01296) 655436 🌐 georgeanddragonquainton.co.uk
4 changing beers (sourced locally) 🅗
Delightful free house with an adjoining coffee shop. It is split between public and saloon bars, both offering home-cooked food. The friendly public bar offers darts, a jukebox and TV; the saloon is dedicated to dining. Four LocAles are served alongside two guest beers. Parts of this well-maintained pub date back to the 1700s; traditional features include inglenook fireplaces, beams and a quarry-tiled floor. In summer the pub hosts regular beer festivals overlooking the green.
🌞🏮🕽🕭♣♠🅿🚍(16)🐾🍴 🛜

Saunderton

Golden Cross
Wycombe Road, HP14 4HU
☎ (01494) 565974 🌐 thegoldencrosspub.co.uk
Adnams Ghost Ship; 2 changing beers (sourced nationally) 🅗
A family-friendly village local, close to the station and on the main road between High Wycombe and Princes Risborough. It serves one regular beer and two ever-changing guests. The large garden includes a children's play area. The pub is in the heart of the Chilterns in an Area of Outstanding Natural Beauty, ideal for walks in the surrounding countryside. 🌞🏮🕽🕭🚲🅿🚍(X30)🐾 🛜

Stoke Goldington

Lamb 🅛
16-20 High Street, MK16 8NR
☎ (01908) 551233
Tring Death or Glory; 2 changing beers (sourced regionally; often Oakham, Phipps NBC, Tring) 🅗
Family-run pub in a peaceful village between Milton Keynes and Northampton, offering a warm and friendly welcome. Its main bar has five handpumps, usually serving three ales and a cider. There is also a smaller room beyond, plus a restaurant and large garden. The home-cooked food uses local produce and includes award-winning pies, with steak & ale a favourite. The pub has featured in this Guide for more than 20 consecutive years, and has been local CAMRA Pub of the Year several times. Q🌞🏮🕽🕭🚲🅿🐾🍴

Turweston

Stratton Arms ✅
Main Street, NN13 5JX
☎ (01280) 704956
Otter Bitter; Sharp's Doom Bar; 2 changing beers (sourced nationally; often St Austell, Shepherd Neame, Timothy Taylor) 🅗
Popular with walkers, this stone-built pub on the edge of a quiet village dates back to the early 18th century. Before becoming a pub it was the village morgue; the current cellar was once a tunnel to the church. Four real ales are usually served. Food is offered all week – pizzas only on Monday and Tuesday evenings. Booking is advised for Friday and Saturday night meals and Sunday lunch. Outside is an extensive grassed area with tables and seating, some covered by marquees. There is free overnight parking for motor homes (phone to book). Q🌞🏮🕽🕭🏕♠🅿🚍(131,132)🐾 🛜

Twyford

Crown Inn
The Square, MK18 4EG
☎ (01296) 730216
2 changing beers 🅗
A freehold locals' pub central to the life of the village. The landlady has seen pubs nearby decline and close, and has increased opening hours and food provision with the help of her family. The Crown is a deceptively large brick building opposite the village hall. A spacious bar area leads to an even larger lounge/function space on the left. The pub serves one frequently changing beer from the barrel, and usually offers seven different ales during the week. 🌞🏮🕽🕭🚲♣🚍(16)🐾 🛜

Wendover

King & Queen ✅
17 South Street, HP22 6EF
☎ (01296) 696872 🌐 thekingandqueenwendover.co.uk
Timothy Taylor Landlord; Young's London Original; 2 changing beers 🅗
Situated just off the High Street within easy reach of the station, this three-room village pub has a pleasant, homely ambience. Good food is served in the restaurant. Comedy nights, quizzes and televised sport are shown. There is an impressive wall map of the local countryside in one room. A wood-burning fire helps to provide a warm winter welcome for walkers returning from the nearby Chiltern Hills. The pub features in the novel The Paper Lantern by Will Burns. Q🌞🏮🕽🕭🚲♣🚲♠🅿🐾

Wing

Queen's Head 🅛
9 High Street, LU7 0NS
☎ (01296) 688268 🌐 thequeensheadwing.co.uk
2 changing beers 🅗
A 16th-century free house in the village centre, featuring a comfortable public bar and a restaurant with a well-deserved reputation for good food. The LocAle accredited pub serves guest beers from nearby Tring, Vale, Hopping Mad and other micros. Log fires in winter help give a welcoming atmosphere, and there is no TV. The large garden has a patio with a covered and heated smoking area. There is ample car parking. 🌞🏮🕽🕭🚲🅿🚍(100,150)

Wooburn Common

Royal Standard 🅛 ✅
Wooburn Common Lane, HP10 0JS (follow signs to Odds Farm)
☎ (01628) 521121 🌐 theroyalstandard.biz
Hop Back Summer Lightning 🅗; **Timothy Taylor Landlord** 🅗/🅖; **7 changing beers** 🅗
A warm welcome is guaranteed at this award-winning pub near Burnham Beeches, set in the countryside and ideal for walks. It serves seven changing beers, some straight from the barrel, alongside real cider. A disused red phone box outside at the front contains books that patrons can borrow. There is no public transport nearby but the pub has a large car park. Q🌞🏮🕽🕭🚲♣🐾

Breweries

Blackened Sun

3 Heathfield, Stacey Bushes, Milton Keynes, Buckinghamshire, MK12 6HP ☎ 07963 529859
🌐 blackenedsunbrewing.co.uk

⊠ Blackened Sun began brewing in 2017 and is mainly focused on brewing beers using Belgian yeast. The brewery continues to diversify and innovate with its core range. It is involved in other brewing projects including a mixed fermentation programme and a project brewing with local home brewers ◆LIVE ✦

Boobytrap (NEW)

7b, Upper Barn Farm, Bicester Road, Westcott, HP18 0JX
☎ (01296) 651755 ☎ 07811 437185
⊕ boobytrapbrewery.com

A five-barrel brewhouse and taproom established by chef Philip Baker in 2021 and producing beer in bottles and cans. ✦

Brewhouse & Kitchen SIBA

🍴 7 Savoy Crescent, Milton Keynes, Buckinghamshire, MK9 3PU
☎ (01908) 049032 ⊕ brewhouseandkitchen.com

The brewery was recently christened 'The Upside Down' in reference to its inverted design. Brewing is done in the round, perhaps a nod to the pub's location in Milton Keynes' Theatre District. The brewery's core beers are named after local heroes, history and place names. The brewery, like other Brewhouse & Kitchen breweries offers brewdays and beer sampling masterclasses. ◆

Bucks Star

23 Twizel Close, Stonebridge, Milton Keynes, Buckinghamshire, MK13 0DX
☎ (01908) 590054 ⊕ bucksstar.beer

⊠ A solar-powered brewery opened in 2015 using a 10-barrel, purpose-built plant. Only organic malt is used and no sugars or syrups are added. The beers are unfiltered, vegan, and primarily available through Bucks Star's own zero-waste innovation (Growler Swap). This range of beers is conditioned inside reusable glass growlers, and are available at farmers' markets locally, and at various London locations. The brewery tap opened in the opposite unit in 2020. ‼🍺LIVE V

Chiltern SIBA

Nash Lee Road, Terrick, Buckinghamshire, HP17 0TQ
☎ (01296) 613647 ⊕ chilternbrewery.co.uk

⊠ Founded in 1980, Chiltern, located on a working farm, was one of the first microbreweries in the country. Family-run, its emphasis has always been on producing natural, wholesome beers using the best British malt and hops (some grown in Buckinghamshire). Now run by the second generation, George and Tom, it supplies around 100 outlets including its tap, the King's Head, Aylesbury, and has recently been expanded on-site. Some bottled beers are suitable for vegans, and some are gluten-free. ‼🍺◆LIVE GF V✦

Chiltern Pale Ale (ABV 3.7%) PALE
An amber, refreshing beer with a slight fruit aroma, leading to a good malt/bitter balance in the mouth. The aftertaste is bitter and dry.

Chiltern Black (ABV 3.9%) PORTER
Beechwood Bitter (ABV 4.3%) BITTER
This pale brown beer has a balanced butterscotch/toffee aroma, with a slight hop note. The taste balances bitterness and sweetness, leading to a long bitter finish.

Concrete Cow

59 Alston Drive, Bradwell Abbey, Milton Keynes, Buckinghamshire, MK13 9HB
☎ (01908) 316794 ☎ 07889 665745
⊕ concretecowbrewery.co.uk

⊠ Concrete Cow opened in 2007 on a 5.5-barrel plant. The beers are named after aspects of local history. The brewery supplies pubs, farmers' markets, local shops and restaurants. English single malt whisky is also available, produced from the brewery's own malt at a local distillery. ‼◆LIVE

Pail Ale (ABV 3.7%) BLOND
Fenny Popper (ABV 4%) GOLD
Cock 'n' Bull Story (ABV 4.1%) BITTER
Old Bloomer (ABV 4.7%) BITTER

Hopping Mad

Small House, 6 High Street, Sherington, Buckinghamshire, MK16 9NB ⊕ hoppingmad.com

Hopping Mad began brewing again in 2022 after having closed in 2014. Now at a new location it currently brews one beer, which is supplied to one pub, the White Hart in Sherington. There are plans to open a taproom and to brew bottled beer.

Landlord's Choice (ABV 4.3%) BITTER

Hornes SIBA

19b Station Road, Bow Brickhill, Buckinghamshire, MK17 9JU
☎ (01908) 647724 ⊕ hornesbrewery.co.uk

A purpose-built, six-barrel brewery established in 2015 and producing a range of beers called Triple Goat after the three goats kept in a paddock at the brewery. A shop was added in 2018. 🚚◆

Featherstone Amber Ale (ABV 3.6%) BITTER
Dark Fox (ABV 3.8%) BITTER
Ryestone (ABV 4%) RED
Unlocked Hornes (ABV 4.3%) GOLD

Brewed under the Triple Goat brand name:
Pale Ale (ABV 3.9%) PALE
Porter (ABV 4.6%) PORTER
IPA (ABV 5%) PALE

Malt SIBA

Collings Hanger Farm, 100 Wycombe Road, Prestwood, Buckinghamshire, HP16 0HW
☎ (01494) 865063 ⊕ maltthebrewery.co.uk

⊠ Family-owned brewery, founded in 2012 using a 10-barrel plant. Based on a dairy farm in the heart of the Chiltern Hills, it has sustainability built into its brewing with spent grains going to feed the pigs on the farm and spent hops being composted. The brewery tasting bar stocks vegan-friendly bottled beers, alongside local ciders. In-house deliveries are made to trade and direct customers in six surrounding counties. National distribution is through leading distributors and wholesalers. ‼🚚◆✦

Moderation (ABV 3.4%) GOLD
Missenden Pale (ABV 3.6%) PALE
Starry Nights (ABV 4%) BITTER
Voyager (ABV 5%) PALE

moogBREW

Meads End, Ye Meads, Taplow, Berkshire, SL6 0DH
☎ 07941 241954 ⊕ moogbrew.co.uk

⊠ The brewery was set up in 2016 and moved to new premises in 2019. The majority of the production is keg, with bottle-conditioned beer and a small amount of cask also available. The focus of this tiny brewery is serving the local community and distribution is targeted to within a 10-mile radius. ‼ ⬛ ♦ LIVE ⚲

Old Luxters

Old Luxters Vineyard, Dudley Lane, Hambleden, Buckinghamshire, RG9 6JW
☎ (01491) 638330 ⊕ chilternvalley.co.uk

Situated in a 17th century barn beside the Chiltern Valley Vineyard, Old Luxters is a traditional brewery established in 1990 and awarded a Royal Warrant of Appointment in 2007. It produces a range of bottle-conditioned beers. ‼ ♦ LIVE

Rebellion SIBA

Rebellion Brewery, Bencombe Farm, Marlow Bottom, Buckinghamshire, SL7 3LT
☎ (01628) 476594 ⊕ rebellionbeer.co.uk

⊠ Established in 1993, Rebellion has grown steadily with one site move and several expansion projects. It currently brews approximately 100,000 pints per week, supplying more than 600 local pubs and clubs within a 30-mile radius of Marlow. A taproom opened in 2021. Its ever-popular membership club now has over 4,500 active members. ‼ ⬛ ♦ ⚲

IPA (ABV 3.7%) BITTER
Copper-coloured bitter, sweet and malty, with resinous and red apple flavours. Caramel and fruit decline to leave a dry, bitter and malty finish.
Smuggler (ABV 4.2%) BITTER
A red-brown beer, well-bodied and bitter with an uncompromisingly dry, bitter finish.
Overthrow (ABV 4.3%) PALE
Roasted Nuts (ABV 4.6%) BITTER

Vale SIBA

Tramway Business Park, Ludgershall Road, Brill, Buckinghamshire, HP18 9TY

☎ (01844) 239237 ⊕ valebrewery.co.uk

⊠ Established in 1995 initially in Haddenham, Vale moved to Brill in 2007. In 2010 it expanded to a 20-barrel brew plant. Four pubs are owned, including the Hop Pole, where sister brewery Aylesbury Brewhouse operated 2011-2019. When it closed, brewing moved back to Vale. In 2021, Phil and Mark Stevens decided it was time for a new set of brothers to take the reigns, and sold Vale Brewery to Joe and Jimmy Brouder. ‼ ⬛ ♦ LIVE

Brill Gold (ABV 3.5%) GOLD
Best IPA (ABV 3.7%) BITTER
This pale amber beer starts with a slight fruit aroma. This leads to a clean, bitter taste where hops and fruit dominate. The finish is long and bitter with a slight hop note.
VPA (Vale Pale Ale) (ABV 4.2%) PALE
Red Kite (ABV 4.3%) BITTER
Black Beauty Porter (ABV 4.4%) PORTER
A very dark ale, the initial aroma is malty. Roast malt dominates initially and is followed by a rich fruitiness, with some sweetness. The finish is increasingly hoppy and dry.
Gravitas (ABV 4.8%) PALE

XT SIBA

Notley Farm, Chearsley Road, Long Crendon, Buckinghamshire, HP18 9ER
☎ (01844) 208310 ⊕ xtbrewing.com

⊠ XT started brewing in 2011 using an 18-barrel plant. It supplies direct to pubs across southern England and the Midlands. The brewery taproom and shop sell draught and bottled beers to drink in or take out. A range of limited edition, but ever-changing, one-off brews is produced under the Animal Brewing Co name. ‼ ⬛ ♦ LIVE ⚲

Four (ABV 3.8%) BITTER
Hop Kitty (ABV 3.9%) GOLD
One (ABV 4.2%) BLOND
Three (ABV 4.2%) PALE
Eight (ABV 4.5%) PORTER
Fifteen (ABV 4.5%) PALE
Squid Ink (ABV 5.5%) STOUT

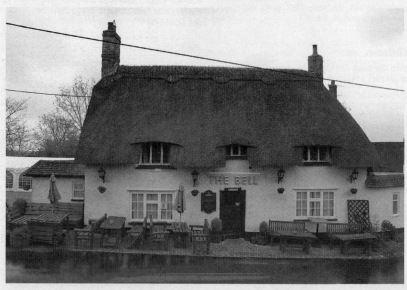

Bell, Chearsley (Photo: adam w / Flickr CC BY 2.0)

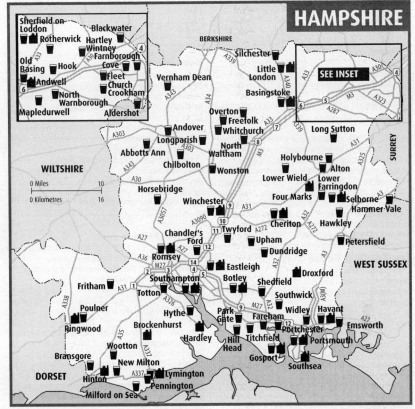

Please note: Ringwood Brewery renamed Best Bitter to Razorback but it is still available in some outlets as Best Bitter

Abbotts Ann

Eagle Inn 🅛
Duck Street, SP11 7BG
☎ (01264) 710339 ⊕ theeagleinn.wordpress.com
Bowman Wallops Wood; 4 changing beers (sourced locally) ⒣
Located in a picturesque village just two miles from Andover, this well-loved pub run by a long-serving couple is at the heart of the community. Friendly conversation rules the house. The public bar has a pool table and there is a skittle alley at the back. Outside, to the rear, is a pleasant landscaped beer garden. A beer and cider festival is held annually in June. Food is available at weekends but ring directly to confirm.
❀◗♣P🚆(87)🐾🛜

Aldershot

Garden Gate 🅛 ✅
2 Church Lane East, GU11 3BT
☎ (01252) 219717
Surrey Hills Ranmore; house beer (by Marston's); 1 changing beer (sourced regionally; often Courage, Young's) ⒣
Close to the town's bus and railway stations and near to Aldershot Town's football ground, this pub at the heart of its local community repays a visit. Conversation reigns supreme, accompanied by background music. At least three and often four beers are on tap, with Surrey Hills Ranmore, rarely seen locally, the best seller. The

Thursday night quiz is well attended, likewise the music quiz on the first Sunday of the month. The pub is a popular stop-off for dog walkers. ❀≈P🚆🐾🛜

Alton

Eight Bells 🅛
33 Church Street, GU34 2DA
☎ (01420) 82417
Flower Pots Perridge Pale, Pots Bitter; 1 changing beer (sourced nationally; often Crafty Brewing, Flack Manor) ⒣
This genuine free house, a pub since at least the 1840s, is a regular outlet for Flower Pots ales. Guest beers tend to be local to Hampshire but may come from anywhere. The main bar, with an open fire for the winter months, is a haven for good beer and conversation, while the rear drinking area has a TV for major sporting events. Floral shrub borders around the paved patio in summer add to the welcoming ambience. Q❀≈🚆(13)🐾🛜

George ✅
Butts Road, GU34 1LH
☎ (01420) 513398 ⊕ georgepubalton.co.uk
St Austell Tribute, Proper Job; Timothy Taylor Landlord; 2 changing beers (sourced nationally; often Laine, Woodforde's) ⒣
Built shortly after the 1746 Battle of Culloden and originally named for the victorious Duke of Cumberland, this historic pub was the site of the inquest on 'Sweet Fanny Adams' in 1867. Following a period of closure

from 2020, it reopened under the management of a Punch tenant in 2021, and now has a cosy feel enhanced by warm wood tones and lush hangings. Three regular cask beers and two rotating guests from far and wide are available. ⊛⊕⅃P🏠(64,38)🐾🍽🛜

Railway Arms ⅃

26 Anstey Road, GU34 2RB
☎ (01420) 542316
Triple fff Alton's Pride, Moondance; 5 changing beers (sourced nationally; often Fuller's, Red Cat, Triple fff) Ⓗ

Friendly pub close to the Watercress Line and mainline station. Owned by Triple fff Brewery, its beers, including seasonals, are supplemented by guest ales, often from local microbreweries. Real cider is from Seacider at this 2022 local CAMRA Cider Pub of the Year. The rear bar, which holds occasional music nights, is available for hire. The patio area incorporates a covered smoking area. There are tables outside at the front under a striking sculpture of a steam locomotive. Well-behaved dogs are welcome. ⊛⇌♣🏠(64,65)🐾🛜

Ten Tun Tap House 🍴 ⅃

1 Westbrook Walk, GU34 1HZ
☎ 07971 076657 ⊕ tentuntaphouse.beer
4 changing beers (sourced nationally; often Red Cat, Siren) Ⓗ

Up to four handpumps plus eight taps dispense real ale, craft keg and cider from around the country, with local Hampshire and Sussex brews often available. The style is bare wood minimalist in this independent bar but a buzz is generated by the varied clientele and the jazzy background music. Wednesday is 'bring your own vinyl' night. Watch out for the popular brewery visits. Voted local CAMRA Pub of the Year 2022 – an impressive achievement for a pub that only opened two years ago, just two days before the first Covid lockdown. ⊱⊛⇌🍴🏠🐾🛜

Andover

Andover Tap at the Lamb ⅃

21 Winchester Street, SP10 2EA
☎ (01264) 323961 ⊕ theandovertap.co.uk
Longdog Bunny Chaser; 11 changing beers (often Unity) Ⓗ

The Lamb was a traditional pub dating from the 17th century, situated near the town centre. It is now a joint venture between Wessex Spirits and the Andover Tap, with each occupying half the building. The Tap serves up to 12 beers – four on handpump, four casks on gravity dispense and four KeyKeg – plus real ciders. It has a two-room layout, with a small front bar and a cosy back room. Families are welcome until 8pm and simple snacks are served. Special food and beer events are held regularly. Q⊱♨🏠🐾

Basingstoke

Basingstoke Sports & Social Club ✅

Fairfields Road, RG21 3DR
☎ (01256) 473646 ⊕ basingstokesportsandsocialclub.com
Arkell's Hoperation IPA; Fuller's London Pride; 2 changing beers (sourced locally; often Andwell, Little London, Longdog) Ⓗ

This is a sports-based members' club but the bar is open to all. Home to cricket, squash, football and rugby, and the annual Hampshire OctoberFest in September, widescreen TVs show sports events. An annual programme of social activities is held and facilities can be hired. The Greek Street franchise operates a daily food

service. Opening hours and meal times vary – please call for details. A three-times local CAMRA Club of the Year. ⊱⊕♣P🏠(1,3) 🐾🛜

New Inn

Sarum Hill, RG21 8SS
☎ (01256) 3232 ⊕ newinnbasingstoke.co.uk
Theakston Best Bitter; 2 changing beers (sourced nationally; often Marston's, Rebellion) Ⓗ

Corner pub set on a crossroads in a residential area between the town centre and the college. The bar area splits the pub between a games zone (with pool, darts, etc) and a quieter lounge area which includes TVs showing live sports. Roadside tables and barrels provide an outdoor drinking area. The pub serves three changing ales from a national list, alongside two craft keg beers from Beavertown, a wide spirits selection, an independent wine list and hot drinks. ♿⇌♣🏠🐾🛜

Queens Arms ⅃

Bunnian Place, RG21 7JE (E of station entrance)
☎ (01256) 465488 ⊕ thequeensarmspub.co.uk
St Austell Tribute; Sharp's Doom Bar; 4 changing beers (sourced nationally) Ⓗ

Just outside the main shopping area, this cosy pub is handy for all transport links. It attracts a wide-ranging clientele of all ages from all walks of life, and is a regular port of call for rail commuters. The choice of up to four guest beers is imaginative and the turnaround can be swift. A food service is available but ring to confirm. During warmer weather the shady courtyard garden at the rear is a popular attraction. Q⊛⊕⇌P🏠🛜

REAL ALE BREWERIES

Alfred's Winchester
Andwell ✦ Andwell
Botley ✦ Botley
Bowman Droxford
Brewhouse & Kitchen 🍴 Portsmouth
Brewhouse & Kitchen 🍴 Southampton
Brewhouse & Kitchen 🍴 Southsea
CrackleRock Botley
Dancing Man 🍴 Southampton
Drop The Anchor ✦ Hinton
Emsworth ✦ Havant
Fallen Acorn ✦ Gosport
Flack Manor ✦ Romsey
Flower Pots Cheriton
Gilbert White's Selborne
Growling Gibbon Winchester (NEW)
Irving Portsmouth
Little London Little London
Longdog ✦ Basingstoke
Makemake 🍴 Southsea (brewing suspended)
Monkey 🍴 ✦ Lymington (NEW)
Newtown Gosport
Pig Beer Brockenhurst
Queen Inn 🍴 Winchester
Red Cat Winchester
Red Shoot 🍴 Ringwood (brewing suspended)
Ringwood Ringwood
Sherfield Village Sherfield on Loddon
Southsea Portsmouth
Staggeringly Good ✦ Southsea
Steam Town 🍴 Eastleigh
Tap It ✦ Southampton
Triple fff ✦ Four Marks
Unity ✦ Southampton
Urban Island ✦ Portsmouth
Vibrant Forest ✦ Hardley

Wheatsheaf

Winton Square, RG21 8EU

☎ (01256) 479601

Butcombe Original; Otter Ale; Sharp's Doom Bar, Atlantic ⊞

This is a lively wet-led local with the atmosphere you would expect from a popular town centre pub. There is a good choice of cask beers, sold at prices that are good for the area. The beers are well kept, and at weekends and some evenings large-screen TVs show sports fixtures. Food is served daily. A traditional boozer with no frills but a warm welcome. ◖▯≢♣P☲

Blackwater

Mr Bumble ⳑ

19 London Road, GU17 9AP

☎ (01276) 32691

Fuller's London Pride; 3 changing beers (sourced regionally; often Ascot, Windsor & Eton) ⊞

Very much a community local, Mr Bumble is near the station and bus stops. The regular London Pride is accompanied by a wide range of real ales and four still ciders. There is a large L-shaped bar with comfortable seating, tables and chairs. Just around the corner is a sports bar with darts and three pool tables. Wide-screen TVs show major sporting events, and live music is staged on Thursday and Saturday. ⮞❀≢♣P☲(3)❀☏

Botley

CrackleRock Tap Room ⳑ

30A High Street, SO30 2EA (down alley between Clarke Mews and Botley MTB) SU5130213037

☎ 07733 232806 ⊕ cracklerock.co.uk

CrackleRock Verified, Fire Cracker, Gold Rush, Dark Destroyer, Crafty Shag, Crackatoa IPA; 3 changing beers (sourced locally; often Bowman, Steam Town, Urban Island) ⊞

A cosy brewery tap room, just across the road from the brewery, down a narrow alley in the centre of Botley village. The full range of the brewery's beers, alongside some guests, are served from a single bar, with seven of the beers on cask and occasional beers on keg. The subtly lit L-shaped room has booth-type seating situated each side of a single central pathway. Various board games and table games are available to play. ⮝♣(3,X9)❀

Bransgore

Three Tuns ⊘

Ringwood Road, BH23 8JH (between Burley Rd and Harrow Rd)

☎ (01425) 672232 ⊕ threetunsinn.com

Otter Amber; Ringwood Razorback, Fortyniner; 6 changing beers (sourced nationally; often Crafty Brewing, Flack Manor) ⊞

Large, multi-bar, thatched free house between Christchurch and Burley on the verge of the New Forest National Park. A bank of handpumps graces the extensive public bar, offering three regular ales and several guests, and a small beamed snug bar at the north end repeats this theme. The dining room provides an all-day food service, recognised by both Egon Ronay and the AA for quality. Functions can be catered for in a big barn and a marquee. A New Forest pétanque team is based here. Q⮞❀◖⮝♣⬥●P☲(125)❀☏

Chandler's Ford

Steel Tank Alehouse ⳑ

1 The Central Precinct, Winchester Road, SO53 2GA

☎ 07379 553025 ⊕ thesteeltank.com

Alfred's Saxon Bronze; 6 changing beers (sourced nationally; often Eight Arch, Flower Pots) ⊞

Former bank in a modern shop unit converted to a micropub. The bar sports a wide choice with eight handpumps – six for beer, two for cider – together with an array of keg taps. Conveniently situated near Chandler's Ford station and on the Southampton to Winchester No.1 bus route, this friendly place can get busy at weekends. Two-times local CAMRA Pub of the Year. Q⮝≢●⊡☲(1)❀☏

Cheriton

Flower Pots Inn ⳑ

Brandy Mount, SO24 0QQ (¾ mile N of A272 Cheriton/ Beauworth crossroads) SU5812928293

☎ (01962) 771318 ⊕ theflowerpots.co.uk

Flower Pots Perridge Pale, Pots Bitter, Buster's Best, Goodens Gold, Stottidge Stout, IPA; 2 changing beers (sourced locally; often Flower Pots) �Ⓖ

Built in the early 1800s but recently substantially extended, the pub has a central island bar serving gravity dispensed beers to its three rooms. A glazed walkway connects to a barn/function room at the rear. The brewery is immediately next door and produces all the cask beers on offer. Good, home-cooked food is served and two B&B rooms are planned. A great place to round off a day on the nearby Watercress Line heritage railway. Q⮞❀◖⬥●P☲(67)❀☏

Chilbolton

Abbots Mitre

Village Street, SO20 6BA

☎ (01264) 860348 ⊕ abbotsmitre.co.uk

4 changing beers ⊞

A traditional local pub in the village centre with a spacious garden and covered outside terrace. The changing beer range comes mainly from Hampshire breweries such as Alfreds, Andwell, Flack Manor and Hogs Back – sometimes including a more unusual ale. There is an extensive food menu including specials, featuring local produce. The area has many walks and there are nearby nature reserves. ⮞❀◖P☲

Church Crookham

Foresters

Aldershot Road, GU52 9EP

☎ (01252) 616503 ⊕ foresters-dining.co.uk

Hogs Back TEA; 2 changing beers (sourced regionally) ⊞

Food led pub with up to three real ales. The single L-shaped bar is decorated in a modern rustic style, with logs and solid wooden tables. The area to the left is laid out for dining and contains a suspended fire pit. The remainder of the pub is more informal with a bookshelf to browse. Popular with dog walkers and, especially in summer, families. The large beer garden has an attractive verandah. Food is available all day, call to check finishing time. ⮞❀◖⬥P❀☏

Fox & Hounds ⊘

71 Crookham Road, GU51 5NP

☎ (01252) 663686 ⊕ foxandhoundscc.co.uk

Courage Best Bitter; Fuller's London Pride; St Austell Tribute ⊞

Old-style community pub set alongside a picturesque section of the Basingstoke Canal, popular with locals and boaters alike. Three cask ales are available. Traditional home-cooked pub food is served daily, with dogs welcome in a section of the dining area. The garden and children's play area are always busy on warmer days. Panelled walls are adorned with historic pub photos. There is live music on Friday and a pub quiz every other Tuesday. Q⏾☺Ⓓ&♣P🚪(10)☻🕏

Wyvern
75 Aldershot Road, GU52 8JY
☎ (01252) 624772 ● thewyvernpub.co.uk
Morland Old Speckled Hen; Wadworth 6X; 3 changing beers (sourced nationally; often Theakston, Tiny Rebel) Ⓗ
Pronounced 'Wivern', to rhyme with 'given', this community local can become very lively at times, especially during sporting events, but is always family friendly. Darts is played and there is a regular Thursday quiz night. Six screens show Premier League football and other sporting events. Outside, the sunny garden features heated beach huts. The pub hosts live music, often tribute acts, and supports local charities with fundraising events. ⏾☺Ⓓ&♣P🚪(10)☻

Cove

Thatched Cottage
122 Prospect Road, GU14 8NU
☎ (01252) 444180 ● thatchedcottagefarnborough.co.uk
3 changing beers (sourced nationally; often Hogs Back, St Austell, Vale) Ⓗ
Previously a private home, this thatched pub in the western suburbs of Farnborough has served its local community for over 50 years, being sympathetically refurbished, rethatched and reopened as a free house in 2021. There are two distinct bar areas and a large garden. Three cask ales are generally on offer, with regular beers from Vale. Meals are served throughout the pub, with breakfast at the weekend from 10.30am. ⏾☺ⓄP🚪(10) ☻

Dundridge

Hampshire Bowman Ⓛ
Dundridge Lane, SO32 1GD (turn E off B3035 ½ mile N of Bishops Waltham, then it's another 1½ miles)
SU5778218424
☎ (01489) 892940 ● hampshirebowman.com
Bowman Swift One; Flower Pots Goodens Gold; Steam Town Barton; 2 changing beers (sourced regionally; often Flack Manor, Hop Back, Stonehenge) Ⓖ
Remote yet busy 19th-century pub, popular with walkers and dog owners. The interior divides into two rooms, each with its own small bar offering four usually local real ales served direct from the cask, eight ciders and a range of locally sourced food. The rooms are adorned with various memorabilia including bows, beer bottles, model planes and even an ancient tricycle. Outside is a vast garden that is bustling in summer, with numerous benches and a children's play area. Q⏾☺Ⓓ&♣P☻🕏

Eastleigh

Steam Town Brew Co Ⓛ
1 Bishopstoke Road, SO50 6AD (on the B3037)
☎ (023) 8235 9139 ● steamtown.co.uk
Steam Town Stoke Extra Pale, Barton; 5 changing beers (sourced locally; often Steam Town) Ⓗ

Eastleigh's highly successful microbrewery is based at this newly established pub, and is visible from the restaurant area. An array of eight handpumps serves mostly the brewery's ales, with one or two other local guests, a cider and sometimes even a perry. The decor is intended to reflect Eastleigh's industrial railway past – the restaurant is furnished with first-class carriage seating, the bar is steel-fronted. Live music features frequently and a function room has now opened upstairs. ⏾☺Ⓓ≠🚌♣☻🕏

Emsworth

Blue Bell ✅
29 South Street, PO10 7EG
☎ (01243) 373394 ● bluebellinnemsworth.co.uk
Sharp's Doom Bar; 2 changing beers (sourced nationally; often Emsworth Brewhouse, Irving) Ⓗ
Although there has been a Blue Bell for many years, this is a relatively modern pub having been rebuilt in the current location in 1960. The brewery associated with the original pub, however, did not survive. The single bar has wood beams and panels, and is decorated with nautical memorabilia. At the front is a small patio seating area and there is a similar larger walled and part-covered one to the rear. ☺Ⓓ≠🚌(700)🕏

Coal Exchange
21 South Street, PO10 7EG
☎ (01243) 375866 ● coalexchangeemsworth.co.uk
Dark Star Hophead; Fuller's London Pride; Gale's Seafarers Ale, HSB; 2 changing beers (sourced nationally; often Butcombe, Fuller's) Ⓗ
A short distance from the harbour, this traditional pub has a single L-shaped bar. The front is part tiled and still bears the name of its former owner, Gale's of Horndean. The pub's name derives from when it was used as a trading place between local farmers and merchants delivering coal by sea. To the rear is a covered smoking area and a small walled garden, a real suntrap in warmer months. ⏾☺Ⓓ≠🚌(700)☻

Fareham

West Street Alehouse
164A West Street, PO16 0EH
☎ (023) 9435 0971
3 changing beers (sourced regionally) Ⓗ
Fareham's first micropub opened in 2019, within walking distance of the bus and rail stations. The bar serves three ales on handpump, five craft beers on the tap wall and up to four ciders, all of which are listed on the TV screen. There is a bottle shop with local and foreign cans and bottles available to buy. Hungry drinkers can bring in takeaway food, and a list of recommended outlets is displayed. Q☺≠🚌Ⓓ🚪☻

Farnborough

Goat in the Garden Ⓛ
21 Church Avenue, GU14 7AT
☎ 07920 153452
3 changing beers (sourced nationally; often Ascot, Church End, Fallen Acorn) Ⓗ
Attractive bar room, hidden away in the grounds of a small hotel – Melford House – but accessed via its own entrance. The single bar stocks up to four changing guest beers, sourced mainly from local breweries. The bar is primarily for residents of the hotel and their guests, but CAMRA members and users of this Guide are warmly welcome to visit – simply contact the owner in advance by phone or email. ⏾🛏♣P🚪(1)🕏

Prince of Wales L ✓

184 Rectory Road, GU14 8AL
☎ (01252) 545578 ⊕ theprinceofwalesfarnborough.co.uk
Dark Star Hophead; Fuller's London Pride; Hogs Back TEA; 6 changing beers (sourced nationally; often Ascot, Hop Back, Vibrant Forest) Ⓗ

This cosy free house has featured in the Guide for 40 years. There is a central bar around which are several distinct but interconnected areas, with a wonderful wood-burning stove between the snug and adjacent seating area. Five guest beers, invariably including both dark and local brews, are served from the lower snug, with the pub's regular offerings found on the front bar. Trestle tables at the front and back are popular in fine weather, while the rear patio is covered and heated. ಹ❀₹(North) ☙ 🛜

Tilly Shilling ✓

Unit 2-5, Victoria Road, GU14 7PG
☎ (01252) 893560
Greene King Abbot; Ruddles Best Bitter; Sharp's Doom Bar; 4 changing beers (sourced nationally) Ⓗ

Modern town-centre Wetherspoon pub named after Beatrice Shilling, a celebrated engineer at the nearby former Royal Aircraft Establishment. Its aviation theme includes a row of airline seats and various Spitfire memorabilia. The large rectangular open-plan lounge features a glass frontage that opens in good weather, extending the pub on to the pavement. Ten handpumps leave lots of space for regular and guest beers. Alcoholic drinks are on sale from 9am. ಹ❍&₹🛒🛜

Fleet

Prince Arthur L ✓

238 Fleet Road, GU51 4BX
☎ (01252) 622660
Greene King Abbot; Ruddles Best Bitter; Sharp's Doom Bar; 6 changing beers (sourced nationally; often Irving, Twickenham, Windsor & Eton) Ⓗ

A traditionally designed Wetherspoon pub housed in a former grocery shop, more than 100 years old, with alcoves and wood surrounds. It is named after Prince Arthur, son of Queen Victoria, who lived in Fleet in the 1890s when he was commander of Aldershot Garrison. Up to six different guest beers are on tap, including local ales supplied direct from breweries across Hampshire, Berkshire and Surrey. There are monthly tap takeovers from breweries local and further afield. The pub is celebrating its 10th successive year in this Guide. Qಹ❀❍&🛒(7,10) 🛜

Freefolk

Watership Down Inn L

Freefolk Priors, RG28 7NJ (just off B3400)
☎ (01256) 892254 ⊕ watershipdowninn.com
5 changing beers (sourced locally) Ⓗ

Built in 1840 in the Upper Test Valley, and still affectionately known locally as the Jerry, the pub has been named in honour of local author Richard Adams' book Watership Down, set in the downland to the north of the pub. Outside there is an extensive garden, patio and family area. The pub is popular with walkers and cyclists. Occasional live music evenings are arranged and a beer festival is held in May. A famous gin distillery is nearby. Qಹ❀❧❍P🛒(76)☙🛜

Fritham

Royal Oak L ✓

SO43 7HJ (W end of village on no through road)
SU2321614135
☎ (023) 8081 2606 ⊕ royaloakfritham.co.uk
Flack Manor Flack's Double Drop; Hop Back Summer Lightning; house beer (by Bowman); 3 changing beers (sourced locally; often Fine Tuned, Steam Town, Stonehenge) Ⓖ

This tiny thatched gem is a survivor from a bygone era, and worth the map-reading required to find it. Two rooms – one with a bar, the other served via a hatchway – both have open log fires. Behind the bar an eight-cask stillage provides direct gravity dispense. As well as welcoming cyclists, walkers and their dogs, equestrians have their own tethering area. Food (lunchtime only) is ploughman's style but top quality. A vast garden has marquees as well as posh accommodation in three shepherd's bothies. Qಹ❀❧❧&☙

Gosport

Fallen Acorn Tap Room L

Unit 7, Clarence Wharf Industrial Estate, Mumby Road, PO12 1AJ
☎ (023) 9307 9927 ⊕ fallenacornbrewing.co/tap-room
Fallen Acorn Pompey Royal, Hole Hearted, Expedition IPA; 5 changing beers (sourced regionally; often Fallen Acorn) Ⓖ

The Tap Room is inside the brewery, with seating set up during opening hours. Up to eight real ales are available, plus keg beers, and bottles and cans for on and off sales. Several foreign beers are also available, plus one cider. Special events are held from time to time, which may include offering beers from other breweries. There are plans to install handpumps on the bar. Street food is available outside (not Sun). Q❍❧P🛒(11)☙🛜

Four-Ale Taproom

45 Stoke Road, PO12 1LS
☎ (023) 9258 4455 ⊕ fouraletaproom.co.uk
4 changing beers (sourced regionally; often Flower Pots) Ⓖ

The first micropub in the Portsmouth area, the Taproom opened in 2018. The beers are on a gravity stillage along one wall of the bar; the furniture includes high stools and old casks with industrial tables. There are four cask ales – normally from the south of England – plus four ciders and several craft beers, as well as bottles and cans to take away. A cheeseboard is available on Sunday lunchtime. Q♣❧P🛒☙🛜

Junction Tavern

1 Leesland Road, Camden Town, PO12 3ND
☎ (023) 9258 5140
3 changing beers (sourced nationally; often Parkway, Portobello) Ⓗ

Relatively small pub situated on the site of Leesland Junction on the disused Fareham to Gosport line, which is now a cycle track. Old railway photographs adorn the walls as well as pumpclips over the bar. The real ales normally include a dark beer and there are ciders from Healeys. A beer festival takes place over the Easter weekend. ಹ❀♣❧🛒(E1)☙🛜

Hammer Vale

Prince of Wales

Hammer Lane, GU27 1QH
☎ (01428) 652600 ⊕ princeofwaleshaslemere.co.uk

Dark Star Hophead; Fuller's London Pride; Gale's HSB; 2 changing beers (sourced nationally; often Fuller's) ⓗ

An interesting pub dating from 1924 with many original features such as stained-glass windows, including one for Amey's of Petersfield who built this imposing roadhouse-style venue in anticipation of an A3 route that did not materialise. It is well worth visiting in order to sample the Pride, HSB and other Fuller's, Gale's and Dark Star guests. There is a large outside seating area and car park, and the pub is well sited for walkers and campers. The enthusiastic and friendly hosts serve excellent meals and bar snacks. Q❺❀◑♿ΔP❀🕏

Hartley Wintney

Waggon & Horses
High Street, RG27 8NY
☎ (01252) 842119
Butcombe Original; Gale's HSB; 4 changing beers (sourced nationally; often Castle Rock, Flower Pots, Sharp's) ⓗ

This award-winning village high-street pub is recognised by CAMRA as having a regionally important historic pub interior. The pub's lively public bar with its original flagstone floor contrasts with the quiet lounge. Real fires feature in both bars. Outside, pavement tables enable customers to enjoy the atmosphere of the village, renowned for its unique shops. At the rear is a large, pleasant courtyard garden and heated, covered marquee with a smokers' area. Food is served but ring ahead for details. Q❀◑🖢🖵(7)❀🕏

Havant

Wheelwright's Arms 🅛 ✓
27 Emsworth Road, PO9 2SN
☎ (023) 9247 6502 ⊕ wheelwrighthavant.co.uk
Fallen Acorn Pompey Royal; 3 changing beers (sourced locally; often Crafty Brewing, Irving, Langham) ⓗ

This imposing Edwardian pub on the edge of town is well known for its quality food and drink. Up to four cask beers are sourced from local microbreweries, with a hand-pulled cider also offered. The front terrace and courtyard garden are popular in warm weather. The pub hosts a number of local organisations and offers private hire space. Major sporting fixtures are shown on TV. Diners are advised to book in advance to ensure a table at busier times. Q❺❀◑🖢≢♣🖢P🖵(27,700)❀🕏

Hawkley

Hawkley Inn ✓
Pococks Lane, GU33 6NE
☎ 07540 160187 ⊕ hawkleyinn.co.uk
Flower Pots Perridge Pale, Goodens Gold; 4 changing beers (sourced regionally; often Flower Pots, Red Cat, Triple fff) ⓗ

A genuine free house, popular with locals and passers-by alike. The current landlord has refurbished the interior tastefully, adding a personal touch while respecting the locals' wishes and creating a warm, welcoming establishment that proves difficult to leave. Although the landlord insists real ale is the hub of the business, the pub is gaining a reputation for quality food, with a steak night each Tuesday. A beer festival is held in May. B&B accommodation is available. To the rear is a spacious garden, with some veranda seating at the front. ❺❀◑🖢❀🕏

Hill Head

Crofton ✓
48 Crofton Lane, PO14 3QF
☎ (01329) 609925 ⊕ ourlocal.pub/pubs/crofton-fareham
St Austell Tribute; Sharp's Doom Bar; 4 changing beers (sourced nationally; often Flower Pots, Laine) ⓗ

The pub changed hands in summer 2020, with many of the original staff retained. A subsequent major refurbishment included a new kitchen. The premises comprise a large lounge bar and dining area, and a smaller public bar. The function room with skittle alley gets booked up well in advance. The guest beer range includes SIBA beers. No food Sunday evenings. ❺❀◑🖢♣P🖵(21)❀🕏

Holybourne

Queen's Head
20 London Road, GU34 4EG
☎ (01420) 513617
Greene King Abbot; St Austell Tribute; 1 changing beer (sourced regionally; often Palmers) ⓗ

Traditional, friendly, sprawling local on the edge of the village, with two beers from the Greene King list and a guest usually from the southern counties. The separate restaurant, available to drinkers, serves home-made food in generous portions – the pies are not for the faint-hearted and Sunday lunches are renowned. Booking is required if eating. Darts and pool are played. The extensive garden with plenty of children's activities is popular in the summer months, when opening hours may be extended (ring to check). ❺❀🖢♣P🖵(65)❀

Hook

Crooked Billet
London Road, RG27 9EH
☎ (01256) 762118
Sharp's Doom Bar; Timothy Taylor Landlord; 1 changing beer ⓗ

The Crooked Billet is situated on the London Road just outside Hook and has been a free house under the same ownership for 32 years. In the summer you can enjoy the pleasant riverside garden or the air-conditioned bars, restaurant or snug. In winter, warm up by one of the traditional log fires. An annual beer and music festival is held over the August bank holiday weekend. Food served until 8pm Sunday, and the first Monday of the month is quiz night. Q❺❀◑🖢P❀🕏

Horsebridge

John o' Gaunt Inn
Horsebridge Road, SO20 6PU (½ mile off A3057)
☎ (01794) 388644 ⊕ johnofgaunt.co.uk
Exmoor Ale; Palmers IPA; 2 changing beers (sourced regionally; often Bicester, Exmoor, Palmers) ⓗ

The John o' Gaunt is situated just off the Test Way long-distance walking trail along the route of the old Romsey to Andover railway. The pub is a free house with ales from Exmoor and Palmers plus a changing house beer specially brewed by Bicester recreating old recipes. It has an L-shaped bar with a log-burner and outside, to the rear, a heated and covered seating area. Freshly prepared and locally sourced food is served along with bar snacks. Families and dogs are welcomed. Q❺❀◑♣P❀🕏

Hythe

Dusty Barrel

Unit 5 Pylewell Road, SO45 6AP

🌐 thedustybarrel.co.uk

4 changing beers (sourced regionally; often Flower Pots, Steam Town, Vibrant Forest) Ⓗ

Located in Hythe precinct, this lovely micropub serves a selection of four ever-changing real ales plus five draught ciders, all from a central facing bar which also has six keg taps. Snacks including crisps, nuts, biltong and pretzels are also available. Both the bar and outside area have seating and tables made from reclaimed scaffolding boards and metalwork. Located beyond the bar, a staircase leads to extra seating in a room that becomes the function/music room on Saturdays.

Q❀♿♣●🖥🖵(8,9)❀

Little London

Plough Inn

Silchester Road, RG26 5EP

☎ (01256) 850628

3 changing beers (sourced regionally; often Bowman, Flower Pots, Little London) Ⓖ

This is an unpretentious, rustic but cosy traditional village local that can rightly be called a gem. Enjoy real ale on tap and occasionally direct from the wood. You can join lively conversation, sit in front of a log fire or relax in the peaceful, spacious garden. A range of baguettes is available at lunchtime. Dogs and families are welcome. Popular with visitors to Pamber Forest and nearby Silchester Roman site. A former local CAMRA Pub of the Year. Cash payments only. Q☆❀P🖵(14)❀

Long Sutton

Four Horseshoes

The Street, RG29 1TA (follow brown signs from B3349) SU748470

☎ (01256) 862488

2 changing beers (sourced nationally; often Andwell, Palmers, Slater's) Ⓗ

A simply decorated quintessential rural pub, situated in a popular walking area to the east of Long Sutton. Formerly a Gale's tied house, it has been free of tie for many years, offering two low-strength guest beers. There are twice-monthly quiz and jazz nights in the spacious but cosy bar which has two real fires. Simple English dishes are served, with a popular roast on Sunday. Midweek lunchtime opening is only by prior arrangement.

Q☆❀◐●P❀🛜

Longparish

Cricketers Inn

SP11 6PZ

☎ (01264) 720424 🌐 thecricketersinnlongparish.co.uk

Otter Ale; Palmers Copper Ale; 2 changing beers Ⓗ

Characterful village inn with a large beer garden and an outdoor wood-fired pizza oven. The garden has some covered marquee seating with picnic tables as well as a permanent summer house and fire pits to enjoy. Specialising in game and seafood dishes, the pub has its own smokehouse and home-smoked foods are included on the menu. Families and well-behaved dogs are welcome. The area is popular with walkers and cyclists.

Q☆❀◐♿P❀🛜

Plough

SP11 6PB

☎ (01264) 720069 🌐 ploughinn.org

West Berkshire Good Old Boy; 3 changing beers Ⓗ

This traditional village pub at the heart of the Test Valley dates from 1721 but was closed and earmarked for redevelopment in 2015, until the local community purchased and refurbished it extensively. Fresh, locally sourced food is available, with a special pie night on Tuesday and Sunday roasts. It has a pleasant beer garden, parking, and is a good base for local walks and cycle routes. Real fires make for cosy winter drinking. Dogs and families are welcome. Q❀◐♿P❀🛜

Lower Farringdon

Golden Pheasant Ⓛ

Gosport Road, GU34 3DJ

☎ (01420) 588255 🌐 golden-pheasant.com

Crafty Brewing Crafty One; Sharp's Doom Bar, Atlantic; 3 changing beers (sourced regionally; often Andwell, Dark Star, Otter) Ⓗ

The owners have run pubs in the area for many years and over 10 years ago brought their expertise to this delightful privately owned free house. Seven handpumps serve three permanent and four guest beers. The food is freshly cooked, with vegetarian options; the fish & chips warrants special mention due to the secret recipe batter. Opens at 8.30am for tea and coffee. Reached down the A32 four miles from Alton, this is a pub not to be missed. Q☆❀◐P❀🛜

Lower Wield

Yew Tree Ⓛ

SO24 9RX SU636398

☎ (01256) 389224 🌐 theyewtreelowerwield.co.uk

House beer (by Flower Pots); 2 changing beers (sourced locally; often Bowman, Ringwood) Ⓗ

This isolated family-run inn is surrounded by picturesque rolling Hampshire countryside and has an old yew tree growing outside. It is situated on a quiet lane opposite the local cricket pitch. A popular pub, it is food-led with a changing menu of locally sourced home-made meals. The outside space to the side is extensive and cyclists, ramblers, horse riders and dog owners are all welcome. A rural gem. Q☆❀◐P❀🛜

Lymington

Fisherman's Rest

All Saints Road, SO41 8FD (1 mile S of Lymington)

☎ (01590) 670754 🌐 fishermansrestlymington.co.uk

Fuller's London Pride; Gale's Seafarers Ale; 1 changing beer (sourced nationally; often Dark Star) Ⓗ

Cosy, candlelit pub with a nautical theme, fresh flowers and a large open fire. The restaurant has an extensive menu with an emphasis on local seafood. Close to Lymington & Keyhaven Marshes Nature Reserve, the sea wall and marinas, the pub is busy with yachtsmen, walkers and well-behaved dogs, and drinkers are welcome in the separate bar seating area. Sea navigation charts double as wallpaper, and fish decor catches the eye, together with various other artefacts. Bookings by telephone advised for dining. Q❀◐P❀🛜

Mapledurwell

Gamekeepers

Tunworth Road, RG25 2LU

☎ (01256) 322038 🌐 thegamekeepers.co.uk

Andwell Resolute Bitter; 2 changing beers Ⓗ

Dating from the 1880s, this charming country inn with exposed beams and a flagstone floored interior is nestled in the lovely thatched village of Mapledurwell. It has a

183

covered well and a large garden boasting views over the surrounding fields and countryside. Good, upmarket food is offered from a regularly changing blackboard menu incorporating ingredients from the owners' favourite local producers. ◖❙

Milford on Sea

Wash House
27 High Street, SO41 0QF
☎ (01590) 644665 ⊕ thewashhousebar.co.uk
4 changing beers (sourced locally; often Fine Tuned, Hop Back, Piddle) Ⓗ
A former launderette, hence the name, this delightful micropub has been beautifully converted and now serves four ever-changing local real ales and up to 10 ciders. The one-roomed bar is filled with a mismatched selection of tables and chairs. The usual variety of bar snacks is available and more substantial food can be ordered from the bar for delivery from nearby outlets. Customers can also bring fish & chips from the local chippy to eat in the bar. Q ❂ ♿ ♠ 🚆 (X1) ❀

New Milton

Hourglass
8 Station Road, BH25 6JU
☎ (01425) 616074 ⊕ hourglassmicropub.co.uk
12 changing beers (sourced nationally) Ⓖ
The Hourglass is certainly the best craft alehouse in New Milton, hosting a good selection of local ales as well as others from well-known breweries further afield. A converted shop unit, it has plenty of space. Always a friendly bar, it has good regular attendance from the locals. Located close to New Milton station, it is a good choice of venue if travelling from out of the area. No food, but you are welcome to bring in orders from the local takeaways. Q ≈ ♣ ♠ 🚆 ❀ 🛜

North Waltham

Fox Ⓛ ⊘
Popham Lane, RG25 2BE (off Frog Ln, between village and A30, M3 jct 7)
☎ (01256) 397288 ⊕ thefox.org
Courage Best Bitter; Sharp's Doom Bar; West Berkshire Good Old Boy; 1 changing beer (sourced locally; often Hogs Back, Ringwood, Young's) Ⓗ
Lovely traditional country inn on the southern edge of the village on a quiet country lane overlooking extensive farmland. The pub is divided into a popular 55-seat restaurant and a public bar where food is also served – booking is advisable. Daily specials and local seasonal produce is featured in the menu. Outside there is an extensive beer garden and a children's adventure play area. The Ushers signage is still on the back of the building. Q ❂ ❀ ❄ ◖❙ ♣ P 🚆 ❀ 🛜

North Warnborough

Mill House Ⓛ
Hook Road, RG29 1ET
☎ (01256) 702953
Hogs Back TEA; house beer (by St Austell); 5 changing beers (sourced regionally; often Andwell, Longdog, Triple fff) Ⓗ
This Grade II-listed building was one of eight mills of Odiham mentioned in the Domesday Book. Last used as a corn mill in 1895, it became a pub and restaurant in the 1980s. It has a pleasant central upstairs bar area, downstairs oak-panelled dining areas and a lower level which has a view of the waterwheel. The extensive

landscaped area around the millpond has outdoor seating and there is an old barn used for functions. Q ❂ ❀ ◖❙ P 🚆 (13) ❀ 🛜

Old Basing

Bolton Arms
91 The Street, RG24 7DA
☎ (01256) 819555 ⊕ thebolton.com
3 changing beers Ⓗ
The Bolton Arms is situated in quiet and picturesque Old Basing, less than two miles from Basingstoke centre. The building dates from 1490 and renovations in 2008 uncovered many period features including vaulted ceilings, oak beams and a central brick fireplace, which enhance the drinking and dining experience. The Inn Between bar was built with bricks from Old Basing House and is allegedly haunted by a Cavalier ghost. The spacious rear beer garden is attractively landscaped. Events include a charity quiz. Q ❀ ◖❙ P 🛜

Crown
The Street, RG24 7BW
☎ (01256) 321424
Fuller's London Pride; Sharp's Doom Bar; 2 changing beers (often St Austell) Ⓗ
This Grade II-listed building thought to date from the Civil War is a pleasant pub and restaurant in the heart of Old Basing. It offers classic, hearty food and a drinks range to suit everyone. Outside is a large garden and a small patio at the front. The Crown is family friendly with a play area for children and a children's menu. Q ❂ ❀ ◖❙ ♣ P ❀

Overton

Old House at Home
Station Road, RG25 3DU
☎ (01256) 770335 ⊕ theoldhouseathome.com
Black Sheep Best Bitter; Dark Star Hophead; St Austell Tribute; 2 changing beers (often Brains, Exmoor, Penton Park) Ⓗ
The Old House at Home has a traditional village pub feel, and an excellent Thai restaurant and takeaway. Good pub food and great value Sunday dinners are also served. There is a large garden with a play area and decking. A fun quiz is held on a Sunday and teams participate in local crib, pool and quiz leagues. Q ❂ ❀ ❄ ◖❙ ♣ P 🚆 (76) ❀ 🛜

Park Gate

Gate Ⓛ
27-29 Middle Road, SO31 7GH
☎ (01489) 886677
Steam Town Barton; 2 changing beers (sourced regionally) Ⓗ
A good sized micropub, which opened in 2019, on the site of a former estate agents. The real estate map of the local area has been retained on one wall. Comfortable seating is provided for about 40 customers, with additional outside tables and chairs in the summer. Alongside the three cask ales are four ciders and seven craft keg beers. The pub hosts a monthly meeting of local home brewers. ❂ ❀ ♿ ≈ (Swanwick) ♣ ♠ P 🚆 (X4) ❀ 🛜

Pennington

White Hart ⊘
17 Milford Road, SO41 8DF
☎ (01590) 673495 ⊕ whitehartpennington.co.uk

Ringwood Fortyniner; Sharp's Doom Bar; 2 changing beers (sourced nationally; often Fallen Acorn, Goddards, Wantsum) Ⓗ
Attractive, welcoming inn serving four ales including two changing guests. Gluten-free bottled ale is available. The public bar is dog-friendly with snacks and water for well-behaved canines. Local artists' work is displayed in the family-friendly restaurant, which leads to a large enclosed garden and play area. The front patio and separate covered smoking space are adjacent to the large car park. The pub hosts weekly games and Sunday evening jam sessions. Home-made sausage rolls are available to take away. ⏳✿◑♣P🖳(X1,X2)💮🛜

Petersfield

Townhouse Ⓛ

28 High Street, GU32 3JL
☎ (01730) 265630 ∰ townhousepetersfield.co.uk
3 changing beers (sourced regionally; often Downlands, Langham, Red Cat) Ⓗ
A friendly and welcoming pub on the High Street with three handpumps and nine keg fonts, plus many Belgian and local beers in the fridges for takeaway sales. There are plenty of tables and seating, with more in the upstairs function room when available. Food is served at lunchtime and in the evening from Wednesday to Sunday. Children and dogs are welcome.
⏳✿◑⇌♣P🖳💮🛜

Portchester

Cormorant ✔

181 Castle Street, PO16 9QX
☎ (023) 9237 9374 ∰ cormorantpub.co.uk
Gale's Seafarers Ale, HSB; Sharp's Doom Bar; 2 changing beers (sourced nationally; often Flower Pots, Fuller's, Vibrant Forest) Ⓗ
Close to the northern reaches of Portsmouth Harbour, the Cormorant is a traditional-style pub whose walls are decorated with numerous seafaring pictures and artefacts. Several stuffed birds are also on display including a cormorant, puffin and kingfisher. A short walk down Castle Street lies Portchester Castle, reputed to be the best preserved Roman fortress in Europe. The castle grounds and the 12th-century St Mary's Church are open to the public, although there is a charge to enter the keep. ⏳✿◑♣P🖳(3)💮🛜

Portsmouth

Apsley House

13 Auckland Road West, Southsea, PO5 3NY
☎ (023) 9282 1294
Hop Back Summer Lightning; Sharp's Doom Bar; Timothy Taylor Landlord Ⓗ
Named after the London residence of Arthur Wellesley, 1st Duke of Wellington, the building is depicted on the pub sign along with a parody of its address. The pub is a short walk from Southsea Common and the shops of Palmerston Road. Inside, the single bar has a U-shaped counter. To the right is a raised seating area. The decor is basic with simple wooden tables and chairs. There is a small patio seating area at the front. ❀♣🖳💮🛜

Barley Mow ✔

39 Castle Road, Southsea, PO5 3DE
☎ (023) 9282 3492 ∰ barleymowsouthsea.com
Fuller's London Pride; Gale's HSB; 6 changing beers (sourced nationally) Ⓗ
A large community pub built by A.E. Cogswell, although it is not typical of his designs. The lounge bar retains its

wood panelling and for many years had a mural depicting the Battle of Southsea fixed to the ceiling. This now resides in the City Museum. The smaller public bar is more simply decorated. To the rear is an award-winning patio garden, a real suntrap on warmer days. Games, including bar billiards and shove ha'penny, are available.
❀◑♿♣🖳(3)💮🛜

Brewhouse & Kitchen Ⓛ ✔

26 Guildhall Walk, Landport, PO1 2DD
☎ (023) 9289 1340
Brewhouse & Kitchen Mucky Duck, Sexton, Black Swan; 1 changing beer (sourced locally; often Brewhouse & Kitchen (Portsmouth)) Ⓗ
The first of the Brewhouse & Kitchen chain, this Grade II-listed pub is distinctive with its Brewers' Tudor styling. Inside there is a single island bar, the rear of which forms an open-plan kitchen. Much of the interior wood panelling and floor tiles have been retained. To the right is the pub's microbrewery and the pub is often filled with the aromas of brewing. The rooftop garden has its own bar and can be booked for private functions.
⏳✿◑⇌(Portsmouth & Southsea) ♣🖳(700)💮🛜

Bridge Tavern

54 East Street, Old Portsmouth, PO1 2JJ
☎ (023) 9275 2992 ∰ bridge-tavern-portsmouth.co.uk
Fuller's London Pride; Gale's Seafarers Ale, HSB; 2 changing beers (sourced nationally; often Fuller's) Ⓗ
A traditional pub set in the heart of the Camber Docks, it is named after the double swing bridge that used to span the dock and can be seen on the pub sign. The interior is divided into several drinking areas and is decorated with a nautical theme. One exterior wall has a large mural of Thomas Rowlandson's cartoon Portsmouth Point. There is also a dockside patio area and an upstairs dining room for private functions. ❀◑🖳(25)🛜

Dolphin Ⓛ ✔

41 High Street, Old Portsmouth, PO1 2LU
☎ (023) 9282 0762 ∰ thedolphinportsmouth.co.uk
Sharp's Doom Bar; house beer (by Urban Island); 2 changing beers (sourced nationally; often Irving, Red Cat) Ⓗ
A Grade II-listed building dating from the 18th century and located opposite Portsmouth's Anglican cathedral. It claims to be the oldest surviving pub in Portsmouth and is one of a few buildings in the area to have survived the bombings of World War II virtually intact. The narrow frontage leads to a long bar area with a small partly-partitioned area to the right. To the rear is a part-covered patio garden. Q❀◑🖳(25)💮🛜

Eastney Tavern Ⓛ

100 Cromwell Road, Eastney, PO4 9PN
☎ (023) 9282 6246 ∰ eastneytavern.co.uk
3 changing beers (sourced nationally; often Fallen Acorn, Irving) Ⓗ
A large single-bar pub close to Eastney seafront and the former Royal Marines barracks. The frontage is curved to match the road. The interior is spacious and divided into three areas. One has large TV screens mainly showing sporting fixtures, the second is quieter with plenty of seating and forms a restaurant area. To one side of the building is a small patio garden decorated with flowers and shrubs in planters. ⏳✿◑♿🖳(1,2)💮🛜

Fawcett Inn Ⓛ

176 Fawcett Road, Southsea, PO4 0DP
☎ (023) 9229 8656
Titanic Plum Porter; 2 changing beers (sourced locally; often Banks's, Irving, Marston's) Ⓗ

An imposing street-corner pub with a half-timbered Brewers' Tudor frontage and witch's hat tower. Internally, it has a single curved bar room with traditional furniture and several comfortable chairs. At one end is a small raised area used as a stage for live music. Outside to the rear is a small walled patio garden.

♿🐕👨‍🦽♿≷(Fratton) ♣🚪🚌(18) ☻ 🗢

Hole in the Wall 🅛

36 Great Southsea Street, Southsea, PO5 3BY
☎ (023) 9229 8085 ⊕ theholeinthewallpub.co.uk
Flower Pots Goodens Gold 🅖; 5 changing beers (sourced nationally) 🅗
A multiple award-winning pub, the Hole is a true free house, with an ever-changing selection of cask beers, an interesting selection of cans to take away and a sweet tuckshop. During lockdown the pub made amazing efforts to provide takeaway beer. Sadly it no longer serves food. Thursday is quiz night. On Friday last admission is one hour before closing. Check the website for current beers and opening times. Q🌣🍴🚪🚌(3,23)☻ 🗢

King Street Tavern ✅

70 King Street, Southsea, PO5 4EH
☎ (023) 9307 3568 ⊕ kingstreettavernsouthsea.co.uk
Wadworth Horizon, 6X, Swordfish; 3 changing beers (sourced nationally; often Wadworth) 🅗
A Grade II-listed street-corner pub designed by architect A.E. Cogswell. It has a green tiled exterior with ornate writing above the doors and windows. Inside, the single bar has a bare wooden floor with tiles around the counter, which is remarkably uncluttered with just the set of handpumps. The keg taps are fitted to the rear green tiled wall. Although open plan, the bar is divided into two distinct areas. There is a small patio garden.
☻🍴≷(Portsmouth & Southsea) 🚌(3) ☻ 🗢

Lawrence Arms 🅛 ✅

63 Lawrence Road, Southsea, PO5 1NU
☎ (023) 9282 1280
Harvey's Sussex Best Bitter; 5 changing beers (sourced nationally; often Irving, Langham, Urban Island) 🅗
A relatively large pub a short walk from Albert Road, this is a former local CAMRA Pub of the Year and current Cider Pub of the Year. The single bar is spacious and has an open-plan feel with small tables and wall seating. Beers are mainly from independent breweries from various parts of the country. In addition to the cask beer there is an extensive range of ciders and bottled and canned beers. The pub holds several cider festivals.
♿☻🍴♣🚌(18) 🗢

Merchant House

9-11 Highland Road, Eastney, PO4 9DA
4 changing beers (sourced nationally) 🅗
A modern street-corner pub converted from two shops. The main bar is divided into two areas, one being on a slightly raised level. Seating consists of traditional wooden tables and chairs. To the rear, steps lead down to a third drinking area. The walls are bare brick and wood. A large TV screen lists all the beers available, which includes a number of KeyKeg and canned beers to complement the cask offerings. Beers are from small independent breweries. ☻🍴🚌(1,2)

Northcote 🅛

35 Francis Avenue, Southsea, PO4 0HL
☎ (023) 9278 9888
Irving Invincible; Timothy Taylor Landlord; 2 changing beers (sourced locally; often Irving, Langham) 🅗
Originally built at the end of the 19th century for the Pike Spicer brewery, this large and imposing building is one of

a few pubs in the area to retain two bars. The public bar has a raised area with a dartboard. The smaller comfortable lounge has curved booth style seating and the walls are adorned with memorabilia of early cinematic comedy acts and the most famous creation of former Portsmouth resident Sir Arthur Conan Doyle – Sherlock Holmes. ☻♣●🚌(2)

Old Customs House

Vernon Building, Gunwharf Quays, Gunwharf, PO1 3TY
☎ (023) 9283 2333 ⊕ theoldcustomshouse.com
Fuller's London Pride, ESB; Gale's Seafarers Ale, HSB; 2 changing beers (sourced nationally; often Dark Star) 🅗
A splendid conversion of the administrative offices of HMS Vernon, this Grade II-listed building is the only traditional pub in the Gunwharf Quays shopping complex. The pub retains the original rooms which form different drinking areas, some of which are named after old Portsmouthians. Not surprisingly, it is decorated with naval memorabilia. There is an open patio area at the front and a smaller enclosed one to the rear.
♿☻🍴👨‍🦽≷(Harbour) 🚌☻ 🗢

Pembroke

20 Pembroke Road, Old Portsmouth, PO1 2NR
☎ (023) 9282 3961
Draught Bass; Fuller's London Pride; Greene King Abbot 🅗
A traditional street-corner pub opposite the Royal Garrison Church. It has strong naval connections, being on the route that Lord Nelson walked to join HMS Victory and sail to Trafalgar. Under its original name, the Little Blue Line, it features in books by Frederick Marryat. Not surprisingly, the decor of the single U-shaped bar has a nautical theme. The pub is also close to the Hotwalls art hub, and Square and Round Towers, some of the city's earliest fortifications. ♣🚌(25)☻

Phoenix 🅛

13 Duncan Road, Southsea, PO5 2QU
☎ (023) 9278 1055
Gale's HSB; 2 changing beers (sourced nationally; often Irving, Red Cat, Urban Island) 🅗
Set a short distance off Albert Road, this traditional street-corner local is a true community pub and retains two bars. It has a strong association with the nearby Kings Theatre, evidenced by the numerous photos and posters in the lounge. Both bars are quirkily decorated and the public bar also has a number of articles about Portsmouth on display. The lounge gives access to a small patio garden and a separate cosy snug bar.
☻●🚌(2) ☻ 🗢

Rose in June ✅

102 Milton Road, Milton, PO3 6AR
☎ (023) 9282 4191 ⊕ theroseinjune.co.uk
Arundel Sussex IPA; Gale's HSB; Goddards Wight Squirrel; Otter Amber; 2 changing beers 🅗
A substantial two-bar pub a short walk from Fratton Park. Popular with football fans, it can be busy on match days. Both bars are traditionally decorated, with comfortable seating in the lounge. The public bar has a pool table and dartboard and the pub has teams for both games. To the rear is probably the largest pub garden in the city, which now has its own bar. Several beer festivals are held during the year. Q♿☻🍴🚌☻ 🗢

Sally Port Inn 🅛

57-58 High Street, Old Portsmouth, PO1 2LU
⊕ thesallyport.co.uk
Irving Frigate, Invincible, Iron Duke 🅗

A Grade II-listed former hotel a short walk from the Square Tower and Hot Walls, some of the city's oldest fortifications. The pub is formed from part of the hotel's original bar. The central staircase next to the bar is built from a 40ft-long ship's top spar. In 1956 the pub briefly hit the headlines following the disappearance in mysterious circumstances of Royal Navy frogman Lionel 'Buster' Crabb during the visit of a Russian cruiser to the naval base. ☐(25)

Urban Tap 🅛

Unit 28, Limberline Spur, Hilsea, PO3 5DZ
☎ (023) 9266 8726 ⊕ urbanislandbrewing.uk
Urban Island Mosaic, Dolly's Special Beer; 2 changing beers (sourced locally; often Urban Island) 🅖
Set in the middle of the brewery, you are surrounded by the various brewing vessels and other equipment. Seating consists mainly of trestle tables with some stools and converted kegs. At the front is a small separate drinking area, and on warmer days additional seating is provided outside the brewery. Cask beers are served from a small stillage in the cold store.
Q❀≠(Hilsea) ❀P☐(21) ❀

Poulner

London Tavern 🅛 ✅

Linford Road, BH24 1TY (off Gorley Road)
☎ (01425) 473819 ⊕ thelondontavern.com
Ringwood Razorback, Fortyniner; Timothy Taylor Landlord; 3 changing beers (sourced nationally; often Hop Back) 🅗
Decorative brick-fronted pub, created by 'Johnnie Londoner' in the 1860s, who opened a bar in his house after being refused medicinal brandy from his local. Inside there is wood and stone-tile flooring, half-panelled walls and dried flowers decorating the bar. At the rear is a restaurant area that serves tapas, burgers and a variety of main dishes (no food Mon). Behind the pub are benches on covered decking and a small patio area. Live music plays at weekends.
🌣❀◑♣P☐(Ringo) ❀🛜

Romsey

Old House at Home

62 Love Lane, SO51 8DE (NE of town centre near Waitrose car park)
☎ (01794) 513175 ⊕ theoldhouseathomeromsey.co.uk
Fuller's London Pride; Gale's Seafarers Ale, HSB; 2 changing beers (sourced nationally; often Fuller's) 🅗
Formerly a brewpub, since the 1920s it has been run by a succession of breweries. It comprises an 18th-century thatched building and a 19th-century extension that was originally a house. The pub has three distinct areas: a bar with booths and wood-burner, a plainer upper area, and a cosy restaurant. The courtyard garden has heating and shelter. Major sporting events are shown on TV, and major saints' and other days are celebrated with special menus. ❀◑≠P☐❀🛜

Rotherwick

Coach & Horses 🅛

The Street, RG27 9BG
☎ (01256) 768976 ⊕ coachandhorses-rotherwick.co.uk
Adnams Ghost Ship; Andwell 5 Little Fishes; Ascot Gold Cup; Hogs Back TEA; Longdog Red Runner; house beer (by Sherfield Village) 🅗
This authentic unspoiled village tavern is set in stunning Hampshire countryside and offers good old-fashioned hospitality. It boasts a lovely south-facing garden to the

rear, overlooking tranquil farmland. The friendly staff and locals (and, in cold weather, a large open fireplace and two wood-burning stoves) guarantee a warm welcome every time. Now a free house, it offers a variety of real ales, mostly from local breweries. The keenly priced food menu is put together using local suppliers where possible. Q🌣❀◑P❀

Selborne

Selborne Arms 🅛

High Street, GU34 3JR
☎ (01420) 511247 ⊕ selbornearms.co.uk
Bowman Swift One; Ringwood Fortyniner; 3 changing beers (sourced regionally; often Crafty Brewing, Red Cat, Triple fff) 🅗
A traditional two-bar village pub, but greatly extended, it has real fires and a friendly atmosphere. Up to three guest beers are available, many from local microbreweries, with more stocked during the village's October Zig Zag Festival. Beer bats offering three third-pints of cask ales for the price of a pint are a welcome feature. Extensive menus showcase local and home-made produce, with vegetarian and gluten-free options. The safe play area in the garden is popular with children. Q🌣❀◑P☐(38) ❀🛜

Shedfield

Wheatsheaf Inn 🅛

Botley Road, SO32 2JG (on A334)
☎ (01329) 833024
Flower Pots Bitter, Goodens Gold; 3 changing beers (sourced locally; often Flower Pots, Steam Town, Stonehenge) 🅖
With great ales and a wonderful welcome, the Wheatsheaf is always a pleasure to visit. The award-winning pub, which has continuously appeared in this Guide since 1998, serves three Flower Pots beers and two guest beers, all dispensed by gravity. Popular home-cooked food is available at lunchtimes every day. At the rear is a large garden with benches to enjoy a summer's day pint when the colourful flowers are at their best. Q❀◑⅙♣P☐(69) ❀🛜

Sherfield on Loddon

Four Horseshoes 🅛 ✅

Reading Road, RG27 0EX
☎ (01256) 882296 ⊕ the4horseshoes.co.uk
Timothy Taylor Landlord; 1 changing beer (often Sherfield Village) 🅗
This family-run village pub is Grade II listed and dates back to the 16th century, with traditional low beams, some bench seating and wood-burners. The single bar serves four areas, one with a sports TV. At the front is a pleasant patio and at the rear a summer beer garden with play equipment. Families and dogs are welcome. The changing beer is normally from Sherfield Village. There is a cider festival on the May bank holiday. Q🌣❀◑♣P☐(14) ❀

Silchester

Calleva Arms

The Common, RG7 2PH
☎ (0118) 970 0305 ⊕ callevaarms.co.uk
Dark Star Hophead; Fuller's London Pride; Gale's Seafarers Ale, HSB; 1 changing beer 🅗
An attractive village pub opposite the common, named after the local Roman settlement Calleva Atribatum. A Fuller's establishment, it has five handpumps serving

four regular Fuller's ales plus one guest ale, often a Fuller's seasonal or from a local brewery. There is a welcoming bar with a separate comfortable dining area and a conservatory, and the excellent choice of bar and restaurant food can also be enjoyed in the large garden in the summer months. ❤️❀🌑▶♣🅿️🚃(14)❀🛜

Southampton

Beards & Boards

33 Bedford Place, SO15 2DG
🌐 beardsandboards.co.uk
3 changing beers (sourced nationally; often Flower Pots, Steam Town, Vibrant Forest) Ⓗ
Welcoming craft beer micropub that has appeared in this Guide since opening in 2019. This former shop, with an industrial-urban and skateboard theme decor, supplies up to three changing national and local real ales on handpump, 10 keg craft beers, boxed and draught ciders, and a range of cans and bottles. Featuring regular tap takeovers, an app-based jukebox, a PlayStation 2 and board games, this family and dog friendly venue is a popular asset within the local area. ❤️❀&♣🚃❀

Bookshop Alehouse

21 Portswood Road, SO17 2ES
4 changing beers (sourced locally; often Eight Arch, Elusive, Vibrant Forest) Ⓗ
Formerly a bookshop, this micropub has a main room with steps up to a narrow bar, with four handpumps and four keg taps. The blackboard and pumpclips note beers that are unfined and vegan friendly. The front area, with a wall of bookshelves and several tables and chairs, provides a relaxing atmosphere. There is additional seating downstairs. No food is served, but you are welcome to collect from the nearby takeaways, and cutlery is provided. Q&≢(St Denys)♣🍴🚃❀🛜

Butcher's Hook

7 Manor Farm Road, SO18 1NN
☎ (023) 8178 2280 🌐 butchershookpub.com
3 changing beers (sourced nationally) Ⓖ
A beautifully preserved Victorian butcher's shop transformed into a traditional alehouse, providing some of the most sought-after cask and keg beers on the Southampton beer scene. The town's smallest micropub, it always has a buzzy vibe. Three cask ales and up to six craft keg lines are served. Occasional musical evenings and an annual pie competition add to the community feel of this gem. No food is served, but you may bring your own. Q❀&≢(Bitterne)♣🚃(7)❀🛜

Dancing Man 🅛

Wool House, Town Quay, SO14 2AR
☎ (023) 8083 6666 🌐 dancingmanbrewery.co.uk
6 changing beers (sourced locally; often Dancing Man) Ⓗ
The Grade I-listed Wool House was built in the 14th century, initially as a wool warehouse. It has had many uses since then including a prison for French POWs during the Napoleonic wars, and more recently a maritime museum; the must-see sweeping curved staircase dates from this time. It became the Dancing Man pub and brewery in 2015. A popular place that offers a very good range of unfined beer, it is worth a visit for its architecture alone. Near the Isle of Wight car ferry. ❀🌑&🍴🚃❀🛜

Freemantle Arms 🅛

31 Albany Road, SO15 3EF
☎ (023) 8077 2536 🌐 thefreemantlearms.co.uk

Flower Pots Goodens Gold; house beer (by Ringwood); 3 changing beers (sourced regionally; often Bowman, Dorset, Goddards) Ⓗ
Founded as a cider house in the mid-19th century, the Freemantle retains much Victorian charm and is well worth taking a diversion off the main streets to find. The old Marston's etched glass windows remain, along with separate public and saloon bar entrances, though inside all is now unified. Framed photos of historic Southampton along with old stringed instruments and carpentry tools are additional heritage reminders. To the back is a decent sized conservatory and a pleasant garden. ❀≢(Millbrook)♣🚃❀

Guide Dog 🅛

38 Earl's Road, SO14 6SF (corner with Ancasta Rd)
☎ (023) 8063 8947
Dark Star American Pale Ale; Flower Pots Goodens Gold; Steam Town Stoke Extra Pale; 7 changing beers (sourced nationally; often Arbor, Red Cat, Steam Town) Ⓗ
Free house situated on the corner of a Victorian terrace, carrying up to nine changing real ales from local and national breweries. A cosy bar area, comfortable back room (the Dog House) and rear patio space contribute to the charm and atmosphere of this welcoming award-winning pub. With local musicians often playing, a Thai curry night on Wednesday, and football fans visiting before Southampton FC home matches, this long-standing Guide regular is full of character. Q🚃(7,U6)❀🛜

Handle Bar 🅛

69 The Avenue, SO17 1XS (at Stag Gates)
☎ 07754 769620 🌐 handlebarale.com
6 changing beers (sourced regionally; often Dancing Man, Steam Town, Twickenham) Ⓗ
A welcome addition to the Southampton real ale scene, the Handle Bar opened just before the March 2020 lockdown. It is a medium-sized pub with an unusual raised central section and a roadside decked area. The decor is modern-rustic in style with a mix of old signs and modern murals - one of which is of the eponymous moustache. Six handpumps offer a changing range of local and regional beers. The small kitchen produces an imaginative selection of food, and tapas is available in the summer. ❀🌑♣🚃❀

Hop Inn 🅛

199 Woodmill Lane, SO18 2PH
☎ (023) 8055 7723
Gale's HSB; Steam Town Stoke Extra Pale, Firebox; 1 changing beer (sourced nationally) Ⓗ
The unassuming Hop Inn could easily be overlooked, but step inside and it feels like home. Good homely food is served Tuesday to Saturday alongside three cask ales, two of which are local. The lounge bar is divided by a fireplace and the walls are adorned with decorative plates and other interesting ornaments. The more modern public bar features darts and sporting themes. Wednesday is the popular folk music night and there is occasional live music on other nights. ❤️❀🌑&♣🚃(16,7)❀🛜

Key & Anchor

90 Millbrook Road East, SO15 1JQ
☎ (023) 8022 5674
Dartmoor Jail Ale; St Austell Proper Job; Wadworth 6X Ⓗ
The Key & Anchor is approximately a 10-minute walk east of Southampton Central station. Inside, the drinking area is a compact U-shape around the bar with a variety of seating, supplemented by a small room at the back.

There are tables outside the front, and to the rear is a small garden with a covered area for smokers. The jukebox offers a wide choice of music. The beers are well kept by the landlord. ✿✦🛒🐾😊📶

Olaf's Tun 🍺
8 Portsmouth Road, SO19 9AA
☎ (023) 8044 7887 ● olafstun.co.uk
6 changing beers (sourced regionally; often Bowman, Flower Pots, Red Cat) Ⓗ
Local CAMRA Pub of the Year 2022, this friendly micropub features up to six changing local and national real ales, eight keg craft beers, six bag-in-box ciders and a wide selection of bottled and canned beers. With a name hinting at local history and its rustic decor, this welcoming pub's charm is enhanced by the many community groups that meet here. Backed by a high quality pizza and snack menu, this pub is well worth a visit. Q✿🕹️👍≠(Woolston)✦🛒🐾😊📶

Park Inn
37 Carlisle Road, SO16 4FN
☎ (023) 8078 7835 ● theparkinn.co.uk
Wadworth Henry's IPA, 6X, Swordfish; 3 changing beers (sourced nationally) Ⓗ
A welcoming, street-corner local that provides an oasis from the bustle of the nearby Shirley shopping area. Split into lounge and public areas, the walls are adorned with photos, mirrors and posters. It is easily reached using the numerous buses to Shirley Precinct from the city centre and Central station. Quizzes are held on Wednesday and Sunday evenings and a meat draw Sunday lunchtimes. ✿✦🛒😊📶

Platform Tavern Ⓛ ✅
Town Quay, SO14 2NY
☎ (023) 8033 7232 ● platformtavern.com
Dark Star Hophead; Fuller's London Pride; 2 changing beers (sourced locally) Ⓗ
Victorian pub near the city's QE2 Mile and God's House Tower. The main bar, decorated with a bias towards ethnic-style art, has comfortable leather sofas and traditional pub tables; a stone archway leads to the restaurant area. Well-known for its live music, the pub takes part in the annual Music in the City festival. Of historic interest is a small section of the old city wall and a plaque for the last victim of the Titanic to be recovered. ✿🕹️✦🛒😊📶

South Western Arms
38-40 Adelaide Road, SO17 2HW
☎ (023) 8122 0817
9 changing beers (sourced nationally) Ⓗ
Adjoining St Denys railway station, this pub was remodelled in the 1980s and opened up into a single area with plenty of bare brick and wood. Pub games are in the upstairs area, which is occasionally used for private events. The enclosed garden to the rear has a water feature. No food is served, but a takeaway trailer is often in the car park Tuesday to Sunday evenings. Licensing restrictions mean there is no entry after 10.30pm. ✿≠(St Denys) ✦🅿️(7) 🐾

Witch's Brew Ⓛ
220 Shirley Road, SO15 3FL
☎ 07403 871757
5 changing beers (sourced nationally; often Flower Pots, Steam Town, Wantsum) Ⓖ
A gem of a micropub with a warm welcome. The Victorian building has two cosy rooms with a small serving bar at the back. Decorated with witch paraphernalia, it is a fascinating place. The landlady prides herself on the quality of the ever-changing

gravity-dispensed ales. The heated marquee in the garden attracts customers all the year round. Local CAMRA Cider Pub of the Year 2021 and finalist in Pub of the Year, a visit is a must. Q✿✦🍴🛒🐾

Southwick

Golden Lion Ⓛ
High Street, PO17 6EB
☎ (023) 9221 0437 ● goldenlionsouthwick.co.uk
Langham Arapaho; Palmers Tally Ho!; 4 changing beers (sourced regionally; often Bowman, Flower Pots, Triple fff) Ⓗ
Historic free house in a village that, apart from Church Lodge, is still privately owned by Southwick Estates. In the car park is the historic brewhouse museum. Nearby Southwick House was the centre of planning for Operation Overlord during the Second World War and the pub was visited by many of those involved including Generals Eisenhower and Montgomery. The lounge bar was the unofficial officers' mess during that period. Tuesday is jazz night.
Q🐕🕹️👍≠(Portchester) ✦🅿️🛒🐾📶

Titchfield

Wheatsheaf Ⓛ
1 East Street, PO14 4AD
☎ (01329) 842965
● thewheatsheaf-titchfield.foodanddrinksites.co.uk
Fallen Acorn Hole Hearted; Flower Pots Pots Bitter; 3 changing beers (sourced regionally; often Flower Pots) Ⓗ
Situated in a conservation area, the pub is owned by the licensee, bought with the help of crowdfunding. The premises comprise a main bar and a small snug with an outdoor area, and a bistro restaurant. Food is also served in the bar. Sunday lunches are popular and need to be booked well in advance. Biannual beer festivals are held in December or January, and July. No food Sunday evenings. Q🐕🕹️👍🅿️(X4)🐾

Totton

6 Barrels
31 Salisbury Road, SO40 3HX
☎ (023) 8178 3030 ● 6barrels.co.uk
Steam Town Stoke Extra Pale; 3 changing beers (sourced locally; often Hop Back, Twisted, Vibrant Forest) Ⓗ
Situated near the centre of Totton, this micropub offers a range of local ales from Steam Town, Hop Back, Twisted and Vibrant Forest breweries. It has a friendly welcome with bench seating inside and an outside seating area for warmer months. No food is available but you are welcome to order in food from local takeaways. Live bands play on Saturday evening. A selection of board games is available. 👍≠🛒😊📶

Twyford

Phoenix Inn Ⓛ ✅
High Street, SO21 1RF
☎ (01962) 713322 ● thephoenixinn.co.uk
Flower Pots Pots Bitter; Morland Old Speckled Hen; Timothy Taylor Landlord; 3 changing beers (often Flower Pots, Hop Back) Ⓗ
Situated in the centre of Twyford, and run as a part of the Greene King local hero beer scheme, the four beers are from Greene King and local or regional breweries such as Flower Pots, Hop Back and Steam Town. There is a large single bar at the front with an open fire, and at the rear,

a skittle alley that doubles as a function room. Food is served daily except Sunday evening and Monday. Outside seating is available, and there is a large car park. ᗌ❀◑♣🅿🍽(69,E1) 🛜

Upham

Brushmakers Arms

2 Shoe Lane, SO32 1JJ (at the top of Upham village, near the pond) SU5399620606

☎ (01489) 860231 ● thebrushmakersarms.com

Bowman Swift One; Flack Manor Flack's Double Drop; Flower Pots Goodens Gold; 1 changing beer (sourced locally; often Hop Back, Steam Town, Stonehenge) ⊞ Friendly village inn serving four local real ales and a cider. The 600-year-old building was previously a school and brush makers. It has a cosy feel, with low-beamed ceilings, rustic tables and chairs, and walls decorated with various vintage memorabilia. Outside seating is available at the front and in the lovely old English style garden at the rear. Locally sourced food is served from an ever-changing menu (not Mon and Tue).
Q❀◑♣♥🛜

Vernham Dean

George Inn

Back Lane, SP11 0JY

☎ (01264) 737279 ● thegeorgeatvernhamdean.co.uk

Bowman Swift One; Flack Manor Flack's Double Drop; Stonehenge Pigswill; 2 changing beers ⊞ This traditional village pub dates back to the 17th century and features eyebrow windows. It is situated in the upper reaches of the Bourne Valley, with numerous foot and cycling paths including to the nearby Fosbury Hillfort. There is outside seating to the front and rear, and the large beer garden is enclosed. The interior features low oak-beamed ceilings and inviting fireplaces. Fresh cooked food is available most days (check website for details) and themed nights are regularly held.
Q❀◑🅿♥🛜

Whitchurch

Prince Regent 🅛

104 London Road, RG28 7LT

☎ (01256) 892179

Hop Back Crop Circle, Summer Lightning ⊞ The Prince is a traditional friendly locals' local, at the top of the hill in this rural town. It has a single bar and a small rear drinking area overlooking the Test Valley. A jukebox and pool table feature, and sports TV screens with the emphasis on football. Occasional quizzes and live music, including karaoke, are held. The pub may open until 1am at weekends. ♣🅿(76)♥

Widley

George Inn

Portsdown Hill Road, PO6 1BE

☎ (023) 9222 1079 ● the-george-inn.co.uk

Flower Pots Goodens Gold; Fuller's London Pride; Gale's HSB; Timothy Taylor Landlord; 3 changing beers (sourced nationally; often Goddards, Irving, Langham) ⊞ Set alongside the old London to Portsmouth coaching route, this Grade II-listed pub offers views across Portsmouth to the Solent and the Isle of Wight. It was also a stop on the Portsdown & Horndean Light Railway (actually a tram service) until its closure in 1935. The single bar is quite spacious and decorated with brewery memorabilia, mostly relating to the former Brickwoods

brewery. The bar counter itself has unusual wood panelling. Various games, including chess and shove ha'penny, are available. Q❀◑♣🅿🍽♥🛜

Winchester

Albion 🅛

2 Stockbridge Road, SO23 7BZ

☎ (01962) 867991

Flower Pots Perridge Pale, Pots Bitter, Goodens Gold; 1 changing beer (sourced locally) ⊞ Small and cosy traditional street-corner local. Facing a busy junction and Winchester railway station, this is an ideal spot to take a break in your train journey. Enjoy a stop-off to and from the station, or watch the world go by from the windows while you relax with a pint from Hampshire's (now) oldest independent brewery, Flower Pots. The guest ale is sometimes from another local brewery. There is no food service, but snacks including pies are often available. Q⇌🍽♥🛜

Black Boy 🅛

1 Wharf Hill, SO23 9NQ (just off Chesil St B3404)

☎ (01962) 861754 ● theblackboypub.com

Alfred's Saxon Bronze; Flower Pots Pots Bitter; Hop Back Summer Lightning; 2 changing beers (sourced locally; often Bowman, Hop Back) ⊞ A quite extraordinary establishment. A central bar services a number of interconnected rooms that are all overflowing with eclectic, eccentric and often even quite disturbing decor; large stuffed animals in one room, a gigantic Aga kitchen unit in another, tools of every trade woven into elaborate artworks. Real cider is normally available. There are 10 en-suite double accommodation units in the co-owned Black Hole next door, while across the road is the also co-owned Black Rat restaurant.
Q❀🛏♣♥🍽(4)♥🛜

Fulflood Arms 🅛

28 Cheriton Road, SO22 5EF (take Western Rd off Stockbridge Rd)

☎ (01962) 842996 ● thefulfloodarms.co.uk

Greene King IPA; Morland Old Speckled Hen ⊞; 5 changing beers (sourced locally; often Flower Pots, Red Cat, Steam Town) ⊞/🇬 A traditional tiled street-corner pub in a residential area near the centre of Winchester, serving up to four cask beers on handpump and three gravity-fed ales at the back of the bar. The single bar room is simply furnished with tables and chairs and the walls are adorned with scenes of old Winchester. Outside is a compact back garden and a small drinking area at the front. Two darts teams play on Monday with social darts on Sunday.
❀⇌♣🍽(4,3) ♥🛜

Hyde Tavern 🅛

57 Hyde Street, SO23 7DY

☎ (01962) 862592 ● hydetavern.co.uk

Flower Pots Pots Bitter; Harvey's Sussex Best Bitter ⊞; 4 changing beers (sourced locally; often Flower Pots, Steam Town, West Berkshire) ⊞/🇬 The pub frontage is dominated by two giant gables. From the central door there are steps down to the low-beamed front bar with its tiny serving counter. Up to six beers are usually available, four on handpumps and two on gravity from a small stillage; the Harvey's beer is a rarity in Winchester. Numerous activities are popular with customers: Mondays and Wednesdays often feature folk groups, and on the first Sunday of each month is a quiz. A downstairs cellar room hosts many local groups' private functions. Q❀⇌♣♥🍽🍽♥🛜

Old Vine L ✅

8 Great Minster Street, SO23 9HA
☎ (01962) 854616 ⊕ oldvinewinchester.com
Alfred's Saxon Bronze; Timothy Taylor Landlord; 2 changing beers (sourced locally; often Andwell, Bowman, Steam Town) Ⓗ

An 18th-century inn and hotel with wood-beamed ceilings, overlooking the cathedral green. The bar is in the main area of the pub, serving mostly local ales, and to left is a restaurant area. At the rear is extra seating in a modern extension with skylights, and there is a tiny patio outside. A varied menu includes modern pub classics with a choice of luxury pies of the day, plus breakfast and sandwiches at lunchtimes. Upstairs are six spacious guest rooms. ❀🛏️◑🚪(1,69)🍴🎵🛜

Queen Inn L ✅

28 Kingsgate Road, SO23 9PG
☎ (01962) 853898 ⊕ thequeeninnwinchester.com
Flack Manor Flack's Double Drop; Flower Pots Goodens Gold; house beer (by Queen Inn); 8 changing beers (sourced locally; often Bowman, Fallen Acorn, Steam Town) Ⓗ

A relaxed and affable pub, situated close to Winchester College and a pleasant walk from the city centre. A refurbishment has included a new replacement microbrewery, which can be viewed from the front bar. Up to eight real ales are also sourced from other Hampshire breweries. The comprehensive food menu uses locally sourced ingredients, complemented by various roast lunches on Sunday. Outside, the large garden to the rear and a sheltered front patio provide extra seating. Q🛏️❀◑P🚪(1,69)🍴🎵🛜

Wykeham Arms

75 Kingsgate Street, SO23 9PE
☎ (01962) 853834 ⊕ wykehamarmswinchester.co.uk
Dark Star Hophead; Flower Pots Goodens Gold; Fuller's London Pride; Gale's Seafarers Ale, HSB; 1 changing beer (sourced regionally) Ⓗ

Lovely Georgian building dating from 1755, a few yards from Winchester College and the Kingsgate. Inside the interconnected set of rooms a plethora of memorabilia abounds: pewter pots hang everywhere, much 'Nelsoniana' adorns the walls, and school desks are repurposed as seating. Although a Fuller's tied house, one of the local Flower Pots Brewery's ales features, and there are several dozen wines available by the glass. Outside, in the wall opposite, a rare Victorian postbox attracts enthusiasts from far and wide. Q❀🛏️◑🚪(1,69)🍴🛜

Wonston

Wonston Arms 🍸 L

Stoke Charity Road, SO21 3LS
☎ 07909 993388 ⊕ thewonston.co.uk
4 changing beers (sourced locally; often Bowman, Oakham, Red Cat) Ⓗ

This is a gem of a pub in the heart of the village, around a 15-minute walk from Sutton Scotney and the nearest bus stop. It is a true community local catering for everyone. Although it doesn't serve food, frequent pop-up street food vendors visit. Folk music is on the first and third Wednesdays of the month and jazz sessions, quizzes and Friday curry nights also feature. A three-times local CAMRA Pub of the Year and former CAMRA National Pub of the Year. Q❀🌿🍴P🍴🛜

Wootton

Rising Sun L

Bashley Common Road, BH25 5SF (on B3058, 1½ miles SE of A35)
☎ (01425) 610360 ⊕ therisingsunbashley.co.uk
Flack Manor Flack's Double Drop; Otter Ale Ⓗ

Prominent and attractive pub on the edge of the open forest with ample seating and a meet-and-greet system at the main entrance. A spacious, separate and enclosed family room leads to an adventure playground. Dogs are welcome on hard floor areas, horses may be tethered next to the large car park. Attractive stained-glass windows and many old prints and antiques catch the eye. Gluten-free bottled beer is available and there are occasional guest ales in busy periods. An extensive food menu is served during the day. 🛏️❀◑♿🚪(C32,C33)🍴🛜

Breweries

Alfred's

Unit 6, Winnall Farm Industrial Estate, Easton Lane, Winchester, Hampshire, SO23 0HA
☎ (01962) 859999 ⊕ alfredsbrewery.co.uk

Alfred's is a nine-barrel, state-of-the-art brewery located close to the centre of Winchester. Production of Saxon Bronze is complemented by returning favourites and experimental beers. ‼🛒♦

Saxon Bronze (ABV 3.8%) BITTER
Well-balanced, copper-coloured bitter, with minimal aroma. Malt dominates the taste with some hops in the finish.

Andwell SIBA

Andwell Lane, Andwell, Hampshire, RG27 9PA
☎ (01256) 761044 ⊕ andwells.com

⊠ Brewing commenced in 2008 on a 10-barrel plant. The brewery relocated and expanded in 2011 to an idyllic riverside location with a new bespoke 20-barrel plant. Beer is distributed to Hampshire, Surrey, Wiltshire, Berkshire, Greater London and the Isle of Wight. More than 200 outlets are supplied. In 2020 Andwells new brewhouse shop, bar and café opened behind the brewery. ‼🛒♦🔧

Resolute Bitter (ABV 3.8%) BITTER
An easy-drinking bitter. Malty aroma, leads into a similarly malty flavour with some bitterness and a sweetish finish.

Gold Muddler (ABV 3.9%) BLOND
Light, golden, standard bitter. Aroma of hops and malt; characteristics carried into flavour with solid bitterness and dry, biscuity finish.

King John (ABV 4.2%) BITTER
Malty bitter, low in hops with loads of caramel and toffee underlying sweetness, leading to some dryness in the finish.

Botley

Botley Mills, Mill Hill, Botley, Hampshire, SO30 2GB
☎ (01489) 784867 ☎ 07909 337212
⊕ botleybrewery.com

⊠ Botley Brewery was established in 2010 and uses a five-barrel plant. A small bar next door, appropriately named the Hidden Tap, serves three of its ales Tuesday-Sunday. 🛒♦LIVE🔧

Pommy Blonde (ABV 4.3%) BITTER

Amber bitter with malty, orange and grapefruit nose. Hops come through in taste leading to pronounced bitterness and dry finish.
Barista (ABV 4.6%) SPECIALITY
Coffee milk stout with enticing coffee and blackberry aroma. Rather thin, roast and toffee leading to slightly sour, sharp finish.
English IPA (ABV 5.1%) PALE
An earthy, rich and piny English IPA. Decent hoppiness with lasting, pronounced dryness, but a well-rounded malt character throughout.
Wildern (ABV 5.7%) RED

Bowman SIBA

Wallops Wood, Sheardley Lane, Droxford, Hampshire, SO32 3QY
☎ (01489) 878110 ⊕ bowman-ales.com

⊠ Brewing started in 2006. A new 40-barrel plant came on line in 2013, this is now working alongside the original 20-barrel plant. In addition to the standard beers, a range of seasonal brews and monthly specials are produced. Bowman also brew the Suthwyk Ales range of beers. ‼♦LIVE

Swift One (ABV 3.8%) BLOND
Easy-drinking blonde, well-balanced, sweet maltiness and clean, fresh hoppiness, leading to bittersweet finish, and slightly dry, hoppy aftertaste.
Meon Valley Bitter (ABV 3.9%) BITTER
Complex, well-balanced traditional, copper-coloured bitter; sweet with initial maltiness in taste and aroma leading to a lingering bitterness.
Wallops Wood (ABV 4%) BITTER
Malt dominates this light brown session bitter. Some dried fruit flavours balanced by toffee notes and sweetness in the finish.

Contract brewed for Suthwyk Ales:
Old Dick (ABV 3.8%) BITTER
Pleasant, clean-tasting pale brown bitter. Easy-drinking and well-balanced. Brewed using ingredients grown on Bowman's farm.
Liberation (ABV 4.2%) BITTER
Skew Sunshine Ale (ABV 4.6%) GOLD
An amber-coloured beer, brewed using Bowman's homegrown ingredients. Initial hoppiness leads to a fruity taste and finish.
Palmerston's Folly (ABV 5%) SPECIALITY

Brewhouse & Kitchen SIBA

🏠 26 Guildhall Walk, Portsmouth, Hampshire, PO1 2DD
☎ (023) 9289 1340 ⊕ brewhouseandkitchen.com

⊠ Part of the Brewhouse & Kitchen chain, producing its own range of beers. Carry outs and brewery experience days are offered. ‼▪♦

Brewhouse & Kitchen SIBA

🏠 47 Highfield Lane, Southampton, Hampshire, SO17 1QD
☎ (023) 8055 5566 ⊕ brewhouseandkitchen.com

⊠ Part of the Brewhouse & Kitchen chain. Opened in 2015 it offers its own range of eclectic beers; producing three core beers and a regularly changing Project Cask beer. ‼▪♦LIVE

Brewhouse & Kitchen SIBA

🏠 51 Southsea Terrace, Southsea, Hampshire, PO5 3AU
☎ (023) 9281 8979 ⊕ brewhouseandkitchen.com

Part of the Brewhouse & Kitchen chain, producing its own range of beers. Carry outs and brewery experience days are offered.

CrackleRock

The Old Cooperage, High Street, Botley, Hampshire, SO30 2EA ☎ 07733 232806 ⊕ cracklerock.co.uk

⊠ Cracklerock began brewing in 2014 at the Old Cooperage in the centre of Botley. Its taproom moved to larger premises near the brewery in 2018. ‼▪♦

Crackerjack (ABV 3.8%) BITTER
Verified (ABV 4%) PALE
Fire Cracker (ABV 4.2%) BITTER
Gold Rush (ABV 4.5%) GOLD
Dark Destroyer (ABV 4.9%) PORTER
Crafty Shag (ABV 5%) BITTER
Crackatoa IPA (ABV 6.2%) IPA

Dancing Man

🏠 Wool House, Town Quay, Southampton, Hampshire, SO14 2AR
☎ (023) 8083 6666 ⊕ dancingmanbrewery.co.uk

⊠ The Dancing Man opened in the iconic Wool House in 2015 and has proved to be a very popular venue. The business has invested in a canning machine and it is now possible to purchase the sought-after beers in cans. One-off and rare brews are available throughout the year. ‼▪♦LIVE

Drop The Anchor

9 East Close Farm, Lyndhurst Road, Hinton, BH23 7EF
☎ 07806 789946 ⊕ droptheanchorbrewery.co.uk

⊠ Neil Hodgkinson began brewing in 2017 using a 2.5-barrel plant situated in the loft area of the Christchurch Emporium. This has now relocated to Hinton. Beer is available in a number of local pubs, and a small bar and shop is situated in the brewery (open Friday-Sunday). All beers are unfined. ♦LIVE✦

Silent Stones (ABV 4.7%) PALE
Tucktonia (ABV 4.7%) PALE
Priest Hole Porter (ABV 4.9%) PORTER
Fusee Chain (ABV 5%) PALE

Emsworth

Unit 45, Basepoint Business Centre, Havant, Hampshire, PO9 1HS ☎ 07840 876854 ⊕ theemsworthbrewhouse.co.uk

Emsworth Brewhouse was launched in 2015 as a half-barrel plant, and upgraded to 1.5-barrels in 2016. It was sold in 2017 and is now in the capable hands of Jonathan Khoo, who moved it to larger premises in Havant with a shop and taproom. The brewery has moved away from bottles and now sells all its beers in cans. All beers are unfined and vegan-friendly. ▪LIVE V✦

Mainsail (ABV 3.8%) GOLD
Starboard (ABV 4%) PALE
Flotilla (ABV 4.4%) BITTER
Wodehouse (ABV 4.8%) BITTER
Portside (ABV 5.2%) PORTER
SkIPA (ABV 5.4%) PALE

Fallen Acorn SIBA

Unit 7, Clarence Wharf, Mumby Road, Gosport, Hampshire, PO12 1AJ ⊕ fallenacornbrewing.co

Fallen Acorn is a 20-barrel microbrewery in Gosport, Hampshire. Striving to deliver the highest quality beer from traditional styles and brewing techniques, to pushing modern boundaries and combining a range of brewing experience with a passion for innovation. Offering a range of styles, it aims to brew something for all tastes, breaking the divide between traditional and craft. !! ▬ ♦LIVE ✦

Pompey Royal (ABV 4.3%) BITTER
Well-balanced, malty, traditional bitter. Initial strong caramel flavours, with hints of chocolate leads towards a sweet and slightly bitter finish.

Awaken (ABV 4.5%) IPA

Hole Hearted (ABV 4.7%) GOLD
A golden ale with strong citrus hop aroma. This continues to dominate the flavour, leading to a long, bittersweet finish.

Expedition IPA (ABV 5.5%) IPA
British-style IPA. Well hopped with a citrusy nose and balancing malt. Taste is similarly balanced, leading to dry, bitter finish.

Flack Manor SIBA

8 Romsey Industrial Estate, Greatbridge Road, Romsey, Hampshire, SO51 0HR
☎ (01794) 518520
⊕ flack-manor-brewery.myshopify.com

⊗ Flack Manor commenced brewing in 2010, and continues as the sole upholder of Romsey's long brewing tradition, and one of the few remaining in the British Islands to use the double-drop method. Its 20-barrel capacity was recently increased by the addition of a one-barrel pilot plant. All barley used is Maris Otter, and most beers contain only British hops. Flack's beers are supplied to many outlets within 50 miles of Romsey, and may also be found in JD Wetherspoon outlets. !! ▬ ♦LIVE ✦

Flack's Double Drop (ABV 3.7%) BITTER
A classic amber session bitter. Hops, malt and some bitterness in the taste, with more hop and some malt in the finish.

Romsey Gold (ABV 4%) GOLD

Catcher Pale Ale (ABV 4.4%) PALE

Flower Pots SIBA

Brandy Mount, Cheriton, Hampshire, SO24 0QQ
☎ (01962) 771735 ⊕ theflowerpots.co.uk

⊗ Flower Pots began production in 2006, now making it Hampshire's oldest independent brewery. The 10-barrel brewery, and neighbouring pub of the same name, are in a pretty Hampshire village. It brews six core beers, plus a monthly special. In 2019 the brewery and pub were taken over by three local partners, while the two sibling pubs (Wheatsheaf and Albion) were retained by the original owners. ♦

Perridge Pale (ABV 3.6%) GOLD
Very pale, easy-drinking golden ale. Honey-scented with high hops, grapefruit and bitterness throughout. Crisp with some citrus notes.

Pots Bitter (ABV 3.8%) BITTER
Refreshing, easy-going bitter. Dry, earthy hop flavours balanced by robust maltiness. Bitter throughout with hoppy aroma and dry, bitter finish.

Buster's Best (ABV 4.2%) BITTER

Cheriton Porter (ABV 4.2%) PORTER
Dry porter packed with blackcurrant flavours. Distinctive roastiness and malty throughout, combining with pleasing bitterness leading to a bittersweet finish.

Goodens Gold (ABV 4.8%) PALE

Complex, full-bodied, golden-coloured ale, bursting with hops and citrus fruit and a snatch of sweetness, leading to long, dry finish.

IPA (ABV 6%) IPA
Rich and full-bodied IPA. Uncompromising hoppiness and strong grapefruit character, a robust maltiness, and rich, fruity finish.

Gilbert White's

Gilbert White's House, High Street, Selborne, Hampshire, GU34 3JH
☎ (01420) 511275 ⊕ gilbertwhiteshouse.org.uk/the-brewhouse

Nanobrewery staffed by volunteers that opened in 2020. It is attached to the Gilbert White Museum and produces bottled, cask-conditioned and keg beer using a modern one-barrel kit in Gilbert White's original brewhouse, dating from 1765. Bottled beer is sold through the museum shop: cask beer is often available in the nearby Selborne Arms and increasingly through free trade outlets locally and festivals. ▬

Growling Gibbon (NEW) SIBA

The Incuhive Space, Hursley Park Road, Winchester, Hampshire, SO21 2JN ⊕ growlinggibbon.com

Growling Gibbon Brewery was established by brewer Ralph McFadyen in 2022. Located in the former stables of Hursley House, mainly focussing on brewing pale ales and IPAs using a one-barrel brew plant. Currently supplying local outlets, beer is available in KeyKeg or can. Draught beer can be purchased in growlers direct from the brewery. !! ▬

Irving SIBA

Unit G1, Railway Triangle, Walton Road, Portsmouth, Hampshire, PO6 1TQ
☎ (023) 9238 9988 ⊕ irvingbrewers.co.uk

⊗ Established in 2007 by former Gale's brewer Malcolm Irving using a 15-barrel plant. Around 120 outlets are supplied in Hampshire, Sussex and Surrey with beers available further afield through beer swaps with other breweries. Speciality beers may be ordered for festivals. Off-sales available Thursdays and Fridays. !! ▬ ♦

Frigate (ABV 3.8%) PALE
Satisfying session bitter. Hoppy, with a floral aroma and initial sweetness, leading to bitterness and a smooth, slightly dry finish.

Type 42 (ABV 4.2%) BITTER
Traditional brown bitter. Burnt toffee aroma leads to hedgerow fruitiness complementing crystal malt. Resinous hops grow into surprisingly dry finish.

Admiral Stout (ABV 4.3%) STOUT
Well-balanced oatmeal stout, with plenty of fruit and roast, together with pleasant hint of coffee. Short bitter finish.

Invincible (ABV 4.6%) BITTER
Tawny-coloured strong bitter. Sweet and fruity with underlying maltiness throughout and gradually increasing dryness, contrasting with the sweet finish.

Iron Duke (ABV 5.3%) IPA
Refreshing, well-balanced English IPA. Marmalade nose, with strong bitterness and a robust sweetness throughout, which softens the lemony sherbet finish.

Little London

Unit 6B, Ash Park Business Centre, Ash Lane, Little London, Hampshire, RG26 5FL

☎ (01256) 533044 ☎ 07785 225468
⊕ littlelondonbrewery.com

⊗ Brewing began in 2015 using a six-barrel plant. Three fermentation vessels ensure a production capability of 60 firkins per week, with capacity for expansion.

Doreen's Dark (ABV 3.2%) MILD
Blacksmith's Gold (ABV 3.5%) GOLD
Red Boy (ABV 3.7%) BITTER
Hoppy Hilda (ABV 3.8%) GOLD
Luvly (ABV 3.9%) BITTER
Pryde (ABV 4.2%) BITTER
Ash Park Special (ABV 4.9%) BITTER

London Road Brew House

🍺 67-75 London Road, Southampton, Hampshire, SO15 2AB
☎ (023) 8098 9401 ☎ 07597 147321
⊕ londonroadbrewhouse.com

⊗ Brewing commenced in 2017 in the London Road Brew House using a six-barrel plant. Now owned by the Tap It Brewery, all beer brewed on site is keg.

Longdog

Unit A1, Moniton Trading Estate, West Ham Lane, Basingstoke, Hampshire, RG22 6NQ
☎ (01256) 324286 ☎ 07579 801982
⊕ longdogbrewery.co.uk

⊗ Established in 2011, the Longdog Brewery is named after a type of Lurcher used for hare coursing – once a popular pastime in the North Hampshire downs.
‼ 🍽 ♦ LIVE ⬥

Skinny Dog (ABV 1.5%) BITTER
Refreshing, low-alcohol bitter. Predominantly malty, fruity aroma continues into the taste combined with some dry bitterness. A short finish.
Bunny Chaser (ABV 3.6%) BITTER
Malt dominates this amber-coloured, session bitter throughout. Some hops come through with growing bitterness and a fading background sweetness.
Golden Poacher (ABV 3.9%) BLOND
Light, refreshing, blond with lemony nose and honeyed taste. Lingering, malty, sweetness and some hops and residual bitterness in finish.
Basingstoke Pride (ABV 4.2%) BITTER
Malty and rather sweet session bitter. Decent level of English hops in the taste combined with some subtle fruitiness.
Red Runner (ABV 4.2%) BITTER
Satisfying mahogany-coloured, red ale, with solid malt backbone. Hedgerow fruits and hops, with peppery tones and lasting, dry hop bitterness.
Ruby Mild (ABV 4.5%) MILD
Lovely Nancy (ABV 4.8%) PALE
Full-bodied, golden, straw-coloured pale ale. Hints of honey, lemon and pineapple, with malty sweetness that diminishes into increasingly bitter finish.
Lamplight Porter (ABV 5%) PORTER
Splendid porter, smoky and drier than many, with strong roast flavours giving way to blackberry taste and slightly vinous finish.
Longdog IPA (ABV 6%) IPA
Classic English IPA; rich and earthy with hops pushed hard. Lemony notes, hints of spice lead to a bittersweet finish.

Makemake

🍺 39 Osborne Road, Southsea, PO5 3LR
☎ (023) 9273 5939 ⊕ makemake.beer

Makemake Brewing, based in the Greenwich Brewpub in Southsea, have been producing modern craft beers since 2019. Brewing is currently suspended.

Monkey (NEW)

🍺 Monkey Brewhouse, 167 Southampton Road, Lymington, Hampshire, SO41 9HA
☎ (01590) 676754 ☎ 07835 270153
⊕ monkeybrewhouse.co.uk

A five-barrel brewery housed in an oak-framed extension to the pub. ⬥

Newtown

25 Victoria Street, Gosport, Hampshire, PO12 4TX
☎ (023) 9250 4294 ⊕ newtownbrewery.co.uk

Newtown is one of the smallest UK breweries with just a half-barrel plant. Full mash beers are produced on demand for local pubs and beer festivals in either firkins or, for outlets with a relatively small turnover, pins.

Pig Beer

Hop House, Setley Ridge, Brockenhurst, SO42 7UF
☎ (01590) 607237 ☎ 07747 462139 ⊕ pigbeer.com

Pig Beer is an 18-barrel brewery operated by two brothers and their cousin. Currently producing bottled beers only, but expected to produce KeyKeg beers for local outlets if there is a demand.

Powder Monkey SIBA

Priddy's Hard, Heritage Way, Gosport, Hampshire, PO12 4FL ⊕ powdermonkeybrewing.com

The 25-hecolitre brewery, situated in a unique 1878 former gunpowder magazine, started production in 2021. There is a visitors centre and shop on the premises, and a nearby pub which serves as a taproom. Currently only keg and canned beer is produced for around 20 outlets. A cold room is planned to open in 2023, which will enable the production of cask beer. ‼ 🍽 ♦

Queen Inn SIBA

🍺 28 Kingsgate Road, Winchester, Hampshire, SO23 9PG
☎ (01962) 853898 ⊕ thequeeninnwinchester.com

The brewery was installed in 2013 during a pub refurbishment. The brewery expanded to a three-barrel brew plant in 2022. Brewing takes place twice a week, producing beers just for the pub.

Red Cat SIBA

Unit 10, Sun Valley Business Park, Winnall Close, Winchester, Hampshire, SO23 0LB
☎ (01962) 863423 ⊕ redcatbrewing.co.uk

Red Cat Brewing Company was established in 2014 using an 11-barrel plant. It supplies Hampshire and bordering counties. A small bar and shop in the brewery sells a range of products. 🍽 ♦

Art of T (ABV 3.6%) SPECIALITY
Easy-drinking, speciality pale ale with a slight fruit aroma. Refreshing, dry astringency and bitterness in the taste and lingering aftertaste.
Prowler Pale (ABV 3.6%) PALE
Pale yellow session bitter with dominant hop flavours and some fruit in the taste and aftertaste.
Scratch (ABV 4%) BITTER

Session pale golden bitter, low aroma but well-balanced hop, malt and fruit flavours in the taste and aftertaste.
Mr M's Porter (ABV 4.5%) PORTER
A rich, fruity porter, complex flavours with good roast aroma and taste well-balanced with fruit flavours throughout.
Mosaic Pale (ABV 4.9%) PALE
American pale ale style beer with rich floral aroma leading to balanced fruit and hop flavours fading to a hop, fruit and bitter finish.

Red Shoot

🍴 Toms Lane, Linwood, Ringwood, Hampshire, BH24 3QT
☎ (01425) 475792 ⊕ redshoot.co.uk

⊗ The 2.5-barrel brewery was commissioned in 1998 and can be viewed from inside the pub. Production is slightly seasonal, about 2-3 brews a week. Surplus output is sold to a selection of other Wadworth pubs. Brewing is currently suspended.

Ringwood

Christchurch Road, Ringwood, Hampshire, BH24 3AP
☎ (01425) 471177 ⊕ ringwoodbrewery.co.uk

⊗ Ringwood was bought in 2007 by Marston's. Production has been increased to 50,000 barrels a year. Some 750 outlets are supplied. Ringwood beers are now available in Marston's pubs all over the country. Part of Carlsberg Marston's Brewing Co. ‼️🍴◆

Razorback (ABV 3.8%) BITTER
Copper-coloured session bitter dominated by malt with some toffee and berry fruit character, leading to a short, bittersweet finish.
Boondoggle (ABV 4.2%) BITTER
Golden-coloured light, easy-drinking, session bitter. Quite malty with some peach and apricot nose and sweet, tropical fruit palate.
Fortyniner (ABV 4.9%) BITTER
Caramel, biscuity aroma, with hints of damson, lead to a sweet taste, balanced with some malt, fruit and hop flavours.
Old Thumper (ABV 5.1%) BITTER
Powerful, sweet, copper-coloured bitter. A fruity aroma preludes a sweet, malty taste with fruit and caramel and a bittersweet aftertaste.

Sherfield Village SIBA

Goddards Farm, Goddards Lane, Sherfield on Loddon, Hampshire, RG27 0EL ☎ 07906 060429
⊕ sherfieldvillagebrewery.co.uk

Production started in 2011 in a converted barn on a working dairy farm. Using a five-barrel plant, the brewery supplies local pubs and regional festivals. Extensive use is made of New World hops, particularly those from New Zealand. All beers are unfined. ◆LIVE

Southern Gold (ABV 4%) GOLD
Green Bullet (ABV 4.3%) GOLD
A strong lemony nose, with hops dominating the taste building to a strong aftertaste with a big astringent hit at the end.
Single Hop (ABV 4.3%) GOLD
Pioneer Stout (ABV 5%) STOUT

Southsea

Southsea Castle, Clarence Esplanade, Southsea, Portsmouth, Hampshire, PO5 3PA ☎ 07939 063970
⊕ southseabrewing.co.uk

⊗ Launched in 2016, Southsea Brewing is located in an old ammunition storage room within the walls of a coastal defence fort built by Henry VIII in 1544. All beers are unfined, unfiltered and unpasteurised, and bottled on-site. ‼️🍴LIVE

Low Tide (ABV 3.8%) PALE
Casemate IPA (ABV 5.4%) PALE

Staggeringly Good SIBA

Unit 10, St Georges Industrial Estate, Rodney Road, Southsea, Hampshire, PO4 8SS
☎ (023) 9229 7033 ⊕ staggeringlygood.com

⊗ Brewing began in 2014, originally using spare capacity at other breweries. In 2015 a 10-barrel plant at its own premises came on stream. All beers are real ale but only available in KeyKeg or can, unfined and vegan-friendly. There is an on-site shop and taproom. In 2019 the brewery acquired a large unit to allow for more brewing kit and to expand the taproom. ‼️🍴◆LIVE V◆

Steam Town SIBA

🍴 1 Bishopstoke Road, Eastleigh, Hampshire, SO50 6AD
☎ (023) 8235 9130 ⊕ steamtownbrewco.co.uk

⊗ Steam Town is a six-barrel microbrewery with its own craft beer bar and restaurant, established in 2017. Many other local pubs, clubs and micropubs within a 10-mile radius also sell its ales, as well as beer festivals and outlets further afield by arrangement. Steam Town beers are available in many formats: cask, keg, mini-cask/keg, bottles and cans. ‼️🍴◆LIVE

Stoke Extra Pale (ABV 3.8%) GOLD
Light golden ale with hops dominating but complemented by some light pineapple notes and sweetness, with a short, dry, bitter finish.
Barton (ABV 4%) BITTER
Traditional light brown bitter with some toffee notes leading to malty sweetness balanced by bitterness and a lingering dry finish.
NZ Pale (ABV 4.2%) PALE
Reefer (ABV 4.2%) PALE
Modern pale ale, with an aroma of citrus fruits and grapefruit flavours leading to a smooth but predominantly bitter finish.
Steam Stout (ABV 4.5%) STOUT
Bishops Gold (ABV 4.6%) GOLD
Firebox (ABV 4.6%) RED
Complex American red with distinctive aroma of redcurrants and jelly, leading to full-bodied malty sweetness and a refreshing hop bite.
West Coast IPA (ABV 5.4%) PALE

Tap It

Unit 6, Muira Industrial Estate, William Street, Southampton, Hampshire, SO14 5QH ☎ 07484 649425 ⊕ tapitbrew.co.uk

The first brew by enthusiastic homebrewer Rob Colmer was in 2018. Tap It is an eight-barrel plant producing eight regular beers mainly in KeyKeg and bottles. Occasional cask-conditioned beers are available. There is an on-site brewery tap and a bar in Southampton is planned. ‼️🍴◆

Triple fff SIBA

Magpie Works, Station Approach, Four Marks, Hampshire, GU34 5HN
☎ (01420) 561422 ⊕ triplefff.com

⊗ Established in 1997 close to a stop on the Watercress Line Heritage Steam Railway, the brewery and all the beers (except Alton's Pride) are named following a musical theme. The fff refers to fortissimo, meaning louder or stronger. Brewing on a 50-barrel plant since 2006, multiple CAMRA awards have been won. Two pubs are owned: the Railway Arms, Alton, and the Artillery Arms, Southsea. !! ⇌ ♦ LIVE ⚒

Alton's Pride (ABV 3.8%) BITTER
Full-bodied, brown session bitter. Initial maltiness fades as citrus notes and hoppiness take over, leading to lasting, hoppy, bitter finish.

Pressed Rat & Warthog (ABV 3.8%) MILD
Toffee aroma, hints of blackcurrant and chocolate lead to well-balanced flavour with roast, fruit and malt vying with hoppy bitterness.

Moondance (ABV 4.2%) PALE
An aromatic citrus hop nose, balanced by bitterness and sweetness in the mouth. Bitterness increases in finish as fruit declines.

Goldfinger (ABV 5%) SPECIALITY

Unity SIBA

23-27 Princes Street, Northam, Southampton, SO14 5RP
☎ (023) 8178 2627 ⊕ unitybrewingco.com

Founded in 2016, Unity produce modern craft beer combining innovation with creativity. It likes to experiment and has collaborated with many inspiring breweries. Unity also have a side project, May Provisions, focussing on continental and traditional beers. A modern taproom and bottle shop house 12 lines of Unity beer with fridges of guest beers, local wine and cider, with one of its own beers on cask. ⇌ ⚒

Urban Island SIBA

Unit 28, Limberline Industrial Estate, Limberline Spur, Portsmouth, Hampshire, PO3 5DZ
☎ (023) 9266 8726 ⊕ urbanislandbrewing.uk

⊗ Urban Island began production in 2015 and now has a capacity of 12 barrels. The range is distributed throughout Hampshire and neighbouring counties. In addition to cask it also has a range of beer available in cans and KeyKeg. Canned beers can be ordered online and delivered nationwide. !! ⇌ ♦ ⚒

Urban Pale (ABV 3.8%) GOLD
Unfined yellow ale. Aroma of orange, pink grapefruit and tangerine, leading to a robust, hoppy taste and softer bittersweet finish.

Mosaic (ABV 4%) GOLD
Great use of Mosaic hops. Dry and hoppy with pronounced citrus, tropical fruit and grapefruit throughout. Lingering, bitter finish. Unfined.

DSB (Dolly's Special Beer) (ABV 4.6%) BITTER
A well-balanced, refreshing, golden-coloured bitter. Unfined, with hints of strawberry and some bitterness in the finish.

Porter 28 (ABV 5%) PORTER
Dark berry aromas build into a roast chocolaty flavour and pleasing tartness in the mouth and a dry, bitter finish. Unfined.

Urban Graffiti (ABV 6%) IPA
Cross between a stout and black IPA. Bursting with chocolate, vanilla, citrus hops, plums and oranges, leading to predominantly dry finish. Unfined.

Vibrant Forest

The Purlieu Centre, Units 3-6, Hardley Industrial Estate, Hardley, Hythe, Hampshire, SO45 3NQ
☎ (023) 8200 2200 ☎ 07921 753109
⊕ vibrantforest.co.uk

⊗ Vibrant Forest Brewery began commercial brewing in 2011 as a one-barrel plant. This gradually increased to 10 barrels over the next five years at Lymington. It relocated to a four unit brewery at Hardley and increased in size to a 12-barrel plant, with its own canning machine, plus taproom. A mezzanine floor has been added, increasing the capacity of the taproom (can new be hired for functions). !! ⇌ ♦ ⚒

Summerlands (ABV 3.5%) PALE
PUPA (ABV 4.5%) PALE
Farmhouse (ABV 5%) SPECIALITY
Single Hop Pale Ale (ABV 5%) PALE
Kick-Start (ABV 5.7%) SPECIALITY
Metropolis (ABV 6%) IPA
Intense resinous hoppiness dominate this Black IPA. Complex with chocolate notes and tropical fruits lead to a dry, hoppy finish.
Kaleidoscope (ABV 6.5%) IPA
Umbral Abyss (ABV 8.8%) SPECIALITY

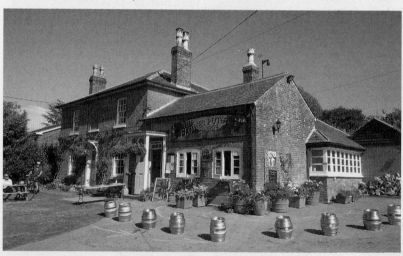

Flower Pots Inn, Cheriton (Photo: Pete Horn)

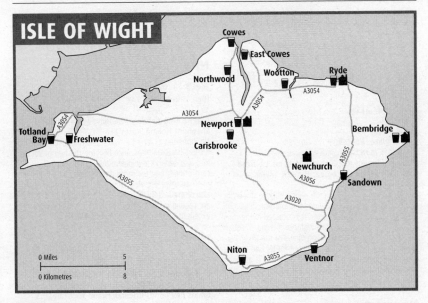

ISLE OF WIGHT

Cowes
East Cowes
Wootton
Ryde
Northwood
A3054
Newport
Bembridge
Carisbrooke
Totland
Bay
Freshwater
A3054
A3054
Newchurch
A3055
A3056
Sandown
A3020
A3055
Niton
A3055
Ventnor

0 Miles 5
0 Kilometres 8

Bembridge

Olde Village Inn

61 High Street, PO35 5SF
☎ (01983) 872616 ⊕ yeoldevillageinn.co.uk
4 changing beers (sourced nationally; often Gale's, Goff's, Timothy Taylor) Ⓖ

Traditional inn in the High Street, reputed to have been serving pints since 1787. The pub has had a massive rethink and rebuild over nearly four years including the lockdown period. No longer one continuous bar, it now has five cosy areas, a separate restaurant with kitchen and pizza oven, and a room for events. Real ales are now in casks on the bar, all cooled to the correct temperature. Good home-cooked food is served featuring local ingredients. This classic community pub is well worth a visit. Q✿❀☆◑♣P🖵(8)✿🕏

Carisbrooke

Waverley Ⓛ

2 Clatterford Road, PO30 1PA
☎ (01983) 522338 ⊕ waverleyinn.co.uk
2 changing beers (sourced locally; often Goddards, Island) Ⓗ/Ⓖ

Large village inn at the roundabout opposite the church in the village of Carisbrooke. It has a public bar and a beautiful lounge with painted Victorian ceilings. The pub has a fine reputation for good-quality well-priced traditional food. There is a largescreen TV, and an open mic night is hosted weekly. Outside, there is ample garden seating and a large marquee. Accommodation is available in six en-suite rooms, ideal for walkers on the Tennyson Trail and cyclists discovering the island. ✿❀☆◑&♣P🖵✿🕏

Cowes

Anchor Inn Ⓛ

1 High Street, PO31 7SA (opp Sainsbury's)
☎ (01983) 292823 ⊕ theanchorcowes.co.uk
Goddards Fuggle-Dee-Dum; Marston's 61 Deep; 2 changing beers (sourced nationally) Ⓗ

Originally the Three Trumpeters back in 1704, this inn is close to the marina, tempting visiting yachtsmen for

their first pint ashore. A recent conversion has integrated the stables and added a pleasant beer garden. A good selection of beer is on offer, with one Island ale and two or more guests available. The varied menu is served in prodigious quantities. Live entertainment features regularly. Accommodation is in seven comfortable rooms. ✿❀☆◑♣🖵(1)✿🕏

Duke of York Ⓛ

Mill Hill Road, PO31 7BT (towards floating bridge)
☎ (01983) 295171 ⊕ dukeofyorkcowes.co.uk
Timothy Taylor Landlord; 2 changing beers (sourced regionally; often Goddards, Yates') Ⓗ

Popular street-corner town pub with a reputation for interesting and appetising freshly prepared food. The welcoming interior features comfortable armchairs and memorabilia and signs celebrating Cowes and its association with yachting and the sea. Beers are always in fine condition. There are outside tables on the front terrace and a drinking area to the side. Well-priced accommodation is available for a comfortable weekend away. Q✿❀☆◑P🖵(1)✿🕏

Painters Arms ✅

51 Cross Street, PO31 7TA
☎ (01983) 300977
Timothy Taylor Landlord; 1 changing beer (sourced nationally) Ⓗ

This superb building dates from 1903. Join in with the friendly banter at the bar, dominated by sports TV, or find a table outside in Francki Place, named after the Polish captain whose destroyer ORP Blyskawica defended Cowes during air raids in 1942. The beer garden also has TV, and in summer a wagon with burritos, burgers and veggie choices. An earlier Painters Arms stood at the head of Temperance Terrace, a renowned Cowes alley, now sadly a car park. ✿❀P🖵(1)✿🕏

East Cowes

Ship & Castle Ⓛ

21 Castle Street, PO32 6RB
☎ 07493 694457
Fuller's London Pride; 2 changing beers (sourced regionally; often Adnams, Goddards, Island) Ⓗ

Handy for the ferry terminal and near the floating bridge to Cowes, this characterful town-centre drinking establishment is now a free house, offering three well-kept real ales all year round. It is not overly large, and you are assured of a warm welcome. Prices are reasonable, especially during happy hour. Frequent and lively music sessions are held. Q☺&A♣무❀

Freshwater

Red Lion ℀

Church Place, PO40 9BP SZ34508738

☎ (01983) 754925 ⊕ redlion-freshwater.co.uk

St Austell Proper Job; 3 changing beers (sourced nationally; often Butcombe, Timothy Taylor, West Berkshire) ⊞

Former three-bar coaching inn dating back to the 11th century, now converted to one large bar but still retaining much of its character. It is situated in the most picture-postcard area of Freshwater in the church square and by the Causeway, enjoying views of the River Yar towards Yarmouth. The pub is noted for its fine food (diners are advised to book ahead). A guide is available for a walk to the Wheatsheaf in Yarmouth. Closing time may be earlier in winter. Q❀◑P무(7,12)❀☂

Newport

Bargeman's Rest ℀

Little London Quay, PO30 5BS

☎ (01983) 525828 ⊕ bargemansrest.com

Goddards Fuggle-Dee-Dum; Ringwood Razorback, Fortyniner; 3 changing beers (often Andwell, Marston's, Wychwood) ⊞

This massive, locally owned pub has previously been an animal feed store and a sail and rigging loft for the barge fleet that once used the river. The huge bar room provides intimate drinking areas, and the nautical memorabilia, decor and ambience are what you would expect from a traditional, well-seasoned pub. The outdoor drinking area is only a few feet from the bustling River Medina. Beer and food are consistently good and the range is varied. Live entertainment features most nights. ☺❀◑&P무❀☂

Man in the Moon ℀ ●

16-17 St James Street, PO30 5HB

☎ (01983) 530126

Greene King Abbot; Sharp's Doom Bar; 7 changing beers (often Goddards, Island) ⊞

Opened in 2014, this impressive Wetherspoon conversion of the former Congregational Church maintains the character of the original while adding sympathetic extensions. The drinking and dining areas include an upstairs gallery and an outdoor area where dogs and children are welcome. Although a food-led pub, the beers are well kept, with a good selection of local brews among the large rotating selection of ales. You may find the excellent Island Brewery RDA here and often a cider on handpump. ☺❀◑&무☂

Newport Ale House ℀

24A Holyrood Street, PO30 5AZ

☎ 07708 018051

3 changing beers (sourced nationally) Ⓖ

This listed building has previously traded as a hairdresser, undertaker and posting house and stables. It is the Island's smallest pub, recalling the days when there were many such establishments in Newport. This is a hugely popular place with all generations, where conversation comes easy – it can get crowded and noisy. Live music is hosted, often on a Sunday afternoon. The

beer choice is always interesting and varied. No meals are available, but snacks are high quality. A former local CAMRA Pub of the Year. Q☺무❀☂

Niton

No.7 ℀ ●

High Street, PO38 2AZ

☎ (01983) 730280

Greene King Abbot; 2 changing beers (often Shepherd Neame, Yates') ⊞

No.7 opened as Joe's Bar when the village inn closed for a short time, and has since become the hub of village life, also serving as a post office, newsagent, confectioner and tea room. Pizzas from the wood-fired oven are ever-popular, with soup and jacket potatoes also offered. Ruby Mild, Plum Porter and local specialities are regular visitors. A unique establishment with an excellent garden and patio. Q☺❀◑무(6)

Northwood

Travellers Joy ♈ ℀ ●

85 Pallance Road, PO31 8LS SZ48009360

☎ (01983) 298024 ⊕ travellersjoycowes.co.uk

Brains Rev James Original; Island Wight Gold; 3 changing beers (sourced nationally; often Theakston) ⊞

This long-standing country inn was the Island's first beer exhibition house and offers up to five ales including local favourite Island Brewery Wight Gold. A good range of home-cooked food is served. With a recently refurbished garden and play area, and camping nearby, the pub is a good base for visitors as well as a thriving centre for the local community. Popular events are Derek's Sunday quiz and bingo night on Monday. Local CAMRA Pub of the Year 2021. Q☺❀◑A♣P무(1)❀☂

Ryde

S. Fowler & Co ℀ ●

41-43 Union Street, PO33 2LF

☎ (01983) 812112

10 changing beers (sourced nationally) ⊞

Although probably not the most charismatic pub in the Wetherspoon chain, this converted drapery store offers a constantly changing range of well-kept beers. Its name was at the suggestion of the local CAMRA branch – not only is Fowler the name of the former store, which was a familar landmark for more than a century, but also that of the first local CAMRA chairman and revered early campaigner. The family-friendly food area is upstairs. Situated in the centre of town, there is a bus stop conveniently outside. Q☺◑&≉(Esplanade)무☂

Solent Inn

7 Monkton Street, PO33 1JW

☎ (01983) 584265

Timothy Taylor Landlord; Wychwood Hobgoblin Gold; 1 changing beer (sourced nationally; often St Austell) ⊞

Excellent street-corner local with a warm, welcoming atmosphere. Parts of this handsome pub are ancient, going back to medieval times. It originally fronted the sea before reclamation of land, hence the name. Meal

REAL ALE BREWERIES	
Goddards	Ryde
Island	Newport
Wight Knuckle ⬛	Bembridge (NEW)
Yates'	Newchurch

times can change depending on the season. There is live music at the weekend. Beware – the public bar slopes alarmingly! Q✿♿⌖☺♪●ꔪ≋(Esplanade)♣ꔪ❀

Sandown

Boojum & Snark
105 High Street, PO36 8AF
☎ 07886 437688 ∰ boojumandsnark.co.uk
4 changing beers ⓟ
Opened during the Covid lockdown, this brewpub and tap room is aimed at the real ale/craft beer enthusiast. Situated on the High Street in the centre of town, it serves conditioned beer from KeyKegs in addition to a wide range of canned beer from neighbouring brewers. The range is always changing, with new brews underway. There are regular cultural events and the walls function as an art gallery. ♿●⌖ꔪ❀

Castle Inn Ⓛ
12-14 Fitzroy Street, PO36 8HY (off High St)
☎ (01983) 403169 ∰ sandowncastle.co.uk
Gale's HSB; Goddards Fuggle-Dee-Dum; Wychwood Hobgoblin Gold; 3 changing beers (sourced regionally; often Andwell, Hop Back, St Austell) Ⓗ
The Castle is an excellent town free house and locals' pub, home to crib and darts teams. Six real ales are on offer including the best from local breweries. There is a children's room at the back and a patio for warm weather. The TV is only turned on for special events. Happy hour (5-7pm nightly) is popular, as is the Sunday quiz. Beer festivals are held twice a year, usually featuring local ales and cider. Q✿♿≋♣ꔪ(3,8)❀🗢

Culver Haven Inn Ⓛ
Culver Down Road, PO36 8QT (Culver Down, about 3 miles from Sandown) SZ63258565
☎ (01983) 406107 ∰ culverhaven.com
2 changing beers (sourced nationally; often Fuller's, Goddards, Ringwood) Ⓗ
Surely one of the best pub views in the whole of Great Britain, perched on Culver Down overlooking Sandown Bay and Bembridge Harbour. Nearby is the Culver Battery, an impressive remnant of the Napoleonic Wars and built to protect Portsmouth (opened regularly by the National Trust). An excellent and varied food menu, from snacks to full meals, is served at this cosy restaurant and pub. The view back down the hill is spectacular. Closed throughout February. Q✿♿⌖ꔪAP❀🗢

Totland Bay

Highdown Inn Ⓛ
Highdown Lane, PO39 0HY (E of Alum Bay on Old Rd) SZ32348596
☎ (01983) 752450 ∰ highdowninn.com
5 changing beers (sourced regionally; often Island, Ringwood, Wychwood) Ⓗ
Situated close to Farringford House, once home to Alfred Lord Tennyson, this hospitable pub is an ideal base for walkers and cyclists alike. A range of home-cooked food includes a seasonal variety of fresh local game, fish and vegetables, and a children's menu. B&B accommodation is in three comfortable rooms, and there is a campsite close by. A large covered area outside is good for all seasons. Unfortunately, no buses serve the pub in winter. Q✿⌖⌖APꔪ(7,12) 🗢

Waterfront Ⓛ
The Beach, Madeira Road, PO39 0BQ
☎ (01983) 756969 ∰ thewaterfront-iow.co.uk

Sharp's Doom Bar; 3 changing beers (sourced regionally; often Dorset, Island, St Austell) Ⓗ
Pleasant and popular pub-restaurant beside the sea, enjoying excellent Solent views to Portland and beyond. Beers are reasonably priced and the constantly changing range has increased in recent years, with up to 12 ales in the cellar including stouts and milds. During the summer months a tented area provides more space outside, and the pub is accessible from the cliff path. Food includes a Sunday roast. Q✿♿⌖PꔪQ❀🗢

Ventnor

Crab & Lobster Tap Ⓛ
Grove Road, PO38 1TH
☎ (01983) 852311 ∰ crabandlobstertapventnor.co.uk
Timothy Taylor Landlord; 2 changing beers (sourced nationally; often Goddards, Yates') Ⓗ
Town pub with a warm welcome. You may strike lucky and be there when a rings league match is taking place – Ventnor has one of the few leagues in Great Britain. Local ale is available all year, additional beers may be stillaged on the bar for beer festivals. The atmosphere is lively, with Thursday quiz night and BT and Sky Sports shown on five TVs. There is a large public car park nearby. A convenient stop on the coastal path.
✿⌖♣ꔪ(3,6)❀🗢

Volunteer Ⓛ
30 Victoria Street, PO38 1ES
☎ (01983) 852537
5 changing beers (sourced regionally; often Goddards, Wychwood, Yates') Ⓗ
Built in 1866, the Volunteer is one of the smallest pubs on the island and a former local CAMRA Pub of the Year. It has been tastefully refurbished in recent years. Up to five beers are available including a local brew from Goddards or Yates'. No chips, no children, no fruit machines, no video games – just a pure adult drinking house and one of the few places where you can still play rings and enjoy a traditional games night. A wonderful old pub. Q♣ꔪ(3,6)❀

Wootton

Cedars
2 Station Road, PO33 4QU
☎ (01983) 882593 ∰ cedarsisleofwight.co.uk
Fuller's London Pride; Gale's Seafarers Ale, HSB Ⓗ
Late Victorian two-bar village local in a prominent position at the top of Wootton High Street, refurbished in 2022. It is a large pub though, curiously, it has one of the smallest front doors on the Island. There is a children's room and a large garden with a play area. Smokers are spoilt as the outdoor smoking area is adapted from a beautiful Victorian outbuilding. An extensive food menu is offered, and the friendly bar staff ensure a welcoming atmosphere. The steam railway is nearby.
Q✿♿⌖≋♣Pꔪ(4,9) 🗢

Breweries

Goddards SIBA
Barnsley Farm, Bullen Road, Ryde, Isle of Wight, PO33 1QF
☎ (01983) 611011 ∰ goddardsbrewery.com

⌧ Anthony Goddard established, what is now the oldest, active brewery on the Isle of Wight, in 1993. Originally occupying an 18th century barn, a new brewery was built in 2008, quadrupling its capacity. It has since been

increased again. Goddards' remain a locally-focused business distributing ales on the island, and easily accessible southern English counties. Beers are also contract brewed for Crumbs Brewery, where breadcrumbs replace about a quarter of the malt usual in the brewing process. ♦

Ale of Wight (ABV 3.7%) BITTER
Starboard (ABV 4%) GOLD
Wight Squirrel (ABV 4.3%) BITTER
Fuggle-Dee-Dum (ABV 4.8%) BITTER
Brown-coloured strong ale with plenty of malt and hops.

Island SIBA

Dinglers Farm, Yarmouth Road, Newport, Isle of Wight, PO30 4LZ
☎ (01983) 821731 ⊕ islandbrewery.co.uk

⊠ Island Brewery is the realisation of Tom Minshull's ambition to brew real ales to complement the existing family-owned drinks distribution business. Brewing commenced in 2010 using a 12-barrel brewery. More than 100 outlets are supplied direct. ‼♦

Nipper Bitter (ABV 3.8%) GOLD
Wight Gold (ABV 4%) BITTER
Yachtsmans Ale (ABV 4.2%) BITTER
Wight Knight (ABV 4.5%) BITTER
Vectis Venom (ABV 4.8%) BITTER
Earls RDA (ABV 5%) STOUT

Wight Knuckle (NEW)

⬔ Pilot Boat Inn, Bembridge, Isle of Wight, PO35 5NN
☎ (01983) 872077 ⊕ wightknucklebrewery.com

Wight Knuckle Brewery was founded in 2021 by two brothers and their father and is based at the Pilot Boat, Bembridge. They wanted to bring modern, craft beers to the Isle of Wight so created the island's first microbrewery. It uses natural British ingredients and is brewed in a sustainable way. All beers are unfined, unfiltered, unpasteurised and 100% vegan. The brewery also features a taproom and pizzeria. V

Yates' SIBA

Unit 4C, Langbridge Business Centre, Newchurch, Isle of Wight, PO36 0NP
☎ (01983) 867878 ⊕ yates-brewery.co.uk

Brewing started in 2000 on a five-barrel plant at the Inn at St Lawrence. In 2009 it moved to Newchurch and upgraded to 10-barrel plant. The brewery was moved on the same site in 2015 to sit alongside the wholesale unit at Newchurch. In 2022 the old kit was replaced with a newly-commissioned 15-barrel plant, including five fermenting vessels. ♦

Golden Bitter (ABV 4%) GOLD
Islander (ABV 4%)
Sea Dog (ABV 4%) GOLD

Red Lion, Freshwater (Photo: Charles Hutchins / Flickr CC BY 2.0)

Public transport information

Leave the car behind and travel to the pub by bus, train, tram or even ferry...

Using public transport is an excellent way to get to the pub, but many people use it irregularly, and systems can be slightly different from place to place. So, below are some useful websites and phone numbers where you can find all the information you might need.

Combined travel information

The national **Traveline** system gives information on all rail and local bus services throughout England, Scotland and Wales. Calls are put through to a local call centre and if necessary your call will be switched through to a more relevant one. There are also services for mobiles, including a next-bus text service and smart-phone app. The website offers other services including timetables and a journey planner with mapping.

- 0871 200 22 33
 www.traveline.info

LONDON

In London use Traveline or **Transport for London (TfL)** travel services. TfL provides information and route planning for all of London's Underground and Overground, Docklands Light Railway, National Rail, buses, River Buses, Tramlink. Detailed ticketing information helps you find the most cost-effective ways to travel.

- 0343 222 1234
 www.tfl.gov.uk

Train travel

National Rail Enquiries covers the whole of Great Britain's rail network and provides service information, ticketing, online journey planning and other information.

- 03457 48 49 50
 www.nationalrail.co.uk

Coach travel

The two main UK coach companies are **National Express** and **Scottish Citylink**. Between them, they serve everywhere from Cornwall to the Highlands. Their websites offer timetables, journey planning, ticketing, route mapping, and other useful information. CAMRA members can benefit from 20% off travel with National Express*. See **camra.org.uk/benefits** for details.

- National Express: 08717 81 81 81
 www.nationalexpress.com

- Scottish Citylink: 0141 352 4444
 www.citylink.co.uk

Megabus

(A Stagecoach Company) operate various long-distance services between major cities and towns in England and Scotland, also Cardiff in Wales.

- 0900 160 0900 (Premium phone line).

Scottish ferries

Caledonian MacBrayne (CalMac) operate throughout Scotland's islands, stretching from Arran in the south to Lewis in the north.

- 0800 066 5000
 www.calmac.co.uk

Northern Ireland & islands

For travel outside mainland Britain but within the area of this Guide, information is available from the following companies:

NORTHERN IRELAND

- Translink: 028 9066 6630
 www.translink.co.uk

ISLE OF MAN

- Isle of Man Transport: 01624 662 525
 www.iombusandrail.im

ISLE OF WIGHT

- Southern Vectus Bus services covering all the Island: 0330 0539 182

JERSEY

- Liberty Bus: 01534 828 555
 www.libertybus.je

GUERNSEY

- Island Coachways: 01481 720 210
 www.buses.gg

Public transport symbols in the Guide

Pub entries in the Guide include helpful symbols to show if there are stations and/or bus routes close to a pub. There are symbols for railway stations (⇌); tram or light rail stations (Ⓡ); London Underground, Overground or DLR stations (⊖); and bus routes (🚌). See the 'Key to symbols' on the inside front cover for more details.

*Membership benefits are subject to change.

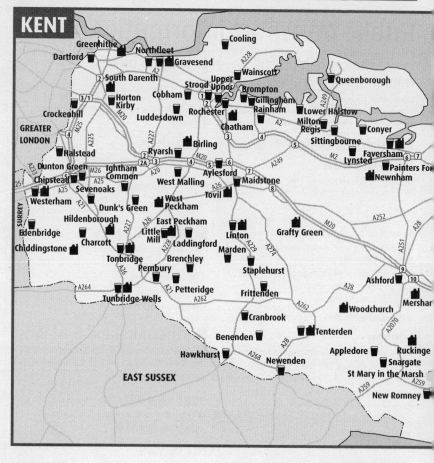

KENT

Greenhithe
Dartford
Northfleet
Gravesend
Cooling
Wainscott
Queenborough
South Darenth
Upper Upnor
Strood
Brompton
Horton Kirby
Cobham
Rochester
Gillingham
Rainham
Lower Halstow
Milton Regis
Conyer
Crockenhill
Luddesdown
Chatham
GREATER LONDON
Birling
Sittingbourne
Faversham
Halstead
Ryarsh
Lynsted
Painters For Newnham
Dunton Green
Ightham Common
Aylesford
Maidstone
Chipstead
West Malling
Sevenoaks
Westerham
Dunk's Green
Tovil
West Peckham
Hildenborough
East Peckham
Grafty Green
Edenbridge
Little Mill
Linton
Chiddingstone
Charcott
Laddingford
Marden
Tonbridge
Pembury
Brenchley
Staplehurst
Ashford
Mershar
Petteridge
Frittenden
Woodchurch
Tunbridge Wells
Cranbrook
Tenterden
Benenden
Appledore
Ruckinge
Hawkhurst
Newenden
Snargate
St Mary in the Marsh
EAST SUSSEX
New Romney

Appledore

Black Lion Ⓛ

15 The Street, TN26 2BU (in the centre of the village)
☎ (01233) 758206 🌐 blacklion-pub.com
Greene King IPA; 4 changing beers (sourced locally) Ⓗ

A traditional village pub and restaurant set in the historic village of Appledore, which can trace its history back to Viking times, when it was a busy port. The bar is decorated with an interesting collection of historic pumpclips and blowlamps. An extensive menu is available every day with locally reared lamb and freshly caught fish as specialities. Handy for ramblers on the Saxon Shore Way and the Royal Military Canal.
Q❄☕◑♿🚃(11B)🔊

Ashford

County Hotel ✅

10 High Street, TN24 8TD (at lower end of High St)
☎ (01233) 646891
Greene King Abbot; Ruddles Best Bitter; Sharp's Doom Bar; 4 changing beers (sourced nationally) Ⓗ

This pub was built around 1710 as a doctor's home and medical practice, becoming a hotel in the 19th century and acquired by Wetherspoon in 1988. It has a spacious bar with three separate seating areas and a courtyard outside. Two real ciders are dispensed from polypins in the fridge. Food is available all day, every day. Children are allowed in the dining area until 9pm. Summer and autumn national and international beer festivals are staged. Q❄☕◑♿🚃(International)●P🚃🔊

Aylesford

Little Gem

19 High Street, ME20 7AX
☎ (01622) 715066
Goacher's Fine Light Ale Ⓗ/Ⓖ**; 3 changing beers (sourced locally; often Goacher's)** Ⓖ

Beware the low doorway as you step down into this Grade II-listed 12th-century building with low ceilings and exposed beams. It has been a pub since 1968, and is one of Kent's smallest, but a mezzanine floor has extended its capacity. Closed for nine years but now restored by local brewer Goacher's, it features the brewery's ales, and former local residents have happily returned to renew fond memories. A large inglenook fireplace provides winter warmth. Snacks, cider and other drinks are available. Q❄●🚃🐾

Beltinge

Copper Pottle Ⓛ

84 Reculver Road, CT6 6ND
☎ 07710 001261

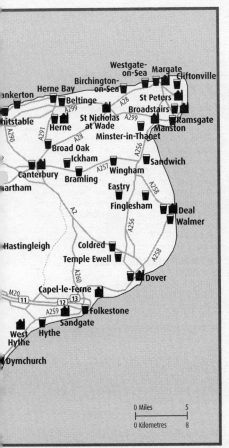

night on alternate Tuesdays, and three en-suite letting rooms are available. Everything a village pub should be! Q❄🛏🏠⏰◑♣🍴P🚲(297) ❀🌐

Birchington-on-Sea

Old Bay Alehouse
137 Minnis Road, CT7 9NS
🌐 oldbayalehouse.co.uk
3 changing beers Ⓖ
Fine micropub an easy five minute stroll from the beach at Minnis Bay, near Birchington. The bar counter on the right serves real ales and ciders on gravity dispense from a temperature-controlled cool room behind. Seating is at wall-mounted benches with high tables, plus some low tables and chairs. There are comfy armchairs in the front window. The real ale selection always includes at least one local beer. Bar snacks are available and there are occasional pop-up food events. Q❄🚲♣🍴🚲(34)❀

Bramling

Haywain Ⓛ
Canterbury Road, CT3 1NB
☎ (01227) 720676 🌐 thehaywainbramling.co.uk
Fuller's London Pride; Hopdaemon Incubus; 2 changing beers (sourced regionally; often Goacher's, Ramsgate) Ⓗ
Classic friendly country pub featuring hop bines, a cosy snug and a charity library where books are sold for 50p each. Traditional games include bat and trap. There is a Wednesday crib night. Guest beers are usually from Kent breweries, and an annual beer festival is hosted over the late spring bank holiday weekend in a marquee in the attractive garden. Excellent home-cooked food is served, using local produce. 🏠⏰◑♣🚲(43,44)❀🌐

Brenchley

Halfway House Ⓛ ✅
Horsmonden Road, TN12 7AX (½ mile SE of village)
☎ (01892) 722526 🌐 halfwayhousebrenchley.co.uk
Goacher's Fine Light Ale; Kent Session Pale; Long Man Best Bitter; Tonbridge Rustic; house beer (by Tonbridge); 3 changing beers (sourced locally; often Canterbury Ales, Cellar Head, Rother Valley) Ⓖ
In an attractive rural setting, this award-winning free house offers up to 10 beers direct from cooled casks, along with Chiddingstone and Turners ciders. Substantial home-made dishes using local produce are served, including traditional Sunday roasts. There is a choice of seating across three levels – all decorated in rustic style, with hanging hops and aged farming equipment. The spacious garden to the rear incorporates an external bar and a separate family area. Beer festivals are held on the Whitsun and August bank holidays.
Q❄⏰◑♣🍴P🚲(297) ❀🌐

Broad Oak

Golden Lion
Mayton Lane, CT2 0QJ
☎ (01227) 710454 🌐 goldenlioncanterbury.co.uk
Shepherd Neame Whitstable Bay Pale Ale; 1 changing beer (sourced locally; often Shepherd Neame) Ⓗ
Traditional village local built 500 years ago to serve waggoners carrying timber from the nearby Blean Woods. There is a spacious bar and separate restaurant, each decked out in traditional style. The large garden has

Ramsgate Gadds' No. 5 Best Bitter Ale; 3 changing beers (sourced regionally) Ⓖ
Originally a pet food shop, this friendly micropub, Beltinge's first, opened in 2015 and has an attractive blue-tiled frontage. Drinks are dispensed from a temperature-controlled cellar via a small bar counter. Conversation is encouraged with a layout of high and low narrow tables, and the walls are decorated with amusing posters and postcards. Every six weeks there is a charity fundraising event, in aid of the local Strode Park Foundation, which might be a quiz evening, food night or a barbecue. The south-facing garden is a good place to enjoy a beer, cider or wine. Open on bank holiday Mondays. Q❄♣🍴🚲(6,7)❀

Benenden

Bull
The Street, TN17 4DE
☎ (01580) 240054 🌐 thebullatbenenden.co.uk
Dark Star Hophead; Harvey's Sussex Best Bitter; Larkins Traditional Ale; 1 changing beer (sourced locally; often Long Man) Ⓗ
Imposing 17th-century free house beside the large and picturesque village green. The public bar is characterised by wooden floors, exposed oak beams and a large inglenook fireplace. A separate dining room serves locally grown produce, although meals may also be taken in the bar (no food Sun eve). Booking is advisable for the Friday fish & chips evening. There is an open mic

two bat and trap pitches which are used in summer for league games and the county finals, and can be hired for corporate team-building events. The restaurant can also be hired, and there is an option to hire a 70-seater marquee in the garden. Q ⬧▣❄◐◑⬧⚬♣P⛁(7)❁

Broadstairs

Magnet
37 Albion Street, CT10 1NE
☎ 07515 600527
3 changing beers (sourced regionally; often Hop Fuzz, Pig & Porter, Wantsum) ⓗ
Former restaurant opened as a micropub in 2019 serving real ales, craft keg beers, ciders, wine and gins, run by two real ale and cider enthusiasts. Furnished with high and low scrubbed-top rustic-style tables, it is on a corner site with large picture windows on two sides for watching the world go by. Real ales are dispensed from three handpumps on the bar counter, and ciders from handpump and boxes in the fridge. Real ales major on Kentish breweries but beers from further afield also feature. ≉♣●⛁🐾❁

Brompton

King George V ⓛ
1 Prospect Row, ME7 5AL
☎ (01634) 787430 ⊕ kgvpub.co.uk
Dark Star Hophead; 2 changing beers (sourced locally; often Wantsum) ⓗ
Dating back to 1690, the pub was originally known as the Prince of Orange, then becoming the King of Prussia, finally the King George V. It has a strong connection to the navy due to the dockyard in Chatham. The interior is decorated with the plaques of naval vessels and army regiments. A whisky society and a rum club both meet monthly. Food is available lunchtimes (not Mon) and evenings, including pizzas. On Sunday lunchtime a Sunday roast is served. ⬧❄◒◐◑♣⛁(101,182)☂

Canterbury

Bell & Crown ⓛ
10-11 Palace Street, CT1 2DZ
☎ (01227) 784639
Ramsgate Gadds' No. 5 Best Bitter Ale; 3 changing beers (sourced locally; often Hop Fuzz, Iron Pier, Old Dairy) ⓗ
Traditional city centre wood-panelled inn with an ever-changing range of local beers and a cosy atmosphere making it a lunchtime favourite. The seating in front of the pub gives a superb view of Canterbury Cathedral, enjoyed by locals and visitors alike. The flint walls of the ancient King's School are opposite. Palace Street is part of the King's Mile and has many small independent shops. The classic jukebox is renowned and makes the pub a lively weekend location. ❄◑≉(West)⛁❁

Foundry Brew Pub ⓛ
77 Stour Street, CT1 2NR (just off High St)
☎ (01227) 455899 ⊕ thefoundrycanterbury.co.uk
Canterbury Brewers & Distillers Foundryman's Gold, Foundry Torpedo, Streetlight Porter ⓗ
The home of Canterbury Brewers and Distillers. Double doors from the bar open into the attractive brewery and restaurant area, which is available for functions and brewery tours. Three ales are usually on tap, and a wide range of keg-conditioned beers, all brewed on the premises. The taster palette of five third-pints is popular.

Vodka, rum and gin are also made here. Food is served every day. A former winner of Kent Tourism Pub of the Year. ⬧❄◐◑⚬≉(East)●⛁☂

New Inn ▼
19 Havelock Street, CT1 1NP (off ring road nr St Augustine's Abbey)
☎ (01227) 464584 ⊕ newinncanterbury.co.uk
7 changing beers (often Oakham, Ramsgate, Thornbridge) ⓗ
A Victorian back-street terraced pub a few minutes' walk from the cathedral, St Augustine's Abbey and the bus station. The welcoming main bar has a cosy wood-burner, a jukebox and a changing range of seven cask beers. The floor is hand-stencilled by the landlady. At the back is a long, bright conservatory with a range of board games. Beer festivals are held on the Whitsun and August bank holiday weekends indoors and in the attractive garden. There is a self-catering apartment upstairs. Local CAMRA Pub of the Year 2022.
Q⬧❄◒♣●⛁❁☂

Thomas Tallis Alehouse ⓛ
48 Northgate, CT1 1BE
⊕ thethomastallisalehouse.co.uk
3 changing beers (sourced locally; often Kent, Old Dairy, Ramsgate) ⓖ

REAL ALE BREWERIES

Amazing ▤ Sandgate
Angels and Demons Capel-le-Ferne
Boutilliers Faversham
Breakwater ◆ Dover
By The Mile Broadstairs (brewing suspended)
Canterbury Ales Chartham
Canterbury Brewers ▤ ◆ Canterbury
Constellation Tonbridge
Dartford Wobbler South Darenth
Farriers Arms ▤ Mersham
Fonthill ▤ Tunbridge Wells
Four Candles ▤ St Peters
Goacher's Tovil
Goody ◆ Herne
Hildenborough Hildenborough
Hinks Ruckinge
Hop Fuzz West Hythe
Hopdaemon Newnham
Iron Pier ◆ Gravesend
Isla Vale Margate
Kent Birling
Larkins Chiddingstone
Mad Cat Faversham
Musket ◆ Linton
Nelson ◆ Chatham
No Frills Joe ◆ Greenhithe
Northdown ◆ Margate
Old Dairy ◆ Tenterden
Pig & Porter Tunbridge Wells
Ramsgate (Gadds') Broadstairs
Romney Marsh New Romney
Running Man Chatham
Shepherd Neame Faversham
Shivering Sands ◆ Manston (NEW)
Stag Woodchurch
Swan on the Green ▤ West Peckham
Time & Tide Deal
Tír Dhá Ghlas ▤ Dover
Tonbridge East Peckham
Wantsum ◆ St Nicholas at Wade
Westerham ◆ Westerham
Whitstable Grafty Green

This alehouse opened in 2016, located in a lovely 15th-century half-timbered building, part of the historic Hospital of St John. Two to four Kent cask beers and many national and international beers are stocked – in KeyKeg, bottles and cans – as well as several Kentish ciders. One of the two front rooms has a log-burning stove, the rear snug has armchairs and a sofa. Generally a seat/table service applies. Outside seating is available on the street. Q ⏳❄♿🍴(West) ♣●🚍🐾♿🛜

Unicorn Ⓛ ✅
61 St Dunstan's Street, CT2 8BS
☎ (01227) 463187 ● unicorninn.co.uk
Shepherd Neame Master Brew; 3 changing beers (often Canterbury Ales, Kent, Ramsgate) Ⓗ
Comfortable pub near the historic Westgate that dates from 1604 and has an attractive suntrap garden. Bar billiards is played and a quiz is held every Sunday evening. Guest beers are often from one of several Kent microbreweries, and beer updates are posted on Facebook, Twitter and Instagram. The cider is from Kentish Pip, and there is a wide range of bottled beers. Food is good value, with a meal deal on selected days. Sporting events (not Sky) are televised unobtrusively. ⏳❄🍴◑≷(West) ♣●🚍🐾🛜

Charcott

Greyhound Ⓛ
off Camp Hill, TN11 8LG (½ mile N of B2027 at Chiddingstone Causeway)
☎ (01892) 870275 ● thegreyhoundcharcott.co.uk
Larkins Traditional Ale; 3 changing beers (sourced locally; often Canterbury Ales, Northdown, Old Dairy) Ⓗ
The Greyhound has a very relaxed country feel, yet is easily accessible from Penshurst rail station along a surfaced path. The interior is bright and cheerful with various quirky farm-related features. Brewed only a couple of miles away, Larkins Trad is joined on the bar by three mostly Kentish guests, and cider from Chiddingstone and Dudda's Tun. Produce from local suppliers is used for the thoughtful, good-quality dishes. The pub hosts a local folk group on the first Sunday evening of the month. Q ⏳❄🍴◑≷(Penshurst) ♣●🚍(210) 🐾🛜

Chipstead

Bricklayers Arms ✅
39-41 Chevening Road, TN13 2RZ (opp entrance to sailing club)
☎ (01732) 743424 ● the-bricklayers-arms.co.uk
Harvey's IPA Ⓗ, **Sussex Best Bitter** Ⓖ; **2 changing beers (sourced regionally; often Harvey's)** Ⓗ
Often busy with diners seeking good-quality, good-value dishes, served in a cottage pub environment, booking is recommended if dining, especially on Sunday. The diverse clientele includes locals, hikers, dog walkers, and the village football and cricket teams – all here to enjoy Harvey's Best straight from the cask, supported by the brewery's seasonal ales. Popular quiz nights are held every Tuesday and live music is now a regular feature, with an open mic night on the first Sunday in every month. ⏳❄🍴◑♿🚍(1,401)🐾🛜

Cliftonville

Banks Ale & Wine House
244 Northdown Road, CT9 2PX

☎ (01843) 221251 ● banks-ale.square.site
3 changing beers Ⓗ
Ale and wine house in a former bank in the Cliftonville district of Margate. It is tastefully decorated, with low tables and chairs and a collection of old keg beer fonts displayed on shelves and the window ledges. The front bar counter has four handpumps that are purely decorative – real ales are served either through two handpumps or by gravity dispense through wall taps connected to casks in the cellar room behind the wall. Q ⏳●🚍

Laughing Barrel
35A Summerfield Road, CT9 3EZ
☎ 07970 867189
3 changing beers (often Goody, Tonbridge, Wantsum) Ⓖ
This micropub opened in 2018 serving ales, cider and wines in part of what was previously a 60s estate pub, the Northdown – the rest of the premises now houses a pharmacy. The real ales and a large range of ciders and perries are sold on gravity dispense from a room behind the L-shaped bar counter, the beers stored in jacket-cooled casks. The focus is on ales and ciders from local Kentish producers. ⏳❄🍴◑●🚍(8A)🐾

Cobham

Darnley Arms
40 The Street, DA12 3BZ
☎ (01474) 814218 ● thedarnleyarms.com
Greene King IPA; Iron Pier Perry St. Pale, Bitter Ⓗ
In the centre of a charming small village, this is a friendly local. It has a large horseshoe-shaped bar with a separate small side room for meetings. The decor features local memorabilia, including the coat of arms of the Darnley family who lived at nearby Cobham Hall. The wide food menu offers traditional English food with fish specialities. Q ⏳❄🍴◁◑♣●P🚍(416)🐾🛜

Coldred

Carpenters Arms Ⓛ
The Green, CT15 5AJ
☎ (01304) 830190
2 changing beers (sourced locally; often Kent, Ramsgate, Romney Marsh) Ⓗ/Ⓖ
Overlooking the village green and duck pond, this 18th-century two-roomed inn is a real gem and well worth seeking out. It has been in the Fagg family for over a century, and largely unchanged for the last 50 years. The pub is the centre of the community and conversation is king. At least two real ales are served, alongside three real ciders from Kentish Pip. Regular community events are hosted including quizzes and vegetable competitions, and a beer festival is held in June. Q ⏳❄🅰♣●P🐾🛜

Conyer

Ship
Conyer Quay, ME9 9HR
☎ (01795) 520881 ● shipinnconyer.co.uk
3 changing beers (sourced regionally; often Adnams, Old Dairy) Ⓗ
An 18th-century creekside inn with a nautically themed interior. Bare floorboards, scrubbed pine tables and a real fire add rustic charm and character. Popular with the boating fraternity, walkers and cyclists, the pub is located on the Saxon Shore Way. Teynham train station is a 20-

minute walk away. Food, with an emphasis on local produce, is served from midday. There is a small courtyard garden overlooking the creek.

🚫❀⛲🍴♣P🚪(344,345) ❀ 🛜

Cooling

Horseshoe & Castle 🅛

Main Road, ME3 8DJ
☎ (01634) 221691 🌐 horseshoeandcastle.com
Shepherd Neame Master Brew; 1 changing beer (sourced locally) 🅗
Friendly and welcoming free house nestling in the quiet village of Cooling. The owners are approaching three decades in charge. Quality accommodation is available, as well as a separate restaurant where good quality seafood is a speciality. The choice of beers always includes a real ale from one of Kent's many microbreweries, and a local cider from Longtail. The pub is near a ruined castle that was once owned by Sir John Oldcastle, on whom Shakespeare's Falstaff was modelled. Q❀❀🍴⛲🍴♣P❀

Cranbrook

Larkins' Alehouse 🏆

7 High Street, TN17 3EB
☎ 07786 707476 🌐 larkins-alehouse.co.uk
4 changing beers (sourced locally; often Cellar Head, Goacher's, Larkins) 🅖
A former florist's shop, now a community focused micropub putting the heart back into the town. Inside, you will find a simply furnished room with the servery at the rear. Beyond the cool room and toilet is the courtyard garden. Welcoming staff can guide you through the chalkboard menu displaying beers, ciders and other drinks. Home-made snacks and chutneys are available and customers are welcome to bring their own food or takeaways. Local CAMRA Pub and Cider Pub of the Year 2019-2022. Q🚫❀♣🍴🚪(5,297)❀🛜

Crockenhill

Chequers ✅

Cray Road, BR8 8LP
☎ (01322) 662132 🌐 chequerscrockenhill.co.uk
Courage Best Bitter; 3 changing beers (sourced regionally; often Fuller's, Southwark, Woodforde's) 🅗
Friendly village local offering one permanent beer and three changing guest ales from a wide selection of breweries. Meals are served every day, with seniors' discounts at the beginning of the week. There is a quiz on Monday evening and various other events on regular occasions. Several pictures of old Crockenhill indicate that the pub has been a hub of village life for many years. Opening hours are subject to demand and the pub may close earlier in the evening. 🚫❀🍴♣P🚪(477)❀🛜

Dartford

Dartford Working Men's Club 🅛

Essex Road, DA1 2AU
☎ (01322) 223646 🌐 dartfordwm.club
Courage Best Bitter 🅗**; 9 changing beers (sourced regionally; often Dark Star, Leatherbritches, Oakham)** 🅗/🅖
A former CAMRA National Club of the Year, this modern CIU club serves 10 ales on handpump plus ciders on gravity. It hosts the BBC award-winning Dartford Folk

Club every Tuesday night and has free live music every Thursday and Saturday night plus the last Sunday afternoon every month. Tribute acts perform every other Friday night and a quiz takes place on the first Wednesday of the month. CAMRA members are welcome as guests. ❀🍴≋♣❀🚪🛜

Foresters ✅

15-16 Great Queen Street, DA1 1TJ
☎ (01322) 223087
Adnams Ghost Ship; Harvey's Sussex Best Bitter; 1 changing beer (sourced nationally; often Timothy Taylor) 🅗
Traditional Victorian side-street local, just off East Hill, five minutes' walk from the town centre. It is quiet at lunchtime but often busy in the evening with live sports on TV and darts, pool and crib. The U-shaped bar has a log-burning fire at one end. The graveyard opposite contains the unmarked pauper's grave of famed steam pioneer Richard Trevithick, its approximate location indicated by a plaque on the north wall.
🚫❀≋♣P🚪❀🛜

Malt Shovel ✅

3 Darenth Road, DA1 1LP
☎ (01322) 224381 🌐 maltshovelda1.co.uk
St Austell Tribute; Young's London Original, London Special; 1 changing beer (sourced nationally; often Fuller's) 🅗
Traditional country-style pub, dating from 1673, five minutes' walk from the town centre. It has two separate bars, a small tap room with a low ceiling featuring an 1880s Dartford Brewery mirror, and a larger saloon bar leading to a conservatory where meals are served Thursday to Sunday lunchtimes and Thursday to Saturday evenings. The large beer garden is accessed from the conservatory. A popular open quiz is held on Monday evening and crib on Tuesday. The small car park is adjacent to the pub. Q❀🍴≋♣P🚪

Deal

Farrier 🅛 ✅

90 Manor Road, CT14 9DB
☎ (01304) 360080
3 changing beers (sourced locally; often Canterbury Ales, Old Dairy, Wantsum) 🅗
This Grade II-listed traditional black-and-white beamed pub is one of the oldest in Deal. It has a friendly atmosphere with a real community feel to it, and is a relaxing place for a drink and a chat. There is plenty of seating and three open fires. The variety of ales on offer comes mostly from Kent breweries. At the back there is a large covered and heated patio. Events includes pool and darts matches, a monthly quiz night and a Sunday meat raffle. 🚫❀🅰♣🚪(80,81)❀🛜

Just Reproach 🅛

14 King Street, CT14 6HX
4 changing beers (sourced nationally; often Kent) 🅖
A town-centre micropub with a welcoming ambience. Its high benches and table service make for a friendly, convivial atmosphere. Up to five real ales, regularly featuring Kent breweries, are gravity dispensed from a temperature-controlled cool room. Ciders also typically include one from Kent. A wide selection of craft beers is available alongside wines, gins and soft drinks. Events include cheese Sunday and quiz nights. The pub has no keg beer, fruit machines or music, and make sure your mobile phone is switched off. Q🚫❀❀≋♣🍴🚪🐾

Ship Inn Ⓛ

141 Middle Street, CT14 6JZ

☎ (01304) 372222

Dark Star Hophead; Ramsgate Gadds' No. 7 Bitter Ale, Gadds' No. 5 Best Bitter Ale; Timothy Taylor Landlord; 1 changing beer (often Ramsgate) Ⓗ

Just 10 minutes' walk from the town centre, this unspoilt, traditional inn is in Deal's historic conservation area. Dark wooden floors and subdued lighting create a warm and comfortable atmosphere, complemented by a nautical theme. The wood-burning stove is welcome in winter. A wide variety of drinkers enjoys a good range of beers dispensed from five handpumps, including ales from Ramsgate and Dark Star. The small, cosy rear bar overlooks a large patio garden, accessed by a staircase, with a covered smoking area. ⬥✿♣🛏🐾

Smugglers Records Shop Ⓛ

9 King Street, CT14 6HX

☎ (01304) 362368 ⊕ shop.smugglersrecords.com

3 changing beers (sourced locally; often Time & Tide) Ⓖ

Independent and vibrant vinyl record shop and bar, situated just off Deal's seafront. A large selection of vinyl is for sale, and the background music is an eclectic mix featuring local bands, world, folk, psych and roots. Two cask ales are served on gravity, with a third on busier weekends, usually from local breweries. Real cider is from Kentish Pip and there is a great selection of craft, canned and bottled beers, cider and wines. ⬥✿🌰🚃🐾🎵

Dover

Breakwater Brewery Taproom Ⓛ

St Martin's Yard, Lorne Road, CT16 2AA

☎ 07866 198075

Breakwater Dover Pale Ale, Blue Ensign, Cowjuice Milk Stout; 4 changing beers (sourced locally; often Breakwater) Ⓖ

Opened in 2016, the brewery and taproom are on the site of Harding's Wellington Brewery, which closed in 1890. The bar is modern, well-lit and furnished with chunky, wooden furniture. The bar counter resembles a stone breakwater. There is a large patio at the front and a smaller one overlooking the river. Cask ales from the brewery are dispensed on gravity along with the pub's own house ciders. Stone-baked pizzas are served from the in-house pizzeria (available Thu-Sun). Regular live music events are held. ⬥✿🌰♿●🛏🐾🎵

Eight Bells Ⓛ ✅

19 Cannon Street, CT16 1BZ

☎ (01304) 205030

Greene King Abbot; Ruddles Best Bitter; Sharp's Doom Bar; 9 changing beers (often Wantsum, Whitstable) Ⓗ

This popular and bustling Wetherspoon pub is situated on the precinct. Its name is linked to the church opposite. Inside, it has a large open-plan room with a long bar and a raised restaurant area at the back. At the front, an enclosed seating area looks out on to the precinct. Twelve handpumps dispense a range of regular and guest beers, including ales from Kent microbreweries. There are real ale offers on Monday and two beer festivals are held each year. Q⬥✿🌰♿🚃(Priory)🛏🎵

Hoptimist Taproom & Bar Ⓛ

3 Bench Street, CT16 1JH

☎ 07515 367802 ⊕ thehoptimisttaproomandbar.co.uk

6 changing beers (sourced locally; often Kent, Northdown, Time & Tide)

This modern taproom, near Dover's Market Square, provides a comfortable environment to enjoy a pint of cask ale or real cider. Ales are from Kent breweries, with occasional guests from further afield. There is also modern craft beer, premium keg beers and an ever-changing gin menu. The aim is to offer a selection of beer styles at all times. On Sunday a courtesy cheeseboard is provided. A selection of board games is available and occasional music and food events are held. ⬥✿🚃(Priory)♣●🛏(62,68)🐾

Louis Armstrong Ⓛ

58 Maison Dieu Road, CT16 1RA

☎ (01304) 204759

4 changing beers (sourced locally; often Old Dairy, Ramsgate, Romney Marsh) Ⓗ

Down-to-earth pub and music venue that has featured live music for over 50 years. The large L-shaped bar and stage is surrounded by music posters, a large mirror and long bench seating. Up to four real ales are sold, principally from Kent microbreweries, with an occasional real cider from a Kent cider maker. On Wednesday evening good-value food is served. Occasional charity quizzes are held. To the rear is a pleasant beer garden. Opens at 5.30pm on Sunday if jazz is playing. ✿●♣●🛏🐾🎵

White Horse Ⓛ ✅

St James Street, CT16 1QF

☎ (01304) 213066 ⊕ thewhitehorsedover.co.uk

Harvey's Sussex Best Bitter; Timothy Taylor Landlord; 1 changing beer (sourced locally; often Old Dairy, Wantsum) Ⓗ

The pub's history can be traced back to 1574, possibly making it the oldest hostelry in Dover. An eclectic mix of locals and tourists enjoy the traditional surroundings and simple but comfortable furniture. In 2002 the venue was adopted by Channel swimmers and the walls are covered with their signatures. Up to three real ales are served from local and national breweries, and home-cooked food is available. At the back is a terrace garden. The pub is a short walk from the bus station. ⬥✿🌰🛏🐾

Dunk's Green

Kentish Rifleman Ⓛ

Roughway Lane, TN11 9RU (jct with Dunks Green Rd, 4 miles N of Tonbridge, off A227)

☎ (01732) 810727 ⊕ thekentishrifleman.co.uk

Harvey's Sussex Best Bitter; 3 changing beers (sourced locally; often Old Dairy, Pig & Porter, Tonbridge) Ⓗ

Dating from the 16th century, the Rifleman oozes character and is a delightful place to spend time, whether it be in the oak-beamed and carpeted interior complete with wood fires, or in the pretty, quiet garden with its marquees. Three guest ales, sourced mainly from Kent, are normally sold, along with Biddenden cider. The pub enjoys a reputation for good home-cooked meals using local produce. Although located in a quiet country hamlet, a convenient bus service from Tonbridge delivers you to the front door. Q⬥✿🌰●🛏(222)🐾🎵

Dunton Green

Miners Arms Ⓛ ✅

22 London Road, TN13 2UF

☎ (01732) 462214

3 changing beers (sourced locally; often Musket, Old Dairy, Tonbridge) Ⓗ

Community pub with attractive front signage from a now-defunct 100-year-old brewery that was revealed during a recent restoration. Three rotating, mostly Kentish, beers are available, along with Westons Rosie's Pig cider. A log fire close to the bar warms in the colder months while two log-burners do likewise on the covered rear terrace. The surprisingly spacious garden incorporates substantial huts complete with luxurious seating, and a children's play area. Regular live music and quiz nights are advertised on Facebook.
ॐ✿❍▶≈♣♠ロ(1,8)☻☂

Dymchurch

Hidden Treasure L
30 High Street, TN29 0NU
☎ (01303) 874049 ⊕ thehiddentreasure.co.uk
3 changing beers (sourced locally) Ⓗ
Family-run friendly micropub in the heart of Dymchurch close to the historic Martello Tower (open to the public by appointment) and the beach. Beers, one usually from a Kentish brewer, are served through three handpumps. Ciders are on gravity and occasional extra beers are dispensed from a fridge cabinet. There are several drinking areas, with a corridor connecting them to the bar area. Q ॐ✿ଛΔ≈♠ロ(102,103)☻☂

Eastry

Five Bells L ✔
The Cross, CT13 0HX
☎ (01304) 611188 ⊕ thefivebellseastry.com
2 changing beers Ⓗ
Traditional community pub in the heart of the village, with a comfortable lounge bar and dining room. Two or three ales are served, sometimes local, with an occasional mild. The sports bar and function room was previously the village fire station, and houses historic memorabilia. The busy calendar features live music, quiz nights and an Easter beer festival. Home-made food is served all day. The suntrap garden has a children's play area and pétanque pitch. ॐ✿↩❍▶Δ♣Pロ(81)☻☂

Edenbridge

Secret Cask L
91 High Street, TN8 5AU (S end of High St near bridge)
☎ 07595 262247
4 changing beers (sourced locally; often Bedlam, Iron Pier, Kent) Ⓖ
Housed in a former florist shop at the south end of the High Street, this friendly micropub can be relied upon to provide an interesting selection of four beers served direct from the cask. The ales are sourced from Kent and Sussex breweries and are chosen to offer a range of styles for customers to explore. Real ciders from Biddenden and craft keg beers supplement the choice. A dog-friendly pub, the two simply-furnished and cosy rooms have a pleasant ambience. Q≈(Town)●ロ☂

Faversham

Bear Inn ★
3 Market Place, ME13 7AG
☎ (01795) 532668 ⊕ bearinnfaversham.co.uk
Shepherd Neame Master Brew; 1 changing beer (sourced locally; often Shepherd Neame) Ⓗ
A 16th-century inn in the historic market square, popular with visitors to Faversham and locals alike. It has an

interior that has been identified by CAMRA as having regional importance, with wood panelling. Three separate bar areas open off the corridor running the length of the building. A general knowledge quiz is held on the last Monday of the month. The Shepherd Neame beers are often joined by a seasonal or guest beer. A couple of tables out at the front of the pub are well used in summer. Q❍≈♣ロ☂

Elephant L
31 The Mall, ME13 8JN
☎ (01795) 590157
5 changing beers (sourced regionally; often Hopdaemon, Mighty Oak, Rother Valley) Ⓗ
Traditional two-roomed free house with a separate function room at the rear and nautical memorabilia on the walls. The landlord takes pride in serving good real ale, occasionally including a beer matured in the cellar. The pub has won numerous CAMRA awards over the years. Local clubs meet here and regular live music is hosted. A well-tended, attractive walled garden at the back and a log fire within make it a good pub to visit at any time of the year. Close to Faversham railway station.
ॐ✿≈♣●ロ☻

Furlongs Ale House
6A Preston Street, ME13 8NS
☎ 07747 776200
5 changing beers (sourced locally; often Canterbury Ales, Kent, Ramsgate) Ⓗ
This busy micropub has extended to include a heated and covered outside seating area at the rear. Beers are drawn by handpump from the cellar to the small bar, many sourced from Kent microbreweries, with others from across the UK. The emphasis is on the beer range is on the hop. There is wooden bench-style seating and solid tables within and, when required, air-conditioning. Kentish gin and a selection of wines and ciders are also served. Q ॐ✿≈●ロ☻

Shipwrights Arms L
Hollowshore, ME13 7TU (over 1 mile N of Faversham at confluence of Faversham and Oare creeks) TR017636
☎ (01795) 590088 ⊕ theshipwrightsathollowshore.co.uk
Kent Prohibition; house beer (by Goacher's); 3 changing beers (sourced locally; often Goacher's, Harvey's) Ⓖ
A 300-year-old family-run free house with welcoming hosts. It is well worth the 45-minute walk from Faversham, or along the slightly longer picturesque sea wall path. The wooden-clad building's cosy interior reflects a nautical heritage, with associated ornaments and pictures on display. There are comfortable seating options around the fireplaces, a large garden at the rear (closed in winter), and outside seating at front. Opening hours are extended in summer, but in severe winter weather ring ahead. Q ॐ✿✿●P☻

Finglesham

Crown Inn L
The Street, CT14 0NA
☎ (01304) 612555 ⊕ thecrowninnfinglesham.co.uk
Dark Star Hophead; 2 changing beers (often Canterbury Ales, Romney Marsh) Ⓗ
Traditional village pub with a warm welcome and a friendly atmosphere. Three real ales are served, one usually from a local microbrewery. Quality home-made food is available lunchtimes and evenings, including a roast on Sunday. Eat in the bar or the restaurant, which opens onto the pleasant garden, with its children's play area, gazebo and pods. Occasional live music events take

place and bat and trap is played in summer. B&B accommodation is available in modern lodges behind the pub. ♿🏠🅿🚲🅿🚃(81)♨ 🛜

Folkestone

Bouverie Tap 🇱

45 Bouverie Road West, CT20 2SZ
☎ (01303) 255977 🌐 thebouverietap.co.uk
3 changing beers (sourced locally) 🅷
This alehouse was extended into the adjacent shop and courtyard in 2020 and is decorated with interesting old posters. It offers three changing local ales alongside cider. Food is prepared from locally sourced ingredients and wholesome roasts are available on Sunday. Breakfasts are available on Saturday and Sunday, and alcohol is served for those who like a 'hair of the dog' with their breakfast. Dogs are welcome and children up to 7pm. ♿🏠🅚🚲🕭🚃(Central)●🚃♨ 🛜

Chambers 🇱

Radnor Chambers, Cheriton Place, CT20 2BB (off the Hythe end of Sandgate Rd)
☎ (01303) 223333 🌐 thechamberspub.co.uk
4 changing beers (sourced regionally) 🅷
A spacious cellar bar with six handpumps, beneath a licensed coffee shop. Beers include some from local breweries and at least two real ciders. A beer festival is held over the Easter weekend. Food including Mexican, European and daily specials is served except on Mondays and Friday evenings. There is a disco on Friday, a quiz on the first Sunday of the month, and live music on Thursday, usually with free admission. ♿🅚🚃(Central) ●🚃🛜

East Cliff Tavern

13-15 East Cliff, CT19 6BU
☎ (01303) 251132
2 changing beers (sourced regionally) 🅷
A pub since 1862, this friendly terraced back-street local, run by the same family for over 50 years, can be approached via the footpath across the disused railway line, a short walk from the harbour. It usually offers two beers, often from local breweries, along with Biddenden or Kingswood cider on gravity behind the bar. Old photographs of Folkestone decorate the walls and community events include weekly raffles. Opening hours may vary. Q🏠🚲●🚃(91)♨

Firkin Alehouse

20 Cheriton Place, CT20 2AZ
☎ 07894 068432 🌐 firkinalehouse.co.uk
4 changing beers (sourced regionally) 🅖
Welcoming micropub serving up to four cask beers, one usually from a Kent microbrewery, and up to six ciders dispensed by gravity from a temperature-controlled room. The display fridge offers a choice of bottled and canned foreign and British beers, and there is a limited wine selection. Bar snacks include pickled eggs, pickled onions, and other basic fare. There is no music or pub games, just good company and conversation, making the Firkin an ideal place to relax and enjoy a drink. Q🚃(Central) ●🚃♨

Kipps' Alehouse

11-15 Old High Street, CT20 1RL
☎ (01303) 246766 🌐 kippsalehouse.co.uk
3 changing beers (sourced regionally; often Mad Cat) 🅖
This alehouse follows the general principle of a micropub. Real ale is served directly from the cask, usually including a Kentish ale, an award-winner and

another unusual beer from around the country, sourced from small independent microbreweries. Several ciders are on sale from boxes and a variety of bottled craft beers and draught international lagers. A range of international vegetarian food is available. Music is played on some Sunday afternoons. ♿🏠🅚🕭♣🚃🚃♨ 🛜

Mariner 🇱 ✔

16 The Stade, CT19 6AB
☎ (01303) 254546
Adnams Ghost Ship; Harvey's Sussex Best Bitter; Sharp's Doom Bar; 2 changing beers (sourced regionally; often St Austell, Shepherd Neame, Timothy Taylor) 🅷
Formerly the Jubilee in Mackeson's days, this welcoming pub has an outstanding location overlooking the old fishing harbour and the revived harbour arm, and just 50 yards away from the Sunny Sands, one of Kent's best bathing beaches. Approached through mid-19th century railway arches, the Stade was rebuilt in the 1930s. All major sporting events are shown and there is even a handy postbox for those holiday postcards. ♣🚃(91,102) 🛜

Frittenden

Bell & Jorrocks ✔

Biddenden Road, TN17 2EJ TQ815412
☎ (01580) 852415 🌐 thebellandjorrocks.co.uk
Goacher's Fine Light Ale; Harvey's Sussex Best Bitter; 1 changing beer (sourced nationally; often Goacher's) 🅷
An archetypal village pub and social centre of the local community. Excellent food is served. Previously called the Bell, it gained its current name when the pub opposite, the John Jorrocks, closed in 1969. Originally a coaching inn dating from the early 18th century, its stables are used for a mid-April beer festival with about 25 different beers on offer. A good base for walks in the picturesque Low Weald countryside surrounding the village and for visiting nearby Sissinghurst Castle. ♿🏠🅚🅰♣♨ 🛜

Gillingham

Frog & Toad

38 Burnt Oak Terrace, ME7 1DR
☎ (01634) 852231
4 changing beers (sourced nationally; often Parkway, Wantsum, Young's) 🅷
This traditional back-street local is just 10 minutes' walk from the town centre. A three-times local CAMRA Pub of the Year winner, there are three changing beers on handpump. The pub is home to both men's and women's darts teams. A large patio garden at the rear has covered wooden tables and seating, along with an outdoor bar and stillage used for the beer festival the pub runs. A collection of vintage photographs of the area adorns the walls. ♿🏠🚃♣●🚃(176,177)♨ 🛜

Past & Present Ale House 🇱

15 Canterbury Street, ME7 5TP
☎ 07725 072293
4 changing beers (sourced nationally) 🅖 ˙
A change of location and name in 2020 hasn't stopped Medway's first micropub winning four local CAMRA Pub of the Year awards, and six for cider. It provides drinkers with three cask ales, two KeyKeg beers, up to 12 ciders and a good selection of gins, rums and whiskies, alongside an assortment of of bar snacks. The pub hosts a Wednesday darts night and opens at 11am for

Gillingham FC Saturday home games. Closing time is earlier in January and February.
Q ⑤ ⊁ ⟵ ♣ ◑ 🖥 🖵 (116,176) ☙

Will Adams

73 Saxton Street, ME7 5EG (on corner with Lock St)
☎ (01634) 575902
3 changing beers (sourced nationally; often Adnams, Oakham) Ⓗ
This traditional backstreet pub has been in the Guide for over 25 years. It offers up to three ales, usually including one from Oakham brewery, plus five ciders in boxes on the bar and over 20 single malt whiskies. There is a pool table, two dartboards and four darts teams. Food is only available when Gillingham FC are playing at home on a Saturday. Closed Monday and Tuesday unless Gillingham are at home when it opens at 5pm.
⊛◑⊁♣🖵(116,176) ☙ 🛜

Gravesend

Compass Alehouse ♈ Ⓛ

7 Manor Road, DA12 1AA
☎ 07951 550949 ⊕ thecompassalehouse.co.uk
4 changing beers (sourced nationally) Ⓖ
Micropub with a small front room with high bench seats and a smaller snug off a little courtyard to the rear. Four ever-changing real ales and three ciders are available, often from Kent producers. Conversation is paramount at this convivial establishment, and talking on mobile phones is discouraged and incurs a fine for charity. A water bowl is provided for dogs. Regular events include a games night on Tuesday and two beer festivals. Local CAMRA Pub of the Year 2022. Q ⑤ ⊛ ♣ ⟵ ♣ ◑ 🖥 ☙

Jolly Drayman

1 Love Lane, Wellington Street, DA12 1JA (off Milton Rd, E of town centre)
☎ (01474) 352355 ⊕ jollydrayman.co.uk
Dark Star Hophead; St Austell Proper Job; Skinner's Betty Stogs; 1 changing beer (sourced nationally; often Iron Pier) Ⓗ
This cosy pub on the eastern edge of the town, also known as the Coke Oven, is part of the former Walker's Brewery. It features quirky low ceilings and a relaxed atmosphere. Daddlums (Kentish skittles) is played most Sunday evenings and three men's darts teams are hosted. There is regular live music, monthly open mic sessions and quizzes on alternate Tuesdays. Food is limited to hot snacks at present but something more substantial is planned as well as a second guest beer.
⑤⊛◖♿⊁♣🖵◑☙🛜

Ship & Lobster Ⓛ

Mark Lane, Milton, DA12 2QB (E of town, follow Ordnance Rd then Canal Rd into Mark Lane)
☎ (01474) 324571
1 changing beer (often Iron Pier)
Historic building at Denton Wharf with Dickensian connections, popular with walkers and sea anglers. There is an outside drinking area on the river wall with views of the Thames. One changing Iron Pier beer is always available and the range increases in summer. Food includes steak on Wednesday, fish on Friday and breakfast on Saturday morning (no food Mon). It is advisable to book for the popular Sunday lunches. May close early if quiet, particularly in winter. ⑤⊛◑♣◑🅿☙

Three Daws Ⓛ

Town Pier, DA11 0BJ
☎ (01474) 566869 ⊕ threedaws.co.uk

5 changing beers (sourced nationally; often Dartford Wobbler, Iron Pier, Mighty Oak) Ⓗ
Historic riverside inn with stories of ghosts, press gangs, smugglers, secret tunnels and more, offering views of the Thames and passing river traffic. The bar is upstairs with a large function room below. The interior is divided into small rooms with photos and pictures of local or marine interest and very few right angles. Meals are served until 9pm every day using local ingredients. The pub hosts live music on Friday, a quiz on Sunday and beer festivals in August and October. ⑤⊛◑⊁🖥🛜

Three Pillars Ⓛ

25 Wrotham Road, DA11 0PA (on A227 opp Civic Centre)
☎ 07794 348529 ⊕ threepillarsgravesend.co.uk
6 changing beers (sourced nationally; often Kent, Mighty Oak, Musket) Ⓖ
Small cellar bar underneath the Masonic Hall, reached by steep steps to the right. Two carpeted front rooms lead to the brick-floored bar area. The ceilings are low throughout and there are photos of Gravesend pubs past and present. There is a quiz on the third Thursday of each month and live music on some Sundays. Six or more real ales are on offer, and about 10 ciders. Patrons must not use the Masonic Hall car park. ⑤⊁◑🖵☙

Halstead

Rose & Crown Ⓛ

Otford Lane, TN14 7EA
☎ (01959) 533120
Larkins Traditional Ale; 5 changing beers (sourced nationally; often Bexley, Cellar Head, Rudgate) Ⓗ
An often busy flint-faced village pub offering a pleasantly surprising choice of five ales sourced from both near and far, in addition to local favourite Larkins Trad. Sports fans are catered for in the bustling public bar with a dartboard and Sky TV, while others may like to relax in the quieter cottage-style lounge complete with wood fire and interesting historical photos of the area. The rear garden houses a children's play area and barbecue. Regular live music events are held on alternate Wednesdays.
Q⑤⊛◖♿♣🖵(R10,R5)☙🛜

Hastingleigh

Bowl Inn ♈ Ⓛ

The Street, TN25 5HU TR095449
☎ (01233) 750354 ⊕ thebowlonline.co.uk
2 changing beers (sourced locally) Ⓗ
This lovingly restored listed village pub near the Wye National Nature Reserve displays vintage advertising material while retaining many period features. The main bar welcomes families but the snug room is child free and used for village meetings. A beer festival is held on the August bank holiday Monday. Excellent sandwiches and baguettes are available at the weekend. A frequent local CAMRA Pub of the Year winner, including in 2022.
Q⑤⊛◖♣☙🛜

Hawkhurst

Queen's Inn

Rye Road, TN18 4EY
☎ (01580) 754233 ⊕ thequeensinnhawkhurst.co.uk
Harvey's Sussex Best Bitter; 1 changing beer (sourced locally; often Cellar Head, Long Man, Only With Love) Ⓗ

A picturesque hotel, set back from the main road, with seven letting rooms. The large L-shaped bar has a number of seating areas and the layout has a comfortable and cosy feel. A large fireplace adds character. Locally sourced beers and food are offered. Harvey's Sussex Best is permanently kept and there is also a guest beer. Pizzas are served throughout the day. A separate fine-dining restaurant is to the left. There is a popular roast on Sunday. ⏰❄️🍴◐🅿🚲(5,304)🐾 ≋

Herne

Butcher's Arms 🅛
29A Herne Street, CT6 7HL (opp church)
☎ 07908 370685 ● micropub.co.uk
Adnams Broadside; Fuller's ESB; Old Dairy Uber Brew; 1 changing beer (sourced locally; often Ramsgate) 🄶
Britain's first micropub, opened in 2005, is a real ale gem and the inspiration for others. Once a butcher's shop, it still has the original chopping tables. The compact drinking area ensures lively banter. The range of ales changes frequently and customers can also buy beer to drink at home. The Butcher's Arms has won many CAMRA awards and the landlord was voted one of CAMRA's top 40 campaigners. Opening hours are now limited to midweek evenings, but groups can be accommodated at other times. Q🅰️👢🚲🐾

Herne Bay

Bouncing Barrel 🅛
20 Bank Street, CT6 5EA
☎ 07777 630685
4 changing beers (sourced regionally; often Goody, Old Dairy, Ramsgate) 🄶
A welcoming micropub with bench seating for 20 customers around old workshop tables. The beer range changes regularly and comes mainly from microbreweries, with generally at least one from a Kent brewery. Local snacks are available. The venue is named after the bombs used in the Dambuster Raids, which were tested off the coast nearby. The pub has a mural of a bomber flying past the Reculver Towers. Regular small beer festivals are held throughout the year.
Q🚲♿♣🍴🐾

Parkerville
219 High Street, CT6 5AD
☎ 07939 106172
4 changing beers (sourced locally) 🄶
Lively micropub in a former music store. The spacious front seating area has a corner bar, and a small stage with a piano in the front window. The back bar has a TV screen for big events only. Beers are often from local microbreweries and there is a good selection of ciders, whiskies, rums, artisan gins and wines. Occasional live music is staged, and the pub celebrates its birthday every 24 July with music and food. Q🚲♿🍴🐾

Horton Kirby

Bull 🅛
Lombard Street, DA4 9DF
☎ (01322) 860341 ● thebullhortonkirby.com
Dark Star Hophead; Hardys & Hansons Bitter; 2 changing beers (sourced nationally; often Kent, Oakham) 🄷
Friendly comfortable one-bar village local with a large garden affording views across the Darent Valley. The pub has two regular and two rotating guest ales, one of

which is often dark. Food includes pizzas on Tuesday nights. Booking is recommended for the Sunday roasts. There is an open mic night on the first Friday of each month and a quiz on the last Monday. Games include cribbage and board games. Parking can be difficult in the vicinity. ⏰❄️◐♣🚲(414)🐾≋

Hythe

Potting Shed 🅛
160A High Street, CT21 5JR
☎ 07780 877226
4 changing beers (sourced regionally) 🄶
Hythe's only micro-alehouse at the Folkestone end of Hythe High Street serves an interesting range of ales from around the country – the majority on gravity, except for one which is sometimes pulled through a handpump. There is usually one local Kentish beer on offer. A range of three chilled ciders is also usually dispensed from boxes. Limited bar snacks are available. A good place to enjoy a drink and interesting conversation after visiting the High Street. ❄️🍺🐾≋

Three Mariners 🅛
37 Windmill Street, CT21 6BH
☎ (01303) 260406
Young's London Original; 4 changing beers (sourced regionally) 🄷
This traditional back-street corner pub is well worth a visit and an ideal destination for a relaxing drink when visiting Hythe. Friendly staff and customers are happy to chat while you enjoy a pint of local or regional beer. With no food served, the pub attracts drinkers with an excellent selection of quality real ales and cider, which can be enjoyed in the bars or the partly-heated outside area. ❄️≋♣🍺🚲🐾

Ickham

Duke William
The Street, CT3 1QP
☎ (01227) 721308 ● thedukewilliamickham.com
Harvey's Sussex Best Bitter; 2 changing beers (sourced locally; often Angels and Demons, Hop Fuzz) 🄷
This attractive, busy pub in a quintessentially English village attracts locals, diners and drinkers. A roaring log fire welcomes visitors in winter. The guest ales are sourced mostly from local microbreweries. There is a large outside area with a heated patio and garden. The pub is well known for good food championing local suppliers – from traditional meals served in the restaurant to the bar menu available Monday to Saturday, with a popular roast on Sunday. ⏰❄️🍴◐🚲(11) 🐾≋

Ightham Common

Old House ★ 🅛
Redwell Lane, TN15 9EE (½ mile SW of Ightham village, between A25 and A227) TQ590558
☎ (01732) 886077 ● oldhouse.pub
6 changing beers (sourced locally; often Harvey's, Larkins, Long Man) 🄶
Kentish red-brick, tile-hung cottage in a narrow country lane, with a CAMRA-listed nationally important historic pub interior. The main bar features a Victorian wood-panelled counter, parquet flooring and an imposing inglenook fireplace. Up to six changing beers are dispensed by gravity, often from wooden casks,

including at least one bitter, a golden ale and a dark beer. Kentish ciders are always available. Local CAMRA Pub of the Year 2018-2021. May close earlier in the evening if not busy. Q✿▲♣♠P☺🖤🛜

Laddingford

Chequers
The Street, ME18 6BP TQ689481
☎ (01622) 871266 ⏺ chequersladdingford.co.uk
Harvey's Sussex Best Bitter; 2 changing beers (sourced nationally) ⓗ
An attractive oak-beamed pub dating from the 15th century, at the heart of village life. A variety of events is held throughout the year, including a beer festival at the end of April. A log fire burns in winter, and the pub frontage is a sea of flowers in summer. Good food is served, and on Thursday a wide selection of sausage dishes is available. The large garden has children's play equipment. Buses stop outside.
Q☎✿🖤◑♣P🖵(23,25) 🖤🛜

Linton

Armoury
Loddington Farm, Loddington Lane, ME17 4AG
☎ (01622) 749931 ⏺ musketbrewery.co.uk
6 changing beers (sourced locally; often Musket) ⓖ
The Musket brewery tap overlooks the new brewhouse visible through its windows. There are up to eight casks on the stillage, and beers may be ordered for collection. Comfortable seating is provided in a good-sized area, and a large grassed space opposite offers tables, umbrellas and cushioned casks on sunny days, with cover in a marquee for cold and/or wet days. Monthly bookable themed dining events like Burns Night or St George's night are held, and pizzas are usually available.
Q☎✿◑&♠P🖵🖤🛜

Little Mill

Man of Kent 🄻 ✔
226 Tonbridge Road, TN12 5LA (½ mile W of East Peckham)
☎ (01622) 871345 ⏺ themanofkentpub.co.uk
Harvey's Sussex Best Bitter; Timothy Taylor Landlord; Tonbridge Coppernob; 1 changing beer (sourced regionally; often Gun) ⓗ
Located on the outskirts of East Peckham and by the banks of the river Bourne, this Grade II-listed former coaching inn dates back to 1588. The attractive tile-hung façade overlooks a sunny terrace with table seating and parasols, and further seating extends around by the streamside where customers may feed the expectant fish. Internally, a striking double-sided wood-burning fireplace separates a cosy bar from the characterful saloon where care needs to be taken when negotiating the low oak-beamed ceiling. Q☎✿◑▲P🖵(208)🖤🛜

Lower Halstow

Three Tuns 🍺 🄻
The Street, ME9 7DY
☎ (01795) 842840 ⏺ thethreetunsrestaurant.co.uk
4 changing beers (sourced locally; often Goacher's, Wantsum) ⓗ
A true family village pub with a friendly, bustling atmosphere and lively chatter. The owners actively support real ale, offering mainly Kentish ales (third-pint

flights are available if indecisive) and several local ciders including Dudda's Tun. The pub has a good reputation for high-quality locally-sourced food and has won many awards. A beer festival is held during the August bank holiday. A log fire, sofa seating, brick walls and beams add character. The owners celebrated their 10th year in 2020. Local CAMRA Pub of the Year 2022.
☎✿🥂◑&♠P🖵🖤🛜

Luddesdown

Cock Inn 🄻
Henley Street, DA13 0XB TQ664672
☎ (01474) 814208 ⏺ cockluddesdowne.com
Adnams Southwold Bitter, Broadside; Goacher's Real Mild Ale, Fine Light Ale; Harvey's Sussex Best Bitter; Shepherd Neame Master Brew ⓗ
Proudly traditional rural free house dating from 1713, under the same ownership since 1984. Keen walkers can reach it by footpath from Sole Street station. It has two distinct bars, a large conservatory, a comfortable heated smoking area, and a separate function room where local clubs and societies meet. Traditional pub games are played, including bar billiards and darts with several different types of board. Children are not allowed in the bars or garden. Q✿♣P🖤

Golden Lion 🄻 ✔
Luddesdown Road, DA13 0XE
☎ (01474) 815644 ⏺ thegoldenlionpub.uk
Iron Pier Perry St. Pale, Bitter; Young's London Original ⓗ
Large rural pub with a comfortable bar area, and a restaurant extension offering good-value meals. It hosts several local groups, from custom car owners to an investment group, and holds regular quiz evenings, open mic nights and charity race nights. There is a log fire, a covered outside smoking area and a large car park. The pub is both family and dog friendly, and popular with walkers. Beer festivals are held on Whitsun Saturday and August bank holiday Saturday. ☎◑♣P🖤🛜

Lynsted

Black Lion 🄻
The Street, ME9 0JS
☎ (01795) 521229 ⏺ blacklionlynsted.co.uk
Goacher's Fine Light Ale, Best Dark Ale; Mad Cat Pow Wow Session Pale Ale ⓗ
Welcoming village local frequented by discerning drinkers and popular with walkers. A free house, among the range are four Goacher's beers including rarely-seen occasionals such as Old Ale and Imperial Stout. The characterful and jovial landlord holds court with a cluster of regulars and always has a story to tell. The pub has a large garden, bar billiards and is full of memorabilia. Home-made meals are served. ☎✿🥂◑P🖵(345)🖤🛜

Maidstone

Cellars Alehouse
The Old Brewery, Buckland Road, ME16 0DZ (if front gates in Rocky Hill are closed, use rear entry via alley alongside railway; access is by steps down from yard)
☎ (01622) 761045 ⏺ thecellarsalehouse.co.uk
14 changing beers (sourced nationally; often Boutilliers, Iron Pier, Kent) ⓖ
In the former barley wine cellar of the old Style & Winch brewery, flagstone flooring, vaulted ceilings and a collection of old pub signs await. Comfortable pub

seating and oil lamps add to the cosy atmosphere. Six cask and eight keg ales as well as 10 local and 10 fruited ciders are all perfectly kept in a temperature-controlled cool room. A wide selection of wines, spirits, canned and bottled beers are also served. Bar snacks are available. Local CAMRA Pub of the Year finalist 2022.
Q ≈ (West) ♣ ♠ P ☕ ❀

Flower Pot
96 Sandling Road, ME14 2RJ
☎ (01622) 757705 ⊕ flowerpotpub.com
Goacher's Gold Star Strong Ale; 8 changing beers (sourced nationally; often Fyne, Oakham, Thornbridge) Ⓗ
A street-corner alehouse with split-level bars. The upper bar has nine handpumps serving ales from microbreweries, and a log fire in the winter. The lower bar has a pool table and is used for Tuesday jam nights and music nights on some Saturdays. Up to four ciders and perries are usually available, and a small selection of KeyKeg beers. An outdoor covered and heated seating area is open most of the year. Food is served Wednesdays to Saturdays, with pizzas being particularly popular. ❀ ▷ ≈ (East) ♣ ♠ ☕ ☕ (101,155) ❀ 🛜

Olde Thirsty Pig ✅
4A Knightrider Street, ME15 6LP
☎ (01622) 299283 ⊕ thethirstypig.co.uk
4 changing beers (sourced locally; often Musket, Tonbridge) Ⓗ
Reputedly the third-oldest building in the town, dating from around 1430, the pub was originally a farmhouse within the estate of the archbishop's palace. There are massive timber beams, sloping floors and curious nooks and crannies on two storeys. Outside is a heated and covered courtyard area. The bar has four handpumps dispensing ales mainly from Kent microbreweries. Draught cider is stocked, and many bottled beers, including several foreign ones. Two small meeting rooms are available. The bus station is a few minutes' walk away. ❀ ♠ ☕ ❀ 🛜

Rifle Volunteers
28 Wyatt Street, ME14 1EU
☎ (01622) 750540 ⊕ theriflevolunteers.co.uk
Goacher's Real Mild Ale, Fine Light Ale, Gold Star Strong Ale; 1 changing beer (sourced locally; often Goacher's) Ⓗ
One of Goacher's three tied houses, just a short walk from Maidstone town centre. The Victorian stone-built single-bar pub has been recognised by CAMRA for its unspoiled interior. No jukebox or gaming machines emphasise that this is a place for conversation and a quiet drink. A popular fun quiz, open to all, is held on alternate Tuesdays, with a local winter quiz league on other weeks. Snacks are made to order.
Q ❀ ▷ ≈ (East) ♣ ♠ ☕ ☕ ❀ 🛜

Walnut Tree
234 Tonbridge Road, ME16 8SR
☎ (01622) 727260
Goacher's Fine Light Ale; Harvey's Sussex Best Bitter; 1 changing beer (sourced nationally; often Constellation, Musket, St Austell) Ⓗ
A cosy L-shaped local warmed by a central fire. Comfortable furnishings feature throughout, and the interior displays various sayings and quotes. Live music is hosted weekly on Friday evening, and there is a popular comedy night on the third Thursday of the month. A live band music quiz is also held, and a jukebox is provided. The locally-brewed Goacher's Fine Light Ale is a regular, as is Harvey's Sussex Best. Private functions may be catered for on request. ♿ ❀ ▷ ♣ ♠ P ☕ (3,7) ❀

Marden

Marden Village Club
Albion Road, TN12 9DT
☎ (01622) 831427 ⊕ mardenvillageclub.co.uk
Shepherd Neame Master Brew; 5 changing beers (sourced regionally; often Goacher's, Kent, Ramsgate) Ⓗ
Six real ales are offered at this Grade II-listed club and community hub. Five change regularly and are generally from local Kent microbreweries, and one is always a dark beer. Many members are involved in the club's snooker and darts teams, others simply enjoy the friendly ambience. Bingo and music evenings are held. CAMRA members are welcome but regular visitors will be required to join. A regular local CAMRA Club of the Year. ♿ ≈ ♣ ♠ ☕ (23) ❀ 🛜

Margate

Ales of the Unexpected
105 Canterbury Road, CT9 5AX
☎ 07720 442892
4 changing beers Ⓖ
This micropub is housed in a former fishmonger's in a row of shops in the Westbrook district of town. The pub has a front seating area with various tables and chairs, and is decorated with maps of the UK and the world. The serving counter is in a room to the rear, decorated with pumpclips of the various ales served since the pub opened in 2013, beyond which is a separate temperature-controlled cold room where the beers are served direct from the cask. Q ≈ ♠ ☕ ❀

Two Halves 🍺
2 Marine Drive, CT9 1DH
☎ 07538 771904
5 changing beers Ⓖ
This friendly, welcoming micropub has an incredible location on Margate's seafront. The beers are from all regions of the country and are regularly changed, with a landlord who knows his ale. No matter what the weather, this venue has a great aspect – you can enjoy sunsets out of the window or just watch the world go by. The beer and cider are kept in immaculate condition in a large stillage room. Look for the old-fashioned postcards in the loo. Local CAMRA Pub of the Year. Q ≈ ♠ ☕ ❀

Milton Regis

Three Hats
93 High Street, ME10 2AR
☎ (01795) 427645
4 changing beers (sourced nationally) Ⓗ
Popular and friendly local in the medieval High Street which is the focal point for many social activities. The open-plan interior has low beams to the front, which rise just enough at the rear to accommodate a dartboard, beyond which is a large patio area and garden. Pub food is from a well-priced menu. There are always three to four changing beers available. Occasional live music and karaoke take place, with a meat raffle on Sunday. ♿ ❀ ▷ ♣ ♠ ☕ (347) ❀ 🛜

Minster-in-Thanet

Hair of the Dog
73 High Street, CT12 4AB
☎ 07885 362326

3 changing beers G

This micropub, previously a dog groomer's, offers a warm welcome on the village high street. There are usually three real ales and at least three ciders, all served from the cask in a cool room directly off the bar. The furniture is rustic with a mix of high and low seating and tables, and customers can play a mix of old games such as shove ha'penny, or crack some of the puzzles left out. Unsurprisingly, dogs are welcome. Q ⛄ ≢ ♣ ♠ 🖰 ❀

New Romney

Smugglers' Alehouse L

10 St Lawrence Court, High Street, TN28 8BU

☎ 07919 156336

3 changing beers (sourced locally) H

A micropub at the south end of the High Street, where you can relax with a drink or join in with the varied conversations between customers and staff. Well-behaved dogs on leads are welcome. In addition to the ever-changing beers and ciders on offer, there is a selection of wines and spirits. Tea and coffee are usually available on request, and various snacks including pickled eggs are also sold. Q ▲ ♠ 🖰 ❀

Newenden

White Hart L

Rye Road, TN18 5PN (on A28 in centre of village)

TQ834273

☎ (01797) 252166 ⊕ thewhitehartnewenden.co.uk

Harvey's Sussex Best Bitter; Rother Valley Level Best; 2 changing beers H

The White Hart is a characterful 16th-century free house serving the local community with an ever-changing selection of fine cask ales. It is an ideal base from which to explore the area, whether it be a nostalgic steam train journey through beautiful countryside with the Kent and East Sussex Railway, a visit to one of the many National Trust properties on the doorstep, or a drive down to the coast. Pub quizzes are held on the first Monday of the month, except on bank holidays. ⛄ ❀ ◑ ♿ ▲ ≢ (Northiam) ♣ ♠ 🖰 (2) ❀ 🛜

Northfleet

Earl Grey

177 Vale Road, DA11 8BP

⊕ earlgreynorthfleet.co.uk

Shepherd Neame Master Brew, Bishops Finger; 1 changing beer (often Shepherd Neame) H

An old-fashioned local boozer in a distinctive late-18th century cottage-style building with a Kentish red brick and flint exterior. Internally there is an L-shaped bar with a raised seating area at the rear. The pub hosts two darts teams and euchre is played on Wednesday. Children and dogs are welcome in the large garden. There might also be a seasonal ale or a special brew from the Shepherd Neame range. ❀ ♣ 🖰 (481,483)

Iron Pier Taproom L

Units 6 & 7, May Industrial Estate, May Avenue, DA11 8RU

☎ (01474) 569460 ⊕ ironpier.beer

Iron Pier Perry St. Pale, Bitter, Wealdway G

Brewery taproom opened in 2018. The Iron Pier brewery is only the second to operate in the Gravesend area since Russell's was swallowed by Truman's in the 1930s. There is plenty of seating, with an excellent view of the brewery itself, and a large TV for sports fans. Three regular Iron Pier beers are available, with others depending on production at the time. A selection of KeyKeg and bottled beers, gins, wines and soft drinks is also available. P🖰 (481,483) ❀

Painters Forstal

Alma

ME13 0DU

☎ (01795) 533835 ⊕ almafaversham.co.uk

Shepherd Neame Master Brew; 1 changing beer (sourced regionally; often Shepherd Neame) H

Popular country pub situated in the centre of the village. It is well regarded for its food, for which tables may be booked. There is a small car park and a large, well maintained garden. The pub also has bat and trap and hosts occasional themed events. Up to three Shepherd Neame beers are available. Dogs on leads are allowed in the public bar. Q ⛄ ❀ ◑ ♣ ♠ P🖰 (660)

Pembury

King William IV

87 Hastings Road, TN2 4JS

☎ (01892) 458241 ⊕ kingwilliampembury.com

Greene King IPA; St Austell Proper Job; 4 changing beers (sourced regionally; often Fuller's, Long Man, Titsey) H

A short walk from the village centre, the King Will offers a bright and airy atmosphere, a warm welcome and a good choice of six ales beckoning the visitor towards the bar. A cider from Biddenden is also available. Very much a community pub, there is a strong emphasis on supporting good causes. A good-sized back garden can be reserved for private parties, and there is ample front garden seating. Live music is performed on most Saturday evenings during the summer months. ⛄ ❀ ♣ ♠ P🖰 (6,297) ❀ 🛜

Petteridge

Hopbine L

Petteridge Lane, TN12 7NE (1 mile E of Matfield)

☎ (01892) 722561 ⊕ thehopbine.pub

Long Man Best Bitter; Tonbridge Traditional Ale; house beer (by Cellar Head); 1 changing beer (sourced locally; often Gun) H

Enjoying an enviable sunny position opposite a row of pretty cottages, the Hopbine has a picture-postcard quality with white weatherboarding, tiling and former King & Barnes brewery signage prominent. A central fireplace warms both the main bar and the cosy side snug. Three regular ales and a guest, all from Kent and Sussex, are accompanied by a real cider from Turners in the busier months. Pizzas from the pub's wood-fired oven are a big attraction, as is the quiet, tiered rear garden and play area. ⛄ ❀ ◑ ♣ ♠ P🖰 (297) ❀ 🛜

Queenborough

Admiral's Arm L

West Street, ME11 5AD (in Trafalgar Court, 30yds left from crossroads of High Street and Park Rd)

☎ (01795) 668598 ⊕ admiralsarm.co.uk

4 changing beers (sourced nationally; often Ilkley, Oakham, Ramsgate) H/G

Located in the historic heart of Queenborough, with a nautical theme including local shipping maps, the pub is frequented by locals and visitors alike. The welcoming

owners happily serve a good range of beers direct from the cask or via handpump, plus eight KeyKeg beers, ciders and many gins. Regular events include quiz nights and cheese Sundays. Excellent pizzas are served at the weekend from the pizza oven. Mobile phone calls must be taken outside. A three-times local CAMRA Pub and Cider Pub of the Year, and a former overall winner for Kent. Q❄☕◗➔♣🅿🚫(334)☼🛜

Rainham

Angel ⬭

Station Road, ME8 7UH
☎ 07510 642542
Goacher's Gold Star Strong Ale; 1 changing beer (sourced regionally; often Ringwood) Ⓗ
This former local CAMRA Pub of the Year is a welcoming traditional-style pub popular with dog walkers and locals. The large single room with an L-shaped bar has a pool table, dartboard and a TV showing Sky Sports. There is an open fire to keep customers cosy in the winter months. Outside, the walled garden is a suntrap in summer.
❄☕♣🅿🚫(327) ☼

Mackland Arms ⬭

213 Station Road, ME8 7PS (5 mins' walk N of railway station)
☎ (01634) 232178 ● macklandarms.co.uk
Shepherd Neame Master Brew, Spitfire; 1 changing beer (sourced nationally) Ⓗ
This popular local, a tied house for Kent brewer Shepherd Neame, has an L-shaped bar housing three handpumps for ale as well as a draught cider tap. The large garden at the rear gives respite from noisy traffic. Sports are shown on two TVs and the pub has darts and pool teams. Its neat furnishings and friendly staff make it well worth a visit. No food is served. ❄☕🚃♣🚫(327)☼

Prince of Ales ⬭

121 High Street, ME8 8AN (nr centre of Rainham, next to Post Office)
☎ 07982 756412 ● princeofales.co.uk
4 changing beers (sourced nationally; often Kent, Oakham, Tonbridge) Ⓖ
Situated on the main A2, opposite the Citroen dealer and two minutes from bus stops, this attractive micropub is run by a dedicated team. Four ever-changing, mostly Kent-based local ales are served direct from casks in the chiller room, as are three ciders of the bag-in-box type. Wooden tables and benches predominate. There is a small outside area similarly fitted. An annual beer festival is held. Wine, prosecco and soft drinks are also available. No food is served, and children and pets are not permitted. Q☕🚃♣🚫🚫(132)

Ramsgate

Artillery Arms

36 West Cliff Road, CT11 9JS
☎ (01843) 853202
Oakham Citra; Ramsgate Gadds' No. 5 Best Bitter Ale; 3 changing beers (often Titanic, Wantsum) Ⓗ
Celebrated alehouse a short walk from the town, it is popular and attracts a diverse clientele. Stairs from the lower bar area lead to an upper area with more seating. Handpumps serve a selection of beers from Kent and around the country, and the landlord maintains a long tradition of stocking a carefully-considered range of real ales. Interesting old painted windows depict battle scenes and the theme is continued with displays of other militaria. ◗♣🚫🚫(Loop,9)☼

Hovelling Boat Inn

12 York Street, CT11 9DS
☎ 07968 800960
4 changing beers Ⓖ
This sympathetic shop-conversion micropub in a handy town centre location was destined to have had another name, until the landlord discovered it had originally been the Hovelling Boat pub that ceased trading in 1909. The pub, with exposed brickwork displaying breweriana, offers up to four constantly-changing beers from Kent and beyond, served at customers' tables by friendly staff. Local cider alongside wine, cold snacks, tea and coffee are also available. Q❄☕♣🚫🚫☼

Montefiore Arms

1 Trinity Place, CT11 7HJ
☎ (01843) 593265
Ramsgate Gadds' No. 7 Bitter Ale; 3 changing beers (often Ramsgate) Ⓗ
Award-winning traditional backstreet local, which enjoys a good reputation with real ale drinkers in the Thanet area. The pub's name and sign are unique, honouring the great Jewish financier and philanthropist Sir Moses Montefiore who lived locally for many years and was a benefactor to the town's poor. The pub showcases beers from the Ramsgate Brewery along with changing guest ales and Biddenden cider. ☕♣🚫(Loop)🛜

Rochester

12 Degrees ⬭

352 High Street, ME1 1DJ
☎ 07512 040453 ● rams-micropub-12degrees.business.site
6 changing beers (sourced locally) Ⓖ
Also known as RAMS Micropub 12 Degrees, a row of seven glass doors behind the excellently crafted bar houses six gravity-fed ales and bag-in-box ciders. The pub is full of quirky signs and objects – check the beer o'clock. A hidden gem is the basement with a dartboard, pool table and TV as well as extra seating. A deal with two local takeaways allows customers to order in food to the pub, to enjoy with their ale. Prices are very reasonable here. Q🚃(Chatham)♣🚫

Coopers Arms

10 St Margarets Street, ME1 1TL (behind cathedral)
☎ (01634) 404298 ● thecoopersarms.co.uk
Courage Best Bitter; Young's London Special; house beer (by Tonbridge); 4 changing beers (sourced regionally; often Canterbury Ales, Tonbridge, Westerham) Ⓗ
Situated behind both the cathedral and castle, a short stroll from the busy High Street, this charming building dating from 1199 first became a pub in 1543. Previously the home of monks, the front bar is of particular interest with an impressive beamed ceiling and fireplace. A short passageway leads to a more modern rear bar and pleasant garden which is busy in summer. Lunchtime and evening meals are available Thursday to Sunday and there is a fortnightly quiz night. ☕◗🚃🅿🚫☼🛜

Three Sheets to the Wind

173 High Street, ME1 1EH
● threesheetspub.co.uk
Old Dairy Blue Top Ⓗ/Ⓖ**; 2 changing beers (sourced locally; often Pig & Porter)** Ⓗ
A blend of Kentish real ales and Austrian beers makes this micropub unique among Rochester drinking establishments. The pub is divided in two, with a small front bar leading to a cosy drinking room which has access to a pebbled courtyard garden. Two Kentish ales and an Austrian house beer are served, plus a selection

of Austrian bottled beers. Gins and Kent cider are also available, and customers can bring in takeaway food to eat on the premises. ✿⇌⬤🖵(140,190)❀ 🛜

Who'd Ha' Thought It

9 Baker Street, ME1 3DN (off Maidstone Rd)
☎ (01634) 830144 ⊕ whodha.com
3 changing beers (sourced nationally) Ⓗ
On a side street off Maidstone Road, this welcoming pub has three TVs showing sporting events. There is a log fire in winter. On the bar are three ever-changing beers, one usually from a Kent brewery. To the right is a small snug with books and games, which leads to a raised garden with wooden tables and benches, and a covered stillage used for beer festivals. ♿✿♣🅿🖵(155)❀ 🛜

Ryarsh

Duke of Wellington

Birling Road, ME19 5LS
☎ (01732) 842318 ⊕ dukeofwellingtonryarsh.com
Harvey's Sussex Best Bitter; St Austell Proper Job; Twickenham Naked Ladies; 1 changing beer (sourced nationally) Ⓗ
A 16th-century pub with inglenook fireplaces in each of its two bars. The bar to the left leads to toilets and includes a small snug area. To the right, the restaurant displays part of an original wattle and daub wall behind glass. A covered and heated patio opens onto the garden, with additional tables outside at the front. Sunday roasts are popular. A jazz evening is held on the first Thursday in the month. Ramblers are welcome. A small bus stops nearby. Q♿✿◖🅿🖵(58)❀ 🛜

St Mary in the Marsh

Star Inn

TN29 0BX TR065279
☎ (01797) 362139 ⊕ thestarinnthemarsh.co.uk
Courage Directors; Shepherd Neame Master Brew; Young's London Original; 2 changing beers Ⓗ
This traditional pub is well worth a visit, located opposite St Mary the Virgin Church where Edith Nesbit, author of The Railway Children, is buried in the graveyard. The Star was built in the reign of Edward IV, and Noel Coward used to live in an adjacent cottage, where it is said he wrote his first books. Opening hours may be extended during the summer months. ♿✿◖Å♣⬤🅿🖵(11A)❀ 🛜

Sandwich

Red Cow

12 Moat Sole, CT13 9AU
☎ (01304) 613399
Harvey's Sussex Best Bitter; 2 changing beers (often Ramsgate) Ⓗ
You can't miss the large red cow on the front of this timber-framed building which was used by market traders in years gone by. Its tiled floors and exposed beams give it a comfortable and traditional country pub ambience. Up to three real ales are served, usually including one from the Ramsgate Brewery. The menu offers traditional pub food, alongside pie & pint night, Friday fish special and a Sunday roast. There is a large, pleasant sun-trap garden. Dogs are allowed in the restaurant. ♿✿◖Å♣🅿❀ 🛜

Sevenoaks

Anchor

32 London Road, TN13 1AS
☎ (01732) 454898 ⊕ anchorsevenoaks.co.uk
House beer (by Wantsum); 2 changing beers (sourced regionally; often Kent, Ramsgate) Ⓗ
The Anchor is a traditional town-centre pub forming the heart of the community. Effervescent landlord Barry has been its driving force for more than four decades. Three well-kept cask ales are always available, with two guests, one usually from Ramsgate Brewery, supporting the house beer from Wantsum. Substantial and good-value meals are served at lunchtimes, with roasts proving popular. Darts, pool and poker are played and regular live music is performed on Wednesday evening. ◖♣🖵❀ 🛜

Sittingbourne

Donna's Ale House ⅃

20 West Street, ME10 1AB
5 changing beers (sourced locally; often Goody, Mad Cat, Wantsum) Ⓗ
A welcome town centre addition to the real ale scene, this micropub opened in 2017 and has proved to be popular with all. The decor is contemporary, with seating at high benches, tables and stools. Four handpumps dispense ales with an emphasis on Kentish makers, and occasional brews from further afield. A blackboard gives information about the beers on offer. Over 100 gins are also available. A selection of snacks is served – typically cheeseboards, pie and mash, and chilli with nachos. ♿◖⇌⬤❀

Paper Mill ⅃

2 Charlotte Street, ME10 2JN (N of station, almost in Milton Regis; at corner of Church St and Charlotte St)
☎ 07927 073584 ⊕ thepapermillmicropub.co.uk
3 changing beers (sourced regionally; often Dark Revolution, Goacher's, Salopian) Ⓖ
Popular one-room micropub close to Sittingbourne town centre and railway station. It has bench seating around four large wood tables. Local beers feature alongside ales from national brewers such as Blue Monkey and Cloudwater. A range of real ciders is also available. Check the blackboards for the beer list, which includes a number of interesting KeyKeg offerings. Occasional events such as Meet the Brewer and pub quizzes take place. Opening hours can be flexible with advance notice. Q♿ઠ⇌♣⬤🖵🖵(334,347)❀

Yellow Stocks

22A High Street, ME10 4PD
☎ 07572 180627
2 changing beers (sourced locally; often Canterbury Ales, Iron Pier, Ramsgate) Ⓖ
Named after a type of handmade building brick once made in large quantities in the surrounding countryside, this micropub serves real ales and ciders/perries from a temperature-controlled cellar room behind the small bar counter. There is a garden and outside smoking area at the rear, and a spotlessly-kept unisex toilet. The real ales and ciders mainly have a Kentish provenance, but some unusual regional beers are offered. There is occasional comfort food on the bar. ♿✿⇌♣⬤🖵❀ 🛜

Snargate

Red Lion ★ L

TN29 9UQ (on B2080, 1 mile NW of Brenzett) TQ990285
☎ (01797) 344648
Goacher's Real Mild Ale; 3 changing beers (often Canterbury Ales, Goacher's, Rother Valley) Ⓖ
A regular Guide entry since 1981, this unspoilt 16th-century smugglers' inn has been in the same family for over 100 years. It passed to the next generation in 2016, but is still universally known as Doris's. Inside, the multi-room layout is decorated with posters from the 1940s and the Women's Land Army. A beer festival is held in June near to the summer solstice, and a mini festival in October. With a nationally important historic pub interior, this pub is well worth a visit. Q❀♣♦P♿(11B)❀

Staplehurst

Lord Raglan

Chart Hill Road, TN12 0DE (half a mile N of A229 at Cross-at-Hand bus stop) TQ786472
☎ (01622) 843747 ⊕ lord-raglan.co.uk
Goacher's Fine Light Ale; Harvey's Sussex Best Bitter; 1 changing beer (sourced locally) Ⓗ
An unspoilt free house retaining the atmosphere of a country pub from bygone days and owned by the same family for many years. The bar is hung with hops and warmed by two log fires and a stove. The large orchard garden catches the evening sun. Excellent food is served from a popular menu. Perry and local Double Vision cider are stocked. Well-behaved children and dogs are welcome. It is a short walk from the Cross-at-Hand (No.5) bus stop on the A229. Q❀◑♦P❀

Strood

10:50 From Victoria ♀ L

Rear of 37 North Street, ME2 4SJ (in railway arch opp Asda car park)
☎ 07941 449137
Goacher's Special/House Ale; Grainstore Ten Fifty Ⓖ; 5 changing beers (sourced regionally) Ⓗ/Ⓖ
A local CAMRA Pub of the Year, this micropub is popular with locals and visiting real ale fans. Wood-panelled throughout, the walls are adorned with railway memorabilia and other bric-a-brac. A log burner keeps customers cosy on colder days and there is a large patio and garden area to the front with some areas under cover, including three brightly-painted beach huts. Q❀♿≉♣♦P♿(191)❀🐾

Tankerton

Tankerton Arms L

135 Tankerton Road, CT5 2AW
☎ 07897 741811 ⊕ thetankertonarms.co.uk
4 changing beers (sourced locally) Ⓖ
Situated among Tankerton's small shops, this friendly micropub has a firm policy of supporting Kent microbreweries, and the range of four cask beers changes frequently. There are some Keykeg beers and occasional beer swaps with regional breweries. The pleasant, airy room is lined with high wooden tables and stools, and is adorned with bunting and pictures of Thames sailing barges and the sea forts. Italian antipasti evenings are held every few weeks. There is a patio in front for outdoor drinking. Q❀♿❀♣♦♿❀🐾

Temple Ewell

Fox

14 High Street, CT16 3DU
☎ (01304) 823598
3 changing beers (sourced nationally; often Courage, Marston's, Timothy Taylor) Ⓗ
A traditional village pub with a warm welcome for locals and visitors. Enjoy real ales in a good range of styles and strengths in the main bar or in one of the smaller rooms. A variety of events, quiz nights, curry nights and occasional music evenings keeps the place busy. In June, a charity beer festival is organised by the local Rotary Club. There is an attractive streamside garden with a skittle alley. Close to Kearsney Abbey gardens and public transport. ❀🐾◑≉(Kearsney)♣P♿(15,68)❀🛜

Tenterden

Old Dairy Tap Room

Tenterden Station Yard, Station Road, TN30 6HE
☎ 07961 769672 ⊕ cattleshedbrew.co/taproom
4 changing beers (sourced locally; often Old Dairy) Ⓗ
The Tap Room is located at the front of the brewery and offers the range of Old Dairy and Cow Shed beers along with a selection of bottled beers. There is also a selection of local ciders from the local Nightingale Cider Company. Kentish gin, whisky, vodka and local wines are also available, alongside soft drinks including a variety of teas and coffees. ❀≉(Town)♦P♿

This Ancient Boro'

3 East Cross, TN30 6AD
☎ (01580) 388815 ⊕ thisancientboro.com
9 changing beers (sourced nationally) Ⓖ
A Whitbread pub that closed in 1968 and reopened as an alehouse and tapas bar in 2018, winning local CAMRA Pub of the Year in 2020. Now a hybrid of the original and a micropub, there is no live music or gaming machines. An ever-changing variety of beers is available by gravity, dispensed from cooled casks on stillage behind the bar, together with various ciders served from a fridge. There is an interesting snack/tapas menu. Q❀🐾◑≉(Town)♣♦P♿(2,2A)❀🛜

Tonbridge

Beer Seller L

64 High Street, TN9 1EH
☎ (01732) 666336 ⊕ thebeerseller.co.uk
Cellar Head Session Pale Ale; Constellation Draco; Goacher's Gold Star Strong Ale; 3 changing beers (sourced locally; often Canterbury Ales, Iron Pier, Kent) Ⓖ
A rustic conversion from a former shop has given Tonbridge its own rural barn-style pub in the centre of town selling at least six local ales and four ciders served directly from the cask. An upstairs private meeting room is available for hire, adjacent to the pub's Hidden Seller shop offering a wide range of beers, wines and spirits. Regular tasting events are also organised. Live music is hosted every Friday evening and a quiz night on Tuesday. Q♿♣♦♿❀🛜

Constellation Brewery Tap L

Unit 21, Orchard Business Centre, Sanderson Way, TN9 1QF (off Cannon Lane A26)
☎ (01732) 756564 ⊕ constellationbrewery.co.uk
Constellation Indus, Draco, Aquila Ⓟ

Located on an edge-of-town industrial estate, the Tap serves all of Constellation's currently brewed cask and keg beers, sometimes including a seasonal brew, along with Kent cider. There is a decked drinking area with table seating outside at the front, and a stellar-themed bar with seating inside, which is in the micropub style. A Greek street food outlet sets up on the premises on varying days and times according to season. Occasional music and themed events are held. ♿☕🍴P🐕🏳️‍🌈

Fuggles Beer Café 🅛 ✅

165 High Street, TN9 1BX (N end of Tonbridge High St near parish church)
☎ (01732) 666071 ⊕ fugglesbeercafe.co.uk/locations
Tonbridge Coppernob; 2 changing beers (sourced nationally; often 360 Degree, Downlands, Iron Pier) ⓗ
A popular continental-style beer café where good table service is the norm. One regular beer from Tonbridge Brewery and two ales from an ever-changing selection from local and national independent breweries are served alongside an extensive range of craft keg beers. Two real ciders are also on handpump, one of which is often rare for the area. Regular themed events featuring breweries from home and abroad are held, and a Beer Club provides home deliveries. Toasties and snacks are available to keep hunger at bay. ♿🍴🔔≠♣🍴🐕🏳️‍🌈

Nelson Arms 🍷 🅛

19 Cromer Street, TN9 1UP
☎ (01732) 358284 ⊕ thenelsonarms.com
8 changing beers (sourced nationally; often Kent, Rother Valley, Surrey Hills) ⓗ
Situated in a quiet residential area within easy walking distance of the railway station and High Street, the Nelly was voted local CAMRA Pub of the Year 2022. A range of six to eight beers across a range of styles representing national and local independent breweries is usually served. Up to 15 real ciders are also available along with craft keg beers. Regular Sunday quizzes, music and themed evenings and occasional beer festivals are organised. Home-cooked meals are served and Sunday roasts highly recommended. ☕🍴≠♣🍴🐕🏳️‍🌈

Tunbridge Wells

Fuggles Beer Café 🅛 ✅

28 Grosvenor Road, TN1 2AP (opp Tesco bus stop)
☎ (01892) 457739 ⊕ fugglesbeercafe.co.uk/locations
Tonbridge Coppernob; 3 changing beers (sourced nationally; often 360 Degree, Anspach & Hobday, Durham) ⓗ
The recipient of numerous local CAMRA accolades, this independent café-style establishment continues to offer the drinker a mesmerising array of cask ales, ciders, wines, spirits and bottled beers which are also available to take away. Always friendly and welcoming, a vibrant atmosphere pervades during busier periods while calm reigns at quieter times of the day. Frequent British and continental brewery showcasing events are organised, reinforcing an enthusiasm for and commitment to exploring the world of beer. Toasties and bar snacks are served. ♿🍴≠♣🍴🐕🏳️‍🌈

George 🅛

29 Mount Ephraim, TN4 8AA
☎ (01892) 539492 ⊕ thegeorgepubtunbridgewells.co.uk
Fonthill Good Morning Captain, Creedence; Long Man Best Bitter; 4 changing beers (sourced locally; often 360 Degree, Gun, Pig & Porter) ⓗ
Formerly a Georgian coaching inn and now a local award-winning friendly hostelry, the George serves a range of

beers from its on-site Fonthill Brewery together with a choice of ales from Kent and Sussex, and ciders from Turners and Dudda's Tun. The decor is modern-casual with subdued lighting, wooden flooring and sofas complementing the regular more wooden tables and seating. A rear staircase leads down to a secluded, decked courtyard garden with a relaxing ambience. Occasional pop up food events are held. ♿☕🍴≠♥🍴🐕🏳️‍🌈

Grove Tavern ✅

19 Berkeley Road, TN1 1YR
☎ (01892) 526549 ⊕ grovetavern.co.uk
Harvey's Sussex Best Bitter; Timothy Taylor Landlord; 2 changing beers (sourced nationally; often Black Sheep, Otter) ⓗ
Located in the old village quarter only a short walk away from the High Street and railway station, the Grove is an established Guide favourite. Redecoration during lockdown has given a fresh feel to this quiet little pub, one of the oldest in town. Local patrons freely engage newcomers in conversation and the friendly resident dog will greet you with a wagging tail. No food is served but locals may bring in snacks for all to share. ♿≠♣🍴🐕🏳️‍🌈

Mount Edgcumbe 🅛

The Common, TN4 8BX (signposted lane off Mt Ephraim)
☎ (01892) 618854 ⊕ themountedgcumbe.com
Harvey's Sussex Best Bitter; 3 changing beers (sourced regionally; often Cellar Head, Long Man, Siren) ⓗ
With the feel of a country hotel surrounded by woodland, the Mount Edgcumbe can be a welcome retreat from the bustle of the town centre. A display of glass lamps containing stuffed and ceramic animals, and a 6th-century sandstone cave with sofa seating greet the customer on entering. A delightful paved, covered and heated patio overlooks the common and rock formations to the rear. Traditional-style pub quizzes are held twice monthly on Sundays and there are six boutique letting rooms. ♿🛏️☕🍴≠♣P🍴🐕🏳️‍🌈

Royal Oak 🅛

92 Prospect Road, TN2 4SY
☎ (01892) 542546 ⊕ theroyaloaktw.co.uk
Harvey's Sussex Best Bitter; 4 changing beers (sourced regionally; often Cellar Head, Five Points, Iron Pier) ⓗ
A short walk from the town centre, the Oak is a family-owned community pub with a landlord who has a passion for beer. The large open-plan panelled room has a central bar serving an eclectic range of real ales and ciders, with third-pint taster racks available. Classic pub food including Sunday roasts is served every day except Monday. There is usually a quiet background buzz here but it can get lively when sports events are screened on TV or live music is performed, often on a Saturday evening. ♿☕🍴≠♣♥P🍴(6,285)🐕🏳️‍🌈

Sussex Arms 🅛

Sussex Mews, TN2 5TE (off the Pantiles)
☎ (01892) 549579 ⊕ thesussextw.co.uk
Long Man Long Blonde; Timothy Taylor Landlord; 4 changing beers (sourced regionally; often Adnams, Fonthill, Musket) ⓗ
A little gem tucked away at the back of the lower walk of the Pantiles and accessed through Coach and Horse Passage, the Sussex has a good reputation for its range of beers and live music most weekends. Beers are sourced mostly from the South East. With a homely and comfortable interior, a suntrap patio to one aspect and a glass-covered terrace to the other, the pub provides a welcoming refuge from the busy Pantiles. Quiz nights are organised for Thursday evenings. ♿☕🍴≠♣🐕🏳️‍🌈

Upper Upnor

King's Arms
2 High Street, ME2 4XG
☎ (01634) 717490 ● kingsarmsupnor.co.uk
5 changing beers (sourced nationally) Ⓗ
Situated at one end of the cobbled High Street that leads down to the River Medway and the historic Upnor Castle, the pub is close to the free village car park. You will find a good selection of five real ales here including a dark one, plus four ciders, a perry and a selection of European bottled beers. The pub has a reputation for quality food, served in the restaurant and bar. In the large garden there is covered seating. Q ➤ ✿ ◑ ● P ☐ (197) ✿ ☎

Wainscott

Crafty Fox
1 Hollywood Lane, ME3 8AG
☎ (01634) 921088
3 changing beers (sourced regionally; often Goacher's, Ramsgate) Ⓗ /Ⓖ
This friendly recently-reopened two-roomed pub is set on the site of the old working men's club. Popular with real ale drinkers, the front bar has a log burner to keep customers warm on cold days and the large rear room has a dartboard and various board games. There is a small outside seating area to the front.
➤ ✿ & ♣ ● P ☐ (191) ✿

Walmer

Berry ☏ Ⓛ
23 Canada Road, CT14 7EQ
☎ (01304) 362411 ● theberrywalmer.co.uk
Harvey's Sussex Best Bitter; Oakham Citra; Thornbridge Jaipur IPA; 12 changing beers (often Ramsgate, Time & Tide) Ⓗ
A multi award-winning alehouse with a warm welcome and friendly service located off Walmer seafront. The bar has a light and airy feel and at the back is a pleasant patio. There is plenty of choice of quality ales and ciders, with up to 11 cask beers, seven KeyKeg ales (many from Time & Tide), and more than 12 ciders. Three beer festivals are hosted annually. Events include monthly quizzes, live music and pop-up food nights. There is a free car park opposite. ➤ ✿ ● ● ☐ ✿

Freed Man Ⓛ
329 Dover Road, CT14 7NX
☎ (01304) 364457 ● thefreed-man.co.uk
4 changing beers Ⓗ
This pub with a micropub atmosphere offers everything for the discerning drinker. The decor is cosy and warm with nautical memorabilia covering the reclaimed-wood walls. Up to four real ales, predominantly from local breweries, are served from the Victorian beer engine. Alongside these are real ciders, wines, selected spirits and authentic draught and bottled European lagers. Food can be brought in and the staff will provide plates and cutlery. Regular events include a Thursday ladies' night and monthly quiz night. Q ➤ ▲ ≥ ♣ ● ☐ ✿ ☎

West Malling

Bull Inn
1 High Street, ME19 6QH
☎ (01732) 842753

Goacher's Gold Star Strong Ale; Timothy Taylor Landlord; Young's London Original; 4 changing beers (sourced nationally; often Goacher's, Musket) Ⓗ
At the north end of the town, near the railway bridge, is this free house with wooden panelling and a real fire. There is a focus on local beers. Good food is served, using locally sourced ingredients whenever possible. A lower priced beer from Musket, Bull's Malling Special, is normally available. The pub hosts a quiz on Monday evening and live music on some Saturdays. To the rear is a pleasant terraced garden with covered seating areas for outdoor drinking. Q ➤ ✿ ◑ ● ☐ (72,151) ✿ ☎

Malling Jug
52 High Street, ME19 6LU (in narrow alley opp Swan St, between funeral directors and charity shop)
☎ (01732) 667832
Kent Session Pale; 6 changing beers (sourced nationally; often Goacher's, Kent, Tiny Rebel) Ⓖ
A small stylish modern pub down an alleyway off the High Street. Current and forthcoming beers are shown on a board near the bar and on clipboards dotted around. Various bottled and canned beers mainly from the UK, USA and Belgium are listed. A periodic table of beer styles helps you find your preferred style. There are no electronic machines though some quiet music may be played. Snacks are served to accompany the drinks, with table service available at busy times.
Q ✿ & ≥ ● ☐ (72,151) ✿

Westerham

Real Ale Way Ⓛ
23 High Street, TN16 1RA
☎ 07838 786576
Larkins Pale; house beer (by Tonbridge); 3 changing beers (sourced locally; often Goody, Kent, Tonbridge) Ⓖ
A keen supporter of Kentish ales, ciders and wines, this friendly, family-run micropub and free house offers a cottage-style ambience in the centre of town. The choice of drinks is prominently displayed by the bar and served from a cooled room behind. Live music plays on the final Wednesday of each month – check the Facebook page for vinyl nights. A good bus service connects it to its sister pub of the same name in Hayes, so why not visit both? Q ➤ ● ☐ ✿ ☎

Westgate-on-Sea

Bake & Alehouse
21 St Mildred's Road, CT8 8RE
☎ 07913 368787 ● bakeandalehouse.com
5 changing beers Ⓖ
A welcoming micropub situated down the alleyway between the Carlton Cinema and a bookmakers, this is an oasis for the local real ale drinker. A selection of around five ever-changing beers, sourced mainly from Kentish breweries, is served straight from the barrel kept in a temperature-controlled room alongside a range of Kentish ciders. With seating for around 20 people, the small interior has been managed well, creating a welcoming, friendly atmosphere. Locally produced cheese and pork pies are also available. Local CAMRA Pub of the Year 2019 and 2020. Q ◑ ≥ ♣ ● ☐ ✿

Whitstable

Handsome Sam ⓛ

3 Canterbury Road, CT5 4HJ
☎ 07947 984991
4 changing beers (sourced locally; often Angels and Demons, Four Candles, Pig & Porter) Ⓖ
Popular micropub named after the original owner's late cat, just outside the town centre and 10-minutes walk from the railway station. The high-ceilinged pub has original exposed beams, the walls are adorned with modern art and guitars, and the bay windows with hops. Three or more beers always include a pale ale, a bitter and an IPA. Ales are all from any of 16 different Kent breweries. The draught cider is from Biddenden.
Q☆常●🛈🚊🐾

Ship Centurion ⓛ ✅

111 High Street, CT5 1AY
☎ (01227) 264740
Adnams Southwold Bitter; 4 changing beers (sourced regionally; often Canterbury Ales, Goacher's, Ramsgate) Ⓗ
A friendly and traditional town-centre pub. Colourful hanging baskets add to its charm in summer, and pictures of Whitstable are displayed in the bar. A Kentish beer is always served. Home-cooked bar food includes authentic German dishes. A roast is served on Sundays. Live music plays on Thursday evenings (except in January). A good place to watch sport on Sky and BT.
☆◐常♣●🚊🐾🛜

Twelve Taps

102 High Street, CT5 1AZ
☎ (01227) 770777 ⊕ thetwelvetaps.co.uk
12 changing beers (sourced regionally; often Buxton, Pig & Porter, Wild Beer) Ⓚ
Craft beer bar decorated in warm colours with wooden floors and a pleasant suntrap courtyard. Twelve KeyKeg beers are served – try a sample paddle of three beers to find your favourites. Many artisan gins, including the in-house Whitstable Gin, are also available, plus interesting soft drinks, snacks and cocktails. Look out for the drag bingo night on the last Tuesday of the month. Check Twitter for the winner of the dog of the day award. Open on bank holiday Mondays. ☆🐾♿常🚊🐾🛜

Wingham

Anchor Inn ⓛ ✅

High Street, CT3 1BJ
☎ (01227) 720392 ⊕ theanchoratwingham.com
Harvey's Sussex Best Bitter; 3 changing beers (often Ramsgate, Sharp's, Timothy Taylor) Ⓗ
This family-run, traditional inn has a welcoming environment, with its rambling interior, dark beams and wooden floors. Multiple awards attest to the effort that has gone into running it. There are three real ales, usually including one from Kent. The menu features traditional pub food, fish, sandwiches and Sunday roasts. Events include live music, quiz nights, clubs, social and charity activities. The function room/arts centre doubles as a community resource and the large garden has bat and trap and pétanque pitches.
☆🐾◐♣P🚊(11,43)🐾🛜

Breweries

Amazing

🏠 Ship Inn, 65 High Street, Sandgate, Kent, CT20 3AH
☎ (01303) 248525

⊗ Amazing was set up in 2016 using a four-barrel plant and is situated at the Ship Inn, Sandgate. The pub and local beer festivals are supplied. The brewery can be viewed from inside the pub. ‼

Angels & Demons

Great Cauldham Farm, Cauldham Lane, Capel-le-Ferne, Folkestone, Kent, CT18 7HQ
☎ (01303) 255666 ⊕ fantasticbeer.co.uk

Brewing began in 2016 using a 20-barrel plant. The brewery produces two ranges of beers, the McCanns range of traditional ales and the Angels & Demons range of more experimental brews.

Bombay Social (ABV 3.8%) PALE
Racing Tiger (ABV 4.2%) SPECIALITY
Panama Jazz (ABV 4.8%) RED
I Spy Dragonfly (ABV 5%) GOLD
ADH Me (ABV 5.2%) PALE
Goldilocks is Dead (ABV 5.3%) GOLD
Black Taxi to the Moon (ABV 5.4%) SPECIALITY

Brewed under the McCanns brand name:
Harry Hop (ABV 3.7%) BITTER
Folkestone Best (ABV 4%) BITTER
Hockley Soul (ABV 4.2%) STOUT

Boutilliers

The Hop Shed, Macknade Fine Foods, Selling Road, Faversham, Kent, ME13 8XF ☎ 07743 372434
⊕ boutilliers.com

Founded in 2016, Boutilliers is a small brewery specialising in left field brews. Its beers are mainly bottled or canned. Cask-conditioned beers are supplied to a few local pubs and are sometimes available at the brewery on open days. 🚚♦LIVE

Breakwater

St Martin's Yard, Lorne Road, Dover, Kent, CT16 2AA
☎ (01304) 410144 ☎ 07979 867045
✉ andrea@breakwater.brewery.co.uk

⊗ Brewery and taproom run on micro-pub lines behind Buckland Corn Mill in former industrial premises and on site of the former Wellington Brewery. Outside drinking area now covered. ♦LIVE 🌿

Dover Pale Ale (ABV 3.5%) BITTER
East Kent Gold (ABV 4.2%) GOLD
Red Ensign (ABV 4.2%) BITTER
Blue Ensign (ABV 4.3%) BITTER
Cowjuice Milk Stout (ABV 4.4%) STOUT
American Pale Ale (ABV 5%) PALE

By The Mile

Broadstairs, Kent, CT10 1SL ☎ 07900 954680
✉ jon@bythemilebrewery.co.uk

⊗ By the Mile began brewing in 2016 in domestic premises. Brewing is currently suspended.

Canterbury Ales SIBA

Canterbrew Ltd, Unit 7 Stour Valley Business Park, Ashford Road, Chartham, Kent, CT4 7HF

☎ (01227) 732541 ☎ 07944 657978
⊕ canterbury-ales.co.uk

⊠ Brewing commenced in 2010. An eight-barrel plant is used. ‼♦

The Wife of Bath's Ale (ABV 3.9%) GOLD
A golden beer with strong bitterness and grapefruit hop character, leading to a long, dry finish.
The Reeve's Ale (ABV 4.1%) BITTER
The Miller's Ale (ABV 4.5%) RED

Canterbury Brewers SIBA

🯅 Foundry Brew Pub, 77 Stour Street, Canterbury, Kent, CT1 2NR
☎ (01227) 455899 ⊕ thefoundrycanterbury.co.uk

⊠ Canterbury Brewers started in the Foundry Brewpub in the heart of Canterbury in 2011. The eight-barrel plant is purpose-built. Popular events are held there including the Kent Green Hop Festival (late September/early October). A wide range of spirits are now distilled in the brewpub, and three ciders are produced. ‼♦LIVE ✦

Constellation SIBA

Unit 21, Orchard Business Centre, Sanderson Way, Tonbridge, Kent, TN9 1QF
☎ (01732) 756564 ⊕ constellationbrewery.co.uk

From a nascent idea in 2019 to a fully formed brewery in 2020, Constellation is a 30-barrel brewery in the heart of Tonbridge. Owner/brewer Rob Jenner has over 10 years brewing experience. In addition to cask, beers are available in can and keg.

Indus (ABV 3.9%) PALE
Draco (ABV 4.2%) BITTER
Aquila (ABV 4.6%) GOLD

Curious

Unit 1, Victoria Road, Ashford, TN23 7HQ
☎ (01580) 763033

Office: Level 2, Civic Centre, Tannery Lane, Ashford, TN23 1PL ⊕ curiousbrewery.com

⊠ Situated next to Ashford International Railway Station, this multi-million pound investment by parent company Chapel Down, opened in 2019. It is a modern, state-of-the-art brewery, with a shop, tasting room (ground floor), bar and 120-seater restaurant (upstairs) featuring the Curious Brew core range, and special/seasonal brews. Products are widely available in keg, bottle and can (previously contract brewed). Fresh unpasteurised, filtered beer from the brewery is served from tanks above the bar. Tours and tastings offered. ‼🍽✦

Dartford Wobbler

St Margaret's Farm, St Margaret's Road, South Darenth, Kent, DA4 9LB
☎ (01322) 866233 ⊕ dartfordwobbler.com

☺John and Miriam Millis started with a 0.5-barrel plant at their home in Gravesend. Demand outstripped the facility, and the brewery moved in 2003 to its current location – a former farm cold store – using a 10-barrel plant. It supplies around 40 outlets within a 50-mile radius. 🍽♦LIVE

Curiously Dark (ABV 3.6%) MILD
Guinea Guzzler (ABV 3.7%) MILD
Peddlars Best (ABV 4%) BITTER
Golden Wobbler (ABV 4.1%) GOLD
Dartford Wobbler (ABV 4.3%) BITTER
Thieves & Fakirs (ABV 4.3%) PORTER

Penny Red (ABV 4.4%) RED
Country Wobbler (ABV 4.8%) BITTER

Farriers Arms

🯅 The Forstal, Mersham, Kent, TN25 6NU
☎ (01233) 720444 ⊕ thefarriersarms.com

Brewing commenced in 2010 in this brewpub owned by a consortium of villagers. ‼♦

Fonthill

🯅 c/o George, 29 Mount Ephraim, Tunbridge Wells, Kent, TN4 8AA
☎ (01892) 539492
⊕ thegeorgepubtunbridgewells.co.uk

⊠ Fonthill is a small-batch brewery located in the George pub. Beers are available in the pub as well as its two sister pubs in Tunbridge Wells.

Four Candles

🯅 1 Sowell Street, St Peters, CT10 2AT ☎ 07947 062063 ⊕ thefourcandles.co.uk

⊠ Based in the cellar of the micropub of the same name, Four Candles uses a 2.5-barrel plant and produces up to 10 nine-gallon casks with each brew. Never brewing the same ale twice, the brewery supplies the micropub, which is named after the well known Two Ronnies sketch. ‼

Goacher's

Unit 8, Tovil Green Business Park, Burial Ground Lane, Tovil, Maidstone, Kent, ME15 6TA
☎ (01622) 682112 ⊕ goachers.com

A traditional brewery that uses only malt and Kentish hops for all its beers. Phil and Debbie Goacher have concentrated on brewing good, wholesome beers without gimmicks. Two tied houses and around 30 free trade outlets in the mid-Kent area are supplied. Special is brewed for sale under house names. ‼♦

Real Mild Ale (ABV 3.4%) MILD
A rich, flavourful mild with moderate roast barley and a generous helping of chocolate malt.
Fine Light Ale (ABV 3.7%) BITTER
A pale, golden brown bitter with a strong, floral, hoppy aroma and aftertaste. A hoppy and moderately malty session beer.
Special/House Ale (ABV 3.8%) BITTER
Best Dark Ale (ABV 4.1%) BITTER
Dark in colour but light and quaffable in body. This ale features hints of caramel and chocolate malt throughout.
Crown Imperial Stout (ABV 4.5%) STOUT
A good, well-balanced, roasty stout, dark and bitter with just a hint of caramel and a lingering creamy head.
Gold Star Strong Ale (ABV 5.1%) BLOND

Goody SIBA

Bleangate Brewery, Braggs Lane, Herne, Kent, CT6 7NP
☎ (01227) 361555 ⊕ goodyales.co.uk

Goody Ales began brewing in 2012 using a 10-barrel plant. A wood-burning boiler is used to heat the water for the brews using wood from its copse, thereby minimising the use of non-renewable fuel. An on-site bar and shop, the Cathedral, is open (limited hours). ♦LIVE ✦

Good Evening (ABV 3.4%) MILD
Genesis (ABV 3.5%) RED

Good Health (ABV 3.6%) BITTER
Good Life (ABV 3.9%) BLOND
Good Heavens (ABV 4.1%) BITTER
Good Sheppard (ABV 4.5%) BITTER
Goodness Gracious Me (ABV 4.8%) BITTER
Good Lord (ABV 5%) PORTER

Hildenborough

8 Birch Close, Hildenborough, Kent, TN11 9DU
☎ 07557 117078 ⊕ hildenboroughbrewery.com

Formed in 2018 after owner and brewer Gregg Ellar left investment banking to turn his brewing hobby into a business. All beers are brewed, bottled and labelled by hand, and the home-based nano kit, containing many components built by the brewer himself, claims to be the smallest commercial brewery in the UK. All beers are bottle-conditioned and sold direct to local customers via the website and nearby farmers' markets. ♦LIVE

Hinks

1 Dimon Villas, Hamstreet Road, Ruckinge, Kent, TN26 2NT ☎ 07518 569041

A nanobrewery established in 2018.

Hop Fuzz SIBA

Unit 8, Riverside Industrial Estate, West Hythe, Kent, CT21 4NB ☎ 07858 562878/ 07730 768881
⊕ hopfuzz.co.uk

Hop Fuzz was started by two friends in 2011. It is situated on an industrial estate next to the Royal Military Canal at West Hythe. The brewery delivers bottles, minikegs and cans within 20 miles. The Unit 1 microbar, on the same estate, has been community-owned and run since 2019. ♦

Martello (ABV 3.8%) RED
American (ABV 4.2%) GOLD
Bullion (ABV 5%) BLOND

Hopdaemon SIBA

Unit 1, Parsonage Farm, Seed Road, Newnham, Kent, ME9 0NA
☎ (01795) 892078 ⊕ hopdaemon.com

Tonie Prins originally started brewing in Tyler Hill near Canterbury in 2000 and moved to a new site in Newnham in 2005. The brewery currently supplies more than 100 outlets. !!♦LIVE

Golden Braid (ABV 3.7%) BITTER
A refreshing, golden, session bitter with a good blend of bittering and aroma hops underpinned by pale malt.
Incubus (ABV 4%) BITTER
A well-balanced, copper-hued best bitter. Pale malt and a hint of crystal malt are blended with bitter and slightly floral hops to give a lingering, hoppy finish.
Skrimshander IPA (ABV 4.5%) BITTER
Green Daemon (ABV 5%) SPECIALITY
Leviathan (ABV 6%) BITTER

Iron Pier SIBA

Units 6 & 7, May Industrial Estate, May Avenue, Northfleet, Gravesend, Kent, DA11 8RU
⊕ ironpier.beer

⊗ Iron Pier Brewery was established in 2017 using a 15-barrel plant. It takes its name from the oldest iron pier in existence residing on the River Thames at Gravesend. An onsite taproom offers the brewery's beers plus other local brews. !!♦⚒

Perry St Pale (ABV 3.7%) GOLD
Joined at the Hop Pale Ale (ABV 3.8%) GOLD
Bitter (ABV 4%) BITTER
Wealdway (ABV 4.5%) GOLD
Cast Iron Stout (ABV 4.7%) STOUT
Rosherville Red (ABV 4.8%) RED
Porter (ABV 5.3%) PORTER

Isla Vale

Margate, Kent, CT9 5DJ
☎ (01843) 292451 ☎ 07980 174616
⊕ islavalealesmiths.co.uk

⊗ Isla Vale was established in 2014 from a residential address in Westbrook (Margate) and supplies local micropubs. A one-barrel plant is used to brew its core range as well as a specially commissioned beer for the Wheel Alehouse, Birchington. Outlets are supplied locally. ♦

Kent SIBA

The Long Barn, Birling Place Farm, Stangate Road, Birling, Kent, ME19 5JN
☎ (01634) 780037 ⊕ kentbrewery.com

⊗ Kent Brewery was founded in 2010 by Toby Simmonds (ex-brewer from Dark Star) and Paul Herbert. A 10-barrel plant has been in operation at the Birling site since 2011. More than 300 outlets are supplied direct, mainly throughout Kent, Sussex and London. A dozen regular beers are produced plus a constantly changing list of specials. House beers are also brewed for The Craft Beer Co pubs. Casks are also sold thoughout the UK and abroad, particularly in Sweden and Finland. ♦LIVE

Session Pale (ABV 3.7%) PALE
Black Gold (ABV 4%) PALE
Pale (ABV 4%) PALE
Cobnut (ABV 4.1%) BITTER
Golding Bitter (ABV 4.1%) BITTER
Zingiber (ABV 4.1%) SPECIALITY
Quiet American (ABV 4.2%) GOLD
Single Hop (ABV 4.5%) GOLD
Stout (ABV 4.5%) STOUT
Prohibition (ABV 4.8%) PALE
The New Black (ABV 4.8%) PALE
Tropic Ale (ABV 4.9%) PALE
Brewers Reserve (ABV 5%) GOLD

Koomor

New Dartford Sports Bar, 13 Spital Street, Dartford, Kent, DA1 2DJ

Formed in 2020, the brewery now cuckoo brews at various locations, however, initial brews were conducted in the cellar of the Dartford Sports Bar. Koomor produce cask and bottled beers, currently only for the local area. The beers are all vegan and utilise whole hops from Kent, and may be cloudy. V

Trunk (ABV 3.8%) BITTER
Branch (ABV 4.2%) GOLD
Earth (ABV 4.8%) PORTER
Petal (ABV 4.8%) PALE

Larkins SIBA

Larkins Farm, Hampkins Hill Road, Chiddingstone, Kent, TN8 7BB
☎ (01892) 870328 ⊕ larkinsbrewery.co.uk

⊗ Larkins brewery was founded by the Dockerty family in Rusthall in Kent in 1986, on the site of the original Royal Tunbridge Wells Brewery. In 1988 the brewery

relocated to Larkins Farm in Chiddingstone. All beers include hops grown on a four-acre site near Larkins Farm and are brewed with its own yeast strain. The brewery delivers direct to around 40-50 pubs and restaurants within a 20-mile radius. ‼♦

Traditional Ale (ABV 3.4%) BITTER
Pale (ABV 4.2%) PALE
Best (ABV 4.4%) BITTER
Full-bodied, slightly fruity and unusually bitter for its gravity.

Mad Cat SIBA

Brogdale Farm, Brogdale Road, Faversham, Kent, ME13 8XZ
☎ (01795) 597743 ☎ 07960 263615
⏚ madcatbrewery.co.uk

⊗ Established in 2012 by Peter Meaney in a refurbished cold store using an eight-barrel plant. Beers are distributed to local pubs. Bottles and polypins are available from the brewery and Peter often attends local markets, festivals and events. ‼♦

Red Ale (ABV 3.9%) RED
Crispin Ale (ABV 4%) BLOND
Golden IPA (ABV 4.2%) PALE
Platinum Blonde (ABV 4.2%) BLOND
Emotional Blackmail (ABV 4.5%) SPECIALITY
Jet Black Stout (ABV 4.6%) STOUT

MootBrew (NEW)

Court Farm, Pilgrims Road, Upper Halling, Kent, ME2 1HR ⏚ mootbrew.co.uk

An independent microbrewery in the heart of Kent. A brewery and onsite taproom are being built but at present beers are cuckoo brewed in partnership with the London Beer Lab in Brixton.

Musket SIBA

Unit 7, Loddington Farm, Loddington Lane, Linton, Kent, ME17 4AG
☎ (01622) 749931 ☎ 07967 127278
⏚ musketbrewery.co.uk

Launched in 2013 with a five-barrel plant, this family-owned brewery is based at Loddington Farm, Linton, in the heart of the Kent countryside. Expanding to a 15-barrel plant with on-site brewery tap, Musket Brewery now supplies more than 300 pubs, micropubs and clubs throughout Kent and Medway. ♦♦

Trigger (ABV 3.6%) BLOND
Fife & Drum (ABV 3.8%) BLOND
Matchlock (ABV 3.8%) MILD
Ball Puller (ABV 4%) BITTER
Flintlock (ABV 4.2%) BITTER
Muzzleloader (ABV 4.5%) SPECIALITY

Nelson SIBA

Unit 2, Building 64, The Historic Dockyard, Chatham, Kent, ME4 4TE
☎ (01634) 832828 ⏚ nelsonbrewery.co.uk

⊚Nelson have been in the Historic Dockyard, Chatham since 1995. Nelson supplies over 350 outlets across the country, thanks in part, to a deal with a national courier. It also carries out brewery swaps. Home to the Gemstone Ales range, whose beers are supplied to its own pub, the Fisherman's Arms, Maidstone, as well as in the free trade. All ales can be supplied bottle-conditioned, in cans, kegs, polypins, and cask. ‼ ╦♦LIVE ♦

Sirius Session Pale (ABV 3.7%) BLOND
Admiral IPA (ABV 4%) BITTER
Midshipman Dark Mild (ABV 4%) MILD
Trafalgar Bitter (ABV 4.1%) BITTER
Buccaneer Pale Ale (ABV 4.2%) PALE
Silver EPA (ABV 4.2%) GOLD
Powder Monkey (ABV 4.3%) BITTER
Friggin' in the Riggin' (ABV 4.5%) BITTER
Pursers Pussy Porter (ABV 4.8%) PORTER
Nelsons Blood (ABV 6%) BITTER

No Frills Joe

50 Wakefield Road, Greenhithe, Kent, DA9 9JE
☎ 07516 725577

⊗ Unpasteurised, unfiltered, and unfined vegan beers are produced on a small five-barrel plant, and may be cloudy. The range is available in a small on-site taproom (check social media), and pubs nationwide. Up to eight different beers are available in cans. LIVE V♦

Candy Soup (ABV 4.5%) GOLD
Dreamland IPA (ABV 4.5%) GOLD
Lockdown Joe (ABV 4.8%) GOLD
Joe Solo Pale Ale (ABV 5.5%) GOLD

Northdown SIBA IFBB

Unit J1C/A, Channel Road, Westwood Industrial Estate, Margate, Kent, CT9 4JS ☎ 07791 441219
⏚ northdownbrewery.co.uk

⊗ Northdown began brewing in 2018 using a seven-barrel plant. It is run by Jonny and Katie Spanjar and takes its name from their original intention to run out of the Northdown area of Margate. The origins of a Northdown brewery date back to the 1600s. ‼╦♦LIVE ♦

Dune Buggy (ABV 3.8%) IPA
Bitter Seas (ABV 4%) BITTER
Pale Ale Mary (ABV 4%) BITTER
Reginald Perrin (ABV 4%) BLOND
Tidal Pool (ABV 4.6%) PALE
Easterly (ABV 6%) IPA

Old Dairy SIBA

Tenterden Station Estate, Station Road, Tenterden, Kent, TN30 6HE
☎ (01580) 763867 ⏚ olddairybrewery.com

⊗ Old Dairy was founded in 2009. It relocated from Rolvenden in 2014 to larger premises near the Kent & East Sussex Railway in Tenterden in order to increase capacity. A taproom and beer garden along with the brewery shop are open seven days a week. ‼╦♦LIVE ♦

Red Top (ABV 3.8%) BITTER
A sweetish, copper-coloured bitter with hints of caramel and a subtle hop character.
Uber Brew (ABV 3.8%) PALE
Copper Top (ABV 4.1%) BITTER
Blue Top (ABV 4.8%) PALE
Rich and full-bodied, this pale brown ale has a long bittersweet finish and a hint of aroma hop.

Pig & Porter

9 Chapman Way, Tunbridge Wells, Kent, TN2 3EF
☎ (01892) 615071 ⏚ pigandporter.co.uk

⊗ Originally brewing at several microbreweries in Sussex and Kent, brewing has taken place on its own plant in Tunbridge Wells since 2013, using a 10-barrel plant. ♦

Farmboy's Wages (ABV 3.8%) PALE

Blackbird (ABV 4%) STOUT
Skylarking (ABV 4%) PALE
Slave to the Money (ABV 4.1%) BITTER
Stone Free (ABV 4.3%) PALE
Got the Face On (ABV 4.5%) PALE
Jumping Frog (ABV 4.5%) PALE
All These Vibes (ABV 5.3%) PALE

Ramsgate (Gadds') SIBA

1 Hornet Close, Pyson's Road Industrial Estate,
Broadstairs, Kent, CT10 2YD
☎ (01843) 868453 ⊕ ramsgatebrewery.co.uk

Ramsgate was established in 2002 at the back of a
Ramsgate seafront pub. In 2006 the brewery moved to
its current location, allowing for increased capacity and
bottling. A 25-hectolitre brew plant is used. ‼☞♦

Gadds' Hoppy Pale (ABV 3.6%) BLOND
Gadds' No. 7 Bitter Ale (ABV 3.8%) BITTER
Gadds' Seasider (ABV 4.3%) BITTER
Gadds' No. 5 Best Bitter Ale (ABV 4.4%) BITTER
Gadds' She Sells Sea Shells (ABV 4.7%) GOLD
Gadds' No. 3 Kent Pale Ale (ABV 5%) BLOND
Gadds' Faithful Dogbolter Porter (ABV 5.6%)
PORTER
Gadds' Black Pearl (ABV 6.2%) STOUT

Rockin' Robin

c/o Old Dairy Brewery, Tenterden Station Estate,
Station Road, Tenterden, Kent, TN30 6HE ☎ 07787
416110/ 07779 986087

Office: 6 Pickering Street, Loose, ME15 9RS
✉ sales@rockinrobinbrewery.co.uk

Brewing began in 2011 using a one-barrel plant in a
garden shed in Loose. It moved to Boughton Monchelsea
in 2014, and in 2019 began cuckoo brewing at Old Diary.

Reliant Robin (ABV 3.7%) BITTER

Romney Marsh

Unit 7, Jacks Park, Cinque Ports Road, New Romney,
Kent, TN28 8AN
☎ (01797) 362333 ⊕ romneymarshbrewery.com

⊠ Romney Marsh Brewery launched in 2015. The team
consists of husband and wife, Matt Calais and Cathy
Koester, plus Matt's dad, Brian Calais. The barley, wheat
and oats used for the beers are sourced in Britain, and
hops are worldwide. Beer is supplied to outlets
throughout Kent and East Sussex, plus cases of bottled
beers can also be ordered online for nationwide delivery.
‼☞LIVE

Romney Best Bitter (ABV 4%) BITTER
Romney Amber Ale (ABV 4.4%) PALE
Marsh Sunset (ABV 4.8%) RED
Romney APA (ABV 5%) PALE

Running Man

26 Greenway, Davis Estate, Chatham, Kent, ME5 9UX

Running Man began brewing in 2018.

Shepherd Neame IFBB

17 Court Street, Faversham, Kent, ME13 7AX
☎ (01795) 532206 ⊕ shepherdneame.co.uk

⊠ Shepherd Neame traces its history back to at least
1698, making it the oldest continuous brewer in the
country. The company has around 300 tied houses in the
South-East, nearly all selling cask ale. More than 2,000

other outlets are also supplied by this independent
family brewer. The cask beers are made with mostly
Kentish hops, and water from the brewery's own artsian
well. The Cask Club offers a new and different cask ale
every month or so. ‼☞♦LIVE

Master Brew (ABV 3.7%) BITTER
A distinctive bitter, mid-brown in colour, with a hoppy
aroma. Well-balanced, with a nicely aggressive bitter
taste from its hops, it leaves a hoppy/bitter finish, tinged
with sweetness.
Whitstable Bay Pale Ale (ABV 3.9%) PALE
Spitfire (ABV 4.2%) BITTER
Malty caramel with bitter hops and caramelised fruit and
citrus flavours. Spiciness builds and remains in the hoppy,
dry finish.
Bishops Finger (ABV 5%) BITTER

Shivering Sands (NEW)

91 Maple Leaf Business Park, Manston, Kent,
CT12 5GD ☎ 07805 061343
⊕ shivering-sands-brewery.business.site

Established in 2020, just as Covid hit. Situated in an
industrial estate outside the airfield at Manston, near
Ramsgate, it uses an eight-barrel plant, brewing once a
week. Its onsite taproom is open on Saturdays and at
other times by arrangement. ♦

Spring Tide (ABV 3.8%) PALE
Maunsell (ABV 4%) BITTER
Estuary Porter (ABV 4.1%) STOUT
Golden Sands (ABV 4.5%) PALE
Knock John (ABV 4.5%) BITTER
Ribersborg Stout (ABV 40.7%) STOUT

Stag

Little Engeham Farm, Woodchurch, Kent, TN26 3QY
☎ 07539 974068 ⊕ stagbrewery.co.uk

Stag began brewing in 2016.

Jane Doe (ABV 4%) BITTER
Screaming Sika (ABV 5%) GOLD

Swan on the Green

⬛ Swan on the Green, West Peckham, Maidstone,
Kent, ME18 5JW
☎ (01622) 812271 ⊕ swan-on-the-green.co.uk

⊠ The brewery was established in 2000 in an old coal
shed behind the Swan on the Green pub using a two-
barrel plant. ‼♦

Time & Tide

Statenborough Farm, Felderland Lane, Deal, Kent,
CT14 0BX ☎ 07739 868256
⊕ timeandtidebrewing.co.uk

This award-winning brewery began brewing in 2013. It
produces a number of cask beers using hops from the
Deal Community Hop Farm. To date over 13 varieties of
beer have been produced. In addition to these, KeyKeg
and canned beers are produced, some of which are
barrel-aged, ranging through IPAs, stouts, sours, lagers
and mild. ☞♦LIVE

Bitter (ABV 4%) BITTER
Green Hop (ABV 4.8%) BLOND
ESB (ABV 5.8%) BITTER

Tír Dhá Ghlas

⊟ Cullins Yard, 11 Cambridge Road, Dover, Kent,
CT17 9BY
☎ (01304) 211666 ⊕ cullinsyard.co.uk

⊗ Brewing began in 2012 using a two-barrel plant.
Beers are only available in the bar/restaurant and
occasionally at the nearby Royal Cinque Ports Yacht Club.

Tonbridge SIBA

Unit 19, Branbridges Industrial Estate, East Peckham,
Kent, TN12 5HF
☎ (01622) 871239 ⊕ tonbridgebrewery.co.uk

⊗ Tonbridge Brewery was launched in 2010 using a
four-barrel plant, expanding to a 12-barrel one in 2013. It
supplies pubs, clubs and restaurants throughout Kent,
East Sussex and South-East London. While cask-
conditioned beer remains its core focus, the brewery
started bottling and canning, which has expanded its keg
range. It continues using the live yeast which originated
from Barclay Perkins of Southwark. While the range has
expanded to include hops from Europe, North America
and New Zealand, the majority are still sourced in Kent.

Golden Rule (ABV 3.5%) GOLD
Traditional Ale (ABV 3.6%) BITTER
Coppernob (ABV 3.8%) BITTER
Countryman (ABV 4%) BITTER
Rustic (ABV 4%) MILD
Blonde Ambition (ABV 4.2%) BLOND
Old Chestnut (ABV 4.4%) BITTER
American Pale (ABV 5%) PALE
Velvet Raven (ABV 5.2%) STOUT

Wantsum SIBA

Kent Barn, St Nicholas Court Farm, Court Road, St
Nicholas at Wade, Kent, CT7 0PT
☎ (01227) 910135 ⊕ wantsumbrewery.co.uk

⊗ Wantsum Brewery, established by James Sandy in
2009, takes its name from the nearby Wantsum Channel.
Located in St Nicholas at Wade just outside Canterbury.
Wantsum brews a wide range of traditional and modern
craft ale styles packaged in cask, keg, minikegs, polypins,
bottles and cans, supplied to outlets throughout the
south of England. An on-site taproom/shop showcases a
wide selection of the beers. It has an online shop which
ships nationwide. ‼ ⬛ ◆ LIVE ◆

More's Head (ABV 3.7%) SPECIALITY
Ruby golden brown beer with fruity American hops and
rye.
1381 (ABV 3.8%) PALE
Black Prince (ABV 3.9%) MILD
Imperium (ABV 4%) BITTER
Montgomery (ABV 4%) PALE
An amber-coloured, light, easy, summer session beer
with American hops that are light and refreshing. Spicy
finish. Simcoe, Columbus, Centennial hops.
One Hop (ABV 4.2%) GOLD
Dynamo (ABV 4.3%) GOLD
Turbulent Priest (ABV 4.4%) BROWN
Hurricane (ABV 4.5%) GOLD

Fortitude (ABV 4.6%) BITTER
Black Pig (ABV 4.8%) PORTER
Black porter with sweet aroma. The flavour is of sweet
malt, roasty chocolate and fruit that fades in the finish.
Golgotha (ABV 5.5%) STOUT
Smooth, rich dry roasty stout with dark fruits and malt
throughout.
Ravening Wolf (ABV 5.9%) SPECIALITY

Westerham SIBA

Beggars Lane, Westerham, Kent, TN16 1QP
☎ (01732) 864427 ⊕ westerhambrewery.co.uk

⊗ Having moved in 2017 to a new, purpose-built
brewery, Westerham opened a taproom with 12 taps
serving beer straight from the maturation tank. The
brewery benefits from the supply of Greensand aquifer
water from an on-site borehole. It also utilises original
heritage yeasts from the former Black Eagle Brewery,
thus maintaining a link to the Kent style of the past. More
than 500 outlets are supplied in Kent, Surrey, Sussex and
London. ‼ ⬛ ◆ LIVE ◆

Grasshopper Kentish Bitter (ABV 3.8%) BITTER
Summer Perle (ABV 3.8%) BITTER
Spirit of Kent (ABV 4%) GOLD
British Bulldog (ABV 4.1%) BITTER
1965 – Special Bitter Ale (ABV 4.8%) BITTER
Audit Ale (ABV 6.2%) BITTER

Whitstable SIBA

Little Telpits Farm, Woodcock Lane, Grafty Green,
Kent, ME17 2AY
☎ (01622) 851007 ⊕ whitstablebrewery.co.uk

Whitstable Brewery was founded in 2003. It currently
provides all the beer for the Whitstable Oyster
Company's three restaurants, its hotel and a brewery tap,
as well as supplying pubs all over Kent, London and
Surrey. ◆

Native Bitter (ABV 3.7%) BITTER
A classic, copper-coloured, Kentish session bitter with
hoppy aroma and a long, dry, bitter hop finish.
Renaissance Ruby Mild (ABV 3.7%) MILD
East India Pale Ale (ABV 4.1%) PALE
A well-hopped golden ale with good grapefruit aroma
hop character and lingering bitter finish.
Oyster Stout (ABV 4.5%) STOUT
Pearl of Kent (ABV 4.5%) BLOND
Winkle Picker (ABV 4.5%) BITTER
Kentish Reserve (ABV 5%) BITTER

XYLO

⊟ Unit 1, 2-14 High Street, Margate, Kent, CT9 1AT
☎ (01843) 229403 ⊕ xylobrew.com

Neil Wright and Ben Atkins set up the XYLO brewery and
pub in 2019 using a four-barrel brew plant built in the
pub cellar. Keg and canned beer only at the moment. ‼

Join CAMRA

The Campaign for Real Ale has been fighting for more than 50 years to save Britain's
proud heritage of cask-conditioned ales, independent breweries, and pubs that offer a
good choice of beer. You can help that fight by joining the campaign:
see www.camra.org.uk

OXFORDSHIRE

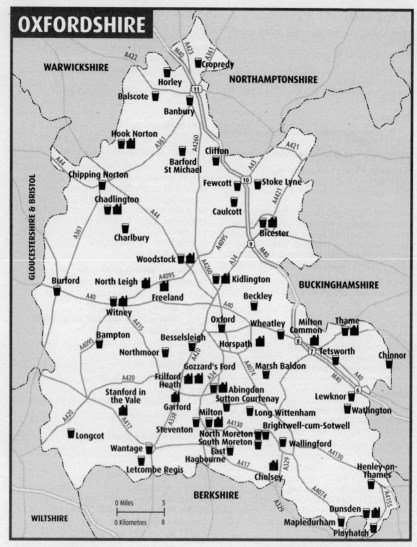

WARWICKSHIRE

NORTHAMPTONSHIRE

Cropredy

Horley

Balscote

Banbury

Hook Norton

Clifton

Barford
St Michael

Chipping Norton

Fewcott

Stoke Lyne

Chadlington

Caulcott

Charlbury

Bicester

Woodstock

BUCKINGHAMSHIRE

Burford

North Leigh

Kidlington

Beckley

Freeland

Witney

Oxford

Wheatley

Milton
Common

Thame

Bampton

Besselsleigh

Horspath

Tetsworth

Chinnor

Northmoor

Gozzard's Ford

Marsh Baldon

Frilford
Heath

Abingdon

Lewknor

Stanford in
the Vale

Sutton Courtenay

Watlington

Garford

Milton

Long Wittenham

Longcot

Steventon

Brightwell-cum-Sotwell

Wantage

North Moreton
South Moreton

Wallingford

East
Hagbourne

Letcombe Regis

Cholsey

Henley-on-
Thames

BERKSHIRE

Dunsden

Mapledurham

WILTSHIRE

0 Miles 5

0 Kilometres 8

Playhatch

GLOUCESTERSHIRE & BRISTOL

Abingdon

Brewery Tap ⃝

40-42 Ock Street, OX14 5BZ

☎ (01235) 521655 ⊕ thebrewerytap.net

Loose Cannon Bombshell; LoveBeer Doctor Roo; 3 changing beers (sourced locally; often Loddon, White Horse, XT) ⃝

Morland created a tap for its brewery in 1993 from three Grade II-listed town houses. The brewery is no more but the pub, run by the same family since it opened, has thrived. It offers a diverse range of beers, all sourced locally, and hosts two or three beer festivals each year featuring ales from further afield. The pub has three rooms, two of them away from the bar, and a courtyard outside. Regular local CAMRA Town and Village Pub of the Year. Q⃝☼⊛⃝⃝⃝P⃝⃝⃝

Broad Face ⃝

30-32 Bridge Street, OX14 3HR

☎ (01235) 538612

Dark Star Hophead; 5 changing beers (sourced nationally; often Loose Cannon, Morland, White Horse) ⃝

Deceptively large, two-roomed, Grade II-listed pub near the river with a small outside seating area on Thames Street. The building was erected in 1840 but there are records of a pub on the site back to 1734, and possibly before that under a different name. Mystery surrounds the stories behind the pub's unique name, which are written on the outside wall, but omit the most likely explanation – that it was originally called the Saracen's Head and the sign was over-painted. Q⃝☼⊛⃝⃝⃝⃝

Balscote

Butchers Arms ⃝

Shutford Road, OX15 6JQ

☎ (01295) 730750 ⊕ butchers123.site123.me

Hook Norton Hooky; 3 changing beers (sourced nationally) ⃝

Hook Norton beers and a monthly guest are served straight from the cask behind the bar in this cosy parlour

pub. Owned by the brewery since 1878, the building was once an abattoir and still has an ice-house in the garden. Home-made food offerings include an Italian night and Friday catch of the day. The pub hosts a monthly quiz on a Wednesday, and occasional live music. A roaring fire in winter and a lovely beer garden make this an all year destination. Open all day at weekends and from late afternoon Monday-Friday. Q❤️♿🏠🍴♣️🅿️🚃(270)♿

Bampton

Morris Clown

High Street, OX18 2JW
☎ (01993) 850217
2 changing beers (sourced regionally; often Chadlington, North Cotswold, White Horse) Ⓗ

This simply furnished single-bar free house, run by the same family for two generations, features a log fire in winter and some unusual murals on the wall, painted by one of the family depicting other members of the family. The name change by former owners Courage (in 1975 from New Inn) proved controversial as morris dancing teams have a fool, not a clown; this led to a boycott for 25 years. Closed lunchtimes and weekday afternoons. Q❤️♿🏠♣️🍴🅿️🚃♿🛜

Banbury

Coach & Horses

Butchers Row, OX16 5JH
☎ (01295) 266993 ⊕ thecoachandhorsesbanbury.com
Hook Norton Hooky, Off The Hook, Old Hooky; 1 changing beer (sourced locally; often Hook Norton) Ⓗ

Popular town-centre pub that provides an energetic vibe and a comfortable, relaxing space for refreshment and socialising. It serves three or four Hook Norton beers along with ciders and home-made-to-order cocktails. The Coach hosts regular events including a monthly Sunday quiz and live music, notably Banbury Folk Club on Wednesday nights. The locally sourced menu is changed regularly. Alfresco drinking and dining can be enjoyed in the small enclosed beer garden to the rear. Closed Monday. 🏠🍴♿♣️🚋🚃

Exchange ✅

49-50 High Street, OX16 5LA
☎ (01295) 259035
Greene King Abbot; Ruddles Best Bitter; Sharp's Doom Bar; 9 changing beers (sourced nationally) Ⓗ

An imposing split-level pub near Banbury Cross, formerly the main post office and telephone exchange. The walls display old photos and pictures of the town and surrounding area. Alcoholic drinks are served from 9am daily. Two banks of handpumps offer a changing range of ales, usually including at least one local brew, plus two regulars and real cider. Good-value food is offered. The pub hosts a spring festival focusing on international beers, and Wetherspoon festivals in March or April and October. 🍴🍴♿♣️🚋🛜

Olde Reine Deer Inn ✅

47 Parsons Street, OX16 5NA
☎ (01295) 270972 ⊕ ye-olde-reinedeer-inn-banbury.co.uk
Hook Norton Hooky Mild, Hooky, Off The Hook, Old Hooky; 3 changing beers (sourced locally; often Hook Norton) Ⓗ

Welcoming and popular traditional pub that dates back to 1570 and played a role in the Civil War. Cromwell's soldiers are thought to have planned the siege of Banbury Castle from the oak-panelled Globe Room. A wide range of Hook Norton beers is served, along with food from a varied menu all day. There is an outside

seating area with some cover. Identified by CAMRA as having a regionally important historic pub interior. Q❤️🍴♣️🏠🍴🅿️🚃♿

White Horse Ⓛ

50-52 North Bar Street, OX16 0TH
☎ (01295) 277484 ⊕ whitehorsebanbury.com
Everards Tiger; Turpin Golden Citrus; 2 changing beers (sourced nationally) Ⓗ

Friendly community pub that always has at least four handpumps in use, offering the discerning drinker a range of beer styles and strengths along with several ciders. Friday nights are busy, alternately featuring a disco or local bands. Sunday attractions include popular lunches and an entertaining monthly quiz. The small, partially covered courtyard outside is a lovely space for a drink. A beer festival takes place at Easter. Local CAMRA Pub of the Year 2022 finalist. Closed Monday. Q❤️♿🍴♿♣️🍴🚃♿🛜

Barford St Michael

George Inn

Lower Street, OX15 0RH (off B4031)
☎ (01869) 338160 ⊕ thegeorgebarford.co.uk
3 changing beers (sourced nationally) Ⓗ

This charming 17th-century thatched inn manages to be both a vibrant village pub and a relaxing getaway. It serves a variety of ales, both local and from further afield, to be enjoyed in the flagstoned bar, by the fireplace or outside in the lovely rear garden with its covered terrace. A wide range of food is available, made with locally sourced ingredients. There are nine beautiful bedrooms for those who would like to stay. Q❤️♿🏨🍴♿🛏️🅿️🛜

Beckley

Abingdon Arms Ⓛ

High Street, OX3 9UU
☎ (01865) 655667 ⊕ theabingdonarms.co.uk
Little Ox Yabba Dabba Doo; Oxford Prospect; 2 changing beers (sourced locally; often Chadlington, Vale, White Horse) Ⓗ

A lovely old pub with a fine garden affording great views across Otmoor. There is a small bar and separate dining

REAL ALE BREWERIES

Amwell Springs Cholsey
Barn Owl Gozzard's Ford
Bicester 🍺 Bicester
Brakspear Witney
Chadlington Chadlington
Church Hanbrewery ⭐ North Leigh
Craftsman Abingdon
Earth Ale Frilford Heath
Hook Norton Hook Norton
Little Ox Freeland
Loddon ⭐ Dunsden
Loose Cannon ⭐ Abingdon
LoveBeer Milton
Oxford ⭐ Horspath
Parlour Garford (NEW)
Philsters Milton Common
Tap Social Movement ⭐ Kidlington
Thame 🍺 Thame
Turpin Hook Norton
White Horse Stanford in the Vale
Woodstock Woodstock
Wriggly Monkey ⭐ Bicester
Wychwood Witney

area. The arms in question are of James Bertie (1653-1699) who was created 1st Earl of Abingdon in 1682. The Bertie family owned the village until 1919 when it was broken up and sold off in lots. The pub was put up for sale in 2016 and bought by a local community group after a community share offer. Q🕭🍽🌙♣P🐾🕏

Besselsleigh

Greyhound Ⓛ

OX13 5PX

☎ (01865) 862110 ● greyhound-besselsleigh.co.uk

Loose Cannon Gunners Gold; North Cotswold Cotswold Best; Timothy Taylor Landlord; 3 changing beers (sourced regionally) Ⓗ

A 400-year-old former coaching inn that stood on a major toll road from Oxford to the West Country. At one time the pub had a blacksmith's forge next door to facilitate the reshoeing of horses. Now it is a popular pub/restaurant run by the Brunning & Price chain. It serves six real ales on handpump, including three regularly changing guests, and offers an extensive food menu. Q🕭🍽🌙♿P🚌(66)🐾🕏

Bicester

Angel ✿

102 Sheep Street, OX26 6LP

☎ (01869) 360410 ● theangelbicester.co.uk

6 changing beers (sourced regionally; often Bicester, Rebellion, Vale) Ⓗ

Town-centre brewpub with a pleasant ambience and a welcoming bar area. It serves a range of guest ales and occasionally one of its own. A log fire adds extra comfort on chilly days. Outside are a snug, a large seating area and a permanent marquee, plus a barn that is home to a pop-up pizza restaurant on Wednesday to Friday evenings. Open all day at weekends, from late afternoon Monday to Friday. Q🕭🍽♿➕(North)P🚌🐾🕏

Penny Black ✿

58 Sheep Street, OX26 6JW

☎ (01869) 321535

Greene King Abbot; Hook Norton Old Hooky; Ruddles Best Bitter; 8 changing beers (sourced nationally) Ⓗ

The old post office with its elegant façade is the setting for this Wetherspoon pub. The single large room has a long bar serving up to 12 real ales. A monthly tap takeover showcases local breweries. Beer festivals are usually hosted every March and October. The rear garden is popular in fine weather. Alcoholic drinks are available from 9am. Q🕭🍽🌙➕(North)🚌🕏

Brightwell-cum-Sotwell

Red Lion Ⓛ

Brightwell Street, OX10 0RT (S off A4130)

☎ (01491) 837373 ● redlionbcs.co.uk

Amwell Springs Eazy Geez; Loddon Hullabaloo; St Austell Tribute; 2 changing beers (sourced nationally; often Amwell Springs, Loddon, White Horse) Ⓗ

A popular Grade II-listed thatched inn dating from the 16th century in a quiet village. Its cosy bar features exposed beams and an inglenook fireplace with log-burner, and leads to a restaurant area. The beers are usually from local breweries and a good-quality seasonal menu is served (no food Sun eve or Mon and Tue). The rear courtyard garden is a summer suntrap, and a heated marquee allows comfortable dining and drinking all year round. The pub hosts weekly meat raffles and monthly live music. Closed Monday, Tuesday lunchtime and weekday afternoons. 🕭🍽🌙♿♣P🚌(33)🐾🕏

Burford

Angel Inn ✿

14 Witney Street, OX18 4SN

☎ (01993) 822714 ● theangelatburford.co.uk

Hook Norton Hooky, Old Hooky; 2 changing beers (sourced locally; often Hook Norton) Ⓗ

A cosy 16th-century inn just off the main High Street, warmed by a real fire. Stools and comfortable seating in front of the bar area cater for those enjoying the four draught ales from Hook Norton brewery. Bar meals feature locally sourced ingredients; the restaurant is filled with original features. Outside are a lovely courtyard and walled garden with covered seating. Families and dogs are welcome. Q🕭🍽♿🌙♿🚌(233,853)🐾🕏

Caulcott

Horse & Groom

Lower Heyford Road, OX25 4ND

☎ (01869) 343257 ● horseandgroomcaulcott.co.uk

3 changing beers (sourced nationally; often Church End, Goff's, Vale) Ⓗ

A charming 16th-century coaching house, warm and cosy with a welcoming fire in winter. A free house, it serves three changing ales. The French landlord's passion for food is reflected in a changing menu based on local fresh seasonal produce, with a traditional croque monsieur at lunchtime. Booking is recommended, especially for the Thursday steak night and Sunday lunch. The garden is popular in summer, and the Bastille Day beer festival weekend in July is not to be missed. Local CAMRA Pub of the Year on several occasions. Open Wednesday to Saturday lunchtimes and evenings, lunchtime only on Sunday. Q🕭🍽🌙P🕏

Chadlington

Tite Inn

Mill End, OX7 3NY

☎ (01608) 676910 ● thetiteinn.co.uk

Chadlington Oxford Blue; 2 changing beers (sourced locally; often Chadlington) Ⓗ

A friendly welcome awaits at this comfortable country pub in the Evenlode Valley. It serves a choice of three or four beers from the nearby Chadlington Brewery. In winter there is a roaring fire, and for summer a beautiful hillside beer garden where a peaceful pint can be enjoyed. Good locally sourced food is available. Tite is old local dialect for spring – water runs under the pub and down the hill. Q🕭🍽♣P🚌(S3,X9)🐾🕏

Charlbury

Rose & Crown

Market Street, OX7 3PL

☎ (01608) 810103 ● roseandcrown.charlbury.com

Hop Kettle Cricklade Ordinary Bitter; Salopian Oracle; 6 changing beers (sourced nationally; often Dark Star, Oakham, XT) Ⓗ

A traditional, ever-popular wet sales pub that has earned a place in this Guide for 36 consecutive years. It offers a traditional front bar, a back bar and an outside space to enjoy a summer pint. The pub serves six changing ales alongside regular brews Hop Kettle Cricklade and Salopian Oracle. Six ciders or perries add to the fantastic choice at the bar. Live music is hosted regularly. A former local and county CAMRA Pub of the Year. 🕭🍽Å➕♣🚌(S3,X9)🐾🕏

Chinnor

Red Lion L ✓

3 High Street, OX39 4DL
☎ (01844) 353468 ⊕ theredlionchinnor.co.uk
4 changing beers (sourced nationally) ⊞
Multi-roomed pub that is over 300 years old and was
originally three cottages. Beyond the crowded bar is a
lounge area with an inglenook fireplace and wood-
burning stove. The pub serves a varied range of ales,
many from microbreweries both local and national.
Regular events including quiz nights are hosted. Outside
is rear decking with ample seating that extends into a
marquee in the car park. Open all day at weekends, from
mid afternoon Monday to Friday. ᶲ🅿🏠(40)😊🐾🛜

Chipping Norton

Chequers

Goddards Lane, OX7 5NP (next to theatre, on corner of
Spring St)
☎ (01608) 644717 ⊕ chequerschippingnorton.co.uk
**Dark Star American Pale Ale; Fuller's London Pride;
Gale's HSB; 3 changing beers (sourced nationally)** ⊞
Traditional English pub with an emphasis on real ale and
home-cooked food. Up to six ales from the Fuller's,
Gale's and Dark Star ranges are available. The bar has
three separate areas, all with flagstones and beams. To
the rear is an airy restaurant and large function space.
The small main bar area is warmed by a feature fireplace
in winter, providing an excellent place to relax. Handy for
the local theatre and cinema. Closed Monday.
Qᶲ🅒🏠🐾🛜

Clifton

Duke at Clifton L

Main Street, OX15 0PE
☎ (01869) 226334 ⊕ thecliftonduke.co.uk
**Turpin Golden Citrus; 3 changing beers (sourced
regionally; often North Cotswold, Tring, XT)** ⊞
This 17th-century Grade II-listed thatched country inn,
originally named for Prince Rupert, is steeped in history,
particularly from the Civil War. Whatever the season it is
a perfect setting to sample the award-winning ales,
many of which are from local brewers. The pub is
warmed by a roaring fire in the inglenook fireplace, and
has a superb garden for fine weather. The food menu is
locally sourced. Accommodation is available in shepherd
huts, an Airstream caravan and serviced campsite.
Walkers, dogs and wellies are welcome. Closed Monday,
and Tuesday and Wednesday lunchtime.
Qᶲ🅒🏠🐾🛜

Cropredy

Red Lion L ✓

8 Red Lion Street, OX17 1PB
☎ (01295) 758680 ⊕ redlioncropredypub.co.uk
**Butcombe Original; Purity Bunny Hop; 3 changing
beers (sourced nationally; often Fuller's)** ⊞
Nestling between the churchyard and the Oxford Canal,
this part-thatched pub offers a warm welcome to
boaters, walkers and their dogs. The bar services three
distinct areas, offering a good choice of beers from the
Stonegate list. Wholesome food is available. Bands
perform in the outside space as part of the alternative
line-up at the popular Cropredy music festival in August.
Closed Monday lunchtimes. Qᶲ🅒🏠🐾🛜

Dunsden

Loddon Tap Yard L

Dunsden Green Farm, Church Lane, RG4 9QD
☎ (0118) 948 1111 ⊕ loddonbrewery.com/tapyard
**Loddon Hullabaloo; 2 changing beers (sourced locally;
often Loddon)** ⊞
An increasingly popular tap yard next to the main Loddon
brewhouse, serving three of the brewery's ales on
handpump. With both indoor and outdoor seating,
including covered decking, it is the perfect place to enjoy
a pint in the beautiful countryside. Street food is
frequently available from vendors in the courtyard. The
farm shop sells local produce including cheese,
vegetables, bread and meat as well as bottled Loddon
beers and local ciders, wines, spirits and liqueurs. Closed
Monday, and winter evenings Tuesday-Thursday.
ᶲ🅒🏠🅿🏠(800) 🐾🛜

East Hagbourne

Fleur de Lys L

30 Main Road, OX11 9LN
☎ (01235) 813247 ⊕ thefleurdelyspub.co.uk
**Morland Original Bitter; house beer (by LoveBeer); 4
changing beers (sourced nationally)** ⊞
A family- and dog-friendly 17th-century pub in this rural
village, the Fleur offers two regular ales – one a house
beer, Wibbly Wobbly Whippet, from nearby
microbrewery LoveBeer – alongside up to four nationally
sourced guests. The spacious bar and dining area are
comfortable and cosy, warmed by an open fire. The pub
hosts regular live music evenings and holds two summer
weekend music festivals. Aunt Sally is played in the
garden, which features a large semi-enclosed 'beer hall'.
A multiple former local CAMRA Pub of the Year. Closed
Monday, Tuesday lunchtimes, and Wednesday and
Thursday afternoons. ᶲ🅒🏠🅿🏠(94,94S)🐾🛜

Fewcott

White Lion ✓

Fritwell Road, OX27 7NZ
☎ (01869) 346676
3 changing beers (sourced nationally) ⊞
A family-friendly rural free house that is a good place to
enjoy conversation and excellent beer, or to watch
sporting events on TV. It is warm and cosy, with a
welcoming fire in winter. Three changing ales are
served, including new and seasonal brews. The garden is
popular in summer, with Aunt Sally sometimes played.
The pub hosts a US Super Bowl party in February. Finalist
for local CAMRA Pub of the Year 2022. Open Wednesday
to Sunday from the afternoon. ᶲ🅒🐾🛜

Henley-on-Thames

Bird in Hand

61 Greys Road, RG9 1SB
☎ (01491) 575775
**Brakspear Gravity; Fuller's London Pride; 3 changing
beers (sourced nationally; often Rebellion, Timothy
Taylor, Tring)** ⊞
Celebrating 28 consecutive years in the Guide, the Bird
has flourished under the stewardship of the same family
throughout. Three guest beers complement the two
regulars. TVs show sporting events, and the pub is home
to darts and cribbage teams and hosts regular quiz
nights. The family room leads to a delightful garden
boasting a pond and aviary. Dogs on leads are welcome.
A frequent winner of local CAMRA Pub of the Year. Closed
weekday afternoons. Qᶲ🅒🏠🐾🛜

Hook Norton

Pear Tree Inn L ✅

Scotland End, OX15 5NU (follow brown tourist signs to Hook Norton Brewery)

☎ (01608) 737482 ⊕ peartreeinnhooknorton.co.uk

Hook Norton Hooky Mild, Hooky, Off The Hook, Old Hooky; 2 changing beers (sourced locally; often Hook Norton) ⊞

Welcoming rural local under the excellent management of a long-standing village resident, close to the Grade II-listed Victorian tower brewery with its restaurant and shop. The wet sales driven pub serves the full range of Hooky beers, which can be enjoyed in the cosy bar or large, family-friendly beer garden. Pizzas are offered. Accommodation is available, making this the ideal destination before or after a tour of the award-winning brewery. Q ❤ ⌖ ✿ ⇐ ◀ ◐ & ♣ � 🖵 (488) ❀ 🛜

Horley

Red Lion ♟ L

Hornton Lane, OX15 6BQ

☎ (01295) 730427

Hook Norton Hooky; Turpin Golden Citrus; 1 changing beer (sourced nationally) ⊞

Friendly pub that is a focal point of the village, offering a warm welcome to locals, visitors, walkers and well-behaved dogs. It serves three handpumped ales all year round, and a fourth on special occasions. Darts, dominoes and Aunt Sally are played here. The lovely tranquil garden is ideal for a summer evening tipple. The annual St George's Day beer festival is a must. Local CAMRA Pub of the Year 2022. Open Tuesday to Saturday evenings and Sunday lunchtime. ✿ ♣ 🖵 ❀ 🛜

Kidlington

King's Arms ✅

4 The Moors, OX5 2AJ (close to jct of High St and Church Rd)

☎ (01865) 373004

Ringwood Razorback; 3 changing beers (sourced nationally; often Chadlington, Hook Norton, Weetwood) ⊞

An unspoiled two-roomed local that was built around 1815 and retains some thatched outbuildings, one of which houses the Gents. The pub has two small bay-fronted rooms: a lounge to the left and a rather cluttered bar to the right, with a dartboard and collection of trophies. There is a skittle alley that can be hired, and a heated and covered patio where occasional beer festivals are held. The King's Arms has been identified by CAMRA as having a regionally important historic pub interior. Closed Monday lunchtime and Monday-Thursday afternoons. Q ❤ ✿ ◀ ◐ & ♣ 🖵 ❀ 🛜

Letcombe Regis

Greyhound Inn ♟ L

Main Street, OX12 9JL

☎ (01235) 771969 ⊕ thegreyhoundletcombe.co.uk

4 changing beers (sourced nationally; often Oakham, Salopian, Thornbridge) ⊞

Large, welcoming pub in the centre of the village, featuring a single bar with dining areas and an original inglenook fireplace. It serves four constantly changing handpumped beers. Food is locally sourced and home-cooked; the garden hosts outdoor dining in summer. The pub is within a couple of miles of the Ridgeway and provides a place of refreshment and rest for wayfarers, with accommodation in eight en-suite bedrooms.

Parking is available alongside of the pub; the provision for tethering horses has been replaced by secure bicycle storage. Local CAMRA Pub of the Year 2022. Q ❤ ✿ ⌖ ◀ ◐ & ♣ 🖵 ❀ 🛜

Lewknor

Leathern Bottle

1 High Street, OX49 5TW (N off B4009 near M40 jct 6)

☎ (01844) 351482 ⊕ theleathernbottle.co.uk

Brakspear Gravity; Courage Directors; Young's London Special ⊞

Featuring in all but one edition of the Guide, this traditional Grade II-listed country pub has been run by the same family since 1980. It serves good home-cooked pub food, and has a family-friendly garden. The venue offers a warm welcome to all, including walkers from the nearby Ridgeway; some of the best trails start and finish here. It is also a short walk from stops on the London-Oxford and airline coach routes. Closed Monday, Tuesday-Saturday afternoons and Sunday evenings. Q ❤ ✿ ◐ & ♣ 🖵 ❀ 🛜

Long Wittenham

Plough L

24 High Street, OX14 4QH

☎ (01865) 407738 ⊕ theploughinnlw.co.uk

Butcombe Original; 2 changing beers (sourced nationally; often Amwell Springs, Loose Cannon) ⊞

A traditional Grade II-listed family-friendly pub built in the 17th century in this rural south Oxfordshire village. Its large garden stretches down to the River Thames and has ample outdoor seating and a children's play space. There are two bar areas and a separate restaurant. One regular and two changing beers are served, from breweries and microbreweries mainly in the South-East. The pub hosts many community events, notably Wittfest, a music festival each June/July that raises money for local charities. Closed Monday. ❤ ✿ ◐ ⌖ ♣ 🖵 (D1) ❀ 🛜

Longcot

King & Queen L

Shrivenham Road, SN7 7TL

☎ (01793) 784348 ⊕ longcotkingandqueen.co.uk

Loose Cannon Gunners Gold; 3 changing beers (sourced nationally; often Little Ox, Ramsbury, White Horse) ⊞

It is thought that the King & Queen was constructed about 200 years ago to cater for navvies working on the Wilts & Berks Canal, which passes nearby. Its interior comprises an extensive open-plan drinking area and, to one side, a restaurant serving substantial meals. A good selection of ales from local breweries is on offer. Outside is a tranquil beer garden. The pub provides one of the best views of White Horse Hill and the famous 3,000-year-old white horse. Closed Monday lunchtimes. Q ❤ ✿ ⌖ ◀ ◐ & ⌖ 🖵 (67) ❀ 🛜

Mapledurham

Pack Saddle at Mapledurham L

Chazey Heath, RG4 7UD (just E off A4074)

☎ (0118) 946 3000 ⊕ thepacksaddle.com

Loddon Hoppit; Rebellion IPA; 2 changing beers (sourced nationally; often Loddon, Rebellion, West Berkshire) ⊞

An independently owned country venue on the Mapledurham Estate, refurbished in 2020 to provide a welcoming main bar in the lower area, and an upstairs area for dining. Four of the five handpumps are normally

in use at any one time, serving two regular ales alongside changing beers from other local breweries. An innovative modern British menu uses fresh seasonal ingredients, often from local producers. The pub also has a community garden that provides the freshest possible salad, fruit and vegetables for its kitchen. Closed Monday and Tuesday. ♿🕮⏀◑♣P🖳❄☀🌐

Marsh Baldon

Seven Stars on the Green

The Green, OX44 9LP (15 mins' walk from Nuneham Courtenay)
☎ (01865) 343337 🌐 sevenstarsatmarshbaldon.co.uk
House beer (by Lakeland Brewhouse); 3 changing beers (sourced nationally; often Purity, Timothy Taylor, Young's) Ⓗ
An old coaching inn that has been community owned since 2013, offering a welcoming main bar plus a restaurant in an attractive barn extension. The pub is next to the village green, which is claimed to be the largest in Europe, and has its own big garden for summer. Three ales are always available and good food is served, including extensive gluten-free and vegetarian options. Closed Monday and Tuesday. Q♿🕮⏀◑♿P❄☀🌐

Milton

Plum Pudding Ⓛ

44 High Street, OX14 4EJ
☎ (01235) 834443 🌐 theplumpuddingmilton.co.uk
Loose Cannon Abingdon Bridge; LoveBeer OG; 1 changing beer (sourced nationally) Ⓗ
Plum Pudding refers to the Oxford Sandy and Black pig, one of the older and rarer British breeds. The pub serves three real ales plus up to four real ciders. It hosts regular live music, and beer festivals in April and October. Sitting in the pleasant walled garden, you would not suspect that you are only a couple of minutes from the busy A34. Six en-suite rooms are available. The pub is a former local CAMRA Pub of the Year and repeat local Cider Pub of the Year. 🕮🏠⏀◑♿♣♠P🖳❄☀🌐

North Moreton

Bear

High Street, OX11 9AT (S off A4130)
☎ (01235) 811311 🌐 thebearinn.co.uk
3 changing beers (sourced nationally; often Cotleigh) Ⓗ
Originally a 15th-century coaching inn, this is a friendly local next to the village cricket pitch. Its front main bar is relaxed, with sofas and an open fire. The traditional beamed and brick interior was refurbished in 2020, with polished floorboards in the bar and carpet in the dining area. Unusually for the area, the pub rarely stocks local real ales, instead serving a wide range chosen from all over the rest of the country. Closed weekday afternoons and Monday. 🕮🏠◑♣P🖳(94S,D2)☀🌐

Northmoor

Red Lion Ⓛ ✓

Standlake Road, OX29 5SX
☎ (01865) 300301 🌐 theredlionnorthmoor.com
Brakspear Gravity; Loose Cannon Abingdon Bridge; 2 changing beers (sourced locally; often Cotswold Lion, North Cotswold, Vale) Ⓗ
Traditional village inn with whitewashed stone walls, heavy oak beams, real fires and a large garden. The pub has gone from strength to strength since it was purchased by the local community from Greene King in

2014. Its focus is on local produce with a changing menu of home-cooked food, some of which is grown in the pub's kitchen garden. The small bar serves a selection of three or four local beers; sometimes two in winter. Closed Monday and Tuesday, and Wednesday-Friday afternoons. Q♿🏠⏀◑♣P☀🌐

Oxford

Bear Inn Ⓛ

6 Alfred Street, OX1 4EH
☎ (01865) 728164 🌐 bearoxford.co.uk
Fuller's London Pride, ESB; Gale's HSB; 2 changing beers (sourced regionally; often Dark Star, Fuller's, Oxford) Ⓗ
The Bear's precise age is open to debate but it is definitely old; the present building dates back to 1606 and has been identified by CAMRA as having a regionally important historic pub interior. Tucked away behind the town hall, it is a tied house in more ways than one, renowned for its collection of tie remnants taken from customers. A small pub popular with students and visitors, it gets crowded at times but has additional seating in a paved area to the rear. Closed Monday and Tuesday lunchtimes. Q♿🕮⏀◑♿♣🖳☀🌐

Butchers Arms

5 Wilberforce Street, Headington, OX3 7AN (from centre of Headington, past the shark, first left, first right)
☎ (01865) 742470 🌐 butchersarmsheadington.co.uk
Dark Star Hophead; Fuller's London Pride, ESB; 2 changing beers (sourced regionally; often Dark Star, Windsor & Eton) Ⓗ
A friendly late-Victorian red-brick pub in the back streets, slightly hard to find but worth searching out. Its long single room has the bar in the middle; outside is a paved seating area. The pub offers a good range of Fuller's beers, supplemented by traditional pub food. The inn sign, a parody of the arms of the Worshipful Company of Butchers, and the motto, which means 'God gives us everything', are both of unknown origin. Closed Monday, and Tuesday-Friday lunchtimes. Q♿🕮⏀♿♣♠🖳☀🌐

Chequers Ⓛ ✓

130a High Street, OX1 4DH (down narrow passageway off High St, 50yds from Carfax)
☎ (01865) 727463
Fuller's London Pride; St Austell Nicholson's Pale Ale; 4 changing beers (sourced nationally; often Hook Norton, St Austell, Timothy Taylor) Ⓗ
A Grade II-listed pub down a passageway off the High Street. Much of the building dates back to the early 16th century when it was converted from a moneylender's tenement to a tavern, hence the name. Note the fine carvings and windows, and the ceiling in the lower bar. There is also an upstairs bar with three handpumps. A cobbled courtyard provides space for alfresco drinking, dining and smoking. Q♿🕮⏀◑♿≒♣🖳☀🌐

Gardener's Arms Ⓛ

39 Plantation Road, Walton Manor, OX2 6JE
☎ (01865) 559814 🌐 thegardenersarms.com
3 changing beers (sourced locally; often Little Ox, Loose Cannon, XT) Ⓗ
Established in the 1830s, this is a cosy pub down a narrow street off Woodstock Road. A popular and relaxing place to eat and drink, it serves some of the finest vegetarian and vegan food in the city. At the rear is a large and pleasant garden, as well as the outside toilets. The famous weekly quiz is on Sunday evening. Table service is in operation due to the small bar area. Closed Monday-Tuesday lunchtimes and Monday-Saturday afternoons. Q♿🕮⏀♣🖳☀🌐

Harcourt Arms

1 Cranham Terrace, Jericho, OX2 6DG (off Walton St)
☎ (01865) 556669 ∰ harcourtarmsjericho.co.uk
Dark Star Hophead; Fuller's London Pride; 1 changing beer (sourced regionally; often Dark Star, Oxford) ℍ

A wet-led pub behind the Phoenix cinema in the Jericho district near the city centre. An inn was first recorded here in 1871, and the pub was rebuilt in the 1930s by Ind Coope to the brewery's standard design. Seating is on couches, pews or at tables. French-themed art prints and posters decorate the walls. With welcoming log fires in winter, this is the sort of pub where you can fall into conversation or enjoy a quiet drink on your own. Opens at 5pm every day. Q ☎ ❀ ≋ ♣ ● ⬜ (17) ❀ ☂

Mason's Arms ⌷ ⊘

2 Quarry School Place, Headington Quarry, OX3 8LH
☎ (01865) 764579 ∰ themasonsarmshq.co.uk
Harvey's Sussex Best Bitter; Rebellion Smuggler; Vocation Bread & Butter; 2 changing beers (sourced nationally) ℍ

Family-run community pub hosting many games leagues, including bar billiards and Aunt Sally. The guest ales are varied and turn over quickly, and a wide range of bottled beers is also stocked. The venue is home to the Headington beer festival in September. A heated decking area and garden lead to the function room, which hosts music and comedy nights. A regular local CAMRA City Pub of the Year. Closed Mondays, Tuesday-Saturday lunchtimes, and Tuesday-Friday afternoons. Closes at 7pm on Sunday. Q ☎ ❀ & ♣ ⬜ (H2) ❀ ☂

Old Bookbinders

17-18 Victor Street, Jericho, OX2 6BT
☎ (01865) 553549 ∰ craftybelle.uk/oldbookbinders
Timothy Taylor Landlord; house beer (by Greene King); 3 changing beers (sourced nationally; often Black Sheep, Greene King, Wadworth) ℍ

This family-run pub near the Oxford canal is a combination of Victorian tavern and French bistro. Called the Bookbinders Arms when it belonged to Morrell's Brewery, it has two rooms served by a single bar and is furnished in typical style with an eclectic mix of decor and bric-a-brac. Free monkey nuts are available from the barrel by the entrance. The pub's exterior featured in the very first episode of Inspector Morse. Closed Monday, and Tuesday lunchtime. Q ☎ ❀ ◑ & ≋ ♣ ⬜ (17) ❀ ☂

Rose & Crown ⌷

14 North Parade Avenue, North Oxford, OX2 6LX (½ mile N of city centre, off Banbury Rd)
☎ (01865) 510551 ∰ roseandcrownoxford.com
Adnams Southwold Bitter; Hook Norton Old Hooky; Oxford Trinity; 1 changing beer (sourced locally) ℍ

This characterful free house on a vibrant north Oxford street is a time capsule with two small rooms and many original features. A friendly community pub, it has been run by the same landlords for over 30 years. There is no intrusive music, and mobile-phone use is not permitted. The pub's fame has even spread to Everest – see the photo on the wall. It has been identified by CAMRA as having a regionally important historic pub interior. Closed Monday-Thursday afternoons in August and September. Q ☎ ❀ ◑ ♣ ☂

Royal Blenheim ⌷

13 St Ebbes Street, OX1 1PT
☎ (01865) 242355
Everards Tiger; Titanic Plum Porter; White Horse Bitter; Village Idiot; 6 changing beers (sourced nationally; often Dark Star, Titanic, White Horse) ℍ

Single-room Victorian pub next to Modern Art Oxford – the building is all that is left of Hanley & Co Ltd, City

Brewery. It was built in 1889 for Hanley's on the site of two alehouses, in what was then a rough part of the city. The pub is owned by Everards but leased to Titanic, who run it in partnership with White Horse Brewery. Ten handpumps dispense a range of White Horse and Titanic beers, one from Everards, plus guests. A recent local CAMRA City Pub of the Year. Q ☎ & ❀ ≋ ♣ ● ❀ ☂

Tile Shop Ale House

10 Windmill Road, Headington, OX3 7BX
☎ 07838 809303 ∰ alehead.co.uk
Tring Side Pocket for a Toad; 1 changing beer (sourced locally; often Oxford, Rebellion, Tring) ℍ

Headington's first micropub forms part of a tile shop near the central crossroads of this eastern suburb. Predictably it is small and features numerous tiles; there is also a brightly coloured fireplace. Mobile phone use is discouraged and there is no music or Wi-Fi. The pub serves two ales straight from the cask, one a regularly changing brew. It also offers a real cider, local gin and wine. Closes at 8pm every day. Q ❀ & ♣ ● ⬜

White Hart

12 St Andrew's Road, Headington, OX3 9DL (opp church in Old Headington village)
☎ (01865) 761737 ∰ thewhitehartheadington.com
Everards Tiger; 4 changing beers (sourced nationally; often Castle Rock, Everards, Oakham) ℍ

Terraced stone-built pub offering a good selection of Everards ales and guests. The interior is divided into three, with two small bars, and there is a large garden. Note the framed extract from a play, The Tragi-Comedy of Joan of Hedington, by Dr William King of Christ Church, written in 1712 about the proprietor of a dishonourable alehouse – thankfully the pub now has a much better reputation. The food is traditional and home-made, with pies a speciality. Closes at 6pm on Sunday. Q ☎ ❀ ◑ P ⬜ ❀ ☂

White Hart ⌷

126 Godstow Road, Wolvercote, OX2 8PQ
☎ (01865) 511978 ∰ thewhitehartwolvercote.co.uk
3 changing beers (sourced locally; often Amwell Springs, Loose Cannon, XT) ℍ

A former bakery, this small open-plan local opposite the green at Lower Wolvercote was possibly also once a blacksmith's. Since 2014 it has been a community-run pub with a welcoming and family-friendly feel. It serves three or four changing local ales. Food is available on Wednesday to Friday evenings, and Sunday brunch is offered. The pub hosts regular music nights featuring jazz, sea shanties and Irish folk. Closed Monday and Tuesday afternoons and Monday-Friday lunchtimes. ☎ ❀ ◑ & ♣ P ⬜ (6) ❀ ☂

White Rabbit ⌷

21 Friars Entry, OX1 2BY (alley between Magdalen St and Gloucester Green)
☎ (01865) 241177 ∰ whiterabbitoxford.co.uk
5 changing beers (sourced locally) ℍ

Before being renamed the White Rabbit in 2012, this was the Gloucester Arms, and described itself as Oxford's premier rock pub. It has a small bar surrounded by three separate areas. Five local real ales are usually on offer; one is sometimes swapped for cider. Hand-made pizzas are a speciality, with gluten-free bases available. Outside is a covered paved space with heated seating. The pub has been identified by CAMRA as having a regionally important historic interior. ❀ ◑ ≋ ♣ ● ⬜ ☂

Playhatch

Flowing Spring
Henley Road, RG4 9RB (on A4155)
☎ (0118) 969 9878 ⊕ theflowingspringpub.co.uk
Tring Colley's Dog, Ridgeway; 2 changing beers (sourced nationally; often Andwell, Palmers, Tring) Ⓗ
Sociable 18th-century country pub on the edge of the Chilterns. A free house owned by the former tenants, it features two regular plus one or two varying beers. It serves home-made food with award-winning gluten-free, dairy-free, vegetarian and vegan options. Events include monthly unplugged nights, classic car and bike meets, and summer concerts in the large garden. The pleasant covered balcony and large riverside garden are ideal for summer. Closed Mondays, Tuesday-Saturday afternoons (except Sat in summer) and Sunday evenings.
Ⓑ❀◧♣⬢Ⓟ♻♿

South Moreton

Crown ♛ Ⓛ
High Street, OX11 9AG (in centre of village)
☎ (01235) 810005 ⊕ thecrown-southmoreton.co.uk
Loose Cannon Abingdon Bridge; house beer (by Amwell Springs); 1 changing beer (sourced nationally; often North Cotswold, White Horse, XT) Ⓗ
Community pub that was previously owned by Wadworth and closed for several years. The licensees place emphasis on showcasing local ales, including collaborating with Amwell Springs for a regular house beer, Ye Olde Dash & Tipple. Food is sourced from fresh local produce and the menu is refreshed regularly to reflect this. Local CAMRA Pub of the Year and Cider Pub of the Year 2022. Closed Tuesday, and Monday and Wednesday lunchtimes.
Ⓠ Ⓑ❀◧Å♣⬢Ⓟ(94S,D2)♻♿

Steventon

North Star ★ Ⓛ
2 Stocks Lane, OX13 6SG (at end of the Causeway off B4017)
3 changing beers (sourced regionally; often Amwell Springs, Butts, Loose Cannon) Ⓖ
Identified by CAMRA as having a historic interior of outstanding national importance, this Grade II-listed pub is next to the Causeway, a listed ancient monument. Popular with locals and visitors, it hosts many village clubs and social events. Inside are two bars, one with three settles around an open fireplace, and a separate function room. Three beers are served by gravity and presented through a stable door or hatch. Closed Monday-Friday lunchtimes, and Monday-Thursday afternoons. Ⓑ❀♣⬢Ⓟ(X2)♻♿

Stoke Lyne

Peyton Arms ★
School Lane, OX27 8SD
☎ 07546 066160
Hook Norton Hooky, Old Hooky Ⓖ
A rural gem whose heart is a single unspoiled bar with no handpumps. Two Hook Norton ales are served directly from the cask from a room behind the bar. The walls feature memorabilia gathered over the years. This is pub for conversation by the fire or around the bar, which is for adults only. Children are welcome in the garden but dogs are not allowed. The pub has been identified by CAMRA as having a regionally important historic interior. Closed Monday and Tuesday; other hours vary so call to check. Ⓠ❀Ⓟ

Sutton Courtenay

George Ⓛ ✓
4 Church Street, OX14 4NJ
☎ (01235) 848142 ⊕ georgesuttoncourtenay.co.uk
Amwell Springs Rude Not To; Loose Cannon Abingdon Bridge Ⓗ
An imposing 16th-century half-timbered pub with a beamed interior. It is on the main road through the village, overlooking the war memorial on the green. The churchyard next door is the final resting place of Lord Asquith, who was Prime Minister at the outbreak of WWI, and Eric Blair, better known as the novelist George Orwell. Closed Monday-Thursday afternoons.
Ⓠ Ⓑ❀Ⓟ🚌(33)♻♿

Tetsworth

Old Red Lion Ⓛ
40 High Street, OX9 7AS
☎ (01844) 281274 ⊕ theoldredliontetsworth.co.uk
XT Four; 1 changing beer (sourced locally) Ⓗ
A friendly refurbished pub that is warmed by wood-burning stoves in winter. It serves up to three well-kept real ales from local breweries. Traditional pub food is available all day. The pub also serves as the village shop and offers B&B accommodation. It is a member of Brit Stops and allows motorhomes free overnight parking. Truly an Asset of Community Value. Closed Sunday evening. Ⓠ Ⓑ❀◧◧◧Å♣⬢Ⓟ(275)♻♿

Thame

Cross Keys Ⓛ ✓
East Street, OX9 3JS
☎ (01844) 218202 ⊕ crosskeysthame.co.uk
XT Four; 7 changing beers (sourced nationally) Ⓗ
A drinkers' local, serving an ever-changing range of ales and ciders, local breweries often feature alongside ales from small and microbreweries from around the country. On busy evenings, it is not uncommon for several beers to be changed. The pub hosts many community events, such as weekly quizzes, live music and local clubs. A former local CAMRA Cider Pub of the Year. Closed Monday-Friday afternoons. Ⓠ❀♣⬢Ⓟ♻♿

Wallingford

Royal Standard Ⓛ
32 St Marys Street, OX10 0ET
☎ (01491) 599105 ⊕ royalstandardwallingford.co.uk
Amwell Springs Eazy Geez, Rude Not To; 1 changing beer (sourced nationally; often Amwell Springs) Ⓗ
A 19th-century pub that serves local ales from Amwell Springs alongside a great menu. On Tuesday to Friday daytimes it also operates as a coffee shop, offering light lunches and a soft play area for under-fives. In the evening it has a warm atmosphere with sports TV, quiz nights and entertainment. The large beer garden has an 85-inch TV - perfect for those summer sports events. Alcoholic drinks are served from midday. Closed Monday lunchtime.
Ⓑ❀◧Å➤(Cholsey & Wallingford)🚌♻♿

Wantage

King's Arms Ⓛ ✓
39 Wallingford Street, OX12 8AU (E of Market Square)
☎ (01235) 765465 ⊕ kingsarmswantage.co.uk
6 changing beers (sourced nationally) Ⓗ
A friendly open-plan pub, featuring panelling and polished wooden floors, that gained a new lease of life

when refurbished by owners Oak Taverns in 2020. Its six handpumps serve constantly changing beers; six ciders are also available. The large rear garden has a grassy slope and tables for drinkers. Opens at 2pm on weekdays. Q♿🛏🍴&♣🚪🐕☀🛜

Lamb

59 Mill Street, OX12 9AB
☎ (01235) 766768 ● lambinnwantage.co.uk
Fuller's London Pride; Gale's Seafarers Ale; 1 changing beer (sourced nationally; often St Austell) Ⓗ
A 17th-century inn near the mill, this is the second oldest building in Wantage after the parish church, and the town's only thatched building. It has never been sold and has had only two landlords in the last 50 years. It serves an extensive range of pub food, freshly made using ingredients from local suppliers. This family pub extends a warm and friendly welcome to all. 🛏🍴🕦&🚪🐕☀🛜

Royal Oak Ⓛ

Newbury Street, OX12 8DF (S of Market Square)
☎ (01235) 763129 ● royaloakwantage.co.uk
Wadworth 6X; 8 changing beers (sourced nationally) Ⓖ
A multi award-winning street-corner pub that is a mecca for the discerning drinker. It serves all its beers by gravity, alongside 30 or more ciders and perries. The walls display photographs of ships bearing the pub's name. The lounge features wrought-iron trelliswork covered in pumpclips. Table football is played in the public bar. Awarded local CAMRA Pub of the Year and Cider Pub of the Year many times, including in 2020. Closed weekday lunchtimes and every afternoon. Q🛏♣🚪🐕☀🛜

Shoulder of Mutton Ⓛ

38 Wallingford Street, OX12 8AX (E of Market Square)
☎ (01235) 767158 ● theshoulder.pub
Butts Barbus Barbus; 5 changing beers (sourced nationally) Ⓗ
Friendly and popular Victorian corner pub a short walk from the town centre, serving five constantly changing beers on handpump to suit all tastes. Its interior has recently been redesigned to give customers more space. The pub hosts an open mic evening on Tuesdays. It has featured in this Guide many times and is a former local, county and regional CAMRA Pub of the Year. Q🍴🚐🐕☀🛜

Watlington

Spire & Spoke Ⓛ

21 Hill Road, OX49 5AD (E off B4009)
☎ (01491) 614956 ● theSpireandSpoke.co.uk
Timothy Taylor Landlord; 4 changing beers (sourced locally; often Oxford, White Horse, XT) Ⓗ
The former Carriers Arms serves three or four beers sourced from local breweries such as Oxford and XT. It also offers coffee and home-made cakes, and pizzas cooked in the external wood-fired oven. The Ridgeway crosses the road nearby. The pub's garden gives a good view of the chalk triangle on Watlington Hill, originally cut to look like a spire on the parish church. Alcoholic drinks are served from 11am. 🛏🍴🕦&🅿🚪🐕🛜

Wheatley

Cricketer's Arms Ⓛ

38 Littleworth, OX33 1TR (walk W along Littleworth Rd from Wheatley)
☎ (01865) 872738 ● the-cricketers.com

2 changing beers (sourced nationally; often Loddon, Loose Cannon, Woodforde's) Ⓗ
A typical village local that was smartened up when new management took over in 2020. It normally serves three ales in summer. The fenced-off garden has an Aunt Sally throw. The pub is also on National Cycle Route 57. Opens at 5pm Monday-Thursday. Q🛏🍴♣🚪🐕(46)☀🛜

Witney

Angel Inn Ⓛ ✔

42 Market Square, OX28 6AL
☎ (01993) 703238
Brakspear Oxford Gold; Wychwood Hobgoblin Gold, Hobgoblin Ruby; house beer (by Marston's) Ⓗ
A Grade II-listed free house at one time owned by Joseph Early of the blanket manufacturing dynasty and a brewer. It has a fine front bar with low beams and a bay window, with plenty of space for drinkers and diners beyond. Outside is a small paved and walled courtyard. The beer range is mostly from Marston's – its Wychwood Brewery is just around the corner, but the beer goes to Burton-on-Trent to be casked. One of the regular beers is sometimes replaced with a guest. 🍴🕦♣🚪(S1,S2)☀🛜

Drummer's Bar Ⓛ

8 Langdale Court, OX28 6FG (walk down passageway directly opp Blue Boar in town centre)
☎ (01608) 677717 ● drummersbar.co.uk
2 changing beers (sourced locally; often Church Hanbrewery, Goff's, Little Ox) Ⓗ
Witney's first micropub was founded by a father and son team who started a nearby brewery, Oxbrew, that merged with Little Ox Brewery. The pub has two handpulls from casks and six taps from kegs, and serves an ever-changing selection of beers from local breweries. Closed all day Monday and Tuesday; Wednesday-Thursday lunchtimes and afternoons; and after 7pm on Sunday. Q🍴🚪(S1,S2)🛜

Eagle Tavern Ⓛ ✔

22 Corn Street, OX28 6BL
☎ (01993) 700121
Hook Norton Hooky, Hooky Gold, Old Hooky; 1 changing beer (sourced locally; often Hook Norton) Ⓗ
This Grade II-listed building has been an inn from the beginning of the 19th century, when it was the Coach & Horses, and was given its current name in 1862. It has been owned by Hook Norton for over 20 years and serves a range of the brewery's ales alongside malt whiskies, bourbons, gins and rums. The interior has three seating areas and lots of dark wood. The cellar is visible through a window next to the bar. Closed Monday. Q🍴&♣🚪(S1,S2)☀🛜

Woodstock

Black Prince

2 Manor Road, OX20 1XJ
☎ (01993) 811530 ● theblackprincewoodstock.com
Loddon Hullabaloo; St Austell Tribute; 2 changing beers (sourced nationally; often Vale) Ⓗ
A historic 16th-century riverside pub opposite the grounds of Blenheim Palace. Four ales – two regular and two changing, often locally sourced – are served, alongside fresh well-cooked meals and snacks. Inside there are stone walls, two roaring log fires and even a suit of armour; outside there is a lovely riverside garden. Aunt Sally is played, and families, walkers and well-behaved dogs are all welcome. This is a lovely place to relax with a pint in summer and winter alike. Closed Monday. Q🛏🍴🕦♣🚪🐕☀🛜

Breweries

Amwell Springs SIBA

Westfield Farm House, Cholsey, Wallingford, Oxfordshire, OX10 9LS ☎ 07812 396619
🌐 asbco.co.uk

Brewing began in 2017 on a 70-litre plant using water from a spring in the farmhouse grounds. Capacity expanded in 2019 to six barrels. Beers are available in local pubs. LIVE

Chairman Dave (ABV 3.5%) BITTER
Stay Jammy (ABV 3.8%) BITTER
Rude Not To (ABV 4%) GOLD
Easy Geez (ABV 4.5%) GOLD
Mad Gaz (ABV 5.2%) PALE

Barn Owl

Buildings Farm, Faringdon Road, Gozzard's Ford, Oxfordshire, OX13 6QH ☎ 07724 551086

⊠ Located in a spacious barn on a farm just outside Abingdon, brewing began in 2016 using a four-barrel plant. Beers can be found in local free trade outlets.

Old Scruttock's Bitter (ABV 3.9%) BITTER
Golden Gozzard (ABV 4%) GOLD
Gozzard's Guzzler (ABV 4.4%) BITTER
Special Best Bitter (ABV 4.5%) BITTER
Old Scruttock's Dirigible (ABV 5%) PORTER

Bicester

🍺 Angel, 102 Sheep Street, Bicester, Oxfordshire, OX26 6LP
☎ (01869) 360410 🌐 theangelbicester.co.uk

Brewing commenced in 2017 in an outhouse behind the Angel, Bicester. Beers are brewed occasionally and supplied solely to the pub.

BMAN

50 Monument Business Park, Chalgrove, OX44 7RW
🌐 bmanbrewery.co.uk

Established by food scientist Alex Berryman in a freight container in 2021. Production is currently limited to kegs and cans of American-style IPAs. Outlets include the Big Scary Monsters Social Club and the Library in Oxford.

Brakspear

Eagle Maltings, The Crofts, Witney, Oxfordshire, OX28 4DP
☎ (01993) 890800 🌐 brakspear-beers.co.uk

Brakspear beers have been brewed in Oxfordshire since 1779. They continue to be traditionally crafted at the Wychwood Brewery (qv) in the historic market town of Witney using the original Victorian square fermenters and the renowned double drop fermenting system. Part of Carlsberg Marston's Brewing Co. 🍴 🍺 ♦ LIVE

Gravity (ABV 3.4%) BITTER
Oxford Gold (ABV 4%) GOLD

Chadlington SIBA

Blaythorne Farm, Chadlington, Oxfordshire, OX7 3NE
☎ (01608) 676823 ☎ 07931 482807
🌐 chadlingtonbrewery.com

Based in the Cotswolds, brewing was small to start with, but the new brewhouse, which opened in 2019, is capable of supplying a growing range of customers. The brewery utilises renewables and pure spring water. Family-owned, it makes visitors very welcome, hosting events and holding Brew-your-Own days. A taproom is planned.

Golden Ale (ABV 4%) GOLD
Oxford Blonde (ABV 4%) BLOND
Oxford Blue (ABV 4.2%) GOLD

Church Hanbrewery

Unit F2, New Yatt Business Centre, North Leigh, Oxfordshire, OX29 6TJ
☎ (01993) 774986 ☎ 07907 272617

Office: Tithe Barn South, Church Hanborough, OX29 8AB 🌐 churchhanbrewery.com

⊠ Brewing commenced in 2016 on a small scale in the owner's kitchen. A year later, a 250-litre plant was installed in a small industrial unit in New Yatt near Witney. It was upgraded to 500-litres in 2021. Now producing mainly bottles and keg, plus some cask for the taproom next door, and the Teardrop bar in Oxford's indoor market (one-off brews regularly seen in both). 🍺 LIVE ♦

Ale X IPA (ABV 4.5%) PALE
Rauk (ABV 5%) SPECIALITY
Red Beetter (ABV 5%) SPECIALITY
Bluenette (ABV 5.5%) PORTER
Mat Black (ABV 5.5%) PALE

Craftsman

21 Isis Close, Abingdon, Oxfordshire, OX14 3TA
☎ 07743 041916 ✉ justinlevans@btinternet.com

A 100-litre microbrewery in the owner's garage which started commercial production in 2021. Only bottling at the moment and selling in local markets and similar.

Earth Ale

Bothy Vineyard, Faringdon Road, Frilford Heath, Oxfordshire, OX13 6QW ☎ 07508 553546
🌐 earthale.com

After brewing at various London breweries, Earth Ale settled down at the Chocolate Factory complex in 2019, then moved to the Vale of The White Horse in 2021, using a six-barrel plant. A wide range of beers is available in kegs, cans and bottles.

Elements

Unit 2, Upton Downs Farm, Upton, Burford, Oxfordshire, OX18 4LY ☎ 07984 308670
🌐 elementsbrewery.co.uk

Began brewing in 2018 on a six-barrel plant, producing small-batch, hop-forward beers initially in keg. A taproom opened in 2019. No real ale. 🍺 ♦

Heavy Water

c/o Church Hanbrewery, Unit F2, New Yatt Business Centre, North Leigh, Oxfordshire, OX29 6TJ
☎ (01993) 868998

Office: Williams Stanley & Co,, 43-45 Newcombe House, Notting Hill Gate, London, W11 3LQ
🌐 heavywaterbrewing.co.uk

Established in 2020. Brewing suspended until suitable premises are found. ♦

Hook Norton SIBA IFBB

Brewery Lane, Scotland End, Hook Norton, Oxfordshire, OX15 5NY
☎ (01608) 737210 ⊕ hooky.co.uk

⊗ One of the finest examples of a Victorian tower brewery, and the oldest independent brewery in Oxfordshire, Hook Norton has been brewing since 1849. The current premises were built in 1900 and still house much of the original machinery, including a 25hp steam engine. Shire horses make deliveries to local pubs. Family-owned, it combines its heritage with a modern approach. Various parts of the brewery are available for hire. Customers can spend a day brewing beer. !! ⬛ ♦ LIVE

Hooky Mild (ABV 2.8%) MILD
A chestnut brown, easy-drinking mild. A complex malt and hop aroma give way to a well-balanced taste, leading to a long, hoppy finish that is unusual for a mild.
Hooky (ABV 3.5%) BITTER
A classic golden session bitter. Hoppy and fruity aroma followed by a malt and hops taste and a continuing hoppy finish.
Off The Hook (ABV 4.3%) GOLD
Old Hooky (ABV 4.6%) BITTER
A strong bitter, tawny in colour. A well-rounded fruity taste with a balanced bitter finish.

Little Ox SIBA

Unit 6, Wroslyn Road Industrial Estate, Freeland, Oxfordshire, OX29 8HZ
☎ (01993) 881941 ☎ 07730 496525

Office: 25 Castle Road, Wootton, OX20 1EQ
⊕ littleoxbrewery.co.uk

⊗ An award-winning brewery, Little Ox began production in 2016 and uses its 17-hectolitre (10 barrel) plant to produce beer in cask, keg and can. It offers a small core range of beers, a larger range of seasonal and occasional beers and also brews an experimental beer every month, which includes a barrel-aged project released at the end of the year. Little Ox supply more than 50 pubs, restaurants and off licences and offer free local delivery to homes around Oxfordshire. ⬛ ♦ GF

Hufflepuff (ABV 3.8%) GOLD
Wipeout (ABV 4.2%) GOLD
Ox Blood (ABV 4.3%) RED
Yabba Dabba Doo (ABV 4.8%) BITTER
Dark and Seedy (ABV 5.5%) STOUT

Loddon SIBA

Dunsden Green Farm, Church Lane, Dunsden, Oxfordshire, RG4 9QD
☎ (0118) 948 1111 ⊕ loddonbrewery.com

☺ This family-run brewery was established in 2002 in a brick-and-flint barn (originally a grain store). The custom-built, 17-barrel plant typically produces 120 barrels per week and supplies more than 700 outlets far and wide. To complement the existing taproom, an onsite farm shop opened in late 2021. !! ⬛ ♦ GF V ♦

Hoppit (ABV 3.5%) BITTER
Pale session bitter with hops dominating the aroma. Malt and hops in the balanced taste followed by a bitter aftertaste.
Hullabaloo (ABV 4.2%) BITTER
Session bitter with fruit in the initial taste. This develops into a balance of hops and malt in the mouth followed by a bitter aftertaste.
Citra Quad (ABV 4.4%) GOLD
Ferryman's Gold (ABV 4.4%) GOLD

Premium golden ale with a strong hoppy character throughout, accompanied by fruit in the taste and aftertaste.
Hocus Pocus (ABV 4.6%) OLD
Ruby-coloured old ale with dark malt, fruit and caramel aroma, joined by sweetness in the taste. There is a malty, bitterness to the finish.
Dragonfly (ABV 5.2%) PALE

Loose Cannon SIBA

Unit 6, Suffolk Way, Abingdon, Oxfordshire, OX14 5JX
☎ (01235) 531141 ⊕ lcbeers.co.uk

Brewing began in 2010 using a 15-barrel plant, reviving Abingdon's brewing history after the Morland Brewery closed in 2000. Beers can be found in an increasing number of local pubs and within 50 miles of the brewery. Loose Cannon operates an attractive taproom and a membership scheme enables customers to buy beer at a 10% discount. !! ⬛ ♦ ♦

Gunners Gold (ABV 3.5%) GOLD
Abingdon Bridge (ABV 4.1%) BITTER
Detonator (ABV 4.4%) BITTER
Porter (ABV 5%) PORTER
India Pale Ale (ABV 5.4%) PALE

LoveBeer SIBA

95 High Street, Milton, Oxfordshire, OX14 4EJ
☎ 07434 595145 ⊕ lovebeerbrewery.com

Starting as a small-scale passion project in 2013, LoveBeer quickly outgrew its original 0.5-barrel plant and expanded to six barrels in 2017. The family-run brewery supplies pubs around Oxfordshire and Berkshire as well as beer festivals and farm shops. In addition to its core and seasonal range, LoveBeer brews bespoke beers for special occasions. ⬛ ♦ LIVE

Doctor Roo (ABV 3.7%) BITTER
Molly's (ABV 4%) BITTER
Not on Your Nelly (ABV 4%) GOLD
OG (ABV 4.1%) PALE
Skyfall (ABV 4.3%) GOLD
Bonnie Hops (ABV 4.6%) PALE

Lovibonds

Friar Park Stables, Badgemore, Henley-on-Thames, Oxfordshire, RG9 4NR
☎ (01491) 576596 ⊕ lovibonds.com

Lovibonds was founded by Jeff Rosenmeier and has been brewing American-style, craft beer since 2005. It is named after Joseph William Lovibond (inventor of the Tintometer to measure beer colour). Beers are unfiltered and unpasteurised. In 2017, a purpose-built brewery was established on the outskirts of Henley, with a steam-heated mash tun and copper. Beers are available at a number of local outlets.

Oxford SIBA

Coopers Yard, Manor Farm Road, Horspath, Oxfordshire, OX33 1SD
☎ (01865) 604620 ☎ 07710 883273
⊕ oxfordbrewery.co.uk

⊗ A family-owned and run brewery, it began brewing in 2009 and supplies outlets in the Oxford area. Recently changed its name from Shotover Brewery to Oxford Brewery. !! ⬛ ♦ ♦

Prospect (ABV 3.7%) BITTER
Trinity (ABV 4.2%) GOLD
Vivid Dreams (ABV 4.2%) GOLD

Let the Dragon See the Wolf (ABV 4.5%) GOLD
Scholar (ABV 4.5%) BITTER
Matilda's Tears (ABV 5%) PALE

Parlour (NEW)

Chadwick Farm, Garford, Nr Abingdon, OX13 5PD
☎ (01865) 392227 ☎ 07799 183119
✉ ben@milletsfarmcentre.com

Run by three brothers-in-law, this small brewery was set up in a converted milking parlour in 2020. It brews beer in 240L batches, which can be bottle-conditioned or kegged.

Philsters

Unit 16 Camp Industrial Estate, Rycote Lane, Milton Common, Oxfordshire, OX9 2NP ☎ 07747 827489
Office: Beehive Cottage, Little Haseley, OX44 7LH
⊕ philsters.co.uk

Named after the owner/brewer's nickname, this small brewery, established in 2015 at the brewer's home, expanded with a 4.5-barrel plant into new premises in 2019. It supplies a number of local pubs. ♦

New Normal (ABV 3.8%) BITTER
Milton Gold (ABV 4.1%) GOLD
Rising (ABV 4.8%) GOLD
Under the Wire (ABV 5%) PALE
Darkside (ABV 5.1%) SPECIALITY

South Oxfordshire (NEW)

Office: Windrush Innovation Centre, Howbery Business Park, Benson Lane, Wallingford, Oxfordshire, OX10 8BA ☎ 07704 307182
⊕ soxbrewery.co.uk

South Oxfordshire Brewery aka SOX was established in 2020 and commenced test brewing of cask ales in 2022. Beers are cuckoo brewed until suitable premises have been found.

Tap Social Movement SIBA

Unit 16a, Rowles Way, Kidlington, OX5 1JD
☎ (01865) 236330
Office: 27 Curtis Industrial Estate, North Hinksey Lane, Botley, Oxfordshire, OX2 0LX
⊕ tapsocialmovement.com

The three founders have a background in the criminal justice system and established the brewery in 2016 to provide training and work opportunities for people serving prison sentences. Brewing is conducted on its 6,000-litre plant. Beer is produced in kegs, cans and occasionally cask, the latter appearing as guest ales at the White House, Oxford, and Lock 29, Banbury. Its former LAM brewery site in Kennington is now closed and its original Botley site is a popular taproom. ♦

Thame

⊟ East Street, Thame, Oxfordshire, OX9 3JS
☎ (01844) 218202
✉ thamebrewery@btinternet.com

⊠ This one-barrel brewery was set up in 2009 by Peter Lambert and Oak Taverns in the old stables at the Cross Keys. Beer is produced from time to time for that pub.

Turpin

Turpins Lodge, Lodge Farm, Tadmarton Heath Road, Hook Norton, Oxfordshire, OX15 5DQ
☎ (01608) 737033 ⊕ turpinslodge.co.uk/turpin-brewery

⊠ Brewing started in 2013, with brewing capacity extended in 2019. A number of local pubs are supplied regularly, as well as a few pubs further afield in Oxford, Rugby and Birmingham. ♦

Golden Citrus (ABV 4.2%) GOLD

White Horse SIBA

3 Ware Road, White Horse Business Park, Stanford in the Vale, Oxfordshire, SN7 8NY
☎ (01367) 718700 ⊕ whitehorsebrewery.co.uk

⊛ White Horse was founded in 2004. In 2018 a new management team took over the running of the brewery. It has major outlets in Oxfordshire, as well as supplying other outlets nationally. In addition to its regular beers, a range of seasonal monthly beers is brewed. A number of one-off beers are brewed under the Luna brand name. ‼ ⤆ ♦

WHB (White Horse Bitter) (ABV 3.7%) BITTER
Black Beauty (ABV 3.9%) MILD
Stable Genius (ABV 4%) BITTER
Village Idiot (ABV 4.1%) GOLD
Dark Blue Oxford University Ale (ABV 4.3%) BITTER
Wayland Smithy (ABV 4.4%) BITTER
West Coast IPA (ABV 4.6%) GOLD

Woodstock

24 Shipton Road, Woodstock, Oxfordshire, OX20 1LL
☎ 07481 569419 ⊕ woodstockbrewery.co.uk

A nanobrewery which started in mid-2021 on 70-litre brewing kit. A range of bottle-conditioned beers are produced, which are sold online, at local pubs and shops and at local markets through the Thames Valley Farmers' Market cooperative. LIVE

Wriggly Monkey SIBA

B.131 Motor Transport Yard, Bicester Heritage Centre, Bicester, Oxfordshire, OX27 8AL
☎ (01869) 246599 ☎ 07590 749062
⊕ wrigglymonkeybrewery.com

Established in 2018 on a 1.25-barrel kit and later expanded to 10 barrels, the brewery and its taproom are based in an old motor transport workshop at an automotive centre on the old RAF Bicester site. It is named after the compartment of a chain-drive mechanism of the Fraser Nash car. The brewery has an online shop and offers mail delivery, 'click & collect', and free local delivery options. ‼ ⤆ LIVE ⤳

Super Sports (ABV 3.2%) PALE
Gullwing Lager (ABV 4%) BLOND
Full Tilt (ABV 4.2%) BITTER
Charabanc (ABV 5.3%) BITTER
Ambassador (ABV 5.5%) IPA

Wychwood

Eagle Maltings, The Crofts, Witney, Oxfordshire, OX28 4DP
☎ (01993) 890800 ⊕ wychwood.co.uk

Wychwood brewery is located in the Cotswold market town of Witney. The brewers take inspiration from the myths and legends associated with the ancient medieval Wychwood forest. Part of Carlsberg Marston's Brewing Co. ‼ ⤆ ♦ LIVE

Hobgoblin Gold (ABV 4.2%) GOLD
Hobgoblin Ruby (ABV 4.5%) OLD

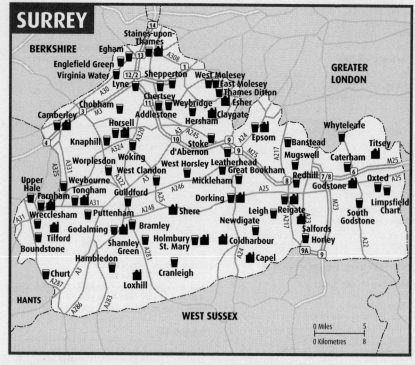

SURREY

Staines-upon-Thames
BERKSHIRE Egham
Englefield Green
Virginia Water Shepperton West Molesey
Lyne East Molesey
Chobham Chertsey Thames Ditton
Camberley Addlestone Weybridge Esher
Horsell Claygate
Knaphill Hersham
Stoke Epsom GREATER
Worplesdon d'Abernon Banstead LONDON
Woking West Horsley Leatherhead Mugswell Whyteleafe
West Clandon Great Bookham Caterham Titsey
Upper Weybourne Mickleham Redhill Oxted
Hale Tongham Guildford Godstone
Farnham Dorking Limpsfield
Wrecclesham Puttenham Shere Leigh Reigate South Chart
Godalming Newdigate Godstone
Tilford Bramley Salfords
Boundstone Shamley Holmbury Coldharbour Horley
Hambledon Green St. Mary Capel
Churt Cranleigh
Loxhill

HANTS
WEST SUSSEX

0 Miles 5
0 Kilometres 8

Addlestone

RAOB Club

136 Church Road, KT15 1SQ
☎ (01932) 883335
Shepherd Neame Spitfire; 1 changing beer (sourced nationally; often Adnams) Ⓗ

The principal aims of the Royal Antediluvian Order of Buffaloes are described as friendship, charitable works, social activity and mutual support. A 10-minute walk from the town centre, this community social club offers pub games, sports TV and a snooker table. There is live music some Saturday nights and a monthly quiz. The bar prides itself on its real ale. CAMRA members can be signed in as guests. ☒❀♣P🚻(461,557)🛜

Banstead

Woolpack

186 High Street, SM7 2NZ
☎ (01737) 354560 ⏚ woolpackbanstead.co.uk
Shepherd Neame Whitstable Bay Pale Ale, Spitfire, Bishops Finger; 2 changing beers Ⓗ

The Woolpack is a brick and tile building with a large porch over the main entrance. Inside, it has a single bar with a log burner and a restaurant. Outside, there is a terraced open-air dining area under a canopy and a small grassed area equipped with tables. Meals are served all day until 9pm. The guest beers may be from Shepherd Neame or local breweries such as Pilgrim or Hogs Back. An annual beer festival is held over the August bank holiday. ❀🍴P🚻🐾🛜

Boundstone

Bat & Ball Ⓛ

15 Bat & Ball Lane, GU10 4SA (off Sandrock Hill Rd via Upper Bourne Lane) SU833444

☎ (01252) 792108 ⏚ thebatandball.co.uk
Dark Star Hophead; Hop Back Summer Lightning; Triple fff Moondance; 3 changing beers (sourced locally) Ⓗ

A traditional country free house dating back 150 years, set in the Bourne Valley. It has been run by the same family for two generations. The pub has several different rooms, with an open log fire, panelled walls and oak beams. The attractive garden has a children's play area and is popular with families on warmer days. There is an annual beer festival, a weekly quiz on Tuesday and live music once a month. An afternoon menu is served at weekends. Q☒❀🍴&♣P🚻(16,17)🐾🛜

Bramley

Jolly Farmer Ⓛ

High Street, GU5 0HB
☎ (01483) 893355 ⏚ jollyfarmer.co.uk
Crafty Brewing Hop Tipple; house beer (by Crafty Brewing); 6 changing beers (sourced nationally; often Crafty Brewing, Firebird, Heritage) Ⓗ

Originally a stagecoach inn, this is now a privately owned free house serving eight real ales. It has a cosy, welcoming atmosphere, with dark wood beams and a decor that is a celebration of the countryside and beer, featuring historic beer mats and pumpclips. The L-shaped bar offers a diverse range of real ales, keg beers, plus real ciders in summer. Accommodation is available in four en-suite rooms and a three-bedroom flat. Bramley is served by buses from Guildford and Horsham. ☒❀🍴🛏🍴♣P🚻🐾🛜

Camberley

Claude du Vall Ⓛ ✅

77-81 High Street, GU15 3RB
☎ (01276) 672910

Greene King Abbot; Ruddles Best Bitter; Sharp's Doom Bar; 3 changing beers (sourced nationally; often Ascot, Tillingbourne, Windsor & Eton) ⓗ
The Claude du Vall is conveniently close to the station and bus stops, at the end of the High Street. The large, modern interior is divided into a number of different areas. The long bar offers three regular beers and three guests, including at least one LocAle. Wetherspoon's reputation for good-value food and drink attracts customers throughout the day, from breakfast onwards. Silent TVs generally show news programmes and occasional sports events. ⓢ❀⟨Ⅰ⟩&⇌⟦⟧🛜

Caterham

King & Queen ⓛ
34 High Street, CR3 5UA (on B2030)
☎ (01883) 345303 ⊕ kingandqueencaterham.co.uk
Fuller's London Pride, ESB; 1 changing beer ⓗ
Dating back to the 1840s and converted from three former cottages, the pub retains three distinct areas. The front section is a public bar, the high-ceilinged middle section is a games room with a dartboard, and there is a small cosier section at the back. Outside, there are patios front and back and a covered smoking section at the rear. The pub is named after the joint monarchy of William and Mary and displays their portraits. ⓢ❀⟨Ⅰ⟩♣P🛜❀🛜

Chertsey

Olde Swan Hotel ⓨ
27 Windsor Street, KT16 8AY
☎ (01932) 562129 ⊕ theoldeswanhotel.co.uk
Sharp's Doom Bar; Timothy Taylor Landlord; 1 changing beer (sourced nationally; often Dorking, Thames Side) ⓗ
Refurbished when acquired by Mclean Inns, without spoiling its charm, the Olde Swan gives drinkers and diners a mellow experience with its shabby-chic decor. Four ales are usually on offer, as well as real cider from SeaCider. The menu features stone-baked pizza, home-made burgers and sizzling steaks, with Mexican night on Friday. Accommodation includes double, twin and family rooms. Chertsey is handy for the M3 and Thorpe Park. ⓢ❀⇌⟨Ⅰ⟩⇌❀P🛜(446,456) 🛜

Chobham

Horse & Groom
30 High Street, GU24 8AA
☎ 07785 283573
⊕ horse-and-groom-micropub.business.site
3 changing beers (sourced locally) ⓗ
The first micropub locally, the Horse & Groom is on the site of an old hairdresser's; however, long before that, it was part of the original inn that closed in 1960. The micro describes itself as 'a village pub but smaller' – it has the feel of a local, with conversation a key part of the ambience. Beers are sourced locally and all come direct from the brewery, and a local traditional cider is served. Cheese plates are available to accompany your beer. Qⓢ❀❀🛜(39A,73)

White Hart ⓛ
58 High Street, GU24 8AA
☎ (01276) 857580 ⊕ whitehart-chobham.co.uk
House beer (by St Austell); 4 changing beers (sourced locally) ⓗ
A lovely rambling building next to the village church on the historic High Street. It serves five ales in a range of strengths and styles; guest beers are sourced from any of the local breweries, with the distance from the pub

displayed. There are two restaurant areas and a less formal space for drinkers as you enter. Log fires keep the pub warm in winter, and there is a garden area to watch cricket in summer. McLaren supercars from the nearby factory often pass by. Qⓢ❀⟨Ⅰ⟩&P🛜(39A,73)❀🛜

Churt

Crossways Inn ⓛ
Churt Road, GU10 2JS
☎ (01428) 714323 ⊕ thecrosswaysinn.co.uk
Arundel Sussex IPA; Hop Back Crop Circle ⓗ**; 4 changing beers (sourced nationally)** ⓖ
Friendly two-bar pub with a homely ambience. At the centre of village life, it is popular with local groups as well as customers from further afield including ramblers and cyclists. Food is set to feature in the future but, at time of writing, drinkers are welcome to bring their own sandwiches. Three traditional ciders are usually available and may be from any independent cider maker. Close to lovely countryside and walks, what better place to finish up. ❀⟨Ⅰ♣❀P🛜(19)❀

Cranleigh

Three Horseshoes ⓛ ✅
4 High Street, GU6 8AE (on B2128)
☎ (01483) 276978 ⊕ threehorseshoescranleigh.co.uk
Harvey's Sussex Best Bitter; 5 changing beers ⓗ
This two-bar 17th-century inn features an inglenook fireplace with a roaring wood fire in winter. The long-gone Brufords Brewery used to stand behind the pub and some photos in the lounge bar show the building. Good home-made food is served daily except Sunday evening. The elaborate walled garden has a spectacular children's playhouse and the patio is covered against the weather. Five constantly changing guest beers are sold, mostly from local brewers. ⓢ❀⟨Ⅰ⟩♣P🛜❀🛜

Dorking

Cobbett's ⓛ
23 West Street, RH4 1BY (on A25 one-way system eastbound)
☎ (01306) 879877 ⊕ cobbettsdorking.co.uk
4 changing beers ⓗ/ⓖ
This excellent micropub and real ale off-licence is in an old part of town and was once a dolls' house shop. Up to

REAL ALE BREWERIES	
Ascot ✦ Camberley	
Big Smoke ✦ Esher	
Brightwater Claygate	
By the Horns Salfords	
Craft Brews ✦ Farnham	
Crafty Loxhill	
Dorking ✦ Capel	
Felday 🍺 Holmbury St Mary	
Fuzzchat 🍺 Epsom	
Godalming Beerworks 🍺 Godalming (NEW)	
Godstone ✦ Godstone	
Hogs Back ✦ Tongham	
Leith Hill 🍺 Coldharbour	
Pilgrim ✦ Reigate	
Surrey Hills ✦ Dorking	
Thames Side ✦ Staines-upon-Thames	
Thurstons Horsell	
Tilford 🍺 Tilford	
Tillingbourne Shere	
Titsey ✦ Titsey	
Trailhead ✦ Dorking	

four constantly changing cask beers, plus six keg and around 200 different canned and bottled beers are available, sold by knowledgeable staff. The tiny pub is in a back room with its own patio garden and is a great place to go and chat. Q ⊗ ☆ ₹ (West)♠ 🚌 ♣ 🐾 ?

Cricketers 🅛 ✅

81 South Street, RH4 2JU (on A25 one-way system westbound)
☎ (01306) 889938 ⊕ cricketersdorking.co.uk
Dark Star Hophead; Fuller's London Pride, ESB; 1 changing beer Ⓗ
Comfortable pub with an L-shaped bar with old mirrors, photographs and adverts on the bare-brick walls. The guest beer may be from Dark Star or something from the Fuller's list. There are normally two beer festivals a year which are held in the garden. The pub also holds events such as an onion competition. Terrestrial sport, especially rugby, may be shown, and there are board games, darts and a monthly quiz. ⊗ ❀ ◑ ♣ 🚌 🐾 ?

Old House ✅

24 West Street, RH4 1BY (on A25 eastbound)
☎ (01306) 889664 ⊕ oldhousedorking.co.uk
5 changing beers Ⓗ
Attractive timber-framed inn dating from the 15th century and situated in the Dorking Conservation Area. The pub has been well modernised but does not disguise the antiquity of the building. Very good home-made food ranging from bar snacks to daily specials, featuring local suppliers, is available each day. Outside is a surprisingly large and pleasant patio garden which can be quite a suntrap. The beer range will always include a selection from Dorking Brewery and Laines. ⊗ ❀ ◑ ₹ (West) 🚌 🐾 ?

East Molesey

Bell 🅛 ✅

4 Bell Road, KT8 0SS (off B369)
☎ (020) 8941 0400
Greene King IPA; Morland Old Speckled Hen; 4 changing beers (often Hogs Back, St Austell, Twickenham) Ⓗ
A quirky, welcoming back-street inn, close to the main shopping street. The pub claims to date from 1460, although the main structure is 16th century – it was later East Molesey's first post office. The 18th-century highwayman Claude Duvalier hid from the Bow Street Runners here. Separate drinking areas make it ideal for a quiet pint or a larger gathering. The large garden has a children's play area. TV screens show sport, which can be avoided if preferred. Quiz night is Tuesday. ⊗ ❀ ◑ ♣ P 🚌 (411) 🐾 ?

Egham

Egham United Services Club 🅛

111 Spring Rise, TW20 9PE (close to A30 Egham Hill)
☎ (01784) 435120 ⊕ eusc.club
Rebellion IPA; Surrey Hills Ranmore; 3 changing beers (sourced nationally; often Kent, Oakham, Titanic) Ⓗ
Local CAMRA Club of the Year and a former National Club of the Year finalist. A changing range of guest ales includes something dark, and a real cider is usually available from the cellar. Three beer festivals a year showcase an eclectic range of ales, mostly from the newest micros around. The club is comfortably furnished with sports TV, and hosts live music most Saturday evenings. Show a CAMRA membership card to be signed in. ⊗ ❀ ♿ ₹ ♣ P 🚌 ?

Englefield Green

Beehive 🅛

34 Middle Hill, TW20 0JQ (200yds N of A30 Egham Hill)
☎ (01784) 431621 ⊕ beehiveegham.co.uk
Fuller's London Pride; 2 changing beers (sourced locally; often Dark Star) Ⓗ
This cosy well-kept Fuller's local is open plan with a light and airy feel. It offers a full range of hot drinks including posh coffees, and an extensive daily food menu, with offers Monday to Wednesday and traditional roasts on Sunday. On cooler days there is a real log fire, and on warmer ones a sheltered patio garden as well as seating at the front. Closed on Monday. ⊗ ❀ ◑ P 🚌 🐾 ?

Happy Man ✅

12 Harvest Road, TW20 0QS (off A30)
☎ (01784) 433265 ⊕ thehappyman.co.uk
4 changing beers (sourced nationally; often Goff's, Ossett, Tring) Ⓗ
In Victorian times two houses were converted to a pub serving workers building nearby Royal Holloway College. Refurbished but virtually unchanged, this former local CAMRA Pub of the Year is a popular haunt for students and locals. Four varying ales are usually available, both local and national, and occasional beer festivals are held on the heated and covered rear patio. Pub games include darts, and quiz nights are hosted. Food is usually available every day. ❀ ◑ ♣ 🚌 🐾

Epsom

Jolly Coopers 🅛

84 Wheelers Lane, KT18 7SD (off B280 via Stamford Green Rd)
☎ (01372) 723222 ⊕ jollycoopers.co.uk
Surrey Hills Ranmore; 2 changing beers (sourced regionally; often Fuzzchat) Ⓗ
Close to Epsom Common, this pub is more than 200 years old. The interior is divided in two – a carpeted bar area to the left, and another larger area with polished parquet flooring to the right used more for dining, although not exclusively so. The decor is modern, with painted walls. There is a large paved garden at the rear. It can get busy at weekends but is quieter during the week. The Fuzzchat Brewery is in an outbuilding at the back. Harry's Cider is sold. ⊗ ❀ ◑ ♣ ♣ P 🚌 (E9,E10) 🐾 ?

Rifleman 🅛

5 East Street, KT17 1BB (on A24)
☎ (01372) 721244
Greene King London Glory; house beer (by Hardys & Hansons); 3 changing beers (sourced locally; often Hogs Back, Twickenham, Windsor & Eton) Ⓗ
Small corner pub in the shadow of a bridge carrying the railway to and from London. It is decorated in a traditional style featuring two fireplaces and dark-green wood panelling, but also has some modern features such as bare brickwork and high tables at the front. There is a pleasant garden to the rear, an oasis of calm close to central Epsom. The name comes from the Surrey Rifle Volunteers who trained nearby. ⊗ ❀ ◑ ₹ 🚌 🐾

Farnham

Hop Blossom

50 Long Garden Walk, GU9 7HX (between Waitrose and Castle St)
☎ (01252) 710770 ⊕ hopblossom.co.uk
Dark Star Hophead; Fuller's London Pride; Gale's Seafarers Ale; 1 changing beer (sourced nationally; often Fuller's) Ⓗ

A hidden treasure in the heart of Farnham with hops decorating the traditional bar counter. There are comfortable stools at the bar. On cold days a real log fire adds more atmosphere. The pub is dog friendly, and children are welcome until early evening. It can be busy when there are events in town such as the fireworks, food and craft festivals. ♿♿⬤♖⬤🏠🐕🦴🌐

Godalming

Richmond Arms ✓
149 High Street, GU7 1AF
☎ (01483) 416515 ⊕ therichmondarmsgodalming.co.uk
St Austell Tribute; Young's London Original; 2 changing beers (sourced regionally) Ⓗ
A traditional and unspoilt locals' pub at the southern end of Godalming's High Street, handy for buses and the station. The main bar at the front has maroon half panelling and a fireplace at each end. The public bar to the rear has a separate entrance. There is a raised garden at the back with plenty of seating. ♿⬤🍴⬤⬤🏠🐕🌐

Star Inn ✓
17 Church Street, GU7 1EL
☎ (01483) 417717 ⊕ starinngodalming.co.uk
St Austell Tribute Ⓗ; 11 changing beers (sourced nationally; often Godalming Beerworks) Ⓗ/Ⓖ
Dating from around 1830, the Star has a small public bar at the front and a main room to the side leading to a patio garden and separate lounge with bespoke cider bar. Up to 12 real ales are stocked as well as 10 ciders and perries plus mead. Beer festivals are held at Easter and Halloween. The pub is a regular winner of CAMRA cider awards and is home of Godalming Beerworks Brewery. ♿⬤🍴⬤⬤♣⬤🏠🐕🌐

Great Bookham

Anchor
161 Lower Road, KT23 4AH (off A246 via Eastwick Rd)
☎ (01372) 452429
Fuller's London Pride; Surrey Hills Ranmore; Young's London Original Ⓗ
Historic Grade II-listed inn dating from the 15th century. Low-beamed ceilings, wooden floors, exposed brickwork and an inglenook with a real fire in winter give the pub a traditional and homely feel. A charity quiz night is held every Tuesday (book ahead) and a meat raffle quarterly on a Sunday. There is a patio garden with a pond and heated smoking area at the front. Children are not allowed in the bar. Q⬤🍴♣P🚍(479)🐕🌐

Guildford

King's Head
27 King's Road, GU1 4JW
☎ (01483) 568957 ⊕ kingsheadguildford.co.uk
Dark Star Hophead; Fuller's London Pride, ESB; Gale's HSB; 1 changing beer (sourced nationally; often Dark Star, Fuller's, Twickenham) Ⓗ
Built in 1860 as two cottages, then soon after a beer house, this pub is noted for its attractive hanging baskets. The interior is deceptively spacious and now much enlarged. Service is from both sides of a central bar, with the full range of Fuller's beers available, including seasonals. TV sport is screened in most areas. Quiz night is Tuesday and acoustic music plays fortnightly on Thursday. ♿⬤🍴⬤🚆(London Rd)♣P🚍🐕🌐

Rodboro Buildings Ⓛ ✓
1-10 Bridge Street, GU1 4SB
☎ (01483) 306366

Greene King IPA, Abbot; Sharp's Doom Bar; 7 changing beers (sourced nationally; often Surrey Hills, Tillingbourne) Ⓗ
This Wetherspoon pub maintains a range of up to 10 real ales, often from local breweries. It is spread over three levels in a Grade II-listed former industrial building that was the original home of the Dennis car (later truck) company. The community noticeboard publicises a range of local events. The pub also hosts occasional Meet the Brewer nights and brewery battles. ♿⬤⬤🚆🏠🌐

Royal Oak
15 Trinity Churchyard, GU1 3RR
☎ (01483) 457144 ⊕ royaloakguildford.co.uk
Fuller's London Pride; Gale's HSB; 3 changing beers (sourced nationally; often Dark Star, Fuller's) Ⓗ
This former Gale's pub has been serving real ale since 1870. It was built as an extension to the rectory next door, with a hall upstairs and rooms at ground level. These rooms are now the bar area and show the building's heavily beamed structure. Outside there is a patio area on one side and a couple of tables overlooking Trinity churchyard on the other. Three brewery-supplied guest beers are available. ♿⬤♣P🚍🐕🌐

Hambledon

Merry Harriers Ⓛ ✓
Hambledon Road, GU8 4DR SU967391
☎ (01428) 682883 ⊕ merryharriers.com
Surrey Hills Shere Drop; 3 changing beers (sourced locally; often Crafty Brewing, Dorking, Greyhound) Ⓗ
This impressive 16th-century country inn, popular with walkers and cyclists, takes you back in time. It is in the heart of a picturesque village, set against the backdrop of the Surrey Hills, surrounded by open fields, in a designated area of outstanding natural beauty. The free house is owned by local resident Peter de Savary. An open field at the rear is home to the pub's llamas. Q♿⬤⬤⬤♣P🐕🌐

Hersham

Bricklayers Arms
6-8 Queens Road, KT12 5LS (off A317)
☎ (01932) 220936
Hogs Back TEA; Hop Back Crop Circle; Shepherd Neame Spitfire Ⓗ
This two-bar Victorian pub, just off the green, has been run by the same landlord for the past 40 years and has built up a fine reputation. It is divided into a spacious public bar and comfortable saloon. Excellent food is served in the lounge, including daily specials. Features include wonderful external floral displays and a secluded rear garden. Two letting rooms are available. Parking can be difficult. Q♿⬤⬤♣🚍(458,515)🐕🌐

Royal George ✓
130 Hersham Road, KT12 5QJ (off A244)
☎ (01932) 220910 ⊕ royalgeorgehersham.com
Young's London Original; 3 changing beers (often Harvey's, Sharp's, Surrey Hills) Ⓗ
The pub was built in 1964 – the name refers to a 100-gun ship from the Napoleonic Wars. It has one L-shaped bar with a tartan carpet and upholstered banquette seating. A real fire adds to the comfortable atmosphere. The menu features excellent Thai food alongside more traditional British fare, with a roast on Sunday lunchtime. There are paved outdoor seating areas to the front and rear for the warmer months. Quiz night is Tuesday. ♿⬤⬤⬤P🚍(555) 🐕🌐

Holmbury St Mary

Royal Oak 🅻

The Glade, Felday Road, RH5 6PF
☎ (01306) 898010 ⊕ theroyaloakholmbury.co.uk
Felday Legacy; Surrey Hills Shere Drop; 1 changing beer ⱨ
In a beautiful setting by the picturesque church and village green, this 17th-century pub is a popular destination for walkers and cyclists. The Felday Brewery is located at the pub – the guest beer is often from Felday or Big Smoke. Home-made meals are served in the cosy bar, with a real fire, and the rear dining room, up some stairs. There are gardens at the front and rear plus an outside bar. ⌂❀◖P🖵🐾🛜

Horley

Jack Fairman ✅

30 Victoria Road, RH6 7PZ
☎ (01293) 827910
Greene King Abbot; Ruddles Best Bitter; Sharp's Doom Bar; 4 changing beers ⱨ
This distinctive town centre Art Deco style building was formerly a garage used by local motor racing driver Jack Fairman, after whom it was named. Historical racing-related items can be found on the walls of the industrial-look interior. It then became a tyre centre before reopening as a Wetherspoon pub, and is conveniently close to the station and bus stops. Food is available all day. Televised news and sport are shown on three screens on silent with subtitles. Q⌂❀◖&≠🖵🛜

Horsell

Crown 🍺 🅻

104 High Street, GU21 4ST
☎ (01483) 771719
Surrey Hills Shere Drop; Thurstons Horsell Gold; 4 changing beers (sourced regionally; often Thurstons) ⱨ
Welcoming two-bar community local with six real ales in the saloon bar. A rarity for the area, this is a wet pub with no food. Three beers are from Thurstons, who started brewing in the pub and are now located next door. It hosts at least one beer festival a year. There is a large garden with two pétanque pistes. Motorcycle and scooter clubs meet here. Local CAMRA Pub of the Year 2022. ⌂❀♣P🖵(48)🐾🛜

Knaphill

Royal Oak 🅻

Anchor Hill, GU21 2JH
☎ (01483) 473330
Wye Valley Bitter; 5 changing beers (sourced nationally; often St Austell, Thurstons, Windsor & Eton) ⱨ
An attractive 17th-century building set back from the road at the bottom of the hill. Up to seven ciders are served alongside the beers. Food is available Wednesday to Sunday, with a roast on Sunday. Behind the pub is a superb garden with a barbecue and children's play equipment. An outside bar opens at the weekend in summer. Live music is hosted twice a month, plus an annual beer festival and two cider festivals.
⌂❀◖♣◉P🖵(48,91)🐾🛜

Leatherhead

Running Horse 🍺 🅻

38 Bridge Street, KT22 8BZ (off B2122)

☎ (01372) 372081 ⊕ running-horse.co.uk
Shepherd Neame Spitfire; 1 changing beer (often Surrey Hills) ⱨ
Overlooking the River Mole, this Grade II*-listed two-room pub, dating from 1403, features a log fire, home-made food, a courtyard seating area and a large back garden. Elizabeth I is said to have spent the night here. The public bar has TV, a pool table and dartboard, and the cosy lounge bar features low ceilings and exposed beams. Quiz night is Tuesday. Live jazz plays on Sunday lunchtime and live bands monthly, with a charity music event on May Day. Children are welcome until 9pm.
Q🚶⌂❀◖≠♣P🖵🐾🛜

Leigh

Seven Stars

Bunce Common Road, Dawes Green, RH2 8NP
☎ (01306) 611254 ⊕ 7starsleigh.co.uk
Fuller's London Pride; Surrey Hills Ranmore, Shere Drop ⱨ
This attractive two-bar tile-hung building has been an inn since at least 1637 when a former landlord wrote a welcoming message on the wall in the saloon bar, which can still be seen. This wood-beamed bar has a large inglenook at one end and a log-burning stove at the other. The lounge bar is mainly used by diners enjoying excellent home-made food. Q🚶⌂❀◖&P🖵🐾🛜

Limpsfield Chart

Carpenters Arms 🅻

12 Tally Road, RH8 0TG (off B269)
☎ (01883) 722209 ⊕ carpenterslimpsfield.co.uk
Larkins Traditional Ale; Westerham Spirit of Kent, British Bulldog, 1965 Special Bitter Ale; 1 changing beer ⱨ
Dating from the 19th century, this former Westerham Brewery tied house is adjacent to the National Trust's Limpsfield Common and attracts both walkers and horse-riders. The L-shaped bar has parquet flooring and the walls are adorned with an interesting collection of old photos and artwork. One side of the bar caters for diners enjoying the good food on offer. There is a separate function room. 🚶⌂❀◖♣P🖵(594)🐾🛜

Lyne

Royal Marine

Lyne Lane, KT16 0AN
☎ (01932) 873900 ⊕ royalmarinelyne.co.uk
Ruddles Best Bitter; 1 changing beer (sourced nationally; often Fuller's) ⱨ
The name of this cosy rural inn commemorates Queen Victoria's review of her troops in 1853 on nearby Chobham Common. Royal Marine memorabilia, a collection of drinking jugs and other bric-a-brac are on display. Generous portions of home-cooked food are served Monday to Friday and Sunday lunchtime. Friday is bingo quiz night. There is an extensive garden to the rear. Note that the pub is closed on Saturday.
Q🚶⌂❀◖♣🐾🛜

Mickleham

King William IV 🅻

4 Byttom Hill, RH5 6EL (off A24 southbound behind Frascati restaurant)
☎ (01372) 372590 ⊕ thekingwilliamiv.com
Surrey Hills Shere Drop; 2 changing beers (sourced locally; often Crafty Brewing, Hogs Back) ⱨ

A quaint, welcoming country pub, nestled on a hillside and dating from 1790. The main bar is homely with a log fire and there is a smaller bar to the front. An attractive outside terrace, with some tables under cover, enjoys stunning views over the Mole Valley. Good home-made food is served – book ahead for lunch, especially on summer weekends. Steep steps can make access difficult. A shared car park is on the A24 southbound. Q❤🕭🛏🏵🛒🅿🚃(465) 🌸🛜

Mugswell

Well House Inn 🄻 ✅
Chipstead Lane, CR5 3SQ (off A217) TQ25845526
☎ (01737) 830640 🌐 thewellhouseinn.co.uk
Fuller's London Pride; Surrey Hills Shere Drop; 2 changing beers 🅗
Rurally located but not too far from the M25, this Grade II-listed building dates from the 16th century and is reputedly haunted. The pub is named after St Margaret's Well, with the well in the garden listed in the Domesday Book. Inside is a maze of small rooms including a public bar with a dartboard and a lounge bar, each with an open fireplace. The remaining rooms are mostly given over to dining. There is an extensive outdoor area with wood burners and fine views. ❤🕭🏵🛒♣🅿🌸🛜

Newdigate

Surrey Oaks 🍷 🄻
Parkgate Road, Parkgate, RH5 5DZ (between Newdigate and Leigh) TQ20524363
☎ (01306) 631200 🌐 thesurreyoaks.com
Surrey Hills Ranmore, Shere Drop; 4 changing beers 🅗
This multi award-winning 16th-century free house serves a changing range of six cask beers including a dark ale, 18 craft keg beers and 16 ciders. The interior has a number of distinct areas with low beams, flagstones and an inglenook fireplace with log-burning stove. Good home-made food includes daily specials. The excellent large garden has a heated and covered area plus, in one corner, a children's play area. Popular beer festivals are hosted in May and August. Q❤🕭🏵🛒♣🌭🅿🚃(21,50) 🌸🛜

Oxted

Oxted Inn ✅
Units 1-4 Hoskins Walk, Station Road West, RH8 9HR
☎ (01883) 723440
Greene King Abbot; Ruddles Best Bitter; Sharp's Doom Bar; 4 changing beers 🅗
The only pub in New Oxted, this small purpose-built Wetherspoon pub is adjacent to the railway station. Oxted is on the Greenwich Meridian and the interior is decorated with more than 20 clocks showing the time in various parts of the world. Local historians will find the many photos on display of interest. Food is served all day. Q❤🕭🏵🛒🚃♿🛜

Puttenham

Good Intent
60-62 The Street, GU3 1AR
☎ (01483) 923434 🌐 goodintentputtenham.co.uk
Sharp's Doom Bar; Timothy Taylor Landlord; house beer (by Crafty Brewing); 1 changing beer (sourced nationally) 🅗
Attractive, welcoming village pub. Classic red carpets, contrasting dark varnished woodwork and a massive inglenook fireplace contribute to a warm, comfortable ambience. The layout and bar are L-shaped, with the

handpumps split between the long and short sides of the bar. Low partitions break up the floor space creating separate areas. The North Downs Way is at the other end of the village, as is one of Surrey's few remaining hop growers. Q❤🕭🏵🛒♿🅿🌸🛜

Redhill

Garibaldi 🄻
29 Mill Street, RH1 6PA
☎ (01737) 773094 🌐 thegaribaldiredhill.co.uk
4 changing beers 🅗
The pub, situated opposite Redhill Common, has stood here for over 150 years and is now not-for-profit and community owned. The single-room interior has a small side area with a dartboard. Two TV screens show sport at a discreet volume. A large number of social events are run including two beer festivals annually. The beer range changes frequently. The large garden, with views across Redhill, is extremely well tended and well worth seeking out. ❤🏵🚃(Earlswood)♣🛒🌸🛜

Sun 🄻 ✅
17-21 London Road, RH1 1LY
☎ (01737) 766886
Greene King Abbot; Ruddles Best Bitter; Sharp's Doom Bar; 5 changing beers 🅗
This pub, on the site of a former kitchen store, was Wetherspoon's 150th pub. It comprises a single large room with a raised dining area at one end, with a corner allocated to families until 6pm. The pub's name commemorates local astronomer Richard Carrington who built an observatory in Redhill in 1853 and studied the spots on the sun. A number of modern paintings by local artist Robert Jones depicting life in Redhill are on display. Q❤🕭🏵🛒♿🚃🛒🌸🛜

Reigate

Bell Inn 🄻 ✅
21 Bell Street, RH2 7AD
☎ (01737) 244438 🌐 thebellreigate.co.uk
6 changing beers 🅗
This town-centre pub is one of the oldest in Reigate. The tiny frontage leads to a long, narrow and cosy interior where six frequently changing beers, often local, are to be found. There is a patio garden to the rear. Renowned for its burger menu, meat is supplied by a local butcher. Children are welcome until 9pm. Note the large old Ordnance Survey map on the ceiling. ❤🕭🏵🛒🚃🛒🌸🛜

Hop Stop Bar
73 Bell Street, RH2 7AN
☎ (01737) 221781 🌐 hopstopbeers.co.uk
2 changing beers 🅗
The beer range changes constantly in this continental-style bar, with two cask ales, eight keg beers and around 80 cans and bottles available for drink-in or take-away. These, and the gin and wine, are all from small suppliers. Draught beers are in a wide variety of styles and are all beautifully kept with individual temperature control. The comfortable bar has several different seating areas and a modern decor. The owners also have a bottle shop by Oxted station. ❤🛒🌸🛜

Pilgrim Brewery Tap Room 🄻
11 West Street, RH2 9BL
☎ (01737) 222651 🌐 pilgrim.co.uk
Pilgrim Surrey, Session IPA; 4 changing beers 🄶
The oldest brewery in Surrey has been under the current ownership since 2017, with a growing beer range. The brewery is in a yard set back from the main road, and the

tap room is in what used to be the brewery office. There are usually six cask and six keg beers available, all of them brewed on site. Table-top games are available. Outdoor seating is in the yard. Open Thursday to Saturday plus Sunday in summer. Q ♿ ⊛ ❄ ♣ P ➡ ❀ 🐕 ？

Shamley Green

Bricklayers Arms

The Green, GU5 0UA

☎ (01483) 898377 ⊕ bricklayersarmspub.co.uk

Harvey's Sussex Best Bitter; Sharp's Doom Bar; Wadworth 6X; 2 changing beers (often Surrey Hills) Ⓗ

This Georgian pub is an ideal place to stop off while exploring the Surrey Hills. It has been extended over the years, with the bar opened out to create space for different seating areas, including sofas around the fire, and games areas. There are usually two guest beers available, one from the local area. The food is all home-made, with roasts on Sunday lunchtime and a monthly curry night. There is poker on Wednesday, a monthly quiz night and occasional live music.
♿ ⊛ ⦿ ♣ ➡ (53,63) ❀ ？

Shepperton

Barley Mow Ⓛ

67 Watersplash Road, TW17 0EE (off B376 in Shepperton Green)

☎ (01932) 225326

Hogs Back TEA; Hop Back Summer Lightning; 3 changing beers (sourced locally; often Thames Side, Tillingbourne, Twickenham) Ⓗ

Friendly community local in Shepperton Green to the west of the main village centre. Five handpumps serve two regular beers plus up to three usually local guest ales. Entertainment includes jazz on Wednesday, a quiz night on Thursday, live rock or blues bands on Friday or Saturday night, and a traditional charity meat raffle on Sunday afternoon. Outside is a covered, heated patio at the rear. ⊛ ♣ P ➡ (400,458) ❀ ？

South Godstone

Fox & Hounds Ⓛ ✔

Tilburstow Hill Road, RH9 8LY

☎ (01342) 893474 ⊕ foxandhounds.org.uk

Fuller's London Pride; Greene King Abbot; 4 changing beers Ⓗ

This delightful building, parts of which date back to 1368, first became a pub in 1601. Many original features remain including a large inglenook in the restaurant. The cosy low-ceilinged bar area has high-backed settles and a fireplace. Typical guest beers may come from Hogs Back, Firebird and Tonbridge breweries. The garden at the rear has a play area for children. An extensive menu of locally sourced good-quality food is available.
♿ ⊛ ⦿ ♣ P ❀ ？

Staines-upon-Thames

George ✔

2-8 High Street, TW18 4EE

☎ (01784) 462181

Courage Best Bitter; Greene King Abbot; Ruddles Best Bitter; Sharp's Doom Bar; 6 changing beers (sourced nationally; often Maxim, Ringwood, Surrey Hills) Ⓗ

A welcome return to the Guide for this two-storey, town-centre Wetherspoon pub built in the 1990s. The spacious downstairs bar with its mixture of tables and booths is always busy; a quieter bar is upstairs. Up to five guest

ales are available, occasionally from local brewers as well as the national brands. A varied selection of foreign bottled beers is also stocked. Value-for-money pub food is served all day, every day. Q ♿ ⊛ ⦿ ♿ & ➡ ➡ ？

Thames Side Brewery & Tap Room Ⓛ

15-18 Clarence Street, TW18 4SU

☎ 07749 204242 ⊕ thamessidebrewery.co.uk

Thames Side Heron Ale, White Swan Pale Ale, Egyptian Goose India Pale Ale; 4 changing beers (sourced locally; often Thames Side) Ⓗ

Five or more real ales from the brewery and Mr Whitehead's cider are served in the tap room, which overlooks the brewery equipment. Regular ales are supplemented by new additions from the small batch brew plant, with up to 10 beers available at the weekend. When in-house food is not available, meals can be delivered from the nearby Greek takeaway.
♿ ⊛ ⦿ & ♣ P ❀

Wheatsheaf & Pigeon Ⓛ

Penton Road, TW18 2LL

☎ (01784) 452922 ⊕ wheatsheafandpigeon.co.uk

Fuller's London Pride; Otter Ale Ⓗ

Community local situated between Staines and Laleham, a short signposted walk from the Thames Path, with Staines Town FC also nearby. Ales often include local micro or West Country guests. Good-value, interesting food is served Tuesday to Sunday. The pub is dog friendly, with water bowls provided. Outside seating is available at the front and back, plus a covered area.
♿ ⊛ ⦿ & ♣ P ➡ (458,570) ❀ ？

Stoke D'Abernon

Old Plough Ⓛ

2 Station Road, KT11 3BN

☎ (01932) 862244

Fuller's London Pride; Surrey Hills Shere Drop Ⓗ

Dating from the late 16th century, this building was once a courthouse with the gallows outside, and the stables were used for hansom cab trade. It has been opened out but retains much of its character, particularly at the front. An extension houses the dining area at the rear. The decor is a mix of bare brick, wood panelling and painted walls. There is a pleasant garden area to the side and rear. This popular pub has a deservedly good reputation for food.
Q ♿ ⊛ ⦿ & ➡ (Cobham & Stoke d'Abernon) P ➡ ❀ ？

Thames Ditton

George & Dragon

High Street, KT7 0RY

☎ (020) 8398 2206 ⊕ thegeorgeanddragonpub.com

Shepherd Neame Master Brew, Spitfire; house beer (by Shepherd Neame); 1 changing beer (often Shepherd Neame) Ⓗ

Set off the road with its own car park, this attractively refurbished village centre pub has several drinking areas and a separate restaurant serving traditional English fare. Open fires welcome customers in winter months and a recently extended outside drinking area is popular in warmer weather. Several TVs show live sport both inside and outside, with a marquee set up for major events. Quiz night is every Tuesday. ♿ ⊛ ⦿ & ➡ P ➡ ❀ ？

Tongham

Hogs Back Brewery Shop & Tap Room Ⓛ

Manor Farm, The Street, GU10 1DE

☎ (01252) 784495 ⊕ hogsback.co.uk/pages/
brewery-tap-and-beer-garden
**Hogs Back Surrey Nirvana, TEA; 2 changing beers
(often Hogs Back)** �H /G
In rural Surrey, nestling under the Hogs Back ridge, the
Tap Room is a converted kiln. Tables can be booked in
advance but walk-ins are also welcome. Two regular
beers are supplemented by seasonal specials and real
Somerset cider in bottles. The Hanger Bar is used for
harvesting in September and otherwise hosts special
events including live music and comedy nights, and
screens major sporting fixtures. There is also a shop
onsite, open daily. ❧❀●P❀

Upper Hale

Alfred Free House
9 Bishops Road, GU9 0JA
☎ (01252) 820385 ⊕ thealfredfreehouse.co.uk
**6 changing beers (sourced nationally; often Ascot,
Wantsum)** H
This friendly local pub, tucked away down a residential
road, features a bar area and a restaurant/function room.
There are six regularly changing ales sourced nationally,
including at least one dark beer. Fresh home-made food,
using locally sourced ingredients, is served Wednesday to
Saturday evenings and Sunday lunchtime. The pub hosts
events including charity quiz nights and two beer
festivals each year, at Easter and in October.
Q❧❀◑&♣P🖩(5)❀🍺

Virginia Water

Rose & Olive Branch
Callow Hill, GU25 4LH
☎ (01344) 854653 ⊕ theroseandolivebranch.co.uk
**Windsor & Eton Guardsman, Knight of the Garter; 1
changing beer (sourced locally; often Windsor &
Eton)** H
A first time in the Guide for this Windsor & Eton Brewery
pub. Decorated in shades that suit the name, it has
comfy sofas in one corner. The menu features burgers,
pies and salads, as well as teas and coffees. There is
outside seating in the garden at the rear and on the patio
at the front. The unusual name of this old beer house
derives from a peace treaty signed here during the
English Civil War, when there was an exchange of a rose
and an olive branch. ❧❀◑P❀🍺

West Clandon

Bull's Head 🅛
The Street, GU4 7ST
☎ (01483) 222444 ⊕ bullsheadwestclandon.co.uk
Surrey Hills Shere Drop; Young's London Original H
Sixteenth-century village inn with several areas on
different levels – beware of the low ceilings and oak
beams. Food is an important part of the pub's trade and
the focus is on traditional British cooking at reasonable
prices (no food Sun eve). To the rear is a hedged garden
where you can while away a secluded couple of hours
enjoying the two regular beers. Q❧❀◑P🖩(463)❀🍺

West Horsley

Barley Mow 🅛
181 The Street, KT24 6HR
☎ (01483) 282693 ⊕ barleymowhorsley.com
**Fuller's London Pride; Surrey Hills Ranmore, Shere
Drop; 1 changing beer** H
A classic pub set in the heart of the Surrey Hills with
some traditional flagstone flooring. The building is large

and incorporates the Malting House to the rear, which is
used for functions. Thai food is available lunchtime and
evening and traditional English cooking each lunchtime
(no food Sun). The garden has a substantial open grassed
area, which is great for dogs, and seating dotted around.
❧❀◑●♣P🖩(478)❀🍺

West Molesey

Royal Oak ✅
317 Walton Road, KT8 2QG
☎ (020) 8979 5452
**Butcombe Original; Fuller's London Pride; St Austell
Proper Job; Sharp's Doom Bar** H
Situated next to the church, this pub dating from about
1860 is very much at the heart of the community. The
comfortably furnished open-plan bar is divided into two
areas, with a quiet lounge to the left. Wood panelling
adds to the traditional pub feel, along with oak beams,
horse brasses and plates. Families are welcome and
there is a secure garden to the rear. Live music is hosted
weekly, a quiz monthly, and open mic nights on Monday
and Wednesday. Darts competitions are held.
❧❀♣P🖩(411,461)❀🍺

Weybourne

Running Stream ✅
66 Weybourne Road, GU9 9HE
☎ (01252) 323750
**Greene King IPA, Abbot; Hardys & Hansons Bitter;
Morland Old Speckled Hen; Timothy Taylor Dark Mild;
1 changing beer** H
A good old-fashioned friendly locals' pub. The
handpumps dispense Greene King beers, with one free
of tie for a dark mild, usually from Timothy Taylor. A
choice of daily specials is served at lunchtime.
Wednesday to Friday evenings you can order and eat
food served from a food van in the car park. There is a
pleasant garden at the rear. Regular events include
vintage car rallies and open mic nights. ❀◑P🖩❀🍺

Weybridge

Jolly Farmer
41 Princes Road, KT13 9BN
☎ (01932) 856873
**St Austell Tribute; Sharp's Doom Bar; Surrey Hills
Shere Drop; 2 changing beers (often Ringwood,
Twickenham)** H
Friendly back-street local in a residential area near the
Weybridge Cricket Club pitch. The comfortable mid-
Victorian pub has an L-shaped single room with a low
beamed ceiling and upholstered bench seats opposite
the small bar. Photos of old Weybridge are displayed on
the walls. Guest beers are often from local brewers. The
conservatory (orangery) at the back can be booked for
private functions. Outside is a large garden.
Q❧❀◑P🖩(515,436)❀🍺

Old Crown
83 Thames Street, KT13 8LP (off A317)
☎ (01932) 842844 ⊕ theoldcrownweybridge.co.uk
**Courage Best Bitter; Young's London Original; 2
changing beers (often Bombardier, Courage,
Ringwood)** H
A Grade II-listed pub with a weatherboarded façade that
dates from at least 1729, situated at the confluence of
the River Thames and the River Wey. The two gardens
are popular in summer and mooring for small boats is
provided at the waterside. There are several areas inside
to meet the needs of drinkers and diners. The changing

beers vary in source and can be from a micro. Food is available every lunchtime and Wednesday to Saturday evenings. Q ☜ ✿ ⚙ ▯ P ▯ ☙ 🐾 ⚲

Whyteleafe

Radius Arms

205 Godstone Road, CR3 0EL
☎ 07514 916172
4 changing beers ⊞ /⒢
This friendly and popular micropub thrives on its ever-changing selection of beer and cider. There are at least four cask ales on offer – two pales, one bitter and one dark. Four KeyKegs and 12 ciders provide more choice. A pickled onion competition, beermat ceiling and furniture recycled from the Olympic Park are some of the bar's quirky features. There is also a small library. Local CAMRA Cider Pub of the Year. Closed on Monday. Q ✿ ⇜ 🐾

Woking

Herbert Wells ⓛ ✓

51-57 Chertsey Road, GU21 5AJ
☎ (01483) 722818
Courage Best Bitter; Greene King Abbot; Hogs Back TEA; Sharp's Doom Bar; 7 changing beers (sourced nationally) ⊞
A varied range of up to seven guest beers is served at this popular town-centre Wetherspoon, which is close to bus stops and the railway station. The large open-plan bar is decorated with HG Wells-inspired features including an invisible man sitting in the window and its own time machine. A wealth of information about local history covers the walls of both the main bar and the smaller side room. Q ☜ ◑ ⑤ ⚙ ⇜ 🚃 ⚲

Woking Railway Athletic Club

Goldsworth Road, GU21 6JT
☎ (01483) 598499
3 changing beers (sourced nationally) ⊞
Lively social club tucked away near Victoria Arch, serving three or four beers. The walls are decorated with old railway pictures. One side of the bar is sports-oriented with darts, free-to-play pool, and Sky Sports; the other is quieter. Children are always welcome. Show a CAMRA membership card or copy of this Guide for entry. The area is due to be redeveloped but the club is assured of a place in the new development. Local CAMRA Club of the Year 2019 to 2022. ☜ ⇜ ♣ P ▯ ⚲

Worplesdon

Fox Inn ⓛ ✓

Fox Corner, GU3 3PP
☎ (01483) 234024 ⊕ thefoxinnfoxcorner.com
Dark Star Hophead; Skinner's Betty Stogs; Timothy Taylor Landlord; 3 changing beers (sourced nationally; often Hogs Back, Surrey Hills) ⊞
Convivial and welcoming free house rescued from closure by a local resident. The three separate rooms have subdued lighting and low beams and contain an eclectic collection of effects that make the rooms interesting without being cluttered. Beside the pub is a patio, and beyond that a substantial garden. Food is provided by a different pop-up stall each evening. ☜ ✿ ◑ P ▯ (28,91) 🐾 ⚲

Wrecclesham

Sandrock ⓛ

Sandrock Hill Road, GU10 4NS
☎ (01252) 447289 ⊕ sandrockwrecclesham.co.uk

Bowman Swift One; Exmoor Gold; Hogs Back TEA; St Austell Proper Job; Timothy Taylor Landlord; Triple fff Moondance; 1 changing beer (sourced nationally; often Fuller's, Hop Back, Ringwood) ⊞
Traditional pub with a contemporary feel, offering seven regular cask ales including Fuller's London Pride, plus a guest ale on handpump. Thai food is available in the separate restaurant Wednesday to Sunday evening and weekend lunchtimes. There is a patio garden terrace at the rear and a small car park. Live music is hosted once a month on a Saturday. Major sporting events are shown on TV. Q ☜ ✿ ◑ ⑤ ⚙ & ♣ P ▯ (16,17) 🐾 ⚲

Breweries

Ascot SIBA

Unit 4, Lawrence Way, Camberley, Surrey, GU15 3DL
☎ (01276) 686696 ⊕ ascotbrewing.co.uk

⊗ Fonded in 2007 and rebranded as Ascot Brewing Company in 2017. The brewery moved to new premises with an expanded 22,000-litre fermentation capacity in 2020. The new taphouse is on a mezzanine floor with a view over the brewery and is the venue for regular comedy nights and live events. A beer range is brewed under the brand name Disruption IS Brewing. ‼ 🍴 ♦ LIVE 🍃

Gold Cup (ABV 4%) GOLD
A lemon aroma leads to a dry, bitter taste, with more citrus flavours. Hoppy finish with a hint of sweetness.
Starting Gate (ABV 4%) BITTER
A pale brown session bitter with malt flavours present throughout. Dry, with a lasting sharp and bitter finish.
Final Furlong (ABV 4.2%) BITTER
A well-balanced, copper-coloured bitter, with biscuity malt sweetness to the fore. Some citrus fruitiness and clean, hoppy aftertaste.
5/4 Favourite (ABV 4.6%) PALE
Grapefruit aroma, with Cascade hops providing a crisp bitterness in the taste, balanced with some biscuit in aroma and aftertaste.
Front Runner (ABV 4.8%) PALE
Anastasia's Stout (ABV 5%) STOUT
Burnt coffee aromas lead to a roast malt flavour in this black beer. Notably fruity throughout, with a bittersweet aftertaste.

Big Smoke SIBA

Unit D3, Sandown Industrial Estate, Esher, Surrey, KT10 8BL
☎ (01372) 469606 ☎ 07859 884190
⊕ bigsmokebrew.co.uk

⊗ Brewing began at the Antelope, Surbiton, in 2014. In 2019 Big Smoke moved to a new purpose-built 30-hectolitre brewery in Esher with an onsite taproom. ♦ 🍃

Solaris Session Pale Ale (ABV 3.8%) PALE
Unfined, golden ale with bitter grapefruit flavour, some malt and a long dry bitter finish. Hoppy, fruity nose.
Dark Wave Porter (ABV 5%) PORTER
Creamy black porter with a dry, roasty, bitter character balanced by a caramelised sweetness.
Electric Eye Pale Ale (ABV 5%) PALE
Underworld (ABV 5%) SPECIALITY
Sweet, smooth stout with hints of chocolate and coffee in the aroma and taste coupled with toasted nuts and vanilla.

Brightwater

9 Beaconsfield Road, Claygate, Surrey, KT10 0PN

☎ (01372) 462334 ☎ 07802 316389
🌐 brightbrew.co.uk

⊠ Established in 2013 at Claygate in Surrey, Brightwater is a five-barrel brewery producing traditional beers. The range is available at its brewery tap, Platform 3, outside Claygate Station, and other Surrey and South London pubs.

Little Nipper (ABV 3.3%) BITTER
A rather thin, hoppy bitter with a hint of a citrus taste and a bitter, slightly dry finish.

Top Notch (ABV 3.6%) BITTER
Citrus notes dominant the aroma of this mid-brown bitter. It has a reasonably well-balanced taste with some bitterness in the finish.

Ernest (ABV 3.7%) PALE
TPL (ABV 3.7%) BITTER
Village Green (ABV 3.8%) GOLD
Daisy Gold (ABV 4%) BITTER
Golden-coloured ale with a moderate tropical fruit, hoppy character and some balancing malt leading to a bittersweet finish.

Wild Orchid (ABV 4%) SPECIALITY
All Citra (ABV 4.3%) GOLD
Lip Smacker (ABV 4.8%) BITTER
Coal Porter (ABV 4.9%) SPECIALITY

By the Horns SIBA

Unit 11, The IO Centre, Salbrook Road Industrial Estate, Salbrook Road, Salfords, Surrey, RH1 5GJ
☎ (020) 3417 7338 🌐 bythehorns.co.uk

⊠ By the Horns began brewing in 2011 with a 5.5-barrel plant but had outgrown its original site by 2020. A new site in Salfords, Surrey opened in 2021. Cask is a big part of the production, with the rest of its output in keg and cans. Its brewery tap is near to its old site inside the AFC Wimbledon Stadium. 🍺

Stiff Upper Lip (ABV 3.8%) BITTER
Classic, amber-coloured bitter, well-balanced with hops throughout with hints of citrus and honey. Dry, bitter finish.

Hopadelic (ABV 4.3%) GOLD
Smooth golden ale with grapefruit, gooseberry, citrus and lemon rind notes overlaid with hops. Building bitterness in the lingering finish.

Lambeth Walk (ABV 5.1%) PORTER
Black/ruby-coloured, full-bodied porter with black cherry, sultanas, coffee and a sweet treacle character. Developing, lingering, dark bitter roast cocoa.

Craft Brews

The Old Dairy, Pierrepont Home Farm, The Reeds, Farnham, Surrey, GU10 3BS ☎ 07774 982174
🌐 craftbrews.uk

⊠ Set in the Surrey countryside, the microbrewery and taproom (formerly known as Frensham Brewery) are situated in a 17th-century restored barn, on a working dairy farm. Beers are not generally sold to pubs, so can only be obtained from the taproom. 🍺♦🥢

i. PL (ABV 3.2%) BITTER
RPA (ABV 3.7%) PALE
USB (ABV 4.3%) BITTER
i.PA (ABV 5.3%) PALE
CAB (ABV 6.3%) PORTER
Dark chocolate and malt in the aroma. Bitterness builds on initial sweetness leading to dry balanced by chocolate and vanilla.

Crafty SIBA

Thatched House Farm, Dunsfold Road, Loxhill, Surrey, GU8 4BW
☎ (01483) 276300 ☎ 07702 305595
🌐 craftybrewing.co.uk

⊠ Established in 2014 behind the famous Dunsfold aerodrome, Crafty Brewing opened a new plant in 2019. It brews contemporary versions of traditional beer styles. The 'Crafty Cares' beers support various charities, including Surrey Search & Rescue. It supplies nearly 200 regional pubs, local shops and markets. All beers are available nationally to order online in mini-kegs, bottles, and cans. The brewery hosts regular open days (see website for details). 🍺♦

Loxhill Biscuit (ABV 3.6%) BITTER
Golden bitter which belies its strength. Initial biscuity aroma and taste with a dry, bitter finish, from the hops.

One (ABV 3.9%) PALE
Golden-yellow beer with Chinook and Sorachi Ace hops. Tropical fruits aroma, leads to full dry fruity finish. Hints of coconut.

Blind Side (ABV 4%) BITTER
A traditional, light brown bitter. Predominantly malty throughout. Toffee and some roast character lead to a bittersweet finish.

Hop Tipple (ABV 4.2%) GOLD
Beautifully balanced pale ale. Light and easy drinking with resinous modern hops and a crisp finish coming from dry-hopping.

Dorking SIBA

Aldhurst Farm, Temple Lane, Capel, Surrey, RH5 5HJ
☎ (01306) 877988 🌐 dorkingbrewery.com

⊠ Dorking started brewing in 2008 at premises in west Dorking. In 2017 production moved to a new, larger site in Capel capable of producing 35,000 pints per week. Beers can be found in Surrey, Sussex, Hampshire and London. ‼🍺♦V👤

Surrey XPA (ABV 3.8%) BITTER
Pilcrow Pale (ABV 4%) GOLD
Smokestack Lightnin' (ABV 4%) SPECIALITY
DB One (ABV 4.2%) BITTER
Hoppy best bitter with underlying orange fruit notes. Some balancing malt sweetness in the taste leads to a dry, bitter finish.

Black Noise (ABV 4.5%) PORTER
Rich, full-flavoured porter with blackberries dominating the aroma. Rounded bitterness with underlying hop character throughout, with a biscuity finish.

Winter's Coming (ABV 4.5%) SPECIALITY
Red India (ABV 5%) RED
Five Claw (ABV 5.1%) PALE

Felday

🏠 **Royal Oak, Village Green, Felday Glade, Holmbury St. Mary, Surrey, RH5 6PF**
☎ (01306) 730654 🌐 feldaybrewery.co.uk

Brewing began in 2017 on a custom-made plant in a small, purpose-built, building next to the Royal Oak pub car park. Almost all of the beer is supplied to the pub although it may very occasionally be seen elsewhere. ♦

Fuzzchat

🏠 **Jolly Coopers, 84 Wheelers Lane, Epsom, Surrey, KT18 7SD**
☎ (01372) 723222 🌐 fuzzchatbrewery.co.uk

⊠ Fuzzchat is Epsom's first brewery in more than 90 years. Housed behind the Jolly Coopers, it used to be an old blacksmith's cottage, recently restored after being derelict for several years. A Fuzzchat is anyone born on Epsom Common. ⧈♦

Godalming Beerworks (NEW)

᠊ Star Inn, 17 Church Street, Godalming, Surrey, GU7 1EL ⊕ godalming.beer

⊠ A unique nanobrewery attached to a CAMRA award-winning pub.

Godstone SIBA

Flower Farm, Oxted Road, Godstone, Surrey, RH9 8BP
☎ 07791 570731

Office: 3 Willow Way, Godstone, RH9 8NQ
⊕ thegodstonebrewers.com

⊠ The Godstone Brewers was established in 2015 using a one-barrel plant but moved to larger premises on a farm in Godstone. It now uses a 12-barrel plant to produce core beers, and a five-barrel plant for a variety of 'specials' and one-off's. Beers are named with local themes. Local outlets are supplied, and a taproom has been built. Increasingly casks and bottles are being produced without finings (suitable for vegans).
⧈ 〓♦LIVE V⌀

Up Up and Away (ABV 2.7%) GOLD
Trenchman's Hop (ABV 3.8%) BITTER
Redgate (ABV 4%) BITTER
Pondtail (ABV 4.1%) PALE
Junction 6 (ABV 4.2%) BLOND
Forever (ABV 4.3%) GOLD
Rusty's Ale (ABV 4.4%) BITTER
Tunnel Vision (ABV 4.6%) SPECIALITY
Buzz (ABV 4.7%) SPECIALITY
Bitter Entropy (ABV 5.3%) BITTER
Polly's Potion (ABV 6.5%) PORTER

Hogs Back SIBA

Manor Farm, The Street, Tongham, Surrey, GU10 1DE
☎ (01252) 783000 ⊕ hogsback.co.uk

⊠ Established in 1992, this traditional, family-owned brewery boasts an extensive range of award-winning ales. In 2014 the brewery planted its own hop garden; it now has 6,500 plants in the field by the farm. The brewery is open for guided tours and the shop sells all its beers plus more than 300 of the best UK and World bottled beers, craft cans and cider. Its newly opened brewery tap is housed in a former hop kiln, offering a varied programme of live music, comedy, quizzes and live sport showings as well as hosting an annual Hop Harvest festival in September. ⧈〓♦LIVE ⌀

Surrey Nirvana (ABV 4%) PALE
Refreshing session pale ale. Sweet, moderately full-bodied leading to an initially sweet finish with hop bitterness becoming more evident.
TEA (ABV 4.2%) BITTER
A tawny-coloured best bitter with toffee and malt present in the nose. A well-rounded flavour with malt and a fruity sweetness.

Leith Hill

᠊ c/o Plough Inn, Coldharbour Lane, Coldharbour, Surrey, RH5 6HD
☎ (01306) 711793 ⊕ ploughinn.com

⊠ Leith Hill was established in 1996 at the Plough Inn and was moved to converted storerooms at the rear in 2001, increasing capacity to 2.5 barrels in 2005. New owners took over in 2016. ⧈LIVE

Pilgrim SIBA

11 West Street, Reigate, RH2 9BL
☎ (01737) 222651 ⊕ pilgrim.co.uk

⊠ Pilgrim was the first microbrewery in Surrey, set up in 1982 in Woldingham before moving to its current premises in Reigate in 1984. New owners from 2017 are developing new ales to complement the current selection, and have enlarged to a 12-barrel brew length and opened a taproom. Beers are available in many local outlets. ⧈〓♦⌀

Surrey (ABV 3.7%) BITTER
Pineapple, grapefruit and spicy aromas. Biscuity maltiness with a hint of vanilla balanced by a hoppy bitterness and refreshing bittersweet finish.
Session IPA (ABV 3.9%) PALE
Progress (ABV 4%) BITTER
Well-rounded, tawny-coloured bitter. Predominantly sweet and malty with an underlying fruitiness and hint of toffee, balanced with a subdued bitterness.
Quest (ABV 4.3%) GOLD
Saracen (ABV 4.5%) STOUT

Surrey Hills SIBA

Denbies Wine Estate, London Road, Dorking, Surrey, RH5 6AA
☎ (01306) 883603 ⊕ surreyhills.co.uk

⊠ Surrey Hills began brewing in 2005 near Shere, moving to Dorking in 2011. Nearly 95% of production is sold within 15 miles of the brewery. The beers have won several local and national awards. ⧈〓♦⌀

Ranmore (ABV 3.8%) GOLD
Glorious, light, flavoursome session beer. An earthy hoppy nose leads into a grapefruit and hoppy taste and a clean, bitter finish.
Shere Drop (ABV 4.2%) PALE
Hoppy with some balancing malt. Pleasant citrus aroma, noticeable fruitiness in taste, with some sweetness.
Gilt Complex (ABV 4.6%) GOLD
Initial citrus fruitiness quickly gives way to a piercing hit of bitter hops fading slowly in a big dry finish.
Gilt Trip (ABV 4.6%) GOLD
Greensand IPA (ABV 4.6%) PALE
A strong-flavoured and easy-drinking IPA, with intense grapefruit and hops in the aroma and taste and soft citrus finish.
Collusion (ABV 5.2%) GOLD
Golden ale with a changing hop mix. Has a pale malt backbone with citrus and tropical flavours combined with characteristics of marmalade.

Thames Side SIBA

Thames Edge, 15-18 Clarence Street, Staines-upon-Thames, Surrey, TW18 4SU ☎ 07703 518956
⊕ thamessidebrewery.co.uk

⊠ Founded in 2015 by CAMRA member Andy Hayward using a four-barrel plant. In 2020 a one-barrel pilot brew kit for experimental and developmental brews was added. It moved to its current brewery and taproom on the banks of the River Thames in 2022. A full range of beers are named after birds found on or near the nearby river, while specials follow a musical theme.
⧈〓♦LIVE V⌀

Harrier Bitter (ABV 3.4%) BITTER
Heron Ale (ABV 3.7%) BITTER

Malty, traditional English bitter, with a tangerine fruit flavour. Balanced with impressive dry finish and loads of flavour for strength.

Cormorant Stout (ABV 4.2%) STOUT

White Swan Pale Ale (ABV 4.2%) PALE
New World pale ale. Grapefruit pith and grassy hops almost overpowering biscuit maltiness. Some sweetness in finish with crisp biscuitiness.

Egyptian Goose India Pale Ale (ABV 4.8%) PALE
English IPA with initial floral aroma leading to an earthy, mango fruitiness as sweetness builds and a balanced bitter finish.

Wryneck Rye IPA (ABV 5.6%) IPA
Spicy IPA with lychees and an increasing lemony taste balanced by rye and New World hops. Short, dry, bitter finish.

Thurstons

The Courtyard, 102c High Street, Horsell, Surrey, GU21 4ST
☎ (01483) 729555 ☎ 07789 936784
⊕ thurstonsbrewery.co.uk

⊠ Originally based in the Crown, Horsell, Thurstons moved next door in 2014 when the brewery upgraded to a 4.5-barrel plant. The brewery supplies pubs across Surrey. ♦LIVE

Horsell Best (ABV 3.8%) BITTER
Traditional, well-balanced bitter, initially malty with strong caramel and redcurrant flavours throughout and balancing bitterness, becoming drier in finish.

Horsell Gold (ABV 3.8%) PALE
Light fruit and slightly nutty aroma, lead to some bitterness and malt, which soon fades into a light bitter finish.

Milk Stout (ABV 4.5%) STOUT
Smooth, sweet stout, with chocolatey and sweet malt flavour. Pleasant sharpness as lactose comes through leading to slightly dry finish.

Un-American Pale Ale (ABV 4.6%) PALE
Well-hopped, American-style pale using English grown hops. Grapefruit and pineapple grow into full-bodied sweetness and lingering bitterness.

Tilford

⬛ Duke of Cambridge, Tilford Road, Farnham, Surrey, GU10 2DD ☎ 07710 500967
✉ mark@tilfordbrewery.beer

⊠ Tilford Brewery celebrated its fifth birthday in 2022. Using a 2.5-barrel plant situated in an old coaching house adjacent to The Duke of Cambridge Pub, it supplies its award-winning cask ales to pubs and clubs in Surrey and Hampshire plus beer festivals. ‼🍴

Punchbowl (ABV 3.7%) BITTER
Hankley Gold (ABV 3.9%) BLOND
Rushmoor Ripper (ABV 4.4%) BITTER

Tillingbourne

Old Scotland Farm, Staple Lane, Shere, Surrey, GU5 9TE
☎ (01483) 222228 ⊕ tillybeer.co.uk

⊠ Tillingbourne was established in 2011 on a farm site previously used by Surrey Hills Brewery using its old 17-barrel plant. Around 25 local outlets are supplied. ‼🍴♦

The Source (ABV 3.3%) GOLD
Light and crisp golden ale with strong grapefruit flavours. Packed full of Citra hops and drinks well above its strength.

Black Troll (ABV 3.7%) PALE
A black IPA in which initial roast notes are eventually overpowered by citrus hop through to the finish.

Dormouse (ABV 3.8%) BITTER
Predominately sweet and malty, with strong toffee notes and a short, fruity finish.

AONB (ABV 4%) GOLD
Golden ale in which Cascade hop dominates throughout. Some balancing malt in the aroma and taste.

Falls Gold (ABV 4.2%) GOLD
Whilst hops dominate, balancing malt is evident throughout. Hints of grapefruit in aroma and taste lead to a dry finish.

Whakahari (ABV 4.6%) PALE

Hop Troll (ABV 4.8%) PALE
Big hop flavours together with peach and apricot. Sweet, fruity taste leads to a floral, bitter finish.

Summit (ABV 6%) IPA

Titsey SIBA

Botley Hill Farmhouse, Limpsfield Road, Titsey, Surrey, CR6 9QH
☎ (01959) 528535 ⊕ titseybrewingco.com

⊠ A microbrewery established in 2017 on the Titsey Estate. It is in the process of moving to larger premises, still on the Titsey Estate, a borehole has been sunk and is doubling the size of the brewing plant. There will also be a taproom on-site. It supplies two associated pubs, the Botley Hill Farmhouse, and the White Bear, Fickleshole, and increasingly to other local outlets. Ales are named after historic owners of the Titsey Estate. Innes Lager and all the bottles are suitable for vegans. ♦LIVE V❤

Gresham Hopper (ABV 3.7%) GOLD
Leveson Buck (ABV 3.7%) PALE
Gower Wolf (ABV 4%) BITTER

Trailhead

Goldenlands Farm, Punchbowl Lane, Dorking, RH5 4DX ⊕ trailheadbrew.com

Established in 2021 in farm buildings just south of Dorking. Beers are mostly available in keg, but may occasionally appear in cask. The taproom is open daily. ♦

Publican – a posset, if you please

Anne Boleyn as a Maid of Honour had an allowance of two gallons of ale a day – perhaps to be shared with others? – but to make such ale interesting it was served in possets and caudles, the warmest sweet liquor mixed with honey, spices, roasted crabs or anything else which took the fancy. The weaker ales were relatively baby food. Elizabeth, when queen, issued repeated regulations in defence of weak ale and against strong beer; yet for herself, although she was abstemious, when she wished for a nip drank beer 'so strong that was no man durst touch it'.

Frank Morley, The Great North Road, 1961

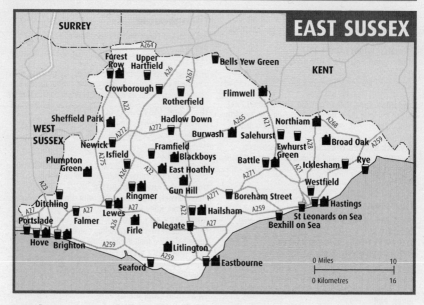

Battle

Battle Tap 🅛

52 High Street, TN33 0EN
☎ (01424) 772838 ⊕ battlebrewery.co.uk
Battle Abbey Pale IPA; 3 changing beers Ⓖ
Situated in the heart of the shopping area, the Battle Tap was converted from an off-licence with the acquisition of the premises next door. The bar is set up as a micropub – a gap in a wall leads to another more spacious room, also fronting onto the High Street with chairs around low tables. Up to four cask ales from Battle Brewery are served alongside local ciders. Off-sales are available for cask brews, beer-in-a-box, bottled ales and local wines.
Q🕭&♿🚃🍴🚃🖪(95,305) 🌑🛜

Squirrel 🅛

North Trade Road, TN33 9LJ
☎ (01424) 772717 ⊕ thesquirrelinn-battle.co.uk
Harvey's Sussex Best Bitter; 3 changing beers (sourced locally; often Battle) Ⓗ
An 18th-century family-run traditional free house to the west of Battle in the heart of 1066 country. There are four handpumps, with a beer from the neighbouring Battle Brewery featuring on one. Menus change frequently, reflecting the seasonal availability of local produce. Meat is free-range, with fish sourced from the nearby Hastings day boats. The bar and restaurant areas offer ample seating. Outside there is a large area of covered decking, also with plenty of tables.
🕭🌑🕽♿🖪🚃(95) 🌑🛜

Bells Yew Green

Brecknock Arms

Bayham Road, TN3 9BJ
☎ (01892) 750237
Harvey's IPA, Sussex Best Bitter; 1 changing beer (sourced locally; often Harvey's) Ⓗ
Close to Frant station, the Brecknock has three seating areas, two with real fires. The licensees are keen to provide everything that makes a friendly, welcoming pub – with well-kept beers and traditional pub food, including fresh fish from Rye on Fridays. There is a large, secluded beer garden to the rear where a beer festival is

held in September. A newly erected barn can be used for various functions, seating up to 60 people. There is also a games room. Q🕭🌑🕽♿♿≈(Front)♣🖪🚃🌑🛜

Bexhill on Sea

Albatross Club (RAFA) 🅛

15 Marina Arcade, TN40 1JS (on seafront 200yds E of De La Warr Pavilion)
☎ (01424) 212916 ⊕ bexhillrafa.co.uk
5 changing beers Ⓗ
An award-winning club – previously CAMRA national, regional, and currently local Club of the Year – that welcomes CAMRA members. After a recent extensive refurbishment, it serves up to five ever-changing real ales (which can be viewed using the Real Ale Finder app) plus real cider, always in a friendly atmosphere. With two beer festivals a year and a busy social calender, it is a very active club that continues to go from strength to strength under new stewardship. Food is served Friday lunchtime only. Q🕭🕽♿♿🍴🖪🚃(98,99)🌑🛜

Brickmaker's Alehouse 🍷

27 Sea Road, TN40 1EE
☎ (01424) 602778 ⊕ brickmakersalehouse.co.uk
5 changing beers Ⓖ
Bexhill's first micropub was opened in 2019 by two real ale enthusiasts. In 2021 this former shop and showroom of a local brick manufacturer won the CAMRA Conversion to Pub Use national award, and in 2022 it was local CAMRA Pub of the Year. At least five changing ales are served by gravity from a cool room in the bar, along with three real ciders. Centrally located, it is close to Bexhill Station, bus routes and the seafront. ≈🍴🖪(98,99)🌑🛜

Boreham Street

Bull's Head 🅛

The Strait, BN27 4SG
☎ (01323) 831981 ⊕ bullsheadborehamstreet.com
Harvey's Sussex Best Bitter; house beer (by Harvey's); 2 changing beers Ⓗ
This traditional country inn, the first Harvey's tied house, has been a Guide regular over the last 12 years. It boasts large grounds, including a beer garden with covered

seating, a terrazza hosting occasional live music, ample parking, and a campsite. Charity and community events are held, such as classic car rallies. Traditional English pub food is offered, including renowned pies. Alongside Harvey's Sussex Best Bitter, the exclusive Bull's Head Bitter is always available, plus a seasonal and an occasional beer. Q ☺ ☺ ⓓ ⚲P🚃 (98)❀ 🛜

Brighton

Basketmakers Arms ⓛ

12 Gloucester Road, BN1 4AD

☎ (01273) 689006 ⊕ basket-makers-brighton.co.uk

Dark Star Hophead; Fuller's London Pride, ESB; Gale's Seafarers Ale, HSB; 4 changing beers (sourced nationally; often Butcombe, Fuller's) Ⓗ

A much-loved Brighton institution, now under new management. This busy two-room street-corner pub, popular with young and old alike, is located on the edge of Brighton's famous bohemian North Laine. Eight handpumps serve a selection of the Fuller's range plus guests. Locally sourced home-made food is available every day including Seafood Saturday and popular traditional Sunday roasts. The walls are adorned with old metal signs and tobacco tins. Live Jazz music features on the first Sunday of every month. Q ☺ ⓓ ⇄🚃❀ 🛜

Battle of Trafalgar ⓛ

34 Guildford Road, BN1 3LW

☎ (01273) 327997

Fuller's London Pride; Harvey's Sussex Best Bitter; 3 changing beers (sourced nationally) Ⓗ

Locals' pub a minute's walk from Brighton railway station. A long narrow room leads down to another room behind the bar and the beer garden. There are some appropriate sea-themed prints on the walls. If you operate the Engine Room Telegraph, you'll be expected to donate to the RNLI – the locals will insist! The pub hosts monthly Sunday music nights, a weekly quiz night, curry night every Wednesday and a monthly meeting of MENSA. The excellent menu includes vegan and gluten-free options plus a renowned Sunday roast.
Q ☺ ☺ ⓓ ⇄🚃❀ 🛜

Brighton Bierhaus ⓛ

161 Edward Street, BN2 0JB

☎ (01273) 686386 ⊕ brightonbierhaus.pub

5 changing beers (sourced locally; often Brighton Bier) Ⓗ

A single-bar pub, centrally situated near the Royal Pavilion and Brighton Pier. It serves up to five changing beers and two ciders on handpump along with keg and bottled beers. Food may be ordered from various local carry-out establishments and occasionally there is food available from pop-up vendors in the bar. There is a free cheeseboard on Sundays. The muted TV shows BT Sport. A former local CAMRA Pub of the Year. ☺●🚃❀🛜

Evening Star ⓛ

55-56 Surrey Street, BN1 3PB (200yds S of station)

☎ (01273) 328931 ⊕ eveningstarpub.co.uk

7 changing beers (sourced regionally; often Dark Star, Pig & Porter) Ⓗ

A classic, compact Brighton pub/alehouse, five minutes' walk from the station, majoring in good real ale and craft beers. It is fairly basic in decor, with a few tables outside on the street. The original home of Dark Star Brewery, which was formerly housed in the cellar, it is no longer tied to the brewery, but Dark Star beers may be on, together with several interesting brews from around Britain. There are board games, window seats and the Trollburger van serves food Thursday to Saturday.
☺ⓓ⚴⇄♣●🚃❀🛜

Hole in the Wall 🍷

Queensbury Mews, BN1 2FE

☎ (01273) 328159 ⊕ theholeinthewall.net

5 changing beers (sourced nationally; often Hand, Oakham, Thornbridge) Ⓗ

Formerly the Queensbury Arms, this cosy two-bar traditional pub is tucked away behind the Metropole hotel. The walls display posters from old Brighton seaside shows, and toad-in-the-hole can be played in the back bar. Keg beers and a bag-in-box cider are served in addition to real ales, with the latter always including a dark beer, and many tap takeovers and Meet the Brewer events are organised. Local CAMRA Pub of the Year 2022.
Q♣●🚃❀🛜

Lord Nelson Inn ⓛ ✅

36 Trafalgar Street, BN1 4ED

☎ (01273) 695872 ⊕ lordnelsonbrighton.co.uk

Harvey's Sussex Best Bitter; 5 changing beers (sourced locally; often Harvey's) Ⓗ

A flagship Harvey's pub just down Trafalgar Street from the station. It is still cosy and traditional, despite a makeover in 2016 incorporating the shop next door. This is the place to sample Harvey's beer range including its craft brews. The interior is divided into separate drinking areas based on the original layout, with bare wood floors and the occasional rug. Being on a gently sloping road, the levels vary a bit. Food is served into the evening.
☺ⓓ⇄🚃❀🛜

Maris & Otter ⓛ

114 Western Road, BN1 2AB

☎ (01273) 900845 ⊕ themarisandotter.co.uk

Harvey's IPA, Sussex Best Bitter, Old Ale; 3 changing beers (sourced locally; often Burning Sky, Harvey's) Ⓗ

The first of a new style of Harvey's tied house, with keg taps and a guest beer alongside the traditional handpumps. Previously known as the Revelator, the pub has undergone a smart, extensive refurbishment in a

REAL ALE BREWERIES

1648 🍺 East Hoathly
360 Degree 🍃 Sheffield Park
Battle 🍃 Battle
Beak 🍃 Lewes
Bedlam Plumpton Green
Beer Me 🍺 Eastbourne
Brewery at the Watchmaker's Arms 🍺 Hove
Brewing Brothers 🍺 🍃 Hastings
Brighton Bier Brighton
BritHop 🍃 Ringmer
BRZN Brighton
Burning Sky Firle
Cellar Head 🍃 Flimwell
FILO Hastings
Flying Trunk Forest Row (NEW)
Furnace Brook Hailsham
Gun 🍃 Gun Hill
Hand 🍺 Brighton / Worthing
Harvey's Lewes
Laine 🍃 Brighton
Lakedown 🍃 Burwash
Long Man 🍃 Litlington
Loud Shirt 🍃 Brighton
Moon 🍺 Brighton (NEW)
Old Tree Brighton
Rother Valley Northiam
Three Acre Blackboys
Three Legs 🍃 Broad Oak
Unbarred 🍃 Brighton

traditional pub style. There is plenty of seating divided between the two rooms. Food service starts early morning with breakfast, then later the menu turns to burgers and hot dogs, along with vegan options. Four or five cask beers are usually available on handpump. ⚲🍴◐♿🖵🛜

Mitre Tavern 🅛 ✅
13 Baker Street, BN1 4JN
☎ (01273) 622759
Harvey's Dark Mild, Sussex Best Bitter; 3 changing beers (sourced locally; often Harvey's) Ⓗ
Situated between the London Road shops and the Level park, this good old-fashioned side-street pub has seemingly not changed in decades. Subdued background music does not detract from the lively banter in this two-roomed Harvey's establishment. The two regular beers are supplemented by Harvey's Old Ale in winter and Olympia during the summer, when a cider is also available. A small rear patio caters for smokers. ✸≒♣🖵🐾🛜

Crowborough

Cooper's Arms 🅛
Coopers Lane, TN6 1SN
☎ (01892) 654796
Harvey's Sussex Best Bitter; 3 changing beers (sourced nationally) Ⓗ
A Guide regular for many years now, this friendly drinkers' local has recently been completely refurbished internally. Apart from the regular Harvey's Sussex Bitter, three changing beers, often from local breweries, are usually on offer and are always in top condition. Food may be available – it is best to phone ahead if this is important. In the warmer months, the secluded garden offers superb views over Ashdown Forest. Q⚲✸P🖵🐾🛜

Wheatsheaf 🅛 ✅
Mount Pleasant, TN6 2NF
☎ (01892) 663756 ⊕ wheatsheafcrowborough.co.uk
Harvey's Sussex Best Bitter; 2 changing beers (sourced locally; often Harvey's) Ⓗ
This 18th-century traditional English pub is situated in the quiet outskirts of Crowborough near the station. It has three separate seating areas around the three-sided bar. Log fires can be found in each section, and photos of the pub's history are displayed. The outside seating space features many colourful hanging baskets during the summer. Occasional live music events are held. Q⚲✸◐≒♣P🖵(228,229)🐾🛜

Ditchling

White Horse 🅛
16 West Street, BN6 8TS
☎ (01273) 842006 ⊕ whitehorseditchling.com
Harvey's Sussex Best Bitter; Long Man Long Blonde; 3 changing beers (sourced locally) Ⓗ
A 12th-century inn that lies below the parish church in the picturesque, historic village of Ditchling. Its cellar leads to a network of tunnels under the village, thought to have been used for smuggling in times past. The venue can cater for weddings, birthday parties or provide accommodation for a stopover while walking the South Downs Way. Log fires in winter, excellent food and ever-changing quality guest beers are certain to fortify the traveller. Q⚲✸✸◐P🖵(167,168)🐾🛜

Eastbourne

Crown 🅛
22 Crown Street, Old Town, BN21 1PB
☎ (01323) 724654
Gun Scaramanga Extra Pale; Harvey's Sussex Best Bitter Ⓗ**; Young's London Special** Ⓗ/Ⓖ**; 2 changing beers** Ⓖ
Traditional comfortable two-bar pub with a large enclosed rear garden with children's play equipment and in which summer barbecues take place. It was the local CAMRA Community Pub of the Year in 2020 and is popular with locals and visitors alike. It serves two changing beers which may be local or national. There are log fires in winter and three annual beer festivals are held. Regular events include quiz nights, Sunday lunchtime competitions and meat raffles, and occasional live music. ⚲✸🖵🐾🛜

Hurst Arms 🅛 ✅
76 Willingdon Road, Ocklynge, BN21 1TW
☎ (01323) 419440 ⊕ thehurstarms.pub
Harvey's Sussex Best Bitter; house beer (by Harvey's); 3 changing beers (sourced locally; often Harvey's) Ⓗ
A good locals' drinking pub with lounge and public bars serving Harvey's beers. The public bar has a pool table, darts, jukebox and TV; music events are held fortnightly. A range of up to five regular beers and seasonals is expertly kept by the proprietor. No food is served. Outside are a front garden with seating and an undercover heated smoking area at the rear. The pub is on local bus routes, but car parking is limited. ✸♿♣P🖵🐾🛜

Lamb Inn 🅛 ✅
36 High Street, Old Town, BN21 1HH
☎ (01323) 720545 ⊕ thelambeastbourne.co.uk
Harvey's Sussex Best Bitter, Armada Ale; 1 changing beer (sourced locally; often Harvey's) Ⓗ
An historic Harvey's inn, dating from 1180, in the heart of Eastbourne's old town, next to the parish church of St Mary's. Period features include beamed ceilings and a glass-covered well. There are two bars, one showing occasional televised sport, a first-floor function room and B&B accommodation. Live music, comedy nights and theatrical productions are regular events. Food is available, including vegetarian and vegan options. Tours of the crypt/beer cellar are available on request. Q⚲✸◐♿♣P🖵🐾🛜

London & County 🅛 ✅
46 Terminus Road, BN21 3LX
☎ (01323) 746310
Greene King Abbot; Ruddles Best Bitter; Sharp's Doom Bar; 3 changing beers (sourced nationally) Ⓗ
Arranged over two floors, each with a bar; the upstairs can be hired for functions. This Wetherspoon Lloyds No.1 bar occupies the former London & County Bank, located in the town centre close to bus stops and the railway station. Varying guest beers are on offer, including at least one LocAle. Food is served all day. Muted TV screens display news, and music is played in the evening, with a DJ on Friday/Saturday, when a smart casual dress code applies. ⚲◐♿≒🖵🛜

Ship Inn 🅛
33-35 Meads Street, Meads, BN20 7RH
☎ (01323) 733815 ⊕ shipatmeads.co.uk
Harvey's Sussex Best Bitter; 2 changing beers (often Long Man) Ⓗ
Situated in the Meads village area, this is a welcoming family-run pub serving local ales and good food. A range

of comfortable seating areas and a large, terraced garden provide a choice to suit your mood, and the weather. A Sunday night quiz is held, as is occasional live music. There are local shops opposite and the sea and South Downs are nearby. ⏃❀⬤🖵(3)🛜

Ewhurst Green

White Dog Inn ⓛ ✅

Village Street, TN32 5TD

☎ (01580) 830264 ⊕ thewhitedogewhurst.co.uk

Harvey's Sussex Best Bitter; house beer (by Rother Valley); 2 changing beers Ⓗ

A debut in the Guide for this characterful family-run pub offering a warm, friendly welcome to drinkers and diners alike. With exposed beams featuring hops and horse brasses, it retains the atmosphere of a traditional old English rural pub. In the corner of the restaurant there's a large painted mural of nearby Bodiam Castle. Excellent food is served lunchtime and evening, and all day in summer. The large garden offers impressive views of Bodiam Castle and the Rother Valley. Local CAMRA Rural Pub of the Year. Q⏃❀❀🕮⬤♣⬤P🖵(349)❀🛜

Falmer

Swan Inn ⓛ ✅

Middle Street, BN1 9PD (just off A27 in N of village)

☎ (01273) 681842

Palmers Tally Ho!; 5 changing beers (sourced regionally; often Downlands, Long Man, Palmers) Ⓗ

Traditional family-run free house in the village of Falmer near the universities. It has three bar areas and a barn available for functions. Food is served but phone ahead to check for times. It gets very busy when Brighton & Hove Albion play at home, and the pub opens at varying times on match days and will open for Monday evening games. There is a small courtyard area at the side of the pub. Q⏃❀🕮⬤≥♣P🖵(28,29)❀🛜

Forest Row

Swan

1 Lewes Road, RH18 5ER

☎ (01342) 822318 ⊕ theswanatforestrow.com

Cellar Head India Pale Ale; Harvey's Sussex Best Bitter Ⓗ

A country pub with a large family garden, six bedrooms, a restaurant and a bar. The regularly updated food menu focuses on seasonal, locally sourced, hand-prepared produce. The pub is operated by Kent winery Hush Heath – its wines are featured, as is its own keg IPA and lager, brewed by Cellar Head. A local produce market is held in the car park on Wednesday morning. ⏃❀❀🕮⬤▲❀

Framfield

Hare & Hounds ♈ ⓛ

The Street, TN22 5NJ

☎ (01825) 890118 ⊕ hareandhounds.net

Harvey's Sussex Best Bitter; 1 changing beer (sourced locally) Ⓗ

A recently refurbished historic village pub, dating from 1428. It offers a separate dining area, bar and a snug with inglenook fireplace and comfortable chairs. The pub has a reputation for its food, including Sunday roasts, and has a lively programme of community events, quiz nights and live music. Dog-friendly, with a good-sized garden including a children's play area, the pub offers something for all ages. Q⏃❀🕮⬤♣AP🖵❀🛜

Hadlow Down

New Inn ★ ⓛ

Main Road, TN22 4HJ (on the 272)

Harvey's IPA, Sussex Best Bitter; 1 changing beer (often Harvey's) Ⓗ

Welcoming village inn identified by CAMRA as having a nationally important historic pub interior on account of its back bar fittings, ceramic spirit casks and panelled counter. These date from 1885 when the pub was rebuilt following a fire. There is another bar at the back and a function room. The no-frills environment is more than compensated for by the conviviality and excellently-kept beer. No food is available other than bar snacks. Q⏃♣P🖵(248)❀

Hailsham

George Hotel ⓛ ✅

3 George Street, BN27 1AD

☎ (01323) 445120

Greene King Abbot; Ruddles Best Bitter; Sharp's Doom Bar; 2 changing beers (sourced nationally) Ⓗ

A busy town-centre pub that shows Wetherspoon's model at its best. Popular with locals and visitors, it is opposite the Hailsham Pavilion cinema. At least five real ales, including one LocAle are offered, and seven ciders and perries, including two or three real options. There is a quiet enclosed rear patio and an outdoor terrace at the side. Local CAMRA Cider and Perry Pub of the Year 2018 and 2019, and runner-up in 2020. Q⏃❀🕮⬤🖵🛜

Hastings

Crown ⓛ

64-66 All Saints Street, Old Town, TN34 3BN

☎ (01424) 465100 ⊕ thecrownhastings.co.uk

2 changing beers (sourced locally) Ⓗ

Set in picturesque All Saints Street, in the heart of the old town, this superbly refurbished local combines traditional style with a touch of the modern. An illuminated artwork proclaims Please Let's All Get Along. Visitors can expect two local real ales plus up to nine quality craft beers alongside an award-winning food menu featuring locally sourced ingredients. The back bar hosts regular art exhibitions. The pub is family and dog friendly, and there are wooden tables and benches outside. ⏃🕮♣⬤🖵(20,100) ❀🛜

Dolphin ⓛ ✅

11-12 Rock-A-Nore Road, Old Town, TN34 3DW

☎ (01424) 434326 ⊕ thedolphinpub.co.uk

Dark Star Hophead; Harvey's Sussex Best Bitter; Young's London Special; 3 changing beers (sourced nationally) Ⓗ

Traditional family-run pub next to the town's famous fishing huts and close to Europe's largest beach-launched fleet. It is adorned with memorabilia and old photographs of the local fishing community. Six cask beers are available including three regularly changing guests. There is a wood-burning stove, and a front terrace that is popular in summer. Fish & chip suppers are served on Monday evening. Live music, showcasing local bands, takes place on Tuesday, Friday and Saturday. Q⏃❀🕮⬤♣🖵❀🛜

First In Last Out ⓛ

14-15 High Street, Old Town, TN34 3EY (nr Stables Theatre)

☎ (01424) 425079 ⊕ thefilo.co.uk

FILO Crofters, Churches Pale Ale, Old Town Tom, Gold; 1 changing beer (sourced regionally) Ⓗ

In the heart of ever-popular old town and serving the range of its own FILO beers, this is a friendly, welcoming traditional pub, with a fireplace in the middle adding warmth during the winter months. Up to six FILO ales and a guest are served along with excellent food in the restaurant to the rear and in the bar. Live music is a feature – check the website for details.
Q ⓦ ◗ ♣ ⌂ ⇆ ♥ 🕏

Jenny Lind 🅛 ✓

69 High Street, Old Town, TN34 3EW
☎ (01424) 421392 ⊕ jennylindhastings.co.uk
Long Man Best Bitter; 4 changing beers Ⓗ
A traditional back-street pub located in the old town of Hastings. It is a vibrant establishment with music events taking place most weekdays and at weekends. The back bar or the steeply terraced outside areas offer a quieter escape. The pub's name is taken from the famous opera singer who may have stayed locally in the late 1800s.
ⓦ ❀ ⌁ ♣ ⇆ ♥ 🕏

Jolly Fisherman

3 East Beach Street, Old Town, TN34 3AR
☎ (01424) 428811 ⊕ jollyfishermanhastings.com
3 changing beers Ⓗ
The Jolly faces the seafront, has a single bar and was Hastings' first micropub. It is popular with locals and tourists alike, and is intimately furnished in traditional style which adds to the friendly atmosphere and encourages conversation. Three changing cask ales are available and six nationally sourced craft keg beers. The pub also specialises in traditional ciders and perries, with up to six available, and was local CAMRA Cider Pub of the Year in 2020. There is a wood-burning stove in the bar.
ⓦ ♣ ♥ ⇆ (20,100) ❀

White Rock Hotel 🅛

White Rock, TN34 1JU (opp pier)
☎ (01424) 422240 ⊕ thewhiterockhotel.com
3 changing beers (sourced locally) Ⓗ
Situated on the seafront next to the White Rock Theatre, opposite the pier, the White Rock Hotel bar and outside terrace are superb locations from which to watch the world go by, especially in good weather. There is restaurant-style seating inside as well as a comfortable area for a relaxing drink. Three or four ales are served, all from Sussex, and at least one LocAle. Light meals and snacks are available throughout the day.
Q ⓦ ❀ ⌁ ◗ ⇆ P ⇆ ❀ 🕏

Hove

Foghorn 🅛

55 Boundary Road, BN3 4EF
☎ (01273) 419362 ⊕ thefoghornmicro.com
5 changing beers (sourced regionally; often Brighton Bier, Burning Sky) Ⓖ
The Foghorn may be situated on the busy corner of New Church Road and Boundary Road, but within there is a quiet haven for drinkers. Opened in 2018, this micropub enterprise has quickly become a go-to venue, with its wide-ranging selection of beers. The cellar sits just behind the bar and can be viewed through the glass partition. Furniture and decor are best described as minimalist with cloud-like cushions hanging from the ceiling to help deaden noise. Toilets are very well maintained. Q ⓦ ♿ ⇆ (Portslade) ● ⇆ ❀ 🕏

Neptune Inn 🅛

10 Victoria Terrace, BN3 2WB (on coast road E of King Alfred leisure complex)
☎ (01273) 736390 ⊕ theneptunelivemusicbar.co.uk

Greene King Abbot; Harvey's Sussex Best Bitter; 2 changing beers (sourced regionally) Ⓗ
Friendly, no frills single-bar Victorian pub close to the King Alfred centre and Hove seafront. A reclining figure of Neptune rests above the old Courage signage at the front. Four beers are available including two ever-changing guests. Live music features strongly, with blues or rock every Friday and jazz Sundays – see website for details. The pub is dog friendly, and welcomes children until evening. ⇆ (700) ❀

Poets Ale & Smoke House 🅛 ✓

33 Montgomery Street, BN3 5BF
☎ (01273) 272212 ⊕ thepoets.pub
Harvey's IPA, Sussex Best Bitter; 3 changing beers (sourced locally; often Harvey's) Ⓗ
This is a street-corner Harvey's tied house in the Poets Corner district of Hove, managed by a local pub company. The public bar shows sports events on big screen TV whereas the saloon is quieter. There is outside seating at the front and a patio area to the rear. American-style comfort food is served lunchtimes and evenings plus Sunday roasts. Four to five handpumps dispense excellent Harvey's beers. A function room is available upstairs. ⓦ ❀ ◗ ⇆ (Aldrington) ● ⇆ ❀

Watchmaker's Arms 🅛

84 Goldstone Villas, BN3 3RU
☎ (01273) 776307 ⊕ thewatchmakersarms.co.uk
4 changing beers (sourced regionally; often Brighton Bier, Downlands) Ⓖ
This micropub has a small outside seating area on the pavement with two tables, which are well-used. The pub generally has four cask beers on sale, served from a cold room behind the bar, rotating fortnightly. Cask beers are almost always from small breweries, with many from Sussex, Hampshire, and Kent. Real cider is also always available, mainly sourced from local producers. Check the website for details of the beers currently on the bar.
Q ⇆ ♣ ● ⇆ (7,21) ❀

Icklesham

Queen's Head 🅛

Parsonage Lane, TN36 4BL (opp village hall)
☎ (01424) 814552 ⊕ queenshead.com
Greene King Abbot; Harvey's Sussex Best Bitter; 2 changing beers (sourced locally) Ⓗ
Built in 1632 as two dwellings, a pub since 1831, this delightful 17th-century inn has been in the Guide for over 40 years. Open fires and excellent good-value home-made food make it popular with locals, walkers on the 1066 Country Walk and other visitors. Pub quizzes, live music and mini beer festivals are held to provide additional entertainment. Outside is a beer garden with pétanque piste and superb views over the Brede Valley.
ⓦ ❀ ◗ ♣ ● P ⇆ (100) ❀ 🕏

Isfield

Laughing Fish 🅛 ✓

Station Road, TN22 5XB (off A26 between Lewes and Uckfield)
☎ (01825) 750349 ⊕ laughingfishisfield.com
Long Man Best Bitter; 5 changing beers (sourced locally; often Greene King, Gun) Ⓗ
Formerly the Half Moon, then the Station Hotel, this 1860s pub is next to the preserved Lavender Line. WWII brought the custom of Canadian troops, not without incident. In the 1950s it was the HQ of the District Angling Club, the probable origin of the present name. It combines the Greene King portfolio and guest beers from

Sussex breweries. Good pub food is served and there is a range of games including bar billiards. Regular live music events are held. ❦✿◑◔✦♣P🖬(29,29B)✿❦

Lewes

Black Horse 🅛

55 Western Road, BN7 1RS

☎ (01273) 473653 🌐 theblackhorselewes.co.uk

Burning Sky Plateau; Greene King Abbot; Harvey's Sussex Best Bitter; 4 changing beers (sourced regionally; often Dark Star, Greene King, Old Dairy) 🅗

A Greene King Local Heroes pub that allows the licensee to source and stock Sussex ales and produce. This traditional community pub in the western end of the town has feature bay windows and a large main bar with a real fire, together with a quieter back bar. Two TVs show most sporting events. Home-made food includes vegan options. The pub's teams play a wide variety of games including toad-in-the-hole and crib. ❦✿❦◑◔᪄♣🖬(28,29)✿❦

Brewers Arms 🅛

91 High Street, BN7 1XN (near Lewes Castle)

☎ (01273) 475524 🌐 thebrewersarmslewes.com

Harvey's Sussex Best Bitter; 4 changing beers (sourced regionally; often Burning Sky, Gun, Harvey's) 🅗

A two-bar pub with separate characteristics – the front bar being quiet and more food oriented, the back bar offering sports TV, darts and pool. It is popular on match days with Lewes FC, Brighton & Hove Albion and away fans. There is an annual beer festival, and the pub has a dwyle flunking team. Food, including traditional breakfasts, is served until early evening. The exterior features the signage of former owners, Page and Overton's Croydon Ales. ✿◑◔≠♣🖬(28,29)✿❦

Dorset 🅛 ✅

22 Malling Street, BN7 2RD

☎ (01273) 474823 🌐 thedorsetlewes.co.uk

Harvey's Sussex Best Bitter; 3 changing beers (sourced locally; often Harvey's) 🅗

Refurbished in 2006, this Harvey's tied house has several drinking and dining areas, a large patio and six reasonably priced en-suite bedrooms. It serves at least four ales on handpump. An extensive food menu features traditional home-cooked dishes and an ever-changing fish selection, using ingredients fresh from Newhaven. The pub is the home of the Cliffe Bonfire Society – the largest of the five Lewes bonfire societies. Closing times may vary in winter so it is advisable to check beforehand. ✿🛏◑◔᪄≠♣🖬(28,29)

Elephant & Castle 🅛

White Hill, BN7 2DJ (off Fisher St, near old police station)

☎ (01273) 473797

Harvey's Sussex Best Bitter; 3 changing beers (sourced locally) 🅗

A spacious pub with three rooms, showing football, rugby and other sports in different areas. On Thursday a large selection of craft bottled and canned beer is available to drink on the premises at takeaway prices. There is a large function room upstairs available for hire. The pub is home to many clubs including the Commercial Bonfire Society. Food is locally sourced. ✿◑◔≠♣🖬(127,132) ❦

Gardener's Arms 🅛

46 Cliffe High Street, BN7 2AN

☎ (01273) 474808

Harvey's Sussex Best Bitter; 5 changing beers (sourced regionally; often Harvey's, Rother Valley) 🅗

A traditional, genuine free house near Harvey's Brewery in Cliffe High Street. It is a one-roomed pub with a wooden floor and central bar. Five changing guest ales are dispensed, generally sourced from small breweries across the country. It is popular with Lewes and Brighton FC fans on match days. A real cider is always available, and a dark beer festival is held in March. Dogs are especially welcome but no children allowed. ≠♣◔🖬(28,29) ✿❦

John Harvey Tavern 🅛 ✅

1 Bear Yard, Cliffe High Street, BN7 2AN (opp Harvey's Brewery)

☎ (01273) 479880 🌐 johnharveytavern.co.uk

Harvey's IPA 🅗**, Sussex Best Bitter** 🅖**, Armada Ale** 🅗**; 3 changing beers (sourced locally; often Harvey's)** 🅗/🅖

Housed in a former stable block of the Bear Inn, opposite Harvey's Brewery and next to the River Ouse, the bar boasts wooden beams, a slate floor, log-burner and two large wine vats, providing cosy seating areas. Children are only allowed in the restaurant. There is a large function/dining room upstairs. The outside tables are a suntrap in summer and therefore very popular. There is a folk night on Tuesday and music on Sunday. Q❦◑◔≠♣🖬(28,29) ✿❦

Lansdown Arms 🅛

36 Lansdown Place, BN7 2JU

☎ (01273) 470711

Harvey's Sussex Best Bitter; Timothy Taylor Boltmaker; 2 changing beers (sourced locally; often Gun, Long Man, Timothy Taylor) 🅗

Close to the railway station at the foot of a steep hill, this smallish hostelry is popular with fans and visitors to both Lewes FC and Brighton & Hove Albion on match days. The dark and cosy pub was built in 1827, before the arrival of the railway in Lewes, and was at one time a Whitbread house. It hosts popular live music, regularly featuring local bands, and has a free jukebox. Local artists display on the walls. ❦◑◔≠🖬✿❦

Rights of Man 🅛 ✅

179 High Street, BN7 1YE

☎ (01273) 486894 🌐 rightsofmanlewes.com

Harvey's IPA, Sussex Best Bitter; 5 changing beers (sourced locally; often Harvey's) 🅗

A small two-bar pub near the law courts. The front bar has two tall tables near the front windows, wonderful for having a pint and watching the world go by. Dark oak-panelled walls and etched-glass screens form booths. The small Martyr's bar has pictures of each local bonfire society on the wall and more seating. Good-quality food is served, lunch and evening. The Astroturf-covered roof terrace is a real suntrap in the summer. ✿◑◔≠🖬(28,29) ✿❦

Royal Oak 🅛

3 Station Street, BN7 2DA

☎ (01273) 474803 🌐 royaloaklewes.co.uk

Harvey's Sussex Best Bitter; St Austell Tribute; 2 changing beers (sourced locally; often Bedlam, Five Points, Gun) 🅗

This single-room pub at the top of the station hill is the birthplace of Lewes FC (1875) and home to the Waterloo Bonfire Society. The good food is complemented by a range of five beers, usually at least one from Bedlam. There is a function room upstairs with its own bar which hosts regular live music sessions. There are DJs in the bar on Friday nights and sometimes karaoke sessions. To the rear of the pub is a secret garden. ✿◑◔≠🖬✿❦

Newick

Crown Inn ☐ ✓
22 Church Road, BN8 4JX
☎ (01825) 723293 ⊕ thecrownatnewick.co.uk
Harvey's Sussex Best Bitter; 2 changing beers (sourced regionally; often Harvey's, Pig & Porter) ⊞
This family-run free house is at the southern end of the village near the post office. The 121 bus stops just round the corner. There is a central bar with two smaller rooms off to either side and a very pleasant garden to the rear. Good-value meals using local produce are served. With two other pubs on the village green, Newick is well worth a whole afternoon's stay, but don't miss the last bus! ☎※◑➻⬥♦P🛏(31,121)🕮🐾

Polegate

Dinkum ☐
54 High Street, BN26 6AG
☎ (01323) 482106
Harvey's Sussex Best Bitter; 1 changing beer (sourced locally; often Harvey's) ⊞
This local Harvey's pub is located in Polegate High Street, a short walk away from the train station and bus stops. The Dinkum is frequented by local patrons, but visitors are always warmly welcomed. There are two bars – a quieter saloon at the front and a larger public bar with a pool table, darts, and other classic pub games. Harvey's Sussex Best Bitter is always on tap and at least one seasonal ale. ☎※≒♦P🛏🐾🕮

Portslade

Railway Inn ☐
2 Station Road, BN41 1GA
☎ (01273) 271220 ⊕ therailwayinnportslade.co.uk
Harvey's Sussex Best Bitter; 3 changing beers (sourced regionally) ⊞
Following a full refurbishment, the former Whistlestop has reverted to its old name. Four handpumps serve Harvey's Sussex Best and three changing guest ales, plus a real cider and perry. This family and dog-friendly pub, close to Portslade station, aims to be a focal point of the community. All are welcome for a drink or a bite to eat. There is an extensive food menu served all day, plus a gelato bar. ☎※◑➻🛏🐾🕮

Stanley Arms ☐
47 Wolseley Road, BN41 1SS (on corner of Wolseley Rd and Stanley Rd)
☎ (01273) 701738 ⊕ thestanley.com
Harvey's Sussex Best Bitter; 4 changing beers (sourced regionally; often Downlands, Harvey's, Long Man) ⊞
A welcoming no-frills back-street pub, the hub of the local community, with an ever-changing range of guest beers from Sussex and beyond. Cellar Night is a feature every second Monday of the month where you can visit the cellar and get reduced prices on your beer together with free nibbles at the bar. TV sport is regularly shown. Wednesday is quiz night and there are occasional beer festivals, advertised on the pub's Facebook page. Q☎※≒(Fishersgate)♦🛏(2,46)🐾🕮

Ringmer

Anchor Inn ☐
Lewes Road, BN8 5QE
☎ (01273) 812370 ⊕ anchorringmer.com
Harvey's Sussex Best Bitter; 3 changing beers (sourced locally; often Harvey's) ⊞
Situated opposite the village green, this family-run free house dates to 1742 and occupies a prominent position in the centre of Ringmer. Food is served lunchtimes and evenings in the week and all day Saturday, with roasts available on Sunday. The two guest ales are usually from local Sussex breweries. Two large garden areas adjoin the building, with a separate small terrace garden containing seating and the heated/covered smoking area. ☎※◑➻♦P🛏(28,29B)🐾🕮

Rotherfield

King's Arms ☐
High Street, TN6 3LJ
☎ (01892) 853441 ⊕ katn6.com
Harvey's Sussex Best Bitter; 3 changing beers (sourced locally) ⊞
The King's Arms is a spacious 17th-century community pub in the village centre. The attractive interior hosts two traditional bar areas, both with inglenook fireplaces. There is ample seating for enjoying the range of local ales and food from the varied menu. Customer service is excellent, and families and dogs are welcome. The large garden is ideal for gatherings in the summer and has panoramic views of the local countryside. Q☎※◑➻P🛏(252)🐾🕮

Rye

Waterworks ☐
Tower Street, TN31 7AT
☎ (01797) 224110 ⊕ ryewaterworks.co.uk
House beer (by Three Legs); 7 changing beers (sourced locally) 🄶
In its 300-year history the building has been the town's pumphouse, soup kitchen and toilets. It was reinvented as a micropub in 2018, with the well, soup coppers and open fireplace remaining as features. It brews its own beers off the premises and one of these real ales is always available, accompanied by seven changing beers and 16 ciders, all from local brewers and cider makers. Pork pies and Scotch eggs are popular snacks. Current local CAMRA Cider Pub of the Year. Q☎※⬥≒♦🛏🐾🕮

Ypres Castle Inn ☐
Gun Garden, TN31 7HH (accessed from A259 up flight of steps; for fewer steps approach from Church Square)
☎ (01797) 223248 ⊕ yprescastleinn.co.uk
House beer (by Rother Valley); 3 changing beers (sourced locally) ⊞
An attractive weatherboarded pub, set just below the Rye Castle Museum and above the A259. The large beer garden, with 25 tables, and other outside drinking areas give superb views across Romney Marsh. There is one large bar with a log fire and a smaller adjoining room. Quality bar snacks are offered alongside local cheeses, cured meats and pork pies. The house beer from Rother Valley is Ypres Castle Bitter. Open on bank holiday Monday, otherwise closed Monday to Wednesday. ☎※≒🛏(100,101)🐾🕮

St Leonards on Sea

Nag's Head
8-9 Gensing Road, TN38 0ER
☎ (01424) 445973
Harvey's Sussex Best Bitter; 3 changing beers (sourced locally) ⊞
This recently renovated pub is tucked away in a quiet residential street to the west of London Road. The front door brings you straight to the central U-shaped bar

which has five handpumps – all in use at busy times – serving both local and national ales. The pub hosts a Wednesday quiz night, a Saturday afternoon meat raffle and live music nights once or twice a month.
ᗧ❀≠(Warrior Square) ♣🚐❀

Tower

251 London Road, Bohemia, TN37 6NB
☎ (01424) 721773
Dark Star Hophead, American Pale Ale; 4 changing beers (sourced nationally) 🅗
A lively community pub with a convivial atmosphere, warmed by a wood-burning stove, offering six reasonably priced ales and up to seven ciders. An annual beer festival is held in February. HD TV screens showing all the main rugby, cricket and football matches, and other sports. Occasional visits to sporting events and breweries are arranged. Local CAMRA Pub of the Year 2019 and runner-up in 2020.
ᗧ≠(Warrior Square) ♣●🖩🚐❀🛜

Salehurst

Salehurst Halt 🅛

Church Lane, TN32 5PH (follow Church Lane from A21 Robertsbridge roundabout)
☎ (01580) 880620 ⊕ salehursthalt.co.uk
Harvey's Sussex Best Bitter; 1 changing beer (sourced locally) 🅗
Loved by the community, this cosy family-run free house nestles in a peaceful Rother Valley hamlet. It proudly serves local ales, ciders, wines, spirits and fruit juices. A popular and interesting blackboard menu includes fish from Hastings, meat, game and local vegetables, plus wood-fired pizza in summer months. There is a small private dining room; live music, parties, and weddings are hosted. A gorgeous garden overlooks hop fields. Robertsbridge, Bodiam Castle and Great Dixter are nearby. Q ᗧ❀🕦 ♣●❀🛜

Seaford

Old Boot Inn 🅛

16 South Street, BN25 1PE
☎ (01323) 895454
Harvey's Sussex Best Bitter; 4 changing beers (sourced regionally; often 360 Degree, Gun, Harvey's) 🅗
This deceptively large pub, under the same ownership as the Gardener's Arms in Lewes, has entrances in both South Street and High Street. Harvey's Best Bitter is always to be found on one of the six handpumps, along with Old Ale in season. Four ever-changing guests and six bag-in-box ciders complete the range. There are plenty of tables and food is served, with a wide range of roasts on Sundays. Wheelchair access is possible.
ᗧ❀🕦♿≠●🚐❀🛜

Upper Hartfield

Gallipot Inn 🅛

Gallipot Street, TN7 4AJ
☎ (01892) 770008 ⊕ the-gallipot-inn.co.uk
Harvey's Sussex Best Bitter; 1 changing beer (sourced locally) 🅗
The Gallipot Inn, built in the late 16th century, is a fine example of a family-run, traditional English pub with a strong community focus. It is situated on the outskirts of Hartfield close to the popular Winnie the Pooh Bridge walking area. An open fire creates a cosy atmosphere in winter and in the summer the beautiful rear garden offers rewarding views over Ashdown Forest. The cask

ales are usually from local breweries and the freshly-cooked food is also locally sourced.
Q ᗧ❀🕦 ♣♿🚐 (291) ❀🛜

Westfield

New Inn 🅛

Main Road, TN35 4QE
☎ (01424) 752800 ⊕ newinnwestfield.com
3 changing beers (sourced locally) 🅗
This delightful community-focused village pub, refurbished in 2015, serves local cask ales, including Long Man and Angels & Demons, plus other changing beers from its three handpumps. Situated in the heart of the village, just 300 yards from the 1066 Country Walk, the pub is popular with locals and visitors alike. Excellent home-cooked, locally sourced food is available at reasonable prices; booking is advisable. There is a light, airy conservatory and outside seating for warmer weather. Q ᗧ❀🕦♿🚐❀🛜

Breweries

1648

🍴 **Old Stables Brewery, Mill Lane, East Hoathly, East Sussex, BN8 6QB**
☎ (01825) 840830 ⊕ 1648brewing.co.uk
⊠ The 1648 brewery, set up in the old stable block at the King's Head pub in 2003, derives its name from the year of the deposition of King Charles I. One pub is owned and more than 40 outlets are supplied. ‼️ 🍺 ♦ LIVE

Hop Pocket (ABV 3.7%) GOLD
Triple Champion (ABV 4%) BITTER
Signature (ABV 4.4%) GOLD
Laughing Frog (ABV 5.2%) BITTER

360°

Unit 24b, Bluebell Business Estate, Sheffield Park, East Sussex, TN22 3HQ
☎ (01825) 722375 ⊕ 360degreebrewing.com
⊠ Under new management since 2020 but still brewing at Sheffield Park, adjacent to the famous Bluebell Railway. The brewery is committed to producing high quality cask conditioned ales and has increased its output of craft keg and cans. ‼️ 🍺 ♦ 🗝

Double Act Pale (ABV 4.1%) GOLD
Bluebell Best (ABV 4.2%) BITTER
Session IPA (ABV 4.3%) PALE
Fastback Pale Ale (ABV 5%) PALE

Abyss SIBA

Unit 3, The Malthouse, Davey's Lane, Lewes, BN7 2BF
⊕ abyssbrewing.co.uk
⊠ Established in Lewes in 2017, later that year Abyss relocated to the ex-Black Cat premises in Framfield. In 2021 it returned to Lewes using part of the old Southdown Brewery malthouse. The eight-barrel plant produces a changing range of vegan-friendly beers, available in keg in the on-site taproom (open Thursday-Saturday) or for home delivery (see website). Cask beer occasionally available in the taproom but not generally distributed. V🗝

Battle SIBA

The Calf House, Beech Farm, North Trade Road, Battle, East Sussex, TN33 0HN

☎ (01424) 772838 ⊕ battlebrewery.co.uk

Battle Brewery is an eight-barrel brewery located in the heart of 1066 country in the historic town of Battle. Established in 2017, local pubs cafés and shops are supplied. A brewtap/micropub was opened in 2021 at the top of Battle High Street selling beers direct from the cask, plus its bottled range. 🍽◆

Fyrds Gold (ABV 3.8%) GOLD
Conquest (ABV 4.1%) BITTER
One Hop Wonder (ABV 4.3%) GOLD
Alan the Red (ABV 4.4%) RED
Black Arrow (ABV 4.5%) PORTER
Abbey Pale IPA (ABV 5%) PALE
Harolds EyePA (ABV 5.6%) PALE
Senlac Imperial Stout (ABV 10.5%) STOUT

Beak

Unit 14, Cliffe Industrial Estate, Lewes, East Sussex, BN8 6JL ☎ 07985 708122 ⊕ beakbrewery.com

Originally a gypsy brewery, with recipes tested on a nano-kit, Beak now has its own 15-barrel brewery and taproom in Lewes. ◆

Bedlam SIBA

St Helena Farm, St Helena Lane, Plumpton Green, East Sussex, BN7 3DH
☎ (01273) 978015 ⊕ bedlambrewery.co.uk

Eco-friendly Bedlam Brewery operates from the heart of the South Downs on a farm with solar power. All spent grain is donated to cattle on the farm and hops are composted. More than 1,000 pubs and bars are supplied across London and the South of England. ♯LIVE

Phoenix IPA (ABV 3.9%) PALE
Benchmark (ABV 4%) BITTER
Wilde (ABV 4.4%) PALE
Amagansett (ABV 5%) PALE

Beer Me

▤ The Belgian Café, 11/23 Grand Parade, Eastbourne, East Sussex, BN21 3YN
☎ (01323) 729967 ⊕ beermebrewery.co.uk

⊗ Beer Me was launched in 2014 by the owners of the Belgian Café in Eastbourne, building on 10 years in the catering industry. It uses a 2.5-barrel plant and produces continental-style beers which are served direct from the brewery. ♯◆

Brewery at the Watchmaker's Arms

▤ 84 Goldstone Villas, Hove, East Sussex, BN3 3RU

Hove's first micropub has its own 100-litre microbrewery, producing under the Beercraft Brighton brand name. Beer is primarily for the Watchmakers but is available in other local pubs.

Brewing Brothers

▤ Imperial, 119 Queens Road, Hastings, East Sussex, TN34 1RL ☎ 07985 505810 ⊕ brewingbrothers.org

⊗ Brewing began in 2016 in the Imperial, Hastings. The brewery has a 2.5-barrel capacity with four fermenting vessels. A wide range of brother-themed beers have been brewed to date, including a collaboration with Half Man Half Burger. Up to eight beers on cask and keg can feature at any one time. A taproom in Ivy House Lane opened in 2022. ◆✦

Brighton Bier

Unit 10, Bell Tower Industrial Estate, Roedean Road, Brighton, East Sussex, BN2 5RU ☎ 07967 681203 ⊕ brightonbier.com

Brighton Bier was established in 2012. It operates a 15-barrel brewery close to the centre of the city and also owns the Brighton Bierhaus pub, in Brighton. Beers are available throughout the UK and exported to Europe and Asia.

Thirty Three (ABV 3.3%) GOLD
Brighton Bier (ABV 4%) GOLD
West Pier (ABV 4%) GOLD
Underdog (ABV 4.2%) BITTER
IPA (ABV 5%) PALE
No Name Stout (ABV 5%) STOUT
Grand Porter (ABV 5.2%) PORTER

BritHop

Highfields Farm, The Broyle, Ringmer, East Sussex, BN8 5AR ☎ 07883 223127 ⊕ brithopbeer.com

Established in 2018, BritHop Brewing Co moved from Kent to East Sussex in 2022. A penchant for the Britpop music scene of the 90s comes through in the beer names. ◆

Filmstar (ABV 3.8%) PALE
Pit (ABV 3.8%) BITTER
Sandstorm (ABV 3.8%) GOLD
One to Another (ABV 4.1%) BITTER
Sweet Symphony (ABV 4.2%) RED
Thirst for Knowledge (ABV 4.3%) PALE
Shakermaker (ABV 4.5%) GOLD
Marblehead (ABV 5.5%) IPA

BRZN

Unit 2, Cobblers Thumb, 10 New England Road, Brighton, East Sussex, BN1 4ZR
✉ buybrzn@gmail.com

BRZN was founded as a cuckoo brewery in 2019 but in 2020 moved into its own premises in the Preston Circus region of Brighton. Its range is brewed in small batches, without isinglass finings and in keg and cask. Seasonals and specials are always available. ◆

Burning Sky SIBA

Place Barn, The Street, Firle, East Sussex, BN8 6LP
☎ (01273) 858080 ⊕ burningskybeer.com

⊗ Burning Sky started brewing in 2013 using a 15-barrel plant, based on the Firle Estate in the South Downs. It is owned and run by Mark Tranter (ex-Dark Star head brewer). The brewery has its own yeast strains suited to the beer styles. It specialises in pale ales and Belgian-inspired farmhouse beers and has an extensive barrel-aging programme. LIVE

Plateau (ABV 3.5%) GOLD
Aurora (ABV 5.6%) IPA

Cellar Head SIBA

The Barn, Pillory Corner, Flimwell, East Sussex, TN5 7QG ☎ 07391 557407 ⊕ cellarheadbrewing.com

⊗ Cellar Head Brewery is situated on the border between Sussex and Kent, in Flimwell. It has recently installed and commissioned a new, gas-fired, 20-barrel brewhouse with fermentation capacity in excess of 280HL. It uses predominately local hops and malts to produce a range of beers in cask and keg, varying in style

and taste. The modern brewery building also houses a taproom, shop and canning line, allowing for off-sales. Besides core beers, new and innovative small batch brews are often available. !! ☕ ♦

Session Bitter (ABV 3.5%) BITTER
Amber Ale (ABV 4%) GOLD
Session Pale Ale (ABV 4.2%) PALE
Single Hop Pale (ABV 4.6%) SPECIALITY
India Pale Ale (ABV 5%) PALE

FILO

The Old Town Brewery, Torfield Cottage, 8 Old London Road, Hastings, East Sussex, TN34 3HA
☎ (01424) 420212 ⊕ filobrewing.co.uk

⊗ Owners of the First In Last Out (FILO) set up their own brewery in the back of the pub in 1985, to become Hastings first brewpub. The current owners took over in 1988, and in 2011 relocated the brewery to the nearby Grade II-listed stable at Torfield Cottage. The brewery continues to supply ales to the FILO pub, together with many other pubs within Hastings, and throughout Sussex and Kent. ♦

Crofters (ABV 3.8%) BITTER
Churches Pale Ale (ABV 4.2%) PALE
Old Town Tom (ABV 4.5%) SPECIALITY
Gold (ABV 4.8%) GOLD

Flying Trunk (NEW)

The Cement Stores, Highgate Works, Tomtits Lane, Forest Row, East Sussex, RH18 5AT ☎ 07710 642848
✉ hello@flyingtrunkbrewery.co.uk

Brewing began in 2022 based in premises formerly used by High Weald Brewery.

Furnace Brook

Trolliloes Lane, Cowbeech, Hailsham, East Sussex, BN27 4QR
☎ (01435) 830835 ⊕ Furnacebrooke.co.uk

Small-batch brewery producing hand-crafted bottled beers with local hops and no finings or sulphites.

Good Things

Rendlye Farm, Sandhill Lane, Eridge, TN3 9LP
✉ chris@goodthingsbrewing.co

Brewing began in 2018. Good things is a sustainable brewery, meaning that its aim is to be energy-efficient, with everything recycled and reused. Beer is available in kegs and cans in more than 100 outlets. No real ale. Brewing is currently suspended due to a serious fire in 2021.

Gun SIBA

Hawthbush Farm, Gun Hill, East Sussex, TN21 0JX
☎ (01323) 700200 ☎ 07900 683355
⊕ gunbrewery.co.uk

⊗ Gun Brewery is located on a beautiful 140-acre, organic, mixed farm in the Sussex Weald. After selling its first pint in 2015 and outgrowing the converted barn it started in, a brand new brewery and taproom was built on the farm, opening in 2022. Using its own spring water, a core range of beers is brewed with monthly specials as well as a barrel-aging programme.
!! ☕ ♦ LIVE GF V♦

Scaramanga Extra Pale (ABV 3.9%) PALE
Parabellum Milk Stout (ABV 4.1%) STOUT

Chummy Bluster Best Bitter (ABV 4.4%) BITTER
Project Babylon Pale Ale (ABV 4.6%) PALE
Zamzama IPA (ABV 6.5%) IPA

Hand SIBA

▤ 33 Upper St James's Street, Kemptown, Brighton, East Sussex, BN2 1JN ☎ 07508 814541

Worthing: Brewery & Taproom, Unit 6a, Garcia Trading Estate, Canterbury Road, Worthing, BN13 1AL ☎ (01273) 286693

⊛ Brighton's tiny Hand in Hand Brewpub hides the smallest commercially operating tower brewery in the world, and is the smaller sibling of its production site in Worthing. It was founded in 1989. !!

Low 5 (ABV 3.8%) PALE
Bird (ABV 4.2%) BITTER
Chop (ABV 5%) STOUT

Harvey's IFBB

Bridge Wharf Brewery, 6 Cliffe High Street, Lewes, East Sussex, BN7 2AH
☎ (01273) 480209 ⊕ harveys.org.uk

⊗ Established in 1790, this independent, family brewery operates from the banks of the River Ouse in Lewes. A major development in 1985 doubled the brewhouse capacity to more than 38,000 barrels a year. There are plans to re-establish small brew lengths of special beers, including replicating old recipes. Harvey's supplies real ale to all its 43 pubs and about 550 free trade outlets in the South East. !! ☕ ♦ LIVE

Dark Mild (ABV 3%) MILD
A dark copper-brown colour. Roast malt dominates the aroma and palate leading to a sweet, caramel finish.
IPA (ABV 3.5%) PALE
Sussex Wild Hop (ABV 3.7%) GOLD
Sussex Best Bitter (ABV 4%) BITTER
Full-bodied brown bitter. A hoppy aroma leads to a good malt and hop balance, and a dry aftertaste.
Old Ale (ABV 4.3%) OLD
Armada Ale (ABV 4.5%) BITTER
Hoppy, amber best bitter. Well-balanced fruit and hops dominate throughout with a fruity palate.

Laine

▤ North Laine Bar & Brewhouse, 27 Gloucester Place, Brighton, East Sussex, BN1 4AA
☎ (01273) 683666 ⊕ laine.co.uk

⊗ Laine launched its first brewery in 2012, in Brighton, using a five-barrel plant based within the North Laine pub. The brewing equipment and process can be viewed from the bar. A number of sister breweries in pubs in Acton, Hackney and Battersea in London were established between 2013-2015 but have since been closed. !! ☕

Lakedown SIBA

Lakedown Farm, Swife Lane, Burwash, East Sussex, TN21 8UX
☎ (01435) 685001 ⊕ lakedownbrewing.com

Lakedown Brewing Co was established in 2020. Beers are available in can, bottle, keg and cask. ☕ ♦

American Pale Ale (ABV 4.2%) PALE
English Pale (ABV 4.2%) PALE
Best Bitter (ABV 4.4%) BITTER
American Red (ABV 4.8%) RED
IPA (ABV 5%) IPA

Larrikin

Urchin, 15-17 Belfast Street, Hove, West Sussex, BN3 3YS
☎ (01273) 241881 ✉ hello@urchinpub.co.uk

Following two years of homebrewing research, commercial brewing began in 2018 in the Urchin, Hove, a shellfish and craft beer pub. Beer is only available in the pub, mainly in keg, with cask-conditioned beer available infrequently.

Long Man SIBA

Church Farm, Litlington, East Sussex, BN26 5RA
☎ (01323) 871850 ⊕ longmanbrewery.com

⊗ Long Man began brewing in 2012 using a 20-barrel stainless steel plant. Hops and grain are sourced-locally alongside homegrown barley and locally-drawn water. A traditional strain of Sussex yeast is used. ⅋⟲✦

Long Blonde (ABV 3.8%) BLOND
Best Bitter (ABV 4%) BITTER
Copper Hop (ABV 4.2%) BITTER
Old Man (ABV 4.3%) OLD
Sussex Pride (ABV 4.5%) BITTER
Rising Giant (ABV 4.8%) PALE

Lost + Found

12-13 Ship Street, Brighton, East Sussex, BN1 1AD
⊕ lostandfoundbrewery.com

Brewing began in 2016. No real ale.

Lost Pier

28 Fourth Avenue, Hove, BN3 2PJ ⊕ lostpier.com

Launched in 2017, the three founders transferred more than 50 years of joint experience in the wine industry to brewing. Cuckoo brewing at two local breweries, the beer is unpasteurised, unfiltered and vegan-friendly. The Assemblage series blends beer and wine. **V**

Loud Shirt SIBA

Unit 5, Bell Tower Industrial Estate, Roedean Road, Brighton, East Sussex, BN2 5RU
☎ (01273) 087077 ☎ 07979 087945
⊕ loudshirtbeer.co.uk

⊗ The brewery was established in 2016 using a 10-barrel plant in the Kemptown area of Brighton. The current owner, Elias, took over in 2021. The taproom is open in the summer months Thursday-Sunday (website for times). Most production goes into bottles and cans; however there are usually at least two cask beers available. Look out for its psychedelic van around town and at festivals. Beers are available at selected Sussex pubs and bottle shops and at Whitehawk football club. ⅋⟲✦

Psychedelic IPA (ABV 5.1%) GOLD

Merakai

Unit 12, Squires Farm, Palehouse Common, Framfield, Uckfield, East Sussex, TN22 5RB
⊕ merkaibrewing.com

Merakai Brewing was established in 2020. It produces cans and one-litre bottles.

Moon (NEW)

Independent, 95 Queens Park Road, Brighton, East Sussex, BN2 0GH

☎ (01273) 602822 ⊕ theindepentent.pub

Nanobrewery situated in the Independent in Brighton, established in 2020. Beers are produced under the watchful eye of head brewer Martyn Haddock.

Old Tree

Old Tree, Yachtwerks, 28-29 Richmond Place, Brighton, East Sussex, BN2 9NA ☎ 07413 064346 ⊕ oldtree.house

A co-operative based in Brighton producing a unique range of small-batch, probiotic and celebration drinks. It supplies its own zero-waste Silo restaurant. Brewing and gardening are combined, and a production process is used that contributes to land regeneration. LIVE

Only With Love SIBA

Little Goldsmiths Farm, Beechy Road, Uckfield, East Sussex, TN22 5JG
☎ (01825) 608410 ☎ 07786 830368
⊕ onlywithlove.co

⊗ Only with Love was founded in 2020 by Steve Keegan and Roger Warner. It produces kombucha and beer in the heart of Sussex with all products sustainably created, packaged and delivered.

People's Captain

39 Sackville Road, Hove, East Sussex, BN3 3WD
⊕ peoplescaptain.co.uk

People's Captain was an idea conceived by Greg Bateman, a professional Rugby player. Along with friends Stewart Beale and Jason Reeves, the company was established to brew craft beer while also contributing to positive mental health. Every beer sold raises money via the People's Captain Foundation.

Rother Valley

Gate Court Farm, Station Road, Northiam, East Sussex, TN31 6QT
☎ (01797) 252922 ☎ 07798 877551
⊕ rothervalleybrewery.co.uk

⊗ Rother Valley Brewey was established in Northiam in 1993, overlooking the Rother Levels and the Kent & East Sussex Railway. Brewing on a 10-barrel plant, around 100 outlets are supplied direct. Established and new hop varieties are sourced locally. ♦

Black Ops (ABV 3.8%) PALE
Smild (ABV 3.8%) MILD
Valley Bitter (ABV 3.8%) BITTER
Level Best (ABV 4%) BITTER
Full-bodied, tawny session bitter with a malt and fruit aroma, malty taste and a dry, hoppy finish.
Copper Ale (ABV 4.1%) BITTER
Hoppers Ale (ABV 4.4%) BITTER
Boadicea (ABV 4.5%) BLOND
Blues (ABV 5%) OLD
NIPA (ABV 5%) GOLD

Route 21 (NEW)

145 Bridgemere Road, Eastbourne, BN22 8TY
⊕ route21brewing.co.uk

Established in 2020 Route 21 produces hoppy, hazy and juicy, unfiltered and unfined vegan craft beers. **V**

Southbrew

Broyle Mill Farm, Ringmer, East Sussex, BN8 5AR
🌐 southbrewcompany.co.uk

Nanobrewery formed by three friends, influenced by both traditional and modern beer styles. No real ale. Brewing is currently suspended.

Three Acre SIBA

Dairy Yard, Little Goldsmiths Farm, Beechy Road, Blackboys, East Sussex, TN22 5JG ☎ 07450 315960
🌐 threeacrebrewery.co.uk

⊠ Established in 2019 by three lifelong friends, Three Acre brewery has undergone significant expansion. A new 10-barrel brew plant and extra tanks have increased overall capacity by 150%. Based on a working farm, used water runs away into a natural reed bed and spent grain goes to feed livestock. Keg beers have been introduced, though the brewery remains passionately committed to cask beer, which is available in selected local pubs. Details of bottles, minicasks and cartons for home delivery are on the website. ◆LIVE

Best Bitter (ABV 4%) BITTER
Hazy Pale (ABV 4.6%) PALE
IPA (ABV 5%) GOLD

Three Legs

Unit 1, Burnt House Farm, Udimore Road, Broad Oak, East Sussex, TN31 6BX ☎ 07939 997622
🌐 thethreelegs.co.uk

⊠ The Three Legs was started in 2014 by two friends who met studying winemaking and viticulture at university. It has grown from a nanobrewery to a 10-barrel plant in a converted farm barn. Beers can be found in most free-houses and bottle shops across the south east as well as its brewery tap. Beers are ever changing with the majority modern, hop-forward and unfined. ⁌🍴⤶LIVE ◆

Pale (ABV 3.7%) PALE
Session IPA (ABV 4.5%)

Unbarred

Unbarred Brewery & Taproom, Elder Place, Brighton, East Sussex, BN1 4GF ☎ 07850 070471
🌐 unbarredbrewery.com

⊠ UnBarred was born and bred in Brighton and Hove, established in 2014 in the shed of founder and head brewer, Jordan. It now has a brewery and taproom in central Brighton. Beers are brewed with creativity and passion, with the brewery best known for its NEIPA's and stout styles. LIVE ◆

Waterworks, Rye (Photo: Peter Adams)

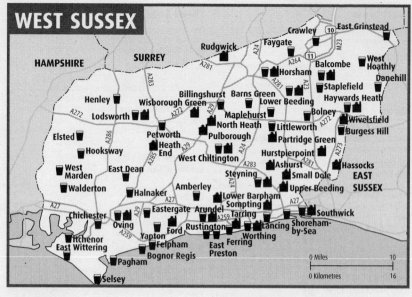

WEST SUSSEX

Amberley

Bridge Inn 🅛 ✓

Houghton Bridge, BN18 9LR (on B2139 just W of railway bridge at Amberley station)
☎ (01798) 831619 🌐 bridgeinnamberley.com
Harvey's Sussex Best Bitter; Long Man Rising Giant; 1 changing beer (sourced nationally; often Timothy Taylor) 🅗
Close to Amberley Working Museum, the South Downs Way and Amberley railway station, this Grade II-listed inn serves three real ales. Inside is a single cosy bar with open log fires in winter, and a large dining area to the side, offering mainly locally sourced home-cooked produce. There is a patio at the front and an attractive gated beer garden to the side. Q🕭🕭🏵🕭🕯➡️P🚃(73)🌸🛜

Arundel

King's Arms 🅛 ✓

36 Tarrant Street, BN18 9DN
☎ (01903) 885569
Fuller's London Pride; 2 changing beers (sourced regionally; often Firebird) 🅗
Situated in one of the more bohemian back streets, below the cathedral, this cosy free house, built in around 1625, is the oldest pub in town. Popular with locals and visitors alike, it has two separate bars, a secluded patio garden with smokers' area and tables on the cobbles outside. Welcoming of families and dogs, it offers board games, darts and a monthly Meet the Brewer evening with sausages. The pub hosts many outside events during the summer including the local festival in August. Q🕭🏵♣🕭(85,700)🌸🛜

Red Lion ✓

45 High Street, BN18 9AG (opp war memorial in centre of town)
☎ (01903) 882214 🌐 redlionarundel.com
Dark Star Hophead; Sharp's Doom Bar; Timothy Taylor Landlord; 1 changing beer (sourced nationally) 🅗
Reputed to be over 200 years old, this handsome red-brick building occupies a prominent position in the main street of this historic and characterful castle town, being well placed for the castle, cathedral, river and Wildfowl Trust. Changing guest beers usually include a LocAle. Excellent food is served all day and there is a quieter restaurant area to the rear. Music plays every Saturday.
🕭🏵🕭🕯🕭🍴🌸🛜

Balcombe

Half Moon

Haywards Heath Road, RH17 6PA
☎ (01444) 811582 🌐 halfmoonbalcombe.com
Harvey's Sussex Best Bitter; 2 changing beers (sourced locally; often Long Man) 🅗
This small pub is north Sussex's first community-owned establishment, with tables in the lower part as you enter, and the bar beyond up a couple of steps. The venue is food-led and serves a varied range of locally sourced meals. There are four handpumps, one usually dispensing Harvey's Sussex Best, with rotating, mainly local, guest beers on the others. 🕭🕯➡️🕭P🌸🛜

Barns Green

Queen's Head 🅛

Chapel Road, RH13 0PS
☎ (01403) 730436 🌐 thequeensheadbarnsgreen.co.uk
Adnams Ghost Ship; Harvey's Sussex Best Bitter; 1 changing beer (sourced regionally) 🅗
A cosy 17th-century village pub, with old timber beams and a large inglenook fireplace used in winter. It is open plan, with three seating areas and a small separate room. A garden with covered seating is at the back. There is a quiz night on the second Tuesday of the month, an open mic night on the first Thursday, and a charity coffee morning on the last Friday.
Q🕭🏵🕭AP🌸🛜

Billingshurst

Billi Tap 🅛

44 High Street, RH14 9NY
🌐 brollybrewing.co.uk/the-billi-tap
2 changing beers (often Brolly, Little Monster)
Opened in 2021, this high street micropub is the brewery tap for Brolly and Little Monster breweries, with two cask

ales and seven keg lines. The beer range is ever changing and there is a local cider. Food is provided some days, particularly Saturdays, by food trucks that park behind the pub. Check Facebook for current opening hours. Q♿(100)♣

Bognor Regis

Dog & Duck
65 High Street, PO21 1RY
2 changing beers (often Langham, Vibrant Forest) Ⓗ
Originally opened in 2018, this micropub moved round the corner to its new, more spacious premises in July 2021. Two changing cask ales are served, one usually a stronger beer, with tasters available from knowledgeable staff. Two ciders are also available alongside five craft keg taps. It has a friendly atmosphere, with regular tap takeovers and an annual beer festival in March held in a local hall. There is also a large range of interesting bottled and canned beers.
Q♿≠♣♠🚃♥♐

Bolney

Bolney Stage Ⓛ
London Road, RH17 5RL
☎ (01444) 881200
4 changing beers Ⓗ
An historic pub dating back to the 16th century, on the old A23 coaching route. It has a large bar area with three separate dining areas and an enclosed beer garden to the rear. The rooms feature huge inglenook fireplaces, ancient flagstones, open-timbered ceilings and crooked beams, together with comfy old furniture. A blackboard by the bar gives tasting notes on the four regularly changing beers, mainly from Sussex breweries.
♿❀❶👍♙🚃(273) ♣♐

Burgess Hill

Quench Bar & Kitchen Ⓛ
2-4 Church Road, RH15 9AE
☎ (01444) 253332 🌐 quenchbar.co.uk
Harvey's Sussex Best Bitter; 2 changing beers (sourced regionally) Ⓗ
Close to the railway station and bus stops, this bar is at the top end of the town's original shopping street. It comprises a bar area together with a comfortable lounge. In addition to cask beers there is a varied range of bottled beers, spirits, teas and espresso coffees. There are old clocks above the bar and a display case of old cameras in the lounge. A limited number of tables and chairs are provided outside. ❶≠🚃♐

Chichester

Bell Inn
3 Broyle Road, PO19 6AT (on A286 just N of Northgate)
☎ (01243) 783388 🌐 thebellinnchichester.com
3 changing beers (sourced regionally) Ⓗ
Cosy and comfortable city local with a traditional ambience enhanced by exposed brickwork, wood panelling and beams. It has recently become a free house and offers three locally sourced real ales, complemented by a monthly changing food menu. The rear patio garden with covered smoking area is heated by a chimney in winter, and the car park is now an additional summer pub garden. The pub tends to be busiest when the Festival Theatre is open, pre- and post-show. Q♿❀❶👍🚃(60)♣♐

Chichester Inn Ⓛ
38 West Street, PO19 1RP (at Westgate roundabout)
☎ (01243) 783185 🌐 chichesterinn.co.uk
Harvey's Sussex Best Bitter; 3 changing beers (sourced regionally; often Langham, Vibrant Forest) Ⓗ
Pleasant two-bar pub with a real fire in the front bar surrounded by comfortable chairs, with a mix of seating and table types elsewhere. The larger public bar to the rear features regular live music on Wednesday, Friday, and Saturday evenings. Outside is an attractive walled garden with a heated and covered smoking area. Four B&B rooms are available. Food includes Sunday lunches. There is a strong emphasis on LocAles.
♣≠❶≠♣♥👍🚃♣♐

Eastgate
4 The Hornet, PO19 7JG (500yds E of Market Cross)
☎ (01243) 774877 🌐 eastgatechichester.co.uk
Dark Star Hophead; Fuller's London Pride; Gale's Seafarers Ale, HSB; 1 changing beer (sourced nationally; often Dark Star, Fuller's) Ⓗ
Welcoming town centre pub with an open-plan bar and tables for diners. Good-quality traditional pub meals are served daily. There is a heated patio garden to the rear, which is the venue for a beer festival in July. The pub attracts locals, holidaymakers and shoppers from the nearby market, with a warm welcome and traditional pub games such as darts, cribbage and pool. Music is turned up on Friday and Saturday late evenings, live bands perform once a month. ♿❀❶♥👍(51,700)♣♐

Hole in the Wall
1A St Martins Street, PO19 1NP (just off East St, almost opp back door to Marks & Spencer)
☎ (01243) 788877 🌐 theholeinthewall-pub.co.uk
Big Smoke Solaris Session Pale Ale; 8 changing beers (sourced nationally; often Harvey's, Kent, Purity) Ⓗ
The building is believed to have started as a 17th-century brewery and was later used as a debtors' prison. This traditional pub is now knocked-through, wrapping around the bar to form three areas featuring brick pillars and painted wood panelling, creating a cosy, friendly atmosphere. There are two open fires in winter. Operated by Big Smoke Brewing Company, the pub has 12 handpumps, including four serving real cider, plus the keg wall with 20 craft beers. Food is good too.
♿❀❶≠♥🚃♣♐

Hornet Alehouse Ⓨ
23 The Hornet, PO19 7JL (due E from the Market Cross)
☎ (01243) 696387 🌐 thehornetalehouse.co.uk
5 changing beers (sourced nationally; often Downlands, Elusive, Vibrant Forest) Ⓖ
Busy split-level micropub with plenty of standing room at the bar in addition to seating both downstairs and upstairs. There are also two tables outside. The upstairs room has board games and hosts monthly quizzes and Meet the Brewer events. Friendly, knowledgeable staff serve an ever-changing range of cask ales from a temperature-controlled cool room (tasters available). Three ciders are always available alongside four keg taps. With a large range of canned ales and foreign beers as well, this is a mecca for beer lovers.
Q♿♣♥🚃🚃(700) ♣♐

Crawley

Brewery Shades Ⓨ Ⓛ
85 High Street, RH10 1BA
☎ (01293) 514255 🌐 breweryshades.co.uk

Dark Star Revelation; Morland Old Speckled Hen; Timothy Taylor Landlord; 5 changing beers H
Possibly the oldest building in Crawley High Street, this wet-led pub dates back to the 1400s when it was a gaol, and claims to come complete with two ghosts. The licensee has a true passion for the trade, demonstrated by the inspired range of guest ales and ciders which are always in excellent condition. The 'haunted' upstairs room is now available for meetings. Good food is served during the day and evening – check the specials board.
ठ✿ை✪≉●◨☂

Danehill

Coach & Horses ⅃
School Lane, RH17 7JF
☎ (01825) 740369 ⊕ coachandhorses.co
Harvey's Sussex Best Bitter; 1 changing beer (sourced locally; often 360 Degree, Cellar Head) H
A traditional country pub in the heart of the Sussex countryside dating from 1847 and retaining many original features. The public and saloon bars have real fires and simple farmhouse-style furniture. Locally produced Black Pig cider is always on the bar, and occasionally its perry too. The separate restaurant area serves locally sourced, high-quality food. The large garden is a delight in summer and includes a children's play area. Q✿ᴇ●♣●P◨(270)✿☂

East Dean

Star & Garter ⅃
PO18 0JG (village centre, E end of village green)
☎ (01243) 811318 ⊕ thestarandgarter.co.uk
Arundel Sussex IPA; 2 changing beers (sourced regionally) H
An 18th-century free house situated by the duckpond in this charming downland village. The large bar with wooden floors and a log fire has an area for dining. It is renowned for good food, using local seasonal produce, with fresh local seafood a speciality (Sun lunchtime booking is essential). Beer is poured straight from the cask from a cold room behind the bar. There is a large walled garden to the rear which can host outdoor functions. Check with the pub for opening hours.
ठ✿ᴇ●◑ᵬᴑP✿☂

East Grinstead

Engine Room ⅃
The Old Mill, 45 London Road, RH19 1AW
☎ (01342) 327145 ⊕ theengineroomeg.com
5 changing beers (sourced locally) G
Up a path between the shops close to Whitehall bus stop in London Road, the pub is a labyrinth of small seating areas, good for small groups to hold conversations. Between five and seven ever-changing cask ales are served on gravity, plus four via membrane keg and six or seven ciders. Beer festivals are held in March and October. Note that the pub's downstairs location limits accessibility. Q≉●◨☂

East Preston

SP Alehouse
23 Sea Road, BN16 1JN
☎ 07736 928347
House beer (by Langham) G; 1 changing beer (often Firebird) H
This micropub in East Preston opened in 2020. It sells the house beer plus a changing selection of cask ales, mainly sourced from Sussex and Hampshire breweries. At least

four good-quality craft keg beers are served, again constantly changing. Cider is available along with wines, gins, soft drinks and a traditional mead. Bar snacks are offered, with a free cheeseboard on Sunday. Limited seating is available outside. ◨(700)✿

East Wittering

Shore ⅃
Shore Road, PO20 8DZ (50yds from sea)
☎ (01243) 674454 ⊕ theshorepub.co.uk
Hop Back Summer Lightning; Langham Hip Hop; Palmers Copper Ale, Dorset Gold; Sharp's Doom Bar H
Friendly beachside pub popular with the locals (particularly dog owners) and the many summer visitors. There are two main bars offering good-value beers, a children's area, and an outside area, partly covered, for eating, drinking and smokers. A good-quality lunchtime menu can be enjoyed both in the bar and restaurant, with extremely inviting dishes on offer at fair prices (see selection on blackboard). Occasional live music is hosted – see the website for details. Qठ✿ை◑ᵬ♣P◨ᴇ(52,53)✿

Eastergate

Wilkes' Head ⅃ ✔
Church Lane, PO20 3UT (off A29 in old village, 350yds S of B2233 roundabout, 1¼ miles W of Barnham station) SU943053
☎ (01243) 543380
5 changing beers (sourced nationally; often Bedlam, Downlands, Langham) H
Small Grade II-listed red-brick pub built in 1803 and named after 18th-century radical John Wilkes. There is a cosy lounge left of the central bar and to the right a larger room with inglenook fireplace, flagstones and low beams, plus a separate restaurant. At the rear is a permanent marquee with seating plus a heated smokers'

shelter and a large garden. There are five well-chosen changing beers, and regular beer festivals are held. Q❄️🛏️🍴🍽️♿️🅿️🚃(66,85) 🐾📶

Elsted

Three Horseshoes

GU29 0JY (at E end of village)
☎ (01730) 825746 🌐 3hs.co.uk
Bowman Wallops Wood; Flower Pots Pots Bitter; Young's London Original; 2 changing beers (sourced locally; often Hop Back) 🇬

Old and cosy rural inn divided into small rooms, including one reserved for dining and one with a blazing wood-burning stove in winter. Outside, the large, pleasant garden enjoys superb views of the South Downs. There are five beers in summer (mainly from local micros) and three in winter, all served by gravity from a stillage alongside the bar. Meals are substantial and of high quality. This is a popular and homely pub that you will be reluctant to leave. Q❄️🍴🍽️♣🅿️🐾

Faygate

Frog & Nightgown 🇱

Wimlands Lane, RH12 4SS
☎ (01293) 852764 🌐 thefrogandnightgown.co.uk
Harvey's Sussex Best Bitter; Surrey Hills Ranmore; 2 changing beers (sourced locally) 🇭

Formerly two cottages, this vibrant, cosy, countryside pub was comprehensively refurbished after changing hands in 2015. There are normally two real ales available. Regular events include quiz nights, classic car meets, live music, and open mic nights. A pizzeria restaurant was added to the rear of the pub in 2021, in addition to the tea room annexe. Q❄️🛏️🍴🍽️🅿️🚃🐾📶

Felpham

George

102 Felpham Road, PO22 7PL (in village 120yds from Felpham Way traffic lights)
☎ (01243) 824177 🌐 georgeinnfelpham.co.uk
Goldmark Dave, Liquid Gold, American Pale 🇭

A traditional 16th-century coaching inn with two bars. There is a small bistro area to the right and a larger bar to the left with a fire. Towards the back is a large conservatory leading to a very pleasant enclosed garden. A choice of three well-kept cask beers from Goldmark is offered. Q❄️🛏️🍴🍽️♣🅿️🚃(600,700)🐾📶

Ferring

Henty Arms 🇱 ✅

2 Ferring Lane, BN12 6QY (just N of level crossing in Ferring)
☎ (01903) 241254 🌐 hentyarms.co.uk
Fuller's London Pride; Harvey's Sussex Best Bitter; Sharp's Doom Bar; 1 changing beer (often Timothy Taylor) 🇭

The Henty Arms was constructed on its present site in 1830, which predates the nearby railway line. It was then called the New Inn and was renamed the Henty Arms in 1927 when the brewers were Henty & Constable. There are two bar areas, one of which is largely used for food. The excellent menu features home-made dishes. The large beer garden is used for an annual beer festival in July. 🍴🍽️🅿️🚃🐾📶

Halnaker

Anglesey Arms 🇱 ✅

Stane Street, PO18 0NQ (on A285)
☎ (01243) 699644 🌐 theangleseyarms.com
Timothy Taylor Landlord; 3 changing beers (sourced locally; often Langham) 🇭

Close to the Goodwood Estate, which owns the freehold, this is a family-run, listed Georgian pub and dining room. The wood- and flagstone-floored public bar, with a log fire, retains the atmosphere of a traditional village pub, and the comfortable restaurant is renowned for good food made with local produce. Dogs are welcome. The quiet two-and-a-half-acre rear garden includes tables in a spacious covered area. Q❄️🛏️🍴🍽️♿🅿️🚃(55,99)🐾📶

Haywards Heath

Lockhart Tavern 🇱

41 The Broadway, RH16 3AS
☎ (01444) 440696 🌐 thelockharttavern.co.uk
6 changing beers (sourced nationally; often Gun, Heathen) 🇭

This centrally located free house conversion of a retail premises is often busy. The pub comprises two distinct areas – drinkers are catered for at the front with high tables and matching seating, and towards the rear is a wood-panelled dining area. Outside, there are picnic tables on the patio. Good food is served lunchtimes and evenings, with regular menu changes. The pub also offers a choice of wines, spirits, keg, canned and bottled beers. Q❄️🛏️🍴🚆🚃🐾📶

Henley

Duke of Cumberland 🇱

GU27 3HQ (off A286, 2 miles N of Midhurst) SU894258
☎ (01428) 652280 🌐 dukeofcumberland.com
Harvey's Sussex Best Bitter; Langham Hip Hop; Timothy Taylor Landlord; 1 changing beer (sourced locally; often Langham) 🇬

A stunning 15th-century inn nestling against the hillside in over three acres of terraced gardens with extensive views. The rustic front bar has scrubbed-top tables and benches, plus log fires at both ends. To the rear is a dining extension that blends in perfectly with the original pub and offers much-needed additional space. Outside is a smokers' shelter with its own wood-burner. A former local CAMRA Pub of the Year, this is a rural gem. May close early on Sunday evenings in winter.
Q❄️🛏️🍴♣🅿️(70) 🐾📶

Hooksway

Royal Oak

PO18 9JZ SU815163
☎ (01243) 535257 🌐 royaloakhooksway.co.uk
Arundel Castle, Sussex IPA; Langham Hip Hop; 2 changing beers (sourced nationally) 🇭

An idyllic country pub, unspoilt and with great country walks, close to the South Downs Way; perfect for getting away from it all. It is popular with hikers, horse riders and families. There is a large garden with a play area for children. In winter two lovely log fires greet you. On offer are three permanent real ales and a regular guest beer, mainly from local breweries. An extensive menu caters for all tastes and includes a varied children's menu.
Q❄️🛏️🍴🐾

Horsham

Anchor Tap L
16 East Street, RH12 1HL
3 changing beers (sourced nationally) ⓗ
Now free of tie, this popular pub continues to offer customers an eclectic choice of brews. The knowledgeable team behind the bar sources interesting beers both local and from afar. There are three handpumps in use, plus a back bar dispensing 10 keg beers. The pub was originally the tap of the Anchor Hotel. In January 1975 a Horsham Branch of CAMRA was formed here. ⓑ♿🎔🚌🐱📶

Black Jug
31 North Street, RH12 1RJ
☎ (01403) 253526
Firebird Parody; Harvey's Sussex Best Bitter; 2 changing beers (sourced nationally) ⓗ
A large, bustling town-centre pub, the Jug is something of a Horsham institution. It has a welcoming interior with bookshelves, pictures, a fire and friendly efficient staff. Two regular ales are available with rotating guests and a cider. Excellent food is served all day and the pub is equally popular as a venue to meet and chat, with no intrusive music. It is close to the railway station and arts complex. There is an extensive range of whisky and gin. Q🕏🏵🕪♿🎔🚌🅿🐱📶

King's Arms L
64 Bishopric, RH12 1QN
☎ (01403) 451468 ⊕ kingsarmshorsham.com
Crafty Brewing Hop Tipple; Firebird Heritage XX; 3 changing beers (sourced locally) ⓗ
This 18th-century coaching inn in the town centre was the King & Barnes brewery tap and is situated in the Bishopric, some hundred yards from the site of the former brewery. It is a comfortable two-bar pub, operated by North and South Leisure Ltd, with five handpumps serving mostly local ales and fine keg lines. Food is served, including quality Sunday roasts. Live music features every Friday, plus Monday quiz nights, and Thursday open mic on alternate weeks. 🏵🕪🚌📶

Malt Shovel L
15 Springfield Road, RH12 2PG
☎ (01403) 252302
Surrey Hills Shere Drop; 5 changing beers (sourced regionally) ⓗ
Close to the town centre, the pub has six handpumps on year-round, plus two ciders and a mix of bottles and canned ales. It does not stock regular ales but has a focus on local beers and usually offers at least one dark brew. There is live music every Saturday night, as well as regular open mic and jam events. The landlord and his staff take great pride in the real ale. There is good parking for a town-centre pub. 🏵🕪♿♣🅿🚌🐱📶

Piries Bar
15 Piries Place, RH12 1NY (down narrow alley adjoining Horsham's Carfax)
☎ (01403) 267846 ⊕ piriesbar.com
Long Man Long Blonde; Timothy Taylor Landlord ⓗ
In a building dating from the 15th century with exposed original timber beams, the pub is tucked away down a narrow alley adjoining Horsham's Carfax. It comprises a small downstairs room, an upstairs lounge bar and a small modern extension in character with the building. Regular charity events are organised. Evenings here can be lively, with karaoke on Sunday and quiz night on Tuesday. With two cask ales always on the go, this bar is well worth a visit. ⓑ🕪🎔🚌🐱📶

Itchenor

Ship
The Street, PO20 7AH (on main street, 100yds from waterfront)
☎ (01243) 512284 ⊕ theshipinnitchenor.co.uk
Arundel Castle; Langham Hip Hop; Long Man Best Bitter; 1 changing beer (often Red Cat) ⓗ
A popular pub in the main street of an attractive village on the shore of picturesque Chichester harbour. The cosy bar decorated with yachting memorabilia adds to the pub's character and is complemented by a pleasant front patio and further outside seating and a bar at the back. The separate restaurant area offers a wide range, including local seafood. Accommodation is available in a two-bedroom apartment and a three-bedroom cottage. Q🕏🏵🛏🕪♿🅿🐱📶

Lancing

Stanley Ale House L
5 Queensway, BN15 9AY (200yds N of Lancing railway station)
☎ (01903) 366820 ⊕ thestanleyalehouse.com
Langham Arapaho; 3 changing beers (sourced regionally; often Downlands) ⓗ
This former launderette opened as a family-run micropub/ale house in 2014. Located 200 yards north of the railway station, near local shops, it serves several changing ales, plus ciders, wine and gin. The owners have listened to customers and now have both keg and cask beers. There is ample seating inside and outside, and bar snacks are offered. Events includes a weekly quiz, regular music nights, takeaway nights and more. A variety of board games is available. Q🕏🏵♿🎔♣🚌🐱📶

Littleworth

Windmill
Littleworth Lane, RH13 8EJ (from A24 or A272 follow signs to Partridge Green along the B2135, pub is signposted)
☎ (01403) 710308 ⊕ windmilllittleworth.com
Harvey's Sussex Best Bitter; 2 changing beers (sourced nationally; often Dorking, Long Man) ⓗ
A quiet, independently-owned country pub with friendly staff and locals. It has recently undergone a refurbishment but retains many original features, including the stone-flagged floor between the two bars. There is an open inglenook fire in the lounge and the public bar ceiling is decorated with old farming implements. Darts and bar billiards can be played here. A range of secondhand books is for sale in the lobby. Guest ales are sourced from throughout the country. Q🕏🏵🛏🕪♿♣🅿🚃(17)🐱📶

Lodsworth

Langham Brewery Tap
The Granary, Langham Lane, GU28 9BU (½ mile N of A272 at Halfway Bridge) SU92682260
☎ (01798) 860861 ⊕ langhambrewery.co.uk
Langham Session Bitter, Hip Hop, Arapaho; house beer (by Langham) ⓗ; 6 changing beers (sourced locally; often Langham) ⓖ
A new brewery tap, opened in April 2021, converted from outbuildings of the 18th-century granary barn that houses Langham Brewery. Fronting onto a courtyard behind the brewery, it has indoor and outdoor seating and a bar with five handpumps plus six keg taps dispensing a selection of Langham beers. Additional ales

(as available) can be fetched from the brewery's cold store across the yard, and take-outs of Langham's cask-conditioned, keg, bottled and canned beers can also be purchased. ⬛🕮🌢◑🕭♿♣Ⓟ🚆❀🛜

Lower Beeding

Kissingate Brewery

Pole Barn, Church Lane Farm Estate, Church Lane, RH13 6LU

☎ (01403) 891335 ⊕ kissingate.co.uk

Kissingate Sussex, Black Cherry Mild, Chennai, Pernickety Pale; 4 changing beers (sourced locally) Ⓖ

This is the taproom for Kissingate Brewery. You will find a selection of beers from the Kissingate range served on gravity, plus cider and perry from local producers such as Black Pig, Seacider and JB on the well-stocked bar. Events include Saturday festivals in May and October and curry nights. There is a function area upstairs. 🌢♿♣Ⓐ🚆❀🛜

Maplehurst

White Horse Ⓛ

Park Lane, RH13 6LL

☎ (01403) 891208 ⊕ whitehorsemaplehurst.co.uk

4 changing beers (often Downlands, Harvey's, Kissingate) Ⓗ

Under the same ownership for 38 years, this splendid and welcoming country pub has featured in the Guide 35 times, and is popular with locals, cyclists and walkers. The cosy interior, with its unusually wide wooden bar, boasts real fires and many interesting artefacts and bric-a-brac. Good honest fare is provided, with the emphasis on beer and conversation. Many local ales feature, with a good selection of dark brews. Local JB cider is also available. Q⬛🌢🕮◑♣❀Ⓟ❀🛜

Oving

Gribble Inn Ⓛ

Gribble Lane, PO20 2BP (at W end of village)

☎ (01243) 786893 ⊕ gribbleinn.co.uk

Gribble Gribble Ale, Fuzzy Duck, Pig's Ear; 2 changing beers (often Gribble) Ⓗ

Once home to a Miss Gribble, this attractive thatched cottage has been a traditional village pub for over 30 years and shares the premises with the Gribble Brewery. The full range of Gribble regular beers complemented by seasonals is always available. The pub is cosy, with log fires in winter. Home-made food is served in the bar/restaurant. In summer a large attractive garden offers occasional weekend barbecues. The skittle alley is also available for functions. Q⬛🌢🕮◑♿♣Ⓟ🚆(85,85A)❀🛜

Pagham

Inglenook Ⓛ

255 Pagham Road, PO21 3QB SZ892986

☎ (01243) 262495 ⊕ the-inglenook.com

Fuller's London Pride; Langham Best; 4 changing beers (sourced nationally; often Arbor, Moor Beer, Vibrant Forest) Ⓗ

A 16th-century Grade II-listed hotel, restaurant and free house, owned and run by the Honour family for over 40 years. There is always a selection of excellent well-hopped real ales available from highly-regarded microbreweries, alongside local real ciders. The cosy bar areas have real fires and there is a large garden to the rear and a patio area at the front. A three-times local CAMRA Pub of the Year. Q⬛🌢🕮◑◑❀Ⓟ🚆(600)❀🛜

Petworth

Angel Inn

Angel Street, GU28 0BG

☎ (01798) 344445 ⊕ angelinnpetworth.co.uk

Arundel Sussex IPA; Langham Hip Hop; house beer (by Langham) Ⓗ

This historic inn is a welcoming pub/restaurant with friendly, knowledgeable staff. There is one long bar with three handpumps, serving one house ale and two other local beers. With timber beams, slate and wooden flooring, and lots of cubby holes to nestle in, it has a homely feel inside. One of the three fireplaces is used to spit-roast meat. The large courtyard to the rear has lots of seating and ornamental animals. Q⬛🌢🕮◑Ⓟ🚆(1,99)❀🛜

Welldiggers Arms Ⓛ

Low Heath, GU28 0HG (on A283 E of Petworth)

☎ (01798) 344288 ⊕ thewelldiggersarms.co.uk

Langham Arapaho; 1 changing beer (sourced regionally; often Bedlam, Langham) Ⓗ

The Welldiggers Arms is over 300 years old, with oak furniture and a traditional inglenook fireplace in the bar. It also has ensuite rooms and a restaurant serving locally sourced food. The pub reopened in 2016 after extensive refurbishment inside and out, and is now a spacious and elegant dining venue where there is still a welcome for drinkers. Look out for the spade handle beer pumps. Superb views can be enjoyed from the rear garden. Q⬛🌢🕮◑Ⓟ🚆(1)❀🛜

Rustington

Georgi Fin Rustington

106 The Street, BN16 3NJ

☎ (01903) 785743 ⊕ thegeorgifin.co.uk

4 changing beers (sourced locally; often Oakham) Ⓗ

This micropub opened in 2020 at one end of a busy shopping street. It has the same name as the owner's other micropub in West Worthing and the premises has been fully refitted with a similar theme. Ales are served by gravity direct from casks in a cool room, with KeyKeg beers from fonts on the bar. The beers include several from local brewers. Bottled and canned brews are available alongside wine, gin and other drinks. The outside seating is good in warmer weather. ⬛♿🚆(700,9)❀

Selsey

Seal Ⓛ ✅

6 Hillfield Road, PO20 0JX (on B2145, 600yds from sea)

☎ (01243) 602461 ⊕ the-seal.com

Dark Star Hophead; Young's London Original; 3 changing beers (sourced nationally; often Dorking, Hop Back) Ⓗ

A real community hub, the Seal has been family run for over 45 years. It has a spacious public bar with a pool table at one end and a comfortable lounge with a restaurant serving quality home-cooked food including locally caught fish (booking advised). A good variety of guest beers is sourced mostly from southern micros. Acoustic live music often features on Sundays. The patio has seating and umbrellas to cater for smokers. There are 13 en-suite B&B rooms and camping is available nearby at Seal Bay Caravan Park. ⬛🌢🕮◑◑♿♣Ⓐ❀Ⓟ🚆(51)❀🛜

Shoreham-by-Sea

Duke of Wellington Ⓛ

368 Brighton Road, BN43 6RE (on A259)

☎ (01273) 441297 ⊕ dukeofwellingtonbrewhouse.co.uk/home

Dark Star Hophead; 5 changing beers (sourced regionally) Ⓗ

Previously owned by Dark Star, this local pub was formerly a weekend music venue. The live music still applies, but the excellent range of beers is much more varied than before. Old signage has been restored and flooring replaced, but for the rest a philosophy of 'if it ain't broke, don't fix it' prevails. Leaded window glass, historical photos and maps add to the atmosphere. ॐ❄❦♣➔⊟ (2,700) ✿ 🌐

Old Star Ale & Cider House Ⓛ

Church Street, BN43 5DQ

☎ 07999 915242 ⊕ oldstarshoreham.co.uk

3 changing beers (sourced regionally; often 360 Degree, Downlands, Gun) Ⓖ

A well-run micropub just off the High Street. Three beers are available through the week, with up to five on Saturday, almost always including one dark ale. They come mainly from Sussex microbreweries, and are served direct from the casks on stillage behind the bar. There is also a range of real and craft ciders and perries, and a cider festival is held over the August bank holiday. A complimentary cheeseboard is on offer every Saturday evening. Q❄♣♦⊟ (2,700) ✿ 🌐

Southwick

Southwick Beer Engine Ⓛ

2 Southwick Square, BN42 4FJ

☎ (01273) 945694 ⊕ southwickbeerengine.co.uk

6 changing beers (sourced locally) Ⓗ

This former travel agent's opened as a micropub in 2018 and is larger than most, with a capacity of 50 people. Its decor is basic, with paint and bare wood; the air conditioning is a boon in hot weather. Six handpumps serve a selection of local beers with an occasional guest from further afield. Four real local ciders are available, mainly from Seacider, alongside a wide selection of gins. Live music is hosted on a Friday evening. The pub is closed on Mondays in winter. ॐ❀❅♦⊟ ✿ 🌐

Staplefield

Jolly Tanners Ⓛ

Handcross Road, RH17 6EF

☎ (01444) 400335

Harvey's Sussex Best Bitter; 5 changing beers (sourced locally) Ⓗ

On the north corner of the village green, this welcoming venue combines all the best elements of a village inn. The spacious bar is divided into two distinct areas, with two log fires adding to the cosy feel. There is an extensive range of guest beers, always including two dark ales, and real cider is also sold. A good selection of tasty food is served at all sessions. This is a friendly place and still very much a locals' pub. Q♣❀❀◐⊾Å♣P⊟ (271) ✿ 🌐

Steyning

Chequer Inn Ⓛ

41 High Street, BN44 3RE (in centre of village)

☎ (01903) 814437 ⊕ chequerinn.co.uk

Shepherd Neame Spitfire; Timothy Taylor Landlord; 3 changing beers (sourced nationally; often Dark Star, Long Man) Ⓗ

A 15th-century coaching inn with many original design features. It has several drinking areas, including a covered courtyard garden and cosy saloon bar with an open log fire. Live sport is shown in the public bar. There is a 100-year-old, three-quarter-sized snooker table. The handpumps serve national ales. Home-cooked food uses locally sourced ingredients – breakfast is recommended. The pub features live music, usually on Thursday or Saturday. It is well located for those walking the South Downs Way or Downs Link. Q♣❀❀◐♣➔⊟ (2,100) ✿ 🌐

Walderton

Barley Mow

Breakneck Lane, PO18 9ED SU790106

☎ (023) 9263 1321 ⊕ thebarleymow.pub

Harvey's Sussex Best Bitter; Otter Amber; 3 changing beers (sourced regionally; often Dark Star, Harvey's, Ringwood) Ⓗ

An attractive free house in the centre of this picturesque village, popular with walkers and visitors to the South Downs National Park. Much of this cosy traditional pub caters for diners, but drinkers are most welcome in the large bar area. There are log fires in winter and the pretty garden alongside the River Ems is a delight in summer. Five handpumps are usually in use, featuring two beers from Harvey's. The skittle alley can double as a function room. Q♣❀❀◐⊾P⊟ (54) ✿ 🌐

West Chiltington

Five Bells Ⓛ

Smock Alley, RH20 2QX (approx 1 mile S of West Chiltington old village centre) TQ092171

☎ (01798) 812143 ⊕ thefivebellsinn.com

5 changing beers (sourced nationally; often Harvey's, Jennings, Palmers) Ⓗ

A friendly village free house that is a Guide regular. Dating from 1935, this former King & Barnes pub has been run by the same couple since 1983. The handpumps are on what is probably Sussex's longest copper-top counter. Local and regional ales are served, one of them usually a dark. There is a large copper-hooded open fire. Locally sourced home-cooked food is served in the bar and large conservatory (no food Sun eve). Q❀❀◐P⊟ (1,74) ✿ 🌐

West Hoathly

Cat Ⓛ

Queen's Square, North Lane, RH19 4PP

☎ (01342) 810369 ⊕ catinn.co.uk

Harvey's Sussex Best Bitter; 2 changing beers (often Firebird, Harvey's, Long Man) Ⓗ

Set in a picturesque hilltop village in the heart of the Sussex countryside, this 16th-century free house is within reach of several attractions. It retains oak beams and two inglenook fireplaces. Five local ales are on the bar and good-quality food is cooked to order, using mostly local suppliers. There is an outside terrace, where food and drink can be enjoyed in the summer months. This cosy pub has four letting rooms. Q♣❀❀◐⊾ÅP⊟ (84) ✿ 🌐

West Marden

Victoria Ⓛ

PO18 9EN (just W of B2146 in village centre)

☎ (023) 9263 1330 ⊕ victoriainnwestmarden.com

Harvey's Sussex Best Bitter; Langham Hip Hop; 1 changing beer (sourced locally; often Langham) Ⓗ

Comfortable old rural inn at the heart of its tiny downland community, now free of all ties after being purchased by a young couple in 2021. Many country pursuits, including walking, riding and shooting, are

supported. Inside there are several intimate spaces in which to drink and dine, with a log-burning stove for cold evenings. The front garden has splendid views of surrounding hills. Changing beers come from mainly local breweries alongside others from further afield.
Q☺☺⚪♣P🚇(54) ✿ 🛜

Worthing

Anchored in Worthing 🅛

27 West Buildings, BN11 3BS (close to sea front)
☎ (01903) 529100 ⊕ anchoredinworthing.co.uk
3 changing beers (sourced locally; often Gun, Hand, Rother Valley) 🅖
Look for the Tardis-style entrance to Sussex's original micropub, where you are assured of a warm welcome. High wooden tables are arranged so customers face each other, and conversation quickly flows. The ceiling is adorned with pumpclips from the many ales previously sold. The walls have maps showing breweries and micropubs, plus CAMRA and local event information. All ale, cider, wine, gin, soft drinks and even the crisps are from Sussex producers. A former Surrey and Sussex CAMRA Regional Pub of the Year. Q♣●P(7,8)✿🛜

Brooksteed Alehouse 🅛

38 South Farm Road, BN14 7AE (100yds N of South Farm Rd level crossing; 5 mins walk from Worthing station)
☎ 07484 840103 ⊕ brooksteedalehouse.co.uk
House beer (by Arundel); 2 changing beers (sourced nationally; often Brighton Bier, Goldmark, Gun) 🅖
Worthing's second micropub opened in 2014, with a change of ownership in 2017. The decor is stylish and interesting, with high tables and comfortable seating inside plus outside seating areas at front and rear. With a strong community spirit, this friendly and popular pub organises events with local businesses and for charity. It has a good selection of regularly changing cask ales, KeyKeg beers and cider/perry, plus a range of bottled beers, wines and gin. There is a cheeseboard on Sundays.
Q☺☺➔P🚇(16) ✿ 🛜

Fox & Finch Alehouse 🅛

8 Littlehampton Road, BN13 1QE (on N side of A259, opp Thomas a Becket pub) ⊕ thefoxandfinch.co.uk
Fallen Acorn Pompey Royal; 1 changing beer (often Downlands) 🅖
Worthing's fifth micropub opened in 2019 and quickly became popular, offering a warm welcome to all. The premises are decorated in a homely, traditional pub style with high and low tables and comfortable seating. A cold room behind the bar houses the ales served directly from the cask while the keg selection is from taps on the bar. There is a range of Belgian beers, fine wine, and a small selection of spirits. It has limited outside seating. Local CAMRA Pub of the Year 2020. ☺♿♣🚇(1,5)✿🛜

Green Man Ale & Cider House 🅛

17 South Street, Tarring, BN14 7LG
☎ 07984 793877
5 changing beers (sourced regionally; often Langham, Tring, Wantsum) 🅖
Micropub that opened in 2016 in a former café 40 yards north of West Worthing crossing. The temperature-controlled cool room is visible from the pub which is furnished with high-level tables, benches and stools arranged to encourage interaction and chat. The pub is known for its friendly atmosphere. A good selection of gravity-dispensed ales, one of which is a dark brew, is available, plus ciders/perries, whiskies, gins and wines. A former local CAMRA Pub of the Year and Cider Pub of the Year. Q➔(West Worthing)♣●🚇(7,10)✿

Hare & Hounds 🅛 ✅

79-81 Portland Road, BN11 1QG
☎ (01903) 230085 ⊕ hareandhoundsworthing.co.uk
Exmoor Ale; Harvey's Sussex Best Bitter; St Austell Proper Job; Timothy Taylor Landlord 🅗
Located a short walk from the shopping precinct in the heart of Worthing, this 18th-century Grade II-listed flint building became a pub in 1814, extending into the adjoining property in the 1990s. The large, wood-panelled U-shaped bar leads to the rear conservatory and covered patio. The pub always has a selection of local and national ales. There is a good-value food menu. Tuesday evenings feature live jazz, Saturday evenings live bands play, and Sunday night is a music quiz.
Q☺☺⚪➔🚇🛜

Parsonage Bar & Restaurant 🅛

6-10 High Street, Tarring, BN14 7NN (at S end of Tarring High St – not to be confused with High St Worthing)
☎ (01903) 820140 ⊕ theparsonage.co.uk
Burning Sky Plateau; Harvey's Sussex Best Bitter; 1 changing beer (sourced locally; often Harvey's) 🅗
Situated in the heart of Tarring village, this lovely Grade II-listed 15th-century building was originally three cottages. It has been a quality restaurant since 1987 and the bar now has several well-kept local ales, often including a dark brew. Customers are welcome to drink without having a meal although the bar menu is good value. The courtyard garden is great for the warmer weather. A former local CAMRA Pub of the Year.
Q☺⚪➔(West Worthing) 🚇(6,16) ✿🛜

Selden Arms 🍺 🅛

41 Lyndhurst Road, BN11 2DB (about 5 mins from the centre of town and 2 mins from Worthing Hospital)
☎ (01903) 523361 ⊕ seldenarms.co.uk
Palmers Dorset Gold; 5 changing beers (sourced nationally; often Gun, Hand, Vibrant Forest) 🅗
This welcoming 19th-century free house has been in the Guide for 24 years. The handpumps serve a regularly-changing selection of local and national ales, one of which is always a dark brew. There is also a selection of craft keg beers, plus cans and bottles, including an extensive range of bottled Belgian beers. A blackboard displays upcoming ales. A log fire heats the pub in winter, and there is an annual winter beer festival in January. Local CAMRA Pub of the Year 2022.
⚪➔♣🚇(106,Pulse) ✿🛜

Yapton

Maypole 🅛

Maypole Lane, BN18 0DP (off B2132 ½ mile N of village; pedestrian access across railway from Lake Lane, 1¼ miles E of Barnham station) SU978042
☎ (01243) 551417
Bedlam Phoenix IPA; Lister's Best Bitter; 2 changing beers (sourced locally; often Downlands, Pitchfork) 🅗
This cosy 18th-century flint-built free house is full of character, hidden away from the village centre down a narrow lane ending in a pedestrian crossing over the railway. The cosy, often lively, lounge boasts an inglenook with a log-burner and a row of six handpumps dispensing up to four beers from local breweries. Real cider is served from the cellar. There is also a traditional public bar with jukebox, bar billiards and darts. Dogs are welcome throughout the pub. Q☺☺♿▲♣●P🚇✿🛜

Breweries

Adur

Brick Barn, Charlton Court, Mouse Lane, Steyning, West Sussex, BN44 3DG
☎ (01903) 867614

Office: 2 Sullington Way, BN43 6PJ
⊕ adurvalleycoop.com

⊗ Adur Brewery, nestled in the heart of the South Downs, was launched in 2008 on a 5.5-barrel plant, marking the return of brewing to the Adur Valley after an interval of nearly 100 years. The brewery was sold to the Adur Valley Co-Operative in 2012, including the Adur Brewery name and recipes. A large part of the output is sold as bottle-conditioned beer. ‼◆LIVE

Ropetackle Golden Ale (ABV 3.4%) GOLD
Hop Token: Amarillo (ABV 4%) BITTER
Hop Token: Summit (ABV 4%) BITTER
Velocity (ABV 4.4%) BITTER
Black William (ABV 5%) STOUT
Robbie's Red (ABV 5.2%) RED

Arundel

Unit C7, Ford Airfield Industrial Estate, Ford, Arundel, West Sussex, BN18 0HY
☎ (01903) 733111 ⊕ arundelbrewery.co.uk

⊗ Founded in 1992, Arundel Brewery is the historic town's first brewery in 70 years. It also brews for the Bison Crafthouse, Brighton. A taproom was opened in 2019 called the Brewhouse Project, which is based on the Lyminster Road on the outskirts of Arundel. ‼🍺◆

Black Stallion (ABV 3.7%) MILD
A dark mild with well-defined chocolate and roast character. The aftertaste is not powerful but the initial flavours remain in the clean finish.
Castle (ABV 3.8%) BITTER
A pale tawny beer with fruit and malt noticeable in the aroma. The flavour has a good balance of malt, fruit and hops, with a dry, hoppy finish.
Sussex Gold (ABV 4.2%) GOLD
A golden-coloured best bitter with a strong, floral hop aroma. The ale is clean-tasting and bitter for its strength, with a tangy citrus flavour. The initial hop and fruit die to a dry and bitter finish.
Sussex IPA (ABV 4.5%) PALE
Stronghold (ABV 4.7%) BITTER
A smooth, full-flavoured, premium bitter. A good balance of malt, fruit and hops comes through in this rich, chestnut-coloured beer.
Wild Heaven (ABV 5.2%) PALE

Balcombe

⊟ Half Moon, Haywards Heath Road, Balcombe, West Sussex, RH17 6PA
☎ (01444) 811582 ✉ mail@halfmoonbalcombe.com

Balcombe is a microbrewery established in 2021 by 13 beer enthusiasts.

Bestens

Unit 17, Church Lane Farm Estate, Church Lane, Lower Beeding, West Sussex, RH13 6LU
☎ (01403) 892556 ⊕ bestensbrewery.co.uk

The brewery opened in 2018 in Lower Beeding as a one-barrel plant, increasing to four-barrel capacity in 2020. A percentage of all beer sold is donated to a community fund, which supports local charities and initiatives. The brewery operates a mobile taproom in Haywards Heath, as well as hosting events at the brewery itself. No real ale. 🍺

Brew Studio

39 Meadowview Road, Sompting, West Sussex, BN15 0HU ☎ 07980 978350

⊗ Brew Studio started off as a 0.5-barrel nanobrewery in 2017 and has since upgraded to a 2.5-barrel plant. Around 20 outlets are supplied direct.

Brewery 288 (NEW)

Burton Park Road, Heath End, West Sussex, GU28 0JU
☎ 07487 600288 ⊕ brewery288.co.uk

Brewery 288 is a microbrewery specialising in traditional real ales. All beers are bottle conditioned. LIVE

Brewhouse & Kitchen SIBA

⊟ 38 East Street, Horsham, West Sussex, RH12 1HL
⊕ brewhouseandkitchen.com

A 2.5-barrel plant producing cask and keg bees. 'Project Cask' beers are produced alongside the core range. Brewery experience days are available.

Brewhouse & Kitchen (NEW) SIBA

⊟ Wykeham Road, Worthing, West Sussex, BN11 4JD
☎ (01903) 948222 ⊕ brewhouseandkitchen.com

⊗ Part of the Brewhouse & Kitchen chain, producing its own range of beers. Carry outs and brewery experience days are offered. ‼◆

Brolly

No 5, Kiln Industries, Lowfold Farm, Fittleworth Road, Wisborough Green, West Sussex, RH14 0ES ☎ 07720 847017 ⊕ brollybrewing.co.uk

Brolly was established in 2017 by keen homebrewer Brook Saunders. Beers are available in local pubs, at the on-site bar, and at the brewery tap, Billi Tap in Billingshurst. 🍺◆

Little Pearl (ABV 3.5%) STOUT
Aroha (ABV 3.8%) PALE
Lifeline (ABV 3.8%) MILD
Madre (ABV 4%) PALE
Choco-lots (ABV 4.1%) STOUT
Chub IPA (ABV 4.3%) PALE
Spanky McDanky (ABV 4.5%) PALE
COW (ABV 4.8%) PALE
How Now (ABV 5%) BROWN
Natural Spring Water (ABV 5%) PALE
Jolly Brolly Brown Ale (ABV 5.2%) BROWN
Old Ale (ABV 5.4%) OLD

Chapeau

Unit 8, Redkiln Close, Horsham, West Sussex, RH13 5QL
☎ (01403) 252459 ⊕ chapeaubrewing.com

⊗ Chapeau Brewing is a microbrewery based in Horsham. The brewery and beer names reflect the owner's interest in cycling. A brewery tap is owned, and a beer club operated (see website for details). 🍺

False Flat (ABV 3.3%) MILD
Slip Stream (ABV 3.5%) BITTER
Rouleur (ABV 4%) BITTER
Summit (ABV 4%) GOLD
Echelon (ABV 4.2%) SPECIALITY

Flamme Rouge (ABV 4.2%) SPECIALITY
Open Road (ABV 4.5%) STOUT
Out of Steam (ABV 4.5%) BLOND
Hard Yards (ABV 4.6%) BITTER
Attrition (ABV 5.5%) IPA
Breakaway (ABV 6%) PORTER

Cloak & Dagger SIBA

Unit 6a, Garcia Trading Estate, Canterbury Road, Worthing, West Sussex, BN13 1AL ☎ 07378 300570 ⊕ cloakanddaggerbrewing.com

Cloak & Dagger was established by three friends from Brighton in 2017. Beers are available in can and keg. The brewery tap is Cloak Room, Kemptown. ⬛

Dark Star

22 Star Road, Partridge Green, West Sussex, RH13 8RA
☎ (01403) 713085 ⊕ darkstarbrewing.co.uk

⊠ The Dark Star Brewing Co is named after a Grateful Dead song and was established in the cellar of the Evening Star in Brighton back in 1994, moving to its current home in Partridge Green in 2010. Purchased by Fuller's in 2018 and subsequently sold to Asahi in 2019, the 45-barrel plant produces a wide range of beers. ‼⬛♦LIVE

The Art of Darkness (ABV 3.5%) BITTER
Hophead (ABV 3.8%) GOLD
A golden-coloured bitter with a fruity/hoppy aroma and a citrus/bitter taste and aftertaste. Flavours remain strong to the end.
Partridge Best Bitter (ABV 4%) BITTER
Espresso (ABV 4.2%) SPECIALITY
American Pale Ale (ABV 4.7%) PALE
Festival (ABV 5%) BITTER
Original (ABV 5%) OLD
Revelation (ABV 5.7%) IPA

Downlands SIBA

Unit Z (2a), Mackley Industrial Estate, Small Dole, West Sussex, BN5 9XE
☎ (01273) 495596 ⊕ downlandsbrewery.com

⊠ A 10-barrel brewery set up in 2012 distributing beers across the south east of England. ‼♦

Root Thirteen (ABV 3.6%) GOLD
Best (ABV 4.1%) BITTER
Bramber (ABV 4.5%) BITTER
Devils Dyke Porter (ABV 5%) PORTER
Devils Dyke Salted Caramel (ABV 5%) SPECIALITY

Endangered (NEW)

Building OPQ Unit D&E, S.M Tidy Industrial Estate, Ditchling Common, Hassocks, BN6 8SG
✉ hello@endangeredbrewing.com

With a focus to brew an easy-to-navigate core range of premium session beers with lower ABV, hops and malts sourced from the UK. Can artwork features endangered species. Currently does not have its own brewhouse so is utilises spare capacity of other brewers.

Fauna (NEW)

Norfolk Estate Office, London Road, Arundel, West Sussex, BN18 9AS ☎ 07742 144340
⊕ faunabrewing.com

Combining three core values of conservation, environmentalism and good beer, Fauna Brewing was launched in 2021. The brewery work with three charity partners in aid of endangered species that benefit from each beer sale. V♦

Firebird SIBA

Old Rudgwick Brickworks, Lynwick Street, Rudgwick, West Sussex, RH12 3UW
☎ (01403) 823180 ⊕ firebirdbrewing.co.uk

⊠ Firebird began brewing in 2013 and has grown rapidly with new beers, new vessels, an extended warehouse and an expanded team. There is an upstairs bar on-site. ‼⬛♦LIVE♦

Two Horses (ABV 3.8%) PALE
Heritage XX (ABV 4%) BITTER
Parody (ABV 4.5%) GOLD
Festive 51 (ABV 4.8%) BITTER

Goldmark SIBA

Unit 23, The Vinery, Arundel Road, Arundel, West Sussex, BN18 9PY
☎ (01903) 297838 ☎ 07900 555415
⊕ goldmarks.co.uk

⊠ Ex-biochemist and homebrewer Mark Lehmann began commercial brewing in 2013 using an 11-barrel plant. ‼⬛LIVE♦

Session Pale (ABV 3.7%) PALE
Dave (ABV 3.8%) BITTER
Liquid Gold (ABV 4%) GOLD
Hop Idol (ABV 4.4%) PALE
Mosaic Pale (ABV 4.4%) PALE
American Pale (ABV 4.8%) PALE
Black Cherry (ABV 4.8%) PORTER
Sussex Warrior (ABV 4.8%) BITTER
Vertigo Craft Lager (ABV 4.8%) SPECIALITY
Pitch Shifter IPA (ABV 5%) PALE

Goodwood SIBA

Office: The New Brewery, Stane Street, North Heath, West Sussex, RH20 1DJ ⊕ goodwood.com/estate/ home-farm/goodwood-brewery

Beers are available in bottle and keg in restaurants and bars across the Goodwood estate. The beer is brewed by Hepworth (qv) using ingredients grown on the estate.

Greyhound

Watershed, Smock Alley, West Chiltington, West Sussex, RH20 2QX
☎ (01798) 815822 ☎ 07973 625510
⊕ greyhoundbrewery.co.uk

⊠ Established in 2015 by husband-and-wife team Nick and Sarah Allen, Greyhound is a 7.5-barrel brewery. In 2017 the brewery took over production of Ballard's Brewery beers. Cask beer was discontinued in 2022, with the brewery now concentrating on bottles and cans. All beers are unfined, unfiltered, gluten free and vegan-friendly. ‼♦LIVE GF V

Gribble

⬛ Gribble Inn, Oving, West Sussex, PO20 2BP
☎ (01243) 786893 ⊕ gribbleinn.co.uk

⊠ Established in 1980 using a five-barrel plant, the Gribble Brewery is the longest-serving brewpub in the Sussex area, independently-owned and run by the licensees since 2005. A number of local outlets are supplied. ♦

Hairy Dog

Unit 38, More House Farm, Wivelsfield, Haywards Heath, West Sussex, RH17 7RE
⊕ hairydogbrewery.beer

⊠ Overlooking the South Downs National Park, the brewery's ethos is to use Sussex ingredients wherever possible and to pursue a policy of sustainability. An on-site taproom is open on Fridays. ⬧

Gun Dog (ABV 0.4%) PALE
Hounded Best Bitter (ABV 4.1%) BITTER
Far Fetched Pale Ale (ABV 4.2%) PALE
Bloodhound Red IPA (ABV 5.5%) RED

Heathen

Hop Sun, Triangle Road, Haywards Heath, West Sussex, RH16 4HW
☎ (01444) 456217 ☎ 07825 429428
⊕ heathenbrewers.co.uk

Heathen opened its new brewery in 2021, moving from the more restricted premises at the Grape & Grain off-licence into a former barn. The new premises has an adjoining taproom, which is open Thursday-Saturday. Beers are unfiltered, unpasteurised and mostly vegan-friendly, served via air pressure from tanks or in casks. ‼⬧LIVE V⬧

Atemporal Rites (ABV 3.9%) PALE
Medlar Sour (ABV 4.8%) SPECIALITY
Black Eye PA (ABV 4.9%) PALE
West Coast (ABV 5.4%) PALE

Hepworth

Stane Street, North Heath, West Sussex, RH20 1DJ
☎ (01403) 269696 ⊕ hepworthbrewery.co.uk

⊠ Hepworth's was established in 2001. 274 outlets are supplied. Originally situated in Horsham, a new brewery site in North Heath opened in 2016. Its organic status is ratified by the Soil Association. Beers are contract brewed for Hiver. ‼🍺⬧LIVE

Traditional Sussex Bitter (ABV 3.5%) BITTER
A fine, clean-tasting, amber, session beer. A bitter beer with a pleasant fruity and hoppy aroma that leads to a crisp, tangy taste. A long, dry finish.
Dark Horse (ABV 3.8%) BITTER
Summer Ale (ABV 3.8%) BITTER
Pullman First Class Ale (ABV 4.2%) BITTER
A sweet, nutty maltiness and fruitiness are balanced by hops and bitterness in this easy-drinking, pale brown best bitter. A subtle bitter aftertaste.
Prospect Organic (ABV 4.5%) GOLD
Classic Old Ale (ABV 4.8%) OLD
Iron Horse (ABV 4.8%) BITTER
There's a fruity, toffee aroma to this light brown, full-bodied bitter. A citrus flavour balanced by caramel and malt leads to a clean, dry finish.

Horsham

Unit 3, Blatchford Close, Horsham, West Sussex, RH13 5RG ✉ horshambrewingco@mail.com

Horsham Brewery Company Ltd began brewing in 2021.

Hurst SIBA

Highfields Farm, Hurstpierpoint, West Sussex, BN6 9JT
☎ 07866 438953 ⊕ hurstbrewery.co.uk

Hurst was founded in 2012, but reviving a name dating back to 1862.

Founders Best Bitter (ABV 4.2%) BITTER
Keepers Golden Ale (ABV 4.4%)

Kiln

Chiddinglye Farm, West Hoathly, RH19 4QS ☎ 07800 556729

Office: 1st Floor, 30 Church Road, Burgess Hill, RH15 9AE ⊕ thekilnbrewery.co.uk

Kiln brewery was set up by two friends in 2014. Following a search for new premises, they have joined forces with Missing Link brewery. Although Kiln's website is focusing on keg and canned beer, they are continuing to produce cask beers, but are no longer sticking with a core range.

Kissingate

Pole Barn, Church Lane Farm Estate, Church Lane, Lower Beeding, West Sussex, RH13 6LU
☎ (01403) 891335 ⊕ kissingate.co.uk

⊠ Kissingate Brewery was founded in 2010 by husband-and-wife team Gary and Bunny Lucas. Current production capacity is eight barrels. The brewery building is a converted barn set in a wooded valley near the village of Mannings Heath. It has a taproom and minstrels gallery. The brewery is available to hire for private events. ‼🍺⬧LIVE⬧

Storyteller (ABV 3.5%) GOLD
Ripple Raspberry Stout (ABV 4%) STOUT
Sussex (ABV 4%) BITTER
Black Cherry Mild (ABV 4.2%) SPECIALITY
Moon (ABV 4.5%) BITTER
Old Tale Porter (ABV 4.5%) PORTER
Chocolate & Vanilla Oatmeal Stout (ABV 4.8%) STOUT
Chennai (ABV 5%) BITTER
Micro Lot Coffee Porter (ABV 5%) SPECIALITY
Nooksack (ABV 5%) IPA
Pernickety Pale (ABV 5%) BITTER
Smelter's Stout (ABV 5.1%) STOUT
Powder Blue (ABV 5.5%) PORTER
Stout Extreme Jamaica (ABV 6%) STOUT
Six Crows (ABV 6.6%) STOUT
Blackeyed Susan (ABV 7%) STRONG
Murder of Crows (ABV 10%) STOUT

Langham SIBA

Old Granary, Langham Lane, Lodsworth, West Sussex, GU28 9BU
☎ (01798) 860861 ⊕ langhambrewery.co.uk

⊠ Langham Brewery was established in 2006 in an 18th century granary barn and is set in the heart of West Sussex with fine views of the rolling South Downs. It is owned by Lesley Foulkes and James Berrow who brew and run the business. The brewery is a 10-barrel, steam-heated plant and more than 200 outlets are supplied. ‼🍺⬧

Session Bitter (ABV 3.5%) BITTER
Saison (ABV 3.9%) SPECIALITY
Hip Hop (ABV 4%) BLOND
Triple XXX (ABV 4.4%) MILD
Best (ABV 4.5%) BITTER
Arapaho (ABV 4.9%) PALE
LSD (Langham Special Draught) (ABV 5.2%) BITTER

Lister's SIBA

Michelgrove Lane, Lower Barpham, West Sussex, BN13 3XW

☎ (01903) 885950 ☎ 07775 853412
⊕ listersbrewery.com

Brewing began in 2012 using a 0.25-barrel kit. The brewery relocated in 2014 and expanded to a five-barrel plant.

Best Bitter (ABV 3.9%) BITTER
Golden Ale (ABV 4.1%) GOLD
Limehouse Porter (ABV 4.1%) PORTER
American Pale Ale (ABV 4.2%) PALE
IPA (ABV 4.3%) PALE
Special (ABV 4.6%) BITTER

Little Monster

Office: Burton Warren, Burton Park Road, Petworth, West Sussex, GU28 0JS ⊕ littlemonsterbrew.com

Brewing began in 2018. Owner Brenden collaborates with other breweries to produce his beers.

Missing Link

The Old Dairy, Chiddinglye Farm, West Hoathly, West Sussex, RH19 4QS ⊕ missinglinkbrewing.com

Missing Link was established in 2017 by Jeremy Cook. A state-of-the-art brewery, it welcomes other users, branding itself as a collective of like-minded breweries. Contract brewing and canning are also carried out. No real ale.

Pin-Up

Unit 3, Block 3, Chalex Industrial Estate, Manor Hall Road, Southwick, West Sussex, BN42 4NH
☎ (01273) 411127 ☎ 07888 836892
⊕ pinupbrewingco.com

⊠ Pin-Up began brewing in 2011, initially having its beers contract brewed at an Essex brewery. In 2014 it obtained its own plant and began brewing in Southwick, and expanded from a five-barrel to a 10-barrel plant in 2015. Its first pub, the United Brethren, Chelmsford, opened in 2016. ♦LIVE

Honey Brown (ABV 4%) BITTER
Session IPA (ABV 4.1%) PALE
Summer Pale (ABV 4.1%) PALE
Red Head (ABV 4.2%) RED
Milk Stout (ABV 4.5%) STOUT

Ridgeway

Stane Street, North Heath, Pulborough, West Sussex, RH20 1DJ
☎ (01491) 873474

Office: Ridgeway Brewing Ltd, South Stoke, RG8 0JW
⊕ ridgewaybrewery.co.uk

Set up by ex-Brakspear head brewer Peter Scholey, Ridgeway specialises in bottle-conditioned beers, although cask beers are occasionally available at beer festivals and locally. A new brewery has been operational since 2016, located within Hepworth Brewery's new premises near Pulborough, sharing some facilities. LIVE

Riverside

Unit 6, Beeding Court Business Park, Shoreham Road, Upper Beeding, West Sussex, BN44 3TN
☎ (01903) 898030 ⊕ riversidebreweryltd.co.uk

Riverside began brewing in 2015 using a five-barrel plant. Beers are available locally. LIVE

Rambling Monarch (ABV 3.6%) BITTER
Steyning Stinker (ABV 4%) PALE
Beeding Best Bitter (ABV 4.2%) BITTER
Sneaky Steamer (ABV 5.1%) GOLD
Tubbers' Tipple (ABV 5.6%) BITTER

Silver Rocket

6 Meadows, Hassocks, West Sussex, BN6 8EH
☎ 07950 099424 ⊕ silverrocketbrewing.co.uk

Silver Rocket Brewing is a microbrewery in Hassocks, run by two friends who love craft beer and Sonic Youth. Beers are available in can, keg and occasionally cask.

Sussex Small Batch

c/o 23 The Vinery, Poling, West Sussex, BN18 9PY
☎ 07718 22425

Office: 48 Henty Road, Worthing, BN14 7HE
✉ ssbbrewery@outlook.com

⊠ Jim Brown started the Sussex Small Batch Brewery in 2018, focusing on producing quality stouts with a difference. Brewing takes place using spare capacity at Goldmark Brewery (qv). Cask stout is available from time to time in a few select pubs in Worthing, but most production is canned and available throughout the UK via Eebria. Collaboration brews are also sometimes available.

Top-Notch

Office: 60 Wickham Way, Haywards Heath, West Sussex, RH16 1UQ ☎ 07963 829368
✉ topnotchbrewing@hotmail.com

A one-barrel brewery situated in a converted residential outbuilding in Haywards Heath. Beer styles change with each brew. LIVE

Vine

🬀 **Vine, 27-29 High Street, Tarring, West Sussex, BN14 7NN**
☎ (01903) 201121 ✉ thevinepub@hotmail.com

⊠ Brewery established in 2018 in the barn at the rear of the Vine pub. Beer is sold exclusively at the pub. Brewing is currently suspended.

Wingtip

The Grain Shed, Ford Lane, Ashurst, West Sussex, BN44 3AT
☎ (0333) 224 4888 ⊕ wingtipbrewing.com

⊠ Established in 2015, Wingtip is influenced by the history of Shoreham Airport and its founders experience of aviation and travel. Beers are available in pubs and bars around Sussex and London.

Autopilot (ABV 3.9%) BLOND

Good ale is the true and proper drink of Englishmen. He is not deserving of the name of Englishman who speaketh against ale, that is good ale.
George Borrow, Lavengro

JOIN THE CAMPAIGN

CAMRA, the Campaign for Real Ale, is an independent, not-for-profit, volunteer-led consumer group. We promote good-quality real ale and pubs, as well as lobbying government to champion drinkers' rights and protect local pubs as centres of community life.

CAMRA has over 155,000 members from all ages and backgrounds, brought together by a common belief in the issues that CAMRA deals with, and their love of good-quality British beer.

From just £28.50[†] a year, you can join CAMRA and enjoy the following benefits:

- A **welcome pack**, including membership card, to help you make the most of your membership

- Access to award-winning, quarterly **BEER magazine** and **What's Brewing** online news

- £30[*] worth of **CAMRA real ale**[**] vouchers

- Access to the **Real Ale Discount Scheme**, where you receive discounts on pints at over 3,500 participating pubs nationwide

- **Learn & Discover** online resources to help you discover more about beer and brewing

- **Free or reduced entry** to CAMRA beer festivals

- The opportunity to **campaign for great real ale, cider and perry**, and to save pubs under threat from closure

- **Discounts on CAMRA books** including our best-selling *Good Beer Guide*

- Social activities in your local area and **exclusive member discounts online**

Whether you're a dedicated campaigner, a beer enthusiast looking to learn more about beer, or you just love beer and pubs, CAMRA membership is for you. Join us today!

Join the campaign at
camra.org.uk/join

CAMRA, 230 Hatfield Road, St Albans, Herts AL1 4LW.
Tel: 01727 798440 Email: camra@camra.org.uk

Rates and benefits are subject to change.
[†] Concessionary rates may be lower.
[*] Joint members receive £40 worth of vouchers.
[**] real ale, cider and perry, subject to terms and conditions.

Campaign for

South West

The South West is famously the location of the English Riviera, with beautiful beaches along the South Devon coast to explore including Oddicombe Beach and Anstey's Cove. Or visit the Jurassic Coast, a World Heritage Site stretching from Exmouth to Studland Bay in Dorset. The best way to take in the views is to hike the South West Coast Path, although it stretches for 630 miles in total so you might want to schedule a pub lunch or two along the way!

One of the UK's traditional cider and perry making regions, it is well worth stopping off at Dunkerton's Cider Shop & Taproom in Cheltenham. As well as making their own organic cider, the Dunkerton's rapidly expanding bottle shop is a great place to sample some of the very best in real cider and perry.

Visit Bristol, with its wide range of leading museums and art galleries. You can even enjoy a self-guided tour of Banksy's iconic works around the city. Bristol is also a great place to enjoy a tipple from some of the most exciting breweries in the country. You can find craft brewers like Arbor, Wiper & True and Left Handed Giant, alongside more established names like Butcombe and Moor Beer Company. Many of these businesses host brewery tours, and twice a year the East Bristol Brewery Trail allows you to sample a good range.

In the South West you can find the excellent family brewer St Austell, who brew a number of popular cask ales, including Proper Job and Tribute. St Austell hosts the annual Celtic Beer Festival in November featuring more than 200 beers from Cornwall, Ireland, Scotland and Wales. It has a large visitor centre and provides brewery tours daily.

In the largely rural county of Cornwall, many of the pubs remain the focus of their local community. You might like to pop in for a swift half at the Blue Anchor in Helston. It was one of only four surviving brewpubs at the time of CAMRA's foundation and is still brewing today. Spingo Ales have been brewed in an outbuilding at the rear of the pub since the middle of the 18th century and before that they were produced within the pub itself. They still brew using water drawn from their own well.

CORNWALL

ISLES OF SCILLY

ST MARTIN'S

TRESCO

ST MARY'S

Isles of Scilly

ST AGNES

Trebarwith Strand

Rock

St Kew Highway

Padstow

St Mabyn

Edmonton

A389

Newquay

St Mawgan

Bodmin

A39

A3059

Treisaac

A392

A30

A391

Perranporth

A3075

Quintrell Downs

A3058

Trevaunance Cove

St Austell

Pa

Towan Cross

A30

A39

Truro

A390

Grampound

A390

Redruth

Vogue

A3078

St Ives

Perranwell

A30

A39

Zennor

Piece

A393

Treen

Lelant

Ponsanooth

Pendeen

Hayle

A394

Penryn

Trewellard

St Erth

Nancenoy

Falmouth

St Just

Crowlas

Helston

A3071

A30

Penzance

A394

Porthleven

Pednavounder

A3083

Cadgwith

Lizard

Blisland

Blisland Inn

The Green, PL30 4JF (off A30 NE of Bodmin) SX100732

☎ (01208) 850739

Dowr Kammel Blisland Gold; house beer (by Sharp's) ⊞**; 4 changing beers (sourced nationally; often Dowr Kammel, Draught Bass)** ⊞/Ⓖ

A friendly rural community pub by the village green and former CAMRA National Pub of the Year. The Blisland, on the edge of Bodmin Moor, retains its reputation as a real ale destination and has served more than 3,000 different real ales over the years. It usually has at least five or six

beers available, with several brewed locally, alongside frequently changing draught ciders including more unusual varieties. Freshly prepared meals feature local produce. Popular with walkers and cyclists, well-behaved children and dogs are also welcome. Q ⌖ ❀ ❁ ◑ ♣ ♠ 🖫 🖢 ♦

Bodmin

Hole in the Wall 🄻 ⊘

16 Crockwell Street, PL31 2DS (entrance from town car park)

☎ (01208) 72397 ⊕ theholeinthewallbodmin.co.uk

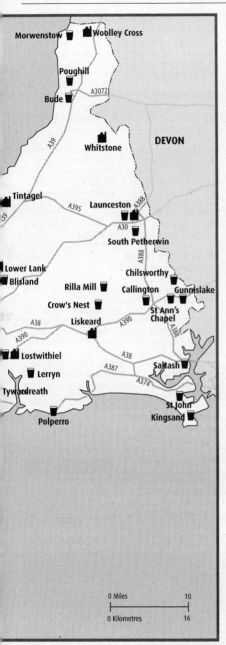

Bude

Barrel at Bude

36 Lansdown Road, EX23 8BN

☎ (01288) 356113 ⊕ thebarrelatbude.com

5 changing beers (sourced locally) 🅗

This small micropub opened in 2017 in a former fancy dress shop in the centre of town. All the beers and ciders are sourced from within Cornwall and Scilly by the owner/proprietor without recourse to the wholesale trade. The philosophy is that the beers in place on opening on Thursday should all be consumed by Sunday ('Drink the Barrel Dry' afternoon), ready for restocking the following week. Cornish organic gins and local wines are also available. ♠P🖳🌣

Cadgwith

Cadgwith Cove Inn

TR12 7JX

☎ (01326) 290513 ⊕ cadgwithcoveinn.com

Sharp's Doom Bar; Skinner's Betty Stogs; 2 changing beers (often Otter, Sharp's)

Three-roomed inn tucked away by the harbour and the South-West Coastal Path in a compact fishing village on the Lizard peninsula. Over 300 years old, the pub remains largely unspoilt since its smuggling days. Relics from the seafaring past and photos of shipwrecks and local scenes adorn the half-panelled walls, while the bar sports rope handles hanging from the beams for when the pub lists! Expect some lively singing in the evenings, with itinerant musicians often performing. ॐ❀☎◖♣🌣🛜

Callington

Cornish Ancestor

6 Newport, PL17 7AS (just off A386)

☎ (01579) 208300

4 changing beers (sourced regionally; often Butcombe) 🅖

Once a pet shop, Cornwall's latest micropub serves four varying real ales by gravity dispense, and up to eight varying real ciders, depending on demand. It is a quiet pub – conversation is the main entertainment with no distracting noisy machines. The bar area has a worktop, with a beer and cider menu chalkboard. The interestingly shaped interior is furnished throughout with functional barrels, wooden furniture and walls adorned with local pictures. No food, but a local pizza house will deliver. Q ॐ❀&♣🖳🌣🛜

Chilsworthy

White Hart

PL18 9PB (signposted from A390) SX416721

☎ (01822) 833876 ⊕ whitehartchilsworthy.com

Uley Bitter; 3 changing beers (sourced regionally) 🅗

Solid rural community pub and village shop tucked into the northern slopes of the Tamar Valley near the prominent landmark of Kit Hill. Carpeted throughout, the main drinking area is simply furnished with wooden tables and chairs. It is warmed in winter by wood-burning stoves set in two stone chimney breasts in what used to be separate rooms. The bar is decorated with brasses and other commonly found pub artefacts, and leads at the rear to a veranda offering impressive views towards Dartmoor. ॐ❀◖♣P🌣🛜

Crow's Nest

Crow's Nest

PL14 5JQ (near B3254) SX264693

Butcombe Original; Dartmoor Jail Ale; Draught Bass; Sharp's Atlantic, Sea Fury; 2 changing beers (sourced nationally) 🅗

Popular locals' hostelry built in the 18th century as a debtors' prison. The pub can be accessed direct from the public car park or through a secluded, leafy garden containing its own hop bine and stream, and presided over by a rather bleached stuffed lion. The single bar, which is subdivided by archways, contains a large and eclectic collection of antiques and military memorabilia. Upstairs is a separate function room. The pub has twice won local CAMRA Pub of the Year.

Q ॐ❀&⇌(Bodmin & Wenford) ♠🖳(27,11A) 🌣🛜

☎ (01579) 345930 ⊕ thecrowsnestcornwall.co.uk
**St Austell Proper Job, Tribute; 1 changing beer
(sourced regionally; often Dartmoor)** ⊞
Seventeenth-century granite community inn below
Caradon Hill. Formerly a mine captain's house, the
miners were paid partly with pub 'money' – the only way
to spend being to buy ale in the pay office. The bell to
summon miners remains on the wall. Inside, the pub is
cosy – mind your head! – with horsey artefacts and an old
settle from the former village chapel. The building is
allegedly haunted by more than four ghosts.
Q ☎ ⊛ ◑ & ♣ P ⋤ (74) ☻ �⌚

Crowlas

Star Inn ⓛ

TR20 8DX (on A30, 2½ miles E of Penzance)
☎ (01736) 740375
**Penzance Mild, Potion No 9, Crowlas Bitter, Brisons
Bitter; 3 changing beers (sourced nationally)** ⊞
This welcoming free house is the brewery tap for the
Penzance Brewing Company, with an extensive range of
excellent beers produced at the rear of the pub. There is
a good-sized U-shaped bar with a pool area, no noisy
machines, a cosy lounge space with comfortable seating
and an adjacent meeting room. This is essentially a beer-
drinkers' local where friendly conversation is the main
entertainment. Don't miss it! ⊛ ♣ P ⋤ ☻ ⏌

Edmonton

Quarryman Inn ⓛ

PL27 7JA (just off A39 near Royal Cornwall showground)
☎ (01208) 816444 ⊕ thequarryman.co.uk
**Otter Bitter; Padstow May Day; 1 changing beer
(sourced locally; often Padstow, Skinner's)** ⊞
A diversion to this ever-popular gem rewards the effort.
Conversation and banter thrive in this characterful and
convivial free house. Its quiet, comfortable interior
divides into a small public bar with flagstoned flooring
and a larger carpeted lounge, with dining in both areas.
Local art and sporting memorabilia feature among the
somewhat eclectic decor. The pub is renowned for the
quality of its local beers and food. Beers usually vary,
except the Otter Bitter, and are generally from local
breweries. Q ☎ ⊛ ◑ Å ♣ P ⋤ (10,95) ☻ ⏌

Falmouth

'front ⓛ

Custom House Quay, TR11 3JT
**Sharp's Sea Fury; Skinner's Lushingtons, Porthleven;
6 changing beers (sourced nationally; often
Firebrand, Tintagel, Treen's)** ⊞
A warm welcome is assured at this friendly quayside
cellar-style bar on Custom House Quay. The bar front is
decorated with old wooden cask sections, while a large
range of ales are dispensed from up to nine handpumps
in use. Beers are sourced mainly from Cornwall, catering
for all styles and tastes. No food is available but you may
bring your own. A 10 per cent discount on real ales is
offered before 6pm daily. Q ☎ ⊛ & ⇌ (Town) ♣ ☻ ☼

Beerwolf Books

3-4 Bells Court, TR11 3AZ (up side alley off main
shopping street opp M&S clock)
☎ (01326) 618474 ⊕ beerwolfbooks.com
**6 changing beers (sourced nationally; often
Blackjack, Penzance, Shiny)** ⊞
Pub or bookshop? Actually, it's both. Popular with all
ages, this former maritime storage loft and pleasant
outside courtyard is tucked away off Market Street. It is

accessed via a steep flight of stairs, at the top of which is
the bookshop, while to the right is the bar, dispensing an
adventurous selection of beers from near and far. A
selection of real local bag-in-a-box ciders are available.
No food is served, but you are welcome to bring your
own. ☎ ⊛ ♣ ⋤ ☻ ⏌

Boathouse ⓛ

Trevethan Hill, TR11 2AG (top of High St)
☎ (01326) 315425 ⊕ theboathousefalmouth.co.uk
**4 changing beers (sourced nationally; often
Skinner's)** ⊞
Bright and airy maritime themed pub up a short steep hill
off the town centre, offering impressive views across
Carrick Roads to Flushing and beyond. The bar area itself
is traditional, but the dining area has a more modern
vibe with large windows. An additional room has been
recently updated to feature floor to ceiling windows. The
large patio outside has heaters to make it suitable for
year-round use. Four ales are usually available, from local
or national breweries. ☎ ⊛ ◑ ♣ ⋤ ☻ ⏌

Moth & the Moon

31 Killigrew Street, TR11 3PW
☎ (01326) 315300
**Treen's Essential, Krowsek; 2 changing beers (sourced
regionally; often Firebrand)** ⊞
This small town-centre pub has a dark yet modern, cosy
interior. Downstairs, the bar room is open plan with an
intimate snug. More seating upstairs surrounds a tiny
glass-sided outdoor smoking area in the centre. To the
rear of the pub is a large sun-trap terrace, very popular in
summer. Up to two changing ales are generally available
from local breweries. On Tuesday there is a folk, acoustic
and song session night, and on Wednesday an open mic
night. ⊛ ⋤ ☻ ⏌

Oddfellows Arms

Quay Hill, TR11 3HA
☎ (01326) 218611

REAL ALE BREWERIES	
Ales of Scilly	St Mary's: Isles of Scilly
Atlantic	Treisaac
Black Flag ◈	Perranporth
Blue Anchor ▤	Helston
Castle	Lostwithiel
Cornish Crown ◈	Penzance
Dowr Kammel	Lower Lank
Driftwood Spars ▤	Trevaunance Cove
Dynamite Valley	Ponsanooth
Firebrand	Launceston
Forge	Woolley Cross
Harbour	Bodmin
Keltek	Redruth
Krow	Redruth
Lizard	Pednavounder
Longhill	Whitstone
Mine	St Ives (NEW)
Newquay Brewing Project	Lostwithiel (NEW)
Padstow	Padstow
Penzance	Crowlas
Point Break	Liskeard
Seven Stars ▤	Penryn
Sharp's	Rock
Skinner's ◈	Truro
St Austell ◈	St Austell
St Ives ◈	Hayle
Tintagel	Tintagel
Treen's	Ponsanooth
Tremethick	Grampound
Verdant ◈	Falmouth

Sharp's Atlantic; house beer (by Sharp's); 1 changing beer (sourced locally; often Treen's) Ⓗ
Unpretentious single-bar community pub tucked away up a hilly side street off the town centre. Popular with locals and visitors alike, it is decorated with old photographs, and has a cosy, convivial atmosphere in which to enjoy the three beers normally available. The front bar hosts the dartboard, while a small back room has the pool table and real fire in winter. The pub holds jam nights and organises various outings for the locals throughout the year. Q🚲(Town)♣🖵🐾🕿

Seaview Inn
Wodehouse Terrace, TR11 3EP
🕿 (01326) 311359 🌐 seaviewinnfalmouth.co.uk
2 changing beers (sourced nationally; often Treen's) Ⓗ
This comfortable, traditional town pub has a large open-plan island bar and, as the name suggests, excellent views over Falmouth harbour and Carrick Roads, with all their maritime activity. The front terrace is a wonderful spot to sit and watch the world go by. The locals are a friendly mix of all ages, and children and dogs are welcome. A games area hosting darts and pool is at the back of the pub. Q🚲🕀🖷�(♪♣🖵🐾🕿

Seven Stars ★
The Moor, TR11 3QA
🕿 (01326) 312111 🌐 thesevenstarsfalmouth.com
Draught Bass; Sharp's Atlantic, Sea Fury; 3 changing beers (sourced locally; often Firebrand, Skinner's, Treen's) Ⓖ
This timeless and unspoilt town centre local, in the same family for over 170 years, is recognised by CAMRA as having a nationally important historic interior and has recently undergone a sympathetic makeover. It has a lively narrow taproom with beers served on gravity, and two quieter rooms at the rear, further supplemented by an upstairs drinking area created from a former bottle store. The old 'bottle and jug' hatch is still in use. A real gem, not to be missed. Q🚲🕀�(●🐾🕿

Gunnislake

Rising Sun Inn
Calstock Road, PL18 9BX (off A390) SX432711
🕿 (01822) 832201
Dartmoor Legend, Jail Ale; 2 changing beers (sourced regionally) Ⓗ
Friendly oak-beamed country inn dating from the 17th century with much charm and character, set in a conservation area in a rural setting off the beaten track. It serves a good choice of up to four real ales, mainly from Cornish or other West Country breweries. Exposed stone walls and wooden beams allow an extensive display of chinaware, and a beautiful terraced garden affords views over the Tamar Valley. A true community pub hosting various local activities.
Q🚲🕀�(♪🚲♣●P🖵(79,118)🐾🕿

Hayle

Bird in Hand
Trelissick Road, TR27 4HY
🕿 (01736) 753974 neal@birdinhandhayle.co.uk
🌐 birdinhandhayle.co.uk
Sharp's Doom Bar; 2 changing beers (sourced regionally; often Bays, Treen's) Ⓗ
Families are welcome in this spacious pub converted from a Victorian coach house and stables, adjacent to Paradise Park wildlife sanctuary. The one-room bar is decorated with a mix of local industrial paraphernalia,

horse paintings, coach and stable fitments and an end wall supporting a large frieze by Terry English depicting scenes from Cornwall's industrial past. Tables are separated by elaborate cast iron partitions. There is spacious outdoor seating. Two changing beers are offered in the summer and one in the winter.
🚲🕀�(♪♣P🖵🐾🕿

Helston

Blue Anchor
50 Coinagehall Street, TR13 8EL
🕿 (01326) 562821 🌐 spingoales.com
Blue Anchor Flora Daze, Jubilee IPA, Spingo Middle, Spingo Special; 2 changing beers (sourced locally; often Blue Anchor) Ⓗ
A former monks' rest, this 15th-century brewpub is one of the oldest in Britain, changing little over the years and retaining much of its original character. Two separate small bars are found to the right of the central passageway, one with an open fire, and two sitting rooms to the left, all with slate floors. To the rear are a skittle alley and partly covered garden area with its own bar and barbecue. An anchor is visible on the thatched roof. Q🚲🕀🌕🕀♣●🖵🐾

Kingsand

Devonport Inn
The Cleave, PL10 1NF
🕿 (01752) 822869 🌐 devonportinn.com
Dartmoor Legend; 2 changing beers (sourced locally; often Bays, Otter) Ⓗ
Between a narrow lane and the sea, this old pub was formerly divided into two bars but is now partly opened out to one, albeit still with distinct drinking areas. The small wooden-floored bar has snug recesses and is ship-themed. There are up to two constantly changing real ales available, mostly from Devon. Live bands play once a month in winter, more during the summer months. A welcome halt, both for walkers on the Cornwall Coast Path and the less energetic. 🚲🕀🌕(♪🖦🖵(70)🐾🕿

Launceston

Bell Inn
1 Tower Street, PL15 8BQ (in town centre next to parish church tower)
🕿 (01566) 779970 🌐 bellinnlaunceston.co.uk
House beer (by Holsworthy Ales); 5 changing beers (sourced regionally) Ⓗ
Cosy 16th-century town hostelry, originally built to house stonemasons erecting the nearby church. Conversation rules in this locals' pub. The ever-changing beer range includes mostly local beers, and two ciders, although the selection may be reduced out of season. A separate family room, available for local groups to use, features frescoes uncovered when previous owners stripped away decades of modernisation. Cribbage and other pub games are played. Food is limited to a pasty or pork pie. Q🚲🕀♣●🖵🐾🕿

Lelant

Watermill Inn 🄻
Old Coach Road, TR27 6LQ (off A3074, on secondary St Ives road)
🕿 (01736) 757912 🌐 watermillincornwall.co.uk
Skinner's Betty Stogs; 3 changing beers (sourced locally; often Bays, Sharp's, St Austell) Ⓗ
This family-friendly two-storey free house stands in attractive surroundings, a short walk from St Erths

Station. A former 18th-century mill house, its original working watermill, complete with millstones, features in the lower floor bar. The interior has distinct drinking and dining areas where bar meals are served. The ever-changing beer menu offers up to four local ales. Upstairs, the former mill loft functions as a stylish evening-only restaurant. An extensive beer garden straddles the mill stream. Live music plays on Friday evening.
Q ⏴ ❀ ◖ ▌ P ⟲ ❀ �fi

Lerryn

Ship Inn ✓
Fore Street, PL22 0PT
☎ (01208) 872374 ⊕ theshipinnlerryn.co.uk
Dartmoor IPA, Jail Ale; Sharp's Abbey Christmas; 2 changing beers (sourced locally) Ⓗ
Beside the River Fowey stands this charming free house, a truly traditional village inn. Its quiet, convivial interior divides into distinct areas: a slate-floored bar at the front, where up to five quality ales are offered and an extensive menu served, and at the rear, the popular Willows restaurant, with its interesting home-cooked menu. A raised terrace conservatory extension affords river views. Comfortably furnished throughout, wooden partitions, old photographs and a vintage jukebox add character. Riverside parking is nearby.
Q ⏴ ❀ ◖ ▥ ◖ ▌ ❀ ❀ fi

Lizard

Witchball Ⓛ
Lighthouse Road, TR12 7NJ
☎ (01326) 290662 ⊕ witchball.co.uk
St Austell Tribute; Sharp's Sea Fury; 1 changing beer (sourced locally) Ⓗ
This 600-year-old building, formerly a restaurant, was converted to a cosy inn in 2007. Handy for the coastal footpath, it is the most southerly pub on the mainland. It has a small bar and snug, and a restaurant where you will find the witchball hanging in the window – said to ward off evil spirits. Four handpumps deliver three Cornish ales and a real cider – a charity beer festival is held each August. A stove warms the main bar area in winter. Watch out for the low beams!
⏴ ❀ ◖ ▐ Å ♣ ◖ ▌ (L1,34) ❀ fi

Lostwithiel

Globe Inn Ⓛ
3 North Street, PL22 0EG (near railway station, town side of river bridge)
☎ (01208) 872501 ⊕ globeinn.com
Skinner's Betty Stogs; 3 changing beers Ⓗ
Cosy 13th-century pub in the narrow streets of an old stannary (tin-mining) town, close to the station and medieval stone river bridge. Conversation thrives in the quiet ambience within, ideal to enjoy a pint. The atmospheric interior accommodates a single bar with several drinking and dining spaces. Towards the rear is an intimate restaurant adjoining a sheltered sun-trap patio. An extensive home-cooked food menu features fish and game. The varying beer menu offers up to four ales. En-suite accommodation is available.
Q ⏴ ❀ ❀ ◖ ▐ Å ♣ ❀ ❀ fi

Morwenstow

Bush Inn
Crosstown, EX23 9SR (off A39, N of Kilkhampton)
SS208150
☎ (01288) 331242 ⊕ thebushinnmorwenstow.com

St Austell Tribute, Hicks; 1 changing beer (sourced locally; often Forge, Tintagel) Ⓗ
This ancient former chapel dates in parts back to 950AD. Unassuming externally, it is a gem internally and is simply furnished, with slate floors, granite walls and exposed beams in the two small bar rooms, one of which is subdivided into separate drinking areas. Conversation is the main entertainment, although there is occasional live music. A large garden offers outstanding views over the valley and seawards. The guest beer will be Cornish or from a nearby Devon brewery such as Otter.
Q ⏴ ❀ ❀ ◖ ▐ ♣ ◖ ▌ P ⟲ (217) ❀ fi

Nancenoy

Trengilly Wartha Inn Ⓛ
TR11 5RP (off B3291 near Constantine) SW732283
☎ (01326) 340332 ⊕ trengilly.co.uk
Sharp's Original; 3 changing beers (sourced locally; often Penzance) Ⓗ
This versatile inn lies in extensive grounds that include a lake, in an isolated steeply wooded valley – the pub's name means 'settlement above the trees'. Originally a farmhouse, it has a variety of rooms and furnishings, the wood-beamed bar displaying pictures by local artists. A conservatory extension doubles as a family room. The real ales are mainly from local microbreweries, while a wide-ranging and imaginative food menu uses fresh local produce from named suppliers. Accommodation includes garden rooms and safari tents.
Q ⏴ ❀ ❀ ◖ ▐ ♣ ◖ ▌ P ❀ fi

Newquay

Red Lion ✓
North Quay Hill, TR7 1HE (NW side of town centre, overlooking harbour)
☎ (01637) 872195 ⊕ classicinns.co.uk/redlionnewquay
Sharp's Atlantic, Doom Bar, Sea Fury; 3 changing beers (sourced nationally; often Firebrand, Timothy Taylor) Ⓗ
Deceptively spacious open-plan pub with a flagstoned bar and a log fire in winter, overlooking the north quay of Newquay's historic harbour. Offering eight real ales and six real ciders, it is a former local CAMRA Cider Pub of the Year. Locals and tourists alike are drawn also by the diverse food menu, and live bands playing on Friday and Saturday nights. The pub is within easy walking distance of the town centre, and is very dog-friendly.
⏴ ❀ ◖ ▐ & ◖ ▌ P ⟲ ❀ fi

Par

Welcome Home Inn
39 Par Green, PL24 2AF
☎ (01726) 816894
St Austell Tribute, Hicks; 1 changing beer (sourced locally; often St Austell) Ⓗ
Quiet, small locals' pub in the centre of Par, featuring a slate floor and with good accessibility throughout. The single bar has a variety of wooden furniture. Meals are home-made using locally sourced ingredients and reasonably priced. The pub opens on to a large lawned secret garden for outside drinking, with a serving station for busier times, and a low-fenced children's play area, and is very popular in fine weather.
Q ⏴ ❀ ◖ ▐ & ≢ P ⟲ (25) ❀ fi

Pendeen

North Inn
TR19 7DN (on B3306)

☎ (01736) 788417 ⊕ thenorthinnpendeen.co.uk
St Austell Tribute, Proper Job; 1 changing beer (sourced locally; often Bath Ales) Ⓗ
Set in an old mining village near the coastal path and Geevor and Levant Mines, in an Area of Outstanding Natural Beauty with spectacular cliffs and good walking, this is a welcoming locals' pub. The single large room is carpeted and has a wood-beamed ceiling. A good-value food menu features a comprehensive range of home-cooked curries, the landlord's speciality, as well as traditional fare. The pub offers accommodation in four double rooms as well as having its own campsite.
Q✿🛏🕙▲♣P🖵(7,18) ☸ 🛜

Penzance

Dock Inn
17 Quay Street, TR18 4BD
☎ (01736) 362833 ⊕ thedockinnpenzance.co.uk
Blue Anchor Spingo Middle; Penzance Potion No 9; Sharp's Doom Bar Ⓗ
Old one-time fishermen's pub near the dockside and close to the Isles of Scilly ferry pier. The pub extends through two old cottages with the bar in the upper level and a comfortable lounge/dining area in the lower, beyond which is a pool room. The décor includes a large picture mirror as well as a mix of nautical and mining pictures and bric-à-brac, and a stuffed bird in a cage. Meals are served Wednesday-Saturday evenings and Sunday lunchtimes. Q🛏✿🛏🕙⇥♣P🖵☸🛜

Navy Inn
Lower Queen Street, TR18 4DE (off Western Promenade)
☎ (01736) 448349 ⊕ navyinnpenzance.co.uk
St Austell Tribute; Skinner's Porthleven Ⓗ
Tucked just off the promenade, this is a basic back-street pub with a homely atmosphere, enhanced by exposed granite walls and bare floorboards. There is a central bar with two smaller areas at the front left and rear right. The bar dispenses mostly locally brewed beers, generally from Cornish breweries, although Dartmoor Jail Ale makes an occasional appearance. Meals are served lunchtimes and evenings daily. The pub's name dates from when the Royal Navy had a depot in Penzance.
🛏🕙🖵☸

Perranwell

Royal Oak Ⓛ
TR3 7PX
☎ (01872) 863175 ⊕ theroyaloakperranwellstation.co.uk
4 changing beers (sourced locally; often Exeter, Harbour, Penzance) Ⓗ
This small 18th-century cottage-style village inn prioritises both good beer and food. Most tables are set for dining, but drinkers are equally welcome, as the many sociable regulars at the bar will testify. Booking for meals is advisable however, especially in the evening. The beers vary frequently and are mostly from local or Devon breweries. A busy community pub, it holds monthly quiz nights and fundraising events for local charities. Q🛏✿🕙⇥♣P🖵(36,46)☸🛜

Piece

Countryman Inn
TR16 6SG (on Four Lanes-Pool road) SW679398
☎ (01209) 215960 ⊕ countrymaninns.com
St Austell Tribute; Theakston Old Peculier; 4 changing beers (sourced regionally; often Courage, Dartmoor, Treen's) Ⓗ

A traditional and friendly country pub and former miners' shop, run by the same landlord for more than 35 years. Built in the 19th century, it is set in a historic local mining landscape, close to walking and cycle trails. There are two bars, the larger with a granite fireplace and cast-iron range. The smaller room is more public bar in style and is where families are welcome. Entertainment features most evenings and Sunday lunchtimes.
🛏✿🕙▲♣P🖵(42) ☸ 🛜

Polperro

Blue Peter Inn Ⓛ
Quay Road, PL13 2QZ (far end of W side of harbour)
☎ (01503) 272743 ⊕ thebluepeterinn.co.uk
St Austell Tribute; 4 changing beers (sourced regionally; often Dartmoor) Ⓗ
Named after the naval flag, this friendly inn is reached up a steep flight of steps near the quay, and is the only pub in the village with a sea view. In summer it offers up to six ales from Cornwall and Devon, and a varied menu of home-cooked dishes available all day. Featuring low beams, wooden floors, unusual souvenirs and work by local artists, the pub is popular with regulars, fishermen and visitors. 🛏✿🕙▲♣☸

Crumplehorn Inn Ⓛ
The Old Mill, Crumplehorn, PL13 2RJ (on A387, top of town near coach park)
☎ (01503) 272348 ⊕ thecrumplehorninn.co.uk
St Austell Tribute, Proper Job; Tintagel Castle Gold, Harbour Special; 2 changing beers (sourced locally) Ⓗ
Once a mill and mentioned in the Domesday Book, this 14th-century inn at the entrance to the village still has a working waterwheel outside. The split-level bar has three comfortable areas with low ceilings and flagstone floors. Outside, the spacious patio by the millstream offers large parasols as sunshades. A varied menu includes locally sourced food. Accommodation is B&B or self-catering. In summer, catch the milk float tram down to the harbour from the nearby public car park.
🛏✿🛏🕙▲P🖵☸🛜

Porthleven

Ship Inn
Mount Pleasant Road, TR13 9JS
☎ (01326) 564204 ⊕ theshipinnporthleven.co.uk
Sharp's Doom Bar; Skinner's Porthleven; 1 changing beer (sourced locally) Ⓗ
Perched on the southwest corner of the harbour, this 17th-century fishermen's inn is accessed up a steep flight of steps. It enjoys a commanding view over the harbour – here you can sit comfortably and watch the rough seas on stormy days. The rambling split-level interior has wooden and slated floors, beams decorated with an eclectic mix of coins, banknotes, beermats and brass artefacts, and sketches of local characters on the walls. A large log fire usually warms the pub in winter.
🛏✿🕙🍺🖵(U4) ☸ 🛜

Poughill

Preston Gate Inn
Poughill Road, EX23 9ET (just outside Bude, on Sandymouth Bay road) SS224077
☎ (01288) 354017 ⊕ prestongateinn.co.uk
Sharp's Atlantic, Sea Fury; 2 changing beers (sourced regionally) Ⓗ
This cosy 16th-century building, originally two cottages, has been a village pub since 1983. The spacious U-shaped room hosts a dartboard at one end of the bar; the

other end is roomier with more seating and a roaring log fire in winter. Conversation rules here, and the pub is home to darts and quiz teams. Meals include steak nights and fish & chips lunchtimes. The beer range may reduce in winter and the cider varies. The name Preston comes from the Cornish word for priest.
Q🕮🚳🍴🅟♿♣⏰️🅿🚐(128,218) 😊🛜

Quintrell Downs

Two Clomes
East Road, TR8 4PD (on A392)
☎ (01637) 871163
Sharp's Doom Bar; 2 changing beers (sourced regionally; often Dartmoor, Sharp's) Ⓗ
Named after the two ovens set either side of the open fireplace – which is now fitted with a wood-burning stove – this 18th-century free house is popular for dining out. Various extensions to the original building have added a large restaurant (booking is advisable, even in winter). Background music plays and there is a TV for sporting occasions. The pub is conveniently situated on a main route into Newquay and close to campsites.
🚳🕮🍴♿🅐🅟♣⏰️🅟🚐(21,91) 😊🛜

Rilla Mill

Manor House Inn
PL17 7NT (NE of Liskeard, off B3254)
☎ (01579) 362354 ⊕ manorhouserilla.co.uk
Dartmoor Legend; Draught Bass; 1 changing beer (sourced locally) Ⓗ
Comfortable community pub and restaurant in the Lynher Valley, on the edge of Bodmin Moor. It has three rooms – one with slated and carpeted flooring, the other two the restaurant areas. The changing beers are mainly from Cornish breweries and meals generally feature local produce. Dating from the 17th century, the pub is allegedly haunted by three ghosts. Nearby are the open air Sterts Theatre and a dairy that makes a variety of Cornish cheeses. Dartmoor's Jail Ale may alternate with the Legend. Q🚳🕮🍴♣🅟🚐(236)😊🛜

St Ann's Chapel

Rifle Volunteer Inn
PL18 9HL (on A390)
☎ (01822) 851551 ⊕ riflevolunteer.com
St Austell Tribute; 2 changing beers (sourced regionally; often Dartmoor, Tintagel) Ⓗ
Former mine captain's house, converted to a coaching inn during the mid-19th century. The main bar has been extended to accommodate a conservatory, popular with diners for the view over the garden. Meals are cooked using locally sourced ingredients. A separate public bar caters for more dedicated drinkers and has a pool table and dartboard. The changing beer is usually from a local brewery. The pub offers panoramic views across the Tamar Valley and is in good walking country.
Q🚳🕮🍴♿🅟♣⏰️🅟🚐(79) 😊🛜

St Erth

Star Inn ✅
1 Church Street, TR27 6HP (off A30, near Hayle causeway)
☎ (01736) 602944 ⊕ thestarsterth.com
Sharp's Doom Bar; Timothy Taylor Landlord; 2 changing beers (sourced regionally; often Dartmoor, St Austell) Ⓗ
Traditional 17th-century village pub with wood-burner fires and a rambling beamed interior spread over three

levels. It has a covered patio and a pleasant garden. There are always four beers on handpump. Food ranges from bar snacks to pub grub and more substantial specials. Family, bike, dog and welly friendly. The busy schedule includes quizes on Wednesday afternoon, Thursday and Saturday; Monday darts night; Tuesday acoustic jam sessions; Wednesday guitar club; and Saturday live music night. 🚳😊🛏🍴♣⏰️🅟🚐(515)😊🛜

St Ives

Pilchard Press Alehouse
Wharf Road, TR26 1LF (in alley between Talay Thai and Cornish Pasty Shop)
☎ (01736) 791665
6 changing beers (sourced locally; often Mine, Penzance, Treen's) Ⓗ/🄶
Opened in 2016, this tiny bar in an old stone-walled cellar was Cornwall's first micropub. Located up an alleyway off the harbourside, it can be difficult to find but is well worth seeking out. A friendly little pub with a wood-topped bar, it is furnished with bar stools and a few tables and chairs, offering space for around 25 customers. It offers up to six real ales, mainly from Cornish breweries, and local ciders dispensed by gravity.
Q🚳🅐♣⏰️🚐😊

St John

St John Inn 🏆
PL11 3AW
☎ (01752) 829299 ⊕ stjohninn.co.uk
Draught Bass; 2 changing beers (sourced nationally; often Exmoor, Woodforde's) Ⓗ
Reached down narrow country lanes, this 16th-century village inn and community shop was formerly two cottages. It has a cosy ambience, with an L-shaped bar room featuring a beamed ceiling and a floor of red tiles, wooden furniture and a warming open fire for winter. A snug opposite the bar, a patio with seating at the front, and an attractive beer garden add to the appeal at this picturesque and welcoming pub. Live events are hosted in a semi-permanent marquee. Local CAMRA Pub of the Year 2022. Q🚳🕮🍴🅐♣🅟😊

St Just

Star Inn ✅
1 Fore Street, TR19 7LL
☎ (01736) 788767
St Austell Cornish Best Bitter, Tribute, Proper Job; 3 changing beers (sourced regionally; often Bath Ales, St Austell) Ⓗ
How pubs used to be: there is no food here, just excellent beer and friendly banter. The atmospheric main bar is enhanced by its dark, quirky décor, open fire and mining and rowing artefacts. The wood-beamed ceiling is adorned with flags, mostly of the Celtic nations. A room opposite doubles as a meeting place for community groups, and there is an enclosed beer garden at the rear. Live music features on occasional Saturdays, with a popular open mic night every Thursday.
🚳😊♿🅐🚐😊🛜

St Kew Highway

Red Lion Inn Ⓛ
PL30 3DN (just off A39)
☎ (01208) 841271 ⊕ redlionstkew.com
St Austell Tribute; 2 changing beers (sourced locally; often Padstow) Ⓗ

Central to community activities is this picturesque family-run 17th-century pub. Its L-shaped single-bar interior divides distinctly in two – the front area mainly for drinking, though it includes an elevated dining space, and the rear a restaurant for more leisurely dining. An appealing food menu includes tapas and local produce. Comfortable furnishings and open fires contribute to the cosy, relaxed ambience. Up to three ales are offered from Cornwall or Devon breweries. Interesting freshly cooked meals feature local produce. There is a large car park at the rear. Q ♿ 🎵 🍽 ◑ ▶ ♣ P 🚆 (95) 🐾 🛜

St Mabyn

St Mabyn Inn

Churchtown, PL30 3BA

☎ (01208) 841266 ⊕ stmabyninn.com

Sharp's Doom Bar; Tintagel Cornwall's Pride, Arthur's Ale; 1 changing beer (sourced locally) Ⓗ

Next to the church stands this attractive 17th-century free house, the village local where conversation thrives. A charming traditional pub, it features a single bar with adjoining snug, games room, well-appointed restaurant and extensive beer garden. Open fires, wood furnishings including settles, stained-glass partitions and windows add character, complemented by an interesting collection of toby jugs, horse brasses and vintage advertising. With four quality ales, local cider and an ever-changing food choice, this pub is well worth seeking out. Q ♿ 🎵 🍽 ◑ ♿ Å ♣ ♠ P 🚆 (55) 🐾 🛜

St Mary's

Atlantic

Hugh Street, TR21 0PL

☎ (01720) 422417 ⊕ atlanticinnscilly.co.uk

St Austell Tribute, Proper Job, Hicks; 1 changing beer (sourced regionally) Ⓗ

Don't be put off by the 'restaurant' sign outside – this is a busy pub and hotel. The spacious open-plan interior has distinct drinking areas and a separate dining room offering a good range of food – bar meals are also available. Food is an important part of the operation but this also a good pub for beer and conversation. Children are welcome until 9pm. A small patio to the rear overlooks the harbour. Q ♿ 🎵 🚲 ◑ ▶ Å 🐾 🛜

St Mawgan

Falcon Inn Ⓛ

TR8 4EP (near Newquay airport, in village centre)

☎ (01637) 860225 ⊕ thefalconinnstmawgan.co.uk

Dartmoor Legend; Sharp's Original; 1 changing beer (sourced locally; often Tintagel) Ⓗ

Sixteenth-century stone-built inn nestling in a tranquil village near Cornwall International Airport, offering a quiet retreat not far from the bustle of Newquay. The single bar interior exudes a warm, welcoming atmosphere for locals and visitors alike. Meals are served in the restaurant, bar and covered garden. A July beer festival is usually held in the garden. Opposite the pub is an interesting church with Carmelite convent behind a walled garden. There are only two buses a day on weekdays, three on Saturday. Q ♿ 🎵 🚲 ◑ ♣ P 🚆 (A5) 🐾 🛜

Saltash

Cockleshell

73 Fore Street, PL12 6AF

☎ 07776 343673

House beer (by Atlantic); 3 changing beers (often Harbour, Summerskills, Treen's) Ⓖ

This independently owned micropub in the centre of Saltash was newly opened in the summer of 2020 in a converted retail unit. It has no TV, loud music or electronic gaming machines to distract from the convivial environment. A selection of unusual real ales and ciders can be found here, plus a range of wines and gins. National brands of lager are also on offer as well as five craft/keg beers. Q ⇌ ♣ 🚆 🐾

South Petherwin

Frog & Bucket

PL15 7LP (just off B3254)

☎ (01566) 776988 ⊕ frogandbucket.co.uk

5 changing beers (sourced nationally) Ⓗ

Roomy purpose-built village pub, opened in 1989 despite local opposition, and now providing a friendly focus for community social life and a warm welcome to all ages. Up to five varying guest ales are on offer. Off the main bar are a separate lounge, games room and two other rooms, one of which doubles as a restaurant and function room. Offering fine Dartmoor views, the pub is a meeting place for vintage vehicles in summer. Q ♿ 🎵 ◑ ♿ ♣ ♠ P 🚆 (235,236) 🐾 🛜

Tintagel

Olde Malt House

Fore Street, PL34 0DA

☎ (01840) 770461 ⊕ malthousetintagel.com

Tintagel Castle Gold, Cornwall's Pride, Harbour Special Ⓗ

This charming 14th-century inn retains many of its original features. Located in the heart of the historic village of Tintagel, it has a suntrap front courtyard offering country views and spectacular sunsets. The pub serves three real ales from the local brewery and offers a varied food menu featuring Cornish produce. It has three distinct drinking areas, each of which can seat up to 20 people. Accommodation is available at reasonable prices. Q 🎵 🚲 🍽 ◑ Å 🚆 🐾

Towan Cross

Victory Inn Ⓛ

TR4 8BN

☎ (01209) 890359

St Austell Tribute; Skinner's Betty Stogs, Lushingtons; 1 changing beer (sourced locally; often Skinner's) Ⓗ

Welcoming family-run free house, well worth a visit, where you can enjoy fine Cornish ales and locally sourced quality food. Originally a 17th-century coaching inn, opened to quench the thirst of local miners, it now satisfies numerous locals and tourists alike. Set on the clifftop over Porthtowan, its quaint open-plan single bar interior divides into several drinking and dining areas, extending to a conservatory. The spacious beer garden features raised decking and extensive seating in a restful setting. Q ♿ 🎵 🍽 ◑ ▶ Å ♣ P 🚆 (304,315) 🐾 🛜

Trebarwith Strand

Mill House Inn

PL34 0HD (off B3263, near Tintagel) SX058865

☎ (01840) 770200 ⊕ themillhouseinn.co.uk

Tintagel Castle Gold; house beer (by Tintagel); 1 changing beer (sourced locally; often Sharp's, Tintagel) Ⓗ

Converted 16th-century corn mill and waterwheel set beside a stream in a deep wooded valley. This friendly

inn has a stone-flagged bar area accessible up a flight of steps beside the adjacent drinking terrace. The restaurant is in an extension, offering an imaginative menu that changes daily. While the Mill House is primarily a food and accommodation establishment, drinkers are nevertheless welcome in the bar, with a mix of local beers mostly from nearby Tintagel Brewery. Q🕏🌜🖎◁◑♣P☼❀🛜

Treen (Zennor)

Gurnard's Head 🅛

TR26 3DE (on B3306, Lands End-St Ives coast road)
☎ (01736) 796928 ⊕ gurnardshead.co.uk
3 changing beers (sourced locally; often Firebrand, Skinner's, St Ives) Ⓗ
Situated on the spectacular St Just to St Ives coastal road and close to the South West Coast Path, this welcoming and strikingly coloured inn takes its name from the nearby headland. It has a large bar, cosy snug and stylish restaurant, with open fires, wooden furnishings and local artworks adding to the ambience. Beers are always from Cornish microbreweries, while daily choices in the food menu reflect the availability of local produce. With accommodation available, this is a popular stopover for coast path and moorland walkers. Q🕏🌜🖎◁◑♣♠P🚌(7,16A)❀🛜

Trevaunance Cove

Driftwood Spars ✪

Quay Road, TR5 0RT
☎ (01872) 552428 ⊕ driftwoodspars.co.uk
Driftwood SPARS; 5 changing beers (sourced locally; often Atlantic, Harbour, Tintagel) Ⓗ
Friendly brewpub with accommodation, well worth a visit. A former 17th-century mine warehouse and sail loft, it features three wood-beamed bars on different levels, with lead-light windows and granite fireplaces. The decor is mainly nautical and shipwreck-themed. Upstairs, the restaurant affords panoramic sea views, above that is a cliff beer garden. Over the road, the lower beer garden faces the Driftwood Brewery, whose beers are always on the bar alongside favourite guests. The pub holds three annual beer festivals. Q🕏🌜🖎◁◑&♣♠P🚌(U1A,315)❀🛜

Trewellard

Trewellard Arms 🅛

Trewellard Road, TR19 7TA (on B3318/B3306 jct)
☎ (01736) 788634
4 changing beers (sourced regionally; often Tintagel) Ⓗ
A warm welcome is assured at this family-run free house in what was formerly a mining count house, then a hotel. It has a cosy beamed single bar and a restaurant with a secluded dining space. Log burners enhance the homely atmosphere. Taste of the West award-winning home-cooked food is served. The beer menu varies constantly with up to four regionally sourced ales and two ciders. Outside is a paved patio area where a beer festival is held each May. Q🕏🌜◁◑♠A♣♠P🚌(7,18)❀🛜

Truro

Old Ale House

7 Quay Street, TR1 2HD (near bus station)
☎ (01872) 271122
Skinner's Betty Stogs, Hops 'n Honey, Lushingtons, Porthleven; 2 changing beers (sourced nationally; often Skinner's) Ⓗ

This friendly and lively city-centre pub is Skinner's brewery tap. A former milliner's shop, the lower main bar is mainly for the casual drop-in drinker. It is atmospheric with beamed ceilings, subtle lighting, wooden flooring, various artefacts and plentiful seating. Up to six real ales and several ciders are offered, plus an impressive range of craft ales and 14 foreign beers. Upstairs is a quieter drinking area and function room. Customers may bring their own food. Live music features weekly. Q🕏&♣♠🖳❀🛜

Rising Sun

Mitchell Hill, TR1 1ED
☎ (01872) 240003 ⊕ therisingsuntruro.co.uk
Fuller's London Pride; Skinner's Betty Stogs, Porthleven Ⓗ**; 1 changing beer (sourced locally)** Ⓖ
Near the city centre up a steep hill, this award-winning hostelry is worth seeking out. Its narrow frontage belies a spacious interior accommodating a small public bar with adjacent dining area, a lounge bar, and a raised restaurant section. Outside is a sheltered patio where periodic beer festivals are held. The pub is comfortably furnished throughout, its decor including old Truro scenes. The ever-changing beer menu offers up to four ales, two dispensed straight from casks. The popular food menu features locally sourced ingredients – booking is advised. Q🕏🌜◁◑♣♠P🖳❀🛜

Tywardreath

New Inn 🅛

Fore Street, PL24 2QP
☎ (01726) 813901
Bath Ales Gem Ⓖ**; Draught Bass; St Austell Tribute, Proper Job; Timothy Taylor Landlord; 1 changing beer (sourced nationally)** Ⓗ
A classic village pub, built in the mid-18th century by mine owners – a perfect example of a community local and the hub of village life. Groups meet here regularly and fêtes are held in the extensive gardens. Although tied to a brewery, the pub is covenanted to sell Draught Bass in perpetuity, and there will also be a guest beer. Pub games, good conversation and regular live music provide the entertainment. There is a separate restaurant area to the rear. Q🕏🌜◁◑A P🚌(24,25)❀🛜

Vogue

Star Inn 🅛 ✪

St Day Road, TR16 5NP (on Redruth-St Day road)
☎ (01209) 820242 ⊕ starinnvogue.biz
5 changing beers Ⓗ
This innovative community village inn hosts a library branch, hairdressing salon, boules court, campsite, meetings and social events, plus music, quizzes and karaoke. Lively, welcoming and family friendly, the pub slakes the thirst of a diverse custom, offering an ever-changing range of beers, plus good quality home-cooked food for the hungry. The cosy, relaxed and characterful interior accommodates a single bar, quiet lounge and separate restaurant. Outside are sheltered seating, an extensive garden with marquee and ample parking. Worth seeking out. Q🕏🌜◁◑&A♣♠P🚌(47)❀🛜

Zennor

Tinner's Arms

TR26 3BY (off B3306 St Ives-St Just coast road)
☎ (01736) 796927 ⊕ tinnersarms.com
House beer (by Sharp's); 2 changing beers (sourced locally; often Firebrand) Ⓗ

Popular with locals, walkers and tourists, this ancient granite inn is nestled next to the church, in a picturesque village with links to local mermaid legends and DH Lawrence. It is an atmospheric pub in an idyllic setting. The single bar has a warm ambience enhanced by exposed wood, granite walls and rustic furnishings. There is also a suntrap beer garden. The adjacent restaurant features local produce – booking is recommended. ⏰⌖✉◁🍴🍴🅿🚏(77,16A) ✿☎

Breweries

Ales of Scilly

2b Porthmellon Industrial Estate, St Mary's, Isles of Scilly, TR21 0JY ☎ **07737 721599** ⊕ **alesofscilly.co.uk**

⊗ Opened in 2001, Ales of Scilly is the most south-westerly brewery in Britain. Several island pubs and restaurants are regularly supplied, plus the occasional mainland pub outlet and beer festival. Special one-off beers are produced in celebration of significant island events. Most real ale output occurs during the busier holiday months (March-October). ‼🛒◆

Challenger (ABV 4.2%) BITTER
Amber best bitter with faint malt and hop nose. A refreshing, light beer with apricot flavours throughout and gentle malty bitterness.

Atlantic

Treisaac Farm, Treisaac, Newquay, Cornwall, TR8 4DX ☎ **(01637) 880326** ⊕ **atlanticbrewery.com**

⊗ Specialist microbrewery producing organic and vegan ales. All ales are unfiltered and finings-free. There are eleven core brews including four food-matched dining ales developed with Michelin recognised chef Nathan Outlaw. Casks are supplied locally and to London, with bottle-conditioned beers available nationally. ◆LIVE V

Soul Citra (ABV 4%) PALE
Azores (ABV 4.2%) GOLD
Unfined golden ale. Citrus and resinous hops dominate the aroma and taste with tropical fruits. Refreshing bitter and dry finish.
Earl Grey PA (ABV 4.5%) SPECIALITY
Cloudy, amber, organic, speciality ale. Hop aroma leads to powerful citrus fruit flavours becoming intense. Fairly bitter and dry.
Elderflower Blonde (ABV 4.5%) SPECIALITY
Pale yellow, light, crisp floral beer with elderflower nose. Elderflower and gooseberry fruits with soft citrus and pine hops flavours.
Mandarina Cornovia (ABV 4.5%) SPECIALITY
Pale gold speciality beer with full mandarin citrus fruit flavour matched by firm biscuit malt and resin/earthy hop notes.
Masala Chai PA (ABV 4.5%) SPECIALITY
Sea Salt Stout (ABV 4.5%) SPECIALITY
Coffee stout. Roast malt, chocolate and toffee aroma. Complex smoky malt with underlying resinous hops, salt and sweet stone fruits.
Simcotica (ABV 4.5%) GOLD
Blue (ABV 4.8%) PORTER
Smooth, rich porter with heavy roast malt aroma and taste. Smoky liquorice, bitter coffee and chocolate flavours with sweet fruit.
Honey Ale (ABV 4.8%) SPECIALITY
Fistral Pilsner (ABV 5.2%) SPECIALITY
Full-flavoured, copper wheat beer. Sweet, stone-fruit flavours blend with biscuit malt and citrus hops. Malt finish with hops and dryness.

Black Flag

Unit 1D, New Road, Perranporth, Cornwall, TR6 0DL ☎ **(01872) 858004** ⊕ **blackflagbrewery.com**

⊗ Black Flag began brewing in 2013 and relocated to Perranporth in 2019. A new eight-barrel plant was installed in 2020 and the brewery began producing a wider range of beer styles, all unfined and unpasteurised, available in cans, bottles and kegs. A small amount of cask-conditioned beer is often available in the taproom during summer months. ◆LIVE V⌀

Blue Anchor

🏠 **50 Coinagehall Street, Helston, Cornwall, TR13 8EL** ☎ **(01326) 562821** ⊕ **spingoales.com**

⊛A family-run, 15th century, thatched brewpub, the oldest continuously brewing in the country. Home of the famous Spingo ales, which are produced from the well water beneath the pub. All regular brews are also available bottle-conditioned. ‼◆LIVE

Flora Daze (ABV 4%) BITTER
Pale brown bitter with light flowery aroma, caramel and balanced malt, fruit and hops in the mouth. Lingering bitter finish.
Jubilee IPA (ABV 4.5%) PALE
Amber, premium bitter with malty, fruity hop nose and taste, balanced by fresh hop bitterness. Gentle bitter finish with sweet malt.
Ben's Stout (ABV 4.8%) STOUT
Creamy dark stout with coffee roast aroma. Roast malt with liquorice and cherry flavours. Bittersweet finish with apples and cloves.
Spingo Middle (ABV 5%) BITTER
Heavy, tawny ale with dominant malt and balancing peppery hop bitterness. Nuts, spices and dates flavours. Long, malty, earthy finish.
Spingo Special (ABV 6.6%) STRONG
Smooth, red, strong ale. Red wine aroma. Kaleidoscope of powerful sweet stone fruits, smoky malt and hop flavours. Vinous and earthy.

Bluntrock

Pityme Industrial Estate, St Minver, Wadebridge, Cornwall, PL27 6NS

Office: 1a Eddystone Road, Wadebridge, PL27 7AL ⊕ **bluntrockbrewery.co.uk**

This nanobrewery commenced brewing in three converted shipping containers in 2021, as Lowlands Brewing. It re-branded to Bluntrock in 2022. ⌀

Castle SIBA

Unit 9A, 7 Restormel Industrial Estate, Liddicoat Road, Lostwithiel, Cornwall, PL22 0HG ☎ **07880 349032** ⊕ **castlebrewery.co.uk**

⊗ The brewery was established in 2007 using a one-barrel plant. A new 200-litre plant was added in 2016. All brews are unfined and are suitable for vegetarians/vegans. The brewery carries out its own bottling, and some for other breweries. 🛒◆LIVE V

Golden Gauntlet (ABV 4%) GOLD
Light, golden bitter with gentle fruity nose. Heavy malt and bitter taste dominate the fruity hop, persisting into the finish.
Restormel Gold (ABV 4.1%) PALE
Cornish Best Bitter (ABV 4.2%) BITTER
Once A Knight (ABV 5%) BITTER

Cornish Crown

End Unit, Badger's Cross Farm, Badger's Cross, Penzance, Cornwall, TR20 8XE
☎ (01736) 449029 ☎ 07870 998986
⊕ cornishcrown.co.uk

⊗ This six-barrel brewery was launched in 2012 on a farm high above Mounts Bay by the brewer, and landlord, of the Crown Inn, Penzance, which acts as the brewery tap. Beer is available locally and as far as the Southampton Arms in London. ‼LIVE ◆

Causeway (ABV 4.1%) BITTER
Tawny bitter with a malty caramel nose. Initially malty with resinous hop bitterness gradually emerging. Stone fruits. Long, bitter finish.

Red IPA (ABV 5.9%) SPECIALITY
Strong, tawny, speciality ale. Resinous hops, biscuit malt, with plums, raspberries and oranges and later smoky hints. Long, fruity finish.

Dowr Kammel

Deaconstowe, Lower Lank, St Breward, Cornwall, PL30 4PW ☎ 07774 427635

Office: 9 Tregarne Terrace, St Austell, Cornwall, PL25 4DD ✉ dowrkammel@btinternet.com

⊗ Brewing began in 2016. A small number of local free houses are supplied. LIVE

Blisland Gold (ABV 3.9%) BLOND
Light blond ale with strong citrus aroma. Dominant citrus and grassy hops with summer fruit sweetness. Long, bitter hop finish.

Demelza (ABV 4.2%) BITTER

Devil's Jump (ABV 4.6%) GOLD
Balanced, golden best bitter with malt and hops aroma. Assertive malt and bitterness in the mouth with smooth, zesty lemon hops.

Driftwood Spars SIBA

🍺 Driftwood Brewery, Trevaunance Cove, St Agnes, Cornwall, TR5 0RY
☎ (01872) 552591 ⊕ driftwoodsparsbrewery.com

⊗ Established in 2000, production on the custom-built, five-barrel plant expanded with the installation of additional fermentation and conditioning capacity. Annual production now stands at 1,500 barrels. A small batch beer range named Cove is produced, from which a portion of sales income is donated to local charities.
‼🍴◆LIVE

Bawden Rocks (ABV 3.8%) BITTER
Refreshing amber bitter. Grassy/honey aromas. Malt and citrus/resin hop taste with honey and stone fruits. Long dry finish.

Spars (ABV 3.8%) BITTER
Refreshing session bitter with a balance of sweet malt and earthy hops, hedgerow and stone fruit flavours. Rising bitter finish.

Blue Hills Bitter (ABV 4%) BITTER
Amber with caramel malt aroma. Refreshing balance of non-citrus hops and malt. Long bitter finish with a little dryness.

Bolster's Blood (ABV 5%) PORTER
Dark brown porter. Coal-smoke and peaty malt flavour with dark chocolate and dried fruits. Bitterness and burnt malt persist.

Lou's Brew (ABV 5%) GOLD
Golden beer laden with orange and grapefruit flavours, spice notes and some malt. Tropical fruit aromas and long-lasting tangy bitterness.

Alfie's Revenge (ABV 6.5%) STRONG
Rich strong red ale with dominant malt aroma and flavour. Kaleidoscope of dried and stone fruit, bitter-sweet flavours. Long, dry finish.

Dynamite Valley

Units 5 & 6, Viaduct Works, Frog Hill, Ponsanooth, Cornwall, TR3 7JW
☎ (01872) 864532 ☎ 07990 887613
⊕ dynamitevalley.com

⊗ Dynamite Valley was set up in 2015 following a successful crowdfunding campaign and is located close to a historic gunpowder site near Falmouth. Beers are influenced by European and US beer styles. The brewery has expanded into bottling and canning. It has acquired the Rebel Brewery brand name and beers. 🍴

Gold Rush (ABV 4%) BITTER
Smooth, gold bitter with light malt nose. Malt dominates throughout with bitterness, honey, lemon and apricot flavours. Long, malty, bitter finish.

Ambrys Cornish Amber Ale (ABV 4.3%) BITTER

Kennall Vale Pale (ABV 4.3%) PALE

Viaduct Pale Ale (ABV 4.4%) PALE
Yellow pale ale with grapefruit and toffee aroma. Bitter citrus and pineapple hops and biscuit malt flavours with barley sugar.

TNT IPA (ABV 4.8%) PALE
Robust, amber, American IPA with malt and fruity hop aroma. Heavy, hop bitter taste with sweet toffee apples and malt balance.

Black Charge (ABV 5%) STOUT
Black, oatmeal-style, sweet stout. Powerful flavours of roast coffee, dark chocolate, malt and molasses throughout. Smooth but short finish.

Frog Hill Cornish IPA (ABV 6%) IPA

Firebrand SIBA

Unit 2, Southgate Technology Park, Pennygillam Industrial Estate, Launceston, Cornwall, PL15 7ED
☎ (01566) 86069 ⊕ firebrandbrewing.co.uk

⊗ Formerly known as Penpont and also as Altarnun, Firebrand began brewing in 2008 and has steadily increased its range and production since then. The award-winning brewery currently uses a 25-barrel plant, with an eight-barrel plant for special brews. Beers are available in pubs across Cornwall. ‼🍴◆LIVE

Big Hop, Little Beer (ABV 3.6%) BITTER

Cross Pacific Pale Ale (ABV 4%) PALE

Graffiti IPA (ABV 5%) PALE

Brewed under the Penpont Ales brand name:

St Nonna's (ABV 3.7%) BITTER
Tawny session bitter with floral nose and balanced malt and hop bitterness throughout with roast and sweet notes. Bitter finish.

Cornish Arvor (ABV 4%) BITTER
Golden bitter with good malt and pine/resin/earth hop presence. Complex mix of stone fruit and esters. Dry finish.

Creation Pale Ale (ABV 4.2%) PALE
Gold bitter with hop aroma. Quite hoppy taste with sweet peach, citrus zing and roast malt. Bitter, slightly dry finish.

Shipwreck Coast (ABV 4.4%) PALE
Gold bitter with sweet malt well-balanced by citrusy/tropical fruits hop flavour. Dry finish.

Roughtor (ABV 4.7%) BITTER
Copper strong ale with malt and citrus hop aroma. Hop bitterness balanced by malt, plum and marmalade. Bitter, dry finish.

Beast of Bodmin (ABV 5%) BITTER
Tawny, strong ale. Burnt sugar, tobacco and leather with stone fruit flavour. Mellow toffee/caramel and earthy hop finish.
Stormer IPA (ABV 5.2%) PALE

Forge

Wilderland, Woolley Cross, Cornwall, EX23 9PW
☎ (01288) 331669 ☎ 07837 487800

⊠ This multi-award-winning brewery was set up near Bideford in Devon by Dave Lang, who commenced brewing in 2008 using a five-barrel plant. The brewery relocated to Cornwall in 2017. ◆LIVE

Discovery (ABV 3.8%) BITTER
Gold-coloured bitter bursting with hops from start to finish. Some subtle hints of fruit to the discerning palate too.
Blonde (ABV 4%) BLOND
Pale ale with light citrus aroma. Zesty citrus hop in the mouth balanced by a little malt. Bitter and dry.
Litehouse (ABV 4.3%) PALE
Pale ale with faint tropical fruit hop aroma. Light balance of sweet malt and hop bitterness fading into a short finish.
IPA (ABV 4.5%) PALE
Rev Hawker (ABV 4.6%) BITTER
Tamar Source (ABV 4.6%) BITTER
Premium bitter with malt and earthy hop aroma. Dominant crystal malt with bitterness and sweet stone fruit flavours. Bitterness rises.

Goodh

Unit 3, Moorland Road Business Park, Indian Queens, Cornwall, TR9 6GX
☎ (01726) 839970 ☎ 07834 407964
⊕ goodhbrew.com

Formerly called Woodman's, the name changed to Goodh Brewing after former owner and head brewer, Stuart Woodman, left in 2021. Now under management of new owner Louis Simpson. It now focuses on canned and kegged beers with numerous variations and names, IPAs dominating. The brewery opened a taproom in Truro (The Old Print Works) serving its own beers, guests (keg), and food. ➤

Harbour

Trekillick Farm, Kirland, Bodmin, Cornwall, PL30 5BB
☎ (01208) 832131 ☎ 07870 305063
⊕ harbourbrewing.com

⊠ Harbour is an innovative brewery founded on the outskirts of Bodmin in 2011. Brewed using local spring water, the regular beers are established in an increasing number of outlets. A new 30-barrel plant was installed in 2016, and more conditioning tanks in 2017. The brewery produces cask and keg beers. Bottling and canning is done on-site (no RAIB). ◆

Light (ABV 3.7%) BLOND
Yellow beer with citrus hop aroma. Dominant zesty citrus hops with some pineapple and pear drops. Long hoppy finish.
Daymer Extra Pale (ABV 3.8%) PALE
Pale ale with citrus aroma. Lemon and lime dominate with grainy malt and earthy hop. Bitterness remains, sweetness fades, becoming dry.
Amber (ABV 4%) BITTER
Pale brown bitter with a floral hop aroma and malt. Biscuit malt throughout with apple, peach and plum, balanced by hops.
Cornish Bitter (ABV 4%) BITTER

Amber session bitter with fruity aroma. Sweet tropical and faint citrus flavours with apple and robust biscuit malt. Bitter finish.
New Zealand Gold (ABV 4.2%) GOLD
Golden ale with light hop nose. Strong pine needle hop flavour. Bitter, sweet and dry throughout.
Ellensberg (ABV 4.3%) PALE
Amber ale with powerful tropical and citrus aroma. Strong juicy mango and grapefruit flavour. Both sweet and bitter. Long finish.
Session IPA (ABV 4.3%) PALE
India Brown Ale (ABV 4.9%) BROWN
Smooth copper beer. Heavy body and balanced sweet malt and bitter hop flavour, with plums, prunes and some butterscotch.
IPA (ABV 5%) GOLD
Amber American IPA with powerful citrus hop aroma and taste. Marmalade, red grapefruit and orange flavours with assertive bitterness.
Panda Eyes (ABV 5%) SPECIALITY
Puffin Tears (ABV 5%) BITTER
Cascadia (ABV 5.2%) BITTER
Light no2 (ABV 5.2%) BITTER
Antipodean IPA (ABV 5.5%) IPA
Little Rock IPA (ABV 5.5%) IPA
Porter (ABV 5.5%) PORTER
Smooth, creamy, black porter with roast malt aroma. Malty, smoky and sweet followed by a bitter tang. Sweet finish.
Hellstown West Coast IPA (ABV 5.8%) IPA
Harbour Pale (ABV 6%) IPA
New World IPA with powerful citrus hop aroma. Intense citrus hop flavour with marmalade, orange and bitterness. Hoppy, slightly dry finish.

Keltek SIBA

Candela House, Cardrew Way, Redruth, Cornwall, TR15 1SS
☎ (01209) 313620 ⊕ keltekbrewery.co.uk

⊛Keltek (Celtic in Cornish) began brewing award-winning ales by Stuart Heath. It started as a 2.5-barrel plant in Stuart's disused stable block on the Roseland Peninsula. Several moves and expansions mean it is now based in Redruth, and can brew more than 250 barrels a week. In 2013 Keltek acquired four pubs in south-west Cornwall (the second brewery in Cornwall to own an estate of pubs). Two more were acquired in 2016. ➤◆

Even Keel (ABV 3.4%) BITTER
Pale brown session bitter. Refreshing malt and hop taste with apple, plum and pear drops. Gentle dry and bitter finish.
Lance (ABV 4%) PALE
Gold bitter with light fruity aroma. Grassy citrus hops, apples, malt and hints of elderflower and butterscotch. Long bitter finish.
Magik (ABV 4%) BITTER
Pale brown bitter with smoky malt and zesty hop aroma. Sweet, woody malt with spicy and orange marmalade hop flavours.
King (ABV 5.1%) BITTER
Copper-coloured premium bitter with a mix of malt and hop aromas. Biscuit malt balanced by tropical and citrus hops.
Reaper (ABV 6%) BITTER
Beheaded (ABV 7.5%) STRONG
Tawny, strong old ale with a balanced heavy body. Rich vine fruit accompanied by plum, raisin, apple and sherry flavours.

Krow

Penventon Terrace, Redruth, Cornwall, TR15 3AD
✉ contact@krowbrewing.co.uk

Microbrewery established in Redruth. The head brewer gained experience brewing with several breweries in Cornwall, having initially started out as a homebrewer. It is currently producing small-batch brews and developing a core range.

Lacuna

Unit 19, Kernick Industrial Estate, Penryn, TR10 9EP
⊕ lacunabrewing.com

Owners Tristan and Ben's ethos for Lacuna Brewing is simple and sustainable, being committed to reaching zero carbon brewing as soon as possible. Three canned beers are available. Its taproom is open every Saturday. No real ale. ✦

Lizard

The Old Nuclear Bunker, Pednavounder, Coverack, Cornwall, TR12 6SE
☎ (01326) 281135 ⊕ lizardales.co.uk

⊗ Launched in 2004 in St Keverne, Lizard Ales is now based at former RAF Treleaver, a massive disused nuclear bunker in the countryside near Coverack on the Lizard Peninsula. Specialising in bottle-conditioned ales, it mainly supplies local shops and pubs. ‼LIVE

Longhill

Longhill Cottage, Whitstone, Holsworthy, Cornwall, EX22 6UG
☎ (01288) 341466

⊗ Longhill began brewing in 2011 using a 0.5-barrel plant, upgraded in 2012 to a four-barrel plant to meet demand. Paul and Sue brew one beer, available in the bar at the rear of the brewery.

Hurricane (ABV 4.8%) BITTER
Full-bodied, tawny, premium bitter with earthy malt aroma. Quite bitter with fruit and resinous hop flavours. Refreshing and persistent bitterness.

Mine (NEW)

The Brewery, Consols, St Ives, TR26 2HW
☎ (01736) 793001 ☎ 07500 957962
✉ minebrew@outlook.com

☺A recent start-up nanobrewery located in St Ives, Cornwall, brewing small batch beers available in cask, bottle and an occasional keg. It is hoped to install a new larger capacity kit during the currency of this Guide. ♦LIVE

Mild (ABV 3.1%) MILD
Consols (ABV 3.7%) BITTER
Ransom (ABV 4.2%) PALE
Cousin Jack (ABV 4.6%) PALE
Mines Best (ABV 4.6%) BITTER
In Vein (ABV 4.7%) STOUT
Adit (ABV 6%) IPA

Newquay Brewing Project (NEW)

Unit 3F, 3-4 Restormel Industrial Estate, Liddicoat Road, Lostwithiel, Cornwall, PL22 0HG ☎ 07720 399942 ⊕ newquaybrewingproject.com

After travelling the world, owners Ash and Kez purchased the eight-barrel former Fowey brewplant to brew a range of beer styles similar to those they enjoyed while travelling. They are trying to be as carbon neutral and environmentally friendly as possible, without compromising on flavour. A small but growing range of three beers are all vegan-friendly, unfined and unpasteurised and are available can-conditioned or in kegs. A taproom in Newquay is planned. LIVE V

Newquay Steam

▤ New Inn, Newquay Road, Goonhavern, Cornwall, TR4 9QD

Newquay Steam Brewery commenced in 2020. Three beers, one cider, a rum and gin are currently produced under the name.

Padstow SIBA

The Brewery, Unit 4a, Trecerus Industrial Estate, Padstow, Cornwall, PL28 8RW
☎ (01841) 532169 ☎ 07834 924312
⊕ padstowbrewing.co.uk

⊗ Owners Des and Caron Archer established the brewery in 2013, using a 0.5-barrel plant, which has since been upgraded to 10 barrels. Besides the integral brewery shop, two licenced town-centre tasting rooms have been established. ‼▰♦LIVE

Pale Ale (ABV 3.6%) PALE
Thin golden beer. Citrus hops dominate flavours with bitter grapefruit, sweet tropical fruits and a trace of malt. Lingering finish.

Padstow Local (ABV 4%) BITTER
Amber session bitter with a fruity aroma. Dominant apricot and bitter flavour with some biscuit malt. Long, sweet, fruity finish.

Windjammer (ABV 4.3%) BROWN
American brown ale with dominant malt plus summer and citrus fruits. Distinct malt and citrus aroma. Bitter and dry finish.

IPA (ABV 4.8%) PALE
Refreshing IPA. Fully-hopped on nose and taste with orange bitterness. Sweet finish with citrus hops and faintly dry.

Padstow May Day (ABV 5%) PALE
Premium gold/yellow ale with mango and other tropical fruit leading aromatic citrus hops. Gentle malt sweetness and quite bitter.

Penzance

Star Inn, Crowlas, Cornwall, TR20 8DX
☎ (01736) 740375 ☎ 07763 956333
⊕ penzancebrewingcompany.co.uk

⊗ Owner Peter Elvin began brewing in 2008 on a self-built, five-barrel plant in the old stable block of the Star Inn. Following expansion, full production now exceeds 1,400 barrels a year. Production now includes bottled core range beers. ‼♦

Mild (ABV 3.6%) MILD
Creamy dark brown mild, chocolate and roast aroma. Coffee and chocolate dominate the taste with fruit notes, bittersweet, balanced finish.

Crowlas Bitter (ABV 3.8%) BITTER
Refreshing, copper, session bitter with light malt aroma. Light biscuit maltiness and hops. Lingering finish of malty bitterness with dryness.

Potion No 9 (ABV 4%) PALE
Refreshing pale ale. Grapefruit and tropical fruit flavours dominate with some pine resin notes, biscuit malt and flashes of bubblegum esters.

Crows-an-Wra (ABV 4.3%) BLOND

Golden beer with citrus hoppy aroma. Grapefruit bitter hops dominate the long-lasting taste with underlying malt and a little dryness.

Brisons Bitter (ABV 4.5%) BITTER
Full-bodied, tawny bitter with malt aroma. Biscuit malt dominates the taste with robust sweetness, fruit esters and hop bitterness.

Trink (ABV 5.2%) BLOND
Blond ale with grapefruit nose. Punchy pine-resin hop flavours with grapefruit, marmalade and peaches. Dry, bittersweet and hoppy finish.

Zythos (ABV 5.3%) GOLD

IPA (ABV 6%) IPA
Smooth, golden, genuine IPA with hoppy aroma. Powerful hop bitterness with light malt and tropical fruits, finishing bitter and dry.

Scilly Stout (ABV 7%) STOUT
Black, full-bodied, creamy stout with chocolate aroma. Chocolate roast malt with liquorice and plums. Long finish with strong roast malt.

Pipeline

Great Western Railway Yard, St. Agnes, TR5 0PD
☎ 07973 178877 ⊕ pipelinebrewing.co.uk

Pipeline Brewing Co crafts small batches of vibrant, hoppy beers on the North Cornwall coast. Using fresh ingredients and Cornish water, it creates craft beers that showcase the best of New World hops. 🍺✦

Point Break

Trevelmond, Liskeard, Cornwall, PL14 4LZ
⊕ pointbreakbrewery.com

Established near Liskeard, Cornwall, in mid-2020 during the pandemic. Four bottled beers are brewed in small batches on its 65-litre plant. All bottle labels use uncoated paper and are plastic-free. The brewery supports Surfers Against Sewage. LIVE

St Austell SIBA IFBB

63 Trevarthian Road, St Austell, Cornwall, PL25 4BY
☎ (0345) 241 1122 ⊕ staustellbrewery.co.uk

⊕Founded in 1851, St Austell brewery remains fully independent and family-owned. Cask ale is available in all its pubs, and is widely available nationally. St Austell also brews limited edition cask beers throughout the year as well as a range of keg and bottled beers. A ten-barrel, small-batch plant is used to brew regular beers for its Cask Club (available in 40 selected outlets, and at its Hicks Bar), and to make a range of experimental bottle beers. In 2016 it purchased Bath Ales (qv). ‼🍺✦LIVE✦

Cornish Best Bitter (ABV 3.5%) BITTER
Light, refreshing bitter with malt aroma. Gentle biscuit malt and hops flavour with fruity bitterness. Malty, bitter, faintly dry finish.

Anthem (ABV 3.8%) GOLD

Nicholson's Pale Ale (ABV 4%) PALE
Copper bitter. Hops dominate the taste with citrus and tropical fruits and malt. Dry bitterness rises in the finish.

Tribute (ABV 4.2%) BITTER
Amber bitter with malt and fruity hop aroma. Dominant hop bitterness balanced by sweet malt, ending refreshingly bitter and fruity.

Proper Job (ABV 4.5%) GOLD
Smooth premium golden ale with citrus hop aroma. Copious citrus fruits with bitterness, dryness and crisp hop bitter and grapefruit finish.

Hicks (ABV 5%) BITTER

Tawny premium bitter with malt nose. Powerful malt and vine fruit flavour with balancing bitterness. Long, malty and floral finish.

St Ives SIBA

Unit 5, Marsh Lane Industrial Estate, Hayle Industrial Park, Hayle, TR27 5JR
☎ (01736) 793467 ☎ 07702 311595

St Ives: Trewidden Road, St Ives, Cornwall, TR26 2BX
⊕ stives-brewery.co.uk

⊗ Originally located in St Ives, it purchased a larger site in Hayle with a state-of-the-art, 25-barrel plant as the main brewery. The new site also incorporates a taproom, café and shop. The original two-story site in St Ives remains for test brewing, and acts as a tourist attraction. The brewery has also established a St Ives town-centre tasting room and shop. ‼🍺✦LIVE✦

Hella Pale (ABV 4.2%) PALE
Porth Pilsner (ABV 4.4%) SPECIALITY
Meor IPA (ABV 4.8%) PALE
Slipway (ABV 5%) PALE
Alba IPA (ABV 5.2%) PALE
Back Road East NEIPA (ABV 5.8%) IPA
Back Road West (ABV 6.5%) IPA

Seven Stars SIBA

▤ **Seven Stars, 73 The Terrace, Penryn, Cornwall, TR10 8EL**
☎ (01326) 531398 ⊕ sevenstarspenryn.co.uk

Brewing began in 2020 using a 2.5-barrel plant. The brewery is located in an outbuilding of the Seven Stars pub, adjacent to the beer garden. Beers appear in the pub under the Hidden Brewery brand name.

Sharp's

Pityme Business Centre, Rock, Cornwall, PL27 6NU
☎ (01208) 862121 ⊕ sharpsbrewery.co.uk

⊗ Sharp's was founded in 1994 and within 15 years had grown from producing 1,500 barrels a year, to 60,000. It was bought by Molson Coors in 2011. Heavy investment has brought the capacity up to 200,000 barrels a year. The company owns no pubs and delivers beer to more than 1,200 outlets across South England via temperature-controlled depots in Bristol and London. Part of Molson Coors PLC. 🍺✦LIVE

Cornish Coaster (ABV 3.6%) BITTER
Pale brown bitter with malt and tropical fruit nose. Apples, citrus and hedgerow fruits with biscuit malt and caramel notes.

Doom Bar (ABV 4%) BITTER
Amber bitter with sweet taste, balanced biscuit malt and grassy hops. Stone fruits, lemon and raisins. Lingering malty, bitter finish.

Atlantic (ABV 4.2%) BITTER
Amber bitter with citrus hops and caramel aroma. Malt, elderflower and caramel sweetness balanced by grapefruit hops with resin notes.

Original (ABV 4.4%) BITTER
Mid-brown best bitter with pleasant hop and malt aroma. Prune and berry fruits on the palate with smoky malt.

Sea Fury (ABV 5%) BITTER
Smooth, auburn, premium bitter with malt and caramel aromas. Dominant sweet malt with berry, stone and dried fruits with spice hints.

Skinner's SIBA

Riverside, Newham Road, Truro, Cornwall, TR1 2DP
☎ **(01872) 271885** ⊕ **skinnersbrewery.com**

⊠ Award-winning brewery established in 1997. Moving to bigger premises in 2003, with a shop and visitor centre. The 25-barrel plant produces more than 26,000 hectolitres per year. It has now established an external events area featuring a tap-yard bar, sheltered seating, and pop-up street-food venders. ⏸🛒◆⊘

Betty Stogs (ABV 4%) BITTER
Deep amber bitter. Resinous hops balanced by sweet malt and fruit flavours. Sweet malt fades into the long, bitter finish.

Hops 'n Honey (ABV 4%) SPECIALITY
A gold speciality beer containing honey. Balance of light citrus, grassy hops, apple and sweet malt. Pleasant long, dry finish.

Lushingtons (ABV 4.2%) BLOND
Refreshing blond beer. Mango, spicy hops and orange aroma. Tropical fruits dominate the flavour. Long fruity, bitter finish with rising dryness.

Cornish Knocker (ABV 4.5%) PALE
Smooth, golden pale ale. Blend of citrus, floral, piney and earthy hops with biscuit malt and hints of toffee and honey.

Pennycomequick (ABV 4.5%) STOUT
Creamy, dark brown, sweet stout with roast grain aroma. Heavy bitter roast coffee, malt, fig and cherry flavours. Roast, dry finish.

Porthleven (ABV 4.8%) PALE
Robust pale ale with citrus hop aroma. Assertive citrus bitterness with sweet fruity flavours and light malt. Bitter citrus finish.

Tintagel SIBA

Condolden Farm, Tintagel, Cornwall, PL34 0HJ
☎ **(01840) 213371** ⊕ **tintagelbrewery.co.uk**

⊠ Established in 2009 in a redundant milking parlour on the highest farm in Cornwall, using a 7.5-barrel plant. A new purpose-built brewery, shop, restaurant and visitor centre opened in 2017. ⏸🛒◆

Castle Gold (ABV 3.8%) PALE
Refreshing pale ale with malt aroma. Citrus hop, tropical fruits, cherries, sweet malt and dry, bitter flavour. Hop bitter finish.

Cornwall's Pride (ABV 4%) BROWN
Pale brown bitter with malt aroma. Sweet, grainy malt with toffee and summer fruits. Late dried fruit and coffee hints.

Sir Lancelot (ABV 4.2%) BITTER
Arthur's Ale (ABV 4.4%) BITTER
Pale brown complex beer with balance of sweet toffee, malt and earthy hops. Hints of figs, vine fruits and liquorice.

Pendragon (ABV 4.5%) PALE
Golden beer with citrus hop nose. Refreshing, strong grapefruit citrus and pine hop bitterness. Hints of toffee, honey and malt.

Poldark Ale (ABV 4.5%) MILD
Brown, strong mild with malt aroma. Assertive malty flavour with stone fruits, dates, sweet caramel, smokiness and a citrus edge.

Harbour Special (ABV 4.8%) OLD
Tawny old ale with ripe fruity, malty aroma. Rich nutty malt, stone fruits and esters taste, finishing bitter and malty.

Merlins Muddle (ABV 5.2%) BITTER
Auburn, creamy, premium bitter. Spicy hop bitterness balanced by smoky malt flavours and a complex mixture of fruits. Bitter finish.

Caliburn (ABV 5.8%) OLD
Dark old ale. Smoky, roast malt and Christmas pudding fruits with rich and complex flavours including treacle and earthy hops.

Treen's

Unit 3, Viaduct Works, Frog Hill, Ponsanooth, Cornwall, TR3 7JW
☎ **(01872) 719633** ☎ **07552 218788**

Office: 18 St Michael's Road, Ponsanooth, TR3 7EA
⊕ **treensbrewery.co.uk**

⊠ This family-run brewery was founded in 2016, initially using spare capacity at another local brewery. It now has its own premises using a 12-barrel plant. Bottling was introduced in 2018. An additional 12-barrel fermentation vessel was acquired in 2021. ◆

Essential (ABV 3.8%) PALE
Robust, bitter golden pale ale with grassy, peppery hops and biscuit malt flavours. Citrus and stone fruit notes. Long, bitter finish.

Classic (ABV 4.3%) BITTER
Tawny bitter with malt aroma. Robust malt balanced by spicy hop bitterness. Coffee, molasses with light summer and stone fruits.

Sunbeam (ABV 4.8%) PALE
Smooth gold beer. Refreshing citrus, spicy hop and malt flavours with hints of fruits and caramel. Pronounced bitterness. Long, bitter finish.

Resolve (ABV 5.2%) STOUT
Dark brown, strong, sweet stout with dark chocolate aroma. Dominant smoky coffee, bitter chocolate, molasses flavours with malt and stone fruit.

Tremethick

Grampound, Cornwall, TR2 4QY ☎ **07726 427775**
⊕ **tremethick.co.uk**

⊠ Brewing began in 2015, and it is now well established as a small, village brewery with strong community support. Brewery open evenings are popular. ⏸LIVE

Gwella (ABV 3.7%) BITTER
Amber bitter with bready malt and citrus hop aroma. Assertive malt is balanced by citrus hops with candied fruit peel.

Pale Ale (ABV 4.3%) PALE
Gold pale ale with light aroma. Dominant bitter grapefruit and grassy hops, underlying malt and fruit. Long, bitter, citrus finish.

Dark Ale (ABV 4.6%) MILD
Complex, dark brown ale. Nutty malt with kaleidoscope of fruit flavours. Quite sweet with hints of coffee-roast. Faintly bitter and hoppy.

Red IPA (ABV 4.8%) PALE
Auburn bitter with light grapefruit and malt aroma. Grapefruit and marmalade flavours masking malt and other fruits. Long bitter, dry finish.

Verdant

Unit 30, Parkengue, Kernick Road, Penryn, Cornwall, TR10 9EP
☎ **(01326) 619117** ⊕ **verdantbrewing.co**

Verdant was established by keen homebrewers in 2014. It moved to new premises in 2020 and upgraded from a 10-barrel to a new 20-barrel plant. The brewery started producing cask ale in 2020. 🛒◆

Where Can I Find Friday? (ABV 4.2%) PALE
I Remember Having One (ABV 4.4%) PALE

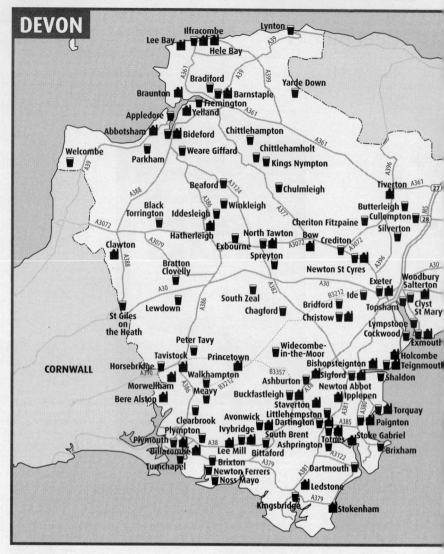

DEVON

Appledore

Champ ⓛ

Meeting Street, EX39 1RJ (just off Appledore Quay)
☎ (01237) 421662
Clearwater Expedition Ale; 3 changing beers Ⓗ
This cosy and quirky pub, open evenings only, is the brewery tap for nearby Clearwater Brewery, with up to four of its ales available. It is renowned for live music, with artists playing on Friday and Saturday, and popular open-mic evenings on Tuesday, Wednesday and Thursday. Customers are welcome to bring in food to eat on the premises. A nearby public car park accommodates camper vans overnight for a modest fee.
🛏️&♣️♠️🚍☀️🛜

Ashburton

Old Exeter Inn ⓛ

26 West Street, TQ13 7DU (on main road through centre of Ashburton, opp church)

☎ (01364) 652013 ⊕ oldexeterinn.com
1 changing beer Ⓖ
This friendly local is the oldest pub in Ashburton, originally built in 1130 to house the workers building the nearby church, with later additions from the 17th century. It has seated areas either side of the entrance, which leads to a wood-panelled L-shaped bar with a granite shelf behind for serving the gravity-fed ales. There are also two rear seating areas and a flagstone-floored corridor leading to the secluded walled garden at the back. Local cider and perry are sold.
Q🛏️🏵️♠️◀️●🚍(88,X38)☀️🛜

Ashprington

Durant Arms

TQ9 7UP (exit Totnes on the A381, left turn signposted after 1500yds)
☎ (01803) 732240 ⊕ durantarms.co.uk
Dartmoor Jail Ale; Noss Beer Works Church Ledge Ⓗ**; 2 changing beers (sourced regionally)** Ⓗ/Ⓖ

and live music. The lounge is now used as a restaurant. Alongside the ale, up to 10 ciders are available from Ashridge, Countryman, Sandford Orchards and Westons. The village is served by Country Bus 91 between Plymouth and Totnes. Closing times may vary depending on custom. ⛁☕🌙🚶♿♣☕P🚃(91)☺

Axminster

Ale Way
Axminster Station, EX13 5PF
☎ 07488 277251 ⊕ thealeway.co.uk
3 changing beers (sourced locally) Ⓗ
The Ale Way micropub stocks a continually changing line of independent real ales, craft beers, ciders and a variety of specialist cans and bottles. A small selection of soft drinks, red and white wine, and a house gin are also available. Housed in part of the station building, the seating inside is on two floors, and the rooms have been tastefully renovated to preserve a railway feel. There are additional tables outside overlooking the platform where you can watch the trains. Q⛁☕🌙♿≠♣☕P🚃☺

Axminster Inn 🍷 Ⓛ
Silver Street, EX13 5AH
☎ (01297) 34947 ⊕ axminsterinn.pub
Palmers Copper Ale, IPA, Dorset Gold, Tally Ho!; 1 changing beer (sourced locally) Ⓗ
The Axminster Inn is a friendly, traditional pub, just outside the town centre, with a real log fire for the winter months and a lovely enclosed beer garden to enjoy in warmer weather. It is a Palmers house, offering a good range of the brewery's real ales. Live music is featured. There is a skittle alley and dartboard. The pub is dog friendly and children are welcome until 7pm. Local CAMRA Pub of the Year 2022. ⛁☕🌙≠♣☕P🚃☺🍃

Barnstaple

Panniers Ⓛ ✅
33-34 Boutport Street, EX31 1RX (opp Queen's Theatre)
☎ (01271) 329720
Greene King Abbot; Ruddles Best Bitter; Sharp's Doom Bar; 4 changing beers (sourced regionally) Ⓗ
Centrally located opposite the Queen's Theatre and close to the historic Pannier Market, this popular Wetherspoon pub maintains an ever-changing selection of real ales from local and West Country breweries, as well as those from further afield. Framed prints throughout the comfortable premises depict various items relating to the history of Barnstaple. To the rear, a pleasant courtyard garden drinking area is a suntrap in summer.
⛁☕🌙♿♣🚃🍃

Reform Inn Ⓛ
Reform Street, Pilton, EX31 1PD
☎ (01271) 323164 ⊕ reforminn.co.uk
Barum Original, Breakfast; 1 changing beer (sourced locally) Ⓗ
Well-established, popular community local and tap for Barum Brewery. From the main road, look above roof level for the pub sign to locate it. The annual Green Man beer festival is held in the skittle alley in July and other regular beer festivals are hosted throughout the year. In the public bar there is a pool table and dartboard. Music events feature occasionally – check the website or Facebook for details. ♣🚃☺🍃

The family-run Durant Arms has a good reputation for beer and food quality. A true country hostelry, with wood-burning fires, slate floors and traditional furnishings, it has two dining areas. Outside seating at the front overlooks the war memorial and village centre, and there is a pretty courtyard at the back. Both family and dog friendly, the pub is popular with walkers and cyclists. B&B accommodation is offered. Close to Sharpham vineyard and the River Dart.
Q⛁☕🌙🛏🌙♣☕P🚃(B2C)☺🍃

Avonwick

Avon Inn Ⓛ
TQ10 9NB
☎ (01364) 73475 ⊕ avon-inn.org.uk
Dartmoor Legend, Jail Ale; Draught Bass; 1 changing beer (sourced regionally) Ⓗ
At the crossroads in the centre of the village, the inn is at the heart of the community, with various events regularly taking place including quiz nights, barbecues

Beaford

Globe Inn ▼ 🛗

Exeter Road, EX19 8LR (on main Exeter Rd in centre of village)

☎ (01805) 603920 ⊕ globeinnpub.co.uk

3 changing beers (sourced regionally) 🅗

Traditional and cosy country inn, with a passion for real ale and craft beers to suit all tastes. Three changing and mainly local ales are usually available, alongside a comprehensive drinks menu that includes more than 40, often legendary, bottled and bottle-conditioned beers from around the world. Proud of its environmental credentials, the pub also offers a seasonal and attractively priced food menu, using the best ingredients from local producers. Local CAMRA Pub of the Year 2022. Q🏵🕮🕭➊♣♠🚲🐾📶

Beer

Barrel o' Beer 🛗

Fore Street, EX12 3EQ

☎ (01297) 22824

Branscombe Golden Fiddle; Otter Bitter; Sharp's Doom Bar 🅗

A friendly, family-run village pub in the middle of the main street of this picturesque fishing village. Three drinking areas surround the smart modern bar, with the back area offering a quieter family-friendly dining space. Sports are shown on TV and are very popular. Dogs are welcome. 🕮♣🚲🐾📶

Bideford

Joiners Arms

EX39 2DR

☎ (01237) 472675

Sharp's Doom Bar; 2 changing beers (sourced regionally) 🅗

The Joiners Arms is a friendly old-style English pub with accommodation. Local ales, lagers and cider are on offer. Situated in the heart of the town next to the historic Pannier Market, the pub hosts a number of clubs, and is the focus of regular community events including popular music nights. There is live music every weekend, and a skittle alley and function room. 🕭🛏♣♠🐾📶

Bittaford

Horse & Groom 🛗

Exeter Road, PL21 0EL

☎ (01752) 892358

Dartmoor Jail Ale; house beer (by Hunters); 3 changing beers (sourced locally; often Exeter, South Hams, Summerskills) 🅗

A family-owned pub run by a real ale enthusiast, featuring good home-cooked food and seven handpumps predominantly offering ales from south Devon and Cornwall. Two are dedicated to real cider. Third-pint tapas are available. There is a long bar and separate dining area, with pictures of the former Moorhaven Hospital on the wall. A beer festival and a cider and sausage festival are hosted during the year, supporting charities in the area. Local CAMRA Pub of The Year 2020. 🕮🕭➊▲♣♠🅿🚌(X38,Gold)🐾

Black Torrington

Black River Inn

Broad Street, EX21 5PT SS465056

☎ (01409) 231888 ⊕ blackriverinn.co.uk

3 changing beers (sourced regionally) 🅗

Village pub with a growing reputation for real ale and good food. Three regularly changing real ales are on offer, together with two local ciders. The tastefully decorated public bar with adjacent dining area leads through to the separate restaurant which can also be used as a function room. Outside, the attractive garden has views over the Torridge Valley and surrounding countryside. Close to both the Tarka Trail and Ruby Way, the pub is popular with walkers and cyclists. Bar snacks only on Tuesday and Wednesday. Q🏵🕮🕭➊▲♣🅿🐾📶

Bradiford

Windsor Arms 🛗

55 Bradiford, EX31 4AD (on main road through village, approximately ½ mile N of Pilton)

REAL ALE BREWERIES

Barnaby's Staverton
Barum 🏭 Barnstaple
Bays Paignton
Beer Engine 🏭 Newton St Cyres
Bere ◆ Bere Alston
Black Tor Christow
Branscombe Branscombe
Bridgetown Totnes
Buckland Bideford
Checkstone 🏭 Exmouth
Clearwater Bideford
Combe ◆ Ilfracombe
Cottage Beer Project Tiverton
Country Life Abbotsham
Crossed Anchors 🏭 Exmouth
Dartmoor Princetown
Devil's Pleasure Sigford
Devon Earth Buckfastleigh
Exeter ◆ Exeter
Fat Belly Ilfracombe
Grampus 🏭 Lee Bay
GT Braunton
Hanlons Newton St Cyres
Hatherland Tiverton
Holsworthy Clawton
Hunters Ipplepen
Isca Holcombe
Ivybridge ◆ Ivybridge
Madrigal ◆ Ilfracombe: Hele Bay
Morwell Morwellham
New Devon Exeter
New Lion ◆ Dartington
Noss Beer Works Lee Mill
Otter ◆ Luppitt
Platform 5 Torquay
Powderkeg Woodbury Salterton
Red Rock ◆ Bishopsteignton
Riviera Stoke Gabriel
Roam ◆ Plymouth
Salcombe ◆ Ledstone
South Hams Stokenham
Stannary ◆ Tavistock
Steel Brew ◆ Plymouth (brewing suspended)
Summerskills Plymouth: Billacombe
Tally Ho! 🏭 Hatherleigh
Taw Valley North Tawton
Teignmouth Teignmouth
Teignworthy Newton Abbot
Topsham ◆ Exeter
Totnes 🏭 Totnes
TQ Beerworks South Brent
Turk's Head 🏭 Exeter
Utopian Bow
Yelland Manor ◆ Yelland

☎ (01271) 343583
GT Ales Thirst of Many; 1 changing beer (sourced locally) Ⓗ
A community-oriented, friendly village local within easy walking distance of Barnstaple town centre. Two changing real ales are kept, both from the local GT Ales brewery. Good, freshly-cooked and locally sourced food is served Friday to Sunday in the separate lounge bar. A function room, with skittle alley, pool table and dartboard is at the rear of the pub. ☕☻◑♣🖾🐾

Branscombe

Fountain Head Inn Ⓛ
EX12 3BG (on the outskirts of Branscombe, 1 mile W of village centre)
☎ (01297) 680359 ⊕ fountainheadinn.com
Branscombe Branoc, Golden Fiddle; 1 changing beer (sourced locally) Ⓗ
Set in a beautiful coastal valley, this walker-friendly old pub is at the west end of one of England's longest villages, approximately a mile and a quarter from Branscombe beach. Ancient features such as the inglenook fireplace, wood panelling and flagstone floors greet customers, while the bar offers Branscombe Brewery ales and ciders. Good value home-cooked food is served. A beer festival is held on the closest weekend to the summer solstice. Q☕☻◑♣🖾(899)🐾

Bratton Clovelly

Clovelly Inn Ⓛ
EX20 4JZ (between A30 and A3079) SX464919
☎ (01837) 871447 ⊕ clovellyinn.co.uk
Dartmoor Jail Ale; Sharp's Doom Bar; 1 changing beer (sourced regionally) Ⓗ
Dating back to the 18th century, this truly authentic rural Devon pub lies at the heart of the local community. The cosy main bar features an oak fireplace lintel inscribed 1789, above a large wood-burning stove. It is complemented by two separate dining areas (booking advisable for evening meals) and a games room. Three real ales are served, with a cider from local Sandford Orchards. Good home-cooked food is available seven days a week. ☕☻◑🐕♣🖾(633)🐾

Bridford

Bridford Inn Ⓛ
EX6 7HT
☎ (01647) 252250 ⊕ bridfordinn.co.uk
Dartmoor Jail Ale; 3 changing beers (sourced nationally) Ⓗ
An idyllic 17th-century Devon longhouse nestled within the Dartmoor National Park, converted to a pub in 1968. The interior is open plan, with oak beams and an inglenook fireplace complete with bread oven and warming wood-burner. Freshly cooked and locally sourced food is served daily except Monday and Tuesday. There is a beer garden out front with comfy benches and views to die for. The cellar stocks an interesting selection of local ciders. ☕☻◑🐕♣🖾(360)🐾

Brixham

Blue Anchor ✅
83 Fore Street, TQ5 8AH
☎ (01803) 854575 ⊕ theblueanchorbrixham.co.uk
Dartmoor Jail Ale; Sharp's Doom Bar; 1 changing beer Ⓗ
This 500-year-old building was originally a fisherman's cottage and a sail loft. Now a pub-restaurant, it comprises two rooms with exposed stone walls and timber beams, the left-hand room being the bar, the right a dining room. The Port & Starboard restaurant is famed for its pub classics seafood menu, complemented by a daily selection of specials, all prepared from locally sourced produce. ☕◑🅿🖾(17,17E)🐾

Queen's Arms Ⓛ ✅
31 Station Hill, TQ5 8BN (from Brixham library go up Church Hill East, then up Station Hill)
☎ (01803) 852074 ⊕ thequeensarmsbrixham.co.uk
House beer (by Teignworthy); 5 changing beers (sourced nationally; often Branscombe, Hunters, Salcombe) Ⓗ
This single bar, end-of-terrace pub has a well-deserved reputation for the quality of its beers and multiple real ciders. It has a welcoming atmosphere with a strong community ethos and, on cold winter days, wood-burning stoves. Live music features on Wednesday and weekends, with a Friday meat draw and a Sunday quiz. In early December the pub hosts a charity beer festival with over 50 real ales and ciders. ☕☻♣🖾(17)

Vigilance Ⓛ ✅
5 Bolton Street, TQ5 9DE
☎ (01803) 850489
Greene King Abbot; Ruddles Best Bitter; Sharp's Doom Bar; 5 changing beers (sourced nationally) Ⓗ
Town centre Wetherspoon pub named after the last sailing ketch built in Brixham's Upham shipyard in 1926, now fully restored and moored in the harbour. Local, mostly nautical, prints adorn the walls and an imposing old ship's figurehead looks down on customers from its wall mounting. Food is served all day. The pub holds various beer, cider and wine festivals throughout the year. ☕◑🐕♣🖾🐾

Brixton

Foxhound Inn Ⓛ
Kingsbridge Road, PL8 2AH
☎ (01752) 880271 ⊕ foxhoundinn.co.uk
Courage Directors; house beer (by Summerskills); 3 changing beers (sourced nationally; often Caledonian, Courage, Summerskills) Ⓗ
An 18th-century former coaching house in a rural village just east of Plymouth, with two separate bars and a small restaurant. Traditional English meals are served daily, featuring locally sourced ingredients. Look out for Red Coat, an ale crafted by the landlord, among four guest beers. A monthly charity quiz night is held. The village is served by a frequent daytime bus service. Q☕☻◑🐾♣🖾(94)🐾

Broadhembury

Drewe Arms Ⓛ
EX14 3NF
☎ (01404) 841267 ⊕ drewearmsinn.co.uk
Dartmoor Dartmoor Best; Otter Bitter, Amber; 1 changing beer (sourced locally) Ⓗ
Grade II-listed 16th-century thatched pub with a large secluded garden, set in a picturesque estate village of cob and limewashed cottages within the Blackdown Hills. There are low-beamed ceilings and uneven floor levels throughout the many rooms. This is a friendly and welcoming family-run venue with the emphasis on local real ales and produce. Good food is served Monday to Friday lunchtime and evening, all day Saturday and lunchtime on Sunday. ☕☻◑🐾🐾

Buckfastleigh

Kings Arms

14-15 Fore Street, TQ11 0BT (in centre of town)
☎ (01364) 643432
Bridgetown Shark Island Stout; Teignworthy Gun Dog; 1 changing beer (sourced locally) Ⓗ
Following purchase and refurbishment by Admiral Taverns a few years ago, this is now a free house selling mainly local ales. There is a small public sports bar at the front and a larger lounge bar at the rear with plenty of comfortable seating. A small function room is available and at the rear is a pleasant beer garden with plenty more seating. ⑂❀♿Å⇌(S Devon)♣P🚫(88,X38)🌐🐱📶

Butterleigh

Butterleigh Inn Ⓛ

The Green, EX15 1PN (opp church) SS9746108212
☎ (01884) 855433 ⊕ butterleighinn.co.uk
3 changing beers (sourced regionally) Ⓗ
Situated in a small, tranquil village, this proper country inn has been in the Guide for over 35 years. Four handpumps serve three ales and one cider. The beers rotate from regional breweries and are often seasonal specials, with real cider from at least three different cider producers. There is a garden with patio, and a separate modern dining room at the rear where wholesome home-made food is served. Q⑂❀🖾◑♣🐱P🐱📶

Chagford

Globe Inn Ⓛ ✅

9 High Street, TQ13 8AJ
☎ (01647) 433485 ⊕ theglobeinnchagford.co.uk
Dartmoor IPA, Jail Ale; Otter Bitter; 1 changing beer (often Exeter) Ⓗ
Overlooking the church, this Grade II-listed pub was once a coaching inn and coopery. It's a focal point of this historic Dartmoor stannery town, providing good food, music, a cinema club and other events. The public bar retains its Victorian counter and a bar-back thought to date from the 1930s. This bar, and the separate lounge bar and dining room, both have open log fires. A courtyard garden is at the rear and parking is nearby. The ciders are from Sam's. ⑂❀🖾◑🐱🚫(173,178)🐱📶

Cheriton Fitzpaine

Ring of Bells Ⓛ

EX17 4JG
☎ (01363) 860111 ⊕ theringofbells.com
2 changing beers (sourced regionally) Ⓗ
This thatched Grade II-listed pub sits by the parish church in the heart of a picturesque village. Two changing beers are normally available at the single bar. Fine food, largely locally sourced, is available lunchtimes and evenings, but the pub is equally sought out by those just seeking a snack, a quiet pint by the fire or a few drinks with friends in the garden. The landlady has made this a pub that welcomes everyone including children and dogs. ⑂❀◑♣🐱P🐱

Chittlehamholt

Exeter Inn Ⓛ

EX37 9NS
☎ (01769) 540281 ⊕ exeterinn.co.uk
GT Ales Thirst of Many; Otter Ale; St Austell Proper Job Ⓗ
Traditional 16th-century coaching inn on the old road from Barnstaple to Exeter, with four cosy dining areas

and a pleasant south-facing patio. The food is locally sourced, home-cooked and varies with the seasons. The pub retains many of its original architectural features including two real fireplaces, one with a bread oven, while various historic photographs of the village adorn the walls. There is a popular quiz night once a month and self-catering accommodation is available. Q⑂❀🖾◑♿♣🐱P🐱

Chittlehampton

Bell Inn Ⓛ

The Square, EX37 9QL (opp St Hieritha's parish church) SS636254
☎ (01769) 540368 ⊕ thebellatchittlehampton.co.uk
Butcombe Original; 1 changing beer (sourced regionally) Ⓗ
In the same family since 1975, and popular with locals and visitors alike. This busy village local celebrated 26 continuous years in the Guide in 2022, and has won several CAMRA awards in recent years including local CAMRA Pub of the Year. The bar area displays notable sporting memorabilia and there is a games room downstairs. Good-value food is home-cooked and served both in the bar and adjoining restaurant. The gardens outside are extensive with great views, and are ideal for children. ⑂❀🖾◑♿Å♣🐱P🚫(658,859)🐱📶

Christow

Teign House Inn Ⓛ

Teign Valley Road, EX6 7PL
☎ (01647) 252286 ⊕ teignhouseinn.co.uk
3 changing beers (sourced regionally; often Black Tor, Hunters, Powderkeg) Ⓗ
A welcoming and atmospheric country inn with exposed beams and warming log fires in winter, situated on the edge of Dartmoor in the Teign Valley. The pub enjoys strong local support with its sizeable beer garden attracting families, while the adjoining field has space for caravans, campervans and campers. There is regular live music. Great pub food is all home-cooked, and the pub offers a special Thai menu, also available as a takeaway. Q⑂❀◑♿Å♣P🚫(360)🐱📶

Chulmleigh

Old Court House

South Molton Street, EX18 7BW
☎ (01769) 580045 ⊕ oldcourthouseinn.co.uk
Butcombe Original; Dartmoor IPA; 1 changing beer (sourced regionally) Ⓗ
Charles I stayed here in 1634 when he held court (hence the name) and this is commemorated with an original coat of arms in one of the bedrooms, while a replica hangs above the fireplace in the main bar. Today this friendly, cosy local features two regular real ales, usually joined by a guest beer in summer. Good home-cooked food can be taken in the bar area, the separate dining room, or the pretty cobbled courtyard garden. ⑂❀🖾◑♿♣🚫(377)🐱📶

Clearbrook

Skylark Inn Ⓛ

PL20 6JD
☎ (01822) 853258 ⊕ skylarkclearbrook.com
Dartmoor Jail Ale; St Austell Tribute; 1 changing beer (sourced regionally; often Butcombe, Otter) Ⓗ
Typical Dartmoor village pub, popular for its excellent food, offering up to four South West real ales, one of which is usually from Dartmoor. Food is served daily and

all day at weekends. The beer range may vary occasionally, with beers from Butcombe and Otter making regular appearances. An annual beer festival is held over the August bank holiday weekend. Catch the Stagecoach bus from Plymouth or Tavistock to Cross – the pub is approximately 20 minutes' walk. Q♿☺🕽P☀

Clyst St Mary

Half Moon Inn
Frog Lane, EX5 1BR
☎ (01392) 873515 ⊕ thehalfmoonclyst.co.uk
Exeter Ferryman; 2 changing beers Ⓗ
Friendly village pub with a great atmosphere. Locally sourced food at reasonable prices is served lunchtime and evening, with smaller portions available. Two or three real ales are on offer. The pub was completely refurbished in 2020 and is within walking distance of Exeter Chiefs Rugby Club and Westpoint exhibition centre. There are three en-suite B&B rooms available. Dogs are welcome in the bar area.
Q♿🛏🕽🍴♿🚆(9)☀🛜

Cockwood

Ship Inn Ⓛ ✅
Church Road, EX6 8NU (just off A379, outside Starcross, close to Cockwood harbour)
☎ (01626) 890373 ⊕ shipinncockwood.co.uk
Dartmoor Jail Ale; St Austell Tribute, Proper Job; 2 changing beers (sourced nationally) Ⓗ
A busy family-run pub close to the picturesque harbour at Cockwood. It has a large beer garden with views of the estuary, and a roaring log fire in winter. Popular with drinkers and diners alike, it offers a choice of three regular ales and usually two rotating guests, and there is an excellent food menu. Meals are prepared with local produce where possible, including a varied choice of locally-caught fish. The bus stops 100 yards away across the bridge. Q♿☺🕽Å♣♿P🚆(2)☀🛜

Crediton

Duke of York
74 High Street, EX17 3JX
☎ (01363) 775289
Dartmoor IPA; 2 changing beers (sourced regionally) Ⓗ
This one-bar Grade-II listed pub at the top of the high street has been a family-run free house since 2002. One regular beer is on offer, plus one or two changing beers, depending on demand. Sky, BT and Amazon sports are televised on the three screens. Mens and womens darts teams play here, and there is a south-facing garden. The number 5 bus passes the door. ☺♣🚆☀🛜

Cullompton

Pony & Trap Ⓛ ✅
10 Exeter Hill, EX15 1DJ (on B3181 S of town)
☎ (01884) 34182
Dartmoor Jail Ale; Draught Bass; Exmoor Ale; Otter Bright; 4 changing beers (sourced regionally) Ⓗ
A traditional local with a good atmosphere and mixed clientele. Many local darts and skittles teams are based here, and pub games are played. It has a smart interior featuring a logburner, making it cosy in winter; flowers and ornaments give it a homely feel. Up to eight real ales are on offer including a house beer, plus three real ciders. There is a garden and outdoor seating area. Live music features once a month. Q☺🕽♣♿🚆(1)☀

Dartington

New Lion Brewery Taproom & Bottle Shop
Meadowbrook Community Centre, Shinners Bridge, TQ9 6JD
☎ (01803) 226277 ⊕ newlionbrewery.co.uk
New Lion Totnes Stout, Pandit IPA; 2 changing beers (sourced locally; often New Lion, Unity, Verdant) Ⓗ
Community-owned brewery taproom, located at Meadowbrook Community Centre in Dartington since 2021. It was named after Lion Brewery (renowned for its Totnes Stout – closed circa 1920). In addition to the core beer range, many seasonals and dozens of one-off white-label beers are produced, many in collaboration with local producers and businesses. Pizzalogica is the in-house pizza purveyor (Wed-Sat), along with many guest food vendors at weekends. There are lots of live events weekly – see the brewery's social media for details.
Q♿🛏♿♣P🚆(GOLD,88)☀🛜

Dartmouth

Cherub Inn ✅
13 Higher Street, TQ6 9RB
☎ (01803) 832571 ⊕ the-cherub.co.uk
5 changing beers (sourced locally; often Otter, St Austell) Ⓗ
Situated in the centre of Dartmouth, a nautical town famous for its Tudor buildings, the Cherub is one of the best and the oldest, a Grade-II listed 14th-century former merchant's house. Beams made from old ships' timbers feature in the bar, which boasts six handpumps serving local and national cask ales. An intricate winding staircase leads to the cosy restaurant and facilities on the two upper floors. Q♿🕽Å⇌(Kingswear)🚆(3,92)☀🛜

Seven Stars
8 Smith Street, TQ6 9QR
☎ (01803) 839635 ⊕ sevenstars-dartmouth.co.uk
Dartmoor Jail Ale; 3 changing beers (sourced locally; often Exeter, Otter) Ⓗ
Grade II listed and near to the church, the present building was originally two cottages that were merged in the 18th century, although 16th- and 17th-century features enable the Seven Stars to claim to be the oldest ale house in Dartmouth. The ground floor bar, with five handpulls and two fireplaces, is both atmospheric and contemporary, and children and dogs are welcome. Upstairs there is a restaurant and function room, and six en-suite rooms. 🛏🕽⇌(Kingswear)♣♿🚆(3,90)☀🛜

Exbourne

Red Lion Ⓛ ✅
High Street, EX20 3RY (200yds N of jct with A3072) SS602018
☎ (01837) 851551 ⊕ theredlionexbourne.co.uk
Dartmoor IPA, Legend; 1 changing beer (sourced regionally) Ⓖ
This friendly village local has a well-deserved reputation for the quality and consistency of its ales, and has been local CAMRA branch Pub of the Year several times in recent years. Casks are set on stillage at the end of the L-shaped bar and feature Legend from Dartmoor alongside other locally brewed ales. The pub does not serve food but customers can bring their own snacks or get a takeaway delivered. There is always good conversation to be enjoyed here. Q♿☺♿P🚆(5A,631)☀🛜

Exeter

Bowling Green L ✓
29-30 Blackboy Road, EX4 6ST
☎ (01392) 490300 ⊕ bowlinggreenpub.co.uk
3 changing beers (sourced locally) Ⓗ
Originally an 18th-century pub called the Ropemakers, the Bowling Green is a cosy local situated away from the main city centre and close to Exeter City football club at St James Park. It offers an extensive selection of reasonably priced pub food including pizzas, with gluten-free and vegetarian options. Four real ales are available, three are rotating and sourced from local breweries. Live music plays every Saturday night and on Sunday afternoon, followed by a quiz in the evening.
Q ☺ 🏠 🕙 & ⧗ (St James Park) ♣ 🍴 🖵 (J,K) 🐾 🛜

Fat Pig L
2 John Street, EX1 1BL (behind Fore St)
☎ (01392) 437217 ⊕ thefatpigexeter.co.uk
3 changing beers (sourced locally) Ⓗ
Formerly the Coachmakers Arms, and at one time a brewpub, this Victorian corner local behind Fore Street was brought back to life in 2008 as a traditional inn, featuring a range of locally sourced food. There are malt whisky evenings and homebrew competitions.
☺ 🕙 ⧗ (Central) ♣ 🖵 🐾 🛜

George's Meeting House L ✓
38 South Street, EX1 1ED (nr bottom of South St)
☎ (01392) 454250
Greene King IPA, Abbot; Sharp's Doom Bar; 4 changing beers Ⓗ
This Wetherspoon opened in 2005 having been sympathetically converted from a Unitarian Chapel dating from 1760. Many of the original features remain unaltered; these include two upstairs galleries with seating, a pulpit and stained-glass windows. A range of national, regional and local real ales is served. Food is available throughout the day and evening. A newer extension at the rear of the main building leads to an outdoor seating area which was refurbished in 2021.
Q ☺ 🏠 🕙 & ⧗ (Central) 🖵 🛜

Great Western Hotel L
St David's Station, EX4 4NU
☎ (01392) 274039 ⊕ greatwesternhotel.co.uk
Dartmoor Legend, Jail Ale; Exeter Avocet; Pitchfork Pitchfork; Quantock QPA; 2 changing beers Ⓗ
The building, next to St David's railway station, dates from 1840. The ground floor bars and the Karma Indian restaurant have all been refurbished to a high standard, and a log fire installed in the main bar. Up to six real ales are on offer. The venue has a good community atmosphere and there is easy access throughout the main bar, restaurant and disabled toilets.
Q ☺ 🏠 🕙 & ⧗ (St David's) 🖵 🐾 🛜

Imperial L ✓
New North Road, EX4 4AH
☎ (01392) 434050
Greene King IPA, Abbot; changing beers Ⓗ
This pub features a range of beers from local and national breweries. It was built in 1810 as a private house, later converted to a hotel, and opened as a Wetherspoon in 1996. It has an orangery and a large beer garden. Regular beer festivals are held, featuring local, national and international breweries. Food is served all day. Close to the university, there is a bus stop directly outside the premises, and St David's railway station is nearby.
Q ☺ 🏠 🕙 & ⧗ (St David's) P 🖵 🛜

Royal Oak
79-81 Fore Street, EX1 2RN
☎ (01392) 969215 ⊕ royaloakpubheavitree.co.uk
Dartmoor Jail Ale; Exeter Avocet; Otter Ale; St Austell Tribute; 2 changing beers (sourced regionally) Ⓗ
This historic thatched pub dates from the 1800s and is on the B3183 through Heavitree, close to two public car parks. Entering via an original Dartmoor Prison door, a relaxing snug is on the right and tack from the last heavy horse at the prison is above the welcoming fireplace. The public bar to the left leads to several roomy areas. Outside there are front and rear courtyard seated areas. Bar snacks are available. Q ☺ 🏠 & 🕙 🖵 🐾 🛜

Sawyer's Arms L ✓
121 Cowick Street, EX4 1JD (opp St Thomas church)
☎ (01392) 269520
Greene King IPA, Abbot; Sharp's Doom Bar; 5 changing beers (sourced nationally) Ⓗ
This 1960s pub on the main street running past St Thomas Church replaced an earlier public house on the same road. It is now a Wetherspoon establishment, following all conventions of the well-established chain. Roomy with a good-sized bar, there are plenty of tables and seating both inside and outside. Beer festivals and Meet the Brewer events are held. Large TVs mostly show BBC News 24 on mute with subtitles.
Q ☺ 🏠 🕙 & ⧗ (St Thomas) 🖵 🛜

Ship Inn ✓
1-3 Martins Lane, EX1 1EY
☎ (01392) 272040
Exeter Avocet; Greene King IPA, Abbot; Otter Ale; 2 changing beers (sourced regionally) Ⓗ
A historic city-centre pub situated along a narrow passageway between the high street and Cathedral Green. It is one of the oldest pubs in Exeter and Sir Francis Drake used to visit. Four regular ales feature along with two guests, mostly local, and up to four ciders. The pub offers good-value food served all day including a children's menu. Live entertainment features on Wednesday, Friday and Saturday.
☺ 🕙 & ⧗ (Central) 🍴 🖵 🐾 🛜

Thatched House Inn L ✓
Exwick Road, EX4 2BQ
☎ (01392) 272920 ⊕ thatchedhouse.net
Greene King Abbot; 6 changing beers (sourced locally; often Dartmoor, Hanlons, Salcombe) Ⓗ
This thatched building dates from the 1600s and is a community establishment next to Exwick playing fields, opposite the Exeter College Sports Hub. It is close to the river and convenient for dog walkers, cyclists and sightseers. Seven real ales and one real cider are usually served, alongside great-value home-cooked food featuring local ingredients and producers. On-street parking is available nearby and the pub is on the Stagecoach E1 and E2 bus route.
☺ 🏠 🕙 ⧗ (St David's) ♣ 🖵 🐾 🛜

Topsham Brewery Taproom
Haven Road, EX2 8GR
☎ (01392) 275196
3 changing beers Ⓖ
Historic stone building on the popular Exeter Quay, with a garden seating area and a view from the bar of the brewery next door. Often busy with families and dog walkers during the day, it can get even livelier at night with regular music, and a pizza van at the front door. Hours are extended during the summer, with an earlier weekday opening, and it closes later on busy Sundays.
🏠 ⧗ (St Thomas) 🐾

Exmouth

Bicton Inn L ✓

5 Bicton Street, EX8 2RU
☎ (01395) 272589 ⊕ bictoninn.co.uk
Dartmoor Jail Ale; Hanlons Citra IPA, Port Stout; 5 changing beers (sourced locally) Ⓗ
A friendly and popular back-street local, offering good beer and chat. It has won the local CAMRA Community Pub of the Year three times and has also previously been local Pub of the Year. Regular live music including a weekly folk night takes place, along with a monthly quiz. The pub hosts an annual beer festival, normally in late winter. Up to eight real ales, including several LocAles, plus three keg ciders and one real cider are usually on offer. ♿❄♣🚪(57)🐾☀🛜

First & Last Inn L

10 Church Street, EX8 1PE (off B3178 Rolle St)
☎ (01395) 263275
Dartmoor Jail Ale; Otter Ale; Teignworthy Neap Tide; 2 changing beers (sourced locally; often Checkstone) Ⓗ
A genuine free house near the town centre, with a public car park opposite. The Victorian building has three distinct areas and a courtyard patio with heated awnings. Checkstone Brewery started brewing in 2016 and supplies the pub with changing ales from an increasing range, plus seven keg ciders occasionally including Checkstone Cider and two real ciders. Games include pool and darts, and there is a skittle alley. Televised sport is prominent and there is regular live music early on Sunday evening. ☀&❄♣🚪(57)

Grapevine L

2 Victoria Road, EX8 1DL
☎ (01395) 222208 ⊕ thegrapevineexmouth.com
Crossed Anchors Bitter Exe, American Pale Ale; 4 changing beers Ⓗ
Situated in the centre of Exmouth, the Grapevine is a stylish Victorian building which also houses Crossed Anchors Brewing (CAB) and Ruby Diner burgers. There are six handpumps and 12 craft taps, and CAB beers sold bottle-conditioned. Two keg ciders and two bag-in-a-box real ciders are rotated regularly. Bottled German and Belgian beers are also available. There is live music on the first Friday of the month and live rugby shown on the big screen. ♿☀🍽&❄♣🚪(57)🐾

GWRSA Railway Club L

3-5 Royal Avenue, EX8 1EN
☎ (01395) 274010 ⊕ gwrsaexmouth.co.uk
Greene King Abbot; Hanlons Yellow Hammer; 2 changing beers Ⓗ
A community-focused club with several small outdoor seating areas and superb views of the Exe estuary. This bar has four real ales on handpump, two of which are changing beers usually from local breweries. Traditional games are played, live music is usually hosted on Saturday night, and there is a quiz night every Thursday. Bar snacks are available. The club is open to the public and everyone is welcome. ♿☀🍽&❄♣🚪🛜

Holly Tree

161 Withycombe Village Road, EX8 3AN (leave A376 at Gipsy Lane lights, turn left at roundabout)
☎ (01395) 273740
St Austell Tribute, Proper Job; 3 changing beers (sourced nationally) Ⓗ
A popular pub about a mile from Exmouth town centre. Although owned by St Austell, the guest beers are from national breweries. There are several rooms off the large open bar, one housing the pool table and dartboards. This vibrant pub supports four darts teams and two pool teams. Locals can often be found playing the card game euchre on a Sunday afternoon, only stopping for the meat draw. Families are welcome until 7pm. ♿☀♣🚪(97)🐾

Strand

1 The Parade, EX8 1RS
☎ 07971 174466
Sharp's Doom Bar; 1 changing beer (sourced nationally) Ⓗ
A popular traditional town-centre pub with a long narrow bar room offering various areas with comfy seating, high stools and tables. A sheltered outdoor area provides additional drinking space. Well placed for local transport, the pub used to be called the South Western, as did the railway. There are several screens showing a variety of sports, games machines and a dartboard. The guest beer is usually Timothy Taylor Landlord. ☀&❄♣🚪🐾🛜

Fremington

New Inn

Old School Lane, EX31 2NT
☎ (01271) 373859 ⊕ thenewinnfremington.com
2 changing beers (sourced locally; often GT Ales) Ⓗ
Friendly family-run village local, offering a warm welcome, usually featuring at least two ales from GT brewery. The pub has a growing and well-deserved reputation for its home-cooked food, particularly Indian and spiced cuisine. There is a separate snug and a games room with pool, darts and extra large Jenga. Dogs are made welcome. Live music is hosted Saturday evening from about 9pm, and a quiz and karaoke on alternating Wednesday evenings. The large car park is very useful. Q♿☀🍽♣🚪🐾🛜

Horsebridge

Royal Inn

PL19 8PJ (off A384 Tavistock-Launceston road) SX401748
☎ (01822) 870214 ⊕ royalinn.co.uk
Otter Ale; St Austell Proper Job Ⓗ**; 3 changing beers (sourced regionally; often Draught Bass, Exeter, Skinner's)** Ⓖ
Originally built as a nunnery in 1437 by French Benedictine monks, and reported to have been visited by Charles I, the pub overlooks an old bridge on the River Tamar, connecting Devon to Cornwall. It features half-panelling, stone floors, log fires and traditional styling in the bar and lounge. There is another larger room off the lounge, and a terraced garden with sheltered seating. Guest beers are usually served on gravity; the locally sourced food is recommended. Q☀🍽♣🚪(115)🐾🛜

Iddesleigh

Duke of York

EX19 8BG (off B3217 next to church) SS570083
☎ (01837) 810253 ⊕ dukeofyorkdevon.co.uk
Bays Topsail; Otter Bitter; 1 changing beer (sourced nationally) Ⓖ
A 15th-century thatched village inn with old beams, inglenook fireplaces and an unfailingly friendly atmosphere. Real ales are dispensed on gravity, while cider comes from nearby Sam's. The pub is renowned for its generous portions of locally sourced, home-cooked food. Close to the Tarka Trail, River Torridge and Stafford Moor Fishery, there are seven en-suite rooms for visitors. A popular beer festival is held every August bank holiday weekend. Q♿☀🛏🍽&▲♣🚪🐾🛜

Ide

Poachers Inn 🗘

55 High Street, EX2 9RW (3 miles from M5 jct 31, via A30)

☎ (01392) 273847 ⊕ poachersinn.co.uk

Branscombe Branoc; Exeter Tomahawk; 3 changing beers (sourced locally) 🄶

Busy village pub with a friendly atmosphere, serving a varied menu of home-made locally sourced produce, including excellent-value fish & chips on Wednesday evenings to eat in or take away. Dogs are welcome in the bar which is comfortably furnished with old sofas, chairs and a big log fire in winter. There is also a large beer garden overlooking the glorious Devon countryside. The landlord is a keen rugby fan and games are shown on the TV in the bar. Q ➤ ❀ ⇆ ◀❶ 🅰 ♣ ● P 🚆 (360)❀ 🛜

Ilfracombe

Second Stage 🗘

Wilder Road, EX34 9AJ

☎ 07967 530936

Exmoor Stag; 1 changing beer (sourced locally) 🄷

Opposite the Theatre, this old Victorian building is located on the seafront and within easy reach of Ilfracombe's seaside attractions. There is a strong commitment to real ale, with the regular Exmoor Stag invariably accompanied by a beer from the GT Ales range. The bar area has a cinema theme, while the raised-level pool room and its high-quality pool tables make the pub something of a mecca for local enthusiasts. Opens from noon in summer. ➤ ◀❶ ♣ 🚆 ❀

Wellington Arms 🗘

66-67 High Street, EX34 9QE

☎ (01271) 864720

Sharp's Doom Bar; Fuller's London Pride; Greene King Abbot; 2 changing beers (sourced nationally) 🄷

Grade II-listed, this friendly town-centre local was originally two pubs. The cosy lounge retains its original beams and large open fire, and there is a separate public bar and a games room. TVs and sound systems enable different channels to be shown, making the pub particularly popular with sports enthusiasts. Up to five competitively priced ales are usually available. Regular live music sessions, quiz nights and beer festivals are held. No under 18s allowed. ❀ 🅰 ♣ P 🚆 ❀ 🛜

Ivybridge

Imperial Inn

28 Western Road, PL21 9AN

☎ (01752) 651091

Dartmoor Jail Ale; St Austell Tribute; 1 changing beer 🄷

A warm and welcoming pub that was tastefully refurbished a couple of years ago. Dartmoor Jail Ale and St Austell Tribute are the regular real ales, complemented by a popular and varied daily food menu (no food Tue). There is a designated live sports viewing area and occasional live entertainment takes place on Sunday evening. ➤ ❀ ◀❶ ♣ ● P 🚆 (X38,GOLD)❀ 🛜

Kilmington

New Inn 🗘

The Hill, EX13 7SF (500yds from A35)

☎ (01297) 33376 ⊕ newinnkilmington.co.uk

Palmers IPA, Dorset Gold, 200 🄷

This thatched Devon longhouse became a pub in the early 1800s. It was rebuilt after a major fire in 2004,

retaining a welcoming atmosphere and gaining excellent accessible toilets. There is a large, safe garden and a well-used skittle alley. A quiz night is held monthly on the first Sunday, with other events that maintain the pub's position as an important part of village life. Plans are in place for a food service. Q ➤ ❀ ♣ ● P 🚆 ❀ 🛜

Kings Nympton

Grove Inn 🗘

EX37 9ST (in centre of village) SS683194

☎ (01769) 580406 ⊕ thegroveinn.co.uk

Exmoor Ale; Hanlons Yellow Hammer 🄷

This thatched Grade II-listed 17th-century inn has low beams, flagstone floors, an open fire in winter and a pretty enclosed terrace to enjoy in summer. A recent local CAMRA Pub of the Year and Cider Pub of the Year, it usually has four real ales available, together with a very good range of ciders. The pub also has a reputation for its excellent home-cooked food, which can be enjoyed in the dining area, adjacent to the bar.

Q ➤ ⇆ ◀❶ ♣ ● P ❀ 🛜

Kingsbridge

Hermitage Inn

8 Mill Street, TQ7 1ED

☎ (01548) 853234 ⊕ the-hermitage-inn.edan.io

2 changing beers (sourced regionally; often Cotleigh, Teignworthy) 🄷

Popular with the locals of Kingsbridge, this extremely friendly pub with log fires and a traditional interior has a pleasant enclosed beer garden to the rear. The pub boasts an eclectic range of local beers, normally two at any given time, with bar snacks and basket meals on Friday night and lunchtimes during the summer. Live music is held regularly. Q ➤ ❀ ♣ ● P 🚆 ❀ 🛜

Lewdown

Blue Lion Inn 🗘

EX20 4DL

☎ (01566) 783238

Sharp's Doom Bar; Dartmoor Jail Ale; 1 changing beer (sourced regionally) 🄷

Family-owned and run roadside inn, set on the old, now bypassed A30 between Okehampton and Launceston. Originally a 17th-century farmhouse on the Lewtrenchard Estate, the property was extended in the early 1900s. Now home to numerous local groups, several pub teams are also supported. Although predominantly drinks-oriented, good value food is served Tuesday to Saturday evenings. Accommodation is offered in two well-appointed rooms. ➤ ❀ ⇆ ◀❶ ♣ ● P 🚆 ❀ 🛜

Littlehempston

Tally Ho 🍷 🗘

TQ9 6LY SX813627

☎ (01803) 862316 ⊕ tallyhoinn.co.uk

Dartmoor Legend; New Lion Pandit IPA; 1 changing beer (sourced locally; often Exeter, Teignworthy) 🄷

Idyllic 14th-century stone-built inn, community owned since 2014. The single-roomed bar with timber beams is furnished with pews and wooden settles, the cosy feel enhanced by two wood-burners. The pub hosts numerous events including an annual beer festival, occasional local live music, and a regular Sunday night quiz. Guest beers are sourced from local breweries, and a real cider is sold. An enclosed beer garden is to the rear of the building. Q ➤ ❀ ◀❶ ♣ ● P 🚆 (X64,177)❀ 🛜

Lympstone

Redwing Bar & Dining
Church Road, EX8 5JT
☎ (01395) 222156 ⊕ redwingbar-dining.co.uk
Branscombe Branoc; St Austell Proper Job; Sharp's
Doom Bar Ⓗ
This welcoming, tastefully decorated pub was once
known as the Redwing Inn. While the emphasis is now
more on food, there is plenty of seating for drinkers at
small tables near the bar, or on comfortable furnishings
elsewhere. The restaurant area extends into a
conservatory, there is a small function room upstairs and
the garden is a suntrap. Excellent fresh food is served
either as full meals or bar snacks. Dogs are welcome in
the bar area. Q♨✿❁◑☀≈(Village)P❀❤ 🛈

Lynton

Cottage Inn Ⓛ
Lynbridge, EX35 6NR (on B3234 between Barbrook and
Lynton)
☎ (01598) 753496 ⊕ nartnapa.co.uk
Fat Belly Guzzler, Ocean Gold, Carver Doone; 2
changing beers (sourced nationally) Ⓗ
Characterful 17th-century riverside inn with
accommodation and an authentic Thai restaurant. Fat
Belly ales began here and, although now brewed nearby
at Mullacott, they remain a key part of the business. At
least three of the brewery's beers are always available,
often accompanied by other specials. A further selection
of craft beers is served through a USA-style craft beer
dispenser. Please check first if visiting in midwinter, as
opening hours and meal times can vary.
♨✿✉◑⅄⚲P🛏❤ 🛈

Meavy

Royal Oak Inn Ⓛ
PL20 6PJ (on village green)
☎ (01822) 852944 ⊕ royaloakinn.org.uk
Dartmoor Jail Ale; St Austell Proper Job; house beer
(by Black Tor); 1 changing beer (sourced regionally;
often Dartmoor, Otter) Ⓗ
People come from miles around to enjoy the food and
drink at this tucked-away, civilised but unpretentious
16th-century pub. In the summer you can sit outside on
one of the benches by the legendary tree and watch
children play on the village green. In winter, relax in the
public bar and enjoy the conversation, dogs and roaring
fire. There is an interesting range of cider, a festival in
August, and occasional live music. Local CAMRA Country
Pub of the Year runner-up in 2020.
Q♨✿❁◑⅄♣♥🚍(56) ❤ 🛈

Musbury

Hind Ⓛ
The Street, EX13 8AU
☎ (01297) 553553 ⊕ thehindmusbury.co.uk
3 changing beers Ⓗ
The Hind is a free house situated on the crossroads of the
A358, in the village of Musbury, three miles south of
Axminster. There is a public bar and a lounge/restaurant
where good-value home-cooked food is available
lunchtime and evening. Breakfast is also served on
Saturday morning. Outside, the front courtyard enjoys
stunning views over the Axe Valley. A good sized
function room/skittle alley has recently been opened.
Q♨✿❁◑♣🚍(885) 🛈

Newton Abbot

Dartmouth Inn
63 East Street, TQ12 2JP
☎ (01626) 202309 ⊕ the-dartmouth-inn.business.site
Dartmoor Legend, Jail Ale; 1 changing beer (sourced
locally; often Exeter, Teignworthy) Ⓗ
Split-level pub with timber beams, panelling, columns,
stone walls and large open fireplaces, where the
emphasis is on good quality beer. On the higher level is
the main L-shaped bar. To the right down two steps is
the Tap Room, which has an open fireplace. There is also
a pool table in another area, and a small walled garden
at the rear. A quiet pub, other than when live music is
played. Q♨✿❁⅃♣♥P🚍❤ 🛈

Railway Brewhouse
197 Queen Street, TQ12 2BS
☎ (01626) 354166 ⊕ therailwaybrewhouse.co.uk
Dartmoor Jail Ale; Draught Bass; Timothy Taylor
Landlord; 2 changing beers (sourced locally) Ⓗ
Originally the Railway Hotel, its proximity to the railway
station gave the name to Platform 5 brewery. The
brewery has now moved, but the beers are often still
available at the pub. A straightforward one-bar
establishment, it has solid cast-iron pillars hosting
screens showing TV sports. At the front is a covered
veranda area with tables for smokers and drinkers. There
are plans to reopen the brewery area as a sports bar.
♨✿⅃≈♣P🚍❤ 🛈

Teign Cellars Ⓛ
67 East Street, TQ12 2JR
☎ (01626) 332991 ⊕ teigncellars.com
2 changing beers (sourced nationally) Ⓗ/Ⓖ
Originally part of the old workhouse of 1836 and used by
paupers to pick oakum, the pub operated as the Devon
Arms and the Green Man before its latest incarnation.
The interior has one elongated bar room – the lower area
has a fridge stocking foreign beers, and the upper part is
mostly used for dining. Beers and ciders are often local
and are complemented by a wide range of craft beers.
One of the few pubs in the area to have a rear beer
garden. Q♨✿❁◑≈♥P🚍❤ 🛈

Newton Ferrers

Dolphin Inn
Riverside Road East, PL8 1AE
☎ (01752) 872007 ⊕ dolphininn.weebly.com
Draught Bass; St Austell Tribute; Salcombe Shingle
Bay; 1 changing beer (sourced locally; often Hanlons,
Salcombe, Summerskills) Ⓗ
Situated close to the tidal estuary, with views across to
Noss Mayo, the pub reopened under new management
in early 2019 after a short period of closure. Good home-
cooked food is served daily at both lunchtime and
evening. Up to four real ales usually feature, mainly
sourced from within the West Country. The pub has a
small car park, and friendly dogs are welcome.
Q♨✿❁◑♥P🚍(94) ❤ 🛈

Newton Poppleford

Cannon Inn
High Street, EX10 0DW
☎ (01395) 568266 ⊕ pubindevon.com
2 changing beers (sourced nationally) Ⓖ
Cheery welcoming two-bar pub with tables for dining in
the lounge bar and restaurant area. Real ales are served
by gravity from a stillage behind the bar. This is a friendly
locals' pub with busy passing trade. Good-value home-
cooked food, served lunchtime and evening, covers most

traditional pub favourites, and is of a very tasty standard. Well-behaved dogs are allowed. There are two large gardens and a skittle alley. This is the only pub in the village and a real community hub. Q☺️🍽️◑🚻♿♣️♠️🅿️🚲 (52,157) 🐾 🛜

Newton St Cyres

Beer Engine 🅛

EX5 5AX (beside railway station, N of A377)
☎ (01392) 851282 ⊕ thebeerengine.co.uk
Beer Engine Rail Ale, Piston Bitter; 3 changing beers Ⓗ
Victorian pub, built in 1850 on the Exeter to Barnstaple Tarka Line. Home-cooked food made with locally sourced produce is served lunchtimes and evenings. Part of the downstairs area has been converted into a second bar to accommodate sports fans and customers, in the large covered area between the pub and the railway line. The downstairs bar also allows views of the brewery. The pub brews its own ales and five are usually available. Q☺️🍽️◑🚻♿⇌🅿️🐾

North Tawton

Railway Inn 🅛

Whiddon Down Road, EX20 2BE (1 mile S of town, just off A3124; next to former North Tawton railway station) SS666000
☎ (01837) 82789 ⊕ therailwaynorthtawton.co.uk
Teignworthy Reel Ale; 1 changing beer (sourced regionally) Ⓗ
Good value and a warm welcome always await you at this friendly Devon local. Adjacent to the former North Tawton railway station, there are numerous old railway photos on the walls. Reel Ale from Teignworthy is normally joined by a guest ale from another West Country brewery, together with a real cider in summer. The dining room is popular in the evening (no food Thu), also Sunday lunchtimes. Assistance dogs only. Q☺️🍽️◑♣️♠️🅿️🚲(51,315) 🛜

Noss Mayo

Ship Inn 🅛

Noss Mayo, PL8 1EW
☎ (01752) 872387 ⊕ nossmayo.com
Dartmoor Jail Ale; Noss Beer Works Church Ledge, Ebb Rock; St Austell Tribute; 1 changing beer (sourced regionally; often Bath Ales, Noss Beer Works) Ⓗ
Popular with ramblers and seafarers alike, this fine split-level pub is situated on an inlet of the Yealm estuary. Four ales and excellent food are available daily. A former local CAMRA Pub of the Year, it is an ideal start/finish point for a walk to sample the breathtaking river and sea views along the route of Lord Revelstoke's Drive. If sailing, ring ahead to ascertain the tide times and mooring availability. There is no bus service in the evening or on Sunday. Q☺️🍽️◑🚻♿▲🅿️🚲(94)🐾

Ottery St Mary

London Inn

4 Gold Street, EX11 1DG
☎ (01404) 812045 ⊕ thelondoninnottery.com
4 changing beers (sourced nationally) Ⓗ
A friendly locals' pub, this 17th-century coaching inn is located close to the historic 14th-century parish church. There are two separate bars offering six changing real ales sourced from breweries near and far, with a good range of styles and strengths all at the same price. Good-value home-cooked food, including a roast on Sunday, is

served and four B&B rooms are available. There is a pool room, function room and live music is regularly promoted. Q☺️🍽️🛏️◑♿♣️🚲(4,4A)🐾 🛜

Paignton

Henry's Bar 🅛 ✅

53 Torbay Road, TQ4 6AJ
☎ (01803) 551190 ⊕ henrysbarpaignton.co.uk
Sharp's Doom Bar; house beer (by Sharp's); 2 changing beers (sourced nationally; often Dartmoor) Ⓗ
A gem of a traditional town centre pub serving real ales and ciders from near and far. Henry's is a real hub of the community and has close ties with the locals and local events. The impressive long bar has four handpumps with three regular beers, one guest, and traditional cider on the fifth, plus various bottles and polyboxes. Home-cooked food is served daily, with a renowned roast on Sunday. Dogs are welcome, and families until 10pm. ☺️🍽️◑≉♠️🅿️🐾 🛜

Paignton Conservative Club

34 Palace Avenue, TQ3 3HB
☎ (01803) 551065
Dartmoor Jail Ale; 3 changing beers (often Exmoor, Salcombe, Skinner's) Ⓗ
This private members' club since 1885 usually serves three real ales on handpump from local and national brewers and is renowned for its consistent quality. The old stone-carved entrance leads through to the bar before going downstairs to a very spacious function room where many events such as bingo, cabaret and quiz nights take place. Upstairs is another function room and a snooker room with two tables. Q☺️◑♿⇌♠️🅿️🚲(22,125) 🛜

Torbay Inn ✅

34 Fisher Street, TQ4 5ER (300yds from big tree bus stop)
☎ (01803) 392729
St Austell Tribute; Sharp's Sea Fury; Twickenham Naked Ladies; Wye Valley HPA; 1 changing beer (often St Austell) Ⓗ
Paignton's oldest inn, dating back to the early 1600s when the sea was on its doorstep and the fish market opposite, hence the address of Fisher Street. It has a traditional layout with separate lounge and public bars. The bars boast four handpumps serving national and local real ale, and a warm welcome. Time is called via a ship's bell recovered from a wreck by a local diver. It is documented that the Roundhead General Fairfax stayed here prior to a civil war battle in Exeter. Q☺️🍽️♿♠️🅿️🚲(12,120) 🐾 🛜

Parkham

Bell Inn 🅛 ✅

Rectory Lane, EX39 5PL (½ mile S of the A39 at Horns Cross, on opp corner to village primary school) SS387212
☎ (01237) 451201 ⊕ thebellinnparkham.co.uk
3 changing beers (sourced regionally) Ⓗ
Sympathetically restored after a serious fire in 2017, this 13th-century thatched inn, with its cob walls, oak beams and woodburner fires, has retained all of its old world charm. Three and sometimes four changing real ales are available, with usually at least one of these coming from a local brewery. Very good home-cooked food is served lunchtimes and evenings Wednesday to Saturday, either in the bar or the adjacent raised restaurant area, while the Sunday roast is also popular. Q☺️🍽️◑♣️♠️🅿️🚲(372) 🐾 🛜

Peter Tavy

Peter Tavy Inn

Lane Head, PL19 9NN
☎ (01822) 810348 ⊕ petertavyinn.com
Dartmoor IPA, Jail Ale; 3 changing beers (sourced regionally; often Black Tor) Ⓗ
In a quiet village on the edge of Dartmoor, the inn has a small central bar serving two Dartmoor ales, supplemented by a varying range of up to three local guest beers. Traditionally attired throughout, it also has two larger rooms. A patio and hidden garden are added attractions. The pub is renowned for its food, but drinkers are made welcome. The inn is situated on the National Cycle Route 27, near a caravan and camping site.
Q ❀ ✿ ❀ ◑ ♠ ❖ ➹ (118,122) ☙ ♞

Plymouth

Admiral MacBride

1 The Barbican, PL1 2LR
☎ (01752) 262054 ⊕ admiralmacbride.com
Dartmoor Jail Ale; St Austell Tribute; Salcombe Shingle Bay Ⓗ
Popular pub on the historic Barbican, decorated throughout with a nautical theme. The original Mayflower steps would have been at the rear of the pub. Up to three real ales are served, mainly from local breweries. It can get busy in the summer with locals and visitors alike. Live music is hosted on Friday, and a quiz night held on the first Tuesday of the month. No meals are served at the weekend. Accommodation is available, and some rooms have sea views. May close early on Sunday evening if quiet. ❀ ❀ ✿ ◑ ➹ (25) ☙ ♞

Artillery Arms 🅛

6 Pound Street, Stonehouse, PL1 3RH (behind Stonehouse Barracks and Millbay Docks)
☎ (01752) 262515
Draught Bass; 1 changing beer (sourced locally; often Dartmoor, South Hams, Summerskills) Ⓗ
Cracking back street local tucked away in the old quarter of Stonehouse, close to the magnificent Grade I-listed Royal William Yard, which maintains the area's military connections. One South West guest beer and Thatchers Heritage cider are normally available. A beach party takes place on the last weekend of February, and charity monkey racing also features. Also popular with local hockey teams, this place is a real find.
❀ ❖ ➹ (34,34A) ☙ ♞

Bread & Roses 🅛

62 Ebrington Street, PL4 9AF
☎ (01752) 659861 ⊕ breadandrosesplymouth.co.uk
Exeter Avocet; 2 changing beers (sourced regionally; often Black Tor, Hanlons, Salcombe) Ⓗ
This friendly, sympathetically restored late-Victorian pub is popular with university staff, but also has a mixed clientele. Up to three real ales are sold, organic or Fairtrade wherever possible, just like the snacks. The ales are selected from local and regional breweries, including small batch and speciality beers unusual for the area. The pub promotes artistic and musical creativity, and is a vibrant music hub for local talent. ❖ ➹ (23,24) ☙ ♞

Britannia Inn 🅛 ✓

2 Wolesely Road, Milehouse, PL2 3BH
☎ (01752) 607596
Dartmoor Jail Ale; Greene King Abbot; Ruddles Best Bitter; Sharp's Doom Bar; changing beers (sourced nationally; often Bays, Exmoor, Summerskills) Ⓗ
An Edwardian pub, built in the 1830s, opposite the Plymouth Citybus depot, Central Park and the Life Centre,

and a short walk from Home Park, the home of Plymouth Argyle FC. The pub itself was built by the grandfather of Captain Scott (of Antarctic fame). Ten handpumps dispense at least one real cider, with Westons and other local ciders appearing regularly. Since becoming a Wetherspoon pub in 1999, it has established a well-earned reputation for its beer. Q ❀ ❀ ✿ ◑ ♿ ❖ ➹ ♞

Cherry Tree

291 Ham Drive, Pennycross, PL2 3NH
Sharp's Doom Bar; Timothy Taylor Landlord; 1 changing beer (sourced nationally; often Dartmoor, Fuller's) Ⓗ
Large estate pub with teams for pool, darts and euchre. A large-screen TV caters for less energetic sports fans. A varying selection of nationally sourced real ales is served on four handpumps, with three beers usually available. There is live entertainment on Friday or Saturday evenings. Food is not served, but you may bring in your own. Note that pool is available only after 6pm.
❀ ❀ ✿ ❖ ➹ (61,62) ☙

Dolphin Hotel 🅛 ✓

14 The Barbican, PL1 2LS
☎ (01752) 660876
Dartmoor Jail Ale; Draught Bass; Roam Tavy IPA; St Austell Tribute; Sharp's Doom Bar; Skinner's Betty Stogs; 2 changing beers (sourced regionally; often Roam, St Austell, Sharp's) Ⓖ
A Plymouth institution, this unpretentious hostelry is steeped in history. Up to eight ales are all dispensed by gravity from the cask. Full of character, this charming pub has tiled floors, well-used wooden benches and a traditional open fire, all creating the perfect ambience. The walls are adorned with paintings by local artist, the late Beryl Cook, who painted many of the characters she encountered in the Dolphin. Local CAMRA City Pub of the Year 2020. ❖ ➹ (25) ☙

Fawn Private Members Club 🅛

39 Prospect Street, Greenbank, PL4 8NY
☎ (01752) 226385
Bays Topsail; Dartmoor Legend; 4 changing beers (sourced regionally; often St Austell, Sharp's, Teignworthy) Ⓗ
This mid 19th-century establishment was originally the Fawn Inn/Hotel, prior to converting to a club. CAMRA members are welcome with a membership card, regular visitors will be required to join. Four guest ales from the local area are generally served, as well as a rotating range of local cider from Countryman. The club is popular for rugby and other televised sports, and supports multiple dart and euchre teams. Local CAMRA Club of the Year 2020. ≈ ♣ ❖ ➹ ☙

Ferry House Inn 🅛 ✓

888 Wolseley Road, Saltash Passage, PL5 1LA
☎ (01752) 361063 ⊕ ferryhouseinn.com
Dartmoor IPA, Jail Ale; Sharp's Doom Bar Ⓗ
A warm welcome awaits both you and your dog from the landlord and locals at this picturesque riverside pub on the river Tamar. Three regular West Country ales are served, as well as good home-cooked food. A decking area on the edge of the river gives spectacular views of both the road bridge and Brunel's iconic 1859 railway bridge. Photos, some dating back to the turn of the 20th century, adorn the walls. Quiz night is Sunday.
❀ ❀ ✿ ◑ ♿ ❖ ➹ (13) ☙ ♞

Fortescue Hotel 🅛 ✓

37 Mutley Plain, PL4 6JQ
☎ (01752) 660673

Bays Devon Dumpling; Blue Anchor Spingo Special; Dartmoor Legend; St Austell Proper Job; Skinner's Betty Stogs; Summerskills Devon Dew; 4 changing beers (sourced nationally; often Exeter, Salcombe, South Hams) Ⓗ

This multi award-winning and lively local is frequented by a broad section of the community, and conversation flourishes. Nine real ales are usually on tap, and up to eight real ciders. A perfect Sunday can be spent here – a good-value home-cooked roast washed down with a pint of Spingo Special, followed by a brain-teasing quiz in the Cellar Bar in the evening. The patio beer garden draws crowds in the summer and is heated in winter. ⑤⑤⑧◐≈♣●🖿❀?

Lounge

7 Stopford Place, Devonport, PL1 4QT
☎ (01752) 561330

Draught Bass; 2 changing beers (sourced nationally; often Cotleigh, Hunters, Skinner's) Ⓗ

Located in a quiet residential area, this street-corner local is situated near to Devonport Park, and offers a very warm welcome. The wood-panelled bar is comfortable and relaxing, although it may be busy at times, as Plymouth Albion RFC's ground is nearby. 'One weaker, one stronger' than the regular Bass is the rule for guest beers, with lighter and darker brews also alternating. A secluded garden at the front offers a retreat for smokers. Food is only available at lunchtimes (no food Mon). Q⑤⑧◐≈(Devonport)♣●🖿(32,34)❀

Minerva Inn ⓛ

31 Looe Street, PL4 0EA
☎ (01752) 223047 ⊕ minervainn.co.uk

St Austell Trelawny, Tribute; 2 changing beers (sourced locally; often Dartmoor, Roam, Summerskills) Ⓗ

Plymouth's oldest hostelry, dating from around 1540, and within easy walking distance of the city centre and the historic Barbican, attracts a varied clientele. It has a long and narrow bar, leading through to a cosy seating area at the rear. Two guest beers are supplemented by the spring and autumn beer festivals, where beer could, and does, come from all over the country. Live music takes place Thursday to Sunday evenings, and at Sunday lunchtime. ⑤⑤⑧♣●🖿❀?

Prince Maurice ⓛ ✅

3 Church Hill, Eggbuckland, PL6 5RJ
☎ (01752) 771515

Dartmoor Jail Ale; St Austell Tribute, Proper Job; Sharp's Doom Bar; South Hams Sherman; 2 changing beers (sourced locally; often Hunters, Roam, Summerskills) Ⓗ

There is very much a village feel to this four-times local CAMRA Pub of the Year, which sits between the church and village green. The six regular ales are supplemented by a changing guest ale. It is named after the Royalist General, the King's nephew, who had his headquarters nearby during the siege of Plymouth in the Civil War. Two log fires keep you warm in winter, adding to the ambience. No food is served at weekends. ⑤⑧◐♣●🖿(28A)❀

Providence ⓛ

20 Providence Street, Greenbank, PL4 8JQ
☎ (01752) 946251

3 changing beers (sourced regionally; often Bridgetown, St Austell, Summerskills) Ⓗ

This welcoming hostelry, tucked away within the back-street labyrinth of Greenbank, is well worth seeking out. One of the smallest pubs in Plymouth, what it lacks in size it makes up in atmosphere and character. The

interior is smart but comfortable and the real fire in winter is wonderful. Three competitively priced beers, from a range of breweries, are generally available, as are two or three real ciders. There are no fruit machines here; the sound is generated by conversation. Q≈♣🖿❀?

Queen's Arms

55 Southside Street, PL1 2LA
☎ (01752) 662915

Dartmoor Jail Ale; Otter Amber; St Austell Proper Job; 1 changing beer (often Butcombe) Ⓗ

A public house has stood on this site since the mid-19th century. The current building dates from the mid-1960s after its predecessor was blitzed in 1941. It is a traditional pub that tends to attract older customers. Up to four real ales are usually available. The Otter Amber may alternate with Otter Ale, as may the Tribute and Proper Job. Q🖿(25)❀

Roam Brewery Tap ⓛ

New Victoria House, Western Park Road, Peverell, PL3 4NU
☎ (01752) 396052 ⊕ roambrewco.uk

Roam Hometown Pale Ⓖ, Tavy IPA; 2 changing beers (sourced locally; often Roam) Ⓗ

Situated in the former New Victoria Brewery Company premises, the taproom has a light and airy feel, with two large tinted windows allowing the sun to flood in. Two real ales from the range are always available, supplementing five craft beers also on tap. There is a range of cans, and guest beers are sometimes available. Third-pint tapas are offered. As well as the brewery itself, there is an on-site brewery shop and bakery open six days a week, and pizzas when the tap is open, Thursday to Sunday. ⑤⑤⑧◐▶♿P🖿(61,62)❀

Plympton

London Inn ⓛ ✅

8 Church Road, Plympton St Maurice, PL7 1NH
☎ (01752) 343322 ⊕ londoninnpub.co.uk

Draught Bass; changing beers (sourced regionally; often Bays, Dartmoor, Skinner's) Ⓗ

This friendly 16th-century pub, situated next to the church, is the epitome of a typical village inn. It serves up to eight real ales, supplemented by several real ciders. The cosy lounge bar is adorned with a large collection of Royal Naval memorabilia, while the public bar boasts a pool table, dartboard and TVs for sports enthusiasts. Regular beer festivals are held. The pub is allegedly haunted by Captain Hinds. Dogs are welcome. Q⑤⑧♣●P🖿(19,21A)❀?

Union Inn ⓛ

17 Underwood Road, Underwood, PL7 1SY
☎ (01752) 336756 ⊕ unioninnplympton.com

4 changing beers (sourced regionally; often Exeter, Summerskills, Tintagel) Ⓗ

The landlord of this family-run community pub is a beer hunter, sourcing changing brews to charm his regulars' palates, and create a year-round beer festival. The four beers on offer are regional, but could be from almost anywhere. The cider selection is also sourced from far and wide but Old Rosie is a regular. A warm welcome is assured at this traditional, cosy, early 19th-century hostelry. A former local CAMRA Cider Pub of the Year runner-up. Q⑤⑧♣●P🖿❀?

St Giles on the Heath

Pint & Post 🅛

PL15 9SA (just off main road through village, on opp side of road to village shop)
☎ (01566) 779933
2 changing beers (sourced locally; often Dartmoor) Ⓗ
This thatched village local was once two cottages, then a pub and post office, hence the name. A friendly family-run pub close to the Cornish border, it offers good home-cooked food, including takeaways, and a regular Wednesday quiz night. Legend from Dartmoor is one of the two well-kept ales, joined by a locally sourced guest beer. The pub is dog-friendly throughout.
Q🕭🅐🕭🅓🕭🅐🅟🕭🕭

Shaldon

Shipwrights Arms 🅛

Ringmore Road, TQ14 0AG
☎ (01626) 439226 🌐 shipwrights-arms.co.uk
House beer (by Teignbrook); **2 changing beers** (often Exeter) Ⓗ
Named after a once-flourishing boat building industry on the estuary, the pub is approached via a small alleyway from the road or an even narrower one from the rear into the garden. Inside are three different areas on three levels, with a central bar area. The garden has been partially covered, and to the rear is a well patronised farm shop. The house beer, Shipwrights Ale, is from Teignbrook Brewery across the water, with at least two other beers on offer, often from Exeter Brewery.
🕭🅐🅓🕭🅐🅟🅓(22) 🕭🕭

Sidmouth

Anchor Inn ✅

Old Fore Street, EX10 8LP
☎ (01395) 514129 🌐 theanchorinn-sidmouth.co.uk
St Austell Tribute, Proper Job; Sharp's Doom Bar; 1 changing beer (sourced locally) Ⓗ
Large, welcoming pub, situated just off the Esplanade, with a good ambience and friendly helpful staff. It is popular with tourists and locals alike, with seating outside and a garden at the rear. Three regular ales are usually on tap and a guest added in summer. Good-value home-cooked food, is served all day, every day. The pub is especially busy during Sidmouth Folk Week when the garden and car park are given over to events. Dogs are welcome outside but not inside. 🕭🅐🅓🕭🅐🅟🕭🕭

Swan Inn ✅

37 York Street, EX10 8BY
☎ (01395) 512849 🌐 swaninnsidmouth.co.uk
3 changing beers (sourced nationally) Ⓗ
A quiet and traditional back-street inn, established around 1770, just off the centre of this picturesque town, a short walk from the seafront and bus terminus. An old-style wood-panelled bar with an open fire attracts a strong local trade, and leads to a dedicated dining area serving good food. Three changing beers are normally available. Dogs, but not children, are welcome indoors. Hosts the King of Chit - a traditional competition - and the Black Rod fishing contest.
Q🕭🅐🅓🕭🅐🕭🅓(52,157) 🕭🕭

Silverton

Lamb Inn 🅛

Fore Street, EX5 4HZ
☎ (01392) 860272 🌐 thelambinnsilverton.co.uk
Exeter Avocet; 2 changing beers (sourced locally) Ⓖ
Popular family-run pub located in the centre of Silverton, with stone floors, stripped timber, old pine furniture, and a large open fire. Three ales are served by gravity from a temperature-controlled stillage behind the bar. There is a well-used function room, regular quiz nights and occasional live music. Good-value home-cooked food is served lunchtimes and evenings, plus a popular Sunday roast. Q🕭🅐🅓🕭🅓🕭(55B)🕭🕭

South Zeal

King's Arms 🅛

EX20 2JP (centre of village) SX649936
☎ (01837) 840300 🌐 thekingsarmssouthzeal.com
Dartmoor IPA, Legend; 1 changing beer (sourced regionally) Ⓗ
Thatched 14th-century village local, which is not only at the hub of the community, but also attracts the many visitors exploring the area. Well-behaved dogs are made particularly welcome here. The regular Dartmoor beers are accompanied by a changing guest ale, and locally made cider during summer months. Good food is served lunchtime and evening every day. Regular live music sessions are held throughout the year and the pub plays a central role during the Dartmoor Folk Festival in August. Q🕭🅐🅓🕭🅓🕭🅐🅟🅓🕭🕭

Spreyton

Tom Cobley Tavern 🅛

EX17 5AL (off A3124 in village) SX6986096761
☎ (01647) 231314 🌐 tomcobleytavern.co.uk
Exeter Darkness; Otter Ale; Parkway Cheeky Monkey Ⓗ; **5 changing beers** (sourced regionally) Ⓗ/Ⓖ
Nestling on the edge of Dartmoor, this 16th-century pub is named after a local folklore figure and a visit should be on everyone's bucket list. The bar area has a warming fire in the winter months and a small side room. At the rear is a separate restaurant and access to the garden. Four ales are available in winter, with up to 10 in summer, always including a dark beer. There are also four real ciders. A former National CAMRA Pub of the Year and winner of many other accolades.
Q🕭🅐🅓🕭🅐🅟🕭🕭

Teignmouth

Blue Anchor Inn 🅛

Teign Street, TQ14 8EG
☎ (01626) 772741
6 changing beers (sourced regionally; often Exeter, Summerskills, Teignworthy) Ⓗ
This friendly free house on the edge of town hosts beer festivals over the Easter and August bank holidays, and the Christmas decorations are an absolute showstopper. Six handpumps serve ever-changing and varied real ales - often including a dark beer. A woodburner adds warmth in winter and the wonderfully maintained outdoor areas are popular in the spring and summer. 🕭🅓🕭🅓(2,22) 🕭

Molloys 🅛

1 Teign Street, TQ14 8EA
☎ (01626) 774661
2 changing beers (sourced locally) Ⓗ
Well-established town-centre pub - previously called the Kangaroo and selling Bass, as the original pub sign towards the back of the pub testifies - but now selling Platform 5 beers on a rotational basis. There is one central bar with separate drinking areas on different levels. The left-hand wall has a line of mirrors. Outside,

drinkers are catered for with benches in a pedestrianised area by the main entrance. Real cider is only sold in the summer months. ♿🌳🍴◐⃥≠♣🚲🚪(2,22)🌸🐕🛜

Topsham

Bridge Inn ★ 🅛
Bridge Hill, EX3 0QQ
☎ (01392) 873862
Branscombe Branoc; changing beers (sourced regionally) 🅖
An historic, cosy, 16th-century inn, beautifully positioned overlooking the River Clyst. Run by five generations of the same family since 1897, it was visited by the Queen in 1998. This pub is a delight for real ale fans, offering a continually varying range of beers dispensed by gravity direct from the cellar. There are two rooms in the unspoilt interior, plus the malthouse which is used at busy times and for functions. Traditional lunches such as ploughman's and sandwiches served.
Q🌳🐕◐≠♣🚪(57,T)🐕

Exeter Inn 🅛
68 High Street, EX3 0DY
☎ (01392) 873131
St Austell Proper Job; 3 changing beers (sourced regionally) 🅗
A pub since at least 1860, some parts of this partially thatched building date from the 17th century when it was a coaching inn and blacksmiths. The Exeter Inn is a friendly local serving up to four ales and two ciders. Three TVs show various sports, while the front area has a dartboard and more seating. There is a small, sheltered garden at the side. ♿🌳🐕≠♣🚪🐕🛜

Torquay

Hole in the Wall 🅛
6 Park Lane, TQ1 2AU
☎ (01803) 200755 🌐 holeinthewalltorquay.co.uk
Butcombe Blond; Dartmoor Jail Ale; Timothy Taylor Landlord; 4 changing beers (sourced regionally; often Butcombe, Otter, St Austell) 🅗
Torquay's most ancient inn, circa 1540, is tucked behind the harbour in one of the town's oldest areas. It is an atmospheric pub popular with tourists and locals. The interior is beamed, has cobbled floors, and the walls are adorned with placards and artefacts from Torbay's maritime history. This pub is a hotspot for real ale drinkers, with local and national beers on offer throughout the year. It has a large restaurant serving a variety of foods for all tastes. ♿🌳◐🍴♣🚪🐕🛜

Molloys
20 Fore Street, St Marychurch, TQ1 4LY
☎ (01803) 311825
Platform 5 The Coaster, APA, The Black Crow; 1 changing beer (often Platform 5) 🅗
Once the Manor Hotel, Molloys is now owned by White Rose Taverns. It is also an outlet for Platform 5 Brewery's beer, in common with other Molloys in south Devon. Spacious and dog-friendly, with three beers on handpump, it is a favourite with locals. All beers are served on handpump and are brewed in Torquay by Platform 5 Brewery. 🍴♣🚪🐕🛜

Totnes

Albert Inn 🅛
32 Bridgetown, TQ9 5AD (from town centre cross river, 100yds on left)
☎ (01803) 863214 🌐 albertinntotnes.com
Bridgetown Albert Ale, Shark Island Stout, Westcountry IPA; 2 changing beers (sourced locally) 🅗
A cracking old-school community pub which commemorates the scientist Albert Einstein. It is the only public house in the Bridgetown district of Totnes and is home to darts, quiz and hockey teams. Based in an old chapel of rest, it hosts regular beer and cider festivals and boasts a small, but delightful, beer garden to the rear. Noted for its traditional meals, the pub also holds themed culinary evenings. It is the brewery tap for the Bridgetown Brewery. Q♿🌳🐕◐🍴▲♣🚪🐕🛜

Bay Horse Inn 🅛
8 Cistern Street, TQ9 5SP (at top of main shopping street)
☎ (01803) 862088 🌐 bayhorsetotnes.com
2 changing beers (sourced locally; often New Lion, Salcombe, Teignworthy) 🅗
This welcoming community-minded inn is an excellent find at the very top of the main shopping street in Totnes. The characterful pub is especially noted for its large, well-kept beer garden, in which many events are held. It also hosts jazz nights, folk sessions, quiz nights and beer festivals. Although there is no food, patrons are welcome to bring in their own from the many nearby food emporiums. Q♿🌳🍴◐≠♣🚪(92,164)🐕🛜

Waterman's Arms
Victoria Street, TQ9 5EF
☎ (01803) 863038
Dartmoor Jail Ale 🅗**; 2 changing beers (sourced locally; often Hunters)** 🅗/🅖
This classic Grade II-listed back-street pub is set back off the main road in a conservation area. It has an open fire in winter, mainly banquette seating and pictures of old Totnes inside the otherwise uncluttered interior. There is a selection of over 200 different spirits behind the bar. Outside is a beer garden. Q♿🌳🐕▲≠♣🚪🐕🛜

Turnchapel

Boringdon Arms 🅛 ✅
13 Boringdon Terrace, PL9 9TQ
☎ (01752) 402053 🌐 boringdon-arms.net
Dartmoor Jail Ale; Fuller's London Pride; 2 changing beers (sourced regionally; often Exmoor, Sharp's) 🅗
The Bori is a traditional and dog-friendly former CAMRA regional Pub of the Year. It has six letting rooms, and sits in a waterside village on the South West Coastal Footpath, benefitting from a regular bus service from Plymouth or a water taxi from the Barbican. Four regular ales are available, with more during the four beer festivals held during the year. Good-value, home-cooked food is served daily. There are two secluded gardens to the rear. Q♿🌳🐕🛏◐♣🚪(2,2A)🐕🛜

Walkhampton

Walkhampton Inn 🅛
PL20 6JY
☎ (01822) 258697 🌐 walkhamptoninn.co.uk
3 changing beers (sourced regionally; often Bays, Dartmoor, Sharp's) 🅗
Set in the centre of the village, this welcoming 17th-century local displays traditional features throughout the bar, dining areas and snug. Up to four different real ales are sold, and six real ciders. There are quiz nights, live music and open mic nights throughout the year, and annual real ale and cider festivals. The pleasant courtyard beer garden hosts summer events. This is a good, old-fashioned country pub. Q♿🌳◐▲♣🚪(55,56)🐕🛜

Weare Giffard

Cyder Presse L

EX39 4QR
☎ (01237) 425517 ⊕ cyderpresse.co.uk
Timothy Taylor Landlord; Fuller's London Pride; Otter Ale; 1 changing beer (sourced regionally) Ⓗ
Family-run local in a picturesque village on the banks of the River Torridge, with cosy bar and restaurant areas, a beer garden and two en-suite twin rooms. A former local CAMRA Cider Pub of the Year, and finalist in 2022, it usually features more than nine real ciders, alongside up to four real ales. Home-cooked food made from local produce is served Thursday to Saturday and Sunday lunchtime. Upcoming events are posted on the website.
Q❁⛺✿⍅◑⟵Å♣❂🅿🚆(7A)❀🐾🛜

Welcombe

Old Smithy Inn L

EX39 6HG (turn off A39 Bideford to Kilkhampton road at Welcombe Cross and follow signs to Welcombe and then to the pub)
☎ (01288) 331305 ⊕ theoldsmithyinn.co.uk
3 changing beers (sourced regionally) Ⓗ
A 13th-century thatched inn, nestled near the Cornish border at the top of the Welcombe Valley and just a mile from the sea. Quality ales from nearby Forge and other local breweries, good ciders and a range of excellent, locally sourced food can all be enjoyed here in a most welcoming atmoshere. Outside there is a pleasant garden and a separate function room. An outstanding beer and music festival is held in July.
⛺✿⍅◑Å♣🅿❀🛜

Widecombe-in-the-Moor

Rugglestone Inn L

TQ13 7TF (¼ mile from village centre)
☎ (01364) 621327 ⊕ rugglestoneinn.co.uk
Dartmoor Legend; house beer (by Teignworthy); 2 changing beers (sourced regionally) Ⓖ
An unspoilt Grade II-listed Dartmoor building which was converted to a pub in 1832. Beers can be served through a hatch in the passageway or from the cosy bar with its woodburner. There are two further rooms, one with an open fire. Across the stream is a large grassed seating area, with the car park just down the road. A wide selection of home-cooked food is available. Local Hunts cider is among the real ciders and perries on offer.
Q⛺✿⍅◑Å♣❂🅿🚆(271,672)❀

Winkleigh

King's Arms L

The Square, Fore Street, **EX19 8HQ** (in village square)
☎ (01837) 682681 ⊕ kingsarmswinkleigh.co.uk
Hanlons Yellow Hammer; Teignworthy Reel Ale; 3 changing beers (sourced locally) Ⓗ
Grade II-listed 16th-century thatched village pub. The single bar has low-beamed ceilings, a flagstone floor and a welcoming wood-burning fire for colder months. Good food from a varied menu can be enjoyed in a series of intimate dining rooms featuring naval memorabilia, books and an intriguing, glass-capped well. To the rear is a cosy private function room. Up to five, mainly Devon-sourced real ales are usually available, together with two ciders from nearby Sam's. Q⛺✿◑Å♣❂🚆(315)❀🛜

Yarde Down

Poltimore Arms L

EX36 3HA (2 miles E of Brayford on jct with unclassified road from South Molton to Simonsbath) SS725356
Exeter Lighterman; 1 changing beer (sourced regionally) Ⓖ
Dating back to the 13th century, this ivy-clad coaching inn lies in an isolated area of glorious Exmoor countryside. The beamed building is so remote it is not connected to mains power and generates its own electricity. Water is from a spring. An atmospheric and welcoming locals' pub, the Poltimore Arms retains many interesting and original features, including, it is said, a friendly ghost. Q⛺✿Å♣🅿❀🛜

Breweries

Anchor House

c/o 3 Osmand Gardens, Plympton, Devon, PL7 1AA
☎ 07940 270918 ✉ info@anchorhousebrewery.com

A family-run brewery, established in 2019, to brew small-batch vegan-friendly, experimental beers using spare capacity at other local breweries. All ingredients are locally sourced where possible. A number of local charities are supported. **V**

Barnaby's SIBA

The Old Stable, Hole Farm, Staverton, Devon, TQ11 0LA
☎ (01803) 762730 ⊕ barnabysbrewhouse.com

Soil Association-certified organic brewery established in 2016. Occasional cask ale production. A planned doubling of the size of the premises will enable a four-fold increase in production. New beers have been added to the range. ♦

Dark Dunkel (ABV 4.8%) SPECIALITY
Pilsner (ABV 4.8%) SPECIALITY
Red Helles (ABV 4.8%) SPECIALITY
English IPA (ABV 5.4%) PALE
Green Tomato Saison (ABV 6%) SPECIALITY

Barum SIBA

🏢 c/o Reform Inn, Pilton High Street, Pilton, Barnstaple, Devon, EX31 1PD
☎ (01271) 329994 ⊕ reforminn.co.uk/barum-brewery

⊗ Barum Brewery was established in 1996 by Tim Webster and is housed in a conversion attached to the Reform Inn, which is now run by Tim. The Reform continues to act as the brewery tap as well as serving other locally-sourced ales. Distribution is exclusively within Devon. ‼♦LIVE

Bays SIBA

Aspen Way, Paignton, Devon, TQ4 7QR
☎ (01803) 555004 ⊕ baysbrewery.co.uk

Bays Brewery is a multiple award-winning, family-run business based in Torbay on the Devon coast. Its passion is to brew premium ales using the finest local ingredients whilst also supporting the community and protecting the environment. ‼🏭♦

Topsail (ABV 4%) BITTER
A tawny session bitter with complex aroma. Malty, bitter taste leading to a long, dry and refreshing aftertaste.
Gold (ABV 4.3%) GOLD

Smooth, golden ale. Light aroma and taste of hops, malt and caramel. Lingering hoppy aftertaste.
Breakwater (ABV 4.5%) PALE
Devon Dumpling (ABV 5.1%) BITTER
Strong ale, easily drinkable. Light aromas of hops and fruit continue through taste and lingering aftertaste.

Beer Engine SIBA

Newton St Cyres, Devon, EX5 5AX
☎ (01392) 851282 ⊕ thebeerengine.co.uk

⊗ The Beer Engine was established in 1983 and is the oldest working microbrewery in Devon. The brewery is visible in the downstairs bar in the pub through multiple viewing windows. Several outlets are supplied, as well as local beer festivals. ‼◆

Bere

Homefield, Bere Alston, Devon, PL20 7JA
☎ (01822) 840382 ⊕ berebrewery.co.uk

Established in 2016 by growers Jeremy & Buffy on their smallholding. The brewery has been self-sufficient in hop growing since 2019. Bottle-conditioned beers are made using their hops, with a 1.3-barrel system and a 50-litre, small-batch kit. Six regular beers are available, with one-off experimental beers (available around March and always named Bere Alston brew). Beers are sold from the brewery Wednesdays and Saturdays, and from Roots & Vines, Tavistock, Olde Plough Inn, Bere Ferrers, and the Tavistock Farmers Market. ☛◆LIVE ⚘

Black Tor SIBA

Units 5-6, Gidley's Industrial Estate, Christow, Exeter, Devon, EX6 7QB
☎ (01647) 252120 ⊕ blacktorbrewery.com

⊗ This independent, family-run brewery is located on the eastern edge of the beautiful Dartmoor National Park and has been under the current family ownership since 2015. Several changes of ownership and brewery name have occurred since brewing began on-site in 1998, with the present Black Tor name established in 2013. ◆

Pride Of Dartmoor (ABV 4%) BITTER
Raven (ABV 4.2%) BITTER
Devonshire Pale Ale (ABV 4.5%) PALE

Branscombe SIBA

Branscombe, Devon, EX12 3DP
☎ (01297) 680511 ⊕ branscombebrewery.co.uk

⊗ The brewery was set up in 1992 in cowsheds at the back of a National Trust-owned farm, overlooking the sea at Branscombe. The brewery owners converted the sheds, digging its own well. In 2008 a new 25-barrel plant was shoehorned in through the roof to increase capacity. ◆LIVE

Branoc (ABV 3.8%) BITTER
Amber session bitter. Hops and malt throughout with good bitterness in taste and aftertaste.
Golden Fiddle (ABV 4%) GOLD
Summa This (ABV 4.2%) BITTER
Summa That (ABV 5%) GOLD

Bridgetown SIBA

Albert Inn, Bridgetown Close, Totnes, Devon, TQ9 5AD
☎ (01803) 863214 (Pub) ☎ 07517 926040
⊕ albertinntotnes.com/bridgetown-brewery

⊗ Bridgetown started brewing in 2008 using a two-barrel plant in the outbuildings of the Albert Inn, Totnes.

Beers are available in an increasing number of local outlets ‼◆LIVE
Albert Ale (ABV 3.8%) BITTER
Pale bitter, malt dominating throughout. Roast and caramel in aroma, taste and aftertaste with a little bitterness on the tongue.
Bridgetown Bitter (ABV 4.2%) BITTER
A tawny-coloured bitter with malt on the nose. The taste is malt and slightly fruity with a bitter, malty, dry finish.
Cheeky Blonde (ABV 4.5%) GOLD
Shark Island Stout (ABV 4.5%) STOUT
Smooth stout with strong malt and roast throughout. Touches of liquorice and chocolate lead to a bitter finish.
Westcountry IPA (ABV 4.7%) PALE

Buckland

Higher Thornhill Head, Bideford, Devon, EX39 5NU
☎ (01805) 601625 ☎ 07882 019255
⊕ thebucklandbrewers.co.uk

Brewing began in 2016. The original plant was replaced in 2018 with a new purpose-built microbrewery. It specialises in Belgian-style, bottle-conditioned beers, which are now supplied to more than 40 local pubs, farm shops, restaurants and visitor attractions. ‼☛◆LIVE

Bulletproof

91 Mutley Plain, Plymouth, Devon, PL4 6JJ ☎ 07703 733570

Office: Highlands, 1 Queen's Road, Lipson, Plymouth, PL4 7PJ ⊕ bulletproofbrewing.co

⊗ Small-scale brewery established in an outbuilding in 2016. It uses a 50-litre pilot plant to refine recipes before upscaling, using spare capacity at larger breweries. All beers are unfiltered and unfined. ⚘

Checkstone

▤ First & Last Inn, 10 Church Street, Exmouth, Devon, EX8 1PE
☎ (01395) 263275

Checkstone Brewery, named after the Checkstone reef outside the Exe Estuary, is a one-barrel plant inside the First & Last pub, Exmouth, established in 2016. Like the brewery, the beers are named after various sea features around Exmouth. ◆

Clearwater

Unit 1, Little Court, Manteo Way, Gammaton Road, Bideford, Devon, EX39 4FG
☎ (01237) 420492 ☎ 07891 562005
⊕ clearwaterbrewery.co.uk

⊗ Established in 1998, Clearwater is a 10-barrel brewery regularly supplying more than 250 outlets across the South West and nationally with its Devon's Own-labelled beers. Beers are also available at the brewery tap, the Champ, Appledore. ‼◆LIVE

Expedition Ale (ABV 3.7%) BROWN
Real Smiler (ABV 3.7%) GOLD
Mariners (ABV 4.2%) GOLD
Proper Ansome (ABV 4.2%) BITTER
A dark brown bitter, malty-flavoured, slightly sweet. In the style of a winter warmer.
Riff IPA (ABV 4.3%) PALE

Combe

Unit 4, Lundy View, Mullacott Cross Industrial Estate, Ilfracombe, Devon, EX34 8PY

☎ (01271) 267030 ☎ 07973 488409
⊕ combebrewingcompany.co.uk

⊠ Combe Brewing Co was established in early 2020, in a recently closed brewery. It produces bottle-conditioned ales to meet its small but growing client base. The owners, Richard and Michelle, have previous experience in the trade. A five-barrel plant is used. Bottle label artwork is designed by a local artist, Karen French. ‼ ☞ LIVE ✦

Harbour (ABV 3.7%) BITTER
Beach Blonde (ABV 4.1%) BLOND
Ruby Sunset (ABV 4.7%) RED
Dark & Stormy (ABV 5%) PORTER

Cottage Beer Project

Brockhole Cottage, Morebath, Tiverton, Devon, EX16 9BZ ☎ 07422 731152
⊕ cottagebeerproject.co.uk

Nanobrewery opened in 2021, using new 200-litre kit, and operating part-time. Bottle-conditioned beers are sold online, at local retailers, cafés and at numerous events, primarily within Devon and Somerset. The core range is supported by seasonal and one-off beers, with occasional cask for special events. ✦LIVE V

Country Life SIBA

The Big Sheep, Abbotsham, Bideford, Devon, EX39 5AP
☎ (01237) 420808 ☎ 07971 267790
⊕ countrylifebrewery.co.uk

⊠ Country Life is based at the Big Sheep tourist attraction. The brewery offers a beer show and free samples in the shop during the peak season (April-October). A 15.5-barrel plant was installed in 2005, making Country Life the biggest brewery in North Devon. Regular, seasonal and bottle-conditioned beers are available at approximately 100 outlets, the brewery shop, and online. ‼ ☞ ✦LIVE

Old Appledore (ABV 3.7%) BITTER
Reef Break (ABV 4%) BITTER
Shore Break (ABV 4.4%) GOLD
Black Boar/Board Break (ABV 4.5%) PORTER
Complex, well-balanced aromas. Unusual dry bitter hop taste leading to softer aftertaste with unexpected roasted malt and caramel.
Golden Pig (ABV 4.7%) BITTER
Country Bumpkin (ABV 6%) OLD

Crossed Anchors

▤ c/o Grapevine, 2 Victoria Road, Exmouth, Devon, EX8 1DL
☎ (01395) 222208 ☎ 07843 577608
⊕ crossedanchors.co.uk

⊠ Crossed Anchors was established in 2015. In 2016 a six-barrel plant became operational in the old stables of the Grapevine in Exmouth town centre. In 2022 an additional two 2,100-litre conical fermenters were added. Beers are increasingly available across Devon and the South-west, as well as in the Grapevine. ‼☞✦

Sweet Session O'Mine (ABV 3.8%) PALE
Bitter Exe (ABV 4%) BITTER
Devon Steam Gold (ABV 4.1%) SPECIALITY
American Pale Ale (ABV 4.2%) PALE
Very light brown-coloured ale. Has a lot of sweet malt and fruit on aroma. Sweet tropical fruits dominate the taste with slight bitter finish.
Big Red Ale (ABV 5.2%) RED

Bee Serker Honey Braggot (ABV 8.5%) SPECIALITY
Naturally hazy with honey evident on the nose. Easy-drinking, generally sweet but there is complexity in the taste with a bitter kick in the finish.

Dartmoor SIBA

The Brewery, Station Road, Princetown, Devon, PL20 6QX
☎ (01822) 890789 ⊕ dartmoorbrewery.co.uk

⊠ Formerly named Princetown, Dartmoor Brewery was established in 1994. It is the highest brewery in England at 1,465 feet above sea level. In 2005 the brewery moved locally to a new, purpose-built building. In both 2012 and 2013 capacity was increased. In 2017 a further extension was built which now gives a brewing capacity of 540 barrels. The brewery is a traditional ale producer and all beer is brewed using English Malt. ‼☞✦

Best (ABV 3.7%) BITTER
IPA (ABV 4%) PALE
There is a flowery hop aroma and taste with a bitter aftertaste to this full-bodied, amber-coloured beer.
Dragon's Breath (ABV 4.4%) SPECIALITY
Sweet, winter warmer best bitter. Full-bodied, sweet, fruity with treacle hints. Malt, roast and caramel from start to finish.
Legend (ABV 4.4%) BITTER
Well-rounded, complex beer full of aromas and flavours. Malt and caramel dominate balanced in an aftertaste of bitter hops.
Jail Ale (ABV 4.8%) BITTER
Stronger session ale with complex notes dominated by malty sweet bitterness. Well-rounded caramel and fruit with a pleasant aftertaste.

Devil's Pleasure

Higher Sigford Farm, Sigford, TQ12 6LD ☎ 07977 148006 ⊕ thedevilspleasure.com

Brewery founded in 2020 on the edge of Dartmoor National Park, near Newton Abbot. It specialises in brewing punchy, bold craft beers which are unfiltered and naturally hazy.

Devon Earth SIBA

Buckfastleigh, Devon ☎ 07927 397871

Office: 7 Fernham Terrace, Torquay Road, Paignton, TQ3 2AQ ✉ info@devonearthbrewery.co.uk

⊠ Devon Earth brewery is located on the banks of the River Dart on the edge of Dartmoor and is run on a part-time basis. The brewery is proud to support local charities and supplies local and national beer festivals and free houses. ✦

Devon Earth (ABV 4.2%) GOLD
Grounded (ABV 4.7%) BITTER
Lost in the Woods (ABV 5.2%) PORTER

Exeter SIBA

Unit 1, Cowley Bridge Road, Exeter, Devon, EX4 4NX
☎ (01392) 259059 ⊕ exeterbrewery.co.uk

⊠ Exeter began brewing in 2003 and is the largest brewery in the city, supplying more than 600 outlets in Devon, Cornwall, Dorset and Somerset. It moved to its present site in 2012, having outgrown its previous location. ‼☞✦✦

Lighterman (ABV 3.5%) BITTER
Tomahawk (ABV 3.5%) BITTER

Slight biscuit/malty aroma, biscuit and a tinge of orange and a slight toffee bitter finish.
Avocet (ABV 3.9%) BITTER
A lager-coloured bitter, fruity and sweet from nose to aftertaste. Slight maltiness balances pineapple. Light session ale.
'fraid Not (ABV 4%) GOLD
Ferryman (ABV 4.2%) BITTER
Lovely-flavoured session bitter, a mix of sweet/bitterness.
County Best (ABV 4.6%) BITTER
Darkness (ABV 5.1%) STOUT
Full-bodied stout. Roasted malt dominates the aroma. Complex taste with roast chocolate. Hints of liquorice in a bitter finish.

Fat Belly

Unit 8F, Commercial Point, Mullacott Cross Industrial Estate, Ilfracombe, Devon, EX34 8PL
☎ (01598) 753496 ☎ 07946 133332
⊕ fatbellybrewery.co.uk

⊗ Established in Lynbridge in 2016 at the Cottage Inn, using a three-barrel plant located at the rear of the pub. It relocated to its current premises in 2018, installing a new 10-barrel plant. As well as the pub it also supplies a growing number of outlets in the Exmoor area. Further beers are planned. ♦LIVE

FPA Pale Ale (ABV 3.8%) PALE
Guzzler (ABV 3.8%) BITTER
Ocean Gold (ABV 4.2%) GOLD
Carver Doone (ABV 4.5%) STOUT

Gilt & Flint

Haye Farm, Haye Lane, Musbury, EX13 8ST ☎ 07904 035640 ⊕ giltandflint.com

This brewery is based on the beautiful Haye Farm in an Area of Outstanding Natural Beauty in East Devon. Using age old traditional brewing techniques, it has created organic, modern, New World, bottle-conditioned beers, ciders and soft drinks. All of the agricultural by-product goes to feed the free-range livestock on the farm. LIVE

Grampus

▤ **Grampus Inn, Lee Bay, Devon, EX34 8LR**
☎ (01271) 862906 ⊕ thegrampus-inn.co.uk

⊗ Grampus was established in 2014 at the back of the Grampus Inn by Bill Harvey, the pub owner and brewer. It is a small plant using traditional brewing methods, but combining unique and unusual ingredients. All beers are available in the local area. A small batch gin distillery was added in 2019. ♦LIVE

GT

Unit 5, The Old Aerodrome, Chivenor Business Park, Braunton, Devon, EX31 4AY
☎ (01271) 267420 ☎ 07909 515170 ⊕ gtales.co.uk

⊗ Established in 2013, GT Ales is housed in a World War II aircraft hangar at Chivenor. An onsite brewery shop has been added to the five-barrel brewery. All five award-winning core ales are available in cask, bottle (limited availability) and can. Limited edition small batch brews are regularly produced and own brand beers are also brewed for local customers. ‼🍴♦LIVE

Thirst of Many (ABV 4.2%) BITTER
North Coast IPA (ABV 4.3%) PALE
Blonde Ambition (ABV 4.5%) BLOND
Dark Horse (ABV 4.5%) BITTER

Crimson Rye'd (ABV 4.8%) RED

Hanlons SIBA

Hill Farm, Half Moon Village, Newton St Cyres, Devon, EX5 5AE
☎ (01392) 851160 ⊕ hanlonsbrewery.com

⊗ Hanlons, one of Devon's largest brewers since 2013, supply a range of award-winning ales nationwide. The purpose-built brewery also has a shop, bar and restaurant. In 2019, it bought Prescott Ales of Cheltenham. Bottled beers are contract brewed for Frank & Otis Brewing Ltd. ‼🍴♦

Firefly (ABV 3.7%) BITTER
Malty, fruity, light bitter. Hints of orange in the taste.
Citra IPA (ABV 4%) PALE
An easy-drinking citrus/floral IPA.
Yellow Hammer (ABV 4.2%) PALE
Zesty fruit aroma, pineapples on taste with a nice sweetness counteracted by bitterness. Even though available all year, its got a summer ale style to it. Very refreshing.
Brewers Blend (ABV 4.5%) BITTER
Port Stout (ABV 4.8%) SPECIALITY
Strong, black, speciality ale. Mild coffee and chocolate with fruity port notes. Lots of body like having a liquid meal.
Stormstay (ABV 5%) BITTER
Tawny and full-bodied. Caramel with hints of malt on the nose. Triumvirate of malt, caramel, hops develop into lingering bitterness.

Brewed under the Prescott Ales name:
Hill Climb (ABV 3.8%) PALE
Pit Stop (ABV 4%) PALE
Chequered Flag (ABV 4.2%) BITTER
Podium Finish (ABV 4.8%) STOUT
Grand Prix (ABV 5%) BITTER

Hatherland

Hatherland Mill Farm, Lower Washfield, Tiverton, EX16 9PG
☎ (01398) 351165 ⊕ hatherland.co.uk

Owner and founder, Lawrence Bunning, decided to combine his love for beer with reutilising unused space on his family farm, setting up the brewery in the old dairy shed. Water is drawn from a bore hole. Passionate about the environment, solar energy is utlised from panels on the brewery roof and heat from the wood chip boiler. Brewing waste is used to feed the farm's prize-winning, rare-breed cattle. LIVE

Sand Martin (ABV 4.7%) PALE

Holsworthy

Unit 5, Circuit Business Park, Clawton, Holsworthy, Devon, EX22 6RR
☎ (01566) 783678 ☎ 07879 401073
⊕ holsworthyales.co.uk

⊗ Holsworthy Ales is a 5.5-barrel microbrewery situated in the heart of Devon's Ruby Country. Brewing began commercially in 2011. Its intention is to make its beers taste as clean and natural as possible, so no chemicals or finings are added to the soft Devon water used in many of its ales. ‼🍴♦LIVE

Mine's A Mild (ABV 3.5%) MILD
Sunshine (ABV 4%) GOLD
Smooth golden ale. Hops overwhelm all else. Hints of fruit. Fresh and bitter hoppy aftertaste
St George (ABV 4.1%) GOLD

Bang On (ABV 4.2%) BITTER
Muck 'n' Straw (ABV 4.4%) BITTER
Hops dominate with hints of malt in aroma and taste. Well-balanced with slight dryness in aftertaste
Tamar Black (ABV 4.8%) STOUT
Dark stout with hints of liquorice and coffee. A complex mix full of malt, roast, fruit, hops and caramel.
Hop on The Run (ABV 5%) PALE
Proper Lager (ABV 5%) SPECIALITY
Old Market Monk (ABV 6.1%) SPECIALITY

Hunters SIBA

Bulleigh Barton Farm, Ipplepen, Devon, TQ12 5UA
☎ (01803) 873509 ☎ 07540 657115
⊕ thehuntersbrewery.co.uk

⊗ Hunters began brewing in 2008. The award-winning brewery has a 60-barrel brew length and 4,000 gallon fermenting capacity. A bottling, labelling and packing plant means it can turn out 3,000 bottle-conditioned beers per hour; this, coupled with a dedicated conditioning room, is enabling Hunters to bottle for others as well as itself. !! ➤ ◆ LIVE

Old Charlie (ABV 3.8%) BITTER
Crispy Pig (ABV 4%) SPECIALITY
Very different ale, a cross between a golden bitter and cider. Aroma of very strong apples. Tastes of apples. A refreshing drink which would go well on a hot summers day.
Half Bore (ABV 4%) SPECIALITY
Light colour and body. Malt dominates from start to finish. Lots of flavour and slightly flowery.
Devon Dreamer (ABV 4.1%) BITTER
Amber session bitter with hop aroma and undertones of caramel. Hops in the taste and slight bitterness develops later.
Pheasant Plucker (ABV 4.3%) BITTER
Session bitter ale leans slightly towards an old ale style in looks and taste. Slight charcoal sweet taste.
Premium (ABV 4.8%) BITTER
A nice, traditional, strong best bitter. Slight winter fruits on taste with after tones of a bitter pine finish.
Royal Hunt (ABV 5.5%) BITTER
An easy-drinking strong ale. Malt dominates, with rich roast and caramel tones bursting through.
Black Jack (ABV 6%) SPECIALITY
A sweet strong stout, very drinkable with a woody caramel taste on the palate.

Isca SIBA

Court Farm, Holcombe Village, Dawlish, Devon, EX7 0JT ☎ 07773 444501 ✉ iscaales@yahoo.co.uk

⊗ Established in a disused milking parlour in 2009, Isca has developed a large range of ales. Seasonal and special brews are often available at beer festivals, including outside of the region. ◆ LIVE

Citra (ABV 3.8%) BITTER
Dawlish Summer (ABV 3.8%) GOLD
Golden Ale (ABV 3.8%) GOLD
Dawlish Bitter (ABV 4.2%) BITTER
Glorious Devon (ABV 4.4%) BITTER
Holcombe White (ABV 4.5%) SPECIALITY
ISCA Gold (ABV 4.5%) GOLD
Dawlish Pale (ABV 5%) PALE
Black IPA (ABV 6%) IPA
Devon Pale (ABV 6.8%) IPA

Ivybridge

Unit 3, Glanvilles Mill, Ivybridge, PL21 9PS
☎ (01752) 894295 ☎ 07512 961085

Office: 41 Rue St Pierre, Ivybridge, PL21 0HZ
⊕ ivybridgebrewing.co.uk

Established in 2018, Ivybridge is a social enterprise brewery that provides training and employment for people with learning disabilities. It currently produces two bottle-conditioned beers. ➤ LIVE ◆

Madrigal

Unit 2, Hele Business Park, Witheridge Place, Hele Bay, Ilfracombe, Devon, EX34 9RA ☎ 07857 560677
⊕ madrigalbrewery.co.uk

⊗ Originally established in Combe Martin in 2014, the brewery relocated to larger premises in Lynmouth, and has now relocated again to a new site in Hele Bay, Ilfracombe. A taproom opened in 2021. !! ◆ LIVE ◆

In The Pine IPA (ABV 3.9%) PALE
Severed Hand (ABV 4%) PORTER
Fossil (ABV 4.1%) BITTER
Hanged Man (ABV 4.2%) SPECIALITY
Wheatear (ABV 4.3%) SPECIALITY
Garland (ABV 4.4%) SPECIALITY
Surfer Rosa (ABV 4.7%) RED
Monkey's Fist (ABV 4.8%) OLD
Smooth, dark old ale with strong fruit and roast from start to lingering, slightly sour finish. Heavy, sweet but satisfying.
Lost & Found (ABV 5%) BLOND
North Coast Voodoo (ABV 5.1%) PALE
Burning House (ABV 5.2%) SPECIALITY

Many Hands

Dunkeswell Airfield, Dunkeswell, EX14 4LF
☎ (01404) 892100 ⊕ manyhandsbrew.com

Many Hands Brew Co began brewing in 2017, producing small-batch, bottled beers. Each bottle sold makes a contribution to local charities.

Morwell

Morwellham Quay, Morwellham, Devon, PL19 8JL
☎ (01822) 832766 ⊕ morwellham-quay.co.uk/ morwellham_brewery

Established in 2017 at Victorian tourist attraction by brewer George Lister. Using a 100-litre plant, three bottle-conditioned beers are brewed, which are available in the on-site shop and café, the Ship Inn, and a growing number of local outlets. It also supplies cask beers to the Ship Inn. ➤ LIVE

Adit (ABV 4.2%) BITTER
Miner (ABV 4.4%) GOLD
Hop (ABV 4.8%) PALE

New Devon

Froginwell Vineyard and Cider Barn, Woodbury Salterton, Exeter, EX5 1EP
☎ (01395) 239900 ☎ 07976 981334
⊕ newdevonbrewing.co.uk

A collective of brewers and cider makers who have been inspired by the craft beer movement. Initially producing one beer, New Devon Ale, but others will make an appearance during the year. ◆

New Devon Ale (ABV 4.5%) PALE

New Lion SIBA

Unit 6E, Webbers Way, Shinners Bridge, Dartington, Devon, TQ9 6JY
☎ (01803) 226277 ⊕ newlionbrewery.co.uk

⊗ Community-owned brewery, established in 2013 and named after the Lion Brewery (renowned for Totnes Stout but closed in the 1920s). It is a modern, five-barrel brewhouse, producing a range of core ales, seasonals and dozens of one-off White Label beers annually; many in collaboration with local producers and businesses. It runs a popular membership scheme and taproom/bottle shop, which also acts as a live venue. ⊞♦LIVE♦

Pandit IPA (ABV 4.9%) PALE
In the style of an American IPA. Slightly sweet with a fruity, hoppy taste.

Noss Beer Works SIBA

Unit 6, Ash Court, Pennant Way, Lee Mill, Devon, PL21 9GE ☎ 07977 479634 ⊕ nossbeerworks.co.uk

⊗ Noss Beer Works was formed in 2012 using a six-barrel plant. The beers are made from only the finest locally-sourced hops and malts. ⊞LIVE

Black Rock (ABV 4%) PALE
Church Ledge (ABV 4%) BITTER
Bitter dominated by hops and fruit throughout. Hoppy and citrusy, slight caramel balances bitter dryness. Slight kick at the end
Mew Stone (ABV 4.3%) BITTER
Ebb Rock (ABV 4.9%) BITTER

Otter SIBA

Mathayes, Luppitt, Honiton, Devon, EX14 4SA
☎ (01404) 891285 ⊕ otterbrewery.com

⊗ A family-run brewery set high up in the Blackdown Hills. Environmental responsibility lies at the heart of its ethos. Otter's eco cellar has been built underground and is naturally chilled. The beers are made from the brewery's own spring water and locally-sourced ingredients. ♦♦

Bitter (ABV 3.6%) BITTER
Well-balanced, amber, session bitter with a fruity nose and bitter taste and aftertaste.
Amber (ABV 4%) BITTER
Light, refreshing and mellow with hints of citrus hoppiness. Creamy and delicate with hops and fruit.
Bright (ABV 4.3%) GOLD
A light and refreshing golden ale with delicate malt, and fruit leading through hops to a lingering bitter aftertaste.
Ale (ABV 4.5%) GOLD
Malt dominates from nose to throat. Sweet fruit, toffee and caramel with a dry aftertaste, full of flavour.
Head (ABV 5.8%) BITTER
Smooth strong ale. Caramel malt throughout. Full-bodied with rich malty fruitiness and a chocolate hint, leaving a bitter aftertaste.

Platform 5 SIBA

2, Magdalene Mews, Torquay, Devon, TQ1 4AF
☎ 07779 000081 ⊕ platform5brewing.co.uk

⊗ This family-run brewery was established in 2013 using a six-barrel plant. The Railway Inn is supplied along with Molloys in Teignmouth and Torquay.

The Coaster (ABV 4%) BITTER
The Antelope (ABV 4.3%) PALE
APA (ABV 4.6%) PALE
The Whistleblower (ABV 4.6%) BITTER
Complex nose with roast and caramel leading to fruit and sweet hops with bitterness on the tongue. Dry aftertaste.
Western Gold (ABV 4.8%) PALE
Blitzen (ABV 5%) BITTER
IPA (ABV 5%) PALE

The Black Crow (ABV 5.2%) STOUT
Very smooth, satisfying oatmeal stout.

Powderkeg SIBA

10 Hogsbrook Units, Woodbury Salterton, Devon, EX5 1PY
☎ (01395) 488181 ⊕ powderkegbeer.co.uk

⊗ Powderkeg was established in 2015 brewing small batches of beer. It combines international beer styles with new ingredients sourced from around the world.

Idler (ABV 3.9%) BITTER
A classic session bitter, crisp, refreshing, malty ale, fruity (lemon) hop taste.
Speak Easy Transatlantic Pale Ale (ABV 4.3%) BITTER

Red Rock SIBA

Higher Humber Farm, Bishopsteignton, Devon, TQ14 9TD
☎ (01626) 879738 ⊕ redrockbrewery.co.uk

⊗ Red Rock first started brewing in 2006 using a four-barrel plant and upgraded in 2011 to a 7.5-barrel one. It is based in a converted barn on a working farm using locally-sourced malt, fresh hops and the farm's own spring water. It has a bar and can accommodate private functions. ⊞♦LIVE♦

Lighthouse IPA (ABV 3.9%) PALE
Red Rock (ABV 4.2%) BITTER
Break Water (ABV 4.6%) BITTER

Riviera

4 Yonder Meadow, Stoke Gabriel, Totnes, Devon, TQ9 6QE ☎ 07857 850110 ⊕ rivierabrewing.co.uk

⊕ Riviera started brewing commercially in 2015 using a one-barrel plant. European and New World hops are used in addition to various British varieties. ♦

RBC Best (ABV 3.8%) BITTER
RPA (Riviera Pale Ale) (ABV 3.9%) PALE
Devonian (ABV 4.1%) BITTER
Gold (ABV 4.2%) GOLD

Roam SIBA

New Victoria House, Weston Park Road, Plymouth, Devon, PL3 4NU
☎ (01752) 396052 ☎ 07971 411727
⊕ roambrewco.uk

⊗ Roam produce small batch beers using a combination of traditional and modern brewing techniques and local ingredients. A six-barrel plant is used. ⊞♦LIVE♦

Tavy Gold (ABV 4%) BITTER
Hometown Pale (ABV 4.1%) PALE
A nice, fruity, hopped, American-style pale ale. Fruit aroma, tastes of grapefruit and mango with lasting finish on the palate.
Tavy Best Bitter (ABV 4.3%) BITTER
Malt dominates the nose and taste with caramel, roast and hops overpowering a subtle hint of fruit. A complex aftertaste.
Sound Bitter (ABV 4.5%) BITTER
A good, drinkable best bitter, full-flavoured on body content.
Tavy IPA (ABV 4.8%) PALE
Gold ale dominated by hops and fruit from start to finish. Slight fruit/straw aroma. Citrus/hoppy dry taste. Dry/bitter finish.
Tavy Porter (ABV 5.2%) PORTER

Full-bodied porter. Malt, liquorice, chocolate nose. Slightly bitter fruity taste. Roasted coffee and touch of vanilla in the aftertaste.
Double Take (ABV 7.1%) STRONG
An American brown ale with lots of body, swimming in fruity hops. Sweet on taste, complex mix of malty/roast flavours. A beer to savour.

Salcombe SIBA

Estuary View, Ledstone, Devon, TQ7 4BL
☎ **(01548) 854888** ⊕ **salcombebrewery.com**

⊗ Salcombe Brewery was purpose built on the site of a decommisioned water reservoir, which utilises the natural ambient temperature of the underground facility for storing ales at perfect conditioning temperature. The brewery has close ties with both the RNLI and the Seahorse Trust. ♨🍴♦⚘

Devon Amber (ABV 3.8%) BITTER
Salcombe Gold (ABV 4.2%) GOLD
Shingle Bay (ABV 4.2%) BITTER
Seahorse (ABV 4.4%) BITTER
Toffee malt is evident throughout this complex yet subtle mix of everything you would expect from a best bitter.
Lifesaver (ABV 4.8%) BITTER
A refreshing ale, deep copper in colour, with a smack of citrus and orange peel and luscious malty flavour. A dry citrus finish with a taste of liquorice.
Island Street Porter (ABV 5.9%) PORTER
A really good porter. Creamy head, aroma of chocolate/coffee and cherries giving a black forest gateau taste. Flavours linger on tongue during aftertaste.

South Hams SIBA

Stokeley Barton, Stokenham, Kingsbridge, Devon, TQ7 2SE
☎ **(01548) 581151** ⊕ **southhamsbrewery.co.uk**

⊗ South Hams has been brewing ales for more than 13 years in Start Bay, Devon. A family-run brewery, it supplies more than 350 outlets in Plymouth and South Devon with wholesalers distributing further afield. ♨🍴♦LIVE

Devon Pride (ABV 3.8%) BITTER
Shippen (ABV 4%) BITTER
Stumble Bee (ABV 4.2%) SPECIALITY
Wild Blonde (ABV 4.4%) BLOND
Subtle notes of malt, roast and caramel, dominated by fruity hops. These persist to a refreshing hint of lemon.
Hopnosis (ABV 4.5%) GOLD
Eddystone (ABV 4.8%) BITTER
Strong, amber, summery ale. Hoppy, caramel, slightly citrus nose. Dryer taste with light fruit and hops. Dry yet fruity finish.
Pandemonium (ABV 5%) BITTER
A fruit/bready malty aroma. Tastes of toffee, caramel and blackcurrant. A slight old ale style to this strong beer.
Sherman (ABV 6.4%) IPA
A strong American pale ale, a thick-flavoured beer, very fruity and sweet on aroma/taste and aftertaste.

Stannary SIBA

Unit 6, Pixon Trading Centre, Tavistock, Devon, PL19 8DH
☎ **(01822) 258130** ⊕ **stannarybrewing.co.uk**

Stannary began operating in 2016 using a 2.5-barrel plant, moving to larger premises with a six-barrel plant in 2018. The brewery tap is open on a Friday and Saturday, showcasing its many unfined and unfiltered craft beers. 🍴♦⚘

Steel Brew

Mills Bakery Building, Royal William Yard, Plymouth, Devon, PL1 3RP
☎ **(01752) 987728**

Office: 22 Aquarius Drive, Sherford, PL9 8FH
⊕ **steelbrew.co**

Brewing began in a garage in 2018, producing a range of craft beers on a six-barrel plant. The brewery relocated to the Grade 1*-listed Melville Building in 2020. Four core beers and numerous one-off specials are brewed, available in its onsite taproom. Its bottled beers are also sold in the Plymouth Gin Distillery on the Barbican. Brewing is currently suspended. ♨🍴♦

Summerskills SIBA

15 Pomphlett Farm Industrial Estate, Broxton Drive, Billacombe, Plymouth, Devon, PL9 7BG
☎ **(01752) 481283** ⊕ **summerskills.co.uk**

⊗ Established in a vineyard in 1983 at Bigbury-on-Sea, Summerskills moved to its present site in 1985. It is the oldest brewery in Plymouth. Wholesalers and pub companies provide national distribution and the beers regularly appear in a selection of local outlets. ♦LIVE

Start Point (ABV 3.7%) GOLD
Westward Ho! (ABV 4.1%) BITTER
Malt dominates a light nose. Gentle bitterness introduces its malty-fruit friends. Malt and bitterness remain, with bitterness dominating the conversation.
Tamar (ABV 4.3%) BITTER
Bitter hop taste and finish. A mid-strength best bitter.
Stout (ABV 4.4%) STOUT
Strong coffee aroma, slight sweetness on the taste with coffee/chocolates on tongue. Bitter finish.
Devon Dew (ABV 4.5%) GOLD
Pine aroma with a slight grapefruit taste. A refreshing golden ale.
Devon Frost (ABV 4.5%) GOLD
A slight nutty roast on the nose and also on taste with grapefruit flavours on the tongue.
Menacing Dennis (ABV 4.5%) BITTER
Bolt Head (ABV 4.7%) BITTER
Fruit-hop nose has roast-malt hints. Bitter flavours with sweet malt, roast and hoppiness. Lingering bitter finish with background malt and fruit.
Whistle Belly Vengeance (ABV 4.7%) RED
Full-flavoured, strong red ale. Roast and malt aroma with roasted chestnut taste. Sweetness and bitterness mingle in the aftertaste.
Dragon Pioneer (ABV 4.8%) PALE
Ninja (ABV 5%) BITTER
Plymouth Porter (ABV 5%) PORTER
Strong, sweet chocolate aroma, tastes of chocolate and toffee. Aftertaste dies off quickly, a nice drinkable sweet Porter.
First Light (ABV 5.5%) GOLD
Strong golden ale. Fruity, hoppy aroma. Sweet grapefruit and hops on the palate. Aftertaste continues with fruit and hops.
Indiana's Bones / South Star (ABV 5.6%) OLD
Old ale with good body. Rich malty roasts aroma bursting with strong sweet flavours on the tongue. Slightly dryer finish.

Tally Ho!

🏠 **14 Market Street, Hatherleigh, Devon, EX20 3JN**
☎ **07779 339089** ⊕ **tallyhohatherleigh.co.uk**

⊗ Having stood idle at the rear of the Tally Ho! pub for 14 years, the brewery was resurrected in 2015, and then sold in 2018. The current owner and brewer took over in

2020. As well as the pub, several local free houses and other establishments are supplied. ♦

Taw Valley

Westacott Farm, Westacott Lane, North Tawton, Devon, EX20 2BS ☎ 07900 002299
⊕ tawvalleybrewery.com

Established in 2017 in a Grade-II listed, 17th century thatched barn. Beer is delivered in the brewery dray, a VW camper van. ♦LIVE

Black Ops (ABV 3.9%) BITTER
Tawton Session Ale (ABV 4%) PALE
Devon Jester (ABV 4.2%) PALE
Kennard's Steam (ABV 4.3%) BITTER
Copper Best (ABV 4.4%) BITTER

Teignmouth SIBA

Warehouse 1, Old Quay Street, Teignmouth, TQ14 8ES
☎ (01626) 770846 ⊕ teignmouthbrewery.co.uk

The brewery opened in 2019. Currently a six-barrel brew length, brewing three regular beers (also available bottle-conditioned) and a number of seasonal beers. There is a continued focus on quality cask beers and these are distributed across the south Devon area. ♦LIVE

Templer (ABV 4%) BITTER
Portside (ABV 4.3%) BITTER
Deckhand (ABV 4.5%) GOLD

Teignworthy

The Maltings, Teign Road, Newton Abbot, Devon, TQ12 4AA
☎ (01626) 332066 ⊕ teignworthybrewery.com

⊠ Teignworthy Brewery opened in 1994 within the historic Tucker's Maltings building. The 20-barrel plant produces 50 barrels a week and supplies around 300 outlets in Devon and Somerset plus wholesalers further afield on a pre-arranged basis. It diversified in 2017 with the addition of the Black Dog gin distillery. ‼♠♦LIVE

Neap Tide (ABV 3.8%) PALE
Reel Ale (ABV 4%) BITTER
Subtle aromas, taste is also gentle with malt and fruit dominating the hops, with a dry aftertaste.
Thirsty Blonde (ABV 4.2%) BLOND
Gun Dog (ABV 4.3%) BITTER
Easy-drinking, session best bitter. Fruity throughout. Dry aftertaste lingers; sweetness and fruit over malt and caramel, progressing into hoppiness.
Old Moggie (ABV 4.4%) BITTER
Best bitter. Hoppy and bitter with fruity undertones. Complex aftertaste with a balance of malt, hops and fruit.
Beachcomber (ABV 4.5%) GOLD
A pale brown beer with a light, refreshing fruit and hop nose, grapefruit taste and a dry, hoppy finish.

Topsham

The Warehouse, Haven Road, Exeter, Devon, EX2 8GR
☎ 07735 591557

The brewery was established in 2018 and moved to its current location at the popular Exeter Quay in 2019, using a 3.5-barrel plant. The taproom, with an outside drinking area, is next to the brewery and the brewery is visible from the bar. There are frequent one-off brews, normally available as keg, with some appearing as cask along with the regular and seasonal beers at the brewery tap. ♦♠

Serenity (ABV 3.8%) BITTER

Ask Your Dad (ABV 4.3%) BITTER
Goat Walk (ABV 4.6%) PALE

Totnes

🯅 59a High Street, Totnes, Devon, TQ9 5PB
☎ (01803) 849290 ☎ 07974 828971
⊕ thetotnesbrewingco.co.uk

⊠ Brewing began in 2014 at a family-run pub at the foot of Totnes Castle. The brewery is situated immediately behind the bar. An increase in the portfolio of the brewery has also meant a greater emphasis on keg and KeyKeg output. Beers are available almost exclusively at the pub. All ales are unfined and unfiltered. ♦

TQ Beerworks

Unit 6, Kingswood Court, Long Meadow, South Brent, Devon, TQ10 9YS
☎ (01803) 364925 ⊕ tqbeerworks.com

TQ is a small, family-run brewery dedicated to bringing craft beer to Torbay and the surrounding area. A core range of five bottle-conditioned beers are available, plus a rolling programme of seasonal one-off brews. All beers are unfined, unfiltered and vegan-friendly. LIVE V

Turk's Head

🯅 202 High Street, Exeter, EX4 3EB
☎ (01392) 706013 ⊕ turksheadexeter.com

A historic public house, refurbished by City Pub Group during 2020/2021, brewing a range of up to five real ales. The range is expected to increase. ‼

Utopian SIBA

Unit 4, Clannaborough Business Units, Bow, Devon, EX17 6DA
☎ (01392) 769765 ⊕ utopianbrewing.com

Utopian began brewing in 2019 producing craft lagers. In 2022 a live beer was introduced. ♦

Bow (ABV 4%) BITTER

Whyte Bar

c/o 25 Paris Street, Exeter, Devon, EX1 2JB

Whyte Bar, pronounced Whyte Bear, was founded in 2018 as a cuckoo brewery by Andy Whyte and Joel Barnard. Brewing also takes place at other local breweries, such as Many Hands and Topsham (qv). Its own bar, Cuckoo Bar, is due to open. ♠

Yelland Manor

Lower Yelland Farm, Yelland, Barnstaple, Devon, EX31 3EN ☎ 07770 267592
✉ yellandmanor@gmail.com

⊠ Located on the Taw Estuary and close to the Tarka Trail, this five-barrel plant in a converted milking parlour, was established in 2013. It supplies a small number of local pubs and hotels, although the majority of sales are now made from the premises, either as takeaways or for consumption as part of a 'brewery experience'. Small functions are also catered for. ‼♠♦♠

English Standard (ABV 4.1%) BITTER

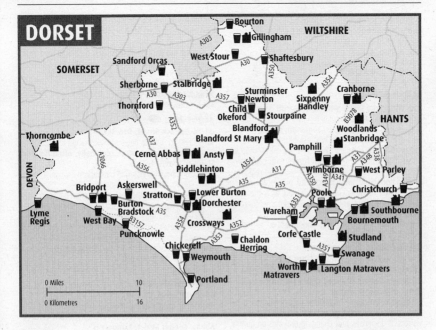

DORSET

Map showing locations: Bourton, Gillingham, West Stour, Shaftesbury, Sandford Orcas, Sherborne, Stalbridge, Sturminster Newton, Sixpenny Handley, Cranborne, Thornford, Child Okeford, Stourpaine, Woodlands, Stanbridge, HANTS, Thorncombe, Cerne Abbas, Ansty, Blandford, Blandford St Mary, Pamphill, Piddlehinton, Wimborne, West Parley, Bridport, Askerswell, Stratton, Lower Burton, Dorchester, Poole, Christchurch, Burton Bradstock, Wareham, Southbourne, Lyme Regis, West Bay, Crossways, Bournemouth, Puncknowle, Chickerell, Chaldon Herring, Corfe Castle, Studland, Weymouth, Worth Matravers, Langton Matravers, Swanage, Portland. SOMERSET, WILTSHIRE, DEVON.

0 Miles 10, 0 Kilometres 16

Ansty

Fox Inn

DT2 7PN

☎ (01258) 880328 ● foxinnansty.co.uk

2 changing beers (sourced locally) Ⓗ

A free house in the heart of the Dorset countryside, formerly home to the Woodhouse family, brewers of Badger Beers. It stocks two or three regularly changing ales, mostly from Dorset micros, and an occasional real cider. A separate bar, away from the restaurant, is a relaxing place to rest after a country walk. There are further rooms for functions and meetings, plus an outside bar in summer. All food is locally sourced.

Q ॐ ❀ ⊁ ⬤ & ♣ P ♿ ⬤ ☞

Askerswell

Spyway Inn

DT2 9EP

☎ (01308) 485250 ● thespywayinn.com

3 changing beers (sourced locally; often Cerne Abbas, Copper Street, Quantock) Ⓖ

Family-friendly 16th-century smugglers' inn perched on a hill outside Askerswell. It has a traditional snug main bar plus futher rooms for dining. Local and West Country beers are served on gravity, typically from Cerne Abbas, Copper Street and Exmoor, with local ciders also available. Mind your head when going into the large garden, which has plenty of seating including six covered pods and provides superb views across the countryside.

Q ॐ ❀ ⊁ ⬤ ♣ P ♿ ⬤ ☞

Bournemouth

Acorn

1492 Wimborne Road, Kinson, BH11 9AD

☎ (01202) 575062

6 changing beers (sourced regionally; often Goddards, Hattie Brown's, Sixpenny) Ⓗ

This imposing 17th-century pub, originally built as a coaching inn, is rich in history and has a connection with local smuggler Isaac Gulliver. It is now in the safe hands of a family who previously ran an award-winning pub close by. A well-chosen selection of ales is on offer at the large L-shaped bar, which serves two distinct areas. The landlord plays music on Sunday afternoon, and live music sometimes also features. No children after 6pm.

❀ ♣ ⬤ P ♿ ⬤

All Hail Ale

10 Queens Road, Westbourne, BH2 6BE

☎ 07786 045996

4 changing beers (sourced nationally) Ⓗ

A vibrant micropub and bottle shop, this former restaurant has been skilfully converted, with wooden flooring and polished-wood bar and tables. Five handpumps serve a range of ales from independent breweries nationwide, alongside a real cider. Ten keg pumps offer a varied and well-chosen selection of beers. Popular tap takeovers are held to showcase some of the major new craft ales; a large blackboard lists the beers available.

⬤ ⬤ ♿ ⬤ ☞

Firkin Shed

279 Holdenhurst Road, Springbourne, BH8 8BZ

☎ (01202) 302340

4 changing beers (sourced regionally) Ⓗ

A quirky, friendly, family-run micropub that is a former CAMRA National Cider Pub of the Year. Tables and benches hug the walls of the main bar area and snug, which are decorated with flags, musical instruments, puppets and skulls. A shed is used as the bar, hosting constantly changing cask and keg beers alongside an impressive cider range. The garden is a great place to relax and enjoy summer sunshine.

❀ ⇌ ⬤ ♿ (2) ⬤

Goat & Tricycle ✔

27-29 West Hill Road, BH2 5PF

☎ (01202) 314220 ● goatandtricycle.co.uk

Butcombe Adam Henson's Rare Breed, Original, Gold; Liberation Ale, Herm Island Gold, IPA; 3 changing beers (sourced nationally) Ⓗ

Popular, award-winning split-level venue that was created by combining two adjoining pubs. Its pleasant interior offers space for drinkers and diners. Eleven

handpumps serve mostly Butcombe and Liberation ales, plus a guest or two, alongside Stan's Ciders. Excellent freshly-cooked food is available daily, including gluten-free options. A partly covered sunny courtyard caters for smokers and alfresco drinkers. Under-18s are not admitted. ⍟⍟⬤⬤⬤⬤⬤

Micro Moose
326 Wimborne Road, Winton, BH9 2HH
⊕ micromoose.co.uk
5 changing beers (sourced regionally) ⍟
Friendly and cosy bar that was established when the Canadian owner decided to convert her coffee shop into a micropub offering 'Great British Ales with Canadian Hospitality'. It serves a selection of local and regional ales on both handpump and gravity, plus local cider. The bottled beer range is Canadian-themed, as is the decor, complete with flags and moose-related items. There is a good selection of bar snacks. Table-sharing is encouraged, in micropub tradition. Q⬤⬤⬤⬤

Silverback Alehouse
518 Wimborne Road, Winton, BH9 2EX
☎ (01202) 510988 ⊕ silverbackalehouse.co.uk
4 changing beers (sourced regionally; often Brew Shack, Gritchie, Plain) ⍟
Micropub on Winton's high street with a relaxed atmosphere that makes it popular with locals and visitors. It dispenses four changing real ales on gravity alongside traditional ciders. Friendly staff serve the benches and tables lining the perimeter. Snacks are available and customers are welcome to bring in a takeaway. Q♣⬤⬤⬤⬤

Bourton

White Lion
High Street, SP8 5AT
☎ (01747) 840866 ⊕ whitelionbourton.co.uk
Otter Amber; 1 changing beer (sourced locally) ⍟
Traditional inn dating from 1712, featuring a stone-flagged bar with an open fireplace and many quiet corners for a drink or meal. A separate restaurant leads off the bar for more formal dining. There is a large beer garden to the rear. The pub is near Stourhead house and gardens, and convenient for local attractions including Stonehenge. Parking is either opposite the pub or in the car park. Q⍟⍟⬤⬤P🚃(X4)⬤⬤

Bridport

Pursuit of Hoppiness
15 West Street, DT6 3QJ
☎ (01308) 427111 ⊕ hoppiness.co.uk
Brew Shack Bills Bitter; 5 changing beers (sourced nationally; often Eight Arch, Tapstone) ⍟
Popular town-centre micropub whose single room accommodates up to 25 people, with a few more seated outside. Its six handpumps serve beers of all styles, changing every few days and sourced from small West Country brewers plus some from further afield. A porter or stout is always available, normally alongside six ciders including a regular from West Milton. Payment is by card only. Q⍟♣⬤P🚃⬤⬤

Ropemakers 🍸 ⎣
36 West Street, DT6 3QP
☎ (01308) 421255 ⊕ theropemakers.com
Palmers Copper Ale, IPA, Dorset Gold, 200, Tally Ho!; 1 changing beer (sourced locally; often Palmers) ⍟
Deceptively large pub in the centre of town serving the full Palmers range of beers. The interior is divided into numerous themed areas decorated with memorabilia and items depicting local history. There is a large, partially covered courtyard at the rear and wheelchair access via the back door. Tuesday is quiz night, and music features on weekend evenings. The pub closes around 4pm on Sunday in winter (later on bank holiday weekends or if there is live music). ⍟⍟⬤⬤♣⬤P🚃⬤⬤

Tiger Inn ✔
14-16 Barrack Street, DT6 3LY
☎ (01308) 427543 ⊕ tigerinnbridport.co.uk
5 changing beers (sourced regionally; often Hanlons, Sharp's, Yeovil) ⍟
A busy and popular Victorian pub tucked away just off the town centre. The five changing real ales are predominately from the region. The main bar, decorated with dried hops and beer mats, boasts a dartboard and a TV focusing on rugby and other sports. There is also a smaller, quieter bar. Outside are two recently refurbished and well maintained seating areas. Look for the rare Groves Brewery etched window. There are seven en-suite rooms. ⍟⍟⬤⬤♣⬤🚃⬤⬤

Woodman Inn
61 South Street, DT6 3NZ
☎ (01308) 456455 ⊕ thewoodman.pub
4 changing beers (sourced regionally; often Cerne Abbas, Copper Street, Exmoor) ⍟
A friendly pub with a focus on quality real ales, which vary widely in style and are frequently changed. It also serves up to 12 boxed real ciders. Handy for the twice weekly market, the pub has a cosy one-bar interior with a fire and stone floor. Tables at the front make the most of the sunny aspect; to the rear is a quiet, pleasant garden. Regular events include folk nights, story-telling and wassailing. Extended Sunday hours in summer. ⍟⍟Å⬤P🚃⬤⬤

Burton Bradstock

Anchor Inn
High Street, DT6 4QF
☎ (01308) 897228 ⊕ anchorinn.pub

REAL ALE BREWERIES

Barefaced ✦ Blandford
Brew Shack Sixpenny Handley
Brewers Folly Stanbridge
Brewhouse & Kitchen 🍺 Bournemouth
Brewhouse & Kitchen 🍺 Dorchester
Brewhouse & Kitchen 🍺 Poole
Brewhouse & Kitchen 🍺 Southbourne
Cerne Abbas ✦ Cerne Abbas
Copper Street ✦ Dorchester
Dorset ✦ Crossways
Eight Arch ✦ Wimborne
Gyle 59 Thorncombe
Hall & Woodhouse ✦ Blandford St Mary
Hattie Brown's Worth Matravers
Isle of Purbeck 🍺 Studland
Palmers Bridport
Piddle Piddlehinton
Poole Hill ✦ Bournemouth
Remedy Oak ✦ Woodlands
Sandbanks ✦ Poole
Sixpenny ✦ Cranborne
Small Paul's Gillingham
Stripey Cat 🍺 Bridport (brewing suspended)
Way Outback ✦ Southbourne
Wriggle Valley ✦ Stalbridge

Dartmoor Jail Ale; Otter Bitter; Timothy Taylor Landlord; 1 changing beer (sourced regionally; often Exmoor, St Austell, Skinner's) Ⓗ
One of the few free houses in this part of Dorset, the Anchor is in the centre of the village with an excellent beach nearby. Inside, the Stables Bar offers a traditional pub feel and bar food. The larger restaurant area has an extensive menu, with local seafood the speciality. Up to four beers are selected from mostly regional breweries. There is accommodation in three rooms.
Q❤️🚪◐🌙▲♠P🚆(X53)🐾

Three Horseshoes Ⓛ
Mill Street, DT6 4QZ
☎ (01308) 897259 🌐 threehorseshoesburtonbradstock.co.uk
Palmers Copper Ale, IPA, Dorset Gold, 200, Tally Ho!; 1 changing beer (sourced locally; often Palmers) Ⓗ
A 300-year-old thatched pub and restaurant in the heart of the village, popular with families using the renowned Hive Beach. The full Palmers range is available plus the brewery's seasonal beer or Dorset Orchards First Press cider. Good home-cooked food is served. The pub is closed Sunday evening and Mondays (and Tues in winter). Food is offered all day April to September; winter hours are shorter. Dogs are welcome in the bar area and garden. Q❤️🚪◐🌙▲♠🌙P🚆(X53)🐾🛜

Cerne Abbas

Giant Inn Ⓛ ✅
24 Long Street, DT2 7JF
☎ (01300) 341441 🌐 thegiantcerneabbas.co.uk
Butcombe Adam Henson's Rare Breed; 3 changing beers (sourced locally; often Cerne Abbas, Exmoor, Ringwood) Ⓗ
Traditional brick-built pub in the village centre, dating from the 15th century and remodelled in Victorian times by the John Groves and Sons brewery – admire the windows! It has become a welcoming inn offering local ales, usually including at least one from Cerne Abbas Brewery, and serving a good range of home-cooked food. Outside are a beer garden and skittle alley, plus a covered passageway with tables. Definitely worth a visit.
Q❤️🚪◐🌙♠🚆(X11)🐾🛜

Chaldon Herring

Sailor's Return Ⓛ
DT2 8DN
☎ (01305) 854441 🌐 sailorsreturnpub.com
Cerne Abbas Ale; Otter Ale; Palmers Copper Ale; 1 changing beer (sourced regionally; often Cerne Abbas, Flack Manor, Palmers) Ⓗ
Historic thatched inn on the edge of a tranquil village, a few miles from the Jurassic Coast. The pub dates from the 1860s and the buildings are much older. There are several dining and drinking areas, with flagstone floors throughout. An original inn sign hangs in the main bar. Wednesday is pie night. On Friday night food is only served in the restaurant area (booking advisable).
Q❤️🚪◐🌙♠P🐾🛜

Chickerell

Lugger Inn Ⓛ
West Street, DT3 4DY
☎ (01305) 766611 🌐 theluggerinn.co.uk
St Austell Tribute, Proper Job; 1 changing beer (sourced regionally; often Dorset, Exmoor, Piddle) Ⓗ
Popular village pub that is over 200 years old, tucked just off the picturesque coast road. The menu offers pub classics and family-friendly dishes. The pub hosts

interesting themed evenings, live music most Sunday afternoons, and monthly quiz nights. Its skittle alley doubles as a function room and there are 14 en-suite letting rooms, one on the ground floor with wheelchair access. There is outside seating in a sunny garden across a quiet road. ❤️🚪◐🌙▲♠P🚆(8,X53)🐾🛜

Child Okeford

Saxon Inn
Gold Hill, DT11 8HD
☎ (01258) 860310 🌐 saxoninn.co.uk
Butcombe Original; 3 changing beers (sourced regionally; often Exmoor, Sixpenny) Ⓗ
This 300-year-old village inn is hidden behind a row of cottages. Its bar and restaurant areas are cosy, boasting a log fire, and are popular with locals and visitors. Three guest beers are served alongside the one permanent ale. The large garden is perfect for alfresco dining, with quality home-cooked food available. The pub offers B&B and is an ideal base for exploring the Dorset countryside.
❤️🚪◐🌙♠🌙P🚆(X10)🐾🛜

Christchurch

Saxon Bar
5 The Saxon Centre, Fountain Way, BH23 1QN
☎ (01202) 488931
4 changing beers (sourced nationally) Ⓖ
A friendly single-room micropub, close to the town centre, featuring perimeter seating and high tables made from reclaimed wood from Bournemouth Pier. The pub offers a variety of well-chosen ales plus up to 10 real ciders, all served direct to your table. Four KeyKeg beers are also available, along with local and international spirits and speciality bar snacks. Winter hours vary. Local CAMRA Cider Pub of the Year 2022. 🚪🚆♠🚆🐾

Corfe Castle

Bankes Arms Hotel Ⓛ ✅
23 East Street, BH20 5ED
☎ (01929) 288188 🌐 bankesarmshotel.co.uk
Palmers IPA, 200; 2 changing beers (sourced regionally) Ⓗ
Historic 16th-century Grade II-listed hotel, owned by the National Trust, that retains many original features including a front drinkers' bar. Regular beers from Palmers are served alongside ales recreated by the Dead Brewers Society, brewed by Barnet. Excellent home-cooked food is available in the restaurant to the rear. A large picturesque garden overlooks Swanage Steam Railway and Corfe Castle station and enjoys fantastic views of the Purbeck Hills. Occasional beer festivals are held in summer. ❤️🚪◐🌙🚆♠P🚆(40,30)🐾🛜

Corfe Castle Club
70 East Street, BH20 5EQ (off A351)
☎ (01929) 480591
Ringwood Razorback; Timothy Taylor Landlord; 1 changing beer (sourced nationally) Ⓗ
Friendly club in a Purbeck stone-built former school in the village centre. The main bar features upholstered bench seating and a TV for major sporting events, plus darts and Purbeck longboard shove-ha'penny. An upstairs room has a pool table and can be hired for meetings. Filled rolls are available all day. The spectacular garden boasts a boules court and views over the Purbeck Hills. Visitors are welcome with a CAMRA membership card or copy of the Guide. Convenient for the castle or steam railway. 🚪🚆♠P🚆(40,30)🐾🛜

Fox Inn 🅛

8 West Street, BH20 5HD
☎ (01929) 480449 ⊕ thefoxinncorfecastle.com
Box Steam Soul Train; Butcombe Adam Henson's Rare Breed; Hattie Brown's Moonlite; 1 changing beer ⊞
Delightful 16th-century inn nestled in the heart of historic Corfe Castle and retaining many original features. Its front door opens into a small traditional snug with steps down to the main bar area, where good pub food is served. Towards the rear is a fabulous garden, complete with barbecue shack, offering fine views over the castle and surrounding Purbeck Hills. Closed on Wednesday.
Q ⏷ ❀ ◑ ▲ ✈ ⬤ 🚍 (40,30) ✿

Cranborne

Sixpenny Tap 🅛

Holwell Farm, Holwell, BH21 5QP (1 mile E of village)
☎ (01725) 762006 ⊕ sixpennybrewery.co.uk
Sixpenny 6d Best Bitter, 6d Gold, 6d IPA; 3 changing beers (sourced locally; often Sixpenny) ⊞
Housed in a converted Victorian stables and packed full of quirky miscellaneous items, the Sixpenny Tap has established itself at the heart of the local community. With the brewery located next door, its popular range of ales is served with pride and enthusiasm. The pub hosts many successful and colourful community and charity events in the extensive courtyard, with a warm welcome for all who visit. This is a real countryside gem set within picturesque farmland, and even has its own Tardis.
Q ❀ ♿ ♣ ⬤ P ✿ 🛜

Dorchester

Convivial Rabbit

1 Trinity House, Trinity Street, DT1 1TT
☎ 07717 158853 ⊕ convivialrabbit.co.uk
6 changing beers (sourced nationally) Ⓖ
Popular micropub, rustically decorated and run by a friendly and knowledgeable licensee. It serves a changing choice of around six real ales of varying styles and strengths from micro and independent British breweries. Canned craft beer and lager are also available alongside local ciders, gins and wines. The pub is tucked away down an alley off Trinity Street and is well worth seeking out. Live music is hosted regularly.
Q ❀ ✈ (West) ♣ ⬤ 🚍 ✿ 🛜

Copper Street Brewery Tap Room 🅛

8 Copper Street, DT1 1GH
☎ 07970 766622
3 changing beers (often Copper Street) Ⓖ
Lively tap on the site of the old Eldridge Pope brewery on vibrant Brewery Square, opposite Dorchester South railway station. The Copper Street Brewery was established in 2018. Its tap room can accommodate approximately 20 people with more seated outside. It opens Thursday to Saturday, serving three changing own-brewed ales plus a small selection of rums. The premises includes a bottle shop selling ales from the brewery and other micros. Q ❀ ♿ ✈ (South) 🚍 (10) ✿

King's Arms

High East Street, DT1 1HF
☎ (01305) 238238 ⊕ thekingsarmsdorchester.com
3 changing beers (sourced locally; often Copper Street, Otter, Piddle) ⊞
A historic, 300-year-old coaching inn that featured in Thomas Hardy's Mayor of Casterbridge. The Stay Original company bought it and spent four years sympathetically refurbishing the building, winning CAMRA's Pub Design Award in the process. It reopened in 2020. Beers from

local breweries (Copper Street, Piddle, Cerne Abbas, Otter) are served alongside a good selection of gin and rum. Lunch and evening meals are available in the bar and restaurant. The inn has a rear patio and offers accommodation in 34 bedrooms.
Q ⏷ ❀ ⇌ ◑ ♿ ❀ (South) P 🚍 ✿ 🛜

Tom Browns 🅛 ✅

47 High East Street, DT1 1HU
☎ (01305) 264020 ⊕ tombrownspub.co.uk
Copper Street Saxon Gold; Dorset Tom Brown's; 2 changing beers (sourced regionally; often Cerne Abbas, Copper Street, Plain) ⊞
Town-centre alehouse featuring an open fire, skittle alley and function room. In addition to serving four local real ales, it usually offers two real ciders and a selection of more than 20 gins. The large riverside garden is ideal for lazy pints in the sun. Food is served Thursday to Saturday evenings, and customers are welcome to bring in takeaways. Dogs are allowed except when live music is hosted. ⏷ ❀ ♣ ⬤ 🚍 ✿ 🛜

Gillingham

Dolphin

Peacemarsh, SP8 4HB
☎ (01747) 824007 ⊕ the-dolphin-inn-pub.business.site
3 changing beers (sourced regionally; often Dartmoor) ⊞
Following refurbishment this popular pub serves up to three regularly changing real ales sourced from local and regional breweries, often from Devon. The food menu changes regularly and meals are cooked to order – booking is recommended. There are two dining rooms plus seating for drinkers in the bar. Outside, the beer garden offers a grassed area, patio and covered smoking. Overnight camper van parking is permitted if purchasing dinner in the pub. Q ⏷ ❀ ◑ P 🚍 (X2,25) ✿ 🛜

Phoenix

The Square, SP8 4AY
☎ (01747) 823277
St Austell Proper Job; Sharp's Doom Bar ⊞
Originally a 15th-century coaching inn with its own brewery and stable, this pub was rebuilt and renamed the Phoenix following a fire in the 17th century. It has an open-plan layout with a log fire. Guest beers are regularly available, often from Hattie Browns. No meals are served but freshly filled rolls are available. Picnic tables now occupy the former car park outside; parking is available on-street and in two public car parks nearby.
❀ ✈ 🚍 (X2) ✿ 🛜

Langton Matravers

King's Arms

27 High Street, BH19 3HA
☎ (01929) 422979
Ringwood Razorback; 3 changing beers (sourced nationally) ⊞
Dating back to 1743, this traditional Purbeck stone-built pub features rooms off a central bar area, with original flagstone floors. It is a family-friendly community pub that welcomes dogs and is popular with visitors. It serves fine pub food and hosts a village shop. The rear garden is a suntrap. The seaside town of Swanage with its steam railway is close by, as are many fine walks where you can explore the Purbecks and the South West Coast Path.
Q ⏷ ❀ ◑ ▲ ♣ ⬤ 🚍 (40) ✿ 🛜

Lower Burton

Sun Inn

Lower Burton, DT2 7RZ

☎ (01305) 250445 ⊕ sun-inn-dorchester.co.uk

3 changing beers (sourced nationally; often Brains, Butcombe, Sharp's) Ⓗ

This 17th-century stone and brick pub is a fairly short river walk from Dorchester town centre. It offers a popular carvery as well as a good menu in a vast open-plan bar and dining area. Children are welcome inside, except near the bar, and also outside where there is a small play area plus seating with tables, along with two car parks. ⭑❀⬤❶♿🅰🅿🚌(X11)❀🛜

Lyme Regis

Nags Head Ⓛ

32 Silver Street, DT7 3HS

☎ (01297) 442312 ⊕ nagsheadlymeregis.com

Otter Bitter, Ale Ⓗ

A fine brick and flint coaching inn, situated above the town with superb views from its beer garden across Lyme Bay towards Portland Bill. Three TV screens show sport. Simple basket meals are served in the evenings. There is regular live music on Saturday night and a popular meat draw and disco on Friday.
❀🍴❶🅰♣🚌(X51,X53) ❀🛜

Pilot Boat Inn

1 Bridge Street, DT7 3QA

☎ (01297) 443157 ⊕ thepilotboat.co.uk

Palmers Copper Ale, IPA, Dorset Gold, 200, Tally Ho! Ⓗ

A 'Tardis' of a pub, tastefully renovated to provide a large main bar opening out to a courtyard and overlooked by a roof terrace. There is a 110-seat restaurant at the rear and an open-plan kitchen which serves pizzas and other modern pub-style food all day. Most Palmers beers are normally available. Accommodation is in three sea-view rooms named after Palmers beers.
⭑❀🍴❶♿🅰♣🚌(X51,X53) ❀🛜

Rock Point Inn

1-2 Broad Street, DT7 3QD

☎ (01297) 443153 ⊕ rockpointinn.co.uk

St Austell Tribute, Proper Job; 2 changing beers (sourced regionally; often Bath Ales, St Austell) Ⓗ

Large, extensively renovated and expanded 18th-century inn in the centre of town. It offers fabulous sea views from inside the pub and from the outdoor balcony. The outside space has gas heaters for cold evenings but is sometimes closed in rough weather. Proper Job and Tribute are regular beers, alongside two changing brews from St Austell and Bath Ales. There are nine bedrooms, some with views of the sea.
⭑❀🍴❶🅰🚌(X51,X53) ❀🛜

Pamphill

Vine Inn ★

Vine Hill, BH21 4EE (off B3082)

☎ (01202) 882259

2 changing beers (sourced regionally; often Otter, Plain) Ⓗ/Ⓖ

Identified by CAMRA as having a nationally important historic pub interior, this multi award-winning country pub, owned by the National Trust, has been managed by the same family for 120 years – the current landlady presiding for more than 30 years. It has two cosy bars and an upstairs room, plus a large suntrap patio and garden that provides the perfect place to relax and enjoy a drink. Light snacks including ploughman's and toasties

are served at lunchtime. This gem of a pub is popular with walkers and cyclists. Opening times vary in winter.
Q❀❶♣🅿❀

Piddlehinton

Thimble Inn Ⓛ

14 High Street, DT2 7TD

☎ (01300) 348270 ⊕ thimbleinn.co.uk

Palmers Copper Ale, IPA, Dorset Gold Ⓗ

This partially thatched Palmers house is the last remaining in the Piddle Valley. It has been tastefully refurbished in recent years and retains a traditional country pub feel. The dining areas are mostly open plan but there is plenty of cosy seating in the bar and dartboard area, which has wood panelling and an open fire. The Perspex-covered well is a feature; its water level varies with ground saturation. Outside are two riverside gardens. ⭑❀❶♿🅰♣🅿❀🛜

Poole

Barking Cat Alehouse

182-184 Ashley Road, Upper Parkstone, BH14 9BY

☎ (01202) 258465 ⊕ thebarkingcatalehouse.co.uk

8 changing beers (sourced nationally; often Bristol Beer Factory, Hattie Brown's, Siren) Ⓗ

Popular, vibrant two-roomed alehouse serving an interesting choice of beers, mainly from small breweries around the UK. There are eight real ales and six traditional ciders or perries on handpump alongside 10 craft keg beers. A rear function room houses a pool table and is used for meetings and private parties. The pub hosts a Sunday quiz plus occasional live music and beer festivals. Customers are welcome to order takeaways to eat here. ⭑♿🚲(Branksome)♣🍴🚌❀🛜

Bermuda Triangle

10 Parr Street, Lower Parkstone, BH14 0JY

☎ (01202) 748047 ⊕ bermudatrianglepub.com

5 changing beers (sourced nationally; often Dark Star, Oakham, Palmers) Ⓗ

Established in 1870, this great local drinkers' pub is at the heart of Ashley Cross. Its cosy interior has five distinct bar areas – find your way through the bookcase to discover the hidden sixth room. It is nautically themed and decorated to reflect the Bermuda Triangle story. Five ales on handpump are complemented by two real ciders and speciality keg beers. The pub has a welcoming atmosphere and hosts live music on Saturday. Its outside drinking area features fairy lights and is a must in summertime. ❀🚲(Parkstone)♣🚌(M1,M2)❀🛜

Brewhouse

68 High Street, BH15 1DA

☎ (01202) 685288

Frome Funky Monkey, The Usual; 1 changing beer (sourced nationally; often Frome) Ⓗ

This multi award-winning venue is a long-established feature of the town, and a reliable source of interesting ales from Frome Brewery as well as from national microbreweries. Real cider is also available. Entering from the High Street you find tables in the window; past the busy bar area is a space for pool and darts. A no-frills traditional community pub that offers a warm welcome to locals and visitors, and their dogs. ❀🚲♣🚌❀🛜

Butcher's Dog

37-39 Parr Street, Lower Parkstone, BH14 0JX

☎ (01202) 739539 ⊕ butchersdogdorset.com

4 changing beers (sourced regionally; often Brew Shack, Eight Arch, New Bristol) Ⓗ

Single-room bar with a welcoming and cosy feel, decorated in a modern industrial style. It has mixed-level seating from which to peruse the wall-mounted beer lists. The ale range blends traditional and modern, with up to four cask and 16 craft beers from micros. A fridge of canned brews is available for takeaways or on-site consumption. Outside there is street seating at the front and a large covered garden to the rear. ❀≢(Parkstone) ⬤🚌(M1,M2) ❀ 🛜

Poole Arms 🅛 ✓

19 The Quay, BH15 1HJ
☎ (01202) 673450 ⬤ poolearms.co.uk
Dorset Jurassic; Flack Manor Flack's Double Drop; St Austell Proper Job; 1 changing beer (sourced regionally) 🅗

Originating from 1635 and steeped in history, this distinctive green-tiled quayside pub is popular with locals and tourists alike. Up to five real ales are served in its cosy bar, whose walls display photographs of historic Poole. The pub offers an extensive menu and is renowned for its award-winning locally sourced seafood. Bench seating at the front provides a great space to watch activities in the bustling harbour. Q❀◑🚌

Portland

Royal Portland Arms

Fortuneswell, DT5 1LZ (on A354)
☎ (01305) 862255
2 changing beers (sourced regionally; often Cerne Abbas, Pitchfork, Quantock) 🅗/🅖

A basic one-bar Portland stone pub on the main road, dating back 200 years. It serves a varying choice of regional and local ales plus a real cider. Attractions include card nights on Tuesday and Wednesday and a popular early-evening cheese club on Wednesday. Live music is hosted on Friday night and on Sunday night in winter. A bus stop and free public car park are opposite. Q❀♣🚌(1) ❀ 🛜

Puncknowle

Crown Inn 🅛

Church Street, DT2 9BN
☎ (01308) 897711 ⬤ crowninndorset.co.uk
Palmers IPA, Dorset Gold, 200 🅗

Popular thatched pub at the heart of the village (pronounced 'Punnel'), consisting of two bars, with log fires and a further dining room off the main drinking area. It serves well-kept Palmers ales, occasionally including Tally Ho!, and offers traditional pub food with a specials menu. Outside are a marquee and large garden giving extensive views across the Bride Valley. Wheelchair access is via the back door from the car park. Q🕭❀☕◑🚹♣▲♣❀ 🛜

Sandford Orcas

Mitre Inn

DT9 4RU
☎ (01963) 220271 ⬤ mitreinn.co.uk
3 changing beers (sourced nationally; often Apex, Church End, Quantock) 🅗

A classic family-friendly free house, run by the same couple since 1992. Its cosy bar and separate restaurant have flagstoned floors and open fires; mind your head on the door lintels. Alongside regional beers the pub serves three changing ales from local breweries such as Apex and Yeovil. Two beer festivals are held each year. The elevated rear garden is accessed by steps. Booking is essential for Sunday lunch. Q🕭❀☕◑♣🚌(39)❀ 🛜

Shaftesbury

Ship Inn ✓

24 Bleke Street, SP7 8JZ
☎ (01747) 853219
Butcombe Original; Sixpenny 6d IPA; 1 changing beer 🅗

Stone-built town pub at the top of the steep Tout Hill. The single bar serves four different areas – the main bar, lounge bar, a snug with an open fire, and a games room with pool, darts, fruit machine and jukebox. Outside are a sunny patio and covered smoking area. No hot food is available but you can order from local takeaways or bring your own. ❀🚌❀ 🛜

Sherborne

Digby Tap ✓

Cooks Lane, DT9 3NS
☎ (01935) 813148 ⬤ digbytap.co.uk
4 changing beers (sourced regionally; often Cerne Abbas, Otter, Teignworthy) 🅗

A lively, long-established free house close to the abbey, railway station and all town-centre amenities. The owners of over 20 years have retained the character and atmosphere of the old building, with its four separate drinking areas, pine panelling, flagstone floors, old beams and three fireplaces. Up to four changing beers, mostly from West Country independent brewers, are sold at extremely reasonable prices. Lunchtime meals are also good value and there is a monthly Sunday roast. Q❀◑≢♣🚹🚌❀

Stourpaine

White Horse Inn ✓

Shaston Road, DT11 8TA
☎ (01258) 453535 ⬤ whitehorse-stourpaine.co.uk
Gritchie English Lore; Sharp's Doom Bar; house beer (by Flack Manor); 2 changing beers (sourced locally; often Cerne Abbas, Sixpenny) 🅗

Wonderful village free house incorporating the local shop and post office. Originally two adjoining cottages, the pub has multiple cosy spaces with beams and open fireplaces. Five handpumps serve national and regional ales, and cider lovers can enjoy Cranborne Chase direct from the box. Close to the North Dorset Trailway, the pub offers walkers and cyclists a well-earned break; dogs are welcomed with their own firkin of water. Pleasant gardens help make this an appealing destination all year round. Q🕭❀◑♣⬤🚹🚌(X3)❀ 🛜

Stratton

Saxon Arms

20 The Square, DT2 9WG
☎ (01305) 260020 ⬤ thesaxon-stratton.co.uk
Butcombe Original; St Austell Tribute; Timothy Taylor Landlord; 1 changing beer (sourced nationally; often Butcombe) 🅗

Thatched stone-and-flint pub in a quintessential village setting next to the church, village hall and green. Built in 2001, it features a welcoming open-plan area that is warmed by a log fire in winter. This leads to a good-sized restaurant; the pub is a must for food and offers a changing specials board. It serves local and national ales plus ciders and wines. A regular in this Guide. Q🕭❀◑🚹♣⬤P❀ 🛜

Sturminster Newton

White Hart Alehouse

Market Cross, DT10 1AN

☎ (01258) 472558 ● whitehartalehouse.co.uk

6 changing beers (sourced nationally; often Cerne Abbas, Dorset, Plain) Ⓗ

A thatched Grade II-listed free house in the town centre, opposite the museum and remains of the 15th-century market cross. This is a lively venue whose beamed, open-plan bar holds ample seating and an open fire. Up to six handpump-drawn real ales are served alongside a variety of ciders, lagers and craft beers from the keg. Live music features occasionally and there is a large outdoor space for alfresco drinking. ⑤❀◑♣●P➤(X4)

Swanage

Black Swan Ⓛ ✿

159 High Street, BH19 2NE

☎ (01929) 423846 ● blackswanswanage.co.uk

Dorset Knob; 2 changing beers (sourced locally; often Timothy Taylor) Ⓗ

A traditional Grade II-listed pub on the High Street, half a mile from the seafront. It has two bars with stone floors and log fires, and serves three well-kept ales. The pub is renowned for its quality food (telephone booking is essential). The secluded suntrap garden is pleasant on a summer evening. Q⑤❀◑≒●P➤(40,50)❀✿

Thornford

Kings Arms Ⓛ

Pound Road, DT9 6QD

☎ (01935) 872294 ● kingsarmsthornford.com

Butcombe Original; Palmers Tally Ho!; 2 changing beers (sourced regionally; often Exmoor, Parkway, St Austell) Ⓗ

The pub is at the heart of the village, next to the unusual red-brick Victorian clock tower. It features a traditional bar and a separate comfortable restaurant. Pleasant outside seating areas with children's play facilities are adjacent to a large skittle alley; one of the two gardens is no-smoking. Parking is on the road and in the small car park. ⑤❀◑♣●P❀✿

Wareham

Horse & Groom ♟ Ⓛ ✿

St Johns Hill, BH20 4LZ

☎ (01929) 552222

5 changing beers (sourced regionally) Ⓗ

Free house offering four real ales, with a proud emphasis on those brewed in Dorset, plus real cider. Comfortable, welcoming and spacious, it has a reputation for good pub food. It is cosy in winter, warmed by two real fires, and also delivers in summer with a pleasant garden tucked away at the rear. The pub hosts quiz nights and occasional curry evenings, offering something for everyone. Local CAMRA Pub of the Year 2020.
⑤❀◑●➤(40,X54)❀✿

King's Arms ✿

41 North Street, BH20 4AD

☎ (01929) 552503 ● kingsarmswareham.co.uk

6 changing beers (sourced nationally; often Dorset, Ringwood, Sharp's) Ⓗ

Traditional, award-winning thatched pub that has roots in the 1500s and survived the great fire of 1762. The new tenants are dedicated to serving good-quality ales and home-cooked food. They recently added a sixth handpump and now offer breakfast in addition to lunch

and dinner. There is a cozy bar, with real fire in winter, plus a drinking corridor and dedicated dining area. The large rear garden has a covered area for smokers. Live music often features. ⑤❀◑≒●P➤(40,X54)❀✿

West Bay

George Hotel Ⓛ

18 George Street, DT6 4EY

☎ (01308) 423191 ● georgewestbay.com

Palmers Copper Ale, IPA, Dorset Gold, Tally Ho!; 1 changing beer (sourced locally; often Palmers) Ⓗ

Large Georgian pub in the heart of the West Bay harbour area, close to the seaside kiosks. It serves an extensive range of Palmers beers, and offers food in all areas including the separate public bar. Home-made pies and burgers are a speciality and local seafood also features on the 50-seater dining room's menu. The riverside garden has its own bar in summer. Eight rooms provide accommodation. Q⑤❀⇔◑▲♣P➤(X53)❀✿

West Parley

Owls Nest

196 Christchurch Road, BH22 8SS

☎ (01202) 572793 ● theowlsnest-westparley.com

4 changing beers (sourced regionally; often Flack Manor, Otter, Sixpenny) Ⓗ

Charming and welcoming Tudor-style building whose beamed ceilings and wood-burner contribute to a relaxed and comfortable atmosphere. Four handpumps dispense local and regional ales. The pub is popular for home-made food including Sunday roasts; booking is recommended. Check the website or phone for opening hours and details of the occasional live music events. ⑤◑●P➤(13,X6)❀✿

West Stour

Ship Inn

A30, SP8 5RP

☎ (01747) 838640 ● shipinn-dorset.com

Butcombe Original; 2 changing beers (sourced locally) Ⓗ

Once a coaching inn, this popular roadside pub has views across the Blackmore Vale. The public bar features a flagstone floor; the separate light and airy restaurant area has stripped-oak floorboards. There is a patio and large garden at the rear. This friendly hostelry is renowned for superb home-cooked food (no meals Sun eve) and comfortable accommodation. It usually offers a choice of six local ciders alongside the three ales. Dogs are welcome in the bar. A beer festival is hosted in July. Q❀⇔◑♣●P❀

Weymouth

Belvedere Inn ✿

High West Street, DT4 8JH

☎ (01305) 459099

4 changing beers (sourced nationally; often Copper Street, Isle of Purbeck, Otter) Ⓗ

A real gem of a Victorian bar on the fringes of the town centre, featuring bare-wood flooring throughout. It serves a varied selection of interesting real ales from microbreweries, as well as Guinness and up to nine ciders. This is one of the few pubs that still have a piano in the bar, and it also hosts music most days. Tuesday is quiz night. The must-see terrace garden is referred to as the Narden. Families and dogs are welcome. ⑤❀◑♣●➤(1)❀

Dolphin Hotel

67 Park Street, DT4 7DE
☎ (01305) 839273
Hop Back Crop Circle, Summer Lightning; 1 changing beer (sourced regionally; often Hop Back) ⊞

A light and airy Hop Back Brewery pub a few minutes' walk from the beach, near local bus routes and the railway station. It has two lounge rooms, one with sports TV, plus a rear function room with pool table. Alongside the regular Summer Lightning and Crop Circle beers it serves one Hop Back guest ale, usually Entire Stout. Karaoke night is held on the last Saturday of the month. Dog-friendly only in the front room. ᒼ⇔♨≢♣⊟❀ 🛜

Globe Inn

24 East Street, DT4 8BN
☎ (01305) 786061
Dartmoor Jail Ale; St Austell Proper Job; Sharp's Doom Bar; 2 changing beers (sourced regionally; often Cerne Abbas, Fine Tuned, Palmers) ⊞

Free house with a friendly welcome, tucked away on a street corner just 30 yards from the iconic harbourside. The Globe is only a short distance from the town centre, the beach and the esplanade, and offers a distinct change from the packed waterside. There is a jukebox and a separate games room with pool table, darts and pub games. A fun quiz is held on Sunday afternoon. Guest ales are mainly from local or South West breweries. ᒼ♣⊟❀ 🛜

King's Arms

15 Trinity Road, DT4 8TJ
☎ (01305) 772200
Dartmoor Jail Ale; St Austell Proper Job; Sharp's Sea Fury; 1 changing beer (sourced regionally; often Dorset, Exmoor) ⊞

Tourists and locals enjoy this 16th-century quayside hostelry whose recent facelift has provided a lighter bar area and modernised lounge. A stone's throw from the town centre, it is ideally situated for views of the busy harbour with its lifting bridge. The pub holds live music at weekends, and hosts the local ukulele group on the first and third Thursday of the month. All drinks are discounted early afternoons Monday to Thursday. Q♣⊟(3,8) ❀

Market House

37 Maiden Street, DT4 8AZ
☎ (01305) 771236
Greene King Abbot; Morland Old Speckled Hen; 2 changing beers (sourced regionally; often Exmoor, Otter, Plain) ⊞

Corner bar in quiet street off the main town centre. Two regular beers from Greene King are supplemented by two from small independent breweries. Sport from Sky and BT is shown on TV. Prices are very reasonable for the area and there is an early-evening happy hour every day. No dedicated parking but there is a public car park only 50 yards away. ≢♣⊟(3,8)❀

Wimborne

Green Man ✔

1 Victoria Road, BH21 1EN
☎ (01202) 881021 ● greenmanwimborne.com
Wadworth Henry's IPA, 6X, Swordfish; 1 changing beer ⊞

A friendly, traditional 18th-century pub, with one bar and four separate drinking areas. It features award-winning floral displays, a wood-burner, ubiquitous brasses and the infamous Green Man in the entranceway floor. Games are available on the patio. Excellent food is served in the early afternoons, a quiz is hosted on Thursdays and live music is played on Fridays. Q੬✿◑♣⊛P⊟(3,13) ❀ 🛜

Oddfellows Arms ⒧

Church Street, BH21 1JH
☎ (01202) 889669
Hall & Woodhouse Badger Best Bitter, Fursty Ferret; 1 changing beer (sourced locally; often Hall & Woodhouse) ⊞

A one-bar local just off the Square, near the site of the former Oddfellows Hall. A pub since the 1800s, it was previously a morgue and may have been a pub before that; this cannot be verified because property numbers were not then used. Bar snacks are always available including sausage rolls, pies and occasionally pasties. ⊟(3,13) ❀

Taphouse

11 West Borough, BH21 1LT
☎ (01202) 911200
8 changing beers (sourced locally) ⊞

Quirky, busy bar near the centre of this historic market town. It is a happy gathering place, full of atmosphere, and serves a great range of beers and ciders. The friendly staff are helpful and are always on hand. Conversation rules; this is a place to meet and make friends. Live music is played on Sundays. ⊛♣⊛⊟(3,13)❀ 🛜

Worth Matravers

Square & Compass ★ ⒧

BH19 3LF (off B3069)
☎ (01929) 439229 ● squareandcompasspub.co.uk
Hattie Brown's HBA, Moonlite; 3 changing beers (sourced regionally) Ⓖ

A real gem, this multi award-winning pub has been identified by CAMRA as having a nationally important historic pub interior. It has been in the same family since 1907, and has appeared in every edition of this Guide. Two rooms either side of a serving hatch convey an impression that little has changed over the years. Pasties are available. The sea-facing garden offers views across the Purbecks, and fossils are displayed in the adjacent museum. Beer and cider festivals are held in October and November. Q੬✿🐾❀

Breweries

Barefaced SIBA

Unit 1, Holland Business Park, Blandford, Dorset, DT11 7TA ☎ 07435 157767
● barefacedbrewing.co.uk

⊗ Barefaced Brewing was established in 2017 by two friends, Nick Horne and Tom Cooper, in one of their garden sheds in Wimborne. A move to Bournemouth was followed by a move to its new location in Blandford, which has allowed for expanded production and a taproom bar. ‼🍴♦LIVE ⚭

Big Bang Blueberry Cream Ale (ABV 4.4%) SPECIALITY
So You've Travelled (ABV 4.4%) GOLD
Heartbreak Stout (ABV 5.4%) STOUT
Flash IPA (ABV 5.9%) IPA
Sucker Punch Saison (ABV 6.4%) SPECIALITY

Boscombe (NEW)

c/o Christchurch Road, Bournemouth, Dorset
● bbco.beer

A nanobrewery launched commercially in 2022 using a three-barrel plant in a converted outhouse of a residential property. Brewer Jarrod Thompson began homebrewing in his native Nassua in New Hampshire more than twenty years ago. No real ale.

Brew Shack

Sixpenny Handley, Dorset ☎ **07580 120258** ● **thebrewshack.co.uk**

⊠ Brewing began in 2015 on a 1.5-barrel plant in purpose-built premises, later upgraded to 10 barrels. The brewery is located on a working farm so there is no access for the general public.

Bills Bitter (ABV 4%) BITTER
A traditional style bitter with fruity aroma, good malt balance and moderate hoppiness leading to hoppy, dry finish. Vegan-friendly.
Pale Ale (ABV 4.5%) PALE
Intense hop citrus taste with some fruit coming through. Leads to a pleasant, slightly dry stringent finish. Unfined.
Eight Grain Porter (ABV 5%) PORTER
Light, drinkable porter with prominent roast notes in the aroma and taste with roast notes adding astringency in the taste leading to a fruity aftertaste.

Brewers Folly

Ashton Farm House, Stanbridge, Wimborne, Dorset, BH21 4JD ● **brewersfolly.co.uk**

⊠ Dean and Rufus have been avid homebrewers for a very long time. They began brewing on a 1.4-barrel system bought from Brew Shack in 2017. They currently work full-time and brew part-time, but hope to go full-time and expand the range in the future. ‼◆

Session Pale Ale (ABV 4.2%) PALE
10w-40 (ABV 5%) STOUT
V1 Simco IPA (ABV 5.5%) IPA
V2 Ekuanot IPA (ABV 5.5%) IPA
V3 Galaxy (ABV 5.5%) IPA

Brewhouse & Kitchen SIBA

🏠 **154 Commercial Road, Bournemouth, Dorset, BH2 5LU**
☎ **(01202) 055221** ● **brewhouseandkitchen.com**

⊠ Part of the Brewhouse & Kitchen chain, producing its own range of beers. Carry outs and brewery experience days are offered. ‼🍴

Brewhouse & Kitchen SIBA

🏠 **17 Weymouth Avenue, Dorchester, Dorset, DT1 1QY**
☎ **(01305) 265551** ● **brewhouseandkitchen.com**

⊠ Part of the Brewhouse & Kitchen chain, producing its own range of beers. Carry outs and brewery experience days are offered. ‼

Brewhouse & Kitchen SIBA

🏠 **3 Dear Hay Lane, Poole, Dorset, BH15 1NZ**
☎ **(01202) 771246** ● **brewhouseandkitchen.com**

⊠ Opened in 2015 this outlet is an excellent addition to the Brewhouse & Kitchen chain. Following the B&K style of a two barrel brewery on open display; producing beers for the pub and off-sales with beer also offered out to the free trade. Two seasonal beers are brewed each quarter. Brewery experience days, meet the brewer and tapping parties are regular events. ‼◆LIVE

Brewhouse & Kitchen SIBA

🏠 **147 Parkwood Road, Southbourne, Dorset, BH5 2BW**
☎ **(01202) 055209** ● **brewhouseandkitchen.com**

⊠ Part of the Brewhouse & Kitchen chain, breathing new life into the once derelict Malt & Hops pub in the heart of Southbourne. The brewery opened in 2016 and has a core range of nine ales. Tours and brewing days are offered, as well as a number of special events. ‼

Cerne Abbas SIBA

Chescombe Barn, Barton Meadows Farm, Cerne Abbas, Dorset, DT2 7JS
☎ **(01300) 341999** ☎ **07506 303407**

Office: The Mill House, Mill Lane, Cerne Abbas, DT2 7LB ● **cerneabbasbrewery.com**

⊠ Established in 2014 by Vic Irvine and Jodie Moore. Operating a five-barrel plant, beers are made naturally as possible using chalk-filtered water from its own spring. Many seasonal beers are produced, some with non-conventional ingredients. All beers are brewed with organic Maris Otter barley from Cerne Valley. On the second Saturday in September each year, a community brew is produced using hops grown by people living in the village and surrounding areas. ‼🍴◆◆

Ale (ABV 3.8%) BITTER
Gold/amber ale with gentle hop aroma. Refreshing, balanced bitter sweet taste. Long dry finish.
The Big Lubelski (ABV 3.9%) BLOND
Best Pale Ale (ABV 4%) PALE
Blonde (ABV 4.2%) BLOND
Hops to the fore in New World style, fairly light on palate with spicy bitterness balanced with sweetness fading to astringency
Tiger Tom Ruby Mild (ABV 4.4%) MILD
Mellow, malty, ruby brown ale with hints of chocolate in aroma, taste and aftertaste. Malt balanced by bitterness leading to a dry, slightly bitter aftertaste.
Leggless Jester (ABV 4.7%) GOLD
Mrs Vale's Ale (ABV 5.6%) OLD
Caramel and dried fruit have a strong presence. A warming, enduring finish in this complex Old Ale. Presents as much stronger than the advised ABV.
Gurt Stout (ABV 6.2%) STOUT
Gurt Coconuts Rum Stout (ABV 7.2%) SPECIALITY
A strong, sweet stout with very prominent coconut elements in aroma, taste and aftertaste.

Copper Street

8 Copper Street, Brewery Square, Dorchester, DT1 1GH ☎ **07970 766622**
✉ **copperstreetbrewery@outlook.com**

⊠ Anthony and Ann Buckton started this 2.5-barrel brewery in 2018. It is situated in the new Brewery Square development, ex Eldridge Pope, next to Dorchester South Station. The brewery can be seen from the shop, which sells a good selection of bottled beers, ciders and other drinks. Some 12-14 ales are produced throughout the year. A taproom is open Thursday to Saturday. 🍴◆◆

Scramasax (ABV 4.1%) PALE
871 (ABV 4.3%) BITTER
Egbert's Stone (ABV 4.3%) BITTER
Shield Wall (ABV 4.3%) BITTER
Aethel Sword (ABV 4.5%) BITTER
Saxon Gold (ABV 4.7%) GOLD
Dark Ages (ABV 5.5%) PORTER

Dorset (DBC) SIBA

Unit 7, Hybris Business Park, Warmwell Road, Crossways, Dorset, DT2 8BF
☎ (01305) 777515 ⊕ dbcales.com

⊠ Founded in 1996, Dorset Brewing Company started in Hope Square, Weymouth, which was once the home of the Devenish and Groves breweries. In 2010 it moved to purpose-built premises near Dorchester. Here spring water is used in its state-of-the-art brewing equipment. Beers are available in local pubs and selected outlets throughout the South West. ‼🍺♦⚭

Dorset Knob (ABV 3.9%) BITTER
Complex bitter ale with strong malt and fruit flavours despite its light gravity.
Jurassic (ABV 4.2%) BITTER
Clean-tasting, easy-drinking bitter. Well-balanced with lingering bitterness after moderate sweetness.
Origin (ABV 4.3%) GOLD
Durdle Door (ABV 5%) BITTER
A tawny hue and fruity aroma with a hint of pear drops and good malty undertone, joined by hops and a little roast malt in the taste. Lingering, bittersweet finish.

Eight Arch SIBA

Unit 3a, Stone Lane Industrial Estate, Wimborne, Dorset, BH21 1HB
☎ (01202) 889254 ☎ 07554 445647
⊕ 8archbrewing.co.uk

⊠ This award-winning brewery commenced in 2015 on a five-barrel plant on a small industrial estate on the outskirts of Wimborne. It expanded into the unit next door in 2018 and upgraded to a 10-barrel plant in 2021. An onsite taproom offers street food. Beer is distributed to local pubs and clubs as well as nationally. ‼🍺♦LIVE⚭

Session (ABV 3.8%) PALE
Square Logic (ABV 4.2%) GOLD
Easy Life (ABV 5%) PALE
Corbel (ABV 5.5%) IPA
Strong golden ale with hops dominating yet balanced with bitterness.

Gyle 59 SIBA

The Brewery, Sadborow Estate Yard, Thorncombe, Dorset, TA20 4PW
☎ (01297) 678990 ☎ 07508 691178 ⊕ gyle59.co.uk

⊠ Gyle 59 is a 10-barrel brewery that began commercial production in 2014. Bottling takes place onsite with bottles being available by mail order. ‼🍺LIVE

Take It Easy (ABV 2.5%) BITTER
Freedom Hiker (ABV 3.7%) BITTER
Lyme Regis Ammonite (ABV 3.7%) BITTER
Toujours (ABV 4%) SPECIALITY
Vienna Session Lager (ABV 4.2%) SPECIALITY
Capitalist Hippie-Flower Power (ABV 4.3%) BITTER
Capitalist Hippie-Far Out (ABV 5%) PALE
Halcyon Daze (ABV 5%) SPECIALITY
IPA (ABV 5.3%) PALE
Nettle IPA (ABV 5.3%) SPECIALITY
Dorset GIPA (ABV 5.4%) SPECIALITY
Capitalist Hippie-Summer of Love (ABV 6.6%) STRONG
Starstruck (ABV 6.6%) SPECIALITY
The Favourite (ABV 6.6%) PORTER
Double IPA (ABV 7.3%) IPA

Hall & Woodhouse (Badger) IFBB

Bournemouth Road, Blandford St Mary, Dorset, DT11 9LS
☎ (01258) 452141 ⊕ hall-woodhouse.co.uk

⊠ Hall & Woodhouse has been brewing in the heart of the Dorset countryside since 1777. Owned and run by the seventh generation of the Woodhouse family, it brews with local spring water filtered through the Cretaceous chalk downs and drawn up 120ft from its wells. A leading, independent UK brewer, its well-known range of Badger ales is award-winning, and it has an estate (around 200 pubs) across southern England. Its ales are available exclusively in Hall & Woodhouse public houses. ‼🍺♦⚭

Badger Best Bitter (ABV 3.7%) BITTER
Well-balanced bitter with malt caramel sweetness and hop fruitiness.
Fursty Ferret (ABV 4.1%) BITTER
Easy-drinking best bitter with sweet bitterness that lingers into a dry after taste with a hint of orange.
Tanglefoot (ABV 4.7%) GOLD
Relatively sweet-tasting and deceptive, given its strength. Pale malt provides caramel overtones and bittersweet finish.

Hattie Brown's

c/o The Square & Compass, Worth Matravers, Dorset, BH19 3LF
☎ (01929) 439229

⊠ Hattie Brown's began brewing in 2014 at the Wessex brewery. In 2015 it moved to its present location. It is owned by the manager of the Square & Compass, Worth Matravers, and partner, Jean, the brewer.

HBA (ABV 3.8%) BITTER
Well-balanced session bitter with initial malt flavours followed by a balanced hop and sweet finish.
Moonlite (ABV 3.8%) PALE
Easy-drinking, session pale ale, richly-hopped with refreshing strong citrus flavours and long, lingering finish.
Zephyr (ABV 4.2%) PALE
Mustang Sally (ABV 4.3%) BITTER
Agglestone (ABV 4.5%) BITTER
Kirrin Island (ABV 4.5%) PALE
Premium, blonde-coloured pale ale with hop flavours dominating the malt biscuit base.
Spangle (ABV 4.6%) BITTER
Nut Brown (ABV 4.8%) BROWN
Sirius (ABV 4.8%) PALE
Full Moon (ABV 5%) GOLD
Herkules (ABV 5%) PALE
Crow Black (ABV 5.1%) PORTER
Excellent strong mild with roast aromas, and rich malt and dried fruit pudding flavours. Lovely lingering aftertaste. Deceptively easy-drinking.
Dog on the Roof (ABV 6%) GOLD

Isle of Purbeck SIBA

🛏 **Bankes Arms, Manor Road, Studland, Dorset, BH19 3AU**
☎ (01929) 450227 ⊕ isleofpurbeckbrewery.com

Founded in 2003, and situated in the grounds of the Bankes Arms Inn, in the heart of the magical Isle of Purbeck. The pub and brewery overlook the sea at Studland and Old Harry Rocks on the Dorset section of the Jurassic World Heritage Coast. This 10-barrel plant produces five core beers, several seasonal beers and Purbeck Pommes cider, available locally, and also

nationwide via exchange swaps with other micros, and at beer festivals. ◆LIVE

Purbeck Best Bitter (ABV 3.6%) BITTER
A classic, malty best bitter with rich malt aroma and taste, and smooth, malty, bitter finish.
Equinox (ABV 4%) BLOND
Fossil Fuel (ABV 4.1%) BITTER
Amber bitter with complex aroma with a hint of pepper; rich malt dominates the taste, leading to a smooth, dry finish.
Solar Power (ABV 4.3%) GOLD
Tawny mid-range ale brewed using Continental hops. Well-balanced flavours combine to provide a strong bitter taste but short, dry finish.
Studland Bay Wrecked (ABV 4.5%) BITTER
Deep red ale with slightly sweet aroma reflecting a mixture of caramel, malt and hops that lead to a dry, malty finish.
Wind Generator (ABV 4.7%) GOLD
Full Steam Ahead (ABV 4.8%) BITTER
Mid-brown beer with hop/malt balance in the flavour and a long dry aftertaste.

Knight Life

27 Feversham Avenue, Queenspark, Bournemouth, Dorset, BH8 9NH ☎ 07722 564444
⊕ knightlifebrewing.com

Established in 2018, Knight Life has a three-barrel system, with six three-barrel fermenters. Canning machine is in-house. It now has its own tap house, with 12 lines in the heart of busy Ashley Cross, in Poole.

Lyme Regis SIBA

Lyme Regis Brewery, Mill Lane, Lyme Regis, Dorset, DT7 3PU
☎ (01297) 444354 ⊕ lymeregisbrewery.com

⊠ Lyme Regis Brewery (formerly Town Mill Brewery) began brewing in 2010 and is situated in a part of the Town Mill that previously housed the Lyme Regis electricity generator. Historically also used as a brewer's malthouse, the building now houses its licenced taproom with a one-barrel pilot kit. All cask beers are currently brewed on contract by Gyle 59 Brewery to the original Town Mill Brewery recipes. ⧯◆LIVE V◆

Rebel (ABV 4.2%) BITTER

Palmers SIBA IFBB

Old Brewery, West Bay Road, Bridport, Dorset, DT6 4JA
☎ (01308) 422396 ⊕ palmersbrewery.com

⊠ Palmers is one of Britain's only thatched breweries and dates from 1794. It is situated in Bridport, the heart of the Jurassic Coast in south-west Dorset. The company continues to make substantial investment in its 54 tenanted pubs, all serving cask ale. An additional 400 outlets are supplied within the free trade. ‼⧯

Copper Ale (ABV 3.7%) BITTER
Beautifully-balanced, copper-coloured, light bitter with a hoppy aroma.
IPA (ABV 4.2%) PALE
Hop aroma and bitterness stay in the background in this predominately malty best bitter, with some fruit on the aroma.
Dorset Gold (ABV 4.5%) GOLD
More complex than many golden ales thanks to a pleasant banana and mango fruitiness on the aroma that carries on into the taste and aftertaste.
200 (ABV 5%) BITTER

This is a big beer with a touch of caramel sweetness adding to a complex hoppy, fruit taste that lasts from the aroma well into the aftertaste.
Tally Ho! (ABV 5.5%) OLD
A complex dark old ale. Roast malts and treacle toffee on the palate lead in to a long, lingering finish with more than a hint of coffee.

Piddle

Unit 24, Enterprise Park, Piddlehinton, Dorchester, Dorset, DT2 7UA
☎ (01305) 849336 ☎ 07730 436343
⊕ piddlebrewery.co.uk

⊠ Established in 2007, with new owners in 2014. The brewery produces a broad range of beers from its location in the Piddle Valley in Dorset. Some beer names reflect this unusual name. Beers are available in pubs and retail outlets across Dorset and beyond. ◆

Dorset Rogue (ABV 3.9%) BITTER
Piddle (ABV 4.1%) BITTER
Cocky (ABV 4.3%) PALE
Bent Copper (ABV 4.8%) BITTER
Slasher (ABV 5.1%) BLOND

Poole Hill SIBA

41-43 Poole Hill, Bournemouth, Dorset, BH2 5PW
☎ 07469 172568 ⊕ poolehillbrewery.com

⊠ Award-winning Poole Hill Brewery is located in a former car show room. Jennifer Tingay (former technologist and brewer for Ringwood) renovated it after crowdfunding. Cuckoo brewing from 2013, production started on a new 20-barrel plant at the site in 2018. Located in The Triangle area of Bournemouth, it includes a large taproom with cinema and regular live music. The Southbourne Ales brand features traditional styles (cask-conditioned or bottle-conditioned), and the Tingay's brand (cask-conditioned and in cans) is exciting, modern craft beers. All beers are unfined. ‼⧯◆LIVE◆

Brewed under the Southbourne Ales brand name:
Paddlers (ABV 3.6%) BITTER
Easy-drinking bitter with subtle malt flavour and hints of hop bitterness in the aftertaste.
Sunbather (ABV 4%) BITTER
Dry red ale with some caramel sweetness and a lingering nutty aftertaste.
Headlander (ABV 4.2%) BITTER
Traditional best bitter with intense malt aroma and sweet flavour. Complex and moreish with hop bitterness in aftertaste.
Grockles (ABV 4.5%) GOLD
Refreshing, well-balanced golden ale with subtle sweet aromas and gentle hop finish.
Stroller (ABV 4.6%) STOUT
Strong mild crossed with old ale, complex flavours of hop malt and fruit but well-balanced.

Brewed under the Tingay's brand name:
Peace Keeper (ABV 1%) BITTER
Armed with Flowers (ABV 4.5%) SPECIALITY
Smoke Grenade (ABV 4.5%) SPECIALITY
Digies (ABV 5%) PALE
Active Denial System (ABV 7%) SPECIALITY

Remedy Oak SIBA

Horton Road, Wimborne, Dorset, BH21 8ND
☎ (01202) 612509 ⊕ remedyoakbrewery.co.uk

The Remedy Oak Brewing Company was established commercially in 2020. It is based in a redeveloped barn in the grounds of the Remedy Oak Golf Club. Traditional

styles as well as hop-forward craft beers are produced. An onsite taproom opened in 2021. 🍺◆

Sandbanks SIBA

Unit 6, 4-6 Abingdon Road, Nuffield Industrial Estate, Poole, Dorset, BH17 0UG
☎ (01202) 671950 ⊕ sandbanksbrewery.net

⊗ Opened in 2018 on the site of the old Bournemouth Brewery with a new five-barrel plant. The beer is becoming increasingly available in the local free trade with one-off and special beers from the one-barrel plant available in the taproom. 🍺◆◆

Bitter (ABV 3.9%) BITTER
Refreshing session bitter with pleasant malt character.
Freebird (ABV 4.2%) PALE
Golden Years (ABV 4.3%) GOLD
Back in Black (ABV 5%) STOUT
Easy-drinking stout with roast malt on tongue and hints of liquorice and coffee, lingering rich fruit aftertaste.
Wayward Son IPA (ABV 5%) PALE

Sixpenny SIBA

The Old Dairy, Holwell Farm, Cranborne, Dorset, BH21 5QP
☎ (01725) 762006 ⊕ sixpennybrewery.co.uk

⊗ Founded in 2007, Sixpenny moved into its present home of renovated Victorian farm buildings near Cranborne, in 2016. This allowed for the expansion of the brewery bar and shop (Sixpenny Tap), in converted stables next door. Sixpenny has been brewing to its 20-barrel plant capacity for some while now to meet demand. Plans are afoot to increase the amount of bottled beer available all year round. !! 🍺◆◆

6d Best Bitter (ABV 3.8%) BITTER
6d Gold (ABV 4%) GOLD
6d IPA (ABV 5.2%) PALE

Small Paul's

Gillingham, Dorset, SP8 4SS
☎ (01747) 823574 ✉ smallbrewer@btinternet.com

⊗ Launched in 2006, this half-barrel brewery is located in the owner's garage. Brewing is now reduced to about once a month and on demand. A small number of local pubs, clubs and beer festivals are supplied direct and beers can be brewed to order.

Stripey Cat

🏠 Tiger Inn, 14-16 Barrack Street, Bridport, Dorset, DT6 3LY
☎ (01308) 427543 ⊕ tigerinnbridport.co.uk/the-stripey-cat-craft-brewery

Brewing began in 2017 at the Tiger Inn, producing ales exclusively for the pub. Brewing is currently suspended.

Way Outback

Southbourne, Bournemouth, Dorset, BH5 2HZ
⊕ thewayoutback.co.uk

Started in 2017 and born in a shed, Way Outback is based in Southbourne. It is run by owner and head brewer Richard Brown (with help from his four-legged assistant Arthur), and specialises in beers using high quality ingredients with provenance. ◆

Wriggle Valley SIBA

Unit 4, The Sidings, Station Road, Stalbridge, Dorset, DT10 2SS
☎ (01963) 363343 ☎ 07599 677139
⊕ wrigglevalleybrewery.co.uk

Wriggle Valley began brewing in 2014 using a three-barrel plant in a converted garage. It relocated to Stalbridge in 2017 to an industrial unit and changed hands in 2020. Beers are mainly supplied within a 20-mile radius of the brewery. A taproom was opened at the brewery in 2019. 🍺◆LIVE◆

Dorset Nomad (ABV 3.8%) BITTER
Golden Bear (ABV 4%) BLOND
Golden ale with fruit notes in the aroma and taste leading to a dry, slightly astringent finish.
Dorset Pilgrim (ABV 4.2%) BITTER
A traditional best bitter with some malt and fruit in the aroma developing hop and bitterness in the taste with a more bitter, balanced finish.
Copper Hoppa (ABV 4.5%) BITTER
Light malt and hop aroma with a relatively sweet taste predominated by fruit and caramel which linger in a pleasant aftertaste along with slight bitterness coming forward.
Valley Gold (ABV 4.5%) GOLD
Golden ale with some fruit and hop in the aroma with bitterness and astringency developing with a light citrus note in the taste and through to a bitter aftertaste.

Kitchen of an inn

In the evening we reached a village where I had determined to pass the night. As we drove into the great gateway of the inn, I saw on one side the light of a rousing kitchen fire beaming through a window. I entered, and admired for the hundredth time that picture of convenience, neatness, and broad honest enjoyment, the kitchen of an English inn. It was of spacious dimension, hung around by copper and tin vessels, highly polished, and decorated here and there with a Christmas green. Hams, tongues, and flitches of bacon were suspended from the ceiling; a smoke-jack made its ceaseless clanking behind the fireplace, and a clock ticked in one corner. A well-scoured deal table extended along one side of the kitchen, with a cold round of beef, and other hearty viands upon it, over which two foaming tankards of ale seemed mounting guard. Travellers of inferior order were preparing to attack this stout repast, while others sat smoking or gossiping over their ale, on two high-backed oaken settles beside the fire.
Washington Irving, Travelling at Christmas, 1884

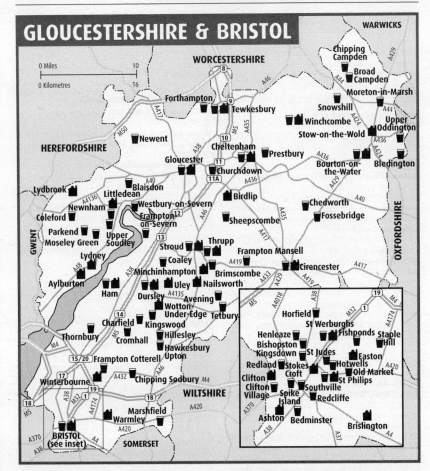

GLOUCESTERSHIRE & BRISTOL

Avening

Bell 𝕃

29 High Street, GL8 8NF (at bottom of High St on B4014)
☎ (01453) 836422 🌐 thebellavening.co.uk
Box Steam Soul Train; Timothy Taylor Landlord; 1 changing beer (often Butcombe) ⊞
Featuring exposed stone walls, two bay window seats and a roaring woodburner, this friendly, confidently-run old inn is a pleasant village local, with the amicable regulars always happy to chat. The attractive open bar offers up to four different ales at busy times. The refurbished, comfortable dining area serves a competitively priced menu in collaboration with a local Indian restaurant. This pub can be quietly addictive and difficult to leave. Q⑃✿❀⬧♣⊟♫⬤🐶🕸

Blaisdon

Red Hart 𝕃

GL17 0AH (signed from A4136 E of Longhope or N of A48)
☎ (01452) 831717 🌐 redhartinn.co.uk
Otter Bitter; 3 changing beers (sourced nationally; often Bespoke, Kingstone, Wye Valley) ⊞
Local CAMRA Pub of the Year 2022, the Red Hart is a lovely old pub deservedly popular for its excellent food and well-kept ales. A warm welcome is assured. There are designated dining areas, but no separate restaurant,

so everyone can enjoy the convivial atmosphere. A well-tended garden is an ideal place for families to enjoy in the summer. The bar area has flagstones, worn through generations of use, and the walls are adorned with memorabilia. Paintings from local artists are displayed for sale. ⑃✿❀⬧&♣⬥♣♫P🕸

Bledington

King's Head 𝕃 ✓

The Green, OX7 6XQ (off B4450 on village green)
☎ (01608) 658365 🌐 kingsheadinn.net
Hook Norton Hooky; 3 changing beers (sourced regionally) ⊞
Delightful 16th-century stone-built inn overlooking the village green. It has original beams and an open inglenook log fire with high back settles. A free house, it offers two guest beers selected from local brewers, and is renowned for its wide range of ales and food. The village of Bledington is about four miles from Stow-on-the-Wold, and there are good local walks to nearby villages, with Kingham station close by. Accommodation is in with 12 comfortable letting rooms.
Q⑃✿❀⬥♣♣P🕸🌐

Bourton-on-the-Water

Mousetrap Inn ♟ 𝕃

Lansdowne, GL54 2AR (300yds W of village centre)

☎ (01451) 820579 ⊕ themousetrapinn.co.uk
3 changing beers (sourced locally) 🅷
Recently refurbished traditional Cotswold stone free house, in the Lansdowne part of Bourton close to the centre. Three changing local beers are on offer. A friendly welcome is extended to locals, tourists, children and dogs. A patio area in front of the pub with tables and hanging baskets provides a suntrap in the summer. Local CAMRA Pub of the Year 2022
Q☺🚼🕒ᵹ&P🚃(801,855)❀🛜

Brimscombe

Ship Inn 🅛
Brimscombe Hill, GL5 2QN (turn right off A419 from Stroud, pub is 50yds on the right)
☎ (01453) 619132 ⊕ theshipstroud.co.uk
Butcombe Gold; Uley Bitter; 2 changing beers (sourced nationally; often Fresh Standard, Nene Valley, Northern Monk) 🅷
A handsome former canalside pub, reopened in 2021 by a local caterer and restaurateur who has thrown out the tired carpets in favour of stripped wooden floors to complement the exposed stone walls. The interior is open-plan, though divided into three distinct areas, and surprisingly spacious. The line of the long-closed Thames & Severn Canal runs through the pub's car park – work is underway to reconnect the inland Brimscombe Port across the road to the Gloucester and Berkeley Canal at Saul junction. ☺❀🕒&Å♣P🚃(61,69)❀🛜

Bristol

Bank Tavern 🅛
8 John Street, BS1 2HR (take lane next to arcade on All Saints St)
☎ (0117) 930 4691 ⊕ banktavern.com
4 changing beers 🅷
Compact and popular one-bar pub, hidden away near the old city wall. The four beers of varying styles are often from microbreweries in the South West or sometimes further afield. Quirky humour and varied events define the place – it is a great alternative to the more predictable establishments nearby. Quiz night is Tuesday and live music features every other Thursday. Quality food is served lunchtimes, with booking essential for the award-winning Sunday lunch. ☺❀🕒♣●🚃❀🛜

Bridge Inn
16 Passage Street, BS2 0JF
☎ (0117) 929 0942 ⊕ bridgeinnbristol.co.uk
4 changing beers (sourced locally; often Moor Beer, Quantock) 🅷
Conveniently located near Temple Meads station and Cabot Circus shopping centre, this small, friendly venue is a good place to start a visit to Bristol. It is close to the centre and many other good pubs, and an adventurous choice of ales is offered. Musical memorabilia adorn the walls and board games are available to play. Thirty malt whiskies and selected vodkas, gins and rums are also stocked, together with Belgian bottled beers. Outside tables increase capacity during good weather.
❀≢(Temple Meads)♣●🚃❀🛜

Christmas Steps
2 Christmas Steps, BS1 5BS
☎ (0117) 925 3077 ⊕ thechristmassteps.com
Twisted Oak Crack Gold; 4 changing beers (often Arbor, Bristol Beer Factory, Good Chemistry) 🅷
Just outside the city centre, this fascinating pub has welcomed drinkers since the 17th century, and is one of Bristol's heritage treasures. The compact, cosy drinking areas reveal many original features and the top level includes a dining area. Food ingredients and drinks are sourced locally where possible. Five real ales in a variety of styles are served from the lower bar, including Crack ales brewed for the pub by Twisted Oak Brewery.
☺❀🕒🚃❀🛜

Commercial Rooms 🅛 ✅
43-45 Corn Street, BS1 1HT
☎ (0117) 927 9681
Greene King IPA, Abbot; Sharp's Doom Bar; 9 changing beers (often Bath Ales, Butcombe, Hop Union) 🅷
This Grade II-listed building dating from 1810 was Bristol's first Wetherspoon pub. In a central location, it is a good start or end point for a pub tour of Bristol, with up to nine guest beers available. There is a quieter galleried room at the rear, but the Great Room does get busy at peak times. The interior features Greek revival-style decor, a stunning ceiling with dome, portraits, and memorabilia from its days as a businessmen's club. Wheelchair access is via the side entrance in Small Street.
Q☺🕒&●🚃🛜

REAL ALE BREWERIES

Arbor Bristol
Artisan Minchinhampton
Ashley Down Bristol
Ashton Cheltenham
Basement Beer ✦ Bristol: Stokes Croft
Bath Ales Bristol: Warmley
Battledown ✦ Cheltenham
Bespoke ✦ Littledean
Brewhouse & Kitchen 🍺 Bristol: Clifton
Brewhouse & Kitchen 🍺 Cheltenham
Brewhouse & Kitchen 🍺 Gloucester
Bristol Beer Factory ✦ Bristol: Ashton
Clavell & Hind ✦ Birdlip
Corinium ✦ Cirencester
Cotswold Bourton-on-the-Water
Cotswold Lion Cheltenham
Dawkins ✦ Bristol: Easton
DEYA ✦ Cheltenham
Donnington Stow-on-the-Wold
Fierce & Noble ✦ Bristol: St Werburgh's
Forest, The Lydney
Fresh Standard ✦ Stroud
Gloucester ✦ Gloucester
Goff's Winchcombe
Good Chemistry ✦ Bristol: St Philips
Hal's Dursley (brewing suspended)
Hop Union Brislington
Incredible Bristol: Brislington
Inferno ✦ Tewkesbury
Keep 🍺 Nailsworth
King Street 🍺 Bristol
Left Handed Giant ✦ Bristol
Little Martha 🍺 ✦ Bristol: St Philips (NEW)
Lucifer Wotton-under-Edge
Lydbrook Valley 🍺 Lydbrook
Moor ✦ Bristol
New Bristol ✦ Bristol
Stroud ✦ Thrupp
Tapestry ✦ Bristol: St Philips
Three Engineers ✦ Winterbourne
Tiley's 🍺 Ham
Two Tinkers Aylburton (NEW)
Uley ✦ Uley
Volunteer Tavern 🍺 Bristol
Wiper and True ✦ Bristol
Wookey Bristol
Zerodegrees 🍺 Bristol

Cornubia

142 Temple Street, BS1 6EN

☎ 07961 796406 ● thecornubia.co.uk

6 changing beers Ⓗ

Originally built in 1775, this cosy, traditional pub has been tastefully refurbished to give it a lighter feel, with pictures and horse brasses on the walls. It is a longstanding Guide entry with a good range of changing beers, usually including a dark ale, plus Cornubia house beer from Twisted Oak Brewery. The attractive beer garden has an extended seating area to both the front and side, some of which is lit and covered. Bar snacks, including pies, sausage rolls and Scotch eggs, are usually available. ❀≠(Temple Meads)●➡(1,2)❀🐾

Gryphon

41 Colston Street, BS1 5AP

☎ 07894 239567

4 changing beers Ⓗ

The Gryphon is a shrine to dark beer and great rock and heavy metal music. Posters, guitars and pumpclips adorn the walls. Up to four rapidly changing brews are served, many dark and often strong. Triangular in shape due to its corner plot, it is situated just a few yards uphill from the Bristol Beacon concert hall. Live bands sometimes play upstairs, and beer festivals are held in March and September. Children and dogs are admitted at the licensee's discretion. Sunday opening time may vary. ➡❀🐾

Lime Kiln

17 St Georges Road, BS1 5UU (behind City Hall formerly Council House)

☎ 07903 068256

6 changing beers Ⓗ

Located near College Green, directly behind the City Hall, this unpretentious free house has six handpumps dispensing ever-changing beers from independent breweries, in a variety of styles. Many of the breweries featured are seldom seen in Bristol, but beers from local breweries are also stocked, along with at least one traditional cider. You are welcome to bring your own food. Beer festivals are occasionally held. There is on-street metered parking and a public car park directly opposite. ♿●P➡❀🐾

Llandoger Trow

King Street, BS1 4ER

☎ 07908 226603 ● llandogertrow.co.uk

5 changing beers Ⓗ

Architecturally important and impressive historic inn in which Daniel Defoe reputedly met Alexander Selkirk, who became the inspiration for Robinson Crusoe. It is also said to be the inspiration for the Admiral Benbow pub in Stephenson's Treasure Island. Reopened in 2021 after a closure of more than two years, it has been reinvented as an alehouse while retaining distinct drinking areas. Five changing cask ales are served along with 28 keg lines from UK and overseas breweries, including an interesting selection from Germany. ❀●➡🐾

Old Fish Market

59-63 Baldwin Street, BS1 1QZ (200yds from city centre)

☎ (0117) 921 1515 ● oldfishmarket.co.uk

Fuller's Oliver's Island, London Pride, ESB; 2 changing beers (sourced nationally; often Dark Star, Fuller's) Ⓗ

There's something for everyone at this Fuller's outlet, which was refurbished in 2014 with decor, seating and lighting in the style of a relaxed lounge. There is a stadium-like atmosphere when major sporting events are shown on the big screen. Live jazz music features

every Sunday evening. Between 20 and 30 gins are a great attraction for any fan of the spirit. Food includes a range of chowders, stone-baked pizzas and Sunday roasts. Dog-friendly, with treats and water bowls provided. ♿🕙👌♣●➡❀🐾

Seven Stars

1 Thomas Lane, BS1 6JG (just off Victoria St)

☎ (0117) 927 2845 ● 7stars.co.uk

6 changing beers Ⓗ

Popular free house tucked away in a lane 10 minutes' walk from the city centre and Temple Meads station. For many years one of Bristol's premier ale houses, it offers up to six beers of all styles and strengths plus ciders and perries. Sunday afternoons feature quality live acoustic music. No food is served but you may bring in your own. There is an outdoor seating area and an informative plaque detailing how the pub featured in the 18th-century anti-slavery campaign. ❀≠(Temple Meads) ♣●➡❀🐾

Shakespeare 🍷 ✓

68 Prince Street, BS1 4QD

☎ (0117) 929 7695

Greene King IPA, Abbot; 5 changing beers (sourced locally; often Bristol Beer Factory, Gloucester, Plain) Ⓗ

By Bristol's historic docks, close to the city centre and Queen's Square, this converted Georgian town house claims to have the longest continuous ale licence in Bristol. Seven handpumps offer two regular ales plus four or five changing guests of varying styles from breweries near and far. There is a regular Wednesday night pub quiz and monthly Friday night live music. A large selection of classic meals is on offer. There are benches on the front terrace for watching the world pass by. Local CAMRA Pub of the Year 2022. Q♿🕙♣●➡❀🐾

Volunteer Tavern Ⓛ

9 New Street, BS2 9DX (close to main Cabot Circus car park, across carriageway from shops)

☎ (0117) 955 8498 ● volunteertavern.co.uk

4 changing beers Ⓗ

Tucked away in a quiet side street, close to the shopping centre and convenient for Old Market bus interchange, this vibrant pub is over 300 years old. It offers an interesting range of changing beers, as well as real cider. The large, fully enclosed, paved and heated garden hosts beer festivals, live music and DJs. Sunday roasts are hugely popular, with booking recommended, while the food offerings Monday to Saturday are all vegan. Adjacent to the pub is a brewery housed in a container. ♿❀♣●➡❀🐾

Zerodegrees

53 Colston Street, BS1 5BA

☎ (0117) 925 2706 ● zerodegrees.co.uk/bristol

Zerodegrees Our Mango, Bohemian, Downtown; 5 changing beers (sourced locally; often Zerodegrees (Bristol)) Ⓗ

A former CAMRA National New Build Pub, the building has separate bar and restaurant areas, as well as several balconies, and outdoor seating areas open until 10pm. Beer is brewed on-site with the equipment visible behind the bar. As well as the three core beers, up to five ever-changing specials are served. All beers are served unfiltered, unpasteurised and cold, from serving tanks, including all the specials. Wood-fired pizzas and pasta dishes are specialities. ♿❀🕙👌➡❀🐾

Bristol: Bedminster

Bristol Beer Factory Tap Room

291 North Street, BS3 1JP

☎ (0117) 902 6317 ⊕ bristolbeerfactory.co.uk/taproom

Bristol Beer Factory Fortitude; 3 changing beers (often Bristol Beer Factory) Ⓗ

A short walk from Ashton Gate Stadium, and busy on match days, this comfortable brewery taproom showcases one regular and three rotating real ales plus six keg beers from Bristol Beer Factory. Visitors are welcome to bring in food from local bakeries and shops. The taproom provides both on- and off-sales. Regular beer events are held, both for the Bristol Beer Club and the general public. Six Nations rugby is shown on a big screen. There is a small outdoor seating area on the pavement. ❀🖫(24)❀🛜

Old Bookshop

65 North Street, BS3 1ES

☎ (0117) 373 8907 ⊕ theoldbookshopbristol.com

2 changing beers (often Tiley's)

Recently refurbished with a light, airy feel, this friendly and eclectic café bar offers a large range of German and Belgian beers, plus two guest cask ales served from unlabelled handpumps. On Friday there is usually an additional cask beer served directly from a pin on the bar. Check the extensive printed beer menu to see what is available on the day. Food is entirely plant based, including Sunday pies. ❀◑🖨♦🖫(23,24)❀

Tobacco Factory Café Bar

Raleigh Road, BS3 1TF

☎ (0117) 902 0060 ⊕ tobaccofactory.com/cafe-bar

Bristol Beer Factory Fortitude; 5 changing beers (often Arbor, Good Chemistry, Siren) Ⓗ

Built in 1912, the Tobacco Factory was part of the vast Imperial Tobacco estate across South Bristol. Saved from demolition in 1993, the café bar opened in 2001, and has been transformed into a vibrant venue offering good-quality, locally produced vegetarian and vegan food and drink. The six handpumps feature mainly local breweries. The outside yard is open for special events such as local brewery tap takeovers and the very popular Factoberfest beer festival held in mid-September. Card payment only. ♿❀◑🖫♿🖫(24) 🛜

Bristol: Bishopston

Annexe

Seymour Road, BS7 9EQ (directly behind Sportsman pub)

☎ (0117) 949 3931

Dark Star Hophead; St Austell Tribute; Timothy Taylor Landlord; 4 changing beers Ⓗ

Spacious community pub close to Gloucestershire County Cricket Ground and not far from the Memorial Stadium which means it can be busy on match days. At one side is a conservatory where families are welcome until mid-evening. Several TVs show live sport, including one on the partially covered patio outside. Good-value food including pizza is served until late every evening. The regularly changing guest beers can include some interesting options. No dogs are allowed, even on the patio. ♿❀◑🖫🛜

Bristol: Clifton Village

Portcullis

3 Wellington Terrace, BS8 4LE (close to Clifton side of Suspension Bridge)

☎ (0117) 973 0270 ⊕ theportcullisclifton.com

Dawkins Bristol Blonde, Bristol Best; 4 changing beers (sourced nationally) Ⓗ

A pub since 1821, rescued by Dawkins Taverns in 2008, and featuring a downstairs bar and an upstairs lounge that is also used for functions. The building is part of a Georgian terrace close to Clifton Suspension Bridge, and has a cosy decor with many photos of film stars. As well as one or two Dawkins beers there are four changing guests from local breweries and further afield, along with a large range of Belgian beers in bottles and on tap. The rear garden is accessed from upstairs. ❀◑♣🖫(8,505) ❀🛜

Bristol: Fishponds

Snuffy Jack's

800 Fishponds Road, BS16 3TE

☎ (0117) 965 1198 ⊕ snuffyjacks.co.uk

6 changing beers Ⓖ

The name of Bristol's third micropub, opened in 2017, relates to a former head miller at the nearby Snuff Mills. Up to six real ales are served on gravity from a chilled cabinet, plus two or more changing real ciders, as well as several gins and wines. Local beers feature, plus some from further afield, with a range of styles offered. Food is limited to bar snacks. A new beer garden at the rear of the pub opened in 2022. Conveniently close to multiple bus routes with direct links to many areas. Q♿❀♠🖫❀

Bristol: Henleaze

Westbury Park Ⓛ

Northumbria Drive, BS9 4HP

☎ (0117) 962 4235 ⊕ westburyparkpub.co.uk

Butcombe Original; Timothy Taylor Landlord; 4 changing beers (sourced locally; often Arbor, St Austell, Purity) Ⓗ

Featured as the Kebab & Calculator in the BBC series The Young Ones, this circular pub is smartly decorated and furnished with comfortable seating throughout the open-plan interior. Outside there are extensive seating areas, and in front of the pub nine wooden booths with lighting and heating have been added, each accommodating six people. There are six cask ales on handpump, with one of them being substituted for real cider in the summer. Quality fresh, locally sourced food, with regularly changing seasonal menus, is served lunchtimes and evenings. ♿❀◑♿♦P🖫❀🛜

Bristol: Horfield

Drapers Arms Ⓛ

447 Gloucester Road, BS7 8TZ

⊕ thedrapersarms.co.uk

7 changing beers Ⓖ

Bristol's first micropub, opened in 2015, the Drapers Arms prides itself on its changing selection of up to seven real ales on gravity, mostly from Bristol and the surrounding counties. Beer miles are noted for each beer on the blackboard beer menu. Wine and bar snacks are also served, but no keg beer, bottled beer, lager or cider. This popular and friendly place follows the micropub tradition of focusing on good beer and conversation, with no music or TV. Two beer festivals are normally held each year. Q❀🖫❀

Bristol: Hotwells

Bag of Nails

141 St Georges Road, BS1 5UW (5 mins' walk from cathedral towards Hotwells)

☎ 07941 521777 ⊕ catpub.co.uk

6 changing beers ⊞
Close to the floating harbour, this small partially gas-lit terraced free house dates from the 1860s. It serves six changing cask ales from independent breweries both local and further afield. A dark ale is usually available, but no draught lager is served. The interior features terracotta colours, portholes in the floor, pub cats roaming free, and eclectic music from a proper record player. Board games and an extensive Lego collection are available for customers, and toys for the cats. 🖥

Grain Barge

Mardyke Wharf, Hotwell Road, BS8 4RU (moored by Hotwell Rd, opp Baltic Wharf Marina)
☎ (0117) 929 9347 ⊕ grainbarge.com
Bristol Beer Factory Notorious, Fortitude, Independence; 2 changing beers (sourced locally; often Arbor, Good Chemistry, New Bristol) ⊞
This moored barge, built in 1936 and converted into a floating bar by Bristol Beer Factory in 2007, boasts great views of the SS Great Britain, the floating harbour and passing boats. There is seating with wooden tables at either end of the central bar, an extended shelf by the window overlooking the water, an outdoor drinking area on the top deck and seating on the pavement outside. It hosts regular themed food nights, a quiz on Mondays, and live music some evenings. Open from 10am on weekends for coffee and breakfast, licensed from noon.
🕭❀◑●🖥❀🛜

Merchants Arms

5 Merchants Road, BS8 4PZ
☎ (0117) 907 3047
Cheddar Ales Gorge Best; 3 changing beers ⊞
A traditional pub, free of tie, close to the Cumberland Basin, selling mainly South-West cask-conditioned ales. Both rooms are furnished with dark-wood seating and there is a real log fire in the front room. A wide range of board games is available and regular poetry nights take place. The pub is renowned for home-made Scotch eggs, hand-finished pork pies and real Cornish pasties. Access has recently been improved, with a new pedestrian crossing to the bus stop across the busy road.
Q🕭♣P🖥❀🛜

Bristol: Kingsdown

Green Man

21 Alfred Place, BS2 8HD
☎ (0117) 925 8062 ⊕ dawkinsales.com/gm.html
Dawkins Bristol Best; 3 changing beers (sourced locally; often Arbor, Bristol Beer Factory, New Bristol) ⊞
This small Grade II-listed Dawkins pub, licensed since 1851, in a heritage listed street with many fine Georgian buildings, offers a selection of cask beers from local breweries. West Country ciders are sold too, as well as local keg beers and a large range of gins. The pub hosts regular live music and a quiz every Wednesday. The interior is furnished in a green theme, with wooden panelling throughout, and there is a small patio to the rear for smokers. ●🖥(13,72)❀🛜

Hare on the Hill

41 Thomas Street North, BS2 8LX
☎ (0117) 987 8462
4 changing beers (sourced locally; often Arbor, Bristol Beer Factory, Moor Beer) ⊞
Small street-corner local with an impressive traditional green-tiled frontage. It is tastefully furnished and has a warm and welcoming feel. Four handpumps offer a range of beers, usually including a dark ale. A good selection of foreign bottled beers is also available as well

as several craft keg beers from local breweries. The pub hosts an array of live entertainment including sea shanty singing, jazz, folk and open mic sessions. Traditional roasts are served at Sunday lunchtime, with booking advisable. ❀🚄(Montpelier)●🖥❀🛜

Robin Hood

56 St Michael's Hill, BS2 8DX
☎ (0117) 983 1489
6 changing beers (sourced regionally; often Bristol Beer Factory, Moor Beer, Siren) ⊞
Originally a grocer's but a licensed premises since 1841, this Grade II-listed pub has a lovely arched-window frontage. Inside there are wood-panelled walls, wooden flooring and furniture. At the front of the building there is a small seating area, and a hidden outdoor area at the rear. There are six handpumps serving beers from local breweries, as well as from further afield. Food offerings come from pop-up kitchens in the evening. Wednesday is quiz night and there is occasional live music.
🕭❀◑🖥(72)❀🛜

Bristol: Old Market

Stag & Hounds ✔

74 Old Market Street, BS2 0EJ
☎ (0117) 239 9156
3 changing beers (often Bristol Beer Factory, Frome, Stroud) ⊞
Historic Grade-II listed pub adjacent to the Old Market bus interchange and close to Castle Park and the shopping centre. The first floor juts out over the entrance and houses the Court Room which is available for functions. At the rear of the pub is a hand operated 19th-century iron water pump featuring a wheel six feet in diameter. A good range of local beers is served and the pub attracts a wide range of customers for drinking, dining and watching live sport on the TVs.
◑🚄(Temple Meads)●🖥❀🛜

Bristol: Redcliffe

Golden Guinea

19 Guinea Street, BS1 6SX
☎ (0117) 987 2034 ⊕ thegoldenguinea.co.uk
House beer (by St Austell); 3 changing beers (sourced locally; often Arbor, Bristol Beer Factory, New Bristol) ⊞
Cosy back-street local, close to the waterside, with wooden floors, contemporary flock wallpaper and urban art on the walls. Reclaimed furniture and French mirrors give the pub a modern but retro feel. There are three terraces and an eclectic music policy. No food is served, but customers are welcome to bring in a takeaway or order in. Cask beers are often from local breweries, and a range of local bottled and canned beers is also stocked.
❀🖥❀

Bristol: Redland

Chums

22 Chandos Road, BS6 6PF
☎ (0117) 973 1498 ⊕ chumsmicropub.com
Timothy Taylor Landlord; Wye Valley HPA, Butty Bach; 3 changing beers (often Cheddar Ales, Dawkins, Hop Union) ⊞
A micropub in a converted shop, which opened in 2016. Conversation rules and electronic devices should be used with discretion. Real ales are dispensed from six handpumps, with a dark ale always available. Six traditional ciders are also on offer, as well as a selection of wines and spirits. Food consists of simple bar snacks

including filled rolls, pies and cockles. Quiz night is every other Wednesday and a beer festival is held annually, which coincides with the local community street party. Q♿➤(Redland)♣🚌🅿️🐕♿

Bristol: St Judes

Swan with Two Necks

12 Little Ann Street, BS2 9EB (off Wade St, near Old Market)
☎ (0117) 955 1837
4 changing beers (sourced locally; often Arbor, Good Chemistry, Moor Beer) Ⓗ

This small, single-bar venue, tucked away in a side street near Old Market, is rapidly becoming a beer destination as it was back in the 1990s. Three regularly changing beers are served, mainly, but not always, from local breweries, plus a real cider. In addition 14 keg lines dispense a variety of beers, lagers and cider. Food is currently limited to simple snacks, and music is from the vinyl collection behind the bar. ♿🚌🐕♿

Bristol: St Philips

Barley Mow

39 Barton Road, BS2 0LF (400yds from rear exit of Temple Meads station over footbridge)
☎ (0117) 930 4709
Bristol Beer Factory Notorious, Fortitude; 6 changing beers (often Bristol Beer Factory, Siren, Tapestry) Ⓗ

Bristol Beer Factory's flagship outlet has eight handpumps offering up to four beers from the brewery plus constantly changing guests of varying styles from renowned breweries all over the UK. There is also a good bottled and canned beer selection from around the world and an interesting craft keg offering, including some from local breweries. Occasional beer-related events are held, along with a regular Tuesday pub quiz. The small food menu includes vegan options. There is a walled rear beer garden, and benches at the front.
Q♿🚌➤(Temple Meads)🚌(506)♿♿

Bristol: St Werburghs

Duke of York Ⓛ

2 Jubilee Road, BS2 9RS (S side of Mina Rd park)
☎ (0117) 941 3677
4 changing beers (sourced locally; often Arbor, Electric Bear, Moor Beer) Ⓗ

Tucked away down a side street, this popular local has an eclectic clientele and decor to match. The wooden floors, coloured fairy lights, and intriguing range of memorabilia and artefacts create a welcoming grotto-like atmosphere. Notable features include a rare refurbished skittle alley, carved wooden mirrors and a Grand Old Duke of York exterior mural painted by a local artist. Upstairs is a room with sofas to lounge on. Four changing beers are served, mostly from breweries in Bristol and the surrounding area. ♿🚌➤(Stapleton Road)♣🚌(5)♿

Bristol: Southville

Coronation

18 Dean Lane, BS3 1DD
☎ (0117) 940 9044
Bath Ales Gem; Butcombe Original; 2 changing beers (often Bristol Beer Factory, Twisted) Ⓗ

Popular traditional local in a residential area a short walk from Gaol Ferry Bridge. Five reasonably priced real ales are served as well as a good range of cans and bottles. Straightforward food, with extensive vegan options, is available most evenings, as well as a Sunday roast.

Furnishings are simple and cosy and the licensee is the creator of the eclectic artwork that decorates the walls. There is a small raised seating area at the rear and on-street seating outside. Table service and payment via Butlr app only. ♿🚌🕎➤(Bedminster)🚌(24)♿♿

Bristol: Spike Island

Orchard Inn

12 Hanover Place, BS1 6XT (off Cumberland Rd near SS Great Britain)
☎ 07405 360994 🌐 orchardinn.co.uk
Otter Bitter; St Austell Tribute; 3 changing beers (sourced regionally; often Box Steam, Gloucester, Otter) Ⓖ

Nestled on a street corner in Spike Island, this friendly, traditional pub is close to the marina and just a short stroll or ferry ride from the city centre. Up to six ales are available, either straight from the barrel behind the bar or fetched from the cellar, where they share space with up to 20 ciders and perries. Sport is occasionally shown on TV in a raised area that doubles up as a stage for live jazz or blues music. ♿🚌♿🚌(506,M2)♿

Broad Campden

Bakers Arms Ⓛ

GL55 6UR (signed off B4081, at NW end of village)
☎ (01386) 840515 🌐 bakersarmscampden.com
Prescott Hill Climb; Wye Valley HPA, Butty Bach; 1 changing beer (sourced locally) Ⓗ

Fine old village local and genuine free house, first licensed as a public house in 1724. A photograph of the building in 1905 shows it as the village bakery and grain store. It boasts Cotswold stone walls, exposed beams and a fine inglenook. Excellent food is available in the bar and dining room extension, and there is a large garden and children's play area outside. Local guest beers are served from the handsome oak bar alongside the regular ales. Q♿🚌🕎♣🚌P♿♿

Charfield

Plough Inn

68 Wotton Road, GL12 8SR
☎ (01453) 845297
4 changing beers Ⓗ

Attractive single-room micropub that was extensively remodelled in 2019, and features two open fireplaces. The large outdoor seating area also has service via the original off-sales hatch. The bar offers four real ales plus lagers and ciders. There is a piano and live music is a regular feature. One of the more unusual features is the large gnu head above the fireplace, which gives its name to the occasional house beer. Q♿🚌P🚌(60,85)♿

Chedworth

Seven Tuns

Queen Street, GL54 4AE (NE of village, near church)
☎ (01285) 720630 🌐 seventuns.co.uk
Hook Norton Hooky; Otter Amber; 1 changing beer (sourced locally) Ⓗ

Attractive 17th-century stone-built village pub, recently reopened after extensive refurbishment as a free house. It has a main bar and a snug, plus a converted barn restaurant with exposed stone walls and a fire. Three handpumps serve local and regional beers. In the centre of the Cotswolds village of Chedworth, there are excellent walks in the area. Q♿🚌🕎♿♣P♿♿

Cheltenham

Angry Parrot 🅛

28 St James Street, GL52 2SH (just off High St at E end of town, turn left by Vine pub)
☎ 07565 782829
4 changing beers (sourced regionally) 🅖

New micropub opened March 2020, close to several other pubs, making this the area to visit for real ale in Cheltenham. The bar room is small, but there are several other rooms, mainly upstairs, for quiet drinking. There is racking for six ales, but generally up to three are on offer at any time, with three in reserve. Two keg beers are also available. A quiz night is held monthly on a Sunday.
Q✿♠P🖵❀

Cheltenham Motor Club 🅛

Upper Park Street, GL52 6SA (first right off Hales Rd from London Rd lights, 100yds on right; pedestrian access from A40 via Crown Passage opp Sandford Mill Rd jct)
☎ (01242) 522590 ⊕ cheltmc.com
6 changing beers (often Tiley's) 🅗

Friendly club just off London Road. Six regularly changing beers from across the country are served, including a dark ale and a local ale. There is also at least one keg beer, generally from Deya, and at least one real cider, plus a range of bottled Belgian beers. An annual beer festival is held, plus meet the brewer/takeover evenings. The club is home to local darts and pool teams. Non-members are welcome for occasional visits for a nominal fee. A three-times winner of CAMRA's National Club of the Year, as well as multiple other awards.
Q✿♣🖵(B,51)❀🛜

Jolly Brewmaster 🍺 🅛

39 Painswick Road, GL50 2EZ (off A40 between The Suffolks and Tivoli)
☎ (01242) 772261
7 changing beers (often Arbor, Bespoke, Moor Beer) 🅗

Frequent local CAMRA Pub of the Year including in 2022. The 13 handpumps offer a changing range of ales sourced nationally, and up to six ciders. This busy and friendly community hub features original etched windows, a horseshoe bar and an open fire. A traditional drinking pub, there is no food menu, although hot bar snacks such as pasties and pies are generally available later in the week. The attractive courtyard garden is popular in the summer, with regular Friday barbecues.
Q✿♠🖵(10,94U)❀🛜

Kemble Brewery 🅛 ✅

27 Fairview Street, GL52 2JF (off Northern ring road, jct of Fairview Rd/St Johns Avenue, turn left into Fairview St beside Machine Mart, pub is 100yds on right)
☎ (01242) 701053
Wye Valley HPA, Butty Bach; 4 changing beers 🅗

Popular back-street local, hard to find, but well worth the effort. Originally a butcher's building in 1845, it became a pub in 1847 and was soon producing ciders, hence the name, although no brewing has taken place in recent times. Up to six ales from near and far are generally available. There is an attractive small walled garden to the rear, featuring a new servery for summer barbecues and pizzas. Q✿🕪♣❀🛜

Moon under Water 🅛 ✅

16-28 Bath Road, GL53 7HA (from E end of High St take Bath Rd; pub is 100yds on left)
☎ (01242) 583945
Greene King Abbot; Ruddles Best Bitter; Sharp's Doom Bar; 5 changing beers 🅗

Open-plan Wetherspoon Lloyds bar just off the east end of the pedestrianised high street (Strand). A decked area at the back overlooks the River Chelt and Sandford Park. Some five changing guest ales from local to countrywide supplement the regular beers, plus a selection of real ciders. The dance floor is only used Friday and Saturday evenings, with a generally quiet atmosphere at other times. There is an interactive quiz night on Monday.
🕭✿🕪♿♠🖵🛜

Sandford Park Alehouse 🅛

20 High Street, GL50 1DZ (E end of High St, past Strand on right)
☎ (01242) 690242 ⊕ sandfordparkalehouse.co.uk
Oakham Citra; Wye Valley Butty Bach; 7 changing beers 🅗

A former CAMRA National Pub of the Year and frequent local winner in recent years, this contemporary alehouse has a U-shaped main bar area with bar billiards, a cosy front snug with wood-burning stove, and a large south-facing patio garden. A function room/lounge is on the first floor. Ten handpumps feature constantly changing ales from microbreweries, sourced nationally and locally, plus at least one cider and 16 speciality lagers and craft beers. Q✿🕪🕪♣♠🖵❀🛜

Strand 🅛

40-42 High Street, GL50 1EE (at E end of High St just past pedestrian area)
☎ (01242) 373728 ⊕ thestrandcheltenham.co.uk
7 changing beers (sourced regionally; often Clavell & Hind) 🅗

Modern wine bar style pub, offering at least three beers mainly sourced from the region and often from a brewery of the month, plus a cider. Good-value food is served daily, with a gourmet burger night on Wednesday. An upstairs function room is available for hire, along with a cellar bar, home to live comedy and music nights. The large south-facing patio/garden provides a pleasant outdoor drinking area for summer days. 🕭✿🕪🖵❀🛜

Chipping Campden

Eight Bells 🅛

Church Street, GL55 6JG
☎ (01386) 840371 ⊕ eightbellsinn.co.uk
Hook Norton Hooky; North Cotswold Cotswold Best; Purity Pure UBU; Wye Valley HPA 🅗

The Eight Bells was originally built in the 14th century to house the stonemasons that built St James' church, and was later used to store the peal of eight bells that were hung in the church tower. It was rebuilt during the 17th century using most of the original stone and timbers. What exists today is an outstanding example of a traditional Cotswolds inn with a cobbled courtyard. Four handpumps dispense local and regional ales and two real ciders. Q✿🕪🕪🕪♿♣♠🖵(21)🛜

Chipping Sodbury

Horseshoe

2 High Street, BS37 6AH
☎ (01454) 325658 ⊕ horseshoechippingsodbury.co.uk
St Austell Tribute; 6 changing beers (sourced regionally; often Clavell & Hind, Otter, Uley) 🅗

One of the oldest buildings in the town, this hub of the community was formerly a stationery shop, then briefly a wine bar, and was converted into a pub at the start of 2014. It serves seven beers, often unusual but mostly from the West Country, including dark or strong choices, as well as a real cider and many different gins. There are

three linked rooms with assorted furniture, a restaurant upstairs and a pleasant rear garden. Breakfasts and lunchtime meals are served. ♿🅿️🍴♣️🚲🍽️🐾☂️

Churchdown

Old Elm L
Church Road, GL3 2ER
☎ (01452) 530961 ⊕ theoldelminn.co.uk
Sharp's Atlantic; 4 changing beers (sourced locally; often Stroud) Ⓗ
Set in the heart of Churchdown village, the Old Elm is a popular pub with a deserved reputation for its food. The menu includes good vegetarian options (booking is advisable). Five quality beers are served, including LocAles. The pub hosts lively quiz and music nights, and food and drink tasting evenings. Major sporting events are shown in the sports bar. Families are welcome and the garden features a children's play area. There are five letting rooms. ♿🅿️🍴♣️🐾☂️

Cirencester

Drillman's Arms
34 Gloucester Road, GL7 2JY (on old A417, 200yds from A435 jct)
☎ (01285) 653892
House beer (by Marston's); 3 changing beers (sourced nationally) Ⓗ
A lively Georgian inn perched beside a busy thoroughfare, featuring a convivial lounge with wood-burner, a pub games dominated public bar, and a popular skittle alley. Graced by the same landlady for over 25 years, this cracking free house has low-beamed ceilings, horse brasses, fresh flowers and brewery pictures. Well-priced pub food is available lunchtimes only. An annual beer festival swamps the small front car park on the August bank holiday weekend. 🅿️🍴♣️🐾☂️

Hop Kettle
4 The Woolmarket, GL7 2PR (in the Woolmarket between Dyer St and The Waterloo) SP025020
⊕ hop-kettle.com
Hop Kettle Cricklade Ordinary Bitter, North Wall; 3 changing beers (often Hop Kettle (Cricklade)) Ⓗ
A new micropub housed in a former toy shop in Cirencester's Woolmarket shopping square. Operated by the local Hop Kettle Brewery, it is a welcome addition to the real ale offering in the town. There are five handpumps, eight craft kegs and two cider taps, alongside a range of interesting local and brewery-based gins and other spirits. It is furnished in a modern, comfortable fashion with a range of seating options for small and larger groups. The kitchen has been leased to Tommys Streat Kitchen. ♿🍴🚲☂️

Marlborough Arms L
1 Sheep Street, GL7 1QW
☎ (01285) 651474
Goff's Jouster; North Cotswold Windrush Ale; 3 changing beers (sourced nationally; often Corinium) Ⓗ
A real ale haven, offering five beers sourced from regionals and microbreweries, plus boxed ciders and perries, and a fridge stocked with an interesting range of cans and bottles. This lively, wooden-floored pub, a previous local CAMRA Pub of the Year, lies opposite the old GWR station. Brewery memorabilia adorns the walls, with pews and a deep-set fireplace adding character. The ceiling is disappearing behind the encroaching pumpclip collection. There is a small sheltered rear patio. Occasional beer festivals are held. 🍴♣️🐾☂️

Twelve Bells L ✅
12 Lewis Lane, GL7 1EA (straight ahead at traffic lights off A435 roundabout)
☎ (01285) 652230 ⊕ twelvebellscirencester.com
Wye Valley Bitter; 2 changing beers Ⓗ
This Grade II-listed pub is named after the peal of 12 bells in the parish church. Located just outside the main shopping area, it comprises three areas: the front room with the bar is a popular spot for a beer and a chat; the middle and back rooms are primarily for dining but not exclusively. Outside is a sunny and colourful garden. Parking is limited but there is a large car park 200 yards away and on-street after 6.30pm. Q♿🅿️🍴♣️🐾☂️

Coaley

Old Fox L
The Street, GL11 5EG (in the centre of village)
☎ (01453) 890905 ⊕ oldfoxatcoaley.co.uk
Otter Bitter; Uley Pig's Ear Strong Beer; 4 changing beers Ⓗ
An attractive 300-year old stone-built village local in the centre of the village, close to the Cotswold Way. Following extensive refurbishment it is now a free house with a single room, featuring a large oak bar and seating on benches and at tables. A wood-burning stove provides a focal point. The bar has six real ale handpumps and three for cider. A traditional pub menu is available and there are outdoor seating areas to the front, rear and side. Q♿🍴♣️🐾☂️

Coleford

Dog House Micro Pub
13-15 St John Street, GL16 8AP
☎ 07442 787015 ⊕ thedoghousemicropub.co.uk
4 changing beers (sourced locally) Ⓗ/🄶
A friendly welcome is guaranteed, both for two- and four-legged customers, at the local CAMRA Cider Pub of the Year for 2022. The small front bar extends back into another room. The four changing ales almost invariably include a strong ale or stout, and there is also a good selection of cider in boxes, and a fine gin and rum collection. Social events include charity quiz nights, vinyl nights, knit & natter, and a fishing club. Acoustic live music and talent showcase evenings are hosted most weekends. No admittance after 10.30pm. Q♿🐾

Cromhall

Royal Oak L
Bibstone, GL12 8AD (on B4058; 3 miles E of M5 jct 14)
☎ (01454) 430993 ⊕ royaloak-cromhall.co.uk
5 changing beers (sourced locally; often Clavell & Hind, Uley) Ⓗ
Built in 1674, this spacious single-bar pub is situated in the hamlet of Bibstone at the edge of Cromhall. The bar has up to five ales on handpump and a draught cider. The main bar area has a glass-covered well and a splendid stained-glass window behind the bar. There are two separate dining areas, both with impressive Jacobean inglenook fireplaces. There is good access throughout and families and dogs are welcome (no dogs in the restaurant area). Q♿🍴🐾☂️

Dursley

New Inn L
82-84 Woodmancote, GL11 4AJ (on A4135 Tetbury road)

☎ (01453) 519288
5 changing beers (sourced regionally) ⊞
Known as a dog-friendly establishment, the owners' pooches often help provide a warm welcome. This is a comfortable pub with a large L-shaped public bar with tiled floor, and a smaller lounge. There is an eclectic selection of regularly changing guest beers – usually, but not exclusively, from smaller breweries – often requested by regulars. The garden at the rear is popular on sunny days. ⏾❀♣♠P▯(61)❀

Old Spot Inn ⓛ

2 Hill Road, GL11 4JQ (by bus station and free car park)
☎ (01453) 542870 ⊕ oldspotinn.co.uk
Uley Old Ric; 7 changing beers (sourced nationally) ⊞
Excellent free house dating from 1776, serving up to eight ales, plus ciders and perries. Named after the Gloucestershire Old Spot pig, a porcine theme blends with the extensive brewery memorabilia, low ceilings, wood-burning stove and welcoming staff to create a convivial atmosphere. There is an attractive garden and a heated outdoor covered area. Freshly prepared food is served at lunchtime. On the Cotswold Way, the pub is popular with walkers, and hosts regular events in the evenings. Q⏾❀◑⬥♣●🖩❀🛈

Forthampton

Lower Lode Inn ⓛ

GL19 4RE (follow sign to Forthampton from A438 Tewkesbury to Ledbury road) SO8788231809
☎ (01684) 293224 ⊕ lowerlodeinn.co.uk
Sharp's Doom Bar; 4 changing beers (often Bespoke, Brains, Malvern Hills) ⊞
Blessed with views across the River Severn to Tewkesbury Abbey, this attractive 15th-century brick-built venue, with its three acres of lawns, is a popular stopover for boats and is a Camping and Caravan Club site. Food, advertised as simple and wholesome, is excellent quality and value for money. A beer festival is held in September. A small ferry operates from the Tewkesbury side from Easter to mid-September. Day fishing is available, as well as en-suite accommodation. Opening times are reduced in winter so check ahead. Q⏾❀🛏◑♣♠P❀

Fossebridge

Inn at Fossebridge ✓

GL54 3JS (on A429)
☎ (01285) 720721 ⊕ innatfossebridge.co.uk
Butcombe Original; Wadworth 6X; 3 changing beers (sourced locally; often North Cotswold) ⊞
This inn is set in the pretty hamlet of Fossebridge, where the Fosse Way drops into the Cotswolds valley of the River Coln, an Area of Outstanding Natural Beauty. An attractive one-bar pub with old timbers, a fine flagstone floor and open fires, the premises also benefits from an outstanding four-acre garden with a lake and river. A selection of regional ales and guests from local breweries is served in cosy surroundings. Q⏾❀🛏◑●P❀🛈

Frampton Cotterell

Globe Inn

366 Church Road, BS36 2AB
☎ (01454) 778286 ⊕ theglobeframptoncotterell.co.uk
Fuller's London Pride; St Austell Tribute, Proper Job; 1 changing beer (often Bristol Beer Factory, Otter) ⊞
Independent free house opposite the parish church and situated on the Frome Valley Walkway, which links the

Cotswold Way with Bristol. It is open-plan, but the L-shaped bar, low ceilings and patterned carpet give the pub a comfortable feel. There is a large enclosed lawned garden with children's play area, which is popular in the summer. At the far end of the bar is a large function room. The pub specialises in home-made, freshly cooked food. ⏾❀◑●P▯(222,Y4)🛈

Rising Sun

43 Ryecroft Road, BS36 2HN
☎ (01454) 772330 ⊕ gwbrewery.co.uk/rising-sun
Hop Union Hambrook Pale Ale / HPA, Maiden Voyage, Moose River; 2 changing beers (often Draught Bass, Hop Union, Wadworth) ⊞
Village local and brewery tap for the Hop Union Brewery in Brislington. The log-burning stove, archways and slate pillars add to the ambience. Additional seating can be found up the stairs to the left, and there is a restaurant in the warm conservatory. Lunchtime snacks and more substantial evening meals are served from an extensive menu, with all food made in-house. The skittle alley can be used for private functions. Q❀◑●P▯(Y4,Y6)❀🛈

Frampton Mansell

Crown Inn ⓛ

GL6 8JG (off A419 Cirencester to Stroud road, opp Jolly Nice café and farmshop)
☎ (01285) 760601 ⊕ thecrowninn-cotswolds.co.uk
Sharp's Doom Bar; Stroud OPA/Organic Pale Ale; Uley Taverner; 2 changing beers (often Clavell & Hind, Corinium, Uley) ⊞
This thriving, friendly village inn dates from 1633, when it was a cider house with a slaughterhouse next door. The three simply but elegantly furnished rooms feature exposed stone walls, wooden beams and real fires. In summer, lighted candles replace the fires. The suntrap front garden offers fine views over the Golden Valley. Children are welcome and books are provided for them. Attached is a modern 12-bedroom hotel annexe with ample car parking. A vintage AA 'Guest Accommodation' sign hangs beside the inn's own sign. ⏾❀🛏◑⬥🅰♣♠P▯(54,54A) ❀🛈

Frampton-on-Severn

Three Horseshoes ⓛ

The Green, GL2 7DY (off B4071)
☎ (01452) 742100 ⊕ threehorseshoespub.co.uk
Timothy Taylor Landlord; Uley Bitter; 1 changing beer ⊞
A 19th-century two-bar rural community pub, originally built by a farrier, at the south end of England's longest village green. The food is home-cooked, especially the unique 3-Shu pie, which is freshly baked to order. Both bars have coal fires, and dogs are very welcome in the flagstoned public bar. Evening jamming sessions are popular (mostly folk music) and there are regular community events. A lovely garden features a double boules court which hosts annual championships. Q⏾❀◑⬥🅰♣●❀🛈

Gloucester

Brewhouse & Kitchen (Gloucester Quays)

Unit R1, St Anne Walk, Gloucester Quay, GL1 5SH
☎ (01452) 222965
Brewhouse & Kitchen Shed Head, Stevedore, SS Banner ⊞
Situated by the side of the Gloucester & Sharpness Canal, in Gloucester Quays, this bar and restaurant brews its

own range of beers on site. Outdoor seating by the canal is popular on a fine day, and seating indoors allows customers to watch the brewing in progress. Beer tasting events, Meet the Brewer and brewing days are all regularly held. Three regular beers are available, plus a seasonal cask and a range of keg beers all brewed on site. ♿🍴♿🚪🐾🏳️

Fountain Inn 🇱 ✅

53 Westgate Street, GL1 2NW (down an alley between nos 51 & 55)

☎ (01452) 522562 🌐 thefountaininngloucester.com

Bristol Beer Factory Independence; Dartmoor Jail Ale; St Austell Tribute; 3 changing beers 🅷

A stone's throw away from Gloucester Cathedral, this interesting 17th-century inn is on the site of an ale house known to have existed in 1216. A passage leads from Westgate Street into an attractive courtyard where there is a plaque to commemorate King William III riding his horse up the stairs. The Cathedral bar has a panelled ceiling and carved stone fireplace. The Orange Room serves as a restaurant or as a room for private functions. 🏨🍴♿🐾🏳️

Linden Tree

73-75 Bristol Road, GL1 5SN (on A430 S of docks)

☎ (01452) 527869 🌐 lindentreepub.co.uk

2 changing beers 🅷

This Grade II-listed Georgian terraced building has a cosy interior with beamed ceilings and an open log fire with an unusual canopy. The front bar offers a variety of seating, and at the rear there are a skittle alley, function room and sports bar. Outside to the front is a small patio. Four ales are usually served. Accommodation is available, and food includes a Sunday carvery. Bus 12 from the city centre stops nearby. 🏨🚆🍴🚪(12,60)🏳️

Pelican Inn 🍷 🇱 ✅

4 St Marys Street, GL1 2QR (WNW of cathedral)

☎ (01452) 582966 🌐 pelicangloucester.co.uk

Wye Valley Bitter, The Hopfather, HPA, Butty Bach, Wholesome Stout; 4 changing beers (sourced regionally) 🅷

Popular inn tucked just behind the cathedral, the Pelican was licensed as an alehouse in the 17th century. Some of its beams are reputedly from Drake's Golden Hind which began life as the Pelican. Owned by Wye Valley, the pub offers a wide range of its beers, complemented by an interesting range of guest ales and ciders, but no lager. There is a main bar area, a side room and an attractive outdoor drinking area. A real fire features during the colder winter months. Local CAMRA Pub and Cider Pub of the Year 2022. Q🏨♿🚲🍴🐾🚪🏳️

Tank ✅

12-14 Llanthony Road, GL1 2EH (in Gloucester Docks)

☎ (01452) 690541 🌐 tankgloucester.com

4 changing beers (sourced nationally) 🅷

This brewery tap is a welcoming, urban warehouse-style bar with a contemporary feel, located in the heart of the Gloucester Docks and the Quays. Though primarily selling Gloucester ales, it also offers a wide range of guest beers, craft ales, bottled beers and ciders. Food includes local meats and cheeses served on platters, along with a selection of hand-made pizzas. Live music and quiz nights are popular events. 🍴♿🚪(10)🐾🏳️

Ham

Salutation Inn 🇱

Ham Green, GL13 9QH (from Berkeley take road signposted to Jenner Museum)

☎ (01453) 810284 🌐 the-sally-at-ham.com

Tiley's Ordinary Bitter; 5 changing beers (sourced nationally; often Arbor, Bristol Beer Factory, Moor Beer) 🅷

Multi-award winning rural free house, popular with locals and visitors alike, offering up to seven real ales and nine real ciders and perries, plus an extensive bottled beer and cider menu. The on-site microbrewery (Tiley's Ales) produces a range of traditional ales. There are three bars (two cosy ones share a central wood burner) and a skittles alley/function room. Food is available at lunchtimes and on occasional evenings only; there are also folk nights and singalongs. Q🏨🏖️🍴♿🐾🚪P🐾🏳️

Hawkesbury Upton

Beaufort Arms 🇱

High Street, GL9 1AU (off A46, 6 miles N of M4 jct 18)

☎ (01454) 238217 🌐 beaufortarms.com

Bristol Beer Factory Independence; Butcombe Original; 3 changing beers (sourced regionally) 🅷

An attractive Grade II-listed Cotswold stone free house, built in 1602, close to the historic Somerset Monument. It has separate public and lounge bars, a dining room and a skittle alley/function room. A large collection of ancient brewery and local memorabilia features throughout. Up to five ales and a traditional cider are served on handpump. There is an attractive garden with a barbecue used for local community activities. The friendly locals assure visitors a warm welcome. Q🏨🏖️🍴♿🐾🚪P🐾🏳️

Hillesley

Fleece Inn 🇱

Chapel Lane, GL12 7RD (between Wotton-Under-Edge and Hawkesbury Upton)

☎ (01453) 520003 🌐 thefleeceinnhillesley.com

Wye Valley Butty Bach; 5 changing beers (often Arbor, Church End, Oakham) 🅷

An attractive 17th-century village pub set in the heart of Hillesley. It has a bar room with a wood-burning stove, a separate lounge/dining room and a snug area. The bar offers up to six real ales along with guest craft keg beer and draught cider. Food is available at lunchtime and in the evening. There is a large, attractive lawned garden with a safe play area for children, and a private car park. Dogs are welcome. Q🏨🏖️🍴🐾🚪P🐾🏳️

Kingswood

Lyons Den

121 Regent Street, BS15 8LJ

4 changing beers (often Bristol Beer Factory, New Bristol, Tiny Rebel) 🇬

Micropub opened in May 2019 in a former charity shop at the eastern end of the main shopping street. The bar area as you enter is simply furnished and there is a small snug space at the rear. Current cask and keg beers and ciders are displayed on a retro-style computer screen on the wall. Board games are available to play and there is low-volume background music. Look out for regular tap takeovers from local breweries and some from further afield. Dogs are made very welcome. Q🏨♿🐾🚪🐾

Marshfield

Catherine Wheel

39 High St, SN14 8LR (if using postcode in sat nav check it is not showing Colerne)

☎ (01225) 892220 🌐 thecatherinewheel.co.uk

Butcombe Original; 2 changing beers (sourced locally; often Stroud) 🅷

The Catherine Wheel is an impressive example of provincial baroque architecture, much of it dating back to the 17th century, although some interior features look older. Simple, sympathetic decor complements the exposed stone walls and large open fireplaces. There is a large cosy bar area with rooms off, and a courtyard-style garden with a covered area. Inside it feels like a traditional Cotswold pub, with good ale, good food and a warm and welcoming interior. Q❄☺❀⊞◑P⊟❀🐾

Moreton-in-Marsh

Bell Inn L ✅

High Street, GL56 0AF (on A429)

☎ (01608) 651688 ⊕ thebellinnmoreton.co.uk

Prescott Hill Climb; Purity Pure UBU; Timothy Taylor Landlord; 2 changing beers (sourced locally; often Hook Norton, North Cotswold) H

Old High Street coaching inn dating from the 18th century, now pleasantly refurbished. The interior is mainly open plan but has been sympathetically divided into more intimate snug sections, and is warmed by a real fire. A large courtyard is found through the old arched entrance, with an enclosed garden at the rear. Famed for its links with Lord of the Rings author JRR Tolkien, a map of Middle Earth adorns the walls. Local and national ales and good food are available. Q❄☺❀⊞◑🅰🚲P⊟(801) ❀🐾

Moseley Green

Rising Sun L

GL15 4HN (off A48 at Blakeney toward Parkend, and first left)

☎ (01594) 562008 ⊕ risingsunmoseleygreen.co.uk

3 changing beers (sourced nationally) H

Located in splendid isolation deep in the woodlands of the Forest of Dean, this pub is popular with walkers, cyclists and locals. It originally served miners working at the nearby collieries – although, enjoying the panoramic views, it is difficult to imagine it was once a scene of industrial activity. The pub has extensive grounds with patios for alfresco dining and is ideal for families. On Sunday evenings in summer brass bands play in the garden. ☺❀⊞◑♣♠P⊟❀

Newent

Cobblers L

7 Church Street, GL18 1PU

☎ 07507 177409

3 changing beers (often Jennings, Ringwood) H

Cobblers can claim to be Gloucestershire's first micropub, located in the centre of Newent. The pub is bigger than you might imagine, with the cosy front bar leading to two further rooms at the back converted from what was once local council offices. There are usually three gravity fed ales on offer, plus cider and a large selection of artisan gins. If you are hungry, you can order a meal from the local Indian restaurant, to be delivered to your table. Thursday is live music night. Q♠⊟

King's Arms

Ross Road, GL18 1BD (on B4221)

☎ (01531) 820035 ⊕ kings-arms-newent.business.site

4 changing beers (often Bespoke, Shepherd Neame, Titanic) H

Following major improvements, the pub has a comfortable refitted bar area with open fires, a large function room and skittle alley, and a big lower bar and dining room. There is also a spacious outdoor decked courtyard. With a good reputation for home-cooked food,

the wide menu includes speciality pizzas, midweek offers and popular Sunday lunches. Voted local CAMRA Pub of the Year 2020. Q❄◑♣P

Newnham

Black Pig Ale House

High Street, GL14 1BY (up alleyway to side of Ship Inn)

☎ (01594) 516283

4 changing beers (sourced nationally; often St Austell) G

This wonderful new venture is situated inside a 16th-century Grade II-listed horse stable, within the grounds of the Ship Inn. Effectively a micropub, an impressive wooden bar lies opposite a huge fireplace, with the drinks stillaged against the thick stone walls. The regularly changing ales are served direct from the barrel, and there is an upstairs mezzanine area for darts, Space Invaders and conversation. The winsome garden and courtyard are an enjoyable spot on warmer evenings. ❀♣⊟(23) ❀

Parkend

Fountain Inn

Fountain Way, GL15 4JD (off B4234)

☎ (01594) 562189 ⊕ thefountaininn.info

Wye Valley HPA, Butty Bach; 2 changing beers H

The Fountain makes an ideal refreshment stop after a leisurely journey on the Dean Forest Railway to its nearby terminus at Parkend – a branch line once extended directly in front of the pub. Interesting artefacts depicting local and railway history adorn the walls. Good food and well-kept beer provide sustenance to visitors and locals alike. A footpath leads directly to the Whitemead Forest Park. Accommodation and an adjoining bunkhouse cater for larger groups. In the height of the tourist season, Parkend can be a bustling place. Q❄☺❀⊞◑🅰♣♠P❀🐾

Prestbury

Royal Oak ✅

43 The Burgage, GL52 3DL

☎ (01242) 522344

Butcombe Adam Henson's Rare Breed, Original; 2 changing beers (often Bespoke, Timothy Taylor) H

Attractive 16th-century Cotswold stone inn featuring a main bar plus restaurant bar, which has recently doubled in size. The closest pub to the racecourse, it is popular with racegoers. The food is primarily home made. The large rear garden boasts a skittle alley/function room (the Pavilion). A beer festival is held in May and a cider festival in October. Butcombe Brewery owns the pub but generally at least one non-Butcombe guest ale is available. There is free parking opposite. The closest bus is the N – the more frequent A serves the village but is a longer walk. Q❄☺◑♣♠⊟(N)❀🐾

Sheepscombe

Butchers Arms L ✅

GL6 7RH (signed off A46 N of Painswick, and B4070 N of Slad) SO8911610434

☎ (01452) 812113 ⊕ butchers-arms.co.uk

Bristol Beer Factory Notorious; 2 changing beers (sourced nationally; often Battledown, Exeter, Fresh Standard) H

A handsome 17th-century Cotswold-stone pub overlooking a wooded valley. Its inn sign, a painted three-dimensional carving of a butcher quaffing ale while tethered to a pig, is world famous. The guest

pumps offer an adventurous range of ales from across the country. In 2014 the lean-to outdoor toilets metamorphosed into a new bar, seamlessly executed in reclaimed stone and Welsh oak. This complements a quality inter-war refurbishment that added the generous bay windows and porch. A wood-burning stove offers warmth in winter while the forecourt tables and sloping side garden are suntraps in summer. Q❄✿❶&♣P❒❀♥

Snowshill

Snowshill Arms L

WR12 7JU (centre of village)
☎ (01386) 852653 ⊕ snowshillarms.co.uk
Donnington BB, Gold, SBA ⊞
Set in a pretty village, this is a 15th-century family-friendly pub that also welcomes pets. Good home-made pub food and Donnington ales are on offer in charming surroundings. A large play area for children and a lovely log fire in the winter offer enticements to visit all year round. Locals mix comfortably with the many tourists visiting Snowshill Manor. Q❄✿❶&♣P❀♥

Staple Hill

Wooden Walls Micropub

30 Broad Street, BS16 5NU
☎ 07858 266596 ⊕ thewoodenwallsmicropub.com
5 changing beers ⊞
Micropub opened in 2018 in a former carpet shop on the main shopping street. The single room is pleasantly furnished with wooden booths and walls. Drinks currently available are displayed on a large blackboard surrounding the serving hatch. Five real ales are usually on offer alongside real ciders, several craft keg beers, gin and wine, but no lager. There are a few steps up to the toilets and paved rear garden. Board games are available to play. Q❄✿♣●❒♥

Stroud

Ale House L

9 John Street, GL5 2HA (opp Cornhill Farmers' Market)
☎ (01453) 755447 ⊕ thealehousestroud.com
Burning Sky Plateau; Tiley's IPA; 6 changing beers (sourced nationally; often Grey Trees, Kirkstall, Nightjar) ⊞
Built in 1837 for the Poor Law Guardians, this Grade-II listed building is a mecca for ale lovers. The bar occupies the double-height former boardroom, where an all-year-round beer festival showcases beers from Fierce & Noble, Mallinsons, Vocation and many others – plus a cider and perry. Opposite is a blazing log fire and adjoining are two smaller rooms. Live music plays at weekends, with jazz once a month on Thursday. Sunday is quiz night. Food includes home-made curries, chilli and more. A restored 1932 bar billiards table is a welcome addition. ✿❶&♣♣●❒♥♥

Bowbridge Arms L

London Road, Bowbridge, GL5 2AY (on A419)
☎ (01453) 298914 ⊕ thebowbridgearms.co.uk
St Austell Proper Job; 2 changing beers (often Bath Ales, Dartmoor, Stroud) ⊞
Friendly, traditional, Cotswold-stone pub on the eastern fringe of Stroud. Close to Bowbridge Lock on the Thames & Severn Canal, it is a 15-minute walk from the town centre and railway station. The comfortable modernised interior is dominated by a stonking Clearview stove. A small lounge, also with a stove, leads to an even smaller room with a large flat-screen TV, available to hire for

meetings or private dining. The large, south-facing, suntrap patio has a children's play area and views across the valley to Rodborough Common. Good-value home-cooked food includes typical pub grub. Q❄✿❶&AP❒❀♥

Crown & Sceptre L

98 Horns Road, GL5 1EG
☎ (01453) 762588 ⊕ crownandsceptrestroud.com
Stroud Budding; Uley Bitter, Pigs Ear; 1 changing beer (sourced regionally; often Artisan, Blue Anchor, North Cotswold) ⊞
Lively back-street local at the heart of its community. The walls display an eclectic mix of framed prints, posters and clocks. Local groups meet round a large oak table in a side room – including knit & natter on Tuesday. The pub also has its own motorcycle society. It is renowned for its Up The Workers good-value set meal on Wednesday, and Sunday roasts. Sport is screened in the back bar. A terrace to the rear offers panoramic views across the valley to Rodborough Common. ✿❀❶&♣P❒(8)♥♥

Prince Albert L ✔

Rodborough Hill, GL5 3SS (corner of Walkley Hill)
☎ (01453) 755600 ⊕ theprincealbertstroud.co.uk
Timothy Taylor Landlord; 4 changing beers (sourced nationally; often Bristol Beer Factory, Church End, Thornbridge) ⊞
This lively, cosmopolitan, Cotswold-stone inn below Rodborough Common has been run by the same family for 26 years. It manages to be simultaneously bohemian, homely and welcoming, with a big reputation for live music. The L-shaped bar is full of local art, music and film posters, and an idiosyncratic mix of furniture, fittings and memorabilia. Pizzas and burgers are served from a new kitchen off the covered courtyard. Stairs lead up to a walled garden with an elegant cruck-framed shelter. Live music on Sunday and Monday evenings is ticketed. Current local CAMRA Pub of the Year. ✿❀❶A♣❒(40)♥♥

Tetbury

Royal Oak L ✔

1 Cirencester Road, GL8 8EY (on B4067)
☎ (01666) 500021 ⊕ theroyaloaktetbury.co.uk
2 changing beers (sourced regionally; often Hop Kettle Cricklade, Moor Beer, Otter) ⊞
This wonderful, award-winning pub utilises clever design to marry a traditional feel to a modern layout. The swathe of wooden surfaces provides a welcoming feel, with a small fireplace adding warmth. Six handpumps include Severn Cider and a vegan ale from Moor – chosen to match the vegan menu option. The one-pot dish is handy, especially on quiz nights. Upstairs dining rooms and six letting rooms are popular, as are the lively music and beer festivals. ✿❀❶&♣●P♥♥

Tewkesbury

Berkeley Arms ♀ ✔

8 Church Street, GL20 5PA (between Tewkesbury Cross and abbey on old A38)
☎ (01684) 290555 ⊕ berkeleyarms.pub
Wadworth Henry's IPA, 6X, Swordfish; 2 changing beers (often Goff's) ⊞
A 15th-century half-timbered Grade II-listed pub, just off Tewkesbury Cross. At the rear of this two-bar venue, a barn, believed to be the oldest non-ecclesiastical building in this historic town, is used as a meeting room year round and as a rehearsal space for the famous Tewkesbury Pub Singers. Live music is performed on

Friday and Saturday evenings. Buses to Cheltenham and Gloucester stop close by. Local CAMRA Pub of the Year 2022. ♿❀♿▲♣♠🚃(41)❀🕏

Cross House Tavern ⓛ

108 Church Street, GL20 5AB
☎ 07931 692227 ⊕ thecrosshousetavern.pub
5 changing beers (often Clavell & Hind, Enville, Salopian) Ⓗ

Tewkesbury's first micropub was originally two houses in the early 16th century. It was extended in the 17th century, and extensively renovated throughout in about 1865. The Cross House Tavern's heritage has been preserved with a great deal of dedication. It has again become a Victorian-style establishment serving real local ales (including vegan beer), ciders, perries, wines and snacks – most sourced within 20 miles. The ale is served from tapped casks, much as it was when the building was known as the Tolsey Inn & Coach House in the early 20th century. Q▲♠♠🚃❀🕏

Nottingham Arms ⓛ ✅

129 High Street, GL20 5JU (on A38 in town centre)
☎ (01684) 491514 ⊕ ourlocal.pub/pubs/
the-nottingham-arms-tewkesbury
Sharp's Doom Bar; Wye Valley Butty Bach; 2 changing beers Ⓗ

A 14th-century town-centre hostelry with two welcoming rooms: the public bar at the front and the restaurant behind, with timber predominating. Framed photographs of old Tewkesbury adorn the walls. The pub is getting a reputation for its excellent, well-priced food, served lunchtime and evening. Knowledgeable staff will happily tell you about the resident ghosts. Live music plays on most Sunday evenings and Thursday is quiz night. ♿◑▲♣♠🚃❀🕏

Royal Hop Pole ⓛ ✅

94 Church Street, GL20 5RS (centre of town between the abbey and Tewkesbury Cross)
☎ (01684) 278670
Greene King IPA; Hook Norton Old Hooky; Hop Union Old Higby; Ruddles County; 4 changing beers (sourced locally) Ⓗ

This well-known landmark is an amalgamation of historic buildings from the 15th and 18th centuries. It has been known as the Royal Hop Pole since it was visited in 1891 by Princess Mary of Teck (Queen Mary, Royal Consort of George V). The Hop Pole is mentioned in Dickens' Pickwick Papers. Purchased by JD Wetherspoon, it reopened in 2008. There is wood panelling on almost every wall of this spacious, multi-roomed drinking establishment, with a large patio and garden area at the rear. Q♿❀🛏◑♿▲P🚃(41,42)🕏

Thornbury

Anchor Inn ⓛ ✅

Gloucester Road, BS35 1JY
☎ (01454) 281375 ⊕ theanchorthornbury.co.uk
Draught Bass; St Austell Proper Job; 6 changing beers (often Butcombe, Frome, Hop Union) Ⓗ

Licensed since 1695, this friendly, traditional inn serves two regular beers and five or six changing guests. Good home-cooked food is available daily, including a Tuesday lunch club. There are two large rooms, one of which has been split to provide a function/meeting area and is also used by local artists. The pub has its own darts, cribbage and cricket teams, and an angling syndicate. The garden includes a boules piste and children's play area. ♿❀◑♠P🚃(60,T1) ❀🕏

Thrupp

Stroud Brewery Tap ⓛ

Kingfisher Business Park, London Road, GL5 2BY (take A419 from Stroud, turn right down Hope Mill Lane just before painted bus shelter, immediate right turn and the brewery is over the bridge at the end)
☎ (01453) 887122 ⊕ stroudbrewery.co.uk
Stroud Tom Long, OPA/Organic Pale Ale, Budding; 1 changing beer (often Stroud) Ⓗ

Occupying a new purpose-designed building beside the Thames & Severn Canal, the brewery taproom opens directly onto a terrace beside the towpath. To one side is an open kitchen with an Italian wood-fired pizza oven. Seating consists mostly of wooden benches beside long tables – resembling at times a diminutive Bavarian beer hall. These benches are augmented by squishy leather sofas and large oak casks for vertical drinking. At the far end – and with small windows allowing glimpses of the brewery – is a small stage with an upright piano. ♿❀◑♿▲♠P🚃❀🕏

Upper Oddington

Horse & Groom ⓛ ✅

GL56 0XH (top of village signed off A436 E of Stow)
☎ (01451) 830584 ⊕ horseandgroom.uk.com
Prescott Hill Climb; Wye Valley Butty Bach; 1 changing beer (sourced locally) Ⓗ

You are assured of a warm welcome at this privately-owned 16th-century inn run by friendly licensees. There is an extended bar area with its own sitting room linked by a real open log fire in an inglenook setting. A weekly changing guest ale is usually from a Gloucestershire brewer and real cider is from Dunkertons. There is a large car park and attractive garden and patio area. Situated in good walking country close to Stow, there are eight letting bedrooms for overnight stays. Q♿❀🛏◑P🚃❀🕏

Upper Soudley

White Horse Inn

Church Road, GL14 2UA (on B4227)
☎ (01594) 825968
2 changing beers (sourced nationally) Ⓗ

Built as a railway hotel, next to the now-defunct Soudley Halt, the inn has great views across the valley from the garden. With its proximity to the Blue Rock Trail and Soudley ponds, it is an interesting venue for geologists and walkers. The lovely old village pub has a small main bar with a welcoming fireplace and two regularly changing guest ales. The old dining room down the passageway is used for functions, and leads through to a much-loved skittle alley. ♿❀♿♠P🚃(717)❀

Westbury-on-Severn

Lyon Inn

The Village, GL14 1PA (on A48)
☎ (01452) 760221 ⊕ thelyoninn.com
3 changing beers Ⓗ

Conveniently situated on the main Gloucester to Chepstow road, the Lyon has welcomed travellers for generations. Earliest references go back as far as the 16th century, but the ancient-looking timbers are an early 20th century addition. The new owners have revived the fortunes of the old Red Lion, sensitively opening up previously under-used areas to create dining spaces while retaining the traditional ambience. Food is available daily (not winter Wed) with different options each evening. The recently refurbished and imposing

spire of the parish church dominates the scene, with the National Trust's Westbury Court Gardens nearby.
Q☼☀⚟⊀◑♣P♿

Winchcombe

Corner Cupboard

83 Gloucester Street, GL54 5LX (on B4632)
☎ (01242) 602303 ● cornercupboardwinchcombe.co.uk
Skinner's Betty Stogs; Timothy Taylor Landlord; Wye Valley Butty Bach; 1 changing beer (sourced locally) Ⓗ

A traditional inn dating from around 1550 that has several bars and rooms, leaving the customer to choose their own style and company. Good-value food is served in pleasant surroundings. The bar, complete with flagstone floors, oak panelling and Cotswold stone walls, serves guest ales alongside the regular beers. There is a car park at the rear. Q☼☀◑&♣P➡♿ 🌐

Breweries

Arbor SIBA

181 Easton Road, Easton, Bristol, BS5 0HQ
☎ (0117) 329 2711 ● arborales.co.uk

⊗ Founded in 2007, Arbor has a brew length of 20 barrels with 16 fermenting vessels. Willing to experiment, more than 300 beers have been produced. The current range reflects modern tastes and leans towards hoppy pale ales and IPAs plus some interesting red and dark ales. ◆LIVE GF

Mosaic (ABV 4%) PALE
Hoppy aroma, flavours of soft tropical fruit with floral notes on a light malt background leaving a gentle, bittersweet aftertaste.

Shangri La (ABV 4.2%) PALE
Yellow best bitter with hoppy aroma, light malt and tropical fruit on the palate and a clean, refreshing, bitter finish.

Blue Sky Drinking (ABV 4.4%) BITTER
Malty aroma and background flavour with hints of berry fruits and spice. Hop bitterness increases in the short, balanced finish.

C Bomb (ABV 4.7%) PALE

The Devil Made Me Brew It (ABV 5.5%) STOUT
A velvety speciality beer in stout style. Floral and citrus hops in the aroma, coffee and slightly burnt toffee flavours – sweet but with a bitter finish.

Yakima Valley (ABV 7%) IPA
A strong, full-bodied IPA. Hoppy and very fruity. Sweetness which is well-balanced with bitterness, lasting into a soft, bitter aftertaste.

Breakfast Stout (ABV 7.4%) STOUT
Roast aroma with a hint of marmite. Sweet oatmeal on the palate, with a good balance of dark fruits, hints of liquorice and vanilla with leather notes. Long, rich, bittersweet finish.

Artisan

Building 1A, Aston Down Business Park, Minchinhampton, Stroud, Gloucestershire, GL6 8GA
☎ 07780 449102 ● artisan-ales.co.uk

⊗ Artisan is located in a former fire station next to the gatehouse of a business park. It brews a range of beer styles, which are available for members of the public to purchase from the adjacent shop most Fridays, or through the online shop. ‼️🛒◆LIVE

PA03 (ABV 3.6%) PALE

BB01 (ABV 3.7%) BITTER
PA02 (ABV 3.9%) PALE
BB02 (ABV 4.2%) BITTER
ST01 (ABV 4.6%) STOUT
PA01 (ABV 4.9%) PALE
DB01 (ABV 5.2%) BITTER

Ashley Down

St Andrews, Bristol, BS6 5BY
☎ (0117) 983 6567 ☎ 07563 751200
✉ ashleydownbrewery@gmail.com

⊗ Ashley Down began brewing in 2011 using a 5.5-barrel plant in the owner's garage. It suffered a major fire in 2017. For a while it cuckoo-brewed but is now back in production, reinstated in the owners garage. Settling into a regular brewing cycle and of beers brewed.

Ashton

Cheltenham, Gloucestershire, GL53 9LW ☎ 07796 445822 ● ashtonbrewery.co.uk

⊗ Nanobrewery established in Ashton Keynes, Wiltshire, in 2018. The brewery moved in 2020 to Cheltenham. A range of real ales are produced which are unfined cask and bottle-conditioned. LIVE

Kakapo (ABV 4.3%) PALE
Mosaic (ABV 4.4%) GOLD
Gold (ABV 4.5%) PALE
Shot in the Dark (ABV 4.6%) SPECIALITY
Hazy Blonde (ABV 4.8%) PALE

Basement Beer

32 Upper York Street, Stokes Croft, Bristol, BS2 8QN
☎ 07702 430808 ● basementbeer.co.uk

⊗ Basement has steadily expanded to brew a range of innovative and progressive beers at its new home in Stokes Croft, supplying both the on-site taproom and a number of Bristol pubs and bars from the 3.5-barrel plant. Several of the beers feature collaborations with local tea blenders and coffee roasters. ◆

Citra Single Hop Pale (ABV 3.9%) PALE
Galaxy Hopping (ABV 6.2%) IPA

Bath Ales

Hare Brewery, Southway Drive, Warmley, Bristol, BS30 5LW
☎ (0117) 947 4797 ● bathales.com

⊗ Established in 1995, Bath Ales was taken over by St Austell in 2016. Since 2018 Bath Ales' beers have been brewed in a new high-tech brewery, including cask, bottling and kegging lines. Over 2020/2021 the Hare Brewery layout was fine tuned and more automation added. In 2022 a new canning line was installed. 🛒

Gem (ABV 4.1%) BITTER
Pale brown best bitter with sweet fruit and malt flavours and a hint of caramel. Little aroma but a balanced taste with a short, bitter finish.

Battledown SIBA

Coxhorne Farm, London Road, Cheltenham, Gloucestershire, GL52 6UY ☎ 07734 834104
● battledownbrewery.com

⊗ A family brewery since 2005, it brews a range of ales, lager and craft beers on its new 13-hectolitre plant, installed in 2020. The brewery is supplied by spring

water from the Cotswold hills, which are located behind the brewery. ‼ ☰ ♦ LIVE ✦

Pale Ale (ABV 3.8%) PALE
Original (ABV 4.4%) BITTER
West Coast IPA (ABV 5.2%) PALE

Bespoke SIBA

Church Farm, Church Street, Littledean, Gloucestershire, GL14 3NL
☎ (01452) 929281 ☎ 07951 818668
⊕ bespokebrewery.co.uk

⊗ Brewing moved to premises at Littledean, with a farm tap. Both cask-conditioned and keg beers are produced using a 12-barrel plant. Beers are available from the farm tap and brewery shop. Special-labelled bottles are offered for celebratory occasions. ‼ ☰ ♦ ✦

Saved by the Bell (ABV 3.8%) BITTER
Forest Gold (ABV 4%) GOLD
Beware The Bear (ABV 4.2%) BITTER
Going Off Half-Cocked (ABV 4.6%) PALE
Money for Old Rope (ABV 4.8%) STOUT
Over a Barrel (ABV 5%) OLD

Brewhouse & Kitchen SIBA

◾ **31-35 Cotham Hill, Clifton, Bristol, BS6 6JY**
☎ (0117) 973 3793 ⊕ brewhouseandkitchen.com

⊗ This addition to the Brewhouse & Kitchen chain opened in 2015. A 2.5-barrel plant is used to produce five core ales and regular seasonal brews. Head Brewer Will Bradshaw, formerly of Gloucester Ales, joined in 2016. All beers are unfined. ‼ ♦

Brewhouse & Kitchen SIBA

◾ **Unit 7, The Brewery, St Margaret's Road, Cheltenham, Gloucestershire, GL50 4EQ**
☎ (01242) 509946 ⊕ brewhouseandkitchen.com

⊗ This addition to the Brewhouse & Kitchen chain opened in 2016 using a three-barrel plant. ‼ ♦

Brewhouse & Kitchen SIBA

◾ **Unit R1, St Anne Walk, Gloucester Quay, Gloucester, GL1 5SH**
☎ (01452) 222965 ⊕ brewhouseandkitchen.com

⊗ Opened in 2015 as part of the Brewhouse & Kitchen chain using a three-barrel plant. Based by the canal, it has a lovely outdoor area. ♦

Bristol Beer Factory SIBA

The Old Brewery, Durnford Street, Ashton, Bristol, BS3 2AW
☎ (0117) 902 6317

Office: 291 North Street, Ashton, Bristol, BS3 1JP
⊕ bristolbeerfactory.co.uk

⊗ A fiercely independent brewery at the heart of the Bristol beer scene since 2004. Based on North Street, the cultural hub of south Bristol, in a 200-year-old red brick building with 180 years of brewing heritage (including Ashton Gate Brewing Co, which closed in 1933). More than 40 beers are produced annually. ‼ ☰ ♦ ✦

Notorious (ABV 3.8%) BITTER
Fruity hop aroma, light malt on the palate overlaid with citrus and tropical fruits before a lingering, dry, bitter aftertaste.
Fortitude (ABV 4%) BITTER

Amber ale with light malt and hop nose, mildly fruity flavours balanced with hop bitterness and a short, dry finish.
Milk Stout (ABV 4.5%) STOUT
Roasted malt aroma, creamy flavours of chocolate-dusted cappuccino, with dark stone and dried vine fruit, increasingly bitter aftertaste.
Independence (ABV 4.6%) BITTER
Initial hop aroma, well-balanced flavours blend the fruity, citrus hops with a malty backbone leaving a clean, bittersweet aftertaste.

Clavell & Hind SIBA

The Old Haulage Yard, Old Cirencester Road, Birdlip, Gloucester, Gloucestershire, GL4 8JL
☎ (01452) 238050 ⊕ clavellandhind.co.uk

Clavell & Hind is a 20-barrel brewery based in the Cotswold countryside with an on-site taproom. ‼ ✦

Coachman (ABV 3.8%) SPECIALITY
Blunderbuss (ABV 4.2%) GOLD
Rook Wood (ABV 4.4%) BITTER

Corinium

Unit 1a, The Old Kennels, Cirencester Park, Cirencester, Gloucestershire, GL7 1UR ☎ 07716 826467 ⊕ coriniumales.co.uk

⊗ Established in 2012, Corinium Ales brew classic and contemporary award-winning ales on a 2.5-barrel plant located in small, historic old kennels in Cirencester Park, just outside the town centre. An on-site taproom showcases the range, which is also available at a growing number of local outlets, events and pubs. ‼ ☰ ♦ LIVE ✦

Firebird VI (ABV 4%) BITTER
Corinium Gold I (ABV 4.2%) GOLD
Mosaic (ABV 4.5%) PALE
Plautus V (ABV 4.5%) PALE
Bodicacia IV (ABV 4.7%) PALE
Centurion II (ABV 4.7%) STOUT
Ale Caesar III (ABV 5%) PALE

Cotswold SIBA

College Farm, Stow Road, Lower Slaughter, Bourton-on-the-Water, Gloucestershire, GL54 2HN
☎ (01451) 824488 ⊕ cotswoldbrew.co

An independent producer of craft lager and speciality keg beers. The brewery was established in 2005 and expanded in 2010. More than 150 outlets are supplied, mainly in the Cotswolds and London. ‼ ☰ ♦ LIVE

Cotswold Lion SIBA

Hartley Farm, Hartley Lane, Leckhampton Hill, Cheltenham, Gloucestershire, GL53 9QN
☎ (01242) 870164 ⊕ cotswoldlionbrewery.co.uk

⊗ Previously located in a grain store on a farm in the Cotswolds, Cotswold Lion brewery relocated in 2021. It produces a core range of five beers using a 10-barrel plant. ☰ LIVE

Shepherd's Delight (ABV 3.6%) BITTER
Hogget (ABV 3.8%) BITTER
Best in Show (ABV 4.2%) BITTER
Malty, spicy, earthy aroma. Hedgerow fruits, caramel and bitter balance. Hops, caramel, pear esters develop on aftertaste. Light dry finish.
Golden Fleece (ABV 4.4%) PALE
Drover's Return (ABV 5%) BITTER

Dawkins SIBA

Unit 2, Lawnwood Industrial Units, Lawnwood Road, Easton, Bristol, BS5 0EF
☎ (0117) 955 9503 ⊕ dawkinsgeorgesltd.selz.com

⊠ The established Dawkins Taverns group of independent Bristol pubs bought the Somerset-based Matthews Brewery in 2009. New premises in Easton, Bristol, opened in 2015 with a 20-barrel plant. The brewery distributes to its own five pubs and directly to another 80 outlets in the area. A sister company was set up in Edinburgh in 2017, reviving the long-defunct Steel Coulson brewing name for a bar in Leith. ‼️▛♦LIVE ☙

Bristol Blonde (ABV 3.8%) BLOND
Pale yellow-coloured golden ale. Citrus aroma. Refreshing lemon taste with grassiness, which fades to astringent bitterness.

Bristol Best (ABV 4%) BITTER
Copper-coloured bitter with malty aroma and taste. Hints of apple. Astringent aftertaste.

Bristol Gold (ABV 4.4%) GOLD
Light hop aroma, pale malt with hops, spice and a hint of apple on the palate before a crisp bitter finish.

Easton IPA (ABV 4.4%) PALE
Hazy, golden yellow, unfined ale. Hop and ripe apple aroma. Slightly sour citrus on the palate. Dry and bitter aftertaste.

Foresters Black (ABV 4.8%) STOUT

Resolution IPA (ABV 5%) PALE
Naturally hazy, golden yellow with aromas of tropical fruit. Flavours of grapefruit and lemon continue into the bitter finish.

DEYA SIBA

Unit 27, Lansdown Industrial Estate, Gloucester Road, Cheltenham, Gloucestershire, GL51 8PL
☎ (01242) 269189 ⊕ deyabrewing.com

DEYA Brewing Company was established in 2016. It brews innovative, hop-forward beers, all of which are unfiltered, unfined and unpasteurised, and available in keg and cans, with occasional casks. It has recently expanded into a new 25,000sq ft premises with a bespoke 40-hectolitre four-vessel brewhouse to significantly increase capacity. A new taproom has also been opened. ▛☙

Donnington IFBB

Upper Swell, Stow-on-the-Wold, Gloucestershire, GL54 1EP
☎ (01451) 830603 ⊕ donnington-brewery.com

Thomas Arkell bought a 13th century watermill in 1827 and began brewing on-site in 1865. The waterwheel is still in use. Thomas's descendant Claude owned and ran the brewery until his death in 2007, supplying 20 outlets direct. It has now passed to Claude's cousin, James Arkell, also of Arkells Brewery, Swindon (qv). ▛LIVE

BB (ABV 3.6%) BITTER
A pleasant, amber bitter with a slight hop aroma, a good balance of malt and hops in the mouth and a bitter aftertaste.

Cotswold Gold (ABV 4%) GOLD
Citrus malty/sweet caramel aroma. Bright with developing hops, fruit notes and malt. A dry hop bitter finish with some citrus.

SBA (ABV 4.4%) BITTER
Malt dominates over bitterness in the subtle flavour of this premium bitter, which has a hint of fruit and a dry, malty finish.

Fierce & Noble

25 Mina Road, St Werburgh's, Bristol, BS2 9TA
☎ (0117) 955 6666 ⊕ fierceandnoble.com

Founded in 2017 to supply beer to the Grounded community café chain in Bristol, beers can now be found across Bristol and the South West. A range of IPAs and occasional specials are brewed on an eight-barrel plant. The on-site taproom and brewery shop regularly hold events, and are open year round on Friday-Sunday. ‼️▛♦☙

Session IPA (ABV 4.2%) PALE

American Pale Ale (ABV 5%) PALE
Abundant powerful hop flavours add pine and tropical fruit to the slightly sweet malt background, before a lingering bitter aftertaste.

Forest, The

The Old Workshop, Lydney Park Estate, Lydney, Gloucestershire, GL15 6BU ☎ 07766 652837
⊕ theforestbrewery.co.uk

Originally named Brythonic Beer (a trading name it still retains), The Forest nanobrewery began in a Bristol suburb in 2015. The brewery relocated several times within Gloucestershire, finally settling in Lydney. Beers can be found at the Dog House micropub and the Forest Deli, both Coleford – mainly available bottle-conditioned, but the occasional cask beer also makes an appearance. LIVE

Hang Hill Hazy (ABV 4%) PALE

Black Spell Porter (ABV 5.7%) SPECIALITY

FSB (Forest Strong Bitter) (ABV 5.8%) BITTER

Fresh Standard

Unit 25, Merrets Mill Industrial Centre, Bath Road, Woodchester, Stroud, Gloucestershire, GL5 5EX
☎ (01453) 802400

Office: 3 West Tynings, Nailsworth, GL6 0EH
⊕ thefreshstandard.co.uk

⊠ Founded at the end of 2020 by experienced brewer Richard Taylor, in space rented from Artisan Ales. It initially brewed two core beers, alongside frequent, one-off, experimental brews. It relocated to its own premises, complete with taproom, in 2022, when the core beers increased to three. Beers may be purchased from the website. ♦☙

Horse Brass (ABV 4%) BITTER

Solution (ABV 4.8%) PALE

Pothering (ABV 6.2%) IPA

Gloucester SIBA

Fox's Kiln, West Quay, The Docks, Gloucester, GL1 2LG
☎ (01452) 668043 ☎ 07503 152749
⊕ gloucesterbrewery.co.uk

⊠ Situated in the historic Gloucester Docks, brewing began in 2011 and has expanded into larger dockside premises to meet demand. Further expansion is planned. The original site is now its bar, named Tank. The full range of beers is regularly available in Gloucestershire and beyond. Beers are brewed in cask, keg and cans, most are unfined. A range of gins and vodkas is also distilled on-site. The brewery is committed to being carbon neutral by the end of 2022. ‼️▛♦LIVE V☙

Session Pale (ABV 3.7%) PALE

Gold (ABV 3.9%) GOLD

Priory Pale (ABV 3.9%) GOLD

Cascade (ABV 4.2%) BITTER

Session IPA (ABV 4.5%) PALE
Dockside Dark (ABV 5.2%) PORTER
New England IPA (ABV 5.2%) PALE

Goff's SIBA

9 Isbourne Way, Winchcombe, Cheltenham,
Gloucestershire, GL54 5NS
☎ (01242) 603383 ⊕ goffsbrewery.com

⊗ Goff's is a family concern that has been brewing cask-conditioned ales since 1994. The ales are available regionally in more than 200 outlets and nationally through wholesalers. Three regular ales are supplemented by the seasonal 'Jester' range (12 beers). 🍽♦

Lancer (ABV 3.8%) GOLD
Jouster (ABV 4%) BITTER
A drinkable, tawny-coloured ale, with a light hoppiness in the aroma. It has a good balance of malt and bitterness in the mouth, underscored by fruitiness, with a clean, hoppy aftertaste.
Tournament (ABV 4%) BITTER
Dark golden in colour, with a pleasant hop aroma. A clean, light and refreshing session bitter with a pleasant hop aftertaste.
Fallen Knight (ABV 4.4%) BITTER
Cheltenham Gold (ABV 4.5%) GOLD
Bright gold with a strong US hop/citrus aroma. Balanced citrus hop, malt sweetness, with no dominating flavour. Citrus aftertaste, long drying finish.
White Knight (ABV 4.7%) BLOND
Bright, light malt aroma with fruit, hops and earthy sweetness. Citrus hops and fruit lead to a bitter, drying finish.
Jester Brew 6 (ABV 5%) SPECIALITY
Hazy orange with a massive mango aroma. Malt, hops, citrus, yeast and sulphur add balance. A fruity, bitter, drying finish.

Good Chemistry SIBA

Unit 2, William Street, St Philips, Bristol, BS2 0RG
☎ (0117) 903 9930 ⊕ goodchemistrybrewing.co.uk

⊗ Good Chemistry was established in 2015 in a warehouse in St Philips, Bristol, by Bob Cary and Kelly Sidgwick, using a 10-barrel plant. As the name suggests, all brewery and beer logos have a scientific theme. The brewery has a taproom and can shop. 🍽LIVE♦

Time Lapse (ABV 3.8%) BITTER
Natural Selection (ABV 4%) PALE
Hops and pale malt aromas. Initial sweet body is followed by hoppy bitterness which continues into the short, dry finish.
Kokomo Weekday (ABV 4.3%) PALE
Hazy, golden-coloured ale with hop and sweet fruit aroma which continues onto the palate before a short, bitter finish.

Hal's

22A, Woodmancote, Dursley, Gloucestershire,
GL11 4AF ☎ 07765 890946

Hal's is a one-barrel microbrewery established in Dursley in 2016, occasionally producing a number of small-batch beers for the New Inn, Woodmancote, Dursley and beer festivals. Brewing is currently suspended. ♦

Hop Union SIBA

20 Bonville Road, Brislington, BS4 5QH
☎ (0117) 957 2842 ⊕ hopunionbrewery.co.uk

⊗ Originally established as Great Western in 2008, the brewery relocated and rebranded to Hop Union in 2021. The move has allowed for much-needed expansion and will enable canning and kegging on site. One pub, the Rising Sun, Frampton Cotterell, is owned, as well as a shop at the new brewery site. A taproom is due to open in late 2022. 🍽🍽♦

HPA (Hambrook Pale Ale) (ABV 4%) PALE
Hoppy, yellow bitter with zesty citrus flavours and hints of tropical fruit, leading to a moreish bittersweet finish.
Maiden Voyage (ABV 4%) BITTER
An amber bitter with a light aroma of malt and fruit which continues to the palate before leading to a strong bitter finish.
Old Higby (ABV 4.8%) BITTER
Full-bodied, malty bitter with roast notes on the nose. Hints of fruit flavour give way to a bitter hop finish with some astringency throughout.
Moose River (ABV 5%) PALE
Light citrus aroma, delicate hop taste with long-lasting bitter finish.

Incredible SIBA

214/224 Unit 1, Broomhill Road, Brislington, Bristol,
BS4 5RG ☎ 07780 977073
⊕ incrediblebrewingcompany.com

⊗ This microbrewery specialises in producing small batches of beer using a 2.5-barrel plant. It was established in 2014 by head brewer Stephen Hall with the aim of promoting experimental beers and traditional recipes. 🍽♦LIVE

Milk Stout (ABV 4.4%) STOUT
Pale Ale (ABV 4.4%) PALE
Amber Ale (ABV 5.2%) BITTER
Black IPA (ABV 5.6%) IPA
Grapefruit IPA (ABV 5.6%) IPA
Indian Pale Ale (ABV 6.6%) IPA

Inferno

17 Station Street, Tewkesbury, GL20 5NJ
☎ (01684) 294873 ☎ 07854 949731
✉ infernobrewery@yahoo.com

⊗ Inferno began in 2018, after many years of home brewing, using a 2.5-barrel kit which was installed in 2019. Four regular ales and a number of well-received seasonal ales are brewed. The beers are available in local Gloucestershire pubs, clubs and at beer festivals. ♦♦

Spark (ABV 3.8%) PALE
Golden Embers (ABV 4.2%) PALE
Citrus hop aroma, mandarin, white pepper, earthy notes, minimal malt. Initial sweetness leads to a long, dry, bitter, citrus aftertaste.
Mental Martha (ABV 4.2%) SPECIALITY
Emerald Flame (ABV 4.5%) SPECIALITY
Tinder Box (ABV 4.5%) PALE
Dark colour, hedgerow fruits, spice and a malty nose. Earthy, bittersweet autumn fruits with some caramel. Long, bitter dry finish.
Cinder Stout (ABV 4.8%) STOUT
Wheat Storm (ABV 5%) SPECIALITY
Fresh, zingy Belgian Wit. Yeasty banana, clove, coriander and pear esters. Wheat, biscuit, spicy banana with floral/wood.
Prometheus (ABV 5.8%) IPA
Triple-hopped, bright, spicy, earthy aroma with oyster mushroom notes and honey. Spicy hops, strong malt backbone. Long, bitter finish.
Vulcan (ABV 6%) PORTER

Keep

▤ Village Inn, The Cross, Nailsworth, Gloucestershire, GL6 0HH

☎ (01453) 835715 ☎ 07877 569586

✉ paul@dropinpubs.com

After a break of 96 years, brewing returned to Nailsworth in 2004, at the Village Inn. The pub and brewery were sold in 2016 to Paul Sugden and Adam Pavey, who changed the brewery name from Nailsworth to Keep Brewing. Brewing takes place on a six-barrel kit below the bar, with new recipes trialled on a 40-litre pilot plant. ♦LIVE

King Street SIBA

▤ Riverside House, Welsh Back, Bristol, BS1 4RR

☎ (0117) 405 8948

Office: City Pub Group Plc, Essel House, 2nd Floor, 29 Foley Street, London, W1W 7TH

⊕ kingstreetbrewhouse.co.uk

⊗ The King Street Brew House is owned by The City Pub Group, which has several pubs and brewpubs around the country. The compact brewery is on the ground floor, with the fermenting vessels and conditioning tanks in the basement. The enthusiastic on-site brewer produces a wide range of beers, from regular favourites (all year), to one off/seasonal specials. Guest beers are also available. The Group's other pub in Bristol, the Prince Street Social, is also supplied. ‼♦LIVE

Left Handed Giant

Unit 3, Wadehurst Industrial Park, St Philips Road, St Philips, Bristol, BS2 0JE

LHG Brewpub: Compressor Building, Hawkins Lane, Bristol, BS1 6EU ⊕ lefthandedgiant.com

Originally launched in 2015 as a cuckoo brewery using spare capacity at other local breweries, Left Handed Giant has operated since 2017 using its own 15-barrel plant to brew modern, progressive beers. A second 15-barrel plant was added in 2019 when the Left Handed Giant Brewpub in Bristol city centre was added, doubling its capacity. A small amount of the output goes into cask. ‼☷♦LIVE ⚒

Little Martha (NEW)

▤ 23 Oxford Street, St Phillips, Bristol, BS2 0QT

⊕ littlemarthabrewing.co.uk

This new brewpub and taproom is located in a railway arch close to Bristol Temple Meads Station. Brewing commenced in late 2021 prior to the official taproom opening at the end of the year. Two core beers are brewed along with one-off specials. ☷♦⚒

Lost & Grounded SIBA

91 Whitby Road, Bristol, BS4 4AR

☎ (0117) 332 7690 ⊕ lostandgrounded.co.uk

Brewing began in 2016. The brewery has a focus on German and Belgian-style beers. No real ale.

Lucifer

9 Ellerncroft Road, Wotton-Under-Edge, Gloucestershire, GL12 7AX ☎ 07886 604690

⊕ luciferbrewhouse.co.uk

Lucifer Brewhouse was established in 2019 using a one-barrel plant. It produces a growing number of small batch beers for pubs in the local area. Most of the cask-conditioned beers are also available bottle-conditioned. ♦LIVE

Mild Side (ABV 3.6%) MILD
Mocha Choc Stout (ABV 4.2%) STOUT
Fallen Angel Bitter (ABV 4.3%) BITTER
Wotton Hop Project (ABV 4.4%) GOLD
GL12 (ABV 4.7%) PALE

Lydbrook Valley

▤ Forge Row, Lydbrook, Gloucestershire, GL17 9NP

☎ (01594) 860310 ✉ andy@theforgehammer.co.uk

Brewing commenced in 2018 in the Forge Hammer pub in Lydbrook. Alison and Andrew Jopson use full mash to produce beers for sale in the pub.

Mills

Jumpers Lane Yard, Berkeley, Gloucestershire, GL13 9BW ☎ 07848 922558 ⊕ millsbrewing.com

Mills was established in Berkeley in 2016 by husband-and-wife team Genevieve and Jonny Mills. Wort is produced in multiple locations, which is then fermented in wooden vessels at its premises in Berkeley using 100% wild yeasts and bacteria from the local surroundings. The lambic-style bottle-conditioned beers are mostly available via its online store. LIVE

Moor

Days Road, Bristol, BS2 0QS

☎ (0117) 941 4460 ⊕ moorbeer.co.uk

⊗ Starting out in Somerset in 2007, Moor is an established part of the Bristol beer scene and exports throughout the UK and around the world. The central Bristol brewery features a taproom and shop, while there is also a Moor London Vaults in Bermondsey, which doubles as a taproom and facility for ageing beers. All beers are unfined and naturally hazy, vegan-friendly and naturally-conditioned with live yeast. Moor's canned beers were the first in the UK to be recognised as real ale by CAMRA. Moor were one of only 16 breweries recognised with a CAMRA Gold awared during the 50th Anniversary celebrations. ‼☷♦LIVE V⚒

Nano Cask (ABV 3.8%) BITTER
Hints of fruit in the aroma, bittersweet flavours of malt and hops which soon fade in the short finish.

Revival (ABV 3.8%) PALE
Cloudy orange colour with some peachy aroma, flavours of slightly resinous hops and a gentle bitterness in the short finish.

Resonance (ABV 4.1%) PALE
Golden yellow unfined beer with spicy hops on the nose. Citrus flavours of grapefruit and lemon, short bitter aftertaste.

Illumination (ABV 4.3%) BITTER
Distortion (ABV 4.7%) PALE
Stout (ABV 5%) STOUT
A classic black stout. Smoky roast malts and dark fruit aroma with hint of vanilla. Prunes and liquorice notes follow into the taste. Pleasant dark chocolate aftertaste.

PMA (ABV 5.3%) PALE
Aroma and flavours are both well-balanced with biscuity malt, hops and tropical fruit before a short, bittersweet ending.

Hoppiness (ABV 6.5%) IPA
Hop-forward nose with hints of honey. Full-bodied, with tropical fruit flavours and bitterness which increases into the finish.

Old Freddy Walker (ABV 7.3%) STRONG

Roasted malt and dark fruit aromas, flavours balance roasted malt with liquorice treacle and blackberry before a slightly dry finish.

New Bristol SIBA

20a Wilson Street, Bristol, BS2 9HH ☎ 07837 976871
⊕ newbristolbrewery.co.uk

⊗ Having started out in 2013 with his brother Tom, Noel James, wife Maria and assistants now brew on a fifteen-barrel plant. Year-round beers are supplemented by regularly released brews based on progressive and modern themes which include IPAs and stouts. All beers are unfined and unfiltered, with some oak barrel-aged, and many available in cans. The premises house a shop and the Brewery Tap which opens on weekends. ‼️🍽️♦LIVE♦

Cinder Toffee Stout (ABV 4%) SPECIALITY
Caramelised honey and roasted malt aromas, sweet flavours of honeycomb and chocolate, some hop bitterness in the slightly dry finish.
Wonderland IPA (ABV 4.1%) PALE
Tropical fruit aroma and juicy fruit hop burst of pineapple and mango flavours with some bitterness in the short finish.
Joy of Sesh (ABV 4.2%) BITTER
Powerfully-hopped, naturally hazy, unfined beer with citrus and tropical fruits on the palate and a long, bitter finish.
Super Deluxe Stout (ABV 7%) SPECIALITY
Banana and vanilla aromas. The taste and mouthfeel is like vanilla ice cream, but this sweetness contrasts with an assertive bitterness.

Newtown Park

Unit 9, Wadehurst Industrial Park, St Philips Road, St Philips, Bristol, BS2 0JE ⊕ newtownparkbrewing.co

Established by a small group of friends in 2020, it produces a range of beers that reflect a diversity of taste and flavours with five canned beers being available at any one time. 🍽️♦

Stroud SIBA

Kingfisher Business Park, London Road, Thrupp, Stroud, Gloucestershire, GL5 2BY
☎ (01453) 887122 ⊕ stroudbrewery.co.uk

⊗ Established in 2006, Stroud Brewery supports the local ecomomy and it's ales are available in 40-50 pubs, independent retailers and its brewery shop. All beers have full organic status and are available in cask or keg as well as in cans. Beers are no longer available in bottles. ‼️🍽️♦♦

Tom Long (ABV 3.8%) BITTER
OPA (Organic Pale Ale) (ABV 4%) PALE
Big Cat (ABV 4.5%) STOUT
Budding (ABV 4.5%) PALE

Tanners

Office: 118 High Street, Staple Hill, Bristol, BS16 5HH
⊕ tanners-ales.co.uk

Tanners were established in late 2015 in the old stables at the rear of the White Hart Inn, Wiveliscombe. However, the stables have been demolished and the beer is now believed to be brewed under contract by an unknown brewer.

Box O' Frogs (ABV 4.5%) GOLD

Tapestry

Unit B, Totterdown Bridge Industrial Estate, Albert Road, St Philips, Bristol, BS2 0XH
⊕ tapestrybrewery.com

Previously known as Cocksure, this 10-barrel brewery was established in 2017, and moved from the Severn Vale to Bristol in 2018. Tapestry is a social enterprise brewery that provides training and employment for people with learning disabilities. ‼️♦LIVE♦

Three Engineers SIBA

The Cow Byers, Winterbourne Medieval Barn, Church Lane, Winterbourne, BS36 1SD
⊕ threeengineersbrewery.co.uk

⊗ Nanobrewery established near Bristol in 2017. Eight cask beers are brewed and supplied to a number of local pubs and micropubs. The premises at Winterbourne Medieval Barn include a taproom and shop (see website for details). ♦

Beluga Wheat Beer (ABV 3.9%) SPECIALITY
Generously-hopped hazy German-style wheat beer. Refreshing clean taste with some light malt and lemon undertones, long bitter finish.
Corsair American Pale Ale (ABV 4.1%) PALE
Gladiator (ABV 4.4%) BITTER
Sweetish malt aroma is overlaid on the palate with ripe fruit and hop bitterness which continue in the long finish.
Mosquito (ABV 5.1%) PORTER
Dark roasted malt on the nose, flavours of bitter dark chocolate with liquorice and blueberry hints, short and dry ending.
Redwing (ABV 5.1%) RED
Red ale with background hop bitterness, malty sweetness and ripe dark fruit flavours leaving a short yet rounded aftertaste.
Mustang IPA (ABV 5.4%) PALE
Spruce Goose (ABV 5.5%) IPA
Aromas and flavours combine pine notes, citrus and tropical fruits on a pale malt background, giving a complex bittersweet experience.
Vulcan (ABV 6%) PALE

Tiley's

🏠 Salutation Inn, Ham, Gloucestershire, GL13 9QH
☎ (01453) 810284 ⊕ sallyatham.com

⊗ This 2.5-barrel microbrewery was established in an outbuilding of the award-winning Salutation Inn in 2015. It concentrates on producing small batches of beer, predominantly in cask, some in KeyKeg. Some of the brewery's output is sold onsite at the Salutation Inn. The rest goes to more than 25 selected local pubs.

Ordinary Bitter (ABV 3.8%) BITTER
Ordinary Pale (ABV 3.8%) PALE
Special Bitter (ABV 4.3%) BITTER
Special Pale (ABV 4.5%) PALE
ESB (ABV 5.2%) BITTER
IPA (ABV 6.5%) IPA

Two Tinkers (NEW)

Aylburton, Gloucestershire
☎ (01594) 840100 ☎ 07711 368397
⊕ twotinkers.co.uk

The Two Tinkers are husband and wife Tim and Esther Kearsey, who established the brewery in 2020. They try to be as low impact on the environment as possible and make everything in as sustainable way as possible. All spent malt goes to feed local farm animals, and hops and

yeast are composted. There are three core beers, and a growing number of seasonal ales. All beers produced are can-conditioned and vegan-friendly, and are available in more than 20 local shops. ◆LIVE V

Uley

The Old Brewery, 31 The Street, Uley, Gloucestershire, GL11 5TB
☎ (01453) 860120 ⊕ uleybrewery.com

⊗ Brewing at Uley began in 1833 as Price's brewery. After a long gap, the premises were restored and Uley Brewery opened in 1985. Now operating a 10-barrel plant, it uses its own spring water. Uley delivers to 40-50 outlets in the Cotswolds area. ➹◆✦

Pale (ABV 3.8%) PALE
Bitter (ABV 4%) BITTER
A copper-coloured beer with hops and fruit in the aroma and a malty, fruity taste, underscored by a hoppy bitterness. The finish is dry, with a balance of hops and malt.
Old Ric (ABV 4.5%) BITTER
A full-flavoured, hoppy bitter with some fruitiness and a smooth, balanced finish. Distinctively copper-coloured, this is the house beer for the Old Spot Inn, Dursley.
Taverner (ABV 4.5%) BITTER
Old Spot Prize Strong Ale (ABV 5%) BITTER
A ruby ale with an initial strong malty sweetness that develops into a smooth, dry, malty finish. Deceptively easy to drink.
Pigs Ear (ABV 5%) PALE
A golden pale ale with an initial refreshing taste with a hint of fruitiness that develops into a light malty finish. A smooth, quaffable, strong ale.

Volunteer Tavern

🯁 **9 New Street, Old Market, Bristol, BS2 9DX**
☎ (0117) 955 8498 ⊕ volunteertavern.co.uk

⊗ The Volunteer Tavern is a vibrant 17th century pub tucked away in a quiet street, yards from Bristol's main shopping quarter. ◆

Wickwar

Old Brewery, Station Road, Wickwar, Gloucestershire, GL12 8NB
☎ (01454) 292000 ⊕ wickwarbrewing.co.uk

Wickwar was established as a 10-barrel brewery in 1990. In 2004 it expanded to 50 barrels. Moles Brewery and pubs were acquired in 2017, bringing its pub estate up to 20. This has now been rationalised to 16. 350 outlets are supplied on a regular basis and the beers are available nationally through most distributors and SIBA. Beers are contract brewed by an unknown third party. ◆

BOB (ABV 4%) BITTER
Amber-coloured, this has a distinctive blend of hop, malt and apple/pear citrus fruits. The slightly sweet taste turns into a fine, dry bitterness, with a similar malty, lasting finish.
Cotswold Way (ABV 4.2%) BITTER
Amber-coloured, it has a pleasant aroma of pale malt, hop and fruit. Good dry bitterness in the taste with some

sweetness. Similar though less sweet in the finish, with good hop content.
Falling Star (ABV 4.2%) GOLD
Stand-Up IPA (ABV 4.6%) PALE
Station Porter (ABV 6.1%) PORTER

Brewed for Moles Brewery:
Gold (ABV 3.8%) GOLD
Golden hoppy beer with subtle citrus fruit aroma and flavour derived from the Brewers Gold hops, with a malty background.
Best (ABV 4%) BITTER
An amber-coloured bitter, clean, dry and malty with some bitterness, and delicate floral hop flavour.
Elmo's (ABV 4.4%) PALE
Medium-bodied bitter with subtle fruit aroma and flavours, leading to a long, bitter finish.

Wiper and True SIBA

Units 11-15, City Business Park, Easton Road, Bristol, BS5 0SP
☎ (0117) 941 2501 ⊕ wiperandtrue.com

Originally launched in 2012 by Michael Wiper as a gypsy brewery, Wiper and True has operated since 2015 using its own 20-barrel plant. Producing an ever-changing range of seasonal specials along with several core beers. A proportion of its output goes into cask. The beers are available locally in Bristol and Bath, nationally and internationally. ‼➹◆LIVE✦

Wookey

Albion Dockside Building, Hanover Place, Bristol, BS1 6UT ☎ 07487 352280

Office: High Street, Wookey, BA5 1JZ
⊕ wookeyale.co.uk

Wookey Ale was established in 2020 by Samuel and Simon to create a local beer for the famous village of Wookey Hole. ➹◆

Arthur's Point (ABV 4%) BITTER
Light roast aroma, hop and dark chocolate bitterness with sweet plums on the palate, short liquorice and sherbert finish.
Witch Way Home (ABV 4%) PALE
Hop-forward aroma, refreshing citrus and tropical fruit flavours on a light malt background before a lingering, dry finish.
Autumn Gail (ABV 4.2%) BITTER
Sweetish malt nose, balanced flavours of hop bitterness with caramel and banana esters with some peppery spice in the aftertaste.

Zerodegrees SIBA

🯁 **53 Colston Street, Bristol, BS1 5BA**
☎ (0117) 925 2706 ⊕ zerodegrees.co.uk

⊗ A chain of four brewpubs, the first began brewing in 2000 in Blackheath, London. Each incorporates a computer-controlled, German plant producing unfiltered and unfined ales and lagers. All beers use natural ingredients, are suitable for vegetarians, and are served from tanks using air pressure (not CO2). ‼◆

'What is your best – your very best – ale a glass?' 'Twopence-halfpenny,' says the landlord, 'is the price of the genuine Stunning Ale.' 'Then,' says I, producing the money, 'Just draw me a glass of the Genuine Stunning, if you please, with a good head to it.'
Charles Dickens, David Copperfield

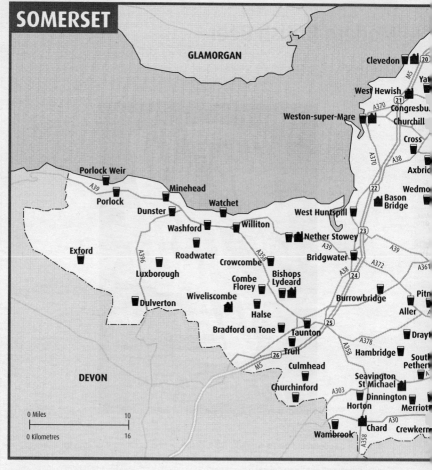

SOMERSET

GLAMORGAN

Clevedon
West Hewish
Congresbu
Weston-super-Mare
Churchill
Cross
Axbric
Porlock Weir
Wedmo
Bason
Bridge
Minehead
Porlock
Watchet
Dunster
Williton
West Huntspill
Washford
Nether Stowey
Exford
Roadwater
Crowcombe
Bridgwater
Luxborough
Combe
Florey
Bishops
Lydeard
Burrowbridge
Pitn
Dulverton
Wiveliscombe
Aller
Halse
Dray
Bradford on Tone
Taunton
Hambridge
South
Trull
Pether
DEVON
Culmhead
Seavington
St Michael
Churchinford
Dinnington
Merriot
Horton
Wambrook
Chard
Crewkern

0 Miles 10
0 Kilometres 16

Aller

Old Pound Inn

1 High Street, TA10 0RA (centre of village)
☎ (01458) 250469 ⊕ oldpoundinn.com
Butcombe Original; Teignworthy Reel Ale; 1 changing beer (sourced regionally; often Exmoor, Otter) Ⓗ
A lovely 16th-century inn which stands on the ground of the old village pound. It has a varying selection of three regional ales and a local cider on handpump. A wonderful open Dutch fire is a feature in the centre of the bar. There is a separate restaurant/function room, public lounge and a delightful snug. Excellent food, including a Sunday carvery, is served in the bar or restaurant. ☢❄♿⚐♣↔♿Pᵂ⛟(16)☀🐾🛜

Axbridge

Lamb ✓

The Square, BS26 2AP
☎ (01934) 732253 ⊕ butcombe.com/the-lamb
Butcombe Original; 1 changing beer (sourced locally; often Butcombe) Ⓗ
Lovely Butcombe-owned Grade II-listed coaching house in the village square. Inside is a large low-beamed bar with several smaller, quieter areas leading off it where traditional pub games can be played. Outside drinking spaces are to the front, and also to the rear via the courtyard. There is an interesting food menu, including

bar snacks. Directly opposite is the National Trust's medieval King John's Hunting Lodge, where Hanging Judge Jeffreys held court. Q☢❄⚐◗♿🚆⛟(26,126)🐾🛜

Bath

Bath Brew House ✓

14 James Street West, BA1 2BX
☎ (01225) 805609 ⊕ thebathbrewhouse.com
Bath Brew House Gladiator, Emperor; 3 changing beers (sourced regionally; often Bath Brew House) Ⓗ
A 2013 refurbishment turned the Midland Hotel into a City Pub Company brewpub. The on-site James Street Brewery produces two regular beers – the malty Gladiator and the hoppy, citrussy Emperor – and rotating seasonal ales. There can up to four additional beers, usually from the on-site brewery. A large L-shaped bar leads to a dining area and a good-sized beer garden. The upstairs room hosts sports TV, quizzes, comedy, and so on. ❄◗♿≋(Spa)♿⛟🐾🛜

Bell

103 Walcot Street, BA1 5BW
☎ (01225) 460426 ⊕ thebellinnbath.co.uk
Box Steam Tunnel Vision; Bristol Beer Factory Independence; Butcombe Adam Henson's Rare Breed; Hop Back Summer Lightning; Otter Ale; 3 changing beers (sourced regionally) Ⓗ

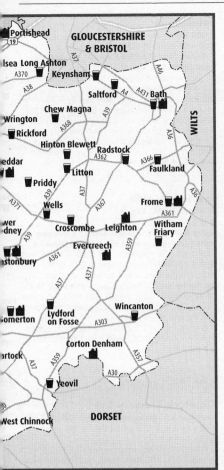

Fuller's ESB, London Pride; 2 changing beers (often Butcombe, Wild Beer) ⊞
Set on the pretty Abbey Green and refurbished by Fuller's in 2014, this city-centre pub has an upmarket feel. There are usually at least two Fuller's beers on plus a couple of guest ales; some local, others from further away but usually featuring interesting breweries. Full table service is available in the lounge. There is a glass-covered sitting area at the rear of the pub. ⏱❀❍🚶&⇌(Spa)🚪❀🍽📶

Huntsman

1 Terrace Walk, BA1 1LJ
☎ (01225) 482900 ⊕ huntsmanbathpub.co.uk
Bath Ales Prophecy; Fuller's London Pride; Gale's HSB; 2 changing beers (sourced regionally; often Dark Star) ⊞
Dating back to around 1750, this is now a smart gastropub, having being taken over by Fuller's in 2012 and fully refurbished. It has a bar on the ground floor and an à la carte-style restaurant with its own bar upstairs. Two guest beers are usually on offer. Live music is played on the second Friday of the month. This pub is popular on the days Bath Rugby play at home.
⏱❍&⇌(Spa)🚪❀📶

New Inn

23-24 Monmouth Place, BA1 2AY
☎ (01225) 442944 ⊕ newinnbath.co.uk
3 changing beers (sourced regionally; often Bath Ales, Butcombe, Dawkins) ⊞
A small and friendly pub with a modern tiled bar area and further seating upstairs in a small room and on a roof terrace. Originally owned by Wadworth Brewery, it was reopened 2016 after major internal and external refurbishment by Banwell House, who also operate the Victoria Pub & Kitchen in Bath. Beers are usually sourced from local brewers. ❀❍⇌(Spa)🍽🚪❀📶

Old Green Tree ★

12 Green Street, BA1 2JZ
☎ (01225) 448259
Butcombe Original; Pitchfork; house beer (by Blindmans); 2 changing beers (sourced locally) ⊞

Purchased by 536 of its regulars, fans and staff as a community buy-out in 2013, the Bell has six regular ales plus three ever-changing guests from local micros. Live music is a mainstay with bands playing Monday and Wednesday evenings and Sunday lunchtimes. Open-mic nights on Thursday evenings are held in the separate Back Bar to the rear. Other features include bar-billiards, board games and even a tiny launderette. At the rear is a walled garden with covered seating. ❀❍♣❀🚪❀📶

Cross Keys ✅

Midford Road, Combe Down, BA2 5RZ
☎ (01225) 849180 ⊕ crosskeysbath.co.uk
Butcombe Original; 3 changing beers (sourced locally) ⊞
Historic inn, dating from 1718, on the southern outskirts of the city. It is close to the beautiful Midford valley and popular with walkers. Four ales are served, including guests that are often from a local Brewery of the Month range. Highly recommended, gastro-standard, homemade food is available all sessions. The main bar on the left still has many original features including an open fire. The restaurant is on the right and split across three levels. Parking is a bit restricted.
⏱❀❍&❀🅿(3,D2)❀📶

Crystal Palace

10-11 Abbey Green, BA1 1NW
☎ (01225) 482666 ⊕ crystalpalacepub.co.uk

REAL ALE BREWERIES

Abbey Bath
Apex Corton Denham (NEW)
Bason Bridge Bason Bridge
Bath Brewhouse 🍺 Bath
Black Bear 🍺 🌾 Wiveliscombe
Blindmans Leighton
Butcombe Wrington
Cheddar 🌾 Cheddar
Clevedon 🌾 Clevedon
Electric Bear 🌾 Bath
Epic West Hewish
Exmoor Wiveliscombe
Fine Tuned Somerton
Frome Frome
Glastonbury Glastonbury
Nuttycombe Wiveliscombe (NEW)
Parkway Somerton
Pinkers Weston-Super-Mare (NEW)
Portishead 🍺 Portishead
Quantock 🌾 Bishops Lydeard
Ralph's Ruin 🍺 Bath
Stowey Nether Stowey
Tapstone 🌾 Chard
Twisted Oak Wrington
Verse 🍺 Bath
Wild Beer Evercreech
Windy 🍺 Seavington St Michael

A classic, unspoilt pub in a 300-year-old building. The three oak-panelled rooms include a superb northern-style drinking lobby. Although it can get crowded, there is often space in the comfortable back bar. Guest beers are generally sourced from local microbreweries, with a stout or porter usually on offer in the winter months. A local farmhouse cider is also available, along with a range of fine wines and malt whiskies. Sunday hours may be longer in winter. Q⇥(Spa)⬤🛏

Pulteney Arms ✔

37 Daniel Street, BA2 6ND (on corner of Daniel St and Sutton St)
☎ (01225) 463923 🌐 thepulteneyarms.co.uk
Bath Ales Gem; Timothy Taylor Landlord; Wye Valley HPA; 2 changing beers (sourced nationally; often Exmoor, Fuller's, Otter) Ⓗ
Tucked away near the end of Great Pulteney Street, the pub dates back to 1792. There are five gas light fittings (now sadly condemned) above the bar. The decor has an emphasis on sport, particularly rugby. The cat symbol on the pub sign refers to the Pulteney coat of arms. The food menu is deservedly popular (no food Sun eve). The guest beers are usually from a national brewery. Closed Monday and Tuesday, and midweek winter afternoons – check before travelling. ⬤❀◐♣⬤🛏❀🛜

Raven

6-7 Queen Street, BA1 1HE
☎ (01225) 425045 🌐 theravenofbath.co.uk
House beer (by Blindmans); 4 changing beers (sourced regionally) Ⓗ
A busy 18th-century free house in the heart of Bath, voted the local CAMRA Pub of the Year in 2018. The six ales include two brewed exclusively by Blindmans. Guest ales come from far and wide, with several mini beer festivals a year. The main bar and the quieter first-floor bar serve the same range of ales. Famous for its sausages and Pieminister pies, the Raven is one of the few pubs in Bath serving food on Sunday evening.
Q❀◐⇥(Spa)♣⬤🛏🛜

Ring o' Bells

10 Widcombe Parade, BA2 4JT
☎ (01225) 448870
Butcombe Original; 3 changing beers (often Butcombe, Exeter, Timothy Taylor) Ⓗ
Friendly and lively Widcombe pub only a stone's throw from the centre of Bath, yet with a village pub feel. Rugby is often shown on one of several TV screens which makes it especially popular on match days when the large upstairs function room is brought into use. The main bar is a single long room with wooden tables overlooking the street and ranged along one wall, facing the bar counter. A menu of well-regarded home-made food is available most sessions. ⬤❀◐⇥(Spa)🛏🛜

Royal Oak

Lower Bristol Road, Twerton, BA2 3BW (on A36 at intersection with road to Windsor Bridge)
☎ (01225) 481409 🌐 theroyaloakbath.co.uk
Ralph's Ruin Ivory Tower, Sirius, Dark Side of the Ralph; 5 changing beers (often Bristol Beer Factory, Butts, Downton) Ⓗ
Up to four beers from its own brewery, Ralph's Ruin, and up to six guest beers from microbreweries near and far, are served here alongside an interesting range of ciders, perries and bottled British and Belgian beers. There is live music on Wednesday evening and most weekends. Regular quiz nights and occasional beer festivals are held. Outside is a secluded little garden and a small car park. Local CAMRA Pub of the Year 2020.
❀⇥(Oldfield Park)⬤🛏(5,15)❀

Salamander

3 John Street, BA1 2JL
☎ (01225) 428889 🌐 salamanderbath.co.uk
Bath Ales Gem; St Austell Proper Job; 2 changing beers (often Bath Ales, St Austell) Ⓗ
An 18th-century building tucked away in a side street, the Salamander opened as a coffee bar in 1957 and got a pub licence five years later. Taken over by St Austell in 2017, it looks and feels like a pub that has been in place for a century or more, with a ground-floor pub bar created from several small rooms. Wooden floorboards, wood panelling and subdued lighting add to the ambience. A popular restaurant upstairs uses local ales in cooking.
◐⇥(Spa)♣⬤🛏❀🛜

Star Inn 🍺 ★ ✔

23 Vineyards, BA1 5NA
☎ (01225) 425072
Abbey Bellringer Ⓗ**; Draught Bass** Ⓖ**; 3 changing beers (sourced nationally; often Abbey, Titanic)** Ⓗ
A main outlet for Abbey Ales, this classic town pub was fitted out by Gaskell and Chambers in 1928. Its four small rooms have benches around the walls, wood panelling and roaring fires. The smallest room has a single bench, called Death Row, while the pub itself, which dates from around 1760, is coffin-shaped. Abbey Bellringer is served from the cask and complimentary snuff is available. Cheese night is every Thursday and live music features on Friday evening. Local CAMRA Pub of the Year 2022.
Q♣⬤🛏❀🛜

Bishops Lydeard

Quantock Brewery Tap Ⓛ

Westridge Way, Broadgauge Business Park, TA4 3RU (follow signs to West Somerset Railway WSR, shop is on left just before station)
☎ (01823) 433812 🌐 quantockbrewery.co.uk
Quantock QPA, Wills Neck, Stout, Plastered Pheasant; 2 changing beers (sourced locally; often Quantock) Ⓗ
Quantock Brewery tap room with up to six of its cask beers on handpump. There are also two Quantock KeyKeg beers always available plus a monthly small batch KeyKeg (subject to availability). One or two guest KeyKeg beers, typically from Northern Monk, Salopian, Thornbridge and Weird Beard are also served. A brewery shop supplies takeaway bottles and other gifts. There is an annual beer festival in July and regular live band, comedy and quiz nights. Street food is available on Fridays and most Saturday evenings.
⬤❀❀⇥(Bishop's Lydeard)⬤🛏(28)❀🛜

Bradford on Tone

White Horse Inn Ⓛ

Regent Street, TA4 1HF (off A38 between Taunton & Wellington at Worlds's End junction)
☎ (01823) 461239 🌐 whitehorseinn.pub
3 changing beers (sourced regionally; often Exeter, Otter, St Austell) Ⓗ
A friendly well-established and well-run free house with real fires in winter warming both the bar and restaurant. Three ever-changing ales are either local or regional. Good home-cooked pub food is served at reasonable prices. The beautiful large garden hosts a barbecue in summer. Regular events include music, skittle matches, quiz nights and gatherings of local interest groups. The pub closes at 5pm on Sundays in winter.
⬤❀◐Å♣🛏(22)❀🛜

Bridgwater

West India House
101 Durleigh Road, TA6 7JE (top of Durleigh Rd hill)
☎ (01278) 452533 ● westindiahouse.co.uk
Butcombe Original; Sharp's Doom Bar; 1 changing beer (sourced locally; often Cheddar Ales) Ⓗ
The current building was constructed in 1936, but there has been a pub on this site for many years, the name derived from the days when Bridgwater was a bustling port. For a quiet drink in cosy surroundings there is the lounge bar complete with open log fire. For a more vibrant atmosphere try the saloon bar which has been extended and refurbished with modern decor and has three good ales from Butcombe, Sharp's and, occasionally, Cheddar Ales. Q✿❀⬤❶♣P🚪(14)🛜

Burrowbridge

King Alfred Inn Ⓛ
Burrow Drove, TA7 0RB (on A361, 9 miles from Taunton)
☎ (01823) 698379 ● king-alfred.co.uk
Bristol Beer Factory Fortitude; Butcombe Original; Otter Amber Ⓗ
A welcoming and friendly free house on the Somerset Levels between Taunton and Glastonbury. Positioned under Burrow Mump, allegedly where King Alfred burnt the cakes, the pub is a perfect stopping-off point for walkers on the River Parrett Trail. The three cask ales rarely change but are always good quality and there are usually a couple of local real ciders. Good homemade food is served, including specialist burgers with different fillings; many dishes are cooked to order. The bus stops outside the pub, and there is a car park to the rear.
Q✿❀⬤❶♣P🚪(29)🛜

Cheddar

Cheddar Ales Tap Room
Unit 5, Winchester Farm, Draycott Road, BS27 3RP
☎ (01934) 744193 ● cheddarales.co.uk
Cheddar Ales Gorge Best, Potholer, Hardrock, Crown And Glory; 2 changing beers (often Cheddar Ales) Ⓗ
Taproom for Cheddar Ales brewery, situated just outside the world-famous village. The venue is a pleasant diversion from the tourist hotspot and serves up to six cask ales brewed on site. A takeaway service is also available. Cider, gins and wines are also served, along with wood-fired pizzas at weekends, except during the winter months. There is indoor and outdoor seating, and occasional live music events take place on Saturdays.
✿❀⬤♣P❀

Chew Magna

Bear & Swan
13 South Parade, BS40 8SL
☎ (01275) 331100 ● thebearandswan.co.uk
Butcombe Original; Fuller's London Pride; 2 changing beers (often Fuller's) Ⓗ
Situated at the heart of an historic village, this large 19th-century pub is popular with locals and visitors alike. The modern yet rustic decor gives the large space an upmarket intimate country pub feel. It is one of the few Fuller's pubs in the area, and there is usually a guest beer available in addition to the two regular ales. The quality food offerings come from an imaginative menu, and you can dine either inside or outside in a lovely rear garden.
✿❀⬤❶P🚪(67,640)❀🛜

Queens
Silver Street, BS40 8RQ
☎ (01275) 627647 ● thequeenschewmagna.co.uk
Butcombe Original; 2 changing beers (sourced locally; often Box Steam, Bristol Beer Factory) Ⓗ
Tucked away behind the parish church, this attractive and secluded pub was totally refurbished in 2021. It is popular with local residents as well as diners from further afield. The focus is on high-quality food, but drinkers are made very welcome. Butcombe Original plus two changing local cask ales are served. There is a private dining room, a large outside area to the rear, and new luxury B&B accommodation. Cribbage nights are held weekly. ✿❀✉⬤❶♣P❀🛜

Churchill

Crown Inn Ⓛ
The Batch, Skinners Lane, BS25 5PP (off A38, 400yds S of A368 junction)
☎ (01934) 852995 ● crowninnchurchill.co.uk
Bristol Beer Factory Milk Stout; Butcombe Original; Exmoor Ale; Palmers IPA; St Austell Tribute; house beer (by St Austell); 1 changing beer Ⓖ
Long-time Guide regular and winner of many CAMRA awards, the Crown is tucked away down a small lane close to the village centre. Several cosy rooms with stone-flagged floors are warmed by two log fires, and offer an assortment of seating. Excellent food is provided at lunchtimes using local ingredients. Up to eight beers, usually local, are served on gravity. Outside drinking areas are to the front and rear. Families are welcome away from the bar itself. An old, classic, unchanged pub.
Q✿❀⬤♠P🚪(A2)❀🛜

Churchinford

York Inn ✔
Honiton Road, TA3 7RF
☎ (01823) 601333 ● yorkinn.co.uk
Dartmoor Jail Ale; Otter Bitter, Amber; 1 changing beer (sourced regionally) Ⓗ
Situated in the Blackdown Hills, the York Inn is a traditional hostelry with some areas that date back to the 16th century. It has an open fireplace and oak beams, but at the same time it offers contemporary facilities and a good range of four cask ales and one real cider. The menu features good traditional home-cooked food and includes a specialist range of pies. ✿❀⬤♣P❀🛜

Clevedon

Fallen Tree Micropub Ⓛ
43 Hill Road, BS21 7PD
☎ 07934 924386
6 changing beers (sourced locally; often Cheddar Ales, Pitchfork, Twisted Oak) Ⓖ
This micropub opened in 2018 in a shopping area up a hill from the Grade I-listed Clevedon Pier. Originally owned by Twisted Oak Brewery, it is now privately owned, but still serves Twisted Oak beers. Between four and six ales, usually from local breweries such as Cheddar Ales, Pitchfork/3D and Yeovil Ales are served straight from casks in the wooden stillage behind the bar. Reasonably priced gins, prosecco, wines and soft drinks are also sold. Q✿🚪(53,X6)❀

Royal Oak ✔
35 Copse Road, BS21 7QN (behind ice cream parlour nr pier; footpath along alley leads to pub)
☎ (01275) 563879 ● theroyaloakclevedon.co.uk

Butcombe Original; Sharp's Doom Bar, Atlantic; Timothy Taylor Landlord; 1 changing beer (sourced regionally) Ⓗ

Lively, friendly, mid-terrace venue close to the seafront and connected via an alley. It has a large front window and an unexpectedly spacious interior with many rooms. This community hub is home to cribbage and cricket teams, with a quiz on Monday and acoustic music one Sunday a month. The winner of various awards, it hosts many events for the local community. Food is served lunchtimes and includes daily specials and a range of salad options. Q⑤◑♣🖳(53,X6)🐾🛜

Combe Florey

Farmers Arms ⒧

TA4 3HZ (on A358 between Bishops Lydeard and Williton)
☎ (01823) 432267 ⊕ farmersarmsatcombeflorey.co.uk
Exmoor Ale, Gold; 2 changing beers (sourced nationally) Ⓗ

A beautiful thatched 14th-century Grade II-listed pub with cob walls, a medieval chimney and fireplace and a restored staircase. The bar serves up to four cask ales and three real ciders plus some unusual keg beers, bottled brews and a large selection of gins and malt whiskies. The restaurant offers high-quality food with various special evening menus. The garden is splendid is summer and has a large pizza oven that is used for functions. Q⑤🏵◑Ġ♣🅿🐾🛜

Congresbury

Plough ⒧

High Street, BS49 5JA (off A370 at B3133 jct)
☎ (01934) 877402 ⊕ the-plough-inn.net
Cheddar Ales Potholer; Twisted Oak Fallen Tree; 3 changing beers (sourced locally; often Exmoor, St Austell, Twisted Oak) Ⓗ/Ⓖ

Characterful village inn with flagstone floors and many original features, decorated with interesting local artefacts. Four guest beers, mainly from local breweries, are served from a row of old cask heads behind the bar. Several real ciders are also stocked. The pub has a deserved reputation for the quality of its food, which is served lunchtimes and evenings, except Sunday evening, which is quiz night. The pub has real fires and a large garden. Mendip morris men meet here.
Q🏵◑Ġ♣🅿🖳(X1,X2)🐾🛜

Crewkerne

King William Inn

Barn Street, TA18 8BP (take A30 towards Chard; at fringe of town uphill Barn St is on left)
☎ (01460) 279615 ⊕ kingwilliamcrewkerne.com
3 changing beers (sourced nationally; often Bristol Beer Factory, Oakham, Quantock) Ⓗ

A short walk from the town centre towards Chard takes you to this well-hidden traditional pub. There are three changing ales and two ciders, and the array of pump clips adorning the beams is testament to the huge range of beers that have been served. There is an early-evening happy hour every Monday and Wednesday. For music lovers there is an acoustic night the last Wednesday of each month. ⑤🏵♣🅿🖳🐾

Croscombe

George Inn

Long Street, BA5 3QH (on A371 between Wells and Shepton Mallet)

☎ (01749) 342306 ⊕ thegeorgeinn.co.uk
House beer (by Blindmans); 2 changing beers (often Cheddar Ales, St Austell) Ⓗ

Attractive 17th-century inn refurbished by its owner, serving at least four guest ales from West Country independents and hosting two beer festivals a year. Blindmans King George, and George and the Dragon are exclusively brewed for the pub. Four real ciders are available, with Hecks Kingston Black and Thatchers ciders as regulars. There is a large main bar, a snug with fireplace, a family room and a separate dining room. Food is home-cooked using locally sourced ingredients in a modern theatre kitchen. There is a skittle alley/meeting room to rear and a large garden with covered terrace. Q⑤🏵🚋◑Ġ♣🅿🖳🐾🛜

Cross

New Inn

Old Coach Road, BS26 2EE (on the A38/A361 jct)
☎ (01934) 732455 ⊕ newinncross.co.uk
4 changing beers (often Bristol Beer Factory, Cheddar Ales, Moor Beer) Ⓗ

A 17th-century roadside inn on the A38, close to the historic medieval town of Axbridge. Four guest beers, often rare for the area, are usually available. The pub is popular for its extensive food menu, using quality local produce, served all day. Families and dogs are welcome. The large hillside garden with children's play facilities offers a fine view of the Mendip Hills and Somerset Levels. There is a small car park opposite.
⑤🏵◑Å♣🅿🖳(126)🐾🛜

White Hart

Old Coach Road, BS26 2EE
☎ (01934) 733108 ⊕ whitehartcross.co.uk
Bath Ales Gem; St Austell Trelawny; 2 changing beers (often Bath Ales, St Austell) Ⓗ

A 17th-century inn, reopened in 2019 after refurbishment. It is reputed to be haunted by one of Hanging Judge Jeffreys' victims. Inside there is a games bar with pool and darts, and a door leading to a lounge-style area. Beers come from the St Austell stable. The kitchen opens for lunches, with evening meals available for groups by arrangement. The nearby bus stop is a Hail and Ride halt, and there is a large car park opposite.
⑤🏵◑Å♣🅿🖳(491)🐾🛜

Crowcombe

Carew Arms ⒧

TA4 4AD (village signed off A358)
☎ (01984) 618631 ⊕ thecarewarms.co.uk
Exmoor Ale, Gold; 2 changing beers (sourced regionally; often Quantock, St Austell) Ⓗ

A 17th-century rural pub at the foot of the beautiful Quantock Hills. The large garden looking towards the Brendon Hills makes this popular with locals, walkers and dogs. The flagstoned public bar has an inglenook, and the bar/restaurant serves locally sourced food with some restaurant tables set within the old stables area. The skittle alley doubles as a function room. Up to four ales, including two changing guests, and two real ciders are served. Q⑤🏵🚋◑ĠÅ♣🅿🖳(28)🐾🛜

Culmhead

Holman Clavel Inn

TA3 7EA (¼ mile off B3170)
☎ (01823) 421070 ⊕ theholmanclavelinn.co.uk
Hanlons Yellow Hammer; Otter Bitter, Amber; 1 changing beer (sourced regionally) Ⓗ

This is a real country pub set in the Blackdown Hills Area of Outstanding Natural Beauty. There are no TVs or machines, but it offers four good ales straight from the barrel, Tricky cider, wine, food and good company. Children, dogs, walkers, cyclists and muddy boots are very welcome. Food is sourced from local farmers, suppliers and local businesses, and gluten-free diners and vegetarians are catered for. Local musicians play Irish-style sessions every first Thursday of the month. Q ☺ ⛨ ✠ ◑ ♣ ◐ P ✿

Dinnington

Dinnington Docks Inn ◎

TA17 8SX (approx 3 miles E of Ilminster off B3168)
☎ (01460) 52397 ⊕ dinningtondocks.com
Butcombe Original; Hanlons Yellow Hammer; Teignworthy Gun Dog; 1 changing beer (sourced locally; often Bristol Beer Factory, Exmoor, Fine Tuned) ⊞
A quirky gem, this traditional Somerset country pub has beautiful views from the large garden. It wears its heart on its sleeve, supporting the local community and offering a warm welcome to locals and visitors alike. The range of three permanent and one guest ales will suit all tastes, which, along with a good selection of wines and spirits and its renowned hearty meal menu makes this a must-visit pub. Q ☺ ⛨ ◑ ♣ ◐ P ✿

Drayton

Drayton Crown

Church Street, TA10 0JY (in centre of village nr church)
☎ (01458) 250712 ⊕ thedraytoncrown.co.uk
Butcombe Original; Timothy Taylor Landlord; 2 changing beers (sourced nationally; often Butcombe, Otter, Tapstone) ⊞
This pub has undergone a modern refurbishment but has retained character with its flagstone floors and beams. Food is provided from a modern kitchen and there is a skittle alley/function room. There are normally three or four ales from regional and national breweries, and a cider. Outside there is lots of seating and a lawn area. The pub has four quality en-suite B&B rooms if you want to stay. ☺ ⛨ ✠ ◑ ♣ ◐ P ☏

Dulverton

Bridge Inn ⛯

20 Bridge Street, TA22 9HJ
☎ (01398) 324130 ⊕ thebridgeinndulverton.com
Exmoor Ale; St Austell Tribute; 2 changing beers (sourced regionally; often Bath Ales, St Austell) ⊞
A warm and welcoming pub dating from 1845. As the name implies, it is close to a bridge that crosses the River Barle upstream from its confluence with the River Exe. Situated in the delightful small town of Dulverton, the pub has a cosy single-room bar with a wood-burning stove and an extended restaurant area. There is always an interesting selection of national cask ales, and bottled beers include a Belgian selection. Check the website for restricted opening hours in winter.
Q ☺ ⛨ ◑ ♣ ◐ P ◄ ✿ ☏

Dunster

Luttrell Arms Hotel

36 High Street, TA24 6SG
☎ (01643) 821555 ⊕ luttrellarms.co.uk
Exmoor Ale; Otter Amber; 2 changing beers (sourced locally; often Quantock) ⊞

The hotel with its 28 characterful bedrooms is on the site of three ancient houses dating back to 1443. The back bar with its open log fire features some of the oldest glass windows in Somerset and there is fine plasterwork on the lounge ceiling. You can dine in the à la carte restaurant or order a bar snack if you prefer. The view of Dunster Castle from the back garden is spectacular. Mini beer and cider festivals are held.
Q ☺ ⛨ ✠ ◑ ▲ ♣ ◐ ◄ (28,198) ✿ ☏

Exford

White Horse Inn

TA24 7PY (on the B3224 W of Wheddon Cross)
☎ (01643) 831229 ⊕ exmoor-whitehorse.co.uk
Exmoor Ale, Gold; 3 changing beers (sourced locally) ⊞
Set in the pretty village of Exford, within Exmoor National Park, this is an ideal base for walking, fishing and various country pursuits. The long bar features a selection of fine ales, with a choice of 200 malt whiskies in the separate whisky bar. There are 28 en-suite bedrooms and a honeymoon suite. The outside tables are set on the bank of the River Exe. The food menu ranges from fine dining to bar snacks, featuring locally sourced produce.
Q ☺ ⛨ ◑ ♣ ◐ P ✿ ☏

Faulkland

Tucker's Grave ★

BA3 5XF
☎ (01373) 834230 ⊕ tuckersgraveinn.co.uk
Butcombe Original ⑤
A gem from a bygone age, with a nationally important historic pub interior, this pub was built in the 1600s and has changed little since. It was named after Tucker, who hanged himself close by and was buried at the crossroads outside. There is no bar in the original inn; the ale and Thatchers cider are served from an alcove. Shove-ha'penny is played and there is a skittle alley. The old milking parlour was converted to a modern function room and bar in 2021. A large 50-pitch campsite is to the rear. Q ☺ ⛨ ▲ ♣ ◐ P ☏

Frome

Cornerhouse

1 Christchurch Street East, BA11 1QA
☎ (01373) 472042 ⊕ thecornerhousefrome.co.uk
Bath Ales Gem; St Austell Proper Job; Timothy Taylor Landlord; 1 changing beer ⊞
This smart pub and hotel, situated on the brow of a hill not far from Frome town centre, was originally called the Lamb and was the brewery tap for the long-closed Lamb brewery. It was acquired by the nearby Blindman's brewery in 2007 and refurbished to a very high standard and the name was changed to the Cornerhouse. The interior has a modern, light and spacious feel. On the ground floor is the bar and restaurant with local artwork on the walls. There is a function room upstairs.
Q ⛨ ◑ ♣ ◐ P ◄ ☏

Just Ales

10 Stony Street, BA11 1BU
☎ (01373) 462493 ⊕ Justalespart2.com
4 changing beers (sourced nationally; often Magpie, Slaughterhouse, Tollgate) ⊞
Frome's first micropub opened in 2018 serving up to four real ales on handpump as well as a large range of local ciders. Previously a small café in the heart of the vibrant St Catherine's district, it is simply furnished and dog friendly – the pub dog is a constant presence. Watch out

for the steep stairs down to the basic toilet in the cellar. Cash only – cards are not accepted. Opening hours may vary. Q✪🍴🍽️🚭🐕🛜

Three Swans

16-17 King Street, BA11 1BH
☎ (01373) 452009 ⊕ thethreeswans.com
Abbey Bellringer; Butcombe Original; 1 changing beer (sourced nationally) Ⓗ
A 17th-century, Grade II-listed, quirky but traditional two-bar pub in the centre of Frome. Extensively refurbished, it has an eccentric but comfortable and inviting feel. Paintings and various ornaments adorn the walls. The back door leads out to a beautiful secluded courtyard, and there is a function room upstairs. The two regular beers are supplemented by a single guest, which can be from all over the country. The Gents loos have some unusual sanitary wear. ✪🚭🐕🛜

Glastonbury

George & Pilgrims

1 High Street, BA6 9DP (nr the Market Cross)
☎ (01458) 831146
Otter Bitter; St Austell Tribute; 2 changing beers (sourced nationally; often Bristol Beer Factory, Quantock) Ⓗ
This three-storied Grade I-listed stone-built gatehouse inn boasts a panelled embattled frontage with mullion windows. Walking through the stout doorway there is a corridor leading to the rear patio and several tabled alcoves on the right. The Pilgrims Bar on the left oozes old-world charm and displays medieval artefacts. There are four well-kept real ales and a choice of ciders. You can read about the history of the inn over a pint. Q✪🛏️🚆🍴🍽️🛜

King Arthur Ⓛ

31-33 Benedict Street, BA6 9NB
☎ (01458) 830338 ⊕ thekingarthurglastonbury.com
3 changing beers (sourced locally; often Bristol Beer Factory, Parkway, St Austell) Ⓗ
Lively free house hidden away in a road just off the High Street. It concentrates on beer, a good range of ciders and music, attracting an interesting mixed clientele. Music is hosted most nights. The pub has a garden. Parking is available in the street only or in the town car parks. Bus routes are within easy walking distance. ✪🍴🐕🍽️🚭🐕🛜

Halse

New Inn

TA4 3AF
☎ (01823) 432352 ⊕ newinnhalse.com
Exmoor Ale; Quantock QPA; 1 changing beer Ⓗ
Nestling between the Quantock Hills and Exmoor National Park, the New Inn is an 18th-century former coaching inn situated in the quaint village of Halse, five miles from Taunton on the A358 at Bishops Lydeard and only 40 minutes' walk from the West Somerset Railway. Ales are from Quantock and Exmoor, with one handpump providing a changing local brew. There are B&B rooms, a quiz, folk music and themed menu evenings. Local CAMRA Pub of the Year runner-up in 2022. Q✪🛏️🍴🍽️🐕🍴🐕🛜

Hambridge

Lamb & Lion

The Green, TA10 0AT (on B3168 in village)
☎ (01460) 281774

St Austell Proper Job, Tribute; 1 changing beer (often Goff's, Quantock) Ⓗ
A splendidly refurbished 17th-century village inn, with some parts dating from the 16th century. It has Hamstone mullion windows, flagstone floors and a wealth of beams throughout. A fireplace sits at each end of the pub, which has a bar area for drinkers and a restaurant area for diners. There is an upstairs terrace with lovely views of the surrounding countryside. Unusually, there is a Port and Cheese Room for private dining. 🛏️🍴🍽️🛜🍴🐕P🛜

Hinton Blewett

Ring o' Bells

Upper Road, BS39 5AN (2 miles W of Temple Cloud from A37) ST594569
☎ (01761) 451245 ⊕ ringobellshinton.co.uk
Butcombe Original; 3 changing beers (often Butcombe, Timothy Taylor) Ⓗ
Popular pub dating from the 19th century in a fairly remote area, accessed via narrow lanes. A dining/function room with its own garden was recently added, and blends nicely with the cosy bar and snug. Quality food is served, using local produce when possible. Local sports clubs meet here and much memorabilia is on show, particularly cricket-related. Free boules is played on Tuesday evening. Cyclists, walkers, children and dogs are all most welcome. Q🍴🛏️🚆🍴🍽️🐕🍴P🐕🛜

Horton

Five Dials Inn

Goose Lane, TA19 9QQ
☎ (01460) 55359 ⊕ thefivedials.co.uk
Otter Bitter; Sharp's Doom Bar; 1 changing beer (often Otter) Ⓗ
Old coaching inn given a contemporary facelift. It serves three real ales, and traditional local ciders from Perry's and Burrow Hill, including the famous Somerset Cider Brandy. Fresh seasonal food is offered, with a daily changing specials board. The inn has six en-suite guest rooms, and was awarded four stars by Enjoy England. There is also a self-contained studio apartment with kitchen and dining facilities. Open on bank holidays. 🛏️🍴🍽️P🐕🛜

Keynsham

Old Bank

20 High Street, BS31 1DQ
☎ (0117) 904 6356
2 changing beers (often Exmoor, Palmers, Twisted Wheel) Ⓗ
This Grade II-listed building was originally a coaching inn, then a branch of Westminster Bank, before becoming a pub again. It is a free house with one large room for drinking, and a covered, heated outdoor area at the back. The landlord tries to have at least one dark, often strong, beer on at all times. There is a large TV screen for sport and the place can sometimes get lively on late weekend openings. A small car park is to the rear. 🛏️🍴🐕🚆🍴P🚭🐕🛜

Litton

Litton

BA3 4PW
☎ (01761) 241554 ⊕ thelitton.co.uk
Cheddar Ales Potholer; Quantock QPA; house beer (by Hop Union); 2 changing beers (often Cheddar Ales, Hop Union) Ⓗ

A large 15th-century village pub where the emphasis is on comfort without ruining the character of the lovely building. The old part has a country pub feel, while the restaurant area is bright and breezy. There is a riverside terrace at the rear and a large patio garden at the front with steps up to the car park. Accessible parking is at the rear of the building, from where you can get to the pub and the upmarket accommodation. ⚦⍟🛏🍴◑♿⚠♣Pˆ🐕♥🛜

Long Ashton

Angel Inn
172 Long Ashton Road, BS41 9LT
☎ (01275) 392244
Sharp's Doom Bar; St Austell Tribute; 2 changing beers (sourced nationally; often Draught Bass, Otter, Timothy Taylor) 🅗
This late 15th-century free of tie roadside inn retains a real rural charm despite being less than a mile from Bristol. The Smoke Room acts as a snug. Diners can enjoy the Parlour, with its lovely old fireplace, branched off the main bar area. The rear courtyard has traditionally been a haven for swallows in summer. Quiz night is every third Wednesday of the month, and there is occasional live music. ⚦⍟🛏🍴🚌(X2,X7)🐕♥🛜

Lower Godney

Sheppey Inn
BA5 1RZ
☎ (01458) 831594 ● thesheppey.co.uk
4 changing beers (sourced locally; often Frome, Pitchfork, Wookey Ale) 🅗
A quirky, many-roomed pub, set in the wilds of the Somerset Levels to the west of Wells. The decor includes graphic arts, taxidermy and surreal ornaments. The pub serves a good range of ever-changing real ales, plus six or more craft beers from home and overseas, and up to 12 ciders on gravity. The food is highly recommended. Outside the barn-like interior is a lovely terrace overlooking the river from which the pub takes its name, and where otters have been spotted. Closed Monday. ⚦⍟🛏🍴◑♿♣♠P🐕

Luxborough

Royal Oak Inn 🅛 ✅
TA23 0SH (2½ miles from B3224 between Wheddon Cross and Raleghs Cross)
☎ (01984) 641498 ● royaloakinnluxborough.co.uk
Exmoor Ale; 3 changing beers (sourced nationally; often Butcombe, Cheddar Ales, Quantock) 🅗
Set in the Brendon Hills, this ancient village pub has an original flagstone floor and a large inglenook fireplace in the main bar, and serves a range of four cask ales. A second bar has a pool table and a radiogram if you wish to play some vinyl. Three intimate dining areas serve meals freshly cooked using seasonal produce. The pub is popular with ramblers and shooting parties. If you wish to sit outside there is a sunny courtyard. Q⚦⍟🛏🍴♠♥P🐕

Lydford on Fosse

Cross Keys Inn 🅛
TA11 7HA (next to the A37 between Yeovil and Shepton Mallet at traffic lights in village)
☎ (01963) 240473 ● crosskeysinn.info
Bristol Beer Factory Fortitude; Church End Goat's Milk; 2 changing beers (sourced regionally; often Fine Tuned, Hanlons, Hop Back) 🅖

An 18th-century traditional pub with flagstone floors, blue lias stonework and a wealth of beams. It has an open-plan bar with two fireplaces at each end and a snug area. Up to five gravity-poured ales are available, including a house beer. This is a community pub with many events hosted including live music, a beer festival, comedy nights and charitable functions. Camping is available on-site with 29 pitches, a shower block and toilets. Q⚦⍟🛏🍴◑♣♠♥🚏(667)🐕🛜

Martock

White Hart Hotel 🅛
East Street, TA12 6JQ (centre of the village)
☎ (01935) 822005 ● whitehearthotelmartock.co.uk
Sharp's Doom Bar; 1 changing beer (sourced regionally; often Bays, Exmoor, St Austell) 🅗
This Hamstone Grade II-listed coaching inn dates from 1735 and is located in a central position in the village. It is warm and welcoming and serves great chef-cooked food, with three real ales on handpump, mainly from local breweries. Local groups such as music and film clubs use the pub as a meeting place. There is a main bar for drinks and a cosy restaurant for table service. There are 10 en-suite letting rooms including a family room. Q⚦⍟🛏🍴◑♿♣P🚏(52)🐕🛜

Merriott

King's Head
Church Street, TA16 5PR
☎ (01460) 78912 ● thekingsmerriott.com
Timothy Taylor Landlord; 2 changing beers (sourced regionally; often Fine Tuned, Hop Back, Quantock) 🅗
A traditional 17th-century inn with open-plan rooms and a mix of flagstones and wood flooring. In the flagstone area a raised wood-burning stove makes it welcoming in winter. As well as cask ales there is a selection of up to seven local ciders. The owner is a gin connoisseur, and more than 80 are available. Outside is a large beer garden with a smoking area featuring a wood-burner. The inn is dog friendly and popular with walkers. Q⚦⍟◑♣♠♥P🐕🛜

Minehead

Kildare Lodge ✅
Townend Road, TA24 5RQ
☎ (01643) 702009 ● kildarelodge.co.uk
St Austell Tribute; 3 changing beers (sourced regionally) 🅗
This cracking locals' pub is two minutes from the town centre. A Grade II-listed building in the Arts and Crafts style, it has a bar, two lounges and a dining room. There are 12 en-suite rooms including a bridal suite with four-poster bed. Two beer festivals are held every year with up to 20 ales available. The pub is in the local boules and quiz leagues. It is a great base for exploring Exmoor National Park, Dunster and the coast. Q⍟🛏🍴◑♿⚠♣♥P🚏(28,198)🐕

Queen's Head Inn 🅛
Holloway Street, TA24 5NR (just off the Parade)
☎ (01643) 702940 ● queensheadminehead.co.uk
Exmoor Gold; St Austell Tribute; house beer (by Hancocks); 6 changing beers (sourced nationally; often Otter, Sharp's) 🅗
In a side street just off the Parade, this popular town-centre pub sells up to eight ales including the house beer Queens Head which is very reasonably priced. There is an extensive food menu offering English and Thai food as well as a Wednesday and Sunday carvery. The spacious

single bar has a raised seating area for dining and families. The pub features a skittle alley and games room at the back. Live music is hosted on a Saturday. ᎒⛫❍◐♿✦♣❖🚐

Nailsea

Nailsea MicroPub

Unit 4, Ivy Court, 63A High Street, BS48 1AW
☎ 07496 428350
4 changing beers (sourced locally) Ⓖ
Nailsea's first micropub, which opened in 2019, serves up to six ales straight from the cask, along with two or three real ciders. Beers of all styles can come from around the country but are mainly sourced from local breweries. Bottles and cans of beers and ciders are sold alongside gins, wines, alcohol-free beers and soft drinks. Reasonably-priced bar snacks are also available. There is no dedicated parking but there are ample public car parks nearby. Q⛫♣❖🚐❀

Nether Stowey

George Ⓛ

1 St Mary Street, TA5 1LJ
☎ (01278) 732248 ⊕ georgestowey.com
Stowey Heather Beer; 1 changing beer (often Bays, St Austell) Ⓗ
The George is the oldest pub in the village and can trace its history back to 1616, although the original building dates back another century. It is a friendly multi-roomed pub with a real fire, dark-wood interior, Tiffany lamps and historical photographs of the village on the walls. The pub serves as an outlet for the nearby Stowey Brewery. Live music plays on occasion. A function room is available upstairs. ᎒⛫❀♣❖❀🛜

Pitney

Halfway House Ⓛ

Pitney Hill, TA10 9AB (on B3153 between Langport and Somerton)
☎ (01458) 252513 ⊕ thehalfwayhouse.co.uk
Hop Back Summer Lightning; Otter Bright; Teignworthy Reel Ale; 5 changing beers (sourced regionally; often Fine Tuned, Parkway, Quantock) Ⓖ
An outstanding hostelry serving eight to 10 regional ales on gravity alongside many bottled beers and four real ciders. The inside is traditional with flagstone flooring, old solid wooden tables and benches, and three real fires. This basic but busy pub deserves its many accolades and has been in this Guide for over 25 years, gaining the ultimate award of CAMRA National Pub of the Year in 1996. Superb home-cooked food is served, and a recent addition is accommodation provided in The Hut.
Q᎒⛫❀❍◐♿P🚐(54)❀🛜

Porlock

Castle at Porlock ✅

High Street, Exmoor National Park, TA24 8PY
☎ (01643) 862504 ⊕ thecastleporlock.co.uk
Courage Best Bitter; St Austell Tribute; 2 changing beers (often Parkway, Pitchfork) Ⓗ
A cosy and friendly family-run village pub, B&B and restaurant, ideally situated for exploring the Somerset coastline and Exmoor National Park. A good range of two permanent and two changing cask ales, plus real ciders and a large variety of spirits and gins means there is something to suit every taste. There are 12 lovely en-suite letting rooms. ᎒❀❍◐♣❖P🚐(10,EXMO)❀🛜

Ship Inn Ⓛ ✅

High Street, TA24 8QD
☎ (01643) 862507 ⊕ shipinnporlock.co.uk
Exmoor Ale, Beast; Otter Amber; St Austell Tribute, Proper Job; 2 changing beers (sourced regionally; often Quantock) Ⓗ
Known locally as the Top Ship, the bar is a gem with its flagstone floor, open fire and settle seating. It has changed little since featuring in RD Blackmore's novel Lorna Doone. The pub dates from the 13th century and sits at the bottom of the notorious Porlock Hill that takes you up to Exmoor. Eight ales and a local cider are available and good food can be enjoyed in its restaurant or delightful three-tiered garden in summer.
Q᎒⛫❀◐♿▲♣❖P🚐(10,EXMO)❀

Porlock Weir

Ship Inn Ⓛ

TA24 8PB (take the B3225 from Porlock)
☎ (01643) 863288 ⊕ shipinnporlockweir.co.uk
Exmoor Ale, Stag; St Austell Tribute, Proper Job; 2 changing beers (sourced regionally; often , Otter) Ⓗ
This 400-year-old pub is set next to the small harbour and pebbled beach and offers fantastic views of the Bristol Channel and South Wales. Situated in Exmoor National Park, and on the South West Coast Path, it is ideal for walkers and gets busy in the summer. A beer festival is held early July with up to 50 ales on offer. Dog-friendly accommodation is available, and there is parking in the Pay & Display car park opposite.
Q⛫❀◐♿▲♣❖P🚐(10)❀🛜

Portishead

Ship

310 Down Road, BS20 8JT
☎ (01275) 848400
Draught Bass; Otter Bitter; Sharp's Doom Bar Ⓗ
A large hostelry with traditional opening hours, on the coast road between Clevedon and Portishead. You can enjoy spectacular sunsets over the Severn Estuary from the award-winning garden. The landlord has been at the pub he built since 1973, and is a fount of local knowledge with a singular sense of humour. Meals are served at lunchtimes only, but you can get pasties in the evening. There is a small library of books on-site with a particularly good selection on local history.
⛫◐♣P🚐(X4)❀

Siren's Calling Ⓛ

315 Newfoundland Way, Portishead Marina, BS20 7PT
☎ (01275) 268278 ⊕ sirenscalling.co.uk
5 changing beers Ⓗ
A modern single-room waterside bar, opened in 2018, serving up to six cask ales and nine craft keg beers in a variety of styles. Some are from breweries in the Bristol area, others from further afield. Still ciders are also sold. The pub is simply furnished, with large front windows overlooking the many boats moored in the marina. Food is always available but limited to cheese platters, Scotch eggs, pork pies and sausage rolls. Regular beer festivals are held. ᎒⛫❍◐♿♣❖🚐❀🛜

Windmill Inn Ⓛ

58 Nore Road, BS20 6JZ (next to former municipal golf course above coastal path)
☎ (01275) 818483 ⊕ thewindmillinn.org
Butcombe Original; Fuller's Oliver's Island, London Pride; 1 changing beer (often Fuller's) Ⓗ
Large split-level pub with a spacious patio to the rear for drinking and dining, plus an extension enjoying

panoramic views. It is above the coastal path on the edge of town; the Severn Estuary and both Severn bridges can be seen on clear days. It started life as a windmill in the 1830s, became a pub in 1960, and was acquired by Fuller's in 2014. A varied menu is served all day with table bookings available. Dogs are allowed in the main bar area only. Q☎❀❍❸⅃♿P🚪(X4)🐕🕸

Priddy

Hunters' Lodge ★

Old Bristol Road, BA5 3AR (at isolated crossroads 1 mile from A39 close to TV mast) ST549500

☎ (01749) 672275

Butcombe Original; Cheddar Ales Potholer; 1 changing beer (often Butcombe) Ⓖ

The landlord at this classic timeless roadside inn has been in charge for 52 years. Priddy is the highest village in Somerset, and is popular with cavers and walkers. The pub's three rooms include one with a flagged floor. All beer is served direct from casks behind the bar; local cider is also on offer. Simple home-cooked food is excellent and exceptional value. A folk musicians' drop-in session is held on Tuesday evening. The garden is pleasant and secluded. Mobile phones are not welcome but dogs are. Cash payments only.
Q☎❀❍⅃♣P🚪(683)🐕

Queen Victoria Inn ✅

Pelting Drove, BA5 3BA

☎ (01749) 676385 ⊕ thequeenvicpriddy.co.uk

Butcombe Adam Henson's Rare Breed, Original Ⓗ

A creeper-clad inn, a pub since 1851, with four rooms that feature low ceilings, flagged floors and three log fires. It is a wonderfully warm and relaxing haven on cold winter nights, and is particularly popular during the Priddy Folk Festival in July. Reasonably priced home-cooked food is a speciality. There is a lovely new beer garden with six sheds named after royal palaces. Children are welcome and there is a play area by the car park. Q☎❀❍♠♣P🐕🕸

Radstock

Fromeway

Frome Road, BA3 3LG

☎ (01761) 432116 ⊕ fromeway.co.uk

Butcombe Original Ⓗ; **2 changing beers (sourced nationally; often Otter, Twisted)** Ⓗ/Ⓐ

This friendly free house has been run by the same family for six generations and is now in the capable hands of Emily, the youngest daughter of the present generation. It serves a great selection of weekly-changing ales from all over the country. The food puts an emphasis on traditional classics alongside more contemporary dishes (booking recommended). There is an award-winning garden. Regular charity events, quiz nights and walks take place from month to month. Closed Monday and Tuesday. ☎❀❍⅃♿P🚪(768,178)🐕🕸

Rickford

Plume Of Feathers

Leg Lane, BS40 7AH (off A368, 2 miles from A38; approaching from Churchill, left U-turn into Leg Lane is extremely tricky)

☎ (01761) 462682 ⊕ theplumeoffeathers.com

Bristol Beer Factory Fortitude; Sharp's Doom Bar Ⓗ; **1 changing beer (sourced locally; often Bristol Beer Factory)** Ⓖ

This 17th-century building has been a pub since the 1800s. Its interior is divided into several areas, including a restaurant with a real fire. There is a garden to the rear and a stream running along the front, leading to a ford. Guest beers are often from Bristol Beer Factory. A popular charity duck race takes place in July. The pub provides a pleasant and convenient base from which to walk, fish or explore the Mendips. Car parking is limited. Q☎❀❍⅃♠♣P🚪(791)🐕🕸

Roadwater

Valiant Soldier Ⓛ ✅

TA23 0QZ (off A39 at Washford)

☎ (01984) 640223 ⊕ thevaliantsoldier.co.uk

Dartmoor Jail Ale; 1 changing beer (sourced locally; often Exmoor) Ⓗ

This vibrant locals' pub dates back to 1720 and is ideal for country walks and exploring nearby Exmoor, the coast and Dunster. There is a quiz, pool, darts and nine skittles teams to see it through the winter months. The pub is by a small river, so you can relax and watch the ducks and, if you are lucky, also kingfishers. It has been run by the current landlord for over 30 years and offers excellent locally sourced food. ☎❀❍♠♣P🐕🕸

Saltford

Bird in Hand ✅

58 High Street, BS31 3EJ

☎ (01225) 873335 ⊕ birdinhandsaltford.co.uk

Butcombe Original; Sharp's Doom Bar; 1 changing beer (often Exmoor, Yeovil) Ⓗ

A convenient stopping-off point for cyclists on the Bristol and Bath Railway Path, this traditional 19th-century country inn is very close to the River Avon and only 400 yards from the A4. It has a long L-shaped bar and a pleasant conservatory with fine views across the garden to the hills beyond. Quality food, including tapas, is served lunchtimes, evenings, and all day at weekends, with gluten-free options. There is a pétanque piste in the garden. ☎❀❍♿♣P🚪🐕🕸

Somerton

Etsome Arms

6 West Street, TA11 7PS

☎ 07907 046213

6 changing beers (sourced locally; often Bristol Beer Factory, Fine Tuned, Parkway) Ⓖ

This micropub, among the first of its breed in Somerset and winner of local CAMRA awards, is well worth a visit. It is cosy, friendly and serves between four and six ales on gravity, depending on season and time of week, with all changing regularly. Seating is comfortable sofas or traditional tables and chairs. Quality cold bar snacks, sourced locally, include a range of scotch eggs and pies. Children and dogs are welcome. ☎❀♣♣🚪(54,77)🐕🕸

White Hart Inn

Market Place, TA11 7LX (centre of village)

☎ (01458) 272273 ⊕ whitehartsomerton.com

Cheddar Ales Potholer; 2 changing beers (sourced regionally; often Fine Tuned, Otter) Ⓗ

The White Hart has been trading as an inn in Somerton's delightful market square since the 16th century; the large model of a White Hart over the entrance porch making it hard to miss. It is much larger inside than you might first envisage and there are plenty of tables for dining or coffee and cakes. A courtyard provides alfresco eating and drinking. A winner of numerous awards and recommended in multiple reviews by the national press. ☎❀❍⅃♿♣🚪(54,77)🐕🕸

South Petherton

Brewers Arms ⃝

18-20 St James Street, TA13 5BW (½ mile off A303 in centre of village)

☎ (01460) 241887 ⊕ the-brewersarms.com

Otter Bitter; 3 changing beers (sourced nationally; often Bristol Beer Factory, Fine Tuned, Hop Back) ⃝

This pub is just half a mile from the A303 and has appeared in over 20 consecutive editions of the Guide. During this time around 3,000 different ales have been served and documented. The Brewers is the hub of village life, a true community pub that keenly supports local events and charities. Beer festivals are held over both spring and summer bank holiday weekends. Regular live music and quiz nights feature. The adjoining Old Bakehouse offers excellent food.

తⓗ⊞⊰❍Å♣⊖❑(81) ✿ ♠ ⬤

Taunton

Ring of Bells ⃝

16-17 St James Street, TA1 1JS

☎ (01823) 259480 ⊕ theringofbellstaunton.com

5 changing beers (sourced nationally; often Dark Star, Oakham, Otter) ⃝

Close to the town's cricket ground, this wooden-floored pub is a favourite haunt of cricket fans. Sporting events are shown on a TV in the bar. There are two bar areas with open fires, a downstairs dining space, upstairs restaurant and a large courtyard outside. The five cask ales are from local, regional and national breweries and you may find some interesting keg beers if that is your preference. Excellent locally produced food is served; booking is recommended. తⓗ⊰❍♦❑❀ ✿ ⬤

Wyvern Social Club ⃝

Mountfields Road, TA1 3BJ (off South Rd, approx 1 mile from town centre)

☎ (01823) 284591 ⊕ wyvernclub.co.uk

Exmoor Ale; 2 changing beers (sourced regionally; often Exmoor, St Austell) ⃝

For over 30 years this club has been a great venue at which to drink real ale, and more recently real cider. It is a members-only club with a visitors' licence; card-bearing CAMRA members can be signed in as guests. The club is the hub for the rugby, cricket and squash clubs who use the playing fields alongside. It holds an annual beer festival in October. The 99 bus route is Saturday daytime only. Local CAMRA Club of the Year 2018, 2019 and 2022. తⓗ⊰❍♦♣⊖P❑(99)⬤

Trull

Winchester Arms

Church Road, TA3 7LG

☎ (01823) 284723 ⊕ winchesterarmstrull.co.uk

4 changing beers (sourced regionally; often Otter, St Austell) ⃝

Thriving community free house on the outskirts of Taunton, near the Blackdown Hills. A comfortable bar area, usually serving a range of four cask ales, is separated from a long dining area by a fireplace. Locally sourced home-cooked food is excellent. The streamside gardens, perfect for families and dogs, are also the venue for entertainment and barbecues. A popular quiz takes place on Sunday nights and there is occasional live music. Good-value accommodation is available.

Qతⓗ⊰❍♦⊖P❑(97) ✿ ⬤

Wambrook

Cotley Inn

TA20 3EN (from A30 W out of Chard, take left fork by toll house and almost immediately left again. Following signs for the pub, continue 1 mile on lane)

☎ (01460) 62348 ⊕ cotleyinnwambrook.co.uk

Otter Bitter; 2 changing beers (sourced regionally; often Exeter, Teignworthy) ⃝

A traditional country pub that is well worth finding. Inside the main entrance is a bar area with a welcoming wood-burning stove to greet you in the winter months. To the right of the bar is a challenging skittle alley and to the left you will find dining areas where you can sample the excellent food. Ales are served from gravity racking behind the bar. The pub is in a wonderful rural setting where sitting outside is a delight. తⓗ⊰❍♣⊖P✿ ⬤

Washford

White Horse Inn ⃝

Abbey Road, TA23 0JZ (take road towards Cleeve Abbey off the A39)

☎ (01984) 640415 ⊕ exmoorpubs.co.uk

3 changing beers (sourced regionally; often Sharp's, St Austell) ⃝

Dating from 1709, this riverside free house is near the ruins of Cleeve Abbey and close to the Torre cider farm. It is an ideal base for visits to the coast, Exmoor National Park, Quantock Hills and the West Somerset Steam Railway. A good range of locally sourced food is available. Various charity events are held, including the famous bike pub run. B&B accommodation is available in the pub and in a separate lodge.

Qⓗⓣ⊰❍♦♣⊖P❑(28) ✿ ⬤

Watchet

Esplanade Club ⃝

5 The Esplanade, TA23 0AJ (opp the marina)

☎ 07876 353819 ⊕ esplanadeclub.net

House beer (by St Austell); 4 changing beers (sourced regionally; often Exmoor, Quantock, St Austell) ⃝

Built in the 1860s as a sail-making factory and now home to the National Association of Boat Owners, the club is an archive of local history and memorabilia with unique murals and even its own Tardis. There are great views over the Marina and Bristol Channel. The club is a busy music venue with live acts every weekend, open mic on the first Tuesday of the month and folk every fourth Wednesday. Local CAMRA Club of the Year 2020.

తⓗ♦Å⇌♣⊖❑(28) ✿ ⬤

Pebbles Tavern

24 Market Street, TA23 0AN (nr museum)

☎ (01984) 634737 ⊕ pebblestavern.co.uk

Timothy Taylor Boltmaker, Landlord ⃝; **1 changing beer (sourced nationally)** ⃝/⃝

Small and unique tavern that has won numerous local CAMRA awards for Cider Pub of the Year. In 2015 it was the National runner-up. As well as the ales there can be up to 30 ciders, 60 gins, 24 rums and 64 whiskies. You are welcome to bring in fish & chips from the shop next door. Poetry night is the first Tuesday of the month and regular music nights include folk, sea shanty, acoustic and jazz. తÅ⇌♣⊖⊟❑(28)✿ ⬤

Star Inn ⃝ ✓

Mill Lane, TA23 0BZ

☎ (01984) 631367 ⊕ starinnwatchet.co.uk

6 changing beers (sourced nationally; often Butcombe, Dartmoor, Exmoor) ⃝

Twice winner of local CAMRA Pub of the Year and runner-up in 2019, the Star has been in this Guide for more than 20 consecutive years. It is renowned for its friendly staff and congenial atmosphere. The pub hosts darts, quiz and boules teams and holds music nights in the summer. It also hosts port and cheese nights and is home to the Sunday night Bad Boys club. Mick's beer tours have run more than 100 trips from the pub.
ॐ঺❀◖❤♣A▬●Q▤(28) ✿ ◆

Wedmore

New Inn L

Combe Batch, BS28 4DU

☎ (01934) 712099

Butcombe Original; Timothy Taylor Landlord; 1 changing beer (sourced regionally; often Cheddar Ales, Exmoor, Fine Tuned) Ⓗ

This classic village inn is the centre for many local events including the famous annual Turnip Prize, spoof and penny chuffin'. The public bar, lounge and dining areas are complemented by a beer garden to the rear. A chalkboard lists forthcoming ales, mainly from the West Country, with two dispensed from handpumps and two on gravity. Traditional, good-value home-cooked food is served. There is a skittle alley/function room and winter skittles and darts generate a hive of activity.
Q঺❀◖&A♣●Q▤(67) ✿ ◆

Wells

Crown Inn

Town Hall Square, BA5 2RP

☎ (01749) 673457 ⊕ crownatwells.co.uk/bar

Butcombe Original; Cheddar Ales Crown & Glory; Sharp's Doom Bar; 2 changing beers (sourced nationally; often Wild Beer) Ⓗ

A hotel and bistro with a separate bar that is run as a pub, now with a recently extended range of well-kept ales. You enter the bar via the door on the left of the main entrance. The Crown is a lovely old building overlooking the main square and marketplace, with the cathedral just a few minutes' walk away. William Penn, the prominent Quaker and founder of the Commonwealth of Pennsylvania, preached to a large crowd outside the building in 1685. ঺◖◖Q▤✿◆

Full Moon

42 Southover, BA5 1UH

☎ (01749) 678291

House beer (by Fine Tuned); 3 changing beers (sourced regionally; often Cheddar Ales, Pitchfork, St Austell) Ⓗ

A friendly locals' free house just outside the city centre. The interior comprises a public bar with sports TV and jukebox, and a quieter lounge area, which is divided between the bar, a snug-like area and a section used for dining. Out back is the city's largest pub courtyard, with a beer garden beyond. Thatchers Traditional cider is served. Families and dogs are welcome. ❀A♣●Q▤✿◆

West Chinnock

Muddled Man L ◉

Lower Street, TA18 7PT

☎ (01935) 881235 ⊕ themuddledmaninn.co.uk

3 changing beers (often Bays, Hopback, Otter) Ⓗ

A popular traditional free house in a picturesque village. The large beer garden has exceptional flower boxes, troughs and baskets which are a sight to be seen. A warm welcome is extended to visitors and locals alike. Home-cooked food is served by the family team, with a

variety of steaks the speciality, and a Sunday lunch so popular it must be pre-booked. There is always a good range of three well-kept ales and a real cider.
Q঺❀◖◖&♣❀✿◆

West Huntspill

Crossways Inn �troph L

Withy Road, TA9 3RA (on A38)

☎ (01278) 783756 ⊕ thecrosswaysinn.com

Dartmoor Jail Ale; Pitchfork Pitchfork; 6 changing beers (sourced nationally; often Arbor, Bristol Beer Factory, Quantock) Ⓗ

A fabulous, characterful 17th-century inn that was the well-deserved winner of local CAMRA Pub of the Year in 2022 and for the previous seven years. It has several charming bar areas and a dining room, with two log fires during winter, plus an outside fireplace for smokers. There is a wide selection of drinks for all tastes, with eight cask, three keg and 20 craft canned ales, plus a selection of real ciders. A beer festival is held in July. Good pub food is available, mainly at lunchtimes.
঺❀◖◖&A●Q▤(21) ✿◆

Weston-super-Mare

Black Cat L

135 High Street, BS23 1HN

☎ (01934) 620153

5 changing beers Ⓖ

A micropub that opened in 2018 in a former clothes shop at the Playhouse Theatre end of the High Street. Up to five cask ales of varying styles and strengths are served, chosen from local breweries, with a few from further afield, plus at least one real cider and several craft keg beers. Dogs are welcome, as are children until later in the evening. Look out for the impressive black cat mural.
Q঺♣●▤▤✿◆

Brit Bar L ◉

118 High Street, BS23 1HP

☎ (01934) 632629

5 changing beers Ⓗ

Formerly the Britannia, this long-standing town-centre pub was bought by the current owners at auction after a period of closure and has now been given a bright, modern makeover while retaining the important traditional elements. Five changing beers are served, always including some dark brews. Bag-in-box real cider is usually sold too. Live music features at weekends and families are welcome all hours in the covered courtyard, which is heated in cold weather. ঺❀≷●Q▤✿◆

Cabot Court Hotel ◉

Knightstone Road, BS23 2AH (on seafront, 300yds north of main pier)

☎ (01934) 427930

Greene King Abbot; Ruddles Best Bitter; Sharp's Doom Bar; 5 changing beers Ⓗ

Large Wetherspoon conversion on the seafront between the Grand Pier and Winter Gardens. It is set across four levels, each with a distinctive style. There are bars on the ground and second floors, with different guest ales in each. The first-floor room is particularly comfortable with sofas and a real fire in winter – a haven from the TVs and speakers in the other rooms. Local breweries are supported, with Exmoor and GWB often featured. There are 21 letting rooms. ঺❀◖◖●▤✿◆

Criterion ◉

45 Upper Church Road, BS23 2DY

☎ 07983 851707

Courage Directors ⊞**; St Austell Tribute; 3 changing beers (often Bath Ales)** Ⓖ
Genuine free house and traditional community pub, just off the seafront in the Knightstone area. Believed to be one of the oldest pubs in town, it has interesting local photos on the walls. Pub games feature strongly, with darts, table skittles and a cribbage team. Bar snacks are available, and filled rolls at lunchtime. Between three and five guest ales are sold, with all beer styles and local breweries well supported. The pub is big on rugby and dogs. ♿♣☒(1,4)🌸

Duke of Oxford Ⓛ
27 Oxford Street, BS23 1TF
☎ (01934) 417762 ⊕ dukeofoxford.co.uk
Exmoor Gold; 3 changing beers (sourced locally; often Quantock, Twisted Oak) ⊞
Reopened in 2016 after a long period of closure, this pub is just outside the main shopping area and near the seafront. It was refurbished as a café-style bar with accommodation, and has a grand piano; jazz music sometimes features. The beers are usually from local breweries and there is real cider. A small outdoor space is accessible via stairs. Note that the pub may close early during the off-season. ☒🌸🍴⏴◗♿⬛≩♣●☒🌸☲

Fork n' Ale Taproom & Kitchen
18 Walliscote Road, BS23 1UG
☎ (01934) 627937 ⊕ forknale.com
6 changing beers (sourced locally; often 3D Beers, Pitchfork) ⊞
Opened in 2019, this pub is conveniently located in the town centre near the seafront and railway station. It has a modern look and feel, with an interior of wood, metal and brick, as well as a few comfy sofas. There is a big focus on beer, with between four and six on at any one time, usually from Pitchfork and 3D. Food is a range of small plates of modern food. The toilets are upstairs. ⏴◗≩☒🌸☲

Regency
22-24 Lower Church Road, BS23 2AG
☎ (01934) 633406
Bath Ales Prophecy; Butcombe Original; St Austell Tribute, Proper Job; Timothy Taylor Landlord; 1 changing beer (sourced nationally; often Dark Star) ⊞
Comfortable, friendly town-centre local serving a good range of regular beers plus one guest. It has pool, skittles and crib teams, and also offers a quiet refuge for conversation. There is a games room to the left as you enter, with TV and jukebox separate from the main bar area; children are welcome here. Outside are front and rear patios. Live music often features on Sunday afternoons. Filled rolls are available all day. ☒🌸❀♿☒(4,5)🌸

Williton

Masons Arms Ⓛ
2 North Road, TA4 4SN
☎ (01984) 639200 ⊕ themasonsarms.com
Dartmoor Best; Exmoor Gold; 1 changing beer (sourced regionally; often Dartmoor) ⊞
This beautiful thatched 16th-century inn has oak beams throughout and offers five en-suite rooms in the adjoining annexe. The pub hosts quiz teams in the local league. It has a pleasant beer garden where locals and visitors alike sit and relax, and has a great reputation for its food and for serving three quality cask ales. Rich's cider is always available. Close to the Quantock Hills and West Somerset Railway it is a short drive to Exmoor National Park. Q☒🌸🍴⏴◗♿⬛♣●☒(28)🌸☲

Wincanton

Nog Inn
South Street, BA9 9DL
☎ (01963) 32998 ⊕ thenoginn.com
Otter Amber; Sharp's Sea Fury; 2 changing beers (sourced regionally; often Cotleigh, Otter) ⊞
This attractive listed pub has a striking Georgian façade which fronts a long, narrow building with parts dating back to the 16th century. A secluded sunny garden with covered seating can be found at the far end of the property. The guest ales are often seasonal and an extensive range of continental beers is always available. A menu of home-cooked pub classics uses locally sourced and seasonal ingredients where possible. ☒🌸❀🍴⏴♣☒(58,667)🌸☲

Witham Friary

Seymour Arms ★
BA11 5HF
☎ (01749) 684280
Cheddar Ales Potholer ⊞
A hidden rural gem, this pub has seemingly changed little over the last 50 or so years (apart from new loos). Built in the 1860s as a hotel to serve the nearby Mid-Somerset GWR branch railway station, it was part of the Duke of Somerset's estate. The station was closed during the Beeching cuts of the 1960s, after which the hotel became a quiet country pub. Cider and one locally sourced beer are served from a glass-panelled hatch in the central hallway. Q☒🌸❀♣●☒🌸

Yatton

Butchers Arms Ⓛ
31 High Street, BS49 4JD
☎ (01934) 838754 ⊕ thebutchersarms.info
St Austell Tribute; Sharp's Doom Bar; Twisted Oak Fallen Tree ⊞**/**Ⓖ**; 1 changing beer (sourced locally; often Twisted Oak)** ⊞
On the main road through the village, this free-of-tie pub occupies a 14th-century building that retains many original features, including a feature bay window. Mind your head as you go in – there are low ceilings throughout. Steps lead up to a rear restaurant area and toilets, with a beer garden beyond. The changing beers are often from Twisted Oak in Wrington but may include offerings from other local breweries. Wheelchair users can access the garden and the bar via portable ramps. ☒🌸⏴◗⬛♣☒(54,X2)🌸☲

Yeovil

Quicksilver Mail ✓
168 Hendford Hill, BA20 2RG (at jct of A30 and A37)
☎ (01935) 424721 ⊕ quicksilvermail.com
Butcombe Original; 2 changing beers (sourced nationally; often St Austell, Timothy Taylor) ⊞
A roadside inn with a unique name commemorating a high-speed mail coach. It has been run by the same landlord since 2002 and has been almost ever-present in this Guide. There is a large single bar plus a separate dining area serving excellent food and a well-priced range of wines. The pub is a well-known live music destination and also holds comedy, bingo and quiz nights in the bar or function room. ☒🌸❀⏴◗⬛♣●☒(6,96)🌸☲

Breweries

Abbey SIBA

Abbey Brewery, Camden Row, Bath, BA1 5LB
☎ (01225) 444437 ⊕ abbeyales.co.uk

Founded in 1997 Abbey Ales was the first brewery in Bath for more than 50 years. It supplies more than 80 regular outlets within a 20-mile radius and its beers are more widely available in the South West via wholesalers. Four pubs are operated in Bath. ♦

Bath Best (ABV 4%) BITTER
Bath Pale Ale (ABV 4.2%) PALE
Bellringer (ABV 4.2%) BITTER
Refreshing and clean tasting with balanced flavours of pale fruit, English hops and biscuity malt before a bittersweet dry aftertaste.

Apex (NEW)

Denham Cottage, 2 Queen's Court, Corton Denham, Somerset, DT9 4LR ☎ 07817 806730 ⊕ apex.beer

Apex Beer is a nanobrewery based near Sherborne. Its mission is to brew beer to the highest standards using the latest technology. All beers are unfined, meaning they are slightly cloudy. Expansion is planned to supply direct to the public as well as to the trade. V

Ryecing Line (ABV 4.2%) RED
Camber Ale (ABV 5%) GOLD
Eau Rouge (ABV 5%) PALE
Full Chat (ABV 5%) BITTER
Lights Out (ABV 5%) IPA
Pit Stop (ABV 5%) PALE
Portier (ABV 5%) PORTER
Stirling IPA (ABV 5%) IPA

Bason Bridge SIBA

Unit 2, 129 Church Road, Bason Bridge, Highbridge, Somerset, TA9 4RG ☎ 07983 839274
⊕ bbbrewery.co.uk

⊗ Brewery founded in Somerset in 2018. Initially, two beers were brewed, but after the successful launch, a third is now available. All beer is brewed on the 12-barrel plant.

Harding's Pale Ale (ABV 3.9%) PALE
Harding's Best Bitter (ABV 4%) BITTER
Harding's IPA (ABV 4.8%) PALE

Bath Brewhouse

▤ City Pub Company, 14 James Street West, Bath, BA1 2BX
☎ (01225) 805609

Office: City Pub Group Plc. Essel House, 2nd Floor, 29 Foley Street, London, W1W 7TH
⊕ thebathbrewhouse.com

⊗ Previously known as the James Street Brewery, Bath Brewhouse opened in 2013. It is owned by the City Pub Company, which owns several other pubs and brewpubs around the country. The compact brewery is on the ground floor, with the fermenting vessels and conditioning tanks on the first floor. The on-site brewer produces a wide range of beers. The company's other pub, the Cork, Bath, is also supplied. ‼ ▰ ♦

Black Bear

▤ c/o Bear Inn, 8-10 North Street, Wiveliscombe, Somerset, TA4 2JY
☎ (01984) 623537 ⊕ blackbearbrewery.co.uk

⊗ Established in 2013, Black Bear is situated at the Bear Inn, Wiveliscombe, where Head Brewer Jon Coward and Assistant Brewer Peter Saxby create Black Bear Bitter and Goldihops, and a selection of seasonal offerings for the small estate of four pubs. ♦ ✦

Blindmans SIBA

Talbot Farm, Leighton, Frome, Somerset, BA11 4PN
☎ (01749) 880038 ⊕ blindmansbrewery.co.uk

Established in 2002 in a converted milking parlour and purchased by its current owners in 2004, this five-barrel brewery has its own water spring. In addition to its core range of ales, which are available locally and nationally, the brewery produces bespoke branded beers for pubs and other customers. ♦

Buff Amber (ABV 3.6%) BITTER
Funny Farm (ABV 4%) PALE
Golden Spring (ABV 4%) GOLD
Mine Beer (ABV 4.2%) BITTER
Icarus (ABV 4.5%) BITTER

Butcombe SIBA

Cox's Green, Wrington, Somerset, BS40 5PA
☎ (01934) 863963 ⊕ butcombe.com

⊗ Originally established in 1978, Butcombe moved to a purpose-built brewery with a 150-barrel plant in 2005. The brewery was bought by the Jersey-based Liberation Group for a reported £15m in 2015. Around 500 outlets are supplied direct and similar numbers via wholesalers and pub companies. Butcombe opened a new distribution centre with a bottling line in Bridgewater in 2018. The brewery has an estate of around 20 managed and 20 tenanted pubs. ‼ ▰ ♦

Adam Henson's Rare Breed (ABV 3.8%) GOLD
Subtle aroma of unripe fruit with sulphurous hints. Malty flavour is masked by dry bitterness which continues into the finish.
Original (ABV 4%) BITTER
A brown bitter with little aroma. Sweet and malty taste with faint fruit notes. The hop gradually asserts itself leaving a slightly bitter finish.
Gold (ABV 4.4%) GOLD
Amber golden ale with light aroma of fruit and hops, leading to well-balanced flavours of malt, pale fruit and hops. Bitter aftertaste.

Cheddar SIBA

Winchester Farm, Draycott Road, Cheddar, Somerset, BS27 3RP
☎ (01934) 744193 ⊕ cheddarales.co.uk

⊗ Established in 2006 in the heart of the Mendips, Cheddar Ales has expanded capacity to enable it to brew up to 100 barrels a week. Production is split approximately 75% cask-conditioned ale, 25% bottle-conditioned. Its bottling plant produces around 120,000 bottles annually and all bottled ales are gluten-free. Around 450 outlets are supplied including pubs, clubs and the off trade. A visitor centre and brewery tap opened in 2020. ‼ ▰ ♦ LIVE GF ✦

Bitter Bully (ABV 3.8%) BLOND
Light session bitter with flowery hops on the nose and a dry, bitter finish.
Gorge Best (ABV 4%) BITTER

Malty bitter with caramel and fruit notes followed by a short, bittersweet aftertaste.

Piney Sleight (ABV 4%) GOLD

Potholer (ABV 4.3%) GOLD
Refreshing flavours combine soft fruit sweetness with hop bitterness on a light malt background before a clean, balanced finish.

Hardrock (ABV 4.4%) GOLD
Fruity hop aroma, balanced flavours of tropical fruit and bitterness on a pale malt background before a clean, bitter ending.

Totty Pot (ABV 4.5%) PORTER
Roasted malts dominate this smooth, well-flavoured porter. Hints of coffee and rich fruits follow with a well-balanced bitterness.

Crown And Glory (ABV 4.6%) BITTER
Lightly-hopped aroma, background malt balanced with fruity hops in the crisp, bittersweet flavour before a dry and bitter finish.

Goat's Leap (ABV 5.5%) IPA
Light malt aroma with enticing toffee and red liquorice hints. Traditional hop flavours and fruity sweetness, clean, bitter finish.

Clevedon SIBA

Unit 1, Tweed Road Trading Estate, Clevedon, Somerset, BS21 6RR ☎ 07907 583415
✉ cheers@clevedonbrewery.co.uk

A small brewery founded in 2016. Ownership changed in 2019. It is regarded as a local brewery by owners and patrons alike. Following a complete rebranding, most of the beers, including seasonal ones, are now named with a twist to the locality. It focuses on using British malts and hops for its core beers. !! ▬ ◆ ✦

Gold (ABV 3.8%) GOLD

BS21 (ABV 4.1%) BITTER

Best (ABV 4.4%) BITTER

Percy's Porter (ABV 4.4%) PORTER
Roasted malt with coffee and chocolate balanced with blackberry and liquorice notes on the palate before a short, dry finish.

IPA (ABV 5%) PALE

Blonde (ABV 5.2%) BLOND

Electric Bear SIBA

Unit 12, Maltings Trading Estate, Locksbrook Road, Bath, BA1 3JL
☎ (01225) 424088 ⊕ electricbearbrewing.com

Electric Bear began brewing in 2015 using a purpose-built, 18-barrel plant, expanding capacity in 2016, 2018, and 2020. Its brewery tap showcases a selection of the range, including exclusive one-offs. A wide range of beer is available in cans and kegs and all are unfiltered, unfined and unpasteurised. It also offers a single ever-changing cask-conditioned beer. !! ▬ ◆ LIVE V ✦

Werrrd! (ABV 4.2%) BLOND
Hazy, straw-coloured ale, hoppy citrus aroma, grapefruit lemon and pineapple flavours with slight peppery spice, increasingly dry, bitter aftertaste.

Epic SIBA

The Brewery, West Hewish, Weston-Super-Mare, Somerset, BS24 6RR
☎ (01934) 384044 ⊕ pitchforkales.com & 3D-beer.com

⊠ Epic Beers was formed in 2017 on the site of the former RCH brewery, with several original staff. Epic trade under two distinct brands. Pitchfork beers are cask-conditioned and made with 100% British ingredients. Many specials add to the regular brews. 3D Beers produce monthly specials using international hops (mostly cask but some keg). It opened its first pub in Weston-Super-Mare in 2019. In 2020 it set up its 'Beer Drive Thru' and national delivery service. Canned beers have been introduced. !! ▬ ◆ LIVE

Brewed under the 3D Beers brand name:

3D Sheridans (ABV 5%) STOUT

Brewed under the Pitchfork Brewery brand name:

Goldbine (ABV 3.8%) GOLD
Hoppy aroma leads into dry and bitter hop flavours with some added earthy spice, before a notably bitter ending.

PG Steam (ABV 3.9%) BITTER
Light malt and faint hop aroma. Pale fruit combines with dry bitterness in the flavour, before a lasting dry aftertaste.

Pitchfork (ABV 4.3%) BITTER
Pale gold, some hops on the nose, flavours combine light malt with citric hop bitterness, lingering dry and bitter aftertaste.

Old Slug Porter (ABV 4.5%) PORTER
Smoky, full-bodied porter with roasted malt and dark fruits on the palate and a short dry bitter finish.

East Street Cream (ABV 5%) BITTER
Balanced beer with aroma and flavours of malt, English hops and soft fruit, leaving a bittersweet aftertaste.

Exmoor SIBA

Golden Hill Brewery, Old Brewery Road, Wiveliscombe, Somerset, TA4 2PW
☎ (01984) 623798 ⊕ exmoorales.co.uk

Somerset's largest independent brewery was founded in 1980 in the old Hancock's brewery, which closed in 1959. In 2015 it moved to new, larger premises within 100 yards of the original site, doubling capacity. More than 400 outlets in the South West are supplied, plus others nationwide via wholesalers and pub chains. In 2017 it developed a sub-brand, Exile Ales, to represent a new, modern breed of beers. ◆

Ale (ABV 3.8%) BITTER
Mid-brown, medium-bodied session bitter. Mixture of malt and hops in the aroma and taste lead to a hoppy, bitter aftertaste.

Fox (ABV 4.2%) BITTER

Gold (ABV 4.5%) BITTER
Golden best bitter with balance of malt and fruity hop on the nose and palate with sweetness following. Bitter finish.

Stag (ABV 4.8%) BITTER
A pale brown beer, with a malty taste and aroma, and a bitter finish.

Beast (ABV 6.6%) STRONG

Fine Tuned SIBA

Unit 16, Wessex Park, Bancombe Trading Estate, Bancombe Road, Somerton, Somerset, TA11 6SB
☎ (01458) 897273 ☎ 07872 139945
⊕ finetunedbrewery.com

Established in Langport, Somerset in 2016, but relocated to its current site in 2017. ◆ LIVE

Pitch Perfect (ABV 3.8%) BITTER

Langport Bitter (ABV 4%) BITTER

Sunshine Reggae (ABV 4.2%) PALE

Free Style (ABV 4.5%) GOLD

Twist and Stout (ABV 4.5%) STOUT

Hop Culture (ABV 5%) GOLD

Frome SIBA

Unit L13, Marshall Way, Commerce Park, Frome, Somerset, BA11 2FB
☎ (01373) 467766 ⊕ fromebrewingcompany.com

⊗ Formerly Milk Street Brewery, the business changed its name in 2018. The brewery was established in 1999 behind the Griffin, Frome, before moving to an industrial unit on the edge of town in 2016, and increasing its capabilities to 60 barrels. Beer is supplied direct to local outlets and wholesalers are used to distribute further afield. !!♦

Funky Monkey (ABV 4%) BITTER
Ra (ABV 4.1%) GOLD
The Usual (ABV 4.4%) BITTER
Zig-Zag Stout (ABV 4.5%) STOUT
Gulp IPA (ABV 4.8%) BITTER
Beer (ABV 5%) BLOND
Galaxy Australian Pale Ale (ABV 5.2%) PALE

Gert Lush

Hurn Farm Buildings, Ashmore Drove, Wells, Somerset, BA5 1NS ☎ 07476 662948
⊕ gertlushbeer.co.uk

Gert Lush is a craft brewery situated near Wells on the Somerset Levels. All beers are brewed using organic malt, hops, carefully-cultured yeasts and spring water and are suitable for vegans. Most are also gluten-free. No real ale. GF V

Glastonbury

Park Corner Farm, Glastonbury, Somerset, BA6 8JY
☎ (01458) 830750 ⊕ glastonburyales.com

Established in 2002 as Glastonbury Ales on a five-barrel plant, it changed ownership and moved to Somerton, increasing capacity to a 20-barrel plant. Cider is also produced. In 2019 it relocated to Glastonbury. !!♦LIVE

Nuttycombe (NEW)

Ford Road, Wiveliscombe, Somerset, TA4 2RE
☎ (01823) 802400 ⊕ nuttycombebrewery.co.uk

Cotleigh Brewery announced that they were closing in 2021. However, a well-respected and long-established local publican, Ross Nuttycombe, purchased the brewery and production recommenced in 2022.

Just One More! (ABV 4%) BITTER
Doonicans (ABV 4.2%) PALE
Sovereign (ABV 4.3%) PALE
Supreme (ABV 4.6%) PALE

Parkway

Unit 11, Wessex Park, Somerton Business Park, Somerton, TA11 6SB
☎ (01458) 897240 ⊕ parkwaybrewing.co.uk

Parkway began its journey into brewing in 2018, having purchased the former Glastonbury Ales plant and equipment. Although located in the small market town of Somerton, Parkway is named after a road in North London's Camden Town. The brewery also contract brew under license. LIVE

Giggle & Titter (ABV 3.8%) BITTER
Cheeky Monkey (ABV 4%) BLOND
Norwegian Blue (ABV 4.2%) BITTER

Contract brewed for Glastonbury Brewery:
Mystery Tor (ABV 3.8%) BITTER

Golden bitter with floral hop and fruit on the nose and palate, sweetness giving way to bitter hop finish. Full-bodied.
Lady of the Lake (ABV 4.2%) BITTER
Full-bodied amber best bitter with hops balanced by fruity malt flavour and a hint of vanilla. Clean, bitter hop aftertaste.
Love Monkey (ABV 4.2%) GOLD
Black As Yer 'At (ABV 4.3%) STOUT
Hedge Monkey (ABV 4.6%) BITTER
Golden Chalice (ABV 4.8%) GOLD
Thriller Cappuccino Porter (ABV 5%) SPECIALITY

Pinkers (NEW)

148 Quantock Road, Weston-Super-Mare, Somerset, BS23 4DP ⊕ pinkerscraftbrewery.co.uk

Small-batch microbrewery brewing all grain craft beers using fresh ingredients from British suppliers. LIVE

Portishead

▤ **Unit 3, The Precinct, Portishead, BS20 6AH**
☎ 07526 636167 ⊕ portisheadbrewing.com

Brewing started in 2018 before relocating the next year into its permanent home in Portishead centre. In 2020, it expanded into the adjacent unit. It started supplying local businesses in 2022. Around twelve beers are regularly brewed, ranging from lagers to stouts, available as keg-conditioned and bottle-conditioned, in the brewpub and for online sales. Brewing equipment is visible from the brewpub. Guest beers and food available. ⭆♦LIVE

Quantock SIBA

Westridge Way, Broadgauge Business Park, Bishops Lydeard, Somerset, TA4 3RU
☎ (01823) 433812 ⊕ quantockbrewery.co.uk

⊗ Quantock is a family-run brewery that started trading in Wellington in 2007 on an eight-barrel plant. It has since expanded and moved to its current location in 2015. The brewery supplies beer to outlets throughout the South West, and further afield via wholesalers. The brewery taproom and shop are open five days and three evenings a week, with the taproom regularly playing host to live bands and comedy nights. An annual beer festival is held in July. ⭆♦◆

QPA (ABV 4%) PALE
Wills Neck (ABV 4.3%) GOLD
Stout (ABV 4.5%) STOUT
Plastered Pheasant (ABV 4.8%) PORTER
Titanium (ABV 5.1%) PALE

Ralph's Ruin

▤ **c/o Royal Oak, Lower Bristol Road, Bath, BA2 3BW**
☎ (01225) 481409 ⊕ ralphsruin.co.uk

Brewing commenced in 2017 using a two-barrel plant in the old kitchen of the Royal Oak. Beer is only available in the pub.

Stowey

Old Cider House, 25 Castle Street, Nether Stowey, Somerset, TA5 1LN
☎ (01278) 732228 ⊕ stoweybrewery.co.uk

Somerset's smallest brewery was established in 2006, primarily to supply the owners' guesthouse and to provide beer to participants at events run from the accommodation. The small quantities of beer produced are also supplied to the George, Nether Stowey. !!♦

Tapstone

11 Bartlett Park, Millfield, Chard, Somerset, TA20 2BB
☎ (01460) 929156 ⊕ tapstone.co.uk

⊠ Founded in 2015, the brewery was custom built around a brewing process that preserves delicate hop oils – making beers with a saturated hop flavour. It is growing its own hops two miles from the brewery. There is a small, on-site taproom. All beers are unfined and hazy. ‼🍺◆

Sea Monster (ABV 4.2%) PALE
Soma (ABV 4.6%) GOLD
Hop Wire (ABV 4.8%) GOLD
Kush Kingdom (ABV 5%) GOLD

Twisted Oak SIBA

Yeowood Farm, Iwood Lane, Wrington, Somerset, BS40 5NU
☎ (01934) 310515 ⊕ twistedoakbrewery.co.uk

⊠ Twisted Oak began brewing in 2012 using a five-barrel plant, crafting small batches of unique ales. It is situated in a former agricultural building on a working farm in the North Somerset countryside. Beer is available in several local outlets. ◆LIVE

Fallen Tree (ABV 3.8%) BITTER
Superb bittersweet session bitter. Aroma and flavour of hops and ripe fruit. Complex and satisfying bitter, astringent finish.

Crack Gold (ABV 4%) BITTER
Balanced, golden-coloured ale. Hints of honey on the nose, flavours of malt biscuit and hops, a short, hoppy ending.

Crack Hops (ABV 4.2%) PALE
Hops on the nose, pale malt with fruity orange and grapefruit hints on the palate leaving a balanced bittersweet aftertaste.

Old Barn (ABV 4.5%) RED
Fruity red ale. Well-balanced flavour with a very long, bitter finish.

Spun Gold (ABV 4.5%) GOLD
Classic golden ale with a soft mouthfeel. Spicy notes to the fruity malt aroma and flavour. Hops in the aroma develop into a bitter finish.

Leveret (ABV 4.6%) BITTER
Amber best bitter with light citrus aroma. Initial pale malt flavours combine with hoppy bitterness that lingers in the aftertaste.

Solstice (ABV 4.7%) BITTER
Nicely-balanced ale with English hop bitterness and impressions of dark fruit overlaid on a rich and smooth, malty background.

Sheriff Fatman (ABV 5%) GOLD
Amber-coloured ale with hops dominant on both the nose and the slightly citrus palate, also in the bitter finish.

Slippery Slope (ABV 5.3%) PORTER

Aromas of roast malt and coffee, flavours of black toffee and hints of dark fruits, rather dry and moreish ending.

Verse

🍴 1a Piccadilly Place, London Road, Bath, BA1 6PL

Verse Brewing began production in 2021 and is based in the Chapter One pub. 🍺

Wild Beer SIBA

Lower Westcombe Farm, Evercreech, Somerset, BA4 6ER
☎ (01749) 838742

Lovington: The Old Cheese Dairy, Hornblotton, Lovington, Castle Cary, Somerset, BA7 7PS ☎ (01963) 240551 ⊕ wildbeerco.com

Brewing began in 2012 using a 24-hectolitre plant (15 barrels). Set on a Somerset farm, it shares premises with Westcombe Dairy in an adjacent building. A wide range of beers are produced, including sour beers, using alternative fermentation methods, unorthodox yeasts, alongside barrel-ageing and a blending program. It also forages seasonal, wild ingredients. Wild Beer purchased the former Cottage Brewing site and all brewing equipment. ◆LIVE

Bibble (ABV 4.2%) PALE

Windy

🍴 Volunteer Inn, New Road, Seavington St Michael, Somerset, TA19 0QE
☎ (01460) 240126 ⊕ thevolly.co.uk

The brewery was established at the Volunteer Inn in 2011 using a four-barrel plant. The name stems from the time when alterations were carried out to the back of the pub and the workmen suffered extremes of varying weather conditions. All beers are named with a weather theme. ‼◆

Yonder

The Workshop, Rookery Farm, Binegar, Radstock, Somerset, BA3 4UL
☎ (01749) 681378 ⊕ brewyonder.co.uk

A farmhouse-style brewery founded by Stuart Winstone and Jasper Tupman, formally of Wild Beer fame, in 2018. Yonder focuses on wild yeasts, foraged ingredients and barrel-aging. All ingredients are sourced locally, within about 40 minutes of the brewery. ◆

The discreet barman

Over the mahogany, jar followed jorum, gargle, tincture and medium, tailor, scoop, snifter and ball of malt, in a breathless pint-to-pint. Discreet barman, Mr Sugrue thought, turning outside the door and walking in the direction of Stephen's Green. Never give anything away – part of the training. Is Mr so-and-so there, I'll go and see, strict instructions never to say yes in case it might be the wife. Curious now the way the tinge of wickedness hung around the pub, a relic of course of Victorianism, nothing to worry about as long as a man kept himself in hand.

Jack White, The Devil You Know

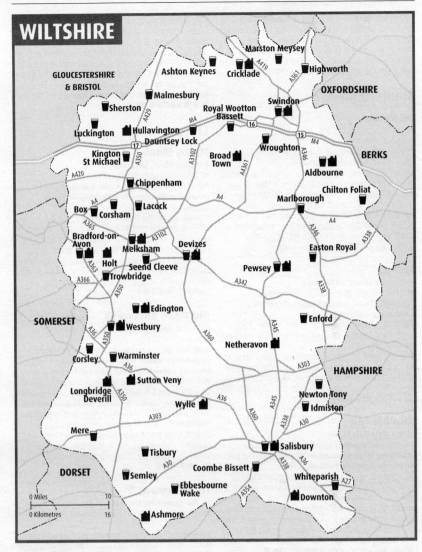

WILTSHIRE

Marston Meysey
Ashton Keynes
Cricklade
Highworth
GLOUCESTERSHIRE & BRISTOL
A419
A361
OXFORDSHIRE
Malmesbury
Swindon
Sherston
Royal Wootton Bassett
A429
Luckington
Hullavington
M4
Dauntsey Lock
16
15
M4
BERKS
Kington St Michael
A350
A3102
Broad Town
Wroughton
A346
A361
Aldbourne
Chilton Foliat
A420
Chippenham
A4
Marlborough
Box
A4
Corsham
Lacock
A4
A365
A3102
Bradford-on-Avon
Melksham
Devizes
Easton Royal
A338
A363
Holt
A346
Seend Cleeve
Pewsey
A366
Trowbridge
A350
A342
A338
Edington
Enford
SOMERSET
A36
A350
Westbury
A345
A360
Corsley
Warminster
Netheravon
A36
A303
HAMPSHIRE
Sutton Veny
A345
A338
A36
Longbridge Deverill
A350
Wylie
Newton Tony
Idmiston
A303
A360
A338
A30
Mere
Salisbury
Tisbury
A338
A36
Coombe Bissett
DORSET
Semley
A30
Whiteparish
A27
Ebbesbourne Wake
A354
Downton
Ashmore

0 Miles 10
0 Kilometres 16

Aldbourne

Crown ✓
The Square, SN8 2DU
☎ (01672) 540214 ⊕ thecrownaldbourne.co.uk
Ramsbury Gold; Sharp's Doom Bar; Timothy Taylor Landlord; 1 changing beer (sourced nationally) Ⓗ
The Crown, thought to have been a coaching inn, is set opposite the duck pond, with a Dalek standing guard outside. At the heart of the local community, it has a relaxed and pleasant atmosphere, with two bars and a welcoming fire in winter. The smaller bar shows films on Monday night. There is a Sunday carvery, a meat draw on Saturday afternoon and a regular quiz night. An ideal base for walkers, the ancient Ridgeway is nearby. Accommodation is in four en-suite rooms.
❀⇔❶Å♣🚍(46,48) ✿ ☞

Ashton Keynes

White Hart Ⓛ ✓
High Road, SN6 6NX

☎ (01285) 861247 ⊕ thewhitehartashtonkeynes.com
Ramsbury Gold; St Austell Tribute; 2 changing beers (sourced nationally; often Box Steam) Ⓗ
A popular community hub for beautiful Ashton Keynes. The interior divides into three distinct areas: a small bar with games and TV, the main bar and the restaurant. There is a separate function room at the back. Four real ales are served, two of them constantly changing guests. Good-quality food uses locally sourced ingredients. Outside there is a secluded garden at the back and one of the four village crosses at the front.
🐕❀❶♣P🚍(93A) ✿ ☞

Box

Quarrymans Arms Ⓛ ✓
Box Hill, SN13 8HN (signed from A4)
☎ (01225) 743569
Butcombe Original, Gold; 2 changing beers (sourced nationally) Ⓗ
A Butcombe Brewery pub in a hamlet off the A4 between Box and Corsham. Dating back over 250 years,

the inn has views over the Bybrook Valley towards Bath, and is very popular with locals and visitors. A high-quality varied menu is served in the restaurant, bar and garden. Wheelchair access is limited although assistance is happily provided. The steep walk up from the bus stop is well worth the effort. Q ⑤ ✿☜✐❶ ♣ P ⬚ (X31) ✿ 🛜

Bradford-on-Avon

Castle Inn

Mount Pleasant, BA15 1SJ
☎ (01225) 865657
Palmers IPA; 2 changing beers (sourced regionally; often Arbor, Kettlesmith, Otter) Ⓗ
A very popular, comfortable pub, commanding splendid views across the town towards Salisbury Plain. A wide range of hand-pulled real ales is complemented by excellent food. The guest beers are usually from microbreweries in Wiltshire, Bristol and east Somerset. There is a good-sized garden at the front and children are welcome. A former local CAMRA Pub of the Year.
⑤ ✿☜❶⛺♿🚶⬚ (D1) ✿ 🛜

George

67 Woolley Street, BA15 1AQ
☎ (01225) 865650 ⊕ thegeorgebradfordonavon.co.uk
3 changing beers (sourced regionally; often Kettlesmith, Twisted) Ⓗ
Following a major refurbishment, this pub has been transformed. There is a bar area with sofas and armchairs and a separate seating area with tables and chairs, separated from the bar by three great stone arches. At the back is a pleasant garden with plenty of tables and benches. There are now three beers, changing often, and usually from West Country breweries such as Kettlesmith and Twisted. ⑤ ✿❶ P ⬚ (D1) ✿ 🛜

Stumble Inn

Market Street, BA15 1LL
☎ (01225) 862115 ⊕ thestumbleinnboa.business.site
4 changing beers (sourced locally; often Bristol Beer Factory, Kettlesmith, Twisted) Ⓗ / Ⓖ
This micropub opened in 2017 on the ground floor of what was a local club in the centre of town. There is a main bar room with seating at the back and a good-sized comfortable room at the front overlooking the main street. A varying range of up to four beers is offered, with two on handpump and two on gravity, usually from local West Country breweries – often Bradford-on-Avon based brewery Kettlesmith. Q ⑤ ≈ ♣ ⬚ (D1) ✿ 🛜

Three Horseshoes

55 Frome Road, BA15 1LA
☎ (01225) 865876
3 changing beers (sourced locally; often Cheddar Ales, Plain, Stonehenge) Ⓗ
The Horseshoes is a nice old coaching inn on the edge of the town centre next to the railway station. It comes complete with the old wooden door where the horses went through to the yard. At the bar there are usually three ever-changing beers, often local. Live bands play Friday, Saturday and Sunday evenings. Outside at the back is a small garden with seating. Parking is at the rear and is a bit limited. ✿≈♣P⬚ (D1) ✿ 🛜

Chilton Foliat

Wheatsheaf Ⓛ ✅

RG17 0TE
☎ (01488) 680936 ⊕ thewheatsheafchiltonfoliat.co.uk
Ramsbury Gold; house beer (by Butts); 1 changing beer (sourced locally; often Hop Kettle Swindon) Ⓗ

This 18th-century Grade II-listed thatched building has been in the hands of a local couple since 2015. It is an award-winning, sustainable hub with a bar, music, first-floor art gallery and shop. There are three local real ales including a changing guest, and cider from Hungerford Park. The kitchen features a wood-fired oven for home-made pizzas to complement the excellent menu of locally sourced food. Live music is hosted monthly.
⑤ ✿❶▶♣P⬚ ✿ 🛜

Chippenham

Flying Monk

6 Market Place, SN15 3HD
☎ (01249) 460662
North Cotswold Windrush Ale; 3 changing beers (sourced nationally; often Nethergate, North Cotswold) Ⓗ
Situated beside the historic Buttercross, the pub's name refers to an 11th-century would-be aviator – there is no longer any connection with the brewery of the same name. A selection of real ales, Belgian and craft beers and draught cider is available. There are periodic live musical and other performances, rock 'n' roll bingo and a twice-monthly meat raffle. Closed most Sunday evenings. ≈♦⬚ ✿ 🛜

Old Road Tavern ✅

Old Road, SN15 1JA (over bridge from station)
☎ (01249) 247080
Bath Ales Gem; Exmoor Ale; Marston's 61 Deep; Stonehenge Danish Dynamite; 2 changing beers (sourced nationally; often Adnams, Harvey's) Ⓗ
Welcoming staff dispense well-kept ales at this 140-year-old Grade II-listed community local, situated close to the railway station. A diverse mix of locals ensures lively and friendly conversation. The pub has a large garden with plenty of seating and a new cabin with heated seats. Bar snacks, including Panda's Baps are available. The pub is home to local folk music and is a venue for the annual Chippenham Folk Festival.
⑤ ✿≈♣⬚ ✿ 🛜

Three Crowns 🍷 Ⓛ

18 The Causeway, SN15 3DB (S of town centre)
☎ (01249) 449029 ⊕ threecrownschippenham.co.uk

7 changing beers (sourced nationally; often Arbor, Slater's) Ⓗ
A pub since the early 18th century, with a main bar warmed by a real fire plus a cider/snug bar. An excellent selection of real ales is available, always including at least two dark beers. Three or more ciders and a perry are served from a separate bar. Quarterly beer festivals extend the range to 12 ales and eight ciders. Food is limited to traditional pub snacks, filled rolls and pork pies. A multiple CAMRA award winner.
Q❀≉♣●P🖵🚇🐾🛜

Coombe Bissett

Fox & Goose ⓛ
Blandford Road, SP5 4LE
☎ (01722) 718437 ⊕ foxandgoose-coombebissett.co.uk
Sharp's Doom Bar; Sixpenny 6d Best Bitter; 1 changing beer (sourced nationally) Ⓗ
An 18th-century coaching inn on the A354, three miles south of Salisbury. This popular community pub has a loyal village clientele and a welcoming atmosphere. Divided into a bar and restaurant, it offers an extensive food menu with ever-changing specials. Outside, there are pleasant gardens to the rear and a covered smoking area. Guest ales are from local and national breweries.
🏃❀⏺️◑P🖵(20)🐾🛜

Corsham

Three Brewers
51 Priory Street, SN13 0AS
☎ (01249) 701733 ⊕ threebrewerscorsham.co.uk
Draught Bass; 2 changing beers (sourced nationally; often Stonehenge, Wychwood) Ⓗ
Traditional, welcoming, community pub set in the heart of Corsham, serving real ales plus a large wine and gin range, high-quality hot and cold bar snacks, coffee and cake. It has two good-sized rooms - a bar area and a snug - both with tables and seating. The games room, with a skittle alley, pool table, darts and board games, also hosts meetings. There is a beer garden at the rear with the entrance to the side of the pub.
🏃❀♣P🖵(X31)🐾🛜

Corsley

Cross Keys Inn
Lye's Green, BA12 7PB
☎ (01373) 832406 ⊕ crosskeyscorsley.co.uk
Butcombe Original; 1 changing beer (sourced locally; often Frome, Plain) Ⓟ
This rural gem has a large open fire and a warm, welcoming atmosphere. In 2016 it was taken over by a village consortium. It is set in the shadow of Cley Hill, famed for its UFO sightings. A good selection of guest ales mainly sourced from local breweries is available, along with excellent bar food and restaurant meals. The pub is in an excellent walking area, only yards from the Somerset border, and close to Longleat House and its safari park. 🏃❀◑ Å♣●P🐾🛜

Cricklade

Red Lion ⓛ
74 High Street, SN6 6DD
☎ (01793) 750776 ⊕ theredlioncricklade.co.uk
Hop Kettle Cricklade Ordinary Bitter, North Wall; St Austell Tribute, Proper Job; 6 changing beers (sourced nationally; often St Austell, Hop Kettle Cricklade) Ⓗ
A friendly, popular and comfortable pub which features part of the old Saxon town wall in the building. There is a

large garden where beer festivals are held. Home to the original Hop Kettle brewery, the brewery remains despite the pub being acquired by St Austell. There are 10 real ales on offer - three Hop Kettle, four St Austell, plus three guests. Excellent food is served and there are five B&B rooms. Q🏃❀🍴◑🚲●🖵🐾🛜

Dauntsey Lock

Peterborough Arms ⓛ
SN15 4HD
☎ (01249) 247833 ⊕ peterborougharms.com
3 changing beers (sourced regionally; often Flying Monk, Twisted) Ⓗ
Saved by the Wilts & Berks Canal Trust and restored by its volunteers, the pub is alongside the old canal. It offers three real ales, real cider and good pub food. It is home to both skittles and darts teams. There is a beer garden for the summer and a log-burner for the winter. Winner of a CAMRA Design Award in 2020. 🏃❀◑&Å♣●P🚇🛜

Devizes

British Lion ✓
9 Estcourt Street, SN10 1LQ (on A361 opp Kwik Fit)
☎ (01380) 720665 ⊕ britishliondevizes.co.uk
4 changing beers (sourced nationally; often Palmers, Plain, Stonehenge) Ⓗ
The British has been ever-present in the Guide for over 27 years. An unpretentious free house with wooden floors, cosy settles and an eclectic group of talkative regulars, it is an essential post of call in town. There are four handpumps and the beers change frequently throughout the week - time it right and you can savour eight different ales. The knowledgeable landlord is always pleased to offer his advice. Not to be missed.
❀●P🖵🚇🛜

Southgate Inn
Potterne Road, SN10 5BY
☎ (01380) 722872
Hop Back GFB, Fuggle Stone, Crop Circle, Taiphoon, Entire Stout; 1 changing beer (sourced regionally; often Downton, Hop Back) Ⓖ
The five-minute walk from the town centre is well worth it for the welcome you will receive here. This cosy, friendly pub has three separate bar areas, lots of nooks and crannies and a large courtyard. Still ciders and perry accompany the ales from Hop Back, which vary with the season and may be joined by a guest from Downton or elsewhere. Attractions include live music throughout the weekend, an acoustic jam session on Wednesday and a ukulele group on Friday afternoon. Well-behaved dogs are positively encouraged. 🏃❀♣●P🖵(2,210)🐾🛜

Vaults Micropub
28A St John's Street, SN10 1BN (opp Town Hall)
☎ (01380) 721443 ⊕ thevaultsdevizes.com
5 changing beers (sourced nationally; often Stealth) Ⓗ
A galley-style bar with five handpumps usually offering at least two ales from Stealth Brew Co plus other changing beers. There is normally at least one dark beer, plus up to three still ciders. Beer paddles are available - three or five third-pints - and a selection of bottles and cans from around the world is also stocked. Conversation rules here - there are no fruit machines or loud music, just a great atmosphere. The large cellar room is used for events including quizzes, a poetry club and an annual Christmas story evening. ◑●P🖵🐾🛜

White Bear ✅

33 Monday Market Street, SN10 1DN

☎ (01380) 727588

Wadworth Henry's IPA; 5 changing beers (sourced nationally) ⊞

Recently refurbished throughout, this old coaching inn with original beams and wood-burning stoves dates from the 1500s. It has six pumps serving real ales, two from Wadworth – usually IPA and a varying beer – plus up to four guests. A dark ale is often among the range, alongside a still cider. Food is served all week. The pub does not have a car park but there is plenty of parking nearby. 🏚◑●❀❄

Easton Royal

Bruce Arms ★ Ⅼ

Easton Road, SN9 5LR

☎ (01672) 810216 ⊕ brucearms.co.uk

Butcombe Original; St Austell Tribute; 2 changing beers (sourced regionally) ⊞

A family and dog friendly rural local, this mid 19th-century inn has been identified by CAMRA as having a nationally important historic pub interior. It has a cosy bar with a log fire and furniture that probably goes back to the 1850s, a small lounge with easy chairs and a piano, and a larger dining/function room at the back. The pub exists in splendid isolation, so its campsite with full facilities, open all year, is an asset that makes it a good venue for meetings and rallies. Q⛺❀◑▲♣●P🖵❀❄

Ebbesbourne Wake

Horseshoe

The Cross, SP5 5JF

☎ (01722) 780474 ⊕ thehorseshoe-inn.co.uk

Bowman Swift One; Gritchie English Lore; 2 changing beers (sourced nationally; often Brew Shack) Ⓖ

Unspoilt 18th-century inn in a remote rural setting at the foot of an old ox drove, run by the same family for 51 years and by the present landlord for 35. There are two small bars displaying an impressive collection of old farm implements, and a pleasant garden. The original serving hatch just inside the front door is still in use. Good local food is available Wednesday to Sunday. Real cider is usually available. Local CAMRA Country Pub of the Year since 2019. Q⛺❀◑▲●P🖵(29)❀

Edington

Three Daggers

Westbury Road, BA13 4PG

☎ (01380) 830940 ⊕ threedaggers.co.uk

Three Daggers Blonde, Ale, Edge ⊞

Refurbished village pub offering its own range of beers brewed by local brewery Stonehenge. Up to three ales are usually available, depending on the time of year. The pub has a main bar with three distinct drinking areas, leading into a seating area and a dining room. Two mirrors hide TV screens that are occasionally used for sporting events. At the rear is a lovely garden. Accommodation is available. Q⛺❀❄◑Ⅼ&P🖵❀❄

Enford

Swan Ⅼ ✅

Long Street, SN9 6DD

☎ (01980) 670338 ⊕ theswanenford.co.uk

5 changing beers (sourced locally; often Plain, Stonehenge, Twisted) ⊞

Everyone is welcome at this 16th-century, Grade II-listed pub, purchased by villagers for the community in 1998. It is one of only a handful of pubs in the country with the inn sign hanging on a gantry over the road. Old beams, an inglenook fireplace, sloping walls and quiet nooks and crannies add to its character. Flights of three third-pints help you sample a selection of mainly local ales. ⛺❀◑♣●P🖵(X5)❀❄

Highworth

Rose & Crown

19 The Green, SN6 7DB

☎ (01793) 764699

Sharp's Doom Bar, Sea Fury; 3 changing beers (sourced nationally; often Timothy Taylor, Young's) ⊞

This free house is one of the oldest pubs in Highworth. Friendly staff help make it popular with locals. The interior features wooden beams decorated with hops and old adverting signs on the walls. There are five handpumps serving changing ales, with a Sharp's beer a regular. The lunch menu offers good quality and value. Occasional folk sessions are hosted on a Saturday evening. Outside is the garden with a boules pitch. Q⛺❀◑♣P🖵❀❄

Idmiston

Earl of Normanton ✅

Tidworth Road, SP4 0AG

☎ (01980) 610251 ⊕ theearlofnormanton.co.uk

Exmoor Gold; Hop Back Summer Lightning; St Austell Tribute; 2 changing beers (sourced locally; often Cotleigh) ⊞

Popular roadside pub with a welcoming atmosphere enhanced by two real fires in winter months. A recent extension has increased the dining area and added accessible toilets. Good-value, home-cooked food is served, with a traditional roast on Sunday lunchtime. There is a small, pleasant garden on the terraced hill behind the pub, with a fabulous view across the River Bourne to countryside beyond. Live music plays on occasion. A former local CAMRA Country Pub of the Year. Q⛺❀◑&P🖵(66)❀❄

Kington St Michael

Jolly Huntsman Ⅼ

SN14 6JB (signposted from A350)

☎ (01249) 750305 ⊕ jollyhuntsman.com

4 changing beers (sourced locally; often Moles) ⊞

An 18th-century building in the centre of the village. Formerly the White Horse brewery, one of the wells used for brewing still remains. Situated on the high street, you can be sure of a friendly welcome at this free house, with an open log fire in winter. A good choice of ales is served, and two regional draught ciders are also often available. The menu is excellent, but check ahead for food service hours. Q⛺◑◑&P🖵(99)❀❄

Lacock

Bell Inn Ⅼ

The Wharf, SN15 2PJ

☎ (01249) 730308 ⊕ thebellatlacock.co.uk

House beer (by Hop Union); 3 changing beers (sourced regionally; often Hop Union) ⊞

Renowned for its friendly welcome, this popular free house is set on the edge of the National Trust village of Lacock. Nine times local CAMRA Pub of the Year, it has an excellent reputation for quality ale and food – there are usually four ales and a cider on offer. The house beer

Beau Bell is brewed to the pub's own recipe. The Barn, built recently beside the pub, provides extra dining space and has its own bar and drinking area heated by wood-burners in winter. Q⑤❄️◐♣P♿♠🐾🛜

Luckington

Old Royal Ship 🅛

SN14 6PA

☎ (01666) 840222 ⊕ oldroyalship.co.uk

Flying Monk Elmers; Wadworth 6X; 1 changing beer (sourced locally) 🅷

This tastefully refurbished and extended country inn is at the heart of the community, hosting the village shop, a skittle alley, coffee shop and fabulous food. Run by the current landlady for over 30 years, the popular, friendly and welcoming pub is surprisingly roomy yet has a cosy feel. It has seating areas inside and out, a function room, and serves good pub food all day every day. There is a focus on local ales. Q⑤❄️🚲◐♿♣A♣P🚌(41)♠🛜

Malmesbury

Whole Hog 🅛

8 Market Cross, SN16 9AS

☎ (01666) 825845

Ramsbury Farmer's Best; Stonehenge Pigswill; Wadworth 6X; 2 changing beers (sourced nationally; often Hook Norton, Young's) 🅷

Situated between the 15th-century market cross and abbey, this popular pub has a commanding position at the top of the high street, offering a fine view of everyday life in this busy hilltop town. A good selection of wholesome, locally sourced food complements the excellent beer selection, local draught cider and a good choice of wines. A pub central to the community, it provides a relaxed and welcoming atmosphere for locals and visitors alike. Q❄️◐♣♠🚌🛜

Marlborough

Wellington Arms 🅛 ✅

46 High Street, SN8 1HQ

☎ (01672) 516697 ⊕ thewellingtonarmsmarlborough.co.uk

Ramsbury Deerstalker, Gold; 2 changing beers (sourced locally; often Ramsbury) 🅷

Friendly 18th-century pub with an open fire that creates a cosy atmosphere. To the rear is a smart garden with a covered area and heat lamps. Four ales are usually available – two regular and two guests mostly from Ramsbury brewery. A choice of Pieminister pies is served. The pub hosts a variety of events including a weekly pub quiz and regular live music. ⑤❄️◐♣♠🚌(X5,80)♠🛜

Marston Meysey

Old Spotted Cow

SN6 6LQ

☎ (01285) 810264 ⊕ theoldspottedcow.com

3 changing beers (sourced regionally; often Prescott) 🅷

With large gardens and a cosy interior with log fires and beamed ceilings, this pub is popular with locals and visitors alike. There is a strong emphasis on good food, the ingredients sourced from local producers and suppliers. In the bar there are three real ale handpumps. The Thames Path is nearby, making the pub attractive to hikers, and the source of the River Thames is only a few miles away. Accommodation is in two B&B rooms. Q⑤❄️🚲◐♿♣P♠🛜

Melksham

Hiding Place Micropub

15 High Street, SN12 6JY

☎ (01225) 899022 ⊕ thehidingplace.co.uk

4 changing beers (sourced locally; often Stealth) 🅷

This micropub and wine, beer and spirits shop offers a selection of beers from Melksham's own Stealth brewery, alongside guests from the whole of the UK. Up to four real ales are available plus a choice of keg craft beers, as well as locally produced spirits. Real ciders are served on gravity from the chilled cellar behind the bar. The downstairs area is bright and welcoming, much of it constructed with reclaimed wood, with an open-plan layout encouraging conversation. There is also comfortable seating upstairs with sofas and armchairs. Payment is by card only. ♠🚌♠🛜

Mere

Butt of Sherry

Castle Street, BA12 6JE

☎ 07765 072796

Exmoor Ale; Otter Amber, Ale 🅷

This single-bar pub with a courtyard at the rear is well supported by locals and visitors alike. The Grade II-listed building in the centre of Mere dates from the late 18th century and features coursed limestone rubble walls and a plain tile mansard roof. Local cider is often available and bottled beers from Wriggle Valley. Live music is hosted with acoustic sessions on the first Tuesday of the month. There is a free public car park opposite as well as street parking. Q⑤🚲◐🚌

Newton Tony

Malet Arms 🅛

SP4 0HF

☎ (01980) 629279 ⊕ maletarms.co.uk

4 changing beers (sourced locally) 🅷

Charming and historic pub, with a restaurant extension, in the conservation area of the village and with the River Bourne flowing past in winter. The window in the larger bar is reputed to come from a galleon. Run by the same family for 23 years, the landlord is as enthusiastic and proud of his high-quality food as he is of his ales. The range of four mainly local beers changes weekly and Old Rosie cider is served. The pub welcomes walkers and dogs. Q⑤❄️◐♠P♠

Pewsey

Crown Inn 🅛

60 Wilcot Road, SN9 5EL

☎ (01672) 562653 ⊕ thecrowninnpewsey.com

5 changing beers (sourced locally; often Stonehenge, Three Castles, World's End) 🅷

This traditional local is the brewery tap for World's End, which is behind the pub, and run by the family. At least two of the brewery's own beers are always among the five on offer. The small bar has an attractive stone and brick fireplace in its centre. Poetry and live music are hosted every Thursday, with a ukulele night on the last Thursday of the month. Food is generally only served on theme nights, Friday evenings and Sunday lunchtimes. Q⑤❄️♿🚲♣🚌(X5)♠🛜

Royal Wootton Bassett

Five Bells 🅛 ✅

Wood Street, SN4 7BD

☎ (01793) 849422

Black Sheep Special Ale; Fuller's London Porter; 5 changing beers (sourced nationally; often Ramsbury, Sharp's, Timothy Taylor) ⓗ
Dating from before 1841, this is a busy and cosy traditional thatched local with a beamed ceiling and open fires. It has been run by the same couple for nearly 25 years. The bar has seven handpumps for two regular beers, five guests and Old Rosie cider. Food is served lunchtimes and Tuesday and Wednesday evenings (booking recommended). The pub has darts and crib teams. Ever present in the Guide since 2002 and a regular winner of local CAMRA Pub of the Year.
Q✿❀◐➧P☷(55,31) ✿ 🛜

Salisbury

Deacons ⬡ ✔
118 Fisherton Street, SP2 7QT
☎ (01722) 322866 ⊕ deaconssalisbury.com
Hop Back Summer Lightning; St Austell Tribute; 2 changing beers (sourced regionally; often Dark Revolution) ⓗ
A friendly, independently owned free house a stone's throw from Salisbury railway station and a short walk from the cathedral. The small front bar, with a digital jukebox, leads up a couple of steps to a larger back room. The landlord works with local breweries to showcase quality real ale. The pub hosts occasional live music, quiz nights and beer festivals. Local CAMRA Pub of the Year 2020. ⇎♣☷✿🛜

Duke of York ⭐ ⬡
34 York Road, SP2 7AS
☎ 07881 812218
Hop Back GFB; Sixpenny 6d Best Bitter; 5 changing beers (sourced locally; often Downton, Plain, Stonehenge) ⓗ
A popular free house sporting local beers and two changing traditional ciders. The focus is on the community, with an informal Sunday night quiz, wine club, whisky club and thriving conversation. The pub is home to the Fisherton History Society which meets on the second Wednesday of the month and hosts occasional events. Live music plays every other Saturday. Barbecues are held at weekends during the summer. Local CAMRA Pub of the Year 2022. ✿❀⇎♣●☷✿🛜

Haunch of Venison ★ ⬡
1 Minster Street, SP1 1TB
☎ (01722) 411313 ⊕ haunchpub.co.uk
Butcombe Original; Stonehenge Danish Dynamite; Wye Valley HPA; 1 changing beer (sourced regionally) ⓗ
A fine old inn, identified by CAMRA as having a nationally important historic interior. The main bar, the Commons, has a rare pewter-topped bar. A tiny second bar features original spirit taps and floor tiles recovered long ago from a refurbishment of the cathedral. Upstairs, the House of Lords area contains the mummified hand of a card cheat. Upstairs again, there are two separate dining rooms, one with a fireplace dating back to 1588. A must-visit for whisky drinkers, with up to 130 varieties of malts.
✿◐◗⇎☷✿🛜

Pheasant
19 Salt Lane, SP1 1DT
☎ (01722) 421841 ⊕ pheasantsalisbury.co.uk
Butcombe Original; St Austell Proper Job; Sharp's Doom Bar; 1 changing beer (sourced regionally) ⓗ
Historic building dating back to 1435 when it was known as the Crispin Inn. Steeped in history, the Pheasant is a characterful, atmospheric and cosy pub. It has been sympathetically restored and has a modern country feel

with exposed brick walls, beams and a log burner. The function room upstairs was once the local shoemakers' guildhall. A small, partially covered courtyard provides a little outdoor seating. Situated close to the city centre, it is opposite Salt Lane car park. Proud to be dog friendly.
✿❀◐&☷✿🛜

Rai d'Or ⬡
69 Brown Street, SP1 2AS
☎ (01722) 327137 ⊕ raidor.co.uk
2 changing beers (sourced locally; often Downton) ⓗ
Historic 13th-century city centre free house bearing a blue plaque commemorating a 14th-century landlady. An inglenook fireplace and low ceilings make for an appealing ambience. Excellent, reasonably priced Thai food is complemented by two changing beers, one usually local. The pub can be busy at mealtimes (book ahead) but drinkers are always welcome. There is a discount on food before 6.30pm. A regular in the Guide since 2004. ✿◗♣●☷✿🛜

Rugby Club ⬡
Castle Road, SP1 3SA
☎ (01722) 325317 ⊕ salisburyrfc.org
Hop Back GFB, Crop Circle, Summer Lightning; 1 changing beer (sourced locally) ⓗ
Occupying a corner of the large club house, this cosy, refurbished lounge bar is open to the public. Retaining its sporting roots, the bar features rugby memorabilia. Two TVs generally show rugby or other sport. The function room bar is open at busy times such as match days. Three Hop Back ales are often joined by a Hop Back or Downton seasonal brew. Quiz night is Wednesday. A beer festival is held in May. There are camping facilities close by.
✿❀A P☷✿🛜

Village Freehouse ⬡
33 Wilton Road, SP2 7EF
☎ (01722) 329707
Downton Quadhop; 2 changing beers (sourced nationally) ⓗ
A fully refurbished, lively pub near the train station. Microbrewery beers come from near and far. There is always at least one dark brew, stout, porter or mild available, with customer requests welcome. Teams are fielded in the local crib, cricket and football leagues, and two TVs shows BT Sport, with the sound off much of the time. Filled rolls are available or you are welcome to bring your own food. Three-time local CAMRA Pub of the Year. ⇎☷✿🛜

Winchester Gate ⬡
113-117 Rampart Road, SP1 1JA
☎ (01722) 503362 ⊕ thewinchestergate.com
4 changing beers (sourced regionally; often Dark Revolution, Plain, Red Cat) ⓗ
Characterful free house, an inn since the 17th century, which once provided for travellers at the city's east tollgate. Four handpumps offer changing ales, and boxes of real cider from across the country are frequently available. Beer and cider festivals are held, sometimes in association with a live music event. A small partially covered garden offers a pleasant area to sit out, particularly in the summer. The pub is renowned for its live music which features every Friday and Saturday, and frequently on Thursday too. ❀◐➧●P☷✿🛜

Wyndham Arms ⬡
27 Estcourt Road, SP1 3AS
☎ (01722) 331026
Hop Back GFB, Citra, Crop Circle, Summer Lightning; 1 changing beer (often Hop Back) ⓗ

The birthplace of the Hop Back Brewery, the pub is now celebrating 36 consecutive years in the Guide. A traditional ale house, it has a single bar serving a selection of Hop Back ales including seasonal offerings – normally Taiphoon in summer and Entire Stout in winter – alongside a fine selection of bottled beers and wines. Two small rooms off the main bar area provide quiet spaces and more seating. This is a pub for conversation, good-natured banter and fine ales. Local CAMRA Pub of the Year 2019. ㅎ♣ㅁ❀

Seend Cleeve

Brewery Inn

SN12 6PX

☎ (01380) 828463

Butcombe Original; Otter Ale; 1 changing beer (sourced regionally; often Exmoor, Plain, Ramsbury) Ⓗ

Well-run and welcoming traditional pub which has been much improved of late. It has a strong community focus, hosting various well-supported events. The outside area has dining pods, a decking area and a large grassed beer garden. Inside, there is a bar area and an annexe with a pool table, used as additional dining space as needed. There are always two cask ales, with a third on Friday. Q♻️❀⬤❶♣♠P❀🅿️

Semley

Benett Arms

Village Green, SP7 9AS (1 mile E of A350) ST891270

☎ (01747) 830221 ● thebenettarms-semley.co.uk

Gritchie English Lore; Exmoor Ale; 2 changing beers (sourced nationally) Ⓗ

A genuine free house sitting by the green and pond in a quiet village, in an area popular with walkers. It has a single small bar, separate dining areas and tables outside overlooking the green. The beer choice varies but there are usually four to choose from. Open all day, with excellent home-cooked food available lunchtimes and evening. A warm welcome is extended to all, including families and dogs. There are three letting rooms. Q♻️❀⬤❶P❀🅿️

Sherston

Rattlebone Inn Ⓛ ✔

Church Street, SN16 0LR

☎ (01666) 840871 ● therattlebone.co.uk

St Austell Tribute; Timothy Taylor Landlord; 1 changing beer (sourced nationally; often Otter) Ⓗ

A well-managed classic Cotswold village pub, with rambling rooms, perfectly conditioned ales and a warm welcome. Popular with locals and visitors alike, the building dates from the 17th century and the comfortable interior with lots of cosy nooks gives it a relaxed ambience. The traditional pub food is sourced locally. Of special note are the double garden and terrace with boules pitches as well as a skittle alley and other pub games. Q♻️❀⬤♣P❀🅿️

Swindon

Beehive ✔

55 Prospect Hill, SN1 3JS

☎ (01793) 523187 ● bee-hive.co.uk

House beer (by Hardys & Hansons); 5 changing beers (sourced regionally; often Goff's, Pitchfork, Greene King) Ⓗ

This four-room pub retains its quirky charm and layout. It dates from 1871 and is built on a corner on a hill, giving a nearly triangular layout on five different levels. The walls display pictures and other art for sale. A popular live music venue, it hosts performances on most Thursday and Friday nights. The long-standing landlord is proud of the Beehive's traditional feel, community role and support for local charities. ♣ㅁ❀🅿️

Glue Pot

5 Emlyn Square, SN1 5BP

☎ (01793) 497420

Downton New Forest Ale; Hop Back Entire Stout, Citra, Crop Circle, Summer Lightning; 2 changing beers (sourced nationally; often Hop Back) Ⓗ

A traditional backstreet boozer, the last remaining pub in the historic stone-built Railway Village built in the 1800s, and now in the centre of the GWR preserved heritage village in central Swindon. An Allsopp's Brewery logo adorns one window. The Glue Pot has long been a destination pub for those who appreciate a good choice of well-kept ale and cider, and has been at the heart of the community providing conversation and debate since 1853. A range of sandwiches and rolls is available. Q❀♿≠♣⬤🅿️❀

Goddard Arms ✔

1 High Street, Old Town, SN1 3EG

☎ (01793) 619090

Prescott Hill Climb; Ringwood Fortyniner; St Austell Tribute, Proper Job; Sharp's Doom Bar; 1 changing beer (sourced nationally) Ⓗ

The Goddards boasts a huge bar with many disconnected areas accommodating a wide variety of customers. There is something for everyone, from afternoon teas to hearty meals to a lively public bar. This Grade II-listed building was the home of the magistrates' court until 1852. The bar features five real ales and Lilley's cider. Good-value food is available all day, making the pub busy most of the time. Sports TV is screened in the background. There is accommodation and a separate function room upstairs. ♻️❀⬤❶♿P❀🅿️

Hop Inn ♥ Ⓛ

8 Devizes Road, Old Town, SN1 4BH

☎ (01793) 613005 ● hopinnswindon.co.uk

House beer (by Ramsbury); 7 changing beers (sourced regionally; often Arbor) Ⓗ

The pub that began the Devizes Road real ale boom, the Hop Inn moved two doors down from its original location to larger premises in 2019. This free house now has eight handpumps serving seven changing guest ales and Hop Inn Bitter brewed by Ramsbury. Two ciders from Hungerford Park are also sold plus another four ciders. The interior is decorated in an eclectic style, including tables and chairs made from reclaimed wood. Hop Nosh food is available, and roasts are served on Sunday. Q♻️❀⬤⬤♣🅿️❀🅿️

Tap & Brew Ⓛ

51 Devizes Road, SN1 4BG

9 changing beers (often Hop Kettle Cricklade, Hop Kettle Swindon) Ⓗ

Building on the success of Hop Kettle beers in the nearby Eternal Optimist bar, the Tap & Brew opened in 2019, a follow-up to its outlet in Cricklade. The bar offers a wide selection of Hop Kettle cask and keg ales to suit every taste, including single batch experimental beers. This is a dedicated outlet with the tap room, microbrewery and shop all within the same premises. There is plenty of seating inside and out. Q❀♿♣🅿️❀🅿️

Wyvern Tavern ✔

49-50 Bridge Street, SN1 1BL

☎ (01793) 484924

Butcombe Original; 3 changing beers (sourced nationally) Ⓗ

Large town-centre chain pub which has a better-than-average interest in and sale of real ales and ciders, offering one regular and five changing guest beers. It can be very lively, especially later in the week and at the weekend. Essentially a sports bar, it has a number of TV screens showing various sports and news. The pub was refurbished and renamed in 2019, with more seating and facilities all on one level. ⌂⊛Ⓞ♿≠♣♠▢☯♥

Tisbury

Boot Inn Ⓛ

High Street, SP3 6PS
☎ (01747) 870363
3 changing beers (sourced locally) Ⓖ

Fine village free house built of Chilmark stone, licensed since 1768 and run by the same family since 1976. It has a relaxed, friendly atmosphere and offers a cordial welcome to all. Join in the conversation at the bar or find a quiet table at which to enjoy well-kept ales served from casks behind the bar. The beer range often increases at weekends and in summer. Excellent food is served and there is a spacious garden. The third Tuesday of the month is quiz night.

Q⌂⊛ⓄⒿ≠♣♠▢(25,26)☯♥

Trowbridge

Stallards

15-16 Stallard Street, BA14 9AJ
☎ (01225) 767855 ⊕ thestallards.co.uk
Plain Innocence Ⓗ

The Stallards, originally built in 1857, has a modern, light, welcoming feel. A single bar serves three drinking areas. At weekends live bands play in the lower bar area, while there is comfortable seating next to the fire near the bar. There is a pool table to the rear, and a secluded patio area outside. ⊛♿≠♣♠▢☯♥

Warminster

Fox & Hounds

6 Deverill Road, BA12 9QP
☎ (01985) 216711
2 changing beers (sourced regionally; often Bath Ales, Palmers) Ⓗ

A friendly two-bar local – the main bar with a pool table and sports TV is at the rear, and a quiet snug bar is on the right-hand side of the entrance. There is a large skittle alley and function room at the back. Guest real ales are usually from local and regional breweries. Regular ciders are from Thatchers and Rich's, plus up to five guests. Closing time may be later than 11pm. A local CAMRA multiple award-winning pub. Q⊛♿♠♥▢☯♥

Westbury

Angel

3 Church Street, BA13 3BY
☎ (01373) 822648
4 changing beers (sourced locally; often Kettlesmith, Plain, Twisted) Ⓗ

Recently reopened, this pub has multiple rooms including a main bar area and a library for customers. There are usually four or more beers available, always including one from local brewer Twisted. Others are mainly from the south and West Country microbreweries. A couple of ciders are also often available. Food is planned for the future. ⊛⊯♠▢(D1)☯♥

Horse & Groom

18 Alfred Street, BA13 3DY
☎ (01373) 859433 ⊕ horseandgroomwestbury.co.uk
Sharp's Doom Bar; 2 changing beers (sourced regionally; often Twisted) Ⓗ

A spacious pub on the north-eastern edge of the town centre. It has two separate bars – one is essentially a restaurant. The two guest ales are very often from excellent local brewery Twisted. Outside, there is an attractive patio-style drinking area at the front, which can be something of a suntrap in the summer, as well as a large garden with plenty of seating, which runs down to the Bitham Brook. There is a good-sized car park. ⌂⊛⊯Ⓞ♿♠▢(87)☯♥

Whiteparish

Parish Lantern Ⓛ

Romsey Road, SP5 2SA
☎ (01794) 884392 ⊕ theparishlantern.co.uk
Hop Back Citra; St Austell Tribute, Proper Job; 2 changing beers (sourced locally; often Downton, Hop Back) Ⓗ

A welcoming pub run by the same couple since 1991. The single bar has a central fireplace and areas for dining and darts. Guest beers are from Hop Back, Downton or other local breweries. Food is served lunchtimes and evenings, and there are regular themed dining nights. A large garden with play equipment for children leads to a camping area with space for five caravans. The pub hosts family events on bank holidays and occasional beer festivals. Q⌂⊛Ⓞ♿▲♠▢(X7)☯♥

Wroughton

Carters Rest Ⓛ

57 High Street, SN4 9JU
☎ 07816 134966
Ramsbury Deerstalker; 6 changing beers (sourced regionally) Ⓗ

First mentioned in 1671, this popular real ale pub was extensively altered around 1912 to give its current Victorian appearance, and was refurbished in 2017. The smart interior retains a two-room feel, with a single shared bar. There are 12 handpumps but currently the beer range is seven, with eight at the weekend. Ales are mainly from small independent breweries within a 50-mile radius, although occasionally they may be from further afield. Poker night is Tuesday and quiz night Thursday. Q⌂⊛♿♠▢(9,49)☯♥

Breweries

Arkell's SIBA IFBB

Kingsdown, Swindon, Wiltshire, SN2 7RU
☎ (01793) 823026 ⊕ arkells.com

⊗ Arkell's Brewery was established in 1843 by John Arkell. The Arkell family still brew in the original Victorian brewhouse. The brewery owns nearly 100 pubs across Wiltshire, Gloucestershire, Oxfordshire, Berkshire and Hampshire. In 2018 a brewery shop and visitor centre opened on-site to mark its 175th anniversary. Seasonal beers are brewed frequently, often linked to sporting/national events. ‼▤◆

Wiltshire Gold (ABV 3.7%) GOLD
3B (ABV 4%) BITTER
A medium brown beer with a strong, sweetish malt/caramel flavour. The hops come through strongly in the aftertaste, which is lingering and dry.

Hoperation IPA (ABV 4.2%) PALE

Blonde Brothers

Great Bathampton Farm, Wylie, Wiltshire, BA12 0QD
☎ 07538 872379 ⊕ blondebrothers.beer

Established in 2019 on an organic family farm. It uses home-grown barley and water drawn from its own chalk aquifer borehole.

Best Bitter (ABV 4.3%) BITTER
Caramel and biscuits taste, using Magnum and Fuggle hops. Aroma of toffee and grass.

Box Steam SIBA

15, The Midlands, Holt, Wiltshire, BA14 6RU
☎ (01225) 782700 ⊕ boxsteambrewery.com

⊗ Founded in 2004, the brewery boasts a Fulton steam-fired copper, hence the name. New ownership since 2006 meant expansion and increased capacity with the brewery moving to larger premises in Holt in 2011. Two pubs are owned and more than 100 outlets supplied.
‼ ☷ ♦ ✦

Golden Bolt (ABV 3.8%) GOLD
Soul Train (ABV 4%) PALE
Light and refreshing pale ale with aromas and flavours of both citrus and tropical fruits before a soft, bittersweet finish.
Tunnel Vision (ABV 4.2%) BITTER
New Normal (ABV 4.3%) GOLD
Piston Broke (ABV 4.5%) GOLD

Broadtown

29 Broad Town Road, Broad Town, Wiltshire, SN4 7RB
☎ 07889 078648 ⊕ broadtownbrewery.co.uk

Opened in 2019, Broadtown is brewing in the old coach house of the 19th century Hart brewery. 118 years on, the village has a brewery again. Broadtown have a range of five core ales and produce an ever-changing list of seasonal and one-off ales. In 2021 the Hop Chapel, a Trappist-themed taproom and beer garden, opened on site. The brewery is home to three alpacas and a lime green double-decker bus. ♦ LIVE ✦

Spring Back (ABV 3.8%) GOLD
Fettler's Finest (ABV 4.7%) BITTER
Black Llama (ABV 4.8%) PORTER
Gricer's Choice (ABV 4.8%) PALE
Wide to Gauge (ABV 5.2%) PALE
Line of Sight (ABV 5.6%) IPA

Dark Revolution

Unit 3-5, Lancaster Road, Salisbury, Wiltshire, SP4 6FB
☎ (01722) 326993 ⊕ darkrevolution.co.uk

Dark Revolution started commercial brewing in 2015 using a one-barrel plant (the owner had been homebrewing for the previous decade). It upgraded to a 15-barrel brew plant in 2017, with more fermenting vessels added in 2019, retaining the smaller plant for trial brews and short runs. Barrel-aging is a speciality and a canning line is now operational. An onsite taproom is open seven days a week. ☷ ♦ LIVE ✦

Orbital (ABV 3.5%) BLOND
So.LA (ABV 4.5%) PALE
A cloudy, light, naturally-carbonated, West Coast-style pale ale. Surprises the nose and the palate with citrus hoppy freshness that fades to dry, citrus, floral finish.
Velveteen (ABV 4.8%) STOUT

A smooth, rich, black stout, served unfined. Noticeable malt and roast in the taste with balanced bitterness through to the finish.
Sonic (ABV 4.9%) PALE
A citrusy, hop-forward, pale, unfined premium ale with pronounced grapefruit taste from the American hops used.

Downton

Unit 11, Batten Road, Downton Industrial Estate, Downton, Wiltshire, SP5 3HU
☎ (01725) 513313 ⊕ downtonbrewery.com

⊗ Downton was set up in 2003. The brewery has a 20-barrel brew length and produces around 1,500 barrels a year. Around 100 outlets are supplied direct. A range of regular beers is produced together with speciality and experimental beers. The brewery offers an off-site mobile bar service and has an online shop. A regular bar is open on Fridays and sales are available on-site.
☷ LIVE ✦

New Forest Ale (ABV 3.8%) BITTER
An amber-coloured bitter with subtle aromas leading to good hopping on the palate. Some fruit and hoppiness in the aftertaste.
Quadhop (ABV 3.9%) GOLD
Pale golden session beer. Initially hoppy on the palate with some fruit and a strong hoppiness in the aftertaste. Its all about the hops.
Elderquad (ABV 4%) SPECIALITY
Golden yellow bitter with a floral fruity aroma leading to a good, well-hopped taste with hints of elderflower. Dryish finish with good fruit and hop balance.
Honey Blonde (ABV 4.3%) SPECIALITY
Straw-coloured golden ale, easy-drinking with initial bitterness giving way to slight sweetness and a lingering, balanced aftertaste.
Nelson's Delight (ABV 4.5%) SPECIALITY
Downton Dream (ABV 4.8%) PALE
A premium pale ale with obvious East European influences. Hoppy on aroma and taste with a particularly dry finish and a hint of lemon citrus notes.
Moonstruck (ABV 5.5%) BITTER
A dark, ruby-coloured, premium bitter with malt and caramel in the aroma and taste which also carries notes of dried fruit and plum. A dry finish with some bitterness and lingering taste.
Chimera IPA (ABV 6.8%) IPA
Golden yellow, strong IPA with good balance of hops and fruit, slight sweetness and some malt notes, all through to the aftertaste.

Drink Valley (NEW)

Unit C, Fleet Square, Swindon, Wiltshire, SN1 1RQ
☎ (01793) 692980 ⊕ thedrinkvalley.com

Drink Valley microbrewery opened in 2021. It has an open, airy, café-style layout to the bar area of its onsite taproom, where the brewing equipment can be seen.
♦ ✦

Pale Ale (ABV 3.8%) PALE
Best Bitter (ABV 4.5%) BITTER
Crown Ale (ABV 6.5%) STRONG

Flying Monk SIBA

Unit 1, Bradfield Farm, Hullavington, Wiltshire, SN14 6EU
☎ (01666) 838415 ⊕ flyingmonkbrewery.com

⊗ Named after Elmer, an 11th century monk at nearby Malmesbury Abbey who attempted flight from the tower

using self-made wings. Now owned by the farm business at which it is located, allowing reduced waste by using brewery by-product as cattle feed. A stone-built barn next to the brewery has been converted to a café and tap, offering some of the brewery's cask beers and incorporating the brewery shop. ☕◆✦

Wingman (ABV 3.7%) GOLD
Elmers (ABV 3.8%) PALE
A refreshing, session beer with floral and citrus aromas, followed by an encouraging bitter finish.
Habit (ABV 4.2%) BITTER
An amber-coloured, traditional English best bitter with a contrast of sweet and bitter flavours from a Maris Otter mash and Kentish hops.
Mighty Monk (ABV 4.3%) BLOND

Gritchie SIBA

Ashgrove Farm, Ashmore, Wiltshire, SP5 5AW
☎ (01747) 828996 ⊕ gritchiebrewingcompany.co.uk

⊗ Owned by film director Guy Ritchie, this 20-barrel brewery, in converted farm buildings on the Ashcombe Estate, started brewing in 2017. It uses its own borehole water and estate-grown barley. Expansion to 40-barrel capacity and a taproom are planned. Both cask and KeyKeg beers are produced, with new beers regularly developed. There are three five-barrel fermenters for experimental beers. Beers are distributed locally with plans to expand nationally. The Lore of the Land, Fitzrovia, London, is the brewery tap. ◆

Moon Lore (ABV 3.6%) GOLD
Summer Lore (ABV 3.6%) GOLD
English Lore (ABV 4%) BITTER
A copper-coloured bitter with some hint of fruit in the aroma. A sweet slightly bitter taste which diminishes quickly.

Hop Back

Units 22-24, Batten Road Industrial Estate, Downton, Wiltshire, SP5 3HU
☎ (01725) 510986 ⊕ hopback.co.uk

⊗ Founded in 1987, Hop Back owns nine pubs and distributes nationally. The flagship beer, Summer Lightning, has won numerous CAMRA awards. ‼☕◆LIVE

GFB (ABV 3.5%) BITTER
A light gold, refreshing, session bitter. The hoppy aroma leads to bitterness initially, lasting through to the finish with some fruit.
Citra (ABV 4%) BLOND
Pale yellow, almost straw-coloured with lemon and grapefruit on the aroma and taste, rapidly developing a balanced hoppy aftertaste.
Fuggle Stone (ABV 4%) BITTER
Fresh-tasting, slightly sweet, malty, session bitter with the sweetness and hops leading to a gentle dry aftertaste.
Crop Circle (ABV 4.2%) GOLD
A pale yellow best bitter with a fragrant hop aroma, complex hop, fruit and citrus flavours with a balanced hoppy, bitter/sweet aftertaste.
Taiphoon (ABV 4.2%) SPECIALITY
A clean-tasting, light, fruity beer with hops and fruit on the aroma. Complex hop character and lemongrass notes in the taste, slight sweetness balanced with some astringency in the aftertaste.
Entire Stout (ABV 4.5%) STOUT
A smooth, rich, ruby-black stout with strong roast and malt aromas and flavours, with a long bitter sweet and malty aftertaste.
Summer Lightning (ABV 5%) BLOND

Strong golden ale with a hoppy aroma and slightly astringent bitterness in the taste, balanced with some fruit sweetness, in the dry aftertaste.

Hop Kettle SIBA

Swindon: Unit 4, Hawksworth Industrial Estate, Newcombe Drive, Swindon, Wiltshire, SN2 1DZ
☎ (01793) 750776

Cricklade: Red Lion, High Street, Cricklade, SN6 6DD

Tap & Brew: 51 Devizes Road, Swindon, SN1 4BG
⊕ hop-kettle.com

Brewing began in a barn behind the Red Lion Inn, Cricklade, in 2012, using a one-barrel plant. Due to demand, a larger four-barrel plant followed, which supplies the pub and is also used for experimental brews. A new ten-barrel plant was installed in an old Royal Mail warehouse in Swindon in 2016. A new Tap & Brew pub followed in 2019 which also brews experimental beers for sale in that pub. ◆GF✦

(COB) Cricklade Ordinary Bitter (ABV 3.8%) BITTER
Chameleon (ABV 4%) BITTER
Dog Star (ABV 4%) PALE
Lode Star (ABV 4.3%) PALE
North Wall (ABV 4.3%) BITTER
Rising Star (ABV 4.8%) GOLD
East Star (ABV 5%) BITTER
Red Star (ABV 5.2%) RED
Evening Star (ABV 5.5%) PORTER

Kettlesmith SIBA

Unit 16, Treenwood Industrial Estate, Bradford-On-Avon, Wiltshire, BA15 2AU
☎ (01225) 864839 ⊕ kettlesmithbrewing.com

⊗ Kettlesmith is an independent microbrewery established in 2016. It brews modern interpretations of a wide variety of beer styles, drawing inspiration from the brewer's background in America and England, as well as a love of Belgian beer. ‼☕◆LIVE✦

Streamline (ABV 1.2%) SPECIALITY
Outline (ABV 3.8%) BITTER
Faultline (ABV 4.1%) PALE
Plotline (ABV 4.4%) STOUT
Fogline (ABV 4.7%) SPECIALITY
Coastline (ABV 4.9%) SPECIALITY
Ridgeline (ABV 5%) RED
Timeline (ABV 5.4%) PALE
Skyline (ABV 5.6%) SPECIALITY

Plain

Unit 17b-c Deverill Trading Estate, Sutton Veny, Wiltshire, BA12 7BZ
☎ (01985) 841481 ⊕ plainales.co.uk

⊗ Plain Ales started production in 2008 on a 2.5-barrel plant in a garage, and expanded to a 10-barrel plant in 2010 to keep up with demand for its award-winning ales. 2018 saw the introduction of its Kult Brewing Co brand to brew edgier beers. Bottling now forms an important part of its sales. ‼◆✦

Sheep Dip (ABV 3.8%) BITTER
Innocence (ABV 4%) PALE
Hoppy aroma, sweet tropical fruit on the palate balanced with hop bitterness which both continue in the satisfying, bittersweet finish.
Inspiration (ABV 4%) BITTER
Independence (ABV 4.5%) PALE

Refreshing hoppy pale ale with balanced bittersweet flavours of citrus and tropical fruits with subtle hints of pine and spice.

Ramsbury SIBA

Stockclose Farm, Aldbourne, Wiltshire, SN8 2NN
☎ (01672) 541407 ⊕ ramsburybrewery.co.uk

⊠ The Ramsbury Brewing & Distilling Company started brewing in 2004 using a 10-barrel plant, situated high on the Marlborough Downs in Wiltshire. The brewery uses home-grown barley from the Ramsbury Estate. Expansion in 2014 saw an upgrade to a 30-barrel plant with a visitor centre and a well to provide the water. A distillery that uses grains grown on the estate became operational in 2015. ‼🍴♦

Farmer's Best (ABV 3.6%) BITTER
Deerstalker (ABV 4%) BITTER
Ramsbury Pale Ale (RPA) (ABV 4%) PALE
Gold (ABV 4.5%) GOLD
Red Ram (ABV 4.5%) SPECIALITY
Chalk Stream (ABV 5%) PALE
Belapur IPA (ABV 5.5%) IPA

Rusty Garage

Unit 115, Rivermead Business Centre, Westlea, Swindon, SN5 7EX ☎ 07889 928241
⊕ rustygaragecraftbrewery.com

Microbrewery established in Swindon in 2020, producing a range of small batch beers available in canned and bottle formats, all named after a motoring theme. ♦

Shed Ales

Broadfields, Pewsey, Wiltshire, SN9 5DT
☎ (01672) 564533 ☎ 07769 812643
⊕ shedales.com

Shed Ales was launched in 2012 operating from a one-barrel plant in a converted garden shed. The brewery currently produces three core ales and several bespoke beers, available at selected local outlets including the brewery-owned Shed Alehouse, a micropub in Pewsey. Brewing is currently suspended. ♦

Stealth

Unit 3, Intercity Industrial Estate, Melksham, Wiltshire, SN12 8DE
☎ (01225) 707111 ☎ 07917 272482
⊕ stealthbrew.co

Business commenced in 2014 and under the current name since 2018. Late 2021 saw a move to new premises where it is hoped to establish a taproom. Most beers are unfined and the range changes frequently. Sales in cask, keg, bag and cans are to the trade as well as directly to the public. In addition, an associated company owns three micropubs in local towns. ‼♦

Covert (ABV 3.9%) PALE
Doublecrosser (ABV 4%) PALE
Tiptoe (ABV 4.2%) BITTER
Camouflage Black IPA (ABV 4.7%) PALE
Hibernation (ABV 5%) GOLD
Surreptitious (ABV 7.3%) IPA

Stonehenge SIBA

The Old Mill, Mill Road, Netheravon, Salisbury, Wiltshire, SP4 9QB
☎ (01980) 670631 ⊕ stonehengeales.co.uk

⊠ The brewery was founded in 1984 in what was originally a water-driven mill built in 1914. In 1993 the company was bought by Danish master brewer Stig Andersen and his wife Anna Marie, and now supplies more than 300 outlets. From 2013 a new borehole, accessing the Salisbury Plain aquifer, has been supplying the brewery's water. It is of such pristine quality that the brewery now bottle and sell it under the Stonehenge name. ‼♦

Spire Ale (ABV 3.8%) BITTER
A pale golden-coloured session bitter with an initial bitterness giving way to a well-rounded bitter aftertaste with discernible fruit balance.
Pigswill (ABV 4%) BITTER
A tawny-coloured session bitter with an initial pleasant hop aroma and slight bitterness to the initial taste moving to a well-rounded bitter finish with slight malt and fruit in the finish.
Heel Stone (ABV 4.3%) BITTER
A copper-coloured best bitter with some malt and fruit in the aroma continuing into the initial taste along with pleasant hoppiness. Medium-bodied with plenty of flavour in the aftertaste with noticeable malt, fruit and hops.
Great Bustard (ABV 4.8%) BITTER
A copper brown-coloured, strong bitter. Complex malt and fruit flavours at first with a long fruit and bitter aftertaste.
Danish Dynamite (ABV 5%) GOLD
Golden ale with good hop and fruit aromas. Complex flavours in the initial taste with a beautifully-balanced, full-bodied aftertaste with hops and fruit to the fore.

Three Daggers SIBA

47 Westbury Road, Edington, Westbury, Wiltshire, BA13 4PG
☎ (01380) 830940 ⊕ threedaggersbrewery.com

⊠ The brewery consists of a purpose-built, 2.5 barrel plant in a building used as a farm shop beside the Three Daggers pub. During lockdown the plant has not been used and brewing has been at, and with the assistance of, Stonehenge Brewery. It is intended to brew again at Edington when economic conditions improve. Until then only the pub is supplied with cask, and the farm shop with bottles. ‼

Daggers Blonde (ABV 3.6%) BLOND
Daggers Ale (ABV 4.1%) BITTER
Daggers Edge (ABV 4.7%) BITTER

Twisted SIBA

Unit 8, Commerce Business Centre, Commerce Close, Westbury, Wiltshire, BA13 4LS
☎ (01373) 864441 ⊕ twisted-brewing.com

⊠ Twisted began brewing in 2014. It is an independent brewery producing traditional ales with a modern twist. ♦

Three & Sixpence (ABV 3.6%) PALE
Rider / Three Lions (ABV 4%) BITTER
Pirate (ABV 4.2%) BITTER
Fruity aroma, malty flavours combine with sweet ripe fruit and hop bitterness before fading in the short finish.
Urban Legend (ABV 4.3%) GOLD
Canteen Cowboy (ABV 4.5%) GOLD
Gaucho / Fly Half (ABV 4.6%) BITTER

Wadworth SIBA IFBB

Northgate Brewery, Devizes, Wiltshire, SN10 1JW
☎ (01380) 723361 ⊕ wadworth.co.uk

⊗ Established in 1875 by Henry Alfred Wadworth, this impressive, family-owned brewery has a modern brewhouse and a microbrewery, which enables it to create unique, small-batch beers. Its traditional horse-drawn drays deliver beer daily around Devizes. Wadworth has more than 150 pubs in the South-West of England. ‼ ⌑ ♦ LIVE ⚓

Henry's IPA (ABV 3.6%) BITTER
Horizon (ABV 4%) BITTER
6X (ABV 4.1%) BITTER
Copper-coloured ale with a malty and fruity nose, and some balancing hop character. The flavour is similar, with some bitterness and a lingering malty, but bitter finish.
Swordfish (ABV 5%) SPECIALITY

Wessex

Rye Hill Farm, Longbridge Deverill, BA12 7DE
☎ (01985) 844532 ✉ wessexbrewery@gmail.com

⊗ This four-barrel brewery, hidden away on a farm industrial complex in the West Wiltshire Area of Outstanding Natural Beauty, was established in 2001. The brewery sources its malt from the nearby Warminster Maltings. Around 2010, two new fermenters were installed. A handful of regular outlets are supplied, with wider availability via selected wholesalers. The brewery is able to brew beer for other concerns when capacity permits. Beers are occasionally brewed for Isle of Avalon (qv). ♦

Stourton Pale Ale (ABV 3.5%) PALE
Mild (ABV 3.9%) MILD
Kilmington Best (ABV 4.2%) BITTER
Deverill's Advocate (ABV 4.5%) GOLD
Maltings Gold (ABV 4.5%) GOLD
Warminster Warrior (ABV 4.5%) BITTER
Golden Apostle (ABV 4.8%) GOLD
Beast of Zeals (ABV 6.6%) BARLEY
Festive Ferret (ABV 7%) STOUT

World's End

⊟ Crown Inn, 60 Wilcot Road, Pewsey, Wiltshire, SN9 5EL
☎ (01672) 562653 ⊕ thecrowninnpewsey.com

⊗ World's End Ales was established in 2009 on a one-barrel plant at the rear of the Crown Inn, Pewsey. World's End is the 18th century name for the area in which the brewery is located. ‼ ♦

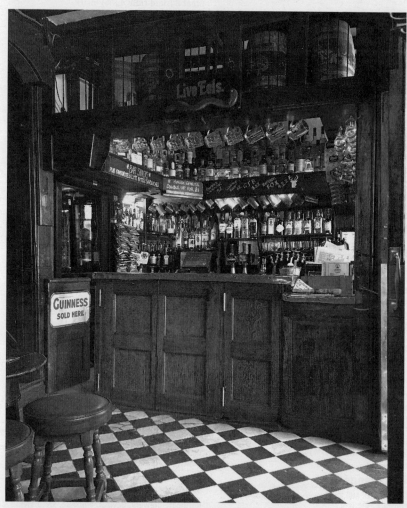

Haunch of Venison, Salisbury (Photo: Sarah Stierch / Flickr CC BY 2.0)

West Midlands

While it is well known for its role in the Industrial Revolution, you can also find areas of great natural beauty in the West Midlands, notably in Worcestershire, Shropshire, and the Staffordshire Moorlands. Each part of the region was formerly known for various industries, such as the potteries around Stoke on Trent and glass working around Stourbridge. The area known as the Black Country became famous for its 'metal bashing' industries including nail and chain making. Heritage lovers will enjoy a day out at the Black Country Living Museum, made complete with a locally brewed pint at the Bottle & Glass Inn.

There can be no UK beer pilgrimage without a trip to Burton upon Trent, formerly the UK's brewing capital. At its peak, one in every four pints were brewed in this Staffordshire town and the composition of its water is still mimicked by brewers the world over in the process of Burtonisation, which is the act of adding sulphate to water used for brewing to bring out the flavour of the hops.

The National Brewery Centre (NBC) was perhaps the main attraction in Burton, with daily tours and a fantastic collection of vintage brewery vehicles to boot. As this Guide went to press it was announced the NBC – the only national celebration of Britain's brewing heritage – was to close with a proposal the collection would continue to be displayed in alternative premises in Burton town centre. While disappointed at the closure, CAMRA urges Molson Coors and East Staffordshire Borough Council to ensure the NBC is rehomed as quickly as possible and given the space and prominence to rightly celebrate our brewing history.

To the south of the region, Purity Brewing in Alcester offers tours that give a brilliant insight into the sustainability measures it has implemented to make its brewery more eco-friendly.

Herefordshire and Worcestershire are classic cider and perry making regions, with Worcester's coat of arms featuring a black pear. The Hereford Cider Museum is a great place to discover more about this heritage, while both Hereford and Worcester hold large beer and cider festivals that are particularly family friendly.

Birmingham is the UK's second city and is home to a growing high-quality brewing scene. Across the Jewellery Quarter, Digbeth and Stirchley, look out for the likes of Rock & Roll Brewhouse, Burning Soul and Dig Brew.

HEREFORDSHIRE

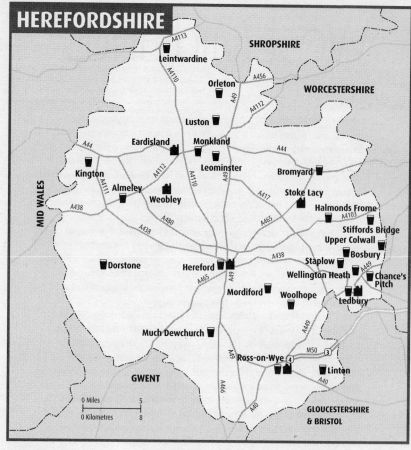

Almeley

Bells Inn 🅛

HR3 6LF (in village)
☎ (01544) 327216 ⊕ thebellsinnalmeley.com
Goff's Lancer; 2 changing beers (sourced locally; often Hobsons) Ⓗ

A genuine welcome is guaranteed at this enthusiastically run, traditional country inn set in the heart of its rural community, which incorporates an award-winning farm shop and delicatessen. The bar has a low ceiling and an alcove housing the dartboard. Home-prepared lunches are served plus fish & chips every Friday evening (booking required). A food van visits every first Saturday evening of the month. The guest beers are typically from local breweries. ☒☆❀◖♣●P🖵🐾🖤

Bosbury

Bell Inn 🅛 ✅

HR8 1PX (on B4220, in village)
☎ (01531) 640285 ⊕ bosburyandcoddington.co.uk/
the-bell-inn-bosbury
Otter Bitter; Wye Valley Butty Bach; 1 changing beer Ⓗ

A two-bar black and white half-timbered inn in a terrace opposite the imposing village church, the bells of which lend the place its name. The dining area (no food served Sun eve or all day Mon) contrasts with the basic yet comfortable public bar, replete with grand fireplace, alcoves, books and newspapers. Friendly and welcoming, this pub lies at the heart of its community. A large garden features at the rear. Plenty of on-street parking is available. Q☒☆❀◖♣●🖵(417)🐾🖤

Bromyard

Rose & Lion 🅛 ✅

5 New Road, HR7 4AJ
☎ (01885) 482381
Wye Valley Bitter, HPA, Butty Bach Ⓗ

A longstanding member of the Wye Valley pub estate, the Rosie is very much a town pub of the old school, with a loyal following from locals. Two small, largely unaltered rooms are complemented by a further bar area to the rear, plus a more contemporary annexe and a pleasant garden. Furnished throughout in a modern but appropriate style, there is always a buzz about the place. No food is served. The car park is small, but there is free on-street parking nearby. Q☒☆❀♣P🖵(420)🐾

REAL ALE BREWERIES

Hereford 🍺 Hereford
Ledbury Ledbury
Motley Hog 🍺 Ross on Wye
Simpsons 🍺 Eardisland
Weobley Weobley
Wobbly ✦ Hereford
Wye Valley Stoke Lacy

Chance's Pitch

Wellington Inn 🅛

WR13 6HW (on A449, near B4218 jct)
☎ (01684) 540269
**Goff's Tournament; 2 changing beers (often
Butcombe, Gloucester, Ledbury)** 🅗
Isolated roadside inn on the main Ledbury to Malvern
road, this is a much-extended, multi-level inn that
majors on dining, but also happily caters for drinkers,
with a focus on local ales. A comfortable and plainly
decorated drinkers bar area has a traditional feel, with a
lounge on the lower level offering views across open
country. Two restaurant areas to the rear offer a wide
range of often locally-sourced meals, from sandwiches to
full à la carte. Q🕭🐾❄◑P🍽🐕📶

Dorstone

Pandy Inn 🅛

HR3 6AN (signed off B4348)
☎ (01981) 550273 ⊕ thepandyinn.co.uk
**Sharp's Atlantic; Wye Valley Butty Bach; house beer
(by Grey Trees); 1 changing beer** 🅗
Opposite the small village green, the Pandy has a history
dating back to the 12th century. Although opened out
inside, discrete areas give an intimate feel, alongside
timber framing, exposed stone walls and a huge
fireplace. The pub caters equally for drinkers and diners,
with an interesting range of dishes including vegetarian
options. It will open on weekday lunchtimes for groups
by prior arrangement. Gwatkins cider is on handpump. A
monthly quiz and curry night is hosted (booking
advisable). Q🕭❄◑♣🍽P🐕📶

Halmonds Frome

Major's Arms 🅛

WR6 5AX (¾ mile N of A4103 at Bishops Frome)
SO675481
☎ (01531) 640261
Otter Bitter; Purity Pure Gold; Wye Valley HPA 🅗
An isolated hillside ex-cider mill that achieved national
fame in 1991 when it temporarily became the Miners
Arms as the coal mines were being closed wholesale.
Entry is via a simple, no-frills, high-ceilinged room with
stone walls and a large wood-burner. An archway leads
through to another drinking area and a patio, from which
there are superb views, particularly sunsets, over west
Herefordshire and into Wales. Complimentary bar snacks
are often provided, and occasionally live music.
🕭❄Å♣P🐕📶

Hereford

Barrels 🅛 ✅

69 St Owen Street, HR1 2JQ
☎ (01432) 274968
**Wye Valley Bitter, The Hopfather, HPA, Butty Bach,
Wholesome Stout; 1 changing beer (sourced locally;
often Wye Valley)** 🅗
Local CAMRA Pub of the Year seven times, the Barrels is a
must-visit Hereford institution with a warm welcome for
all. With no food, no gimmicks, but oodles of character
across five rooms, this is a community inn of the highest
order. It has a fantastic covered courtyard to the rear.
Events include jazz on the first Monday of the month and
comedy on some Wednesday evenings. There are TVs
throughout, turned on for major events.
🕭❄🚲♣🚌🐕📶

Beer in Hand

136 Eign Street, HR4 0AP
☎ 07543 327548
5 changing beers 🅖
Herefordshire's first micropub, this minimalist, single-bar
establishment was converted from a launderette in
2013. In recent years it has won local CAMRA Pub of the
Year and Cider Pub of the Year. With an impressive
chilled racking system, it typically sells up to five ales on
cask, six keg beers (including one from Odyssey Brew
Co), and eight mainly local ciders and perries. Snacks are
always available, and artisan pizzas are made on-site on
Thursday evenings. Quiz night is the first Wednesday and
folk night the third Thursday of the month.
Q🕭🐾♣♠🚌🐕

Britannia 🅛 ✅

7 Cotterell Street, HR4 0HH
☎ (01432) 341780
Wye Valley Bitter, HPA, Butty Bach 🅗
Reopened by Wye Valley Brewery following an
impressive refurbishment, which included a new
extension with an oak-vaulted ceiling and a landscaped
rear garden/patio, this is a back-street venue with real
pedigree. The large central bar-servery is bookended by
two distinct seating areas with modern decor. Snacks
such as sandwiches are always available, with pork pies
and barbecues in summer. A quiz is held monthly on a
Thursday. A popular pub for an area of the city otherwise
devoid of quality choices. 🕭❄♣🚌🐕📶

Kington

Olde Tavern ★ 🅛

22 Victoria Road, HR5 3BX
☎ (01544) 231417
**Hobsons Mild; 4 changing beers (often Ludlow,
Salopian, Swan)** 🅗
A living and breathing Victorian time warp – once called
the Railway Tavern (the railway closed in the 1950s) and
before that the Tavern in the Fields – the pub is a
microcosm of the town's development. On entering the
lobby, with original serving hatch intact, to the left is a
small bar with original timberwork, bench and alcove
seating, and multifarious curios. To the right is the old
smoke room with its fine flagstone floor and bench
seating. The place has a strong local following.
Q🕭❄Å♣🚌🐕

Ledbury

Feathers Hotel

25 High Street, HR8 1DS
☎ (01531) 635266 ⊕ feathersledbury.co.uk
3 changing beers (often Ledbury) 🅗
An elegant black and white Elizabethan coaching inn,
one of the flagship hotels for the county, the Feathers
has benefited from a major refurbishment. Features
inside this fine Grade II*-listed building include a function
room that was once the town theatre, and hand-painted
murals in the upstairs corridors. The smart, plush, quiet
bar is complemented by a restaurant and separate coffee
shop and eatery (open daytimes). The toilets are fully
accessible. Q🕭❄🛏◑👤♿P🐕📶

Prince of Wales 🅛 ✅

Church Lane, HR8 1DL
☎ (01531) 632250 ⊕ powledbury.com
**Eagle IPA; Hobsons Town Crier; Ledbury Dark; Otter
Amber; Wainwright; 2 changing beers** 🅗
Tucked away down a picturesque cobbled alley leading
up to the church, this 16th-century timber-framed pub

boasts two bars, plus an alcove where a folk jam session is held each Wednesday evening. A multi award-winner, it is a genuine community pub – always bustling with locals and visitors. Rosie's Pig and Snailsbank draught ciders are available as well as one rotating craft beer and an extensive range of foreign beers in bottles and cans. The bar meals are good value (booking advisable for Sunday roasts). ⏵☕🍴🍺♿🐾🛏️🌳🚩♿🎵🛜

Leintwardine

Sun Inn ★ 🅛

Rosemary Lane, SY7 0LP (off A4113, in village)
☎ (01547) 540705
Hobsons Mild, Best; Ludlow Stairway; 1 changing beer (sourced locally; often Ludlow, Three Tuns) 🅗
A national treasure and one of the last parlour pubs, the Sun was saved in 2009 following a CAMRA-led campaign. The redbrick-tiled public bar features bench furniture and a simple fireplace. There is also the untouched parlour, from where landlady of 74 years, Flossie, once held court. To the rear is a stylish pavilion-style extension overlooking the garden (venue for the August bank holiday Sunday beer festival). Light lunches are served daily. You can bring in fish & chips from next door to eat in the garden. Q⏵☕🍴🛗🚶♿🚩🐾🌳🛜

Leominster

Chequers 🅛 ✅

63 Etnam Street, HR6 8AE
☎ (01568) 612473
Wye Valley Bitter, HPA, The Hopfather, Butty Bach, Wholesome Stout; 1 changing beer (often Wye Valley) 🅗
Probably the oldest pub in the town, with a fine timber-framed façade and interesting protruding gables. A wonderful front bar was at one time two bars, but still has much charm, with a fine tiled floor, original fireplace, timbers and cosy window alcoves. To the rear is a more conventional lounge bar, games room and patio with a feature oak-timbered shelter. Snack food is available. Children over 13 are admitted. A quiz is held monthly on Wednesdays, and jazz on the first Fridays in summer. Q🌻≒🐾🛗🚩🐾🛜

Linton

Alma Inn 🅛

HR9 7RY (off B4221, W of M50 jct 3) SO659255
☎ (01989) 720355 ⊕ almainnlinton.co.uk
Butcombe Original; Ludlow Gold; Malvern Hills Black Pear; Oakham JHB; 1 changing beer (often Bristol Beer Factory, Hop Shed, Swan) 🅗
Hidden behind a plain façade is an understated but multi award-winning pub of outstanding calibre. The convivial front bar with wood-burner and original timber furniture contrasts with the rear pool room and a separate wood-panelled dining room. Hearty, freshly prepared pub classics are offered, with seasonal specials, light bites and bar snacks. Events include the nationally renowned Linton Music Festival in July, hosted in the extensive gardens along with a beer festival. A quiz is held every last Sunday of the month. Local CAMRA Pub of the Year 2020. Q⏵☕🍴🐾🚩🐾

Luston

Balance Inn 🅛

HR6 0EB (on B4361, in village)
☎ (01568) 616801 ⊕ thebalanceinnluston.business.site

Hobsons Best; Wye Valley HPA, Butty Bach; 1 changing beer (often Swan) 🅗
Located on the site of an old wool weighing station – hence the name – in a small village, the Balance has an unspoilt interior with exposed beams and open fires. The main bar is complemented by a snug with chesterfield sofa, a games room with pool table and dartboard, and a large conservatory. Locally sourced meals are served daily, including in-house stone-baked pizzas, and takeaways are available. ⏵☕🍴🐾🛗🚩(490)🐾🛜

Monkland

Monkland Arms 🅛

HR6 9DE (on A44, W end of village)
☎ (01568) 720510 ⊕ themonklandarms.co.uk
Hobsons Best; Wye Valley Butty Bach; 2 changing beers (sourced locally; often Ludlow) 🅗
A single bar serves the main area, with more drinking and dining areas to the side and back. The beer garden to the rear has seating under cover, with views across open country. Home-cooked, locally sourced food is served, including traditional Sunday lunches. Up to seven local draught ciders are available and a range of four real ales. Quiz night is the last Wednesday of the month and live music is hosted on some Saturdays and Sundays. ⏵🌻☕🍴🐾🅿🚩(502)🐾🛜

Mordiford

Moon Inn ✅

HR1 4LW (on B4224, in village)
☎ (01432) 873067 ⊕ mooninnmordiford.co.uk
Ludlow Gold; Otter Bitter; St Austell Proper Job; Timothy Taylor Landlord 🅗
This comfortable half-timbered two-bar village inn started life as a farmhouse over 400 years ago. Popular with locals and families tripping out from Hereford, it benefits from its proximity to the Mordiford Loop – a well-known local walk – as well as the rivers Lugg and Wye. Traditional, locally sourced pub food is served, with a pie and pud night on Wednesday. There is a children's play area in the garden, plus a camping and caravan site to the rear. ⏵☕🍴🛗🚶🐾🅿🚩(453)🐾🛜

Much Dewchurch

Black Swan 🍷

HR2 8DJ (on B4348, in village)
☎ (01981) 540295
Timothy Taylor Landlord; 2 changing beers (often Butcombe, Slater's) 🅗
One of the oldest pubs in Herefordshire, this delightful 15th-century beamed village inn comes complete with its own priest hole. It has a small lounge leading to the dining room with open fire, a separate public bar with flagstone floors, and a pool and darts room. Home-prepared, mainly locally sourced food is available every session. The guest beers are typically from regional breweries. Draught Gwatkins perry is available plus ciders from Cockyard, Colcombe House and other local makers. Thursday is folk night. Local CAMRA Pub of the Year 2021. ⏵🌻☕🍴🐾🅿🚩🐾🛜

Orleton

Boot Inn 🅛

SY8 4HN (off B4361, in village)
☎ (01568) 780228 ⊕ bootinnorleton.co.uk
Hobsons Best, Twisted Spire; Ludlow Ludlow Blonde; 1 changing beer 🅗

The Boot reopened under community ownership in 2019, following a period of closure. A major refurbishment of this distinguished Grade II-listed, 16th-century, half-timbered masterpiece has been achieved to good effect – it has been sympathetically opened out while maintaining a separate dining room, snug and original inglenook fireplace. Good seasonal food is served and booking is advised (and essential at weekends). ⍾❀◑♠ÅP⌂(490)

Ross-on-Wye

Tap House 🅛
1 Millpond Street, HR9 7BZ
☎ 07510 156708
6 changing beers (sourced nationally; often Hop Shed) Ⓗ
Opened in 2018, this micropub occupies what was, until 1965, the brewery tap for Alton Court Brewery. Serving six real ales from smaller breweries far and wide plus a local cider, it has transformed the choice of real ale in Ross. With a simply furnished room and a snug, the Tap does not serve meals, but cobs are available Friday to Sunday. A new brewery, Motley Hog, initially installed upstairs at the pub, is being moved during 2022 to a farm building just outside the town. A former local CAMRA Pub of the Year. Q♠⌂❀

Staplow

Oak Inn 🅛
HR8 1NP (on B4214)
☎ (01531) 640954 ⊕ theoakinnstaplow.co.uk
Ledbury Ledbury Pale ale; Wye Valley Bitter, Butty Bach; 1 changing beer (often Bathams) Ⓗ
A stylishly renovated and well-run roadside country inn offering exceptional food, good beer and quality accommodation. The contemporary public area neatly divides into three – a reception bar area with modern sofas and low tables, a snug, and a main dining area featuring an open kitchen. At the rear is a further room with scrubbed tables. Such is the reputation of the Oak that booking is essential for food and accommodation. Q⍾❀❄◑♿P⌂(417)❀🛜

Stiffords Bridge

Red Lion Inn 🅛
WR13 5NN (on A4103)
☎ (01886) 880318 ⊕ redlioncradley.com
Pitchfork; Wye Valley Butty Bach; 4 changing beers (often Ledbury, Malvern Hills) Ⓗ
This multi-roomed roadside pub is as popular with out-of-town diners as it is with locals and drinkers. A survivor of multiple floods, it is characterised by modern flagstone floors, wood panelling, bare brick walls, cosy window alcoves and a large fireplace with a wood-burner. There are pleasant and extensive gardens to the rear where events are hosted. Traditional locally sourced food dominates the menu. The guest beers are from breweries far and near, many unusual for the area, supplemented by a craft keg beer and two real ciders. ⍾❀◑♿♠P❀🛜

Upper Colwall

Chase Inn 🅛
Chase Road, WR13 6DJ (off B4218, turning at upper hairpin bend signed British Camp) SO766431
☎ (01684) 540276 ⊕ thechaseinnmalvern.co.uk
Enville Ale; Malvern Hills Black Pear; 2 changing beers (often Bathams) Ⓗ

Small and cosy two-bar free house hidden away in a quiet wooded backwater on the western slopes of the Malvern Hills. With a genteel atmosphere, it is popular with walkers and locals alike. It comprises a small lounge for dining (booking advisable at weekends) and a long, narrow public bar, both adorned with many artefacts and curios. A delightful manicured rear beer garden commands panoramic views across Herefordshire to the Welsh Hills. A quiz is held on the first Monday of the month. Q⍾❀◑♣♦♠P⌂(675)❀🛜

Wellington Heath

Farmers Arms 🅛
Horse Road, HR8 1LS (in village, E of B4214)
☎ (01531) 634776 ⊕ farmersarmswellingtonheath.co.uk
Ledbury Bitter; Wye Valley Butty Bach; 2 changing beers (often Ledbury, Pitchfork, Salopian) Ⓗ
Follow the signs carefully to find this pub in its dispersed rural community. The bar and main dining area are in the original mid 19th-century building, and on either side are more modern extensions housing a restaurant and a games room with pool table. The food ranges from burgers and pub classics to steaks and speciality dishes. Up to four local draught ciders are available in summer. A popular Beer & Beast festival is held in July. ⍾❀◑♿♣♦♠P⌂(675) ❀🛜

Woolhope

Crown Inn 🅛
HR1 4QP (in village) SO611357
☎ (01432) 860468 ⊕ thecrowninn.pub
Ledbury Bitter; Wye Valley HPA; 1 changing beer Ⓗ
Situated next to the church, the Crown has a large bar complemented by a restaurant and a public bar area in the conservatory by the front door. Sandwiches and meals are all locally sourced and home-prepared. Curries feature on Monday evenings and a gourmet night is held on the third Thursday of the month. A wide range of local cider and perry is stocked, in bottle and on draught, the latter including the pub's own produce under the brand name Kings. ⍾❀◑♿Å♣♦♠P⌂(453)❀🛜

Breweries

Hereford

🍴 **88 St Owen Street, Hereford, HR1 2QD**
☎ (01432) 342125 ✉ jfkenyon@aol.com

☺Although there has been a small brewery on this site since 1992, Hereford began life as the Spinning Dog Brewery in 2000, changing its name in 2010. After a period as primarily a brewpub, in 2017 it began to expand its distribution to pubs in Herefordshire and Pembrokeshire. ‼♦LIVE

Herefordshire Owd Bull (ABV 3.9%) BITTER
Dark (ABV 4%) MILD
HLA (Herefordshire Light Ale) (ABV 4%) PALE
Celtic Gold (ABV 4.5%) GOLD
Mutley's Revenge (ABV 4.8%) BITTER
Mutts Nuts (ABV 5%) BITTER

Ledbury SIBA

Gazerdine House, Hereford Road, Ledbury, Herefordshire, HR8 2PZ
☎ (01531) 671184 ☎ 07957 428070
⊕ ledburyrealales.co.uk

☺Established in 2012, Ledbury Real Ales uses hops grown in Herefordshire and Worcestershire with other materials sourced locally, where possible. The beers are sold mainly within a 15-mile radius of the brewery. ‼♦

Bitter (ABV 3.8%) BITTER
Dark (ABV 3.9%) MILD
Gold (ABV 4%) GOLD
Pale Ale (ABV 4%) PALE

Motley Hog

▤ The Tap House, 1 Millpond Street, Ross on Wye, HR9 2AP ☎ 07510 156708
✉ motleyhogbrewery@gmail.com

Gaining HMRC registration early in 2021, Motley Hog is a 300-litre brewery based at The Tap House, Ross on Wye. The aim is to bring small scale, commercial brewing back to the town for the first time since 1956, with two core ales, and various specials during the year.

Odyssey

Brockhampton Brewery, Oast House Barn, Bromyard, Herefordshire, WR6 5SH
☎ (01885) 483496 ☎ 07918 553152
⊕ odysseybrewco.com

⊗ This six-barrel brewery was established in 2014 by Alison and Mitchell Evans, who previously owned the Beer in Hand, Hereford. The original building, a restored barn on a National Trust estate, has been retained. A wide range of beers is brewed, predominantly served in keg and can and occasionally bottled for special release.

Simpsons

▤ White Swan, Eardisland, Herefordshire, HR6 9BD
☎ (01544) 388635 ⊕ thewhiteswaneardisland.com

Tim Simpson acquired the White Swan in 2011 and set up the brewery at the rear of the pub in 2013. All beers are brewed for consumption in the White Swan. ♦

Weobley

Jules Restaurant, Portland Street, Weobley, Herefordshire, HR4 8SB
☎ (01544) 318206 ☎ 07493 269189
⊕ theweobleybrewing.co

Commercial brewing began in 2019 at this nanobrewery, which is part of Jules restaurant in the village of Weobley

and is run by chef and head brewer Tom Evans. Four beers are regularly brewed along with two occasional beers, available from the brewery, restaurant and other local outlets and pubs. The bulk of the production is bottled, cask is a rare bonus.

Wobbly

Unit 22c, Beech Business Park, Tillington Road, Hereford, HR4 9QJ
☎ (01432) 355496 ⊕ wobblybrewing.co

Wobbly began brewing in 2013 in a small business park in Hereford and is closely linked with its sister canning company, BPS. The brewery has a refurbished tap house open every day selling its cask-conditioned beers, cider and street food, plus an onsite shop. A new canning line has greatly increased capacity. Core beers are now available in several pubs throughout Herefordshire. ‼➥♦LIVE❧

Wabbit (ABV 4%) PALE
Gold (ABV 4.2%) GOLD
American Amber Ale (ABV 4.5%) BITTER
Crow (ABV 4.5%) STOUT
Welder (ABV 4.8%) BITTER
IPA No. 3 (ABV 6%) IPA

Wye Valley SIBA IFBB

Stoke Lacy, Herefordshire, HR7 4HG
☎ (01885) 490505 ☎ 07970 597937
⊕ wyevalleybrewery.co.uk

Founded in 1985 in the back of a village pub, this award-winning brewery is now producing around 250,000 pints per week and delivers direct to more than 1,200 pubs, including eight of its own. Its products are also available through selected wholesale and retail stockists. ‼➥♦LIVE

Bitter (ABV 3.7%) BITTER
A beer whose aroma gives little hint of the bitter hoppiness that follows right through to the aftertaste.
The Hopfather (ABV 3.9%) BITTER
HPA (ABV 4%) PALE
A pale, hoppy, malty brew with a hint of sweetness before a dry finish.
Butty Bach (ABV 4.5%) BITTER
Wholesome Stout (ABV 4.6%) STOUT
A smooth and satisfying stout with a bitter edge to its roast flavours. The finish combines roast grain and malt.

Barrels, Hereford (Photo: P.G. Clasby)

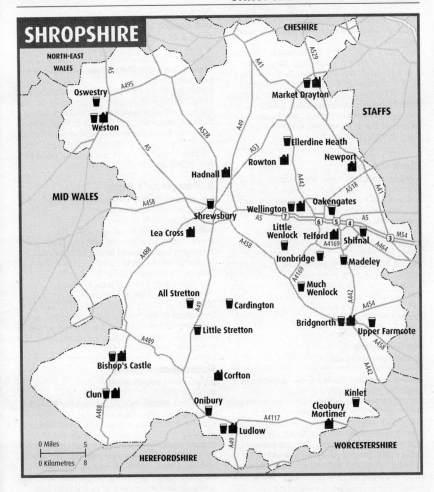

SHROPSHIRE

CHESHIRE
NORTH-EAST WALES
Oswestry
Weston
Market Drayton
STAFFS
A495
A5
A41
A529
A578
A49
A53
Ellerdine Heath
Rowton
Newport
Hadnall
MID WALES
Wellington
Oakengates
A442
A518
A41
A458
Shrewsbury
Lea Cross
Little Wenlock
Telford
Shifnal
M54
A5
A5
A458
A488
Ironbridge
Madeley
A4169
A464
All Stretton
Cardington
Much Wenlock
A442
A454
Little Stretton
Bridgnorth
Upper Farmcote
A453
Bishop's Castle
A489
Corfton
Kinlet
Clun
Onibury
Cleobury Mortimer
A488
A4117
Ludlow
A49
WORCESTERSHIRE
HEREFORDSHIRE

0 Miles 5
0 Kilometres 8

All Stretton

Yew Tree Inn L

Shrewsbury Road, SY6 6HG
☎ (01694) 328953
Wye Valley HPA, Butty Bach; 2 changing beers (sourced locally) Ⓗ
A Grade II-listed, two-roomed local in a pretty village surrounded by the Shropshire Hills. The public bar and separate lounge each have their own character, but there is an atmosphere of comfort, permanence and tradition throughout. There are low beams and log fires, and plenty of photographs, paintings and ornaments adorning the walls. Outside is a pleasant, sheltered drinking area by the main door, and dogs are welcome.
Q❀ⓒ◑♣🅿🚊(435) ❀

Bishop's Castle

Three Tuns Inn L

Salop Street, SY9 5BW
☎ (01588) 638797 🌐 thethreetunsinn.co.uk
Three Tuns Rantipole, Stout, XXX, Cleric's Cure; 1 changing beer (sourced locally; often Three Tuns) Ⓗ
A truly historic inn, this is one of the Famous Four still brewing in the early 1970s. The brewery is now separately owned but supplies the pub's beer. The interior has been extended into four rooms – on one side

is the lounge, on the other, the ever-popular front bar leading to a central snug and oak-framed glass-sided dining room. A function room is available for hire.
Q❀ⓒ❀◑🍴▲♣🚊(553) ❀🐕🛜

Bridgnorth

Black Boy L

58 Cartway, WV16 4BG
☎ (01746) 769911

REAL ALE BREWERIES

All Nations 🍺 Telford
Clun 🍺 Clun
Corvedale 🍺 Corfton (brewing suspended)
Finney's Wellington
Hobsons 🌾 Cleobury Mortimer
Joule's Market Drayton
Ludlow 🌾 Ludlow
Plan B Newport
Rowton 🍺 Rowton/Wellington
Salopian Hadnall
Severn Valley Bridgnorth (brewing suspended)
St Annes Lea Cross
Stonehouse 🌾 Weston
Three Tuns 🍺 Bishop's Castle

Hobsons Town Crier; Ludlow Blonde; Three Tuns Best; Wychwood Hobgoblin Gold; 1 changing beer (sourced regionally) Ⓗ
This Grade II-listed hostelry, first licensed in 1790, stands on the historic Cartway linking High Town with the quayside. Popular with locals, the pub offers a range of beers from Shropshire and beyond complemented by a range of traditional bar snacks. At the rear is a partially covered patio with views overlooking the River Severn. Bridgnorth Cliff Railway, England's only inland funicular railway and one of the steepest, is nearby in Underhill Street. ⬭❀≷(SVR)♣🖵❀🛜

Black Horse Ⓛ
4 Bridge Street, Low Town, WV15 6AF
☎ (01746) 762415 ⊕ theblackhorsebridgnorth.co.uk
Bathams Best Bitter; Hobsons Town Crier; Three Tuns XXX; Wye Valley HPA, Butty Bach; 1 changing beer (sourced regionally; often Enville) Ⓗ
First licensed in 1810, this Low Town Free House is popular with all ages. It has three rooms: a front bar with a rustic feel but modern atmosphere, a panelled lounge bar, and a conservatory to the side. There are also two external drinking areas. Two rooms have TVs which show a variety of live sports to an enthusiastic audience. There is often live entertainment on Saturday night. En-suite B&B accommodation is available.
⬭❀🛏♿≷(SVR) ♣🅿🖵❀🛜

Fosters Arms Ⓛ
56 Mill Street, WV15 5AG
☎ (01746) 765175
Adnams Ghost Ship; Banks's Amber Ale; Hobsons Town Crier; Wye Valley HPA Ⓗ
This popular Low Town pub has been in the same family since 1988. The busy front bar hosts regular pub games as well as showing major sporting events. A side corridor leads to a comfortable lounge on the left and then to the pool room. Beyond is a long garden, also accessed from Doctor's Lane alongside, which leads down to the riverbank, Severn Park and the Edgar Davis Ground, home of Bridgnorth Rugby. ⬭❀♿≷(SVR)♣🖵❀🛜

George Ⓛ
Hollybush Road, WV16 4AX (opp SVR entrance)
☎ (01746) 768868 ⊕ thegeorgebridgnorth.co.uk
Hobsons Town Crier; Ludlow Stairway; Timothy Taylor Landlord; Wye Valley HPA, Butty Bach Ⓗ
The George is a traditional family-friendly pub with real ales, open fires, good food and four-star accommodation. Live music is provided every Saturday evening and on bank holidays, complemented by the resident musician Jumping Jack Flash. The pub is dog friendly and has a sunny west-facing patio. Parking is available in the SVR car park opposite at a small charge.
⬭❀🛏◗♿≷(SVR) ♣🖵❀🛜

Golden Lion ⍩ Ⓛ
83 High Street, High Town, WV16 4DS
☎ (01746) 762016 ⊕ goldenlionbridgnorth.co.uk
Holden's Black Country Bitter, Black Country Mild, Golden Glow, Special; 1 changing beer (sourced locally) Ⓗ
Seventeenth-century coaching inn with bar and lounges connected by a central serving area. The main area is the front public bar, with a smaller front lounge featuring a display of pictures recording the pub's history, and the rear lounge with a large fireplace. The public bar has sports TV. Outside is a smoking area and garden patio adjacent to the car park. Q⬭❀🛏≷(SVR)♣🅿❀🛜

Old Castle Ⓛ ✅
10/11 West Castle Street, WV16 4AB (between SVR and town centre)
☎ (01746) 711420 ⊕ oldcastlebridgnorth.co.uk
Hobsons Town Crier; Sharp's Doom Bar; Wye Valley HPA, Butty Bach Ⓗ
Popular pub off the town centre dating from the 17th century, a short walk from the SVR station. The bar has four handpulls offering local and national ales. Quality meals are served all day – booking is recommended at peak times. Outside is a heated gazebo and a garden full of flowers in spring and summer. Excellent views make this an ideal spot to drink and dine alfresco. Table service only. ⬭❀◗♿≷(SVR)🅿(436,890)🛜

Railwayman's Arms Ⓛ
Severn Valley Railway Station, Hollybush Road, WV16 5DT (follow signs for SVR)
☎ (01746) 760920 ⊕ svr.co.uk
Bathams Best Bitter; Bewdley Baldwin IPA, Worcestershire Way; Hobsons Mild, Best, Town Crier; 2 changing beers (sourced locally; often Bewdley) Ⓗ
The Severn Valley Railway's popular pub located on Platform 1 at Bridgnorth Station has been licensed continuously since 1861 and is full of railway memorabilia. There are 10 handpumps, six reserved for the regular ales, three for guests and one for real cider. The platform drinking area is a great place to soak up the atmosphere of a steam railway. It gets busy at weekends and holidays. Pork pies are usually available.
Q⬭❀♿≷(SVR)🖵(9,436)❀🛜

Shakespeare Inn Ⓛ
West Castle Street, WV16 4AD
☎ (01746) 768863
Joule's Pure Blonde, Pale Ale, Slumbering Monk; 1 changing beer (often Joule's) Ⓗ
Extensively refurbished in 2018, the pub is divided by a central bar serving both sides. The lounge area at the front has cosy corners and snugs warmed by a log-burner fire, while the smaller bar area to the side, also with a log-burning stove, has French doors opening onto a covered courtyard. Off this is a function room decorated with reclaimed oak panelling. Up to four beers from Joule's are available and home-cooked food is served every day. Q⬭❀◗♿≷(SVR)♣🖵❀🛜

Cardington

Royal Oak
SY6 7JZ
☎ (01694) 771266 ⊕ at-the-oak.com
Ludlow Best; Sharp's Doom Bar; 2 changing beers Ⓗ
The Royal Oak, dating back to the 15th century, is reputedly Shropshire's oldest continually licensed pub, and is the archetypal country inn. The single room is multi-functional, with a bar, lounge and dining area, and has a relaxed ambience. It is low-beamed and dominated by a large inglenook fireplace that provides a home for various interesting artefacts. A good choice of beers includes a mix of local and regional brews. A draught cider is also on offer.
Q❀◗▲♣🖵(540) ❀🛜

Clun

White Horse Inn Ⓛ ✅
The Square, SY7 8JA
☎ (01588) 640305 ⊕ whi-clun.co.uk
Clun Loophole, Pale Ale, Citadel; Hobsons Best; Wye Valley Butty Bach; 2 changing beers (often Salopian) Ⓗ

Sixteenth-century inn and posthouse standing in the old market square, at the centre of a timeless town described by AE Housman as one of the quietest places under the sun. Inside is an L-shaped bar with low beams and adjoining dining room, which has been extended into the property next door, serving excellent, reasonably priced food. The pub is linked to the Clun Brewery and stocks its beers. Rotating real ciders are available. Outside is a secluded garden. Jam nights are held once a month. ⮑🛉🍴🏧🞣🍺⛽🐾🟊🛜

Ellerdine Heath

Royal Oak 🅛 ✅

Hazles Road, TF6 6RL (1 mile from A442, signposted Ellerdine Heath) SJ603226
☎ (01939) 250300
Hobsons Best; Rowton Bitter; Wye Valley HPA; 3 changing beers (sourced locally; often Rowton, Salopian) Ⓗ
A long-standing Guide entry, known locally as the Tiddly, and at the heart of the rural community. It offers three regular beers, three guests and real cider. Substantial cobs and snacks are always available. Dominoes is played every Monday, poker on the last Tuesday of the month. Outside is a smoking shed and large car park, with disabled access at the rear. Bike night is hosted on Wednesdays, March to October. Winter opening hours may vary. Q⮑🛉🍴🚶🞣🍺🅿🐾🟊🛜

Kinlet

Eagle & Serpent 🅛

DY12 3BE
☎ (01299) 841227
Hobsons Mild, Town Crier; Wye Valley HPA Ⓗ
This beamed 17th-century pub in a rural village has a roomy bar and a large dining area to the rear. Further drinking areas surround a log fire. There are four handpulls dispensing at least three cask ales from local breweries. Bar snacks, lunchtime and evening menus are available. A welcoming family-run pub, it is popular with walkers and cyclists. The hourly Bridgnorth-Kidderminster bus stops outside. On the Geopark Way Trail and close to the Wyre Forest. ⮑🛉🍴🚶🍺🅿🚌(125)🟊🛜

Little Stretton

Green Dragon

Ludlow Road, SY6 6RE
☎ (01694) 722925 ⊕ greendragonlittlestretton.co.uk
Ludlow Gold; Ruddles Best Bitter; Wye Valley HPA, Butty Bach; 1 changing beer Ⓗ
Set in a picturesque location in the Shropshire Hills Area of Outstanding Natural Beauty, with an abundance of walks in the district. The pub's L-shaped bar has a comfortable and welcoming feel, and the pleasant dining areas are always popular. A collection of wonderfully shaped clay pipes on the bar wall may be of interest. Beer are mostly from local breweries, as are the ciders. ⮑🛉🍴🐾🚌(435)🟊🛜

Little Wenlock

Huntsman Inn

Wellington Road, TF6 5BH
☎ (01952) 503300 ⊕ thehuntsmanoflittlewenlock.co.uk
Wye Valley Bitter; house beer (by Ruddles); 4 changing beers (sourced locally; often Hobsons, Rowton, Salopian) Ⓗ
This pub is located in a quiet village nestling below the prominent Wrekin Hill. It is popular with walkers and

locals, and forms a focus for village life. Food is served all day, both in the restaurant and cosy bar – a separate menu is available. There are hook-ups for motor caravans and a holiday cottage available for visitors to this lovely area. Dogs are allowed in the bar only.
Q⮑🛉🍴🚶🍴🅿🐾🟊🛜

Ludlow

Blue Boar

52 Mill Street, SY8 1BB (opp Assembly Rooms)
☎ (01584) 878989 ⊕ blueboarludlow.co.uk
Black Sheep Best Bitter; Hobsons Town Crier; Three Tuns Cleric's Cure; 1 changing beer (often Hobsons, Wye Valley)
A popular hostelry built in the 1600s just off the local square, this pub has a long history including an alleged ghost. The single bar room divides into three areas – the front area is wood panelled with a real fire, and the others have their own distinct character. Upstairs is a separate function room, and outside a courtyard drinking area. The pub serves mainly local beers but can stock the occasional surprising guest. ⮑🛉🍴🞣🚌🟊🛜

Charlton Arms

Ludford Bridge, SY8 1PJ (just over Ludford Bridge)
☎ (01584) 872813 ⊕ thecharltonarms.co.uk
Hobsons Best; Ludlow Gold, Stairway; Wye Valley Butty Bach; 1 changing beer (often Hobsons) Ⓗ
A fine building overlooking the River Teme and just across the historic Ludford Bridge, up towards Ludlow's last remaining fortified gate and the town centre. It has an attractive bar and a spacious lounge leading to a separate dining room with a terrace. The impressive function suite and roof bar offer fine views across the river towards the town. Accommodation is in 10 en-suite rooms. Dogs are allowed in the bar.
Q⮑🛉🍴🍴🅿🐾🟊🛜

Church Inn

The Buttercross, SY8 1AW
☎ (01584) 874034 ⊕ thechurchinn.com
Hobsons Best; Ludlow Gold; Wye Valley HPA, Butty Bach Ⓗ
This popular 14th-century town-centre pub has undergone a comprehensive refurbishment. The ground floor drinking area has a contemporary feel with a range of seating. The upstairs seating area has spectacular views of the Church of St Laurence, from which the pub takes its name. Traditional, hearty pub grub is served. Accommodation is available. ⮑🛉🍴🚶🍴🚌🟊🛜

Ludlow Brewing Co 🅛

Station Drive, SY8 2PQ
☎ (01584) 873291 ⊕ theludlowbrewingcompany.co.uk
Ludlow Ludlow Best, Ludlow Blonde, Gold, Black Knight, Stairway; 1 changing beer (sourced locally; often Ludlow) Ⓗ
The brewery tap and visitor centre for the Ludlow Brewing Company, known as the Railway Shed. As the name suggests, the building was once a goods depot. An imaginative conversion, it is built on two levels, with two huge mash tuns on the upper level, and comfortable seating and tables. On the ground floor are hand-crafted timber tables and benches, together with a shop. Brewery visits are welcome and the centre is available for hire. Occasional beer festivals and live music events are hosted. Q⮑🛉🍴🚶🍴🅿🚌🟊🛜

Rose & Crown

8 Church Street, SY8 1AP
☎ (01584) 875726 ⊕ roseandcrowninnludlow.co.uk

Joule's Pure Blonde, Pale Ale, Old No.6, Slumbering Monk; 2 changing beers (often Hobsons, Hop Back) ⊞
Hidden away in a courtyard, the Rose & Crown is probably Ludlow's oldest inn, possibly 12th century, and certainly with 15th-century elements. Refurbishment has created a much larger pub with exposed beams and fireplace. The Sun Room is open to the elements on one side and there is a garden area. A private room is available upstairs for small groups. Food is good honest pub grub such as bangers & mash or bubble & squeak. There is a carvery on Sunday. ⏺❁⏺❶⏺⏺⏺❀

Market Drayton

Red Lion ▼ 𝕃

Great Hales Street, TF9 1JP
☎ (01630) 652602
Joule's Pure Blonde, Pale Ale, Slumbering Monk; 1 changing beer (sourced locally; often Joule's) ⊞
A previous winner of the CAMRA/English Heritage Pub Design Awards, this Joule's brewery tap is a former coaching inn built in 1623. Its unique features include the Mouse Room – a Robert Thompson-inspired function room featuring carved mice – and an illuminated well in the main bar. Log fires and oak beams create a comfortable atmosphere. Locally sourced food features on an extensive menu along with the Joule's range of beers produced in the adjacent brewery.
Q⏺❁❶⏺P🚆(64,164) ❀ ⏺

Much Wenlock

Gaskell Arms Hotel 𝕃

High Street, TF13 6AQ
☎ (01952) 727212 ⊕ gaskellarms.co.uk
Wye Valley Butty Bach; 3 changing beers (sourced regionally) ⊞
Seventeenth-century coaching inn on a corner of the main road. The front door opens onto the larger of two lounges and bar. The adjacent lower lounge and restaurant have beamed ceilings, open fires and bay windows. The rear door from the car park leads to the hotel reception and public bar, which has a display of mirrors and jugs. Additional accommodation is in self-contained converted mews. Dogs are welcome in the walled garden and terrace.
Q⏺❁⏺❶⏺▲⏺P🚆(88) ❀ ⏺

George & Dragon 𝕃

2 High Street, TF13 6AA
☎ (01952) 727009 ⊕ thebestpubintheworld.com
Greene King Abbot; Hobsons Town Crier; Wye Valley HPA; 2 changing beers (sourced nationally) ⊞
Centrally located in this historic market town, the pub has a bar at the front and rooms to the rear. The main bar has a quarry-tiled floor, two fireplaces and original beams displaying whisky water jugs. The rear rooms, used for dining during meal times, have comfortable seating at small tables. There is a door leading to seating outside in the 'Shutt' alleyway. A variety of meals is served (no food Mon or Sun eve). Dogs are welcome in the front bar. Q⏺❶▲⏺🚆(18,436)❀ ⏺

Onibury

Apple Tree

SY7 9AW (up short side road from A49 level crossing)
☎ (01584) 856633
Ludlow Gold, Stairway; Wye Valley HPA ⊞
Formerly the Griffin Inn, back in 1877, the building spent a considerable period as a retail outlet but is a welcoming village pub once again. It has a quirky

appearance, with three rooms, each with their own purpose and character – the main bar is at the front – and a small garden. The emphasis is now on beer and conversation. Car parking is available in the nearby village hall car park. Q❁❶⏺P🚆(435)❀ ⏺

Oswestry

Bailey Head 𝕃

SY11 1PZ (in Market Square opp Guildhall)
☎ (01691) 570418 ⊕ baileyhead.co.uk
Stonehouse Station Bitter; 5 changing beers (sourced nationally; often Salopian) ⊞
Award-winning free house in the market square, near the old castle. Seven constantly changing real ales, including vegan beers, plus three KeyKeg beers and draught cider are on offer. Beers are sourced locally, regionally and nationally, usually from microbreweries, and served in thirds on request. Locally produced, traditional food is available, including vegan options. Events include Meet the Brewer and music and quiz nights. Dogs are especially welcome. The market car park is close by. ⏺⏺⏺⏺🞄🚆❀ ⏺

Shifnal

Anvil Inn 𝕃

22 Aston Road, TF11 8DU
☎ (01952) 462686
Black Country Bradley's Finest Golden, Pig on the Wall, Fireside; 5 changing beers (sourced regionally) ⊞
Black Country Ales pub thoroughly modernised and extended, leaving the original real fire for winter. The dartboard is in an enclosed booth. The bar has 10 handpulls – two usually for real cider, three always devoted to house beers, with seasonal and guests on the remainder. Substantial fresh bar snacks are available, plus Indian or Chinese takeaways on evenings weekly. Parking is available in the nearby municipal car park, the railway station is accessed via the station car park. Dogs are allowed. Q❁⏺≈⏺P🚆❀ ⏺

Kings Yard

2 Cheapside, Bradford Street, TF11 8BN
☎ (01952) 453553
Wye Valley HPA, Butty Bach; 2 changing beers (sourced regionally) ⊞
A new Guide entry, this micropub is in a retail unit in the centre of town. There are seating areas upstairs and downstairs, both conducive to drinking and conversation. Four handpulls include two dedicated to Wye Valley beers and one to a dark beer. Numerous craft beers are also available on eight taps, in bottles and cans. Hot food, including speciality home-made burgers, is served weekday lunchtimes. Council car parks are nearby. Q⏺⏺❶⏺≈⏺P🚆⏺

Plough Inn 𝕃

26 Broadway, TF11 8AZ
☎ (01952) 463118 ⊕ theploughinnshifnal.com
Hobsons Mild, Best; 6 changing beers (sourced regionally; often Bathams, Sarah Hughes, Three Tuns) ⊞
Traditional, family-run free house dating back to the 17th century, run by the same family since 2012. A cosy interior leads to an extensive function room. The suntrap garden, which is incredibly popular in the warmer months, includes a large covered and heated outdoor area. Up to eight cask ales and two handpulled ciders are available. Hearty pub food is served, the home-made pies always a favourite. Q⏺❁❶⏺≈⏺⏺🚆❀ ⏺

Shrewsbury

Abbey L ✓

83 Monkmoor Road, Monkmoor, SY2 5AZ
☎ (01743) 236788
Sharp's Doom Bar; 6 changing beers ⊞
A large pub with several alcoves, plus a beer garden with heated and covered areas. The publican is an ale enthusiast, offering beers from a range of breweries in varied styles, as well as craft keg. A number of sparkling and still ciders are also available, although not all real. Food is served until 10pm every night. There are regular community events including quizzes, occasional live music, Meet the Brewer and beer festivals.
ॐ⊛◑♿♣♠P☐(1) 훅

Admiral Benbow L

24 Swan Hill, SY1 1NF (just off main square)
☎ (01743) 244423
Ludlow Gold; 2 changing beers (sourced locally; often Hobsons, Salopian, Wye Valley) ⊞
Spacious free house serving a range of Shropshire and Herefordshire beers plus a selection of ciders from Rosie's including Black Bart and Wicked Wasp. A good choice of Belgian, American and other foreign bottled beers is also offered. A small room off the bar can be used for private functions, and there is a seating and smoking area outside at the rear. Children are not permitted. Q⊛⇄♣♠☐훅

Armoury

Victoria Quay, SY1 1HH
☎ (01743) 340525
Ludlow Gold; Three Tuns XXX; house beer (by St Austell); 4 changing beers (often Cotleigh, Monty's, Salopian) ⊞
At one time an armoury, the riverside building was renovated in 1995. Three regular and four changing guest beers aim to please allcomers. Tasting notes are provided on chalkboards. A huge number of malt whiskies is also available. Excellent food is served and children are welcome until 9pm. A quiet pub during the day, it becomes much livelier in the evening. Board games are available on request. Q⊛◑♿⇄♠P☐❀

Coach & Horses L

23 Swan Hill, SY1 1NF
☎ (01743) 365661 ⊕ coachswanhill.co.uk
Salopian Shropshire Gold, Oracle; Stonehouse Station Bitter; 2 changing beers ⊞
Set in a quiet street off the main shopping area, the pub is a peaceful haven in which to enjoy great LocAle beers, with magnificent floral displays in summer. Victorian in style, it has a wood-panelled bar, a small side snug area and a large lounge where meals are served lunchtimes and evenings. Bar snacks are also available at lunchtimes. Cheddar Valley or Sweeney Mountain cider is dispensed on handpull. Q◑♿⇄♣♠☐❀훅

Cross Foxes

27 Longden Coleham, SY3 7DE (close to River Severn in suburb of Longden Coleham)
☎ (01743) 355050
Draught Bass; Salopian Shropshire Gold; Three Tuns XXX ⊞
The pub has been a free house since its purchase from Mitchells & Butlers in the late 1980s, and run by the same family since 1985. It has one large, L-shaped room, with the bar and major drinking area on the large stroke, the smaller stroke occupied by darts and another drinking area. The main part has an efficient wood-burner and the walls are adorned with sports trophies and a fine Bass mirror. Q♿♠☐훅

Loggerheads ★ L ✓

1 Church Street, SY1 1UG
☎ (01743) 362398
Brakspear Oxford Gold; Marston's EPA, Pedigree; 2 changing beers (sourced nationally) ⊞
This 18th-century, Grade II-listed pub in the town centre has been identified by CAMRA as having a nationally important historic interior. It has a small bar room and three other rooms: the Lounge; the Poet's Room (featuring portraits of Shropshire poets) and the Gentlemen's Room (so-called because until 1975 it was gents only). The Gentlemen's and Poet's are served from a hatch. The pub hosts regular folk and acoustic music events. Q⇄☐❀

Nag's Head L

22 Wyle Cop, SY1 1XB
☎ (01743) 362455
Hobsons Best; Timothy Taylor Landlord; Wye Valley HPA; 2 changing beers (often Titanic) ⊞
A Grade II-listed, timber-framed building situated on the historic Wyle Cop. The pub's main architectural features are best appreciated externally – to the front is the upper-storey jettying and, in the pleasant beer garden to the rear, the timber remnants of a 14th-century hall house. The traditional interior has remained unaltered for many years. The pub is said to be haunted and features on the Shrewsbury Ghost Trail. ⊛⇄♣☐❀

Prince of Wales ♟ L

30 Bynner Street, Belle Vue, SY3 7NZ
☎ (01743) 343301 ⊕ theprince.pub
Hobsons Mild, Twisted Spire; St Austell Tribute; Salopian Golden Thread; 2 changing beers (sourced locally; often Rowton, Stonehouse) ⊞
Welcoming two-roomed community pub with a heated smoking shelter and a large suntrap deck adjoining a bowling green overlooked by a 19th-century maltings. Darts, dominoes and bowls teams abound. Beer festivals take place in February and May. Shrewsbury Town FC memorabilia adorn the building, with some of the seating from the old Gay Meadow ground skirting the bowling green. Westons Rosie's Pig is on handpull. In 2019 the pub deservedly reached the last 16 of CAMRA National Pub of the Year. Q♥⊛♿♣♠P☐❀

Salopian Bar L ✓

Smithfield Road, SY1 1PW
☎ (01743) 351505
Oakham Citra; Salopian Oracle; 3 changing beers (often Oakham, Salopian) ⊞
This two-room pub, popular with all age groups, was extended and refurbished following flooding in 2020. The bar's management strives to rotate the beer, cider and perry range to satisfy demand for variety. Regular cider and perry are provided by Westons and Thatchers, and an interesting and increasing range of bottled beers, including gluten-free, is also available. Largescreen TVs show coverage of major sporting events. Live music features on Friday evening. A previous winner of local CAMRA Pub of the Year and Cider Pub of the Year.
♿⇄♠☐❀훅

Shrewsbury Hotel ✓

Mardol, SY1 1PU (by Welsh Bridge, access from bottom of Mardol)
☎ (01743) 236203
Greene King IPA, Abbot; Sharp's Doom Bar; 4 changing beers (sourced nationally) ⊞
Large pub/hotel on a busy corner site near the Welsh Bridge – the first Wetherspoon hotel in the town. There are a number of nooks and crannies to hide away if necessary. Outside, the car park has been replaced by a

large outdoor drinking area. The pub hosts an annual beer festival and a summer real cider festival. Alcohol is served from 9am daily. 🌳🍴⏰🚲🗘♿🚃🚌🚗🚻

Tap & Can

13 Castle Gates, SY1 2AB
☎ 07837 490495
4 changing beers Ⓗ

Opened in 2019, this single-room bar near the town railway station has its counter at the far end. Four handpumps offer a changing range of real ales, plus KeyKeg and keg craft beers. Cans are served from vast fridges near the bar, available to drink here or take away. The rear wall of the Gents is the exposed castle foundations and is over 900 years old. Dogs are welcome. 🚃🚌🐾🌸

Three Fishes Ⓛ

4 Fish Street, SY1 1UR
☎ (01743) 344793
Ludlow Best; 3 changing beers (sourced regionally; often Oakham, Salopian) Ⓗ

Fifteenth-century building standing in the shadow of two churches, St Alkmund's and St Julian's, within the maze of streets and passageways in the town's medieval quarter. Freshly prepared food is served lunchtimes and early evenings Monday to Saturday. The pub offers a range of up to five local and national ales, usually including some dark beers, and a choice of real ciders and perries. Although the lease has changed hands (to a CAMRA member), cellar management has not.
Q🕙🍴🚃♣🚌🌸🐾🗘

Woodman Ⓛ

32 Coton Hill, SY1 2DZ
☎ (01743) 351007
Ossett White Rat; Salopian Shropshire Gold; Wye Valley Butty Bach; 2 changing beers (sourced regionally) Ⓗ

Part-brick and part-timbered black and white corner pub, originally built in the 1800s, destroyed by fire in 1923, and rebuilt in 1925. The building is reputedly haunted by the ex-landlady who died in the fire. The wonderful oak-panelled lounge has two real log fires and traditional settles, and the separate bar has the original stone-tiled flooring, wooden seating, fire and listed leaded windows. The courtyard has a heated smoking area and seating. The bar specialises in pale, hoppy beers.
Q🐕🌳🍴♣🚌🌸🐾🗘

Telford: Ironbridge

Coracle Micropub & Beer Shop

27 High Street, TF8 7AD
☎ (01952) 432664
4 changing beers (sourced nationally; often Salopian) Ⓗ/🅰

This welcoming gem of a pub is only a few yards from the historic Ironbridge. The building was formerly a printer's, a jeweller's, and a butcher's, in true micropub tradition. The name reflects the local production and operation of coracles on the adjacent River Severn. There is always one Salopian beer plus three changing beers. Around 120 bottled and canned beers are available for sale. Locally made bar snacks including pies and Scotch eggs are available, but customers may bring in their own food. Children are welcome until 7pm.
Q🕙🅰♣🚌(8,18)🌸🗘

Telford: Madeley

All Nations Ⓛ

20 Coalport Road, TF7 5DP (signed off Legges Way, opp Blists Hill Museum)
☎ (01952) 585747 ⊕ allnationsinn.co.uk
House beer (by All Nations); 2 changing beers (sourced regionally; often Hobsons, Ludlow) Ⓗ

One of the last four historic brewhouses from 1974, near Blists Hill Museum and the World Heritage Area. Now a CAMRA Golden Award winner, the pub is famed for its friendly clientele, substantial fresh baps (black pudding & cheese a speciality), and All Nations beer plus three guests. The small, cosy, dog-friendly interior has a wood-burner for winter, and outside there are various drinking areas. Camping is available in the field at rear of the pub. Evening opening times may vary. Q🕙🌳🍴🏕🅰♣P🌸🗘

Telford: Oakengates

Crown Inn Ⓛ ✓

Market Street, TF2 6EA
☎ (01952) 610888
Hobsons Twisted Spire, Best; 10 changing beers (sourced nationally; often Backyard, Beartown, Rudgate) Ⓗ

Cosy, traditional, three-room town pub with real fires in the front and rear bars. The Crown is a CAMRA Golden Award winner, Cask Marque accredited, and offers real cider, mild, stout or porter. It has 14 cooled handpulls – with more for beer festivals in May and October, where some 19,000 different beers have been served since 1995. A comedy club, live music and quiz are hosted regularly. There is level access via a suntrap courtyard at the rear from the bus station and car park.
Q🕙🐕🌸🚃♣🚌🌸🗘

Old Fighting Cocks Ⓛ

48 Market Street, TF2 6DU
☎ (01952) 615607
Everards Tiger; Rowton Ironbridge Gold, Area 51; 6 changing beers (sourced regionally) Ⓗ

Popular, family-run Rowton Brewery pub with 12 handpulls, four for Rowton's own beers, plus three ciders and five changing beers. The building retains many period features including stained glass and a horse-feeding hatch in the accessible toilet. As well as the two main rooms with log burners, there are a rear room and a snug, and a large outside area with a covered space. Situated near other real ale pubs, this pub stands out with its variety of beers. Bar snacks are available.
Q🌸♿🚃♣🚌🌸🗘

Station Hotel Ⓛ

42 Market Street, TF2 6DU
☎ (01952) 612949
Bathams Best Bitter; 8 changing beers (sourced nationally; often Abbeydale, Pictish) Ⓗ

Located on the Oakengates triangle, this pub has been in the Guide for a number of years. An ever-changing selection of beers is dispensed from nine handpulls, and three beer festivals are held a year – over the May and August bank holidays and in December. The front bar has a welcoming fire, and along with two further rooms is fully accessible. Home-made rolls and pies are served. A heated smoking patio is at the rear. Opening times may vary. Q🌸♿🚃♣🚌🌸🗘

Telford: Wellington

Pheasant Inn 🍸 Ⓛ

54 Market Street, TF1 1DT
☎ (01952) 260683

Everards Tiger; Rowton Ironbridge Gold, Area 51; 4 changing beers (sourced nationally; often Finney's, Rowton) Ⓗ

The Pheasant, situated near the historic Wellington Market, is a traditional family-run pub and the tap for Rowton Brewery. It has nine handpulls, three for Rowton ales and four for changing beers (at least one a dark beer), plus two changing ciders. A large beer garden with a covered area is next to the brewery. Home-made food is available Tuesday to Saturday until 4pm, with bar snacks at any time. Disabled access is via the rear door. There is a public car park next door. Local CAMRA Pub of the Year in 2020. Q⅊👪🍴🚃🅿🚗🛜

William Withering Ⓛ ✅

43-45 New Street, TF1 1LU

☎ (01952) 642800

Greene King Abbot; Ruddles Best Bitter; Sharp's Doom Bar; 3 changing beers (sourced nationally; often Slater's) Ⓗ

Named after a local physician who is best remembered for discovering the benefits of the drug Digitalis for heart failure. The building is a former supermarket built in the 1970s but there was a pub on the site from 1828, the Duke of Wellington. The pub has a large, single-room, open-plan interior styled as an 18th-century study, themed with foxglove motifs and quotations by Withering. A statue of a woman with children hints at the original plan to name the pub after Hesba Stretton, a local children's rights campaigner. Q⅊👪🍴&🚃🚗🛜

Upper Farmcote

Lion o' Morfe Ⓛ

WV15 5PS (½ mile from A458 signposted Claverley)
SO770919

☎ (01746) 389935

Hobsons Town Crier; Wye Valley HPA; 1 changing beer (sourced locally; often Enville, Ludlow, Three Tuns) Ⓗ

This former Georgian farmhouse became an inn in the early 1850s. A popular locals' pub and a regular stop-off for walkers and cyclists, it has justifiably won several recent CAMRA awards. There is a choice of rooms: bar, snug, lounge and conservatory, plus a beer garden. Five local ales and a local cider are usually on handpump. Substantial meals are served every lunchtime and Wednesday to Saturday evenings. Q⅊👪🍴&🅰♣🅿🚗

Weston

Stonehouse Brewery Ⓛ

Stonehouse, Weston Road, SY10 9ES (just off A483 Oswestry bypass)

☎ (01691) 676457 ⊕ stonehousebrewery.co.uk

Stonehouse Wrangler, Station Bitter, Cambrian Gold; 1 changing beer (often Stonehouse) Ⓗ

The family-run Stonehouse Brewery bar and shop is part of the brewery and is next to the preserved Cambrian Railway. The bar area has a pleasant rustic style and serves only Stonehouse products – at least four cask ales plus keg beers, Sweeney Mountain Cider and Henstone spirits (whisky, gin, applejack, vodka) distilled on-site. Bottles, gift packs and 'fill your own' are available. Food is served Wednesday to Sunday. Brewery tours are by appointment. Q⅊👪🍴&♣🅿🚗🛜

Breweries

All Nations

🏠 20 Coalport Road, Madeley, Telford, TF7 5SU

☎ (01952) 585747 ✉ allnationsinn@btinternet.com

☺One of the Famous Four last brewpubs, it was established in 1832 and run by just two families for the first 151 years. Brewing became intermittent for a while early this century and restarted in 2016 on a nine-barrel plant.

Clun SIBA

🏠 White Horse Inn, The Square, Clun, Shropshire, SY7 8JA

☎ (01588) 640523 ✉ clunbrewery@gmail.com

☺Established in 2007 behind the White Horse, Clun, as a microbrewery. A 2.5-barrel plant was installed in 2010, and brewing has increased steadily since then, with beers supplied to the trade across the West Midlands and the Welsh Marches. Cask, bottle-conditioned and bright beer is available for sale to the public. Ad-hoc brewery tours are available (enquire at bar). ♦

Loophole (ABV 3.5%) BITTER
Pale Ale (ABV 4.1%) BITTER
Solar (ABV 4.3%) SPECIALITY
Green Man (ABV 4.4%) BITTER
Citadel (ABV 5.9%) BITTER

Corvedale

🏠 Sun Inn, Corfton, Craven Arms, Shropshire, SY7 9DF

☎ (01584) 861239 ⊕ corvedalebrewery.co.uk

☺Brewing started in 1999 behind the pub. Due to the recent sale of the pub and brewery brewing is suspended. It is likely that the new owner will start brewing again. ‼♦LIVE

Finney's

51 Wrockwardine Road, Wellington, Shropshire, TF1 3DA

☎ (01952) 412224 ✉ finney@blueyonder.co.uk

A half-barrel capacity microbrewery supplying local pubs in Wellington and Oakengates as well as Shropshire beer festivals on an occasional basis since 2010. The brewery produces a small but steadily expanding range of hand-crafted ales in a range of styles, upon request from the pubs they appear in. Most made with traditional hop varieties. Beers produced commercially include an award-winning strong dark bitter and a pale bitter often produced for Christmas.

Hobsons SIBA

Newhouse Farm, Tenbury Road, Cleobury Mortimer, Shropshire, DY14 8RD

☎ (01299) 270837 ⊕ hobsons-brewery.co.uk

Established in 1993 in a former sawmill, Hobsons relocated to a farm site with more space in 1995. A second brewery, bottling plant and a warehouse have been added along with significant expansion to the first brewery. Beers are supplied within a 50-mile radius. The brewery utilises environmental sustainable technologies where possible. A visitor centre was added in 2014, which also now operates as a brewery tap. ‼🍴LIVE♦

Mild (ABV 3.2%) MILD
A classic mild. Complex layers of taste come from roasted malts that predominate and give lots of flavour.
Twisted Spire (ABV 3.6%) GOLD
Best (ABV 3.8%) BITTER
A pale brown to amber, medium-bodied beer with strong hop character throughout. It is consequently bitter, but with malt discernible in the taste.
Old Prickly (ABV 4.2%) PALE

Town Crier (ABV 4.5%) GOLD

Joule's

The Brewery, Great Hales Street, Market Drayton, Shropshire, TF9 1JP
☎ (01630) 654400 ⊕ joulesbrewery.co.uk

Re-established in 2010, following a break of 40 years. Joule's is situated in Market Drayton, and has access to pure mineral water drawn from the same aquifer as the original brewery. It runs a collection of over 40 taphouses across its heartland of Shropshire, Staffordshire and Cheshire. ‼◆

Pure Blonde (ABV 3.8%) BLOND
Pale Ale (ABV 4.1%) PALE
Slumbering Monk (ABV 4.5%) BITTER

Ludlow SIBA

The Railway Shed, Station Drive, Ludlow, Shropshire, SY8 2PQ
☎ (01584) 873291
⊕ theludlowbrewingcompany.co.uk

☺Established in 2006, the brewery occupies a converted railway sidings shed. Beers are produced using a 20-barrel plant and and a micro plant called the Derailed Brewing Co. for one-off beers. The premises also function as a brewery tap (which now has regularly-changing beer from the micro plant including some experimental keg beers), visitor centre and event's area. ‼☕◆

Ludlow Best (ABV 3.7%) BITTER
Ludlow Blonde (ABV 4%) BLOND
Gold (ABV 4.2%) GOLD
Black Knight (ABV 4.5%) STOUT
Red Dawn (ABV 4.5%) RED
Stairway (ABV 5%) GOLD

Plan B

Audley Avenue Enterprise Park, Audley Avenue, Newport, TF10 7DW
☎ (01952) 810091 ⊕ newbrew.co.uk

☺Plan B is a family-run brewery set up in 2016 using a 10-barrel plant. Cask-conditioned ale is available within a 30-mile radius of the brewery. It has its own bottling plant and all beers are available from the shop or online. ‼☕LIVE

New Alchemy (ABV 3.9%) BITTER
New Session IPA (ABV 4%) PALE
American Pale Ale (ABV 4.1%) IPA
New Tun (ABV 4.2%) IPA
Boscobel Bitter (ABV 4.3%) BITTER
Newport Pale Ale (ABV 4.4%) PALE

Rowton SIBA

🍺 Pheasant, 56 Market Street, Wellington, Shropshire, TF1 1DT ☎ 07854 885870

Rowton: Stone House, Rowton, Telford, TF6 6QX
⊕ rowtonbrewery.com

Rowton Brewery is family-run and was established in 2008 in a converted Victorian cowshed on a farm. The brewing operation is split over two locations. The original brewery is still in the village of Rowton and uses water from a borehole on the farm. The second brewery, at the Pheasant Pub in Wellington, is now the main brewing site. Combined brew length over the two plants is 10 barrels. ◆

Wrekin No. 1 (ABV 3.9%) GOLD
Meteorite (ABV 4.2%) BITTER

Ironbridge Gold (ABV 4.4%) GOLD
Area 51 (ABV 5.1%) BITTER

St Annes

St Annes Church Shorthill, Lea Cross, Shrewsbury, Shropshire, SY5 8JE
☎ (01743) 860296 ☎ 07530 556951

Office: 38 Hafren Road, Shrewsbury, SY3 8NQ
⊕ shropshirebeers.co.uk

⊗ Brewing began in 2017. This independent brewery is in the quirky location of a restored and occasionally functioning church. Recipes are Scandinavian-influenced but traditional British real ales. A broad range of beer styles is produced. ‼◆

Three Erics (ABV 3.7%) BITTER
Golden Dart (ABV 3.8%) GOLD
Lea Cross Dark (ABV 3.9%) MILD
Tumbledown Dick (ABV 4.2%) BITTER
Round The Wrekin (ABV 4.7%) BITTER
Iron & Fire (ABV 7.5%) STOUT

Salopian SIBA

The Old Station Yard, Station Road, Hadnall, Shropshire, SY4 3DD
☎ (01743) 248414 ⊕ salopianbrewery.co.uk

☺The brewery was established in 1995 in an old dairy on the outskirts of Shrewsbury but moved in 2014 to its new location in an industrial unit in the village of Hadnall, where it now produces more than 150 barrels a week of its multi award-winning ales, for distribution throughout the midlands, and further afield. To capitalise on the small pack market, the brewery has invested in its own canning plant. ‼☕◆LIVE

Shropshire Gold (ABV 3.8%) GOLD
Oracle (ABV 4%) GOLD
Citrus aromas lead to an impressive dry and increasing citrusy taste.
Darwins Origin (ABV 4.3%) BITTER
Pale brown in which hops and fruit are dominant. Hops top the aftertaste with a pleasing lingering bitterness. Well-balanced with a moreish demand.
Hop Twister (ABV 4.5%) GOLD
Lemon Dream (ABV 4.5%) SPECIALITY
Golden Thread (ABV 5%) GOLD
Kashmir (ABV 5.5%) BITTER
Automaton (ABV 7%) STRONG
Gold with pine forest aromas and peaches! Syrup with a kick. Dry hints and exotic astringency as hops give a dry finish but sweet balance.

Severn Valley

The Stables, Hollow Ash Lane, Bridgnorth, Shropshire, WV15 6ET ☎ 07402 636482 ⊕ severnvalleyales.co.uk

The trading name of Bridgnorth Brewery Ltd, Severn Valley Ales started brewing in 2019 producing a range of beers in different packaging formats. The main outlet is Bridgnorth Rugby Club, but beers can be found in other pubs in Bridgnorth. Brewing is currently suspended.

Stonehouse SIBA

Stonehouse, Weston, Oswestry, Shropshire, SY10 9ES
☎ (01691) 676457 ⊕ stonehousebrewery.co.uk

Stonehouse is a family-run brewery, distillery and cider maker. Established in 2007, it operates a 22-barrel plant. It is next to the Cambrian Heritage Railways line and includes a shop, bar and restaurant. Direct delivery is within 30 miles of the brewery. ‼☕◆

Sunlander (ABV 3.7%) PALE
Wrangler (ABV 3.8%) IPA
Station Bitter (ABV 3.9%) BITTER
Cambrian Gold (ABV 4.2%) GOLD

Three Tuns SIBA

⌂ Salop Street, Bishop's Castle, Shropshire, SY9 5BN
☎ 07973 301099
Office: 16 Market Square, Bishops Castle, SY9 5BW
⊕ threetunsbrewery.co.uk

Brewing on this site started in the 16th century and was licensed in 1642. A small-scale tower brewery from the late 19th century survives. Three Tuns was one of only four pub breweries still running in the 1970s. Today its beers can be found throughout the Midlands at selected free houses. ⏚ ⤢ ◆LIVE

Mild (ABV 3.4%) MILD
Rantipole (ABV 3.7%) BITTER
Best (ABV 3.8%) BITTER
Solstice (ABV 3.9%) PALE
XXX (ABV 4.3%) BITTER
A pale, sweetish bitter with a light hop aftertaste that has a honey finish.
Stout (ABV 4.4%) STOUT
Dark brown to black. Mixed dried fruit aroma with yeast. Bitter start, fruity with roast. Balanced finish with fruit and sweetness among the hops.
Cleric's Cure (ABV 5%) IPA
Old Scrooge (ABV 6.5%) BARLEY

Admiral Benbow, Shrewsbury (Photo: Dermot Kennedy)

STAFFORDSHIRE

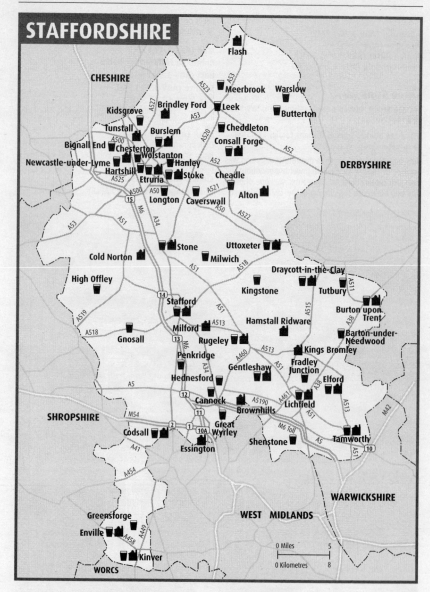

Barton-under-Needwood

Royal Oak

74 The Green, DE13 8JD (½ mile S of B5016 via Wales Lane)

☎ (01283) 713852

Marston's Pedigree; 2 changing beers (sourced nationally) Ⓗ/Ⓖ

Bustling community local on the southern edge of the village, home to many traditional pub games teams. Parts of the building date back to the 16th century, and the pub has existed since the mid-1800s. Public bar and lounge customers are served from a central sunken bar below the level of the rest of the ground floor. A separate conservatory offers access to the garden. Beers are dispensed via handpump or, on request, by gravity direct from the cask. Q❤️🅟🚱♣🖷(12)🐾🛜

Bignall End

Swan

58 Chapel Street, ST7 8QD (just off B5500 ½ mile E of Audley)

☎ (01782) 720622 ⊕ dorbiere.co.uk/the-swan

Draught Bass; Oakham Citra; 6 changing beers (sourced nationally) Ⓗ

A warm welcome awaits you from both staff and customers at this popular pub, located in the heart of the community. It has a bar area, a comfortable lounge and a large, pleasant beer garden, where you can enjoy the eight real ales sourced from many different breweries, plus a range of ciders and perries. Bingo and charity events are hosted regularly, and beer and cider festivals are held throughout the year. 🐕❤️♣♠🖷(4,4E)🐾🛜

Burton upon Trent

Burton Bridge Inn

24 Bridge Street, DE14 1SY (on A511, at town end of Trent Bridge)

☎ (01283) 536596 ⊕ burtonbridgeinn.co.uk

Burton Bridge Golden Delicious, Sovereign Gold, Bridge Bitter, Burton Porter, Stairway to Heaven, Festival Ale; 1 changing beer (sourced locally) ⊞

This 17th-century pub is the flagship of the Burton Bridge Brewery estate and fronts the brewery itself. It incorporates two rooms served from a central bar: a smaller front room, with wooden pews and displaying many awards, brewery memorabilia, and framed old maps of Burton; and a back room featuring oak beams and panels. A small function room and a skittle alley are upstairs. Live music is occasionally hosted on Saturdays. Q✿♣🚆🖳🐾🛜

Coopers Tavern ★

43 Cross Street, DE14 1EG (off Station St)

☎ (01283) 567246

Draught Bass; Joule's Pale Ale 🄶**, Slumbering Monk** ⊞**; 6 changing beers (sourced regionally)** ⊞**/**🄶

Classic 19th-century ale house, once the Bass Brewery tap but currently part of the Joule's estate. Following a sympathetic refurbishment and expansion in 2017, the pub now incorporates five linked rooms. The intimate inner taproom has retained its barrel tables and bench seating, with the beer served from a small counter by the cask stillage. Fruit wines, plus up to six ciders/perries (choice varies), are also available. Impromptu folk music regularly features on Tuesday evenings, and live music most Sunday afternoons. ♿✿≈♠🖳🐾🛜

Devonshire Arms

86 Station Street, DE14 1BT (on corner of jct with Milton St)

☎ (01283) 480022

Burton Bridge Bridge Bitter; Draught Bass; Gates Burton Reservoir; 4 changing beers (sourced regionally) ⊞

Popular old pub, now a free house, dating from the 19th century and Grade II listed. Brewery memorabilia is displayed in the refurbished public bar at the front; to the rear is a larger, more comfortable, split-level lounge featuring an 1853 map of Burton, old local photographs and unusual arched wooden ceilings. An extended rear patio is adorned with flower borders and hanging baskets. The Tuesday food evening has a theme, such as fish, pies or steak. Football fans are welcome, including away supporters. ✿🅳≈♠🅿🖳🐾🛜

Dog Inn

5 Lichfield Street, DE14 3QZ (opp Burton College, near jct with High St/New St)

☎ (01283) 517060

Black Country Bradley's Finest Golden, Pig on the Wall, Fireside; 7 changing beers (sourced regionally) ⊞

An attractive half-timbered terrace pub near the town centre. It dates back to the early 19th century, and was revitalised by Black Country Ales in 2015. The large, comfortable, square single room surrounds a central bar and features a wood-framed ceiling and wood panelling on the walls, plus three real fires and numerous old photographs of Burton. An impressive selection of cask ales is offered. Available beers and other drinks are listed on a wall-mounted screen near the bar. ♿♣●🖳🐾🛜

Elms Inn

36 Stapenhill Road, Stapenhill, DE15 9AE (on A444)

☎ (01283) 535505 ⊕ dorbiere.co.uk/the-elms

Draught Bass; Timothy Taylor Landlord; 2 changing beers (sourced nationally) ⊞

Lively local on the opposite bank of the River Trent from the town centre. Built as a private house in the late 19th century, this is one of Burton's original parlour pubs. Sensitively renovated, the small public bar, snug and a side room at the front of the pub are largely unchanged. In contrast, the lounge to the rear has been extended and refurbished in a modern style. Food is normally limited to light snacks, but themed food evenings are sometimes held. There is occasional live entertainment. ✿♣🐾🛜

Old Royal Oak 🍸

11 Market Place, DE14 1HA (on N side of Market Place, off High St)

☎ (01283) 532202 ⊕ oldroyaloak.co.uk

Fownes Elephant Riders, Royal Oak Bitter, King Korvak's Saga; 3 changing beers (sourced regionally) ⊞

This half-timbered three-storey pub on the end of a terrace is one of the oldest in the town, with parts dating back to the 17th century. After a chequered recent history, it was taken over by Fownes in 2020 and has become a convivial drinkers' hostelry. The single open-plan room features some partitioning, with a few old oak beams retained towards the rear. A TV screen near the bar scrolls through the drinks menu. Meals are limited to pizzas, early evenings Thursday to Saturday. Live music plays most Friday and Saturday evenings, and some Sundays. ✿🅳♣●🖳🐾

Weighbridge Inn

Grain Warehouse Yard, Derby Street, DE14 2JJ (off S end of Derby St, A5121, one-way section)

☎ 07758 546922

REAL ALE BREWERIES

Beowulf Brownhills
Blythe Hamstall Ridware
Brewhouse & Kitchen 🍴 ♦ Lichfield
Burton Bridge Burton upon Trent
Burton Town ♦ Burton upon Trent
Consall Forge Consall Forge
Crown Brewhouse 🍴 Elford
Enville Enville
Firs 🍴 Codsall
Flash Flash
Front Row Brindley Ford
Gates Burton Burton upon Trent
Gentlewood Gentleshaw
Heritage Burton upon Trent
Inadequate 🍴 Stoke-on-Trent: Etruria
Izaak Walton Cold Norton
Kickabo ♦ Stoke On Trent
Kinver Kinver
Lymestone Stone
Marston's Burton upon Trent
Morton Essington
Peakstones Rock Alton
Quartz Kings Bromley
Roebuck Draycott-in-the-Clay
Shugborough Milford (brewing suspended)
Six Towns 🍴 Tunstall (brewing suspended)
Slater's Stafford
Tamworth ♦ Tamworth
Titanic Stoke-on-Trent: Burslem
Tower ♦ Burton upon Trent
Trinity ♦ Lichfield
Uttoxeter ♦ Uttoxeter
Vine Inn ♦ Rugeley
Weal ♦ Chesterton

Muirhouse Tick Tock ⊞; **3 changing beers (sourced regionally)** ⊞/🅖

Two-room micropub created in 2015 in a late-Victorian former coal yard office and now operated by the Muirhouse Brewery. It is close to the railway station and en route to Burton Albion's Pirelli Stadium, nearly a mile distant. The bar counter is in the main room, with the available beers and other offerings listed on a blackboard. A cosy smaller room is located through a doorway at the far end; both rooms feature fireplaces. Meals are limited to pre-booked Sunday lunches. Children welcome until early evening. ⏰❀◐≒♣●🅟🐾

Butterton

Black Lion Inn 🅛

ST13 7SP (in centre of village next to church)
☎ (01538) 304232 ⊕ blacklioninn.co.uk
4 changing beers (often Storm, Wincle) ⊞

A charming pub with plenty of olde-worlde charm set in the heart of the village next to the church, within the Peak District National Park and close to the Manifold trail. There is a single bar, a separate restaurant and a good-sized car park. The old range is warming on cold winter days. The landlady sources her guest beers from local independents. The ales are diverse for a country pub, and normally include a brew that is unusual in the area. Q❀⋈◐❧♣P🐾

Cannock

Arcade

49 Mill Street, WS11 0DR (opp Morrisons car park)
3 changing beers (sourced locally; often Green Duck, Hobsons, Salopian) ⊞

This friendly local comprises two rooms; one with a post-industrial theme of exposed brickwork and steelwork, the other a back room set out as a comfortable lounge with period furniture. The latter leads to an outside area with wooden decking. The pub serves up to three real ales, usually local and ever-changing. Bar snacks are also available. Attractions include open mic evenings, a Wednesday quiz night and monthly retro games nights. ⏰❀♣🐾🗣

Linford Arms ✔

79 High Green, WS11 1BN
☎ (01543) 469360
Greene King Abbot; Ruddles Best Bitter; Sharp's Doom Bar; 5 changing beers (sourced nationally; often Backyard, Salopian, Slater's) ⊞

Established town-centre Wetherspoon pub serving up to eight real ales and ciders. The pub name originates from the builders' merchant that formerly occupied the premises. The seating area is on two floors with quieter alcoves and a separate snug. Food is served daily. Two ale festivals are held each year and local breweries feature regularly. There are good bus and rail links. Not to be missed if you are visiting Cannock. ⏰◐♣●🗣

Newhall Arms

81 High Green, WS11 1BN
☎ 07852 573042 ⊕ thenewhallarms.co.uk
8 changing beers (often Green Duck, Shiny, Wye Valley) ⊞

This friendly local pub has a traditional feel with no loud music or TV, just good conversation and great beer. Located in the centre of the town, it serves up to eight ales and two ciders. The beers are ever-changing, with local and national brews. Cobs are available alongside the usual snacks. A real gem that any beer-loving visitor to the town would enjoy. Q❀♣●P🐾🗣

Caverswall

Auctioneers Arms 🅛

The Green, ST11 9EQ
☎ (01782) 461127 ⊕ auctioneersarms.co.uk
Draught Bass; 3 changing beers (often Titanic) ⊞

The Knocks, as it is affectionately known to locals, reopened in 2018. It is now a thriving pub at the heart of village life, owned and run by the community. Four real ales are dispensed in good condition. Cakes and light snacks are served all day, with a fuller menu some lunchtimes and early evening. Food events, including a pie special night, are growing in popularity. Regular quizzes and live music help support this great little local boozer. Q⏰❀◐♣P🐾🗣

Cheadle

Bird in Hand 🅛

117 Tape Street, ST10 1ER
☎ (01538) 421126
Burton Bridge Bitter; Dancing Duck 22; 2 changing beers (often Brunswick, Burton Bridge) ⊞

A well-deserved entry into the Guide, this traditional, terraced street-corner pub occupies a main road position just outside the town centre. Its licensees and bar staff always give a warm welcome. Two rooms have lovely coal fires. A large screen shows major sporting events. Another room houses a dartboard, and a third room features a pool table. The cosy snug is quieter and also has a real fire. Outside is a patio for smokers. Q♣🚌(32,32X)🐾

Huntsman 🅛

The Green, ST10 1XS (at bottom of hill)
☎ (01538) 750502 ⊕ thehuntsmancheadle.com
Brains Rev James Original; Marston's Pedigree; Sharp's Doom Bar; 3 changing beers (sourced regionally; often Geeves, Peakstones Rock, Slater's) ⊞

A Guide regular on the edge of this market town, ideal for visiting Alton Towers, the Potteries or the Peak District. It is a family-friendly pub with a welcoming atmosphere and stylish interior. Guest beers are sourced locally and regionally. The food is cooked from scratch, with the beef and lamb coming from a neighbouring farm. A beer and music festival is held at the end of May, and there are gin and cider festivals later in the year. ⏰❀⋈◐♣P🚌(IN2)🐾🗣

Cheddleton

Black Lion 🅛

12 Hollow Lane, ST13 7HP (turn off A520 into Hollow Lane, opp Red Lion; pub is 100yds up hill on right)
☎ (01538) 360620
Draught Bass; Timothy Taylor Landlord; 4 changing beers (often Salopian, Wincle) ⊞

A comfortable village pub, warmed by real fires in winter. Recently refurbished in a modern rustic style, it has a patio area outside to the front and an enclosed beer garden at the rear. An excellent range of well-kept beers is offered. The pub is close to the Flint Mill Museum and the Cauldon Canal, and beside the Grade II-listed St Edward's Church with its Arts and Crafts features. Q⏰❀◐≒♣P🚌(16)🐾🗣

Codsall

Codsall Station 🅛

Chapel Lane, WV8 2EJ
☎ (01902) 847061

Holden's Black Country Bitter, Golden Glow, Special; 2 changing beers (sourced nationally; often Holden's) ⊞

Sensitively converted from the waiting room, offices and stationmaster's house, the Grade II-listed building comprises a bar, lounge, snug and conservatory and displays worldwide railway memorabilia. Steps lead to the outside drinking area with tables and benches overlooking the working platforms. Bar meals are served except Sunday and Monday, with cobs and locally made pork pies available all week. Beer festivals are held on the May and August bank holiday weekends.
Q ⊠ ❀ ⏴ ⇌ P ⊟ (5,10B) ❀ ⌘

Firs Club 🄻

Station Road, WV8 1BX (entrance from shared Co-op car park off Station Rd)
☎ (01902) 844674 ⊕ thefirscodsall.com
5 changing beers (sourced locally) ⊞
A frequent local CAMRA Club of the Year, it comprises a bar area, quiet lounge and separate sports lounge with a pool table. Five changing ales usually include a mild and are mainly local, occasionally featuring a beer from the in-house brewery. A beer festival is held in November. The Firs Suite, a dedicated function area, is available to hire for weddings and other events. A pedestrian entrance in Wood Road is handy for the bus stop.
Q ⊠ ❀ ♿ ⇌ ♣ P ⊟ (5,10B) ⌘

Love & Liquor ⌘

1-3 Church Road, WV8 1EA
☎ (01902) 843277
5 changing beers (often Abbeydale, Salopian, Wye Valley) ⊞
Converted from a shop in 2019, this village-centre bar is now an established and popular addition to the real ale choice in Codsall. Five changing ales are served, usually including a stout or porter. An upstairs room with bench seating has a large TV showing sport. Downstairs is a bar area with comfortable seating, a wood-burning stove and another TV. Pavement tables provide an outdoor drinking area. ❀ ⇌ ⊟ (5,10B)

Consall Forge

Black Lion 🄻

ST9 0AJ (off A522 follow signs to Consall Gardens, then Nature Reserve on hairpin bend; go straight on, ignore No Vehicular Access sign; at bottom of hill go left along track to car park)
☎ (01782) 550294 ⊕ blacklionpub.co.uk
Peakstones Rock Black Hole; 3 changing beers (sourced regionally; often Consall Forge, Falstaff) ⊞
Walk, drive or travel by boat or train to visit this destination pub with its changing beer and cider selections. Regular beer festivals are held, normally to coincide with a steam gala on the neighbouring Churnet Valley Railway. Typical pub food is served; arrive hungry as the portions are large. Set in an Area of Outstanding Natural Beauty, the pub is not easy to find by car but well worth the effort. Seek it out!
Q ⊠ ❀ ⏴ ▲ ⇌ (Consall) ♣ ♥ P ❀ ⌘

Draycott-in-the-Clay

Roebuck

Toby's Hill, DE6 5BT (at Toby's Hill/A515 jct, 600yds N of village)
☎ (01283) 821135 ⊕ theroebuckdraycott.co.uk
Roebuck Blonde, Hopzester, Bitter, IPA; 1 changing beer (sourced locally) ⊞

Welcoming family-owned free house, dating from the early 19th century and close to the A50/A515 junction and Staffordshire/Derbyshire boundary. The pub showcases beers from the associated Roebuck Brewery, which is in a splendid oak-framed building to the rear of the large car park. Traditional home-cooked food is served in the restaurant and cosy bar (no meals Sun eve). The Klondike Mill Steam Preservation Centre is nearby and the National Trust's Sudbury Hall and Museum of Childhood are within easy reach, as is the national football centre at St George's Park.
⊠ ❀ ⏴ P ⊟ (402,402A) ❀ ⌘

Elford

Crown Inn 🄻

The Square, B79 9DB (600m E of A513) SK189106
☎ (01827) 383602
Draught Bass; 2 changing beers (sourced locally; often Backyard, Burton Bridge) ⊞
Grade II-listed village pub, featuring a number of cosy rooms around the bar area, and a quirky little space that was formerly the above-ground cellar. In the 18th century the upstairs rooms were used as a courthouse, and today's dining room once served as the cells. Solid fuel heating gives a rosy glow in winter. Food is served Wednesday to Saturday evenings – often featuring themed events – and Sunday lunchtime. There is a separate children's room. ⊠ ⏴ P ♣ ❀ ⌘

Enville

Cat Inn 🄻

Bridgnorth Road, DY7 5HA (on A458)
☎ (01384) 872209 ⊕ thecatinn.com
Enville Simpkiss, Ale, Ginger Beer; Olde Swan Original; 4 changing beers (sourced nationally; often Enville, Wye Valley) ⊞
A warm welcome is guaranteed at this idyllic country pub, which serves as the tap house for Enville. Its interior is reminiscent of a country cottage and has multiple rooms in which to dine and imbibe, with several having their own real fires. Most of the cask ales are regular and seasonal Enville brews, but you will also find a number of guest beers and up to two real ciders. Home-made food is served. Q ⊠ ❀ ⏴ ♥ P ❀ ⌘

Fradley Junction

Swan Inn

DE13 7DN (by Trent & Mersey Canal, about 1 mile W of Fradley village) SK140140
☎ (01283) 790330 ⊕ swaninnfradley.co.uk
Everards Beacon Hill, Sunchaser, Tiger, Old Original; 1 changing beer (sourced regionally) ⊞
Known locally as the Mucky Duck, this late 18th-century, Grade II-listed, mid-terrace pub overlooks the junction of the Trent & Mersey and Coventry canals. The cosy public bar, which retains an old-fashioned charm, and the smaller lounge are on opposite sides of a central serving area. There is also a cellar room, with vaulted brick ceiling. Guest beers are usually from Midlands microbreweries, with one available in winter and two in summer. No meals are served on Sunday evening. Boaters, walkers and gongoozlers welcome.
Q ⊠ ❀ ⏴ ▲ ♣ P ❀ ⌘

Gentleshaw

Olde Windmill

Windmill Lane, WS15 4NF SK051118
☎ (01543) 682468 ⊕ yeoldewindmill.co.uk

Draught Bass; 3 changing beers (sourced nationally; often Beowulf, Castle Rock) ⊞
A welcoming 400-year-old country pub. The friendly staff are sharply attired, and serve equally sharp food and drink offerings. The guest ales are usually interesting microbrews. Dogs are welcome in the cosy bar; the wood-panelled lounge offers freshly cooked meals including interesting specials. Both rooms feature old beams and open fires. The crown bowling green is used by numerous teams. Q❀☺✪❶&🚲♿🅿🚍(62)❀☂

Gnosall

George & the Dragon

46 High Street, ST20 0EX
☎ 07779 327551 ⊕ georgeandthedragongnosall.com
Holden's Golden Glow; 4 changing beers (sourced locally) ⊞
This lovely little pub opened in 2015 and soon received acclaim, winning the local CAMRA Pub of the Year and Cider Pub of the Year awards in 2016. The building dates from 1736 with a past life as a home, shop and off-licence. It has two rooms served by one bar. With no TVs, no music and no bandits it has a good old-fashioned appeal. Tasty home-made snacks are available at the bar, and sell out fast. Only cash is accepted. Q❀♣♿🅿🚍(5)❀

Great Wyrley

Andys' Ale House 🅛

Unit 38 Quinton Court, WS6 6DZ (in Quinton Court Precinct)
☎ 07311 661688
5 changing beers (often Bristol Beer Factory, Green Duck, Sarah Hughes) ⊞
Friendly staff make you feel welcome at this pub, which has no loud music or TV, just good conversation and great beer. It is a small venue with a traditional feel, located in the Quinton Court Shopping Centre. The recently updated bar serves five ales and four ciders. Bar snacks are available. ❀&♿(Landywood)♣♿🅿🚍(X51)❀☂

Greensforge

Navigation

Greensforge Lane, DY6 0AH
☎ (01384) 273721
Enville Ale; Three Tuns XXX; 2 changing beers (often Hobsons, Holden's, Olde Swan) ⊞
Modern, food-oriented, open-plan pub with an unspoiled interior. Popular with both locals and walkers, it is on the towpath of the Staffordshire and Worcestershire Canal that connects Stourton and Hinksford. Drinkers can enjoy their beer and take in the relaxing pastoral views from a spacious outdoor area. There is a large car park directly opposite. Q❀☺✪❶🅿❀☂

Hednesford

Bridge Inn 🍷

387 Cannock Road, WS11 5TD (on jct of Belt Rd and Cannock Rd)
☎ (01543) 423651
Banks's Amber Ale; 6 changing beers (sourced nationally; often Oakham, Ossett) ⊞
A real ale focused pub, close to Cannock Chase, that offers a friendly welcome and prides itself on serving an ever-changing selection of beers, plus real cider. It was recently renovated in a modern style. Pool and darts teams are based here. Theme nights are hosted and live music plays on most Saturday nights.
❀☺✪❶≅♣🅿🚍❀☂

Cross Keys Hotel 🅛

42 Hill Street, WS12 2DN
☎ (01543) 879534
Draught Bass; Holden's Golden Glow; Salopian Oracle; Wye Valley HPA; 5 changing beers (sourced nationally; often Beowulf, Ludlow, Three Tuns) ⊞
A former coaching inn dating back to 1746. Sporting and historic photographs decorate the walls of this traditionally styled pub. It serves up to eight real ales including several guests. Fans of the local Hednesford Town FC flock here on match days. Monthly quiz nights are held. Notorious highwayman Dick Turpin is rumoured to have stopped here on his famous overnight ride from London to York. ❀☺♣🅿🚍(33,60)❀☂

Heddin's Ford

69 Market Street, WS12 1AD
Backyard The Hoard, Blonde; 2 changing beers (sourced nationally) ⊞
A recently redeveloped micropub in the centre of town, with just one room and a welcoming feel. It is a friendly pub that serves good beer and offers conversation undisturbed by loud music. Four ales are dispensed: two permanent Backyard brews plus two ever-changing beers from local and national breweries. Entertainment is hosted on Saturday at least once a month. Closed on Monday except bank holidays. Q❀&≅♿🅿❀☂

High Offley

Anchor Inn ★

Peggs Lane, Old Lea, ST20 0NG (from A519 at Woodseaves turn W on High Offley Rd by chapel, then left on Peggs Lane) SJ775256
☎ (01785) 284569
Wadworth 6X ⊞
It is worth searching out this pub on the banks of the Trent and Mersey Canal, by bridge 42. Little changed since the 19th century, it is recognised by CAMRA as having a nationally important historic interior. There are two rooms, each with a coal fire. Beer is brought up from the cellar. Between the pub and towpath is a gorgeous garden with seating. The pub is normally open Friday to Sunday, plus some weekday evenings in summer – check before visiting. Q❀☺✪♣♿🅿❀

Kidsgrove

Blue Bell

25 Hardingswood, ST7 1EG (off A50 near Tesco, by canal bridge)
☎ (01782) 774052 ⊕ bluebellinnkidsgrove.com
Whim Arbor Light; 5 changing beers (sourced nationally) ⊞
Traditional canalside pub offering six real ales and a range of ciders, plus a warm welcome from the hosts. It has two separate areas off the main bar, and a smaller room at the back. The well-kept beer range features different styles, always including one dark ale. There is a beer garden to the rear. The pub holds an annual beer festival as well as seasonal and charity events. It is popular with locals, walkers and canal users.
Q❀☺✪❶&≅♿🅿🚍(3,4A) ❀☂

Kingstone

Shrewsbury Arms 🅛

Uttoxeter Road, ST14 8QH
☎ (01889) 500181 ⊕ shrewsburyarmskingstone.co.uk
Dancing Duck Ay Up; Marston's Pedigree; Uttoxeter Bartley Bitter; 2 changing beers (sourced regionally; often Dancing Duck, Uttoxeter) ⊞

Run by the community, this delightful country inn at the village centre is the perfect place to enjoy excellent ales and traditional home-cooked food. A warm and friendly atmosphere awaits in both bar and restaurant. Several permanent and changing handpulled ales from independent brewers are served. Facilities include a beer garden and large outside seating area. Families and dogs are welcomed. Q☆☜❄◑❖▲P❀☀

Kinver

Cross Inn L
Church Hill, DY7 6HZ
☎ (01384) 878481
Black Country Bradley's Finest Golden, Pig on the Wall, Fireside; 4 changing beers (sourced nationally; often Fixed Wheel, Oakham, Salopian) H
A popular Black Country Ales outlet, serving up to six guest beers. Tasty and tempting food is offered at the weekend, including hot pork sandwiches. Several flatscreen TVs show major football matches. There is also a real fire. Outside is a large car park. Stourbridge buses stop nearby but there is no service after 6pm or on Sunday. ☆♿♣◑P❀(228)❖☀

Leek

Blue Mugge L
17 Osbourne Street, ST13 6LJ (off A53 Buxton Rd)
☎ (01538) 384450 ⊕ bluemugge.co.uk
Draught Bass; 4 changing beers (sourced nationally; often Coach House, Slater's) H
An established entry in the Guide, this unassuming terraced street-corner local just outside the town centre has been owned and run by the same family for over 40 years. It has several distinct themed rooms, a result of three adjoining properties being knocked into one. The unique layout provides bar service from a central octagonal pillar. The beer pumps and taps are to the back – two handpulls are believed to be 120 years old. Constantly changing guest ales are listed on a blackboard. Good-value food is available lunchtimes. The bus station is nearby. Q☆◑♣♨❀☀

Fountain Inn L
14 Fountain Street, ST13 6JR
☎ (01538) 382060
Draught Bass; Exmoor Gold; Wye Valley Butty Bach; 5 changing beers (sourced nationally; often Exmoor, Front Row, Wincle) H
A magnificent bank of 10 handpulls greets the eye on entering this smart town-centre local, a former CAMRA Regional Pub of the Year. Eight real ales change regularly and always include a darker, stronger brew. Two real ciders are also on sale. Live music on Sunday plus a beer raffle help make this a real gem of a friendly community pub. Two well-appointed rooms upstairs offer accommodation, and there are plenty of places to eat nearby. Q☆☜❄♣❀☀

Roebuck L
18 Derby Street, ST13 5AB (on main shopping street)
☎ (01538) 385602
Everards Tiger; Titanic Steerage, Iceberg, White Star, Plum Porter, Captain Smith's Strong Ale; 4 changing beers (sourced regionally; often Magic Rock, Salopian, Tiny Rebel) H
A town-centre pub whose Guide entry is well deserved. This Titanic Brewery-owned former coaching inn dates back to 1626 and features a distinctive black and white wooden-framed frontage. It offers up to 13 ales at busier times, mostly from the Titanic range, including the

award-winning Plum Porter. Four guest ales, real cider and a range of craft beers are also available. High-quality food is served all day, including breakfast. Regular live music and outdoor events take place in the large rear beer garden. The bus station is nearby. Q☆☜◑P♨❀☀

Lichfield

Beerbohm
19 Tamworth Street, WS13 6JP
☎ (01543) 898252 ⊕ beerbohm.bar
4 changing beers (sourced nationally) H
Cosily atmospheric café-bar with a Belgian feel, decorated with beer enamels, gilded mirrors and globular chandeliers. There is an additional comfortable room upstairs. Three or four changing ales are partnered by continental draught beers and a good selection of Belgian and German bottled brews. Draught ales can be canned for takeout. Simple snacks are served, and customers are welcome to bring their own food. The unisex toilets are upstairs. Q☆➔(City)♨❀☀

BitterSuite L
55 Upper St John Street, WS14 9DT
☎ 07852 179340 ⊕ bittersuite.co.uk
5 changing beers (sourced nationally) G
The success of this splendid micropub means that since opening in 2017 it has evolved into a full-blown pub. It now has three comfortable rooms, offering service to your table. The five real ales and five ciders are complemented by gins, wines and bottled beers. Simple snacks are available, or you can bring your own food. Live music is hosted occasionally. To the rear is a large beer terrace. Children are welcome until early evening. Payment is by card only. Q☆❄➔(City)♨❀

Horse & Jockey L
8-10 Sandford Street, WS13 6QA
☎ (01543) 410033
Holden's Golden Glow; Marston's Pedigree; Timothy Taylor Landlord; Wye Valley HPA; 4 changing beers (sourced nationally) H
Lichfield's longest-serving Guide entry is popular with locals and a must for visitors enjoying the city's vibrant real ale scene. The four guest beers are generally from smaller breweries. Various comfy areas surround the central bar, and there is a large suntrap beer terrace to the rear. Sports screenings are well attended. Food is served at lunchtime, and a pork pie/cheeseboard selection is always available. A 21-plus age policy applies. ❄◑➔(City)♣♨❀

Meerbrook

Lazy Trout L
ST13 8SN
☎ (01538) 300385 ⊕ thelazytrout.co.uk
Greene King IPA, Yardbird; house beer (by Beartown); 2 changing beers (often Storm, Wincle) H
This pub's location, on the edge of the Peak District National Park and almost across the road from Tittesworth Water reservoir, makes it a natural haunt for ramblers, cyclists, dog walkers and families. Wellies and walking boots are welcome. Five cask ales are served, at least one from a local brewery. Food is available all day every day with booking strongly advised at busier times. The pub is warmed by a cosy real fire, and has ample outdoor seating at the front and rear with stunning views. ☆❄◑P❀

Milwich

Green Man

Sandon Lane, ST18 0EG (on B5027 in the centre of the village)
☎ (01889) 505310 ⊕ greenmanmilwich.com
Adnams Southwold Bitter; Draught Bass; 2 changing beers (sourced nationally) ⊞

A true community gem in the countryside, featuring a lush beer garden. You are assured of a tip-top pint here – the pub has been in this Guide continually for 30 years. It also has a good reputation for food, which is served Thursday to Sunday evenings and at weekend lunchtimes. Children and dogs are welcome. Local CAMRA Rural Pub of the Year on numerous occasions.
Q ☺ ☆ ◑ ♣ P ❀ ♥ 🛜

Newcastle-under-Lyme

Boat & Horses

2 Stubbs Gate, ST5 1LU (opp Morrisons, 500yds from bus station)
☎ (01782) 911528
Draught Bass; Facer's North Star Porter; Salopian Oracle; Thornbridge Jaipur IPA; 2 changing beers (sourced nationally) ⊞

Reopened in 2019 under an award-winning licensee, this friendly free house on the edge of the town centre has gone from strength to strength. It offers six real ales, at least four ciders and a selection of craft beers in cans and bottles. No food is served but customers are welcome to bring their own and eat it with a purchased drink or two. There is additional seating on either side of the bar. The pub hosts music on Sunday evenings and a popular quiz on Wednesdays. The toilets are up a small step.
☆ ❀ ♣ ♥ 🛜

Bridge Street Ale House ⓛ

31 Bridge Street, ST5 2RY
☎ (01782) 499394 ⊕ bridgestreetalehouse.co.uk
5 changing beers (sourced nationally; often Beartown, Facer's) ⊞ / ⓖ

This first micropub in the area is a special place for regulars and newcomers alike. In the capable hands of its charismatic owner and his hospitable staff it oozes charm and appeal, enhanced by the quirky decor. Five changing guest beers from various breweries are served on handpull, with more occasionally available straight from the barrel. Nine real ciders and an extensive range of speciality rums add to the individuality of this fantastic pub, a Newcastle real ale institution. Q ❀ ♣ ● ♥ ❀

Cask Bar

1-2 Andrew Place, ST5 1DL
☎ (01782) 870560
Sarah Hughes Dark Ruby Mild; 4 changing beers (sourced nationally) ⊞

Award-winning microbar that opened just outside the town centre in 2017. One room houses various types of seating, from standard tables and chairs to higher tables. Sarah Hughes' Dark Ruby, the permanent cask beer, is served alongside four changing guests, two real ciders, a rotating craft keg offering and one of the best gin selections in the area. Meals are available Wednesday to Sunday. Q ◑ ● ♥ ❀ 🛜

Hopinn

102 Albert Street, ST5 1JR
☎ (01782) 711121 ⊕ hopinn.net
Black Sheep Best Bitter; Draught Bass; Oakham Citra; 5 changing beers (sourced nationally; often Mallinsons, Northern Monk, Oakham) ⊞

The Hopinn offers an outstanding range of quality national and local beers. Its three rooms are comfortably furnished, with Art Deco features to admire, all contributing to a wonderful atmosphere. Staff are attentive and extend a warm welcome to all. The eight cask ales come from regional and local brewers and are supplemented by five KeyKeg beers. ☆ ♣ ● ♥ ❀

Hopwater Cellar ⓛ

2 Bridge Street, ST5 2RY
☎ (01782) 713311
10 changing beers (sourced nationally)

This cellar bar, which opened in 2015, offers an amazing range of beers and other drinks for such a small space. There are drinking areas to the left and right of the main bar area. More than 400 bottles and cans from around the globe are accompanied by 10 KeyKeg beers of different styles and strengths sourced countrywide, mainly from independent breweries. Premium whiskies, ciders and mead are also offered. Regular tap takeovers are featured. Q ☆ ❀ ♥ ❀ 🛜

Wellers ⓛ

3 Pepper Street, ST5 1PR
☎ (01782) 698080
4 changing beers (sourced nationally; often Weal) ⊞

Wellers is the taphouse for Weal Ales and showcases its award-winning beers alongside two nationally sourced rotating guests. Two real ciders, two craft ales and speciality gins and vodkas are also available. Just off the High Street, this is a modern, comfortable, family-friendly pub for a quality beer served by welcoming staff. Thursday is quiz night. No food is on offer but you can bring your own. ☆ ● ♥ ❀ 🛜

Penkridge

Star Inn ✓

Market Place, ST19 5DJ
☎ (01785) 712513 ⊕ thestarpenkridge.wixsite.com/home
Marston's Pedigree; Wainwright; 4 changing beers (sourced nationally)

A usually busy one-room pub with several distinct areas and a welcoming feel. Pub food and excellent Scotch eggs are available. There is a covered and heated patio area where dogs are welcome. The pub is situated in the old Market Place and first traded as an inn in 1830. It closed in about 1908 and became a shop, then a private residence. It was restored and converted back into a pub in 1981. ☆ ❀ ◑ ♣ ♥ ⚲ ♣ ● P ♥ ❀ 🛜

Rugeley

Rusty Barrel

Fernwood Shopping Centre, Green Lane, WS15 2GS
⊕ therustybarrel.co.uk
4 changing beers (sourced locally; often Beowulf, Blythe, Slater's) ⊞

A one-room micropub with a friendly atmosphere, its name deriving from the owner's love of classic and rusty VW vehicles. The decor is simple painted brick; the ceiling is adorned with pumpclips showing the vast array of beers that have been sold. The four handpumps offer an ever-changing selection of ales alongside five ciders. Bar snacks are available. Q ☆ ♿ ♣ ● P ♥ (22,825) ❀

Vine Inn

Sheep Fair Close, WS15 2AT
☎ (01889) 574443
Vine Inn EPA, Vanilla Porter, Grapefruit IPA; 2 changing beers (sourced nationally; often Draught Bass, Vine Inn) ⊞

An old-style pub on a quiet street. It retains a traditional multi-room layout with a spacious bar to the front, small snug behind the bar, and a room to the rear. There is also a large function room upstairs. The bar feels pleasantly dated, with quarry tiles and an open log fire. The Vine now has its own brewery on site. Food is available Wednesday to Sunday, with a themed night on Thursday. ♿🏠👪♣😺🐾🛜

Shenstone

Plough

2 Pinfold Hill, WS14 0JN

☎ (01543) 481800 🌐 theploughatshenstone.co.uk

Holden's Black Country Bitter, Golden Glow; St Austell Tribute; Wye Valley HPA, Butty Back 🅗

Closed for four years, the Plough reopened in 2013 after a major refurbishment. The bar is furnished in a comfortable contemporary fashion. Heading towards the rear takes you past an open-view kitchen and into a series of ever more elegant dining rooms. Upstairs is a stylish function/dining room. Outside to the front is a tidy beer terrace for summertime tippling. Children are welcome until 7pm, and dogs are allowed in the bar only. ♿🏠🕮👪♿≒P🛒😺🛜

Stafford

bod

57-59 Bodmin Avenue, ST17 0EF

☎ (01785) 661506

Titanic Steerage, Iceberg, Plum Porter; 3 changing beers (often Titanic) 🅗

The first of Titanic Brewery's bod chain of café bars opened in 2018, named after its location on Bodmin Avenue. It occupies a former Co-op shop; ironically the new Co-op opposite is on the site of a former pub. The bar promises breakfast, brunch, lunch, dinner, snacks or simply a well-deserved pint after a hard day's graft. It is open from 8am for coffee, from noon for alcoholic drinks. Four Titanic beers are on draught. The food menu includes gluten-free and vegan options. Q♿🏠🕮👪🛒😺🛜

Greyhound

12 County Road, ST16 2PU (off A34, opp jail)

☎ (01785) 222432

Bradfield Farmers Blonde; 4 changing beers (sourced nationally) 🅗

A short walk from the town centre, this two-room free house is well worth a visit. The pub dates from 1831; a newspaper article from the day it opened can be seen above the bar. Today it serves an ever-changing range of five beers, often from Yorkshire breweries, and a choice of bottled ciders. The pub has won a number of CAMRA awards including local Pub of the Year. Outside are roadside tables and a smoking area. Q♿♣🛒😺🛜

Railway Inn

23 Castle Street, ST16 2EB

☎ (01785) 601237

Timothy Taylor Landlord; 1 changing beer 🅗

The Railway, dating from 1848, is at the end of a row of terraced houses, with the railway in view. Its traditional public bar at the front has a real fire and has retained its identity despite now being linked to the lounge behind and another small room. The decor includes brick fireplaces and much wooden panelling. The pub can be busy when televised sport is shown. Outside is a suntrap garden offering a grassy area with tables and a covered smoking space. Q♿🏠👪≒♣🛒😺🛜

Shrewsbury Arms

75 Eastgate Street, ST16 2NG

☎ (01785) 248240

Black Country Bradley's Finest Golden, Chain Ale, Pig on the Wall, Fireside; 6 changing beers (sourced nationally) 🅗

Part of the Black Country Ales chain, this pub complements the firm's own range by serving a wide range of beers from breweries both local and nationwide. It also offers three ciders, which are not always real. Light snacks are available. Three open fires provide warmth in cold weather. A conservatory is bookable for private functions. Q♿🏠🕮≒♣🛒😺🛜

Spittal Brook ✓

106 Lichfield Road, ST17 4LP (1 mile SE of centre off A34 at Queensville Bridge)

☎ (01785) 251343 🌐 thespittalbrookstafford.co.uk

St Austell Tribute; 3 changing beers (sourced nationally) 🅗

Within walking distance of the town centre, this traditional and friendly two-roomed local is thriving following a refurbishment and change of management in 2019. Its front room offers TV and darts; dogs are welcome here and in the spacious garden. The rear room is both a lounge and a restaurant where fresh home-cooked food is served daily. Three ever-changing guest beers are dispensed. The popular quiz night is Wednesday, with poker on Thursday and live entertainment most Saturdays. Q♿🏠🕮👪🕮♣🛒P🛒😺🛜

Sun

7 Lichfield Road, ST17 4JX

☎ (01785) 248361

Everards Tiger; Titanic Steerage, Anchor Bitter, Iceberg, White Star, Captain Smith's Strong Ale; 5 changing beers (sourced nationally) 🅗

A multi-roomed, multi-level pub with 12 handpumps, owned by Titanic Brewery. Food is served throughout the day, using locally sourced ingredients. The Sunday menu includes a traditional roast. An outdoor drinking area with its own bar is great on warmer days. Beer festivals are held in spring and late summer in a large marquee at the rear of the pub. Buses stop outside the front door. Q♿🏠🕮👪≒♣P🛒😺🛜

Stoke-on-Trent: Burslem

Bull's Head 🅛

14 St John's Square, ST6 3AJ

☎ (01782) 834153

Everards Tiger; Titanic Steerage, Iceberg, White Star, Plum Porter; 5 changing beers (sourced nationally) 🅗

The Titanic Brewery tap offers 10 real ales, 10 ciders and perries served from the cellar, and a selection of draught and bottled Belgian beers. It has a large central bar where bar billiards, a skittles table and a jukebox can be found. Customers can also opt for the intimacy of the snug. A beer garden is to the rear. The pub is close to Port Vale FC and opens early on home match days – all fans are welcome. It is involved with community events in the area. ♿🏠♣🍴🛒(3,98)😺🛜

Johny's Micro Pub 🅛

9 St John's Square, ST6 3AH

4 changing beers (sourced nationally) 🅗

This comfortable micropub on St John's Square opened in 2016. Its small, square ground-floor room with chairs and tables ensures that conversation is never far away. The four well-kept real ales change regularly and are sourced from anywhere in the country. The fridge contains a number of real ciders plus a good selection of botttles

and cans. The toilets are on the first floor, as is the Harold Harper suite which is available for meetings and small parties. Q➡(Longport)●🖨(3,98)♣

Stoke-on-Trent: Etruria

Holy Inadequate ☂ Ⓛ

67 Etruria Old Road, ST1 5PE

☎ 07771 358238

Inadequate Roundhouse Stout, Tickety Boo; Joule's Pale Ale; 6 changing beers (sourced nationally; often Inadequate) Ⓗ

A warm welcome is guaranteed at this popular pub on the outskirts of Hanley. It features an L-shaped lounge and bar area plus a rear room – both with log-burners – and also two outdoor seating areas, one of them covered. This gives a choice of places in which to enjoy the excellent variety of beers, including those from the in-house brewery, which goes from strength to strength. Pork pies and snacks are offered all day. The pub hosts regular mini beer festivals. It is a frequent recipient of local CAMRA awards, including Pub of the Year on four occasions. Q❀●P🖨(4,4A)♣ 🐾

Stoke-on-Trent: Hanley

BottleCraft

33 Piccadilly, ST1 1EN (next to the Regent Theatre)

☎ (01782) 911819 ● bottlecraft.beer

14 changing beers (sourced nationally)

A modern and comfortable craft beer bar in the heart of the city centre, serving two cask ales on handpull plus 12 KeyKeg beers and one or two ciders. It also offers a huge range of real ale and craft beer in bottles and cans. The friendly and experienced bar staff are more than happy to advise. There is a larger seating space upstairs and an outdoor area at the front. Tasting events are run regularly. Q♿♿●♣🐾

Coachmakers Arms ★

65 Lichfield Street, ST1 3EA (opp Hanley bus station)

☎ 07876 144818 ● coachmakersarms.co.uk

Draught Bass; 4 changing beers (sourced nationally) Ⓗ

A hidden gem that has been identified by CAMRA as having a historically important corridor interior. It consists of four rooms, one of them the tiny front bar that can accommodate maybe half-a-dozen customers. The authentic Victorian-era experience might include a short trip outside to the Gents. Four beers are served alongside up to five real ciders. The pub is opposite Hanley bus station so is handy to while away the minutes waiting for the next bus. Q♿♣●P🖨♣

Unicorn Inn ✓

40 Piccadilly, ST1 1EG

Draught Bass; Fuller's London Pride; 4 changing beers Ⓗ

A comfortable old-style pub in Hanley's cultural quarter, opposite the Regent Theatre. It is popular with regulars and theatregoers alike: enjoy a drink pre-show, order one for the interval and call back afterwards. Beers on the bar include Bass and London Pride, alongside four more rotating ales plus one handpull cider. An unusual feature of the pub is a narrow-gauge rail track, once used for beer delivery, in the adjacent entrance. ●🖨🐾

Victoria Lounge Bar Ⓛ

5 Adventure Place, ST1 3AF (next to Hanley bus station, opp Victoria Hall entrance)

☎ (01782) 273530 ● thevictorialoungebar.co.uk

Draught Bass; Salopian Oracle; 4 changing beers (sourced nationally) Ⓗ

Family run since 1983, this city-centre free house is close to both the bus station and Victoria Hall, making it the perfect venue for pre- and post-show drinks. Its spacious split-level room with chesterfield seating adds to the appeal. Six handpulls on the bar serve the popular house beers Bass and Oracle plus four well-sourced rotating ales. A large range of whiskies and gins is also available. Q♿♿♿🖨🐾

Woodman Ⓛ

3 Goodson Street, ST1 2AT

☎ (01782) 213996

House beer (by Facer's); 6 changing beers (sourced nationally) Ⓗ

This outstanding, multi award-winning Caldmore Taverns pub prides itself on offering customers old and new a warm reception, adding to the friendly atmosphere here. The large split-level bar extends back to a cosy lounge area and is supplemented by a comfy snug room. Two resident beers are dispensed, including the unique Woodman Pale, alongside six rotating ales and two handpulled ciders. Quality food is served from opening to early evening. Q♣●🖨🐾

Stoke-on-Trent: Hartshill

Artisan Tap

552 Hartshill Road, ST4 6AF

☎ (01782) 618378

4 changing beers (sourced nationally) Ⓗ

A vibrant, friendly pub on the Hartshill Mile, Artisan is a popular venue for ale drinkers. It serves four rotating real ales from across the UK alongside a good bottled beer selection. The pub hosts a Tuesday quiz night plus frequent live music events. It has plenty of indoor seating, plus a substantial outdoor area that allows alfresco drinking in the warmer months. Q❀♣●🖨(11,25)🐾

Greyhound Ⓛ

67 George Street, ST5 1JT

☎ (01782) 635814

Titanic Steerage, Iceberg, White Star, Plum Porter; 5 changing beers (sourced nationally; often Titanic) Ⓗ

A warm welcome awaits at this dog-friendly venue on the outskirts of Newcastle. The second pub in the Titanic fleet, it boasts nine handpumps showcasing the brewery's beers as well as a fantastic, ever-changing range of ales from across the UK. A great selection of bottled beers as well as country wines and ciders makes this an excellent choice for a quality drink. Tasty bar snacks are available. The pub hosts a quiz on Sunday evening and occasional live music from local groups. Q♿❀●🖨🐾

Sanctuary Ⓛ

493-495 Hartshill Road, ST4 6AA

☎ (01782) 437523 ● sanctuaryhartshill.co.uk

4 changing beers (sourced locally) Ⓗ

This firmly established and popular venue is a joy to visit, and epitomises the original concept of what a micropub should be. It is comfortable and comforting; welcoming to people and dogs, and to customers old and new. It serves four well-sourced handpull beers, all of them ever-changing, alongside four ciders. Gins are also a speciality. A huge range of bar snacks is available. ♿♣●🖨🐾

Stoke-on-Trent: Longton

Congress Inn 🅛

14 Sutherland Road, ST3 1HJ (nr Longton police station)
☎ (01782) 763667 ⊕ congressinnlongton.co.uk
Adnams Broadside; 6 changing beers (sourced nationally; often Castle Rock, Townhouse) 🅗
A convivial, multi award-winning, two-roomed pub just outside the centre of Longton, dedicated to the dispense of good-quality real ale from a whole host of microbreweries. The left-hand room contains the bar where the three permanent beers are joined by up to six guest ales. The right-hand room houses the dartboard, and is also used for meetings and the annual beer festival in May. It is hard for the real ale fan to go wrong in a place like this. Four ciders and a good selection of bottles beers are also available. ⇌(Longton)♣🌳🚃

Stoke-on-Trent: Stoke

Glebe 🅛

35 Glebe Street, ST4 1HG
☎ (01782) 860670
Joule's Pure Blonde, Pale Ale, Slumbering Monk; 1 changing beer (sourced nationally; often Joule's) 🅗
A short walk from Stoke railway station, this superb Joule's establishment has justifiably become one of the must-visit pubs in the city. Magnificent features, including beautifully restored stained-glass windows and candlelit tables, add to the welcoming atmosphere. Three mainstay Joule's ales are supplemented by one guest beer. Home-made meals are served at lunchtimes and early evenings and are of a high standard; there is also an extensive cheeseboard to choose from all day. ◑⇌🚃🌳

London Road Ale House 🅛

241 London Road, ST4 5AA
☎ (01782) 698070
6 changing beers (sourced nationally) 🅗
Conversation is encouraged in this vibrant, convivial one-room pub near the town centre. It serves six changing high-quality real ales plus rotating guest ciders. Smaller breweries feature heavily and all beer styles are accounted for. The pub also offers an excellent bottled and canned beer selection, plus wines and spirits. Home-made Thai food is served most evenings – booking is highly recommended, or order to take away. Tuesday is quiz night. Q◑♣🌳🚃(21)🌳

Wheatsheaf 🅛 ✅

84-92 Church Street, ST4 1BU
☎ (01782) 747462
Greene King Abbot; Ruddles Best Bitter; Sharp's Doom Bar; 6 changing beers (sourced nationally) 🅗
The oldest Wetherspoon pub in the Potteries, established in 1999 and occupying the site of a previous venue that specialised in live music; the fledgling Oasis played here on the day their debut single was released. It is small and cosy, with everything on one level, including a small smoking patio to the rear and some outside seating at the front. Around six guest ales are usually available, often from local breweries. Q🌳◑👶⇌🚃🛜

Stone

Borehole

Unit 5, Mount Road Industrial Estate, Mount Road, ST15 8LL
☎ (01785) 813581 ⊕ lymestonebrewery.net
Lymestone Stone Cutter, Stone Faced, Foundation Stone, Ein Stein, Stone the Crows; 1 changing beer (sourced nationally) 🅗
The Lymestone tap, a few yards from the brewery, is effectively two rooms with a log-burner in between. It serves the full range of Lymestone beers plus the seasonal ale, sometimes with a regional guest too. Real cider is also available. Snacks are offered at all times. To the rear is a lovely enclosed suntrap garden. Dogs are welcome, as are children until the evening. The pub hosts an open mic evening on Wednesday, and occasional live entertainment. A former local CAMRA Pub of the Year. Q🌳🌳⇌♣🌳P🌳🛜

Royal Exchange

26 Radford Street, ST15 8DA (on corner of Northesk St and Radford St)
☎ (01785) 812685
Everards Tiger; Titanic Steerage, Anchor Bitter, White Star, Plum Porter, Captain Smith's Strong Ale; 1 changing beer (sourced nationally) 🅗
A comfortable, welcoming Titanic establishment serving all the brewery's regular beers plus its seasonals and one or two guest ales. The long, single-roomed pub has an open fire at one end and a log-burner at the other. There is no TV or piped music here, just good craic. Children and dogs are welcome. Pie night is Monday (booking advised). There is live entertainment from time to time. A former local CAMRA Pub of the Year and winner of numerous awards. Q🌳🌳⇌♣🚃🌳🛜

Swan Inn 🍺

18 Stafford Street, ST15 8QW (on A520 nr Trent and Mersey Canal)
☎ (01785) 815570
House beer (by Coach House); 8 changing beers (sourced nationally) 🅗
The Swan offers a permanent beer festival, serving one house brew and eight ever-changing ales. Up to four real ciders are also available. The pub has one long room with open fires at each end, plus a partially covered outside seating area to the rear. Live music sessions are hosted frequently, often featuring heavy rock and national acts. A multiple local CAMRA Pub of the Year winner. Strictly over-21s only. 🌳👶🌳🚃(101)🌳🛜

Tamworth

King's Ditch 🅛

51 Lower Gungate, B79 7AS
☎ 07989 805828 ⊕ kingsditch.co.uk
Changing beers (sourced nationally; often Pentrich, Shiny) 🅖
A friendly micropub that opened in 2014. Its single ground-floor room is plainly decorated, and there is a small additional drinking area upstairs. Between four and six ales are offered, always including a dark brew. The pub is also well known for cider. It serves up to 30 ciders and perries and has been a finalist in CAMRA's national Cider Pub of the Year competition several times. Simple snacks are available. Occasional beer festivals are held. Children are welcome until early evening. Q🌳⇌🌳🍴🚃🌳

Old Bank House

9 Ladybank, B79 7NB
☎ 07907 097935
5 changing beers 🅗
This prominent Victorian building dates from 1845 and was formerly home to Sir Robert Peel's Tamworth Savings Bank. A blue plaque marks its history. It opened as a pub in 2021 and features four beautifully decorated rooms. There is a pleasant beer terrace to the rear, and seating to the front for fine weather. Five varied and interesting ales are usually served. Monday is a 'drink-up day' with lower beer prices. 🌳🚃🌳🛜

Sir Robert Peel ⓛ

13-15 Lower Gungate, B79 7BA
☎ (01827) 300910
5 changing beers (often Church End, Salopian) Ⓗ
Popular town-centre free house that was recognised in CAMRA's national Golden Awards. It is named after the former prime minister, known for his role in the creation of the police force. Five changing ales are dispensed by friendly and knowledgeable staff. There is also a good selection of foreign bottled beers. Live music is hosted occasionally. To the rear is a large and peaceful beer garden with ancient stone walls, overlooked by the historic St Editha's Church. ❀≋⊟❀

Tamworth Tap ♀ ⓛ ✅

29 Market Street, B79 7LR
☎ (01827) 319872 ⊕ tamworthbrewing.co.uk
Ossett White Rat; 8 changing beers (often Bristol Beer Factory, Oakham, Thornbridge) Ⓗ
An elegant building, home to Tamworth Brewing Company. The cosy upstairs rooms have Tudor features. Outside there is café-style seating to the front, and the historic courtyard beer terrace at the rear offers striking views of Tamworth Castle. Eight handpulls usually offer one Tamworth ale, with the others sourced from near and far. There is also a wide range of bottled beers, ciders, gins and wines. Various snacks are available. Live music is hosted regularly. Staffordshire CAMRA Pub of the Year 2022. ❀≋●⊟❀♥

Tutbury

Cross Keys ✅

39 Burton Street, DE13 9NR (E side of village, 300yds from A511)
☎ (01283) 813677
Burton Bridge Draught Burton Ale; 3 changing beers (sourced regionally) Ⓗ
Privately owned 19th-century free house, overlooking the Dove valley and giving a fine view of Tutbury Castle from its extended patio. The two split-level rooms – public bar and lounge – have a homely feel and are served from a similarly split-level bar. A separate large dining room to the rear provides evening meals Friday and Saturday, and Sunday lunches. This is the only pub in the area that has offered Draught Burton Ale from its launch by Ind Coope in 1976 through its 2015 reincarnation by Burton Bridge. ⏵❀◑占♣P⊟❀♥

Uttoxeter

Night Inn ♀ ⓛ

Lion Building, 8 Market Place, ST14 8HP (adjacent to Hohm coffee bar)
☎ 07426 191886
Uttoxeter Buntings Blonde, Question Mark, Admiral Gardner; 1 changing beer Ⓗ
Modern bar that was established in 2020 as a joint venture between Uttoxeter Brewing Company and Hohm coffee bar. The brewery and Hohm are run as separate entities sharing the same premises. Three Uttoxeter ales are served on a rotating basis alongside one guest. Events are hosted regularly, including music and comedy nights. An upstairs area can be booked for functions. Q⏵❀占≋P⊟❀♥

Old Swan ⓛ ✅

Market Place, ST14 8HN
☎ (01889) 598650
Greene King Abbot; Ruddles Best Bitter; Sharp's Doom Bar; 3 changing beers (sourced locally; often Backyard, Lymestone, Slater's) Ⓗ

Centrally located near the marketplace, this Wetherspoon pub attracts a varied clientele throughout the day. Up to six handpumps are in use, serving a varied choice of frequently changing local and national ales. A large open-plan seating area downstairs is supplemented by a quieter upper level to the rear. A small rear outdoor patio and separate smoking area are also available. Food is served all day. Gets busy on race days.
Q⏵❀◑占▲≋●⊟(841,402) 🖋

Plough Inn ⓛ

Stafford Road, Blounts Green, ST14 8DW (on A518)
☎ (01889) 569777
Marston's Pedigree; Wainwright; 1 changing beer (often Izaak Walton, Uttoxeter) Ⓗ
Warm and welcoming pub a 15-minute walk from the town centre and close to several other good bars. Its customers are drawn mainly from the local community, supplemented by passing trade. The Plough attracts both drinkers and diners, with no part of the building reserved for either. It serves up to four real ales, sourced from national and smaller breweries. Well worth a visit if you are in the area. Q⏵❀◑占♣P❀🖋

Warslow

Greyhound Inn ⓛ

Leek Road, SK17 0JN
☎ (01298) 84782 ⊕ thegreyhoundinnwarslow.co.uk
Marston's Pedigree; Sharp's Doom Bar; 6 changing beers (sourced locally; often Beartown, Wincle) Ⓗ
Attractive village pub in the Peak District National Park, owned and run by a local family. It has recently been renovated throughout to include six en-suite bedrooms, and the outside has a fresh look with a seating area and flower beds. Eight handpulls adorn the bar, two dispensing familiar permanent beers and the other six serving ales sourced from around the Peak District. Pub food is offered from a large menu.
⏵❀🛏◑♣P⊟(442) ❀

Wolstanton

Archer ⓛ

21 Church Lane, ST5 0EH
☎ (01782) 740467
Hop Back Citra, Summer Lightning; 4 changing beers (sourced nationally; often Hop Back) Ⓗ
Traditional village inn, friendly to both people and dogs, serving six guest ales including a dark beer. This is Hop Back's most northern outpost and it offers two of the Wiltshire brewery's beers as part of its impressive range. The single-room pub has three distinct drinking areas, plus an outdoor space that is popular in the summer months. It is not a sports bar but the landlord always goes the extra mile for major football or rugby events. A popular quiz night is hosted on Sunday.
Q❀♣P⊟(98,99)

Breweries

Beowulf

Forest of Merica, Chasewater Country Park, Pool Lane, Brownhills, Staffordshire, WS8 7NL
☎ (01543) 454067 ☎ 07789 491801
⊕ beowulfbrewery.co.uk

Beowulf celebrated its 25th anniversary in 2022. Beowulf is noted for its award-winning ales. Its range of beers appear throughout the Midlands in independent outlets.

Bottled beers can be purchased from the brewery. ‼♦LIVE

Beorma (ABV 3.9%) BITTER
A perfectly-balanced session ale with a malty hint of fruit giving way to a lingering bitterness. Background spice excites the palate.

Chasewater Bitter (ABV 4.4%) BITTER
Golden bitter, hoppy throughout with citrus and hints of malt. Long mouth-watering, bitter finish.

Black & Blueberry (ABV 4.5%) SPECIALITY

Boomer (ABV 4.5%) BITTER
Pale brown with lots of caramel aroma. Bitter start with a sweet malty background which develops to a mouth-watering finish with dry lips.

Chase Buster (ABV 4.5%) BLOND

Dark Raven (ABV 4.5%) MILD
So dark with apple and bonfire in the aroma, so sweet and smooth like liquid toffee apples with a sudden bitter finish.

Swordsman (ABV 4.5%) BITTER
Pale gold, light, fruity aroma, tangy hoppy flavour. Faintly hoppy finish.

Folded Cross (ABV 4.6%) BITTER
Malt and caramel aromas and tastes with hints of fruity biscuits are nudged aside by the robust hops which give lingering bitter edges.

Hurricane (ABV 4.6%) BITTER

Wuffa (ABV 4.6%) GOLD

Chocolate Porter (ABV 4.7%) PORTER

Dragon Smoke Stout (ABV 4.7%) STOUT
Black with a light brown creamy head. Tobacco, chocolate, liquorice and mixed fruity hints on the aroma. Bitterness fights through the sweet and roast flavours and eventually dominates. Hints of a good port emerge.

Finn's Hall Porter (ABV 4.7%) PORTER
Dark chocolate aroma, after dinner mints, coffee and fresh tobacco. Good bitterness with woodland hints of Autumn. Long late bitterness with lip drying moreishness.

Heroes Bitter (ABV 4.7%) BITTER
Gold colour, malt aroma, hoppy taste but sweetish finish.

Mercian Shine (ABV 5%) BITTER
Amber to pale gold with a good bitter and hoppy start and a hint of nutmeg. Plenty of caramel and hops with background malt leading to a good bitter finish with caramel and hops lingering in the aftertaste.

Clout (ABV 6%) BITTER

Nordic Noir (ABV 6%) MILD
Dark brown with full liquorice aroma. Rich liquorice tastes with subtle tastes of chocolate and cinnamon. Gently moreish.

IPA (ABV 7.2%) STRONG

Killer Stout (ABV 7.3%) STOUT

Blythe SIBA

Blythe House Farm, Lichfield Road, Hamstall Ridware, Staffordshire, WS15 3QQ
☎ (01889) 504461 ☎ 07483 248723
⊕ blythebrewery.co.uk

⊗ Blythe began brewing in 2003 using a 2.5-barrel plant in a converted barn. Only organic ingredients are used wherever possible. Following a buyout by two brothers in 2017, the brewery increased its range of beers. 15 outlets are supplied direct with others supplied by wholesalers throughout the region. ‼♦LIVE

Bagot's Bitter (ABV 3.8%) BITTER
Amber in colour with a fruit start and sweetness which develops to a smooth, bitter finish. A lightly-hopped, easy-drinking beer.

Ridware Pale (ABV 4.3%) BITTER

Bright and golden with a bitter floral hop aroma and citrus taste. Good and hop-sharp, bitter and refreshing. Long, lingering bite with ripples of citrus across the tongue.

Summer Breeze (ABV 4.3%) BITTER

Staffie (ABV 4.4%) BITTER
Hoppy and grassy aroma with hints of sweetness from this amber beer. A touch of malt at the start is soon overwhelmed by hops. A full hoppy, mouth-watering finish.

Palmers Poison (ABV 4.5%) BITTER
Refreshing darkish beer. Tawny but light-headed. Coffee truffle aroma, pleasingly sweet to start but with a good hop mouthfeel.

Gold Rush (ABV 4.6%) BITTER

Dark Horse (ABV 4.7%) STOUT

Knobbled Horse (ABV 4.7%) SPECIALITY

Dark Ruby (ABV 5%) MILD

Johnsons (ABV 5.2%) PORTER
Black with a thick head. Refreshingly hoppy and full-bodied with lingering bitterness of chocolate, dates, coal smoke and liquorice.

Brewhouse & Kitchen SIBA

🖪 **1 Bird Street, Lichfield, Staffordshire, WS13 6PW**
☎ (01543) 224740 ⊕ brewhouseandkitchen.com

⊗ Part of the Brewhouse & Kitchen chain, producing its own range of beers. Carry outs and brewery experience days are offered. ‼🍴♦✦

Burton Bridge SIBA

24 Bridge Street, Burton upon Trent, Staffordshire, DE14 1SY
☎ (01283) 510573 ⊕ burtonbridgebrewery.co.uk

☺The brewery was established in 1982 by Bruce Wilkinson and Geoff Mumford and owns three pubs in the local area, including its award-winning brewery tap. More than 300 outlets are supplied direct. ‼🍴♦LIVE

Golden Delicious (ABV 3.8%) BITTER
A Burton classic with sulphurous aroma and well-balanced hops and fruit. An apple fruitiness, sharp and refreshing start leads to a lingering mouth-watering bitter finish with a hint of astringency. Light, crisp and refreshing.

Sovereign Gold (ABV 4%) BITTER
Sweet caramel aroma with a grassy hop start with malt overtones. Fresh and fruity with a bitterness that emerges and continues to develop.

XL Bitter (ABV 4%) BITTER
Another Burton classic with sulphurous aroma. Golden with fruit and hops and a characteristic lingering aftertaste hinting of toffee apple sweetness.

XL Mild (ABV 4%) MILD
Black treacle initial taste after liquorice aroma. Sweet finish with a touch of bitterness.

Bridge Bitter (ABV 4.2%) BITTER
Gentle aroma of malt and fruit. Good, balanced start, finishing with a robust mouthfeel.

Bitter (ABV 4.3%) BITTER

Burton Porter (ABV 4.5%) PORTER
Chocolate aromas and sweet, smooth taste of smoky, roasted grain and coffee.

Damson Porter (ABV 4.5%) SPECIALITY
Faint roast, caramel and dark fruit nose. Cough mixture and Blackjack beginning. Uncomplicated profile with a fractious mix of bitter fruitiness and yeasty maltiness.

Draught Burton Ale (ABV 4.8%) BITTER
Fruity orange aroma leads to hoppy start, hop and fruit body then fruity aftertaste. Dry finish with fruity hints.

Bramble Stout/Top Dog Stout (ABV 5%) SPECIALITY

Smoky aroma with a fruit hint from black liquid. Roast start with briar dry fruit emerging then a sharp black fruit taste emerges to balance the burnt effect with a sweetish dry blackberry finish with prolonged mouth-watering.

Stairway to Heaven (ABV 5%) BITTER
Golden bitter. A perfectly-balanced beer. The fruity and hoppy start leads to a hoppy body with a mouth-watering finish.

Festival Ale (ABV 5.5%) BITTER
Caramel aroma with plenty of hop taste balanced by a full-bodied, malty sweetness.

Thomas Sykes (ABV 10%) BARLEY
Kid in a sweetshop aroma. Rich fruity spirited tastes – warming and dangerously drinkable.

Contract brewed for Boot Beer:
Bitter (ABV 4.3%) BITTER

Burton Town

Unit 8, Falcon Close, Burton upon Trent, Staffordshire, DE14 1SG
☎ (01283) 510839 ☎ 07428 968702
⊕ burtontownbrewery.co.uk

⊗ Open since 2015, Burton Town Brewery is run by Steve Haynes and head brewer Andrew Hollick from converted premises off Hawkins Lane. The brewery was expanded in 2019 to a 12-barrel plant. An onsite taproom is open to the public. !! ⊨ LIVE GF V ✦

Albion (ABV 3.9%) PALE
Born Slippy (ABV 4%) SPECIALITY
That Burton Beer (ABV 4%) BITTER
Modwena (ABV 4.8%) STOUT
Thomcat (ABV 5.1%) PALE
Cascade IPA (ABV 5.6%) IPA
Black As Your Hat (ABV 6.2%) STOUT

Consall Forge

3 Railway Cottages, Consall Forge, Staffordshire, ST9 0AJ

A one-barrel brewery set in the heart of the Staffordshire Moorlands adjacent to the Churnet Valley Railway. The Black Lion at Consall Forge is a regular outlet.

Dark Ruby Mild (ABV 5.2%) MILD
Equilibrium (ABV 6%) STOUT

Crown Brewhouse

🍺 **The Square, Elford, Staffordshire, B79 9DB**
☎ (01827) 383602 ✉ bluecatsup@hotmail.com

A one-barrel plant, established in 2017, housed in a former store room attached to the Crown pub. Beers are brewed almost exclusively for the pub, but can be found at local beer festivals and events.

Enville SIBA

Coxgreen, Hollies Lane, Enville, DY7 5LG
☎ (01384) 873728 ⊕ envilleales.com

⊗ Enville Brewery is sited on a picturesque Victorian, Grade II-listed farm complex, using natural well water, traditional steam brewing and a reed and willow-effluent plant. Enville Ale is infused with honey and is from a 19th century recipe for beekeeper's ale passed down from the former proprietor's great-great aunt. ⊨ ✦

Simpkiss (ABV 4%) BITTER
Caramel smooth start, caramel body with sweet malt and hop bite. Fruity hop finish, easing finish and satisfying.
American Pale Ale (ABV 4.2%) PALE

White (ABV 4.2%) SPECIALITY
Yellow with a malt, hops and fruit aroma. Hoppy but sweet finish.

Ale (ABV 4.5%) SPECIALITY
Sweet malty aroma and taste, honey becomes apparent before bitterness finally dominates.

Old Porter (ABV 4.5%) PORTER
Black with a creamy head and sulphurous aroma. Sweet and fruity start with touches of spice. Good balance between sweet and bitter, but hops dominate the finish.

Ginger Beer (ABV 4.6%) SPECIALITY
Golden bright with gently gingered tangs. A drinkable beer with no acute flavours but a satisfying aftertaste of sweet hoppiness.

Firs

🍺 **Station Road, Codsall, Staffordshire, WV8 1BX**
☎ (01902) 844674 ⊕ thefirscodsall.com

Beers are brewed on-site in the CAMRA award-winning Firs, and are exclusive to the club.

Flash

Moss Top Farm, Moss Top Lane, Flash, Quarnford, Staffordshire, SK17 0TA ☎ 07967 592345
⊕ flashbrewery.uk

The brewery is located high in the Peak District and was founded by two friends who brew on a part-time basis. All natural ingredients are used including spring water and seaweed finings which make the beer suitable for vegans. Three bottle-conditioned beers are produced and are sold at Leek Market (only sales outlet). LIVE V

Freedom SIBA

1 Park Lodge House, Bagots Park, Abbots Bromley, Staffordshire, WS15 3ES
☎ (01283) 840721 ⊕ freedombrewery.com

Freedom specialises in producing hand-crafted English lagers, all brewed in accordance with the German Reinheitsgebot purity law. No real ale. !! ⊨

Front Row SIBA

Unit A3, The Old School, Outclough Road, Brindley Ford, Staffordshire, ST8 7QD ☎ 07861 718673
⊕ frontrowbrewing.co.uk

After starting operations in Congleton in 2012 on a 2.5-barrel plant, Front Row expanded to an eight-barrel plant in 2014. It moved to its current location at the end of 2018 to allow for further increase in capacity. There is a brewery tap in nearby Biddulph. !! ✦

Number 8 (ABV 3.7%) MILD
Crouch (ABV 3.8%) BITTER
LOHAG (Land of Hops and Glory) (ABV 3.8%) GOLD
Touch (ABV 4%) BITTER
Sin Bin (ABV 4.2%) GOLD
Try (ABV 4.2%) BITTER
Half-Time (ABV 4.5%) SPECIALITY
Pause (ABV 4.5%) STOUT
Red Roses (ABV 4.5%) STOUT
Pride (ABV 4.6%) BITTER
Blindside (ABV 4.7%) GOLD
Crafty Flanker (ABV 4.7%) GOLD
Rucked (ABV 5.2%) OLD
Converted (ABV 5.4%) PORTER
Oblensky (ABV 7.3%) PORTER

Gates Burton

Reservoir Road, Burton upon Trent, Staffordshire, DE14 2BP
☎ (01283) 532567 ☎ 07957 930772
⊕ gatesburtonbrewery.co.uk

The Gates Burton Brewery was established in 2011 using a one-barrel plant. Now expanded to a three-barrel plant, representing cottage brewing at its finest. All beer is available in cask in the free trade. ‼◆

Reservoir (ABV 4.6%) BITTER
Light brown beer with a white head provides a malt and hop aroma. Caramel starts before a spicy hop and malt middle leads to a mouthwatering bitter finish.
Gates Burton Ale (GBA) (ABV 4.8%) BITTER
Damn (ABV 5%) BITTER
Reservoir Gold (ABV 7.5%) BARLEY

Gentlewood

Fir Tree Cottage, Tithe Barn, Gentleshaw, Staffordshire, WS15 4LR ☎ 07544 146900
✉ gentlewoodbrewery@hotmail.com

Gentlewood began in 2018 and is co-owned and run by Darren Williams and Ben Colthorpe, it is a Staffordshire-based brewery specialising in traditional cask ales using British hops and grain. Frequent seasonal brews complement the core range.

Heritage (ABV 4.2%) BITTER

Heritage SIBA

National Brewery Centre, Horninglow Street, Burton upon Trent, Staffordshire, DE14 1NG
☎ (01283) 777006
⊕ heritagebrewingcompany.co.uk

Heritage Brewing Company (formerly William Worthington's Brewery) was established in 2015 by Planning Solutions Ltd, operators of the National Brewery Centre (NBC). It purchased the 25-barrel brewery and nearby bottling plant from the previous owners, Molson Coors. The team has set out to utilise the resources, history and knowledge available at the NBC to breathe new life into heritage beers, including those produced 10-15 years ago by the former Museum Brewing Co. ‼☰◆LIVE

Victoria Ale (ABV 3.8%) PALE
Charrington Oatmeal Stout (ABV 4%) STOUT
Massey's Original Mild (ABV 4%) MILD
Offilers' Best Bitter (ABV 4%) BITTER
St. Modwen Golden Ale (ABV 4.2%) BLOND
Charrington IPA (ABV 4.5%) PALE
Masterpiece IPA (ABV 5.6%) IPA
Old-fashioned amber ale, strong with lots of bitterness.

Inadequate

⧈ Holy Inadequate, 67 Etruria Old Road, Stoke-On-Trent, ST1 5PE
☎ (01782) 915170 ☎ 07771 358238
✉ paulcope.cope@gmail.com

This one-barrel plant commenced brewing behind the Holy Inadequate in 2018 and mainly supplies the pub with an ever-changing range of beers (up to four at any one time). Other local pubs are sometimes supplied, along with local beer festivals.

Kickabo

Unit 7B, Harvey Works, Lingard Street, Stoke On Trent, ST6 1ED ⊕ kickabobrewery.com

A small, three-barrel brewery set up in Burslem in the Potteries in 2020. Its aim is to recreate beers that will feature styles from across the world. Currently available in keg or cans. ◆

Kinver SIBA

Unit 1, Britch Farm, Rocky Wall, Kinver, Staffordshire, DY7 5NW ☎ 07715 842676 ⊕ kinverbrewery.co.uk

Established in 2004, Kinver brewery produces a wide range of different beer styles including one-off specials. The brewery relocated in 2012 to a new 10-barrel plant on the edge of Kinver due to increased demand. An ever-increasing number of pubs, mainly in the midlands, and beer festivals are supplied with the award-winning ales. ‼◆LIVE

Light Railway (ABV 3.8%) BLOND
Straw-coloured. session beer. A fruity and malty start quickly gives way to well-hopped bitterness and lingering hoppy aftertaste.
Cavegirl Bitter (ABV 4%) BLOND
Edge (ABV 4.2%) BITTER
Amber with a malty aroma. Sweet fruity start with a hint of citrus marmalade in the spicy-edged malt. Lasting hoppy finish that is satisfyingly bitter.
Noble (ABV 4.5%) GOLD
Fruity hop aroma. Very fruity start then the grassy hops give a sharp bitter finish with malt support.
Maybug (ABV 4.8%) BLOND
Half Centurion (ABV 5%) BITTER
A golden best bitter; malty before the Chinook hop takes command to give a balanced, hoppy finish and provide the great aftertaste.
Black Ram Stout (ABV 5.2%) STOUT
Witchfinder General (ABV 5.5%) PORTER
Khyber (ABV 5.8%) BITTER
Golden, strong bitter with a Centennial hop bite that overwhelms the fleeting malty sweetness and drives through to the long, dry finish.

Lymestone SIBA

The Brewery, Mount Road, Stone, Staffordshire, ST15 8LL
☎ (01785) 817796 ☎ 07891 782652
⊕ lymestonebrewery.co.uk

Lymestone commenced brewing in 2008. Based in the old Bents Brewery, it uses a 10-barrel plant. A family-run business, daughter Sarah has joined the brew team as one of the UK's youngest brewsters. The brewery delivers in a 50-mile radius, works with national wholesalers and has its own pub adjacent to the brewery. ‼☰◆

Stone Cutter (ABV 3.7%) BITTER
Hoppy and grassy aroma, clean, sharp and refreshing. A hint of caramel start then intense bitterness emerges with a good bitter aftertaste and touch of mouthwatering astringency.
Stone Faced (ABV 4%) BITTER
Foundation Stone (ABV 4.5%) BITTER
An IPA-style beer with pale and crystal malts. Faint biscuit and chewy, juicy fruits burst on to the palate then the spicy hops pepper the taste buds to leave a dry, bitter finish.
Ein Stein (ABV 5%) GOLD
Stone the Crows (ABV 5.4%) STOUT
A rich dark beer from chocolate malts. Fruit, roasts and hops abound to leave a deep lingering bitterness from the hop mix.
Abdominal Stoneman (ABV 7%) STRONG

405

Marston's

Shobnall Road, Burton upon Trent, Staffordshire, DE14 2BW
☎ (01283) 531131 ⊕ marstons.co.uk

☺Brewing in Burton since 1834, it houses the only working Burton Union fermenters. Developed in the 19th century, they're used to cleanse the new style of pale ale yeast. Only Pedigree is fermented in them, but the yeast is used in other beers. A nanobrewery within the visitors centre (DE14) is used for small-batch brews. Contract brewing includes Draught Bass brewed for AB Inbev. A joint venture with Carlsberg in 2020 led to the company being renamed Carlsberg Marston's Brewing Company. !! ☎ ◆ LIVE

EPA (ABV 3.6%) PALE
61 Deep (ABV 3.8%) GOLD
Light, golden to amber ale with intense tropical fruit and citrus aromas. Sweet, tropical start with hints of spice. Hoppy bitterness overcomes the fruit and leaves a pleasant mouthwatering feel.
Pedigree (ABV 4.5%) BITTER
Pale brown to amber with a sweet hoppy aroma and hint of sulphur. Malt with a dash of hop flavours give a satisfying, tasty finish.
Old Empire (ABV 5.7%) IPA
Sulphur dominates the gentle malt aroma. Malty and sweet to start but developing bitterness with fruit and a touch of sweetness. A balanced aftertaste of hops and fruit leads to a lingering bitterness.

Brewed for A-B InBev:
Draught Bass (ABV 4.4%) BITTER
Hints of caramel aroma and taste, lightly-hopped for a short, bitter finish.

Brewed under the Jennings Brewery name:
Cumberland BITTER
Fruit and caramel in the aroma gives way to a sweet middle, balanced by a gentle bitter finish.

Molson Coors (Burton)

137 High Street, Burton upon Trent, Staffordshire, DE14 1JZ
☎ (01283) 511000 ⊕ molsoncoorsbrewers.com

Molson Coors is the result of a merger between Molson of Canada and Coors of Colorado, US. Coors established itself in Europe in 2002 by buying part of the former Bass brewing empire, when Interbrew (now A-B InBev) was instructed by the British government to divest itself of some of its interests in Bass. Coors owns several cask ale brands. It brews 110,000 barrels of cask beer a year (under licensing arrangements with other brewers) and also provides a further 50,000 barrels of cask beer for other breweries. In 2011 Molson Coors bought Sharp's brewery in Cornwall (qv) in a bid to increase its stake in the cask beer sector. No cask ale is produced in Burton or Tadcaster.

Morton

Unit 10, Essington Light Industrial Estate, Essington, Wolverhampton, Staffordshire, WV11 2BH ☎ 07988 069647
Office: 96 Brewood Road, Coven, WV9 5EF
⊕ mortonbrewery.co.uk

☺This family-run brewery was established in 2006 on a three-barrel, purpose-built plant. Beers are supplied locally, further afield by reciprocal arrangements, to various beer festivals and a selection is always available at the brewery's own award-winning micropub, Hail to the Ale. !! ◆

Essington Bitter (ABV 3.8%) BITTER
Merry Mount (ABV 3.8%) BITTER
Essington Blonde (ABV 4%) PALE
Essington Ale (ABV 4.2%) PALE
Jelly Roll (ABV 4.2%) GOLD
Essington Gold (ABV 4.4%) GOLD
Essington Supreme (ABV 4.6%) BITTER
Scottish Maiden (ABV 4.6%) BITTER
Essington IPA (ABV 4.8%) PALE
Yellow with lots of hop and fruit aromas. A good mouthful of bitterness with hops and fruit jostling for taste. Great lingering bitter finish.

Peakstones Rock SIBA

Peakstones Farm, Cheadle Road, Alton, Staffordshire, ST10 4DH ☎ 07891 350908 ⊕ peakstonesrock.co.uk

⊗ Peakstones Rock are a family-run brewery established in 2005 with a five-barrel plant located on a farm in the Peak District National Park. The brewery was expanded to 10-barrel capacity in 2009. It supplies an expanding free trade market in the North Midlands and surrounding areas. !! ◆ LIVE

Nemesis (ABV 3.8%) BITTER
Biscuity aroma with some hop background. Sweet start, sweetish body then hops emerge to give a fruity middle. Bitterness develops slowly to a tongue-tingling finish.
Pugin's Gold (ABV 4%) GOLD
Chained Oak (ABV 4.2%) BITTER
Alton Abbey (ABV 4.5%) BITTER
Black Hole (ABV 4.8%) OLD
Grassy aroma with malt background. Hops hit the mouth and intensify. Bitterness lingers with some mouth-watering astringency
Oblivion (ABV 5.5%) BITTER

Quartz SIBA

Archers, Alrewas Road, Kings Bromley, Staffordshire, DE13 7HW
☎ (01543) 473965 ⊕ quartzbrewing.co.uk

☺Quartz is a small craft brewery which was established in 2005 by Scott and Julia Barnett. Around 50 outlets are supplied direct. !! ☎ ◆

Blonde (ABV 3.8%) BLOND
Little aroma, gentle hop and background malt. Sweet with unsophisticated sweetshop tastes.
Crystal (ABV 4.2%) BITTER
Sweet aroma with some fruit and yeasty Marmite hints. Hoppiness begins but dwindles to a bittersweet finish.
Extra Blonde (ABV 4.4%) BITTER
Sweet malty aroma with a touch of fruit. Sweet start, smooth with a hint of hops in the sugary finish.
Heart (ABV 4.6%) BITTER
Pale brown with some aroma of fruit and malt. Gentle tastes of fruit and hops eventually appear to leave a bitter finish.
Cracker (ABV 5%) BITTER

Roebuck SIBA

Roebuck, Tobys Hill, Draycott-in-the-Clay, Staffordshire, DE6 5BT ☎ 07903 396885
⊕ theroebuckdraycott.co.uk

☺Brewing began in 2017 using a six-barrel plant, in a purpose-built, English oak-framed, new building behind the Roebuck Inn. Master Brewer Steve Topliss was Carlsberg Tetley's last head brewer in Burton. Enquiries welcomed for brewery visits and tasting tutorials, with good food at the family-owned adjacent pub. !!

Blonde (ABV 3.7%) BLOND
Hopzester (ABV 4.2%) BITTER
Roebuck Bitter (ABV 4.5%) BITTER
Porter (ABV 4.6%) PORTER
Roebuck IPA (ABV 5.2%) PALE

Shugborough

Shugborough Estate, Milford, Staffordshire, ST17 0XB
☎ (01782) 823447 ⊕ shugborough.org.uk

Brewing in the original brewhouse at Shugborough (home of the Earls of Lichfield) restarted in 1990, but a lack of expertise led to the brewery being a static museum piece until Titanic Brewery of Stoke-on-Trent (qv) began helping in 1996. Brewing is currently suspended. ‼

Six Towns

▤ **Wheatsheaf, 234 High Street, Tunstall, Staffordshire, ST6 5TT**
☎ (01782) 922628 ⊕ sixtownsbrewery.com

Previously known as Sunset Taverns, Six Towns is a small, independent brewery at the rear of the Wheatsheaf pub in the Potteries. Brewing is currently suspended.

Slater's SIBA IFBB

St Albans Road, Common Road Industrial Estate, Stafford, ST16 3DR
☎ (01785) 257976 ⊕ slatersales.co.uk

☺The brewery started as a 10-barrel plant in 1995, at the George in Eccleshall. In 2006 it moved onto a new, larger 30-barrel brewing plant at its new premises. It has won numerous awards from CAMRA and SIBA. The brewery supplies an ever increasing number of outlets throughout the midlands and further afield. ‼ ☛

Ultra (ABV 3.7%) BITTER
Rye IPA (ABV 3.8%) SPECIALITY
1 Hop (ABV 4%) GOLD
Yellow-hued with a fruit and hop nose. Big malty start leads to citrus hints with mouth-watering edges. Dry finish with tangs of lingering lemon bitterness.
Premium (ABV 4.4%) BITTER
Pale brown bitter with malt and caramel aroma. Malt and caramel taste supported by hops and some fruit provide a warming descent and satisfyingly bitter mouthfeel.
Smoked Porter (ABV 4.8%) SPECIALITY
Nose full of smoke, bonfire tastes with bacon. Hops break out to a bitter finish; a real treat.
Western (ABV 4.9%) PALE
Haka (ABV 5.2%) PALE
Exotic aromas of tropical fruits lead to a sweet fruity start with background bitterness. This erupts into a mouthy bitterness with a long finish.
Neon Kiss (ABV 6%) IPA
Strong golden ale with fruit and bitterness. Refreshing and dangerously strong.

Staffordshire

12 Churnet Court, Cheddleton, Staffordshire, ST13 7EF
☎ (01538) 361919 ☎ 07971 808370
⊕ staffordshirebrewery.co.uk

Brewing started in 2002. The brewery was renamed from Leek Brewery in 2013 at which time cask production ceased, being replaced by filtered, pasteurised bottled beers only. A small pilot plant is sometimes used to contract brew for Wicked Hathern (qv) when time permits. ‼

Contract brewed for Wicked Hathern Brewery:

Albion Special (ABV 4%) BITTER
Hawthorn Gold (ABV 4.6%) GOLD

Tamworth

29 Market Street, Tamworth, Staffordshire, B79 7LR
☎ (01827) 319872 ☎ 07712 893353
⊕ tamworthbrewing.co.uk

Owner/brewer George Greenaway brought brewing back to Tamworth town centre after a gap of 70 years. Brewing started in 2017 in a former shop, which dates back to Tudor times and also serves as a taproom. In 2020 brewing moved into the adjacent building, which records indicate was a brewhouse in the 1750s. The move allowed production on its five-barrel plant to double, and included the provision of an off-licence. Around 25 outlets are supplied. ‼☛◆✦

Hopmaster (ABV 4.2%) GOLD
Big Game (ABV 4.5%) BITTER
Amber-hued with a malty aroma. Generous malt taste with spicy sides. Hints of pepper and lemon lurk under the hop bitterness which emerges with a mouthwatering bite.
Ethelfleda (ABV 4.5%) BITTER
Full malt aroma from this golden beer. Sweet and grassy mix to start, developing to a bitter finish.
Hoppy Poppy (ABV 4.6%) GOLD
Our Aethel (ABV 4.8%) STOUT
Whopper (ABV 6.5%) IPA

Titanic SIBA

Callender Place, Burslem, Stoke-on-Trent, Staffordshire, ST6 1JL
☎ (01782) 823447 ⊕ titanicbrewery.co.uk

☺One of the earliest microbreweries, founded in 1985. Now owned by two local beer loving brothers, it has grown from a small, seven-barrel brewery, to producing over four million pints of its award-winning ales per year. With an expanding fleet of tied pubs and the Bod chain of café bars, it also supplies free trade customers in the Midlands, North West and further afield. Captain Smith, captain of the Titanic was born in Stoke on Trent, hence the name. ‼◆LIVE

Mild (ABV 3.5%) MILD
Fresh, fruity hop aroma leads to a caramel start then a rush of bitter hoppiness ending with a lingering, dry finish.
Steerage (ABV 3.8%) BITTER
Pale yellow bitter. Flavours start with hops and fruit but become zesty and refreshing in this light session beer with a long, dry finish.
Lifeboat (ABV 4%) BITTER
Dark brown with fruit, malt and caramel aromas. Sweet start, malty and caramel middle with hoppiness developing into a fruity and dry, lingering finish.
Anchor Bitter (ABV 4.1%) BITTER
Amber beer with a spicy hint to the fruity start that says go to the rush of hops for the dry bitter finish.
Iceberg (ABV 4.1%) SPECIALITY
Yellow gold, sparkling wheat beer with a flowery start leading to a great hop crescendo.
Cherry Dark (ABV 4.4%) SPECIALITY
Cappuccino Stout (ABV 4.5%) SPECIALITY
Black with a vanilla and strong coffee nose leading to a sweet taste, again with strong coffee. Aftertaste is sweet.
Chocolate and Vanilla Stout (ABV 4.5%) SPECIALITY
Chocoholic paradise with real coffee and vanilla support. Cocoa, sherry and almonds lend depth to this creamy, drinkable 'Heaven in a glass' stout.
Stout (ABV 4.5%) STOUT

Roasty, toasty with tobacco, autumn bonfires, chocolate and hints of liquorice; perfectly-balanced with a bitter, dry finish reminiscent of real coffee.

White Star (ABV 4.5%) BITTER
Hints of cinnamon apple pie are found before the hops take over to give a bitter edge to this well-balanced, refreshing, fruity beer.

Plum Porter (ABV 4.9%) SPECIALITY
Dark brown with a powerful fruity aroma. A sweet plum fruitiness gives way to a gentle bitter finish.

Captain Smith's Strong Ale (ABV 5.2%) BITTER
Red brown and full-bodied, lots of malt and roast with a hint of honey but a strong, bittersweet finish.

Tower

Old Water Tower, Walsitch Maltings, Glensyl Way, Burton upon Trent, Staffordshire, DE14 1PZ
☎ (01283) 562888 ☎ 07771 926323
⊕ towerbrewery.co.uk

☺Tower was established in 2001 by John Mills, once a brewer at Burton Bridge, in a converted derelict water tower, originally built for Thomas Salt's Brewery in the 1870s. The conversion was given a Burton Civic Society award for the restoration of an industrial building. The premises incorporate a public bar, open Friday evenings only, plus an outside bar in summer. Tower has around 20 regular outlets. ♨☰♦⬧

Bitter (ABV 4.2%) BITTER
Gold-coloured with a malty, caramel and hoppy aroma. A full hop and fruit taste with the fruit lingering. A bitter and astringent finish.

Gone for a Burton (ABV 4.6%) BITTER
Imperial IPA (ABV 5%) PALE

Trinity

Unit 4, The Shires, Essington Close, Lichfield, Staffordshire, WS14 9AZ ☎ 07886 809835
⊕ trinitybrewco.com

Set up in 2021, the name refers both to the three spires of Lichfield's cathedral and the three owners. An eight-barrel brew kit is used, along with a pilot plant for trial brews. A wide range of styles is produced, mainly for can and keg, but cask output is growing. Barrel-aged beers are planned. There is an on-site taproom, generally open at weekends. Beers are widely available in the local free trade. ⬧

Uttoxeter SIBA

26b Carter Street, Uttoxeter, Staffordshire, ST14 8EU
☎ 07789 476817 ⊕ uttoxeterbrewingcompany.com

Established in 2016, The Uttoxeter Brewing Company is a microbrewery producing hand-crafted real ales. A combination of passion, knowledge and hard work produces ales demonstrating distinctive aromas and delicious flavours, exploiting the famous Burton-Upon-Trent hard water. ☰⬧

Bunting's Blonde (ABV 3.7%) BLOND
Dark Horse Mild (ABV 3.7%) MILD
Ground Breaker (ABV 4%) GOLD
? (Question Mark) (ABV 4.5%) PALE
Admiral Gardner (ABV 4.5%) GOLD
Bartley Bitter (ABV 4.5%) BROWN
Dr Johnson's Contrafibularity (ABV 4.5%) PALE
Earthmover (ABV 4.5%) GOLD
Final Furlong (ABV 4.5%) BITTER
Sargeant's Special Ale (ABV 4.6%) PALE
Chinook (ABV 4.7%) PALE
Earthmover Gold (ABV 4.7%) PALE

Full Gallop (ABV 4.7%) BROWN
Paddock Porter (ABV 4.8%) PORTER
Uxonian (ABV 4.9%) BITTER
American IPA (ABV 5.2%) PALE
Yogi Beer (ABV 6.1%) IPA

Vine Inn

🍺 **Vine Inn & Brewery, Sheep Fair, Rugeley, Staffordshire, WS15 2AT**
☎ (01889) 574443 ✉ chris@thevinebrewery.com

⊗ The Vine Brewery is based in Rugeley, within the Vine Inn public house, parts of which date back to the 16th century. The brewery's beers can be found in a number of pubs in the Cannock Chase area.

Izaak Walton

Whitehouse Farm, Cold Norton, Stone, Staffordshire, ST15 0NS
☎ (01785) 760780 ☎ 07496 097883
✉ steve@iwbrewhouse.co.uk

Small brewery in rural location, on a small trading estate. Brewing plant salvaged from The Flowerpot in Derby with adaptions. Core beer range with seasonal beers, all with an angling / fly fishing theme as Izaak Walton resided in the vicinity during the 17th century.

Grayling (ABV 3.9%) PALE
Rainbow Trout (ABV 4.2%) GOLD
Petrifying Piranha (ABV 4.3%) PORTER
Redeye Bass (ABV 4.4%) BITTER
Gudgeon (ABV 4.5%) BITTER
Zonker IPA (ABV 4.6%) IPA
King Carp (ABV 4.8%) PALE
Gentle gold beer. Gentle hoppy taste but deceptively strong.

Woolley Bugger (ABV 5.1%) SPECIALITY
Pike (ABV 6%) MILD

Weal SIBA

Unit 6, Newpark Business Park, London Road, Chesterton, Newcastle under Lyme, Staffordshire, ST5 7HT
☎ (01782) 565635 ☎ 07980 606966
⊕ wealales.co.uk

Weal Ales is a multiple SIBA award-winning microbrewery supplying events and independent outlets both locally and nationally. Established in 2014 by husband and wife team Paul and Andrea Wealleans, it uses a six-barrel plant and bottles many of its beers. Its taphouse, Wellers, in Newcastle under Lyme, opened in 2016. ☰LIVEV⬧

This is the Modern Weal (ABV 3.8%) PALE
Wagon Weal (ABV 4.1%) BITTER
Wealy Hopper (ABV 4.2%) PALE
Weller Weal (ABV 4.6%) PALE
Noir (ABV 4.8%) PORTER
Sweet aroma from this black as black beer. Sweet tastes with lots of liquorice and smoky notes. Balanced between sweet, smoke and hoppy undertones. A moreish finish for another mouthful. Dark beer at its best.

Centwealial Milk Stout (ABV 4.9%) STOUT
Weally Wonka (ABV 5.4%) PALE
Ginger Weal (ABV 5.5%) SPECIALITY
Lemon & Ginger Weal (ABV 5.5%) SPECIALITY

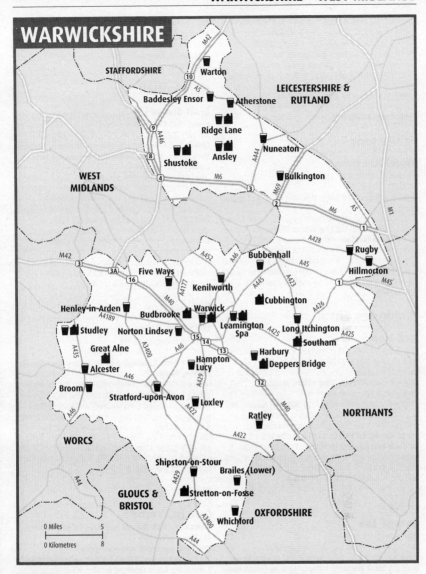

WARWICKSHIRE

STAFFORDSHIRE
Warton
10
A5
Baddesley Ensor
Atherstone
9 A46
Ridge Lane
8
Shustoke
Ansley
Nuneaton
WEST MIDLANDS
4 M6
3
Bulkington
2
M69
M6 A5 M1
LEICESTERSHIRE & RUTLAND
1
A428
Rugby
Hillmorton
M45
M42
3
3A
Five Ways
16
A177
Bubbenhall
A452 A46
A45
A445
A423 A426
1
Kenilworth
M40
Henley-in-Arden
A4189
Budbrooke
Warwick
Cubbington
Studley
Norton Lindsey
Leamington Spa
A445
Long Itchington
A425
Great Alne
15
14
Southam
A435
Alcester
A3400
A46
13
Harbury
Deppers Bridge
Broom
Hampton Lucy
A429
12
A46
Stratford-upon-Avon
Loxley
A422
Ratley
WORCS
A422
NORTHANTS
M40
Shipston-on-Stour
Brailes (Lower)
A429
Stretton-on-Fosse
GLOUCS & BRISTOL
A3400
Whichford
OXFORDSHIRE
A44
A44

0 Miles 5
0 Kilometres 8

Alcester

Royal Oak
44 High Street, B49 5AB
☎ (01789) 565211
Brains Rev James Original; St Austell Tribute; Wye Valley Bitter; 1 changing beer (sourced nationally; often Fuller's) Ⓗ
Friendly Grade II-listed pub with an open-plan layout and snug areas, warmed by a log fire in winter. The landlord and loyal staff have a passion for real ales and ciders, and serve a varied selection. Food includes an excellent Sunday lunch. The pub hosts live music sessions on Thursday and often holds themed food events on Friday night. The small rear garden has seating.
⏳🏠🐕🍺🚃🐾🛜

Turks Head 🍷
4 High Street, B49 5AD
☎ (01789) 765948 ⊕ theturkshead.net

Purity Jimbo; 3 changing beers (sourced nationally; often St Austell, Salopian, Wye Valley) Ⓗ
A busy, centrally located town pub that is well worth a visit, with its exposed beams and roaring log fires. The landlords, who have been in place for 20 years, are dedicated to real ale. They source beers from local breweries as well as from Shropshire, Yorkshire and South Wales. Good food is a daily feature and there is a separate dining room as well as a quiet garden. The pub provides street bars for the annual town festivals.
Q⏳🏠🕭🍺🚃🐾🛜

Ansley

Lord Nelson Inn Ⓛ
Birmingham Road, CV10 9PQ
☎ (024) 7639 2305 ⊕ thelordnelsoninnansley.co.uk
Sperrin Ansley Mild, Head Hunter, Band of Brothers, Third Party, Thick as Thieves; 3 changing beers Ⓗ

Nautically themed inn that has been run by the Sperrin family since 1974, incorporating a brewery at the rear of the building for the last decade. Nine handpulls dispense the brewery's own beers plus guests from microbreweries. There is an extensive food menu with meal nights and tribute nights hosted. A monthly quiz is held in the Victory restaurant. The suntrap courtyard garden is a venue for a beer festival and barbecue in August. This is the pub's 29th consecutive entry in the Guide. ⏱🕮🍴🅿🚫🐾🛜

Atherstone

Angel Ale House ⅃

24 Church Street, CV9 1HA

☎ 07525 183056

Leatherbritches Mad Ruby; Oakham Citra; 4 changing beers Ⓗ

This attractive pub on the market square is a frequent local CAMRA Pub of the Year winner. Its interior features an inglenook fireplace with log-burning stove. The pub serves six real ales, often local and always including a dark beer, plus up to 10 real ciders. Music is via customer select-and-play from a large vinyl collection. The council car park to the rear is free for the first two hours.
🚫≈♿🅿🐾

Baddesley Ensor

Red Lion

The Common, CV9 2BT (from Grendon roundabout on A5 go S up Boot Hill) SP273983

☎ (01827) 718186

Draught Bass; Greene King Abbot; Marston's Pedigree; 3 changing beers Ⓗ

Convivial village pub where food does not feature, just ale and conversation. Comfy seating and a log fire enhance the music-free environment. Three guest ales are served, typically from major concerns such as Greene King and Everards and sometimes from small local breweries. The sparkler is willingly removed on request. Off-road parking is available opposite. Lunchtime opening is weekends only. Q♣♿🅿🐾

Brailes (Lower)

George Inn ⅃

High Street, OX15 5HN

☎ (01608) 685788 ⊕ thegeorgeatbrailes.co.uk

Hook Norton Hooky Mild, Hooky, Old Hooky; house beer (by Hook Norton); 1 changing beer (often Hook Norton) Ⓗ

A 16th-century Grade II-listed coaching inn that is popular with locals and welcomes walkers, cyclists and dog owners. The stone-built pub's interior has flagstone floors, an inglenook fireplace, exposed beams and an array of drinking tankards lining the ceiling. To the left of the bar is an attractive dining area. Attractions include a pool table and fortnightly live music. The lovely large garden has an Aunt Sally pitch and children's play area.
⏱🕮🍴♣🅿🐾🛜

Broom

Broom Tavern ⅃

32 High Street, B50 4HL

☎ (01789) 778199 ⊕ broomtavern.co.uk

Wye Valley HPA; 2 changing beers (often North Cotswold, Purity) Ⓗ

A lovely brick and timber multi-room building with a great amount of character. It has been tastefully made over while keeping the cosy snug and log fire in winter.

Local beers are frequently served here along with at least one real cider. The two experienced chefs offer great food lunchtimes and evenings, made with local ingredients. There is a choice of beer gardens.
Q🕮🍴♿🐾🛜

Bubbenhall

Malt Shovel ⅄ ⅃

Lower End, CV8 3BW

☎ (024) 7630 1141

Church End Fallen Angel; Courage Directors; Greene King Abbot; Sharp's Doom Bar; 1 changing beer (sourced nationally) Ⓗ

Traditional Grade II-listed village pub dating from the 17th century. Its main bar is the hub of the community, enjoyed by regulars who always offer a friendly welcome. The large L-shaped lounge is oriented towards the highly recommended home-cooked food, and regularly hosts pie nights and fish nights. Behind the spacious carp park lies the large walled garden and adjacent bowling green. The pub is handy for the Ryton Pools Country Park and the National Agricultural and Exhibition Centre at Stoneleigh Park. Local CAMRA Pub of the Year 2022. Q⏱🕮🍴🅿(24)🐾

Bulkington

Weavers Arms

12 Long Street, CV12 9JZ

☎ (024) 7631 4415 ⊕ weaversarms.co.uk

Draught Bass; 2 changing beers (often Black Sheep, Timothy Taylor) Ⓗ

Family-owned, two-roomed village pub that is worth visiting for the quality of its Bass and the banter from its landlord. Converted from weavers' cottages, it has a wood-panelled games room, log-burning fireplace and slate floor. Children are welcome and private functions can be catered for. The Pork Pie Club, Weavers Walkers and Hillbilly Golf Society hold regular meetings here. The extensive, well-kept beer garden hosts barbecues in summer. ⏱🕮♣🅿(56)🐾🛜

Five Ways

Case is Altered ⅃

Case Lane, CV35 7JD (off Five Ways Rd near A4141/ A4177 jct) SP225701

☎ (01926) 484206 ⊕ caseisaltered.com

Old Pie Factory Pie In The Sky; Wye Valley Butty Bach; 3 changing beers (sourced locally) Ⓗ

A classic unspoilt country pub with a bar and separate snug, identified by CAMRA as having a regionally important historic pub interior. The landlady has been here for more than 30 years, after taking over from her grandmother. The traditional bar billiards table still takes

REAL ALE BREWERIES	
Church End	Ridge Lane
Church Farm	Budbrooke
Fizzy Moon 🍺	Leamington Spa
Fosse Way	Southam
Freestyle 🍺	Shustoke
North Cotswold	Stretton-on-Fosse
Old Pie Factory	Warwick
Purity	Great Alne
Slaughterhouse	Warwick
Sperrin 🍺	Ansley
Warwickshire	Leamington Spa: Cubbington
Weatheroak	Studley
Windmill Hill	Deppers Bridge

old sixpences, which have to be bought from the bar. Monday is cribbage night. Memorabilia includes a World War I fighter plane's propeller on the ceiling. Q✿&♠P

Hampton Lucy

Boars Head 🄻 ✅
Church Street, CV35 8BE
☎ (01789) 840533 ⊕ theboarsheadhamptonlucy.com
Ringwood Razorback; 4 changing beers (sourced locally; often Church End, North Cotswold, Slaughterhouse) Ⓗ
Friendly, popular village pub that was built in the 17th century as a cider house. Situated on a Sustrans route and close to the River Avon, it is frequented by cyclists, walkers and visitors to nearby Charlecote Park. Five real ales are served including at least two LocAles. The menu offers fresh, locally sourced, home-made food. The walled rear garden is popular in good weather. An annual themed beer festival is held in late May.
&✿◖P☺🐾

Harbury

Crown Inn
Crown Street, CV33 9HE
☎ (01926) 614995 ⊕ crowninnharbury.co.uk
Butcombe Original; St Austell Proper Job; 2 changing beers Ⓗ
A Grade II-listed limestone pub that was built in this picturesque village in 1785. It has a cosy bar, comfortable rear lounge and a separate restaurant, plus a covered outside drinking area at the back. Two regular beers and one changing guest are normally served. The pub hosts a crib team and holds occasional music nights and quizzes.
Q&✿◖&▲♠P🖨(200) ☺🐾

Henley-in-Arden

Three Tuns 🏆
103 High Street, B95 5AT
☎ (01564) 792723
Church End Goat's Milk; Fuller's London Pride; Sharp's Atlantic, Doom Bar; Wye Valley Butty Bach Ⓗ
Small, unpretentious 16th-century drinkers' pub whose single bar serves two rooms. Popular with locals, many of whom come here to play darts and cribbage, it is usually busy and the atmosphere is always friendly. Five real ales are served in consistently good condition. Pub snacks plus home-made cobs and sausage rolls are usually available. Parking is on the main street.
Q&≠&≈♠🖨(X20) 🐾🍺

Hillmorton

Bell
High Street, CV21 4HD
☎ (01788) 544465 ⊕ thebellhillmorton.co.uk
Sharp's Doom Bar; 2 changing beers (sourced nationally) Ⓗ
Popular, recently refurbished family-friendly pub with a restaurant and a spacious bar, offering three excellent real ales. The food includes hearty British pub classics, Sunday roasts, and breakfasts served from 9.30am. Televised sport is shown in the bar area, occasional live music features on Saturday night, and there is a regular quiz night. There is large child-friendly garden at the rear which is also the scene for regular barbecues in the summer months. &✿◖♠P☺🐾

Kenilworth

Ale Rooms & Gin Bar 🄻
7 Smalley Place, CV8 1QG (opp clock tower)
☎ (01926) 854585
Framework Friday St. IPA; 6 changing beers (sourced regionally; often Church End, Silhill) Ⓗ
Popular contemporary bar in a former shop near the town centre and main shopping precinct. Up to seven changing real ales and real ciders are on offer. Although closely linked to Framework Brewery, it also serves beers from a wide variety of other brewers. There is a designated chill-out lounge upstairs, and a small patio at the front of the pub. Live music features at weekends. &&≈●🖨(11,X17) ☺🍺

Old Bakery 🄻
12 High Street, CV8 1LZ (near A429/A452 jct)
☎ (01926) 864111 ⊕ theoldbakerykenilworth.co.uk
Wye Valley HPA; 3 changing beers (sourced regionally) Ⓗ
Small pub located in a former bakery at the heart of Kenilworth old town. Beams and rustic furniture give the pub a cosy feel across its two distinct drinking areas. Four changing ales are complemented by a large range of malt whiskies. A good mix of locals and visitors, plus guests enjoying the 14 en-suite rooms, ensures that the main focus is on conversation. Disabled access is to the rear of the premises. Q&✿🛏&P🖨(11)☺🍺

Leamington Spa

Benjamin Satchwell ✅
112/114 The Parade, CV32 4AQ (almost opp town hall)
☎ (01926) 883733
Greene King Abbot; Ruddles Best Bitter; Sharp's Doom Bar; 4 changing beers Ⓗ
Named after a renowned local benefactor who discovered Leamington's second spa spring in 1784, this pub bears all the hallmarks of the Wetherspoon style. Converted from two shops, it is large, stretching back to Bedford Street. The building's split levels have been used well to create comfortable seating areas. The upper level hosts an impressively long bar. Wall panels depict local history and personalities. &◖&≈●🖨🍺

Boiler Room
6 Victoria Terrace, CV31 3AB
☎ (01926) 420006 ⊕ theboilerroomleamington.com
4 changing beers (sourced nationally) Ⓗ/Ⓖ
Independent ale, wine and artisan gin bar with an ever-rotating selection of craft drinks in the heart of town. Its chic industrial-themed interior features brick, concrete, copper, and steel with artwork inspired by vintage racing cars. Ale is served directly from the barrel. Food comprises bar snacks including flavoured pork pies and home-made sausage rolls, plus pizza from a local restaurant. &≈

New Inn
197 Leam Terrace, CV31 1DW
☎ (01926) 422861 ⊕ thenewinnleamington.co.uk
Eagle IPA; Sharp's Atlantic, Doom Bar, Sea Fury; 2 changing beers (often Byatt's) Ⓗ
Traditional pub in a wide Victorian terrace on the outskirts of town. The original pub has been extended into the next-door property. A central door opens directly onto the bar, with seating to the left and a games area to the right leading to a rear extension. Quality home-cooked food is served. Local bands are hosted and the pub holds a quiz every other Wednesday. Outside is a good-sized walled garden. &✿◖&♠🖨(63/64)☺🍺

Woodland Tavern 🄻

3 Regent Street, CV32 5HW
☎ (01926) 425868
Slaughterhouse Saddleback Best Bitter; Timothy Taylor Landlord; 2 changing beers Ⓗ
Traditional Victorian street-corner pub near the town centre, enjoyed by locals and visitors alike. It has a public bar and a lounge that doubles as a function room. The unique, partially covered courtyard features murals depicting local references and jokes. On the side of the building is a large, colourful mural showing a dray and horses delivering ale to the pub. Real cider is from Napton Cidery. ❀&⇌♣🖩🌸🛜

Long Itchington

Harvester 🄻

6 Church Road, CV47 9PE (off A423 at village pond, then first left)
☎ (01926) 812698 🌐 theharvesterinn.co.uk
2 changing beers (often Church End, Purity) Ⓗ
White-fronted pub near the village pond, on the corner of the square. Inside is a main bar, a small drinking area and a restaurant specialising in good-value steaks. The ale range changes frequently, usually supporting smaller breweries. Real cider and a Belgian fruit beer are also served. The pub hosts a beer festival each May bank holiday. A large walled courtyard garden to the rear has a wood-fired pizza oven. ᗺ❀🕽&🅰🖩(64)🌸🛜

Loxley

Fox Inn

Goldicote Road, CV35 9JS
☎ (01789) 840933 🌐 foxloxley.co.uk
2 changing beers (sourced regionally; often North Cotswold, Windmill Hill) Ⓗ
Friendly pub in the heart of the village. It was bought in 2020 by the community and is owned by shareholders from the Loxley area and supporters from around the world. As well as offering traditional pub food it serves Sibling cider, brewed locally from apples grown in the village. The pub is popular with walkers and cyclists; National Cycle Route 41 runs nearby. ᗺ❀🕽&🌸🖩(7)🌸🛜

Norton Lindsey

New Inn 🄻 ✅

Main Street, CV35 8JA
☎ (01926) 258411 🌐 thenewinn.pub
Greene King IPA; Timothy Taylor Landlord; 2 changing beers (sourced locally; often Church End, M&B, Slaughterhouse) Ⓗ
Warwickshire's first community owned pub opened in 2017 after fundraising saved it from closure – it was purchased by a collective of more than 200 people. Located on a street corner in the heart of the village, it has a wooden-floored open-plan interior with a light and airy feel. Food is locally sourced, with many specials on offer. Circular walks start and end here. Q ᗺ❀🕽P🌸

Nuneaton

Anker Inn ✅

Weddington Road, CV10 0AN
☎ (024) 7632 9193
Ossett White Rat; Sharp's Doom Bar; Theakston Old Peculier; 1 changing beer Ⓗ
A community focused pub on a main route into Nuneaton, renowned for the quality of its Theakston Old

Peculier. Numerous sports teams are based here, and other activities include quizzes and a Wednesday afternoon coffee and crafts get-together. The pub hosts several charity events including a music festival in August. ᗺ❀🕽◑⇌♣P🖩🌸🛜

Felix Holt 🄻 ✅

3 Stratford Street, CV11 5BS
☎ (024) 7634 7785
Greene King Abbot; Ruddles Best Bitter; Sharp's Doom Bar; changing beers (often Byatt's, Oakham) Ⓗ
Large Wetherspoon outlet in the town centre. The pub takes its name from a novel by George Eliot; the literary theme is reflected in the decor of books and pictures of local history. Look out for the comical metal sculptures on the walls. Food is served alongside a good range of guest beers that includes local ales. There are tables and chairs outside for alfresco drinking and eating. Q ᗺ🕽&⇌🖩🛜

Lord Hop 🍷 🄻

38 Queens Road, CV11 5JX
☎ (024) 7798 1869 🌐 lordhopnuneaton.co.uk
4 changing beers Ⓗ
Town-centre micropub on two floors, the large upper level boasting settees, a small library and a selection of board games. Four or more real ales are served from handpull alongside up to eight ciders or perries from the chiller. Wine, gins, bottled lager and soft drinks are also sold. Snacks are available, or bring your own takeaway. CAMRA magazines are provided for reading. No under-18s, and assistance dogs only. Local CAMRA Pub of the Year. Q⇌P🖩🛜

Rose Inn

Coton Road, CV11 5TW (adjacent to Stuarts Plumbing Supplies)
☎ (024) 7674 2991
Banks's Amber Ale; 2 changing beers (sourced regionally; often Marston's) Ⓗ
This is the pub that CAMRA chose for its first AGM back in 1972 – an occasion commemorated by a brass plaque on the wall. The L-shaped lounge houses a pool table and dartboard. At the rear of the pub is a paved, heated and partially covered area for alfresco drinkers and smokers, its border planted with roses and shrubs. Riversley Park and Nuneaton Museum are across the road. Q ᗺ❀♣P🖩(41,48)🌸🛜

Ratley

Rose & Crown 🄻

Featherbow Lane, OX15 6DS (at bottom of village, near church)
☎ (01295) 678148 🌐 roseandcrownratley.co.uk
4 changing beers (sourced locally; often Church End, North Cotswold, Purity) Ⓗ
A 11th-century pub built in golden stone with a wealth of detail, tucked away at the bottom of this ancient village on the northern edge of the Cotswold escarpment. It features cosy log fires in winter and a suntrap garden in summer. This friendly local is reputedly haunted by the ghost of a Roundhead soldier. It serves high-quality food alongside a selection of bottled beers, ciders and non-alcoholic drinks. Walkers and dogs are welcome. Q ᗺ❀🕽🅰♣🌸🖩🌸🛜

Ridge Lane

Church End Brewery Tap 🄻

Ridge Lane, CV10 0RD (2 miles SW of Atherstone)
☎ (01827) 713080 🌐 churchendbrewery.co.uk

Church End Goat's Milk, Gravediggers Ale, What the Fox's Hat, Fallen Angel; 4 changing beers ⊞
This brewery tap is hidden from the road, with access opposite Tom Piper Close. The brewery is visible from the bar area. Eight handpulls serve the bar and vestry, with a mild always on tap. Ciders are dispensed direct from the barrel. Under-18s are allowed in the vestry until 6pm, and are welcome in the meadow garden. The pub hosts a monthly quiz night. It opens Thursday to Sunday all year, plus Wednesday in summer. Q⑤❀&AP🖰🐾🐾🎵

Rugby

Merchants Inn ♈ �Ⓛ

5-6 Little Church Street, CV21 3AW
☎ (01788) 571119
Nethergate Venture; Oakham Bishops Farewell; Purity Mad Goose ⊞; 6 changing beers (sourced nationally) ⊞/Ⓖ
Busy town-centre pub with a varied local clientele. Flagstone floors and an open fire greet you on entering – the interior is a museum of brewery memorabilia. Rugby and cricket are popular on the TV. Activities held around the calendar include Belgian and German nights, beer festivals and gin and cider weekends. Sunday roasts are provided by Market Street Kitchen. ⑤❀◑♣🖰🖰🐾🎵

Rugby Tap Ⓛ

4 St Matthews Street, CV21 3BY (close to town centre adjacent to A426 gyratory)
☎ 07540 490377 ⊕ rugbytap.com
Changing beers (sourced regionally; often Byatt's, Church End, Phipps NBC) Ⓖ
Micropub featuring a long room with a large selection of gravity-served draught ales and ciders racked at the far end. The atmosphere promotes conversation and there is no electronic entertainment. The pub serves up to six LocAles, plus beers from Oakham; two draught craft beers from New Bristol Brewery, an Oslo pilsner and a selection of canned and bottled craft beers. There is outside seating at the front. Q⑤❀🖰🐾

Seven Stars Ⓛ

40 Albert Square, CV21 2SH
☎ (01788) 535478 ⊕ sevenstarsrugby.co.uk
Byatt's Platinum Blonde; Everards Tiger; 7 changing beers (sourced nationally) ⊞
Traditional multi-roomed community pub with a focus on quality beer and cider. Its 14 handpumps dispense an ever-changing selection of light and dark ales, plus four ciders. Food highlights include pie, pint and pudding on Wednesday evening and Sunday lunchtime, and seasonal menus Friday and Saturday evenings. Pub-made Scotch eggs, filled rolls and locally made pork pies are also available. Rugby is popular on the bar's TV. A former local CAMRA Pub of the Year. No children after 7pm. Q⑤❀◑🍴♣♣P🖰🐾🎵

Squirrel Inn Ⓛ

33 Church Street, CV21 3PU
☎ (01788) 578527
4 changing beers (sourced nationally; often Dow Bridge, Marston's, Pitchfork) ⊞
A warm welcome is guaranteed at this historic free house, Rugby's jewel in the town. A real fire and pictures of old Rugby contribute to the intimate ambience. Ales from Dow Bridge, Pitchfork and 3D breweries are frequently served alongside Marston's beers and four ciders. Live music is a regular attraction, with various genres performed on Saturday evening and an open mic night on Wednesday. Poetry features on the last Sunday of the month. National CAMRA Golden Award winner.
♣🖰🐾🎵

Town & County Ⓛ

12 Henry Street, CV21 2QA
☎ 07487 413960
Church End Gravediggers Ale; 2 changing beers (sourced nationally; often Donnington, Otter, Timothy Taylor) ⊞
Small town-centre club that has been trading since 1933 and is making its fifth appearance in this Guide. Its four handpumps include two dispensing changing guest ales from breweries near and far. The club hosts dominoes and skittles teams, and holds regular events including Tuesday bingo and monthly quizzes, plus occasional live music and coach trips. CAMRA members are welcome and guests may be signed in. Q⑤♣🖰🐾

Victoria Inn

1 Lower Hillmorton Road, CV21 3ST
☎ (01788) 544374
Hook Norton Hooky; Oakham Citra; 4 changing beers (sourced nationally; often Abbeydale, Titanic) ⊞
A beautiful Victorian corner pub just outside the town centre – a true gem and the last of its kind in the town. Built in a wedge shape, the multi-roomed local features a traditional bar, larger refurbished lounge and two relatively new snugs converted from the kitchen and store room. Filled rolls are available at the weekend. The pub shows sport on TV and hosts quiz nights on Thursday and Sunday. ⑤❀♣🖰🐾🎵

Shipston-on-Stour

Black Horse Inn Ⓛ

Station Road, CV36 4BT
☎ (01608) 238489 ⊕ blackhorseshipston.co.uk
Prescott Hill Climb; Wye Valley Butty Bach; 1 changing beer (sourced regionally; often Courage) ⊞
Stone-built 15th-century inn that is Shipston's only thatched building and its oldest pub; its licence dates back to 1540. The cosy and welcoming lounge has a large inglenook log fire. Traditional pub games and sports TV are popular in the left-hand bar. The excellent Thai food restaurant has a takeaway service. Children and dogs are welcome in the enclosed rear garden, which has a large decking area and hosts live music in summer. Q⑤❀◑♣🖰P🖰🐾🎵

Thirst Edition

46B Church Street, CV36 4AS
☎ (01608) 664974 ⊕ thirstedition.co.uk
4 changing beers (sourced regionally; often Acorn, Allsopp's, Hop Back) Ⓖ
A micropub in this small market town serving up to four real ales, mostly local or regional, straight from the cask. Real ciders, craft beers, wines and six gins are also available. Since opening in 2018 the pub has offered well over 350 real ales. It hosts regular live music including a singalong on the last Sunday of the month. The free-to-enter Thursday quiz has raised more than £3,000 for local causes. The bus from Stratford stops outside. Q&♣🖰🐾(50)🐾🎵

Shustoke

Griffin Inn Ⓛ

Church Road, B46 2LB (on B4116 on sharp bend)
☎ (01675) 481205
Freestyle Griffin Dark; Oakham Citra; Theakston Old Peculier; Wye Valley Butty Bach; 8 changing beers (sourced nationally; often Freestyle, Oakham) ⊞
A long-standing real ale venue and recipient of a CAMRA National Golden Award. Its interior features a stone bar, inglenook fireplaces and beams decorated with old beer

mats. No music is played. The pub serves up to eight guest beers, usually including Freestyle ales from the adjacent brewery. There is always one real cider, and up to four in summer. Home-cooked lunches are served (no food Sun). Children are welcome on the beer terrace and in the conservatory and meadow-style garden.
Q❤️🕮🍴♿️&P❄️🌳🛇

Plough

The Green, B46 2AN
☎ (01675) 481557 🌐 theploughinnshustoke.co.uk
Draught Bass; 4 changing beers Ⓗ
Attractive 200-year-old inn on the village green, the building retains much of the original charm, featuring four low-ceilinged rooms around the bar, a separate games room and modern rear conservatory. The pub is popular for food with plenty of dining space. The pleasantly green front beer terrace has cosy enclosed pods that can be booked for drinking and dining. There is a pets' corner at the rear. ❤️🕮🍴🔥♣️P🛇

Stratford-upon-Avon

Stratford Alehouse Ⓛ

12B Greenhill Street, CV37 6LF
☎ 07746 807966 🌐 thestratfordalehouse.com
4 changing beers (sourced nationally; often Byatt's, North Cotswold, XT) Ⓖ
A family-run, one-bar micropub offering the finest real ales, ciders, wines and gins. There are no gaming machines to distract you here, just a friendly welcome in a relaxing environment for chatting, making new friends or reading the papers. More than 1,500 different beers have been served since the pub opened in 2013. Snacks are available. Occasional TV sport is shown and live music events are hosted. ≈♿️🚆(Local)🛇

Studley

Weatheroak Tap House Ⓛ

21A High Street, B80 7HN (up Studley High St next to chip shop)
☎ (01527) 854433 🌐 weatheroakbrewery.co.uk
Weatheroak Bees Knees, Victoria Works, Keystone Hops, The Dark Side; 1 changing beer (sourced locally) Ⓗ
Popular and welcoming micropub with two small, cosy rooms. It opened in 2016 and is an outlet for the nearby Weatheroak Brewery, whose off-sales are available in various sizes. Food is limited to basic snacks and sweets, but takeaways can be brought in and there is a chip shop next door. Q❤️♣️♿️P🚆🛇🌳

Warton

Office Ⓛ

Church Road, B79 0JN
☎ (01827) 894001
Church End Goat's Milk; Draught Bass; 2 changing beers Ⓗ
Formerly the Boot, this is now the sole pub in a large residential village, catering for a varied clientele. It has a U-shaped bar dominated by sports TV, a raised side area and a comfy upstairs room with free pool table. Open fires warm both floors. The pub hosts regular quizzes and live music. At its rear is a suntrap beer terrace on two levels. ❤️❄️♣️♿️P🛇🌳

Warwick

Cape of Good Hope Ⓛ

66 Lower Cape, CV34 5DP (off Cape Rd)

☎ (01926) 498138 🌐 thecapeofgoodhopepub.com
Church Farm Harry's Heifer; Hook Norton Hooky; Wye Valley Butty Bach; 3 changing beers Ⓗ
Historic alehouse on the Grand Union Canal, dating from 1798 and welcoming to canal users and locals alike. It comprises a front bar in the original waterside building plus a modern rear extension. The interior displays canal memorabilia including interesting maps. Three permanent real ales are served alongside three locally sourced guests. The friendly staff are knowledgeable, and proud to serve local beers and food. There is outdoor waterside seating next to a double lock that can get busy. ❤️🕮🍴🔥🚆♣️♿️🚆(G1)🛇🌳

Four Penny Pub

27/29 Crompton Street, CV34 6HJ (near racecourse, between A429 and A4189)
☎ (01926) 491360 🌐 4pennyhotel.co.uk
6 changing beers Ⓗ
The pub is part of a Georgian building dating from around 1800, a short distance from the town centre, close to the racecourse and castle. Its name derives from the price of a cup of coffee and tot of rum that was charged to workers building the nearby Grand Union Canal in the early 1800s. The single, split-level room has a contemporary feel and a relaxed atmosphere, enhanced by the absence of machines or loud music. There is an outside seating area. Q❤️🕮🍴🔥♣️P🚆🛇🌳

Oak ✓

27 Coten End, CV34 4NT
☎ (01926) 493774
Fuller's London Pride; 3 changing beers Ⓗ
The Oak is a traditional pub dating back to the 1800s. It could be easily missed, set as it is in a terrace of houses and shops. The premises opens straight off the street and features a long thin seating and bar area leading out to a small courtyard. It serves a selection of four real ales, craft beer, lagers and wines. There are two TVs showing BT Sport and Sky Sports. 🕮♿️≈♣️🚆(X17)🛇

Old Post Office Ⓛ

12 West Street, CV34 6AN
☎ 07765 896155
Slaughterhouse Saddleback Best Bitter Ⓗ**; 3 changing beers** Ⓗ/Ⓖ
Warwick's first alehouse is popular with real ale enthusiasts and locals. It is in a former shop just below the West Gate and within easy walking distance of the castle. The small bar is decorated with a collection of pub memorabilia. It offers a friendly, relaxed atmosphere and serves traditional beers both on handpump and straight from the cask, plus a changing selection of four craft brews. A good selection of ciders is also available. No food is served but you are welcome to bring your own. ❤️🚆♣️🚆🛇

Wild Boar Ⓛ

27 Lakin Road, CV34 5BU
☎ (01926) 499968
Slaughterhouse Saddleback Best Bitter; 9 changing beers (often Everards, Slaughterhouse) Ⓗ
This taphouse for Slaughterhouse Brewery is an award-winning Project William community pub near the railway station. The end-of-terrace Victorian building has a bar, snug and a separate beer hall that was previously a skittle alley. The 10 handpumps deliver Slaughterhouse, Everards and guest ales, with two real ciders also available. Outside is an attractive patio hop garden – the hops are used for Slaughterhouse's annual brew, the Green Hopper. Q❤️🕮🍴♿️≈♣️🚆(X17)🛇🌳

Whichford

Norman Knight ⚃

CV36 5PE (2 miles E of A3400 at Long Compton, facing village green)
☎ (01608) 684621 ⊕ thenormanknight.co.uk

Hook Norton Hooky; Prescott Hill Climb; house beer (by Goff's); 2 changing beers (sourced regionally; often Goff's, Purity, XT) Ⓗ

A friendly pub in the centre of this picturesque village. Attractive decor and a stone-flagged floor contribute to the cosy and comfortable ambience that attracts locals and visitors. High-quality food features locally sourced ingredients where possible. The pub holds monthly music nights, and in summer hosts classic car meetings on the third Thursday of the month. Accommodation is available in high-spec glamping pods behind the garden. Electric car charging is available and motorhomes are welcome – as are muddy boots and paws.

Q ➤ ✿ ⛽ ◑ Å ♣ ♦ P ⏰ 🐾 ☎

Breweries

Church End SIBA

Ridge Lane, Warwickshire, CV10 0RD
☎ (01827) 713080 ⊕ churchendbrewery.co.uk

⊗ The brewery started in 1994 in an old coffin shop in Shustoke. It moved to its present site in 2001 and has expanded over the years. It currently operates a 24-barrel, purpose-built plant. Many one-off specials and old recipe beers are produced. Its award-winning beers are available throughout the Midlands. ‼ 🍺 ♦LIVE

Brewers Truth (ABV 3.6%) PALE
Goat's Milk (ABV 3.8%) PALE
Gravediggers Ale (ABV 3.8%) MILD
What the Fox's Hat (ABV 4.2%) BITTER
A beer with a malty aroma, and a hoppy and malty taste, with some caramel flavour.
Vicar's Ruin (ABV 4.4%) BITTER
A straw-coloured best bitter with an initially hoppy, bitter flavour, softening to a delicate malt finish.
Stout Coffin (ABV 4.6%) STOUT
Fallen Angel (ABV 5%) PALE

Church Farm SIBA

Church Farm, Budbrooke, Warwickshire, CV35 8QL
☎ (01926) 411569 ⊕ churchfarmbrewery.co.uk

Brewing commenced in 2012 on repurposed milking equipment after departure of the diary herd. Production moved to a purpose-built 20-barrel plant in 2016 as sales expanded. Farm connection retained as some barley is grown on the farm and water comes from an on-site well. Over 150 regular outlets across the south Midlands and further afield. Mobile bar often attends food festivals, outdoor music and motorsport events. ‼LIVE

Pale Ale (ABV 3.8%) PALE
Session IPA (ABV 3.8%) PALE
Ren's Pride (ABV 4%) BITTER
Brown's Porter (ABV 4.2%) PORTER
Harry's Heifer (ABV 4.2%) BITTER
IPA (ABV 5%) PALE

Fizzy Moon

🍴 Fizzy Moon, 35 Regent Street, Leamington Spa, Warwickshire, CV32 5EE
☎ (01926) 888715 ⊕ fizzymoonbrewhouse.com

Fizzy Moon is a bar and microbrewery in the heart of Leamington Spa, brewing a range of small batch beers, exclusively for consumption in the bar. All beers are unfined and so naturally hazy.

Fosse Way SIBA

Elms Farm, Plough Lane, Bishops Itchington, Southam, Warwickshire, CV47 2QG ☎ 07956 179999 ⊕ fossebrew.co.uk

⊗ In 2022 the brewery was relocated and expanded and a full time partner taken on (a former owner of the Red Moon brewery). The beer range includes a lager influenced by the owner's extensive experience in South Africa. Most production is bottled and sold in Warwickshire markets. Some Red Moon brands, plus ciders, have been added to the range. ♦LIVE

Aurora (ABV 3.6%) PALE
Sentinel (ABV 4.5%) BITTER
Dark Side (ABV 4.8%) PORTER

Freestyle

🍴 Church Road, Shustoke, Warwickshire, B46 2LB
☎ (01675) 481205 ⊕ griffininnshustoke.co.uk

Griffin Inn started brewing in 2008 in the old coffin shop adjacent to the pub. In 2017 the brewery was updated to a modern, more efficient 2.5-barrel plant. At this time the name was changed to Freestyle though the business is still owned by the Pugh family who run the Griffin. Beers are available for the free trade as well as selling through the pub. ‼♦

Griffin Dark (ABV 3.8%) MILD
Griffin Pale Ale (ABV 3.8%) BITTER
Shawbury Blonde (ABV 4.2%) BLOND
Bullion (ABV 4.4%) GOLD
Yeti IPA (ABV 4.5%) PALE
Black Magic Woman (ABV 4.8%) PORTER
Muzungu (ABV 5.5%) BITTER
Red Rye PA (ABV 5.5%) RED

North Cotswold SIBA

Unit 3, Ditchford Farm, Stretton-on-Fosse, Warwickshire, GL56 9RD
☎ (01608) 663947 ⊕ northcotswoldbrewery.co.uk

☺North Cotswold started in 1999 as a family run 2.5-barrel plant, which has since been upgraded to 10-barrel capacity. Beers are also produced under the Shakespeare brand name, available in cask and bottles. 🍺♦LIVE

Windrush Ale (ABV 3.6%) BITTER
Jumping Jack Flash (ABV 3.8%) GOLD
Moreton Mild (ABV 3.8%) MILD
Cotswold Best (ABV 4%) BITTER
Green Man IPA (ABV 4%) PALE
Shagweaver (ABV 4.5%) BITTER
Hung, Drawn 'n' Portered (ABV 5%) PORTER

Brewed under the Shakespeare Brewery brand name:
Bard's Best (ABV 4.2%) GOLD
Falstaff's Folly (ABV 4.2%) BITTER

Old Pie Factory

4 Montague Road, Warwick, CV34 5LW ☎ 07816 413026 ⊕ oldpiefactorybrewery.co.uk

☺Brewing began in 2011 using a 5.5-barrel plant and is a joint venture between Underwood Wines, Stratford upon Avon, and the Case is Altered, Five Ways.

Old Pie Bitter (ABV 3.9%) BITTER

Pie In The Sky (ABV 4.1%) PALE
Humble Pie (ABV 4.2%) BITTER
I.Pie.A. (ABV 4.5%) PALE
American Pie (ABV 5.5%) IPA

Purity SIBA

The Brewery, Upper Spernal Farm, Spernal Lane,
Great Alne, Warwickshire, B49 6JF
☎ (01789) 488007 ⊕ puritybrewing.com

⊕Brewing began in 2005 in a purpose-designed plant
housed in converted barns. The brewery prides itself on
its eco-friendly credentials. It supplies its award-winning
beers into the free trade within a 70-mile radius (plus
London postcodes), delivering to more than 500 outlets.
‼☞♦

Bunny Hop (ABV 3.5%) PALE
Pure Gold (ABV 3.8%) GOLD
Mad Goose (ABV 4.2%) BITTER
Pure UBU (ABV 4.5%) BITTER

Slaughterhouse SIBA

Bridge Street, Warwick, CV34 5PD
☎ (01926) 490986 ☎ 07951 842690
Pub: Wild Boar, 27 Lakin Road, Warwick, CV34 5BU
☎ (01926) 499968 ⊕ slaughterhousebrewery.com

⊕Production began in 2003 on a four-barrel plant in a
former slaughterhouse. Around 30 outlets are supplied,
mostly within five miles of the brewery. The brewery
premises are licensed for off-sales direct to the public. In
2010 Slaughterhouse opened its first pub, the Wild Boar
in Warwick, adding a two-barrel brew plant that brews
specials for the pub. ‼

Saddleback Best Bitter (ABV 3.8%) BITTER
Extra Stout Snout (ABV 4.4%) STOUT
Boar D'eau (ABV 4.5%) GOLD
Wild Boar (ABV 5.2%) BITTER

Sperrin

▤ Lord Nelson Inn, Birmingham Road, Ansley,
Warwickshire, CV10 9PQ
☎ (024) 7639 2305 ☎ 07917 772208
⊕ sperrinbrewery.co.uk

Sperrin began brewing in 2012 on a six-barrel plant at
the side of the Lord Nelson Inn. The pub always has five
of its beers available and two or three at its sister pub,
the Blue Boar, Mancetter. Around 25 other outlets are
supplied direct. ‼♦LIVE

Warwickshire

Bakehouse Brewery, Queen Street, Cubbington,
Leamington Spa, Warwickshire, CV32 7NA
☎ (01926) 450747 ⊕ warwickshirebeer.co.uk

A six-barrel brewery in a former village bakery which has
been in operation since 1998. Bottled beers are available
from local farm shops, garden centres, wine specialists
and supermarkets, as well as from the brewery direct
and its four pubs. More unusual craft beers are available
under the Bakehouse Brewery brand name. ☞♦LIVE

SPA (Spa Pale Ale) (ABV 3.8%) PALE
Darling Buds (ABV 4%) PALE
Duck Soup (ABV 4.2%) BITTER
Lady Godiva (ABV 4.2%) GOLD
Yer Bard (ABV 4.3%) BITTER

Brewed under the Bakehouse Brewery brand
name:
Liquid Bread (ABV 4.5%) GOLD

Weatheroak

Unit 7, Victoria Works, Birmingham Road, Studley,
Warwickshire, B80 7AP
☎ (01527) 854433 ☎ 07771 860645

Office: Weatheroak Tap House, 21a High Street,
Studley, B80 7HN ⊕ weatheroakbrewery.co.uk

⊠ The brewery was set up in 1997 at Weatheroak Hill. It
is now in a spacious factory unit in Studley. Weatheroak
supplies 20 outlets. Off-sales available for all beers at the
Tap House on the High Street in Studley. 18 and 36 pint
polypins are available with notice. ‼♦

Light Oak (ABV 3.6%) BITTER
Bees Knees (ABV 3.7%) BITTER
This straw-coloured quaffing ale has lots of hoppy notes
on the tongue and nose, and a fleetingly sweet
aftertaste.
The Dark Side (ABV 4.3%) MILD
Victoria Works (ABV 4.3%) PALE
Redwood (ABV 4.4%) BITTER
Keystone Hops (ABV 5%) BITTER
A golden yellow beer that is surprisingly easy to quaff
given the strength. Fruity hops are the dominant flavour
without the commonly associated astringency.

Windmill Hill SIBA

Unit 1, Eastfield Farm, Deppers Bridge, CV47 2SU
☎ (01926) 355450 ⊕ whbrewery.co.uk

Windmill Hill is an independent microbrewery using a
three-barrel plant brewing small-batch beers. Around 30
outlets are supplied direct. Beers are available in cask
and keg formats as well as small package.

Table Beer (ABV 2.9%) BITTER
Amber Post (ABV 4.2%) BITTER
The Chesterton (ABV 4.2%) BITTER
Grindstone (ABV 4.5%) GOLD

Choosing pubs

CAMRA members and branches choose the pubs listed in the Good Beer Guide. There
is no payment for entry, and pubs are inspected on a regular basis by personal visits;
publicans are not sent a questionnaire once a year, as is the case with some pub guides.
CAMRA branches monitor all the pubs in their areas, and the choice of pubs for the
guide is often the result of democratic vote at branch meetings. However,
recommendations from readers are welcomed and will be passed on to the relevant
branch: write to Good Beer Guide, CAMRA, 230 Hatfield Road, St Albans, Hertfordshire,
AL1 4LW; or send an email to: gbgeditor@camra.org.uk

WEST MIDLANDS

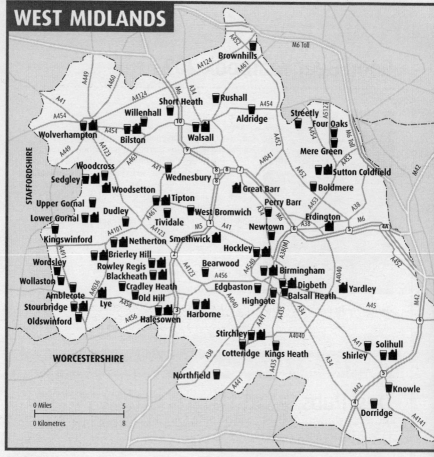

Aldridge

Turtle's Head 🅛

14 Croft Parade, WS9 8LY
☎ (01922) 325635 🌐 theturtleshead.co.uk
4 changing beers (sourced locally; often Backyard, Bristol Beer Factory, Dancing Duck) 🅷
A micropub in the centre of Aldridge that opened in 2015 and offers a warm welcome. Its four handpulls serve a range of ales from throughout the UK. Bar food includes freshly made rolls and bar snacks, with complimentary cheese and pâté on a Sunday. You can bring your own food if you are drinking. Closed on Mondays except bank holidays. Discounts are available on a Tuesday.
🍴♿🅿🚬🐾🛜

Amblecote

Robin Hood 🅛

196 Collis Street, DY8 4EQ (on A4102 one-way street off Brettell Lane, A461)
☎ 07436 793462
Bathams Best Bitter; St Austell Proper Job; Three Tuns XXX; Wye Valley HPA, Butty Bach; 3 changing beers 🅷
A traditional Black Country local offering fine ales, quality food and a warm welcome. It has been a licensed house for more than 170 years. The front rooms house a wonderful beer bottle collection including international and historic brews. Freshly made cobs and pork pies are

served. Some national guest ales are featured but the pub has an emphasis on LocAle, with more local beers on permanent sale. The rear outside area now has a permanent marquee. Q🍴♿🕴️🅿🚲🅿🚌(6,16)🛜

Swan

10 Brettell Lane, DY8 4BN (on A461, ½ mile after A491)
☎ (01384) 591600
Enville Ale; Holden's Golden Glow; Salopian Oracle; Wye Valley HPA; 4 changing beers 🅷
This free house has been totally refurbished by the owners of the Red Lion down the road. There is now only one bar room, served by a central bar. The difficult entry, with the old serving hatch, is no more, allowing customers to walk straight to the bar. The original metal bar separator from the lounge is now used as a garden feature. Cobs and snacks are available. Derelict buildings to the rear have gone and a tidy smoking area has been created. ♿🍴🅿🚬(6)🐾🛜

Bearwood

Bear Tavern ✅

500 Bearwood Road, B66 4BX
☎ (0121) 429 1184
Greene King IPA, Abbot; 4 changing beers (sourced nationally) 🅷
Busy open-plan community local dominated by a central bar, with sports screens scattered throughout – live

6 changing beers (sourced nationally) ⊞
Accessed at the end of the same side street off Church Street as the Metro stop, this micropub's main room has a friendly atmosphere with good seating. A separate servery features a well-stocked bottleshop. Large cobs, bar snacks and pork pies are always available. Occasional beer festivals and live music are hosted. A small outside seating area is to the right of the front door.
Q&♿(Central) ●P🚪🐾🛜

Trumpet 𝕃
58 High Street, WV14 0EP
☎ (01902) 493723 ⊕ thetrumpet-bilston.com
Holden's Black Country Bitter, Golden Glow, Special ⊞
Welcoming one-room local with jazz (mainly trad) featured seven nights a week and Sunday lunchtimes. The music and Holden's award-winning ales draw in customers from around the area. Music memorabilia of all styles and eras line the walls. A collection plate for the band is handed around when live music is being played. Around a 10-minute walk from the bus and Metro stations. ❀♿(Central)🚪

Birmingham: Balsall Heath

Old Moseley Arms 𝕃
53 Tindal Street, B12 9QU (400yds off Moseley Rd)
☎ (0121) 440 1954 ⊕ oldmoseleyarms.co.uk
Bathams Best Bitter; Church End Goat's Milk; Enville Ale; Wye Valley HPA, Butty Bach ⊞
Another of Birmingham's hidden gems. Its left bar has an 80-inch TV screen for sport, the right bar has a jukebox. Upstairs is for functions, and there are comfy sofas in the newly extended garden/smoking area. A superb tandoori menu is served in the evening and all day Sunday. A 60-cover restaurant extension will be completed soon. The pub gets busy when international and T20 cricket matches are played at Edgbaston, 10 minutes' walk away. ⛵❀▶🚪(50)🛜

Birmingham: City Centre

Bull 🍷 𝕃
1 Price Street, B4 6JU (off St Chads Queensway)
☎ (0121) 333 6757 ⊕ thebullbirmingham.co.uk
Hook Norton Old Hooky; Oakham Citra; 2 changing beers (sourced nationally) ⊞
A country pub in the city centre near Aston University, this friendly and popular back-street local is one of Birmingham's oldest pubs and has a comfortable, homely feel. Two distinct drinking areas surround a U-shaped bar, with a smaller back room for more privacy. There is a large collection of jugs, plus a number of old pictures and memorabilia. Traditional, hearty pub food is served, and guest beers change regularly. At the rear is a small garden. Eleven en-suite bedrooms are available.
Q⛵❀◀🚶♿≷(Snow Hill) ♿(St Chads)🚪🐾🛜

Colmore
116 Colmore Row, B3 3BD
☎ (0121) 238 1041 ⊕ colmoretap.co.uk
Thornbridge Astryd, Brother Rabbit, Lord Marples, Jaipur IPA; 5 changing beers (sourced nationally; often Saltaire) ⊞
This Thornbridge pub is a worthy winner of a CAMRA design award in the conversion to pub category. It retains extensive wood panelling and high quality fixtures and fittings from its previous days when it was a bank. Four regular Thornbridge beers are served plus four guests, as well as 20 gins, along with a comprehensive pizza menu. There is a pool table downstairs.
⛵◀♿≷(New St) ♿(Town Hall) ♣🚪🐾🛜

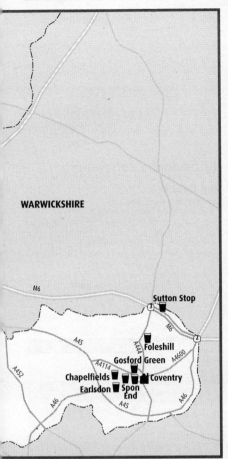

WARWICKSHIRE

Sutton Stop

Foleshill
Gosford Green
Chapelfields
Earlsdon Spon End Coventry

matches are often shown. Attentive staff offer an interesting range of nationally sourced real ales and up to two bag-in-box real ciders. There is a large wooden-floored function room upstairs, available to hire. Affordable classic pub food is served. The pub attracts a diverse clientele spanning all age groups.
⛵❀◀♿♣●🚪🐾🛜

Midland
526-528 Bearwood Road, B66 4BE
☎ (0121) 429 6958
Black Country Bradley's Finest Golden, Pig on the Wall, Fireside; 9 changing beers (sourced nationally; often Black Country) ⊞
A former HSBC bank, this single-room, open-plan pub began trading in 2014 following a thorough refurbishment, and is now decorated in the established Black Country Ales theme to a high standard. It serves up to 13 real ales and three still ciders. It has a beer cellar on the same floor which can be viewed through a glass inspection panel. Standard bar snacks including crusty cobs are available. Q⛵◀♿♣●🚪🐾🛜

Bilston

Cafe Metro 𝕃
46 Church Street, WV14 0AH (opp St Leonards Church and town hall)
☎ (01902) 498888 ⊕ cafe-metro.co.uk

Craven Arms 🄻

Upper Gough Street, B1 1JG (in side street near Mailbox)

☎ (0121) 643 2852

Black Country Bradley's Finest Golden, Pig on the Wall, Fireside; 6 changing beers (sourced nationally; often Mallinsons, Salopian) Ⓗ

This Black Country Ales gem is a welcoming back-street local, built in the early 19th century, with an attractive blue-tiled exterior and a cosy one-room interior wrapped around a splendid bar. The knowledgeable publican is a real ale enthusiast. The pub serves three regular Black Country ales plus up to seven local and national beers on handpull, and a real cider. Cobs, pork pies and sausage rolls are available at most times. A real fire may await on cold days. Q≷(New St)◗(Town Hall)♣ 📶

Good Intent 🄻

32-33 Great Western Arcade, B2 5HU

☎ (0121) 572 5788

Craddock's Crazy Sheep, Saxon Gold; 4 changing beers (sourced regionally; often Craddock's) Ⓗ

An upmarket refurbishment of a shop in the Great Western Arcade opposite Snow Hill station, this is a not-for-profit pub operated by Craddock's Brewery. The ground floor bar has six handpumps serving Craddock's ales and guests from the Midlands area, alongside keg products, wines, spirits and continental/craft beers. Part of the upstairs cellar is visible (there is also a cellar downstairs). A function room is available for hire. Don't be alarmed by the frequent rumbling and slight vibration from below – it's the trains going through Snow Hill tunnel below the pub.
Q♿♿≷(Birmingham Snow Hill) ◗(Bull St) ♣🖸♣ 📶

Head of Steam

Somerset House, 36 Temple Street, B2 5DP

☎ (0121) 643 6824

4 changing beers (sourced regionally; often Blue Monkey, Camerons) Ⓗ

As part of Camerons' chain, Birmingham's Head of Steam hosts up to 10 local or national well-known and lesser-known beers on handpulls. The upper level features an island bar and classy wood decor with spacious seating options for various sized groups. There is a food menu all day with options ranging from rump steak kebabs to sides and sharers. With Sky Sports on screens the pub can get busy at weekends, particularly when big sporting events are on.
♿◑♿≷(New St) ◗(Corporation St) 🖸♣ 📶

Post Office Vaults 🄻

84 New Street, B2 4BA (entrances on both New St and Pinfold St)

☎ (0121) 643 7354 ⊕ postofficevaults.co.uk

Hobsons Mild; house beer (by Kinver); 6 changing beers (sourced nationally) Ⓗ

A two-minute walk from the Stephenson Street entrance to New Street station and close to Victoria Square, this subterranean bar offers a range of eight traditional beers in excellent condition. It also stocks at least 350 different bottled beers from all over the world – one of the largest ranges in the country – and serves 14 ciders and perries. The extremely knowledgeable staff will make your visit a pleasure. Q≷(New St)◗(Town Hall)♣♥🖸 📶

Wellington 🄻

37 Bennetts Hill, B2 5SN (5 mins from New St and Snow Hill stations)

☎ (0121) 200 3115 ⊕ thewellingtonrealale.co.uk

Black Country Bradley's Finest Golden, Pig on the Wall, Fireside; Oakham Citra; Purity Mad Goose; Wye

Valley HPA; 9 changing beers (sourced nationally; often Froth Blowers, Titanic) Ⓗ

A stalwart of the Birmingham real ale scene, the Wellington has the feel of a community local in the heart of the city. There are 27 handpulls over two floors, dispensing well-kept ale and three traditional ciders. A huge range of whiskies is also available – the ground floor offering Scotch, the rest of the world represented on the first-floor bar. The suntrap roof terrace is a hidden urban gem. Regular quizzes, folk nights and cheese nights are held. There is no food but you can bring your own – plates, cutlery and condiments are provided.
Q♿♣≷(Snow Hill) ◗(Grand Central) ♣♥🖸 📶

Birmingham: Cotteridge

Red Beer'd 🄻

1891 Pershore Road, B30 3DJ

2 changing beers (often Fownes) Ⓗ

A nice addition to the Cotteridge and Stirchley pub scene, this micropub featuring four cask and up to 10 keg taps is located close to Kings Norton railway station. There is comfortable seating for about 12 downstairs, and a few more chairs around barrels upstairs. The staff are friendly, knowledgeable and passionate about their beers. Card payment only. ♿≷(Kings Norton)♥🖸♣ 📶

REAL ALE BREWERIES

Ajās Walsall
Angel Ales Halesowen
Backyard ♪ Walsall
Banks's Wolverhampton
Bathams Brierley Hill
Beat ♪ Lye
Birmingham Birmingham
Black Country 🍺 Lower Gornal
Brewhouse & Kitchen 🍺 Sutton Coldfield
Britt Rowley Regis
Burning Soul Birmingham: Hockley
Byatt's ♪ Coventry
Craddock's 🍺 Stourbridge
Cult Of Oak Netherton (NEW)
Davenports Smethwick
Dhillon's ♪ Coventry
Dig ♪ Birmingham
Fixed Wheel ♪ Blackheath
Fownes Brierley Hill
Froth Blowers Erdington
Glasshouse ♪ Stirchley
Green Duck ♪ Stourbridge
Halton Turner Birmingham: Digbeth
Holden's Woodsetton
Indian Great Barr
Leviathan ♪ Sutton Coldfield
Mashionistas Coventry
New Invention ♪ Walsall
Newbridge Bilston
Olde Swan Netherton
Ostlers 🍺 Harborne
Printworks 🍺 Stourbridge
Red Moon Birmingham: Yardley
Rock & Roll Birmingham
Sarah Hughes 🍺 Sedgley
Silhill Solihull
Toll End 🍺 Tipton
Triumph Coventry
Twisted Barrel Coventry
Two Towers Birmingham
Underground Medicine Coventry (NEW)

Birmingham: Digbeth

Halton Turner
1 Rea Court, 40 Trent Street, B5 5NL
☎ 07939 328451 ⊕ haltonturnerbrew.co/halton-wp
1 changing beer (often Halton Turner)
A lively brewery tap in the heart of the city earning a great reputation following its relocation and massive expansion during lockdown. A vast array of beers and an evolving selection of real cider are available. This airy establishment offers great street food and an expanding selection of live entertainment. It is focused predominantly on its own beers, but also stocks regionally sourced gems to complement the line-up.
さ🏵️👶✦(Moor St) 🚃(Corporation St) ●🚌

Spotted Dog Ⓛ
104 Warwick Street, B12 0NH
☎ (0121) 772 3822 ⊕ spotteddog.co.uk
Castle Rock Harvest Pale; Holden's Black Country Mild; Oakham Citra Ⓗ
A multi-roomed traditional pub, family-owned and with the same landlord since the 1980s. There is a competitively priced cask mild on the bar. Rugby and Irish sports are shown on largescreen TVs. Outside is an extensive covered garden and smoking area with heaters, a large real fireplace, a barbecue, a projection screen and eclectic adornments. Traditional Irish music night is on alternate Mondays, jazz night on Tuesdays, and the pub is the home of Na Madrai golf society and the Digbeth O'lympics. It gets busy when Birmingham City play at home. Q さ🏵️👶≠(Bordesley)●🚌🐾🛜

White Swan ★ Ⓛ
276 Bradford Street, B12 0QY
☎ (0121) 622 7277
Fixed Wheel Wheelie Pale; Hobsons Best; 4 changing beers Ⓗ
Two-roomed unspoilt Victorian red-brick pub, identified by CAMRA as having a nationally important historic interior. The main drinking area has a wooden bar with large bar back and etched mirrors, with stools and bench seating around the walls. An impressive ornately tiled hallway leads to a small lounge and smoking area. Close to Digbeth coach station, the pub gets busy when sporting events are shown on large pull-down TV screens. Sandwiches, pies and cobs are available. Guest beers are from the Marston's portfolio.
さ≠(Bordesley) ●🚌🐾🛜

Birmingham: Edgbaston

Physician
Harborne Road, B15 3DH
☎ (0121) 272 5900
Brunning & Price Original; Timothy Taylor Landlord; Titanic Plum Porter; 3 changing beers (sourced regionally) Ⓗ
Large historic former BMI building used to house the vast Sampson Gamgee Library for the History of Medicine, recently converted into a pub. It is an upmarket establishment with several drinking and dining areas. A range of ales is served, often featuring numerous local brews, alongside a good selection of wines, gins and whiskies. Excellent food is available, including a gluten-free menu. 🏵️🍽️👶≠(Five Ways)●P🐾

Birmingham: Harborne

Hop Garden
19 Metchley Lane, B17 0HT (100yds from High St, at back of M&S)
☎ (0121) 427 7904

5 changing beers (sourced nationally) Ⓗ
A small pub serious about craft beer, with few mainstream products. It serves five real ales from small and local breweries, seven craft beers and five craft ciders, as well as real cider. There is also an interesting selection of bottled beers. The decor is original and eclectic. There is a new covered area outside, and there really are hops growing in the garden!
Q さ🏵️🍽️👶♣●🚌🐾

White Horse Ⓛ ✅
2 York Street, B17 0HG
☎ (0121) 608 7641 ⊕ whitehorseharborne.com
Greene King Abbot; Ostlers Terry's Gold; Wye Valley HPA; 3 changing beers (sourced regionally; often Bathams, Church End) Ⓗ
Traditional community local just off the High Street, a former Festival Alehouse with a long history of real ale. It brews on the premises as Ostlers Ales. There are four rotating craft beers on KeyKeg – check what beers are on in real time via the website beerboard. Entertainment includes live music at the weekend, quizzes on Tuesday and Thursday, and Sky/BT sport on TV. Q さ🏵️👶●🚌🐾🛜

Birmingham: Highgate

Lamp Tavern Ⓛ
157 Barford Street, B5 6AH (500yds from A441 Pershore Rd near bottom of Hurst St)
☎ (0121) 688 1220
4 changing beers (sourced nationally; often Froth Blowers, Hobsons) Ⓗ
This hidden gem has one permanent real ale and four changing guests, often including one from Hobsons as well as local breweries. It has been run by the friendly licensee for over 28 years now and has a proper homely feel, with a folk club on Friday and a jazz club some Tuesdays. There is road parking only, but good bus routes nearby. It closes early if quiet, so ring ahead if planning a late visit. Cash only accepted. Q さ👶♣🚌(35,45)

Birmingham: Hockley

1000 Trades
16 Frederick Street, B1 3HE
☎ (0121) 233 6291 ⊕ 1000trades.org.uk
House beer (by Rock & Roll); 3 changing beers (sourced nationally) Ⓗ
This delightful addition to the Jewellery Quarter has distinctive bare boards and brickwork with full-width doors opening on to the pavement, giving the independent craft beer bar a distinctive atmosphere. Four handpumps serve a changing range of beers, usually with at least one sourced from a local microbrewery. The cask offering is supported by five KeyKeg taps and an interesting range of bottled beers. The bar is a music venue showcasing independent labels. ▶👶≠(Jewellery Quarter) 🚃(Jewellery Quarter)

Black Eagle Ⓛ
16 Factory Road, B18 5JU (turn right out of Soho Benson Road Metro station, cross road and walk 200yds)
☎ (0121) 523 4008
Holden's Golden Glow; Timothy Taylor Landlord; Wye Valley HPA, Butty Bach; 5 changing beers (often Church End, Oakham, Salopian) Ⓗ
Traditional award-winning multi-room pub that also features a restaurant to the rear. While slightly off the beaten track, this real ale oasis is well worth seeking out for its excellent range of beers and good-value food. Three guest beers are always available and an annual beer festival is held in the summer. Occasional barbecues

are held – check with the pub. Real cider and perry usually come from Westons and Gwynt Y Ddraig. Q⬭♿☕◑♿(Soho Benson Rd) ♣🚻❀

Burning Soul Brewery Ⓛ
Unit 1, Mott Street Industrial Estate, B19 3HE
☎ 07826 813377 ⊕ burningsoulbrewing.com
13 changing beers (sourced locally; often Burning Soul)
A changing list of smaller, experimental pilot brews is available here so the brewery can capture at first-hand what people think of the beers – the favourites are rebrewed and sold outside the brewery. Brewery tours can be arranged. There is one handpump for cask ale plus 10 KeyKeg taps, with all Burning Soul beers being real ales. Bottled mead is also sold. Card payment is preferred, but cash is accepted.
☕�561(Jewellery Quarter) 🚆(St Paul's) ♣P🚻

Rock & Roll Brewhouse Ⓛ
19 Hall Street, B18 6BS
☎ 07969 759649
Rock & Roll Brew Springsteen, Thirst Aid Kit, Voodoo Mild Ⓗ
A quirky brewery taproom bedecked with music memorabilia. The bar staff and their knowledge of beer is excellent – the brewery's other shared love is music and a playlist of what you're hearing is on the wall. There are three vegan-friendly ales available on a rotating basis. Hogan's cider is also available. It opens Friday evenings and Saturday afternoons only, and there are occasional live bands. Check Facebook before visiting as the taproom is occasionally closed for music festivals.
�561(Jewellery Quarter) 🚆(St Paul's)

Birmingham: Kings Heath

Hop & Scotch Ⓛ
9 Institute Road, B14 7EG
☎ (0121) 679 8807 ⊕ hopscotchbrum.com
4 changing beers (sourced locally; often Green Duck, Kinver) Ⓗ
Friendly and welcoming microbar with three to four cask beers, often from local producers Green Duck and Kinver, together with an interesting range of KeyKeg beers from local breweries, some of which are vegan-friendly. Bottled and canned ales are also sold. There are various seating areas in differing styles. The bar attracts a wide age range and can get busy in the evening. Dogs are welcome, with treats offered. Opening hours can change – see the website for up-to-date times. ⬭◑♣🚻❀📶

Kings Heath Cricket & Sports Club
Charlton House, 247 Alcester Road South, B14 6DT
☎ (0121) 444 1913 ⊕ kingsheathsportsclub.com
Wye Valley HPA, Butty Bach; 2 changing beers (sourced nationally) Ⓗ
Welcoming sports club where CAMRA members are permitted entry on production of a membership card (maximum 10 visits per year). The club has two rooms – a comfortable lounge for relaxed drinking, and a large room for watching sporting events on large screens, which also houses two full-size snooker tables. The beer range always includes two rotating guest ales. Various social events, including live music, are held throughout the year. Q⬭☕◑♿&♣P🚻📶

Birmingham: Newtown

Bartons Arms ★
144 High Street, B6 4UP
☎ (0121) 333 5988 ⊕ thebartonsarms.com

Oakham JHB, Inferno, Citra, Bishops Farewell; 2 changing beers (sourced nationally; often Oakham) Ⓗ
This Grade II*-listed building is a classic example of late-Victorian splendour. From the main bar the superb original stained-glass windows can be viewed, with the M&B logo as it was in 1901. There are ornate Minton tiles and a fancy tiled staircase. The restaurant is well known for its excellent Thai cuisine. As well as the regular Oakham beers and seasonals, at least one guest ale is usually served. The pub can get busy when Aston Villa are at home. ⬭◑&♣P🚻📶

Birmingham: Northfield

Black Horse Ⓛ ✓
Bristol Road South, B31 2QT (opp Sainsbury's)
☎ (0121) 477 1800
Greene King Abbot; Ruddles Best Bitter; Sharp's Doom Bar; changing beers (sourced nationally; often Adnams, Fuller's, Purity) Ⓗ
Large mock-Tudor road house offering the only extensive real ale choice in this part of the city. It has been transformed from an undesirable local to a popular pub serving good-quality beer. Unusually for Wetherspoon, this pub has a multi-room layout and bars on two levels. It still retains the original Baronial Hall entrance but the bar has been tastefully refurbished with an etched-glass entrance door. There is a bowling green with original outbuildings to the rear. Q⬭☕◑&�561(Northfield)P🚻📶

Birmingham: Perry Barr

Arthur Robertson ✓
51-53 One Stop Retail Park, Walsall Road, B42 1AA
☎ (0121) 332 5910
Greene King Abbot; Ruddles Best Bitter; 3 changing beers Ⓗ
A popular large open-plan Wetherspoon at the One Stop shopping centre in Perry Barr, named after Birchfield Harriers' very first Olympian and medal winner. The manager tries to keep three local guest ales available alongside the standard offerings when possible. The pub serves the standard Wetherspoon food menu. It can get busy when Aston Villa are playing at home. Q⬭☕◑�561(Perry Barr) ♣P🚻📶

Birmingham: Stirchley

Birmingham Brewing Company Taproom
Unit 15 Stirchley Trading Estate, Hazelwell Road, B30 2PF
☎ (0121) 724 0399 ⊕ birminghambrewingcompany.co.uk
Birmingham Pale Brummie, Bitter Brummie; house beer (by Birmingham); 3 changing beers (often Birmingham) Ⓗ
Craft beer brewery based on Stirchley Trading Estate, just off Pershore Road. The tap room is open alternate Fridays and Saturdays; opening dates and times are on the website. The bar has four cask lines, four keg lines and also serves locally brewed cider, wine and soft drinks. There are five regular beers. Food is available from a rotating street food vendor on site. There is a large outdoor seating area. ⬭◑�561(Bournville)♣🚻❀

Wildcat Tap
1381-1383 Pershore Road, B30 2JR
⊕ stirchleywildcat.co.uk
5 changing beers (sourced nationally) Ⓗ
This bar is much changed from the original Wildcat just down the road. It attracts all ages and is spacious for a

micropub, with adequate seating, although it does get busy at weekends. The beer range of cask and keg is adventurous and interesting, with five casks on handpump, eight craft keg lines and a real cider, complemented by a selection of bottled craft beers, gins, whiskies and soft drinks. ⇌(Bournville)🚲🚌

Blackheath

Britannia 🏆

124 Halesowen Street, B65 0ES
☎ (0121) 559 0010

Greene King Abbot; Ruddles Best Bitter Ⓗ; Sharp's Doom Bar Ⓗ/🅖; 6 changing beers (sourced nationally; often Backyard, Kinver, Slater's) Ⓗ

An L-shaped Wetherspoon outlet at the very heart of Blackheath. The garden at the rear provides a pleasant space away from the main A4099. The exposed brick façade is often decorated with hanging baskets in the warmer seasons. Six changing beers are accompanied by three permanent brews. Pictures placed throughout the pub depict local monuments and historic characters. Food is served all day, every day. A small car park for customers can be accessed via Cross Street.
🛏️🅿️🍴🅭🅶⇌(Rowley Regis)♣🚲🅿️🚌(4H,X8) 🛜

Cyder & Cobb

167 Halesowen Street, B65 0ES (exit Market Place island onto Halesowen St and pub is on right)
☎ 07849 402244

Wye Valley Butty Bach; 3 changing beers (sourced nationally) Ⓗ

An intimate and well-appointed micropub that opened in 2021 and is a very pleasant place to spend a few hours. Inside, there are six wooden tables and benches, and a standing bar. Up to four beers are served, with guests sourced nationally, plus a selection of real ciders. Beers from Salopian and Thornbridge are usually featured. A selection of cobs is also available. Easy-listening music is played. 🛏️🅶⇌(Rowley Regis)♣🚲🅿️🐾🛜

Boldmere

Bishop Vesey Ⓛ

63 Boldmere Road, B73 5XA
☎ (0121) 355 5077

Greene King Abbot; Oakham Citra; Ruddles Best Bitter; Sharp's Doom Bar; 11 changing beers (sourced nationally; often Backyard, Oakham) Ⓗ

A popular Wetherspoon pub which has racked up over 20 consecutive years in the Guide, unique in the area. Named after the region's Tudor benefactor, it features a carved wooden pulpit by the entrance. Up to four interesting guest beers are offered. As well as extensive seating areas upstairs and down, there is a spacious rooftop garden, and a smaller beer garden downstairs.
🛏️🅭🅶⇌(Wylde Green)♣🚌🛜

Cask & Craft

56 Boldmere Road, B73 5TJ
☎ 07497 828911

2 changing beers (sourced nationally) Ⓟ

Craft-leaning micropub which opened in 2019 and features 12 taps. One or two real ales are offered, served through keg taps but fed by electric pumps. A number of well-stocked fridges feature a wide range of canned craft beers and a few eclectic bottles. Wines, gins and cocktails are also available. The bar area is on the small side but there is a larger room upstairs, plus an expansive covered and heated terrace to the rear.
⇌(Wylde Green)🚌🛜

Brierley Hill

Garrison Saloon Bar

Waterfront E, DY5 1XL
☎ (01384) 349644

Enville Ale; house beer (by Salopian); 3 changing beers (sourced nationally; often Green Duck, Salopian, Titanic) Ⓗ

Popular Peaky Blinders-themed saloon bar, based on the Waterfront business park, with a mural adorning one of the walls as well as a jukebox in the corner. The seven real ales include Garrison Gold (Salopian Shropshire Gold), Garrison Pale (Fixed Wheel Chain Reaction), Enville Ale, rotating offerings from Green Duck and two changing beers, alongside real ciders. Live music features most Sundays and some Fridays. Q🛏️🅶🚲🅿️🚌(8,6)🐾

Pens Ale

High Street, DY5 4RP (adjacent to Pensnett Fish Bar)
☎ 07496 419811

Holden's Golden Glow; 3 changing beers (sourced nationally) Ⓗ

The sister bar to the popular Tivi Ale micropub in Tividale, Pens Ale opened in September 2021. It is a smart, plush, modern open-plan bar with a wide customer mix. It serves up to four real ales, sourced nationally and locally, alongside other refreshments and a range of traditional bar snacks. A quiz night is held monthly on a Tuesday.
🛏️🐾🐾

Rose & Crown Ⓛ

161 Bank Street, DY5 3DD (on B4179)
☎ (01384) 936166

Holden's Black Country Bitter, Golden Glow, Special; 1 changing beer (often Holden's) Ⓗ

This traditional pub was originally two terraced properties. One end of the bar is dominated by a dartboard. A conservatory provides extra space and is used as a function room, opening onto a small garden with tables and benches. There is a bus stop outside, or a five-minute walk takes you to Brierley Hill High Street, which is served by several bus routes. Holden's seasonal beers are rotated. Q🛏️🐾♣🅿️🚌🐾🛜

Vine

10 Delph Road, DY5 2TN
☎ (01384) 78293

Bathams Mild Ale, Best Bitter Ⓗ

An unspoilt brewery tap with an ornately decorated façade proclaiming the Shakespearian quotation, 'Blessing of your heart, you brew good ale'. It is an elongated pub with a labyrinthine feel. The front bar is staunchly traditional, while the larger rear room has its own servery, leather seating and a dartboard. The homely lounge was partly converted from former brewery offices. Black Country lunches, such as faggots and home-made pies, are served weekdays, with generously filled rolls and pork pies at all times.
Q🛏️🅭🅶🅿️🚌(8) 🐾🛜

Brownhills

Jiggers Whistle Ⓛ

5-7 Brownhills High Street, WS8 6ED
☎ 07854 356976

House beer (by Green Duck); 3 changing beers (sourced nationally; often AJs, Backyard, Green Duck) Ⓗ

Micropub that opened in 2017 and has grown hugely in popularity; it now supports its own darts team. One room is split into three interconnected drinking areas, offering a wide range of cask and craft keg ales plus around eight real ciders. Bar snacks are available at weekends. The

owners offer customers a warm and friendly welcome and are keen to support local events.

Q🐾♣🟢♿P🖵(10) 🐾🐾📶

Coventry: Chapelfields

Hearsall Inn 🅛

45 Craven Street, CV5 8DS (1 mile W of city centre, off Allesley Old Rd)

☎ (024) 7671 5729 ⊕ hearsallinn.com

Church End Goat's Milk; Draught Bass; 2 changing beers (sourced locally; often Byatt's) 🅗

Built in the 1850s to serve the historic watchmaking district, this free house has been run by the same family for 25 years. It has separate bar and lounge areas with a paved patio to the front. The pub is home to darts, dominoes and football teams and hosts traditional Irish music on Tuesday nights. Four handpumps dispense local and regional beers. Freshly made batches are available throughout the day. The building has an externally mounted defibrillator. 🚺🟢♣🟢🐾📶

Coventry: City Centre

Gatehouse Tavern 🅛

44-46 Hill Street, CV1 4AN (close to Belgrade Theatre and Spon St, nr jct 8 of ring road)

☎ (024) 7663 0140

6 changing beers (sourced locally; often Byatt's, Church End) 🅗

A small single-roomed pub that was converted from the former Leigh Mill gatehouse by the landlord. A long-term entry in the Guide, it is dedicated to high-quality real ale, good-value food and televised sports of all kinds; the latter evidenced by the depiction of the emblems of the six nations in a stained-glass window. The beer garden is the largest in the city centre and is popular during the summer months. 🚺🟢🌓♿🟢🐾📶

Golden Cross 🅛 ✅

8 Hay Lane, CV1 5RF (nr old cathedral ruins)

☎ (024) 7655 1855 ⊕ thegoldencrosscoventry.co.uk

Wye Valley HPA; 3 changing beers (sourced nationally; often Bath Ales, Byatt's, Church End) 🅗

One of the few remaining medieval buildings in the city centre, located next to the cathedral and on the site of an old mint. Historically the meeting place of the Philanthropic Society in the 1800s, the pub has experienced several renovations. The most recent has sympathetically returned it to a comfortable and welcoming venue. There is a small courtyard at the rear and an upstairs bar providing more space. Gluten-free food is served. 🟢🌓🟢📶

Hops d'Amour 🍷 🅛

67 Corporation Street, CV1 1GX

☎ (024) 7767 2100 ⊕ hops-damour.business.site

6 changing beers (sourced regionally) 🅗

Coventry's first and only micropub is located in a former sewing machine shop. It serves a changing choice of six mostly regional ales, including many that are rarely seen in the area. These are supplemented by four craft keg beers and a wide range of boxed ciders and perries, together with cans and growlers to take out. In keeping with the micropub ethos, conversation takes the place of electronic entertainment and gaming machines. Local CAMRA Pub of the Year 2022. Q🟢🖵

Old Windmill 🅛 ✅

22-23 Spon Street, CV1 3BA (behind IKEA)

☎ (024) 7625 1717

Theakston Old Peculier; 5 changing beers (sourced nationally; often North Cotswold, Timothy Taylor) 🅗

A popular timber-framed pub in historic Spon Street; one of two that are claimed to be the city's oldest. It is split into several small rooms, with the Victorian brewhouse being of particular interest. The pub now has freedom to source a wide range of interesting beers. Locally produced pork pies, pasties and a range of cheeses are available and recommended. Beer festivals are held at least once a year. 🟢♣🟢🟢🐾📶

Town Crier ✅

Corporation Street, CV1 1PB (close to Spon St)

☎ (024) 7663 2317

Marston's Pedigree; Wychwood Hobgoblin Gold; 3 changing beers (sourced nationally; often Marston's) 🅗

A popular city-centre pub with friendly, helpful staff and a good-value food menu. Built in the late 1980s by Banks's Brewery, it has a single bar serving a large room, and outdoor seating to the front. The pub hosts an open mic night on Thursday plus live music sessions on Saturday evening. It attracts a wide clientele and is ideally located for exploring the adjacent historic Spon Street and other city attractions. 🟢🌓♿🟢📶

Town Wall Tavern

Bond Street, CV1 4AH (behind Belgrade Theatre)

☎ (024) 7622 0963

Brains Rev James Original; Draught Bass; Theakston Best Bitter, Old Peculier; Wye Valley HPA; 3 changing beers (sourced nationally; often North Cotswold) 🅗

Hidden away behind the Belgrade Theatre and surrounded by modern structures, this is a rare city-centre example of a traditional boozer. The bar and lounge areas are supplemented by the Donkey Box, a tiny bar deemed only big enough to hold a donkey. A window depicting the long defunct Atkinsons Brewery marks the original external wall of the building. The pub is popular with theatregoers and those seeking out the excellent food. 🌓🟢🖵🐾

Coventry: Earlsdon

City Arms 🅛 ✅

1 Earlsdon Street, CV5 6EP (on roundabout at centre of Earlsdon)

☎ (024) 7671 8170

Greene King Abbot; Ruddles Best Bitter; Sharp's Doom Bar; 7 changing beers (sourced nationally; often Byatt's, Grainstore, Purity) 🅗

A large 1930s mock-Tudor pub on the roundabout in the heart of the bustling suburb of Earlsdon. Regular Wetherspoon beers are augmented by up to seven changing guest ales. There are information boards dotted around inside the pub describing the history of the local area. On-site parking is limited but there are good bus links to the city centre and Coventry railway station. It can get busy at weekends. 🚺🟢🌓♿P🖵(5,11)📶

Coventry: Foleshill

Byatt's Brewhouse Bar 🅛

Unit 7-8 Lythalls Lane Industrial Estate, Lythalls Lane, CV6 6FL

☎ (024) 7663 7996 ⊕ byattsbrewery.co.uk

6 changing beers (sourced locally; often Byatt's) 🅗

Comfortable brewhouse bar on a small industrial estate, showcasing up to six rotating real ales from Byatt's range. Drinkers can relax and enjoy the atmosphere across various seating areas, including a mezzanine level. Additional space is created in the adjacent brewery on

match days. Commissioned artworks add to the modern decor. Off-sales and Byatt's bottle-conditioned beers are available. The bar opens some Sundays if a fixture is being played at the nearby Coventry Arena.
ℒ⅊P🛒(5,48) ♣🐾

Coventry: Gosford Green

Twisted Barrel Brewery & Tap House ℒ

Unit 11, FarGo Village, Far Gosford Street, CV1 5ED
☎ (024) 7610 1701 ⊕ twistedbarrelale.co.uk
Twisted Barrel Beast Of A Midlands Mild, Detroit Sour City, God's Twisted Sister, Sine Qua Non, Naido; 18 changing beers (sourced nationally) Ⓗ/℗
An entirely vegan brewery tap in FarGo Village, a bustling area that is home to artisanal businesses, independent food outlets and arts and music event spaces. Beer can be tasted where it is made here. The wide range of ales on offer includes guests and collaborations which can be enjoyed in the spacious hall or the outside seating area. The pub hosts a popular home-brew club and regular special events. ᔑ🐾&🛒♣🐾

Coventry: Spon End

Broomfield Tavern ℒ

14-16 Broomfield Place, CV5 6GY (adjacent to rugby ground but hidden from main road)
☎ (024) 7663 0969
Church End Fallen Angel; Froth Blowers Piffle Snonker; 5 changing beers (sourced nationally; often Pitchfork) Ⓗ
A genuine free house and popular community pub with a strong focus on real ale and cider. It is going through a long-term programme of renovation, but the friendly staff maintain a welcoming and comfortable venue. The character and cosiness of the pub will be retained when work is complete. It gets busy when rugby takes place at the adjacent Butts Park Arena. Local CAMRA Cider Pub of the Year 2022. Q ᔑ♣♠P🛒(6,6A)🐾

Coventry: Sutton Stop

Greyhound Inn

Sutton Stop, Hawkesbury Junction, CV6 0DF (off Grange Rd at jct of Coventry and Oxford canals)
☎ (024) 7636 3046 ⊕ thegreyhoundlongford.co.uk
Draught Bass; Greene King Abbot; 3 changing beers (sourced nationally) Ⓗ
An award-winning pub dating from the 1830s. Located at Hawkesbury Junction where the Coventry and Oxford canals meet, it is popular with regulars and visitors alike. The canalside patio is an idyllic setting for narrowboat watching. In the winter drinkers and diners can enjoy a real fire in the cosy bar area. At the rear there is a separate bar and garden for summer events. A wide range of food is served in the bar and restaurant.
ᔑ🐾⏺♣P🐾🛜

Cradley Heath

Plough & Harrow

82 Corngreaves Road, B64 7BT
☎ (01384) 638351
Banks's Mild; Wye Valley HPA, Butty Bach; 2 changing beers (sourced nationally; often Bristol Beer Factory) Ⓗ
A former local CAMRA Pub of the Year, this popular and homely pub has thrived under the stewardship of the current owner. The venue specialises in strong and hoppy pale beers, and now serves two guests. Music features

every Saturday. There is an accent on community-based events, with various sports teams, and money is regularly raised for a variety of charitable causes. At the rear is an enclosed outdoor seating area, some of which is sheltered. Q ᔑ🐾≉♣P🛒(18,14A)🐾🛜

Dorridge

Knowle & Dorridge Cricket Club ✅

Station Road, B93 8ET (corner of Station Rd and Grove Rd)
☎ (01564) 774338 ⊕ knowleanddorridgecc.co.uk
3 changing beers (sourced nationally) Ⓗ
This established cricket club, set in an upmarket residential area, has won local CAMRA Club of the Year for three years in succession. There are no entry restrictions, but club members are able to purchase drinks at a reduced price. Visitors are welcome to try the ever-changing range of up to three cask conditioned ales, which are always in excellent condition and often from interesting breweries. There is outside seating to watch high-class cricket in the Birmingham league. Bar snacks and filled rolls are usually available.
ᔑ🐾⏺&≉♣P🛒(S2,S3) 🐾🛜

Dudley

Malt Shovel

46 Tower Street, DY1 1NB (off Broadway A459; opp Dudley College Evolve Campus)
☎ (01384) 252735
Holden's Golden Glow; 4 changing beers (sourced nationally; often Oakham) Ⓗ
Originally known as the Lord Wellington in the 19th century, this exciting and trendy town-centre establishment is now part of the Red Pub Co portfolio and attracts a wide variety of customers. It serves a popular balance of locally produced cask beers and modern, nationally sourced brews, with Yorkshire breweries often showcased. The mixture of seating styles includes classic benches, which contrast nicely with the high stools. There is a small number of gaming and betting machines. Live music often features at weekends. ᔑ⏺P🛒(1,X8)🐾🛜

Four Oaks

Butlers Arms ✅

444 Lichfield Road, B74 4BL
☎ (0121) 308 0765 ⊕ butlersarms.co.uk
4 changing beers Ⓗ
A family-run pub that is geared towards dining but has a large bar area where drinkers are welcome. Large leaded-glass windows, along with mirrors and lamps, give a light and airy feel. The wide-ranging food menu has an emphasis on fresh fish. Guest ales often come from well-known breweries. The last Friday of the month features live music. A small beer terrace is to the front. Parking is free but requires registration number entry at the bar. Q ᔑ🐾&≉(Butlers Lane)P🐾

Halesowen

Crafty Pint H'ales'owen ℒ

8 Wassell Road, B63 4JU
☎ 07789 203219
Wye Valley HPA, Butty Bach; 5 changing beers (sourced nationally) Ⓗ
A micropub that expanded in 2022 when an adjacent building was incorporated into the bar. Run by a local resident, it offers traditional ales, ciders, wines and beverages. Coffee is generally available during the week.

Crusty cobs, pork pies and sausage rolls are also served. No children are allowed in the evening.
Q❄☝✦P🖵(142,192) ❀🛜

King Edward VII L ✅

88 Stourbridge Road, B63 3UP
☎ (0121) 602 2537
Enville Ale; Holden's Golden Glow; 6 changing beers H

Friendly, comfortable pub next to Halesowen Town football ground, on the main road just out of the town centre towards Stourbridge. It has a large front lounge and smaller rear lounge with sports TV. Both are served by a central bar, offering eight real ales plus one cider. Bar snacks are offered Wednesday to Sunday. Several nearby pubs also sell quality real ale. ❄❀♿✦P🖵(9)❀

Kingswinford

Bridge Inn

110 Moss Grove, DY6 9HH (a491)
☎ (01384) 293880
Black Country Bradley's Finest Golden, Chain Ale, Pig on the Wall, Fireside; 5 changing beers (sourced nationally; often Black Country) H

Open-plan Black Country Ales pub that is deservedly popular with a wide mix of customers. It offers a broad range of up to nine cask beers along with ciders, some of which are real. Cobs, pork pies, sausage rolls and samosas are available daily. The accent is very much on a homely feel with a lot of community atmosphere, and it's well worth a visit. Q❄☝❀♿✦P🖵(15,16)❀🛜

Cottage

534 High Street, DY6 8AW
☎ (01384) 287133
Holden's Golden Glow; Wye Valley HPA, Butty Bach; 2 changing beers (sourced nationally) H

Comfortable pub set on two levels, serving a good menu including lunchtime specials, sandwiches and cobs. There is a carvery available on Sundays, which also supplies meat for delicious sandwiches and cobs. The layout is L-shaped, and diners and drinkers intermingle throughout this spacious pub. Changing beers are always pale session ales. A range of country wines is also available. The frontage would not look out of place on a postcard, and the interior is homely and inviting.
Q❄◗P🖵(16) ❀🛜

Knowle

Ale Rooms

1592 High Street, B93 0LF
☎ (01564) 400040 ⊕ alerooms.co.uk
7 changing beers (sourced nationally; often Church End, Framework) H

This micropub in a converted shop (formerly a funeral director's) on the High Street is a welcome addition to the Knowle real ale scene. The pub stocks at least one beer from Framework Brewery along with one from Church End, plus guest ales, real cider, wines and spirits including speciality gins. The usual pub snacks are available. A two times local CAMRA Pub of the Year and former West Midlands County Pub of the Year.
✦🖵(S3) ❀🛜

Lower Gornal

Fountain Inn

8 Temple Street, DY3 2PE (on B4157 5 mins from Gornal Wood bus station)
☎ (01384) 596317

Church End Fallen Angel; Greene King Abbot; Hobsons Town Crier; Wye Valley HPA, Butty Bach; 5 changing beers (sourced nationally; often Green Duck, Oakham) H

This venue is a destination for both quality real ales and pub food. To the rear, the courtyard with bench tables has been refurbished to a high standard. Up to 10 real ales are served, and more conditioning in the cellar are listed on a board opposite the main bar. There is an elevated, separate restaurant to the rear of the pub.
❄❀♿✦(17A,27A) ❀

Old Bull's Head

1 Redhall Road, DY3 2NU (at jct with Temple St, B4175)
☎ (01384) 231616
Black Country Bradley's Finest Golden, Pig on the Wall, Fireside; 4 changing beers (often Fixed Wheel, Oakham, Salopian) H

The brewery tap for Black Country Ales; the beers are brewed on a 10-barrel kit at the rear of the pub. The pub comprises three well-appointed rooms with a bar, a lounge and an outdoor seating area. Cobs, samosas and Scotch eggs are available. Traditional pub games are played, live football is regularly shown on TV, and occasional beer festivals are hosted on the patio outside.
❀♿✦✦P🖵(17A,27A) ❀🛜

Mere Green

Ale Hub

4 Hill Village Road, B75 5BA
⊕ alehub.co.uk
Wye Valley Butty Bach; 3 changing beers (sourced nationally) H

Formerly a solicitor's office, this two-roomed micropub opened in 2021. It is part of a small family-run chain now comprising four bars of the same name. The three guest ales are generally from smaller brewers. Craft beers, wines, and a range of gins are also offered. The toilets are on the first floor. ❄≷(Butlers Lane)🖵❀🛜

Netherton

Old Swan ★ L

89 Halesowen Road, DY2 9PY (in Netherton centre on A459 Dudley-Old Hill road)
☎ (01384) 253075
Olde Swan Original, Dark Swan, Entire, Netherton Pale Ale, Bumble Hole Bitter; 1 changing beer (sourced locally; often Olde Swan) H

Attracting customers from near and far, the home of the Olde Swan Brewery is one of the last four remaining English home-brew pubs that was brewing when CAMRA was formed in 1974. Recognised by CAMRA as nationally important, the labyrinthine interior features an ornate Swan ceiling and standalone burner in the bar. The pub also has a cosy snug and a two-roomed lounge where food is available, plus other nooks and crannies to imbibe in. Q❀◗♿✦P🖵❀🛜

Old Hill

Wheelie Thirsty L

215 Halesowen Road, B64 6HE
☎ 07876 808468
Fixed Wheel Wheelie Pale, Chain Reaction Pale Ale, Blackheath Stout, No Brakes IPA; 4 changing beers (often Fixed Wheel) H

Located on the high street, this is the second outlet for Fixed Wheel Brewery. A wide cross section of customers regularly uses the pub, and it is popular with out-of-town visitors. A range of up to nine ciders, a guest cask ale and

an enterprising variety of keg craft beers are also served. Events such as quiz and pizza nights take place every month, and live music is hosted every second Sunday. ⏰🏵♣♠🚃(19,X10) ❀ 🛜

Oldswinford

Seven Stars 🅛
Brook Road, DY8 1NQ (on B4186, opp roadway to front entrance of Stourbridge Jct station)
☎ (01384) 441566
Black Country Bradley's Finest Golden, Pig on the Wall, Fireside; 19 changing beers Ⓗ
A magnificent Edwardian Grade II-listed building; look for the ornate tiling and timber bar inside. There are two bars with three rooms – lounge, bar and snug – plus a function room, and a spacious courtyard and smoking area to the side. A total of 25 handpulls are split between the two bars, both featuring Black Country Ales beers and guest ales, with some of the handpulls used for cider. Black Country grub is served. There are rooms available to rent. ⏰🏵🍴①&⇌(Stourbridge Jct)♣♠🅿🚃❀🛜

Rowley Regis

Britannia Pub & Brewery
Rowley Village, B65 9AT
☎ (0121) 559 3415
House beer (by Britt); 5 changing beers (sourced regionally; often Fownes, Milestone, Three Tuns) Ⓗ
Following a high-specification refurbishment, this multi-roomed pub reopened in 2017 offering a welcome combination of real ales, real ciders and hearty food. The bay windows in the shabby chic lounge provide natural lighting and there are multiple real fires throughout the building. The lounge, bar and conservatory are all spacious and each room has a unique feel. Blues and rock bands regularly perform in the conservatory area. Q⏰🏵①&♣♠🅿🚃(X8,14A)❀🛜

Rushall

Manor Arms ★ 🅛
Park Road, off Daw End Lane, WS4 1LG (off B4154 at canal bridge)
☎ (01922) 642333
Banks's Amber Ale, Sunbeam; Bombardier; Wainwright; 1 changing beer (often Young's) Ⓗ
A canalside inn built around 1105, thought to have held a licence for ale since 1248, and therefore one of the oldest pubs in the country. Recognised by CAMRA as having a historic pub interior of national importance, it is traditionally styled with exposed beams and open fires remaining in both bars. Beer pulls come straight out of the wall, resulting in it being known locally as the pub with no bar. There is a country park and nature reserve close by. Although a little off the beaten track, the Manor Arms is well worth a visit. Q⏰🏵🅿🚃(355,356)❀

Sedgley

Beacon Hotel ★ 🅛
129 Bilston Street, DY3 1JE (on A463)
☎ (01902) 883380 ⊕ sarahhughesbrewery.co.uk
Sarah Hughes Pale Amber, Sedgley Surprise, Dark Ruby Mild; 3 changing beers (sourced nationally) Ⓗ
A unique destination brewery tap for Sarah Hughes, also offering progressive guest beers. This popular Grade II-listed pub is brimming with character – queues have been known to assemble ahead of opening time. The biggest selling beer by some margin is the award-winning Sarah Hughes Dark Ruby Mild. The large garden

has children's play facilities at the rear and is used to host various annual events such as Black Country Day. Q⏰🏵🅿🚃(229,224)

Mount Pleasant
144 High Street, DY3 1RH (on A459)
☎ 07950 195652
9 changing beers (sourced nationally; often Enville, Oakham, Wychwood) Ⓗ
Known locally as the Stump, this popular free house serves a selection of nine beers. It has a mock-Tudor frontage and a Tardis-like interior. The front bar is the first room off a long corridor. The lounge areas have an intimate feel, with two rooms on different levels housing various nooks and crannies, both with a real coal stove. The pub is on the main No.1 bus route, or a five-minute walk from the centre of Sedgley. Q🏵♣🅿🚃(1)❀

Shirley

Ale Hub
277 Longmore Road, B90 3ER
⊕ alehub.co.uk
Wye Valley Butty Bach; 3 changing beers (sourced nationally) Ⓗ
This pub on the site of a former newsagent is part of a family-run, four-micropub enterprise. It specialises in cask ales, craft ales and gins, and listens to its customers, bringing that traditional pub feel to the community. There are four well-kept ales on at all times from breweries nationwide, including Wye Valley Butty Bach. A variety of classic pub snacks is available. There is a regular Monday quiz night and a bingo evening on the first Tuesday of every month. Q⏰&🚃❀🛜

Shaking Hand
Unit 24 Parkgate, Stratford Road, B90 3GG
☎ (0121) 733 1176 ⊕ theshakinghand.co.uk
4 changing beers (sourced nationally) Ⓗ
A friendly, light and airy – though small – single-room pub in the Shirley Parkgate shopping centre. It serves four regularly-changing guest ales; usually two from local breweries and two from further afield. The pub has all of the feel of a micropub but has embraced some of the needs of the modern clientele, including sports TV. It always offers a warm welcome and excellent quality ale and cider. Q⏰&♠🚃❀🛜

Short Heath

Duke of Cambridge 🅛
82 Coltham Road, WV12 5QD
☎ (01922) 712038
Black Country Bradley's Finest Golden, Pig on the Wall, Fireside; 3 changing beers (sourced nationally; often Burton Bridge, Green Duck, Salopian) Ⓗ
A traditional homely, welcoming pub converted from 17th-century cottages. The public bar has a wood-burner and wooden beams. The quieter lounge has been tastefully refurbished. A rear room caters for darts and pool and is also used for functions and beer festivals. A quiz is held every other Wednesday. There is a beer garden at the rear. Q⏰🏵&♣♠🚃(41,69)❀

Solihull

Fieldhouse
10 Knightcote Drive, B91 3JU
☎ (0121) 703 9209
Purity Pure UBU; St Austell Proper Job; house beer (by Black Sheep); 3 changing beers (sourced nationally; often Black Sheep) Ⓗ

Part of the Ember Inns chain, this large, modern pub is tastefully decorated and comfortably furnished. Often busy, it attracts a wide age range. It features three large fires (one real, two coal-effect) and pleasant patio areas. Six ales are normally served, with three guest brews from across the country, often unusual ones, changing frequently. Quiz nights are Sunday and Tuesday; on Monday cask ales are discounted. The pub holds monthly tribute acts and occasional Meet the Brewer events. ⌂❀⊪&P☒(S15,5)☂

Pup & Duckling

1 Hatchford Brook Road, B92 9AG
☎ (0121) 247 8358 ● pupandduckling.co.uk
6 changing beers (sourced nationally; often Fixed Wheel) Ⓗ
Solihull's first micropub, opened in 2016 in a vacant shop. Family run, it has added a garden area and another room to the initial two-room layout. Six rapidly changing real ales are available on handpull, along with six ciders. Latest ales are listed on Facebook, but can sell out in an evening. Bar snacks are available and customers are welcome to bring in their own food from the nearby Chinese, Indian and fish & chip takeaways. Local CAMRA Pub of the Year 2017 and 2020. Q❀❀☒(73,957)❀☂

Stourbridge

Red House Boutique Ⓛ

21-26 Foster Street East, DY8 1EL
☎ (01384) 936430
Enville Ale; Holden's Golden Glow; 6 changing beers (sourced nationally) Ⓗ
Large, single-bar free house near to Stourbridge Interchange. Originally part of the Hogshead chain, this refurbished pub has returned to being an alehouse. Beers from Enville, Fixed Wheel and Three Tuns will usually be on the bar, but may change from those listed. A range of KeyKegs is also on sale. Gourmet snacks can be enjoyed at all times including Scotch eggs and flavoured scratchings. Fridges behind the bar are stocked with many bottles from around the world. ❀&➤(Town)●☒❀☂

Waggon & Horses Ⓛ

31 Worcester Street, DY8 1AT
☎ (01384) 395398
Enville Ale, Ginger Beer; Ludlow Gold; house beer (by Purple Moose); 3 changing beers Ⓗ
A recent refurbishment has created a comfortable, welcoming alehouse. There is a small cask ale bar to the front with a narrow passageway leading to a larger rear bar. To the side is a cider bar with a small serving hatchway, offering two or more real ciders. A heated seating area is at the rear. Parking can be difficult in the narrow surrounding streets. A previous local CAMRA Cider Pub of the Year. ❀&➤(Town)●☒(7,125)❀☂

Streetly

Brew House

49 Boundary Road, B74 2JR
☎ (0121) 353 3358
4 changing beers Ⓗ
A pleasant micropub which is an ale oasis in an area dominated by chain pubs. Opened in 2018, it sits at the end of a parade of suburban shops. Up to four ales are offered, with a growing array of pumpclips showing those you have missed. Craft beers, ciders and spirits are also on sale. There are occasional sports screenings and live music. Car parking is available at the front in the area shared by the row of shops. ⌂❀&P☒❀☂

Sutton Coldfield

Station ✓

44 Station Street, B73 6AT (nr Sutton station southbound platform)
☎ (0121) 362 4961
Timothy Taylor Landlord; 7 changing beers Ⓗ
Rail-themed hostelry right next to the station, ideal for commuters, with a view of the departures board from the bar. Up to eight ales are served on handpulls in both front and back bars – check the board for what is available. A wide range of comfort food is offered throughout the day. Quizzes, live music and comedy nights are among the entertainment. In summertime, the multi-level beer terrace to the rear hosts DJs and live music. ⌂❀❀◐&➤☒❀☂

Tipton

Rising Sun Ⓛ

116 Horseley Road, DY4 7NH (off B4517)
☎ (0121) 557 1940
Black Country Bradley's Finest Golden, Pig on the Wall, Fireside; 7 changing beers (sourced nationally) Ⓗ
A former CAMRA National Pub of the Year which reopened in 2013 following refurbishment by Black Country Ales. This imposing Victorian hostelry has two distinct rooms warmed by open fires, and a large yard at the rear with patio heaters and an outbuilding. There are seven changing guest beers plus the three Black Country Ales core beers and up to five traditional ciders. Cobs are served. Great Bridge, a 10-minute walk away, has frequent bus services to Dudley, West Bromwich and Birmingham. ❀♣●☒(22)❀☂

Tame Bridge

45 Tame Road, DY4 7JA (off A461)
☎ (0121) 557 2496
3 changing beers (sourced nationally; often Abbeydale, Oakham, Ossett) Ⓗ
A friendly back-street local, the Tame Bridge is situated alongside the River Tame. The bar features a large coal fire and leads to a cosy snug. There is a family room which can be hired for private functions. All rooms have widescreen TV. The garden area at the back, with a patio, also has a covered smoking area. ⌂❀❀(Dudley Port)☒(74)❀☂

Tividale

Tivi Ale

45-47 Regent Road, B69 1TL
☎ 07496 419811
Holden's Golden Glow; 3 changing beers (sourced nationally; often Enville, Mad Squirrel, Salopian) Ⓗ
Popular microbar that opened in 2018 in a former convenience store. One of the guest beers is from a local brewery; the other two are national ales. Fresh cakes are available daily, and afternoon tea can be served (book ahead). Regular family-friendly events, which often spill out onto the front terrace, are held throughout the year. An array of interesting gins and tonics is also on sale. ⌂❀&☒(14,14A)☂

Upper Gornal

Jolly Crispin

25 Clarence Street, DY3 1UL (a459)
☎ 07714 224283
Abbeydale Absolution; Fownes Crispin's Ommer; Oakham Citra, Bishops Farewell; 5 changing beers

(sourced nationally; often Blue Bee, Neepsend, Saltaire) Ⓗ

A popular free house that was brought under the Red Pub Company umbrella in 2021. The house ale is brewed by Fownes and the changing beers are sourced from a wide array of breweries. The spacious lounge encourages cask and conversation. There is also a smaller bar, plus an outbuilding with flatscreen TVs showing sport. Various crusty cobs are available every day; hot pork cobs with stuffing and roast potatoes on Fridays and Saturdays. Regular tap takeovers and beer festivals are held.
☠⊛♣♠P🅿(1)☺🅿

Walsall

Black Country Arms 🅛

High Street, WS1 1QW (in market, opp Asda)
☎ (01922) 640588 ⊕ blackcountryarms.co.uk

Black Country Bradley's Finest Golden, Pig on the Wall, Fireside; 13 changing beers (sourced nationally; often Fixed Wheel, Mallinsons, Salopian) Ⓗ

A short walk from the train and bus station, this Grade II listed pub has an unrivalled selection of constantly changing real ales and ciders. It is open plan with comfortable seating and various quieter areas. The staff offer a warm welcome to all, even during their busier periods, and food is served during the day. Entertainment is held regularly on Saturday nights, and sports TVs are spread around the pub. Dogs are welcome in all areas. ⊛◖⇌♣♠P🅿☺🅿

Butts Tavern 🅛

44 Butts Street, WS4 2BJ (200yds from arboretum's Lichfield St entrance)
☎ (01922) 629332 ⊕ buttstavern.co.uk

Holden's Golden Glow; Wye Valley Butty Bach; 1 changing beer (sourced nationally) Ⓗ

A large community-based local, with a spacious main bar including a stage and sports TV. There is a smaller bar at the rear with pool table and darts facilities. A warm welcome is assured from the staff, and there is an outside patio area for smokers and summer drinking. Local domino and crib teams are based here and entertainment is often held on Friday or Saturday nights.
☠⊛♠🅿🅿

Fountain Inn 🅛

49 Lower Forster Street, WS1 1XB (off A4148 ring road)
☎ (01922) 633307

Backyard The Hoard, Blonde; 6 changing beers (sourced regionally; often Beowulf, Fixed Wheel, Green Duck) Ⓗ

The brewery tap for Backyard Brewhouse, this family-run community pub has a friendly atmosphere and welcoming staff. Two rooms are served by a central bar with up to eight beers on handpull. Bar snacks include pork pies and filled rolls. Vinyl night takes place once a month, and a weekly sourdough session has proved very popular. A heated outdoor terrace provides shelter for smokers and alfresco drinkers.
Q☠⊛⇌♣♠🅿(10,977)☺

Pretty Bricks 🅛

5 John Street, WS2 8AF (nr magistrates court, off B4210)
☎ (01922) 612553

Black Country Bradley's Finest Golden, Pig on the Wall, Fireside; 6 changing beers (sourced nationally) Ⓗ

This small, friendly, cosy pub on the edge of town dates from 1845. It has a front bar with a wood fire, plus a lounge, upstairs function room and small blue brick courtyard. Originally called the New Inn, it gained its current name from a part-glazed frontage. Cobs and pork

pies provide sustenance alongside the great range of ales. A folk night is held every second Thursday of the month. Q⊛❋⇌♣♠🅿☺🅿

St Matthew's Hall ⊘

Lichfield Street, WS1 1SX (adjacent to town hall)
☎ (01922) 700820

Greene King Abbot; Ruddles Best Bitter; Sharp's Doom Bar; 4 changing beers (sourced regionally; often AJs, Backyard, Salopian) Ⓗ

A stunning Grade II-listed Wetherspoon outlet in the centre of Walsall town, easily accessible by public transport and with plenty of parking nearby. A selection of national guest ales supplement the three regular beers. Beer festivals feature throughout the year and there is entertainment every Friday and Saturday evening until 2am. Outside, to the side, is a large beer garden. ☠⊛◖⇌♣♠🅿☺🅿

Victoria 🅛

23 Lower Rushall Street, WS1 2AA
☎ (01922) 635866

Backyard Bitter; Banks's Sunbeam; Church End Gravediggers Ale; Wye Valley Butty Bach; 3 changing beers (sourced regionally; often AJs, Fixed Wheel, Salopian) Ⓗ

Popular two-roomed pub close to the town centre, dating from 1845. It has a former brew house, a pleasant garden and smoking facilities at the back. A large Pay & Display car park is also to the rear. Bar snacks are available along with Sunday lunches. Open mic and quiz nights are held regularly, Sunday evening has live entertainment, and retro games nights are on a monthly cycle. A pool table is located upstairs. One real cider is permanently available. ☠⊛◖⇌♣♠🅿☺🅿

Walsall Arms 🅛

17 Bank Street, WS1 2EP (behind Royal Hotel, off A34)
☎ (01922) 649839

Wye Valley Bitter, HPA, Butty Bach; 3 changing beers (sourced locally; often Salopian) Ⓗ

Refurbished back-street pub with one large, carpeted comfy bar area. The location is just a short walk from Walsall town centre, behind the Royal Hotel. There is a small bar accessed via the passageway. The pub features an open fire, old Walsall photographs and two TV screens. It hosts a quiz on the first Monday of the month, themed food every Thursday and regular jazz nights. A refurbished patio painted in an Italianate fashion is at the rear. ⊛◖♠P🅿(51,377)☺🅿

Walsall Cricket Club

Gorway Road, WS1 3BE (off A34, by university campus)
☎ (01922) 622094 ⊕ walsall.play-cricket.com

Wye Valley HPA; 1 changing beer (sourced regionally; often Backyard, Castle Rock) Ⓗ

On a fine summer day, the click of bat on ball welcomes you to this green oasis on the outskirts of town. The club room has had a major renovation and now provides luxurious comfort with a panoramic view of the field. The club contains local cricket memorabilia and two large sporting screens. There is occasional entertainment and the venue is popular for function hire. Entry for non-members is by CAMRA membership card. Sunday hours are reduced in winter. ☠⊛♠P🅿(51)☺🅿

Wednesbury

Bellwether ⊘

3-4 Walsall Street, WS10 9BZ
☎ (0121) 502 6404

Greene King Abbot; Oakham JHB; Ruddles Best Bitter; 7 changing beers (sourced nationally) Ⓗ

Just off the marketplace and main shopping area, this pub has one large L-shaped room on two levels, with open-plan seating in front of the bar and more intimate bench seating at the rear. It is decorated inside with images of historic events and characters associated with the town. There is a garden area at the rear offering a tranquil oasis for contemplation. Ten handpulls are available to serve the usual Wetherspoon range and various guest beers. Q ➧ ⚘ ◑ 🦽 ♣ 🍴 🚌 📶

Olde Leathern Bottel ✓

40 Vicarage Road, WS10 9DW (just off A461; bus 311 from Walsall is 5 mins' walk)
☎ (0121) 505 0230
4 changing beers (sourced nationally; often Adnams, Marston's, Wye Valley) H

The front areas of the bar and snug are set in cottages dating from 1510; a later extension has a comfy lounge. The small snug is often used as a function room. All four rooms display many old photographs – in the bar is a picture of the pub from 1887 and a map of Wednesbury from 1846. Friendly staff are happy to help. There is entertainment on Saturday nights. ➧ ⚘ ◑ ♣ 🅿 🚌(11) 🐾 📶

West Bromwich

Royal Oak Ⓛ ✓

14 Newton Street, B71 3RQ (down side road off A4031 Hollyhedge Rd)
☎ (0121) 588 5857
St Austell Proper Job; Wye Valley HPA; 2 changing beers (sourced nationally) H

Traditional back-street local with two small rooms, both showing TV sport. The bar on the left is adorned with West Bromwich Albion memorabilia, and on the right is the quieter lounge. There is a terrace in the rear yard for smokers, and two benches outside the front to bask on in the summer. Street parking and bar snacks are available. ➧ ⚘ ♣ 🚌 🐾 📶

Three Horseshoes Ⓛ

86 Witton Lane, B71 2AQ
☎ (0121) 502 1693
Black Country Bradley's Finest Golden, Pig on the Wall, Fireside; 4 changing beers (sourced nationally) H

A refurbished one-roomed pub, taken on by Black Country Ales in 2016, with 10 handpulls added. The spacious interior is furnished in a traditional style with TVs showing live sport. The warm welcome provided by the staff in this expansive hostelry makes you feel right at home. Bar snacks are available. There is a beer garden to enjoy in fine weather. ➧ ⚘ 🦽 ♣ 🍴 🅿 🚌(79,49) 🐾 📶

Willenhall

Robin Hood Ⓛ

54 The Crescent, WV13 2QR (200yds from A462/B4464 jct)
☎ (01902) 635070
Black Country Bradley's Finest Golden, Pig on the Wall H**, Fireside** H/G**; 6 changing beers (sourced nationally; often Backyard, Beowulf, Salopian)** H

A traditional L-shaped public house with welcoming staff, friendly clientele and a real fire to provide winter warmth. Up to nine real ales and three real ciders are served, with a variety of cobs, hot pies and pork pies on offer throughout the day. A quiz is held on Thursday, and a local archery club meets on the adjacent land on Saturday. ⚘ ♣ 🍴 🅿 🚌(529) 🐾 📶

Wollaston

Foresters Arms Ⓛ ✓

Bridgnorth Road, DY8 3PL (on A458 towards Bridgnorth)
☎ (01384) 394476 ⊕ foresterswollaston.co.uk
Enville Ale; Holden's Golden Glow; Ludlow Gold; Wye Valley HPA; 1 changing beer H

Located on the ridge and ideal for ramblers, this warm, cosy and friendly traditional local is situated on the outskirts of Wollaston next to the countryside. The L-shaped room provides a convenient area where diners can enjoy good-value quality food. Quizzes are usually held on the first and third Sunday of each month, with regular themed evenings also hosted. There is a heated and covered smoking area, plus in summer a large, furnished marquee that is available for hire. ➧ ⚘ ◑ 🅿 🚌(8,242) 🐕 📶

Plough Ⓛ ✓

154 Bridgnorth Road, DY8 3PD (on A458 towards Bridgnorth)
☎ (01384) 393410 ⊕ theploughwollaston.co.uk
Timothy Taylor Landlord; Black Sheep Best Bitter; Enville Ale; Three Tuns XXX; Wye Valley Bitter, Butty Bach; 1 changing beer H

Built in 1898, this beautiful late-Victorian pub features a central bar. A long bar counter serves the lounge and eating area; drinkers in the bar room have access through the hatches. A sampler with six one-third pint glasses is available for those wanting to make the most of the beer range. The pub has a wonderful collection of old wirelesses, cameras and mechanical artefacts. Traditional games are played in the bar, and quizzes are held on a regular basis. There is a weekly folk session on Tuesdays. ➧ ⚘ ◑ 🦽 ♣ 🅿 🚌(8,242) 📶

Unicorn Ⓛ

145 Bridgnorth Road, DY8 3NX (on A458 towards Bridgnorth)
☎ (01384) 394823
Bathams Mild Ale, Best Bitter H

A former brewhouse purchased by Bathams, the Unicorn has barely altered in appearance since the Billingham family sold up in the early 1990s. It is a traditional two-bar drinking house, with a small back room, popular with all age groups, where children are welcome, and conversation is the order of the day. The brewhouse remains but is no longer in use. Fresh cobs – with hot pork and stuffing on Saturday lunchtimes – are available on request. Bathams XXX is available in the winter. Q ➧ ⚘ 🦽 🅿 🚌(7,8) 🐕 📶

Wolverhampton

Chestnut Tree ✓

2 Castlecroft Road, Finchfield, WV3 8BT
☎ (01902) 765619
Banks's Sunbeam; St Austell Tribute; Sharp's Doom Bar; Wainwright; 1 changing beer (sourced nationally) H

Single large-roomed family-friendly community pub. Dogs are welcome at the top end of the bar. Bingo is played from 3pm on Tuesday afternoon and a quiz is held on Wednesday evening. TVs show live sport. On Thursday the pub's Cask Ale Club offers discounted ale. An extension has added three outdoor seating areas. Open daily at 9am for breakfast, with a full menu available from noon. ➧ ⚘ ◑ 🦽 🅿 🚌(3) 🐕 📶

Chindit Ⓛ

113 Merridale Road, WV3 9SE
☎ 07986 773487

7 changing beers (often Dark Star, Ossett, Wye Valley) H
This pub was built in the 1950s as an off-licence; its first landlord served in the Chindit Regiment in Burma in WWII and named it after his comrades. It is thought to be the only pub in the country honouring Major General Orde Wingate's WWII special forces, whose history is displayed in the lounge. The two-roomed pub comprises a small lounge and a bar featuring an original Wurlitzer jukebox stocking 45rpm records from the 60s and 70s.
ॐ爨♠🖨(3,15) ✿ 🌐

Combermere Arms
90 Chapel Ash, WV3 0TY (on A41 Tettenhall road)
☎ (01902) 421880
Timothy Taylor Landlord; 5 changing beers (sourced nationally) H
A Grade II-listed building with original sash windows. Situated a short walk or bus ride from the city centre, it comprises three charming rooms with cosy fireplaces replete with classic adverts. One locally brewed beer and four ales from the Greene King portfolio are served alongside a varying cider. Pie, sausage and cheese-tasting festivals are held annually and there is occasional live entertainment. The rear has a courtyard and beer garden. The renowned tree in the Gents is still growing despite being trimmed. Q ॐ爨✿♠🖨🌐✿

Great Western L
Sun Street, WV10 0DG (pedestrian access from city centre via Corn Hill)
☎ (01902) 351090
Bathams Best Bitter; Holden's Black Country Mild, Black Country Bitter, Golden Glow, Special; 2 changing beers (sourced nationally) H
A previous CAMRA National Pub of the Year, this Grade II-listed venue near the former low-level railway station was refurbished in 2021. It attracts a varied clientele, including a rock-climbing club and railway groups. Railway memorabilia is on display and cosy real fires blaze in the winter. Cobs and pork pies are available every day, and meals are served at lunchtimes and evenings except on Sunday. Holden's products are available (by pre-order only) at the same price as in the brewery's shop. Q ॐ爨🍴≠🚆(St George's)♠🖨✿🌐

Hail to the Ale ▼ L
2 Pendeford Avenue, Claregate, WV6 9EF (at Claregate island)
☎ 07846 562910 🌐 mortonbrewery.co.uk/httahome.htm
6 changing beers (sourced locally; often Morton) H
The West Midlands' first micropub was opened in 2013 by Morton Brewery and is a welcoming one-room pub with a focus on beer and conversation. Six handpulls serve up to four Morton beers plus guests, usually from local microbreweries. Three ciders or perries are also available from the cellar. Locally sourced pies, cheese, sausage rolls and Scotch eggs are available along with 10 fruit wines. Check the website for bank holiday hours, events and staff holiday closures. Local CAMRA Pub of the Year five years running 2015-2019.
Q ॐ爨🍴♠🖨(5,6)✿

Hogshead L ✓
186 Stafford Street, WV1 1NA
☎ (01902) 717955 🌐 craft-pubs.co.uk/hogsheadwolverhampton
10 changing beers (sourced nationally) H
Large 19th-century traditional city-centre building with an attractive terracotta brick exterior. A stained-glass window above the entrance displays the original name, the Vine. The large single room is divided into separate areas, with TVs showing sport throughout. It serves a

range of 10 cask ales with more available through membrane KeyKeg dispense, and a large number of ciders, mostly from Lilley's. The pub hosts regular brewery tap takeovers and is popular with all age groups.
ॐ爨🍴≠🚆(St George's) ♠🖨🌐

Keg & Comfort L
474 Stafford Road, Oxley, WV10 6AN
☎ 07952 631032 🌐 kegandcomfort.co.uk
4 changing beers (sourced locally) H
The city's second micropub opened in 2018 in a former bank. Its contemporary main room has a striking bar, custom-built using coloured bottles. It has seating for around 40, and old barrels serve as tables for those who prefer to stand. A small side room houses a large sofa and a games cupboard. Four changing ales (one dark) are offered alongside five ciders or perries and a selection of fruit wines. Local CAMRA Cider Pub of the Year 2019 and 2020. Q ॐ爨♠🖨(3)✿

Posada ★ L
48 Lichfield Street, WV1 1DG
Wye Valley HPA; 3 changing beers (sourced nationally; often Bath Ales, Ossett) H
Dating from 1886, this is a Victorian Grade II-listed city-centre pub with a ceramic exterior and interior tiled walls, and original bar fittings including rare snob screens. It is little altered since a remodelling in 1900 by local architect Fred T Beck. The pub attracts a varied clientele and is quiet during weekdays but busy in the evening and at weekends, especially when Wolverhampton Wanderers are at home. Cobs are served. There is a courtyard to the rear with a smoking area. ॐ爨🍴≠🚆(St George's)♠🖨🌐

Royal Oak L
7 School Road, Tettenhall Wood, WV6 8EJ (up Holloway from Compton Island, A454)
☎ (01902) 248093
Banks's Mild, Amber Ale P; 3 changing beers H
Dating back to around 1888, the pub was originally called the Spotted Cow. It offers the choice of bar or lounge, plus a separate restaurant area in an extension off the lounge. An old stables to the rear, with its own bar servery, can host concerts and meetings or be used as a children's room. To the side and rear of the pub is a large enclosed garden. ॐ爨♠🖨🌐✿🌐

Royal Oak L ✓
70 Compton Road, WV3 9PH
☎ (01902) 422845 🌐 theoakchapelash.com
Banks's Mild, Amber Ale, Sunbeam; Wainwright; Wychwood Hobgoblin Gold; 3 changing beers (sourced nationally) H
Friendly hostelry, a short walk or bus ride from the city centre, serving a wide range of real ales from Marston's portfolio. This bustling pub hosts open mic evenings on Tuesdays and live bands on Fridays and Saturdays and on Sunday afternoons in summer. Part of the community, it raises money for local and national charities, and is the headquarters of Old Wulfrunians Hockey Club. Pub and local history maps are displayed on the wall, including a list of former licensees. Cobs and Scotch eggs are served. There is covered, heated outdoor seating available.
ॐ爨♠🖨(10,9)✿🌐

Starting Gate L
134 Birches Barn Road, Penn Fields, WV3 7BG
☎ 07834 673888
5 changing beers (sourced regionally; often Ludlow, Sarah Hughes, Wye Valley) H
Opened in 2018, this small outlet occupies a former bank branch and retains the original counter and wings. This

previous use is also seen in the impressive rear door to the garden, where there is covered seating. The small bar area leads to a cosy lounge; another lounge upstairs is reached via an open spiral staircase. Paintings, silks and other memorabilia reflect the owner's brother's passion for horse racing, as does the name of the pub. Q❀&♿🖶(2) ❀🛜

Stile Inn L ✅

3 Harrow Street, Whitmore Reans, WV1 4PB (off Newhampton Rd East/Fawdry St)
☎ (01902) 425336
Banks's Mild, Amber Ale, Sunbeam; 1 changing beer (sourced regionally; often Church End) 🅗
A typical late-Victorian street-corner pub built in 1900, featuring a public bar, smoke room and snug. It is a true community local with an emphasis on sports – darts and dominoes feature inside, crown green bowls on the unusual L-shaped green outside, and it is busy with Wolverhampton Wanderers fans on match days. Excellent-value food, including Polish dishes, is served all day. Friday is disco night and Saturday is karaoke. Sky and BT Sports are shown in all rooms.
🌲❀🕪♣🖶(5,6) ❀🛜

Swan L

Bridgnorth Road, Compton, WV6 8AE (at Compton Island, A454)
☎ (01902) 754736 🌐 swanpubwolverhampton.co.uk
Banks's Mild, Amber Ale, Sunbeam; Marston's Old Empire; Wainwright; 1 changing beer (sourced nationally) 🅗
Built around 1780, this Grade II-listed former coaching inn is popular with locals, boaters, ramblers and cyclists, as it is close to the Staffordshire and Worcestershire Canal and Smestow Valley Nature Reserve. It comprises a lively bar with local banter, a games room and a more sedate snug. A quiz is held on Tuesday, a darts team plays on Wednesday, and a folk group entertains on Thursday. The pub hosts charity dog shows and, weekly, the local pigeon flyers' club. Q🌲❀♣P🖶(10,9)❀🛜

Woodcross

Horse & Jockey L

Robert Wynd, WV14 9SB
☎ (01902) 662268
Hobsons Twisted Spire, Town Crier; St Austell Tribute; 4 changing beers (sourced locally) 🅗
This friendly and thriving community pub comprises a bar, large contemporary lounge with a seasonal open fire, a rear beer garden and a small smoking shelter at the front. Good-value home-cooked food, including vegetarian options, is served daily until the evening (early eve Sun). Under-18s are allowed in the lounge area and the newly refurbished garden during the day. Darts and regular quiz nights are featured and the bar area welcomes well-behaved dogs.
🌲❀🕪♿♣P🖶(81,223) ❀🛜

Wordsley

Bird in Hand �

57 John Street, DY8 5YS
☎ (01384) 865809
Enville Ale; Hobsons Town Crier; Holden's Golden Glow; 3 changing beers (sourced nationally) 🅗
There is a friendly and homely atmosphere at this Red Pub Company venue. The traditional back-street corner local has a wide customer mix and serves an enterprising range of up to three guest beers, including some rarely seen brews. It has a bar that shows live sports matches

on TV, a quiet lounge and an outside covered seating area with heating. Current local CAMRA Pub of the Year.
Q🌲❀🕪♣♿🖶(16,17A) ❀🛜

Breweries

AJ's

Unit 11, Ashmore Industrial Estate, Longacre Street, Walsall, West Midlands, WS2 8QG ☎ 07860 585911
✉ ajs-ales@hotmail.com

⊗ Set up by experienced brewer Andy Dukes and his wife Charlotte, AJ's Ales was established in 2015 and uses a four-barrel plant with three fermenting vessels and a cool room. It brews three times a week, mainly supplying local pubs and further afield through local wholesalers. ♦

Blackjack Mild (ABV 3.6%) MILD
Stuck on Blondes (ABV 3.9%) BLOND
Best Bitter (ABV 4%) BITTER
Dukey's Delight (ABV 4.1%) GOLD
SPA (ABV 4.2%) PALE
Gold (ABV 4.3%) GOLD
Stuck in the Mud (ABV 4.3%) STOUT
Ruby (ABV 4.4%) BITTER
IPA (ABV 4.6%) PALE
Stuck in the Doghouse (ABV 4.7%) GOLD

Angel Ales SIBA

62A Furlong Lane, Halesowen, West Midlands, B63 2TA ☎ 07986 382919 🌐 angelales.co.uk

Angel Ales began commercial brewing in 2011. The brewery building has been a chapel of rest, a coffin makers' workshop and a pattern makers' before becoming a brewhouse. Beers are produced using organic ingredients where possible. ‼♦LIVE

Ale (ABV 4.1%) PALE
Krakow (ABV 4.5%) SPECIALITY
Ginger Stout (ABV 4.8%) SPECIALITY

Attic SIBA

29b Mary Vale Road, Stirchley, Birmingham, B30 2DA ☎ 07470 643758 🌐 atticbrewco.com

A natural progression from homebrewing, Attic Brewery Co was launched in 2018 by two friends. Its taproom is open Friday evening and all day Saturday and Sunday. Beer is mostly available in the tap but it is expanding into the local free trade. Main production is keg. Collaboration brews have taken place with Castle Rock and New Bristol. ♦

Backyard SIBA

Unit 8a, Gatehouse Trading Estate, Lichfield Road, Brownhills, Walsall, West Midlands, WS8 6JZ ☎ (01543) 360145 🌐 tbb.uk.com

⊛ Backyard began brewing in 2008 and expanded in 2012 to a 12-barrel plant brewing up to 50 barrels a week. Its award-winning ales are distributed to its two pubs, the Fountain, Walsall and the Saddlers Arms, Solihull. A half-barrel experimental plant is also in operation, and a taphouse is open every Friday (1-8pm). ‼🍴♦◆

Bitter (ABV 3.8%) BLOND
The Hoard (ABV 3.9%) GOLD
Blonde (ABV 4.1%) BLOND
Americana (ABV 4.3%) PALE

Gold (ABV 4.5%) GOLD
IPA (ABV 5%) PALE
Antipodean (ABV 5.6%) IPA

Banks's

Park Brewery, Wolverhampton, West Midlands, WV1 4NY
☎ (01902) 711811 ⊕ bankssbeer.co.uk

Banks's was founded as maltsters in 1840, commencing brewing in 1874 and moving to the current Park Brewery in 1875. It became the principal brewery of Wolverhampton and Dudley Breweries (W&DB), founded in 1890. In 2007 the Marston's name was adopted following the takeover by W&DB in 1999. A joint venture with Carlsberg in 2020 led to the company being renamed Carlsberg Marston's Brewing Company. Alongside the traditional Banks's beers it also produces Wainwrights, Lancaster Bomber and Bombardier, as well as contract brewing. Part of Carlsberg Marston's Brewing Co. ‼☛

Mild (ABV 3.5%) MILD
An amber-coloured, well-balanced, refreshing session beer.
Amber Ale (ABV 3.8%) BITTER
A pale brown bitter with a pleasant balance of hops and malt. Hops continue from the taste through to a bittersweet aftertaste.
Sunbeam (ABV 4.2%) BLOND

Brewed for Marston's:
Wainwright Amber (ABV 4%) BITTER
Wainwright Golden (ABV 4.1%) GOLD
Lancaster Bomber (ABV 4.4%) BITTER

Brewed under the Bombardier brand name:
Bombardier (ABV 4.1%) BITTER
A heavy aroma of malt and raspberry jam. Traces of hops and bitterness are quickly submerged under a smooth, malty sweetness. A solid, rich finish.
Gold (ABV 4.1%) GOLD

Brewed under the Mansfield brand name:
Cask Ale (ABV 3.9%) BITTER

Bathams IFBB

Delph Brewery, Delph Road, Brierley Hill, West Midlands, DY5 2TN
☎ (01384) 77229 ⊕ bathams.com

☺A classic, Black Country, small brewery established in 1877. Tim and Matthew Batham represent the fifth generation to run the company. The Vine, one of the Black Country's most famous pubs, is also the brewery site. The company has 12 tied houses and supplies around 30 other outlets. Batham's Best Bitter is sometimes delivered in 54-gallon hogsheads to meet demand. A sixth generation family member, Tim's daughter, Claire, has joined the on-site team as Business Development Manager. ♦

Mild Ale (ABV 3.5%) MILD
A fruity, dark brown mild with malty sweetness and a roast malt finish.
Best Bitter (ABV 4.3%) BITTER
A pale yellow, fruity, sweetish bitter, with a dry, hoppy finish. A good, light, refreshing beer.

Beat SIBA

9 Old Forge Trading Estate, Dudley Road, Lye, West Midlands, DY9 8EL ☎ 07821 132297 ⊕ beatales.com

⊗ Beat Ales has been remarketed as Beat Brewery. Originally brewing in North Curry, it moved to Lye, near

Stourbridge in 2018. Beer names reflect the owners musical inspiration, taking in different genres. Its taproom is open Friday, Saturday and Sunday afternoons
‼☛♦LIVE⊘

Raver (ABV 3.8%) PALE
Metal Head (ABV 4.8%) STOUT
Jungle Drum Machine (ABV 5%) PALE
Funk (ABV 5.5%) IPA
Cosmic Pop (ABV 6%) IPA

Birmingham SIBA

Unit 17, Stirchley Trading Estate, Hazelwell Road, Birmingham, B30 2PF
☎ (0121) 724 0399 ☎ 07717 704929
⊕ birminghambrewingcompany.co.uk

Birmingham Brewing Co was established in 2016 and is based in a small unit on a trading estate in Stirchley. Its growing range of vegan and gluten-free beers are available in the trade in cask or keg, and also in cans direct from the brewery or many local bottle shops.
‼♦GFV

Pale Brummie (ABV 4%) PALE
Bitter Brummie (ABV 4.1%) BITTER

Black Country IFBB

⬛ Rear of Old Bulls Head, 1 Redhall Road, Lower Gornal, West Midlands, DY3 2NU
☎ (01384) 401820

Office: 69 Third Avenue, Pensnett Trading Estate, Kingswinford, DY6 7FD ⊕ blackcountryales.co.uk

☺A compact brewery located at the back of the Bull's Head in Lower Gornal, which recommenced brewing in 2004. In 2012 much of the old equipment was replaced with a new kit, which can brew up to 15 barrels at a time and is currently doing so three times a week. Its sister company, Black Country Inns, now has 42 pubs in its portfolio and is always looking out for new acquisitions. ‼♦

Bradley's Finest Golden (ABV 4.2%) GOLD
Chain Ale (ABV 4.2%) GOLD
Pig on the Wall (ABV 4.3%) MILD
A ruby brown-coloured beer with an aroma of dried fruit and a hint of banana, a malt and fruit initial taste leading to a subtle finish with a hint of astringency.
Fireside (ABV 5%) BITTER

Brewhouse & Kitchen SIBA

⬛ 8 Birmingham Road, Sutton Coldfield, West Midlands, B72 1QD
☎ (0121) 796 6838 ⊕ brewhouseandkitchen.com

☺Sutton Coldfield's first modern brewery commenced production in 2016. The 2.5-barrel plant produces traditional cask and craft keg beers using hops from Hereford and New World for in-house consumption, for other pubs as guest ales and beer festivals on request. ‼♦

Britt

Brittania Inn, Rowley Village, Rowley Regis, B65 9AT
☎ 07816 018777 ⊕ pigironbrewingco.co.uk

☺Formerly known as Pig Iron, the brewery was set up in 2015 and is currently situated to the rear of the Britannia pub in Rowley village. The bulk of production is sold in the pub, with some Pig Iron branded beers being sold further afield. ♦

Burning Soul

Unit 1, 51 Mott Street, Hockley, Birmingham, B19 3HE
☎ (0121) 439 1490 ☎ 07793 026624
⊕ burningsoulbrewing.com

Established in 2016, the name Burning Soul reflects a passion for beer and brewing. A five-barrel, full-mash brewery with an onsite brewery tap. It's less than one mile from Birmingham City centre, offering KeyKeg real ale on tap. The core range is always available along with various special brews and selected guests. Beers are occasionally released into the trade in cask form. !! ↻ ◆

Byatt's SIBA

Unit 7-8, Lythalls Lane Industrial Estate, Lythalls Lane, Coventry, CV6 6FL
☎ (024) 7663 7996 ⊕ byattsbrewery.co.uk

⊛ Since being established in 2011 and expanding in 2016, Byatt's has gained many fans with its extensive beer list brewed throughout the year, together with an increasing range of seasonal beers. A brewhouse bar with six handpumps also serves ciders on draught or gravity. Tours and tasting sessions can be booked and private hire is available. Coventry Building Society Arena is nearby. !! ↻ ◆ LIVE ◆

XK Dark (ABV 3.5%) MILD
Coventry Bitter (ABV 3.8%) BITTER
Easy-drinking session bitter. Has an earthy taste from the bitter hops used. The aftertaste retains the strong bitterness.
Platinum Blonde (ABV 3.9%) BLOND
Very subtle perfume in the aroma. A highly-hopped blond beer leading to a citrus bitterness with a mild peppery aftertaste.
Phoenix Gold (ABV 4.2%) GOLD
All Day Foreign Extra Stout (ABV 4.9%) STOUT
Regal Blond (ABV 5.2%) GOLD

Craddock's

🬳 **Duke William, 25 Coventry Street, Stourbridge, West Midlands, DY8 1EP**
☎ (01384) 440202 ⊕ craddocksbrewery.com

⊗ Craddock's brews exclusively for its pubs; the Duke William and Plough & Harrow in Stourbridge, the King Charles, Worcester, and the Talbot, Droitwich. In 2019 The Good Intent, was opened in Birmingham as a not-for-profit enterprise selling Craddock's and other beers, with profits donated to charity. Ten beers in the core range, availability varies. !! ◆ LIVE

Cult Of Oak (NEW)

Unit 15, Central Park Industrial Estate, Netherton, DY2 9NW ☎ 07530 193543

Cult of Oak was set up by Beer Sommelier Roberto Ross in 2019. Specialising in barrel-aged strong ales of varying styles, most of the beers are brewed collaboratively and are canned or bottled with some going into the trade or festivals in cask. Beers are available at Roberto's Bar, Birmingham.

Davenports SIBA

Unit 5, Empire House, 11 New Street, Smethwick, West Midlands, B66 2AJ
☎ (0121) 565 5622
✉ info@davenportsbrewery.co.uk

⊛ Davenports brewery occupies part of a distribution warehouse in an industrial unit in Smethwick on the outskirts of Birmingham. The 7.5-barrel plant produces a selection of beers under the Davenports name with some occasional beers branded as being from the former Highgate brewery of Walsall and Dares brewery of Birmingham. ◆

Mild (ABV 3.5%) MILD
Gold (ABV 3.9%) PALE
Original Bitter (ABV 4.2%) BITTER
IPA (ABV 4.4%) PALE

Dhillon's SIBA

14a Hales Industrial Estate, Rowleys Green Lane, Coventry, West Midlands, CV6 6AL
☎ (024) 7666 7413 ⊕ dhillonsbrewery.com

Established in 2014 as Lion Heart and relaunched as Dhillon's in 2015 with a new range of beers. The main focus is on craft bottled and canned beers but cask ales are also brewed. The brewery tap is open Friday evenings and before rugby and football matches at the nearby Coventry Building Society Arena. !! ◆ ◆

Bright Eyes GPA (ABV 3.8%) PALE
Ambler Gambler (ABV 4.5%) GOLD
Fair Lady (ABV 4.5%) PALE
Red Rebel IPA (ABV 6.2%) IPA

Dig

43 River Street, Digbeth, Birmingham, B5 5SA
☎ (0121) 773 2111 ⊕ digbrewco.com

Dig Brew Company is a craft brewing project founded by Oliver Webb and Peter Towler of Mad O'Rourke's Pie Factory. The brewery and taproom is housed within a repurposed industrial unit in Digbeth, Birmingham. A constantly changing range of beers are available throughout the area, most also available in cans and bottles for the take home trade. ◆

Mad O'Rourkes Lump Hammer Bitter (ABV 3.6%) BITTER
9th July (ABV 4%) BITTER
Mad O'Rourke's Lump Hammer Gold (ABV 4.2%) GOLD
Space is the Place (ABV 4.5%) PALE
Mad O'Rourke's Sledge Hammer IPA (ABV 5.6%) BITTER

Fixed Wheel

Unit 9, Long Lane Trading Estate, Long Lane, Blackheath, West Midlands, B62 9LD ☎ 07766 162794 ⊕ fixedwheelbrewery.co.uk

⊗ Set up in 2014 by cycling and brewing enthusiasts Scott Povey and Sharon Bryant, this full mash brewery is situated on a trading estate on the Blackheath/Halesowen border. It brews several times a week using an eight-barrel plant. Alongside the core range, there are regular single hop and other specials brewed. Its award-winning ales are available throughout the Midlands and further afield. A canning plant was purchased in 2021 to service the expanding market for small package beers. !! ↻ LIVE ◆

Through and Off (ABV 3.8%) PALE
Wheelie Pale (ABV 4.1%) PALE
Chain Reaction Pale Ale (ABV 4.2%) PALE
Blackheath Stout (ABV 5%) STOUT
No Brakes IPA (ABV 5.9%) IPA

Fownes SIBA

Unit 2, Two Woods Estate, Talbots Lane, Brierley Hill,, West Midlands, DY5 2YX ☎ 07790 766844

Office: 42 The Ridgeway, Sedgley, DY3 3UR
⊕ fownesbrewing.co.uk

☺The brewery was established in 2012 by James and Tom Fownes in premises to the rear of the Jolly Crispin, Upper Gornal. A later expansion saw the brewery moved to a new larger site in Brierley Hill. Frequent specials along a 'Dwarfen Ales' theme are brewed in addition to the core range. Fownes opened its first pub in Burton in 2020. ‼◆LIVE

Elephant Riders (ABV 4%) BITTER
Gunhild (ABV 4%) SPECIALITY
Bright with creamy, lingering head. Smooth mouthfeel. Pleasant earthy aroma with hints of blackcurrants and honey. Peardrops and caramel with some malt and blackcurrant flavour. Dry malty aftertaste.
Crispin's Ommer (ABV 4.1%) BITTER
Royal Oak Bitter (ABV 4.2%) BITTER
Frost Hammer (ABV 4.6%) PALE
Blonde and bright with a clingy head. Pine resin, nutmeg, malt, lemon and floral aroma. Dry mouthfeel with coffee, sweet malt and grapefruit flavours. Grapefruit and hoppy aftertaste.
Firebeard's Old Favourite No. 5 Ruby Ale (ABV 5%) MILD
Creamy head, rich red colour. Malty, fresh earth, rhubarb and some coffee in the aroma. Smooth mouthfeel, dark chocolate and plum dominate the flavour with hints of malt and coffee. A pleasant dryness in the aftertaste, with hints of coffee, plum and cocoa.
King Korvak's Saga (ABV 5.4%) PORTER
Peardrop and cocoa aroma with hints of coffee. Coffee, toasted malt, blackcurrant and slight cocoa taste, with rich, malty tones in the aftertaste.

Froth Blowers

Unit P35, Hastingwood Industrial Park, Wood Lane, Erdington, West Midlands, B24 9QR ☎ 07966 935906
⊕ frothblowersbrewing.com

☒ Froth Blowers began brewing in 2013, the name derived from the Ancient Order of Froth Blowers, an organisation dedicated to 'Lubrication in Moderation'! The brewery has the capacity to brew 20 barrels at a site only metres away from its original one, with most of the beers consumed within 30 miles of the brewery. In addition to the core range, half a dozen seasonal beers are brewed. Certain beers are available in five-litre minikegs. ◆

Piffle Snonker (ABV 3.8%) BLOND
Straw-coloured. Aroma is almost jammy with a little malt and hop. Taste is well-balanced with a slightly hoppier aftertaste.
Bar-King Mad (ABV 4.2%) BITTER
Wellingtonian (ABV 4.3%) PALE
John Bull's Best (ABV 4.4%) BITTER
Gollop With Zest (ABV 4.5%) GOLD
Hornswoggle (ABV 5%) BLOND

Glasshouse

Unit 6b, Waterside Business Park, Stirchley, B30 3DR
⊕ glasshousebeer.co.uk

Situated at the far end of Waterside Business Park, Glasshouse opened in 2018. The brewery is run by Josh Hughes and has expanded to employ an experienced team. Beer is available in a variety of styles, mainly produced in KeyKeg and can and can be found in local outlets as well as those wider afield. Its brewery tap is open Fridays and Saturdays. ◆

Green Duck SIBA

Unit 13, Gainsborough Trading Estate, Rufford Road, Stourbridge, West Midlands, DY9 7ND
☎ (01384) 377666 ⊕ greenduckbrewery.co.uk

☺Green Duck began brewing in 2012 and relocated to its present site in Stourbridge in 2013. Experimental beers are brewed alongside a core range. The brewery has an onsite brewery tap, the Badelynge Bar, where the brewing equipment is visible through a glass partition. Demand for small package beers saw the brewery invest in a canning plant together with Twisted Barrel Brewery in 2020. ‼◆◆

ZPA Zesty Pale Ale (ABV 3.8%) PALE
Session IPA (ABV 4%) PALE
Pale gold with a tropical aroma derived from mosaic hops. Very refreshing with a dry pine and resin aftertaste.
Blonde (ABV 4.2%) SPECIALITY
Gold with a sharp fruity aroma. Lots of passionfruit in the taste. Aftertaste is balanced with fruit sweetness and hops.
American Pale (ABV 4.5%) PALE

Halton Turner

40 Trent Street, 1 Rea Court, Digbeth, Birmingham, West Midlands, B5 5NL ☎ 07821 447329
⊕ haltonturnerbrew.co

Established in 2018, Halton Turner started on a small plant in Hall Green, Birmingham, but moved to a larger plant in Digbeth in 2021. Brewing a wide range of beers in cask and KeyKeg, the beers are mainly found in the local area.

Babyface (ABV 3.8%) PALE
Primo (ABV 4.5%) BITTER

Holden's SIBA IFBB

George Street, Woodsetton, Dudley, West Midlands, DY1 4LW
☎ (01902) 880051 ⊕ holdensbrewery.co.uk

☺A family brewery spanning four generations, Holden's began life as a brewpub in 1915. Continued expansion means it now has 19 tied pubs in its estate. ‼🍺◆

Black Country Mild (ABV 3.7%) MILD
A good, red/brown mild. A refreshing, light blend of roast malt, hops and fruit, dominated by malt throughout.
Black Country Bitter (ABV 3.9%) BITTER
A medium-bodied, golden-coloured ale. Light, well-balanced bitter with a subtle, dry, hoppy finish.
Golden Glow (ABV 4.4%) BITTER
Special (ABV 5.1%) BITTER
A sweet, malty, full-bodied, amber ale with hops to balance in the taste and in the good, bittersweet finish.

Sarah Hughes

🏠 **Beacon Hotel, 129 Bilston Street, Sedgley, West Midlands, DY3 1JE**
☎ (01902) 883381 ⊕ sarahhughesbrewery.co.uk

☒ Nationally-renowned, Victorian tower brewery behind The Beacon Hotel which has been brewing since 1987. It attracts visitors from near and far. The brewery is famous for its Dark Ruby Mild which has a cult following. The beers are served in the Beacon Hotel as well as a growing number of free trade outlets. ‼◆

Pale Amber (ABV 4%) BITTER
Sedgley Surprise (ABV 5%) BITTER

A bittersweet, medium-bodied, hoppy ale with some malt.

Dark Ruby Mild (ABV 6%) MILD
A dark ruby, strong ale with a good balance of fruit and hops, leading to a pleasant, lingering hops and malt finish.

Indian

119b Baltimore Trading Estate, Baltimore Road, Great Barr, B42 1DD
☎ (0121) 296 9000 ⊕ indianbrewery.com

Six-barrel brewery, established in 2005 as the Tunnel Brewery at the Lord Nelson Inn. It relocated to the picturesque stable block at Red House Farm in 2011. In 2015 Tunnel's owners went their separate ways, with Mike Walsh retaining the brewery and renaming it the Indian Brewery. Later that year it was sold to new owners and relocated to the outskirts of Birmingham. Beers are normally only found in its own two pubs. ⚑

Indian Summer (ABV 4%) GOLD
IPA (ABV 4.9%) PALE
Bombay Honey (ABV 5%) SPECIALITY
Peacock (ABV 5%) BITTER

Infinity (NEW)

Sladepool Farm Road, Birmingham ☎ 07915 948058 ⊕ infinitybrewing.uk

Infinity Brewing Company was established in 2020 and is a one-barrel nanobrewery producing small batch craft beer in Birmingham.

Leviathan

Unit 4, 17 Reddicap Trading Estate, Sutton Coldfield, West Midlands, B75 7BU ☎ 07983 256979
⊕ leviathanbrewing.co.uk

Leviathan was established in 2018 by keen homebrewer Chris Hodgetts. Initial production was of keg and canned beers, but cask ales are now becoming increasingly available for festivals and the new on-site taproom. ♦

Mashionistas

Coventry, CV5 6AF ☎ 07960 196204
⊕ mashionistas.com

Mashionistas was formed in 2018 by Flo, Jon and Simon, who built a one-barrel plant in a garage, with several years of home brewing experience between them. All output is vegan-friendly. Brewing in their spare time, it produces only small batches which gives the flexibility to experiment using a host of different ingredients. Since its inception, a wide variety of well-received KeyKeg beers have been produced. V

New Invention

Unit 2 Pinfold Industrial Estate, Walsall, WS3 3JS
⊕ newinventionbrewery.co.uk

Opened in 2020, the brewery produces a wide range of beer styles, mainly in keg and can for its own taproom, and distribution into the local free trade. ♦

Newbridge

Unit 3, Tudor House, Moseley Road, Bilston, West Midlands, WV14 6JD ☎ 07970 456052
⊕ newbridgebrewery.co.uk

First established in 2014, the five-barrel plant incorporates six original Grundy cellar tanks. Occasional

specials are brewed to complement the regular beers. Bottle-conditioned beers are produced. LIVE

Little Fox (ABV 4.2%) BITTER
Solaris (ABV 4.5%) BITTER
Indian Empire (ABV 5.1%) BITTER

Olde Swan

⬕ Old Swan, 89 Halesowen Road, Netherton, West Midlands, DY2 9PY
☎ (01384) 253075

☺A famous brewpub best known as Ma Pardoe's after the matriarch who ruled it for years. The pub has been licensed since 1835 and the present brewery and pub were built in 1863. Brewing continued until 1988 and restarted in 2001. More than 30 outlets are supplied. ⚑♦

Original (ABV 3.5%) MILD
Straw-coloured light mild, smooth but tangy, and sweetly refreshing with a faint hoppiness.
Dark Swan (ABV 4.2%) MILD
Smooth, sweet dark mild with late roast malt in the finish.
Entire (ABV 4.4%) BITTER
Faintly hoppy, amber premium bitter with sweetness persistent throughout.
NPA (Netherton Pale Ale) (ABV 4.8%) PALE
Bumble Hole Bitter (ABV 5.2%) BITTER
Sweet, smooth amber ale with hints of astringency in the finish.

Ostlers

⬕ White Horse, 2 York Street, Harborne, West Midlands, B17 0HG
☎ (0121) 427 8004 ⊕ whitehorseharborne.com

Started up at the rear of the White Horse pub in Harborne, the brewery was in occasional production for a few years. It now has a 4.5-barrel plant, brewing a small range of core beers alongside frequent specials and seasonal beers, many available in KeyKeg as well as cask. The beer is mainly found in the White Horse pub but can be found in other free houses in the Birmingham area.

Printworks SIBA

⬕ Windsor Castle Inn, 7 Stourbridge, Lye, Stourbridge, DY9 7BS
☎ (01384) 897809 ⊕ printworksbrewery.co.uk

☺Printworks started full production in 2019 with Emily Sadler at the helm. Based at the Windsor Castle pub, Lye, which is the main outlet for the beers. Beers are mostly named after typefaces to reflect a family printing heritage. Core beers and various specials are produced. Equipment is visible through a window in seating area. ⚑♦

Red Moon

25 Holder Road, Yardley, Birmingham, West Midlands, B25 8AP ☎ 07825 771388

Office: 39 Kimberley Rd, Solihull, B92 8PU

Red Moon Brewery was started in 2015 by two friends. Beer names are inspired by their own life events. The bulk of production is bottled, however some cask beer finds its way into the local free trade. Currently only brewing occasionally for specific events.

Rock & Roll

19 Hall Street, Jewellery Quarter, Birmingham,
B18 6BS ☎ 07922 554181
✉ rnrbrewhouse@outlook.com

⊠ The Rock & Roll brewery started as Birmingham's only rooftop pub brewery, set up by experienced brewer Mark Shepherd. In 2014 Brewster Lynn Crossland joined and now does all of the brewing. In 2016 the brewery moved and expanded to a six-barrel plant. In 2020 it moved to its current location in the Jewellery Quarter. Specials and experimental beers are regularly available. A brewhouse bar is open at weekends. All beers are suitable for vegans. ‼♦V

Brew Springsteen (ABV 4.2%) PALE
Thirst Aid Kit (ABV 4.2%) PALE
Mash City Rocker (ABV 4.5%) PALE
Voodoo Mild (ABV 5%) MILD

Silhill

Oak Farm, Hampton Lane, Catherine-de-Barnes,
Solihull, West Midlands, B92 0JB
☎ (0845) 519 5101 ☎ 07977 444564

Office: PO Box 15739, Solihull, B93 3FW
⊕ silhillbrewery.co.uk

⊠ Established in 2010, Silhill is a small, independent brewery based in premises just outside Solihull town centre using a 10-barrel plant. Bottling operations commenced in 2015. Beers are available in Solihull, Birmingham and Stratford-upon-Avon. ‼LIVE

Gold Star (ABV 3.9%) SPECIALITY
Blonde Star (ABV 4.1%) BLOND
Hop Star (ABV 4.2%) PALE
Pure Star (ABV 4.3%) BITTER
Super Star (ABV 5.1%) GOLD

Sommar (NEW)

Unit 3B, Arena Birmingham Canal Side, King Edwards
Road, Birmingham, B1 2AA

Office: 41 St Marks Crescent, Ladywood, Birmingham,
B1 2PY ⊕ sommar.co.uk

Started in 2019, this brewery has a canalside location near to the Utilia Arena in the heart of the city. It brews a wide range of styles and strengths for sale in its own taproom and across the region. Beers are available in keg and KeyKeg. Brewing masterclass tours are available (see website). ♦

Toll End

🍺 c/o Waggon and Horses, 131 Toll End Road, Tipton,
West Midlands, DY4 0ET
☎ (0121) 502 6453 ☎ 07903 725574

The four-barrel brewery opened in 2004. With the exception of Phoebe's Ale, named after the brewer's daughter, all brews commemorate local landmarks, events and people. Nearly all of the brewery's output is sold in the Waggon & Horses. ‼LIVE

Triumph

39 Hawthorn Lane, Tile Hill, Coventry, CV4 9LB
☎ 07903 131512 ✉ triumphbrewing@aol.com

Triumph is a nanobrewery offering brew days to the public who want to try homebrewing with professional standard equipment. Occasional collaboration brews are done with other brewers.

Twisted Barrel

Unit 11, Fargo Village, Far Gosford Street, Coventry,
CV1 5ED
☎ (024) 7610 1701 ⊕ twistedbarrelale.co.uk

⊠ Founded in 2013 in a garage, the brewery moved in 2015 to Fargo Village, home to artisanal businesses and to arts and music events. It has since relocated to larger premises on the same site. With a capacity of 5,200 litres, and an onsite bar, the brewery hosts a variety of events on a regular basis. Beers are distributed throughout the UK and abroad. A canning machine was purchased in 2021 giving greater flexibility. ‼🍺♦LIVE

Gotta Light (ABV 3%) PALE
Beast of a Midlands Mild (ABV 3.5%) MILD
Pixel Juice (ABV 4%) GOLD
The Fourth Spire (ABV 4%) BITTER
The Great Went (ABV 4%) SPECIALITY
Detroit Sour City (ABV 4.5%) SPECIALITY
God's Twisted Sister (ABV 4.5%) STOUT
Sine Qua Non (ABV 4.5%) PALE
Vurt (ABV 4.5%) PALE
Naido (ABV 5%) IPA
Kazan (ABV 5.5%) IPA
Lonely Souls (ABV 6.3%) SPECIALITY

Two Towers SIBA

29 Shadwell Street, Birmingham, B4 6HB
☎ (0121) 439 3738 ☎ 07795 247059
⊕ twotowersbrewery.co.uk

⊠ Originally established in 2010 on a site in the Jewellery Quarter, the 10-barrel brewery is now located behind its taphouse, the Gunmakers Arms, and is visible from the beer garden. Frequent specials and bespoke beers supplement the core range. ‼🍺♦LIVE

Baskerville Bitter (ABV 3.8%) BITTER
Hockley Gold (ABV 4.1%) GOLD
Complete Muppetry (ABV 4.3%) BITTER
Chamberlain Pale Ale (ABV 4.5%) PALE
Peaky Blinders Mild (ABV 4.5%) MILD
Jewellery Porter (ABV 5%) STOUT

Underground Medicine (NEW)

Upper Eastern Green Lane, Coventry, CV5 7DN
☎ 07921 120932

A Coventry nanobrewery producing a wide range of craft beers in keg/keykeg.

Noted ales

At one time or another nearly every county town in England of any size has been noted for its beers or ales. Yorkshire claims not only stingo but also Hull and North Allerton ales whilst Nottingham, Lichfield, Derby, Oxford and Burton have almost branded their ales. During the eighteenth century the fame of Dorchester beer almost equalled the popularity of London porter. **Frank A. King, Beer has a History, 1947**

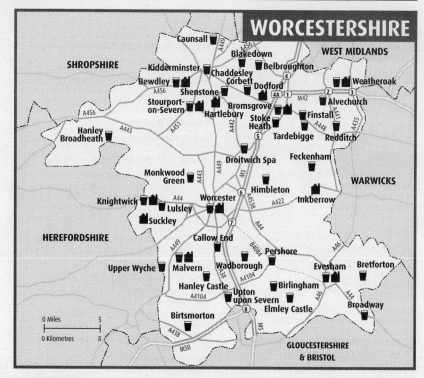

WORCESTERSHIRE

Alvechurch

Weighbridge ⅃

Scarfield Wharf, Scarfield Hill, B48 7SQ (follow signs to marina from village) SP022721

☎ (0121) 445 5111 ⊕ the-weighbridge.co.uk

5 changing beers (sourced locally; often Kinver, Oakham, Wye Valley) Ⓗ

This cosy canalside pub has won many CAMRA awards. It has two small lounges, a public bar and a pleasant garden. A covered area outside can be used for functions. There are changing beers from Kinver, Weatheroak and Wye Valley, plus guests from other breweries, one of which is a mild, as well as a real cider. Spring and autumn beer festivals are held. Q❄♿⊁♠P🏵

Belbroughton

Holly Bush Inn

Stourbridge Road, DY9 9UG (on A491 Stourbridge Rd)

☎ (01562) 730207

Hobsons Mild, Twisted Spire, Town Crier; 1 changing beer (sourced regionally; often Hobsons, Salopian, Three Tuns) Ⓗ

Set back from the A491 dual carriageway, this traditional inn with open fire was originally built in the 1700s. Beers from the Hobsons range are served along with a guest ale and a Westons real cider. Full of character, it has a lounge/dining area, central bar section and a small raised restaurant. The pub menu includes good-value specials and fish options. Cards and dominoes are played. Dogs are welcome. A winner of CAMRA awards including local Pub of the Year. Q❄☺⒩♿♠P🚌(318)🏵

Bewdley

Bewdley Brewery Tap

Bewdley Craft Centre, Lax Lane, DY12 2DZ

☎ (01299) 405148 ⊕ bewdleybrewery.co.uk/visit-bar

Bewdley Worcestershire Way, William Mucklow's Dark Mild, Worcestershire Sway; 2 changing beers (sourced locally; often Bewdley) Ⓗ

Bewdley Brewery produces a range of six regular cask ales and a greater number of bottled beers, some for the Severn Valley Railway. The spacious taproom, to the rear of a former school building, is adorned with railway and brewery memorabilia, and has an old-fashioned feel. Five of the brewery's cask ales are served through half-pint pulls, giving each pint a perfectly clear dispense, and the full range of bottled beers is available. Open on bank holidays; winter hours may vary. ☺♿P🏵

Black Boy ⅃

50 Wyre Hill, DY12 2UE (up Sandy Bank from Cleobury Rd at Welch Gate)

☎ (01299) 400088 ⊕ theblackboybewdley.co.uk

Bewdley Worcestershire Way; Hobsons Town Crier; Three Tuns XXX; Wye Valley Bitter; 1 changing beer (sourced locally; often Fownes) Ⓗ

Up a hill from the town centre, this friendly, ancient inn is worth the climb. The attractive, half-timbered building is the oldest pub in Bewdley, with a beamed interior and an open fire in winter. Up to five beers are served, plus a real cider or two. Cobs and pork pies are always on offer, with hot meals available three evenings a week. Attractions include bar skittles, bagatelle, board games and shove-ha'penny. A folk session is hosted on the second Wednesday of each month and a quiz on Sunday. Q❄☺♠♣♠(8,292)🏵

Great Western ⅃

Kidderminster Road, DY12 1BY (near SVR station – walk past signal box and under viaduct)

☎ (01299) 488828

Bewdley 2857, Worcestershire Way; 3 changing beers (sourced locally; often Hobsons, Ludlow, Three Tuns) Ⓗ
Conveniently located a short way from the Severn Valley Railway station, the pub has a traditional interior with a railway theme reminiscent of an earlier age. Overlooking the bar is an upper level from which to admire the fine glazed decorative tiling. Snacks such as cobs and tasty local pork pies are in keeping with the traditional ambience. On the bar are five real ales, including the house beer 2857, from Bewdley, named after a GWR locomotive often seen on the nearby railway viaduct.
ᗡ❀≈(SVR) ♣P🖵❀🐾

Old Waggon & Horses Ⓛ
91 Kidderminster Road, DY12 1DG (on Bewdley to Kidderminster road at Catchem's End)
☎ (01299) 403170
Banks's Mild; Bathams Mild Ale, Best Bitter; Ludlow Gold; 1 changing beer (sourced regionally; often Timothy Taylor, Wye Valley) Ⓗ
Popular locals' and visitors' pub with a central bar serving three distinct areas. The small wooden-floored snug has a dartboard, the larger room a wood-burner and a roll-down screen for major sporting events, but at most times conversation prevails. An old kitchen range adds to the cottagey feel. Guest ales come from local and regional independents. Pub food is available, plus a pie night and a tapas night once a month, and a carvery on Sunday. The attractive terraced flower garden is on many levels.
ᗡ❀🍴◑≈(SVR) ♣P🖵❀🐾

Real Ale Tavern Ⓛ
67 Load Street, DY12 2AW (on main street)
☎ (01299) 404972
Black Country Bradley's Finest Golden, Chain Ale, Pig on the Wall, Fireside; 8 changing beers (sourced nationally; often Beowulf, Byatt's, Mallinsons) Ⓗ
A traditionally styled pub, converted in 2017 from a former bank. The cosy front lounge, with an open fire in winter, leads from one area to the next into the depths of the pub. Specialising in real ales and cider, there is an impressive array of 12 handpulls, with beers from Black Country Ales, local and national breweries, and sometimes two real ciders. Current beers are displayed on screens, making it easy to order at the bar. Cobs and pies are always available. ❀&≈(SVR)♣🐾🖵❀🐾

Birlingham

Swan
Church Street, WR10 3AQ
☎ (01386) 750485 ⊕ theswaninn.co.uk
Goff's Cheltenham Gold; 1 changing beer (often Teme Valley, Three Tuns) Ⓗ
A pretty thatched free house tucked away at the edge of a quiet village. Although the emphasis is on dining, it has a small separate black-and-white beamed bar. The conservatory overlooking the fine garden is for dining, with fresh fish specials featuring on the menu. The new log cabin-style covered seating in the garden is ideal for outdoor drinking. Q❀◑P🖵(382)❀🐾

Birtsmorton

Farmers Arms
Birts Street, WR13 6AP (off B4208) SO790363
☎ (01684) 833308 ⊕ farmersarmsbirtsmorton.co.uk
Hook Norton Hooky, Old Hooky; Wye Valley Butty Bach; 2 changing beers (sourced locally; often St Austell, Wye Valley) Ⓗ

Black and white Grade II-listed village pub dating from 1480, found in a quiet spot down a country lane. The large bar area features a splendid inglenook fireplace while the cosy lounge has old settles and very low beams. Good-value, home-made, traditional food is on offer daily. Beer from a small local independent brewery is often available. The safe, spacious garden, complete with swings, provides fine views of the Malvern Hills. A caravan site is nearby. There is level access to the bar.
Qᗡ❀◑♣P❀🐾

Blakedown

Swan
9 Birmingham Road, DY10 3JD (in centre of village)
☎ (01562) 700229 ⊕ swanblakedown.co.uk
3 changing beers (sourced regionally; often Hobsons, Printworks, Wye Valley) Ⓗ
Comfortable and modern in style, this is a pub and restaurant offering good-value home-cooked meals from a varied and interesting menu, including vegetarian and vegan options. A children's menu is also available. The extensive secluded garden has many tables to enjoy a meal or drink, including a covered area for inclement weather. The three changing beers are from local and regional brewers. ᗡ❀◑≈P🖵(192)❀🐾

Bretforton

Fleece Inn 🍷 ★ Ⓛ
The Cross, WR11 7JE (near church)
☎ (01386) 831173 ⊕ thefleeceinn.co.uk
Purity Mad Goose; Uley Pig's Ear Strong Beer; Wye Valley Bitter; 3 changing beers (sourced regionally; often North Cotswold, Wye Valley) Ⓗ
Fifteenth-century timber-framed village pub owned by the National Trust on the edge of the Cotswolds. It has been identified by CAMRA as having a nationally important historic pub interior, and has a world-famous 17th-century pewter collection. The pub also has its own orchard garden which is very popular with families in the summer, and the food comes highly recommended. Morris dancers and music feature all year round. This really is a pub not to be missed.
Qᗡ❀🍴◑&♣🐾P🖵❀🐾

Broadway

Crown & Trumpet Inn Ⓛ ✅
14 Church Street, WR12 7AE
☎ (01386) 853202 ⊕ crownandtrumpet.co.uk
North Cotswold Green Man IPA, Shagweaver; Timothy Taylor Landlord; 1 changing beer (sourced locally; often North Cotswold) Ⓗ

REAL ALE BREWERIES
Ambridge Inkberrow (brewing suspended)
Bewdley ✦ Bewdley
BOA ✦ Stourport-on-Severn
Boat Lane ✦ Evesham
Brew61 Bromsgrove
Friday Beer Malvern
Hartlebury Hartlebury
Hop Shed Suckley
Lakehouse Malvern
Malvern Hills ✦ Malvern
Sociable ✦ Worcester
Teme Valley 🍺 Knightwick
Weatheroak Hill 🍺 Weatheroak
Woodcote Dodford
Worcester Worcester

Picturesque 17th-century Cotswold-stone inn situated just off the village green. This hostelry has welcoming and friendly staff, and an abundance of character, with oak beams, a log fire and Flowers Brewery memorabilia. Good honest home-made local dishes are offered at reasonable prices, alongside regular ales and guests plus ciders and perries. Entertainment includes midweek live jazz and blues nights. Q✿🛏🍴🕽♣♨❀🐕🛜

Bromsgrove

Ladybird Inn L

2 Finstall Road, B60 2DZ (on B4184 on corner of roundabout near station) SO969695
☎ (01527) 878014 🌐 ladybirdinn.co.uk
Bathams Best Bitter; Sharp's Doom Bar; Wye Valley Butty Bach, HPA; 2 changing beers ℍ
This popular local is situated near the town's railway station. It has a light and airy decor, with a large busy bar to the front, and the lounge with a polished wooden floor to the rear. A meeting room is available on the first floor and a function room for parties on the ground floor. Filled rolls and other substantial snacks are served, plus hot pies at the weekend. 🛏✿♿⇌♣P🚝🐕🛜

Little Ale House

21 Worcester Road, B61 7DL (on corner of Station St)
☎ 07791 698641
6 changing beers (often Hobsons, Malvern Hills, Woodcote) 🄶
A micropub with a cosy atmosphere, with raised seating to one side. Up to six ales are served straight from the cask, typically from Hobsons, Malvern Hills, Wye Valley and Woodcote. A range of ciders and perries is also stocked and takeaways are available. A council car park is nearby and the bus station is parallel with the high street. Q🛏♣🐾🚝🐕🛜

Park Gate

Kidderminster Road, B61 9AJ
☎ (01527) 272665 🌐 parkgateinn.co.uk
4 changing beers ℍ
Just off the A448, the pub has a function/events lounge and a small bar. A mixed range of local ales is available – four to five ales off-peak, but in festival season there can be 10 or more, with gravity poured ales served from stillages in the terraced area. Boxed real cider is also kept. Folk night is on a Wednesday, with pool and darts among other attractions. Offering attractive views and a large dog-friendly garden and play area, the pub is popular with walkers and families.
Q🛏✿♿🅰♣🐾P🚝(42,322)🐕🛜

Callow End

Old Bush L

Upton Road, WR2 4TE (small lane off B4424) SO835497
☎ (01905) 830792 🌐 old-bush.com
Butcombe Original; Hobsons Twisted Spire; Wye Valley Butty Bach; 1 changing beer (sourced locally) ℍ
Village local with a black-and-white exterior, situated in a quiet road. The cosy, beamed interior has a log-burner in the lounge area and walls adorned with an eclectic mix of artefacts and pictures. One guest beer, sourced locally, is usually available. There are separate dining areas for the good home-made food, though you can also eat in the bar. The spacious and attractively laid out garden has country views, benches, a play area for children and a large aviary with many colourful birds.
🛏✿🕽🅰♣P🚝🐕🛜

Caunsall

Anchor Inn L

DY11 5YL (off A449 Kidderminster to Wolverhampton road)
☎ (01562) 850254 🌐 theanchorinncaunsall.co.uk
Hobsons Best, Town Crier; Wye Valley Butty Bach, HPA; 1 changing beer (sourced regionally; often Kinver Brewery) ℍ
Friendly village inn renowned for its five real ales, traditional ciders and, especially, its well-filled cobs. A central doorway leads into the bar with its original 1920s furniture and horse-racing memorabilia. Outside, the garden is a suntrap in summer, and this popular pub can get busy, especially at lunchtimes and weekends. Easily reached from the nearby canal, this gem is well worth stopping off for. A winner of many local CAMRA awards, most recently Bronze Pub of the Year 2022.
Q🛏✿🕽♣🐾P🚝(9A,9C)🐕🛜

Chaddesley Corbett

Swan L

High Street, DY10 4SD (along High St from A448)
SO892737
☎ (01562) 777302 🌐 theswanchaddesleycorbett.co.uk
Bathams Mild Ale, Best Bitter ℍ
Dating from 1606, this traditional inn sits at the heart of the village, featuring a public bar, side room with a real fire and an impressive lounge with a raised area for entertainment. Filled rolls and pies are available. A quiz night is held every Wednesday and a monthly jazz night on a Thursday. There is a large garden and children's play area at the rear overlooking beautiful countryside. The pub is popular with walkers and cyclists alike. Bathams XXX is available in December. Q🛏✿🅰♣P🚝(52)🐕🛜

Droitwich Spa

Hop Pole L

40 Friar Street, WR9 8ED (100yds from Norbury Theatre)
☎ (01905) 770155
Wye Valley Butty Bach, HPA, Wholesome Stout; 1 changing beer (often Ambridge) ℍ
Popular 18th-century inn located in the old part of Droitwich between the Norbury Theatre and the fire station. There is a separate pool room adjoining the bar and a recently refurbished patio area at the rear. Three locally sourced beers are usually available as well as an occasional guest. Good-value food is served at lunchtimes. Pub games and live music on some weekends ensure a convivial atmosphere.
🛏✿🕽♣🐾P🚝🐕🛜

Talbot

19 High Street, WR9 8EJ
☎ (01905) 773871
Craddock's Crazy Sheep, King's Escape, Monarch's Way, River Steam, Saxon Gold; 1 changing beer (sourced locally; often Hobsons) ℍ
A friendly traditional inn at the top of the High Street. It comprises a front bar, large rear room, beer garden, sun terrace and separate function room. There are eight handpulls serving the Craddock's beer range, with the brewery's loyalty card available. The food menu is based on traditional pub dishes. A monthly quiz and cheese club is held. Q🛏✿🕽⇌♣P🚝(144)🐕🛜

Elmley Castle

Queen Elizabeth L

Main Street, WR10 3HS

☎ (01386) 710251 ⊕ elmleycastle.com
Purity Mad Goose; Wye Valley Bitter; 2 changing beers (sourced nationally; often Goff's, North Cotswold) Ⓗ
Named after the visit of Elizabeth I to the village in August 1575, this old inn has a fresh, modern feel. It is a community pub, owned by 26 local residents who rescued it from closure. The bar has a flagstone floor, timber beams and a roaring fire. The comfortable lounge and separate dining room also serve as a café during the day. Beer festivals are held annually on the May and August bank holidays. The pub is a good place to start or end a walk up Bredon Hill. Q ☻ ⌖ ◑ P ⅁ ♣ ☻ ☎

Evesham

BCM

64 Bridge Street, WR11 4RY (in courtyard off Bridge St)
☎ 07703 753064
House beer (by Green Duck); 3 changing beers (sourced locally; often Green Duck, Tiny Rebel) Ⓗ
At the end of a gated courtyard, this 16th-century, Grade II-listed building has a single bar room decorated in a contemporary style with lots of natural wood and exposed beams. The family-run pub offers three real ales including a house beer from Green Duck Brewery, together with a variety of craft beers and cans. There is a small courtyard outside. Open Thursday to Sunday only.
Q ☻ ⌖ ⅋ ⋏ ≈ ♣ ⅁ ♣ ☻ ☎

Trumpet Inn 🅛 ✅

13 Merstow Green, WR11 4BD (off Merstow Green car park)
☎ (01386) 442816
Hook Norton Hooky, Off The Hook, Old Hooky; 1 changing beer (often Hook Norton) Ⓗ
Probably the most westerly outlet of the Hooky tied estate, this friendly traditional inn is tucked away at the southern end of the High Street. It has a large grassed garden at the rear and further outdoor seating at the front. Home-made food is served daily, with many weekly specials and Sunday roasts. Regular darts matches are held and both Sky and BT Sports are available. The pub offers a warm welcome to locals and visitors alike. ☻ ⌖ ◑ ⅋ ≈ ♣ ☻ ☎

Feckenham

Rose & Crown ✅

High Street, B96 6HS
☎ (01527) 892188 ⊕ roseandcrownfeckenham.co.uk
Banks's Amber Ale; Brakspear Oxford Gold; 1 changing beer (sourced locally; often Brew61) Ⓗ
A welcoming family-run Grade II-listed inn in this old village. Its traditional bar offers up to four real ales, plus at least one real cider. A wide menu of pub classics is served in the cosy lounge, with wooden settles for seating. There is a large enclosed beer garden at the rear. An annual beer festival is held over the August bank holiday. Parking is limited but there is a free car park nearby. Q ☻ ⌖ ◑ ♣ ☻ ☻ ☎

Finstall

Cross Inn ♟ 🅛

34 Alcester Road, B60 1EW (on B4184 Finstall corner)
☎ (01527) 577328
Black Country Bradley's Finest Golden, Pig on the Wall, Fireside; 4 changing beers (sourced nationally) Ⓗ
Black Country Ales pub that features its portfolio of beers as well as guest beers and ciders. Nine handpumps

dispense beers (including a dedicated dark ale) and ciders, all displayed on electronic screens. Cobs, pork pies and local Scotch eggs are served. The pub also holds charity and other events, crib and dominoes are played here, and it has a small garden area with a heated shelter. Local CAMRA Pub of the Year 2021 and 2022.
☻ ☻ ⌖ ♣ ◑ P ⅁ (43,42) ☻ ☎

Hanley Broadheath

Fox Inn 🅛

WR15 8QS (on B4204 E of Tenbury Wells) SO671652
☎ (01886) 853189
Bathams Best Bitter; Brakspear Oxford Gold; 1 changing beer Ⓗ
A spacious 16th-century black-and-white timbered free house. The bar is decorated with hops and has a large fireplace with a wood-burning stove. The panelled dining area is separated from the bar by wood beams. The games room has a pool table, TV and darts. Home-made food, including Sunday lunch, is available, with bar snacks at any time. Q ☻ ⌖ ◑ ⋏ ♣ P ⅁ (309) ☻ ☎

Hanley Castle

Three Kings ★ 🅛

Church End, WR8 0BL (signed off B4211) SO838420
☎ (01684) 592686
Butcombe Original; 4 changing beers (often Beowulf, Hop Shed, Malvern Hills) Ⓗ
This unspoilt 15th-century country pub on the village green near the church has been identified by CAMRA as having a nationally important historic pub interior. Run by the Roberts family since 1911, it remains a rare example of a place to enjoy conversation over a pint. There is a small snug with a large inglenook, serving hatch and settle wall. Nell's Lounge has another inglenook and plenty of beams. The three guest ales are often from local breweries, and include a stout or porter. Live music features on Sunday evening with regular lunchtime sing-arounds on Friday. Cash only.
Q ☻ ⌖ ♣ ◑ P ⅁ (332) ☻

Himbleton

Galton Arms 🅛

Harrow Lane, WR9 7LQ
☎ (01905) 391672 ⊕ thegaltonarms.co.uk
Banks's Amber Ale; Bathams Best Bitter; Prescott Hill Climb; Wye Valley HPA Ⓗ
Splendid rural pub on the edge of the village with a friendly welcome, popular with locals and visitors alike. It is one of very few outlets for Bathams in the area. The unspoilt interior is divided by the original wood beams and warmed by open fires. The bar area shows sports TV. Good-value food is served in two separate dining areas. The beer garden is suitable for children.
Q ☻ ⌖ ◑ ⌖ P ⅁ (356) ☻

Kidderminster

Bear & Wolf ♟ 🅛

11-17 Worcester Street, DY10 1EA
☎ (01562) 227150
House beer (by Fixed Wheel); 5 changing beers (sourced nationally; often Burning Soul, Fownes, Vocation) Ⓗ
This modern town-centre pub opened in 2019, specialising in real ales. The interior is deceptively spacious, with a mix of sofas, tables and high stools. Quiet background music encourages conversation, and on some Saturdays there is live music. Six beers are

offered from local and regional breweries, including a dark ale, some unusual beers and up to four ciders. A variety of canned craft beers is also available. Local CAMRA Gold Pub of the Year 2022. ⅃♿✦🍴🖶♣🛇

Beer Emporium & Cider House

Oxford Street, DY10 1AR (between railway station and town centre)

☎ (01562) 752852

6 changing beers (sourced nationally) Ⓖ

Micropub convenient for the station and the town centre, where table service is the norm. A chalkboard shows four or more changing real ales from around the country, usually including a dark one. Four or five ciders and perries, a large selection of canned, foreign bottled beers, craft tap beers, wines and soft drinks ensure there is something for everyone. Local CAMRA Gold Cider Pub of the Year 2019, 2020 and 2022. Closed Monday and Tuesday, and for some of January. Q☕🛇♿✦🅿🖶🖵♣🛇

Olde Seven Stars ✔

13-14 Coventry Street, DY10 2BG (not far from upper end of High St facing Swan Centre)

☎ (01562) 228641 ∰ enquiries464.wixsite.com/yeoldesevenstars

4 changing beers (often Draught Bass, Salopian, Wye Valley) Ⓗ

With up to four changing real ales, this historic town-centre inn is well worth visiting. The front and rear bars display many features from previous ages. Snacks include pork pies, and customers can bring their own food (there are plenty of takeaways nearby), with tableware and condiments provided. Live music plays on the last Friday of the month. Families are welcome and the rear garden is popular in summer. This friendly pub is a former local CAMRA Bronze Pub of the Year. ☕❀♣🖶♣🛇

Weavers Real Ale House Ⓛ

98 Comberton Hill, DY10 1QH (300yds down hill from railway station)

☎ (01562) 229413

Three Tuns XXX; Wye Valley Butty Bach; 6 changing beers (sourced nationally; often Bristol Beer Factory, Church End, Fownes) Ⓗ

One-room conversational pub serving eight interesting and changing real ales and four ciders on handpump, often including a perry, along with six craft beers on tap. There is always at least one dark ale. Cobs are available. Close to the railway station, the pub is convenient for a pint and a chat on the way into town. An award-winning local CAMRA Pub and Cider Pub of the Year and National Pub of the Year finalist. Q☕🛇♿✦🖶♣🛇

Knightwick

Talbot Ⓛ

WR6 5PH (on B4197, 400yds from A44 jct)

☎ (01886) 821235 ∰ the-talbot.co.uk

Teme Valley T'Other, That, This Ⓗ; **changing beers (often Teme Valley)** Ⓖ

A coaching inn off the main road, dating from the 14th century. It has a large lounge bar divided into two by a fireplace, a separate taproom and an attractive conservatory. The small wood-panelled restaurant at the back serves an imaginative menu using local ingredients. There is a beer garden to the side and another at the front leading down to the river. A food trailer operates in summer. Teme Valley brewery is behind the pub. Beer festivals are held in April, June and early October (for green-hopped beers). Dogs and walkers are welcome. Q☕🛇❀🌢◑♿🅿🖶(420)♣🛇

Lulsley

Fox & Hounds Ⓛ

WR6 5QT

☎ (01886) 821228 ∰ foxandhoundslulsley.com

Ledbury Gold; Wye Valley HPA; 2 changing beers (often Goff's, Three Tuns) Ⓗ

A large pub in a rural village with two bars from the original Victorian building, warmed by an open fire. The building has been extended with a large dining room and a conservatory on the side featuring a baby grand. There is level access to the bar through the front door. At the back is an extensive garden and children's play area, with the River Teme and the Worcestershire Way beyond. Local beers and local produce are on the menu. There is a spring bank holiday beer festival. Q☕🛇❀◑♣🅿♣🛇

Malvern

Great Malvern Hotel Ⓛ

Graham Road, WR14 2HN (by crossroads with Church St)

☎ (01684) 563411 ∰ great-malvern-hotel.com

Malvern Hills Black Pear; St Austell Proper Job; Timothy Taylor Landlord; Wye Valley Butty Bach; 1 changing beer Ⓗ

Popular hotel public bar, a short walk from the Malvern Theatres complex, ideal for pre- and post-performance refreshment. Meals are served in the bar and the adjoining brasserie, including breakfast and Sunday lunch. There is a separate comfortable lounge with lots of sofas, fresh coffee and daily newspapers. Live music sessions are hosted during the week. The Great Shakes cellar bar features sports TV and is available for hire. Parking is limited. ☕❀🍴◑≠(Great Malvern)🅿🖵♣🛇

Nags Head Ⓛ ✔

19-21 Bank Street, WR14 2JG (off Graham Rd at Link Top common)

☎ (01684) 574373 ∰ nagsheadmalvern.co.uk

Banks's Amber Ale; Hook Norton Old Hooky; Purity Bunny Hop; Teme Valley This; Timothy Taylor Landlord; Wainwright; 7 changing beers (often Otter) Ⓗ

A free house with a wide selection of permanent beers and guests, plus two draught ciders. Mismatched furniture, nooks and crannies, newspapers, foliage and fires in winter create a homely environment, and the pub is busy throughout the week. Quality food is served in the bar and separate restaurant, which has level access (but the bar does not). There is a large, covered, heated outdoor area to the front and quiet garden at the rear. The car park is small but there is ample on-street parking. Dogs are welcome and numerous. ❀◑🌢✦🅿🖶(44)♣🛇

Weavers

14 Church Street, WR14 2AY

5 changing beers Ⓗ

Modern craft and draught ale bar in a former shop, with five handpumps for craft real ales and two for draught still cider. A few tables are outside on the street and there is a small patio garden at the rear. The room upstairs has comfy sofas, a dartboard and board games. There is level access to the bar and ground floor. Snacks are available but no hot food is served – customers can order from The Fig across the road. No car park but there is plenty of parking nearby. Q❀♿≠(Great Malvern)🌢✦🖶♣

Monkwood Green

Fox 🅛

WR2 6NX (S edge of Monkwood Nature Reserve)
SO803601
☎ (01886) 889123
Malvern Hills Feelgood; Wye Valley Butty Bach Ⓗ
Single-bar village local on the common with seating around the fireplace. The Fox is the centre of many events including skittles and indoor air rifle shooting, and has traditional pub games. It is dog friendly, and ideally placed for walks in the Monkwood nature reserve that is renowned for butterflies and moths. Music night is the last Friday of the month. A rare outlet for Barkers cider and perry. Q ⛺ 🏮 ▲ ♣ 🚶 P 🚍 (308) 🌑

Pershore

Pickled Plum 🅛

135 High Street, WR10 1EQ
☎ (01386) 556645 ● pickledplum.co.uk
Wychwood Hobgoblin Ruby; Wye Valley Bitter; 2 changing beers (often Church End, North Cotswold, Purity) Ⓗ
A large, smart pub with a modern airy interior, divided into several areas, with exposed beams and real fires giving it a cosy old world charm. There is outside seating on the patio at the rear. Food is served lunchtimes and evenings. The pub hosts a regular Sunday night quiz and an acoustic jam on the first Monday of the month. There is level access to the bar from the car park and patio at the rear. ⛺ 🏮 ◑ ◗ ♣ 🚶 P 🚍

Redditch

Black Tap 🅛

Church Green East, B98 8BP (near top of Church Green East opp fountain)
☎ (01527) 585969 ● blacktapredditch.co.uk
4 changing beers (sourced locally; often Church End, Oakham, Purity) Ⓗ
A converted former brewery building and former brewpub, conveniently located near the town centre. The main bar has a roaring fire, adding to the friendly atmosphere among regulars. A good mix of beer styles is usually available along with cider. A small side room can be booked, and live music usually features at weekends. A Pay & Display car park is nearby. ⛺ 🏮 🥾 ♣ 🚶 P 🚍 🌑 🛜

Shenstone

Plough 🅛

DY10 4DL (off A450/A448 in village) SO865735
☎ (01562) 777340
Bathams Mild Ale, Best Bitter Ⓗ
This traditional pub has been at the heart of the village since 1840. The long single bar serves both the public bar and the lounge, which has a real fire and memorabilia of the Parachute Regiment and the Falklands War. Bathams Mild and Bitter are served all year while the stronger XXX is available in December. Snacks include cobs and pork pies. A large enclosed courtyard acts as an overflow, and there is a small patio to the front. Q ⛺ 🏮 ▲ ♣ P 🌑 🛜

Stoke Heath

Hanbury Turn

44 Hanbury Road, B60 4LU
☎ (01527) 577187
Black Country Bradley's Finest Golden, Pig on the Wall, Fireside; 6 changing beers (often Beartown, Downton, Oakham) Ⓗ

A recently refurbished Black Country Ales pub with a single large and comfortable bar/lounge surrounding a large central serving area. It offers a selection of up to 10 real ales from Black Country Ales plus guests, and two real ciders. Substantial snacks are served including cobs, home-made Scotch eggs and samosas. There is a small patio area to the side, and the pub offers B&B. Avoncroft Museum of buildings is nearby. The 145 bus stop is adjacent. ⛺ 🏮 🅿 ◑ ◗ ♣ 🚶 P 🚍 (145,144) 🌑 🛜

Stourport-on-Severn

Black Star 🅛 ✅

Mitton Street, DY13 8YP (just off top end of High St next to canal)
☎ (01299) 488838 ● theblackstar.co.uk
Wye Valley The Hopfather, HPA, Butty Bach, Wholesome Stout; 5 changing beers (sourced regionally; often Fixed Wheel, Hobsons, Three Tuns) Ⓗ
Situated next to the canal, there are moorings just through the bridge towards the basins. An attractive beer garden with a shelter, tables and raised flowerbeds overlooks the water. A changing selection of excellent quality beers is available from Wye Valley and other local breweries. The varied food menu includes steaks, fish, burgers, vegetarian and vegan options, sandwiches, baguettes and a variety of home-cooked meals (no food Sun eve & Mon). Local CAMRA Gold Pub of the Year 2020. ⛺ 🏮 ◑ ◗ 🚍 🌑 🛜

Hollybush 🅛

Mitton Street, DY13 9AA (a short walk from main street down Gilgal)
☎ (01299) 827435
Black Country Bradley's Finest Golden, Pig on the Wall, Fireside; 5 changing beers (sourced nationally; often Hop Shed, Oakham, Salopian) Ⓗ
A welcoming pub with a relaxed atmosphere offering eight real ales from independent breweries and real ciders. A single bar serves a split-level lounge with many ancient timbers, a snug, an upstairs function room with dartboard, and a quiet beer garden at the back. Good-value cobs, pork pies and Scotch eggs are available at any time. Regular weekly events include live music, quizzes and TV sports. An annual beer festival is held in the main lounge. Q ⛺ 🏮 ♣ 🚶 🚍 🌑 🛜

Tardebigge

Alestones

Unit 23 Tardebigge Court, B97 6QW
☎ (01527) 275254 ● alestones.co.uk
4 changing beers (sourced locally; often Woodcote) Ⓗ
A well-maintained micropub, opened in 2016, which sits in a courtyard alongside several small independent shops and businesses. Although opened out, it retains its cosy, convivial atmosphere. There are usually four beers, including a golden ale, a dark beer and a best bitter, plus real cider and perry. Pub snacks are usually available. Local musicians play monthly on a Sunday.
Q ⛺ 🏮 🚶 P 🚍 (52,52A)

Upper Wyche

Wyche Inn 🅛

Wyche Road, WR14 4EQ (on B4218, follow signs from Malvern to Colwall)
☎ (01684) 575396 ● thewycheinn.co.uk
Wye Valley HPA; 3 changing beers (sourced regionally; often Ledbury) Ⓗ

Situated above Great Malvern, this free house is the highest pub in Worcestershire, with panoramic views towards the Cotswolds from the bar and patio. It has two bars on different levels with a dedicated dining area in one, offering a large choice of home-made food. The regular real ales are paired with others from small and microbreweries – sometimes Ledbury Brewery specials. Green-hop beers are available throughout October. Ideally situated for hill walkers, B&B, self-contained flats and a cottage are available for those who wish to stay over. Q❀☸❹◑P♻(675)✿ 🛜

Upton upon Severn

Olde Anchor Inn 🛈

5 High Street, WR8 0HQ

☎ (01684) 593735 ⊕ anchorupton.co.uk

Hobsons Best; St Austell Tribute; Sharp's Doom Bar; Wye Valley Butty Bach; 2 changing beers ⊞

An old oak-beamed pub dating from 1601 and mentioned in Cromwell's dispatches. It has low ceilings and many small rooms and alcoves, plus a patio garden. The bar, featuring a large fireplace and range, is separate from the restaurant area. An additional wood-panelled function room is available for meetings and parties. Q❀◑♻✿🛜

Wadborough

Masons Arms

Station Road, WR8 9HA

☎ (01905) 841457 ⊕ themasonswadborough.co.uk

Timothy Taylor Landlord; Wye Valley HPA, Butty Bach ⊞

An idyllic village inn dating from 1835 with sympathetic extensions. The L-shaped lounge bar boasts a real fire, tables for dining and comfy armchairs. There is also a lovely quiet snug. Outside, there is a garden adjacent to woodland. Food is served lunchtimes and evenings, plus speciality nights including curry on Thursday, fish on Friday and roasts on Sunday (book ahead). The pub hosts ad-hoc community events. Q❀◑P

Weatheroak

Coach & Horses 🛈

Weatheroak Hill, B48 7EA (Alvechurch to Wythall road) SP057740

☎ (01564) 823386 ⊕ coachandhorsesinn.co.uk

Holden's Golden Glow; Hook Norton Old Hooky; Weatheroak Hill Slow Lane, IPA (Icknield Pale Ale), Cofton Common; 5 changing beers (sourced nationally; often Hobsons, St Austell) ⊞

Traditional rural coaching inn with an idyllic beer garden. The bar remains untouched, with a log fire, tiled floor and old church pews, while a modern lounge offers comfy sofas and a restaurant. Four beers are usually stocked from the on-site brewery housed in the former stables, alongside a wider selection from regional independents. Freshly made rolls are always available. Sunday evening opening hours may vary in winter. The pub is adjacent to Icknield Street, the old Roman road. ☸❀◑&♣P✿🛜

Worcester

Ale Hub Micropub 🛈

Unit 1B Abbotsbury Court, WR5 3TY

⊕ alehub.co.uk

Wye Valley Butty Bach; 3 changing beers (sourced locally) ⊞

Opened in 2021, this micropub is in a converted shop premises in the residential district of St Peter's to the south of the city, accessible by bus. It offers four changing, and often unusual handpulled ales, alongside cocktails and craft keg. The pub has a warm, friendly atmosphere, and hosts weekly bingo and quiz nights. There is level access in the bar and dogs are welcome. Q☸♻(32) ✿

Bull Baiters Inn 🍸

43-49 St Johns, WR2 5AG

☎ (01905) 427601 ⊕ bullbaiters.com

6 changing beers (sourced locally) ⊞

A small bar housed in a medieval building with an interesting history, previously a hall house. A high beamed ceiling and a large stone fireplace add to the old-world ambience, conducive to conversation. A small room upstairs provides additional seating and features an original painted wall and a mummified cat. Ever-changing beers – up to six – are usually sourced locally, and complemented by eight ciders and perries. Simple snacks are available. Q❀♣♠♻✿🛜

Dragon Inn

51 The Tything, WR1 1JT (on A449, 300yds N of Foregate St station)

☎ (01905) 25845 ⊕ thedragoninnworcester.co.uk

Church End Goat's Milk, Gravediggers Ale, What the Fox's Hat, Fallen Angel; 4 changing beers (often Church End) ⊞

A Georgian building on the edge of the city centre run by Church End Brewery. The room at the front has a cosy fire, while the bar is towards the back. The old covered passageway to the side is decorated with odds and ends, and has seating. The yard behind features another covered area, with a log-burner for colder days, and more seating beyond. There is easy level access through the gates at the rear. Bar snacks such as Scotch eggs are always available. Q❀&⬤≠(Foregate St)♣♠♻✿🛜

Imperial Tavern 🛈

35 St Nicholas Street, WR1 1UW

☎ (01905) 619472

Black Country Bradley's Finest Golden, Pig on the Wall, Fireside; 6 changing beers (often Oakham, Salopian) ⊞

This smart city pub is run by Black Country Brewery. It serves three real ales from the brewery alongside up to six from small breweries across the country, and up to 10 real ciders. Three drinking areas are joined by the bar running front to back. Pictures of old Worcester pubs and street scenes decorate the walls. Cobs are available at lunchtimes. A former local CAMRA Pub of the Year. Q☸&≠(Foregate St) ♣♠♻✿🛜

Oil Basin Brewhouse

7 Copenhagen Street, WR1 2HB

☎ 07964 196194 ⊕ wintripbrew.co

4 changing beers (often Salopian) ⊞

A cosy, dimly lit bar with comfy chairs, wood-beamed ceiling and bare boards. It serves a variety of interesting real ales, mostly local, and craft keg, with a good selection of craft beers and ciders in the fridge. The pub is centrally located, just off the High Street. The Horsebox Diner serves a variety of burgers, meatballs and hotdogs. There is level access to the bar and toilets. ◑≠(Foregate St) ♣♻✿

Plough 🛈

23 Fish Street, WR1 2HN (on Deansway)

☎ (01905) 21381

Hobsons Best; Malvern Hills Black Pear; 4 changing beers (sourced regionally; often Salopian) ⊞

A Grade II-listed pub near the cathedral. There is a short flight of steps leading to a tiny bar with rooms leading off to either side. The beers usually come from breweries in Worcestershire and surrounding counties, but occasionally from small breweries further afield. Draught cider and perry are from Barbourne in the city. There is also an ever-changing range of whiskies. Outside is a small patio area. Rolls are available at weekends and when the cricket is on. ⛷❀⇌(Foregate St)♣🍴🚐❀

Postal Order ✅

18 Foregate Street, WR1 1DN
☎ (01905) 22373
Greene King Abbot; Ruddles Best Bitter; Sharp's Doom Bar; 6 changing beers (sourced nationally) ⊞
This Wetherspoon pub has a spacious room at the front with tables for drinking and dining, edged by booths and bench seating, plus a little alcove room off to the side. The bar area with high tables is towards the rear. The pub is renowned for a wide choice of interesting real ales, often from local breweries, in addition to the usual selection. Regular beer festivals are held throughout the year. The noise of conversation dominates, though the TV sound may be turned up for big sports games. There is level access to the bar from the side entrance.
Q⛷◑♿⇌(Foregate St)🚐🛜

Breweries

Ambridge

Unit 2a, Priory Piece Business Park, Priory Farm Lane, Inkberrow, Worcestershire, WR7 4HT ☎ 07498 628238 ⊕ ambridgebrewery.co.uk

⊛Ambridge commenced brewing in 2013, initially for the family run pub, and expansion was achieved by acquiring the Wyre Piddle brewery. As well as the main beer range a number of seasonal and specials are brewed throughout the year. Occasional small run bottling is also carried out. Brewing is currently suspended. ‼◆LIVE

Bewdley SIBA

Unit 7, Bewdley Craft Centre, Lax Lane, Bewdley, Worcestershire, DY12 2DZ
☎ (01299) 405148 ⊕ bewdleybrewery.co.uk

⊗ Bewdley began brewing in 2008 on a six-barrel plant in an old school. This was upgraded to a 10-barrel plant in 2014. Beers are brewed with a railway theme for the nearby Severn Valley Railway. The brewery has an on-site tap and shop. Element gin is also produced.
🚂◆LIVE◆

Worcestershire Way (ABV 3.6%) GOLD
Refreshing golden ale with a citrus, faintly orange peel aroma, leading to a balanced hop, malt and grapefruit taste and a lingering, hoppy finish.
Baldwin IPA (ABV 4.2%) GOLD
Jubilee (ABV 4.3%) GOLD
Pale colour, fruit and citrus aroma, sweet malt with underlying citrus taste.
Red Hill (ABV 4.4%) BITTER
Worcestershire Sway/ 2857 (ABV 5%) BITTER
Complex, amber-coloured bitter, sometimes badged as 2857. Fragrant, malty aroma, well-balanced, slightly sweet malt and hops taste with hints of toffee and marmalade, malt with citrus and meadow grass finish.
William Mucklow's Dark Mild (ABV 6%) MILD
Dark in colour, malty, sweetish fruity flavour with slight liquorice finish.

BOA (Brothers of Ale)

Unit 3, Anglo Buildings, Baldwin Road, Stourport-on-Severn, Worcestershire, DY13 9AX
☎ (01299) 488100 ☎ 07725 724934
⊕ brothersofale.co.uk

What started as a hobby soon became a passion and BOA Brewery was established in 2018, before opening its doors in 2019. It is situated in the heart of Stourport-on-Severn producing hop-forward, New World-style beers.
◆

Peace Out (ABV 3.6%) BITTER
Lock N Load (ABV 4.2%) GOLD
The 7 (ABV 4.2%) BITTER
2 Step (ABV 4.4%) PALE
Re-wind (ABV 4.7%) IPA
VVD Oatmeal Stout (ABV 4.7%) STOUT
Bone Idle (ABV 4.8%) GOLD
Loud Mouth (ABV 5.2%) IPA

Boat Lane

Unit 3, Streamside Business Park, Boat Lane, Offenham, Evesham, Worcestershire, WR11 8RS
☎ (01386) 719558. ⊕ boatlanebrewery.co.uk

A microbrewery established in 2017 by Ian Hazeldene in a small village near Evesham. An ever-changing range of beers are brewed, with up to eight available in the brewery bar at weekends. ◆

Brew61 SIBA

Greenfields Farm, Upton Warren, Bromsgrove, B61 7EZ
☎ (01527) 879472 ⊕ brew61.co.uk

Tim Dunkley started brewing as a hobby, opening a small 'pub' for friends and family on the farm. As his brewing prowess grew the equipment he used grew, and he needed more space. A purpose-built brewery with newer larger equipment, enabled him to supply a growing demand locally. Bottles and kegged ales are sold direct from the farm. 🚂

Greenfields Gold (ABV 3.8%) PALE
Grazing Girls (ABV 4.5%) GOLD
Hop On (ABV 4.5%) GOLD

Friday Beer

Unit 4, Link Business Centre, Link Way, Malvern, Worcestershire, WR14 1UQ
☎ (01684) 572648 ⊕ thefridaybeer.com

Founded in 2011, the Friday Beer Co primarily produces bottle-conditioned ales. The range of bottles now sells across the region and to a growing number of outlets, from Birmingham to London, and south of the M4 corridor (including local restaurants and venues). Beer is rarely available in cask form. ‼🚂LIVE

Jubilee (ABV 3.1%) MILD
Summer Hill Blonde (ABV 4.3%) BLOND
Pinnacle (ABV 4.5%) BITTER
WR14 (ABV 4.7%) BITTER
Friday Gold (ABV 5.6%) GOLD

Hartlebury

Station Park, Station Road, Hartlebury, Worcestershire, DY11 7YJ
☎ (01299) 253617 ☎ 07831 570117
✉ hartleburybrewingco@icloud.com

Formerly the site of Attwoods Brewery, the Hartlebury Brewing Co was established in 2019 by David Higgs, the

owner of the Tap House pub adjacent to Hartlebury railway station. It supplies the Tap House and local free trade.

Bitter Strikes Back (ABV 3.8%) BITTER
Hooker (ABV 4%) PALE
Pale ale, malt and hops predominate on the nose, background berry fruits, then notes of grapefruit, hops, pear and melon in the taste. Finish is grapefruit fading into bitterness and finally malt.
Off the Rails (ABV 4.2%) GOLD
Golden ale, fruity aroma with a hint of honey sweetness, flavours of grapefruit, hint of nectarine and some toffee leading to a spicy aftertaste of grapefruit and a long bitter finish.
Rambo Mango (ABV 4.3%) SPECIALITY
Yellow speciality beer with mango, aromas of yeast, biscuit and a hint of mango, fruity bitter taste of hops, grapefruit, mango in the background followed by a long hoppy then bitter finish.
APA (ABV 4.5%) PALE
Smooth yellow ale, malt and hops predominate on the nose with some background berry fruits, grapefruit, hops and pear followed by grapefruit fading into bitterness and malt in the aftertaste.

Hop Shed SIBA

Old Chicken Shed, Stocks Farm, Suckley, Worcestershire, WR6 5EQ
☎ **(01886) 884110** ☎ **07484 688026**
⊕ **hopshed.co.uk**

Originally named Unity Brew House, brewing began in 2016, using a 10-barrel plant. It is the only brewery in the UK located on a commercial hop farm. Based in an old chicken shed, the beers are named after breeds of chicken. An on-site bar is open on Fridays and Saturdays.

Wybar (ABV 3.6%) BITTER
Sebright Golden Ale (ABV 3.8%) GOLD
Pekin (ABV 4%) PALE
Sultan (ABV 4.2%) GOLD
Frizzle British IPA (ABV 4.5%) GOLD

Lakehouse

Lake House, Peachfield Road, Malvern, Worcestershire, WR14 3LE ☎ **07532 440634**
⊕ **lakehousebrewery.com**

⊛Lakehouse was established in 2016 and is situated at the foot of the idyllic Malvern Hills, within the grounds of a country house and fishing lake, from which it takes its name. Beers can be found in pubs, bottle shops, restaurants, supermarkets and online retail outlets. ‼LIVE

Amber Session Ale (ABV 3.9%) BITTER
Golden-coloured session beer, aroma of hops and citrus fruits, complex slightly citrus taste with grassy undertones followed by a pleasant, hoppy finish.
Citrus Pale Ale (ABV 4%) PALE
Pale amber, aroma of hops with hints of apple and grapefruit, pronounced hoppy taste with lemon and orange peel followed by a lingering citrus then bitter, hoppy aftertaste.

Malvern Hills

15 West Malvern Road, Malvern, Worcestershire, WR14 4ND
☎ **(01684) 560165** ⊕ **malvernhillsbrewery.co.uk**

⊠ Still in its original (1998) home of an old quarrying dynamite store. Established presence in the Three Counties, Birmingham and the Black Country. Seasonals and specials are determined more by ad-hoc requests

from publicans, as opposed to a planned timetable. Notable exceptions are the green-hopped beers in September. Recently opened an on-site taproom. ‼♦⬧

Beacon Gold (ABV 3.7%) GOLD
Feelgood (ABV 3.8%) BITTER
Bertie's Best (ABV 4.2%) BITTER
Malvern Spring (ABV 4.2%) BITTER
Priessnitz Plzen (ABV 4.3%) SPECIALITY
Straw-coloured, Pilsner-style cask lager having a mix of soft fruit and citrus. Well-balanced, light in colour, with a resinous aromatic finish.
Black Pear (ABV 4.4%) BITTER
Citrus hoppiness is the main constituent of this golden best bitter that has a long, dry aftertaste.

Sociable SIBA

6 – 8 Britannia Road, Worcester, WR1 3BQ ☎ **07957 583984** ⊕ **thesociablebeercompany.com**

⊛A small craft brewery just outside Worcester city centre, established in 2017. An on-site taproom is open on Fridays. A small range of core beers is brewed, mainly for sale in the local area. ⬧

Shindig (ABV 3.6%) BITTER
Bash (ABV 4%) BITTER
Wingding (ABV 4.2%) GOLD

Teme Valley SIBA

▤ **Talbot, Bromyard Road, Knightwick, Worcestershire, WR6 5PH**
☎ **(01886) 821235** ☎ **07792 394151**
⊕ **temevalleybrewery.co.uk**

⊛Teme Valley was established in 1997 to brew beer for the Talbot, Knightwick. Only hops grown in Herefordshire and Worcestershire are used in brewing, including Green Hop specials during the season. Beers are supplied throughout the West Midlands and Marches. ‼♦LIVE

T'Other (ABV 3.5%) PALE
This (ABV 3.7%) BITTER
That (ABV 4.1%) BITTER
Talbot Blonde (ABV 4.4%) BLOND
Wotever Next? (ABV 5%) BITTER
Roasted malt and toffee aromas lead to a complex taste of stone fruits, dark malt, hops and melon. The finish is at first of slightly smokey malt and fruits fading into lingering, dry hops.

Weatheroak Hill

▤ **Coach & Horses, Weatheroak Hill, Alvechurch, Worcestershire, B48 7EA**
☎ **(01564) 823386** ☎ **07496 289924**
✉ **weatheroakhillbrewery@gmail.com**

Established in 2008, Weatheroak Hill Brewery has been supplying the Coach & Horses -with quality beers brewed onsite on its six-barrel brewery for over a decade, travelling a mere 50 meters from grain to glass. The free trade and CAMRA festivals are also supplied, and customers can order online for pick up and delivery. ‼♦

IPA (Icknield Pale Ale) (ABV 3.8%) PALE
Impossible IPA (ABV 4.1%) PALE
Slow Lane (ABV 4.4%) PALE
Cofton Common (ABV 4.9%) SPECIALITY

Woodcote SIBA

Woodland Road, Dodford, Worcestershire, B61 9BT
☎ **07779 166174** ⊕ **woodcotebrewery.co.uk**

⊗ Opened in 2015 as Woodcote Manor in former dairy outbuildings attached to the brewer's house, the name was shortened to Woodcote in 2020. The original one-barrel plant has now expanded to seven barrels at new premises nearby, with a new mash tun and copper. The regular beers are distributed to a number of local pubs.
◆ LIVE

SSS (ABV 3.8%) GOLD
XPA (ABV 3.9%) BLOND
Half Cut (ABV 4.2%) PALE
SPA (ABV 4.2%) PALE
Weavers Exclusive (ABV 4.4%) GOLD
Squire's Gold (ABV 4.5%) GOLD
IPA (ABV 4.6%) GOLD
Golden, well-balanced and hoppy, grapefruit aromas are followed by a pronounced hop and slightly spicy taste, with a lingering bitter finish.
Oatmeal Stout (ABV 4.9%) STOUT

Dark in colour, roasted malt, chocolate and coffee tones are evident in the aroma and flavour, leading to a satisfying, slightly bitter finish.
Cap'n Will's Rum & Raisin Stout (ABV 6%) SPECIALITY

Worcester

Arch 49, Cherry Tree Walk, Worcester, WR1 3AU
☎ 07906 432049 ⊕ worcesterbrewingco.co.uk

A small brewery in the heart of Worcester and home to Sabrina Ales. A range of beers is brewed in rotation using traditional British hops, named with a loose association to the English Civil War.

Holy Ground (ABV 4.2%) BITTER
Powick Porter (ABV 4.5%) PORTER
1651 (ABV 5.1%) BITTER
Sabrina's Dark Ruby Ale (ABV 5.5%) BITTER

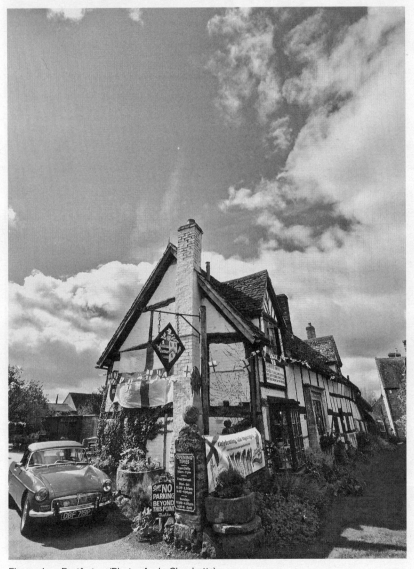

Fleece Inn, Bretforton (Photo: Andy Checketts)

GREAT BRITISH STAYS

Explore real Britain from the comfort of a Great British Pub.

A pub feels like home; full of warmth and laughter, character and authenticity. A stay in a pub is where you'll find real places, real people and real stays – Great British Stays.

Discover & book our 1,700 boutique pubs with rooms and traditional country inns at

www.stayinapub.co.uk

STAY IN A PUB

East Midlands

No matter how you like to take in the scenery, the East Midlands offers something special for every traveller. Vintage transportation abounds at the Crich Tramway Village near Matlock, and you can enjoy steam power in action on the Great Central Railway or at a Steam Day at Leicester's Abbey Pumping Station.

Those looking to get back to nature will not be short of an adventure in the region either. Nottingham's beautiful Wollaton Hall is set in 500 acres of incredible parkland, while Rutland Water can be enjoyed both from terra firma and on the water itself.

CAMRA's LocAle scheme was developed by the Nottingham branch in 2007 to encourage the celebration of locally made beers and reduce beer miles. The scheme is now popular nationwide, and Nottingham has rightfully earned a reputation as a great beer city. In 2010 Castle Rock's Harvest Pale was named Champion Beer of Britain and is still the most widely available beer in the area, but look out for awesome craft brewers Black Iris, Liquid Light and Neon Raptor who all have taprooms within Nottingham.

Derbyshire boasts the most breweries of any county in the East Midlands. Thornbridge Brewery in Bakewell is perhaps the biggest, known for its consistent quality across a broad range of styles as well as big name beers like Jaipur. Drop in for a tour to see how it gets things done. However, Dancing Duck in Derby, Tollgate Brewery in Calke, and Pentrich Brewery in Ripley are also notable and multi-award-winning breweries in the county that are worth keeping an eye out for.

A visit to Lincolnshire, the largest county in this region, would not be complete without sampling the delights of Brewster's in Grantham. This hugely decorated brewery is run by the legendary Sara Barton and offers sales direct to the public from a small shop on-site, or visit their taphouse, the Marquis of Granby in Granby.

People who enjoy a drop of cider or perry will feel right at home in the East Midlands, even though it is not a region traditionally associated with their production. There are now more than 40 producers in the region, with one of the best beer festivals to try a selection being the Nottingham Beer & Cider Festival, most recently held at the Trent Bridge Cricket Ground.

DERBYSHIRE

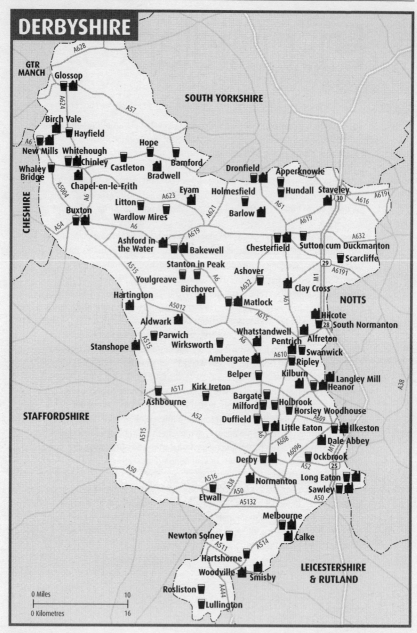

GTR MANCH

Glossop

Birch Vale

Hayfield

New Mills Whitehough

Whaley Bridge Chinley

Chapel-en-le-Frith

Buxton

Castleton

Bradwell

Hope

Bamford

Eyam

Holmesfield

Barlow

Dronfield

Apperknowle

Hundall Staveley

SOUTH YORKSHIRE

CHESHIRE

Litton

Wardlow Mires

Ashford in the Water

Bakewell

Stanton in Peak

Youlgreave Birchover

Hartington

Aldwark

Parwich

Stanshope Wirksworth

Ashbourne

Kirk Ireton

Matlock

Ashover

Chesterfield

Sutton cum Duckmanton

Scarcliffe

Clay Cross

NOTTS

Whatstandwell

Ambergate Pentrich

Belper

Bargate Milford

Duffield

Kilburn

Holbrook

Little Eaton

Hicote

South Normanton

Alfreton

Swanwick

Ripley

Langley Mill

Heanor

Horsley Woodhouse

Ilkeston

Dale Abbey

STAFFORDSHIRE

Derby

Normanton

Etwall

Ockbrook

Long Eaton

Sawley

Melbourne

Newton Solney

Calke

Hartshorne

Woodville Smisby

Rosliston

Lullington

LEICESTERSHIRE & RUTLAND

0 Miles 10

0 Kilometres 16

Apperknowle

Traveller's Rest 🅛

High Street, S18 4BD SK384782

☎ (01246) 460169

Acorn Barnsley Bitter; Bradfield Farmers Blonde; Timothy Taylor Landlord Ⓗ; 3 changing beers (sourced nationally; often Rudgate, Timothy Taylor, Welbeck Abbey) Ⓖ

Often referred to as the Corner Pin, the Traveller's Rest is a traditional country pub with several seating areas around a corner bar. Up to six quality real ales are available together with numerous fruit-based ciders and perries. Good-quality food is on offer including the ever-

popular cheese and pork pie platters, which can be ordered to eat in or take out. Outside, the roadside seating area affords sweeping views across the Drone Valley. Q⌖🐾⏪🕪▲♣🅿🚌(15)❀🛜

Ashbourne

Smith's Tavern 🍷 🅛

36 John Street, DE6 1GH

☎ (01335) 300809

Banks's Sunbeam; Brakspear Gravity; Marston's Pedigree; Ringwood Fortyniner; 1 changing beer (often Aldwark, Dancing Duck, Whim) Ⓗ

Small, highly traditional town-centre pub, serving as many as seven real ales from the Marston's portfolio, plus a guest ale at weekends, usually from a local brewery. Locally sourced pork pies are usually available. A good selection of around 25 malt whiskies are on offer, with tutored tastings throughout the year. Frequent winner of local branch Pub of the Year, six times in the past nine years, including 2022. Q♿♣❀🐕🛜

Ashover

Old Poets' Corner 🅛

Butts Road, S45 0EW (downhill from church)
☎ (01246) 590888
Everards Tiger; Titanic Iceberg, Plum Porter, Captain Smith's Strong Ale; 7 changing beers (sourced regionally; often Castle Rock, Everards, Thornbridge) 🅗
An award-winning village pub, owned by Titanic Brewery since 2019. It stocks up to 10 cask beers, four keg ales, a selection of Belgian beers and a range of locally produced Ashover ciders. With a welcoming atmosphere and a real fire, it is ideal for walkers visiting this quaint village and surrounding countryside, and is just a short walk from the main Chesterfield to Matlock road. Two or three beer festivals are held annually. Dogs are welcome. Q❀🛏🍴♿♣🚲🅿🚌(63,64)❀🛜

Bakewell

Joiners Arms 🅛

1-2 Rutland Buildings, DE45 1BZ
☎ 07834 950693
6 changing beers (often Peak Ales, Thornbridge) 🅗
A small, friendly micropub converted from a newsagents' in the heart of Bakewell town centre, with excellent and knowledgeable staff. Six cask beers on handpull and six craft keg beers on rotation are usually, but not exclusively, from local breweries. The pub has a stylish interior and a warm fireplace for cold winter evenings. It hosts occasional live music and other events.
Q♿❀🚌❀🛜

Manners Hotel 🅛

Haddon Road, DE45 1EP
☎ (01629) 812756 🌐 mannersbakewell.co.uk
Robinsons Dizzy Blonde, Unicorn, Trooper; 1 changing beer (sourced regionally) 🅗
A Robinsons Brewery-owned hotel and bar with a large garden and parking facilities, situated close to Bakewell town centre. There are four cask ale offerings, with Trooper, Unicorn and Dizzy Blond as regulars and other lines on rotation. Food is served at lunchtime and early evening. There is a range of accommodation available – check out the website for details. ♿🛏🍴♿🅿

Bamford

Anglers Rest 🅛

Main Road, S33 0DY
☎ (01433) 659317 🌐 anglers.rest
Black Sheep Best Bitter; 4 changing beers (sourced locally; often Abbeydale, Bradfield, Little Critters) 🅗
At the heart of Bamford and not far from Ladybower Reservoir, this is a community hub in every sense, where the locals have been running the pub (and associated Post Office and café) since 2013. The main bar is the focal point and is extremely popular with families, walkers and particularly cyclists who have access to dedicated cycle parking and a DIY repair shop. There is also a quieter snug. Good-value, rustic bar food is served Wednesday to Sunday. Q♿❀🍴♿🅿(257)❀🛜

Bargate

White Hart

Sandbed Lane, DE56 0JA
☎ (01773) 827397
Oakham Citra; Timothy Taylor Boltmaker; 4 changing beers (sourced nationally) 🅗
The White Hart is a cosy two-roomed pub in the heart of this village situated above the town of Belper. With a reputation for friendly staff, good beer and a welcoming atmosphere, the pub is popular with locals and has an excellent selection of changing cask and keg ales. A large beer garden is situated to the rear and walkers are

REAL ALE BREWERIES

3P's Woodville
Aldwark Artisan Aldwark
Alter Ego Alfreton
Ashover Clay Cross
Aurora Ilkeston
Bad Bunny Ambergate
Bang The Elephant Langley Mill
Bentley Brook ✦ Matlock
Big Stone Chinley
Birch Cottage Sawley
Birchover ✦ Birchover
Black Hole Little Eaton
Bottle Brook Kilburn
Brampton Chesterfield
Brunswick 🍺 Derby
Buxton ✦ Buxton
Chapel-en-le-Frith Chapel-en-le-Frith
Collyfobble 🍺 Barlow
Dancing Duck Derby
Derby Derby
Distant Hills ✦ Glossop
Dovedale Stanshope
Draycott Dale Abbey
Drone Valley Dronfield
Eyam Eyam
Falstaff 🍺 Derby: Normanton
Furnace 🍺 Derby
Globe 🍺 Glossop
Hartshorns Derby
Hollow Tree Whatstandwell
Instant Karma 🍺 Clay Cross
Intrepid Bradwell
Leadmill Heanor
Leatherbritches Smisby
Little Derby
Marlpool 🍺 Heanor
Matlock Wolds Farm Matlock
Moody Fox Hilcote
Moot 🍺 Matlock
Morgan Brewmasters ✦ Melbourne
Muirhouse Ilkeston
Old Sawley 🍺 Long Eaton
Peak Ashford in the Water
Pentrich Pentrich
RBA Derby
Resting Devil 🍺 Chesterfield (NEW)
Rock Mill 🍺 New Mills
Shiny ✦ Little Eaton
Silver Brewhouse Chesterfield
Thorley & Sons Ilkeston
Thornbridge Bakewell
Thornsett ✦ Birch Vale
Tollgate ✦ Calke
Torrside New Mills
Townes 🍺 Staveley
Urban Chicken Ilkeston
Whim Hartington

always welcome. Bar snacks are usually available. A former East Midlands CAMRA Pub of the Year and three-times local award winner. Q❂✿♣●P🖵(71)❂☀

Belper

Angels Micro Pub

Market Place, DE56 1FZ (top right of Market Place)
☎ 07527 163316
Oakham Citra; Thornbridge Jaipur IPA; Titanic Plum Porter; 5 changing beers (sourced nationally) ©
A quirky, friendly and popular micropub, offering real ales from the cask and an excellent choice of real ciders, wines, gin and juices. A full selection of at least eight and up to 12 beers, plus at least 10 ciders, is available – gradually decreasing by Sunday when the majority has been consumed! Live artists perform most Sunday afternoons. Local CAMRA Cider Pub of the Year 2020.
❂❂&⪦♣●P🖵❂☀

Arkwright's Real Ale Bar

6 Campbell Street, DE56 1AP
☎ (01773) 823117
Marston's Pedigree ©; 6 changing beers (sourced nationally) ⊞
Situated below the Strutt Club in the centre of Belper, Arkwright's is a modern, friendly, one-roomed real ale bar. Named after Sir Richard Arkwright, an important 18th-century mill owner, Arkwright's is a popular pub with local drinkers. Home-made bar snacks are always available, and some sporting events on terrestrial TV are shown. A no under-14s rule ensures a quiet and relaxing environment for adults, often with live acoustic music at weekends. &⪦●🖵❂☀

Railway ⊘

25 King Street, DE56 1PW
☎ (01773) 689987
Lincoln Green Marion, Archer, Hood, Tuck; 4 changing beers (sourced nationally; often Lincoln Green) ⊞
A large town centre pub, refurbished to a good standard and now operated by Lincoln Green Brewery, offering eight cask and six keg ales, with a loyalty card scheme on cask ales. Bar meals are available until early evening. This is a welcome addition to the award-winning main shopping street of Belper, providing a link between the Bridge Street and Market Place pubs. There is a large beer garden to the rear. ❂❂◑&⪦●P🖵❂☀

Buxton

Ale Stop ⌁

Chapel Street, SK17 6HX
☎ 07801 364619
4 changing beers (sourced nationally) ⊞
The first micropub in the High Peak, its two rooms were converted from a former wine shop off Buxton Market Square. Beer is the main event here, with four changing ales from microbreweries up and down the country, as well as three boxed ciders from Farmer Jim's. The objective is to bring to Buxton beers that are rarely, if ever, seen in the town. The enthusiastic staff ensure a warm and friendly welcome. An eclectic choice of background music on vinyl is played. A log-burning stove is a welcome addition for the winter. ❂&●🖵❂☀

Buxton Brewery Cellar Bar

George Street, SK17 6AT
☎ (01298) 214085
4 changing beers (sourced locally; often Buxton) ⊞
Owned and run by Buxton Brewery, the bar is next door but one to the Tap House, but is focused on drinks, with

no food available. The single room is divided into two seating areas and the decor is simple with an original brick vaulted ceiling. Four cask beers, mainly from Buxton, are served from handpumps on the bar. There is also a selection of Buxton keg, canned and bottled beers, as well as cider from Hogan's. An outdoor covered seating area is at the front. ❂⪦●🖵❂

Cheshire Cheese ⌁

37-39 High Street, SK17 6HA
☎ (01298) 212453
Everards Tiger; Titanic Steerage, Iceberg, White Star, Plum Porter, Captain Smith's Strong Ale; 4 changing beers ⊞
A double-fronted building of considerable age with old associations with the livestock trade, which was refurbished before reopening under the management of Titanic in 2013. The pub is essentially open plan but is split into several distinct areas. Low ceilings with original beams add to the cosy atmosphere and there are two open fires. The bar boasts an array of 10 handpumps serving a range of Titanic beers and guests. Home-made food is available. Entertainment is provided on Saturday evenings and there is a quiz on Sundays.
Q❂❂◑&AP🖵❂☀

RedWillow Buxton ⌁

1 Cavendish Circus, SK17 6AT
● redwillowbrewery.com
RedWillow Wreckless; 4 changing beers (sourced locally) ⊞
Opened in late 2017 and located in a former bank in the centre of Buxton, this is RedWillow Brewery's second bar. Original features have been retained such as etched windows and the mahogany and glass office, alongside a new bar and smaller mezzanine area. The five cask ales comprise four RedWillow beers and a guest. Cider is from Hogan's. Small plates and pizzas are served. There is also live music weekly and occasional beer festivals. The beers available, together with pricing, are displayed on TV screens. ❂◑&⪦♣●🖵❂☀

Castleton

Olde Nag's Head ⌁

1 Cross Street, S33 8WH
☎ (01433) 620248 ● yeoldenagshead.co.uk
Abbeydale Moonshine; Sharp's Doom Bar; 4 changing beers (sourced locally; often Abbeydale, Bradfield, Intrepid) ⊞
The bar area of this busy family-run 17th-century coaching inn has a feature fireplace, exposed stone walls and carved wooden chairs, and is adjacent to the stylish restaurant. An impressive array of handpumps dispense what is possibly the largest range of cask beers in the Hope Valley, mainly sourced from local breweries. There is a quiz on Friday night and live music every Saturday night. Accommodation is in nine en-suite rooms.
❂◨◑AP🖵(173,272)❂☀

Chesterfield

Anchor ⌁

Factory Street, Brampton, S40 2FW
☎ (01246) 229224
Timothy Taylor Landlord; 4 changing beers (often Ashover, Empire, Thornbridge) ⊞
This imposing pub, situated just away from the main road through Brampton, has recently been refurbished under new management. It has comfortable seating areas alongside a long bar that offers up to five handpulls, with one permanent beer and four on rotation

– usually Ashover, Thornbridge or Empire brews. Keg craft offerings are also usually available. This lively pub has music, and a dartboard and pool table. There is outside seating for warmer days. ❀♣🚐🖂

Beer Parlour L

1 King Street North, Whittington Moor, S41 9BA
☎ 07870 693411 ● the-beer-parlour.co.uk
8 changing beers (sourced nationally; often Abbeydale) ⑭

A cosy, single-roomed, popular drinking establishment situated just off the main route through Whittington Moor. Up to eight ever-changing quality real ales are available to drink in or take out, plus an extensive selection of draught continental ales. Bottled continental beers and boxed ciders and perries are also sold. The pub is convenient for the Chesterfield football stadium.
Q&🖶🖂(43,25)❀

Chesterfield Alehouse L

37 West Bars, S40 1AG
6 changing beers ⑭

A popular micropub that opened in 2013 in a former shop unit. It has friendly staff and an excellent selection of beers, offering up to six lines of cask ales, up to 12 keg lines (often KeyKeg), and an extensive bottle range, with real ciders from Ashover Cider Co. Regular tap takeovers often feature breweries rare for the area. There is more seating upstairs where free-to-air sports events are often shown. Downstairs is split-level with disabled facilities on the lower level. Q&♣●🖶🖂❀🖥

Chesterfield Arms L

40 Newbold Road, S41 7PH
☎ (01246) 236634 ● chesterfieldarms.co.uk
Draught Bass; Everards Tiger; Timothy Taylor Landlord; 6 changing beers (sourced nationally; often Abbeydale, Oakham, Thornbridge) ⑭

Multi award-winning real ale pub that serves home-made pizzas alongside real ales, craft beers, ciders, and everything else in between. In 2022 it introduced its own brewery, the Resting Devil, and its house brew, Twisted Pale, is always on the bar. There is a weekly quiz on Wednesday, regular live music, and beer festivals. The conservatory doors open up on warm evenings, extending the outdoor seating area.
Q🚶❀♣🍴&🖂(10)❀🖥

Derby Tup L

387 Sheffield Road, Whittington Moor, S41 8LS
☎ 07930 873072
Brunswick Rocket; Saltaire South Island; Whim Hartington Bitter; 5 changing beers (sourced regionally; often Ashover) ⑭

A traditional local offering up to 10 real ales, usually including a stout or porter, plus a choice of boxed ciders and a good selection of gins. The public bar has a real fire, a variety of wooden settles and original etched glass windows. There is also a small snug. Quiz night is Thursday and live music features twice a month. The pub is handy for the Chesterfield football stadium and opens at noon on Saturday match days. Q❀♣🖂❀🖥

Maggie May's

Breckland Road, Walton, S40 3LJ
● maggiemayswalton.co.uk
3 changing beers (sourced regionally; often Brampton, Peak Ales, Timothy Taylor) ⑭

This friendly and welcoming community-focused micropub and coffee shop in the Walton area of Chesterfield is run by a local couple. Up to three ales come from regional breweries on a changing basis, and meals are supplied through the owners' deli a few units

along. There is covered outdoor seating at the back while a gazebo and grass verge are well used in good weather. 🚶❀🍴P🖂❀🖥

Neptune Beer Emporium L

46 St Helen's Street, S41 7QD
☎ (07739 517734) ● the-neptune.com
Abbeydale Moonshine; Thornbridge Jaipur IPA; 6 changing beers (sourced nationally; often Dancing Duck, Drone Valley) ⑭

A free house and self-styled beer emporium, this is a compact back-street local serving excellent ales in two drinking areas either side of a central bar. The beer range is ever-changing, often from local breweries, complemented by an extensive selection of continental and craft beers on draught and in bottles, all displayed on a very descriptive chalkboard. Local CAMRA Pub of the Year 2020. 🚶❀➿♣🖂❀🖥

Pig & Pump L

16 St Mary's Gate, S41 7TJ
☎ (01246) 229570 ● pigandpump.co.uk
Oakham Citra; Ossett White Rat; Peak Ales Chatsworth Gold; Thornbridge Jaipur IPA; 6 changing beers (sourced nationally; often Abbeydale, Peak Ales, Thornbridge) ⑭

This imposing and friendly pub is situated opposite Chesterfield's parish church with its famous crooked spire. The long well-stocked bar hosts up to 10 cask ales plus a wide selection of craft and bottled beer. The open-plan pub is split into two comfortable areas, one slightly raised. An upstairs function room is available for hire. Popular for food, the home-made Sunday roast is recommended. 🚶❀🍴&➿P🖂❀

Rectory L ✅

Church Way, S40 1SF (adjacent to Chesterfield Parish Church and tourist information centre)
☎ (01246) 277283 ● therectorychesterfield.co.uk
Marston's Pedigree; 5 changing beers (sourced locally; often Dancing Duck, Marston's) ⑭

Run by the Secret Dining Company, who also operate the Exeter Arms in Derby, the Devonshire in Belper and the Crossing in Burton, the pub has friendly staff and an extensive menu. It is adjacent to St Mary and All Saints church, otherwise known as the Crooked Spire, and to the town's tourist information centre. The decor is traditional and there is plenty of seating. Five regularly rotating cask offerings usually include Dancing Duck ales. Two ciders are also available. Q🚶❀🍴&➿🖂

Rose & Crown L ✅

104 Old Road, Brampton, S40 2QT (1¼ miles from town centre on jct of Old Rd and Old Hall Rd)
☎ (01246) 563750 ● roseandcrownbrampton.co.uk
Brampton Golden Bud, Best; 9 changing beers (sourced regionally; often Brampton, Everards) ⑭

A Project William pub by Everards, this award-winning hostelry is a Brampton Brewery tied house, situated at the top end of the Brampton Mile. It has a compact snug, and memorabilia from the original Brampton Brewery festoons the walls. There are monthly live jazz sessions, regular real ale festivals, and live music events throughout the year. The drinks selection includes bottled Belgian beers, nine changing beers on handpump and keg, and up to 10 ciders and perries. Q🚶❀🍴P🖂(170)❀🖥

Derby

Alexandra Hotel L

203 Siddals Road, DE1 2QE
☎ (01332) 293993 ● alexandrahotelderby.co.uk

Castle Rock Harvest Pale; 7 changing beers (sourced nationally) ⊞

A Castle Rock pub serving the brewery's own beers and up to five guest ales, including a mild and a stout/porter. There is also a wide range of UK and continental bottled and canned beers of varying styles. Monthy themed food nights are held. The lounge is adorned with breweriana and the bar with railway memorabilia. A class 37 railway locomotive cab resides in the car park. This was the birthplace of the local CAMRA branch in 1974.

Q ☆ ⚙ ⊞ ≒ ♣ ⬤ P ⬛ ✿ 🛜

Brunswick Inn ⓛ

1 Railway Terrace, DE1 2RU

☎ (01332) 290677 ⊕ brunswickderby.co.uk

Brunswick White Feather, Triple Hop, The Usual; Everards Beacon Hill, Tiger; Timothy Taylor Landlord; 8 changing beers (sourced nationally) ⊞

Built in 1841, this is the oldest purpose-built railway inn in the UK. The flatiron-shaped pub is part of the North Midland Railway Village – it was restored from a derelict condition and reopened in 1987 (see press cuttings in the main bar). Derby's oldest microbrewery was added in 1991 and is visible at one end of the building. The large interior features four separate rooms and an upstairs function area, and gets busy on match days. Truly not to be missed. Q ☆ ⚙ ⓵ ⅋ ≒ ♣ ⬤ P ⬛ ✿ 🛜

Creaky Floorboard ⓛ

179 Kedleston Road, DE22 1FT

☎ 07974 749517

Navigation New Dawn Pale; 3 changing beers (sourced locally) ⊞

This hidden gem, established in 2018, is a sociable community hub. The layout is deceptively spacious with two interior rooms, one with a real fire, and a courtyard garden. The bar has five handpumps plus cider, lager, wine and spirits. Pork pies, cobs and four-pint takeaways are available. Books, cards and board games are on offer, and an open mic night is hosted every Tuesday. There is limited parking at the front. Q ⚙ ⬤ ⬛ ✿

Exeter Arms ⓛ ✔

13 Exeter Place, DE1 2EU

☎ (01332) 605323 ⊕ exeterarms.co.uk

Dancing Duck Ay Up; Marston's Pedigree; 4 changing beers (sourced nationally) ⊞

This quirky, multi-roomed pub has the feel of a traditional country inn despite its city-centre location, with numerous real fires ablaze. The site has been a licensed premises for over 100 years. Offering six handpumps, including the best selection of Dancing Duck ales in any Derby pub, complemented by contemporary, cutting-edge food, this gem also boasts a secluded courtyard garden and memorabilia from the punk rock band Anti-Pasti. ☆ ⚙ ⓵ P ⬛ ✿ 🛜

Falstaff ⓛ

74 Silverhill Road, Normanton, DE23 6UJ

☎ (01332) 342902 ⊕ falstaffbrewery.co.uk

Falstaff Fist Full of Hops, Phoenix, Smiling Assassin; 1 changing beer (sourced locally) ⊞

A 20-minute walk from the city centre into the Normanton district rewards you with this atmospheric and reputedly haunted free house. Tucked away in the back streets, it was originally a coaching inn before the neighbourhood was built up. Now the Falstaff Brewery tap, it is the only real ale house in the area. The rear lounge is a shrine to Offiler's Brewery, with a display of memorabilia. Other collectables can be viewed in the games room and second bar room. Q ☆ ⚙ ♣ ⬛ (4,7) ✿

Five Lamps ⓛ

25 Duffield Road, DE1 3BH

☎ (01332) 348730 ⊕ fivelampsderby.co.uk

Draught Bass; Everards Tiger; Greene King Abbot; Peak Ales Chatsworth Gold; St Austell Proper Job; Titanic Plum Porter; 8 changing beers (sourced regionally) ⊞

Since reopening in 2010, the pub has gone from strength to strength thanks to the dedication of the licensees and staff. Fourteen handpumps showcase an excellent range of styles and usually feature Derbyshire breweries. The Lamps is essentially open plan, but has many little nooks and crannies giving it a homely feel. It has been tastefully refurbished with wood panelling and leather seating in a traditional style. A patioed area is available both front and rear. ✿ ⅋ ⬤ P ⬛ ✿ 🛜

Flowerpot ⓛ

23-25 King Street, Cathedral Quarter, DE1 3DZ

☎ (01332) 204955 ⊕ flowerpotderby.com

Lenton Lane Pale Moonlight; Marston's Pedigree; Oakham Bishops Farewell; Whim Hartington Bitter ⊞; 6 changing beers (sourced nationally) ⊞ /ⓖ

Dating from around 1800 but much expanded from its original premises, this vibrant pub reaches back from the roadside frontage and divides into several interlinking rooms. One room provides the stage for regular live bands; another has a glass cellar wall revealing stillaged casks. Popular Gurkha curry nights take place every Tuesday and Wednesday evening, and an attractive outside seating area provides summer entertainment. Up to 10 real ales and five ciders are offered. Good en-suite accommodation is available. ☆ ⚙ ⊞ ⅋ ♣ ⬛ ✿ 🛜

Furnace Inn ⓛ

9 Duke Street, DE1 3BX

☎ (01332) 385981

Furnace Fun Sponge; Shiny 4 Wood; 6 changing beers (sourced nationally) ⊞

A former Hardys & Hansons pub that was reopened in 2012 and transformed into a real ale mecca. It is now the tap for Furnace Brewery, with up to eight real ales and three ciders/perries complemented by a variety of UK craft beers. There are two distinct open-plan rooms with a central bar and a large rear garden. Poker, quiz and cheese nights feature weekly and regular beer festivals are held throughout the year. ☆ ⚙ ⓵ ⅋ ♣ ⬤ P ✿ 🛜

Golden Eagle ⓛ

55 Agard Street, DE1 1DZ

☎ (01332) 230600

Castle Rock Harvest Pale; Titanic Plum Porter; 3 changing beers (sourced nationally) ⊞

Now a stand-alone corner building in an area of student accommodation, a large mural on the outside pays homage to Derby history. Inside, the long single room is comfortable and welcoming, with a wooden floor throughout and a table next to the bar for newspapers and local interest books. A walled paved area at the back provides a pleasant alternative drinking spot. There is an upstairs function room. ☆ ⚙ ♣ P ⬛ ✿ 🛜

Hole in the Wall ⓛ

24A Uttoxeter Road, Mickleover, DE3 0ZQ

☎ (01332) 501301 ⊕ holeinthewall-dbc.co.uk

Derby Business As Usual, Dashingly Dark; 4 changing beers (sourced locally) ⊞

Opened in March 2020 in a former NatWest bank building on the corner of Station Road in the centre of Mickleover, the pub has a large single room with the bar to one side at the back. Operated by the Derby Brewing Co, there are six handpulled beers on offer, one of which is a guest. ⬛

Little Chester Ale House L

4A Chester Green Road, Chester Green, DE1 3SF
☎ 07830 367125
Hartshorns Ignite; 2 changing beers (sourced nationally) ⊞
A friendly, welcoming community hub, this pub offers three handpulled beers, lager, keg beer, wine, spirits, tea and coffee. The drinks offering is complemented by a selection of (localish) pork pies, flapjacks, and genuinely local dog snacks to purchase. The first micropub in Derby, and Hartshorns Brewery's tap, the layout has been reworked, with every inch of space being put to good use. There is a sheltered garden area to the rear and vibrant, fresh, quirky decoration throughout.
Q ☼ ♣ ♠ 🗐 ☺ 🛜

No.189 L

189 Blenheim Drive, Allestree, DE22 2GN
Little Epiphany Pale Ale; Shiny Affinity; 4 changing beers (sourced regionally) ⊞
Opened in 2018 in the large Allestree estate, this former launderette, and then beauticians', has proved popular. The single-room micropub offers a choice of six real ales, including two from Little Brewery. Three craft ale taps are also on the bar. Furnishings include a mix of high and low seating, while outside there is a large covered seating area. The centre of Derby is a 15-minute bus ride.
Q ☼ ❀ 🗐 ♠ 🛜

Pot Hole

Unit 17, Park Farm Shopping Centre, Park Farm Drive, Allestree, DE22 2QQ
☎ 07714 388344
Falstaff Fist Full of Hops; 5 changing beers (sourced nationally) ⊞
Formerly a dry-cleaner's, the premises was transformed into Allestree's first micropub in 2017; a welcome return of a licensed venue in the Park Farm shopping area. This friendly single-roomed pub serves six real ales, including at least three from the local Falstaff Brewery who took over the running in 2020, and three guests. Outdoor seating is available at pavement tables. Q ❀ ♣ ♠ 🗐 ☺

Seven Stars Inn L ✓

97 King Street, DE1 3EE
☎ 07979 746299
Marston's Pedigree; 3 changing beers (sourced nationally) ⊞
The pub dates from 1680 and has many original features, giving it plenty of character. The building is now lower than the busy A6 that passes either side. There is a main bar at the front, a lounge at the back and a small snug at the very rear. A raised patio area provides outside drinking space. Do not miss the glass-topped well in the back bar. Four real ales are normally available, including three changing guest ales. ☼ ❀ ♣ ♠ 🗐 ☺ 🛜

Smithfield ▼ L

Meadow Road, DE1 2BH
☎ (01332) 986601 🌐 smithfieldderby.co.uk
Draught Bass; 9 changing beers (sourced nationally) ⊞
Situated near the city centre on the banks of the River Derwent, this pub is opposite Bass's Rec and a short walk from the main bus station. The main bar boasts an eclectic range of ever-changing interesting beers, including two darks, supported by the permanent Draught Bass. A subtle collection of breweriana is on view. A quiet separate room with a real fire overlooks the patio next to the river. The pub has regular live music and hosts many beer-related activities.
☼ ❀ ♣ ♠ 🗐 ☺ 🛜

Standing Order

28-32 Iron Gate, Cathedral Quarter, DE1 3GL
☎ (01332) 207591
Draught Bass; Greene King Abbot; Kelham Island Pale Rider; Marston's Pedigree; Ruddles Best Bitter; Sharp's Doom Bar; 12 changing beers (sourced nationally) ⊞
Named after its former role as a bank, this is the first, grandest and certainly the tallest of the three Wetherspoon outlets in Derby. High on the wall are full-size reproductions of paintings of Derby worthies from the time of the Industrial Revolution. There are a few quieter corners but generally this has the feeling of a busy city-centre pub. There is a good large selection of changing guest ales, complemented by the standard food range. Q ☼ ◑ ♠ ☺ 🛜

White Swan L ✓

Shepherd Street, Littleover, DE23 6GA
☎ (01332) 766481 🌐 thewhiteswanlittleover.co.uk
Greene King Abbot; Marston's Pedigree; Morland Old Speckled Hen; 6 changing beers (sourced regionally) ⊞
A popular community inn occupying a traditional site adjacent to the parish church in what was once Littleover village. Formerly a Festival Ale House and still keeping a choice range of guest ales, it is now owned by Greene King. Nine beers are usually served; three national brands and six local beers, and the pub is a long-standing holder of Cask Marque accreditation. Wonderful hanging baskets adorn the exterior, and the pub has a good reputation for food, with no booking policy. There is a big screen TV in the bar for sports fans. ☼ ❀ ◑ ♣ ♠ 🗐 ☺ 🛜

Dronfield

Coach & Horses L ✓

Sheffield Road, S18 2GD
☎ (01246) 413269 🌐 mycoachandhorses.co.uk
Thornbridge Lord Marples; Jaipur IPA; 4 changing beers (sourced locally; often Thornbridge) ⊞
Located next to Sheffield FC's ground, on the northern edge of Dronfield, the pub is operated by Thornbridge Brewery and showcases a good range of its beers across a wide range of styles. An occasional guest ale is also available. The large outdoor drinking area has been improved recently and is particularly popular when Sheffield FC have a home fixture or when live music is played. Quiz night is on Thursday and an open mic acoustic night is on Tuesday. ☼ ❀ ♣ ♠ 🗐 (43) ☺ 🛜

Duffield

Town Street Tap L

17 Town Street, DE56 4EH
☎ 07925 461706 🌐 thetownstreettap.co.uk
6 changing beers (sourced nationally) 🄶
Situated on the main road in Duffield, this is a micropub for Tollgate Brewery. Six changing real ales are offered, with table service - two from Tollgate and at least one a dark beer. Four-pint take-out containers are also available. The nicely decorated interior has modern-style high tables. There are occasional street food nights. Walkers with boots are welcome. The rear pub entrance and toilets have level access. Q ⇌ ♣ ♠ 🗐 ☺

Etwall

Spread Eagle

28 Main Street, DE65 6LP
☎ (01283) 735224

Draught Bass; Oakham Citra; Timothy Taylor Landlord; Thornbridge Jaipur IPA; 2 changing beers (sourced regionally) ⊞
This large village pub opposite the church in the middle of Etwall was obviously originally several different buildings. It has a single large room that was formerly many rooms and still retains a feel of different sections. The well-kept real ale offering continues to thrive and delivery is available to the local area. There is a paved seating area to the front. ❀♣P🚃🐾🛜

Glossop

Star Inn ✪
2 Howard Street, SK13 7DD (next to railway station)
☎ (01457) 761816
4 changing beers (sourced regionally; often Abbeydale, Distant Hills, Pictish) ⊞
A popular town-centre pub, run by a dedicated CAMRA member. The large, comfortable main room, where conversation predominates, features wood panelling, while a smaller room to the rear has a large map of part of the Peak District National Park on one wall. Guest beers are sourced mainly from local microbreweries. Close to the railway station, the pub is an ideal start or finish point for walking or cycling within the Dark Peak area. Q♣≉P🖪🚃🐾🛜

Hartshorne

Admiral Rodney Inn ✪
65 Main Street, DE11 7ES (on A514)
☎ (01283) 227771
Draught Bass; 3 changing beers (sourced nationally) ⊞
Traditional village local dating back to the early 19th century, but rebuilt and extended in the late 20th century to provide an open-plan L-shaped drinking space while retaining the original oak beams in the former snug. There is also a secluded raised area tucked away behind the bar. Hot food, often pop-up, is available Wednesday to Friday evenings. There is a meat bingo on the first Wednesday of the month, open mic night on the third Wednesday, and a quiz night every Sunday. The grounds include a cricket pitch, home of Hartshorne Cricket Club. 🚃❀🌙♣♠P🚃(2)🐾

Hayfield

Kinder Lodge ⒧
10 New Mills Road, SK22 2JG
☎ (01663) 743613 ⊕ kinder-lodge.co.uk
4 changing beers (often Moorhouse's, Morland, Storm) ⊞
A terraced stone-built pub dating from 1778 located on the edge of Hayfield village and close to the Hayfield Visitor Centre and the end of the Sett Valley Trail in the heart of the Peak District. The regular beer is usually Thornbridge Crackendale and is accompanied by three changing beers. On-site parking is limited, but the public P&D car park and the bus station are close by. There are five guest bedrooms. 🚃❀🛏♣P🚃🐾🛜

Heanor

Redemption Ale House ⒧
Ray Street, DE75 7GE
☎ 07887 568576
7 changing beers ⊞
This large open-plan micropub which opened in 2016 was previously a butcher's shop. The original abattoir is still outside and used as an area for the regular beer

festivals that are held here. Old framed photographs depict the pub's previous life. Six ever-changing beers and up to 20 real ciders are served. The pub has an upstairs area that offers a variety of board games to play. A large collection of pumpclips adorns the walls. Q❀♿♠🚃🐾🛜

Holbrook

Dead Poets Inn ⒧
38 Chapel Street, DE56 0TQ
☎ (01332) 780301
Draught Bass; Everards Old Original; Oakham Citra; 4 changing beers (sourced regionally; often Brunswick, Everards) ⊞
This beautiful old-worldly village pub was built in 1800 and was initially called the Cross Keys. It is now owned by Everards Brewery and leased by the Brunswick Brewery, based in Derby. A main stone-flagged bar area with low ceilings, high-backed pews and a large open fire is flanked by a cosy snug. A newer, delightfully airy, conservatory extension sits at the back, which leads to an outside drinking area. The pub holds an annual beer festival. Q🚃❀◑♠P🚃(71)🐾🛜

Holmesfield

Rutland Arms ⒧
96 Main Road, S18 7WT
☎ (0114) 289 0374
Bradfield Farmers Blonde; Peak Ales Bakewell Best Bitter; Theakston Best Bitter; 2 changing beers (sourced locally; often Bradfield, Marston's) ⊞
A popular, traditional village pub with open fires and low wooden beams offering a relaxing, warm and snug atmosphere. Up to six well-kept cask ales are served. A handsome collection of Wards breweriana can be seen throughout the pub. Outside, there is an extensive seating area with a grassed children's play area. A new heated log cabin style drinking shelter is a welcome addition. Morning coffee and lunchtime bar snacks are also available. Please note that last orders are called 45 minutes before closing time. Previous winner of several local CAMRA awards. Q🚃❀◑P🚃(16)🐾🛜

Hope

Cheshire Cheese Inn ⒧
Edale Road, S33 6ZF
☎ (01433) 620381 ⊕ thecheshirecheeseinn.co.uk
Abbeydale Moonshine; Bradfield Farmers Blonde; 4 changing beers (sourced locally; often Abbeydale, Bradfield, Peak Ales) ⊞
A cosy country inn dating from 1578 with an open-plan bar area and a smaller room at a lower level that was probably originally used to house animals, but now is mainly used as a dining area. Home-cooked meals featuring local produce are served lunchtimes and evenings. The pub is situated in good walking country but the parking is limited as the road outside is narrow. Q🚃❀🛏◑P🚃🐾🛜

Old Hall Hotel ✪
Market Place, S33 6RH
☎ (01433) 620160 ⊕ oldhallhotelhope.co.uk
Theakston Best Bitter, Lightfoot, Old Peculier; 3 changing beers (sourced nationally) ⊞
Set in the heart of the village of Hope, this large and atmospheric 16th-century building has been an inn since 1730. It is popular for its locally sourced food, and has five letting rooms together with extra facilities in the adjoining tearooms. Home of the Hope Valley Beer and

Cider Festival held on three bank holiday weekends a year, it also boasts a large collection of malt whiskies.
Q ⌂ ⛲ ❄ ◑ ▲P🅿😺🛜

Horsley Woodhouse

Old Oak Inn

176 Main Street, DE7 6AW
☎ (01332) 881299
8 changing beers (sourced regionally; often Bottle Brook, Leadmill) Ⓖ

As the tap house for the Leadmill and Bottlebrook breweries, the Old Oak features a variety of their ales plus guests, all currently served on gravity from the RuRAD (Rural Real Ale Drinkers) bar. This traditional, homely and welcoming pub has four rooms of differing character, some with open fires and all with a WiFi-free conversational atmosphere. At weekends additional beers are available at the RuRAD bar – making it effectively a mini beer festival. Q ⌂ ♿ ♣ ● P🖺😺

Hundall

Miners Arms 🏆 Ⓛ

Hundall Lane, S18 4BS
☎ (01246) 414505
Drone Valley Dronny Bottom Bitter; Pictish Alchemists Ale; 3 changing beers (sourced nationally; often Church End, Titanic, Welbeck Abbey) Ⓗ

A traditional open-plan village inn that has won numerous CAMRA awards at both local and regional levels. It offers a wide range of beers and fruit-based ciders, with regular ales from Pictish and the nearby Drone Valley Brewery, and real cider from Sandford Orchard. Three ever-changing guest beers are served in lined pint glasses. Dog-friendly, there is an excellent beer garden to the rear, and a large-screen TV with a good range of sports channels. A limited range of bar snacks is available all day. ⌂ ⛲ ◑ ♣ ● P🖺😺(15)😺🛜

Ilkeston

Burnt Pig Ⓛ

53 Market Street, DE7 5RB
☎ 07538 723722
5 changing beers Ⓗ/Ⓖ

This popular micropub has now been in the Guide since it opened over five years ago. It sells a wide range of top quality ales which are usually sourced personally by the landlord. Regulars and newcomers are welcomed with equal gusto. The interior is spread over three areas, from the busy bar to two rooms at the rear. A variety of bottled continental ales plus a selection of pork pies and cheeses are available to eat in or take away. Q ♣ ● 🖺😺

Dew Drop Inn Ⓛ

24 Station Road, DE7 5TE
☎ (0115) 932 9684
Oakham Bishops Farewell; house beer (by Oakham); changing beers (often Acorn, Blue Monkey, Castle Rock) Ⓗ

A longstanding entrant in the Guide, this is an unchanged, three-roomed, historic corner house pub with roaring fires in winter. There is a bar and lounge on either side of the serving area and a separate snug. Up to eight real ales are served, all kept to an excellent standard. Also on offer are two ciders and a bar menu during the day. The reopened Ilkeston railway station is a short walk away. Winner of numerous local CAMRA awards over the years. Q ⌂ ⛲ ◑ ➤ ♣ ● 🖺(27)😺

Observatory 😊

14A Market Place, DE7 5QA
☎ (0115) 932 8040
Greene King Abbot; Ruddles Best Bitter; Sharp's Doom Bar; 4 changing beers (often Exmoor) Ⓗ

Named after John Flamsteed, first Astronomer Royal, who was born locally, this Wetherspoon pub has returned to the Guide after fours years. The large bar, which looks out onto the Market Place through a glass frontage, dispenses seven cask beers. This pub has ground-floor toilets. Upstairs is a smaller seating and drinking area and an outside terrace. It is a short walk to Wharncliffe Road for all bus routes. Q ⌂ ⛲ ◑ ♿ ● 🖺🛜

Kirk Ireton

Barley Mow ★ Ⓛ

Main Street, DE6 3JP
☎ (01335) 370306 🌐 thebarleymowinn.co.uk
Whim Hartington Bitter, Hartington IPA; 2 changing beers (sourced locally; often Dancing Duck, Falstaff, Whim) Ⓖ

A firm favourite for generations, one of Britain's most venerated pubs set in a charming village. This gabled Jacobean building houses several interconnecting rooms and features low beams, mullioned windows and well-worn woodwork, with a welcoming open fire in the main room. It doesn't have a bar as such, but instead a small serving hatch through which the cask ales are fetched directly from the cellar. Good home-cooked food is available. Q ⌂ ⛲ ◑ ● 😺🛜

Little Eaton

Bell & Harp

227 Alfreton Road, DE21 5AE
☎ (01332) 986922
Draught Bass; 4 changing beers (sourced regionally) Ⓗ

Established in the early 19th century, this elevated pub on several levels was originally two adjacent stone cottages. The original steps to the cellar can be seen under a glass panel. A former Marston's pub, it was refurbished and reopened in 2019 by three local enthusiasts, and is now a free house. A comfortable patio outside overlooks fields and there is another garden adjacent to the car park. ⛲ ♣ P🖺😺🛜

Litton

Red Lion Ⓛ 😊

Church Lane, SK17 8QU
☎ (01298) 871458 🌐 theredlionlitton.co.uk
Abbeydale Absolution; Peak Ales Bakewell Best Bitter; 2 changing beers (sourced locally; often Acorn, Bradfield, Moorhouse's) Ⓗ

Nestling on the green and the only pub in the village, the Red Lion is a welcome refuge for locals and visitors alike. A large fireplace warms several rooms off a central passageway. Fresh food is served all day, every day. The pub holds a beer festival during the annual Wakes Week at the end of June, with village events including a well dressing on the green. ⌂ ⛲ ♿ ◑ ♣ P🖺(65,173)😺🛜

Long Eaton

York Chambers Ⓛ

40 Market Place, NG10 1LT
☎ (0115) 946 0999
6 changing beers (sourced nationally) Ⓗ

This micropub inhabits the old Midland Counties Bank which was built in 1904 by Scottish architects Ross & Gorman. A Grade II listed building with an impressive façade, its little-changed interior has high ceilings and an impressive wood-panelled fireplace. Six ever-changing real ales are dispensed by gravity. A range of ciders and quality wines is also available. This popular and friendly establishment is close to a number of bus routes.
Q&♿🚪🚧🐾🕸

Lullington

Colvile Arms ♥
Main Street, DE12 8EG (centre of village)
☎ 07510 870980 ⊕ thecolvilearms.com
Draught Bass; Marston's Pedigree; 2 changing beers (sourced regionally) Ⓗ
Leased from the Lullington Estate, seat of the Colvile family until the early 1900s, this popular 18th-century free house is at the heart of an attractive hamlet at the southern tip of the county. The public bar incorporates an adjoining hallway and features high-backed settles with wood panelling. The bar and a comfortable lounge are situated on opposite sides of a central serving area. A snug/function room overlooks the beer garden and lawn. Pop-up food vans visit every day except Sunday. Quiz night is the last Sunday of the month.
Q♀😊♣🚲P🐾🕸

Matlock

Farmacy Ⓛ
76 Smedley Street, DE4 3JJ (jct of Bank Rd/Smedley St)
☎ (01629) 583350 ⊕ aaabrewery.co.uk
5 changing beers (often Aldwark Artisan) Ⓗ
Up the hill from the town centre and behind County Hall on Smedley Street, this cosy, split-level micropub is the tap for Aldwark Artisan Ales. The five handpulls usually feature several real ales from the Aldwark range, and often an Ashover real cider. There is also a good choice of gins and wines. Pork pies and other snacks are available. Themed nights include music and quiz nights. Dogs are welcome. 😊≢🚪🐾🕸

Newsroom Ⓛ
75-77 Smedley Street East, DE4 3FQ
☎ (01629) 583625
4 changing beers Ⓗ
This smart conversion from a newsagent to a micropub is an L-shaped room with some exposed brickwork and renovated sash windows. There are four real ales from interesting local and sometimes national microbreweries. Six craft ales are also usually available, often including a stout and a lager – at least one will be KeyKeg. There are upwards of 60 different bottled and canned beers for drinking in or to take away, alongside a good range of gins and wines. ♿≢🚪(X17)🐾

Red Lion Ⓛ
65 Matlock Green, DE4 3BT
☎ (01629) 584888 ⊕ theredlionmatlock.co.uk
7 changing beers (often Moot) Ⓗ
Set back from the A615 behind the bus stop and shops in the Green area of Matlock, and just a short walk past the Hall Leys park and football ground away from the town centre, this is a large, impressive, open-plan building with several comfortable seating areas and a dining room to the left of the central entrance. Seven handpulls dispense up to four ales from the on-site Moot Ales Brewery. Dogs are welcome. Q😊🌞🍴🍽🏀♿&Ⅰ≢♣P🚪

Twenty Ten ♥ Ⓛ
16 Dale Road, DE4 3LT
☎ (01629) 259793 ⊕ twentytenmatlock.co.uk
4 changing beers (sourced regionally) Ⓗ
A stone's throw from the local train and bus stations, the bar nestles among the antique shops of Dale Road. It serves up to four real ales on handpull, with the focus mainly on LocAles, often Thornbridge. These are complemented by 16 draught craft beers, of which at least eight are KeyKeg. Lunchtime food is followed by a light bites menu until the evening. Live music is often performed on Friday and Saturday evenings.
😊🌞🍴🍴🐾🕸

Melbourne

Spirit Vaults Ⓛ
53 Church Street, DE73 8EJ
☎ (01332) 300542 ⊕ thespiritvaults.co.uk
House beer (by Morgan Brewmasters); 1 changing beer (sourced locally) Ⓗ
This pub was called the Blue Bell in the late 19th century – before then it was known by the ghostly title of the Spirit Vaults, and it has reverted to that name. The pub is well located for visitors to Melbourne Hall and its 12th-century Norman church. It has an outdoor heated drinking area and is popular with walkers. The in-house brewhouse, Morgan Brewmaster, supplies all the cask beers. There is also a good range of keg and Belgian beers. 🌞≢♣🚪(2)🐾🕸

Milford

King William
The Bridge, DE56 0RR
☎ (01332) 840842
Draught Bass; Greene King Abbot; Timothy Taylor Landlord; 3 changing beers (sourced nationally) Ⓗ
On the A6 between Derby and Belper, this stone-built Georgian inn is dramatically situated at the foot of sandstone cliffs and close to the river bridge. An open fire at one end of the elongated bar adds to the ambience of the cosy pub interior. Original period furniture and quarry-tiled flooring date from the time the pub was built. Ales may be available straight from the cask. Regular live music is an added attraction.
😊🍴♿♣🚪🐾🕸

New Mills

Beer Shed
47B Market Street, SK22 4AA
☎ (01663) 742005
Ossett White Rat; 3 changing beers (sourced locally; often Rock Mill, Torrside) Ⓗ
The Beer Shed is a micropub situated in a former video hire shop in the centre of New Mills close to all transport links. With a long, narrow main room, an additional room downstairs and a gazebo in the rear yard, this bar packs a lot into a small space. Four cask and six KeyKeg beers are on offer plus at least one lager (from Rothaus) and a real cider, usually from Heck's or Harry's. Occasional comedy nights and monthly Mikkeller Running Club events are held. 🌞≢(Central)🚪🚪🐾

Masons Arms
57 High Street, SK22 4BR
☎ (01663) 635466
Wainwright; 4 changing beers (sourced locally; often Stockport, Storm) Ⓗ
The only pub in the conservation area of New Mills, situated close to the Sett River Valley and Torrs

Millennium bridge. Extensively refurbished after its takeover from Robinsons, the bar offers a good selection of cask ales predominantly from local micros. It is a lively, friendly venue with a strong sports orientation and regular live music at weekends featuring local bands. There is a small drinking area outside. ⊛≉(Central) ♣P🅿🚱⚙🛜

Rock Mill Brewery – The Pits

Unit 1B, Rock Mill Lane, SK22 3BN (behind carpentry workshop off top of Union Rd)
☎ 07971 747050

4 changing beers (sourced locally; often Rock Mill) Ⓗ
Opened in 2018 and known as the Pits, the bar is located within the secluded RB Pine Joinery courtyard. The small craft brewery is in an adjacent building, producing traditional-style English ales and a few speciality beers. The small bar now sits in the old garage premises next door, with seating above the original pits where mechanics previously examined the cars. Three to four Rock Mill cask beers are available plus a keg beer, and Pitsberger Bohemian-style lager beer. Walkers and dogs are welcome. Q⊛≉(Central)🚱⚙

Newton Solney

Brickmakers Arms

9-11 Main Street, DE15 0SJ (on B5008, opp jct with Trent Lane)
☎ 07525 220103 🌐 brickmakersarms.pub

Burton Bridge Sovereign Gold, Bridge Bitter, Top Dog Stout, Stairway to Heaven; 1 changing beer (sourced regionally) Ⓗ

This cosy local at the end of an 18th-century terrace of cottages was converted into a pub in the early 19th century for workers at a nearby brickworks. It features a narrow central bar leading at one end to a room served through a hatch, and at the other to an impressive oak-panelled room. The street entrance hallway houses a small bring-and-take library, beyond which is a small function/meeting room. A semi-permanent marquee now occupies the former car park. There is an open mic night on Tuesday. Q👪⊛♣♠🚱(V3)⚙🛜

Ockbrook

Royal Oak ★ 🅛

55 Green Lane, DE72 3SE
☎ (01332) 662378 🌐 royaloakockbrook.com

Draught Bass; 4 changing beers Ⓗ

An attractive 18th-century pub with a number of small rooms. Run by the Wilson family since 1953, they have brought about many improvements while retaining the original character and features. Excellent home-cooked food is served every day. A large function room allows the pub to host many community and public events including live music and open mic nights. Outside there are two pleasant gardens, one with an enclosed play area for children. Local CAMRA Country Pub of the Year 2022. Q👪⊛🕪&♣♠P🚱(9,9A)⚙🛜

Parwich

Royal British Legion Club 🅛

Dam Lane, DE6 1QJ
☎ (01335) 390501

Dancing Duck Ay Up, Dark Drake; 1 changing beer (often Dancing Duck, Howard Town) Ⓗ

Sitting in the heart of the village, not far from the village pub, this welcoming club is open to all visitors. At least three real ales are usually available, one tapped direct from the cellar room, from local breweries such as

Dancing Duck, Wincle or Howard Town. Local branch Club of the Year 2022 and Derbyshire Club of the Year. Q👪⊛⚙🛜

Ripley

Red Lion ✅

Market Place, DE5 3BS
☎ (01773) 512875

Greene King Abbot; Ruddles Best Bitter; Sharp's Doom Bar; 8 changing beers (sourced nationally; often Exmoor, Thornbridge) Ⓗ

A former Home Brewery pub built in the 1960s and easily identified by the large red lion rampant on the pub frontage. Facing the Victorian Ripley Town Hall and Market Place at the centre of this busy market town, close to the main bus stops, it is a typical Wetherspoon outlet serving a large selection of guest beers and food all day. 👪⊛🕪&♣P🚱🛜

Talbot 🍷

1 Butterley Hill, DE5 3LT

8 changing beers (sourced nationally) Ⓗ

A traditional Victorian flatiron-shaped inn, the Talbot is free of music, instead preferring the sounds of conversation, laughter and traditional games. An excellent selection of real ales is on offer from casks stored on an original stone stillage. Look for the locally turned pump handles in various designs. A real fire adds warmth in winter at this welcoming and popular pub. Local CAMRA Pub of the Year and former Cider Pub of the Year. Q👪&♣♠P🚱(9.1,9.3)⚙

Rosliston

Bull's Head

Burton Road, DE12 8JU (NW edge of village)
☎ (01283) 762642 🌐 bullsheadrosliston.co.uk

Draught Bass; Marston's Pedigree; 2 changing beers (sourced regionally) Ⓗ

Late 19th-century brick-built free house with a comfortable public bar and smart, cosy lounge, both featuring open fires and beamed ceilings. There is also a large function room in a converted stable block. A collection of china bulls is displayed behind the bar, and intricate encased models of a Burton union brewing system can be found in both the public bar and the function room. Bingo is played on alternate Wednesday evenings, with an open mic night on Thursday. The National Forest Rosliston Forestry Centre is about half a mile away. 👪⊛🕪&♣♠P🚱(22)⚙🛜

Sawley

Lockkeeper's Rest 🅛

Tamworth Road, NG10 3AD
☎ (0115) 972 7651

4 changing beers Ⓖ

A new entry in this Guide, this micropub is situated in the old lockkeeper's cottage on the River Trent. Access is via a five to ten minute walk from Tamworth Road along the all-weather canal path, or as part of a longer walk incorporating Trent Lock. The bar is decorated with canal memorabilia. There are four changing beers on gravity, plus a number of real ciders. The outside area is ideal for watching the busy lock in operation. Q⊛🚱⚙

White Lion 🅛

Tamworth Road, NG10 3AT
☎ (0115) 946 3061 🌐 oldsawley.com

Old Sawley Oxbow, Little Jack; 1 changing beer (sourced locally) Ⓗ

Located close to the River Trent and Sawley Marina, the building dates back to the 18th century and is the home of the Old Sawley Brewery, offering up to four of its beers. The bar and lounge are separated by a central serving area. There is a large, attractive beer garden which occasionally stages live music during the summer. A pizza shack with a wood-burning pizza oven is open for food most Fridays or Saturdays May to October. ⍟❀♥P🚃🚆🛇

Scarcliffe

Horse & Groom 🅛

Mansfield Road, S44 6ST (on B6417 between Clowne and Stoney Houghton)
☎ (01246) 823152
Black Sheep Best Bitter; Greene King Abbot; Welbeck Abbey Red Feather, Atlas; 3 changing beers (often Abbeydale, Oakham, Ossett) 🅗
Up to seven beers and a cider are served at this early 19th-century coaching inn, which has been owned by the same family for 26 years. It has a tap room, a main bar, a spacious conservatory where families and dogs are welcome, and a large beer garden at the rear. There are two bus stops just outside the pub, one serving Chesterfield/Langwith and the other Mansfield/Sheffield. Q⍟❀♿P🚃(53,1)♥

South Normanton

Clock Inn

107 Market Street, DE55 2AA
☎ (01773) 811396 ⊕ theclockinn.co.uk
Peak Ales Bakewell Best Bitter; 2 changing beers 🅗
Multi-room pub with a lounge and a public bar area, both served by a central bar. Up to three ales are available including the house beer, an offering from Peak Ales. A nice lawned garden is to the rear with seating and a covered smoking area. Sky Sports and BT Sports are available in both rooms on large projection screens. Dogs are welcome on the bar side only. Q⍟❀P🚃(9.1)♥🛇

Market Tavern 🅛 ✅

41 High Street, DE55 2BP
5 changing beers (often Blue Monkey, Marble, Thornbridge) 🅗
Two-roomed micropub lovingly converted from what was previously a charity shop. Located on the market place, it offers up to five ever-changing real ales, usually sourced from local breweries, and up to six traditional ciders. Dogs and children are welcome at all times. A range of craft cans is also available. Q⍟♣♥P🚃(9.1)♥🛇

Stanton in Peak

Flying Childers Inn

Main Street, DE4 2LW (under a mile from B5056 Bakewell-Ashbourne road)
☎ (01629) 636333 ⊕ flyingchilders.com
3 changing beers (sourced regionally) 🅗
Four cottages were knocked into one during the 18th century, to create this unspoilt village pub named after a famous racehorse owned by the Duke of Devonshire. Set in the heart of a pretty village and near the historic Stanton Moor and Nine Ladies stone circle, it is popular with tourists, walkers and locals alike. The interior is welcoming with real fires, and there is a pleasant beer garden. Good home-made soups and snacks are available at lunchtime. Dogs are very welcome. Q❀◑♣P🚃♥

Sutton cum Duckmanton

Arkwright Arms 🅛

Chesterfield Road, S44 5JG (on A632 between Chesterfield and Bolsover)
☎ 07803 006926 ⊕ arkwrightarms.co.uk
Whim Arbor Light; 9 changing beers (sourced locally; often Ashover, Thornbridge, Whim) 🅗
Recently refurbished throughout, this Tudor-fronted freehouse boasts three rooms wrapped around a cental bar. It offers a varied range of up to 10 guest ales, often from Ashover, Thornbridge and Whim, and an extensive choice of fruit based/traditional ciders and perries. Good food is served from noon to early evening, except Monday and Tuesday. The pub holds regular beer festivals, is a winner of numerous local and regional CAMRA awards for beer and cider, and has been in this Guide for over 20 years. ⍟❀◑▲♣P🚃(1,1A)♥

Swanwick

Steampacket Inn

Derby Road, DE55 1AB
☎ (01773) 607771
Draught Bass; 5 changing beers (sourced nationally; often Blue Monkey, Derby, Nottingham) 🅗
A friendly and welcoming Pub People Company pub situated in the centre of Swanwick. The Steampacket boasts an excellent and constantly changing range of well-kept real ales and ciders, many of them from local microbreweries. A popular and lively pub at the weekend, it hosts regular live music, and a beer festival in winter and summer. There is a welcoming fire in winter and outdoor tables in summer. Q⍟♿♣♥P🚃♥🛆

Wardlow Mires

Three Stags' Heads ★ 🅛

Mires Lane, SK17 8RW (jct A623/B6465)
☎ (01298) 872268
Abbeydale Deception, Absolution; house beer (by Abbeydale); 1 changing beer (sourced regionally) 🅗
A quaint 300-year-old pub with two small rooms, stone-flagged floors and low ceilings. Unspoilt, it is one of the few pubs in the area identified by CAMRA as having anationally important historic pub interior. An ancient range warms the bar and the house dogs, one of which gave the name to the house beer – Black Lurcher. Traditional cider is only available in summer. Q❀▲P🚃(173)♥🛆

Whaley Bridge

Goyt Inn ✅

8 Bridge Street, SK23 7LR
☎ (01663) 732710
5 changing beers (sourced nationally; often Distant Hills, Timothy Taylor) 🅗
The Goyt is tucked away in the centre of Whaley Bridge and close to the historic Whaley Bridge Canal Basin at the end of the Peak Forest Canal, which once was the northern end of the Cromford and High Peak Railway. This end-of-terrace pub is a true local and fulfils its role well. It is characterful, dog friendly and welcoming, with a changing range of real ales and a small but attractive patio/beer garden. Well worth a visit. Q❀🚆♣🚃♥

Whaley Nook

20 Old Road, SK23 7HR (turn up Old Rd opp Co-op, bar is on left)

Abbeydale Deception; 3 changing beers (sourced locally; often Abbeydale, Eyam, Thornbridge) Ⓗ
Two-room pub with a small, cosy front bar and another small room at the rear, plus some French café-style seating outside on the pavement. Four handpumps offer one regular and three changing ales from local breweries, plus six craft beers and a real cider (Hogan's) on fonts. A loyalty card system operates during the week. An interesting selection of gins from far and wide is also available. Works of art by local artists are displayed for sale. Q✿☙●➡(199,61)❁ 🛜

Whitehough

Old Hall Inn Ⓛ

SK23 6EJ (nr Chinley, 750yds off B6062)
☎ (01663) 750529 ⊕ old-hall-inn.co.uk
Abbeydale Deception; Wainwright; 6 changing beers (sourced locally; often Big Stone, Marble, Thornbridge) Ⓗ
The 16th-century Whitehough Hall forms part of this quintessential country inn, which has previously won CAMRA Regional Pub of the Year, the Great British Pub award for best cask pub in the region for several years, and is a regular entry in this Guide. Eight ales, including six regularly changing beers from quality local micros, complement those available at the adjacent Paper Mill Inn (under the same ownership). Cider is from Hogan's. A popular food menu features dishes using local produce. A well-attended beer festival is held in September. Card payment only. ☙✿☙●Å♣P➡(190)❁ 🛜

Paper Mill Inn

Whitehead Lane, Chinley, SK23 6EJ (nr Chinley, 750yds off B6062)
☎ (01663) 750529 ⊕ old-hall-inn.co.uk
4 changing beers (sourced locally; often Abbeydale, Marble, Thornbridge) Ⓗ
This former Marston's pub was refurbished during lockdown to emerge as a country inn where drinking areas blend into dining rooms served by a pizzeria and pop-up kitchens. The pub is a maze of cosy rooms, flagstone floors and real fires. The handpulled ales and a range of KeyKeg beers are mainly from smaller local breweries. Belgian bottled beers are available, and occasional tap takeovers showcase guest breweries. The cider is from Hogan's. A beer festival is held in September in conjunction with the Old Hall Inn (under the same ownership). ☙✿☙●Å♣●P➡(190)❁ 🛜

Wirksworth

Feather Star Ⓛ

Market Place, DE4 4ET (in the Red Lion Hotel)
☎ 07931 424117 ⊕ thefeatherstar.co.uk
5 changing beers (sourced regionally) Ⓗ
Located inside the Red Lion Hotel, this bar serves five regularly changing handpumped beers, sourced locally and regionally. The tap wall offers up to 13 craft beers and lagers, plus five ciders. The owners have joined forces with Umami restaurant in the same building to provide hot bar snacks, and takeaway food can be brought into the bar. A Feather Star is the name for a Crinoid fossil found locally in the limestone around Wirksworth. Q☙➡➡❁

Youlgreave

George Hotel ✪

Alport Lane, DE45 1WN
☎ (01629) 636292

Theakston Best Bitter; 2 changing beers (sourced regionally) Ⓗ
A traditional multi-roomed Georgian pub in the centre of the village. The public bar features leather settees and a dartboard and is popular with locals. The main room includes a dining area where classic pub dishes are served. A display of Wedgwood plates adorns the walls. There is also a lounge to the rear.
Q☙✿☙●●&Å♣P➡🛜

Breweries

3P's

Burton Road, Woodville, Derbyshire, DE11 7JE
☎ 07590 285975 ⊕ 3psbrewery.co.uk

Innovative nanobrewery with a 600-litre Elite stainless steel two vessel system, founded in 2020 by an enthusiastic homebrewer. Using only the freshest natural ingredients, all beers are vegetarian and vegan-friendly (apart from the milk stout). 3P's brew beers with innovative twists throughout the year, alongside its core range. The name comes from Pits, Pots and Pipes for which Woodville was once renowned. Micropubs in Burton, Swadlincote and Derby are supplied. ◆V

Fools Gold (ABV 4.3%) PALE
Bob Ole (ABV 4.5%) BITTER
Knocker Upper (ABV 4.8%) BLOND
Big Butty (ABV 5%) BITTER
Tub Thumper (ABV 5.3%) PALE

Aldwark Artisan

Lydgate Farm, Aldwark, Matlock, Derbyshire, DE4 4HW
☎ (01629) 540720 ☎ 07834 353807
⊕ aabrewery.co.uk

⊠ This 10-barrel plant is housed in an old milking shed on a rural working farm, producing its first brew in 2017. Water comes from the farm's own bore hole, filtered through the strong limestone hills of the peak district. It has created the 'AAA' range of craft ales.

Nostrum Gold (ABV 3.8%) GOLD
Elixir Gold (ABV 3.9%) GOLD
Barbarian Gold (ABV 4%) PALE
Roan (ABV 4%) BITTER
Nostrum Amber (ABV 4.2%) BITTER
Eight Million (ABV 4.5%) GOLD
Hare of the Hill (ABV 4.6%) BLOND
Aldwark Pale (ABV 4.8%) PALE
Frankenstein (ABV 5.4%) PORTER

Alter Ego SIBA

Unit B2, Salcombe Road, Meadow Lane Industrial Estate, Alfreton, Derbyshire, DE55 7RG ☎ 07989 655828 ⊠ matt@alteregobrewing.co

Alter Ego upgraded in 2022 to a six-barrel brewery located in Alfreton producing full-flavoured, small-batch beers in cask and keg. The brewery tap is the Tip Inn micropub, Loscoe.

Echo Chamber (ABV 3.8%) PALE
Mr Brown (ABV 4.2%) BITTER
Blonde Protagonist (ABV 4.3%) BLOND
S'more Fire (ABV 5.2%) STOUT
Incognito (ABV 5.8%) IPA

Aristotle (NEW)

c/o Unit 4, Silver House, Griffen Close, Staveley,
Chesterfield, S43 3LJ
☎ (01246) 470074 ☎ 07496 757619
✉ richard@silverbrewhouse.com

⊗ A splinter brewery company set up from within Silver
Brewhouse to produce alternative beers on the same kit
for cask, keg, bottles and can. ♦

Ashover SIBA

Unit 1, Derby Road Business Park, Clay Cross,
Derbyshire, S45 9AG
☎ (01246) 251859

Second brewery: 1 Butts Road, Ashover, Derbyshire,
S45 0EW ⊕ ashoverbrewery.com

⊗ Brewing began in 2007 on a 3.5-barrel plant in the
garage of the cottage next to the Old Poets' Corner,
Ashover. Since its acquisition of a 10-barrel brewery in
the neighbouring village of Clay Cross in 2015, Ashover
now brews at both sites. The brewery serves local
freehouses across Derbyshire and further afield as well as
the Old Poets' Corner. ‼LIVE

Light Rale (ABV 3.7%) BITTER
Light in colour and taste, with initial sweet and malt
flavours, leading to a bitter finish and aftertaste.
Font (ABV 3.8%) GOLD
Poets Tipple (ABV 4%) BITTER
Complex, tawny-coloured beer that drinks above its
strength. Predominantly malty in flavour, with increasing
bitterness towards the end.
Littlemoor Citra (ABV 4.1%) PALE
The Fabrick (ABV 4.4%) GOLD
Rainbows End (ABV 4.5%) GOLD
Slightly smooth, bitter golden beer with an initial
sweetness. Grapefruit and lemon hop flavours come
through strongly as the beer gets increasingly dry
towards the finish, ending with a bitter, dry aftertaste.
Red Lion (ABV 4.6%) RED
Coffin Lane Stout (ABV 5%) STOUT
Excellent example of the style, with a chocolate and
coffee flavour, balanced by a little sweetness. Finish is
long and quite dry.
Butts Pale Ale (ABV 5.5%) PALE
Pale and strong yet easy to drink golden bitter.
Combination of bitter and sweet flavours mingle with an
alcoholic kick, leading to a warming yet bitter finish and
aftertaste.
Milk Stout (ABV 6%) STOUT

Aurora

Unit 6, Gallows Industrial Park, off Furnace Road,
Ilkeston, Derbyshire, DE7 5EP ☎ 07740 783631
⊕ aurora-ales.co.uk

Aurora was established in 2016. Joint owner Mark
Derbyshire, formerly of Hardy & Hanson's, brews on a 10-
barrel plant. Many local outlets, and a few further away,
are supplied direct. The brewery swaps beers with other
breweries throughout the UK, many of which can be
found in its micropub, the Ilson Tap.

Bad Bunny

26 Bullbridge Cottage, Ambergate, Derbyshire,
DE56 2EW ☎ 07519 605362
⊕ badbunnybrewery.co.uk

Founded by husband-and-wife team Mike and Clare
Chettle, brewing commenced in 2019. They now run a
1000-litre plant at their home in Bullbridge, Derbyshire,

supplying local pubs with fresh unfiltered casks as well as
occasional can and bottle releases. ☛♦LIVE

Johnny Utah (ABV 4.5%) IPA

Bang The Elephant

Unit 14, Bailey Brook Industrial Estate, Amber Drive,
Langley Mill, Derbyshire, NG16 4BE ☎ 07539 652055
✉ bangtheelephantbrewing@hotmail.com

⊗ Bang The Elephant is a neo-victorian, steam punk-
inspired, six-barrel brewery, creating small batch beers
for the cask, keg and bottle market.

Malty Coves (ABV 3.8%) BITTER
Gigglemug (ABV 4%) BITTER
Podsnappery (ABV 4%) GOLD
Half Rats (ABV 4.4%) PALE
Penny Dreadful (ABV 4.5%) STOUT
Sons of Liberty APA (ABV 5%) PALE
Kali Yuga (ABV 5.9%) PORTER
Odissi (ABV 6%) IPA

Bentley Brook

Unit 3, Lumsdale Mill, Lumsdale, Matlock, Derbyshire,
DE4 5EX ☎ 07483 831640

Office: 1 Hilltop Terrace, The Cliff, Matlock, DE4 5FY
⊕ bentleybrook.co.uk

⊗ Formed in 2018, this 1.5-barrel brewery is located in
the heart of Lumsdale Valley and named after the local
brook. It offers unfined, small batch beers available to
purchase in the local area and at the brewery. LIVE ♦

Big Stone SIBA

Ashen Clough, Maynestone Road, Chinley,
Derbyshire, SK23 6AH ☎ 07867 652062
✉ bigstonebeer@gmail.com

This small operation started brewing on a 2.5-barrel kit in
2019. It is based in large out-buildings connected to a
private house, on the outskirts of Chinley, in the heart of
the Peak District. Beers are available in bottles from local
outlets. Casks are supplied to a limited number of local
pubs. An onsite spring provides all the water used in
production. ♦LIVE V

Dimpus (ABV 3.5%) BITTER
Kinder Stout (ABV 4.2%) STOUT
Downfall (ABV 4.3%) PALE
Rough Rock (ABV 4.3%) BITTER
The Naze (ABV 4.5%) SPECIALITY
Mount Famine (ABV 5.5%) IPA

Birch Cottage

Birch Cottage, Wilne Road, Sawley, Derbyshire,
NG10 3AP ☎ 07966 757407
✉ birchcottagebrewery@outlook.com

Birch Cottage is a nanobrewery established in 2018
brewing small batch beers. Its brewery tap, Sawley
Junction, opened in 2018.

Birchover

▤ Red Lion, Main Street, Birchover, Derbyshire,
DE4 2BN
☎ (01629) 650363 ⊕ red-lion-birchover.co.uk

⊗ Brewing started at the Red Lion pub in the
picturesque Peak District village of Birchover in 2016, and
upgraded to a five-barrel plant by enthusiastic pub/
brewery owner in 2017. Core range beers are named

after local Stanton Moor landmarks and are to be found alongside seasonal specials on the pub bar. ◆LIVE

Black Hole SIBA

Unit 3a, Old Hall Mill Business Park, Alfreton Road, Little Eaton, Derbyshire, DE21 5EJ
☎ (01283) 619943 ☎ 07812 812953
⊕ blackholebrewery.co.uk

⊗ Black Hole was established in 2007 with a 10-barrel plant in the former Ind Coope bottling stores in Burton-on-Trent (since demolished). It moved to its current location in 2017. Fermenting capacity of 36 barrels enables the production of up to four brews per week, some of which are marketed under the Little Eaton Brewery and Mr Grundy's Brewery names. Around 400 outlets are supplied direct, and many more via wholesalers. Since 2014, the brewery has been owned by GHH Llp, which also owned the now closed Mr Grundy's Brewery. ‼◆

Bitter (ABV 3.8%) BITTER
Amber glow and malt and spicy hop aroma. Fresh, lively, session beer hopped to give a clean, crisp finish of hoppy dryness and touch of astringency.
Cosmic (ABV 4.2%) BITTER
Almost golden with an initial malt aroma. The complex balance of malt and English hops give lingering tastes of nuts, fruit and dry hoppy bitterness.
Supernova (ABV 4.8%) GOLD
Pure gold. Like marmalade made from Seville oranges and grapefruit the aroma mimics the sweet start but gives into the hops which deliver a dry lingering bitter finish.
IPA (ABV 5.2%) PALE
Milky Way (ABV 6%) SPECIALITY
Honey and banana nose advises the sweet taste but not the sweet, dry, spicy finish from this wheat beer.

Brewed for Small Beer, Lincoln:
Lincoln Imperial Ale (ABV 3.8%) GOLD

Brewed under the Little Eaton brand name:
Bates' Pale Ale (ABV 3.8%) PALE
Bagnall Bros Bitter (ABV 4.2%) BITTER
Delver's Drop IPA (ABV 4.8%) SPECIALITY
Old Mill Stout (ABV 5%) SPECIALITY

Brewed under the Mr Grundy's brand name:
Passchendaele (ABV 3.9%) PALE
Big Willie (ABV 4.3%) GOLD
Sniper (ABV 4.6%) BITTER
Lord Kitchener (ABV 5.5%) IPA

Bottle Brook

Church Street, Kilburn, Belper, Derbyshire, DE56 0LU
☎ (01332) 880051 ☎ 07971 189915
✉ information@leadmill.co.uk

⊗ A sister brewery to Leadmill (qv), Bottle Brook was established in 2005 using a 2.5-barrel plant on a tower gravity system. New World hops are predominantly used. The core range of beers is supplemented by one-off brews.

Columbus (ABV 4%) GOLD
Heanor Pale Ale (ABV 4.2%) PALE
Roadrunner (ABV 4.8%) GOLD
Mellow Yellow (ABV 5.7%) GOLD
Rapture (ABV 5.9%) GOLD
Sand in the Wind (ABV 6.1%) GOLD

Brampton SIBA

Units 4 & 5, Chatsworth Business Park, Chatsworth Road, Chesterfield, Derbyshire, S40 2AR
☎ (01246) 221680 ⊕ bramptonbrewery.co.uk

☺The original Brampton Brewery closed in 1955. In 2007 a new brewery was established, and brewing commenced on an eight-barrel plant. Three tied houses are situated close to the brewery. ‼☭◆LIVE

Golden Bud (ABV 3.8%) GOLD
Crisp and refreshing golden bitter with a pleasant balance of citrus, sweetness and bitter flavours. Light and easy to drink.
1302 (ABV 4%) PALE
Griffin (ABV 4.1%) PALE
Best (ABV 4.2%) BITTER
Classic, drinkable bitter with a predominantly malty taste, balanced by caramel sweetness and a developing bitterness in the aftertaste.
Impy Dark (ABV 4.3%) OLD
Strong, roasted coffee aroma and a rich flavour of vine fruit and chocolate combine to make this a tasty mild ale.
Jerusalem (ABV 4.6%) BITTER
Tudor Rose (ABV 4.6%) PALE
Wasp Nest (ABV 5%) BITTER
Strong and complex with malt and hop flavours and a caramel sweetness.
Speciale (ABV 5.8%) IPA

Brunswick SIBA

🍺 **1 Railway Terrace, Derby, DE1 2RU**
☎ (01332) 410055 ☎ 07534 401352
⊕ brunswickbrewingcompany.co.uk

⊗ Derby's oldest brewery. It is a 10-barrel tower plant built as an extension to the Brunswick Inn in 1991. Bought by Everards in 2002, the brewery is now run separately, yet in conjunction with the pub. It supplies the Brunswick Inn, Dead Poets Inn, Everards, wholesalers, and the free trade within 100 miles. Brunswick also swaps with other breweries. Beers are also produced under the Engine Shed Project brand name. ‼◆LIVE

White Feather (ABV 3.6%) PALE
Triple Hop (ABV 4%) BLOND
The Usual (ABV 4.2%) BITTER
Railway Porter (ABV 4.3%) PORTER
Rocket (ABV 4.7%) PALE
Black Sabbath (ABV 6%) OLD

Brewed under the Engine Shed Project brand name:
Ubiquitous (ABV 6%) IPA

Buxton

Units 4 A & B, Staden Business Park, Staden Lane, Buxton, Derbyshire, SK17 9RZ
☎ (01298) 24420 ⊕ buxtonbrewery.co.uk

Set up in 2009 as a five-barrel plant, Buxton now uses a 20-barrel plant. Its brewery tap is in Buxton and there is a tasting room at the brewery with views of the Derbyshire countryside. A wide range of small-batch beers is brewed throughout the year. ☭◆LIVE ✦

Little Tor (ABV 3%) BITTER
Moor Top (ABV 3.6%) PALE
Low Tor (ABV 3.8%) RED
Right to Roam (ABV 3.8%) BITTER
Gatekeeper (ABV 4.1%) PORTER
SPA (ABV 4.1%) PALE
Best Bitter (ABV 4.2%) BITTER
Blonde (ABV 4.6%) BLOND
Mild (ABV 6%) MILD

Chapel-en-le-Frith SIBA

5 Market Place, Chapel-en-le-Frith, Derbyshire,
SK23 0EW ☎ 07951 524003
⏺ chapelcraftbrewing.co.uk

☺Opened in 2016, this small brewery is located at the rear of Chapel-en-le-Frith post office. The brewing kit consists of a single 200-litre capacity integrated system supplemented by a 20-litre trial kit. Bottles and five-litre mini casks are available from the post office. Cask ales are available from a limited number of local outlets. 🍺

Siena (ABV 4.1%) GOLD
Savinjski (ABV 4.2%) GOLD
Rye The Hell Not (ABV 4.3%) RED
Isambard (ABV 4.4%) PALE
Busted Monkey (ABV 4.6%) BROWN
Leningrad (ABV 5%) RED
Elysium Amber Ale (ABV 5.4%) BITTER
Acadian (ABV 5.6%) IPA
Hoppy as Funk (ABV 5.8%) IPA
Sinamarian Black IPA (ABV 6%) IPA
USA (ABV 8%) IPA

Collyfobble SIBA

🍴 Peacock, Hackney Lane, Barlow, Derbyshire,
S18 7TD
☎ (0114) 289 0340 ⏺ collyfobblebrewery.com

☺This impressive looking, gleaming brewery is housed in the grounds of the Peacock at Barlow and can be viewed through the large glass panels built into the design. There is also a tasting room available to hire. The ales are brewed mainly for the Peacock although they may be also found at the neighbouring Tickled Trout Inn.
‼

Dancing Duck SIBA

1 John Cooper Buildings, Payne Street, Derby,
DE22 3AZ
☎ (01332) 205582 ☎ 07581 122122
⏺ dancingduckbrewery.com

⊠ Dancing Duck was established in 2010 by Rachel Mathews using a 10-barrel brew plant. Its name comes from the local greeting 'ay up me duck'. The Exeter Arms in Derby is the brewery tap. ‼🍺♦

Quack Addict (ABV 3.8%) BITTER
Ay up (ABV 3.9%) PALE
Brown Clough (ABV 4%) BITTER
Waitangi (ABV 4%) PALE
Ginger Ninja (ABV 4.1%) SPECIALITY
Nice Weather (ABV 4.1%) BITTER
Back Sack & Quack (ABV 4.2%) MILD
Donald *UCK! (ABV 4.2%) GOLD
Release The Quacken (ABV 4.2%) GOLD
Sapphire (ABV 4.2%) GOLD
22 (ABV 4.3%) BITTER
DCUK (ABV 4.3%) PALE
Beaky Blinders (ABV 4.5%) GOLD
Dark Drake (ABV 4.5%) STOUT
Waddle it be? (ABV 4.5%) PALE
Gold (ABV 4.7%) GOLD
Indian Porter (ABV 5%) PORTER
Quack Me Amadeus (ABV 5%) SPECIALITY
Abduction (ABV 5.5%) IPA
Imperial Drake (ABV 6.5%) STOUT

Derby SIBA

Masons Place Business Park, Nottingham Road,
Derby, DE21 6AQ

☎ (01332) 365366 ☎ 07887 556788
⏺ derbybrewing.co.uk

A family-run microbrewery, established in 2004 in the old Masons paintworks varnish shed by Trevor Harris, founder and former brewer at the Brunswick Inn, Derby (qv). The business has grown over the years and five venues are now owned across Derbyshire and Staffordshire with more in the pipeline. More than 400 outlets are supplied including major retailers. In addition to the core range there are at least two new beers each month. ‼🍺♦

Hop Till You Drop (ABV 3.9%) GOLD
Business As Usual (ABV 4.4%) BITTER
Penny's Porter (ABV 4.6%) PORTER
Dashingly Dark (ABV 4.8%) STOUT
Mercia IPA (ABV 5%) PALE
Quintessential (ABV 5.8%) OLD

Distant Hills SIBA

Hawkshead Mill, Hope Street, Glossop, Derbyshire,
SK13 7SS
☎ (01457) 869800 ⏺ howardtownbrewery.co.uk

☺Established in 2005, this award-winning brewery moved to its current location in 2007. In 2019 it moved into the premises next door, increasing the capacity of the brewery from eight barrels to 15. Six core beers are available for the free trade, along with seasonal beers. Its Tap is now open Wednesday-Sunday. New owners (in 2021) saw a name change in 2022 (previously Howard Town). ‼🍺 LIVE ♦

Longdendale Lights (ABV 3.9%) BLOND
Monk's Gold (ABV 4%) GOLD
Kerala (ABV 4.2%) GOLD
Wren's Nest (ABV 4.2%) BITTER
Super Fortress (ABV 4.4%) BITTER
Escapade Stout (ABV 4.7%) STOUT

Dovedale

Damgate Farm, Stanshope, Derbyshire, DE6 2AD
☎ 07714 105035 ✉ info@dovedalebrewing.co.uk

⊠ A small, independent craft brewery with a six-barrel (1,000-litre) capacity, specialising in small batch brewing, enabling it to produce a large range of different and limited edition beers. By concentrating on online sales locally and nationally, it has found new markets as well as consolidating its position as a premium local craft beer producer. Beer is available in cask, KeyKeg, bottle and minikeg. ♦LIVE

Echo Beach (ABV 3.8%) GOLD
Pale (ABV 3.8%) BLOND
Stout (ABV 4.6%) SPECIALITY
IPA (ABV 5.6%) IPA
Blonde (ABV 5.9%) BLOND

Draycott

Ladywood Lodge Farm, Spondon Road, Dale Abbey,
Derbyshire, DE7 4PS ☎ 07834 728540
✉ draycottbrewingcompany@yahoo.co.uk

⊠ Microbrewery established in 2014, supplying local pubs and beer festivals. It relocated to new premises in 2015, which saw beer range and capacity increase. A tap house in Draycott village is also operated.

Top of the Hops (ABV 3.8%) PALE
Lamb & Flag (ABV 4%) PORTER
Butcher's Bitter (ABV 4.2%) BITTER
California Steam Beer (ABV 4.2%) RED
Piano Man Blues (ABV 4.2%) RED

Lord Have Mercy (ABV 4.5%) SPECIALITY
Obsidian (ABV 4.5%) SPECIALITY
Tap House Tipple (ABV 4.5%) PALE
Minnesota North Star American Red
Ale (ABV 4.7%) RED
Irish Red Ale (ABV 5%) RED

Drone Valley SIBA

Unstone Industrial Complex, Main Road, Unstone,
Dronfield, Derbyshire, S18 4AB ☎ 07794 277091
⊕ dronevalleybrewery.com

☺Community-owned, five-barrel brewery that began
brewing commercially in 2016. All the brewing is carried
out by volunteers under the supervision of qualified,
experienced brewers. Profits go to local good causes.
New owner members are always welcome. The brewery
is open every Saturday and holds open days throughout
the year. ‼️🍴◆LIVE

Dronny Bottom Bitter (ABV 3.7%) BITTER
Gosforth Gold (ABV 4%) GOLD
Dronfield Best (ABV 4.3%) BITTER
Coal Aston Porter (ABV 4.5%) PORTER
Fanshaw Blonde (ABV 4.8%) PALE
Stubley Stout (ABV 5%) STOUT
Drone Valley I.P.A. (ABV 5.2%) GOLD
Candelriggs (ABV 5.8%) MILD
Carr Lane Black Label (ABV 6%) BITTER

Eyam

Unit 4, Eyam Hall Craft Centre, Main Road, Eyam,
Hope Valley, Derbyshire, S32 5QW ☎ 07976 432682
⊕ eyamrealalecompany.com

Brewing began in 2017 using a 1.5-barrel plant
producing keg and bottle-conditioned beers. Most output
goes to its shop and events but 10 local outlets are also
supplied.

Falstaff

🍺 24 Society Place, Normanton, Derby, DE23 6UH
☎ (01332) 342902 ☎ 07947 242710
⊕ falstaffbrewery.co.uk

⊗ Attached to the Falstaff freehouse, the brewery dates
from 1999 but was refurbished and reopened in 2003
under new management as a 3.5-barrel plant. Updated
again in 2017, it now operates as a six-barrel plant
producing a core range of six beers plus specials. More
than 30 outlets are supplied. ◆

Furnace

🍺 9 Duke Street, Derby, DE1 3BX
☎ (01332) 385981

Six-barrel brewhouse in the beer garden of the Furnace
Inn on Duke Street. Supply is mainly for the pub, but
beers can be seen at beer festivals and specialist pubs
across the UK.

Globe

🍺 144 High Street West, Glossop, Derbyshire,
SK13 8HJ
☎ (01457) 852417 ⊕ theglobeglossop.co.uk

Globe was established in 2006 by Ron Brookes on a 2.5-
barrel plant, in an old stable behind the Globe pub.
Grandson Toby now has a major role in the brewery
under the watchful eye of Ron. The beers are mainly for
the pub but special one-off brews are produced for beer
festivals. ◆

Hartshorns

Unit 4, Tomlinsons Industrial Estate, Alfreton Road,
Derby, DE21 4ED ☎ 07830 367125
✉ hartshornsbrewery@gmail.com

⊗ Hartshorns began brewing in 2012 using a six-barrel
plant installed by brothers Darren and Lindsey Hartshorn.
The brewery owns three pubs, the Little Chester Ale
House, Peacock in Derby, and Belper House, Belper.

Barley Pop (ABV 3.8%) BITTER
Ignite (ABV 3.9%) GOLD
Full Nelson (ABV 4.6%) PALE
Fusion (ABV 4.6%) GOLD
Shakademus (ABV 5.4%) GOLD
Psychotropic (ABV 5.8%) GOLD
Apocalypse (ABV 6.2%) GOLD

Hollow Tree

3 Glen Road, Whatstandwell, Matlock, Derbyshire,
DE4 5EH ☎ 07920 843754
⊕ hollowtreebrewing.co.uk

☺Nanobrewery with five core beers. Brewing began in
2019. There are also limited and seasonal releases which
use ingredients sourced and foraged from the local area.
◆LIVE

Instant Karma

🍺 4 John Street, Clay Cross, Derbyshire, S45 9NQ
☎ (01246) 250366 ⊕ instantkarmabrewery.co.uk

Instant Karma began brewing in 2012 using a five-barrel
plant with a brew length of 15 barrels per week. The
brewery is part of the Rykneld Turnpyke brewpub.

Intrepid SIBA

Unit 12, Vincent Works, Stretfield Road, Bradwell,
Derbyshire, S33 9HG ☎ 07936 174364
⊕ intrepidbrewing.co

Based in the Hope Valley in the Peak District, Intrepid
commenced brewing in 2014 using an eight-barrel plant
located in an old smelting mill. It's a small-batch
brewery, producing beers in cask, keg and bottle.

Leadmill

Unit 3, Heanor Small Business Centre, Adams Close,
Heanor, Derbyshire, DE75 7SW ☎ 07971 189915
✉ information@leadmill.co.uk

⊗ Set up in Selston in 1999, Leadmill moved to Denby in
2001 and again in 2010 to Heanor. A sister brewery to
Bottle Brook (qv), the brewery tap is at the Old Oak,
Horsley Woodhouse. ◆

Langley Best (ABV 3.6%) BITTER
Mash Tun Bitter (ABV 3.6%) BITTER
Old Oak Bitter (ABV 3.7%) BITTER
Dream Weaver (ABV 4.3%) GOLD
Linebacker (ABV 4.6%) BLOND
B52 (ABV 5.2%) BITTER
American Girl (ABV 5.6%) IPA
Rajah Brooke (ABV 5.6%) BLOND
Mellow Yellow (ABV 5.7%) BITTER
Slumdog (ABV 5.9%) GOLD

Leatherbritches

Brewery Yard, Tap House, Annwell Lane, Smisby,
Derbyshire, LE65 2TA ☎ 07976 279253
⊕ leatherbritches.co.uk

⊕The brewery, founded in 1993 in Fenny Bentley, has relocated and expanded over the years. It moved to its current address in 2011, where it effectively took over the existing Tap House Brewery (established 2010) but continued to brew the latter's beers. Since 2015, however, Tap House beers have become rebadged Leatherbritches products. ‼◆LIVE

Goldings (ABV 3.6%) BITTER
Bounder (ABV 3.8%) GOLD
Lemongrass and Ginger (ABV 3.8%) SPECIALITY
Ashbourne Ale (ABV 4%) PALE
Cad (ABV 4%) BITTER
Dr Johnson (ABV 4%) BITTER •
Scoundrel (ABV 4.1%) PORTER
Mad Ruby (ABV 4.4%) BITTER
Raspberry Belter (ABV 4.4%) SPECIALITY
Ashbourne IPA (ABV 4.7%) PALE
Hairy Helmet (ABV 4.7%) GOLD
Spitting Feathers (ABV 4.8%) BITTER
Bespoke (ABV 5%) BITTER
Game Over (ABV 5%) BITTER
Porter (ABV 5.5%) PORTER
Scary Hairy Export (ABV 7.2%) IPA

Little SIBA

Unit 9, Robinson Industrial Estate, Shaftesbury Street, Derby, DE23 8NL
☎ (01332) 987100 ⊕ littlebrewing.co.uk

Littleover Brewery was established in 2015. In 2020 it changed hands to the current owners, who rebranded as Little Brewing Company in 2022 in order to grow national sales. The team brew three times a week on an eight-barrel plant. GF V

Loop Extra Pale Ale (ABV 3.7%) PALE
Here Comes the Sun (ABV 3.9%) PALE
King George's Bitter (ABV 4%) BITTER
Epiphany Pale Ale (ABV 4.1%) PALE
The Panther Oatmeal Stout (ABV 4.2%) STOUT
Taj Session IPA (ABV 4.6%) PALE
Rambler (ABV 5.6%) PALE

Marlpool

⊜ 5 Breach Road, Marlpool, Heanor, Derbyshire, DE75 7NJ
☎ (01773) 711285 ☎ 07963 511855
⊕ marlpoolbrewing.co.uk

Marlpool was founded in 2010 by brothers Andy and Chris McAuley. The two-barrel brewery is situated behind the Marlpool Ale House. The brewery yard doubles up as a beer garden and the majority of the beer is sold through the Ale House and served unfined. The remainder is sold to reputable outlets. ‼◆LIVE

Matlock Wolds Farm SIBA

South Barn, Cavendish Road, Farm Lane, Matlock, Derbyshire, DE4 3GZ
☎ (01629) 697989 ☎ 07852 263263
⊕ woldsfarm.co.uk

⊗ Since starting in 2014 this family-run brewery has expanded several times. A five-barrel plant is currently used in a converted barn on the owner's 17th century farm. The full range of cask and bottle-conditioned ales are vegetarian and vegan-friendly. Seasonal beers are available, including in KeyKeg. ◆LIVE V

Simcoe (ABV 3.8%) GOLD
High Tor (ABV 4%) PALE
To the Bitter End (ABV 4.2%) BITTER
Riber Gold (ABV 4.3%) GOLD

100cc (ABV 4.9%) BITTER
Classic Porter (ABV 4.9%) PORTER

Moody Fox

Hilcote Country Club, Hilcote Lane, Hilcote, Derbyshire, DE55 5HR ☎ 07702 253235
✉ moodyfoxbrewery@gmail.com

Established in 2016, Moody Fox is a microbrewery specialising in traditional ales using the finest hops and barley from around the world. One micropub is owned, the Garrison, Mansfield.

Cub (ABV 3.8%) BITTER
Pale Tale (ABV 5.4%) PALE

Moot

⊜ c/o Red Lion Inn, Matlock Green, Matlock, Derbyshire, DE4 3BT
☎ (01629) 584888 ⊕ moot-ales.co.uk

⊕Moot Ales Brewery was established in 2018. All its beers are available in the Red Lion pub, to which it is attached, as well as other local outlets. Six core beers are available in cask and bottle. LIVE

Morgan Brewmasters

Spirit Vaults, 53 Church Street, Melbourne, Derbyshire, DE73 8EJ
☎ (01332) 300542 ☎ 07946 851828
✉ matt@thespiritvaults.pub

⊕Fully refurbished in 2020, this brewery is incorporated into the Spirit Vaults, Melbourne (formerly the Blue Bell Inn, brewery tap for Shardlow brewery), and can be viewed from within the pub. It brews new recipes with a modern twist, plus the ever popular Reverend. ‼◆

Vaults Gold (ABV 4.2%) GOLD
Reverend (ABV 4.5%) BITTER
Vaults Dark (ABV 5%) STOUT

Muirhouse

Unit 1, Enterprise Court, Manners Avenue, Manners Industrial Estate, Ilkeston, Derbyshire, DE7 8EW
☎ 07916 590525 ⊕ muirhousebrewery.co.uk

Muirhouse was established in 2009 in a domestic garage in Long Eaton. It expanded in 2011 to its present location in Ilkeston and the plant was upgraded in 2016 to 7.5 barrels. ‼◆

Hop Garden (ABV 4%) PALE
Summit Hoppy (ABV 4%) PALE
HDB (ABV 4.3%) GOLD
Magnum Mild (ABV 4.5%) MILD
Tick Tock Boom (ABV 4.5%) BITTER
Hat Trick IPA (ABV 5.2%) PALE

Old Sawley SIBA

⊜ White Lion, 352a Tamworth Road, Long Eaton, NG10 3AT
☎ (0115) 837 0250 ☎ 07722 311209
⊕ oldsawley.com

⊗ A 10-barrel microbrewery installed at the rear of the White Lion in Sawley. The White Lion stocks a full range of brews and the brewery is supplying Midland beer festivals, local pubs and pubs across the East Midlands. ‼◆LIVE

Peak SIBA

3-6 Park Farm Industrial Units, Longstone Lane, Ashford in the Water, Derbyshire, DE45 1NH
☎ **(01246) 583737**

Chatsworth: The Barn Brewery, Chatsworth, Bakewell, DE45 1EX ⊕ peakales.co.uk

⊕Peak Ales opened 2005 in a former derelict farm building on the Chatsworth estate, aided by a DEFRA Rural Enterprise Scheme grant and support from trustees of Chatsworth Settlement. Main production moved to a new facility at Ashford in the Water in 2014 to increase capacity. A shop and visitor centre opened in 2017 at the original site on the Chatsworth Estate, where a pilot brewery for experimental and occasional brews is now operational (with its own gin distillery). ☒◆

Swift Nick (ABV 3.8%) BITTER
Easy-drinking, copper-coloured bitter with balanced malt and hops and a gentle, hoppy, bitter finish.
Bakewell Best Bitter (ABV 4.2%) BITTER
Ful-bodied, tawny bitter with a hoppy bitterness against a malty background, leading to a happy, dry aftertaste.
Chatsworth Gold (ABV 4.6%) SPECIALITY
Speciality beer made with honey, which gives a pleasant sweetness leading to a hop and malt finish.
Black Stag (ABV 4.8%) STOUT
DPA (Derbyshire Pale Ale) (ABV 5%) GOLD
IPA (ABV 6%) IPA

Pentrich SIBA

Unit B, Asher Lane Business Park, Asher Lane, Pentrich, Derbyshire, DE5 3RB
☎ **(01773) 741700**
✉ pentrichbrewingco@gmail.com

Two former home brewers began producing beer in their garage in Pentrich, before moving to share the plant of Landlocked Brewing Co at the Beehive Inn, Ripley, in 2014. In 2016 they moved into their own premises using secondhand equipment. In 2019 a made-to-order 16-barrel plant was purchased. Every brew produced is a special (no regular beers produced). ◆

RBA

Oakwood, Derby, DE21 2RT ☎ **07943 367765**
✉ rbabrewery@gmail.com

In 2015 two friends, Richard Burton and Colin Fryer, began homebrewing in a shed in a back garden. Five years later they decided to sell commercially, and production increased accordingly. The 0.25-barrel plant brews three times a week with occasional brews being bottled.

Resting Devil (NEW)

▤ Chesterfield Arms, 40 Newbold Street, Chesterfield, Derbyshire, S41 7PH

Established in 2022 at the Chesterfield Arms, producing cask ales for the pub and occasionally for beer festivals. Bottled beers are also available. GF V

Rock Mill

▤ 1b Rock Mill Lane, New Mills, Derbyshire, SK22 3BN
☎ **(01663) 743999** ☎ **07971 747050**

Office: 81-83 Bridge Street, New Mills, SK22 4DN
✉ rbpine@Hotmail.co.uk

⊗ Rock Mill is a microbrewery established by Ray Barton, a former homebrewer, in 2016. ☒◆

Shiny

Unit 10, Old Hall Mill Business Centre, Little Eaton, Derby, Derbyshire, DE21 5EJ
☎ **(01332) 902809** ⊕ shinybrewing.com

Brewing commenced in 2012 using a six-barrel plant sited in the beer garden of the Furnace Inn, Derby. After initially brewing solely for the pub, 2014 saw an increase in scale and output, with beers distributed across most of the country. A second 12-barrel brew plant was built in 2015 to increase capacity and host a visitor centre, taproom and shop. ☒◆LIVE◆

New World (ABV 3.7%) BITTER
Happy People (ABV 4.1%) PALE
Wrench (ABV 4.4%) STOUT
4 Wood (ABV 4.5%) BITTER
Affinity (ABV 4.6%) GOLD
Disco Balls (ABV 5.3%) PALE

Shottle Farm

c/o School House Farm, Lodge Lane, Shottle, Derbyshire, DE56 2DS
☎ **(01773) 550056** ⊕ shottlefarmbrewery.co.uk

Located in the hills above Belper, the Grade II-listed farm is part of the Chatsworth Estate. Established in 2011 with a 10-barrel plant, beers are now contract brewed elsewhere. Shottle Farm has an onsite bar (limited opening hours), the Bull Shed, which is the only outlet for its beers. ◆LIVE◆

Shottlecock (ABV 3.6%) BITTER
Black Peggy (ABV 3.9%) MILD
Shottle Pale Ale (ABV 4%) PALE
BOB (Best of Both) (ABV 4.1%) SPECIALITY
Eight Shilling (ABV 4.1%) BITTER
Shottle Gold (ABV 4.3%) GOLD
Dilks (ABV 5%) BITTER

Silver SIBA

Units 3 & 4, Silver House, Adelphi Way, Staveley, Chesterfield, Derbyshire, S43 3LJ
☎ **(01246) 470074** ☎ **07496 757619**
⊕ silverbrewhouse.com

⊠ Silver Brewhouse is a 12-barrel brewery producing hop-forward and traditional ales. It also brews under the brand names Industrial Ales and Funky Hop Donkey including a range of single hopped ales under the Arkwright Pal label. ◆LIVE

West Coast Pale Ale (ABV 3.7%) PALE
Baby Ghost (ABV 3.9%) GOLD
Independence APA (ABV 4.1%) PALE
Eyup Cocker (ABV 4.3%) GOLD
Anubis Porter (ABV 5.2%) PORTER
Grey Ghost IPA (ABV 5.9%) IPA

Brewed under the Industrial Ales brand name:
Brickworks Bitter (ABV 4%) BITTER
Stephensons Pale (ABV 4%) PALE
Arkwrights Pale (ABV 4.1%) PALE
Coal Face Stout (ABV 4.5%) STOUT
Iron Ore IPA (ABV 5%) PALE

Taddington

Blackwell Hall, Blackwell, Buxton, Derbyshire, SK17 9TQ
☎ **(01298) 85734** ⊕ moravka-lager.co.uk

Taddington started brewing in 2007, and brews one Czech-style, unpasteurised lager in two different strengths. No real ale

Temper (NEW)

Dronfield Arms (Basement), 91 Chesterfield Road, Dronfield, S18 2XE ☎ 07725 639648

Office: 18 Egerton Road, Dronfield, S18 2LG
⊕ temperbrewing.com

⊗ Using the Hopjacker brewery kit situated in the basement of the Dronfield Arms, Temper Brewery is owned and run by Chris Wigg and started brewing in 2021. While the beers are mainly available on the bar at the Arms, they can also be obtained wholesale.

Resolve (ABV 4%) PALE
Wild Light (ABV 4.6%) GOLD
Sinter (ABV 4.8%) STOUT

Thorley & Sons

Ilkeston, Derbyshire, DE7 5JB ☎ 07899 067723
✉ dylan.thorley1@yahoo.co.uk

Thorley & Sons began brewing commercially in 2016 on a 1.5-barrel plant located in an old coach house at the rear of brewer Dylan Thorley's house.

Pale & Interesting (ABV 4.5%) PALE

Thornbridge SIBA

Riverside Business Park, Buxton Road, Bakewell, Derbyshire, DE45 1GS
☎ (01629) 815999 ⊕ thornbridgebrewery.co.uk

☺The first Thornbridge craft beers were produced in 2005 using a 10-barrel brewery, housed in the grounds of Thornbridge Hall. The beers have gained considerable success with over 300 consumer and industry awards won. A 30-barrel brewery opened in Bakewell in 2009. The original site continues to develop new, seasonal and speciality beers. 200 outlets are supplied direct. 12 pubs are managed and owned. ‼ ☰ ♦ LIVE

Wild Swan (ABV 3.5%) BLOND
Extremely pale, yet flavoursome and refreshing beer. Plenty of lemony citrus hop flavour, becoming increasingly dry and bitter in the finish and aftertaste.
Astryd (ABV 3.8%) GOLD
Brother Rabbit (ABV 4%) BITTER
Lord Marples (ABV 4%) BITTER
Smooth, traditional, easy-drinking bitter. Caramel, malt and coffee flavours fall away to leave a long, bitter finish.
The Wednesday (ABV 4%) BLOND
Ashford (ABV 4.2%) BITTER
AM:PM (ABV 4.5%) GOLD
Market Porter (ABV 4.5%) PORTER
Kipling (ABV 5.2%) GOLD
Golden pale bitter with aromas of grapefruit and passion fruit. Intense fruit flavours continue throughout, leading to a long bitter aftertaste.
Jaipur IPA (ABV 5.9%) IPA
Flavoursome IPA packed with citrus hoppiness that's nicely counterbalanced by malt and underlying sweetness and robust fruit flavours.
Cocoa Wonderland (ABV 6.8%) PORTER
Saint Petersburg Imperial Russian Stout (ABV 7.4%) STOUT
Good example of an imperial stout. Smooth and easy to drink with raisins, bitter chocolate and hops throughout, leading to a lingering coffee and chocolate aftertaste.

Thornsett

Thornsett Fields Farm, Briargrove Road, Birch Vale, Derbyshire, SK22 1AX ☎ 07803 477812
⊕ thornsettbrewery.co.uk

☺Located on Thornsett Fields Farm in Thornsett, High Peak, the brewery uses a one-barrel plant with two fermenters. The brewery is as sustainable and eco friendly as possible, relying on renewable energy sources – gas and solar. Alongside the brewery is an organic hop yard with eight different hop varieties. Its onsite taphouse has open days with local food stalls. LIVE ♦

Tollgate SIBA

Unit 1, Southwood House Farm, Staunton Lane, Calke, Derbyshire, LE65 1RG
☎ (01283) 229194 ⊕ tollgatebrewery.co.uk

⊗ This six-barrel brewery was founded in 2005 on the site of the old Brunt & Bucknall Brewery in nearby Woodville, but relocated to new premises on the National Trust's Calke Park estate in 2012. Only around 20 outlets are now supplied direct, mainly in the North Midlands, with most cask production directed to the brewery's three micropubs: Queens Road Tap, Leicester, Tap at No.76, Ashby-de-la-Zouch, and Town Street Tap, Duffield, plus the brewery tap, the Milking Parlour. ‼ ☰ ♦ LIVE ♦

Hackney Blonde (ABV 3.9%) SPECIALITY
Melbourne Bitter (ABV 4%) GOLD
California Steam (ABV 4.2%) SPECIALITY
Eclipse BIPA (ABV 4.2%) GOLD
Mystic (ABV 4.2%) GOLD
Red Storm (ABV 4.2%) RED
Duffield Amber (ABV 4.4%) BITTER
Ashby Pale (ABV 4.5%) PALE
Old Rasputin (ABV 4.5%) STOUT
Red Star IPA (ABV 4.5%) PALE
Billy's Best Bitter (ABV 4.6%) BITTER
High Street Bitter (ABV 4.7%) BITTER
Spark IPA (ABV 5.6%) IPA

Torrside

New Mills Marina, Hibbert Street, New Mills, Derbyshire, SK22 3JJ
☎ (01663) 745219 ☎ 07539 149175
⊕ torrside.co.uk

☺Established by three friends in 2015, Torrside brews a wide range of beers on a 10-barrel plant, under the tagline Hops, Smoke, Monsters. A changing line-up of largely hop-driven, smoked and strong beers are sold to pubs, bars and bottle shops within a 50-mile radius. All beers are unfined. Brewery tap events usually take place one weekend each month (March-September) and there's also a smoked beer festival held in September. The Shrub Club, Torr Vale Mill, permanently serves five Torrside beers (KeyKeg). ‼ ☰ LIVE

Candlewick (ABV 4%) STOUT
Trespasser (ABV 4%) PALE
West of the Sun (ABV 4.5%) GOLD
I am Curious Lemon (ABV 4.8%) SPECIALITY
Franconia (ABV 5.2%) SPECIALITY
I'm Spartacus (ABV 6.8%) IPA

Townes

Speedwell Inn, Lowgates, Staveley, Chesterfield, Derbyshire, S43 3TT
☎ (01246) 472252

Townes Brewery was started by Alan Wood in 1994 at an old ice cream factory and moved to its present site, the Speedwell Inn at Staveley, in 1997. The brewery and pub were taken over by Lawrie and Nicoleta Evans on Alan's retirement in 2013. They continue to use Alan's recipes at the five-barrel brewery. Townes beers are rarely found

outside the pub, other than occasional swaps and at beer festivals.

Urban Chicken SIBA

Ilkeston, Derbyshire, DE7 5EH ☎ **07976 913395**
⊕ urbanchickenale.co.uk

Upgraded in 2022 to a 2.5-barrel brewery, producing small batch beer for local pubs, restaurants, bottle shops and beer festivals. Registered as a commercial brewery in 2016. Cask and bottle, unfined.

Mad Van Mild (ABV 4.2%) MILD
Rooster Juice (ABV 4.3%) PALE
Earthquake (ABV 5.6%) STOUT
Insane in the Henbrain (ABV 5.9%) GOLD
Chick Weed Revenge (ABV 6.3%) IPA
Pit Pony Plus (ABV 6.5%) STOUT

Whim

Whim Farm, Hartington, Derbyshire, SK17 0AX
☎ **(01298) 84991** ⊕ whimales.co.uk

Whim Ales began brewing in 1993 in an outstanding location at Whim Farm near Hartington in the Derbyshire Dales, Peak District. It produces cask ales using the finest ingredients, Derbyshire hill water and its own yeast. The beers are available in 50-70 outlets and the brewery's tied house, Wilkes Head, Leek. ♦

Arbor Light (ABV 3.6%) GOLD
Hartington Bitter (ABV 4%) PALE
Caskade (ABV 4.3%) PALE
Hartington IPA (ABV 4.5%) PALE
Red House Porter (ABV 4.7%) PORTER
Flower Power (ABV 5.3%) GOLD

Alexandra Hotel, Derby (Photo: James Williams)

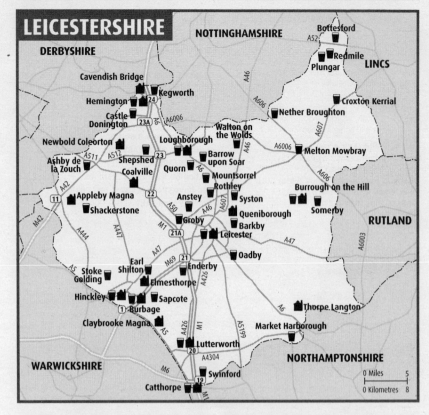

LEICESTERSHIRE

Anstey

Mash & Press
46C Albion Street, LE7 7DE
☎ 07960 776843 ● ansteyale.co.uk
House beer (by Anstey); 3 changing beers (often Anstey) Ⓗ
The Mash & Press is a collaboration between Anstey Ale Brewery and Charnwood Cider, and serves as the tap house for both. The upstairs bar offers up to four changing cask ales on handpull. There are also up to four keg lines and eight real ciders, plus local wines and a wide range of gins and other spirits. Dogs are welcome both in the pub and in the refurbished beer garden, which has plenty of seating. ➤❀✿●🚲(74,54A)🐾🅦

Ashby De La Zouch

Tap at No.76
76 Market Street, LE65 1AP
Tollgate Ashby Pale; 4 changing beers (often Tollgate) Ⓗ
Welcoming high street micropub that is a relatively recent addition to the Ashby scene. This Tollgate Brewery pub serves five real ales; four by handpump and the other by gravity. Three third-pint tasting trays are available for those wishing to try the full range of beers. A large selection of bottle-conditioned Tollgate ales is available to take away. Snacks include pork pies. Q🚲🐾

Barkby

Malt Shovel
27 Main Street, LE7 3QG

☎ (0116) 269 2558 ● maltshovelbarkby.co.uk
Thwaites Original, Gold, Amber; 1 changing beer (often Thwaites) Ⓗ
Family-friendly village pub that offers drinkers a warm welcome and serves good-value home-cooked food in its bar and restaurant. Guest beers are supplied by Thwaites, often from other breweries in the North West. The pub has a large garden for summer, and hosts a beer festival on the first weekend of August. ➤❀◑&🅿🚲(100)🐾🅦

Barrow upon Soar

Navigation
87 Mill Lane, LE12 8LQ
☎ (01509) 412842
Greene King Abbot; 2 changing beers (sourced nationally; often Adnams, Marston's, Moorhouse's) Ⓗ
A warm and friendly pub that welcomes muddy boots and dogs, and children until 9pm. Its open-plan main bar features distinct seating areas and a warming log-burner. There is a small snug at the front. Note the bar top incorporating old penny coins. A function room is available for hire. The canalside patio is popular in summer. Moorings are available for passing pleasure boats. ➤❀◑⚓♣🚲(2)🐾🅦

Bottesford

Bull Ⓛ
Market Street, NG13 0BW
☎ (01949) 842288
Castle Rock Harvest Pale; Fuller's London Pride; Theakston Best Bitter Ⓗ

Set on the main road through this busy village, well served by train and bus, the Bull has a large bar area with a real fire, pool table and plenty of seating. There is also a separate lounge for quieter drinking, plus a function room that regularly hosts live music. Three cask ales are served, including one LocAle. Memorabilia in the lounge and a plaque outside commemorate Stan Laurel and Oliver Hardy's visits in the 1950s, when Laurel's sister was the landlady. Outside are a seating area and a good sized car park. ⏰&⇌♣P🗐🛜

Burbage

Lime Kilns Brew Pub 🅛 ✅

Watling Street, LE10 3ED

☎ (01455) 631158 🌐 limekilnsinn.co.uk

Purity Mad Goose; Timothy Taylor Landlord; 2 changing beers (sourced locally; often Buswells) Ⓗ

Situated alongside the Ashby Canal and the A5, this was originally an 18th-century coaching inn. The large canalside beer garden offers free moorings, a functions marquee and wet weather cover. The first floor lounge has canal views and an open fire. The ground floor stable bar, with wood burner, opens onto the garden. Traditional food is served all week with homemade pies being the speciality. It is home to the Buswells microbrewery and serves eight real ciders.
🛇⏰🕪&♣P🛜

Burrough on the Hill

Stag & Hounds 🅛

4 Main Street, LE14 2JQ

☎ (01664) 454250 🌐 stagnhoundspub.co.uk

Parish PSB; 1 changing beer (sourced nationally) Ⓗ

A 16th-century inn, the Stag & Hounds operated as Grant's Free House before reclaiming its original name following subtle refurbishment in 2019. It has a bar on two levels, a cosy lounge and a restaurant to the rear. A central servery dispenses PSB from the Parish Brewery, which is located in an adjacent outbuilding, plus a guest ale. The restaurant serves a varied menu of locally sourced food and champions the area's best suppliers.
🛇⏰🕪P🗐🛜

Castle Donington

Flag

32 Borough Street, DE74 2LA

☎ 07841 374441

6 changing beers Ⓗ

A thriving micropub in the heart of a busy street. It serves real ale on handpump straight from the cask, visible from a temperature-controlled cool-room cellar. A range of six ciders and quality wines is also kept. There is outside seating for fine weather. Skylink bus services make the pub accessible from Derby, Nottingham, Loughborough and Leicester. Q🛇🕪🗐🛜

Catthorpe

Cherry Tree 🅛

Main Street, LE17 6DB (on main road through village ½ mile from A5)

☎ (0116) 482 7042 🌐 cherrytreecatthorpe.co.uk

3 changing beers (sourced locally; often Dow Bridge, Purity) Ⓗ

Welcoming two-roomed village local with a modern twist, sympathetically renovated by new owners. Ales from Catthorpe's Dow Bridge Brewery take pride of place on the bar alongside English red and white wines and local gins and whiskies. Locally sourced home-cooked

food includes vegetarian, vegan and children's options. The south-facing terrace and garden overlook the Avon Valley. 🛇⏰🕪AP🛜🛜

Croxton Kerrial

Geese & Fountain 🅛

1 School Lane, NG32 1QR

☎ (01476) 870350 🌐 thegeeseandfountain.co.uk

5 changing beers Ⓗ

Village inn with a quiet, relaxed atmosphere, featuring wood fires, a flagstone floor and rustic seating. Local ales are always among the beers on five handpumps, with guests from nearby microbreweries, plus lagers and three real ciders. Food is served every day, and B&B rooms are available. Regular live music nights and occasional mini beer and cider festivals are held throughout the year. Children, cyclists, walkers and dogs are all welcome. Local CAMRA Cider Pub of the Year 2022. Q🛇⏰🚲🕪&♣P🛜🛜

Earl Shilton

Shilton Vaults 🅛

3 The Hollow, LE9 7NA

☎ 07715 106876

Draught Bass; 4 changing beers Ⓗ

Previously a bank, this welcoming pub with friendly staff pub opened in 2018. There are three rooms: the main bar, centre room and the original vault with a small outdoor space. There are 12 cask spaces on racks in an air-conditioned ground floor cellar. Three or four real ales are available alongside craft lagers, eight traditional ciders and speciality gins. Accessed directly from the street; toilets are upstairs. Sister pub to the Pestle and Mortar, Hinckley. Q🛇⏰&♣🗐🛜

Enderby

Mill Hill Cask & Coffee

12-14 Mill Hill, LE19 4AL

🌐 millhillcaskandcoffee.com

4 changing beers Ⓗ

Micropub with a modern decor, a relaxed atmosphere and a clientele of locals and passing trade. The owners have established a reputation for well-conditioned beers from top UK microbreweries, with up to four cask ales and up to 10 KeyKegs to choose from. Food includes

home-made sandwiches, cakes and locally sourced pies. An outside seating area with heaters and a retractable roof is a popular addition.
Q♿️🅿🐾♿⚙️(Narborough) ♦P�🚃(50,X55) 🐾🐕 📶

New Inn

51 High Street, LE19 4AG
☎ (0116) 286 3126
Everards Tiger; 2 changing beers (often Everards) Ⓗ
Friendly thatched village local that dates from 1549, tucked away at the top of the High Street. Everards' first tied house, the pub is renowned locally for its beer quality and is frequented by the brewery's staff. Its three rooms are served by a central bar. To the rear are a snooker room and an area for long alley skittles, plus a patio and garden outside. Lunches are served Tuesday to Saturday. Q🏵🐕♣🚃(50)

Groby

Stamford Arms Ⓛ

2 Leicester Road, LE6 0DJ
☎ (0116) 287 5616 ● stamfordarms.co.uk
Everards Beacon Hill, Tiger; 5 changing beers (sourced nationally; often Everards) Ⓗ
A superb village pub that serves good food, modernised in 2020 and continuing to develop into an outstanding venue. It offers seven cask ales plus craft beer, cider and an extensive gin selection. The food is traditional, with a pizza oven and daily specials. Covered outdoor dining pods are available, seating up to four people. A recent local CAMRA Country Pub of the Year.
♿🏵🅾🍴♣♦P🚃🐾📶

Hemington

Jolly Sailor

21 Main Street, DE74 2RB
☎ (01332) 812665
Draught Bass; 4 changing beers (sourced regionally) Ⓗ
This 17th-century building is thought to have once been a weaver's cottage. A pub since the 19th century, it is now the only one in the village. It retains many original features including old timbers, open fires and a beamed ceiling – convenient for hanging a collection of beer mugs. Well-filled rolls are available. Q♿🏵♿P🐾📶

Hinckley

Greyhound Ⓛ ✅

9 New Buildings, LE10 1HN
☎ (01455) 697519 ● thegreyhoundhinckley.co.uk
Marston's Pedigree; 3 changing beers (sourced locally; often New Buildings) Ⓗ
A traditional three-roomed town-centre wet house. A pub since at least 1815, it features a traditional interior. Reopened in 2013 under the management of the landlady of the New Plough Inn round the corner, it became a free house in 2014 and its bars were refurbished in 2022. There is a popular Sunday carvery and a spacious function room for hire. A blue plaque commemorating William Butler of Mitchells & Butlers adorns the exterior of the pub. 🍴♣🚃(X55,8)🐾📶

New Plough Inn 🍷

Leicester Road, LE10 1LS
☎ (01455) 615037 ● thenewploughinn.co.uk
Marston's Pedigree; 5 changing beers (often Brains, Courage, Tetley) Ⓗ
Opened at the beginning of the last century, it was named the New Plough because a pub called the Plough

was already in existence in Hinckley. The pub features old settles, a skittles alley, over 50 gins and rugby memorabilia that reflects sponsorship of the local team. The landlady is a CAMRA member and the pub has raised over £100,000 for charity via the monthly quiz. Local CAMRA Pub of the Year in 2011/12 and 2022.
♿🏵🐕♣🚃(159) 🐾📶

Pestle & Mortar Ⓛ

81 Castle Street, LE10 1DA
☎ 07715 106876 ● thepestlehinckley.co.uk
Draught Bass; 8 changing beers (sourced nationally) Ⓗ
Opened in 2015, Hinckley's first micropub satisfies a wide range of drinking tastes, with up to 22 changing real ciders available, including Westons Old Rosie Rhubarb. Handpumps deliver up to eight changing real ales from casks behind the bar. Cobs are available. This comfortable, pleasantly quirky micropub with a friendly atmosphere was awarded local CAMRA Cider Pub of the Year 2016-20 and 2023, East Midlands Cider Pub of the Year 2016 and local CAMRA Pub of the Year 2019-20.
Q♿🐾♣♿🚃(8,X55) 🐾📶

Kegworth

Red Lion

24 High Street, DE74 2DA
☎ (01509) 672466 ● redlionkegworth.co.uk
Charnwood Salvation, Vixen; Courage Directors; Marston's Pedigree; 3 changing beers (sourced nationally) Ⓗ
Refurbished Georgian building on the historic A6 route, with six rooms including a restaurant and new function room. The pub serves seven cask beers alongside a large selection of gins, whiskies and wines. Sunday lunch is popular. Outside is a car park as well as a large beer garden with ample seating. Q♿🏵♿🅾🍴♣♦P🚃🐾📶

Leicester

Ale Stone

660 Aylestone Road, Aylestone, LE2 8PR
☎ (0116) 319 2320 ● alestone.co.uk
House beer (by Shiny); 5 changing beers Ⓗ
Micropub in a converted shop unit, featuring a nicely furnished interior with wooden benches and dados all round. Up to five real ales, plus four ciders and perries, are stillaged in a temperature-controlled glass-fronted cellar. Ham and cheese cobs and coffee are available.
Q♿♿🚃🐾📶

Ale Wagon

27 Rutland Street, LE1 1RE
☎ (0116) 262 3330
Hoskins Hob Bitter, IPA Ⓗ**; house beer (by Hoskins)** Ⓟ**; 4 changing beers (sourced regionally; often Hoskins)** Ⓗ
City-centre pub whose 1930s interior features an original oak staircase, two rooms with tiled and parquet floors and a central bar. The walls display photos of the former Queen's Hotel, which was across the road from the pub, and the old Hoskins Brewery. Hoskins family recipe beers are still served. A function room is available to hire. Handy for the nearby Curve Theatre. ♿♦🚃

Black Horse Ⓛ

1 Foxon Street, LE3 5LT
☎ (0116) 254 0446
Everards Sunchaser, Tiger, Old Original; 3 changing beers (sourced nationally) Ⓗ

The only remaining traditional community pub in a street of youth-oriented bars. It has two rooms separated by a central bar, with wood-panelled walls and practical furniture providing a comfortable setting. Guest beers are selected through Everards. The pub hosts live music four nights a week and a quiz on the first Sunday of the month. A roof terrace is popular for open-air drinking. 🏠♣🖳🐾📶

Black Horse

65 Narrow Lane, Aylestone, LE2 8NA

☎ (0116) 283 7225

Everards Tiger; 3 changing beers (often Titanic, Everards) 🅷

Welcoming, traditional Victorian pub with a distinctive bar servery, set in a village conservation area on the city's edge. Up to eight real ales and a changing range of four real ciders are offered alongside home-cooked food. Quiz night is Sunday and comedy features regularly. There is a large beer garden, and a skittle alley and function room available to hire. Beer festivals and community events are regularly hosted. Coaches are welcome by prior arrangement. Q🚶🏠🌗♣🖳🐾📶

Blue Boar 🗅

16 Millstone Lane, LE1 5JN

☎ (0116) 319 6230 🌐 blueboarleicester.co.uk

Beowulf Finn's Hall Porter; house beer (by Shiny) 🅷; **11 changing beers** 🅷/🅶

A light and airy single-room micropub, named after the Blue Boar Inn where Richard III stayed before the Battle of Bosworth Field. The cellar is visible through a glass partition behind the bar. The house beer is brewed by Bang the Elephant; guest ales come from microbreweries around the country. Q🚶🌗🚴♣🖳🐾📶

Globe

43 Silver Street, LE1 5EU

☎ (0116) 253 9492 🌐 theglobeleicester.com

Everards Sunchaser, Tiger, Old Original; 3 changing beers (often Everards) 🅷

A snug near the entrance and an island servery surrounded by small rooms are features of this historic pub, which offers a range of beers and ciders alongside good food. Upstairs is a function room with its own servery. There is an interesting collection of local photos and bric-a-brac throughout. Restored gas lights are used on special occasions. 🌗🌗🖳🐾📶

King's Head

36 King Street, LE1 6RL

☎ (0116) 254 8240

Black Country Bradley's Finest Golden, Pig on the Wall, Fireside; 7 changing beers 🅷

A traditional one-room city-centre local owned by Black Country Ales. Its 12 handpulls dispense seven regularly changing guest beers and a cider. A range of bottles is also stocked. Meals are not served but filled cobs are often available. The pub shows sport on TV. Its open fire and roof terrace help make it popular throughout the year with real ale and cider enthusiasts, as well as visitors to the local football and rugby grounds. 🏠🚴♣🐾📶

Old Horse ✅

198 London Road, LE2 1NE

☎ (0116) 254 8384 🌐 oldhorseleicester.co.uk

Everards Sunchaser, Tiger, Old Original; 3 changing beers (sourced nationally; often Everards) 🅷

Traditional 19th-century coaching inn, handy for dog walkers, students and sports fans. It has four guest beers which change monthly, and a cider bar serving a variety of handpulled options. Tasty, good-value food is offered,

including a Sunday carvery. Behind the building is the largest pub garden in Leicester, complete with children's play equipment. Regular quiz nights, karaoke and special events take place. 🌗🏠🌗🚶♣🐾P🖳🐾📶

Parcel Yard

48A London Road, LE2 0QB

☎ (0116) 261 9301

Steamin' Billy Bitter, Skydiver; 2 changing beers (sourced nationally) 🅷

Spacious, modern bar in a former sorting office of the adjacent railway station. It has a strong beer focus, with four handpumps and craft keg taps, and also serves a good range of cocktails and wine. The restaurant area at one end of the bar offers tapas, pizzas and burgers. The pub can be entered down the stairs from a shop front on London Road, or via level access from Station Street. 🌗🚴🖳🐾📶

Queens Road Tap

109 Queens Road, Clarendon Park, LE2 1TT

6 changing beers (often Tollgate) 🅷

Well-established micropub in a former shop, run by the Tollgate Brewery, based at the Calke Estate in south-east Derbyshire. The modern single-room interior has rustic furniture. The bar serves a constantly varying range of six real ales, including three or four from Tollgate, plus several guests and two ciders. There is no music or TV. The bus to Leicester stops right outside but evening services are limited. Q🖳(44/A,83/A)

Real Ale Classroom 🗅

22 Allandale Road, Stoneygate, LE2 2DA

☎ (0116) 319 6998 🌐 therealaleclassroom.com

4 changing beers (often Pentrich, Polly's, Two by Two) 🅶

Classroom themed micropub run by career-change former teachers in a converted suburban shop. The furniture includes reclaimed desks with original graffiti; the beers are written up on a blackboard. A home-made chiller cabinet behind the high bar serves cask and KeyKeg ales plus ciders. A log-burner warms the rear room. In both rooms seating around large tables encourages conversation between regulars and visitors. The pub offers crisps, nuts and scratchings and sells take-away cans. Q🚶🏠♣🖳🖳🐾📶

Salmon

19 Butt Close Lane, LE1 4QA (from Clock Tower walk down Churchgate; Butt Close Lane is second left)

☎ (0116) 253 2301

Black Country Bradley's Finest Golden, Chain Ale, Pig on the Wall, Fireside; 7 changing beers (sourced nationally) 🅷

A small corner local whose single U-shaped room is decorated in bright traditional style. A Black Country Ales pub since 2016, it has a friendly atmosphere and a strong sports following. The 12 handpumps serve two real ciders alongside beers from Black Country Ales and guest breweries. Cobs, pork pies and Scotch eggs are available throughout the day. Bus stations are nearby. Q🚶🏠🚴♣🖳🐾📶

Two-Tailed Lion

22 Millstone Lane, LE1 5JN

☎ (0116) 224 4769 🌐 thetwotailedlion.com

3 changing beers 🅷

A modern, beer-oriented pub featuring three handpumps and six keg taps with a regular rotation of beers. It also has a well stocked bottle shop. Unobtrusive music is played in the bar. As well as the small downstairs bar with a range of comfortable seating there are two upstairs rooms that can be hired. 🌗🖳🐾📶

West End Brewery

68-70 Braunstone Gate, LE3 5LG

☎ 07875 745302 ⊕ thewestendbrewery.co.uk

West End Project Pale, Stout, West Coast IPA; 3 changing beers (sourced nationally; often West End) Ⓗ

Leicester's original brewpub opened in 2016; the brewery is behind the pub and can be visited by customers. The brewer aims to produce innovative beers, and experiments with recipes, sometimes adopting customers' suggestions. Four house beers are served alongside at least two farmhouse ciders or guest ales, sourced from quality local microbreweries or further afield. The pub hosts live music once a month.
ᗐ♣●🛏❀🛜

Wygston's House

12 Applegate, LE1 5LD

☎ (0116) 296 4301 ⊕ wygstonshouse.co.uk

Charnwood Vixen; 3 changing beers (sourced locally) Ⓗ

The best preserved medieval house in Leicester opened as a bar/restaurant in 2017. Its central entrance leads into a stone-flagged passage; on each side are small elegant rooms. The corridor opens out at the back into the medieval part of the house, a bar area with an old beamed ceiling. A light airy room upstairs also has a beamed ceiling and gives good views of a historic part of Leicester. Outside is a large, attractive patio.
ᗐ❀❍🖐&●🛏❀🛜

Loughborough

Moon & Bell ✔

6 Wards End, LE11 3HA

☎ (01509) 241504

Greene King Abbot; Ruddles Best Bitter; Sharp's Doom Bar; 10 changing beers (sourced nationally; often Oakham, Titanic) Ⓗ

Large venue in the Grade II-listed Atherstone House, which used to be an Inland Revenue tax office. Its interior is fairly dark with carpet and comfortably furnished seating. Walls display old photos of Loughborough. The pub serves a fine selection of house and guest ales plus an extensive food menu. It hosts frequent beer and cider festivals. The main toilets are upstairs; there is outdoor seating to the rear.
ᗐ❀❍&●🛜

Moonface Brewery & Tap

13 Moira Street, LE11 1AU (Moira St is accessed from Barrow St)

☎ (01509) 700171

4 changing beers (sourced nationally; often Moonface)

A small, neat bar in a former warehouse building and art studio. It serves a constantly changing range of three to five real ales direct from casks stillaged behind the counter. The in-house Moonface microbrewery is visible in a room directly behind the bar. There are no keg beers but the pub also stocks a range of bottled Belgian brews. Do not miss the outdoor drinking area experience. Local CAMRA Pub of the Year winner 2020 and 2021.
Q❀&●🛏(2,127)❀🛜

Needle & Pin

15 The Rushes, LE11 5BE

☎ 07973 754236

4 changing beers (sourced nationally) Ⓗ

A well-established micropub in the premises of the former H&R electronics shop. It serves a frequently changing range of handpulled and gravity-fed real ales

plus a choice of several ciders and perries. More than 80 varieties of foreign and craft bottled beers are also on offer. Extensive seating is available upstairs. A former local CAMRA Pub of the Year. Q ᗐ●🛏❀

Organ Grinder

4 Woodgate, LE11 2TY

☎ (01509) 264008

Blue Monkey BG Sips, Guerrilla, Infinity, Primate Best Bitter; 4 changing beers (sourced locally; often Blue Monkey) Ⓗ

Previously known as the Pack Horse, this pub has interesting original features that were uncovered when it was renovated after being bought by Blue Monkey Brewing a decade ago. The stable bar at the back reflects the pub's past life as a coaching inn. Eight cask ales are served alongside bottled Belgian beers. The choice of four real ciders sometimes features a perry. Bar snacks include an interesting range of pork pies. A former local CAMRA Pub of the Year. ᗐ❀●🛏🛏❀🛜

Swan in the Rushes

21 The Rushes, LE11 5BE

☎ (01509) 217014

Castle Rock Harvest Pale, Preservation, Elsie Mo; 7 changing beers (often Castle Rock, Charnwood) Ⓗ

Traditional three-room Castle Rock pub comprising a quiet, traditionally styled lounge and a lively bar with a jukebox. It serves a constantly changing range of guest beers, including one dark brew. More than 30 varieties of real cider or perry are also available, alongside a wide range of continental bottled and draught beers, country wines and a good choice of malt whiskies. The games room features darts, pool, table football and a vintage arcade game. Upstairs are the Hop Loft function room and a first-floor outside terrace. Local CAMRA Cider Pub of the Year 2021 and 2022. Q ᗐ❀❍&●🛏🛏❀🛜

Wheeltapper

60 Woodgate, LE11 2TZ

☎ (01509) 230829 ⊕ wheeltapper.co.uk

10 changing beers (sourced regionally; often Nene Valley, Shiny, Shipstone's)

Ground-floor pub in a modern building whose decor has a railway theme, including reproduction posters and a board displaying photos of the Great Central Railway, the nearby heritage line. Furniture is basic. Five handpulls dispense the wide range of real ales, with regularly changing craft beers and real ciders also available. The pub is wheelchair accessible and dog friendly.
❀&⇌(Central)♣●🛏❀🛜

White Hart

27 Churchgate, LE11 1UD

☎ (01509) 236976 ⊕ benpimlico.com/whitehart/home

Charnwood Salvation, Vixen; Timothy Taylor Landlord; 3 changing beers (sourced locally; often Leatherbritches) Ⓗ

Reopened in 2013 as a freehouse after an extensive refurbishment, the secluded patio and beer garden to rear are very popular in sunny weather. Regularly changing guest beers come from local breweries such as Leatherbritches and Charnwood. Bar snacks and tapas are available until early evening. Live music is played on Friday and Saturday evenings and occasionally at weekends. There is a 21 and over policy. Local CAMRA Pub of the Year 2017. ᗐ❀❍♣●🛏❀🛜

Lutterworth

Fox

34 Rugby Road, LE17 4BN (½ mile on main road from M1; 400yds from Whittle roundabout)

☎ (01455) 553877 ⊕ fox-lutterworth.co.uk
Draught Bass; Sharp's Doom Bar; 2 changing beers (sourced nationally; often Purity, Timothy Taylor, Wadworth) Ⓗ
Welcoming 18th-century establishment at the southern end of Lutterworth, described as the town's village pub. An L-shaped, open-plan interior with a wooden-floored bar and carpeted dining area is warmed by two open fires. Meals are served lunchtimes and evenings, including excellent Sunday roasts. Thai food is available in the evenings in the adjacent Sawasdee restaurant. Outside is a large, award-winning landscaped garden and drinking area. Quiz night is Tuesday.
✿❶➊P🚌(58,X44) ✿ 🛜

Real Ale Classroom

4 Station Road, LE17 4AP
☎ 07824 515334 ⊕ therealaleclassroom.com
4 changing beers (sourced nationally) Ⓖ
A spacious micropub with a schoolroom theme, owned by former teachers. It offers a constantly changing line-up of four cask and four craft keg ales plus a wide range of bottled and canned beers and five ciders. The bar has a log-burner for winter and a fantastic beer garden to enjoy in summer. Friendly staff are knowledgeable about the drinks on offer, including excellent gins and spirits from local distillers. Snacks are from local suppliers. A sister pub to the Real Ale Classroom in Leicester.
Q♿✿♣🚌(X84,58) ✿ 🛜

Unicorn

29 Church Street, LE17 4AE (town centre, near church)
☎ (01455) 552486
Adnams Southwold Bitter; Draught Bass; Greene King IPA; 2 changing beers (sourced nationally; often Sharp's) Ⓗ
Traditional street-corner local with a black and white frontage, built in 1919 on the site of an 18th-century coach house in the town centre. The large public bar, with its open fire, shows TV sport and hosts teams playing darts, dominoes and skittles. The small, comfortable lounge, divided by a central fireplace, displays photographs of old Lutterworth. Alongside the adjacent dining room it forms a family-friendly area that is used to serve the pub's good, inexpensive lunchtime food, which includes vegetarian and children's options.
♿❶♣P🚌(8,X44) ✿ 🛜

Market Harborough

Beerhouse

76 St Mary's Road, LE16 7DX (directly behind St Mary's chippy)
☎ (01858) 465317
8 changing beers (sourced nationally) Ⓟ
Market Harborough's first micropub is in a former furniture shop directly behind the chip shop on St Mary's Road. The focus is very much on beer – no food, gaming machines or loud music. There are 20 taps for draught products – eight for cask ales, the rest for KeyKegs and ciders. Monday is quiz night, and the pub hosts occasional comedy evenings, vinyl nights and live music. Other attractions include a book club and cider festival.
♿✿♿≉♦P🚌✿ 🛜

Melton Mowbray

Boat

57 Burton Street, LE13 1AF
☎ (01664) 500969
Bombardier; Draught Bass; Timothy Taylor Boltmaker, Landlord Ⓗ

A traditional single-roomed pub that takes its name from a canal basin that was once adjacent. Many of the walls are wood panelled and decorated with old pictures of the town and a map of the old Melton-Oakham canal. The pub is always busy and popular with those who enjoy good conversation with their pint. An open fire gives plenty of warmth and adds to the atmosphere in winter.
≉♣🚌✿ 🛜

Half Moon ⊘

6 Nottingham Street, LE13 1NW
☎ (01664) 562120
Castle Rock Harvest Pale; Draught Bass; 1 changing beer (sourced nationally) Ⓗ
A long and narrow two-roomed building, next door to Ye Olde Pork Pie Shoppe in the middle of a row of old half-timbered buildings. Its front bar starts at street level before climbing to the higher serving area. The small rear lounge leads to a courtyard. Alongside the pub is a covered smoking area with tables and chairs.
♿✿≉♣🚌✿ 🛜

Paint the Town Red

7 King Street, LE13 1XA
☎ 07852 232937
1 changing beer
A wide range of beer styles from some new and innovative breweries is on offer, along with ciders, at this pub in a 14th-century former manor house. One of the town's oldest buildings, it was the manor of John Mowbray in the 1500s and has a timber frame that dates back to 1301. More recently the building was a dressmaker's; the signage remains on the front of the pub. ✿≉🚌(5,19)✿

Mountsorrel

Sorrel Fox

75 Leicester Road, LE12 7AJ
☎ (0116) 230 3777
Charnwood Salvation, Vixen; 2 changing beers (sourced locally; often Charnwood) Ⓗ
Charnwood Brewery's first micropub is cosy with a lovely log-burner. It serves the brewery's popular cask ales and craft beers as well as an imported Austrian lager, complemented by bottled ciders, quality wines, a selection of gins and a couple of rums. Bar snacks and freshly made sausage rolls are offered, with cobs at the weekend. Q♦🚌(127)✿ 🛜

Swan

10 Loughborough Road, LE12 7AT
☎ (0116) 230 2340
Black Sheep Best Bitter; Castle Rock Harvest Pale; Grainstore Ten Fifty; 2 changing beers Ⓗ
A 17th-century, Grade II-listed coaching inn on the banks of the River Soar, entered via a narrow arch into a courtyard. Its split-level interior has open fires, stone floors and low ceilings, and includes a small dining area with a polished wood floor. Good-quality, interesting food is cooked to order, the menu changing weekly and featuring regular themes. Outside is a long, secluded riverside garden. The attached Soar microbrewery started in May, 2022. Local CAMRA Pub of the Year 2022.
Q♿✿❶♦🚌✿

Nether Broughton

Anchor

Main Road, LE14 3HB
☎ (01664) 822461
Ringwood Razorback; 1 changing beer Ⓗ

A cosy village roadside pub on the A606, featuring a main bar with a real fire and dartboard, plus a separate dining area offering a quieter space. Traditional fare is served, with occasional themed nights. The pub hosts regular charity events, and welcomes families and dogs. ७⊛◑♣Pₓ☺

Oadby

Cow & Plough
Gartree Road, LE2 2FB
☎ (0116) 272 0852
Steamin' Billy Bitter; 3 changing beers ⊞
Situated in a former farm building with a conservatory, the pub is decked out with breweriana. It is home to Steamin' Billy beers, named after the owner's now departed Jack Russell who features on the logo and pumpclips. Four pumps are situated in the rear bar; a beer list is on a chalkboard on the main room bar. Former dairy buildings house a renowned restaurant.
Q৬⊛◑点♣Pₓ☺

Plungar

Anchor ▼ 𝕃
Granby Lane, NG13 0JJ
☎ (01949) 860589
3 changing beers ⊞
This brick-built pub in the heart of the village dates from 1774 and was at one time the local courtroom. It has a large bar, cosy lounge and a separate pool room. Up to three cask ales are served, with at least one a local brew. Outside is an attractive beer garden and seating area plus a substantial car park, which helps make the pub popular with cyclists and horse riders. Local CAMRA Pub of the Year 2022. Q৬⊛点♣Pₓ(24)☺❆

Quorn

Royal Oak
2 High Street, LE7 8DT
☎ (01509) 415816 ⊕ theroyaloakquorn.co.uk
Charnwood Vixen; St Austell Tribute; Timothy Taylor Landlord; 1 changing beer ⊞
A 160-year-old inn in the centre of the village, formerly three terraced cottages. The internal walls were removed to open up the building, retaining many original features including beamed ceilings, tiled floors and an open log fire. Draught cider is occasionally available as the guest brew but no food is served. To the side of the pub is a sheltered and covered courtyard. Q⊛⇆▲♣Qₓ☺❆

Redmile

Windmill ✓
4 Main Street, NG13 0GA
☎ (01949) 842281 ⊕ thewindmillinnredmile.co.uk
2 changing beers (sourced locally; often Castle Rock, Shipstone's) ⊞
A privately owned and run restaurant and bar, a mile down the hill from Belvoir Castle. It has two rooms: a lounge and a stone-floored bar complete with log fire. Outside is a generous terrace. The pub has cult status among fans of the TV show Auf Wiedersehen, Pet, in which it appeared as the Barley Mow. Photos taken during filming are on display. Q৬⊛◑▲PₓⒻ☺❆

Rothley

Woodman's Stroke
1 Church Street, LE7 7PD
☎ (0116) 230 2785 ⊕ woodmansstroke.co.uk

Charnwood Vixen; Draught Bass; Woodforde's Wherry; 1 changing beer ⊞
Quintessentially English village pub, with thatched roof, exposed ceiling joists and stone floors. The Woodies has an extensive outside area with heated parasols and sofa type seating, pétanque and a large garden rolling down to Rothley Brook. A family-run free house for many years, it has a large display of sports memorabilia and three regular ales with one rapidly changing guest, a fine selection of wines and on weekday lunches, good home-cooked food. The old-fashioned pastime of conversation is encouraged. Q৬⊛点♣Pₓ(126,127)☺❆

Sapcote

Sapcote Club
19-21 Hinckley Road, LE9 4FS
☎ (01455) 272300 ⊕ sapcoteclub.co.uk
2 changing beers (sourced nationally) ⊞
This club offers a warm and friendly welcome in three different rooms all with their own private bars. Regular games nights and entertainment with thought are featured. The club was extensively refurbished in spring 2020, with new flooring, wall tiles, bar top and surround, with reupholstered benches in the bar, new tiling in the foyer and toilets, a new hand rail and repainted walls and doors. Local CAMRA joint Club of the Year 2022. ৬点♣Pₓ(X55)

Shackerstone

Rising Sun
Church Road, CV13 6NN
☎ (01827) 880215 ⊕ risingsunpub.com
Draught Bass; Marston's Pedigree; Timothy Taylor Landlord; 1 changing beer ⊞
Traditional family-owned free house located in the heart of Shackerstone village near the Ashby Canal and the preserved Battlefield Railway. It features a wood-panelled bar serving traditional ales, restaurant, pool room, family-friendly conservatory and an attractive garden. The pub, popular with locals and visitors alike, is renowned for the quality and variety of its ales and serves good pub food – the ideal hub for visiting this rural part of Leicestershire.
৬⊛◑▲⇆(Battlefield)♣Pₓ(7)☺❆

Shepshed

Black Swan ✓
21 Loughborough Road, LE12 9DL
☎ (01509) 458929
Draught Bass; Greene King Abbot; Timothy Taylor Landlord; 2 changing beers (sourced nationally) ⊞
Multi-roomed pub in a prominent position close to the town centre, serving two guest beers alongside the regular ales. It also offers a choice of more than 200 whiskies – the best selection in the Midlands. The main room has two drinking areas, both with comfortable seating. A further small room is used by families and can be hired for functions. Wednesday is quiz night. Local events include music by a ukulele orchestra. Shepshed Dynamo football ground is nearby. Q৬⊛♣PₓⒻ☺❆

Hall Croft Tap
20-22 Hall Croft, LE12 9AN
☎ (01509) 729920
Charnwood Salvation, Vixen; 2 changing beers (sourced locally; often Charnwood) Ⓟ
A recently opened Charnwood Brewery micropub, featuring a central courtyard with a large snug on one side and a bar/lounge on the other. Snacks including

pork pies are available but no meals are served. Children are welcome in the snug at weekends until 7pm. The rear courtyard leads via steps to a large garden with seating. The pub and courtyard are wheelchair accessible but the garden is not. ♿❀♿🚐(126,127)

Somerby

Stilton Cheese ♈ L

High Street, LE14 2QB

☎ (01664) 454394 ⊕ stiltoncheeseinn.co.uk

Marston's Pedigree; Grainstore Ten Fifty; 3 changing beers (sourced nationally) 🅗

Welcoming family-run pub, built in local ironstone in the late 16th century. It has a cosy bar and an adjoining room displaying an eclectic collection of copper pots and pans, horse brasses, pictures of hunting scenes and a stuffed pike and badger. At least four real ales are always available, often from local breweries. Local CAMRA Pub of the Year 2019, 2020 and 2022. Q♿❀🕙❶♣P🚐🛜

Stoke Golding

George & Dragon L

Station Road, CV13 6EZ

☎ (01455) 213268 ⊕ churchendbrewery.co.uk/pubs

Church End Goat's Milk, Gravediggers Ale, What the Fox's Hat, Stout Coffin, Fallen Angel; 3 changing beers (sourced locally; often Church End) 🅗

Renowned village local serving eight real ales from Church End brewery and a real cider. Good, home-cooked lunches feature local produce, and bar snacks made on the premises are always available. The second Tuesday of each month is steak night, and lunch is served on the last Sunday. Close to the historic Bosworth Battlefield, the pub supports a number of clubs and societies. A popular destination for walkers, cyclists, and boaters from the nearby Ashby Canal. Q♿❀🕙♣A♣❶P🚐(66)🐾🛜

Swinford

Chequers ✅

High Street, LE17 6BL (near church)

☎ (01788) 860318 ⊕ chequersswinford.co.uk

Adnams Southwold Bitter; 2 changing beers (sourced nationally; often St Austell, Timothy Taylor) 🅗

A warm welcome is assured at this family-run community local, whose landlord has been in place for more than 35 years. The menu caters for all and includes vegetarian and children's options. The large garden and play area are popular with families in good weather. A marquee provides the venue for the annual beer festival and is available for private hire. Pub games include table skittles. Within a mile is the 18th-century Stanford Hall, with a caravan park and museum. ♿❀🕙A♣P🐾🛜

Syston

Pharmacie Arms L

3 High Street, LE7 1GP

☎ (0116) 269 6933

Shipstone's Mild, Original; 3 changing beers (sourced nationally; often Leatherbritches, Pentrich, Oakham) 🅗

Syston's first micropub has been engaging customers since 2018 with its 1950s pharmacy theme – it displays medical artefacts, equipment, advertisements and a friendly skeleton sitting on a dentist's chair. The pub offers a varying selection of real ales plus up to six craft kegs. No meals are served but cheese cobs and other snacks are available. Upstairs, the theme is 1950s movies

in a vinyl lounge with seating for about 70 people. Another room is available for private hire. Q♿❀♣❶🚐🐾🛜

Walton on the Wolds

Anchor

2 Loughborough Road, LE12 8HT

☎ (01509) 880018

Charnwood Salvation; Draught Bass; Timothy Taylor Landlord; 1 changing beer (sourced regionally) 🅗

The Anchor is in the centre of a small village within easy reach of Leicester and Nottingham via the A46. It is a popular venue for locals as well as the many walkers, with or without dogs, who stop for a well-earned rest. Outside are an elevated seating area to the front and a garden and large car park to the rear. Q♿❀🕙♣P🚐(27)🐾

Breweries

Buswells

🏠 Lime Kilns Pub, Watling Street, Burbage, Leicestershire, LE10 3ED

☎ (01455) 631158 ⊕ limekilnsinn.co.uk

Brewing started at the Lime Kilns pub, Burbage, in 2016 as a small batch brewery. It expanded to a two-barrel plant in 2017, providing up to 14 ales for the pub and other outlets, on demand. Bespoke brews are provided for events including several local beer festivals.

Charnwood SIBA

22 Jubilee Drive, Loughborough, Leicestershire, LE11 5XS

☎ (01509) 218666 ☎ 07872 651561

⊕ charnwoodbrewery.co.uk

⊛Family-run, 10-barrel brewery established in 2014. Three core beers and up to three monthly specials, with a wide range of styles (all widely available locally). The frontage features a shop (large windows give a good view in). The shop sells brewery merchandise, bottled beers, mini-kegs, bag-in-box and local gins. Online ordering available for local deliveries. It has two micropubs, the Sorrel Fox, Mountsorrel, and the Hall Croft Tap, Shepshed. ‼🏪♦

Salvation (ABV 3.8%) GOLD
Vixen (ABV 4%) BITTER
Blue Fox (ABV 4.2%) GOLD
APA (American Pale Ale) (ABV 4.8%) PALE
Old School (ABV 5%) OLD

Dow Bridge

2-3 Rugby Road, Catthorpe, Leicestershire, LE17 6DA

☎ (01788) 869121 ☎ 07790 633525

⊕ dowbridgebrewery.co.uk

Dow Bridge commenced brewing in 2001 and takes its name from a local bridge where Watling Street spans the River Avon. The brewery uses English whole malt and malt with no adjuncts or additives. Seasonal and bottle-conditioned beers are also available. 🏪♦LIVE

Bonum Mild (ABV 3.5%) MILD
Complex dark brown, full-flavoured mild, with strong malt and roast flavours to the fore and continuing into the aftertaste, leading to a long, satisfying finish.
Acris (ABV 3.8%) BITTER
Centurion (ABV 4%) BITTER
Legion (ABV 4.1%) GOLD

Ratae'd (ABV 4.3%) BITTER
Tawny-coloured, full-bodied beer with bitter hop flavours against a grainy background, leading to a long, bitter and dry aftertaste.
DB Dark (ABV 4.4%) MILD
Gladiator (ABV 4.5%) BITTER
Fosse Ale (ABV 4.8%) BITTER
Praetorian Porter (ABV 5%) PORTER
Onslaught (ABV 5.2%) BITTER

Elmesthorpe

Church Farm, Station Road, Elmesthorpe, Leicestershire, LE9 7SG ☎ 07754 321283
⊕ elmesthorpebrewery.com

Elmesthorpe was established in 2017 by a beer enthusiast and pub landlord. The brewery has gone from strength to strength and now supplies many pubs and taprooms in Leicestershire, Nottinghamshire, Warwickshire, Derbyshire and Staffordshire.

Tight Bar Steward (ABV 3.7%) MILD
C.A.P.A (ABV 3.8%) BITTER
Aylmers Ale (ABV 4.1%) BITTER
Barons Best Bitter (ABV 4.3%) BITTER
Hansom Ale (ABV 4.4%) GOLD
Lord Cullens Ruby (ABV 4.5%) BITTER
Debbie Does (ABV 4.9%) GOLD
Ale O' Clock (ABV 5.2%) BITTER
Taking the Biscuit (ABV 5.3%) BITTER

Emperor's

Newbold Farm, 2 Worthington Lane, Newbold Coleorton, Coalville, Leicestershire, LE67 8PH
⊕ emperorsbrewery.co.uk

Former homebrewer now brewing imperial stouts and porters commercially.

Everards SIBA

Everards Meadows, Cooper Way, Leicester, Leicestershire, LE19 2AN
☎ (0116) 201 4100 ⊕ everards.co.uk

☺Everards was established in 1849 by William Everard and remains an independent, fifth generation family company. It has an estate of 153 pubs throughout the East Midlands and beyond. In 2021, a new state-of-the-art brewery was opened, comprising a main brewery, small batch brewery, beer hall, shop and offices. All beers are brewed in-house again. Limited edition beers, small batch beers, and brewery tours are also available. !!◆

Beacon Hill (ABV 3.8%) BITTER
Light, refreshing, well-balanced pale amber bitter in the Burton style.
Sunchaser (ABV 4%) GOLD
Tiger (ABV 4.2%) BITTER
A mid-brown, well-balanced best bitter crafted for broad appeal, benefiting from a long, bittersweet finish.
Old Original (ABV 5.2%) BITTER
Full-bodied, mid-brown, strong bitter with a pleasant rich, grainy mouthfeel. Well-balanced flavours, with malt slightly to the fore, merging into a long, satisfying finish.

Framework

The Old City Depot, 72-74 Friday Street, Leicester, LE1 3BW
☎ (0116) 262 4037
✉ beer@frameworkbrewery.com

⊠ Framework is a six-barrel brewery in an historic Victorian red-brick City Centre building, that started brewing in 2016. Alongside its core range of ales it also offers changing seasonal beers, collaboration and one-off experimental brews. Both traditional and modern hop-forward beers are available. !!◆V✦

Leicester Central (ABV 3.8%) BLOND
Five Leaves (ABV 4%) BITTER
Noctua (ABV 4.2%) SPECIALITY
Semper (ABV 4.4%) GOLD
Friday Street IPA (ABV 4.5%) PALE

Golden Duck

Unit 2, Redhill Farm, Top Street, Appleby Magna, Leicestershire, DE12 7AH ☎ 07846 295179
⊕ goldenduckbrewery.com

Golden Duck began brewing in 2012 using a five-barrel plant. It is run by the father, son and daughter team of Andrew, Harry and Hayley Lunn. Beers have a cricket-related theme and are always available in Mushroom Hall, Albert Village and Cellar Bar, Sir John Moore Hall, Appleby Magna (Friday evenings only). ◆LIVE

Mawbs (ABV 3.7%) GOLD
Hayles' Ale (ABV 3.8%) BITTER
Golden Duck Extra Pale (ABV 4.2%) PALE
LFB (Lunns First Brew) (ABV 4.3%) GOLD
Carry on Edward (ABV 4.5%) GOLD
Lunnys No8 (ABV 4.8%) BITTER

Great Central

Unit B, Marlow Road Industrial Estate, Leicester, LE3 2BQ ☎ 07584 435332 ⊕ gcbrewery.co.uk

⊠ After a hiatus of some three years brewing restarted in 2019 on a two-barrel plant, primarily to supply the brewery tap, the Wheeltapper in Loughborough. Beers are named with a railway theme. ◆

Hemlock

37 Main Street, Hemington, Derbyshire, DE74 2RB
☎ 07791 057994 ✉ hembrew@yahoo.com

Established in 2015 in Leicestershire on the borders of Derbyshire & Notts, this two-barrel plant is located in the outbuildings of a 17th Century thatched cottage. The brewery originally supplied beers in the immediate area. It has now branched out with increasing sales in Derbyshire, Nottinghamshire, Leicestershire & Staffordshire. It produces a growing number of pale ales plus seasonal beers. !!◆LIVE

Lemonhead (ABV 3.8%) GOLD
Harvest Moon (ABV 4.1%) GOLD
Twisterella (ABV 4.1%) PALE
Bossanova (ABV 4.3%) BLOND
Hoptimystic (ABV 4.3%) BITTER
Village Idiot (ABV 4.3%) BITTER
California Dreaming (ABV 4.5%) PALE

Langton SIBA

Grange Farm, Welham Road, Thorpe Langton, Leicestershire, LE16 7TU
☎ (01858) 540116 ☎ 07840 532826
⊕ langtonbrewery.co.uk

Established in 1999 in outbuildings behind the Bell Inn, East Langton, the brewery relocated in 2005 to a converted barn at Thorpe Langton, where a four-barrel plant was installed. Further expansion in 2010 and 2016 significantly increased capacity. !!◆LIVE

Rainbow Bridge (ABV 3.8%) GOLD
Caudle Bitter (ABV 3.9%) BITTER
Copper-coloured session bitter that is close to pale ale in style. Flavours are relatively well-balanced throughout with hops slightly to the fore.
Union Wharf (ABV 4%) BITTER
Inclined Plane Bitter (ABV 4.2%) BLOND
Thomas Lift (ABV 4.4%) BITTER
Bullseye (ABV 4.8%) STOUT

MonsteX

Falcon Business Park, Meadow Lane, Loughborough, Leicestershire, LE11 1HL ☎ 07960 776843
⊕ monstex.co.uk

Anstey Ale Brewery started as a one-barrel garage plant in 2015. In 2017 the plant was upgraded to 2.5-barrels and relocated. Onsite taproom the Mash & Press opened in 2019 in conjunction with Charnwood Ciders. Rebranded as MonsteX, regular one-off brews are relased under the Anstey (cask) and MonsteX (craft keg) names. Beers are available in the taproom and occasionally at local freehouses. ♦ ✦

Brewed under the Anstey Ale brand name:
Lakeside (ABV 3.9%) BITTER
Neddy's (ABV 3.9%) PALE
Brewsters Bitter (ABV 4%) BITTER
Packhorse Bridge (ABV 4%) BITTER
Fluthered (ABV 4.5%) SPECIALITY
Darkroom (ABV 4.7%) STOUT
Nook IPA (ABV 5%) PALE

Contract brewed for Hoskins Brothers:
Hob Bitter (ABV 4%) BITTER
IPA (ABV 4%) BITTER

Moonface

13 Moira Street, Loughborough, LE11 1AU
☎ (01509) 700171 ⊕ moonfacebrewery.co.uk

⊗ Moonface Brewery has been running since 2018, brewing in six-firkin batches. Two Moonface beer types are on the bar in the tap at any time, one often served from a wooden cask. ✦

X No.1 (ABV 3.6%) MILD
Best Bitter (ABV 4.2%) BITTER
Citra (ABV 4.5%) PALE
Mid Atlantic Pale (ABV 4.7%) PALE
London Porter (ABV 5.6%) PORTER

Mount St Bernard SIBA

Oaks Road, Coalville, Leicestershire, LE67 5UL .
☎ (01530) 832298 ☎ 07453 760874
⊕ mountsaintbernard.org/tynt-meadow

This Cistercian monastery has been brewing its Trappist beer since 2017. It is the first ever recorded such beer to be brewed in England. Currently its only brew is the bottle-conditioned Tynt Meadow, which is available at the monastery and through outlets around the country. ‼ ☐LIVE

New Buildings SIBA

Unit 3, Southways Industrial Estate, Coventry Road, Hinckley, Leicestershire, LE10 0NJ
☎ (01455) 635239 ☎ 07795 954392

Office: 24 Leicester Road, Hinckley, LE10 1LS
⊕ newbuildingsbrewery.com

⊙New Buildings Brewery brew using the David Porter 5.5-barrel system and a recently purchased two beer

barrel system. It offers six core beers that cover the range from IPAs to porter. Beers are available through Heritage swaps, particularly in Nottinghamshire and Derbyshire, and sometimes at local pubs.

Lighthouse Pale Ale (ABV 3.9%) PALE
Windmill Best Bitter (ABV 4.1%) BITTER
Farmhouse (ABV 4.2%) GOLD
Courthouse Porter (ABV 4.5%) PORTER
Cruckhouse (ABV 4.5%) RED
Manorhouse (ABV 4.5%) RED

Parish

6 Main Street, Burrough on the Hill, Leicestershire, LE14 2JQ
☎ (01664) 454801 ☎ 07715 369410
✉ bazbrewery@gmail.com

Parish began brewing in 1983 and now operates on a 20-barrel plant, with capacity to brew a further 12 barrels. The brewery is located in a 400-year-old building next to the Stag & Hounds, where its flagship beer, PSB, is permanently available. Other local outlets are also supplied. One-off brews are produced for beer festivals both locally and across surrounding counties. ‼LIVE

PSB (ABV 3.9%) BITTER
A refreshing, pale, session ale. Distinctive floral aroma with mild hints of pine. Sharp hop bitterness balanced with crisp malt flavours in the taste giving way to a lovely, lingering, floral finish.

Pig Pub

🗐 Pig In Muck, Manor Road, Claybrooke Magna, Leicestershire, LE17 5AY
☎ (01455) 202859 ⊕ piginmuck.com/brewery

Brewing began in 2013 using a two-barrel plant, upgraded to a five-barrel plant built by head brewer Kev Featherstone. ☐♦LIVE ✦

Q Brewery

16 The Ringway, Queniborough, Leicestershire, LE7 3DL ☎ 07762 300240 ⊕ qbrewery.co.uk

A microbrewery situated in a converted building behind the house of head brewer Tim Lowe. It was established in 2014 and uses a 0.5-barrel brew kit. Beers can also be brewed on demand.

Ridgemere Bitter (ABV 3.8%) BITTER
Hop (ABV 4.2%) GOLD
Invincibull Stout (ABV 4.4%) STOUT
Solstice Sundance (ABV 4.5%) GOLD
IPA (ABV 5%) PALE
Millies All Rounder (ABV 5.3%) BLOND
1630 (ABV 5.5%) BITTER

Round Corner

Melton Mowbray Market, Scalford Road (Gate 2), Melton Mowbray, Leicestershire, LE13 1JY
☎ (01664) 569855 ⊕ roundcornerbrewing.com

Round Corner Brewing was launched in 2018. The state-of-the-art brewery and its taproom are in the old sheep shed in the historic Melton Mowbray Market. Multi award-winning, it produces a range of keg beers covering a variety of styles. Its barrel-aged programme continues, which began in 2019, but it has made the decision to cease brewing cask beers for now. Following the installation of a canning line in 2020 the brewery is able to sell many of its beers directly from its online shop. ✦

Steamin' Billy

Office: 5 The Oval, Oadby, Leicestershire, LE2 5JB
☎ (0116) 271 2616 ⊕ steamin-billy.co.uk

Pub Company that has a range of beers contract brewed for its pubs.

Tipsy Fisherman (ABV 3.6%) BITTER
Bitter (ABV 4.3%) GOLD
1485 (ABV 5%) BITTER
Skydiver (ABV 5%) BITTER

Treehouse (NEW)

Cavendish Bridge, Leicestershire, DE72 2HL
✉ brewers@treehousebrewery.co.uk

Treehouse Brewery was established in 2022 and is based in Cavendish Bridge.

West End

⬛ 68-70 Braunstone Gate, Leicester, LE3 5LG
☎ 07875 745302 ⊕ thewestendbrewery.co.uk

⊛Leicester city centre's original brewpub, which opened in 2016 using a 2.5-barrel plant. Total capacity doubled in 2019. An in-house beer canning machine was added in 2021. Beers are available in the pub, through a webshop and occasionally in other local outlets. ◆LIVE ⚲

Zero Six (NEW)

37 High Street, Lutterworth, Leicestershire, LE17 4AY
⊕ zerosixbrew.co.uk

⊛Zero Six Brew Co Ltd launched in 2021. The brewery is situated in a 200-year-old building which was once a wine merchants. Beer is available in bottle, keg and cask. There are plans to develop a range of beers to reflect an original town brewery from 1900, and a taproom is planned for 2023. LIVE V

Parcel Yard, Leicester (Photo: It's No Game / Flickr CC BY 2.0)

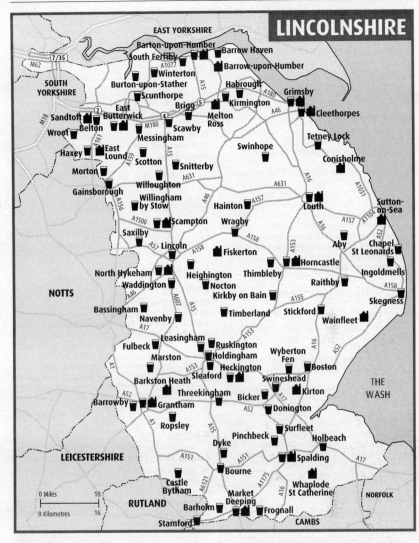

LINCOLNSHIRE

Aby

Railway Tavern

Main Road, LN13 0DR (off A16 via South Thoresby)

☎ (01507) 480676 ⊕ railwaytavern-aby.co.uk

2 changing beers (sourced nationally) Ⓗ

A rural inn that was closed when the licensees took it on over 19 years ago; since then it has grown to the successful pub it is now, serving the community and raising money for charity. It has won numerous awards including local CAMRA Country Pub of the Year four times. It offers a wide range of real ales and a menu based on produce from the area. Two holiday cottages are available for short breaks or week-long bookings.

Q ﹥ ⚪ ≈ ① ⓕ & ♣ P ☺

Barholm

Five Horseshoes Ⓛ

PE9 4RA

☎ (01778) 560238

Adnams Southwold Bitter; Draught Bass; Oakham JHB; 3 changing beers (often Church End, Grainstore, Hopshackle) Ⓗ

A classic 18th-century country pub built from local Barnack stone, well known for its support of local charities. It has two bars, two cosy side rooms and a pool room. A wood fire burns throughout the winter. A real cider is served along with three permanent and three changing ales. Pizzas are available on Friday and street food on Saturday evening, while barbecues and live music in the large garden are a feature of the summer months. Q ﹥ ⚪ ⊛ ① & ● P ☺ ☎

Barrow Haven

Haven Inn

Ferry Road, DN19 7EX (approx 1½ miles E of Barrow-upon-Humber)

☎ (01469) 530247 ⊕ thehaveninn.co.uk

Timothy Taylor Landlord; 2 changing beers (sourced nationally; often Theakston) Ⓗ

Built in 1730 as a coaching inn in the quiet North Lincolnshire countryside for travellers using the former

ferry, the Haven has been renowned for hospitality, good food and drink, and comfortable lodgings ever since. Full of character, a warm welcome awaits, with a bar, lounge and large conservatory. The perfect place for walkers on the Humber Bank to call in for a well-kept pint. ▷🕮🏠�óⓓ&≥P🌸

Barrowby

White Swan ✅

Main Street, NG32 1BH
☎ (01476) 562375
Castle Rock Harvest Pale; Sharp's Doom Bar; 2 changing beers Ⓗ
Popular and welcoming village pub run by the same landlord for almost 30 years, who is an enthusiastic CAMRA member. There is a comfortable lounge, separate bar area and a further area where the local darts, cribbage and pool teams play. Offering two regular and two changing guest ales, it also provides locally sourced traditional home-made food Wednesday to Saturday. Outside there is a heated smoking area and a pleasant secluded garden. Quiz night is the first Sunday of the month. Q▷🕮�óⓓ&♣P🖵🌸🛜

Barton-upon-Humber

Sloop Inn

81 Waterside Road, DN18 5BA (follow Humber Bridge viewing signs)
☎ (01652) 637287
Batemans XB, Gold; Theakston Best Bitter; Timothy Taylor Boltmaker; 1 changing beer (sourced regionally) Ⓗ
This welcoming 19th-century multi-roomed pub, popular with both locals and walkers, has recently been refurbished throughout, but original features such as the Delft fireplace tiles and stained-glass windows remain. Traditional pub food is served, and four real ales are normally available. The Far Ings nature reserve, Waters' Edge Visitor Centre, Ropewalk, Ropery Hall and the Humber Bridge are all nearby attractions. ▷🕮�óⓓ&≈♣P🖵(350,250)🌸

White Swan Ⓛ

66 Fleetgate, DN18 5QD (follow signs for railway station)
☎ (01652) 661222
House beer (by Westgate); 4 changing beers (sourced nationally; often Great Newsome, Horncastle Ales) Ⓗ
Multi award-winning 17th-century coaching inn opposite the bus/train interchange. The Swan offers a warm welcome to all, hosting community groups, traditional pub games and a monthly vinyl night. Four ever-changing cask ales are complemented by a craft keg beer from local brewery Little Big Dog. An annual beer festival is held in the characterful, renovated coaching outbuildings. Popular weekend brunches are available. Q▷🕮🏠�ó&♣P🖵(250,350)

Bassingham

Bugle Horn Inn

19 Lincoln Road, LN5 9HQ
☎ (01522) 789773 🌐 bassinghambuglehorn.co.uk
2 changing beers (sourced nationally) Ⓗ
Built in the 17th century as an inn, the Bugle Horn is a locals' pub retaining many original features, including beamed ceilings and real fires. The lounge bar has an open fire and the bar has two TV screens showing sports. Food is available in a separate dining room, with menu options including curry nights, steak nights and a Sunday

lunch. At least two constantly-changing beers are available. The pub hosts two darts teams and regular quizzes. ▷🕮�óⓓ♣🍴P🖵(47)🌸

Belton

Crown Inn Ⓛ

Church Lane, DN9 1PA (turn off A161 at All Saints Church and follow road behind)
☎ (01427) 872834
Bradfield Farmers Blonde; Oakham Citra; Wainwright; Wychwood Hobgoblin Gold; 2 changing beers (sourced regionally) Ⓗ
Difficult to find (situated behind All Saints Church) but well worth the effort, this is a haven for the discerning drinker. The pub has a friendly atmosphere and takes part in the life of the local community. At least four cask ales (sometimes up to six) are always available. A regular in the Guide for many years, the Crown has been the recipient of several local CAMRA awards. ▷🕮Å♣P🖵(399)🌸🛜

Bicker

Red Lion

Donington Road, PE20 3EF
☎ (01775) 821200 🌐 redlionbicker.co.uk
Adnams Southwold Bitter; Courage Directors; Greene King IPA; 1 changing beer Ⓗ
A typical welcoming country inn with low beams and tiled floor, in a pleasant setting. Extensively and tastefully redecorated in 2015, it reopened after two years' closure. This multi-roomed pub has a small bar and is popular for dining, with a varied, extensive menu. It is known to date from at least 1665, the year of the Great Plague of London. ▷🕮�óⓓ&♣P🖵(59)🛜

Boston

Coach & Horses

86 Main Ridge, PE21 6SY
☎ (01205) 612649

REAL ALE BREWERIES

8 Sail 🔌 Heckington
Austendyke Spalding
Bacchus 🍺 Sutton-on-Sea
Batemans 🔌 Wainfleet
Blue Bell 🍺 Whaplode St Catherine
Brewsters Grantham
Consortium 🍺 🔌 Louth
Dark Tribe 🍺 East Butterwick
Docks Grimsby
Don Valley 🔌 Sandtoft
Ferry Ales Fiskerton
Firehouse 🔌 Louth
Fuddy Duck Kirton
Greg's 🍺 Scampton
Hopshackle Market Deeping
Horncastle 🍺 Horncastle
Lincolnshire Craft Melton Ross
Little Big Dog Barrow-upon-Humber
Newby Wyke Grantham
Pig Barn East Lound (NEW)
Poachers 🔌 North Hykeham
Shadow Bridge 🔌 Barton-upon-Humber (NEW)
Welland Spalding
Wickham House Conisholme
Willy's 🍺 Cleethorpes
Zest Barkston Heath

Batemans XB, XXXB; 1 changing beer (sourced locally; often Batemans) ℍ
Situated close to the Boston United football ground, this pub hosts pool, darts, poker and quiz teams and is popular with football supporters. The open-plan lounge has a polished wooden bar frontage and wood-panelled ceiling. Wooden cabinets showcase a large collection of miniature bottles. Other items such as a deer's antlers, a large clock and photographs of musicians adorn the walls. There is regular entertainment at weekends. 🏵♣🛏🔗

Eagle
144 West Street, PE21 8RE
☎ (01205) 361116
Castle Rock Harvest Pale, Preservation, Screech Owl; 5 changing beers (often Castle Rock) ℍ
Part of the Castle Rock chain, the Eagle is known as the real ale pub of Boston. This two-roomed, friendly hostelry has an L-shaped bar with a large TV screen for big sports events. The smaller lounge has a cosy feel. The pub stocks a wide range of guest ales, and at least one cider. A function room upstairs is home to Boston folk club. Friday is quiz night – allegedly the hardest in town. Q🏵♿≠♣🛏🔗

Goodbarns Yard ✓
8 Wormgate, PE21 6NP
☎ (01205) 355717 🌐 goodbarnsyard.co.uk
Adnams Ghost Ship; Timothy Taylor Landlord; 1 changing beer (sourced nationally) ℍ
Situated in a cobbled medieval street, which runs northwards away from the Boston Stump, parallel to the River Witham. The 700-year old pub is popular for meals, with a busy restaurant. Old signs and pictures of Boston adorn the walls. A large garden with tables and covered patio areas overlooks the river. In winter, an open fire welcomes you. 🛒🏵◐≠🔗

Bourne

Anchor
44 Eastgate, PE10 9JY
☎ (01778) 422347
House beer (by Dancing Duck); 4 changing beers (sourced regionally; often Nene Valley, St Austell, Thornbridge) ℍ
Traditional two-roomed locals' pub with an attractive patio by the banks of a tributary of the River Glen, strong on sports, with darts played, BT Sports on the TV and several sporting trophies on display. It raises funds for the local Air Ambulance service. The house beer, Bourne Particular, is supplied by Dancing Duck, as is Roundheart, brewed for sister pub the Hand & Heart in Nottingham. There is a small car park. 🛒🏵♣♿P🔗

Brigg

Black Bull
3 Wrawby Street, DN20 8JH
☎ (01652) 653995 🌐 blackbull-brigg.craftunionpubs.com
Sharp's Doom Bar; 1 changing beer (sourced nationally; often Adnams, Theakston, Timothy Taylor) ℍ
A busy, friendly town-centre hostelry with reasonably priced beers. There are three rooms and a courtyard beer garden with cabins. The pub is sports oriented, with large TVs, has its own football club and organises darts tournaments. It also hosts themed days, fundraising events for charities and regular live music. If you want to watch sport with a well-kept ale in hand, this is the pub for you. 🏵♿≠♣P🛏(4)🛒🔗

Yarborough Hunt 🄻
49 Bridge Street, DN20 8NS (across bridge from marketplace)
☎ (01652) 658333
Lincolnshire Craft Best Bitter, Lincoln Gold, Bomber County; 3 changing beers (sourced nationally; often St Austell) ℍ
Formerly Sargeant's brewery tap, originally built in the 1700s, this is a traditional pub that retains its original features. Simply furnished and with open fires, it has been extended to give five rooms. There is an outdoor courtyard with separate cabins. Daily newspapers are provided. No food is served but you may bring in your own. The main outlet for Lincolnshire Craft Beers, it also has an extensive range of up to 14 craft beers and ciders. Dogs are welcome. Q🛒🏵♿≠♣🛏(4,X4)🛒🔗

Burton-upon-Stather

Ferry House Inn 🄻 ✓
Stather Road, DN15 9DJ (follow campsite signs through village, down hill at church)
☎ (01724) 721783 🌐 ferryhousepub.co.uk
3 changing beers (sourced regionally; often Lincolnshire Craft, Wold Top) ℍ
Friendly village pub on the banks of the River Trent, which has been in the same family for over 60 years. It has its own microbrewery – check ahead for available beers. Real cider is sold, and good-quality food is served Friday to Sunday. The local heritage group meets here and holds a beer festival in September. Live music is hosted throughout the summer. The large outside decking and seating area is popular with walkers and cyclists. Traditional pub games are played, and there is a pub quiz. A tea room is planned. Q🛒🏵◐♿Å♣♿P🛏(60)🛒🔗

Castle Bytham

Castle Inn 🄻
High Sreet, NG33 4RZ
☎ (01780) 411223 🌐 castleinnbytham.co.uk
Hop Back Summer Lightning; Oakham Citra; 2 changing beers ℍ
One of the original public houses in an historic village, the decor features old oak beams, period furnishings and walls hung with antique prints. This 17th-century gem has Summer Lightning permanently available alongside regularly-changing guest ales sourced regionally and nationally. An excellent menu of home-made food cooked on a wood-fired stove in the bar is served lunchtime and evening. Q🛒🏵◐♣🛒🔗

Chapel St Leonards

Admiral Benbow
The Promenade, PE24 5BQ
☎ (01754) 871847 🌐 admiralbenbowbeachbar.co.uk
Black Sheep Best Bitter; 2 changing beers ℍ
A beach bar on the promenade, with an outside seating area on the Hispaniola boat deck. Opening times and facilities are dependent on the weather and are limited in winter (see the website for current times). Bar snacks and hot food are sold, with picnic trays and plastic glasses to take your favourite food and ale onto the beach. Dogs are welcome on leads, with blankets and dog treats available. If the flag is flying the bar is open. 🛒🏵◐🛏🛒🔗

Cleethorpes

Message in a Bottle
91-97 Cambridge Street, DN35 8HD
☎ (01472) 453131 ⊕ miabcleethorpes.net
2 changing beers
A champion of local beers, this specialist bottle shop has a pop-up bar at weekends offering two cask ales, attracting a mixed crowd of those seeking something different. The drinking area is outdoors so wrap up in cold weather. Background music is played, and events where food and beer are paired can be busy, but a seat can usually be found for passersby. 🌞≷🚌(4)♥

No. 2 Refreshment Room ♥
Station Approach, DN35 8AX
☎ 07905 375587
Hancocks HB; Rudgate Ruby Mild; Sharp's Atlantic, Sea Fury; 2 changing beers (sourced nationally) ⊞
Known locally as Under the Clock, this small one-roomed bar has become a regular feature in the Guide. The local CAMRA award-winning bar is set on the railway station forecourt itself, so handy if you're waiting for a train. Quality real ales are served in a convivial atmosphere. There is always an excellent selection, usually including one dark beer, alongside a range of ciders. ❀≷🚌🛜

No.1 Pub
Railway Station, DN35 8AX
☎ (01472) 696221
Batemans XXXB; Draught Bass; 6 changing beers (sourced regionally; often Horncastle Ales) ⊞
A large railway bar situated on Cleethorpes station, this popular local has a main bar with a smaller real ale-themed back room overlooking the station platform. The walls are adorned with local railway memorabilia, and there is outside seating at the front for warmer weather. The pub is known for its home-cooked meals, live music is a feature most weekends, and an annual music festival is held. ◑≷♣♥🚌🛜

Nottingham House
7 Seaview Street, DN35 8EU
☎ (01472) 505150
Oakham Citra; Tetley Bitter; Timothy Taylor Landlord; 4 changing beers (sourced regionally) ⊞
A popular traditionally styled pub, with three rooms all accessible from the front bar. A cosy snug can be found at the rear. All bars and toilets are on the ground floor. The public bar shows sports matches on the TV, and cards and dominoes are available to play. Children and dogs are made welcome in this old coaching house. Q🌞◑🅰◑≷🚌🛜

Willy's
17 High Cliff, DN35 8RQ
☎ (01472) 602145
Willy's Original; 2 changing beers (sourced nationally) ⊞
A seafront bar with views over the Humber estuary to the Yorkshire coast. There is a microbrewery on the site in which Willy's Original bitter is brewed. Service is mainly from the downstairs bar – an upstairs bar is used for functions. Limited outdoor seating is available. Good-quality locally sourced home-made food is served. The pub attracts a diverse clientele, with a gentler, quieter crowd of an afternoon, and gets livelier at weekends when a DJ plays. 🌞❀≷♥🚌♥

Donington

Black Bull
7 Market Place, PE11 4ST
☎ (01775) 822228 ⊕ theblackbulldonington.co.uk
Batemans XB; Sharp's Doom Bar; 2 changing beers (often Batemans) ⊞
Busy local just off the A52. Five handpumps feature three regular beers and occasionally two varying guest beers from small brewers as well as large regionals. The comfortable bar has low, beamed ceilings, wooden settles and a cosy fire in winter. Due to the return in 2020 of the remains of Captain Matthew Flinders, navigator and cartographer, born 1774, to his birthplace, Donington, the pub has an exclusive beer named in his honour, brewed by Batemans. 🌞❀◑♣♥🚌♥🛜

Dyke

Wishing Well Inn ✓
21 Main Road, PE10 0AF
☎ (01778) 422970 ⊕ thewishingwellinn.co.uk
Greene King Abbot; Timothy Taylor Landlord; 1 changing beer (often Black Sheep, Hop Back) ⊞
Despite its popularity for meals, the Wishing Well still has a comfortable pub atmosphere in the bar. Housed in what was once a row of three shops, the well that gives the pub its name can be seen in the restaurant. There is a large campsite attached, as well as eight letting rooms. The village takes its name from the nearby Roman Car Dyke, which runs along the western edge of the Fens. 🌞❀🚰◑♣♥🛜

East Butterwick

Dog & Gun ▯
High Street, DN17 3AJ (off A18 at Keadby Bridge, E Bank)
☎ (01724) 782324 ⊕ doggunpub.com
3 changing beers (sourced locally; often Dark Tribe) ⊞
Set on the bank of the River Trent, this village pub is a favourite with walkers, cyclists and motor enthusiasts. Three rooms indoors are supplemented by some riverside seating which is popular in good weather. Food is increasingly popular here and available from Thursday to Sunday (check times). Beers from the onsite Dark Tribe microbrewery are always available and occasional seasonal brews are offered. 🌞❀◑👟♣♥🚌(12)♥🛜

Frognall

Goat ♥ ▯
155 Spalding Road, PE6 8SA
☎ (01778) 347629
House beer (by Hopshackle) ⊞; **5 changing beers (often Bakers Dozen, Grainstore, Nene Valley)** ⊞/🅖
An attractive country pub with several dining areas, but with space for drinkers in the bar. Six handpumps serve a range of regional and microbrewery beers, including at least one LocAle and a strong ale. There are at least two real ciders on gravity. A large selection of malt whiskies is available. A popular beer festival is held in the summer. The large garden has two separate children's play areas. Local CAMRA Rural Pub of the Year 2022. Q🌞❀◑👟♥🚌(100) 🛜

Fulbeck

Hare & Hounds
The Green, NG32 3JJ
☎ (01400) 273322 ⊕ hareandhoundsfulbeck.com
Adnams Broadside; Timothy Taylor Landlord; Wadworth 6X; Woodforde's Wherry ⊞
This well presented village pub originating from the 17th century faces the village green of the charming village of

Fulbeck. It is a picture-postcard country inn serving four regular ales. Locally sourced food is used where possible in the restaurant. The pub has accommodation, making it an ideal base for exploring the surrounding picturesque countryside, including the adjacent 10th-century church, Lincoln Cathedral and the Battle of Britain Memorial Flight at RAF Coningsby. A function room is also available for use. ❀🛏️◀🕭&P🖳

Gainsborough

Blues Club

Northolme, North Street, DN21 2QW
☎ (01427) 613688
Horncastle Ales Angel of Light; 2 changing beers 🖽
The club has a bar area with several TVs showing sport, a quieter lounge and a large function room that hosts regular live entertainment (admission charges may apply). Two or three changing real ales are usually available and details of forthcoming beers can be emailed to customers on request. CAMRA guests are always welcome on production of a membership card. 🕭➡️(Central)♣🖳🛜

Eight Jolly Brewers 🅛

Ship Court, DN21 2DW
5 changing beers 🖽
Gainsborough's flagship real ale haven, in this Guide since 1995, based in a 300-year-old Grade II-listed building. Six or more ever-changing beers are always on sale, many from northern micros, but new breweries from all areas feature. Real cider and continental bottled beers are available. Customers bring in food to share on Sunday lunchtimes. Live music is making a return this year. Q&➡️(Central)●P🖳(200)

Sweyn Forkbeard ✅

22-24 Silver Street, DN21 2DP
☎ (01427) 675000
Greene King Abbot; Ruddles Best Bitter; Sharp's Doom Bar; 4 changing beers 🖽
This town-centre Wetherspoon establishment, a former local CAMRA Pub of the Year, is one of the must-visit pubs in town. Three or four rotating guest beers often include some oddities for this part of the country. Customers can ask for their favourite beer and it often appears. The pub is named after the Danish King of England in 1013, whose son Canute is rumoured to have stopped the Aegir (Trent tidal bore). 🕭◀&➡️(Central)●🖳🛜

Grantham

Beehive

10-11 Castlegate, NG31 6SE
☎ (01476) 404554
2 changing beers (often Newby Wyke) 🖽
Famous for its living sign, this two-room inn dates back to the 18th century. With a main bar, pool table and a large terraced beer garden to the rear, this town-centre pub with superbly kept ales is well worth a visit. The beers are sourced from local award-winning Grantham brewery Newby Wyke, with changing guests. Accommodation is available (book online). Q❀🛏️◀➡️♣🛜

Blue Pig

9 Vine Street, NG31 6RQ
☎ (01476) 574502 ⊕ bluepiggrantham.co.uk
Bombardier; Timothy Taylor Boltmaker; Wychwood Hobgoblin Ruby; 2 changing beers (often Zest) 🖽

One of only a few half-timbered buildings remaining in town, this award-winning pub is situated just off the main High Street. Once inside you are met with an open fire, beamed ceilings and a bar with seating spread all around. You can be served from both sides of the bar and there is an impressively-sized beer garden winding its way through the space out back with views of the stunning St Wulframs Church. ❀◀▶♣🖳

Grantham Railway Club 🅛

Huntingtower Road, NG31 7AU
☎ (01476) 564860
2 changing beers 🖽
A community-run club, voted local CAMRA Club of The Year since 2020, which supports Grantham's three local brewers. This former British Rail Staff Association club plays host to numerous cribbage, darts and domino teams as well as supporting various social and community organisations. There is live music every Saturday night, with a spacious back room available to hire. CAMRA members are welcome. See Facebook for up-to-date entertainment information. 🕭❀&➡️♣P❀🛜

Lord Harrowby 🍷 🅛

65 Dudley Road, NG31 9AB
☎ (01476) 563515
4 changing beers 🖽
A friendly back-street community pub, one of the few in Grantham, with a bar, snug and lounge with a real fire – just how pubs used to be. There is a dartboard on the corner and crib is played in leagues. At the back is an excellent enclosed area where at least two beer festivals with live music are held. A LocAle is always on offer while the landlord, a CAMRA member and real ale enthusiast, sources four changing guest beers. Afternoon meals are available Thursday to Sunday (booking advisable). Q❀◀➡️♣●❀🛜

Nobody Inn 🅛

9 North Street, NG31 6NU (opp Asda car park)
☎ (01476) 562206 ⊕ nobodyinn.com
6 changing beers (often Black Sheep, Newby Wyke, Sharp's) 🖽
A superb example of a well run independent town pub, selling a range of six beers. The pub regularly has beer from the award-winning Newby Wyke brewery in Grantham. It gets lively at the weekends and when big sporting events are taking place, but it is also a nice place for a quiet drink with good bar staff. Popular live music is staged most Saturday nights. Watch out for the giant spider! ♣●🖳❀🛜

Grimsby

Barge

Victoria Street, DN31 1NH
☎ (01472) 340911 ⊕ thebargegrimsby.co.uk
Bombardier; Navigation Brewery New Dawn Pale; 1 changing beer 🖽
As its name implies, this is an old converted grain barge, berthed in the town centre near all bus routes. It has a slight list to starboard, but don't worry – it has had it for over 20 years. Afternoon trade tends to be food-oriented, while the evenings have more of a rock music vibe when the jukebox is turned on. There is a quiz on Monday night with a free supper. Outside at the front is a seating area. 🕭❀◀➡️(Town)🖳

Rutland Arms

26 Rutland Street, DN31 3AF
☎ (01472) 357362
Old Mill Traditional Bitter; 3 changing beers 🖽

Close to both bus and train stations, and recently refurbished, this pub tends to be a favourite with local and away football supporters. The single long room has a pool table and dartboard at the end. Formerly an Old Mill pub, there is generally still one Old Mill beer among the selection of ales on four handpumps. A TV shows live sporting events. Q★❄️❀≕(New Clee)♣P☐(3,9,10)🕏

Yarborough Hotel ✅
29 Bethlehem Street, DN31 1JN
☎ (01472) 268283
Greene King Abbot; Ruddles Best Bitter; Sharp's Doom Bar; 12 changing beers (sourced regionally) Ⓗ
Large open-plan hostelry serving 12 real ales from both national brands and breweries in the Lincolnshire area. Like many pubs in the Wetherspoon chain, it can be very busy. After a troubled past where it was under threat of demolition, the building has been restored and is once again a grand hotel and a thriving pub. Grimsby Town railway station is next door. Q★❄️🍴◑🕭≕(Town)♦☐

Habrough

Station Inn
Station Road, DN40 3AP
☎ (01469) 572896
3 changing beers (sourced regionally; often Bradfield, Theakston, Timothy Taylor) Ⓗ
Originally a hotel, built in 1848 for the Great Grimsby and Sheffield Junction Railway, this pub has a good community spirit. It has one large room with access to the bar and a smaller area for pool and bar games. Live bands feature once a month on Saturday, as well as karaoke nights, theme nights and traditional pub games, contributing to a lively environment. Three handpumps offer changing beers from regional brewers. Dogs are welcome. ★❄️≕♣P❀

Hainton

Heneage Arms
1 Louth Road, LN8 6LX
☎ (01507) 313145 ● theheneagearms.co.uk
1 changing beer Ⓗ
The Heneage Arms is a country pub in a village on the edge of the Lincolnshire Wolds, an Area of Outstanding Natural Beauty. Since 2012 it has been run by volunteers from a community group, and although only open on Friday and Saturday, it has built a good following. An annual beer festival is held and visitors can take advantage of the attached campsite and stay over. Q★❄️P☐(50)

Haxey

King's Arms
18 Low Street, DN9 2LA (on jct of B1396 and A161)
☎ (01427) 311364
3 changing beers (sourced regionally; often Pheasantry) Ⓗ
A friendly village which reopened in 2019 after a long period of closure. The present licensee has restored the features that previously made the pub successful. Two cask ales from local breweries are always available with a third in the summer months. The pub participates in the traditional Haxey Hood game which has been held in January since medieval times, and is the current holder of the trophy. ★❄️♣P☐(399)❀

Heckington

8 Sail Brewery Bar
Heckington Mill, Hale Road, NG34 9JW
☎ (01529) 469308 ● 8sailbrewery.co.uk
8 Sail Ploughmans Lunch, Windmill Bitter, Froglet, Rolling Stone, King John's Jewels, Oat Malt Stout; 3 changing beers (sourced locally; often 8 Sail) Ⓗ
Situated in part of the Heckington Windmill complex, the brewery's bar room features a restored Victorian bar, and church pew and Britannia bar seating. Three changing 8 Sail Brewery beers and occasional guest ales are usually available. A selection of German bottled beer and local cider is also stocked. Beer festivals are held in mid July on Heckington Show weekend. The bar tends to close early on winter weekends – check times on the Facebook page. Q★❄️🕭≕♣♦P☐❀🕏

Heighington

Butcher & Beast
High Street, LN4 1JS
☎ (01522) 790386 ● butcherandbeast.co.uk
Batemans XB, XXXB; Timothy Taylor Landlord; Oakham Citra; 2 changing beers (sourced nationally; often Batemans, Castle Rock) Ⓗ
An important building in the Heighington Conservation Area, this is a classic village local. At the front is the main bar, to the side a snug, and the restaurant is at the rear. The garden has a large covered patio and a grassed area. The four regular beers are supplemented by guests, including seasonal offerings from Batemans. Real cider may be available in the summer. A local group of 'grumpy old men' hold a Christmas charity event. Q★❄️◑♣P☐(2,10)❀

Holbeach

Horse & Groom
65 High Street, PE12 7ED
☎ (01406) 422234 ● horseandgroomholbeach.co.uk
Adnams Southwold Bitter; 1 changing beer (sourced nationally) Ⓗ
Classic town-centre coaching inn dating from the 1800s with low beamed ceilings, a feature fireplace and log burner. Lively and welcoming, it offers good food and two well-kept ales, often from local independent breweries. There is a focus on traditional pub games, with many teams participating in local leagues. Live music is hosted occasionally. A winner of Holbeach in Bloom, it has an attractive family-friendly beer garden, and an excellent bus service stops at the door. ★❄️🍴◑🕭♣P🕏

Holdingham

Jolly Scotchman ✅
18 Lincoln Road, NG34 8NP
☎ (01529) 304864
Greene King Abbot, IPA; 2 changing beers (sourced regionally; often 8 Sail) Ⓗ
Located at the northern end of Sleaford, near the A17 Holdingham roundabout, the pub boasts a modern open-plan interior with a mix of seating styles. A multicoloured tiled floor surrounds the wooden bar front. The restaurant area is of garden room format, with large picture windows. Part of the Flaming Grill chain and very much food oriented, there are plenty of meal offers. It can be busy at times, so advance booking is advisable. ★❄️◑P🕏

Horncastle

King's Head
16 Bull Ring, LN9 5HU
☎ (01507) 523360
Batemans XB, Gold, XXXB; 1 changing beer (sourced regionally) ⊞
A comfortable, cosy and friendly pub. Unusually for this locality, the building has a thatched roof, hence its local name the Thatch. Three beers from Batemans are generally available plus a guest. Reputedly the pub inspired an OO gauge Hornby model, an example of which is displayed behind the bar. Summertime sees the pub resplendent with hanging baskets and it has been the winner of Batemans' Floral Display competition. Try spotting the pub cat, Rufus. ⏴🏠⍟🛋🍴🚖😋🎵

Old Nick's Tavern
8 North Street, LN9 5DX
☎ (01507) 526862
4 changing beers (sourced locally; often Horncastle Ales) ⊞
Built in 1752 as a coaching inn, this original building is now a town-centre pub with its own microbrewery, Horncastle Ales. The pub has been refurbished and the decor incorporates the old pub sign and old photos. Live bands play regularly. There are five handpumps, four of which usually showcase beers from Horncastle. The head brewster is the landlord's daughter. No food is currently served. ⏴🏠🍴🛋🚖😋🎵

Ingoldmells

Countryman 🅛
Chapel Road, PE25 1ND
☎ (01754) 872268
House beer (by 8 Sail) ⊞
The privately-owned Countryman appears to be a modern building but it incorporates the early 19th-century Leila Cottage. A notorious smuggler, James Waite, used to reside here when Ingoldmells was a wild and lonely place – he certainly wouldn't recognise the current holiday coast, with Skegness, Butlin's and Fantasy Island nearby. The pub is on northern bus routes from Skegness. Beers were previously supplied by the pub's own on-site brewery, but this has now closed and the house beers are brewed by 8-Sail Brewery in Heckington. ⏴🏠⍟🍴🚶🅿🚖

Kirkby on Bain

Ebrington Arms
Main Street, LN10 6YT
☎ (01526) 354560 ● ebringtonarms.com
Batemans XB; Timothy Taylor Landlord; 2 changing beers ⊞
Attractive country pub close to the River Bain and dating from 1610. World War II airmen used to slot coins into the ceiling beams to pay for beer when they returned from missions over Germany. Sadly, many of these coins are still in situ and make a unique memorial to those who lost their lives. The popular restaurant offers good food made with local produce (booking advised). One guest beer is available in winter, often increasing to two in summer. ⚄⏴🏠⍟🛋🍴🚶🅿🚖(65)😋🎵

Kirmington

Marrowbone & Cleaver
High Street, DN39 6YZ
☎ (01652) 688335 ● marrowboneandcleaver.com

Sharp's Doom Bar; house beer (by Batemans); 1 changing beer ⊞
Following a period of closure, this village inn was refurbished and reopened by motorbike racer Guy Martin. It is family-run, with Guy's sister Sally managing operations. Inside, it is adorned with racing memorabilia and also items from the 166 Squadron. Although mainly food-oriented, there are three handpumps, and drinkers are given as warm a welcome as diners. The house beer was developed in a collaboration between Guy and Batemans Brewery. ⚄⏴🏠⍟🍴🛋🍴🚶🅿🚖

Leasingham

Duke of Wellington
19 Lincoln Road, NG34 8JS
☎ (01529) 419300 ● leasinghamcbs.com
Marston's Pedigree; Wainwright; 2 changing beers ⊞
A community owned pub in every sense, with games days and nights, daytime and evening quizzes, food-themed nights, as well as open mic once a month. The two guest ales are often Wherry and Directors. Originally a thatched pub named the Sun, it was renamed when it was bought by a local officer following the Battle of Waterloo. It has a cosy, comfortable lounge and a spacious garden with plenty of seating. ⚄⏴🏠⍟🍴🚶🅿🚖😋🎵

Lincoln

Adam & Eve Tavern
25 Lindum Road, LN2 1NT
☎ (01522) 537108 ● adamandevelincoln.co.uk
Morland Old Speckled Hen; Castle Rock Harvest Pale; Timothy Taylor Landlord; 1 changing beer (sourced nationally) ⊞
Arguably one of the oldest taverns in the city, dating back to the 18th century. Sitting atop Lindum Hill, it provides a beery oasis to quench the thirst of those who make the journey up. The pub is multi-roomed, providing areas for a quiet drink or a larger gathering. Other spaces house a pool table and dartboard. Fans of sport will appreciate the two screens for major sporting events. ⏴🏠⍟🍴🚶🅿🚖😋🎵

BeerHeadZ
4 Eastgate, LN2 1QA
☎ (01522) 255430 ● beerheadz.biz
3 changing beers (sourced nationally) ⊞
A bright, colourful pub with an industrial feel situated in the uphill city area. It is part of a small chain of new generation indie-pubs and serves up to three cask ales, craft keg beers, two ciders and a range of bottled and canned beers. Oversized glasses are used. Customers are welcome to bring in their own food. Regular events include quizzes and tap takeovers. 🍴🚖🚖😋🎵

Birdcage ✅
54 Baggholme Road, LN2 5BQ
☎ (01522) 274478 ● birdcagelincoln.co.uk
Sharp's Doom Bar; 3 changing beers (sourced nationally; often Ferry Ales, Milestone, Zest) ⊞
A single-roomed, street-corner pub refurbished in a clean, modern style with a mix of traditional tables and chairs. The enclosed patio area is a suntrap. Three changing beers complement the regular ale and a selection of boxed ciders. There are frequent music nights, with open mic, karaoke and bands, plus comedy and spoken-word events. Fortnightly Sunday lunches can be booked. Friendly bar staff and locals greet all who enter this dog-friendly pub. 🏠⍟🚖😋🎵

Cardinal's Hat

268 High Street, LN2 1HW
☎ (01522) 527084
Adnams Mosaic; Timothy Taylor Landlord; Ossett White Rat; house beer (by Lincolnshire Craft); 4 changing beers (sourced nationally) ⊞
Said to be named after Cardinal Wolsey, Bishop of Lincoln from 1514 to 1515, this pub is housed in a building formerly used by St John Ambulance. The area the pub resides in was restored in 2015, but the Grade II*-listed building dates back to the 15th century, and its current form shows off some original features. Multiroomed, it is ideal for a quiet drink for a few, or larger groups enjoying the extensive drinks menu, bar snacks, charcuterie boards and cheeses. ⬤❀◑&≡(Central)◖❀

Golden Eagle

21 High Street, LN5 8BD
☎ (01522) 521058
Castle Rock Harvest Pale; Sharp's Doom Bar; 7 changing beers (sourced nationally; often Castle Rock, Pheasantry, Welbeck Abbey) ⊞
A popular pub at the southern end of the High Street, close to Lincoln City's football ground and very busy on match days. The building dates from the 1700s, and up to nine real ales are served from two bars. Dogs are welcome and the cosy front lounge has a log burner. The large garden has covered and heated seating. Two beer festivals are held annually and, in summer, the barbecue may be fired up. ⬤♣❀▬P❀❀

Joiners Arms ✔

4 Victoria Street, LN1 1HU
☎ 07871 887459
4 changing beers (sourced nationally) ⊞
Nestled among the Victorian terraces running up Lincoln's escarpment, this traditional back-street boozer has a main lounge with an open fire and two steps that lead to the bar. The back room has a pool table, dartboard and a retro Space Invaders machine. The pub hosts pool and target-shooting teams. The small patio has a remarkable fence constructed from old hand tools. Tuesday is quiz night and there is a weekly open mic night. Beers are sourced from microbreweries nationwide. ❀♣❀❀

Morning Star ✔

11 Greetwell Gate, LN2 4AW
☎ (01522) 514269 ∰ morningstarlincoln.co.uk
Timothy Taylor Boltmaker; Sharp's Doom Bar; Pheasantry Dancing Dragonfly; Wainwright; 2 changing beers (sourced nationally) ⊞
Handily situated in uphill Lincoln close to the city's cathedral and castle. Described by a local as one of the few proper pubs in the area, it is a place where drink and conversation flows. Visitors are welcomed by the regulars. This multiroomed pub is great for a gathering or a quiet drink in the lounge. The rear beer garden is a perfect spot to be in the summer enjoying an alfresco ale or several. Q❀P▬❀❀

Strugglers Inn ❰ 🅻 ✔

83 Westgate, LN1 3BG
☎ (01522) 535023
Sharp's Sea Fury; Timothy Taylor Landlord; 8 changing beers (sourced nationally; often Brewsters, Pheasantry, Welbeck Abbey) ⊞
Tradition is the watchword for this award-winning, ale-mighty beacon of a pub which attracts discerning drinkers from near and far. Enter right for the cosy snug with bench seats, polished chess tables, books and a real fire. The main bar has another real fire and a plethora of visual cues for the hundreds of glorious beers served.

Live music is hosted inside and in the secret, sunken garden with its splendid brewing process mural and floral displays. Q❀♣▬❀

Tiny Tavern

107 High Street, LN5 7PY
☎ 07761 123697
5 changing beers (sourced nationally) ⊞
A recent conversion of two 17th-century cottages in the middle of a Grade II-listed terrace. The long public area has a window seat and a fireplace at the front, the bar counter in the middle and a dartboard area and access to the garden at the rear. A separate room may be used for community purposes. The five handpumps dispense beers from all over the country. Up to three bag-in-box ciders are also available. ❀≡♣▬▬

Louth

Boar's Head

12 Newmarket, LN11 9HH
☎ (01507) 654127 ∰ theboarsheadlouth.co.uk
Caledonian Deuchars IPA; Theakston Best Bitter; Timothy Taylor Landlord; 1 changing beer ⊞
A traditional three-roomed pub just outside the centre of this market town, adjacent to the cattle market. It is well known locally for its real ales. Games include darts, dominoes and pool. On Thursday – cattle market day – it may open early. Q⬤❀◑&♣◖▬❀❀

Brown Cow ✔

133 Newmarket, LN11 9EG (top of Newmarket on jct with Church St)
☎ (01507) 605146
Black Sheep Best Bitter; Castle Rock Harvest Pale; Fuller's London Pride; 1 changing beer ⊞
The owners are celebrating 10 years behind the bar of this friendly freehouse. With a great atmosphere and excellent beer, it's a must when visiting Louth. A free quiz is held on the first Sunday of the month. The kitchen serves traditional, home-cooked food, made with locally sourced products. The pub is a popular community meeting place. ⬤❀◑&♣▬❀❀

Cobbles Bar

New Street, LN11 9PU (off Cornmarket)
Black Sheep Best Bitter; 1 changing beer ⊞
Traditional pub-style bar based in the centre of town, with friendly staff at all times. This small but accommodating venue has multiple personalities, from a bustling coffee shop serving light lunches to a busy pre-club local with a DJ and live music at weekends. It has a good beer trade, with two contrasting cask ales, as well as a huge selection of exotic spirits. Wheelchair access is right through the front doors. ◑&▬❀

Consortium Micropub ❰ 🅻

13C Cornmarket, LN11 9PY
☎ (01507) 600754 ∰ theconsortiumlouth.co.uk
Consortium Best Bitter, Obliging Blonde, Black Frog, Thanks Pa, ZigZag ⊞
The Consortium Micropub was opened in 2017 to give people the opportunity to try ales, ciders and lagers from around the UK. It is situated in a small courtyard 50 yards from the Market Place next to the Masons Arms Hotel. The pub has its own microbrewery and distillery on a nearby industrial estate, which produces a massive range of diverse real ales and gins. There are six of the brewery's ales on the bar, as well as a well-stocked gin shelf. A local market stall sells bottled ales, ciders and lagers. Q⬤&♣◖P▬(51)❀❀

Gas Lamp Lounge Ⓛ

13 Thames Street, LN11 7AD (bottom of Thames St by Navigation Warehouse)
☎ (01507) 607661 ● firehouse-brewery.co.uk/the-gas-lamp
1 changing beer Ⓗ
A unique pub – one of only 22 in the UK still lit by gas lamps. There is no music or games machines, just good pub traditions. There are four regular beers from the upstairs Firehouse brewery, plus a guest ale. Benches are set along the canalside, where you can enjoy a drink during the summer. Inside there is a roaring log-burning fire to sit beside in the winter months. Dogs are welcome. Q☕&♣●P🏠😺🛜

Wheatsheaf

62 Westgate, LN11 9YD
☎ (01507) 606262
Batemans XB; Black Sheep Special Ale; Brains Bitter; Thornbridge Jaipur IPA; 1 changing beer Ⓗ
This picturesque inn lies close to Louth's historic St James' Church, which boasts the tallest spire of any medieval parish church in England, measuring some 288 feet and visible from miles around. It offers a good selection of real ales and a tasty home-made food menu. There is a lovely beer garden and the pub is a popular meeting place for walkers and ramblers. ☕◑&P😺

Woolpack Ⓛ

Riverhead Road, LN11 0DA
☎ (01507) 606568 ● woolpacklouth.com
Batemans XB, Gold, XXXB; 1 changing beer Ⓗ
The Woolpack is located close to the theatre and is popular with drinkers and diners alike. It usually offers four or five real ales on handpump. The Grade II-listed building is dog-friendly, and has wheelchair access and baby-changing facilities. There is a beer garden and ample parking. ☕🅭◑&P🏠😺🛜

Market Deeping

Vine Inn Ⓛ

19 Church Street, PE6 8AN
☎ (01778) 348741
Sharp's Doom Bar; house beer (by Hancocks); 3 changing beers (often Abbeydale, Blue Monkey, Skinner's) Ⓗ
Formerly a Charles Wells outlet, now a free house, this small, friendly pub features oak beams and stone floors, with many 20th-century prints on the walls. There is a large patio at the rear. Five handpumps dispense a changing range of guests, including Hancock's HB (badged as Vine Ale). Boxed real cider is available. Free nibbles are provided on Sunday lunchtime and early evenings during the week. The TV is only used for major sporting events. 🅭♣P🏠(101)😺🛜

Marston

Thorold

Main Street, NG32 2HH
☎ (01400) 251849
Batemans XB, Gold; Timothy Taylor Landlord Ⓗ
Community-owned pub with its own shop, serving amazing home-cooked food. The locals have put in many hours of hard work, and as a result the pub is thriving and looks wonderful. The interior been beautifully refurbished, with a flagstone floor, all-wooden bar and two log burners. Booking in advance for food is strongly recommended. ☕🅭◑P🏠😺🛜

Messingham

Horn Inn

61 High Street, DN17 3NU (on main road through village)
☎ (01724) 761190 ● horninn.co.uk
Courage Directors; Timothy Taylor Landlord; 2 changing beers (sourced regionally; often Adnams, Marston's) Ⓗ
Village local on the main road, decorated in traditional style to a high standard. It has an open-plan design with three distinct areas for drinking/dining, all served from a central bar. One area acts as a snug complete with brewery memorabilia and a dartboard. The pub is popular for meals, with food served in the evenings Wednesday to Friday and all day Saturday and Sunday. Up to four real ales are available. A sheltered patio is at the rear for outdoor drinking. Dogs are welcome in the bar area. ☕🅭◑&♣P🏠(100,103)😺🛜

Pooley's

46 High Street, DN17 3NT
☎ 07860 799178
5 changing beers (sourced regionally; often Batemans, Ossett, Salopian) Ⓗ
Welcoming traditionally-styled local, which is open in the evenings Wednesday to Sunday. A bar at one end serves three distinct drinking areas with bare brick walls, rustic furniture, wooden and flagstone floors and real fires. Vintage posters and signs are displayed throughout. Five changing real ales are usually available, often from Batemans, Ossett/Rat, Salopian and Thornbridge, plus an extensive range of wines and spirits including 22 different gins. Winner of several local CAMRA awards. Q&🏠(100,103)😺🛜

Morton

Ship Inn ✅

34 Front Street, DN21 3AE
☎ (01427) 613298
Wainwright; 2 changing beers Ⓗ
To the north of Gainsborough, this is a quaint traditional village inn. There are weekly darts, dominoes and pool matches, and regular quiz evenings. Two rotating cask ales are on offer, and food is served four days a week, with Sunday lunches always popular. A frequent local CAMRA Pub of the Season. Q☕🅭◑&♣🏠😺🛜

Navenby

Lion & Royal

57 High Street, LN5 0DZ
☎ (01522) 810368
Greene King IPA, Abbot; 3 changing beers (sourced nationally; often Parkway, Welbeck Abbey) Ⓗ
Formerly the Lion, the name changed after a visit by the Prince of Wales in 1870. Guy Gibson of 617 Squadron fame spent his wedding night in this imposing, Grade II-listed building. The bar has a flagged floor and an impressive fireplace. There is a weekly quiz and regular live music. Bar food is served. Outside is an enclosed beer garden and a large car park. The pub is on the Lincoln to Grantham bus route. ☕🅭◑&♣P🏠(1)😺🛜

Nocton

Ripon Arms Ⓛ

Main Street, LN4 2BH
☎ 07989 449353
3 changing beers (sourced nationally) Ⓗ

Community-run pub housed within Nocton Village Hub, offering a friendly reception and a wide selection of drinks. A wooden ramp provides additional access to the lounge and outside seating area from the car park. An annual Beerfest and an Oktoberfest are held, and there is a quiz night on the first Saturday of the month. Traditional pub games are available and occasional live music is hosted. Families and dogs are welcome. ⭐❀❀♿♣♠P🚆(31,IC5)❀🐾

North Hykeham

Centurion

Newark Road, LN6 8LB
☎ (01522) 509814
Bombardier Gold; Sharp's Doom Bar; house beer (by Black Sheep); 2 changing beers (sourced nationally; often Adnams, Oakham, St Austell) Ⓗ
The Centurion was named to reflect the rich Roman history of the area. Built in the late 60s alongside the route of the Fosseway Roman road, the pub is a community hub popular with diners and drinkers alike. Booking is advised if you want to guarantee a table. Whether dining, drinking or both, a friendly welcome awaits, enhanced in the colder months with a warming real fire. Outside is a spacious beer garden. ⭐❀❀♿P🚆🐾

Pinchbeck

Ship

Northgate, PE11 3SE
☎ (01775) 711746
Greene King Abbot; Morland Old Speckled Hen; 2 changing beers (often Hopshackle, Welland) Ⓗ
Thatched inn on the banks of the River Glen by the railway bridge at the western end of Knight Street. The pub has been given a sympathetic update and is smart, neat and tidy, but retains a warm and cosy appeal. Food is farm to fork, locally sourced, fresh quality produce. Events are held throughout the year, ranging from beer, wine and spirit tasting evenings to an annual garden party, car shows and live music. ⭐❀❀P🚆🐾

Raithby

Red Lion

Raithby Road, PE23 4DS
☎ (01790) 753727
Batemans XB; 2 changing beers (often Ferry Ales, Batemans) Ⓗ
Cosy village pub built around 1650, with beamed low ceilings in the many small rooms that surround the bar. Pictures of outdoor pursuits and old photographs adorn the walls. The various small rooms are now popular dining areas. The pub sits in an attractive quiet village in the Wolds and is an excellent base for walking and cycling. Closed on bank holidays. Q⭐❀❀♿♣P🚆🐾

Ropsley

Green Man

24 High Street, NG33 4BE
☎ (01476) 585897 ⊕ green-man-ropsley.co.uk
Wainwright; 3 changing beers (sourced nationally; often Caledonian, Grainstore, Theakston) Ⓗ
Back-to-back winner of local CAMRA Pub of the Year in 2020 and 2021, and Country Pub of the Year 2019, this 17th-century village pub has an impeccable reputation for innovative food, including exotic meats, locally sourced game and seafood. Its relaxed tearoom area is frequented by walkers and cyclists, who also enjoy the pleasant tranquil beer garden. Themed food and drink matching evenings are held regularly. The pub is also renowned for an extensive bottled range. ⭐❀❀♣P🐾🐾

Ruskington

Shoulder of Mutton

11 Church Street, NG34 9DU
☎ (01526) 832220
Bombardier; Sharp's Doom Bar; 2 changing beers (sourced regionally) Ⓗ
A popular and thriving pub in the heart of the village attracting customers of all ages. It is one of the oldest buildings in the village and was once a butcher's shop, hence the name. A few old meat hooks can still be seen in the wooden ceiling in the bar. Changes made in recent years have not spoiled the essential character. Standing guard outside is Knight and Day, a sculpture from Lincoln's 2017 Knight's Trail. ❀➤♣P🚆(31)🐾🐾

Saxilby

Anglers ✪

65 High Street, LN1 2HA
☎ (01522) 702200 ⊕ anglerspublichouse.com
Theakston Best Bitter; 3 changing beers (sourced nationally; often Beermats, Pheasantry, Welbeck Abbey) Ⓗ
A community local at the heart of village life, it hosts several sports and pub games teams and there are regular charity fund-raising events. It is convenient for bus and train services and close to visitor moorings on the Fossdyke, the country's oldest canal. The lounge bar has old photos of the village, and the outside drinking area, partly covered, includes a boules court. Guest beers often include a local ale, in addition to those sourced nationally. Q❀➤♣P🚆🐾🐾

Scampton

Dambusters Inn Ⓛ

23 High Street, LN1 2SD
☎ (01522) 731333 ⊕ dambustersinn.co.uk
Greg's Scampton Ale, Dambusters Ale; Lancaster Bomber; 5 changing beers (sourced nationally; often Bradfield, Ossett, Pheasantry) Ⓗ
Formerly the village post office, the Dambusters has been local CAMRA Pub of the Year four times. It has been sympathetically extended and an impressive collection of Dambusters memorabilia adorns four separate rooms. The pub serves eight ales, including two from its own microbrewery, and two annual beer festivals are held. It is also a popular food destination. Outside is a beer garden and sun terrace. The licensee has two holiday cottages nearby, making this an ideal base for aviation buffs. Q❀➤❀❀♠P🚆(103)🐾🐾

Scawby

Sutton Arms

10 West Street, DN20 9AN (on main road through village)
☎ (01652) 652430 ⊕ suttonarmsscawby.co.uk
Sharp's Doom Bar; house beer (by Milestone); 1 changing beer (sourced regionally; often Milestone) Ⓗ
Spacious roadside pub in Scawby village, decorated in country inn-style with ceiling beams and dark wood fittings. There is a large lounge for dining, a separate dining room and a small narrow snug facing the road, served from a two-sided central bar. A recent addition is

a large outdoor gazebo with bar for dining. The extensive food menu includes daily specials. Two stock real ales are available, including a house beer from Milestone and a rotating guest. Quiz night is Sunday. ✰❀◐♿♣P♥☂

Scotton

Three Horseshoes
Westgate, DN21 3QX
☎ (01724) 763129 ⊕ threehorseshoesuk.com
Black Sheep Best Bitter; Greene King IPA; 1 changing beer ⊞
Situated in rural Lincolnshire, the pub is very much a family business. Run by the Butler family for 60 years, the third generation is currently in charge. There is a weekly charity quiz on Thursday, and the pub runs a dominoes team. Locally sourced produce is used in the regularly-changing menu. The 100 Stagecoach, which links Lincoln and Scunthorpe, stops outside the door. Q✰❀◐♣P♥☂

Scunthorpe

Blue Bell ✅
1-7 Oswald Road, DN15 7PU (at town-centre crossroads)
☎ (01724) 863921
Greene King Abbot; Ruddles Best Bitter; 6 changing beers (sourced regionally; often Goose Eye, Saltaire) ⊞
Popular town-centre Wetherspoon pub with an open-plan layout on two levels and tables for dining. The large beer garden includes a heated patio area for smokers. Food is served all day. Wetherspoon's beer festivals are supported. Other popular events are mini beer festivals from regional breweries, Burns Night and Valentine's Day. A large council-run car park is available at the rear. Reopened for business in December 2019 after a major expansion and refurbishment. A lift is available. ✰❀◐P♥☂

Honest Lawyer
70 Oswald Road, DN15 7PG
☎ (01724) 276652 ⊕ honestlawyerbar.co.uk
3 changing beers (sourced regionally; often Acorn, Milestone) ⊞
Town-centre real ale pub with a legal theme, refurbished in late 2021. Three changing, regional real ales are usually available in the long, narrow bar area. Outside at the front is a small heated drinking area. As part of the refurbishment, the upstairs restaurant reopened with a tapas menu, also available in the bar. Regular open mic nights are held as well as local live music. ❀♿♥☂

Malt Shovel
219 Ashby High Street, DN16 2JP (in Ashby Broadway shopping area)
☎ (01724) 843318
Brains Rev James Original; Ossett White Rat; Rooster's TwentyFourSeven; 3 changing beers (sourced regionally; often Abbeydale, Rooster's, Titanic) ⊞
Roughly two miles from the centre of Scunthorpe, the Malt Shovel feels like a village pub in a town and advertises itself similarly. Food is always popular and booking is advised if you are dining. There are three permanent real ales and three rotating guests. The beers are always well kept and you can often find rare and unusual offerings here. A members-only social and snooker club is next door with a new sports bar upstairs. ✰❀◐♿♣🚌

Skegness

Seathorne Arms
Seathorne Crescent, PE25 1RP
☎ (01754) 767797
2 changing beers (often Batemans, Greene King) ⊞
Set back from Roman Bank and 15 minutes' walk from Butlin's, the pub has a large outside seating area, extended during lockdown. The spacious single-room interior is partitioned for eating, pub games, drinking and TV watching. The landlord operates a constantly rotating two-beer selection. Close to local caravan sites, the pub's trade is seasonal – it is closed in January and closing time varies in February and March. ✰❀◐♿♣🚌♥☂

Vine Hotel
Vine Road, PE25 3DB (off Drummond Rd)
☎ (01754) 763018 ⊕ thevinehotel.com
Batemans XB, XXXB; 1 changing beer (often Batemans) ⊞
A delightful building, one of the oldest in Skegness, dating from the 18th century and set in two acres of pleasant grounds. Inside are comfortable wood-panelled bars in which to enjoy a quiet pint or two after experiencing some of the noisier attractions and bustle of Skegness. Within striking distance of the Gibraltar Point National Nature Reserve, walking trails, the beach and golf links, the inn is reputed to have connections with the poet Tennyson. ✰❀◐♿♣P♥☂

Sleaford

Carre Arms Hotel
Mareham Lane, NG34 7JP
☎ (01529) 303156 ⊕ carrearmshotel.co.uk
3 changing beers (often Draught Bass, Marston's, Springhead) ⊞
A privately run hotel previously owned by Bass, adjacent to the Bass Sleaford maltings complex which is now awaiting a regeneration scheme. The comfortable two-room bar area offers three real ales which regularly change, showcasing both local and larger regional breweries. A cider is often available on handpump. An extensive food menu is served in the bar area and restaurant. There is a pleasant covered courtyard, handy on inclement days. ✰❀◐♿≒♣P🚌

White Horse
Boston Road, NG34 7HD
☎ (01529) 968003
Milestone Cromwell Best; 1 changing beer (often Batemans, Horncastle Ales) ⊞
Located on the junction of Carre Street and Boston Road, the pub serves the nearby housing area. It is one of the few remaining traditional locals' pubs in Sleaford, with wet sales only. The interior has been opened out into a single L-shaped room, but retains a cosy feel. Sports predominate, with both darts and pool teams. ✰❀≒♣P♥☂

Snitterby

Royal Oak
High Street, DN21 4TP (1½ miles from A15)
☎ (01673) 818273 ⊕ royaloaksnitterby.co.uk
JW Lees Bitter; Rooster's Buckeye ⊞; 5 changing beers (sourced nationally; often Ferry Ales, Wadworth) ⊞/🅖
Traditional family-run village pub with wooden floors and log fires, offering good beer, company and conversation. At least five real ales and a cider are on offer, including two from local breweries. Outside, a landscaped seating area is in the shade of a weeping

ash, beside a small stream. The snug room has live sports on the TV. Note that opening hours may vary and are updated on the website. Q ⏵ ☺ ᵹ ♣ ♦ P ☸

South Ferriby

Nelthorpe Arms

School Lane, DN18 6HW (off A1077 Scunthorpe to Barton road)

☎ (01652) 633260 ⊕ nelthorpe-arms.business.site

Shadow Bridge Battle Standard, Dragon Slayer, Elvish Fury; 2 changing beers (sourced locally; often Shadow Bridge) ⊞

An attractive local just off the main road through the village. The main bar has darts and pool, and a separate restaurant and a cosy room named the Wilson Snug. The main outlet for the new Shadow Bridge Brewery, three core Shadow Bridge beers are rotated with the brewery's seasonal offerings. Food is available from Tuesday to Sunday, but check times. Accommodation is provided in six well-appointed rooms. Visit the pub's Facebook page for upcoming events such as live music, quizzes and special meal and show nights. ⏵ ☺ ⓓ ᵹ ♣ P 🚍 (350) ☸ 🛜

Spalding

Prior's Oven 🄻

1 Sheep Market, PE11 1BH

☎ 07866 045778

4 changing beers (sourced locally; often Austendyke) Ⓖ

The first micropub to be opened in Lincolnshire, the building was part of the Priory of Spalding and is believed to be almost 800 years old. Because of its shape it has always been known as the Oven or the Prior's Oven and was at one time Spalding Monastic Prison. Its more recent use was as a bakery and it became a pub in 2013. The ground floor bar has a vaulted ceiling. Beers can be served in third-pint measures. Q ⇌ ♦ 🚍

Red Lion Hotel

Market Place, PE11 1SU

☎ (01775) 722869 ⊕ redlionhotel-spalding.co.uk

Draught Bass; 2 changing beers (sourced nationally) ⊞

The Red Lion is a carefully refurbished 18th-century family-run hotel. The cosy, comfortable and welcoming bar overlooks the market place. The bar is popular owing to its consistently well-kept range of cask ales, which the bar staff take great pride in serving in top condition. It is a rare outlet for Bass in the locality. On fine sunny days tables and chairs outside beneath attractive floral displays add to the appeal. ⏵ 🛏 ⓓ ᵹ ⇌ P 🚍 ☸ 🛜

Stamford

Jolly Brewer 🄻

1 Foundry Road, PE9 2PP

☎ (01780) 755141 ⊕ jollybrewerstamford.co.uk

Brewsters Marquis; 3 changing beers (sourced nationally; often Fuller's, Oakham, Purity) ⊞

A traditional pub built of local stone, dating back to 1830 and twice local CAMRA Pub of the Year. The Brewer boasts a roomy split-level drinking area with open fires in the winter and a separate dining room. The car park and large patio host beer festivals in spring and autumn, while pub games, including the World Pushpenny Championships, are a feature. Four handpumps dispense local and national ales. One handpump is devoted to cider, and a range of malt whiskies is available. Q ☺ ⓓ ⇌ ♣ ♦ P 🚍 (9,202) ☸ 🛜

King's Head

19 Maiden Lane, PE9 2AZ

☎ (01780) 753510 ⊕ kingsheadstamford.co.uk

4 changing beers (sourced regionally; often Bakers Dozen, Drum and Monkey, Nene Valley) ⊞

A 19th-century family-run free house of small stature, but with a big reputation for excellent food and beer. This one-roomed stone-built pub features a wood-burning stove and wooden-beamed ceiling with a quaint suntrap garden to the rear, with cover and heating for inclement weather. The pub serves four constantly-changing ales from the length and breadth of the country, and has eight craft taps. Popular with diners at lunchtime, it was voted local CAMRA Town Pub of the Year in 2022. Q ☺ ⓓ ⇌ 🚍 🄿

Tobie Norris

12 Saint Pauls Street, PE9 2BE

☎ (01780) 753800

Hopshackle Special Bitter; Oakham Citra ⊞**; 3 changing beers (sourced regionally; often Abbeydale, Nene Valley)** ⊞/Ⓖ

This ancient stone building, parts of which date back to 1280, was bought by Tobie Norris in 1617 and used as a bell foundry. Formerly a RAFA club, a major refurbishment gained it CAMRA's Conversion to Pub Use Award in 2007. It now has many small rooms with real fires, stone floors and low beams. Five handpumps serve beers from local and country-wide breweries, with other ales sometimes available directly from the cask. A former local CAMRA Pub of the Year. Q ⏵ ☺ ⓓ ⇌ ♣ 🚍 (202,203) ☸

Stickford

Red Lion Inn 🄻

Church Road, PE22 8EP

☎ (01205) 480395

3 changing beers (often Black Hole, Greene King, St Austell) ⊞

The pub name Red Lion, one of the most common in England, is frequently found hereabouts because it was a heraldic emblem of the 14th-century John of Gaunt, Earl of Lancaster and Lord of the Manor at nearby Bolingbroke Castle. The pub has one large open-plan room, with a small separate dining and function room. The owners are keen on live music and host regular events. ⏵ ☺ ⓓ Å ♦ P 🚍 (113) ☸ 🛜

Surfleet

Crown Inn

6 Gosberton Road, PE11 4AB

☎ (01775) 680830

Sharp's Sea Fury; 1 changing beer ⊞

This little gem of a pub, tastefully refurbished, has comfortable settees and couches in the bar/lounge area near a large open fire. The adjacent mezzanine floor with its intimate area adds to the ambience, as does the grand piano in the restaurant. Lana, the pub's resident ghost, is reputed to be a constant companion – she was run over by the London stagecoach. The guest beer changes on a weekly basis. ⏵ ⓓ ᵹ ♣ P 🚍 🛜

Swineshead

Green Dragon

Market Place, PE20 3LJ

☎ (01205) 821381

Batemans XB; Theakston Traditional Mild; 3 changing beers (sourced regionally) ⊞

Originally called the Green Dragon, its fortunes gradually declined until new owners brought it back to life with a new name. A change of ownership has now seen the pub revert to its original name, and it is a vibrant and thriving village local, successfully blending old and new to recreate a genuine community pub with an emphasis on beer and traditional pub games. Pizza and bar snacks to eat in or take away are available Thursday to Saturday. ♿🕮🌢🏕️🚃(K59)🌸🛜

Swinhope

Clickem Inn

Binbrook Road, LN8 6BS (2 miles N of Binbrook on B1203)
☎ (01472) 398253 🌐 clickem-inn.co.uk
Batemans XXXB; Timothy Taylor Landlord; house beer (by Pheasantry); 3 changing beers (sourced regionally; often Horncastle Ales, Rudgate, Springhead) 🅷
Set in the picturesque Lincolnshire Wolds and a popular stopping place for walkers and cyclists, the pub's name originates from the counting of sheep passing through a nearby clicking gate. Renowned for its home-cooked food served in the bar and conservatory, it offers a choice of drinks, including six real ales and a traditional cider. The house beer is Terry's Tipple. There is pool, darts and a jukebox. Monday is quiz night. A covered, unheated area is provided for smokers. Q🕮🕩🌢🏕️P🌸🛜

Tetney Lock

Crown & Anchor

Lock Road, DN36 5UW
☎ (01472) 388291
Sharp's Doom Bar; 3 changing beers (sourced nationally) 🅷
Overlooking the historic but now defunct Louth Navigation canal, this is a convenient watering hole for lovers of outdoor pursuits. Dogs are welcome in the public bar – the landlord keeps a jar of dog biscuits on the bar for them. There is a pleasant garden at the rear, while at the front is a patio overlooking the canal. Traditional Sunday lunches are served. Guest beers are available in the summer months. Q♿🕮🕩P🌸🛜

Thimbleby

Durham Ox

Main Road, LN9 5RB
☎ (01507) 527152 🌐 durhamoxpubthimbleby.co.uk
Adnams Ghost Ship; Batemans XB; 1 changing beer (sourced regionally) 🅷
Fine country inn over 200 years old and reopened in 2013. This welcoming pub with its beamed ceilings, cowshed bar and RAF corner has a large field at the rear for caravans and camper vans. There is an extensive food menu serving local produce. The pub is named after a huge 18th-century ox that toured the country and which, at its largest, weighed 270 stone. ♿🕮🕩🅰🏕️P🚃🌸

Threekingham

Three Kings Inn

Saltersway, NG34 0AU
☎ (01529) 240249 🌐 thethreekingsinn.com
Draught Bass; Morland Old Speckled Hen; Timothy Taylor Landlord; 1 changing beer (sourced regionally) 🅷
A classic country inn with charm and character. Its bright and comfortable lounge bar with attractive rural prints, and panelled dining room serving locally-sourced food,

are deservedly popular with locals and visitors. Guest beers are usually from independent brewers. There are a pleasant beer terrace and garden for the summer months and a large function room. The pub's name refers to the slaying, by the Saxons, of three Danish chieftains in battle in 870 at nearby Stow; look for the effigies above the entrance. Q♿🕮🕩P🌸

Timberland

Penny Farthing

4 Station Road, LN4 3SA
☎ (01526) 378881 🌐 thepennyfarthinginn.co.uk
Timothy Taylor Landlord; 1 changing beer (sourced nationally; often Milestone) 🅷
A country pub in the heart of the village. It has a large open-plan layout with various spaces for dining and a comfortable seating area. Families and dogs are welcome. Food is sourced locally and specials are on offer from Tuesday to Friday. The Wednesday steak nights and Sunday lunches are always popular. A regular quiz takes place on Tuesday and occasional comedy and music evenings are held. Five en-suite bedrooms are available. Q♿🕮🕩🌢🛏️&🏕️P🌸🛜

Waddington

Three Horseshoes

High Street, LN5 9RF
☎ (01522) 720448
Pheasantry Pale Ale, Ringneck Amber Ale; John Smith's Bitter; 1 changing beer (sourced nationally; often Newby Wyke, Ossett, Saltaire) 🅷
A real community pub in the heart of the village. A warm welcome awaits in this dog-friendly, two-roomed local. Both rooms have real fires and are well used for a wide variety of social events, including live music, bingo, poker and darts. A beer garden provides additional space. Large TV screens show sports events, and traditional pub games are played. Regular beers include a couple from Pheasantry Brewery just across the border in Nottinghamshire. ♿🕮🏕️🚃(1,13)🌸🛜

Willingham by Stow

Half Moon 🅛

23 High Street, DN21 5JZ
☎ (01427) 788340
Batemans XB, Gold; Sharp's Doom Bar; 1 changing beer 🅷
A traditional-style village pub in a building dating back to 1850, with a public bar, lounge bar, an open fire and a beer garden. There are usually four beers available, three regular and one changing. Food is available Thursday to Sunday and fish & chips is especially popular with locals and visitors. Entertainment nights feature on a relatively regular basis, as well as themed charity nights. Opening times may vary, always check. Q♿🕮🕩&🏕️🍴🚃🌸

Willoughton

Stirrup Inn 🅛

1 Templefield Road, DN21 5RZ
☎ (01427) 668270
Ferry Ales Just Jane; Lincolnshire Craft Lincoln Gold; 1 changing beer 🅷
Built from local Lincolnshire limestone, this hidden gem is over 350 years old and is well worth seeking out – you can be sure of a warm welcome. The pub oozes character with a roaring log fire in winter and is popular with locals and folk from further afield. A choice of locally sourced ales is always available, with two regular beers and one

changing guest. Lincolnshire bell target shooting, doubles darts and dominoes are regularly played.
Q ☺ ◇ & ♣ P ♦

Winterton

George Hogg 🅛 ✅
25 Market Street, DN15 9PT
☎ (01724) 732270 ∰ thegeorgehogg.co.uk
Batemans XB; Draught Bass; 3 changing beers (sourced regionally; often Batemans, Lincolnshire Craft) ⊞
Popular Grade II-listed building in the market place, a winner of local CAMRA awards. It has a large L-shaped bar and a lounge, both with real fires. Outside, there is a patio and seating area. A beer festival is held on the May bank holiday. The pub is a popular meeting place for local football and sports teams as well as a football supporters' club. No food is available. Q ☺ ☺ ♣ P ♒ (350) ♦ 🤶

Wragby

Ivy
Market Place, LN8 5QU
☎ (01673) 858768 ∰ theivywragby.co.uk
4 changing beers (sourced nationally; often Oakham, Ringwood, St Austell) ⊞
A 17th-century, village-centre pub, nine miles east of Lincoln. Tables fill the alcoves and edges of the wooden-beamed and panelled bar, off which are two separate rooms. A wood-burning stove gives a homely feel. Sport is screened in the main bar area and there is a popular quiz on Sunday evening. Sandwiches and toasties are served throughout the day. Upstairs are six en-suite bedrooms. There is free parking opposite and a bus stop nearby. Q ⇆ ◀ ♣ ♒ (50,56) ♦ 🤶

Wroot

Cross Keys
High Street, DN9 2BT (on main street in centre of village)
☎ (01302) 770231
Theakston Best Bitter; 2 changing beers (sourced regionally; often Old Mill, Pheasantry, Welbeck Abbey) ⊞
A genuine and popular village inn in Lincolnshire's westernmost community. It is well supported by locals and takes an active part in local life. At least two cask ales, up to three in summer, are always available. There are four separate rooms, two bars and a snug. Meals are available Thursday to Sunday. A former local CAMRA Pub of the Season and a regular in this Guide.
Q ☺ ◇ ◑ ▲ ♣ P ♦ 🤶

Wyberton Fen

Hammer & Pincers ✅
Swineshead Road, PE21 7JE
☎ (01205) 361323 ∰ hammerandpincers-boston.co.uk
Adnams Ghost Ship; Fuller's London Pride; Sharp's Doom Bar; Woodforde's Wherry ⊞
A lively family-run community pub on the outskirts of Boston, situated close to the Downtown Shopping Centre and supermarket. It has two rooms and a conservatory area, with a 1970s feel to the main public bar. Popular reasonably priced home-cooked meals are served from a traditional pub food menu, starting with breakfast. Poker nights, team pool and darts nights are held and live football screened. The outside seating area to the front is decorated with flower baskets in summer.
☺ ◇ ◑ & ♣ P ♦ 🤶

Breweries

8 Sail SIBA
Heckington Windmill, Hale Road, Heckington, Lincolnshire, NG34 9JW
☎ (01529) 469308 ☎ 07866 183479
∰ 8sailbrewery.co.uk

Established in 2010, 8 Sail Brewery operates on a six-barrel brew plant. It nestles in the shadow of Heckington Windmill, Britain's only eight-sailed windmill, from where it takes its name. The Mill helps to mill malted grain for the brewery. The shop stocks bottle-conditioned beers alongside local ciders. The front of the brewery has been converted into a Victorian-style bar, which has beer on handpump daily. The large outside area is weather dependent (hours may vary). ▆ ♦ LIVE ∅

Ploughmans Lunch (ABV 3.8%) PALE
Windmill Bitter (ABV 3.8%) BITTER
Fenman (ABV 4.1%) BITTER
Froglet (ABV 4.2%) PALE
Pilgrim Pale (ABV 4.2%) PALE
Rolling Stone (ABV 4.3%) PALE
Red Windmill (ABV 4.4%) SPECIALITY
Millstone (ABV 4.5%) BITTER
Windy Miller (ABV 4.6%) STOUT
Mayflower IPA (ABV 4.7%) PALE
Fen Slodger (ABV 4.8%) BITTER
Damson Porter (ABV 5%) SPECIALITY
Victorian Porter (ABV 5%) PORTER
Old Colony (ABV 5.3%) PALE
Black Widow (ABV 5.5%) MILD
John Barleycorn IPA (ABV 5.5%) PALE

Austendyke
The Beeches, Austendyke Road, Weston Hills, Spalding, Lincolnshire, PE12 6BZ ☎ 07866 045778

Austendyke Ales began brewing in 2012 using a seven-barrel plant. The brewery is operated on a part-time basis by brewer Charlie Rawlings and business partner Nathan Marshall, who handles sales. The brewery owns and runs micropub the Prior's Oven, Spalding.

Long Lane (ABV 4%) BITTER
Sheep Market (ABV 4%) GOLD
Bakestraw Bitter (ABV 4.1%) PALE
Bake House (ABV 4.5%) BITTER
Holbeach High Street (ABV 4.5%) BITTER
Hogsgate (ABV 5%) BITTER

Bacchus
⬛ Bacchus Hotel, 17 High Street, Sutton-on-Sea, Lincolnshire, LN12 2EY
☎ (01507) 441204 ∰ bacchushotel.co.uk

Bacchus began brewing in 2010 and now has a two-barrel plant supplying the Bacchus Hotel. ‼ LIVE

Batemans SIBA IFBB
Salem Bridge Brewery, Mill Lane, Wainfleet, Lincolnshire, PE24 4JE
☎ (01754) 880317 ∰ bateman.co.uk

☺ Bateman's Brewery is one of Britain's few remaining independent, family-owned and managed brewers. Established in 1874, it has been brewing award-winning beers for four generations. Justifiably proud of its heritage it is, nevertheless, forward-looking and progressive. All 62 tied and managed houses serve cask-

conditioned beer. See website for seasonal and speciality beers. ‼️🍴♦️◆

XB (ABV 3.7%) BITTER
A well-rounded, smooth, malty beer with a blackcurrant fruity background. Hops flourish initially before giving way to a bittersweet dryness that enhances the mellow, malty ending.

Gold (Also known as Yella Belly Gold) (ABV 3.9%) GOLD

Salem Porter (ABV 4.8%) PORTER
A black and complex mix of chocolate, liquorice and cough elixir.

XXXB (ABV 4.8%) BITTER
A brilliant blend of malt, hops and fruit on the nose with a bitter bite over the top of a faintly banana maltiness that stays the course. A russet-tan brown classic.

Blue Bell

🏠 Cranesgate South, Whaplode St Catherine, Lincolnshire, PE12 6SN
☎ (01406) 540300 ☎ 07788 136663
🌐 thebluebell.net

🍺Founded in 1998 behind the Blue Bell pub. The brewery is owned by the pub after previously operating as a separate business. Beers are only available at the pub and to private customers. ‼️♦️LIVE

Brewsters SIBA

Unit 5, Burnside, Turnpike Close, Grantham, Lincolnshire, NG31 7XU
☎ (01476) 566000 🌐 brewsters.co.uk

⊗ Brewster is the old English term for a female brewer, and Sara Barton (who was named Brewer of the Year by the All Party Parliamentary Beer Group in 2018) is a modern example. Originally established in the Vale of Belvoir in 1998, it moved to Grantham in 2006. Brewster's produces a range of traditional and innovative beers with two regularly-changing ranges. ‼️🍴♦️

Hophead (ABV 3.6%) BITTER
Marquis (ABV 3.8%) BITTER
A well-balanced and refreshing session bitter with maltiness and a dry, hoppy finish.
Aromantica (ABV 4.2%) BITTER
Hop A Doodle Doo (ABV 4.3%) BITTER
Decadence (ABV 4.4%) GOLD
Aromatic Porter (ABV 4.5%) PORTER
Dragon Street Porter (ABV 4.9%) PORTER
American Pale Ale (ABV 5%) PALE
Rundle Beck Bitter (ABV 5.5%) BITTER
Virago IPA (ABV 5.8%) IPA

Consortium

🏠 Consortium, 13D Cornmarket, Louth, LN11 9PY
☎ (01507) 600754 🌐 theconsortiumlouth.co.uk

🍺The Consortium Brewing Company was setup in 2016 to serve the Consortium micropub and tasting lounge. It is situated in the Cornmarket of Louth, down a small passageway close to the Masons Arms. A large, diverse range of ale and gin styles is now brewed on the Fairfield Industrial Estate. It has produced more than 100 different ales since production started and bottle them for sale on the market (Wednesday, Friday, Saturday), within 20 metres of the pub. ‼️♦️◆

Dark Tribe

🏠 Dog & Gun, High Street, East Butterwick, Lincolnshire, DN17 3AJ
☎ (01724) 782324 🌐 darktribe.co.uk

🍺Situated on the banks of the River Trent in the Dog & Gun pub, this 2.5-barrel brewing plant produces beers for the pub and local outlets. The award-winning brewery has been established since 1996. A range of one-off beers is produced throughout the year. ‼️♦️

Docks SIBA

The Church, King Edward Street, Grimsby, DN31 3JD
☎ (01472) 289795 🌐 docksbeers.com

Brewing began in 2018 using a 15-barrel plant in a converted Edwardian Church in Grimsby. The brewery was originally named Axholme Brewing Co, with beers brewed under that name.

Brewed under the Axholme Brewing Co name:
Magnitude (ABV 3.9%) PALE
Hard Graft (ABV 4%) PALE
Cleethorpes Pale Ale (ABV 4.2%) SPECIALITY
Lightning Pale Ale (ABV 4.3%) PALE
Graveyard Shift (ABV 4.5%) STOUT
Never Say Die (ABV 6%) IPA
Special Reserve (ABV 7.2%) STRONG

Don Valley

The Old Airfield, Belton Road, Sandtoft, Lincolnshire, DN8 5SX
☎ (01709) 580254 ☎ 07951 212722
🌐 donvalleybrewery.co.uk

🍺The brewery, established in 2016, changed ownership in 2018. It moved in 2019 to a new site in Sandtoft in Lincolnshire with new brewing equipment, doubling the capacity. A canning line was installed in 2020. ♦️V◆

Our House (ABV 3.8%) BITTER
Atomic Blonde (ABV 4.3%) BLOND
Gongoozler (ABV 4.5%) STOUT
Go Your Own Way (ABV 5%) GOLD

Ferry Ales SIBA

Ferry Hill Farm, Ferry Road, Fiskerton, Lincolnshire, LN3 4HU
☎ (0800) 999 3226 ☎ 07790 241999
🌐 ferryalesbrewery.co.uk

Ferry Ales Brewery (FAB) began brewing in 2016 using a five-barrel plant. It is situated just outside Fiskerton, Lincolnshire. Beers can be found in the Lincoln area and beyond. A range of between 12-15 beers are available in cask, keg, bottle and can. 🍺

Just Jane (ABV 3.8%) BITTER
Spirit of Jane (ABV 3.8%) BITTER
Lincoln Lager (ABV 4.3%) SPECIALITY
Golden Fleece (ABV 4.5%) GOLD
Witham Shield (ABV 4.5%) PALE
Slippery Hitch (ABV 4.7%) SPECIALITY
49 SQN (ABV 4.9%) BITTER
Smokey Joe (ABV 4.9%) PORTER

Firehouse

13 Thames Street, Louth, Lincolnshire, LN11 7AD
☎ (01507) 608202 ☎ 07961 772905
🌐 firehouse-brewery.co.uk

🍺Owned by Jason Allen and Louise Darbon, Firehouse Brewery was founded in 2014 and started production in the village of Manby on part of the site of the former RAF station. In 2016 a 2.5-barrel plant was purchased from Fulstow Brewery and relocated to the Thames Street Brewery in Louth. Beers are available in the free trade and from the bar located at the brewery, the Gas Lamp Lounge. ♦️◆

Mainwarings Mild (ABV 3.6%) MILD
Endeavour Gold (ABV 3.8%) GOLD
Luda Stout (ABV 4.5%) STOUT
Pride (ABV 4.5%) PALE
Lincolnshire Country Bitter (ABV 5.1%) BITTER

Fuddy Duck

Unit 12, Kirton Business Park, Willington Road,
Kirton, Lincolnshire, PE20 1NN ☎ 07881 818875
⊕ thefuddyduckbrewery.co.uk

Small brewery based in Kirton near Boston, where
brewing commenced in 2016.

Pale Ale (ABV 4%) PALE
American Red Ale (ABV 4.5%) RED
Blonde Ale (ABV 4.5%) SPECIALITY
Dark Porter (ABV 4.5%) PORTER
German Ale Altbier (ABV 4.5%) SPECIALITY
Biere de Garde (ABV 6.5%) SPECIALITY

Greg's

⌷ Dambusters Inn, 23 High Street, Scampton,
Lincolnshire, LN1 2SD
☎ (01522) 730123 ⊕ dambustersinn.co.uk

⊛Established in 2013, the microbrewery is situated on
the premises of the Dambusters Inn. A number of house
ales are produced by publican Greg Algar. ♦

Hopshackle

Unit F, Bentley Business Park, Blenheim Way,
Northfields Industrial Estate, Market Deeping,
Lincolnshire, PE6 8LD ☎ 07894 317980
⊕ hopshacklebrewery.co.uk

⊛Hopshackle was established in 2006 using a five-
barrel plant. A 10-barrel plant was installed in 2015.
More than 20 outlets are supplied direct. Bottled beer is
available online. ‼♦LIVE

Simmarillo (ABV 3.8%) GOLD
Zen (ABV 3.8%) BITTER
PE6 (ABV 4%) GOLD
American Pale Ale (ABV 4.3%) PALE
Special Bitter (ABV 4.3%) BITTER
Hopnosis (ABV 5.2%) GOLD

Horncastle

⌷ Old Nicks Tavern, 8 North Street, Horncastle,
Lincolnshire, LN9 5DX
☎ (01507) 526862 ✉ horncastleales@gmail.com

Brewing began in 2014 using a 3.75-barrel plant. The
brewery is situated at the rear of Old Nicks Tavern with
beer available in the pub plus other Lincolnshire
outlets. It has its own bottling plant and a beer in box
scheme is also available for pre-ordering. ‼▬

Lincolnshire Craft SIBA

Race Lane, Melton Ross, Lincolnshire, DN38 6AA
☎ (01652) 680001 ⊕ lincolnshirecraftbeers.com

Lincolnshire Craft Beers is the company formed by Mark
Smith who bought the Tom Wood Brewery in 2017. It
continues to brew the Tom Wood range of beers on the
60-barrel Melton Ross plant. ♦

Best Bitter (ABV 3.7%) BITTER
A good citrus, passion fruit hop dominates the nose and
taste, with background malt. A lingering hoppy and bitter
finish.

Lincoln Gold (ABV 4%) GOLD
Bomber County (ABV 4.8%) BITTER
An earthy malt aroma but with a complex underlying mix
of coffee, hops, caramel and apple fruit. The beer starts
bitter and intensifies to the end.

Little Big Dog

Barrow-upon-Humber, Lincolnshire, DN19 7SH
⊕ littlebigdogbeer.co.uk

Commercial home-based brewery, first brewed in 2020.
Beers are available in cask, keg and can.

Pantiles (ABV 3.8%) BITTER

Melbourn

All Saints Brewery, All Saints Street, Stamford,
Lincolnshire, PE9 2PA
☎ (01780) 752186

A famous Stamford brewery that opened in 1825 and
closed in 1974. It re-opened in 1994 and is owned by
Samuel Smith of Tadcaster (qv). No real ale. ‼

Newby Wyke SIBA

Unit 24, Limesquare Business Park, Alma Park Road,
Grantham, Lincolnshire, NG31 9SN
☎ (01476) 565682 ⊕ newbywyke.co.uk

⊠ The brewery is named after a Hull trawler skippered
by brewer Rob March's grandfather. It started life in 1998
as a 2.5-barrel plant in a converted garage then moved
to premises behind the Willoughby Arms, Little Bytham.
In 2009 it moved back to Grantham. ‼♦

Banquo (ABV 3.8%) BLOND
Summer Session Bitter (ABV 3.8%) BITTER
Orsino (ABV 4%) BLOND
Comet (ABV 4.1%) BITTER
Kingston Topaz (ABV 4.2%) GOLD
Black Beerd (ABV 4.3%) STOUT
Bear Island (ABV 4.6%) BLOND
White Squall (ABV 4.8%) BLOND
Blonde-hued with a hoppy aroma. Generous amounts of
hop are well-supported by a solid malty undercurrent. An
increasingly bittersweet tang makes itself known
towards the finish.
HMS Quorn (ABV 5%) GOLD
White Sea (ABV 5.2%) BITTER
The Deep (ABV 5.4%) STOUT
Chesapeake (ABV 5.5%) BITTER
HMS Queen Elizabeth (ABV 6%) BLOND
Yamoto (ABV 6%) BLOND

Pig Barn (NEW)

Low Hall Road, East Lound, Lincolnshire, DN9 2LU
☎ (01427) 754339

Established in 2019 and located in a converted piggery,
this is one of the smallest breweries in the UK. At present
the brewery mostly produces bottle-conditioned beers,
with cask available on demand. LIVE

Poachers

439 Newark Road, North Hykeham, Lincolnshire,
LN6 9SP
☎ (01522) 807404 ☎ 07954 131972
⊕ poachersbrewery.co.uk

⊛The brewery was founded in 2001 in buildings on the
former RAF Swinderby site. In 2006 the plant was
relocated to outbuildings at the rear of the brewer's
home. Regular outlets in Lincolnshire and surrounding

counties are supplied direct; outlets further afield, via beer swaps with other breweries. An onsite bar is open to public on a Friday evening and for groups at other times by prior arrangement. ⚑◆✦

Trembling Rabbit Mild (ABV 3.4%) MILD
Shy Talk Bitter (ABV 3.7%) BITTER
Rock Ape (ABV 3.8%) BITTER
Poachers Pride (ABV 4%) BITTER
Tedi Boy (ABV 4%) PALE
Bog Trotter (ABV 4.2%) BITTER
Lincoln Best (ABV 4.2%) BITTER
Billy Boy (ABV 4.4%) BITTER
Imp Ale (ABV 4.4%) BITTER
Black Crow Stout (ABV 4.5%) STOUT
Hykeham Gold (ABV 4.5%) SPECIALITY
Monkey Hanger (ABV 4.5%) BITTER
Jock's Trap (ABV 5%) BITTER
Trout Tickler (ABV 5.5%) BITTER

Shadow Bridge (NEW)

Unit 1, Old Tile Yard, Barton-upon-Humber, Lincolnshire, DN18 5RF
✉ shadowbridgebrewery@hotmail.com

Brewery with an onsite taproom and shop, opened in 2022. ✦

Welland

Cradge Bank, Spalding, Lincolnshire, PE11 3AN
☎ 07732 033702 ⊕ wellandbrewery.co.uk

Welland Brewery commenced in 2018 and was set up by Tom Bradshaw and Dave Jackson, assisted by the owner and brewer of nearby Austendyke Ales, Charlie Rawlings. A brewery taphouse is planned.

Shipshape Blonde (ABV 3.7%) GOLD
Fen Tiger (ABV 4%) GOLD
Flatland Bitter (ABV 4%) BITTER
Pale RyeNo (ABV 4.1%) SPECIALITY
YFM (ABV 4.2%) GOLD
Jack Rawlshaw (ABV 4.4%) BITTER
Black Cow (ABV 4.7%) STOUT
Rusty Giraffe (ABV 5%) BITTER
Red Tsar (ABV 10%) STOUT

Wickham House

Church Lane, Conisholme, Louth, Lincolnshire, LN11 7LX ☎ 07817 467303
✉ bearplumb64@gmail.com

☺Wickham House was formed in 2018 as a small, artisan brewery concentrating on traditional ales produced in small batches. It has started producing bottled-conditioned beers (Blonde and Bitter range). Plans are underway to get licenced, with a small B&B attached. It has also increased capacity to 200-litres. LIVE

Blonde Jester (ABV 4%) BLOND
Kings Island Bitter (ABV 5.2%) BITTER

Willy's

🍴 **17 High Cliff Road, Cleethorpes, DN35 8RQ**
☎ (01472) 602145

The brewery opened in 1989 to provide beer mainly for its in-house pub in Cleethorpes, although some beer is sold in the free trade. It has a five-barrel plant with maximum capacity of 15 barrels a week. The brewery can be viewed at any time from pub or street. ⚑◆

Zest SIBA

Heath Lane, Barkston Heath, Lincolnshire, NG32 2DE
☎ (01476) 572135 ⊕ zest-brewery.co.uk

☺In 2020 Zest was rebranded from Oldershaw Brewery, which had been brewing since 1997. Owned and run by brewster Kathy Britton, Zest produces a core range of beers in both traditional and contemporary styles, as well as seasonal ales. Bespoke bottled and cask beers can be created to order and a mobile bar service (Bar Zest) is also available. ⚑🛒◆

Heavenly Blonde (ABV 3.8%) BITTER
Newton's Drop (ABV 4.1%) BITTER
Balanced malt and hops but with a strong bitter, lingering taste in this mid-brown beer.
Mosaic Blonde (ABV 4.3%) BLOND
Atomic IPA (ABV 4.5%) GOLD
Blonde Volupta (ABV 5%) BLOND

Blue Pig, Grantham (Photo: It's No Game / Flickr CC BY 2.0)

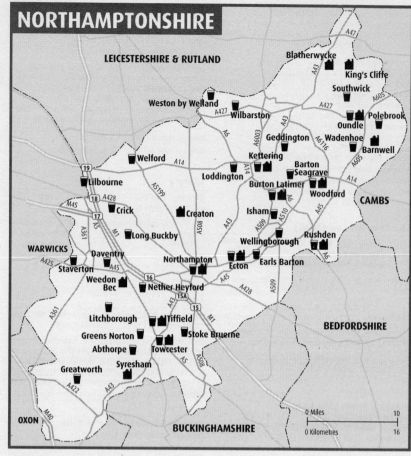

NORTHAMPTONSHIRE

LEICESTERSHIRE & RUTLAND

Blatherwycke
King's Cliffe
Southwick
Weston by Welland
Wilbarston
Polebrook
Oundle
Geddington
Wadenhoe
Kettering
Barnwell
Welford
Loddington
Barton Seagrave
Burton Latimer
Woodford
Lilbourne
Woodford
CAMBS
Crick
Creaton
Isham
Long Buckby
Wellingborough
Rushden
WARWICKS
Daventry
Northampton
Ecton
Earls Barton
Staverton
Weedon Bec
Nether Heyford
Litchborough
Tiffield
Greens Norton
Stoke Bruerne
Abthorpe
Towcester
BEDFORDSHIRE
Greatworth
Syresham

OXON

BUCKINGHAMSHIRE

0 Miles 10
0 Kilometres 16

Abthorpe

New Inn L
Silver Street, NN12 8QR (off Main St, left at church)
☎ (01327) 857306 ⊕ newinnabthorpe.uk
Hook Norton Hooky, Off The Hook, Old Hooky; 1 changing beer (often Hook Norton) ⊞
A tranquil country hostelry tucked away close to the green and church. It is a quintessentially English village pub built of local mellow sandstone, complete with low ceilings and an inglenook fireplace with seating. Welcoming to visitors and locals alike, it serves good food including meats from the owner's farm, plus ales that are still brewed in the traditional way by Hook Norton – its seasonal beers feature as guests. Fish from Billingsgate Market is a speciality. ⌖⊛◑☕♣P❀♠

Barton Seagrave

Stirrup Cup L ✅
Woodland Avenue, NN15 6QR (off A14 jct 10)
☎ (01536) 722841 ⊕ thestirrupcupbartonseagrave.co.uk
Ruddles Best Bitter; 2 changing beers (sourced regionally; often Nene Valley, Potbelly) ⊞
A welcoming community-focused estate pub about to celebrate its half century. Under new management since 2017, there is a greater emphasis on beer choice, with regular guests often from Potbelly. The traditional sports bar features darts, pool and skittles along with large sports TVs. The coffee lounge offers breakfast, lunch and

afternoon tea from Monday to Friday. Events include a quiz on Wednesday, jazz on Thursday plus live bands once a month. Q⌖⊛◑☕♣P❀♠

Burton Latimer

Duke's Arms L ✅
123 High Street, NN15 5RL (off A14 jct 10)
☎ (01536) 390874
3 changing beers (sourced nationally; often Potbelly) ⊞
For many years keg only, this community pub now has three handpumps for real ale. The central U-shaped bar serves the opened-out rooms, with comfortable-leather seating and more traditional seating in the small bay windows. The walls are adorned with vinyl LPs and there is a collection of books to read. The pub supports the local Three Hills Brewery, with occasional casks on the bar and an array of canned ales. There is no parking but a free car park is just across the road. ⌖⊛♣♠❀

Crick

Wheatsheaf L
15 Main Road, NN6 7TU (on main road through village)
☎ (01788) 823824 ⊕ wheatsheafcrick.com
4 changing beers (sourced regionally; often Greene King, Oakham, Phipps NBC) ⊞

Village free house built out of local ironstone situated on the main road through the village. To the front, the comfortable bar has tables and settees. To the rear is a large restaurant catering for up to 80 diners. Food, much of it sourced locally, ranges from pub favourites to restaurant specials, with a variety of vegetarian options and regular theme nights. Occasional live music is played. Good-value accommodation is available in a recent extension. Q ᗡ ᗉ ◖ ᗕ ♣ P ☐ (96)❀

Daventry

Early Doors ⌶

3 Prince William Walk, NN11 4AB
☎ 07944 649426 ⊕ earlydoorsdaventry.co.uk
Phipps NBC India Pale Ale; 5 changing beers (sourced locally; often Towcester Mill, Vale, XT) Ⓖ
The very first Northamptonshire micropub, this is run by a father-and-son team who took over from the founders. Tucked away down a narrow alley, it is a warm and welcoming oasis in the heart of Daventry, with a real community feel. The bar is made from reclaimed doors and weathered scaffolding planks, and is simply decorated. Ales, including a dark beer, are all on gravity, and locally produced cider is made within one mile of Welton. Q ᗕ ♠ P ☐ ❀

Earls Barton

Saxon Tavern ⌶

25B The Square, NN6 0NA
☎ 07956 462352
6 changing beers (often Potbelly, Roman Way, Towcester Mill) Ⓗ
A large, comfortable and relaxed single-room micropub with welcoming hosts. It has a central village location between the famous Barker Shoes and the historic Saxon tower and was previously the local headquarters of the Magic Circle. Six casks with cooling jackets are stillaged behind the bar. A wide selection of 90 gins is featured, along with bottled beers and box ciders from the fridge.
Q ❀ ♣ ♠ P ☐ ❀

Ecton

Three Horseshoes ⌶

23 High Street, NN6 0QA (off A4500)
☎ (01604) 407446
St Austell Proper Job; house beer (by Benjamin Franklin); 1 changing beer (sourced locally) Ⓗ
A whitewashed ironstone pub that has been extended over many years, although the original building is said to date from 1757. The name is taken from the forge that was originally on the site, where Benjamin Franklin's uncle Thomas was the last of the family to work. The Franklin name is now used for the brewery that was established two years ago in outbuildings. The traditional multi-room layout has been retained, with a separate bar and games area for Northants skittles and darts.
ᗡ ❀ ♣ P ☐ ❀ ☏

Geddington

Star Inn ⌶

2 Bridge Street, NN14 1AD
☎ (01536) 745990 ⊕ thegeddingtonstar.co.uk
Greene King IPA, Abbot; 2 changing beers (sourced locally; often Digfield, Nene Valley) Ⓗ
Attractive 17th-century pub situated directly opposite what is considered to be the finest of the surviving Eleanor Crosses. The main entrance contains the former off-sales window, with doors leading to a traditional bar

and lounge bar. A restaurant leads off the lounge bar, with a further raised area towards the rear. Two guests beers are from local breweries. Good-quality home-cooked pub food is served. ᗡ ❀ ◖ ᗕ ♣ P ☐ (8)❀ ☏

Greatworth

Greatworth Inn ⌶

Chapel Road, OX17 2DT (off B4525)
☎ (01295) 521426 ⊕ thegreatworthinn.co.uk
Adnams Mosaic; Goff's Cheltenham Gold; Hook Norton Old Hooky; St Austell Proper Job Ⓗ
A 16th-century stone-built pub in the centre of an attractive village. Following the return of its owners to the village, the pub is back to its former glory and is now a free house. Numerous improvements have been undertaken while retaining a cosy and traditional atmosphere. The bar area features an inglenook fireplace and log-burning stove, and there is a dining area. A soap box derby is held in June and a music/beer festival in August. An outside bar is open in the summer.
ᗡ ❀ ◖ ᗕ ♣ P ❀ ☏

Greens Norton

Butchers Arms ⌶

10 High Street, NN12 8BA
☎ (01327) 358848 ⊕ thebutchersarms.pub
St Austell Tribute; 4 changing beers (sourced locally; often Great Oakley, Phipps NBC, Roman Way) Ⓗ
A large two-room pub at the centre of the village, with wooden flooring and panelling throughout, complemented by bay window seating and a real wood-burning fire. It was listed as an Asset of Community Value by the parish council, and the freehold was bought by a group of local investors keen to see it remain at the heart of the village. Outside is a landscaped, tiered garden for summer. Q ᗡ ❀ ◖ ᗕ ♣ ♠ P ☐ (86/87)❀ ☏

Isham

Lilacs ⌶

39 Church Street, NN14 1HD (off A509 at the church)
☎ (01536) 722348 ⊕ thelilacsisham.co.uk
Greene King IPA; 3 changing beers (sourced locally; often Oakham, Potbelly) Ⓗ
Unusually, this traditional inn is named after a local breed of rabbit. A welcome retreat for the community, the freehold was purchased by locals in order to preserve a pub in Isham, and it is popular with diners and drinkers alike. There is a small lounge, the former snug with a dartboard, and a large room to the rear. Quiz and live

REAL ALE BREWERIES

Avalanche Burton Latimer
Benjamin Franklin ᗡ Ecton (NEW)
Boot Town Burton Latimer
Creaton Grange Creaton
Digfield Barnwell
Great Oakley Tiffield
King's Cliffe King's Cliffe
Maule Northampton
Nene Valley ✦ Oundle
Phipps NBC Northampton
Potbelly Kettering
Rockingham Blatherwycke
Roman Way ✦ Weedon Bec
Silverstone Syresham
Three Hills Woodford
Towcester Mill ✦ Towcester
Weldon Rushden

music nights are held regularly. Two of the guests beers are from Oakham and Potbelly.
Q☂❀◐▷å♣P🖳(X4)❀🌐

Kettering

Alexandra Arms 🅛
39 Victoria Street, NN16 0BU
☎ (01536) 522730
Hop Back Summer Lightning; Marston's Pedigree; Wychwood Hobgoblin Gold; 11 changing beers (sourced nationally) Ⓗ
You will always find a beer from a little-known brewery in this classic street-corner local in the centre of town. The landlord continues to search out new and interesting ales, which are served through 14 handpumps. Ales are sourced from anywhere in the country, but often include one from nearby Potbelly Brewery. Two opened-out rooms contain settees, with the walls covered in breweriana and pumpclips. The rear bar has a TV and Northants skittles. A patio to the rear is a real suntrap.
Q❀♣♦🖳❀

Kettering Midland Band Social Club 🅛
2 Hallwood Road, NN16 9RG
☎ (01536) 512929 ⊕ midlandbandsocialclub.co.uk
St Austell Tribute; Sharp's Doom Bar; house beer (by Potbelly); 5 changing beers (sourced regionally; often Titanic) Ⓗ
This popular club is a new entry to the Guide, tucked away close to Rockingham Road Pleasure Park. It has a long public bar, a small sunken lounge area, a separate games area and a large concert room. The five guest ales are from established micros and will always include a dark beer. An active social diary features regular entertainment and trips. CAMRA Northamptonshire Club of the Year 2022. ☂❀◐å♣P🖳❀🌐

Piper 🅛 ✅
Windmill Avenue, NN15 6PS (near Wicksteed Park)
☎ (01536) 513870 ⊕ thepiper.net
Fuller's London Pride; Oakham JHB; 2 changing beers (sourced nationally; often Goff's, Theakston) Ⓗ
Popular 1950s two-roomed pub which has been run by a CAMRA member for 32 years. It has a quiet lounge to the left, and to the right is a more lively bar/games room where a quiz is held on Sunday night. A dark beer is usually among the guest ales. A beer festival is held on the third weekend in August. Nearby Wicksteed Park was one of Britain's first theme parks, and Tresham College is opposite. Q☂❀◐▷å▲♣P🖳❀🌐

Three Cocks 🅛
48 Lower Street, NN16 8DJ (opp Morrisons)
☎ 07909 698798
Full Mash Seance; 6 changing beers (sourced regionally; often Church End, Froth Blowers, Oakham) Ⓗ
Popular locals' pub in the town centre. It has an L-shaped servery at the centre looking after the two main bar areas, furnished with comfortable armchairs and high-backed stools. On an upper level is a games area featuring Northants skittles and darts. Guest ales are on the main bar, the regulars to the side, usually including a dark, strong, light and citrus beer. The pub is home to two skittles teams and also hosts board games and monthly quiz evenings. Q☂å♣♦🖳❀

Lilbourne

Head of Steam
10 Station Road, CV23 0SX (just off Rugby Rd)
☎ 07933 100850
2 changing beers (sourced nationally; often St Austell, Wye Valley) Ⓗ
Converted from a house in 2013, this thriving, railway-themed venue is a regular winner of local CAMRA Country Pub of the Year. Friendly conversation dominates in this welcoming pub, adding to the comfortable ambience. Beers often come from Wye Valley. Sunday lunches are served, and there is a steak and cheese night every other Thursday. The large garden, with an outside bar throughout the summer, makes this a popular destination in warmer weather. Q☂❀◐▷å♦P❀🌐

Litchborough

Old Red Lion 🅛
4 Banbury Road, NN12 8JF (opp church)
☎ (01327) 830064 ⊕ oldredlionlitchborough.co.uk
Great Oakley Wagtail; house beer (by Grainstore); 1 changing beer (sourced regionally) Ⓗ
A traditional four-roomed stone-built village pub that is well worth seeking out, popular with walkers and cyclists on the Knightly Way. The original pub bar remains relatively unchanged, with flagstone flooring and seats inside a large inviting inglenook. The rear snug is a comfy casual room with double doors leading to a courtyard. The extension houses a restaurant and shop with local farm produce. Three guest beers are available.
Q☂❀◐å♦P🖳❀🌐

Loddington

Hare at Loddington 🅛
5 Main Street, NN14 1LA (on village loop)
☎ (01536) 710337
Morland Old Speckled Hen; Sharp's Doom Bar; 2 changing beers (sourced regionally; often Church End, King's Cliffe, Phipps NBC) Ⓗ
The Hare is a listed building set in a conservation area in a picturesque village built from local ironstone. It stands back in the middle of Main Street, surrounded by listed houses, and has a pleasant front garden. Inside, it comprises four areas – two are spread around the central bar and two are for dining, serving good home-cooked food from local producers. The guest beers are from established breweries or local microbreweries.
Q☂❀◐å♦P🖳(35)❀

Long Buckby

Badgers Arms 🅛
2 High Street, NN6 7RD
☎ (01327) 843003
4 changing beers (sourced regionally; often North Cotswold, Potbelly, XT) Ⓖ
Opened in 2017, this micropub rapidly gained an excellent reputation for quality local beers and ciders, and has an ambience and welcome second to none. Unusually, the bar is upstairs and has two drinking areas. Downstairs is a tiny courtyard drinking area. A former CAMRA Regional Cider Pub of the Year, finalist in the National awards and local CAMRA Pub of the Year 2022. Q☂♦🖳(96,D4)❀

Nether Heyford

Foresters Arms 🅛
22 The Green, NN7 3LE

☎ (01327) 340729
2 changing beers (sourced locally) Ⓗ
The owners have made many improvements since buying this attractive ironstone pub in 2012, not least the introduction of an enlightened choice of two rotating real ales, one of which is always sourced locally. Real cider is available on gravity dispense behind the bar. The pub remains the hub of village life and while predominantly wet-led, simple bar meals and snacks are often available. On Thursday and Friday evenings a mobile pizza van sets up shop in the forecourt.
🏠🌑♣🚶P🚲(D3) 🐾🐕🛜

Northampton

Albion Brewery Bar Ⓛ
54 Kingswell Street, NN1 1PR
☎ (01604) 946606 ⊕ phipps-nbc.co.uk
Phipps NBC Red Star, Cobbler's Ale, India Pale Ale, Ratliffe's Celebrated Stout, Steam Roller, Bison Brown; 1 changing beer (sourced nationally) Ⓗ
Phipps NBC went back to its roots in 2014, returning to this Victorian brewery in the heart of Northampton, 40 years after Phipps' Bridge Street brewery closed. The brewery bar subsequently opened, featuring an oak and glass partition between the bar and brewery enabling the brewing process to be viewed. Almost all the bar fittings are reclaimed, with many coming from closed Phipps NBC pubs. Much memorabilia is on display. Eight handpumps serve six ales from the brewery plus a rotating guest, with the final pump reserved for a Northamptonshire cider. Q🏠🌑♣🚶🌾♣🚲(7,X6)🐾🛜

Cordwainer Ⓛ ✪
The Ridings, NN1 2AQ (near jct with Fish St)
☎ (01604) 609000
Fuller's London Pride; Greene King Abbot; Oakham JHB; Phipps NBC Gold Star; Ruddles Best Bitter; Sharp's Doom Bar; 7 changing beers (often Theakston) Ⓗ
This large, popular Wetherspoon town-centre pub has recently been refurbished and now has a first-floor terrace and a ground-floor garden area. There is a large bar on each floor with two sets of handpumps. A wide choice of 12 real ales is available and real cider on occasion. Food is served throughout the day with daily specials. There are up to four beer festivals each year. The pub has one TV screen. 🐾🏠🌑♣🚲🛜

Kingsley Park Working Men's Club Ⓛ
120 Kingsley Park Terrace, NN2 7HJ
☎ (01604) 715514
Fuller's London Pride, ESB; Greene King IPA; Shepherd Neame Spitfire; Tetley Bitter; 3 changing beers (sourced nationally; often Elgood's, Phipps NBC) Ⓗ
Long-established and thriving working men's club, founded in 1892 in a nearby street and now on the main road in a residential area. Its eight handpumps serve five regular and three changing beers, overseen by an award-winning steward. Live music is hosted two nights a week and trips out are organised for members. Q🏠♣♣🚲🛜

Lamplighter Ⓛ
66 Overstone Road, NN1 3JS
☎ (01604) 631125 ⊕ thelamplighter.co.uk
3 changing beers (sourced locally; often Nene Valley) Ⓗ
A traditional street-corner pub, just off the town centre, deservedly popular with young and old alike. It has an open fire in the bar and a heated courtyard. Five rotating beers come from established micros, including LocAles. Home-cooked food is served and children are welcome during mealtimes. It hosts weekly DJ nights, live music

and quiz nights, and beer festivals throughout the year. Food and drinks are sourced from local businesses.
🐾🏠🌑♣🚶♣🚲🐕🛜

Malt Shovel Tavern Ⓛ
121 Bridge Street, NN1 1QF
☎ (01604) 234212 ⊕ maltshoveltavern.com
Nethergate Melford Mild; Oakham Bishops Farewell, JHB; Phipps NBC India Pale Ale; 5 changing beers (sourced locally; often Phipps NBC, Purity) Ⓗ
Popular award-winning pub close to the town centre and opposite the Carlsberg brewery. Breweriana features throughout inside. The pub serves real cider, local ales and Belgian draught and bottled beers. Home-made lunches are available Thursday to Sunday. Live blues bands play at least one Wednesday every month. The pub has a strong rugby following and is well worth a visit. 🐾🏠🌑♣🌾♣🚲(3,11)🐾🛜

Olde Cobbler Ⓛ
Acre Lane, Kingsthorpe, NN2 8BN
☎ (01604) 844016 ⊕ oldecobbler.co.uk
Greene King Abbot; Phipps NBC India Pale Ale; 2 changing beers (sourced locally; often Phipps NBC, Potbelly) Ⓗ
A family pub and restaurant in the residential area of Kingsthorpe. With three distinct areas – bar, restaurant and function room – alongside a good-sized garden, it's an ideal place for families and friends to meet. Four ales are always available, with the emphasis on LocAle. A varied food menu is served, with pie night on Monday, pasta night on Wednesday, afternoon tea on Friday plus steak night, and breakfast Saturday and Sunday.
🐾🏠🌑♣P🚲(14) 🐾🛜

Pomfret Arms Ⓛ
10 Cotton End, NN4 8BS
☎ (01604) 555119 ⊕ pomfretarms.co.uk
Great Oakley Wot's Occurring, Abbey Stout; 6 changing beers (sourced locally; often Great Oakley) Ⓗ
Town pub on the south-west side of the River Nene in Cotton End. Its small central bar has six handpumps serving both the front opened-out room and rear bar. There is a function room in the lovely beer garden. Great Oakley beers are always available. Seasonal opening hours vary. 🐾🏠🌑♣🚲🐕🛜

Road to Morocco Ⓛ
Bridgwater Drive, NN3 3AG
☎ (01604) 632899
Greene King IPA; Phipps NBC Gold Star; St Austell Tribute; Theakston Old Peculier; 3 changing beers (sourced nationally) Ⓗ
Run by a CAMRA member, this popular 1960s brick-built estate pub has a Moorish theme in some of its decor, reflecting its name. There are two connected but distinctly different rooms. The bar area is quite lively, particularly when sporting events are shown on TV, and is where darts and pool are played. The homely lounge is generally quieter. Quiz night is Tuesday.
🐾🏠♣♣P🚲(5) 🐾🛜

St Giles Ale House
45 St Giles Street, NN1 1JF
☎ (01604) 636332
6 changing beers (sourced nationally; often Framework, Grainstore) Ⓗ
Northampton's first and only micropub, opened in 2016 following conversion from retail premises. The one-room pub specialises in real ale and real cider, sourcing beers from around the country which tend to be new releases or from more obscure breweries. With no music or fruit

machines, this is an ideal place for drinking and chatting. A beer club runs from Tuesday to Thursday teatime.
Q❀❀❀⑪&♣♞⊟(5) ❀ ☎

Oundle

Ship Inn ⃝L
18 West Street, PE8 4EF
☎ (01832) 273918 ⊕ theshipinnoundle.co.uk
Brewsters Hophead, Marquis; Fuller's London Pride; St Austell Tribute ⊞
This Grade II-listed pub is full of character with original beamed ceilings and the ghost of a former landlord. It has three bars with many small rooms adjoining, and a large function room available to hire for birthday celebrations and small weddings. Good food is served in all rooms. Accommodation is in two stone annexes and a small cottage at the back. Outside there is a drinking area with a large screen, projector and retractable awning.
Q❀☎✉⑪&♣♞⊟(X4) ❀ ☎

Tap & Kitchen
Oundle Wharf, Station Road, PE8 4DE
☎ (01832) 275069 ⊕ tapandkitchen.com
Nene Valley Australian Pale, Release the Chimps, Egyptian Cream; 5 changing beers (sourced locally) ⊞
The main outlet for the Nene Valley Brewery, this pub has spacious eating and drinking areas, and waterside seating at the front. Built in a revamped wharfside warehouse, the Industrial Revolution theme has been retained, with chrome and wood, cogs and rails. An extensive menu of home-cooked and locally sourced food is available. Live music plays on occasion. Up to eight real ales from Nene Valley Brewery are available plus a selection of craft beers and ciders. ❀⑪♞⊟❀☎

Polebrook

King's Arms ⃝L
Kings Arms Lane, PE8 5LW
☎ (01832) 272363 ⊕ kingsarmspolebrook.co.uk
Timothy Taylor Landlord; 2 changing beers (sourced locally; often Brewsters, Digfield) ⊞
A traditional stone-built thatched inn, with doors at the front and rear off the car park. The pub is open plan with a main bar, three areas for diners, and an enclosed garden with a children's play area. Interesting photos reflect the history of the local wartime RAF base. Three beers are dispensed via handpump, always including at least one from the nearby Digfield Ales. Third-pint glasses are available, giving the opportunity to taste a wider variety of beer. Food is offered from an extensive menu and specials board. Q❀❀⑪♣♞⊟❀☎

Rushden

Rushden Historical Transport Society ⃝L
Station Approach, NN10 0AW (on ring road)
☎ (01933) 318988 ⊕ rhts.co.uk
Phipps NBC India Pale Ale; 5 changing beers (sourced regionally; often Marston's, Woodforde's) ⊞
This award-winning club occupies the former Midland Railway station. The ladies' waiting room is now the bar, with gas lighting and walls adorned with enamel advertising panels, railway photos and many CAMRA awards. On the platform, carriages house a meeting room, Northants skittles, and a buffet for the numerous open days held during the year when steam and diesel train rides are provided. A beer festival is held in September. Show a copy of the Guide to sign in.
Q❀❀&♣♞⊟❀

Southwick

Shuckburgh Arms ⃝L
Main Street, PE8 5BL
☎ (01832) 272044 ⊕ shuckburghpub.co.uk
Digfield Chiffchaff, Barnwell Bitter; 2 changing beers (sourced locally; often Brewsters, Grainstore) ⊞
Thatched stone-built pub in the village centre, with a bar serving four real ales, and a small side room. The bar area doubles as a restaurant. To the rear is a covered outdoor area, car park, large garden and the village cricket pitch. The pub is run by the local community with shareholders and a small committee. It hosts the annual World Conker Championship in October. Popular well-priced food is available, including breakfast by arrangement. Q❀❀⑪♣♞⊟❀☎

Staverton

Countryman ⃝L ✅
Daventry Road, NN11 6JH (on A425)
☎ (01327) 311815 ⊕ thecountrymanstaverton.co.uk
Bombardier; 2 changing beers (sourced locally; often Church End, Hook Norton) ⊞
This delightful and popular 17th-century ironstone coaching inn is the last survivor of the three pubs that once served this lovely village close to Daventry. The long wooden-beamed bar serves four areas, with an open hearth fire between the rooms providing some seclusion. The landlord offers a good selection of ales, always including one locally brewed beer. There is also a wide choice of reasonably priced food, sourced locally whenever possible. Q❀❀❀⑪&♞⊟(66)❀☎

Stoke Bruerne

Boat Inn ✅
Bridge Road, NN12 7SB
☎ (01604) 862428 ⊕ boatinn.co.uk
Banks's Amber Ale; Marston's 61 Deep, Old Empire; Ringwood Razorback; Wychwood Hobgoblin Ruby; house beer (by Marston's); 1 changing beer (sourced nationally; often Marston's) ⊞
Situated on the banks of the Grand Union Canal, the Boat Inn has been owned and operated by the Woodward family since 1877. The delightful tap bar's interconnecting rooms have canal views, open fires, original stone floors and window seats; an adjoining room has Northants skittles. A large extension houses the lounge, plus the restaurant and bistro which are popular with diners. Meals are served from breakfast onwards. Additional beers are sold in summer. A canal boat is available to hire. Q❀❀❀⑪&♣❀☎

Tiffield

George at Tiffield ⃝L
21 High Street North, NN12 8AD (in centre of village)
☎ (01327) 350587 ⊕ thegeorgeattiffield.co.uk
Great Oakley Wot's Occurring; 2 changing beers (often Abbeydale) ⊞
A 16th-century building with Victorian additions. This true community pub takes part in many village activities. It has a cosy bar, games room with Northants skittles, and back room restaurant (available to book for small functions). The tap for Great Oakley brewery, which is just outside the village, it features one of the brewery's beers. A beer festival is held in October.
❀❀⑪&♣♞⊟❀☎

Towcester

Towcester Mill Brewery Tap 🅛

Chantry Lane, NN12 6YY

☎ (01327) 437060 🌐 towcestermillbrewery.co.uk

Towcester Mill Crooked Hooker, Amarillo, Bell Ringer, Steam Ale, Black Fire; 2 changing beers (sourced locally) 🅗

Popular and welcoming brewery tap in a historic Grade II-listed mill dating from 1794, straddling the old mill race and adjacent to Bury Mount on which the town's fort once stood. The bar retains many original features including beams, stonework and a wooden floor. There is a second room to cope with demand, plus two upstairs rooms. Outside is a large garden alongside the mill. Two guest ales from local breweries and six ciders are available. Q 🕏 ❀ ♿ ♣ 🚃 P ☂ 🐾 🥝 ?

Wadenhoe

King's Head

Church Street, PE8 5ST

☎ (01832) 720024 🌐 kingsheadwadenhoe.com

6 changing beers (sourced nationally; often Digfield, Great Oakley, Nene Valley) 🅗

This 1700 stone-built part-thatched public house is at the end of the village next to the old school. The main pub is split on two levels – a public bar with four handpumps on the higher level and a tea shop on the lower. Impressive grounds overlook the River Nene, with 20 moorings, a pizza terrace and two more bars which can cater for large events. Al fresco dining is popular in the summer. A beer festival is held every September, jazz nights every first Thursday of the month and open mic nights every third. The popular Nene Way and Lyveden Way footpaths are close by. Q 🕏 ❀ 🕦 ♣ P 🐾 ?

Welford

Wharf Inn 🅛 ✅

NN6 6JQ (on A5199 by canal basin)

☎ (01858) 575075 🌐 wharfinnwelford.co.uk

Grainstore Ten Fifty; Marston's Pedigree; Oakham Bishops Farewell; 3 changing beers (sourced locally) 🅗

This original ironstone building dates from 1814 and is situated at the end of the Welford arm of the Grand Union Canal, a few yards from the border with Leicestershire. Inside, the main room is divided by an open fireplace between the two rooms. A smaller snug and back bar is occasionally used. Guest beers are often sourced locally or regionally. Good-value food is served. Popular with walkers – ask for the leaflet with suggested routes. Q 🕏 ❀ 🛏 🕦 ♿ P 🚃 (60) 🐾 ?

Wellingborough

Coach & Horses 🅛

17 Oxford Street, NN8 4HY (800yds from Market Square)

☎ (01933) 441848

🌐 thecoachandhorseswellingborough.co.uk

12 changing beers (sourced nationally; often Castle Rock, Elland, Salopian) 🅗

A regular CAMRA award winner and long-standing Guide entry, this popular town-centre local is a former CAMRA East Midlands Leicestershire and Northamptonshire Pub of the Year. A constantly changing choice of 12 real ales and 15 ciders is always on offer. The central bar serves three drinking areas adorned with breweriana. Traditional home-cooked food is available including a wide choice of pies (no food Sun eve, Mon & Tue). Live

music and quiz nights are held regularly. Beer festivals are hosted on the Whitsun and August bank holidays. Q 🕏 ❀ 🕦 ♿ ♣ 🚃 🛏 🐾 🥝 ?

Little Ale House 🅛

14A High Street, NN8 4JU

☎ 07870 392011

4 changing beers (sourced locally; often Oakham, Potbelly) 🅗/🅖

Wonderfully friendly one-roomed micropub whose small size encourages interaction between customers. Four rotating real ales are served on handpump including a mild, porter or stout. In addition, four draught ciders and a good selection of gins, single malt whiskies, wines and soft drinks are stocked. There are pavement tables and a rear garden is now open. Close to Jackson's Lane car park. Local CAMRA Town Pub of the Year 2022. Q 🕏 ❀ ♣ 🚃 P 🚃 🐾 ?

Weston by Welland

Wheel & Compass

Valley Road, LE16 8HZ (off B664)

☎ (01858) 565864 🌐 thewheelandcompass.co.uk

Banks's Amber Ale; Greene King Abbot; Marston's Pedigree; 2 changing beers (sourced nationally) 🅗

This rural pub in the picturesque Welland Valley has been refurbished to open up the entrance lobby and incorporate part of the former dining area, with flagstone floors, a wood-burner and sofas. Good-value food includes lunchtime specials. The outside drinking area offers views across the valley and is an ideal playground for children. A handy stopping-off place for walkers on the Jurassic Way which runs close by. 🕏 ❀ 🕦 ♿ ♣ P 🐾 ?

Wilbarston

Fox Inn 🅛

Carlton Road, LE16 8QG

☎ (01536) 771270

Grainstore Beesting; Sharp's Doom Bar; 1 changing beer (sourced locally) 🅗

Local 18th-century ironstone inn in the centre of the village, on a narrow and sharp-bended road. This community pub has a bar, lounge and dining room and is very sports and games orientated. The two local ales are mainly from Grainstore, King's Cliffe and Langton breweries, and a Westons cider and local gin are always on offer. The food menu is centred around seafood and grills, and many specials nights also feature. Q 🕏 ❀ 🛏 🕦 ♿ ♣ P 🚃 🐾 ?

Woodford

Dukes 🅛

83 High Street, NN14 4HE (off A510)

☎ (01832) 732224

Fuller's London Pride; Greene King Abbot; Sharp's Doom Bar; 5 changing beers (sourced nationally; often Oakham, Phipps NBC, Digfield) 🅗

A community focused pub overlooking the green, renamed in honour of the Duke of Wellington who was a frequent visitor to the village. The interior includes a split main bar, lounge restaurant, rear room and an upstairs games room. The pub holds a May bank holiday beer festival and an August bank holiday music festival, plus regular open mic, disco, karaoke and acoustic music nights. Local CAMRA Rural Pub of the Year 2022 – every village should have a pub like this. Q 🕏 ❀ 🕦 ♣ 🚃 P 🚃 (16X) 🐾 ?

Breweries

Avalanche

5 Goodwood Close, Burton Latimer,
Northamptonshire, NN15 5WP
⊕ avalanchebrew.co.uk

Avalanche Brewery is a nanobrewery formed by two former homebrewers, aiming to put a modern twist on classic styles. Most cask beers produced are one-off beers to allow creativity to thrive. Beers are unfined and unfiltered. Output is primarily cask and keg alongside short canning runs. ♦

Boot Town

c/o Copper Kettle Brewing, Bosworths Garden Centre, 110 Finedon Road, Burton Latimer,
Northamptonshire, NN15 5QA
☎ (01536) 725212 ☎ 07958 331340
⊕ boottownbrewery.co.uk

One-barrel microbrewery, established in 2017, based at the old Copper Kettle Homebrew Shop, producing an ever-changing range of beers with a modern craft theme, pushing the boundaries of modern recipes, innovations and techniques.

Carlsberg-Tetley

Jacobson House, 140 Bridge Street, Northampton, NN1 1PZ
☎ (01604) 668866 ⊕ carlsberg.co.uk

International lager brewery, which while brewing no real ales is a major distributor of cask beer. The Tetley-owned real ales are mostly brewed by Camerons Brewery of Hartlepool. A joint venture with Carlsberg in 2020 led to the company being renamed Carlsberg Marston's Brewing Company.

Creaton Grange

Old Wash House, Creaton Grange, Grooms Lane, Creaton, Northamptonshire, NN6 8NN ☎ 07943 595829 ⊕ creatongrangeales.co.uk

Microbrewery started in 2017 and based in a converted disused building on a family farm in rural Northamptonshire.

Four Sons (ABV 3.5%) MILD
Pheasant Tale (ABV 3.8%) GOLD
March Yard (ABV 4.2%) PALE

Digfield SIBA

Lilford Lodge Farm, Barnwell, Northamptonshire, PE8 5SA
☎ (01832) 273954 ⊕ digfield-ales.co.uk

⊗ Digfield Ales started brewing in 2005 and has continually expanded brewing capacity to keep up with demand. In 2012 it moved to a larger premises near Barnwell, where a reed bed was installed and the brewhouse was equiped with a new 15-barrel plant. More than 40 free houses are supplied. ♦

Fools Nook (ABV 3.8%) GOLD
The floral aroma, dominated by lavender and honey, belies the hoppy bitterness that comes through in the taste of this golden ale. A fruity balance lasts.
Chiffchaff (ABV 3.9%) GOLD
An amber-gold pale ale with a distinct hoppy aroma.
Barnwell Bitter (ABV 4%) BITTER

A fruity aroma introduces a beer in which sharp bitterness is balanced by dry, biscuity malt.
Old Crow Porter (ABV 4.3%) PORTER
A rich, full-bodied porter with a balanced, roasted malt finish.
March Hare (ABV 4.4%) BLOND
A straw-coloured, premium ale with a subtle fruit flavour.
Shacklebush (ABV 4.5%) BITTER
This amber brew begins with a balance of malt and hop on the nose which develops on the palate, complemented by a mounting bitterness. Good dry finish with lingering malt notes.
Mad Monk (ABV 4.8%) BITTER
Fruity beer with bitter, earthy hops in evidence.

Benjamin Franklin (NEW)

▤ Three Horseshoes, 23 High Street, Ecton, Northamptonshire, NN6 0QA
☎ (01604) 407446

The Benjamin Franklin is a new microbrewery at the Three Horseshoes in Ecton village. Its name is directly associated with the family of one of the founding fathers of the USA. ♦

Great Oakley SIBA

Ark Farm, High Street South, Tiffield, Northamptonshire, NN12 8AB
☎ (01327) 351759 ⊕ greatoakleybrewery.co.uk

⊗ Award-winning brewery established in 2005 in Great Oakley, relocating to Tiffield in 2012. It is run by Guy Jenkins who took over in 2017. More than 60 outlets are supplied, including brewery tap, the George, Tiffield.
♦LIVE

Welland Valley Mild (ABV 3.6%) MILD
Egret (ABV 3.8%) GOLD
Wagtail (ABV 3.9%) GOLD
Wot's Occurring (ABV 3.9%) BITTER
Nuggernaut (ABV 4%) GOLD
Tiffield Thunderbolt (ABV 4.2%) PALE
Harpers (ABV 4.3%) BITTER
Gobble (ABV 4.5%) BLOND
Delapre Dark (ABV 4.6%) OLD
Abbey Stout (ABV 5%) STOUT
Tailshaker (ABV 5%) GOLD

King's Cliffe

Unit 10, Kingsmead, Station Road, King's Cliffe, Northamptonshire, PE8 6YH ☎ 07843 288088
⊕ kcbales.co.uk

⊗ In 2014, exactly 100 years after the last brewery in King's Cliffe ceased brewing, village resident Jeremy O'Neill set up this venture. It currently produces five barrels a week. ‼♦

5C (ABV 3.8%) GOLD
A light bitter with balanced taste of malt and hops and a refreshing, bitter finish.
No. 10 (ABV 4%) PALE
Amber beer with a clean, malty taste and a long, bitter finish.
66 Degrees (ABV 4.6%) BITTER
Amber beer with a floral aroma, a balanced taste of malt and hops, and a long, bitter finish.
B5 (ABV 4.6%) PALE
P51 (ABV 5.1%) PORTER
A rich, dark porter with a smooth roast and chocolate taste and a malt, fruit and bitter chocolate finish.

Maule SIBA

Rothersthorpe Trading Estate, Northampton, NN4 8JH
⊕ maulebrewing.com

Brewing began in 2014 on a self-built plant. Production is mainly unfiltered keg and bottle-conditioned beers, but cask-conditioned ales are occasionally produced for festivals. The beers are available from various local stockists, including its tap in Northampton, as well as featuring on the London craft beer scene. LIVE

Nene Valley

Oundle Wharf, Station Road, Oundle, Northamptonshire, PE8 4DE
☎ (01832) 272776 ⊕ nenevalleybrewery.com

⊠ Nene Valley Brewery was established in 2011. A bespoke 15-barrel plant was installed in former Water Board premises in 2012. Further expansion in 2016 has doubled the floorspace. A brewery tap, Tap & Kitchen, opened on the same site in 2014. ‼️🍽♦LIVE ✦

Simple Pleasures (ABV 3.6%) GOLD
A light, clean and refreshing beer with a pleasing citrus hop aroma and flavour.
Blonde Session Ale (ABV 3.8%) GOLD
Manhattan Project (ABV 4%) BITTER
Bitter (ABV 4.1%) BITTER
Floral hop and malt aroma introduces a full clean biscuit malt taste balanced by bitterness and some fruit, ending with a long malt and bitter finish.
Release the Chimps (ABV 4.4%) PALE
Egyptian Cream (ABV 4.5%) STOUT
Big Bang Theory (ABV 5.3%) PALE
Well-balanced pale ale with a huge hop aroma giving way to malty sweetness and a gentle bitter finish.
Bible Black (ABV 6.5%) PORTER
An inviting aroma of malt and fruit leads to a rich-tasting beer where blackberry dominates but is balanced by malt, hops and some bitterness. The lingering finish is bittersweet, with fruit assertive.

Phipps NBC SIBA

Albion Brewery, 54 Kingswell Street, Northampton, NN1 1PR
☎ (01604) 946606 ☎ 07717 078402
⊕ phipps-nbc.co.uk

Originally founded in Towcester in 1801, Phipps had been brewing in Northampton since 1817. Following a takeover by Watney Mann in 1960 the brewery closed in 1974 but the company continued as a pub chain. The company name, trademark and recipes were acquired by local management and Phipps beers reappeared in 2008. The founding Phipps family rejoined the company in 2014 allowing the historic Albion Brewery to be restored and Phipps brewing to return to the town after a 40 year absence. ‼️♦LIVE

Diamond Ale (ABV 3.7%) BITTER
Rich honey, sweetish aroma, a full bitter flavour with citrus notes and a bitter aftertaste with hints of grapefruit.
Red Star (ABV 3.8%) BITTER
Honey malt aroma, a flavour of rye, some sweetness, hints of dark cherry, and a dry, bitter aftertaste.
Midsummer Meadow (ABV 3.9%) BITTER
Cobbler's Ale (ABV 4%) BITTER
Phipps IPA (ABV 4.3%) BITTER
Ratliffe's Celebrated Stout (ABV 4.3%) STOUT
Steam Roller (ABV 4.4%) BITTER
Biscuity aroma with some sweetness followed by earthy, spiced bitterness with hints of plum which continue in the dry aftertaste.

Becket's Honey Ale (ABV 4.5%) SPECIALITY
Bison Brown (ABV 4.6%) MILD
Solar Star (ABV 4.6%) GOLD
Black Star (ABV 4.8%) BITTER
Roasted malt aromas with liquorice notes followed by a bitter coffee chocolate flavour and a dry, bitter, coffee aftertaste
Gold Star (ABV 5.2%) PALE
Stingo Number 10 (ABV 9.5%) BARLEY

Potbelly SIBA

31-44 Sydney Street, Kettering, Northamptonshire, NN16 0HY
☎ (01536) 410818 ☎ 07834 867825
⊕ potbellybrewery.co.uk

Potbelly started brewing in 2005 on a 10-barrel plant and supplies around 200 outlets. A new craft brand called A Bloke Down the Pub was launched in 2021. Beers are also contract brewed for the Olde England Ales estate under the Olde England name. ‼️🍽♦LIVE

Potbelly Best (ABV 3.8%) BITTER
Lager Brau (ABV 3.9%) SPECIALITY
A Piggin' IPA (ABV 4%) PALE
Hop Trotter (ABV 4.1%) GOLD
Piggin' Saint (ABV 4.2%) PALE
Beijing Black (ABV 4.4%) MILD
Pigs Do Fly (ABV 4.4%) GOLD
Hedonism (ABV 4.5%) BITTER
Black Sun (ABV 5%) STRONG
SOAB (ABV 5%) BITTER
Crazy Daze (ABV 5.5%) BITTER

Brewed under the A Bloke Down the Pub brand name:
Clever Colin (ABV 4%) GOLD
Handy Andy (ABV 4.2%) GOLD
Dangerous Darren (ABV 4.3%) BROWN
Gorgeous Gary (ABV 4.5%) GOLD
Majestic Mark (ABV 5.1%) BITTER
Philanthropist Phil (ABV 5.2%) BITTER
Incredible Ian (ABV 5.6%) BLOND

Contract brewed for Olde England Ales estate:
Black Prince (ABV 6%) PORTER

Rockingham SIBA

Blatherwycke, Northamptonshire, PE8 6YN
☎ (01832) 280722

Office: 25 Wansford Road, Elton, PE8 6RZ
⊕ rockinghamales.co.uk

⊠ Rockingham is a small brewery established in 1997 that operates from a converted farm building near Blatherwycke, Northamptonshire, with a two-barrel plant producing a prolific range of beers. It supplies half a dozen local outlets. ♦

Forest Gold (ABV 3.9%) BLOND
Hop Devil (ABV 3.9%) GOLD
White Rabbit (ABV 4%) GOLD
Saxon Cross (ABV 4.1%) BITTER
Fruits of the Forest (ABV 4.3%) BITTER

Roman Way

Building 79, The Old Depot, Bridge Street, Weedon Bec, Northamptonshire, NN7 4PS
⊕ romanwaybrewery.co.uk

Roman Way Brewery was established in 2019. Its shop and taproom are usually open to the public on Fridays and Saturdays. 🍽✦

Barbarian Best (ABV 3.8%) BITTER

Carpe Diem (ABV 3.9%) PALE
Tribune (ABV 3.9%) PALE
Senate Gold (ABV 4.1%) GOLD
Claudius IPA (ABV 4.7%) GOLD
Boudicca (ABV 5.5%) IPA
Pantheon (ABV 6%) PALE

Silverstone SIBA

Kingshill Farm, Syresham, Northamptonshire, NN13 5TH ☎ **07835 279400**
⊕ silverstonebrewery.co.uk

Established in 2008 Silverstone Brewery is a traditional tower brewery located near the celebrated motor racing circuit. The brewery has won multiple awards for it's beers which are supplied in bottles, cask and KeyKeg. ‼♦

Ignition (ABV 3.4%) BLOND
Pitstop (ABV 3.9%) BITTER
Polestar (ABV 4.1%) STOUT
Chequered Flag (ABV 4.3%) BITTER
Octane (ABV 4.8%) BITTER
Classic IPA (ABV 5.6%) SPECIALITY

Three Hills

4 Thrapston Road, Woodford, Northamptonshire, NN14 4HY ☎ **07400 706884**

Outpost: Arch 7, Almond Road, Bermondsey, London, SE16 3LR ⊕ **threehillsbrewing.com**

Named after the ancient communal tombs that stand on the outskirts of the village of Woodford, Three Hills is a small-batch brewery established in 2016. Initially producing only in bottle, can and KeyKeg, it now produces occasional cask beers. Three Hills purchased the Affinity brewery site/kit in 2020 and beers produced in London are under the Outpost name. Fruit and sour beers are brewed in Woodford, although existing beers may be brewed at either site, with all canning done at Woodford.

Towcester Mill SIBA

The Mill, Chantry Lane, Towcester, Northamptonshire, NN12 6AD

☎ **(01327) 437060** ⊕ **towcestermillbrewery.co.uk**

⊗ A five-barrel brewery situated at the Grade-II listed Old Mill in Towcester. There is a brewery tap and beer garden on-site together with off-sale facilities. ‼☒♦⬧

Crooked Hooker (ABV 3.8%) BITTER
Golden/amber colour with a honeyed fruit aroma, a slighlty earthy taste with some fruit and a bitter finish.
Mill Race (ABV 3.9%) BLOND
Slightly citrus aroma followed by a dry citrus taste with hints of grapefruit with a long bitter aftertaste.
Amarillo (ABV 4.2%) BLOND
Bell Ringer (ABV 4.4%) GOLD
Steam Ale (ABV 4.5%) BITTER
Black Fire (ABV 5.2%) STOUT
Roman Road (ABV 5.2%) PALE
Tropical fruit aroma followed by a good balance of malt and hops with pineapple notes and a long bitter aftertaste.

Weldon

Bencroft Grange, Bedford Road, Rushden, Northamptonshire, NN10 0SE
☎ **(01536) 601016**

Office: 12 Chapel Road, Weldon, NN17 3HP
⊕ **weldonbrewery.co.uk**

Weldon Brewery originally started brewing in 2014 on a two-barrel plant at the Shoulder of Mutton, after which the brewery was originally named. In 2016 the brewery acquired the premises and 3.5-barrel kit of the former Copper Kettle brewery in Rushden and became the main production facility, with the brewery being renamed Weldon. ♦

Diab-Lo (ABV 3.7%) PALE
Essanell (ABV 3.8%) MILD
Dragline (ABV 3.9%) GOLD
Stahlstadt (ABV 4%) BLOND
Galvy Stout (ABV 4.2%) STOUT
Windmill (ABV 4.2%) BITTER
Mad Max (ABV 4.4%) PALE
Paradisium (ABV 4.4%) PALE
Roman Mosaics (ABV 4.6%) PALE

Alexandra Arms, Kettering (Photo: Ben Coulson / Flickr CC BY-SA 2.0)

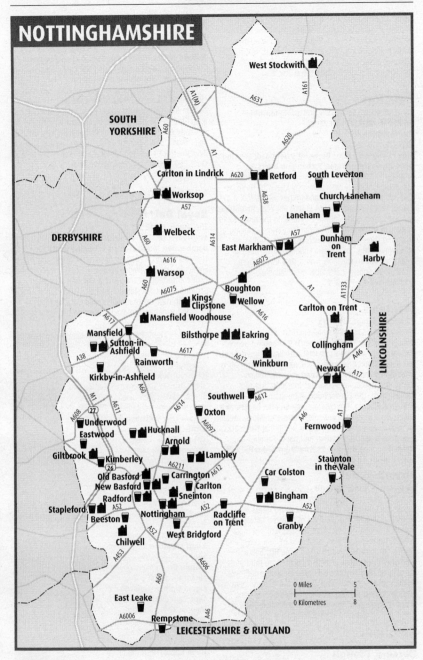

NOTTINGHAMSHIRE

Arnold

Abdication L

89 Mansfield Road, Daybrook, NG5 6BH (opp gates of former Home Brewery) ⊕ theabdication.co.uk

4 changing beers ⊞

This modern, friendly micropub is part of the Home Brewery Coronation Buildings built opposite the former brewery in 1936/37, and for many years was a shop. The four ever-changing cask ales, four craft lines and three ciders are sourced from microbreweries, small producers or the on-site nanobrewery, Good Stuff Brewing, and come in a mix of styles. An archway splits the single room, giving the appearance of a much larger area. Dogs are very welcome. Closed the first two weeks in January. Q↺&♣♠🚌🐾

Robin Hood & Little John L ✓

1 Church Street, NG5 8FD (on corner of Cross St)
☎ (0115) 920 1054 ⊕ therobinhoodandlittlejohn.co.uk

Lincoln Green Archer, Hood, Marion, Tuck; 16 changing beers (often Everards) ⊞

Former Home Brewery pub now operated between Lincoln Green and Everards breweries. The bar features

Home Ales memorabilia, while the lounge has details of the pub's history and the local area, and there is a piano. The rear courtyard has outdoor seating and a covered skittles alley. Along with 10 real ale pumps in each bar offering microbrewery beers, the real cider wall has four taps dispensing ciders. ⚲🏠🦽🍴♣🍺🐾🛏📶

Beeston

Crown Inn ★ ℐ

Church Street, NG9 1FY
☎ (0115) 967 8623
Blue Monkey BG Sips; Brewster's Hophead; Dancing Duck 22; Everards Tiger; 7 changing beers ℍ
Nineteenth-century, Grade II-listed alehouse, acquired and sympathetically refurbished by Everards. Up to 11 ales and several real ciders and perries are served at this former East Midlands CAMRA Pub of the Year. An outside bar opens during the summer, extending the range to 19 beers. There are five distinct drinking areas including a snug and three-seat 'confessional', once used as a hideaway by the local vicar. Although busy, the pub retains a community feel, with a cosy atmosphere throughout. Substantial snacks are available. Q⚲🏠🦽≅🚃♣🍺🅿🚍🐾📶

Star Inn ℐ

22 Middle Street, NG9 1FX
☎ (0115) 854 5320 🌐 starbeeston.co.uk
House beer (by Totally Brewed); 9 changing beers ℍ
This former Shipstone's pub, still with branded windows, has been restored beyond its former glory. The decor is tasteful and minimal, with three separate rooms complemented by a permanent marquee and sports/games room. The bar featured in Boon and Auf Wiedersehen, Pet. Ten cask ales are on offer as well as a wide selection of whiskies, gins, rums and wines. Meals are served along with a range of traditional bar snacks. Outside is a spacious garden and patio. Families are welcome during the day. ⚲🏠🚕🍴🦽≅🚃♣🍺🅿🚍🐾📶

Victoria Hotel ℐ

85 Dovecote Lane, NG9 1JG
☎ (0115) 925 4049 🌐 vichotelbeeston.co.uk
Castle Rock Harvest Pale; 12 changing beers ℍ
Located alongside the platform of Beeston railway station, this restored Victorian masterpiece has mass appeal. Thirteen real ales are joined by real ciders and perries, an extensive whisky and wine list, and a renowned food menu. Taster trays of three third-pints are offered. Two distinct bars are complemented by a dining room and a covered, smoke-free seating area outside. VicFest is hosted in July in addition to beer festivals throughout the year. Q⚲🏠🚕≅🚃♣🍺🅿🚍🐾📶

Bingham

Horse & Plough ℐ

Long Acre, NG13 8AF
☎ (01949) 839313
Castle Rock Harvest Pale, Preservation; 7 changing beers ℍ
A former Methodist chapel in the heart of a busy market town, this small pub has a traditional interior and flagstone floor, and a terrace outside. Up to nine cask ales and four ciders are served. Four times local CAMRA Pub of the Year, the pub always offers a wide range of styles and strengths of real ale and cider, showcasing smaller producers alongside Castle Rock and other established favourites. A pool table is a new addition. ⚲🏠🦽♣🍴🍺🐾📶

Wheatsheaf

Long Acre, NG13 8BG
☎ (01949) 837430 🌐 thewheatsheafbingham.co.uk
Rufford Abbey Rufford Poacher; 6 changing beers ℍ
The Wheatsheaf reverted to its traditional name when it reopened in 2016 under new ownership. Ten handpumps offer a changing range of cask ales and ciders. Food is served daily lunchtimes and evenings, both in the bar and the separate restaurant. The pub has a real fire in the bar, a fantastic outdoor terrace and regularly hosts live music. Accommodation is in five en-suite rooms and a private dining room/function space is available for hire. A former local and regional CAMRA Cider Pub of the Year. ⚲🏠🚕🍴🦽≅🍺🅿🚍🐾📶

Car Colston

Royal Oak ✅

The Green, NG13 8JE
☎ (01949) 20247 🌐 royaloakcarcolston.co.uk
Bombardier; Wainwright; 2 changing beers ℍ
This country inn – a former hosiery factory – is on one of England's largest village greens. The pub has a cosy bar with comfortable seating and a real fire, a separate, generously sized restaurant and a function room. Four beers, all from the Marston's range but often less-heralded varieties, are available in the bar. Food is

REAL ALE BREWERIES

Angel 🛢 ✦ Nottingham
Beermats ✦ Winkburn
Beeston Hop Nottingham: Sneinton
Black Iris ✦ Nottingham: New Basford
Black Market 🛢 Warsop
Blue Monkey Nottingham: Giltbrook
Brewhouse & Kitchen 🛢 Nottingham
Castle Rock ✦ Nottingham
Cat Asylum ✦ Collingham
Dukeries 🛢 Worksop
FireRock Sutton-in-Ashfield
Fish Key 🛢 Lambley
Full Mash Stapleford
Good Stuff 🛢 Arnold
Grafton Worksop
Harby 🛢 Harby
Harrison's Retford
Idle 🛢 West Stockwith
Kings Clipstone Kings Clipstone
Lenton Lane Nottingham
Lincoln Green Nottingham: Hucknall
Linear Bingham
Liquid Light ✦ Nottingham
Lord Randalls Newark
Magpie ✦ Nottingham
Maypole Eakring
Milestone ✦ Newark
Navigation Nottingham
Neon Raptor ✦ Nottingham
Newark Newark
Nottingham ✦ Nottingham: Radford
Pheasantry East Markham
Prior's Well Mansfield Woodhouse
Reality Nottingham: Chilwell
Reckless Dweeb Bilsthorpe
Rufford Abbey Boughton (brewing suspended)
Scruffy Dog 🛢 Sutton-In-Ashfield
Shipstone's Nottingham: Old Basford
Tom Herrick's Carlton on Trent
Totally Brewed Nottingham
Vaguely Bingham
Welbeck Abbey Welbeck

served lunchtimes and evenings. There is a skittle alley to the rear, a beer garden and camping facilities.
🏠🕯️🌑🍴🚲⚓🅿️🐾🌼🛜

Carlton in Lindrick

Grey Horses Inn 🅛
The Cross, S81 9EW (in centre of old village)
☎ (01909) 730252
6 changing beers (sourced locally; often Chantry, Welbeck Abbey) 🅗
The Grey Horses is situated at the heart of the village within the conservation area, and has a front bar accessible from the street, a spacious lounge bar where excellent food is served and a large beer garden. It serves six real ales – two or three usually from Welbeck Abbey and three or four guests from local breweries. A former winner of local CAMRA Pub of the Season, there is always a welcoming atmosphere here.
Q🏠🕯️🌑🍴🚲🅿️🚇(21,22) 🌼🛜

Church Laneham

Ferryboat Inn
DN22 0NQ (opp River Trent, close to church)
☎ (01777) 228350
Greene King Abbot; Pheasantry Dancing Dragonfly; 2 changing beers (sourced locally) 🅗
Friendly Trent-side pub with an open-plan bar area with TV, a separate dining room, a conservatory and outside seating. Abbot and Dancing Dragonfly are the regular real ales, plus two guests, usually from local breweries. An extensive, reasonably priced food menu is available. Close to a caravan park, the pub can get busy. It is not unusual for the river to flood opposite the pub.
Q🏠🕯️🌑🍴🚲⚓🐖🅿️🚇(P190) 🌼🛜

Dunham on Trent

White Swan
Main Street, NG22 0TY (on A57 as you enter from Markham Moor)
☎ (01777) 228307
Pheasantry Pale Ale; 2 changing beers (sourced locally) 🅗
An attractive village pub at the side of the A57 and close to the River Trent. It has a separate bar, a reasonably-sized dining room and a function room. Pheasantry PA is the regular beer and there are two changing guests, usually from local breweries. Outside there is ample seating and a large children's play area. The pub also has its own fishing lake and camping and caravan park.
🏠🕯️🌑🍴⚓🚲🅿️🚇🌼

East Leake

Round RobINN 🅛
54 Main Street, LE12 6PG
☎ (0115) 778 8168
6 changing beers (sourced locally) 🅖
Micropub opened in 2015, serving six local beers on gravity, cooled on racks behind the bar. A range of ciders and continental bottled beers are also available. The single room accommodates up to 45 patrons – seating is a mixture of chairs, cushioned benches and high stools. A small outdoor area to the front offers alfresco drinking. Light bar snacks are served. Q🏠🚲🐖🚇(1)🌼

East Markham

Queen's Hotel
High Street, NG22 0RE

☎ (01777) 870288
Adnams Southwold Bitter; Brains Rev James Original; Everards Old Original, Tiger; house beer (by Everards); 1 changing beer (sourced regionally; often Everards) 🅗
Situated on the main street, this cosy pub has a friendly atmosphere enhanced by an open fire in winter. A single bar with six real ales serves the lounge and dining areas. Food ranges from hot and cold snacks to full home-cooked meals. There is a large garden area at the rear of the car park. The Queen's has received several local CAMRA awards. Q🏠🕯️🌑🚲🅿️🚇(136,37)🌼

Eastwood

Gamekeeper's 🅛
136 Nottingham Road, NG16 3GD
5 changing beers 🅗
Opened in 2017, this friendly micropub in the centre of Eastwood serves up to five local ales. The bar is at the back, with a seating area at the front and an alcove space to the left. There is also an extensive garden/patio area at the rear. Pub snacks are normally available.
Q🏠🕯️🚲🐖🚇🌼🛜

Tap & Growler 🅛
209 Nottingham Road, Hill Top, NG16 3GS
🌐 tapandgrowler.co.uk
Acorn Barnsley Bitter; Oakham Bishops Farewell 🅗; 8 changing beers (sourced locally) 🅗/🅖
This micropub sells up to 10 real ales, five on handpump and up to five more on gravity. Local ciders are also available, and six craft beer taps are on the back wall of the bar. While the pub name partially comes from the US word for a take-out container (growler), when the building was renovated a ceramic lion was found, now proudly on display as The Growler. The patio garden at the rear seats around 30. Q🏠🕯️🐖🚲🐾🌼🛜

Fernwood

Brews Brothers Micropub & Coffee House
Rubys Avenue, NG24 3RQ
☎ (01636) 705475
4 changing beers 🅗
A new entry in the Guide, Brews Brothers is a modern micropub on the recently built Fernwood Estate, on the outskirts of Newark and just off the A1. It offers a range of three cask ales, often from independent breweries, draught cider and craft ales on tap. It is also a coffee shop for the local community, serving food Wednesday to Sunday, specialising in home-made pies. There is a regular quiz night and live music. Q🏠🕯️🌑🚲🐖🚇🌼🛜

Granby

Marquis of Granby 🍸
Dragon Street, NG13 9PN
☎ (01949) 859517
Brewster's Hophead, Marquis; 4 changing beers 🅗
Believed to be the original Marquis of Granby, dating back to 1760 or earlier, this small two-roomed pub is the brewery tap for Brewster's. Alongside the brewery's beers, guests mostly come from microbreweries. Yorkstone floors complement the yew bar tops and wood-beamed rooms, and the lounge has a welcoming open fire in the winter months. No food is served but regular visits from Great Street Food vans are popular. The pub also houses a small village store. Local CAMRA Pub of the Year 2022. Q🏠🕯️🚲🅿️🚇🌼🛜

Hucknall

Byron's Rest 🅛

8 Baker Street, NG15 7AS
Shipstone's Gold Star; Titanic Plum Porter; 7 changing beers (often Black Iris, Blue Monkey, Magpie) Ⓗ
This former sewing shop was converted into a micropub in 2018. A narrow pub with a recently refurbished snug just off the entrance, it extends considerably to the rear where the bar is located, and has comfortable bench seating. Outside at the back, the covered secret garden provides a tranquil oasis in the heart of Hucknall. Up to five real ales are available along with real cider.
Q❀⇔🅡♣●🖰❀

Kimberley

Roots Emporium

17 Nottingham Road, NG16 2NB
☎ 07864 572037
6 changing beers Ⓗ
Converted from a furniture and gift shop, much of this micropub's fixtures and fittings are made from the stock of the former business. The pub was originally quite small, but a rear garden and former garage have increased the available space. The patio at the front extends the drinking area further. Walls are adorned with interesting memorabilia, including items relating to the former Kimberley Brewery. Beers are generally from microbreweries, always including a number of local beers. Q♿❀♿♣●🖰❀

Kirkby-in-Ashfield

Dandy Cock Ale House ✅

184A Victoria Road, NG17 8AT
☎ 07854 054060 ⊕ thedandycock.co.uk
4 changing beers (sourced locally; often Dancing Duck, Little Critters) Ⓗ
Micropub offering four real ales and up to six real ciders on tap. There are two small rooms, with views into the cellar behind the bar. A range of wines and spirits including over 200 gins is also available. Acoustic nights are hosted on occasion. There is on-street parking and a bus stop outside the front door. Very dog friendly.
Q♿👍⇔●🖰❀❀

Lambley

Woodlark Inn 🅛

Church Street, NG4 4QB
☎ (0115) 931 2535 ⊕ woodlarkinn.co.uk
Theakston Best Bitter; Timothy Taylor Landlord; 4 changing beers (often Fish Key) Ⓗ
Located in the quaint-sounding Upper Dumbles area of the village, this traditional pub dating back to the 19th century is the home of the Fish Key microbrewery. It is popular with locals and visitors from afar. A music-free environment encourages customers and staff to engage in the lost art of conversation. Cask ales (usually LocAles) are to be found in the bare red-brick bar with exposed beams, and excellent home-cooked food is served in the lounge/restaurant. Q♿❀🅓♣●🖰(46/47)❀ �𝄡

Laneham

Bees Knees 🅛

Main Street, DN22 0NA (centre of village)
☎ (01777) 228090
Don Valley Atomic Blonde; Ossett Silver King; Pheasantry Dancing Dragonfly; 3 changing beers (sourced nationally) Ⓗ

A quirky country pub, converted from a former shop, with three small rooms and some outside seating. Well supported by locals, it serves three regular real ales, three rotating guest beers including a stout or porter, over 180 gins and excellent food (booking recommended). Quiz night is Wednesday and live jazz plays on the first Sunday of the month. A former local CAMRA Pub of the Season. Q♿❀🅓👍Ⓐ●🖰❀ ⟐❀

Mansfield

Brown Cow

31 Ratcliffe Gate, NG18 2JA
☎ (01623) 645854 ⊕ browncow-mansfield.co.uk
Everards Tiger; 9 changing beers Ⓗ
Owned by Everards Brewery and run by Silver Brewhouse as a Project William business. A range of up to 12 real ales is offered alongside ciders and international bottled beers. There are two separate bar areas and a function room upstairs. The pub is a short walk from the town centre. Q♿❀🅓⇔♣●🖰❀ ⟐❀

Garrison

Leeming Street, NG18 1NA
☎ 07702 253235 ⊕ moodyfoxbrewery.com
Moody Fox Cub, Pale Tale; 4 changing beers Ⓗ
This is the brewery tap for the Moody Fox Brewery based nearby in Hilcote. It is inspired by the TV show Peaky Blinders, with some beer names reflecting the theme. Six real ales and a range of ciders are available. Located in the pedestrianised area of the town centre, it is a five-minute walk from public car parks. Q⇔●🖰❀

Priors Well Brewery 🅛

Littleworth, NG18 1AH
☎ (01623) 632393 ⊕ priorswellbrewery.co.uk
Changing beers Ⓗ
Prior's Well Brewery opened its brewpub on the ground floor of the former Mansfield Brewery in 2019. There is a large seating area outside. The bar offers a wide range of ever-changing real ales from Prior's Well and others. Entertainment includes soul music on a Sunday afternoon, and a silent disco with different DJs for different tastes. An area can be booked for private parties and events. ❀⇔🖰

Railway Inn

9 Station Street, NG18 1EF
☎ (01623) 623086
4 changing beers (often Dukeries, Full Mash, Pheasantry) Ⓗ
Close to the town centre bus and train stations, this community pub serves popular home-cooked meals. As well as the main bar area there are two separate rooms for diners or those looking for a quieter space. Up to four real ales and one or two real ciders are offered. There is a walled garden for the summer. Q♿❀🅓⇔●🖰❀ ⟐

Stag & Pheasant ✅

4 Clumber Street, NG18 1NU
☎ (01623) 412890
Greene King Abbot; Ruddles Best Bitter; 3 changing beers (often Titanic) Ⓗ
A spacious Lloyds No.1 bar not far from the town centre. It gets busy at weekends, with music after 6pm, and a DJ after 9pm on Friday and Saturday when there is an entry charge. Two regular cask ales and three rotating guests are usually available, plus two real ciders. Food is served until late every day. There is a large covered smoking area to the front. ♿🅓👍⇔●🖰❀ ⟐

Newark

Flying Circus [L]
53 Castle Gate, NG24 1BE
☎ (01636) 302444 ⊕ flyingcircuspub.co.uk
4 changing beers (sourced nationally) [H]
Reopened in its present incarnation in 2014, Monty Python quotes and brewery logos decorate the walls, and old aircraft are suspended from the ceiling. The four changing cask ales are complemented by a wide range of keg, bottled and canned craft beers. There is regular live music and a quiz night. The large outdoor courtyard is popular in the summer. ♿🕮❄(Castle)🖥️🐶🕸

Just Beer Micropub
32A Castle Gate, NG24 1BG (in Swan & Salmon Yard, off Castle Gate)
☎ (01636) 312047 ⊕ justbeermicropub.biz
4 changing beers (sourced nationally) [H]
Friendly micropub offering a varied range of cask ale, craft beer from a tap wall, cider and perry, and world and unusual UK craft ales from the fridge. Several beer festivals are held throughout the year and there is a popular quiz night once a week. Snacks include local pork pies, cheeseboards and pork scratchings. Traditional pub games are played, with an annual cribbage tournament. Twice regional CAMRA Pub of the Year and a repeat local Pub of the Year. Q♿Å❄(Castle)♣🍴🖥️🐶🕸

Organ Grinder 🍺
21 Portland Street, NG24 4XF
☎ (01636) 671768
Blue Monkey BG Sips, Primate Best Bitter, Infinity, Guerrilla, Ape Ale, Infinity Plus 1; 1 changing beer (sourced regionally) [H]
Opened as the Organ Grinder in 2014, this no-nonsense beer-drinking pub offers six or seven real ales from Blue Monkey Brewery. Real cider and a range of bottled beers are also sold, along with an extensive range of spirits. Bar snacks are served to accompany the ales. A popular quiz is held every other Wednesday. The Monkey Room has a dartboard and a large TV screen. Books, games and a piano are available for customer use. A covered smoking area is to the rear. ❄(Castle)♣🍴🖥️🐶🕸

Prince Rupert [L]
46 Stodman Street, NG24 1AW
☎ (01636) 918121
Brains Rev James Original; Oakham Citra; 4 changing beers (sourced nationally) [H]
Reopened in 2010, this historic Grade II listed pub dates back to around 1452. Multi-roomed on two separate levels, exposed beams are evident in several rooms and various interesting artefacts and brewery memorabilia decorate the walls and ceilings. There is a small but pleasant patio garden. An extensive lunchtime and evening menu featuring fresh local produce is available, with stone-baked pizzas a speciality. Private rooms are available for functions and meetings. A former local CAMRA Pub of the Year, it has featured in the Guide for 12 consecutive years. Q♿🕮🕰❄(Castle)🍴🐶🕸

Nottingham: Carlton

Brickyard ✅
Standhill Road, NG4 1JL
☎ (0115) 987 8707 ⊕ brickyardcarlton.co.uk
Lincoln Green Archer, Hood; 3 changing beers [H]
Formerly a social club, the Brickyard was renovated by Lincoln Green and reopened in 2018. Although fairly small inside, there is plenty of seating and a snug at the back to the right of the bar. A number of items of Hardys & Hansons memorabilia is displayed including a scale model of the former brewery cleverly built into a table. The beers are mainly from Lincoln Green but there are occasional guests. Craft keg beers are also sold. 🐶🖥️

Old Volunteer [L]
35 Burton Road, NG4 3DQ
☎ (0115) 987 2299
10 changing beers (often Flipside) [H]
Refurbished by Flipside Brewery in 2014, the brewery tap showcases four of its beers alongside guests and a real cider. The interior is separated into distinct areas using unusual bare wood dividing beams, with a raised corner and varied floor materials. Outside is a patio area with parasols, leading to the main entrance. Food choices include speciality burgers with wedges. Snacks are on offer at all times. Beer festivals are held in a car park marquee. 🕮🕰♿🍴🐶🖥️🕸

Nottingham: Carrington

Doctor's Orders [L]
351 Mansfield Road, NG5 2DA
☎ (0115) 960 7985 ⊕ doctorsordersmicropub.co.uk
5 changing beers (sourced locally) [H]
Small beer emporium with two distinct areas. A square lounge leads to a corridor flanked on one side by a raised narrow benched seating area with a small bar-cum-serving area at the rear. Beer and cider are served at your table from handpumps at the bar. Although no longer run by Magpie Brewery, the pub maintains the original philosophy of providing a range of microbrewery beers in an intimate atmosphere. Q♿🕮🕰♣🍴🐶🖥️🕸

Nottingham: Central

Barrel Drop
7 Hurts Yard, NG1 6JD (in passageway off Upper Parliament St)
☎ (0115) 924 3018
5 changing beers (often Magpie) [H]
Tucked away on Hurts Yard between Angel Row and Upper Parliament Street, this city centre micropub opened in 2014 and is now operated in conjunction with Magpie Brewery. Beers are still regularly available from Magpie as well as other microbreweries around the country. In addition, several taps dispense keg beers and real ciders. There is a small seating area to the right with steps leading down to the bar, then further seating off the bar. Q🕮🚉(Royal Centre)♣🍴🐶🕸

BeerHeadZ
Cabman's Shelter, 1A Queens Road, NG2 3AS (adjoining Nottingham station)
☎ 07542 773753
5 changing beers [H]
Small but sympathetically restored Edwardian cabman's shelter, adjacent to the main railway station entrance. The single room has a central bar and retains period features including bench chests, wooden panelling, windows and coat hooks. There is a long table/shelf with stools opposite the bar, and beer barrels with wooden tops serve as seats. The five real ales change regularly and are seldom repeated. Three real ciders are served. A large choice of bottles and cans is also available to enjoy in or take out. 🕮❄🚉(Station)🍴🖥️🐶🕸

Fox & Grapes [L]
21 Southwell Road, NG1 1DL
☎ (0115) 841 8970
Castle Rock Harvest Pale, Preservation, Elsie Mo, Screech Owl; 4 changing beers [H]

Impressive renovation of an Edwardian-fronted Victorian pub by Castle Rock Brewery in 2017, nicknamed Pretty Windows from the fancy Edwardian window frames sadly lost in a 1970s refit. The former two-room layout has been opened up into a single L-shaped room with raised areas on either side of the front door. A high ceiling and large windows give a light, airy feel. The pub serves eight real ales, ciders, seven keg beers, locally produced coffee and gin, and artisan food. ⚲👪◑ὕ&ᴈ(Lace Market) ●🖟🐾🛜

Good Fellow George

11-15 Alfreton Road, Canning Circus, NG7 3JE
🌐 thegoodfellowgeorge.co.uk
4 changing beers ⑭
Conversion of a former bank, in a curved mid 20th-century building overlooking the busy Canning Circus junction. The bar frontage is adorned with 2p pieces, commemorating the building's former use. Four handpumps and 15 craft taps supply the beer. Seating is mainly varnished tables and chairs, with upholstered settles at window tables. To the rear, there is a small mezzanine level and covered outdoor smoking area with wooden benches. ⚲&♣🖟🐾🌸

King William IV 🅛

6 Eyre Street, Sneinton, NG2 4PB
☎ (0115) 958 9864 🌐 new.thekingbilly.co.uk
Black Iris Snake Eyes; Oakham Citra, Bishops Farewell; 5 changing beers ⑭
Known widely as the King Billy, this Victorian gem on the edge of the city centre is close to the Motorpoint Arena. A family-run free house that oozes charm and character, it is a haven for real ale drinkers, with a choice of up to eight microbrewery ales from near and far, as well as real cider. Folk music is popular on Thursday night. Look for the pub sign, which won a national award in 2015. Q⚲👪◑♣●🖟(43,44)🌸🛜

Lincolnshire Poacher 🅛

161-163 Mansfield Road, NG1 3FR
☎ (0115) 941 1584
Castle Rock Harvest Pale, Elsie Mo, Screech Owl; 6 changing beers (often Castle Rock) ⑭
Thirteen handpumps offer a wide selection of guest ales, mainly from microbreweries. A mild, stout or porter are always available alongside real ciders and perries, continental bottled beers and a fine selection of whiskies. The food menu includes locally sourced ingredients. The pub displays artwork celebrating its 30-years-plus twinning with In de Wildeman bar in Amsterdam, as well as various memorabilia of local and international interest. Live music plays on Sunday and Wednesday. Q👪◑&ᴈ(Nottingham Trent University) ♣●🖟🌸🛜

Organ Grinder 🅛

21 Alfreton Road, Canning Circus, NG7 3JE
☎ (0115) 970 0630
Blue Monkey BG Sips, Infinity, Primate Best Bitter, Guerrilla, Infinity Plus 1; 4 changing beers (sourced locally) ⑭
Previously the Red Lion, this single-room, multi-level pub has a piano and a wood-burning fire. To the rear is a small courtyard leading up to a raised covered and heated decked area and the first floor function room. The full Blue Monkey range of beers is offered, as well as two guests. An ever-increasing monthly programme of events is held in the bar, the function room and on the terrace. ⚲👪◑ᴈ(Nottingham Trent University)♣🖟🌸🛜

Partizan Tavern

13-15 Manvers Street, NG2 4PB
☎ 07974 361645
4 changing beers (sourced regionally) ⑭
Opened in 2021, this micropub is a new addition to the growing beer scene in the Sneinton Market area. The name comes from the the Serbian football club – the landlord is a fan and a collection of Partizan Belgrade FC programmes hangs on the wall. The L-shaped single room has two large windows overlooking the street. The bar serves four varying real ales, four real ciders/perries and four craft beers. Cobs are available Friday to Sunday. Q⚲&♣●🖟🌸🛜

Sir John Borlase Warren 🅛 ✅

1 Ilkeston Road, Canning Circus, NG7 3GD
☎ (0115) 988 1889 🌐 sirjohnborlasewarren.co.uk
Everards Tiger; 11 changing beers (often Lincoln Green) ⑭
An Everards Project William pub with Lincoln Green, situated in the centre of Canning Circus. The lower bar area can be hired for private parties, and there is a small snug at the far end of the bar. Outside is a secluded, enclosed garden and a large rooftop patio – a quiet haven in the centre of a busy area. Tap takeovers often take place, when at least four handpumps feature a single brewery. ⚲👪◑ᴈ(Nottingham Trent University) ♣●🖟🌸🛜

Vat & Fiddle 🅛

Queens Bridge Road, NG2 1NB
☎ (0115) 985 0611
Castle Rock Harvest Pale, Session, Preservation, Elsie Mo, Screech Owl; 5 changing beers ⑭
This 1937 Art Deco gem is the tap for the adjoining Castle Rock Brewery, two minutes from Nottingham rail and tram station. Thirteen handpumps serve at least seven beers from the Castle Rock range, with guests including LocAles and others from further afield. At least 10 real ciders are also available. The recently extended outside area to the rear features an impressive mural depicting a myriad of Nottingham events over time. Hot food is served all week. ⚲👪◑&≉ᴈ(Station)●🖟🌸🛜

Nottingham: New Basford

Lion Inn 🅛

44 Mosley Street, NG7 7FQ
☎ (0115) 970 3506 🌐 thelionatbasford.co.uk
Draught Bass; 9 changing beers ⑭
A large, traditional free house with a horseshoe central bar and rustic bare-brick decor. The focus is on an ever-changing range of cask ales and traditional ciders from near and far. Outside there are extensive covered and heated decking areas and a large garden with plenty of seating. Live music in various styles features every weekend. The pub welcomes pooches and is a past winner of a Rover Dog Friendly Pub of the Year award. ⚲👪◑&ᴈ(Shipstone St) ♣●🅿🌸🛜

Nottingham: Radford

Plough Inn 🅛

17 St Peter's Street, NG7 3EN
☎ 07972 094425
Nottingham Rock Ale Bitter Beer, Rock Ale Mild Beer, Legend, Extra Pale Ale; 2 changing beers ⑭
This traditional two-roomed public house is the brewery tap for the adjoining Nottingham Brewery and features a number of its ales plus some changing guests. It has a wide clientele including university students from the extensive accommodation nearby. The cosy interior has

two wood-burning stoves, and the garden area features a skittle alley. The pub hosts a popular quiz night once a week and live music evenings fortnightly.
Q⛲🕍🍴♣🅿🚪🐾🛜

Oxton

Old Green Dragon 🅛 ✅
Blind Lane, NG25 0SS
☎ (0115) 965 2243
6 changing beers Ⓗ
Restored to its former glory by the current owners nearly a decade ago, this local CAMRA Village Pub of the Year is now a classic, traditional village pub which incorporates a contemporary, popular eating venue. There is an ever-changing selection of six real ales from both local and national breweries as well as at least two local ciders. To the front is a patio area with an enclosed garden at the rear. The pub has three electric car-charging points.
🕍🍴♣🅿🐾🛜

Radcliffe on Trent

Chestnut 🅛 ✅
Main Road, NG12 2BE
☎ (0115) 933 1994
Brewster's Hophead; Timothy Taylor Boltmaker; 4 changing beers (sourced regionally) Ⓗ
Popular cask beer-led village pub. Originally the Cliffe Inn, following a major refurbishment in 2006 it became the Horse Chestnut and in 2015 simply the Chestnut. Seven real ales are served including ever-changing guests, one always a local brew. Quality home-made food, ranging from stone-baked pizzas to classic British dishes, is served in a relaxed, casual atmosphere.
🕍🍴♣🅿🚪🐾🛜

Yard of Ale
1 Walkers Yard, NG12 2FF (off Main Rd, between Costa and public car park)
☎ (0115) 933 4888 🌐 yard-of-ale.business.site
7 changing beers Ⓗ
A small, friendly micropub, opened in 2016 in a former café and chocolate shop in the centre of the village. The premises are narrow, with access from the side, and a step up to a small room. Up to seven ever-changing guest ales, always including at least one local brew and a dark ale, are available. There is a separate gin bar known as Gin Within. Q≈🅿🚪🐾

Rainworth

Inkpot
Kirklington Road, NG21 0JY
☎ (01623) 230500
4 changing beers (often Batemans, Bradfield, Leatherbritches) Ⓗ
This micropub usually serves a range of up to four real ales and 11 real ciders. Based in what was once a betting shop, it is named after the octagonal building that used to stand nearby, now demolished, which was the toll house for the road to Mansfield. Local CAMRA Cider Pub of the Year 2019. Q⛲🚪(141,28)🐾

Rempstone

White Lion 🅛
Main Street, LE12 6RH
☎ (01509) 889111
Charnwood Salvation, Vixen; Draught Bass; 1 changing beer Ⓗ

This small welcoming village pub was saved from closure some years ago by four locals. There is only one room but you will be greeted by a cosy fire in winter, friendly fellow imbibers and a choice of local and guest beers. No food apart from bar snacks but weekly themed events are held, along with a visiting fish and chip van.
Q⛲🕍♣🚪🐾🛜

Retford

Beer under the Clock 🍷
3 Town Hall Yard, DN22 6DU (off Market Square, through arch at side of town hall, opp Butter Market)
☎ 07985 102192 🌐 beerundertheclock.com
5 changing beers (sourced nationally) Ⓗ
This small and cosy pub, formerly known as BeerHeadZ, offers five rotating guest beers including a dark beer and a bitter, three ciders, a range of bottled and canned beers and a limited range of wines and spirits. The beers, often one-offs from near and far, are kept in excellent condition and served in oversized glasses. Local CAMRA Pub of the Year 2022. Q♣🅿🚪🐾🛜

Black Boy Inn 🅛
14 Moorgate, DN22 6RH (just off ring road on road to Gainsborough)
☎ (01777) 7099 🌐 the-black-boy.edan.io
3 changing beers (sourced locally; often Pheasantry) Ⓗ
A traditional hostelry just off the town centre with a good regular trade. Recently refurbished, this cosy open-plan pub has a dartboard, live sport on TV, a comfortable smoking area and some outside seating. Three changing real ales are normally available, sourced from local breweries and reasonably priced. Visitors are always made welcome in this cosy hostelry. Q⛲🕍♣🅿🚪🐾🛜

Brew Shed
104-106 Carolgate, DN22 6AS (on Carolgate bridge opp Masonic Hall) SK706807
☎ (01777) 948485 🌐 harrisonsbrewery.com/the-brew-shed
Harrisons Vacant Gesture, Best Bitter, Pale Ale, Proof of Concept, Stout; 2 changing beers (sourced nationally; often Harrisons) Ⓗ
The Brew Shed is the tap for Harrisons Brewery. It has an open-plan room at street level and a smaller downstairs room that leads onto a large canal-side patio. Between five and seven Harrisons beers, sometimes a number of guests, a variety of kegs, a good selection of gins, spirits, wines and real cider are all on offer. A former Nottinghamshire CAMRA Pub of the Year and East Midlands runner-up. Q⛲🕍🍴♣🅿🚪🐾🛜

Idle Valley Tap 🅛
Carolgate, DN22 6EF (at S end of main shopping area)
☎ (01777) 948586
7 changing beers (sourced regionally; often Kelham Island, Welbeck Abbey) Ⓗ
A welcoming pub, initially the tap for Idle Valley Brewery but following the closure of the brewery, beers are now sourced from elsewhere. Up to seven rotating real ales, keg beers and lagers, ciders, gins, wines and spirits are on the bar. The one-room pub has a pool table and dartboard, and the outside space has been put to good use, with plenty of seating attracting large numbers in fine weather. 🕍♣🅿🚪🐾🛜

South Leverton

Plough Inn
Town Street, DN22 0BT (opp village hall)
☎ (01427) 880323

2 changing beers (sourced locally; often Beermats, Milestone) H

You could drive through the village and not see this pub opposite the village hall, but then you would miss out on a little gem. The small, two-roomed local is an old-fashioned, traditional inn where everyone is made welcome. Some of the seating appears to be old church pews, and there is plenty more seating outside. Two rotating beers are available, usually from local breweries. Q❄️✿♣️P🚆♿⭐🔊

Southwell

Final Whistle
Station Road, NG25 0ET
☎ (01636) 814953
Brewster's Hophead; Draught Bass; Everards Tiger; Salopian Oracle; 6 changing beers (sourced nationally; often Oakham) H

Located at the end of the Southwell Trail, a disused railway line, this comfortable multi-roomed pub has a railway theme and is teeming with memorabilia. The courtyard garden is laid out like a mock station and has a separate bar and function room called The Locomotion. The main bar has 10 handpumps, with Bass and a stout or porter always available. Quiz nights are Sunday and Tuesday, folk club is on a Thursday. Quality bar snacks are available and pop up food stalls feature. Q❄️✿&♣️♥️P🚆(26,28)♿🔊

Old Coach House L
69 Easthorpe, NG25 0HY
☎ (01636) 819526
Oakham JHB; 6 changing beers (sourced nationally) H

Traditional open-plan pub with five drinking areas, oak beams and a large range fire. Six regularly changing real ales are on handpump from local and national breweries, often including Oakham JHB and Timothy Taylor Landlord. Live music features regularly on Saturday night and an open mic session is held on the last Sunday of the month. Outside to the rear is a well-kept patio garden. A previous winner of local CAMRA Pub of the Year. Q❄️✿&♣️♦️🚆♿🔊

Stapleford

Horse & Jockey ♀ L
20 Nottingham Road, NG9 8AA
☎ (0115) 875 9655 ⊕ horseandjockeystapleford.co.uk
Full Mash Horse & Jockey; 12 changing beers H

This pub offers 13 ales, always including a house beer from the local Full Mash Brewery, plus a range of ever-changing ales, and three real ciders. The main room has the bar and open-plan seating, and there is a further seating area up a couple of steps, which can also serve as a function room. Food includes bar snacks (filled rolls, pork pies and sausage rolls), pies, and pizzas on Thursday. Accommodation is available. Q❄️✿🍴🍺&♥️P🚆♿🔊

Staunton in the Vale

Staunton Arms L ✓
NG13 9PE
☎ (01400) 281218 ⊕ stauntonarms.co.uk
Castle Rock Harvest Pale; Draught Bass; 1 changing beer H

Two hundred-year-old listed pub in the far north of the Vale of Belvoir, carefully restored while retaining its original character. The large bar offers comfortable seating for drinkers and diners, with a further separate raised restaurant area. The pub has built a reputation for good food, with freshly prepared meals served lunchtimes and evenings. There are three cask beers on the bar, one always a LocAle. Mini festivals are held regularly, with upcoming events publicised on the website. Q❄️✿🍴🍷🍴&♣️P🔊

Sutton-in-Ashfield

Duke of Sussex
Alfreton Road, NG17 1JN
☎ (01623) 511469 ⊕ duke-of-sussex.co.uk
5 changing beers (often Oakham, Pentrich, Welbeck Abbey) H

Large open-plan pub with up to six real ales, owned by the Pub People Company of South Normanton. A good-value pub food menu is available, with Sunday roasts and the Thursday steak club always popular. Jazz night is the first Thursday of the month and there is a quiz every Sunday. Live music features on some Saturday evenings. Q❄️🍷&P🚆(9.1)♿🔊

FireRock
24 Outram Street, NG17 4FS
☎ 07875 331898
3 changing beers (often Adnams, Oakham, FireRock) H

Opened in 2018, this large open-plan bar is the tap for FireRock Brewing. Up to two real ales are on offer alongside a wide range of KeyKeg beers, bottles and cans. A good selection of (often rare) spirits is also available. Regular live music is hosted on the stage and there is a smaller snug space with a nautical decor. FireRock brewery is on-site in a room to the rear. ❄️&P🚆♿

Picture House ✓
Forest Street, NG17 1DA
☎ (01623) 554627
Greene King Abbot; Ruddles Best Bitter; 6 changing beers H

A popular open-plan Wetherspoon pub near the bus station. Art Deco in style with a high ceiling, it was originally built as the King's Cinema in 1932, then closed and reopened in 1967 as the Star Bingo & Social Club. The bingo hall survived into the 1990s, and the building then became the Picture House Night Club. Sky Sports and BT Sports are shown on several TVs behind the bar, but the main feature is a huge screen projected onto the wall above the front door. ❄️🍷&♥️🚆🔊

Scruffy Dog
Station Road, NG17 5HF
☎ (01623) 550826 ⊕ thescruffydog.co.uk
6 changing beers (often Scruffy Dog) H

Comfy sofas and a real fire on colder days welcome visitors to this dog-friendly pub. Refurbished by the current owners, it has its own on-site Scruffy Dog microbrewery – the brew plant is visible from the end of the main seating area. Eight changing real ales are usually available from the brewery, plus up to five guest ales. Q❄️✿&♦️P🚆♿🔊

Underwood

Ginger Giraffe Micro Pub & Gin Bar
14 Alfreton Road, NG16 5GB
☎ (01773) 533090
5 changing beers (often Castle Rock, Thornbridge, Titanic) H

This large micropub located within an old factory unit has expanded several times to cope with demand. It offers five real ales, a range of real ciders and a wide choice of

spirits, especially gin. There is a main bar area and a separate games room with a pool table and sports TV. Q✤⛄♿♣♠P🅿🚃🐕🛜

Wellow

Olde Red Lion 🅛

Eakring Road, NG22 0EG (opp maypole on village green)

☎ (01623) 861000

House beer (by Maypole); 2 changing beers (sourced regionally; often Bombardier, Castle Rock) Ⓗ

Situated on the village green, this 400-year-old village pub participates in a large event on May Day. The traditional wood-beamed interior includes restaurant, lounge and bar areas. Photographs and maps illustrating the history of the village are on the walls. Three real ales are available – Olde Lion Ale and two rotating guests. Rufford Park, Sherwood Forest and Clumber Park are nearby. Q✤⛄♿♠♣P🅿🛜

West Bridgford

Poppy & Pint 🅛

Pierrepont Road, NG2 5DX

☎ (0115) 981 9995

Castle Rock Harvest Pale, Preservation, Screech Owl; 8 changing beers Ⓗ

Former British Legion Club converted in 2011 by Castle Rock. It has a large main bar with a raised area and a family space with a café bar (children are welcome until 9pm). A large upstairs function room hosts a folk club, and the beer garden overlooks a former bowling green. Twelve handpumps dispense Castle Rock beers plus guests, often from new breweries. There are usually two real ciders, and excellent food is served. The car park has two electric car-charging points. ✤⛄♿◑♿♠P🅿🐕🛜

Stratford Haven 🅛

2 Stratford Road, NG2 6BA

☎ (0115) 982 5981

Castle Rock Harvest Pale, Preservation, Elsie Mo, Screech Owl; 5 changing beers Ⓗ

A former pet shop, the 'Strat' has a single central bar with extended seating at the back and a secluded snug to the right. Up to nine cask ales plus a cider are available on handpump at any one time, including at least four from owner Castle Rock's portfolio. Guest ales are predominantly from microbreweries near and far. Pizza night is Wednesday and traditional roasts are served on Sunday. Q✤⛄♿◑♿♠🐕🛜

Worksop

Fuggle's Chapter One

20 Park Street, S80 1HB

☎ 07813 763347 ∰ fugglebunnybrewhouse.co.uk

3 changing beers (sourced locally; often Fuggle Bunny) Ⓗ

This L-shaped single-roomed ale house serves three changing real ales from the Fuggle Bunny Brew House, as well as gins, spirits and wine. Opened in 2017, modernised and refurbished, it is now firmly established with a cosmopolitan clientele. The Savoy cinema is nearby. Closed Monday to Wednesday. Q♿♠P🅿🐕

Mallard 🅛

Station Approach, S81 7AG (on railway station platform, entrance from main car park)

☎ 07973 521824

4 changing beers (sourced nationally) Ⓗ

Formerly the station buffet, this small, cosy pub offers a warm welcome. Four changing real ales are on handpump, usually including a dark beer and a bitter. Two ciders, a selection of foreign bottled beers, country fruit wines and specialist gins are also available. There is a downstairs room used for special occasions. Four beer festivals are held each year. The recipient of many local CAMRA awards. Q✤⛄♣♠P🅿🐕

Station Hotel 🅛

Carlton Road, S80 1PS (opp railway station car park entrance)

☎ (01909) 474108

5 changing beers (sourced regionally) Ⓗ

Situated opposite the railway station, just out of the town centre. Up to five regularly changing real ales are available. The long bar serves the lounge drinking area, a separate dining room and a further small room suitable for meetings. A spacious and well-maintained garden with seating is to the rear. Food is served lunchtimes and evenings, and accommodation is offered. There is always a warm welcome at this pub. Q✤🛏◑🚃♣♠P🚃🅿(5)🐕🛜

Breweries

Angel

🏠 Angel, 7 Stoney Street, Nottingham, NG1 1LG

☎ (0115) 948 3343

✉ angelmicrobrewery@gmail.com

Situated inside one of Nottingham's oldest, haunted, and cave-filled pubs. The Angel Microbrewery uses a 2.5-barrel plant, nestled in the taproom of the 400-year-old pub. Beers are available at the Angel, and the Golden Fleece in Nottingham. ◆

Beermats SIBA

New Yard, Winkburn, Nottinghamshire, NG22 8PQ

☎ (01636) 639004 ∰ beermatsbeer.co.uk

⊛Beermats was founded in 2017 by three friends while drinking in a pub. The brewery is located on the Winkburn Estate in old dairy buildings. Beers are named around the theme of the humble beermat. ‼🛒◆

Charismatic (ABV 3.8%) BITTER
Pragmatic (ABV 3.8%) BITTER
Format (ABV 3.9%) PALE
Team Mates (ABV 3.9%) PALE
Soul Mate (ABV 4.2%) GOLD
Diplomat (ABV 4.6%) STOUT
Ultimate (ABV 4.9%) RED

Beeston Hop

Windmill Lane, Sneinton, Nottingham, NG2 4QB

✉ john@beestonhop.co.uk

⊗ A nanobrewery launched in 2015 producing mainly bottle-conditioned beers. Cask beers are occasionally produced for festivals using capacity at other breweries. The beers are unfined, unfiltered and unpasteurised. LIVE

Black Iris SIBA

Unit 1 Shipstone Street, New Basford, Nottingham, NG7 6GJ

☎ (0115) 979 1936 ∰ blackirisbottleshop.co.uk

⊛Black Iris began brewing in 2011 using a six-barrel plant behind the Flowerpot pub in Derby. It expanded to a brand new 10-barrel plant in 2014 and relocated to

premises in Nottingham. Beers are distributed nationally through wholesalers and by direct order to the local free trade. Innovation and collaboration ensure that new beers are consistently being added to the range. Brewery taproom opened in 2021. ▰✦

Snake Eyes (ABV 3.8%) PALE
Golden-coloured ale with intense hoppy aroma and taste with lingering bitter finish.

Bajan Breakfast (ABV 4%) BITTER

Bleeding Heart (ABV 4.5%) BITTER
Red rye, malty ale balanced with roast and hops and a bitter finish.

Endless Summer (ABV 4.5%) BITTER
Golden in colour with a tropical citrus fruit presence throughout, from aroma to aftertaste with a gentle bitter finish.

Stab in the Dark (ABV 5%) STOUT
Black stout with New Zealand hops, roast malt and coffee flavours, moderate bitter finish.

Black Market

▤ The Workman's, 43 High Street, Warsop, Nottinghamshire, NG20 0AE ☎ 07824 363373
⊕ blackmarketbrewery.co.uk

Beers first appeared from Black Market in 2016. The 2.5-barrel plant is situated in the basement of its brewery tap, the Workman's/Black Market Venue in Warsop. There are three regular beers brewed. Nearly all the brews are consumed on-site, though a few go to pubs and beer festivals in the locality.

Blue Monkey SIBA

10 Pentrich Road, Giltbrook Industrial Park, Giltbrook, Nottingham, Nottinghamshire, NG16 2UZ
☎ (0115) 938 5899 ⊕ bluemonkeybrewery.com

☺Blue Monkey was established in 2008 as a 10-barrel plant, but moved in 2010 to a bigger site to meet increasing demand. It now brews around 15,000 pints a week to supply more than 1,000 local outlets, and selected national distributors. The brewery has four pubs all called the Organ Grinder (Nottingham, Arnold, Loughborough and Newark). ‼▰✦

Marmoset (ABV 3.6%) BITTER

BG Sips (ABV 4%) PALE
Pale golden, hoppy beer. Very fruity and bitter.

Primate Best Bitter (ABV 4%) BITTER

99 Red Baboons (ABV 4.2%) RED

Infinity IPA (ABV 4.6%) PALE
Golden ale packed with Citra hops.

Chocolate Amaretto (ABV 4.9%) SPECIALITY

Chocolate Guerrilla (ABV 4.9%) SPECIALITY

Chocolate Orange (ABV 4.9%) STOUT

Guerrilla (ABV 4.9%) STOUT
A creamy stout, full of roast malt flavour and a slightly sweet finish.

Ape Ale (ABV 5.4%) PALE
Intensely-hopped, strong, golden ale with dry, bitter finish.

Infinity Plus 1 (ABV 5.6%) BITTER

Brewhouse & Kitchen SIBA

▤ Trent Bridge, Nottingham, NG2 2GS
☎ (0115) 986 7960 ⊕ brewhouseandkitchen.com

Part of the Brewhouse & Kitchen chain, producing its own range of beers. Carry outs and brewery experience days are offered. ‼

Castle Rock SIBA

Queensbridge Road, Nottingham, NG2 1NB
☎ (0115) 985 1615 ⊕ castlerockbrewery.co.uk

☺Castle Rock, established in 1998, quickly developed a reputation for producing high quality, consistent cask beers, which continues to this day, with three from the core range winning awards at national level. Throughout the year, Castle Rock brew an eclectic range of special and one-off beers in cask, keg and can, from the traditional to the more experimental and modern styles. ‼▰✦LIVE✦

Black Gold (ABV 3.8%) MILD
A dark ruby mild. Full-bodied and fairly bitter.

Harvest Pale (ABV 3.8%) PALE
Pale yellow beer, full of hop aroma and flavour. Refreshing with a mellowing aftertaste.

Session (ABV 4%) GOLD

Preservation (ABV 4.4%) BITTER
A traditional, copper-coloured best bitter with malt predominant. Fairly bitter with a residual sweetness.

Oatmeal Stout (ABV 4.6%) STOUT

Elsie Mo (ABV 4.7%) BITTER
A strong golden ale with floral hops evident in the aroma. Citrus hops are mellowed by a slight sweetness.

Screech Owl (ABV 5.5%) BITTER
A classic golden IPA with an intensely hoppy aroma and bitter taste with a little balancing sweetness.

Cat Asylum

12 Besthorpe Road, Collingham, Nottinghamshire, NG23 7NP
☎ (01636) 892229 ☎ 07773 502653
✉ henry.bealby@lineone.net

☺Established in 2017, Cat Asylum is a microbrewery specialising in historic recipes from Britain and around the world. ‼▰✦

Wee Moggie (ABV 3.8%) BLOND

Columbus Pale (ABV 4.9%) BLOND

Simcoe Pale Ale (ABV 5.1%) BLOND

The Big Smoke Stout (ABV 5.8%) PORTER

Newark IPA (ABV 6.1%) IPA

Dukeries

▤ 18 Newcastle Avenue, Worksop, Nottinghamshire, S80 1ET
☎ (01909) 731171 ☎ 07500 119299
⊕ dukeriesbrewery.co.uk

☺Founded in 2012 the brewery is located in the Dukeries Tap premises in the heart of Worksop. Beer brewed is available at the Tap only which is open on Friday and Saturday. ✦

FireRock

20-24 Outram Street, Sutton-in-Ashfield, Nottinghamshire, NG17 4FS ☎ 07875 331898
⊕ firerockbrewing.com

☺FireRock Brewing Co is an independent microbrewery and craft beer bar specialising in hop-forward craft beers.

Fish Key

▤ c/o Woodlark Inn, Church Street, Lambley, NG4 4QB
☎ (0115) 931 2535 ☎ 07814 019250
⊕ woodlarkinn.co.uk/micro-brewery

⊠ The brewery was originally established in East Looe by Pete and Elaine Delaney in 2016, getting its name from its location on the old fish quay in Looe. It has now

relocated and is firmly established in one of the cellars at the Woodlark Inn, Lambley.

Flipside

c/o Magpie Brewery, Unit 4 Ashling Court, Iremonger Road, Nottingham, NG2 3JA
☎ (0115) 987 7500 ☎ 07958 752334

Office: Old Volunteer, 35 Burton Road, Carlton, NG4 3DQ ● flipsidebrewery.co.uk

⊗ Andrew and Maggie Dunkin established an initial six-barrel brewery in an industrial unit in Colwick in 2010, expanding to 12 barrels in 2013 in a larger adjacent unit. The brewery opened its own tap, the Old Volunteer, Carlton, in 2014. In 2016 it relocated again to share the plant at Caythorpe Brewery (qv). With the closure of that brewery it now shares with Magpie. All beers are vegan-friendly. ◆LIVE V

Sterling Pale (ABV 3.9%) PALE
Golden ale with a citrus aroma and hoppy taste, leading to a bitter and peppery finish
Dark Denomination (ABV 4%) MILD
Blt C01n (ABV 4.1%) GOLD
Copper Penny (ABV 4.2%) BITTER
Golden Sovereign (ABV 4.2%) GOLD
Franc in Stein (ABV 4.3%) GOLD
Golden ale with a floral hop aroma, leading to a hoppy and bitter finish.
Random Toss (ABV 4.4%) GOLD
Kopek Stout (ABV 4.5%) STOUT
Full-bodied dark stout with a coffee aroma and assertive roast flavours throughout and a balanced bitterness.
Flipping Best (ABV 4.6%) BITTER
Brown-coloured, malty, strong bitter with lasting malt, bitterness and subtle hop flavours.
Dusty Penny (ABV 5%) PORTER
Clippings IPA (ABV 6.5%) IPA
Russian Rouble (ABV 7.3%) STOUT
Strong dark stout with balanced malt, roast and fruit flavours.

Full Mash

17 Lower Park Street, Stapleford, Nottinghamshire, NG9 8EW
☎ (0115) 949 9262 ● fullmash.co.uk

⊚ Brewing commenced in 2003 and has grown steadily since, with a gradual expansion in outlets and capacity. ◆

Horse & Jockey (ABV 3.8%) GOLD
Easy-drinking golden ale with moderate hoppy aroma and finish.
Whistlin' Dixie (ABV 3.9%) BITTER
Séance (ABV 4%) GOLD
Predominantly hoppy golden beer, with a refreshing bitter finish.
Illuminati (ABV 4.2%) BITTER
Gently-hopped golden ale with initial hops and bitterness giving way to a short, bitter finish.
Wheat Ear (ABV 4.2%) SPECIALITY
Warlord (ABV 4.4%) BITTER
Amber-coloured beer with an initial malt taste leading to a dry, bitter finish.
Apparition (ABV 4.5%) BITTER
A pale hoppy bitter brewed with Brewers Gold hops.
Northern Lights (ABV 4.7%) STOUT
Manhattan (ABV 5.2%) PALE
Bhisti (ABV 6.2%) IPA

Good Stuff

🏠 Abdication, 89 Mansfield Road, Daybrook, Arnold, Nottinghamshire, NG5 6BH ● theabdication.co.uk

A nanobrewery located inside the Abdication micropub. Capacity is 0.5-barrels so occasional beers can only be found at the pub and local beer festivals.

Grafton

Walters Yard, Unit 4 Claylands Industrial Estate, Worksop, Nottinghamshire, S81 7DW
☎ (01909) 307710 ☎ 07542 012610

Office: 8 Oak Close, Crabtree Park Estate, Worksop, S80 1BH ● graftonfineales.co.uk

⊚ Founded in 2007 as Grafton Brewing Company, behind the Packet Inn on Bescoby Street in Retford. Relocated to the present premises in Worksop in 2014, where the plant was increased in size from five to 15 barrels to meet demand. The brewery tap is its micro bar, the Malt House on Potter Street, Worksop. !!◆

Pasha Pasha (ABV 4%) GOLD
Raspberry Redemption (ABV 4%) SPECIALITY
Golden ale with a raspberry aroma and taste, leading to a sweet and slightly bitter finish.
Vanilla Heights (ABV 4%) SPECIALITY
Copper Jack (ABV 4.5%) BITTER
Garside Gold (ABV 4.5%) GOLD
Priorswell Pale (ABV 4.5%) PALE
Apricot Jungle (ABV 4.8%) SPECIALITY
Bananalicious (ABV 4.8%) SPECIALITY
Caramel Stout (ABV 4.8%) STOUT
Tango with a Mango (ABV 4.8%) SPECIALITY
Black Abbots (ABV 5%) STOUT
Coco Loco (ABV 5%) SPECIALITY
Dark-coloured, smooth-drinking ale, infused with coconut, gentle bitterness.
Don Jon (ABV 5%) PALE

Harby

🏠 Bottle & Glass, 5 High Street, Harby, Nottinghamshire, NG23 7EB
☎ (01522) 703438
● wigandmitre-lincoln.blogspot.co.uk

Harby Brewstore is a four-barrel malt extract brewery established in 2015 and located at the Bottle & Glass in Harby. Most output goes to the three pubs in the small Wig & Mitre pub group; the Wig & Mitre, Lincoln, Caunton Beck, Caunton and the Bottle & Glass itself.

Harrison's

Unit 1, 108 Carolgate, Retford, Nottinghamshire, DN22 6AS ☎ 07850 228383 ● harrisonsbrewery.com

⊚ A three-barrel brewery built completely from scratch by brewer Christopher Harrison-Hawkes. The first brew was in 2018. Shortly afterwards four beers were available at its own pub, the Brew Shed (which stands metres from the brewery). In 2019 the pub moved next door to larger premises (seven Harrison beers available and a guest) with an outside area next to the canal. 2019 saw the production of bottle-conditioned beers, and in 2020 real ale in a can, produced and packaged on-site. !!◆LIVE

Vacant Gesture (ABV 3.8%) BLOND
Best Bitter (ABV 4%) BITTER
Pale Ale (ABV 4%) PALE
Ruby Mild (ABV 4%) MILD
Proof of Concept (ABV 4.3%) PALE
Stout (ABV 4.3%) STOUT

American Brown Ale (ABV 4.9%) BROWN
Plum Porter (ABV 5.6%) PORTER
Porter (ABV 5.6%) PORTER

Tom Herrick's

The Stable House, Main Street, Carlton on Trent,
Nottinghamshire, NG23 6NW ☎ 07877 542331
✉ tomherricksbrewery@hotmail.com

Tom Herrick installed his bespoke, 2.5-barrel, stainless steel brewery at the front of his premises during 2014, and began small scale commercial brewing the following year. The brewery is only operated on a part-time basis with output going to festivals and local pubs.

Bomber Command (ABV 4.2%) BITTER

Idle

▤ White Hart Inn, Main Street, West Stockwith,
DN10 4EY
☎ (01427) 892672 ☎ 07949 137174
✉ theidlebrewery@btinternet.com

⊕The brewery began production in 2007 and is situated in a converted stable at the back of the White Hart Inn, which Brian Cooper, the brewer, now owns. ‼◆

Kings Clipstone

Keepers Bothy, Kings Clipstone, Nottinghamshire,
NG21 9BT
☎ (01623) 823589 ☎ 07790 190020
⊕ kingsclipstonebrewery.co.uk

Located close to the heart of Sherwood Forest, Kings Clipstone began brewing in 2012 using a five-barrel plant. The owners, David and Daryl Maguire, produce a range of core beers plus one-off brews and seasonals. Beers are available to freehouses, festivals and wholesale markets. ◆

Palace Pale (ABV 3.6%) GOLD
Hop On (ABV 3.8%) PALE
Amazing Gazing (ABV 4%) BITTER
Isabella (ABV 4.1%) BLOND
Tabaknakas (ABV 4.1%) GOLD
Hopical (ABV 4.2%) GOLD
Moonbeam (ABV 4.2%) BITTER
Sire (ABV 4.2%) BITTER
Monarch Ale (ABV 4.3%) BITTER
King John's EPA (ABV 4.4%) BITTER
Royal Stag Stout (ABV 4.5%) STOUT
Squires Desire (ABV 4.8%) BITTER
Queen Bee (ABV 5.1%) BITTER

Lenton Lane SIBA

Unit 5G, The Midway, Lenton Industrial Estate,
Nottingham, NG7 2TS ☎ 0333 003 5008
⊕ lentonlane.co.uk

⊗ Lenton Lane began brewing in 2014 under the name Frontier, after taking over the brewing plant at the Flower Pot pub, Derby. Lenton Lane changed its name in 2016 and relocated to a purpose-built brewery in Nottingham using a 10-barrel plant. The brewery produces a range of Single Malt & Single Hop beers (SM&SH), along with various other regular beers including its award-winning 200 Not Out. 🍺◆LIVE

Newbird (ABV 3.7%) PALE
Pale Moonlight (ABV 3.7%) PALE
36 North (ABV 3.9%) BITTER
Gold Rush (ABV 4.2%) GOLD
Outpost (ABV 4.5%) BITTER
Twist & Stout (ABV 5%) STOUT

200 Not Out (ABV 6%) IPA

Lincoln Green SIBA

Unit 5, Enterprise Park, Wigwam Lane, Hucknall,
Nottingham, NG15 7SZ
☎ (0115) 963 4233 ☎ 07748 111457
⊕ lincolngreenbrewing.co.uk

⊕Anthony Hughes established the Lincoln Green Brewing Company in 2012 using a 10-barrel plant. The brewery takes its name from the colour of dyed woollen cloth associated with the legend of Robin Hood. Beers are named with a respectful nod towards the Nottinghamshire legend. A range of craft beers is available in KeyKeg. Bottled beers are available online and in supermarkets, including limited edition, special bottle-aged, bottle-conditioned beers. 🍺◆LIVE

Marion (ABV 3.8%) PALE
Subtly-hopped golden ale with citrus aroma and a dry, bitter finish.
Archer (ABV 4%) PALE
Citrus golden ale with American hops and a moderately bitter finish.
Hood (ABV 4.2%) BITTER
Tawny-coloured ale with balanced hops and bitterness.
Bowman (ABV 4.3%) BITTER
Fountain Dale (ABV 4.3%) BLOND
Little John (ABV 4.3%) BITTER
Malty best bitter, well-balanced with hops and bitterness throughout.
Arrow (ABV 4.5%) PALE
Shot Firer (ABV 4.5%) STOUT
Tuck (ABV 4.7%) PORTER
Full-bodied and rich dark ale with roast and malt flavours throughout.
Scarlett (ABV 4.8%) BITTER
Gin & Beer It (ABV 5%) SPECIALITY
Longbow (ABV 5%) GOLD
Quarterstaff (ABV 5%) STOUT
Black in colour with roasty aromas and taste, leading to a dry coffee and bitter finish.
Shackler (ABV 5%) PALE
Buttermuch (ABV 5.5%) STOUT
Dark brown beer with strong butterscotch caramel taste throughout, and a gentle bitter finish.
Sheriff (ABV 5.5%) IPA
Golden, full-bodied IPA, citrus hop taste and bitterness balanced throughout.

Linear

Bingham, Nottinghamshire, NG13 8EU ⊕ linear.beer

Small-scale, 50-litre brewery, started production in 2016 and is located at the owner's home. Primarily produces a range of bottle-conditioned beers, on occasion it supplies casks for selected local stockists. Also collaborates with other nanobreweries for local beer festivals and events. LIVE

Liquid Light

Unit 9, Robin Hood Industrial Estate, Alfred Street
South, Nottingham, NG3 1GE
⊕ liquidlightbrewco.com

A strong ethos of community and inclusiveness at its core, with beers influenced by rock and psychedelic music. Moving to its own premises in 2021, with a taproom open at weekends featuring many visual and music oriented events throughout the year. A popular inclusion at tap takeovers and craft beer festivals across the country. 🍺◆❖

Lord Randalls

Holme View Farm, High Street, Laxton, Newark, Nottinghamshire, NG22 0NX ☎ 07712 078346
✉ randallig@aol.com

The five-barrel brewery equipment was purchased in 2018 from the defunct Market Harborough Brewery. Brewing commenced 2020. The proprietors are the Randall family and the head brewer is Dean Penny.

Huntsman Best Bitter (ABV 4%) BITTER
Laxton Original (ABV 4%)
Tally-Ho Light Ale (ABV 4%) PALE
Landlords De-Light (ABV 4.9%) GOLD

Magpie SIBA

Unit 4, Ashling Court, Ashling Street, Nottingham, NG2 3JA
☎ (0115) 874 5467 ☎ 07419 991310
⊕ magpiebrewery.com

☺Launched in 2006 using a six-barrel plant, the brewery upgraded to 17.5-barrels in 2017. Only British hops and malt are used in the core range, with the Wanderlust range taking more worldly influences and ingredients. A 2.5-barrel plant is used for small batch brews and trials. Beers also appear under the Mardy Bum brand name. Its shop/tap opened in 2019 at the brewery (see website for details). ☕♦♦

Hoppily Ever After (ABV 3.8%) BLOND
Golden bitter, gently-hopped with biscuit malt flavours and a bitter finish.
Flipside Sterling Pale (ABV 3.9%) PALE
Best (ABV 4.2%) BITTER
A malty, traditional, pale brown best bitter, with balancing hops giving a bitter finish.
Cherry Raven (ABV 4.4%) SPECIALITY
Raven Stout (ABV 4.4%) STOUT
Dark stout with roast coffee aroma and taste leading to a dry, bitter finish.
Thieving Rogue (ABV 4.5%) GOLD
A hoppy golden ale with a long-lasting, bitter finish.
Flipside Flipping Best (ABV 4.6%) BITTER
Jay IPA (ABV 5.2%) PALE

Maypole

North Laithes Farm, Wellow Road, Eakring, Nottinghamshire, NG22 0AN ☎ 07971 277598
⊕ maypolebrewery.co.uk

☺The brewery opened in 1995 in a converted 18th-century farm building. After changing hands in 2001 it was bought by the former head brewer, Rob Neil, in 2005. ♦

Midge (ABV 3.5%) PALE
Little Weed (ABV 3.8%) GOLD
Mayfly Bitter (ABV 3.8%) BITTER
Celebration (ABV 4%) BITTER
Gate Hopper (ABV 4%) GOLD
Mayfair (ABV 4.1%) SPECIALITY
Hop Fusion (ABV 4.2%) GOLD
Maybee (ABV 4.3%) SPECIALITY
Major Oak (ABV 4.4%) BITTER
Wellow Gold (ABV 4.6%) BLOND
Platinum Blonde (ABV 5%) BLOND

Milestone SIBA

Great North Road, Cromwell, Newark, Nottinghamshire, NG23 6JE
☎ (01636) 822255 ⊕ milestonebrewery.co.uk

☺Established in 2005, Milestone currently brews on a 12-barrel plant. More than 150 outlets are supplied.
♦♦♦LIVE♦

Best Bitter (ABV 3.7%) BITTER
Lion's Pride (ABV 3.8%) BITTER
New World Pale (ABV 3.9%) PALE
Classic Dark Mild (ABV 4%) MILD
Shine On (ABV 4%) BITTER
Azacca Gold (ABV 4.2%) BLOND
Loxley Ale (ABV 4.2%) GOLD
Black Pearl (ABV 4.3%) STOUT
Maid Marian (ABV 4.3%) GOLD
Cromwell Best (ABV 4.4%) BITTER
Crusader (ABV 4.4%) BLOND
Rich Ruby (ABV 4.5%) RED
American Pale Ale (ABV 4.6%) PALE
Imperial Pale Ale (ABV 4.8%) PALE
Honey Porter (ABV 4.9%) PORTER
Olde Ale (ABV 4.9%) BITTER
Little John (ABV 5%) BITTER
Fletcher's Ale (ABV 5.2%) GOLD
Colonial Pale Ale (ABV 5.5%) PALE
Raspberry Wheat Beer (ABV 5.6%) SPECIALITY

Navigation SIBA

Trent Navigation Inn, 17 Meadow Lane, Nottingham, NG2 3HS
☎ (0115) 986 9877 ⊕ navigationbrewery.com

☺Located in Nottingham, just a stone's throw from the iconic Trent bridge, the brewery combines historic Victorian premises, cutting edge technology and a team of brewing experts. ♦♦♦

Patriot (ABV 3.8%) BITTER
Tawny-coloured, malty bitter.
New Dawn Pale (ABV 3.9%) PALE
Golden-coloured ale with initial fruit and hops, and a bitter finish.
Sailing on the 7 C's (ABV 4%) RED
Tropical Pale (ABV 4%) GOLD
Eclipse (ABV 4.1%) STOUT
Dark roast stout aroma and aftertaste with bitterness and some sweetness.
Green Hopped Patriot (ABV 4.2%) GOLD
Rebel (ABV 4.2%) GOLD
Hazy Pale (ABV 4.5%) BLOND
American IPA (ABV 5.2%) GOLD
Saviour (ABV 5.5%) PALE
Golden in colour with assertive hop aroma and citrus fruit taste throughout with a balanced bitterness.

Neon Raptor

Unit 14, Avenue A, Sneinton Market, Nottingham, NG1 1DT ☎ 07367 358661
⊕ neonraptorbrewingco.com

Established in 2016 Neon Raptor is a small, independent brewery that utilised spare capacity at neighbouring breweries. Production commenced in 2018 in a brand new 10-barrel plant in the Sneinton Market area of Nottingham, which also has a licensed taproom. All beers are unfiltered, unfined and unpasteurised. ♦

Newark

77 William Street, Newark, Nottinghamshire, NG24 1QU ☎ 07804 609917 ⊕ newarkbrewery.co.uk

Established in 2012 on the site of a former maltings, Newark Brewery uses an eight-barrel plant.

Newark Best (ABV 3.8%) BITTER
NPA (Newark Pale Ale) (ABV 3.8%) PALE

BLH4 (ABV 4%) PALE
Norwegian Blue (ABV 4%) GOLD
Pure Gold (ABV 4.5%) GOLD
Summer Gold (ABV 4.5%) GOLD
Winter Gold (ABV 4.5%) BITTER
Phoenix (ABV 4.8%) BITTER
5.5 (ABV 5.5%) BITTER

Nottingham SIBA

Plough Inn, 17 St Peter's Street, Radford,
Nottingham, NG7 3EN
☎ (0115) 942 2649 ☎ 07815 073447
⊕ nottinghambrewery.co.uk

The former owners of the Bramcote and Castle Rock
Breweries re-established the Nottingham Brewery in
2000 in a purpose-built brewhouse behind the Plough
Inn. Philip Darby and Niven Balfour set out to revive the
brands of the original Nottingham Brewery, closed by
Whitbread in the 1950s. Within the LocAle ethos, beers
are supplied widely to the local trade including the
brewery tap house, the Plough Inn. !! ✦

Rock Ale Bitter Beer (ABV 3.8%) BITTER
A pale and bitter, thirst-quenching hoppy beer with a dry
finish.
Rock Ale Mild Beer (ABV 3.8%) MILD
A reddish-black malty mild with some refreshing
bitterness in the finish.
Trent Bridge Inn Ale (ABV 3.8%) BITTER
Legend (ABV 4%) BITTER
A fruity and malty pale brown bitter with a touch of
sweetness and bitterness.
Extra Pale Ale (ABV 4.2%) PALE
A hoppy and fruity golden ale with a hint of sweetness
and a long-lasting bitter finish.
Cock & Hoop (ABV 4.3%) BITTER
Dreadnought (ABV 4.5%) BITTER
Well-balanced best bitter. Blend of malt and hops give a
rounded, fruity finish.
Bullion (ABV 4.7%) GOLD
A refreshing, premium golden ale. Brewed with a single
malt variety, it is triple-hopped and exceptionally bitter.
Foundry Mild (ABV 4.7%) MILD
Supreme (ABV 5.2%) GOLD
A strong, amber, fruity ale. A touch of malt in the taste is
followed by a sweet and slightly hoppy finish.

Pheasantry SIBA

High Brecks Farm, Lincoln Road, East Markham,
Nottinghamshire, NG22 0SN
☎ (01777) 872728 ☎ 07948 976749
⊕ pheasantrybrewery.co.uk

☺Pheasantry began brewing in 2012 using a new 10-
barrel plant from Canada. Situated in a listed barn on a
farm, the brewery incorporates a wedding and events
venue, with the brewery visible through glass partitions.
It supplies more than 200 pubs and retail outlets in
Nottinghamshire, Lincolnshire, Derbyshire and South
Yorkshire. A bottling line was installed in 2018. Seasonal
beers are produced on a monthly basis. 🛒

Best Bitter (ABV 3.8%) BITTER
Pale Ale (ABV 4%) PALE
Ringneck Amber Ale (ABV 4.1%) BITTER
Amber-coloured best bitter, initial malt and caramel
leading to a brief, bitter, dry finish.
Black Pheasant Dark Ale (ABV 4.2%) PORTER
Lincoln Tank Ale (ABV 4.2%) BITTER
Excitra (ABV 4.5%) GOLD
Dancing Dragonfly (ABV 5%) BLOND

Prior's Well SIBA

Unit 8, Block 22, Farm Way, Old Mill Lane Industrial
Estate, Mansfield Woodhouse, Nottinghamshire,
NG19 9BQ
☎ (01623) 632393 ☎ 07970 885204
⊕ priorswellbrewery.co.uk

Originally established in a National Trust building on the
Clumber Park Estate, but brewing ceased there in 2014.
The brewery was subsequently sold and the five-barrel
plant modernised and relocated to a new site in
Mansfield Woodhouse in 2016 with an on-site bar. !!

Citra (ABV 3.9%) GOLD
Baby Wolf (ABV 4%) GOLD
Incensed (ABV 4%) BITTER
Silver Chalice (ABV 4.2%) GOLD
Kumquat May (ABV 4.3%) SPECIALITY
Mosiac (ABV 4.4%) BLOND
Blade (ABV 4.7%) BITTER
Priory Gold (ABV 4.7%) GOLD
Prior's Pale (ABV 4.8%) PALE
Resurrected (ABV 4.8%) BITTER
Wolfcatcher (ABV 4.8%) PALE
Dirty Habit (ABV 5.8%) IPA

Reality

127 High Road, Chilwell, Beeston, Nottingham,
NG9 4AT ☎ 07801 539523
✉ alandenismonaghan@hotmail.com

⊗ Since starting in 2010, the brewery has built up a loyal
following of pubs locally, while supplying beer festivals
across the country, functions and individual customers. ♦

Virtuale Reality (ABV 3.8%) PALE
No Escape (ABV 4.2%) PALE
Bitter Reality (ABV 4.3%) BITTER
Stark Reality (ABV 4.5%) SPECIALITY
Reality Czech (ABV 4.6%) SPECIALITY

Reckless Dweeb

Forest Link, Bilsthorpe, Nottinghamshire, NG22 8PR
☎ 07969 779763 ⊕ recklessdweeb.com

Established in 2020 and upgraded in 2022 to a 200-litre
plant, Reckless Dweeb Brew Co is a nanobrewery nestled
in a quiet village in the heart of Nottinghamshire.

Son of My Brother (ABV 5.1%) GOLD
Did You See That Ludicrous Display Last
Night (ABV 8.2%) IPA

Rufford Abbey

Meden Road, Boughton, Nottinghamshire, NG22 9ZD

Originally known as Headstocks, the brewery was
established in 2017 to produce Prussia Lager in
collaboration with a partner brewery in Kaliningrad on
the Lithuania/Poland border. In 2018 cask-conditioned
beer was added to the range. Brewing is currently
suspended.

Scruffy Dog

🏠 94 Station Road, Sutton-In-Ashfield,
Nottinghamshire, NG17 5HF
☎ (01623) 550826 ⊕ thescruffydog.co.uk

Microbrewery at the Scruffy Dog pub in Sutton-in-
Ashfield.

Shipstone's SIBA

Little Star Brewery, Fox & Crown, 33 Church Street, Old Basford, Nottingham, NG6 0GA
☎ (0115) 837 4200 ⊕ shipstones.com

⊛Established 1996 as Fiddlers Ales, becoming Alcazar Brewery on change of ownership in 1999. A full-mash, 10-barrel brewery, it is located behind the Fox & Crown. It changed hands in 2016, the name changed again, and a new portfolio of beers was established, but was short-lived. It soon reverted back to Alcazar. In late 2016 Shipstone's took over brewing, producing its range of beers that had previously been contract brewed at Belvoir Brewery (qv). Beers are also brewed under the Hollow Stone Brewing Co brand name. ‼◆

Mild (ABV 3.5%) MILD
Original Bitter (ABV 3.8%) BITTER
Pale brown, malty, traditional bitter, well-balanced in both hops and bitterness without either becoming overpowering.
Nut Brown Ale (ABV 4%) BITTER
Gold Star Pale (ABV 4.2%) GOLD
Golden in colour with a delicate citrus hop and slight dry, bitter finish.
India Pale Ale (ABV 5.5%) IPA

Brewed under the Hollow Stone Brewing Co brand name:
Kazumura (ABV 3.4%) RED
Oligo Nunk American Pale (ABV 4%) GOLD
Pale Ale (ABV 4.2%) PALE
Temple of Baal (ABV 4.8%) PALE
Krubera Stout (ABV 5.2%) STOUT
Sorbeto Grapefruit WIT IPA (ABV 6%) SPECIALITY

Source House (NEW)

Edwalton, Nottingham, NG12 4DA
⊕ sourcehouse.co.uk

Established in 2020, Source House brew beers produced from local and homegrown ingredients.

Totally Brewed

Units 8 & 9, Meadow Lane Fruit & Veg Market, Clarke Road, Nottingham, NG2 3JJ ☎ 07702 800639
⊕ totallybrewed.com

⊗ Totally Brewed began brewing in 2014 using a seven-barrel plant previously used at White Dog Brewery. A diverse range of hop-forward beers are produced. ◆

Guardian of the Forest (ABV 3.8%) PALE
Slap in the Face (ABV 4%) BLOND
Golden-coloured ale with citrus fruit hop aroma and taste with a dry, bitter finish.
Crazy Like A Fox (ABV 4.5%) BITTER

Copper-coloured, malty best bitter with a caramel aroma and a gentle bitter finish.
Papa Jangle's Voodoo Stout (ABV 4.5%) SPECIALITY
Full-bodied, dark stout oozing complex malt tastes throughout.
Punch in the Face (ABV 4.8%) PALE
Golden-coloured ale, assertive hop aroma leading to grapefruit and malt taste with a hoppy bitter finish.
Four Hopmen of the Apocalypse (ABV 5.2%) PALE
Immense, big-hopped, fruity, golden ale, moderate bitterness with a lasting hoppy finish.
Captain Hopbeard (ABV 5.5%) IPA
Amber-coloured ale with citrus hops aplenty with a strong bitter finish.

Vaguely

15 Lune Way, Bingham, Nottinghamshire, NG13 8YX
☎ 07969 137248 ⊕ vaguelybrewing.co.uk

⊗ Vaguely Brewing launched as a commercial nanobrewery in 2019 following four years of homebrewing and recipe development. It produces vaguely traditional beers that are naturally-conditioned, unfiltered and unfined. LIVE

Bitter (ABV 4.2%) BITTER
Hazy (ABV 4.5%) PALE
Porter (ABV 4.7%) STOUT
Pale Ale (ABV 6%) IPA

Welbeck Abbey SIBA

Brewery Yard, Welbeck, Nottinghamshire, S80 3LT
☎ (01909) 512539 ☎ 07921 066274
⊕ welbeckabbeybrewery.co.uk

Starting in 2011, General Manager Claire Monk has grown the brewery to focus on supplying just over 17,000 pints of quality beer into local pubs, bottled beer shops and restaurants. Produce from the brewery, bakehouse and dairy can all be found under one roof in the Welbeck Farm Shop. Welbeck is one of the historic Nottinghamshire estates. Beer is also brewed for Stocks Brewing Co, Doncaster. ‼

Hennymoor (ABV 3.7%) GOLD
Red Feather (ABV 3.9%) BITTER
Skylight (ABV 4.4%) PALE
Atlas (ABV 5%) IPA

Brewed for Stocks Brewing Co:
St Leger Gold (ABV 4.1%) BLOND
Select (ABV 4.3%) BITTER
Old Horizontal (ABV 5.3%) OLD

The soul of beer

Brewers call barley malt the 'soul of beer'. While a great deal of attention has been rightly paid to hops in recent years, the role of malt in brewing must not be ignored. Malt contains starch that is converted to a special form of sugar known as maltose during the brewing process. It is maltose that is attacked by yeast during fermentation and turned into alcohol and carbon dioxide. Other grains can be used in brewing, notably wheat. But barley malt is the preferred grain as it gives a delightful biscuity / cracker / Ovaltine note to beer. Unlike wheat, barley has a husk that works as a natural filter during the first stage of brewing, known as the mash. Cereals such as rice and corn / maize are widely used by global producers of mass-market lagers, but craft brewers avoid them.

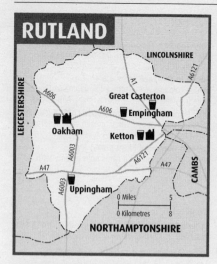

RUTLAND

LINCOLNSHIRE

LEICESTERSHIRE

Great Casterton

Empingham

Oakham

Ketton

CAMBS

Uppingham

0 Miles 5

0 Kilometres 8

NORTHAMPTONSHIRE

Empingham

Empingham Cricket & Social Club

Exton Road, LE15 8QB

☎ (01780) 460696 ● empinghamcsc.org

Magpie Best; 2 changing beers (often Greg's, Stockport) ⊞

The Cricket & Social Club is noted for the quality and variety of the ales served, many from microbreweries. It has limited hours, often extended by sporting and other functions – check the website for events. An annual beer festival is held to coincide with the final matches of the Six Nations Rugby in March. A local CAMRA award winner. Q❀❀⑮P➡❀🧡

Great Casterton

Crown

Main Street, PE9 4AP

☎ (01780) 753838 ● thecrowncasterton.co.uk

Digfield Shacklebush; Oakham JHB; Sharp's Doom Bar, Sea Fury ⊞

This popular dog-friendly inn on the old Great North Road serves the village and surrounding area. The former Melbourns/Pubmaster pub has undergone a major refurbishment and has four handpumps for regular and guest ales. Food is well established (booking advised for Sunday lunch). Outside, there is a pétanque area and an attractive beer garden. A regular local CAMRA award winner. Q❀❀⑩⑮♣P➡❀🧡

Ketton

Railway

Church Street, PE9 3TA

☎ (01780) 721050

Grainstore Beesting, Ten Fifty; Oakham JHB; 1 changing beer (often Bakers Dozen) ⊞

A traditional village local situated in the shadow of the impressive church, serving good beer and wine in a welcoming and friendly atmosphere. The Grade II-listed building is several hundred years old, with much character and more than a little charm. There is no food but functions can be catered for. A fourth beer may be added at busy times. Two-time local CAMRA Pub of the Year. Q❀❀P➡❀

Oakham

Grainstore Brewery Tap

Station Approach, LE15 6EA

☎ (01572) 770065 ● grainstorebrewery.com

Grainstore Rutland Bitter, Rutland Panther, Cooking, Daniel Lambert, Triple B, Ten Fifty; 3 changing beers (often Grainstore) ⊞

A pub and brewery in a small cleverly converted warehouse adjacent to Oakham Station, retaining some original features. Brewery tours are available but must be booked in advance. Ten handpumps offer a range of beers, always including a mild. Home-made food is served including breakfast at weekends. Walkers and their dogs are welcome. Live bands and comedy nights feature regularly. A regular local CAMRA and SIBA award winner. Q❀⑩⑮♣♣P➡❀🧡

Uppingham

Crown Inn Ⓛ

19 High Street East, LE15 9PY

☎ (01572) 822302

Everards Beacon Hill, Tiger; 1 changing beer ⊞

The Crown was originally a coaching inn, dating back to 1704 when two separate dwellings were altered to make one building. Under new management, it offers two Everards ales and occasional guest beers. Tapas-style food is served in the bar and restaurant, and live music often plays at weekends and bank holidays. The pub participates in the Uppingham Town beer festival. En-suite accommodation is available. ❀🛏⑩⑮♣P➡❀🧡

Exeter Arms

3 Leicester Road, LE15 9SB

☎ (01572) 822900

Langton Inclined Plane Bitter; 1 changing beer (often Thornbridge) ⊞

This friendly, recently refurbished, old-fashioned drinking establishment, situated to the west of the town centre, is a real survivor and its furniture dates from a previous era. There are several seating spaces, and a separate area with a pool table. With a large widescreen TV, the pub can get extremely busy when live rugby and football matches are on. The pub participates in the Uppingham Town beer festival. A local CAMRA award winner. ❀⑩⑮♣❀🧡

Vaults ⏺

Market Place, LE15 9QH

☎ (01572) 823259 ● thevaultsuppingham.co.uk

Adnams Broadside; Marston's Pedigree; Theakston Black Bull Bitter; 1 changing beer (often Grainstore) ⊞

Attractive historic stone building adjacent to the church and overlooking the market place. It gets lively in the summer months, with an outdoor seating area providing a great view of activities in the town square. There are five regular real ales and one changing guest on handpump, and beer festivals are hosted. The pub is both dog and child friendly. ❀🛏⑮♣➡🧡

Breweries

Bakers Dozen SIBA

Unit 5, Ketton Business Estate, Pit Lane, Ketton, PE9 3SZ
☎ (01780) 238180 ⊕ bakersdozenbrewing.co.uk

☺Baker's Dozen is a two-person microbrewery with brewing taking place on a five-barrel plant installed in 2015. The beers favour hoppy styles with some occasional brews unfined. ◆

Acoustic Landlady (ABV 3.4%) PALE
Jentacular (ABV 3.5%) GOLD
Magic Potion (ABV 3.8%) GOLD
Stamford Pale (ABV 4%) PALE
Cuthbert's Fee (ABV 4.1%) PALE
Straight Outta Ketton (ABV 4.5%) PALE
Electric Landlady (ABV 5%) GOLD

Grainstore SIBA

Station Approach, Oakham, Rutland, LE15 6RE
☎ (01572) 770065 ⊕ grainstorebrewery.com

☺Grainstore, the smallest county's largest brewery, has been in production since 1995, founded by Tony Davis and Mike Davies. After 45 years in the industry Tony decided to retire, handing the reins to his son, William, and Peter Atkinson. More than 200 outlets are supplied. Beers are also brewed under the Stoney Ford brand name. ‼◆✦

Rutland Bitter (ABV 3.4%) BITTER
Rutland Panther (ABV 3.4%) MILD
This superb reddish-black mild punches above its weight with malt and roast flavours combining to deliver a brew that can match the average stout for intensity of flavour.
Cooking (ABV 3.6%) BITTER
Tawny-coloured beer with malt and hops on the nose and a pleasant grainy mouthfeel. Hops and fruit flavours combine to give a bitterness that continues into a long finish.
Red Kite (ABV 3.8%) BITTER
Rutland Osprey (ABV 4%) GOLD
Triple B (ABV 4.2%) BITTER
Initially hops dominate over malt in both the aroma and taste, but fruit is there, too. All three linger in varying degrees in the sweetish aftertaste of this brown brew.
Zahara (ABV 4.2%) GOLD
Gold (ABV 4.5%) BITTER
Springtime (ABV 4.5%) GOLD
Tupping (ABV 4.5%) BITTER
Ten Fifty (ABV 5%) BITTER
Pungent banana and malt notes on the nose. On the palate, rich malt and fruit is joined by subtle hop on a bittersweet base. Dry malt aftertaste with some fruit.
Rutland Beast (ABV 5.3%) OLD
Nip (ABV 7.3%) BARLEY

Brewed under the Stoney Ford brand name:
Sheepmarket Supernova (ABV 3.8%) GOLD
PE9 Paradise Pale (ABV 4%) PALE
All Saints Almighty (ABV 4.2%) BITTER

Reading the runes

There are terms and expressions used in the pub trade that need to be translated into a language understood by consumers:

'Wet pub' doesn't mean the roof leaks but indicates that beer and other alcohols are the main feature, rather than food.

Stillage is a cradle or platform in the pub cellar where casks of beer are stored horizontally while a secondary fermentation takes place.

'Barrel behind the bar' is a widely-used description but usually inappropriate as a barrel is a large 36-gallon container, too big to store at bar level. The correct term for a container for real ale is cask and casks come in several sizes: 4-and-a-half gallon pins; nine-gallon firkin; 18-gallon kilderkin; 36-gallon barrels; and 54-gallon hogshead. Hogsheads are rare. Most pubs use firkins and kilderkins these days. If a cask is used at bar level to serve a seasonal beer such as winter ale, it's likely to be a pin.

Beer 'served by gravity' means it comes straight from the cask and is not drawn by a beer engine and handpump.

'Tight sparkler' is a small device containing a mesh that's screwed to the nozzle of a beer engine operated by a handpump on the bar. The sparkler agitates the beer as it enters the glass and creates the tight, thick head of foam sometimes preferred by northern drinkers.

'Cask breather' is a system used by a few brewers to prolong the life of cask beer. Casks are connected to cylinders of carbon dioxide and a demand valve injects gas into the cask as beer is drawn off. If the gas is absorbed into the beer, it can become unnaturally gassy.

United Kingdom of Beer

Adrian Tierney-Jones

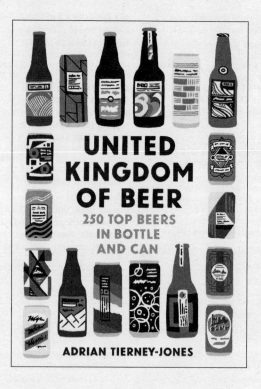

There is a thirst for good beer on these islands, a thirst for beer that satisfies the soul, quenches the thirst and leaves the drinker glowing with satisfaction. You might be in the mood for a muscular Best Bitter, or a brooding, midnight-black Imperial Stout as you cosy up with a loved one on a cold winter's night, or perhaps you fancy a crisp and briskly amiable lager while hanging out with friends on a sunny afternoon.

Whatever avenue your desire takes you down, whatever the occasion, be assured that there is a beer for you and acclaimed beer writer Adrian Tierney-Jones will help you make the right choice with his selection of 250 of the very best beers in bottle and can from around these islands.

RRP: £17.99 **ISBN:** 978-1-85249-378-3

For this and other books on beer and pubs, visit CAMRA's online bookshop at **shop1.camra.org.uk** or call 01727 867201.

Discounts are available for CAMRA members.

Yorkshire

No one can fail to be impressed by the captivating Yorkshire Dales, including sites like the incredible Brimham Rocks in the Nidderdale Area of Outstanding Natural Beauty. Less well known is the Forbidden Corner near Middleham; a captivating array of tunnels, sculptures and surprises set within a beautiful four-acre garden.

Happily, combining a satisfying day of sightseeing with some serious beer investigation is not difficult in Yorkshire. The UNESCO World Heritage site of Saltaire is not only a beautifully preserved Victorian village but also the home of the highly regarded SALT Beer Factory and just a short distance from, unsurprisingly, the Saltaire Brewery. Both have taprooms on-site in converted historic buildings.

The city of York itself needs no introduction as a must-see for any visitor to Yorkshire, but it is also encircled by a ring of great breweries. Whether you like your ale traditional or a little more experimental, there is something to suit all tastes. York Brewery Tours are available to take you around a selection of the finest; including the likes of Brew York and the Rudgate Brewery.

Although Yorkshire is not generally seen as a cider producing region, there is a cluster of a dozen cider producers there. In the last 15 years, two pubs in the area have won CAMRA National Cider Pub of the Year.

Visit the Yorkshire coast and as well as exploring the resort towns like Bridlington, Scarborough and Whitby, you can also taste some beautiful local beers. A taproom is available at Whitby Brewery in the shadow of the Abbey. Hull is home to eight breweries, including the Atom Brewing Company, where you can take a tour and then sample a local speciality, the Hull pattie, with its on-site street food partners.

Sheffield is also well regarded for its bustling beer scene, even argued by some proponents to be the finest beer city in the country. The Triple Point Brewery tap is a great place to start, not least because it is only 10 minutes away from the railway station. St Mars of the Desert is a relatively new brewery making huge waves in the industry, not just because of its use of a coolship tray, but because of its small-scale, unique beers in a range of exciting styles. Sheffield Beer Week takes place in March if you want to pack in as much beer-themed adventure as possible into a single visit.

Finally, a visit to Harrogate is unmissable for beer aficionados. Take in the highlights during the phenomenal annual festival, Women on Tap. Alongside a packed event programme, this social enterprise creates opportunities for women to discover and explore their passion for beer.

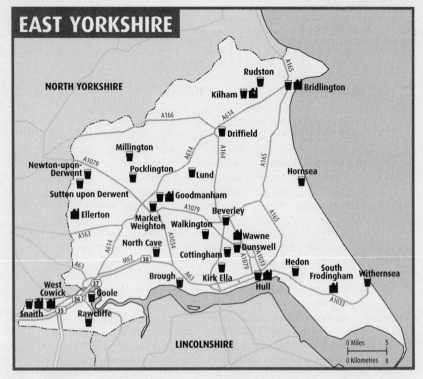

EAST YORKSHIRE

Map of East Yorkshire showing: North Yorkshire, Rudston, Kilham, Bridlington, Millington, Driffield, Newton-upon-Derwent, Pocklington, Lund, Hornsea, Sutton upon Derwent, Goodmanham, Ellerton, Beverley, Market Weighton, Walkington, Wawne, North Cave, Cottingham, Dunswell, Hedon, South Frodingham, Withernsea, Brough, Kirk Ella, Hull, West Cowick, Goole, Snaith, Rawcliffe, Lincolnshire

0 Miles 5
0 Kilometres 8

Beverley

Chequers Micropub ⓛ

15 Swaby's Yard, Dyer Lane, HU17 9BZ (off Saturday Market)

☎ 07964 227906

5 changing beers (sourced regionally; often Brass Castle, Great Newsome, North Riding Brewery) Ⓗ

Yorkshire's first self-styled micropub, converted from a baker's shop, is in a secluded yard off Saturday Market and close to the bus station. Local breweries are well represented on the bar plus micros from throughout the UK. Several ciders/perries are sold as well as three craft keg beers. With no TV or loud music, Chequers is a place for quiet conversation. A selection of board games is available for customers. There is a seating area in the courtyard to the front. Q❀⊁≉♣♨🚐🐾

Dog & Duck ⓛ

33 Ladygate, HU17 8BH (off Saturday Market adjacent to Brown's store)

☎ (01482) 862419 ⊕ bedandbreakfastbeverley.com

Black Sheep Best Bitter; Great Newsome Sleck Dust; John Smith's Bitter; Timothy Taylor Landlord; 1 changing beer (sourced regionally; often Great Newsome) Ⓗ

Built in the 1930s, this pub has been run by the same family since 1972. It consists of three distinct areas: a bar with a period brick fireplace and bentwood seating, a front lounge with an open fire, and a rear snug. It retains some original terrrazzo flooring in the rear lobby. The good-value, home-cooked lunches are popular. Guest accommodation is provided in six purpose-built self-contained rooms to the rear with their own parking. The pub is conveniently located close to Beverley bus station. 🛏🚫🍴◐≉♣♨🚐🐾🛜

Monks Walk ⓛ

19 Highgate, HU17 0DN

☎ (01482) 864972 ⊕ monkswalkinn.com

5 changing beers (sourced regionally; often Brass Castle, Great Newsome) Ⓗ/Ⓖ

Conversation is encouraged at this genuine free house, which dates back to the 13th century and was built as a merchant's warehouse; records show there was a brewery attached in the 19th century. There are two rooms: a small front bar and a longer bar which extends through to the restaurant. Access to the bars is via a passageway with a small pool room on the opposite side. The sheltered beer garden and separate patio have splendid views of the minster. Access to the pub is off both Highgate and Eastgate. Q🛏❀◐&≉♣♨🚐🐾🛜

Sun Inn

1 Flemingate, HU17 0NP (adj to Beverley Minster)

☎ 07541 456215 ⊕ suninnbeverley.co.uk

Black Sheep Best Bitter; Morland Old Speckled Hen; Theakston Lightfoot; 2 changing beers (sourced nationally; often Timothy Taylor) Ⓗ

The pub's medieval timber-framed building, dating from 1530 or earlier, is located opposite the eastern front of Beverley's famous minster. An open-plan pub on two levels with a flagstone floor, this former Tap & Spile establishment has a stripped-back interior together with an interesting display of ornaments. The secluded rear garden has splendid views of the minster. The pub is a live music venue with sessions on most evenings and weekends. There is a popular quiz on Thursdays, and Sunday lunches are served. 🛏❀◐≉♣🚐(6,246)🐾

Bridlington

Old Ship Inn ♈

90 St John Street, YO16 7JS

☎ (01262) 401906

Bridgehouse Porter; 6 changing beers (sourced nationally; often Acorn, Rudgate, Yorkshire Heart) ⓗ

Dating from 1860, this multi-roomed inn comprises the main bar with leather-backed bench seating and a pool table, a refurbished lounge with antique pub mirrors, keeping a traditional look, plus a smaller room to the rear. There is an extensive collection of Frank Meadow Sutcliffe photographs of Whitby and a smaller number featuring Bridlington. The six ales on handpull are usually sourced from regional Yorkshire breweries, with occasional national beers available. A beautiful secluded garden is accessed through the pub. ☼❀◑≠♣☷(124,5A) ❀☞♥

Pack Horse ⓛ

7 Market Place, YO16 4QJ

☎ (01262) 603502

Theakston Old Peculier; 3 changing beers (sourced regionally; often Bingley) ⓗ

This inn, dating from the 17th century, was restored by its owners as a labour of love, creating an open-plan yet intimate layout. There are three customer areas, one to the right of the bar, one to the left and a third at the rear. A restored brewery dray has pride of place in the paved area outside to the rear. The famous wooden stocks remain in place in front of the pub. ☼❀♣☷❀☞♥

Three B's Micropub ⓛ

2 Marshall Avenue, YO15 2DS

☎ (01262) 604235 ⊕ threebspubbrid.co.uk

Acorn Barnsley Bitter; 3 changing beers (sourced nationally; often Bad Seed, Blue Bee, North Riding Brewery) ⓗ

Owned and run by enthusiastic CAMRA members, this former sweet shop is a two-storey building that has become one of the premier drinking establishments in Bridlington. Serving one permanent and three nationally-sourced guest beers and an extensive range of ciders, including the locally produced Colemans Cider, plus home-made snacks, this is a must-visit destination. A special dining menu features on Wednesday evening. The upper floor has comfy sofas and there is patio seating to the front of the pub. Q☼❀◑♿≠♣♥☷❀☞♥

Brough

Centurion Arms ⓛ

39 Skillings Lane, HU15 1BA

4 changing beers (sourced regionally; often Great Newsome, Half Moon, Wold Top) ⓗ

A converted shop unit, one of a number of nearby small businesses supporting the local community. This is unlike any other pub in the village; its ever-changing variety of real ale and cider is evidenced from the extensive collection of pump badges which add to the eclectic variety of paraphernalia decorating the pub. Social interaction and conversation is encouraged with regulars and strangers. Locally produced artwork is also on show. There is a quiz on Sunday evenings. Dog snacks provided. ☼❀♿≠♣♥☷(158)❀

Cottingham

Hugh Fitz-Baldric ⓛ

144 Hallgate, HU16 4BB

⊕ the-hugh-fitz-baldric-of-cottingham.business.site

Salopian Lemon Dream; Titanic Plum Porter; house beer (by Marston's); 3 changing beers (sourced nationally; often Timothy Taylor) ⓗ

Converted from a shop on the main street of the largest village in England, the pub has just one room with quiet corners. It is furnished with repurposed items and a log-burner adds cosiness in winter. It is a peaceful place to enjoy the range of real ales, real ciders and gins, and a range of other drinks that mirror changing tastes. Children are welcome until the evening. Former local CAMRA Village Pub of the Year. Q☼❀♿♥≠♣♥☷❀

Driffield

Benjamin Fawcett ⓛ ✓

Middle Street North, YO25 6SW

☎ (01377) 249130

Greene King Abbot; Ruddles Best Bitter; Sharp's Doom Bar; 4 changing beers ⓗ

This family-friendly, JD Wetherspoon pub is located across from a well-known Methodist chapel dating from the 1880s. The standard open-plan layout of a large bar area is complemented by an additional comfortable seating area to the front of the building. The pub is named in celebration of the 19th-century printer renowned as the 'finest of Victorian colour printers', and examples of his work decorate the walls. Tribute is also paid to the members of the armed forces stationed nearby during WWII. Q☼❀◑♿≠♣♥☷♥

Butcher's Dog ♈

57 Market Place, YO25 6AW (entrance is via archway)

☎ (01377) 252229 ⊕ thebutchersdog.co.uk

6 changing beers (sourced locally; often Half Moon, Wold Top) ⓗ

This micropub has moved further up Market Place and taken over the premises formerly known as Middle Pub. Upon entering from the arched passageway there is a long thin room leading through to a small dining room behind the bar. The food provision is primarily of the tapas variety. A range of beers can be sampled on a three-drink paddle. Social and community events take place on a regular basis. Q☼◑≠♣♥☷❀☞♥

Dunswell

Ship Inn ⓛ

Beverley Road, HU6 0AJ

☎ (01482) 854458 ⊕ shipsquarters.co.uk

3 changing beers (sourced regionally; often Black Sheep, Great Newsome) ⓗ

Fronting the old Hull to Beverley main road, this inn once served traffic on the nearby River Hull, as indicated by the nautical memorabilia displayed in the pub, including the bell from the shipwrecked Caroline. Log fires warm the convivial interior which is partly divided to create a separate dining area with church pew seating. Former outbuildings have been developed to create en-suite

REAL ALE BREWERIES

Aitcheson's Wawne
All Hallows 🍴 Goodmanham
Atom Hull
Belschnickel Hull (NEW)
Bone Machine ✦ Hull
Bricknell Hull
Bridbrewer 🍴 ✦ Bridlington
Great Newsome South Frodingham
Half Moon ✦ Ellerton
Old Mill Snaith
Raven Hill Kilham
Spotlight West Cowick (brewing suspended)
Vittles Hull
Woolybutt Brew Shed Hull
Yorkshire Brewhouse Hull
Yorkshire Coast 🍴 Bridlington

accommodation, the Ship's Quarters. The large garden has an outside bar and barbecue area for summer events. ⌂❁✉◑❤⛟♣P🖵(121,122)🌸🛜

Goodmanham

Goodmanham Arms ⌶

Main Street, YO43 3JA

☎ (01430) 873849

All Hallows Peg Fyfe Dark Mild; Hambleton Stallion Amber; Theakston Best Bitter; 3 changing beers (sourced regionally; often All Hallows, Oakham, Wold Top) Ⓗ

Unique village local with the All Hallows Brewery attached, also close to the Wolds Way footpath. Three log fires warm the bar, dining room and kitchen, and the pub is candlelit during dark winter nights. An extension decorated with vintage artefacts has been added to give extra space. Hearty meals are freshly cooked. Events are held on bank holidays. Local CAMRA Village Pub of the Year many times. Q⌂❁◑❤P

Goole

Tom Pudding

20 Pasture Road, DN14 6EZ (2 mins' walk from Goole station)

☎ 07762 525114

4 changing beers (sourced regionally; often Great Newsome, Hambleton, Wold Top) Ⓗ

Opened in 2017 by two CAMRA members with an enthusiasm for real ale, this micropub was once a newsagent's. The pub can accommodate up to 50 people and is often sought out by travelling football fans on their way to Hull and Doncaster. A gluten-free beer is always available and up to four real ciders, such as Henry Weston and Gwynt y Ddraig. There is interesting internal brickwork and an exposed wooden-beamed ceiling. ➷♣❤🖵(155,X55)🌸

Hedon

Hed'On Inn

7 Watmaughs Arcade, St Augustine Gate, HU12 8EZ

☎ (01964) 601100

Black Sheep Best Bitter; 4 changing beers (sourced nationally) Ⓗ

Adjacent to a car park at the end of a shopping arcade in the centre of this historic market town, this micropub was converted from a disused carpet shop office. The premises are tastefully decorated with recycled fittings. The one regular and four changing beers cover the full spectrum of styles, complemented by real ciders, bottled ales and a range of spirits and wines. Acoustic music sessions are held on Tuesday nights and Sunday afternoons, with a quiz night on Wednesdays. Q♣❤P🖵

Hornsea

Stackhouse Bar

8A Newbegin, HU18 1AG

☎ (01964) 534407

4 changing beers (sourced nationally) Ⓗ

Established in 2014, this micropub converted from a shop can be found opposite the church by the traffic lights. The single room is fitted out with repurposed furniture providing an intimate atmosphere for drinking and conversation and attracting a mixed clientele. An interesting choice of cask ales is complemented by an extensive range of craft beers and real ciders. There is a separate function room. ⌂🅰🖵(24,25)🌸🛜

Hull

Alexandra Hotel ⌶

69 Hessle Road, HU3 2AB

☎ (01482) 327455

Yorkshire Brewhouse EYPA; 7 changing beers (sourced locally; often Rudgate, Yorkshire Brewhouse) Ⓗ

Known locally as the Alex, this Grade II-listed building has been given new life by the current owners through a sympathetic restoration. The pub has many architectural features that make it stand out, including a Victorian glazed brick frontage and an impressive bar back. The old gas lighting, now electrified, makes for a traditional appearance. Interesting historical pub artefacts add to the atmosphere. It is home to the Pickled Parrot brewery, which launched in 2022. Nine en-suite rooms are available. ⌂✉♣❤P🖵🐾🌸

George Hotel

Land of Green Ginger, HU1 2EA

☎ (01482) 226373

Sharp's Doom Bar; Timothy Taylor Landlord; Wainwright; 3 changing beers (sourced regionally; often Ossett) Ⓗ

Totally refurbished in early 2020, the George is in the heart of the old town on Hull's most famous street. The downstairs real ale bar, with wood-panelled walls and ceiling beams, retains some period fittings. Splendid, glazed leaded windows have been retained and also of note is reputedly the smallest pub window in England, dating from the pub's days as a coaching inn. Upstairs a second bar has TVs for sporting events. ♣🖵

Hop & Vine ⌶

24 Albion Street, HU1 3TG (250yds from Hull New Theatre and Central Library)

☎ 07507 719259

4 changing beers (sourced nationally; often Acorn, Goose Eye, Great Newsome) Ⓗ

An atmospheric basement bar free house serving three to four changing guest beers, largely from independent Yorkshire breweries. Six nationally sourced still ciders and perries are stocked along with a large list of bottled continental beers and a good selection of international whiskies, including from Yorkshire's own distillery. Oversized lined glasses used for real ales. A variety of pub games is available to customers, including nine men's morris and shove ha'penny; there is a monthly Sunday games night. ⌂❁◑🅰♣❤🖵🐾🌸

Kingston Hotel

25 Trinity House Lane, HU1 2JA

☎ (01482) 223635

Jennings Cumberland Ale; Marston's EPA; Ringwood Boondoggle; 1 changing beer (sourced nationally; often Marston's) Ⓗ

A Grade II-listed, traditional street-corner pub with a curved frontage. The interior consists of one large room which houses the main bar, decorated with six carved prow heads, and a smaller back room with paraphernalia reflecting Hull's fishing history. The pub is also home to a stunning dark-wood bar back that dates from Victorian times. There is outdoor pavement seating allowing customers to enjoy the sunshine with views of the adjacent Hull Minster. ❁➷♣

Minerva Hotel ⌶

Nelson Street, HU1 1XE

☎ (01482) 210025 ⊕ minerva-hull.co.uk

Tetley Bitter; 5 changing beers (sourced regionally; often Bone Machine, Yorkshire Brewhouse) Ⓗ

Overlooking the Humber Estuary and Victoria Pier, this famous pub, built in 1829, is a great place to watch the ships go by. Photos and memorabilia are a reminder of the area's maritime past. The central bar serves various rooms including a tiny three-seat snug. Locally brewed ales are regularly available. The former brewhouse was converted to provide an additional drinking area and is available for functions. The area is connected to The Deep visitor attraction by a footbridge at the mouth of the River Hull. ♿🕑🌙▯➡(16)🛜

New Clarence 🄻

77-79 Charles Street, HU2 8DE (just off Freetown Way)
☎ (01482) 961666 ⊕ thenewclarence.co.uk
6 changing beers (sourced regionally; often Abbeydale, Acorn, Chin Chin) Ⓗ
Community pub close to the New Theatre offering mainly Yorkshire ales, real ciders, a selection of tequilas and a food menu of burgers and home-cooked world food. Regular events include live music, local history talks, film nights, science talks, a quiz night and weekly Wednesday rock nights. Open-plan, it has a split-level bar room, a small enclosed beer garden and a function room upstairs. Special interest groups who use the pub include barber shop singing practice, adult Lego fans and various community groups. ♿🕑🌙➡♣♠▯🌂🛜

Olde White Harte ★ ✅

25 Silver Street, HU1 1JG (in alley between Silver St and Bowlalley Lane)
☎ (01482) 326363 ⊕ yeoldewhiteharte.com
Ossett Yorkshire Blonde; Theakston Best Bitter, Old Peculier; 3 changing beers (sourced nationally; often Caledonian, Ossett, Theakston) Ⓗ
Historic pub in a 17th-century merchant's house, with strong connections to the English Civil War, hidden down an alley near Hull's Old Town. The existing ground-floor interior, which dates back to a major 1881 refurbishment, was an idealised recreation of an old English inn, complete with two impressive inglenook fireplaces and stained-glass windows. The first floor features the Plotting Parlour and restaurant facilities, while a secluded courtyard provides an outdoor drinking area. ♿🌂♣♠▯🌂

Scale & Feather

21 Scale Lane, HU1 1LF
☎ 07808 832295
4 changing beers (sourced nationally; often North Riding Brewery, Ossett) Ⓗ
Previously known as Walters, this has been an Old Town favourite for some time due to its wide range of real ales and ciders together with craft keg and cans plus numerous spirits. It is a large single-roomed pub with a thoroughly modern feel. The upper floor provides function room facilities and increased capacity for busy periods. Over-21s only. 🕑▯●▯🌂🛜

St John's Hotel

10 Queens Road, HU5 2PY
☎ (01482) 341013 ⊕ stjohnshull.com
Banks's Sunbeam; Marston's Old Empire; Wainwright; 2 changing beers (sourced nationally; often Brakspear, Ringwood) Ⓗ
An unspoilt Grade II-listed community local, recognised by CAMRA as having a regionally important historic pub interior, and once a regular haunt of the late poet laureate Philip Larkin. Built in 1865 and remodelled by Hull Brewery in around 1904, it comprises three unique, characterful rooms. Both the front, L-shaped public bar and the rear lounge, which has original bench seating, encourage friendly conversation. Another larger room houses a pool table and is used for regular beer festivals.

Live music is hosted every Tuesday. Two separate garden areas, one paved, are popular in summer.
Q🕑🌂🌂♣♠●P▯🌂🛜

Station Inn 🄻

202 Beverley Road, HU5 1AA
4 changing beers (sourced regionally; often Great Newsome, Milestone, Rudgate) Ⓗ
Built in 1870, this two-roomed pub, about half a mile north of the city centre, has an attractive interior and black and white mock-Tudor exterior, dating from an inter-war restoration. The present owner bought the pub from the Old Mill Brewery, saving it from likely conversion to flats, and refurbished it sympathetically reflecting its history. Internal features include 1920s and 1960s bar fronts and two coal fires. It boasts a friendly atmosphere and holds a regular pub quiz.
🕑🌂♣♠●▯🌂🛜

White Hart ★ 🄻

109 Alfred Gelder Street, HU1 1EP
☎ 07538 470546 ⊕ whiteharthullpub.co.uk
5 changing beers (sourced regionally; often Great Newsome, North Riding Brewery, Rudgate) Ⓗ
Located on the edge of Hull's Old Town, this Grade II-listed pub features a half-timbered frontage. It has a nationally important historic pub interior, with a rare example of a ceramic bar, made by Burmantofts of Leeds, as well as many other original features, such as the original bar back, dating from 1904. There is a pool table in the large back bar and sports are shown in both bars. Outside is a sheltered beer garden to the right hand side. Q♿🕑🌙♣♠●P▯🌂🛜

Kilham

Old Star Inn

Church Street, YO25 4RG
☎ (01262) 420619
Theakston Best Bitter; 2 changing beers (sourced regionally; often Great Newsome, Ossett) Ⓗ
Located in the centre of the village, opposite the imposing church, this delightful pub with beamed ceilings contains three distinct areas off the bar. In winter two of these have real fires, giving a homely and welcoming atmosphere. A corridor gives access to the sizeable garden with covered portions in case of inclement weather. Locally sourced, high-quality food is served all day. Locals, walkers, bikers and cyclists are all made equally welcome. The pub has family ties with the local Raven Hill brewery. Q♿🕑🌙♠♣P🌂🛜

Kirk Ella

Beech Tree

South Ella Way, HU10 7LS
☎ (01482) 654350
Brakspear Gravity; Tetley Bitter; house beer (by Black Sheep); 5 changing beers (sourced nationally) Ⓗ
Open-plan pub on the western outskirts of Hull, owned by a pub company committed to cask ale. Up to eight real ales are available, including at least one dark beer – try-before-you-buy is encouraged. Food is served lunchtime to evening every day with brunch on weekends. Monday and Wednesday are quiz nights. Families with children are welcome throughout and a real fire makes for a hospitable winter feel. Buses stop close to the pub until early evening, and a later-running route is only a 10-minute walk away.
♿🌂🕑🌙♿P▯(154,180) 🛜

Lund

Wellington Inn L
19 The Green, YO25 9TE
☎ (01377) 217294 🌐 thewellingtoninn.co.uk
Timothy Taylor Landlord; Theakston Best Bitter; 1 changing beer (sourced locally; often Great Newsome, Wold Top) Ⓗ
Multi-roomed pub in a prime location on the green in this award-winning Wolds village. Renovated by the long-serving licensee, it features stone-flagged floors, beamed ceilings, three real fires and a games room. Most of the pub's trade comes from locals, including the farming community, although excellent-quality food attracts diners from further afield. Guest beers are usually sourced locally. The division of dining to drinking space is agreeably balanced. ⑤❀🌙&♣P🖵(142)

Market Weighton

Bay Horse
75 Market Place, YO43 3AN
☎ (01430) 876822 🌐 thebayhorsemw.co.uk
Timothy Taylor Landlord; 3 changing beers (sourced regionally; often Bradfield, Half Moon, Theakston) Ⓗ
Dating from the mid 18th-century, the Bay Horse is a Grade II-listed former coaching inn on the old Hull to York main road. An independent family-run free house, it serves four real ales and a food menu specialising in fresh fish and seafood, with the ingredients sourced locally. In addition to the bar area there is a restaurant and function room. Outside, a spacious patio garden to the rear offers alfresco dining. ⑤❀🌙P🖵

Millington

Gait
Main Street, YO42 1TX
☎ (01759) 302045
Black Sheep Best Bitter; Tetley Bitter; Theakston Best Bitter; 3 changing beers (sourced locally; often C'84, Half Moon, Wold Top) Ⓗ
Delightful Yorkshire Wolds pub that provides a warm welcome (seasonally by means of a wood-burning stove) to both locals and the many walkers enjoying the attractions of Millington Woods and Pastures. An idiosyncratic bar is filled with a range of ornaments and local pictures. Sit at kitchen-style tables to enjoy hearty home-made food from an extensive menu. An annual beer festival is held with up to 35 beers on offer. Three regular ales are served with at least one guest, typically all from Yorkshire. ⑤❀🌙&♣P❀🛜

Newton-upon-Derwent

Half Moon
Main Street, YO41 4DB
☎ (01904) 608883 🌐 thehalfmoonnewton.co.uk
Ainsty Flummoxed Farmer; Old Mill Traditional Bitter; Blonde Bombshell; Timothy Taylor Landlord; 1 changing beer Ⓗ
The Half Moon free house has served the community of Newton-upon-Derwent since 1743. Originally a single-storey thatched building, it had taken on its current guise by 1904, and underwent some refurbishment in the 1930s. In the 1800s inquests were conducted here and from 1852 the Newton Agricultural Shows were held in the grounds, ending the day with a wonderful village dinner with many toasts. ⑤❀🌙P❀🛜

North Cave

White Hart L
20 Westgate, HU15 2NJ
☎ (01430) 470940
House beer (by Great Newsome); 2 changing beers (sourced regionally; often Great Newsome, Theakston, Wold Top) Ⓗ
This welcoming traditional village pub is a credit to the community it serves. There is a long bar room to the side and rear while the quieter front bar has comfortable seating and is where the three real ales are on offer. The house beer, 1776, provides an insight to the history of the pub. Third-pint taster trays are now available. Open fires are lit during the winter months, providing further home comforts. Walkers and dogs are welcome. A popular stop off for visitors to Beverley races.
Q⑤❀♣P🖵(155)❀

Pocklington

Market Tap
11-13 Market Place, YO42 2AS
☎ (01759) 307783
9 changing beers (often Brew York) Ⓗ
Situated overlooking the market place, this 19th-century building and former newsagent has a light, spacious and modern feel, set over two floors. An extensive range of up to nine cask beers and nine craft keg beers is on offer, including five cask regulars from Brew York. Off-sales of wines, beers and ciders are available too. Food is served on weekend lunchtimes, and evenings Wednesday to Sunday. ⑤🌙❀🛜

Rawcliffe

Jemmy Hirst at the Rose & Crown
26 Riverside, DN14 8RN (from village green turn N on Chapel Lane)
☎ (01405) 837902
Timothy Taylor Landlord; 5 changing beers (sourced locally; often Bradfield, Little Critters) Ⓗ
An established traditional free house in the heart of the village, recognised as an award-winning real ale pub. New owners have kept this pub in its traditional style while investing in modernising the cellar, decorating and cleaning to give a fresh, cared-for atmosphere that is appreciated by existing and new customers. All are assured of a warm and friendly welcome, including families and dog owners. Q⑤❀❀≠♣P🖵(401)❀

Rudston

Bosville Arms
Main Street, YO25 4UB (on the B1253 at edge of village)
☎ (01262) 371426 🌐 rudstoncommunitypub.co.uk
Bradfield Farmers Blonde; Timothy Taylor Landlord; Wold Top Bitter; 3 changing beers (often Wold Top) Ⓗ
Purchased by the local community in 2020 following a campaign to save it, this pub was subsequently refurbished and reopened in mid 2021. It is now a welcoming establishment that features a central bar and provides several areas for fine dining to complement the excellent beers. Seasonal ingredients are locally sourced wherever possible. Externally there is a car park, a beer garden and a separate accommodation block.
Q⑤❀🌙🌙AP❀

Snaith

Yorkshire Ales Beer Café Bar
Selby Road, DN14 9HT (on edge of Market Place)

☎ (01405) 860603
Bad Seed Session IPA; 2 changing beers (sourced regionally; often Revolutions) ▣
Yorkshire Ales promotes beers brewed by small, independent Yorkshire microbreweries. The building dates back to 1750 and has seating for 80 over two floors, plus the beer garden. Food is snacks only, but artisan chefs and street food vendors are booked regularly. Music is at background volume and there are no TVs, promoting the art of conversation. Local cycling and photography clubs meet regularly, and the weekly general knowledge quiz is very popular.
Q ⑤ ❀ ◖ ⇌ ♣ ● 🖤🖵 (401) ❀ ♥ 🛜

Sutton Upon Derwent

St Vincent Arms ⓛ
Main Street, YO41 4BN
☎ (01904) 608349 ⊕ stvincentarms.co.uk
Fuller's London Pride; Kirkstall Three Swords; Timothy Taylor Golden Best, Landlord; Theakston Old Peculier; 1 changing beer (sourced nationally) ▣
A winner of many local CAMRA awards, this pretty white-painted village free house has been family owned and well run for generations. It has a large but consistent beer range, the changing ale usually from a local independent brewer. The cosy bar to the right, featuring a large Fuller, Smith & Turner mirror, is popular with locals. Another small bar to the left, with a serving hatch, leads to the dining rooms. Excellent food is served, beyond the usual pub offerings. Q ⑤ ❀ ◖◗ ● P

Walkington

Barrel Inn
35 East End, HU17 8RX
☎ 07550 078833 ⊕ barrelwalkington.co.uk
Thwaites IPA; Wainwright ▣
Friendly drinkers' local in a quiet three-pub village, one of only a handful of Thwaites pubs in East Yorkshire. The front bar, with a log fire and beamed ceiling, has a step leading to a connecting lounge, also with a log fire. To the rear is a secluded cottage-style garden. Families and dogs are welcome. Although this is essentially a quiet pub, major Premier League football matches and some other sporting events are shown. Thursday is quiz night.
⑤ ❀ ♣ P 🖵 (180,61,X80) ♥

Withernsea

Captain Williams ⓛ
The Promenade, HU19 2DP
☎ (01964) 612083
Timothy Taylor Boltmaker, Knowle Spring; 1 changing beer (sourced regionally; often Great Newsome, Titanic, Wold Top) ▣
Formerly known as the Marine Bar, the pub was built as a private dwelling in 1893 and is named after the original builder and owner Captain William Newman. The interior has been fully refurbished including adding a nautical feature wall. Relax in the comfortable lounge area with panoramic views of the beach and North Sea. Accommodation is provided courtesy of five en-suite letting rooms and three chalets. Booking is recommended for Sunday lunches. Live acts perform monthly at weekends. ⑤ ❀ ❀ ◖◗ ♿ P 🖵 ❀

Old BoatShed ⓛ
2 Seaside Road, HU19 2DL
☎ 07812 446689
4 changing beers (sourced regionally; often Black Sheep, Great Newsome, Wold Top) ▣

This small pub was opened in 2016 in the building originally built in 1881 to house the Withernsea lifeboat station before being decommissioned in 1913. Four cask ales and three real ciders are served in this community-focused bar where conversation is actively encouraged in preference to loud music or TV. Beers and ciders can be sampled using a beer bat holding three thirds. There is a comfortable raised seating verandah outside to the front. Children and dogs are welcome.
Q ⑤ ❀ ♣ ♿ ♣ ● 🖵 (76,129) ❀

Breweries

Aitcheson's

Windham Farm, Ferry Road, Wawne, Hull, East Yorkshire, HU7 5XY ☎ 07456 063670
Office: 2 Wheelhouse Court, Hull, HU6 5BF
⊕ eastyorkshirebeer.co.uk

☺Formerly the East Yorkshire Beer Company, Aitcheson's was established by Steve Aitcheson in 2020 after relocating from Beverley. Ingredients are sourced as locally as possible, grains malted in Bridlington and Castleford and UK hops used where possible. The beer range is named after historic Hull and East Yorkshire pubs. Brewing experience days can be booked. ♦

Top House Mild (ABV 3.8%) MILD
King Billy Bitter (ABV 4.2%) BITTER
Earl de Grey IPA (ABV 4.5%) PALE
Full Measure Porter (ABV 4.5%) PORTER
Star of the West Pilsner (ABV 4.6%) SPECIALITY
Odd Fellows Irish Red (ABV 4.7%) RED

All Hallows

▤ **Main Street, Goodmanham, East Yorkshire, YO43 3JA**
☎ (01430) 873849 ⊕ goodmanhamarms.co.uk

☺Abbie Logozzi, landlady of the Goodmanham Arms, started brewing in 2012 in outbuildings behind the pub. The ex-Goodmanham Brewery buildings were purchased and a five-barrel plant installed. The brewery name comes from the adjacent 12th century All Hallows Church. Local legendary characters are used in the naming of some of the beers. Brews are supplied to the pub and its sister pub, the Bay Horse, Burythorpe. 🚚♦

Atom SIBA

Unit 4, Food & Tech Park, Malmo Road, Sutton Fields Industrial Estate, Hull, East Yorkshire, HU7 0YF
☎ (01482) 820572 ⊕ atombeers.com

⊠ Atom Brewing Co was founded in 2014 by Allan Rice and Sarah Thackray. Most of its production goes into can and keg, but cask ales are produced in rotation or on demand, around a core range of four. Atom's ethos is science and education based, so working with local colleges, it runs regular brewing schools and classes. All beers are unfined and unfiltered (so naturally hazy). ‼♦

Schrodingers Cat (ABV 3.5%) BITTER
Blonde Ale (ABV 4%) BLOND
Dark Matter (ABV 4.5%) SPECIALITY
Critical Temperature (ABV 5.5%) SPECIALITY

Belschnickel (NEW) SIBA

Hull, HU5 3AU
☎ (01482) 348747 ⊕ belschnickel.co.uk

Launched in 2022, Belschnickel Brewery work on a small scale with a 50-litre brewhouse to produce a small core range of canned beers and bottle-conditioned speciality beers brewed for aging. All the brewing, canning and packaging is completed in-house. All beers are unfiltered and unpasteurised. Its branding and labels are produced in collaboration with a local artist. LIVE

Bone Machine

20 Pier Street, Hull, East Yorkshire, HU1 1ZA
☎ (01482) 618000 ☎ 07931 313438
✉ beer@bonemachinebrewing.com

Originally established in Pocklington in 2017, Bone Machine transferred operations to Hull's Fruit Market in 2019, brewing on an eight-barrel plant. Finnish brothers Marko and Kimmo previously worked at Atom and Brass Castle Brewery before setting up on their own. Beers are mainly available in keg and can, with a small amount in cask. ◆

Back Bone (ABV 3.7%) BITTER
Cloud Piercer (ABV 4.7%) BITTER
Dream Machine (ABV 5.2%) BITTER

Bricknell

Bricknell Avenue, Hull, East Yorkshire, HU5 4ET
☎ 07729 722953 ⊕ bricknellbrewery.co.uk

Bricknell's range comprises of 18 bottle-conditioned, vegan-friendly ales, two of which are seasonal. Some hops are grown on-site, some sourced locally. Everything is hands-on, from brewing, to hand-bottling and labelling, to delivery. Brewing takes place twice a week, and includes many ales from 19th-century recipes. The brewery sells to local pubs, bars and restaurants as well as directly to the public and to local beer festivals. ◆LIVE V

Anchor Pale Ale (ABV 4.1%) PALE
Cascade Pale (ABV 4.8%) PALE
Bosphorous 1875 Ruby Ale (ABV 5.4%) MILD
Double Anchor IPA (ABV 5.6%) IPA
Lodona 1862 (ABV 5.8%) IPA
Zoroaster 1818 (ABV 5.8%) IPA
Chocolate Porter (ABV 6%) SPECIALITY

Bridbrewer

🖫 2a Chapel Street / 5 King Street, Bridlington, East Yorkshire, YO15 2DN
☎ (01262) 674300 ☎ 07727 107435
⊕ bridbrewerandtaproom.co.uk

After two years developing his recipes as a homebrewer, Stuart Fisher launched his unfined beers commercially in 2020 from his brewpub, located in central Bridlington. A 20-litre Braumeister kit is used and most beers are vegan-friendly. ◆LIVE V◆

Great Newsome SIBA

Great Newsome Farm, South Frodingham, Winestead, East Yorkshire, HU12 0NR
☎ (01964) 612201 ⊕ greatnewsomebrewery.co.uk

☺Nestled in the Holderness countryside, Great Newsome began brewing in 2007 in renovated farm buildings. A range of beers is now brewed using barley from the farm and brewing can be seen from a viewing area. Expansion into other farm buildings in 2018, and again in 2019, increased brewing capacity to 20-barrels. Contract brewing is carried out on behalf of other local breweries. Beer is distributed throughout the UK and overseas. ‼️🛒◆

Sleck Dust (ABV 3.8%) BLOND

Pricky Back Otchan (ABV 4.2%) BITTER
Frothingham Best (ABV 4.3%) BITTER
Holderness Dark (ABV 4.3%) MILD
Jem's Stout (ABV 4.3%) STOUT
Liquorice Lads Stout (ABV 4.3%) SPECIALITY

Half Moon

Forge House, Main Street, Ellerton, York, East Yorkshire, YO42 4PB
☎ (01757) 288977 ☎ 07741 400508
⊕ halfmoonbrewery.co.uk

Established in 2013 by Tony and Jackie Rogers, the brewery is situated in a former blacksmith's forge with a capacity of 5.5-barrels. Brewing takes place two-three times a week. ◆LIVE ◆

Dark Masquerade (ABV 3.6%) MILD
Old Forge Bitter (ABV 3.8%) BITTER
F'Hops Sake (ABV 3.9%) BITTER

Old Mill SIBA

Mill Street, Snaith, East Yorkshire, DN14 9HU
☎ (01405) 861813 ⊕ oldmillbrewery.co.uk

☺Opened in 1983 in a 200-year-old former malt kiln and corn mill, the brew-length is 60 barrels. The brewery is building a tied estate, now standing at 16 houses. Beers can be found nationwide through wholesalers and around 80 free trade outlets are supplied direct. The RT Brew Co range is produced for HB Clark (qv). ‼️◆

Bullion IPA (ABV 3.7%) GOLD
Jack's Batch 34 (ABV 3.8%) BITTER
Traditional Bitter (ABV 3.8%) BITTER
Blonde Bombshell (ABV 4%) BLOND
La Bolsa Coffee Porter (ABV 4.5%) SPECIALITY

Pumphouse

Unit 10d, Twydale Business Park, Skerne Road, Driffield, East Yorkshire, YO25 6JX ☎ 07811 180195
✉ david@pumphousebrewing.co.uk

Launched in 2019, Pumphouse Brewing are a craft brewery producing small batch, one-off beers available in keg and bottle. The constantly-changing range is unfined and unfiltered. ◆

Raven Hill

Raven Hill Farm, Driffield, East Yorkshire, YO25 4EG
☎ 07979 674573 ⊕ ravenhillbrewery.com

Raven Hill Brewery started trading in 2018. Based on a Yorkshire farm near Kilham, it brews four regular beers of varied styles and produces regular seasonal beers in small batch quantities.

Summit (ABV 3.6%) PALE
Chalk Stream (ABV 4%) GOLD
Brook (ABV 4.3%) GOLD
Ridge Way (ABV 5.5%) STOUT
Elevation (ABV 6.2%)

Spotlight

The Goddards, Goole Road, Goole, West Cowick, East Yorkshire, DN14 9DJ ☎ 07713 477069
✉ ric@spotlightbrewing.co.uk

☺Spotlight is a social enterprise that is passionate about good beer. All beers are brewed, packaged and delivered by people with learning disabilities. The beer names reference medical conditions. Brewing is currently suspended. ‼️🛒◆

Vittles

Hull Trinity Market, Trinity House Lane, Hull, East Yorkshire, HU1 2JH ☎ 07598 098632 ⊕ vittlesandcompany.co.uk

Vittles & Co started brewing in 2018 at the Trinity Market, Hull. The site can produce just 50 litres at a time. The brewery name comes from the fact that the owner loves to pair beer and food, hence the old name for food, vittles. 🍴

Woolybutt Brew Shed

Hull, East Yorkshire, HU5 2NS ☎ 07966 511242 ⊕ woolybuttbrewshed.co.uk

⊙Woolybutt Brew Shed is a two-barrel brewery. Rob Sutherland moved to commercial brewing after years of homebrewing experience.

English Pale Ale (ABV 4.4%) PALE

Yorkshire Brewhouse

Matrich House, Goulton Street, Hull, East Yorkshire, HU3 4DD ☎ (01482) 755199 ⊕ yorkshirebrewhouse.com

⊙Founded in 2017 by friends Jon Constable and Simon Cooke as a weekend family venture. The brewery started with a 200-litre capacity and has now expanded to 2,500 litre per batch. It supplies cask, bag in box and bottle-conditioned ale to East Yorkshire outlets, and online. Most of the beers are given names that mirror Yorkshire dialect or have a local connection. LIVE

1904 (ABV 3.8%) BITTER
Reet (ABV 3.8%) BITTER
EYPA (ABV 3.9%) PALE
Tenfoot (ABV 3.9%)
Ey Up (ABV 4%) BITTER
Faithful (ABV 4.5%) STOUT
Flippin Eck (ABV 4.6%) OLD
Red Robin (ABV 4.6%) STOUT
Well Chuffed (ABV 4.9%) PALE

Yorkshire Coast

105 Hilderthorpe Road, Bridlington, East Yorkshire, YO15 3ET ⊕ yorkshire-coast-brewery.com

Established in the basement of the Funny Onion pub in 2019, Yorkshire Coast Brew Co was launched commercially in 2020. With 30 years experience of brewing, head brewer Steve Golden brews small batches of traditional ales. 🍴

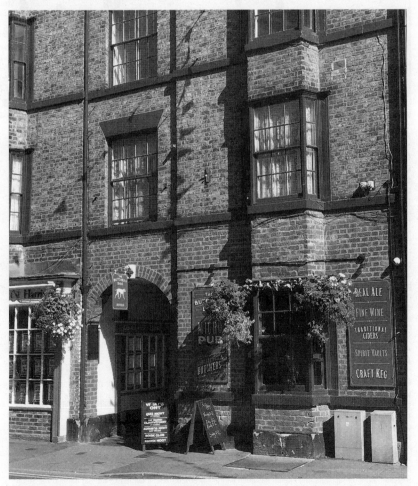

Butcher's Dog, Driffield (Photo: Stewart Campbell)

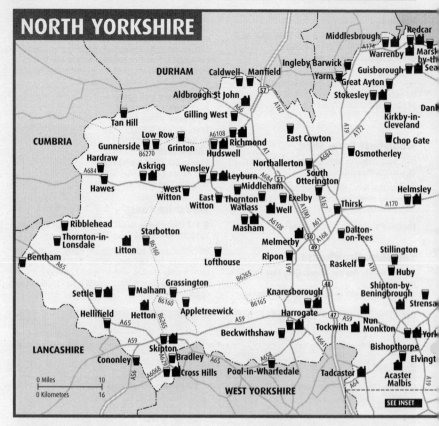

NORTH YORKSHIRE

Appletreewick

Craven Arms ⚏

BD23 6DA

☎ (01756) 720270 ⊕ craven-cruckbarn.co.uk

**Dark Horse Craven Bitter, Hetton Pale Ale, Night Jar;
Theakston Old Peculier; Wharfedale Wharfedale
Blonde; 2 changing beers (sourced regionally)** Ⓗ

Dating from 1548, this multi-roomed Dales free house
has stone-flagged floors, oak beams and gas lighting.
The main bar features an original Yorkshire range while
the cosy taproom has an open fire and the game of ring
the bull. A snug behind the bar leads to the cruck barn,
added in 2006 using traditional techniques. This can be
hired for functions and hosts occasional events including
music and a beer festival in October. Two additional
guest beers are available in summer. Accommodation is
in three shepherd's huts.

Q ☻ 🏠 🛏 🍴 ⅃ & ▲ ♣ ◆ ₽ ➡ (74A) ❀ 🛜

Askrigg

Crown Inn ⚏ ✅

Main Street, DL8 3HQ

☎ (01969) 650387 ⊕ crowninnaskrigg.co.uk

**Theakston Best Bitter; Wensleydale Semer Water; 2
changing beers (sourced locally; often Theakston,
Wensleydale)** Ⓗ

A three-roomed family-run pub, at the top of the main
street of the village, which attracts a good mix of locals
and visitors, and is particularly popular for its bar meals
sourced from local suppliers. The interior has been partly
opened out but retains much of its traditional character,
with a very impressive range in the cosy snug, and open
fires to warm walkers seeking shelter from the fells.

☻ ◀ ● ▲ ♣ ₽ ➡ ❀ 🛜

King's Arms ⚏

Main Street, DL8 3HQ

☎ (01969) 650113 ⊕ kingsarmsaskrigg.com

**Black Sheep Best Bitter; Theakston Best Bitter; 3
changing beers (sourced locally; often Yorkshire
Dales)** Ⓗ

A historic Grade II-listed Dales free house of great
character which starred as the Drover's Arms in the
original All Creatures Great and Small. A huge open
fireplace and a painting of the Askrigg Friendly Society
add character to the stone-flagged bar. There are
separate dining rooms plus a vaulted games room to the
rear and a small outdoor courtyard. Three house beers
are from the Yorkshire Dales brewery, a few hundred
yards away. If you want to eat at busy times reserving a
table is recommended. ☻ ❀ ◀ ▲ ⅃ ➡ (156) ❀ 🛜

Beck Hole

Birch Hall Inn ★ ⚏

YO22 5LE (approx 1 mile N of Goathland)

☎ (01947) 896245 ⊕ beckhole.info

**Black Sheep Best Bitter; North Yorkshire Beckwatter;
1 changing beer** Ⓗ

Unspoilt, family-run rural gem, resting among a hamlet
of cottages, run by an accomplished fine artist who is
also celebrating 42 years of continuous service to the
licensed trade. It comprises the Big Bar and the Small
Bar, which sandwich a sweet shop. Pleasant outdoor

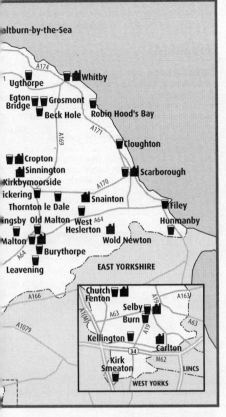

Looking like what it is – the top floor of a barn, with bare floorboards and stonework – it was converted to a pub in 1986. A variety of furniture includes grotesque wooden shapes made by the landlord. Most of the interior is open to the rafters: the loft space houses a Harley-Davidson and a motor scooter; the pub bills itself as biker-friendly but the clientele is quite mixed. Opening hours may vary during school holidays. ✿▲⇌P🚌(80)✿♣🌐

Bishopthorpe

Marcia Inn 🅛 ✅
29 Main Street, YO23 2RA
☎ (01904) 706185 🌐 marciainnbishopthorpe.co.uk
Leeds Pale; Timothy Taylor Landlord; 3 changing beers (sourced locally; often Half Moon, Rudgate, Treboom) 🅗
The landlord of this popular village local is so passionate about real ale that an onsite brewery Bishy BrewHouse is underway. Five handpumps serve mainly LocAles and there is an annual beer and cider festival in the large rear garden, which also has covered seating and a children's play area. A good range of award-winning food is served. Pub games, a Wednesday quiz night and support for local clubs and teams make for a relaxed and friendly atmosphere. Q😋✿❀🌙&▲♣P🚌(11)✿🌐

Woodman
16 Main Street, YO23 2RB
☎ (01904) 706507 🌐 thewoodmaninnpub.com
Timothy Taylor Landlord; 3 changing beers (often Ainsty, Ossett, Rudgate) 🅗
This spacious traditional pub has a pleasant decked area built around the front door. There are three handpulls with a range of rotating LocAles that offer plenty of variety, including beers from Ainsty, Ossett and Rudgate. To the rear there is a large, child-friendly garden with plenty of seating and a purpose-built adventure area. The food menu is focused on using fresh local produce to create classic British food with a modern twist.
😋✿❀&▲P🚌(11)✿

Bradley

Slaters Arms 🅛 ✅
Crag Lane, BD20 9DE (SE corner of village on back road to Kildwick)
☎ (01535) 632179
Timothy Taylor Golden Best, Boltmaker; 1 changing beer (sourced locally; often Ossett, Saltaire) 🅗
Two-roomed local, half a mile from the canal. The large outdoor area has extensive views of the Aire Valley. The main horse brass and wooden beam-style lounge has an open fireplace and real fire. The separate cosy back room is adorned with sporting photos, mainly of the local cricket teams which are based at the pub. Children are permitted early doors or if eating. The last Wednesday of the month is quiz night. A Timothy Taylor Champion Club member. 😋✿❀♣P🚌(71,78A)✿↻

Burn

Wheatsheaf 🅛
Main Road, YO8 8LJ
☎ (01757) 270614 🌐 wheatsheafburn.co.uk
5 changing beers (often Ossett, Timothy Taylor) 🅗
Traditional country pub that serves a varied range of guest beers, mainly from Yorkshire breweries, and is popular for its excellent, reasonably priced food. There is a collection of artefacts from bygone days and memorabilia of 578 and 431 Squadrons, stationed at Burn in World War II. The Wheatsheaf stages regular beer

drinking facilities overlook the Murk Esk. The house beer, Beckwatter, is brewed organically by North Yorkshire. Sandwiches, pies, beer cake and traditional sweets are always available. Hours change during winter.
Q😋✿&♣✿🐾

Beckwithshaw

Smiths Arms 🅛 ✅
Church Row, HG3 1QW
☎ (01423) 504871
Black Sheep Best Bitter; Greene King IPA; Timothy Taylor Landlord; 2 changing beers (often Great Newsome) 🅗
A Chef & Brewer food-led venue in an 18th-century building that, as the name suggests, was formerly a blacksmith's forge. Set in a quiet hamlet to the south-west of Harrogate, the pub comprises an L-shaped bar area and a separate restaurant. An excellent menu with many seasonal dishes is offered throughout the day in both the restaurant and bar. The five handpumps serve three permanent beers and two widely sourced guest ales. Boxed ciders are also usually available.
😋✿❀&P✿🌐

Bentham

Hoggs 'n' Heifers
Main Street, LA2 7HF (on Auction Mart Yard)
☎ (015242) 98950
Kirkby Lonsdale Monumental Blonde; 2 changing beers 🅗

festivals, quiz nights, live music, barbecues and many other activities. The pub is dog friendly.
Q🚲🛏🍴🐕🛤♣P🚃(476,405) 🌸🛜

Burythorpe

Bay Horse
Main Street, YO17 9LH
☎ (01653) 658700 ⊕ bayhorsepub.co.uk
All Hallows Peg Fyfe Dark Mild, No Notion Porter, Ragged Robyn; 3 changing beers (sourced locally; often Hambleton, Ossett, Theakston) ⊞
Nestled in the Yorkshire Wolds, the multi-roomed Bay Horse is homely with farming paraphernalia, low lighting, multiple real fires, traditional furniture and a tiled floor. The range of beers includes three from the All Hallows Brewery, which is situated at its sister pub in Goodmanham. The attractively priced menu is wide ranging and adventurous, using locally sourced ingredients, with steak and pie night on Tuesday. The pub reopened following an extensive renovation in 2016 after a previously uncertain future.
Q🛏🛴🍴🐕♣P🚃🌸🛜

Caldwell

Brownlow Arms
DL11 7QH
☎ (01325) 718471 ⊕ brownlowarms.co.uk
Timothy Taylor Landlord; 2 changing beers (sourced nationally) ⊞
Set in the quiet village of Caldwell, the Brownlow Arms could be described as the perfect country inn. It boasts a fine dining restaurant as well as two cosy bars with open log fires where you are guaranteed to find some welcoming locals. Three cask ales always include Timothy Taylor Landlord, the others are ever-changing, but often from the Yorkshire Dales – requests are always welcome. There is a huge choice of home-cooked food to accompany your ale. Q🛏🛴🍴🐕P🌸🛜

Chop Gate

Buck Inn 🄻
TS9 7JL (on B1257, between Stokesley and Helmsley)
☎ (01642) 778334 ⊕ the-buck-inn.co.uk
3 changing beers ⊞
Set amid a walkers' paradise, and close to the route of Wainwright's Coast-to-Coast walk, this picturesque family-run village pub offers a slice of Yorkshire with a Teutonic twist. Three locally sourced beers and seven especially imported draught lagers, brewed under the 506-year-old German Purity Laws, are served, together with real home-made food, again half Yorkshire/half German. There are six en-suite bedrooms, some designated dog friendly, while free camping is offered to those campers who also choose to dine here. Check winter opening hours. Q🛏🛴🍴🛌🐕♣P🚃(M4)🌸🛜

Church Fenton

Fenton Flyer 🄻
Main Street, LS24 9RF
☎ (01937) 558137
Ossett White Rat; 3 changing beers (sourced regionally; often Ilkley, Leeds, Ossett) ⊞
Friendly village pub with pictures of the nearby WWII airbase that is now a commercial airport. The beers are chosen from the SIBA list and are often LocAle. Live music is played on the first Friday of each month, with a monthly Saturday disco with karaoke and a quiz night on Wednesday raising money for local charities. Sky and BT

sports TV are in the main bar and there is an adjacent games room with pool table and darts. Beer festivals are held in June and November. 🛴🛏🛌🐕♣P🚃(492)🌸🛜

Cloughton

Bryherstones Country Inn
Newlands Road, YO13 0AR (½ mile up Newlands Rd off A171 at Cloughton)
☎ (01723) 870744 ⊕ bryherstonescountryinn.co.uk
Timothy Taylor Landlord; 1 changing beer (sourced regionally; often York) ⊞
A stone-built pub nestling between the North York Moors and the coast, just outside the village of Cloughton. Back in the hands of the Shipley family since 2009, it has been restored to its former glory. Its many rooms, full of interesting features and ornaments, include a separate games room. As well as being a designated Timothy Taylor Champion Club establishment, it offers an extensive locally sourced food menu (booking is

REAL ALE BREWERIES

3 Non Beards 🍺 York
Ainsty 🔨 Acaster Malbis
Another Beer 🔨 Elvington
Bad Seed Malton
Black Sheep 🔨 Masham
Brass Castle 🔨 Malton
Brew York 🔨 York
C'84 🍺 Cropton
Captain Cook Stokesley
Copper Dragon Skipton
Craven 🔨 Cross Hills (NEW)
Crooked 🔨 Church Fenton
Daleside Harrogate
Dark Horse Hetton
Great British Breworks Kirkbymoorside
Guisborough 🔨 Guisborough
Hambleton Melmerby
Harrogate 🔨 Harrogate
Helmsley 🔨 Helmsley
Ice Cream Factory York
Jolly Sailor 🍺 🔨 Selby
Kirstall Cross Hills
Lady Luck 🍺 Whitby
LAMB Litton
Little Black Dog Carlton
Live Hudswell (brewing suspended)
Malton Malton
Mithril Aldbrough St John
North Riding (Brewery) Snainton
North Riding (Brewpub) 🍺 Scarborough
North Yorkshire Warrenby
Pennine Well
Play Brew 🔨 Middlesbrough
Redscar 🍺 Redcar
Richmond Richmond
Rooster's 🔨 Harrogate
Rudgate Tockwith
Ryedale Sinnington
Samuel Smith Tadcaster
Scarborough Scarborough
Selby Middlebrough Selby (NEW)
Settle Settle
Theakston 🔨 Masham
Treboom Shipton-by-Beningbrough
Turning Point 🔨 Knaresborough
Wensleydale 🔨 Leyburn
Whitby 🔨 Whitby
Wold Top Wold Newton
Yorkshire Dales 🔨 Askrigg
Yorkshire Heart Nun Monkton

advised). Children and dogs are welcome; there is a play area in the spacious beer garden.
Q🌞✤🍴◗Å♣●P🚭(115) 🐾🕏

Hayburn Wyke Hotel L
Newlands Road, YO13 0AU (off Ravenscar road, 1½ miles N of jct with the A171)
☎ (01723) 870202 🌐 hayburnwykeinn.co.uk
Black Sheep Special Ale; Theakston Old Peculier; 2 changing beers (sourced regionally; often Wold Top) Ⓗ
An 18th-century coaching inn in woodland next to the disused Scarborough to Whitby railway, and only minutes away from the Cleveland Way coastal path and rocky beach. It is popular with cyclists and walkers. Home-made food is served lunchtimes and evenings (no food Mon eves), with the Sunday carvery a local favourite. En-suite accommodation is available. Outside is a well-provisioned children's play space and a sizeable heated smoking area. Q🌞✤🍴◗Å♣P🚭(115)🐾🕏

Cononley

New Inn L ✅
Main Street, BD20 8NR
☎ (01535) 636302
Timothy Taylor Golden Best, Boltmaker, Knowle Spring, Landlord; 1 changing beer (often Timothy Taylor) Ⓗ
A real community local with mullioned windows and low-beamed ceilings. The bar area is warmed by a wood-burning stove in a huge stone fireplace. Pot plants and china animals adorn the shelves and windowsills. The Archives room has a pool table and TV. Although just a short walk from Cononley railway station, if catching a train south allow time at the level crossing as the barriers often come down early. Quiz night is on Tuesday.
🌞✤Å≈♣🚆(78A) 🐾

Cropton

New Inn L
Cropton Lane, YO18 8HH (leave A170 at Wrelton and follow signs for Cropton)
☎ (01751) 417330 🌐 newinncropton.co.uk
C'84 Yorkshire Classic, Yorkshire Golden, Yorkshire Moors, Yorkshire Blackout, Monkmans Slaughter; 1 changing beer (sourced locally; often C'84) Ⓗ
The brewery tap for C'84 (formerly Cropton/Great Yorkshire Brewery), this is a family-run pub on the edge of the North Yorkshire Moors National Park. An attractive stone building, it is a perfect base for walking and cycling, offering good food in the bars, conservatory or restaurant, and B&B or camping accommodation. With up to six of the well-regarded Great Yorkshire ales, it doesn't get more LocAle than this. A legendary beer festival is held every November, plus a music festival in summer. Dog and rambler friendly.
Q🌞✤🍴◗Å♣P🚭🐾🕏

Cross Hills

Gallagher's Ale House L
1-3 East Keltus, BD20 8TD (in village centre)
☎ (01535) 957270
5 changing beers (sourced nationally) Ⓗ
This popular micropub is located in what used to be Gallagher's bookmakers shop. The five changing ales usually include a dark beer, a pale bitter and a strong or speciality beer. The cellar can be viewed through a window to the left of the bar. No electronic music or TV disturbs the conversation. Gallagher's supports a number

of groups and causes in the local area. Parking is available adjacent to the Co-op store round the corner.
Q♣●🚆(M4,66) 🐾🕏

Dalton-on-Tees

Chequers Inn ✅
The Green, DL2 2NT
☎ (01325) 721213
Bombardier; Ringwood Boondoggle; 1 changing beer (sourced nationally) Ⓗ
Traditional inn dating back to the 1840s, comprising a bar, lounge and restaurant, with a warm welcome guaranteed from the friendly staff. The atmosphere is a combination of traditional pub and contemporary restaurant. Up to three of the beers are Marston's mainstays. Food is available every day, with traditional Sunday lunches served. Overnight accommodation comprises five rooms overlooking the green and its pump. Handy for Croft motor racing circuit.
Q🌞✤🍴◗♣P🚆(X27) 🐾🕏

Danby

Duke of Wellington L
West Lane, YO21 2LY (300yds N of railway station)
☎ (01287) 660351 🌐 dukeofwellingtondanby.co.uk
Daleside Bitter; Whitby Saltwick Nab; 1 changing beer Ⓗ
This 18th-century inn is set in idyllic countryside, close to the Moors National Park Centre and the local traditional baker's shop. The inn was used as a recruiting post during the Napoleonic Wars. A cast-iron plaque of the first Duke of Wellington, unearthed during restorations, hangs above the fireplace. All beers are from Yorkshire. At lunchtime, sandwiches can be brought into the pub. During the evening, the kitchen offers traditional home-cooked meals using local produce. Q🌞✤◗≈♣●🚆🐾

East Cowton

Beeswing ✅
Main Road, DL7 0BD
☎ (01325) 378349 🌐 thebeeswing.weebly.com
3 changing beers (sourced nationally) Ⓗ
Traditional country village pub with two bars, a pool room and a highly rated restaurant. The welcoming staff and real fires create a relaxing atmosphere. The pub is named after a locally bred champion racehorse, and there are numerous racing references inside. Up to three ever-changing beers and one craft ale are served. The pub caters to the local community with regular music and quizzes. Q🌞✤◗♿♣P🐾🕏

East Witton

Cover Bridge Inn L
DL8 4SQ (½ mile N of village on A6108 to Middleham)
☎ (01969) 623250 🌐 thecoverbridgeinn.co.uk
Black Sheep Best Bitter; Timothy Taylor Landlord; Theakston Old Peculier; 5 changing beers (sourced regionally; often Wensleydale) Ⓗ
A splendidly traditional Dales inn. The River Cover runs along the foot of the attractive garden and play area, near its confluence with the River Ure. Fathom out the door latch and you will be able to enjoy the warm welcome in the unspoiled public bar, or sit in the tiny lounge or pleasant beer garden. There is a choice of local beers and guests, and the popular food menu includes pub classics such as ham and eggs. Middleham Castle and Jervaulx Abbey are both within a mile.
Q🌞✤🍴◗Å♣●🚆(159) 🐾🕏

Egton Bridge

Horseshoe Hotel

YO21 1XE

☎ (01947) 895245 ● thehorseshoehotel.co.uk

Theakston Best Bitter; 3 changing beers ℍ

Secluded unspoilt 18th-century gem nestled in a horseshoe-shaped hollow. Located in beautiful countryside, it can be accessed by road, from the railway station, or by walking over the stepping stones across the River Esk. Old-fashioned settles and a large fire furnish the bar, and picnic tables make outdoor drinking a pleasure. Four handpumps feature some interesting beers. A farm shop has recently been added. An outdoor bar with two extra handpulls opens during summer. Accommodation is in six en-suite bedrooms.

Q ♿ 🏮 ⌂ ◖ ❄ (Egton) ♣ P 🚏 (95) ❀ 🅿

Exelby

Exelby Green Dragon 🄻

High Row, DL8 2HA

☎ (01677) 427715 ● exelbygreendragon.co.uk

Black Sheep Best Bitter; Timothy Taylor Landlord; 2 changing beers (sourced regionally; often Ossett, Rudgate, Wensleydale) ℍ

Reopened in 2018 following a community buyout and renovations. The knocked-through interior provides a number of different areas and a deli, and features two real fires. A spacious separate restaurant opens onto the decked terraced beer garden. The slightly altered new name distinguishes the pub from the Green Dragon in nearby Bedale. Music events include the twice-monthly folk club and weekly Wednesday sing-alongs, and numerous village activities include the book, art and gardening clubs. ♿ 🏮 ⌂ ◖ ♿ ♣ P ❀ 🅿

Filey

Cobblers Arms

2 Union Street, YO14 9DZ

☎ (01723) 512511

Wainwright; 4 changing beers (sourced regionally; often Great Newsome, Isaac Poad) ℍ

A micropub in the centre of Filey that started out as a private residence before becoming a cobbler's shop, from which the pub takes its name. The front bar area encourages conversation and there is a second smaller snug to the rear available for meetings free of charge. Four changing guest ales and five ciders are always served. The bar is dog and family-friendly. There is a regular quiz on a Tuesday night and live music occasionally. Q ♿ ♿ ● 🚏 (12,13) ❀ 🅿

Star Inn ✔

23 Mitford Street, YO14 9DX

☎ (01723) 512031 ● thestarfiley.co.uk

Black Sheep Special Ale; Bradfield Farmers Blonde; Theakston Best Bitter; 3 changing beers (sourced nationally) ℍ

Located just off Filey town centre, the Star is a family-run pub with a large main room incorporating a pool table to the left hand side, and a separate restaurant/function room to the rear. Three regular beers and three rotating guests are offered. Freshly cooked meals are served lunchtimes and evenings (except Mon). Live entertainment features occasionally, and pub teams participate in a local pool league. Smokers are catered for outside at both the front and rear.

♿ 🏮 ◖ ◖ ❄ ♣ 🚏 (12,13) 🅿

Gilling West

Angel Inn

62 High Street, DL10 5JW

☎ (01748) 824304

Timothy Taylor Landlord; 2 changing beers (sourced nationally) ℍ

A traditional free house in the picturesque village of Gilling West, which is mentioned in the Domesday Book as Gillinghesse. The Angel derives its name from the fact that it is built on the site of an old monastic building and was an important coaching inn. It is a welcoming pub to both locals and visitors alike. Tasty locally sourced pub grub and three real ales in the summer make this a place to visit. ♿ ❀ ◖ ◖ ♿ ♣ P 🚏 (29) ❀ 🅿

Grassington

Foresters Arms 🄻 ✔

20 Main Street, BD23 5AA

☎ (01756) 752349 ● forestersarmsgrassington.co.uk

Black Sheep Best Bitter, Riggwelter; Timothy Taylor Landlord; Tetley Bitter; 2 changing beers (sourced locally; often Timothy Taylor, Tetley) ℍ

Located uphill just off the cobbled town square, the Foresters is a lively, friendly inn, popular with locals and visitors alike. A real community pub, it has been run by the same family for decades. The main bar and pool/TV area are to the left and an area with further seating to the right leads to a separate dining room. There is a quiz on Mondays. Accommodation is available in seven en-suite rooms and fishing permits for the local River Wharfe can be bought at the pub. Secure cycle storage is available for staying guests.

♿ ❀ 🏮 ◖ ◖ ♣ 🚏 (72,72B) ❀ 🅿 ↺

Great Ayton

Royal Oak Hotel 🄻 ✔

123 High Street, TS9 6BW (in centre of village opp High Green)

☎ (01642) 722361 ● royaloakgreatayton.co.uk

Timothy Taylor Landlord; Theakston Old Peculier; Wainwright; 1 changing beer (sourced regionally) ℍ

A warm welcome is extended at this family run, extensive 18th-century Grade II-listed former coaching house, which sits at the heart of the community and village life. Always busy, the pub is equally famed for its four beers and its food. Breakfast, lunch and dinner are served, with various offers promoted throughout the week. There is a separate bar, a function room and an enclosed courtyard. Four en-suite bedrooms are also available. Q ♿ ❀ 🏮 ◖ ◖ 🚏 (28,81)

Tannery

The Arcade, High Street, TS9 6BW (go through archway next to baker's shop and continue for 50yds)

☎ (01642) 909030 ● thetanneryayton.co.uk

4 changing beers ℍ

Set back from the High Street within a courtyard, this former hairdresser's has been tastefully refurbished and is now the village's micropub. Opened in 2018 by experienced licensees, it has always attracted a discerning clientele. Four rotating guest beers generally include a stout, with craft ales and an extensive gin menu are also served by knowledgeable staff. Third-pint bats are available. Free cheese and biscuit evenings are hosted on Mondays, with any donations going to charity.

♿ 🚏 (28A,81) ❀

Grinton

Bridge Inn
DL11 6HH (on B6270, 1 mile E of Reeth) SE046984
☎ (01748) 884224
Jennings Cumberland Ale; house beer (by Marston's); 3 changing beers (sourced nationally; often Marston's) Ⓗ
A friendly, well-run historic inn, this pub lies beneath the towering hills of Fremington Edge and Harkerside and is close to a crossing of the River Swale, as its name suggests. It has a comfortable lounge, wood-panelled bar and two restaurant rooms offering home-made food. It is a haven for walkers and cyclists on the Coast-to-Coast and Inn Way walks and the Dales Cycle Way; a Youth Hostel is half a mile up the hill. May close early at quiet times. Q🕏🏵🏚🅐❶♣️🅿️🚇(30)🌡️🤶

Grosmont

Crossing Club
Co-operative Building, Front Street, YO22 5QE (opp NYMR car park – ring front door bell for entry)
☎ 07766 197744
4 changing beers Ⓗ
Set amid beautiful scenery in the Esk Valley, this former local CAMRA Club of the Year is located opposite the NYMR/Esk Valley railway stations in what was the village Co-op's delivery bay. It was converted by dedicated locals 24 years ago, and a warm welcome always awaits CAMRA members. Over 1,500 different beers have been served during the club's history. Railway enthusiasts will note both the steam and diesel memorabilia adorning the walls. Opens every evening in summer; hours may vary during winter. Q🕏♣️🛇🍴🌡️

Guisborough

Monk Ⓛ
27 Church Street, TS14 6HG (at E end of Westgate)
☎ (01287) 205058
Timothy Taylor Landlord; 4 changing beers Ⓗ
This contemporary venue is an upmarket addition to the town's social life and attracts a discerning clientele. It is situated opposite Gisborough Priory, which was razed to the ground by King Henry VIII in 1540. Legend has it that a 12th-century Black Monk made use of a tunnel, discovered during recent renovations, for his nefarious night-time activities. The tunnel's access steps are on view. Five beers are served, several from the local brewery, with multi-drink paddles available.
🅰️🚇(5,X93)🌡️🤶

Gunnerside

King's Head Ⓛ
DL11 6LD
☎ (01748) 883412 🌐 kingsheadgunnerside.com
Black Sheep Best Bitter; Theakston Old Peculier; Yorkshire Dales Butter Tubs; 1 changing beer (often Yorkshire Dales) Ⓗ
An atmospheric inn prominently located next to Gunnerside Beck. Most of the local cottages were built in the 18th century when the village was a lead mining centre. The village later gave its name to Operation Gunnerside, the commando raid made famous by the film The Heroes of Telemark. The single-room stone-flagged bar is dominated by a magnificent stone fireplace and offers a range of bar snacks and home-cooked meals. Q🕏🛇❶🅰️♣️🚇(30,830)🌡️🤶

Hardraw

Green Dragon Inn Ⓛ
Bellow Hill, DL8 3LZ (about 1 mile N of Hawes, just off Buttertubs Rd)
☎ (01969) 667392 🌐 greendragonhardraw.com
Theakston Best Bitter, XB, Old Peculier; 2 changing beers (sourced locally; often Wensleydale, Yorkshire Dales) Ⓗ
Hardraw Force, England's highest single-drop waterfall, is located in the grounds of this characterful old pub, and you can visit the spectacular attraction for a small fee. The bar has flagged floors, low beams and two impressive ranges, and offers beers from local independent brewers. Regular live music events are hosted, including a brass band competition in September. It can get busy, so booking is sometimes advisable. Breakfasts are served at the weekend.
🕏🏵🏚❶🅰️🅿️🚇(855)🌡️🤶

Harrogate

Blues Café Bar Ⓛ
4 Montpellier Parade, HG1 2TJ
☎ (01423) 566881 🌐 bluesbar.co.uk
4 changing beers (often Isaac Poad, Ossett, Rooster's) Ⓗ
A small single-room café bar in the town centre, modelled on an Amsterdam café bar, which has been running for more than 30 years. It overlooks the lovely Montpellier gardens. Noted for live music seven days a week, with three sessions on a Sunday, it is popular with music lovers and can get busy. Upstairs is the Gin Bar and Yorkshire Tapas restaurant, a room with seating in large booths where customers can watch the band on a TV screen while dining or drinking. ❶🔺🍴🌡️🤶↻

Devonshire Tap House Ⓛ
10 Devonshire Place, HG1 4AA
☎ (01423) 568702 🌐 devonshiretaphouse.business.site
Timothy Taylor Boltmaker; 7 changing beers (often Brass Castle, Harrogate, Wilde Child) Ⓗ
A cosy old pub, rescued, restored and renovated in 2014, then refurbished and reopened again by new independent operators in 2019. It retains its original semi-circular counter and stained-glass canopy, has wood flooring throughout and a mix of wooden benches, tables and chairs. Four handpumps on each side of the bar dispense a changing selection of beers from Yorkshire and northern breweries, and there are 12 keg lines and a beer fridge. The food offering is pizzas, including gluten-free and vegan options. 🕏🏵🔺🍴🌡️🤶

Disappearing Chin
38 Beulah Street, HG1 1QH (opp bus station)
☎ 07539 942344 🌐 thedisappearingchin.co.uk
3 changing beers Ⓗ
This small bar, opened in 2019 in a shop unit opposite the bus station, is accessible from either Beulah Street or Station Parade. Long and narrow, it has soft seating in the windows at both ends, and stools at the bar, with some standing room. There are tables and chairs for outside drinking on Beulah Street. Three handpumps serve changing cask ales, always including a dark beer, and there are eight craft keg fonts; sometimes there are tap takeovers. Card payments only. 🕏🔺🍴🌡️🤶

Fat Badger Ⓛ
Cold Bath Road, HG2 0NF
☎ (01423) 505681 🌐 thefatbadgerharrogate.com
Black Sheep Best Bitter; Timothy Taylor Landlord; Tetley Bitter; 4 changing beers (often Ossett, Saltaire) Ⓗ

Single-room pub created in part of the historic White Hart Hotel. It has a large bar area with high-quality ornate furnishings throughout. Raised floor levels around the edges, interspaced with part-glazed screens along one wall, give an intimate atmosphere. Outside is a large patio area, partly covered for all year round drinking and dining; dogs are welcome in the outside areas. The pub can get very busy, especially at weekends. Bar meals are available at all times or diners can choose the separate adjoining restaurant. ⏰🕯️👨🍴⏱️&♿🅿️🐾🛜♻️

Harrogate Tap 🅛
Station Parade, HG1 1TE
☎ (01423) 501644 ⊕ harrogatetap.co.uk
12 changing beers (often Brew York, Harrogate, Rooster's) ℍ

Overlooking platform 1 of Harrogate station, this is an impressive transformation of a neglected railway building. The pub is of similar style to the Tapped Brew Company's other bars in York and Sheffield. It comprises a long bar room and a separate snug; the decor features dark-wood panelling, a tiled floor and tasteful Victorian-style fittings. A diverse range of cask ales is available on two banks of six handpumps, always including a gluten-free beer. The ales are complemented by boxed ciders such as Broadoak or Pulp, as well as craft kegs and bottled world beers. Bar snacks are also served. ⏰&⏱️🚇🐾

Little Ale House 🍷
7 Cheltenham Crescent, HG1 1DH
⊕ alehouseharrogate.co.uk
5 changing beers ℍ

Harrogate's first micropub, comprising one room with the counter at the back, and a downstairs cellar room. As with many micropubs, the beers are kept cool in a glass cabinet to one side. Five handpumps dispense cask ales, always including a dark, and there are also boxed ciders from producers such as Broadoak, Pulp and Thornborough. KeyKeg beer, whiskies and small-batch gins are also available. There is an outside seated area at the front as well as a yard with bench seating at the rear, with service at the window in summer. Card payments only. Q🌼🚇🚇🐾

Major Tom's Social 🅛
The Ginnel, HG1 2RB
☎ (01423) 566984 ⊕ majortomssocial.co.uk
4 changing beers (often Rooster's, Turning Point) ℍ

A café bar housed above a vintage shop in a former antiques emporium, providing real ale, craft keg, pizza, music and art. Described on its website as a 'youth club for grown ups', it is simply furnished, with wooden tables and chairs. The decor is in a mix of styles to suit its eclectic customers, and includes artwork for sale. Four handpumps dispense a variety of ales, usually from a range of smaller breweries, often including the local Rooster's Brewery, as well as Turning Point from nearby Knaresborough. ⏰👨⏱️🚇🐾🛜

Old Bell 🅛 ✅
6 Royal Parade, HG1 2SZ
☎ (01423) 507930
Timothy Taylor Boltmaker; 6 changing beers (often Ilkley, Kirkstall, Okell's) ℍ

A Market Town Taverns establishment, the Old Bell opened in 1999 on the site of the Blue Bell Inn which closed in 1815 and was later demolished. President Bill Clinton visited the inn during a visit to Harrogate in 2001. Later the same year the pub expanded into the former Farrah's toffee shop, where there is a collection of Farrah's memorabilia. The interior was refurbished in 2017, with new leather armchairs and updated decor.

Eight handpumps serve beers from mostly local breweries, always including a dark. Cask cider such as Old Rosie is also usually available. ⏰👨⏱️🚇🐾♻️🛜

Starling Independent Bar Café Kitchen 🅛
47 Oxford Street, HG1 1PW
☎ (01423) 531310 ⊕ murmurationbars.co.uk
Kirkstall Three Swords; Timothy Taylor Boltmaker; 3 changing beers (sourced locally; often Rooster's, Turning Point, Vocation) ℍ

A relaxed café bar with a contemporary feel and stripped-back brickwork. A downstairs wall features a mural of a murmuration of starlings. The pallet-fronted counter holds six handpulls offering a well-chosen range of mainly Yorkshire beers in a good mix of styles and strengths, usually including a dark beer. The sixth pump is devoted to cider, such as Rosie's Pig. A large blackboard on the bar back lists the current beers and is updated regularly. Stone-baked pizzas are a favourite here. Card payments preferred. ⏰👨⏱️🚇🐾♻️🛜

Tap on Tower Street 🅛 ✅
Tower Street, HG1 1HS
☎ (01423) 565600 ⊕ thetapontowerstreet.co.uk
6 changing beers (often Rooster's, Timothy Taylor) ℍ

Although the pub was completely refurbished in a modern style by new operators in 2017, the three-room layout of the old Tap & Spile remains unchanged. Food is available all day, mainly in the form of hot and cold snacks rather than formal cooked meals. Takeaway bottles and cans are available from fridges in the public bar, and the rear room has a selection of over 300 board games. There are four handpumps in each of the front bars with up to six changing beers, and one pump devoted to a cider such as Westons Old Rosie. ⏰🌼👨⏱️🚇🐾♻️🛜

Winter Gardens 🅛 ✅
4 Royal Baths, HG1 2WH
☎ (01423) 877010
Greene King Abbot; Ruddles Best Bitter; Sharp's Doom Bar; 6 changing beers (often Daleside) ℍ

Tasteful conversion of the main hall of the Victorian Royal Baths complex retaining many original features, with Harrogate Turkish Baths next door. Entering from the Parliament Street entrance, the sweeping Hollywood-style double stone staircase carries you down to the vast bar area where, in addition to the usual Wetherspoon core range of beers, numerous locally sourced guests are dispensed across three sets of handpumps. There is a separate function room and courtyard drinking area. Wheelchair access is from the entrance in the Ginnel. ⏰🌼👨⏱️&⏱️🚇🛜

Hawes

Board Inn 🅛 ✅
Market Place, DL8 3RD
☎ (01969) 667223 ⊕ theboardinn.co.uk
Black Sheep Best Bitter; Theakston Best Bitter; Timothy Taylor Landlord; 1 changing beer (sourced locally) ℍ

A comfortable and traditional pub located in the heart of this busy Dales town, popular with walkers and other visitors. The main front bar has a warming coal fire in winter and there is also a pleasant dining room, plus an outdoor seating area at the front. Home-cooked food is served all day during the summer but not during winter afternoons. The guest beer may not be available in winter. There are five en-suite letting rooms. ⏰🛏️👨⏱️🅰️♣️🚇🐾🛜

Hellifield

Black Horse Hotel L

Main Road, BD23 4HT
☎ 07425 868011
3 changing beers ⊞
Large rambling village pub, a popular venue for dining and drinking. The spacious main lounge has comfy settees and coffee tables as well as more conventional seating. Note the collection of musical instruments on display. There is also a tap room, accessed off the main A65, and a small dining room suitable for meetings and family gatherings. Paved areas either side of the building offer ample outdoor seating. Three changing real ales are available (four in summer), often from local breweries. A Sunday carvery is served. ☆❀☎❍◗&♣P☷(580)❀ᐠ

Helmsley

Helmsley Brewing Co

18 Bridge Street, YO62 5DX
☎ (01439) 771014 ⊕ helmsleybrewingco.co.uk
Helmsley Yorkshire Legend, Striding the Riding, Howardian Gold; 4 changing beers (sourced locally; often Helmsley) ⊞
The brewery tap for the Helmsley Brewing Company is close to the market square in the picturesque settlement of Helmsley, the only market town in the North York Moors National Park, and the perfect base for enjoying the wider area. Three regular and four changing beers come from the brewery's own range. Brewery tours and an onsite shop complete the full beer experience. There is a large covered beer garden. ☷ᐠ

Huby

Mended Drum L

Tollerton Road, YO61 1HT
☎ (01347) 810264 ⊕ themendeddrum.com
Tetley Bitter; 4 changing beers (sourced locally; often Brass Castle) ⊞
With a Terry Pratchett connection, this large, open-plan pub is bigger than it looks. Welcoming to families and cyclists, it is the lively centre of this rural community. The pub is known for its interesting range of frequently changing local beers and its knowledgeable staff. The food offering is pub classics with a modern twist, and includes vegan, vegetarian and gluten-free options. Three beer festivals are held each year. A former local CAMRA Pub of the Year. ☆❀◗&Å♣●P☷(40)❀ᐠ

Hudswell

George & Dragon ♀ L

DL11 6BL
☎ (01748) 518373 ⊕ georgeanddragonhudswell.co.uk
Rudgate Ruby Mild; Wensleydale Falconer; 5 changing beers (sourced locally) ⊞
At the heart of the village, this homely multi-roomed country inn was CAMRA National Pub of the Year for 2016, a runner-up in 2020, and has been Champion Pub of Yorkshire several times. A pleasant walk from Richmond (if you do not mind the 300+ steps) brings you to the pub's large beer terrace with fantastic panoramic views over the Swale valley. Rescued by the community, the inn boasts a library, shop, allotments and other community facilities. It is open all day on bank holidays. Q☆❀◗Å♣●P☷(30)❀ᐠ

Hunmanby

Piebald Inn

65 Sands Lane, YO14 0LT
☎ (01723) 447577 ⊕ thepiebaldinn.co.uk
Timothy Taylor Landlord; house beer (by Greene King); 3 changing beers (sourced regionally) ⊞
The Piebald Inn is located on the outskirts of Hunmanby village adjacent to the Sands Lane level crossing. This is a large multi-roomed pub which is predominantly food-oriented. PiePub Co Bitter is one of two house beers in addition to three guests. Food is served all day every day. A particular feature of the menu is the extensive range of 50 different pies on offer. At the side is a terraced area and large garden for drinking/smoking. Accommodation is available. ☆❀☎❍◗&Å⇌●P❀ᐠ

Ingleby Barwick

Beckfields ✓

Beckfields Avenue, TS17 0QA (W off A1045, along Ingleby Way, then first left along Beckfields Ave)
☎ (01642) 766263
4 changing beers ⊞
If your passion is for well-known and stronger best and premium beers, then this popular and uniquely named community pub will serve you well. The pub is situated at the heart of one of the six villages that make up what is reputedly Europe's largest private housing estate. Under the stewardship of a licensee with many years' service to the trade, four handpulls operate on a rotating guest basis. An extensive pub grub menu is also served. ☆❀◗&♣P☷(15)❀ᐠ

Kellington

Red Lion

1 Ings Lane, DN14 0NT (follow road from A19 into centre of village)
☎ (01977) 661008 ⊕ redlionkellington.co.uk
1 changing beer ⊞
A friendly, family-run pub that plays an active part in the local community. The interior consists of an extensive lounge with adjoining area containing a pool table; the pub runs three pool teams and hosts charity events. White Dragon from Brown Cow brewery is the regular beer. There is a Sunday quiz night, and a happy hour 3-6pm on weekdays. The pub also has a function room, and bedrooms to let. Parking is at the rear. Q☆❀☎&♣P☷(476)❀ᐠ

Kirk Smeaton

Shoulder of Mutton

Main Street, WF8 3JY (follow signs from A1)
☎ (01977) 620348
Black Sheep Best Bitter; 1 changing beer (sourced regionally; often Bradfield, Stancill) ⊞
Convenient for the Went Valley and Brockadale Nature Reserve, this welcoming, traditional village pub is popular with walkers and the local community. It is an award-winning free house and comprises a large lounge with open fires and a cosy, dark-panelled snug. The beer comes direct from the brewery and the quality is superb. The spacious beer garden has a covered and heated shelter for smokers. There is ample parking. Quiz night is Tuesday. Q☆❀♣P☷(409)❀ᐠ

Kirkby-in-Cleveland

Black Swan

Busby Lane, TS9 7AW (800yds W of B1257) NZ539060

☎ (01642) 712512 ⊕ theblackswankirkby.co.uk
Bradfield Farmers Blonde; Sharp's Doom Bar; Timothy Taylor Landlord; Wainwright; 1 changing beer ⓗ
A cosy free house at the foot of the Cleveland Hills, at the crossroads of this ancient village. The pub is under the stewardship of a licensee of 25 years' standing, and is a place where a warm welcome is guaranteed from the friendly staff. There is a bar, pool room, lounge/restaurant, conservatory and patio seating area. Four regular beers and a guest are dispensed and good-value meals are served, including daily specials and bar meals.
☺❀◑&♣P☂➡(89)❀🐾☞

Knaresborough

Blind Jack's Ⓛ
19 Market Place, HG5 8AL
☎ (01423) 860475
Black Sheep Best Bitter; 5 changing beers (sourced nationally) ⓗ
An entry in this Guide for over 30 years, this is a Georgian listed building with bare-brick walls and wooden floorboards, comprising two small rooms on the ground floor and two similar rooms up a steep staircase. It provides a focal point both for locals and the many visitors who appreciate the excellent selection of ales, the cosy ambience and lively banter. The diverse beer range includes at least one dark and one gluten-free choice, as well as a range of craft kegs. A trompe l'oeil painting on the exterior features the pub's namesake, Blind Jack Metcalf. Q⇌➡🐾☞

Cross Keys ✅
17 Cheapside, HG5 8AX
☎ (01423) 863562
Ossett Butterley, Yorkshire Blonde, White Rat, Silver King; 2 changing beers (sourced locally; often Ossett, Rudgate) ⓗ
A former Tetley's house, refurbished by Ossett Brewery in its trademark style, with stone-flagged floors, bare-brick walls and stained glass. This traditional pub serves up to six cask ales, mostly from the Ossett stable, always including a dark; sometimes there are beers from other breweries too. There are also at least two boxed ciders, such as Lilley's. Thursday is quiz night and a live band plays monthly on Saturday nights. A DJ performs on the first Sunday of every month. ☺❀⇌◑🐾☞↺

Half Moon Ⓛ
1 Abbey Road, HG5 8HY
☎ (01423) 313461 ⊕ thehalfmoonfreehouse.com
Rooster's YPA (Yorkshire Pale Ale); 3 changing beers (sourced locally) ⓗ
Popular riverside free house, next to Low Bridge, offering a warm and welcoming atmosphere, with a real fire and a wood-burning stove. There is a small, attractive, enclosed outdoor space, with tables and chairs and some benches under heated awnings; dogs are welcome in the outside area. Four handpumps dispense a varying range of beers, mostly from Yorkshire breweries. A grazing menu of meat and cheese boards served every day complements the beers; you can order pizzas on weekday evenings. Coffee and home-made cakes are also available. ☺❀◑⇌➡(8)☞

Mitre Ⓛ ✅
4 Station Road, HG5 9AA (opp railway station)
☎ (01423) 868948
Timothy Taylor Boltmaker; 4 changing beers (often Ilkley, Rooster's) ⓗ
Opposite Knaresborough's Grade II-listed railway station and signal box, this Market Town Taverns pub offers a modern split-level bar with wooden flooring throughout.

There is a side room mostly used for dining, a function room in the basement, and a sunny terrace at the back with views of the local church. Handpumps on the lower bar dispense ales from both Yorkshire and sometimes smaller national breweries. Food is served every day and well-behaved dogs and children are welcome.
☺❀◑&⇌➡(1)🐾☞

Leavening

Jolly Farmers Ⓛ
Main Street, YO17 9SA
☎ (01653) 658276
Timothy Taylor Landlord; York Guzzler; 2 changing beers (sourced locally; often Great Newsome, Half Moon) ⓗ
A 17th-century pub on the edge of the Yorkshire Wolds between York and Malton. With its low ceilings and tiled flagged floors and intriguing series of rooms, the pub is homely and welcoming, serving locally sourced food and a range of local and regional ales. It is a popular stopping-off point for ramblers as well as locals. The outside drinking area boasts table football and a cask of drinking water for dogs complete with handpump. There are annual beer and gin festivals. Q☺❀◑&♣P☂🐾☞

Leyburn

King's Head Ⓛ
Grove Square, DL8 5AE
☎ (01969) 622798
Timothy Taylor Landlord; Theakston Best Bitter; Wensleydale Semer Water; 1 changing beer (sourced locally; often Wensleydale) ⓗ
Set off the main market place, at the junction of the moor road and the Richmond road, this friendly locals' pub is a rare example of a wet-led house in this tourist area, offering a selection of well-kept cask ales at attractive prices. Despite being knocked through, the bar, lounge and games room have the feel of separate areas. The pub is an enthusiastic provider of sports TV, especially football, which is well-supported, and a host of regular live music. It has a pool table, two dartboards, fruit machines, open fires and the only jukebox in town.
☺⇌♣➡🐾☞

Lofthouse

Crown Hotel Ⓛ
Thorpe Lane, HG3 5RZ
☎ (01423) 755206
Black Sheep Best Bitter; Dark Horse Hetton Pale Ale; Theakston Best Bitter ⓗ
A traditional Dales pub and hotel in the Nidderdale Area of Outstanding Natural Beauty, a short way uphill from the main part of the village on a road with spectacular views. There is an unusual panelled entrance corridor leading to a traditionally furnished, comfortable bar decorated with local pictures, maps and brassware; an open fire blazes to warm your bones after winter walking. A more formal dining room is reached through the bar. Note there is no mobile phone coverage indoors.
Q☺❀◑▲♣P🐾

Low Row

Punch Bowl Inn Ⓛ
DL11 6PF
☎ 0333 700 0779 ⊕ pbinn.co.uk
3 changing beers (often Rudgate, Wensleydale, Yorkshire Dales) ⓗ

A smart two-room 17th-century inn with a focus on food, owned by the same people as the CB Inn at nearby Langthwaite. The bar area is pleasant, featuring a Mouseman Thompson bar, bare floorboards and old pine tables, with comfortable leather settees around the stove. The pub offers a welcome respite for walkers returning from the adjacent fells and riverside (provided muddy boots are removed). Q⭫⇔◑♣P🖳(30,830)♨🌐

Malham

Lister Arms 🄻 ✅

Gordale Scar Road, BD23 4DB

☎ (01729) 830444 ⊕ listerarms.co.uk

Thwaites Original, IPA, Gold; 3 changing beers (sourced locally; often Dark Horse, Settle, Thwaites) 🄷

Substantial stone-built Grade II-listed inn dating from 1723 or earlier, overlooking the green. The tiled entrance hall opens to the stone-flagged main bar, with separate areas to left and right and a dining room/restaurant beyond. The large secluded garden at the rear has ample comfortable seating. Food is served all day, with breakfast and brunch on offer in the morning, and the main menu thereafter. Home-made cakes and cream teas are also available. Malham can get busy on weekends and school holidays. ⭫⇔◑⛰AP🖳♨🌐

Malton

Blue Ball

14 Newbiggin, YO17 7JF

☎ (01653) 690692 ⊕ theblueballinnmalton.co.uk

Timothy Taylor Landlord; Tetley Bitter; 1 changing beer (sourced locally) 🄷

This Grade II-listed establishment dating from the 16th century is recognised by CAMRA as having a historic interior of regional importance. It was named the Blue Ball in 1823. The low front elevation hides a maze-like interior, with the frontward cosy bar, compact servery and linking corridor retaining most of the historical flavour. A smoking area is at the rear. Home-cooked food is served daily (except Wed). Q⭫♨◑&♣P🖳(843)♨🌐

Brass Castle Brewery Tap House 🄻

10 Yorkersgate, YO17 7AB

☎ (01653) 698683 ⊕ brasscastle.co.uk

2 changing beers (sourced locally; often Brass Castle) 🄷

Formerly a town-centre temperance hotel, Malton's newest hostelry is a short walk from the railway station. The single-roomed bar is tastefully designed in a rustic style, with one wall partially adorned with barrel staves. Two regularly changing cask ales are offered, together with six craft keg ales and an extensive range of bottled beers. Snacks may be purchased at the bar. There is a smoking/drinking area to the rear of the premises and an upstairs seating area. Q⭫&⇌♣🖳(843)♨🌐

Manfield

Crown Inn 🄻

Vicars Lane, DL2 2RF (500yds from B6275)

☎ (01325) 374243 ⊕ thecrowninnmanfield.co.uk

Draught Bass 🄷**; Village White Boar** 🄷**/🄿; 5 changing beers (sourced nationally)** 🄷

Set in a quiet village, this 18th-century inn has been voted local CAMRA Country Pub of the Year 16 times, and was previously Yorkshire Pub of the Year. It has two bars, a games room and an extensive beer garden. A mix of locals and visitors creates a friendly atmosphere. Up to six guest beers from microbreweries and up to five ciders or perries are available. There is a real log fire in the main bar. Q⭫♨◑♣P🖳(29)♨🌐

Marske-by-the-Sea

Clarendon 🄻

88-90 High Street, TS11 7BA

☎ (01642) 490005

Black Sheep Best Bitter; Camerons Strongarm; Copper Dragon Golden Pippin; Theakston Best Bitter, Old Peculier; 1 changing beer 🄷

The Middle House, as it is also known, is a popular one-room locals' pub, where little has changed since the 1960s. Six beers are served from the mahogany island bar, a rarity on Teesside. The walls are adorned with interesting photographs of yesteryear. There is no TV, no pool table, no children or teenagers, just regulars indulging in convivial conversation. There is no catering either, but tea and coffee are always available. A recent local CAMRA award winner. Q♨⇌P🖳(X3,X4)🌐

Smugglers Den 🄻

7 Redcar Road, TS11 6AA (next to St Mark's church)

☎ 07802 469727

4 changing beers 🄷

Located in the centre of town, this converted two-story cottage is a quirky but stylish and friendly microbar, now in its fourth year of operation. Four rotating LocAle guest beers are served in the downstairs bar, where a log-burner keeps everybody warm. Three additional rooms upstairs include a gin bar. Live music is performed on Friday and Saturday, either in the bar or upstairs in the Den. ⇌🖳(X3,X4)♨

Masham

Bay Horse 🄻

5 Silver Street, HG4 4DX

☎ (01765) 688158 ⊕ bayhorseatmasham.co.uk

Black Sheep Best Bitter; Timothy Taylor Landlord; Theakston Best Bitter, Old Peculier; 2 changing beers (sourced locally; often Ossett, Pennine, Wensleydale) 🄷

Friendly pub just off the Market Place welcoming tourists and locals alike. As well as the front bar there is a dining area up a short flight of steps, a rear garden and five en-suite letting rooms. A selection of home-cooked food is served using fresh local produce; note that meal times may vary in winter. A good range of cask ales is available from both Masham and local Yorkshire breweries. Cask ends and pipework form a feature in the main front bar. ⭫♨◑🖳♨🌐

White Bear 🄻 ✅

Wellgarth, HG4 4EN

☎ (01765) 689319 ⊕ whitebearmasham.co.uk

Theakston Best Bitter, Lightfoot, Old Peculier; 1 changing beer (often Theakston) 🄷

Theakston's only pub, an award-winning venue and a great favourite with the locals as well as directors and staff from the brewery. A large dining area to the left and a cosy taproom to the right offer exclusively Theakston's beers. Unusually for the Yorkshire Dales, this building was a victim of wartime bombing, following which it was derelict for many years before it was rescued and renovated to a high standard. A popular beer festival is hosted in June featuring over 30 ales. ⭫♨⇔◑&♣P🖳♨🌐

Middleham

Black Bull Inn Ⓛ
Market Place, DL8 4NX
☎ (01969) 624792 🌐 theblackbullinn.co.uk
Theakston Best Bitter; Wensleydale Semer Water; 2 changing beers (sourced locally; often Yorkshire Dales) Ⓗ
Friendly family-owned pub with a good selection of real ales, situated in a major racehorse training centre. It has three rooms, the largest more for dining than drinking, with TVs in each bar. The pub serves good-quality food and has a log-burner in the main bar. A good centre for Dales walking, it hosts regular events and offers tailor-made cycling packages for Tour de Yorkshire enthusiasts. ✿🚪🍽(159) 🐾♿🛜

Richard III Hotel Ⓛ
Market Place, DL8 4NP
☎ (01969) 623240 🌐 richard111hotel.co.uk
Black Sheep Best Bitter; Theakston Best Bitter, Old Peculier; Wensleydale Semer Water; 1 changing beer (sourced locally) Ⓗ
A family-run pub in a principal racehorse training hub. It is next to Middleham Castle, and a great place for starting or ending a variety of walks. There is a modest bar area with a big adjoining space and snug to the rear, and then a dining room. Tiled throughout, the pub has real fires in the bar and snug, and a log-burner in the adjoining bar area. It opens early for breakfast, so you can sit at tables on the cobbles at the front and start your day watching and listening to the racehorses trot by. Regular live music is played. ✿🚪🍽(159,859)🐾

Middlesbrough

Bottled Note Ⓛ
55-57 Borough Road, TS1 3AA (just N of university campus)
☎ (01642) 644214
4 changing beers Ⓗ
One of several micropubs located in a series of parallel streets just south of the Cleveland Centre, now in its seventh year of operation. Half of this double-fronted Victorian terrace is a micropub. The other half, which opens at weekends, is a cocktail and wine bar. Four handpumps generally include a beer from Three Brothers, and a stout or a porter is also usually served. A wide selection of bottled ales is also available. 🏢♿�‹🛜

Chapel @ Whitehouse Street
Whitehouse Street, TS5 4BY (adjacent to former St Cuthbert's Church, near Newport bridge)
☎ 07974 212073 🌐 whitehousestreet.co.uk
6 changing beers Ⓗ
A former Primitive Methodist Mission Hall, dating to about 1890, located at the west end of the town. It has been sympathetically renovated throughout, retaining many original features from its former use. The refurbishment has created a bright, airy, friendly atmosphere. Six beers, ranging from lighter ales to dark brews and stouts, are dispensed on a rotating guest basis. Three third-pint glasses are served on bespoke miniature chapel pews. Live music and beer/cider festivals are held. Q✿🍽♿🅿️🐾♿🛜

Infant Hercules Ⓛ
84 Grange Road, TS1 2LS (just S of Cleveland Centre and N of university campus)
☎ 07980 321626
4 changing beers Ⓗ

Friendly micropub, located in the town's original solicitors' quarter and handy for the Law Courts. This local CAMRA award-winner is named after Gladstone's description of the town in 1862, after he had witnessed the rapid expansion of the area's steel furnaces and ship-building industries. Third-pint tasting bats are available. Teesside University's Real Ale Society (TURAS) meets here on Thursdays. It is a 20-minute walk to the Riverside Stadium. Q✿🏢♿🚪🐾🛜

Isaac Wilson Ⓛ
61 Wilson Street, TS1 1SF (at N end of town, close to railway station)
☎ (01642) 247708
Camerons Strongarm; Sharp's Atlantic; 3 changing beers Ⓗ
Popular pub named after a 19th-century railway industry magnate and company director of the world's first railway, the Stockton and Darlington. The Isaac, a former Wetherspoon conversion of the old Law Courts, has recently gained new owners and continues to follow, more or less, the chain's formula. Two regular beers and three local guests, together with good-value food, are served. The single-room interior has walls adorned with photographs of old Middlesbrough. Third-pint glasses are available. ✿🍽♿🚪🛜

Northallerton

Oddfellows Arms Ⓛ
251 High Street, DL7 8DJ (off main part of High St, behind parish church)
☎ (01609) 259107
3 changing beers (sourced locally; often Ossett, Wensleydale) Ⓗ
Hidden behind the parish church, by the cemetery gates, the Oddies does not appear to be on the High Street, despite its address. A thriving back-street community pub, it handles a mainly local trade and is popular with darts players, TV football fans and church bell ringers. Refurbished in a simple but traditional style with an open-plan interior, it has a games room upstairs and a secluded beer garden to the rear. ✿🏢♣🅿️🚪🐾🛜

Standard ✓
24 High Street, DL7 8EE (at N end of High St)
☎ (01609) 772719
Bradfield Farmers Blonde; Purity UBU; house beer (by Marston's) Ⓗ
Half a mile north of the town centre, opposite Sainsbury's supermarket on the A167 Darlington road, this community local takes its name from the English defeat of the Scots at the nearby Battle of the Standard in 1138. The interior decor is old world-style with bare stone, brickwork and old photographs. There are three distinct drinking areas. The menu offers good-value, wholesome food. ✿🏢♣🚪🐾🛜

Stumble Inn Ⓛ
4 Garthway Arcade, DL7 8NS (in pedestrian arcade off High St next to Grovers shop)
☎ 07817 568042
5 changing beers (sourced regionally; often Durham, Northern Monk) Ⓗ
This friendly and cosy micropub is hidden away in a shopping arcade off the town's High Street, near the Applegarth car park. It serves a selection of local ales, always including a dark brew, craft beers and up to 20 ciders; staff are keen to offer tasting advice and guidance. With no music, gaming machines, WiFi, children or sports TV, there is just good old-fashioned chat. A quiz is held on the last Sunday of each month and there are seasonal beer and cider festivals. Q🐾🚪🐾

Old Malton

Royal Oak Pub & Kitchen
47 Town Street, Old Malton, YO17 7HB (400yds off A64 Malton bypass)
☎ (01653) 696968 ● theroyaloakoldmalton.co.uk
Leeds Leeds Pale; 3 changing beers (sourced regionally) ⊞
Historic Grade II-listed inn in a picturesque village off the A64 close to Eden Camp military museum. At the front of the pub is a cosy snug, to the rear is a larger room with original beams complete with brasses and a log fire. This leads to an extensive beer garden with a large covered smoking area. Three handpumps serve beers mainly from Yorkshire. Traditional home-cooked meals are available. Children and dogs are welcome. The bus stops outside. ご&①&♣P₪(840)❀ 🖥

Osmotherley

Golden Lion ⎌
6 West End, DL6 3AA
☎ (01609) 883526 ● goldenlionosmotherley.co.uk
Timothy Taylor Landlord; 3 changing beers (sourced locally; often Great Newsome, Rudgate, Three Brothers) ⊞
Set in the centre of a picturesque village on the edge of the North York Moors National Park and at the start of the long-distance Lyke Wake Walk, this old inn is popular with hikers, casual visitors and locals. Much of the focus is on high-quality locally sourced food but drinkers are always made welcome. Regularly changing beers are from Yorkshire and County Durham breweries and there is a beer festival each November. Outside tables offer a good view on fine days. Q❀⇔①▸Å₪(80,89)❀ 🖥

Pickering

Sun Inn ⎌ ⎌
136 Westgate, YO18 8BB (on A170, 400yds W of traffic lights in town centre)
☎ (01751) 473661 ● thesuninn-pickering.co.uk
Tetley Bitter; 5 changing beers (sourced regionally) ⊞
Friendly local CAMRA Rural Pub of the Year, close to the steam railway. Six real ales are offered, often from Yorkshire micros, and several traditional ciders. A cosy bar with a real fire leads to a separate room, ideal for families and special events, where local artists display their work. The large beer garden is used for the annual beer festival in September. Regular events include fortnightly acoustic music, charity quizzes and monthly vinyl nights. Dogs (on leads), children and walkers are welcome. ご❀&⇌♣●①₪(128,840)❀

Pool-in-Wharfedale

Hunters Inn ⎌
Harrogate Road, LS21 2PS
Abbeydale Moonshine; Black Sheep Best Bitter; Morland Old Speckled Hen; Ossett Yorkshire Blonde, White Rat; 3 changing beers (often Bradfield, Copper Dragon, Goose Eye) ⊞
A single-storey building on the main Harrogate to Bradford road with views across lower Wharfedale. The large single-room interior incorporates a raised area with a warming real fire during the colder months, while the windowed front wall gives views across to the southern ridge of Wharfedale. The long bar houses an array of handpumps dispensing a varied selection of ales sourced mainly from Yorkshire breweries. There is a pool table and video jukebox at one end. Children are allowed during the day. ご❀♣P₪❀🖥ʊ

Raskelf

Old Black Bull ⎌
North End, YO61 3LF
☎ (01347) 821431 ● northyorkshotel.co.uk
Theakston Best Bitter, Old Peculier; 1 changing beer ⊞
Whether you visit in winter, when the massive central fire will match the warm welcome, or in summer, to enjoy the refreshing ales, do not miss the chance to appreciate this traditional village pub which has stood the test of time. With accommodation, food and a pool table to boot, if it wasn't for the convenient buses to either Thirsk or York you might plant roots. ご⇔①♣P₪(30)

Redcar

Rita's Pantry ⎌
1 Esplanade, TS10 3AA (opp Beacon)
☎ 07730 445483
3 changing beers ⊞
A former amusement arcade is now the town's first micropub. Situated on the seafront, from where the petrified forest can be seen at low tide, a warm welcome is extended to CAMRA members, locals and visitors alike. Three interesting rotating beers are served, and third-pint glasses are available. The amiable licensee hosts various social events, including a music quiz on Sunday. The pub is popular on social media.*A previous local CAMRA Pub of the Season. ❀①&Å⇌(Central)₪(X3,X4) ❀🖥

Ribblehead

Station Inn
Low Sleights Road, LA6 3AS (on B6255 nr B6479 jct)
☎ (015242) 41274 ● thestationinnribblehead.com
Black Sheep Best Bitter, Riggwelter; house beer (by Tirril); 2 changing beers (sourced locally; often Settle) ⊞
Built in 1874 at the same time as the nearby viaduct, this is a welcome refuge in a bleak spot in the midst of superb walking country, and is much used by hikers. Refurbished in 2017 to provide a rustic look throughout, with a cheery range in the snug, it is frequented by a surprisingly large number of locals. There is a good train service, but buses are rare. A bunk barn is available next door - the wild camping behind the pub is no more. ご❀⇔①⇌♣P₪(830) ❀🖥

Richmond

Buck Inn ✔
29 Newbiggin, DL10 4DX
☎ (01748) 517300 ● thebuckrichmond.co.uk
Timothy Taylor Landlord; 2 changing beers (often Black Sheep, Ossett) ⊞
A rambling old free house, full of character and situated on a cobbled street just off the town centre. It has a small snug at the front, comfortably furnished eating areas, and a main bar to the rear which features dartboard, pool table and sports TV. Beyond this is the suntrap beer garden with spectacular views over the River Swale and Norman castle. Qご❀⇔①▸₪❀🖥

No 29 Alehouse & Gin Bar ⎌
29 Frenchgate, DL10 4HZ
☎ (01748) 850491
● number-29-alehouse-gin-bar.business.site
3 changing beers (sourced locally; often Mithril, Rudgate, Wensleydale) ⊞

Real ale, craft beer, gin, wine and tapas bar just off the foot of Richmond's market place on the road down to the former station complex. The single, small bar has a simple decor with a wooden floor. Interesting food such as cured meat and cheese sharing boards, ploughman's and various tapas dishes are available. The beers are usually local. May close early if quiet. ◑🖪☙

Ripon

One Eyed Rat ⓛ

51 Allhallowgate, HG4 1LQ
☎ (01765) 607704

Ossett White Rat; Saltaire Blonde; 4 changing beers Ⓗ
A real ale destination in Ripon for many decades, the One Eyed Rat was refurbished and reopened under new management in 2020. A Grade II-listed building set within a terrace of 200-year-old houses, its narrow frontage leads to a warm and welcoming hostelry. The pub has a long, narrow interior with traditional seating and an open fire, and there is a large garden at the rear, with a sizeable covered area. A varied selection of cask ales are served, usually including a dark beer. Real cider is often Orchards of Husthwaite. Q⅄❀☙🖪☙Ʊ

Royal Oak ⓛ

36 Kirkgate, HG4 1PB
☎ (01765) 602284 ⊕ royaloakripon.co.uk

Saltaire Blonde; Timothy Taylor Golden Best, Boltmaker, Landlord, Landlord Dark; 1 changing beer (often Timothy Taylor) Ⓗ
This venue is in what was an 18th-century coaching inn, now beautifully renovated in the modern idiom, in the centre of historic Ripon between the cathedral and the market square. Timothy Taylor's most northerly tied house, the Royal Oak serves a top-quality range of the brewery's beers alongside the regular Saltaire Blonde. The pub is separated into relaxed dining areas with log-burning stoves and comfortable seating, and offers a first-class locally sourced menu. You can stay in one of the six stylish and comfortable bedrooms, and a hearty English breakfast is included. ⅄❀🛏◑P🖪(36)☙🤍

Water Rat ⓛ

24 Bondgate Green, HG4 1QW
☎ (01765) 602251 ⊕ thewaterrat.co.uk

Rudgate Jorvik Blonde; Theakston Best Bitter; 2 changing beers (often Rudgate) Ⓗ
Located by the side of the River Skell with a fine view of Ripon Cathedral and the river from its large windows and terrace, this is Ripon's only riverside pub, in fact so close to the river that it has been flooded in the past. An emphasis on affordable home-cooked traditional English pub food means it can get busy at times. There is a small drinking area near the bar, and a snug at the front. Four cask ales are served and a popular Northern Soul event is held monthly. ⅄❀◑🖪☙🤍

Robin Hood's Bay

Bay Hotel ⓛ

The Dock, YO22 4SJ (at end of a very steep road, down towards bay from top car park)
☎ (01947) 880278 ⊕ bayhotel.info

Adnams Ghost Ship; Theakston Best Bitter, Lightfoot; Wainwright Ⓗ
This magnificent Grade II-listed 1822 building is the finish line for Wainwright's Coast-to-Coast 192-mile walk from St Bees. The bottom bar, named in his honour, provides access to the Dock patio, situated at the water's edge, which provides superb panoramic views. With a licensee of 20 years' service, a friendly welcome awaits regulars,

visitors, their children and their dogs. An extensive good-value home-cooked menu is available. Access to this part of the village is not easy for the less mobile. ⅄❀🛏◑🖪(X93)☙

Saltburn-by-the-Sea

Saltburn Cricket, Bowls & Tennis Club ⓛ

Marske Mill Lane, TS12 1HJ (next to leisure centre)
☎ (01287) 622761 ⊕ saltburn.play-cricket.com

3 changing beers Ⓗ
Visitors are made most welcome at this local CAMRA multi-award winner. Just north of the centre, the club is well supported by the local community, and is now celebrating 26 years of continuous Guide recognition. Three interesting beers are served, often not even lasting the evening. An enthusiastic steward hosts a variety of events, including a monthly blues club. The balcony, ideal for those lazy summer afternoons, overlooks the cricket field. Please check winter opening hours. ♿🚶♣P🖪(X3,X4)☙

Scarborough

Craft Bar

7 Northway, YO11 1JH
☎ 07460 311059 ⊕ thecraftbar.co.uk

4 changing beers (sourced nationally) Ⓗ
A welcome addition to the Scarborough beer scene, the bar is located opposite Stephen Joseph Theatre and adjacent to the railway station. It is a single-room shop conversation, with a mix of contemporary and vintage furnishings. There is a choice of four cask ales, 13 craft keg taps and a wide selection of ciders, together with a range of wines and spirits. An extensive choice of bottles and cans can also be enjoyed here or taken away. There is regular live music at weekends and a quiz night on Wednesday. ⅄🚶♦🖪☙🤍

North Riding Brew Pub ⓛ

161-163 North Marine Road, YO12 7HU
☎ (01723) 370004 ⊕ northridingbrewpub.com

6 changing beers (sourced nationally; often North Riding Brewery, North Riding Brewpub) Ⓗ
Scarborough's only brewpub, serving at least six ever-changing beers from local breweries and from microbreweries around the UK. It always has one or more ales from the North Riding Brewery, together with some brewed on the premises. These are complemented by up to six craft keg beers from around the world, and an extensive range of craft bottled brews. There is a public bar, complete with pool table, and a quiet comfortable lounge, refurbished in 2022, both with real fires. Quiz night is Thursday. Q⅄🛏♣♦🖪(843,X94)☙🤍

Scarborough Borough Council Employees Welfare Club ⓛ

Dean Road, YO12 7QS
☎ (01723) 364593

3 changing beers (sourced regionally; often Great Newsome, Mallinsons, North Riding Brewery) Ⓗ
Close to the town centre, this club, dating from 1935, comprises a large bar area with an adjacent snooker room. Three cask ales often include one from Mallinsons, reflecting the preference of the steward, and a dark beer. Club teams participate in local snooker, darts and dominoes leagues. The club welcomes guests and is popular with cricket-goers, especially during Scarborough CC-hosted Yorkshire county games. An outdoor drinking/smoking area is available. Customers can bring in their own food. ⅄❀🚶♣🖪(11,333)☙

Scholars Bar

6 Somerset Terrace, YO11 2PA
☎ (01723) 372826
Hambleton Nightmare Porter; Ossett Yorkshire Blonde, White Rat; Theakston Old Peculier; 2 changing beers (sourced regionally; often Rat, Thornbridge, Timothy Taylor) Ⓗ
A warm, friendly atmosphere prevails at this town-centre pub at the rear of the main shopping centre. The large front bar is dominated by TV screens showing major sporting events, and there is a smaller games area to the rear. Two rotating guest beers, usually from Yorkshire microbreweries, are offered, plus numerous ciders and perries. The Thursday night quiz is popular, with a first prize of 28 pints. ὠ�♣♠🖨(10)🐾🕸️

Valley Bar Ⓛ

51 Valley Road, YO11 2LX
☎ (01723) 372593 ⊕ valleybar.co.uk
5 changing beers (sourced nationally; often Pennine, Rooster's, Scarborough) Ⓗ
The bar, recently relocated to the building adjacent from its original cellar location, is a large room divided into several drinking areas. There is also a pool room and a separate function room. Of note is the remarkable decor utilising antique furniture. Five guest beers are offered, usually including one or more from Scarborough Brewery. Up to 10 real ciders and perries are also sold, together with a selection of Belgian bottled beers. Accommodation is available. Q➲🕸️🛏️♣♠🖨🐾🕸️

Wilsons

West Sandgate, YO11 1QL
☎ 07544 775051 ⊕ wilsonsscarborough.co.uk
6 changing beers (sourced nationally) Ⓗ
The Grade II-listed Wilsons (formerly the Leeds Hotel) is close to the seafront and offers a warm welcome to locals and visitors. This is a single-roomed venue with a horseshoe bar adorned with numerous photographs relating to the local fishing industry. The balcony offers panoramic sea and harbour views. Teams participate in the local darts league, and there is live music on Sunday afternoon and a quiz on Monday. En-suite accommodation is available in five letting rooms.
🕸️🛏️ὠ➲♠🖨(8) 🐾🕸️

Selby

Doghouse Ⓛ

8 Park Street, YO8 4PW
☎ 07495 026173 ⊕ littleblackdogbeer.com
3 changing beers (often Little Black Dog) Ⓗ
Selby's first craft beer café, featuring three cask ales from its own brewery based at Carlton, together with four ciders and a large range of craft keg beers. The upstairs room is a meeting place for many local groups and there is a weekly quiz night, regular live music and occasional guest food suppliers. You can be sure of a warm welcome at this family-run bar. 🕸️➲♠

Settle

Golden Lion Ⓛ ✅

Duke Street, BD24 9DU
☎ (01729) 822203 ⊕ goldenlionsettle.co.uk
Thwaites Mild, Original, IPA, Gold, Amber; 1 changing beer (sourced locally; often Settle) Ⓗ
Built around 1670, this former coaching inn has two comfortable high-ceilinged rooms for drinking. The main bar has wood panelling, a grand staircase and a huge fireplace. The Lion's Den is accessed from the bar or via a low door off the street. The separate dining area is bright and colourful. Outside seating is in the sheltered yard. Breakfast is served, with alcoholic drinks available from 10am. The external door is locked at 10pm (earlier in winter) except for residents. ὠ🕸️🛏️🍴Å➲♣♠🖨🐾🕸️

Talbot Arms Ⓛ ✅

High Street, BD24 9EX
☎ (01729) 823924 ⊕ talbotsettle.co.uk
Settle Mainline; Theakston Best Bitter; 3 changing beers (sourced regionally; often Pennine, Wensleydale, Wishbone) Ⓗ
Just off the square, this family-run free house, claiming to be the oldest pub in town, offers a welcoming and friendly atmosphere. In winter a stove glows in the large stone fireplace to the left. A pleasant, terraced beer garden is at the rear. The guest beers are usually from Cumbria, Lancashire or Yorkshire. A 'bingo' quiz is held on the first and third Monday of the month. Good-value food is served all day, seven days a week, with booking advisable on weekends and school holidays.
🕸️🍴Å➲♣♠P🖨🐾🕸️

Skipton

Beer Engine Ⓛ

1 Albert Street, BD23 1JD
☎ 07930 810763
6 changing beers (sourced nationally) Ⓗ
A well-established micropub in a tiny street between the town centre and the canal, with a friendly and welcoming ambience. Six handpumps dispense varying beers, always including one blonde or pale ale and one dark brew, plus a character beer. Extended in 2022, the bar now includes craft keg fonts. A still cider and a fruit cider are also on tap alongside a selection of bottled beers, cans and wines. The beers are stored in refrigerated cabinets behind the bar. Well-behaved dogs are welcome. Q➲🕸️➲♠🖨🐾🕸️

Boat House Ⓛ

19 Coach Street, BD23 1LH
☎ (01756) 701660
Wishbone Tiller Pin; 4 changing beers (sourced regionally) Ⓗ
Tucked out of the way, this pub is accessed through an arch from Coach Street or via the canalside path. The bar is light and airy with picture windows looking onto the canal basin and the decor has a canal theme. A cobbled outdoor drinking area offers the opportunity to enjoy a beer while watching the boats go by. An old-style stove keeps the bar warm in winter. One dark cask ale and craft keg beers are usually available. 🕸️🕸️ὠ➲🖨🐾🕸️

Narrow Boat Ⓛ

36-38 Victoria Street, BD23 1JE (alleyway off Coach St near canal bridge)
☎ (01756) 797922
Ilkley Mary Jane; Okell's Bitter; Timothy Taylor Landlord; 5 changing beers Ⓗ
This long-standing Guide entry's eight handpulls dispense an eclectic selection of cask ales – there should be one to suit most tastes. Bottled and keg continental and craft beers and up to three ciders or perries complement this offering. Two separate rooms downstairs and an upstairs gallery and function room, plus a drinking/smoking area at the front, provide ample space. Note the unusual interpretation of the Leeds-Liverpool canal map on the wall. Children are welcome if eating. Skipton Folk Unplugged play on Mondays.
🕸️🕦ὠ➲♠🖨🐾🕸️

Slingsby

Grapes

Railway Street, YO62 4AL
☎ (01653) 628076 ⊕ thegrapesinn-slingsby.co.uk
Timothy Taylor Landlord; Theakston Best Bitter; house beer (by Elland); 1 changing beer (sourced regionally) ⊞
The Grapes is a Grade II-listed building whose deeds go back to 1759. An earlier building on this site was described then as a 'cottage or tenement with a brew house'. Its multi-roomed interior is cosy in winter with two real fires, and it has been extensively improved in recent years since coming back into local private ownership. Well located for visiting Castle Howard.
🏠◖▲P🖵❀

South Otterington

Otterington Shorthorn 🗓

DL7 9HP
☎ (01609) 773816 ⊕ otteringtonshorthorn.co.uk
Daleside Bitter; 2 changing beers (sourced locally; often Ossett, Three Brothers) ⊞
Old free house on the A167 crossroads, featuring a comfortable interior which has been opened out into a carpeted lounge bar, and an eating area in a separate room off the bar. Guest ales are usually sourced from small Yorkshire breweries and typically feature differing styles, often including a dark beer. The pub has its own holiday let to the rear. Q🕭🍴▲♣P🖵❀

Starbotton

Fox & Hounds 🗓

BD23 5HY
☎ (01756) 760269 ⊕ foxandhoundsstarbotton.co.uk
Timothy Taylor Landlord; Wharfedale Blonde; 2 changing beers (often Dark Horse, Wensleydale, Yorkshire Dales) ⊞
A family-run, whitewashed 17th-century inn, divided into two cosy rooms, with flagstone floors and a large stone fireplace enhancing the atmosphere. In fine weather the sheltered patio at the front provides additional seating. A locally brewed golden ale and dark beer are served alongside the regular beers. Lunch is available daily and evening meals are served Wednesday to Sunday. The daytime community-run bus stops outside. 🕭🏠🛏◖P🖵(72B,874)❀

Stillington

White Bear 🗓

Main Street, YO61 1JU
☎ (01347) 810338 ⊕ thewhitebearinn-york.co.uk
Leeds Pale; house beer (by Rudgate); 3 changing beers (sourced regionally) ⊞
You will always get a warm welcome in this traditional pub. On the left is a gem of a restaurant, with booking advised, and on the right is a classic pub bar. The autovac system is put to good use so beer is always fresh and lively, and the staff are helpful, warm and friendly. Twice winner of local CAMRA Pub of the Season, this is a pub definitely worth making the effort to visit if you are not already a regular. 🕭🏠🛏◖♣P🖵(40)❀🛜↻

Stokesley

Green Man 🗓 ✓

63 High Street, TS9 5BQ (near police station, towards West Green)
☎ 07500 045598

Timothy Taylor Landlord; 2 changing beers ⊞
A warm welcome is assured at Stokesley's first micropub, which has become the go-to place for locals and visitors alike. With its back-to-basics approach following established micropub norms, the bar, seating and tables have all been constructed from beech trees by a local family friend. There is no TV, no music, no jukebox, no one-armed-bandit and no food, just pleasant conversation with the engaging owners. Three handpulls, real cider and several Belgian bottled beers help the conversation flow. ●🖵(29,81)

White Swan 🗓 ✓

1 West End, TS9 5BL (at W end of town, 150yds beyond shops)
☎ (01642) 714985 ⊕ whiteswanstokesley.co.uk
Captain Cook Sunset, Endeavour, Slipway; 5 changing beers ⊞
Home of the Captain Cook Brewery, this friendly 18th-century pub is at the west end of the pretty market town. Eight handpulls serve six beers from the Captain Cook portfolio of 10 beers, together with two interesting guests, while two real ciders are also always available. Beer festivals are held at Easter and in October. Open-mic night is Tuesday, quiz night is Wednesday, and music night is Thursday. The sheltered outdoor drinking area overlooks the brewery. Over-18s only. 🏠♣●🖵❀🛜

Strensall

Ship

23 The Village, YO32 5XS
☎ (01904) 490302 ⊕ theshipinn-strensall.co.uk
Timothy Taylor Landlord; 2 changing beers (sourced regionally) ⊞
Popular family-run village pub north of York, offering three real ales, one real cider and restaurant food. Open all day, it is popular with walkers, cyclists and caravanners in summer, with outside seating and a children's play area at the rear. Families and dogs are made welcome. Regular events are held including music, a quiz and an annual spring beer festival. The bus stop from York is just across the road. 🕭🏠◖🛜▲P🖵❀🛜

Tan Hill

Tan Hill Inn

DL11 6ED
☎ (01833) 628246 ⊕ tanhillinn.com
Black Sheep Best Bitter; Theakston Old Peculier; house beer (by Dent); 2 changing beers (sourced locally; often Black Sheep, Pennine) ⊞
Britain's highest inn, at 1732 feet above sea level, is famed for its isolated and exposed setting at a high point on the Pennine Way. With character in abundance, the low-beamed, stone-floored bar is warmed for much of the year by the fire in a heavy stone fireplace. B&B and bunkhouse accommodation are available and motorhomes are welcome provided drivers make a small donation to charity. The pub is licensed for weddings, hosts stargazing nights in outdoor domes and features frequent live music. 🕭🏠🛏◖▲P❀🛜

Thirsk

Little 3 🗓

13 Finkle Street, YO7 1DA
☎ (01845) 523782 ⊕ littlethree.co.uk
5 changing beers (sourced nationally; often Hambleton, Pennine, Rooster's) ⊞
Just off the Market Place on the road down to Cod Beck, this old, low-beamed, characterful pub claims a history

from 1214. A warren of nooks and crannies, all decorated in mock half-timbering, it has an impressive fireplace in the main bar. Formerly the Old Three Tuns, it was renamed to avoid confusion with the nearby Three Tuns. Regularly changing guest beers are from local and national brewers, though usually with an emphasis on Yorkshire. There is live music every Thursday and Saturday. ⏵✿P☕♻️🎵

Thornton le Dale

New Inn ✓

The Square, YO18 7LF
☎ (01751) 474226 ● the-new-inn.com
Theakston Best Bitter; 1 changing beer (sourced nationally; often Castle Rock, Ossett, Wye Valley) ⊞
Family-owned Grade II-listed inn, restored to create the feel of yesteryear. Dating to around 1720, this former coaching inn overlooks the medieval village stocks and market cross. The pub prides itself on freshly cooked food, with a wide range of specials. The large main room is separated into a drinking and eating area. Dogs are welcome away from dining areas. A smoking/drinking space is to the rear, and en-suite accommodation is available. An ideal touring base for the North Yorkshire moors, Dalby Forest and Ryedale. Close to Mathewson's Car Auctions. Q⏵✿♻️●♿👶⛺♣P☕(128,840)♻️🎵

Thornton Watlass

Buck Inn 🗽 ✓

Village Green, HG4 4AH
☎ (01677) 422461 ● buckwatlass.co.uk
Black Sheep Best Bitter; Timothy Taylor Landlord; Theakston Best Bitter; Wensleydale Falconer; 1 changing beer ⊞
Overlooking the village green, this traditional country inn, with five letting rooms, features a cosy bar room with a real fire, a lounge/dining room and a large function room known as the Long Room. The building has been refurbished throughout by the owners, while retaining a village pub atmosphere. Excellent meals are available and four regular Yorkshire beers are served, with a changing ale added in summer. Live trad jazz music is hosted on Sunday lunchtimes once a month. ✿♻️●P☕♻️

Thornton-in-Lonsdale

Marton Arms

LA6 3PB (¼ mile from A65/A687 jct)
☎ (015242) 42204 ● martonarms.co.uk
Black Sheep Best Bitter; 2 changing beers (sourced regionally; often Farm Yard) ⊞
In a hamlet with a parish church, old stocks and little else is this independently-owned free house. Behind the 1679 datestone and old oak door, a flagged passage leads to a modern bar with a 2017 refurbishment and 56 gins. The pub has an attractive little garden with a view of Ingleborough, and is 10 minutes' walk from the start of the Waterfalls Walk. There are longer opening hours in summer. ✿♻️●⛺♣P☕(80,581)♻️🎵

Ugthorpe

Black Bull Inn 🗽

Postgate Way, YO21 2BQ
☎ (01947) 840286 ● blackbullwhitby.co.uk
Theakston Old Peculier; 1 changing beer ⊞
A warm welcome is assured at this Grade II-listed traditional, pantiled country inn, where photographs of yesteryear adorn the walls. This comfortable, family-run

establishment comprises a main bar, snug, restaurant and games room. The guest beers complement the Old Peculier, and change weekly. Portions of the home-cooked food are such that going home hungry is not an option. Drinkers and diners also travel from far and wide for the impressive Sunday lunch carvery, for which booking in advance is advised. Q⏵●♿👶♣P

Wensley

Three Horseshoes 🗽

DL8 4HJ (on A684)
☎ (01969) 622327 ● thethreehorseshoeswensley.co.uk
Black Sheep Best Bitter; Theakston Best Bitter; Wainwright; Wensleydale Semer Water; house beer (by Marston's); 1 changing beer (sourced nationally) ⊞
Traditional old country pub on the A684, with its small bar and dining room both featuring low beams and real fires. Outside there is a terraced beer garden offering glorious views across Wensleydale, forming a real suntrap on fine days. Wholesome and reasonably priced lunchtime and evening meals are served daily, except Monday. Guest beers in busier months are usually from the Marston's range. Q⏵✿●♣P☕(156)♻️🎵

West Heslerton

Dawnay Arms 🗽

Church Street, YO17 8RQ
☎ (01944) 728507 ● dawnayarms.co.uk
Theakston Best Bitter; 3 changing beers (sourced regionally; often Great Newsome, Half Moon, Wold Top) ⊞
This village local located just off the A64 has a main bar divided into drinking, eating and games areas, together with a separate restaurant. One regular beer is offered in addition to three guests from Yorkshire microbreweries. High-quality, locally sourced, home-cooked meals are available with booking recommended for Sundays. Teams participate in local pool, darts and dominoes leagues. At the rear is a spacious beer garden and a partially covered smoking/drinking area. Two en-suite rooms are available. ⏵✿♻️●♿👶⛺♣P☕(843)♻️🎵

West Witton

Fox & Hounds 🗽

DL8 4LP (on A684)
☎ (01969) 623650 ● foxwitton.com
Black Sheep Best Bitter; Theakston Best Bitter, Old Peculier; 2 changing beers (sourced locally; often Yorkshire Dales) ⊞
This welcoming, Grade II-listed family-run free house is full of character. A real community local, it has a down-to-earth bar and games room popular with locals and visitors alike. Good-value meals are served all week and the dining room boasts an inglenook fireplace with quaint stone oven. Once a rest house for 15th-century Jervaulx Abbey monks, it has a pleasant patio at the rear; beware the tight entry to the car park. Known to locals as the Fox to distinguish it from the Fox & Hounds in West Burton further up the dale. ⏵✿●⛺♣P☕♻️🎵

Whitby

Arch & Abbey

2-4 Skinner Street, YO21 3AJ (at S end of Skinner St, towards St Hilda's Terrace)
4 changing beers ⊞
A well-established and popular micropub, situated close to the noted Botham's Bakery, operated by enthusiastic

licensees who follow the micropub ethos. This successful crowd-funded start-up is located in what was once an old-fashioned ladies' dress shop that would not look out of place in a heritage museum. Four interesting beers, eight or more ciders, and a huge range of spirits, all distilled in Yorkshire, are served. Children are allowed until 9pm. Q✿⌂≢♠♣☀❄

Black Horse 🅻 ✔

91 Church Street, YO22 4BH (on E side of swing bridge on way to Abbey steps, close to market place)
☎ (01947) 602906 ⊕ the-black-horse.com
5 changing beers Ⓗ
This busy little multi-roomed gem, dating from the 1600s, offers a warm welcome. The frontage, with its frosted glass, together with one of Europe's oldest public serving bars, was built in the 1880s and remains largely unchanged. Beers from the Punch list are served from five handpumps. Snuff, tapas, olives, Yorkshire cheeses and hot drinks are always available, and hot lunches are served in winter. Accommodation is in four bedrooms.
Q✿⌂◐♿≢♣☀❄

Little Angel ✔

18 Flowergate, YO21 3BA (200yds W of swing bridge, 200yds N of railway/bus stations)
☎ (01947) 820475 ⊕ littleangelwhitby.co.uk
5 changing beers Ⓗ
Locals and visitors alike are afforded a friendly welcome at this popular pub, now the home of Lady Luck Brewery. It is rumoured that remains of the castle form part of the structure. Five beers are served to three separate rooms from a central bar. Features include large-screen sports TVs, live music, an outdoor beer terrace and even a horse mount for those requiring it. A former local CAMRA award winner for three years running. ✿✫≢♣☀❄

Station Inn 🅻 ✔

New Quay Road, YO21 1DH (opp bus and NYMR/EVR stations)
☎ (01947) 600498 ⊕ stationinnwhitby.co.uk
Black Sheep Best Bitter; Ossett Yorkshire Blonde, Silver King; Timothy Taylor Boltmaker; Theakston Old Peculier; Whitby Jet Black; 2 changing beers Ⓗ
Next to the harbour and marina, this popular multi-roomed pub is under the proud stewardship of an enthusiastic licensee who ensures that the eight ales, including two guests, always encompass an eclectic range of varying beer styles. Situated opposite the bus station and NYMR/Esk Valley Railway station, this pub has become the discerning travellers' waiting room. Live music features three evenings a week. There are four letting bedrooms. ⌂≢🚌(X93,840)☀❄

Waiting Room 🅻

2 Whitby Station, Langborne Road, YO21 1YN (by main entrance to NYMR/EVR station)
☎ (01947) 821640
6 changing beers Ⓗ
The friendly staff at Whitby's first micropub, located on the platform that the NYMR steam trains use, follow the original micropub ethos: no keg beers/lagers, no spirits, no jukebox and no television. Six handpumps and 10 traditional and fruit ciders help to promote lots of convivial conversation. The six-yards-square pub gets busy at times, so do not be disappointed if there is no room. Local CAMRA Cider Pub of the Year.
Q♿≢♠🚌(X93,840) ☀❄

Whitby Brewery Tap 🅻

East Cliff, YO22 4JR (at top of 199 steps)
☎ (01947) 228871 ⊕ whitby-brewery.com

Whitby Abbey Blonde, Whitby Whaler, Saltwick Nab, Smugglers Gold, Jet Black, IPA Ⓗ
Away from the hustle and bustle of the town, perched on the cliff edge and in the shadow of the abbey, the brewery now includes a small bar that serves up to five of its seven beers, together with a bottle shop. Drinkers can imbibe indoors, close to the liquor tank, mash tun and copper, or sit in the courtyard when the weather is not too inclement. Tours are available (please book ahead), and include tastings of the beers.
Q✿✫◐♿♣🅰≢P☀

Yarm

New Inn 🅻

119 High Street, TS15 9BB (enter via Brandlings Court ginnel at N end of High St)
4 changing beers Ⓗ
This former chocolate boutique is now Yarm's first micropub, with a contemporary atmosphere enhanced by light background music. As well as four guest beers and real cider, cans of craft ales and bottled Belgian beers are also served. Third-pint glasses are available. Conversation is a must where rubbing shoulders with fellow drinkers becomes inevitable. Top quality snacks, sourced from a local award-winning farm shop, are offered, as are luxury teas, sweets and doggie treats.
Q♠🚌(7,17) ☀

York

Ackhorne 🅻

9 St Martins Lane, YO1 6LN
☎ (01904) 671421
Ainsty Cool Citra; Rudgate Jorvik Blonde, Ruby Mild; house beer (by Half Moon); 2 changing beers (sourced locally; often Brew York, Rooster's, Yorkshire Heart) Ⓗ
This traditional 18th-century pub, with a family-friendly atmosphere that appeals to all age groups, is hidden off the beaten track down a cobbled lane at the bottom of Micklegate. It is partially open plan, with separate areas up a couple of steps or through an archway. There is a pleasant, heated beer garden on a raised area to the back of the pub. Six ales are available, Sunday lunches are served, and there is a regular evening quiz.
✿✫◐≢♣🐕🐾☀

Blue Bell 🍺 ★ 🅻 ✔

53 Fossgate, YO1 9TF
☎ (01904) 654904 ⊕ bluebellyork.com
Bradfield Farmers Blonde; Rudgate Battleaxe; Timothy Taylor Landlord; Wold Top Bitter; house beer (by Brass Castle); 2 changing beers (sourced locally; often Half Moon, Rooster's) Ⓗ
Full of character, this small Edwardian pub has a nationally important Grade II* historic interior (from 1903), with a central bar supplying two small rooms and a side corridor. It can get full, and entry is restricted at busy times. The strict house rules include a no groups policy. The permanent beers are complemented by great range of rotating guests through seven handpulls. Bar snacks and pork pies are available. The pub's charismatic landlord, friendly staff and welcoming atmosphere led to the Blue Bell being voted local CAMRA Pub of the Year 2022. Q♿♣♠🚌☀❄

Brew York Beer Hall & Tap Room 🅻

Unit 6, Enterprise Complex, Walmgate, YO1 9TT
☎ (01904) 848448 ⊕ brewyork.co.uk

Brew York Calmer Chameleon, Haze of Thunder, Tonkoko; changing beers (sourced locally; often Brew York) 🅷

Brew York's Beer Hall and Tap Room are inside the original brewery and old maltings; the production brewery is outside the city centre. Ten handpulls and 50 KeyKeg pumps ensure that you will find different tastes on each visit. Regular, seasonal, experimental and collaboration brews emanate from this brewery, which has won multiple awards, including SIBA 2021 Brewery of the Year. There is plentiful seating indoors by the brew tanks and in the garden by the River Foss. Innovative fresh food is served. 🛥🏶🅾🕭🦽🖨🐾❀🛜

Fox

168 Holgate Road, Holgate, YO24 4DQ
☎ (01904) 787722
Ossett Yorkshire Blonde, Silver King, Excelsius; Rat White Rat; Tetley Bitter; 4 changing beers (sourced regionally; often Fernandes, Rat, Riverhead) 🅷
Set in the Holgate district of York, the Fox is a venue whose history is linked to the golden age of rail. Sympathetically restored by Ossett Brewery, it is recognised by CAMRA as having a historic interior of regional importance. It offers a good range of Ossett beers plus cider and interesting guest ales. It also has a large, popular beer garden. 🛥🏶🅿🖨(1,5)❀🛜

Golden Ball ★ 🅻

2 Cromwell Road, YO1 6DU
☎ (01904) 849040 ⊕ goldenballyork.co.uk
Acorn Barnsley Bitter; Ainsty Assassin; Timothy Taylor Golden Best; 3 changing beers (sourced regionally; often Salopian, Stubbee, Whitby) 🅷
A fine Victorian street-corner community-run local with an impressive glazed brick exterior that was extensively refurbished by John Smith's in 1929. Grade II listed, it has four very different rooms: a main bar, back room, comfortable lounge and snug. Outside is a large south-facing beer garden. Seven handpumps showcase three permanent ales plus three changing guests. Local produce is on sale in the bar as well as Scotch eggs, pork pies and nuts. Q🛥🏶🥀🌥🦽❀❀

Maltings 🅻

Tanners Moat, YO1 6HU
☎ (01904) 655387 ⊕ maltings.co.uk
Black Sheep Best Bitter; Treeboom Yorkshire Sparkle; York Guzzler; 3 changing beers (sourced nationally; often Bad Seed, Rooster's) 🅷
A popular pub with a rustic interior, featuring enamel advertising signs on the walls. The main bar has wood-panelled walls and tile floors; the side bars have wooden floors. There is a choice of seven cask beers and up to four real ciders, with the cask ales often including rare and aged brews. The Dragon's Pantry serves a selection of traditional pub grub. Local CAMRA Cider Pub of the Year 2020. 🏶🅾🌥🦽🖨

Market Cat

6 Jubbergate, YO1 8RT
☎ (01904) 637023 ⊕ marketcatyork.co.uk
Thornbridge Lord Marples, Jaipur IPA; 6 changing beers (often Hawkshead, Tapped Sheffield, Thornbridge) 🅷
Operated by Thornbridge and Pivovar UK, this three-storey building has seating on all three floors with excellent views across the Shambles Market and towards the minster from the upper two. A changing range of real ales is served from eight handpumps with a mixture of beers from Thornbridge, Tapped and other breweries. A pizza menu is supplemented by a range of bar snacks. 🅾🌥

Minster Inn ✅

24 Marygate, YO30 7BH
☎ (01904) 849240 ⊕ minsterinn.co.uk
Banks's Sunbeam; Ringwood Boondoggle; 3 changing beers (sourced nationally) 🅷
There is always a friendly and colourful welcome in this traditional pub, where you are sure to get a great pint and strike up a conversation with the locals. Dating from 1903, the Edwardian interior is mostly unchanged, with two rooms off the corridor bar and the main bar in the third room. Dogs are welcome, and there are table puzzles and games for all. Guest beers come from the Marston's range. Q🛥🏶🥀🅾🌥🦽🖨🐾❀

Phoenix

75 George Street, YO1 9PT
☎ (01904) 656401 ⊕ phoenixinnyork.co.uk
Timothy Taylor Landlord; Wold Top Anglers Reward; 3 changing beers (sourced regionally) 🅷
A friendly welcome awaits visitors and locals at this independently run free house with its regionally important historic pub interior. It is close to the city walls, and Dick Turpin's grave is in the garden nearby. This is a traditional pub with no noisy gaming machines, TV or jukebox, where you can enjoy your beer while reading a newspaper or just chatting with fellow drinkers. In the colder months an open fire warms the front parlour. The rear room boasts bar games and weekly music events. A true gem that is not to be missed. Q🛥🏶🥀🌥🖨❀❀🛜

Rook & Gaskill 🅻

12 Lawrence Street, YO10 3WP
☎ (01904) 671548 ⊕ rookandgaskillyork.co.uk
6 changing beers (sourced nationally; often Bad Seed, Treeboom, Turning Point) 🅷
Across from Walmgate Bar, this thriving pub is home to locals, students and beer devotees. A wide range of reasonably priced ales is on offer, many of which are local, including from on-site brewery 3 Non Beards. They are served from six casks and 20 KeyKeg taps which, along with three real ciders, means the pub can cater for all tastes. The freshly cooked food features generous portions and reasonable prices. A former local CAMRA Pub of the Year, visit and you will see why. 🏶🅾🌥🦽🖨❀🛜

Slip Inn 🅻

Clementhorpe, YO23 1AN
☎ (01904) 621793
Leeds Pale; Rudgate Ruby Mild; Timothy Taylor Boltmaker; 5 changing beers (sourced regionally; often Revolutions, Ridgeside) 🅷
An independent free house that is a thriving community local, featuring two bars, a snug and a sheltered courtyard beer garden. A big scheme of investment in the buildings in 2019 has doubled the beer range on the bar and created a dedicated outside festival bar. The pub supports traditional pub games including darts, dominoes and cribbage. It hosts regular beer festivals and events each year, including one run jointly with the Swan just up the road. Local CAMRA Pub of the Year 2020. 🛥🏶🦽🖨(11)❀🛜

Swan ★ 🅻

16 Bishopgate Street, YO23 1JH
☎ (01904) 634968 ⊕ theswanyork.co.uk
Timothy Taylor Landlord; Tetley Bitter; house beer (by Treeboom); 4 changing beers (sourced regionally; often Half Moon, Revolutions, Stubbee) 🅷
This thriving Grade II-listed street-corner hostelry, within sight of the city walls, has been free of tie since 2017. Its traditional West Riding-style drinking lobby and two bars help make the interior friendly and comfortable – the pub

has been identified by CAMRA as having a nationally important historic interior. To the back is a heated and partially covered beer garden where an annual beer festival is hosted jointly with the nearby Slip Inn.
🏠♣🍴🚫(11) ♿

Volunteer Arms 🅛

5 Watson Street, YO24 4BH
☎ (01904) 541945 🌐 volunteerarmsyork.co.uk
Black Sheep Best Bitter; Leeds Yorkshire Gold; Saltaire Blonde; Timothy Taylor Dark Mild; 3 changing beers (sourced locally) Ⓗ
A totally independent free house situated just off Holgate Road, close to the centre of York. The pub has a real community feel and is welcoming to all. It offers an excellent beer range for a suburban pub, with loyalties firmly with local breweries, emphasising its commitment to LocAle. There are five permanent beers and two ever-changing guests. Other features include live blues every Saturday night and a quiz every Sunday night.
Q🏠🌟🚃🍴🚫(1,10) ♿ 📶

Waggon & Horses 🅛

19 Lawrence Street, YO10 3BP
☎ (01904) 637478 🌐 waggonandhorsesyork.com
Batemans XB, XXXB; Oakham Citra; 4 changing beers (sourced nationally; often Bad Seed, Ossett, Rooster's) Ⓗ
A real ale-loving landlord runs this Batemans-owned pub which serves seven cask beers including LocAle, and occaionally a beer from the wood. The bar area and front room have TVs showing BT Sport. Two other rooms at the back are quieter and used by various local groups to hold meetings. Bar billiards and board games are available. A former local CAMRA Pub of the Year.
🌳🏠♿⚓♣🍴🚫♿ 📶

York Tap

Railway Station, Station Road, YO24 1AB
☎ (01904) 659009 🌐 yorktap.com
Timothy Taylor Golden Best, Boltmaker, Knowle Spring, Landlord; 18 changing beers (sourced nationally; often Anarchy, Tapped (Sheffield), Thornbridge) Ⓗ
A conversion of the Victorian tea rooms on York station which opened as a pub in 2010. The ornate ceiling, Art Deco stained-glass windows, terrazzo floors and stained-glass ceiling domes create an award-winning backdrop to the central bar with its 20 handpumps. On sale are 18 cask beers plus two ciders or perries, as well as a large range of keg and bottled ales. The beers are sourced by parent company Pivovar from many of Britain's finest breweries. All styles and strengths are represented. No meals are served but pies are available at the bar.
🏠♿🚃🍴🚫♿

Breweries

3 Non Beards

🍴 Rook & Gaskill, 12 Lawrence Street, York, YO10 3WP ☎ 07980 994210 🌐 3nonbeards.co.uk
☺Launched in 2019 as a partnership of three friends, this one-barrel plant is in the basement of the award-winning Rook & Gaskill. Advised by innovative local brewers, the beer range can be found in the pub and at beer festivals. Around 30 brews per year means an eclectic variety of mainly one-offs, and frequent single hop beers. ♦

Ainsty SIBA

Manor Farm, Intake Lane, Acaster Malbis, York, North Yorkshire, YO23 3UJ
☎ (01904) 703233 ☎ 07983 604989
🌐 ainstyales.co.uk
☺Established in 2014 as a cuckoo brewery, its own 10-barrel brewery opened in 2016 in the ancient York & Ainsty Wapentake in York. Beers (cask, keg, can, bottle) can be found across York, throughout Yorkshire and other areas of the UK, and on its online shop.
‼🍴♦🗲

Northern Lights (ABV 3.6%) GOLD
Flummoxed Farmer (ABV 4%) BLOND
Bantam Best (ABV 4.2%) BITTER
Cool Citra (ABV 4.4%) PALE
Assassin (ABV 4.9%) STOUT

Another Beer

Unit 3, Handley Park, Elvington Industrial Estate, York Road, Elvington, YO41 4AR ☎ 07403 264242
🌐 anotherbeer.co.uk
Launched in 2019 by James Fawcett, Another Beer moved from York city centre into the former Hop Studio site in Elvington in 2022. Additional space and increased brewing capacity has seen an expansion into cask production. Beers are available in York as well as having distribution across Yorkshire, Manchester and the Midlands. ♦

Bad Seed

7 Rye Close, York Way Industrial Estate, Malton, North Yorkshire, YO17 6YD
☎ (01653) 695783 🌐 badseedbrewery.com
☺Bad Seed produce an award-winning range of new wave and traditional beers in cask, keg and can. Established in 2013, the brewery is based in Malton, the 'food capital' of Yorkshire, and operates on a 12-barrel brew kit. Alongside the core range it makes regular specials, unique brews and collaborations with other cutting-edge breweries. All beers are unfined, unfiltered and vegan-friendly. ‼♦V

Kiwi (ABV 3.8%) PALE
Dalliance (ABV 4%) PALE
Session IPA (ABV 4%) PALE

Bayonet (NEW)

Office: Cotswold Street, Brompton, North Yorkshire, DL6 2BX 🌐 bayonetbrewing.co.uk
Serviceman Alex Postles launched Bayonet in 2021. The nanobrewery produces small-batch craft beers available in keg and can. V

Black Sheep SIBA

Wellgarth, Masham, Ripon, North Yorkshire, HG4 4EN
☎ (01765) 689227 🌐 blacksheepbrewery.co.uk
☺Established in 1992 by Paul Theakston, a member of Masham's famous brewing family, the brewery operation is now run by his two sons. It is situated in the former Wellgarth Maltings and uses the traditional Yorkshire Square fermenting system. The company supplies the free trade across Yorkshire and the North, with national supply through pubcos and wholesale channels. It acquired York Brewery in 2018 and six pubs/bars are owned in Yorkshire. ‼🗲♦🗲

Best Bitter (ABV 3.8%) BITTER

Respire (ABV 4%) PALE
Special Ale (ABV 4.4%) BITTER
Riggwelter (ABV 5.9%) BITTER

Brewed for Ember Inns:
Twilighter IPA (ABV 4%) PALE

Brewed under the York Brewery name:
Guzzler (ABV 3.6%) BITTER
Refreshing golden ale with dominant hop and fruit
flavours developing throughout.

Brass Castle SIBA

10A Yorkersgate, Malton, North Yorkshire, YO17 7AB
☎ (01653) 698683 ⊕ brasscastle.co.uk

⊕The brewery is based in the centre of Malton with a
12-barrel plant, having begun life in 2011 on a one-
barrel kit in the owner's garage. It has an on-site
taproom with many beers available for on and off-sales.
‼ ◢ ◆ ◈

Northern Blonde (ABV 3.9%) BLOND
Misfit (ABV 4.3%) GOLD
Bad Kitty (ABV 5.5%) SPECIALITY
Sunshine (ABV 5.7%) IPA
Disruptor (ABV 7.4%) IPA

Brew York SIBA

Unit 6, Enterprise Complex, Walmgate, York, YO1 9TT
☎ (01904) 848448

Osbaldwick: Handley Park, Outgang Lane,
Osbaldwick, YO19 5UP ⊕ brewyork.co.uk

⊕Established in 2016, Brew York was born out of two
friends' passion for beer and brewing. The original
brewery is located within York's historic city walls, a 15-
minute walk from the station. A unique taproom and
beer hall (including kitchen) with riverside beer garden
sits alongside the original 10-barrel brewery which now
specialises in barrel-aged and mixed fermentation beers.
A new state-of-the-art, twin 30-barrel brewery has been
built to the east of the city for larger scale production.
‼ ◢ ◆ ◈

Calmer Chameleon (ABV 3.7%) PALE
Minstermen Pride (ABV 3.7%) PALE
Haze of Thunder (ABV 4.2%) PALE
Tonkoko (ABV 4.3%) SPECIALITY

C'84

⊟ Rear of New Inn, Main Street, Cropton, North
Yorkshire, YO18 8HH
☎ (01751) 469632 ⊕ c84.co.uk

⊕Established in 1984, the brewery was built behind the
New Inn in 1994. In 2010 Cropton Brewery rebranded as
Great Yorkshire and again in 2019 to C'84. Beers are
available throughout Yorkshire and nationally through
wholesalers. A pilot kit was installed in 2020 for short-
run, special batch brews. ‼ ◆ LIVE

Yorkshire Classic (ABV 4%) BITTER
Yorkshire Golden (ABV 4.2%) GOLD
Yorkshire Blackout (ABV 5%) PORTER

Captain Cook

Rear of White Swan, 1 West End, Stokesley, North
Yorkshire, TS9 5BL
☎ (01642) 714985 ⊕ whiteswanstokesley.co.uk

⊕Having celebrated its 20th anniversary in 2019, the
Captain Cook Brewery is located behind the 18th century

White Swan pub. The brewery, which supplies the pub,
uses a four-barrel plant. ‼ ◆

Navigator (ABV 4%) GOLD
Sunset (ABV 4%) GOLD
Slipway (ABV 4.2%) BLOND
Endeavour (ABV 4.3%) BROWN
Skippy (ABV 4.3%) GOLD
Black Porter (ABV 4.4%) PORTER
APA (ABV 4.7%) PALE
Schooner (ABV 4.7%) STOUT
IPA (ABV 5.1%) PALE

Cold Bath

⊟ 46 Kings Road, Harrogate, North Yorkshire,
HG1 5JW
☎ (0330) 880 7009 ⊕ coldbathbrewing.com

Launched in 2018, Cold Bath's on-site brewery can be
viewed on the mezzanine level above the bar. All beers
are exclusively available in the pub.

Copper Dragon

Snaygill Industrial Estate, Keighley Road, Skipton,
North Yorkshire, BD23 2QR
☎ (01756) 243243 ⊕ copperdragon.co.uk

⊕Copper Dragon brew in Skipton using a 15-barrel
plant. As well as the core range of Copper Dragon beers,
Recoil Craft beers are also brewed, with both brands also
featuring special editions.

Best Bitter (ABV 3.8%) BITTER
Golden Pippin (ABV 3.9%) BITTER
Golden session beer, fruity and hoppy in aroma and
taste. Citrus comes comes through in the aftertaste
which is increasingly bitter.
Black Gold (ABV 4%) BITTER
Silver Myst (ABV 4%) SPECIALITY
Scotts 1816 (ABV 4.1%) BITTER

Brewed under the Recoil brand name:
Antidote (ABV 3.8%) BLOND

Craven (NEW) SIBA

Units 9 & 10, Midland Mills, Station Road, Cross Hills,
North Yorkshire, BD20 7DT
☎ (01535) 637451 ⊕ cravenbrew.co.uk

A cask led and focused brewery established in Cross Hills
in 2022. The 16-barrel plant brews twice weekly
producing five core beers together with specials. The
adjacent taproom is open daily. ◆

Session Pale Ale (ABV 3.7%) PALE
Best Yorkshire Bitter (ABV 3.8%) BITTER
Extra Fine Ale (ABV 4.2%) BITTER
Black Angus Porter (ABV 4.5%) PORTER
Yorkshire Pale Ale (ABV 4.8%) BITTER

Crooked

Units 12-15, The Garages, Leeds East Airport, Church
Fenton, LS24 9SE ☎ 07890 526505
⊕ crookedbrewing.co.uk

⊕After teaching homebrewing, Steve, Andy, Hudson
and Mark started brewing in 2017 on the old RAF airfield
at Church Fenton. Beers are increasingly available in a
number of city centre pubs and bars in York and Leeds
and many brews are canned for wider distribution. The
brewery tap, Crooked Tap, opened in 2019 at Acomb
Green, York. ◆ ◈

Spokes (ABV 4%) BITTER
Standard Bitter (ABV 4.2%) BITTER

The Lash (ABV 4.4%) PALE
XX (ABV 4.6%) PALE
Rufus (ABV 4.8%) PORTER

Daleside SIBA

Camwal Road, Starbeck, Harrogate, North Yorkshire, HG1 4PT
☎ (01423) 880022 ⊕ dalesidebrewery.com

Daleside Brewery was established in the mid-1980s, and moved to its current site in 1992. Beers are sold to local, regional and national customers and export markets include Denmark, Sweden and Australia. ☞◆

Bitter (ABV 3.7%) BITTER
Blonde (ABV 3.9%) BLOND
Old Leg Over (ABV 4.1%) BITTER
Monkey Wrench (ABV 5.3%) OLD

Dark Horse SIBA

Coonlands Laithe, Hetton, North Yorkshire, BD23 6LY
☎ (01756) 730555 ⊕ darkhorsebrewery.co.uk

Dark Horse began brewing in 2008. The brewery is based in an old hay barn within the Yorkshire Dales National Park. Around 50 outlets are supplied direct.

Craven Bitter (ABV 3.8%) BITTER
Well-balanced bitter with biscuity malt and fruit on the nose continuing into the taste. Bitterness increases in the finish.
Blonde Beauty (ABV 3.9%) GOLD
Hetton Pale Ale (ABV 4.2%) PALE
Earthy bitterness on the palate overlaying a malty base and a spicy citrus character.
Night Jar (ABV 4.2%) BITTER
A malty, fruity bitter in aroma and taste. Caramel and dark fruits lace the finish.

Elvington (NEW)

Station Yard, York Road, Elvington, YO41 4EL
☎ (01904) 607167 ⊕ pivovarorders.co.uk/elvington-brewery

Part of the Pivovar Group that was established in 2021 to brew Mittel Pils lager for its pubs. The Czech pilot test plant will be upgraded to a £1 million German-built plant during the currency of this Guide. No real ale. ◆

Farmers

Office: 98 Main Street, Haworth, North Yorkshire, BD22 8DP
☎ (01748) 886297 ⊕ farmersarmsmuker.co.uk/brewery

Formerly known as Haworth Steam, the five-barrel brewery has been in the Gascoigne family for more than 30 years. Beers are supplied exclusively to the two family-owned establishments. Beers are also sold under the Whitechapel brand name. ☞

Great British Breworks

34 Dove Way, Kirkby Mills Industrial Estate, Kirkbymoorside, North Yorkshire, YO62 6QR
☎ (01751) 433111 ☎ 07876 827475

Office: c/o The Black Swan Hotel, 18 Birdgate, Pickering, YO18 7AL ⊕ blackswan-pickering.co.uk/breworks

Brewing started on a permanent basis in the yard of the Black Swan, Pickering, in 2016, on a 2.5-barrel plant. In 2020, the brewery expanded by taking over the 12-barrel brewing plant in Kirkbymoorside previously used by Turning Point brewery (this was deferred until 2021 due to the pandemic). The Black Swan serves as the brewery tap. ◆

Great Scot (ABV 3.8%) BITTER
Lightheaded (ABV 4%) PALE
Istanbul (ABV 4.5%) BITTER
Coal Porter (ABV 4.6%) PORTER
Simcoe Pale (ABV 5.2%) PALE

Guisborough

14 South Buck Way, Guisborough, North Yorkshire, TS14 7FJ ☎ 07703 002858
✉ info@guisboroughbrewery.co.uk

Established in 2020 using a five-barrel plant. The core range consists of eight beers and a summer special. Events are held regularly and visitors, by arrangement, are made welcome. The brewery is open on Fridays for on and off sales. ♬☞◆♠

Dark Habit (ABV 3.7%) MILD
Delight (ABV 3.7%) BITTER
Alchemy (ABV 3.8%) BITTER
Phoenix (ABV 4%) RED
Daze (ABV 4.3%) IPA
Elevator (ABV 4.5%) IPA
BOBA (ABV 5%) BROWN
Vypa (ABV 5.5%) IPA

Hambleton SIBA

Melmerby Green Road, Melmerby, North Yorkshire, HG4 5NB
☎ (01765) 640108 ⊕ hambletonbrewery.co.uk

Hambleton Ales was established in 1991 by Nick Stafford in a shed at the bottom of his in-laws' garden. It is now run by Nick's daughter and son-in-law. Since 2007 the company has operated from purpose-built premises near Ripon with 100 barrels a week capacity. Along with a core range of eight beers, cask ale is contract brewed for Village Brewer, Black Dog and Wharfe Brewery. A bottling line handles brands for other breweries and a canning line has recently been added with some unfiltered beers on sale. ♬☞◆

Session Pale (ABV 3.6%) PALE
Bootleggers Pale Ale (ABV 3.8%) PALE
Thoroughbred IPA (ABV 4%) PALE
Pink Grapefruit (ABV 4.1%) SPECIALITY
Stallion Amber (ABV 4.2%) BITTER
Stud Blonde (ABV 4.3%) GOLD
Black Forest (ABV 5%) SPECIALITY
Nightmare Porter (ABV 5%) STOUT

Contract brewed for Black Dog Brewery:
Whitby Abbey Ale (ABV 3.8%) BITTER
Schooner (ABV 4.2%) PALE
Rhatas (ABV 4.6%) BITTER

Contract brewed for Village Brewer:
White Boar (ABV 3.8%) BITTER
Bull (ABV 4%) GOLD

Contract brewed for Wharfe Beers:
Verbeia (ABV 3.6%) BITTER
Tether Blond (ABV 3.8%) GOLD

Harrogate SIBA

Unit 7, Hookstone Centre, Hookstone Chase, Harrogate, North Yorkshire, HG2 7HW ☎ 07593 259425 ⊕ harrogatebrewery.co.uk

Established in 2013, the brewery also uses the names Spa Town Ales, and It's Quicker By Ale on its logo and

pumpclips. The brewery has a capacity of 10 barrels, and brews several times each week. 🛒🧹

Harrogate Pale (ABV 4.2%) GOLD
Cold Bath Gold (ABV 4.4%) BLOND
Pinewoods Pale Ale (ABV 4.4%) GOLD
Plum Porter (ABV 4.8%) SPECIALITY
Vanilla Porter (ABV 4.8%) SPECIALITY
Beeching Axe (ABV 5.2%) BITTER
Kursaal Stout (ABV 6.7%) STOUT

Helmsley SIBA

18 Bridge Street, Helmsley, North Yorkshire, YO62 5DX
☎ (01439) 771014 ☎ 07525 434268
⊕ helmsleybrewingco.co.uk

☺Located within the North York Moors National Park, brewing began in 2014. The brewery has a viewing gallery, tasting room and brewery tap. Local pubs are supplied. LIVE 🧹

Yorkshire Legend (ABV 3.8%) BITTER
Striding the Riding (ABV 4%) BITTER
Howardian Gold (ABV 4.2%) GOLD
Honey (ABV 4.5%) SPECIALITY
H!PA (ABV 5.5%) IPA

Ice Cream Factory

21 Fetter Lane, York, YO1 9TA ☎ 07880 547393
⊕ theicecreamfactory.com

Nano-brewery located in the old Capaldi's ice cream factory, established in 2017.

Isaac Poad SIBA

Office: Hay House, Baxby Manor, Husthwaite, North Yorkshire, YO61 4PW
☎ (01423) 358114 ⊕ isaacpoadbrewing.co.uk

☺Established in 2016 by a local grain merchant, which formerly supplied malting barley to local maltsters, the brewery continues despite the subsequent demise of the parent company. Pending construction of its own brew plant, production is actually carried out at another local brewery. ♦

No. 86 Golden Ale (ABV 3.6%) GOLD
1863 Best Bitter (ABV 3.8%) BITTER
No. 91 Craft Ale (ABV 3.9%) GOLD
All Four Yorkshire Red Ale (ABV 4.2%) RED
No. 84 India Pale Ale (ABV 4.5%) PALE
Piccadilly Porter (ABV 4.8%) PORTER

Jolly Sailor SIBA

🏠 Olympia Hotel Tap House, 77 Barlby Road, Selby, North Yorkshire, YO8 5AB
☎ (01757) 707564 ☎ 07923 635755
⊕ jollysailorbrewery.uk

☺The Jolly Sailor Brewery is an independent family-run microbrewery established in 2013 in the grounds of the Olympia Hotel Tap House in Selby, on the nearby River Ouse and close to the 11th century abbey. Beers are brewed on a six-barrel plant and available at the brewery's Jolly Sailor Inn, Cawood, and extensively in the free trade. ‼🛒♦🧹

Selby Bitter (ABV 3.8%) BITTER
Selby Blonde (ABV 3.8%) BLOND
Selby Pale (ABV 3.9%) PALE
Selby Mild (ABV 4%) MILD
Milk Stout (ABV 4.5%) STOUT
Dark Nights Porter (ABV 5%) PORTER

Lady Luck

🏠 Little Angel, 18 Flowergate, Whitby, North Yorkshire, YO21 3BA
☎ (01947) 820475 ☎ 07920 282506

☺Lady Luck is a 0.5-barrel brewery situated at the back of the Little Angel, Whitby. Brewing began in 2018 and takes place four times a week. Beers, some infused with spirits, are distributed across North Yorkshire as well as at beer festivals. ♦LIVE

LAMB

Queens Arms, Litton, North Yorkshire, BD23 5QJ
☎ 07900 013245 ⊕ lambbrewing.com

☺The LAMB Brewing Company brews on a 600-litre plant behind the Queen's Arms in Litton. Independently-owned, the beer is served in the pub, as well as a few other outlets in the local area. Cask, boxed and pouched beers are available.

X Mild (ABV 3.2%) MILD
X Mild (Dark) (ABV 3.2%) MILD
Bitter (ABV 3.7%) BITTER
Pale (ABV 3.9%) GOLD

Little Black Dog

Carlton Brewery, Duddings Farm, Carlton, North Yorkshire, DN14 9LU ☎ 07495 026173
⊕ littleblackdogbeer.com

Established in 2015, Little Black Dog is a small batch, family-run brewery. All beer is unfined, unpasteurised and unfiltered. The brewery tap is the Doghouse, Selby. 🛒♦

Yorkshire Bitter (ABV 3.8%) BITTER
Big Red American Amber (ABV 4.5%)
Oatmeal Stout (ABV 4.5%) STOUT

Live

Hudswell ⊕ live-brew.com

Four-barrel microbrewery set up by the team behind the 2016 National Pub of the Year, the George & Dragon, Hudswell. It specialises in small-scale one-off brews utilising traditional techniques and locally foraged ingredients. Brewing is currently suspended.

Malton

5 Navigation Wharf, Off Yorkersgate, Malton, YO17 7AA ☎ 07946 776613 ⊕ maltonbrewery.com

Microbrewery situated on the banks of the Derwent, operating since 2018. Owner Howard Kinder had previously launched Horsetown Beers in 2016 with a donation to Racing Welfare made for each sale. LIVE

Mithril

Aldbrough St John, North Yorkshire, DL11 7TL
☎ (01325) 374817 ☎ 07889 167128
✉ mithril58@btinternet.com

☺Mithril started brewing in 2010 in old stables opposite the brewer's house on a 2.5-barrel plant. Owner Pete Fenwick, a well-known craft brewer, brews twice a week to supply the local areas of Darlington, Richmond and Teesdale. A new beer is usually brewed every week. ♦

Dere Street (ABV 3.8%) BITTER
Flower Power (ABV 3.9%) SPECIALITY
A66 (ABV 4%) GOLD
Kingdom of Ovingtonia (ABV 4%) BROWN

Molson Coors (Tadcaster)

Tower Brewery, Wetherby Road, Tadcaster, North Yorkshire, LS24 9JR ⊕ molsoncoorsbrewers.com

Molson Coors is the result of a merger between Molson of Canada and Coors of Colorado, US. Coors established itself in Europe in 2002 by buying part of the former Bass brewing empire, when Interbrew (now A-B InBev) was instructed by the British government to divest itself of some of its interests in Bass. Coors owns several cask ale brands. It brews 110,000 barrels of cask beer a year (under licensing arrangements with other brewers) and also provides a further 50,000 barrels of cask beer for other breweries. In 2011 Molson Coors bought Sharp's brewery in Cornwall (qv). No cask ale is produced in Burton or Tadcaster.

North Riding (Brewery)

Unit 6, Barker's Lane, Snainton, North Yorkshire, YO13 9BD
☎ (01723) 864845 ⊕ northridingbrewery.com

☺Having outgrown the brewpub in Scarborough, Stuart Neilson established a 10-barrel brewery in East Ayton on the outskirts of Scarborough in 2015. In early 2019 operations moved to a much larger premises in Snainton, enabling further expansion of brewing capacity. Concentrating on hop-forward beers, distribution is throughout the North of England and the Midlands. ◆LIVE

Mosaic Pale Ale (ABV 4.3%) PALE
Citra Pale Ale (ABV 4.5%) PALE

North Riding (Brewpub)

▤ North Marine Road, Scarborough, North Yorkshire, YO12 7HU
☎ (01723) 370004 ⊕ northridingbrewpub.com

☺Brewing commenced in 2011 using a two-barrel plant situated in the cellar of the pub, which is now brewing to capacity with three fermenting vessels. ◆

North Yorkshire SIBA

Unit 7, South Gare Court, Tod Point Road, Warrenby, North Yorkshire, TS10 5BN
☎ (01642) 497298 ⊕ nybrewery.co.uk

Founded in Middlesbrough in 1989 the brewery moved to Guisborough in 1998. In 2017, following the purchase of the brewery, the new owner moved the entire operation to new premises on an industrial estate in Warrenby, near Redcar. ◆LIVE

Temptation (ABV 3.8%) BITTER
Yorkshire Coble (ABV 3.8%) BITTER
Beckwatter (ABV 4%) BITTER
Yorkshire Porter (ABV 4.4%) PORTER
NYPA (ABV 4.6%) PALE
XPA (ABV 4.6%) PALE
Flying Herbert (ABV 4.7%) BITTER
Valhalla (ABV 5.5%) BITTER
White Stout (ABV 6.2%) STOUT

Pennine SIBA

Well Hall Farm, Well, Bedale, North Yorkshire, DL8 2PX
☎ (01677) 470111 ⊕ pennine-brewing.co.uk

☺Located in the village of Well near Masham, the brewery has been in production on this site since 2013 using an 18-barrel plant complete with lauter tun. Beer is supplied to pubs throughout the North of England as well as to beer festivals and local outdoor events. ‼◆

Amber Necker (ABV 3.9%) BITTER
Hair of the Dog (ABV 3.9%) BITTER
Heartland (ABV 3.9%) BITTER
Millie George (ABV 4.1%) PALE
Scapegoat (ABV 4.2%) GOLD
IPA (ABV 4.4%) PALE

Play Brew

8 Cannon Park Way, Middlesbrough, North Yorkshire, TS1 5JU
☎ (01642) 244769 ⊕ playbrewco.com

Launched in 2019, Play Brew is a brewery, taproom and event space. The 20-hectolitre plant produces unfiltered beers available in keg, cans and occasionally in cask, distributed throughout the north. ◆✦

Redscar SIBA

▤ c/o The Cleveland Hotel, 9-11 High Street West, Redcar, North Yorkshire, TS10 1SQ
☎ (01642) 513727 ☎ 07828 855146
⊕ redscar-brewery.co.uk

☺Redscar first brewed in 2008. In 2014 it increased its capacity to a five-barrel plant. The brewery supplies the hotel, local pubs and beer festivals. ‼◆

Blonde (ABV 3.8%) BLOND
Poison (ABV 4%) BITTER
Beach (ABV 5%) BITTER

Richmond SIBA

Station Brewery, Station Yard, Richmond, North Yorkshire, DL10 4LD
☎ (01748) 828266 ⊕ richmondbrewing.co.uk

☺Richmond opened in 2008 in the renovated Victorian station complex beside the River Swale. Producion is split 50/50 between cask-conditioned and bottled beers. The former are available in the local area at the Hildyard Arms, Colburn, and the Castle Tavern, Richmond, as well as direct from the brewery. ‼🍴◆LIVE

SwAle (ABV 3.7%) MILD
Gundog Bitter (ABV 3.8%) BITTER
Station Ale (ABV 4%) BITTER
Greyfriars Stout (ABV 4.2%) STOUT
Dale Strider (ABV 4.5%) GOLD
Stump Cross Ale (ABV 4.7%) OLD
Richmond Pale Ale (ABV 5%) PALE

Rooster's SIBA

Unit H5, Fifth Avenue, Hornbeam Park, Harrogate, North Yorkshire, HG2 8QT
☎ (01423) 865959 ⊕ roosters.co.uk

☺Roosters is an independent, family-owned brewery and taproom. Weekly production capacity is 200 barrels, which includes one-off experimental beers, brewed as part of the brewery's Outlaw Project. 🍴◆✦

Buckeye (ABV 3.5%) GOLD
Highway 51 (ABV 3.7%) PALE
Capability Brown (ABV 4%) BITTER
YPA (Yorkshire Pale Ale) (ABV 4.1%) PALE
London Thunder (ABV 4.2%) PORTER
Yankee (ABV 4.3%) PALE
Hops and gentle fruitiness make this an easy-drinking, well-balanced, light gold beer, some grapefruit present, finishing dry.
TwentyFourSeven (ABV 4.7%) PALE
Thousand Yard Stare (ABV 5.4%) PALE
Baby-Faced Assassin (ABV 6.1%) IPA

Strength In Numbers (ABV 7%) IPA

Rudgate SIBA

2 Centre Park, Marston Moor Business Park, Tockwith, York, North Yorkshire, YO26 7QF
☎ (01423) 358382 ⊕ rudgatebrewery.co.uk

☺Rudgate Brewery celebrated it's 30th birthday in 2022. It is situated in the heart of Yorkshire, in the Vale of York, on the old RAF Marston Moor airfield. The old Roman road of Rudgate runs through the airfield and led the Vikings into Jorvik (York), which is what inspires many of the beer names. It brews six core cask beers and two seasonals each month. ◆

Jorvik Blonde (ABV 3.8%) BLOND
Viking (ABV 3.8%) BITTER
An initially warming and malty, full-bodied beer, with hops and fruit lingering into the aftertaste.
Battleaxe (ABV 4.2%) BITTER
A well-hopped bitter with slightly sweet initial taste and light bitterness. Complex fruit character gives a memorable aftertaste.
Ruby Mild (ABV 4.4%) MILD
Nutty, rich ruby ale, stronger than usual for a mild.
Valkyrie APA (ABV 5%) PALE
York Chocolate Stout (ABV 5%) STOUT

Ryedale

Roseberry, Moor Lane, Sinnington, North Yorkshire, YO62 6SE ☎ 07850 510859 ⊕ ryedalebrewing.co.uk

☺Ryedale began brewing in 2013 using a four-barrel plant. In 2016 it relocated to Cross Hills and again in 2019 to Sinnington. Brews only on an occasional basis.

Salt Steel

Office: 24 St Cuthberts Way, Darlington, DL1 1GB
⊕ saltsteelbrewing.com

Established in 2020 and forged from the industrial landscapes of Teeside and Cheshire, Salt Steel Brewing have been collaborating with other brewers in the North East.

Scarborough SIBA

Unit 21b, Stadium Works, Barry's Lane, Scarborough, YO12 4HA
☎ (01723) 367506 ⊕ scarboroughbrewery.co.uk

☺Scarborough is a family-run brewery established in 2010, now using a 10-barrel plant. Beers can be found in the family-owned Valley Bar and Rivelyn Hotel as well as being the sole suppliers to Merchant Bar, Scarborough. ◆

Trident (ABV 3.8%) PALE
Citra (ABV 4.2%) GOLD
Sealord (ABV 4.3%) GOLD
Stout (ABV 4.6%) STOUT
Hello Darkness (ABV 5%) PORTER

Selby Middlebrough (NEW) SIBA

131 Millgate, Selby, YO8 3LL
☎ (01757) 702826 ✉ martinsykesuk@yahoo.com

Small batch brewery launched in 2022. Beers are produced primarily for its brewery tap, Howden Arms, Howden, East Yorkshire.

Settle SIBA

Unit 2B, The Sidings, Settle, North Yorkshire, BD24 9RP
☎ (01729) 824936 ⊕ settlebrewery.co.uk

☺Settle Brewery is located in an industrial unit adjacent to Settle Railway Station. Brewing started in 2013 using a 12-barrel plant. It supplies more than 40 outlets across Cumbria, North and West Yorkshire and Lancashire. The beers are also available through wholesalers. Beers are occasionally branded as Nine Standards. ‼◆

Jericho Blonde (ABV 3.6%) BLOND
Mainline (ABV 3.8%) BITTER
Creamy, traditional Yorkshire bitter. Good balance of rich malt and bittering hops, giving a pronounced raspberry fruitiness and hints of nuts in both aroma and taste.
Ribblehead Bitter (ABV 3.8%) BITTER
Hoffman Gold (ABV 4.1%) GOLD
Attermire Pale (ABV 4.3%) PALE
Epic IPA (ABV 4.4%) PALE
Ernie's Milk Stout (ABV 4.5%) STOUT
Old Smithy Porter (ABV 4.7%) PORTER
Roasty porter with coffee and dark fruits. Hints of liquorice and plums in the aroma. The finish is bitter and roasty.

Samuel Smith

The Old Brewery, High Street, Tadcaster, North Yorkshire, LS24 9SB
☎ (01937) 832225 ⊕ samuelsmithsbrewery.co.uk

☺Fiercely independent, family-owned company. Tradition, quality and value are important, resulting in brewing without any artificial additives. The majority of products are vegan-friendly, with the exception of Old Brewery Bitter and Yorkshire Stingo. All real ale is supplied in traditional wooden casks. LIVE V

Old Brewery Bitter (ABV 4%) BITTER

John Smith

The Brewery, Tadcaster, North Yorkshire, LS24 9SA
☎ (01937) 832091 ⊕ heineken.com

The brewery was built in 1879 by a relative of Samuel Smith (qv). John Smith's became part of the Courage group in 1970 before being taken over by S&N and now Heineken UK. John Smith's cask Magnet has been discontinued. No real ale.

Theakston

The Brewery, Masham, North Yorkshire, HG4 4YD
☎ (01765) 680000 ⊕ theakstons.co.uk

☺An independent, family business, established in 1827 by Robert Theakston. From 1984, for 19 years the brewery was in non-family hands. Following a successful buy back in 2003, the company returned to family control, managed by Simon Theakston and his three brothers (great-great grandsons of the founder). Significant investment in the brewery since then has provided additional capacity and flexibility to meet growing demand and variety of beers brewed. ‼◆❧

Best Bitter (ABV 3.8%) BITTER
Black Bull Bitter (ABV 3.9%) BITTER
Lightfoot (ABV 4.1%) PALE
XB (ABV 4.5%) BITTER
Old Peculier (ABV 5.6%) OLD
A complex, full-bodied, dark brown, strong ale. Malty and roasty with hints of treacle, coffee and liquorice, finishing sweet and fruity.

Treboom SIBA

Millstone Yard, Main Street, Shipton-by-Beningbrough, North Yorkshire, YO30 1AA

☎ (01904) 471569 ☎ 07761 608662
🌐 treboom.co.uk

Established in 2011 this 10-barrel brewery produces a range of core beers alongside monthly seasonal specials using water from its own borehole, whole hops and locally-malted barley. Green hops grown at the brewery are used in the autumn. The award-winning mix of contemporary and traditional beers are distributed throughout Yorkshire and via the online shop. 🛒♦LIVE

Tambourine Man (ABV 3.9%) GOLD
Yorkshire Sparkle (ABV 4%) PALE
Kettle Drum (ABV 4.3%) BITTER
Orions Belt (ABV 4.5%) STOUT
Hop Britannia (ABV 5%) PALE
Myricale (ABV 5%) SPECIALITY
Baron Saturday (ABV 5.2%) PORTER

Turning Point SIBA

Unit 3, Grimbald Park, Wetherby Road, Knaresborough, North Yorkshire, HG5 8LJ
☎ (01423) 869967 🌐 turningpointbrewco.com

⊗ Two friends, Cameron Brown and Aron McMahon, began brewing in Kirkbymoorside in 2017, before relocating to the former Roosters brewery in Knaresborough in 2019. All beers are unfined and unfiltered. A partnership with Fossgate Tap in York designates it as the brewery tap. ♦♦

Wavelength (ABV 4.5%) GOLD
Lucid Dream (ABV 5%) SPECIALITY
Disco King (ABV 5.1%) PALE

Wensleydale SIBA

Unit 4, Badger Court, Harmby Road, Leyburn, North Yorkshire, DL8 5BF
☎ (01969) 622463 ☎ 07765 596666
🌐 wensleydalebrewery.co.uk

☺Wensleydale was set up in 2003 and moved to larger premises in Leyburn in 2018 utilising a 12-barrel plant. Around 200 outlets are supplied direct in Yorkshire, Co Durham and Cumbria. There is an onsite special events bar. ‼🛒♦♦

Falconer (ABV 3.9%) BITTER
Semer Water (ABV 4.1%) PALE
Gamekeeper (ABV 4.3%) BITTER
Black Dub (ABV 4.4%) STOUT

Whitby SIBA

East Cliff, Whitby, North Yorkshire, YO22 4JR
☎ (01947) 228871 ☎ 07516 116377
🌐 whitby-brewery.com

Whitby Brewery was established in 2012 under the Conquest name. It expanded in 2016 to a new site in the shadow of Whitby Abbey, with a 20-barrel capacity. Music events are hosted occasionally at weekends. Due to local demand, most of the beer is only distributed in the Whitby area. ‼🛒♦♦

Abbey Blonde (ABV 3.8%) BLOND
Whaler (ABV 4%) PALE
Saltwick Nab (ABV 4.2%) RED
Smugglers Gold (ABV 4.2%) BITTER
Jet Black (ABV 4.5%) PORTER
IPA (ABV 5.2%) BITTER

Wold Top SIBA

Hunmanby Grange, Wold Newton, Driffield, East Yorkshire, YO25 3HS

☎ (01723) 892222 🌐 woldtopbrewery.co.uk

☺Family-owned, farm-based brewery Wold Top has been creating exceptional beer on the Yorkshire Coast since 2003. Using sustainably home-grown malting barley, chalk-filtered water, and powered by renewable energy, the brewery's range includes bitters, pale ales, golden ales, porters and IPAs, of which five are gluten-free. All beers are produced and packaged in-house and on-site using a modern 40-barrel brew kit. It also has the facility to contract package for other breweries too. ‼🛒♦GF

Bitter (ABV 3.7%) BITTER
Anglers Reward (ABV 4%) PALE
Wolds Way (ABV 4%) PALE
Headland Red (ABV 4.3%) BITTER
Against the Grain (ABV 4.5%) BLOND
Wold Gold (ABV 4.8%) GOLD
Marmalade Porter (ABV 5%) SPECIALITY
Scarborough Fair IPA (ABV 6%) IPA

York

c/o Black Sheep Brewing, Wellgarth, Masham, Ripon, North Yorkshire, HG4 4EN 🌐 york-brewery.co.uk

York started production in 1996 and was bought out of administration by Black Sheep Brewery (qv) in 2018. Four pubs are owned in York and Leeds. Brewing of all York Brewery beers is temporarily taking place at Black Sheep until new premises can be found. ‼♦

Yorkshire Dales

Abbey Works, Askrigg, North Yorkshire, DL8 4LP
☎ (01969) 622027 ☎ 07818 035592
🌐 yorkshiredalesbrewery.com

☺Situated in the heart of the Yorkshire Dales, brewing started in a converted milking parlour in 2005. In 2016 the brewery moved to larger premises. More than 150 pubs are supplied throughout the north of England. A tap and bottle shop opened at the brewery in 2017. ‼♦LIVE ♦

Butter Tubs (ABV 3.7%) GOLD
Askrigg Bitter (ABV 3.8%) BITTER
Aysgarth Falls (ABV 3.8%) BLOND
Bainbridge Blonde (ABV 3.8%) BLOND
Buckden Pike (ABV 3.9%) BLOND
Drovers Arms (ABV 3.9%) MILD
Nappa Scar (ABV 4%) GOLD
Muker Silver (ABV 4.1%) BLOND
Askrigg Ale (ABV 4.3%) PALE
Garsdale Smokebox (ABV 5.6%) SPECIALITY

Yorkshire Heart SIBA

The Vineyard, Pool Lane, Nun Monkton, North Yorkshire, YO26 8EL
☎ (01423) 330716 ☎ 07838 030067
🌐 yorkshireheart.com

☺Yorkshire Heart has been brewing since 2011 and is situated near to York adjacent to the Yorkshire Heart vineyard and winery run by the same family. The brewery uses a five-barrel plant. ‼🛒♦

Hearty Bitter (ABV 3.7%) BITTER
Rhubarbeer (ABV 3.7%) SPECIALITY
Blonde (ABV 3.9%) BLOND
SilverHeart IPA (ABV 4%) PALE
Blackheart Stout (ABV 4.8%) STOUT
Platinum EPA (ABV 5%) PALE
Ghost Porter (ABV 5.4%) PORTER

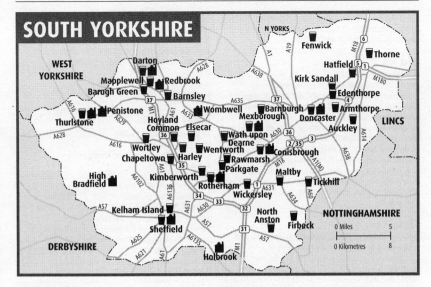

Armthorpe

Wheatsheaf

Church Street, DN3 3AE

☎ (01302) 835868

Purity Pure UBU; 2 changing beers (often Sharp's, Timothy Taylor) ⊞

A roadside pub serving excellent beers and a variety of good-quality food. Donna and Colin make you feel welcome, and there is plenty of entertainment here, including darts, dominoes and pool. Food is served Tuesday to Saturday, lunchtimes and evenings, with a popular carvery on Sunday. There is a good-sized outside drinking area at the front.

Q☆❀◑&♣🕭P🚲(81,82) ❀ 🛜

Auckley

Eagle & Child ✅

24, Main Street, DN9 3HS

☎ (01302) 770406 ⊕ eagleandchildauckley.co.uk

Acorn Barnsley Bitter; Black Sheep Best Bitter; Timothy Taylor Landlord; 2 changing beers (sourced regionally; often Milestone, Welbeck Abbey) ⊞

A much-loved pub on the main road in the village, a winner of numerous CAMRA awards. Dating from the early 19th century, it has real character. There are two bars, one with a TV, the other quieter, with tables for bar meals. The separate restaurant is decorated with photographs of local historic interest, and home-cooked meals have a deserved reputation. There is an outside seating area and a beer garden. Robin Hood Airport is a mile away. Q☆❀◑▲♣🕭P🚲(57f)❀ 🛜

Barnburgh

Coach & Horses ★

High Street, DN5 7EP

☎ (01709) 352045

Don Valley Atomic Blonde, Gongoozler, Go Your Own Way; 5 changing beers (sourced regionally; often Don Valley) ⊞

Recently reopened after a period of closure, this Grade II-listed pub, with its unchanged multi-room layout and Art Deco grandeur, has been identified by CAMRA as having a nationally important historic interior. In 2020 it was purchased by enlightened new owners who also own the Don Valley Brewery, and they have carried out an exemplary refurbishment. Look out for the Andy Capp mural in the tap room. Real ales come from Don Valley and are supplemented by guest beers.

☆❀◑♣P🚲(219) ❀ 🛜

Barnsley

Heaven & Ale 🍷 ㋫

66 Agnes Road, S70 1NH

☎ 07981 703786

4 changing beers (sourced nationally) ⊞

This former Co-op store has had a wonderful conversion into a multi-roomed pub, with three rooms on the ground floor and a function room upstairs. The outside drinking area to the front is popular. The four real ales are sourced from small micro and regional breweries across the UK, but a couple are often local to the area. A former local CAMRA Pub of the Year.

Q☆❀🕭🚲(43,44) ❀

Jolly Tap on the Arcade ㋫

31 The Arcade, S70 2QP

⊕ jollyboysbrewery.co.uk

Jolly Boys Blonde; 4 changing beers (sourced locally; often Hilltop, Jolly Boys, Outhouse) ⊞

Barnsley's first micropub, opened in 2017 by Two Roses Brewery. This tiny one-up one-down pub is now owned by Jolly Boys Brewery, and serves up to five real ales alongside a choice of craft beers, all sourced locally. The pub is situated in the lovely Victorian Arcade and was formerly a cake shop. The staff are welcoming and knowledgeable about the cask and craft beers on offer.

Q🍴🚲❀ 🛜

Maison du Biere Barnsley

Lower Castlereagh Street, S70 1AR

⊕ maisondubiere.com

Changing beers (sourced nationally)

This new addition to the Barnsley beer scene offers a selection of over 600 brews, ranging from traditional real ale in a bottle to cans with weird and wacky flavours from local and national craft breweries. The bar hosts 28 craft draught lines, as well as traditional ciders and spirits. The building was once the ironmonger's M C Mills, which was established in Barnsley in 1935. The family-

run company ceased trading in 2019. This is the sister bar to Maison du Biere at Elsecar Heritage Centre. Card payments only. ⛔&≉➡️P🏠🐾❄️🎵

Old No 7 🅛

7 Market Hill, S70 2PX

☎ (01226) 244735 ⊕ oldno7barnsley.co.uk

Acorn Barnsley Bitter, Blonde, Old Moor Porter; 5 changing beers (sourced regionally; often Chin Chin, Elland, Redemption) 🄷

This popular town-centre ale house offers up to eight real ales from Acorn and other microbreweries, a wide range of craft and continental beers, and a choice of real ciders and perries. This is its 11th consecutive year in the Guide. The downstairs bar is available for functions and meetings, and opens on match days and busy Friday and Saturday evenings. Regular live music is hosted. ≉♣🏠🐾🎵

Tipsy Cow 🅛

Unit 2B, Gateway Plaza, Sackville Street, S70 2RD

4 changing beers (sourced regionally) 🄷

This micropub near the entrance to the Gateway Plaza complex opened in 2018. It is split over two levels with a mezzanine floor looking over part of the ground floor. A café bar outdoor drinking area was added in 2019 and is popular in the summer months. The pub offers four changing real ales, craft beers and cider, and is renowned for its gin selection. No under-12s and no dogs allowed. Q🐱&≉P🏠🎵

Barugh Green

Crown & Anchor 🅛

Barugh Lane, S75 1LL (on B6428)

☎ (01226) 387200 ⊕ thecrownandanchor.com

5 changing beers (sourced regionally; often Acorn, Bradfield, True North) 🄷

Known locally as the Whitehouse, this large pub is the Barnsley outpost of the True North portfolio. Seven handpulls (three always serving True North beers, the others from anywhere in the country) ensure that there are styles to suit all drinkers, along with a good selection of bottled world beers and a lengthy list of gins. The food menu changes often. The beer garden has a shipping container as an external bar. ⛔🐱🍽&♣➡️P🏠🐾❄️🎵

Conisbrough

Hilltop 🅛

Sheffield Road, DN12 2AY (on main A630)

☎ (01709) 868811 ⊕ thehilltophotel.co.uk

Hilltop Classic Bitter, Golden Ale; 2 changing beers (often Hilltop) 🄷

A traditional free house serving beers from its own brewery. On the Rotherham side of the village, standing alone on the main A630, it offers a relaxed and friendly atmosphere. It is split into a public bar and lounge/dining area serving locally sourced home-prepared food. The menu includes pie night on Wednesdays, steak night Saturdays and renowned Sunday lunches. Quiz night is Thursday. The pub has won multiple local CAMRA awards. Q⛔🐱🍽♣P🏠(X78) ❄️

Terminus

2 New Hill, DN12 3HA (10 mins' walk downhill from town centre)

☎ 07397 853206

4 changing beers (sourced locally) 🄷

This micropub, sited near a former trolleybus terminus, offers a warm and friendly welcome to all. It has four, usually local, rotating cask ales, and its decor reflects

local history, with a large photo wall picturing eight local men who all joined up to serve in WWI on the same day. Dogs have their own treat jar on the bar. Children are welcome until 7pm. It is close to the castle and 20 minutes' walk from the railway station. Q⛔&🏠(X78,221) 🐾❄️🎵

Darton

Anvil Arms 🅛

28 Church Street, S75 5HG

☎ (01226) 805225

6 changing beers (sourced locally; often Nailmaker) 🄷

Formally the Old Co-op Ale House, this micropub is now owned by Nailmaker Brewery and serves six real ales and three ciders on handpull, with a 12-tap beer wall. During lockdown, sympathetic updates to improve the pub added new seating and outdoor drinking areas to the front and side of the building, while keeping the original much-loved features like the stone brick walls and log fire. This venue has definitely cemented itself on the Mapplewell and Darton real ale corridor. Q&≉♣🏠🐾

Darton Tap 🅛

70 Church Street, S75 5HQ

☎ (01226) 383444 ⊕ dartontap.co.uk

Ossett White Rat; house beer (by Nailmaker); 2 changing beers (sourced locally) 🄷

Formerly a micropub, the premises has now extended into next door and become a pub, situated in the increasingly popular Darton and Mapplewell real ale corridor. This stylish venue has four cask lines, several draft lines and a large spirits selection. Drinkers can enjoy

REAL ALE BREWERIES

1086 ✦ Doncaster
Abbeydale Sheffield
Acorn Wombwell
Blue Bee Sheffield
Both Barrels Mexborough (NEW)
Bradfield High Bradfield
brewSocial Sheffield (NEW)
Chantry Rotherham
Dead Parrot Sheffield
Doncaster ✦ Doncaster
Exit 33 Sheffield (brewing suspended)
Fuggle Bunny Holbrook
Gorilla ✦ Mexborough
Grizzly Grains Sheffield
Heist ✦ Sheffield
Hilltop 🍺 Conisbrough
Imperial 🍺 Mexborough
Jolly Boys Redbrook
Kibble 🍺 Thurlstone
Little Critters Sheffield
Little Mesters ✦ Sheffield
Lost Industry Sheffield
Loxley 🍺 Sheffield
Nailmaker ✦ Darton
Neepsend ✦ Sheffield
On the Edge Sheffield
St Mars of the Desert ✦ Sheffield
Stancill Sheffield
Tapped 🍺 Sheffield
Toolmakers ✦ Sheffield
Triple Point ✦ Sheffield
True North Sheffield
White Rose Mexborough
Whitefaced ✦ Penistone

a beer in a modern and comfortable environment, close to transport links. Dogs are welcome with doggie treats and paw towels provided. Strictly over-18s only.
&≠P🖵🛜

Doncaster

Doncaster Brewery Tap Ⓛ

7 Young Street, DN1 3EL

☎ (01302) 376436 ⊕ doncasterbrewery.co.uk

Doncaster Sand House; 5 changing beers (sourced locally; often Doncaster) Ⓗ

Convenient for the town centre, down a quiet side street, Doncaster Brewery Tap was opened in 2014. The brewery, originally launched in 2012, was relocated here, and provides up to six beers, all served in lined glasses. Guest beers are often available, as are six traditional ciders and perries. There's always something going on at the Tap, from quiz night on Tuesday to spoken word night on Thursday. Ukulele sessions are held on Saturday. Winner of several CAMRA awards.
Q≠♣🍴🖵(15,81/82)🐾🛜

Draughtsman Alehouse

Station Court, DN1 1PE (on Platform 3B of Doncaster station)

☎ 07999 874660 ⊕ thedraughtsmanalehouse.co.uk

3 changing beers (sourced regionally; often Allendale, Northern Monkey, Thornbridge) Ⓗ

Located on platform 3B of Doncaster Station and opened in 2017, this pub was highly commended in CAMRA's Pub Design Awards. The former Victorian buffet bar stood empty for 18 years, before restoration. Be sure to inspect the Victorian tiles and mounted plan drawings of steam locomotives. The real ales on offer come mainly from regional brewers with occasional collaborations and exclusives. Locally made pies and other pub snacks are available. There are regular tap takeovers and special events. Q&≠🖵(21)🛜

Hallcross

33-34 Hall Gate, DN1 3NL

⊕ hallcrossdoncaster.co.uk

4 changing beers (sourced nationally; often Acorn, Elland, Rudgate) Ⓗ

This pub has made a welcome return to the real ale scene in Doncaster. The front bar plays background music and shows sport, with sound only, for major events. There is a separate soundproofed function room for live music at weekends. A courtyard at the rear also includes an undercover snug. The Hallcross is the home of the resurrected Stocks Beers, now brewed by Welbeck Abbey, which were previously brewed on the premises.
🌸&≠🖵(21,25)🐾🛜

Leopard ✔

2 West Street, DN1 3AA (less than 5 mins' walk from station)

☎ (01302) 739460

6 changing beers (sourced regionally; often Acorn, Stancill, Titanic) Ⓗ

This street-corner pub, close to the town centre and railway station, has been a regular CAMRA award winner over the years. It has a superb tiled frontage, recalling its days as a Warwick & Richardson's house. There are two rooms downstairs, and a large one upstairs where live music is hosted at weekends. The pub is now run by Doncaster Culture and Leisure Trust, and one of the five real ales on offer is often from its own 1086 brewery.
🌸🕩&≠♣🍴P🖵(71,72)🐾🛜

Little Plough ★ Ⓛ

8 West Laith Gate, DN1 1SF (close to Frenchgate shopping centre)

☎ (01302) 738310

Acorn Barnsley Bitter; Bradfield Farmers Blonde; 2 changing beers (sourced regionally) Ⓗ

A friendly haven for anyone wishing to escape the hustle and bustle of the town centre. Up to four cask ales are served on handpump in the front bar, with local breweries well supported. There is a quiet lounge to the rear and pictures of traditional agricultural scenes adorn the walls. The interior is little changed since 1934, evidenced by plans displayed in the corridor, and has been identified by CAMRA as being nationally important.
Q🌸≠♠🖵🐾🛜

Queen Crafthouse & Kitchen

1 Sunny Bar, DN1 1LY (on corner of Sunny Bar and Market Place)

☎ (01302) 562908

5 changing beers (sourced regionally) Ⓗ

An old established market place pub, recently renovated under new ownership. An interior created out of unusual boarding sets the scene, attracting customers young and old to sample the real ales, atmosphere, and live music at weekends. Close to the historic Corn Exchange and market, this is a welcome addition to the town's real ale scene. Five changing real ales are on the bar, usually from regional breweries, and two real ciders are also on offer. Q🌸&≠🍴🖵(15)🐾🛜

Edenthorpe

Eden Arms

Eden Field Road, DN3 2QR (adjacent to Tesco)

☎ (01302) 888682

Abbeydale Moonshine; Black Sheep Twilighter Pale Ale; 2 changing beers (sourced regionally) Ⓗ

A fine, modern and busy estate pub, built in the late 1980s. Attractive and comfortable, with a modern internal design, it is partly open plan with some divided areas featuring fires that give a cosy feel. Two regular beers are served, plus two guests. On Monday and Thursday all cask ales are discounted. There are quiz nights and the pub is notable for good-quality meals, which are available all day. It is one of the area's most CAMRA-friendly pubs. Q⏾🌸🕩&P🖵(87,8)🐾🛜

Elsecar

Maison du Biere Ⓛ

Wath Road, S74 8HJ (in Elsecar Heritage Centre, Unit 15)

☎ (01226) 805255 ⊕ maisondubiere.com

Changing beers (sourced nationally)

This popular beer shop and tap is in the heart of the historic heritage centre, serving up over 400 bottled, canned and draught beers and ciders, 10 lines of draught craft beers and many real ciders. The knowledgeable staff can guide you on a taste experience. The tap is popular with locals and visitors to the heritage centre alike. ⏾🌸&≠♣🍴P🖵(66,227)🐾🛜

Market Hotel Ⓛ

2-4 Wentworth Road, S74 8EP

☎ (01226) 742240

Acorn Barnsley Gold; 4 changing beers (often Acorn, Bradfield) Ⓗ

A multi-roomed pub with a popular drinking corridor. Look for the 'horse and gig for hire' sign chiselled into the stonework. Constantly changing beers from local microbreweries are charged at the same price, regardless of strength. To the rear is a beer garden with a large

brick-built barbecue. A popular meeting place for various groups, it is well used by walkers enjoying open scenic countryside. Next to Elsecar Heritage Centre. Q✿✍⧖♣P☐(66,227) ✿

Fenwick

Baxter Arms

Fenwick Lane, DN6 0HA (between Askern and Moss)
☎ (01302) 702671
House beer (by Theakston) Ⓗ

This award-winning free house is truly a rural gem. The pub has been run by the same family for nearly 30 years, and there is always a warm welcome. Three real ales from small independent breweries are always available, and reasonably priced fresh food sourced locally is served all day. Outside is a drinking area with seating, and ample parking. Quiz night is Wednesday. A former local CAMRA Pub of the Year. Q✤✿✪▲♣P✿ ⧖

Firbeck

Black Lion Ⓛ

9 New Road, S81 8JY (opp village hall)
☎ (01709) 812575
Chantry New York Pale; Timothy Taylor Landlord; 2 changing beers (sourced locally; often Abbeydale, Bradfield, Stancill) Ⓗ

Traditional village free house which reopened in 2017 after a period of closure, attracting drinkers, diners, walkers and the local community. Four real ales are offered with the two changing beers usually from local microbreweries. The renowned food is freshly cooked to order. Pictures of old Firbeck adorn the walls of the snug area. The No.20 bus only serves the village Monday-Saturday daytime. Handy for the ruins of Roche Abbey and countryside walks. The horse race that led to the famous St Leger race was held nearby.
Q✤✿✪▲♣P☐(20) ✿

Harley

Horseshoe Ⓛ

9 Harley Road, S62 7UD (off A6135 on B6090, 1 mile from Wentworth)
☎ (01226) 742204 ⊕ thehorseshoeharley.co.uk
Neepsend Blonde; 2 changing beers (often Acorn, Greene King, Little Critters) Ⓗ

This cosy village local has been in the same family for many years. A community hub for well over a century and home to sports teams, it is busy when the pool team are at home and when the village gala is held in July. Real ales change frequently and often come from local breweries. Food is available Friday and Saturday evenings with a carvery on Sunday afternoons. The pub is handy for the nearby Wentworth estate, Needle's Eye and Elsecar Heritage Centre. There is some outside seating at the front, and a small area to the rear.
✿✪♣P☐(44) ✿

Hatfield

Jack Hawley at the Grange Ⓛ

Manor Road, DN7 6SB
☎ 07769 927603
Timothy Taylor Boltmaker; 4 changing beers (sourced regionally; often Don Valley, Pheasantry, Welbeck Abbey) Ⓗ

This micro is the project of a real ale enthusiast who was previously landlord of the Black Swan in Asselby. Access is via a staircase to the first floor. There is a long, narrow lounge, with mixed seating. One wall has four guitars

and the other has the story of Jack Hawley, a local character from the 19th century, who was renowned for his hospitality. Q✿♣♣P☐(84,87A)

Hoyland Common

Tap & Brew Ⓛ

9 Hoyland Road, S74 0LT
☎ (01226) 824614
6 changing beers (sourced regionally) Ⓗ

This popular micropub was converted from a tea room in 2017. New owners took over in 2019 and have kept the pub pretty much how the regulars like it. The bar serves a fine selection of cask ales, as well as good selection of bottled beers and artisan spirits. No meals are served, but you won't go hungry, with a wide selection of bar snacks, pies and pastries. There are weekly quiz and music nights, and a popular open mic night adds to the great atmosphere. ✿♣✿ ⧖

Kimberworth

Steptoes Café Bar ❢ Ⓛ

192 High Street, S61 2DT
☎ (01709) 431637
4 changing beers (sourced regionally; often Chantry, Gorilla, Industrial Ales) Ⓗ

A café bar and micropub located in a former hair salon. Originally scheduled to open in April 2020, lockdown forced a series of closures until May 2021. Real ales on the four handpumps come from microbreweries near and far and can often be rare. Luxury coffees and teas, wines, spirits and cakes are also on offer. The interior is cosy and welcoming with an interesting decor that includes a display of old bus blinds, reclaimed furniture and other eclectic objects. QP☐(135A,136)

Kirk Sandall

Glasshouse

1 Doncaster Road, DN3 1HP (opp station)
☎ (01302) 884268 ⊕ glasshousebar24.co.uk
Greene King Abbot; Sharp's Doom Bar; 2 changing beers (sourced nationally) Ⓗ

A local landmark, and well known in this area, the Glasshouse has a long historical connection with the glass industry, being close to the former Pilkington glassworks. The open-plan single-room bar has many largescreen TVs showing sport or news. Varied seating areas offer sofas, armchairs and coffee tables. The pub serves up to four real ales on handpump. Good-quality meals are available lunchtimes and evenings.
✿✿◐⧖⧖P☐(84,84A/B) ✿ ⧖

Maltby

Queen's Hotel ⊘

Tickhill Road, S66 7NQ (on A631)
☎ (01709) 812494
Greene King Abbot; Ruddles Best Bitter; Sharp's Doom Bar; 4 changing beers (sourced locally; often Bradfield, Stancill) Ⓗ

A former residential hotel and pub on a busy crossroads, reopened and completely refurbished by Wetherspoon after a lengthy period of closure. Now firmly established, this spacious pub has an attractive family dining area offering typical Wetherspoon value for money food and drink. Maltby is not blessed with many real ale outlets and the Queen's has raised its profile in the township. Regular Meet the Brewer nights are held. Next to Coronation Park and handy for Maltby Crags and Roche Abbey. ✿✿◐⧖P☐ ⧖

Mapplewell

Talbot Inn L ✓

Towngate, S75 6AS

☎ (01226) 385629 ● thetalbotmapplewell.co.uk

Nailmaker Anvil Porter; 3 changing beers (sourced locally) ⊞

The first and original tap for Nailmaker Brewery, this pub spearheaded the real ale revival in the area, with four rotating beers from the brewery and occasional guests and tap takeovers from the likes of Magic Rock and North Brewing. This pub is extremely popular with locals, whether for a quick pint and a meal or the well-attended Speed Quiz. There is a restaurant upstairs and food is also served at all tables daily. During 2021 the pub had an extensive, sympathetic refurbishment from top to bottom, including the exterior.

Q ⌾ ☆ ◑ ♣ P ♮ (1,X10) ❀ ☞

Mexborough

Imperial Brewery Tap L

Cliff Street, S64 9HU (opp bus station)

☎ (01709) 584000

Imperial Classical Bitter, Platinum Blonde; 4 changing beers (sourced locally; often Imperial) ⊞

A friendly brewery tap with lots to offer, especially for music lovers. It has a main entertainment bar, separate lounge area and a games/function room. The six handpumps serve two permanent Imperial beers, with four rotating from either Imperial, local or national breweries. Entertainment includes a battle of the bands on Tuesday, karaoke on Wednesday, an award-winning acoustic night on Thursday and a wide range of live music on Friday, Saturday and Sunday.

⌾ ☆ ⅙ ≠ ♣ ♮ (220,221) ❀

North Anston

Little Mester L ✓

Nursery Road, S25 4BZ

☎ (01909) 562484

Greene King IPA; 4 changing beers (sourced locally; often Stancill, Welbeck Abbey) ⊞

A large modern food and family-oriented estate pub built in the 1960s, it reopened following refurbishment in 2016 and now has an emphasis on real ale. Beers may be from far and wide but local breweries often feature strongly among up to four guest beers. There is a Cask Ale Club with a free pint offered for every seven purchased. The L-shaped interior can be lively at the weekend, when a DJ and live entertainment feature. Handily sited for visiting the nearby Tropical Butterfly House and walks around Anston Stones.

⌾ ☆ ◑ ⅙ P ♮ (19,19A)

Parkgate

Little Haven Micro Bar L

96 Broad Street, S62 6EN

☎ (01709) 710134

● the-little-haven-micro-bar.business.site

4 changing beers (sourced locally; often Chantry, Little Critters) ⊞

A compact, friendly micropub, opened in 2018 in a former post office and hair salon. The former kitchen has been converted to a snug. Four handpumps and four craft taps dispense beer, with local microbreweries often favoured such as Chantry Brewery. Nibbles are sold, but no meals. Board games are available and live acoustic music plays on Tuesday and Saturday evenings. There is limited outside seating, accessed via the pub. It is a

welcome break from Parkgate Retail World and just 15 minutes' walk from the tram/train stop there.

Q ☆ ♣ ♦ ♮ ❀ ☞

Rawmarsh

Something BREW INN L

2 Stocks Lane, S62 6NL (behind Star pub)

☎ 07717 502307

Bradfield Farmers Blonde; 2 changing beers (sourced locally; often Abbeydale, Bradfield, Chantry) ⊞

A micropub and coffee house in a former office building which opened in 2018 in an area not known for selling real ale. The changing beers are often from Chantry and other local microbreweries. Boxed ciders include some real ciders, and craft keg and bottled beers are also sold. The L-shaped room is tastefully decorated, and outside seating is provided at the front and rear of the pub. There are Sunday jam sessions and occasional guest singers plus Wednesday quiz nights. Q ☆ ♦ ♮ ❀ ☞

Rotherham

Bluecoat L ✓

The Crofts, S60 2DJ (behind town hall, off Moorgate Rd, A618)

☎ (01709) 539500

Greene King Abbot; Ruddles Best Bitter; Sharp's Doom Bar; Stancill Stainless; 6 changing beers (sourced regionally) ⊞

Former charity school, opened in 1776 by the Ffeoffees of Rotherham. It became a pub named Ffeofees in 1981 then a Wetherspoon outlet in 2001. Up to 10 hand-pulled beers include six changing guests, with local and national microbreweries favoured. Two real ciders or perries are usually served from boxes behind the bar. A Guide regular and winner of numerous local CAMRA awards, the pub holds regular Meet the Brewer nights. Pictures of old Rotherham adorn the walls and a blue plaque on the façade commemorates its history.

⌾ ☆ ◑ ⅙ ≠ (Central) ♣ ♦ P ♮ ☞

Cutlers Arms L

29 Westgate, S60 1BQ

☎ (01709) 382581 ● cutlersarms.co.uk

Chantry New York Pale, Iron and Steel Bitter, Diamond Black Stout; house beer (by Chantry); 4 changing beers (sourced locally; often Chantry) ⊞

Dating from 1825, this pub was rebuilt in 1907 for Stones Brewery of Sheffield to the design of R Wigfull, with an impressive façade. It was saved from demolition in 2004, following a Grade II listing. Restored to Edwardian splendour by Chantry Brewery, it reopened in 2014, and retains its original Art Nouveau windows, tiling and curved bar counter with dividing screens. It is recognised by CAMRA as having a historic interior of regional importance. The full range of Chantry beers, two real ciders and quality craft ales are served. It can get busy, with live music at weekends. Snacks are available plus pizzas at the weekend. Q ☆ ◑ ≠ (Central) ♦ ♮ ❀ ☞

Dragon's Tap L

477 Herringthorpe Valley Road, Broom, S65 3AD

☎ 07864 680301

Chantry New York Pale; 5 changing beers (sourced regionally; often Kirkstall, North Riding Brewery, Oakham) ⊞

A micropub on two floors, opened in 2018 in a former DIY shop. It is simply but tastefully decorated with modern art prints. Five changing beers are sourced from local and national microbreweries. Four craft keg beers are also served, plus bottled brews. Only snacks are

available but you can bring in food from nearby takeaways. There are outdoor tables at the front of the pub. A general knowledge quiz is held on Wednesday evening and live acoustic music is performed upstairs on the third Sunday of the month. Q❀♿♣P➡❀

New York Tavern L

84 Westgate, S60 1BD (jct of Coke Lane)
☎ (01709) 371155 ⊕ newyorktavern.co.uk
Chantry New York Pale, Iron and Steel Bitter, Diamond Black Stout; house beer (by Chantry); 4 changing beers (sourced locally; often Chantry) Ⓗ
Wedge-shaped house that became a pub in 1856, and was refurbished and reopened by Chantry Brewery in 2013 as a real ale-led pub. Previously the Prince of Wales Feathers, it was renamed after a pub demolished when the nearby ring road was built, but retains the same manager as when it was the Feathers. At least six Chantry beers and two real ciders or perries are served, at very competitive prices. Snuff and bar snacks are available. The pub is handy for New York Stadium; Rotherham United memorabilia is on display. A regular winner of local CAMRA awards. ₹(Central)●➡❀❀

Stag L ✓

111 Wickersley Road, Broom, S60 4JN (on A6021)
☎ (01709) 838929
4 changing beers (sourced regionally; often Acorn, Bradfield, Robinsons) Ⓗ
A former coaching inn on a busy roundabout east of town. It was refurbished in 2017 to provide one large room and a conservatory leading to extensive gardens on two levels. Up to four changing beers from local and national breweries are served. Food is limited to occasional home-made sandwiches and snacks. TV sport is popular, with several screens. There is karaoke and a music quiz on Thursday evenings, and live music or a DJ most Friday or Saturday evenings.
♿❀♣P➡(X1,X10) ❀❀

Sheffield: Central

Dog & Partridge L ✓

56 Trippet Lane, S1 4EL
☎ (0114) 270 6156 ⊕ thedogsheffield.co.uk
Chantry Diamond Black Stout; 3 changing beers (sourced regionally; often Abbeydale, Bad Seed, Blue Bee) Ⓗ
Behind an impressive Gilmour's Brewery frontage lies a comfortable multi-roomed pub served by a central bar. To the right of the entrance is a spacious taproom with dartboard, and on the left a smaller seating area. Behind the servery is a cosy snug with a hatch for service. The four changing beers are usually sourced from local breweries. The lounge at the rear often features live music. A popular quiz is held on Tuesday evenings.
♿❀《》◗Ɽ(City Hall) ♣➡❀❀

Fagans L

69 Broad Lane, S1 4BS
☎ (0114) 272 8430
Abbeydale Moonshine; Tetley Bitter; Timothy Taylor Landlord Ⓗ
With no significant changes in over 60 years, this traditional local comprises a main bar area, a smaller room to the rear and a tiny snug at the front. The walls are decorated with pictures of bombers in tribute to the former landlord Joe Fagan, after whom the pub is named, and who had previously served as a pilot in Bomber Command. The pub is noted for its folk music and the challenging quizzes. ♿《》Ɽ(City Hall)♣➡❀

Head of Steam L

103-107 Norfolk Street, S1 2JE
☎ (0114) 272 2128
Camerons Strongarm; 6 changing beers (sourced regionally; often Abbeydale, Camerons) Ⓗ
A pub for some 20 years, this former bank was acquired by Camerons Brewery in 2015 and after extensive refurbishment reopened as part of the Head of Steam chain. Behind the imposing frontage, the large single room is served by a central island bar, with a separate seating area at the rear leading on to an outside drinking area in Tudor Square. In addition to the brewer's own beers, the handpumps usually dispense ales from independents in Yorkshire and the North-East.
❀《》♿₹Ɽ(Cathedral) ●➡❀❀

Red Deer L ✓

18 Pitt Street, S1 4DD
☎ (0114) 263 4000 ⊕ thereddeersheffield.co.uk
Abbeydale Moonshine; 6 changing beers (sourced regionally) Ⓗ
A genuine, traditional local in the heart of the city. The small frontage of the original three-roomed pub hides an open-plan interior extended to the rear, with a gallery seating area. As well as the impressive range of up to eight cask beers, there is also a selection of continental bottled brews. Meals are served lunchtimes and evenings daily. The popular quiz is held Tuesday night, and an upstairs function room is available for bookings.
Q❀《》◗Ɽ(West St) ➡❀❀

Rutland Arms L

86 Brown Street, S1 2BS
☎ (0114) 272 9003 ⊕ rutlandarmssheffield.co.uk
Blue Bee Reet Pale; 6 changing beers (sourced regionally; often Blue Bee) Ⓗ
Occupying a corner site in the Cultural Industries Quarter and near Sheffield's main railway station, the pub has operated as a freehouse since 2009. The comfortable interior provides ample seating either side of the central entrance, and the walls are covered in the pumpclips and font badges of the huge number of guest beers that have featured over the years. The beers are mostly from local and regional microbreweries. Food is served throughout the day, although only until early evening on Sundays.
♿❀《》₹Ɽ(Sheffield Station) ●➡❀❀

Sheffield Tap ★ L

Platform 1B, Sheffield Station, Sheaf Street, S1 2BP
☎ (0114) 273 7558 ⊕ sheffieldtap.com
Thornbridge Jaipur IPA; 9 changing beers (sourced nationally; often Tapped (Sheffield)) Ⓗ
Opened in 2009, this was originally the first class refreshment room for Sheffield Midland Station, built in 1904. After years of neglect the main bar area has been the subject of an award-winning restoration, retaining many original features. Further seating is provided in the entrance corridor and to the right of the bar. Three beers are usually from the on-site Tapped Brewery, opened in 2013 in the impressive former dining room, which can be viewed behind a glass screen.
Q♿❀♿₹Ɽ(Sheffield Station) ●➡❀❀

Sheffield: Chapeltown

Commercial L

107 Station Road, Chapeltown, S35 2XF
☎ (0114) 246 9066 ⊕ thecommie.co.uk
Abbeydale Moonshine; 7 changing beers (sourced nationally; often Durham, Neepsend, White Rose) Ⓗ
Built in 1890 by long-closed Strout's Brewery of Neepsend, this friendly well-established free house

provides six guest beers, including a porter or stout, together with at least one real cider. A central island bar serves the games room, lounge and tap room. There is a rear outdoor area, and an upstairs function room with regular folk sessions. Beer festivals are occasionally held. Monthly tutored whisky tastings showcase the extensive range. No meals Sunday evening.
ॐ❀◑●₹(Chapeltown) ♣●P🖂(2,44) ✿🐾

Sheffield: East

Chantry Inn 🅛
400 Handsworth Road, Handsworth, S13 9BZ
☎ (0114) 288 9117
Chantry New York Pale, Iron and Steel Bitter, Diamond Black Stout; 2 changing beers (sourced regionally; often Chantry) 🅗
Housed in the churchyard of St Mary's Church, in a former ecclesiastical building dating from the 13th century, this is believed to be one of only four UK pubs set in consecrated ground. It became a pub in 1804 as the Cross Keys; the name was changed to Chantry Inn in 2019 when it was taken over by the Chantry Brewery of Rotherham. The three rooms – taproom, lounge and snug at the rear – are served from a central bar. ❀●🖂🐾₹

Sheffield: Kelham Island

Bar Stewards
163 Gibraltar Street, Kelham Island, S3 8UA
☎ (0114) 327 3580 ⊕ thebarstewards.uk
4 changing beers (sourced nationally; often Abbeydale, Blue Bee, North Riding (Brewery)) 🅗
Opened in a shop unit in 2017, the Bar Stewards is a modern-style bar and bottle shop, and is a welcome addition to the Kelham Island circuit. The four well-chosen cask beers often include a local ale, and there is also a good range of keg beers, bottles and cans from independent breweries. The venue can be hired for private functions and a mobile bar service is available.
❀🅡(Shalesmoor) 🖂🐾₹

Crow Inn 🅛
35 Scotland Street, Kelham Island, S3 7BS
☎ (0114) 201 0096
Abbeydale Heathen; 4 changing beers (sourced nationally; often Abbeydale, Arbor) 🅗
The former Old Crown Inn, after several years running as a hotel, reopened in 2019 as a freehouse under its new name, the Crow Inn. The old pub layout is still discernible with two comfortably furnished seating areas either side of the entrance corridor, which leads to the bar area. With five handpumps and 11 keg lines, a wide range of cask and craft beers is available, together with a large spirit selection including 40 malt whiskies. Accommodation is provided in seven hotel rooms.
❀🛏🅡(Cathedral) ●🖂🐾₹

Fat Cat 🅛
23 Alma Street, Kelham Island, S3 8SA
☎ (0114) 249 4801 ⊕ thefatcat.co.uk
Kelham Island Best Bitter, Pale Rider; Timothy Taylor Landlord; 6 changing beers (sourced nationally; often Kelham Island) 🅗
Opened in 1981, this is the pub that started the real ale revolution in the area. Beers from around the country are served alongside those from the adjacent Kelham Island Brewery. Vegetarian and gluten-free dishes feature on the menu. The walls are covered with the many awards presented to the pub and brewery. An anniversary beer festival is held in August.
Q ॐ❀◑🅡(Shalesmoor) ●P🖂🐾

Harlequin
108 Nursery Street, Kelham Island, S3 8GG
☎ 07794 156916 ⊕ theharlequinpub.wordpress.com
Jolly Boys Yorkshire Bitter, Jolly Cascade Blonde; 3 changing beers (sourced regionally; often Jolly Boys, North Riding Brewery) 🅗
The Harlequin takes its name from another former Ward's pub just round the corner, now demolished. The large open-plan interior features a central bar with seating on two levels. There are two regular beers from Jolly Boys, as well as guests from far and wide, with the emphasis on microbreweries. A large range of real ciders is also available. Wednesday is quiz night and there is live music at weekends.
ॐ❀◑🅡(Castle Square) ♣●🖂🐾

Kelham Island Tavern 🅛
62 Russell Street, Kelham Island, S3 8RW
☎ (0114) 272 2482
Abbeydale Moonshine; Acorn Barnsley Bitter; Pictish Brewers Gold; 10 changing beers (sourced nationally; often Abbeydale, Blue Bee, North Riding Brewery) 🅗
Former CAMRA National Pub of the Year and a regular regional and local winner, this small gem was rescued from dereliction in 2002. Thirteen handpumps dispense an impressive range of beers, always including a mild, a porter and a stout. At the rear of the L-shaped front bar area a conservatory has been added and in the warmer months you can relax in the pub's multi award-winning beer garden. Regular folk music features. No meals Sunday. Q ॐ❀◑🅡(Shalesmoor)♣🖂🐾

Shakespeare's Ale & Cider House 🅛
146-148 Gibraltar Street, Kelham Island, S3 8UB
☎ (0114) 275 5959 ⊕ shakespeares-sheffield.co.uk
Abbeydale Deception; RedWillow Feckless; 7 changing beers (sourced nationally; often Bad Seed, Blue Bee, North Riding Brewery) 🅗
Originally built in 1821, the pub reopened as a free house in 2011 following a refurbishment including incorporation into the building of the archway to the rear yard. The central bar serves three rooms, including the extension, and there is a further room across the corridor. The eight handpumps have featured over 6,000 different beers over the last 10 years, and up to 100 whiskies are also available. There is regular live music, and beer festivals are held twice a year.
Q❀🅡(Shalesmoor) ♣●🖂🐾₹

Wellington 🅛
1 Henry Street, Kelham Island, S3 7EQ
☎ (0114) 249 2295
Neepsend Blonde; 6 changing beers (sourced regionally; often Neepsend) 🅗
A traditional two-roomed local opened as a free house in 1993. Now part of the small Sheaf Inns group of pubs, it is the brewery tap for the nearby Neepsend Brewery. Sympathetically refurbished, the rooms are comfortably furnished and welcoming. The handpumps feature at least three Neepsend beers and up to three changing guests mainly from micros. An extensive range of malt whiskies is also on offer. Q❀🅡(Shalesmoor)♣🖂🐾

Sheffield: North

Blake Hotel 🅛
53 Blake Street, Upperthorpe, S6 3JQ
☎ (0114) 233 9336
Neepsend Blonde; 5 changing beers (sourced regionally; often Blue Bee, Neepsend) 🅗
This extensively restored community pub is located at the top of a steep hill (pedestrian handrails provided). It

retains many Victorian features, including etched windows and mirrors. To the rear is a large decked garden. The pub has one of the largest whisky selections in Sheffield and a growing range of other spirits. There are no electronic games, TV or jukebox. The Blake reopened in 2010 after being closed for seven years and is part of the local Sheaf Inns chain, alongside fellow Guide entries the Sheaf View and the Wellington.
Q✿🏠(Langsett) ♣🚲🚆(135) ♣

Blind Monkey ✔

279 Whitehouse Lane, S6 2WA
☎ (0114) 233 0015 🌐 theblindmonkey.co.uk
Don Valley Atomic Blonde, Gongoozler, Go Your Own Way; 2 changing beers Ⓗ
Reopened in 2018 by the owners of Don Valley Brewery after a period lying empty, this pub has undergone an extensive and outstanding renovation, coupled with detailed design. The formerly open-plan pub is now divided into four areas, with furnishings obtained from a variety of sources. Much is of its time – little is recent. The outside area is well planned and offers a comfortable experience on sunnier days. ♿✿🍴🍺🏠(Langsett)🚆(135)

Gardeners Rest Ⓛ ✔

105 Neepsend Lane, Neepsend, S3 8AT
☎ (0114) 272 4978 🌐 gardenerscomsoc.wordpress.com
8 changing beers (sourced nationally) Ⓗ
Taken over by the Gardeners Rest Community Society in 2017, this friendly pub provides guest beers from independent breweries sourced nationwide. The cosy Dram Shop includes a bar billiards table and, to the rear, a conservatory leading to an eclectically decorated beer garden overlooking the River Don. The pub hosts live music at weekends and regular beer festivals. A former local CAMRA Pub of the Year.
Q✿🚴♿🏠(Infirmary Rd) ♣🍺🚆(7,8) ♣

New Barrack Tavern Ⓛ

601 Penistone Road, Hillsborough, S6 2GA
☎ (0114) 232 4225 🌐 newbarracktavern.com
Bradfield Farmers Bitter; Castle Rock Harvest Pale, Screech Owl; 6 changing beers (often Castle Rock) Ⓗ
Friendly multi-roomed pub with an original 1936 floor plan, including a Gilmours-branded door step and distinctive colourful exterior tiles. The snug has a local sports theme; the lounge features live bands and a monthly comedy club on the first Sunday. The separate function room has three handpumps. In 2018 a new bottle/cider room was converted from a kitchen. Outside is an award-winning heated and covered patio garden. A former CAMRA Yorkshire Cider Pub of the Year.
Q♿✿🏠(Bamforth St) ♣🍺🐾🌐

Wisewood Inn Ⓛ ✔

539 Loxley Road, Loxley, S6 6RR
☎ (0114) 233 4310 🌐 wisewoodinn.co.uk
6 changing beers (often Bradfield, Loxley, Stancill) Ⓗ
The main bar has three rooms, including one for pool, and below is the cellar bar, which is available for hire. Adjacent to the cellar bar is Loxley Brewery, which started production in 2018. In addition to Loxley beers, the five handpumps invariably include local brews. There are also eight keg taps, often featuring Beavertown and Thornbridge. The extensive food menu includes continental sausages, pizzas and tapas. A large garden to the rear overlooks the Loxley Valley. Sister pub to the Raven in nearly Walkley. ♿✿🍴♣🍺🐾🌐

Sheffield: South

Broadfield Ⓛ

452 Abbeydale Road, Nether Edge, S7 1FR

☎ (0114) 255 0200 🌐 thebroadfield.co.uk
Abbeydale Moonshine; True North Blonde; 7 changing beers (sourced nationally; often Abbeydale, Ilkley, True North) Ⓗ
Dating from 1896, the Broadfield has established a deserved reputation for quality food served daily, with an extensive menu including hearty meat pies and home-made sausages. There are nine cask ales including beers from owners True North, and a large range of bottled beers and whiskies. Located in the City's Antiques Quarter, the pub has a great atmosphere, and is now a leading player in the local social scene.
♿✿🍴🚴🍺🏠🐾🌐

Brothers Arms Ⓛ

106 Well Road, Heeley, S8 9TZ
☎ (0114) 258 3544
Abbeydale Deception; 7 changing beers (sourced nationally) Ⓗ
A classic, traditional local, the pub's name reflects its association with locally well-known parody ukulele band The Everly Pregnant Brothers, and live music is hosted every Thursday evening. Although the interior is open plan, it is designed so the various seating areas and the games area all feel individual and cosy. A lovely beer garden is to the rear. The bar features eight real ales with six changing guests, together with a real cider. A quiz is held on Tuesday. ♿✿♣🍺🏠🐾🌐

Sheaf View Ⓛ

25 Gleadless Road, Heeley, S2 3AA
☎ (0114) 249 6455
Neepsend Blonde; 7 changing beers (sourced regionally; often Neepsend, Pictish, Saltaire) Ⓗ
A 19th-century pub near Heeley City Farm, the Sheaf experienced a chequered history before reopening as a free house in 2000 and becoming a real ale oasis. The walls and shelves are adorned with assorted breweriana and provide an ideal background for good drinking and conversation. A wide range of international beers, together with malt whiskies and a real cider, complement the eight reasonably priced real ales. It can get busy, especially on Sheffield United match days.
Q✿🚴♣🍺🐾

White Lion Ⓛ

615 London Road, Heeley, S2 4HT
☎ (0114) 255 1500 🌐 whitelionsheffield.co.uk
Dancing Duck Abduction; Ossett Yorkshire Blonde; Tetley Bitter; Wychwood Hobgoblin Ruby; 8 changing beers (sourced nationally) Ⓗ
This Grade II-listed pub has been respectfully refurbished over the years. A tiled central corridor links a number of delightful small rooms and leads to the larger rear concert room. A wide selection of cask-conditioned beers always includes a vegan option, and the pub is also proud of its selection of whiskies. It hosts many community events and is renowned for its live music, which is hosted every night except Wednesday, which is quiz night. ♿✿♣🍺🐾🌐

Sheffield: West

Beer House Ⓛ

623 Ecclesall Road, Sharrow, S11 8PT
🌐 the-beer-house-172.mytoggle.io
6 changing beers (sourced nationally; often Abbeydale, Blue Bee, Neepsend) Ⓗ
Sheffield's first micropub opened in a small former shop unit in late 2014. The front of two rooms has level access from the street and contains the bar with its bank of six handpumps displaying an ever-changing range of beers. These are mainly from microbreweries, with local

breweries well represented. The rear room has seating focused around the fireplace. There is a quiz on Wednesday evenings. Q❧⚮♣➡☺🐾☂

Ecclesall Ale Club Ⓛ

429 Ecclesall Road, Sharrow, S11 8PG

☎ (0114) 453 6818 ⊕ thebrewfoundation.co.uk/tap-house

5 changing beers (sourced regionally; often Bad Seed, Brew Foundation, Don Valley) Ⓗ

A busy one-roomed micropub in the heart of the bustling Ecclesall Road social scene, but only a stone's throw from the tranquil Botanical Gardens. Comfortably furnished with a cosy atmosphere in contrast to the usual spartan decor of many micropubs, it is owned by the Brew Foundation. In addition to the cask ales there is an extensive range of craft keg beers, bottles and cans from independent brewers. Q❧⚮♣➡🐾☺

Greystones Ⓛ ⊘

Greystones Road, S11 7BS

☎ (0114) 266 5599 ⊕ mygreystones.co.uk

Thornbridge Astryd, Brother Rabbit, Lord Marples, Jaipur IPA; 4 changing beers (sourced locally) Ⓗ

A family-friendly pub with a passion for craft beer, the Greystones offers a wide selection of cask and keg beers from the Thornbridge Brewery and beyond. The Backroom is a dedicated live music venue hosting some of the finest local, national and even international musical acts up to seven nights a week. With a large outdoor area and a kitchen serving fresh home-made pizzas, the pub offers something for everyone. ⚮❀◑♿♣➡(83)☺☂

Itchy Pig Ale House Ⓛ

495 Glossop Road, Broomhill, S10 2QE

☎ (0114) 327 0780 ⊕ theitchypig.co.uk

5 changing beers (sourced regionally; often Abbeydale) Ⓗ

A cosy, friendly micropub with a relaxed atmosphere and a continental feel. The whitewashed walls are decorated with porcine-themed artwork, hop sacks and dried hops. There is craftsman-standard carpentry including a bar made from Victorian-era doors with a glass-covered bar top formed from two pence coins set in resin. A wide range of pork scratchings is available. Q♣➡(120)☺

Rising Sun 🍴 Ⓛ ⊘

471 Fulwood Road, Nether Green, S10 3QA

☎ (0114) 230 3855 ⊕ risingsunsheffield.co.uk

Abbeydale Daily Bread, Deception, Moonshine, Absolution; 7 changing beers (sourced regionally; often Blue Bee, Revolutions, Welbeck Abbey) Ⓗ

A brewer suburban roadhouse operated by local brewer Abbeydale. There are two comfortably furnished rooms with a log-burning fire between the main bar and the glass-roofed extension, which also has glass panels in the end wall. A range of four Abbeydale real ales is always served, with three or four guest real ales mainly from micros. Quizzes are on Sunday evenings. The Sunfest beer festival is in July. Q⚮❀◑♿♣➡(120,83A)☺☂

University Arms Ⓛ

197 Brook Hill, Broomhall, S3 7HG

☎ (0114) 222 8969

Kelham Island Pale Rider; Welbeck Abbey Red Feather Ⓗ**; house beer (by Acorn)** Ⓗ**/**Ⓖ**; 5 changing beers (sourced regionally)** Ⓗ

Owned by the University of Sheffield, this former staff club has an open-plan lounge with a bar at one end adjacent to a small alcove seating area, and a conservatory leading to the large garden. There is additional seating upstairs with separate rooms for

snooker and darts. The guest beers are mostly sourced locally and there are regular beer festivals. Entertainment includes a quiz on Tuesday and open mic night on Wednesday during term time. Q⚮❀◑♿♿(University of Sheffield)♣➡➡☺☂

Thorne

Windmill

19 Queen Street, DN8 5AA

☎ (01405) 812866

Kelham Island Pale Rider; Stancill Barnsley Bitter; 3 changing beers (sourced regionally; often Theakston, York) Ⓗ

With four handpumps, this excellent pub on a quiet back street is a regular in the Guide. The lounge at the rear is cosy and well furnished, with many trophies won by the Windmill Golf Club. There are interesting old pictures on the walls. The front bar has a pool table and large-screen sports TV. The beer garden has play equipment. A quiz is held on Sunday, and there are special prices on cask ale on Monday. ⚮❀☀(North)♣P➡(87,88A)☺☂

Thurlstone

Crystal Palace

Towngate, S36 9RH (round corner from war memorial on A628)

☎ (01226) 766331

Abbeydale Moonshine; house beer (by Kibble); 2 changing beers (sourced locally; often Kibble) Ⓗ

Large stone-built pub on a back road. It has an uncomplicated interior with a pool table at one end. The pubs offers three permanent beers along with seasonal brews. Since 2021 it has been serving Kibble beers which are brewed in a former stable block in the car park. The owner/brewer is a former miner and beers are often named after coal seams. A kibble is a big bucket used in pit shafts and resembles a mash tun. ❀♣P➡☺

Huntsman Ⓛ

136 Manchester Road, S36 9QW (on main A628 through village)

☎ (01226) 764892 ⊕ thehuntsmanthurlstone.co.uk

Black Sheep Best Bitter; Timothy Taylor Landlord; 4 changing beers (sourced nationally) Ⓗ

A genuinely friendly village local that has been a Guide entry for 13 consecutive years. Drinking and talking makes up this pub's lifeblood. Old-fashioned pub games, LocAle and a seriously dog-friendly attitude also combine to make this a venue that should not be passed by, and the choice of six real ales makes it a great destination for drinkers. The pub's location on the main east-west Pennine route provides an interesting mixture of regulars and passing trade. Food is served Tuesday evening and Sunday lunchtime only. No jukebox or TV but Wednesday evening is live music night. Q⚮❀◑♣➡➡☺☂

Tickhill

Scarbrough Arms Ⓛ

Sunderland Street, DN11 9QJ (on A631 near Buttercross)

☎ (01302) 742977

Greene King Abbot; John Smith's Bitter; Timothy Taylor Landlord; 2 changing beers (sourced locally; often Abbeydale, Bradfield, Welbeck Abbey) Ⓗ

A regular in the Guide since 1990, this stone-built pub originally dates back to the 16th century. There is a tap room at the rear which features darts and sports TV; a spacious lounge can be found at the front. Between the two is a Barrel Room snug with barrel-shaped furniture.

Outside are a large attractive beer garden and a covered smoking area. Quiz nights are Monday and Thursday. Beer festivals feature in the summer.
Q ⑤ ❀ ♣ ● P ☒ (22,205) ❀ ⑨

Wath upon Dearne

Church House L ⊘

Montgomery Square, S63 7RZ
☎ (01709) 879518
Greene King Abbot; Ruddles Best Bitter; Sharp's Doom Bar; 3 changing beers (often Acorn, Elland, Stancill) ⊞
Large pub with an impressive frontage, set in a pedestrianised town-centre square, with excellent access to bus services across the square. It was built around 1810 and consecrated by the nearby church in 1912. It became a pub in the 1980s and a Wetherspoon outlet in 2000. A wide variety of real ales is served from both national and local breweries, with real ciders or perries also on handpull. There is a large outside area to the front. Handy if exploring the RSPB Old Moor Wetlands Centre and for Manvers Commercial Park.
⑤ ❀ ◑ ⑤ ● P ☒ ⑨

Wath Tap L

49 High Street, S63 7QB
☎ (01709) 872150 ⊕ wathtap.co.uk
6 changing beers (sourced regionally; often Elland, North Riding Brewery, Ossett) ⊞
A warm welcome is guaranteed at Rotherham's first micropub, opened in a former butcher's shop in 2016. Six changing real ales, mostly from local breweries, and five real ciders are listed on chalkboards by the bar. Food may be brought in from the surrounding takeaways. The pub was recently extended to the rear with the cellar moved. Seats at the front are protected from the rain by the original shop canopy. Jam sessions are sometimes held and board games are available. A regular local CAMRA award-winner. Q ⑤ ♣ ● ☒ ❀ ⑨

Wentworth

George & Dragon L

85 Main Street, S62 7TN (stands back from road on B6090)
☎ (01226) 742440 ⊕ georgeanddragonwentworth.com
Theakston Old Peculier; 7 changing beers (sourced locally; often Bradfield, Chantry, Geeves) ⊞
A village free house, licensed since 1804, offering seven changing real ales from local and regional brewers. It has a front patio and a large garden with a children's adventure playground at the rear. It boasts a craft shop and the Hoober Room, available for hire. Home-cooked food is served from an extensive menu, and a pop-up pie shop opens every Saturday and Sunday. A Guide regular and winner of numerous local CAMRA branch awards, it is handy for historic Wentworth Woodhouse, Needle's Eye and Hoober Stand. Access is available from the parish church behind. Q ⑤ ❀ ◑ ① P ☒ (44,136) ❀ ⑨

Wickersley

Three Horseshoes ⊘

133 Bawtry Road (A631), S66 2BW
☎ (01709) 739240
Black Sheep Best Bitter; Timothy Taylor Landlord; 3 changing beers (sourced regionally; often Dukeries, Pennine, Welbeck Abbey) ⊞
A popular pub, standing back from the busy A631 M1/M18 link-road in the heart of this lively village. It reopened in 2016 following extensive refurbishment

that saw it opened out into a large room with a central bar. The three guest beers usually come from local or regional brewers. There is a large upstairs function room, and outside seating at the front and in the rear garden. Historic pictures of the area adorn the walls. Good-value food is available. It can get lively on weekend evenings.
⑤ ❀ ◑ ● P ☒

Wortley

Wortley Men's Club L ⊘

Reading Room Lane, S35 7DB (in centre of village at the back of Wortley Arms public house)
☎ (0114) 288 2066 ⊕ wortleymensclub.co.uk
Timothy Taylor Landlord; 2 changing beers (sourced nationally) ⊞
This multiple CAMRA award-winning club has received accolades including local, regional and national Club of the Year, and is celebrating its 11th consecutive year in the Guide. Show your CAMRA membership card or a copy of this Guide on entry. The club is situated in the pretty rural village of Wortley, near to Wortley Hall and gardens. The lovely building has exposed timber frames, ornate ceilings, wooden panelling and a real fire. Guest ales are sourced from local and national breweries. The club runs an annual beer festival in July. Q ❀ ⑤ ♣ ● P ☒ (23,23A)

Breweries

1086

Old Brewhouse, Cusworth Hall, Cusworth Lane, Doncaster, South Yorkshire, DN5 7TU
☎ (01302) 639880

Office: Doncaster Culture & Leisure Trust, The Dome Doncaster Lakeside, Bawtry Road, Doncaster, DN4 7PD ⊕ 1086brewery.co.uk

⊕1086 was established in 2018, in the original brewhouse of Cusworth Hall, an 18th century, Grade I, country house in Cusworth, near Doncaster. The brewery shares space with its popular brewery tap, the Old Brewhouse. Beers are available in the taproom, and occasionally at the Leopard in Doncaster. ♦

Abbeydale SIBA

Unit 8, Aizlewood Road, Sheffield, South Yorkshire, S8 0YX
☎ (0114) 281 2712 ⊕ abbeydalebrewery.co.uk

⊕Established in 1996, Abbeydale, the oldest, and one of the larger Sheffield breweries, produce more than 220 barrels a week of which more than 70% is cask. At least one new beer is produced weekly. Small batch, mixed fermentation and barrel-aged brews are part of the Funk Dungeon project and the Dr Morton's range (tribute to the owners). Innovation, investment and expansion have enabled growth, including a substantial online offering. One pub, the Rising Sun, Nether Green, is owned. ♦

Daily Bread (ABV 3.8%) BITTER
Deception (ABV 4.1%) PALE
Heathen (ABV 4.1%) PALE
Moonshine (ABV 4.3%) PALE
Absolution (ABV 5.3%) PALE
Black Mass (ABV 6.6%) STOUT

Acorn SIBA

Unit 3, Aldham Industrial Estate, Mitchell Road, Wombwell, Barnsley, South Yorkshire, S73 8HA
☎ (01226) 270734 ⊕ acorn-brewery.co.uk

Acorn was set up in 2003 with a 10-barrel plant, expanding to 20 barrels when the brewery moved to larger premises. It currently has a 160-barrel a week capacity. All beers are produced using the Barnsley Bitter yeast strain, dating back to the 1850s. ‼️🍺♦LIVE

Yorkshire Pride (ABV 3.7%) BITTER
This session beer is golden in colour with pleasing fruit notes. A mouthwatering blend of malt and hops create a fruity taste which leads to a clean, bitter finish.

Barnsley Bitter (ABV 3.8%) BITTER
This brown bitter has a smooth, malty bitterness throughout with notes of chocolate and caramel. Fruity, bitter finish.

Blonde (ABV 4%) PALE
A clean-tasting, golden-coloured hoppy beer with a refreshing bitter and fruity aftertaste.

Barnsley Gold (ABV 4.3%) GOLD
This golden ale has fruit in the aroma with a hoppy and fruitiness flavour throughout. A well-hopped, clean, dry finish.

Old Moor Porter (ABV 4.4%) PORTER
A rich-tasting porter, smooth throughout with hints of chocolate and liquorice. This is a moreish porter.

Gorlovka Imperial Stout (ABV 6%) STOUT
This black stout is rich and smooth and full of chocolate and liquorice flavours with a fruity, creamy finish.

Blue Bee

Unit 29-30, Hoyland Road Industrial Estate, Sheffield, South Yorkshire, S3 8AB ☎ 07375 659349
🌐 bluebeebrewery.co.uk

Established in 2010, this independently-owned, 10-barrel brewery supplies throughout Yorkshire and the East Midlands, although it is often seen further afield. Blue Bee collaborate with other like-minded breweries and also produce regular innovative specials. Many beers emphasise New World hops. An IPA and a stout are always available. ♦

Hillfoot Best Bitter (ABV 4%) BITTER
Reet Pale (ABV 4%) PALE
American 5 Hop (ABV 4.3%) PALE
Triple Hop (ABV 4.3%) PALE

Both Barrels (NEW)

56A Main Street, Mexborough, S64 9DU ☎ 07753 746618 ✉ anthony@bothbarrelsbrewing.com

Small-batch craft brewery specializing in a wide variety of beers and lagers, founded in 2021. Beers are available in all formats. No filtering or pasteurization of any products.

Bradfield SIBA

Watt House Farm, High Bradfield, Sheffield, South Yorkshire, S6 6LG
☎ (0114) 285 1118 🌐 bradfieldbrewery.co.uk

Based on a working farm in the Peak District National Park, Bradfield is one of the largest breweries in Sheffield. Utilising pure Millstone Grit spring water, this family-run business was established in 2005. Direct delivery covers both the Midlands and the North. Beer is supplied further afield and there is also a local home-delivery service. Monthly specials are available. Three pubs are owned: the King & Miller, Deepcar; the Nag's Head, Loxley; and the Wharncliffe Arms, Wharncliffe Side. 🍺♦LIVE

Farmers Bitter (ABV 3.9%) BITTER
Farmers Blonde (ABV 4%) BLOND
Farmers Brown Cow (ABV 4.2%) BITTER
Farmers Steel Cow (ABV 4.5%) BITTER
Farmers Stout (ABV 4.5%) STOUT
Farmers Pale Ale (ABV 5%) PALE
Farmers Sixer (ABV 6%) GOLD

brewSocial (NEW)

Princess Street, Sheffield, South Yorkshire, S4 7UU

Launched in 2022 brewSocial is a social enterprise dedicated to supporting and training people who are disadvantaged in the labour market. Located in a railway arch in Attercliffe and utilising the brewkit that was formerly in use at Little Ale Cart and then Neepsend. Brewery tap, theSocial, on Snig Hill is a regular outlet. V

Chantry SIBA

Unit 1-2, Callum Court, Gateway Industrial Estate, Parkgate, Rotherham, South Yorkshire, S62 6NR
☎ (01709) 711866 ☎ 07815 727285
🌐 chantrybrewery.co.uk

Brewing returned to Rotherham with the opening of Chantry in 2012 using the latest brewing technology in a 20-barrel plant built by Sheffield-based Moeschle UK. As well as the brewery tap, Cutlers Arms, two other pubs are owned; New York Tavern, Rotherham, and Chantry Inn, Handsworth. Six of Chantry's eight core beers are award-winning. Delivery is nationwide, with free local delivery. ‼️🍺♦

New York Pale (ABV 3.9%) PALE
Iron & Steel Bitter (ABV 4%) BITTER
Steelos (ABV 4.1%) PALE
Full Moon (ABV 4.2%) PALE
Diamond Black Stout (ABV 4.5%) STOUT
Kaldo (ABV 5.5%) BLOND
Mighty Millers (ABV 5.5%) BLOND
Special Reserve (ABV 6.3%) OLD

Dead Parrot

44 Garden Street, Sheffield, South Yorkshire, S1 4BJ

Established in Sheffield city centre in 2018 by the Simmonite brothers. Expansion in recent years has seen increased production using a 15-barrel plant followed by the opening of a brewery tap, Perch, in 2022. In 2021 Jamie Allsopp approached Dead Parrot with the aim of recreating some original 19th century recipes from Allsopps of Burton.

Doncaster

7 Young Street, Doncaster, South Yorkshire, DN1 3EL
☎ (01302) 376436 ☎ 07921 970941
🌐 doncasterbrewery.co.uk

Established in 2012 and initially based at an industrial unit in Kirk Sandall, Doncaster, the brewery moved to new premises in 2014 using a 15-barrel plant, and opened a micropub taproom. The brewer frequently trials new recipes for beers. ♦LIVE 🎋

Sand House (ABV 3.8%) BLOND
Cheswold (ABV 4.2%) BITTER

Exit 33

Unit 1, Petre Drive, Sheffield, South Yorkshire, S4 7PZ
☎ (0114) 270 9991 ✉ office@exit33.beer

This eight-barrel brewery was founded in Sheffield in 2008 as Brew Company but rebranded as Exit 33 in 2014. In 2022 it began producing beers under the HQ Beers name. Social enterprise schemes are supported from the sales through the Harlequin, Sheffield. The plant and

equipment is available for use by cuckoo breweries. Brewing is currently suspended. ♦

Fuggle Bunny SIBA

Unit 1, Meadowbrook Park Industrial Estate, Station Road, Holbrook, Sheffield, South Yorkshire, S20 3PJ
☎ (0114) 248 4541 ☎ 07813 763347
⊕ fugglebunny.co.uk

⊗ Fuggle Bunny was established in 2014 and is an independent, family-run brewery. The plant, originally obtained from Flipside Brewery, has since been expanded. The core range is supplemented by occasional seasonal and special brews. Beers are delivered direct within a 40-mile radius of the brewery and are available nationally through wholesalers. Its first pub opened in Worksop in 2017. !! ⊨

Chapter 5 Oh Crumbs (ABV 3.8%) BITTER
Chapter 9 La La Land (ABV 3.9%) PALE
Chapter 2 Cotton Tail (ABV 4%) GOLD
Chapter 6 Hazy Summer Daze (ABV 4.2%) GOLD
Chapter 8 Jammy Dodger (ABV 4.5%) BITTER
Chapter 1 New Beginnings (ABV 4.9%) BITTER
Chapter 3 Orchard Gold (ABV 5%) GOLD
Chapter 7 Russian Rare-Bit (ABV 5%) STOUT
Chapter 4 24 Carrot (ABV 6%) BITTER

Gorilla SIBA

Unit 3, Glasshouse Lane, Cliff Street, Mexborough, S64 9HU ☎ 07747 484368 ⊕ gorillabrewing.co.uk

Co-founders Jason White and Phil Paling launched Gorilla Brewing in 2020, utilising a 6-barrel kit, next to the Sheffield and South Yorkshire Navigation canal. Two pubs are operated, Rockingham Tap, Swinton and Track & Sleeper on Knaresborough station. ♦

Silverback Blonde (ABV 3.8%) PALE
Monkey Magic (ABV 4.5%) SPECIALITY
Orang-A-Tang (ABV 4.5%) SPECIALITY
Kong (ABV 6%) IPA
Vanilla Gorilla (ABV 6%) SPECIALITY

Grizzly Grains

Unit 6, Sheaf Gardens, Duchess Road, Sheffield, South Yorkshire, S2 4BB ☎ 07807 242545
✉ sambrewsbeers@gmail.com

Having purchased the equipment from Crosspool Alemakers in 2019, Sam Bennett commenced brewing in the Walkley area of Sheffield in 2020 before moving to an industrial unit in 2021. Sam produces a range of mostly one-off beers, including bottle-conditioned ales.
♦ LIVE

Heist

107 Neepsend Lane, Sheffield, South Yorkshire, S3 8AT ⊕ heistbrewco.com

Established by Dan Hunt and Adam France in 2017 as a craft bar and bottle shop, Heist began brewing operations in Clowne, Derbyshire in 2018. In 2021, there was the launch of the new brewery and taproom in Neepsend, showcasing 30 fresh beers on tap, alongside a strong community-focussed environment. !! ♦

Hilltop

⊟ Sheffield Road, Conisbrough, South Yorkshire, DN12 2AY
☎ (01709) 868811 ☎ 07947 146746
⊕ thehilltophotel.co.uk

⊕ Established in 2016, Hilltop Brewery is a 3.5-barrel plant situated in the outbuildings of the Hilltop Hotel in Conisbrough. Beers are available in the hotel and other local outlets. !! ♦ LIVE

Imperial

⊟ Arcadia Hall, Cliff Street, Mexborough, S64 9HU
☎ (01709) 584000 ☎ 07428 422703
✉ impbrewery@gmail.com

⊕ Brewing began in 2010 using a six-barrel tower brewery system located in the basement of the Imperial Club, Mexborough. Beer is available in the club as well as local outlets. !! ♦ LIVE

Classical Bitter (ABV 3.9%) BITTER
Platinum Blonde (ABV 4%) BLOND
Bees Knees (ABV 4.2%) GOLD
Nah Than (ABV 4.5%) GOLD
Stout wi' Nowt Tekkin' Owt (ABV 6%) STOUT

Jolly Boys

Unit 16a, Redbrook Business Park, off Wilthorpe Road, Redbrook, South Yorkshire, S75 1JN ☎ 07808 085214 ⊕ jollyboysbrewery.co.uk

⊕ Jolly Boys started brewing using spare capacity at a local brewery in 2016, prior to brewing on its own plant later the same year. The Jolly Tap, Wakefield, and the Jolly Tap on the Arcade, Barnsley, are owned. !! ♦

Yorkshire Bitter (ABV 3.8%) BITTER
Blonde (ABV 4%) BLOND
Jolly Cascade Blonde (ABV 4%) BLOND
La Joll'a Blonde (ABV 4%) BLOND
Golden Best (ABV 4.5%) GOLD
Yorkshire Pale Ale (ABV 4.8%) PALE
Jolly Collier Porter (ABV 5%) PORTER
Jolly IPA (ABV 5.8%) IPA

Kibble

⊟ Rear of Crystal Palace, 11 Towngate, Thurlstone, South Yorkshire, S36 9RH ☎ 07952 790245

⊕ Brewing began in 2021 in the former stable block of the Crystal Palace pub. The owner (an ex miner) on seeing the mash tun exclaimed it looked like a kibble (a big bucket used in pit shafts to move men and machinery) and the brewery name was born. A 2.5-barrel kit is used to produce mining-themed beers mostly named after local coal seams. The beers are rarely found outside the pub.

Little Critters SIBA

80 Parkwood Road, Sheffield, South Yorkshire, S3 8AG
☎ (0114) 276 3171

Office: Horizon House, 2 Whiting Street, Sheffield, S8 9QR ⊕ littlecrittersbrewery.com

A small batch, family-owned microbrewery. It opened in 2016, and operates on a 10-barrel brewing plant. Pubs are supplied throughout Yorkshire, the East Midlands and nationally. Brewery improvements took place in 2020 and the core range expanded. It also supplies beer in cans through a number of bottle shops and via its online shop. ♦ LIVE

Little Hopper (ABV 3.6%) GOLD
Blonde Bear (ABV 4.2%) BLOND
Raspberry Blonde (ABV 4.5%) BLOND
Sleepy Badger (ABV 4.5%) SPECIALITY
White Wolf (ABV 5%) PALE

Coco Nutter (ABV 6%) STOUT
Nutty Ambassador (ABV 6%) STOUT
Sultanas of Swing (ABV 6%) SPECIALITY
C Monster (ABV 6.5%) IPA

Little Mesters SIBA

352 Meadowhead, Sheffield, S8 7UJ ☎ 07859 889547
⊕ littlemestersbrewing.co.uk

Microbrewery and taproom established in 2020 producing beers in cask, keg and can. ◆

Lost Industry

14a Nutwood Trading Estate, Sheffield, South Yorkshire, S6 1NJ
☎ (0114) 231 6393
✉ beer@lostindustrybrewing.com

Lost Industry is a craft beer brewery run by a family of beer enthusiasts which opened in 2015. Pushing boundaries and brewing a wide range of creative beers, it is becoming well known, in particular, for its sours. There is no core range although favourites may be repeated. In a little over two years over 100 distinct beers have been brewed in a wide range of styles. It began a barrel-ageing programme in 2018. Spare brewing capacity is utilised by Steel City (qv).

Loxley

▌ 539 Loxley Road, Sheffield, South Yorkshire, S6 6RR
☎ (0114) 233 4310 ⊕ loxleybrewery.co.uk

Established in 2018, Loxley use a five-barrel plant located at the Wisewood Inn, partner-pub to the Raven in nearby Walkley. Six regular beers complement occasional specials. The beers, brewed with water from a natural spring, are increasingly available locally, with over 30 pubs supplied. Live beers are bottled on-site and all brews (except milk stout) are vegan-friendly. Branded merchandise is available from both pubs. LIVE V

Fearn (ABV 3.8%) PALE
Halliday (ABV 4%) BITTER
Revill (ABV 4%) BLOND
Lomas (ABV 4.4%) PALE
Gunson (ABV 4.8%) PALE
Black Dog (ABV 5%) STOUT

Mitchell's Hop House

354 Meadowhead, Sheffield, South Yorkshire, S8 7UJ
☎ (0114) 274 5587 ⊕ mitchellswine.co.uk

Brewing began in 2016 in a converted space at the back of Mitchell's Wine Merchants. Beers are available from the brewery shop and a growing number of local pubs and beer retailers. All production is now bottled.

Nailmaker

Unit 9, Darton Business Park, Barnsley Road, Darton, South Yorkshire, S75 5NH
☎ (01226) 380893 ☎ 07973 824790
⊕ nailmakerbrewing.co

☺Nailmaker Brewery is located in an old carpet mill by the river Dearne, using an eight-barrel plant. Nailmaking was one of the largest local occupations in the early 19th century. The extensive list of draught cask ales are supplemented by bottles, cans, pouches and beer in a box. There's an on-site tap, a taphouse in nearby Darton (Anvil Arms) and two more in Mapplewell (Talbot Inn, and Wentworth Arms). 2021 saw the addition of brewery and distillery tours, and events in the visitor centre.
‼️🍴◆◈

Yorkshire Bitter (ABV 3.6%) BITTER
Wapentake (ABV 3.8%) GOLD
Auckland (ABV 4%) BITTER
Cascade (ABV 4%) PALE
Chinook (ABV 4%) PALE
Jester Pale Ale (ABV 4%) PALE
Mango Magic Pale Ale (ABV 4%) PALE
Mosaic (ABV 4%) PALE
Paleton Pale Ale (ABV 4%) PALE
Citra Grapefruit Pale Ale (ABV 4.1%) PALE
Citra Pale Ale (ABV 4.1%) PALE
Anvil Porter (ABV 4.4%) PORTER
Plum Porter (ABV 4.4%) PORTER
Wentworth (ABV 4.8%) BITTER
Clout Stout (ABV 5%) STOUT
Chocolate Safari Stout (ABV 5.5%) STOUT
Triple Chocolate Stout (ABV 5.5%) STOUT
Imperial Stout (ABV 8.8%) STOUT

Neepsend

Unit 13, 92 Burton Road, Sheffield, South Yorkshire, S3 8DA
☎ (0114) 276 3406 ⊕ neepsendbrewco.com

☺Established in 2015 by James Birkett and Gavin Martin, after taking over Little Ale Cart Brewery, and moving to new premises in Sheffield's Valley of Beer. A 10-barrel plant is used, supplying beers locally, including to the company's own pubs, Sheaf View, the Blake Hotel and the Wellington. Despite only having one core beer, the brewery produces an ever-changing range of hop-forward seasonal ales. There is an on-site taproom that opens occasionally. ◆◈

Blonde (ABV 4%) BITTER

On the Edge

Sheffield, South Yorkshire ☎ 07854 983197
⊕ ontheedgebrew.com

On the Edge started brewing commercially in 2012 using a 0.5-barrel plant in the brewer's home. Brewing takes place once a week. Three local pubs are supplied as well as beer festivals. There is no regular beer list as new brews are constantly being tried.

Outhouse

c/o Unit 16a, Redbrook Business Park, off Wilthorpe Road, Redbrook, Barnsley, South Yorkshire, S75 1JN
☎ 07572 164446

Office: Henry Morgan House, Industry Road, Carlton, Barnsley, South Yorkshire, S71 3PQ
⊕ outhousebrewing.co.uk

☺After a 13 year teaching career Andy Jones established Outhouse Brewing in 2018 using spare capacity at Jolly Boys (qv).

Pristavba (ABV 3.7%) GOLD
Garden Shed (ABV 4%)
Bikeshed (ABV 4.5%) GOLD

St Mars of the Desert

90 Stevenson Road, Attercliffe, Sheffield, South Yorkshire, S9 3XG ☎ 07365 222101
⊕ beerofsmod.co.uk

A family-run brewery, recognised as one of the 'top ten new breweries in the world' by Rate Beer in 2020. Dann, Martha and Scarlet brew a range of beers inspired by many regional brewing cultures (American IPAs, or lagers inspired by Franconia and the Czech Republic, for

example). The taproom is open most weekends between March and December for drinks and cans to take away. The brewery also ships cans to many independent retailers nationwide. 🍺✦

Stancill SIBA

Unit 2, Oakham Drive, off Rutland Road, Sheffield, South Yorkshire, S3 9QX
☎ (0114) 275 2788 ☎ 07809 427716

😊Stancill began brewing in 2014 and is named after the first head brewer and co-owner. It is situated on the doorstep of the late Stones' Cannon Brewery, taking advantage of the soft Yorkshire water. 🍴

Barnsley Bitter (ABV 3.8%) BITTER
Blonde (ABV 3.9%) BLOND
India (ABV 4%) BITTER
No.7 (ABV 4.3%) BITTER
Stainless (ABV 4.3%) BITTER
Porter (ABV 4.4%) PORTER
Black Gold (ABV 5%) STOUT

Steel City

c/o Lost Industry Brewing, 14a Nutwood Trading Estate, Sheffield, South Yorkshire, S6 1NJ

⊗ Steel City was established in 2009 and operates as a cuckoo brewery, brewing on an occasional basis and when inspired. Brewing currently takes place at Lost Industry Brewing (qv). Much of the Steel City output is collaborations with other like-minded brewers, having a little fun producing interesting and experimental beers. ✦

Tapped

🏠 **Sheffield: Sheffield Tap, Platform 1b, Sheffield Station, Sheaf Street, Sheffield, South Yorkshire, S1 2BP**
☎ (0114) 273 7558

Leeds: 51 Boar Street, Leeds, LS1 5EL ☎ (0113) 244 1953 🌐 tappedbrewco.com

Brewing began in 2013 after the old Edwardian dining rooms were converted into a four-barrel, on-site brewery with a viewing gallery at the Sheffield Tap pub. The beer is mostly sold on site and via the company's specialist beer wholesale business, Pivovar, to its other outlets and occasionally into the free trade. A further onsite brewery was opened at the Leeds Tap in 2014.

Toolmakers SIBA

6-8 Botsford Street, Sheffield, South Yorkshire, S3 9PF
☎ 07956 235332 🌐 toolmakersbrewery.com

Toolmakers is a family-run brewery established in 2013 in an old tool-making factory. The regular brews are supplemented by a varying range of different styles and strengths and are available in the adjourning Forest pub which is owned. The function room at the brewery also doubles as the brewery taproom. 🍴✦

Lynch Pin (ABV 4%) BITTER
Razmataz (ABV 4.2%) BLOND
Flange Noir (ABV 5.2%) STOUT

Triple Point SIBA

178 Shoreham Street, Sheffield, South Yorkshire, S1 4SQ
☎ (0114) 229 4769 ☎ 07828 131423
🌐 triplepointbrewing.co.uk

Father and son-operated, modern brewery and bar conversion, of what was formerly a carpet showroom. The brewery is clearly visible from the drinking area which operates as the taproom. Convenient for the train station and Bramall Lane Football Ground. 🍴✦

Gold (ABV 4%) GOLD
Cryo (ABV 4.2%) IPA
Porter (ABV 4.4%) PORTER
Debut (ABV 5.5%) IPA

True North SIBA

47 Eldon Street, Sheffield, South Yorkshire, S1 4GY
☎ (0114) 272 0569

Office: 127-129 Devonshire Street, Sheffield, S3 7SB
🌐 truenorthbrewco.uk

True North began brewing in 2012 using spare capacity at Welbeck Abbey Brewery (qv). It opened its own plant in Sheffield in 2016. Dean Hollingworth is head brewer, supplying 11 pubs owned by the company plus other independent outlets.

Best Bitter (ABV 3.8%) BITTER
Blonde (ABV 4%) GOLD
Polaris (ABV 4.3%) BITTER

Ward & Houldsworth

62 Drakehouse Lane West, Beighton, Sheffield, South Yorkshire, S20 1FX ☎ 07912 028880 🌐 ifinfused.com

Former Kelham Island brewer Paul Ward together with Darren Houldsworth established the company in 2019. Beers are contract brewed at Pheasantry (qv) and distributed from storage in Sheffield.

White Rose

Premises R/0, 7 Doncaster Road, Mexborough, South Yorkshire, S64 0HL
☎ (0114) 246 6334

Office: 119 Chapel Road, Burncross, Chapeltown, Sheffield, S35 1QL
✉ whiterose.brewery@btinternet.com

😊Established in 2007 by Gary Sheriff, former head brewer at Wentworth Brewery. Formerly sharing premises with Little Ale Cart, White Rose then brewed in Mexborough, sharing premises with Imperial Brewery (qv). In 2018 it moved to its own premises using a new seven-barrel plant. 🍴✦

Original Blonde (ABV 4%) BLOND
Stairlift to Heaven (ABV 4.2%) BLOND
Raven (ABV 4.9%) STOUT

Whitefaced

14 Market Street, Penistone, Sheffield, South Yorkshire, S36 6BZ ☎ 07894 532456

Established in 2017 producing bottled and keg beers, the brewery moved into cask production in 2019, winning CAMRA awards the same year. Cans were introduced in 2020. Originally brewing from his residence, owner/brewer David Hampshaw soon relocated the two-barrel brewery into a tap house in Penistone town centre. Popularity of the brewery continues to grow and David has secured additional space close by for installaton of a five-barrel brewery. The brewery is named after the highly-prized, local, whitefaced woodland sheep. ✦LIVE✦

Painted Tiles (ABV 4%) PALE
First Flight (ABV 6%) PALE

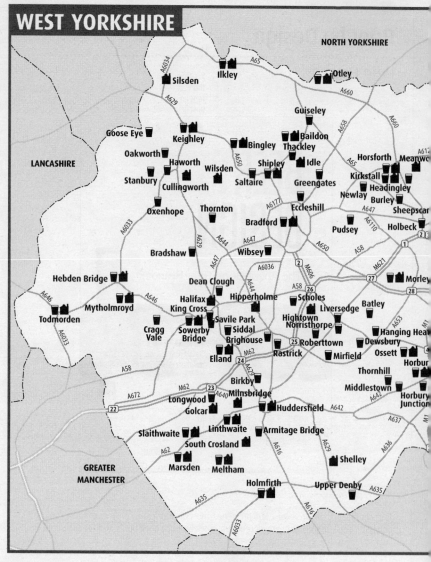

WEST YORKSHIRE

Ackworth

Masons Arms 🅛

Bell Lane, WF7 7JD (turn off A628 by disused railway bridge)

☎ 07966 501827

Bradfield Farmers Bitter, Farmers Blonde, Farmers Brown Cow; 1 changing beer (sourced locally) 🔢

Grade II-listed former coaching house just off the Pontefract Road, dating from 1682 and built of locally quarried stone. A unique display of old photographs portrays the local social and industrial heritage. A central bar serves the main room, pool room and a smaller lounge. Log-burning fireplaces in both the main rooms were discovered 15 years ago during a sensitive refurbishment. Live music is hosted on Saturday and Sunday, bingo on Tuesday and a quiz on Thursday – all are well attended. Its spacious beer garden is popular in the summer months. ☼🕯♿🅿🚪🛜

Altofts

Robin Hood 🅛

10 Church Road, WF6 2NJ (from Normanton town centre take road over railway into Altofts, continue through Lee Brigg, then High Green Rd and left on to Church Rd)

☎ (01924) 892911 ⊕ robinhoodaltofts.co.uk

Tarn 51 Summer Blonde; 3 changing beers (sourced locally; often Tarn 51) 🔢

A traditional, independent, locally owned pub, popular with the local community. At least four real ales are on offer, with two always from Tarn 51 brewery, situated at the rear of the pub. Other guest ales are often from Yorkshire microbreweries. The pub is dog friendly in all areas. A book club takes place on the last Wednesday of the month, and a beer festival is held in July – see the website for details. A former local CAMRA Pub of the Season and Pub of the Year award winner.

☎🕯♣🅿🚪🛜

☎ (01484) 522370
House beer (by Empire); 3 changing beers (sourced locally; often Ashover, Empire, Goose Eye) Ⓗ
Refurbished and air conditioned, this thriving and friendly little club in the hamlet of Armitage Bridge serves up to three changing guest beers and one regular house brew from Empire. A regular local CAMRA Club of the Year, it is well worth seeking out and is a great place to relax with a pint on an evening. There is a pool room upstairs. ☎❀&♣🖃❀📶🔌

Baildon

Junction Ⓛ
1 Baildon Road, BD17 6AB (on A6038/B6151 jct)
Junction Blonde; Tetley Bitter; 3 changing beers (sourced nationally; often Acorn, Junction, Oaks) Ⓗ
Popular traditional three-roomed local comprising a lounge, public bar and games area. The regular beers, usually including at least one from the in-house Junction brewery, are complemented by up to three guest ales. Bottled ciders and foreign beers are also sold. Sports events on TV are popular. Quiz nights are hosted on Tuesdays and Thursdays and music jamming sessions on Sundays. A piano is available for those wanting to provide impromptu live music and sing-alongs. ☎❀♣🖃❀📶🔌

Batley

Cellar Bar Ⓛ
51 Station Road, WF17 5SU
☎ (01924) 444178 ⊕ thecellarbar.weebly.com
Acorn Barnsley Bitter; Saltaire Blonde; 2 changing beers Ⓗ
This atmospheric bar in the basement of a Grade II-listed building has an exquisite carved stone exterior and is located opposite the railway station in a historic area of Batley that has sometimes been used as a film set. It has a mixture of comfortable seating, and a pleasant ambience. The upstairs function room seats up to 40. Three or four handpumps dispense a variety of real ales which are always well kept. ☎❀≈♣🖃❀📶🔌

Bingley

Chip N Ern Ⓛ
73 Main Street, BD16 2JA
☎ (01274) 985501
7 changing beers (sourced locally; often Bingley, Goose Eye, Yorkshire Heart) Ⓗ
A micropub on Bingley's Main Street and a popular destination on the local real ale scene. The wood-panelled ground floor bar has a distinctive and eclectic range of decorations. The seven cask ales include a varying range from local and regional breweries. Additional seating is available in the more modern-styled upstairs room with its own bar selling bottles and cans. Close to the railway station and handy for exploring the famous Five Rise Locks on the adjacent Leeds-Liverpool Canal. ☎&●🖃❀📶🔌

Peacock Bar
Wellington Street, BD16 2NB (opp railway station)
☎ 07480 711643 ⊕ peacockbar.co.uk
Thornbridge Jaipur IPA; 3 changing beers (sourced regionally; often Bingley, Ossett, Vocation) Ⓗ
Opened under new ownership and a new name in 2019, this modern basement pub is opposite the railway station. It comprises a small bar area and an adjacent larger room downstairs. Up to four real ales are offered including guests from local and regional breweries; a

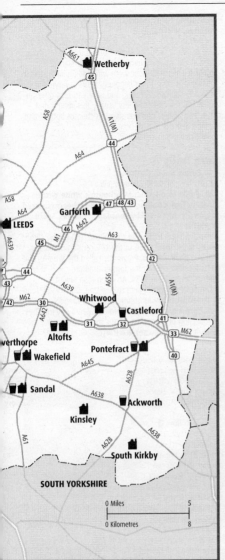

0 Miles 5

0 Kilometres 8

Alverthorpe

New Albion
2 Flanshaw Lane, WF2 9JH (take Cliffe Lane to Batley Rd, continue to traffic lights in Alverthorpe, left onto Flanshaw Lane and pub is on right)
☎ (01924) 362301
Ainsty Flummoxed Farmer; 5 changing beers Ⓗ
Traditional, multi-roomed free house with a raised area containing sofas and easy chairs. The large outside seating area is a suntrap. Sports TV is available to armchair enthusiasts in two of the four rooms. Five rotating guest beers and a traditional cider are available at all times. Wednesday is quiz night.
Q❀♣●P🖃(212) ❀📶

Armitage Bridge

Armitage Bridge Monkey Club Ⓛ
Dean Brook Road, HD4 7PB

fifth handpull serves cider. Kegged beers and ciders are available alongside an extensive range of bottled and canned craft beers. Indian-style street food is offered and popular with customers. ☜◑♿≢🖾♥🛜

Birkby

Magic Rock Brewery Tap Ⓛ

Willow Park Business Centre, Willow Lane, HD1 5EB
☎ (01484) 649823 ⊕ magicrockbrewing.com
Magic Rock Hat Trick, Ringmaster; 3 changing beers (sourced locally; often Magic Rock) Ⓗ
Following relocation from Quarmby, the brewery has had a meteoric rise that has been mirrored by the tap. It opens every day, serving up to five cask beers. The back wall provides views into the brewery, with barrel-ageing beers to one side. There is plenty of undercover seating outside. Exhibitions, festivals and Saturday tours are staged, and street food outlets and various other caterers operate at weekends. The venue is less than 10 minutes' walk from the town centre and has a good bus service.
☜❀◑♿P🖾(327,360) ♥🛜

Bradford

Boar & Fable

30 North Parade, BD1 3HZ
⊕ boarandfable.com

3 changing beers (sourced regionally; often Arbor, Vocation, Wishbone) Ⓗ
Opened in 2020, this small, stylish and comfortable bar gets its name from the legend of a ferocious boar that lived in the woods where Bradford now stands. It comprises a ground-floor room with additional seating in a basement area. Three handpulls serve a varying range of locally sourced real ales, and nine keg taps offer an additional selection of beers usually including a dark brew and a sour. An extensive selection of bottled and canned beers is also stocked.
☜≢(Forster Square) 🖾♥🛜

Corn Dolly Ⓛ

110 Bolton Road, BD1 4DE
☎ (01274) 720219 ⊕ corndolly.pub
Abbeydale Moonshine; Moorhouse's White Witch; Timothy Taylor Boltmaker; 5 changing beers (sourced regionally; often Kirkby Lonsdale, Pennine, Small World) Ⓗ
Award-winning traditional free house, run by the same family since 1989, close to the city centre and Forster Square railway station. Previously called the Wharfe, due to its location near to the former Bradford canal, it first opened its doors in 1834. An open-plan layout incorporates a games area to one end. Good-value food is served weekday lunchtimes. It has a friendly atmosphere and is popular before Bradford City matches. A collection of pumpclips adorns the beams.
❀◑&≢(Forster Square) ♣♥P🖾(640,641) ↻

REAL ALE BREWERIES	
Anthology ✦ Leeds	**Magic Rock** ✦ Huddersfield
Barker's South Crosland	**Mallinsons** Huddersfield
Beer Ink ✦ Huddersfield	**Marlowe** Otley (NEW)
BEEspoke 🍽 Shipley	**Meanwood** ✦ Leeds
Bingley ✦ Wilsden	**Mill Valley** ✦ Hightown
Bini Ilkley	**Milltown** Milnsbridge
Bone Idle Idle	**Morton Collins** 🍽 Sandal
Bosun's ✦ Wetherby	**Nightjar** Mytholmroyd
Bridgehouse Keighley	**Nomadic** ✦ Leeds
Briggs Signature Huddersfield	**Nook** 🍽 Holmfirth
Briscoe's Otley	**North** ✦ Leeds
Burley Street 🍽 Leeds (brewing suspended)	**Northern Monk** ✦ Leeds
Chevin Otley	**Old Spot** Cullingworth
Chin Chin South Kirkby	**Ossett** ✦ Ossett
Cobbydale 🍽 Silsden	**Outgang** 🍽 Kinsley (brewing suspended)
Cooper Hill Leeds	**Piglove** ✦ Leeds
Darkland Halifax	**Quirky** ✦ Leeds: Garforth
DMC Wakefield (NEW)	**Rat** 🍽 Huddersfield
Eagles Crag ✦ Todmorden	**Revolutions** Whitwood
Elland Elland	**Rideside** ✦ Leeds: Meanwood
Empire Slaithwaite	**Riverhead** 🍽 Huddersfield: Marsden
Fernandes 🍽 ✦ Wakefield	**Salt** ✦ Shipley
Frisky Bear ✦ Leeds: Morley	**Saltaire** ✦ Shipley
Ghost Baildon	**Shadow** ✦ Otley (brewing suspended)
Goose Eye ✦ Bingley	**Small World** Shelley
Halifax Steam 🍽 Hipperholme	**Stod Fold** Halifax
Henry Smith 🍽 Pontefract	**Stubbee** ✦ Bradford
Hogs Head 🍽 Sowerby Bridge	**Sunbeam** Leeds
Horbury 🍽 Horbury	**Tapped** 🍽 Leeds
Horsforth ✦ Leeds: Horsforth	**Tarn 51** ✦ Altofts
Ilkley Ilkley	**Three Fiends** Meltham
Junction 🍽 Baildon	**Tigertops** Wakefield
Kirkstall ✦ Leeds: Kirkstall	**Timothy Taylor** Keighley
Lazy Turtle Holmfirth	**Truth Hurts** ✦ Leeds: Morley
Leeds Leeds	**Vocation** Hebden Bridge
Legitimate Industries Leeds	**Wetherby** 🍽 ✦ Wetherby
Linfit 🍽 Linthwaite	**Wharfedale** 🍽 Ilkley
Little Valley Hebden Bridge	**Wilde Child** ✦ Leeds
Lord's ✦ Golcar	**Wishbone** ✦ Keighley
Luddite 🍽 Horbury Junction	**Zapato** ✦ Marsden

Exchange Craft Beer House L

14 Market Street, BD1 1LH

☎ (01274) 306078

5 changing beers (sourced regionally; often Neptune, Nightjar, Revolutions) ⊞

This establishment is located under the Victorian splendour that is the Wool Exchange building. Despite being a cellar bar, the pub has a light and airy feel and is open plan. It has a large seating area and bar under a brick barrel ceiling, and a smaller raised seating area near the entrance. The five handpulls usually feature a real ale from the owner, Nightjar brewery. Others beers come from smaller regional breweries or further afield, in a variety of styles from light to dark.
ठ≉(Forster Square) ♣◲☺ᕯ

Fighting Cock L

21-23 Preston Street, BD7 1JE (close to Grattans, off Thornton Rd)

☎ (01274) 726907

Pictish Alchemists Ale; Timothy Taylor Boltmaker, Landlord; Theakston Old Peculier; 8 changing beers (sourced nationally; often Millstone, Oakham, Thornbridge) ⊞

A drinkers' paradise in an industrial area, this multi award-winning traditionally-styled free house is 20 minutes' walk from the city centre and close to bus routes along Thornton Road and Legrams Lane. Up to 12 real ales usually include at least one dark beer. A variety of real ciders is also available along with foreign bottled beers. Good-value lunches are served Monday to Saturday. Twice-yearly beer festivals take place. There is a large beer garden opposite the pub. ☺◖◗◲☺ᕯU

Jacobs Well L

14 Kent Street, BD1 5RL (by Jacobs Well roundabout at end of Hall Ings)

☎ (01274) 395628 ⊕ jacobs-well.co.uk

Abbeydale Deception; Half Moon Dark Masquerade; Sunbeam Bright Day; 6 changing beers (sourced regionally; often Bingley, Mobberley, Wensleydale) ⊞

Traditionally styled real ale and cider free house dating from 1811, formerly known as Jacobs Beer House. It has an open-plan layout with a rustic feel and a snug to the side of the bar. Nine handpulls offer a varying range of beers from local and regional independents, always featuring darker ales. Numerous ciders are available together with a good range of foreign bottled beers. The hand-made pies have some interesting fillings. Sit outside and watch the city bustle while enjoying good ale. ☺◖◗≉(Interchange)◖◲☺ᕯU

Record Café

45-47 North Parade, BD1 3JH

☎ (01274) 723143 ⊕ therecordcafe.co.uk

4 changing beers (sourced regionally; often Brass Castle, North Riding, Wishbone) ⊞

Multi award-winning modern café-style bar in the city's independent quarter selling ale, vinyl and ham. Four handpulls serve real ales sourced regionally in varying styles, always including a dark beer. Real cider and perry are also offered. There are nine craft keg beers from independent brewers on tap. Food is offered in a charcuterie style specialising in hams and cheeses from Spain. You can also purchase vinyl records in the upstairs mezzanine area. Payment is by card only.
ठ☺◖◗⅄≉(Forster Square) ◖◲☺ᕯU

Sparrow L

32 North Parade, BD1 3HZ

☎ (01274) 270772

Kirkstall Black Band Porter, Three Swords; 3 changing beers (sourced nationally; often Buxton, Five Points, Pentrich) ⊞

This simply furnished café-style pub was refurbished in 2018 by new owners Kirkstall Brewery. The interior has a traditional feel, with painted walls displaying pictures and mirrors, many having a breweriana theme, and dark wood panelling. There is additional seating in the basement. Six handpulls dispense Kirkstall beers and two guest ales. Nine taps behind the bar serve kegged beers and a cider. The pub can be busy when Bradford City FC are playing at home. ठ☺≉(Forster Square)◲☺ᕯ

Bradshaw

Golden Fleece L ✓

1 Bradshaw Lane, HX2 9UZ

☎ 07522 190990 ⊕ goldenfleecebradshaw.co.uk

Saltaire Blonde; Tetley Bitter; 4 changing beers (sourced nationally) ⊞

You are assured of a warm welcome at this traditional village pub. There is a comfortable lounge and a separate area for pool; two pool teams and a dominoes team play in a local league. There is a quiz night every Wednesday, a free buffet on Friday and entertainment every Saturday with a themed disco and occasionally karaoke and live music. The pub has a large beer garden where barbecues are held during the summer months.
ठ☺⅄♣P◲(504,526) ᕯU

Brighouse

Crafty Fox

44 Commercial Street, HD6 1AQ

☎ 07847 205425 ⊕ craftyfox.bar

6 changing beers (sourced regionally; often Neepsend, Salopian, Vocation) ⊞

A family-run bar on the main shopping street, with a back door opening into Brighouse bus station. The industrial-style interior has wood-panelled walls, pallet tables and stools. The upstairs room has similar decor and is available for private functions and meetings. Blind beer tastings are organised once a month, and live acts and a quiz are hosted weekly. Food can be ordered in from the nearby Crust & Crumb pizza restaurant.
ठ≉◲☺ᕯ

Market Tavern L

2 Ship Street, HD6 1JX

☎ (01484) 769852

6 changing beers (sourced regionally; often Abbeydale, Neepsend, Salopian) ⊞

Micropub in a single-storey former pork pie factory next to the canalside open-air market. It has comfortable seating in the bar, a small snug by the entrance, and a sheltered outside drinking area. At least one dark beer and two changing ciders are on sale at all times. Snacks are available for customers and their dogs. Open bank holiday Mondays. Qठ☺⅄≉◖◲☺ᕯ

Castleford

Doghouse L

16 Carlton Street, WF10 1AY (bottom end of main shopping street)

☎ (01977) 559793 ⊕ littleblackdogbeer.com/thedoghousecastleford

4 changing beers (sourced locally; often Henry Smith, Little Black Dog, Stod Fold) ⊞

A quirky, family owned craft ale bar within the historic Roman settlement town of Castleford, offering a choice of regular and rotating ales. The cosy establishment has a

small outside seating area to the rear. Interior walls are adorned with song lyrics from years gone by, and hand-painted art features throughout. The bar hosts regular live music and quiz nights. Families and dogs are welcome. Q ♿☕🅰❤♣♠P🚆😺🐾🛜

Griffin Inn 🅛

Lock Lane, WF10 2LB (10 mins' from town centre on A656)

☎ (01977) 324435

2 changing beers (sourced regionally; often Daleside) Ⓗ

Traditional refurbished two-roomed pub with a separate lounge and bar, offering two regularly changing cask beers and real cider. Entertainment includes live music, quiz nights and sports TV. Families and dogs are welcome. Situated next to the Aire & Calder canal, where moorings are available, it is 10 minutes' walk from the town centre and Castleford Tigers Rugby Ground. ♿☕♣♠P🚆😺🛜

Junction 🅛

Carlton Street, WF10 1EE (enter Castleford on A655; pub is on corner with Carlton St at top of town centre)

☎ (01977) 277750 ⊕ thejunctionpubcastleford.com

5 changing beers (sourced locally) Ⓗ

This rejuvenated pub specialises in beers from the landlord's own wooden casks. Up to six changing guest ales are available in the wood from enterprising local brewers. The large L-shaped bar is kept warm with open fires, and a stove-heated snug can be used for functions. Folk afternoons are held on the last Sunday of the month. The pub is dog friendly and handily situated for the bus and railway stations. Q ♿☕❤♣🚆😺🛜

Cragg Vale

Robin Hood 🅛

Cragg Road, HX7 5SQ (on B6138 1½ miles S of Mytholmroyd)

☎ (01422) 885899

Timothy Taylor Boltmaker, Landlord; 3 changing beers (sourced regionally; often Goose Eye, Millstone, Oakham) Ⓗ

A warm welcome is assured at this friendly, two-roomed, split-level local in a beautiful wooded valley popular with walkers and cyclists. On entering, the cosy bar – with a real fire in winter – is to the right and the larger dining room is to the left. Food is served Thursday to Sunday. Two Timothy Taylor beers are complemented by up to three guests from regional breweries. Real cider is sometimes available. Q ♿☕🍽♣▲🚆(900,901)😺🛜🔄

Dewsbury

West Riding Refreshment Rooms 🏆 🅛

Dewsbury Railway Station, Wellington Road, WF13 1HF

☎ (01924) 459193

Timothy Taylor Landlord; 8 changing beers (sourced nationally; often Black Sheep, Brass Castle, Vocation) Ⓗ

A multi award-winning pub in a Grade II-listed station building which has been in the Guide for 27 years. Nine handpumps dispense a range of real ales of differing styles and strengths, with another for real cider. Sunday lunches and Saturday breakfasts are served. At other times pizzas and other bar snacks are available. Live music plays in the beer garden in summer. This was the first pub in the Beerhouses Group, which has now grown to seven outlets. ☕🍽❤♣♠P🚆😺🛜🔄

Eccleshill

Greedy Pig

17 Stony Lane, BD2 2HL

3 changing beers (sourced regionally; often Kirkby Lonsdale) Ⓗ

Opened in 2018, this small and comfortable single-room bar close to the village centre was formerly a butcher's shop. References to the previous use include a tiled wall now covered with pumpclips, stainless steel tables and numerous photographs and memorabilia. The varying range of real ales usually includes beers from Kirkby Lonsdale Brewery. Pies are sold in recognition of the bar's former use. Payment is by cash only. Closing times may vary depending upon demand. Q♣🚆(640,641)🔄

Elland

Elland Craft & Tap 🅛

102 Southgate, HX5 0EP

☎ (01422) 370630 ⊕ craftandtap.co.uk

House beer (by Elland); 5 changing beers (sourced regionally; often Elland, Wensleydale) Ⓗ

A community hub next to the market square, renowned for its friendly, convivial atmosphere. A converted bank with taproom and bar and a lower lounge area, it is popular with locals, visitors and CAMRA members. It has no music, screens or machines. There is always one bitter and one dark beer on handpull, plus the house ale from the local Elland Brewery. It has floral displays in summer and a private room upstairs for hire. Buses from Halifax stop outside. Quiz night is Wednesday. Q♿☕🅰P🚆(501,503)😺🛜

Goose Eye

Turkey Inn 🅛

20 Goose Eye, BD22 0PD SE028406

☎ (01535) 666342 ⊕ theturkeyinn.co.uk

Goose Eye Bitter, Chinook Blonde; Timothy Taylor Landlord; 4 changing beers (sourced regionally) Ⓗ

A friendly, historic inn in a tiny hamlet approached by steep roads or a riverside footpath. There are three snugs, each with a real fire to keep out the winter chill, and a pool table. The pub holds a quiz night and hosts occasional live music and special theme nights. Food is served every day. Up to four guest beers are usually available. A good base for exploring the surrounding countryside. ♿☕🍽♣P🚆(K14)😺🛜🔄

Greengates

Cracker Barrel

832 Harrogate Road, BD10 0RA

Tetley Bitter; 4 changing beers (sourced regionally; often Eagles Crag, Frisky Bear, Nomadic) Ⓗ

Refurbished in 2020, this small, friendly, family-run micropub comprises a single room with the bar positioned to the right-hand side. It has a cosy, homely feel. Tetley Cask Bitter is the regular real ale, while the other four handpulls serve an ever-varying range of real ales, often including a dark beer, from regional breweries. The pub welcomes families and dogs. Outside seating to the front is next to a busy main road, and there is a small beer garden to the rear. ♿☕😺🛜

Guiseley

Coopers 🅛 ✅

4-6 Otley Road, LS20 8AH

☎ (01943) 878835

Ilkley Blonde; Timothy Taylor Landlord; 6 changing beers (sourced locally) Ⓗ
Modern-style bar converted from a former Co-op store, with a main bar area, separate dining area and upstairs function room. It serves eight cask beers, generally from Yorkshire or northern breweries, with dedicated dark beer and gluten-free handpumps, and a large selection of other beers on tap and in bottles and cans. A diverse range of meals is available. Events are held in the large upstairs function room and this area also serves as extra dining space. Children are allowed until early evening.
Q☆❀❁◐&⇌🚆(33,33A)🐾🎵

Guiseley Factory Workers Club Ⓛ
6 Town Street, LS20 9DT
☎ (01943) 874793 ⊕ guiseleyfactoryworkersclub.co.uk
Theakston Best Bitter; 3 changing beers (sourced locally; often Goose Eye, Mallinsons, Pennine) Ⓗ
Multi-award winning three-roomed club founded over 100 years ago by the Yeadon and Guiseley Factory Workers' Union. The bar serves both the lounge and the concert room and has changing guest ales sourced locally and nationally. There is also a snooker room with TV lounge and a large, lawned beer garden with stone-flagged patio. Many local clubs and organisations are hosted, and occasional concerts are held at weekends. CAMRA members are welcome with this Guide or a membership card. A former National CAMRA Club of the Year. ❀⇌♣P🚆(33A,97)🐾🎵

Halifax: Dean Clough

Stod Fold Dean Clough Ⓛ
Dean Clough, HX3 5AH
☎ (01422) 355600 ⊕ stodfolddeanclough.co.uk
Stod Fold Gold, West APA, Dark Porter, Dr Harris; 3 changing beers (sourced locally; often Stod Fold) Ⓗ
A sympathetically restored, industrial chic bar tucked just inside the architecturally significant Dean Clough Mills. Seven handpumps serve five core Stod Fold Brewing Company beers, plus seasonal beers from its brewery. Food is provided by the Stod Fold Yorkshire Kitchen, with a range of meals and snacks. There are monthly comedy nights, live music planned for Sundays and a monthly supper club. The outside seating area has heaters for cooler days. The bar recently expanded into the adjacent unit, offering private functions. ☆❀◐&🚆🐾🎵

Halifax: King Cross

Wainhouse Tavern Ⓛ ✔
Upper Washer Lane, Pye Nest, HX2 7DR (take Edwards Rd off Pye Nest Rd)
☎ (01422) 339998 ⊕ wainhousetavern.co.uk
House beer (by Rudgate); 5 changing beers (sourced regionally; often Goose Eye, Rooster's, Rudgate) Ⓗ
Formerly home to the industrialist JE Wainhouse, more famous for his elegant tower nearby, this pub became the Royal Hotel in the 1960s and acquired freehold status in 2014 as the Wainhouse Tavern. It boasts interesting architectural and decorative features and comprises a comfortable lower lounge bar at the front and a larger bar behind with pub games area and plenty of seating at tables. A good selection of beers is available, with home-cooked meals served in the evenings and at weekends.
Q☆❀◐♣P🚆(579,560) 🐾🎵

Halifax: Savile Park

Big Six
10 Horsfall Street, HX1 3HG (adjacent to Spring Edge Park at top of Free School Lane)
☎ 07878 854447
Old Mill Traditional Bitter; 4 changing beers (sourced regionally) Ⓗ
Characterful hidden gem in a row of terraces close to the Free School Lane Recreation Ground. A generously sized garden is situated behind the pub. The emphasis in this friendly pub is good beer and conversation. Identified by CAMRA as having a regionally important historic interior, it has a corridor separating the bar and cosy snug from the games room and the two lounges. A variety of well-kept beer from quality independent brewers is served alongside a fine range of gins and whiskies. A quiz is held weekly on Mondays. Q❀♣🚆(577)🐾↻

Halifax: Siddal

Cross Keys Ⓛ
3 Whitegate, HX3 9AE
☎ (01422) 300348 ⊕ crosskeyshalifax.co.uk
8 changing beers (sourced regionally; often Elland, Goose Eye, Wensleydale) Ⓗ
This 17th-century tavern has a real traditional feel. A snug beside the bar opens up to a much larger room with a central inglenook fireplace which is particularly cosy in winter. A smaller room behind the bar is ideal for small groups and for meetings. Live music is often featured on Sunday afternoons. Walkers and cyclists are always welcome. There is a large yard often used for events such as the annual beer and music festival held on the second weekend of August. Q❀♣P🚆(542,555)🐾🎵

Halifax: Town Centre

Grayston Unity Ⓛ
1-3 Wesley Court, HX1 1UH (opp town hall entrance)
☎ 07807 136520 ⊕ thegraystonunity.co.uk
Goose Eye Chinook Blonde; 3 changing beers (sourced regionally) Ⓗ
A quirky little bar opposite the town hall in a Grade II-listed building dated 1862. It consists of a single room with a covered backyard seating area; there is also seating outside the town hall in summer. One of the UK's smallest music venues, it hosts gigs, quizzes, talks and exhibitions. The beers always include a bitter and a dark ale plus five craft keg lines. ☆❀⇌♣🚆🐾🎵

Kobenhavn Ⓛ
6 Westgate Arcade, HX1 1DJ
⊕ kobenhavn.beer
6 changing beers (sourced nationally; often Arbor, Marble, Vocation) Ⓗ
A spacious, minimalist, Scandinavian-style bar that opened in Westgate Arcade in central Halifax in 2019. It has three tiered seating areas plus a covered outdoor drinking area in the arcade itself. Six beers are served on handpump, always including a dark brew, and there are also 24 keg lines in a wide range of styles.
☆❀&⇌🚆🐾🎵↻

Meandering Bear Ⓛ
21-23 Union Street, HX1 1PR
☎ 07807 136520 ⊕ meanderingbear.co.uk
5 changing beers (sourced nationally; often Lakes, Neptune, Torrside) Ⓗ
Located close to Halifax Piece Hall and Westgate Arcade in the town centre, this modern and tastefully decorated bar opened in 2019. Its name is derived from a large grizzly bear that escaped from Halifax Zoo in 1913. The

classy interior incorporates comfortable seating and is split level, with the bar on a higher level. Five beers are provided on handpull and there are seven keg lines. Locally sourced bar food is available. Occasional beer festivals are held. ➳⬤❙❐≒◻☎♥☀🖤

Three Pigeons ★ Ⓛ ✅

1 Sun Fold, HX1 2LX
☎ (01422) 347001
Ossett Butterley, Yorkshire Blonde, White Rat; 5 changing beers (sourced regionally; often Ossett) Ⓗ
A striking octagonal drinking lobby forms the hub from which five distinctive rooms radiate in this Art Deco pub, built in 1932 by Websters Brewery. Sensitively refurbished and maintained by Ossett Brewery, this venue attracts a variety of local groups and societies along with football and rugby enthusiasts. Three Ossett beers are always on; the fourth is a stout or a porter on a rotational basis. Four guest beers also feature.
Q❀≒♣P◻(561,562) ♥☀🖤↺

Upper George Ⓛ ✅

Crown Street, HX1 1TT (front entrance off Crown St on Cheapside)
☎ (01422) 353614
Greene King IPA; 7 changing beers (sourced regionally; often Acorn, Elland, Moorhouse's) Ⓗ
A town-centre pub in a historic building with a friendly atmosphere and knowledgeable staff. The recently-refurbished interior retains traditional design and features, with several rooms around a central bar area and large outdoor courtyard. This northern outpost of Suffolk-based Greene King always offers one of the brewery's beers, plus seven changing beers usually sourced regionally, including a porter or stout. Half a dozen large TV screens show sport and there is a separate pool room. Live rock bands play on Saturday.
❀❙❐≒♣◻☀🖤

Victorian Craft Beer Café Ⓛ

18-22 Powell Street, HX1 1LN
⊕ victorian.beer
9 changing beers (sourced nationally; often Bristol Beer Factory, Squawk, Vocation) Ⓗ
An award-winning pub, opened in 2014, situated behind the Victoria Theatre. The main seating area has wooden floors and a tiled bar; to the left abundant cosy seating can be found in multiple rooms. It offers nine rotating ales from a wide range of breweries alongside 18 keg lines, a choice of Belgian and world beers and two draught ciders. Many beer-themed events and tap takeovers are held, including the celebrated annual dark beer festival, Back in Black. ➳♿❙≒◻☀🖤↺

Hanging Heaton

Hanging Heaton Cricket Club

Bennett Lane, WF17 6DB
☎ (01924) 461804 ⊕ hangingheatoncc.co.uk
Bradfield Farmers Blonde; 3 changing beers (sourced regionally; often Acorn, Bradfield) Ⓗ
A long-established, welcoming community club, local CAMRA Club of the Year in 2020/21 and Yorkshire regional runner-up in 2019. The successful cricket team plays in the local league and snooker is taken very seriously too – the two snooker tables are well used and bring home prizes. There are occasional visits by sporting celebrities. The handpumps have increased from one to four under the steward who is knowledgeable and enthusiastic about real ale. Well-chosen guest beers come from far and wide. ➳❀❙♿♣◻P◻(202)🖤↺

Haworth

Fleece Inn Ⓛ ✅

67 Main Street, BD22 8DA
☎ (01535) 642172 ⊕ fleeceinnhaworth.co.uk
Timothy Taylor Golden Best, Boltmaker, Knowle Spring, Landlord, Landlord Dark; 1 changing beer (often Timothy Taylor) Ⓗ
A stone-built coaching inn on Haworth's famous cobbled Main Street, with spectacular views over the Worth Valley and close to the Keighley & Worth Valley historic heritage railway. A cosy room to the right and a lower-level dining area offer quiet alternatives to the busy bar. Locally sourced food and accommodation are offered, and breakfast is available to all. The beer garden is three storeys up from the bar, on the roof. A Timothy Taylor tied house, popular with tourists and locals alike.
➳❀❙◑♿▲≒♣◻(B1,B2) ♥☀🖤

Hebden Bridge

Fox & Goose 🍺 Ⓛ ✅

7 Heptonstall Road, HX7 6AZ (at traffic lights on jct of A646 and Heptonstall Rd)
☎ (01422) 648052 ⊕ foxandgoose.org
Pictish Brewers Gold; 5 changing beers (sourced nationally; often Eagles Crag, Nomadic, Torrside) Ⓗ
West Yorkshire's first community co-operative pub extends a warm welcome to locals and visitors alike. A single bar serves three different rooms and an upstairs covered, heated beer garden. The main bar is warmed by a real fire in winter while the room to the left exhibits the work of local artists and often hosts live music. The room to the right has a dartboard. At least one vegan beer and one dark beer are usually available. Local CAMRA Pub of the Year 2019 and 2022.
Q❀♣⬤◻◻(590,592) ♥🖤

Nightjar Ⓛ

New Road, HX7 8AD
☎ (01422) 713015 ⊕ nightjarhebden.co.uk
3 changing beers (sourced nationally; often Blackedge, Bristol Beer Factory, Nailmaker) Ⓗ
Opened in 2017 in the listed Picture House building, this compact micropub is the tap for the Mytholmroyd-based Nightjar Brew Co. It serves three real ales, often two from its own brewery and a guest from another small independent. A range of craft keg beers is also available. Stripped-back brick walls and a flagstone floor offset the tiny brick-built bar and unusual split olivewood tables. There are additional tables and seating on the pavement outside. Q➳❀♣◻◻♥☀🖤

Pub Ⓛ

3 The Courtyard, Bridge Gate, HX7 8EX (in yard at start of pedestrian section of Bridge Gate)
☎ 07711 994240
6 changing beers (sourced nationally; often Fell, Thornbridge, Wilde Child) Ⓗ
This was Calderdale's first micropub when opened in 2015 by previous owners. The new proprietors have expanded the beer range to six handpumps with a greater number of breweries represented. The range always includes one dark beer. The compact bar room has flagstone floors and reclaimed wood decor. Outside is a suntrap courtyard which is covered and heated for winter drinking. No piped music disturbs the conversation. Food from the adjacent pizzeria may be brought in to the pub. Q❀≒◻☀🖤

Holmfirth

Nook L ⊘

7 Victoria Square, HD9 2DN (down alley behind Barclays)
☎ (01484) 682373 ⊕ thenookbrewhouse.co.uk
Nook Best, Blond, Oat Stout; 4 changing beers (often Nook) ⊞
The Nook, properly the Rose & Crown, dates from 1754, and is a well-known real ale pub in the village. It has been dispensing beers from its own adjacent brewhouse since 2009, alongside occasional guest beers and Pure North ciders. Home-cooked food is served daily. There is a popular folk evening every Sunday, and real ale festivals on the weekend before Easter and on the August bank holiday. The log fire is particularly warming on cold winter nights. ☺⊛⇔◑♣♠⊟(313,314)⊛☂⟲

Horbury

Boons Horbury L ⊘

6 Queen Street, WF4 6LP (off B6128 Horbury-Ossett road, opp Co-Op)
☎ (01924) 280442
Timothy Taylor Landlord; 7 changing beers (sourced nationally) ⊞
A popular community pub in the centre of town just off the High Street, attracting people of all ages. The interior is based on a traditional layout around a central bar, with Rugby League memorabilia on the walls. The sizeable outdoor drinking area is well used in summer. A guest cider is available. The pub traditionally holds a beer festival on the first weekend in June. ⊛♣♠⊟(126,231)☂

Cricketers Arms L

22 Cluntergate, WF4 5AG (right fork off High St at lower end)
☎ (01924) 267032
Timothy Taylor Landlord; 6 changing beers (sourced regionally) ⊞
On the edge of the town centre, this former Melbourne/Tetley's house is now a genuine free house. A multiple award-winning pub, it is a former local CAMRA Pub of the Year and Pub of the Season several times. It hosts a poker night on Monday, quiz night on Wednesday, meat raffle on Friday, open mic night on the second Sunday of each month and live music on the last Sunday. A range of craft and keg beers is stocked. Q☺⊛♣♠Ⓟ⊟♠☂

Horbury Junction

Calder Vale Hotel L

Millfield Rd, WF4 5EB (from main A642 follow signage through housing estate to Horbury jct industrial area; also walkable from canalside via tubular bridge)
6 changing beers (sourced locally; often Bad Seed, Luddite, Revolutions) ⊞
Established in 1874, this lovingly restored Victorian Commercial Hotel is steeped in local industrial history. Reopened in 2019, it is home to the Luddite Brewery, and has been since been voted local CAMRA Pub of the Season and Yorkshire's most dog-friendly pub. It boasts Yorkshire stone floors, log-burning fires and a delightful garden. There are canal walks nearby. Street-food weekends are hosted, and there is occasional entertainment in an upstairs room. Q☺⊛◑♿♣♠Ⓟ⊟(119,120)♠

Horsforth

Granville's Beer & Gin House L

24 Long Row, LS18 5AA
☎ (0113) 258 2661 ⊕ granvilleshouse.co.uk
5 changing beers (sourced locally; often Concept) ⊞
Former shop unit, now a long and relatively narrow single-room pub with the bar separating front and rear areas, the latter giving access to further covered seating outside. The beers are listed on a board opposite the bar. There is an emphasis on local breweries, often including Concept beers brewed at sister pub the Malt Brewhouse a short distance away. As might be expected from the name, there is a wide choice of gins available with a table menu. The inner front door is opened with a repurposed handpump handle. There are a couple of tables outside at the front. ☺⇌⊟♠☂

Huddersfield

Cherry Tree ⊘

14-18 John William Street, HD1 1BG
☎ (01484) 448190
Elland 1872 Porter; Greene King Abbot; Ruddles Best Bitter; 7 changing beers (sourced nationally; often Acorn, Saltaire, Sharp's) ⊞
Converted in 2001 from a bed shop, this is a modern, town-centre Wetherspoon outlet. Its prosaic architecture is outshone by the range and quality of ales, resulting in the pub featuring several times in this Guide. Alongside the permanent beers are seven changing guests, regularly featuring Saltaire, Leeds, Adnams, Naylor's, Acorn and Moorhouses's breweries. American craft brews on cask are an occasional feature at beer festivals. Three real ciders are always available. Food is served all day, alcohol from 9am. ☺◑♿⇌♠⊟☂

Grove L

2 Spring Grove Street, HD1 4BP
☎ (01484) 318325 ⊕ thegrove.pub
Kirkstall Pale Ale; Oakham Citra, Green Devil; Thornbridge Jaipur IPA; 9 changing beers (sourced regionally; often Brass Castle, Mallinsons, Marble) ⊞
The Grove has a style of its own, expressed through its distinctive artwork, snacks and live music. It is a veritable drinkers' paradise with 13 hand-pulled ales taking in the full range of styles and strengths. Featured breweries include Kirkstall, Mallinsons, Marble, Brass Castle, Oakham, Vocation and Thornbridge. Two craft ciders are always available. In addition there is a superb menu of 100-plus bottled and canned beers and a comprehensive spirits range. A must for visitors to Huddersfield. Q☺⊛⇌♣♠⊟♠☂

King's Head

St George's Square, HD1 1JF (in station buildings, on left when exiting station)
☎ (01484) 511058
Bradfield Farmers Blonde; Magic Rock Ringmaster; Timothy Taylor Golden Best, Landlord; 6 changing beers (sourced regionally; often Abbeydale, Oakham, Pictish) ⊞
A friendly welcome always awaits you in this award-winning pub. Situated in the Grade I-listed railway station, and winner of a railway heritage award, it has been carefully restored with features including a beautiful tiled floor, wood panelling and wood-burning stoves. It serves four permanent and six rotating beers from breweries near and far. A mild, a dark beer and one real cider are always available. There is live music on Sunday afternoon, and hot food is served on match days. ◑⇌♠⊟♠☂⟲

Rat & Ratchet ♀ Ⅼ ✅
40 Chapel Hill, HD1 3EB (on A616, just off ring road)
☎ (01484) 542400
Ossett Butterley, Yorkshire Blonde, White Rat, Silver King; Rat King Rat; 3 changing beers (sourced regionally; often Fernandes, Riverhead, Small World) Ⓗ

A multi award-winning pub owned by Ossett, with an on-site Rat microbrewery. The large open-plan main area still retains the feel of separate rooms. Eleven handpumps offer beers from a range of breweries including the firm's own, with two permanent dark ales available. A generous range of ciders and perries is stocked. The pub has a dartboard and pinball table. It hosts live music on the first and third Sunday of the month and the first Tuesday and Friday. There is a quiz on Wednesday. ⑤❀❁♣♦P☐✿❖?Ѱ

Sportsman ★ Ⅼ
1 St John's Road, HD1 5AY
☎ (01484) 421929
Timothy Taylor Boltmaker; 7 changing beers (sourced regionally; often Brass Castle, Thornbridge, Vocation) Ⓗ

This 1930s pub, with a 1950s refit by Hammonds (note the windows), is a previous winner of the CAMRA/English Heritage Conservation Pub Design award. The superb curved central bar has a parquet floor and an interesting wooden entrance. Eight ales are arranged in strength order, with a dark beer always available. There is an excellent real cider offering, with two on handpump and two from boxes. Regular Meet the Brewer/Cider Producer nights are hosted, and two rooms are regularly used for meetings by organisations including poker, poetry and music clubs. ⑤❀❁≥♦☐✿❖?Ѱ

Star Ⅼ
7 Albert Street, Folly Hall, HD1 3PJ (off A616 ½ mile from town centre)
☎ (01484) 545443 ⊕ thestarinn.info
Pictish Brewers Gold; 5 changing beers (often Briggs Signature, Mallinsons) Ⓗ

A multi award-winning local that has featured in many previous Guides. The Star showcases numerous local and countrywide breweries, with dedicated pumps for Mallinsons and Pictish, and usually a dark beer. The pub has no jukebox or games; a real fire in the winter and friendly conversation make it a must when visiting the town. The landlady and her staff run local events as well as occasional beer festivals at the pub. Q⑤❀❀❖?

Ilkley

Bar T'at Ⅼ ✅
7 Cunliffe Road, LS29 9DZ
☎ (01943) 608888
Ilkley Mary Jane; Timothy Taylor Boltmaker, Landlord; 5 changing beers (sourced regionally; often Brass Castle, Rooster's, Saltaire) Ⓗ

Popular and comfortable side-street pub in the Market Town Taverns group which was converted from a former china shop. It has a music-free bar area, additional seating in a basement room and outdoor seating. The pub is renowned for the quality of its beer and food. The guest real ales feature a good, often eclectic, variety of beer styles, many from Yorkshire breweries. A wide range of foreign beers is also offered. A menu of home-cooked food is served every day. Q⑤❀❀◗≥☐❖?

Flying Duck Ⅼ ✅
16 Church Street, LS29 9DS (on A65)
☎ (01943) 609587 ⊕ theflyingduck.co.uk

Dark Horse Hetton Pale Ale; Wharfedale Black, Blonde, Best; 4 changing beers (sourced regionally; often Ilkley, Stancill, Wharfedale) Ⓗ

A beautifully refurbished Grade II-listed traditional-style pub close to the town centre. Originally constructed as a farmhouse in 1709, it is reputed to be Ilkley's oldest pub building and retains many original features including York stone and oak flooring, beamed ceilings, internal stonework and mullioned windows. Up to eight real ales, including four regulars, and two real ciders are available. Wharfedale Brewery is located to the rear. Food is served Tuesday to Sunday and also on bank holiday Mondays. ⑤❀◗≥♦☐❖?Ѱ

Keighley

Brown Cow ♀ Ⅼ
5 Cross Leeds Street, BD21 2LQ
☎ (01535) 382423
Timothy Taylor Boltmaker, Landlord; 4 changing beers Ⓗ

A short walk from the town centre, this family-run free house focuses on quality, choice and the comfort of customers. Up to five guest beers come mainly from local micros, including at least one session beer, a strong ale and a dark brew. A quiz is hosted on the second and last Wednesday of the month. The pub has a no bad language policy. Local CAMRA Pub of the Year 2022. ⑤❀♣♦P☐❖?

Leeds: Burley

Cardigan Arms ★ Ⅼ
364 Kirkstall Road, LS4 2HQ
☎ (0113) 226 3154 ⊕ cardiganarms.co.uk
Kirkstall Bitter, Pale Ale, Three Swords, Dissolution IPA, Black Band Porter; 1 changing beer (sourced locally; often Anthology, Kirkstall, Vocation) Ⓗ

Originally built in 1896, this classic Grade II-listed Victorian pub reopened in 2017 as a Kirkstall Brewery outlet following an award-winning refurbishment. It is named after the Cardigan family, who owned land locally, and has four rooms off an L-shaped bar area. The fine woodwork, etched glass and ornamented ceilings are now displayed in their full glory. The refurbishment added period furniture and fittings, including some splendid brewery mirrors and antique chandeliers. There is an upstairs function room.
⑤❀◗◖≥(Burley Park) ♣☐❖?

Kirkstall Brewery Tap & Kitchen Ⅼ
100 Kirkstall Road, LS3 1HJ
☎ (0113) 898 0280 ⊕ kirkstallbrewery.com
Kirkstall Pale Ale, Three Swords, Black Band Porter; 4 changing beers (sourced locally; often Kirkstall) Ⓗ

A brewery tap that opened in January 2020 on the Kirkstall Brewery site, in a room in the modern brewery building. It has been given a traditional pub feel and is decorated with an array of breweriana. There is also a popular outside seating area. A range of cask and keg beers from the brewery is available on the bar alongside a guest keg beer, a lager and a cider. Bottles, cans and five-litre mini kegs are also available. ⑤❀◗P☐❖

Leeds: City Centre

Bankers Cat
29 Boar Lane, LS1 5DA
☎ (0113) 440 7998 ⊕ bankerscat.co.uk
Thornbridge Lord Marples, Jaipur IPA; house beer (by Thornbridge); 3 changing beers (often Buxton, Thornbridge, Wild Beer) Ⓗ

This Thornbridge Brewery outlet has a variety of seating surrounding the central bar. Features include a stained glass window to the right of the bar, and quirky cat portraits. Downstairs there is additional seating in the old bank vault, which still has the old vault door. Three regular Thornbridge beers are normally available plus two other Thornbridge brews and a guest ale, including at least one dark beer. ≈🖵

Brewery Tap 🅛

18-24 New Station Street, LS1 5DL
☎ (0113) 243 4414 ⊕ brewerytapleeds.co.uk
Leeds Pale, Best, Midnight Bell; 5 changing beers (sourced locally; often Camerons, Ilkley, Leeds) 🅗
A busy pub on the the approach road to the front of Leeds railway station. The downstairs area has a light and airy main bar with a variety of comfortable seating. Upstairs are a function room with a bar and a small roof terrace with seating. Four beers from Leeds Brewery are served, with one of the guests regularly from Camerons and the other three often from Yorkshire breweries. A wide range of other beers is also available. ◑≈🖵🛜

Duck & Drake 🅛

43 Kirkgate, LS2 7DR
☎ (0113) 245 5432 ⊕ duckndrake.co.uk
Bridgehouse Blonde; Rooster's Yankee; Timothy Taylor Landlord; Theakston Old Peculier; 10 changing beers (sourced locally; often Daleside, Elland, Saltaire) 🅗
A fine example of a two-roomed Victorian corner pub, retaining some original features. The central bar with 15 handpumps sits in between and serves both rooms, with at least one dark beer usually available. Live music is played most nights. The Gents features traditional porcelain units from J Duckett and Son Ltd of Burnley. To the rear is the well-maintained beer garden – one of the nicest places in Leeds for enjoying a pint on a sunny afternoon. 🏵◑≈🖵🐾🛜↻

Friends of Ham 🅛

4-8 New Station Street, LS1 5DL
☎ (0113) 242 0275 ⊕ friendsofham.co.uk
Kirkstall Pale Ale; 3 changing beers (sourced locally) 🅗
Modern bar and charcuterie that features a wide range of interesting beers for all tastes on its modern-style scaffolded bar. A large blackboard provides information on the beers available both on cask and keg, as well as the two ciders on offer. A sampling tray of three or six third-pint measures is available. Around the central bar is a modern shabby-chic interior, with diners and drinkers sharing the same space. The downstairs area hosts events including beer tastings. ◑≈●🖵🐾🛜

Head of Steam 🅛

13 Mill Hill, LS1 5DQ
☎ (0113) 243 6618
Camerons Strongarm; Timothy Taylor Boltmaker; 5 changing beers (sourced locally; often Camerons, Ilkley, Wilde Child) 🅗
A grand three-storey stone and brick pub with a curved frontage. Its octagonal island bar dispenses beers from all around the world with a strong emphasis on cask and Belgian brews. Although essentially one opened-out room, it has different areas, with a few tables close to the bar, an alcove that can be used for live music (notably jazz on Sunday), a raised area to the rear, and the recent addition of an upstairs balcony. ≈🖵🐾

Hop 🅛

Granary Wharf, Dark Neville Street, LS1 4BR
☎ (0113) 243 9854 ⊕ thehopleeds.co.uk

Ossett Butterley, Yorkshire Blonde, White Rat, Silver King, Voodoo, Excelsius 🅗
Beneath the arches of Leeds station's platform 17, the Hop serves a range of cask ales from Ossett Brewery. The bar is surrounded by comfortable seating, and bare brick walls decorated with murals and pictures of rock bands. Stairs on either side of the bar lead to another seating area where live music is hosted. The cellar is on ground level and can be viewed through windows in the drinking area. 🏵◑≈🖵🐾🛜↻

Lamb & Flag 🅛

1 Church Row, LS2 7HD
☎ (0113) 243 1255 ⊕ lambandflagleeds.co.uk
Leeds Pale, Yorkshire Gold, Best, Midnight Bell; 4 changing beers (sourced locally; often Brass Castle, Nomadic, Ridgeside) 🅗
Known as the Thirteen Bells in the 19th century, named after the bells of the nearby parish church (now Leeds Minster). After a long period of closure it was tastefully restored by Leeds Brewery and changed its name. It has two floors of exposed brickwork, timber and large windows. An upstairs balcony has seating and overlooks a covered courtyard that is heated in winter. Award-winning food is available. 🌀🏵◑♿≈🖵🐾🛜

North Bar 🅛

24 New Briggate, LS1 6NU
☎ (0113) 242 4540 ⊕ northbar.com/northbar
2 changing beers (sourced locally; often North) 🅗
This bar has a relaxed, friendly atmosphere. When it opened in 1997 it was a pioneer for beer, and it retains that status. It serves a wide range of keg beers, many from North Brewery, in a variety of styles and ABVs. Packed fridges provide an interesting selection of UK and international packaged ales. One of the cask beers is a pale from North, with the second sometimes from a guest brewery. Cyclists are particularly welcome here. Card payment only. ◑≈●🖵🛜

Reliance 🅛

76-78 North Street, LS2 7PN
☎ (0113) 295 6060 ⊕ the-reliance.co.uk
3 changing beers (sourced locally; often Rooster's, Sunbeam) 🅗
A modern bare-boarded pub, divided into three areas, serving a good selection of local food and beer. The main room makes the most of its corner location with windows stretching virtually from floor to ceiling to give an open and airy feel. To the right is a smaller room with booth-style seating and behind the bar is a raised area used by diners. Food options include home-cured charcuterie. Outside is a small pavement drinking area. There is a quiz on Sunday. 🌀🏵◑●🖵🐾🛜

Scarbrough Hotel ✅

Bishopgate Street, LS1 5DY
☎ (0113) 243 4590
Black Sheep Best Bitter; St Austell Nicholson's Pale Ale, Tribute; Tetley Bitter; 3 changing beers (sourced nationally; often Oakham, Timothy Taylor, Titanic) 🅗
Often misspelled, the Scarbrough is named after its first owner, Henry Scarbrough, rather than the seaside town. The building, with its impressive tiled frontage, dates from 1765, becoming a pub in 1826. There is a long bar opposite the entrance with seating areas to either side and it provides a convenient spot to wait for a train from Leeds station across the road. The selection of guest ales is sourced from around the country. Westons cider is also available on handpump at cellar temperature. 🏵◑♿≈🖵🛜

Tapped Leeds 🅛

51 Boar Lane, LS1 5EL
☎ (0113) 244 1953 ⊕ tappedleeds.co.uk
7 changing beers (often Kirkstall, Tapped, Wild Beer) Ⓗ

A wide bar with large windows opening onto the street and a small seating area outside. The fixtures and fittings blend retro and modern designs. The pub serves a variety of beers on draught plus a good list of bottled and canned ales and ciders. A couple of the beers are brewed on-site. Freshly-baked pizzas are offered until two hours before closing. Under-18s are welcome until 8pm. No football colours are allowed, and the dress code on Friday and Saturday nights prohibits shorts and tracksuit bottoms. ⮌✿◑&≠⬚🖤🛜

Templar 🅛 ⊘

2 Templar Street, LS2 7NU
☎ (0113) 243 0318
Greene King IPA; Kirkstall Three Swords; Tetley Bitter; 5 changing beers (sourced locally; often Acorn, Bradfield) Ⓗ

A traditional, Grade II-listed city-centre locals' pub, featuring fine wood panelling from 1928 and a splendid exterior with green and cream Burmantofts tiling. The bowing courtier logo in the leaded window panes is from when this was a Melbourne Brewery pub. The landlord and many staff have been here over 30 years. The cask beers are mainly from Yorkshire, with a couple from the Greene King stable. League darts and dominoes are played. ≠♣🖤⬚🛜

Town Hall Tavern 🅛 ⊘

17 Westgate, LS1 2RA
☎ (0113) 244 0765 ⊕ townhalltavernleeds.com
Timothy Taylor Golden Best, Boltmaker, Knowle Spring, Landlord, Landlord Dark Ⓗ

Small, traditional pub dating from 1926 with a range of Timothy Taylor beers and a good reputation for food. It comprises a single room with open alcoves to the left and right of the door. The semi-circular bar is along the left-hand wall. Features include old photographs of Leeds on the walls. Tables for dining can get booked up on busy days; conversely the pub may close early if quiet. ◑≠⬚🛜

Wapentake 🅛

92 Kirkgate, LS2 7DJ
☎ (0113) 243 6248 ⊕ wapentakeleeds.co.uk
3 changing beers (sourced locally; often Kirkstall, Nailmaker, Nomadic) Ⓗ

Wapentakes used to be the administrative subdivisions of the Yorkshire ridings. Describing itself as a little piece of Yorkshire that welcomes grumpy old men, children and dogs, this bar attracts a wide age range and has generated a community feel. Friendly and upbeat equally describes the bar staff and unobtrusive background music. Beers, one of which is often dark, are usually from smaller breweries within the county. Eclectic framed prints and beer mats adorn the walls and there is a TV upstairs showing sports. ⮌✿◑≠🖤⬚🐾🛜

Whitelock's Ale House ★ 🅛

Turk's Head Yard, LS1 6HB (off Briggate)
☎ (0113) 245 3950 ⊕ whitelocksleeds.com
Five Points Best, Pale; Kirkstall Pale Ale; Timothy Taylor Landlord; Theakston Old Peculier; 4 changing beers (often Ridgeside, Thornbridge, Vocation) Ⓗ

Described by John Betjeman as the very heart of Leeds, Whitelock's dates from 1715 and occupies a medieval burgage plot. The interior is largely unchanged since 1895 and is a feast of mirrors, polished metal and woodwork, stained glass, iron pillars and faience tiling.

The newly refurbished outside yard is shared with the Turk's Head bar and has over 20 tables, most of which are covered and have heaters. Food made from locally sourced ingredients is served daily. Card payment only. ✿◑≠⬚🖤🐾🛜

Leeds: Headingley

Arcadia Ale House 🅛

34 Arndale Centre, Otley Road, LS6 2UE (corner of Alma Rd)
☎ (0113) 274 5599
Timothy Taylor Boltmaker; 7 changing beers (sourced locally; often Kirkstall, Ridgeside) Ⓗ

An award-winning urban bar in the main Headingley shopping area, with two ground floor rooms and an upstairs mezzanine level. A mural of local landmarks features above the bar. Alongside the real ale handpumps is an extensive range of canned, bottled and draught beers, always including several vegan beer options. Also available is a wide selection of gins, some locally produced. Under 18s, large groups and fancy dress are not permitted. Dogs are positively encouraged. Q&🖤⬚🐾🛜

Leeds: Holbeck

Grove Inn 🅛

Back Row, LS11 5PL
☎ (0113) 244 2085 ⊕ thegroveinnleeds.co.uk
Daleside Blonde; 6 changing beers (sourced regionally; often Ilkley, Saltaire) Ⓗ

A traditional West Yorkshire pub hidden away among modern office blocks and a short walk from the city centre. Cask beers from both local and regional breweries are served to both the public bar and corridor. There are two small side rooms providing quiet away from the busier tap room. To the rear of the building is the Concert Room where a wide range of live music is performed – including, since 1962, reputedly the oldest folk club in the country. ✿◑≠♣⬚🐾🛜↻

Leeds: Kirkstall

Kirkstall Bridge Inn 🅛

12 Bridge Road, LS5 3BW
☎ (0113) 278 4044 ⊕ kirkstallbridge.co.uk
Kirkstall Pale Ale, Three Swords, Dissolution IPA, Black Band Porter; 2 changing beers Ⓗ

A stone-built roadside pub next to the river Aire. Inside, the walls are decorated with pub memorabilia, chiefly mirrors. The main bar, at road level, has eight handpumps predominantly serving Kirkstall Brewery beers, and 10 keg lines also include Kirkstall ales. An easy-to-miss snug is behind the bar. Down some steep stone stairs and level with the beer garden entrance is a second bar, where dogs are welcome. The accessible toilet is also at this lower level. ⮌✿◑≠(Headingley) P⬚🐾🛜

West End House

26 Abbey Road, LS5 3HS
☎ (0113) 278 6332 ⊕ thewestendhouse.co.uk
3 changing beers (sourced nationally; often Black Sheep, Harviestoun, Purity) Ⓗ

A stone-built pub open as a beer house since at least 1867, this busy community local is located on the A65 adjacent to Kirkstall Leisure Centre and close to Kirkstall Abbey and Headingley railway station. It shows sports TV and hosts regular quiz nights. Four handpumps offer three beers from the Stonegate Group list and one cider. Home-cooked food is served every day with takeaway

available. There is a small beer garden and smoking area outside. Level access is via the rear entrance. ☐☀☺◖➤(Headingley) ☐(33,33A) ❀♠☡

Leeds: Newlay

Abbey Inn 🄻

99 Pollard Lane, LS13 1EQ (vehicle access from B6157 only)

☎ (0113) 258 1248

Kirkstall Three Swords, Black Band Porter; 5 changing beers (sourced locally; often Kirkstall, Leeds, Ossett) 🄷

A historic ale house and celebrated community pub situated between the River Aire and canal towpath, showcasing a selection of mostly local ales. One pump is dedicated to a dark ale and another to Old Rosie cider. Craft beers, international lagers, wines and a great selection of spirits are also available. The Abbey bustles with friendly locals throughout the week, hosting a folk night on Tuesday and quizzes on Thursday and Sunday. Ample seating outside attracts dog walkers, cyclists and families. ☐☀☺◖➤(Kirkstall Forge)♣P❀♠☡

Leeds: Sheepscar

Nomadic Beers 🄻

Unit 11, 15 Sheepscar Street, LS7 1AD

☎ 07868 345228 ⊕ nomadicbeers.co.uk

3 changing beers (sourced locally; often Nomadic) 🄷

Open on Friday and Saturday only, this taproom is usually housed in the main brewery area, but during the winter it moves to a smaller heated room. Three or four cask ales are normally available and may include guest beers, plus ciders, gins and whiskies. Food is sometimes served from local street food vendors. Bottles and draught beer are sold for takeaway along with brewery merchandise and the brewster's knitted creations. As per the brewery's charter, everyone is very welcome. ☐♿●🚌❀

Linthwaite

Sair 🄻 ✅

139 Lane Top, HD7 5SG (top of Hoyle Ing, off A62)

☎ (01484) 842370

Linfit Bitter, Gold Medal, Janet Street Porter, Autumn Gold, Old Eli, English Guineas Stout 🄷

Overlooking the Colne Valley and home of the Linfit Brewery, the Sair is a multi-roomed stone-built pub of great character. Four rooms, each with a real fire, are served from a central bar. Up to 10 different beers are available, including three dark ales brewed on-site and a cider from Pure North. At the heart of the local community, the pub gives a warm welcome to locals, visitors and their dogs. A former National CAMRA Pub of the Year. Q❀♣●☐(181,183)❀♠☡

Liversedge

Black Bull 🄻 ✅

37 Halifax Road, WF15 6JR (on A649, close to A62)

☎ (01924) 403779

Ossett Butterley, Yorkshire Blonde, Silver King, Voodoo, Excelsius; 4 changing beers (sourced nationally; often Goose Eye, Ossett, Saltaire) 🄷

Ossett Brewery's first pub has five rooms, each providing comfort and atmosphere with a unique style. This regular Guide entry is a popular, sociable community local with a warm welcome. A dark ale is always on offer alongside guest beers from the group and a wide range of independent breweries. Quiz night is Tuesday, with darts

and dominoes on Monday in a local league, and acoustic sessions on Sunday at teatime. A fine, sheltered beer garden sits by a stream. Q☐☀♿♣P☐(254,254A) ❀♠☡

Longwood

Dusty Miller Inn 🄻 ✅

2 Gilead Road, HD3 4XH

☎ 07946 589645 ⊕ dustymillerlongwood.com

Milltown Platinum Blonde, Black Jack Porter; Timothy Taylor Landlord; 4 changing beers (often Brunswick, Milltown, Newby Wyke) 🄷

Local historic photographs and stone floors dominate at this pub which is the Milltown Brewery tap. The cosy interior is open plan but has three distinct areas. Seven real ales are served, showcasing the Milltown brews, alongside two changing guests, always including a dark beer, plus a permanent real cider. Locally made pies from Brosters Farm at Lindley Moor are offered. There are great views up the Colne Valley from the outside benches. Q☐♣●☐(356)❀♠☡

Marsden

Riverhead Brewery Tap 🄻 ✅

2 Peel Street, HD7 6BR

☎ (01484) 844324 ⊕ theriverheadmarsden.co.uk

Ossett Silver King, Excelsius; Riverhead March Haigh, Redbrook Premium; 6 changing beers (often Riverhead) 🄷

At the centre of village life, the Riverhead is a modern brewpub owned by Ossett Brewery. The microbrewery is visible from the main bar – beer doesn't get more LocAle than this. Ten beers are served: six Riverhead ales, two from Ossett as well as guests. A dark beer and a real cider are usually available. The upstairs room has comfy seating and outside there is a riverside terrace for alfresco drinking. A popular venue for locals, visitors and their dogs. ☐☀♿➤●P☐(185)❀♠☡

Meltham

Travellers Rest

Slaithwaite Road, HD9 5NH

☎ (01484) 851320 ⊕ travellersrestmeltham.co.uk

Milltown Platinum Blonde; Timothy Taylor Landlord; 6 changing beers (sourced regionally; often Milltown) 🄷

Located at the edge of the Peak District and offering stunning views, this pub serves as a brewery tap for the Milltown Brewery of Milnsbridge. The pub is arranged on two levels and the decor is modern. Eight handpumps feature beers from both Milltown and other breweries, as well as a real cider. Always providing a friendly welcome, this rural pub is well worth seeking out. The pub has three adjacent holiday apartments available. ☐☀🛏♿♣●P☐(335,324) ❀☡

Middlestown

Little Bull 🄻

72 New Road, WF4 4NR (on A642 at crossroads in centre of village)

☎ (01924) 726142 ⊕ thelittlebull.co.uk

Abbeydale Deception; Timothy Taylor Landlord; 1 changing beer (sourced regionally) 🄷

This free house has been established since 1814. A single bar services a number of smaller rooms and there is an open fire in colder weather. All food is locally sourced and home-cooked. Monday is fish night and Wednesday is pie night. There is a gin bar on the last Saturday of the

month and a beer festival is held on the last weekend in July. The National Coal Mining Museum is nearby.
Q ✿♿◐♣P�"(232,128) ✿ 🛜 ↻

Mirfield

Flowerpot ⬡ ✔
65 Calder Road, WF14 8NN (over river, 400yds S of railway station)
☎ (01924) 496939
Ossett Butterley, Yorkshire Blonde, White Rat, Silver King, Voodoo; 2 changing beers (often Fernandes, Ossett, Rat) ⊞
A pub dating from 1807 and tastefully restored by Ossett Brewery, decorated in a charming rustic style with an impressive tile flowerpot as the centrepiece. It has four separate drinking areas and real fires. Nine ales are offered from Ossett's five breweries and independents, usually including a mild or stout, plus a cider. Outside are a terrace and fine riverside beer garden, great for warm summer days. The pub is withing easy walking distance of the town centre, with access to the Brighouse to Mirfield canal walk. Q✿♿≢♣P�"(261)✿🛜↻

Knowl Club ⬡ ✔
17 Knowl Road, WF14 8DQ
☎ (01924) 493301
Acorn Barnsley Bitter; Saltaire Blonde; 1 changing beer (sourced regionally) ⊞
This town centre club has been open for over 130 years (albeit under different names) and holds both club and public house licences. The single bar is on the ground floor along with a function room and pool room; upstairs is a proper snooker room. There are usually three beers on offer, sometimes increasing to four. Access to the car park at the rear can be tricky.
✿♿≢♣P�"(261,203) ✿🛜↻

Navigation Tavern
6 Station Road, WF14 8NL (next to Mirfield railway station)
☎ (01924) 492476 ⊕ navigationtavern.co.uk
Magic Rock Hat Trick, Ringmaster, High Wire; Theakston Best Bitter, Lightfoot, Old Peculier; 3 changing beers (sourced regionally; often Small World, Theakston) ⊞
Recently refurbished, this family-run free house is a rare outlet in the area for Theakston XB. It is proud of its Donegal history, and attracts a wide range of age groups and drinkers. The pub often hosts live music and its large, sheltered canalside beer garden is used for charity and occasional concerts. A large wood-burning fire provides winter comfort. In the week a light breakfast is served until noon, then hotpots after that, with full English at weekends. The pub offers free moorings for patrons.
✿♿◐♿≢P�"(205,261) 🛜↻

Morley

Oscar's Bar ⬡
2A Queen Street, LS27 9DG
3 changing beers (sourced locally) ⊞
Small, friendly bar and café serving cask beers from mainly local breweries and a good range of draught, canned and bottled beers. Cider is also available on cask and keg. Oscar's was the first of the new bars in the Morley Bottoms area. Dominoes and cards are available on every indoor table. To the right of the bar is the entrance to a small additional seating area called the Nook. At the front is a small pavement seating area.
≢♿�"✿🛜

Mytholmroyd

Barbary's
15-17 Bridge End, HX7 5DR
⊕ barbarys.co.uk
3 changing beers (sourced nationally; often Pomona Island, Squawk, Vocation) ⊞
Formerly a shop, this single-storey two-roomed micropub has modern decor and is situated in the centre of Mytholmroyd. It hosts live music and DJ sets. There is an attractive covered paved area at the side with views over the River Calder, perfect for those sunny afternoons and evenings. ✿♿♿≢�"(590,592)✿🛜

Norristhorpe

Rising Sun ⬡
254 Norristhorpe Lane, WF15 7AN (½ mile off A62)
☎ (01924) 400190
Abbeydale Moonshine; Acorn Barnsley Bitter; Saltaire Blonde; Timothy Taylor Landlord; 3 changing beers (sourced locally; often Black Sheep, Nook) ⊞
Village local with a light and spacious bar area, plus a cosy lounge space with exposed brickwork and real fires. Its beer range is mainly from Yorkshire, with guests from regional and national breweries. The pub hosts occasional live music, and a popular Tuesday evening quiz with prizes. The large, well-maintained beer garden has ample seating and gives extensive views over the valley towards Mirfield and Emley Moor.
Q✿♿P�"(261) ✿🛜↻

Oakworth

Oakworth Social Club ⬡
Chapel Lane, BD22 7HY
☎ (01535) 643931
Goose Eye Chinook Blonde; Timothy Taylor Golden Best; 1 changing beer (sourced locally; often Saltaire) ⊞
Friendly and welcoming, this imposing Victorian building on the main thoroughfare was originally built as the Liberal Club in the late 19th century. Now a social club with a thriving membership, it has a comfortable front lounge and a back bar with traditional games and a TV. Upstairs, a third room caters for functions and meetings. Quiz night is Monday, and regular live music events are staged. A former CAMRA Yorkshire Club of the Year runner-up, and local CAMRA Club of the Year 2022.
✿♿♿♿≢♣P�"(K7) ✿🛜↻

Snooty Fox ⬡
Colne Road, BD22 7PB (on B6143 next to church)
☎ (01535) 642689
Goose Eye Spring Wells; Tetley Bitter; 1 changing beer (sourced locally) ⊞
The Snooty Fox is set in a converted single-storey school. Its layout and proximity to the parish church make it popular as a function venue for christenings, weddings and other family occasions. The main bar has a largescreen TV for sport and a concert stage for regular live music at weekends. A smaller public bar houses the pool table. ✿♿♿P�"(K7)✿🛜

Ossett

Bier Huis ⬡
17 Towngate, WF5 9BL (in shopping parade which backs onto bus station)
☎ (01924) 565121 ⊕ bierhuis.co.uk
3 changing beers (sourced locally) ⊞

A specialist beer shop stocking over 500 bottled beers from many Yorkshire breweries alongside an extensive selection of foreign bottled ales, with emphasis on Belgian and German brews. Bottled beers can be drunk on site along with three changing draught ales and an extensive selection of draught ciders. A former local CAMRA Cider Pub of the Year. Q☺🏃👌●P🖥🚃☺🐕📶

Prop ur Baa
1A Bank street, WF5 8PS
☎ (01924) 265530
Abbeydale Moonshine; 5 changing beers ⊞
An atmospheric, dog-friendly, family-owned micropub near the town hall, established in 2019. A single bar with five handpumps serves real ales from mainly Yorkshire breweries alongside an extensive selection of gins. There are occasional acoustic live music sessions. No meals are offered, but there is complimentary tapas on Friday and a cheeseboard on Sunday. Quiz night is Wednesday with the proceeds going to local charities of the winner's choice. Q🚃🐕📶

Otley

Black Horse ⅃
2 Westgate, LS21 3AS
☎ (01943) 466590 ⊕ blackhorseotley.co.uk
Kirkstall Pale Ale, Three Swords, Dissolution IPA, Black Band Porter; 3 changing beers (sourced locally; often Anthology, Kirkstall) ⊞
An impressive corner building, dating from the start of the 20th century, with a Victorian-style interior. The imposing entrance leads to the main bar area with its wooden floor and array of brewery mirrors on the walls. To the left of the bar is the tap room; to the right an opening leads to additional seating areas. There is also a large covered outside space with seats. Q☺🏃🕸🚋◑👌🚃🐕📶

Junction Inn ⅃ ✓
44 Bondgate, LS21 1AD
Ossett Yorkshire Blonde; Timothy Taylor Boltmaker, Landlord; Theakston Old Peculier; 4 changing beers ⊞
A solid-looking stone-built pub on a prominent street-corner site on the approach from Leeds. To the front, roadside tables allow for outdoor drinking. The single-room interior has a central fireplace and comfortable fixed seating around the walls. Decoration in the half-panelled room includes a collection of pictures of old Otley. Outside to the rear of the building is a covered and heated seating area. Children are allowed until 8pm. 🏃🕸♣🚃🐕

Old Cock ⅃
11-13 Crossgate, LS21 1AA
☎ (01943) 464424
Daleside Blonde; Timothy Taylor Landlord; Theakston Best Bitter; 6 changing beers (sourced locally; often Brass Castle, Briscoe's, Wharfedale) ⊞
An award-winning genuine free house which has been cleverly converted from a former café in such a way that you would think it has been a pub for many years. There are two low-ceilinged rooms downstairs with stone-flagged floors and a further room upstairs. The guest ales are mostly from local breweries. At least two real ciders are also available plus a good range of foreign beers. There is a small outdoor drinking area. No admittance to under-18s. Q🕸👌●🚃🐕📶

Oxenhope

Bay Horse ⅃ ✓
20 Uppertown, BD22 9LN (on A6033)
☎ (01535) 642921
Moorhouse's White Witch, Pride of Pendle; Timothy Taylor Landlord; 4 changing beers (sourced regionally) ⊞
A friendly village local that welcomes families and dogs. It has a pleasant single-bar setup with a real fire, a cosy room to the rear, and a separate seating area up a flight of steps. The guest beers come from local breweries such as Bowland and Goose Eye. The pub is one of the main stopping points for the annual village charity straw race. Regular live music is a feature. 🏃🕸🚆♣P🚃(B3,K14)🐕📶

Dog & Gun Inn ⅃ ✓
Denholme Road, BD22 9SN
☎ (01535) 643159 ⊕ dogandgunoxenhope.co.uk
Timothy Taylor Golden Best, Boltmaker, Knowle Spring, Landlord, Landlord Dark ⊞
One of the highest 17th-century coaching inns in West Yorkshire, this traditional stone building has been sympathetically extended over the years. The emphasis is on food, but locals also enjoy the real ale, warming open fire and good service. The pub hosts numerous charity events throughout the year. Private parties can be booked in the separate restaurant areas. In the Wells Restaurant to the right of the bar, you can see the original well through a glass floor panel. 🏃🛏◑👌♣P🚃(K14)📶

Pontefract

Old Grocers ⅃
26 Beastfair, WF8 1AL
5 changing beers (sourced locally) ⊞
This comfortable and welcoming micropub is the first in the town. Opened in 2019, it occupies a former shop and it is deceptively spacious with seating on two levels and a small outside area. The constantly changing cask beer range mainly features Yorkshire breweries, especially from the Wakefield district, with real cider also available. There are occasional live acoustic music sessions at weekends. Q🕸🚆(Tanshelf)♣●🚃🐕📶↻

Robin Hood ⅃
4 Wakefield Road, WF8 4HN (at town end jct of A645 Wakefield Rd with roads to Barnsley and Doncaster)
☎ (01977) 702231
10 changing beers (sourced regionally; often Abbeydale, Henry Smith) ⊞
Recently bought and totally refurbished by a local landlord, the Robin has been a pub since 1791 when it was owned by the Duchy of Lancaster. It is the home of the Henry Smith Brewery, named after the son of the present owner. The pub hosts a folk session on Sunday and live music on Thursday. It is home to Britain's longest-running vinyl club, the Cat Club. There are two outside drinking areas. Q🏃🕸👌♣🚃🐕

Pudsey

Fleece ⅃ ✓
100 Fartown, LS28 8LU
☎ (0113) 236 2748
Copper Dragon Golden Pippin; Timothy Taylor Landlord; Tetley Bitter; Wainwright; 1 changing beer (sourced locally; often Timothy Taylor) ⊞
This community-focused pub is a regular CAMRA award-winner and evidence of this is proudly displayed in the entranceway. To the left of the front door is a small, basic

tap room with a flagged floor, known as the Snug. On the right is the lounge, which has plenty of comfy settles around its perimeter. It is decorated with movie pictures and memorabilia, with a focus on Laurel and Hardy. To the rear is an attractive beer garden with a covered area and fishpond. 🌞♣️P�ical(4F,205)🛜

Manor Inn L

Manor House Street, LS28 7BJ
Saltaire Blonde; 2 changing beers (sourced locally; often Ossett, Wishbone) Ⓗ
A community-focused, one-roomed pub located round the back of the town hall. It has cushioned benches along one side, and on the other side a long bar with three handpumps dispensing local ales. The fridge is well stocked with a good range of other beverages. Two large TV screens show sport, the news and music channels. Live music usually takes place on a Sunday. Dogs are welcome at all times. 🚲😸🛜

Rastrick

Roundhill Inn L ✓

75 Clough Lane, HD6 3QL (400yds from A643/A6107 jct towards M62 bridge)
☎ (01484) 713418 ⊕ roundhillinn.co.uk
Bradfield Farmers Blonde; Timothy Taylor Golden Best, Boltmaker, Landlord; house beer (by Ashover) Ⓗ
Overlooking Rastrick cricket ground, with spectacular views far beyond the Round Hill from which it takes its name, this two-roomed locals' pub is a genuine free house. Although on the edge of Rastrick, there are hourly bus services from Brighouse, Huddersfield and Halifax (alight at Rastrick Fire Station). In daytimes during the week the pub operates as a private function venue, often hosting funeral teas or wakes, as the crematorium in neighbouring Kirklees is less than half a mile away.
Q♣P🚲(547,549)😸🛜Ü

Roberttown

New Inn L ✓

Roberttown Lane, WF15 7NP
☎ (01924) 500483 ⊕ newinnroberttown.co.uk
Abbeydale Moonshine; Bradfield Farmers Blonde; Leeds Best; Timothy Taylor Landlord; 2 changing beers (sourced regionally; often Jolly Boys, Nailmaker) Ⓗ
A free house centrally located in Roberttown, originally a beer house. The licensees have created a welcoming pub that sits at the heart of the local community. It has a main bar area, a cosy snug, log fires and a games room suitable for functions. Outside are a sunny, refurbished seating area and a covered smoking shelter. There is a popular quiz on Wednesdays and occasional live music at weekends. 🚲😸♣P🚲(229,228)😸🛜Ü

Saltaire

Cap & Collar L

4 Queens Road, BD18 4SJ
⊕ tinyurl.com/capncollar
4 changing beers (sourced nationally; often Bristol Beer Factory, Kirkstall, Wishbone) Ⓗ
Popular modern micropub with an open-plan café-style layout accommodating up to 35 customers. Four handpulls serve an ever-changing range of real ales, many sourced regionally. Real cider is also on draught, and there is a good selection of bottle-conditioned beers. Pub snacks are available. Tap takeover events are held regularly and a home-brew club meets here. Live music

plays on Sunday afternoons and occasional evenings. A beer garden and smoking area are at the rear.
Q🚲😸♣️🚲😸🛜

SALT Bar & Kitchen L ✓

199 Bingley Road, BD18 4DH
☎ (01274) 582111
Ossett Butterley, Yorkshire Blonde, White Rat, Silver King; 5 changing beers (sourced regionally; often Rat, Rudgate, Thornbridge) Ⓗ
A large pub within an old tramshed, originally constructed in 1904, and rebranded by Ossett Brewery in 2019. It has a large open-plan main room with horseshoe bar, a dining room offset to one side and an upper mezzanine dining area. There is also access to the adjacent SALT Beer Factory. Real ales are mainly from Ossett Brewery and associated brands with some guests. Excellent meals include freshly made wood-fired pizzas. The large outdoor seating area is popular in good weather. The pub can get busy at weekends.
🚲😸◐🕹️&♣P🚲🛜Ü

Salt Cellar 🏆 L

192 Saltaire Road, BD18 3JF (on A657)
☎ (01274) 955051
House beer (by Oaks); 4 changing beers (sourced regionally; often Moorhouse's, Nightjar, Rooster's) Ⓗ
A traditional two-roomed pub with a friendly, cosy feel, on the edge of the World Heritage Site of Saltaire village. It has a Victorian character with comfortable seating, stained-glass partitions and bookshelves. Numerous pictures of old Saltaire adorn the walls. Six handpulls offer a varying range of real ales from local and regional breweries with a mixture of styles, usually including at least one dark beer. Bands often play on a Saturday night. 🚲😸&♣P🚲(676,678)😸🛜Ü

Sandal

Star ✓

Standbridge Lane, WF2 7DY (nr Asda on A6186 which links A61 and A636)
☎ (01924) 229674
5 changing beers (sourced regionally; often Morton Collins, Ossett, Wensleydale) Ⓗ
A cosy inn dating from 1821, the Star has an open-plan layout, real fires in winter and a streamside beer garden. It has been leased by the Morton Collins Brewery, which recently moved to the premises, and serves one or two of the brewery's beers plus four or five guests, mainly from local breweries. The welcoming pub holds a quiz night on Tuesday and an annual beer festival. A function room is available for hire. Q🚲😸◐&♣P🚲(110)😸🛜

Scholes

Stafford Arms L ✓

192 Scholes Lane, BD19 6LS (a649)
☎ (01274) 861387
Bradfield Farmers Blonde; Timothy Taylor Landlord; 4 changing beers (sourced regionally; often Acorn, Leeds, Moorhouse's) Ⓗ
An attractive pub on the edge of Scholes village, popular with locals and walkers and offering a warm, friendly welcome to all. It features an open-plan, comfortable layout with a large central fireplace and traditional decor, with a large beer garden to the rear. There is a quiz night on Thursday, open mic on Wednesday and a live band on Sunday. Bus 256 passes by while 254 and 254A stop a few minutes' walk away. 🚲😸♣P🚲(256,254)😸🛜

Shipley

Fox L
41 Briggate, BD17 7BP
☎ (01274) 594826 ⊕ thefoxshipley.co.uk
BEEspoke Plan Bee, Shipley Stout; 4 changing beers (sourced regionally; often Abbeydale, Bingley) ⊞
An independent café-style bar that is friendly and welcoming. Simply but smartly furnished, the single room features recycled church pews. Six handpulled ales include some from the in-house BEEspoke microbrewery. Real ciders, often including one from a local producer, are available, as are a wide range of international bottled beers. There is live music on Tuesday and Wednesday evenings and often on a Saturday night, when the bar can become busy. A handy place to wait for trains as the station is close by. ⟡♿☺⟡≠⬤🚫♥☀🛜

Hullabaloo
37-41 Westgate, BD18 3QX
☎ 07974 910838
4 changing beers (sourced regionally; often Brass Castle, Northern Monk, Wilde Child) ⊞
A popular, modern-style bar close to Shipley town centre and the bus interchange. It has an open-plan interior with four distinct areas in a variety of styles over split levels. Four handpumps serve a variety of real ales, usually from regional brewers and often differing from other pubs in the area. A further handpump serves cider. Artisan craft beers and a cider are also available on six keg taps. Children are welcome. There is a weekly quiz on a Wednesday night. ⟡◑≠⬤🚫☀🛜

Sir Norman Rae L ✓
Victoria House, Market Place, BD18 3QB
☎ (01274) 535290
Elland 1872 Porter; Greene King Abbot; Ruddles Best Bitter; 7 changing beers (sourced nationally; often Goose Eye, Saltaire, Wychwood) ⊞
A typical conversion by Wetherspoon of a former Co-op department store, this large, open-plan pub is a popular feature of the town centre. Ten real ale handpumps dispense three regular beers, including a dark beer from a local brewery, and seven guests, often focusing on local breweries. The good-value food on offer is from the usual Wetherspoon menu. Nicknamed the Waiting Room due to its proximity to Shipley bus interchange; the railway station is also nearby. ⟡◑♿≠🚫🛜

Slaithwaite

Commercial L
1 Carr Lane, HD7 5AN (village centre, off A62)
☎ (01484) 846258
Empire Moonrakers Mild; house beer (by Empire); 7 changing beers ⊞
Since reopening in 2009, this popular freehouse has enjoyed deserved success. Up to nine handpumps serve a variety of beer styles; the keenly priced house beers are supplied by Empire Brewery and include a permanent mild. The open-plan interior retains the feel of separate drinking areas, one featuring a real fire. The pub welcomes walkers and their dogs and is a popular stop on the Transpennine Real Ale Rail Trail. There is a pool room upstairs and live sports are screened in the bar. ☀≠🚫☀🛜

Sowerby Bridge

Hogs Head Brew House & Bar L
1 Stanley Street, HX6 2AH
☎ (01422) 836585 ⊕ hogsheadbrewhouse.co.uk
Hogs Head 6 To 8 Weeks, White Hog, Hoppy Valley, Old Schnozzler; 3 changing beers (sourced regionally; often Goose Eye, Phoenix, Vocation) ⊞
Close to the centre of Sowerby Bridge, the venue is an 18th-century former malthouse which has been extensively renovated. The brewery is at the back of the building and can be viewed from the bar area. Four core Hogs Head beers are available as well as guest ales. There is plenty of seating in the huge, sprawling bar area, with additional seating provided upstairs at weekends, and an extensive, covered outdoor area across from the pub. Q⟡♿☺⟡≠🚫♥☀🛜🔄

Puzzle Hall L
21 Hollins Mill Lane, HX6 2RF (400yds from A58)
☎ (01422) 835237 ⊕ puzzlehall.org.uk
6 changing beers (sourced regionally; often Acorn, Elland, Mallinsons) ⊞
This 17th-century gem overlooks the River Calder, and boasts a proud history of real ale and real music. The building once included a brewery; the tower is now incorporated into the accommodation. Closed in 2016, it reopened as a community pub in 2019, winning a CAMRA pub saving award. The single bar serves two rooms and a large flagstoned area outside. Six rotating real ales and a real cider from Halletts are usually available. ⟡♿☺⟡≠⬤🚫☀🛜

Stanbury

Friendly L
54 Main Street, BD22 0HB (in village centre)
☎ (01535) 645528
Settle Mainline; 2 changing beers (sourced nationally; often Goose Eye, Small World) ⊞
Popular village local that also attracts those walking the Pennine Way or visiting Top Withens, the ruined farmhouse claimed as the inspiration for the setting of Wuthering Heights. The pub is small and retains a traditional layout with two small lounges either side of a central bar, plus a separate games room. Stanbury is only two miles from Haworth but a million miles from its tourist hustle and bustle. At least one beer is usually from Goose Eye brewery. Tea and coffee are available on request. ⟡☺♿🅰♣P🚫☀🛜

Wuthering Heights Inn L ✓
Main Street, BD22 0HB (in village centre)
☎ (01535) 643332 ⊕ thewutheringheights.co.uk
Moorhouse's White Witch; Theakston Best Bitter; 2 changing beers (sourced regionally; often Abbeydale, Bradfield) ⊞
Set in a farming village, this popular, friendly inn dates from 1763. Warmed by log-burners, the traditional main bar displays photographs showing the history of the Stanbury. The cosy dining room has a Bronte theme, and there is a third room that can be booked for parties and meetings. The rear garden has a separate camping area (no caravans) and spectacular views down the Worth Valley. There is a quiz every Thursday. Well-behaved dogs and children are welcome. ⟡☺🏠◑🅰♣P🚫☀🛜

Thackley

Black Rat L
530 Leeds Road, BD10 8JH
☎ 07920 061671
4 changing beers (sourced regionally; often Bingley, Daleside, Stubbee) ⊞
Previously a florist's shop, this tiny micropub with capacity for approximately 15 people changed ownership in August 2021 but has maintained the standards for

which it was known. A friendly welcome is assured. As there is no music, TV or games machines, conversation and banter are key. A varying selection of four real ales, primarily from Yorkshire breweries, is offered, with one line dedicated to dark beers. The pub can be very busy, especially as the working day ends. Q&✿🖳😾

Thornhill

Savile Arms ✓

12 Church Lane, WF12 0JZ (on B6117, 2½ miles S of Dewsbury)
☎ (01924) 463738
Black Sheep Best Bitter; 5 changing beers (sourced regionally; often Bank Top, Marston's, Ossett) Ⓗ
Known as the Church House, this picturesque village community pub dates from 1777. Six handpumps in the beamed bar area offer a varied range of beer. Traditional bar billiards is played in the games room which stands on the consecrated ground of the parish church. A steep staircase leads to a fine 'secret garden' with picnic tables for barbecues and a roomy sheltered area. Children are welcome in the large garden. Home-made food is available for events for small and large groups.
Q❄☺✿♣🖳(128,280)😾🛜↺

Thornton

Watchmaker ✓

South Square, BD13 3LD (off Thornton Rd)
⊕ thewatchmaker.co.uk
Ossett Yorkshire Blonde; Timothy Taylor Landlord; 2 changing beers (sourced regionally; often Goose Eye, Thornbridge) Ⓗ
A small and friendly micropub that reopened in 2019 as the Watchmaker following a change of management. There are two small rooms on the ground floor, with the bar to the front. The pub has a cosy, traditional appearance with plenty of timber on display and an old range in the rear room. Four handpulls serve two regular càsk ales plus varying guests, usually including a dark beer. A courtyard provides additional outdoor seating and access to the toilets which are separate from the pub. ☺✿🖳(67,607)😾🛜

Todmorden

Alehouse Ⓛ

52 Patmos, Burnley Road, OL14 5EY
☎ 07407 747956
Eagles Crag Pale Eagle; 4 changing beers (sourced regionally) Ⓗ
A welcoming micropub with a community feel, in a row of shops set back from the road; the River Calder is culverted under the broad patio area. The wooden bar is at the rear of the single room, which features exposed brickwork. Works by local artists, usually for sale, adorn the walls. Four changing ales usually include a dark option on the right-hand pump. Eagles Crag G++ (a dry hopped version of Golden Eagle) is offered on KeyKeg. ✿≠🖳😾🛜

Upper Denby

George Inn Ⓛ ✓

114 Denby Lane, HD8 8UE
☎ (01484) 861347 ⊕ thegeorgeinn-upperdenby.co.uk
Tetley Bitter; Timothy Taylor Landlord; 2 changing beers (sourced locally; often Acorn, Nailmaker, Small World) Ⓗ
This family-run village inn and free house is a regular winner of the local CAMRA Rural Pub of the Year and was

Welcome To Yorkshire's Favourite Pub 2021. The interior is split into two separate areas – a comfortable lounge and a tap room with pool table. The George is well known for its home-made pie and peas, guided walks and live music. Cyclists, walkers and dogs are welcome, and families until early evening.
Q❄☺🕽🍴♣🖳(D2,D3)😾🛜

Wakefield

Black Rock �机 ✓

19 Cross Square, WF1 1PQ (between Bull Ring and top of Westgate)
☎ (01924) 375550
Oakham Citra; Tetley Bitter; 4 changing beers (sourced regionally) Ⓗ
An arched, tiled façade leads into this compact city-centre local with a warm welcome and comfy interior including photographs of old Wakefield. There is a blue plaque for Archbishop John Potter who grew up here when it was a draper's shop. The Rock stands as one of the few proper pubs left in the middle of the clubs and bars of Westgate and is popular with drinkers of all ages looking for a real pint. Customers are encouraged to suggest beers to try, with four frequently changing guest ales on offer. There is a free function room for private use. Q❄≠(Westgate)🖳↺

Harry's Bar Ⓛ

107B Westgate, WF1 1EL (turn right from Westgate station, cross road at traffic lights and pub is at back of car park on right)
☎ (01924) 373773
House beer (by Five Towns); 7 changing beers (often North Riding Brewery) Ⓗ
A cosy one-roomed pub in an alleyway just off Westgate. A real fire and a bare-brick and wood interior displaying vintage sporting pictures enhance this small pub. It serves a selection of bottled Belgian beers. An extensive decking area has been added to the side of the building. There is a fantastic view of Wakefield's famous 99-arched viaduct which makes you wish steam trains were a regular feature. Q❄&≠(Westgate)✿🖳🛜↺

Henry Boons Ⓛ

130 Westgate, WF2 9SR (100yds below railway bridge on Westgate)
☎ (01924) 378126
Ossett White Rat; Timothy Taylor Boltmaker, Landlord; 3 changing beers (sourced regionally; often Five Towns, Nook, Tigertops) Ⓗ
Quiet in the daytime, this pub gets busy in the evenings as it is on the Westgate run. Hogsheads are used as tables and there are many items of breweriana plus a thatched bar. The pub caters for drinkers of all ages and features live music. Two function rooms are available for hire. Most bus routes to the west of the city pass the door. &≠(Westgate)♣🖳😾🛜↺

Luis Bar @ Fernandes Wakefield Ⓛ

5 Avison Yard, Kirkgate, WF1 1UA (turn right 100yds S of George St/Kirkgate jct)
☎ (01924) 386348 ⊕ luisbar.co.uk
5 changing beers (sourced locally; often Fernandes, Ossett) Ⓗ
A former Ossett managed pub and microbrewery that was transformed into the Luis Bar enterprise in September 2021. The brewers are now the landlady's husband and his friend. The welcoming venue serves a large selection of real ales, craft beers and cocktails, and hosts regular live music events.
Q❄≠(Kirkgate)♣✿🖳😾🛜↺

Polka Hop L

60 George Street, WF1 1DL
☎ (01924) 609760
House beer (by Sunbeam); 3 changing beers (sourced locally; often Chin Chin, Copper Dragon, Durham) Ⓗ
Following major refurbishment, this pub reopened as the Polka Hop in 2018. It is named for a dance performed by morris dancers – the new owner being a member of the local side. The bar has been relocated to a former recess, creating a comfortable seating area with secluded corners. A real fire complements the warm welcome. Numerous board games are provided. Access from the street is difficult for wheelchair users.
Q❄≷(Westgate)♣♠🚲(44¾)🐈🗲

Wakefield Labour Club L

18 Vicarage Street, WF1 1QX (at top of Kirkgate)
☎ (01924) 215626 ⊕ theredshed.org.uk
5 changing beers (sourced regionally) Ⓗ
The Red Shed is a secondhand army hut that has been extensively refurbished with three rooms, two of which can be hired for functions. Home to many union, community and charity groups, it hosts a quiz night on Wednesday, open mic folk music night on the last Saturday of each month, and regular live music. There is an extensive collection of union plates and badges over the bar as well as numerous CAMRA awards adorning the walls. Q❄👶≷(Kirkgate)♣P🚲🐈

Wibsey

Hooper Micropub L

209 High Street, BD6 1JU
⊕ thehoopermicropub.co.uk
5 changing beers (sourced regionally; often Acorn, Beartown, Bridgehouse) Ⓗ
A cosy and friendly split-level micropub that has quickly established itself with local people in the urban village of Wibsey. The bar is situated on the upper level and there is comfortable seating in the lower part. Five handpulls offer a varying selection of beers that are primarily sourced from Yorkshire but occasionally from further afield. Photographs of old Wibsey provide a simple relief from the otherwise minimalist decor. Closing times may vary depending upon the demand.
Q❄♣🚲(643,644)🐈🗲

Breweries

Amity SIBA

🍴 **15-16 Festoon Rooms Sunny Bank Mills, Farsley, Leeds, West Yorkshire, LS28 5UJ** ⊕ amitybrew.co

Launching in 2020 with its online shop, Amity Brew Co was founded by Russ Clarke (ex-BrewDog, Buxton, North Brewing Co, and Beer Hawk team member). Originally cuckoo brewing, its brewpub opened later the same year sporting a 10-hectolitre brew kit, producing modern interpretations of classic beer styles, as well as more experimental brews. No real ale. ‼🍺◆

Anthology

Unit 6, Armley Link, Armley Road, Leeds, West Yorkshire, LS12 2QN ⊕ anthologybrewing.co.uk

Established in 2018, Anthology is a small-batch, 2.5-barrel, Leeds-based brewery. Liam Kane brews an ever-evolving range of beers focussed on bold flavours. Beers are available in outlets around the city, and some further afield. Occasional taproom events throughout the warmer months (check social media). It also likes to work with artistic / charitable organisations. ◆

Barker's

14 Midway, South Crosland, Huddersfield, West Yorkshire, HD4 7DA ☎ 07876 540211
✉ barkersbrewing@gmail.com

James Barker started as a homebrewer six years ago, producing beers for friends. With invaluable help and guidance from Summer Wine Brewery and Neil at Milltown, he made the leap from homebrewer to commercial production in 2019. He continues to use his handbuilt, 60-litre brewplant, bottling a core range of seven beers. Vegan-friendly. V

Beer Ink

Plover Road Garage, Plover Road, Lindley, Huddersfield, West Yorkshire, HD3 3PJ
☎ (01484) 643368 ☎ 07885 676711
⊕ beer-ink.co.uk

The Beer Ink Brewery is based in Lindley and opened in 2015 using an eight-barrel plant. It specialises in barrel-aged beers and regularly collaborates with other forward-looking breweries. Its onsite taproom and facilities were expanded and improved in 2020. ◆◆

Vellum (ABV 4%) PALE
Gutenberg (ABV 4.2%) SPECIALITY
Typo (ABV 4.4%) PALE
Lampblack (ABV 4.6%) STOUT
Scrawler (ABV 5%) IPA

BEEspoke

🍴 **The Fox, 41 Briggate, Shipley, West Yorkshire, BD17 7BP**
☎ (01274) 594826 ⊕ thefoxshipley.co.uk

⊕Brewing began in 2015 in the cellar of the Fox pub using a one-barrel plant. Beers are available in the pub and at local beer festivals. Shiny Cowbird Gin now also produced. ◆

Bingley SIBA

Unit 2, Old Mill Yard, Shay Lane, Wilsden, West Yorkshire, BD15 0DR
☎ (01535) 274285 ⊕ bingleybrewery.co.uk

Bingley is a small, family-run brewery that opened in 2014 using a six-barrel plant. It is located in a rural setting in the village of Wilsden, part of Bingley Rural Ward. Beers are distributed coast to coast and as far south as Derby. ‼◆

Endeavour (ABV 3.7%) BLOND
Goldy Locks Blonde (ABV 4%) BLOND
Azacca (ABV 4.1%) GOLD
Aire Gold (ABV 4.2%) GOLD
Session IPA (ABV 4.2%) GOLD
Steady State (ABV 4.2%) BITTER
Centennial (ABV 4.4%) GOLD
Tri State (ABV 4.5%) PALE
1848 Stout (ABV 4.8%) STOUT
Jamestown APA (ABV 5.4%) PALE

Bini

1b Railway Road, Ilkley, LS29 8HQ ⊕ binibrew.co

Nanobrewery located on the edge of Ilkley Moor producing hazy beers. Launched in 2020.

Bone Idle

28 The Green, Idle, Bradford, West Yorkshire, BD10 9PX ☎ 07525 751574

Established in 2018 in a converted barn situated in the heart of Idle village. The brewery offers the public the opportunity to try brewing. All beers produced are sold exclusively in the Idle Draper pub next door. A mezzanine floor has a mini cinema/ function room.

Bosun's SIBA

Unit 15, Sandbeck Park, Sandbeck Lane, Wetherby, LS22 7TW
☎ (01937) 227337 ⊕ bosunsbrewery.com

☻The first brew was produced in 2013 by a father and son who had both served in the armed forces. The brewery relocated from Horbury to Huddersfield in 2018 and subsequently to Wetherby in 2021 under new ownership. The regular beers are produced on a 10-barrel plant with some nautical themed names. Canned beers are available from the online shop. ‼ ☛ ♦ ✐

Tell No Tales (ABV 3.8%) BITTER
Blonde (ABV 3.9%) BLOND
Maiden Voyage (ABV 3.9%) BITTER
Down The Hatch (ABV 4%) BITTER
King Neptune (ABV 4.3%) BITTER
IPA (ABV 5.6%) IPA
Tempest (ABV 5.6%) IPA

Bridgehouse SIBA

Airedale Heifer, Bradford Road, Sandbeds, Keighley, West Yorkshire, BD20 5LY
☎ (01535) 601222

Office: Unit 1, Aireworth Mills, Aireworth Road, Keighley, BD21 4DH ⊕ bridgehousebrewery.co.uk

☻Bridgehouse began brewing in 2010. The brewery purchased the recipes and branding of Old Bear Brewery in 2014 and moved into its premises in Keighley. In 2015 the brewery relocated to its present address behind the Airedale Heifer pub in Sandbeds. Bridgehouse operate a bespoke 15-barrel brewery. Twelve pubs are operated. ‼♦

Tequila Blonde (ABV 3.8%) SPECIALITY
Initially sweet with hints of lime, finishing with a slight tingling aftertaste.
Blonde (ABV 4%) GOLD
A strong fruity aroma with a sharp burst of grapefruit on the tongue and a touch of sweetness in the background. Bitter finish.
Aired Ale (ABV 4.1%) BITTER
Brown beer with malty aroma. Malt, hops and fruit in equal balance with lingering fruitiness in a long, bitter finish.
Porter (ABV 4.5%) PORTER
Black beer with red hints. Aromas of malt and liquorice lead to coffee, chocolate and wine fruit flavours which carry through to a bitter finish
Landlady IPA (ABV 5.1%) PALE
Holy Cow (ABV 5.6%) BITTER
Strong ale with juicy malt and full hop flavour, citrus overtones. Light hop aroma and a bitter finish.
Cherry Choc (ABV 6%) SPECIALITY

Briggs Signature

c/o Unit 1, Waterhouse Mill, 65-71 Lockwood Road, Huddersfield, West Yorkshire, HD1 3QU ☎ 07427 668004 ⊕ briggssignatureales.weebly.com

⊗ Briggs Signature Ales started brewing in 2014 using spare capacity at Mallinsons (qv). Nick Briggs, also a member of the Mallinsons brewing team, produces a number of modern, hop-forward beers. ☛ LIVE

Northern Soul (ABV 3.8%) BITTER
Rock & Roll (ABV 4%) BITTER
Hip Hop (ABV 4.2%) GOLD
Techno (ABV 4.2%) BITTER
Blues (ABV 4.6%) GOLD
Metal (ABV 5%) PORTER

Briscoe's

Otley, West Yorkshire, LS21 3EL
☎ (01943) 466515 ✉ briscoe.brewery@talktalk.net

☻The brewery was launched in 1998 by microbiologist/ chemist Dr Paul Briscoe, in the cellar of his house, with a one-barrel brew length. He is currently producing several beers on an irregular basis to meet demand. The beers are available in local Otley pubs.

Burley Street

▣ Fox & Newt, 7-9 Burley Street, Leeds, West Yorkshire, LS3 1LD
☎ (0113) 245 4527 ⊕ burleystreetbrewhouse.co.uk

☻Burley Street Brewhouse is in the cellar of the Fox & Newt pub where the first brewery was installed by Whitbread in the 1970s. The freehold was purchased by the current owners, and brewing recommenced in 2010. Following a two-year hiatus from 2013, brewing resumed again in 2015. The Fox & Newt pub is the only outlet for the beers. Brewing is currently suspended.

Chevin

Office: 1 Mount Pisgah, Otley, West Yorkshire, LS21 3DX ✉ chevinotley@gmail.com

Brewed in the shadow of the Chevin, in the famous pub town of Otley, Chevin Brew Co specialises in small batch brews (available in cask, keg and bottle). It is proud to use local ingredients, and works with local artists for the labels. It shares a small one-barrel brewery with sister brewery, Marlowe Beer Project.

Chin Chin

Unit 53F Lidgate Crescent, Langthwaite Grange Industrial Estate, South Kirkby, West Yorkshire, WF9 3NS ☎ 07896 253650
✉ david@chinchinbrewing.co.uk

☻David Currie founded the brewery in 2016 with his brother Andrew, before taking sole control. Initially utilising a one-barrel plant in domestic premises, in 2018 there was expansion to a five-barrel plant, and relocation to its current location. An expanding range of small batch beers is supplied across Yorkshire, and to festivals nationwide. ‼

Clark's

Office: 136 Westgate, Wakefield, West Yorkshire, WF2 9SW
☎ (01924) 373328 ☎ 07801 922473 ⊕ hbclark.co.uk

☻Beers are contract brewed elsewhere. ♦

Classic Blonde (ABV 3.9%) BLOND
Merrie City Atlantic Hop (ABV 4%) BITTER
Merrie City Cascadian (ABV 4%) PALE
Merrie City Crystal Gold (ABV 4.2%) GOLD

Cobbydale

🍺 Red Lion, 47 Kirkgate, Silsden, West Yorkshire, BD20 0AQ
☎ (01535) 930884 ☎ 07965 569885
🌐 cobbydalebrewery.co.uk

⊕ Brewing began in 2017 at the Red Lion, Silsden. Originally only brewing one beer, others are now brewed on an occasional basis.

Cooper Hill

Highcliffe Industrial Estate, Bruntcliffe Lane, Morley, Leeds, LS27 9LR
☎ (0800) 783 2989 🌐 cooperhillbrewery.co.uk

Commenced brewing in 2018 on equipment from the former Trinity Brewery, now relocated to Morley.

Darkland

Unit 4c, Ladyship Business Park, Mill Lane, Halifax, West Yorkshire, HX3 6TA
☎ (01422) 320100 🌐 darklandbrewery.co.uk

⊕ Founded in 2018, Darkland is a microbrewery hidden away in a corner of an industrial estate. Regular and seasonal beers are named after ancient runes and are available at the brewery tap, Pallet Bar, Boothtown. Beers can be ordered online in can, bottle and bag-in-box.

Bohemian Raspberry (ABV 3.8%) SPECIALITY
Reddish, amber-coloured fruit ale. Subtle flavours of malt and raspberries develop in the mouth and become more intense in the aftertaste.

Othala (ABV 3.8%) BITTER

Isa (ABV 4%) BLOND
A pale ale with a hoppy citrus aroma. It is a smooth-tasting beer with a long, dry, bitter finish.

Wolfenbrau (ABV 4%) BITTER
A malty, traditional bitter with a subtle roast flavour. Sweet fruit quickly develops into a strong bitter aftertaste filling the mouth with depth of flavour.

Niflheim (ABV 4.2%) PALE

Drakkar (ABV 4.5%) PORTER
A dark and rich ale with complex toasted rich malt flavours. It has a robust and bitter farewell.

Cat's Eyes (ABV 4.8%) STOUT
Black, velvety, well-balanced oatmeal stout. Plenty of roast and nutty flavours develop on the palate. The long aftertaste retains complexity and is surprisingly refreshing.

Jera (ABV 5%) PALE
Refreshing, well-balanced, hoppy, strong pale ale. Crisp and fruity with a developing bitter finish.

DMC (NEW)

Unit 2a, Cliffe Hill Works, Balne Lane, Wakefield, West Yorkshire, WF2 0DF 🌐 dmcbrewery.com

DMC Brewery, founded by husband and wife team Gez and Ele, produce the finest alcoholic ginger beer, made using fresh, natural ingredients, avoiding the use of synthetics, so the beers are gluten free and mostly vegan. Four signature flavours, available for nationwide delivery, plus small batch, seasonal brews are produced.
◆ GF V

Eagles Crag

Unit 21, Robinwood Mill, Todmorden, West Yorkshire, OL14 8JA
☎ (01706) 810394 🌐 eaglescragbrewery.com

⊕ Eagles Crag is named after, and overlooked by, a prominent landmark, famous in local folklore. Its eight-barrel plant is situated in a former textile mill. Commercial brewing began in 2017 and the two founders both have over 35 years of brewing experience. Expansion has led to a range of styles – including an occasional Imperial Stout aged in whisky casks. Beers can be fined as vegan on request. Eagles Crag supply more than 200 outlets in Lancashire, Yorkshire and Manchester. 🍺◆🌿

The Eagle's Feather (ABV 3.8%) BITTER
Traditional Yorkshire bitter. Malty and fruity with a dry bitter finish.

Pale Eagle (ABV 4%) PALE
Easy-drinking, very well-balanced pale ale. Light citrus notes offset by a touch of sweetness giving a smooth, bitter finish.

Eagle's Jester (ABV 4.3%) PALE

Eagle of Kindness (ABV 4.4%) GOLD
Pale ale with a golden blond hue. Its hoppy character is balanced with notes of malt, packing a lot of flavour into a rounded body.

Black Eagle (ABV 4.6%) STOUT
Luscious black creamy stout. Dry roast flavours develop in the mouth. The aftertaste is bitter and crisp.

The Eagle Has Landed (ABV 4.6%) BITTER
An amber best bitter with a good balance of fruit and malt. Moderate bitterness with a lingering. malty finish.

Golden Eagle (ABV 4.7%) GOLD
A fruity, full-flavoured golden ale. Hoppy bitterness dominates the full mouthfeel and lasting finish.

Eagle of Darkness (ABV 5%) PORTER
Refreshing dark brown porter. A subtle blend of chocolate malt and raisin-like fruit develops into a mellow, sweet aftertaste.

Bald Eagle (ABV 6.9%) IPA

Elland SIBA

Units 3-5, Heathfield Industrial Estate, Heathfield Street, Elland, West Yorkshire, HX5 9AE
☎ (01422) 377677 🌐 ellandbrewery.co.uk

⊕ Originally formed in 2002 as Eastwood & Sanders the company was renamed Elland in 2006 to reinforce its links with the town. The brewery has a capacity of 50 barrels (200 firkins) a week with further expansion and seasonal beers planned. The brewery tap, Elland Craft & Tap, opened in Elland in 2018. ‼◆LIVE

Blonde (ABV 4%) BLOND
Creamy yellow, hoppy ale with hints of citrus fruits. Pleasantly strong, bitter aftertaste.

South Sea Pale (ABV 4.1%) BITTER

Nettlethrasher (ABV 4.4%) BITTER
Smooth amber-coloured beer. A rounded nose with some fragrant hops notes followed by a mellow nutty and fruity taste and a dry finish.

1872 Porter (ABV 6.5%) PORTER
Creamy, full-flavoured porter. Rich liquorice flavours with a hint of chocolate from roast malt. A soft but satisfying aftertaste of bittersweet roast and malt.

Empire SIBA

The Old Boiler House, Unit 33, Upper Mills, Slaithwaite, Huddersfield, West Yorkshire, HD7 5HA
☎ (01484) 847343 ☎ 07966 592276
🌐 empirebrewing.com

⊕ Empire Brewing was set up 2006 in a mill on the bank of the scenic Huddersfield Narrow Canal, close to the centre of Slaithwaite. In 2011 the brewery upgraded from a five-barrel to a 12-barrel plant. Beers are supplied

to local free houses and through independent specialist beer agencies and wholesalers. ‼♦LIVE

Golden Warrior (ABV 3.8%) GOLD
Strikes Back (ABV 4%) GOLD
Valour (ABV 4.2%) GOLD
Longbow (ABV 4.3%) GOLD
Imperium (ABV 5.1%) BITTER

Fernandes

◙ Luis Bar, 5 Avison Yard, Kirkgate, Wakefield, West Yorkshire, WF1 1UA
☎ (01924) 291709 ⊕ ossett-brewery.co.uk

☺Opened in 1997 by David James and housed in a 19th century malthouse, Fernandes Brewery was sold to the Ossett Group in 2007. In 2021 it was extensively refurbished and reopened as Luis Bar @ Fernandes Brewery. ‼♦⚘

Polaris (ABV 3.9%) GOLD

Frank's Head

19 Dymoke Road, Methley, LS26 9FG ☎ 07949 846438 ⊕ franksheadbrewery.co.uk

Established in 2020 in Methley producing small batch, hop-forward beers for canned distribution.

Frisky Bear

Unit 1, Vantage Point, Howley Park Road East, Morley, Leeds, West Yorkshire, LS27 0SU ☎ 07590 540210 ⊕ friskybear.com

☺Established in 2016, Frisky Bear was originally based in Oscar's Bar in Morley Bottoms. An upgrade from one barrel to six barrel in 2019 saw a relocation to an industrial unit across town. The beers are available, unfined, in cask, keg and can, on a regularly rotating brewing schedule. ♦LIVE⚘

Grizzly Bear (ABV 4.5%) PALE

Ghost

Unit D, Tong Business Centre, Otley Road, Baildon, West Yorkshire, BD17 7QD
☎ (0113) 418 2002 ☎ 01896 097882
⊕ ghostbrew.co.uk

Ghost Brew Co is the creation of Steve Crump and James Thompson.

Goose Eye SIBA

Unit 5, Castlefield Industrial Estate, Crossflatts, Bingley, West Yorkshire, BD16 2AF
☎ (01274) 512743 ⊕ goose-eye-brewery.co.uk

☺Goose Eye is a family-run brewery established in 1991, supplying numerous regular outlets, mainly in Yorkshire and Lancashire. Goose Eye moved in 2017 to a custom-built brewery which has enabled them to increase production with a 20-barrel brew of regular beers and monthly specials. The well-appointed brewery bar is open every Friday and Saturday. ♦⚘

Spring Wells (ABV 3.6%) PALE
Blackmoor (ABV 3.9%) MILD
Goose Eye Bitter (ABV 3.9%) BITTER
Traditional Yorkshire, brown, session bitter. Well-balanced malt and hops with a pleasingly bitter finish.
Chinook Blonde (ABV 4.2%) BLOND
Assertive grapefruit hoppiness in the aroma and tropical flavours.
Golden Goose (ABV 4.5%) BLOND

Over and Stout (ABV 5.2%) STOUT
A full-bodied stout with roast and malt flavours mingling with hops, dark fruit and liquorice on the palate. Look also for tart fruit on the nose and a growing bitter finish.
Pommies Revenge (ABV 5.2%) BITTER
Golden, strong bitter combining grassy hops, a cocktail of fruit flavours, a peppery hint and a hoppy, bitter finish.

Halifax Steam

◙ Conclave, Southedge Works, Brighouse Road, Hipperholme, West Yorkshire, HX3 8EF ☎ 07506 022504 ⊕ halifax-steam.co.uk

☺Brewing since 1999, the five-barrel plant supplies only the brewery tap, the Cock o' the North. It is now reputedly the oldest brewery in Calderdale. A range of permanent beers and different rotating beers are brewed throughout the year. ♦

Henry Smith

◙ Robin Hood, 4 Wakefield Road, Pontefract, West Yorkshire, WF8 4HN ☎ 07547 573378

☺Set up behind the Robin Hood pub in Pontefract by Dean Smith in 2019 with the help of Revolutions Brewery (where Head Brewer, Paul Windmill, learned to brew). The plant is the former James & Kirkman kit with a few tweaks. One beer is brewed at Revolutions due to high demand. Small batch specials for Revolutions will be brewed in Pontefract.

Hogs Head

◙ 1 Stanley Street, Sowerby Bridge, West Yorkshire, HX6 2AH
☎ (01422) 836585 ⊕ hogsheadbrewhouse.co.uk

☺The Hogs Head Brewery opened in a huge 18th Century former malthouse at the end of 2015. The sixteen-barrel brewhouse has increased from eight-barrels since 2018. The handsome copper and stainless steel brewing vats of the original brewery are on display at the back of the bar area with the newer brewing vessels being accommodated in the cellar. Almost all the production is sold on the premises with occasional casks being provided to beer festivals. ♦V

Horbury

◙ The Brewhouse, Cherry Tree Inn, 19 Church Street, Horbury, WF4 6LT ☎ 07970 299292

☺Following the closure of Bob's Brewing Co, Horbury Ales took over the plant in 2016 and transferred production to the rear of the brewery tap, Cherry Tree Inn. Beers are available locally, regionally and nationally.

Now Then (ABV 3.8%) PALE
5 Hops (ABV 4.1%) PALE
First Light (ABV 4.1%) PALE
Tiramisu (ABV 4.3%) PORTER

Horsforth SIBA

143 New Road Side, Horsforth, Leeds, West Yorkshire, LS18 5NX ☎ 07854 078330
⊕ horsforthbrewery.co.uk

☺Brewing began on a part-time basis in 2017 in the owner's garage, and then moved on to a small unit. 2020 saw relocation to larger premises, which incorporate a shop and taproom. In addition to the flagship beer, an ever-changing range of specials is produced. The taproom is accessed through an opening on the main street. ♦⚘

My Horse Came Fourth (ABV 3.5%) SPECIALITY
Horsforth Pale (ABV 4.5%) PALE
A modern, easy-drinking, hazy, pale ale well-balanced with hops and gentle fruit such as peach and apricot.
Schwarz Rose (ABV 5%) SPECIALITY
Mosaic (ABV 5.1%) PALE
Weise Rose (ABV 5.4%) SPECIALITY
Aubretia (ABV 5.5%) IPA
Night Ryder (ABV 5.5%) RED
Rubis (ABV 6.2%) SPECIALITY

Ilkley SIBA

40 Ashlands Road, Ilkley, West Yorkshire, LS29 8JT
☎ (01943) 604604 ⊕ ilkleybrewery.co.uk

⊚Ilkley Brewery was founded in 2009 and has expanded rapidly since. Ilkley beers can be found throughout the UK and are now exported into Europe. The brewery is a frequent sponsor of local beer festivals and also holds regular on-site social events and brewery tours. ‼◆LIVE

Mary Jane (ABV 3.5%) PALE
Joshua Jane (ABV 3.7%) BITTER
Blonde (ABV 3.9%) GOLD
Pale (ABV 4.2%) PALE
Lotus IPA (ABV 5.5%) IPA

Junction

◪ **1 Baildon Road, Baildon, West Yorkshire, BD17 6AB**
☎ (01274) 582009 ☎ 07539 923744
✉ andydoug48@gmail.com

Junction is a microbrewery established in 2012 in the cellar of the Junction pub in Baildon, brewing around 300 gallons a week. Beer is sold in the pub and other local outlets. LIVE

Kirkstall SIBA

100 Kirkstall Road, Leeds, West Yorkshire, LS3 1HJ
☎ (0113) 898 0280

Second site: Midland Mills, Station Road, Cross Hills, BD20 7DT ⊕ kirkstallbrewery.com

⊚Established in 2011 a few yards from the original Kirkstall Brewery beside the Leeds-Liverpool canal. In 2017 it moved to a new state-of-the-art brewery incorporating a 60-barrel plant, malting unit and canning line. Nearby Kirkstall Abbey (with its own brewhouse), and lost local industries are beer name inspiration. A secondary site, the former Naylor's brewery, Cross Hills, was purchased and began operation in 2022. The Kirkstall Bridge Inn is the brewery tap. ‼◆◆

Pale Ale (ABV 4%) PALE
A refreshing golden-coloured bitter beer with citric hop flavours, zesty bitterness especially in the finish which is lingering.
Three Swords (ABV 4.5%) GOLD
Good quantities of hops and juicy fruit define this yellow beer, a bitter taste and a tenacious, pithy marmalade finish.
Dissolution IPA (ABV 5%) PALE
Hops define this gold beer from the aroma, through the orange fruit taste. Finishing dryly with yet more hops.
Black Band Porter (ABV 5.5%) PORTER
Dark, smooth and rich with roasty smokiness from the malt also some dried fruit with hints of treacle and liquorice.

Lazy Turtle

Meadowbeck, Barnside Lane, Hepworth, Holmfirth, West Yorkshire, HD9 1TN
☎ (01484) 680589 ☎ 07590 532880
⊕ lazyturtlebrewing.com

Founded in 2018 by Dave Bore, a member of the Penistone Homebrew Collective, after he decided to move into commercial brewing. Production is mostly bottled but cask-conditioned beers are occasionally available.

Leeds SIBA

1 Westland Road, Leeds, West Yorkshire, LS11 5SE
☎ (0113) 244 5866 ⊕ leedsbrewery.co.uk

⊚Production began in 2007 and Leeds Brewery is now one of the largest in the city. It uses a unique strain of yeast originally taken from a now defunct West Yorkshire brewery. Beer is supplied directly across the region and as far as Nottinghamshire, Lancashire and the North East. It formerly ran an estate of pubs, still trading, across Leeds and York. In 2020 the brewery invested in new, state-of-the-art brewing equipment following a move into new premises. ◆

Pale (ABV 3.8%) PALE
Hops and fruit, sometimes lemony, mix with a sweet maltiness through to the bitter, hoppy finish, light gold colour.
Yorkshire Gold (ABV 4%) GOLD
Best (ABV 4.3%) BITTER
A pleasing mix of malt and hops makes this smooth, copper-coloured, bittersweet beer very drinkable.
Midnight Bell (ABV 4.8%) MILD
A full-bodied strong mild, deep ruby brown in colour. Malty and sweet with chocolate being present throughout.

Legitimate Industries SIBA

10 Weaver Street, Leeds, West Yorkshire, LS4 2AU
⊕ legitimateworldwide.com

Founded in 2016, the 30-barrel plant mainly brews keg beer for the company's Red's True Barbecue restaurant chain. However, under new ownership a wider portfolio of non-permanent beers are being produced, with canned output substantially increasing too, aided by the installation of a 200-litre pilot kit. A limited amount of cask beer is sometimes available in the local free-trade.

Linfit

◪ **Sair Inn, 139 Lane Top, Linthwaite, Huddersfield, West Yorkshire, HD7 5SG**
☎ (01484) 842370

⊚A 19th century brewpub that started brewing again in 1982. The beer is only available at the Sair Inn.

Little Valley SIBA

Unit 3, Turkey Lodge Farm, New Road, Cragg Vale, Hebden Bridge, West Yorkshire, HX7 5TT
☎ (01422) 883888 ⊕ littlevalleybrewery.co.uk

⊚Little Valley began brewing in 2005 on a 10-barrel plant. All beers are organic and vegan, and Radical Roots is licensed by the Fairtrade Foundation. Around 300 outlets are supplied. ➤◆LIVE V

Withens Pale (ABV 3.9%) PALE
Creamy, light gold-coloured, refreshing ale. Fruity hop aroma, flavoured with hints of lemon and grapefruit. Clean, bitter aftertaste.

Radical Roots (ABV 4%) SPECIALITY
Full-bodied speciality ale. Ginger predominates in the aroma and taste. It has a pleasantly powerful, fiery and spicy finish.

Cragg Bitter (ABV 4.2%) BITTER
Tawny best bitter with a creamy mouthfeel. Malt and fruit aromas move through to the palate which is followed by a bitter finish.

Dark Vale (ABV 4.5%) SPECIALITY
Dark brown speciality beer. Dark roast and fruit blend successfully with flavours of vanilla to create a smooth, mellow porter.

Hebden's Wheat (ABV 4.5%) SPECIALITY
A pale yellow, creamy wheat beer with a good balance of bitterness and fruit, a hint of sweetness but with a lasting, dry finish.

Stoodley Stout (ABV 4.8%) STOUT
Very dark brown creamy stout with a rich roast aroma and luscious fruity, chocolate, roast flavours. Well-balanced with a clean, bitter finish.

Tod's Blonde (ABV 5%) BLOND
Bright yellow, smooth golden beer with a citrus hop start and a dry finish. Fruity, with a hint of spice. Similar in style to a Belgian blonde beer.

Moor Ale (ABV 5.5%) SPECIALITY
Tawny in colour with a full-bodied taste. It has a strong malty nose and palate with hints of heather and peat-smoked malt. Well-balanced with a bitter finish.

Python IPA (ABV 6%) IPA
Amber-coloured, creamy beer with a complex bitter fruit palate subtly balanced by a malty sweetness, leading to a strongly lingering bitter aftertaste.

Lord's SIBA

Unit 15, Heath House Mill, Heath House Lane, Golcar, West Yorkshire, HD7 4JW ☎ 07976 974162
⊕ lordsbrewing.com

Established in 2015, Lord's Brewing Co is the brain child of three brothers-in-law, Ben, John and Tim. A picturesque 19th century mill houses the eight-barrel plant, large taproom and gift/bottle shop. ♦ ⬧

Hodl Ultra Pale (ABV 3.8%) PALE
To The Moon (ABV 3.9%) PALE
Expedition Blonde (ABV 4%) BLOND
Ape Mafia American IPA (ABV 4.2%) IPA
Chosen Man (ABV 4.4%)
Malamute (ABV 4.5%)
Silver Spur (ABV 4.6%)
The Bandon Car Porter (ABV 4.8%) PORTER
Mount Helix West Coast Pale (ABV 5%) PALE

Luddite

⧈ Calder Vale Hotel, Millfield Road, Horbury Junction, Wakefield, West Yorkshire, WF4 5EB
☎ (01924) 277658

Brewing began in 2019 at the Calder Vale pub in Horbury Junction. The pub was shut for five years until being reopened by a group of three former Horbury school friends, Ian Sizer, Tim Murphy and Gary Portman. The six-barrel plant brews, on average, once per week.

Magic Rock

Units 1-4, Willow Park Business Centre, Willow Lane, Huddersfield, West Yorkshire, HD1 5EB
☎ (01484) 649823 ⊕ magicrockbrewing.com

Magic Rock began brewing in 2011. The brewery is located about half a mile walk from Huddersfield town centre on an industrial estate. The site also houses a taproom and distribution centre. In 2019 Magic Rock was

bought by Lion of Australia, who in turn are owned by Kirin of Japan. The brewery was sold in 2022 to Odyssey Inns Ltd. ‼♦LIVE⬧

Hat Trick (ABV 3.7%) BITTER
Ringmaster (ABV 3.9%) GOLD
Inhaler (ABV 4.5%) GOLD
Common Grounds (ABV 5.4%) PORTER
High Wire (ABV 5.5%) IPA
Dark Arts (ABV 6%) STOUT

Mallinsons

Unit 1, Waterhouse Mill, 65-71 Lockwood Road, Huddersfield, West Yorkshire, HD1 3QU
☎ (01484) 654301 ☎ 07850 446571
⊕ drinkmallinsons.co.uk

⊛Mallinsons was originally set up in 2008 on a six-barrel plant by CAMRA members Tara Mallinson and Elaine Yendall. The company moved to new premises in 2012 with a 15-barrel plant and specialises in hop-forward and single hop beers. It has a permanent presence in numerous Huddersfield pubs. ‼♦LIVE

Wappy Nick (ABV 3.9%) BLOND
The aroma is lemony. Fruity, citrus flavours develop on the palate giving way to smooth, soft bitter aftertaste.

Marlowe (NEW)

Office: 1 Mount Pisgah, Otley, LS21 3DX

One-barrel, small-batch brewery based in Otley, West Yorkshire. Sister brewery to Chevin Brew Co and brewing at same premises. Most of beer produced will go into bottles. Thus far the interesting beer range has included a fruited saison and an imperial stout.

Meanwood

1 Sandfield View, Leeds, West Yorkshire, LS6 4EU
⊕ themeanwoodbrewery.com

⊛The Meanwood Brewery was started by brothers Baz and Graeme Phillips in 2017 and focuses on brewing keg and cask beer styles from around the world. In 2021, installation of an eight-barrel brewkit and canning line expanded production. The Terminus Tap Room & Bottle Shop opened in 2018. ⬧

Herald (ABV 3.9%) PALE
As Above, So Below (ABV 4.5%) PALE
Black Goddess (ABV 4.9%) PORTER
Arecibo Message (ABV 5.7%) PALE

Mill Valley

The Brewhouse, 589 Halifax Road, Hightown, West Yorkshire, WF15 8HQ ☎ 07565 229560
⊕ millvalleybrewery.co.uk

⊛Launched in 2016 on a three-barrel plant in Cleckheaton, the brewery relocated to Liversedge in 2019, taking over the former Partners brewery site together with its 12-barrel plant. More than 40 outlets are supplied as well as numerous beer festivals. Two brewery taps are owned, one at both the old and new brewery sites, which hold regular events. ‼♦⬧

Luddite Ale (ABV 3.8%) GOLD
Panther Ale (ABV 4%) GOLD
Yorkshire Bitter (ABV 4%) BITTER
Mill Blonde (ABV 4.2%) BLOND
Yorkshire Rose (ABV 4.2%) PALE
Black Panther (ABV 4.6%) STOUT
XTRA Fudge Stout (ABV 4.6%) SPECIALITY

Milltown SIBA

The Brewery, The Old Railway Goods Yard, Scar Lane, Milnsbridge, West Yorkshire, HD3 4PE ☎ 07946 589645 ⊕ milltownbrewing.co.uk

Milltown began brewing in 2011 using a four-barrel plant. Two pubs are owned, the Dusty Miller at Longwood, which acts as the official brewery tap, and the Traveller's Rest, Meltham. ‼♦LIVE

Spud's (ABV 3.8%) BITTER
Weaver's Bitter (ABV 3.8%) BITTER
American Pale Ale (ABV 3.9%) PALE
Platinum Blonde (ABV 4%) BLOND
Tigers Tail (ABV 4.1%) GOLD
Black Jack Porter (ABV 4.5%) PORTER

Morton Collins

▤ Star, Standbridge Lane, Sandal, West Yorkshire, WF2 7DY
☎ (01226) 728746 ☎ 07812 111960

Office: 49 Willow Garth, Durkar, Wakefield, WF4 3BX
✉ ged.morton@aol.com

Set up in 2016 by Ged Morton and Sam Collins using a 100-litre plant in Ged's garage. The brewery produces to demand but can brew every day if required. It took over the lease of the Star, Sandal, in 2016. Several of the beers are named after the nearby Nature Reserve at Wintersett. The brewery kit was upgraded to 200 litres per brew in 2017.

Nightjar

2 Richmond House, Caldene Business Park, Mytholmroyd, West Yorkshire, HX7 5QL ☎ 07412 008221 ⊕ nightjarbrew.co.uk

Nightjar Brew Co was initially established in 2011 and was rebranded in 2018. This 10-barrel brewery located in Mytholmroyd has occasional open brewery nights and supplies hundreds of free trade outlets across the UK. It combines a core range with around 15 new beers a year, in both cask and keg, and selected beers are also available in can. Beers are always available in its two brewery taps: Nightjar, Hebden Bridge, and the Exchange Craft Beer House, Bradford. ♦V

School Night (ABV 3.7%) PALE
At One With Citra (ABV 3.9%) GOLD
Naturally cloudy, pale yellow, single-hopped ale. Citrus flavours dominate the aroma and taste. This is followed by a mellow aftertaste.
Chosen (ABV 3.9%) BITTER
Come As You Are (ABV 4%) PALE
Hermit Crab of Hope (ABV 4%) PALE
Release the Pressure (ABV 4.1%) GOLD
Lost in Ikea (ABV 4.2%) PALE
Cosmonaut (ABV 4.4%) STOUT
Dark, creamy stout with roasted malt dominating the aroma and taste. A liquorice flavour develops in the dry and bitter aftertaste.
Zed's Dead (ABV 4.5%) PALE
Moloko Mocha Porter (ABV 4.8%) SPECIALITY
A rich, smooth, well-balanced mocha porter with a light coffee and chocolate aroma. Richly roasted and chocolate flavours develop on the palate but are not overpowering. Lingering mocha finish with no hoppy bitterness.
Tune In, Hop Out (ABV 5%) PALE
Not All Heroes Wear Capes (ABV 5.5%) IPA
You Had Me at Hazy (ABV 5.9%) IPA
Don't Over Think Your Socks (ABV 6.2%) IPA
Supernova (ABV 6.9%) SPECIALITY

A dark, rich, creamy, full-bodied stout with a smooth chocolatey finish.
Emotional Support Hamster (ABV 7%) IPA

Nomadic SIBA

Unit 11, Sheepscar House, 15 Sheepscar Street, Sheepscar, Leeds, West Yorkshire, LS7 1AD ☎ 07868 345228 ⊕ nomadicbeers.co.uk

Established in 2017, brewing originally started in the cellar of The Fox & Newt, Burley. Following a relocation and expansion in 2018, Nomadic Beers found a new home in Sheepscar installing an eight-barrel kit. Nomadic specialise in making modern cask beer. All beers produced are vegan-friendly and are distributed nationally. ‼☚V♦

Pale (ABV 3.8%) PALE
A refreshing pale ale, orange zest at the front supported by hops and a touch of malt too.
Strider (ABV 4.4%) BITTER
Bandit (ABV 4.8%) PALE
Stout (ABV 5.2%) STOUT

Nook SIBA

▤ Riverside, 7b Victoria Square, Holmfirth, West Yorkshire, HD9 2DN
☎ (01484) 682373 ⊕ thenookbrewhouse.co.uk

The Nook Brewhouse is built on the foundations of a previous brewhouse dating back to 1754, next to the River Ribble. Three brewery taps are supplied, two being restaurants with dishes matched to the beer, plus an on-site pub that rotates the 22 different ales. ‼♦LIVE

North SIBA

Springwell Buslingthorpe Lane, Leeds, West Yorkshire, LS7 2DF
☎ (0113) 345 3290

Office: Regents Court. 39A Harrogate Road, Leeds, LS7 3PD ⊕ northbrewing.com

Having opened in 2015, the brewery initially supplied the North Bar group of bars in and around Leeds. Expansion to 15-barrels on the original site quickly followed as the number of other outlets supplied increased. Due to substantially increased canned production, including national availability in supermarkets, further expansion was required, with the current premises opening in 2021. ‼♦♦

Session Pale (Action Against Hunger) (ABV 3.8%) PALE

Northern Monk SIBA

Unit 7, Sydenham Road, Leeds, West Yorkshire, LS11 9RU
☎ (0113) 243 6430

Holbeck: The Old Flax Store, Marshalls Mill, Holbeck, Leeds, LS11 9YJ ⊕ northernmonkbrewco.com

After using spare capacity at other breweries in 2013, a 10-barrel plant was established in 2014 in a Grade II-listed mill. In 2017 a much larger second site with canning line was opened. 2019 saw further expansion into the adjacent former Leeds Brewery site, with a new 50-hectolitre brewkit installed in 2021. The mill hosts a taproom and events space. Most production is keg but cask-conditioned beer is available. ‼♦

Eternal (ABV 4.1%) PALE

Old Spot

Manor Farm, Station Road, Cullingworth, Bradford, West Yorkshire, BD13 5HN
☎ (01535) 691144 ⊕ oldspotbrewery.co.uk

Old Spot, named after the owner's sheepdog, started brewing in 2005. The beers are available in several outlets in West Yorkshire. The acting brewery tap is the George, Cullingworth. !!♦

Light But Dark (ABV 4%) BITTER
OSB (ABV 4%) GOLD
Spot Light (ABV 4.2%) GOLD
This smooth-drinking golden ale has a slightly fruity, hoppy aroma leading to a well-balanced fruit, hop flavour with hints of pineapple, and a long, bittersweet finish.
Spot O'Bother (ABV 5.5%) PORTER

Ossett SIBA

Kings Yard, Low Mill Road, Ossett, West Yorkshire, WF5 8ND
☎ (01924) 261333 ⊕ ossett-brewery.co.uk

Ossett is an independent brewery established in 1998, located in the heart of Yorkshire. Ossett Pub Company was formed in 2003 and now consists of more than 30 sites across Yorkshire. !!☲♦⬧

Butterley (ABV 3.8%) BITTER
Yorkshire Blonde (ABV 3.9%) BLOND
Sweet beer with peachy fruity flavours and gentle bitter finish.
White Rat (ABV 4%) GOLD
Inviting citrus hops and fruit aromas last throughout. Sweet adds body and balance. The hop bitterness rises in the slightly drier finish.
Silver King (ABV 4.3%) PALE
Voodoo (ABV 5%) SPECIALITY
Excelsius (ABV 5.2%) PALE

Outgang

🏨 Kinsley Hotel, Wakefield Road, Kinsley, West Yorkshire, WF9 5EH ☎ 07747 694611
✉ thepub@sky.com

Originally established in 2011, brewing resumed in 2017 after a period of inoperation. Local outlets are supplied as are outlets further afield due to increased production. Brewing is currently suspended. ♦

Piglove

Unit 6, Cross Green Lane, Leeds, West Yorkshire, LS9 8LJ ☎ 07718 630467 ⊕ piglovebrewing.com

Piglove is a small craft brewery based in Leeds. Inspired by the heritage of craft brewing in the UK and influenced by its co-founders' Venezuelan roots, its beers are bold, fragrant, unusual and exotic. Beers are organic and vegetarian. ⬧

OMNIA (ABV 4.5%) IPA
Phantasticum Hop Healer (ABV 6.5%) SPECIALITY

Quirky

Unit 3, Ash Lane, Garforth, Leeds, West Yorkshire, LS25 2HG
☎ (0113) 286 2072 ⊕ quirkyales.com

Established in 2015, Quirky Ales brews two or three times a week on its 2.5-barrel plant. Simon Mustill and Richard Scott acquired the brewery in 2019. Aaron Getliffe is the full-time Brewer. Its on-site taproom is open every weekend from Thursday evening, with occasional live music. Most of its beers are also available in bottles, which can be bought in the taproom and at delicatessens and farm shops. ☲⬧

Porter (ABV 3.5%) PORTER
Blonde Ale (ABV 3.8%) BLOND
Two Islands (ABV 3.8%) GOLD
Bitter (ABV 4%) BITTER
Ruby (ABV 4%) BITTER
1 Hop Wonder (ABV 4.1%) GOLD
ITA (ABV 4.8%) BITTER
Hip Hop (ABV 5.5%) IPA
Classic (ABV 5.7%) MILD

Radiant (NEW)

Office: 50 Eaton Hill, Leeds, LS16 6SE

The brewery, brainchild of Stuart Hutchinson and Richard Littlewood, was launched in late 2021. Stuart started out as a home brewer before taking the leap into commercial brewing. Radiant are currently utilising spare capacity at Darkland Brewery in Boothtown, near Halifax while looking for an appropriate site in North Leeds.

Rat

🏠 Rat & Ratchet, 40 Chapel Hill, Huddersfield, West Yorkshire, HD1 3EB
☎ (01484) 542400 ✉ ratandratchet@ossett-brewery.co.uk

The Rat & Ratchet was originally established as a brewpub in 1994. Brewing ceased and it was purchased by Ossett Brewery (qv) in 2004. Brewing restarted in 2011 with a capacity of 30 barrels per week. A wide range of occasional brews with rat-themed names supplement the regular beers. ♦

Rat Attack (ABV 3.8%) BITTER
Black Rat (ABV 4.5%) PORTER
King Rat (ABV 5%) BITTER
Rat Against the Machine (ABV 7%) IPA

Revolutions SIBA

Unit B7, Whitwood Enterprise Park, Speedwell Road, Whitwood, West Yorkshire, WF10 5PX
☎ (01977) 552649 ☎ 07503 007470
⊕ revolutionsbrewing.co.uk

Revolutions began brewing in 2010. All beers are musically inspired. The Rewind 33 series of bi-monthly specials references music from 33 years ago. !!♦

Candidate US Session Pale (ABV 3.9%) PALE
Frank (ABV 4%) BITTER
Vogue (ABV 4%) BLOND
Clash Porter (ABV 4.5%) PORTER
Spanish Bombs (ABV 4.5%) SPECIALITY
Switch (ABV 4.5%) GOLD
Swoon Chocolate Fudge Milk Stout (ABV 4.5%) SPECIALITY
Marquee US IPA (ABV 5.4%) PALE

Ridgeside SIBA

Unit 24, Penraevon 2 Industrial Estate, Meanwood, Leeds, West Yorkshire, LS7 2AW ☎ 07595 380568
⊕ ridgesidebrewery.co.uk

Ridgeside began brewing in 2010 using a four-barrel plant. Regular outlets are supplied around Leeds and beers can be found across West and North Yorkshire. Cask beers are unfiltered and unfined. ♦⬧

Plato (ABV 4%) PALE

Objects in Space (ABV 4.8%) PALE
Equator (ABV 5.6%) IPA
Milky Joe (ABV 5.6%) SPECIALITY

Riverhead

▪ 2 Peel Street, Marsden, Huddersfield, West Yorkshire, HD7 6BR
☎ (01484) 841270 (pub) ⏺ ossett-brewery.co.uk

⏺Riverhead is a brewpub that opened in 1995, with an upstairs dining room. Ossett Brewing (qv) purchased the site in 2006 but runs it as a separate brewery. Many different beers are produced on a rotating basis. ‼◆

Salt

199 Bingley Road, Shipley, West Yorkshire, BD18 4DH
☎ (01274) 533848

Thamesmead: Unit 35.9 Cobalt, White Hart Triangle Estate, White Hart Avenue, Thamesmead, London, SE28 0GU ⏺ saltbeerfactory.co.uk

Housed in a Grade II-listed Edwardian tramshed, Salt is a state-of-the-art, 200-hectolitre brew plant and one of the Ossett group of independently-run breweries. The site includes a taproom and live music space. Two bars, branded as Craft Asylum, are operated. It bought the Hop Stuff brewery in Thamesmead when it was put up for sale by Molson Coors in 2021. ‼◆🥢

Saltaire SIBA

Unit 7, County Works, Dockfield Road, Shipley, West Yorkshire, BD17 7AR
☎ (01274) 594959 ⏺ saltairebrewery.com

⏺Saltaire Brewery opened in a converted gasworks by the River Aire in 2006 and has established itself as a leading independent brewer of cask ales. There is a stated emphasis on providing quality of product, whilst maintaining a steadfast commitment to an expanding range of cask and KeyKeg beers. Supplies pubs and retail outlets throughout the UK and worldwide. 🚰◆🥢

South Island (ABV 3.5%) PALE
Titus (ABV 3.9%) BITTER
Blonde (ABV 4%) BITTER
Thirst quenching and quaffable, this straw coloured beer is slightly sweet and well rounded with fruit, malt and hops in the taste and a fruity hoppy finish.
Citra (ABV 4.2%) PALE
Best (ABV 4.4%) BITTER
Amarillo (ABV 4.5%) PALE
Cascade (ABV 4.8%) PALE
Triple Choc (ABV 4.8%) SPECIALITY
A creamy, dark brown, roast, chocolate stout with a dry, bitter finish and a rich chocolate aroma.
Unity (ABV 6%) IPA

Shadow

98 Boroughgate, Otley, West Yorkshire, LS21 1AE
☎ 07792 690536 ⏺ shadowbrewing.co.uk

Established in 2019 by Ian Shutt, one of the founders of the Chevin Brewing Collective. He began with a one-barrel plant in his garage and in 2021 set up the kit in a taproom in Otley. Brewing is currently suspended and beers are contract brewed. 🥢

Small World SIBA

Unit 10, Barncliffe Business Park, Near Bank, Shelley, West Yorkshire, HD8 8LU
☎ (01484) 602805 ⏺ smallworldbeers.com

⏺The brewery is situated in the former Barncliffe Mill near the picturesque village of Shelley. The beers are brewed on a 20-barrel Moeschle plant using spring water from an on-site bore hole. SALSA + Beer approved. ‼◆

Barncliffe Bitter (ABV 3.7%) BITTER
A traditional Yorkshire bitter. Malty and fruity with a long bitter farewell.
Long Moor Pale (ABV 3.9%) PALE
It's Never One (ABV 4%) GOLD
Port Nelson (ABV 4%) PALE
Spike's Gold (ABV 4.4%) GOLD
Thunderbridge Stout (ABV 5.2%) STOUT
Twin Falls (ABV 5.2%) PALE

Stod Fold

Stod Fold Farm, Hays Lane, Halifax, West Yorkshire, HX2 8XL ☎ 07745 967740 / 07568 487182 ⏺ stodfoldbrewing.com

⏺The 10-barrel Stod Fold Brewery is located on the edge of the moors in a renovated farm building. It supplies around 300 free trade outlets each year, mainly in Yorkshire, but occasionally distributes out of the region via nationwide brewing partners on the swaps scheme. Beers can always be sampled at the Stod Fold Brewery Tap at Dean Clough Mills, Halifax. ◆V

Gold (ABV 3.8%) PALE
A refreshing, light, malty, fruity session ale with a smooth, hoppy aftertaste.
West APA (ABV 4%) BLOND
A golden-coloured, session blond with a fruity and hoppy aroma. Light, refreshing citrus flavours develop in the mouth leading to a long crisp finale.
Blonde+ (ABV 4.3%) BLOND
A fruity beer with a lingering dry finish. The main hop changes monthly and the fruit favour, therefore, can be citrusy or tropical.
Dark Porter (ABV 4.8%) PORTER
Easy-drinking, well-balanced, dark brown porter. Smooth and mellow with roast to the fore.
Dr Harris (ABV 5.7%) IPA
An amber-coloured, traditional IPA with earthy/floral English hop flavours.

Stubbee SIBA

22 Harry Street, Dudley Hill, Bradford, BD4 9PH
☎ (01274) 933444 ⏺ stubbee.co

⊠ Launched as Salamander Brewery in 2000 the 40-barrel brewery was purchased by the McKenna Group and renamed Stubbee in 2021. Founder, Daniel Gent, remains head brewer and its cask ales retain the Salamander imagery on the pump clips. ‼◆🥢

Blondie (ABV 4%) BITTER
Mudpuppy (ABV 4.2%) BITTER
A well-balanced, copper-coloured best bitter with a fruity, hoppy nose and a bitter finish.
Golden Salamander (ABV 4.3%) GOLD
Citrus hops characterise the aroma and taste of this golden premium bitter, which has malt undertones throughout. The aftertaste is dry, hoppy and bitter.
Spectre Stout (ABV 4.5%) STOUT
Rich roast malts dominate the smooth coffee and chocolate flavour. Nicely-balanced. A dry, roast, bitter finish develops over time.
Bright Black Porter (ABV 4.8%) PORTER

Sunbeam

52 Fernbank Road, Leeds, West Yorkshire, LS13 1BU
☎ 07772 002437 ⏺ sunbeamales.co.uk

⊚Sunbeam Ales was established in a house in Leeds in 2009, with commercial brewing beginning in 2011. Since moving, capacity has increased to a two-barrel plant based in a garage. The core range of ales (available in West and North Yorkshire at present) is brewed on rotation up to twice weekly, with occasional brews every six weeks or so. ♦

Bottoms Up (ABV 3.7%) PALE
Polka Hop (ABV 3.8%) PALE
Sun Beamer (ABV 3.8%) PALE
Bright Day (ABV 4.2%) PALE
Rain Stops Play (ABV 4.5%) BITTER

Tarn 51

🍺 **Robin Hood, 10 Church Road, Altofts, Normanton, West Yorkshire, WF6 2NJ**
☎ **(01924) 892911** ✉ **realale@tarn51brewing.co.uk**

Tarn 51 uses a three-barrel plant situated at the Robin Hood in Altofts. Expansion is planned. Five other outlets are supplied.

Tartarus

Horsforth, West Yorkshire, LS18 4NR

Office: New Road Side, Horsforth, LS18 4NR
⊕ **tartarusbeers.co.uk**

Nanobrewery based in Horsforth, Leeds, launched commercially in 2020. Producing small-batch, craft beers on a 100-litre kit.

Timothy Taylor SIBA IFBB

Knowle Spring Brewery, Keighley, West Yorkshire, BD21 1AW
☎ **(01535) 603139** ⊕ **timothy-taylor.co.uk**

⊚An independent, family-owned company established in 1858, it has occupied the Knowle Spring site since 1863. Pennine spring water is used to brew its award-winning ales on both the established main plant and a 10-barrel plant used to develop new beers, including occasional specials. 19 pubs are operated.

Dark Mild (ABV 3.5%) MILD
Malt and caramel dominate throughout in this sweetish beer with background hop and fruit notes.
Golden Best (ABV 3.5%) MILD
Refreshing, amber-coloured, traditional Pennine mild. A delicate fruit hoppy aroma leads to a fruity taste with underlying hops and malt. Fruity finish.
Boltmaker/ Best Bitter (ABV 4%) BITTER
Tawny bitter combining, hops fruit and biscuity malt. Lingering, increasingly bitter aftertaste. Formerly and sometimes still sold as Best Bitter.
Knowle Spring (ABV 4.2%) BLOND
Tropical fruitiness on the nose leads to a bitter sweetness that carries through into the finish
Landlord (ABV 4.3%) BITTER
Moreish bitter combining citrus peel aromas, malt and grassy hops with marmalade sweetness and a long bitter finish.
Landlord Dark (ABV 4.3%) OLD
A black beer with red highlights topped by a coffee-coloured head. Burnt caramel on the nose, dark fruits with caramel in the taste, leading to a light bitter finish.

Three Fiends

Brookfield Farm, 148 Mill Moor Road, Meltham, West Yorkshire, HD9 5LN ☎ **07810 370430**
⊕ **threefiends.co.uk**

The brewery was set up by three friends in 2015 and is based in one of the outbuildings at Brookfield Farm. The original two-barrel kit was upgraded to an eight-barrel plant in 2019. Beers are available around Huddersfield and at CAMRA beer festivals. The Fourth Fiend, Meltham, is the brewery tap.

Stelfox (ABV 4%) IPA
Bad Uncle Barry (ABV 4.2%) PALE
Bandito (ABV 4.5%) PALE
Fudge Unit (ABV 4.8%) STOUT
Super Sharp Shooter (ABV 5.2%) IPA
Dark Side (ABV 5.3%) PALE
Punch Drunk (ABV 5.5%) PALE
Voodoo (ABV 6%) SPECIALITY
Panic Attack Espresso Stout (ABV 6.8%) SPECIALITY
Stelfoxed (ABV 7.5%) IPA

Tigertops SIBA

22 Oakes Street, Flanshaw, Wakefield, West Yorkshire, WF2 9LN
☎ **(01229) 716238** ☎ **07951 812986**
✉ **tigertopsbrewery@hotmail.com**

⊚Tigertops was established in 1995 by Stuart Johnson and his wife Lynda who, as well as owning the brewery, ran the Foxfield brewpub in Cumbria (qv). After retiring, the brewery is now run on their behalf by Barry Smith, supplying five regular outlets. ♦

Cass 2CV (ABV 4.6%) BITTER

Truth Hurts

c/o MSS City Mills, Peel Street, Morley, Leeds, West Yorkshire, LS27 8QL
☎ **(0113) 238 0382** ☎ **07950 567341**
✉ **chris@truthhurts.co.uk**

⊚Established in 2016 as Blue Square Brewery and rebranded as Truth Hurts in 2019. It produces one-off brews from its four-barrel plant in a split-level building that is part of a mill complex. ☛♦

Vocation SIBA

Unit 8, Craggs Country Business Park, New Road, Cragg Vale, Hebden Bridge, West Yorkshire, HX7 5TT
☎ **(01422) 410810** ⊕ **vocationbrewery.com**

⊚Vocation began brewing in 2015 and is located high above Hebden Bridge. Brewing capacity continues to increase at pace as it expands UK and Worldwide markets with a wide range of beer styles. This includes barrel-aged and a single hop series, as well as collaboration brews. It has local bars in Hebden Bridge called Vocation & Co, and Assembly Underground in Leeds. ☛♦

Bread & Butter (ABV 3.9%) GOLD
A feast of floral hops with citrus aroma and taste. Robust bitter aftertaste.
Heart & Soul (ABV 4.4%) GOLD
A golden ale with a strong citrus aroma. Hops dominate taste and aftertaste.
Pride & Joy (ABV 4.8%) PALE
Flavoursome IPA packed with citrus hoppiness. A hint of sweetness gives way to a mellow aftertaste.
Life & Death (ABV 5.5%) IPA
Naughty & Nice (ABV 5.9%) STOUT
A rich and smooth velvety stout. A combination of chocolate and roasted barley develops on the palate. The finish is bittersweet.

Wetherby

Beer Station, York Road Industrial Estate, York Road, Wetherby, West Yorkshire, LS22 7SU

☎ (01937) 584637 ☎ 07725 850654

⊕ wetherbybrewco.com

⊛ Wetherby Brew Co was established in 2017, and is a short walk from the town centre. It is independently-owned and operated from a three-barrel plant. ▣ ♦ ◆

Wharfedale SIBA

Back Barn, 16 Church Street, Ilkley, West Yorkshire, LS29 9DS

☎ (01943) 609587 ⊕ wharfedalebrewery.com

⊛ Wharfedale began brewing in 2012 using spare capacity at Five Towns brewery in Wakefield. Brewing moved to Ilkley in 2013 using a 2.5-barrel plant located at the rear of the Flying Duck pub, creating Wharfedale's first brewpub.

Wilde Child

Unit 5, Armley Road, Leeds, West Yorkshire, LS12 2DR

☎ (0113) 244 6549 ☎ 07908 419028

⊕ wildechildbrewing.co.uk

Established as one of the smallest breweries in Leeds in 2016, Keir McAllister-Wilde took his operation from a one-barrel plant in a garage to a 10-barrel operation in a 2,000 sq ft unit, within two years. There are a large number of different ales in Wilde Child's portfolio, all are unfined. As well as distributing nationwide, beers are being sent to Holland, Spain and Finland. ◆

Opaque Reality (ABV 5.9%) SPECIALITY

Wishbone

2a Worth Bridge Industrial Estate, Chesham Street, Keighley, West Yorkshire, BD21 4NS

☎ (01535) 600412 ☎ 07867 419445

⊕ wishbonebrewery.co.uk

Established in 2015 and run by a husband and wife team with many years experience in the brewing industry. Beers are brewed on a modern 10-barrel plant. GF ◆

Blonde (ABV 3.6%) BLOND
A hoppy golden ale with a strong citrus character. A bitter hoppy and slightly astringent finish.

Flux (ABV 4.1%) PALE
Drover (ABV 4.2%) GOLD
Tiller Pin (ABV 4.2%) GOLD
Abyss (ABV 4.3%) STOUT
Caramel and coffee bean aroma in a stout of chocolate and liquorice leading into a malty finish.

Gumption (ABV 4.5%) BITTER
Well-balanced, amber best bitter. Look for hints of dried fruit, biscuit and nuts, underpinned by dry hoppiness, leading to a bitter finish.

Zapato

Unit 1a, Holme Mills, West Slaithwaite Road, Marsden, Huddersfield, West Yorkshire, HD7 6LS

☎ (01484) 841201 ☎ 07788 513432

⊕ zapatobrewery.co.uk

Small company, established in 2016, that gypsy brewed in the Leeds and Manchester areas prior to establishing a permanent home in Marsden. It produces innovative beers based on traditional European styles. Collaboration brews are a staple part of its output. ▣ ◆

Pale (ABV 3.5%) GOLD
A light-bodied, refreshing golden ale. It has a hoppy aroma, flavours of citrus fruits develop on the palate, and it slips down easily.

Wuthering Heights Inn, Stanbury (Photo: Dermot Kennedy)

JOIN THE CAMPAIGN

CAMRA, the Campaign for Real Ale, is an independent, not-for-profit, volunteer-led consumer group. We promote good-quality real ale and pubs, as well as lobbying government to champion drinkers' rights and protect local pubs as centres of community life.

CAMRA has over 155,000 members from all ages and backgrounds, brought together by a common belief in the issues that CAMRA deals with, and their love of good-quality British beer.

From just £28.50† a year, you can join CAMRA and enjoy the following benefits:

- A **welcome pack**, including membership card, to help you make the most of your membership

- Access to award-winning, quarterly **BEER magazine** and **What's Brewing** online news

- £30* worth of **CAMRA real ale** ** vouchers

- Access to the **Real Ale Discount Scheme**, where you receive discounts on pints at over 3,500 participating pubs nationwide

- **Learn & Discover** online resources to help you discover more about beer and brewing

- **Free or reduced entry** to CAMRA beer festivals

- The opportunity to **campaign for great real ale, cider and perry**, and to save pubs under threat from closure

- **Discounts on CAMRA books** including our best-selling *Good Beer Guide*

- Social activities in your local area and **exclusive member discounts online**

Whether you're a dedicated campaigner, a beer enthusiast looking to learn more about beer, or you just love beer and pubs, CAMRA membership is for you. Join us today!

Join the campaign at
camra.org.uk/join

North West

As well as the dramatic landscapes of the Lake District, the North West boasts some incredible scenery in the Pennine foothills of the Trough of Bowland – an Area of Outstanding Natural Beauty. It is a relatively unknown gem outside this area. While you are there, keep an eye out for a good Pennine mild. Rare as hen's teeth, this sub-4% ABV pale mild with biscuity flavours and a grain-laden finish is a real treat.

Furness straddles the southern part of the Lakes National Park and the South Lakes Peninsulas. It boasts a unique character and many excellent breweries, including Cumbria Ales. Further north in Cumbria, Carlisle and Penrith lure in beer lovers with breweries like Great Corby and Hesket Newmarket alongside a thriving micropub scene.

Manchester is at the heart of the region and has a lot to offer the most ardent beer lover, including brewery taprooms at Beer Nouveau, Cloudwater and Track to name just three. These relative newcomers share their home with a notable number of traditional family brewers: Holts, Hydes, Robinsons and JW Lees.

Cider lovers will also find a warm welcome in Manchester. Tap into the monthly Manchester Cider Club to find out what's what in the cider world and pick up a few bottles of the best real ciders in the UK from the Cat in the Glass bottle shop.

Liverpool must also take its place in dispatches, with the Roscoe Head having a formidable reputation – it is the only pub in the region to have featured in every edition of the Good Beer Guide. The Ship & Mitre is also worth a look, with a range of around 200 beers on draught and in bottles. Finally, Peter Kavanagh's is well known as the oldest and one of the quirkiest pubs in the city. It is a tied pub but always has a good selection of well-kept beers.

Swerve off the beaten track to towns like Chorley, where the micropub boom has created a vibrant and quirky pub scene with a great range of beers on offer. Southport too offers a delicious mix of traditional public houses, micropubs and craft beer bars that provide enough variety to cater for all comers.

The Manchester Beer & Cider Festival is hailed as one of the finest in the country but has been scuppered by Covid in recent years. Fingers crossed that it will return in 2023.

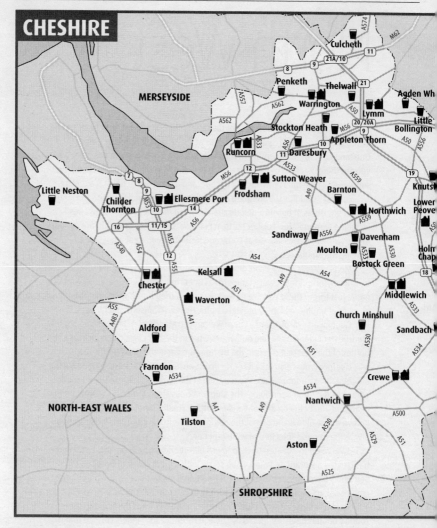

CHESHIRE

MERSEYSIDE

Culcheth
Penketh
Thelwall
Agden Wh
Warrington
Lymm
Stockton Heath
Little Bollington
Runcorn
Appleton Thorn
Daresbury
Sutton Weaver
Barnton
Knuts
Frodsham
Little Neston
Northwich
Lower Peove
Childer Thornton
Ellesmere Port
Davenham
Sandiway
Holm Chap
Moulton
Bostock Green
Kelsall
Chester
Middlewich
Waverton
Church Minshull
Aldford
Sandbach
Farndon
Crewe
NORTH-EAST WALES
Nantwich
Tilston
Aston
SHROPSHIRE

Agden Wharf

Barn Owl

Warrington Lane, WA13 0SW (on Bridgewater Canal, off A56)

☎ (01925) 752020 ● thebarnowlinn.co.uk

Moorhouse's White Witch; Wainwright; 2 changing beers (sourced locally; often Moorhouse's, Pictish, Tatton) Ⓗ

The Barn Owl sits on the banks of the Bridgewater Canal with pleasant views over rolling Cheshire countryside, especially from the heated conservatory and canalside patio – the ideal place to relax in summer. Freshly-cooked food is deservedly popular and includes a good-value menu for the over 60's. Ales are sourced mainly from independent breweries and include local options. Check out the wood carvings in front of the pub.
ざ❀ⓘ&P❀ ♠

Aldford

Grosvenor Arms Ⓛ

Chester Road, CH3 6HJ (on B5130)

☎ (01244) 620228 ● grosvenorarms-aldford.co.uk

Timothy Taylor Landlord; Weetwood Eastgate; house beer (by Phoenix); 4 changing beers (sourced nationally) Ⓗ

A spacious, stylish and unashamedly upmarket pub. Full of character, it is multi-roomed with a pleasant garden room opening on to a terrace and garden leading on to the village green. Inside, the decor is modern-traditional with lots of bare wood, bookcases, pictures and chalkboards. Four changing beers, which occasionally include a mild, complement the house beer brewed by Phoenix, plus beers from Weetwood and Timothy Taylor. High-quality food from an imaginative menu is popular and served all day. Q❀❀ⓘ&♣P➩(5)❀ ♠

Appleton Thorn

Appleton Thorn Village Hall

Stretton Road, WA4 4RT

☎ (01925) 261187 ● appletonthornvillagehall.co.uk

7 changing beers (sourced nationally; often 4Ts, Facer's, Merlin) Ⓗ

At the hub of the community and a CAMRA National Club of the Year more than once, the Hall has a sizeable function room and quieter lounge area. Real ales are

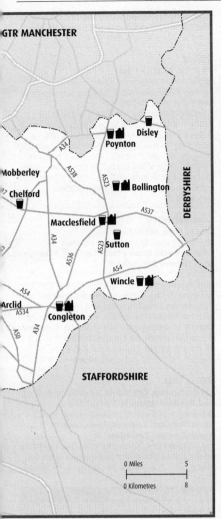

GTR MANCHESTER

Mobberley

Chelford

Disley
Poynton

Bollington

Macclesfield

Sutton

Wincle

Arclid

Congleton

DERBYSHIRE

STAFFORDSHIRE

0 Miles 5

0 Kilometres 8

mainly from independent breweries, with many from Cheshire and North Wales, and can be served in third-pint paddles. There is also a choice of real ciders and perries. Show a CAMRA card for admission – a small fee may be payable. Q✿❀❧♣♠P♿☂(Cat8,Cat7)❁☀

Aston

Bhurtpore 🅻

Wrenbury Road, CW5 8DQ (on Wrenbury Rd, just off A530)
☎ (01270) 780917 ⊕ bhurtpore.co.uk
11 changing beers (sourced nationally) Ⓗ
Winner of numerous CAMRA awards, a veritable cornucopia of real ale choices awaits the regular or casual visitor to this welcoming family-run village inn. Now in its 30th year of consecutive entry in the Guide, the pub also offers a wide range of freshly prepared, mainly locally sourced food. Curries are a speciality, ranging from korma to the Bhurtpore 'extra'. Local Wrenbury real cider is regularly available. A regular meeting place for the Vintage Japanese Motorcycle Club and the Vintage Sports Car Club. Q✿❀◑♣♠Å♠P♿(72)❁☀

Barnton

Barnton Cricket Club 🅻

Broomsedge, Townfield Lane, CW8 4QL (200yds from A533, down a narrow drive to left of Barnton Community Primary School)
☎ (01606) 77702 ⊕ barntoncc.co.uk
Sharp's Doom Bar; 3 changing beers (sourced nationally) Ⓗ
The club is arranged into two distinct rooms – the large function room (proudly displaying an extensive range of CAMRA awards above the bar), where Sky and BT Sports are shown on a projected screen, and the more intimate members' lounge. The patio overlooks the cricket field. A popular beer festival is held in summer. Squash, crown green bowls, darts and dominoes are all played here. Show your CAMRA membership card for admission. Local CAMRA Club of the Year 2022. ✿❀◑♿❧♠P♿(Cat9,4)☀

Bollington

Cotton Tree ✅

3-5 Ingersley Road, SK10 5RE
Timothy Taylor Landlord; 5 changing beers (sourced nationally) Ⓗ
A friendly, family-run, wet-led pub, this stone-built corner terrace building is warmed by a roaring fire in winter. Situated opposite the bus terminus, it features local transport-themed memorabilia. Six real ales are served plus a wide choice of ciders. Apart from occasional live bands and major sporting events there is no music or TV, just good conversation. Outside is a secluded beer garden. This traditional back-street local prefers cash. ✿❀♣♠♿❁☀

Poachers Inn 🅻

95 Ingersley Road, SK10 5RE
☎ (01625) 572086 ⊕ thepoachers.org
Beartown Glacier; Storm Beauforts Ale; Weetwood Old Dog; 3 changing beers (sourced locally) Ⓗ
Family-run community free house near the Gritstone Trail, with a coal fire in winter and a suntrap garden for the summer. An enthusiastic supporter of local breweries, it offers three rotating guests, often including a dark beer, especially in winter. Real cider is also on handpump and world beers in bottles and cans. Well-regarded, good-value, home-prepared food features locally sourced ingredients. Events include Wednesday pie night and a quiz for local charities on the second and last Sunday of the month. ✿❀◑♠P♿❁☀

Vale Inn 🅻

29-31 Adlington Road, SK10 5JT
☎ (01625) 575147 ⊕ valeinn.co.uk
Bollington White Nancy, Long Hop, Best, Oat Mill Stout; 2 changing beers (sourced locally; often Bollington) Ⓗ
The Vale is a mid-terrace pub with a single open-plan room and a cosy corner featuring a coal fire. The Bollington Brewing tap, it offers an ever-changing choice of six real ales plus two guest ciders. Bollington beers are also available to take away. Excellent home-cooked food is served. The separate beer garden provides an ideal spot for watching cricket on the local recreation ground. A convenient watering-hole for visitors to the Macclesfield Canal and Middlewood Way. ✿❀◑♣♠P♿❁☀

Bostock Green

Hayhurst Arms 🅻

London Road, CW10 9JP (off A533 Bostock Rd)
☎ (01606) 541810

House beer (by St Austell); 4 changing beers (sourced locally) ⓗ

The original building was constructed in 1845 as the Reading Rooms, before operating as Bostock Green Social Club. It later became the Hayhurst Arms, named after the France-Hayhurst family who lived in nearby Bostock Hall. The focus now is on quality food from a varied menu, with spacious wood-beamed dining areas plus smaller nooks and open fires. A private dining room is available. There is plenty of seating outside on the terrace. Q✿⌂❀◐⅁♿♣P✿☀

Chelford

Egerton Arms Ⓛ

Knutsford Road, SK11 9BB

☎ (01625) 861366 ⊕ chelfordegertonarms.co.uk

House beer (by Mobberley); 2 changing beers (sourced locally; often Tatton) ⓗ

Large single-roomed pub with a long history dating back to the 15th century when it served as stables. Table candles and a real fire provide a cosy atmosphere in winter, while the garden can be enjoyed in summer. Popular with diners, there is plenty to interest the casual imbiber with two house beers from Mobberley and two guest ales, usually from local brewers such as Tatton. On weekdays food service may finish early if the pub is quiet. ✿❀◐⅁♿≠(Cheshire)♣♠P➡(88)✿☀

Chester

Artichoke Ⓛ

The Steam Mill, Steam Mill Street, CH3 5AN (canalside)

☎ (01244) 329229 ⊕ artichokechester.co.uk

4 changing beers (sourced regionally; often Tatton, Vocation) ⓗ

Canalside bar and bistro on the ground floor of the Steam Mill. The rear space is given over to dining while the front bar features bare brick and wood floors. There are four changing beers from smaller breweries, both local and further afield, together with a range of keg beers. Food includes pizza deals on Monday and roasts on Sunday. Families are welcome until 7pm. There are tables outside alongside the canal. A small shop offers beer and food takeaways. ✿❀◐⅁♿≠➡✿☀

Bluestone

117 Christleton Road, CH3 5UQ (on main A41 route out of Chester)

☎ (01244) 738149 ⊕ bluestonebar.co.uk

3 changing beers (sourced nationally) ⓗ

New bar located in a parade of shops in the Boughton area of Chester. Inside there is a mix of wooden topped tables with either high stools or low-level upholstered benches. Three handpumps provide a choice of beers from local breweries and some further afield. Four real ciders and a varied selection of keg and bottled beers are also usually available. Children are welcome until 7pm. There is some pavement seating directly in front of the bar. Parking is limited. ✿♠➡✿☀

Cavern of the Curious Gnome

61 Bridge Street Row East, CH1 1NW

⊕ thecavernofthecuriousgnome.co.uk

4 changing beers (sourced nationally) ⓗ

Belgian-themed bar located on Chester's famous Rows. Enter via Paysan wine bar, then ascend the steps up to the Cavern of the Curious Gnome, where a large, colourful papier-mache gnome gazes down on proceedings. Red and white spotted toadstool seats plus tables with bench seating catch the eye, with more quirkiness to be found in the decor. Four handpumps

serve changing cask ales from all over the UK. Belgian offerings include lambics, gueuzes, Trappist ales plus Duvel served on draught. ✿◐⅁➡✿☀

Cellar

19-21 City Road, CH1 3AE

☎ (01244) 318950 ⊕ thecellarchester.co.uk

Timothy Taylor Landlord; 5 changing beers (sourced nationally; often Marble) ⓗ

Friendly street-level bar – the name relates to the function room in the cellar below. The bar is deservedly renowned for its excellent selection of cask ales – a regular beer such as Taylor Landlord is complemented by five guest ales and three real ciders. There is also an extensive range of keg and bottled beers from around the world. Sport features on three large TV screens. Food includes pizzas and meat and cheese platters. ≠♣♠➡✿☀

Cornerhouse

4-8 City Road, CH1 3AE

☎ (01244) 347518 ⊕ cornerhousechester.com

Salopian Oracle; Timothy Taylor Landlord; 2 changing beers (sourced nationally) ⓗ

Situated in Chester's thriving Canal Quarter, this attractive candlelit mock-Tudor building features lots of bare brick and wood flooring. It offers two regular beers and two changing ales – usually one dark and one pale – plus an extensive bottled beer selection. Live music is hosted Thursday to Saturday and a quiz on Sunday. There is a free-to-hire function room upstairs. Outdoor seating is at the front of the pub. Food is of the platter variety (cheeses and meats) plus snacks. ✿◐⅁≠♣➡✿☀

Deva Tap

121 Brook Street, CH1 3DU (at city end of Hoole Bridge close to railway station)

☎ (01244) 314440

Ossett White Rat; 3 changing beers (sourced regionally; often Thornbridge) ⓗ

The Deva Tap's long, narrow interior is divided into three areas – a small seating area by the entrance, a larger seating space in the middle and the bar at the far end.

REAL ALE BREWERIES

4Ts Warrington
Beartown Congleton
Blueball ♠ Runcorn
Bollington Bollington
Brewhouse & Kitchen 🍺 Chester
Chapter ♠ Sutton Weaver
Coach House Warrington
Coastal ♠ Crewe (brewing suspended)
Four Priests Middlewich (NEW)
Happy Valley 🍺 Macclesfield
Hush ♠ Northwich
Lymm Lymm
Manning Congleton
Merlin Arclid
Mobberley Lower Peover
Norton Runcorn
Oaks Ellesmere Port
Pied Bull 🍺 Chester
Poynton 🍺 Poynton
RedWillow Macclesfield
Spitting Feathers Waverton
Storm Macclesfield
Tatton Knutsford
Tom's Tap ♠ Crewe
Twisted Wheel ♠ Warrington
Weetwood Kelsall
Wincle ♠ Wincle

The regular White Rat beer is complemented by two changing guests. Four ciders and up to 10 keg beers are also available. There is outside seating in a small courtyard. Food is served all week including meal deals. The pub is convenient for the railway station.
🌳🏚🍽🎲♿⇄🍴🚪🚃🌟🛜

Old Harkers Arms 🅛

1 Russell Street, CH3 5AL (down steps off City Rd to canal towpath)
☎ (01244) 344525
Weetwood Cheshire Cat, Eastgate; house beer (by Phoenix); 6 changing beers (sourced nationally) Ⓗ
Upmarket pub converted from the ground floor of a former Victorian canalside warehouse. Timber flooring, traditional wooden furniture and cast iron pillars provide an insight to its history. Blackboards list real ales with tasting notes. Four regular and up to five guest ales provide a good range of styles. Up to four ciders and perries are served from the cellar. Food is available all day (booking recommended for weekends). Outside seating is alongside the canal. Q🌳🏚🍽♿⇄🍴🌟🛜

Olde Cottage 🍷 ⊘

34-36 Brook Street, CH1 3DZ
☎ (01244) 324065 ⊕ oldecottagechester.co.uk
Otter Bitter; 3 changing beers (sourced nationally; often Merlin, Wye Valley) Ⓗ
Welcoming and traditional community local on the popular eating and drinking Brook Street, between the city centre and railway station. To the left is the games room with pool, darts and a bagatelle table (rarely seen outside Chester). The main bar has another dartboard, a small TV and a real fire for the colder weather. The regular Otter Bitter is supplemented by three guests, one free of tie. Various loyalty and discount schemes are offered. 🏚⇄🚪🚃🌟🛜

Telford's Warehouse 🅛

Canal Basin, Tower Wharf, CH1 4EZ (just off the city walls)
☎ (01244) 390090 ⊕ telfordswarehousechester.com
Salopian Oracle; Weetwood Cheshire Cat; 2 changing beers (sourced nationally) Ⓗ
Converted warehouse with a large glass frontage overlooking the Shropshire Union Canal basin. Some walls retain original features and are adorned with interesting industrial artefacts. Up to six changing beers are available, usually from microbreweries. The pub is a thriving live music venue, charging admission on some evenings after 9pm. Good-quality food is served, and the upstairs restaurant can be hired for private functions. Outside seating is popular in good weather.
🌳🏚🍽🍴🚪🚃(1A)🌟🛜

Childer Thornton

Halfway House

New Chester Road, CH66 1QN (on A41 close to M53 jct 5)
☎ (0151) 339 2202
4 changing beers (sourced nationally; often Weetwood) Ⓗ
Friendly, traditional former coaching inn dating from the 1770s, based at the midpoint between Chester and New Ferry. Note the old prints of the pub and surrounds on the walls. The building retains much of its original character, with several drinking areas offering smart, comfortable seating. A community feel is evident, with darts and dominoes teams plus a golf society. The pub can be busy when sporting events are on TV. Quiz night is Thursday.
🏚♿♣🚪🚃(1,X1)🌟🛜

Church Minshull

Badger 🅛 ⊘

Cross Lane, CW5 6DY (beside St Bartholomew's Church)
☎ (01270) 522348 ⊕ badgerinn.co.uk
House beer (by Tatton); 3 changing beers (sourced locally; often Mobberley, Weetwood) Ⓗ
An 18th-century village inn, sympathetically refurbished and extended in 2011. Food is a main focus of the pub, with full meals and bar snacks available all day, served in two light and airy dining rooms. However, the central bar and cosy room off it, with real fires, ensure there is a welcoming pub atmosphere in which to enjoy a convivial pint of local Cheshire beer. Outside is a sunny patio and garden. Accommodation comprises five comfortable bedrooms. 🌳🏚🛏🍽♿♣🅿🚪(31,31W)🌟🛜

Congleton

BarleyHops

29 High Street, CW12 1BG
☎ (01260) 295247 ⊕ barleyhops.co.uk
House beer (by Thirst Class); 3 changing beers (sourced nationally) Ⓗ
A regular entry in this Guide in its previous micropub location, this popular beer café reopened in 2021 in a former card shop in the centre of town. The card shop is remembered in the regular beer from Thirst Class, Not Just Cards. Three further rotating beers always include something interesting, usually a dark beer among them. The cask offering is complemented by a range of keg lines, cans and bottles. The bar gets busy on weekend evenings, and live music features on occasion.
🌳🍴♣🚪🚃🌟🛜

Beartown Tap 🅛

18 Willow Street, CW12 1RL
☎ (01260) 270775
Beartown Kodiak, Skinful; 4 changing beers (sourced locally; often Beartown, Manning) Ⓗ
Established in 1999, this is the flagship pub for the local Beartown Brewery and a winner of multiple local and regional CAMRA awards. At least five real ales are always available. The traditional, opened-out pub layout has several separate areas. There is an upstairs function room that can be booked for meetings, and is also home to a dartboard. The secluded outdoor beer terrace hosts occasional live music. A community pub for conversation, games and weekly quiz, pizza and street food nights.
🌳🏚🍴♣🚪(92)🌟

Queens Head

Park Lane, CW12 3DE
☎ (01260) 272546
Greene King Abbot; Titanic Plum Porter; 4 changing beers (sourced regionally) Ⓗ
Independent free house next to the railway station and by bridge 75 on the Macclesfield Canal. This pub faced closure a few years ago, but its popularity won the day and new owners took it on after a local campaign. The focus is now more on meals and it offers good-quality food. Guest beers are generally from local and regional breweries. There is plenty of seating outside.
🌳🏚🍽🍴⇄♣🚪(94)🌟🛜

Crewe

Borough Arms 🍷 🅛

33 Earle Street, CW1 2BG (on Earle St railway bridge, entrance up steps in adjoining Thomas St)
10 changing beers (sourced nationally; often Fyne, Oakham, Salopian) Ⓗ

Multi award-winning freehold premises with 10 ever-changing guest ales including at least one porter or stout. Draught cider, a good continental bottle range and many free flow fonts provide more choice. Upstairs, there are three distinct seating areas. The ceiling is adorned with pumpclips, the walls display beer related items. Downstairs the brew kit has gone, allowing more seating. Conservatory doors lead to a spacious walled beer garden and smoking area with bench tables. Local CAMRA Pub of the Year 2022 and one of the 50 years of CAMRA Golden award winners. Q✿⌂❀♣⌒P🚃(8)🐾

Crewe Dog 🅛

Unit L, Market Hall, 27 Earle Street, CW1 2BL (inside Crewe Market Hall, jct Hill St/Earle St) ⊕ salty-dog.co.uk/the-crewe-dog

Tatton Blonde, Gold; 2 changing beers (sourced regionally) Ⓗ

The Crewe Dog is within the recently refurbished Crewe Market Hall and shares its location with various food and other retail outlets. Four handpumps dispense two beers from Tatton Brewing plus two regional guests. An extensive range of craft ales complements the real ales. Thursday quiz night and occasional live music on the stage are popular. The seating is shared between the other outlets within the hall. ✿⊕&♣🚃(8)🐾

Hops 🅛

Prince Albert Street, CW1 2DF (opp Lifestyle Centre at S end of Prince Albert St)

☎ (01270) 211100 ⊕ hopsbelgianbar.co.uk

5 changing beers (sourced nationally; often Mobberley, Salopian, Thornbridge) Ⓗ

A family-run bar with a friendly welcome for its wide clientele (and their dogs). It has a large single room with the bar on the ground floor and further seating in an area upstairs. Styled after a Belgian café-bar, it offers a fabulous choice of bottled Belgian beers to complement the range of real and craft ales and ciders. The useful Hopt app replaces the physical menu to place your order. A European-style sun terrace is at the front. Q✿⌂&♣🚃🐾🛜

Culcheth

Liberty's Gin Bar 🅛

31-33 Common Lane, WA3 4EW

☎ (01925) 767029

House beer (by Merlin); 2 changing beers (sourced nationally; often Merlin, Wainwright) Ⓗ

The enthusiastic landlord takes his real ale very seriously, with three beers on offer, often from Merlins Micro Brewery and other LocAle suppliers. The house beer is brewed by Merlin. Sky Sports and BT Sports are shown on four screens in the main bar. A collection of more than 220 gins is also served. The first-floor function room has a separate bar and capacity for up to 200 people. ✿⌂&♣🚃🐾🛜

Daresbury

Ring o' Bells 🅛 ✅

Chester Road, WA4 4AJ (just off A56 in centre of village)

☎ (01925) 740256

Greene King IPA; 4 changing beers (sourced locally; often Weetwood) Ⓗ

Once the village courthouse, this 19th-century pub retains many of its original features, including a listed horse trough. Although food oriented, this LocAle accredited Chef & Brewer pub has five handpumps serving beers mainly from the Weetwood range. Lewis Carroll (who was born nearby and whose father was the

curate of the church opposite) memorabilia features prominently. Well-behaved dogs are welcome. ✿❀⊕&P🚃(X30) 🐾🛜

Davenham

Davenham Cricket Club 🅛

Butchers Stile, Hartford Road, CW9 8JF (down narrow signed driveway after Mount Pleasant Rd)

☎ (01606) 48922 ⊕ davenham.play-cricket.com

3 changing beers (sourced locally; often Beartown, Brimstage, Mobberley) Ⓗ

This welcoming family-oriented club is a community facility in an idyllic village setting. Extensive seating in front of the pavilion makes it a perfect place to enjoy beer, cricket and the summer warmth. Sporting events are shown on a large-screen TV. Four handpumps serve real ale mainly from local breweries, and two beer festivals are held each year. During the cricket season the opening hours are extended. Show your CAMRA membership card for admission. ✿&P🚃(37)🐾🛜

Disley

Malt Disley 🅛

22 Market Street, SK12 2AA

☎ (01663) 308020 ⊕ maltdisley.com

House beer (by Poynton); 4 changing beers (sourced locally; often RedWillow, Titanic, Torrside) Ⓗ

A vibrant and friendly converted shop in the village centre, opened in 2017. It is spacious for a micropub and includes a downstairs games room. Up to five cask beers are available, mostly from local microbreweries. Ten KeyKeg beers, including three continental beers plus a cider, and a range of British and continental bottled beers are also on offer. CAMRA Branch Pub of the Year 2020 and Cheshire Pub of the Year 2021. ✿🚋♣🚃(199)🐾🛜

Ellesmere Port

Bondies Bar 🅛

1 Pooltown Road, CH65 7AA

☎ (0151) 345 8560

House beer (by Coach House); 3 changing beers (sourced locally; often Oaks) Ⓗ

Ellesmere Port's first micropub, just outside the town centre, named after a former landlord of the Sportsman's Arms which stood nearby. Bondies opened in 2021 and serves a good variety of drinks. The smart wood-panelled downstairs bar has simple wooden chairs and stools, and is complemented by an upstairs lounge with comfortable leather sofas and a variety of games. There are a few outside seats at the front and back. ✿❀♣⊕P🚃🐾

Farndon

Hare 🅛

High Street, CH3 6PU

☎ (01829) 470072 ⊕ hareatfarndon.co.uk

Big Hand Super Tidy; Weetwood Best Bitter; 3 changing beers (sourced regionally; often Purple Moose, Tatton, Three Tuns) Ⓗ

Formerly the Greyhound, this smart village inn was relaunched in 2020. The pub comprises various cosy areas, all with comfortable seating and polished traditional furniture. Potted plants add greenery while a gallery of prints, pictures and photographs, many of a local nature, adorn the walls. The two regular beers are complemented by three guests, often including a darker beer during winter months. Quality food from an imaginative menu is available throughout the day. ✿❀⊕P🚃(C56)🐾🛜

Frodsham

Helter Skelter 🅛

31 Church Street, WA6 6PN

☎ (01928) 733361 ⊕ thehelterskelter.co.uk

Oakham Bishops Farewell; Ossett White Rat; Salopian Oracle; Weetwood Best Bitter; 4 changing beers (sourced nationally) ⊞

Local CAMRA Pub of the Year numerous times, this pub offers four regular cask ales plus a further four changing guest ales from local and national micros, including dark beers. One rotating guest cider, six rotating craft kegs and imported bottled beers are also available. The single-room bar has a welcoming, relaxed atmosphere, attracting both locals and travellers. Excellent food is served both in the bar and upstairs restaurant. ◑➤🌢🍴🚌💰🐾🛜

Holmes Chapel

Beer Emporium Bottle Bank 🅛

24-26 London Road, CW4 7AL

☎ (01477) 534380 ⊕ beeremporiumbottlebank.co.uk

4 changing beers (often Merlin, Mobberley) ⊞

This bar/off-licence derives its name from a previous life as a NatWest bank – the strong room at the rear is now used for spirit bottles. A former local CAMRA Pub of the Year, the modern bar has up to four regularly changing cask ales and eight keg lines, with third-pints available. Various events take place, including visits from a caterer providing wood-fired pizza. 🚼🌢🚲🍴🐾🚌(42,316)💰🛜

Victoria Club 🅛

Victoria Ave, CW4 7BE

☎ (01477) 535858

Merlin Merlin's Gold ⊞; **2 changing beers (sourced locally; often Merlin)** Ⓟ

Welcoming local community sports club which welcomes non-members (members benefit from discounts on drinks prices). Local CAMRA Club of the Year three years running to 2021. Beers are often sourced from the local Merlin brewery, but not exclusively. Enjoy a pint while playing pub games such as pool and darts or watching some local cricket or national televised sports. 🚼🌢🚲♣🚌(42)🐾

Knutsford

Rose & Crown 🅥

62 King Street, WA16 6DT

☎ (01565) 652366 ⊕ knutsfordroseandcrown.co.uk

2 changing beers (sourced locally; often Dunham Massey) ⊞

Built in 1641, this inn has a wonderful historic charm, with a black and white exterior with leaded stained-glass windows, graced with hanging baskets. Inside, there are exposed beams and a beautiful old fireplace. The open-plan ground-floor bar and restaurant are divided into discrete areas, and there are two sharing tables near the bar. There is a good-sized rear outdoor seating area and letting rooms are available. Two hand-pumped cask beers are served, typically from Cheshire. The pub can be busy, especially at the weekends. 🌢🛏◑➤🚌(88,89)🐾🛜

Little Bollington

Swan with Two Nicks 🅛 🅥

Park Lane, WA14 7TJ (signposted off A56)

☎ (0161) 928 2914 ⊕ swanwithtwonicks.co.uk

Timothy Taylor Landlord; 2 changing beers (sourced locally; often Coach, Dunham Massey) ⊞

A country pub offering well-kept ales including Taylor Landlord and two changing local beers. The interior has a front area with warming fires, a central bar and an area to the rear with an emphasis on food. There is extensive outdoor seating, with a covered section, popular in good weather. The pub welcomes children and dogs, and is close to the Bridgewater Canal. Dunham Deer Park is a 10-minute walk away. 🚼🌢◑P🐾

Little Neston

Harp 🅛 🅥

19 Quayside, CH64 0TB (turn left at bottom of Marshlands Rd, pub is 300yds on left overlooking marshes)

☎ (0151) 336 6980

Joseph Holt Bitter; Peerless Triple Blond; Timothy Taylor Landlord; 2 changing beers (sourced nationally) ⊞

A former coal miners' inn, converted from two cottages, the Harp has a basic lounge plus a public bar with a real fire in winter. Set in a glorious location on the Deeside to Neston stretch of the National Cycle Network, the pub overlooks the Dee Marshes and North Wales, with its large garden and drinking area abutting the edge of the marshes. Lunchtime food only except the popular curry night every Tuesday (booking advisable). Q🚼🌢◑P🚌(22,487)🐾🛜

Lymm

Brewery Tap 🅛

18 Bridgewater Street, WA13 0AB

☎ (01925) 755451 ⊕ lymmbrewing.co.uk

Dunham Massey Dunham Dark; Lymm Bitter, Bridgewater Blonde; 4 changing beers (sourced locally; often Dunham Massey, Lymm) ⊞

The Brewery Tap, in the red-brick former post office, is a few steps away from the Bridgewater Canal. The bar area is complemented by the front room, with subdued lighting, comfy armchairs and a wood-fired stove. Four changing beers are either from the pub's own microbrewery or nearby Dunham Massey, and include at least one dark beer. An open mic night features twice a month and live music on Saturday evenings. Local pies are available at all times. 🚼🌢🚲♣🚌🐾🛜

Macclesfield

Castle ★ 🅛

25-27 Church Street, SK11 6LB

☎ (01625) 462646

3 changing beers (often RedWillow, Storm, Wincle) ⊞

A truly spectacular pub set in a Grade II-listed 18th-century building on a quiet cobbled street. It was restored in 2021, with improved lighting to highlight its many interesting internal features. Of particular note are the wooden glazed bar by the snug, moulded plaster ceilings and attractive fireplaces. Food is served from a small yet imaginative menu. The three continuously changing cask beers are often from local breweries. Local cider is available in bottles. 🚼🌢◑➤♣🚌🐾🛜

Jack in the Box 🅛

Picturedrome, 102-104 Chestergate, SK11 6DU

Blackjack Session IPA; 4 changing beers (sourced locally; often Blackjack) ⊞

Blackjack Brewery Bar in the Picturedrome, converted from what was Macclesfield's oldest cinema, dating from 1911. Blackjack provides the house beers, with up to four guests from independent breweries. A wide selection of craft keg and real cider from boxes is also available. The

Picturedrome has many stalls serving different styles of food, with shared seating both indoors and outdoors. Old silent films or cartoons are often projected.
ॐ੩⬤◑⬤⬤⬤⬤(88,130) ⬤ ⬤

Park Tavern ⓛ
158 Park Lane, SK11 6UB
☎ (01625) 667846 ⬤ park-tavern.co.uk
Bollington White Nancy, Long Hop, Best, Oat Mill Stout, Eastern Nights ⓗ
Bollington Brewery owned mid-terrace pub, well worth the short walk from the town centre. Up to six beers from the Bollington range are available, plus two real ciders. An opened-out area surrounds the bar, with a snug by the front door. A popular community venue and a great place for conversation, it hosts regular events including film nights in a mini cinema function room upstairs, and quizzes and science evenings downstairs. There is a small outdoor area at the rear. Food is available Thursday to Sunday. ॐ੩⬤◑⬤⬤⬤⬤⬤⬤⬤⬤

RedWillow ⓛ
32A Park Green, SK11 7NA
☎ (01625) 830718
5 changing beers (often RedWillow) ⓗ
Located half a mile from the RedWillow brewery, this tastefully converted former shop keeps its original period front along with interesting modern decor. A screen above the bar shows an impressive selection of house beers, sometimes a real cider, along with a large selection of craft keg. A dark beer is always featured. Third-pint measures are available. The kitchen has featured a number of local caterers. There is a small pavement seating area outside. ॐ◑⬤⬤⬤⬤⬤⬤⬤⬤

Wharf ⓨ ⓛ
107 Brook Street, SK11 7AW
☎ (01625) 261879 ⬤ thewharfmacc.co.uk
Timothy Taylor Landlord; 3 changing beers (sourced nationally) ⓗ
A traditional end-of-terrace community pub a short walk from the town and close to the canal wharf, with an attractive canalboat theme. This award-winning free house has five handpumps serving a good selection of beers from microbreweries, always including a gluten-free beer. The opened-out single room has a central bar and three distinct seating areas, plus a games area with a dartboard and bar skittles. Live music often features at the weekend. Outside is a well-tended back garden.
ॐ੩⬤⬤⬤⬤(58) ⬤ ⬤

Middlewich

White Bear Hotel ⓛ
Wheelock Street, CW10 9AG (on lower end of Wheelock St, just off A54 St Michael's Way)
☎ (01606) 837666 ⬤ thewhitebearmiddlewich.co.uk
4 changing beers (sourced locally) ⓗ
This 17th-century coaching inn was comprehensively restored in 2011. It serves a wide variety of real ale styles, sourced locally, and is also renowned for excellent food. With a large open-plan room off the bar, a separate restaurant, an alfresco patio and an upstairs function room, it appeals to a wide range of customers. Very much a regular in the Guide. Accommodation is available in three ensuite rooms. ॐ੩⬤⬤◑⬤⬤P⬤(37,42)⬤ ⬤

Mobberley

Church Inn ⓛ
Church Lane, WA16 7RD (opp church, signposted from local roads)

☎ (01565) 873178 ⬤ churchinnmobberley.co.uk
House beer (by Tatton); 2 changing beers (sourced regionally) ⓗ
This Grade II-listed 300-year-old dining pub, sister of the nearby Bull's Head, retains vestiges of its former multi-room layout. There is a firelit cricket-themed bar, a characterful boot room, two dining rooms, a private dining room upstairs, and a beer garden to the rear. A house beer is named in honour of Mallory of Everest, who was born in Mobberley and is commemorated in stained glass in the church opposite (his father was a vicar there). Information on local walks is available.
ॐ੩⬤◑⬤P⬤(88) ⬤ ⬤

Moulton

Lion ⓛ
74 Main Road, CW9 8PB
☎ (01606) 606049
Wainwright; 4 changing beers (sourced locally; often Merlin, Tatton, Weetwood) ⓗ
Featuring in the Guide for eight consecutive years, this welcoming community focused pub is in the centre of the village and dispenses many changing local ales and guest real ciders. It hosts a fun smartphone quiz night each Thursday. Delicious stone-baked pizzas are served in the early evening. Outside, there is a beer garden to the side and a sundeck at the front. A function room is available. A winner of many awards including local CAMRA Pub of the Year. ॐ੩⬤⬤⬤⬤P⬤⬤ ⬤

Nantwich

Black Lion ⓛ
29 Welsh Row, CW5 5ED (on Welsh Row, opp Cheshire Cat)
☎ (01270) 628711 ⬤ blacklionnantwich.co.uk
Weetwood Best Bitter, Cheshire Cat, Old Dog; 3 changing beers (sourced regionally) ⓗ
Totally free of tie, this black and white fronted inn stands among the historic buildings of Welsh Row. An open fire welcomes you into an open-plan area that used to be three separate rooms. The beautiful plaster and wood-beamed interior retains the expected bowed walls and creaking floorboards. The small Hop Room features hop bines on the ceiling and a pot-bellied stove for heating. There is a restaurant upstairs and a covered beer garden to the side. Q੩⬤◑⬤⬤⬤⬤(84)⬤ ⬤

Crown ⓛ
High Street, CW5 5AS (on High St between NatWest and Café Nero)
☎ (01270) 625283 ⬤ crownhotelnantwich.com
Salopian Shropshire Gold; 4 changing beers (sourced regionally) ⓗ
A three-storey Grade I-listed black and white timbered building. Burnt down in the Fire of Nantwich in 1583, it was rebuilt two years later using oak beams sourced from Delamere Forest. The beams, along with the wattle and daub walls and uneven floors, give the building an old-world charm. Upstairs, the Long Gallery is worth a visit. The bar offers a selection of real ales, frequently locally sourced. The pub is a prominent supporter of the annual Nantwich Jazz, Blues & Music Festival.
ॐ⬤◑⬤⬤P⬤(84,85) ⬤ ⬤

Rifleman
68 James Hall Street, CW5 5QE (off B5074 Barony Rd)
☎ (01270) 629977
Robinsons Unicorn ⓗ
Traditional community local warmed by open fires. It has three distinct rooms, all wooden floored, one with a pool

table. There are drinking areas front and rear – the beer garden at the back has a heated smoking shelter and an aviary. A full English breakfast is served on Saturday. On Sunday lunchtimes, roast dinner is available.
ち❀❀❹▷♣P⊒(84) ❀

Wickstead Arms 🅛 ✅

5 Mill Street, CW5 5ST (at jct of Mill St and Barker St)
☎ (01270) 610196 ⊕ wicksteadpubnantwich.co.uk
5 changing beers (sourced nationally) Ⓗ
A busy back-street local, a short stroll from Nantwich town centre, with a sports TV bar and a dining room. A wide range of classic, proper, hearty pub grub from an ever-changing menu is served throughout. Five handpumps offer a range of changing beers from the Punch Taverns list.This is quite a small pub and has a very friendly atmosphere. ち❹▷よ❅⊒(84,85)❀♥

Northwich

Baron's Lounge 🅛

13 Witton Street, CW9 5DE (in pedestrianised town centre)
☎ 07564 083454
4 changing beers (sourced locally; often Beartown, Donkeystone, Weetwood) Ⓗ
Former charity shop close to the Barons Quay development, transformed in 2017 and becoming a two-storey bar in 2018. Although small in size, it packs plenty in with live music and quiz nights. Upstairs there is a record player available for customers to play their own vinyl. Outside is a suntrap patio to the rear. A sister pub to the Hop Emporium in Warrington. Qち❀よ♣⊒❀♥

Salty Dog 🅛

21-23 High Street, CW9 5BY (in pedestrianised town centre) ⊕ salty-dog.co.uk
Tatton Gold; 3 changing beers (sourced locally; often Merlin, RedWillow, Tatton) Ⓗ
This former shop, converted in 2017, retains its black and white exterior. The landlord and co-owner played drums in punk band The Business. Live music features along with comedy nights and a monthly charity quiz for a local hospice. A room at the rear has a jukebox and retro arcade games. Alongside the real ales, an extensive range of bottled and canned British and European beers is available. ち❀よ♣⊒❀♥

Penketh

Ferry Tavern

Station Road, WA5 2UJ (from car park on Station Rd cross railway and canal) SJ5634986649
☎ (01925) 791117 ⊕ theferrytavern.com
8 changing beers (sourced nationally; often Ossett, Titanic, Wily Fox) Ⓗ
In a scenic location next to the River Mersey, cross the railway and canal to get here. Next to the Trans Pennine Trail, it is popular with both cyclists and walkers. The atmospheric interior has low-beamed ceilings and a balcony area which can be set aside for meetings. Outside, there is a large, popular beer garden with plenty of seating overlooking the river. Qち❀P❀♥

Poynton

Cask Tavern

42 Park Lane, SK12 1RE
☎ (01625) 875157 ⊕ casktavern.co.uk
Bollington Long Hop, Best, Oat Mill Stout; 1 changing beer (sourced locally; often Bollington) Ⓗ

Located in the centre of Poynton, this is one of three Bollington Brewery taps in Cheshire, showcasing the range of Bollington beers. It also offers locally brewed Moravka craft lager. The single-room pub has comfortable seating areas, including two outdoor spaces. A regular clientele has developed and a warm welcome is assured to all visitors. Toilets are upstairs. Card payments only. ❀♣●P⊒❀♥

Runcorn

Norton Arms

125-127 Main Street, WA7 2AD
☎ (01928) 567642 ⊕ thenortonarms.co.uk
Greene King IPA; 3 changing beers (sourced nationally; often Hardys & Hansons) Ⓗ
This is the ninth year in the Guide for this Grade II-listed, two-roomed, oak-beamed inn in the centre of Halton village. Although dominated by sports TV, the pub is still a nice find. Among the attractions are open mic nights, live music, quiz evenings and a bowling green. Often busy at weekends, with Sunday roasts very popular.
ち❀❹よ♣P⊒❀♥

Society Tap Rooms (STR) 🅛

33 Ashridge Street, WA7 1HU
☎ (01928) 775628 ⊕ societyltd.co.uk
Changing beers (sourced locally; often Blueball, Chapter) Ⓗ
This brewery and tap was formerly a Co-operative building and a baker's. Its beers are from Blueball Brewery, attached to the building, plus Heavy Industry and Chapter among others. KeyKeg craft beer is also available. Hidden away in the Dukesfield area of the town, the entrance is under the arches of the railway line between Runcorn station and Ethelfleda Bridge which carries the line over the Mersey. ▷よ●P⊒❀♥

Sandbach

Beer Emporium 🅛

8 Welles Street, CW11 1GT (off Hightown roundabout, down one way street)
☎ (01270) 760113 ⊕ thebeeremporium.com
4 changing beers Ⓗ
Large, friendly micropub and bottle shop, popular with locals and visitors alike. Seating is at the front window and in a small room to the rear. Four cask ales are on handpump, often one dark beer, plus four keg lines. A worldwide range of bottled and canned beers, many bottle-conditioned, is also available to drink in or take out. The knowledgeable bar staff are always willing to advise on beer styles, both on draught and in bottle. Qち⊒❀♥

Old Hall 🅛

High Street, CW11 1AL (opp St Mary's Church on High St)
☎ (01270) 758170
Timothy Taylor Boltmaker; Weetwood Cheshire Cat; house beer (by Brunning & Price); 3 changing beers (sourced regionally) Ⓗ
The Old Hall dates from the 1650s and is a Grade I-listed timber-framed building with a stone-flagged roof. It was rescued from structural decay by Brunning & Price in 2010. The interior is a pleasant mix of flagged and wooden floors plus Jacobean fireplaces, and has a priest hole. Beers are sourced from a wide area but often include local brews. Excellent food menus feature local ingredients where possible.
ち❀❹よ♣●P⊒(38,37) ❀♥

Sandiway

Blue Cap 🅛 ✅

520 Chester Road, CW8 2DN
☎ (01606) 883006
Greene King IPA; 5 changing beers (sourced regionally; often Mobberley, RedWillow, Weetwood) 🅗

Dating back to 1716, this roadside inn is named after a hunting hound, Blue Cap, believed to be the fastest in the country at the time. Now part of the Chef & Brewer chain, it is situated alongside the Northwich (Sandiway) Premier Inn. Rotating guest beers are often from local Cheshire breweries or adjoining counties. Live music and quiz nights are held. 🌣🏵🚫🌙🗘🛆ΛP🚆(82)🐾🛜

Stockton Heath

Costello's Bar 🅛

23 Walton Road, WA4 6NJ
☎ (01925) 600910 ⊕ costellosbar.co.uk
Dunham Massey Big Tree Bitter, Dunham Dark; Lymm Bridgewater Blonde; 4 changing beers (sourced locally; often Dunham Massey, Lymm) 🅗

A modern micro-style single-room bar with seven handpumps, offering beers from either the Dunham Massey or sister Lymm Brewery ranges. This is an excellent venue for the discerning drinker who prefers darker beers. Conveniently located in the centre of Stockton Heath, it provides an oasis of calm when the area is busy with a young clientele. There is regular live music, usually on a Sunday. Q🌣🏵🛆🚆🐾🛜

Sutton

Sutton Hall 🅛

Bullocks Lane, SK11 0HE
☎ (01260) 253211
House beer (by Wincle); 4 changing beers (sourced locally) 🅗

More than 480 years old, this former convent and manor house has links to the notorious Lord Lucan's family, and a beer from Wincle to mark this. A Brunning & Price establishment, it offers a selection of local guest beers. This is a popular dining pub but drinkers are equally welcome. Indoors there are nooks and crannies, a library and seven dining areas; outside there are extensive terraces and gardens. Close to Macclesfield Forest and next to the Macclesfield Canal. Q🌣🏵🌙🛆🗘P🚆(14)🐾🛜

Sutton Weaver

Chapter Brewing Tap 🍺 🅛

Unit 2A Clifton Road, WA7 3EH
☎ 07791 516948 ⊕ chapterbrewing.co.uk
1 changing beer (sourced locally; often Chapter) 🅗

The Chapter brewery tap and home of SIBA award-winning beers. At least one cask ale is on offer and up to nine keg beers from the brewery's portfolio. Look out also for the real cider line, a lager line and an occasional guest beer. Noah the brewer and his supporting team provide friendly service. Traditional bar snacks and Gourmeggs (quality Scotch eggs) are served, and take-home beers and brewery merchandise are available. 🛆🗘P🚆🅟(2,X30)🐾

Thelwall

Little Manor 🍺 🅛

Bell Lane, WA4 2SX
☎ (01925) 212070 ⊕ littlemanor-thelwall.co.uk

8 changing beers (sourced regionally; often 4Ts, Coach House, Timothy Taylor) 🅗

A large upmarket food-based inn with a changing range of local and regional cask ales. The pub is charmingly furnished and has extensive outdoor areas for dining and drinking. A frequently changing food menu is served throughout the day. Set in picturesque surroundings, the property was originally the home of the Percival family in the 1600s, with their coat of arms adopted as the pub sign. Local CAMRA Pub of the Year 2022. Q🌣🏵🌙🛆🗘P🚆🐾🛜

Tilston

Carden Arms 🅛

Mount View, Church Road, SY14 7HB
☎ (01829) 250900 ⊕ cardenarms.co.uk
Coach House Gunpowder Mild; Salopian Shropshire Gold; Weetwood Eastgate; 2 changing beers (sourced locally; often Peerless, Spitting Feathers) 🅗

Impressive rural free house at the crossroads in the village. The interior has rug-covered wood and tiled floors, real fires, traditional furniture and attractive framed pictures on the plain white walls. In addition to the three regular beers are two guests, often from local microbreweries. High-quality food is served in the bar area and the stylish dining room. Upstairs, two adjoining Georgian rooms can be booked for groups. Accommodation is available in five bedrooms. Q🚫🌙🛆🗘P🚆(41)🐾🛜

Warrington

Albion 🅛

94 Battersby Lane, WA2 7EG (200yds N of A57/A49 jct)
☎ (01925) 231820
4 changing beers (sourced locally) 🅗

Large Victorian former Greenall Whitley pub on the edge of town. Inside, it has distinctly separate rooms, two with real fires, including a games room with a pool table. Outside is a courtyard surrounded by the original stables. Live music and other events are hosted in aid of local charities. Four real ales are available, often including a couple from Cheshire breweries. Local CAMRA Community Pub of the Year 2022. 🌣🏵🚊(Central)🗘🚆(17,25)🐾

Hop Emporium 🅛

Unit 11, Warrington New Market, Time Square, Academy Way, WA1 2NT
House beer (by Beartown); 3 changing beers (sourced regionally; often Beartown, Tiny Rebel) 🅗

An award-winning micropub in Warrington Market. There is plenty of seating inside, and outside in an area shared by a wide variety of food outlets, based on the modern market concept. Third-pint beer paddles are available together with craft beers. Hours are restricted to the market Cookhouse opening hours. A sister pub to Baron's Lounge in Northwich. Q🌣🏵🌙🛆🚊(Central)🎮🚆🐾🛜

Tavern 🅛

25 Church Street, WA1 2SS
☎ 07747 668817
8 changing beers (sourced regionally; often 4Ts, Abbeydale, Mallinsons) 🅗

The Tavern Sports Bar offers an excellent selection of eight beers, always including two from 4Ts, one bitter and one dark. There are also two or more more craft kegs plus the full range of 4Ts beer in cans. A wide choice of sports fixtures are screened on TVs. The pleasant yard at the rear is a suntrap in good weather and has patio heaters for other times. 🏵🚊(Central)🗘🎮🚆🐾🛜

Wincle

Wincle Brewery Shop 🄻

Tolls Farm Barn, Dane Bridge, SK11 0QE
☎ (01260) 227777 ● winclebeer.co.uk
3 changing beers (sourced locally; often Wincle) Ⓗ
With a breathtaking view across the Dane Valley from the small beer garden, this brewery shop is well worth a visit. Three cask beers from the adjacent brewery are on handpump and selection of bottles from Wincle and The Brew Foundation which brews next door. A few spirits including gin from the nearby Forest Gin distillery are also available. There is a log-burning stove to keep you warm in winter. Seating is extremely limited inside.
Q🏵️🐾🕸️🐱📶

Breweries

4Ts SIBA

Unit 20, Manor Industrial Estate, Lower Wash Lane, Latchford, Warrington, Cheshire, WA4 1PL
☎ (01925) 417820 ☎ 07917 730184
● 4tsbrewery.co.uk

Brewing continues on the 12-barrel brew length kit. A core range of beers is regularly produced with many one-off specials. Occasional brews of Tipsy Angel beers are produced. The beers can be found in the Tavern, Church Street. A taproom is expected soon. ‼️♦

EPA (ABV 3.7%) PALE
SPA (ABV 3.8%) PALE
APA (ABV 4%) GOLD
WA4 (ABV 4%) SPECIALITY
WSB (ABV 4.2%) BITTER
IPA (ABV 4.6%) PALE
Panzer Pils (ABV 4.8%) SPECIALITY
English Stout (ABV 5%) STOUT
Big Daddy DIPA (ABV 7.2%) IPA

Brewed under the Tipsy Angel Brewery name:
Angels Mild (ABV 3.8%) MILD
George Shaw Premium (ABV 4.3%) BITTER
Angels Folly (ABV 5.2%) OLD
Taipur (ABV 5.9%) GOLD

Beartown SIBA

Bromley House, Spindle Street, Congleton, Cheshire, CW12 1QN
☎ (01260) 299964 ● beartownbrewery.co.uk

😊Beartown began brewing in 1994 and uses a 25-barrel plant. The brewery underwent a significant refurbishment in early 2022. It supplies more than 250 outlets. It is now in partnership with Manning Brewers (qv), also of Congleton. ‼️🍺♦

Glacier (ABV 3.6%) BLOND
Best Bitter (ABV 3.7%) BITTER
Bluebeary (ABV 4%) SPECIALITY
Kodiak (ABV 4%) PALE
Hops and fruit dominate the taste of this crisp yellow bitter and these follow through to the dryish aftertaste. Biscuity malt also comes through on the aroma and taste.
Skinful (ABV 4.2%) BITTER
Biscuity malt dominates the flavour of this amber best bitter. There are hops, with a balance of malt and bitterness following through to the aftertaste.
Peach Melbear (ABV 4.4%) SPECIALITY
Strong peach aroma leads to a dry bitter beer with some of that expected fruity sweetness.
Kahuna (ABV 4.5%) SPECIALITY
Lit (ABV 4.5%) BLOND

Creme Bearlee (ABV 4.8%) SPECIALITY
Polar Eclipse (ABV 4.8%) STOUT
Classic black, dry and bitter stout, with roast flavours to the fore. Good hop on the nose follow through the taste into a long, dry finish.
Quantock (ABV 5%) MILD

Blueball

The Old Bakery, 31-33 Ashridge Street, Runcorn, Cheshire, WA7 1HU
☎ (01928) 775628 ● societyltd.co.uk

😊Founded by Alex Haycraft in 2010, Blueball relocated to its current site in Runcorn in 2017. The brewery and on-site taproom (Society Tap Room), is situated in a former bakery and local Co-op building underneath railway arches, a short walk from the station. ♪

Indie Girl (ABV 3.8%) PALE
Gold Digger (ABV 4%) GOLD
Communion (ABV 4.1%) BITTER
Ruby O'Reilly (ABV 4.3%) BITTER
Penny Black (ABV 4.5%) STOUT
Spank (ABV 6%) BITTER

Bollington SIBA

Adlington Road, Bollington, Cheshire, SK10 5JT
☎ (01625) 575380 ● bollingtonbrewing.co.uk

❌Bollington began brewing in 2008 with the Vale Inn, Bollington, as the brewery tap. The Park Tavern, and the Fountain both in Macclesfield, and the Cask Tavern, Poynton, are also owned. Around 40 outlets are supplied direct. ‼️♦

Chinook & Grapefruit (ABV 3.6%) GOLD
Ginger Brew (ABV 3.6%) SPECIALITY
White Nancy (ABV 3.6%) BLOND
Long Hop (ABV 3.9%) BLOND
A hoppy yellow beer with fruit and some sweetness for balance.
Bollington Best (ABV 4.2%) BITTER
A well-balanced bitter beer with plenty of hop bitterness which dominates the fruity, sweet malt flavours, completed with a long mouthfeel and a lasting, rising, bitter finish.
Dinner Ale (ABV 4.3%) BITTER
Oat Mill Stout (ABV 5%) STOUT
Smooth, easy-drinking stout with a fruity, sweet taste that develops into a roast bitter finish with some hop, which intensifies on drinking.
Eastern Nights (ABV 5.6%) IPA
Peachy fruity aromas lead on to a sweet, fruity middle which gives way to hoppy bitterness. A mouthful of complex flavours including alcohol make for an interesting beer.

Brew Foundation

Office: 18 Jarrow Road, Sheffield, South Yorkshire, S11 8YB
☎ (0114) 282 3098 ☎ 07545 618894
● thebrewfoundation.co.uk

A father-and-son brewery, currently using spare capacity at Wincle Brewery (qv). Beer is distributed both east and west of the Pennines.

Pop (ABV 3.6%) PALE
Little Bitter That (ABV 3.8%) BITTER
Hops & Dreams (ABV 4%) PALE
Laughing Water (ABV 4.3%) BLOND
First Light (ABV 4.6%) PALE
Janet's Treat Porter (ABV 4.8%) SPECIALITY
Hop & Glory (ABV 4.9%) PALE

Bitter That (ABV 5%) BITTER

Brewhouse & Kitchen SIBA

Forest House, Love Street, Chester, CH1 1QY
☎ (01244) 404990 ⊕ brewhouseandkitchen.com

☺Part of the national Brewhouse & Kitchen family, this brewpub is situated in a splendid building previously owned by JD Wetherspoon. As with all Brewhouse & Kitchen establishments it offers brewery experience days and beer masterclasses. ‼️ ➤

Burtonwood

Bold Lane, Burtonwood, Warrington, Cheshire, WA5 4TH
☎ (01925) 220022 ⊕ thomashardybrewery.co.uk

Thomas Hardy's only brewery was acquired by Molson Coors in 2015. Currently producing no real ale, and operating solely as a contract brewer.

Chapter SIBA

Unit 2a, Sutton Quays Business Park, Clifton Road, Sutton Weaver, Cheshire, WA7 3EH ☎ 07908 004742
⊕ chapterbrewing.co.uk

Multi-award-winning Chapter Brewing was established in 2016, using an 11-barrel brew plant. It produces diverse 'fictional beers' inspired by literature, from pales to sours, smoked porters to Belgian styles and beyond. ‼️➤♦V⊘

Fossil Dinner (ABV 3.5%) GOLD
The Hay is Waiting (ABV 3.6%) PALE
Bread & Circuses (ABV 3.8%) PALE
Taller Than a House (ABV 3.9%) BITTER
Unconsenting Soul (ABV 4.2%) GOLD
This fruity and hoppy bitter beer has plenty of impact on the palate, with sweetness drying out in the finish.
Practicable & Useful (ABV 4.3%) GOLD
Pemberley (ABV 4.4%) STOUT
Temos Tanta (ABV 4.4%) SPECIALITY
Kandata (ABV 4.7%) PALE
That Old Rope (ABV 5.4%) PALE
Dead Man's Fist (ABV 5.5%) SPECIALITY
A complex smoky beer with a sweet centre, balancing roast flavours leading to a long. peppery finish.
Her Musket (ABV 5.7%) STOUT
As Lazarus (ABV 7.2%) IPA

Coach House SIBA

Wharf Street, Howley, Warrington, Cheshire, WA1 2DQ
☎ (01925) 232800 ⊕ coachhousebrewery.co.uk

Established in 1991 by three former employees of Greenall Whitley Brewery, Coach House was bought by Martin Bailey in 2015. The 40-barrel plant produces up to 240-barrels per week. ♦

Coachman's Best Bitter (ABV 3.7%) BITTER
A well-hopped, malty bitter, moderately fruity with a hint of sweetness and a peppery nose.
Gunpowder Premium Mild (ABV 3.8%) MILD
Aromas of roast malts and caramel attract you to a pleasant sweet and toasty tasting mild with a gentle finish.
Honeypot Bitter (ABV 3.8%) SPECIALITY
Farriers (ABV 3.9%) BITTER
Cromwell Best Bitter (ABV 4%) BITTER
Blonde (ABV 4.1%) BLOND
Cheshire Gold (ABV 4.1%) PALE
Cheshire Oak (ABV 4.1%) BITTER

ClIPAty Hop (ABV 4.3%) PALE
Hoppy, fruity, bitter beer with balancing sweetness and a dry finish.
Flintlock Pale Ale (ABV 4.4%) PALE
Innkeeper's Special Reserve (ABV 4.5%) BITTER
A darkish, full-flavoured bitter. Quite fruity, with a strong, bitter aftertaste.
Postlethwaite (ABV 4.6%) PALE
Blueberry Classic Bitter (ABV 5%) SPECIALITY
A sweet beer with fruity esters and tasting predominately of blueberries, finishing dry.
Post Horn Premium Pale Ale (ABV 5%) PALE

Coastal SIBA

12-14 High Street, Crewe, CW2 7BN ☎ 07305 559243
✉ coastalbrewery2020@gmail.com

⊗ Originally established in 2006 at Redruth in Cornwall, the brewer and the complete brewery plant relocated to Crewe in 2020, and is now in the basement of the Craft Beer Oasis Pub and Bottleshop. Brewing is currently suspended. ♦LIVE ⊘

Four Priests (NEW)

2 Finney's Lane, Middlewich, Cheshire, CW10 9DR
⊕ fourpriests.co.uk

Start-up brewery established in 2022 and run by homebrewer-turned-professional Andy Thomason. The name originates from the carvings on the Saxon crosses in nearby Sandbach, where Andy lives. Much of the kit is from the closed GoodAll's brewery. Andy has been documenting the brewery's setup from the very start on the brewery's YouTube channel.

Happy Valley

73 Oxford Road, Macclesfield, SK11 8JG
☎ (01625) 618360 ☎ 07768 107660
⊕ happyvalleybrewery.co.uk

⊗ Happy Valley was established in 2010 using a 2.5-barrel plant located in Bollington. In 2018 the brewery was sold and relocated to Macclesfield, and is based at the 73 & Pizza pub. ♦

Hush

Unit 4, Navigation Road, Northwich, Cheshire, CW8 1BE ☎ 07973 797500 ⊕ hushbrewing.co

☺Established in 2021 Hush has recently-moved to new premises close to Northwich Town Centre. A five-barrel plant has been installed and a Brewery Tap created on the premises. Producing traditional and craft beers, its core beers are themed to the area and distributed locally to selected free trade outlets. A more extensive range of core beers are planned in the coming year. ♦

My Grain is Earl (ABV 3.7%) PALE
Northwich Pale Ale (ABV 4%) PALE
Weaver Las Vegas (ABV 4.3%) PALE

Lymm

18 Bridgewater Street, Lymm, Cheshire, WA13 0AB
☎ (0161) 929 0663 ⊕ lymmbrewing.co.uk

☺Lymm is a small, family-run brewery, launched in 2013. Located in an old post office, the brewing equipment is downstairs in what used to be the mess rooms with a brewery tap upstairs in what was the sorting office/post office counter. A sister brewery to Dunham Massey (qv), a joint bar opened in 2013, Costello's Bar, Stockton Heath. ♦

Dark (ABV 3.4%) MILD
Bitter (ABV 3.8%) BITTER
Bridgewater Blonde (ABV 4%) BLOND
Gold Leaf (ABV 4.5%) BITTER
Heritage Trail Ale (ABV 4.5%) BITTER
IPA (ABV 4.8%) PALE
Dam Strong Ale (ABV 7.2%) STRONG

Manning

Spindle Street, Congleton, Cheshire, CW12 1QN
☎ (01260) 299964 ⊕ manningbrewers.co.uk

A family-owned and run brewery using only British hops, opened in 2015. It has now joined forces with the established Beartown Brewery (qv), also of Congleton.

Woah Man (ABV 3.8%) PALE
Man Up! (ABV 4%) BITTER
Cave-Man (ABV 4.2%) BITTER

Merlin

3 Spring Bank Farm, Congleton Road, Arclid, Cheshire, CW11 2UD
☎ (01477) 500893 ☎ 07812 352590
⊕ merlinbrewing.co.uk

⊕Merlin started in 2010 using an eight-barrel plant in a farm unit just outside Sandbach. The family firm of three is gently expanding the brewery. The beers are normally supplied to outlets within a 30-mile radius. The brewery is environmentally-friendly, using power from solar panels and a wind turbine, and spent water soaks away naturally through reed beds on the farm. ‼◆LIVE

Merlin's Gold (ABV 3.8%) GOLD
Excalibur (ABV 3.9%) BLOND
Sweet throughout with a hoppy bitterness which takes control of the finish. Malt and fruit flavours add to the mix.
Spellbound (ABV 4%) BITTER
Avalon (ABV 4.1%) PALE
The Wizard (ABV 4.2%) PALE
Sweet, fruity start with building bitterness and malt in the background. Finishes bitter with a long-lasting, full mouthfeel.
Castle Black (ABV 4.4%) STOUT
Dark Magic (ABV 4.8%) MILD
Sweet, malty start with plenty of roast malt flavours. Lightly-hopped with the roast bitterness lingering.
Mythic IPA (ABV 5.5%) IPA
Dragonslayer (ABV 5.6%) OLD

Mobberley SIBA

Meadowside Barn, Hulme Lane, Lower Peover, Cheshire, WA16 9QH
☎ (01565) 873601 ☎ 07879 771209
⊕ mobberleybrewhouse.co.uk

⊗ Mobberley began brewing in 2011. Beers are contract brewed for Burton Road Brewing Company. ◆

Bunji (ABV 3.8%) PALE
Cheshire Pale (ABV 3.9%) PALE
Sidekick (ABV 4.2%) PALE
1924 (ABV 4.5%) BITTER
Fruity malt aromas and taste lead on to a smooth, hoppy, bitter beer.
Summit (ABV 4.6%) GOLD
Onyx (ABV 5%) STOUT
IPA (ABV 5.2%) IPA

Norton

Norton Priory, Tudor Road, Manor Park, Runcorn, Cheshire, WA7 1SX
☎ (01928) 577199 ☎ 07767 354674
⊕ nortonbrewing.com

Situated within the grounds of Norton Priory, the brewery was created as a social enterprise by Halton Borough Council to provide employment opportunities for people with learning disabilities, autism and other disabilities. It opened in 2011 with a 2.5-barrel plant. Beers in bottles, mini-kegs and casks are available for collection from the brewery only.

Oaks SIBA

Unit 6, Stanney Mill Industrial Estate, Dutton Green, Ellesmere Port, Cheshire, CH2 4SA ☎ 07526 437098
⊕ theoaksbrewing.co

Founded as Cheshire Brew Brothers in 2013 and taken into new ownership in 2017. The beers can be found in free and tied trade across North-West England and West Yorkshire. An ever-changing range of beers is produced to satisfy customer demand. LIVE

Chester Gold (ABV 3.5%) GOLD
A fruity, hoppy bitter with a pleasant sweet finish.

Pied Bull

🏠 Pied Bull Hotel, 57 Northgate Street, Chester, CH1 2HQ
☎ (01244) 325829 ⊕ piedbull.co.uk

⊕Pied Bull began brewing in 2011 using a one-barrel plant. Beer is mainly for in-house consumption but local beer festivals are supplied and occasional brewery swaps occur. ◆

Poynton

🏠 Royal British Legion Club, St George's Road West, Poynton, Cheshire, SK12 1JY ☎ 07722 050733
✉ info@thepoyntonbrewery.uk

⊕The Poynton Brewery was established in 2015, and located at the Poynton Legion Club. Around 20 pubs, clubs and bars are supplied in the Stockport, Altrincham, East Cheshire and Macclesfield areas. The Poynton brand is used for cask and cans, and Neighbourhood Brew Co for craft keg and cans. Dre Scuglia joined founder Colin Bavins in 2019, and Jake Astbury joined as a partner in 2022. 🍺◆

All Day IPA (ABV 3.8%) PALE
Chinook Pale (ABV 4.2%) PALE
Idaho (ABV 4.2%) PALE
Session IPA (ABV 4.2%) PALE
79 Bitter (ABV 4.3%) BITTER
Mosaic Pale (ABV 4.5%) PALE
Slumdog IPA (ABV 5%) PALE
Dark Side (ABV 5.2%) PORTER

RedWillow SIBA

The Lodge, Sutton Garrison, Byrons Lane, Macclesfield, Cheshire, SK11 7JW
☎ (01625) 502315 ⊕ redwillowbrewery.com

⊕Established in 2010 by homebrewer Toby McKenzie and his wife Caroline. In 2015 brewing moved to a larger, purpose-built unit on the same site. The award-winning beers are distributed nationwide and are available from the brewery's own RedWillow bars in Macclesfield and Buxton. ◆

Headless (ABV 3.9%) PALE
Nicely-balanced with some malty sweetness. Fruit and hops show in the drinking with hop bitterness lasting to the end.
Feckless (ABV 4.1%) BITTER
Well-balanced best bitter, malt and hop in the taste with some fruit and roast flavours.
Weightless (ABV 4.2%) PALE
Well-rounded pale ale with a promise of fruit and hop at the start, full-bodied, bittersweet, fruity middle, and lasting finish.
Wreckless (ABV 4.8%) PALE
Hoppy, fruity, sweet pale ale that finishes on the drier side.
Heritage Porter (ABV 5.3%) PORTER
Sleepless (ABV 5.4%) RED
Breakfast Stout (ABV 5.6%) STOUT
A dark beer with strong aromas of chocolate, coffee and hazelnut alongside expected malt and roast. Composed to give a long, smooth mouthfeel.
Smokeless (ABV 5.7%) SPECIALITY
Shameless (ABV 5.9%) IPA
Fruit and hops throughout with full-bodied sweetness and a long finish.
Restless (ABV 8.5%) SPECIALITY

Spitting Feathers SIBA

Common Farm, Waverton, Cheshire, CH3 7QT
☎ (01244) 332052 ☎ 07974 348325
⊕ spittingfeathers.co.uk

⊚ Spitting Feathers was established in 2005. The brewery is located in a sandstone building set around a cobbled yard. Around 200 local outlets are supplied. Monthly Brewbarn sessions throughout the year include a brewery tour but tickets must be purchased in advance. All beers are vegan-friendly and gluten free. !! ♦ GF V

Session Beer (ABV 3.6%) PALE
Sweet malts have a consistent presence in this hoppy bitter beer.
Thirstquencher (ABV 3.9%) BLOND
A hoppy blond with citrus notes and some sweetness to balance.
Brainstorm (ABV 4%) GOLD
Special Ale (ABV 4.2%) BROWN
Complex, tawny-coloured beer with a sharp, grainy mouthfeel. Malty with good hop coming through in the aroma and taste. Hints of nuttiness and a touch of acidity. Dry, astringent finish.
Old Wavertonian (ABV 4.4%) STOUT
Creamy and smooth stout. Full-flavoured with coffee notes in aroma and taste. Roast and nut flavours throughout, leading to a hoppy, bitter finish.
Rush Hour (ABV 4.5%) PALE
Sweet fruity start is quickly overtaken by hop bitterness which rises in the finish.
Empire I.P.A. (ABV 5.2%) PALE

Storm SIBA

2 Waterside, Macclesfield, Cheshire, SK11 7HJ
☎ (01625) 431234 ⊕ stormbrewing.co.uk

⊚ Storm Brewing was founded in 1998. In 2001 it moved to its current location, an old riverside pub building, which, until 1937, was called the Mechanics Arms. More than 60 outlets are supplied. ♦ LIVE

Beauforts Ale (ABV 3.8%) BITTER
Desert Storm (ABV 3.9%) BITTER
Bosley Cloud (ABV 4.1%) BLOND
Ale Force (ABV 4.2%) BITTER

Amber, smooth-tasting, complex beer that balances malt, hop and fruit on the taste, leading to a roasty, slightly sweet aftertaste.
Dexter (ABV 4.2%) GOLD
Downpour (ABV 4.3%) PALE
PGA (ABV 4.4%) SPECIALITY
Light, crisp, lager-style beer with a balance of malt, hops and fruit. Moderately bitter and slight dry aftertaste.
Hurricane Hubert (ABV 4.5%) BITTER
Silk of Amnesia (ABV 4.7%) BITTER
Smooth premium, easy-drinking bitter. Fruit and hops dominate throughout. Not too sweet, with a good, lasting finish.
Isobar IPA (ABV 4.8%) PALE
Red Mist (ABV 4.8%) PORTER

Tatton SIBA

Unit 7, Longridge Trading Estate, Knutsford, Cheshire, WA16 8PR
☎ (01565) 750747 ☎ 07738 150898
⊕ tattonbrewery.co.uk

⊚ Tatton is a family-owned business based in the heart of Cheshire. Brewing commenced in 2010 using a steam-fired, custom-built, 15-barrel brewhouse. It supplies pubs throughout Cheshire and the north-west. !! ☰ ♦

Session (ABV 3.7%) BITTER
XPA (ABV 3.7%) PALE
Blonde (ABV 4%) BLOND
Best (ABV 4.2%) BITTER
Black (ABV 4.5%) PORTER
Gold (ABV 4.5%) BITTER

Tom's Tap

4-6 Thomas Street, Crewe, Cheshire, CW1 2BD
☎ 07931 573425
⊕ tomstapandbrewhouse.wordpress.com

Tom's Tap & Brewhouse consists of three units; brewery equipment in the first, live music and special events in the middle (including meet the brewer events), and a taproom in the third (open to the public Thursday-Sunday). Beer is also distributed to four other outlets and local beer festivals. !! ♦

Twisted Wheel

Unit 11, Easter Court, Europa Boulevard, Warrington, Cheshire, WA5 7ZB
☎ (01925) 714019 ☎ 07834 216219
⊕ twistedwheelbrewco.co.uk

Twisted Wheel began brewing in 2020 using a 10-barrel brew plant. In 2020 it moved from Standish to its new home in Warrington, adding a canning line within the new 20-barrel brewhouse. An extensive range of beer is available in can, keg and cask. All beers are unfined. !! ♦ ⦿

Sunday Sessions (ABV 3.8%) PALE
Speed Wobble IPA (ABV 4.7%) PALE
Hoodoo Voodoo IPA (ABV 6.5%) IPA
Soul City New England IPA (ABV 6.5%) IPA
Suede Head Coffee Porter (ABV 6.5%) PORTER
Kick Down Double IPA (ABV 8%) IPA
Velvet Bomber Chocolate Stout (ABV 10%) STOUT

Weetwood SIBA

The Brewery, Common Lane, Kelsall, Cheshire, CW6 0PY
☎ (01829) 752377 ⊕ weetwoodales.co.uk

Weetwood Ales were founded in a barn back in 1992 but now operate out of a modern 30-barrel plant close to Kelsall. The broad range of beers is available across the north-west and North Wales. Besides regular brewery tours and an on-site shop, a distillery (totally complementary to the brewery) produces a range of spirits including gin and vodka, with plans for a single malt release in 2022. ‼️🏴

Southern Cross (ABV 3.6%) PALE
Best Bitter (ABV 3.8%) BITTER
A traditional gentle bitter with a malty sweetness and a dash of fruit. The hop presence increases slightly to provide a drier finish.
Mad Hatter (ABV 3.9%) RED
A typical red beer, malty aromas lead to a fruity, sweet middle backed up with a bitter finish.
Cheshire Cat (ABV 4%) BLOND
Gentle, hoppy blond beer with dominating sweetness.
Eastgate (ABV 4.2%) PALE
Well-balanced and refreshing clean amber beer. Citrus fruit flavours predominate in the taste and there is a short, dry aftertaste.
Oregon Pale (ABV 4.3%) BITTER
Malty, fruity and hoppy mouthfeel with a sweet centre and a lasting finish of hop bitterness.

Old Dog (ABV 4.5%) BITTER
Well-balanced amber beer. Malt, roast and fruit flavours are balanced by bitterness and sweetness.
Jester IPA (ABV 4.8%) PALE

Wincle SIBA

Tolls Farm Barn, Dane Bridge, Wincle, Cheshire, SK11 0QE
☎ **(01260) 227777** ⊕ **winclebeer.co.uk**

Wincle Beer Co was set up in 2008 on a farm, close to its present location. It now has a 15-barrel plant in Wincle. The beers are brewed using water from its own borehole. A brewery shop is housed in a converted stable next to the brewery. There is a monthly tap night on the first Friday of each month (check website for other events). ‼️🏴◆◈

Waller (ABV 3.8%) PALE
Hen Cloud (ABV 3.9%) PALE
Sir Philip (ABV 4.2%) BITTER
Wibbly Wallaby (ABV 4.4%) BITTER
Life Of Riley (ABV 4.8%) PALE
Burke's Special (ABV 5%) BITTER

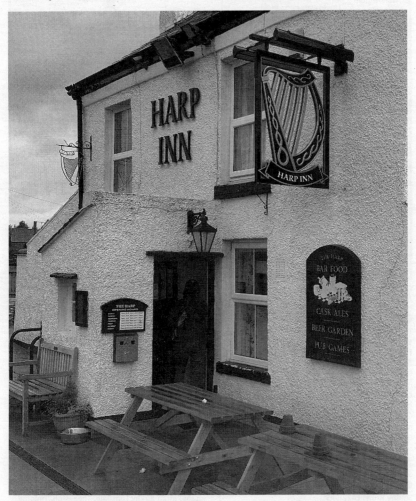

Harp, Little Neston (Photo: Dave Goodwin)

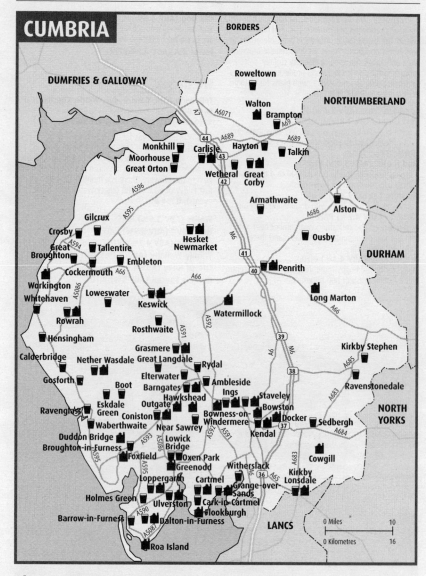

CUMBRIA

Alston

Cumberland Inn 🅛

Townfoot, CA9 3HX

☎ (01434) 381875 ⊕ cumberlandalston.co.uk

Firebrick Blaydon Brick; 2 changing beers 🅷

A 19th-century inn overlooking the South Tyne river. Close to the Coast-to-Coast cycle route and Pennine Way, it is an ideal base to explore the highest market town in England. Guest beers are dispensed from four handpumps. The Cumberland has won many local CAMRA awards, including ones for its cider, and always has a wide selection of beers, ciders and perries to choose from. Q❀🌡️◀🍺🅟🖵(680,681)🌸🐾🛜

Ambleside

Golden Rule ✅

Smithy Brow, LA22 9AS

☎ (015394) 32257 ⊕ goldenrule-ambleside.co.uk

Robinsons Wizard, Dizzy Blonde, Cumbria Way, Cascade IPA; 3 changing beers (sourced regionally; often Robinsons) 🅷

A Guide feature since 1977, time seems to have stood still here, and four generations of loyal Lakes lovers have enjoyed a refreshing pint and a natter by the cosy fire after a day on the fells. The simple old pub serves Robinsons regular range of beers with seasonal small-batch brews, especially in winter. The separate snug room is handy for families and for card games. A small sheltered courtyard at the back has additional seating for sunny days and busy sessions. Q🌡️❀🅟♣🚌🖵🛜

Royal Oak 🅛 ✅

Lake Road, LA22 9BU

☎ (015394) 33382

Greene King IPA, Abbot; 6 changing beers (sourced locally; often Kirkby Lonsdale, Theakston, Timothy Taylor) 🅷

A Greene King 'Local Hero' pub that punches well above its weight. Visitors comment on the quality of the hospitality and the range of beers that includes Kirkby Lonsdale and Timothy Taylor in addition to the parent brews. The sheltered patio is busy throughout the year as a perch for people-gazing in the middle of the tourist maelstrom. Dogs are made as welcome as their owners by the efficient, friendly staff. ✿✿❍&♣♥♣❤♥🖤🛜

Armathwaite

Fox & Pheasant ✿
CA4 9PY
☎ (016974) 72162 ⊕ foxandpheasantarmathwaite.co.uk
Robinsons Dizzy Blonde, Cumbria Way, Unicorn; 1 changing beer (sourced nationally; often Hawkshead, Robinsons) Ⓗ
Atmospheric 17th-century coaching inn overlooking the River Eden. The main bar has a flagstone floor and inglenook fire place. The former stables have been converted into a bar and eating area. Original wooden beams, exposed stonework and stable stalls all add to the ambience. You can be assured of a friendly, welcoming service. Booking is recommended if dining. The guest beer is a seasonal from Robinsons.
✿✿🛏❍≈♣♥P♥🛜

Barngates

Drunken Duck Inn Ⓛ
LA22 0NG (signed off B5286 Hawkshead-Ambleside road)
☎ (015394) 36347 ⊕ drunkenduckinn.co.uk
Barngates Cat Nap, Cracker, Tag Lag; 3 changing beers (sourced locally; often Barngates) Ⓗ
High above Ambleside, this traditional Lakeland dwelling reflects the simplicity, beauty and longevity of its natural environment. From the fells, it draws water for the beers brewed on-site by Barngates Brewery. The bar has six handpumps and serves all the Barngates beers on rotation. The outside seating area at the front offers dramatic views of the fells to the north-east. Dogs are allowed except in the dining room.
Q✿✿🛏❍&AP♥🛜

Barrow-in-Furness

Duke of Edinburgh Ⓛ ✿
Abbey Road, LA14 5QR
☎ (01229) 821039 ⊕ dukeofedinburghhotel.co.uk
Lancaster Amber, Blonde, Red; 5 changing beers (sourced regionally) Ⓗ
On the edge of the town centre near the station, the Duke is not as noisy as similar bars in the town. It has an airy feel with modern, comfortable furniture and a fine open fire. Paintings by local artists are displayed around the walls. Good-quality, reasonably priced bar meals are available; there is also a separate restaurant. Beers are mainly from Lancaster Brewery, with guest ales plus three craft keg ales, and bottled beers from around the world. ✿🛏❍&≈P♥🛜

King's Arms Ⓛ
Quarry Brow, Hawcoat, LA14 4HY
☎ (01229) 828137
Cumbrian Ales Loweswater Gold; Kirkby Lonsdale Monumental; 4 changing beers (sourced locally; often Bowness Bay, Keswick, Kirkby Lonsdale) Ⓗ
A popular local pub conveniently situated near the route of the Number 1 bus in Hawcoat village (between the main town centre and the hospital). It sells ales mainly from Cumbrian micros. A beer menu on a chalkboard lists

forthcoming attractions. The pub, which has been on these premises since the 1860s, has been extensively extended and renovated, and features an open bar with adjacent separate rooms. Friendly staff give a warm welcome. Well-behaved dogs are allowed in one of the rooms. Q✿&♣🖳(1,6)♥🛜

Roa Island Boating Club Ⓛ
Belfast Pier, Roa Island, LA13 0QL
☎ 07874 649200 ⊕ ribc.uk
Roa Island Daylight Saving, Daylight Robbery; 2 changing beers (sourced locally; often Ulverston) Ⓗ
Welcoming boating club situated on an island connected by a causeway to the mainland. The causeway was originally built by the Furness Railway in the 1840s and is now a roadway leading to a jetty from which the foot ferry to Piel Island departs. The club's small solar-powered brewing plant produces a range of four beers which are supplemented by up to two from Ulverston Brewing Company. The outside pagoda and seating area offer superb views across the bay. ✿✿❍&♣P♥🛜

Boot

Brook House Inn Ⓛ
CA19 1TG (200yds walk from Dalegarth station – La'al Ratty)
☎ (019467) 23288 ⊕ brookhouseinn.co.uk

REAL ALE BREWERIES

Appleby Kendal
Barngates Barngates
Bowness Bay ✦ Kendal
Brack'N'Brew ☒ Watermillock
Carlisle Carlisle
Coniston Coniston
Cumbrian Hawkshead
Dent Cowgill
Eden River Penrith
Ennerdale ✦ Rowrah
Fell Flookburgh
Foxfield ☒ Foxfield (brewing suspended)
Gan Yam Kendal
Grasmere Grasmere
Great Corby Great Corby
Greenodd ☒ Greenodd (brewing suspended)
Handsome Bowston
Hawkshead ✦ Staveley
Healey's ☒ Loppergarth
Hesket Newmarket Hesket Newmarket
Keswick ✦ Keswick
Kirkby Lonsdale ✦ Kirkby Lonsdale
Lakeland Ulverston
Lakes ✦ Kendal
Langdale Docker
Logan Beck Duddon Bridge
Old Friends ☒ Ulverston
Old Vicarage ☒ Walton
Roa Island ☒ Roa Island
Shaws of Grange Grange-over-Sands
South Lakes Ulverston
Strands ☒ Nether Wasdale
Tarn Hows Outgate
Tirril Long Marton
Townhouse Dalton-in-Furness
Tractor Shed ✦ Workington
Ulverston ✦ Ulverston
Unsworth's Yard ✦ Cartmel
Westmorland Kendal
Wild Boar ☒ Bowness-on-Windermere
Windermere ☒ Ings

Barngates Goodhew's Dry Stout; Cumbrian Ales Langdale; Hawkshead Bitter; 6 changing beers (sourced nationally) ⊞
Situated in the heart of the western Lake District in beautiful Eskdale, close to the terminus of the Ravenglass and Eskdale miniature railway, this popular family-run tourist pub is renowned for good food and a wide range of well-kept cask ales. Together with other nearby pubs in the Eskdale Valley, the Brook House Inn hosts an annual beer festival in June.
Q❦☺🛏🍴❶◗&▲⬆(Dalegarth for Boot) ●P🐾❄️

Woolpack Inn 🅛

CA19 1TH (¾ mile E of Boot village on approach to Hardknott Pass)
☎ (019467) 23230 ● woolpack.co.uk
Barngates Brathay Gold; Fell Ghyll; Hawkshead Windermere Pale; Tirril Borrowdale Bitter; 2 changing beers (sourced nationally) ⊞
An iconic Lakeland pub on the approach to Hardknott Pass and surrounded by stunning scenery. This popular family-run tourist pub is renowned for good food and well-kept cask ales. The lounge and walkers' bar offer an attractive mix of traditional and modern styles, with wood-burning stoves in both areas. The pub is popular with families. Together with other nearby pubs in the Eskdale Valley, the Woolpack participates in the annual Eskdale beer festival held in June, and also holds a cider festival in April.
Q❦☺🛏❶◗▲⬆(Dalegarth for Boot) ♣●P🖳🐾❄️

Brampton

Howard Arms ✅

Front Street, CA8 1NG
☎ (016977) 42758 ● howardarms.co.uk
Thwaites Mild, Original, Best Cask; 2 changing beers (sourced nationally) ⊞
A modernised 18th-century country inn situated in the town centre and handy for all areas of town. There is a separate games room upstairs, and meeting and function rooms are available. Four handpumps dispense beers from the Thwaites range including one badged as Howard Arms. Charles Dickens is reputed to have slept here. Breakfast is served daily, and the main menu shows a commitment to local produce and home-made cooking. ❦☺🛏❶◗&♣P🖳(685)🐾❄️

Broughton-in-Furness

Manor Arms 🅛

The Square, LA20 6HY
☎ (01229) 716286 ● manorarmsthesquare.co.uk
Great Corby Blonde; Townhouse Charter; 5 changing beers (sourced regionally) ⊞
An outstanding free house owned by the Varty family for more than 30 years. Set in an attractive Georgian square, it has been the recipient of many CAMRA awards. Real ale dominates, and a dark beer is always on offer, along with traditional cider and perry. The constantly changing range on offer makes every day a mini beer festival. Two fires keep the pub warm and the bar staff are always friendly. Q❦☺🛏♣🗑🐾❄️

Calderbridge

Stanley Arms Hotel

CA20 1DN (on the A595)
☎ (01946) 841235 ● stanleyarmshotel.com
Tractor Shed Clocker Stout; Wychwood Hobgoblin Gold; 2 changing beers (sourced nationally; often Tractor Shed) ⊞

The Stanley Arms Hotel is an attractive black and white building on the A595, right by the bridge over the River Calder, with a delightful beer garden overlooking the river. The pub is privately owned and run, and has a long history likely associated with the local Stanley family. Expect friendly service and food cooked by a local chef. The hotel is an ideal base to explore west Cumbria, being only a few miles from the sea, the Western Fells and the famous valleys of Wasdale and Eskdale.
Q❦☺🛏❶◗⬆P🐾❄️

Cark-in-Cartmel

Engine Inn 🅛 ✅

LA11 7NZ
☎ (015395) 58341 ● theengineinncartmel.co.uk
Lancaster Blonde; 3 changing beers (sourced regionally) ⊞
A 17th-century inn, refurbished in 2010, which makes an excellent end to the walk from Grange described in CAMRA's Lake District Pub Walks book. Beers are selected to provide a range of styles. There is an open bar area with a cosy fire, separate rooms away from the bar, and a riverside beer garden. Five en-suite rooms are available. Opening hours and food services times are reduced in winter. ❦☺🛏❶◗&▲⬆♣P🐾❄️

Carlisle

Howard Arms

107 Lowther Street, CA3 8ED
☎ (01228) 648398
Theakston Best Bitter; Wainwright; 2 changing beers (sourced regionally; often Theakston) ⊞
Like all Carlisle pubs over 30 years old, the Howard Arms is an ex-State Management pub. The front rooms have changed little in character since those days and the recent refurbishment has taken its cues from Peaky Blinders to take full advantage of the atmosphere. The pub has a superb tiled exterior which pre-dates its State Management days. There is a big screen for sports events, and a heated patio for smokers.
❦☺❶◗⬆♣🖳🐾❄️

King's Head Inn 🅛

Fisher Street, CA3 8RF
● kingsheadcarlisle.co.uk
4 changing beers ⊞
An excellent city-centre pub, and winner of many CAMRA awards. A range of guest ales is dispensed from four handpumps. Pictures of old Carlisle adorn the internal walls and outside is an explanation of why the city isn't in the Domesday Book. Good-value meals are served at lunchtime. Children and dogs are not allowed. The covered outdoor courtyard has a large-screen TV and regularly features live music. ❦❶◗⬆♣🖳🐾❄️

Milbourne Arms

150 Milbourne Street, CA2 5XB
☎ (01228) 541194
2 changing beers (sourced locally) ⊞
Cosy and friendly single-room pub arranged around a central bar. This is a former State Management pub which, when built in 1853, served the thriving surrounding textile industry. Hand looms, spinning wheels, bobbins and shuttles from Linton Tweeds, which would have been used in the nearby mills, along with archive photos of the industry, are to be found throughout the pub. A short walk from Carlisle train station and on local bus routes. ❦❶◗&⬆♣P🖳🐾❄️

Spinners Arms 🅛

Cummersdale, CA2 6BD

☎ (01228) 532928 ⊕ thespinnersarms.org.uk

Carlisle Spun Gold, Flaxen, Magic Number; 1 changing beer (sourced locally; often Carlisle) 🅗

Cosy family-friendly hostelry, an original Redfern pub with unique and original features. Situated less than half a mile from Carlisle's south-western boundary, it is close to the Cumbrian Way and National Cycle Route 7, which run alongside the picturesque River Caldew. The pub hosts regular live music, with Irish music sessions every first and third Wednesday. Children are welcome until 9pm and well-behaved dogs are permitted. The pub is the brewery tap for Carlisle Brewing Co, and showcases its beers on three handpumps. ⏳❀💧♣P🚌(75)🌑🛜

Sportsman Inn ✅

Heads Lane, CA3 8AQ

☎ (01228) 533799

Timothy Taylor Landlord; Wainwright; 1 changing beer 🅗

The oldest recorded inn in Carlisle, first referred to in 1747. There is a copy of a 15th-century map of the area on display that suggests there was a building on the site at that time. The Sportsman has one large room. It was at one time a State Management pub - a plaque above the bar states it was part of the scheme between August 1916 and May 1973. ⏳❀🍺❶♣🚌🛜

Woodrow Wilson 🅛 ✅

48 Botchergate, CA1 1QS

☎ (01228) 819942

Great Corby Blonde, Corby Ale; Greene King Abbot; Marston's Old Empire; Ruddles Best Bitter; Sharp's Doom Bar; 6 changing beers (sourced nationally) 🅗

One of two adjacent Wetherspoons, this pub is in a refurbished Co-op building and is named after the former US president, whose mother was born in Carlisle. Up to 14 handpumps offer the largest range of real ales to be found in Carlisle. Food is available all day till 11pm. At the rear there is a spacious outdoor seating area, heated patio and smokers' area. Children are welcome in some areas until 8pm. ⏳❀🍺💧♿⇌🌑P🚌🛜

Cartmel

Unsworth Yard Brewery 🅛

4 Unsworth's Yard, LA11 6PG

☎ 07810 461313 ⊕ unsworthsyard.co.uk/brewery

Unsworth's Yard Crusader Gold; 3 changing beers (sourced locally; often Unsworth's Yard, Bowness Bay) 🅗

The tasting room at the front of a five-barrel brewery, it offers up to three of the brewery's beers at all times. The room, which is available for functions by appointment, opens out onto a courtyard with extensive seating. Other retailers in the same courtyard include high quality bread and cheese shops, and a shop specialising in fine wines, giving the area an almost continental ambience. ❀♿🌑🚌(532,530)

Cockermouth

Castle Bar ✅

14 Market Place, CA13 9NQ

☎ (01900) 829904 ⊕ castlebarcockermouth.co.uk

Cumbrian Ales Esthwaite Bitter, Loweswater Gold; 4 changing beers (sourced nationally) 🅗

Situated in the town's market place, this busy pub is just 150 yards from the (now closed) Jennings Brewery. The publican is keen on requests for beers from around the UK. There is a chalkboard outside listing current and

upcoming real ales and ciders. Parts of the building date from the 16th century and it was refurbished in the 2000s (commended in the CAMRA Pub Design Awards 2009). Three TVs show sports across the mazy ground floor. There is a restaurant on the first floor and a relaxing second-floor room with sofas. The terraced courtyard beer garden is popular in summer. ⏳❀🍺❶♿🚌(X4,X5)🌑🛜

Cock & Bull

7 South Street, CA13 9RT (centre of town opp Sainsbury's)

☎ (01900) 827999 ⊕ thenewcockandbull.co.uk

Coniston Bluebird Bitter; Great Corby Blonde, Fox Brown Ale; 2 changing beers (sourced regionally) 🅗

A community pub in the centre of town which has three regular beers supplemented by a constantly changing range of real ales on two handpumps, mainly from smaller Cumbrian breweries. The venue is on three levels – the main area has bar stools plus two seating areas with a TV showing sports in the front corner. The top level has a pool table and dartboard. Below this, off the main bar, is a quieter small room. Food is limited to bar snacks. ⏳❀🚌(X4,X5)🌑🛜

Swan Inn 🅛

52-56 Kirkgate, CA13 9PH

☎ (01900) 822425 ⊕ swaninncockermouth.com

Brakspear Gravity; Jennings Cumberland Ale; Marston's 61 Deep; Wainwright; 2 changing beers (sourced nationally; often Marston's, Wychwood) 🅗

A true community pub, a short walk from the centre of the town, well supported by locals. This 17th-century inn has flagged floors, exposed beams, a real fire and quiet nooks and crannies. It hosts a monthly whisky club and folk music sessions. Six handpumps offer a range of beers including three from the local Jennings Brewery. A large-screen TV at the back of the pub shows sports. ⏳♣🚌(X4,X5)🌑🛜

Coniston

Black Bull Inn & Hotel 🅛

LA21 8DU

☎ (015394) 41335 ⊕ blackbullconiston.co.uk

Coniston Oliver's Light Ale, Bluebird Bitter, Bluebird Premium XB, Old Man Ale, Special Oatmeal Stout, No 9 Barley Wine; 3 changing beers (sourced locally; often Coniston) 🅗

A 16th-century coaching inn, this is Coniston Brewing Company's on-site taphouse, also serving good food in traditional comfortable surroundings. A full menu is served from noon. Six regular beers are supplemented by other beers from the brewery on a rotation basis - a tasting paddle is a good option if you want to sample the range. The spacious bar and lounge are frequented by tourists in this popular, spectacular location near Coniston Old Man. The outside seating area is perfect in summer. Dogs are not allowed in the restaurant. ⏳❀🛏🍺❶♿🌑P🚌(X12,505)🌑🛜

Sun 🅛

LA21 8HQ

☎ (015394) 41248 ⊕ thesunconiston.com

Coniston Bluebird Premium XB; Cumbrian Ales Loweswater Gold; 6 changing beers (sourced locally) 🅗

Take the Walna Scar road up from Coniston village, or down from Coniston Old Man, to visit this 16th-century pub and hotel. The deliberately unmodernised dual-level bar has atmosphere and character, with a slate-topped bar, slate flooring, exposed beams and stone walls, heated by a large open range. Up to eight cask ales are

available, mostly from local brewers. The conservatory and terrace enjoy delightful views over the garden. Winter opening hours vary.
Q✿☞🅰♿♣P🖵(505,X12)❀🛜

Yewdale Inn 🅛 ✅
2 Yewdale Road, LA21 8DU
☎ (015394) 23132 🌐 yewdaleinn.com
Barngates Tag Lag; Cumbrian Ales Loweswater Gold; Theakston Old Peculier; 1 changing beer (sourced nationally) Ⓗ
A welcoming village inn in the centre of Coniston, attracting locals and visitors alike. In winter, a cosy fire and jovial atmosphere prevail. In summer, enjoy a drink on the terrace with stunning views of the Old Man of Coniston and surrounding fells, and Church Beck, a babbling brook running through the village. Opening hours and the availability of food are reduced in winter – see the website for details. Breakfast is served.
☞✿☞🅰🅓♣🖵(505,X12)❀🛜

Crosby

Stag Inn ✅
Lowside, CA15 6SH
☎ (01900) 812549 🌐 staginncrosby.com
Theakston Best Bitter; 3 changing beers (often Tetley, Tirril, Wainwright) Ⓗ
A welcoming pub, popular with locals and tourists alike, the Stag is set in a quiet village with commanding views over the Solway Firth to the Scottish hills. There is a large central bar with two serving points and quiet corners, plus a dining area. An extensive menu is available. Theakston Bitter is permanently on offer, with up to three other cask beers depending on the season.
☞✿🅓♿🅰♣P🖵(300)❀🛜

Dalton-in-Furness

Brown Cow Inn 🅛
10 Goose Green, LA15 8AQ
☎ (01229) 462553 🌐 browncowinndalton.co.uk
6 changing beers (sourced locally) Ⓗ
A warm and friendly atmosphere awaits visitors to this 400-year-old coaching house, which has retained many original features including beams, brasses, local prints and an open fire. A winner of many awards for its six real ales, the pub also serves excellent food from a full and varied menu. Meals can be enjoyed in the large dining room or, on warmer days, on the charming patio with heating and lighting. ☞✿☞🅰🅓P🖵(6,X6)🛜

Elterwater

Britannia Inn 🅛 ✅
LA22 9HP
☎ (015394) 37210 🌐 britinn.co.uk
Langdale Elterwater Gold; house beer (by Coniston); 4 changing beers (sourced locally; often Barngates, Eden River, Langdale) Ⓗ
A tiny pub in a tiny village, the Brit magically squeezes in a surprising number of thirsty walkers arriving hot from the fells in search of fine ales and local fare. The sociably small rooms and hallway spill out onto covered tables on the green. A range of Langdale house ales sits alongside Coniston specials and other Cumbrian beers. Book in early for the popular autumn beer festival and enjoy inclusive use of the Langdale Spa facilities for relaxation and recovery. ☞✿☞🅰🅓♿🅰♣P🖵(516)❀🛜

Embleton

Embleton Spa
CA13 9YA (just off A66 in Embleton village)
☎ (017687) 76606 🌐 embletonspa.co.uk
2 changing beers Ⓗ
Originally an 18th-century Lakeland farmhouse, this luxury hotel with swimming pool and leisure facilities is set in a lovely location. Two well-kept changing ales are served in the modern bar, which has a wood burning stove. There is an excellent south-facing outdoor drinking area with panoramic views of the local fells.
☞✿🅰🅓♿P🖵(X4,X5)❀🛜

Eskdale Green

Bower House Inn
CA19 1TD (short walk from Irton Road station – La'al Ratty)
☎ (019467) 23244 🌐 bowerhouseinn.com
Cumbrian Ales Loweswater Gold; Hawkshead Windermere Pale; Timothy Taylor Landlord; 1 changing beer (sourced nationally) Ⓗ
An 18th-century Eskdale Valley coaching inn on the edge of the village and close to the Outward Bound Mountain School. It is renowned for its cask ales and good food. The dining room has oak-panelled seating and beamed ceilings, and the bar has a real fire. Outside is an attractive beer garden and a play area for children. The pub has a community focus, hosting local cricket and darts teams, and Sunday quizzes for local charities.
Q☞✿☞🅰🅓▲≠(Irton Rd)♣🍴❀🛜

Gilcrux

Masons Arms
CA7 2QX
☎ (016973) 23267 🌐 masonsarmsgilcrux.co.uk
Courage Best Bitter; 2 changing beers (sourced nationally) Ⓗ
Friendly two-bar local with a TV in one bar. The building, with reclaimed ships' timbers in its structure, dates back to 1865 and was originally a boot and shoe makers. There is a large fireplace with wood-burning stove, a fish tank built into a wall and exposed beams. Outside is a beer garden. Closed on a Monday unless a bank holiday.
Q☞✿🅓♿P🍴🛜

Gosforth

Gosforth Hall Inn
Wasdale Road, CA20 1AZ (from A595 follow road signed to Wasdale; adjacent to St Mary's church)
☎ (019467) 25322 🌐 gosforthhall.co.uk
4 changing beers (sourced nationally) Ⓗ
Gosforth Hall is a mid-17th century Grade II-listed building set in attractive surroundings at the edge of this west Lakeland village close to Wasdale. The lounge reputedly has the widest-spanning sandstone hearth in England. In winter there are real fires in both bar and lounge. Accommodation in the main building has recently been extensively refurbished. The menu is changed every two days but always features a selection of the landlord's home-made pies.
Q☞✿🅰🅓♿♣🍴🛜

Grange-over-Sands

Keg & Kitchen 🅛
Main Street, LA11 6AB
☎ (015395) 83003 🌐 kegandkitchen.co.uk

Unsworth's Yard Sir Edgar Harrington's Last Wolf; Wainwright; Wychwood Hobgoblin Gold; 1 changing beer (sourced locally; often Unsworth's Yard) ⎄
Large pub in the centre of Grange, opposite the post office. The main bar and entrance are on the middle floor. The upstairs has been converted to a games area containing a pool table. The lower area, called the Gin Pig, is open Friday and Saturday evenings. It can be accessed from the pub or from a separate entrance and has bottled beers available from Shaws of Grange. ⎄⎄⎄⎄⎄⎄⎄⎄⎄

Grasmere

Tweedies Bar & Lodge ⎄
Red Bank Road, LA22 9SW
☎ (015394) 35300 ⊕ tweediesgrasmere.com
Coniston Old Man Ale; Cumbrian Ales Loweswater Gold; 12 changing beers (sourced nationally; often Coniston, Thornbridge, Track) ⎄
A legend in its own opening time, this bar is a must-visit attraction for regular customers, with knowledgeable bar staff providing advice on the wide-ranging selection of excellent ales. The beer choice is updated daily on the website. Even with third-pint beer bats it is a challenge to sample every ale and cider – but it's fun to try! The garden has plenty of seating and tables. The famous Grasmere Guzzler beer and music festival is hosted every September. ⎄⎄⎄⎄⎄⎄⎄P⎄(555,599)⎄⎄

Great Broughton

Punch Bowl Inn ⎄
19 Main Street, CA13 0YJ
☎ (01900) 267070 ⊕ thepunchbowl.org
3 changing beers (sourced nationally) ⎄
This small community inn run by a committee of local volunteers. Although opening hours are limited, this is more than compensated for by the quality and variation of the usually Cumbrian real ales it serves. Two locally sourced, constantly changing beers are offered. The pub has served 135 different beers over the past year, and holds a guest beer weekend in February. Originally a 17th-century coaching inn, this is very much a community and locals' pub. Q⎄⎄P⎄⎄

Great Corby

Queen Inn ⎄
The Green, CA4 8LR
☎ (01228) 832032 ⊕ thequeeninn-greatcorby.co.uk
Great Corby Ale, Blonde; 1 changing beer (sourced locally) ⎄
Refurbished village inn over two storeys with two restaurant areas where dining is the focus. Booking is essential if you wish to eat. There is a separate room for Sky sports. A conference room is available and also a private dining room. The pub serves a range of ales from the next door Great Corby Brewhouse. It occasionally hosts live music and regularly posts on Facebook. Q⎄⎄⎄⎄P⎄⎄

Great Langdale

Old Dungeon Ghyll Hotel ⎄
LA22 9JY
☎ (015394) 37272 ⊕ odg.co.uk
Cumbrian Ales Loweswater Gold; 5 changing beers (sourced locally; often Barngates, Cumbrian Ales, Fell) ⎄
A unique Lake District hotel located in the remote and unspoilt Langdale Valley, the Hikers' Bar at the Old

Dungeon Ghyll is an institution for generations of weary walkers drawn towards the famous watering hole from high on the fells. The fare is basic, like the facilities (a converted cow-shed with stalls), but the beer always hits the spot. Local breweries are featured with occasional outsiders for variety, but Loweswater Gold is the traditional favourite. There are plenty of tables in the garden and a useful bus service from Ambleside. Q⎄⎄⎄⎄⎄⎄⎄AP⎄(516)⎄⎄

Great Orton

Wellington Inn
CA5 6LZ
☎ (01228) 710775
3 changing beers (sourced locally; often Derwent, Keswick) ⎄
Attractive country inn set in a quiet village. It serves good-value meals using ingredients sourced from the area, including meat from the renowned local butcher. Three handpumps offer ales from mainly local breweries such as Derwent and Keswick. Live music is being reintroduced here, with open mic nights on an occasional basis. There is space for 10 touring caravans on the adjacent campsite. Q⎄⎄⎄⎄⎄⎄P

Hayton

Stone Inn
CA8 9HR
☎ (01228) 670896 ⊕ stoneinnhayton.co.uk
Thwaites Original; 1 changing beer (sourced locally) ⎄
A traditional family-run pub situated in the village of Hayton, community focused and home to the local leek club. The upstairs dining room can be hired for small gatherings. A fine pair of 1904 Christ Church boat club oars adorn one wall; ask to see the CAMRA mirror. There is a guest ale, often from a local brewery, as well as the regular Thwaites Original bitter. ⎄⎄⎄P⎄⎄

Hensingham

Globe Inn
95 Main Street, CA28 8QX (take A595 from Whitehaven and follow signs for Cleator Moor)
☎ (01946) 590772 ⊕ theglobehensingham.co.uk
2 changing beers (sourced nationally) ⎄
An unassuming pub from the outside, as soon as you walk in the friendly character takes hold. There are two separate rooms downstairs and a dining area upstairs. Food is freshly cooked to order. The beer range changes frequently, with two handpumps to choose from. Sports TV is available, also a dartboard, jukebox, and a real fire in winter. Very much a locals' pub but always welcoming to strangers. Card payment is now accepted. ⎄⎄⎄⎄⎄⎄⎄

Hesket Newmarket

Old Crown ⎄ ⎄
CA7 8JG
☎ (016974) 78288 ⊕ theoldcrownpub.co.uk
Hesket Newmarket Haystacks, Black Sail, Helvellyn Gold, Doris' 90th Birthday Ale, Brim Fell IPA; 4 changing beers (sourced locally; often Hesket Newmarket) ⎄
Sitting in the heart of this lovely picturesque fellside village, the Old Crown is a showcase for the Hesket Newmarket Brewery, which is immediately behind the building. It is well known as the first co-operatively owned pub in the country and is popular with locals and

visitors alike, with Prince Charles and Sir Chris Bonington among its supporters. Meals are available featuring local produce. Opening hours are subject to change – please check the website before travelling. Q ☜ 🏠 🍴 ♣ 🐾 ❀ 🛜

Holmes Green

Black Dog Inn 🄻

Broughton Road, LA15 8JP (1½ miles from Dalton-in-Furness Tudor Square on Broughton road towards Askam) SD233761
☎ (01229) 462975

Cumbrian Ales Esthwaite Bitter, Langdale, Loweswater Gold; 5 changing beers (sourced nationally; often Abbeydale, Cumbrian Ales) 🄷
With five real ales on offer, a warm welcome awaits from the landlord and locals alike. This former coaching inn, with two real fires, quarry tiled floor and rustic beams, was recently refurbished but retains plenty of character. There is live music monthly, and the Dog Fest music festival is usually on the August bank holiday Sunday. Outside there is a decked seating area.
☜ 🏠 🍴 ♣ P ❀ 🛜

Ings

Watermill Inn 🄻

LA8 9PY
☎ (01539) 821309 ⊕ watermillinn.co.uk
Windermere Collie Wobbles, A Bit'er Ruff, Blonde; 8 changing beers (sourced locally; often Windermere) 🄷
Windermere Brewery is located in the centre of this multi award-winning converted watermill, which has been owned by the same family for many years. The bar serves as the brewery tap for the wide range of dog-themed beers, and it is no surprise that the menu and bedrooms also cater for four-legged customers who bring their owners. There is a nearby campsite and the Lakes 555 bus stops outside – handy if you're sampling the renowned Shi Tzu Faced at 7% ABV.
Q ☜ 🏠 🍴 ♿ ⅄ ♣ P (555) ❀ 🛜

Kendal

Barrel House 🄻

Unit 10 Castle Mills, Aynam Road, LA9 7DE
☎ 07498 203351 ⊕ bownessbaybrewing.co.uk
Bowness Bay Swan Blonde, Fellwalker, Raven Red, Swan Gold, Swan Black; 7 changing beers (sourced locally; often Appleby, Bowness Bay) 🄷
The tap house for Bowness Bay Brewing is buried in an old mill complex across the river from the town centre and well worth the effort of discovery. At the back of the walled yard are self-contained beer booths, then a large folding-glass door opens to reveal a modern two-storey conversion, with a snug bar and comfy lounge upstairs. The bar showcases the full range of beers brewed on site. Twice-yearly festivals fill the yard and feature over 40 specially selected beers. 🏠 🍴 ♿ ♣ P (555,X6) ❀ 🛜

Factory Tap 🄻

5 Aynam Road, LA9 7DE
☎ (015394) 82541 ⊕ thefactorytap.co.uk
Fyne Jarl; 9 changing beers (sourced nationally; often Brass Castle, Fell, Gan Yam) 🄷
Evergreen and ever-popular, the original 'modern-style' bar in town sprawls around a rambling old mill house and welcomes beer enthusiasts and their dogs. An ever-changing selection of interesting ales, both cask and keg, offers options for every drinker, and occasional tap takeovers ring the changes. Pop-up food stalls cater for

most tastes and are advertised weekly on social media. There are occasional special events and festivals.
☜ 🏠 🍴 ♿ P 🏠 ❀ 🛜

Fell Bar 🄻

3 Lowther Street, LA9 4DH
☎ 07904 488014 ⊕ fellbrewery.co.uk
Fell Ghyll; 11 changing beers (sourced regionally; often Fell, Fyne, Gan Yam) 🄷
A small hidden treasure house of knowledge and enthusiasm about modern beers, you'll discover that a visit is both an education and a taste adventure. The four-storey house by the town hall is a tap bar for artisan Fell Brewery and offers an extensive choice of house and guest ales in cask and keg. The selection includes unctuous stouts and fruity sours alongside more traditional styles. Live music and tap takeovers are advertised. ☜ 🍴 ⅄ ♣ 🏠 ❀ 🛜

Indie Craft Beer 🄻

32 Finkle Street, LA9 4AB
☎ (01539) 721450 ⊕ indiecraftbeer.co.uk
12 changing beers (sourced nationally; often Arbor, Cloudwater, Northern Monk)
Kendal's first craft keg bar is about to expand to add additional live keg and four cask pumps. Meanwhile a regularly changing selection of up to 14 keg beers is available, and the owner is always on hand to discuss each personally selected gem and introduce 'newbies' to live keg. The Madchester vibe includes an upstairs chill-out room with suitably atmospheric vinyl playing. Outdoor tables on the pedestrianised street and the large selection of imported bottled beers add a continental air.
🏠 ⅄ ♣ 🏠 (555,X6) ❀ 🛜

New Union 🍸 🄻

159 Stricklandgate, LA9 4RF
☎ (01539) 726019 ⊕ thenewunion.co.uk
Fyne Jarl; 3 changing beers (sourced regionally; often Bowness Bay, Kirkby Lonsdale, Thornbridge) 🄷
If you're not passionate about real ales, ciders, perries and malt whiskies then the Union is not for you! Keen drinkers beat a path to the door of this town-edge pub to sample the four cask ales and browse the large menu of ciders and perries. There is a weekly quiz, a live music night and regular special events including tutored tastings, tap takeovers and annual beer and cider festivals. Tables outside offer ringside seats for outdoor entertainment. Local CAMRA Pub and Cider Pub of the Year 2022. ☜ 🏠 🍴 ⅄ ♣ 🏠 P 🏠 (555) ❀ 🛜

Keswick

Fox Tap 🄻

Brewery Lane, CA12 5BY
☎ (017687) 80700 ⊕ keswickbrewery.co.uk
Keswick Gold, Fox Pale; 5 changing beers (sourced locally) 🄷
This superbly refurbished and enlarged Keswick Brewery tap reopened in 2019. Situated just outside the town centre, there has been a brewery on the site since 1875. The Tap serves all Keswick's beers and is able to offer brewery tours. Occasional live music and food events feature. The bar is dog friendly and has a seating area outside. Q ❀ ♣ P ❀

Kirkby Lonsdale

Kings Arms Hotel 🄻

7 Market Street, LA6 2AU
☎ (015242) 71220

4 changing beers (sourced locally; often Marble, Settle, Thornbridge)
Despite being the oldest pub in town, there is a young heart to this modern-thinking pub, which encompasses an imaginative menu and a small selection of beers that appeals to all tastes. The main room, overlooking the church, has an old long bar and large inglenook fireplace. Upstairs is a small dining room that can be privately hired; outside at the back is a bijou garden beside the pub's holiday cottages. Live music is a regular attraction. Opening hours may vary.
万券❀₽◑▲♿₽🖵(567,81A)❀🐾

Orange Tree L ✓
9 Fairbank, LA6 2BD (turn left past the churchyard, pub is on your right)
☎ (015242) 71716 ● theorangetreehotel.co.uk
Kirkby Lonsdale Singletrack, Monumental; 3 changing beers (sourced locally; often Bowness Bay, Kirkby Lonsdale) ⊞
This cosy old pub by the church acts as a second tap for Kirkby Lonsdale Brewery, but with food and rooms. The central bar offers six cask beers including Jubilee Stout as a special. There are daily meal deals and a Friday happy hour for local beer lovers, so the pub, including the separate dining room behind the bar, rapidly fills up. The specially-woven carpet featuring orange trees is unique and definitely out-rivals those of a famous pub chain.'
方券◑▲🖵(567)❀🐾

Royal Barn L ✓
New Road, LA6 2AB
☎ (015242) 71918 ● klbrewery.com/the-royal-barn
Kirkby Lonsdale Tiffin Gold, Stanley's, Ruskin's, Singletrack, Monumental, Jubilee; 4 changing beers (sourced locally; often Kirkby Lonsdale) ⊞
The Barn is a buzzing hive of down-to-earth activity in the centre of this upmarket tourist town. A new mezzanine floor overlooking the bar, plus a kitchen with pizza oven, have enlarged the original setting. But despite a few changes, the beers remain a constant and the 12 cask and eight keg lines are still dispensing favourite Kirkby Lonsdale beers along with cider and freshly ground-on-site coffee. Open the door and walk upstairs for a veritable Aladdin's cave.
方◑●🖵(567,81)❀🐾

Kirkby Stephen

La'l Nook L
1 Croft Street, CA17 4QJ
☎ 07506 075625
4 changing beers (sourced locally; often Keswick, Langdale, Tirril) ⊞
This cosy micropub is a local hub for good beer and good conversation. It is located down a side alley off the main street, just outside the centre of this little town. The four handpumps supply weekly-changing ales from every brewery in the surrounding area – blink and you've missed it – so check out the daily-updated beer menu on social media to inform your visit. Opening hours are extended in the summer season. Q方🖵(S5)❀

Taggy Man L
4 Market Street, CA17 4QS
☎ (017683) 72531 ● taggyman.co.uk
House beer (by Kirkby Lonsdale); 3 changing beers (sourced regionally; often Black Sheep, Cross Bay, Keswick) ⊞
Praised for its jolly welcome and easy hospitality, the pub is named after the medieval watchman who called the nightly curfew. A good selection of local ales sits alongside popular national beers, while tasty hand-made

pies are enthusiastically enjoyed by regulars and visitors. Dogs are very welcome. Weekly live music events and a quiz are advertised on social media.
方券◑◑♿▲₽🖵(S5)❀🐾

Loppergarth

Wellington Inn L
Main Street, LA12 0JL (1 mile from A590; between Lindal and Pennington)
☎ (01229) 582388
Healey's Blonde; 4 changing beers (sourced locally; often Healey's) ⊞
Superb village local with its own microbrewery – a custom-made stainless steel plant which is viewable from the snug. Four handpumps dispense Healey's beers, always including an award-winning blonde and a golden bitter. A traditional darker best bitter and a superb mild are occasionally available. Wood-burning stoves make this a cosy pub, with games, books and good conversation. There is a quiz on alternate Saturdays. Well-behaved dogs on leads are welcome. 方券♿♣🐾🐾

Loweswater

Kirkstile Inn
CA13 0RU (off B5289, 7 miles S from Cockermouth)
NY140210
☎ (01900) 85219 ● kirkstile.com
Cumbrian Ales Esthwaite Bitter, Langdale, Loweswater Gold; 3 changing beers (sourced regionally; often Cumbrian Ales) ⊞
CAMRA award-winning 16th-century Lakeland coaching inn, scenically located below Melbreak, Crummock Water and Loweswater. The interior features low-beamed ceilings and solid wood tables, chairs and settles in three bar areas, plus an open fire for chilly days. There is a well-established restaurant, and substantial bar meals are available from midday. The original home of Loweswater Brewery, this is now the brewery tap for Cumbrian Ales and holds an annual beer festival in April. The outdoor seated drinking area has stunning surroundings. Dog friendly up to 6pm.
Q方券❀◑♿●🖵🛏❀🐾

Lowick Bridge

Red Lion Inn L
LA12 8EF (just off A5084 on Ulverston-Torver road)
☎ (01229) 885366 ● redlion-lowick.co.uk
Bank Top Flat Cap; Great Corby Corby Ale; 1 changing beer (sourced locally) ⊞
This former Hartley's ale house, just off the road from Greenodd to Coniston, was purchased by the present owners from Robinsons in 2014. It is now a charming and comfortable country inn, popular with both locals and visitors to the Lakes. Friendly and welcoming, the pub is an ideal base to explore the hidden corners of the southern Lakes, and the Furness and Cartmel peninsulas. Q方券❀◑♿▲🖵(X12)❀🐾

Monkhill

Drovers Rest
CA5 6DB
☎ (01228) 576141
4 changing beers ⊞
A traditional country pub, close to the popular Hadrian's Wall Path, with a strong community focus. Although the interior has been opened up, it still has the feel of three distinct rooms. The bar area is cosy and welcoming with a roaring fire in winter. Some interesting historical State

625

Management Scheme documents adorn the walls. The Drovers is an oasis for lots of different and sometimes obscure (for the area) real ales. Winner of multiple CAMRA awards including at regional level.
&❀❆◐▲♣P🖵(93) ❀

Moorhouse

Royal Oak
CA5 6EZ
☎ (01228) 576475
Timothy Taylor Dark Mild; house beer (by Timothy Taylor); 1 changing beer Ⓗ
This small country pub on the outskirts of Carlisle is over 250 years old, so be prepared to duck as you go through some of the doors. Log-burning stoves help provide a rustic atmosphere. A traditional home-cooked menu is available along with real ale from local breweries. The pub posts regular updates on Facebook. ❀◐❀ 🛜

Near Sawrey

Tower Bank Arms Ⓛ
LA22 0LF (on B5285, 2 miles S of Hawkshead)
☎ (015394) 36334 ⊕ towerbankarms.co.uk
Barngates Tag Lag; Cumbrian Ales Loweswater Gold; Hawkshead Bitter; 3 changing beers (sourced locally) Ⓗ
A 17th-century Lakeland inn, with slate floors, oak beams and a cast-iron range creating a lovely atmosphere, next to the National Trust-run Hill Top (Beatrix Potter's home). Five handpumps serve local beers, with cider and perry dispensed by gravity. Booking is essential for evening meals. Families and dogs are welcome. There is a seasonal bus service connecting to the Windermere ferry and Hawkshead. Accommodation is available in four en-suite rooms. Note that the pub is closed on Monday in winter. Q&❀❆◐▲♣P🖵❀🛜

Nether Wasdale

Strands Inn Ⓛ
CA20 1ET
☎ (019467) 26237 ⊕ thestrandsinn.com
Strands Brown Bitter, Errmmm...; 6 changing beers (sourced locally) Ⓗ
Situated in the centre of the picturesque village of Nether Wasdale, with superb views across to the Wasdale Screes and up towards Wasdale Head, the Strands Inn and brewery tap is popular with both locals and tourists throughout the year. A range of beers from the adjacent Strands Brewery is available. All food is prepared on the premises and a varied menu is served throughout the day. Q&❀❆◐▲P❀🛜

Ousby

Fox Inn Ⓛ
CA10 1QA
☎ (01768) 881374
2 changing beers (often Cross Bay, Eden River) Ⓗ
Nicely refurbished pub with unusual seating in the bar. Situated in the lee of the Pennines with extensive views over the Eden Valley, the pub caters for locals as well as tourists. There is a large games area with two pool tables and darts. A quiz takes place on Thursday evening. Two changing guest ales are on sale, usually from local breweries such as Eden and Cross Bay. A touring caravan site and camping is opposite the pub. &❀◐▲♣P❀🛜

Oxen Park

Manor House Hotel Ⓛ
LA12 8HG
☎ (01229) 861345 ⊕ manorhouseoxenpark.co.uk
3 changing beers (sourced regionally; often Bowness Bay, Coniston, Cumbrian Ales) Ⓗ
In a small village on the outskirts of the Lake District, this former Hartley's pub reopened in 2017 as a free house after an extensive refurbishment to a modern high standard. The beer range varies but includes ales from local breweries. The excellent food menu features a number of vegan dishes, and booking is recommended at weekends. Free overnight parking is available for campervans, with access to toilets and electric hook up. &❀❆◐&▲P❀🛜

Penrith

Agricultural Hotel Ⓛ ✓
Castlegate, CA11 7JE
☎ (01768) 862622 ⊕ the-agricultural-hotel.co.uk
6 changing beers Ⓗ
The hotel is built from local sandstone and the bar and dining room are open plan, with steps from one to the other. There is also a small reception area. The Victorian sash screen-shuttered bar has six handpumps. Food is served in the large dining area, as well as in the bar at quiet times. The pub is a free house and has extended the range of local beers on offer in recent years.
&❀❆◐&≉(North Lakes) ♣P🖵

Fell Bar 🍷 Ⓛ
52 King Street, CA11 7AY
☎ (01768) 866860
6 changing beers Ⓗ
A small and intimate venue in the centre of Penrith, over three floors, which was turned into a pub in 2012. It serves as the tap for Fell Brewery but offers a range of other cask ales and craft beers, as detailed on the blackboard near the bar. The Fell holds regular quiz, comedy and music nights – see its Facebook page for details. Local CAMRA Pub of the Year 2020-22.
&≉(North Lakes) 🖵❀🛜

Royal Ⓛ
Wilson Row, CA11 7PZ
3 changing beers Ⓗ
Traditional pub on the edge of the town centre with tiled walls and lots of mellow wood. It has three separate areas served by one bar. Two handpumps offer beers from all over the UK, including LocAles. It is home to darts, dominoes and pool teams, and there is full sports TV coverage. Live music sessions with a broad appeal are held on Sunday afternoons outside the football season. &❀◐▲≉(North Lakes) ♣🖵❀🛜

Ravenglass

Pennington Hotel
Main Street, CA18 1SD
☎ (01229) 717222 ⊕ penningtonhotel.co.uk
Bowness Bay Swan Blonde; 1 changing beer Ⓗ
This friendly hotel has a long history as a village pub. It is part of the Muncaster Castle estate (which has been owned by the same family for 400 years), the entrance to which is half a mile away. The hotel is situated right on the ancient Main Street, yards from the beautiful Ravenglass Estuary. The hotel has been tastefully modernised while keeping many old features. Quality food is well presented and locally sourced where possible. Q&❆◐&▲≉P🛜

Ravenstonedale

Black Swan Hotel ℄ ✓

CA17 4NG

☎ (015396) 23204 ⊕ blackswanhotel.com

Black Sheep Best Bitter; Timothy Taylor Landlord; 2 changing beers (sourced locally; often Allendale, Coniston, Kirkby Lonsdale) 𝖧

A family-owned hotel with a well-respected bar, the Swan prides itself on attention to detail when catering for the comfort of guests. Two regular ales are complemented by a couple of changing beers sourced from around the area. The lovely garden by the stream makes this tranquil spot – ideal for a leisurely lunch. A Western Dales return bus from Kendal passes the road end on Thursdays. Q ❄ ☎ ❦ ◖ ◆ P ⊟ (S5) ♣ 🕏

Rosthwaite

Scafell Hotel ✓

Borrowdale, CA12 5XB (on B5289, up Borrowdale valley from Keswick)

☎ (017687) 77208 ⊕ scafell.co.uk

Tirril Old Faithful, Borrowdale Bitter; 2 changing beers (sourced locally) 𝖧

The Scafell Hotel is a privately-owned country house hotel located in the very heart of Borrowdale – considered by many to be England's finest valley. The stone-flagged Riverside Bar, with its welcoming open fire, is busy all year round. Owner Miles Jessop has run the hotel for over 50 years.
Q ❄ ☎ ❦ ◖ ◖ ᕲ ▲ ♣ P ⊟ (78) ♣ 🕏

Roweltown

Crossings Inn

CA6 6LG (on B6318 2 miles S of Roadhead)

☎ (016977) 48620

3 changing beers (sourced locally; often Great Corby) 𝖧

Popular country pub with views over the Bewcastle Fells serving a wide rural area. Good food is served in a separate dining room with a focus on local produce. There is a games area with dartboard and pool table. Three handpumps are available but there is usually only one beer on offer – a local ale from Great Corby. Real fires are lit in the winter months. Adjacent to a certificated camping and caravan site. ❄ ❦ ◖ ♣ P 🕏

Rowrah

Ennerdale Brewery Tap ℄

Chapel Row, CA26 3XS

☎ (01946) 862977 ⊕ ennerdalebrewery.co.uk

Ennerdale Craft Blonde, Pale, Darkest, Wild; 2 changing beers (sourced locally) 𝖧

This brewery tap is a café by day and a bistro pub in the evening. It offers a warm, friendly setting with four main ales and four seasonals on handpump, as well as speciality beers. Brewery tours are available if booked in advance via the website. The pub lies on the Coast to Coast cycle route. Public transport is extremely limited. ❄ ◖ ᕲ ♣ P 🕏

Rydal

Badger Bar (Glen Rothay Hotel) ℄

LA22 9LR

☎ (015394) 34500 ⊕ theglenrothay.co.uk

Barngates Goodhew's Dry Stout; house beer (by Old School); 4 changing beers (sourced locally; often Bowness Bay, Fell, Great Corby) 𝖧

The badgers are real – just like the ale – and can be watched at night via the webcam. This quirky old inn overlooking Rydal Water, near one of Wordsworth's homes, is a long-time supporter of CAMRA and serves only local beers, including the specially brewed Badger Ale. In front of the hotel is a large garden with scenic views plus a sheltered side terrace. Note the unique loos built into the rock face. Close to the 555 bus stop.
Q ❄ ☎ ❦ ◖ ◖ ▲ ♣ P ⊟ (555,599) ♣ 🕏

Sedbergh

Thirsty Rambler ℄

14-16 Main Street, LA10 5BN

☎ 07874 838816 ⊕ thethirstyrambler.co.uk

5 changing beers (sourced locally; often Fell, Settle, Wensleydale)

This compact and comfortable micropub in a converted shop on the main street is the new kid in town. Unsurprisingly, given its name, it is designed to look after walkers from the Yorkshire Dales and Lakeland Fells. The bar showcases only local products, including three cask ales and two live keg lines. Although it's early days for this venture, it provides a refreshing change from the other mostly food-based establishments in this Book Town. ⊟ (W1,S4) ♣

Staveley

Beer Hall ℄ ✓

Hawkshead Brewery, Mill Yard, LA8 9LR

☎ (01539) 825260 ⊕ hawksheadbrewery.co.uk

Hawkshead Bitter, Red; 14 changing beers (sourced locally; often Hawkshead) 𝖧

Situated in the artisan village of Staveley, between Kendal and Windermere, this large tap house for Hawkshead Brewery serves the full selection of its beers in cask, keg and bottle. Various events are held during the year – details can be found on social media. Visitors can take advantage of the local Lakes Line train, or the Stagecoach 555 bus which serves the main corridor of the Lake District. Q ❄ ☎ ❦ ᕲ ▲ ⇌ P ⊟ (555) ♣ 🕏

Eagle & Child Hotel ℄

Kendal Road, LA8 9LP

☎ (01539) 821320 ⊕ eaglechildinn.co.uk

5 changing beers (sourced locally; often Bowness Bay, Cumbrian Ales, Fell) 𝖧

Attractively located by the confluence of three Kentdale rivers, this traditional village pub on the edge of the village offers a good selection of Cumbrian ales and hearty dishes. The gardens back and front are popular in all weathers and a large function room caters for private parties. Regular events and occasional beer festivals are advertised on the pub's website along with out-of-season offers. Accommodation is in five rooms. The Central Lakes 555 hourly bus service stops outside and the railway station is a pleasant stroll away.
Q ☎ ❦ ◖ ⇌ ♣ P ⊟ (555) ♣ 🕏

Talkin

Blacksmiths Arms ℄

CA8 1LE

☎ (016977) 3452 ⊕ blacksmithstalkin.co.uk

Black Sheep Special Ale; 2 changing beers 𝖧

Since taking over in 1997, the present owners have made this probably the most popular pub in the vicinity. The winning formula includes four real ales, a superbly stocked bar, friendly efficient staff, no TV, and meticulous attention to detail. With a golf course and country park within two miles and plenty of other outdoor activities

locally, the pub attracts visitors from far outside north Cumbria to this Area of Outstanding Natural Beauty. Q☺☜✿❀◑❍ᴥ♣P☂

Tallentire

Bush Inn

CA13 0PT
☎ (01900) 823707
3 changing beers (sourced nationally) Ⓗ
A genuine, old-fashioned, Grade II-listed village inn with exposed beams, stone floors and a wood-burning stove. A changing selection of three real ales is offered, usually including at least one from a Cumbrian brewery. Well-behaved dogs are welcome. Food is served in the bar and in the separate dining room Thursday to Saturday, March to December. Real cider is served in summer only. The pub is home to the local cricket and darts teams.
Q☺◑♣❀❍☂

Ulverston

Devonshire Arms Ⓛ

Braddyll Terrace, Victoria Road, LA12 0DH (next to railway bridge in town centre)
☎ (01229) 582537
Abbeydale Moonshine; 3 changing beers (sourced regionally; often Abbeydale, Cross Bay, Moorhouse's) Ⓗ
Conveniently situated between the bus and train stations, the Dev is a real locals' pub with a welcoming atmosphere. Four TVs provide comprehensive sports coverage, and there are two dartboards and a pool table. Five constantly changing cask ales and a real cider are all dispensed on handpump. The outside seating area is popular in summer. A meat raffle is held on Sunday evening. The pub has received numerous awards from CAMRA over the years. ☜☺ᴥ♠♣❀P❍❍☂

Gather Ⓛ

7 Market Street, LA12 7AY
⊕ gatherbeers.co.uk
2 changing beers (sourced nationally) Ⓗ
A micropub and bottle shop owned by a CAMRA member. It has two handpumps and eight KeyKeg beers, with an extensive range of interesting local, national and international bottled and canned beers and ciders, plus growler fills in cans to take away. Tap takeovers and other events are occasionally held – check Facebook for details. Recently refurbished to give more seating downstairs, and with additional seating upstairs, the place has a pleasant and relaxing atmosphere. Pizzas are served. ≠☐❍☂

Mill Ⓛ ✔

Mill Street, LA12 7EB
☎ (01229) 581384 ⊕ mill-at-ulverston.co.uk
Lancaster Amber, Blonde, Black, Red; 6 changing beers (sourced nationally) Ⓗ
The Mill has an interesting, characterful layout, centred around a restored original, but now static, waterwheel. The Cask Bar is on the ground floor. On Friday and Saturday both the Loft Bar on the second floor, serving evening cocktails, and the first-floor Terrace Bar with a separate outdoor patio area and large-screen TV, are open. Deservedly popular for quality food, booking is essential for the restaurant. There are picnic tables outside to the front. ☜☺◑ᴥ☐≠(6,X6)❍☂

Old Friends ☗ Ⓛ

49 Soutergate, LA12 7ES
☎ (01229) 208195 ⊕ oldfriendsulverston.co.uk

6 changing beers (sourced nationally; often Old Friends) Ⓗ
A 17th-century Grade II-listed locals' pub 200 yards uphill from the town centre. It has a cosy snug with an open fire in front of the bar. Another room with a TV is separated by a passageway with a hatch to the bar. Beers are mostly local, with three brewed in the pub's own brewery. A popular quiz night is held every Tuesday. There is a wonderful beer garden with heating in the winter. ☜❀♣☐❍☂

Swan Inn Ⓛ

Swan Street, LA12 7JX
☎ (01229) 582519
8 changing beers (sourced nationally) Ⓗ
On the edge of the town centre, overlooking the A590, there's an open-plan feel here, yet there are three distinct drinking areas. Premier League football and major sports events are screened, live music features occasionally, and a jukebox allows for all genres of music. A Sunday night quiz rounds off the entertainment. The beer garden is popular, especially in summer. Children are allowed until 8pm. ❀ᴥ☐≠(6,X6)❍☂

Waberthwaite

Brown Cow Inn

LA19 5YJ (on the A595)
☎ (01229) 717243 ⊕ thebrowncow-inn.simplesite.com
Bowness Bay Swan Blonde, Swan Gold; 3 changing beers (sourced locally; often Great Corby) Ⓗ
A traditional family-run roadside inn just south of Ravenglass and Muncaster Castle on the A595. Four or five real ales, often locally brewed, can be found here. The resident chef produces delicious home-cooked food that is beautifully presented and locally sourced where possible. This is a dog- and family-friendly pub that also offers overnight accommodation, and is ideally placed for exploring the western Lake District. Q☜☺✿❀◑❀♣❍☂

Wetheral

Wheatsheaf Inn Ⓛ ✔

CA4 8HD
☎ (01228) 560686 ⊕ wheatsheafwetheral.co.uk
Great Corby Corby Ale; 2 changing beers Ⓗ
Early 19th-century village pub, deservedly popular with locals and visitors, just a few minutes' walk from the village green and railway station. Along with Corby Ale from the local Great Corby Brewery there are two ever-changing beers sourced from local breweries. Good-value bar meals are served Wednesday to Sunday. Booking is advisable at weekends. The regular Tuesday quiz night is well supported. ☜❀◑≠♣P☐(75)❍☂

Whitehaven

Candlestick ✔

21-22 Tangier Street, CA28 7UX
☎ (01946) 66288
3 changing beers (sourced nationally) Ⓗ
Town-centre pub situated close to Whitehaven harbour, at one time known as the Welsh Arms. The closure of other pubs locally has resulted in an eclectic clientele drawn by the excellent beer quality. This is often reflected in the varied choice of music on the jukebox. The interior comprises a bar area and a comfortable seating area. There is regular live music and the pub gets busy on Friday and Saturday nights. ≠☐❍☂

Witherslack

Derby Arms Hotel Ⓛ

LA11 6RH
☎ (015395) 52207 🌐 derbyarms.co.uk
Bowness Bay Swan Blonde; 4 changing beers
(sourced locally; often Fell, Keswick, Kirkby
Lonsdale) Ⓗ

Easily visited by Stagecoach X6 bus, this old coaching inn
with historic charm remains the heart of the village
community. It offers five local beers, with Bowness Bay
Swan Blonde a well-priced regular. Cyclists and walkers
are frequent overnight guests – as are their dogs.
Traditional pub food is complemented by a pop-up pizza
chalet every weekend. Various rooms lead off the main
bar, including a separate family room above the cycle
store, with a pool table and board games.
🌞🏵️🛏️🕪🐕♣️🅿️🚃(X6) 🐾📶

Breweries

Appleby

**Unit 10, Castle Mills, Aynam Road, Kendal, Cumbria,
LA9 7DE**
☎ (01539) 726800 ☎ 07885 171210
🌐 bownessbaybrewing.co.uk

🕸️Established by Fred Mills in 2015, the brewery
outgrew its original premises in Appleby and moved to a
former horse stable in a local village in 2016. It was
taken over in 2018 and moved to shared premises at
Bowness Bay Brewing, Kendal. The beers are available at
selected pubs across Cumbria, but mainly in the Eden
Valley area. ‼️

Senior Moment (ABV 3.9%) BITTER
Midlife Crisis (ABV 4.2%) PALE
Middle Aged Spread (ABV 5.2%) STOUT

Barngates

Barngates, Ambleside, LA22 0NG
☎ (01539) 436347 🌐 barngatesbrewery.co.uk

🕸️Barngates was established in 1997 to supply only the
Drunken Duck Inn. It became a limited company in 1999.
Expansion over the years, plus a new purpose-built, 10-
barrel plant in 2008, means it now supplies more than
150 outlets throughout Cumbria, Lancashire and
Yorkshire. ‼️

Pale (ABV 3.3%) PALE
A well-balanced, fruity, hoppy pale ale with plenty of
flavour for its strength.
Cat Nap (ABV 3.6%) PALE
Pale beer, unapologetically bitter, with a dry, astringent
finish.
Cracker (ABV 3.9%) BITTER
A full-bodied, hoppy beer with some balancing
sweetness and fruit. There is plenty of taste in this
cleverly-constructed, copper-coloured beer.
Brathay Gold (ABV 4%) PALE
Attractive rich aroma of fruit, malt and hops is followed
by plenty of fruit and bittering hops ending in a long
bitter finish.
Goodhew's Dry Stout (ABV 4.3%) STOUT
The inviting roast aroma leads to an easy-drinking, full-
bodied and well-balanced roasty stout.
Tag Lag (ABV 4.4%) BITTER
This traditional bitter is full on: fruit, noble hops, malt
balance, good body with a crisp, clean finish of hop
bitterness.
Red Bull Terrier (ABV 4.8%) RED

An assertive roasty red beer with full mouthfeel. Initial
sweetness and luscious fruit, give way to a lingering
bitter finish.

Bowness Bay SIBA

**Unit 10, Castle Mills, Aynam Road, Kendal, Cumbria,
LA9 7DE**
☎ (01539) 726800 ☎ 07823 347763
🌐 bownessbaybrewing.co.uk

🕸️Bowness Bay Brewing moved to Kendal in 2015 and
increased capacity from five to 16 barrels. Now
expanded to a 2,500-litre, automated, four-vessel
brewing system, capable of brewing up to six times a
day. The original five-barrel plant is used for small
experimental brews. In 2020 grant funding allowed
further expansion into keg beers. On-site taphouse, the
Barrel House, showcases the core range and seasonal
specials. New live music space, The Venue, hosting beer
festivals, weddings and private parties opened 2021.
‼️♦️🔷

Lakeland Blonde (ABV 3.7%) BLOND
Swift Best (ABV 3.8%) BITTER
Hoppy bitter balanced by some malty sweetness and a
little fruit.
Swan Blonde (ABV 4%) BLOND
Sweet fruity mild beer with gentle bittering hops.
Fellwalker (ABV 4.1%) BLOND
A sweet fruity beer with gentle hop bittering and a
drying finish.
Raven Red (ABV 4.2%) BITTER
Sweet, malty bitter with fruit and roast aromas, gentle
hop bitterness and a dry finish.
Swan Gold (ABV 4.2%) BLOND
Swan Black (ABV 4.6%) STOUT
Stout-like beer with a fruity raisiny middle, grainy
mouthfeel and roast bitter finish.
Tern IPA (ABV 5%) PALE
Well-balanced with some sweet malt and fruit to balance
the lingering hoppy finish.
Steamer IPA (ABV 5.7%) IPA

Brack'N'Brew

🍺 **Brackenrigg Inn, Watermillock, Cumbria, CA11 0LP**
☎ (01768) 486206 🌐 brackenrigginn.co.uk

🕸️Brewing started in 2015, set up in the old stable block
at the rear of the Brackenrigg Inn, on the shores of
Ullswater in the Lake District. A four-barrel plant is used
to produce cask and bottled beers, which are sold across
Cumbria and the north of England.

Carlisle SIBA

**Unit 2, 12a Kingstown Broadway, Kingstown
Industrial Estate, Carlisle, Cumbria, CA3 0HA**
☎ (01228) 594959 ☎ 07979 728780

**Office: Spinners Arms, Cummersdale, Carlisle,
CA2 6BD** 🌐 carlislerealale.com

🕸️Carlisle Brewing Company is a family-run brewery
established in 2013. Initially using a 2.5-barrel plant in a
shed behind the owner's freehouse, by 2015 it had
expanded to a 10-barrel plant in an industrial unit. Beer
is available in the Spinners Arms and other local outlets.
‼️♦️

Cumbrian Bitter (ABV 3.7%) BITTER
Carlisle Bell (ABV 3.8%) PALE
Citadel (ABV 3.8%) BITTER
Spun Gold (ABV 4.2%) PALE
Flaxen (ABV 4.5%) BITTER
Magic Number (ABV 4.5%) BITTER

Coniston

Coppermines Road, Coniston, Cumbria, LA21 8HL
☎ (01539) 441133 ⊕ conistonbrewery.com

The 10-barrel plant commenced brewing in 1995. The brewery is situated behind the Black Bull Inn, Coniston, and currently brews 40 barrels a week. Bluebird, XB and Old Man are bottle-conditioned and are brewed using Ridgeway Brewery. It supplies over 100 outlets with cask beers across the North West, and bottled beers are available in Asda, Sainsburys and Booths, as well as online. Bottled Gold is gluten-free. !! ⬛ LIVE GF

Oliver's Light Ale (ABV 3.4%) BLOND
A fruity, hoppy, gently-bittered, straw-coloured beer with plenty of flavour for its strength.

Bluebird Bitter (ABV 3.6%) PALE
A yellow-gold, predominantly hoppy and fruity beer, well-balanced with some sweetness and a rising bitter finish.

Bluebird Premium XB (ABV 4.2%) PALE
Well-balanced, hoppy and fruity bitter. Bittersweet in the mouth with dryness building.

Old Man Ale (ABV 4.2%) RED
Delicious fruity, winey beer with a complex, well-balanced richness.

Special Oatmeal Stout (ABV 4.5%) STOUT
A well-balanced, easy-drinking stout. Fruity with a balanced ratio of malt to hop bitterness. A good starting point for novice stout drinkers.

Coniston K7 (ABV 4.7%) PALE
Balanced fruity, hoppy bitter, plenty of body and a long, hoppy, bitter finish.

Thurstein Pilsner (ABV 4.8%) SPECIALITY
True to style; mild but unusually sweet, with a hoppy fruitiness.

Infinity IPA (ABV 6%) IPA
High impact IPA. Fruity aromas persist in the powerful but well-balanced hoppiness and sweetness with nothing being lost in the finish.

No 9 Barley Wine (ABV 8.5%) BARLEY
Hops and alcohol dominate with appropriate sweetness and fruit on the tongue. A full-bodied and beautifully-balanced beer.

Cumbrian SIBA

Old Hall Brewery, Hawkshead, Cumbria, LA22 0QF
☎ (01539) 436436 ⊕ cumbrianales.com

First established in 2003, the brewery is located in an idyllic position in a renovated barn on the shores of Esthwaite Water. The success of Loweswater Gold has meant the brewery is thriving. !! ♦

Esthwaite Bitter (ABV 3.8%) PALE
Robust, refreshing bitter with plenty of hops, lasting well into the finish.

Langdale (ABV 4%) GOLD
Fresh grapefruit aromas with hoppy, fruity flavours and crisp long hop finish, make for a well-balanced beer.

Grasmoor Dark Ale (ABV 4.3%) MILD
Dark fruity beer with complex character and roast nutty tones leading to a short, refreshing finish.

Loweswater Gold (ABV 4.3%) BLOND
A dominant fruity body develops into a light bitter finish. A beer that belies its strength.

Dent

Hollins, Cowgill, Dent, Cumbria, LA10 5TQ
☎ (01539) 625326 ⊕ dentbrewery.co.uk

Dent was set up in 1990 in a converted barn next to a former farmhouse in the Yorkshire Dales National Park. In

2005 the brewery was completely refurbished and capacity expanded. One pub is owned. More than 150 outlets are supplied direct. !! ⬛ ♦

Golden Fleece (ABV 3.7%) BLOND
Light, hoppy and fruity, with a bitter aftertaste.

Aviator (ABV 4%) BITTER
Amber ale characterised by caramel and hop flavours that evolve into a bitter finish.

Dales Way IPA (ABV 4%) PALE

Rambrau (ABV 4.5%) SPECIALITY

Rambottom Strong Ale (ABV 4.5%) BITTER
A well-balanced, malty best bitter.

Kamikaze (ABV 5%) PALE
Hops and fruit dominate this full-bodied strong bitter, with a dry bitterness growing in the aftertaste.

T'owd Tup (ABV 6%) STOUT
A rich, full-flavoured, strong stout with a coffee aroma. The dominant roast character is balanced by a warming sweetness and a raisiny, fruitcake taste that lingers on into the finish.

Eden River SIBA

Hawksdale House, Hartness Road, Penrith, Cumbria, CA11 9DB
☎ (01768) 210565 ☎ 07729 677692
⊕ edenbrewery.com

Originally named Eden Brewery, the name changed to Eden River in 2018. Set up in 2011, the brewery is run by Jason Hill, assisted by Linda and Chris. The five-barrel plant was located at historic Brougham Hall but moved in 2017 to premises on a Penrith industrial estate. !! ♦ LIVE

Eden Best (ABV 3.8%) BITTER
A traditional bitter, with a hoppy beginning; a malty, bitter- sweet middle, and a gentle finish.

Fuggles (ABV 3.8%) PALE
Initially sweet, a gently-hopped pale beer with a bitter finish.

Blonde Knight (ABV 4%) BLOND

Eden Dynamite (ABV 4%) BLOND

Eden Atomic Blonde (ABV 4.1%) BLOND
The initially inviting aroma of hops is followed by an intense hop flavour with some fruitiness.

Eden Gold (ABV 4.2%) BLOND
Gentle fruity and honey aromas to start, leading to a well-balanced sweet beer with a lasting hoppy finish.

Emperor (ABV 4.6%) PALE
Fascinatingly fruity beer with balanced malt and hops and a hint of butterscotch combining to a rich, bitter finish.

Ennerdale SIBA

Chapel Row, Rowrah, Cumbria, CA26 3XS
☎ (01946) 862977 ⊕ ennerdalebrewery.co.uk

This family-owned brewery began brewing in 2010 as a 10-barrel brewery in a converted barn. In 2016 the brewery moved to larger premises with plans for expansion. It distributes throughout Cumbria and the North of England. The brewery tap is open daily. !! ⬛ ♦ ♦

Blonde (ABV 3.8%) BLOND
A sweet, fruity, light-coloured beer with gentle bitterness.

Darkest (ABV 4.2%) BROWN
Complex brown beer with a velvety texture. Chocolate, coffee aromas and flavours combine with sweet fruitiness. The finish is of lasting dry roast malts.

Wild (ABV 4.2%) BITTER
Fruity and hoppy beer with some balancing malt remaining in the long, bitter finish.

Fell

Unit 27, Moor Lane Business Park, Flookburgh,
Cumbria, LA11 7NG
☎ (01539) 558980 ☎ 07967 503689
⊕ fellbrewery.co.uk

⊠ Fell Brewery was founded in 2012 by homebrewer
Tim Bloomer and friend Andrew Carter, brewing beers
inspired by their travels in the US and Belgium.
Production capacity has now increased from 12 to 15
barrels. It has three retail outlets situated in Chorlton
(near Manchester), Kendal and Penrith.

Ghyll (ABV 3.7%) GOLD
Inviting citrus aromas follow through nicely in this hoppy
bitter beer with fruit and sweetness present for balance.
Tinderbox IPA (ABV 6.3%) IPA
A complex beer with an immediate and lasting hit of
bitterness. Moderate sweetness balances the resiny and
citrus hop flavours until overtaken by a drying finish.

Foxfield

🍺 Prince of Wales, Foxfield, Cumbria, LA20 6BX
☎ (01229) 716238 ⊕ princeofwalesfoxfield.co.uk

☺Foxfield is a 4.5-barrel plant in old stables attached to
the Prince of Wales. Several other outlets are supplied.
Tiger Tops in Wakefield is also owned. The beer range
constantly changes. Brewing is currently suspended. ‼◆

Gan Yam

3 Benson View Works, Shap Road Industrial Estate,
Kendal, LA9 6NZ ⊕ ganyambrewco.uk

☺Initially a commercial home-based brewery based in
north London when founded in 2018, it relocated to
Kendal in early 2021. An on-site taproom is planned. ◆

PAL (ABV 3.9%) PALE
AYE (ABV 6%) IPA
TAR (ABV 7%) PORTER

Grasmere

Lake View Country House, Lake View Drive, Grasmere,
Cumbria, LA22 9TD
☎ (01539) 435572 ☎ 07840 059561
⊕ grasmerepub.com

Brewing began in 2017 in old farm buildings at Lake
View Country House. Beers are available at its nearby
brewery tap and restaurant, the Good Sport. Cider is also
produced.

Helles Lager (ABV 3.8%) SPECIALITY
Pale Ale (ABV 4%) PALE
Bitter (ABV 4.1%) BITTER
IPA (ABV 5.5%) IPA

Great Corby SIBA

The Green, Great Corby, Cumbria, CA4 8LR
☎ (01228) 560899 ⊕ greatcorbybrewhouse.com

☺The brewery started in 2009 and has been locally-
owned since 2020. The large sandstone, former honey
factory now houses the brewing area and offices. The
former brewing site at the Forge, across the village
green, is now used for cask washing. Monthly brews are
available, encompassing a range of styles and flavours.
‼◆

Corby Ale (ABV 3.8%) BITTER
A fruity session beer with sweetness leading to gentle
bitterness in the aftertaste.
Blonde (ABV 4%) BLOND

Some fruit in the aroma and then a sweet, fruity and
lightly-bittered taste which continues for a short time.
Lakeland Summit (ABV 4%) BLOND
Aroma and taste are dominated by fruity hops. Bitterness
and some sweetness creep into the finish to create
balance.
Signal Peak APA (ABV 4.4%) PALE
Stout (ABV 4.5%) STOUT
Fruity aroma, sweet roast middle and dry finish.
Fox Brown Ale (ABV 4.6%) BROWN
Malty aromas follow into the taste and dominate with
some hop bitterness and fruit. Gentle bitterness helps
balance the malty sweetness.

Greenodd

🍺 Ship Inn, Main Street, Greenodd, Cumbria,
LA12 7QZ
☎ (01229) 861553 ☎ 07782 655294
⊕ theshipinngreenodd.co.uk

☺Established in 2010 at the Ship Inn on a two-barrel
plant. The majority of production goes to the Ship with
the remainder going to the local free trade. Brewing is
currently suspended. ‼◆

Handsome SIBA

Bowstone Bridge Garage, Bowston, Cumbria, LA8 9HD
☎ 0344 848 0888 ⊕ handsomebrew.co.uk

☺Founded in 2016 in the Lakes District following it's
previous existence as Houston Brewery in Scotland,
Handsome is situated on the River Kent in an old MOT
garage, formerly the blacksmith's for James Cropper's
paper mills. In 2021, it opened a bar next to the River
Kent in Kendal, and plans to open another in Leeds
during the currency of this Guide.

Top Knot (ABV 3.7%) PALE
A pale, hoppy, fruity beer with some sweetness
continuing through to the gentle finish. A touch of malt
adds depth.
Stranger (ABV 4.2%) BITTER
Blacksmith (ABV 4.6%) STOUT
Bar Steward (ABV 4.8%) BITTER

Hawkshead

Mill Yard, Staveley, Cumbria, LA8 9LR
☎ (01539) 822644 ⊕ hawksheadbrewery.co.uk

☺Established in 2002, it outgrew its original barn and
moved to Staveley in 2006 to a purpose-built, 20-barrel
brewery. Shortly afterwards a brewery tap was added. In
2018, production of the core range of beers was
transferred to a brand new brewery in Flookburgh (which
also brewed the Sadlers Peaky Blinders range), with the
Staveley plant continuing to produce small batch beers.
Following a business review, the Sadlers range has been
discontinued and the operations at Flookburgh have
been transferred to Staveley. ‼🍴◆LIVE◆

Mill Yard Mild (ABV 3.4%) MILD
Roast malt aromas start the theme and develop in the
taste, with accompanying sweetness in this traditional
mild.
Iti (ABV 3.5%) GOLD
Windermere Pale (ABV 3.5%) BLOND
Bitter (ABV 3.7%) BITTER
Mosaic Pale (ABV 4%) PALE
Red (ABV 4.2%) RED
Session IPA (ABV 4.2%) PALE
Westmorland English Pale Ale (ABV 4.3%) BITTER
Lakeland Gold (ABV 4.4%) PALE

Dry, refreshing beer with good body and bitterness staying to the end.

Dry Stone Stout (ABV 4.5%) STOUT
Black, dry, bitter stout with an astringent, roast finish.

Hawkshead Prime Porter (ABV 4.9%) PORTER
Complex, dark brown beer with plenty of malt, fruit and roast taste. Satisfying full body with a clean finish.

Route 590 IPA (ABV 5%) PALE
A robust hoppy bitter with citrus hops and fruity middle.

Healey's

🍽 **Wellington Inn, Main Street, Loppergarth, Cumbria, LA12 0JL**
☎ **(01229) 582388**

Healey's began brewing in the Wellington Inn in 2012 using a custom-made, 2.5-barrel, stainless steel plant. The brewery can be viewed through full-length windows in the pub. A range of different cask beer styles are brewed and are available at a variety of local pubs in the area including in the Wellington itself. Electrical power is provided by solar panels.

Hesket Newmarket SIBA

Old Crown Barn, Back Green, Hesket Newmarket, Cumbria, CA7 8JG
☎ **(01697) 478066** ⏺ **hesketbrewery.co.uk**

☺Founded in 1988, and bought by a co-operative in 1999 to preserve a community amenity. Cask beers are generally named after Cumbrian fells. Newer look beer styles have been introduced in recent years with traditional beers undergoing a rejuvenation. More than 10 cask ales are supplied across Cumbria with supply also available in bottles and cans. ‼◆

Haystacks (ABV 3.6%) BLOND
Light, easy-drinking, thirst-quenching blond beer; pleasant for its strength.

Skiddaw (ABV 3.7%) BITTER

Black Sail (ABV 4%) STOUT
A sweet stout with roast flavours.

Helvellyn Gold (ABV 4%) BLOND

Doris' 90th Birthday Ale (ABV 4.3%) BITTER

Scafell Blonde (ABV 4.3%) PALE
A hoppy, sweet, fruity, pale-coloured bitter.

Brim Fell IPA (ABV 4.5%) PALE

Catbells (ABV 5%) PALE
An ale with a nice balance of fruity sweetness and bitterness, almost syrupy but with an unexpectedly dry finish.

Smoked Porter (ABV 5.4%) SPECIALITY

Old Carrock Strong Ale (ABV 6%) OLD
Reddy brown strong ale, vine-fruity in flavour with slightly astringent finish.

West Coast Red (ABV 6.3%) RED

Double IPA (ABV 7.4%) IPA

Keswick SIBA

The Old Brewery, Brewery Lane, Keswick, Cumbria, CA12 5BY
☎ **(01768) 780700** ⏺ **keswickbrewery.co.uk**

Keswick, owned by Sue Jefferson, began brewing in 2006 using a 10-barrel plant on the site of a brewery that closed in 1897. The brewery is set up to be environmentally-friendly using sheeps wool insulation in the vessels and reducing its environmental impact. Outlets include the Fox bar at the brewery, the Dog & Gun, Keswick, and many other pubs across Cumbria. ‼🍴◆◆

Black Star (ABV 3.5%) BITTER

Gold (ABV 3.6%) PALE
Predominantly hoppy bitter with malts, sweetness and fruit and a dry bitter finish.

Bitter (ABV 3.7%) BITTER
Gentle bitter with hints of roasted malt and a sweetness which fades.

Thirst Rescue (ABV 3.8%) BITTER
Bitter beer with some fruitiness, full-bodied and a lasting bitter finish.

Park Your Thirst (ABV 3.9%) BITTER

Fox Dark (ABV 4%) MILD

Fox Pale (ABV 4%) PALE

Thirst Run (ABV 4.2%) PALE
A well-balanced golden beer that maintains its fruitiness from start to finish.

Waimia Pale (ABV 4.2%) PALE

Thirst Quencher (ABV 4.3%) BLOND
Light-bodied, fresh, hoppy beer with fruit in the middle and a balancing sweetness.

Pale Ale (ABV 4.4%) PALE

Special Bitter (ABV 4.8%) BITTER

Thirst Celebration (ABV 7%) STRONG

Kirkby Lonsdale SIBA

Royal Barn, New Road, Kirkby Lonsdale, Cumbria, LA6 2AB
☎ **(01524) 272221** ⏺ **klbrewery.com**

☺Kirkby Lonsdale is a family-run business established in 2009 on a six-barrel plant. In 2016 a further six-barrel plant was installed in its new brewery tap, the Royal Barn, Kirkby Lonsdale. ‼◆◆

Crafty Mild (ABV 3.6%) MILD
A typical mild with powerful malty aromas and some caramel, which follows through in the taste and finish.

Tiffin Gold (ABV 3.6%) BLOND
A full-flavoured, grapefruity hoppy and bitter beer with a dry finish.

Stanley's (ABV 3.8%) PALE
Hops dominate this sweet and fruity, well-balanced beer.

Ruskin's (ABV 3.9%) PALE
A tawny bitter with a distinctive aroma of fruit and malt. The clean, hoppy flavour is well-balanced with fruity sweetness leading to a sustained bittersweet finish.

Singletrack (ABV 4%) GOLD
Crisp, citrus hops predominate in a well-balanced beer with a pleasant, bitter finish.

Pennine Amber (ABV 4.1%) BITTER

Radical (ABV 4.2%) RED
Malty beer with a caramel sweetness that is balanced by a bitter finish.

Monumental (ABV 4.5%) BLOND
Distinctly hoppy, a fruity, sweet, pale-coloured, full-bodied bitter.

Jubilee (ABV 5.5%) STOUT
Rich, well-balanced stout with malt. A long aftertaste retains this complexity and is surprisingly refreshing.

Imperial Dragon (ABV 8.2%) IPA

Lakeland SIBA

Units 7-9, Lightburn Industrial Estate, Ulverston, Cumbria, LA12 7NE
☎ **(01229) 581387** ⏺ **lakelandbrewhouse.co.uk**

☺Lakeland Brewhouse was founded in 2020 following the takeover of Stringers by the local Lakeland Inns pub group. In early 2021 the brewery was relocated and expanded to a 10-barrel plant. ◆LIVE

Plan B (ABV 3.7%) SPECIALITY
An easy-drinking, zingy, pale thirst-quencher.

Stout (ABV 4%) STOUT
A robust, drying stout full of roast and hop bitterness.

Lakeland Bitter (ABV 4.2%) BITTER
A fruity, sweet beer in balance with hops and malt. The bitterness grows in the finish without persisting.
Gold (ABV 4.3%) GOLD
Blonde (ABV 4.4%) BLOND
The North (ABV 4.9%) BITTER
Turbine Porter (ABV 5.1%) PORTER
IPA (ABV 5.5%) IPA

Lakes SIBA

Mintsfeet Road South, Kendal, Cumbria, LA9 6ND
☎ (01539) 324005 ⊕ lakesbrewco.com

Brewery opened in 2021 by former employees of Hawkshead brewery. ✦

Pale Ale (ABV 3.5%) GOLD
A powerful aroma of citrus hops follows through to bitterness which builds upon drinking. There is balancing sweetness and fruit to create a cleverly constructed beer for its strength.

Langdale

Cross Houses Farm, Docker, Cumbria, LA8 0DE
☎ 07876 838051 ⊕ langdalebrewing.co.uk

⊕Langdale Brewing was formed in 2018 by Steve Mitchell formerly of Eden Brewery, and Paul Fry of the Britannia Inn, Elterwater. The brewery USP is producing a range of cask ales using water harvested from a Langdale spring.

Bowfell Bitter (ABV 3.5%) BITTER
Elterwater Gold (ABV 3.8%) GOLD
Pikes Pale (ABV 3.9%) PALE
Bowfell Blonde (ABV 4.2%) BLOND
Bowfell Amber (ABV 4.3%) BITTER
Weiss Ghyll (ABV 4.5%) SPECIALITY

Logan Beck

The Barn at Beckfoot Farm, Duddon Bridge, Cumbria, LA20 6EU ☎ 07926 179749
✉ loganbeckbrewing@gmail.com

The brewery has expanded from a 0.75-barrel to a 5.5-barrel plant (formerly Chadwicks). Cans and bottles are planned. Beer availability is limited but there are frequent seasonal specials and 'cupboard' brews. Regular beers use mainly locally-sourced ingredients.

Phoenix Pale (ABV 3.5%) PALE
Dusky Dark (ABV 3.7%) MILD
Gentle mild with some roast malt and sweetness and enough bitterness to give balance.
Proper (ABV 4%) RED
Unbound Blonde (ABV 4.1%) BLOND
Navigator (ABV 4.3%) PALE
Proper XB (ABV 4.4%) PALE

Old Friends

🏠 Old Friends Inn, 49 Soutergate, Ulverston, Cumbria, LA12 7ES
☎ (01229) 208195 ☎ 07563 521575
⊕ oldfriendsulverston.co.uk

⊕Brewing began in 2019 in a room to the rear of the Old Friends pub in Ulverston. Beers are currently only available at the pub.

Old Vicarage

Old Vicarage, Walton, Cumbria, CA8 2DH
☎ (01697) 543002 ⊕ oldvicaragebrewery.co.uk

A microbrewery, bar and B&B accommodation in North Cumbria. Brewing experience days are offered. ✦

OVB (ABV 4%) BITTER
Pesky Pheasant (ABV 4.2%) GOLD
Coachman (ABV 4.6%) BLOND
SB Special (ABV 5%) BLOND

Roa Island

🏠 Belfast Pier, Roa Island, Cumbria, LA13 0PN
☎ 07874 649200 ✉ roaislandbrewing@gmail.com

⊕Brewing commenced in 2017 in a small room at the back of the club house at the Roa Island Boat Club. Beers are brewed once a week in 50-litre quantities and are only available on-site. Following the installation of solar panels, most of the beers carry the name 'Daylight'.

Shaws of Grange

12 Station Yard, Grange-over-Sands, LA11 6DW
☎ (01539) 555349 ☎ 07951 009607
⊕ shawsofgrange.co.uk

This 0.5-barrel brewery began producing beers for sale in 2019. A range of four beers has been developed for sale in cask and by hand bottling. Virtually all the production has been sold in bottles since 2020, although the brewery will supply a cask on demand.

South Lakes

Unit 30, Ulverston Auction Mart, North Lonsdale Road, Ulverston, Cumbria, LA12 0AU ☎ 07795 363523
✉ aaronpos1@hotmail.com

South Lakes began brewing on a 1.5-barrel plant in 2016, in a part of the Auction Mart in Ulverston.

4 Cs Extra Pale (ABV 3.8%) PALE
Lucky Dip (ABV 3.8%) GOLD
Amacoe (ABV 4%) GOLD
Pronounced hoppiness in both the aroma and taste combines with a balancing sweetness and a lasting bitter finish.
Poison Dwarf (ABV 4.1%) PALE
Hoppy and fruity aromas are followed by a full-bodied and lasting bitter finish.
Rakau (ABV 4.4%) PALE
A bitter beer with lots of hops, backed by fruit sweetness and some malt in the background. A well-constructed ambitious bitter with full mouthfeel and lasting bitter finish.
American Pale Ale (ABV 4.8%) BLOND
Ripe (ABV 5.5%) BITTER

Strands

🏠 Strands Inn, Nether Wasdale, Cumbria, CA20 1ET
☎ (01946) 726237 ⊕ strandshotel.com

⊕Strands Brewery is a ten-barrel plant with a 5,000-litre fermentation capacity. Six of the beers are available on the bar of the Strands Inn at all times or in the Screes, across the road. ‼◆LIVE

Green Bullet (ABV 3.5%) GOLD
High-impact hop, so bitterness dominates this low-strength, golden-coloured ale. Loads of finish, great for those who love hops.
Responsibly (ABV 3.7%) BITTER
Brown Bitter (ABV 3.8%) BITTER
A complex tasting brown beer with a lingering bitter aftertaste
Errmmm... (ABV 3.8%) BITTER
A complex, traditional bitter.
Best Bitter (ABV 4.3%) BITTER

Red Screes (ABV 4.5%) RED
An interesting, rich-tasting, smooth, strong bitter; full-flavoured with plenty of roast and malt tastes.
T'errmmm-inator (ABV 4.9%) PORTER
A smooth, dark brown, roast-led beer. Full-bodied and well-balanced.
Traditional IPA (ABV 6%) IPA

Tarn Hows

Low Bield, Knipe Fold, Outgate, Cumbria, LA22 0PU
☎ 07935 789581 ⊕ tarnhowsbrewery.com

This two-barrel microbrewery near Hawkshead in the Lake District National Park was named after a nearby beauty spot. Oak casks may be used for barrel-aging and occasional seasonal beers if a customer requests this. Beers are suitable for vegans (except for Guji Coffee Stout, which is vegetarian). ♦LIVE V

Grized Ale (ABV 3.9%) BITTER
Beertrix Porter (ABV 4%) PORTER
A well-balanced, fruity beer with some liquorice aromas, and a lasting finish of bitterness and roast.
Pale (ABV 4.6%) PALE
Blueberry & Vanilla Oatmeal Stout (ABV 5%) SPECIALITY
Easy-drinking dark beer with fruity aromas and sweet fruity taste. The finish lasts well with roast malt flavours coming through.
Guji Coffee Stout (ABV 5.4%) SPECIALITY

Tirril SIBA

Red House, Long Marton, Cumbria, CA16 6BN
☎ (01768) 361846 ⊕ tirrilbrewery.uk

⊕Established in 1999, Tirril Brewery has twice outgrown its premises. It delivers to more than 170 outlets, 100 of which regularly stock the beer. Contract brewing is also carried out for Bitter End Brewery. !!♦

Original Bitter (ABV 3.8%) BITTER
Ullswater Blonde (ABV 3.8%) BLOND
Grasmere Gold (ABV 3.9%) PALE
Kirkstone Gold (ABV 3.9%) GOLD
Old Faithful (ABV 4%) BITTER
Initially bitter, gold-coloured ale with an astringent finish.
1823 (ABV 4.1%) BITTER
Academy Ale (ABV 4.2%) BITTER
Borrowdale Bitter (ABV 4.2%) BITTER
Windermere IPA (ABV 4.3%) PALE
Red Barn Ale (ABV 4.4%) RED

Townhouse

35 Chapel Street, Dalton-in-Furness, Cumbria, LA15 8BY ☎ 07812 035143

Office: 52 Steel Street, Askam-in-Furness, Cumbria, LA16 7BP ✉ townhousebrewery@gmail.com

⊕Townhouse was setup in 2002 in Audley, Staffordshire with a 2.5-barrel plant that expanded to five barrels in 2004. In 2006 two further fermenting vessels were added producing the bulk of its beer for the Potteries. In 2021 the brewery relocated to Dalton-in-Furness, Cumbria. All cask beers have been vegan since 2005. Canning is planned. Charter is brewed exclusively for the award-winning Manor Arms in Broughton-in-Furness. V

Meg's Mild (ABV 3.9%) MILD
Flowerdew (ABV 4%) BITTER
Golden with a wonderful floral aroma. Fabulous flavour of flowery hops delivering a crisp hoppy bite and presenting a lingering taste of flowery citrus waves.

Brewed for the Manor Arms, Broughton-in-Furness:
Charter (ABV 3.5%) BLOND

Tractor Shed SIBA

Tractor Shed, Calva Brow, Workington, Cumbria, CA14 1DB
☎ (01900) 68860 ⊕ tractor-shed.co.uk

⊕Renamed from Mitchell Krause in 2014 and having previously had its beers brewed under contract, brewing started in an old tractor shed on the family farm in 2013. After initially focusing on bottled and kegged continental-style beers, the first cask-conditioned beer was produced in 2014. The brewery contract brews various beers for Shindigger (qv), mostly for can and keg. !!LIVE ✦

Mowdy Pale Ale (ABV 3.9%) BITTER
An interesting, well-balanced beer with persistent fruitiness, sweet and hoppy centre giving way nicely to hop in the finish.
Clocker Stout (ABV 4%) STOUT
Tasty, easy-drinking start with malt and roast, a fruity centre and some hop joining in at the end.

Ulverston

Lightburn Road, Ulverston, Cumbria, LA12 0AU
☎ (01229) 586870 ☎ 07840 192022
⊕ ulverstonbrewingcompany.co.uk

⊕The brewery occupies the octagonal bull ring of the old livestock market. There is a bar that overlooks the brew plant, which opens by prior arrangement and during some local festivals. Some beers have a Laurel and Hardy theme (Stan Laurel was born in Ulverston). !!ᴿ✦✦

Flying Elephants (ABV 3.7%) PALE
Well-balanced, pale session beer with malt, hops and some fruit and a lasting finish.
Celebration Ale (ABV 3.9%) PALE
Yellow fruity bitter with hints of tangerine and a notably sustained dry finish.
Harvest Moon (ABV 3.9%) BLOND
A well-balanced, pale, hoppy bitter.
Laughing Gravy (ABV 4%) BITTER
Malt and hops in the aroma with pleasing balance of sweet malt and hops in the taste. Some fruitiness adds flavour and the finish is long and clean.
Lonesome Pine (ABV 4.2%) BLOND
A fresh and fruity blond beer; honeyed, lemony and resiny with an increasingly bitter finish.
Fra Diavolo (ABV 4.3%) MILD

Unsworth's Yard SIBA

4 Unsworth's Yard, Ford Road, Cartmel, Cumbria, LA11 6PG ☎ 07810 461313 ⊕ unsworthsyard.co.uk

⊕Unsworth's Yard opened in 2011, brewing on a five-barrel plant. The brewery produces beers named after historic figures and legends associated with the Cartmel area. Beers are available in Cartmel pubs and other local outlets as well as the brewery's tap bar. !!ᴿ✦

Peninsula Best (ABV 3.8%) BITTER
Crusader Gold (ABV 4.1%) GOLD
Eel River IPA (ABV 4.3%) PALE
Sir Edgar Harrington's Last Wolf (ABV 4.5%) BROWN
Well-balanced, rich, fruity, tawny ale with gentle bitterness.
The Flookburgh Cockler (ABV 5.5%) PORTER

Westmorland

Kendal, Cumbria ☎ 07554 562662

Office: Mint Street, Kendal, LA9 6DS
✉ westmorlandbrewery@gmail.com

Westmorland began brewing in 2016 using a one-barrel plant.

Wild Boar

🍺 Wild Boar, Crook Road, Bowness-on-Windermere, Cumbria, LA23 3NF

☎ (0845) 850 4604 ⊕ englishlakes.co.uk/the-wild-boar

⊠ Brewing began in 2013 at the Wild Boar, a large, traditional Lakeland luxury hotel. The hotel is part of the English Lakes Hotels group and supplies beers to hotels within the group. ♦

Windermere SIBA

🍺 Watermill Inn, Ings, Cumbria, LA8 9PY
☎ (01539) 821309 ☎ 07831 873300
⊕ lakelandpub.co.uk

☺ Originally known as Watermill, the brewery was established in 2006 in a purpose-built extension to the Inn. The beers have a doggy theme – dogs are allowed in the main bar. Windermere Brewing was originally a separate brand but all beers are now brewed under the name. ‼♦

Howard Arms, Carlisle (Photo: Mike Tuer)

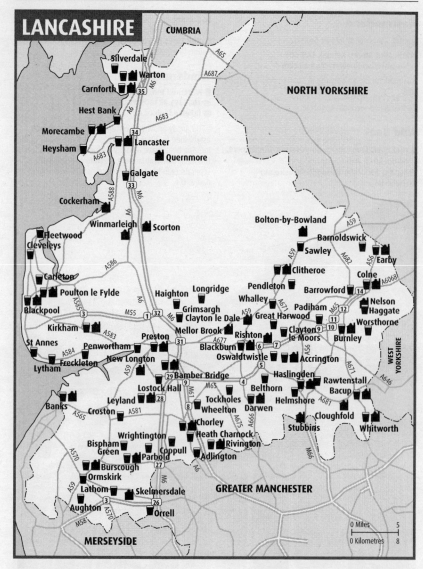

LANCASHIRE

CUMBRIA

NORTH YORKSHIRE

Silverdale
Warton
Carnforth
Hest Bank
Morecambe
Heysham
Lancaster
Quernmore
Galgate
Cockerham
Winmarleigh Scorton
Bolton-by-Bowland
Fleetwood
Cleveleys Barnoldswick
Sawley
Carleton Clitheroe Colne
Poulton le Fylde Pendleton Barrowford
Blackpool Haighton Longridge Whalley Nelson
Kirkham Grimsargh Clayton le Dale Great Harwood Haggate
St Annes Penwortham Mellor Brook Rishton Clayton Worsthorne
 Preston Blackburn le Moors Burnley
Freckleton Oswaldtwistle
Lytham New Longton Bamber Bridge Accrington
 Leyland Lostock Hall Haslingden Rawtenstall
Banks Croston Belthorn Bacup
 Wheelton Tockholes Helmshore
Wrightington Chorley Darwen Cloughfold
Bispham Heath Charnock Stubbins Whitworth
Green Coppull Rivington
Burscough Parbold Adlington
Ormskirk
Lathom Skelmersdale GREATER MANCHESTER
Aughton Orrell

MERSEYSIDE

WEST YORKSHIRE

0 Miles 5
0 Kilometres 8

Accrington

Canine Club L

45-47 Abbey Street, BB5 1EN
☎ (01254) 233999
Tetley Bitter; 3 changing beers (sourced nationally; often Old School, Reedley Hallows) Ⓗ
An award-winning social club on a busy street in an area of the town centre known for its many independent retailers and real ale outlets. The central bar serves a comfortable lounge to the front and a games room to the rear where snooker, pool and darts are played. There is a large upstairs function room. This traditional club is always busy but is welcoming to all. ➤♣🚌(464,X41)🛜

Grants L

1 Manchester Road, BB5 2BQ
☎ (01254) 393938 ⏵ grantsbar.co.uk
Big Clock Pals 1916, Dirty Blonde, Bitter and Twisted, Ruby 100; 4 changing beers Ⓗ

A large, imposing building close to the college on the edge of the town centre. The pub is home to the impressive Big Clock Brewery, which can be viewed from the main drinking area. Up to eight Big Clock ales are on offer along with a large range of boxed real ciders. Third-pint glasses are available to sample the beers or ciders, served on a wooden platter. A range of pizzas and pasta dishes is available with many vegetarian options, the wood-fired pizza oven providing an Italian twist.
Q❄️🚫🌱🛜🍴P🚃

Adlington

Old Post Office L

161 Chorley Road, PR6 9LP
☎ (01204) 228969
4 changing beers (sourced locally; often Escape) Ⓗ
This micropub in the old post office building near the Ridgway Arms (now Tesco) opened in 2021 and is brought to you by Bolton's Escape Brewery in partnership

with MV Pub Group. It is the brewery's tap bar and has four handpumps serving Escape ales and the occasional guest, with additional keg lines for craft ales from smaller North-West breweries such as Rivington, Chain House and Twisted Wheel, as well as lagers and ciders. Q⛲🚲❄️🚌(125)🌸🛜

Spinners Arms 🅛

23 Church Street, PR7 4EX
☎ (01257) 483331
Acorn Barnsley Bitter; 6 changing beers (sourced regionally; often Abbeydale, Oakham, Salopian) 🅗
The pub is known as the Bottom Spinners to differentiate it from the other Spinners Arms in the village. Built in 1838, it is welcoming and friendly; a single bar serves three seating areas. There is a pleasant outdoor drinking area to the front. It has no pool table or gaming machines, just an open log fire. The bar menu offers home-cooked food, with Sunday specials. One regular cask ale and up to six alternating guest ales are served, often from local breweries. Small functions are catered for. 🚲🌸🍴❄️P🚌(8A)🌸🛜

Aughton

Stanley Arms

24 St Michael Road, L39 6SA (off A59 at Aughton Springs) SD391055
☎ (01695) 423241 ⊕ thestanleyarmsaughton.co.uk
Marston's Pedigree; Tetley Mild, Bitter; Timothy Taylor Landlord; 2 changing beers 🅗
Situated beside a historic Norman church, the Stanley has distinctive 18th-century architecture and was originally a coaching stop for postal deliveries. Decorated throughout with Tudor-style woodwork, there are several side rooms containing brewing memorabilia around the centrally placed bar which dispenses from five handpumps. Immaculately kept both inside and out, the pub is exceptionally popular for its excellent home-cooked and locally-sourced food, served daily (booking advised). 🚲🌸🍴👶🛴♿P🚌🛜

Bacup

Crown Inn 🅛

19 Greave Road, OL13 9HQ (off Todmorden Rd)
☎ (01706) 873982
Pictish Brewers Gold; 3 changing beers 🅗
Cosy, traditional country pub, just off the road out to Todmorden, with a large L-shaped bar and stone-flagged floors throughout. It was built in 1865 and once owned by Baxter's Glen Top Brewery. A welcoming coal fire warms the atmosphere in cooler months. There are always three beers available, usually sourced locally. Food is served most evenings. Quiz nights are held on Wednesday and Sunday and live music is hosted regularly. On the second floor is a function room accommodating up to 35 guests. There is a large patio beer garden to the front of the pub. 🚲🌸🍴♿P🚌(465,7)🌸

Bamber Bridge

Beer Box 🅛

Unit 3, 143 Station Road, PR5 6LA
☎ (01772) 339619
5 changing beers (sourced locally) 🅗
Bamber Bridge's second micropub opened in 2018 on the main road running through the northern end of the town in premises previously operated by North West Domestic Services. There is one relatively large room with plenty of seating indoors and some standing room,

with an outside seating area to the front. Up to five real ales are available, mainly from local breweries and including one dark beer. Q♿❄️🌸🚌(125)🌸🛜

Banks

Ralph's Wife's

Hoole Lane, PR9 8BD
☎ (01704) 214678
Fell Crag; 1 changing beer (sourced locally) 🅗
This coffee shop and bar with two changing real ales is now the only real ale outlet in Banks since the closure of the New Fleetwood in 2020. It has the usual friendly, welcoming attributes of a micropub. Tea and coffee are served, including a range of speciality teas. Tapas nights and cheese and wine events are held on occasion. There is some seating outside. A welcome addition to the real ale scene in Southport and West Lancashire. QP🚌🌸🛜

Barnoldswick

Barlick Tap Ale House 🅛

8 Newtown, BB18 5UQ
☎ 07739 088846
5 changing beers (sourced nationally) 🅗

REAL ALE BREWERIES

12 Steps 🍺 Darwen (NEW)
4 Mice 🍺 Bolton-by-Bowland
Accidental Morecambe
Avid Quernmore
BB18 🍺 Earby
Beer Brothers 🔨 Bamber Bridge
Beer Shack 🍺 Clitheroe (NEW)
Ben's 🔨 Chorley
Big Clock 🍺 Accrington
Bowland Clitheroe
Brewsmith Stubbins
Chain House New Longton
Clay Brow Skelmersdale
Crankshaft 🔨 Leyland
Cross Bay 🔨 Morecambe
Farm Yard 🔨 Cockerham
Folly Clayton le Dale
Fuzzy Duck Poulton-le-Fylde
Hop Vine 🍺 Burscough
Hopstar Darwen
Lancaster 🔨 Lancaster
Lytham Kirkham
Mighty Medicine 🔨 Whitworth
Moorhouse's Burnley
Northern Whisper Cloughfold
Old Boot Bacup
Old School 🔨 Warton
Oscars Nelson
Parker Banks
Patten 🍺 Winmarleigh
Peregrine Rishton
Priest Town Preston
Problem Child 🍺 Parbold
Q Brew Carnforth
Reedley Hallows Burnley
Rivington 🔨 Rivington
Rock Solid Blackpool
Rossendale 🍺 Haslingden
Snowhill Scorton
Three B's 🍺 Blackburn
Three Peaks Nelson
Thwaites Mellor Brook
Unbound Colne
West Coast Rock 🍺 Blackpool

This friendly one-room micropub was the first to be set up in the town and is situated just off the town square, two minutes from the main bus stop. A choice of five constantly-changing cask beers is offered, one of which will be a dark beer and one a LocAle. There is also a large selection of continental bottled beers and always two ciders. The pub plays no music, and hosts occasional events and tastings. Very dog friendly. Q🕸🚶♿🚋(M1)🌸

Barrowford

Bankers Draft 🍷

143 Gisburn Road, BB9 6HQ
☎ 07739 870880
5 changing beers (sourced nationally) Ⓗ
This imposing detached former bank is now a small and friendly micropub specialising in real ale and conversation with no loud music or TVs. The five handpumps dispense continually rotating cask ales from national small brewers, offering a great variety of beer styles from hoppy blondes and traditional bitters to dark beers. There is also a good selection of wines and bottled craft lagers and wheat beers, with at least one real cider normally on draught. Q🕸♿🚋(2)🌸

Belthorn

Dog Inn Ⓛ

61 Belthorn Road, BB1 2NN
☎ (01254) 433188 ⊕ thedoginnatbelthorn.net
3 changing beers (sourced locally) Ⓗ
This is the first community-owned pub in East Lancashire and is run as a community benefit society. It has flagged floors on several levels and a real fire. Set in hill country, with great views across the moors and out to the coast, it is a popular stop-off for walkers and their dogs. Full meals are available lunchtime and evening, with a coffee shop menu in between. Beers are mainly from the local Three Bs and Blackedge breweries. 🕸🍴♣♿🚋🌸🅿🚋🌸🛜

Bispham Green

Eagle & Child

Maltkiln Lane, L40 3SG
☎ (01257) 462297 ⊕ eagleandchildbispham.co.uk
Southport Golden Sands; Thwaites Original; Wainwright; 5 changing beers Ⓗ
An 18th-century pub with eight handpumps showcasing local ales. Southport Golden Sands is always available alongside a variety of guest ales include Prospect, Wigan Brewhouse and Moorhouse's. This busy country pub has been Lancashire Dining Pub of the Year and is noted for its food. The huge beer garden, with its wildlife area and great views, hosts a beer festival on the first May bank holiday. Quiz night is every Monday. 🕸🍴♿🚋(337)🌸🛜

Blackburn

Black Bull Ⓛ

Brokenstone Road, BB3 0LL (corner of Brokenstone Rd and Heys Lane) SD666247
☎ (01254) 581381 ⊕ threebsbrewery.co.uk
Three B's Stoker's Slake, Bobbin's Bitter, Oatmeal Stout, Black Bull, Weavers Brew, Knocker Up; 2 changing beers (sourced locally; often Three B's) Ⓗ
In the heart of rural Lancashire, this is an independent award-winning family-run pub with a brewery and beer shop attached. There are eight handpumps serving a fine selection of Three B's ales including the exclusive Black Bull bitter. The three-beer wedges are very popular. The inn was formerly a farmhouse in the 18th century,

purchased by Robert Bell from Thwaites and now transformed to a place for those who appreciate fine beer and friendly conversation. No jukebox, fruit-machines or food – just a friendly, relaxing atmosphere. Q🕸🌸♿♣🅿🌸

Drummers Arms Ⓛ

65 King William Street, BB1 7DT
☎ (01254) 941075
Three B's Stoker's Slake; 4 changing beers (sourced locally; often Big Clock, Cross Bay, Hopstar) Ⓗ
Single-roomed bar opposite the town hall on the edge of the main shopping area, run by a mother and daughter team. The walls are adorned with breweriana and old pub signs. There is live music followed by an open mic session on the first Sunday of every month. At other times expect a range of unobtrusive background music. The majority of beers are sourced from Lancashire breweries, though a visitor from further afield often makes an appearance. There is a pleasant terrace at the front featuring upcycled drum tables and attractive bespoke garden planters. 🌸🚆🚆🅿🌸

Knuzden Tap Ⓛ

35B Windsor Road, BB1 2DQ
☎ (01254) 260243
Moorhouse's Blonde Witch; Three B's Bobbin's Bitter Ⓗ
The Tap opened in 2019 and bills itself as a gin and ale emporium. It is situated in a small row of shops in a residential area and frequent buses stop outside until the early evening. Alternatively, the main Blackburn to Accrington bus route is just five minutes' walk away. The Tap admits over-18s only and adds a touch of class to the Knuzden area. Q🅿🚋🛜

Blackpool

1887 the Brew Room Ⓛ

139-141 Church Street, FY1 3NU
☎ (01253) 319165 ⊕ thebrewroom1887.co.uk
West Coast Rock Golden Mile, Blackpool Blonde, Oyston Stout, Wonky Donkey, Tangerine Dream; 5 changing beers (sourced nationally; often Cross Bay, Tiny Rebel) Ⓗ
Blackpool's only brewpub, home to the West Coast Rock Brewing Company, is situated approximately 150 yards from the Winter Gardens complex. A large Victorian building, Blackpool FC was founded here and boards displaying the club's early history are on display. There is a viewing platform overlooking the brewery to the rear. The bar offers a selection of 10 real ales (five from the on-site brewery), craft beers and German lagers. Live music features most weekend nights and a popular quiz is held on Monday night. 🕸🍴🚆(North) 🚏(North Pier) ♣🚋🌸🛜

Albert's Ale Micropub Ⓛ

117 Albert Road, FY1 4PW
☎ (01253) 292827 ⊕ blackpoolmicrobar.co.uk
4 changing beers (sourced locally) Ⓗ/Ⓖ
A modern Blackpool hotel in the heart of the town's holiday accommodation quarter, close to the Winter Gardens and just 10 minutes' walk from the Tower and Promenade. Its quirky cellar bar has four ever-changing guest ales from local brewers, including a dark beer. Cider, perry and a wide range of predominantly Belgian bottled beers are also offered. The hotel has 11 comfortable bedrooms. Access to the bar is via steep stone steps or via the hotel, but level access can be provided on request.
Q🕸🌸🛏🍴🚆(North) 🚏(Tower) ♿🛏🚋🌸🛜

Blackpool Cricket Club

Barlow Crescent, West Park Drive, FY3 9EQ (follow signs to Stanley Park)
☎ (01253) 393347 ⊕ blackpoolcricket.co.uk
5 changing beers (sourced regionally; often Cumbrian Ales, Moorhouse's) ⊞

On the western edge of Stanley Park around 20 minutes' walk from the town centre, this club, housed in the impressive pavilion, is a vibrant local social centre. A range of five changing beers is available to visitors. It has frequently been voted local CAMRA Club of the Year. Quizzes and entertainment nights are held regularly, several TVs show various sports events, and the upstairs functions rooms are available for social events. There is free entry to the club and to all cricket games except Lancashire's. ঙ❀◑ᕁ&P☐(18)♠

Cask

9 Layton Road, FY3 8EA
☎ (01253) 396321
4 changing beers (sourced nationally; often Bank Top, Deeply Vale) ⊞

Situated about a mile or so from Blackpool town centre, en-route to Poulton-le-Fylde, with six bus routes passing close by, the Cask is a compact dog-friendly micropub. Four ever-changing cask beers are always available, normally including a dark beer. There is a pleasant sun-trap drinking area to the front and a walled area at the rear. Layton Cemetery opposite contains the grave of the last known survivor of the Charge of the Light Brigade. Q❀&♣☐❀♠

Cask & Tap

82 Topping Street, FY1 3AD
⊕ caskandtap.co.uk
8 changing beers (sourced nationally) ⊞

A friendly welcome is always guaranteed at this quirky micropub, tucked just off Blackpool's main central square a little over five minutes' stroll from the Tower. An ever-changing range of up to eight real ales from near and far, normally including a dark beer, and a selection of craft beers and real ciders and perries is available. Some of the lighting is made from recycled electrical test gear and even an old handpull. Dogs are welcome. Q&⇌(North) ⍟(North Pier) ❀☐(3,4) ❀

JD Drinkwater's Alehouse

75 Highfield Road, FY4 2JE
⊕ jddrinkwaters.co.uk
4 changing beers (sourced nationally; often Bowness Bay, Cross Bay, Lancaster) ⊞

One of a number of micropubs opened locally during Covid restrictions, this is a great asset to the local ale scene and was an instant success. The landlord has previously been the licensee of several local pubs and Drinkwater's is named after his father JD. Situated on a busy South Shore thoroughfare, it is frequented by locals and visitors alike. The four ever-changing beers come from near and far. Note the unusual bar with its many quirky features. ঙ&⇌(Pleasure Beach)♣☐❀

No.10 Ale House & Thai Kitchen

258 Whitegate Drive, FY3 9JW
☎ (01253) 694913
5 changing beers (sourced nationally) ⊞

Situated on the outskirts of Blackpool. Enter this pub first into a bright front room and bar area, then pass into a comfortable rear room. A sunny pavement area is at the front. The bar has five ales sourced from all over. The walls indicate the owners' love for Blackpool FC, whose ground is about 10 minutes' walk away, and also display many fine prints of bygone Blackpool. The bus stop is very close by. ❀◑☐(61,4)

Thirsty? Alehouse

277 Church Street, FY1 3PB
☎ (01253) 280900 ⊕ thirsty.pub
5 changing beers (sourced regionally; often Ossett, Thornbridge, Vocation) ⊞

A warm and friendly welcome and an electric, vibrant atmosphere await at this micropub just outside the heart of Blackpool. With three separate areas it caters to all tastes, while focusing on the discerning ale drinker with up to six handpulls offering a wide variety of ales. A selection of craft beers is also available. Food is often served in the afternoon and evening. Several bus routes pass the door. A homage to Manchester's Hacienda nightclub adorns the walls. Q❀◑❀&⇌(North)☐❀♠

Burnley

Bridge Bier Huis ⎣

2 Bank Parade, BB11 1UH
☎ (01282) 411304 ⊕ thebridgebierhuis.co.uk
Moorhouse's Premier; 4 changing beers (sourced regionally) ⊞

An award-winning true free house with a large open-plan bar that has a log burner and a small snug to one side. It offers mainly microbrewery beers alongside a changing real cider. More than 60 foreign bottled beers are also sold plus seven foreign beers on tap including rare German brews. Wednesday is quiz night and live music is hosted on occasional weekends. Normally closed on Monday or Tuesday, this welcoming pub opens at 5pm if Burnley FC are at home. ঙ❀◑⇌(Central) ⍟P☐❀

Craven Heifer

376 Briercliffe Road, BB10 2HA
☎ (07834 738645)
4 changing beers (sourced regionally; often Acorn, Dark Horse, Reedley Hallows) ⊞

An imposing establishment in the Briercliffe district of Burnley. This large pub is immaculately presented and opened out inside but still retains distinct drinking areas. It is a traditional local with weekly pool and quiz nights. There is regular live music at weekends (see Facebook for details). Good-quality food is served, with fish & chips a speciality on Friday. The number 5 bus passes the door but there are no evening services. ঙ◑♣☐(5)❀♠

New Brew-m ⎣

11 St James Row, BB11 1DR
☎ 07902 961426
Reedley Hallows Pendleside; 5 changing beers (sourced nationally) ⊞

This smart micropub in the centre of town is run as the Reedley Hallows tap. There is always at least one of the brewery's beers on the bar alongside five others sourced nationwide using the head brewer's contacts from years in the trade. A good range of foreign bottled beers and bottled ciders are available. The fully-glazed frontage makes the bar feel light and airy. There is a small room upstairs providing extra seating. Closed Tuesday unless Burnley FC are at home. Q⇌(Manchester Rd)☐❀

Burscough

Hop Vine

Liverpool Road North, L40 4BY (on A59 in village centre)
☎ (01704) 893799 ⊕ thehopvinepub.co.uk
Timothy Taylor Landlord; 4 changing beers (sourced regionally; often Hop Vine, Salopian) ⊞

This spacious former coaching house is now a thriving community brewpub renowned for its friendly

atmosphere and popular for its exceptional ale and food. The classic country pub interior has wood panelling and characterful wood flooring throughout and is decorated with historic local maps, photographs and vintage bottled ales. Catering for all age groups, it offers great-value meals, live music and twice-yearly beer festivals. The Hop Vine Brewery operates from the attractive floral courtyard at the rear. ᏠᢀᏝᗡᏖᢒᔆ(Bridge)PᗡᏌᏤ

Thirsty Duck L

Unit 9 & 10 Burscough Wharf, L40 5RZ
☎ (01704) 894600 ⊕ thirstyduck.co.uk
Hawkshead Bitter; 4 changing beers H
This new bar and bottle shop in the Burscough Wharf complex makes a welcome addition to the thriving real ale scene in Burscough. It has a tastefully decorated modern bar with five cask lines, 10 keg lines and real cider as well as a full range of wine and craft beer. The Beer Haul bottle shop is just across the courtyard from the bar and is open whenever the bar is. For access either ring the bell or speak to staff in the Thirsty Duck.
Q⬢ᏝᏖ(Bridge)♣⬤PᏌᏤᔆ

Carleton

Castle Gardens

Poulton Road, FY6 7NH
☎ (01253) 890015
Moorhouse's White Witch; Purity Pure UBU; Wainwright; house beer (by Black Sheep); 5 changing beers (sourced nationally) H
There has been a pub on this site since about 1750. First impressions might suggest that this popular pub is very much a food-led destination pub, however it is also a vibrant community local. A range of up to nine ales is available including several changing guests. A weekly quiz is held every Tuesday with live music performed regularly at weekends. There is a large outdoor drinking area to the side of the pub including many beach huts.
ᏠᢀᏝᗡᏖᏌAPᗡ(14)Ꮴᔆ

Carnforth

Royal Station

Market Street, LA5 9BT
☎ (01524) 733636 ⊕ royalstation.co.uk
4 changing beers H
A traditional Victorian station hotel whose facelift should be complete by the time you read this. The grand entrance and foyer lead to a tapas bar, while round the back is the larger and more basic Junction Bar, where there are games, real ale and live music (on Fri and Sat). The establishment became the Royal Station Hotel in 1900, in recognition of the fact that the Duke of York, later to become George V, availed himself of the hotel's hospitality during a shooting trip. A microbrewery is planned. ⬢ᗡᏖ♣ᏌᏤᔆ

Chorley

Ale Station L ✔

60 Chapel Street, PR7 1BS
☎ (01257) 368003
Abbeydale Deception; Settle Mainline; 7 changing beers (sourced locally; often Hawkshead, Pictish, Rock the Boat) H
Independently run by the same family since 2016, this bar is conveniently situated adjacent to the bus station and just across the road from the railway station. Although a town centre pub, it has a loyal band of local regulars. Up to nine changing real ales are served mainly sourced from northern microbreweries. The landlord

champions traditional English bitter and two examples of this style are always available. A digital display board provides updated train times for the railway traveller. Pictures of old Chorley adorn the walls. Q⬢⬤ᏌᏤᔆ

Bob Inn

24 Market Place, PR7 1DA
☎ 07767 238410
3 changing beers (sourced nationally) H
A tiny bar housed in a market stall, this is the smallest pub in the area. Outside seating is available and more seating in the market food hall. Conversation and banter are an important part of the experience. Three ever-changing cask beers are served, sourced from smaller breweries nationally. No food is served but you are welcome to bring your own. A local CAMRA multi award-winning pub. Q⬢ᏝᏖ⬤Ꮴ

Malt 'n' Hops L

50-52 Friday Street, PR6 0AA
☎ (01257) 260074
Bank Top Dark Mild; Ossett White Rat; 6 changing beers (sourced nationally; often Blackedge, Moorhouse's, Wily Fox) H
Converted from an old shop in 1989, the pub is located close to the town's railway and bus stations. It features a single L-shaped bar on two levels with a bright yet traditional feel and a pleasant beer garden. A genuine free house, it offers up to nine guest ales including a mild, usually sourced from Lancashire and Yorkshire micros including Rat, Wily Fox, Ossett, Elland, Lancaster, Fernandes, Goose Eye and Blackedge. Good-value filled rolls and pork pies are usually available. A former local CAMRA Pub of the Year and Lancashire Pub of the Year. ᏠᢀᏖ⬤ᏌᏤᔆ

Masons Arms L

98 Harpers Lane, PR6 0HU
☎ (01257) 367038
5 changing beers (sourced locally; often Blackedge, Pictish) H
A tastefully modernised multi-room pub a mile from the town centre. The taproom has five changing ales available at any one time, sourced mainly from north-western micros, but sometimes from further afield. The taproom and two distinct lounges complete with wood-burning stoves give distinctly different drinking areas, and there is a partly-covered beer garden to the rear. Pizzas are served in the evening every day except Monday. Light and airy, this is a cosy pub with a reputation for good beer. ᏠᢀᏝᏌ(24,125)Ꮴᔆ

Shed & Garden L

9 Fazackerley Street, PR7 1BG
☎ (01257) 261526 ⊕ theshedandgarden.co.uk
3 changing beers (sourced locally; often Blackedge, Twisted Wheel, Wigan Brewhouse) H
Originally named the Shed, with an interior lined with wood strips, this bar opened in 2017. Five years later the business expanded into the premises next door and became the Shed & Garden. There is plenty of seating and the original rustic feel has been retained. The garden is quite something, with paving, gravel paths, picnic tables and a pergola giving a real outdoor feel. Live music is a regular feature. With three changing cask ales of contrasting styles, often sourced from local breweries, this venue really is worth a visit. ᏖᏌᏤᔆ

Shepherds' Hall Ale House & Victoria Rooms L

67 Chapel Street, PR7 1BS
☎ (01257) 270619
5 changing beers (sourced nationally) H

This friendly and welcoming bar next door to the bus station was the first micropub in Chorley, opening in 2014. Refurbished in 2020 and significantly extended into adjoining premises in 2021, up to five beers are now served from microbreweries all over the country. You should find a wide range of styles, always including a dark beer, and third-pint paddles are available. Two real ciders, four craft keg lines often featuring Rivington beers, and a variety of other drinks are also available to suit all tastes. Q☆✔♠●🏠❀⚲

Clayton le Moors

Old England Forever 🅛 ✓
13 Church Street, BB5 5HT
☎ (01254) 383332
Bank Top Dark Mild, Flat Cap; 4 changing beers (sourced regionally; often Bank Top, Prospect) Ⓗ
A fine, traditional Bank Top brewery-owned pub on a terraced street just off Barnes Square. It is easily reached from the towpath of the Leeds-Liverpool canal. The single long bar offers a large selection from the Bank Top range in a variety of styles and strengths. The area in front of the bar, where dogs are allowed, is basic and features a section of glass flooring from where the cellar can be viewed. Beyond that is a comfortable lounge area. The pub is wheelchair friendly and has fully accessible toilets. There is a purpose-built walled area to the rear for alfresco drinking. Q❀♿♠●🚃(6,7)

Cleveleys

Jolly Tars ✓
154-158 Victoria Road West, FY5 3NE
☎ (01253) 856042
Greene King Abbot; Ruddles Best Bitter; Sharp's Doom Bar; 7 changing beers (sourced nationally; often Acorn, Coach, Lancaster) Ⓗ
Named after a nine-strong, highly popular family troupe of entertainers who entertained locals and visiting crowds during the 1940s, this busy, welcoming venue has a great reputation for food and drinks and friendly staff. Although the popular front drinking area can get lively, there are several secluded booths in which to enjoy a quiet drink. Several bespoke pieces of John Ditchfield Glasform glass decorate the pub.
☆❀◗&🚃♿⚲

Shipwreck Brewhouse 🅛
53 Victoria Road West, FY5 1AJ
☎ (01253) 540597 ⊕ theshipwreckbrewhouse.co.uk
4 changing beers (sourced locally) Ⓗ
An independent micropub and café in the heart of Cleveleys' main street with friendly and knowledgeable staff serving five cask ales, ciders and 30 Lancashire gins. There is an emphasis on Lancashire ales and also a locally sourced food menu comprising substantial snacks and pub food. The modern, seaside-themed decor includes photographs of historic local shipwrecks and well-known landmarks. The forecourt has a heated seating area with a retractable roof, and there is a covered, heated beer garden to the rear. On the first floor is a bottle shop.
❀◗&🚃●♿⚲

Clitheroe

Beer Shack ✓
22-24 King Street, BB7 2EP
☎ (01200) 426368 ⊕ thebeershack.uk
4 changing beers (sourced locally; often Carnival, Moorhouse's, Pentrich) Ⓗ

Opened in 2021, this new bar has now added four handpulls. Beers come mainly from well-known microbreweries and larger ones such as Lancaster, almost always including a dark cask beer. Robb and Sam, the licensees, have now begun brewing on the premises. Food includes a good choice of charcuterie, cheese platters and snacks. The large outdoor area at the rear is a real suntrap. Convenient for both the railway and bus stations. ⇌🚃⚲

Bowland Beer Hall 🅛 ✓
Greenacre Street, BB7 1EB
☎ (01200) 401035 ⊕ holmesmill.co.uk/beer-hall
Bowland Pheasant Plucker, Gold, Boxer Blonde, Hen Harrier, Buster IPA, Deer Stalker; changing beers (sourced nationally) Ⓗ
The enormously popular beer hall is now a major part of Clitheroe's thriving beer scene. It opened in 2016 in a former mill dating back to the 19th century and features a mass of industrial machinery. It has the second-longest bar in Britain at 106ft, with more than 40 handpulls. You can expect to find all of Bowland's beers here, as well as another dozen or more ales from around the UK. The complex hosts a hotel, cinema, coffee shop and delicatessen, and is a short walk from Clitheroe Castle and the town centre. ☆❀◗&⇌●P🚃⚲

New Inn 🅛
20 Parson Lane, BB7 2JN
Coach House Gunpowder Mild, Farrier's Best Bitter, Blueberry Classic Bitter; Moorhouse's Premier, Pride of Pendle, Blonde Witch; 5 changing beers (sourced regionally; often Prospect, Saltaire) Ⓗ
The bar at the New Inn is a very welcome sight, with at least 10 beers on offer. The bar itself is central with a number of smaller rooms clustered around it. In addition to the regular beers from Coach House and Moorhouse's you may also find the likes of Saltaire, Ilkley, Prospect or Wharfedale breweries represented. The back room hosts traditional Irish music sessions every Sunday afternoon and a number of associations meet here regularly. The pub dates from the early 1800s and faces Clitheroe Castle. It's just a short walk from the bus and railway stations. Q❀Å⇌🚃⚲

Colne

Admiral Lord Rodney 🅛
Mill Green, BB8 0TA
☎ (01282) 219759 ⊕ thelordrodney.co.uk
9 changing beers (sourced regionally; often Goose Eye, Ilkley, Reedley Hallows) Ⓗ
A much-loved community pub in Colne's old South Valley area, the old industrial heart of the town. The stone-flagged floor includes mosaics and there are beautiful tiles up the inner staircase. Set across three rooms, the pub has become the meeting place for a number of clubs. It hosts regular live entertainment in the evenings, and displays local history and artwork. There has been a recent refurbishment with open fires and flagged floors, plus a much-improved outdoor seating area and a separate smokers' area. Q☆❀◗♠⚲⚲

Boyce's Barrel
7 New Market Street, BB8 9BJ
☎ 07736 900111
5 changing beers (sourced nationally) Ⓗ
The first micropub in Colne and a member of the Micropub Association, it offers five high-quality real ales with no music, no lager, just a great atmosphere and plenty of banter. Tastefully styled with tall polished wooden sleeper tables, it is reminiscent of a rail staging post. Ales are rotated often, with new beers put on the

bar almost as soon as a barrel runs dry. All ales are sourced from non-local breweries and always include one mild and one porter or stout. A place that's sure to suit any real ale fan's tastes. Q&≈★♥①☷✿

Coppull

Wheatsheaf Ⓛ

1 Westerton Court, Spendmore Lane, PR7 4NY
☎ (01257) 470666
Wychwood Hobgoblin Ruby; 2 changing beers (sourced locally) Ⓗ
The Wheatsheaf has been at the centre of the local community since the 1700s and remains so today. It underwent an extensive refurbishment a few years ago and now has a smart modern interior. Recent improvements include a new outdoor drinking area. There are three handpumps serving a changing selection of real ales with a focus on supporting local microbreweries – beers from Bank Top and Blackedge often feature. Q☎❀&♣P☷✿🖤

Croston

Wheatsheaf ✅

Town Road, PR26 9RA
☎ (01772) 600370 ● wheatsheaf-croston.com
Goose Eye Chinook Blonde; 4 changing beers (sourced nationally; often Blackedge, Bowland, Titanic) Ⓗ
On the main road and overlooking the village green, this tastefully refurbished pub has a contemporary feel. It has a distinct area for dining as well as a comfortable drinking area, and a large patio area to the front. There is a wide choice of beers, generally sourced locally, with one regular and four ever-changing, invariably including a dark beer. Food is served lunchtimes and evenings during the week and all day, including breakfast, at weekends. ☎❀①&≈P☷(112,337)✿🖤

Darwen

Bird in th'hand Ⓛ

225 Duckworth Street, BB3 1AU
☎ 07926 115292
12 Steps Step 1; 4 changing beers (sourced regionally; often Blackedge) Ⓗ
Home to 12 Steps Brewery, named after the number of steps down to the cellar, this is a brewpub and bottle shop with four handpumps, 10 craft lines and three for ciders. It has shelves full of Belgian, international and UK bottled beers and craft ciders, which can be consumed on or off the premises. Three rooms include one with a log burner, and outside is a covered back yard. Toilets are upstairs. The pub's name comes from a previous hostelry that stood here over 100 years ago. ≈♥☷(1)✿

Number 39 Hopstar Brewery Tap Ⓛ

39-41 Bridge Street, BB3 2AA
☎ 07531 425352 ● hopstarbrewery.co.uk
Hopstar Dizzy Danny Ale, Dark Knight, Off T'Mill, Smokey Joe's Black Beer, JC, Lancashire Gold; 2 changing beers (sourced nationally; often Slater's) Ⓗ
Multi award-winning continental-style bar in the centre of Darwen offering both beer and cider. Four handpumps serve beers from the Hopstar range, always including a dark beer. New brews are tried out here first but never last long due to popular demand. Three ciders or perries are always available, and a large variety of bottled continental and world beers. There is live music every Thursday night and most weekends – admission is normally free but the bar may close early due to ticketed events. ☎❀≈♣♥☷(1)✿🖤

Earby

Red Lion Ⓛ

72 Red Lion Street, BB18 6RD
☎ (01282) 843395
4 changing beers (sourced locally; often Settle) Ⓗ
A warm and friendly welcome awaits you from both the host and regulars at the Red Lion. This is a traditional country local, owned by local people. It has two rooms, both attractively renovated – the lounge is heated by a wood burner. An extensive food menu is served in the lounge both lunchtime and evening. The pub is situated close to a youth hostel and is a drinkers' delight. Q☎❀①☷✿🖤

Fleetwood

Steamer

Queens Terrace, FY7 6BT
☎ (01253) 681001
● thesteamerfleetwood.foodanddrinksites.co.uk
Reedley Hallows Pendleside; 5 changing beers (sourced nationally; often Bowness Bay, Cross Bay, Kirkby Lonsdale) Ⓗ
Fleetwood's oldest surviving pub, the Steamer is situated across from the famous market. It offers a varying selection of up to six real ales in a traditional pub setting. The decor is complemented by pictures and photographs of the local area and historic fishing vessels, reflecting the pub's close association with the fishing industry and history of the town. Good food is available daily from noon with regular theme nights. Live entertainment features at weekends. Fleetwood Museum is nearby and is worth a visit to find out about local history. ☎❀①&☷(Victoria St)♣☷(1,14)✿🖤

Freckleton

Vestry Taproom

68-74 Lytham Road, PR4 1XA
☎ (01772) 634924 ● thevestrybar.co.uk
4 changing beers (sourced regionally; often Bowland, Farm Yard, Lancaster) Ⓗ
Situated a short walk from the centre of Freckleton, this micropub opened its doors at the end of 2019. A range of four ales, mostly from local brewers, awaits the thirsty drinker, along with a selection of craft beers. A pleasant outdoor area is to the front. Although there is a TV showing live sporting events and live music is played on many weekends, at most times the pub is an ideal spot for conversation. Buses between Preston and the Fylde Coast stop outside. ❀&♣☷✿🖤

Galgate

New Inn

59 Main Road, LA2 0JW
☎ (01524) 752932 ● thenewinn.online
2 changing beers (sourced locally) Ⓗ
Formed from two 19th-century buildings joined together, this pub has a single bar with three distinct areas – the major feature is a Yorkshire range. Despite the busy road at the front and the proximity to the university, the trade is mainly local. There are two to three guest beers according to season, often from Lancaster and Bowland breweries. Music is played occasionally. ❀🚃&♣P☷(40,41)✿🖤

Great Harwood

1B Tap Ⓛ

1B Glebe Street, BB6 7AA

4 changing beers (sourced nationally; often Snaggletooth) H

Welcoming two-roomed bar opened in former office premises by real ale enthusiasts. It is close to Towngate square and preservation area, on a side street opposite the post office. The main room, featuring plenty of beer and brewery-related items, sells an ever-changing and skilfully selected range of cask beers, usually including a stout or porter. Local breweries predominate. A side room housing a separate bar serving gin and world beers offers additional seating. Note the collection of beer festival glasses on display in the bar. ●P🍽🚐�

Grimsargh

Plough L

187 Preston Road, PR2 5JR
☎ (01772) 700666 ⊕ ploughgrimsargh.co.uk

Timothy Taylor Landlord; 4 changing beers (sourced nationally; often Blackedge, Lancaster, Titanic) H
A traditional village inn with separate bar and dining areas. Situated on the main Preston to Longridge road in the centre of the village, it has a friendly and welcoming atmosphere with good home-cooked food available. Popular with the locals, this is a family-friendly pub. Dogs are welcome in the bar area and there is a large garden at the rear. Five handpumps on the bar serve one regular beer, Timothy Taylor Landlord, and four guests ales, including a dark beer and a LocAle from the SIBA list.
🏠🕏⟐🐾👫🍽🚐(1) 🐾�

Haggate

Hare & Hounds ✓

1 Halifax Road, BB10 3QH
☎ (01282) 424612

4 changing beers (sourced locally) H
A traditional multi-roomed country pub in the Briercliffe area of Burnley, with superb open views over the Pennine moorland to the rear. There are separate rooms at the front and a large dining area at the back. The pleasant beer garden offers comfortable alfresco drinking. Rightly proud of its cider offering, it was a recent local CAMRA Cider Pub of the Year.
Q🏠🕏⟐🐾●🍽🚐🐾�

Haighton

Haighton Manor L

Haighton Green Lane, PR2 5SQ
☎ (01772) 706350

Dark Horse Blonde Beauty; Lancaster Blonde; Moorhouse's White Witch; 2 changing beers (sourced regionally) H
Refurbished and extended in 2016, this former country house hotel is now a bustling pub and dining venue. Five cask ales are available on handpump, with three regular beers and up to two changing beers from smaller local breweries such as Lancaster and Moorhouse's. Quality locally sourced food is served as well as a selection of beer tapas. Stone walls, flagged and wooden floors, low-beamed ceilings and open fires add to the country-house feel, while a conservatory and patio allow views across the fields. Walkers and dogs are welcome.
🏠🕏⟐🐾👫●🐾�

Haslingden

Griffin Inn L

86 Hud Rake, BB4 5AF
☎ (01706) 214021 ⊕ rossendalebrewery.co.uk

Rossendale Floral Dance, Glen Top Bitter, Rossendale Ale, Halo Pale, Pitch Porter, Sunshine; 1 changing beer H
Situated on Hud Rake, this is a traditional community inn and also the home of Rossendale Brewery on the lower floor beneath the pub. The large bar has a separate area for pub games and the spacious lounge has picture windows overlooking the local hills and valleys. On the hill facing the front of the building sits the Halo Panopticon sculpture. The pub is easily accessible but there is a steep uphill walk from the main road bus stops.
Q🕏🐾●🚐(464,X41) 🐾�

Heath Charnock

Yew Tree L

Dill Hall Brow, PR6 9HA
☎ (01257) 480344 ⊕ yewtreeinnanglezarke.co.uk

Blackedge Pike; house beer (by Blackedge); 2 changing beers (sourced locally; often Blackedge, Bowland, Northern Monkey) H
Attractive, isolated stone-built inn with flagged floors and great views over open countryside. The interior is essentially open-plan, but walls and partitions divide it into separate cosy areas. The pub has long had a reputation for quality food, offering a full range of meals made from locally sourced produce wherever possible. The bar showcases ales from the nearby Blackedge Brewery and a guest or two from other independent local breweries. Dogs are welcome in the bar area. Closing times can vary. Q🏠🕏⟐🐾●🐾�

Helmshore

Robin Hood Inn L ✓

280 Holcombe Road, BB4 4NP
☎ (01706) 404200

Hydes Original; 4 changing beers H
Traditional stone-built village inn which, although opened up, retains the impression of having three separate rooms, with two open fires. The original Glen Top Brewery windows are a feature. Beers from the seasonal ranges of Hydes and Beer Studio dominate the selection. A quiz night is held on Thursday. The small beer garden overlooking Helmshore Textile Museum and lodge can be reached by steps to the side of the pub.
Q🏠🕏🐾🚐(11) 🐾

Hest Bank

Crossing

6 Coastal Road, LA2 6HN
☎ 07584 660075

5 changing beers H
Former café opened as a micropub in 2018. A possibly Victorian stone-built building with a timber extension and a plate-glass window from its café days, it has a U-shaped layout, with the bar counter near the entrance in one arm, a wood-burning stove in the middle, and a back room for games. Note the bound copies of Railway magazine and photos of Hest Bank Station which closed in 1969. The pub's name refers to the fact that it is close to both one of the last level crossings on the West Coast Main Line and the ancient route over the sands.
Q🐾🚐(5,55A) 🐾�

Heysham

Bookmakers 🍷 ✓

364 Heysham Road, LA3 2BJ
☎ 07785 257648

5 changing beers H

The Bookmakers, opened in 2019 in a former betting shop among other shops in a suburban neighbourhood, is a welcome addition to the micropub scene in this area. The decor in this single wedge-shaped room is industrial chic, with an arrangement of standing and seating areas and a few comfy chairs and bar stools. The pub is well used by locals. ♿♣🚃(1,2X)♣

Kirkham

Tap & Vent Brewhouse 🄻

26 Poulton Street, PR4 2AB

☎ (01772) 382401 ⊕ tapandventbrewhouse.co.uk

5 changing beers (sourced regionally; often Fuzzy Duck, Lytham) Ⓗ

A traditional-looking shop from the outside, a modern pub on the inside, situated in the centre of Kirkham, just up from the Market Square and bus stops. This is the tap for Lytham Brewery located next door but one, but its beers do not dominate choice and a good range of guest ales, continental lagers and bottled beers is also available. A quieter snug is hidden behind the bar and there is a sunny pavement area to the front. Q🌳🏠🕪♿♣🚃♣🛜

Lancaster

Bobbin ✅

36 Cable Street, LA1 1HH

☎ (01524) 32606

5 changing beers (often Anarchy, Dark Star, Tiny Rebel) Ⓗ

A large mainly Victorian pub with 18th-century elements, entirely open plan inside but divided by raised areas and pillars. It is frequented by a goth/metal crowd but they are by no means the only customers. Expect 70s-style flock wallpaper, laminate flooring and an extremely eclectic jukebox. Live music is played on Friday and Saturday, pool night is Wednesday. Handy for the bus station. 🕸♿≠♣🚃♣🛜

Jailor's Barrel ✅

64 Market Street, LA1 1HP

☎ (01524) 840316 ⊕ jailorsbarrel.co.uk

Hydes Lowry, Original; 4 changing beers (often Hydes) Ⓗ

This pub was converted from retail premises in 2007, retaining the façade with its huge curved windows. Contemporary in style inside, wooden screens and furniture of varying heights break up the area. An upstairs room is also open to the public, and can be reserved. There is a collection of bottled beers, some quite rare, strong and expensive. Cask ale is discounted on Monday. Q🕪≠♣🚃♣🛜

Merchant's ✅

29 Castle Hill, LA1 1YN

☎ (01524) 66466 ⊕ merchants1688.co.uk

8 changing beers (sourced regionally; often Allendale, Kirkby Lonsdale, Tirril) Ⓗ

Converted wine-merchants' cellars, built in 1688, create a peaceful haven in the hubbub of the city centre, enhanced by an extensive outdoor space. The main drinking areas are in three separate tunnels, with a fourth forming the entrance and bar area. One tunnel is now a restaurant, another is used for functions. Look for the stoneware bottles used in the construction of the cellar walls. The house beer, Castle Blonde, is brewed by Old School. Board games are available. Live music is performed late every Saturday evening, quiz night is Sunday. 🕸🕪≠♣🚃♣🛜

Sun ✅

63 Church Street, LA1 1ET

☎ (01524) 66006 ⊕ thesunhotelandbar.co.uk

Lancaster Amber, Blonde, IPA, Black, Red; Wainwright; 4 changing beers (often Lancaster, Marston's, Robinsons) Ⓗ

The primary outlet for Lancaster Brewery in the city, this pub was completely altered in 2004 and extended into next door in 2005. The decor combines a mixture of exposed stonework, wood panelling and solid furniture, with ambient candlelight in the evenings. The original pub has open space for vertical drinking; the extension is mostly furnished with old dining tables. Some original features remain, including stone fireplaces (one with a wood-burning stove) and a well. Outside is a peaceful courtyard with a heated and covered smoking area. 🕸🛏🕪♿≠🚃♣🛜

Water Witch 🄻

Tow Path, Aldcliffe Road, LA1 1SU (on canal towpath near Penny Street bridge)

☎ (01524) 63828 ⊕ waterwitchlancaster.co.uk

4 changing beers (often Cross Bay) Ⓗ

The Water Witch was a passenger packet boat that once plied the Lancaster canal. The building, originally a canal company stable block, assumed its present name and use in 1978 – the first true canalside pub on this stretch of water. Wedged between the towpath and a retaining wall, it is long and narrow, with bare stone walls and floors. A mezzanine floor and the space underneath it are used mainly for dining. There are plenty of seats on the towpath. Quiz night is Thursday. 🕸🕪♿🚃♣🛜

White Cross 🄻 ✅

Quarry Road, LA1 4XT (behind town hall, on canal towpath)

☎ (01524) 33999 ⊕ thewhitecross.co.uk

Timothy Taylor Landlord; Wye Valley HPA; 8 changing beers (sourced regionally; often Allendale, Elland, Titanic) Ⓗ

In the corner of an extensive complex of Victorian textile mills, now converted to other uses, this old canalside warehouse, renovated in 1988, has an open-plan interior and a light, airy feel. French windows open onto extensive canalside seating. There is a Tuesday quiz, and a beer and pie festival each April. The wide open spaces and decor make it look like a circuit pub, but in fact much of the custom comes either from residential areas up the hill or from nearby workplaces. 🕸🕪♿♣P🚃🛜

Wobbly Cobbler

49 Scotforth Road, LA1 4SA

⊕ thewobblycobbler.co.uk

3 changing beers (often Avid, Farm Yard, Old School) Ⓗ

Micropub opened in 2020 in a former florist's, now an established community local. The large windows have been retained, and inside, dark grey walls and unpainted woodwork predominate. Outside, there is plenty of sheltered seating. There are only minimal eats, except when street food is available on a Saturday, but the drinks selection is quite varied. Occasional live music is hosted. Q🕸♣🚃

Lathom

Ship Inn

4 Wheat Lane, L40 4BX (take School Ln from Burscough, turn right after hump-backed bridge) SD452116

☎ (01704) 893117 ⊕ shipatlathom.co.uk

House beer (by Moorhouse's); changing beers (sourced regionally; often Black Sheep, Sharp's) Ⓗ

A traditional country pub set in an idyllic canalside location. The cosy central bar features a real fire and separates the two dining areas which serve food ranging from pub classics through to interesting and changing specials. There is a dog-friendly 'boot room' complete with log burner. The pub is popular all year but especially in summer, with its large beer garden. A highlight is the September Beer, Pie and Sausage festival featuring over 40 handpulled ales.

ॐ❀◑⧗(Hoscar) P☐(337,3A) ❀ 🛜

Leyland

Golden Tap Ale House 🄻

1 Chapel Brow, PR25 3NH

☎ (01772) 431859

6 changing beers (sourced nationally) Ⓗ

Located in a former shop, this cosy one-roomed micropub opened its doors to the public in 2016. Up to six changing cask ales are available, usually including two dark beers, sourced from microbreweries far and wide, and at least one from the local region. No food is served other than a few snacks, but the pub is right in the heart of the town's fast-food and takeaway area.

ॐ⧗♣●☐(111) ❀ 🛜

Market Ale House 🄻

33 Hough Lane, PR25 2SB

☎ (01772) 623363

6 changing beers (sourced nationally) Ⓗ

Opened in 2013, this was the area's first micropub. It is situated at the entrance to the former Leyland Motors North Works, which now serves as the town's market hall. With an extension into the adjoining premises in 2021, and an upstairs lounge, there is plenty of seating. Six changing real ales come from local and national breweries. Changing ciders, wine and a few spirits are also served. There is no TV but live acoustic music plays on Sunday afternoon. Outside to the front is a drinking area with ample tables and seating. ❀◑⧗♣●☐❀🛜

Longridge

Tap & Vent ✅

4 Towneley Parade, PR3 3HU

☎ (01772) 875781

4 changing beers (sourced nationally; often Bowland, Westgate) Ⓗ

Opened in 2016, the Tap & Vent was the first micropub in Longridge. Situated in a row of shops on Towneley Parade, the pub provides a welcoming and friendly atmosphere. Four handpumps serve a selection of rotating cask ales, typically from microbreweries. Craft, bottled and keg beers plus keg cider, fine wines and prosecco are also available. There is also a large range of gins. A genuine free house encouraging the art of conversation. ⧗☐(1)❀🛜

Lostock Hall

Lostock Ale

7 Hope Terrace, PR5 5RU

6 changing beers (sourced locally; often Beer Brothers, Crankshaft, Wily Fox) Ⓗ

Set within the pedestrianised Tardy Gate shopping area, this micropub opened in 2020 in former gift shop premises. Quickly becoming popular, it was local CAMRA Pub of the Season for spring 2022. Six changing cask ales often include beers from local breweries such as Crankshaft and Beer Brothers, while there are also eight keg lines in place. This community-focused pub has a relaxed, friendly atmosphere, and with the acquisition of

the adjoining charity shop premises in late 2021, its floor space has more than doubled in size.

ॐ⧗P☐(109,111) ❀ 🛜

Lytham

Craft House Beer Café

5 Clifton Street, FY8 5EP

☎ (01253) 730512

4 changing beers (sourced nationally; often Cumbrian Ales, Rat) Ⓗ

Now in its sixth year, this cosy micropub guarantees a warm welcome. It has fast developed into a popular destination for real ale drinkers. Four ever-changing beers are served, sourced from far and wide and always including a dark beer. These are supplemented by a selection of world and British bottled beers and craft beers. The bar is dog-friendly and offers pavement seating, weather permitting. A small menu of food is served daily. Q❀◑⧗●☐❀🛜

Taps ✅

12 Henry Street, FY8 5LE

☎ (01253) 736226

Greene King IPA; Robinsons Dizzy Blonde; 6 changing beers (sourced nationally; often Acorn, Moorhouse's) Ⓗ

A multi-award winning pub and former CAMRA National Pub of the Year finalist, the Taps is a local ale institution. Among the many beers sourced from different breweries there is usually a mild. Although it can be a busy pub at times, service is prompt and friendly. A quiz is held every Monday evening. An outside drinking area to the side is heated in cold weather and can be covered to cope with the British summer. ॐ❀◑⧗⧗♣☐🛜

Morecambe

Eric Bartholomew ✅

10-18 Euston Road, LA4 5DD

☎ (01524) 405860

Greene King Abbot; Ruddles Best Bitter; Sharp's Doom Bar; 5 changing beers (often Cross Bay) Ⓗ

Opened in 2004, this Wetherspoon establishment is dedicated to Eric Morecambe (born Eric Bartholomew). The open-plan pub near the seafront functions on two levels with an upstairs lounge and dining area. The long bar is adorned with pictures of 19th-century Morecambe and artwork with a Morecambe and Wise theme. There is a smoking area outside at the front. Close to shops and a public car park. Q❀◑⧗⧗☐🛜

Little Bare

23 Princes Crescent, LA4 6BY

☎ 07817 892370

5 changing beers Ⓗ

Micropub opened in 2017 in a former off-licence and retaining the shop window. With grey paint, bare floorboards and candle-lit after dark, the Bare follows the micropub formula: no food, no music, no machines. There is a second room down a corridor with extra seating. A small beer garden to the rear of the premises is accessed through the back room.

❀⧗(Bare Lane) ♣☐(5,100) ❀

Morecambe Hotel

25 Lord Street, LA4 5HX

☎ (01524) 415239 ⊕ themorecambehotel.co.uk

Cross Bay Halo; 4 changing beers Ⓗ

The place to come if you want a choice of Cross Bay beers. Reopened in 2015 after renovation in contemporary style, this slightly upmarket hotel is light

and airy with flagged floors and a variety of seating and tables. The bar is faced with unplaned wood. Four rooms surround the bar and to the rear is a surprisingly spacious garden, especially popular with families. Screens show videos of 20th-century Morecambe. For most of the day food dominates. The name is not hubris: this was a coaching inn built long before there was a town called Morecambe. No cash payment. ✿❤◐◗&≠🖨✿🌣❡

Torrisholme Taps ✓
312 Lancaster Road, LA4 6LY
☎ 07786 073626
5 changing beers Ⓗ
Micropub opened in 2021 among shops in an old village, now a suburb. Located in a former bridal shop and retaining a picture window, the pub is light and spacious for a micro, with a wide range of beverages. There are pies on sale. A bike rack is available at the front but most customers walk here. Q🖨(100)✿

Ormskirk

Cricketers Ⓛ
24 Chapel Street, L39 4QF
☎ (01695) 571123 ⊕ thecricketers-ormskirk.co.uk
4 changing beers (sourced regionally; often Old School, Reedley Hallows) Ⓗ
Situated close to Ormskirk town centre, the Cricketers prides itself on both quality food and cask ales. It features six cask ales sourced from local and regional breweries, and is a former CAMRA award winner. An extensive food menu is served all day in the restaurant and bar area. Cricket memorabilia around the walls reflects the pub's close relationship with Ormskirk Cricket Club. ❤✿◐◗&≠P🖨(375,385)❡

Kicking Donkey Ⓛ
Narrow Moss Lane, L40 8HY
☎ (01695) 227273
Lancaster Blonde; 3 changing beers (sourced regionally) Ⓗ
This elegant country pub has recently been refurbished. Three handpumps offer a rotating selection of local ales with the aim to have one pale, one amber and one dark beer available at any one time. A collection point for the Ormskirk Food Bank, donations handed in at the bar result in entry to a voucher draw for a prize. Q✿◗&❡

Prince Albert
109 Wigan Road, L40 6HY
☎ (01695) 573656
Moorhouse's Pendle Witches Brew; Tetley Bitter; 3 changing beers Ⓗ
A country community local on the main road between Ormskirk and Skelmersdale. With its warm atmosphere it is well worth the walk or the bus journey from the real ale desert of Skelmersdale. The freshly-cooked food and real ale are both good value for money. The Prince Albert always has some interesting guest ales from north-western breweries. The small central bar serves three distinct areas with real fires in the winter. There is a good selection of pub games such as darts and dominoes. The bus stops outside. Q❤✿◐◗♣P🖨(310,375)❡

Tap Room No. 12 ♟ Ⓛ
12 Burscough Street, L39 2ER
☎ (01695) 581928
4 changing beers (sourced regionally) Ⓗ
This former shop has had a custom conversion into a Belgian-style single-room bar with wooden panels. It features four changing cask ales sourced regionally and aims to offer a porter or stout, an amber bitter and two pale beers of different strengths. There is also an

extensive range of foreign bottled beers and authentic foreign lagers on draft. A quiz is held every Wednesday and live music Friday and Saturday, with background music during the rest of the week. ≠♣🖨✿❡

Orrell

Delph Tavern
Tontine, WN5 8UJ
☎ (01695) 622239
5 changing beers Ⓗ
Free house, popular with locals and visitors, serving five ever-changing ales with an emphasis on local breweries. Food is served every day and offers a balance of traditional pub classics alongside innovative street food. Live sports are shown on a number of unobtrusive screens while a vault area offers pool and darts. The outside space has a small play area as well as tables to enjoy food and drinks. Weekly quiz nights are popular. ❤✿◐◗&♣P✿❡

Oswaldtwistle

Vault Ⓛ
343 Union Road, BB5 3HS
☎ (01254) 872279
Moorhouse's White Witch; 4 changing beers (sourced regionally) Ⓗ
A pleasant single-roomed bar with separate areas on the busy main road through Oswaldtwistle. There is high bench seating around the walls and a standing area at the bar. The six handpumps dispense four changing beers and two ciders. Keen rugby league fans, the Vault sponsors the Accrington Wildcats under-7s – note the framed team photo in the bar. A quiz night is held every Thursday which is popular with the locals. Easy to reach by public transport as buses from Accrington and Blackburn pass the door every few minutes. Q●🖨✿

Padiham

Boyce's Barrel
9 Burnley Road, BB12 8NA
☎ 07736 900111
5 changing beers (sourced nationally; often Hambleton, Hop Back, Rudgate) Ⓗ
A single-roomed micropub, on the main road through town, with a collection of advertising signs adorning the walls. It is the sister pub of Boyce's in Colne and run by the same management team. Seven handpumps dispense two pale, two dark and one bitter ale, and two ciders. Two further boxed fruit ciders are available and there is a small selection of wine and gins. Food is limited to crisps and nuts. Many buses to and from Burnley stop nearby. Q&●🖨(M2,152)✿

Parbold

Wayfarer Ⓛ
1-3 Alder Lane, WN8 7NL
☎ (01257) 464600 ⊕ wayfarerparbold.co.uk
Problem Child Good Spankin'; 5 changing beers Ⓗ
A country pub with a focus on dining, offering six handpulls, one of them for cider, and a range of craft keg beers. The landlord and brewer Jonny is happy to show you around his on-site microbrewery, Problem Child Brewing. The pub has low beamed ceilings with cosy nooks and crannies. Popular with walkers, it is close to the Leeds-Liverpool canal and Parbold Hill – suitable walks are shown on the website. Outside, the countryside beer garden enjoys pleasant views. Q❤✿◐◗&≠●P🖨✿❡

Pendleton

Swan with Two Necks ⃝L
Main Street, BB7 1PT
☎ (01200) 423112 ⊕ swanwithtwonecks.co.uk
5 changing beers (sourced regionally; often Goose Eye, Phoenix) Ⓗ

A plethora of awards acknowledge that this has been one of the best pubs in north-west England for the past decade. It has been run by the same owners for over 30 years. The five handpulls offer an ever-changing range that may feature beers from Blackedge, Fernandes, Rat and Goose Eye. Real cider is available. Rumour has it that the beer is so good because the landlord talks to it! Food is of high quality yet reasonably priced. There are real fires during winter months and a large beer garden with amazing views. Q❀◑♣♠P❀

Penwortham

Tap & Vine
69 Liverpool Road, PR1 9XD
☎ (01772) 751116 ⊕ tapandvine.co.uk
4 changing beers (sourced locally) Ⓗ

Penwortham's first micropub, an upmarket wine bar-type establishment housed in a former arts and craft shop. It has limited seating and can get busy at times. To the rear is a small secluded room with a wood-burning stove, while there is also a covered outdoor seating area for use in warmer weather. Four changing beers are always on offer, including some from lesser known microbreweries. Snacks and serving platters are available. Q❀♣♠🖥❀🛜

Poulton le Fylde

Old Town Hall
5 Church Street, FY6 7AP
☎ (01253) 892257
Moorhouse's Pride of Pendle; 6 changing beers (sourced locally; often Bank Top, Moorhouse's, Pennine) Ⓗ

Set in the heart of Poulton facing the churchyard, the building was originally a pub, then used as council offices until the 1990s, when it returned to its first use. Now open-plan inside, the layout retains some of its heritage features. Up to six ales are available to whet the appetite. The upstairs wine bar can also hold meetings and functions. Live sports play on many TVs and a dedicated area is provided for horse-racing enthusiasts. There is live music every Saturday. ❀♠♣🖥❀🛜

Poulton Elk ⊘
22 Hardhorn Road, FY6 7SR
☎ (01253) 895265
Greene King Abbot; Ruddles Best Bitter; Sharp's Doom Bar; 7 changing beers (sourced nationally; often Bank Top, Bowland, Saltaire) Ⓗ

Formerly the Edge nightclub and the area telephone exchange, the building was converted to a Wetherspoon pub and opened in 2013. It is named after a 13,000-year-old skeleton of an elk that was found nearly, a sharpened flint within being the earliest evidence of man in the area. There are two outdoor drinking areas: a front terrace and a large suntrap area to the rear. It can be busy at weekends and some evenings, but swift service is normally the order of the day. ❀◑♣♠⇌🖥❀🛜

Thatched House ⊘
30 Ball Street, FY6 7BG
☎ (01253) 891063
⊕ thethatchedhousepoulton-le-fylde.co.uk

9 changing beers (sourced regionally; often Bank Top, Cross Bay, Saltaire) Ⓗ

Set in the corner of the churchyard in the centre of Poulton, this mock-Tudor pub is a busy mecca to real ale. Pictures of sports and local history decorate many walls and there are two open fires and a log-burning stove. Many real ales are available, sometimes including beers from the on-site Chapel Street Brewhouse at the rear, which brews occasionally. A small roof terrace is a pleasant spot for a drink in summer. Q❀≈♣🖥❀🛜

Preston

Black Horse ★ ⊘
166 Friargate, PR1 2EJ
☎ (01772) 204855
Robinsons Dizzy Blonde, Old Tom; 6 changing beers (sourced nationally) Ⓗ

A Victorian Grade II-listed inn close to the historic open market. With its tiled bar, walls and mosaic floor, it has been identified by CAMRA as having a nationally important historic pub interior. Two front rooms are adorned with Robinsons memorabilia and photos of old Preston; the famous hall of mirrors seating area is to the rear. Robinsons beers are available alongside an additional six ever-changing guests from far and wide. The pub was awarded the 2019-20 George Lee Memorial Trophy, the local CAMRA branch's premier award. Q❀⏚≈♣🖥❀🛜

Continental
South Meadow Lane, PR1 8JP
☎ (01772) 499425 ⊕ newcontinental.net
House beer (by Marble); 6 changing beers (sourced nationally) Ⓗ

Out of town pub alongside the River Ribble, Miller Park, and the large railway bridge. It has a main bar area, a lounge with a real fire in winter, plus two conservatories overlooking a sizeable beer garden. Live music and theatre are hosted regularly in the Boatyard arts and events space, which has also been used for beer festivals. Eight handpumps serve one cider plus up to seven microbrewery beers, including the house ale and a dark beer. Freshly cooked meals are available. A past winner of local CAMRA Pub of the Year. Q❀⏚❀◑♿≈♣🖥🚂(119)❀🛜

Crafty Beggars Ale House
284 Garstang Road, Fulwood, PR2 9RX
☎ (01772) 954447 ⊕ craftybeggars.co.uk
4 changing beers (sourced nationally) Ⓗ

Crafty Beggars is located in an old estate agent's premises on Garstang Road and opened in 2020. It provides a traditional small pub atmosphere, selling cask ales mainly from the north-west area, craft ales and fine wines. There are four cask ales on handpump, up to five changing keg lines of which some may be KeyKeg, and boxes of real cider in the fridge. Carry-outs are also available. With space for roughly 50 people it is one of the area's larger micros. ❀◑♣♠❀

Guild Ale House
56 Lancaster Road, PR1 1DD
☎ 07932 517444
7 changing beers (sourced regionally; often Elland) Ⓗ

Preston's first micropub, which opened in 2016 just a few doors away from Preston's Guild Hall complex. The main room has high and low level seating, and the high ceilings give a light and airy feel. A small lounge is tucked away to the rear and there is another comfortable lounge upstairs. Seven changing beers are mainly local or from Yorkshire, including at least one dark ale. A range of continental beers in keg and bottle is also stocked. No

jukebox, TV, or food, but live acoustic music plays on Sunday afternoons. A two-times local CAMRA Pub of the Year. Q ☜ ⧖ ⚡ ⋈ ⚲ ⚱ ☎ 🐾 ⚘ 🛜

Moorbrook

370 North Road, PR1 1RU
☎ (01772) 823302 ⊕ themoorbrook.co.uk
8 changing beers (sourced nationally) Ⓗ
Tthe local CAMRA branch was formed at this pub in 1973. It has a traditional-style wood-panelled bar with two rooms off the main bar area, and an enclosed beer garden to the side and rear. Eight guest beers come from all over the country, providing a wide choice of regional beer types while retaining a strong emphasis on microbreweries from the area. The food menu features authentic wood-fired pizzas and home-made shortcrust pies. The venue gets busy on Preston North End match days. A former local CAMRA Pub of the Year.
☜ ⊛ ◑ ⚱ ⚲ ⚱ ⚘ 🛜

Old Vic ⚃

79 Fishergate, PR1 2UH
☎ (01772) 828519
⊕ theoldvic-preston.foodanddrinksites.co.uk
Bombardier; 6 changing beers Ⓗ
Opposite the railway station and on bus routes into the city, this popular pub helpfully provides travellers with a TV screen showing live updates of train departures. It can get busy, particularly at weekends, with a quiz every Sunday evening. The rear of the building has recently been extended, with pool players and darts enthusiasts now having a separate area. Seven handpumps offer a good range of beers, with Yorkshire breweries Ossett and Rat being particularly popular. The car park is only available on a Sunday and in the evenings.
⊛ ◑ ⚡ ⋈ ⚲ ⚱ (2,3) 🛜

Orchard

Earl Street, PR1 2JA (on Preston covered market)
☎ 07756 583621
3 changing beers (sourced nationally) Ⓗ
The Orchard was opened in 2018 as a sister pub to the Guild Ale House. Situated within the Grade II-listed covered market, the decor and framework are of wood recycled from the old market trestle boards plus lots of modern glass. No food is served but there is plenty in the neighbouring market, which can be ordered and brought in. Three cask beers and 10 craft ales are always available alongside real cider. Q ☜ ⊛ ⚡ ⋈ ⚲ ⚱ ⚱ 🛜

Plau

115 Friargate, PR1 2EE
☎ (01772) 561404 ⊕ plau.co.uk
4 changing beers (sourced nationally; often Blackjack, Marble) Ⓗ
On the site of a former pub, the Plough, which closed in 1913, this building, which dates back to the 18th century, has been recently restored and reopened. The main bar is spread over three levels, with further bars in the vault, where there is an exposed 40ft-deep stone well. Four cask ales are available, with three ever-changing, typically sourced from a wide range of local microbreweries, alongside a house beer, brewed by either Blackjack or Marble. Up to eight craft keg beers are also stocked, along with an extensive range of gins.
☜ ◑ ⚲ ⚡ ⋈ ⚱ 🛜

Plug & Taps

32 Lune Street, PR1 2NN
4 changing beers Ⓗ
This is a craft beer and real ale bar featuring 10 keg lines and four handpumps, as well as a large can and bottle fridge with occasional real cider boxes. Expect to find

changing beers from anywhere in the country and worldwide, with a permanent Rivington Brewery line. There are occasional tap takeovers from various breweries. The main bar has air-con, upstairs is a large function room, and outside is a seating area for use in the summer or in warm weather. ☜ ⚡ ⋈ ⚲ ⚱ ⚘ 🛜

Tap End

450 Blackpool Road, Ashton-on-Ribble, PR2 1HX
☎ 07947 246022
4 changing beers (sourced locally) Ⓗ
Opened in 2021 in a former gift shop, this is a high-end micropub with room for around 50 people. The low-key atmosphere is conducive to conversation, enhanced by dark wood and metal with subdued lighting. It specialises in cask and craft ales generally sourced from local microbreweries, with four handpumps offering beers in a variety of styles. Keg lines, bottles and cans provide alternatives. Changes to all beers are immediately uploaded to the Untapped app and beer menus are available, with full descriptions of current and future beers. Q ⚲ ⚱ ⚱ 🛜

Twelve Tellers ✓

14-15 Church Street, PR1 3BQ
☎ (01772) 550910
Greene King Abbot; Ruddles Best Bitter; Sharp's Doom Bar; 7 changing beers (sourced nationally) Ⓗ
Conversion of a former Trustees Savings Bank into a large, mostly open-plan pub with some small rooms and alcoves. It retains some features of its former life including the ornate ceiling and bank vaults, and has two extensively wood-panelled former boardrooms available for functions. The ladies' toilets have the original copperwork. There are 10 cask ales on handpump. Outside to the rear is a large patio with smoking and no-smoking areas. Generally quiet until 5pm, but there are likely to be bouncers on the door on weekend evenings, when more formal dress is expected. ☜ ⊛ ◑ ⚲ ⚡ ⋈ ⚱ 🛜

Vinyl Tap

28 Adelphi Street, PR1 7BE
☎ (01772) 561871
Oakham Citra; house beer (by Kirkby Lonsdale); 3 changing beers (sourced nationally) Ⓗ
This single-room bar adjacent to the university opened in 2018. There are five real ale pumps on the bar. Customers can select from an ever-growing 'pick or choose' vinyl selection or bring their own to be played while enjoying a drink and a bite to eat (authentic German hotdogs are available from late afternoon). Friday and Saturday feature live music with a rock and roots theme. There is a quiz every Thursday and open mic on Wednesday. Local CAMRA Pub of the Season spring 2022. ◑ ⚡ ⚱ 🛜

Winckley Street Ale House ✓

8B Winckley Street, PR1 2AA
☎ (01772) 563797 ⊕ winckleyale.co.uk
4 changing beers (sourced regionally) Ⓗ
This premises initially opened in 2018 as the Otter's Pocket and was a single-room bar and restaurant occupying the whole ground floor of a former shop. It was then closed for renovation in 2020 and has since reopened as the Winckley Street Ale House, offering a wider food menu and great range of beers. Up to four regularly-changing cask ales are now available as well as a range of 10 keg lines with a strong focus on local/regional breweries. Payment is by card only.
☜ ⊛ ◑ ⚲ ⚡ ⋈ ⚱ ⚘ 🛜

Rawtenstall

Casked Ale House & Ginporium L

14-16 Bury Road, BB4 6AA

☎ 07764 695261

House beer (by Reedley Hallows); 5 changing beers (sourced regionally; often Brewsmith, Irwell Works, Nightjar) H

A large open-plan single-roomed bar with varied seating and imaginative lighting. On the edge of Rawtenstall town centre, it is a short walk away from the bus station and East Lancashire heritage railway station. Up to six, mainly local, cask beers are available on handpump plus several modern keg beers. Many of the beers are sourced from breweries around the Rossendale Valley.
⇌🚃🖥(464,X43) 🐾

Hop Micro Pub L

70 Bank Street, BB4 8EG

☎ 07753 775150 🌐 hopmicropubs.com

Deeply Vale Hop; 5 changing beers H

Situated at the top end of Rawtenstall's cobbled Bank Street, close to the market, Hop is a pleasant and congenial venue with the atmosphere of a traditional local pub. In addition to the bar there is a pleasant first floor lounge and a heated outside drinking area. With six handpulled cask ales, including the permanent Hop from Deeply Vale, as well as keg craft beers and ciders, there is always a fantastic choice. A short walk from the bus station and from the northern terminus of the East Lancashire heritage railway. 🏵⇌🖥P🖥🐾

Rivington

Rivington

Horrobin Lane, BL6 7SE

☎ (01204) 691509 🌐 rivingtonbowlingclub.co.uk

Abbeydale Deception; 1 changing beer (sourced regionally; often Abbeydale) H

The Rivington is a tearoom and bar attached to Rivington Bowling Club and has a full pub licence with non-members welcome at all times. There is a single room with a bar serving two cask ales – Abbeydale Deception is a regular and another from Abbeydale is usually on offer. The garden is in an elevated position overlooking the reservoir. There is occasional live music. Opening hours vary so it is advisable to check before setting out. Q🚃🏵♣P🖥(575,577) 🐾

Rivington Brewery Co. Tap L

Home Farm, Horobin Lane, PR6 9HE

☎ 07859 248779 🌐 rivingtonbrewing.co.uk

Rivington Beach House; 11 changing beers (sourced locally; often Rivington) H

Opened in 2019, the Rivington Brewing taproom is housed in a converted stable block at the farm where the brewery is situated. It showcases Rivington's extensive range of ales, with two on handpump and a further 15 on keg tap. Cider and guest craft ales are also available. The bar is lofty with bare stone walls and a large stone-topped bar counter. It was recently extended into the adjoining stable block, providing a family-friendly zone. Walkers and their dogs are welcome, with outdoor seating offering beautiful views across the reservoir towards Winter Hill. 🚃🏵🚪◑ ♣P🐾

St Annes

Fifteens at St Annes 🍷 ⊘

42 St Annes Road West, FY8 1RF

☎ (01253) 725852 🌐 fifteensstannes.com

Joseph Holt Bitter; 8 changing beers (sourced nationally) H

This gem of a pub was once a Lloyds Bank – check out the vault which is the original bank vault, complete with Victorian pictures and a large table that had to be built in situ. This pub has won many local CAMRA awards and is the current Pub of the Year. It is a true free house with the landlord sourcing beers from wherever he wants. There is live music on Saturday night and a quiz on Sunday. Dogs are welcome. ⇌♣🖥🐾

Keg 'n' Cask

17 St Andrews Road South, FY8 1SX

☎ 07913 791476

5 changing beers (sourced locally; often Lancaster, Reedley Hallows) H

A well-established micropub just off the Crescent and handy for local amenities. An interesting range of five constantly-changing ales showcases mostly local beers, usually including one dark beer. The bar's muted decor and soft background music with no TV or jukebox make for a relaxing and calm atmosphere where conversation flows. The pavement drinking area is an excellent spot for people-watching. 🏵♿⇌🖥🐾

Victoria ⊘

Church Road, FY8 3NE

☎ (01253) 721041

Greene King IPA; 4 changing beers (sourced nationally; often Cross Bay) H

A magnificent large late-Victorian pub, saved from developers by local residents several years ago. The main body of the pub is bright and airy, and there is a games room with snooker table and darts. Downstairs is the original vault which has a separate entrance. There is a large and pleasant outdoor area to the front. A well-kept, if modest, range of beers is served, and food is available all day. Dogs are only allowed in the vault.
🚃🏵◑♿⇌♣P🖥(11,68) 🐾🛜

Sawley

Spread Eagle ⊘

BB7 4NH

☎ (01200) 441202 🌐 spreadeaglesawley.co.uk

Dark Horse Hetton Pale Ale; Moorhouse's Pride of Pendle; Wainwright; 1 changing beer H

A traditional coaching inn on the banks of the River Ribble, this is predominantly a dining pub. The bar area has stone flags, settees, armchairs and a welcoming log burner; a separate dining room has more of a club style but all tables have candles. A busy events calendar keeps the pub at the heart of the community and includes monthly quiz nights, a movie club and Sunday lunchtime jazz. Take time from your visit to view the nearby 12th-century Sawley Abbey. 🏵🚪◑P🖥(2)🛜

Silverdale

Woodlands

Woodlands Drive, LA5 0RU

☎ (01524) 701655

4 changing beers H

A large country house on an elevated site, built circa 1878, converted to a pub with only minimal alterations. Most of the trade is provided by locals. The bar has a large fireplace as big as the counter and great views across Morecambe Bay. Beer pumps are in another room, with a list of the four available ales on the wall facing the bar. The smoking area is covered and sheltered. A beer festival of 30 ales is held in October. A quiz features on the last Sunday of the month. Cash payment only.
Q🚃🏵♣P🖥🐾

Tockholes

Royal Arms 🅛

Tockholes Road, Rydal Fold, BB3 0PA (3 miles W of Darwen)

☎ (01254) 705373

3 changing beers (sourced nationally; often Hopstar, Moorhouse's, Three B's) 🅗

Traditional free house that was once two cottages, now knocked together, with an extension that houses R&R's bistro. It is small but has a great atmosphere within its four back-to-back rooms where the original stone walls, real fires and flagged or wooden floors have been retained. Most beers are from local microbreweries. Situated in the West Pennine Moors, close to Darwen Tower and adjacent to Roddlesworth Visitors Centre, it looks over moors, woods and reservoirs. Friendly staff welcome walkers, cyclists, ramblers and dogs alike, and there is a good food menu. Opening and food times vary, so check before travelling. Q🏠🕸🌃♣P🐾☀🛜

Warton

Malt Shovel 🅛

66 Main Street, LA5 9PG

☎ (01524) 874149

5 changing beers (often Old School) 🅗

A pub dating back to the 1700s which suffered through the turn of the century under a pubco, but escaped in 2012 and is now entirely free. It has a single bar with a centrally-located servery and offers comfort without ostentation or trendiness. The photos on the walls, inherited through a number of changes of ownership, are well worth close examination. 🕸🌃♣P🚌(49)☀🛜

Whalley

Dog Inn 🅛

55 King Street, BB7 9SP

☎ (01254) 823009 🌐 dog-innwhalley.co.uk

6 changing beers (sourced regionally) 🅗

Deservedly popular and usually crowded, especially at weekends, the Dog has been run by the same family since the early 1990s. Six handpumps offer an ever-changing range of beers from breweries such as Acorn, Hetton, Moorhouse's, Peerless and Wishbone. Food is served at lunchtimes only and is always excellent. This traditional, historic pub is very close to the ruins of Whalley Abbey and is handy for exploring the picturesque Ribble Valley. 🏠🕸🌃🚌(15,280)☀🛜

Wheelton

Red Lion 🍺 🅛

Blackburn Road, PR6 8EU (in centre of village opp clock tower)

☎ (01254) 659890 🌐 theredlionatwheelton.co.uk

Hawkshead Lakeland Gold; Timothy Taylor Landlord; 6 changing beers (sourced nationally; often Fyne Ales, Oakham, Red Rose) 🅗

Built around 1826, this former Matthew Brown house retains many original features including a large stone lion at roof level above the door. It features a comfortable lounge with an open fire and a second room up a few steps. Food is served seven days a week. There are eight handpumps showcasing two regular beers and six changing real ales from larger independents, usually including a stout and a strong ale. Close to the West Pennine Moors, and many local walks pass by – dogs are welcome. Local CAMRA Pub of the Year 2022.
Q🏠🕸🌃P🚌(24)☀🛜

Whitworth

Whitworth Vale & Healey Band Club 🅛 ✅

498 Market Street, OL12 8QW

☎ (01706) 852484

Wainwright; 3 changing beers (sourced regionally) 🅗

A popular social club, notable for being the home of the local brass band of the same name. The premises is part of a terrace on the main road through the town, with the regular 464 bus service passing by the door. There is plenty of room, despite the low ceiling, and more seating in an area outside. Winner of several local and regional CAMRA Club of the Year awards.
🕸🍽🚌(464)☀🛜

Worsthorne

Crooked Billet 🅛 ✅

1-3 Smith Street, BB10 3NQ

☎ 07766 230175 🌐 crookedbilletworsthorne.co.uk

Acorn Barnsley Bitter; Timothy Taylor's Boltmaker; 2 changing beers (sourced regionally; often Kirkby Lonsdale, Little Valley, Settle) 🅗

An award-winning true free house, this well-presented village inn has a beautiful wood and glass horseshoe bar serving both the main lounge area and snug. Quiz nights are popular, as are Thai nights and soul nights. Its location in the hills close to Burnley makes the pub popular with walkers and cyclists. Dogs are welcome and there is a large covered drinking area outside where you can enjoy the flower-bedecked exterior.
Q🏠🕸🌃♣P🚌(2)☀🛜

Wrightington

White Lion

117 Mossy Lea Road, WN6 9RE

☎ (01257) 425977 🌐 thewhitelionwrightington.co.uk

Banks's Amber Ale; Jennings Cumberland Ale; 6 changing beers 🅗

This popular country pub has plenty for diners and drinkers, with a good range of food and eight handpumps. It hosts a Monday Club with drinks offers, a quiz on Tuesday, a poker league on Thursday, a monthly cocktail night and live music every Saturday. It is community-oriented, running the village scarecrow festival and themed evenings throughout the year. Families are welcome – there is a large beach hut-themed garden area, and board games for inside.
Q🏠🕸🌃🚌(113)

Breweries

12 Steps (NEW)

🍺 **Bird in th'hand, 225 Duckworth Street, Darwen, BB3 1AU** ☎ 07926 115292

Started brewing in 2021 on a 2.5-barrel plant in the cellar of the Bird in th'hand. The name comes from the number of steps down to the cellar of the building.

4 Mice

🍺 **Coach & Horses, Main Street, Bolton-by-Bowland, BB7 4NW**

☎ (01200) 447331

🌐 coachandhorsesribblevalley.co.uk

A four-barrel brewery in a gastro-pub, situated in the Trough of Bowland.

Accidental

Old Market Court, Morecambe, LA4 5HS ☎ 07930 592749 ⊕ accidentalbrewery.com

Initially a brewpub located on the edge of Lancaster city centre in an 18th century converted stable block, which opened in 2018. In 2021 it opened a new brewery in Morecambe where all production was moved to with the original site remaining as a brewery tap. Occasional cask ale is produced.

Avid SIBA

Red Moss Farm, Quernmore Brow, Quernmore, LA2 0QW ☎ 07976 275762 ⊕ avidbrewing.co.uk

Avid was established in 2015 by two experienced homebrewers. The 7.5-barrel microbrewery is based in picturesque Quernmore, near Lancaster. Water is used from a local borehole.

Golden Ale (ABV 3.9%) GOLD
American Pale (ABV 4%) PALE
New Zealand Pale (ABV 4%) PALE
Milk Stout (ABV 4.5%) STOUT
IPA (ABV 5%) PALE
TropicAle (ABV 5%) PALE
Irish Coffee Stout (ABV 6%) SPECIALITY
Pint of (ABV 6.4%) IPA
Whoopass (ABV 7%) IPA

BB18

BB18 Brewing Tap, 31-33 Victoria Road, Earby, BB18 6UN ☎ 07908 591343 ⊕ bb18-brewery-tap.business.site

This brewpub opened 2020. A five-barrel plant is used.

Beer Brothers SIBA

335 Ranglet Road, Walton Summit Centre, Bamber Bridge, Lancashire, PR5 8AR ☎ (01772) 587441 ☎ 07921 519129 ⊕ beerbrothers.co.uk

Founded in 2015 as a nanobrewery, Beer Brothers has seen massive growth over the years and is currently a 10-barrel plant with nine fermenting vessels, with further plans to expand. The ever-growing brewery has its own taproom, along with an on-site shop. !! ☎ ◆ ◆

Bitter Sweet (ABV 3.8%) BITTER
Golden Sky (ABV 3.8%) BLOND
Indigo Blue (ABV 3.9%) PALE

Beer Shack (NEW)

Beer Shack, 22-24 King Street, Clitheroe, Lancashire, BB7 2EP ☎ (01200) 426368 ⊕ thebeershack.uk

This brewery first brewed in 2022 and is based above the Beer Shack.

Ben's

Unit 17, Yarrow Business Centre, Yarrow Road, Chorley, Lancashire, PR6 0LP ☎ (01257) 367480 ⊕ bensbrewery.co.uk

Established in 2021, the brewery is situated in part of an office furniture suppliers showroom. The taproom is only open for special events. ◆

Wellington (ABV 3.8%) GOLD
The Light Brigade (ABV 4%) PALE
Walter (ABV 4.2%) BLOND

Blighty (ABV 4.5%) PALE
The Duke (ABV 4.5%) BITTER
Proper Grafter (ABV 5.7%) STOUT
Three Lions Porter (ABV 6%) PORTER

Big Clock

Grants, 1 Manchester Road, Accrington, Lancashire, BB5 2BQ ☎ (01254) 393938 ☎ 07766 163497 ⊕ thebigclockbrewery.co.uk

Brewing commenced at the iconic Grants Pub and Brewhouse, just off Accrington town centre, in 2014. The specially-commissioned brewery can be viewed from the bar area. A new, smaller brewery has been installed. This is to run along side the existing larger six-barrel plant, for production of smaller, speciality beers for a new canning line. Beer is supplied to around a dozen outlets across East Lancashire.

Bowland SIBA

Holmes Mill, Greenacre Street, Clitheroe, Lancashire, BB7 1EB ☎ (01200) 443592 ⊕ bowlandbrewery.com

Founded in 2003, this family-run business uses a 30-barrel plant, together with a nanobrewery for experimental brews, and serves 250+ outlets. The site features a beer shop and beer hall with 42 handpumps featuring beers from Lancashire and beyond. !! ☎ ◆ LIVE

Pheasant Plucker (ABV 3.7%) BITTER
Gold (ABV 3.8%) PALE
Well-balanced, pale, hoppy ale with delicate citrus hop notes and a long, dry, bitter finish.
Boxer Blonde (ABV 4%) BLOND
Bumble (ABV 4%) SPECIALITY
Hen Harrier (ABV 4%) PALE
Gentle aromas of malt, hops and fruit start this satisfying fruity bitter which has a lasting, rich finish.
Buster IPA (ABV 4.5%) PALE
Deer Stalker (ABV 4.5%) STOUT

Brewsmith SIBA

Unit 11, Cuba Industrial Estate, Stubbins, Ramsbottom, Bury, BL0 0NE ☎ (01706) 829390 ⊕ brewsmithbeer.co.uk

Brewsmith is a 10-barrel microbrewery established in 2014 by the Smith family – James, Jennifer and Ted. It produces a range of cask and bottle-conditioned ales in traditional British beer styles. !! ◆ LIVE

Mosaic (ABV 3.5%) PALE
Amarillo (ABV 3.8%) PALE
Bitter (ABV 3.9%) PALE
Gold (ABV 4.2%) PALE
New Zealand Pale (ABV 4.2%) PALE
Pale (ABV 4.2%) PALE
APA (ABV 5%) PALE
Oatmeal Stout (ABV 5.2%) STOUT

Chain House

20 Brookdale, New Longton, Lancashire, PR4 4XL ☎ 07707 511578 ⊕ chainhousebrewing.com

Brewing began in 2017. Popularity grew and beers occasionally appear in a handful of pubs in the Preston area. Producing predominantly keg and canned beers, there have been successful collaborations with breweries such as Rivington and Farm Yard Ales. Plans are in place for relocation (including a brewery tap) in the heart of Preston, during the currency of this Guide.

Clay Brow

256 Carfield, Skelmersdale, WN8 9DW ☎ 07769 581500 ✉ claybrownano@gmail.com

Nanobrewery that started production in 2017.

Eclipse (ABV 5.4%) STOUT
Mr P's (ABV 5.7%) SPECIALITY
Mrs P's (ABV 6%) IPA

Corless

c/o Station Road, Scorton, Lancashire, PR3 1AN ☎ 07983 563917

Began brewing as a cuckoo brewer in 2018 using spare capacity, mostly at Avid. During the currency of this Guide, the brewery plans to move to it's own site based at the Royal Station Hotel in Carnforth.

Crankshaft SIBA

17e Boxer Place, Leyland, Lancashire, PR26 7QL ☎ 07827 289200 ⊕ crankshaftbrewery.co.uk

☺The brewery launched in 2016 and moved in 2017 before expanding into next door in 2018 resulting in a doubling of capacity to a five-barrel brew plant. A core range of beers in cask, craft, bottle and can are supplemented by a number of special occasional beers. A popular taproom is now open (Fridays and Saturdays). ‼️🍴◆♦

Comet (ABV 3.8%) PALE
Propshaft (ABV 3.8%) BITTER
Foggy Gold (ABV 4%) GOLD
Testbed (ABV 4.1%) BLOND
Sherpa (ABV 4.2%) PALE
Cote De Reiver (ABV 4.4%) BLOND
1511 (ABV 4.7%) PALE
Tenterhook (ABV 5%) PALE
Leyland Tiger Cub (ABV 5.5%) GOLD
Leyland Badger (ABV 5.8%) STOUT

Cross Bay

Unit 1 Newgate, White Lund Industrial Estate, Morecambe, Lancashire, LA3 3PT ☎ (01524) 39481 ⊕ crossbaybrewery.co.uk

☺Cross Bay commenced brewing in 2011 on a 28-barrel brew plant. An on-site taproom opened in 2018. The beers are widely available across north-west England. ‼️🍴◆♦

Halo (ABV 3.6%) BLOND
A crisp and hoppy, pale bitter.
Vesper (ABV 3.8%) PALE
RIPA (ABV 4%) RED
Omega (ABV 4.2%) PALE
Sunset (ABV 4.2%) BLOND
Sweet bitter with a rising bitter finish.
Zenith (ABV 5%) BLOND
Gentle bitterness and fruity sweetness with some dryness in the finish.
Guell (ABV 5.1%) BITTER

Farm Yard SIBA

Gulf Lane, Cockerham, LA2 0ER ☎ (01253) 799988 ⊕ farmyardbrew.co.uk

☺The brewery, set up in 2017 on a remote farm, has continued to expand and diversify with home deliveries, event weekends and even dedicated buses running at certain times, from local urban centres. The brewery underwent a rebranding in early 2022. A vibrant taproom is open every weekend and features regular live bands and street food. ‼️🍴◆♦

Holmes Stead (ABV 3.4%) BITTER
TVO 54 (ABV 3.7%) BLOND
Haybob (ABV 3.9%) GOLD
Sheaf (ABV 4.1%) BLOND
Hoof (ABV 4.3%) SPECIALITY
Chaff (ABV 4.7%) PALE
Gulf (ABV 5.8%) IPA

Folly

18 Beech Close, Clayton le Dale, Lancashire, BB1 9JF ☎ 07709 306467 ⊕ follybrewery.com

☺Commercial home-based brewery set up in 2020 by a former Thwaites employee. A one-barrel plant is used. ◆

Impello (ABV 4%) SPECIALITY
Lux (ABV 4.5%) PALE
Vestigia (ABV 4.5%) SPECIALITY

Fuzzy Duck SIBA

18 Wood Street, Poulton Industrial Estate, Poulton-le-Fylde, Lancashire, FY6 8JY ☎ 07904 343729 ⊕ fuzzyduckbrewery.co.uk

☺Fuzzy Duck was established in 2006. It relocated to Poulton-le-Fylde later that year, expanding capacity to an eight-barrel plant. The brewery delivers over a wide area of North-West England and Yorkshire. Most beers are available bottle-conditioned. ‼️◆LIVE

Golden Cascade (ABV 3.8%) GOLD
Mucky Duck (ABV 4%) STOUT
Pheasant Plucker (ABV 4.2%) BITTER
Cunning Stunt (ABV 4.3%) BITTER
Ruby Duck (ABV 5.3%) OLD

Hop Vine

▤ Hop Vine, Liverpool Road North, Burscough, Lancashire, L40 4BY ☎ (01704) 893799 ☎ 07920 002783 ✉ mikejulie6465@gmail.com

☺Hop Vine began brewing in 2017 using the four-barrel plant of the defunct Burscough Brewery. It is situated in old stable buildings in the courtyard to the rear of the Hop Vine. Beer is usually only supplied to the pub and the Legh Arms, Mere Brow. 🍴◆

Hopstar SIBA

Unit 9 Rinus Business Park, Grimshaw Street, Darwen, BB3 2QX ☎ 07933 590159 ⊕ hopstarbrewery.co.uk

☺Hopstar first brewed in 2004 on a 2.5-barrel plant and expanded in 2010 to a new unit with a six-barrel plant. More than 100 outlets are supplied around Lancashire and the Greater Manchester area. The brewery tap is Number 39 in Darwen. ‼️◆LIVE

Chilli (ABV 3.8%) SPECIALITY
Dizzy Danny Ale (ABV 3.8%) GOLD
Dark Knight (ABV 3.9%) MILD
Off T'Mill (ABV 3.9%) PALE
Smokey Joe's Black Beer (ABV 3.9%) STOUT
Darwen Spitfire (ABV 4%) BITTER
JC (ABV 4%) BITTER
Lancashire Gold (ABV 4%) BLOND
Lush (ABV 4%) BITTER
Saaz Blonde (ABV 4%) BLOND

Interbrew UK

Cuerdale Lane, Samlesbury, Lancashire, PR5 0XD

No real ale.

Lancaster SIBA

Lancaster Leisure Park, Wyresdale Road, Lancaster, LA1 3LA
☎ (01524) 848537 ⊕ lancasterbrewery.co.uk

☺Lancaster began brewing in 2005. The brewery moved to new premises in 2010 and installed a larger 60-barrel brewing plant. As well as the regular beers, seasonal beers are brewed under the T'ales from the Brewhouse name. ‼🍺♦◆

Amber (ABV 3.6%) BITTER
Amber malt flavours lead to an increasingly astringent, bitter finish.
Blonde (ABV 4%) BLOND
Well-balanced, pale bitter with fruity body and hops lasting well into the finish.
Lancaster IPA (ABV 4.2%) PALE
Black (ABV 4.5%) STOUT
A satisfying and robust, roast bitter beer with hints of sweet fruitiness.
Red (ABV 4.8%) RED
A characterful beer with plenty of fruits, roast malt and hops, well-balanced with a lasting finish.

Lytham

Old Bank, 30 Poulton Street, Kirkham, Lancashire, PR4 2AB ☎ 07738 275438 ⊕ lythambrewery.co.uk

☺Lytham is a well-established, family-run brewery that began brewing in 2007. In 2021 it moved to Kirkham where the brewery is situated in the Old Bank restaurant where brewing restarted in early 2022. ♦

Amber (ABV 3.6%) BITTER
Blonde (ABV 3.8%) BLOND
Smooth golden ale with a dry finish.
Gold (ABV 4.2%) GOLD
Royal (ABV 4.4%) RED
Stout (ABV 4.6%) STOUT
IPA (ABV 5.6%) IPA

Mighty Medicine

Unit 4, Daniel Street, Whitworth, Lancashire, OL12 8BX
☎ (01706) 558980 ⊕ mightymedicine.com

Established in 2016, this brewery is committed to using the finest ingredients to produce an eclectic range of beers. A taproom is attached to the brewery. 🍺♦

Stunning Blonde (ABV 3.9%) BLOND
Greedy Boy (ABV 4%) BITTER
Madchester Cream (ABV 4.2%) PALE
Magic Malt (ABV 4.5%) RED

Moorhouse's SIBA

The Brewery, 250 Accrington Road, Burnley, BB11 5EN
☎ (01282) 422864 ⊕ moorhouses.co.uk

Established in 1865 as a soft drinks manufacturer, the brewery started producing cask-conditioned ale in 1978. A new brewhouse and visitor centre opened in 2012. Three pubs are owned. ‼♦

Black Cat (ABV 3.4%) MILD
A dark mild-style beer with delicate chocolate and coffee roast flavours and a crisp, bitter finish.

Premier (ABV 3.7%) BITTER
A clean and satisfying bitter aftertaste rounds off this well-balanced hoppy, amber session bitter.
White Witch (ABV 4%) GOLD
Delicate citrus aroma. Sweet fruity taste balanced with gentle bitterness. Increased bitterness in crisp citrus finish.
Pride of Pendle (ABV 4.1%) BITTER
Well-balanced, amber best bitter with a fresh initial hoppiness and a mellow, malt-driven body.
Straw Dog (ABV 4.2%) GOLD
Blonde Witch (ABV 4.4%) BLOND
Pronounced sweet taste with gentle pithy bitterness and touch of citrus fruit. Dry finish. Slight fruity hop aroma.
Pendle Witches Brew (ABV 5.1%) BITTER
Well-balanced, full-bodied, malty beer with a long, complex finish.

Northern Whisper

Hill End Mill, Hill End Lane, Cloughfold, Lancashire, BB4 7RN
☎ (01706) 230082
⊕ northernwhisperbrewingco.co.uk

First brewing in 2017, the brewery has expanded over time to own two pubs. ♦

Soft Mick (ABV 3.8%) PALE
Oppenchops (ABV 4%) GOLD
Yammerhouse (ABV 4.5%) PALE
Beltie (ABV 4.8%) STOUT
Chinwag (ABV 5.6%) IPA

Old Boot

Waterside Mill, Burnley Road, Bacup, OL13 8AW
☎ 07545 275278 ✉ stepill64@gmail.com

Old Boot started brewing during 2020. Although not based there, much of the output is sold through the Old Boot Café Bar in Bacup.

Old School SIBA

Holly Bank Barn, Crag Road, Warton, Lancashire, LA5 9PL
☎ (01524) 740888 ⊕ oldschoolbrewery.co.uk

☺A 12-barrel brewery, founded in 2012, located in a renovated 400-year-old former school outbuilding overlooking the picturesque village of Warton. Beer is mainly sold to free houses within a 40-mile radius. ‼♦◆

Junior (ABV 3.6%) PALE
Hopscotch (ABV 3.7%) GOLD
Initially hoppy, astringency builds in this satisfying beer, ending with a bitter finish.
Textbook (ABV 3.9%) BLOND
Pale beer with malt and hops in the taste, creamy texture and a dry, bitter finish.
Detention (ABV 4.1%) PALE
Light amber, hoppy bitter with lingering aftertaste.
Headmaster (ABV 4.5%) BITTER

Oscars

Unit 1, Riverside Works, Brunswick Street, Nelson, Lancashire, BB9 0HZ
☎ (01282) 616192 ⊕ oscarsbrewery.co.uk

☺Originally based in Preston, the brewery was taken over in 2017 by the Lancashire Beer Co, a pub supplies wholesaler in Nelson. In 2018 the brewery name was changed to Oscars and a new range of beers introduced. Production moved to purpose-built premises in Nelson at the parent company in 2019.

Notorious D.O.G. (ABV 3.8%) PALE
Top Dog (ABV 3.8%) PALE
Dog Father (ABV 3.9%) BITTER
Gun Dog (ABV 4%) BLOND
Space Dog (ABV 4.2%) PALE

Parker

Unit 3, Gravel Lane, Banks, Lancashire, PR9 8BY
☎ (01704) 620718 ☎ 07949 797889
✉ theparkerbrewery@gmail.com

⊕Parker was established in 2014 using a 25-litre plant, but quickly expanded to a five-barrel plant. In 2018 the brewery opened its own micropub, the Beer Den, Southport. !!LIVE

Centurion Pale Ale (ABV 3.9%) PALE
Barbarian Bitter (ABV 4.1%) BITTER
Saxon Red Ale (ABV 4.5%) RED
Viking Blonde (ABV 4.7%) BLOND
Dark Spartan Stout (ABV 5%) STOUT
Well-balanced stout with a burnt, smoky, roast aroma, roast strong on tasting with a little sweetness, ending with mellow flavours and some bitterness to finish.

Patten

▤ The Patten Arms, Park Lane, Winmarleigh, PR3 0JU
☎ (01524) 791484
✉ thepattenarmswinmarleigh@gmail.com

Brewing started in 2019 using a small plant in the cellar of the Patten Arms. Five different beers are brewed on rotation and only on sale at the pub.

Peregrine

B9 Riverside Industrial Estate, Hermitage Street, Rishton, Lancashire, BB1 4NF ☎ 07757 404231
⊕ peregrinebrewingltd.com

Started brewing in late 2020 using a 1.5-barrel plant. ♦V

What What? (ABV 3.6%) BLOND
Flight of the Falcon (ABV 3.7%) GOLD
Atomic (ABV 3.9%) BLOND
Próst! (ABV 4%) PALE
Bingle Jells (ABV 4.5%) PORTER
Brut IPA (ABV 4.5%) PALE
Hayabusa (ABV 4.5%) PALE
Munity (ABV 4.8%) PORTER
Serendipity (ABV 4.8%) PALE

Priest Town

139 Ribbleton Avenue, Preston, Lancashire, PR2 6YS
⊕ priesttownbrewing.com

Priest Town is a craft microbrewery in Preston, operational since 2017. It uses a 2.5-barrel plant. Almost all production is in small pack form. It runs a bottle shop on Preston Market where it's beers are regularly available.

Problem Child

▤ Wayfarer Inn, 1 Alder Lane, Parbold, Lancashire, WN8 7NL
☎ (01257) 464600 ☎ 07588 736926
⊕ problemchildbrewing.co.uk

Problem Child began brewing in 2013 using a five-barrel plant at the Wayfarer Inn, Parbold, where two beers from the range are always available. !!

Q Brew

58 Lower North Road, Carnforth, Lancashire, LA5 9LJ
☎ (01524) 903105 ⊕ qbrew.co.uk

⊕Q Brew started brewing in 2019 and is Carnforth's first microbrewery.

Reedley Hallows SIBA

Unit B3, Farrington Close, Farrington Road Industrial Estate, Burnley, Lancashire, BB11 5SH ☎ 07749 414513 ⊕ reedleyhallows.co.uk

⊕Brewing started on this four-barrel plant in 2012. Having moved to larger premises, the brewery now has nine fermenters to cope with demand. !!

Beer O'Clock (ABV 3.8%) GOLD
Old Laund Bitter (ABV 3.8%) BITTER
Filly Close Blonde (ABV 3.9%) BLOND
Pendleside (ABV 4%) GOLD
Gentle malt and hops in the aroma lead to a fruity and peppery bitterness which continues to a dry finish.
Monkholme Premium (ABV 4.2%) BLOND
New Laund Dark (ABV 4.4%) STOUT
Griffin IPA (ABV 4.5%) PALE
Fruity, hoppy bitter with sweet fruity flavours and a light bitter finish.
New Zealand Pale (ABV 4.5%) PALE
Nook of Pendle (ABV 5%) BITTER

Rivington

Home Farm, Horrobin Lane, Rivington, Lancashire, PR6 9HE ☎ 07859 248779 ⊕ rivingtonbrewing.co.uk

⊕Established in 2015 using a three-barrel plant, the brewery moved to its current address in 2020. A 12-barrel plant is now used. A number of local outlets are supplied direct from the brewery. Approximately 20 per cent of production is supplied in cask form, but all beers are unpasteurised, unfiltered and unfined. Experimental brews and collaborations are regularly available.
!!▬♦LIVE ✦

Beach House (ABV 3.8%) GOLD

Rock Solid

Office: Thornebank, Blackpool, FY3 8QE ☎ 07963 860080 ✉ rocksolidbrewingcompany@gmail.com

⊕This brewery, based at the owner's home, started brewing in 2017 using a one-barrel plant. ♦

Blonde (ABV 3.9%) BLOND
Pale, dry bitter with modest hops and dry, hoppy finish.
Amarillo Gold (ABV 4%) GOLD
American Pale (ABV 4.5%) PALE

Rossendale

▤ Griffin Inn, 84 Hud Rake, Haslingden, Lancashire, BB4 5AF
☎ (01706) 214021 ⊕ rossendalebrewery.co.uk

⊕The brewery acquired the brew plant previously used by Porter Brewing Co in 2007 and is based in the cellar of the Griffin Inn in Haslingden. The Sportsman in Hyde and many other local outlets are also supplied. ▬

Snaggletooth

c/o Rear of 11 Pole Lane, Darwen, Lancashire, BB3 3LD ☎ 07810 365701
⊕ snaggletoothbrewing.com

Snaggletooth was established in 2012 by three beer geeks with a passion for crafting ales. A 2.5-barrel plant is used at the Hopstar Brewery (qv) in Darwen, Lancashire. Beers are available throughout East Lancashire and Manchester. ♦

Allotropic (ABV 3.8%) PALE
BeEr (ABV 3.9%) PALE
I Ain't Afraid of Noh Ghost (ABV 3.9%) GOLD
Three Amigos (ABV 3.9%) GOLD
Déjà Brewed (ABV 4%) PALE
Rolling Maul (ABV 4.1%) PALE
'Cos I'm a Lobster (ABV 4.2%) RED
Avonaco (ABV 4.3%) PALE

Snowhill

Snowhill Cottage, Snow Hill Lane, Scorton, Lancashire, PR3 1BA
☎ (01524) 791352

☺Snowhill was established in 2015 by Nigel Stokes following several years of small scale brewing. A one-man operation, Nigel brews 3-4 times per month on a 1.5-barrel plant, to supply pubs in North-West Lancashire and South Cumbria. An environmentally-friendly set-up sees the spent grain feeding local cattle and waste water treated through a small reed bed. ♦

Pale (ABV 3.7%) GOLD
Copy Cat (ABV 3.8%) BITTER
Target (ABV 3.8%) BLOND
Blonded (ABV 3.9%) BLOND
Gold (ABV 3.9%) BLOND
Best Bitter (ABV 4.2%) PALE
Black Magic IPA (ABV 4.2%) PALE
Porter (ABV 4.8%) PORTER
Winter Porter (ABV 4.8%) PORTER

Three B's

🏠 **Black Bull, Brokenstone Road, Blackburn, Lancashire, BB3 0LL**
☎ (01254) 581381 🌐 threebsbrewery.co.uk

Robert Bell acquired the Black Bull in 2011 and the brewpub now supplies 50 outlets. ‼♦LIVE

Stoker's Slake (ABV 3.6%) MILD
Lightly-roasted coffee flavours are in the aroma and the initial taste. A well-rounded, dark brown mild with dried fruit flavours in the long finish.
Bee's Knees (ABV 3.7%) PALE
Honey Bee (ABV 3.7%) SPECIALITY
Bobbin's Bitter (ABV 3.8%) BITTER
Bee Blonde (ABV 4%) BLOND
Black Bull (ABV 4%) BITTER
Ju-bee-lation (ABV 4.1%) PALE
Black Bull Lager (ABV 4.5%) SPECIALITY
Doff Cocker (ABV 4.5%) BLOND
Knocker Up (ABV 4.8%) PORTER
A smooth, rich, creamy porter. The roast flavour is foremost without dominating and is balanced by fruit and hop notes.
Old Bee (ABV 5.8%) OLD

Three Peaks

Unit 6, Holt Court, Pendle Street, Nelson, Lancashire, BB9 7EB ☎ 07790 539867

Office: Lloyds Farm, Harden Road, Kelbrook, BB18 6TS
🌐 threepeaksbrewery.co.uk

☺Named after the three Yorkshire Dales mountains and established in 2006, owners Chris and Jennifer Holt moved the five-barrel plant to new modern premises while retaining the services of previous owner/brewer, Colin Ashwell. Its philosophy is to produce quality ales using premium ingredients to celebrate the great outdoors. Beers are currently supplied to outlets in the Dales, West Yorkshire and East Lancashire. ‼♦

Fell Walker (ABV 3.6%) PALE
Pen-y-Ghent Bitter (ABV 3.8%) BITTER
The malty character of this mid-brown session bitter is balanced by fruit in the aroma and taste. The finish is malty and hoppy.
Ingleborough Gold (ABV 4%) GOLD
Whernside Pale Ale (ABV 4.2%) PALE
Blea Moor Porter (ABV 4.5%) PORTER
Dark brown porter has a predominantly roast malt character, with a background of dark fruit and a woody note.
Plum Porter (ABV 4.5%) SPECIALITY
Malham Tarn Stout (ABV 5%) STOUT

Thwaites IFBB

Myerscough Road, Mellor Brook, Lancashire, BB2 7LB
☎ (01254) 686868 🌐 thwaites.co.uk

☺Founded in 1807, Thwaites brewed in Blackburn until 2018 when it moved to a rural site five miles away in the Ribble Valley. A 20-barrel plant brews exclusively for around 215 tenanted pubs, 13 managed Inns of Character, eight hotels and two lodges. Around eight seasonal real ales, and guest beers, appear on a monthly list available to landlords who are members of the 1807 Cask Beer Club. Additionally, Thwaites has an arrangement in place with Marston's for Wainwright and Lancaster Bomber to be supplied to its estate. ♦

Mild (ABV 3.3%) MILD
Refreshing dark mild with gentle fruit and roast in the nose, a sweet centre and a dry clean finish.
Original (ABV 3.6%) BITTER
TBC (Thwaites Best Cask) (ABV 3.8%) BITTER
IPA (ABV 4%) PALE
Gold (ABV 4.1%) GOLD
Amber (ABV 4.4%) BITTER

Unbound SIBA

Lenches Road, Colne, BB8 8EU ☎ 07886 062825
🌐 unboundbrew.co.uk

Brewing commenced early 2021. ♦

Nocturnal (ABV 6.5%) STOUT

West Coast Rock

🏠 **1877 The Brew Room, 137-139 Church Street, Blackpool, FY1 3NX**
☎ (01253) 319165 🌐 thebrewroom1887.co.uk

☺Historic Blackpool pub, which reopened as a specialist beer outlet in 2017 and first brewed in 2018 using a six-barrel plant. Many of the beers have a Blackpool Football Club theme, the club being founded in the pub in 1887. ‼♦

It was my Uncle George who discovered that alcohol was a food well in advance of modern medical thought.
P G Wodehouse, The Inimitable Jeeves

GREATER MANCHESTER

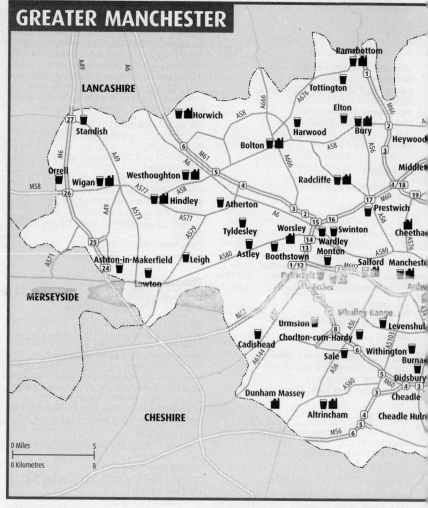

Altrincham

Costello's Bar ⃟

18 Goose Green, WA14 1DW (alleyway from Stamford
New Rd/opp Regent Rd, adjacent to new hospital)
☎ (0161) 929 0903 ⊕ costellosbar.co.uk
**Dunham Massey Big Tree Bitter, Dunham Dark; 5
changing beers (often Dunham Massey)** ⒣
Sitting on one side of Goose Green, Costello's Bar is the
original Dunham Massey Brewery tap house. There are
seven handpumps on the bar serving two ever-present
beers – Dunham Dark and Big Tree – plus an ever-
changing selection of the brewery's many recipes. The
bar has a modern feel and has recently been refurbished.
Outside there is a covered, heated seating area. Quiz
night is every Monday at 8pm. ⬛⛾♿⇌�🅿🐾🐕🛜

Jack in the Box

Altrincham Market Hall, Market Street, WA14 1SA
☎ 07917 792060
**House beer (by Blackjack); 4 changing beers (sourced
nationally)** ⒣
Located in one corner of the ever-popular Altrincham
Market House, Jack in the Box offers six beers on
handpump – two from Blackjack Brewery, the other four

a selection from both local and national breweries. The
bar also has eight keg taps along the back wall offering a
wide range of beer styles. Food is always available from
the various food vendors in the Market House.
⬛⛾♿⇌🚌🅿🐾🛜

Pi ⃟

18 Shaws Road, WA14 1QU
☎ (0161) 929 9098 ⊕ pibar.co.uk
**Tatton Blonde; 2 changing beers (sourced regionally;
often RedWillow, Saltaire, Stubborn Mule)** ⒣
Situated on Shaws Road, Pi is within easy walking
distance of Altrincham Interchange. Downstairs it is
relatively compact but there is a more open seating area
upstairs. Three handpumps offer one permanent beer
from Tatton Brewery plus two guest beers from the likes
of Weetwood, RedWillow and Cloudwater. Outside at the
front are a number of tables and chairs for patrons to
enjoy during better weather, and to the rear is a private
and secluded beer garden. ⬛⛾♿⇌🚌🏡🅿🐾🛜

Rustic

41 Stamford New Road, WA14 1EB
☎ (0161) 928 9190 ⊕ rusticalty.com

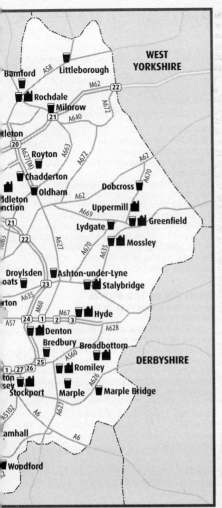

the Rochdale Canal and within the New Islington marina area. It serves a changing range of six handpulled ales from local and regional breweries, plus a cider on handpump and 20 keg beers, some from Spain and other European countries. Local CAMRA Pub of the Year 2021. ♿🚫(New Islington) ♣♣❀❀🎵

Ashton-in-Makerfield

Twisted Vine Ale House 🅛

15 Wigan Road, WN4 9AR
7 changing beers (sourced regionally) Ⓗ
This former local CAMRA Pub of the Year and Cider Pub of the Year opened in 2018. The bar offers seven cask pumps, six keg taps, three boxed ciders and a selection of gins, spirits and wines, alongside a decent craft can range to drink in or take away. There is usually a large selection of beers available from Hophurst Brewery in Hindley. Live music is played on the first Thursday of the month and every Sunday. Over-18's only. ●🚫❀

Ashton-under-Lyne

Half Way House

123 Whiteacre Road, OL6 9PJ
☎ (0161) 343 1344
3 changing beers (sourced locally; often Bridge, Donkeystone, Green Mill) Ⓗ
Taken over by real ale enthusiast Aaron Parkinson in 2020, and recently refurbished, this popular locals' pub was first licensed in 1860. Three changing beers from Glossop, Mossley, Greenfield and from further afield are on handpump. The spacious interior is open-plan, with a function room also available for up to 50 people. Live entertainment takes place on Friday, Saturday and Sunday. ♿🚋🚫🚌(38,39)🎵

Tapsters 🅛

31 Old Street, OL6 6LA (100yds from SE corner of Market Hall)
☎ (0161) 465 0205
3 changing beers (sourced locally; often Bridge, Distant Hills, Stockport) Ⓗ
Previously a high-street shop in the town centre, Tapsters is close to the indoor market and both the bus and rail stations. Opened in 2018, it has been fitted out to a high standard, creating a welcoming, comfortable and spacious place. There is a small courtyard beer garden to the rear. Three rotating mainly local beers, usually differing styles, are on handpump at any time. Real ciders, usually from Snail's Bank or Sheppy's, are also available. Background music plays and the TV is muted when on. Functions of up to 20 people can be catered for. ❀🚋🚫🚌🎵

Astley

Bull's Head

504 Manchester Road, M29 7BP
☎ (01942) 887109
Black Sheep Twilighter Pale Ale; Timothy Taylor Landlord; 1 changing beer (sourced regionally) Ⓗ
A large, comfortable pub next to the village green, offering a good range of beers. Serving good quality pub food, it is very popular, particularly at weekends. Outside, there are various seating areas, some with heaters for colder weather, plus lawns for sun-worshippers. Quiz night is Wednesday. The pub welcomes children over 14 when dining in the evening. Tables can be booked. ♿❀🍽🅿🚌(34)❀🎵

Marble Pint; Vocation Heart & Soul; 4 changing beers (sourced nationally) Ⓗ
Rustic by name, rustic by nature – this bar lives up to its name with lots of natural wood, from the bar to the booth seating. The ground floor area is long and thin with bench seating near the entrance and bar and tables further back. Upstairs there is extra seating space that can also be used as a meeting/event room. There are six handpumps offering two permanent beers from Marble and Vocation and four rotating guests mostly from local breweries. The cask range is supported by keg and bottled beers, wines and cocktails. American diner-style food including ribs and burgers is always available. ♿🍽♿🚋🚫❀🎵

Ancoats

Cask

2 New Union Street, Cotton Field Wharf, M4 6FQ (over bridge from Redhill St)
☎ (0161) 392 0809
6 changing beers (sourced regionally; often Pictish, Squawk) Ⓗ
This sister pub to Cask Liverpool Road is a single-room bar on the ground floor of a newly built complex, adjacent to

Atherton

Taphouse

119 Market Street, M46 0DF
☎ (01942) 367519
5 changing beers (sourced locally) H
Micropub on the main street in the centre of Atherton. Inside this comfortable, friendly one-room bar there are four tables, with extra seating at the sides. Upstairs there are two comfortable lounge areas, one of which is air-conditioned. There is also a small covered smoking area at the back. Beers are generally sourced from small regional microbrewers and are competitively priced. A real-time beer list is available online. ♿🏠🍴🚃(V2)🐾🛜

Bamford

Hare & Hounds

865 Bury Road, OL11 4AA
☎ (01706) 369189
Wainwright; 2 changing beers H
A traditional stone-built pub on the main Rochdale to Bury road, easy to reach by public transport. L-shaped inside with upper and lower bars, it is open-plan but divided into three separate areas, with a real fire in the lower bar/dining area. Although a Thwaites tied house, the landlord is keen to maintain a rotating guest beer policy within the options available from the brewery's range. A new, extended beer garden has recently been opened to the rear. ♿🏠🍴🍺♣P🚃🐾🛜

Bolton

Bank Top Brewery Tap L

68-70 Belmont Road, Astley Bridge, BL1 7AN
☎ (01204) 302837 🌐 banktopbrewery.com
Bank Top Dark Mild, Flat Cap, Pavilion Pale Ale, Palomino Rising; 5 changing beers (sourced locally; often Bank Top) H

The original taphouse for the multi award-winning Bank Top Brewery, based less than a mile away. This street-corner community local has two rooms and a large outdoor area with smoking shelter. There are nine handpumps showcasing ales from the brewery stable – including regulars Flat Cap, Pavilion Pale and Dark Mild plus the current seasonal – and a guest beer. A real cider is also usually among the ciders on offer. ♿🏠🍴♣🍺🚃🐾🛜

Bunbury's

397 Chorley Old Road, BL1 6AH
☎ 07952 344838 🌐 bunburys.co.uk
3 changing beers (sourced locally; often Blackedge, Marble, Siren) H
One of a growing number of micropubs based in former retail outlets, this cosy bottle shop with a bar serves a range of the more unusual beers and beer styles, including three ever-changing ales on handpump from local breweries such as Torrside, Marble and Blackedge, plus beers from similar breweries further afield. It also stocks a wide range of often rare bottled beers from around the world as well as a choice of interesting modern keg beers. Q♿♣🍴🚃(125)🐾🛜

Great Ale at the Vaults L

Vaults Below Market Place, BL1 2AL
☎ (01204) 773458
House beer (by Deeply Vale); 2 changing beers (sourced locally; often Wigan Brewhouse) H
Atmospheric bar situated in the centre of the refurbished vaults of the former Market Hall, whose upper floors contain shops and a cinema. The appearance of the bar is well in keeping with the Victorian cellar in which it is housed. Handpumps dispense two guest beers, one pale, one dark, plus house beer Grey T'Ale, brewed by nearby Deeply Vale. Tasting paddles of a selection of cask ales are available. Cold bar snacks are offered, while in the wider Vaults area there is a choice of other food outlets. Q♿🍴👥≈P🚃🛜

REAL ALE BREWERIES

Alphabet 🍴 Manchester
Bank Top Bolton
Beer Nouveau 🍴 Manchester: Ardwick
Blackedge 🍴 Horwich
Blackjack 🍴 Manchester
Bridge Stalybridge
Brightside Radcliffe
Chadkirk Romiley
Cloudwater Manchester
Deeply Vale Bury
Donkeystone 🍴 Greenfield
Dunham Massey Dunham Massey
Escape Westhoughton
Federation 👥 Altrincham (brewing suspended)
First Chop Eccles
Four Kings 🍴 Hyde
Gasworks 👥 Manchester
Green Mill 👥 Broadbottom
Hideaway Worsley
Hophurst Hindley
Howfen Westhoughton
Hydes Salford
Irwell Works 🍴 Ramsbottom
Joseph Holt Cheetham
JW Lees Manchester: Middleton Junction
Libatory Altrincham (NEW)
Made of Stone 👥 Stockport
Manchester Manchester
Manchester Union 🍴 Manchester

Marble 🍴 Salford
Mayflower Hindley
Millstone Mossley
Northern Monkey 🍴 Bolton
Origami Manchester
P-Noot 👥 Denton
Phoenix Heywood
Pictish Rochdale
Pomona Island 🍴 Salford
Red Rose Ramsbottom
Rising Sun 👥 Mossley
Robinsons Stockport
Runaway 🍴 Manchester
Saddleworth 👥 Uppermill (brewing suspended)
Serious 🍴 Rochdale
Seven Bro7hers 🍴 Salford
Squawk Manchester: Ardwick
State of Kind 🍴 Wigan
Stockport Stockport
Strange Times Salford (NEW)
Stubborn Mule Altrincham (brewing suspended)
Sureshot Manchester (NEW)
Thirst Class Stockport
Tin Head 🍴 Radcliffe
To The Moon Stockport
Track 🍴 Manchester
Wakey Wakey Rochdale (NEW)
Wander Beyond 🍴 Manchester
Wigan Brewhouse Wigan
Wily Fox Wigan

Hope & Anchor 🅛 ✔

747 Chorley Old Road, BL1 5QH

☎ (01204) 842650

Tetley Bitter; Timothy Taylor Landlord; 1 changing beer (sourced locally) 🅗

This traditional pub has a modernised bar area but also retains a wonderful snug complete with bell pushes. A new extension with a pool table leads out to a garden area. It is less than two miles from Bolton town centre, near to Doffcocker Lodge, so convenient for RSPB members visiting the nature reserve. Often referred to as the Little Cocker in deference to the larger Doffcocker Inn across the road. Q🕭&♿♣P🚃(125)🌸🐕🛜

Millstone 🅛

12 Crown Street, BL1 2RU

☎ (01204) 391533

Joseph Holt Bitter; 1 changing beer (sourced locally; often Bootleg, Joseph Holt) 🅗

Comfortable town-centre pub down a side street just off the busier main pub area, a must-visit for real ale drinkers visiting the town, especially at weekends. It serves Joseph Holt Bitter and a guest from Bootleg or another Joseph Holt Beer. There is a large function room adjacent to the main bar on the lower level. The walls display an interesting collection of artwork. 🌸♿♣P🚃🛜

Northern Monkey Bar 🅛

Nelson Square, BL1 1AQ

☎ 07737 125629 🌐 northernmonkeybrew.co.uk

4 changing beers (sourced locally; often Northern Monkey)

This pub was set up and renovated from what was previously a restaurant, though originally it was the dining room of the Pack Horse Hotel which dominated this side of Nelson Square before being converted to student accommodation. The four real ales include Northern Monkey beers, now brewed off-site to provide more space inside, and sometimes a couple of guests. At least one dark ale is normally available. Eight beers serve modern keg beers from Northern Monkey and other breweries. 🕭◗🚃♣🐕🛜

One for the Road

Stalls F14 to F15, Ashburner Street Lifestyle Hall, BL1 1TJ

☎ 07725 338773

House beer (by Stockport); 2 changing beers (sourced locally) 🅗

This microbar is located in the Lifestyle Hall of Bolton's award-winning indoor market, and has a choice of three beers from a wide range of smaller breweries. Sharing the same large seating area at the front of the bar is a choice of takeaway food stalls, with dishes from Malaysia to Cameroon alongside more standard sandwiches and pasties. Opening days and hours are restricted to those of the main market. A former local CAMRA Pub of the Year. Q🕭&♿P🚃🛜

Boothstown

Royal British Legion

Victoria Street, M28 1HQ (close to jct with Vicars Hall Lane)

☎ (0161) 790 2928

Joseph Holt Bitter; Wainwright 🅗

A large, friendly club, welcoming to non-members. A lounge to the right of the entrance leads to a games and TV room, and there is a large function room at the rear. The spacious garden is ideal for summer drinking. Live entertainment is a regular feature, and a beer festival is

held in November. The steward and stewardess have been awarded the Queen's medal for voluntary service. A regular winner in the Club Mirror awards and local CAMRA Club of the Year. Q🕭🌸♿♣P🚃🛜

Royal Oak

18-20 Leigh Road, M28 1LZ (close to jct of Leigh Rd, Simpson Rd and Chaddock Lane)

☎ (0161) 703 8582

Joseph Holt Bitter; 1 changing beer (sourced nationally; often Marston's) 🅗

A thriving and friendly community pub with three rooms. A small, cosy room to the left of the entrance leads to a larger room where live music events, discos and darts are sometimes hosted. A vault to the right has a fire for the colder weather and a dartboard. No meals are served but there are nine different pork pies to choose from. Q🕭🌸♣🚃(34,553)🐕🛜

Bramhall

Mounting Stone

8 Woodford Road, SK7 1JJ (at jct Bramhall Lane South)

☎ (0161) 439 7563 🌐 themountingstone.co.uk

Bollington Best, Long Hop; 4 changing beers (sourced locally) 🅗

The sister venue to Cheadle Hulme's Chiverton Tap, this is a cosy, friendly micropub right in the village centre. The former blacksmith's operates over two floors – ground and basement – with a small beer garden to the rear. The name derives from a local large stone that allowed riders to mount their horses. Alongside the Bollington ales are up to four beers often from microbrewers, one usually a dark brew, and eight keg beers. The pub opened an on-site, one-barrel brewery named Made of Stone in 2018. Q🕭🌸&🚃🐕🛜

Bredbury

Traveller's Call

402 Stockport Road West, SK6 2DT

☎ (0161) 258 1906

JW Lees Manchester Pale Ale, Bitter 🅗

One of the oldest pubs in the area, the building was first licensed in 1874 and has been in the hands of the John Willie Lees brewery since 1929. Once under threat of demolition for a proposed road scheme, its future is now secure. The Traveller's is a well-used community local serving consistently good JW Lees beers, which are rare in this part of Stockport. 🌸◗&P🚃🐕🛜

Broadbottom

Harewood Arms 🅛 ✔

2 Market Street, SK14 6AX

☎ (01457) 762500 🌐 theharewoodarms.co.uk

Green Mill Gold, Northern Lights; 4 changing beers (sourced locally; often Green Mill) 🅗

A large pub for all the community in this quiet village on the edge of the Peak District. Home to the Green Mill Brewery, it serves five regular Green Mill ales plus seasonals and guests. Partially open plan, with various seating areas and two real fires, it also has a beer garden to the rear. Approximately five minutes' walk from Broadbottom railway station and on local bus routes. 🕭🌸◗&▲🚃♣🛢🐕🛜

Burnage

Reasons to be Cheerful

228 Fog Lane, M20 6EL (jct of Elmsmere Rd, near Burnage station and Parrs Wood Rd)

☎ (0161) 425 9678 ⊕ reasonsbeercafe.co.uk
3 changing beers (sourced locally)
Modern beer café in former shop premises near Burnage railway station. The small, inconspicuous frontage hides a long but welcoming interior, including an alcove providing seating and a view of the street. The L-shaped bar is fitted with three handpulls. Eight craft beer taps are mounted on the back bar, and there is also a display rack and fridge for off-sales. A secluded rear room can accommodate up to 20 people. Outside at the front is a small drinking area. Card payment only.
Q ७ ❀ ✿ ≈ ♠ ⊒ ♣ ♀

Bury

Art Picture House ⍺ ✅

36 Haymarket Street, BL9 0AY (opp Metro/Bus Station interchange)
☎ (0161) 705 4040
Brightside Odin Blonde; Greene King Abbot; Moorhouse's Blond Witch; Ruddles Best Bitter; changing beers ⍚
A town-centre Wetherspoon pub in a beautifully restored former 1920s cinema, opposite the Bury Interchange. The large seating area is on two levels, with several private booths facing the back bar. Eight handpumps dispense regular and ever-changing beers, served by a team of experienced bar staff who can help with your selection. Food is available all day, every day.
७ ◖ ♿ ⧗ ≈ (Bolton St ELR) ☒ ♣ ♀

Broad Street Social ⍺

9 Broad Street, BL9 0DA
☎ (0161) 204 7387 ⊕ broadstreetsocial.co.uk
Brewsmith Bitter, Pale, Oatmeal Stout; 1 changing beer (often Brewsmith, Marble) ⍚
Opened in the centre of Bury between the two lockdowns, this welcoming bar is owned by Brewsmith Brewing Co. Beers on handpump are usually from the brewery, with an occasional guest ale. There are no TVs or gaming machines – conversation is the order of the day. A discount card is offered on Wednesday, Thursday and Sunday with a free pint after six stamps.
७ ≈ (Bolton St ELR) ☒ ♣ ♀

Thirsty Fish ⍺

Unit 1A Princess Parade, Millgate Shopping Centre, BL9 0QL
Brewsmith Bitter; Deeply Vale DV8; house beer (by Moorhouse's); 4 changing beers (often Bank Top, Beartown, Phoenix) ⍚
A town-centre microbar in a former shop unit in the town centre Millgate Shopping Precinct. Adjacent to the famous Bury Market and next to the Transport Interchange, it is a more than convenient waiting room for your tram or bus. The bar sells eight changing well-kept real ales, up to six ciders and a good selection of continental beers. Dogs are welcome but children are not permitted.
≈ (Bolton St ELR) ♠ ⊒ ♣ ♀

Trackside Bar ⍺ ✅

Bolton Street Station, BL9 0EY (platform 2 on ELR)
☎ (0161) 764 6461
House beer (by Northern Whisper); changing beers ⍚
A unique Heritage Railway pub coupled with eight ever-changing real ales and one permanent from Brightside make the Trackside a firm favourite with locals and visitors alike. The beer is always in superb condition. Up to eight real ciders/perries are also available. Various craft keg beers are dispensed via taps at the back of the bar with foreign bottled beers also on offer. Tap takeovers are held throughout the year, and themed railway events are also hosted on a regular basis. With a

covered platform and plenty of seating, plus a wall heater for cooler weather, it makes for a very pleasant experience. ७ ❀ ❀ ♿ ▲ ≈ (Bolton St ELR) ☒ ♠ P ⊒ ♣ ♀

Cadishead

Grocers ♀

152A Liverpool Road, M44 5DD (close to Moss Lane)
☎ 07950 522468
3 changing beers (sourced regionally; often Blackedge, Brewsmith, Dunham Massey) ⍚/Ⓖ
This micropub is the local CAMRA Pub and Cider Pub of the Year. It has one room and no bar – beers are brought to your table by the proprietor from a separate air-chilled room. Two beers are on handpull alongside three ciders or perries. The lack of TV, jukebox or other electronic entertainment ensures conversation is king. There is a yard to the rear for outside drinking.
Q ७ ❀ ♿ ♠ ⊒ (67,100) ♣

Castleton

Old Post Office Ale House ⍺

858 Manchester Road, OL11 2SP
☎ (01706) 645464
House beer (by Pictish); 4 changing beers (sourced locally; often Beartown, Outstanding) ⍚
Situated in the heart of Castleton, this microbar offers very good transport links. It has five handpumps on the bar with four beers changing regularly, two real ciders, plus some foreign beers and a good selection of wines, gins and other spirits. Food is not served but you are welcome to bring your own. The bar is dog friendly and there is an area at the rear that has been transformed into a beer garden. Q ❀ ≈ ♠ ⊒ (17) ♣ ♀

Chadderton

Crown Inn ⍺

72 Walsh Street, OL9 9LR (off Middleton Rd via Peel St)
☎ (0161) 915 1557
4 changing beers (sourced locally; often Leatherbritches, Millstone) ⍚
Popular family-run local free house in the industrial centre of Chadderton. It serves Lees Bitter plus an ever-changing second ale from Leatherbritches, Millstone, Naylor's and other local breweries. Football, darts and Hollinwood Rugby League teams play from here. There is live music at weekends and an inviting beer garden to the rear for sunny days. Alight at Metrolink's Freehold station or First Bus 415 for a short walk to the pub.
७ ❀ ♿ ⊒ (Freehold) ♣ ⊒ (415) ♣ ♀

Rose of Lancaster ✅

7 Haigh Lane, OL1 2TQ
☎ (0161) 624 3031 ⊕ roseoflancaster.co.uk
JW Lees Bitter, Manchester Pale Ale; 4 changing beers (sourced locally; often JW Lees) ⍚
This thriving and attractive pub provides a great choice for customers, with a conservatory restaurant, lounge bar and a separate vault showing sporting events. Keen management ensures swift and cheerful service, and drinkers and diners mix comfortably in the busy lounge. Outside, a covered patio with views to Rochdale Canal is very popular, weather permitting. Nearby bus and train links make for easy travel to this well-run and popular pub. Seasonal and Lees Boilerhouse beers are always available. ❀ ◖ ♿ ≈ (Mills Hill) ♣ P ⊒ (59) ♀

Cheadle

James Watts ✔

13 High Street, SK8 1AX (on A560, jct Manchester Rd)
☎ (0161) 428 3361 ⊕ thejameswatts.co.uk
Hydes 1863, Dark Ruby, Hopster, Lowry, Original; 2 changing beers (sourced regionally) Ⓗ

An old pub given a new lease of life by a tasteful refit in 2017. What was once the Old Star is now an upmarket, well-appointed bar. It is traditional at the front, with posing tables in the mid-section, then beyond that is another area laid out with tables for casual dining or drinking. Outside is a convivial patio area. Bar snacks (platters and nibbles) are served Monday-Saturday until 8pm. Quiz night is every Tuesday, live music every Saturday night. ☕◁🍴🚲🛜

Wobbly Stamp

130 Stockport Road, SK8 2DP (jct Park Rd)
☎ (0161) 523 0188
House beer (by Stancill); 3 changing beers (sourced regionally) Ⓗ

Opened in September 2020 in a former post office by a local businessman and owner of Jakes Ale House in nearby Romiley. The deceptively long main room has plenty of seating, with two booths towards the back. The interior is a mix of rough-planed timber, plasterboard and bare brick, all variously adorned with local artwork, breweriana and mirrors. Outside drinking areas are at the front and side of the building. Three rotating guest ales usually include a dark beer. Q☕🍴🚲(11,11A)🛜

Cheadle Hulme

Chiverton Tap ♟

8 Mellor Road, SK8 5AU (off Station Rd)
☎ (0161) 485 4149 ⊕ thechivertontap.co.uk
Bollington Best, Long Hop; 4 changing beers (sourced locally) Ⓗ

Friendly micropub in what was once Arthur Chiverton's draper's shop. Note the mosaic in the doorway of the double-fronted former shop. Alongside the Bollington beers are four cask lines and eight keg taps, ever-changing and all from UK micros, including a cider. In 2019 it added a first-floor function room and an outside area at the rear with tables. Local CAMRA Pub of the Year 2022. Q☕🍴🚲🛜🚍🛜

John Millington ✔

67 Station Road, SK8 7AA (on A5149, jct Monmouth Rd)
☎ (0161) 486 9226 ⊕ thejohnmillington.co.uk
Hydes Hopster, Lowry, Original; 3 changing beers (sourced nationally) Ⓗ

The interior layout of the Grade II-listed former Millington Hall rambles pleasingly through a variety of rooms and areas around a central L-shaped bar. Well-regarded food runs from snacks to full meals, served daily until 9pm in the dining room extension which overlooks neatly tended shrubbery. Outside is an attractive part-covered, part-heated seating area with a designated section for eating. This pub is something of a flagship for Hydes and features seasonal and one-off beers from its varied ranges. ☕🍴🚲🛜🚍P🛜🛜

Chorlton-cum-Hardy

Beer House ♟ Ⓛ

57 Manchester Road, M21 9PW
☎ (0161) 881 9206
Marble Pint, Manchester Bitter; 4 changing beers (sourced regionally; often Kirkstall, RedWillow, Squawk) Ⓗ

Ever-popular micropub whose knowledgeable staff provide a warm welcome. The focus is on quality beer, with regulars Manchester Bitter and Pint plus a changing selection of guests. Top-quality craft beers are served from the keg, along with excellent canned and bottled brews. Traditional games supplement games console favourites from the 1980s. No food is served but bar snacks are available. ☕◁🚲🚍(86)🛜🛜

Chorlton Tap Ⓛ

533 Wilbraham Road, M21 0UE
☎ (0161) 861 7576 ⊕ chorltontap.wixsite.com/chorltontap
Wander Beyond Peak; 4 changing beers (sourced locally; often Marble, Pictish, Squawk) Ⓗ

This taproom for the Wander Beyond brewery was previously a beer specialist for 25 years as the Bar. What was once two distinct properties is now a small bar area and spacious adjacent room. Two handpumps and several keg lines dispense the brewery's beers, alongside four guests on handpump. Monday is quiz night. Food is available Friday to Sunday. There is outside seating front and back. ☕🍴◁🚲🚍🛜🛜

Fell

518 Wilbraham Road, M21 9AW
☎ (0161) 881 7724
4 changing beers (often Fell)

Small but popular bar that opened between lockdowns in 2020 and then survived more lockdowns and is now thriving. One of the taps for Fell brewery, the cask offering is usually all Fell, often including a dark beer, but the keg offering has more variety, with 11 taps from the likes of Verdant, Deya and Kernel – sometimes local collaborations are produced. Hogan's cider is available. A green tiled bar and wood throughout bring a bit of tradition to this modern bar. There's always a good soundtrack – never too intrusive. 🚲🛜🚍

Font Ⓛ

115-117 Manchester Road, M21 9PG
☎ (0161) 871 2022 ⊕ thefontbar.wordpress.com
5 changing beers (sourced nationally; often Mallinsons, RedWillow, Track) Ⓗ

Up to five varying real ales feature on the bar, one usually from RedWillow or Mallinsons, alongside eight regularly changing keg lines. Hogan's cider is available on draught, plus bottled beers and ciders. Good-value cocktails are also well-regarded. The open kitchen serves a full menu daily from breakfast on, changing every few months. A popular quiz is held every Tuesday. Closed Monday except comedy night on the first Monday of the month. Home to Chorlton Homebrewers. ☕🍴◁🚲🛜(86)🛜🛜

Denton

Carters Arms

209 Stockport Road, M34 6AQ
☎ (0161) 320 3752
Black Sheep Best Bitter; 1 changing beer (sourced locally; often Distant Hills) Ⓗ

Friendly local with two large open-plan rooms. The lounge-style room to the left is regularly hired out for functions for up to 70 people; the traditional bar/games room on the right features wood panelling and dark leather seating. Entertainment includes a quiz night on Wednesday, live music on Friday, karaoke and disco on Saturday. Children are welcome until 8pm. There is wheelchair access to the rear. You can reach the pub by bus from Manchester, Stockport, Hyde and Ashton. Q☕🚲🚍P🛜🛜

Crown Point Tavern ⓛ

16 Market Street, M34 2XW (in pedestrianised Denton Civic Square)
☎ (0161) 337 9615 ● thecrownpointtavern.co.uk
Stockport Crown Best Bitter; 5 changing beers (sourced locally) Ⓗ
Micropub in the centre of Denton with six real ales, typically sourced from the Greater Manchester area. A blackboard shows information about the beers including style and taste – flights of three thirds are available. The cask beers are complemented by an extensive selection of bottled craft beers, again mostly from Greater Manchester brewers. Ciders in a box are from Lilley's and Westons. Live music features on Fridays and a DJ on alternate Sundays. Outside seating is available at the front. Senior citizens receive a 10 per cent discount Monday to Friday. ᏝᏜ♣🖵🌣🛜

Didsbury

Fletcher Moss ✅

1 William Street, M20 6RQ (off Wilmslow Rd, A5145 via Albert Hill St)
☎ (0161) 438 0073
Hydes Hopster, Lowry, Original; 4 changing beers (sourced regionally) Ⓗ
This gem of a pub is named after the alderman who donated the nearby botanical gardens to the city. A haven tucked away off the main street, the buzz of conversation is audible before opening the door. It is now a drinks-only operation but this doesn't detract from its popularity. Look for the assortment of porcelain teapots – part of a 100-piece collection. Outside is an attractive garden and patio. Q✿&ᗡ(Village)🖵🛜

Gateway ✅

882 Wilmslow Road, M20 5PG (jct Kingsway and Manchester Rd)
☎ (0161) 438 1700
Greene King Abbot; Ruddles Best Bitter; house beer (by Brightside); 5 changing beers (sourced nationally) Ⓗ
This comfortable and popular 1930s roadhouse is conveniently located opposite the public transport interchange for bus, tram and rail. It stands out due to its welcoming atmosphere, enthusiastic staff and excellent beer. The large Wetherspoon pub's central island bar is surrounded by distinct seating areas, ensuring you can always have a quiet drink somewhere, however busy it gets. Note the imagery detailing the high-frequency 42 bus service that terminates at the nearby Parrs Wood leisure complex. Q🏠✿&ᗡ&�(E Didsbury) ᗡ(E Didsbury) P🖵🛜

Dobcross

Dobcross Band Social Club ⓛ

Platt Lane, OL3 5AD
☎ (01457) 873741 ● dobcross.club
JW Lees Bitter; Joseph Holt Bitter; 2 changing beers (sourced locally; often Bradfield, Millstone, Ossett) Ⓗ
Single-storey building constructed in 1967 with superb views from its bowling green. The club hosts several brass bands and has a well-equipped games room with full size snooker table. A function room stages concerts as well as being a rehearsal space. The John Holden lounge (named after the long-serving steward) seats around 25 in comfortable surroundings. A repeat winner of local CAMRA Club of the Year, and runner-up in the Regional Club awards. ᏝᏜ♣P🖵(356)🌣🛜

Navigation Inn ⓛ

21 – 23 Wool Road, OL3 5NS
☎ (01457) 872418 ● thenavigationdobcross.com
Millstone Tiger Rut; Timothy Taylor Boltmaker; 3 changing beers (often Brains, Skinner's, Titanic) Ⓗ
Next to the Huddersfield Narrow Canal, this stone pub was built in 1806 to slake the thirst of navvies cutting the Standedge Tunnel. It comprises an open-plan bar and an L-shaped interior, and is popular with walkers, canal boaters and families. A family business, it has a justified reputation for excellent freshly prepared meals from an extensive menu. A favourite stop-off point for the Saddleworth Rushcart Festival in August. Q🏠✿🕀&P🖵(184,356)🌣🛜

Swan Inn (Top House) ⓛ

The Square, OL3 5AA
☎ (01457) 238690 ● swaninndobcross.com
Banks's Sunbeam; Courage Directors; Jennings Cumberland Ale; Marston's Pedigree; Wainwright Ⓗ
Built in 1765 for the Wrigley family of chewing gum fame, the Swan is a traditional stone pub overlooking the attractive village square. The ground floor has three separate rooms, each with an open fire. Upstairs, the historic function room hosts occasional music and theatre events. Good home-cooked food is served including weekly specials. Annual events such as the Whit Friday Brass Band Contest, Rushcart Festival and Yanks Weekend are popular. Quiz night is Thursday. Q🏠✿🕀D🖵(353,354)🌣🛜

Droylsden

Silly Country Bar & Bottle Shop 🍷 ⓛ

121 Market Street, M43 7AR
4 changing beers (sourced locally) Ⓗ
Open-plan bar and bottle shop with an outside drinking area. Four cask conditioned beers, mostly from local breweries, and one or two ciders are served (usually Hogan's, Somerset or SeaCider) – one on handpump, one boxed – and occasionally a perry, plus an enterprising selection of bottled beers and ciders. Treats for dogs are available. Customers can bring in their own food. Q🏠✿&ᗡ♣🍴🖵🌣🛜

Eccles

Lamb Hotel ★

33 Regent Street, M30 0BP (opp Eccles Metrolink)
☎ (0161) 789 3882
Joseph Holt Mild, Bitter; 1 changing beer (sourced nationally) Ⓗ
Identified by CAMRA as having a nationally important historic pub interior, this classic Grade II-listed red-brick and terracotta Joseph Holt Edwardian pub dates from 1906. A central bar serves a vault on one side and on the other a lobby that leads to lounges and the Billiard Room. The interior features Jacobean-style door surrounds, a terrazzo floor and a dado of green tiles leading to a screened, curved mahogany bar displaying polished brass and exquisite etched glass. The pub has featured in several TV dramas. Q�(Manchester) ᗡ♣P🖵🌣🛜

Elton

Elton Liberal Club ⓛ

New George Street, BL8 1NW
☎ (0161) 764 1776 ● eltonliberalclub.co.uk
Brewsmith Bitter; Brightside Odin Blonde; Moorhouse's Blond Witch; 2 changing beers Ⓗ

This friendly social club is a private members' club (non-political) – guests must be signed in at £1 per visit. A broad range of entertainment includes line dancing, yoga, slimming club and live music nights on selected Saturday nights. Q🅂♿🕭♣P🖵(480)🐾🐾🛜

Gorton

Vale Cottage
Kirk Street, M18 8UE (off Hyde Rd A57, E of jct Chapman St)
☎ (0161) 223 4568 🌐 thevalecottage.co.uk
Timothy Taylor Landlord; 2 changing beers (sourced nationally) Ⓗ
Hidden away off busy Hyde Road and sited in the Gore Brook conservation area, the Vale Cottage feels like a country local transported to the inner city. The low-beamed ceilings, wood-burning stove and multiple drinking areas all add to the cosy, out-of-town feel. The atmosphere is relaxed and friendly with conversation to the fore. There is a folk night on Sunday, a general knowledge quiz on Tuesday night and, on the last Thursday of each month, a music quiz and steak night. Q🅂🕭🕪♿🚃(Ryder Brow) P🖵🛜

Greenfield

Wellington Inn Ⓛ
29 Chew Valley Road, OL3 7AF
Coach House Gunpowder Mild; Millstone Tiger Rut; Salopian Lemon Dream; Wainwright; 2 changing beers (sourced locally; often Donkeystone, Phoenix) Ⓗ
A family-run village end-of-terrace free house with a friendly feel. The stone-built pub comprises a small bar area, a main room popular with diners, and a side room with dartboard, cribbage and dominoes. Good-value home-cooked food comes from The Stockpot, with daily specials on Wednesday, Friday and Sunday. Pies, puddings and real chips are particularly popular. Some pavement seating is available at the front. 🅂🕭♿Å🚃♣🖵(180,350)🐾🛜

Harwood

House Without a Name Ⓛ
75 Lea Gate, BL2 3ET
☎ (01204) 457802 🌐 housewithoutaname.co.uk
Joseph Holt Bitter; Sharp's Doom Bar; Timothy Taylor Landlord; 4 changing beers (sourced locally; often Moorhouse's, Northern Monkey, Wainwright) Ⓗ
Locally known as the No Name, this cosy terraced venue was two 1830s cottages before being refurbished and sensitively modernised, retaining the flag floors and wooden beams. Its main lounge has a bar servery, real fire and TV showing sport. There is also a small bar to the left. Beers come in a range of styles, with popular national ales supplemented by local guests chosen by the knowledgable landlord. 🅂🐾🖵(480,507)🐾🛜

Heaton Mersey

Griffin
552 Didsbury Road, SK4 3AJ (jct Harwood Rd)
☎ (0161) 443 2077
Joseph Holt Bitter Ⓗ
A large, five-room Victorian house with pleasant gardens to the rear. A host of features evoke that period, from etched glass to a magnificent mahogany bar with glazed sashes. The main bar area with its open-plan room is an extension to the original pub. There is a place for everyone here, with some rooms quiet, others not. On the walls hang pictures of old Heaton Mersey and much Manchester City memorabilia. Quiz night is Thursday, live music or a DJ on Saturday. Pies and barms are served daily. Q🅂🕭♿Ⓛℛ(E Didsbury)♣P🖵🐾🛜

Hindley

Hare & Hounds Ⓛ
31 Ladies Lane, WN2 2QA
☎ 07305 640675
5 changing beers Ⓗ
This small but traditional pub is located between Hindley railway station and the town centre. There is a large, comfortable lounge, a distinct bar/vault area and a charming beer garden to the rear. The lounge displays pictures from bygone Hindley and has a largescreen TV for sports. The pub is home to darts and dominoes teams playing in the local leagues. Beers are from Wigan Brewhouse along with other breweries both local to the area and further afield. 🕭🐾🚃♣🐾🛜

Horwich

Bank Top Brewery Ale House Ⓛ ✓
36 Church Street, BL6 6AD
☎ (01204) 693793 🌐 banktopbrewery.com
Bank Top Bad to the Bone, Dark Mild, Flat Cap, Pavilion Pale Ale; 4 changing beers (sourced locally; often Bank Top) Ⓗ
Award-winning Bank Top Brewery pub, in a conservation area opposite Horwich parish church and alongside 18th and 19th-century cottages associated with the area's history of textiles and bleaching. The pub serves up to eight beers from Bank Top, including Dark Mild, a former Champion Mild of Britain, plus one changing guest. One cellar-cooled real cider is usually available. Walkers and their dogs are welcome. A good place to start your visit to the town, with the bus stop right outside. Q🅂🕭♣🖵(125)🐾

Brewery Bar Ⓛ
Moreton Mill, Hampson Street, BL6 7JH (just off Lee Lane behind Old Original Bay Horse)
☎ (01204) 692976 🌐 thebrewerybar.co.uk
Blackedge Hop, Black, Pike; 4 changing beers (sourced locally; often Blackedge) Ⓗ
This bar on the first floor above the award-winning Blackedge Brewery has seven handpumps serving its beers, plus a range of real ciders. Converted from a former industrial premises and retaining some original features, it has varnished bench tables and stools spread throughout a large drinking area. Locally made pork pies are usually available. The brewery is visible through large glass windows at the entrance. Note: the toilets are on the ground floor and there is no lift. 🅂🕭♣🖵🛜

Crown Ⓛ
1 Chorley New Road, BL6 7QJ
☎ (01204) 693109
Joseph Holt Mild, IPA, Bitter, Two Hoots; 4 changing beers (sourced locally; often Bank Top, Blackedge) Ⓗ
A comfortable and popular landmark pub serving a range of Joseph Holt's beers and up to four guest ales from local breweries. The multi-room layout provides a home to many community activities including darts, dominoes, pool and chess. Elsewhere are quiet drinking areas and a large sports TV. There is live entertainment on weekend evenings and home-cooked food served every day. The Crown's location attracts outdoor enthusiasts stopping for a pint after enjoying the beautiful countryside of the neighbouring West Pennine Moors. 🅂🕭🕪♿♣P🖵(125,575)🐾🛜

Hyde

3 Drinks Behind Ⓛ
285 Stockport Road, Gee Cross, SK14 5RF
☎ (0161) 368 6827
House beer (by Beartown); 3 changing beers (sourced locally) Ⓗ
Microbar facing the cemetery of Hyde Chapel, bought by four locals in May 2021. The house ale is from Beartown, alongside three guest ales, typically from local breweries. Stout or porter is always available. The limited space is well utilised, with room for 30 people to sit comfortably – the layout inevitably encouraging conversation. A huge mirror creates a more spacious feel. Jam sessions are held every fortnight and live music monthly. Available to book for private functions.
Q❤️🚌(202) ✦ 🎵 ⛵

Cheshire Ring Hotel Ⓛ
72-74 Manchester Road, SK14 2BJ
☎ 07917 055629
6 changing beers Ⓗ
One of the oldest pubs in Hyde. Seven handpumps offer a range of ales from Beartown Brewery plus micros near and far, in addition to ciders, perries and continental beers. A selection of bottled beers is also stocked. Home-made curries are available on Thursday evening, and Sunday is quiz night. Opening hours vary with the season – check before visiting. ❤️🐾⇌(Central)P🚌(201)✦

Sportsman Inn Ⓛ
57 Mottram Road, SK14 2NN (exit Morrisons car park)
☎ (0161) 368 5000
Rossendale Floral Dance, Glen Top Bitter, Halo Pale, Pitch Porter, Sunshine; house beer (by Rossendale); 1 changing beer (sourced locally; often Rossendale) Ⓗ
This former regional CAMRA award winner is popular with locals and retains its character while offering a full range of Rossendale Brewery ales. The upstairs restaurant serves Cuban tapas and vegetarian options. Wednesday is curry night from 6pm and on Sunday there is a traditional roast from noon until it's gone. The choice of food varies with day and time. Outside, the rear patio has a covered and heated smoking area. Located on the main road, the pub is close to Hyde United football ground. ❤️🐾⇌(Newton for Hyde)♣P🚌✦🎵

Leigh

Bobbin
38A Leigh Road, WN7 1QR
☎ (01942) 581242 ⊕ thebobbinleigh.co.uk
4 changing beers (sourced locally) Ⓗ
On the northern edge of the town centre, this one-room micropub offers a warm welcome and has comfortable seating. The bar is decorated with pumpclips and there are pictures for sale for charity. Beer prices are very competitive – a dark beer and real cider are always available. Beers are sourced from regional microbreweries, with current and forthcoming selections on the website. Open from 1pm on Sundays when Leigh RLFC are playing at home. Q🐾♣🚌🎵✦

Thomas Burke Ⓛ ✓
20A Leigh Road, WN7 1QR
☎ (01942) 685640
Greene King Abbot; Moorhouse's Blond Witch; changing beers Ⓗ
Popular with all ages, this Wetherspoon pub is named after a renowned Leigh tenor, known as the Lancashire Caruso. The pub divides into three areas: the main long bar, a raised dining area and, in what was once a cinema foyer, lounge-style seating. There is also a small courtyard at the back for outside drinking. A changing range of beers is sourced from breweries local and distant, including the house beer Tommy Burke. Q❤️🐾🕓🍴🚌(V1) ✦

Weavers Arms ✓
9-13 Lord Street, WN7 1DP
☎ (01942) 267510
Black Sheep Best Bitter; Timothy Taylor Landlord; 3 changing beers (sourced regionally) Ⓗ
Located in the centre of Leigh just off the main shopping street, the Weavers attracts a wide clientele. During the day it has a relaxed environment with shoppers and families dining. In the evening it is a popular meeting place, with sports shown on the many TV screens. Entertainment features most Fridays and a DJ every Saturday. The beer selection has recently been extended, with a local ale as well as the usual regional choices. ❤️🕓🍴♣P🚌✦🎵

Levenshulme

Fred's Ale House ✓
843 Stockport Road, M19 3PW (opp Albert Rd)
☎ (0161) 221 0297 ⊕ fredsalehouse.com
Wainwright; 5 changing beers (sourced regionally; often Blackjack, Brightside) Ⓗ
Set over three floors, this is part bar, part coffee shop and art gallery. The entrance area can be opened to the elements in the summer. It is comfortably furnished and features characterful tiling and decorative wall wreaths from when it was a tripe shop. The narrow interior has the stylish bar set to the left and seating front and rear. The spartan basement is a large drinking area plus gallery space and can accommodate live gigs and acoustic acts. An upstairs lounge has more seating. ❤️🕓🚌✦

Littleborough

Hare on the Hill
132 Hare Hill Road, OL15 9HL
☎ (01706) 375220
Vocation Bread & Butter; 3 changing beers (often Pictish, Saltaire, Tiny Rebel) Ⓐ
Although relatively new, the Hare has quickly established itself as a welcoming, busy pub just out of the centre of the village. Four cask ales are available – one regular and three changing. There are also four KeyKeg beers and a real cider. Reasonably priced food is available every day from an inventive menu – it is advisable to book ahead at weekends. The beer garden has cosy huts for inclement Pennine days. Q❤️🐾🕓🍴Å⇌♣🚌(518)✦

White House Ⓛ
Blackstone Edge, Halifax Road, OL15 0LG
☎ (01706) 378456 ⊕ thewhitehousepub.co.uk
Theakston Best Bitter; 3 changing beers (often Abbeydale, Newby Wyke) Ⓗ
Dating from 1671, this is an old coaching house originally called the Coach & Horses. Situated 1,300 feet above sea level, where the Pennine Way crosses the main road, it commands stunning views. Family run for over 30 years, it offers a warm and friendly welcome. Theakston Best is a regular, complemented by three changing beers. Good food is served daily from an extensive menu. A bus stop on the Rochdale to Halifax route is outside the front door. Q❤️🐾🕓🍴ÅP🚌(X58) ✦

Lowton

Ram's Head Inn
248 Slag Lane, WA3 2ED
☎ (01942) 728278
1 changing beer (sourced regionally) Ⓗ
Traditional pub opposite Lowton St Luke's Church, popular with locals for meals and sport on TV. A central bar serves a number of separate areas, with wood furnishings and a large brick fireplace. There is ample seating in the garden at the side of the pub, and a play area for children. Quiz night is every Thursday and live singers and bands entertain on Saturday nights.
🗬🏵🌑🕭♣️P🚲(10)

Travellers Rest ✅
443 Newton Road, WA3 1NZ
☎ (01925) 293222 ⊕ travellersrestlowton.com
2 changing beers (sourced regionally)
Traditional country pub and restaurant, dating back to the 19th century, between Lowton and Newton-le-Willows, popular with locals, walkers and cyclists. There are a number of seating areas and a separate restaurant, with a bar area to the right for drinkers. Outside, there is a large garden and car park. A private room is available to hire for special occasions and Haydock Park race course is only a mile away. Q🗬🏵🌑🕭♣️P🚲(34)🐾🛜

Lydgate

White Hart Inn Ⓛ ✅
51 Stockport Road, OL4 4JJ
☎ (01457) 872566 ⊕ thewhitehart.co.uk
JW Lees Bitter; Millstone Tiger Rut; Timothy Taylor Golden Best Ⓗ
Country pub-restaurant with impressive views over the surrounding countryside and Greater Manchester. A free house, it serves three regular beers from JW Lees, Timothy Taylor and Millstone. The building dates from 1788 and was once a police station. The multi-room layout has log-burning stoves in the bar area and brasserie. Quality food is served daily from an award-winning kitchen. The pub hosts a variety of events including themed dinners and wine tastings. Accommodation and function rooms are available.
Q🗬🏵🛏️🌑🕭♣️P🚲(84,184) 🐾🛜

Manchester

Abel Heywood ✅
38 Turner Street, Northern Quarter, M4 1DZ (corner Red Lion St)
☎ (0161) 819 1441 ⊕ abelheywood.co.uk
Hydes Original, Lowry, Hopster; 3 changing beers (sourced locally) Ⓗ
Opened in 2014, this is a pub conversion from a longstanding building. Up to six beers from Hydes brewery are served. This bar and boutique hotel are named after a former mayor of Manchester, the town hall clock is named 'Great Abel' after him. The large L-shaped main bar area is on the ground floor, frequented by a mixed crowd. The first floor is a restaurant/gin bar. A quiz is held on the first Wednesday of the month.
🛏️🌑➡️(Victoria) 🚇(Shudehill) 🚲

Beatnikz Republic Bar
35 Dale Street, M1 2HF (corner of Dale St and Tariff St)
☎ 07761 800828 ⊕ beatnikzrepublic.com/bar
3 changing beers (sourced nationally)
Open since 2018 in a Grade II-listed former office block, this was originally a bar for the now closed Beatnikz Republic brewery. Entering up a number of steps reveals a long, narrow room with high tables to the left and

table and comfortable bench seating on the right with the bar at the far end. There are four handpumps for cask ales and an occasional cider, plus 14 fonts on a keg wall behind the bar. ➡️(Piccadilly)🚇(Piccadilly Gardens)🐾🛜

Cafe Beermoth
40A Spring Gardens, M2 1EN (entrance on Brown St)
☎ (0161) 835 2049 ⊕ beermoth.co.uk/cafe
7 changing beers (sourced nationally) Ⓗ
Welcoming modern bar near Market Street, with a Belgian flavour and a relaxed and fun city-centre atmosphere. It has a large bar room and a smaller mezzanine floor. An excellent range of beers is served from seven cask handpumps alongside 10 keg lines and a wide range of bottled ales, including many rare German and Belgian beers. Attractions include occasional tap takeover and beer tastings. There is some outdoor seating which is great for watching the world go by.
🗬🛜🚇(Market St) 🐾🛜

Cask
29 Liverpool Road, M3 4NQ
☎ (0161) 819 2527
4 changing beers (sourced regionally; often Mallinsons, Pictish) Ⓗ
A deceptively deep pub in the heart of Castlefield that consistently sells excellent cask ale. With beer on four handpumps, it usually offers a good range of flavours, including a dark. The knowledgeable and friendly staff can help you choose. The selection of international beers is particularly impressive, both on fonts and in bottles. Although no food is provided, customers are permitted to bring their own, including takeouts from the excellent chippy next door.
🏵️➡️(Deansgate) 🚇(Deansgate/Castlefield) 🚌🐾🛜

City Arms ✅
46-48 Kennedy Street, M2 4BQ (near town hall, next door to Waterhouse pub)
☎ (0161) 236 4610
8 changing beers (sourced regionally; often Manchester, Titanic) Ⓗ
A compact pub, nearly 200 years old, with two traditional rooms and many original features. The room facing the street contains the bar and a few tables and is fairly basic. To the rear is a smarter, cosier room to relax in with good company. Eight handpulls offer a full range of beer styles in excellent condition – Titanic Plum Porter is a regular and very popular. The pub is often full and filled with groups of people conversing.
🏵️🌑➡️(Oxford Rd) 🚇(St Peters Sq) ♣️🚌🐾🛜

Crown & Kettle ✅
2 Oldham Road, M4 5FE (corner Great Ancoats St)
☎ (0161) 236 6418
7 changing beers (sourced nationally) Ⓗ
This Grade II-listed street corner building has a large drinking area in front of the bar along with a small vault and a snug at the rear. The high ornate ceiling in the main bar is well worth seeing. For warm weather there is now a terrace outside. Seven handpumps offering nationally sourced ales are joined by 10 craft kegs and a cider. There are tap takeovers and regular music nights.
🏵️🌑➡️(Victoria) 🚇(Shudehill) 🐾🚌🐾🛜

Grey Horse ✅
80 Portland Street, M1 4QX (jct Princess St)
☎ (0161) 228 2595
Hydes 1863, Original, Lowry, Dark Ruby; 1 changing beer (sourced locally; often Hydes) Ⓗ
One of the few smaller pubs in the city centre, like its neighbour the Circus. Mr and Mrs Rustrick started selling their beer here in 1871. Originally two rooms, it is now

one, served by a small semi-circular bar. A good choice of Hydes beer is always available. Busy on match days, the pub is popular with regulars and visitors to the city. Well worth a visit, but it has a stepped entrance that may make access difficult.

≈(Piccadilly) ♠(St Peters Sq) 🚌(1) ✿ 🛜

Hare & Hounds ★

46 Shudehill, M4 4AA (opp bus station)
☎ (0161) 832 4737
Joseph Holt Bitter; 2 changing beers (sourced regionally; often Joseph Holt, Robinsons) Ⓗ
Grade II-listed pub opposite Shudehill transport interchange. It is recognised as a CAMRA Heritage Pub because of the historic interior dating from 1925, though the building dates back to the early 1800s. Take time to admire the mottled tile frontage before entering. The central bar serves all three rooms – front vault, central vault and lounge bar. It is busy most days with loyal regulars and visitors to the city, and is also popular with sports fans. ≈(Victoria)♠(Shudehill)🚌✿🛜

Jack in the Box

1 Eagle Street, M4 5BU
8 changing beers (sourced nationally) Ⓗ
A lively bar with a relaxed atmosphere in the corner of the Mackie Mayor market hall, serving a good selection of quality cask and keg beers. With eight handpumps and 10 keg lines, it offers a changing range of local beers including several Blackjack beers plus some from further afield. Food can be obtained from vendors within the market and bar customers can sit anywhere in the hall. Real cider is available in bottles. Families and dogs are welcome. Closed on Monday.
🐕&♿≈(Victoria) ♠(Shudehill) ●🛗✿🛜

Lass o' Gowrie

36 Charles Street, M1 7DB (off Oxford Rd or Princess St)
☎ (0161) 273 5822
Hardys & Hansons Bitter; Morland Old Speckled Hen; 4 changing beers (sourced regionally; often Beartown, Northern Monkey, Wily Fox) Ⓗ
A Grade II-listed pub with a distinctive tiled exterior and some notable internal features, including the fireplace in the small snug. The Lass is popular with students in term-time and at weekends. It hosts open mic on Wednesday and a quiz night on Thursday. The outside smoking area has a decking area over the River Medlock. See if you can spot the plaque that commemorates the site of the first pissotiére in Manchester, which once drained into the river.
🐕◑≈(Oxford Rd) ♠(St Peters Sq) ♣🚌(50,147) ✿🛜

Marble Arch Inn ★

73 Rochdale Road, Collyhurst, M4 4HY (corner Gould St)
☎ (0161) 832 5914
Marble Manchester Bitter, Pint; 3 changing beers (sourced nationally; often Marble) Ⓗ
The Marble Arch is the birthplace of Manchester's iconic Marble Brewery. Through a grand entrance is a famously sloping mosaic floor leading to an ornate bar. Handpulls serve brewery fresh cask beer, keg lines dispense both Marble and guest beers. There is a small range of carefully selected artisanal real and live ciders. At the rear is a dining area and a yard with well designed kiosk shelters. Local CAMRA Cider Pub of the Year.
Q🐕✿◑≈(Victoria) ♠(Shudehill) ●🚌✿🛜

Molly House

26 Richmond Street, M1 3NB (jct Sackville St)
☎ (0161) 237 9329

3 changing beers (sourced regionally; often Beartown) Ⓗ
The Molly House is within the vibrant Village area. Set on two levels, its decor is described as post-Victorian decadent shabby chic. The beer range features local brewers and examples of many different beer styles. The Tea Room where the open kitchen is sited has the cask ale bar together with food service. Upstairs is the Bordello where the decor and lighting is more intimate, leading to the outdoor Veranda.
Q✿◑≈(Piccadilly) ♠(Piccadilly Gardens) ♣✿🛜

Peveril of the Peak ★

127 Great Bridgewater Street, M1 5JQ (jct of Great Bridgewater St and Chepstow St)
☎ (0161) 236 6364
Millstone Tiger Rut; Timothy Taylor Landlord; Titanic Plum Porter; 1 changing beer (often Brightside) Ⓗ
The Pev's warm welcome for locals and visitors alike has long made it a favourite of Manchester ale lovers. The splendour of its exterior's green tiles is matched by the interior's wood and stained-glass panels. Four handpumps serve cask ale in the front room, with a blackboard displaying the choice. The snug is a cosy alternative to the liveliness often found in the other two rooms. In 2021 it was the 50th anniversary of landlady Nancy's tenure. Q✿≈(Oxford Rd)♠(St Peters Sq)♣🚌✿

Port Street Beer House

39-41 Port Street, M1 2EQ (opp Brewer St)
☎ (0161) 237 9949 ⊕ portstreetbeerhouse.co.uk
7 changing beers (sourced nationally; often Kirkstall, Pomona Island) Ⓗ
Vibrant pub split over two floors of a former shop in the Northern Quarter, its walls adorned with pictures of beer and beer festivals. It serves seven cask beers from a variety of breweries, often showcasing stronger rather than session ales, alongside cider and a range of contrasting worldwide keg beers, bottles and cans. The pub hosts tap takeovers and beer festival fringe events. There is outside seating at the front and a courtyard at the rear.
🐕✿≈(Piccadilly) ♠(Piccadilly Gardens) ♣●🚌✿🛜

Smithfield Market Tavern 🏆

37 Swan Street, M4 5JZ (corner Coop Street)
6 changing beers (sourced nationally; often Blackjack) Ⓗ
One of the premier cask outlets in the Northern Quarter, the Smithfield was refurbished in 2020. A lively, modern take on a traditional pub, it is the flagship venue for the local Blackjack Brewery. It serves six cask ales, the majority from Blackjack, plus 10 keg beers, a cider and an interesting selection of bottled brews. A traditional bar billiards table and other pub games provide entertainment. ≈(Victoria)♠(Shudehill)♣●🛗✿🛜

Vocation & Co

101 Barbirolli Square, M2 3BD (down steps at back of Barbirolli Square) ⊕ societymanchester.com
Vocation Bread & Butter, Heart & Soul; 2 changing beers (sourced locally) Ⓗ
Bar run by Vocation Brewery in a shared food space called Society, opened in May 2021. It is at the back of Barbirolli Square below an office block and accessible down steps or a ramp. The Vocation bar is ahead of you as you enter the main entrance. There are four handpumps on the bar and a wall of keg taps behind – claimed to be the most in Manchester. Street food is available from five different vendors.
🐕✿◑&≈(Deansgate) ♠(St Peters Sq) ✿🛜

Marple

Bevi
Market Street, SK6 7AD
☎ (0161) 427 1383
4 changing beers (sourced regionally) Ⓗ
Formerly a paper shop, this micropub now forms a good addition to the pub options in the centre of Marple. Deceptively spacious, it contains a bar area and a raised lounge seating area. The four guest beers accompany a regularly changing cider or perry. A games room provides pool and darts plus a retro arcade machine. Live music is hosted every Friday and Saturday. It is convenient for local bus services and the Peak Forest Canal and Marple Locks. 15 minutes walk from Marple and Rose Hill railway stations. ✿≉♣♠🏠🚐

Samuel Oldknow
22 Market Street, SK6 7AD
☎ 07766 301627 ⊕ samueloldknow.co.uk
6 changing beers (sourced locally; often Brightside) Ⓗ
Named after a local mill owner who was responsible for much of the development of Marple and Mellor some 200 years ago, this is a somewhat quirky two-level bar in a converted shop. Six vintage-style handpulls dispense five changing real ales plus a real cider. The regular beers are from Brightside, complemented by guests from local micros. A range of bottled beers is also available to take away or to drink on the premises. Snacks and locally made pies keep hunger pangs at bay. Opening hours are subject to change. Q☞✿≉♠🚐♣🛜

Traders
111-113 Stockport Road, SK6 6AF
3 changing beers (sourced regionally) Ⓗ
An interesting combined micropub and bottle shop, based in converted shop premises, which was called Beer Traders before its expansion in 2019. Three handpulls serve regularly changing beers. The aim is to have one traditional bitter, one darker beer and something hoppy. Pie and mash are served at food times. Live music often features on Tuesday evening. ☞✿⊕≉(Rose Hill Marple) 🚐♣

Marple Bridge

Northumberland Arms
64 Compstall Road, SK6 5HD
☎ (0161) 285 3755 ⊕ thenorthumberlandarms.com
Robinsons Unicorn; 3 changing beers (sourced locally; often Robinsons) Ⓗ
Former Robinsons house that reopened in 2017 as a pub owned and run by the community. It retains the feel of an unchanged well-used local. The traditional exterior is enhanced by a pleasant beer garden. A small bar area serves three rooms, one of which is used for pub games. One beer is often a mild or a dark beer. Used by various groups for meetings and activities, the pub fulfils its role as a community venue. Frequent buses stop outside. ☞✿♣P🚐(383,384) ♣ 🛜

Spring Gardens
89 Compstall Road, SK6 5HE
☎ (0161) 637 5950 ⊕ springgardens11.com
3 changing beers (sourced locally; often Thornbridge, Timothy Taylor) Ⓗ
Following a period of closure, the Spring Gardens reopened in 2016. Smart, light and airy, this is a large pub with interconnected but defined spaces running off a large bar area. The bar counter features what may be called industrial chic fittings dispensing a wide range of keg and craft keg beers, in addition to the handpulls

offering three rotating guest beers and three ciders. A Crown Green bowling green is on site. Motorhome stopovers are welcome. ☞✿⊕◑♣P🚐(383,384)♣🛜

Middleton

Ring o' Bells
St Leonards Square, M24 6DJ
☎ (0161) 654 9245
JW Lees Bitter, Manchester Pale Ale; 2 changing beers (sourced locally; often JW Lees) Ⓗ
A pub since 1831, the Ringers enjoys an elevated location opposite the medieval parish church within a conservation area. Visitors can enjoy stunning views across to Oldham and beyond, especially at night. Lees seasonal and Boilerhouse beers are served. Quizzes and live music confirm the pub's community focus. On May bank holiday an annual Maypole event takes place, with a unique Pace Egg play on Easter Monday. The beer garden to the rear is a hidden bonus. ✿♣P🚐(17)♣🛜

Tandle Hill Tavern
14 Thornham Lane, M24 2SD (1 mile on unmetalled road from either A664 or A627)
☎ (0161) 376 4492
JW Lees Bitter, Stout; house beer (by JW Lees); 1 changing beer (sourced locally; often JW Lees) Ⓗ
Nestled among farms, this neat little pub is well worth the one-mile walk from either end of a potholed lane to reach it. It has a main bar and lounge area with a quiet side room. There are benches to the front and side for outdoor drinking. The house beer is dry hopped Lees Bitter, and Lees Boilerhouse and seasonal beers feature. A popular stop-off for walkers, dogs are welcome. In adverse weather or in winter phone ahead to check opening times. No food is served. Q✿P♣

Milnrow

Waggon Inn
35 Butterworth Hall, OL16 3PE
☎ (01706) 648313 ⊕ waggoninnmilnrow.co.uk
Banks's Amber Ale; 2 changing beers (often Jennings, Marston's) Ⓗ
Built in 1782, this pub, known locally as the Back Waggon, has a traditional and pleasant ambience. The building has been sympathetically refurbished, retaining many original features including mullioned windows. Three handpumps are on the bar serving beers from the Marston's portfolio. The pub has a good reputation for its excellent food menu, tapas and Sunday roast at reasonable prices. Convenient for the Milnrow Metrolink stop and local bus services, both a short walk away. ☞✿⊕◑♿🚐P🚐🛜

Monton

Monton Tap
165 Monton Road, M30 9GS
☎ 07413 487560
3 changing beers (sourced locally; often Marble, Salopian) Ⓗ
A converted shop premises, now sporting a long room with a bar at the top end. Opened in 2018, it has become a popular venue serving three ever-changing cask ales – usually including an IPA and a dark beer. There is also a range of KeyKeg beers and lagers. Situated opposite the Park pub and next but one to the Malt Dog. 🚐♣🛜

Mossley

Commercial Hotel L
58 Manchester Road, OL5 0AA
☎ 07919 153879
Millstone Stout, Tiger Rut; Wainwright; 1 changing beer (often Marston's) Ⓗ
The Commercial opened in 1831 and was enlarged in 1859. It was the first pub in Bottom Mossley and initially catered for coach travellers and later for those arriving by rail. Nowadays it is more likely to be a stopping point for rail ale trail enthusiasts. The refurbished open-plan interior has a central bar. The Commie is a boisterous pub, particularly at weekends when you are likely to encounter a disco or karaoke. ᗡ❀≠🚌(343,350)❀ 🛜

Gillery L
1-3 Old Brow, Tameside, OL5 0AD (Stamford Rd above railway station)
☎ (01457) 237007 ● thegilleryinthebank.co.uk
Donkeystone Javanilla; Millstone Tiger Rut, True Grit; 3 changing beers (often Donkeystone, Millstone) Ⓗ
This café-bar was converted from the last remaining bank in Mossley and opened in 2019. The stone building towers over Stamford Road immediately behind the railway station. The owner is keen to welcome runners, walkers, cyclists and all, and food is available until 9pm. Live music features most weekends, often from local musicians, and local artists' work is on display. Four handpumps dispense beers from the town's Millstone Brewery and also from Donkeystone. ᗡ❀◑≠🚌❀ 🛜

Rising Sun L
235 Stockport Road, OL5 0RQ
☎ (01457) 238236 ● risingsunmossley.co.uk
Millstone Stout, Tiger Rut; 6 changing beers (sourced locally; often Rising Sun, Saltaire, Thornbridge) Ⓗ
A former Wilsons pub but a free house for many years, the present owner added a small brewery in 2016 to augment the range of regular and guest beers. Pale, citrusy beers dominate, dispensed from 10 handpumps, with two reserved for cider. Open-plan with log-burning fires, the pub has fine views across the Tame Valley towards the Pennines beyond. Large TVs abound, mainly for City and United matches, and with bands playing some nights, a boisterous atmosphere is assured. ᗡ❀◗P🚌(353) ❀🛜

Oldham

Ashton Arms L
28-30 Clegg Street, OL1 1PL (opp Odeon cinema complex)
☎ (0161) 630 9709
5 changing beers (sourced locally; often Millstone, Ossett, Pictish) Ⓗ
Traditional well-run town-centre free house, recently refurbished, retaining the open fireplace. The open-plan interior is on two levels, with new tables and chairs. An excellent range of four to six handpulled beers is available, many from local microbreweries. The pub also offers a range of Belgian and German beers, and often a real cider on handpump. Good-value home-cooked food is served daily. Live sport is often shown on TV. A perennial entrant in this Guide. Q❀◑P🚌(Central)❀🚌🛜

Cob & Coal Tap L
Units 12-14 Tommyfield Market, Albion Street, OL1 3BG
☎ (0161) 624 0446
6 changing beers (often Pictish, Thirst Class, Wishbone) Ⓗ

This micropub has become a firm favourite with real ale and cider drinkers. Bijou inside, with extra seating outside in the market hall, it is a convivial meeting place for all. It offers six changing real ales on handpump, eight changing real ciders on gravity, and foreign beers on tap and in bottle. Food is available from adjacent market stalls. A warm and friendly welcome is assured. Local CAMRA Cider Pub of the Year 2020 and 2021, and CAMRA Greater Manchester Regional Pub of the Year 2021. Q🚌(Central)❀🚌🛜

Fox & Pine ▼
18 Greaves Street, OL1 1AD
☎ (0161) 628 2475
Draught Bass; 10 changing beers (sourced regionally; often Durham, Mallinsons, Pictish) Ⓗ
Recently opened free house adding greatly to the real ale scene in Oldham town centre. The busy bar area is downstairs, two rooms upstairs offer more relaxed seating arrangements. Ten handpumps serve a choice of beer styles – Draught Bass is always available. Three changing dark beers always feature alongside an excellent changing range of lighter coloured beers. Up to six real ciders are served on gravity from the cellar. In addition there are five Bavarian beers from ABK on tap. Q❀&🅰(Central) ❀🚌❀🛜

Orrell

Posthouse
261B Orrell Road, WN5 8NB
☎ (01942) 203122 ● posthouse-bar.co.uk
Wily Fox Crafty Fox; 4 changing beers (sourced locally; often Wily Fox) Ⓗ
Posthouse was established in 2019 as a modern bar offering a unique food and drink experience. In 2020 it was extended into the adjacent building. There are five handpulls on the bar, usually dispensing at least two beers from Wily Fox, along with up to 10 keg beers. Outside, to the front, is a heated and covered area. A popular quiz night is held on Thursday. ❀◑🚌❀

Patricroft

Queen's Arms
Green Lane, M30 0SH (adjacent Patricroft railway station, up ramp opp James Nasmyth Way)
☎ (0161) 789 2019
Sharp's Doom Bar Ⓗ
Known locally as the Top House, this traditional pub was Grade II listed at the instigation of the local CAMRA branch. Built in 1828 in as a refreshment stop in readiness for the opening of the Liverpool and Manchester Railway, it lays claim to be the world's first railway pub. It was renamed after Queen Victoria visited Salford in 1851. The bar serves a comfortable lounge to the rear, a vault and across a lobby a homely parlour. Winner of the local CAMRA 'Neil Richardson' award for a fine example of a traditional unspoilt pub in 2010 and 2016. Q ᗡ❀≠♣P🚌(67,100)❀ 🛜

Stanley Arms ★
295 Liverpool Road, M30 0QN (corner Eliza Ann St)
☎ 07833 092341
Joseph Holt Mild, Bitter Ⓗ
A small 1920s street corner local with etched windows. Entering through the side door on Eliza Ann Street, turn right into the vault or straight on into the lobby corridor. The tiled corridor leads to two comfortable rooms, the rear one with a replica cast iron range. Notice the old bell push switches built into the seating, once used to summon a waiter, and interesting photographs of early

local scenes. Awarded Grade II-listed status in 2014, the Stanley Arms has been identified by CAMRA as having a nationally important historic pub interior.
❀✦♿🚌(67,100)

Prestwich

Keg, Cask & Bottle

Unit 7 Longfield Centre, M25 1AY
🌐 kegcaskbottle.co.uk
2 changing beers (often Brewsmith, Thornbridge, Track)
Located within the pedestrianised Longfield shopping precinct, this small bar/off sales establishment has two handpumps serving rotating locally sourced cask ales (often Marble, Brewsmith, Track, Squawk, Brightside, Red Willow). In addition there is a selection of nationally and internationally sourced membrane keg, bottled and canned beers. The bar welcomes families and dogs. Bus stops are close by and Prestwich Metrolink station is only a five minute walk. Q🕏🚌🐕♿🖤🛜

Ostrich

163 Bury Old Road, M25 1JF
☎ 07827 850269
Joseph Holt Mild, Bitter, Two Hoots Ⓗ
Built over 300 years ago, this excellent community pub boasts five separate rooms off the bar area. The enclosed beer garden is popular with families, and children are welcome until 7pm. Puzzles are available, or get free camera/PC advice on Wednesday evening from the camera group meeting. You can even pick fruit from the trees and bushes in the rear garden. Functions are bookable, with catering by arrangement.
Q🕏❀♿🚋(Heaton Park) ♣P🐕❀🛜

Royal Oak

23-25 Whittaker Lane, M25 1HA
☎ (0161) 773 8691
Hydes Original, Lowry; 1 changing beer (often Hydes) Ⓗ
Superb traditional local pub close to Heaton Park tram stop and convenient for buses. Three handpumps serve Hydes Ales, kept in excellent condition by the management, who have run this friendly pub for 23 years. A comfortable through lounge area fronts the bar, and to the rear a corridor leads to a large games room where traditional pub games are played. Outside, a pleasant beer garden is available for warmer days.
Q🕏❀♿🚋(Heaton Park) ♣P🐕❀🛜

Radcliffe

New Inn

387 Ainsworth Road, M26 4HF
☎ (0161) 723 0583
Ossett White Rat; Ringwood Razorback; 1 changing beer Ⓗ
A traditional, friendly, red-brick pub, free of tie, with three real ales on offer at reasonable prices. Refurbished inside in 2019, it offers a clean, pleasant decor and comfortable seating. There is a large beer garden at the rear with barbecues in summer. Various activities take place including karaoke, quiz night, a weekly meat raffle and live music on Saturday evenings, giving it a real community feel. 🕏❀♿♣P🚌(98,471)❀🛜

Ramsbottom

Irwell Works Brewery Tap 🄻

Irwell Street, BL0 9YQ
☎ (01706) 825019 🌐 irwellworksbrewery.co.uk

Irwell Works Lightweights & Gentlemen, Breadcrumbs, Copper Plate, Costa Del Salford, Marshmallow Unicorn, Mad Dogs & Englishmen; 8 changing beers (often Irwell Works) Ⓗ
Located in the centre of Ramsbottom and directly over the brewery itself, the Tap is full of character and a friendly pub to visit. Eight handpumps usually offer the full Irwell Works range – beers are traditional in style, brewed with English hops and barley. Snacks are available Friday to Sunday until 5.30pm. The pub is a short walk from the East Lancashire Railway, and is a central point of Ramsbottom's real ale renaissance.
❀🍴🚉(ELR) ♣🚌🛝(472,474) ❀🛜

Ramsbottom Royal British Legion

Central Street, BL0 9AF
☎ (01706) 822483
Fyne Ales Jarl; 1 changing beer (sourced locally) Ⓗ
This is a small, welcoming club just off the main street near the crossroads in the centre of town. Non-members are welcome but regulars are expected to join the club. There are two beers on sale – Fyne Ales Jarl and a rotating guest. The club can be quiet at times but a warm welcome is always guaranteed. Some military memorabilia is on display around the walls.
🕏🚉(ELR) ♣🚌🛜

Rochdale

Baum 🄻

35 Toad Lane, OL12 0NU
☎ (01706) 352186 🌐 thebaum.co.uk
6 changing beers (sourced nationally; often Pictish, Vocation) Ⓗ
The Baum is situated in the Toad Lane conservation area and its attractive appearance and tasteful decor reflect that. A former CAMRA National Pub of the Year, it offers six ever-changing cask ales and up to two guest ciders. As befitting its status, the pub has never rested on its laurels, with knowledgeable staff serving the excellently kept beers. The food menu is inventive but traditional and reasonably priced.
Q🕏❀🍴🚋(Town Centre) ❀🚌❀🛜

Bombay Brew

1 Drake Street, OL16 1LW
☎ (01706) 869502
House beer (by Vocation); 2 changing beers (sourced locally; often Bad Seed, Pictish) Ⓗ
Housed in a former manor and coaching house in the centre of Rochdale, Bombay Brew has brought a whole new experience to the real ale scene – this is a pub where you can drink well-kept real ale and eat Indian food. There are three handpumps, one serving the house beer by Vocation, another a guest ale, and the third usually serving a cider. The food is innovative, more 'Indian influence' rather than the usual curry house staples. 🕏🍴🚉🚋(Town Centre)🚌❀🛜

D'Ale House

18 Drake Street, OL16 1NT
Brightside Odin Blonde; house beer (by Pictish); 4 changing beers (often Brightside, Pictish) Ⓗ
Located in the town centre, this ale house opened in June 2021. A former hairdressers' salon, it has been fully refurbished to a high standard and is in an ideal location for an afternoon or evening out. There are five handpumps usually selling local beers, plus two German lagers, eight keg taps, and a good selection of other drinks. Close to the tram and bus interchange, this micropub has become a welcome addition to Rochdale's Ale Trail. Q🚉🚋(Town Centre)🛝🚌

Flying Horse Hotel L

37 Packer Street, OL16 1NJ

☎ (01706) 646412

JW Lees Bitter; 9 changing beers (sourced locally; often Phoenix, Pictish, Serious) Ⓗ

Known locally as The Flyer, this is a three times winner of CAMRA Greater Manchester Pub of the Year. Built in 1691 and rebuilt in 1926, the pub retains traditional features including log fires. It is situated outside Rochdale's magnificent gothic Town Hall. Ten well-kept, quality cask ales are sold, nine constantly changing, alongside two real ciders. There is an extensive home-made food menu offering good value for money. Live music plays on Thursday, Friday and Saturday.

⑤✌◗➳Ⓡ(Town Centre) ⬥P☲❀ 🛜

Oxford

662 Whitworth Road, OL12 0TB (on A671 Rochdale to Burnley road, approximately 1½ miles from Rochdale centre)

☎ (01706) 345709 ⊕ theoxfordrochdale.com

Wainwright; 4 changing beers (sourced nationally; often Bowland, Hawkshead, Timothy Taylor) Ⓗ

The Oxford is a stone-built, family-run pub, set at the foot of the Pennines, and has a large car park. Internally, the layout is open-plan with two dining areas and the bar in between. The main dining area is largely separated from the bar area. Dining is also available in the large, attractive beer garden. The pub has a good reputation for its real ales and fresh, cooked-to-order and well-presented food. Q⑤❀◗Ⓛ&P☲(486)🛜

Romiley

Jake's Ale House

27 Compstall Road, SK6 4BT

☎ 07927 076941

5 changing beers (sourced locally) Ⓗ

In just a few years this micropub in a former shop has established itself as a popular part of the Romiley pub scene. It has a cosy front bar with a relaxed atmosphere, and a smaller room at the rear. Many of the beers are from local microbreweries. It is close to the railway station and good bus routes, and the Peak Forest Canal is a short walk away. Opening hours may vary.

Q⑤➳♣☲❀

Royton

Puckersley Inn ✔

22 Narrowgate Brow, OL2 6YD (off A671 via Dogford Rd and Fir Lane)

☎ (0161) 652 2834

JW Lees Bitter, Manchester Pale Ale, Supernova; 1 changing beer (sourced locally; often JW Lees) Ⓗ

A detached, stone-fronted pub on the edge of the green belt, with panoramic views from the dining room and garden over Royton, Shaw and Oldham. It has a small vault, an open-plan lounge and a dining extension where children are welcome. An excellent range of meals is served daily. Three handpulled beers are available from the JW Lees range. The large garden runs alongside farmland. A popular local where conversation predominates. ⑤❀◗P☲(408)🛜

Sale

JP Joule L

2A Northenden Road, M33 3BR

☎ (0161) 962 9889

Greene King Abbot; Ruddles Best Bitter; Sharp's Doom Bar; Wychwood Hobgoblin Gold; 4 changing beers (sourced nationally; often Hawkshead, Peerless, Titanic) Ⓗ

Popular Wetherspoon pub on the edge of Sale town centre, well served by tram, bus and taxi. A grand spiral staircase separates the 14 handpumps distributed over two floors, offering eight different well-kept real ales in a range of styles. Beers are sourced from a selection of local, regional and national breweries and served by friendly staff. There is a small covered veranda to the front of the pub popular with smokers. The pub is named after the famous physicist who used to live in Sale. Q⑤❀◗Ⓛ&Ⓡ☲🛜

Salford

Eagle Inn

18-19 Collier Street, M3 7DW (opp Rolla St)

☎ (0161) 819 5002 ⊕ eagleinn.co.uk

Joseph Holt Bitter, Chorlton Pale Ale, Two Hoots Ⓗ

A hidden gem of a traditional back-street boozer, known to locals as the Lamp Oil. A Grade II-listed building dating from 1902, it features a fine terracotta plaque of an eagle above the door – for years this was the only pub sign. There are three small rooms off a central corridor, with a central bar. The cottage next door has been converted into a live music venue. Handy for the Manchester Arena. Q⑤❀&➳(Central) Ⓠ(Victoria) ♣⬥☲❀🛜

New Oxford L

11 Bexley Square, M3 6DB (corner of Browning St, off A6 Chapel St)

☎ (0161) 832 7082 ⊕ thenewoxford.com

House beer (by Phoenix); 16 changing beers (sourced regionally; often Empire, Moorhouse's, Phoenix) Ⓗ

Two-room corner house dating from the 1830s with a refurbished and modernised interior. A winner of many awards, its central bar features 20 handpumps and 24 fonts. The range of 17 cask ales is sourced regionally and usually includes at least two dark beers. The remaining three handpumps are for cider or perry – one from Thatchers plus two guests. There are also around 200 bottled Belgian beers on offer.

⑤❀&➳(Central) ⬥☲❀🛜

Stalybridge

Bridge Beers L

55 Melbourne Street, SK15 2JJ

☎ 07948 617145 ⊕ bridgebeers.co.uk

4 changing beers (sourced locally; often Bridge) Ⓖ

A combined micropub and bottle shop on the main pedestrianised shopping street. Originally a hairdressers', it has a small entrance area leading to the bar, which sits in front of a row of stillaged casks, of which four are generally in use. The bottle display is opposite. Upstairs is a comfortable Victorian style lounge. The four constantly changing beers are mainly from Bridge Beers, dispensed by gravity, although locally sourced guests are also occasionally available. Food is limited to crisps, nuts and pork scratchings. Q⑤➳♣☲❀

Cracking Pint

41 Melbourne Street, SK15 2JJ

☎ 07512 753544

4 changing beers (sourced regionally) Ⓗ

Spacious microbar opened in 2017 by a local CAMRA member and located next to the canal in the main pedestrianised shopping street. It serves four changing real ales, mainly from local breweries but some from further afield. There is also a good selection of bottled beers, many from Germany. This is a bar where

conversation dominates rather than piped music, TV screens or fruit machines. Dogs are welcome, as are children until 6pm. Q♿🕭≠🖶🐾🛜

Society Rooms ✔

49-51 Grosvenor Street, SK15 2JN

☎ (0161) 338 9740

Greene King Abbot; Ruddles Best Bitter; 6 changing beers (sourced nationally) Ⓗ

Popular split-level pub near the town centre bus terminus, named after the former Co-op store it now occupies. It was extended into adjacent premises in 2018, also adding a spacious beer garden, making it one of the largest Wetherspoons in the UK. Enthusiastic management and a strong focus on cask beers make this a favourite with local drinkers, with eight real ales and two ciders usually available. Two beer festivals are held annually. A short walk from bus terminus.
🕭🏵🕭🕭≠🖶🛜

Station Buffet Bar

Stalybridge Railway Station, Platform 4, Rassbottom Street, SK15 1RF (on platform 4)

☎ (0161) 303 0007

6 changing beers (sourced regionally) Ⓗ

One of the few remaining Victorian station buffet bars and well worth missing a train for. This well-loved gem has nine handpumps, with a minimum of six dispensing a variety of local and regionally sourced beers, plus at least one real cider or perry. A good range of bottled beers is also available. Events include Meet the Brewer nights and quiz night every Monday. On the Transpennine Real Ale Trail, it can be especially busy on Saturdays. Q♿≠🕭🖶🖶

White House ✔

1 Water Street, SK15 2AG

☎ (0161) 303 2154

Hydes Original; 5 changing beers Ⓗ

This popular pub, close to both bus and rail stations, is semi open-plan but retains four distinct drinking areas. Up to five varying guest beers from microbreweries and Hydes Studio complement the Original. Pies are available. A popular live music venue, folk night is every Thursday and bands play most Fridays and Saturdays.
🏵≠🖶🐾

Standish

Albion Ale House Ⓛ ✔

12 High Street, WN6 0HL

☎ (01257) 367897 🌐 albionalehouse.co.uk

8 changing beers Ⓗ

The first micropub in Standish, located in a former shop on the High Street. Now well established, it has a loyal clientele and has won local CAMRA Community Pub of the Year. The beer garden was extended during lockdown. At least five cask ales are on offer, sometimes more, including one dark beer. Snacks are also usually available. There are occasional live music and beer festivals. Q🕭🏵🕭🖶(362,113)🐾

Hoot

34A High Street, WN6 0HL

☎ (01257) 806262 🌐 thehoot.bar

7 changing beers (sourced nationally) Ⓗ

This modern café-bar with interesting accent lighting has a tiled slate floor, wood-burning stove and modest silent TVs. Novelty owls feature in the large single-room bar area. Varying local real ales and ciders are available alongside speciality coffees and prosecco, attracting all age groups. Light bites and sandwiches are also served.
Q🕭🏵🕭🕭🖶🖶🛜

Standish Unity Club Ⓛ

Cross Street, WN6 0HQ

☎ (01257) 424007 🌐 standishunityclub.com

Sharp's Doom Bar; 4 changing beers (sourced regionally) Ⓗ

In the centre of Standish but tucked away so a little tricky to find, this popular club offers five real ales including one dark beer, often Titanic Plum Porter. The club is divided in two – a large function room and a bar area including the games room, plus a quieter drinking area. A frequent winner of local CAMRA Club of the Year and a runner-up Regional Club of the Year.
Q🕭🕭♿🖶🖶(362,113)🛜

Stockport

Angel Inn

20 Market Place, SK1 1EY (opp Market Hall)

☎ (0161) 429 0251

House beer (by Beartown); 5 changing beers (sourced regionally) Ⓗ

After 67 years of non-pub use, the Angel was reborn in 2018 by a local consortium. It is a vibrant combination of the traditional and new – stand-up drinking near the bar gives way to two seating areas behind, with a mix of wainscoted and rustic brick walls. The bar is dominated by an impressive array of German lager fonts, without detracting from its commitment to serving real ales on handpump. A large selection of gins is also kept. A popular drop-in for the town's market customers.
🕭🏵♿≠🖶🐾🛜

Arden Arms ★ ✔

23 Millgate, SK1 2LX (jct Corporation St)

☎ (0161) 480 2185

Robinsons Dizzy Blonde Ⓗ**, Old Tom** Ⓖ**, Trooper, Unicorn; 1 changing beer (often Robinsons)** Ⓗ

Grade II listed and identified by CAMRA as having a nationally important historic pub interior, this multi-room pub is just down the hill from Stockport's Market Place. Note the superb curved, glazed bar, the grandfather clock, and particularly the snug, which can only be accessed through the bar area itself (one of only four such in the UK). The building alone warrants a visit, but the food is also highly recommended. The large, attractive courtyard hosts live music on Saturday nights. A true gem. 🕭🏵🕭🖶(384,383)🐾🛜

Bakers Vaults

Market Place, SK1 1ES (jct Vernon St)

Robinsons Dizzy Blonde, Unicorn, Trooper, Old Tom; Titanic Plum Porter; 3 changing beers (sourced nationally) Ⓗ

Located opposite the town's historic market hall, this lively and vibrant pub has a spacious interior with a comfortable arrangement of seating to the front of and behind the central bar. High ceilings and arched windows accentuate the gin-palace style in which the pub was built. This is one of the few Robinsons Brewery houses to serve guest beers from other brewers. A former local CAMRA Pub of the Year. 🕭🏵🕭≠🖶🐾🛜

Blossoms

2 Buxton Road, Heaviley, SK2 6NU (at A6/A5102 jct)

☎ (0161) 222 4150

Robinsons Dizzy Blonde, Unicorn Ⓗ**, Old Tom** Ⓖ

Landmark street-corner local whose three rooms radiate off a traditional drinking lobby, served by a central bar. Many old features remain, particularly in the rear Smoke Room. The full Robinsons range is often available, including a seasonal beer. A popular quiz is held on Thursday night; the upstairs function room hosts live

music on Friday night and at the weekend. Outside drinking is catered for in a cobbled part of the street and former toilets are now a smoking area.
Q✿⑪◗♣P�█●❄

Magnet

51 Wellington Road North, Heaton Norris, SK4 1HJ (jct Duke St)
☎ (0161) 429 6287 ⊕ themagnetfreehouse.co.uk
RedWillow Weightless; Salopian Oracle; Track Sonoma; 11 changing beers (sourced nationally) Ⓗ
This popular, family-run pub has been a free house for over a decade. It offers 14 cask ales alongside 12 craft keg beers, with digital menu boards displaying the available selection. On entry, to the left is a bustling vault leading to a lower pool room, and to the right is a series of other rooms. Outside is a twin-storey beer terrace. A pizza vendor operates at the weekend from 5.30pm. Local CAMRA Pub of the Year 2020. ➤✿❁◗♣P�█●❄

Nursery ★ ✔

258 Green Lane, Heaton Norris, SK4 2NA (off A6, jct Heaton Rd)
☎ (0161) 432 2044 ⊕ nurseryinn.co.uk
Hydes 1863, Dark Ruby, Hopster, Original, Lowry; 1 changing beer (often Hydes) Ⓗ
This former CAMRA National Pub of the Year is a classic, unspoilt 1930s pub hidden away in a pleasant suburb. Now a Grade II-listed building, the multi-roomed interior includes a traditional vault accessed via a separate entrance and a comfortable, wood-panelled lounge. Food is served all day, every day. There is a quiz every Thursday and live music often features on Friday and Saturday. The pub has its own bowling green at the rear surrounded by seating. ➤✿⑪◗♣P�█(25,364)●❄

Olde Vic

1 Chatham Street, Edgeley, SK3 9ED (jct Shaw Heath)
⊕ yeoldevic.pub
6 changing beers (sourced nationally) Ⓗ
Now owned by its regulars, Ye Olde Vic has undergone a continuous programme of improvements over the past three years, all of which has been carried out without compromising its unique atmosphere. There is bric-a-brac at every turn, while pumpclips on the walls and ceiling are testimony to the array of guest beers sold over the years – as well as a reminder of numerous now defunct breweries and beers. Six ever-changing guest ales come from small breweries around the UK. The beer garden at the back is a summer suntrap. Q✿❄♣�█●❄

Petersgate Tap

19A St Petersgate, SK1 1EB (jct Etchells St)
☎ 07925 078426 ⊕ petersgatetap.com
6 changing beers (sourced regionally)
This family-run bar on two floors is a dark beer specialist and multiple award winner, notably for cider and perry. Downstairs, the decor is fairly modern with a continental feel to the bar area. Recycled oak-topped tables and a mix of seating sit under interesting posters and breweriana on the walls. Upstairs is a bottle shop offering a wide range of British and foreign craft beers along with an additional drinking area which hosts regular events and tastings. ➤✿⑥❄➢➢●❄

Swan with Two Necks ★

36 Princes Street, SK1 1RY (jct Hatton St)
☎ 07500 054190
Robinsons Dizzy Blonde, Unicorn, Old Tom; 1 changing beer (often Robinsons) Ⓗ
The pub was rebuilt in the 1920s and the interior remains pretty much unchanged since then – of particular note are the classic light-oak panelled drinking lobby and the

top-lit middle room with mock-Tudor fireplace. Further back is a small lounge-cum-diner. The outside area at the rear has been stylishly reworked and is a lovely spot to enjoy a pint in the warmer months. Home-cooked food, available lunchtimes Monday to Saturday, is recommended. Q➤✿⑪◗♣➢➢(325,330)●❄

Swinton

Wobbly Stool

233 Manchester Road, M27 4TT
☎ 07764 621471
3 changing beers (sourced locally; often Beartown, Brightside)
Opened in 2019 on the main A6 road, this small, interesting bar has three handpumps offering an ever-changing array of beers, usually including a stout and something from Beartown Brewery. There is also a fine selection of craft beers in KeyKeg, plus cider from Westons and bottled Belgian fruit beers. Tuesday is games night. Outside, there is a small garden at the rear and tables at the front. Sadly, none of the bar stools is wobbly.
✿◗♣●❄

Tottington

Dungeon Inn

9 Turton Road, BL8 4AW
☎ 07706 737753
Wainwright; house beer (by Thwaites); 4 changing beers Ⓗ
A traditional, family-friendly Thwaites pub. It has a quiet front lounge featuring an open fire in winter months, and a separate pool room off the main bar seating area. To the rear at a lower level is a beer garden. Four handpumps serve regular and guest ales. The pub is recognised by CAMRA as having a historic interior of regional importance and listed in Real Heritage Pubs of the North West. Dogs are welcome.
➤✿◗♣➢(480,469) ●❄

Tyldesley

Union Arms ⍾

83 Castle Street, M29 8EW
☎ (01942) 870645
Thwaites Gold; Wigan Brewhouse California; 1 changing beer (sourced regionally) Ⓗ
This family-friendly pub is part of the local community, with regular charity events and occasional theme nights including live music. The interior is divided into a number of separate connected areas. On the left is the vault and on the right is a lounge used at meal times. Outside is a large patio area. The guest beer is from Wigan Brewhouse, with California the most regular and popular choice. Fresh home-cooked food is served until 7.45pm, with Sunday lunch until 6pm. Sporting events are shown on TV. ➤✿⑪◗♣➢(V2)●

Urmston

Barking Dog

9A Higher Road, M41 9AB
☎ (0161) 215 0858 ⊕ the-barking-dog.co.uk
House beer (by Marston's); 2 changing beers (sourced nationally) Ⓗ
Converted from a post office, this popular local venue has an L-shaped main room with the bar covering half the length on one side. Five handpumps are on the bar, one usually for a fruity cider, the others for locally and regionally sourced beers. Turning right through a small corridor, the origins of the building are evident, with a

strong room now filled with bottles and further on the snug, a quiet room away from the main bar. ♿🏠🕐👌♿≢♣🚪🐕🛇🛜

Flixton Conservative Club ✔

Abbotsfield, 193 Flixton Road, M41 5DF
☎ (0161) 748 2846 ⊕ flixtonconservativeclub.co.uk
6 changing beers (sourced nationally; often Brightside, Dunham Massey, Pictish) Ⓗ
A multi CAMRA award-winning club with six handpumps offering an ever-changing range of ales from mainly local breweries. A well-maintained, comfortable venue, it has numerous facilities including a bowling green, four snooker tables, darts room and Sky/BT TV showing major sports events. Regular entertainment includes live music, quiz nights, bingo, race nights and charity events. Visitors are warmly welcomed but must apply for membership if using the club on a regular basis.
♿🏠≢(Chassen Rd)♣🚪(255,256)🛜

Lord Nelson

49 Stretford Road, M41 9LG
☎ 07827 850255
Joseph Holt Mild, Bitter; 1 changing beer (sourced locally; often Joseph Holt) Ⓗ
Imposing building on the main road with snugs, a vault and 'best' lounge. The Cask Bitter and Mild from Holt are always in good form due to their high turnover, and a wide range of keg beers is also popular, including the recently added Trailblazer stout. Bottles are also available and there is a gin bar. Quiet during the day, the pub comes to life in the evening, especially when football is shown on the many largescreen TVs. There is a quiz night every Tuesday and Disco Erotica on Saturday.
🏠≢♣🚪🐕🛜

Prairie Schooner Taphouse 🅛

33 Flixton Road, M41 5AW
⊕ prairie-schooner-taphouse.co.uk
4 changing beers (sourced locally; often Brightside, Cloudwater, Squawk) Ⓗ
This larger than normal micropub opened in 2014 and has become a favourite with real ale drinkers, both local and from further afield. The four ever-changing, mainly locally sourced cask ales are supplemented by eight craft beers on tap and by an extensive range of bottled and canned beers from the UK, USA and the continent. Hogan's French Revelation cider and bottled ciders are also available. There are two quiz nights each week, a regular bring-your-own-vinyl music night and occasional live music or a DJ. Q♿🏠👌≢♣🚪(255)🐕🛜

Wardley

Morning Star

520 Manchester Road, M27 9QW (opp Bagot St)
☎ (0161) 727 8373
Joseph Holt Mild, Bitter, Two Hoots; 1 changing beer (sourced locally) Ⓗ
Built in 1890, this red-brick building is a popular community local with a modernised interior. As you enter, the vault is to the left with darts and TV. To the right is a small open front room leading to a much larger main lounge. The three rooms are served from a central bar. This is one of the few pubs still selling Holt Mild. The front terrace beer garden is well used in summer. Wednesday is quiz night, live entertainment features at the weekend. An extensive food menu is served until 8pm. ♿🏠🕐👌≢(Moorside)♣🚪🐕🛜

Westhoughton

Beer School ♈ 🅛

88 Market Street, BL5 3AZ
☎ (01942) 396280 ⊕ thebeerschool.co.uk
4 changing beers (sourced locally) Ⓗ
This micropub, decked out like a school, has developed into a lively and popular part of the Westhoughton community. On the bar are four handpumps offering beers of varied style and strength, some from local suppliers. Up to four bag-in-box real ciders are available, many from leading 'real' producers. Drinks can be sampled before ordering. Note that the toilets are upstairs. Local CAMRA Pub and Cider Pub of the Year 2022. 🏠≢♣🚪🐕🛜

Brewery Tap 🅛

55 Market Street, BL5 3AG
7 changing beers (sourced locally; often Blackedge) Ⓗ
Opened in 2019, this is the second outlet for local award-winning Blackedge Brewery. It has the friendly, community feel of a micropub. The timber and brick decor is complemented by subdued lighting, creating a homely atmosphere. Seven handpumps serve the core range of Blackedge beers supplemented by its seasonal, occasional and one-off beers. There are also nine modern keg fonts, all with beers from Blackedge. Note that the toilets are upstairs. ♿≢♣🚪🛜

Whalley Range

Hillary Step 🅛

199 Upper Chorlton Road, M16 0BH
☎ (0161) 881 1978 ⊕ hillarystep.co.uk
5 changing beers (sourced regionally; often Mobberley, Pomona Island, RedWillow) Ⓗ
Modern bar in a small strip of shops and bars a short walk north of Chorlton. Five handpumps serve beers mostly from local and regional breweries such as RedWillow, Mobberley, Pomona Island and Thornbridge, usually including a dark ale in winter. Eight keg fonts regularly feature beers from smaller national and local craft breweries. Table service is offered. The outside drinking area now has sides for winter protection and is opened up in summer. Nuts and nibbles are available. ♿🏠🚪(Firswood)♣🚪(86)🐕🛜

Wigan

Anvil 🅛

Dorning Street, WN1 1ND
☎ (01942) 239444
Banks's Mild; Brakspear Oxford Gold; Wainwright; 4 changing beers (sourced nationally) Ⓗ
Popular town-centre pub, close to the bus station, with seven handpumps offering various guest beers, two boxed ciders, six draught continental ales and a range of bottled beers. Several TV screens show sports action and the small snug has the wall of fame displaying numerous award certificates. There is a garden at the rear. Over-18s only. 🏠(Wallgate)🚪

Crooke Hall Inn 🅛

Crooke Road, WN6 8LR
☎ (01942) 236088
6 changing beers Ⓗ
Large, multi-roomed canalside pub in picturesque Crooke village, just outside Wigan. Popular with locals and visitors alike, dogs and children are welcome until 9pm. Home-made food features locally sourced ingredients where possible. There is a separate cellar bar, ideal for functions, and a large beer garden. The pub is very much

the hub of the village and is a three-times winner of the local CAMRA Community Pub of the Year.
🛏️☕🍴♿️🅿️🚌 (635,635) 🐕 🛜

Doc's Alehouse 🅛

85 Mesnes Street, WN1 1QJ
☎ 07907 736618 ⊕ docs-alehouse.co.uk
5 changing beers (often Fyne, Twisted Wheel, Wily Fox) ⊞
Doc's AleHouse, formerly Doc's Symposium, is Wigan's first micropub. A warm welcome awaits you from the owners, who have been here since 2020. You will find five cask ales, European beers, ciders and bottled beers behind the bar. Situated on the edge of Wigan town centre, a short walk from the bus and train stations, with outdoor seating overlooking Mesnes Park.
Q🏠☕🍴♿️≹🅿️🚌🐕 🛜

John Bull Chophouse

2 Coopers Row, Market Place, WN1 1PQ
☎ (01942) 242862 ⊕ johnbullchophousewigan.co.uk
House beer (by Thwaites); 10 changing beers ⊞
A vibrant and lively pub in a building that is more than 300 years old, previously cottages, stables and a slaughterhouse. A popular town-centre venue, it has been run by the same family for over 40 years. There are six handpumps serving Thwaites beers. This quirky pub is set over two floors, with the toilets upstairs, and has seating outside. It is reputed to have the best pub jukebox in the north-west. Closed Monday and Tuesday in winter. 🏠≹🚌🐕

Real Crafty 🍷

9 Upper Dicconson Street, WN1 2AD
☎ (01942) 200364 ⊕ realcraftywigan.co.uk
Ossett White Rat; 4 changing beers ⊞
A real ale and craft beer emporium in Wigan town centre on the former site of Bar Legion, just five minutes' walk from the bus station and 10 minutes from both the town's train stations. Expect up to five real ales dispensed via handpull, alongside craft beer, cider and perry served from 30 keg fonts. The Beer Atlas offers a collection of beers in bottles and cans from around the world. A popular weekly quiz is hosted on Tuesday plus frequent tap takeovers and Meet the Brewer events alongside live music. 🛏️🏠♿️≹🍴🅿️🚌🐕 🛜

Sherrington's 🅛

57 Kenyon Road, WN1 2DU
☎ 07500 171114 ⊕ sherringtonsbar.com
Wily Fox Crafty Fox; 5 changing beers (sourced regionally) ⊞
An industrial-themed bar with six real ales on handpump, always including three from the Wily Fox stable and three varying guests. There are also 10 craft/lager/continental beer taps offering Peroni, Moretti and a Wily Fox, along with seven varying guests. A selection of UK and continental bottled beers is also stocked, and there is an upper-floor gin bar. Tea, coffee and hot chocolate are available. Local CAMRA Pub of the Year 2020/21. 🛏️🏠♿️🍴🚌🐕 🛜

Swan & Railway 🅛 ✅

80 Wallgate, WN1 1BA
☎ (01942) 375817 ⊕ swanandrailwayhotelwigan.co.uk
Banks's Sunbeam; Courage Directors; Draught Bass; 4 changing beers (sourced locally) ⊞
Winner of a Historic England Conservation Award in 2021, the pub was built in 1898 by WEV Crompton. This beautiful classic period inn features an impressive stained-glass window, and a collection of historical photos of the old town, the railway and Rugby League. It has seven handpumps celebrating Draught Bass and also

featuring local breweries such as Hophurst, Prospect, Wily Fox and Wigan Brewhouse. Directly opposite Wigan North Western railway station. 🏠🍴♿️≹🅿️🚌🐕 🛜

Tap 'n' Barrel ✅

16 Jaxon's Court, WN1 1LR
☎ (01942) 386966 ⊕ tapnbarrelwigan.co.uk
Hawkshead Windermere Pale; 5 changing beers (sourced regionally) ⊞
This former local CAMRA Cider Pub of the Year is in Wigan's Victorian Quarter, conveniently adjacent to the bus station. The staff are friendly, welcoming and happy to provide advice on the wide selection of drinks available. The bar is split over three areas – the main bar, an upstairs seating area and a pleasant heated undercover back room where live music is hosted on Sunday afternoon. You will find six handpulls on the bar, usually serving three cask ales and three boxed ciders, alongside one or two draft craft beers. Q🛏️≹🍴🚌🐕 🛜

Wigan Central 🅛

Arch No.1&2 Queen Street, WN3 4DY
☎ (01942) 246425 ⊕ wigancentral.bar
House beer (by Bank Top); 6 changing beers (sourced nationally) ⊞
This award-winning two-roomed pub has a railway-themed interior with a live feed displaying arrival and departure times from both railway stations. It sources real ales from all over, alongside a wide range of continental bottled beers. Live music plays on Sunday. Bar snacks are available. Four times winner of local CAMRA Pub of the Year and Cider Pub of the Year, also a former Greater Manchester Pub of the Year and runner-up National Pub of the Year. ♿️≹🍴🚌🐕 🛜

Withington

Victoria ✅

438 Wilmslow Road, M20 3BW (on B5093, jct Davenport Avenue)
☎ (0161) 434 2600
Hydes 1863, Dark Ruby, Hopster, Original, Lowry; 2 changing beers (sourced nationally) ⊞
This friendly Hydes community pub attracts a convivial cross-section of Withington life, from seasoned locals to fresh-faced students. Its late 19th-century exterior features etched windows. The refurbished interior has been opened out to create distinct drinking areas, each with their own atmosphere. It is busy throughout the day and especially in the evenings. A beer patio at the rear provides a useful escape from the bustle. Attractions include a poker school, quizzes and live entertainment at the weekend. 🛏️🏠🍴🚌🐕 🛜

Woodford

Davenport Arms (Thief's Neck)

550 Chester Road, SK7 1PS (on A5102, jct Church Lane)
☎ (0161) 439 2435
Robinsons Wizard, Dizzy Blonde, Cumbria Way, Unicorn, Old Tom; 1 changing beer (often Robinsons) ⊞
Characterful red-brick farmhouse-style pub which has been smartly refurbished while retaining a multi-roomed feel, with real fires in winter. This is its 36th consecutive year in the Guide, and the licence has now been in the same family for a mammoth 90 years. Excellent food is mostly home made, with some adventurous specials. Outside, the spacious forecourt and attractive garden, set well away from the road, are popular in summer, boasting impressive floral displays.
🛏️🏠🍴♣️🅿️🚌 (42B) 🐕 🛜

Breweries

Alphabet SIBA

99 Northern Western Street, Manchester, M12 6JL
☎ (0161) 272 6532 ⊕ alphabetbrewing.co.uk

Founded in 2014, Alphabet Brewing Company is based in central Manchester in a railway arch with an on-site taproom. It focuses mainly on hop-forward, fruit-led session beers in keg and KeyKeg, which are unfiltered and unpasteurised. ‼️☕◆

Assembly (NEW)

Unit 5, Spur Mill, Broadstone Hall Road South, Reddish, SK5 7BY ⊕ assemblybrew.co

Assembly is a small brewery that commenced in 2021. Contemporary beers are mainly available in keg and can.

Bank Top SIBA

The Pavilion, Ashworth Lane, Bolton, BL1 8RA
☎ (01204) 595800 ⊕ banktopbrewery.com

⊕Bank Top was established in 1995. Since 2002, the brewery has occupied a Grade II-listed tennis pavilion housing an 11-barrel plant. Bank Top Brewery Estates was formed in 2010 and now owns three pubs, Bank Top Brewery Tap, Bank Top Ale House and Olde England Forever. ‼️◆

Draymans Draught (ABV 3.6%) PALE
Bad to the Bone (ABV 4%) BITTER
Dark Mild (ABV 4%) MILD
Coffee roast aroma. Smooth mouthfeel, with roasted malt prominent throughout and some fruit. Moderate bitterness in aftertaste.
Flat Cap (ABV 4%) BITTER
Amber-coloured beer with a malty aroma. Balanced and lasting flavour of malt, fruit and bitter hops.
Pavilion Pale Ale (ABV 4.5%) PALE
A yellow beer with a citrus and hop aroma. Big fruity flavour with a peppery hoppiness; dry, bitter yet fruity finish.
Nineteen Ninety Five (ABV 4.8%) PALE
Palomino Rising (ABV 5%) PALE
Port O' Call (ABV 5%) SPECIALITY
Dark brown beer with a malty, fruity aroma. Malt, roast and dark fruits in the bittersweet taste and finish.

Beer Nouveau

75 North Western Street, Ardwick, Manchester, M12 6DY ⊕ beernouveau.co.uk

⊕Beer Nouveau has been producing heritage and experimental beers since 2015. Barrel-aging and beers from the wood are a strong focus, and always feature at its weekend brewery tap. A passion for sustainability sees one-off brew runs using hops or fruit grown in Manchester, and the brewery tap caters from a 'waste food' social enterprise. The tap encompasses a beer garden in its urban orchard and frequently hosts special events. ‼️☕◆LIVE◆

Peterloo Porter (ABV 4%) PORTER
Sunny Lowry (ABV 4.1%) BITTER

Blackedge SIBA

Moreton Mill, Hampson Street, Horwich, BL6 7JH
☎ (01204) 692976 ☎ 07795 654895
⊕ blackedgebrewery.co.uk

⊕Blackedge Brewery brews at a 10-barrel plant visible through a viewing window on the ground floor beneath the Brewery Bar – one of its two outlets. Its CAMRA and SIBA award-winning beers are available throughout NW England and beyond. A strong core range is supplemented by seasonal brews in both cask and unfiltered keg formats. Most are also now freshly canned and bottled on-site. ‼️☕◆LIVE◆

Session (ABV 3.5%) GOLD
Refreshing citrus hops, with a full-bodied citrus hop aroma. Clean, dry finish with lingering bitter hops.
Zinc (ABV 3.5%) GOLD
Hop (ABV 3.8%) BITTER
Assertively hoppy bitter beer. Citrus flavours with a lasting, dry finish.
Dark Mild (ABV 3.9%) MILD
Pleasant chocolate and malt aroma leads to a full-bodied beer with dark fruits, sustained malt presence and roasty finish.
NZP3 (ABV 3.9%) PALE
Black (ABV 4%) STOUT
Well-rounded and creamy dark beer with roast malt and balanced sweetness. Dry, bitter roast finish.
Cascade (ABV 4%) BLOND
Pike (ABV 4%) PALE
Smooth, copper-coloured beer with bitter hops and balanced sweetness, leading to a dry bitter finish.
West Coast (ABV 4.1%) GOLD
Citrus hop aroma and flavour. Sweet fruitiness balances lasting bitter hops.
American (ABV 4.2%) GOLD
Platinum (ABV 4.4%) BLOND
Blonde (ABV 4.5%) BLOND
Ginger (ABV 4.5%) SPECIALITY
Amber-coloured, with fresh ginger prominent in aroma and taste. Spiciness balanced against sweet malt. Dry, bitter finish.
Dark Rum (ABV 4.6%) SPECIALITY
Rich, roast aroma and strong, dry roast flavour. Accompanying taste of dried fruit and drawn-out, sweet finish.
IPA (ABV 4.7%) GOLD
Intense bitter hops with a long, drying finish.
Black Port (ABV 4.9%) SPECIALITY
Black beer with malty, fruity aroma. Rich, with chocolate and dark fruits to taste with a slightly drier finish.
Kiwi (ABV 5%) GOLD
Citrus hops and fruit in the aromas develop in the taste. Sweetness supports the flavours as the bitterness builds in the finish.

Blackjack SIBA

34-36 Irk Street, Manchester, M4 4JT
☎ (0161) 819 2767

Office: The Smithfield Market Tavern, 37 Swan Street, Manchester, M4 5JZ ⊕ blackjack-beers.com

⊕Blackjack began in a railway arch in Manchester's Green Quarter in 2012. A new modern brew plant was installed in 2021, enabling the brewery to develop a new and improved range of traditional and modern vegan beers. Beers are widely available across the North of England and nationally as well as in its own Smithfield Tavern, three Jack In The Box food market bars, and the new brewery taproom which opened in 2022. ‼️◆V◆

Irk Street Pale (ABV 4%) GOLD
Pub Ale: Best (ABV 4.2%) BITTER
A complex mix of malty sweetness characterises this beer, which finishes with a long lasting hop bitterness.
Session IPA (ABV 4.5%) GOLD

Citrus hops to the fore starting with the aromas. The bitterness develops on drinking and there is some fruity sweetness to balance.

Manchester Stout (ABV 4.8%) STOUT
West Coast Pale (ABV 5.6%) GOLD

Bridge

Unit 6, Northend Road Industrial Estate, Northend Road, Stalybridge, SK15 3AZ ☎ 07948 617145 ⊕ bridgebeers.co.uk/brewery

Bridge Beers commenced production in 2021 using a 2.5-barrel plant. Cask-conditioned and bottled ales are supplied to the brewery tap, located in the nearby town centre, as well as to other local outlets. ☞

Citra (ABV 4%) PALE
El Dorado (ABV 4%) PALE
Galaxy (ABV 4%) PALE
4Bs (ABV 4.2%) BITTER
Mumbai (ABV 4.2%) GOLD
Dark Ruby Mild (ABV 4.5%) MILD
Dark Matter (ABV 4.7%) STOUT

Brightside SIBA

Unit 10, Dale Industrial Estate, Radcliffe, M26 1AD ☎ (0161) 725 9644 ⊕ brightsidebrewing.co.uk

⊗ Brightside is a 20-barrel, family-run brewery producing real ales, craft beers and lager. A broad range of styles is produced, including beers brewed with unusual yeasts/ flavours under its Wildside label. It has a brewery shop on-site for collections, and a web shop for deliveries. Brightside prides itself on working as sustainably as possible, by limiting energy expenditure, recycling and reusing waste. All cask, bottle and canned beers are gluten-free. It launched 17 new cask beers, and 12 new bottles and cans during 2022. ☞♦GF

Odin Blonde (ABV 3.8%) PALE
Refreshing bitter hops, with bitterness carrying into finish. Peachy hop aroma with some malt.
Chuck American Brown Ale (ABV 4%) BROWN
B-Side Gold (ABV 4.2%) GOLD
Academy Ale IPA (ABV 4.5%) PALE
The Mancunian (ABV 4.5%) PALE
Full-bodied, sweet, fruity beer with moderate bitter hops.
Maverick IPA (ABV 4.8%) PALE

Bundobust SIBA

61-95 Oxford Street, Manchester, M1 6EJ ⊕ bundobust.com

Bundobust Brewery was established in 2020 but brews were not commercially available until 2021. Beer is exclusively for the Bundobust restaurant chain. No real ale.

Burton Road

Office: 65 Kingsfield Drive, Manchester, M20 6HX ✉ contact@burtonroadbrewing.co.uk

Manchester brewery producing cask, keg, cans and bottles focusing on pales and IPA. While most beer is contract brewed at Mobberley Brewhouse (qv), a small brew plant (30-litres) is also located within Withington Public Hall.

Mosaic Pale (ABV 4.2%) PALE
Pale Ale (ABV 4.8%) PALE

Chadkirk

Lancashire House, Green Lane, Romiley, SK6 3LJ ☎ 07966 125257 ⊕ chadkirkbrew.co.uk

Brewing commenced in 2020 at an industrial unit in Romiley. The brewery focuses on a core range of hop-forward beers using a rotating selection of American hops.

Easy (ABV 3.6%) PALE
US Triple Hop (ABV 4%) PALE
Zappa (ABV 4%) PALE
Motueka (ABV 4.2%) PALE
CCC (ABV 4.3%) PALE
Haze (ABV 4.3%) PALE
Citra (ABV 4.7%) PALE
Stout (ABV 5%) STOUT
APA (ABV 5.2%) PALE

Cloudwater SIBA

Units 7-8, Piccadilly Trading Estate, Manchester, M1 2NP
☎ (0161) 661 5943 ⊕ cloudwaterbrew.co

Cloudwater specialises in producing modern takes on classic styles, with a leaning towards hazy, hop-forward beers. It also releases a series of wild, spontaneous and aged beers from its barrel project, with a strong focus on seasonality of both styles and ingredients. The brewery tap is adjacent. ♦♦

Deeply Vale

Unit 25, Peel Industrial Estate, Chamberhall Street, Bury, BL9 0LU ☎ 07749 856043 ⊕ deeplyvalebrewery.com

⊚Deeply Vale is a family-run business established in 2012. The brewery's name immortalises the Deeply Vale area near Bury, famed for legendary 1970s music festivals. The range of traditional beers with a modern twist produced from the six-barrel plant are distributed largely across North West England and West Yorkshire. ♦

DV US (ABV 3.8%) GOLD
Equilibrium (ABV 3.8%) GOLD
Crisp and refreshing bitter with a pale malt flavour and clean bitter hops. Dry finish with lingering hops.
Hop (ABV 3.8%) BITTER
Maverick (ABV 3.8%) PALE
White Wolf (ABV 3.8%) PALE
Citra Storm (ABV 4%) PALE
Optimum (ABV 4.2%) GOLD
DV8 (ABV 4.8%) STOUT
Supple, fruity sweetness accompanying luscious coffee roast. Clean, gentle malt finish, with lingering sweetness. Coffee and raisin aroma.
Freebird (ABV 5.2%) PALE

Donkeystone

Units A-D Wellington Industrial Estate, Wellington Road, Greenfield, OL3 7AG ☎ (01457) 238710 ⊕ donkeystonebrewing.co.uk

⊚Donkeystone started as a 10-barrel brewery in 2017 at the edge of the Peak District National Park It features an on-site brewery tap and gin distillery. Brewer Thomas Phelan uses a custom-built, stainless steel plant supplied by Oban Ales and has recently expanded. It has a small kit for experimental brews and its own canning line. The brewery relocated to new premises in 2021. ♦♦☞♦

Ferris Muler (ABV 3.7%) PALE
Hoppinsesh (ABV 3.7%) PALE
Bad Ass Blonde (ABV 3.8%) GOLD

Floral hop aroma and a balanced, fruity hop flavour.
Modern Bitter (ABV 3.8%) BITTER
Cotton Clouds Craft Ale (ABV 4%) PALE
Ruby Treasure (ABV 4.8%) RED
Neddy (ABV 4.9%) STOUT
Javanilla (ABV 5%) SPECIALITY
Kaihe (ABV 5%) BITTER
Madagaska (ABV 5%) SPECIALITY
Light-bodied stout. Moderate bitterness with vanilla flavour.

Dunham Massey

100 Oldfield Lane, Dunham Massey, WA14 4PE
☎ (0161) 929 0663 ⊕ dunhammasseybrewing.co.uk

☺Opened in 2007, Dunham Massey brews traditional North-Western ales using only English ingredients. Around 30 outlets are supplied direct, along with the brewery tap, Costello's Bar, Altrincham. A sister brewery, Lymm (qv), opened in 2013 with Costello's Bar in Stockton Heath tied to both breweries. ☗♦LIVE

Castle Hill (ABV 3.5%) PALE
Walker's Bitter (ABV 3.5%) BITTER
Little Bollington Bitter (ABV 3.7%) BITTER
Straw-coloured, light ale with malt and citrus fruit taste and a dry, bitter finish.
Chocolate Cherry Mild (ABV 3.8%) SPECIALITY
Dunham Dark (ABV 3.8%) MILD
Dark brown beer with malty aroma. Fairly sweet, with malt, some roast, hop and fruit in the taste and finish.
Big Tree Bitter (ABV 3.9%) BITTER
Obelisk (ABV 3.9%) BLOND
Alty Ale (ABV 4%) BLOND
Dunham Milk Stout (ABV 4%) STOUT
Landlady (ABV 4%) PALE
Dunham Stout (ABV 4.2%) STOUT
Dunham XPA (ABV 4.2%) PALE
Stamford Bitter (ABV 4.2%) BITTER
Deer Beer (ABV 4.5%) BITTER
Cheshire IPA (ABV 4.7%) PALE
Dunham Porter (ABV 5.2%) PORTER
East India Pale Ale (ABV 6%) IPA
Dunham Gold (ABV 7.2%) STRONG

Escape

Unit P, Dodd Lane Industrial Estate, Chorley Road, Westhoughton, BL5 3NA
☎ (01204) 228969 ⊕ escapebrewery.co.uk

Small brewery launched in Bolton in 2019 brewing a range of regular and occasional beers on a 2.5 barrel plant. It recently opened a pub in Adlington, the Old Post Office.

Runaway Success (ABV 3.6%) BITTER
If the Caravan's A Rockin' (ABV 3.8%) BLOND
Breakout Session (ABV 3.9%) PALE
Long White Cloud (ABV 4%) PALE
Avoid Detection (ABV 4.2%) PALE
The Shackles Are Off (ABV 4.2%) GOLD
Ticket to Ride (ABV 4.3%) PALE
Tom, Dick & Harry (ABV 4.5%) PALE
Clocked Off (ABV 4.9%) PALE
Virgil Hilts (ABV 5%) BITTER

Federation

▤ 48 Greenwood Street, Altrincham, WA14 1RZ
☎ (0161) 696 6870 ⊕ conclubuk.com

Located in the Con Club (a pub with restaurant that was formerly Altrincham Working Mens Conservative Club), this is a small 2.4-barrel plant that began brewing in

2017. Seasonal and speciality beers are produced in addition to the core range. Brewing is currently suspended. ♦

First Chop

B2 Barton Hall Business Park, Hardy Street, Eccles, M30 7NB ☎ 07970 241398 ⊕ firstchop.co.uk

Brewing began at Outstanding Brewery (qv) in Bury in 2012 before transferring to Salford in 2013. The brewery relocated again to Eccles in 2017 with increased capacity. It specialises in producing gluten-free beers. GF

AVA (ABV 3.5%) BLOND
POD (ABV 4.2%) SPECIALITY
IPA (ABV 5%) PALE
SYL (ABV 6.2%) IPA

Four Kings

Unit 15g, Newton Moor Industrial Estate, Lodge Street, Hyde, SK14 4LD ☎ 07951 699428
⊕ fourkingsbrewery.com

☺Four Kings has been brewing since 2016. It's a six-barrel brewery opened in Hyde by friends with a mutual love of beer. Its on-site bar is open most Friday evenings and Saturday afternoons, and is also available for private functions. Beers can typically be found in pubs across Tameside and High Peak and at beer festivals in Greater Manchester and Yorkshire. ⁇☗♦LIVE ✦

4Tune (ABV 4%) BITTER
4Ever (ABV 4.5%) PALE
4Most (ABV 5.5%) PORTER

Gasworks

▤ First Street, Manchester, M15 4FN

Gasworks is a six-barrel brewpub from the team behind Dockyard, opened in 2016. It supplies Salford Quays and Dockyard, Spinningfields, plus Gasworks Tap (city centre).

Green Mill

▤ Harewood Arms, 2 Market Street, Broadbottom, SK14 6AX ☎ 07967 656887 ⊕ greenmillbrewery.com

☺Green Mill started brewing in 2007 on a 2.5-barrel plant and moved in 2010 to the Cask & Feather, Rochdale. The brewery relocated again in 2013 to the Harewood Arms, Broadbottom. A number of occasional beers are brewed. Around 40 outlets are supplied. ♦

Gold (ABV 3.6%) GOLD
Northern Lights (ABV 4.5%) BITTER
Big Chief (ABV 5.5%) BITTER

Heineken Royal Trafford

Royal Brewery, 201 Denmark Road, Manchester, M15 6LD

No real ale.

Hideaway

57 Farm Lane, Worsley, M28 2PG ☎ 07887 732725
⊕ hideawaybrewing.co.uk

Nanobrewery which started brewing in 2020. Each production run is currently limited to 25 litres.

Joseph Holt SIBA IFBB

The Brewery, Empire Street, Cheetham, Manchester, M3 1JD

☎ (0161) 834 3285 ⊕ joseph-holt.com

☺Founded in 1849, Joseph Holt is one of the UK's, leading, independent, family breweries. Now in its sixth generation, the business operates 123 pubs across Manchester and the North West and supplies ales to many pubs and clubs nationally. ☛

Mild (ABV 3.2%) MILD
A dark brown/red beer with a fruity, malty nose. Roast, malt, fruit and hops in the taste, with strong bitterness for a mild, and a dry malt and hops finish.

IPA (ABV 3.8%) BITTER
Golden bitter with biscuity malt, hops and restrained lemony notes. Dry, bitter finish.

Bitter (ABV 4%) BITTER
Pale brown beer with malt and hops in the aroma. Bitter taste with balanced, malty flavour. Increased bitter finish.

Two Hoots (ABV 4.2%) BITTER

Brewed for the Bootleg brand:
Chorlton Pale Ale (ABV 4%) PALE

Hophurst SIBA

Unit 8, Hindley Business Centre, Platt Lane, Hindley, WN2 3PA
☎ (01942) 522333 ☎ 07938 949944
⊕ hophurstbrewery.co.uk

☺Hophurst Brewery was started in 2014 by Stuart Hurst. Stuart's passion for producing craft ales, combined with 20 years of supporting businesses and re-skilling unemployed people, created a unique social enterprise brewery. It employs people over the age of 50 and guides them through its training programme. Twisted Vine Ale House is its award-winning microbar in Ashton-in Makerfield town centre. ⚑◆

Flaxen (ABV 3.7%) PALE
Campfire (ABV 3.9%) MILD
Light-bodied beer with bitter roasted malt.
Twisted Vine (ABV 4.1%) PALE
Cosmati (ABV 4.2%) BLOND
Debonair (ABV 4.9%) STOUT
Porteresque (ABV 5.5%) STOUT
Complex dark beer, with roast and fruit in aroma. Strong roast flavour with a developing sweet fruitiness. Lasting roast finish.

Howfen

Westhoughton, BL5 2BN ⊕ howfenbrew.co

Howfen began brewing in 2018 and is situated in the owner's garage. It is named after the dialect word for Westhoughton.

Hydes SIBA IFBB

The Beer Studio, 30 Kansas Avenue, Salford, M50 2GL
☎ (0161) 226 1317 ⊕ hydesbrewery.com

☺Hydes Brewery has been in the Manchester area since 1863. In 2012 it relocated to a smaller, more modern site in Salford's MediaCity. It recently installed a keg beer processing and packaging facility increasing capacity by 4,000 hectolitres a year, and extending the range / type of beers. It currently produces five core beers plus 18 seasonal cask beers under the Ralf + Alf brand. Three keg beers are brewed under the Copper Kettle brand. ◆

1863 (ABV 3.5%) BITTER
Lightly-hopped, pale brown session beer with some hops, malt and fruit in the taste and a short, dry finish.
Dark Ruby (ABV 3.5%) MILD

Dark brown/red in colour, with a fruit and malt nose. Taste includes biscuity malt and green fruits, with a satisfying aftertaste.

Hopster (ABV 3.8%) BLOND
Original (ABV 3.8%) BITTER
Pale brown beer with a malty nose, malt and an earthy hoppiness in the taste, and a good bitterness through to the finish.

Lowry (ABV 4.7%) GOLD
Malt, hops and fruit compete for dominance in this strong beer. Fruit and bitter prominent in finish.

Irwell Works

Irwell Street, Ramsbottom, BL0 9YQ
☎ (01706) 825019 ⊕ irwellworksbrewery.co.uk

☺Irwell Works has been brewing since 2010 in a building that once housed the Irwell Works steam, tin, copper and iron works. The brewery has a six-barrel plant, and brews nine regular beers, plus a range of seasonal beers. Its brewery tap is situated on the first floor. ⚑◆⚐

Lightweights & Gentlemen (ABV 3.2%) GOLD
Light, refreshing, very pale ale with some fruitiness and a hoppy, bitter finish.

Breadcrumbs (ABV 3.6%) PALE
Tin Plate (ABV 3.6%) MILD
Copper Plate (ABV 3.8%) BITTER
Traditional northern bitter. Copper-coloured with satisfying blend of malt and hops and good bitterness.

Costa Del Salford (ABV 4.1%) GOLD
Steam Plate (ABV 4.3%) BITTER
Malty bitter beer with increasing bitter finish.

Iron Plate (ABV 4.4%) STOUT
Roast malt in the aroma is joined by hop and a toasty bitterness in the taste and finish.

Marshmallow Unicorn (ABV 4.4%) STOUT
Sweet stout with a balanced bitter roast and dry, bitter finish.

Mad Dogs & Englishmen (ABV 5.5%) IPA
Full-bodied, bittersweet beer. Pronounced peppery and earthy hops. Hops develop to pine and citrus in aftertaste with prolonged bitterness.

JW Lees IFBB

Greengate Brewery, Middleton Junction, Manchester, M24 2AX
☎ (0161) 643 2487 ⊕ jwlees.co.uk

☺Family-owned since its foundation by John Lees in 1828, the brewery has a tied estate of 150 pubs, mostly in north Manchester, Cheshire, Lancashire and North Wales. The vast majority serve cask beer. The current head brewer is a family member. An in-house microbrewery, Boilerhouse, came on stream in 2018. ⚑◆

Dark (ABV 3.5%) MILD
Formerly GB Mild. Dark brown beer with a malt and caramel aroma. Creamy mouthfeel, with malt, caramel and fruit flavours and a malty finish.

Manchester Pale Ale (ABV 3.7%) PALE
Golden beer, moderately-hopped and with gentle bitterness.

Bitter (ABV 4%) BITTER
Smooth, copper-coloured beer with caramel malt in aroma and flavour. Dry, bittersweet aftertaste.

Dragon's Fire (ABV 4%) BITTER
Boilerhouse Craft Pale (ABV 4.2%) PALE
Stout (ABV 4.2%) STOUT
Founder's (ABV 4.5%) BITTER
Moonraker (ABV 6.5%) STRONG
A reddish-brown beer with a strong, malty, fruity aroma. The flavour is rich and sweet, with roast malt, and the

finish is fruity yet dry. Available only in a handful of outlets.

Libatory (NEW)

Altrincham ⊕ libatory.co.uk

A commercial home-based brewery which started brewing in 2022. A 150-litre plant is used.

Made of Stone

≡ 8 Woodford Road, Bramhall, Stockport, SK7 2JJ

Nanobrewery situated at the back of the Mounting Stone micropub in Bramhall. Brewing began in 2018 on a one-barrel plant at the rear of the pub. The brewery specialises in twice monthly, one-off brews and collaborations with local brewers. Beers are usually supplied to the pub and the Chiverton Tap, Cheadle Hulme.

Manchester

66 North Western Street, Manchester, M12 6DX
☎ (0161) 273 6167 ⊕ manchesterbrewing.co.uk

Set up by Paul Mellor in 2016 this eight-barrel brewery is housed in a railway arch in the Ardwick district of Manchester. Outlets in Greater Manchester, West Yorkshire and further afield are supplied. An ever-changing selection of seasonally-specific specials are produced as well as the sole core beer.

Factory Pale Ale (ABV 4%) PALE

Manchester Union

96d North Western Street, Manchester, M12 6JL
⊕ manchesterunionbrewery.com

Manchester Union is a Central European-style, lager brewery co-founded by former Six O'clock brewer Ian Johnson. It uses a decoction technique in the mash and German lager malts. The beers under go several weeks conditioning in tanks. Beers are unfiltered and unpasteurised and available across Greater Manchester. There is an on-site taproom. ⬦

Marble SIBA

Unit 7, Boston Court, Salford, M50 2GN
⊕ marblebeers.com

Originally founded at the Marble Arch pub in 1997, Marble Beers moved to a 15-barrel plant in Salford and opened an on-site taproom. Vegetarian beers are available in both its core and speciality ranges. It supplies its own Marble Arch and more than 70 other outlets.
‼⬦⬧

Arm Bar (ABV 3.8%) PALE
Pint (ABV 3.9%) GOLD
Fresh hop aroma of grapefruit. Clean citrus hop flavour with pale malt base. Dry bitter aftertaste and lasting hop.
Manchester Bitter (ABV 4.2%) BITTER
Biscuity aroma with floral hops. Balanced bitter hop and malt in taste. Full fruity palate. Dry, bitter finish.
North South (ABV 4.2%) PALE
Prominent citrus aroma. Bitter citrus hop flavour balanced with moderate sweetness. Bitterness predominates after the initial taste, with drying mouthfeel.
Lagonda IPA (ABV 5%) GOLD
Golden beer with a fruity nose. Powerful citrus and bitter hops backed by pale malt, and a bitter aftertaste.
Uppe Hela Natten (ABV 5.1%) SPECIALITY

Dry stout with prominent roast character throughout and balancing sweetness. Contains coffee.
Cross Collar (ABV 5.2%) PALE
Alf (ABV 5.4%) PALE
Pale (ABV 5.4%) PALE
Bitter orange taste, lasting with dryness. Fruity aroma. Lingering, dry bitter.
Stout (ABV 5.7%) STOUT
Rich aroma of coffee and chocolate. Complex, bittersweet, roasted flavour with fruit and caramel. Smooth mouthfeel, with a drying finish.
Earl Grey IPA (ABV 6.8%) SPECIALITY
Sweet citrus aroma. Full-bodied, creamy mouthfeel. Bold bergamot flavour balanced with sweetness and pronounced bitterness. Lasting hoppy taste.
Cubbio Damage (ABV 7.2%) IPA

Mayflower SIBA

2 Woodford Street, Hindley, WN2 4UR
✉ enquiries@mayflowerbrewery.com

⊛ Originally established in Standish in 2001, the brewery was mothballed before reopening in late 2018, using a five-barrel plant behind the old police station in Hindley, Wigan. As well as an expanding range of core ales, the brewery specialises in bespoke beers for occasions and events, both national and local, and for venues wishing to personalise or brand their bottled and cask ales.

Pie PA (ABV 3.9%) GOLD
Hoppy aromas dominate with hoppy bitter flavours, dry mouthfeel and a dry hop finish.
Douglas Valley (ABV 4%) GOLD
Best Bitter (ABV 4.1%) BITTER
Wigan Bier (ABV 4.2%) GOLD

Millstone SIBA

Unit 4, Vale Mill, Micklehurst Road, Mossley, Lancashire, OL5 9JL
☎ (01457) 835835 ⊕ millstonebrewery.co.uk

Established in 2003 by Nick Boughton and Jon Hunt, the brewery is located in an 18th century textile mill and uses an eight-barrel plant. More than 30 regular outlets are supplied. ☕⬦

Tiger Rut (ABV 4%) PALE
Light, fruity beer with hop aroma and gentle bitterness.
Stout (ABV 4.5%) STOUT
Rising Sunsation (ABV 4.7%) PALE
True Grit (ABV 5%) GOLD

Northern Monkey

68 Chorley Street, Bolton, BL1 4AL ☎ 07825 814631
⊕ northernmonkeybrew.co.uk

Established in 2016 and relocated in 2021, Northern Monkey Brew Co is a six-barrel brewery with an onsite tap bar. The original brewpub remains a town centre outlet. It brews a variety of ales, maintaining a traditional edge but with a modern twist. The ales rotate regularly so no core range is available. ⬦⬧

Origami

75 North Western Street, Manchester, M12 6DY

Office: 83 Ducie Street, Manchester, M1 2JQ
⊕ origamibrewingcompany.com

Brewing began in 2016 at Beer Nouveau's Manchester site where Origami has its own brew plant. Most output is bottled, but cask beer is frequently available at the Beer Nouveau beer tap as well as Manchester beer festivals. Unfined, all beer is vegan. **V**

Fortune Teller (ABV 4%) PALE
1000 Cranes (ABV 5%) BROWN
Valley Fold (ABV 5.3%) SPECIALITY
Rabbit Ear (ABV 5.5%) STOUT
Arctic Fox (ABV 7%) IPA

P-Noot

🖥 301 Hyde Road, Denton, M34 3FF ☎ 07931 986794

Office: 373 Stockport Road, Denton, M34 6EP
⊕ p-nootbrewco.com

☺Single-barrel brewery located in the cellar of the Lowes Arms (was previously named after the pub). It brews a core range of four cask beers primarily for the pub, based on traditional recipes with a modern twist, as well as a wide range of innovative craft keg ales for wider distribution.

Phoenix SIBA

Green Lane, Heywood, OL10 2EP
☎ (01706) 367359 ✉ cheers@phoenixbrewery.co.uk

☺Established in Ellesmere Port in 1982, Oak Brewery moved to the old Phoenix Brewery in Heywood and adopted the name in 1991. It now supplies more than 400 outlets plus wholesalers. Restoration of the old brewery, built in 1897, is ongoing. ♦

Hopsack (ABV 3.8%) BLOND
Navvy (ABV 3.8%) BITTER
Amber beer with a citrus fruit and malt nose. Good balance of citrus fruit, malt and hops with bitterness coming through in the aftertaste.
Monkeytown Mild (ABV 3.9%) MILD
Light roast aroma. Mild, creamy, roast flavour with sweet malt and some astringency. Lasting, dry, bitter finish.
Arizona (ABV 4.1%) GOLD
Yellow in colour with a fruity and hoppy aroma. A refreshing beer with citrus, hops and good bitterness, and a shortish, dry aftertaste.
Spotland Gold (ABV 4.1%) GOLD
Pale Moonlight (ABV 4.2%) PALE
Black Bee (ABV 4.5%) SPECIALITY
White Monk (ABV 4.5%) GOLD
Yellow beer with a citrus fruit aroma, plenty of fruit, hops and bitterness in the taste, and a hoppy, bitter finish.
Thirsty Moon (ABV 4.6%) BITTER
Tawny beer with a fresh citrus aroma. Hoppy, fruity and malty with a dry, hoppy finish.
West Coast IPA (ABV 4.6%) PALE
Golden in colour with a hoppy, fruity nose. Strong hoppy and fruity taste and aftertaste with good bitterness throughout.
Double Gold (ABV 5%) GOLD
Wobbly Bob (ABV 5%) BITTER
A red/brown beer with malty, fruity aroma and creamy mouthfeel. Strongly malty and fruity in flavour, with hops and a hint of herbs. Both sweetness and bitterness are evident throughout.

Brewed for Brunning & Price Pub Co:
Original (ABV 3.8%) BITTER

Pictish

Unit 9, Canalside Industrial Estate, Woodbine Street East, Rochdale, OL16 5LB
☎ (01706) 522227 ⊕ pictish-brewing.co.uk

☺The brewery was established in 2000 and supplies free trade outlets in the North-West and West Yorkshire. Famed for the consistency and clarity of its brews and its ever-changing single hop series of beers. ♦

Brewers Gold (ABV 3.8%) BITTER
Session pale ale with moderate levels of sweetness, malty character and hops.
Talisman IPA (ABV 4.2%) PALE
Strong hoppy aroma; hops and fruit in the taste. Some initial sweetness, but with hoppy bitterness throughout.
Alchemists Ale (ABV 4.3%) BITTER
Bitter beer with malt aroma.

Pomona Island

Unit 33, Waybridge Enterprise Centre, Daniel Adamson Road, Salford, M50 1DS
☎ (0161) 637 2140 ☎ 07972 445474
⊕ pomonaislandbrew.co.uk

Brewery set up in 2017, close to Salford's Media City. Part owned by the people behind the Gas Lamp in Manchester city centre. Head brewer James Dyer is formerly of Tempest Brew Co (qv). Its brewery tap opened in 2021 at Escape to Freight Island. 🛒♦◆

Pale (ABV 3.8%) PALE
Pungent, fruity hop aroma. Sweet, fruity taste with some bitterness. Gentle and balanced. Lasting, delicate, bitter finish.
Stout (ABV 4.5%) STOUT
APA (ABV 5.3%) PALE
Hoppy beer with fruit and moderate bitterness, leading to a rising bitter finish. Brewed with variable hops.

Red Rose SIBA

The Old Brewery, Back Square Street, Ramsbottom, BL0 9FZ
☎ (01706) 827582

Office: 2 Hameldon View, Great Harwood, BB6 7BL
⊕ redrosebrewery.co.uk

Brewing began in 2020.

Treacle Miner's Tipple (ABV 3.6%) MILD
Too Wet To Woo (ABV 3.8%) BITTER
Harlequin (ABV 4%) PALE
Rat Trap (ABV 4.3%) BLOND
Paddy O'Hacker's (ABV 4.6%) STOUT
Likely More Bar Tat (ABV 6.1%) IPA

Rising Sun

🖥 Rising Sun, 235 Stockport Road, Mossley, OL5 0RQ
☎ (01457) 238236 ⊕ risingsunmossley.co.uk

☺Brewing since 2016 using a two-barrel plant at the side of the Rising Sun. The beers are produced occasionally and are only available for sale in the pub. Beers of differing styles and strengths are available throughout the year.

Robinsons SIBA IFBB

Unicorn Brewery, Lower Hillgate, Stockport, SK1 1JJ
☎ (0161) 612 4061 ⊕ robinsonsbrewery.com

☺The sixth generation of the Robinson family now run the brewery, founded in 1838. Following a significant reduction in the tied estate in recent years, there is now gradual expansion. The core range, bi-monthly seasonals, and other one-off beers are brewed, notably the Trooper range, in conjunction with Iron Maiden's Bruce Dickinson. In 2022 Robinsons announced plans to relocate brewing from the town centre site to the botting plant in nearby Bredbury. This move should be complete some time in 2024. ‼🛒♦

Wizard (ABV 3.7%) BITTER
Dizzy Blonde (ABV 3.8%) BLOND

A light-bodied beer, yellow in colour. It has malt and hops in the taste and a dry, bitter finish.

Cumbria Way (ABV 4.1%) BITTER
Pale brown with a malty aroma, this beer has a balance of malt, some hops and a little fruit, with sweetness and bitterness throughout.

Cwrw'r Ddraig Aur (ABV 4.1%) GOLD

Unicorn (ABV 4.2%) BITTER
Amber beer with a fruity aroma. Malt, hops and fruit in the taste with a bitter, malty finish.

Cascade IPA (ABV 4.8%) PALE
Pale brown beer with malt and fruit on the nose. Full, hoppy taste with malt and fruit, leading to a hoppy, bitter finish.

Trooper (ABV 4.8%) BITTER
Well-balanced amber beer with malt and hops in aroma and taste.

Old Tom (ABV 8.5%) STRONG
A full-bodied, dark beer with malt, fruit and chocolate on the aroma. A complex range of flavours includes dark chocolate, full maltiness, port and fruits and lead to a long, bittersweet aftertaste.

Runaway

Unit 4, Millgate, Dantzic Street, Manchester, M4 4JW
☎ (0161) 832 2628 ☎ 07505 237078
⊕ therunawaybrewery.com

Runaway is located in a railway arch outside Manchester Victoria station. It began brewing in 2014 producing KeyKeg and bottle-conditioned beers. All core range beers are unfiltered and unpasteurised, with many available locally. ‼♦LIVE ✦

Saddleworth

🍴 Church Inn, Church Lane, Uppermill, Oldham, OL3 6LW
☎ (01457) 820902 ⊕ churchinnsaddleworth.co.uk

☺Set in an idyllic location near St Chad's Church, Saddleworth started brewing in 1997 in a 120-year old brewhouse at the Church Inn, in a valley overlooking Saddleworth Moor. Brewing is currently suspended.

Serious SIBA

Unit C5, Fieldhouse Industrial Estate, Fieldhouse Road, Rochdale, OL12 0AA ☎ 07840 301797
⊕ seriousbrewing.co.uk

Established in 2015 and run by husband and wife team Ken and Jenny Lynch. The beers are brewed using a six-barrel plant. The focus is on producing high quality beers drawing influences from traditional British ales, US craft beers and artisanal Belgian beers. Many outlets are supplied direct and the beers are available nationwide via wholesalers. A taproom opened at the brewery in 2019. ♦LIVE ✦

Prime (ABV 4.2%) PALE

Evergreen (ABV 4.5%) BITTER
Hoppy aroma. Taste of fruit and bitter hops, with lasting bitterness. Crisp and bitter throughout. Background of sweet malt.

Moonlight (ABV 4.5%) STOUT
Medium-bodied dry stout with roast character that develops into a crisp, bitter finish.

Redsmith (ABV 4.5%) BITTER

Goldrush (ABV 5.6%) SPECIALITY

Seven Bro7hers SIBA

Unit 63, Waybridge Enterprise Centre, Daniel Adamson Road, Salford, M50 1DS

☎ (0161) 228 2404 ⊕ sevenbro7hers.com

Brewing began in 2014 using a 10-barrel plant. A new brewhouse and fermentation tanks doubled brewing capacity in 2017, and allowed for the brewing of speciality and one-off beers, plus a brewery tap. The Seven Bro7hers Beerhouse opened in 2016, and a new Beerhouse opened in 2019 in the Middlewood Locks area near Salford Central Station. Further outlets are planned in Leeds, Liverpool and at Manchester Airport. ‼🍴✦

Session (ABV 3.8%) PALE
Fruity hop taste of tropical fruit, well-balanced with bitter and pale malt. Citrus hop aroma. Refreshing bitter finish.

Soul

Correspondence: 18 Broomfield Road, Heaton Moor, Stockport, SK4 4ND ☎ 07718 155191
✉ bill@soulbrewing.co.uk

⊗ Brewing commenced in 2017 using spare capacity at Manchester Brewing (qv). Beers are supplied to outlets in Greater Manchester and are inspired by Northern Soul music. A move to its own premises is planned. ‼♦

All Nighter (ABV 3.8%) PALE

Magic Touch (ABV 4.7%) GOLD
Powerfully-hopped beer with sweet fruity flavour and bitter throughout.

The Snake (ABV 5.8%) IPA

Double-O Soul (ABV 5.9%) IPA

Squawk

Unit 4, Tonge Street, Ardwick, Manchester, M12 6LY
☎ 07590 387559 ⊕ squawkbrewingco.com

Squawk initially cuckoo-brewed in Huddersfield in 2013, with the first beers from the current Manchester railway-arch site appearing in 2014. In 2019, the brewery expanded to a 32-barrel capacity with additional fermenters and conditioning tanks. A barrel-ageing programme, online shop and a canning line have since been introduced. Some gluten-free beers are now being developed. All beers are widely available in the North of England as well as being distributed nationally. ♦LIVE GF

Pavo (ABV 3.8%) GOLD
Light, hoppy beer with balanced fruity aroma and taste. Dry bitter finish.

Roller (ABV 4%) BITTER

Crex (ABV 4.5%) PALE
Fruity and hoppy aroma. Sweet fruit balanced with bitter hops in the flavour, rising to a lasting, dry, bitter finish.

Corvus (ABV 7.4%) STOUT
Roast malt aroma and strong, lasting dark chocolate taste with touch of fruit.

State of Kind

Unit 4, Hemfield Court, Wigan, WN2 2ER ☎ 07765 808889 ⊕ stateofkindbrew.co

Launched in 2021, initially as a gypsy brewery. State of Kind now has its own brewery and taproom. ✦

Steelfish

c/o 75 North Western Street, Manchester, M12 6DY
✉ steelfishbrewing@gmail.com

Steelfish started brewing in 2020 as a cuckoo brewer based at Beer Nouveau (qv).

Stockport

Unit 16, The Gate Centre, Bredbury Parkway, Stockport, SK6 2SN
☎ (0161) 637 0306
✉ stockportbrewingcompany@gmail.com

Stockport Brewing Company is the longest-running, award-winning microbrewery in Stockport. It began trading in 2014 using an eight-barrel plant under the iconic Stockport Viaduct, before moving in 2017 to a larger, more modern facility at Bredbury. Beers are widely available in local outlets and throughout the UK via a trading agreement with other breweries. The beer range now includes single-hopped and fruit-infused cask ales. ‼◆

Cutting Edge (ABV 3.8%) GOLD
Waimea (ABV 3.8%) PALE
Cascade (ABV 4%) BLOND
Chinook (ABV 4.1%) PALE
Crown Best Bitter (ABV 4.2%) BITTER
Jester (ABV 4.2%) GOLD
West Coast IPA (ABV 4.3%) PALE
Stout (ABV 4.5%) STOUT
StockPorter (ABV 4.8%) PORTER
Malty flavour and aroma with some treacle toffee. Coffee and chocolate roast notes and hint of dark fruit.

Strange Times (NEW) SIBA

Units 1 & 2, Foundry, Ordsall Lane, Salford, M5 3LW
☎ (0161) 873 8090 ⊕ strangetimesbrewing.com

Founded in 2020, a 24-barrel and a four-barrel kit are used. Beers are available in cask and keg. V

Stubborn Mule

Unit 2, Radium House, Bridgewater Road, Altrincham, WA14 1LZ ☎ 07730 515251
⊕ stubbornmulebrewery.com

Brewing began in 2015. Ed Bright, the owner/brewer continues to add new beers to the portfolio and is always searching for interesting ideas to brew. Brewing is currently suspended. ‼◆LIVE

Sureshot (NEW)

5 Sheffield Street, Manchester, M1 2ND
⊕ sureshotbrew.com

Started brewing in early 2022 in premises vacated by Track the previous year.

Thirst Class SIBA

Unit 16 Station Road Industrial Estate, Reddish, Stockport, FY2 9EW
☎ (0161) 431 3998 ⊕ thirstclassale.co.uk

☺Thirst Class opened in 2014 in the centre of Stockport using a purpose-built, two-barrel plant. In 2016 the brewery relocated to larger premises and installed a 10-barrel plant. A collaboration brew is produced each month. ◆LIVE

Don't Panic (ABV 3.5%) PALE
Kiss My Ace (ABV 4%) SPECIALITY
Hoppy Go Lucky (ABV 4.1%) PALE
High Five (ABV 4.2%) PALE
Mosaic Pale Ale (ABV 4.7%) PALE
Stocky Oatmeal Stout (ABV 4.7%) STOUT
Any Porter in a Storm (ABV 4.8%) PORTER
Dark roast in aroma and flavour with balanced sweetness and fruit. Dry throughout and lingering sweetness.
Green Bullet Pale Ale (ABV 4.8%) PALE

Strong hop aroma. Bitter, peppery hop flavour with prominent pale malt and balanced with sweet fruitiness. Dry, bitter finish.
American Brown Ale (ABV 5.6%) BROWN
Full-bodied and smooth brown ale with prominent chocolate roast, fruit notes and gentle hops. Long-lasting flavour.
Hopfordian IPA (ABV 6%) IPA
Hoppy Couple IPA (ABV 6.2%) IPA
Elephant Hawk IPA (ABV 6.5%) IPA

Tin Head

Unit 22f, Bradley Fold Trading Estate, Radcliffe, Bury, BL2 6RT ☎ 07980 262766 ⊕ tinheadbrewery.co.uk

☺Established in 2017, originally for canning Tank Beer, it now operates as a brewery run by a father and son who are passionate about beers. The 60-seater taproom is dog-friendly, and the rear section offers music from solo artists. Generally eight craft keg beers are dispensed on font taps, together with locally-distilled gins. Beers are brewed as per real ale but dispensed as chilled keg type. ‼◆

To The Moon

3 Woodcote Avenue, Bramhall, Stockport, SK7 3ND
☎ 07795 965053 ⊕ tothemoonbrewery.com

A nanobrewery capable of producing 6,000 litres per year, but currently operated part time by its owner-brewer. Concentrating on IPA or pale ale (distributed in KeyKeg), mainly to microbars and the more adventurous pubs. Specialities produced for development with no guarantee they will be repeated.

Track

Units 17 & 18, Piccadilly Trading Estate, Manchester, M1 2NP
☎ (0161) 536 3975 ☎ 07725 692096
⊕ trackbrewing.co

Track Brewing Co was established in 2014. Originally based in a railway arch underneath Manchester's Piccadilly Railway Station, it has recently expanded operations to a new site in central Manchester. It produces a wide range of beers styles as well as growing its barrel-aging program. The new location has an onsite taproom and beer garden. ‼V◆

Sonoma (ABV 3.8%) GOLD
Prominent fruit hop aroma. Balanced, sweet, fruity taste. Moderate bitterness at first with punchy citrus hop after. Unfined.
Roller (ABV 4%) BITTER

Ventile

Unit 4, Spur Mill, Broadstone Hall Road South, Stockport, SK5 7BY ⊕ ventilebrew.co

Ventile Brew Co began brewing in 2021 and is a modern, small-batch microbrewery.

Wakey Wakey (NEW)

100 Brotherod Hall Road, Rochdale, OL12 7ED
✉ wakeywakeybrewingcompany@gmail.com

The brewery gets its name from founder Anthony Jones, a beer lover who started homebrewing in 2018. Having improved his brewing equipment and gaining the required licenses, Anthony started selling his cask ales to pubs in Oldham and Rochdale in 2022. ◆

bUNK (ABV 3.8%) BITTER

Bright & Early (ABV 4%) PALE
Fever Dream (ABV 5%) IPA

Wander Beyond SIBA

98 North Western Street, Manchester, M12 6JL
☎ **(0161) 661 3676** ⊕ **wanderbeyondbrewing.com**

Wander Beyond launched in 2017 in a railway arch under Piccadilly Station. The range of beer available can vary, each beer is brewed for only a short period so the range is constantly changing. Styles and ingredients are unusual and sometimes unique. ✦

Peak (ABV 3.8%) PALE

Wigan Brewhouse

The Old Brewery, Brewery Yard, off Wallgate, Wigan, WN1 1JU
☎ **(01942) 234976** ☎ **07764 936410**
⊕ **wiganbrewhouse.co.uk**

⊛Wigan Brewhouse commenced brewing in 2018 after local businessman Martin Blythe leased the now-defunct AllGates Brewery premises, including the acquisition of beers formerly brewed by AllGates. Beers are also brewed to its own recipes, developed by head brewer Jonathan Provost with Martin's input. ‼✦

Pretoria (ABV 3.6%) BLOND
California (ABV 3.9%) BLOND
A pale yellow beer with a restrained hoppy and fruity aroma. It is clean and fresh tasting, with hops and fruit in the mouth and a bitter, hoppy finish.
Casino (ABV 3.9%) BITTER

Wigan Junction (ABV 3.9%) BITTER
Dry Bones (ABV 4%) GOLD
Slider (ABV 4%) BITTER
Tempo (ABV 4.1%) GOLD
Blue Sky Tea (ABV 4.2%) SPECIALITY
Kicker IPA (ABV 4.2%) PALE
Allnighter (ABV 4.3%) PALE
Station Road Stout (ABV 4.5%) MILD
Dark brown beer with a malty, fruity aroma. Creamy and malty in taste, with blackberry fruits and a satisfying aftertaste.

Wily Fox SIBA

1 Kellet Close, Wigan, WN5 0LP
☎ **(01942) 215525** ⊕ **wilyfoxbrewery.co.uk**

A bespoke 20-barrel brewery, set up in 2016. Head brewer Dave Goodwin previously worked for Thwaites and Samuel Smith. ‼

Blonde Vixen (ABV 3.8%) BLOND
Light-bodied fruity beer.
Prohibition APA (ABV 3.9%) PALE
Hoppy beer with citrus character throughout.
Crafty Fox (ABV 4%) BITTER
Well-balanced bitter and malty sweetness, with fruity hops. Creamy mouthfeel, and bitter finish.
The Fox Hat (ABV 4.2%) GOLD
Fruity aroma. Citrus hop taste and bitter hoppy aftertaste.
Karma Citra (ABV 4.3%) GOLD
Citrus fruit in aroma and taste with balanced bitterness, and a dry finish.
Dark Flagon (ABV 4.4%) SPECIALITY

Swan with Two Necks, Stockport (Photo: Dermot Kennedy)

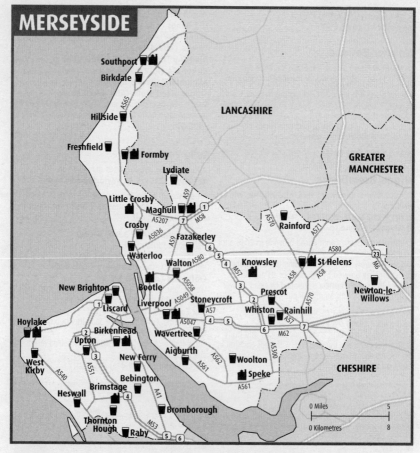

MERSEYSIDE

Bebington

Rose & Crown Ⓛ ✅

57 The Village, CH63 7PL
☎ (0151) 644 5829 ● roseandcrownbebington.co.uk
Thwaites Original, IPA, Gold, Amber; house beer (by
Thwaites); 2 changing beers (sourced locally; often
Big Bog, Brimstage, Neptune) Ⓗ
This old coaching inn, built in 1732, is a thriving, vibrant
and friendly community local. It has a lounge, small bar
and games room, with traditional decor and old photos
of the area. Thwaites brews the house beer, Rose Gold,
and some of the changing ales; the frequent guests are
mostly from local breweries. The nearby Port Sunlight
village was founded by William Lever in 1888 to house
his soap factory workers and is the home of the Lady
Lever Art Gallery.
Q ♿ ≈ (Port Sunlight) ♣P🚌 (410,487) 🐾 �

Traveller's Rest ✅

169 Mount Road, CH63 8PJ
☎ (0151) 608 2988 ● thetravsbebington.co.uk
Ossett White Rat; Timothy Taylor Landlord; 4
changing beers (sourced nationally; often Big Bog,
Fuller's, Oaks) Ⓗ
Reputedly over 300 years old, this cosy former coaching
inn is close to Storeton Woods. It has a country pub feel
and is decorated throughout with brasses and bric-a-
brac. A central bar serves the main bar area and two side
rooms. Guest ales, often from local microbreweries, are
offered alongside one changing real cider. At lunchtime

the emphasis is on food; in the evening this is very much
a traditional pub. No evening meals Monday and
Tuesday. Q ♿ ◖ & ♣🚌 (464,487) 🐾 �

Birkdale

Barrel House Ⓛ

42 Liverpool Road, PR8 4AY
☎ (01704) 566601
2 changing beers (often Parker, Salopian,
Southport) Ⓗ
Micropub that opened in 2014 in a former newsagent's,
and still sells the daily paper. It owed its creation to a
new Sainsbury's supermarket that gave the owner the
idea to change his business. The pub is now an Aladdin's
cave of wonderful bottled beers, wines, loose-leaf teas
and speciality coffees. It also sells two real ales on
handpump, usually from local breweries including
Southport, Parker and Salopian.
Q ♿ ❀ ≈ (Birkdale) ♣🚌 (49,X2) 🐾 �

Birkenhead

Gallaghers Traditional Pub Ⓛ

20 Chester Street, CH41 5DQ
☎ (0151) 649 9095 ● gallagherswirral.com/traditional-pub
6 changing beers (sourced nationally; often
Brimstage, Rat, Salopian) Ⓗ
Multiple award-winning free house close to the Mersey
ferries, rescued after closure and refurbished in 2010. It is

decorated with a fascinating range of military memorabilia and a collection of shipping images. Meals are served daily, except Monday evening. Live music plays every Sunday. The outside rear area has a retractable roof. A mural commemorates the sinking of HMS Birkenhead, which inspired the Birkenhead drill: 'women and children first'.

✪◑ᐅ≠(Hamilton Sq) ♣♦🚫🐾❀

Bromborough

Bow-Legged Beagle 🅛

11 Allport Lane, CH62 7HH
4 changing beers (sourced regionally; often Beartown, Brimstage, Neptune) Ⓗ
This friendly and comfortable addition to the Bow-Legged Beagle chain of micropubs opened in 2020. Its location – in a former shop in the main street, near the ancient market cross in the centre of Bromborough – is convenient for buses and a 10-minute walk from the railway station. The selection of cask ales usually includes a session pale and a stronger IPA, plus a bitter or amber brew and a stout or porter. Q➲♦🚫(1,38)❀

Crosby

Liverpool Pigeon 🅛

14 Endbutt Lane, L23 0TR
☎ 07766 480329 ⊕ liverpoolpigeon.co.uk
5 changing beers (sourced locally; often Bristol Beer Factory, Salopian) Ⓗ
Merseyside's pioneering micropub, named after a now extinct bird from Polynesia, is a fine example of the type. It offers up real ales, ciders and bottled beers but no spirits, alcopops, keg beers or music. The cask ales usually include a local brew and often a dark beer. Locally made pies are available at the bar. A former local CAMRA Pub of the Year. Q♿♣♦🚫🚫(47,X2)❀

Formby

Sparrowhawk

Southport Old Road, L37 0AB (adjacent to Formby bypass opp Woodvale Airfield)
☎ (01704) 882350
Salopian Oracle; Titanic Plum Porter; 3 changing beers (sourced regionally) Ⓗ
Large, open-plan Brunning & Price pub on the original road between Southport and Formby. It was built as the dower house to the nearby Formby Hall and sits in five acres of gardens and woodland. The emphasis is on food but up to six real ales are served in excellent condition. The bus stop at Woodpile traffic lights is a few minutes' walk away. Q➲✪◑♿♣P🚫(47,49)❀☎

Tin Shed 🅛

60 Brows Lane, L37 4ED
☎ (01704) 808220
5 changing beers (sourced locally; often Parker) Ⓗ
Micropub that opened in July 2021 on the town's main street, handy for the local shops and leisure centre. Its interior has ample seating. The beer range features local breweries including Parker and Southport. The pub is a short walk from Formby station, from where trains normally run every 20 minutes to Liverpool or Southport. Q➲✪♿≠♣♦🚫❀☎

Freshfield

Beer Station

3 Victoria Buildings, L37 7DB (opp railway station)
☎ (01704) 807450

3 changing beers (sourced locally; often Beer Station) Ⓗ
Freshfield's first micropub has a focus on all things local. Its beers are chosen to showcase the area's brewers, including the on-site brewery, supplemented by one 'foreign' ale a month from outside the region. The few spirits offered also have their provenance checked. A fridge of bottled beers adds variety. Food is in the form of nuts and local pies. Dogs are welcome on a lead. Q➲✪♿≠♣♦🚫(F1)❀☎

Freshfield 🅛 ✔

1 Massams Lane, L37 7BD (from station turn inland into Victoria Rd and then left into Gores Lane)
☎ (01704) 874871
Greene King IPA, Abbot; Oakham Citra; 8 changing beers (sourced regionally) Ⓗ
A community pub at its heart with three distinct areas – a bar with numerous handpumps, a dining room serving quality food, and 'the flags', where well-behaved dogs are welcome. Sport is shown on three large TVs; a real fire adds warmth in winter. Real cider is available on occasion during festivals. This is a place to meet, talk and spend time with friends old and new. A former CAMRA National Pub of the Year finalist and multi award-winner. ➲✪◑♿≠♣P🚫(F1)❀☎

Heswall

Beer Lab 🅛

53 Telegraph Road, CH60 0AD
☎ (0151) 342 5475 ⊕ thebeerlab.co.uk
4 changing beers (sourced regionally; often Brightside, Neptune, Purple Moose) Ⓗ
Heswall's first micropub opened in 2018 in a former cycle shop, an easy five minutes' walk from the bus station and main shopping area. The relaxed, minimalist single-room bar is bright and airy, making the most of the available space. Five real ciders are always available together with Belgian bottled beers. Beer is served in pint, one-third and two-thirds measures only. Local CAMRA Cider Pub of the Year 2020-22. Q♣♦🚫(22,73)❀☎

Hillside

Grasshopper ✔

70 Sandon Road, PR8 4QD
☎ (01704) 569794

REAL ALE BREWERIES

Ad Hop Liverpool (brewing suspended)
Azvex ✦ Liverpool (NEW)
Beer Station 🍺 Formby
Big Bog ✦ Speke
Black Lodge ✦ Liverpool
Brimstage Brimstage
Brooks Hoylake
Cains ✦ Liverpool (NEW)
Carnival ✦ Liverpool
Handyman 🍺 Liverpool
Howzat 🍺 St Helens
Liverpool Brewing ✦ Liverpool
Love Lane 🍺 ✦ Liverpool
Melwood Knowsley
Neptune ✦ Maghull
Peerless ✦ Birkenhead
Rock the Boat Little Crosby
Southport Southport
Stamps Bootle
Top Rope ✦ Liverpool

8 changing beers (sourced regionally; often Heritage, Salopian, Peerless) Ⓗ
Micropub in a row of shops close to Hillside train station. It opened in 2016 in what was a Martins Bank branch until 1978; the Martins logo was a grasshopper. There is outdoor seating at the front and a secluded beer garden to the rear. Eight changing real ales and six real ciders are served. Local CAMRA Cider Pub of the Year 2022.
Q❀&♿♣Pᐅ❀

Pines

3 Hillside Road, PR8 4QB
☎ 07454 453090
2 changing beers (sourced regionally) Ⓗ
An attractively decorated bar in what was once a hairdresser's in an area that previously had no pubs or bars but now has two award-winning outlets. Two handpumps offer a varied choice of beers, served alongside a selection of bottled ales. Sandwiches are delivered daily. An outside seating area at the front is popular in the warmer months. The bar can be either quiet and relaxing or noisy, depending on the time of day. Dogs are welcome, with treats available.
ᐅ❀&⇌Pᐅ(47) ❀ 🛜

Hoylake

Black Toad Ⓛ

32 Market Street, CH47 2AF
☎ 07835 360691 ⊕ theblacktoad.co.uk
4 changing beers (sourced regionally; often Chapter, Neptune, Peerless) Ⓗ
Micropub that opened in 2019 in an abandoned unit on the main shopping street in central Hoylake. Its narrow main room and bar are attractively decorated with simple furniture. The owners offer a balanced selection of cask beers at all times. In 2020 the pub extended into the next-door shop to create a new lounge area; the small rear room is now a bottle shop. At the rear is a pleasant beer garden. Qᐅ❀⇌ᐅ(38,407)❀ 🛜

Plasterers Arms ⦿

35 Back Seaview, CH47 2DJ
☎ (0151) 345 0249
Ossett White Rat; Purple Moose Cwrw Glaslyn/Glaslyn Ale; Timothy Taylor Landlord; 1 changing beer (sourced nationally) Ⓗ
Friendly, traditional two-room hostelry in a former fishing community, sadly long gone. A pub for over 250 years, it has fascinating decor – note the mirrored ceiling – with information about the inn and local history. Close to the beach, it is popular with walkers and birdwatchers, and a short walk to Market Street for shops, buses and the railway station. There is seating outside and a children's playground opposite. Regular entertainment features at weekends. Parking is on the street nearby.
Qᐅ❀❀⇌(Manor Rd) ♣ᐅ(38,407) ❀ 🛜

Liscard

Lazy Landlord Ale House Ⓛ

56 Mill Lane, CH44 5UG
☎ 07583 135616
Joseph Holt Bitter; Oakham Citra; 3 changing beers (sourced nationally; often Brimstage, Peerless, Rat) Ⓗ
Wirral's first micropub, opened in converted shop premises in 2014. It is run by cask ale enthusiasts the Henry brothers. The two small, cosy rooms, served from the front bar, feature breweriana, artworks and a small library. Two ciders are offered, usually from SeaCider and Snails Bank. The pub hosts meetings of local societies,

and is mostly frequented by a mature, discerning clientele of regulars. A former local CAMRA Pub of the Year. Qᐅ♣♦ᐅ(410,432)❀

Liverpool: Aigburth

Little Tap Room Ⓛ

278 Aigburth Road, L17 9PJ
⊕ aigburthtap.co.uk
5 changing beers (sourced locally; often Chapter, Neptune) Ⓗ
Friendly two-room micropub that opened in 2020 near Sefton Park, on a main road with excellent bus and Merseyrail services close by. The front bar's handpulls serve both beer and cider. Bottled and canned ales are stocked, and the spirit range includes the pub's own Sefton Park gin. Attractions include board games, a book club and background music – there is no TV or jukebox.
Q♣ᐅ(60,82) 🛜

Liverpool: City Centre

Augustus John Ⓛ

Peach Street, L3 5TX (off Brownlow Hill)
☎ (0151) 794 5507
5 changing beers (sourced nationally; often Peerless, Rock the Boat) Ⓗ
Opened in 1968 and run by the University of Liverpool, this is an open-plan pub that is popular with students, lecturers and locals. Its cask ales come in a range of styles – light and dark – and usually includes a local ale. There are two ciders on handpump and many more in the cellar. Pizza is served at all times. A jukebox provides entertainment. Closed over Christmas and New Year. Card payment only. Local CAMRA Cider Pub of the Year. ❀◖&♣ᐅ(79) 🛜

Baltic Fleet Ⓛ

33A Wapping, L1 8DQ
☎ (0151) 709 3116 ⊕ balticfleet.co.uk
Brimstage Trapper's Hat Bitter; 3 changing beers (sourced locally) Ⓗ
Grade II-listed building near the Albert Dock. It has a distinctive flatiron shape and the interior is decorated on a nautical theme. The existence of tunnels in the cellar has led to speculation that the pub's history may involve smuggling. Originally it had many doors to allow customers to escape the press gangs. It can get busy when events are on at the nearby M&S Bank Arena.
❀⇌(James St) ♦Pᐅ❀ 🛜

Belvedere Ⓛ

8 Sugnall Street, L7 7EB (off Falkner St)
4 changing beers (sourced regionally; often Ossett) Ⓗ
Tucked away in the Georgian area of the city, close to the famous Philharmonic Hall, and frequented by its orchestra members, this small two-roomed pub is a free house serving four rotating beers from mainly local microbreweries. Redeemed in 2006 from closure for housing development, this Grade II-listed building retains original fixtures and interesting etched glass features. It is a pub with a mixed local clientele, where various small cultural groups meet and good conversation thrives.
Q❀ᐅ(86,80) ❀ 🛜

Bridewell 🍷 Ⓛ

1 Campbell Square, L1 5FB
☎ (0151) 707 2372 ⊕ thebridewellpub.co.uk
Kirkstall Pale Ale Ⓗ/Ⓖ**; house beer (by Ossett); 2 changing beers (sourced nationally; often Conwy)** Ⓗ
An imposing, Grade II-listed building that dates from the mid-19th century, when it was a police bridewell, or jail.

The former cells are now seating areas and provide an unusual focus in the downstairs bar. There is an outdoor patio at the front. The pub is close to the Liverpool One shopping area, the Albert Dock and the riverfront. Local CAMRA Pub of the Year 2022. ❀≢(Central)🛜

Captain Alexander Ⓛ ✔

15 James Street, L2 7NX
☎ (0151) 227 4197
Greene King Abbot; Ruddles Best Bitter; Sharp's Doom Bar; 8 changing beers (sourced nationally; often Big Bog, Peerless) Ⓗ
One-bar Wetherspoon with an outdoor terrace, close to the Pier Head and Albert Dock. The pub opened in 2019 and is named after Captain Alexander 'Sandy' Allan, founder of the Allan Shipping Line, which had an office next door. The Allan Line pioneered trading with Canada and became the world's largest privately owned shipping firm in the early 19th century.
🖕🕦🐾≢(James St) 🍴🚇🛜

Cracke

13 Rice Street, L1 9BB (off Hope St)
☎ (0151) 709 4171
3 changing beers (sourced nationally) Ⓗ
Characterful back-street pub with two bars. The public bar displays pictures of John Lennon outside the pub; he visited while attending the nearby art college. One of the pub's rooms is a gallery for local artists. The door on Rice Street has an old glass etching of Houlding's Beacon Ales. John Houlding was the brewer and Lord Mayor of Liverpool who founded Liverpool FC.
Q❀≢(Central) 🚇(80,86) 🛜

Denbigh Castle

10 Hackins Hey, L2 2AW (off Dale St)
☎ (0151) 236 8558 ⊕ thedenbighcastle.co.uk
Conwy Welsh Pride; 3 changing beers (sourced nationally; often Five Points, Kirkstall) Ⓗ
Open-plan pub that has had many identities before being refurbished and relaunched in 2020 as the Denbigh Castle, its original name from over 200 years ago. It is a sister pub to the Bridewell. The beer choice includes cask ales, craft beers and German lagers. The ground floor bar is complemented by rooms up and down stairs for functions and events. ≢(Moorfields)🍴🚇🛜

Dispensary

87 Renshaw Street, L1 2SP
☎ 07472 291403 ⊕ dockleafbar.co.uk/thedispensary
Oakham Citra; Ossett White Rat; Titanic Plum Porter; 4 changing beers (often Ossett, Titanic) Ⓗ
This lively city pub is a haven for real ale drinkers of all ages. It was formerly a Cains tied house but is now leased out as a free house. The attractive bar area has Victorian features and there is a raised wood-panelled area to the rear. The pub was originally the Grapes – the old sign is behind the bar. It can be busy when sport is shown on the big screens. There is a food stall outside.
❀🕦≢(Central) 🚇🛜

Doctor Duncan's ✔

St Johns Lane, L1 1HF
☎ (0151) 709 5100 ⊕ doctorduncansliverpool.com
Cains Bitter; 4 changing beers (sourced nationally; often Cains, Salopian) Ⓗ
This former Cains Brewery flagship pub has an impressive Victorian interior with four distinctively different drinking areas, of which the green tiled room is particularly handsome. The pub's name commemorates Doctor Duncan, the first chief medical officer of Liverpool and a ruthless campaigner against poor living conditions in Victorian Liverpool, and medical memorabilia can be

found throughout. Beers come from the resurrected Cains Brewery which is housed in a Mikhail group sister pub.
❀🕦≢(Lime St) 🍴🚇☕🛜

Excelsior Ⓛ ✔

121-123 Dale Street, L2 2JH (close to Birkenhead Tunnel entrance)
☎ (0151) 352 9544 ⊕ excelsiorliverpool.co.uk
Timothy Taylor Landlord; 4 changing beers (sourced regionally; often Liverpool Brewing, Ossett, Salopian) Ⓗ
Named after a sailing ship, this large corner pub is adjacent to what were Higsons Brewery offices. A tastefully decorated and comfortable place, it appeals to both a business and leisure clientele. The main room has a three-sided bar with a series of distinct seating areas. There is a large room off the main bar with a raised seating area – this can be hired for meetings or functions. Large-screen TVs show sports events, particularly football, but are generally silent otherwise.
🕦≢(Moorfields) P🚇🛜

Fly in the Loaf ✔

13 Hardman Street, L1 9AS
☎ (0151) 708 0817
Okell's Bitter; 5 changing beers (sourced nationally; often Kirkstall, Okell's) Ⓗ
A former bakery, the name comes from the slogan 'no flies in the loaf'. Owned by Isle of Man brewer Okell's, it serves its own beers alongside a changing range of guests from around the country, many from microbreweries, and a good selection of foreign beers. The spacious interior has a light, airy frontage with contrasting wood-panelled areas towards the rear. There is a small, attractive on-street drinking area at the front and a function room upstairs.
🕦🐾≢(Central) 🚇(80,86) 🛜

Globe ✔

17 Cases Street, L1 1HW (opp Central Station)
☎ (0151) 707 0067 ⊕ theglobe.pub
Marston's EPA; Sharp's Doom Bar; Timothy Taylor Landlord; Wainwright; 2 changing beers (sourced nationally) Ⓗ
Situated opposite Central Station, this small, traditional pub is a former local CAMRA Best Community Pub. The Globe attracts visitors from all over the city – a buzz of lively conversation prevails and everyone is very welcome. In the small back room, a brass plaque commemorates the inaugural meeting of CAMRA Merseyside – 40th year celebrations were held here in 2014. The sloping floor in the bar area is legendary!
≢(Central) 🚇

Grapes Ⓛ

60 Roscoe Street, L1 9DW
☎ (0151) 708 6870
8 changing beers (often Chapter, Neptune) Ⓗ
This corner local dates back to 1804 and has the original Mellors signage outside. It is known as the 'Little Grapes', but following a major refurbishment some years back, an extension has made the pub larger. Stairs now lead to a partly sheltered patio area atop the extension. Most of the nine handpumps serve beers from local and smaller regional breweries, with one pump now regularly serving a real cider. An extensive selection of rums is kept. Live jazz plays every Sunday.
❀≢(Central) 🍴🚇(82) 🛜

Lime Kiln Ⓛ ✔

Fleet Street, L1 4NR
☎ (0151) 702 6810

Greene King Abbot; Ruddles Best Bitter; 9 changing beers (sourced nationally; often Peerless) H
On first impression, the decor and layout may appear not to offer much for the real ale drinker, but looks can be deceiving. Thanks to continued commitment, real ale is well supported here. Situated in the Concert Square area, the pub is a peaceful haven during the day, but after 8pm becomes a music and disco venue for the younger crowd. There is a drinking terrace outside. A Victorian warehouse occupied the site, which was home to manufacturing chemists, from the early 1900s to the 1950s. ⬚❶♿(Central)●🚌🚐 🛜

Lion Tavern ★ L

67 Moorfields, L2 2BP
⊕ theliontavernliverpool.co.uk
Peerless Triple Blond; Wily Fox Crafty Fox; house beer (by Liverpool Brewing); 3 changing beers (sourced nationally; often Brimstage, Dark Star, Salopian) H
Named after the locomotive that worked the Liverpool to Manchester Railway (and is on display at the Liverpool museum). The Lion features mosaic floors, a tiled corridor plus intricately etched and stained glass. Refurbished in 2017, it retains Grade II-listed status and has been identified by CAMRA as having a nationally important historic pub interior. Up to eight beers are from the SIBA list, usually including ales from local micros. Cider is regularly available and local gins are kept. Local CAMRA Pub of the Year 2021. ❶≹(Moorfields)●🚌🚐❀🛜

Pen Factory

13 Hope Street, L1 9BQ
☎ (0151) 709 7887 ⊕ pen-factory.co.uk
Titanic Plum Porter; 4 changing beers (sourced nationally; often Ossett, Salopian, Titanic) H
The Pen Factory was opened in 2015 by the innovator of the original Everyman Bistro, entrepreneur Paddy Byrne. This large open-plan bistro-style establishment with a wood-burning stove and a small garden is a convivial place to drink and eat. At least five handpumps offer real ales and ciders. The food is excellent, not your average pub grub. The venue can be busy before or after productions at the nearby Everyman Theatre and Philharmonic Hall. ❀❶♿≹(Central)🚌🚐(80,86)❀ 🛜

Peter Kavanagh's ★ ✓

2-6 Egerton Street, L8 7LY (off Catharine St)
☎ (0151) 709 3443
Greene King Abbot; 4 changing beers (sourced nationally; often Castle Rock) H
A Grade II-listed, stuccoed pub in the Georgian quarter which has been identified by CAMRA as having a nationally important historic pub interior. The snugs display murals by Eric Robinson and there are fine stained-glass windows with wooden shutters. The benches have carved armrests thought to be caricatures of Peter Kavanagh, the licensee for 53 years until 1950. These features were not adversely affected when the pub was expanded, firstly in 1964 into next door, then in 1977 into next door but one. Q🚐❀🛜

Roscoe Head

24 Roscoe Street, L1 2SX
☎ (0151) 709 4365 ⊕ roscoehead.co.uk
Tetley Bitter; Timothy Taylor Landlord; 4 changing beers (sourced locally) H
One of the 'Famous Five' pubs that have featured in every edition of the Guide. The freehold was sold to the current tenant in 2020, following a five-year campaign against the previous owners. This is a cosy four-roomed venue where conversation and the appreciation of real ale rule. Six handpumps serve beers from local and national breweries. Run by members of the same family

for over 30 years, the name commemorates William Roscoe, a leading campaigner against the slave trade. Q❶≹(Central)♣🚐🛜

Ship & Mitre L

133 Dale Street, L2 2JH (by Birkenhead Tunnel)
☎ (0151) 236 0859 ⊕ theshipandmitre.com
Flagship Lupa, Silhouette, Sublime; 5 changing beers (sourced nationally; often Big Bog, Flagship) H
The name derives from two previous incarnations, the Flagship and the Mitre. The 1930s Art Deco pub is partly hidden by the Queensway Tunnel entrance. Upstairs is the original bar and function room, downstairs has been converted and given a nautical-themed makeover. Fifteen handpulls offer an ever-changing array of beers and real ciders – friendly and knowledgeable staff are always willing to make a recommendation. There is also an impressive range of world beers. The pub brews its own Flagship beers using the plant at Stamps Brewery. ❶≹(Moorfields) ♣●🛒🚐❀🛜

Thomas Rigby's ✓

23-25 Dale Street, L2 2EZ
☎ (0151) 236 3269
Okell's Bitter, Dr Okell's IPA; 4 changing beers (often Kirkstall, Ossett) H
This multi-roomed, Grade II-listed building, bearing the name of wine and spirit dealer Thomas Rigby, supplies an extensive world beer range on draught and in bottles. The regular beers on handpump come from the pub's owner, Okell's. Good-value food including specials is served until early evening, with one room offering a friendly and efficient table service. The old coaching inn courtyard for outdoor drinking is shared with sister pub Lady of Mann. ❀❶♿≹(Moorfields)🚐🛜

Vernon Arms L

69 Dale Street, L2 2HJ
☎ (0151) 236 6132
Brains Rev James Original; house beer (by Stamps); 3 changing beers H
Situated close to the business district, the Vernon retains the feel of a street-corner local. The single long-roomed bar serves three drinking areas including a back room with frosted glass windows advertising the Liverpool Brewing Company, which once again serves the pub. The main bar has wood panelling, several large columns and a small snug area. Real cider on handpull is unusual for the city centre. ❶≹(Moorfields)●🚐🛜

Liverpool: Fazakerley

Jaxon's Micropub L

21 Longmoor Lane, L9 0EA
☎ (0151) 524 2818
4 changing beers (often Black Lodge, Neptune) H
Opened in 2020, this friendly micropub is a welcome addition to an area where real ale is, sadly, becoming increasingly scarce. This shop conversion has a modern but welcoming interior, and there is pavement seating in the summer. Real ale is dispensed from four handpulls, two of which are normally reserved for LocAles such as Neptune and Black Lodge. Real cider in a box is also available as well as a selection of bottled beer and craft cans. ❀≹(Orrell Park)●❀🛜

Liverpool: Stoneycroft

Cask L

438 Queens Drive, L13 0AR (near jct Queens Drive and Derby Lane)
☎ 07562 713967

5 changing beers (sourced nationally) ⊞
Comfortable, immaculate, one-roomed micropub that
opened in 2015. There are usually four beers on Tuesday
and Wednesday, five on Thursday and up to seven from
Friday. Special beers in wooden pins are sometimes
available. Cider and perry are dispensed direct from taps
at the rear of the bar. Bottled beers are stocked. Some
roadside parking is available. ♣●☐🖪(60,81)

Liverpool: Walton

Raven 🅛 ✅
72-74 Walton Vale, L9 2BU
☎ (0151) 524 1255
Fuller's London Pride; Greene King Abbot; Ruddles
Best Bitter; Sharp's Doom Bar; 5 changing beers ⊞
This open-plan Wetherspoon pub is popular with locals,
particularly at weekends. It is themed on Edgar Allan
Poe's The Raven – local pavement artist James William
Carling created illustrations for the famous poem in the
late 19th century. Aintree, home of horse racing's Grand
National, is less than a mile away. Children are welcome
until 9pm. 🏠🕽&≉(Orrell Park)🖪🛜

Liverpool: Wavertree

Handyman Supermarket 🅛
461 Smithdown Road, L15 3JL
☎ (0151) 222 7422 ⊕ handymansupermarket.co.uk
Handyman Pale; 3 changing beers (sourced locally;
often Handyman, Melwood) ⊞
Brewpub opened in 2017 in what was previously a
hardware shop, hence the name. It has a large open-plan
bar plus an events/function room at the rear. The brew
plant is on a mezzanine above the bar. Handpumps serve
the pub's own cask beers, and there are also craft keg
beers on tap and a selection of bottled beers. Many
events are hosted, from live music to craft fairs. The
brewery beers are unfined and often brewed
collaboratively at other breweries. ●🖪(60,86)🌸🛜

Willow Bank 🅛 ✅
329 Smithdown Road, L15 3JA
☎ (0151) 733 5782
Greene King IPA, Abbot; Tetley Bitter; house beer (by
Greene King); 4 changing beers (sourced nationally;
often Big Bog, Ossett) ⊞
Vibrant, traditional, multi-room pub with the original
public bar dating back to when this was a Walkers house.
Up to eight changing guest beers are on offer – real ale
night is Tuesday – and there are occasional beer festivals.
Good-value food is served including Sunday lunches.
Sports TV is shown on large screens on the roadside
patio. Activities such as the quiz night attract students,
but the pub is also popular with locals and shoppers.
🏠🕽&●🖪(60,86) 🛜

Liverpool: Woolton

Cobden ✅
89 Quarry Street, L25 6HA
☎ 07708 231796
Peerless Pale; Timothy Taylor Landlord; Wainwright;
1 changing beer (sourced locally; often Big Bog) ⊞
A classic and very popular community pub with a main
room and a smaller back room for more convivial
conversation. It hosts quizzes on Monday and Tuesday
nights, and live music on Sundays and some Saturday
evenings. Woolton is famous as the home of the Beatles
– their original name was The Quarrymen, named after
the quarry close to this pub. 🖪(76,81)🌸

Lydiate

Scotch Piper ★ ✅
Southport Road, L31 4HD (800yds N from A5147/Moss
Lane jct)
☎ (0151) 345 6399 ⊕ scotchpiper.com
3 changing beers (sourced nationally; often
Titanic) ⊞
The Scotch Piper is a whitewashed, thatched, medieval
Grade II*-listed building just north of Lydiate. It takes its
name from an incident in 1745 when a Highland piper,
injured in the Jacobite rebellion, took refuge here. The
doorway opens into a traditional bar with a servery on
the left. A passage to the right leads to two further
rooms, the middle one with simple old woodwork. The
end room, added later, is less rustic.
Q🏠🕽🍴▲♣🖪(300) 🌸🛜

Maghull

Frank Hornby 🅛 ✅
38 Eastway, L31 6BR
☎ (0151) 520 4010
5 changing beers (often Brightside, Elland,
Saltaire) ⊞
A Wetherspoon establishment named after local man
Frank Hornby, inventor of the Hornby train set. Samples
of his work are on display in the pub, including Meccano
and Dinky Toys. Situated in a suburban street, the bar is
spacious and light inside, with a decked area outside at
the front. A varied selection of guest ales is available,
some from local breweries. Children are permitted until
10pm. Q🏠🕽🍴&🖪🛜

Maghull Cask Café 🅛
43 Liverpool Road South, L31 7BN
☎ (0151) 526 3877
5 changing beers (sourced locally; often Neptune,
Oakham) ⊞
This micropub is a hidden gem. Opened in 2018, it serves
a good range of changing cask ales, continental bottles
and gins. Beers are from regional brewers such as
Oakham, Titanic and Salopian. Friendly, knowledgeable
staff help to create a welcoming atmosphere where
conversation prevails. The Liverpool to Leeds canal runs
through Maghull and the pub makes an ideal base for a
pleasant walk towards Burscough.
Q&●🖪(300,310) 🌸🛜

New Brighton

Bow-Legged Beagle 🅛
88 Victoria Road, CH45 2JF
☎ 07597 900114 ⊕ thebowleggedbeagle.co.uk
5 changing beers (sourced regionally; often
Beartown, Neptune) ⊞
The first micropub in the Bow-Legged Beagle group
opened in 2017 in a former street corner shop, and
continues to be popular with locals and visitors. It has a
basic no-frills format with a friendly atmosphere and a
regularly changing, varied range of new and unusual
local beers. There is seating outside on the pavement in
summer. The pub is close to the seafront and other local
attractions, in an area that is being rejuvenated with
attractive murals. Q🌸≉●🖪(410,432)🌸🛜

James Atherton
117-119 Victoria Road, CH45 2JD
☎ (0151) 638 8022
Brimstage Trapper's Hat Bitter; Ossett White Rat; 3
changing beers (sourced regionally; often Brimstage,
Hawkshead, Ossett) ⊞

Situated on the main shopping street, the pub was refurbished and reopened in 2019 as part of the regeneration of the Victoria Quarter of New Brighton and renamed after one of the founders of the town. The single-room interior is divided into three areas served from one bar. Bright and airy, with a lively atmosphere, it has comfortable seating and local photos on the walls. Close to seafront attractions and the Floral Pavilion Theatre. ♿☆♿✿➤🚃(410,432)☻🐾

Magazine Hotel 🍷 ⅃ ✅

7 Magazine Brow, CH45 1HP (above Egremont Promenade)
☎ (0151) 630 3169 ⊕ the-magazine-hotel.co.uk
Brimstage Trapper's Hat Bitter; Draught Bass; 3 changing beers (sourced regionally; often Beartown, Big Bog, Brimstage) Ⓗ
This unspoilt multi-roomed pub, dating from 1759, was restored after a fire in 2010 without losing its unique character. Three rooms lead off the main central bar area with its open fireplace. Traditionally renowned for its Draught Bass, other beers are often from local microbreweries. One changing real cider is kept. Overlooking Egremont Promenade, the pub has fine views over the River Mersey to Liverpool. Merseyside CAMRA Pub of the Year 2021 and local CAMRA Pub of the Year 2022. Q♿☆♿❀➤♿P🚃(106,107)☻🐾

New Ferry

Cleveland Arms ⅃

31 Bebington Road, CH62 5BE
☎ 07914 385679
Brimstage Trapper's Hat Bitter; 1 changing beer (sourced locally; often Brimstage, Conwy) Ⓗ
A welcome return to the Guide for this old favourite – a lively town centre local in a pedestrian shopping area in the centre of New Ferry. The pub was reopened in 2017 following structural repairs and refurbishment necessary after a major gas explosion in New Ferry. The refurbishment gave the pub a clean, modern appearance while retaining the traditional layout and atmosphere. Live music and bar games feature. ☆♿≠(Bebington) ♣P🚃(41,42) 🐾

Newton-le-Willows

Firkin

65 High Street, WA12 9SL
☎ (01925) 225700 ⊕ thefirkin.co.uk
8 changing beers (sourced locally) Ⓗ
A former shop, this small, friendly establishment dispenses a selection of eight real ales, including at least one dark, all of which are sourced from micro/SIBA breweries. Two traditional ciders are also available. Small seating areas are to the front and the rear, with pictures of Newton of old on the walls. Free of electronic noise, this is somewhere to engage in conversation with like-minded people, and to make new friends. Closed Monday to Wednesday, over-18s only. Q≠♿🚃(34,22) 🐾🛜

Prescot

Watch Maker ⅃ ✅

60 Eccleston Street, L34 5QL
☎ (0151) 432 7030
7 changing beers (often Peerless) Ⓗ
A Wetherspoon free house with a friendly welcome. Alongside the standard national ales there is a focus on local breweries, earning the pub LocAle accreditation. Prescot was one of the main centres for watchmaking

during the 18th and 19th century, and the pub is decorated with elements of watchmaking memorabilia. It has a small outside area to the front of the building. Coach trips and other social activities are arranged. ♿🌙♿≠♿🚃(10,10A) 🛜

Raby

Wheatsheaf Inn ⅃

Raby Mere Road, CH63 4JH
☎ (0151) 336 3416 ⊕ wheatsheaf-cowshed.co.uk
Brimstage Trapper's Hat Bitter; Tetley Bitter; Wainwright; 3 changing beers (sourced nationally; often Brimstage, Marble, Titanic) Ⓗ
Rebuilt in 1611 after a fire, this is Wirral's oldest pub. Renowned for its thatched roof and black and white exterior, the Grade II-listed interior is also noteworthy, with an old snug created by settles around a large table in front of a large brick fireplace. The three rooms, decorated with local photographs, are served from a single bar. The old cowshed attached to the pub has been converted into a restaurant. No food on Sunday and Monday evenings. Q♿☆🌙♿P☻🐾🛜

Rainford

Junction ⅃

News Lane, WA11 7JU
☎ (01744) 882868 ⊕ junctionpubrainford.co.uk
5 changing beers Ⓗ
A community free house with a strong emphasis on showcasing local produce and local music. Beer festivals take place regularly, including one around the May Day bank holiday. A popular venue for local musicians, live music features most evenings. There is a spacious, family-friendly beer garden. Vintage car and motorcycle events are hosted in the large space to the rear of the premises. ♿☆🌙♿≠♣♿🚃(38,157)☻🐾🛜

Rainhill

Skew Bridge Alehouse ⅃

5 Dane Court, L35 4LU
☎ (0151) 792 7906 ⊕ skewbridge.co.uk
Lister's Best Bitter; Outstanding 3.9; 5 changing beers (sourced locally; often Big Bog, Melwood, North Riding Brewery) Ⓗ
This ale house offers a selection of up to six cask beers, four real ciders and three craft lagers. Locally sourced ales are complemented by beers from across the UK. A range of wines, gins and single malt whiskies is also stocked. With no TV or music to distract customers, conversation is very much encouraged. Outdoor seating is available in the summer months. A folk, roots and acoustic night takes place on the first Tuesday of every month. Q♿☆♿≠♣♿P🚃(10A)🛜

St Helens

Cricketers Arms ⅃

64 Peter Street, WA10 2EB
☎ (01744) 361846
13 changing beers (sourced locally) Ⓗ
A former CAMRA National Pub of the Year, this family-run community establishment has 13 handpulls, real ciders and a range of spirits. The traditional pub hosts quiz nights and fundraising events. Outside is a beer garden and a separate bar, increasing the number of real ales available at weekends (also available to hire for private events). In 2020 the on-site Howzat brewery began production of house beers for this pub and others within the local area. ♿☆♣♿P🚃☻🐾🛜

New Talbot Alehouse L
97 Duke Street, WA10 2JG
☎ (01744) 322185
6 changing beers (sourced nationally) H
Popular newly renovated town centre pub. Six real ales are served, the majority from local breweries – the pub is LocAle accredited. Four real ciders are also available, normally from SeaCider, plus a range of spirits and other popular bar drinks. There is a small beer garden to the front and a larger one to the rear. Regular entertainment includes live music at the weekend. ॐ❀♣●₽❀

Sefton ✪
1 Baldwin Street, WA10 1QA
☎ (01744) 22065
5 changing beers (sourced nationally) H
A modern and comfortable town centre pub that caters for everyone, whether you are looking for good pub food, live sport or just drinks with friends. The large room has a long bar down one side offering five regularly changing cask-conditioned ales. There is a function room upstairs, a small beer garden to the rear and live bands often play at the weekend. ॐ❀◖◗≉(Central)₽❤

Turk's Head L
49 Morley Street, WA10 2DQ
☎ (01744) 751289
14 changing beers H
Attractive Tudor-style 1870s pub near the town centre. Real ales and real ciders are on 14 handpulls, and there is a large whisky and gin selection. The upstairs Tower Lounge serves cocktails plus craft and continental beers, and hosts live music on Saturday evening. Quality home-made food is available every day. Tuesday is quiz night with free half-time refreshments. There is a large beer garden to the side and rear with an outside bar and wood-fired pizza oven. Current local CAMRA Cider Pub of the Year. ॐ❀◖◗●₽⛬❀

Southport

Beer Den L
65-67 Duke Street, PR8 5BT
☎ (01704) 329007
2 changing beers (often Parker) H
Southport's newest micropub, set up by the Parker Brewery, serving two of its own beers on rotation plus two guests. Two German lagers and an American IPA on keg complement the range, alongside a carefully chosen spirit and wine selection. In warmer weather there is seating outside at the front. No food is served but the pub is happy for customers to order takeaway from next door. QP₽

Guest House ▼ ★ ✪
16 Union Street, PR9 0QE
☎ (01704) 537660
Caledonian Deuchars; Ruddles Best Bitter; Theakston Best Bitter; house beer (by Caledonian); 2 changing beers (often Bank Top, Salopian, Southport) H
Located close to the station and Lord Street, this listed building has an impressive frontage and an interior with three separate wood-panelled drinking areas. There are 11 handpumps, one of which serves a beer from a local microbrewery. A wide range of malt whiskies is also stocked. This quiet, traditional pub attracts a mixed clientele. It hosts a quiz night on Thursday and an acoustic folk club on the first and third Mondays of the month. There is seating outside at the front and a courtyard to the rear. Local CAMRA Pub of the Year 2022. Q❀◖◗≉₽❀

Masons Arms
4 Anchor Street, PR9 0UT
☎ (01704) 534123
Robinsons Dizzy Blonde, Trooper; Titanic Plum Porter; 2 changing beers (sourced nationally) H
This small pub is tucked away behind the town's former main post office and close to the railway station. The only Robinsons pub in Southport, it has new tenants, and now has five handpumps, providing more choice in town. A roaring log fire makes it an ideal winter haunt. The interior has been revamped with wood-panelled walls, and it has a small roof garden. Q❀≉₽❀

Tap & Bottles
19A Cambridge Walk, PR8 1EN
☎ (01704) 544322
4 changing beers H
A micropub in the arcade between Chapel Street and Lord Street, next to the Atkinson Centre. It serves four real ales from a wide variety of producers, with a preference for North-West breweries. A huge range of bottles is also offered, not all of them real ale. A cheeseboard is available all day. The staff are knowledgeable on beers both cask and keg. Q❀◖◗≉♣●₽❀❀

Thornton Hough

Red Fox L
Neston Road, CH64 7TL
☎ (0151) 353 2920
Brightside Odin Blonde; house beer (by Phoenix); 7 changing beers (sourced locally; often Brimstage, Neptune, Weetwood) H
An impressive brick and sandstone building dating from the 1860s, set in extensive grounds. Refurbished in 2014, it is now a smart gastro-pub. The front bar area retains a pub feel, with the restaurant areas to either side. A smaller bar section at the back serves the terrace and large garden. Open fires abound throughout. Changing beers are usually from local microbreweries and the house beer by Phoenix is Brunning & Price Original Bitter. Up to 10 ciders are available. A previous winner of numerous local CAMRA awards including local Cider Pub of the Year. Q❀◖◗●P₽(487)❀❀

Upton

Bow-Legged Beagle L
19 Arrowe Park Road, CH49 0UB
☎ 07739 032624
4 changing beers (sourced regionally; often Brimstage, Neptune, Salopian) H
This micropub opened in 2018 on a former bank on a busy row of shops near the centre of the village. The light, airy room has a friendly ambience, with wood-panelled walls, a wood floor and basic furnishings. Some of the old bank safes have been retained at the back of the pub. This is the second of three Bow-Legged Beagle micropubs in Wirral. Q❀₽(16,437)❀❀

Waterloo

Four Ashes L
23 Crosby Road North, L22 0LD
6 changing beers (often Neptune, Liverpool Brewing, Wily Fox) H
A family-run micropub owned by the Ashe family – hence the name. On the site of a former restaurant, it is a great addition to the vibrant real ale scene in and around Waterloo station. Beers are ordered direct from local microbreweries or through a wholesaler, resulting in a

varied and interesting selection, almost always including at least one dark ale. Beers conditioning in the cellar are displayed on the wall. Q&✿≉♣●🚃(47,X2)✿

Volunteer Canteen ★ 🅛

45 East Street, L22 8QR

☎ 07891 407464

4 changing beers (sourced nationally; often Black Lodge, Liverpool Brewing, Salopian) 🄷

A cosy, traditional pub in a Grade II-listed terraced building. The Volly, as it is locally known, still provides table service. Nestling in the back streets of Waterloo, the pub dates from 1871. Until the 1980s it was owned by Higsons, evidence of which can be seen etched into its windows. Small breweries around Merseyside and north Wales often supply guest ales.
Q✿≉♣🚃(53) ✿ 🕾

Waterpudlian 🅛

99 South Road, L22 0LR (diagonally opp Waterloo Station)

☎ (0151) 280 0035

5 changing beers (sourced locally; often Brimstage, Oakham, Salopian) 🄷

Previously Stamps Too, this former local CAMRA Pub of the Year was the area's first accredited LocAle pub. The friendly open-plan bar, where lively banter often prevails, is the haunt both of real ale enthusiasts and live music fans. Five handpumps serve mainly local beers, from Liverpool, Brimstage and Southport breweries in particular, with occasional ales from further afield. A sixth handpump dispenses real cider. Bands and local musicians feature Thursday to Sunday.
&≉●🚃(53,133) ✿ 🕾

West Kirby

West Kirby Tap 🅛

Grange Road, CH48 4DY

☎ (0151) 625 0350 ● westkirbytap.co.uk

Spitting Feathers Session Beer, Thirstquencher; 7 changing beers (sourced regionally; often Black Lodge, Chapter, Neptune) 🄷

A modern open-plan bar with plain wooden panelling, bare brick walls and a log-burning stove. Owned by Spitting Feathers brewery, it serves a wide range of beers, mainly from microbreweries, and one real cider. Food includes platters of cheese, fish, cold meats and vegan snacks – serving times vary so check availability first. Live music plays on Saturday night. Close to the shops and a short walk to the beach for those trekking to Hilbre Island, tides permitting.
🕾✿◐≉●🚃(38,407) ✿ 🕾

White Lion 🅛 ✪

51 Grange Road, CH48 4EE

☎ (0151) 625 9037 ● whitelionwestkirby.co.uk

Brains Rev James Original; Butcombe Original; 3 changing beers (sourced locally) 🄷

A 200-year-old sandstone building close to the centre of West Kirby. This traditional pub is a little quirky and laid out over several different levels, with lots of cosy nooks to sit in, along with a real fire to keep you warm in winter. In summer months you can enjoy the lovely beer garden at the rear. Quiz night is Monday. Thai food is available but serving hours vary – check ahead.
🕾✿◐≉🚃(437) ✿ 🕾

Whiston

Beer EnGin 🍷 🅛

9 Greenes Road, L35 3RE

☎ 07496 616132

6 changing beers 🄷

Set in a row of shops, this cosy single-room microbar is a delight from the moment you walk in. It serves six real ales plus craft beers, wines and a variety of unusual gins. A selection of board games is available. Bank holiday hours may vary. A warm welcome is assured for all, including dogs. Local CAMRA Pub of the Year 2022.
🕾&≉♣●P🚃✿

Breweries

Ad Hop

18 Severs Street, Liverpool, L6 5HJ ☎ 07957 165501

Ad Hop started life in 2014 at the Clove Hitch pub, moving a couple of times before ending up in much larger premises in 2017 where a 5.5-barrel plant was added to its existing 2.5-barrel one. Brewing is currently suspended. ♦LIVE

Azvex (NEW)

Unit 16, King Edward Rise, Gibralter Row, Liverpool, L3 7HJ ● axvexbrewing.com

Azvex Brewing Co is a Liverpool-based brewery producing modern progressive beer. No real ale. ✦

Beer Station

▤ 3 Victoria Buildings, Victoria Road, Formby, Merseyside, L37 7DB

☎ (01704) 807450

⊕A small half-barrel plant set up in 2019 at the rear of the Beer Station micropub, opposite Freshfield station. The beers are railway-themed and generally only available in the Beer Station, but are occasionally seen elsewhere.

Big Bog SIBA

74 Venture Point West, Evans Road, Speke, Merseyside, L24 9PB

☎ (0151) 558 0290 ☎ 07867 792466

● bigbog.co.uk

Big Bog started life in Waunfawr, Wales in 2011, sharing its site with the Snowdonia Parc brewpub. Due to growth and expansion in 2016, the brewery moved to its present location in Speke, Liverpool, into a custom-built plant with a 10-barrel brew length. The brewery has its own licenced bar and is open to the public on Fridays. 🚩♦✦

Bog Standard Bitter (ABV 3.6%) BITTER
Mire (ABV 3.8%) BITTER
Pride of England (ABV 3.8%) BITTER
Blonde Bach (ABV 3.9%) GOLD
Hinkypunk (ABV 4.1%) GOLD
Full-flavoured golden ale, fruity (citrus) hoppy aromas, dry hoppy beer, slightly sweet with a little pepperiness, and a satisfying bitter finish.
Stog (ABV 4.1%) STOUT
Jack O Lantern (ABV 4.2%) BROWN
Welsh Pale Ale (ABV 4.2%) BITTER
Morast (ABV 4.3%) SPECIALITY
Billabong (ABV 4.4%) GOLD
Blueberry Hill Porter (ABV 4.5%) SPECIALITY
Swampy (ABV 4.7%) RED
Will O the Wisp (ABV 4.7%) GOLD

Peat Bog Porter (ABV 4.9%) SPECIALITY
Bayou (ABV 5%) PALE
Quagmire (ABV 6%) BROWN

Brewed under the Strawberry Fields Brewery brand name:
Lucy (ABV 4.5%) GOLD
Marmalade Skies (ABV 4.5%) STOUT
An oatmeal stout with rich roasted malt and caramel aromas with orange notes. Raisin and orange flavours with dry hop bitterness. A light hop pine finish.

Black Lodge

Kings Dock Street, Baltic Triangle, Liverpool, L1 8JU
☎ 07565 299879 ⊕ blacklodgebrewing.co.uk

Recently expanded-capacity brewery producing experimental and speciality beers that can be sampled in its own taproom. Moved to new brewery 2019 with ex-Mad Hatter brewery kit. Frequently brews specials and collaboration beers. Its cask beers are increasingly available in local pubs but only keg and can from the taproom. ♦◆

Brimstage SIBA

Home Farm, Brimstage, Merseyside, CH63 6HY
☎ (0151) 342 1181 ⊕ brimstagebrewery.com

Neil Young began brewing in 2006 using a 10-barrel plant in the heart of the Wirral countryside. Wirral's first brewery since the closure of the Birkenhead Brewery in the late 1960s. Since Neil passed away in 2018, his two sons now own the brewery. Outlets are supplied across the Wirral, Merseyside, Cheshire and North Wales. ‼♦

Sandpiper Light Ale (ABV 3.6%) GOLD
Trapper's Hat Bitter (ABV 3.8%) BITTER
A nicely-balanced beer, strong malt aromas, sweet, hoppy, malt flavours and a smooth, bitter finish.
Rhode Island Red (ABV 4%) RED
Red, smooth, well-balanced, malty beer with a good dry aftertaste. Some fruitiness in the taste.
Elder Pale (ABV 4.1%) SPECIALITY
Scarecrow Bitter (ABV 4.2%) BITTER
This best bitter has a good balance of flavours, some bitterness and sweetness along with a little fruit, these flavours develop in the finish with increased hops.
Oyster Catcher Stout (ABV 4.4%) STOUT
Shed Day Session IPA (ABV 4.4%) PALE
IPA (ABV 6%) PALE

Brooks

17 Birkenhead Road, Hoylake, Merseyside, CH47 5AE
⊕ brooks-brewhouse.co.uk

Brewing starting in 2017 at this nanobrewery, which predominately produces bottle-conditioned beers.

Cains (NEW) SIBA

39 Stanhope Street, Cains Brewery Village, Liverpool, L8 5RE ⊕ cainsbrewery.co.uk

This most recent reincarnation of Cains opened in 2022 in the original Higsons brewery building, now called Cains Brewery Village. It is run by the Mikhail leisure group and Cains beers will be available in their pubs. The new plant can be seen behind the bar in the Cains Brewery pub/taproom. ‼◆

Dark Mild (ABV 3.2%) MILD
Bitter (ABV 4%) BITTER
FA (Formidable Ale) (ABV 5%) PALE
Finest Raison (ABV 5%) SPECIALITY

Carnival

Unit 3, King Edward Industrial Estate, Gibraltar Row, Liverpool, L3 7HJ ⊕ carnivalbrewing.me

Brewery and taproom incorporated in 2017 and opened in 2019 by keen homebrewers Dominic Hope-Smith and Adrian Burke. Specialist styles are brewed and range from light through golden to dark beers. The brewery has a core range but also releases ad-hoc specials or collaborates with other local, national and international breweries to release further specials. It supplies online, retail, a few outlets in Liverpool, and beer festivals. Brewery tasting tours (Friday and Saturday) can be booked on the website. ‼☕♦◆

Carmen (ABV 4%) GOLD
Urban Shaker (ABV 4.5%) STOUT

Flagship

Office: Ship & Mitre, 133 Dale Street, Liverpool, L2 2JH
☎ (0151) 236 0859

☺Launched in 2016, the Ship & Mitre Brewing Co rebranded as Flagship Beer in 2017, and primarily supplies the iconic city centre pub, the Ship & Mitre, with some sales locally and nationally. Beers are brewed using spare capacity at other breweries. ♦

Sublime (ABV 3.7%) GOLD
Lupa (ABV 3.8%) PALE
Level (ABV 4.2%) BROWN
Parade (ABV 4.5%) BLOND
Silhouette (ABV 4.5%) STOUT
Vanilla and liquorice aromas with strong malt roast dominating the flavours, a good dry stout with a malt bitter finish.
Jar (ABV 4.7%) PORTER
Roast and prune aroma, dry through to finish with bitter roast flavours.

Glen Affric

Unit 2 & 3, Lightbox, Knox Street, Birkenhead, Merseyside, CH41 5JG ☎ 07742 020275

Office: 53 Wood Street, Ashton-under-Lyne, OL6 7NB
⊕ glenaffricbrewery.com

⊗ Established in 2016, a small-batch brewery producing only keg beers. Its extensive tank farm allows for a flexible brew length. The brewery contract brews for other breweries. ‼☕

Handyman

🍴 461 Smithdown Road, Liverpool, L15 3JL
☎ (0151) 722 7422

Handyman Brewery is based within the Handyman Supermarket. For years this was a hardware store but has now been refurbished into the Handyman Pub, which opened in 2017. Its 400-litre brew kit is situated on a mezzanine floor above the bar. ♦

Howzat

🍴 Cricketers Arms, Peter Street, St Helens, Merseyside, WA10 2EB
☎ (01744) 758021

A brewery in the grounds of the Cricketer's Arms – a former CAMRA National Pub of the Year.

Liverpool Brewing SIBA

39 Brasenose Road, Liverpool, L20 8HL

☎ (0151) 933 9660
⊕ liverpoolbrewingcompany.com

☺Liverpool Brewing Company was established in 2018. A 20-hectolitre Vince Johnson brewkit with a fermenting volume of 200-hectolitres is used with extensive cold storage capacity to produce a range of traditional and new-wave beers. A number of its own venues are due to open in 2022 which will be a mixture of styles from traditional pub to craft bar. ‼🍺✦

Little IPA (ABV 3.6%) IPA
Dark Mode (ABV 3.7%) MILD
Cascade (ABV 3.8%) GOLD
A medium-bodied, pale golden beer with honeyed flowery citrus hop aromas, dry bitter citrus hop flavours with a dry, fruity bitter finish with some light pine.
Temple (ABV 3.8%) BITTER
Liverpool Pale Ale (ABV 4%) BLOND
Light fruity hop aromas, sweet bitter flavours with a light, malty finish.
24 Carat Gold (ABV 4.1%) GOLD
A medium-bodied, straw beer with hoppy citrus fruity (clementine) aromas, sweet fruity slightly honeyed flavours and dry hop bitterness, dry fruity hop finish.
Bier Head (ABV 4.1%) BITTER
Light amber beer with malt/roast and hop aromas with light apple notes, bitter hop and roasted malt flavours with a light peppery hop finish.
Syren's Call (ABV 4.2%) BITTER
Tropical Pale (ABV 4.2%) PALE
Liverpool Stout (ABV 4.7%) STOUT
Bend Sinister (ABV 5%) STOUT
Black Custard (ABV 5%) STOUT
Campania (ABV 5%) STOUT
A smooth and rich full bodied milk stout with aromas of coffee, liquorice, toffee. A mass of rich fruity (raisin) hazelnut and coffee flavours with light creamy vanilla. Sweet rich fruity finish

Love Lane

⬛ 62-64 Bridgewater Street, Liverpool, L1 0AY
☎ (0151) 317 8215 ⊕ lovelanebeer.com

Established in 2017 in the Baltic Triangle area of Liverpool, the 30-barrel plant can be seen from the Love Lane Bar and Kitchen pub. Craft beers are produced under this name, some cask-conditioned beers are badged as Higsons. A small, one-barrel plant is used for a beer academy for guest brewers. These beers are then sold in the brewery tap on Tuesdays, cask and keg. ‼✦✦

Melwood

The Kennels, Knowsley Park, Knowsley, Merseyside, L34 4AQ ☎ 07545 265283 ⊕ melwoodbeer.co.uk

☺Melwood began brewing in 2013 using a five-barrel plant in an old dairy. In 2016 the brewery moved to bigger premises in nearby old kennels on the Earl of Derby's Knowsley Estate. In 2019 it rebranded to add a small range of core beers, a series of modern beers, one-off specials and began experimenting with new styles and yeasts. ✦V

Lovelight (ABV 3.8%) BLOND
Father Ted (ABV 4.2%) BITTER
High Time (ABV 4.3%) BITTER
Knowsley Blonde (ABV 4.3%) PALE
Moondance (ABV 4.3%) BITTER
Stanley Gold (ABV 4.3%) GOLD

Neptune SIBA

Unit 1, Sefton Lane Industrial Estate, Maghull, Merseyside, L31 8BX
☎ (0151) 222 3908 ⊕ neptunebrewery.com

☺Neptune began brewing in 2015 using a six-barrel plant. Beers are unfined and unfiltered. In keeping with the brewery name the majority of beers are named on a water theme (fish, the sea and mythological creatures). The brewery tap sits alongside the brewery, only opens on Saturdays and usually has a pop-up food vendor on site. V✦

Ezili (ABV 4%) PALE
Galene (ABV 4.3%) PALE
Mosaic (ABV 4.5%) PALE
Wooden Ships (ABV 4.7%) PALE
Abyss (ABV 5%) STOUT
Rich, roasted, fruity aroma, sweet, fruity, oatmeal stout with dry roast finish.

Peerless SIBA

The Brewery, 8 Pool Street, Birkenhead, Merseyside, CH41 3NL
☎ (0151) 647 7688 ⊕ peerlessbrewing.co.uk

Peerless began brewing in 2009 and is under the directorship of Steve Briscoe. Beers are sold through festivals, local pubs and the free trade. ‼✦✦

Pale (ABV 3.8%) PALE
Triple Blond (ABV 4%) BLOND
Skyline (ABV 4.2%) BITTER
Langton Spin (ABV 4.4%) GOLD
Oatmeal Stout (ABV 5%) STOUT
Knee-Buckler IPA (ABV 5.2%) PALE
Full Whack (ABV 6%) IPA

Rock the Boat SIBA

6 Little Crosby Village, Little Crosby, Merseyside, L23 4TS
☎ (0151) 924 7936 ☎ 07727 959356
⊕ rocktheboatbrewery.co.uk

Rock the Boat began brewing in 2015 in a converted 16th century wheelwright's workshop and old blacksmiths. Beer names relate to a local theme, often reflecting the brewer's musical tastes and local landmarks. The beers are increasingly available in central and north Lancashire. Specials are brewed for Market Town Taverns pubs in Liverpool and a green hop beer is produced each year. LIVE

Liverpool Light (ABV 3.4%) BLOND
Light, hoppy aromas on this refreshing, straw-coloured bitter with a delicate hop flavour and a dry, bitter finish.
(Sittin' on) The Dock (ABV 3.5%) MILD
Rich chocolate malt aromas, with caramel roast flavours and light sweetness with a mellow, caramel roast finish.
Bootle Bull (ABV 3.8%) BITTER
Yellow Submarine Special (ABV 3.9%) GOLD
Waterloo Sunset (ABV 4.2%) BITTER
Smooth, medium-bodied, copper beer with rich malt, fruity (orange) aromas, sweet malt and caramel flavours, fruity with light hop bitterness, and a fruit and malt finish.
Fab Four Liverpool IPA (ABV 4.4%) BLOND
A medium-bodied, straw-coloured beer with fruity hop aromas, sweet fruity flavours and dry hop bitterness, finishing with light hop bitterness.

Southport SIBA

Unit 3, Enterprise Business Park, Russell Road, Southport, Merseyside, PR9 7RF ☎ **07748 387652**
🌐 **southportbrewery.co.uk**

◉Southport Brewery was established in 2004 on a five-barrel plant. Outlets are supplied in Southport, North-West England and nationally. ♦

Southport IPA (ABV 3.6%) PALE
Sandgrounder Bitter (ABV 3.8%) PALE
Dark Night (ABV 3.9%) MILD
Full-bodied mild with fruity malt aromas dominating, lasting roast bitterness and hop, lots of flavour for the strength.
Golden Sands (ABV 4%) GOLD

Stamps

St Mary's Complex, Waverley Street, Bootle, L20 4AP
☎ **07913 025319** 🌐 **stampsbrewery.co.uk**

◉Brewing began in 2012, with beers named after famous world postage stamps. The brewery moved to its new site in 2017. There are plans to build a new brewery and pub as part of a local regeneration project alongside the Leeds-Liverpool canal in Bootle. The beers can be found regularly in Stamps Bar, Crosby, and the Lock & Quay, Irlam Road, Bootle. Beers may appear with the Republic of Liverpool brand name. Flagship brewery use the Stamps brew kit as a cuckoo brewery. ‼🍺

Blond Moment (ABV 3.6%) GOLD
Ahtanum (ABV 3.9%) GOLD
First Class (ABV 3.9%) PALE
Mail Train (ABV 4.2%) BITTER
Inverted Jenny (ABV 4.6%) BITTER
Rum Porter (ABV 4.6%) PALE
Penny Black (ABV 5.5%) PORTER

Team Toxic

c/o Liverpool Brewing Co, Unit 39, Brasenose Road, Bootle, L20 8HL ☎ **07976 714585**
✉ **gazza@liverpoolbrewingco.com**

Team Toxic, led by Gazza Prescott, is a commissioner of beers producing a range of sometimes eccentric, one-off brews as well as some core brands. Some of which appear under Gazza's own Mission Creep label. No isinglass is used in any of the beers, some of which are made in collaboration with other breweries. Gazza likes bitter, hoppy pale ales and experimenting with beer styles and ingredients often influenced by his travels. Gazza is constantly trialling new recipes. Brewing is currently suspended.

Top Rope SIBA

Unit 6, Lipton Close, Liverpool, L20 8PU ☎ **07581 483075** 🌐 **topropebrewing.com**

◉Top Rope commenced brewing on a small scale on Merseyside in 2016, and expanded in 2018 moving to Sandycroft industrial estate, Deeside, North Wales. Further expansion led to a return to its current location in Bootle, Liverpool in early 2021 that coincided with the opening of the taproom. Output is mainly keg, but the supply ratio is approximately 45% cask beers (often named on a wrestling theme). ‼♦

Tyton

c/o Ship & Mitre, 133 Dale Street, Liverpool, L2 2JH
☎ **07487 598787** ✉ **tytonbrewing@gmail.com**

Brewer now works at Ship & Mitre, Liverpool and occasionally brews Tyton beer using brew kit used by Flagship.

Rose & Crown, Bebington (Photo: Dave Goodwin)

North East

The North East of England is a region of contrasts; sparsely populated upland hills and vibrant urban neighbourhoods; small sleepy villages and large bustling cities. Take a walk along Hadrian's Wall or visit beautiful ancient sites like Hexham Abbey and Lindisfarne Priory. If you prefer your sightseeing to take a more modern twist, then the Baltic Centre for Contemporary Art is unmissable.

When CAMRA was founded, the region was home to large breweries with tied pub estates serving a limited range of session bitters and Scotch ale - the North East equivalent of mild - with foaming heads. They were brewed to quench the thirst of workers in now-defunct heavy industry. Newcastle was synonymous with Newcastle Brown Ale, but it is no longer brewed in the area. However, there are many small breweries that brew a brown ale inspired by the hallmark Geordie beer.

Beer tourists wanting to take a tour will enjoy a visit to Anarchy Brewing Co, Brinkburn Street, Full Circle or Tyne Bank breweries in Newcastle. In Sunderland, you can take part in a brew day experience at the Darwin Brewery. Durham's oldest brewery, the family-run Durham Brewery, offers tours with tutored tastings.

The Ouseburn, a small neighbourhood just east of Newcastle city centre, has a cluster of great pubs and breweries to visit, with many of those breweries boasting taprooms. Get the full experience by taking an Ouseburn Brewery tour, where you will visit five breweries over a leisurely afternoon.

Micropubs have found a comfortable niche in the North East. Stockton-on-Tees in particular has a strong local beer scene. The first micropub there was the Golden Smog, while Lucifers is the smallest, with seating for just 25 customers.

The oldest beer festival is the Newcastle Beer & Cider Festival, which is held in early spring at the Northumbria Students Union. This festival offers a range of around 150 different beers, ciders and perries alongside an enviable programme of live music to keep you entertained.

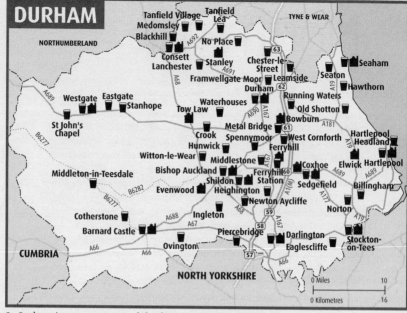

DURHAM

NORTHUMBERLAND

TYNE & WEAR

Tanfield Village
Tanfield Lea
Medomsley
Blackhill
No Place
A692
Consett
Lanchester
Stanley
A63
Seaham
A691
Chester-le-Street
Framwellgate Moor
Leamside
Seaton
A19
Hawthorn
Durham
A62
Westgate
Eastgate
Stanhope
Running Waters
A689
Waterhouses
Old Shotton
Tow Law
Bowburn
A181
St John's Chapel
A690
A167
A61
Hartlepool
Headland
B6277
Metal Bridge
Crook
Spennymoor
West Cornforth
A19
Hunwick
Ferryhill
Hartlepool
Witton-le-Wear
Middlestone
Coxhoe
Elwick
Middleton-in-Teesdale
Bishop Auckland
Ferryhill
Station
A60
Sedgefield
A689
Billingham
Shildon
Heighington
A689
B6282
Evenwood
Newton Aycliffe
A68
Norton
B6277
Cotherstone
A688
Ingleton
A59
A79
Stockton-on-Tees
Barnard Castle
A67
A58
Darlington
CUMBRIA
A66
Ovington
Piercebridge
A167
Eaglescliffe
A66
A57
A66

NORTH YORKSHIRE

0 Miles 10
0 Kilometres 16

Co Durham incorporates part of the former county of Cleveland

Barnard Castle

Old Well Inn L ✓

21 The Bank, DL12 8PH
☎ (01833) 690130 ● theoldwellinn.co.uk
Timothy Taylor Landlord, Golden Best; house beer (by Mithril); 3 changing beers (sourced locally) Ⓗ
The boundary of this 17th-century town-centre inn incorporates part of the medieval castle wall. The pub has a cosy front bar and a comfortable lounge, a separate restaurant and an airy conservatory, plus an enclosed beer garden. At least five well-kept beers are available including two guests from local microbreweries. The house beer is Cummings and Goings from Mithril. Excellent food is served daily, including tasty curries, and there is accommodation in 10 rooms. The Castle Players meet here. Q ❤ ⚲ ⚞ ◑ ♿ ᴥ 🚆 (75,76) ❀ 🛜

Billingham

Billingham Catholic Club L

37 Wolviston Road, TS23 2RU (on E side of old A19, just S of Roseberry Road roundabout, next to bus stop)
☎ (01642) 901143 ● catholicclub.co.uk
3 changing beers Ⓗ
Now in its 14th year of continuous Guide recognition, this Victorian mansion and former school is a friendly club, where actively supporting the local community comes high on the agenda. Dedicated volunteers ensure that the club's reputation for offering 150 different beers annually continues. Three beers and two ciders are normally available, with eight ales available throughout the popular bank holiday beer and music festivals. A previous local CAMRA Community Award winner and regular local Club of the Year winner. ❀ ♿ ♣ P 🚆 (35,36) ❀

Crafty Cock L

113 Station Road, TS23 2RL (at N end of Station Rd, close to level crossing)
☎ (01642) 881478

3 changing beers Ⓗ
This small, cosy bar offers a warm welcome, with friendly and knowledgeable bar staff. It serves three ales, including beers from local breweries, as well as an extensive gin menu. Third-pint tasting bats are available. Mexican food is offered Thursday to Saturday evenings, plus Sunday lunch, with a takeaway and local delivery service available. The bar has become renowned locally for its varied live bands. Quiz night is alternate Wednesdays. ◑ ♿ P 🚆 (36,X10)

Bishop Auckland

Bay Horse

38-40 Fore Bondgate, DL14 7PE (50yds N of bus station)
☎ (01388) 609765
Timothy Taylor Landlord; 1 changing beer (sourced nationally; often Maxim, Anarchy) Ⓗ
There has been an inn on this site since 1530, and this lively, open-plan bar is a quiet relief from shopping during the week. With live music on Friday and karaoke on Saturday, it becomes joyfully boisterous at the weekend, and is popular for televised sport. It retains its roots as a long-established, proper pub, with an open fire and pub games. ❀ ♿ ♣ ❤ ❀ 🛜

Green Tree

Cockton Hill Road, DL14 6EN (close to Station Bridge)
☎ (01388) 417277
2 changing beers (sourced nationally) Ⓗ
A large pub at the south end of the shopping street. It has a bar with pool table area, a spacious lounge, and a big garden patio with a covered smoking area to the rear. Popular for TV sport and the Tuesday quiz, it hosts occasional live music. Interesting football and music memorabilia adorn the walls alongside paintings of the town by local artist Gaz Miller. ❀ ♿ ⚞ ♣ 🚆 (1,6) ❀

Pollards 🅛

104 Etherley Lane, DL14 6TU (400yds W of railway station)

☎ (01388) 603539

5 changing beers (sourced nationally; often Allendale, Consett, Marston's) 🅗

This comfortable and busy establishment is a great combination of traditional pub and pleasant diner, a 10-minute stroll from the town centre. Two of the four original areas, including the bar, boast open fires or log-burners, and there is a spacious restaurant to the rear where the famous Sunday carvery can be enjoyed. Five well-kept ales can be enjoyed along with good conversation. Q🌣🕸🕜&≠♣P🌣

Welcome

Low Waldron Street, DL14 7DS

☎ (01388) 662492

1 changing beer (sourced nationally) 🅗

Very much a proper local pub, only a minute's walk from the bus station and main street. It has a single L-shaped room with a dartboard to the rear, and picnic tables outside at the front. It is a welcoming place for a chat, with everyone made to feel welcome and a great community feel. Live music is hosted on Friday. Closed Tuesday. Q🌣🕸&≠♣P🌣🍴🛜

Blackhill

Scotch Arms 🅛 ✅

48 Derwent Street, DH8 8LZ

☎ (01207) 593709

Wainwright; 3 changing beers (sourced nationally; often Big Lamp, Mordue, Moorhouse's) 🅗

A traditional community hostelry off the main street in Blackhill with a large L-shaped bar. The interior was freshened up to celebrate the licensee's 10-year anniversary in 2018. Up to four cask ales are on offer, always including local beers. The welcoming pub is home to pool and darts teams plus a local football club, and is popular for sports TV. Charity nights and other live events often feature. Toasted sandwiches are available. 🌣🕜&♣🖵🍴🛜

Chester-le-Street

Butchers Arms

Middle Chare, DH3 3QD (off Front St on left from Market Place)

☎ (0191) 388 3605

Jennings Cumberland Ale; Marston's Pedigree; 3 changing beers (sourced nationally; often Ringwood, Wainwright, Wychwood) 🅗

A cosy pub acknowledged for the quality and quantity of its beers, selling at least five cask ales from the Marston's range. It is also noted for its food, with home-cooking a speciality; Sunday lunches are popular and good value. Teas and coffees are also served. Dogs are welcome and it is convenient for the railway station and all buses through the town. Quiz night is Tuesday. Q🌣🕸🏠🕜&♣🖵(21)🐾

Masonic Centre 🅛

Station Road, DH3 3DU

☎ (0191) 388 4905

Black Sheep Best Bitter; 4 changing beers (sourced nationally; often Cheviot, Marston's, Oakham) 🅗

Visitors are more than welcome at the Masonic Centre just off Front Street in the heart of the town. Press the buzzer on the front door and walk in. As well as up to five changing real ales, you will also find one of the biggest selections of single malt whiskies in the area.

Sunday lunches and Friday fish suppers are popular. Local CAMRA Club of the Year 2020 and 2022. 🌣🕜&≠🖵(21)🍴🛜

Wicket Gate 🅛 ✅

193 Front Street, DH3 3AX

☎ (0191) 387 2960

Greene King Abbot; Ruddles Best Bitter; 5 changing beers (sourced nationally) 🅗

This modern JD Wetherspoon pub reopened in 2020 following major refurbishment including a roof terrace. The name acknowledges the strong connection the town has with cricket, and various items of cricket memorabilia decorate the walls. It is situated close to the town club and the county club ground at the Riverside. Very roomy inside, with a single long bar championing local beers. No alcohol served before 9am. 🌣🕸🕜&♣🖵(21)🛜

Consett

Company Row 🅛 ✅

Victoria Road, DH8 5BQ

☎ (01207) 585600

Greene King Abbot; Ruddles Best Bitter; Sharp's Doom Bar; 3 changing beers (sourced nationally) 🅗

Modern pub named after the rows of houses built by the Derwent Iron Company for its workers; most of the buildings were demolished in the mid-1920s. This spacious and well-decorated Wetherspoon establishment is a real asset to Consett town centre. An excellent beer selection, including local ales, and good food, make this social pub popular with a wide clientele of all ages. 🌣🕸🕜&♣🖵🛜

Grey Horse 🍴 🅛

115 Sherburn Terrace, DH8 6NE (A692, then right along Sherburn Terrace)

☎ (01207) 502585

Consett Steeltown Bitter, White Hot, Red Dust; 6 changing beers (sourced nationally) 🅗

Traditional pub dating back to 1848, the oldest in Consett. The interior comprises a lounge and L-shaped bar, with a wood-beamed ceiling. Open log fires are welcoming in winter. Consett Ale Works Brewery is at the rear. Beer festivals are held twice a year, a quiz each Wednesday and open mic on Sunday. The Coast-to-Coast

REAL ALE BREWERIES

Barnard Castle ✦ Barnard Castle
Camerons Hartlepool
Caps Off ✦ Bishop Auckland
Castle Eden Seaham
Consett 🍺 Consett
Crafty Monkey Elwick
Crafty Pint 🍺 Darlington
Dionysiac Darlington (NEW)
Durham ✦ Bowburn
George Samuel Shildon
Hill Island Durham
Hopper House Brew Farm ✦ Sedgefield
Hops & Dots Bishop Auckland
Mad Scientist 🍺 Darlington
McColl's ✦ Evenwood
North Pier Tow Law
S43 Coxhoe
South Causey Stanley (brewing suspended)
Three Brothers ✦ Stockton-on-Tees
Village Brewer 🍺 Darlington
Weard'ALE 🍺 Westgate
Yard of Ale 🍺 Ferryhill

cycle route is close by. There is some bench seating outside at the front. A repeat local CAMRA Town Pub of the Year, including in 2022. Q✿❀♣🍴🅿️❄️🐾📶

Cotherstone

Red Lion 🅛

Main Street, DL12 9QE

☎ (01833) 650236 ● theredlionhotel.blogspot.com

Yorkshire Dales Butter Tubs, Aysgarth Falls 🅷

An 18th-century Grade II-listed coaching inn, built in stone and set in an idyllic village. This homely local, simply furnished and with two open fires, has changed little since the 1960s. It has no TV, jukebox or one-armed bandit, just good beer and conversation. Up to five real ciders are available, often from local cider producer Kemps. The pub is used by various local clubs, and the small garden is a suntrap. Children, dogs and clean boots are welcome. A former local CAMRA Community Pub of the Year. ❄️✿❀♣🍴🚌(95)🐾📶

Crook

Horse Shoe 🅛 ✅

4 Church Street, DL15 9BG

☎ (01388) 744980

Greene King Abbot; Maxim Double Maxim; Ruddles Best Bitter; 6 changing beers (sourced nationally) 🅷

A busy and attractive pub with four interlinked drinking areas making up the main building, plus a pleasant sheltered patio to the side. There is the usual Wetherspoon acknowledgement of previous use, in this case a butcher's, in the metal bar top. Local history is reflected in the decor, with a surprise at the top of the stairs in the shape of old mining equipment. ❄️✿◐🍴🚌(X1,X46)📶

Darlington

Bondgate Tavern

94 Bondgate, DL3 7JY

☎ (01325) 962114

4 changing beers (sourced nationally) 🅷

One of the newest town centre bars, with a focus on local real ales, handily located on Bondgate where a number of pubs and bars serving real ale can be found. Four competitively priced real ales are served from local breweries across the North East. It has a busy calendar, with live music, sports on TV and quizzes during the week, as well as darts, a pool table and a separate function room. ♿♣🍴🐾

Britannia 🅛 ✅

1 Archer Street, DL3 6LR (next to ring road W of town centre)

☎ (01325) 463787

Camerons Strongarm; 5 changing beers (sourced nationally) 🅷

Warm, friendly, local CAMRA award-winning inn – a bastion of cask beer since 1859. The traditional pub retains much of the appearance and layout of the private house it once was – a modestly enlarged bar and small parlour sit either side of a central corridor. Listed for its historic associations, it was the birthplace of teetotal 19th-century publisher JM Dent. Four guest ales along with two regular ales – Camerons Strongarm and house beer Brit 163 – are available. ♣🅿️🐾📶

Crafty Merlin's Micropub & Bottle Shop

33 Bondgate, DL2 1QA

● craftymerlins.co.uk

3 changing beers (sourced nationally) 🅷

This is a new venture opened during the pandemic, very much a one-man operation. Originally a bottle shop, it has one room downstairs with a distinct micropub character. Up to three handpulls are in use, with an equal number of keg ales available. The bar has a homely atmosphere with conversation very much to the fore. Q🐾📶

Darlington Snooker Club 🅛

1 Corporation Road, DL3 6AE (corner of Northgate)

☎ (01325) 241388

4 changing beers (sourced nationally) 🅷

First-floor, family-run and family-oriented private snooker club which celebrated its centenary in 2015. A cosy, comfortable TV lounge is available for those not playing on one of the 10 top-quality snooker tables. Twice yearly, the club hosts a professional celebrity. Four guest beers from micros countrywide are stocked, and two beer festivals are held annually. Frequently voted CAMRA Regional Club of the Year and a former National finalist, it welcomes CAMRA members on production of a membership card or copy of this Guide. The Society for the Preservation of Beers from the Wood North East Club of the Year. ❄️◐🍺

Half Moon 🅛

130 Northgate, DL1 1QS

☎ 07804 305175

7 changing beers (sourced nationally) 🅷

Old-school local pub just across the ring road from the town centre, which reopened in 2013 as a real ale pub following a long period of closure. It offers seven changing cask ales including brews from micros unusual for the area and occasional beers from the on-site Crafty Pint nano brewery, plus two ever-changing real ciders. Friendly staff and customers create a relaxed atmosphere. There is a library area to borrow and exchange books. Dogs are welcome. ❄️♣🐾📶

House of Hop 🅛

4B Houndgate, DL1 5RL

4 changing beers (sourced nationally) 🅷

Smart, contemporary bar in the town centre's Imperial Quarter, with links to the local Three Brothers brewery. The pub serves four ever-changing real ales from across the North East and beyond. It also offers one of the town's widest ranges of craft keg beers, plus ciders and cocktails. Live music features regularly. Q🐾📶

Number Twenty 2 🅛 ✅

22 Coniscliffe Road, DL3 7RG

☎ (01325) 354590

Village Bull, Old Raby, White Boar; 7 changing beers (sourced nationally) 🅷

Town-centre ale house with a passion for cask beer and winner of many CAMRA awards. Ales are dispensed from up to 16 handpumps, including two real ciders and a stout or porter, alongside 10 draught European beers. Huge curved windows, stained glass panels and a high ceiling give the interior an airy, spacious feel. Sandwiches and snacks are available at lunchtime. Home of Village Brewer beers (including Zetland Pale), commissioned from Hambleton by the licensee. To the rear is the in-house nano distillery and microbrewery producing ale, gin and vodka. Q❄️♿📶

Old Yard Tapas Bar 🅛

98 Bondgate, DL3 7JY

☎ (01325) 467385 ● tapasbar.co.uk

5 changing beers (sourced nationally) 🅷

An interesting mix of a bar and Mediterranean taverna offering real ales alongside a fascinating selection of

international wines and spirits in a friendly setting. Five guest beers from local micros and countrywide are stocked, with an extra two sometimes available in a further room. Although this is a thriving restaurant you are more than welcome to pop in for a pint and tapas. The pavement café is popular in good weather. Food is served lunchtime and evening Sunday to Friday and all day Saturday. TV is for sport only. Q ♣ ☆ ◖ ♪ & ♠ ♥ 🖤 ⊛

ORB Micropub 🅻

28 Coniscliffe Road, DL3 7RG

☎ 07903 237246

6 changing beers (sourced nationally) 🅷

The first micropub in Darlington, this bar in a former beauty salon provides the highest quality local real ales, craft beers and a large range of single malt whiskies. Friendly, knowledgeable staff serve six local real ales, eight craft ales and two real ciders. With no TV or loud music, this is a place in which to relax and engage in conversation. ORB stands for Orchard Road Brewery. A former local CAMRA Pub of the Year. Q ⊛

Quakerhouse 🍸 🅻

2 Mechanics Yard, DL3 7QF (off High Row)

⊕ quakerhouse.co.uk

9 changing beers (sourced nationally) 🅷

Eighteen times local CAMRA Town Pub of the Year and a North East Pub of the Year, this gem of a pub is set in one of the town's historic Yards. The bar has nine handpulled guest beers from local and regional breweries and two changing real ciders. This friendly, welcoming and lively venue is popular for live music, catering for all tastes from acoustic to rock. Home to the Mad Scientist microbrewery. ⊛ & ♣ 🅿 🖤 ♠ ⊛

Durham

Bridge Hotel

40 North Road, DH1 4SE (200yds from Durham rail station)

☎ (0191) 386 8090 ⊕ bridgehoteldurham.com

Wainwright; 2 changing beers (sourced nationally; often Greene King, Oakham, Timothy Taylor) 🅷

A friendly pub that attracts a good mix of regulars and visitors to the region. It was built in the 1850s as lodgings for railway workers constructing the viaduct under which it sits, becoming a public house a few years later. The pub has recently been refurbished with a comfortable bar and lower dining area. It serves good-quality home-cooked food every day at reasonable prices, and hosts a quiz on Tuesday night with a free hot buffet (book ahead). ♣ 🏠 ◖ ➔ 🖫 (21) 🖤 ♠ ⊛

Colpitts Hotel ★

Colpitts Terrace, DH1 4EG

☎ (0191) 386 9913

Samuel Smith Old Brewery Bitter 🅷

A refurbishment has given this late-Victorian pub a smart makeover, but it remains little changed from when it was first built. As with all Samuel Smith's pubs, the noise comes from the chatter of conversation rather than from music or TV. The unusual A-shaped building comprises a cosy snug, a pool room and the main bar area partially divided by a fireplace. If you want to take a step back in time, this is the pub for you. Q ♣ ➔ ♠ 🖫

Dun Cow 🅻 ✚

37 Old Elvet, DH1 3HN

☎ (0191) 386 9219

Castle Eden Ale; Timothy Taylor Landlord; 1 changing beer (sourced nationally; often Castle Eden, Moorhouse's) 🅷

A Grade II-listed pub, parts of which date back to the 15th century. In 995AD, Lindisfarne monks searching for a resting place for the body of St Cuthbert came across a milkmaid looking for her lost cow. She directed them to Dun Holm (Durham), and the pub is named after the historic animal. There is a small front snug with a larger lounge to the rear. An occasional guest beer is available. Q ♣ ♣ 🖫 (6,X12) ♠ ⊛

Half Moon Inn ✚

86 New Elvet, DH1 3AQ

☎ (0191) 374 1918 ⊕ thehalfmooninndurham.co.uk

Draught Bass; Sharp's Doom Bar; Timothy Taylor Landlord 🅷

Popular city-centre pub, reputedly named after the crescent-shaped bar that runs through it. The decor throughout is traditional, featuring photos of the pub at the beginning of the 20th century, including many from the Miners' Gala. A friendly venue with a relaxed atmosphere, it offers a good selection of ales. The large beer garden overlooks the river. ⊛ & 🖫 (6) ♠ ⊛

Head of Steam 🅻

Reform Place, DH1 4RZ (through archway from North Rd)

☎ (0191) 383 2173

5 changing beers (sourced nationally; often Camerons, Leeds) 🅷

Vibrant pub with a continental feel, attracting beer lovers of all ages. As well as five real ales, it offers an extensive choice of draught and bottled beers from around the world. Tasting events are often held featuring a wide choice of ales and ciders. Excellent, good-value food is available and families are welcome during the day. ♣ ☆ ◖ & ➔ 🖫 ⊛

Holy Grale

57 Crossgate, DH1 4PR

☎ (0191) 386 3851

Allendale Pennine Pale; 1 changing beer (sourced nationally; often Titanic, Two by Two) 🅷

A former board-games café, this craft beer bar was opened in 2019 by the previous landlord of Ye Old Elm Tree, just up the hill. A friendly open-plan venue, it has several keg taps and two handpulls, all serving an ever-changing range of good beer, alongside large fridges showcasing a range of bottles and cans. A vaulted basement is used for occasional live music. ♣ ➔ ♠ 🖫 ⊛

Old Elm Tree 🅻

12 Crossgate, DH1 4PS

☎ (0191) 386 4621

5 changing beers (sourced nationally; often Abbeydale, Consett, Two by Two) 🅷

Recently refurbished and under new management, this is one of Durham's oldest inns, dating back to at least 1600. The interior comprises an L-shaped bar and a top room linked by stairs, with a friendly atmosphere that attracts a good mix of locals, students and visitors to the city. The pub hosts a Wednesday quiz (arrive early) and a folk group on Monday and Tuesday. A former local CAMRA Town Pub of the Year. ♣ ⊛ ➔ ♦ 🅿 🖫 🖤 ♠ ⊛

Station House 🍸 🅻

North Road, DH1 4SE

⊕ stationhousedurham.co.uk

4 changing beers (sourced nationally; often Fyne, Yorkshire Dales) 🅷 / 🅖

A wedge-shaped pub in the shadow of the railway viaduct, opened in 2015 by CAMRA members. It is very friendly, with a back-to-basics approach and an emphasis on conversation. A changing range of real ale and cider is served directly through a hatch from the cold room.

Handpumps have been installed, with gravity dispense remaining an option. A dark beer is always available, and an extra ale is often added at weekends. Local CAMRA City and Cider Pub of the Year 2022. Closed Monday. Q☻&♿●🏢🚆📶

Victoria Inn ★ Ⓛ
86 Hallgarth Street, DH1 3AS
☎ (0191) 386 5269 ⊕ victoriainn-durhamcity.co.uk
Big Lamp Bitter; 4 changing beers (sourced regionally; often Fyne, Durham) Ⓗ
This warm and welcoming Grade II-listed pub has remained almost unchanged since it was built in 1899. It has been in the same family for 40 years and is popular with locals, students and visitors alike. The quaint decor, coal fires, cosy snug and genuine Victorian cash drawer help create an old-world feel. No meals are served but toasties are available. Voted local CAMRA City Pub of the Year for the 12th time in 2020. Q☻&♿🚆🚌(6,PR2)☀📶

Waiting Room Ⓛ
Northbound Platform, Durham Railway Station, DH1 4RB
☎ (0191) 386 7773
Hadrian Border Tyneside Blonde; 1 changing beer (sourced locally; often Durham, Hadrian Border, Yard of Ale) Ⓗ
This attractive venue on Durham railway station's northbound platform is an interesting relaunch of the original 1872 Ladies' Waiting Room, out of use for many years other than as a storage facility. In keeping with the building's Grade II-listed status, the design is traditional, with Chesterfield-style seating, original floorboards and fireplaces, wood-panelling and a dark-wood bar. Three handpumps showcase local beers. Q☀&🚆P🚌(40)☀📶

Eaglescliffe

Cleveland Bay
718 Yarm Road, TS16 0JE (jct of A67 and A135, N of Tees bridge)
☎ (01642) 780275 ⊕ clevelandbay.co.uk
Timothy Taylor Landlord; Wainwright; 2 changing beers Ⓗ
This three-roomed locals' pub, now with extensive outdoor drinking facilities, has been under the proud stewardship of an enthusiastic licensee with an enviable reputation for serving fine premium bitters for over 20 years. Third-pint glasses and tasting notes are available for the four handpumps. The pub's Blues at the Bay live music evening features bands of various genres, of national and international repute. A free lunch is served on Sunday. A former local CAMRA Community Pub of the Year. Q☀&♣P🚌(7,17)☀📶

Eastgate

Cross Keys Ⓛ
DL13 2HW (on main road)
☎ (01388) 517234 ⊕ crosskeyseastgate.co.uk
2 changing beers (sourced locally; often Allendale) Ⓗ
A proper family-run Weardale pub, adjacent to the A689, popular with holidaymakers and locals. The ancient 17th-century building has a pleasant interior with a lively, welcoming bar and a restaurant providing relaxed dining. Allendale Brewery beers feature regularly. There is a pleasant beer garden to the rear. Comfortable B&B accommodation is available for those wishing to explore the beautiful surrounding countryside. Q☻☀🏢🛏▲♣P🚌(101)☀

Ferryhill Station

Surtees Arms Ⓛ
Chilton Lane, DL17 0DH
☎ (01740) 655933 ⊕ yardofalebrewery.com
Yard of Ale One Foot in the Yard; 4 changing beers (sourced locally; often Yard of Ale) Ⓗ
Traditional pub offering local and national ales and ciders as well as beers from the on-site Yard of Ale Brewery (est 2008). Annual beer festivals are held in the summer and at Halloween. Live music and charity nights are regular events. Lunches are served on Sunday only. A large function room is available. Local CAMRA Country Pub of the Year 2022 and a former regional Pub of the Year. Q☻☀🏢🍺🚌☀📶

Framwellgate Moor

Fram Ferment Ⓛ
29B Front Street, DH1 5EE
⊕ framferment.co.uk
3 changing beers (sourced nationally; often Cullercoats, Durham, Fyne) Ⓟ
A former NHS clinic converted to a bottle shop and tap room in 2019. Large fridges full of bottles and cans of both beer and cider line one wall. A large oak bar, believed to have previously been a Methodist pulpit, sits in front of a tiled tap wall, through which both the cask and keg beers are served. Seating options include a monk's bench, cinema seats and pub stools, along with a couple of tables outside the front window. ☀☀&🚆(Durham)●🚆☀📶

Hartlepool

Anchor Tap Room & Bottle Shop Ⓛ
Stockton Street, TS24 7QY (on A689, in front of Camerons Brewery)
☎ (01429) 868686 ⊕ cameronsbrewery.com
Camerons Strongarm; 1 changing beer Ⓗ
When Camerons Brewery discovered that it owned an adjacent derelict pub, the building's future was secured after it was converted into the brewery's visitor centre. Located close to Stranton All Saints Church, it is possibly of Saxon origin. Now in its 19th successful year, it has rebranded as a tap and bottle shop and reverted to its original 1865 name. Strongarm and the brewery's specials are always available, together with an array of limited edition and continental bottled beers. ☀&🚆P🚌(1,36)☀

Hops & Cheese Ⓛ
9-11 Tower Street, TS24 7HH (100yds S of bus interchange/railway station)
☎ 07704 660417
3 changing beers Ⓗ
Run by an enthusiastic licensee, this unique, modern, original outlet represents a breath of fresh air and is definitely 'something different'. Combining beers and cider with top-class cheeses and charcuterie, served with all the trimmings, and available to take away if required. Newspapers, a book club and low-key background music all feature. In addition, jazz and open-mic sessions, cheese/wine nights, vinyl nights and comedy nights are becoming more popular, with some pre-bookable, making the place closed to the passing visitor. ☻🍽&🚆🚌(1,36)☀

Rat Race Ale House
Station Approach, Hartlepool Railway Station, TS24 7ED (on Platform 1)
☎ 07903 479378 ⊕ ratracealehouse.co.uk
4 changing beers Ⓗ

The second micropub in the country, now celebrating 13 years of continuous Guide recognition, adheres to the original micropub norms: no fizzy lager or beer, no spirits or alcopops, no TV or jukebox, no one-armed bandit, and even no bar. Since opening in 2009, the pub has offered more than 1,900 beers sourced from over 500 breweries, served direct to the table by the landlord himself. Two real ciders are also available, as well as crisps, nuts and scratchings. A winner of multiple local CAMRA awards. Q♿≢♣♠☐呂(1,36)

Hartlepool Headland

Fisherman's Arms Ⓛ ✅

Southgate, TS24 0JJ (on headland close to Fish Quay in Old Hartlepool)
☎ 07847 208599 ⊕ thefishhartlepool.co.uk
3 changing beers Ⓗ
The Fish, a local CAMRA multi award-winner, is a friendly one-room local, recognised by the council for its charitable support of the community. Now free of tie, it serves three changing beers. The pub's theme is 'keeping music alive' - it hosts well-supported open mic nights together with live music on Saturday. A popular quiz is held on Sunday. There is no jukebox, TV or one-armed-bandit. Two beer festivals, also with live music, are held annually. Winter opening hours may vary.
Q☐呂(7)✿❋

Hawthorn

Stapylton Arms Ⓛ

Village Green, SR7 8SD
☎ (0191) 527 0778 ⊕ thestaps.co.uk
3 changing beers (sourced regionally; often Consett, Maxim) Ⓗ
Delightfully welcoming, locally owned village inn serving excellent food. It has two comfortable, well-appointed rooms – one a bar and the other a lounge/restaurant. Three well-kept cask ales showcase the best of North-East breweries. The Monday evening quiz is well-attended. This hidden-away pub is in an ideal location for walkers exploring the nearby Hawthorn Dene.
Q☕❀❶●P✿❋

Heighington

Bay Horse Inn ✅

28 West Green, DL5 6PE (5 mins from A1 at jct 58 with A68)
☎ (01325) 312312 ⊕ bayhorseheighington.co.uk
Pennine Millie George; Timothy Taylor Landlord; 1 changing beer (sourced nationally) Ⓗ
Picturesque, historic, 300-year-old pub overlooking the award-winning village's large green. Its traditional interior with exposed beams and stone walls is partitioned into distinct drinking and dining areas, with a large restaurant extending from the lounge. The pub steps away from traditional pub fare to offer a butcher's counter of meats, cut and cooked to personal preference.
❀❀❶●♿P呂

Hunwick

Joiners Arms

13 South View, DL15 0JW
☎ (01388) 417878 ⊕ thejoinersarmshunwick.co.uk
3 changing beers (sourced nationally; often Timothy Taylor) Ⓗ
Family-run village local with a welcoming bar, restaurant, tiny snug and covered yard/pool room. The bar, with three handpumps serving a changing selection,

is the place for proper conversation. Quality locally sourced food is served Wednesday to Saturday evenings, and Sunday lunchtime in the restaurant. On Monday evening the pub hosts a cheese night. There are picnic tables to the front. ✿❶●♣P呂(108,109)❋

Ingleton

Black Horse Ⓛ

Front Street, DL2 3HS
☎ (01325) 730374
Black Sheep Best Bitter; 3 changing beers (sourced locally) Ⓗ
Free house and restaurant set back from the road in a picturesque village. This is a popular community hostelry with a relaxed atmosphere, and a friendly bar that runs into the dining area. Three guest ales come from local micros within a 30-mile radius. Excellent Italian food is served in the restaurant Wednesday to Sunday. The pub hosts local darts teams and a Sunday night quiz. It has a large car park. Q❀✿❶●♿♣P呂(84)✿❋

Lanchester

Crinnions of Lanchester Ⓛ

25 Front Street, DH7 0LA
☎ (01207) 520376
3 changing beers (sourced nationally; often Allendale, Great North Eastern, Pennine) Ⓗ
Previously the village butcher's shop, owned by the same family since 1959, this is now a bar and restaurant. The bar has three real ales and the separate restaurant, open all day from breakfast, serves locally sourced produce, in particular the meat. Outside there is a sunny courtyard area plus a large walled garden with seating and on occasion a separate bar. Beer festivals are sometimes held. ❀✿❶●♿P呂✿❋

Leamside

Three Horseshoes Ⓛ

Pit House Lane, DH4 6QQ (about ½ mile N of A690, just outside West Rainton)
☎ (0191) 584 2394 ⊕ threehorseshoesleamside.co.uk
Timothy Taylor Landlord; 5 changing beers (sourced nationally) Ⓗ
A country inn with an excellent restaurant, the Back Room (booking advisable). The traditional bar has open fires in winter and a large TV for sport. Five real ales are served. The pub is home to a local cycle club and hosts a quiz on Sunday evening. A former local CAMRA Country Pub of the Year. Q❀✿❶●♿P✿❋

Medomsley

Royal Oak Ⓛ

7 Manor Road, DH8 6QN
☎ (01207) 560336
Hadrian Border Tyneside Blonde; 1 changing beer (sourced nationally; often Consett, Hadrian Border, Mordue) Ⓗ
Traditional country-style pub with a warm, welcoming feel. It has a large bar with a selection of seating including soft sofas and leather chairs, and plenty of dining space. A rotation of quality beers is available as well as good food. There is a large, attractive rear garden and ample parking to the front. Q❀✿❶●♿P呂✿❋

Metal Bridge

Old Mill L

Thinford Road, DH6 5NX (off A1M jct 61, follow signs on A177)

☎ (01740) 652928 ⊕ oldmilldurham.co.uk

4 changing beers (sourced nationally; often Bowland, Durham, Rudgate) H

Originally a paper mill in 1813, the pub offers good-quality food and well-kept ales – four handpumps serve a diverse range, with local breweries supplying at least one of the beers. The food menu is extensive, with daily specials listed on a board above the bar. Larger groups are welcome in the conservatory. Accommodation is of a high standard, with all rooms en-suite. Q❄★✿⊕❶&P☐(56) 🔊

Middlestone

Ship Inn L

Low Road, DL14 8AB (between Coundon and Kirk Merrington)

☎ (01388) 810904 ⊕ theshipinnmiddlestonevillage.co.uk

4 changing beers (sourced nationally) H

Regular drinkers come from far and wide to the Ship. It has a bar divided into three distinct areas with an open fire, and a large function room upstairs which is the location for occasional beer festivals. The rooftop patio has spectacular views. Various pieces of Vaux memorabilia are on display – one of the many subjects of conversation. Sunday lunches are popular. A former local CAMRA Country Pub of the Year. Q❄★✿⊕&✦P☐(56)🔊

Middleton-in-Teesdale

Teesdale Hotel ✅

Market Place, DL12 0QG

☎ (01833) 640264 ⊕ teesdalehotel.co.uk

Black Sheep Best Bitter; 2 changing beers (sourced nationally) H

A former coaching inn updated to provide excellent accommodation. This is a popular village local as well as a resting place for Pennine walkers – Middleton-in-Teesdale is often referred to as 'the capital of Upper Teesdale', with High Force and Cauldron Snout nearby. Up to two guest beers, often from local micros, are served. Meals can be enjoyed in the main bar or the comfortable restaurant. A farmers' market is held on the last Sunday of the month. Q❄★✿⊕ ▲P☐☐(95,96)🔊

Newton Aycliffe

Turbinia L

Parsons Centre, Sid Chaplin Drive, DL5 7PA (off Burnhill Way, next to Methodist church)

☎ (01325) 313034 ⊕ turbiniapub.co.uk

4 changing beers (sourced nationally; often Mithril, Three Brothers, Revolutions) H

Named after the famous Tyneside steamship, this friendly free house comprises a large lounge and function room, with traditional pub decor featuring a pictorial history of the Turbinia. This local favourite serves an ever-changing variety of beers sourced locally and nationally, as well as craft gins. It hosts a beer and cider festival twice yearly. Darts, dominoes and pool are played in the main bar during the week and live music features at the weekend. A repeat CAMRA branch Pub of the Season. ❄★&P☐(7)🔊🔊

No Place

Beamish Mary Inn L

DH9 0QH (follow signs to No Place off A693 from Chester-le-Street to Stanley)

☎ (0191) 392 0543 ⊕ beamish-mary-inn.co.uk

4 changing beers (sourced nationally; often Consett, Big Lamp, Great North Eastern) H

Full of character, this pub is well respected for its warm welcome, generously portioned pub grub and ample selection of well-kept real ale. The location is handy for visitors to the renowned open-air Beamish Museum nearby. Consett Ale Works and Great North Eastern beers are usually included among the range of LocAles on offer. Accommodation is available in twin, double and family rooms. Q❄★✿⊕&P☐(8,8A)🔊🔊

Norton

Highland Laddie ✅

59 High Street, TS20 1AQ

☎ (01642) 539570

Greene King Abbot; Ruddles Best Bitter; Sharp's Doom Bar; 7 changing beers H

Named after the Scottish drovers who herded livestock to cattle markets south as far as London. During the Wetherspoon conversion, the pub was significantly extended and now comprises two large open-plan areas, with the original pub's snug retained. An excellent choice of seven guests is on offer alongside the chain's contracted beers. There is a patio for those wishing to brave the north-easterlies head on. Served by bus links both locally and regionally. ❄★&✦☐(X7,X10)🔊

Old Shotton

Royal George

The Village, SR8 2ND

☎ (0191) 586 6500 ⊕ royalgeorgeoldshotton.co.uk

Timothy Taylor Landlord; 2 changing beers (sourced nationally; often Great North Eastern, Harviestoun, Rooster's) H

Pub and restaurant situated on the old village green, reopened following a major refurbishment of a virtually derelict establishment in 2014 when the bar was reinstated. There is a separate larger lounge and restaurant area as well as two private dining rooms. Traditional pub grub and bar snacks are available. Dogs are welcome, with treats at the bar. Q❄★⊕P☐(24) 🔊🔊

Ovington

Four Alls L

The Green, DL11 7BP (2 miles S of Winston & A67)

☎ (01833) 627302 ⊕ thefouralls-ovington.co.uk

Mithril Kingdom of Ovingtonia; 2 changing beers (sourced locally) H

Friendly stone-built 18tb-century inn opposite the village green in what is known as the 'maypole village'. A Victorian sign denotes the four alls: 'I govern all (queen), I fight for all (soldier), I pray for all (parson), I pay for all (farmer).' The single-room interior has an 'upstairs' snug serving excellent, good-value food made with local ingredients. Real ales include a dark and a light from local Mithril Ales – the house beer is Kingdom of Ovingtonia. There is seating outside at the front and the rear beer garden is perfect on sunny days. Q❄★⊕&✦P🔊🔊

Piercebridge

Fox Hole 🍺

Carlbury, DL2 3SJ (on B6275)
☎ (01325) 374286 ⊕ the-foxhole.co.uk
3 changing beers (sourced nationally) Ⓗ
Set in the Roman village of Piercebridge, the Fox Hole sits almost centrally between the towns of Darlington, Barnard Castle, Bishop Auckland and Richmond. From the welcoming Wellie bar through to the relaxed yet elegant dining room and alfresco dining terrace, the emphasis is on high-quality, locally sourced food and drink, combined with traditional pub values. A warm welcome and friendly service, along with three beers from local micros including Mithril three miles away, make this pub a must-visit. 🏠🕪&P🖵(75,76)♥🛜

Running Waters

Three Horse Shoes 🍺

Sherburn House, DH1 2SR
☎ (0191) 372 0286 ⊕ threehorseshoesdurham.co.uk
3 changing beers (sourced nationally; often Consett, Durham, Yard of Ale) Ⓗ
Country inn nicely situated a few miles from Durham city, offering good food and drink plus comfortable accommodation. Three cask ales are served, with usually at least one sourced locally. Alcohol is served from noon. The interior was extensively refurbished in 2016, while the rear beer garden provides excellent views over open countryside. Q🏠🕪🛏🕪&P🛜

St John's Chapel

Blue Bell Inn 🍺 ✔

Hood Street, DL13 1QJ
☎ (01388) 537256 ⊕ thebluebellinn.pub
2 changing beers (sourced regionally; often Allendale, Consett, Firebrick) Ⓗ
Originally a pair of terraced cottages, the Blue Bell is a friendly and cosy pub with a bar across the front of the building leading to a small pool room, and a garden to the rear. Situated on the A689, it serves the local community and those who holiday in Upper Weardale. Popular for pub games, it also has books to borrow. Q🏠🕪🅰♣🖵(101)♥🛜

Seaham

Coalhouse 🍺

39 Church Street, SR7 7EJ
☎ (0191) 581 6235 ⊕ seahamcoalhouse.uk
4 changing beers (sourced locally; often Cullercoats, Great North Eastern, Yard of Ale) Ⓗ
A former bookmakers', now a much valued part of Seaham's licensed trade. The pub was refurbished in 2018 using 100-year-old timbers salvaged from the town's demolished Co-op. The decor celebrates the area's coal mining heritage, notably one wall's impressive mural depicting Seaham pits. Four changing cask beers are offered along with up to four real ciders and five keg taps. 🏠🍴♣🖵(265,60)♥

Hat & Feathers 🍺 ✔

57-59 Church Street, SR7 7HF
☎ (0191) 513 3040
Greene King Abbot; Sharp's Doom Bar; 4 changing beers (sourced nationally; often Maxim) Ⓗ
This Wetherspoon pub gets its name from the Doggarts store that occupied the site from the 1920s to the 1980s and had a department selling hats and feathers. Upstairs are old photographs depicting the headgear of the best

dressed ladies of the time. Other interesting pictures show old Seaham. The furnishings are a mix of modern and traditional styles, including comfortable settees. Outside is a plaque displaying a history of the building. 🏠🕪🕪&♣P🖵🛜

Seaton

Dun Cow 🍺

The Village, SR7 0NA
☎ (0191) 513 1133
4 changing beers (sourced nationally; often Jennings, Maxim, Wainwright) Ⓗ
Friendly and unspoilt inn on the village green, featuring a public bar and lounge areas. This is a pub for good conversation or a game of darts; the TV is used only for special events. The changing guest beer selection usually comprises two light and two dark ales. No meals are served but toasties are always available. Regular busker and acoustic music nights are hosted. A former local CAMRA Country Pub of the Year. 🏠🕪&♣P🖵(71)♥🛜

Sedgefield

Dun Cow

43 Front Street, TS21 3AT
☎ (01740) 620894
Black Sheep Best Bitter; Timothy Taylor Knowle Spring; 1 changing beer (sourced nationally) Ⓗ
Run by the same landlord for over 40 years, this large and comfortable 18th-century inn has a county-wide reputation for good food using locally sourced produce. Prime minister Tony Blair and US president George W Bush famously had lunch here in 2003. There are three bars including a farmers' bar-cum-snug and restaurant. Three real ales are always available including at least one local beer. Q🏠🕪🛏🕪P🖵(X1)♥🛜

Hardwick Arms Hotel

1 North End, TS21 2AZ
☎ (01740) 622305 ⊕ theherdandherb.co.uk
Draught Bass; 1 changing beer (sourced nationally; often Big Lamp) Ⓗ
Spacious 18th-century coaching inn with some reminders of the golden age of coaching. To the right is primarily a restaurant, while to the left are three small rooms and a bar. The decor has an old world feel with a large defunct fireplace and photos of the inn through the ages. The old courtyard provides a large outdoor drinking space. 🏠🕪🛏🕪P🖵♥

Shildon

Canteen Bar & Kitchen 🍺

Norland House, Byerley Road, DL4 1HE
⊕ canteen-bar-kitchen.co.uk
George Samuel Locomotion No 1, Travelling Light, Harvey Ⓗ
An ambitious conversion of the former canteen of the famous Shildon Wagon Works. The bar and brewery share a single space, and an entrance with other businesses in the building. There is a spacious drinking area with picnic-style tables, where you can sit within feet of the brewing vessels. The pub's railway heritage is reflected in its decor. Opens for breakfast. Q🕪&🚲P🖵(X1)

Spennymoor

Frog & Ferret

Coulson Street, DL16 7RS
☎ (0191) 389 7246

6 changing beers (sourced nationally; often Camerons, Consett, Hadrian Border) Ⓗ
Friendly family-run free house offering up to six constantly changing real ales. These come from far and wide, with local and northern microbreweries well represented. The comfortably furnished lounge has a bar with brick, stone and wood cladding and a solid-fuel burner. Sports TV is featured and children are welcome until 9pm. Live music is hosted on Saturday night and monthly on Thursday and Sunday.
🚲❀◖♠🚋(6,X21)😺🛜

Grand Electric Hall Ⓛ ✅

Cheapside, DL16 6DJ
☎ (01388) 825470
Greene King Abbot; Ruddles Best Bitter; Sharp's Doom Bar; 3 changing beers (sourced nationally; often Daleside, Maxim) Ⓗ
Formerly a cinema and bingo hall in the centre of town, this bright and airy Wetherspoon conversion features film-themed decor and fittings. It has a spacious main area with a high ceiling and a smaller room on a lower level. The large patio drinking area to the front is a suntrap in summer. Alcoholic drinks are served from 9am. 🚲❀◖&🚋(6,X21)🛜

Little Tap Ⓛ

King Street, DL16 6QQ
☎ (01388) 304001
5 changing beers (sourced regionally; often Daleside, Durham) Ⓗ
Clever remodelling of a former sandwich shop as a smart little bar. A plush carpet makes it unusually comfortable for a micropub. The 'cellar' is very close to the pumps – beer is housed in cleverly converted fridges directly beneath the bar. Outside is a small yard in which to take advantage of any sunshine. Handily located next door to a Chinese takeaway. Q❀&🚋😺

Stanhope

Grey Bull

17 West Terrace, DL13 2PB
☎ 07885 676575
3 changing beers (sourced nationally) Ⓗ
A community focused hostelry with a warm welcome, at the foot of Crawleyside Bank at the west end of town. It has a busy bar area at the front and a lounge to the rear with a pool table, served by a central bar offering three cask beers. Tables to the front are popular in fine weather. Convenient for the Coast-to-Coast cycle route.
Q❀◖♠🚋(101)😺🛜

Stockton-on-Tees

Golden Smog

1 Hambletonian Yard, TS18 1DS (in a ginnel between High St and West Row)
☎ (01642) 385022
5 changing beers Ⓗ
The town's original micropub – a multi award-winner including CAMRA Regional Pub of the Year – is named after the environmental conditions that formerly prevailed on Teesside. Five beers, real ciders and a range of craft beers are served alongside an impressive selection of Belgian beers, all served in the continental fashion in their own matching glasses. Third-pints, served on bespoke Smog tasting tables, are also available. An extensive selection of free bar snacks is offered on Sunday. The pub supports various charitable causes. Q●🚋😺

Hope & Union Ⓛ

9-10 Silver Court, TS18 1SL (E of High St, through a ginnel off Silver St)
☎ (01642) 385022
4 changing beers Ⓗ
A bright, modern pub tucked away in a quiet square in the town's cultural quarter. 'Hope' was Robert Stephenson's second locomotive and 'Union' was a horse-drawn coach, both operated by the world's first passenger railway, the Stockton & Darlington. This contemporary pub serves four interesting beers and a large selection of craft ales, gins and whiskies. The cellar is on open display, as is the kitchen – locally sourced, freshly cooked and good-value dishes are available all day, every day. ◖▶🚋

Kopper Keg

27 Dovecot Street, TS18 1LH (just off High St in centre of town)
☎ 07984 624872
2 changing beers Ⓗ
A single-room micro with two handpulls, also serving a wide range of craft beers, bottles and cans. The real ale is always fresh as a cask rarely lasts more than a couple of days. Refectory style tables add to the environment, while two large screens, one at either end, feature sport and bands. The bar's Facebook page keeps drinkers updated on which beers are available.
&♠🚆(Stockton)♣🚋😺🛜

Lucifers Ⓛ

Calvin House, Green Dragon Yard, TS18 1AE (E of High St, through a ginnel off Finkle St)
🌐 lucifers-stockton.business.site
3 changing beers Ⓗ
Situated within a Grade II-listed former warehouse, this local CAMRA Pub of the Year is uniquely named after local chemist John Walker's 19th-century invention, the friction match. Promoted as the smallest bar in town, it can soon get very busy. Benches, booths and stools make for a cosy environment, while friendly staff provide a warm welcome. Three rotating guest beers, normally including a dark beer, and two real ciders are served, in third-pint glasses on request. 🚆●🚋😺🛜

Thomas Sheraton Ⓛ ✅

4 Bridge Road, TS18 3BW (at S end of High St)
☎ (01642) 606134
Greene King IPA, Abbot; Sharp's Doom Bar; 4 changing beers Ⓗ
This Grade II-listed Victorian building is a fine Wetherspoon conversion of Stockton's law courts, and named after one of the great Georgian cabinet makers, born in the town in 1751. The large, airy interior comprises several separate drinking and dining areas, plus a pleasant balcony and outdoor terrace upstairs. The guest beers, usually from the area, are served alongside an extensive and varied range of real ciders. A recent local CAMRA Cider Pub of the Year.
Q🚲❀◖&🚆(Thornaby)♣●🚋🛜

Tipsy Turtle Ⓛ

Unit 5, Regency West Mall, West Row, TS18 1EF (100 yds W of High St through any of the wynds)
☎ (01642) 670171
4 changing beers Ⓗ
Popular micropub, located in a mall containing several other licensed outlets, and now well established on the town's micropub circuit. Ales on four handpulls generally include at least one rarer beer style, while a wide selection of craft beers, a dozen or more mixed traditional and fruit ciders and an interesting selection of bottled continental beers are also available. When the

bar is busy, drinkers overflow into the mall, while at weekends it extends into the adjacent premises. Q🕏🕏👶🍴🚪🐕🛇

Wasps Nest 🅛

Wasps Nest Yard, 1 Calvert's Square, TS18 1TB (E of High St, through a ginnel off Silver St)
☎ 07789 277364
3 changing beers Ⓗ

Tucked away in a quiet square in the town's cultural quarter, between the Grade II-listed Georgian Theatre and the River Tees, the Wasps is firmly established as a feature of Stockton social life. It is a modern and lively pub serving a selection of locally sourced beers and a range of craft ales. Third-pint bats are available. The pub's claim to fame is that it has the town's only outdoor courtyard patio drinking area. Q🕏👶🚪🐕

Tanfield Lea

Tanfield Lea Working Men's Club

West Street, DH9 9NA
☎ (01207) 238783
2 changing beers (sourced nationally) Ⓗ

The village has no pub, reflecting its strong Methodist history, but guests are most welcome in this CIU-affiliated club, which has become something of a flagship for real ale in the area after a diet of keg beer for many years. TV sport is shown in the bar and there is a quiet, comfortable lounge. Traditional club activities such as bingo take place and there is usually a live act on Sunday. Three times local CAMRA Club of the Year. 🕏👶🍴🚪🛇

Tanfield Village

Peacock ✅

Front Street, DH9 9PX
☎ (01207) 232720
Black Sheep Best Bitter; 1 changing beer (sourced nationally; often Purity, Timothy Taylor) Ⓗ

A warm welcome is guaranteed in this friendly, traditional, two-bar pub in a pretty village. The Peacock is popular with locals and visitors alike, including bell ringers from the church opposite. Black Sheep is always available alongside a changing guest beer. Lovely home-cooked meals are served Wednesday to Saturday evenings and Sunday lunchtime – the portions are generous and great value for money. There is a small beer garden and ample parking. Q🕏👶🍴🍴🚪(V8)

Waterhouses

Black Horse 🅛

Hamilton Row, DH7 9AU
☎ (0191) 373 4576
2 changing beers (sourced nationally; often Castle Rock, Durham, S43) Ⓗ

A friendly local with an open fire at one end and a glass-fronted fire at the other helping to create a warm, cosy atmosphere. Two well-kept real ales always include one from a local brewery. Good-value Sunday lunches are served. There is a pool table. An excellent pub for walkers, handily situated adjacent to the Deerness Valley Way. Q🕏🍴🍴🚪(52,725)🐕🛇

West Cornforth

Square & Compass

7 The Green, DL17 9JQ (off Coxhoe-W Cornforth road)
2 changing beers (sourced nationally; often Sharp's, Wadworth) Ⓗ

A proper drinking pub and friendly local on the village green in the old part of Doggy (the village's local nickname). It has sold real ale for more than 40 years. The pub is home to darts and dominoes clubs and hosts a well-attended Thursday night quiz. There are good views towards the Wear Valley and Durham city. Q🕏🕏👶🍴🚪(56)🐕

Westgate

Hare & Hounds 🅛

24 Front Street, DL13 1RX
☎ (01388) 517212
Weard'ALE Chilled Nights, Pilsner, Gold, Dark Nights Ⓗ

On the banks of the Wear, on the A689. The spacious stone-flagged bar is partially fitted out with items salvaged from the former village chapel, and is a great place to catch up on local news. The restaurant's patio overlooks the river; here the beer is being brewed beneath your feet. Food, including the famous Sunday carvery, is locally sourced. Q🕏👶👶🍴🚪(101)

Witton-le-Wear

Dun Cow

19 High Street, DL14 0AY
☎ (01388) 488294
3 changing beers (sourced nationally; often Timothy Taylor) Ⓗ

A welcoming local set back from the road through the village, with a single L-shaped room warmed by open fires at both ends. Dating from 1799, the bar is guarded by a sleeping fox. There are benches to the left of the bar, and seating outside offering pleasant views over the Wear Valley. The decor includes some interesting football memorabilia. Q🐕🍴🚪

Victoria 🅛

School Street, DL14 0AS
☎ (01388) 488058 🌐 thevicwlw.co.uk
3 changing beers (sourced regionally; often Allendale, Great North Eastern, Maxim) Ⓗ

Traditional family-run village inn with a pleasant, bright decor. The central bar serves two distinct drinking areas, the larger of which is split level. The pub has great views over the Wear Valley from the patio to the rear. There is a wood-fired pizza oven in the garden. Close to the preserved Wear Valley Railway. B&B accommodation is available. 🐕🛏🍴🚪🐕🛇

Breweries

Autumn SIBA

8 East Cliff Road, Spectrum Business Park, Seaham, County Durham, SR7 7PS 🌐 autumnbrewing.co.uk

Autumn produce keg and bottled gluten free beers. No real ale.

Barnard Castle SIBA

Quaker Yard, Rear of 24 Newgate, Barnard Castle, DL12 8NG ☎ 07591 236210
🌐 barnardcastlebrewing.com

Brewing commenced in 2017 on a 3.6-barrel plant situated in one of the many yards at Barnard Castle. The brewery has an on-site bottle shop and taproom, while a mobile bar enables it to take beers to events further afield. Beers are named after local themes. 🎣

Low Force (ABV 2.8%) BITTER

Quaker Yard (ABV 3.5%) MILD
Deliberation (ABV 3.7%) BITTER
Bishops Blessing (ABV 3.8%) BLOND
Redhills (ABV 4.3%) RED
Mechanical Swan (ABV 4.5%) GOLD
DLIPA (ABV 4.8%) GOLD
Peg Powler (ABV 5.6%) PORTER

Camerons

Lion Brewery, Stranton, Hartlepool, County Durham, TS24 7QS
☎ (01429) 852000 ⊕ cameronsbrewery.com

☺Camerons was founded in 1865, and is a family-owned business. Brewing is done by various team members, from office staff to brewery staff. A range of cask ales in association with the RNLI is produced throughout the year. A number of limited-run ales are produced through its Tooth & Claw pilot brewery. It also has a pub estate of more than 70 pubs, including the Head of Steam pubs. ‼️➡️♦

Sanctuary Pale Ale (ABV 3.8%) BITTER
Strongarm (ABV 4%) BITTER
A well-rounded, ruby-red ale with a distinctive, tight creamy head; initially fruity, but with a good balance of malt, hops and moderate bitterness.
Old Sea Dog (ABV 4.3%) BROWN
Boathouse Premium Blonde Beer (ABV 4.4%) BLOND
Road Crew (ABV 4.5%) PALE

Brewed for Carlsberg Marston's Brewing Co:
Tetley Bitter (ABV 3.7%) BITTER
Malty sweetness and fruit with well-balanced hops, a smooth body and a lasting bitter finish.
Tetley Gold (ABV 4.1%) GOLD

Caps Off

Unit 4, Henson Close, South Church Industrial Estate, Bishop Auckland, County Durham, DL14 6QA ☎ 07900 551754 ⊕ capsoff.co.uk

Established in 2020, the brewery moved to larger premises in 2022 with new equipment and an onsite taproom. A wide range of styles is brewed. ✎

Pale (ABV 4.3%) PALE
IPA (ABV 5%) PALE
Brown Ale (ABV 7.4%) STRONG

Castle Eden

8 East Cliff Road, Spectrum Business Park, Seaham, SR7 7PS
☎ (0191) 581 5711 ☎ 07768 044484 ⊕ cebl.co.uk

Using the name of the former Castle Eden Brewery (having acquired the intellectual rights and recipes), a new 20-barrel commercial plant was installed in 2015 along with a bottling/kegging plant. Besides its own brand production, the brewery also contract bottles for several local and national companies. ➡️♦

Blond (ABV 3.9%) BLOND
Ale (ABV 4.2%) BITTER
Faint malty and fruity aromas are precursors to a sweet, malty, gently-bittered beer with some hop presence, finishing dry.
Red (ABV 4.4%) RED
Black (ABV 4.6%) STOUT

Consett SIBA

🍺 Grey Horse Inn, 115 Sherburn Terrace, Consett, County Durham, DH8 6NE

☎ (01207) 591540 ⊕ consettaleworks.co.uk

Established 2005, in the stables of a former coaching inn at the rear of the Grey Horse (Consett's oldest pub). The name, beers and branding commemorates the former steelworks in the town which closed in 1980. Beers are also available throughout the North East. ‼️♦

Pale Ale (ABV 3.8%) PALE
Steeltown (ABV 3.8%) BITTER
Steel River (ABV 4%) GOLD
Steelworkers Blonde (ABV 4%) BLOND
White Hot (ABV 4%) GOLD
Men of Steel (ABV 4.2%) BITTER
Stout (ABV 4.3%) STOUT
Complex beer. roasty and sweet with some interesting fruitiness. The hop combines with the roast malts for a satisfying and lasting finish.
The Company (ABV 4.4%) GOLD
Porter (ABV 4.5%) PORTER
Sweet malts and caramel dominate throughout, with some fruit and a lasting finish.
Red Dust (ABV 4.5%) RED
Sweet, fruit and malt lead to a creamy, full-bodied, balanced red ale with caramel flavours and a lasting finish.
Foreman's IPA (ABV 4.8%) PALE

Crafty Monkey SIBA

Benknowle Farm, Elwick, Hartlepool, TS27 3HF
⊕ shop.craftymonkey.beer

Brewing commenced in 2018 using a five-barrel plant in converted farm buildings. Beers are available throughout County Durham, Teesside and North Yorkshire. The brewery has a pop up bar for events.

Telegraph Session IPA (ABV 3.8%) PALE
Moneypenny EPA (ABV 4%) PALE
New Era (ABV 4.3%) BITTER
Ruby Ruby Ruby Ruby (ABV 4.5%) RED
Reward IPA (ABV 4.7%) PALE
Cemetery Gates (ABV 4.8%) PORTER
Black Celebration (ABV 5%) STOUT

Crafty Pint

🍺 c/o Half Moon, 130 Northgate, Darlington, DL1 1QS
☎ (01325) 469965 ☎ 078043 05175

Established in 2013 in the cellar of the Half Moon in Darlington. Originally a 10-gallon brew length, it was upgraded to a one-barrel plant in 2015. One-off beers are produced solely for the pub. ♦

Dionysiac (NEW)

19 Oaklands Terrace, Darlington, DL3 6AX ☎ 07557 502083 ✉ dionysiacbrewing@gmail.com

Starting in 2021, this nanobrewery takes its name from Dionysus, the Greek god of drunken madness. Producing small batches of high quality, artisanal bottled beers, the beer names reflect local history.

Donzoko

Office: Brougham Terrace, Hartlepool, County Durham, TS24 8EY ☎ 07463 863647 ⊕ donzoko.org

Donzoko Brewing Company, founded by Reece Hugill in 2017, takes its inspiration and influences from Germany and translates this beer tradition, combined with techniques from modern UK and US craft brewing, into its beers. It is a cuckoo brewery that has teamed up with Gipsy Hill (qv) to produce its flagship lager in London.

Other beers are brewed at various breweries in the North East. No real ale.

Durham SIBA

Unit 6a, Bowburn North Industrial Estate, Bowburn, County Durham, DH6 5PF
☎ (0191) 377 1991 ⊕ durhambrewery.com

⊕Established in 1994, County Durham's oldest brewery has a portfolio of around 40 beers, some permanent, some on rotation, and with new beers appearing regularly. Beers are available throughout the North East. ‼ 🍺 LIVE ✦

Magus (ABV 3.8%) BLOND
Pale malt gives this brew its straw colour but the hops define its character, with a fruity aroma, a clean bitter mouthfeel, and a lingering dry, citrus-like finish.
White Gold (ABV 4%) PALE
Hop and fruit on the nose builds in the mouth with added bitterness and sweet malts. Hop bitterness gains ground and lasts as the sweet malt and fruit diminish.
Dark Angel (ABV 4.3%) STOUT
This worthy stout is characterised by an abundance of different malty roast aromas and flavours. Balanced with gentle hops, sweetness and a touch of fruit.
Alabaster (ABV 7.2%) IPA

George Samuel

Unit 3 Norland House Business Centre, Shildon, DL4 1HE ☎ 07840 892751

Named after the brewer's two sons, the brewery originally set up as a two-barrel plant in 2014 at the Duke of Wellington pub in Welbury near Northallerton before moving to Spennymoor and closing in late 2018. The brewery reopened as an eight-barrel plant in 2020 in Shildon, the 'Cradle of the Railways', in a unit which formerly housed the offices of Shildon Wagon Works.

Locomotion No 1 (ABV 4%) BLOND
Citrus hops and fruity aromas are complemented by a moderate sweetness with rising and lasting dry bitterness at the end.
Leaves on the Line (ABV 4.2%) BITTER
Travelling Light (ABV 4.5%) PALE
Harvey (ABV 5.2%) PORTER
A smooth, malty beer with some fruity sweetness and a dry roast finish.
Terminus (ABV 5.5%) IPA

Hill Island

Unit 7, Fowlers Yard, Back Silver Street, Durham, DH1 3RA ☎ 07740 932584
✉ hillisland73@gmail.com

⊕Established in 2002, Hill Island is a literal translation of Dunholme, from which Durham is derived. It is part of Fowler's Yard Craft Workshops on the banks of the River Wear and can be reached by steps down from Silver Street. A pop-up bar operates at the brewery most Saturdays (Facebook for updates) including weekends coinciding with Durham events such as the Durham Fire & Ice Festival, and the Durham Miner's Gala. ‼ 🍺 ✦

Peninsula Pint (ABV 3.7%) BLOND
Hill Island Bitter (ABV 3.9%) BITTER
Stout for the Count (ABV 4%) STOUT
Neptune's (ABV 4.2%) BITTER
Cathedral Ale (ABV 4.3%) BITTER
THAIPA (ABV 4.3%) SPECIALITY

Hopper House Brew Farm

Racecourse Road, Sedgefield, TS21 2HL ☎ 07947 874278 ⊕ hopperhousebrewfarm.co.uk

Brewing commenced in 2019 on a one-barrel plant situated in a working dairy farm on the outskirts of Sedgefield. There is a taproom in an old milking parlour. Currently it only has a licence for bank holidays and occasional weekends but aspires to get a full licence. ✦

Hops & Dots

17 Chester Street, Bishop Auckland, DL14 7LP
☎ 07400 558848 ⊕ hopsanddots.com

⊗ Established in 2019 in the Linthorpe suburb of Middlesbrough, the brewery moved in 2021 to share facilities with Caps Off in Bishop Auckland, although now occupying the site alone following further expansion. Hops & Dots was founded by a teacher of the visually impaired, and a solicitor who believe that craft beer should always be accessible to all, which is why it promotes Braille alongside its beers. Beers are available in cask, keg and can. Brewery open days and events are planned. ✦

Do You Want To Buy a Speedboat? (ABV 3.9%) PALE
Fat Fingers (ABV 5.1%) SPECIALITY
Porterhouse 5 (ABV 5.5%) PORTER
Sim Specs (ABV 6.4%) IPA
Coffee Switch (ABV 6.8%) STOUT

McColl's

Unit 4, Randolph Industrial Estate, Evenwood, Bishop Auckland, DL14 9SJ
☎ (01388) 417250 ⊕ mccollsbrewery.co.uk

Brewing commenced in 2017 using a 20-barrel plant. Outlets are supplied across the North-East and further afield. A brewery tap is open fortnightly. ✦

Petite Blonde (ABV 4.1%) BLOND
Lady Marmalade (ABV 4.4%) BITTER
North South (ABV 4.6%) PORTER
Suma IPA (ABV 5%) PALE

Mad Scientist

⬛ c/o The Quakerhouse, 2-3 Mechanics Yard, Darlington, DL3 7QF
☎ (01325) 245052

Brewing commenced in 2017 on a half-barrel plant situated in the cellar of the Quakerhouse.

North Pier

Unit 3a, Tow Law Industrial Estate, Tow Law, DL13 4BB ⊕ northpierbrew.co.uk

Brewing commenced in 2020 with beers available in County Durham and Wearside.

Rokerite (ABV 4%) PALE
Pale (ABV 4.2%) PALE
Cold Brew (ABV 4.7%) PORTER
Bounty Hunter (ABV 4.8%) STOUT

S43 SIBA

Durham Road, Coxhoe, DH6 4HX
☎ (0191) 377 3039 ⊕ sonnet43.com

⊕S43 started production in 2012. It has three outlets, all but one leased out as free houses and an extensive free trade. In addition to four core beers, specials are brewed

every six weeks. The brewery is proud of its apprentice scheme, two apprentices moved onto other breweries recently. Cask production is 30% of capacity, which for several years has been at maximum. The brewery seeks new premises. ◆LIVE

The Mark (ABV 3.9%) GOLD
An inviting aroma of fruity citrus hops introduce this hop-forward beer with lasting impact.
The Doctor (ABV 4%) BITTER
The Raven (ABV 4.3%) STOUT
A sweet milk stout. Roast malt and gentle hops provide balance leading pleasantly to a long finish.
The Phoenix (ABV 4.5%) BLOND
Fruity hop aromas give way to more bittering hops on drinking. Sweetness in the background ensures balance.

South Causey

South Causey Inn, Beamish Burn Road, Stanley, DH9 0LS
☎ (01207) 235 555 ⊕ southcausey.co.uk

Brewer John Taylor moved equipment from the Stables brewery at Beamish Hall Hotel. A selection of beers are only available in the bar and restaurant at South Causey Inn. Bottled beers are available for sale to the public on-site. Bespoke beers can be brewed and personalised for special events held at the establishment. A small still has also been set up at the moment to produce gin but in future different types of spirits may be produced. Brewing is currently suspended.

Steam Machine SIBA

Unit 14, The IES Centre, Horndale Avenue, Newton Aycliffe, DL5 6DS ☎ 07415 759945
⊕ steammachinebrew.com

Founded by a husband and wife team with a homebrewing background of more than 10 years. Since opening in 2015 production has expanded. Beers are available mainly in keg but KeyKegs are occasionally supplied to beer festivals.

Three Brothers SIBA

Unit 4, Clayton Court, Bowesfield Crescent, Stockton on Tees, TS18 3QX
☎ (01642) 678084 ⊕ threebrothersbrewing.co.uk

The vision of Kit Dodd, after brewing for five years with another local brewery. Working with his brother David and brother-in-law Chris, the brewery was established in 2016. It is situated on an industrial estate within the

southern outskirts of Stockton-On-Tees. With backgrounds in chemical and mechanical engineering, the family use these skills to create their own recipes and ensure quality is maintained at the highest level. Beers are traditional with some American inspired beers.
‼️🍺◆LIVE ✦

The Bitter Ex (ABV 3.7%) BITTER
Trilogy (ABV 3.9%) BLOND
Pale, hoppy, citrus-flavoured blond with a bitter aftertaste.
DDH Pale (ABV 4%) PALE
ThaIPA (ABV 4.1%) SPECIALITY
Au (ABV 4.2%) PALE
Ruby Revolution (ABV 4.6%) RED
S'more Porter (ABV 4.8%) PORTER

Village Brewer

🏠 **22 Coniscliffe Road, Darlington, DL3 7RG**
☎ (01325) 354590 ⊕ villagebrewer.co.uk

⊕One-barrel microbrewery, established in 2013, which has been brewing on a regular basis since 2015. The plant is also used to produce the malt wash for the distilling of gin and vodka on-site. The beer strength and style varies from brew to brew.

Weard'ALE

🏠 **Hare and Hounds, 24 Front Street, Westgate, DL13 1RX**
☎ (01388) 517212

Brewing commenced in the Hare & Hounds in 2010. The beers are mainly sold on the premises but some have found their way to nearby beer festivals and other local pubs.

Yard of Ale

🏠 **Surtees Arms, Chilton Lane, Ferryhill, DL17 0DH**
☎ (01740) 655933 ☎ 07540 733513
⊕ thesurteesarms.co.uk

⊕Established in 2008, the 2.5-barrel microbrewery supplies ales to its brewery tap, the Surtees Arms, beer festivals and to a growing number of pubs. ‼️🍺◆LIVE

Gold (ABV 3.6%) GOLD
Yard Dog Brown Ale (ABV 4%) BROWN
Best By Yards (ABV 4.3%) BITTER
One Foot in the Yard (ABV 4.5%) BITTER
Gently hoppy bitter with malty sweetness, finishing marginally more bitter than the other balancing flavours.

Bridge Hotel, Durham (Photo: Stuart McMahon)

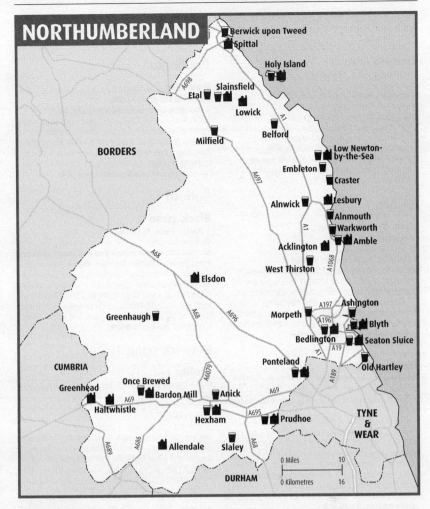

NORTHUMBERLAND

Berwick upon Tweed
Spittal
Holy Island
Etal
Slainsfield
Lowick
Milfield
Belford
Low Newton-by-the-Sea
Embleton
Craster
Alnwick
Lesbury
Alnmouth
Warkworth
Acklington
Amble
West Thirston
Elsdon
Ashington
Greenhaugh
Morpeth
Blyth
Bedlington
Seaton Sluice
Ponteland
Old Hartley
Once Brewed
Greenhead
Bardon Mill
Anick
Haltwhistle
Hexham
Prudhoe
Allendale
Slaley

BORDERS

CUMBRIA

TYNE & WEAR

DURHAM

0 Miles 10
0 Kilometres 16

Alnmouth

Red Lion Inn 🅛 ⊘
22 Northumberland Street, NE66 2RJ
☎ (01665) 830584 ⊕ redlionalnmouth.com
4 changing beers (sourced regionally) 🅗
A charming 18th-century coaching inn with a cosy lounge bar featuring attractive woodwork. The decked area at the bottom of the garden enjoys panoramic views across the Aln Estuary. Guest beers usually include one local ale and two interesting brews from further afield. Occasional live music plays in the open air in summer. An annual beer festival is held in October. The pub opens early for breakfast. Excellent en-suite B&B accommodation is available. Q♿❀🚲◑Ⓟ🚃(X18)🐾🛜

Alnwick

Ale Gate 🅛
25 Bondgate Without, NE66 1PR
☎ 07979 101332
6 changing beers (sourced locally) 🅗
Set in a former shop unit, latterly an insurance office, Alnwick's first micropub opened in February 2019. It has a single open main room to the right, and a raised area to the rear. Six handpumps on the traditionally styled

dark wood bar offer a regularly changing range of beers from local breweries. Music events are regularly hosted. 🚃❀

John Bull Inn 🅛
12 Howick Street, NE66 1UY
☎ (01665) 602055
4 changing beers (sourced nationally) 🅗
A former local CAMRA Pub of the Year, this 180-year-old inn thrives on its reputation as a back-street boozer. The landlord offers a wide range of cask-conditioned ales at varying ABVs, real cider, the widest range of bottled Belgian beers in the county and over 150 single malt whiskies. The darts team competes in the local league and the pub upholds the North-East tradition of an annual leek show. There is a cheese club on Saturday night. Q❀♣🐾❀

Pig in Muck 🅛
Market Place, NE66 1HS
⊕ piginmuckpub.co.uk
4 changing beers (sourced nationally) 🅗
Located in the heart of Alnwick's historic market square, this recent addition to the Alnwick pub scene is part of the Curious Taverns Group. Large glass windows to the front lead to an outdoor seating area in Market Place.

711

Ales and a selection of spirits are served from a wooden counter and back bar. The pub specialises in brunch and tapas. 🏠🍴🍺🚪🐾

Tanners Arms 🅛
2-4 Hotspur Place, NE66 1QF
☎ (01665) 602553
6 changing beers (sourced nationally) Ⓗ
Ivy-covered stone-built pub just off Bondgate Without and a short distance from Alnwick Garden. The rustic single room has a flagstone floor and tree beer shelf. A large fireplace provides added warmth in winter. Acoustic music nights feature regularly, with open mic on the last Friday of the month. The varied real ales frequently come from North-East and Scottish Borders microbreweries. 🚌♿♣🚪🐾🛜

Amble

Cock & Bull 🅛
Queen Street, NE65 0DQ
🌐 cockandbullpub.co.uk
4 changing beers (sourced locally) Ⓗ
Opened in a former tourist information office next to the town square, the interior has dark blue walls and an orange skylight in the ceiling, with bench seating around the walls and trestle tables. Four handpumps serve locally brewed ales. The pub features a local artist of the month, with works on display and for sale. There is some seating outside. Card payment only.
🏠♿🚪(X18,X20) 🐾🛜

Masons Arms 🅛
Woodbine Street, NE65 0NH
☎ (01665) 799275 🌐 masonsarmsamble.co.uk
5 changing beers (sourced nationally; often Hadrian Border, Rigg & Furrow) Ⓗ
A public house for over 100 years with a friendly welcome, this large, multi-roomed building is on a corner at the south edge of the Northumberland coastal village of Amble. Five handpumps adorn the bar, dispensing a range of local brewery beers, often from Hadrian Border. There is a function room to hire and regular quizzes are held. B&B accommodation is in five rooms. Boat trips to Coquet Island are available from the nearby harbour. 🏠🛏♣🚪🐾

Anick

Rat Inn 🅛
NE46 4LN (follow signpost at Hexham A69 roundabout)
☎ (01434) 602814 🌐 theratinn.com
Timothy Taylor Landlord; house beer (by First and Last); 1 changing beer (sourced locally; often Hadrian Border) Ⓗ
Superb 1750 country inn with spectacular views across the Tyne Valley. It has an excellent local reputation for good food prepared with locally sourced ingredients, and appears in several food guides. Half portions are available for children. Bottled beers are stocked. The first Thursday of the month is singers/poetry night. Well worth the short taxi ride from Hexham rail station.
Q🚌🏠🍴♣P🚪(74,684)

Ashington

Hop 77
77 Station Road, NE63 8RS
3 changing beers (sourced nationally) Ⓗ
Ashington's first micropub opened in a former shop unit in 2019. It has a single room with a bar counter in one corner. Furnishings are a mix of sofas and freestanding

tables and chairs. It is on the main street just beyond the old railway station, and an easy walk from the bus station. 🚌🚪🐾

Bedlington

Box Wood Tap 🅛
40C Front Street, NE22 5UB
4 changing beers (sourced nationally) Ⓗ
Set in a small converted shop on the main street in the centre of town. The hand-built wooden bar has four handpumps for beer. A range of ciders is also available from bag-in-box in the fridge. There is some seating including a settee, and an extension into an adjoining former shop unit provides extra space. 🚪🐾

Belford

Black Swan 🅛
1 Market Place, NE70 7ND
☎ (01668) 213266
Alnwick IPA; Rigg & Furrow Run Hop Run; 2 changing beers (sourced nationally; often Rigg & Furrow) Ⓗ
The pub has two rooms immediately inside the entrance with a further room to the rear of the bar, and a separate restaurant up a few steps at the back. Food hours may vary, especially off season, so check ahead if travelling. There are two upstairs letting rooms and self-catering cottages to the rear. 🛏🍴🚪🐾

Berwick upon Tweed

Atelier
41-43 Bridge Street, TD15 1ES
☎ (01289) 298180
3 changing beers (sourced nationally; often Hadrian Border) Ⓗ
Welcoming café bar with a shabby-chic interior. Three real ales are served, usually from Fyne Ales or Wylam, along with kegged craft beers. The food is all locally sourced and a real highlight. Specialities include hot shortcrust pies with a variety of interesting fillings, and a locally sourced meat and cheese platter that rivals those served in continental cafés. 🚌🍴🐾🛜

Curfew 🅛
46A Bridge Street, TD15 1AQ
☎ 07842 912268
4 changing beers (sourced nationally) Ⓗ

Established for more than six years, Berwick's first micropub is located up a small lane that opens out into a large courtyard off Bridge Street. It has a small bar area with a bottle fridge to one side, offering interesting local keg beers and foreign bottles. The courtyard makes a pleasant outdoor drinking area in summer. Excellent pork pies are available. A former local CAMRA Pub of the Year. Q⑤☆❀≢♣⚫❀

Pilot L

31 Low Greens, TD15 1LZ
☎ (01289) 304214
3 changing beers (sourced nationally; often Firebrick, Hadrian Border) Ⓗ
A gem of a pub, popular with locals and sought out by train trippers who have heard all about it. The stone-built 19th century end-of-terrace pub is recognised by CAMRA as having a historic interior of regional importance. It retains the original small room layout and boasts several nautical artefacts over 100 years old. It is home to a darts team and hosts music nights. The friendly bar staff provide a warm welcome to all. ⑤❀🛏♿≢♣❀

Blyth

Lounge

5-7 Simpson Street, NE24 1AX
☎ 07732 533976
5 changing beers (sourced nationally) Ⓗ
Friendly micropub in the centre of Blyth. The tap for the Metal Head Brewery, it also offers a range of over 20 ciders. Live music plays in the bijou L-shaped bar at the weekends. Toasted sandwiches and snacks are available. Handily placed for bus services to Blyth town centre, it is a five-minute walk from the bus station. ♿🖵❀

Craster

Jolly Fisherman ⊘

9 Haven Hill, NE66 3TR
☎ (01665) 576461 ⊕ thejollyfishermancraster.co.uk
Black Sheep Best Bitter; Timothy Taylor Landlord; house beer (by Laine) Ⓗ
A superb coastal inn with excellent views over the adjacent harbour. It is set above the sea and has its own sea wall and beer garden. Good locally sourced food is served, with the emphasis on seafood, including the renowned crab sandwiches. The East Coast Walk passes the pub, popular with tourists and locals. The pub sponsors its own football team. ⑤❀◗♿♣🖵P(418,X18)⚫🛜

Embleton

Greys Inn L

Stanley Terrace, NE66 3UZ
☎ (01665) 576983
5 changing beers (sourced locally; often Alnwick) Ⓗ
Pleasant, traditional inn in a lovely seaside hamlet, just a short walk from a wonderful beach. It has three open fires, and a rare McLennan & Urquhart's Edinburgh Ales mirror on a chimney breast. It is home to a ladies' darts team, clay pigeon club and golf club. Winter hours may vary. ⑤❀◗♣🖵(418,X18)⚫

Etal

Black Bull L

TD12 4TL
☎ (01890) 820200 ⊕ theblackbulletal.co.uk
House beer (by Cheviot); 2 changing beers (sourced locally; often Cheviot) Ⓗ

Northumberland's only thatched pub was renovated and reopened in 2018 in an attractive modern style, following a prolonged closure. An exposed roof structure adds to its charm. Comfortable pale-wood furniture features throughout the spacious, open-plan interior. Three handpumps serve real ales exclusively from Cheviot Brewery, with a special dark bitter made for the pub. There is a function room and large outdoor seating area. ⑤❀◗♿P🖵(267)⚫

Greenhaugh

Holly Bush Inn L ⊘

NE48 1PW
☎ (01434) 240391 ⊕ hollybushinn.net
First and Last Mad Jack Ha'; Hadrian Border Grainger Ale; Twice Brewed Brew House Sycamore Gap; 1 changing beer (sourced locally; often Hexhamshire) Ⓗ
Independently owned pub, over 300 years old and set in the heart of the Northumberland National Park and the Dark Sky Park, making it ideal for those with an interest in real ale and real stars. No TV and no mobile reception make for a peaceful drinking experience. The place hosts informal jam sessions – bring your instrument if you like. Q⑤❀🛏♿P⚫🛜

Hexham

County Hotel L ⊘

Priestpopple, NE46 1PS
☎ (01434) 608444 ⊕ countyhotelhexham.co.uk
Hadrian Border Tyneside Blonde; Timothy Taylor Landlord; 1 changing beer (sourced nationally) Ⓗ
The plush public bar in the famous town centre County Hotel now subsumes the former and much smaller Argyles Bar which was down a side street. The bright and modern interior divides into several areas. Popular for food, it offers an extensive and varied menu supplemented with specials. Very handy for the bus station. Alcoholic drinks are served from 11am. ⑤❀🛏◗♿≢🖵🛜

Platform Bar L

Platform 2 Hexham Railway Station, Station Road, NE46 1ET
☎ (01434) 604997
6 changing beers (sourced locally) Ⓗ
This single-room micropub opened in 2019 in the former waiting room on the westbound platform of Hexham station. It has perimeter seating with freestanding tables, and railway memorabilia on the walls. Alcohol is served from 10am, with tea, coffee and light snacks available earlier. Opening hours may vary depending on demand. The toilets are at the other end of the platform. Q≢(684)🛜

Victorian Tap ⊘

Battle Hill, NE46 1BH
☎ (01434) 602039
3 changing beers (sourced nationally) Ⓗ
Busy, compact, street-corner local that carries a range of changing ales, despite the restrictive list of the owning pubco. The pub is divided into two drinking areas – a bar and lounge both served from a central bar. It has an outside drinking area in the back yard. A handy watering hole for visitors to the nearby Hexham Abbey. Q❀◗≢🖵⚫

Holy Island

Crown & Anchor Hotel ⓛ
Market Place, TD15 2RX (check tidetable for causeway crossing times)
☎ (01289) 389215 ⊕ holyislandcrown.co.uk
Hadrian Border Tyneside Blonde; 2 changing beers (sourced locally; often Cheviot, Rigg & Furrow) Ⓗ
Exposed floorboards and wooden tables and benches provide seating in the cosy bar – note the Gothic carving of a local monk in the corner. There is a comfortable sitting room to the rear. The large beer garden provides scenic views to Lindisfarne Castle and the ruined priory to the rear of the pub. Accommodation is in four ensuite rooms. ✿🛏️◑🖪(477)✿ 🛜

Ship Inn ⓛ
Marygate, TD15 2SJ (check tidetable before crossing causeway)
☎ (01289) 389311 ⊕ theshipinn-holyisland.co.uk
House beer (by Hadrian Border); 2 changing beers (sourced nationally) Ⓗ
The family-run Ship Inn has the feel of a traditional sailing ship, with wood-panelled walls adorned with artefacts of life at sea. In addition, various photographs and paintings portray a history of island life from days past to the present day. Leading off the bar is carpeted lounge area with exposed island stone and wood panelling. At the rear is a sheltered beer garden. ✿🛏️◑🖪(477) ✿

Low Newton-by-the-Sea

Ship Inn ⓛ
Newton Square, NE66 3EL
☎ (01665) 576262 ⊕ shipinnnewton.co.uk
Ship Inn Sea Coal, Sea Wheat; 4 changing beers (sourced nationally; often Hadrian Border) Ⓗ
This small pub nestles in the corner of three sides of a square of former fishermen's cottages, a few yards from the beach. It attracts drinkers seeking ales from the in-house microbrewery, diners enjoying an excellent menu featuring fresh local ingredients, and walkers exploring the scenery. A public car park is close by at the top of the hill. Opening times may vary in winter; phone ahead if travelling. Q🚷✿◑✿

Milfield

Red Lion Inn ⓛ
Main Road, NE71 6JD (in small village E of A697)
☎ (01668) 216224 ⊕ redlionmilfield.co.uk
Black Sheep Best Bitter; 2 changing beers (sourced nationally) Ⓗ
A true local pub at the heart of the village, just eight miles inside the border, dating back to the mid-1700s. The Red Lion is a proper free house, with many varied guest beers served through the third handpump. Freshly prepared food is available, with blackboards proudly displaying where the local produce is sourced. Home to the leek growing club. Q🚷✿🛏️◑▸&♣🖪(267)🛜

Morpeth

Joiners Arms ⓛ
3 Wansbeck Street, NE61 1XZ
☎ (01670) 513540
Black Sheep Best Bitter; Draught Bass; 2 changing beers (sourced nationally; often Anarchy) Ⓗ
This popular former Sir John Fitzgerald outlet is located just over the footbridge from the town centre. A friendly and traditional pub, it has a public bar to the front and

lounge to the rear overlooking the River Wansbeck. There is now a beer garden by the river next to the ornamental cannon. ✿➿🖪✿

Office 🍷 ⓛ
Chantry Place, NE61 1PJ
☎ 07957 721066
6 changing beers (sourced locally) Ⓗ
The Office is a micropub free from music and games machines. It features eight handpulls and three craft keg beers, all of local origin, as well as three real ciders dispensed on gravity from the glass-fronted fridge opposite the bar. No food is served. Dogs are welcome. CAMRA Northumberland Pub of the Year 2022. Q➿🖪✿

Pleased to Meet You ⓛ
Bridge Street, NE61 1NB
☎ (01670) 33397
House beer (by Almasty); 3 changing beers (sourced nationally) Ⓗ
Reopened late in 2021 after a lengthy closure and extensive redevelopment. The layout offers several discrete drinking areas on various levels, with the bar towards the rear. The walls have been taken back to bare brick and the various areas tastefully furnished. Food is available from 9am, alcohol from 12pm. ◑➿🖪

Tap & Spile ⓛ
23 Manchester Street, NE61 1BH
☎ (01670) 513894
Greene King Abbot; Hadrian Border Tyneside Blonde; Timothy Taylor Landlord; 5 changing beers (sourced nationally) Ⓗ
All are welcome at this popular locals' pub near the town bus station. Seven handpulls offer a good choice of beers, with local ales from Northumbrian breweries often available. The bar area at the front is usually busy, though there is a quieter, cosy lounge to the rear accessible from either side of the room. A traditional folk group plays on Sunday lunchtime. Q🚷◑♣🖪✿🛜

Old Hartley

Delaval Arms ⓛ
NE26 4RL
☎ (0191) 237 0489 ⊕ delavalarms.com
6 changing beers (sourced locally; often King Aelle) Ⓗ
Multi-roomed Grade II-listed building dating from 1748, with a listed WWI water storage tower (part of Roberts Battery) behind the beer garden. It is the first pub in Northumberland for those following the coastal route. Good-quality, affordable meals complement the beer, with guest ales coming from local micros. To the left as you enter is a room served through a hatch from the bar and to the right a room where children are welcome. Home to the King Aelle brewery. Q🚷✿◑▸♣P🖪(308,309)✿🛜

Once Brewed

Twice Brewed Inn ⓛ ✅
Miltary Road, Bardon Mill, NE47 7AN (on B6318 Military Road)
☎ (01434) 344534 ⊕ twicebrewedinn.co.uk
6 changing beers (sourced nationally; often Twice Brewed Brew House) Ⓗ
An excellent, remote inn on the Military Road, near to Hadrian's Wall, Steel Rigg and Vindolanda, attracting walkers and tourists. The fully refurbished bar area offers a wide range of bottled beers from around the world. The pub has full wheelchair access and welcomes dogs. B&B is offered in 18 en-suite bedrooms. The Twice

Brewed Brew House started producing its own beers in 2017, using water from its own well.

Q🍴🛏🖧🍽◐🔌⚂♿ＡＰ🐾🐕🏮 🛜

Ponteland

Pont Tap 🅛

10 West Road, NE20 9SU
☎ 07446 098501
4 changing beers (sourced nationally) Ⓗ
The Pont Tap opened in 2020 in what was previously an interior design shop. It serves a good range of mostly local cask and craft keg beers together with wine and spirits. The friendly welcome and comfortable surroundings make this pub a must-visit if you are in the area. Q🖧

Prudhoe

Wor Local 🅛

Front Street, NE42 5HJ
☎ (01661) 598150
4 changing beers (sourced nationally) Ⓗ
Located on Prudhoe's Front Street, Wor Local (Our Local if you're not a Geordie) is a micropub with space for around 40 customers. The layout of the bar, with its comfy seating, encourages conversation. Three local beers in a variety of styles are offered, one always at a lower price. Real ciders are also served. Snacks include pork pies and cheese along with crisps and nuts. Traditional pub and board games are available. 🐾🐕

Seaton Sluice

Melton Constable ✅

Beresford Road, NE26 4QL
☎ (0191) 237 7741 ⊕ themeltonconstable.co.uk
Adnams Southwold Bitter, Broadside; Ossett Yorkshire Blonde; 2 changing beers (sourced nationally) Ⓗ
Large roadside pub a few minutes' walk from the beach and local history sights. It is named after the southern seat of Lord Hastings, a member of the Delaval family – Delaval Hall is close by. Tuesday is steak night, Wednesday is quiz night, and Sunday evening features live music. A fishing club meets here late at night and the BSA owners' club gets together on the first and third Thursdays of the month. 🛏🖧◐🔌♿ＡＰ🐾🐕🏮 🛜

Slainsfield

Cheviot Tap 🅛

TD12 4TP (signposted for Letham Hill and Slainsfield)
NT948393 ⊕ cheviotbrewery.co.uk/cheviot-tap
4 changing beers (sourced nationally; often Cheviot) Ⓗ
Opened late in 2021 beside Slainsfield Wood, the tap was converted from former hunting hound kennels, with the addition of rustic wooden gazebos, cask stools and much wooden panelling. Glamping and camping are available on-site, with a small shop open to residents. Brewery tours can be booked. Designated drivers are welcome to free tea and coffee while onsite.
♿🖧◐Ａ♣Ｐ🐾

Slaley

Rose & Crown 🅛

Main Street, NE47 0AA
☎ (01434) 673996 ⊕ roseandcrownslaley.co.uk
4 changing beers (sourced locally) Ⓗ

The Rose & Crown is a community owned Grade II-listed building dating back to 1675, and has been providing a warm welcome to locals and visitors ever since. It has a traditional bar and separate dining room. There are log fires and a sheltered garden with long views for the summer. A wide food menu is available as well as a great choice of beers, wines and spirits. Summer hours may vary. 🛏🖧◐🔌♿♣Ｐ🐾 🛜

Warkworth

Masons Arms

3 Dial Place, NE65 0UR
☎ (01665) 711398 ⊕ themasonsarmswarkworth.co.uk
Black Sheep Best Bitter; Marston's EPA; Timothy Taylor Landlord Ⓗ
This Grade II-listed 18th-century pub was one of the key sites for the 1715 Jacobite rising – see the plaque on the front of the pub. The L-shaped interior has low ceilings, wooden floors and a mix of wooden and upholstered seating. At one end is a stove fireplace, and there is an ice cream bar. The large drinking area at the rear has a covered area for smokers and a patio with Pizza Shack, leading to a grassy area with picnic seating.
🌼◐🖧(X18,X20)🐾

Sun Hotel

6 Castle Terrace, NE65 0UP
☎ (01665) 711259 ⊕ thesunhotelwarkworth.co.uk
Bombardier; Sharp's Doom Bar; 2 changing beers (sourced regionally; often Firebrick, Great North Eastern) Ⓗ
A Grade II-listed 17th-century coaching inn situated in a designated Area of Outstanding Natural Beauty, with bar and restaurant open to the public, offering stunning views of the castle. Following internal alterations, the Castle Brew House bar is accessed solely through the door on the left, while the No.6 Steak House, serving meals lunchtime and evenings (closed Mon) is accessed through the hotel entrance. 🛏🌼🖧◐Ｐ🖧(X18,X20)🐾 🛜

West Thirston

Northumberland Arms 🅛 ✅

The Peth, NE65 9EE
☎ (01670) 787370 ⊕ northumberlandarms-felton.co.uk
Rigg & Furrow Run Hop Run; Sharp's Doom Bar; 3 changing beers (sourced nationally; often Allendale) Ⓗ
This fine stone pub was originally a coaching inn in the 1820s for Hugh Percy, third Duke of Northumberland. The building has been lovingly restored in an eclectic style while remaining warm, comfortable and welcoming. Bare stone walls and real fires add to the ambience. A large function room caters for groups of up to 30. The beer range is predominantly from local breweries.
🛏🌼🖧◐Ｐ🖧(X15)

Breweries

Allendale SIBA

Allen Mill, Allendale, Northumberland, NE47 9EA
☎ (01434) 618686 ⊕ allendalebrewery.com

⊛Established in 2006, the brewery is a 20-barrel plant in a historic lead smelting mill in the heart of the North Pennines Area of Outstanding Natural Beauty. Many of the beers reflect the heritage and identity of the local area. 🏮🍴♦

Wagtail Best Bitter (ABV 3.8%) BITTER

Amber bitter with spicy aromas and a long, bitter finish.
Golden Plover (ABV 4%) BLOND
Light, refreshing, easy-drinking blonde beer with a clean finish.
Pennine Pale (ABV 4%) PALE
Hop on (ABV 4.7%) GOLD
Adder Lager (ABV 5%) SPECIALITY
Anvil (ABV 5.5%) IPA
Wolf (ABV 5.5%) RED
Full-bodied red ale with bitterness in the taste giving way to a fruity finish.

Alnwick SIBA

Unit E-F, Hawkhill Business Park, Lesbury, Northumberland, NE66 3PG
☎ **(01665) 830617** ☎ **07788 433499**
⊕ **alnwickbrewery.co.uk**

Brewing started in the 1860s in the centre of Alnwick, the capital of Northumberland. The brewery was acquired in 1978 by Scottish brewer Dryboroughs, who closed it in 1986, but relaunched in 2003 with the assistance of the Duchess of Northumberland. Beers are also brewed under the Holy Island name. More than 50 outlets are supplied in the north of England.

Backlash (NEW)

7a Earls Court, Prudhoe, NE42 6QG
☎ **(01661) 830934** ⊕ **backlashbrewery.co.uk**

Brewing commenced in 2018, initially on a small scale for marketing purposes at exhibitions worldwide. Beers are only produced in bespoke batches via pre-order for events and special occasions, and available in bottle, cask or keg.

Beacon Brauhaus

Pilgrims Coffee Falkland House, Marygate, Holy Island, TD15 2SJ
☎ **(01289) 389109** ⊕ **pilgrimscoffee.com**

Nanobrewery situated on Holy Island, the first brewery to be based there in around 500 years. Local outlets are supplied. Brewing is currently suspended.

Bear Claw

Unit 3, Meantime Workshops, Spittal, Northumberland, TD15 1RG ☎ **07919 276715**
⊕ **bearclawbrewery.weebly.com**

Bear Claw began brewing in 2012 using a two-barrel plant, producing a variety of mainly highly-hopped, cask-conditioned ales, and many bottle-conditioned beers, including continental styles. Beers are available in the Green Shop and Curfew pub in Berwick upon Tweed. LIVE

Brewis

Unit 4, Coquet Enterprise Park, Amble, Northumberland, NE65 0PE
☎ **(01665) 714818** ⊕ **brewisbeer.co.uk**

Brewis Beer Co is a family-run nanobrewery featuring a bottle shop and taproom. ⬛⬦

Building Bridges (ABV 4.5%) PALE
Helm (ABV 4.7%) PORTER
Just Like Heaven (ABV 5.7%) IPA
Turning Tides (ABV 5.8%) IPA
Ebb & Flow (ABV 6.5%) IPA

Chasing Everest

15 Ponteland Square, Blyth, NE24 4SH
⊕ **chasingeverestbrew.com**

Founded in 2018 by Zak Everest, focusing on small batch brews. Many of the beers are dry-hopped, giving bold, hoppy flavours.

Plus One (ABV 3%) PALE
Sideswiper (ABV 4%) BITTER
Joana In Five Acts (ABV 4.2%) BITTER
Square Hammer (ABV 6.8%) STOUT

Cheviot

Slainsfield, Northumberland, TD12 4TP ☎ **07778 478943** ⊕ **cheviotbrewery.co.uk**

Brewing commenced in 2018 on a 7.5-barrel plant acquired from Goose Eye Brewery in West Yorkshire. The beers are named after local landmarks. ⬛⬛⬦

Upland Ale (ABV 3.8%) BITTER
ETale (ABV 4%) BITTER
Harbour Wall (ABV 4.3%) PALE
Black Hag (ABV 4.4%) STOUT
Trig Point (ABV 4.5%) PALE
Menhir (ABV 5.1%) STOUT
Flodden Thirst (ABV 5.4%) PALE

First & Last SIBA

⬛ Bird in Bush, Village Green, Elsdon, NE19 1AA
☎ **(01830) 520804** ☎ **07757 286357**
⊕ **firstandlastbrewery.co.uk**

First & Last was established in 2016 by Red Kelly, a founder member of Stu Brew (qv) in Newcastle upon Tyne. It was upgraded to a five-barrel plant in 2018, relocating from Rochester to the Bird in Bush, Elsdon. Other outlets in Northumberland and the Scottish Borders are supplied. ⬛⬦

Flying Gang

Unit 3, Meadowfield Industrial Estate, Ponteland, Northumberland, NE20 9SD ☎ **07789 958782**
⊕ **flyinggangbrewing.com**

Brewing commenced in 2021 in an industrial unit in Ponteland, also incorporating a taproom which opens at weekends. The brewery is also involved in the running of the Left Luggage micropub in Monkseaton. ⬦

Grounding Angels

6 Rear Battle Hill, Hexham, Northumberland, NE46 1BB ☎ **07508 175512** ⊕ **grounding-angels.com**

Brewing started in 2018 by Jamie Robson, using his family's experience of owning global drinks brand Fentimans. Golden Promise malt is used as a base for all of the beers, which are distributed nationwide.

Hetton Law

Hetton Law Farm, Lowick, Berwick upon Tweed, Northumberland, TD15 2UL
☎ **(01289) 388558** ☎ **07889 457140**
⊕ **hettonlawbrewery.co.uk**

Brewing began in 2015 using a 2.5-barrel plant. Run by retired dentists Judith and Nicholas Grasse, it uses local spring water and locally grown malt, which gives the beers a distinctive character. Due to the size of the brewery, availability on draught and in bottles is effectively limited to the local area on both sides of the border. ⬦

Hetton Hermit (ABV 3.8%) BITTER
Hetton Howler (ABV 4.2%) SPECIALITY
Hetton Harlot (ABV 4.8%) BITTER
Hare Raiser (ABV 5.2%) GOLD

Hexhamshire SIBA

Dipton Mill Road, Hexham, Northumberland,
NE46 1YA
☎ (01434) 606577 ⊕ hexhamshire.co.uk

Hexhamshire is Northumberland's oldest brewery and is
run by the same family since it was founded in 1993. The
Brooker family also run the brewery tap, the Dipton Mill.
Outlets are supplied direct and via the SIBA Beerflex
scheme.

Devil's Elbow (ABV 3.6%) BITTER
Amber brew full of hops and fruit, leading to a bitter
finish.
Shire Bitter (ABV 3.8%) BITTER
A good balance of hops with fruity overtones, this amber
beer makes an easy-drinking session bitter.
Blackhall English Stout (ABV 4%) STOUT
Devil's Water (ABV 4.1%) BITTER
Copper-coloured best bitter, well-balanced with a slightly
fruity, hoppy finish.
Whapweasel (ABV 4.8%) BITTER
An interesting smooth, hoppy beer with a fruity flavour.
Amber in colour, the bitter finish brings out the fruit and
hops.

King Aelle (NEW)

🍺 Delaval Arms, Old Hartley, Seaton Sluice, NE26 4RL
☎ (0191) 237 0489

Brewing commenced in 2021 on a 2.5-barrel plant which
was originally based at the Hop & Cleaver, Newcastle
upon Tyne. The brewery is based in an outbuilding at the
Grade II-listed Delaval Arms, Old Hartley, on the
Northumberland coast. Beers are available in both cask
and five litre mini casks.

Metalhead SIBA

Unit 9, Bowes Court, Barrington Industrial Estate,
Bedlington, Northumberland, NE22 7DW ☎ 07923
253890 ⊕ metalhead-brewery.co.uk

⊛Metalhead Brewery began life in 2019 following a
career change and a love of real ale and music. Beers are
available in its micropub, the Lounge, Blyth. LIVE

Hammer Best Bitter (ABV 3.8%) BITTER
Old Knacker (ABV 3.8%) BITTER
Best Mate (ABV 4.2%) BITTER
Simply Red (ABV 4.6%) BITTER
Axl Gold (ABV 4.8%) GOLD
Archer (ABV 5.1%) BITTER

Muckle SIBA

3 Bellister Close, Park Village, Haltwhistle,
Northumberland, NE49 0HA ☎ 07711 980086
⊕ mucklebrewing.co.uk

Established in 2016, Muckle Brewing is a tiny brewery in
rural Northumberland, close to Hadrian's Wall. Beers are
influenced by the local landscape.

Whin Sill Blonde (ABV 3.5%) BITTER
Tickle (ABV 4%) GOLD
Chuckle (ABV 4.2%) GOLD
Buster (ABV 4.5%) BITTER
Kings Crag (ABV 5.4%) PALE

Rigg & Furrow

Acklington Park Farm, Acklington, Morpeth,
Northumberland, NE65 9AA ⊕ riggandfurrow.co.uk

Brewing commenced in 2017 in a former milking parlour.
It is a family-run business celebrating the best of home-
grown Northumbrian and British produce creating
exciting and innovative beers. A brewery tap is open on
selected dates (see website for details). ♠

Best (ABV 4%) BITTER
Run Hop Run (ABV 4.2%) GOLD
Land Bier (ABV 4.8%) PORTER
Farmhouse IPA (ABV 5.6%) IPA

Ship Inn

🍺 Ship Inn, Newton Square, Low Newton by the Sea,
Northumberland, NE66 3EL
☎ (01665) 576262 ⊕ shipinnnewton.co.uk

⊛Brewing commenced in 2008 on a 2.5-barrel plant.
The brewery now brews three times a week producing
7.5 barrels. Sixteen beers are brewed in constant rotation
but are only available on the premises. A special beer is
brewed for every 100 brews. Some beers are now
available in cans but again only available from The Ship
Inn. ♦LIVE

Twice Brewed SIBA

🍺 Twice Brewed Inn, Bardon Mill, Hexham, NE47 7AN
☎ (01434) 344534 ⊕ twicebrewedbrewhouse.co.uk

⊛Brewing commenced on a five-barrel plant in 2017.
Due to the close proximity of Hadrian's Wall, beer names
have a Roman theme. Beers are available at the Twice
Brewed Inn as well as other outlets. ‼🍺♦♠

Gallia (ABV 3.7%) GOLD
Best Bitter (ABV 3.8%) BITTER
Sycamore Gap (ABV 4.1%) PALE
Aesica (ABV 4.2%) BLOND
Ale Caesar (ABV 4.4%) BITTER
Steel Rigg (ABV 4.9%) PORTER
Vindolanda Excavation IPA (ABV 5.3%) PALE

Wrytree

Unit 1, Wrytree Park, Greenhead, Northumberland,
CA8 7JA

Brewing commenced in 2015 as Pit Top Brewery. The
name changed to Wrytree in 2019.

Gold (ABV 3.9%) GOLD
Copper (ABV 4%) BITTER

TYNE & WEAR

Gateshead

Central L

Half Moon Lane, NE8 2AN
☎ (0191) 478 2543

8 changing beers (sourced nationally) H

Marvellous Grade II-listed four-storey building, dating from the mid-19th century. The wedge-shaped pub comprises a revamped public bar, rooftop terrace, and two function rooms that host live music. Its main attraction is the magnificently restored Buffet, identified by CAMRA as a nationally important historic pub interior. It is presented as circa 1900, featuring a great carved U-shaped counter and bar back, plasterwork frieze and panelling. ☼◗🖤♿♣🚬🚪🐾🛜

Old Fox L

10-14 Carlisle Street, Felling, NE10 0HQ
☎ (0191) 447 1980

5 changing beers (sourced nationally) H

A traditional single-room community pub with a roaring fire in winter, only a short walk from Felling Metro station. Ales are drawn both from national and local breweries. Snacks and Sunday lunches are available. There is live music over the weekend, and the dartboard is in frequent use. A friendly and welcoming pub with a beer garden at the rear. ☼🏵🚆(Heworth) 🚉(Felling) ♣🚪🐾🛜

Schooner L

South Shore Road, NE8 3AF (just down from jct between Saltmeadows Rd & Neilson Rd, vehicular access only from E end of South Shore Rd)
☎ (0191) 477 7404 ⊕ theschooner.co.uk

Ossett White Rat; 5 changing beers (sourced nationally) H

On the banks of the Tyne, the Schooner currently has six handpumps for cask ales and one for cask cider. The selection changes regularly to showcase the best local

and national ales and ciders. Great-value home-cooked food is served throughout the week, with traditional roasts on Sunday. Live music plays every Sunday afternoon, some Saturday nights, and on many other occasions. ☼🏵◗🖤♣♿🚪🅿🚏(93,94)🐾🛜

Wheat Sheaf L

26 Carlisle Street, Felling, NE10 0HQ
☎ (0191) 857 8404

Big Lamp Sunny Daze, Bitter, Prince Bishop Ale; 2 changing beers (sourced nationally) H

Welcoming street-corner pub owned by Big Lamp Brewery and patronised by a loyal band of regulars who often travel quite a distance to drink here. The pub has some original details, mismatched furniture and, when needed, real coal fires. It hosts traditional folk music featuring local musicians on Tuesday night, dominoes on Wednesday night and a quiz on Thursday night. An original CAMRA clock keeps time behind the bar. Snacks are available. ☼🏵🚆(Heworth)🚉(Felling)♣🚪🐾🛜

Jarrow

Gin & Ale House L

Walter Street, NE32 3PQ (behind town hall)
☎ (0191) 489 7222

4 changing beers (sourced nationally) H

Dating from 1885, this well appointed conversion of the old Crusader has a single room with wood panelling, local vintage photographs and pub memorabilia. There are four real ales available from local and national breweries. Note the beer list on the blackboard to the right when you walk in. There is an early evening quiz every Sunday and Thursday night is buskers' night. At the back of the pub is a large beer garden. 🏵♿🅿🚪🛜

Newburn

Keelman ⓛ

Grange Road, NE15 8NL
☎ (0191) 267 1689 ⊕ biglampbrewers.co.uk
Big Lamp Sunny Daze, Bitter, Summerhill Stout, Prince Bishop Ale, Keelman Brown; 1 changing beer (sourced nationally) ⓗ
This tastefully converted, Grade II-listed former pumping station is now home to the Big Lamp Brewery – the Keelman is the brewery tap. A conservatory restaurant serves excellent food, and quality accommodation is provided in the adjacent Keelman's Lodge and Salmon Cottage. Attractively situated by the Tyne Riverside Country Park, Coast-to-Coast cycleway and Hadrian's Wall National Trail. ⭐😊🏠◀🚻🅿🚌(22,71)📶

Newcastle upon Tyne: Byker

Brinkburn Street Brewery Bar & Kitchen ⓛ

Unit 1B, Ford Street, Ouseburn, NE6 1NW
☎ (0191) 338 9039 ⊕ brinkburnbrewery.co.uk
8 changing beers (sourced locally) ⓗ
Inspired by American craft breweries and taprooms, the main attraction here is the range and quality of beers, most of which are brewed on-site. There are also a couple of guests, often from Steam Machine. The quirky bar features a collection of armour and objets d'art. Food is a major feature; the kitchen produces traditional regional dishes using locally sourced ingredients. An upstairs hall is used for occasional beer festivals and other events. ◀🍽🚻♣

Cumberland Arms ⓛ

James Place Street, NE6 1LD (off Byker Bank)
☎ (0191) 265 1725 ⊕ thecumberlandarms.co.uk
6 changing beers (sourced nationally) ⓗ
Three-storey venue rebuilt over 100 years ago and relatively little changed since, standing in a prominent position overlooking the lower Ouseburn Valley. The pub is home to traditional dance and music groups. A multiple winner of CAMRA regional Cider Pub of the Year awards, it generally offers up to 12 ciders and perries. Winter and summer beer festivals are held each year. Closing time may vary. Accommodation is in four en-suite rooms. Q🚚😊🏠🚻♣🅿📶📱

Free Trade Inn ⓛ

St Lawrence Road, NE6 1AP
☎ (0191) 265 5764
7 changing beers (sourced nationally) ⓗ
Unique former Scottish & Newcastle pub with wonderful views of the Tyne bridges and Newcastle and Gateshead quaysides. Up to nine beers and five ciders are available on the bar. Interesting ales come from far and wide, with regular tap takeovers and an extensive range of foreign bottled beers. Service is smiling, friendly and knowledgeable. The jukebox is classic and free, and the beer garden is excellent. The pub hosts regular pop-up food vendors. A former local CAMRA Pub of the Year and Cider Pub of the Year. Q🚚😊🚻♣🍽🚌(Q3)📱📶

Tyne Bar ⓛ

1 Maling Street, NE6 1LP
☎ (0191) 265 2550 ⊕ thetyne.com
5 changing beers (sourced nationally; often Anarchy) ⓗ
Waterside pub in the heart of Ouseburn Valley with a well-deserved reputation for good beer and innovative food. Its civilised atmosphere is in marked contrast to the building's seedy past as the Ship Tavern before

refurbishment in 1994. Free live music is a regular feature. The distinctive beer garden is framed by the redbrick arch of Glasshouse Bridge. 🚚😊◀🚻(Q3)♣📶

Newcastle upon Tyne: City Centre

Bridge Hotel ⓛ

Castle Square, NE1 1RQ
☎ (0191) 232 6400
Sharp's Doom Bar; 8 changing beers (sourced nationally) ⓗ
A former Fitzgerald's pub next to the spectacular Robert Stephenson-designed High Level Bridge. The main bar area features stained-glass windows and is divided into a number of seating areas, with a raised rear section. The rear windows and patio have views of the city walls, River Tyne and Gateshead Quays. Guest beers come from far and wide. The upstairs function room hosts live music, including the folk club that is claimed to be the oldest in the country. 😊◀🚇🚌(Central)📶

Crow's Nest ⓛ ✓

Percy Street, NE1 7RY
☎ (0191) 261 2607
Greene King IPA; 7 changing beers (sourced nationally) ⓗ
Large pub near the main bus and metro interchanges, now benefitting from its tasteful refurbishment of a few years ago. Inside it has a largely open-plan main bar plus some more secluded seating areas. Outside is a drinking area with limited seating in front of the pub on the main road, plus a small raised seating area to the rear. 🚚😊◀🚻(Haymarket) 🚌📶

Fitzgeralds ⓛ

60 Grey Street, NE1 6AF
☎ (0191) 230 1350
6 changing beers (sourced nationally; often Anarchy) ⓗ

REAL ALE BREWERIES

Almasty 🍺 Shiremoor
Anarchy 🍺 Newcastle upon Tyne
Big Lamp Newburn
Black Storm 🍺 Percy Main
Blue Gateshead
Brinkburn Street 🍺 Newcastle upon Tyne: Byker
Cullercoats Wallsend
Darwin Sunderland
Dog & Rabbit 🍺 Whitley Bay
Errant Newcastle upon Tyne
Firebrick Blaydon-on-Tyne
Flash House 🍺 North Shields
Full Circle 🍺 Newcastle upon Tyne
Great North Eastern 🍺 Gateshead
Hadrian Border Newburn
Maxim 🍺 Houghton le Spring
Newcastle Newcastle upon Tyne
Northern Alchemy 🍺 Newcastle upon Tyne: Byker
One More Than Two 🍺 South Shields
Out There Newcastle-upon-Tyne
Stu Brew Newcastle upon Tyne
Tavernale 🍺 Newcastle upon Tyne
Three Kings North Shields
TOPS (The Olde Potting Shed) High Spen
Two by Two Wallsend
Tyne Bank 🍺 Newcastle upon Tyne
Vaux 🍺 Sunderland
Whitley Bay 🍺 Whitley Bay
Wylam 🍺 Newcastle upon Tyne

Open-plan pub that is much bigger than it seems from the outside due to its depth; the bar is at the back. Six handpulls serve local and national beers, usually including a dark ale. A large area in front of the bar is kept clear for standing but there is plenty of seating around the pub. A former local CAMRA Pub of the Year.
◖≠Q(Monument) ◼ 🖥 🐾 ☂

Lady Greys Ⓛ ✅
20 Shakespeare Street, NE1 6AQ
☎ (0191) 232 3606 🌐 ladygreys.co.uk
House beer (by Ridgeside); 7 changing beers (sourced nationally) Ⓗ
Close to the historic Theatre Royal and busy shopping areas, this pub – formerly the Adelphi – is a welcome addition to the city-centre real ale scene. Beers are mainly from local brewers Hadrian Border, Allendale and Wylam, with guests from all over the country. Refurbishment has added four more handpumps.
◖≠Q(Monument) ◆ ☂

Mean-Eyed Cat Ⓛ
1 St Thomas Street, NE1 4LE
☎ (0191) 222 0952
Ossett White Rat; house beer (by Almasty); 4 changing beers (sourced nationally) Ⓗ
Situated in a former newsagent's in the street opposite Haymarket bus station, this one-room micropub opened in 2018 with six handpumps. It serves beers from local, national and international suppliers, alongside a range of eight craft keg beers. A good selection of up to six ciders is available – traditional still and served from the 'cellar'. Mexican spirits are also on offer. There are street food pop-ups on occasion. Q(Haymarket)◆◼🐾

Mile Castle ✅
Westgate Road, NE1 5XU
☎ (0191) 211 1160
Ruddles Best Bitter; Greene King Abbot; Sharp's Doom Bar; 7 changing beers (sourced nationally) Ⓗ
Highly regarded Wetherspoon bar featuring 20 handpulls across three floors. Its name refers to the Roman forts that were built a mile apart; one is reputed to have been nearby. Meals are served throughout the pub all day, including in the boothed second-floor dining area that was created by an impressive redecoration. Transport links are excellent, with a bus stop outside and rail and metro stations nearby. 🖥◖♿≠Q(Central)◼☂

Newcastle Tap
Ground Floor, Baron House, 4 Neville Street, NE1 5EN
☎ (0191) 261 6636 🌐 tapnewcastle.com
8 changing beers (sourced nationally) Ⓟ
An open-plan, one-bar pub on the ground floor of a former office block next to the Head of Steam pub and opposite the Central Station and Royal Station Hotel. The beer casks and kegs are displayed behind glass on a mezzanine above the bar. Cask beers are delivered through taps in the bar-back rather than handpumps – there are no dispensers on the bar counter itself. Gravity dispense is assisted by Flojet pumps. A pizza menu is available all day. ◖≠Q(Central)◼

Split Chimp Ⓛ
Arch 7, Westgate Road, NE1 1SA
🌐 splitchimp.pub
6 changing beers (sourced nationally) Ⓗ
Newcastle's first micropub opened in 2015 in a refurbished railway arch behind Central Station opposite the site of the former Federation Brewery. It relocated to this larger arch on Westgate Road in 2016. More spacious than some micropubs and split over two levels, it has six handpumps serving a wide selection of real ales, with

one dedicated to the house beer, Clever Chimp 2. A selection of real ciders is also available, as well as foreign bottled beers. Winter opening hours may vary.
🖥≠Q(Central) ◆◆🐾☂

Town Mouse Ale House Ⓛ
Basement, 11 St Mary's Place, NE1 7PG
🌐 townmousealehouse.co.uk
6 changing beers (sourced nationally) Ⓗ
Well-designed micropub in the basement of a former coffee shop, with space for around 50 customers. The bar area is to the front with more seating to the rear. A large blackboard gives details of the four cask beers and a larger range of keg and bottled ales. Local CAMRA Pub of the Year 2019. 🖥Q(Haymarket)◆◆🐾

Wobbly Duck
4, Eldon Square, NE1 7JG
5 changing beers (sourced nationally) Ⓗ
Micropub that opened in 2021 in the basement of a Georgian terraced house in Eldon Square, near the shopping centre. A thorough refurbishment has given the interior a rustic feel. There are tables outside the front plus an outdoor rear drinking area, the Wobbly Garden, featuring enclosed paving and heaters. A sister pub to both Beer Street in Newcastle and the Old Fox in Felling.
🖥≠Q(Central) ◆

Newcastle upon Tyne: Gosforth

Gosforth Hotel Ⓛ ✅
High Street, NE3 1HQ
☎ (0191) 285 6617 🌐 gosforthhotelnewcastle.co.uk
8 changing beers (sourced nationally; often Anarchy) Ⓗ
Located on the corner of a busy junction at the top of the High Street, this is a stalwart of the lively Gosforth pub scene. Popular with a wide clientele, from nearby office workers to locals and students, the pub often gets busy. The rear bar opens at 5pm Monday to Thursday and midday Friday to Sunday. A good range of local ales is always available. ◖◖Q(Regent Centre)◼☂

Newcastle upon Tyne: Heaton

Chillingham Ⓛ
Chillingham Road, NE6 5XN
☎ (0191) 265 3992
6 changing beers (sourced nationally) Ⓗ
Close to Chillingham Road metro station, this large two-roomed pub has a comfortable lounge and a bar that shows sport on TV. Look out for an excellent choice of local microbrewery beers, plus bottled ales, whiskies and a wine of the month. The food menu is popular with locals and visitors alike. An upstairs function room hosts regular quiz nights. 🖥◖Q(Chillingham Rd)◆◼(62,63)☂

Heaton Tap Ⓛ
41A Warton Terrace, NE6 5LS
4 changing beers (sourced locally) Ⓗ
Micropub and bottle shop just off Chillingham Road, featuring a refurbished lounge to the rear of the bar and an outside drinking area at the front. Four real ales are served, often including some from the wood as well as local brews. The bottle shop in the front room offers a good range of premium bottled beers.

Newcastle upon Tyne: Quayside

Crown Posada ★ Ⓛ
31 Side, NE1 3JE
☎ (0191) 232 1269

6 changing beers (sourced nationally) Ⓗ
An architecturally fine pub which has been identified by CAMRA as having a regionally important historic pub interior. The narrow street frontage has two impressive stained glass windows, behind which lie a small snug, the bar counter and a longer seating area. There is an interesting coffered ceiling, plus local photographs and cartoons of long-gone customers and staff on the walls. Small brewers are enthusiastically supported, with three regular local ales. The building has been sympathetically refurbished over the years by the owners and is an oasis of calm and peace away from the busy Quayside drinking, dining and clubbing circuit.
≠Q(Central) ⬚(53/54,Q3) 🕏

Quayside ✪
35 Close, NE1 3RN
☎ (0191) 211 1050
Greene King Abbot; Ruddles Best Bitter; Sharp's Doom Bar; 3 changing beers (sourced nationally) Ⓗ
Wetherspoon pub on the Quayside just west of the Swing Bridge, with the road on one side and a combined footpath/cyclepath on the other. It serves a good selection of ales from six handpulls, plus bag-in-the-box ciders from the fridge. The chain's typical food menu offers the usual club deals. Special events are hosted to coincide with local events or ale festivals. The horseshoe-shaped building surrounds a cobbled courtyard that is popular in fine weather, and there is a smaller paved patio with seating on the river side of the pub.
⬚🌣⬚≠Q(Central) ⬚(53/54,Q3) 🕏

Newcastle upon Tyne: South Gosforth

Millstone 🄻
Haddricks Mill Road, NE3 1QL
☎ (0191) 285 3429
Allendale Pennine Pale; 3 changing beers (sourced nationally; often Anarchy) Ⓗ
A stylish, modern stylish pub that reopened in 2021 following major refurbishment that included further opening-out and the addition of extra furniture. It serves beers from local microbreweries as well as national favourites; Draught Bass has been a regulars' favourite for years. Live music is played on Thursday evening.
⬚🌣⬚⬚(55) 🕏

Victory ✪
43 Killingworth Road, NE3 1SY
☎ (0191) 285 1254 ⊕ victorysouthgosforth.co.uk
Wainwright; Timothy Taylor Landlord; 4 changing beers (sourced nationally) Ⓗ
Established on this site since 1861, the pub takes its name from Nelson's flagship and once served the local mining community. It is essentially a single room, with two lounge areas each side of the entrance and some seating near the bar. A rear lounge overlooks the Ouseburn river. 🌣⬚⬚⬚🕏

North Shields

Enigma Tap
60 Bedford Street, NE29 0AR
☎ 07792 822063
4 changing beers (sourced nationally) Ⓗ
Micropub in a former shop unit just off the main Northumberland Square. There is a seating area near the entrance and a narrower raised area towards the rear incorporating the photograph-covered bar and craft beer tap board. Outside is a small patio in the back yard.
⬚🌣⬚⬚

Low Lights Tavern 🄻
Brewhouse Bank, NE30 1LL
☎ (0191) 257 6038
Draught Bass; 4 changing beers (sourced nationally; often Three Kings) Ⓗ
Free house that is possibly the oldest pub in the area; it is believed to have been an alehouse for over 400 years. Guest ales are served in the bar area, the central of its three rooms. Music is a feature: Monday is buskers' night, Thursday is acoustic, and the regulars play on Saturday. The socially proactive members' activities include plays and craft evenings. ⬚⬚⬚⬚(333)🌣🕏

Seven Stars 🄻
7 Albion Road, NE30 2RJ
☎ (0191) 435 8450
House beer (by Three Kings); 4 changing beers (sourced nationally) Ⓗ
Recently refurbished single-room pub that serves up to five real ales, including a house beer from Three Kings Brewery. Seven craft ales are also on offer, from local breweries and others around the country, but food is not available. There is a small rear courtyard for outdoor drinking. Q⬚🌣⬚⬚🕏

Old Ryton Village

Olde Cross 🄻
Burnmoor Lane, NE40 3QP
☎ (0191) 447 3460 ⊕ yeoldecrossryton.com
Fyne Jarl; 4 changing beers (sourced locally) Ⓗ
This community owned inn in the Tyne Valley is an attractive Edwardian half-timbered local in a lovely setting by the village green and the cross it is named after. The original Cross Inn dates from the mid-19th century and was partly rebuilt in 1909. The pub is a centre for the local community, hosting entertainment and activities. Two community events – the hirings, which take place in spring and autumn, and the annual carols at Christmas – are held on the village green.
⬚⬚⬚(R1,R3/R4) 🌣🕏

Ryhope

Guide Post 🄻 ✪
Ryhope Street South, SR2 0RN
☎ (0191) 523 5735 ⊕ dorbiere.co.uk/the-guide-post
Maxim Double Maxim; 2 changing beers (sourced nationally) Ⓗ
Friendly, popular and comfortable street-corner local run by an enthusiastic landlord who is passionate about his ale. There are three handpulls with Maxim Double Maxim always on plus two changing guest beers. Sports TVs, a pool table, and regular weekend entertainment feature, with dominoes and poker on Sunday, so there is something for everyone here. At the rear of the pub is a pleasant enclosed garden. ⬚🌣⬚⬚🌣🕏

South Shields

Cask Lounge 🄻
Charlotte Terrace, NE33 1QQ
☎ 07513 906703
5 changing beers (sourced nationally) Ⓗ
South Shields' first micropub, in a former office building opposite the town hall. It is run by an experienced couple who value the micro principle, encouraging conversation in an environment free from TVs and gambling machines. Five handpulls dispense regular changing ales. The pub's two rooms have comfortable seating, soft carpeting and background music. An ever-growing collection of pump clips adorns the bar area. 🌣⬚⬚🕏

Marine ♈ Ⓛ
230 Ocean Road, NE33 2JQ
☎ (0191) 455 0280 ⊕ the-marine.co.uk
Allendale Golden Plover; 8 changing beers (sourced nationally) Ⓗ
Dating from 1838, this family-run free house is opposite Marine Park, near the seafront. The pub serves six changing real ales and two ciders. Left of the bar are raised areas allowing customers to sit in social groups. There is a games area to the right and a function room upstairs. Non-intrusive background music is played and pub food isserved daily. Local CAMRA Pub of the Year 2022. ⬤Ⓓ🎄♣Ⓟ🖶(E1,516)❀🐾🛜

Steamboat Ⓛ ✅
Mill Dam, NE33 1EQ (follow signs for Customs House)
☎ (0191) 454 0134
7 changing beers (sourced nationally) Ⓗ
The only pub in the North East to be awarded a Golden Award as part of CAMRA's 50th celebrations, the Steamboat is full of character. Located opposite The Custom House, the split-level bar and small lounge are decorated in a nautical theme. There are 10 handpulls serving real ale from seven handpulls and boxed cider from three. Popular beer festivals are held, as well as regular music nights. The pub is about 10 minutes' walk from South Shields Interchange. ♈⬤🖶🐾🛜

Sunderland: City Centre

Chaplins Ⓛ
40 Stockton Road, SR1 3NR
☎ (0191) 565 3964
6 changing beers (sourced nationally) Ⓗ
City-centre pub with six real ale handpulls plus one for real cider. The house beer, Happy Chappy, is brewed at nearby Darwin Brewery. Good-value food is served every day. A quiz is held on Thursday evening. There is plenty of seating either side of the main entrance, as well as outside. Some tabletops depict scenes of Sunderland's industrial heritage. Handy for public transport, with Park Lane Interchange two minutes away. ❀Ⓓ🅰♿⇌🚉(Park Lane) 🖶🛜

Chesters Ⓛ ✅
Chester Road, SR4 7DR
☎ (0191) 565 9952
6 changing beers (sourced nationally) Ⓗ
Popular pub just outside the city centre with a smart and comfortable interior. It has a large main bar and a more intimate area at the back. Up to six handpulls serve real ale, with at least one from a local brewery. Meals are available all day. The upstairs function room has a private bar. Outside are a large beer garden and a pay car park; ask for a voucher before paying. 🛏❀Ⓓ♿🚉(Millfield) Ⓟ🖶🛜

Dun Cow ★ Ⓛ
High Street West, SR1 3HA
☎ (0191) 567 2262 ⊕ pubculture.com/dun-cow-sunderland
Allendale Pennine Pale; 5 changing beers (sourced nationally) Ⓗ
A Grade II-listed architectural gem of a building, next door to the Sunderland Empire, which has been identified by CAMRA as having a nationally important historic pub interior. It won two CAMRA/Historic England Awards for best restoration and conservation following its refurbishment in 2014, and has since undergone a major makeover. A plaque outside highlights its history. Real ale is served on up to eight handpulls. There is a function room upstairs. Q♿⇌🚉(Park Lane)Ⓟ🖶❀🛜

Fitzgeralds Ⓛ
12-14 Green Terrace, SR1 3PZ
☎ (0191) 567 0852
Titanic Plum Porter; 8 changing beers (sourced nationally) Ⓗ
A Grade II-listed pub that has been in the Guide since 1983. It serves two regular beers complemented by up to six guests. The interior comprises a large main bar with numerous seating areas and a smaller, quieter, nautically-themed Chart Room. Meals are served daily until early evening. Now owned by the Ladhur Group, the pub has retained its old name and is also known as Fitzy's. 🛏❀Ⓓ⇌🚉(Park Lane)🖶🛜

Ivy House
7A Worcester Terrace, SR2 7AW
☎ (0191) 567 3399 ⊕ ivyhousesunderland.co.uk
6 changing beers (sourced nationally) Ⓗ
Tucked away close to Park Lane public transport interchange, the Ivy House is well worth seeking out. Six changing guest ales are served alongside an extensive range of international bottled beers. Home-made pizzas and burgers are prepared in an open kitchen. There are themed meal nights and a Wednesday night quiz. Live music features on the second Saturday and last Sunday of the month. Recipient of a CAMRA Lockdown Hero Award. ❀Ⓓ♿⇌🚉(Park Lane) Ⓟ🖶❀

Museum Vaults Ⓛ
33 Silksworth Row, SR1 3QJ
☎ (0191) 565 9443
2 changing beers (sourced nationally) Ⓗ
A small former beer house on the edge of the city centre, run by the same family for over 40 years. Its single room is divided into two halves, each with an open fire. One or two cask ales are on offer, always from local breweries, complemented by a small range of canned and bottled beers. The Vaults is a regular outlet for student brews from the Brewlab training centre in Sunderland. ❀⇌🚉(Millfield) 🖶🛜

Ship Isis Ⓛ
26 Silksworth Row, SR1 3QJ
☎ (0191) 567 3720
7 changing beers (sourced nationally) Ⓗ
The Ship Isis dates from 1885 and was restored to its original splendour a decade ago. Its knowledgeable staff serve five cask beers and two real ciders from handpulls. An extensive selection of bottled ales and craft gins ensures there is something for everyone. Opposite the main bar is a quieter lounge. There is extra seating upstairs, where live music sometimes plays at weekends. Monday is quiz night. Local Cider Pub of the Year 2022. ❀♿⇌🚉(Millfield)⬤🖶❀🛜

William Jameson Ⓛ
30-32 Fawcett Street, SR1 1RH
☎ (0191) 514 5016
Greene King Abbot; Ruddles Best Bitter; Sharp's Doom Bar; 5 changing beers (sourced nationally) Ⓗ
Named after William Jameson who laid out the streets nearby on behalf of the Fawcett family, this former department store is opposite the Winter Gardens. This Wetherspoons is a busy corner pub in the heart of the city centre, offering up to five ever-changing real ales to complement the three regular beers. Good value meals are available all day and the pub is a keen supporter of local brewers and has occasional tap takeovers. Twice yearly beer festivals are held. Q🛏❀Ⓓ♿⇌🚉🖶🛜

Sunderland: North

Avenue
Zetland Street, SR6 0EQ (just off Roker Avenue)
☎ (0191) 567 7412 ● theavenue.pub
6 changing beers (sourced nationally) Ⓗ
Fifteen minutes' walk from the Stadium of Light, this local pub is tucked away just off Roker Avenue. It serves up to six varying real ales on handpull, both local and national, and several real ciders. The pub hosts a popular quiz on Thursday night and a domino handicap on Sunday. Its function room is an overflow when the main bar is busy. There is a smart garden to the rear.
🏠&♣⬤P🚌(E1) ❀🎵

Harbour View
Harbour View, SR6 0NU
☎ (0191) 567 1402
6 changing beers (sourced nationally) Ⓗ
A modern local pub opposite Roker harbour and close to the beach, with six handpulls serving regularly changing real ales. It is a true home for real ale lovers and a relaxing place, with seating outside for taking in the sun. An excellent selection of background music is played, and the pub holds a popular speakeasy on Thursday evening. There is a function room upstairs.
🏠P🚌(E1,18) ❀

Lighthouse Ⓛ
7 Sea Road, Fulwell, SR6 9BP
☎ 07817 884157
Maxim Double Maxim; 2 changing beers (sourced nationally) Ⓗ
Sunderland's first micropub is in the centre of Fulwell. The former café has been transformed into a small but comfortable bar with a compact room upstairs and an outdoor drinking area at the rear. The pub has three handpulls and three keg fonts. It has no TV, gaming machines or music – just conversation. There are frequent buses nearby to Sunderland and South Shields. Seaburn Metro is a 10-minute walk. Q🏠🚇(Seaburn)🚌❀

Swalwell

Owa the Road
Unit 1, Spencer House, Market Lane, NE16 3DS
4 changing beers (sourced nationally) Ⓗ
Situated within the old Co-op building directly opposite the Sun Inn, this micropub has no music or TV. It does have four changing ales on handpull, two of which are generally beers from the wood. The owner is working with a number of breweries to bring beers to the pub that are not normally found in wooden casks. Real ciders are served from boxes. Local CAMRA Cider Pub of the Year 2022. Q⬤P❀

Sun Inn
Market Lane, NE16 3AL
6 changing beers (sourced nationally) Ⓗ
A hostelry in the heart of the historic village that spawned many internationally renowned engineers and industrialists, and of course the famous Swalwell cabbage. This truly no-nonsense community pub provides good company for locals and strangers alike. Sword dancers, darts, dominoes handicaps, a monthly pie competition and a buskers' night all feature. Bar food and snacks are available, free on Sunday. There is a regular bus service from Newcastle. 🏠🏠♣🚌❀

Tynemouth

Tynemouth Lodge Hotel Ⓛ
Tynemouth Road, NE30 4AA
☎ (0191) 257 7565 ● tynemouthlodgehotel.co.uk
Black Sheep Best Bitter; Hadrian Border Tyneside Blonde; Marston's Pedigree; 1 changing beer (sourced locally; often Hadrian Border) Ⓗ
An externally tiled 1799 free house, next to a former house of correction, that has featured in every issue of the Guide since 1983. The comfortable one-room pub has a U-shaped lounge with the bar on one side and a serving hatch on the other, and is noted in the area for its Draught Bass. An ideal stopping-off point for those completing the Coast-to-Coast cycle route.
Q🏠🚌P🚌(1) 🎵

Tynemouth Social Club Ⓛ
15/16 Front Street, NE30 4DX
☎ (0191) 257 7542
2 changing beers (sourced nationally) Ⓗ
Formerly a Co-op, this well-established social club at the heart of Tynemouth has a full pub licence and welcomes visitors. After several attempts to sell real ale, the club now has a rotating guest beer policy which has stimulated demand. The beer is well kept by the bar/cellarman and the club is well worth a visit. Local CAMRA Club of the Year 2021. 🚌🚌🎵

Washington

Courtyard Ⓛ
Biddick Lane, NE38 8AB
☎ (0191) 417 0445 ● thecourtyardbar.co.uk
8 changing beers (sourced nationally) Ⓗ
A long-time regular in the Guide, this light and airy café/bar in the Washington Arts Centre offers a warm welcome to drinkers and food lovers alike. Up to eight handpulls serve changing real ales from local, regional and national breweries. An extensive range of food is served in the afternoon and early evening. A spacious courtyard provides outdoor seating. Popular beer festivals are held over the Easter and August bank holidays. 🏠🏠🍽&⬤P🚌❀🎵

Sir William de Wessyngton ✓
2-3 Victoria Road, NE37 2SY
☎ (0191) 418 0100
Greene King Abbot; Ruddles Best Bitter; Sharp's Doom Bar; 4 changing beers (sourced nationally) Ⓗ
A large open-plan pub in a former ice cream parlour and snooker hall opposite Concord bus station, named after a Norman knight and lord of the manor whose descendants emigrated to the USA. Three regular real ales are served alongside at least four guests, some from local micros. Good-value food is available all day. Beer festivals are held in spring and autumn.
Q🏠🏠🍽&P🚌🎵

Steps
47 Spout Lane, NE38 7HP
☎ (0191) 415 0733
5 changing beers (sourced nationally) Ⓗ
Known as the Spout Lane Inn following its opening in 1894, this friendly pub was renamed the Steps in 1976. The small, comfortable lounge bar has two drinking areas with pictures of old Washington on the walls. It serves five changing beers, many chosen by the regulars and some from local microbreweries. The pub hosts a quiz on Tuesday night and live entertainment on the first and last Saturday each month. Opening hours vary.
Q🏠♣P🚌(82,82A) 🎵

Washington Arms ✓

The Green, NE38 7AB
☎ (0191) 418 7843
3 changing beers (sourced nationally) Ⓗ
A popular and well-established pub facing Washington village green. One of the area's oldest pubs, it was built in 1828 and called the Commercial Hotel before a name change in 1937. The main bar has three handpulls and usually serves a Maxim beer. There is a second drinking area to the right, and a large rear lounge overlooking the garden. Food is served until mid-evening.
ᗰ❀◑&Pᗰ(82,82A) 🕸

West Boldon

Black Horse

Rectory Bank, NE36 0QQ (off A184)
☎ (0191) 536 1814
Harviestoun Bitter & Twisted; 1 changing beer (sourced nationally) Ⓗ
Iconic coaching inn-style pub that can trace its history back at least to the early 1700s. Its interior is split between a bar/lounge and restaurant. The walls are decorated with bric-a-brac and photos taken by the owner; note the hats suspended from the ceiling. The two handpulls normally serve a guest ale alongside the regular one. Meals can also be taken in the bar and in the partially covered area outside. ❀◑&Pᗰ❀

Whickham

One-Eyed Stag 🅛

5 The Square, NE16 4JB
☎ 07811 261924
5 changing beers (sourced nationally) Ⓗ
A fairly recent addition to the Whickham drinking scene, this micropub has a tile-topped bar with four handpumps serving beer from local microbreweries. Blackboards on the wall behind the bar give details of the ales and other drinks available. There is an interesting light fitting covering most of the ceiling and an electric stove in an alcove to the right. &Pᗰ❀🕸

Whitburn

Blues Micro Pub 🅛

Percy Terrace, SR6 7EW
4 changing beers (sourced nationally) Ⓗ
In the centre of the village, this micropub offers four cask ale handpulls and four real ciders. The room above is a bottle shop and there is an outdoor seating area. A cask club is held on Wednesday, Thursday is Pie and a Pint night and there is a free cheeseboard every Sunday. This is a small friendly place which encourages conversation, with no TVs or gaming machines. CAMRA North East and local Cider Pub of the Year 2022. Q❀●ᗰ❀

Whitley Bay

Dog & Rabbit 🅛

36 Park View, NE26 2TH
☎ 07944 552716
6 changing beers (sourced nationally) Ⓗ
This bar and brewery, converted from a women's clothing shop, adds to a number of pubs in the area. The corner bar's six handpumps serve mostly local ales. The owner's microbrewery has been installed in the pub brewing Dog & Rabbit beers. With no music, Wi-Fi or sports TV, conversation is encouraged among visitors. Local CAMRA Pub of the Year 2020.
Qᗰᗰ(Monkseaton) ᗰ❀

Split Chimp 🅛

Unit 1, Ground Floor, Spanish City Dome, Marine Avenue, NE26 1BG
🌐 splitchimp.pub
House beer (by Three Kings); 5 changing beers (sourced nationally) Ⓗ
Micropub that opened in 2019 in one of the units of the refurbished Spanish City, overlooking the promenade along the North Sea coast. Its single room has a long bar counter facing the entrance, with seating around the periphery. The house beer from Three Kings is supplemented by a changing range of four ales from near and far. Winter opening hours vary – check before you visit. ᗰ❀❀ᗰ❀

Breweries

Almasty

Unit 11, Algernon Industrial Estate, New York Road, Shiremoor, NE27 0NB
☎ (0191) 253 1639

Second Site: Unit A2A, Benfield Business Park, Benfield, NE6 4NQ 🌐 almasty.co.uk

⊗ Opened in 2014, Almasty brews on two sites, both on 10-barrel kits. The original site runs the mixed/natural fermentation and barrel-aging programme, the new site produces unfined, unfiltered beers with a continuously changing output. Beers include heavily-hopped pale ales, IPAs and rich stouts. A taproom and shop located at Benfield Business Park is open during summer weekends. Pumpclips are made from screen-printed, hand-sawn logs. Beers are supplied nationwide. ‼️🏭◆♦

Alpha Delta SIBA

18 Riversdale Court, Newburn, Newcastle upon Tyne, NE15 8SG 🌐 alphadeltabrewing.com

Alpha Delta Brewing launched in 2019 in the Newburn district of Newcastle. Producing modern-style, high gravity beers in keg and can, the beers are unfined, unfiltered and unpasteurized. Collaborations with various breweries across Europe take place.

Anarchy SIBA

Unit A1 Benfield Business Park, Newcastle upon Tyne, NE6 4NQ 🌐 anarchybrewco.com

A 20-barrel brewery, started in 2012 in Morpeth, and moved to Newcastle upon Tyne in 2018. Its focus is on session beers, plus an eclectic mix of one-offs and collaborations with a host of breweries from the UK and across the globe. ‼️LIVE ♦

Blonde Star (ABV 4.1%) PALE
Citra Star (ABV 4.1%) GOLD
Skin Deep (ABV 4.2%) PALE
Cult Leader (ABV 5.5%) PALE

Big Lamp

Grange Road, Newburn, Newcastle upon Tyne, NE15 8NL
☎ (0191) 267 1689 🌐 biglampbrewers.co.uk

◉ The North East of England's oldest microbrewery celebrated 40 years in 2022. After relocating to a former water pumping station in 1997, it expanded to a 55-barrel plant. The brewery tap, Keelman, is next door with accommodation available. ‼️♦LIVE

Sunny Daze (ABV 3.6%) GOLD

Golden, hoppy session bitter with a clean taste and finish.
Bitter (ABV 3.9%) BITTER
A clean-tasting bitter, full of hops and malt. A hint of fruit with a good, hoppy finish.
Lamplight Bitter (ABV 4.2%) BITTER
Summerhill Stout (ABV 4.4%) STOUT
A rich, tasty stout, dark in colour with a lasting, rich roast character. Malty mouthfeel with a lingering finish.
Prince Bishop Ale (ABV 4.8%) BITTER
A refreshing, easy-drinking bitter. Golden in colour, full of fruit and hops. Strong bitterness with a spicy, dry finish.
Keelman Brown (ABV 5.7%) OLD

Black Storm

31 Coble Dene, Royal Quays, Percy Main, NE29 6DW
☎ 07852 432467 ⊕ blackstormbrewery.com

Beers were originally contract brewed by Hadrian Border Brewery (qv) but the former Blackhill brewery was purchased in 2019 with brewing commencing shortly afterwards. In 2022, the brewery moved to the Royal Quays Outlet on North Tyneside and also includes a taproom. ✦

Blonde (ABV 4%) BLOND
Pilsner (ABV 4.1%) PALE
Gold (ABV 4.3%) GOLD
Porter (ABV 5.2%) PORTER
IPA (ABV 5.5%) IPA

Blue

Unit G21, The Avenues, Eleventh Avenue, North Team Valley Trading Estate, Gateshead, Tyne & Wear, NE11 0NJ
☎ (0191) 491 0221 ⊕ bluebrewing.co.uk

Gypsy brewery using spare capacity at other breweries. Established in 2019 it acquired the rights to the Mordue brand. Beerology branded beers are produced for the eponymous bar in Newcastle.

Brewed under the Mordue Brewery brand name:
5 Bridges (ABV 3.6%) BITTER
Blonde (ABV 4%) BLOND
Howay in a Manger (ABV 4.3%) BITTER
Workie (ABV 4.5%) BITTER
Radgie (ABV 4.8%) BITTER
IPA (ABV 5.1%) IPA

Brinkburn Street SIBA

3 Hume Street, Byker, Newcastle Upon Tyne, NE6 1LN
☎ (0191) 338 9039 ⊕ brinkburnbrewery.co.uk

Brewing began in 2015, much influenced by West Coast US beer styles. Citrus flavours and highly-hopped bitterness is a feature of many of its beers. The brewery relocated to a new site in 2018, which also incorporates a brewery tap. ✦

Fools Gold (ABV 3.8%) GOLD
The Pursuit of Hoppiness (ABV 3.9%) PALE
Byker Brown Ale (ABV 4.8%) BROWN

Cullercoats SIBA

Westfield Court, 19 Maurice Road Industrial Estate, Wallsend, Tyne & Wear, NE28 6BY ☎ 07837 637615 ⊕ cullercoatsbrewery.co.uk

☺Established in 2011, brewing takes place twice a week. The brewery champions English hops. ✦

Shuggy Boat Blonde (ABV 3.8%) BLOND
Lovely Nelly (ABV 3.9%) BITTER

Polly Donkin Oatmeal Stout (ABV 4.2%) STOUT
Fruity, sweet and roast aromas precede a full-bodied stout with a roast sweet caramel centre and a lingering satisfying finish.
Jack the Devil (ABV 4.5%) BITTER
Light brown bitter with a sweet fruit start. Bittering hops last well in the finish.
Grace Darling Gold (ABV 5%) BITTER

Darwin SIBA

1 West Quay Court, Sunderland Enterprise Park, Sunderland, SR5 2TE
☎ (0191) 549 9450 ⊕ darwinbrewery.com

☺Established in 1994, Darwin is based in purpose-built premises in Sunderland with a 3.5-barrel brew plant. A range of established Darwin beers are produced frequently, with core beers and seasonal offerings available around the North East. Some beers produced are based on analysis of historic recipes. Darwin Brewery supports students on brewing courses at sister company, Brewlab, who produce many unique specialist and international beers. ‼✦LIVE

Expedition (ABV 3.8%) PALE
Evolution (ABV 4%) BITTER
Beagle Blonde (ABV 4.1%) BLOND
Rolling Hitch (ABV 5.2%) PALE
Galapagos (ABV 6%) STOUT

Dog & Rabbit

🍺 Dog & Rabbit Micro Brew Pub, 36 Park View, Whitley Bay, Tyne & Wear, NE26 2TH ☎ 07944 552716 ⊕ dogandrabbitbrewery.co.uk

The Dog & Rabbit Brewery was established in 2015 and relocated to its current premises as a small one-barrel micro brewpub in 2016. LIVE

Errant

Arch 19, Forth Goods Yard, Newcastle upon Tyne, NE1 3PG ☎ 07736 333303 ⊕ errantbrewery.com

⊗ Nestled in the heart of Newcastle in an old victorian railway arch, Errant is a hidden gem in Newcastle's industrial playground. Founded in 2015, it brews an ever-changing range of cask, keg and canned beers. ✦

Firebrick SIBA

Units 10 & 11, Blaydon Business Centre, Cowen Road, Blaydon-on-Tyne, Tyne & Wear, NE21 5TW
☎ (0191) 447 6543 ⊕ firebrickbrewery.com

Firebrick began brewing on a 2.5-barrel plant in 2013, expanding to a 15-barrel plant in 2014. Beers are mostly available in pubs within the Tyne & Wear area and a few outlets further afield. ✦

Blaydon Brick (ABV 3.8%) BITTER
Coalface (ABV 3.9%) MILD
Elder Statesman (ABV 3.9%) BITTER
Tyne 9 (ABV 3.9%) SPECIALITY
Pagan Queen (ABV 4%) BLOND
Little Belgium (ABV 4.2%) SPECIALITY
Trade Star (ABV 4.2%) BITTER
Stella Spark (ABV 4.4%) PALE
Well-balanced, sweet, fruity and hoppy beer with a lasting finish.
Toon Broon (ABV 4.6%) BITTER
Cushie Butterfield (ABV 5%) STOUT
Wey-Aye PA (ABV 5.8%) IPA
Well-balanced IPA with citrus hops, fruit and sweetness. The hops prevail in the finish.

Flash House

Unit 1a, Northumberland Street, North Shields, NE30 1DS ☎ 07481 901875
⊕ flashhousebrewing.co.uk

Flash House was set up by Jack O'Keefe in 2016, after a life-long appreciation of ale. It aims to bring the best beer styles the world has to offer to the North East, and continues to produce new guest/seasonal ales rather than maintaining a core range in cask. The brewery and taproom are situated a short walk from North Shields town centre and the revamped North Shields Fish Quay. ‼◆

Full Circle SIBA

Hoults Yard, Walker Road, Newcastle upon Tyne, NE6 2HL
☎ (0191) 481 4114 ⊕ fullcirclebrew.co.uk

Brewing began in 2019 in Hoult's Yard in Byker, another addition to the real ale scene in this area. It also incorporates a taproom, plus the Pip Stop bottled beer shop. ◆

Repeater (ABV 4.2%) PALE
Hoop (ABV 5.5%) IPA
Looper (ABV 6.4%) IPA

Great North Eastern SIBA

Contract House (Unit E), Wellington Road, Dunston, Gateshead, NE11 9HS
☎ (0191) 447 4462 ⊕ gnebco.com

Brewing began in 2016 on a 10-barrel plant. In 2017 the brewery expanded into the adjacent premises and a tap and shop was opened, with an events space for live entertainment. Beers are supplied direct throughout the North-East, and nationally via wholesalers. ☞◆◆

Claspers Citra Blonde (ABV 3.8%) BLOND
Styrian Blonde (ABV 3.8%) BLOND
Gold (ABV 4%) GOLD
Rivet Catcher (ABV 4%) BLOND
Taiheke Sun (ABV 4.2%) PALE
Delta APA (ABV 4.5%) PALE
Foxtrot Premium Ale (ABV 4.5%) BITTER
GNE Stout (ABV 4.6%) STOUT
Graphite (ABV 4.6%) PALE
Hopnicity (ABV 5%) PALE

Hadrian Border SIBA

Unit 5, The Preserving Works, Newburn Industrial Estate, Shelley Road, Newburn, NE15 9RT
☎ (0191) 264 9000 ⊕ hadrian-border-brewery.co.uk

Based in Newburn near Newcastle-upon-Tyne, using a 40-barrel plant, the brewery can produce up to 200 barrels per week. Beer is delivered directly to the area between Edinburgh, North Yorkshire, Carlisle and the East Coast, and is also available nationally through wholesalers. A three-barrel plant is used for experimental craft brews. One pub is run – the Station East, Gateshead. ‼◆LIVE

Tyneside Blonde (ABV 3.9%) BLOND
Refreshing blonde ale with zesty notes and a clean, fruity finish.
Farne Island Pale Ale (ABV 4%) BITTER
A copper-coloured bitter with a refreshing malt/hop balance.
Northern Pale (ABV 4.1%) PALE
Secret Kingdom (ABV 4.3%) BITTER
Grainger Ale (ABV 4.6%) PALE
Northern IPA (ABV 5.2%) PALE

Ouseburn Porter (ABV 5.2%) PORTER
Traditional robust porter, made with chocolate and black malt. Distinct bitter coffee finish.

Maxim SIBA

1 Gadwall Road, Rainton Bridge South, Houghton le Spring, DH4 5NL
☎ (0191) 584 8844 ⊕ maximbrewery.co.uk

⊛Rising from the ashes of Sunderland brewer Vaux, Maxim was set up with a 20-barrel plant in Houghton-le-Spring in 2007. More than 100 outlets are supplied direct and two pubs are owned. A weekday phone and collect service is available and a brewery open night is held on the first Friday of every month. ☞◆◆

Lambtons (ABV 3.8%) GOLD
Samson (ABV 4%) BITTER
Ward's Best Bitter (ABV 4%) BITTER
Swedish Blonde (ABV 4.2%) PALE
Sweet malt and fruit with moderate hop bitterness which lasts to provide a long, dry finish.
Double Maxim (ABV 4.7%) BROWN
A roasty classic brown ale. Hops play their part giving a gentle bitterness to the dominant fruit, which reduces on drinking. A complex beer with an inviting smell of butterscotch.
Raspberry Porter (ABV 5%) SPECIALITY
Maximus (ABV 6%) OLD
Fruit and sweetness dominate this beer throughout along with crystal malts, hops and alcohol, combining to create a lasting full rich mouthfeel.

Newcastle

Arch 2, Stepney Bank, Ouseburn, Newcastle upon Tyne, NE1 2NP ☎ 07446 011941
⊕ newcastlebrewingltd.co.uk

⊠ Mike and Leo Bell initially founded the brewery in the Quayside Development Centre in Ouseburn before moving to new premises under Byker Bridge. ‼☞LIVE

Northern Alchemy

The Old Coal Yard, Elizabeth Street, Byker, Newcastle upon Tyne, NE6 1JS ☎ 07834 386333
⊕ northernalchemy.co.uk

Brewing began in 2014. The brewery was situated in a converted shipping container, known as the Lab, just behind the Cumberland Arms. In 2017 it moved to larger premises in a former coal depot. All beers are unfined and unfiltered. Beers are always available in the Cumberland Arms, and the brewery opens a tap on the last full weekend of the month. ◆◆

US Session Pale (ABV 4.1%) PALE

One More Than Two

Unit J, Portberry Street, South Shields, NE33 1QX
☎ 07927 051236 ⊕ 1morethan2brew.co.uk

Brewing commenced in 2020. The brewery gets its name from Two (the brewers) with One More being the community. Based in an industrial unit, the taproom is open from Thursday to Sunday, selling its own cask ales plus a selection of keg beers from other local microbreweries. Local food outlets are usually in attendance at weekends. ☞◆

Out There

Unit 4, Foundry Lane Industrial Estate, Newcastle-upon-Tyne, NE6 1LH ☎ 07946 579 534
⊕ outtherebrewing.com

Out There was established in 2012 by Steve Pickthall. Branding and beer names are themed around the 1950s space race.

Space is the Place (ABV 3.5%) BITTER
Laika (ABV 4.8%) SPECIALITY
Celestial Love (ABV 5.1%) BITTER

Stu Brew

Newcastle University, Merz Court, Newcastle upon Tyne, NE1 7RU ⊕ stubrew.com

Stu Brew is Europe's first student-run microbrewery, based at Newcastle University. The brewery was set up as part of a research project aimed at reducing waste and costs in all parts of brewing. The university and local pubs are supplied.

Lab Session (ABV 4.3%) PALE
Exam Room Tears (ABV 5%) SPECIALITY

Tavernale

⊟ Bridge Tavern, 7 Akenside Hill, Newcastle upon Tyne, NE1 3UF
☎ (0191) 2321122 ⊕ thebridgetavern.com

A two-barrel plant supplying beers to the Bridge Tavern only. All beers brewed are one-offs. ♦

Three Kings

14 Prospect Terrace, North Shields, NE30 1DX
☎ 07580 004565 ⊕ threekingsbrewery.co.uk

Three Kings started in 2012 using a 2.5-barrel plant, and have steadily upgraded it to its current 25-barrel capacity. Two house beers are brewed for local pubs. As well as the regular beers it typically brews two one-off beers each month. ♦

Shieldsman (ABV 3.8%) BITTER
Billy Mill Ale (ABV 4%) BITTER
Dark Side of the Toon (ABV 4.1%) STOUT
Ring of Fire (ABV 4.5%) PALE
Silver Darling (ABV 5.6%) IPA

TOPS (The Olde Potting Shed)

High Spen, Tyne & Wear

TOPS began brewing in 2013 using a five-barrel plant with a small test kit for experimental beers. Pubs are supplied direct within a 30-mile radius of the brewery.

Blondie (ABV 3.8%) BLOND

Two by Two

Unit 28, Point Pleasant Industrial Estate, Wallsend, NE28 6HA ☎ 07723 959168

Office: 14 Albany Gardens, Whitley Bay, NE26 2DY
✉ twobytwobrewing@gmail.com

Brewing began in 2014 using a five-barrel plant in Wallsend on Tyneside. At the end of 2018 an additional five-barrel plant was installed, increasing capacity to 10 barrels. LIVE

Session IPA (ABV 4%) GOLD
Citrus hops are to the fore in this cloudy and notably hoppy golden ale which is cleverly balanced with fruity sweetness. The hoppy bitter theme persists long after the drinking ends.

Leap Frog (ABV 4.1%) PALE
Foxtrot Pale (ABV 4.5%) PALE
Snake Eyes Pale (ABV 4.6%) PALE
Dragonfly (ABV 5.5%) IPA
Sitting Duck (ABV 5.7%) STOUT
American Pale Ale (ABV 5.8%) IPA
South Paw IPA (ABV 6.2%) IPA

Tyne Bank SIBA

375 Walker Road, Newcastle upon Tyne, NE6 2AB
☎ (0191) 265 2828 ⊕ tynebankbrewery.co.uk

⊗ Tyne Bank is now 10 years old, starting in a small industrial unit to the east of Newcastle city centre. Moving to larger premises in 2016, its combined brewery and taproom hosts an on-going series of events. The brewery is part of the popular Ouseburn real ale circuit. ▮▮▆♦✦

Castle Gold (ABV 3.8%) GOLD
Summer Breeze (ABV 3.9%) SPECIALITY
West Coast IPA (ABV 4%) PALE
Monument Bitter (ABV 4.1%) BITTER
Northern Porter (ABV 4.5%) PORTER
Silver Dollar (ABV 4.9%) GOLD
Helix (ABV 5%) SPECIALITY
Cherry Stout (ABV 5.2%) SPECIALITY

Vaux

Unit 2, Monk Street, Sunderland, SR6 0DB
☎ (0191) 580 5770 ⊕ vaux.beer

Opened in 2020, Vaux is a five-barrel microbrewery resurrecting the old Vaux Brewery name (a major regional brewer which closed in 1999). ▆♦

Black Wave (ABV 5%) STOUT

Whitley Bay

⊟ 2-4 South Parade, Whitley Bay, NE26 2RG ☎ 07392 823480 ⊕ whitleybaybrew.com

⊚Brewing commenced in 2016 on a five-barrel plant and relocated to larger premises, a new brewery tap, in the centre of Whitley Bay in 2018. Around 40 local outlets are supplied.

Slow Joe (ABV 3.9%) BLOND
Warrior (ABV 3.9%) PALE
Kangaroo (ABV 4.2%) PALE
Spanish City Blonde (ABV 4.2%) BLOND
Dark Knight (ABV 4.3%) BROWN
Ghost Ships (ABV 4.3%) PALE
Texas Cleggy (ABV 5%) BITTER

Wylam

Palace of Arts, Exhibition Park, Newcastle upon Tyne, NE2 4PZ ⊕ wylambrewery.co.uk

⊚Wylam commenced brewing in 2000 on a 4.5-barrel plant. In 2016 the brewery moved to Newcastle upon Tyne, and a new 30-barrel kit was installed at the Palace of the Arts, in the city's Exhibition Park. It hosts regular events and concerts in the main hall and has a separate taproom area (Friday-Sunday). ♦✦

Gold (ABV 3.9%) GOLD
Fleek (ABV 4.2%) PALE

World Beer Guide

Roger Protz

The world of beer is on fire!

Traditional brewing countries are witnessing a spectacular growth in the number of beer makers while drinkers in such unlikely nations as France and Italy are moving from the grape to the grain. Innovation in brewing is remarkable. Beer is not simply about ale and lager. Young artisan brewers are pushing the boundaries and are making beers with the addition of herbs, spices, fruit, chocolate, and coffee. Many are ageing beer in oak for additional flavour and character while others, inspired by the Belgian model, are fermenting beers with wild yeasts in the atmosphere. But readers new to beer need not be nervous. The main aim of this guide is to turn the spotlight on the great and often amazing beers being produced by dedicated brewers in every continent. Beer is the world's favourite alcohol. It needs to be revered, respected and, above all, enjoyed.

RRP: £30.00 **ISBN**: 978-1-85249-373-8

For this and other books on beer and pubs, visit CAMRA's online bookshop at **shop1.camra.org.uk** or call 01727 867201.

Discounts are available for CAMRA members.

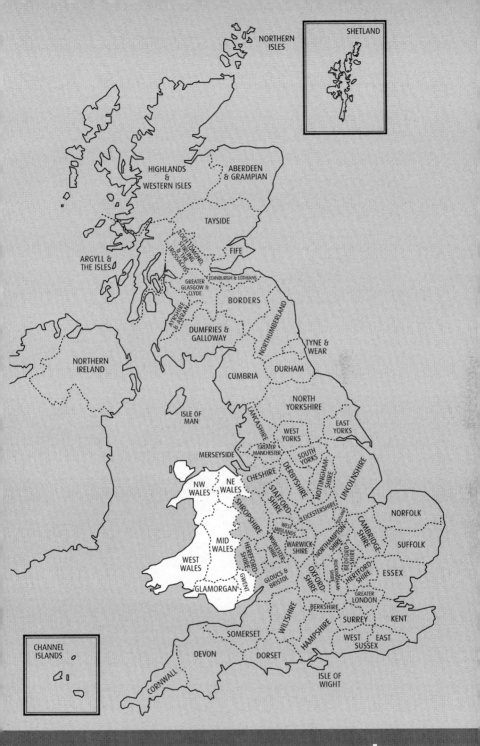

NORTHERN ISLES

SHETLAND

HIGHLANDS & WESTERN ISLES

ABERDEEN & GRAMPIAN

TAYSIDE

LOCH LOMOND, STIRLING & TROSSACHS

FIFE

ARGYLL & THE ISLES

EDINBURGH & LOTHIANS

GREATER GLASGOW & CLYDE

BORDERS

AYRSHIRE & ARRAN

DUMFRIES & GALLOWAY

NORTHERN IRELAND

NORTHUMBERLAND

TYNE & WEAR

CUMBRIA

DURHAM

ISLE OF MAN

LANCASHIRE

NORTH YORKSHIRE

EAST YORKS

WEST YORKS

MERSEYSIDE

GREATER MANCHESTER

SOUTH YORKS

CHESHIRE

DERBYSHIRE

NOTTINGHAM-SHIRE

LINCOLNSHIRE

NW WALES

NE WALES

STAFFORD-SHIRE

SHROPSHIRE

LEICESTERSHIRE

NORFOLK

WEST MIDLANDS

NORTHAMPTON-SHIRE

CAMBRIDGE-SHIRE

SUFFOLK

MID WALES

WORCESTER-SHIRE

WARWICK-SHIRE

BEDFORD-SHIRE

HEREFORD-SHIRE

BUCKINGHAMSHIRE

HERTFORD-SHIRE

ESSEX

WEST WALES

GWENT

GLOUCS & BRISTOL

OXFORD-SHIRE

GREATER LONDON

GLAMORGAN

BERKSHIRE

KENT

WILTSHIRE

HAMPSHIRE

SURREY

SOMERSET

WEST SUSSEX

EAST SUSSEX

DEVON

DORSET

ISLE OF WIGHT

CHANNEL ISLANDS

CORNWALL

Wales

Wales

Wales is a country of coasts and mountains. There are 1,680 miles of coastline to explore, including the Isle of Anglesey, with three National Parks that comprise 20% of its land area. The highest peak in Wales is Mount Snowdon, where you can take a trip to the summit by steam train. No trip to mid-Wales is complete without a tour of the reservoirs and stunning landscapes of the Elan Valley.

Cardiff is the home of the largest brewery in the country, Brains. It has been brewing since 1882 and the first time it brought its beers to England was for the first national CAMRA beer festival, held in Covent Garden in 1975. Felinfoel in Llanelli is equally historic and credited with being the first in Europe to can beers, back in 1936.

When visiting the coastline of North Wales, you can take time out to visit local brewers like the Wild Horse Brewery in Llandudno, who mill their own grain and make exciting, high-quality beers in a range of styles. On Fridays, the Snowdon Craft Brewery throws open its doors for tours and drinks in the taproom. Complete your trip with a ride on the cable-driven tramway to Great Orme.

If you plan to take in the famous castles of Conwy and Caernarvon, it's worth adding in a tour of the Conwy Brewery, which was the first new brewery in the area for a century when it opened in 2003. Now it brews with an eye on environmental impact, using solar power, recycling waste products and minimising water and chemical use.

If your journey through Wales includes a tour of Anglesey, the Menai Straits, and the town with the longest name in the world, affectionately known as Llanfair PG by locals, the Anglesey Brewhouse and Bragdy Cybi Brewery both have taprooms that offer welcome hydration to the weary traveller.

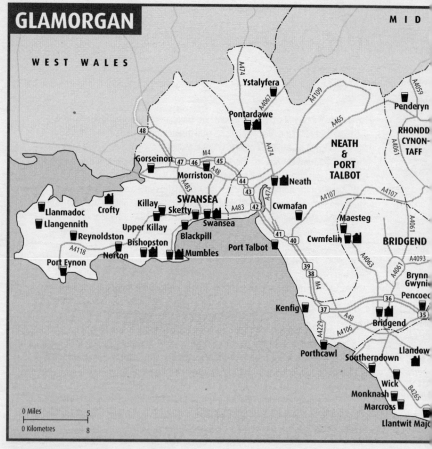

GLAMORGAN

MID

WEST WALES

NEATH & PORT TALBOT

RHONDD CYNON TAFF

BRIDGEND

Ystalyfera
Pontardawe
Penderyn
Gorseinon
Morriston
Neath
Cwmafan
Maesteg
Killay
Sketty
SWANSEA
Swansea
Cwmfelin
Llanmadoc
Crofty
Llangennith
Upper Killay
Blackpill
Reynoldston
Bishopston
Port Talbot
Brynn Gwyni
Pencoe
Norton
Mumbles
Port Eynon
Kenfig
Bridgend
Llandow
Porthcawl
Southerndown
Wick
Monknash
Marcross
Llantwit Majc

0 Miles 5
0 Kilometres 8

Aberdare

Ieuan ap Iago ✅
6 High Street, CF44 7AA
☎ (01685) 880080
**Greene King Abbot; Ruddles Best Bitter; Sharp's
Doom Bar; 4 changing beers (sourced nationally)** Ⓗ
Popular Wetherspoon in the town centre, well placed for
local amenities and public transport. It is named in
honour of Ieuan ap Iago (Evan James), writer of the
words of the Welsh national anthem Hen Wlad Fy
Nhadau. Real cider is always available, together with a
varied selection of national guest ales. The pub is a
modest stroll from the Dare Valley Country Park.
&⊛◐&≠⊕P⊒?

National Tap Ⓛ
Cross Street, CF44 7EG
☎ (01685) 267310 ⊕ greytreesbrewery.com
**Grey Trees Diggers Gold, Drummer Boy, Mosaic Pale
Ale, Afghan Pale; 3 changing beers (sourced
regionally; often Grey Trees, Purple Moose,
Salopian)** Ⓗ
Impressive micropub with a reputation for quality and
value, ideally located in the town centre. The tap room
for award-winning Grey Trees Brewery, it stocks the core
range, seasonal brews and guest beers. Budweiser
Budvar is also available, plus a range of craft beer. The
bar is tall, reminiscent of the American style.
Q&⊛≠⊕⊒⊛?

Whitcombe Inn
Whitcombe Street, CF44 7DA
☎ (01685) 875106
**Sharp's Doom Bar; 2 changing beers (sourced
nationally; often Wye Valley)** Ⓗ
Traditional and friendly street-corner local, close to the
main shopping streets and the market. The single bar
backs on to an area for pool at the rear. Sport often plays
on TV screens but is rarely obtrusive except on rugby
international days. Children are welcome until 9pm. Live
music is hosted occasionally. The pub is approximately
one mile from the picturesque Dare Valley Country Park,
offering great walks and also pitches for campers and
touring vans. ▲≠♣⊕⊒⊛?

Aberthin

Hare & Hounds
Aberthin Road, CF71 7LG
☎ (01446) 774892 ⊕ hareandhoundsaberthin.com
**Hancocks HB; Wye Valley HPA; 2 changing beers
(sourced regionally; often Glamorgan)** Ⓗ
A characterful village pub whose cosy public bar with
thick stone walls, wooden beams and log fire is the focal
point where locals gather. The rustic style dining area
serves award-winning high-quality fare made from
scratch, with some ingredients grown by the chef. A full
menu is also available in the bar, where dogs are
welcome. The guest ales are mainly local; the cider is
from Llanblethian Orchards. Outside, the south facing

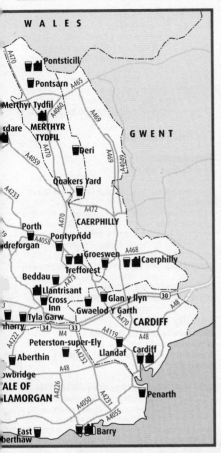

four predominantly Welsh cask ales on gravity, there is a craft keg beer. Most of the cider is fruit flavoured. The licensee is a keen fan of The Jam and named the pub after one of the band's songs – memorabilia includes a series of tiles in the toilet. Q⇌(Docks)🚋(304,96)♣🐾📶

Beddau

Cokeworks Bar
1A Common Approach, CF38 2BL
2 changing beers (sourced regionally) Ⓗ
This innovative micropub, a former newsagents', is a welcome addition to the area. Opened in 2019, it offers two regional/national changing beers, two changing ciders, and a wide range of craft beers. Popular with locals and visitors alike, it is the only pub in this large village. It hosts quizzes every other Monday, and music on Sunday, including karaoke once a month.
🚼🌳🚋(100,400) ♣📶

Bishopston

Joiners Arms Ⓛ
50 Bishopston Road, SA3 3EJ
☎ (01792) 232658
Courage Best Bitter; Marston's Pedigree; Swansea Bishopswood Bitter, Original Wood, Three Cliffs Gold; 1 changing beer (sourced nationally) Ⓗ
Situated in the heart of the village, this 1860s free house remains popular with locals and visitors. Home of the Swansea Brewing Company, the six cask handpumps are in the rear area of the bar. Good-value food is served lunchtimes and evenings (no food Mon and Sun eve) and there are occasional music events, usually around public holidays. Major sporting fixtures are shown on large screens. There is a small car park. 🚼🌳🕙♣🅿🚋(14)♣🐾📶

beer garden has its own bar shack and occasionally hosts live music. There is limited parking.
Q🚼🌳🕙👶♣🅿🚋(321) ♣📶

Barry

Barry West End Club Ⓛ
54 St Nicholas Road, CF62 6QY
☎ (01446) 735739 ⊕ barrywestendclub.webs.com
Sharp's Doom Bar; Wye Valley HPA; 2 changing beers Ⓗ
Multiple local CAMRA Club of the Year overlooking the old harbour and housed in a large multi-floored red brick building. Visitors are welcome and CAMRA members are treated as honorary club members. Home to cricket, football, snooker and skittles teams as well as chess, scuba diving and fishing clubs among others, there is always something going on here. Two beer festivals a year, live music on weekends, pub grub and a friendly atmosphere makes this club an essential visit.
Q🚼🌳🕙👶⇌♣🚋(96,304) 📶

Butterfly Collector
50A Holton Road, CF63 4HE
☎ 07542 673794
4 changing beers (sourced regionally; often Grey Trees, Twt Lol, Well Drawn) Ⓖ
Formerly a shop, converted in 2017, this is a single room with no bar – customers are served at their tables, with blackboards showing what's on offer. As well as up to

REAL ALE BREWERIES

Bang-On ✦ Bridgend
Borough Arms 🍺 Neath
Boss Swansea
Brains Cardiff
Brew Monster ✦ Caerphilly
Brewhouse & Kitchen 🍺 Cardiff
Cerddin 🍺 Cwmfelin
Coach 🍺 Bridgend
Coalshed Caerphilly (NEW)
Cold Black Label Bridgend
Crafty Dragon Pontsticill (brewing suspended)
Dog's Window Bridgend
Freetime Swansea (brewing suspended)
Glamorgan Llantrisant
Gower ✦ Crofty
Grey Trees Aberdare
Little Goat Pontardawe
Mabby 🍺 Trefforest
Mad Dog ✦ Cardiff
Mountain Hare 🍺 Brynnau Gwynion (brewing suspended)
Mumbles Swansea
Pilot Brewery 🍺 Mumbles
Pipes Cardiff
Swansea 🍺 Swansea: Bishopston
Tomos & Lilford Llandow
Tomos Watkin ✦ Swansea
Twin Taff Merthyr Tydfil (brewing suspended)
Twt Lol Trefforest Industrial Estate
Vale Of Glamorgan ✦ Barry
Well Drawn Caerphilly
Zepto Caerphilly

Valley

41 Bishopston Road, SA3 3EJ (on main road through village)

☎ (01792) 234820 🌐 valleyhotelbishopston.com

St Austell Proper Job; Sharp's Doom Bar; 2 changing beers 🅷

Traditional family-run country pub set in the heart of this Gower village. A large porch area (which doubles as the local bus stop) leads to a split-level bar and dining area, with exposed beams, open fire and hearth. A wide variety of home-cooked meals is served daily, with Sunday lunch accompanied by live background guitar music. Quiz night is Tuesday. 🌱🏵🕽🕩&♣🅿🚍(14)🐾🛜

Blackpill

Woodman ✓

120 Mumbles Road, SA3 5AS (near turn off for B4436, opp Blackpill Lido)

☎ (01792) 402700

Greene King IPA, Abbot; 3 changing beers (sourced nationally; often Greene King, Mumbles, Tomos Watkin) 🅷

Historic pub and restaurant dating back to 1819 and attractively refurbished. The deceptively spacious establishment, with its various nooks and alcoves, is on the main seafront road and entrance to the beautiful Clyne Gardens. Popular with families and diners, the pub also welcomes those seeking only liquid refreshment. An ever-changing range of ales is offered, including at least one from a local brewery. There are three outside seating areas including a small beer garden.
🌱🏵🕽🕩&🅿🚍(2,3)🐾🛜

Bridgend

Coach

37 Cowbridge Road, CF31 3DH

Coach Bridgend Pale Ale 🅷**; 3 changing beers (often Coach, New Bristol, Thornbridge)** 🅷/🅶

An incredible commitment to real ale and independent producers has been the basis for the running of this pub since the current owners took it on. Basically furnished but comfortable, there is an art wall for local artists to display their work. Events include open mic nights, outings and two beer festivals a year. The owners began brewing in 2018 – the brewery is visible from inside the pub. Two Coach cask beers are usually on sale and several craft beers. Q🌱🏵🍽♣🚍(303,X2)🐾🛜

Brynnau Gwynion

Mountain Hare

Brynna Road, CF35 6PG

☎ (01656) 860453

3 changing beers (sourced nationally; often Mountain Hare, St Austell, Wye Valley) 🅷

This typical Welsh village inn has featured in the Guide for many years. It has been owned by the same family for over 40 years and has a traditional public bar, games room and a lovely old stone-walled lounge. The licensee began brewing on-site in 2014 and occasionally showcases his own beers. Sport is often on TV in this rugby lovers' pub. Staff and locals are most welcoming to visitors. Q🌱🏵🕽🕩&♣🅿🚍(64,404)🐾🛜

Caerphilly

Malcolm Uphill ✓

89-91 Cardiff Road, CF83 1FQ

☎ (029) 2076 0720

Greene King Abbot; Ruddles Best Bitter; Sharp's Doom Bar; 2 changing beers (sourced nationally) 🅷

Spacious Wetherspoon outlet, conveniently close to the main bus and rail transport hub, named in honour of a local motorcycle racing champion. One or two guest beers are usually available, particularly at weekends, and up to two ciders. This pub can be crowded toward weekends, and hosts a quiz on Sunday, when it tends to be a bit quieter. Ring the main entrance doorbell if the separate accessible entrance is needed. 🌱🕽🕩&🖰🚻🚍🛜

Cardiff: Canton

Lansdowne

71 Beda Road, CF5 1LX

☎ (029) 2022 1312

5 changing beers (sourced regionally; often Grey Trees) 🅷

An award-winning ground-floor community pub with an open-plan layout – it has a central bar with three distinct areas. Five handpumps serve a dark beer and a local beer, with the remainder dedicated to independent brewers, often rare for the area. There is also a traditional cider and keg beer from a local craft brewery. Quality food is served including highly regarded Sunday lunches. A popular pub for families.
🌱🏵🕽🕩&≠(Ninian Park)♣🖰🚍(96,X2)🐾

Romilly 🅻 ✓

69-71 Romilly Crescent, CF11 9NQ

☎ (029) 2025 6345

Brains Bitter, Rev James Original; Marston's Pedigree 🅷

A comfortable local with a variety of interconnecting rooms served by a single bar, with a darts area towards the front. Antique-style prints adorn the walls. Live music is hosted on Tuesday, a quiz on Sunday. Outside, there is a front forecourt and a larger garden at the rear. Now leased by Marston's following its deal with Brains, the tenants have been here for more than 20 years. The pub is CAMRA-accredited for serving consistently well-kept real ales. 🌱🏵&♣🚍(61)

St Canna's Ale House 🅻

42 Llandaff Road, CF11 9NJ

☎ 07890 106449 🌐 stcannas.com

6 changing beers (sourced nationally; often Grey Trees, Tiny Rebel, Untapped) 🅶

A former shop converted to a micropub just off Cowbridge Road East, with two distinct rooms and an outdoor area. Up to six real ales are served on cooled gravity stillage, and four real ciders. The pub is community focused and has integrated itself into the local cultural scene. It has a piano and traditional board games. The yard, reached via a second room, has a covered smoking area and gin bar. Beers are sourced mainly from within Wales. Q🏵&≠(Ninian Park)♣🖰🚍(17,18)🐾

Cardiff: Cathays Park

Pen & Wig ✓

1 Park Grove, CF10 3BJ

☎ (029) 2037 1217

8 changing beers (sourced nationally; often Bristol Beer Factory, Grey Trees, Mumbles) 🅷

Large converted Victorian terraced residence, just off the city centre and near the university and National Museum. The clientele is typically professionals and office workers during the day, students in the evening. The beer range comes from local, regional and national breweries. Monthly Meet the Brewer events and brewery takeovers

WALES

are held. The spacious garden includes a covered section and a smokers' area. Prices are at the higher end for the area. ❀⊄◗& ╼(Cathays)●◲❀ 🛜

Cardiff: City Centre

Central Bar ✅
39 Windsor Place, CF10 3BW
☎ (029) 2078 0260
Greene King Abbot; Ruddles Best Bitter; Sharp's Doom Bar; 5 changing beers (sourced nationally) Ⓗ
A popular Wetherspoon pub just off Queen Street near its eastern end. This former nightclub has an upper storey used as an additional bar, open most times. There is an outdoor drinking area at the rear. The bar usually has the full range of guest beers, with up to five at any one time, as well as a number of real ciders or perries.
🏠❀⊄◗&╼(Queen St) ●🛜

Flute & Tankard
4 Windsor Place, CF10 3BX
☎ (029) 2039 8315 ⊕ thefluteandtankard.com
5 changing beers (sourced nationally; often Grey Trees) Ⓗ
A one-bar pub just off Queen Street at the quieter, eastern end of the city centre. Under the current management, the Flute has become the city centre's leading real ale pub in terms of both the range and quality of its beers. Musical performances, often jazz, and other events take place in an upstairs room. Note that, to avoid restrictions, the pub does not open on Principality Stadium rugby international days. Q❀❀╼(Queen St)●◲

Head of Steam
18-19 Church Street, CF10 1BG
☎ (029) 2037 2582
Camerons Strongarm; 5 changing beers (sourced nationally; often Castle Rock, Hydes) Ⓗ
The Head of Steam is just a few minutes' walk from the main railway station. Now established as part of Cardiff's 'pub mile', it offers a good selection of cask and craft ales, with a range of Belgian/German beers providing further choice. It has a central island bar with seating around it, booths down one side and tables down the other. There is more seating upstairs.
⊄◗&╼(Central) ●❀🛜

Tiny Rebel
26 Westgate Street, CF10 1DD
☎ (029) 2039 9557 ⊕ tinyrebel.co.uk
5 changing beers (sourced regionally; often Tiny Rebel) Ⓗ
Popular and lively bar in the heart of the city, with a quirky interior and knowledgeable and engaging staff. It offers a selection of cask ales from across the UK, usually at least two boxed ciders on handpump, and an eclectic food menu. There are spacious and airy rooms upstairs and down. Entertainment includes a monthly quiz, open mic nights and yoga events. Payment is by card only.
❀⊄◗&╼(Central) ●◲🛜

Cardiff: Grangetown

Grange
134 Penarth Road, CF11 6NJ
☎ (029) 2025 0669
Wye Valley Butty Bach; 3 changing beers (sourced regionally) Ⓗ
An example of how to rescue a pub that had been left to rot by previous operators. This street-corner suburban pub plays an important role in the community in an area where most pubs have vanished in recent years. It has

two rooms and a large rear garden with a covered area. The refurbishment accommodates the remaining architectural features of the original building, including Art Deco-style doors and bench seating around the walls. A former local CAMRA Pub of the Year.
Q🏠❀⊄◗╼♣●◲

Cardiff: Gwaelod Y Garth

Gwaelod Y Garth Inn ♟
Main Road, CF15 9HH
☎ (029) 2081 0408 ⊕ gwaelodygarthinn.co.uk
6 changing beers (sourced nationally; often Thornbridge) Ⓗ
A characterful, stone-built village inn on the edge of Cardiff, on the lower slope of Garth mountain. Frequented by locals, walkers and cyclists, it is the focus of the village. The bar has eight handpumps offering a range of real ales along with two traditional ciders. There is a separate games room next to the main bar area and a high-quality restaurant upstairs. The publican hosts a quiz with a difference on Thursday night. Local CAMRA Pub of the Year 2020 and 2022.
Q🏠❀⊄◗♣●P◲(26B) ●🛜

Cardiff: Llandaf

Heathcock
58-60 Bridge Street, CF5 2EN
☎ (029) 2115 2290 ⊕ heathcockcardiff.com
3 changing beers (sourced regionally) Ⓗ
Situated at a junction on the main road, the pub has seen its fortunes revived under new management. The central bar serves an adjoining public bar and lounge. There is a pleasant outdoor area at the rear with an additional dining area in a former skittles alley. The bar is cosy and traditional, with a small fireplace and a mix of furniture. The lounge is spacious and doubles as a dining room, albeit with a TV. ❀⊄◗◲❀🛜

Cardiff: Plasnewydd

Four Elms
1 Elm Street, CF24 3QR
☎ (029) 2046 2120
2 changing beers (sourced nationally; often Adnams, Exmoor, Tiny Rebel) Ⓗ
Friendly and inclusive street-corner pub situated a short distance east of the city centre. The ale selection changes every three days. A selection of craft beers and up to five bag-in-box ciders are also on offer. The large, impressive garden includes pods. Good-value pub grub is served all day, with a carvery on Sundays until 4pm.
❀⊄◗♣●◲◲❀🛜

Cardiff: Pontcanna

Cricketers
66 Cathedral Road, CF11 9LL
☎ (029) 2034 5102 ⊕ cricketerscardiff.co.uk
Evan Evans Cwrw, Warrior, Welsh Pale Ale; 1 changing beer (sourced locally; often Evan Evans) Ⓗ
The only pub run by Evan Evans in the area, this former Victorian townhouse is in the Cathedral Road Conservation Area. The open-plan interior is divided by a half-width wall into two distinct sections. A large rear yard is a popular suntrap in summer months. The newly refurbished kitchen offers a range of exciting dishes from an innovative menu. Close to the cricket stadium, the pub is busy on match days. Q🏠❀⊄◗&A◲🛜

Halfway ⓛ

247 Cathedral Road, CF11 9PP
☎ (029) 2066 7135
Brains Bitter, SA, SA Gold Ⓗ

Bustling Victorian pub with a varied clientele in the fashionable urban village of Pontcanna. The large open-plan interior offers a number of comfortable areas for drinking and dining – food is served all day. Sporting events are shown on multiple screens, though on mute except for major matches. Monday is quiz night. The skittles alley is available to hire. ⛷⑨♿♣♠☷➤❀☂

Cardiff: Roath

Andrew Buchan

29 Albany Road, CF24 3LH
☎ (029) 2115 5539
Rhymney Bitter, Export, Export Light; 1 changing beer (sourced locally; often Rhymney) Ⓗ

A great community pub in an area just to the north east of the city centre. It is owned by Rhymney Brewery and serves a good range of the brewery's beers, often including Rhymney Dark, plus occasional guests from elsewhere. A good range of ciders, usually from respected local producer Llanblethian Orchards, is also stocked. Real ale takeaways and filled rolls are available. BT Sport is played (silently), there are open mic nights on Mondays, occasional live bands and a jukebox.
❀♿≠(Cathays) ➤☷❀☂

Cathays Beer House

109 Crwys Road, CF24 4NF
4 changing beers (sourced nationally; often Bristol Beer Factory, Liverpool) Ⓖ

A conversion from a former post office, this single-room pub has a small terrace to the front. The beer range is constantly changing, with beers sourced from small breweries across the UK. There is also a choice of around 100 bottled and canned beers, again mainly from small breweries. A thriving off-trade exists, including draught beer and cider. Bag-in-box ciders and perries are also sold, often from Llanbleddian Orchards. Local CAMRA Cider Pub of the Year 2022. Q⛷❀♿♠☷➤☷❀☂

Cowbridge

1 Town Hall Square

1 Town Hall Square, CF71 7DD
⊕ 1townhallsquare.com
Coach Bridgend Pale Ale Ⓗ**; 2 changing beers (sourced nationally; often Coach, Thornbridge, Tiny Rebel)** Ⓗ/Ⓖ

A fairly recent addition to the local beer scene, aimed squarely at the beer enthusiast. There is a small bar with a seating area off it, while upstairs are a further two rooms. The decor is traditional, with exposed stonework, tiled and wooden floors, and low beams. The entrance courtyard is a pleasant suntrap on a sunny day. Food is not served but customers are welcome to bring their own. The Coach brewpub in Bridgend is under the same ownership. ❀♣≠☷(X2,321)❀☂

Vale of Glamorgan Inn

51 High Street, CF71 7AE
☎ (01446) 772252
Wye Valley HPA, Butty Bach; 1 changing beer (sourced nationally; often Glamorgan) Ⓗ

Popular single-room pub in the centre of town where conversation is the main entertainment. The wooden-floored bar has a warming range fire; to the rear is a flagstone-floored area with another stove. Photographs and pictures of local interest adorn the walls. Outside is an attractive enclosed garden with a separate covered and heated smoking area. The now well-established annual beer festival coincides with the town's food and drink festival in May. Good-value home-made food is served at lunchtime Monday to Saturday.
Q⛷❀♿⑨☷(X2,321) ❀☂

Cross Inn

Cross Inn Hotel ⑨ ⊘

Main Road, CF72 8AZ
☎ (01443) 223431
Hancocks HB; Wye Valley HPA; 2 changing beers (sourced nationally) Ⓗ

Local CAMRA Pub of the Year and a recipient of a CAMRA Hospitality Heroes award for its exemplary role during the Covid pandemic. This welcoming, traditional pub is immaculately maintained and attracts a strong following from locals and visitors. The large single room is divided into a bar area and a comfortable lounge in which home-prepared meals are served. Curry night on Wednesday and Sunday lunches are very popular – booking is recommended. There is a large car park at the rear, and a comfortable outdoor drinking area.
Q❀⑨♿♣P☷(124) ❀☂

Cwmafan

Brit ⓛ ⊘

London Row, SA12 9AH
☎ (01639) 680247 ⊕ thebrit.wales
3 changing beers (sourced regionally; often Grey Trees) Ⓗ

This cosy, dog-friendly pub serves three rotating ales, many of which are sourced locally, plus a real cider. Renovated some years ago, accommodation includes three bunk rooms plus a double en-suite room, popular with the Afan Valley mountain bikers. The pub hosts summer and winter beer festivals and is also noted for its good food. It may occasionally close on a Monday in January and February, so check ahead. A former local CAMRA Pub of the Year. Q⛷❀♞⑨♿♠P☷❀☂

Cwmfelin

Cross Inn

Masteg Road, CF34 9LB
☎ (01656) 732476
Cerddin Solar, Cascade; 3 changing beers (often Cerddin) Ⓗ

Multiple local CAMRA Pub of the Year winner and home to the Cerddin Brewery, this is a must-visit pub. Alongside the five cask beers, a range of bottle-conditioned beers is also available. The traditional two-roomed Valleys inn offers a warm welcome, with friendly locals and knowledgeable staff. The Tuesday night quiz raises money for the local food bank. There is a patio area outside the brewery. Twice winner of CAMRA South Wales Regional Pub of the Year.
Q❀≠(Garth) ♣☷(71) ❀☂

Deri

Old Club

93 Bailey Street, CF81 9HX
☎ (01443) 839333
2 changing beers (sourced locally; often Grey Trees) Ⓗ

Friendly village free house, enjoying a new lease of life under fresh ownership. A real community hub, extending a welcome to all. The landlord is an accomplished professional darts celebrity, attracting much interest

among fans. Sports TV often shows, but is rarely intrusive. Award-winning Grey Trees beers feature regularly, sometimes changing to include seasonals. Handy for Cwm Darran Country Park and close to Sustrans route 469 from Bargoed. ▲♣☐❀♥ ?

East Aberthaw

Blue Anchor
CF62 3DD
☎ (01446) 750329 ⊕ blueanchoraberthaw.com
Theakston Old Peculier; Wadworth 6X; Wye Valley HPA; 2 changing beers (often Glamorgan, Harbwr) Ⓗ
Dating from 1380, this attractive thatched pub has been in the same family for over 75 years. Its thick stone walls house a labyrinth of rooms, with stone floors, wooden beams and open fires adding to the character and making the pub a tourist attraction for ale and food lovers alike. Up to five ales and award-winning food are served in the bar and upstairs restaurant. The guest beer and cider are often locally produced.
Q ☜ ❀ ◑ P ☐ (304) ❀

Glan y llyn

Fagins Craft Beer House & Art Café Ⓛ
9 Cardiff Road, CF15 7QD
☎ (029) 2081 1800
3 changing beers (sourced regionally; often Grey Trees, Twt Lol) Ⓗ
Quiet pub with a warm, friendly atmosphere enhanced by a log-burner and the buzz of pleasant chat. The cosy front bar hides a much larger mixed-use area at the rear. Handpulled beers come from local suppliers Grey Trees and nearby Twt Lol, alongside regular guests from further afield including Thornbridge Jaipur. One pull offers real cider. A selection of local and national craft keg beers and bottled ciders are also available. Good-value meals are served in the bar and rear dining area. A popular destination for dog walkers. Q ☜ ❀ ◑ ♥ ☐ (26,132) ❀ ?

Gorseinon

Mardy Inn ✔
117 High Street, SA4 4BR
☎ (01792) 890600
Greene King Abbot; Ruddles Best Bitter; Sharp's Doom Bar; 4 changing beers Ⓗ
This Wetherspoon establishment was formerly a traditional high-street pub. Following a major refurbishment, it is now modern in style. It has a large single bar with several TVs for news and sport, and an adjoining airy extension overlooking the furnished patio area. Some interesting pictures of old Gorseinon are on the walls, depicting the town and its inhabitants in years gone by. A good selection of local and national beers can be enjoyed in the beer garden. ☜ ❀ ◑ ♦ ♣ ☐ P ☐ ?

Groeswen

White Cross Inn
CF15 7UT (overlooking Groeswen Chapel)
☎ (029) 2085 1332
4 changing beers (sourced nationally) Ⓗ
Friendly community pub on the outskirts of Caerphilly, offering excellent choice and value. Six handpumps serve four changing beers, plus two ciders from local producer Williams Brothers. Beers come in a diverse choice of styles, including a dark ale. Home-made ham and cheese rolls are often served. The pub offers an eclectic social calendar appealing to many different tastes. Access is unsuitable for large vehicles. ☜ ❀ ♣ ♥ P ❀ ?

Hendreforgan

Griffin Inn Ⓛ
CF39 8YL (from Tonyrefail on A4093, turn down lane after Gilfach Goch village sign)
☎ (01443) 675144
Glamorgan Cwrw Gorslas/Bluestone Bitter, Jemimas Pitchfork Ⓗ
A friendly welcome is assured at the Griffin (locally known as the Bog), an inn that has been in the same family for more than 60 years. Recognised by CAMRA as a Real Heritage Pub of Wales, the immaculate decor features oak furniture, gleaming brassware, memorabilia everywhere you look, and a Victorian counter with a till from 1870. Full of warmth and character, with roaring fires in winter, this out-of-the-way pub is a very comfortable rarity. Q ☜ ❀ ▲ P ☐ (150,172) ❀

Kenfig

Prince of Wales
CF33 4PR
☎ (01656) 740356 ⊕ princeofwalesinn.co.uk
Draught Bass; Gower Gold; Worthington's Bitter; 1 changing beer (sourced regionally) Ⓖ
A heritage award-winning inn dating from the 15th century and steeped in local history. Visitors can expect three quality ales on gravity, good locally sourced food and a warm welcome. Family friendly and popular with dog walkers, the pub is comfortable and cosy. Outside there is a stunning view over Kenfig Nature Reserve. The Draught Bass is renowned throughout the local area and outsells all the pub's lagers combined. Guest beers and cider are occasionally available. Q ☜ ❀ ◑ P ❀ ?

Killay

Village Bar Café ✔
5-6 Swan Court, The Precinct, SA2 7BA
☎ (01792) 203311
Sharp's Doom Bar; 2 changing beers Ⓗ
Situated in a small shopping precinct in Killay on the gateway to Gower, the Village has changed its focus from a traditional pub to a café bar. It retains a single, split-level bar, offering three real ales. There are quizzes on Sunday and Tuesday nights. The food menu is varied and includes vegetarian and vegan options. The kitchen is closed on Sunday and Monday, but the café/bar is open for coffee, cake and drinks. ☜ ◑ ♦ ♣ P ❀ ?

Llangennith

King's Head Ⓛ
SA3 1HX
☎ (01792) 386212 ⊕ kingsheadgower.co.uk
Gower Gold; 5 changing beers (sourced regionally; often Evan Evans, Mumbles, Tomos Watkin) Ⓗ
Previously a row of three 17th-century stone-built cottages, this large pub has two separate bars and a variety of rooms for drinking and dining. Ales from nearby breweries are on the bar (up to five in summer, fewer in winter). An impressive variety of home-made food is served, with dishes inspired by fresh local produce. The pub is at the western end of the Gower Peninsular, a short distance from the sandy stretches of Llangennith Beach. ☜ ❀ ✉ ◑ ▲ ♣ ♥ P ☐ (116) ❀ ?

Llanharry

Fox & Hounds
Llanharan Road, CF72 9LL
☎ (01443) 222124 ⊕ foxandhoundsllanharry.co.uk

3 changing beers (sourced nationally; often Glamorgan, Oakham, Thornbridge) ⊞

This large pub has an open-plan lounge with an open fire and settees at one end, and more traditional pub furniture at the other. It is popular for food, with meals served in both the lounge area and the separate restaurant area. There is also a games room. The garden at the rear, which backs on to Llanharry Park, has plenty of seating. A large car park is alongside, and the pub is well served by local buses from Bridgend and Talbot Green. ⌂✿❀◑♿P🖵(64,404)🐾🐶🛜

Llanmadoc

Britannia Inn ✔

SA3 1DB

☎ (01792) 386624 ⊕ britanniagower.com

Gower Gold; Sharp's Doom Bar; 1 changing beer (sourced nationally) ⊞

Timbers from ships wrecked on the nearby coast were used in the construction of this pretty and popular 17th-century pub in a quiet corner of Gower. There is a cosy bar at the entrance serving good food and beer; the back bar area has been converted into a fine-dining restaurant. Beer gardens to the front and rear offer stunning views over the nearby estuary, with an aviary and pet area popular with children.
⌂✿❀◑Å♣P🖵(30) 🐾🐶🛜

Llantwit Major

Llantwit Major Rugby Club

Old Market, Boverton Road, CF61 1XZ

☎ (01446) 792276 ⊕ llantwitmajor.rfc.wales

Sharp's Doom Bar; 2 changing beers (often Brains, Wye Valley) ⊞

A friendly community club, proud of its rugby history, which welcomes visitors throughout the year. The regular beer and two changing guest ales are all excellent value for money. There is a cosy, well-appointed lounge bar, and a function room that holds 120 people, hosts frequent live music and is available for hire. The small patio is popular in summer and has a covered smoking area. Dogs are welcome in the players' bar. ⌂♿Å⇌P🖵(303,304)🐾🐶🛜

Old Swan Inn

Church Street, CF61 1SB

☎ (01446) 792230

4 changing beers (sourced locally; often Bluestone, Tomos & Lilford, Vale of Glamorgan) ⊞

The town's oldest pub is near the historic St Illtyd's Church and opposite the town hall. It has a busy front bar and a modern restaurant at the back; both of which serve excellent food and an ever-changing range of up to four ales, often sourced from local brewers. Beer festivals are held in spring and summer, featuring local live bands. A weekly quiz is held on Tuesday evening and steak night on Wednesday. Cider is sold occasionally, particularly in summer. The town car park is nearby.
Q⌂✿❀◑⇌P🖵(303,304) 🐾🐶🛜

White Hart Inn

Wine Street, CF61 1RZ

☎ (01446) 796956 ⊕ oldwhitehart.uk

3 changing beers (often Glamorgan, Tomos & Lilford, Wadworth) ⊞

Dating back to the 15th century, this Grade II-listed pub is set in the picturesque town square. The cosy public bar has a large log-burner, two TVs and three ales on sale. There is a separate restaurant offering a range of traditional food. A large beer garden at the back hosts popular music events and small beer festivals. Seating outside at the front catches the afternoon sun.
⌂✿❀◑Å⇌♿🖵(303,304) 🐾🛜

Maesteg

Federation Bar

26 Commercial Street, CF34 9DH

☎ (01656) 856298

Rhymney Export; 1 changing beer (sourced locally; often Rhymney) ⊞

Rhymney Brewery converted this former florists' shop on the main street in 2015. Decorated in the brewery's typical pub style, it offers excellent beer and good value for money. Chairs and benches are upholstered in a matching grey tartan, adding to the pleasant environment. There are TVs with the sound usually turned down and a jukebox, as well as live music. Strictly no under-21s, but well-behaved dogs are welcome. No entry after midnight at weekends. ⇌🖵(71,72)🐾🛜

Marcross

Horseshoe Inn

CF61 1ZG

☎ (01656) 890568 ⊕ theshoesmarcross.co.uk

Gower Gold; Wye Valley Butty Bach; 1 changing beer (often Tomos & Lilford) ⊞

The Shoes is a beautiful 19th-century pub in the hamlet of Marcross, offering a cosy interior with a large log-burner. There are usually three ales on offer, one a Welsh brew. An extensive menu of good pub fare is served lunchtime and evening. In summer the beer garden is delightful. With its friendly staff, the pub is popular with students from the local international college. It is an ideal starting point for spectacular coastal walks, taking in the nearby Nash Point cliffs and lighthouse.
Q⌂✿❀◑♣P🖵(303)

Monknash

Plough & Harrow

CF71 7QQ

☎ (01656) 890209 ⊕ ploughandharrowmonknash.co.uk

Draught Bass Ⓖ; Glamorgan Jemimas Pitchfork ⊞; 2 changing beers (often Wye Valley) ⊞/Ⓖ

Renowned 14th-century pub, originally a monastic farmhouse, retaining many original features and with an eclectic furnishing style that is always a surprise to newcomers. Up to four real ales are available on handpump or gravity, with local breweries well supported. There is also a selection of ciders and perries from local producers. Good pub meals are cooked from scratch using locally sourced products. The large beer garden hosts festivals and live music in summer. Four holiday apartments are available.
Q⌂✿❀◑Å P🖵(303) 🐾

Morriston

Red Lion Inn ✔

49 Sway Road, SA6 6JA (near central Morriston Cross opp fire station)

☎ (01792) 761870

Greene King Abbot; Ruddles Best Bitter; 6 changing beers (sourced nationally; often Draught Bass, Mumbles, Sharp's) ⊞

Deceptively spacious Wetherspoon pub with a large, comfortable, open-plan room featuring an open log fire at the front and high bar stools at the back. On the walls are a number of pictures depicting the long-gone industrial history of the area. A community board

advertises trips to breweries and other events in the area. At least one guest ale usually comes from a local brewery. ☟⚛️◑Ⅾᶜ♿️🅿️🚋🛜

Mumbles

Park Inn L

23 Park Street, SA3 4DA
☎ (01792) 366738
5 changing beers (sourced regionally; often Evan Evans, Mumbles, Tiny Rebel) Ⓗ
The convivial atmosphere in this small establishment in a village side street helps to attract discerning drinkers of all ages. Five handpumps dispense an ever-changing range of beers, with particular emphasis on independent breweries from Wales and the west of England. Alongside a fine display of pumpclips are pictures of old Mumbles and its pioneering railway. A popular quiz is held on Thursday, with occasional music at weekends.
Q☟⚛️♣️🚋(2,3)♥️🛜

Pilot Inn L

726 Mumbles Road, SA3 4EL
☎ 07897 895511
Draught Bass; 6 changing beers (sourced nationally; often Pilot) Ⓗ
A welcoming and friendly local on the seafront, home to the Pilot Brewery. Seven ales are always available, usually including up to three rotating beers brewed on site. A wide range of bottled cider is also available and hot drinks are served. This historic pub, built in 1849, is next to the coastal path and is popular with lifeboatmen, locals, real ale fans, walkers and cyclists. Dogs are welcome. A former Welsh CAMRA Pub of the Year and local CAMRA Pub of the Year. Q☟♣️♿️🚋♥️🛜

Ty Cwrw

650 Mumbles Road, SA3 4EA (on main seafront road)
☎ 07488 298344
4 changing beers (sourced nationally; often Tenby, Tiny Rebel, Tomos Watkin) Ⓗ
Small and friendly, independently owned pub – the name Ty Cwrw is Welsh for beer house. It serves four real ales and six craft keg beers, all sourced from a variety of Welsh breweries and listed on a large blackboard. Although the frontage appears to be narrow from the outside, there is a second room behind the front room and the long wooden bar. Both rooms have a light, modern decor and feature paintings from local artists.
☟♣️🚋♥️🛜

Neath

Borough Arms L

2 New Henry Street, SA11 1PH (off Briton Ferry road, near Stockhams Corner roundabout)
☎ (01639) 644902
4 changing beers (sourced regionally; often Glamorgan, Grey Trees) Ⓗ
The emphasis in this welcoming, homely local is very much on ales and conversation. The landlord and brewer occasionally has his own ales on tap, but there is always a good choice from regional breweries. The pub holds an annual GlastonBorough festival in May featuring live music, plus a beer festival over the August bank holiday. Live acoustic music plays every Wednesday. Well worth the 10-minute walk from the town centre. Q⚛️♿️🚋🛜

David Protheroe L ✅

7 Windsor Road, SA11 1LS (opp railway station)
☎ (01639) 622130

Greene King Abbot; Ruddles Best Bitter; Sharp's Doom Bar; 5 changing beers (sourced nationally; often Brains, Evan Evans, Grey Trees) Ⓗ
A former police station and courthouse, the David Protheroe is named after the first policeman to be posted in Neath. A Wetherspoon pub, it is ideally positioned in the centre of town, directly opposite the railway station and a short walk from the bus terminus. The chain's familiar food and drinks are available, with three permanent and up to five changing beers, often including a local brew. Ciders are also available.
☟⚛️◑♿️🚆♿️🚋🛜

Norton

Beaufort Arms L

1 Castle Road, SA3 5TF (near A4067 Mumbles Rd and seafront footpath)
☎ (01792) 514246
Draught Bass; 2 changing beers (sourced locally; often Glamorgan, Gower) Ⓗ
Charming 18th-century village local with a welcoming atmosphere. Previously owned by its owning pub group, it was bought by a private couple in 2017 and attractively renovated. There is a traditional main bar with a TV and dartboard, and a small, comfortable lounge. Both rooms have real fires, and outside there is a small beer garden to the rear. A quiz is held on Tuesday. An increase in the range of beers has added to its popularity.
⚛️♣️🚋(2A,3A)♥️🛜

Penarth

Golden Lion

69 Glebe Street, CF64 1EF
☎ (029) 2070 1574
Felinfoel Double Dragon; 3 changing beers (often Glamorgan, Grey Trees, Vale Of Glamorgan) Ⓗ
A genuine locals' pub with a reputation for serving some of the best-kept quality real ale in the area. Three or four beers from Welsh breweries are usually on offer, along with good-value food. The pub can sometimes be loud and lively with its jukebox and numerous sports TVs, and its football team are among the regular customers. The small beer garden is popular in warmer weather, with artificial grass and wall paintings depicting Penarth.
⚛️◑♿️🚆(Dingle Rd)♣️🚋(89A/B,94)🛜

Pilot

67 Queen's Road, CF64 1DJ
☎ (029) 2071 0615
2 changing beers (often Vale of Glamorgan, Well Drawn) Ⓗ
The Pilot has a long-established reputation for high-quality beer, wine and food. Its ales are chosen from a selection of Welsh breweries, alongside more unusual offerings from around the country. There is pleasant seating outside at the front for sunny days, and the rear restaurant with its log-fired stove is comfortable in the winter. Because of its popularity, booking is recommended for meals at peak times. The front bar is dog friendly until 6pm.
Q☟⚛️◑🚆(Dingle Rd)🚋(89A/B,94)♥️🛜

Windsor

95 Windsor Road, CF64 1JE
☎ (029) 2070 8675
3 changing beers (sourced nationally; often Courage, Marston's, Young's) Ⓗ
Following a change in emphasis from dining to a more traditional pub, the Windsor offers a comfortable environment with a variety of seating to accommodate

groups of different sizes. It has a pool table and hosts entertainment through the week – live bands, quizzes, comedy nights. When not lively with events, it is usually quiet and a perfect place for conversation over a superbly kept pint, chosen from the wide range of Marston's beers. Q ⑤ ⑥ ⑦ (Dingle Rd) ⑧ (92,94) ⑨ ⑩

Pencoed

Little Penybont Arms
11 Penybont Road, CF35 5PY
☎ 07734 767937
2 changing beers (often Salopian) G
Cosy micropub offering a couple of changing beers on gravity, several ciders and a large selection of single malt whiskies and gins. Craft keg beer is also available. The Steak & Stamp restaurant two doors down is under the same ownership, and drinks from the pub are also available there. The pub itself sells excellent bar snacks including home-made pork scratchings. There is a quiz and pizza night on Wednesday. Since opening, it has built up a strong local following.
Q ⑤ ⑥ ⑦ ⑧ ⑨ ⑩ (404,64) ⑪ ⑫

Penderyn

Red Lion
Church Road, CF44 9JR
☎ (01685) 811914 ⊕ redlionpenderyn.com
Draught Bass; Gower Best Bitter; 1 changing beer (sourced nationally) G
Family-owned drovers' inn on the edge of the Brecon Beacons National Park. Dating in parts back to the 12th century, at one time it was a Welsh longhouse. Much renovated over the last 40 years, there are two log fires in the small but delightfully cosy bar. Darker, traditional ales predominate. Two or more local ciders and perries are always available. High-quality food is served (booking advised as it can get busy). Q ⑥ ⑦ ⑧ ⑨ P ⑩ ⑪

Peterston-super-Ely

Sportsman's Rest L
CF5 6LH
☎ (01446) 760675 ⊕ thesportsmansrest.co.uk
Timothy Taylor Landlord; Wye Valley HPA; 2 changing beers (sourced nationally) H
Attractive village pub with outdoor seating front and back and a children's play area. The comfortable interior includes a bar area for drinkers and a larger split-level dining section. An emphasis on quality food – with special deals and themed food evenings – is balanced by a good range of real ales, some unusual for the area. Community and charity events are well supported, including an annual beer festival to coincide with the village duck race in May. ⑤ ⑥ ⑦ ⑧ ⑨ P ⑩ (320) ⑪ ⑫

Pontardawe

Pontardawe Inn L
123 Herbert Street, SA8 4ED (off A4067 into town, pub is off A474 flyover)
☎ (01792) 447562 ⊕ pontardaweinnpub.co.uk
Marston's Pedigree; 1 changing beer (sourced nationally; often Marston's) H
Former Welsh longhouse later converted to a drovers' pub, situated alongside the River Tawe and local cycle path. A side room and stable below were added by the Royal Mail in 1850 as a sorting depot. The central bar serves two changing ales sourced from the Marston's range, usually Hobgoblin, as well as a range of real ciders. Food is available daily in this multi award-winning

pub. Seasonal beer festivals and music festivals are held, and live music features at weekends. ⑤ ⑥ ⑦ ⑧ ⑨ ⑩ P ⑪ ⑫

Pontsarn

Aberglais Inn
CF48 2TS (between Trefechan and Pontsticill) SO043098
☎ (01685) 377344 ⊕ aberglais.com
Felinfoel Double Dragon; Tomos Watkin Old Style Bitter; 1 changing beer (sourced nationally) H
On the outskirts of Merthyr between Trefechan and Pontsticill, the pub has a smart and well-appointed main bar complete with a cosy wood stove, and an adjoining restaurant area. It is popular with families, hikers, holidaymakers and cyclists on the nearby trails. Dogs are welcome in the bar and beer garden. Good food is served and booking is essential on Saturday and recommended at other times. ⑤ ⑥ ⑦ ⑧ P ⑨ ⑩

Pontsticill

Red Cow
Main Road, CF48 2UN (in centre of village)
☎ (01685) 387775 ⊕ redcow.wales
Wye Valley Bitter; house beer (by Grey Trees) H
A handsome and tranquil pub in the middle of Pontsticill with views of the Brecon Beacons. Warm, friendly and inviting, the bar room is open plan and comfortably furnished, with a log fire in a cosy snug. Well-kept beers come from Wye Valley and one from the Grey Trees range. Popular for meals, check ahead for food service times. Dogs are welcome, there is a garden and a large car park. Q ⑤ ⑥ ⑦ ⑧ P ⑨ ⑩

Pontypridd

Bunch of Grapes L ✓
Ynysangharad Road, CF37 4DA (off A4054)
☎ (01443) 402934 ⊕ bunchofgrapes.org.uk
Grey Trees Mosaic Pale Ale; 6 changing beers (sourced nationally; often Oakham, Salopian, Tiny Rebel) H
Situated just off the town centre, this thriving pub has won multiple awards and the planned on-site microbrewery is keenly anticipated. Guest ales are constantly changing and include at least one local beer. Two ciders are also available. Beers from the bar can also be enjoyed in the highly acclaimed restaurant. A delicatessen offers many interesting and unusual foods to take home. Events include beer, cider and food festivals. A popular quiz is held on Tuesday evening.
Q ⑤ ⑥ ⑦ ⑧ ⑨ ⑩ P ⑪ ⑫

Llanover Arms L
Bridge Street, CF37 4PE (opp N entrance to Ynysangharad Park, off A470)
☎ (01443) 403215
2 changing beers (sourced nationally; often Salopian) H
This historic free house has been in the same family for over a century and its old-world charm has been carefully conserved. Passageways link its three rooms – each room has its own distinct character and atmosphere and the walls are festooned with a variety of artefacts including old mirrors, paintings and clocks. A convenient stop-off for walkers and cyclists on the Taff Trail, the pub is also near the famous old town bridge and Ynysangharad Park with the restored National Lido of Wales. The modern A470 trunk road passes close by, occupying the route of the old canal that dominated this area for many years.
Q ⑥ ⑦ ⑧ P ⑨ ⑩

Patriot Bar Ⓛ

25B Taff Street, CF37 4UA

☎ (01443) 407915

Rhymney Bevans Bitter, Bitter, Export, Hobby Horse; 1 changing beer (often Rhymney) Ⓗ

A Rhymney Brewery tied pub, near the bus station and a short walk from the railway station. The well-kept beers include a guest from the Rhymney range. There is a steady flow of custom throughout the day, encouraged by keen prices. Real cider is occasionally available. The pub is easy to find, occupying a former travel agents'. It is fondly known as the Wonky Bar, recalling its former twisted entrance. It can be loud and bustling but is a gem. ⇌🖴🐱♿🛜

Tumble Inn ◉

4-9 Broadway, CF37 1BA

☎ (01443) 484390

Greene King Abbot; Ruddles Best Bitter; Sharp's Doom Bar; 3 changing beers (sourced regionally; often Boss, Glamorgan, Rhymney) Ⓗ

Previously the main Post Office, this roomy Wetherspoon pub is near the town centre and railway station, and on several main bus routes. The open-plan interior is mainly on one level, with two smaller raised tiers, served by a single long bar. Food is the usual Wetherspoon fare. The pleasant patio is divided into smoking and no-smoking areas. Beer and cider festivals held through the year. 🖵🕯🍴♿⇌🖴🛜

Port Eynon

Ship Inn Ⓛ

SA3 1NN (in heart of village)

☎ (01792) 390204 ⊕ shipinngower.co.uk

2 changing beers (sourced nationally; often Evan Evans, Gower) Ⓗ

An historic inn set in the middle of a quaint seaside village. Refurbished a few years ago, this surprisingly spacious pub has three large rooms decorated in a modern and airy style with a nautical theme. It is popular with holidaymakers from the nearby caravan- and campsites in season. A good range of meals is available, served throughout the day. Two ales are usually available all year, with two more guest ales in season. 🖵🕯🍴♿🅰♣♿🖴(118)🐱🛜

Port Talbot

Lord Caradoc Ⓛ ◉

69-73 Station Road, SA13 1NW (5 mins' walk from Parkway railway station, on main shopping street)

☎ (01639) 896007

Greene King Abbot; Ruddles Best Bitter; Sharp's Doom Bar; 5 changing beers (sourced nationally; often Glamorgan, Rhymney, Tomos Watkin) Ⓗ

On the main shopping street, this Wetherspoon pub has a relaxed atmosphere, with a spacious open-plan layout and family-friendly area. The choice of beers is open to suggestion from customers, with a wide range always available, including a locally brewed ale. Up to three real ciders are also kept. The walls are adorned with photographs of the town from times gone by and famous local people. The pub has been recognised by Wetherspoon for its high standard of catering, on a number of occasions. 🖵🕯🍴♿⇌♿🖴🛜

Porth

Rheola

Rheola Road, CF39 0LF

☎ (01443) 682633

Rhymney Bitter; 3 changing beers (sourced locally; often Rhymney) Ⓗ

A Rhymney Brewery tied house, this friendly local sells a range of well-kept and good-value beers. The large detached building is situated at the confluence of the two Rhondda rivers, and is well served by both rail and bus. The bar features a jukebox, pool table and dartboard, and is often quite lively. The comfortable lounge generally provides a quiet haven and tends only to get busy at weekends. Activities include a quiz, whist, and live artists and bands at weekends. 🖵⇌♣🖴(120,132)🛜

Porthcawl

Lorelei Hotel

36-38 Esplanade Avenue, CF36 3YU (just off seafront near Grand Pavilion)

☎ (01656) 788342 ⊕ loreleihotel.co.uk

Draught Bass Ⓖ; Rhymney Export; 2 changing beers Ⓗ

Near the seafront and Grand Pavilion, the Lorelei is a long-term Guide regular. Good-quality and value-for-money food is served evenings (no food Mon) and Sunday lunchtime. Four draught beers are available plus cider during the summer. Beer festivals are held twice a year. The pub was built around the end of the 19th century. During WWI, when it was two separate buildings, one half was reportedly used as a hospice for injured soldiers. Q🖵🕯🍴♣🖴(X2,404)🛜

Quakers Yard

Glantaff Inn

Cardiff Road, CF46 5AH

☎ (01443) 488633 ⊕ glantaffinn.com

2 changing beers (sourced nationally; often Brains, Rhymney, Wye Valley) Ⓗ

Pleasant pub overlooking the River Taff, just off the old course of the A470. It is popular with locals as well as walkers and cyclists from the nearby Taff Trail. Local Welsh ales are often available, and good-value meals are served lunchtimes and evenings. Live entertainment is provided occasionally at the weekend. 🕯🍴♿🖴(78)🐱🛜

Reynoldston

King Arthur Hotel

Higher Green, SA3 1AD (on village green)

☎ (01792) 390775 ⊕ kingarthurhotel.co.uk

Gower Gold; Sharp's Doom Bar; 2 changing beers (sourced nationally; often Glamorgan, Tenby, Tiny Rebel) Ⓗ

Traditional family-owned hotel and acclaimed wedding venue, situated at the foot of Cefn Bryn in beautiful Gower, overlooking the village green. There is covered outdoor seating by the pub entrance and a large seating area on the green itself. The cosy, atmospheric main and rear bars are welcoming to drinkers and diners, serving home-cooked food made with local produce. Main meals and bar snacks are available all day, as well as breakfasts for non-residents until 11am. 🖵🕯🍴♿♣🖴🛜

Sketty

Vivian Arms

106 Gower Road, SA2 9BT (at Sketty Cross, jct of A4118 and A4216)

☎ (01792) 516194

Brains Bitter, Rev James Original, SA, SA Gold; 1 changing beer Ⓗ

Situated on the main crossroads in Sketty, the Vivs is a spacious pub that attracts a wide range of customers, young and old. It has a mixture of seating areas and plenty of TV screens throughout showing live sport. There is a small meeting room for up to 18 people. A popular carvery is held on Sunday. Live music features on Friday and occasionally Saturday, a general knowledge quiz on Sunday and a music quiz on Wednesday.
⑤❀◖▣(20,21)❀❖

Southerndown

Three Golden Cups

CF32 0RW
☎ (01656) 880432 ⊕ thethreegoldencups.co.uk
Sharp's Doom Bar; 1 changing beer (sourced locally; often Glamorgan, Gower) ⊞
One of the few pubs on the Glamorgan Heritage Coast from which you can see the sea. The restaurant/lounge has a stone and wooden decor and is named after the Maria Jose, a ship wrecked nearby in 1914. Music evenings are held regularly and summer barbecues are popular. The campsite is adjacent to the pub – generally the camping season starts in March. Breakfast rolls are available until noon. ⑤❀◖Å♣P▣(303)❖

Swansea

Bank Statement ✅

57-58 Wind Street, SA1 1EP
☎ (01792) 455477
Sharp's Doom Bar; 5 changing beers (sourced nationally; often Exmoor, Fuller's, Jennings) ⊞
A former Midland Bank, sympathetically transformed by Wetherspoon while retaining its original ornate interior. Trading as a Lloyds No.1, the pub is at the heart of the city's popular bar quarter and has a large ground floor with plenty of seating. Additional seating is available on the upstairs terrace. Attracting all ages, it is busy throughout the week. Sport is shown on its many screens. The bottled beer selection includes real ales.
⑤◖&≠♠▣❀

Brunswick Arms

3 Duke Street, SA1 4HS (between St Helens Rd and Walter Rd)
☎ (01792) 465676 ⊕ brunswickswansea.com
Butcombe Original; Courage Directors; Wye Valley Butty Bach ⊞; 2 changing beers (sourced nationally) ⊞/Ⓖ
A side-street pub with the air of a country inn in the city. Wooden beams and comfortable seating create a traditional, relaxing atmosphere, with a local artist's work on display and for sale. Up to six beers are usually available – one of the changing beers is gravity dispensed, often from a local microbrewery. Food is served daily. A popular quiz is held on Monday, live music on Thursday and Saturday, and an open mic session on the second Tuesday of the month.
◖&♠▣(200)❀

No Sign Bar

56 Wind Street, SA1 1EG
☎ (01792) 465300 ⊕ nosignwinebar.com
Gower Gold; 3 changing beers (sourced nationally; often Butcombe, Mumbles, Tiny Rebel) ⊞
Historic narrow bar established in 1690, formerly Mundays Wine Bar and reputedly a regular haunt of Dylan Thomas. Architectural signs from various periods of the pub's past remain, some dividing the interior into separate bar areas. Quality food and wine are available, and up to five real ciders. Live music features in the bar

on Friday, Saturday and often Sunday evenings. Bands also play in the Vault basement late evenings.
⑤❀◖&≠♠▣❀

Potters Wheel

85-86 The Kingsway, SA1 5JE
☎ (01792) 465113
Adnams Broadside; Ruddles Best Bitter; Sharp's Doom Bar; 6 changing beers (sourced nationally) ⊞
City-centre Wetherspoon outlet with a long sprawling bar area offering various seating arrangements, attracting customers of all ages and backgrounds. Named after the Dillwyn family, who owned the local Cambrian Pottery. An interesting selection of guest beers is kept, with a commitment to local breweries. Real cider is always available. Photographs on the walls feature local dignitaries associated with the area's industrial past, particularly the ceramics and pottery industries. Look for the CAMRA board and beer suggestion box.
⑤◖&♠▣❀

Queen's Hotel

Gloucester Place, SA1 1TY (near Waterfront Museum)
☎ (01792) 521531
Theakston Best Bitter, Old Peculier; 2 changing beers (sourced nationally; often Bristol Beer Factory, Fuller's, Glamorgan) ⊞
Vibrant free house near the Dylan Thomas Theatre, City Museum, National Waterfront Museum and marina. The walls display photographs depicting Swansea's rich maritime heritage. The pub enjoys strong local support, and home-cooked lunches are popular. Evening entertainment includes a Sunday quiz, bingo on Wednesday and live music on Saturday. This is a rare local outlet for Theakston Old Peculier, in addition to a seasonal guest beer, often from a local microbrewery. A former winner of local CAMRA branch Pub of the Year.
◖▣❖❀

Uplands Tavern ✅

42 Uplands Crescent, Uplands, SA2 0PG
☎ (01792) 458242
Greene King Abbot, IPA; 2 changing beers (sourced locally) ⊞
Situated in the heart of Swansea's student quarter, the Tav attracts regulars from all walks of life, and has a reputation for the quality and variety of its live music at weekends. Open mic night is Monday. The large single-room pub is a former haunt of Dylan Thomas, who is commemorated in a separate snug area. Quiz night is Tuesday. Shufl board (shuffleboard with a concave playing surface) is a popular game here. There is a large heated outdoor drinking area. ❀&♣▣❀

Trefforest

Otley Arms ⓛ

Forest Road, CF37 1SY (150yds from station)
☎ (01443) 402033 ⊕ otleybrewpubandkitchen.com
6 changing beers (sourced regionally; often Mabby, Salopian) ⊞
Hospitable brewpub, appealing to drinkers and diners. Home to Mabby Brewing, three changing beers from the Mabby range are always available, plus three guests – check out both bar counters to see the full range. Staff are happy to offer advice on the beers. The kitchen menu includes a wide range of meals including vegan options. Open plan throughout, a recent outdoor area adds to the variety. A firm favourite with students, the pub is an easy walk from the nearby university. Close to Trefforest Station and bus route 100 to Pontypridd.
⑤❀◖≠♣♠▣(90,100)❖❀

Rickards Arms ⓛ
61 Park Street, CF37 1SN
☎ (01443) 402305
🌐 therickardsarms-pontypridd.foodndrink.uk
Grey Trees Diggers Gold; 1 changing beer (sourced locally) Ⓗ
Easy-to-find pub close to Trefforest railway station, also on bus route 100 to Pontypridd. Backing onto the railway line, the large beer garden is popular with the student population and locals alike. Recently renovated, the central bar serves the main and raised drinking areas. Beers are always well kept and of high quality. Classic pub food is exceptional value. Open early until late, seven days a week. ⠀⠀⠀(90,100)⠀

Tyla Garw

Boars Head
Coedcae Lane, CF72 9EZ (600yds from A473 over level crossing)
☎ (01443) 225400
3 changing beers (sourced nationally) Ⓗ
This former local CAMRA award-winning pub has now shifted focus towards the food trade. However, the comfortable bar area, serving up to three real ales and a selection of keg beers, is popular with a local and regular clientele. To the rear of the pub is a popular coffee shop. Booking is advised for Sunday lunch. There is a quick walking route to Pontyclun railway station from here through an industrial estate. Q⠀⠀⠀⠀(Pontyclun)P

Upper Killay

Railway Inn ⓛ
553 Gower Road, SA2 7DS
☎ (01792) 203746
Swansea Bishopswood Bitter, Original Wood, Three Cliffs Gold; 1 changing beer Ⓗ
Classic locals' pub set in woodlands in the Clyne Valley. The adjacent former railway line forms part of Route 4 of the National Cycle Network. There are two small rooms at the front – one the main bar/snug – and a larger lounge at the rear. In winter the fire in the lounge provides welcome warmth and cheer. At least one guest ale is kept alongside the Swansea Brewing Company beers. A large area outside hosts occasional barbecues and music events. Q⠀⠀⠀P⠀(118)⠀

Wick

Star Inn
Ewenny Road, CF71 7QA
☎ (01656) 890080 🌐 thestarinnwick.co.uk
Wye Valley HPA; 2 changing beers (often Glamorgan) Ⓗ
Originally three farm cottages, the interior comprises a traditional bar with pew seating, a lounge/diner with flagstone flooring – both warmed by log-burning fires – and an upstairs pool/function room. The friendly landlady, staff and locals help make this a pleasant place to visit. Good food is available – the meat is supplied by an award-winning farm butcher a short distance away. Dogs are welcome in the bar. A former local CAMRA Pub of the Year. Q⠀⠀⠀⠀P⠀(303)⠀

Ystalyfera

Wern Fawr ⓛ
47 Wern Road, SA9 2LX (pub is on the main road through Ystalyfera)
☎ (01639) 843625

9 Lives Amber, Dark, Gold; 1 changing beer (sourced regionally; often Glamorgan, Grey Trees, Pitchfork) Ⓗ
Entering this quirky pub feels like stepping back in time. Run by the same family for three generations, the two-roomed inn is full of industrial memorabilia from the local area. It has a cosy lounge and a friendly locals' bar with an old-fashioned stove that keeps the room toasty in wintertime. The beers are brewed locally by 9 Lives Brewing, accompanied by one changing guest ale. Q⠀⠀(X6,121)⠀

Breweries

Bang-On
Unit 3, George Street, Bridgend Industrial Estate, Bridgend, CF31 3TS
☎ (01656) 760790 🌐 bangonbrewery.beer

Established in 2016, this five-barrel plant produces a variety of unique beers. An onsite taproom offers tours and brew day experiences. Limited edition beers are also available. A bespoke service is offered with personalised labels (minimum of six bottles). ⠀⠀⠀⠀

DAD (ABV 3.9%) PALE
Tidy (ABV 4%)
Cariad (ABV 4.1%) BITTER
Bohemian Pilsner (ABV 4.2%)
Thirst Aid (ABV 4.4%) PALE
Fuster Cluck (ABV 9.5%) STRONG

Beer Riff
Pilot House Wharf, Swansea, SA1 1UN ☎ 07897 895511 🌐 beerriffbrewing.com

⊠ An offshoot of Pilot Brewery Mumbles. The four-barrel brewery produces keg and canned beers that are unfiltered and unfined. It offers a variety of styles including one-offs. The integral tap house bar offers great views over Swansea Marina.

Borough Arms
🍴 **2 New Henry Street, Neath, SA11 2PH**
☎ (01639) 644902 🌐 boroughbreweryneath.com

⊗The Borough Arms and Borough Brewery were bought by new owners in 2019. The brewery is at the rear of the pub and has been refurbished. Beers brewed are only available at the pub.

Boss SIBA
176 Neath Road, Landore, Swansea, SA1 2JT
☎ (01792) 450978 ☎ 07825 525735
🌐 bossbrewing.co.uk

⊠ The brewery opened in 2015 by Roy Allkin and Sarah John, using a 10-barrel plant. It relocated in 2017 to larger premises opposite the Liberty Stadium which now includes an onsite tap – the Brewery Bar. Expansion has resulted in the setting up of bottling, canning, kegging as well as casking facilities. 250 outlets are supplied, bottles and cans are distributed to national retailers. In a further trade expansion, exports to France and Germany commenced in 2017. ⠀⠀◆LIVE

Blonde (ABV 4%) BLOND
Saint or Sinner (ABV 4%) PALE
Blaze (ABV 4.5%) GOLD
Beetlejuice (ABV 4.8%) PALE
Bare (ABV 5%) SPECIALITY
Black (ABV 5%) STOUT

Brains IFBB

Dragon Brewery, Pacific Road, Cardiff, CF24 5HJ
☎ (029) 2040 2060 ⊕ sabrain.com

☺There have been significant changes in the recent year, the largest of these being the disposal of the tied estate, in the main to Carlsberg Marston's Brewing Co. However, the brewery itself continues and has aspirations to become a national brewer. It still produces the Brains range of beers which appear in its former pubs as part of a supply deal. ♦

Dark (ABV 3.5%) MILD
A tasty, classic dark brown mild, a mix of malt, roast, caramel with a background of hops. Bittersweet, mellow and with a lasting finish of malt and roast.

Bitter (ABV 3.7%) BITTER
Amber-coloured with a gentle aroma of malt and hops. Malt, hops and bitterness combine in an easy-drinking beer with a bitter finish.

SA (ABV 4.2%) BITTER
A mellow, full-bodied beer. Gentle malt and hop aroma leads to a malty, hop and fruit mix with a balancing bitterness.

SA Gold (ABV 4.2%) GOLD
A golden beer with a hoppy aroma. Well-balanced with a zesty hop, malt, fruit and balancing bitterness; a similar satisfying finish.

Rev James Original (ABV 4.5%) BITTER
A faint malt and fruit aroma with malt and fruit flavours in the taste, initially bittersweet. Bitterness balances the flavour and makes this an easy-drinking beer.

Contract brewed for Molson Coors:
M&B Brew XI (ABV 3.6%) BITTER
Hancocks HB (ABV 3.7%) BITTER
Worthington's Bitter (ABV 3.7%) BITTER

Brew Monster SIBA

Unit 1, Lon Y Twyn, Caerphilly, CF83 1NW ☎ 07772 869856 ⊕ brewmonster.co.uk

☒ Brew Monster launched in 2017. The core range of ales is available in all formats and is brewed in rotation. Brewing relocated from Cwmbran to Caerphilly in 2021; the brewery is housed alongside a new taproom which opened in 2022. The move brought about a change to the core range with new ales introduced alongside some older favourites. One-off beers are also regularly produced. Two 'Tap' bars are in Cardiff city centre and Cardiff Bay (no real ale), as well as the Caerphilly outlet. ♦

Leviathan IPA (ABV 4%) PALE
Ghoul (ABV 4.3%) RED
Phoenix (ABV 4.5%) BITTER
Basilisk (ABV 5%) IPA
Black Widow (ABV 5.4%) STOUT
Djinn (ABV 5.4%) IPA

Brewhouse & Kitchen SIBA

🍴 **Sophia Close, Pontcanna, Cardiff, CF11 9HW**
⊕ brewhouseandkitchen.com

☺Part of the Brewhouse & Kitchen chain, producing its own range of beers. Carry outs and brewery experience days are offered. A former lodge, it has been extended and offers large outdoor areas at the front and rear. ‼

Cerddin

🍴 c/o Cross Inn, Maesteg Road, Maesteg, Cwmfelin, CF34 9LB

☎ (01656) 732476 ☎ 07949 652237
⊕ cerddinbrewery.co.uk

Brewpub established in 2010 using a 2.5-barrel plant in a converted garage adjacent to the pub, now enlarged to a four-barrel plant. Beer is usually only available in the pub. Seasonal beers brewed. ‼♦LIVE

Coach

🍴 **37 Cowbridge Road, Bridgend, CF31 3DH**

Office: 2 Oldfield Road, Bocam Park, Bridgend, CF35 5LJ

Coach Brewing Co is a brewpub based at the award-winning free house the Coach. Launched in 2018, the brewery is located in the middle of the pub for all to see. Occasional seasonal additions are brewed. Beers are also available in keg.

Coalshed (NEW)

69 Pen-Y-Bryn, Caerphilly, CF83 2JZ

Nanobrewery based in Penyrheol, Caerphilly brewing modern ales situated in a former Coalshed in the garden of the brewer.

Honey It's Going Down (ABV 4.3%) GOLD
Mosaic Monster (ABV 4.5%) PALE
Black As Coal (ABV 5%) STOUT
Fallout (ABV 6.5%) PALE
Mango Madness (ABV 6.7%) PALE

Cold Black Label SIBA

5 Squire Drive, Brynmenyn Industrial Estate, Bridgend, CF32 9TX
☎ (01656) 728081 ⊕ coldblacklabel.co.uk

Cold Black Label was initially founded in 2004, concentrating on its eponymous lager brand, and expanded on to cask-conditioned beers 10 years later. In 2018, Cold Black Label and Brecon Brewing merged, with Buster Grant taking over all brewing, and 14 new beers were created. In 2019, Lithic Brewing joined the group, with these gluten-free beers mainly available in keg and can, with the occasional release of casks. ☛GF V

Glyder Fawr (ABV 4.2%) GOLD
Singing Sword (ABV 4.2%) SPECIALITY
Harlech Castle (ABV 4.4%) BITTER
Uncle Phil's Ale (ABV 4.4%) SPECIALITY
Bwlch Passage (ABV 4.5%) SPECIALITY
Chirk Castle (ABV 4.6%) GOLD
Miners Ale (ABV 4.6%) STOUT
Sand Storm (ABV 4.6%) GOLD
Guardian Ale (ABV 4.7%) GOLD
Crib Goch (ABV 5%) PALE
Nutty Ale (ABV 5%) BROWN
Pirate Bay (ABV 5%) PALE
Red Beast (ABV 6%) IPA
Miners Imperial Ale (ABV 7.5%) STOUT

Brewed under the Brecon Brewing name:
WRU Gold (ABV 4%) GOLD
Copper Beacons (ABV 4.1%) BITTER
Gold Beacons (ABV 4.2%) GOLD
Orange Beacons (ABV 4.3%) SPECIALITY
Cribyn (ABV 4.5%) GOLD
Corn Du (ABV 5%) PALE
Red Beacons (ABV 5%) IPA
WRU IPA (ABV 5%) BITTER
Pen y Fan (ABV 6%) IPA
Mind Bleach (ABV 10%) IPA
Mind Peroxide (ABV 10%) IPA

Brewed under the Lithic name:

Session IPA (ABV 4%) BITTER
Pale Ale (ABV 4.7%) PALE
Porter (ABV 4.8%) PORTER
Chocolate Vanilla Stout (ABV 5%) SPECIALITY

Crafty Devil

Unit 3, The Stone Yard, Ninian Park Road, Cardiff, CF11 6HE ☎ 07555 779169
⊕ craftydevilbrewing.co.uk

⊗ Brewery has been in current location since 2017. It does not currently brew cask ale regularly, but produces bottled, canned and keg beer, which are supplied to markets and a number of other outlets in the local area. It currently operates two microbars, one in Cardiff and one in Penarth. ‼️▛

Crafty Dragon

8 Castell Morlais, Ponsticill, Merthyr Tydfil, CF48 2YB
☎ (01685) 723544 ☎ 07967 274272
✉ butchersbunkhouse@gmail.com

⊛ Crafty Dragon began brewing in 2017 and is situated within the Brecon Beacons National Park. Its brewery tap is the Butchers Arms in Pontsticill. Brewing is currently suspended.

Dog's Window

8 Nant-Yr-Adar, Llangewydd Court, Bridgend, CF31 4TY ☎ 07929 292930
⊕ dogswindowbrewery.com

Dog's Window is a small-batch brewery which started production in 2018, producing a range of craft beers to its own recipes. It has a core range of eight beers with an ever-changing list of limited editions under the banner of the Experimental Series. The mainstay of production is bottled beers, with the occasional keg. The brewery can sell bottles direct to the public by appointment (see website). ▛◆LIVE

Fairy Glen

5 The Corn Store, Heol Ty Gwyn, Maesteg, CF34 0BG
☎ 07968 847878

Office: 60 Oaklands Avenue, Bridgend, CF31 4ST

This 10-barrel brewery commenced in 2018, producing keg and canned beers. It has its own canning facility.

Flowerhorn

The Bridge Studios, 454 Western Avenue, Cardiff, CF5 3BL ⊕ flowerhornbrewery.co.uk

Established in 2019 by two friends, Andrew and Arran. Brewing was initially on a gypsy basis, and beers were available in bottle and keg only. In 2020 the brewery moved to its own premises in Cardiff with a bespoke five-barrel plant. A taproom is open Friday to Sunday. A canning line is planned. Beers are occasionally available cask-conditioned for beer festivals. ◆

Frank & Otis

Hanlons Hill Farm, Half Moon Village, Exeter, EX5 5AE

Office: Unit 7a, First Floor Offices, Moy Road Business Centre, Taffs Well, CF15 7QR
✉ info@frankandotisbrewing.co

Frank & Otis was estalished in 2019 with all beers contract brewed by Hanlons. In 2021, it opened its one-barrel onsite brewery for smaller bottle runs. All

production is bottled. It is currently in the process of relocating to a new site in Cardiff. ▛

Freetime

19 St Lukes Court, Clarke Way, Winch Wen, Swansea, SA1 7ER ☎ 07291 253227 ⊕ hello@freetimebeer.co

Microbrewery operations began in 2016, brewing small batches of craft beer available in bottles, keg and cask, under the name West by Three. Brewing is currently suspended.

Gil's

12 Greenfield Avenue, Dinas Powis, CF64 4BW
☎ 07882 076321

Brewing began in 2018. Beer is available in kegs and bottles. Brewing is currently suspended.

Glamorgan SIBA

Unit B, Llantrisant Business Park, Llantrisant, CF72 8LF
☎ (01443) 406080

Office: Unit J, Llantrisant Business Park, Llantrisant, CF72 8LF ⊕ glamorganbrewingco.com

⊛ This family-owned and run brewery moved to its present site in 2013. Production capacity has increased significantly year-on-year and a new, bigger brewery is anticipated. A range of year-round and seasonal ales are produced, with additional brews to mark notable events. The brewery shop is open daily and arranged group brewery tours are available. Direct deliveries are made throughout Wales and distributed further afield by selected wholesalers and breweries. ▛◆

Cwrw Gorslas/ Bluestone Bitter (ABV 4%) BITTER
Welsh Pale Ale (ABV 4.1%) PALE
Jemima's Pitchfork (ABV 4.4%) BITTER
Thunderbird (ABV 4.5%) BITTER

Gower SIBA

Unit 25, Crofty Industrial Estate, Pen-clawdd, Crofty, SA4 3RS
☎ (01792) 850681 ⊕ gowerbrewery.com

⊗ Established in 2011 on a five-barrel brew plant at the Greyhound Inn, Llanrhidian. In 2015 it moved to a new 20-barrel brewery in Crofty, Gower. Seasonal and speciality ales are brewed alongside established beers. An onsite taproom was added in 2021 with promo events held (see website for details). ‼️▛◆⚭

Brew 1 (ABV 3.8%) BITTER
Best Bitter (ABV 4.5%) BITTER
Gold (ABV 4.5%) GOLD
Rumour (ABV 5%) RED
Shipwreck (ABV 5.1%) PALE
Power (ABV 5.5%) BITTER

Grey Trees

Unit 5-6, Gas Works Road, Aberaman, Aberdare, CF44 6RS
☎ (01685) 267077 ⊕ greytreesbrewing.com

National award-winning, small brewery from the Welsh heartlands, now in its twelfth year. Beer is available from its own National Tap in Aberdare, and from local free houses, sometimes further afield. Expansion is planned. ▛◆LIVE

Caradog (ABV 3.9%) BITTER
Black Road Stout (ABV 4%) STOUT
Diggers Gold (ABV 4%) GOLD

Drummer Boy (ABV 4.2%) BITTER
Mosaic Pale Ale (ABV 4.2%) PALE
Valley Porter (ABV 4.6%) PORTER
JPR Pale (ABV 4.7%) PALE
Afghan Pale (ABV 5.4%) PALE

Little Goat

Ynysmeurdy, Pontardawe, SA8 4PP ☎ 07590 520457
🌐 littlegoatbrewery.co.uk

A 2.5-barrel brewery in an outbuilding of owner's private house. The main output goes into bottles but as pub trade picks up, there will be greater concentration on the range of cask beers. All beers are suitable for vegans, being unfined and unfiltered. Brewery holds stalls at local markets for sale of bottles. Distribution of beers is to local areas as wholesalers are not used. V

Siencyn (ABV 4%) RED
Scapegoat (ABV 4.3%) BITTER
Golden Goat (ABV 4.4%) GOLD
Jumping Jack (ABV 4.9%) BITTER
Yankee Doodle Nanny (ABV 6.5%) SPECIALITY
Satan's Little Helper (ABV 6.6%) STOUT

Mabby

🍺 **Mabby Brew Pub & Kitchen, Forest Road, Trefforest, CF37 1SY**
☎ (01443) 402033

Brewpub in the cellar of the Otley Arms supplying the pub and few other outlets. The name is derived from a partnership between brewer Matt Otley and his wife Gabby. The beers have no names as such and each recipe is referred to as a colour, with that colour being reflected on the pumpclip. In response to the recent increase in takeaway purchases, the beers have been made available in five litre casks.

Mad Dog

17-19 Castle Street, Cardiff, CF10 1BS ☎ 07864 923231 🌐 maddogbrew.co.uk

Brewing began in 2014. It relocated from Penperllini to the centre of Cardiff, opposite the castle in a street corner plot. Its new premises includes a taproom. At present, cask-conditioned beers are not being brewed, although its output consists of live beer. ♦

Mountain Hare

🍺 **Mountain Hare Inn, Brynna Road, Brynnau Gwynion, CF35 6PG**
☎ (01656) 860453 🌐 mountainhare.co.uk

☺Paul Jones, licensee of the Mountain Hare, finally realised his ambition of installing a brewery in his family-owned pub. A 1.5-barrel, custom-built brewing plant was installed, and the beer first went on sale in 2013. Paul plans to increase to a six-barrel plant to keep up with demand. Finings are no longer used so the beers have a slight natural haze and are suitable for vegans. Beer is only available in the pub. Brewing is currently suspended. V

Mumbles SIBA

Unit 14, Worcester Court, Swansea Enterprise Park, Swansea, SA7 9FD
☎ (01792) 792612 ☎ 07757 109938
🌐 mumblesbrewery.co.uk

⊠ Mumbles Brewery was established in 2011 and began brewing in 2013. In 2015, the brewery moved to a new permanent location, with a 10-barrel plant. Director/

brewer Rob Turner supplies numerous pubs in South Wales and the Bristol area. 🍺♦

Hop Kick (ABV 4%) PALE
Mile (ABV 4%) PALE
Malt Bitter (ABV 4.1%) BITTER
Murmelt (ABV 4.2%) SPECIALITY
Gold (ABV 4.3%) PALE
Beyond The Pale (ABV 4.4%) SPECIALITY
Oystermouth Stout (ABV 4.4%) STOUT
Lifesaver Strong Bitter (ABV 4.9%) BITTER
India Pale Ale (ABV 5.3%) PALE
Albina New World Pale (ABV 5.7%) IPA
Chocolate Vanilla Porter (ABV 6.2%) PORTER

Pilot Brewery

🍺 **726 Mumbles Road, Mumbles, Swansea, SA3 4EL**
☎ 07897 895511 🌐 thepilotbrewery.co.uk

☺The Pilot Brewery began production on its 2.5-barrel plant in 2013. It is located at the rear of the Pilot Inn on the Mumbles sea front. The output is mainly for the pub but can also be supplied to festivals and other select outlets. The proprietors have also set up BeerRiff brewery (qv).

Pipes

183A Kings Road, Cardiff, CF11 9DF ☎ 07776 382244
🌐 pipesbeer.co.uk

Pipes Beer create examples of some of the unique and least known beer styles from around the globe. No preservatives or additives are used in production. The main output is bottled and keg beers although the occasional cask beer is produced. 🍺♦

Swansea

🍺 **Joiners Arms, 50 Bishopston Road, Bishopston, Swansea, SA3 3EJ**
☎ (01792) 232658

☺Opened in 1996, Swansea was the first commercial brewery in the area for almost 30 years. Beers are regularly available at the Joiners and also the Railway Inn, Killay. ‼♦

Tomos & Lilford SIBA

Unit 11b, Vale Business Park, Llandow, Cowbridge, CF71 7PF
☎ (01446) 677757 ☎ 07747 858514

Office: 117 Boverton Road, Llantwit Major, CF61 1YA
✉ info@tomosandlilford.com

⊠ Tomos & Lilford was launched in 2013 by homebrewers Rolant Tomos, and brothers Rob and James Lilford. The brewery supplies pubs and clubs across the Vale of Glamorgan and further afield. 🍺♦

Summerhouse (ABV 3.6%) BITTER
Gwenith Du (ABV 4%) SPECIALITY
Nash Point (ABV 4%) BITTER
Vale Pale Ale (ABV 4.3%) PALE
Southerndown Gold (ABV 4.6%) GOLD
Big Boot (ABV 4.8%) BROWN

Twin Taff

8 Jenkins Place, Twynrodyn, Merthyr Tydfil, CF47 0ND
☎ 07564 187945 ✉ twintaffbrewery@outlook.com

☺Twin Taff was established in 2018 by twin brothers Darryl and Daniel Williams. It is Merthyr Tydfil's first town centre microbrewery. Brewing is currently suspended.

Twt Lol SIBA

Unit B27, Trefforest Industrial Estate, CF37 5YB
☎ 07966 467295 ⊕ twtlol.com

Established in 2015 using a 10-barrel plant, the brewery has a capacity of 80 firkins a week, with the potential to expand to 160. All of its branding is produced in both Welsh and English. The brewery is now open on the first weekend of each month. ‼☞◆

Bwgan Brain/ Scarecrow (ABV 3.5%) BITTER
Buwch Goch Gota/ Little Red Cow (ABV 3.7%) RED
Glog (ABV 4%) BITTER
Twti Ffrwti (ABV 4%) GOLD
Cwrw'r Afr Serchog/ Horny Goat Ale (ABV 4.2%) GOLD
Cymryd y Pyst (ABV 4.4%) BITTER
Lol! (ABV 4.4%) GOLD
Glo in the Dark (ABV 4.5%) PORTER
Blwbri (ABV 4.6%) SPECIALITY
Pewin Ynfytyn/ Crazy Peacock (ABV 4.8%) PALE
Pyncio Pioden IPA/ Pretty Fly For A Magpie (ABV 5%) PALE
Dreigiau'r Diafol/ Diablo Dragons (ABV 5.5%) IPA

Vale Of Glamorgan

Unit 42, Atlantic Business Park, Barry, CF64 5AB
☎ (01446) 730757 ⊕ vogbrewery.co.uk

⊛ Established 2005 and is now in its third generation of ownership, this 10-barrel brewery moved to a bigger site within Barry in 2022. It has two brands: heritage brand Vale of Glamorgan cask ales celebrating classic styles of yesteryear; and VOG, created in 2015, using predominantly US hops. New styles and recipes are planned. Seasonal lines, and collaborations with other brewers also take place. It has a bottle and a taproom (restricted opening times) and beers are available nationally. ◆LIVE ♦

Brewed under the VOG brand name:
Hotel Barrifornia (ABV 4%) PALE
South Island (ABV 4.2%) PALE

Tomos Watkin SIBA

Unit 3, Alberto Road, Century Park, Valley Way, Swansea Enterprise Park, Swansea, SA6 8RP
☎ (01792) 797280 ⊕ tomoswatkin.com

⊛Brewing began in 1995, originally in Llandeilo behind the Castle Hotel. The brewery moved to Swansea in 2000 and was taken over by Hurns Mineral Water Company in 2002. More than 60% of production is bottled beer (not bottle-conditioned). ‼☞◆♦

Delilah (ABV 4%) GOLD
Swansea Jack (ABV 4%) GOLD
Old Style Bitter/OSB (ABV 4.5%) BITTER
Amber-coloured with an inviting aroma of hops and malt. Full-bodied; hops, fruit, malt and bitterness combine to give a balanced flavour continuing into the finish.
IPA (ABV 4.8%) PALE
Pecker Wrecker (ABV 5%) BITTER

Well Drawn SIBA

Unit 5, Greenway Workshops, Bedwas House Industrial Estate, Caerphilly, CF83 8HW
☎ (029) 2280 2240 ⊕ welldrawnbrewing.co.uk

This six-barrel brewery opened in 2017 and operates out of an industrial unit on the outskirts of Caerphilly. It has four core ales, produces around another 12 as rotational/ seasonal ales, and also brews one-off ales for customers. It predominantly sells to the local market and nationwide via wholesale. Plans for the future include a new brand named Philly Brew Co, which pays homage to its love of Philadelphia, USA, and its roots within the Caerphilly borough. ‼♦LIVE

New Wave (ABV 4%) IPA
WD Gold (ABV 4.4%) GOLD
Red (ABV 4.7%) RED
2nd Breakfast IPA (ABV 5.1%) BITTER

Zepto

Graig Fawr Lodge, Blackbrook Road, Caerphilly, CF83 1NF ☎ 07951 505524 ⊕ zeptobrew.co.uk

Established in 2016, Zepto is a 100-litre brewery set up by CAMRA member Chris Sweet. Although production is mainly bottled, cask-conditioned beers are occasionally brewed. LIVE

Zerodegrees SIBA

🍴 27 Westgate Street, Cardiff, CF10 1DD
☎ (029) 2022 9494 ⊕ zerodegrees.co.uk

A chain of four brewpubs, the first began brewing in 2000 in Blackheath, London. Each incorporates a computer-controlled, German plant producing unfiltered and unfined ales and lagers. All beers use natural ingredients, are suitable for vegetarians, and are served from tanks using air pressure (not CO2).

Spores for thought

Yeast is a fungus, a single cell plant that can convert a sugary liquid into equal proportions of alcohol and carbon dioxide. There are two basic types of yeast used in brewing, one for ale and one for lager. (The yeasts used to make the Belgian beers known as gueuze and lambic are wild spores in the atmosphere). It is often said that ale is produced by 'top fermentation' and lager by 'bottom fermentation'. While it is true that during ale fermentation a thick blanket of yeast head and protein is created on top of the liquid while only a thin slick appears on top of fermenting lager, the descriptions are seriously misleading. Yeast works at all levels of the sugar-rich liquid in order to turn malt sugars into alcohol. If yeast worked only at the top or bottom of the liquid, a substantial proportion of sugar would not be fermented. Ale is fermented at a high temperature, lager at a much lower one. The furious speed of ale fermentation creates the yeast head and with it the rich, fruity aromas and flavours that are typical of the style. It is more accurate to describe the ale method as 'warm fermentation' and the lager one as 'cold fermentation'.

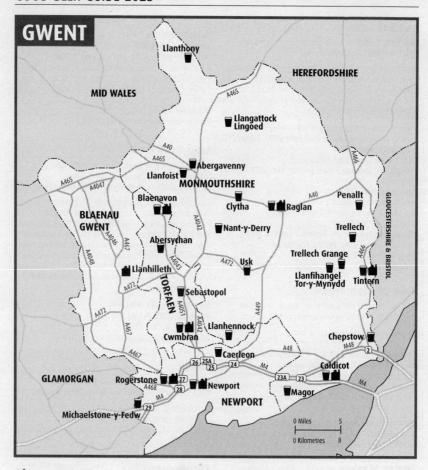

GWENT

HEREFORDSHIRE

MID WALES

Llanthony

Llangattock Lingoed

Abergavenny

Llanfoist

MONMOUTHSHIRE

BLAENAU GWENT

Blaenavon

Clytha

Raglan

Penallt

Nant-y-Derry

Trellech

Abersychan

Trellech Grange

Llanhilleth

Usk

Llanfihangel Tor-y-Mynydd

Tintern

TORFAEN

Sebastopol

Llanhennock

Cwmbran

Chepstow

GLAMORGAN

Caerleon

Caldicot

Rogerstone

Newport

Magor

NEWPORT

Michaelstone-y-Fedw

0 Miles 5

0 Kilometres 8

Abergavenny

Cantreff Inn

61 Brecon Road, NP7 7RA
☎ (01873) 855888
Grey Trees Diggers Gold; Wye Valley Butty Bach; 1 changing beer (often Grey Trees, Wye Valley) Ⓗ
A free house near the hospital; the area's only permanent outlet for Grey Trees' award-winning beers. Its characterful interior features low ceilings, a log fire, antique wall-clock and a variety of furniture. The cosy restaurant is popular at weekends. Picnic tables around the front door are great in warm weather, as is the suntrap rear garden. Well-behaved dogs are welcome. ⏳⌖◗P�# (X4) 🐾 🛜

Grofield Ⓛ

Baker Street, NP7 5BB
☎ (01873) 858939 🌐 grofield.com
Sharp's Doom Bar; 1 changing beer (sourced nationally; often Tomos & Lilford, Wye Valley) Ⓗ
A town-centre pub just off the main shopping street opposite the cinema, owned and run by the same family for many years. It serves a regularly changing guest beer from a local independent or popular regional brewer. Meals are offered lunchtime to mid-evening Wednesday to Saturday; booking is advised for the lunchtime Sunday roast. The well-maintained rear garden is a green oasis for alfresco eating and drinking. ⏳⌖◗♣�# (47) 🐾

Station Hotel

37 Brecon Road, NP7 5UH
☎ (01873) 854759
Draught Bass; Wye Valley HPA, Butty Bach Ⓗ
A short walk from the town centre, the Station remains a traditional, unspoilt pub, although the railway station it refers to is long gone. This solid building of local stone is one of CAMRA's Real Heritage Pubs of Wales. It has a separate bar and lounge plus a small outside drinking area. The pub hosts a Wednesday night quiz and often features music on Fridays with a band or open mic evening. P�# (X4) 🐾

Abersychan

Rising Sun Ⓛ

Cwmavon Road, NP4 8PP
☎ (01495) 773256
Wye Valley Butty Bach; 2 changing beers (sourced locally; often Rhymney, Tudor, Untapped) Ⓗ
Charming roadside pub whose characterful public bar houses a restored inglenook fireplace with log-burning stove. The cosy split-level lounge features another log stove and has pictures of the area on its walls. Beyond the lounge is a spacious dining room where functions can be held. Most of the weekly changing guest ales are Welsh. Outside is a pleasant garden and play area. The pub makes a good base for local walks through Lasgarn Wood. Q⏳⌖◗♣P�# (30) 🐾

Blaenavon

Lion Hotel

41 Broad Street, NP4 9NH
☎ (01495) 792516 ● thelionhotelblaenavon.co.uk
**House beer (by Tomos & Lilford); 1 changing beer
(sourced regionally; often Glamorgan, Tudor)** ⊞
A quality hotel that is enjoyed by regulars and visitors to
the local world heritage sites. Its interior features
contemporary artwork and is attractively decorated with
light wood and soft furnishing. The house beer and
changing guest ale are sourced from Welsh breweries.
Meals are available in the bar or the lower dining room;
the kitchen has an excellent reputation. Highlights of the
hotel's history are recorded on an exterior wall.
🗢🏮🚐◖❶≹(High Level Pontypool and Blaenavon)
P🚊(X24,30) 🛜

Caerleon

Bell Inn ✅

Bulmore Road, NP18 1QQ
☎ (01633) 420613 ● thebellcaerleon.co.uk
**Timothy Taylor Landlord; Wye Valley HPA, Butty
Bach** ⊞
Behind this pub's impressive stone façade are a fireside
bar, a snug and a cosy low-beamed restaurant. The walls
display prints of local features including historic
buildings. The beer range reflects local preferences; the
food offering is very popular. To the rear is a pleasant
secluded garden. Near the bar is a small war memorial
that is opened only on significant dates such as
Remembrance Day. 🗢🏮◖❶♣❶P🚊(27/28,29)🐾🛜

Caldicot

Hive Mind Brewery Taproom 🅛

Unit 5F, Castleway Industrial Estate, NP26 5PR (in
corner of private car park at end of Castleway)
☎ 07402 953998 ● wyevalleymeadery.co.uk
2 changing beers Ⓖ
An attractive and well-designed brewery taproom that
belies its unfashionable location on an industrial estate
on the eastern outskirts of town. It serves a successful
range of real ales brewed in the unit, plus the mead,
made with local honey, with which the enterprise began.
Two of the house beers are generally available,
alongside a choice of craft ales. A shortcut footpath leads
to the pub from a bus stop on the Caldicot bypass.
🏮♿≹P🚊(74) 🐾

Chepstow

Chepstow Athletic Club 🅛

Mathern Road, Bulwark, NP16 5JJ (off Bulwark Rd)
☎ (01291) 622126 ● chepstowac.co.uk
**Wye Valley Bitter, Butty Bach; 1 changing beer
(sourced regionally)** ⊞
A happy blend of community pub and sports club that
welcomes CAMRA members. It offers three keenly priced
cask ales, including at least one from Wye Valley.
Conversation gives way to live TV only for Wales rugby
internationals. Beyond the comfortable lounge is a patio,
perfect for relaxing on sunny summer weekends to
watch cricketers developing a thirst. Real ale is also
served in the large upstairs function room – another
reason why the club attracts so many local organisations.
🗢🏮♿♣P🚊(73,74)

Queen's Head ♥ 🅛

Moor Street, NP16 5DD
☎ 07793 889613

**8 changing beers (sourced regionally; often Gower,
Grey Trees, Untapped)** ⊞
The area's first micropub was a full-sized pub years ago
before a spell as business premises. Since launching in
the smaller form it has grown to include much-needed
additional drinking space. The welcoming bar counter's
array of handpumps dispenses real ales of various styles
and strengths. Natural ciders and perries are also served.
A blackboard dominates one wall listing the beverages
available. A multiple award winner, and local CAMRA Pub
of the Year 2022. Q≹❶🚐(69,74)🐾

Three Tuns Inn 🅛

32 Bridge Street, NP16 5EY
☎ (01291) 645797
**5 changing beers (sourced regionally; often
Butcombe, Kingstone, Untapped)** ⊞
A pleasant walk from the town centre and close to the
River Wye, this fine old inn sits in the shadow of the
stunning Chepstow Castle which towers over the lovely
beer garden. The local beers are attractively priced. At
lunchtime a good selection of locally sourced food can be
enjoyed in traditional surroundings. The pub is a popular
live music venue on Saturday evenings and Sunday
afternoons, with the garden stage used in fine weather.
🗢🏮🚐◖❶≹P🚊🐾🛜

Clytha

Clytha Arms 🅛

Groesonen Road, NP7 9BW (on the B4598 old road
between Abergavenny and Raglan) SO366088
☎ (01873) 840206 ● clytha-arms.com
**Untapped Whoosh; 4 changing beers (sourced
nationally; often Uley)** ⊞
Marking its 30th consecutive year in the Guide, this
country pub has won many awards. To the left through
the distinctive stained-glass arched front doors is the
welcoming but unfussy bar with its eclectic wooden
furniture, a wide choice of ales and a variety of local
ciders and perry. To the right, a dining area serves good-
quality food for which booking is recommended. The
extensive grounds offer an attractive drinking and dining
space in fair weather to complete the picture.
Q🗢🏮🚐◖❶♠♣❶P🚊(83) 🐾

Cwmbran

Bush Inn 🅛

Graig Road, Upper Cwmbran, NP44 5AN
☎ (01633) 483764 ● thebushuppercwmbran.co.uk
**3 changing beers (sourced regionally; often
Glamorgan)** ⊞
A cosy nook tucked into the slopes of Mynydd Maen; the
traditionally styled split-level interior giving a clue that
the pub was originally two cottages. Pictures of the inn
and its formerly industrial locality are on display. There is
typically an interesting selection of two or three guest
ales plus a choice of ciders to help slake thirsts. The food

REAL ALE BREWERIES

Anglo Oregon Newport
Be:Vito Cwmbran (NEW)
Hive Mind 🍴 Caldicot
Kingstone Tintern
Rhymney Blaenavon
Tiny Rebel 🍴 Rogerstone
Tudor 🍴 Llanhilleth
Untapped Raglan
Weird Dad ▤ 🍴 Newport
Zulu Alpha 🍴 Caldicot

menu features curry, pizza or steak on different evenings, with booking advisable. ☺🍴◑♣●P🚏(1,8) ♣ �“¶

Queen Inn

Upper Cwmbran Road, Upper Cwmbran, NP44 5AX
☎ (01633) 484252
2 changing beers (sourced regionally) 🅷
A youthful-looking Queen Victoria on the pub sign invites you into this popular venue with its attractive countryside backdrop. It was formerly three dwellings before becoming a pub. Separate sections cater for drinkers and diners, and there are extensive outdoor facilities. The move to an all-vegan menu has been popular. The food can be washed down by regularly changing ales, vegan where possible, and a choice of ciders. ☺🍴◑♣●P🚏(1,8)♣

Llanfihangel Tor-y-Mynydd

Star on the Hill

NP15 1DT (near Llansoy)
☎ (01291) 650256 ⊕ thestaronthehill.co.uk
Kingstone Gold; Wye Valley Butty Bach; 1 changing beer (sourced regionally; often Wye Valley) 🅷
The public bar is comfortably furnished with sofas and a large wood-burning stove, and has a Great Britain theme with Union Jack memorabilia. Between this and the restaurant is a cosy snug with sofa seating. A separate entrance leads to the restaurant where home-cooked food is made to order. It has three more fireplaces and extends into a large conservatory. Wheelchair access is at the back through the conservatory. Well worth seeking out. Q☺🍴◑&♣P♣

Llanfoist

Bridge Inn

Merthyr Road, NP7 9LH
☎ (01873) 854831 ⊕ bridgellanfoist.com
Glamorgan Jemimas Pitchfork; Rhymney Hobby Horse; Wye Valley Butty Bach 🅷
Attractive pub near the old stone bridge across the River Usk, offering lovely views across the Castle Meadows and up to the hills beyond. Inside is a split-level bar featuring a wood-burner on the lower level. TVs in the upper area show popular sports fixtures but otherwise do not interfere with conversation. The garden is popular in fine weather. Three en-suite rooms provide pleasant accommodation. Well-behaved dogs are welcome. ☺🏨◑●P🚏(X4) ♣ �",

Llangattock Lingoed

Hunter's Moon Inn

NP7 8RR (2 miles off B4521 Abergavenny-Ross old road at Llanvetherine at road bridge at end of village) SO361201
☎ (01873) 821499 ⊕ hunters-moon-inn.co.uk
Wye Valley HPA 🅷/🅶, **Butty Bach** 🅷; **1 changing beer (sourced regionally)** 🅷/🅶
Archetypal village pub next to a medieval church and the Offa's Dyke Path. It is a free house in which three family generations help create a great place to eat and drink. The interior's thick beams, low ceilings and flagstone floors reflect the building's antiquity. The large, well-maintained garden provides views of the church and surrounding unspoilt countryside. Q☺🏨◑♣P♣ 🌐

Llanhennock

Wheatsheaf

NP18 1LT (turn right 1 mile along Usk Road heading N from Caerleon, then bear left at fork) ST353927
☎ (01633) 420468
Fuller's London Pride; 2 changing beers (sourced regionally; often Glamorgan, Timothy Taylor, Wye Valley) 🅷
A fixture in this Guide for more than 30 years, the pub has remained almost unchanged over that time. The main bar is to the right, with a slightly smaller, cosier bar to the left. Walls are festooned with old photographs, bric-a-brac and memorabilia. The bar usually serves a beer from a local brewery. There are views of the hills miles away from front and back, plus a secluded garden. Boules is played seriously in the car park. ☺♣🅰P♣🌐

Llanthony

Half Moon

NP7 7NN (leave A465 Hereford Road at Llanfihangel Crucorney, turn near Skirrid Mountain Inn following signs to Llanthony and abbey. Continue for 6 miles, past abbey; pub is a few hundred yards further, on left) SO286279
☎ (01873) 890611 ⊕ halfmoon-llanthony.co.uk
Wye Valley Butty Bach; 1 changing beer (sourced regionally; often Wye Valley) 🅷
Soaring ridges and picturesque abbey ruins make this a wonderful remote spot, in the heart of the Black Mountains and near Offa's Dyke Path. The bar features a large log burner and stone-flagged floors, and is a focal point for the hamlet. Simple accommodation is available for getting away from it all. The lack of artificial light means notably dark skies and clearly viewed stars. Check opening times before travelling. Q☺🏨◑♣P♣

Magor

Wheatsheaf 🅻 ✅

The Square, NP26 3HN
☎ (01633) 880608 ⊕ wheatsheafinnmagor.co.uk
4 changing beers (sourced regionally) 🅷
There is something for everyone in this family-run pub at the heart of the village community. The spacious restaurant attracts hungry diners and there is plenty of room for those just wishing to enjoy a drink, either in the cosy lounge or the traditional Tap Room public bar, where darts and pool are played. Expect to see a locally-brewed ale alongside other guest beers from national and regional breweries. The interior is characterful with exposed stonework and low beams. ☺♣◑&♣P🚏(62,X74) ♣ 🌐

Michaelstone-y-Fedw

Cefn Mably Arms

CF3 6XS (turn N off A48 at Castleton, follow road for just over a mile)
☎ (01633) 680347 ⊕ cefnmablyarms.com
Wye Valley HPA, Butty Bach; 1 changing beer (often Wadworth) 🅷
A busy country inn with an emphasis on an excellent range of freshly prepared meals. Its layout reflects the foodie focus; the interior is divided into three dining areas. Two well-kept beers are served alongside a range of fine wines. Outside are attractive functional spaces to both front and rear. A celebrated ancient oak tree dominates the large car park. There is no nearby public transport. Q☺☺◑P♣ 🌐

Nant-y-Derry

Foxhunter Inn

NP7 9DN (either over railway line after passing through Penperlleni or just before the railway bridge if travelling from east)

☎ (01873) 881101 ⊕ foxhunterinn.com

Shepherd Neame Spitfire; Tomos & Lilford Nash Point; Wye Valley Butty Bach; 1 changing beer (sourced regionally; often Whitstable) ⊞

A fine old building that once served as the tea rooms for Nant-y-Derry station, which was opposite. Since reopening a few years ago it has been a popular bar and well-regarded restaurant. The garden seating area features heated wooden pods and a marquee. Entertainment is laid on occasionally. Accommodation is available in two adjoining cottages. ⑆✿⑪♿P✿

Newport

Godfrey Morgan ⊘

158 Chepstow Road, Maindee, NP19 8EG ST323883

☎ (01633) 221928

Brains SA; Greene King Abbot; Ruddles Best Bitter; Sharp's Doom Bar; 2 changing beers (sourced nationally; often Rhymney) ⊞

Named after the 1st Viscount Tredegar, survivor of the ill-fated Charge of the Light Brigade, this popular Wetherspoon pub was once a cinema and displays pictures of film stars with local connections. It stocks the usual range of national and regional ales, plus one or two more interesting options. The pub has a small car park at the rear, with some or all of the charge refundable with your first purchase. A real ale oasis in what has become a keg desert. Q⑆✿⑪♿P🚲(8,73)🛜

John Wallace Linton Ⓛ ⊘

19-21 Cambrian Road, NP20 4AD (off Queensway)

☎ (01633) 251752

Greene King Abbot; Ruddles Best Bitter; Sharp's Doom Bar; 3 changing beers (often Brains) ⊞

Wetherspoon's first Welsh outlet continues to attract a wide cross-section of customers. Its spacious interior has a corner dedicated to local WWII naval hero John Wallace 'Tubby' Linton, after whom the pub is named. An enthusiastic management team ensures that interesting guest ales are served alongside the regular beers. The chain's familiar food and drinks packages are offered. Seasonal beer and cider festivals help make this a popular venue. Handy for local shops and transport hubs. ⑆✿⑪♿➔P🚲🛜

Olde Murenger House

52-53 High Street, NP20 1GA

☎ (01633) 263977

Samuel Smith Old Brewery Bitter ⊞

Part of the fabric of Newport's history, this old establishment takes its name from the title of the officer who collected taxes for the upkeep of the town walls. It offers a pleasant and relaxing experience whether supping or dining. A Samuel Smith Brewery outlet with competitively-priced food and drinks, it is styled as a Victorian-era hostelry with wood panelling, high back settles, and memorabilia commemorating local celebrities past and present, and local landmarks and history. ⑪➔🚲✿

Pen & Wig Ⓛ

22-24 Stow Hill, NP20 1JD

☎ (01633) 666818 ⊕ jwbpubs.com/penandwig

Draught Bass; 5 changing beers (sourced regionally; often Brecon, Quantock, Tudor) ⊞

Popular city-centre pub with a traditional vibe. Boasting a wide range of ales and ciders mainly sourced from Wales and the West Country, Draught Bass remains the staple beer. The interior has several linked sections with a couple set aside for diners who enjoy the substantial fare on offer. TV screens are dotted around for sports coverage, including at the large deck patio at the rear. A large upstairs function room is available for hire. ✿⑪➔♿P🚲(151)✿

Red Lion ⊘

47 Stow Hill, NP20 1JH (on jct with Charles St)

☎ (01633) 961438

Wye Valley Butty Bach; 1 changing beer (sourced nationally; often Fuller's) ⊞

Styled as a traditional ale house with wooden casks and beer engines on display, this is where the local CAMRA branch was founded in 1974. Sport looms large here with a variety of sporting memorabilia dotted around the walls and TV screens delivering sports events in season. A games section is at the side of the bar with darts, pool, and the rarely seen shove-ha'penny. Two ales are usually on tap mainly from national brewers. ✿➔♣🚲(1,151)

Ruperra Arms

73 Caerphilly Road, Bassaleg, NP10 8LJ

☎ (01633) 376167

Fuller's London Pride; Glamorgan Welsh Pale Ale; Greene King Abbot; Sharp's Sea Fury ⊞

A cosy two-roomed pub that is a village local during the day before shifting its emphasis towards food at night. In winter a roaring fire near the bar counter provides a welcoming focal point. A decent selection of local and national ales is always available. The wide-ranging menu includes tapas for sharing; booking is advised if you are dining. The small outside area is a pleasant place for a beer and a chat. Q⑆⑪♿P🚲(50)✿🛜

St Julian Inn

Caerleon Road, NP18 1QA

☎ (01633) 243548 ⊕ stjulian.co.uk

Bath Ales Gem; Fuller's London Pride; 1 changing beer (sourced regionally; often Ludlow, Quantock, Wye Valley) ⊞

A long-standing Guide entry in a commanding position on the banks of the River Usk. Its riverside balcony gives pleasant views of the countryside and the ebb and flow of the tide, with small boats bobbing up and down at their moorings. The heart of operations is a central bar that serves several linked areas: balcony bar, public bar, games room and wood-panelled lounge. Decent pub grub can be enjoyed along with good ale, often of a light and hoppy style. ⑆✿⑪♣P🚲(27/28,29)✿🛜

Tiny Rebel

22-23 High Street, NP20 1FX

☎ (01633) 252538

Tiny Rebel Cwtch; 5 changing beers (sourced nationally; often Tiny Rebel) ⊞

The spiritual home of one of the UK's most progressive breweries. The modern bar attracts drinkers to sample a wide range of traditional and contemporary beer styles, both cask and craft. Diners can watch through a window at the back of the bar as their fast-food-done-well, such as burgers or wings, is cooked. Walls display Tiny Rebel's now-familiar quirky artwork. The Cwtch downstairs offers a quieter space when the main room is busy. ✿⑪♿➔♣🚲✿🛜

Weird Dad Brewery Tap

23 Caerleon Road, NP19 7BU

⊕ weirddad.co.uk

2 changing beers (sourced regionally) ⊞

A short stroll from the city centre and Rodney Parade sports ground, this craft beer shop and bar has its own nanobrewery. A small bar from which a mix of cask and other live beers are dispensed sits alongside two fridges full of bottled and canned delights. This area gives access to a marginally larger room with a screen displaying the drinks offerings. The centre of brewing operations can be viewed from here. Limited to 2pm opening from Friday to Sunday. ⬛(27/28,73)🛜

Penallt

Boat Inn
Lone Lane, NP25 4AJ SO535098
☎ (01600) 712615 ⬤ theboatpenallt.co.uk
Wye Valley HPA, Butty Bach; 1 changing beer (sourced regionally; often Kingstone) Ⓗ
This cosy two-roomed pub, nestling in its richly scenic Wye Valley setting, is best reached via a footpath alongside the neighbouring old rail bridge from Redbrook. A largely stone interior, log burners in both rooms are useful for colder days. Two Wye Valley ales and a varying guest are accompanied by several draught ciders. The extensive outdoor seating is ideal in fine weather. A good range of home-prepared dishes grace a tempting menu, which is particularly popular with walkers diverting from the nearby Wye Valley and Offa's Dyke long-distance paths. Closed on Tuesdays in winter.
🧒🏵️🚪🌙♣🅿🚆(69) 🐾

Raglan

Beaufort Arms
High Street, NP15 2DY
☎ (01291) 690412 ⬤ beaufortraglan.co.uk
Untapped Whoosh; Wye Valley Butty Bach Ⓗ
A family-owned former coaching inn, popular as a pub and for its quality hotel accommodation. Two regular ales, one each from Wye Valley and the village's Untapped brewery, are served in a cosy and creatively decorated bar. Beyond that is a large and comfortable lounge. Home-cooked meals often give a Mediterranean twist to traditional and modern local dishes, bringing an exotic taste to this peaceful corner of Wales.
🏵️🚪🌙🅿🚆(60,83) 🐾🛜

Rogerstone

Tiny Rebel Brewery Bar
Cassington Road, Wern Industrial Estate, NP10 9FQ
(off Chartist Drive for vehicles)
☎ (01633) 547378
Tiny Rebel Cwtch; 3 changing beers (sourced locally; often Tiny Rebel) Ⓗ
Modern, trendy barn of a place, with an upstairs balcony and views of the brewery through windows at the back. Much focus is on promoting the Tiny Rebel brand, with merchandising including T-shirts and cans. There is an impressive array of handpulls on the bar, though with some duplication. A huge screen and quality sound system mean the pub can get noisy during sporting events. The veranda with its comfortable seating is a suntrap in summer. 🧒🏵️🌙♣♿🅿🚆(151,56)🐾🛜

Sebastopol

Sebastopol Social Club Ⓛ
Wern Road, NP4 5DU (on corner of Wern Rd with Austin Rd)
☎ (01495) 763808
Wye Valley HPA; 1 changing beer (sourced regionally; often Glamorgan) Ⓗ

Real ale drinkers among this club's members have enjoyed a terrific range of beers and ciders over the years, earning the club many awards. It is open to visiting CAMRA members on production of a card. Attractions include live entertainment, many indoor sports and large TV screens. As well as the main room there is a cosy lounge, upstairs function room and downstairs pool room; all are put to good use.
🧒🏵️♿♣🅿🚆(X3,X24) 🐾🛜

Tintern

Wye Valley Hotel
Monmouth Road, NP16 6SQ
☎ (01291) 689441 ⬤ thewyevalleyhotel.co.uk
Wye Valley Bitter; 1 changing beer (sourced locally; often Kingstone) Ⓗ
A distinctively shaped traditional hotel offering the modern touches needed to appeal both to locals and to visitors who have travelled far to enjoy the superb local scenery. At least one Wye Valley ale is always served, often alongside a beer from the nearby Kingstone brewery. There is also an impressive display of special and commemorative bottled beers. Home-cooked food is available in the bar and the silver-service restaurant.
🧒🏵️🚪🌙♿🅿🚆(69) 🐾🛜

Trellech

Lion Inn
Church Street, NP25 4PA
☎ (01600) 860322 ⬤ lioninn.co.uk
Wye Valley Butty Bach; 3 changing beers (often Kingstone, Wye Valley) Ⓗ
Traditional country inn located in a history-steeped village that is well worth exploring. The charming bar is centred around a fireplace, and serves ales from breweries in South Wales and the West Country. A cosy lounge and dining area, on a slightly higher level, offers good food from an interesting menu. The pub hosts beer and cider festivals throughout the year. Local CAMRA Country Pub of the Year 2022.
Q🧒🏵️🚪🌙♣🅿🚆(65) 🐾🛜

Trellech Grange

Fountain Inn
NP16 6QW (turn left in Tintern by Royal George and follow road towards Trelleck) SO503011
☎ (01291) 689303 ⬤ fountaininntrellech.co.uk
Rhymney Export; Wye Valley Butty Bach; 1 changing beer (sourced locally; often Rhymney) Ⓗ
A fine 17th-century drovers' inn, in the countryside a few miles from Tintern Abbey, somewhat off the beaten track but worth seeking out. Three well-kept ales are available alongside one local cider. In winter two real fires keep you cosy; in summer the garden with its own brook is welcoming. Hours may vary so check ahead, especially in winter. 🧒🏵️🌙♣🅿🐾

Usk

New Court Inn
62 Maryport Street, NP15 1AD
☎ (01291) 671319 ⬤ thenewcourtinn.co.uk
Draught Bass; Glamorgan Welsh Pale Ale; Wye Valley Butty Bach Ⓗ
In a quiet backwater of this attractive town, the New Court Inn is a place where excellent food can be enjoyed in pleasant surroundings. Inside the entrance is a comfortable drinking area in which to enjoy the popular regular ales, occasional guest beers and ciders. To the

rear is a suntrap garden. Good-quality accommodation makes this a convenient base from which to explore the local area. Q☺☺⛄️◑)●🖥(60,63)🍴☂

Breweries

Anglo Oregon

Newport, NP19 4RR ☎ 07854 194966 ⊕ aobc.co.uk

Founded in the Forest of Dean in 2015, the brewery relocated to the owner's garage, in Nash in 2017. It only produces 300ml bottled ale, brewing 300 litres once a month (enough for 900 bottles). Three ales commemorate the wildlife in the nearby Gwent Levels, another three commemorate the 1839 'Newport Rising' which resulted in the massacre of many Chartists by troops. It has a license for off-sales from the brewery.

Be:Vito (NEW)

Unit 89, Springvale Industrial Estate, Cwmbran, NP44 5BH

Be:Vito is a nanobrewery and coffee shop.

Fox One

11 Brecon Walk, Southville, Cwmbran, NP44 3QF
✉ accounts@foxonebrewing.co.uk

Brewing began in 2021, producing bottles and mini kegs.

Hive Mind

Unit 5F Severn Bridge Industrial Estate, Caldicot, NP26 5PR ☎ 07402 983998

Office: 19 River View, School Hill, Chepstow, NP16 5AX ⊕ hivemindbrewery.co.uk

Hive Mind is the beer brewing part of Wye Valley Meadery. Brewing began in 2021 offering beers infused with honey from its own hives. Bottles and casks are available. ‼️🍺◆

The Pollinator (ABV 3.8%) PALE
Golden Hour (ABV 4.5%) GOLD
Honey Citra IPA (ABV 5.7%) IPA
Big Smoke (ABV 7%) PORTER

Interbrew UK

Magor Brewery, Magor, NP26 3DA

UK subsidiary of A-B InBev. No real ale.

> There is not a brewer who doesn't doctor his beer with something or other. Really something is in it.
>
> Four glasses made a Brooklyn man shoot down Dr Duggan in cold blood. Beer made a New York husband put a hole through his wife with a 22-calibre defender.
>
> Murder is in it. Who drinks lager beer is too apt to swallow the murder with it.
> **Elisha Chenery MD, 1889**

Kingstone

Tintern, NP16 7NX
☎ (01291) 680111 ⊕ kingstonebrewery.co.uk

Kingstone Brewery is located in the Wye Valley close to Tintern Abbey. Brewing began on a four-barrel plant in 2005. Special brews are marketed under the Hapax Brewing Co label. ‼️🍺LIVE

Tewdric's Tipple (ABV 3.8%) BITTER
Challenger (ABV 4%) BITTER
Gold (ABV 4%) GOLD
Llandogo Trow (ABV 4.2%) BITTER
No. 1 Premium Stout (ABV 4.4%) STOUT
Classic (ABV 4.5%) BITTER
1503 (ABV 4.8%) BITTER
Abbey Ale (ABV 5.1%) BITTER
Humpty's Fuddle IPA (ABV 5.8%) IPA

Lines

🏠 37a Bridge Street, Usk, NP15 1BQ
⊕ linesbrewco.com

Established in 2020, Lines is located to the centre of Usk. The brewery, led by the former Celt Experience head brewer, Tom Newman, occupies the ground floor of the pub on the High Street. The rustic upper taproom serves beer and pizza. No real ale. ◆

Rhymney

Gilchrist Thomas Industrial Estate, Blaenavon, NP4 9RL
☎ (01495) 790456 ☎ 07831 350635
⊕ rhymneybreweryltd.com

⊛Rhymney is now in its seventeenth year. The full range of beers are available in the 11 tied houses and are widely available in free houses throughout South Wales. Unashamedly traditional in its range of beers, the brewery continues to win a range of CAMRA awards. It is situated in the heart of a Unesco World Heritage Site, close to the National Mining Museum and the Blaenavon Iron Works. ‼️🍺◆LIVE

Hobby Horse (ABV 3.8%) BITTER
Dark (ABV 4%) MILD
Bevans Bitter (ABV 4.2%) BITTER
Golden Ale (ABV 4.2%) GOLD
General Picton (ABV 4.3%) BITTER
Export Light (ABV 4.4%) BITTER
Bitter (ABV 4.5%) BITTER
King's Ale (ABV 4.7%) BITTER
Export (ABV 5%) BITTER

Tiny Rebel

Wern Industrial Estate, Rogerstone, Newport, NP10 9FQ

Office: Sunnybank, St Brides, Wentlooge, Newport, NP10 8SQ ⊕ tinyrebel.co.uk

⊛Tiny Rebel is one of the leading craft breweries in the UK. Founded in Newport, Wales in 2012 by brothers-in-law Brad & Gazz. Originally using a 12-barrel plant, the brewery now operates a dual-stream, 30-barrel plant, and consists of 23 fermentation tanks, and four conditioning tanks. ‼️🍺◆

Cwtch (ABV 4.6%) RED

Tudor SIBA

Unit A, Llanhilleth Industrial Estate, Llanhilleth, NP13 2RX

☎ (01495) 214808 ☎ 07498 734896
⊕ tudorbrewery.co.uk

☺Tudor began brewing in 2007 in Abergavenny and moved it to Llanilleth in 2012. Several local pubs are supplied, in addition to others further afield. There is a bar and function room in the office suite above the brewery, for which it has acquired a full license. It brews 700 litres at a time, five times a week. LIVE ◆

Blorenge (ABV 3.8%) PALE
Black Mountain Stout (ABV 4%) STOUT
IPA (ABV 4%) PALE
Skirrid (ABV 4.2%) MILD
Super Hero (ABV 4.5%) PALE
Sugarloaf (ABV 4.7%) BITTER
Black Rock (ABV 5.6%) PORTER

Untapped

Unit 6, Little Castle Farm Business Park, Raglan, NP15 2BX
☎ (01291) 690074 ⊕ untappedbrew.com

Untapped relocated to its current premises in 2013. All beers except Triple S are vegan-friendly. The 'Premium Range' of beers has recently been introduced. Beers are available in cask or bottle-conditioned. !! ☐ ◆LIVE V

Border Bitter (ABV 3.8%) BITTER
Sundown (ABV 4%) GOLD
Monnow (ABV 4.2%) BITTER

Whoosh (ABV 4.2%) BITTER
Diolch (ABV 4.4%) IPA
UPA (ABV 4.5%) PALE
Triple S (ABV 4.9%) STOUT

Weird Dad

▤ Filling Station, 23-23a Caerleon Road, Newport, NP19 7BU ⊕ weirddad.co.uk

⊠ Started in 2021 from a homebrew background, this Brewtools-based setup has a 120-litre brew length with five fermenters. It produces beers over a variety of styles, all product is live beer, and about a third is cask-conditioned. The majority is dispensed at its onsite taproom, which include a bottleshop. !! ☐◆◆

Zulu Alpha

51b Symondscliffe Way, Caldicot, NP26 5PW ☎ 07578 196275/ 07899 794294
⊠ info@zulualphabrewing.co.uk

Brewing since 2018, Zulu Alpha is a seven-barrel brewhouse, and has six fermenters. A taproom at the brewery is open Friday/ Saturday, and there is an online shop. ◆

New Horizon (ABV 4%) SPECIALITY
Voyager (ABV 4.8%) PALE
Evolution (ABV 5.2%) PALE

All hands to the pumps

British beer is unique and so are the methods used for serving it. The best-known English system, the beer engine operated by a handpump on the pub bar, arrived early in the 19th century. It coincided with and was prompted by the decline of the publican brewer and the rise of commercial companies that began to dominate the supply of beer to public houses. In order to sell more beer, commercial brewers and publicans looked for faster and less labour-intensive methods of serving beer.

In The Brewing Industry in England, 1700-1830, Peter Mathias records that 'most beer had to be stored in butts in the publicans' cellars for the technical reason that it needed an even and fairly low temperature, even where convenience and restricted space behind the bar did not enforce it. This meant, equally inevitably, continuous journeying to and from the cellars by the potboys to fill up jugs from the spigots: a waste of time for the customer and of labour and trade for the publican. Drawing up beer from the cellar at the pull of a handle at the bar at once increased the speed of sale and cut the wage bill.'

The first attempt at a system for raising beer from cellar to bar was patented by Joseph Bramah in 1797. But his system – using heavy boxes of sand that pressed down on storage vessels holding the beer – was so elaborate that it was never used. But his idea encouraged others to develop simpler systems. Mathias writes: 'One of the few technical devices of importance to come into the public house since the publican stopped brewing his own beer was the beer engine. It was, from the first, a simple manually operated pump, incorporating no advances in hydraulic knowledge or engineering skill, similar in design to many pumps used at sea, yet perfectly adapted to its function in the public house.'

By 1801, John Chadwell of Blackfriars, London, was registered as a 'beer-engine maker' and soon afterwards Thomas Rowntree in the same area described himself as a 'maker of a double-acting beer-machine'. By the 1820s, beer engine services had become standard throughout most of urban England and Gaskell & Chambers in the Midlands had become the leading manufacturer, employing more than 700 people in their Birmingham works alone.

MID-WALES

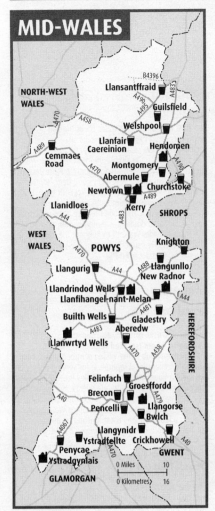

NORTH-WEST WALES

Llansantffraid
B4396
A490
A495
Guilsfield
A483
Welshpool
A458
Llanfair Caereinion
Hendomen
Cemmaes Road
A470
Montgomery
Abermule
Churchstoke
Newtown
A489
Llanidloes
Kerry
A44
SHROPS
A483

WEST WALES
POWYS
Knighton
A470
Llangurig
A44
A488
Llangunllo
New Radnor
Llandrindod Wells
Llanfihangel-nant-Melan
A481
A44
Builth Wells
Gladestry
A483
Aberedw
Llanwrtyd Wells
A470
A438

HEREFORDSHIRE

Felinfach
Groesffordd
Brecon
A479
Pencelli
Llangorse
Bwlch
A40
Llangynidr
Ystradfellte
Crickhowell
A40
Penycae
GWENT
Ystradgynlais

GLAMORGAN

0 Miles 10
0 Kilometres 16

A4067
A40

Aberedw

Seven Stars Inn
LD2 3UW (next to church)
☎ (01982) 560762 ⊕ sevenstarsaberedw.co.uk
2 changing beers
A community buyout saved this historic pub, close to an ancient 11th-century church, castle mound and scenic river gorge. It provides a welcome refreshment stop for village residents and visitors exploring the surrounding countryside. The large main bar features low beams, exposed stonework and a wood-burning stove. Check ahead for opening hours and food availability.
Q✧∿(D)点🛇♣P🌸🍴?

Abermule

Abermule Inn
SY15 6ND
☎ (01686) 639110
3 changing beers (sourced locally) Ⓗ
Known locally as the 'Hotel', this pub has had an impressive makeover in recent years. The existing render has been stripped back to reveal the original brickwork. It has a spacious public bar with sofas and a TV at one end,

plus a separate smart restuarant. The pub is now a free house serving two real ales. There is a patio for outside drinking, and a small caravan park at the rear.
✧✧❀(D)点🅰♣P🖵(X75,71) ?

Brecon

Brecon Tap
6A Bulwark, LD3 7LB
☎ (01874) 622353
4 changing beers (sourced regionally) Ⓗ
In a prime town-centre location, this contemporary bar has a light and airy feel, with comfortable seating throughout and walls lined with bottle-filled shelves. Three or four varying guest ales are served, often from Welsh breweries. There is also an interesting range of international and UK craft ales, plus simple food including sandwiches and pies. Bottled beers, wines, craft spirits and local artisan produce are available for off-sales.
Q✧(D)◆🛢🖵(T4,X43) 🐾?

Hop In Beer & Gin House
37 The Watton, LD3 7EG
☎ (01874) 622092 ⊕ hopinbeerandgin.co.uk
2 changing beers (sourced regionally; often Grey Trees) Ⓗ
Established in 2020 in difficult circumstances, the Hop In has quickly built an excellent reputation and strong following. Although compact, it has drinking areas on the ground and first floors, plus a small rear courtyard outside. It serves two regularly changing real ales, five craft beers on tap and a wide range of bottled and canned brews. The knowledgeable staff are happy to advise on the impressive range of around 40 gins. Food is tapas, and excellent; booking is essential.
Q✧❀(D)🖵(T4,X43) 🐾

Builth Wells

Fountain Inn ✔
7-9 Broad Street, LD2 3DT
☎ (01982) 553888
Wye Valley Butty Bach; 2 changing beers (often Salopian, Tiny Rebel) Ⓗ
Town-centre pub that is popular with locals. Decorated in a modern style, it retains a traditional feel with stonework, exposed floorboards and a welcoming wood-burner. The pub serves up to four regularly changing real ales plus a real cider. Pool and darts are played in the bar, and sports TVs show major events. Next door is a café area and an upstairs terrace with a view of the River Wye. (D)♣🌸P🖵

Bwlch

New Inn
Brecon Road, LD3 7RQ (on A40 between Brecon and Crickhowell)
☎ (01874) 730215 ⊕ beaconsbackpackers.co.uk
Wye Valley Butty Bach; 2 changing beers (sourced regionally; often Grey Trees, Oakham, Salopian) Ⓗ

REAL ALE BREWERIES

9 Lives Ystradgynlais
Heart of Wales 🍺 Llanwrtyd Wells
HWGGA 🔑 Llandrindod Wells
Left Bank Llangorse
Monty's Hendomen
Radnorshire New Radnor
Wilderness Newtown

Lively and cosy village pub popular both with locals and visitors. A comfortable dining area sits to the side of the stone-flagged bar, with armchairs around a huge fireplace. Two interesting guest beers supplement the regular ale, and good-value home-cooked food is served at weekends – the pies are deservedly popular. Bunkhouse accommodation is available, making this an excellent base for exploring the surrounding Brecon Beacons and Black Mountains. A frequent local CAMRA Pub of the Year and former South Wales Regional winner. Q᪶❄️🍴🅿️🚇(X43,43) 🐾 📶

Cemmaes Road

Dovey Valley Hotel ★

SY20 8JZ
☎ (01650) 511335 🌐 doveyvalleyhotel.com
2 changing beers (sourced locally; often Conwy, Evan Evans, Monty's) Ⓗ

Saved from the threat of closure in 2013, this unspoiled gem is now a dog-friendly pub and guest house. Identified by CAMRA as having a nationally important historic pub interior, it features original fittings, slate flooring and an open fire, and displays a photo of the now defunct Cemmaes Road signal box opposite. The pub serves a range of quality, mainly Welsh ales, plus food from Thursday to Sunday. Its large beer garden has a covered seating area. Q᪶❄️🍴🅿️🚇(T12)🐾📶

Churchstoke

Horse & Jockey

SY15 6AE
☎ (01588) 620060
2 changing beers (sourced regionally) Ⓗ

A prominent stone-built pub on the edge of the village. It serves a changing range of guest ales, plus up to nine real ciders and perries during the summer. The wood-beamed public bar hosts pool and darts. The carpeted lounge features comfortable armchairs and wall seating, and leads to a large, smart restaurant. A stone fireplace with wood-burning stove provides winter warmth. ᪶❄️🍴🅿️🚇(81) 🐾📶

Crickhowell

Bear Hotel

High Street, NP8 1BW
☎ (01873) 810408 🌐 bearhotel.co.uk
Brains Rev James Original; Glamorgan Jemimas Pitchfork; 2 changing beers (sourced regionally; often Boss, Butcombe, Gower) Ⓗ

Originally a 15th-century coaching inn, this is now an award-winning hotel and Guide regular. Its grand, multi-roomed bar features exposed beams, wood panelling, settles and an eclectic selection of furnishings and decorations. The two bar rooms have exposed fireplaces, as does one of the side rooms. Four ales are usually served, often including guests from independent Welsh breweries. Food is excellent and the menu features local produce. An ideal base for exploring the Black Mountains and Brecon Beacons National Park. Q᪶❄️🍴🅿️🚇(X43,43) 🐾

Treebeards Bar

Unit 2, 54 High Street, NP8 1BH
☎ (01873) 268668
Untapped Whoosh; 2 changing beers (often Grey Trees, Untapped) Ⓖ

Micropub in the heart of town, occupying part of what was the Corn Exchange pub before it was converted into award-winning smaller units. Established in recent years,

it has built a good reputation and brought variety to the local drinking scene. The comfortable bar has a friendly, cosy atmosphere. It serves up to three real ales straight from the cask plus a selection of craft beers, mainly from Welsh independent breweries. ᪶🍴🚇(X43,43)

Felinfach

Griffin Ⓛ

LD3 0UB (just off A470 3 miles NE of Brecon)
☎ (01874) 620111 🌐 eatdrinksleep.ltd.uk
3 changing beers (sourced locally) Ⓗ

The pub's ethos – the simple things in life done well – says it all. This is a welcoming country pub, restaurant and hotel whose emphasis is on good beer, sourced mainly from local breweries, and excellent food. The multi-roomed layout incorporates discrete areas for drinking and dining. The huge fireplace between bar and main dining area dominates during winter; an Aga in a side room provides warmth throughout the building. The large garden gives superb views of the surrounding mountains. Q᪶❄️🍴🅿️🚇

Gladestry

Royal Oak Inn

HR5 3NR
☎ (01544) 370586 🌐 theroyaloakgladestry.co.uk
2 changing beers (sourced regionally) Ⓗ

A 17th-century pub in the village centre, run by a couple with an excellent local reputation for serving quality ale and food. A house ale from Wye Valley Brewery is always among the beers, alongside two guests. The bar features a stone-flagged floor. The pub is on Offa's Dyke Path, in the wilds of Radnorshire, and welcomes walkers and dogs on a lead. It opens most lunchtimes and evenings but check before travelling. Q᪶❄️🍴🅿️🚇📶

Groesffordd

Three Horseshoes

LD3 7SN (just off B4558 in centre of village)
☎ (01874) 665672 🌐 threehorseshoesgroesffordd.com
St Austell Tribute; 2 changing beers (sourced regionally) Ⓗ

Busy village-centre pub in the heart of the Brecon Beacons, boasting superb views from its outdoor seating areas. It is only a 10-minute walk from the Brynich lock on the Monmouthshire & Brecon Canal and is a popular stop for boaters and other visitors. The pub's emphasis is on its excellent food but the ales are always varied and interesting. Brynich caravan site and the Brecon YHA are nearby. ᪶❄️🅿️🚇📶

Guilsfield

King's Head

SY21 9NJ
☎ (01938) 555930 🌐 kingsheadguilsfield.co.uk
2 changing beers (sourced locally; often Stonehouse, Three Tuns) Ⓗ

Excellent village pub featuring a large, carpeted open-plan bar. This has numerous secluded and comfortable drinking areas, and displays historic photos on the walls. To the right are a pool table and a couple of TVs; to the left is a spacious restaurant. There is a patio at the front for summer drinking, and a large rear garden and children's play area. ᪶❄️🍴🅿️🚇(X71,76)🐾📶

Kerry

Kerry Lamb

SY16 4NP

☎ (01686) 670226 ⊕ thekerrylambpowys.co.uk

Wye Valley Butty Bach; 2 changing beers (often Purple Moose, Three Tuns, Tudor) Ⓗ

Prominent red-bricked pub on the edge of the village, named after the Kerry Hill sheep. Locally owned, it seamlessly flits between its role as a community pub and restaurant, offering something for all tastes. It consists of a large lounge/bar, a games room and dining room. The St Michael and All Angels church backs on to the rear, giving a picturesque view from the beer garden during warmer weather. ಠ✿◑ఈ♣🖵(81)✿🛜

Knighton

Watsons Ale House

24 High Street, LD7 1AT (near clock tower – up pedestrian street, on left next to chippy)

☎ (01547) 740017

3 changing beers Ⓗ

Popular micropub near the clock tower, a regular haunt of discerning real ale drinkers. In a former life it was a tea room, and before that a butcher's shop – spot the hooks and cold-room door. It is now home to Watson's Real Powys farmhouse cider, which is sold on the premises. Walkers and dogs are welcome. Order food at the chippy next door to eat with your drinks. Q✿◑≉♣🖵(46)✿🛜

Llandrindod Wells

Middleton Arms

Tremont Road, LD1 5EB (corner of Trefonen Lane)

☎ (01597) 822066

1 changing beer (sourced regionally) Ⓗ

Friendly street-corner local at the north end of town on the road to Newtown, named after a prominent local Victorian architect. The pub serves a regular ale plus a weekly changing guest. It hosts darts, pool and dominoes teams, and shows sports channels on TV. Outside is an enclosed beer garden. Families and dogs are welcome. Q✿ಠ✿ఈ≉(Llandrindod) ♣🖵(461,T4)✿🛜

Llanfair Caereinion

Goat Hotel

High Street, SY21 0QS (off A485)

☎ (01938) 810428 ⊕ thegoathotel.co.uk

3 changing beers (sourced locally; often Stonehouse) Ⓗ

An excellent 300-year-old beamed coaching inn whose welcoming atmosphere attracts both locals and tourists. The plush lounge, dominated by a large inglenook with open fire, features comfortable leather armchairs and sofas. The real ale selection usually includes a Shropshire beer. Home-cooked food is served in the dining room. There is a games room at the rear. Beware the low-beamed entrance to the Gents. Q✿ಠ✿◑≉(Llanfair Caereinion Welshpool & Llanfair) ♣🖵(87)✿🛜

Llanfihangel-nant-Melan

Fforest Inn

LD8 2TN (jct of A44 and A481)

☎ (01544) 350526 ⊕ thefforest.co.uk

2 changing beers (sourced nationally) Ⓗ

A 16th-century former drovers' inn, steeped in history, now renovated while retaining many original features. It has established a reputation for quality beers, and serves regularly changing guest ales alongside the house brew. The food features fresh local produce. Well-behaved dogs are welcome in the bar and, by prior arrangement, in the accommodation rooms. Q✿ಠ✿◑◑🖵(461)✿

Llangunllo

Greyhound Ⓛ

LD7 1SP (off A488 on B4356, in village centre)

☎ (01547) 550400

1 changing beer (sourced nationally) Ⓗ

A traditional 16th-century pub in picturesque countryside, the first stop on the Glyndwr's Way long distance trail. An open fire maintains a cosy atmosphere on colder days; there is outside seating for fine weather. The owners are keen CAMRA members and take good care of their beers, which are usually from regional breweries. The pub hosts live music with open mic nights. Q✿ಠ✿Å≉(Llangunllo)♣♣P✿

Llangurig

Black Lion Hotel

SY18 6SG

☎ (01686) 440223

Three Tuns Best; 1 changing beer (sourced locally; often Three Tuns) Ⓗ

Originally a shooting lodge, the Black Lion was first licensed in 1633 and rebuilt as a hotel in the late 19th century. It has low ceilings and wooden beams, and is divided into two bars and a conservatory. The first bar acts as a games area, with pool and table skittles. The lounge/dining area has a stone fireplace, wall seating and settles. There is also a side room with comfortable armchairs. Q✿ಠ✿◑◑ఈ♣🖵(X75,525)✿🛜

Llangynidr

Red Lion

Duffryn Road, NP8 1NT (off B4558)

☎ (01874) 730223 ⊕ theredlion1.vpweb.co.uk

Wye Valley The Hopfather; 2 changing beers (sourced regionally) Ⓗ

Popular village local, situated away from the main road, offering a warm welcome to families, walkers, dogs and boaters – the Monmouthshire & Brecon Canal is a short walk away. The beer range changes regularly and good-value home-cooked food is served in the bar. A separate games area, outside seating and children's play space make this a pub for all. Regular quiz nights and live music also feature. ಠ✿◑◑♣P🖵✿🛜

Llanidloes

Crown & Anchor ★

41 Long Bridge Street, SY16 6EF

☎ (01686) 412398 ⊕ crown-anchor-inn-pub.business.site

Wye Valley Butty Bach; 2 changing beers (sourced regionally; often Purple Moose, Wye Valley) Ⓗ

A Grade II-listed pub affectionately nicknamed Ruby's after its long-serving former landlady, who retired a few years ago. It comprises five unspoilt rooms, one of which was a haberdasher's shop before becoming part of the pub in 1948. A small corridor links the rooms, one displaying guitars that visiting musicians are welcome to play. A middle room and snug are connected to the bar by glass serving hatches. A large outdoor area at the rear hosts regular music. Q✿✿♣🖵(X75,525)✿🛜

Llansantffraid

Station Grill Bar & Restaurant
Bodlonfa, SY22 6AD
☎ (01691) 828478 ● thestationgrill.co.uk
Stonehouse Station Bitter, Cambrian Gold; 1 changing beer (sourced nationally) ⊞
Spacious bar and restaurant in a former railway station that was closed by the Beeching cuts in the 1960s. The bar is friendly, with window seating. It has three handpumps, two of which serve Stonehouse beers. A large patio provides a drinking area with stunning views of the local countryside. Q ► ⊛ ◑ ◑ ₺ ♣ ● P ➡ (72,74) ♠

Montgomery

Dragon Hotel
Market Square, SY15 6PA
☎ (01686) 668359 ● dragonhotel.com
4 changing beers (sourced regionally; often Monty's) ⊞
Dating from the mid-1600s, this former coaching inn has a distinctive Tudor black-and-white half-timbered frontage. The bar has been relocated to the rear of the hotel, giving more space to the clientele. There are patio areas outside to the front and rear for alfresco drinking. The hotel boasts an indoor swimming pool and a large function room. Q ► ⊛ ⇱ ◑ ◑ ₺ ● P ➡ (T12,81) ♠ ♠

Newtown

Railway Tavern
Old Kerry Road, SY16 1BH (off A483)
☎ (01686) 626156
2 changing beers (often Clun, Stonehouse, Three Tuns) ⊞
Another year in the Guide for this unspoilt local near the railway station. The pub is essentially two areas, a lower bar and a rear section with benches and tables. Note the poster listing over 50 pubs that once served Newtown. Two guest beers are on offer, usually from regional or small breweries. The outside toilets are located through a passageway – mind the step. Q ⊛ ≉ ♣ ➡

Sportsman ⌷
17 Severn Street, SY16 2AQ (off A483)
☎ (01686) 623978
Monty's Sunshine; Salopian Shropshire Gold, Oracle; Wye Valley HPA, Butty Bach; 2 changing beers (sourced nationally) ⊞
Free house that was formerly Monty's tap house, and always has a Wye Valley and a Salopian beer on tap. The pub is divided into three areas – a snug with comfortable wall seating, a main bar area with a wood-burning stove and a rear tiled games area with pool table, TV and darts. There is a patio at the rear for summer drinking. A former local CAMRA Pub of the Year and Welsh Cider Pub of the Year. Q ⊛ ₺ ≉ ♣ ● ➡ ♠

Pencelli

Royal Oak ⍦
LD3 7LX
☎ (01874) 665396 ● theroyaloakpencelli.com
Brains Rev James Original; 3 changing beers (sourced regionally; often Grey Trees, Tudor) ⊞
Friendly family-run pub in a quiet village alongside the Monmouthshire & Brecon Canal. Its extended opening hours are welcome in this part of the Brecon Beacons. The regular ale is supplemented with two or three others, usually from independent Welsh breweries. The pretty garden next to the canal is a delight on a sunny day. Popular with walkers, cyclists and boaters, with moorings adjacent to the garden. Local CAMRA Pub of the Year 2022. Q ► ⊛ ◑ ◑ ₺ Å ♣ ● P ☍ ➡ (X43) ♠ ♠

Penycae

Ancient Briton
Brecon Road, SA9 1YY (on A4067 Swansea to Brecon road, N of Abercrave)
☎ (01639) 730273
Wye Valley Butty Bach; 6 changing beers (sourced nationally; often Draught Bass, Salopian, Wye Valley) ⊞
Welcoming pub in the Brecon Beacons National Park, notable for its warm and family-friendly atmosphere. Up to eight ales are served regularly. It is close to the famous Dan yr Ogof show caves and Craig Y Nos castle, and is ideal for walkers and campers. There is plenty of car parking on-site, with the bonus of a campsite attached. A former local CAMRA Pub of the Year on numerous occasions for both its ales and ciders. ► ⊛ ◑ ◑ ₺ Å ♣ ● P ➡ (T6) ♠ ♠

Welshpool

Angel
12 Berriew Street, SY21 7SQ
☎ (01938) 553473 ● angelwelshpool.com
3 changing beers (sourced locally; often Hobsons, Salopian, Three Tuns) ⊞
Modernised town-centre pub with a small, comfortable snug near the main door as a reminder of how it once was. The long main bar leads to a rear section featuring a pool table and numerous TVs showing sport – there is even a TV in the Gents. The three ales come from Shropshire breweries. Outside to the rear is an area for drinking and smoking. Happy hour is 4-8pm during the week. ► ⊛ ◑ ₺ ≉ ♣ ➡ ♠

Old Bakehouse
14 Church Street, SY21 7DP
☎ (01938) 558860
3 changing beers (sourced locally; often Clun, Salopian, Stonehouse) ⊞
A micropub that opened in 2021 on the site of an old bakehouse, serving local real ales, ciders, wines and a small selection of local spirits. There are no TVs, fruit machines or jukebox, so good old-fashioned conversation rules. A relaxed, chilled-out environment means you can unwind on your own or with friends. An upstairs area has tables, armchairs, board games and books. Outside is an enclosed drinking space. Takeaway containers are available. Q ⊛ ₺ ≉ ● ➡ ♠

Pheasant Inn
43 High Street, SY21 7JQ
☎ (01938) 553104
3 changing beers (sourced locally; often Ludlow, Salopian, Three Tuns) ⊞
Vibrant pub in a terrace of former 18th-century town houses. The Grade II-listed building is much modified internally, featuring a long room with wooden floor, pool table and dartboard, and comfortable seating at the far end. A rear door leads to the outside drinking area. Ales are usually from small or regional breweries, with a third guest beer often served at weekends. ⊛ ≉ ♣ ➡ ♠

Ystradfellte

New Inn
CF44 9JE
☎ (01639) 721014 ● waterfallways.co.uk

2 changing beers (sourced locally; often Glamorgan, Grey Trees) Ⓗ

A 16th-century village pub in the middle of Waterfall Country, a popular walking area in the Brecon Beacons. With two log fires, and a covered outdoor terrace and beer garden at the front, it offers a welcome whatever the weather. Two local ales are kept on tap, usually from Grey Trees and other Welsh independents. There is a focus on local produce, with spirits from nearby Penderyn Distillery. Home-cooked food includes the popular Boozy Cow Pie, with ale gravy (booking is recommended). Q⛲☸◑▶Å♦P✿

Breweries

9 Lives

Unit 303, Ystradgynlais Workshops, Trawsffordd Road, Ystradgynlais, SA9 1BS ☎ 07743 559736 ⊕ 9livesbrewing.co.uk

◉9 Lives Brewing was established in 2017 by Robert Scott, formerly brewer at the now defunct Bryncelyn Brewery, using the same six-barrel plant. A number of beers are replications of former Bryncelyn beers, which have been renamed. ‼♦LIVE

Amber (ABV 4%) PALE
Pale amber with a hoppy aroma. A refreshing, hoppy, fruity flavour with balancing bitterness; a similar lasting finish. A beer full of flavour for its gravity.

Dark (ABV 4%) MILD
Dark brown with an inviting aroma of malt, roast and fruit. A gentle bitterness mixes roast with malt, hops and fruit, giving a complex, satisfying and lasting finish.

Gold (ABV 4.5%) BITTER
An inviting aroma of hops, fruit and malt, and a golden colour. The tasty mix of hops, fruit, bitterness and background malt ends with a long, hoppy, bitter aftertaste. Full-bodied and drinkable.

Heart of Wales

▤ Stables Yard, Zion Street, Llanwrtyd Wells, LD5 4RD ☎ (01591) 610236 ⊕ heartofwalesbrewery.co.uk

◉The brewery was set up with a six-barrel plant in 2006 in old stables at the rear of the Neuadd Arms Hotel. Beers are brewed using water from its own borehole. Seasonal brews celebrate local events such as the World Bogsnorkelling Championships. Cambrian Heart Ale was commissioned by and is brewed for the Cambrian Mountains Initiative, inspired by the former Prince of Wales, which aims to promote and support the region's rural producers / communities. ‼🍺♦LIVE

HWGGA SIBA

6 Park Crescent, Llandrindod Wells, LD1 6AB ☎ 07739 312917 ⊕ hwggabrew.com

HWGGA was set up in 2021. It produces a range of cask, keg and bottled beers. Each brew is devised, brewed, bottled and labelled on the premises, using all natural ingredients.The range is inspired by and named after

community icons (landmarks/ individuals/ businesses), with labels featuring original artwork by a local artist. ‼🍺♦

Left Bank

Ty Newydd Farm, Llangorse, LD3 7UA ☎ 07815 849523 ⊕ leftbankbrewery.co.uk

The present brewery location commenced operation in 2019 and occupies the premises of the former Lithic Brewery. The 400-litre (2.5-barrel) plant produces cask, bottled and canned beers.

Lucky 7

**Hay On Wye, HR3 5AW
☎ (01497) 822778 ☎ 07815 853353
⊕ lucky7beer.co.uk**

A four-barrel brewery offering unfined beers suitable for vegans. No real ale. V

Monty's

Unit 1, Castle Works, Hendomen, SY15 6HA ☎ (01686) 668933 ⊕ montysbrewery.co.uk

Montgomeryshire's longest operating brewery began in 2009 and brews at Hendomen just outside Montgomery. The brewery produces four main cask beers with a large number of seasonal and bottle-conditioned, gluten free, and low alcohol beers. ♦LIVE GF

Old Jailhouse (ABV 3.9%) BITTER
MPA (ABV 4%) PALE
Sunshine (ABV 4.2%) GOLD
Mischief (ABV 5%) GOLD

Radnorshire

**Timberworks, Brookside Farm, Mutton Dingle, New Radnor, LD8 2SU
☎ (01544) 350456 ☎ 07789 909748
⊕ radnorhillsholidaycottages.com**

◉Set up in 2012 in a barn on the grounds of a farm offering holiday cottage accommodation, Radnorshire uses its own spring water. Drinkers staying at the cottages are supplied, as well as a few local pubs. ‼🍺

Whimble Gold (ABV 3.8%) GOLD
Four Stones (ABV 4%) BITTER
Smatcher Tawny (ABV 4.2%) BITTER
Water-Break-Its-Neck (ABV 5.7%) PALE

Wilderness

**Unit 54, Mochdre Industrial Estate, Newtown, SY16 4LE
☎ (01686) 961501 ⊕ wildernessbrew.co.uk**

The five-barrel brewery focuses on seasonal, barrel-aged and mixed fermentation beers. Belgian and farmhouse-style beers make up the majority of the range. As such, there are no regular beers.

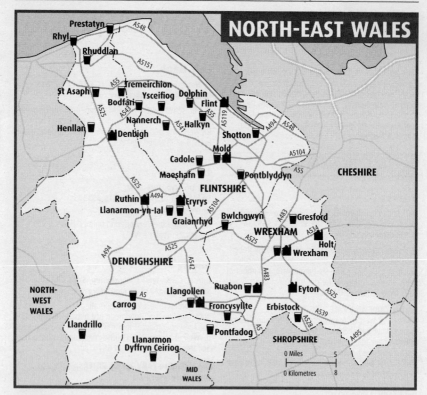

NORTH-EAST WALES

Bodfari

Dinorben Arms ⓛ

LL16 4DA (off A541, down B5429, 350yds on right)
SJ092701
☎ (01745) 775090
**Brunning & Price Original; Facer's North Star Porter;
Timothy Taylor Boltmaker; 4 changing beers (sourced
locally)** Ⓗ
Reputedly established in 1640, the building was derelict
for eight years before it was acquired by Brunning & Price
and transformed into an impressive gastro pub. Its
elevated position by the 16th-century church and tower
offers fine views across the Vale of Clwyd. The spacious
interior has several dining areas in typical B&P style. The
long, rounded bar serves the main eating area that
includes a large feature fireplace. The pub serves food all
day and is a popular destination for meals. It also offers a
good selection of real ales including three regular beers
and four guests, usually from local micros.
ⓈⓍⓄⓁ♿Ⓟ🚃(14)♣🐾🛜

Bwlchgwyn

King's Head Inn ⓛ

Ruthin Road, LL11 5UT (on A525)
☎ (01978) 753089
2 changing beers (sourced locally; often Big Hand) Ⓗ
Friendly locals' free house on the main road through one
of Wales' highest villages. Entrance is through a neat and
tidy room warmed by a large wood-burner, with the bar
facing you. To the side is another comfortable room with
banquette seating. The pub offers hearty meals to
accompany two local beers on handpump, usually from
Big Hand. Bus services are limited. ⓈⓍⓄⓅ🚃(X51)♣🛜

Cadole

Colomendy Arms

Village Road, CH7 5LL (off A494 Mold-Ruthin road)
☎ (01352) 810217
5 changing beers Ⓗ
A wonderful free house just off the main Mold-to-Ruthin
road, run by the same family for more than 30 years and
featuring in the Guide for most of that time. Rooms
recently added at the rear of the car park have provided
extra space without detracting from the pub's character.
An ever-changing range of five beers offers the best
choice of real ales for miles around. Popular with
walkers, as the Loggerheads Country Park is close by.
ⓆⓍ♣Ⓟ🚃🐾

Carrog

Grouse Inn

B5437, LL21 9AT (on B5437, off A5 at Llidiart Y Parc)
☎ (01490) 430272 ⊕ thegrouseinncarrog.co.uk
**JW Lees Bitter, Founder's; 1 changing beer (often JW
Lees)** Ⓗ
Originally a farm and brewhouse, this friendly family-run
inn has a single bar serving several rooms. It was
refurbished in 2020 without losing its fabulous character.
Generous home-cooked food is served in most areas of
the pub. The large covered patio offers splendid views of
the Dee Valley, Berwyn Mountains and 1660 Carrog
Bridge. Carrog station on the Llangollen Railway is a short
walk away. ⓆⓈⓍⓄⓁ♿A🚂♣Ⓟ🚃🐾🛜

Dolphin

Glan yr Afon Inn ⓛ

Milwr, CH8 8HE

☎ (01352) 710052 ⊕ glanyrafoninn.com
Facer's Dave's Hoppy Beer, Landslide Ⓗ
You can expect a warm welcome at this popular pub. It first opened in the 16th century and is in an elevated position with views of the Dee Estuary and the Wirral Peninsula. A central bar serves four separate seating areas and the dining room; the games room has its own bar. The inn serves food in summer and also provides accommodation. Walkers and dogs are welcome and there is a real fire to keep you warm on cold days.
Q☜❀✒◑Ⓓ&♣P❒❀❜

Erbistock

Boat
LL13 0DL (follow signs from A528, approx 1 mile W of Overton)
☎ (01978) 280205 ⊕ theboataterbistock.co.uk
4 changing beers (sourced regionally; often Big Hand, Salopian, Weetwood) Ⓗ
The Boat dates back to the 13th century and has a wonderfully picturesque location. The building takes advantage of its southerly outlook with outdoor seating offering exceptional views of the River Dee's idyllic banks. The pub is mainly laid out for dining but also has plenty of space for drinkers. Its split-level bar has handpumps on both sides and serves up to four cask beers, often from local breweries. Q❀◑&♣P❀

Froncysyllte

Aqueduct Inn
Holyhead Road, LL20 7PY (on A5)
☎ (01691) 777118
2 changing beers (sourced locally; often Slater's, Stonehouse) Ⓗ
A welcoming free house on the busy A5. The small central bar leads to a games room with a TV to the right and a comfortable lounge with a wood-burning stove to the left. Outside, the veranda offers panoramic views of the Pontcysyllte Aqueduct on the Llangollen Canal. Up to four changing ales are available, with Bathams a favourite. Food is served daily, with a traditional roast on Sunday. ☜❀◑♣P❒(64)❀❜

Graianrhyd

Rose & Crown
Llanarmon Road, CH7 4QW (on B5430 off A5104)
☎ (01824) 780727 ⊕ theroseandcrownpub.co.uk
Black Sheep Best Bitter; 2 changing beers Ⓗ
A traditional early 19th-century pub with a strong local following. The long bar serves two rooms – the main room has an open fire, copper-topped tables and a vast array of pumpclips. Guest beers are usually from local breweries. The pub is popular with tourists, walkers, cyclists and runners. Finishers in the local Dash in the Dark run refuel here on chip baps, as do those taking part in the Three Taverns choir walking tour in May.
Q☜❀◑▲♣P❒(2) ❀

Gresford

Griffin Inn
Church Green, LL12 8RG
☎ (01978) 855280
2 changing beers (sourced nationally; often Wye Valley) Ⓗ
Friendly community pub with an irregular, open-plan layout adorned with many interesting pictures. Lively conversation at the bar does not impinge on the quieter corners. The landlady has been running the pub since

1973. Children are welcome in some areas until 8pm. Sited where pilgrims came to drink in the Middle Ages, opposite is All Saints Church, whose bells are one of the Seven Wonders of Wales. There is a lawned area to the side with seating. Bus No.1 (Chester-Wrexham) stops in the village half a mile away. Q☜❀♣P❒(1)❜

Pant-yr-Ochain Ⓛ
Old Wrexham Road, LL12 8TY (off A5156, E from A483 follow signs to The Flash)
☎ (01978) 853525
Purple Moose Cwrw Eryri/Snowdonia Ale; Timothy Taylor Landlord; Titanic Plum Porter; Weetwood Eastgate; house beer (by Phoenix); 4 changing beers (sourced regionally; often Big Hand, Castle Rock, Mobberley) Ⓗ
Impressive 16th-century dower house that retains many historic features, situated beside a small lake within extensive gardens. The central room, dominated by a large double-fronted bar, leads to a variety of seating areas including a garden room, a snug behind a period inglenook fireplace, and the patio and lawn outside. Although hugely popular, the pub retains a quiet feel. Food is served all day and five regular beers are supplemented by four guests and often a draught cider. Q☜❀◑&♣P❀❜

Halkyn

Blue Bell Inn Ⓛ
Rhosesmor Road, CH8 8DL (on B5123)
☎ (01352) 780309
JW Lees Bitter; 3 changing beers (sourced locally; often Facer's) Ⓗ
A traditional rural pub near the top of Halkyn Mountain, the Blue Bell offers free guided walks of the area and is a good base for exploring the local countryside. Built in the 1700s and named after a local privateer's boat, the pub has a strong community focus and hosts regular events and societies. Its beer range usually includes ales from North Wales breweries, often Facer's or Llyn, and is accompanied by a wide selection of real ciders.
☜❀▲♣❀P❒❀❜

Henllan

Llindir Inn
Llindir Street, LL16 5BH
☎ (01745) 812188
4 changing beers (sourced locally) Ⓗ
A rambling, Grade II-listed thatched free house, dating from the 13th century and located opposite the church and its detached tower. The spacious interior retains its character with separate areas including a games room. There are extensive views of the surrounding countryside to the rear. The beer range usually features ales from Chapter and Geipel. Wood-fired sourdough pizzas are

REAL ALE BREWERIES	
Beech Avenue Holt	
Big Hand Wrexham	
Denbigh (Dinbych) Denbigh	
Dovecote Denbigh	
Facer's Flint	
Hafod Mold	
Iâl Eryrys	
Llangollen 🍺 Llangollen	
Magic Dragon Eyton	
McGivern 🍺 Ruabon	
Reaction Ruthin	
Sandstone Wrexham	

available Thursday to Saturday. The unusual name relates to flax, once a mainstay crop locally.
Q❄️🏠️♿️♣️P🚍️(6) 🌸 🛜

Llanarmon Dyffryn Ceiriog

Hand at Llanarmon

LL20 7LD (end of B4500 from Chirk)
☎ (01691) 600666 ● thehandhotel.co.uk
2 changing beers (sourced locally; often Big Hand, Stonehouse, Weetwood) Ⓗ
Cosy free house in a scenic location at the head of the stunning Ceiriog Valley. Look for the giant carved wooden hand outside. The pub's two real ales are usually local brews. The dog-friendly bar is warmed by an open fire. High-quality food and accommodation are available, and the pub also has a spa. Booking is advised at busy times. Walkers, cyclists and tourists are all welcome.
Q❄️🏠️🍴◐️♿️♣️P🚍️(64) 🌸 🛜

West Arms

LL20 7LD (at end of B4500)
☎ (01691) 600665 ● thewestarms.com
Big Hand Super Tidy; Timothy Taylor Landlord; 1 changing beer (sourced locally; often Big Hand) Ⓗ
Lavishly appointed hotel in a stunning village location. The cosy lounge with its period furniture and inglenook fires is an ideal place to relax after a day exploring the Berwyn mountains. The adjacent public bar is frequented by locals and dog walkers. High-quality meals are offered, with sandwiches available between lunchtime and evening serving times. A delightful garden runs down to the River Ceiriog. The beer range may be reduced in winter. Q❄️🏠️🍴◐️♿️♣️P🚍️(64)🌸 🛜

Llanarmon-yn-Ial

Raven Inn Ⓛ

Ffordd-Rhew-Ial, CH7 4QE (signed 500yds W of B5430)
☎ (01824) 780833 ● raveninn.co.uk
Purple Moose Cwrw Eryri/Snowdonia Ale; 2 changing beers (sourced locally) Ⓗ
Run with the help of volunteers for more than a decade, this delightful old pub goes from strength to strength with all profits used to benefit the community. It has a friendly and inviting ambience from the moment you enter. The bar serves two carpeted areas and a tiled section to one side. The three guest beers are from local breweries. Excellent locally sourced home-cooked food is offered Thursday to Sunday. There are three self-catering bedrooms. Q❄️🏠️🍴◐️♿️♣️P🚍️(2)🌸 🛜

Llandrillo

Dudley Arms Hotel Ⓛ

High Street, LL21 0TL
☎ (01490) 440223 ● dudley-arms.wales
Facer's Abbey Red, North Star Porter Ⓗ
Traditional Welsh village inn nestling in the Berwyn mountains. New owners took over in 2022 and extended the opening hours. The pub is full of charm with many period features. It has several separate areas including a lounge, dining area and stone-floored pool room. The regular beers are from Facer's brewery. B&B accommodation is available in an adjacent refurbished cottage. ❄️🏠️🍴◐️♣️P🚍️(T3)🌸 🛜

Llangollen

Chainbridge Hotel Ⓛ

Berwyn, LL20 8BS (off B5103)
☎ (01978) 860215 ● chainbridge.com

Stonehouse Station Bitter; 2 changing beers (sourced locally; often Purple Moose, Stonehouse) Ⓗ
A comfortable, well-run hotel near the Horseshoe Falls, featuring a cosy bar and dining areas set beside the turbulent River Dee with its chainbridge. Outside seating, bedecked in summer with colourful hanging baskets, makes the most of the dramatic riverside location. White-water thrill-seekers and puffing steam locomotives on the Llangollen Railway provide further entertainment. Llangollen itself is a short train ride from Berwyn station, perched opposite, or a pleasant 30-minute stroll along the canalside towpath.
❄️🏠️🍴◐️♿️🚆️(Berwyn) P🚍️(T3) 🌸 🛜

Liberty Tavern

20 Market Street, LL20 8PS
☎ 07734 914286
4 changing beers (sourced locally; often Big Hand) Ⓗ
Originally opened by Cwrw Ial and Dovecote breweries under the name of Hoptimist, this former café was renamed when it was taken over by the current owners in 2020. It now serves a broader range of drinks including up to four real ales, often from local microbreweries. The cosy downstairs area has a prohibitionist theme. The upstairs wine bar has comfortable seating and displays local artwork on its walls. Tuesday is quiz night and live music is hosted. Q❄️♿️🚆️🚍️🌸 🛜

Sun Inn Ⓛ

49 Regent Street, LL20 8HN (400yds E of town centre on A5)
☎ (01978) 860079
5 changing beers (sourced nationally; often Bollington, Rat) Ⓗ
A free house whose large front lounge features two open fires and a stage for live music. A smaller snug at the rear has mirrored panels and a large TV screen, and is accessed via an enclosed, partly covered rear terrace with seating. The pub has a late licence for music Wednesday to Saturday (last entry is at 11pm). It can get busy around that time, especially at weekends, but is quieter in the early evening. 🏠️🅰️🚆️♣️🔵️🚍️(5,T3)🌸 🛜

Maeshafn

Miners Arms Ⓛ

Village Road, CH7 5LR (off A494 in village centre)
☎ (01352) 810464 ● miners-arms-maeshafn.com
Bowland Hen Harrier; Facer's Flintshire Bitter; Theakston Old Peculier; Timothy Taylor Boltmaker Ⓗ
Dating from the 1820s, this pub in the hamlet of Maeshafn was linked to the arrival of lead mining in the area. Surrounded by scenic countryside, it is now popular with hikers. Its central bar is divided from the dining area by a twin-sided wood-burning stove, which creates a warm atmosphere throughout. Food and snacks are available. Outside at the front is a pleasant seating area.
❄️🏠️P🚍️(2) 🌸 🛜

Mold

Gold Cape ✅

8-8A Wrexham Street, CH7 1ES (next to Market Square crossroads)
☎ (01352) 705920
Greene King Abbot; Ruddles Best Bitter; Sharp's Doom Bar; 4 changing beers Ⓗ
Wetherspoon pub named after a 4,000-year-old solid gold ceremonial cape found near Mold in 1831. The original is now displayed in the British Museum in London and there is a copy in Mold Library. The walls display pictures relating to the town's past, including

local poet and novelist Daniel Owen. The familiar range of drinks and food are available and annual beer and cider festivals hosted. Q🏷🛏◑🅰♿🛍🍴🛜

Mold Alehouse 🍺 Ⓛ

Unit 2, Earl Chambers, Earl Road, CH7 1AL
☎ (01352) 218188
4 changing beers (sourced locally; often Cwrw Ial, Facer's, Hafod) Ⓗ
Since opening in 2016, this micropub has won many CAMRA awards and gained a strong following based on sound principles of good beer, fellowship and conversation. It is centrally situated in a Grade II-listed building opposite the town hall and near Daniel Owen Square, and home to Mold Library & Museum. The four cask ales include a dark beer, and there are also five KeyKeg lines and four ciders. Q♿🛍🐾🛜

Nannerch

Cross Foxes Ⓛ

Village Road, CH7 5RD
☎ (01352) 741464 ⊕ cross-foxes.co.uk
3 changing beers (sourced locally; often Big Hand, Cwrw Ial) Ⓗ
This delightful village pub near the church was built in 1780 and originally doubled up as a butcher's – the meat hooks remain over the bar. The entrance leads into a main bar with a large fireplace. Off this area is another small bar, a lounge and a function room. Three pumps serve changing beers, usually from local brewers including Big Hand and Cwrw Ial. Beer festivals are held in March and October. 🏷◑🅰♣🛍🛜

Pontblyddyn

Bridge Inn

Wrexham Rd, CH7 4HN (on A541 3 miles S of Mold)
☎ (01352) 770087
2 changing beers Ⓗ
Fine old building situated at a crossroads, with the River Alyn at the rear. The unspoilt interior has a warm and cosy front bar with a real fire, with another room leading off to the right and a separate restaurant to the left. There is also a courtyard at the front and an extensive riverside beer garden and children's play area at the back. Q🏷🌳◑🚻🛍🐾🛜

Pontfadog

Swan Inn

Llanarmon Road, LL20 7AR (on B4500 next to post office)
☎ (01691) 718473 ⊕ theswaninnpontfadog.com
2 changing beers (sourced locally; often Stonehouse) Ⓗ
Welcoming village free house in the scenic Ceiriog Valley. The cosy red-tiled bar, where the locals tend to congregate, features a central fireplace that divides the TV and darts area from the servery. The separate dining room leads to an outdoor space, where a terrace offers good views. On the bar are two changing ales from local breweries, often Stonehouse.
Q🏷🌳🛏◑🚻♣🛍(64)🐾🛜

Prestatyn

Bar 236 Ⓛ

236 High Street, LL19 9BP
☎ (01745) 850084 ⊕ bar236.co.uk
3 changing beers (sourced locally) Ⓗ

This café bar at the top of the High Street has been established for more than a decade. Its L-shaped room has a minimalist but pleasant feel with a wood-boarded floor and blue-tiled bar front. Glass-fronted on two sides, it offers open views inside and outside. TV sport is well catered for and there is live music at weekends, when it can be quite noisy. 🏷🚲🛍🐾🛜

Halcyon Quest Hotel Ⓛ

17 Gronant Road, LL19 9DT (on A547 just E of town centre)
☎ (01745) 852442 ⊕ halcyonquest-hotel.com
Facer's Flintshire Bitter; 3 changing beers (sourced nationally) Ⓗ
A longstanding supporter of cask beer, the HQ, as it is known, is at the southern end of town. It has just one room packed with sporting and other memorabilia, including a rowing boat suspended from the ceiling dedicated to JR Hartley of fly fishing fame. The extensive garden patio at the rear has a covered area and is popular in summer. Dogs are welcome in the garden only. 🏷🛏🅰🚲♿🛍(35,36)🐾

Rhuddlan

Castle Inn

Castle Street, LL18 5AE
☎ (01745) 590391
Facer's Flintshire Bitter; Theakston Best Bitter; 1 changing beer (sourced nationally) Ⓗ
Friendly pub opposite the 13th-century ruins of Rhuddlan Castle. It has two large rooms plus a covered yard with a pool table. Two regular cask ales from Theakston and Facer's are served alongside one guest beer. The pub attracts families and students visiting the castle as well as the many locals who enjoy a great pint of real ale and a convivial atmosphere. 🌳♣🛍🐾

Rhyl

Cob & Pen Ⓛ ✅

143 High Street, LL18 1UF
☎ (01745) 350446
Facer's Mountain Mild, Flintshire Bitter; 2 changing beers Ⓗ
A fine traditional town-centre pub close to the railway and bus stations with three separate areas to suit all tastes, served from a central bar. It hosts darts, pool and dominoes teams and shows televised sports events, all adding to its popularity. Interesting novelty clocks are displayed in a side bar. The beers are usually from microbreweries including a cask mild, a rarity for these parts. Guest ales change almost every other day, giving customers plenty of choice. 🏷🌳◑🚲♣🛍🛜

Dove at Rhyl Ⓛ

2 St Margarets Buildings, St Margarets Drive, LL18 2HT (on A525, half mile from centre)
☎ 07908 957116
4 changing beers (sourced locally; often Dovecote) Ⓗ
Situated on the outskirts of town, this welcome addition to the local pub landscape is the first in a small chain of pubs operated by Dovecote Brewery under the Dove umbrella. The interior is bright and airy, featuring a mural of Rhyl High Street, and the atmosphere is relaxed and friendly. The cask beer range includes at least two from Dovecote plus two guests from local microbreweries. Closed Monday except bank holidays. Q🏷🌳♿🛍(51)🐾

Esplanade Club

86 Rhyl Coast Road, LL18 3PP (on A548, 1 mile E of centre, next to Morrisons Local)

☎ (01745) 338344
2 changing beers Ⓗ
Friendly club in the Tynewydd area, on the main coast road. It serves up to three real ales from local and national brewers. Attractions include a three-quarter-sized snooker table. The club welcomes families and pets, and attracts visitors to the many holiday parks on its doorstep. Local CAMRA Club of the Year 2022.
ℰ&♣🖵🐱🛜

Ruabon

Bridge End Inn � Ⓛ
5 Bridge Street, LL14 6DA
☎ (01978) 810881
8 changing beers (sourced nationally; often Ossett, Rat, Salopian) Ⓗ
A traditional community-focused local, close to Ruabon station, with three low-ceilinged rooms and a covered outside drinking area. It has deservedly won numerous awards since its revitalisation by the McGivern family, including CAMRA UK and Welsh National Pub of the Year. The changing range of eight cask ales may include a brew from the on-site McGivern Brewery, plus porter or stout. There is usually a real cider. Families and well-behaved dogs are welcome in the lounge.
Q➳ℰ🕮Å✦♣🖵P🖵🐱🛜

St Asaph

New Inn ✓
Lower Denbigh Road, LL17 0EF
☎ 07874 055314
JW Lees Bitter; 2 changing beers (often JW Lees) Ⓗ
The pub has a main lounge bar leading to a games room with pool and darts. The separate back bar has a real open fire. Two changing JW Lees beers are served alongside the brewery's bitter. Outside is a raised area with a large landscaped garden below. The pub backs on to the River Elwy, with easy access for dog walkers and cyclists. There is a large car park to the rear.
Q➳🕮♣P🖵(51)🐱

Shotton

Central Hotel ✓
2-4 Chester Road West, CH5 1BX
☎ (01244) 845510
Greene King Abbot; Ruddles County; Sharp's Doom Bar; 2 changing beers (sourced nationally) Ⓗ
A local landmark that was built in the 1920s beside the railway station, and refurbished in 2008 when it reverted to its original name. It stands on what was marshland, alongside the River Dee. Its interior is in typical Wetherspoon mock-Edwardian style, with a single large bar partially separated into three similarly furnished areas. At the front is an open seating area between the pub and street. Monthly events include Meet the Brewer evenings. ℰ🕮🕮&≷P🖵🛜

Tremeirchion

Salusbury Ⓛ
LL17 0UN (1 mile S of A55 from jct 30)
☎ (01745) 710532
2 changing beers (often Cwrw Ial, Dovecote) Ⓗ
Traditional old village pub with parts reputed to date back to the time of the Magna Carta. It is now under the ownership of the nearby Dovecote Brewery. The interior divides into several areas including dining rooms, a snug and a meeting room. Outside is a large space with a

children's play area. There are usually some beers from other microbreweries on the bar alongside the Dovecote range. ℰ🕮🕮&Å♣P🐱🛜

Wrexham

Elihu Yale ✓
44-46 Regent Street, LL11 1RR
☎ (01978) 366646
Greene King Abbot; Ruddles Best Bitter; Sharp's Doom Bar; 5 changing beers (sourced nationally) Ⓗ
Formerly a cinema, this Wetherspoon town-centre pub is within walking distance of both railway and bus stations. It serves three regular beers plus at least five guest ales, one from a North Wales brewery, and up to two real ciders. There are various seating areas in the large room, with a quieter section near the front. Families are welcome until 10pm. A quiz night is hosted on Wednesday, and poker on Sunday.
Q➳🕮&≷(Central)●🖵🛜

Magic Dragon Brewery Tap Ⓛ ✓
13 Charles Street, LL13 8BT
☎ (01978) 365156
Magic Dragon Ice Dragon, Eyton Gold; 4 changing beers (sourced regionally; often Salopian, Magic Dragon) Ⓗ
Single-roomed pub that is the tap for the Magic Dragon Brewery, based just outside Wrexham. The pub is on the edge of what was known as the Beast Market, in a building that was originally the Elephant & Castle and after several changes of use is now pleasingly back as a pub. Its compact interior features bare brick walls and a wood-panelled bar. Six handpumps dispense at least three Magic Dragon beers including a dark ale.
Q≷(Central)●🖵🐱🛜

Royal Oak
35 High Street, LL13 8HY
☎ (01978) 364111
Joule's Pure Blonde, Pale Ale, Slumbering Monk; 2 changing beers (sourced nationally) Ⓗ
A Grade II-listed building with a long, narrow interior. A real fire, wood panelling and etched brewery mirrors around the bar create a traditional ambience, dominated by a mounted antelope head. Three regular Joule's beers are served alongside one from the brewery's seasonal range. No food is offered but you are welcome to bring your own. Darts and pub games are played. A small beer garden on the roof is open from April to September.
Q🕮&≷(Central)♣🖵🐱🛜

Ysceifiog

Fox ★
Ysceifiog Village Road, CH8 8NJ (signed from B5121)
☎ (01352) 720241 🌐 foxinnysceifiog.co.uk
Weetwood Best Bitter; 2 changing beers Ⓗ
Built around 1730, the Fox is a rare gem in a peaceful village location. It has been identified by CAMRA as having a nationally important historic interior, and features four small rooms, two for dining. The bar is especially interesting with its settles and unique sliding door. The beer range usually includes an ale from Cwrw Llyn. Booking is recommended for the popular Sunday lunches. Outside is a children's playground.
Q➳🕮🕮♣🐱🛜

Breweries

Beech Avenue

Lodge Farm, Borras Road, Holt, LL13 9TE ☎ 07917 841304 ⊕ beechavenuebrewery.co.uk

Brewing commenced using a 30-litre kitchen plant. In 2020 the brewery upscaled and relocated to eco-friendly converted farm buildings. Speciality fruit or dry-hopped beers are available at various times in addition its range of cask-conditioned ales.

Gold (ABV 4%) GOLD
Pale (ABV 4.5%) PALE

Big Hand

Unit A1, Abbey Close, Redwither Business Park, Wrexham, LL13 9XG
☎ (01978) 660709 ☎ 07946 514238
⊕ bighandbrewing.co.uk

Big Hand began brewing in 2013 and continues to operate via a 10-barrel plant on the outskirts of Wrexham. Its broad-ranging selection of beers have won several awards and are widely available throughout North Wales and West Cheshire. ‼♦

Seren (ABV 3.7%) PALE
Pale, full-flavoured and hoppy with a fruity aroma and taste.
Pili Pala (ABV 3.8%) PALE
Ostara (ABV 3.9%) BITTER
Pendragon (ABV 3.9%) BITTER
Copper-coloured and well-balanced with a smooth, rich taste, juicy mouthfeel and hints of spice in the finish.
Super Tidy (ABV 4%) PALE
A pale brown bitter beer with some citrus notes in the taste and peppery hops in the finish.
Bastion (ABV 4.2%) BITTER
A dry, malty best bitter, mahogany in colour with a full mouthfeel. Biscuity flavours and faint roast notes feature throughout.
Freehand (ABV 4.2%) BITTER
Little Black S (ABV 4.2%)
Domino (ABV 4.4%) STOUT
A smooth and fruity stout, quite hoppy and roasty with hints of berries in the initial sweetness leading to a satisfying hoppy finish.
Appaloosa (ABV 4.5%) PALE
A full-bodied pale ale, some initial sweetness with strong New World hop flavours in the taste and spicy finish.
Havok (ABV 5%) PALE
A powerfully-hopped American IPA with strong and tangy citrus fruit bitterness throughout.

Denbigh (Dinbych)

Crown Workshop, Crown Lane, Denbigh, LL16 3SY
☎ 07850 687701 ⊕ bragdybinbych.co.uk

Brewing commenced in 2012 at the rear of the Hope & Anchor pub re-locating to the current premises in 2015. Output is cask and bottle supplying its nearby micro pub, Y-Goran-Fach, and local farmers markets. Also known as Bragdy Dinbych. ♦LIVE

Dovecote

Unit 2, Denbigh Enterprise Centre, Colomendy Industrial Estate, Denbigh, LL16 5TA ☎ 07908 957116
✉ dovecote.brewery@gmail.com

⊗ Also known as Bragdy Colomendy, named after the industrial estate where it is located. Owner and head brewer Richard Green commenced brewing in 2017 on a five-barrel plant. All beers brewed are unfined and unfiltered. ☭LIVE

Dove Dark (ABV 3.6%) MILD
Dove Ale (ABV 4%) BITTER
Dove From Above (ABV 4.2%) PALE
Dove Down Under (ABV 4.8%) GOLD
Dove Pale (ABV 4.8%) GOLD

Facer's

A8-9, Ashmount Enterprise Park, Aber Road, Flint, CH6 5YL ☎ 07713 566370 ⊕ facersbrewery.com

Set up in 2003 by (now retired) Dave Facer, the brewery is now operated by long-time employee Toby Dunn, It is the oldest brewery in Flintshire. Sales average some 30 barrels per week to around 100 outlets in North Wales and north west England. ‼♦

Mountain Mild (ABV 3.3%) MILD
A fruity dark mild, not too sweet, with underlying roast malt flavours and a full mouthfeel for its low ABV.
Clwyd Gold (ABV 3.5%) BITTER
Clean-tasting, session bitter, mid-brown in colour with a full mouthfeel. The malty flavours are accompanied by increasing hoppiness in the bitter finish.
Flintshire Bitter (ABV 3.7%) BITTER
Well-balanced session bitter with a full mouthfeel. Some fruitiness in aroma and taste with increasing hoppy bitterness in the dry finish.
Abbey Blonde (ABV 4%) BITTER
Abbey Original (ABV 4%) BITTER
A sweetish golden beer with a good hop and fruit aroma, juicy taste and a dry, hoppy finish.
Abbey Red (ABV 4%) BITTER
A darker version of Abbey Original, copper-coloured with a sweet, malty taste and a bittersweet aftertaste.
North Star Porter (ABV 4%) PORTER
Dark, smooth, porter-style beer with good roast notes and hints of coffee and chocolate. Some initial sweetness and caramel flavours followed by a hoppy bitter aftertaste.
Game changer (ABV 4.1%) BITTER
Sunny Bitter (ABV 4.2%) BITTER
An amber beer with a dry taste. The hop aroma continues into the taste where some faint fruit notes are also present. Lasting dry finish.
DHB (Dave's Hoppy Beer) (ABV 4.3%) BITTER
A dry-hopped version of Splendid Ale with some sweet flavours also coming through in the mainly hoppy, bitter taste.
This Splendid Ale (ABV 4.3%) BITTER
Refreshing tangy best bitter, yellow in colour with a sharp hoppy, bitter taste. Good citrus fruit undertones with hints of grapefruit throughout.
Welsh Premium Lager (ABV 4.5%)
Landslide (ABV 4.9%) BITTER
Full-flavoured, complex, premium bitter with tangy orange marmalade fruitiness in aroma and taste. Long-lasting hoppy flavours throughout.

Hafod

Old Gas Works, Gas Lane, Mold, CH7 1UR
☎ (01352) 750765 ☎ 07901 386638

Office: Gorwel Hafod Road, Pantglas Gwernaffield, Mold, CH7 5ES ⊕ welshbeer.com

Hafod began brewing in 2011 on a small scale and upgraded to a new plant in the current premises in 2014, concentrating on beers in bottle and cask. The standard

range is accompanied by regular seasonal and special brews throughout the year. The brewery shop operates on a click-and-collect basis and there are occasional open days. ‼◆

Sunrise (ABV 3.8%) GOLD
A pale and refreshing golden ale with citrus fruit bitterness evident throughout and a mouthwatering astringent finish.

Moel Famau Ale (ABV 4.1%) SPECIALITY
A speciality dark ale brewed using local heather giving a dry, roasty taste with underlying sweet malt flavours.

Landmark (ABV 4.6%) BITTER
Copper-coloured and malty with a juicy mouthfeel. Fruit and faint roast flavours also feature in the taste.

Iâl

Pant Du Road, Eryrys, CH7 4DD ☎ 07956 440402
⊕ cwrwial.com

Cwrw Iâl Community Brewery is run as a social enterprise with profits used for local community projects. The 10-barrel plant brews a core range as well as regular specials, in cask, keg and can. A second range is brewed under Crank branding.

Pocket Rocket (ABV 4%) PALE
Yellow in colour with citrus fruit prominent in the aroma and sharp, hoppy taste.

Kia Kaha! (ABV 4.3%) PALE
A dry, bitter beer, gold in colour with a fruity aroma leading to a good hoppy taste and finish.

Limestone Cowboy (ABV 4.5%) BITTER
A copper-coloured best bitter, malty with faint roast notes and fruit flavours. Hops dominate in the dry, bitter finish.

Pothole Porter (ABV 5.1%) PORTER
A rich and fruity porter with a smooth mouthfeel and good roast notes in aroma and taste.

Llangollen

⊟ Abbey Grange Hotel, Horseshoe Pass Road, Llantysilio, Llangollen, LL20 8DD
☎ (01978) 861916 ⊕ llangollenbrewery.com

Brewing began in 2010 on a 2.5-barrel plant. The brewery was updated and upgraded in 2014 to a 10-barrel plant. ‼ ᴾ LIVE

McGivern

⊟ c/o The Bridge End Inn, 5 Bridge Street, Ruabon, LL14 6DA
☎ (01978) 810881 ☎ 07891 676614
⊕ mcgivernales.co.uk

⊛The brewery was established in 2008 and was originally based at the brewer's home in Wrexham, but moved in 2011 to the award-winning Bridge End Inn, Ruabon using a 2.5-barrel plant. Production is continuing on an occasional basis. ◆

Magic Dragon SIBA

Plassey Brewery, Eyton, LL13 0SP
☎ (01978) 781675 ⊕ magicdragonbrewing.co.uk

Originally called Plassey, and later New Plassey. Another new owner, brewer and personnel took over in 2017. Some beer replicates the old Plassey range but others are new recipes.

Burning Dragon (ABV 3.6%) PALE
Old Magic (ABV 3.6%) MILD
A dry, dark mild with some roast and sweet flavours in the mainly fruity taste. Increasing hoppiness in the finish.

Border Bitter (ABV 3.8%) BITTER
A well-balanced session bitter with a fruity aroma, smooth, malty taste, and a satisfying hoppy finish.

Eyton Gold (ABV 4%) GOLD
A full-flavoured golden ale with a dry, hoppy taste and a long-lasting bitter finish.

Green One (ABV 4.2%) GOLD
Golden brown and packed full of citrus hop flavours in the aroma, sharp taste, and peppery hops in the finish.

Polly's

Holland Farm, Blackbrook, Mold, CH7 6LU
☎ (01244) 940621 ⊕ pollysbrew.co

Polly's Brew Co was established in 2016 (originally as Black Brook inside the stable of an old horse called Polly), and has continuously expanded to what is currently a 23-hectolitre plant. It concentrates on KeyKeg and canned beer, widely distributed throughout the UK and further afield. The beer range changes constantly.

Reaction

Ruthin, LL15 1RS ✉ reactionbrewery@gmail.com

Brewing returned to Ruthin after many years when keen home brewer and CAMRA member Clwyd Roberts made his cask and keykeg beers available commercially in 2019. One-off beers are produced on a monthly basis with most of the output going to Mold Alehouse which acts as the brewery tap.

Sandstone

Unit 5a, Wrexham Enterprise Park, Preston Road, off Ash Road, North Wrexham Industrial Estate, Wrexham, LL13 9JT
☎ (01978) 664805 ☎ 07415 409625
⊕ sandstonebrewery.co.uk

⊛Sandstone Brewery was established as a four-barrel plant in 2008. The brewery was taken over by the current owners in 2013. The beers are available at around 50 outlets in North-West England and North Wales. ‼ᴾ◆

Edge (ABV 3.8%) BITTER
A satisfying session ale. This pale, dry, bitter beer has a full mouthfeel and a lingering, hoppy finish that belies its modest strength.

Celtic Pride (ABV 4%) BITTER
Morillo (ABV 4.2%) BITTER
Post Mistress (ABV 4.4%) BITTER
A full-bodied, smooth, premium bitter, ruby-red in colour, with a rich, mellow taste. Good combination of malt, hops and fruit in aroma and initial taste leading to a lasting satisfying finish.

Twisted Dragon (ABV 5.8%) BITTER

Wrexham Lager

42 St Georges Crescent, Wrexham, LL13 8DB
☎ (01978) 266222 ⊕ wrexhamlager.co.uk

Lager was first brewed in Wrexham in 1882 and returned to the town in 2011, following the closure of the original Wrexham Lager brewery in 2000. This German-built, 50-hectolitre brewery produces keg and bottled lagers, but no cask beers are produced.

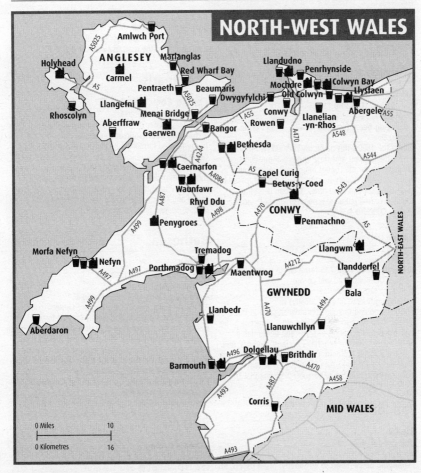

Aberdaron

Ty Newydd

LL53 8BE (follow B4413)
☎ (01758) 760207 ⊕ gwesty-tynewydd.co.uk
2 changing beers (sourced locally; often Purple Moose) Ⓗ

The hotel is at the centre of a picturesque and historic village at the end of the Llyn Peninsula directly overlooking the bay and sandy beach. Beers are generally from two local breweries. Lunch and evening menus are offered, and afternoon tea is served. The outside terrance has stunning beach and sea views. Eleven en-suite bedrooms are available. The pub is dog-friendly in the Yellow room and on the terrace only. The Wales coastal footpath passes through the village. Bus services run from Pwllheli. Q⚲🛏️◑🅿️♿🐾🅿️♿🛜

Aberffraw

Crown

35-36 Bodorgan Square, LL63 5BX
☎ (01407) 840222 ⊕ thecrownaberffraw.co.uk
3 changing beers (sourced locally) Ⓗ

Traditional coastal village pub, popular with both locals and visitors walking the Anglesey coastal path. It is located in the village square, near the bus stop and shop. Inside you will find a welcoming bright and cosy lounge bar, separate games room and a good-sized dining room with access to a secluded rear garden area. There are plenty of tables, and secure bicycle parking. The pub is on bus routes 25 and 42. Q⚲🐾🛜(25,42)♿🛜

Abergele

Castle

67 Water Street, LL22 7SN
☎ (01745) 824849
JW Lees Bitter, Founder's Ⓗ

Large multi-roomed former Bass pub, built in the 1850s to serve the north-east of the town. It benefitted from an extensive and attractive internal refurbishment in 2015 under Lees ownership. The licensees pride themselves on serving and promoting quality real ale. Photographs of old Abergele are displayed in the snug/bar area, which has two dartboards. The games room has a pool table. 🐾≠♣🛜(12)♿🛜

Hoptimist Ⓛ

32 Market Street, LL22 7AA
☎ 07538 336718
4 changing beers (sourced regionally) Ⓗ

An innovative conversion of a former building society, Abergele's first micropub opened in 2018. Originally a joint venture between Cwrw Ial and Dovecote breweries, it was taken over by a local family in 2021. Information regarding the beers and ciders is clearly displayed on a large blackboard on the back wall. The bank of taps

dispenses up to four cask ales, five keg beers and three ciders, served in third-pint glasses on request. The large rear courtyard offers views into the small cellar.
Q✤⚘⇌●🖥(12) ✿

Amlwch Port

Adelphi Vaults
Quay Street, LL68 9HD
☎ (01407) 831754
4 changing beers (sourced locally; often Purple Moose) Ⓖ
Built in the 1800s, this nautically themed two-room pub is near the old port and close to several museums dedicated to the old copper industry. It serves four changing beers, mainly from Wales. The small rear beer garden is a suntrap in summer. The pub is on the Anglesey coastal path and is popular with both locals and tourists. Q✤⚘◑♣✿☂

Bala

STORI Ⓛ
101 High Street, LL23 7AE (on A494 in town centre opposite Old Bulls Head and Co-op)
☎ (01678) 520501 ⊕ storibeers.wales
3 changing beers (sourced locally) Ⓖ
A bottle shop and taproom centrally situated in this popular town close to the lake and other attractions. The shop offers a wide range of beers and beer-related merchandise, with the emphasis on local products, and to the rear is the taproom. Cask and craft keg beers are available to either take away or enjoy in the cosy tasting room. Opening hours may be subject to seasonal variation. Q●🖥(T3)✿

Bangor

Globe
Albert Street, LL57 2EY
☎ (01248) 362095
3 changing beers (sourced nationally; often Ossett, St Austell) Ⓗ
Traditional back-street pub in upper Bangor, popular with locals and students. Three handpumps serve a rotating range of locally and nationally sourced beers. Breakfast, lunch and evening pub meals are offered. The pub is often busy for sporting events shown on its numerous large TV screens. It regularly hosts a variety of ticketed gigs, sometimes with restricted access. ◑⇌♣☂

Patricks
59 Holyhead Road, LL57 2HE
☎ (01248) 353062 ⊕ patricksbar.com
3 changing beers (sourced regionally; often Big Bog, Facer's) Ⓗ
A lively Irish-themed bar in upper Bangor, popular both with the locals and students at Bangor University. Its numerous TVs show sporting events. There are usually two local ales on the bar. Opening hours are extended for sports and late-night drinking. On the bus route towards the Menai Straits and near the railway station. ⇌🖥☂

Barmouth

Royal Hotel
King Edward Street, LL42 1AB
☎ (01341) 406214
4 changing beers Ⓗ
A pub located beneath the main hotel, accessed from the main road. It is on two levels, with the main bar next to

the entrance; the lower level is primarily for playing pool. Beers are usually from Welsh breweries but occasionally come from just over the border. There is a beer garden to the rear. ✤🏠◑Å⇌♣🖥✿☂

Beaumaris

Castle Court Hotel ✔
Castle Square, LL58 8DA
☎ (01248) 810078 ⊕ castlecourtbeaumaris.co.uk
1 changing beer (sourced regionally) Ⓗ
The renovated former White Lion hotel overlooks the castle in the centre of this historic town. It serves two changing guest ales from small independent breweries. Lunchtime meals are available during school holidays only. There is a small beer garden to the rear, and in spring and summer the castle square provides an outdoor seating area. ✤🏠◑Å🖥☂

Bethesda

Y Sior
35-37 Carneddi Road, LL57 3SE
☎ (01248) 600072
4 changing beers (sourced locally) Ⓗ
A friendly locals' pub in the village of Carneddi, on the hillside above Bethesda and ideally located for hill walkers on the Carneddau range. It serves a variety of often locally brewed ales. The pub is popular for sports events and sometimes hosts live music. From outside there are great views across the valley to the local slate quarries, which contain the longest zip wire in Britain. The pub is a few minutes' drive from the A5, with plenty of parking nearby. Q🖥✿

Brithdir

Cross Foxes
LL40 2SG (jct of A470 and A487)
☎ (01341) 421001 ⊕ crossfoxes.co.uk
3 changing beers (sourced locally) Ⓗ/Ⓖ
A refurbished Grade II-listed building near the foot of Cader Idris mountain, four miles from the historic town of Dolgellau. Its beers are mostly from local breweries. Breakfast is served and meals are available all day. The hotel has a five-star rating from the Welsh tourist board. It is popular with walkers, tourists and locals, and welcomes dogs in the bar area.
Q✤⚘🏠◑Å🅿🖥(T2) ✿☂

REAL ALE BREWERIES

Anglesey Brewhouse Llangefni
Anglesey Brewing Carmel (brewing suspended)
Black Cloak ⊜ ✦ Colwyn Bay
Cader Dolgellau
Conwy ✦ Llysfaen
Cybi Holyhead
Geipel Llangwm
Llŷn ✦ Nefyn
Lleu Penygroes
Mona Anglesey: Gaerwen
Myrddins Barmouth
Nant Bettws-Y Coed
Ogwen Bethesda
Purple Moose Porthmadog
Snowdon Craft Mochdre
Snowdonia Parc ⊜ Waunfawr
Ty Mo Caernarfon (NEW)
Wild Horse ✦ Llandudno

Caernarfon

Black Boy Inn ✅
Northgate Street, LL55 1RW
☎ (01286) 673604 ⊕ black-boy-inn.com
5 changing beers (sourced regionally) Ⓗ
Characterful pub set within the town walls between the marina and castle. This historic town, a World Heritage Site, is well worth a visit, ending with a welcome pint at the Black Boy. The public bar and small lounge are warmed by roaring fires. Good-value food is served and a guest beer usually comes from Purple Moose. There is a drinking area outside on the traffic-free street. A former local CAMRA Pub of the Year.
 প্রਤ≓(Welsh Highland) ♣P🚌🛜

Capel Curig

Plas y Brenin ℒ
LL24 0ET
☎ (01690) 720214 ⊕ pyb.co.uk
3 changing beers (sourced locally) Ⓗ
Outdoor centre in an attractive rural area, formerly the Capel Curig Inn after being founded in 1798. Three handpumps dispense local beers. The raised bar overlooks two lakes, Llynnau Mymbyr, with spectacular views of Mount Snowdon. The outdoor drinking area is the best way to enjoy the vista. The decor is basic but modern, with wooden floors, tables and chairs plus a TV. The large dining area offers a hearty and reasonably-priced food menu. Q🏠⛵️🍽️◑ᵼ♣P🛜

Colwyn Bay

Bay Hop
17 Penrhyn Road, LL29 8LG
⊕ thebayhop.co.uk
4 changing beers (sourced regionally) Ⓗ
An award-winning micropub with a welcoming and friendly atmosphere. Furnishings include wooden settles and comfy chairs around larger tables, plus tall barrel tables for those who prefer to stand. Five ciders and perries are available from a fridge in addition to an extensive range of beers in bottles and cans for drinking in or taking out. Formerly CAMRA North Wales Pub of the Year, Cider Pub of the Year and several times local Pub of the Year. 🏠⛵️≓♣🚌(12)🛜

Black Cloak Taproom 🍽 ℒ
71 Abergele Road, LL29 7RU
☎ (01492) 330274
4 changing beers (sourced locally) Ⓗ
Brewpub that was opened in 2018 by two former employees of Heavy Industry Brewing, who are now producing their own beer on-site using a two-barrel plant. Ales are available on cask, keg and direct from a brite tank, and served in thirds, halves, two-thirds or pint measures. Guest beers are from quality breweries throughout the UK and bottled ales are also on offer. The taproom has comfortable seating and a convivial atmosphere. Local CAMRA Pub of the Year. 🏠⛵️≓🚌(12)🛜

Pen-y-Bryn ℒ
Pen-y-Bryn Road, LL29 6DD
☎ (01492) 533360
Purple Moose Cwrw Eryri/Snowdonia Ale; Timothy Taylor Boltmaker; house beer (by Brunning & Price); 1 changing beer (sourced regionally) Ⓗ
Large open-plan pub with bookcases, old furniture and real fires during the winter. The walls are decorated with old photographs and memorabilia from the local area. Panoramic views of the Bay of Colwyn and the Great

Orme can be admired from the terrace and garden. The food menu changes daily and is served throughout the day. A boardroom-style function room for celebrations and meetings has been created in the cellar, opening onto the garden. Q🏠⛵️◑ᵼ♣P🚌(23)🛜

Conwy

Albion Ale House ★ ℒ
Upper Gate Street, LL32 8RF
☎ (01492) 582484
8 changing beers (sourced locally) Ⓗ
Multi-room pub that has been superbly refurbished by the current owners – each room retains original 1920s features and several have interesting fireplaces. There is no music or TV, just pleasant conversation. The pub is managed by three local brewers – Conwy, Purple Moose and Snowdon Craft – and showcases their beers as well as guests. Up to 10 ciders are served plus a good selection of wines and malt whiskies. CAMRA awards include local and Welsh Pub of the Year.
Q🏠⛵️≓♣🚌(5,19)🛜

Bank of Conwy ℒ
1 Lancaster Square, LL32 8HT
☎ (01492) 573741 ⊕ thebankofconwy.wales
3 changing beers (sourced regionally) Ⓗ
Craft beer bar in a Grade II-listed former bank. It uses many fittings from the original building, including the manager's office. The counter is now the bar; the vault still has the original fortified door. An extensive selection of beers is served including cask, keg and bottled brews. There is also a large choice of wines and gins. Food is offered daily until early evening, with breakfasts at the weekend. Sausages are available for dogs. Music is hosted on Wednesday night. 🏠◑≓🚌(5,19)🛜

Mulberry
Conwy Marina, Morfa Drive, LL32 8GU
☎ (01492) 583350
Robinsons Dizzy Blonde, Unicorn; house beer (by Robinsons); 1 changing beer Ⓗ
A nautically themed Robinsons pub on the marina, with a front patio overlooking the marina and the Conwy estuary across to Deganwy. The pub's spacious ground-floor area features a rowing boat in the ceiling, and an open stairwell leading to the first-floor bar and restaurant. The patio hosts a barbecue and also a pirate ship that is a children's play area.
🏠⛵️◑ᵼ≓P🚌(27)🛜

Corris

Slaters Arms
Bridge Street, SY20 9SP
☎ (01654) 761324 ⊕ slatersarmscorris.co.uk
3 changing beers (sourced nationally; often Evan Evans, Monty's, Salopian) Ⓗ
Named after what was once the main trade in the village, this Grade II-listed pub is popular with locals and visitors. The traditional main bar features slate flooring and a decorative mantelshelf above a large inglenook fireplace. A blazing log-burner is a welcome sight in winter. There is a dining area to the rear. Walkers, families and well-behaved dogs are welcome. Accommodation is available in four en-suite rooms.
🏠⛵️◑▲🚌(34)🛜

Dolgellau

Torrent Walk Hotel 🍽 ℒ
Smithfield Street, LL40 1AA

☎ (01341) 422858 ⊕ torrent-walk-hotel.business.site
4 changing beers (sourced nationally)
An 18th-century hotel in the narrow streets of the town centre, retaining most of its multi-roomed interior and old fireplaces, although the bar fittings date from circa 1970. Note the Coffee Room etched panel in the door from the lobby to the room on the right. A real cider is always served alongside up to five ales, mostly from local breweries. An ideal base for walking in the Cader Idris area. Local CAMRA Pub of the Year 2022.
🛏🏠🍴♣🚲🐾🐕☂

Dwygyfylchi

Gladstone
Ysgubor Wen Road, LL34 6PS
☎ (01492) 623231
4 changing beers (sourced nationally) Ⓗ
Attractively refurbished pub renowned for its magnificent sea views over the bay to Puffin Island. It retains many original features including alcoves and traditional decor, with wood panelling and old photographs. Comfortable sofas surround a wood-burning stove; a galleried balcony has tables overlooking the bar. The restaurant serves imaginative, locally sourced food. The pub hosts live music on Saturday and the Conwy Folk Club on Monday. There is a function room, and accommodation is available in six luxury rooms. 🌳🏠🍴♿⛺♣🚲≠(Penmaenmawr)P🚪(5,X5)🐾☂

Llanbedr

Ty Mawr Hotel
LL45 2HH
☎ (01341) 241440 ⊕ tymawrhotel.com
4 changing beers Ⓗ
Small country hotel set in its own grounds. The modern lounge bar has a slate-flagged floor and cosy wood-burning stove. Unusual flying memorabilia reflect connections with the local airfield. French windows open out onto a veranda and landscaped terrace with seating. A summer beer festival is held in a marquee on the lawn. The hotel welcomes children and dogs, and is popular with locals and walkers. Meals are served all day.
Q🏠🍴⛺≠♣🚗🐾🐕

Llandderfel

Bryntirion Inn ⒧
B4401, LL23 7RA (on B4401 4 miles E of Bala)
☎ (01678) 530205 ⊕ bryntirioninn.co.uk
Purple Moose Cwrw Eryri/Snowdonia Ale; 1 changing beer (sourced locally) Ⓗ
Dating back to 1695, this former hunting lodge and coaching inn overlooks the Dee Valley. The cosy and comfortable bar area with a log fire is open all day. There are a number of other rooms to accommodate diners and families including a large function room for special events. There is also a small covered and heated courtyard at the rear. The guest beer varies and may be from a local or national brewer. Two en-suite guest rooms are available upstairs. Q🌳🏠🍴🍴♣🚲♠P🚪(T3)🐾☂

Llandudno

Albert ⒧
56 Madoc Street, LL30 2TW
☎ (01492) 877188
Conwy Clogwyn Gold; Timothy Taylor Landlord; 3 changing beers (sourced regionally) Ⓗ
Pub-restaurant just off the town centre and close to the railway station, featuring modern decor with interesting

photographs and pictures on display. It serves several handpulled ales from local and independent breweries, plus a range of meals throughout the day. Current beers are displayed on blackboards above and beside the L-shaped bar. Third-pint glasses are available. At the front is a heated and covered veranda with seating.
🌳🏠🍴♿≠🚪(5,12)🐾☂

Snowdon
11 Tudno Street, LL30 2HB
☎ (01492) 872166 ⊕ thesnowdon.co.uk
Draught Bass; house beer (by Coach House); 4 changing beers (sourced regionally) Ⓗ
One of the town's oldest pubs, the Snowdon features a large main drinking area with an attractive mirror above the fireplace. Real ales on offer include the house beer, Coach House Blue Sky. The raised pavement garden gives a fine view of the Great Orme and the goats, if you are lucky. The pub is a repeat winner of the annual Llandudno in Bloom award for its floral displays.
🌳🏠🍴🚪(5,12)🐾☂

Tapps ⒧
35 Madoc Street, LL30 2TL
☎ (01492) 870956
Conwy Welsh Pride; 3 changing beers (sourced regionally) Ⓗ
Micropub in a former cake shop, featuring an open-plan bar at the front and a small snug to the rear. Welsh beer is to the fore and there is a large bottled ale selection. Vinyl music is played on an old record player. One of the tables is a chessboard that transforms into a backgammon or card table. Other board games are provided and there are books to borrow.
🌳🏠≠♣🐕🚪(5,12)🐾☂

Llanelian-yn-Rhos

White Lion Inn ⒧ ✔
LL29 8YA
☎ (01492) 515807 ⊕ whitelioninn.co.uk
Theakston Best Bitter; 2 changing beers (sourced regionally) Ⓗ
A regular in the Guide for more than 30 years, this 16th-century inn in the hills above Old Colwyn, next to St Elian's Church, offers a warm welcome. Gracing the entrance are two white stone lions, leading into the bar area with slate-flagged flooring and large comfortable chairs around the log fires. Decorative stained glass is mounted above the bar in the tiny snug. The restaurant serves home-cooked food. Jazz night is Tuesday and quiz night Thursday. Q🌳🏠🍴♣P🐾☂

Llanuwchllyn

Eagles Inn (Tafarn Yr Eryrod) ⒧
LL23 7UB (off A494, 5 miles S of Bala, left at B4403 then 100yds)
☎ (01678) 540278 ⊕ yr-eagles.co.uk
3 changing beers (sourced locally; often Purple Moose) Ⓗ
Traditional 18th-century stone-built village local opposite the church. The bar area operates as a shop, retaining historic features including ceiling meat hooks and a wonderful stone floor. The adjacent lounge/dining area and the patio garden give panoramic views of the surrounding countryside. The family-run pub is a 10-minute walk from Llanuwchllyn station on the Bala Lake Railway. The opening hours and beer range are reduced in winter. The pub always opens on Sunday but check times. 🌳🏠🍴⛺≠(Bala Lake)♣P🚪(T3)☂

Llysfaen

MASH 🅛

Unit 2 Ty Mawr Enterprise Park, off Tan Y Graig Road, LL29 8UE

☎ (01492) 514305 🌐 conwybrewery.co.uk

Conwy Rampart; 3 changing beers (sourced locally) 🅗
Micropub and Conwy Brewery tap that has become a community hub since opening in 2018. It serves a good range of ales, lagers, wines and spirits, with coffee, tea and soft drinks also available. Recent refurbishment has provided an extra indoor drinking space, complete with large-screen TV, that is available for functions. Following the public footpath finger post at the front corner of the brewery leads to views over the bay of Colwyn towards the Great Orme. Third-pint glasses are available.
🌜🏵️P🚂🐕🛜

Maentwrog

Grapes Hotel 🅛

LL41 4HN (on A496 near A487 jct)

☎ (01766) 590365 🌐 grapeshotelsnowdonia.co.uk

3 changing beers (sourced locally) 🅗
Former coaching inn that dates back to the 17th century and overlooks the Vale of Ffestiniog. Its interior comprises a lounge, public bar, veranda and large dining room; outside to the rear is a sheltered beer garden. Most of the beers are local. Plas Halt railway station nearby is on the scenic Ffestiniog line. The village is an ideal base for visiting this beautiful area.
Q🌜🏵️🍴🍽️&🅿🎗️≈(Ffestiniog Railway) ♣🐕P🚂

Marianglas

Parciau Arms

LL73 8NY

☎ (01248) 853766

3 changing beers (often Conwy) 🅗
Set on a sizeable plot on the edge of the village adjacent to a camping site, this free house has up to four ales, often from Conwy. Its stained-glass windows and wood-panelled interior along with nautical themed pictures and memorabilia, give it character. In summer the lawned beer garden is popular while an open fire provides warmth in winter when the opening hours are reduced. 🌜🏵️AP🐕

Menai Bridge

Liverpool Arms ✅

St George's Pier, LL59 5EY

☎ (01248) 712453 🌐 thelivvy.pub

Facer's Flintshire Bitter 🅗/🅖**; 3 changing beers** 🅗
Nautically themed pub frequented by locals, students in term time and the local sailing fraternity. The Livvy has four cask ales on offer and serves good-quality home-cooked food. A short walk takes you beneath the famous Grade I-listed suspension bridge, and the pub is close to the quay for seasonal tourist boats. The Wales Coast Footpath is nearby. 🌜🍺&🚂🛜

Morfa Nefyn

Ty Coch Inn

Porthdinllaen, LL53 6DB (access by foot only)

☎ (01758) 720498 🌐 tycoch.co.uk

3 changing beers (sourced regionally) 🅗
The Ty Coch has been named as one of the top 10 beach bars in the world. Set in an iconic position in this beautiful village, it opened as a pub in 1842 to serve local fishermen. It can only be reached on foot either along the beach or across the golf course. The single open-plan room is served by a central bar. Chargeable parking is available at the NT car park or golf clubhouse. Check for out-of-season opening times. 🌜🍺🐕

Nefyn

Bragdy Llyn

Ffordd Dewi Sant, LL53 6EG

☎ (01758) 721981 🌐 cwrwllyn.cymru

Cwrw Llyn Brenin Enlli, Cwrw Glyndwr, Seithenyn; 1 changing beer (sourced locally) 🅗
A friendly bar located within the purpose-built modern Cwrw Llyn brewery, near the coast and picturesque village of Porthdinllaen. The bar is open to the public all year round and serves three real ales from the brewery, which was established in 2011. Brewery tours are available on request and include ale tasters. &P

Old Colwyn

Crafty Fox 🅛

355 Abergele Road, LL29 9PL

☎ 07733 531766

4 changing beers (sourced regionally) 🅗
Old Colwyn's first micropub opened in 2018 in two former shop units. Its main entrance leads into the bar in a former tattoo parlour, featuring tables upcycled from cast-iron Singer sewing machine bases and oak drop-leaf table tops. The lounge, furnished with stools and leather sofas, is in a former butcher's shop. Photographs on the bar wall contrast the present street scene with that of a century ago. Q🌜♣🐕🚂(12)🐕🛜

Penmachno

Eagles 🅛

LL24 0UG

☎ (01690) 760177 🌐 eaglespenmachno.co.uk

Greene King IPA; 2 changing beers (sourced locally) 🅗
Traditional pub in a peaceful village in a secluded valley at the heart of Snowdonia, four miles from Betws-y-coed. A wood-burning stove in the bar ensures a warm welcome in winter. At least one local ale is always on offer. The pub prides itself on being at the centre of community activities; local musicians perform on the first Wednesday of each month. The rear garden provides delightful views up the valley. Q🌜🏵️🍴🍽️♣🚂(19)🐕🛜

Penrhynside

Penrhyn Arms 🅛

Pendre Road, LL30 3BY (off B5115)

☎ (01492) 549060

Banks's Amber Ale; 4 changing beers (sourced regionally) 🅗
Welcoming free house that serves guest ales, concentrating on new breweries and new beers, plus local ciders and perries. Its spacious single room has an L-shaped bar, two real fires and seating around large tables. Food highlights include Wednesday curry night, Thursday pie night and Sunday lunch; pizza is served every night. The rear conservatory leads to a raised landscaped garden terrace with extensive views of the coastline. Live jazz is hosted on Monday and occasional music on Saturday. 🌜🏵️🍴🍽️🐕🚂(14,15)🐕

Pentraeth

Panton Arms

The Square, LL75 8AZ

☎ (01248) 450959
Purple Moose Cwrw Glaslyn/Glaslyn Ale; 2 changing beers Ⓗ

Spacious 18th-century coaching inn with a long lounge bar and separate taproom, popular with locals and tourists alike. Purple Moose Glaslyn is available all year round. Outside is a large beer garden. The pub's location is ideal for walks in the nearby forest and convenient for the coast, and it is served by a frequent bus service.
Q☺☠⑪♿P🚽🐾🐕🛜

Porthmadog

Australia

31-35 High Street, LL49 9LR
☎ (01766) 515957
Purple Moose Cwrw Eryri/Snowdonia Ale, Cwrw Ysgawen/Elderflower Ale, Ochr Dywyll y Mws/Dark Side of the Moose; 3 changing beers (sourced locally; often Purple Moose) Ⓗ

A pub since 1864, the Australia was taken over by the Purple Moose Brewery in 2017 and serves as its taphouse. Most of the core real ale range is available as well as seasonal and special beers. Two rooms are served by a long wooden bar with six handpumps. There is a small outdoor seating area at the back. The pub is near the Ffestiniog & Welsh Highland Railways station.
☺⑪♿🚌🐕🐾🛜

Red Wharf Bay

Ship Inn Ⓥ

LL75 8RJ (off A5025 between Pentraeth and Benllech)
☎ (01248) 852568 ⊕ shipinnredwharfbay.co.uk
House beer (by Facer's); 2 changing beers Ⓗ

Red Wharf Bay was once a busy port exporting coal and fertilisers in the 18th and 19th centuries. Previously known as the Quay, the Ship enjoys an excellent reputation for its bar and restaurant, with meals served lunchtimes and evenings. It gets busy with locals and visitors in summer. The garden has panoramic views across the bay to south-east Anglesey. The resort town of Benllech is two miles away and the coastal path passes the front door. Q☺☠⑪♿P🐕

Rhoscolyn

White Eagle

LL65 2NJ (off B4545 signed Traeth Beach)
☎ (01407) 860267 ⊕ white-eagle.co.uk
6 changing beers (often Weetwood) Ⓗ

After being saved from closure by its owners, this pub was renovated and rebuilt with an airy, brasserie-style ambience. It has a fine patio enjoying superb views over Caernarfon Bay and the Llyn Peninsula to Bardsey Island. The nearby beach offers safe swimming with a warden on duty in summer. The pub is also close to the coastal footpath. Excellent food is available lunchtimes and evenings, and all day during the school holidays.
Q☺☠⑪♿🅿️P

Rhyd Ddu

Cwellyn Arms

LL54 6TL
☎ (01766) 890321 ⊕ snowdoninn.co.uk
6 changing beers (sourced regionally) Ⓗ

Traditional Welsh country inn in a fabulous scenic location in this village at the foot of Snowdon. The pub's boast that it has nine real ales nine days a week is only slightly exaggerated. It usually offers up to six different ales from local or regional breweries. The lovely log fire

makes the pub cosy and welcoming after a walk on Snowdon, or after a ride on the nearby Welsh Highland Railway. ☺🛏️⑪♿🅰️⇌(Welsh Highland)P🚉🐾

Rowen

Ty Gwyn

High Street, LL32 8YU
☎ (01492) 650232
JW Lees Bitter; 2 changing beers (sourced regionally) Ⓗ

Community village pub in an idyllic setting, offering a warm welcome to locals and visitors alike. The comfortable lounge has horse brasses and old pictures on the walls, and there is a small restaurant area serving good food made with locally sourced ingredients. Traditional Welsh singing features on Friday evenings, live entertainment most Saturdays and charity quiz nights on occasion. There are two walled gardens, one with a stream running by. Opening times may vary seasonally. ☺☠⑪🅰️🐾P🚌(19A)🐕🛜

Tremadog

Union Inn Ⓥ

7 Market Square, LL49 9RB
☎ (01766) 512748 ⊕ union-inn.com
1 changing beer Ⓗ

Friendly venue in the village square, with two separate cosy bars and a restaurant at the rear. The pub has a policy of using locally sourced produce, and the ale range mainly features local beers. Children are welcome and there are board games available. Excellent food is served in the bar and restaurant. Tremadog was the birthplace of TE Lawrence (Lawrence of Arabia) in 1888. Frequent bus services pass by.
Q☺☠⑪♿🅰️⇌(Porthmadog) 🍴🚌(1A,T2)

Waunfawr

Snowdonia Park

Beddgelert Road, LL55 4AQ
☎ (01286) 650409 ⊕ snowdonia-park.co.uk
House beer (by Snowdonia Parc); 5 changing beers (often Snowdonia Parc) Ⓗ

Home of the Snowdonia Brewery, this is a popular pub for walkers, climbers and families, with children's play areas inside and out. Meals are served all day. The pub adjoins Waunfawr station on the Welsh Highland Railway – stop off here before continuing on one of the most scenic sections of narrow-gauge railway in Britain. There is a large campsite adjacent on the riverside. A former local CAMRA Pub of the Year.
Q☺☠⑪♿🅰️⇌(Welsh Highland) 🍴🐕P🚽🐾🛜

Breweries

Anglesey Brewhouse

Unit 12, Pen Yr Orsedd, Industrial Estate Road, Parc Bryn Cefni, Llangefni, LL77 7AW
☎ (01248) 345506 ☎ 07748 650368
⊕ angleseybrewhouse.co.uk

Microbrewery established in 2017 in the centre of Anglesey by a former homebrewer. The brewery relocated to larger premises in 2019 with a 10-barrel plant. Currently producing five can-conditioned beers sold direct from the brewery or in shops around North Wales. 🍺

Anglesey Brewing

Chwaen Ddu, Carmel, LL71 7DE
☎ (01248) 717734 ☎ 07943 697881
⊕ angleseybrewingcompany.co.uk

Brewing began in 2014 in Llanbadrig as Bragdy'r Bwthyn, producing bottle-conditioned beers. In 2017 the brewery relocated to Carmel under the Anglesey Brewing Co name and cask production began. Beers are mostly sold at events and outlets across Anglesey. Brewing is currently suspended. LIVE

Black Cloak

🏠 71 Abergele Road, Colwyn Bay, LL29 7RU ☎ 07701 031121

Office: Glog Ddu Llangernyw, Abergele, LL22 8PS

Black Cloak opened in 2018 in a former café using a one-barrel plant producing cask and keg beer. Beers are usually only available in the bar. 🍺◆

Cader SIBA

Unit 4, Parc Menter Marian Mawr Enterprise Park, Dolgellau, LL40 1UU
☎ (01341) 388080 ☎ 07546 272372
⊕ caderales.com

Cader Ales was founded in 2012, and has since expanded to using the five-barrel, purpose-built plant to its optimum. Situated close to the centre of the picturesque market town of Dolgellau. Deliveries are made to the licensed trade in North and Mid-West Wales, and beers in cask or bottle are available to the general public direct. ‼

Cregennan (ABV 3.8%) GOLD
Gold (ABV 3.8%) GOLD
Machlyd Mawddach (ABV 3.9%) BITTER
Arran Fawddy (ABV 4%) GOLD
Talyllyn Pale Ale (ABV 4.4%) PALE

Conwy SIBA

Unit 2, Ty Mawr Enterprise Park, Tan y Graig Road, Llysfaen, LL29 8UE
☎ (01492) 514305 ⊕ conwybrewery.co.uk

⊛Conwy started 2003, and was the first brewery in Conwy for at least 100 years. In 2013 it increased capacity and moved to bigger premises in Llysfaen, with its own tap, known as Mash. Around 100 outlets are supplied. Monthly seasonals, and the West Coast range (American style) are available. It is now owned by the Cadman Capital Group (early 2021) which also operated 360 Degrees brewery. Part owner of the Albion Ale House and the Bridge, Conwy. ‼🍺◆LIVE◆

Clogwyn Gold (ABV 3.6%) PALE
A full-flavoured golden ale featuring strong citrus fruit flavours throughout. Hoppy bitterness dominates the full mouthfeel and lasting finish.
Welsh Pride (ABV 4%) BITTER
Beachcomber Blonde (ABV 4.2%) BLOND
A pale beer with a citrus taste, initially sweetish with delicate hoppiness in the lingering bitter finish.
Rampart (ABV 4.5%) BROWN
A dark, fruity beer with a sweetish initial taste. Fruit flavours accompanied by the underlying hoppiness continue into the bittersweet aftertaste.
San Francisco (ABV 5.5%) IPA
A robust New World IPA with a powerful smack of hops and tropical fruit flavours in the aroma and taste.

Cybi SIBA

Unit 4a, Penrhos Business Park, Holyhead, Anglesey, LL65 2FD
☎ (01407) 769651

Office: O'r Garw, Porthdafarch Road, Holyhead, LL65 2RU ⊕ bragdycybi.cymru

Nanobrewery established in 2020 using a 200-litre brewing system producing bottle-conditioned beers for local distribution on Anglesey. In 2021 the plant was relocated and upgraded to produce 1,600 litres in bottle and keg forms. All beers are unfiltered. LIVE

Geipel SIBA

Pant Glas, Llangwm, Corwen, LL21 0RN
☎ (01490) 420838 ⊕ geipel.co.uk

Geipel commenced brewing in 2013 producing unpasteurised and unfiltered beers. The brewery specialises in lagers, drawing inspiration from the classic styles of Germany and beyond. Available in keg, KeyKeg and bottle. LIVE

Lleu SIBA

Unit A9, Penygroes Industrial Estate, Caernarfon, LL54 6DB ☎ 07840 910460 ⊕ bragdylleu.cymru

⊛Brewing began in 2014 using a 1.25-barrel plant and was upgraded to six barrels in 2016 to meet demand. In 2022 it moved to larger premises. The four beers are named after Welsh folklore characters of the Mabinogi. ‼🍺

Blodeuwedd (ABV 3.6%) GOLD
Lleu (ABV 4%) BITTER
Gwydion (ABV 4.7%) BITTER
Bendigeidfran (ABV 5%) PALE

Llŷn

1 Parc Eithyn Ffordd Dewi Sant, Nefyn, Gwynedd, LL53 6EG
☎ (01758) 721981 ☎ 07792 050134
⊕ cwrwllyn.cymru

⊛Brewing began in 2011. In 2016 the brewing moved into a new, purpose-built, 15-barrel brewery that includes a brewery shop, taphouse, and a visitor's gallery for tours. ‼🍺◆

Y Brawd Houdini (ABV 3.5%) PALE
Brenin Enlli (ABV 4%) BITTER
A fruity bitter, the initial malty taste leads to a hoppy, bitter aftertaste.
Cwrw Glyndwr (ABV 4%) GOLD
A full-bodied, well-balanced, amber beer, quite fruity with a good hoppy finish.
Seithenyn (ABV 4.2%) GOLD
A fruity golden ale with a tangy citrus taste and a dry, hoppy finish.
Porth Neigwl (ABV 4.5%) PALE

Mona

Unit 6, Gaerwen Industrial Estate, Gaerwen, Anglesey, LL60 6HR ☎ 07988 698260
✉ info@bragdymona.co.uk

Seven enthusiastic locals got together and set up Mona Brewery, which was launched in 2019. The present offering is one cask beer and a range of four keg beers.

Pabo (ABV 3.8%) BITTER

A full-bodied, smooth-tasting session bitter. Underlying sweet malt flavours complement the big hoppy taste and bitter finish.

Myrddins

Church Street, Barmouth, LL42 1EH
☎ (01341) 388060 ☎ 07732 967853
✉ myrddins@talktalk.net

Established in 2016 within a café bar in the centre of Barmouth, the brewery relocated a short distance away in 2018.

Nant

Y Felin Pentrefoelas, Bettws-Y Coed, LL24 0HU

Cwrw Nant began brewing in 2021 at a 16th century mill that was last operational in 1984. The brew plant was acquired from the former Bragdy'r Nant.

Ogwen

5 Rhes Ogwen, Stryd Fawr, Bethesda, LL57 3AY
☎ (01248) 605715 ☎ 07545 684752
⊕ cwrwogwen.cymru

The first brewery in the Ogwen valley for over a century. A local community venture, established in 2016 by a group of shareholders who perform all brewing operations. ‼ ☛ LIVE

Cwrw Caradog (ABV 3.9%) PALE
Ryc (ABV 4%) BITTER
Tryfan (ABV 4.2%) BITTER
Chwalfa (ABV 4.5%) PALE

Purple Moose SIBA

Madoc Street, Porthmadog, LL49 9DB
☎ (01766) 515571 ⊕ purplemoose.co.uk

A 40-barrel plant housed in a former iron works in the coastal town of Porthmadog. It owns the 'Australia' pub on Porthmadog High Street as well as two shops, one in Porthmadog and the other in Betws-y-Coed. The names of the beers reflect local history and geography. ‼ ☛ ♦

Cwrw Eryri/Snowdonia Ale (ABV 3.6%) GOLD
Golden, refreshing bitter with citrus fruit hoppiness in aroma and taste. The full mouthfeel leads to a long-lasting, dry, bitter finish.
Cwrw Madog/Madog's Ale (ABV 3.7%) BITTER
Full-bodied session bitter. Malty nose and an initial nutty flavour but bitterness dominates. Well-balanced and refreshing with a dry roastiness on the taste and a good, dry finish.
Cwrw Ysgawen/Elderflower Ale (ABV 4%) SPECIALITY
A pale and refreshing elderflower beer with a good citrus fruit aroma, bittersweet taste, and a zesty, hoppy, mouthwatering finish.
Cwrw Glaslyn/Glaslyn Ale (ABV 4.2%) BITTER

Refreshing, light, malty, amber-coloured ale. Plenty of hop in the aroma and taste. Good, smooth mouthfeel leading to a slightly chewy finish.
Whakahari (ABV 4.3%) BITTER
Ochr Dywyll y Mws/Dark Side of the Moose (ABV 4.6%) OLD
A dark, complex beer quite hoppy and bitter with roast undertones. Malt and fruit flavours also feature in the smooth taste and dry finish.

Snowdon Craft

Quinton Hazell Enterprise Parc, 55 Glan-y-Wern Road, Mochdre, LL28 5BS
☎ (01492) 545143 ⊕ snowdoncraftbeer.co.uk

☺Snowdon Craft, formerly Great Orme Brewery, is now located in Mochdre near Llandudno and uses an 18-barrel plant. It supplies the local area and the pub, the Albion, Conwy, which it part owns. ‼♦

IPA (ABV 4%) IPA
Bitter (ABV 4.5%) BITTER
Summit Blond IPA (ABV 5.2%) PALE
Porter (ABV 5.7%) PORTER

Snowdonia Parc

🛏 **Snowdonia Parc Brewpub and Campsite, Waunfawr, Caernarfon, LL55 4AQ**
☎ (01286) 650409 ⊕ snowdonia-park.co.uk

Snowdonia Parc started brewing in 1998 in a two-barrel brewhouse. The brewing is now carried out by the owner, Carmen Pierce. The beer is brewed solely for the Snowdonia Parc pub and campsite.

Ty Mo (NEW)

Old Market Hall, Palace Street, Caernarfon, LL55 1RR
☎ 07391 696575

Brewing commenced in 2020 in a 19th century, former market hall building using equipment formerly used by the Old Market Brewery. Output is cask, keg and bottle, supplying local pubs and the market hall bar.

Wild Horse SIBA

Unit 4, Cae Bach Builder Street, Llandudno, LL30 1DR
☎ (01492) 868292 ⊕ wildhorsebrewing.co.uk

Small brewery concentrating on supplying KeyKeg, bottled and canned beers to local bars and off-licences. All products are unfiltered and unpasteurised. Occasional one-off casks are produced. ♦ ⚗

Recipe for buttered beer

Take a quart or more of Double Beere and put to it a good piece of fresh butter, sugar candie an ounce, or liquerise in powder, or ginger grated, of each a dramme, and if you would have it strong, put in as much long pepper and Greynes, let it boyle in the quart in the maner as you burne wine, and who so will drink it, let him drinke it hot as he may suffer. Some put in the yolke of an egge or two towards the latter end, and so they make it more strength-full.

Thomas Cogan, The Haven of Health, 1584

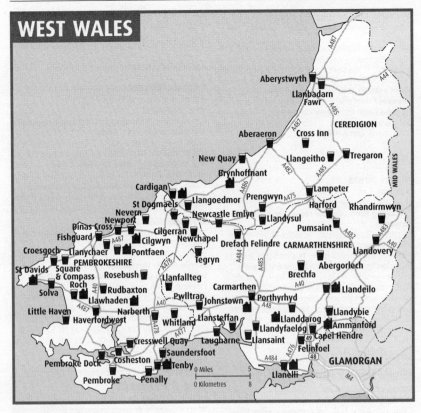

WEST WALES

Aberaeron

Cadwgan Inn

10 Market Street, SA46 0AU (off A487, overlooking harbour)
☎ (01545) 570149
Wye Valley Bitter; 2 changing beers (sourced nationally; often Mantle, Tinworks) Ⓗ
Named after the last ship to be built in this attractive Regency town, this old-fashioned one-bar pub offers a friendly welcome and lively conversation. It is popular for its sports coverage. The guest beers are chosen from a wide range of small and regional breweries. The substantial paved terrace at the front is a real suntrap. Opposite is a free but busy harbourside public car park.
Q❄️Ắ🖭(T1,T5)🌸🍺🛜

Abergorlech

Black Lion

Abergorlech Road, SA32 7SN
☎ (01558) 685271 ⊕ blacklionabergorlech.co.uk
Evan Evans Warrior; 2 changing beers (sourced regionally; often Bluestone, Evan Evans, Tenby) Ⓗ
Traditional village pub that is also a restaurant and coffee shop. It serves home-made food including cakes, using locally sourced ingredients wherever possible. Just a few steps from the pub you can take advantage of signposted walks in the Brechfa Forest or ride the thrilling Brechfa mountain bike trails. Bicycle-locking facilities are provided in the car park and muddy bikers are always welcome; the bar's 300-year-old stone floor is easily cleaned! ☺️❄️🍽️ẮAP🖭🌸🛜

Aberystwyth

Bottle & Barrel

14 Cambrian Place, SY23 1NT
☎ (01970) 625888 ⊕ bottleandbarrel.cymru
2 changing beers (sourced nationally) Ⓗ
A mid-terrace bar in the town centre, providing a cosy yet modern atmosphere in which to enjoy a drink. The relaxed area at the front features comfortable armchairs and wooden tables; to the rear are numerous high tables. The small rear garden has tables and chairs, and is a suntrap in summer. The bar serves two cask ales on handpump, plus a dozen keg lines with a focus on Welsh breweries. Real cider is also available. There is a bottle shop on site. ☺️❄️🍽️🍺♣️🖭🌸🛜

Hen Orsaf ✅

Station Buildings, Alexandra Road, SY23 1LH
☎ (01970) 636080
Greene King Abbot; Ruddles Best Bitter; Sharp's Doom Bar; 6 changing beers (sourced nationally; often Evan Evans, Glamorgan) Ⓗ
An award-winning conversion of Aberystwyth's former GWR railway station, which dates from 1924. This excellent Wetherspoon pub offers up to six guest ales, usually including light and dark beers, and often regional brews. Drinks can be enjoyed outdoors on the old station concourse, which has access to the railway station. The pub hosts regular real ale festivals. It is convenient for trains, buses and taxis. ☺️❄️🍽️🚲Ắ♣️🖭🛜

Ship & Castle 🍺

1 High Street, SY23 1JG
☎ 07773 778785

Wye Valley HPA, Butty Bach; 3 changing beers (sourced nationally; often Oakham, Salopian, Tiny Rebel) ⊞

Aberystwyth's flagship pub offers rapidly-changing and eclectically-sourced microbrewery guest ales from the UK and Ireland. It also serves excellent beer in other formats including craft keg and cans, plus cider and perry from Gwynt y Ddraig. A five-pump platter of third-pint measures is available. The well-considered decor reflects the pub's name and history. The venue can be busy on rugby days but is always welcoming. It hosts an annual beer festival. Q⊛⌂≷♣�⌚ ❀ 🛜

Brechfa

Forest Arms
SA32 7RA
☎ (01267) 202288 🌐 forestarms.com
2 changing beers (sourced regionally; often Glamorgan) ⊞

Community focused pub in the centre of this ancient village. Warmed by a real fire, it has two bars plus a restaurant and function room. Two well-kept real ales are served for much of the year; just one in winter. The wide range of freshly cooked meals features locally sourced ingredients where possible (booking preferred). Outside is a beer garden. Accommodation is available in three interconnecting rooms. The pub gives easy access to the Brechfa hiking and mountain biking trails.
⌚⊛🛏◑P➧❀🛜

Capel Hendre

King's Head Hotel 🅛
Waterloo Road, SA18 3SF
☎ (01269) 842377
2 changing beers (sourced regionally; often Boss, Gower) ⊞

A village pub tucked away just three miles from junction 49 of the M4, and a couple of miles from the former mining town of Ammanford. It has a main bar and dining room, with a sliding door leading to a separate snug. The pub serves two or sometimes three real ales from Wales, with Glamorgan, Bluestone and Neath breweries often represented. ⌚⊛🛏◑&➧P➧(128,129)❀🛜

Cardigan

Black Lion Hotel
High Street, SA43 1HJ
☎ (01239) 612532 🌐 blacklionhotelcardigan.com
Mantle Cwrw Teifi; Wadworth 6X; 1 changing beer (sourced locally) ⊞

Dating from 1105, the Black Lion is said to be the oldest coaching inn in Wales. Its interior is divided into a traditional bar with handpumps, a quieter area for relaxation, a games room and a restaurant. The real fire is a welcome feature on cold days. The pub serves much Welsh produce, including ales from Mantle and other local breweries. Opening times vary in winter.
🛏◑♣❀🛜

Grosvenor
Bridge Street, SA43 1HY SN177459
☎ (01239) 613792 🌐 grosvenorcardigan.co.uk
Sharp's Doom Bar, Atlantic, Sea Fury; 1 changing beer (sourced nationally) ⊞

Large pub on the edge of the town centre, next to Cardigan Castle and the River Teifi. It offers a good choice of ales, mostly from national breweries, plus a selection of bottled beers. The pub has plenty of space for drinking or enjoying the good-value food, plus an upstairs

function room. Live entertainment is hosted, and there is a Tuesday night quiz. Outside is a patio overlooking the river and quay. ⌚⊛◑&♣➧➧❀🛜

Carmarthen

Coracle Tavern
1 Cambrian Place, SA31 1QG
☎ (01267) 468180
Gower Power; 2 changing beers (sourced regionally; often Glamorgan, Wye Valley) ⊞

In the centre of town, close to the main shopping area, this friendly free house offers a warm welcome to locals and visitors alike. Its large open-plan bar area features comfy sofas. Upstairs is a separate restaurant that can be booked for private gatherings. Darts is popular and a number of teams play here. Closed on Tuesdays. ≷♣➧

Friends Arms
Old St Clears Road, SA31 3HH (W of town centre at bottom of Monument Hill B3412)
☎ (01267) 234073
Mantle MOHO; Thornbridge Jaipur IPA; 1 changing beer (sourced regionally; often Tiny Rebel) ⊞

Excellent hostelry half a mile from the town centre, offering a friendly welcome and a cosy atmosphere enhanced by two open fires. Popular with sports fans, it shows the main sports channels on TV. The pub has its own microbrewery, which produces an ale for special events. The local CAMRA branch meets here occasionally. A former local CAMRA Pub of the Year.
⌚⊛♣➧(222,322)❀🛜

Stag & Pheasant
34 Spilman Street, SA31 1LQ
☎ (01267) 232040 🌐 stagandpheasant.co.uk
2 changing beers (sourced nationally; often Glamorgan, Ringwood) ⊞

Busy pub on Carmarthen's main thoroughfare, with a warm and friendly atmosphere that is enjoyed both by locals and tourists. The landlady has the freedom to serve a selection of excellent ales. Two large-screen TVs make this a popular venue for watching sport. The pleasant rear beer garden has heaters for cold weather.
⊛≷♣➧❀🛜

Yr Hen Dderwen ✪
47-48 King Street, SA31 1BH
☎ (01267) 242050
Greene King Abbot; Ruddles Best Bitter; Sharp's Doom Bar; 4 changing beers (sourced nationally; often Exmoor, Rhymney) ⊞

REAL ALE BREWERIES

Bluestone ✦ Cilgwyn
Caffle Llawhaden
Cardigan ✦ Brynhoffnant
Coles Family 🍴 Llanddarog
Electro Cardigan
Evan Evans Llandeilo
Felinfoel Llanelli
Friends Arms 🍴 Johnstown (brewing suspended)
Gwaun Valley 🍴 Pontfaen
Harbwr Tenby ✦ Tenby
Mantle Cardigan
Old Farmhouse St Davids
Tenby Tenby
Tinworks Llanelli
Victoria Inn 🍴 Roch
Zoo Ammanford

Terraced town-centre pub named after the local legend of Merlin and an ancient oak, depicted throughout the premises. A recent refurbishment introduced a first-floor dining area and large roof terrace. Local Welsh ales are always available alongside a good selection of beers from around the world, including bottled and canned craft brews. Food is served all day. The pub hosts beer festivals in the spring and autumn and a cider festival in the summer. ⏰◐♿≈♠🚲🌐

Cilgerran

Masons Arms
Cwnce, SA43 2SR
☎ 07989 990461
Sharp's Doom Bar; 2 changing beers (often Mantle) ⊞
Also known as the Rampin, this venue is thought to have opened in 1836. It is a small, cosy and friendly village pub with an open fire (an old kitchen range). Many local characters can be found here, contributing to an excellent atmosphere. Three real ales are on offer, one changing regularly, usually from a local brewery. Various charity events are held during the year along with an occasional musical evening. Winter opening times may vary – check ahead. ⏰❀♣🅿🌐

Cosheston

Brewery Inn
SA72 4UD
☎ (01646) 686678 ⊕ thebreweryinn.com
Brains Rev James Original; Coles Family Cwrw Blasus; 1 changing beer ⊞
This Grade II-listed free house was once accommodation for monks, with its own brewhouse in outbuildings behind (brewing ceased in 1889). The light and airy stone-built inn has a traditional slate floor and beamed ceiling. To one side is a cosy area for drinkers to enjoy a chat in front of the log fire. The pub has a reputation for fine ales and food. Ingredients for its extensive menu are sourced locally, including fresh fish.
Q⏰❀☸◐♿♠🅿🌐🌙🌐

Cresswell Quay

Cresselly Arms 🄻
SA68 0TE
☎ (01646) 651210
Sharp's Doom Bar ⊞**; Worthington's** Ⓖ**; house beer (by Caffle); 2 changing beers (sourced locally; often Bluestone, Mantle)** ⊞
Situated on the Cresswell River, this 250-year-old ivy-covered hostelry is a throwback to the Victorian age. Its homely farm kitchen interior, where a roaring fire burns in the hearth, is a place for locals and visitors alike. The house beer from Caffle is complemented by Worthington's Bitter dispensed from the barrel by jug. The pub is on several interesting walking routes, and at high tide is accessible by boat from the Milford Haven estuary. Q⏰❀☸♿♠🅿🚌(361)

Croesgoch

Artramont Arms
SA62 5JP
☎ (01348) 831309
2 changing beers (often Shepherd Neame) ⊞
Friendly, family-run village local that has been licensed premises since the 1700s; in the past it also sold petrol and incorporated a post office. It now features a large public bar with tiled floor plus a lounge with dining area. There is also a small library for customers, and a pleasant garden. Good food is available from an interesting and varied menu. Check winter opening times before travelling. ⏰❀◐♠🅿🚌(T11)🌙

Cross Inn

Rhos yr Hafod Inn 🄻
SY23 5NB (at B4337/B4577 crossroads)
☎ (01974) 272644
2 changing beers (sourced regionally; often Bluestone, Evan Evans, Mantle) ⊞
A warm welcome awaits at this family-run pub. Its choice of drinking areas includes the front bar, popular in the early evening with lively locals, and the comfortable rear bar. The range of guest ales includes two constantly changing beers from Welsh breweries. For sunny days there is a large rear garden and a roadside drinking area. Various events are held throughout the year. A former local CAMRA Pub of the Year. Q⏰❀♣🌙🌐

Dinas Cross

Freemasons Arms
Spencer Buildings, SA42 0UW (on A487 coast road between Fishguard and Newport)
☎ (01348) 811674
Gower Gold; 1 changing beer (often Coles Family) ⊞
Traditional sea captains' meeting place in the Pembrokeshire Coast National Park. This pub is conveniently placed for those who enjoy sailing or like to visit attractive beaches and walk the coastal path. It also has the advantage of being on a principal bus route. The main bar, tastefully refurbished while retaining its original character, features a cosy open fire and a dining area at the side. Check winter opening times before venturing forth. Q⏰❀☸◐♿♠🅿🚌(T5)🌙🌐

Ship Aground
SA42 0UY (on A487 between Fishguard and Newport)
☎ (01348) 811124
Wye Valley Butty Bach; 1 changing beer (sourced locally) ⊞
A roomy, welcoming pub that dates back to about 1750, well signposted just off the main A487. A real fire contributes to the family-friendly atmosphere. Food is served early evenings from Monday to Saturday in summer, and from Thursday to Saturday the rest of the year. Live music is hosted on summer weekends. Outside is a spacious beer garden where dogs are welcome. Check winter opening times before travelling. Q⏰◐♠🅿(T5)🌙🌐

Drefach Felindre

John Y Gwas
SA44 5XG SN354383
☎ (01559) 370469
3 changing beers (sourced nationally) ⊞
It's hard to miss the striking yellow and black façade of this village tavern, which is popular with locals and visitors. Three changing ales are usually on tap alongside a range of bottled beers and ciders. The cosy interior, heated by a wood-burning stove, features two rooms plus a restaurant. Home-cooked food, made from locally sourced ingredients, is served all day. Families and dogs are welcome. The TV is reserved for sporting events. ⏰❀♣♠🅿(460)🌙🌐

Felinfoel

White Lion Inn
Parkview, SA14 8BH (on main A476 in Felinfoel)

☎ (01554) 776644
Glamorgan Jemimas Pitchfork; 1 changing beer (sourced nationally) Ⓗ

A family-friendly split-level hostelry with defined drinking and dining spaces plus a function room. A selection of well-kept real ales is available, and a good-value carvery. The pub hosts a quiz on Wednesday and Sunday nights. Outside are covered and open drinking areas. National cycle and walking paths to the Swiss Valley and beyond are nearby. There is ample parking on the roadside. ⛘❀◑◔♿♣P🚪🚲🛜

Fishguard

Royal Oak Inn ♟

Market Square, SA65 9HA
☎ (01348) 218632
Brains Rev James Original; Glamorgan Jemimas Pitchfork; 1 changing beer (sourced locally; often Bluestone) Ⓗ

This Grade II-listed building has a place in history: a French invasion attempt on the west coast of Wales in 1797 was thwarted by locals in the Battle of Fishguard, regarded as the last invasion attempt on Britain. A peace treaty was signed between the British and French in the Royal Oak's bar area. The interior is sparingly decorated with exposed stone and wooden beams, but with little reference to its historic past. Q❀❀◑◔♣♿🚪

Harford

Tafarn Jem

SA48 8HF
☎ (01558) 650633
1 changing beer (sourced nationally; often Morland, Wadworth) Ⓗ

A welcoming 19th-century pub named after landlady Jemima. Its previous name of Mountain Cottage hints at the stunning views. Inside, the open-plan main section consists of a small, comfortable bar and a larger dining space that hosts teas and functions. Occasional curry and steak nights are held, for which booking is essential. The cosy snug on a lower level is ideal for families with well-behaved dogs. ♿P🛜

Haverfordwest

William Owen Ⓛ ✅

6 Quay Street, SA61 1BG
☎ (01437) 771900
Greene King IPA, Abbot; Sharp's Doom Bar; 5 changing beers (sourced regionally; often Bluestone, Boss, Caffle) Ⓗ

Pembrokeshire's first and only Wetherspoon pub occupies a handsome 19th-century building, formerly a shop, hotel and restaurant, with a spacious extension to the rear. It was reputedly built in 1856 for Joseph Thomas, a corn and manure merchant, by local architect William Owen. It has also been a saddler's and, more recently, the Wilton House Hotel. Beer from one of the county's breweries is regularly available. The pub offers the chain's standard menu and promotional deals, and opens early for breakfast. Q⛘❀◑◔♿♣🚆🚪🛜

Lampeter

Nag's Head

14 Bridge Street, SA48 7HG
☎ (01570) 218517
2 changing beers Ⓗ

Vibrant town-centre pub featuring a bright and modern horseshoe-shaped bar area. Friendly and fun, it attracts a good mix of customers – locals, students and tourists. The pub serves a guest ale throughout the year, increasing to two in summer. Most major sports events are screened, and live music often features. The pub also offers B&B, evening and lunchtime meals, and a function room. ❀🛏◑◔♣♿🚪🛒🛜

Laugharne

New Three Mariners Inn Ⓛ

Victoria Street, SA33 4SE
☎ (01994) 427426
2 changing beers (sourced locally; often Courage, Evan Evans, Gower) Ⓗ

Popular locals' pub in the centre of this historic town, close to the early 11th-century castle. The pub moved to its current site when the original alehouse opposite was converted to a carpentry shop. Two beers are served for most of the year, with just one in winter. Evening meals are offered and there is a weekly quiz night. Dylan Thomas lived in Laugharne for a number of years; he and his wife Caitlin are laid to rest in the graveyard of St Martin's Church. ⛘❀🛏◑◔♿♣P🚪🛒🛜

Little Haven

Saint Bride's Inn Ⓛ

St Brides Road, SA62 3UN
☎ (01437) 781266 🌐 saintbridesinn.co.uk
Brains Rev James Original; Hancocks HB; 2 changing beers (sourced locally; often Caffle) Ⓗ

Family-run pub in the centre of this quaint old fishing village in a conservation area of the Pembrokeshire Coast National Park. Open all year round, the pub is known for the ancient well in its cellar. It serves a range of Welsh ales, often including Pembrokeshire brews. The attractive interior includes a separate dining area. Outside there are heaters on the patio in the pretty suntrap garden. Q⛘❀◑◔♣P🚪(311,400)🛜

Llanbadarn Fawr

Black Lion

SY23 3RA
☎ (01970) 636632
Wye Valley Butty Bach; 3 changing beers (sourced nationally; often Banks's) Ⓗ

Modernised pub in the village centre, a mile from Aberystwyth, popular with locals and students. Its spacious main bar has seating at one end, pub games at the other, and a large function room at the rear. Pub teams compete in darts, pool and poker, and a quiz is hosted here every other Friday. The large rear garden, next to the village's ancient church, has a delightful air of rural seclusion. Q⛘❀♣P🚪🛒🛜

Llandeilo

Salutation Inn

33 New Road, SA19 6DF
☎ (01558) 824255
Sharp's Doom Bar; Timothy Taylor Landlord; 2 changing beers (sourced regionally; often Gower, Wye Valley) Ⓗ

A locals' pub near the town centre. Friendly staff dispense four well-kept ales. The interior is divided into two areas, with a pool table on one side and a wood fire on the other. Live music often features at weekends. There is a garden and function area to the rear. The pub hosts a beer festival in the summer. ❀♿🚆♣🚪🛒🛜

Yr Hen Vic
82 New Road, SA19 6DF
☎ (01558) 822596
3 changing beers (sourced regionally; often Glamorgan, Mumbles, Oakham) Ⓗ
A lively venue with a warm welcome for all who pass through its doors. Originally a sports club, it has been a pub for the last 15 years. Three well-kept, constantly changing beers are always available. Several large TVs show sport in the bar. There is a dining area at the front of the pub, and a separate pool room.
Ⓑ◑⇌♣P🖳(X13,281) 🐾🛜

Llandovery

Whitehall
1 High Street, SA20 0PU
☎ (01550) 721139
Mantle MOHO, Cwrw Teifi; 1 changing beer (sourced nationally) Ⓗ
Friendly 17th-century pub in the centre of town, warmed by cosy log fires in winter. It serves three well-kept ales, reducing to two in winter. Meals are offered but weekend availability is limited so booking is recommended. The pub hosts a darts league on Thursday evenings, and is home to the Llandovery Vintage Tractor club. There is outside seating at the front and a beer garden to the rear. Ⓑ🐾🏠◑⇌♣🖳🐾🛜

Llandybie

Ivy Bush
18 Church Street, SA18 3HZ (100yds from church)
☎ (01269) 850272
Timothy Taylor Landlord; 1 changing beer (sourced regionally; often Exmoor) Ⓗ
This friendly local contains a single bar with two comfortable seating areas. It usually serves Timothy Taylor's Landlord alongside at least one guest ale. The pub hosts weekly games and quizzes, and shows sport on TV. The local birdwatching group meets here. The nearby railway station is on the scenic Heart of Wales line. Ⓑ🐾⇌♣P🖳(103,X13)🛜

Llandyfaelog

Red Lion
SA17 5PP (300yds off A484)
☎ (01267) 267530 ⊕ redlionllandyfaelog.co.uk
Wye Valley Butty Bach; 2 changing beers (sourced nationally; often Butcombe, Glamorgan) Ⓗ
A family-run village hostelry that can truly be described as being at the heart of the community – it has an annexe that hosts the local choir's practice evenings and stages concerts and functions for the surrounding area. The large public bar is complemented by a restaurant and a family room. Food is served in both the bar and restaurant. B&B accommodation is in five en-suite rooms. QⒷ🐾◑ᒻ⛽🖳(198,X12)🛜

Llandysul

Porth Hotel
Church Street, SA44 4QS SN418407
☎ (01559) 362202 ⊕ porthhotel.co.uk
2 changing beers (sourced locally) Ⓗ
Run by the same family for three generations, this former 17th-century coaching inn on the banks of the River Teifi is now a village hotel with a bar, restaurant and function room. The public rooms still retain the original oak beams and panels. Food and drink is sourced locally where possible. At the rear are a car park and a lawned garden beside the river, with access to walks and fishing. Ⓑ🐾🏠◑♣♣P🖳🐾🛜

Llanelli

Stradey Arms
1 Stradey Road, SA15 4ET
☎ (01554) 753332 ⊕ thestradeyarms.com
Brains Rev James; Marston's Pedigree; 1 changing beer (sourced nationally) Ⓗ
A popular pub on the outskirts of the town, featuring a comfortable bar and separate restaurant. Friendly and welcoming staff add to the pleasant ambience here. Real ale is served from up to four handpumps. A varied menu of freshly prepared food is offered all day except on Sunday, when there is a lunchtime carvery. The pub gets busy during sporting events, especially rugby internationals. Ⓑ🐾◑ᒻP🖳🐾🛜

York Palace ●
51 Stepney Street, SA15 3YA (opp Town Hall Square Gardens)
☎ (01554) 758609
Greene King Abbot; Ruddles Best Bitter; 8 changing beers (often Glamorgan, Gower, Tomos Watkin) Ⓗ
A refurbished former picture palace retaining much of the original decor, offering a good selection of beers from around the world including bottled and canned craft ales. It also boasts a varied selection of boxed and bottled real ciders, occasionally also on handpull. There are beer festivals in the spring and autumn, and a cider festival in summer. The pub hosts Meet the Brewer sessions throughout the year. Food is served all day. Q◑ᒻ⇌♣🖳🛜

Llanfallteg

Plash
SA34 0UN (off A40 at Llanddewi Velfrey)
☎ (01437) 563472 ⊕ theplashinn.co.uk
Wye Valley Butty Bach; 2 changing beers Ⓗ
At the centre of village life, this terrace-style cottage pub has been an inn for more than 180 years. Its guest beers are usually from small, independent breweries. The pub serves home-made food using locally sourced ingredients, with specials on Wednesday, Thursday and Friday. It holds a quiz night on Tuesday, a regular monthly folk night and other entertainment. An accessible entrance is to the rear. A regular in this Guide for 10 years, and a former local CAMRA Pub of the Year. QⒷ🐾🏠ᒻᒻⓐ♣🐾🛜

Llangeitho

Three Horseshoe Ⓛ
SY25 6TW
☎ (01974) 821244
Wye Valley Butty Bach; 1 changing beer (sourced regionally; often Evan Evans, Monty's) Ⓗ
A traditional, family-run pub that is the hub of life in this historic village. It has a main bar, dining area, function room and sunny rear garden with a beautifully built wooden covered area. The friendly landlord is a keen supporter of real ale and often serves beer from Welsh breweries. Good-value evening meals and Sunday lunch are offered. Pool and darts are played, and there is a monthly open mic night. QⒷ🐾◑♣🖳(585)🐾🛜

Llangoedmor

Penllwyndu

B4570, SA43 2LY (on B4570 4½ miles from Cardigan)
SN240458
☎ (01239) 682533
Hancocks HB; 2 changing beers (sourced regionally; often Brains) Ⓗ
Old-fashioned alehouse standing at an isolated crossroads where Cardigan's evildoers were once hanged – the pub sign is worthy of close inspection. The cheerful and welcoming public bar retains its quaintness, with a slate floor and inglenook with wood-burning stove. Good home-cooked food including traditional favourites is available all day in the bar and the separate restaurant. Free live music plays on the third Thursday evening of the month. ᗡ🏵🍴♣P🌸

Llansaint

King's Arms

13 Maes yr Eglwys, SA17 5JE
☎ (01267) 267487
Glamorgan Jemimas Pitchfork; Young's London Special; 1 changing beer (sourced nationally) Ⓗ
Friendly village hostelry that has been a pub for over 200 years. Situated near an 11th-century church, it is reputedly built from stone recovered from the lost village of St Ishmaels. Attractions include live music every Thursday and a TV for major sporting events. Good-value home-cooked food is served (book ahead, especially Sun). Carmarthen Bay Holiday Park is a few miles away. A former local CAMRA Pub of the Year.
ᗡ🍴&♣P🚃(198) 🎧

Llansteffan

Castle Inn

The Square, SA33 5JG
☎ (01267) 241225
Sharp's Doom Bar; house beer (by Evan Evans); 1 changing beer (often Evan Evans) Ⓗ
The Castle is a traditional inn committed to real ale, with a welcoming atmosphere and friendly staff. It has an open-plan layout but also plenty of cosy corners for customers to relax and unwind in relative peace and quiet. The pub hosts a number of local community groups. It offers bar snacks from an uncomplicated menu. There is an outside seating area overlooking the village square where locals and tourists mingle.
Q ᗡ🏵🍴&♣🚃(227) 🌸🎧

Llanychaer

Bridge End Inn Ⓛ

SA65 9TB (on B4313, 2 miles SW of Fishguard)
☎ (01348) 872545
Mantle Rock Steady, Cwrw Teifi, Dark Heart Ⓗ**; 1 changing beer (sourced locally)** Ⓗ/Ⓖ
Known locally as the Bont, this friendly country pub, over 150 years old, nestles in the beautiful Gwaun Valley at a bridging point across the river. The cosy bars are warmed by log fires, and serve real ales that are mostly local brews. The dining room is housed in the smithy, once run as a complementary business to the inn, and features an external water wheel. Home-made food includes popular Sunday lunches. Check ahead for winter hours and food service. Q ᗡ🏵🍴&🅰♣🚃(345)🌸🎧

Narberth

Dingle Inn

Jesse Road, SA67 7DP
☎ (01834) 869979 🌐 dinglecaravanparknarberth.co.uk
3 changing beers (sourced regionally) Ⓗ
Friendly local next to a caravan and camping site, offering plenty of Narberth's distinctive community spirit. The beer served from the single handpump changes frequently, with customer preference guiding the selection of ales from the local area and further afield. The town boasts a range of specialist shops and attractions, including an award-winning museum, that would be the envy of many larger places.
ᗡ🏵🍴🅰🚃P🚃(381)

Nevern

Trewern Arms

SA42 0NB (off the A487, 2 miles N of Newport)
☎ (01239) 820395 🌐 trewernarms.com
3 changing beers (sourced nationally; often Bluestone, Harbwr, Mantle) Ⓗ
A picturesque 16th-century pub deep within a secluded valley astride the banks of the River Nevern. The village of Nevern is less than a mile from the beautiful fishing town of Newport. This multi-roomed pub caters for all, from those who just want a drink to large parties and wedding receptions. A great place to stay to experience some of the best walks in West Wales.
Q ᗡ🏵🍴&🅰♣P🚃(T5) 🌸🎧

New Quay

Black Lion Ⓛ

Glanmor Terrace, SA45 9PT
☎ (01545) 560122 🌐 blacklionnewquay.co.uk
Sharp's Doom Bar; 2 changing beers (sourced locally; often Purple Moose) Ⓗ
Perched atop a steep street, this striking pub has Dylan Thomas connections. Refurbished in a contemporary style, it has separate dining areas and a main bar that gets busy when big games are screened on TV. The large garden has a play area and stunning sea views (dogs are welcome in the garden). Doom Bar is served alongside two other beers, which are often from Welsh breweries. Excellent food is on offer. Live music is hosted during New Quay's August festival. Accommodation is available in nine bedrooms. The car park is for residents only.
Q ᗡ🏵🍴🅰🚃(T5) 🎧

Newcastle Emlyn

Bunch of Grapes ✅

Bridge Street, SA38 9DU
☎ (01239) 711185 🌐 bunchofgrapes.net
2 changing beers Ⓗ
A Grade II*-listed building dating back to the 17th century, reputed to have been built from the ruins of the nearby 13th-century castle. Set in the heart of the community, the pub offers a warm and welcoming place to eat, drink and relax. Its enclosed rear garden features a children's play area and a covered smoking shelter.
ᗡ🏵🍴&🅰♣🌸P🚃(460) 🌸🎧

Newchapel

Ffynnone Arms Ⓛ

SA37 0EH
☎ (01239) 841800 🌐 ffynnonearms.co.uk
Harbwr North Star; Mantle Cwrw Teifi; 3 changing beers Ⓗ

Charming and traditional 18th-century pub on the borders of three counties – Pembrokeshire, Carmarthenshire and Ceredigion. Local ales are often available alongside the regional and national beers, and Welsh cider Gwynt y Ddraig is also sold. The landlady prides herself on serving good food using locally sourced ingredients where possible, with gluten-free, dairy-free and sugar-free options. Fish & chips night is Wednesday, and on Sunday there is a carvery. Welsh and English are spoken. Q ⑤ ❀ ◑ ⓵ & ♣ ● P ☐

Newport

Royal Oak
West Street, SA42 0TA
☎ (01239) 820632 ⊕ theroyaloaknewport.co.uk
Gower Gold; Greene King IPA; 1 changing beer (sourced nationally) ⒣
A warm welcome awaits at this traditional Welsh country pub, which retains all the charm and atmosphere of its roots, with oak beams, a tiled bar area and many original features. As well as offering quality real ales, the pub is renowned for its good home-made food, notably curries and fish & chips. A pensioners' lunch is served on Tuesday. Q ⑤ ◑ ⓵ & P ☐ ☎

Pembroke

Old King's Arms ⒧
Main Street, SA71 4JS
☎ (01646) 683611 ⊕ oldkingsarmshotel.co.uk
Felinfoel Double Dragon; Marston's Old Empire; 2 changing beers (sourced locally; often Bluestone) ⒣
This former coaching inn is allegedly the oldest inn in Pembroke, dating from around 1520. The hotel's King's Bar is a small room with exposed stone walls, beams and a real fire. It has four handpumps serving local, regional and national beers. There is a separate lounge with a dining area, and a restaurant with room for larger groups. Locally sourced meat and fish dishes feature on the menu. Q ⑤ ❀ ❀ ◑ ⓵ & P ☐ ☎ ☎

Pembroke Dock

First & Last
London Road, SA72 6TX (on A477)
☎ (01646) 682687
Bath Ales Gem; Brains Rev James Original; 1 changing beer (sourced nationally; often Skinner's) ⒣
Friendly single-bar local run by the same family for more than 50 years. Formerly the Commercial, it acquired its more distinctive name in 1991 to reflect its edge-of-town location. An eclectic mix of photos and prints adorns the walls. Guest beers are from local and national breweries, and a menu of good pub fare is served. The quirky Sunday evening quiz is popular. The pub is handy for the Cleddau Bridge, giving easy access to Haverfordwest, and close to the historic naval dockyard and Irish Ferries. Q ⑤ ❀ ◑ ⓵ ⇌ P ☐ ☎

Penally

Cross Inn
SA70 7PU
☎ (01834) 844665 ⊕ crossinnpenally.co.uk
Hancocks HB; Sharp's Doom Bar, Atlantic; 1 changing beer ⒣
There are military and sporting themes to this pub in a picturesque village, with its well-preserved Georgian and Victorian houses. Shields of regiments stationed in a nearby barracks adorn the walls alongside local pictures. The locals' sporting prowess is evident from the awards

on the trophy shelf. A signed photo and a set of darts used by the legendary Phil 'The Power' Taylor is framed in an alcove. The pub's wood and brick bar leads to a restaurant – ring to check food service times. ⑤ ❀ ◑ ⓵ ▲ ⇌ ♣ ☐ ☐ (349,358)

Pontfaen

Dyffryn Arms ★
SA65 9SE (off B4313)
☎ (01348) 881863
Draught Bass ⒢
This much-loved inn, a reminder of the way many rural inns once were, is the hub of life in a secluded valley where there is a tradition of farmhouse brewing. Built in 1845, it has no bar counter; beer is still served by the jug through a sliding serving hatch. Welsh and English is spoken, and conversation is the main form of entertainment. This timeless gem features on CAMRA's inventory of historic pub interiors, and has a long history of appearances in this Guide. Q ⑤ ❀ ▲ ♣ ● P ❀

Porthyrhyd

Mansel Arms ⍦ ⒧ ✔
Banc y Mansel, SA32 8BS (on B4310 between Porthyrhyd and Drefach)
☎ (01267) 275305
Grey Trees Afghan Pale ⒣**; 4 changing beers (sourced nationally; often Evan Evans, Mantle, Rhymney)** ⒣/⒢
Welcoming 18th-century coaching inn with plenty of traditional character, featuring wood fires in both bars. The landlord is passionate about real ale and encourages customers to experience a variety of flavours, with third-pints available. Beers are selected from local and national brewers, with a new ale introduced every couple of days – more than 180 in the last year. The pub's cask ale members' club offers regular brewery visits. Excellent home-cooked food is served. A former CAMRA Wales National Pub of the Year.
⑤ ❀ ◑ ♣ ● P ☐ (129) ❀ ☎

Prengwyn

Gwarcefel Arms
Prengwyn, SA44 4LU (on A475/B4476 crossroads)
SN424442
☎ (01559) 363122
Sharp's Doom Bar; 1 changing beer (sourced nationally) ⒣
Traditional country inn with a friendly atmosphere where all are welcome, including families and dogs. Situated at the junction of five roads in Prengwyn, three miles north of Llandysul, the pub has a main bar with a wood-burning stove, cosy seating, a pool table and dartboard. A separate restaurant area, which caters for functions and parties, offers evening meals and Sunday lunches. The pub hosts a quiz on the first Wednesday of the month. A beer garden and ample car park are to the rear. ⑤ ❀ ◑ ♣ P ❀

Pumsaint

Dolaucothi Arms
SA19 8UW (on A482 between Llanwrda and Lampeter)
☎ (01558) 650237 ⊕ nationaltrust.org.uk/dolaucothi-gold-mines/features/the-dolaucothi-arms-bnb
2 changing beers (sourced regionally; often Evan Evans, Gower) ⒣
A substantial stone-built inn with a friendly welcome, owned by the National Trust and tastefully restored in traditional style. It usually serves two real ales from

Welsh breweries, and has an excellent food menu. The large beer garden provides views over the valley and the rivers Cothi and Twrch, for which the pub has fishing rights. A former BBC Countryfile Pub of the Year. The Dolaucothi Gold Mines are nearby. ᗱ❀ᴞ◑&▲♣Ꮲ❀ᦓ

Pwlltrap

White Lion

SA33 4AT

☎ (01994) 230370 ⏺ whitelion-pwlltrap.co.uk

Greene King Abbot; Shepherd Neame Bishops Finger; Young's London Original; 1 changing beer (sourced locally) ⑭

This roadside pub, just outside St Clears on the road to Whitland, is warm and welcoming, with a real fire in winter. It has an old-world charm, with oak beams and panelled walls. Two cask beers are available in winter, four in summer. The large annexe restaurant serves good food; takeaway meals are also available. Pool and darts are played and a large-screen TV shows sporting fixtures. The pub organises a range of events throughout the year. Q◑&♣Ꮲ (224,322) ❀ᦓ

Rhandirmwyn

Towy Bridge Inn

Rhandirmwyn, SA20 0PE

☎ (01550) 760370

2 changing beers (sourced locally; often Glamorgan) ⑭

A delightful rural riverside location is a highlight of this pub, whose large outdoor seating area gives views across the water. The interior comprises a single room with a table seating area and a bar. An additional space is used for functions and special events. Real ales come from local Welsh breweries. The pub is popular with walkers, bikers and cyclists, and welcomes dogs. Qᗱ❀Ꮲ❀ᦓ

Roch

Victoria Inn

SA62 6AW (on A487)

☎ (01437) 710426 ⏺ thevictoriainnroch.com

Victoria Inn NewgAle, Fine & Dandy, WOW; 1 changing beer (sourced locally; often Victoria Inn) ⑭

A little gem of a brewpub, offering a warm welcome and views across St Brides Bay. The inn was established in 1851, although parts are older, and has retained much of its old-fashioned charm with beamed ceilings and low doorways. The home-brewed house bitter is Fine & Dandy. Food is available every day except Monday; curry and a pint night is Friday. For those in a hurry there is a beer carry-out service. Live music features occasionally. Qᗱ❀ᴞ◑▲♣Ꮲ (T11) ᦓ

Rosebush

Tafarn Sinc ✅

SA66 7QU

☎ (01437) 532214 ⏺ tafarnsinc.cymru/eng/index.php

Worthington's; 3 changing beers (often Gwaun Valley) ⑭

A Victorian hotel that was built to attract tourists to the Preseli Mountains in 1876, when the Clunderwen to Rosebush railway line was opened. Originally called the Precelly Hotel, it closed in 1992 but was bought by locals, refurbished and renamed Tafarn Sinc. Welsh and English are spoken. The building features in the history and social life of the area, and its interior is bursting with old-world

character and charm. Its location in the heart of the mountains ensures scenic views whether driving or walking. ᗱ❀◑&▲Ꮲ

Rudbaxton

Corner Piece Inn

A40, SA62 5PG (on A40 to Fishguard 2 miles from Haverfordwest on turning to Spittal)

☎ (01437) 742185

2 changing beers (sourced locally; often Caffle) ⑭

This is the first pub for two miles from Haverfordwest in one direction and Wolf's Castle in the other. It is a cosy three-roomed hostelry serving good beer and food. The owners are enthusiastic about their real ale and offer two changing beers, normally from Caffle. Pie night is Wednesday and fish night Friday. There is seating and children's play equipment outside but the location on the busy A40 can be noisy. Qᗱ❀◑▲Ꮲ (T5)

St Dogmaels

White Hart

Finch Street, SA43 3EA (on right when entering village from Cardigan)

☎ (01239) 615955 ⏺ whci.cymru

2 changing beers ⑭

A small and cheery community-owned pub in Pembrokeshire's northernmost village, with a good local following. Its guest beers change regularly and are often from breweries rarely seen locally. The restaurant specialises in locally sourced fresh fish and produce. The beach at nearby Poppit Sands marks the northern terminus of the Pembrokeshire Coast Path. The pub opens all day on bank holidays. It is a short walk to St Dogmaels Abbey and visitor centre, one of the area's leading attractions. Qᗱ◑&▲Ꮲ❀

Saundersfoot

Harbwr Bar & Kitchen

1 High Street, SA69 9EJ

☎ (01834) 811413

Harbwr M V Enterprise, North Star, RFA Sir Galahad; 1 changing beer (often Harbwr) ⑭

A modern pub and restaurant in the centre of this popular village, set in the Pembrokeshire Coast National Park and a short walk from the long, sandy beach. The spacious interior features upstairs seating giving superb views, and the outlook from the patio stretches across the bay to Tenby. The pub serves the full range of Harbwr Tenby brewery beers alongside a good selection of gins. It can get a little noisy when busy but is well worth a visit when in the area. ᗱ❀◑&Ꮲ

Solva

Ship

15 Main Street, SA62 6UU (on A487)

☎ (01437) 721528 ⏺ theshipsolva.co.uk

Marston's Pedigree; house beer (by Banks's) ⑭

Families are particularly welcome at this traditional pub, which features black and white timbers both inside and out. The food offering includes authentic Indian curries in the evening, with free delivery available, and a popular Sunday roast. Outside is a covered and heated smoking area. Ample parking is available nearby overlooking the picturesque harbour. Winter opening times vary so check before visiting. A former local CAMRA Pub of the Year. ᗱ❀ᴞ◑&Ꮲ (T11) ❀ᦓ

Square & Compass

Square & Compass Inn

SA62 5JJ

☎ (01348) 831420

Hancocks HB; 2 changing beers (often Caffle, Hardys & Hansons) Ⓗ

A friendly one-bar roadside pub frequented by locals. It serves at least two real ales, often one local brew and one from further afield. Note there is currently no visible pub sign. The pub is near the petrol station in the hamlet of Square and Compass, on the left of the A487 when travelling from St Davids to Fishguard. Welsh and English are spoken. Q❀☎◐Ｐ☱(T11)❀

Tegryn

Butchers Arms

SA35 0BL

☎ (01239) 698680

Gower Gold Ⓗ**; Morland Old Speckled Hen; 2 changing beers** Ⓖ

A rural pub with a great atmosphere, well off the beaten track in a hard-to-find location, but on the National Cycle Network Route 47. It has been attractively refurbished using local slate on the walls and floor. There is a games room featuring a mobile skittle alley plus other traditional pub games. A beer festival is held here every July. Q❀◐&♣Ｐ❀☎

Tenby

Tenby Harbour Brewery Tap & Kitchen Ⓛ

St Julian Street, SA70 7AS (on street linking town square and harbour)

☎ (01834) 842273

Harbwr M V Enterprise, Caldey Lollipop, RFA Sir Galahad; 1 changing beer (sourced locally; often Harbwr) Ⓗ

Harbwr's brewery tap, set in a quaint street linking the town square to the harbour and beaches. The bar area is large but has a cosy feel with beams, stove and Tenby memorabilia adorning the walls. The tap room is at the back of the brewery and showcases its full range of beers. Food is served all day with locally sourced produce, including fresh fish, featuring on the menu. There is a sunny walled beer garden to the rear. ❀☎◐Å⇌●☱❀☎

Tregaron

Talbot Ⓛ

The Square, SY25 6JL

☎ (01974) 298208 ⊕ ytalbot.com

3 changing beers (sourced regionally; often Evan Evans, Ludlow, Mantle) Ⓗ

A heritage pub of immense character. It has a front bar with an open fire and huge beams, a main bar at the rear, a snug with inglenook fireplace and a restaurant. Two real ales are dispensed in winter and three in summer, sourced from Wales and the borders. Real cider from Welsh producers is also offered in busier months. The restaurant and bars serve excellent food from a menu featuring local cheese, fish and meat. Outside are a rear patio and large, beautifully landscaped beer garden that has a memorial to the circus elephant that was reputedly buried here.

Q❀☎❀◐&♣●Ｐ☱(585,588)❀☎

Whitland

Station House Hotel

St Johns Street, SA34 0AP

☎ (01994) 240556 ⊕ stationhousewhitland.co.uk

5 changing beers (often Sharp's, Wye Valley, Young's) Ⓗ

A smile and a warm welcome are always on tap at this friendly hostelry. It is very much a locals' pub for all ages and offers something for everyone, including pool and darts teams, plus bingo on Sunday evening. A small room is available for customers looking for a quiet corner. The outside drinking area is partly under cover. Car parking is to the rear and the railway station is close by.

❀◐⇌♣Ｐ☱❀☎

Breweries

3 Lamps

🍺 2 Castle Street, Swansea, SA1 3JE

✉ hello@thethreelampsswansea.co.uk

Brewing began in 2021 in a three-storey building which includes a taproom and roof terrace. Beers may be marketed as the Ugly Lovely Brewing Co. No real ale. ◆

Bluestone SIBA

Tyriet, Cilgwyn, Pembrokeshire, SA42 0QW

☎ (01239) 820833 ⊕ bluestonebrewing.co.uk

⊠ A family-run business established in 2013 on a working farm in the Preseli Hills, within the Pembrokeshire Coast National Park. The 10-barrel brewery is housed in a 300-year-old dairy, and has a visitor facility/office (website for times). Spring water, filtering down through the Preseli Bluestones to the brewery, gives the beers a unique taste. Outdoor music/events are held in the summer. Local outlets plus wholesalers around the UK are supplied. Green Key accredited for environmental sustainability. ☛◆LIVEV◆

Bedrock Blonde (ABV 4%) BLOND
Stone Cold (ABV 4.2%) PALE
Hammerstone IPA (ABV 4.5%) PALE
Rocketeer (ABV 4.6%) BITTER

Caffle

The Old School, Llawhaden, Narberth, SA67 8DS

☎ (01437) 541502

Office: Park View, Ropewalk, Llawhaden, Fishguard, SA65 9BT ⊕ cafflebrewery.co.uk

⊠ Started in 2013, Caffle is a four-barrel brewery which produces small batch, crafted ales, mainly for the local market. Production consists of a range of core and seasonal cask and bottle-conditioned ales. An annual green hop ale is produced using Pembrokeshire-grown hops via the brewery's hop co-op. ☛LIVE

Skirp Gold (ABV 3.8%) GOLD
Quay Ale (ABV 4%) BITTER
Sholly Amber (ABV 4%) BITTER
Sprilly Maid (ABV 4%) SPECIALITY
In The Grip (ABV 4.7%) RED
Skaddly Pluck (ABV 4.8%) PALE
Drop Squint (ABV 5.2%) BITTER

Camel

Aberaeron, SA46 0BB ☎ 07539 466105

✉ alistair@cwrwcamel.com

Established in 2019, Cwrw Camel was using spare capacity at Bluestone Brewing Co (qv). Brewing is currently suspended.

Cardigan (Teifi)

Y Bryn a'r Bragdy, Brynhoffnant, SA44 6EA
☎ (01239) 614974 ☎ 07961 658701

Office: 5a Morgan Street, Cardigan, SA43 1DF
⊕ cardiganbrewery.com

Cardigan Brewery was established in 2021, offering a range of bottled beers which are marketed as Bragdy Teifi for Welsh sales. Crafty Dai is the brand name for bottled keg beers, while Penlon is the brand name for bottle-conditioned output. LIVE ◆

Coles Family

⬛ White Hart Thatched Inn & Brewery, Llanddarog, SA32 8NT

☎ (01267) 275395 ⊕ thebestpubinwales.co.uk

Brewpub based in the White Hart Inn. It uses a one-barrel plant and also produces a cider. Production invariably is for the pub only. ◆

Electro

Unit 19, Parc Teifi, Cardigan, SA43 1EW

Office: Glenydd Cwmin, St Dogmaels, Cardigan, SA43 3HF ✉ contact@electrobrewing.com

Artisan brewery with beers first appearing 2021. Some of the output is one-off cask beers.

Old School Bitter (ABV 4.3%) BROWN

Evan Evans SIBA

1 Rhosmaen Street, Llandeilo, Carmarthenshire, SA19 6LU
☎ (01558) 824455 ⊕ evanevansbrewery.com

⊠ Evan Evans brews six core beers and an array of seasonal beers. The Company owns the Celt craft beer range and produces the unique Fire Island brand of gluten-free bottle beers. Evan-Evans and James Buckley beers form the traditional beer range, with the new J Buckley Best keg beer available. The Archers brand name is used for occasional beers. It also produces its own Redhog wild cider (gluten-free and vegan-friendly). The brewery bottles its own brands as well as bottling for other independent breweries. ‼ ➤ ◆ LIVE

J Buckley Best Welsh Beer (ABV 4%) BITTER
WPA (Welsh Pale Ale) (ABV 4.1%) PALE
Cwrw (ABV 4.2%) BITTER
Wrecker (ABV 4.5%) BITTER
Sea Scape (ABV 4.6%) GOLD
Warrior (ABV 4.6%) BITTER

Felinfoel SIBA

Farmers Row, Felinfoel, Llanelli, SA14 8LB
☎ (01554) 773357 ⊕ felinfoel-brewery.com

Founded in the 1830s, the company is still family-owned and is now the oldest brewery in Wales. The present buildings are Grade II* listed and were built in the 1870s. It supplies cask ale to half its 84 houses (though some use top pressure dispense), and to approximately 350 free trade outlets. ‼ ➤ ◆

Dragon Welsh IPA (ABV 3.6%) PALE
Celtic Pride (ABV 3.9%) BITTER
Dragon Stout (ABV 4.1%) STOUT
Double Dragon (ABV 4.2%) BITTER

This pale brown beer has a malty, fruity aroma. The taste is also malt and fruit with a background hop presence throughout. A malty and fruity finish.
Nut Brown Ale (ABV 4.3%) BROWN
Dragons Heart (ABV 4.5%) BITTER
Welsh ESB (ABV 4.6%) BITTER
Double Dragon Export (ABV 4.7%) BITTER

Friends Arms

⬛ Old St Clears Road, Johnstown, Carmarthen, SA31 3HH

☎ (01267) 234073 ⊕ thefriendsarms.co.uk

⊠ Friends Arms Brewery opened in 2011 on the premises of the Friends Arms, a traditional local community pub, which acts as the brewery tap. Brewing is currently suspended.

Gwaun Valley SIBA

Kilkiffeth Farm, Pontfaen, SA65 9TP ☎ 07854 767383 ⊕ gwaunvalleybrewery.com

Gwaun Valley began brewing in 2009 on a four-barrel plant in a converted granary. The brewery offers views of the Preseli Hills and has a campsite, a holiday cottage and pitches for five caravans. Folk music sessions are held every Saturday evening. The owners retired early in 2019 and the business has been relaunched by a new tenant brewer who has retained some of the core range of beers, and added others. ‼ ➤

Traditional Porter (ABV 4.3%) PORTER
FSB – Fishguard Special Bitter (ABV 4.5%) PALE
Pembrokeshire Best Bitter (ABV 4.5%) BITTER
St Davids Special (ABV 4.6%) GOLD
Cascade (ABV 4.7%) PALE
Cwrw Melyn (ABV 4.7%) BLOND
Cwrw Gwyn (ABV 5.3%) IPA

Harbwr Tenby

Sargeants Lane, St Julian Street, Tenby, SA70 7BU
☎ (01834) 845797 ⊕ harbwr.wales

A five-barrel brewing plant in an outbuilding of the Harbwr Tap and Kitchen (its associated pub). The beers are available in the pub as well as in the brewery itself, which has a mezzanine bar area overlooking the brewery. Information boards explain the building's history and the brewing process. The brewery offers a tour package named 'Hops and Hwyl'. Beers are found in various outlets in South Wales. ‼ ◆ ◆

M V Enterprise (ABV 4%) PALE
North Star (ABV 4.2%) BITTER
Caldey Lollipop (ABV 4.5%) PALE
RFA Sir Galahad (ABV 4.6%) BITTER
La Nossa Signora (ABV 5%) SPECIALITY

Mantle

Unit 16, Pentood Industrial Estate, Cardigan, SA43 3AG
☎ (01239) 623898 ☎ 07552 609909
⊕ mantlebrewery.com

From start-up in 2013 on a 10-barrel plant, Mantle has become a major player in the West Wales area. Engineer Ian Kimber and his scientist wife Dominique, formerly home brewers, have built a sound reputation for consistent quality. Over 200 outlets are supplied direct with wider distribution via carefully selected wholesalers. ‼ ➤ ◆

Rock Steady (ABV 3.8%) GOLD
MOHO (ABV 4.3%) PALE

Cwrw Teifi (ABV 4.5%) BITTER
Dark Heart (ABV 5.2%) PORTER

Old Farmhouse SIBA

Upper Harglodd, St Davids, SA62 6BX

Brewing commenced in 2021 in a renovated farmhouse. The brewery uses home-grown grain and its own well water in the brewing process.

St Davids

Grange Porthgain, Haverfordwest, SA62 5BJ

Office: Lecha Farm, SOLVA, Haverfordwest, SA62 6YD

Long established "brewery" which owns a number of pubs in far West Wales. It has no brewery and its range of bottled beers are contract brewed at Felinfoel.

Tenby SIBA

Unit 15, The Salterns, Tenby, SA70 8EQ
☎ (01834) 218090 ☎ 07410 169447
⊕ tenbybrewingco.com

Formerly known as Preseli, Tenby Brewing Co uses a six-barrel plant. Beer is supplied to outlets in Pembrokeshire, neighbouring counties and further afield. Spent grain is fed to animals at a local eco farm, and through energy savings the brewery is moving towards becoming carbon neutral. LIVE

Son of a Beach (ABV 4.2%) GOLD
Hang Ten (ABV 4.3%) BITTER
Barefoot (ABV 4.7%) BLOND
Black Flag Porter (ABV 5.6%) PORTER

Tinworks SIBA

Unit 20.1, Trostre Industrial Park, Llanelli, SA14 9UU
☎ 07595 841958 ⊕ tinworksbrewery.co.uk

Brewery commenced operations on a rural farm but relocated and upgraded to a 10-barrel kit in 2019. Cask, bottle and keg beers are produced. ☛

Cwrw Grav (ABV 3.9%) BITTER
Old Castle Pale (ABV 4.6%) PALE
Marshfield Red (ABV 4.7%) RED
Ashburnham Porter (ABV 5%) PORTER
Dafen IPA (ABV 6.3%) IPA

Victoria Inn

🏠 Victoria Inn, Roch, Haverfordwest, SA62 6AW
☎ (01437) 710426 ☎ 07814 684975
⊕ thevictoriainnroch.com

⊠ A small brewery on the site of the Victoria Inn, which also offers Bed & Breakfast. ‼♦

Zoo SIBA

Excal House, Capel Hendre Industrial Estate, Ammanford, SA18 3SJ ☎ 07889 592614
⊕ zoo-brew.com

⊠ Zoo Brew was established in 2019. It produces a small range of cask-conditioned and bottled ales. Beer is mainly supplied to local pubs plus home deliveries.

Amman Eagle (ABV 4.4%) GOLD
Towy Tiger (ABV 5%) BITTER
Merlin's Own (ABV 5.2%) PALE

Black Lion, Llanbadarn Fawr

World's Greatest Beers

Pete Brown, Emma Inch, Jonny Garrett, Joe Stange, Lotte Peplow, Roger Protz, Claire Bullen, John Holl

This book is the definitive guide to the 250 best beers in the world today, selected by a panel of eight renowned international beer writers and influencers. Illustrated in full colour throughout, this high-quality book is a must-have for all self-respecting beer lovers.

Each of the 250 beers from around the world is fully explored with a detailed and personal recommendation from one of the well-established beer writers.

About the Contributors
All the contributors to this book are award-winning beer writers and professionals in their field and are based in Europe and the USA. Many of the writers have won awards for their work at home and abroad and they continue to contribute to the exciting and innovative world of beer publishing.

RRP: £17.99 **ISBN**: 978-1-85249-379-0

For this and other books on beer and pubs, visit CAMRA's online bookshop at **shop1.camra.org.uk** or call 01727 867201.

Discounts are available for CAMRA members.

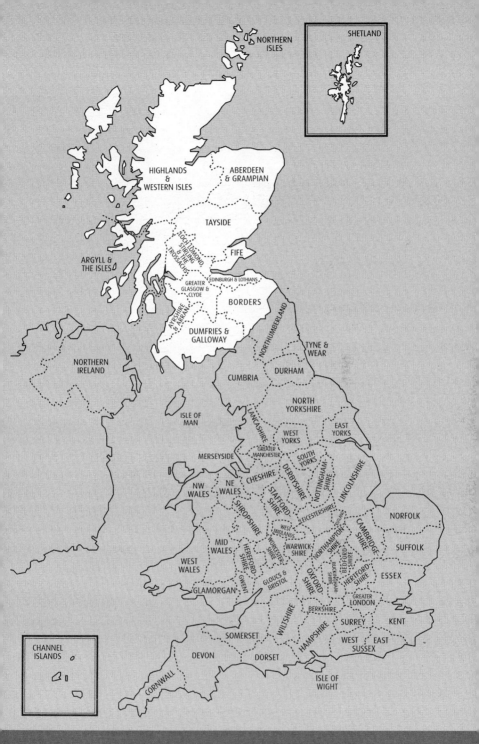

SHETLAND

NORTHERN
ISLES

HIGHLANDS
&
WESTERN ISLES

ABERDEEN
& GRAMPIAN

TAYSIDE

LOCH LOMOND
STIRLING & THE
TROSSACHS

FIFE

ARGYLL &
THE ISLES

GREATER
GLASGOW &
CLYDE

EDINBURGH & LOTHIANS

AYRSHIRE
& ARRAN

BORDERS

DUMFRIES &
GALLOWAY

NORTHUMBERLAND

TYNE &
WEAR

NORTHERN
IRELAND

CUMBRIA

DURHAM

NORTH
YORKSHIRE

ISLE OF
MAN

LANCASHIRE

MERSEYSIDE

WEST
YORKS

EAST
YORKS

GREATER
MANCHESTER

SOUTH
YORKS

NW
WALES

NE
WALES

CHESHIRE

DERBYSHIRE

NOTTINGHAM-
SHIRE

LINCOLNSHIRE

STAFFORD-
SHIRE

SHROPSHIRE

LEICESTERSHIRE

RUTLAND

NORFOLK

WEST
MIDLANDS

CAMBRIDGE-
SHIRE

MID
WALES

HEREFORD-
SHIRE

WORCESTER-
SHIRE

WARWICK-
SHIRE

NORTHAMPTON-
SHIRE

BEDFORD-
SHIRE

SUFFOLK

WEST WALES

GWENT

GLOUCS &
BRISTOL

OXFORD-
SHIRE

BUCKINGHAM-

HERTFORD-
SHIRE

ESSEX

GLAMORGAN

BERKSHIRE

GREATER
LONDON

WILTSHIRE

SURREY

KENT

SOMERSET

HAMPSHIRE

WEST
SUSSEX

EAST
SUSSEX

CHANNEL
ISLANDS

DEVON

DORSET

ISLE OF
WIGHT

CORNWALL

Scotland

Scotland

By far the vastest region in the Guide, Scotland is a patchwork of tourist spots. Take in stunning castles and the Forth Rail Bridge with the Ferry Brewery and taproom situated conveniently at the South Queensferry end of the bridge. Visit the Glenfinnan Viaduct and take the Jacobite steam train between Fort William and Mallaig, described as the greatest railway journey in the world.

Despite there being around 180 breweries in Scotland, real ale availability can still be quite sparse in comparison to other regions. This isn't particularly surprising when you consider that the distance between the most northerly brewery, the Lerwick Brewery on Shetland, and the most southerly, Five Kingdoms in the Isle of Whithorn, is some 400 miles!

That said, Scottish brewing is in an exciting place. There is a proud historic brewing tradition, encapsulated by Traquair House near Peebles, established in the early 1700s. The Belhaven Brewery, now owned by Greene King, was founded in as far back as 1719. Both breweries offer tours.

The Champion Beer of Scotland in 2021 was the incredible Jarl by Fyne Ales. They hold a huge annual outdoor beer and music festival, Fyne Fest, in the stunning glen next to the brewery and taproom, which is located on a picturesque farm.

Cider making is seeing a growth in popularity too, with a network of small producers appearing around the country. Clyde Cider in Glasgow, for example, use apples foraged by the community to make craft cider and reinvests its profits into developing its community orchard.

Many Scottish brewers have a commitment to sustainability and ethical working. The Arran Brewery on the Isle of Arran has installed a growler filling machine to reduce packaging and also support red squirrel charities through the sales of their Red Squirrel beer. Futtle, in the East Neuk of Fife, is a Soil Association recognised organic brewery producing beers with a real sense of place. Both have taprooms if you want to enjoy a taster on site.

If you crave a more urban experience, head to Leith in Edinburgh which has seen a number of breweries and bars open in recent years. Newbarns, Moonwake and Campervan breweries all have a home there and produce excellent beers. Pilot is perhaps the most well-known brewery in the area, producing hazy beers full of flavour. A short hop across to Portobello will take you to Vault City Brewing and its Wee Vault tasting room where you can enjoy its fine selection of modern sour beers.

ABERDEEN & GRAMPIAN

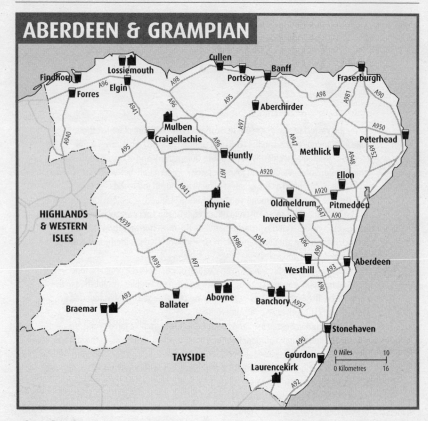

Aberchirder

New Inn

79 Main Street, AB54 7TB

☎ (01466) 780633 ⊕ newinnaberchirder.co.uk

3 changing beers (sourced nationally; often Fuller's, Orkney, Skinner's) Ⓗ

Extensively refurbished during the Covid lockdowns, this traditional, friendly inn has wood-burning stoves, candlelit areas and a vintage atmosphere. It offers a changing selection of three quality ales. A separate dining area provides home-made food prepared by the owner/chef using locally sourced produce – the pork pies are highly recommended. Families are welcome in the dining room until 9pm (booking advised). Dogs are permitted in the bar but should be kept on a lead at busy times. Planning permission has been granted for a microbrewery to brew beers exclusively for the pub. Often closed Monday and Tuesday.

Q ⭐ 🕮 ✿ 🛏 ◀ ◑ & P 🖟 (301,303) ♦ 🛜

Aberdeen

Blue Lamp ★

121 Gallowgate, AB25 1BU

☎ (01224) 647472 ⊕ jazzatthebluelamp.com

1 changing beer (sourced regionally; often Cromarty, Orkney) Ⓟ

Time has stood still in the small public bar, where little has changed since the 1960s. Next door, the cavernous converted warehouse is a popular music venue hosting the March Jazz Festival, various other jazz events and a Wednesday blues jam. Bands play at weekends, for which there may be a charge. Ales are only available in lounge, but staff may carry drinks through on request. The upstairs lounge is available for private functions and small gigs. Opening times may vary – the lounge is open until 2am at weekends. Big Mannys' Pizzas are available via the app. & 🖟 (11,727)

Ferryhill House Hotel

169 Bon Accord Street, AB11 6UA (10 mins' walk from Union St)

☎ (01224) 590867 ⊕ ferryhillhousehotel.co.uk

Orkney Corncrake; Timothy Taylor Landlord Ⓗ

A small city-centre hotel in a quiet residential area, with tables and chairs in the extensive garden, and a children's play area. There is a large, modern lounge bar with a selection of more than 60 malt whiskies, a large restaurant and a conservatory. Four pumps are on the bar, but only two beers are currently available. A wheelchair access ramp leads to the front door. Duthie Park with its famous Winter Gardens is close by.

⭐ ✿ 🛏 ◀ ◑ & ≠ P 🖟 (17,17A) 🛜

REAL ALE BREWERIES

Braemar Braemar
Burnside Laurencekirk
Copper Fox Rhynie
Keith Mulben
Quiet 🍴 Banchory
six°north Laurencekirk
Spey Valley Mulben
Twisted Ankle Aboyne (NEW)
Windswept ⚓ Lossiemouth

Globe Inn

13-15 North Silver Street, AB10 1RJ (off Golden Square)
☎ (01224) 641171 ⊕ the-globe-inn.com
3 changing beers (sourced regionally; often Cromarty, Orkney, Windswept) Ⓗ

This convivial open-plan pub reverted to private ownership in 2018 after being run by Belhaven for several years, and now offers up to three beers from a variety of Scottish breweries. Excellent food is available all day. Alfresco drinking and dining can be enjoyed in the beer garden, which can be partially covered in inclement weather. HM Theatre and the Music Hall are nearby, reasonably priced en-suite accommodation is available. Alcoholic drinks are served from 11am.
➰❀⏴🛏◗❧✿♻☀

Grill ★

213 Union Street, AB11 6BA
☎ (01224) 583563 ⊕ thegrillaberdeen.co.uk
4 changing beers (sourced regionally; often Cromarty, Orkney, Windswept) Ⓗ

With an exquisite interior redesigned in 1926, this is the only pub in the area identified by CAMRA as having a nationally important historic pub interior. It has been part of the McGinty's Group since spring 2019. The ale pumps have been moved to a central position, offering guest beers from various Scottish breweries. The large selection of whiskies has won numerous awards. Bar snacks are now available. Musicians appearing at the Music Hall opposite often visit during concert breaks. A former local CAMRA Pub of the Year. ➷🖛🛱

Krakatoa

2 Trinity Quay, AB11 5AA (facing quayside at bottom of Market St)
☎ (01224) 587602 ⊕ krakatoa.bar
Changing beers (sourced regionally; often Cromarty, Swannay, Windswept) Ⓟ

This historic harbourside bar, formerly the Moorings, changes character from a friendly, laid-back local to a raucous rock bar on weekend evenings, when there may be a cover charge. The eclectic jukebox is popular with the varied clientele. A wide selection of Scottish ales is served on up to 12 American-style fonts to the far left of the bar, and a varied selection of Belgian beers and ciders is also available. A former local CAMRA City Pub of the Year. Open till 3am Friday and Saturday.
♿➷♣🍴🛱🛇♻☀

Prince of Wales ✪

7 St Nicholas Lane, AB10 1HF (lane opp Marks & Spencer and parallel to Union St)
☎ (01224) 640597 ⊕ princeofwales-aberdeen.co.uk
Greene King IPA, Abbot; 6 changing beers (sourced nationally; often Fyne, Stewart, Cromarty) Ⓗ

One of the oldest bars in Aberdeen, the Prince has possibly the longest bar counter in the city, a large following of regulars and a friendly atmosphere buzzing with conversation. The bar was refurbished in 2016 and is listed among CAMRA Scotland's True Heritage Pubs. It offers a varied selection of ales from up to eight pumps, but latterly only 4 beers on at any one time, mostly from Scottish breweries, with tasters for the undecided. Good-value food is served daily including filled rolls. Prize quiz night is Thursday and open mic night Friday. May close earlier if not busy. Q➸◗🖛🛱♻☀

Queen Vic 🍸

126 Rosemount Place, AB25 2YU (approx 10 mins' walk from W end of Union St)
☎ (01224) 638500 ⊕ queenvicaberdeen.co.uk
Timothy Taylor Landlord; 3 changing beers (sourced nationally; often Burnside, Orkney, Windswept) Ⓗ

A cosy one-room locals' lounge bar slightly off the beaten track in two converted shops in the Rosemount residential area. Sporting events are frequently shown, when the pub can get busy and noisy. Cask ales are complemented by an extensive range of locally brewed bottled beers. A popular quiz featuring a Play Your Cards Right jackpot is held on Monday evening and live bands play occasionally at weekends. You can order a Big Mannys' Pizza to your table via the app. Local CAMRA Pub of the Year 2020 and 2022 and Scottish finalist 2022.
🚃(3,3A)❀♻☀

St Machar Bar

97 High Street, Old Aberdeen, AB24 3EN
☎ (01224) 483079
3 changing beers (sourced regionally; often Cromarty, Orkney, Stewart) Ⓗ

Located in the photogenic Old Aberdeen conservation area amid the university buildings and close to King's College, this friendly and historic bar is frequented by academia and locals alike. The bar features a splendid mirror from the long-gone local Thomson Marshall Aulton Brewery, and another from the original Devanha Brewery can be seen at the rear beside the toilets. Alongside the ales is a comprehensive selection of whiskies and gins. The bar is home to a darts team, university football team and rugby team. Food is served from their tiny kitchen to eat in bar or beer garden, which may also be ordered for takeaway via Deliveroo.
❀◗🛱🚃(20)❀♻☀

Stag

6 Crown Street, AB11 6HB
☎ (01224) 592929 ⊕ thestag.co.uk
Courage Directors; Orkney Red MacGregor; 2 changing beers (often Orkney, Stewart) Ⓗ

Originally the Star & Garter, and for a few years MacAndrews, a Scottish themed venue, the Stag reopened in late 2012 after a complete refurbishment. This historic bar is now part of the McGinty's Group. There are many screens for sports lovers, including a large projection screen on the left-hand side as you come in. Four ales are served, two of them varying. Good-quality meals are available until 8pm. ◗🖛🛱♻☀

Under the Hammer

11 North Silver Street, AB10 1RJ (off Golden Square)
☎ (01224) 640253 ⊕ underthehammeraberdeen.co.uk
Timothy Taylor Boltmaker, Landlord Ⓗ

This pub was closed for a couple of years but reopened in 2021 following a major refurbishment by the local McGinty's Group. There may be a varying Scottish beer on handpump when Boltmaker is unavailable. Cocktails are a speciality and the food menu comprises small plates and sharing platters. Located in a quiet side street near Golden Square just minutes off Union Street, this popular pub is located in a basement next to Milne auction house – hence the name. 🖛♻☀

Aboyne

Boat Inn

Charleston Road, AB34 5EL (N bank of River Dee next to Aboyne Bridge)
☎ (01339) 886137 ⊕ theboatinnaboyne.co.uk
3 changing beers (sourced nationally; often Belhaven, Cairngorm) Ⓗ

Popular riverside inn with a food-oriented lounge. Junior diners (and adults) may request to see the model train, complete with sound effects, traverse the entire pub at picture-rail height upon completion of their meal. The Shed public bar has a recess at the back used for live music nights. Three ales are available in summer, two in

winter, usually at least one from Belhaven and another from a local brewery. Breakfast is served. There are 15 twin rooms and a family room for overnight stays.
Q➣⌂◑ᴗ&♠♣P❀🛈

Ballater

Alexandra Hotel

12 Bridge Square, AB35 5QJ
☎ (01339) 755376 ⊕ alexandrahotelballater.co.uk
Cairngorm Trade Winds; 2 changing beers (sourced regionally) Ⓗ
Originally built as a private home in 1800, this friendly, family-owned lounge bar became the Alexandra Hotel in 1915. It is popular both with locals and those visiting for bar suppers. All ales are from Cairngorm Brewery with three available in summer, and two in winter. Benches outside at the front are ideal for alfresco drinking and there is a new smokeless beer pit in the beer garden. A handy stop-off on your way to Braemar for the Highland Games or on a visit with the royals at Balmoral.
➣⌂◑ᴗ&♠P🖵❀🛈

Balmoral Bar

1 Netherley Place, AB35 5QE
☎ (01339) 755462
Braemar Pale Ale; Cairngorm Trade Winds; Caledonian Deuchars IPA Ⓗ
Smart, modern, public bar, situated on a corner opposite the village square in this picturesque Deeside village. Large plasma screens show sports and news while the adjacent pool room also has two large screens. An old poster on the wall shows the coach timetable from Aberdeen of days gone by. Food served every day from noon to 8pm. ➣◑ᴗ&♠♣🖵❀🛈

Glenaden Hotel

6 Church Square, AB35 5NE
☎ (01339) 755488
2 changing beers (sourced regionally; often Windswept) Ⓗ
Situated on the far side of the picturesque town square, this small hotel displays a prominent external sign for its Barrel Lounge. It normally serves three beers in busy periods, usually Scottish, mostly from Windswept. Darker ales are apparently favoured by the locals. There is a large function suite and a beer garden at the rear of the hotel. Q➣❀⌂◑ᴗ&♣P🖵❀🛈

Banchory

Douglas Arms Hotel

22 High Street, AB31 5SR (opp West church)
☎ (01330) 822547 ⊕ douglasarms.co.uk
Cairngorm Trade Winds Ⓗ
The former public bar, identified by CAMRA as being a regionally important historic pub interior, is virtually unchanged over the last century, and is a classic Scottish long bar with etched windows and vintage mirrors, now being operated as the 'Coffee Bothy'. Drinks can still be served here from the main lounge when open and staffed. The redesigned and refurbished lounge bar offers two real ales throughout the year. For big occasions, mostly rugby matches, a screen and projector is used in the lounge. To the rear is a large, south-facing exterior decking area, ideal for fair weather drinking.
Q➣❀⌂◑ᴗ&🖵❀🛈

Ravenswood Club (Royal British Legion)

25 Ramsay Road, AB31 5TS (up Mount St from A93 then 2nd right)

☎ (01330) 822347 ⊕ banchorylegion.co.uk
2 changing beers (sourced nationally) Ⓗ
Large British Legion club with a comfortable lounge adjoining the pool and TV room and a spacious function room frequently used by local clubs and societies as well as members. Darts and snooker are popular and played most evenings. The two handpumps offer excellent value and the beer choice is constantly changing, with ales consistently the best quality in the village. An elevated terrace has fine views of the Deeside hills. Show a copy of this Guide or your CAMRA membership card for entry. ➣❀⌂◑ᴗ&♠♣P🛈

Banff

Market Arms

5 High Shore, AB45 1DB
☎ (01261) 818616
1 changing beer (sourced nationally; often Morland, Ruddles, Timothy Taylor) Ⓗ
This fine building is one of the oldest in historic Banff, dating back to 1585. The courtyard at the back retains many original features. The long public bar has several fine examples of historic brewery and distillery mirrors. One of the two handpumps always serves a changing beer, with two beers on at weekends and holidays. The impressive upstairs lounge is used mainly for meals. The Banff tourist hub is around the corner. ➣◑ᴗ&♠♣🖵❀🛈

Braemar

Invercauld Mews

Glenshee Road, AB35 5YR
Cairngorm Stag, Trade Winds; 2 changing beers (often Bramemar, Cairngorm) Ⓗ
The Mews Bar lies in a separate building behind the, currently under refurbishment, Invercauld Hotel and reopened in January 2020 after a full refurbishment that restored the bar to the way it looked when it closed in 2002. Four brand new handpulls were installed, with ales usually available all year round, mainly from Cairngorm Brewery plus at least one from the expanded range of local Braemar Brewery. There is substantial outdoor seating on the grass outside. Opening hours are subject to seasonal variations. Q➣&♠♣P🖵(201)❀🛈

Craigellachie

Highlander Inn

10 Victoria Street, AB38 9SR (on A95 opp post office)
☎ (01340) 881446 ⊕ whiskyinn.com
3 changing beers (often Orkney, Spey Valley, Windswept) Ⓗ
Picturesque whisky and cask ale bar on Speyside's Whisky Trail and close to the Speyside Way. Twinned with the Highlander Whisky Bar in Tokyo, it offers a fine selection of malts including many from Japan, along with up to three ales. CRAC (Craigellachie Real Ale Club) meets on the first Wednesday of the month and its members help choose the guest ales. An outside decked area with tables and chairs is a delight on a sunny afternoon.
➣❀⌂◑ᴗ&♠♣P🖵(36)🛈

Cullen

Royal Oak Hotel

Castle Terrace, AB56 4SD
☎ (01542) 842762 ⊕ theroyaloakcullen.co.uk
1 changing beer (sourced locally; often Windswept) Ⓚ
Hotel on the west side of town close to the Cullen Viaduct – an imposing multi-arch railway bridge where

the trains that serviced the many fishing villages along the coast used to run. The small modernised bar can be accessed via the side door off the car park. There is also a coffee shop and dogs are permitted. Seniors day is every Tuesday, lunchtimes and evenings. The Moray Lounge function room is available for private hire. One KeyKeg from Windswept is served plus keg Spey Valley Spey's Cadet. ♿★✉①Ⓟ🚪(25)🐾🛜

Elgin

Muckle Cross ✅

34 High Street, IV30 1BU
☎ (01343) 559030
Belhaven 80/-; Greene King Abbot; Sharp's Doom Bar; 6 changing beers (sourced regionally; often Orkney, Windswept) Ⓗ
A typical small Wetherspoon pub converted from what was once a bicycle repair shop. Refurbished in 2018, the pleasant long room has ample seating, a family area and a long bar. Deservedly popular, it can be busy, particularly at weekends. Eight handpumps offer a wide range of beers from national and Scottish microbreweries, and ciders are available during the annual cider fest. Two beer festivals are held annually. Alcoholic drinks are served from 11am.
Q♿★①&≉♣🚪🛜

Ellon

Tolbooth

21-23 Station Road, AB41 9AE (opp Ellon Baptist Church)
☎ (01358) 721308
3 changing beers (sourced regionally; often Cairngorm, Cromarty, Orkney) Ⓗ
A large pub, popular with all ages, close to the centre of the town and just a short walk from the bus stops on Market Street. There are separate seating areas on two split levels as well as an airy conservatory with barrel tables. Two Scottish and one English guest ale, often Directors or London Pride, are usually available. Several National Trust Scotland properties are nearby. No food is served. ♿★&♣🚪🐾🛜

Findhorn

Kimberley Inn

94 Findhorn, IV36 3YG
☎ (01309) 690492 🌐 kimberleyinn.com
2 changing beers (sourced regionally; often Cairngorm, Orkney) Ⓗ
The inn is situated on the shore of Findhorn Bay in a charming seaside village with a fine stretch of beach. It has three areas – a family room with wood-panelled walls, a snug with splendid views of the hills across the Moray Firth, and the bar, with an excellent log fire. Two ales are usually available, only one in winter, mainly from Scottish micros. The extensive food menu features home-cooked meals, with local seafood the speciality, and local ice cream. Q♿★①&▲♣Ⓟ🚪(31)🐾

Forres

Mosset Tavern

Gordon Street, IV36 1DY
☎ (01309) 672981 🌐 mossettavern.com
5 changing beers (sourced regionally; often Spey Valley, Swannay, Windswept) Ⓗ
Described as 'the country pub in the heart of Forres', this smart, extremely popular Scottish lounge bar/restaurant is situated next to the Mosset burn and pond. Friendly,

efficient staff serve ale from a single handpump in the lounge and up to five in the spacious, comfortable public bar, where there are pool tables and large screens showing sport. A large function room is also available, home to the Foot Tapper beer festival in June. Live music plays on Friday evening, and there is a pub quiz every Tuesday. Local CAMRA Country Pub of the Year 2022.
♿★✉①&≉♣Ⓟ🚪(10)🐾🛜

Fraserburgh

Saltoun Inn ✅

Saltoun Square, AB43 9DA
☎ (01346) 519548
Belhaven 80/-; Greene King Abbot; Sharp's Doom Bar; 5 changing beers (sourced nationally; often Orkney, Windswept) Ⓗ
A Wetherspoon renovation of the historic Saltoun Arms Hotel, built in 1801, comprising several interconnecting low-ceilinged rooms, including a lounge area to the left of the entrance. A garden area has been created to the rear. Accommodation is offered in 11 rooms, with reduced rates at weekends. The Scottish Lighthouse Museum is close by, as is the main fishing harbour, and the main surfing beach is one mile south. Alcoholic drinks are served from 11am. Q♿★✉①&▲♣🚪🛜

Gourdon

Harbour Bar

William Street, DD10 0LW
☎ (01561) 361337
1 changing beer (sourced regionally) Ⓗ
Traditional seafaring decor abounds in this harbourside howff. It has a public bar, a smaller tap room with swivelling bar stools and a separate pool room with more seating. Nationally sourced beers are offered in winter and local ales during the summer season. Handy for the Maggie Law Maritime Museum and next door to the locally renowned Quayside Restaurant & Fish Bar.
♿★①&▲♣Ⓟ🚪(747)🐾🛜

Huntly

Crown Bar

4 Gordon Street, AB54 8AJ
☎ (01466) 792244
Windswept Blonde, Wolf; 1 changing beer (sourced locally; often Spey Valley) Ⓟ
Bar situated just off the main square in the centre of Huntly. It has the original small but airy public bar and a separate larger lounge accessed from Richmond Lane, marked 'Harry's Lounge and Beer Garden'. The ale is dispensed from the lounge but is served in either bar. Served on KeyKeg, it can be classed as real ale as Windswept beers are all unfined and unfiltered. The Spey Valley beer is keg. The small outdoor drinking area closes at 10pm and is accessed from the lounge.
♿▲≉♣🚪(10,301)🐾🛜

Inverurie

Gordon Highlander ✅

West High Street, AB51 3QQ
☎ (01467) 626780
Belhaven 80/-; Greene King Abbot; Sharp's Doom Bar; 3 changing beers (sourced nationally; often Orkney, Windswept) Ⓗ
A fine Wetherspoon conversion of a splendid Art Deco building which used to be the Victoria Cinema. The name refers to a locomotive built at the now defunct Inverurie Locomotive Works and there are many references to this

throughout the pub. The famous Gordon Highlander Regiment also features prominently, with displays and a large mural. The books on the shelves are free to borrow, with donations welcome. There are at least three guest ales and the usual Wetherspoon beer festivals feature. Alcoholic drinks are served from 11am.
ⓢ◑⅄♿⇌⊟(10,37) 🐼

Lossiemouth

Windswept Tap Room
13 Coulardbank Industrial Estate, IV31 6NG
☎ (01343) 814310 ⊕ windsweptbrewing.com/tap-room
2 changing beers (sourced locally) Ⓟ
This is a small industrial/office unit converted to a taproom for the brewery next door, with an industrial chic decor and furniture fashioned from pallets. A large adjacent marquee is used in busy periods. Two varying Windswept ales on cask are supplemented by eight KeyKeg beers. Coffee, tea, soft drinks, cakes and snacks are sold, as well as a range of bottled beers and brewery merchandise. The bar is available for private hire and hosts the occasional weekend beer festival. Booking is advised at weekends. Open for merchandise and takeaway beer only Monday to Thursday.
⊛Ⓟ⊟(33A,33C) 🐼

Methlick

Ythanview Hotel
Main Street, AB41 7DT
☎ (01651) 806235 ⊕ ythanviewhotel.co.uk
2 changing beers (sourced regionally; often Fyne, Swannay) Ⓗ
Traditional inn in the village centre, home to the Methlick Cricket Club at nearby Lairds. Log fires warm both the lounge bar at the front and the friendly sports-themed public bar at the rear. Beers are exclusively from Scottish micros. The restaurant is renowned for the owner's chicken curry, and steak night on Thursday is also popular. Meals are served all day at weekends. Live music and quiz nights take place on most Saturdays. Haddo House, Tolquhon Castle and Pitmedden Garden are nearby. Closed weekday afternoons.
ⓢ⊛🛏◑♣Ⓟ⊟(290,291) 🐾🐼

Oldmeldrum

Redgarth
Kirk Brae, AB51 0DJ (signposted off A947)
☎ (01651) 872353 ⊕ redgarth.com
3 changing beers (sourced locally; often Cromarty, Fyne, Swannay) Ⓖ
Offering a warm welcome and excellent views of the eastern Grampian mountains, the Redgarth celebrates 33 years under the same ownership in 2023. The emphasis is on excellent beers served on gravity, with three handpumps on the bar to show which ales are available. Extra choice is offered during occasional Brewer in Residence evenings. Meals are served in the bar, and there is a separate restaurant area. A winner of many CAMRA awards, the pub retains a strong reputation for its imaginative choice of Scottish beers. Closed Monday to Saturday afternoons. ⓢ⊛🛏◑Å♣Ⓟ⊟(35,X35)🐼

Peterhead

Cross Keys ✅
23-27 Chapel Street, AB42 1TH
☎ (01779) 483500

Belhaven 80/-; Greene King Abbot; Sharp's Doom Bar; 3 changing beers (sourced nationally; often Orkney) Ⓗ
A typical Wetherspoon outlet in the centre of a bustling port, close to the local museum where you can learn about the town's maritime history. The pub is named after the chapel dedicated to St Peter that previously stood on the site. The long single room has the bar towards the front and a large seating area at the rear. A sheltered and heated area outside caters for hardy souls and smokers. Children are welcome until 9pm if dining.
Q⅄⊛❀◑⅄♿Å⊟(69,63) 🐼

Pitmedden

Craft Bar
Tarves Road, AB41 7NX
☎ (01651) 842049 ⊕ thecraftpitmedden.wordpress.com
2 changing beers (sourced regionally; often Orkney, Spey Valley, Windswept) Ⓗ
A one-room corner pub run by a local CAMRA member. Old church pews provide seating for some of the tables around the walls, other tables have bench seating. Two handpumps serve ales from Scottish breweries, supplemented by a wide variety of KeyKeg beers from UK breweries. There is also a comprehensive range of bottled and canned beer in the fridge. Also an off-licence, there is an extensive takeaway selection of beers, wines and spirits. Snacks are available. Occasional Brewer in Residence evenings are held. Table bookings are recommended. ⓢÅ♣Ⓟ⊟❀🐼

Portsoy

Shore Inn
Church Street, AB45 2QR (overlooking harbour)
☎ (01261) 842831
2 changing beers (sourced regionally; often Kelburn, Spey Valley, Windswept) Ⓗ
Cosy, comfortable, coastal howff with a warming welcome inside in winter and scenic outdoor views in summer of the oldest harbour on Moray Coast – which was a location for the remake of Whisky Galore. The L-shaped room with low ceilings is a fine example of a nautical bar. Expect the pub to be busy during the Boat Festival in early July. Only one beer is available in winter months. No food is served. ⓢ⊛Å♣❀🐼

Stonehaven

Belvedere Hotel
41 Evan Street, AB39 2ET
☎ (01569) 762672 ⊕ belvederestonehaven.co.uk
1 changing beer (often Orkney) Ⓗ
Large Victorian house in the town centre near the market square, converted to an 11-bedroom hotel and pub. The bar area is in a modern extension to the rear overlooking the large, secluded walled garden, which is partially covered and ideal for outdoor drinking, weather permitting. The bar offers an Orkney ale selected by patrons, and a second pump is planned. Food is served all day. Dunnottar Castle, the picturesque harbour and seasonal open-air bathing pool are close by, as is the chippy that claims to be the home of the deep-fried Mars Bar! ⓢ⊛🛏◑ÅⓅ⊟❀🐼

Marine Hotel
9-10 Shorehead, AB39 2JY (overlooking harbour)
☎ (01569) 762155 ⊕ marinehotelstonehaven.co.uk
Timothy Taylor Landlord; house beer (by Six°North); 4 changing beers (sourced regionally; often Cairngorm, Cromarty, Windswept) Ⓗ

Once the only pub in the area serving Six°North real ale, this is a former Scottish CAMRA Pub of the Year and a multiple local winner. The small harbourside hotel features simple wood panelling in the bar and a rustic lounge with an open fireplace. Seating outside offers a splendid view of the harbour. As well as cask ales, there are numerous Belgian beers and up to 18 craft keg beers including many from Six°North. Dunnottar Castle is one mile south and the open-air bathing pool one mile north. ⛵❀🅿️🕩🍴🅰🚷🚌(747,X7) ❀🕿

Ship Inn

5 Shorehead, AB39 2JY (on harbour front)
☎ (01569) 762617 ⊕ shipinnstonehaven.com
2 changing beers (sourced regionally; often Harviestoun, Inveralmond, Orkney) Ⓗ
Built in 1771, this harbour-front hotel has a maritime-themed, wood-panelled bar and a small seating area outside overlooking the water – note that plastic glasses may be required if sitting on the harbour wall. The long, narrow bar features a mirror from the defunct Devanha Brewery. Two beers are available, both usually from the same Scottish brewery, plus a KeyKeg from local Reids Gold Brewing, and an extensive range of malt whiskies. A modern restaurant with panoramic harbour views is adjacent to the bar, with fish the speciality – food is served all day at the weekend. Accommodation is available in 11 guest rooms.
⛵❀🅿️🕩🚻🅰🚌(747,X7) ❀🕿

Westhill

Shepherds Rest

10 Straik Road, AB32 6HF
☎ (01224) 740208
Greene King Abbot; 3 changing beers (sourced regionally; often Redcastle, Stewart, Williams Bros) Ⓗ
Situated around half a mile from the village across the busy A944, this pub was built in 2000. It has a large, rustic-style interior with plenty of nooks and crannies providing some privacy. Much of the pub is set up for meals, but a large area between the main entrance and the bar is reserved for drinking. The three guest ales are generally from Scottish micros. Popular with families, an extensive food menu is available all day, starting with breakfast. The Premier Inn next door provides accommodation for travellers. ⛵❀🅿️🕩🚻🅿🚌❀🕿

Breweries

Big Fish

c/o 45 Glenury Crescent, Stonehaven, AB39 3LF
✉ info@brewscotland.com
A gypsy brewery established in 2017. Collaboration brews form part of the brewery strategy.

Braemar SIBA

Airlie House, Chapel Brae, Braemar, AB35 5YT
☎ 07709 199914 ⊕ brewbraemar.uk
Small brewery founded in 2021 and located next to Hazelnut Patisserie. It produces cask and bottle-conditioned ales using Scottish malt and British hops. Bottled beers are available direct from the brewery. LIVE

Oat Stout (ABV 4%) STOUT
Pale Ale (ABV 4.2%) PALE
Summer Sun (ABV 4.5%) GOLD
80/- (ABV 5%) BITTER

Brew Toon

72a St Peter Street, Peterhead, AB42 1QB
☎ (01779) 560948 ⊕ brewtoon.co.uk
Established in 2017, beers are brewed in small batches. The brewery has an on-site café/bar.

Brewdog

Balmacassie Industrial Estate, Ellon, AB41 8BX
☎ (01358) 724924

Tower Hill: Unit 3, Minster Building, 21 Great Tower Street, Tower Hill, London, EC3N 5AR ☎ (020) 7929 2545 ⊕ brewdog.com

Established in 2007 by James Watt and Martin Dickie. Most of the production goes into cans and keg. More than 50 bars now exist in the UK. 🍴🍺

Burnside SIBA

Unit 3, Laurencekirk Business Park, Laurencekirk, AB30 1EY
☎ (01561) 377316 ⊕ burnsidebrewery.co.uk

⊗ Burnside began brewing in 2010 using a 2.5-barrel plant, and by 2012 had expanded to a 10-barrel plant. The brewery passed onto the current ownership in 2018, and since then the focus has been to establish the brand by developing a range of cask-conditioned ales, and easy-drinking, bottle-conditioned beers. It regularly introduces new seasonal beers in bottle. Free delivery between Montrose, Banchory, Aberdeen, Dundee and everywhere in-between. Look out for Pie and a Pint offers. Offers a hands-on be-a-brewer experience on scheduled Saturdays. 🍴🍺 LIVE V

Lost Shadow (ABV 3.8%) STOUT
New Tricks (ABV 3.8%) IPA
Lift & Shift (ABV 4%) PALE
Flint's Gold (ABV 4.1%) BITTER
Chain & Anchor (ABV 4.2%) PALE
Wild Rhino (ABV 4.5%) GOLD
Stone River (ABV 5%) IPA
Sunset Song (ABV 5.3%) BITTER

Clinkstone (NEW)

The Steading, Seggiecrook, Insch, AB52 6NR ☎ 07583 027179 ✉ info@clinkstonebrewing.com

Farm-based brewery commissioned in mid-2021. Clinkstone Brewing Company uses sustainable natural resources to produce hop-forward beers predominantly available in small pack formats. No real ale.

Copper Fox

c/o 3 Essie Road, Rhynie, Aberdeenshire, AB54 4GF
☎ (01464) 833289 ☎ 07484 386496
⊕ copperfoxbrewery.co.uk

⊗ Copper Fox Brewery Ltd, founded in 2017, is an independently-run, one-man, small batch microbrewery based in Rhynie, Aberdeenshire. Production is exclusively in 330ml bottles, with 10p credit on bottle returns. Beers can be found at farmer's markets in the region and in Westhill. LIVE

Fierce SIBA

Unit 60, Howe Moss Avenue, Dyce, Aberdeen, AB21 0GR
☎ (01224) 035035 ⊕ fiercebeer.com

The multi-award-winning Fierce Beer was established by Dave Grant and David McHardy, brewing its first beer in

2016. It produces a range of hoppy, fruity, dark and speciality beers. Production is KeyKeg and bottles. Three bars are owned, in Aberdeen, Edinburgh and Manchester.

Keith

Malcomburn, Mulben, Keith, AB55 5DD
☎ (01542) 488006 ⊕ keithbrewery.co.uk

Formerly known as Brewmeister and established in 2012, the brewery was renamed Keith Brewery in 2015. It moved production to Malcolmburn, Mulben, sharing facilities with Spey Valley Brewery (qv). Keith Brewery is part of the Consolidated Craft Breweries Group. ‼️🍴♦LIVE

LabRat

33 Bernham Avenue, Stonehaven, AB39 2WD
☎ 07542 072774

Commercial nanobrewer Peter Mackenzie started brewing in 2019, producing beers based on international styles.

Mad Bush (NEW)

Office: 136 Gardner Drive, Aberdeen, AB12 5SA
⊕ madbushbeer.com

Mad Bush Beer is a small brewery based in Aberdeen producing bottled beers.

Quiet

🍴 **Woodend Barn, Burn O Bennie, Banchory, AB31 5QA**
☎ (01330) 826530 ⊕ buchananfood.com

Quiet Brewery produces bottle-conditioned beers, supplied to Buchanan's Bistro, Banchory. ♦LIVE

Reids Gold

61 Provost Barclay Drive, Stonehaven, AB39 2GE
⊕ reidsgold.com

The brewery was established in 2018. It is a small-batch microbrewery with an average weekly production of five barrels. Beers are unfiltered and unpasteurised and available in cans and mini-kegs.

Six° North

Reekie House, Aberdeen Road, Laurencekirk, AB30 1AG
☎ (01561) 377047 ☎ 07840 678243
⊕ sixdnorth.co.uk

⊗ Established in 2013, the brewery brews beers in the Belgian tradition, using a purpose-built, 470-hectolitre plant. Depending on beer style, the beers are supplied as cask or keg. ‼️♦LIVE

Chopper Stout (ABV 4.1%) STOUT
Roasted coffee malted, with background liquorice.

Spey Valley

Malcolmburn, Mulben, Keith, AB55 6YH
☎ (01542) 488006 ☎ 07780 655199
⊕ speyvalleybrewery.co.uk

⊗ Founded in 2007, Spey Valley Brewery merged with Keith Brewery in 2018 and is part of the Consolidated Craft Breweries Group, along with Alechemy Brewing (qv). It brews on a 20-barrel plant on a purpose-built site at Mulben. Brewing capacity was increased in 2022. ‼️🍴♦

Sunshine on Keith (ABV 3.5%) BITTER
Golden, malt with a light citrus bitter hop. Name is a play on Proclaimers song.
Any Time / Winter Time (ABV 4%) BLOND
David's Not So Bitter (ABV 4.4%) BITTER
Light brown with a good mix of malts, hops and red fruits.
Stillman's IPA (ABV 4.6%) SPECIALITY
Amber hoppy bitter with a whisky background.
Spey's Hopper (ABV 5%) SPECIALITY
Spey Stout (ABV 5.4%) STOUT
Excellent name and a good, thick, dark, malty stout with a smoky blackcurrant background.

Twisted Ankle (NEW)

The Old Mill Of Kincraigie, Aboyne, AB34 4TT
☎ 07814 922442
✉ twistedanklebrewco@gmail.com

Twisted Ankle is a small-batch microbrewery situated in the Howe of Cromar, Aberdeenshire, using home grown hops. Beer is available in bottles at local farmers markets in Aboyne and Ballater. It regularly produces cask and bottle-conditioned ale. LIVE

Windswept SIBA

Unit B, 13 Coulardbank Industrial Estate, Lossiemouth, IV31 6NG
☎ (01343) 814310 ⊕ windsweptbrewing.co.uk

Windswept Brewing Co was established in 2012 and is situated near the gates of RAF Lossiemouth. It is run by two former Tornado pilots who are CAMRA members. The brewery has developed to include a bar (open Friday-Sunday), shop (seven days a week) and regular tours. Bottle-conditioned beers and small casks can be ordered online and delivered locally. ‼️🍴LIVE♦

Blonde (ABV 4%) PALE
Smooth, golden, citrus hoppy brew with hints of peach. Slight malty background.
APA (ABV 5%) PALE
Good mix of malts and grapefruit hop throughout. Tangy finish.
Weizen (ABV 5.2%) SPECIALITY
Cloudy wheat beer full of bananas and pear drops with a hint of spices.
Wolf (ABV 6%) OLD
Dark, strong tasting, slightly sweet, roasted malty brew with chocolate and a vanilla coffee background and a bitter finish.

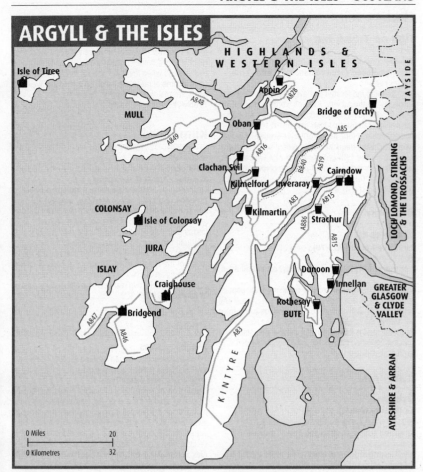

ARGYLL & THE ISLES

SCOTLAND

Appin

Creagan Inn

Creagan, PA38 4BQ (on A828 ½ mile N of Loch Creran bridge)

☎ (01631) 730250 ⊕ creaganinn.co.uk

2 changing beers (sourced regionally; often Fyne) Ⓗ
Originally a ferryman's house, the inn is set in a beautiful scenic location on the shore of Loch Creran. Up to two cask beers are available, one of them from Fyne Ales. Local produce is prominent on the menu, with a good selection of vegetarian/vegan options (booking is recommended). Drivers are catered for with a range of good quality non-alcoholic drinks. Opening times vary – phone ahead. There is a limited bus service from Oban and Fort William. Q੪❀◐⅃Ⓟ☐(405,918)❀ 중

Bridge of Orchy

Bridge of Orchy Hotel

PA36 4AD

☎ (01838) 400208 ⊕ bridgeoforchy.co.uk

Harviestoun Bitter & Twisted; 1 changing beer (sourced regionally; often Harviestoun) Ⓗ
Situated on the A82, the road leading north to Glencoe, Fort William and Skye, and with a railway station not far away, this remote hotel is surprisingly accessible. It procides a convenient resting spot for walkers on the West Highland Way. The bar and lounge at the front are heated by iron stoves and the restaurant to the rear offers a panoramic view of the mountains. Local produce is well represented on the menu.
੪❀⅃◐⇌Ⓟ☐(915) ❀ 중

Cairndow

Fyne Ales Brewery Tap Ⓛ

Achadunan, PA26 8BJ (up side road at head of Loch Fyne)

☎ (01499) 600120 ⊕ fyneales.com/visit

Fyne Jarl; 4 changing beers (sourced locally; often Fyne) Ⓗ
Brewery tap and shop in what was originally a farm building. The bar, with its fine polished granite front, supports five handpumps selling a range of ales from the brewery along with a varied selection of bottled beers. An impressive array of brewing award certificates can be seen above the shelves displaying the beers for sale. Hot snacks are available at weekends. The shop is closed on some public holidays. Q੪❀ఉⓅ❀ 중

REAL ALE BREWERIES

Bun Dubh ▤ Sandaig: Isle of Tiree
Colonsay Scalasaig: Isle of Colonsay
Fyne ⌀ Cairndow
Islay ⌀ Bridgend: Isle of Islay
Jura Isle of Jura: Craighouse (NEW)

Clachan Seil

Tigh-an-Truish Inn

PA34 4QZ
☎ (01852) 300242 ⊕ tigh-an-truish.co.uk
2 changing beers (sourced nationally; often Fyne, Orkney) ⊞

This charming inn located just over Clachan Bridge – the 'Bridge across the Atlantic' – is well worth veering off the A816 for. The rustic wooden interior has an L-shaped counter with an unusual high bench seat (the Perch). Two handpumps (one in winter) serve Scottish ales, with Fyne and Orkney frequent guests. A door by the bar takes visitors from the 19th century to the 21st with a newly refurbished dining area. In summer the garden and patio are a delight. Opening times can vary – phone ahead.
Q❀🚃🕭ᐧÅP🚃(418)❀🛜

Dunoon

Ingrams ✓

21-23 Ferry Brae, PA23 7DJ
☎ (01369) 704141
1 changing beer (sourced nationally; often Belhaven, Fyne) ⊞

Town-centre corner bar halfway up a steep hill, popular with both locals and tourists. The public bar is small and serves mainly as the pool room. The lounge is the main bar, where the handpump can be found. The ale changes frequently and is often from the Greene King stable. A simple food menu is available, often supplemented with specials. 🌥🕭♣🚃🛜

Innellan

Osborne

44 Shore Road, PA23 7TJ
☎ (01369) 830820 ⊕ theosborneinnellan.co.uk
St Austell Tribute; 2 changing beers (sourced nationally) ⊞

A whitewashed seafront hotel a few miles south of Dunoon, built in 1869. The comfortable bar has a pool table to one side and a cosy lounge with a log fire. At the front is the conservatory dining room, with excellent views across the Firth of Clyde. Any good weather can be enjoyed in a small outdoor area to one side. Unlike most Argyll pubs, beers are mainly from English breweries.
🌥❀🚃🕭🚃(489)🛜

Inveraray

George Hotel

Main Street East, PA32 8TT
☎ (01499) 302111 ⊕ thegeorgehotel.co.uk
3 changing beers (sourced regionally; often Fyne) ⊞

Attractive hotel built from two private houses in 1860 by the Clark family, who still own it. The restaurants and bars have been completely restored but retain the original ambience, with an abundance of dark wood, flagstone floors throughout and four roaring fires. The food menu has an emphasis on quality local produce. Two real ales are served in the cocktail bar and there is one pump in the lively public bar (open from 5pm on weekdays) to one side. Q🌥❀🚃🕭ᐧÅP🚃(926)❀🛜

Kilmartin

Kilmartin Hotel

PA31 8RQ (on A816 10 miles N of Lochgilphead)
☎ (01546) 510250 ⊕ kilmartin-hotel.com
3 changing beers (sourced regionally; often Fyne, Loch Lomond, Orkney) ⊞

A pleasant hotel set above Kilmartin Glen, one of Scotland's most important prehistoric sites. The small public bar to one side provides a cosy fireside nook and offers a good selection of whiskies to complement the real ale. Good home-cooked food is served in the evening and when the bar is open at lunchtime. Children are welcome at mealtimes and pub games are available. Beers are mainly from Scottish breweries.
🌥❀🚃🕭ᐧÅP🚃(423)❀🛜

Kilmelford

Cuilfail ★

PA34 4XA
☎ (01852) 200274 ⊕ cuilfail.co.uk
Loch Lomond Southern Summit; 2 changing beers (sourced nationally; often Morland, Orkney) ⊞

A very old former drovers' inn which was extended to become a Victorian hotel. The bar has remained unchanged since a rather remarkable refit in 1957, featuring the exposed boulders (made of applied concrete) of the walling. The theme continues in the facing of the counter which incorporates parts of whisky casks. Enjoy an ale beside the large wood-burning stove – there are usually two real beers on offer, one in winter.
🌥❀🚃ᐧÅP🚃(423)❀🛜

Oban

Markie Dans

1 Victoria Crescent, Corran Esplanade, PA34 5PN
☎ (01631) 564448 ⊕ markiedans.co.uk
1 changing beer (often Fyne) ⊞

Situated on the lower floor of a grand house overlooking Oban Bay, Markie's is a cosy and welcoming locals' pub. A pool table is in use most days, however it is moved away when there is live entertainment. An intimate snug with three tables off the main bar provides welcome seclusion for a quiet chat. One ale, usually from Fyne Ales, is available, which can also be enjoyed on the small beer terrace overlooking the bay. 🌥❀🕭🚃🚃❀

Oban Inn

1 Stafford Street, PA34 5NJ
☎ (01631) 567441 ⊕ obaninn.co.uk
3 changing beers (often Fyne) ⊞

A traditional corner local by the old harbour pier which originally opened 1790. The public bar retains its dark wood panelling and stone floors of Easdale slate. Maritime artefacts are displayed on the walls and currency notes from many nations cover the wooden beams. The comfortable lounge upstairs only has real ales on occasion, but it is worth taking a look to admire the stained-glass panels acquired from an Irish monastery. 🕭🚃🚃❀🛜

Rothesay

Black Bull Inn

3 West Princes Street, PA20 9AF
☎ (01700) 505838
3 changing beers (sourced regionally; often Fyne) ⊞

The pub is situated close to the ferry terminal opposite the marina and within walking distance of all amenities including the famous Victorian toilets. It has two bars, entrances front and rear, and a separate dining area. Real ales are mainly from Scottish breweries. A selection of gins is also available. Food times vary with the seasons so it is best to check in advance. Closed on Monday in winter. 🕭🚃(90,490)🛜

Macs Bar

14-18 Castlehill Street, PA20 0DA
☎ (01700) 502417
1 changing beer (sourced nationally; often Caledonian, Greene King) 🅗

Occupying the ground floor of a three-storey stone building opposite the entrance to Rothesay Castle, Macs has been in the same family since 1951. The cramped bar, decorated with Scottish women's football memorabilia, leads to a surprisingly spacious lounge area with leather seating and a design reminiscent of a bar on a ship. There are three dartboards, and dominoes competitions take place. ♣🚽

Strachur

Creggans Inn 🅛

PA27 8BX (on A815 at N end of village)
☎ (01369) 860279 🌐 creggans-inn.co.uk
2 changing beers (sourced locally; often Fyne) 🅗

A convenient stopping place along Loch Fyne. MacPhunn's bar, named after a half-hung sheep rustler of yore, is comfortable with a real fire and plenty of room for dining. Two handpumps offer a changing selection of beers from Fyne Ales. Drinks may be taken to other lounges, the restaurant or pool room, or enjoyed in the garden overlooking the loch. The games room and toilets are decorated with charts of the sea around Scotland and elsewhere. Q🛏😊🚫🌳🍽🅿🚽(484,486)♣?

Breweries

Bun Dubh SIBA

🍴 Ceabhar, Sandaig, Isle of Tiree, PA77 6XG
☎ (01879) 220684 ☎ 07792 789733
✉ bundubh@gmail.com

Duncan Castling began brewing on his picobrewery in 2016, then catering solely for his restaurant, Ceabhar. The brewery expanded into the adjoining former guesthouse during 2020 and 2021, with its live beer now available in local hotels. With an enviropunk ethos, all production goes into reusable containers, no bottles or cans, and distribution, though wider, remains exclusive to the island. ♦

Colonsay

The Brewery, Scalasaig, Isle of Colonsay, PA61 7YT
☎ (01951) 200190 🌐 colonsaybrewery.co.uk

Colonsay began brewing in 2007 on a five-barrel plant. Beer is mainly bottled or brewery-conditioned for the local trade. LIVE

Fyne SIBA

Achadunan, Cairndow, PA26 8BJ
☎ (01499) 600120 🌐 fyneales.com

😊Fyne Ales has been brewing since 2001 and is situated at the head of Loch Fyne. In 2012 an on-site brewery tap was added. Expansion has allowed for the production of experimental brews. FyneFest runs annually, celebrating local fare and showcasing other breweries. 🎵🍽♦LIVE🦯

Jarl (ABV 3.8%) GOLD
Strong citrus notes, through use of Citra. A light, golden ale that can be drunk in any season.

Maverick (ABV 4.2%) BITTER
Full-bodied, roasty, tawny best bitter. It is balanced, fruity and well-hopped.

Hurricane Jack (ABV 4.4%) GOLD

Vital Spark (ABV 4.4%) PORTER

Avalanche (ABV 4.5%) GOLD
A true golden ale, stunning citrus hops on the nose with fruit balancing a refreshing hoppy taste.

Highlander (ABV 4.8%) BITTER
A full-bodied, bittersweet ale with a good, dry hop finish.

Sublime (ABV 6.8%) STOUT

Superior IPA (ABV 7.1%) IPA

Islay SIBA

The Brewery, Islay House Square, Bridgend, Isle of Islay, PA44 7NZ
☎ (01496) 810014 🌐 islayales.com

😊The only brewery on an island famous for its malt whiskies, Islay Ales started brewing in 2004 and continues to use a four-barrel plant. Situated in converted farm buildings, including a visitor centre and shop. The brewery tap is the only outlet for the brewery's cask-conditioned beers. 🎵🍽🦯

Jura (NEW)

7 Keills Croft, Craighouse, Isle of Jura, PA60 7XG
☎ 07817 456347 ✉ jurabrewery2017@gmail.com

Microbrewery that opened in 2021. Jura bottles the majority of its produce with some available in keg.

The ale diet

Boniface: Sir, I have now in my cellar ten tun of the best ale in Staffordshire; 'tis smooth as oil, sweet as milk, clear as amber, and strong as brandy; and will be just 14 years old the fifth day of next March, old style.

Aimwell: You're very exact, I find, in the age of your ale.

Boniface: As punctual, sir, as I am in the age of my children. I'll show you such ale: I have lived in Lichfield, man and boy, about eight-and-fifty years, and, I believe, have not consumed eight-and-fifty ounces of meat.

Aimwell: At a meal, you mean, if one may guess your sense by your bulk.

Boniface: Not in my life, sir, I have fed purely upon ale; I have eat my ale, drank my ale, and I always sleep upon ale.

George Farquhar, The Beaux-Stratagem, 1701

SCOTLAND

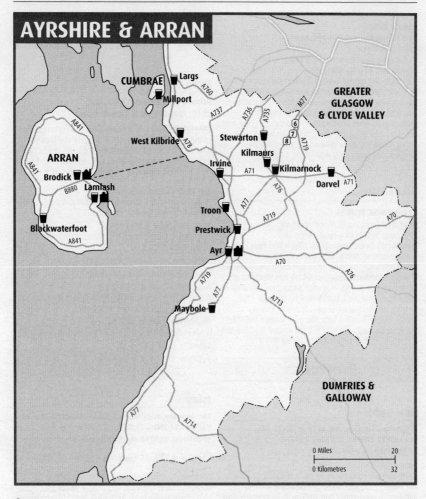

AYRSHIRE & ARRAN

Ayr

Chestnuts Hotel

52 Racecourse Road, KA7 2UZ (on A719, 1 mile S of centre)

☎ (01292) 264393 ⊕ chestnutshotel.com

3 changing beers (often Fuller's, Fyne, Kelburn) Ⓗ

A sandstone villa that used to be a synagogue, with a stone bay window, real open fire and timber-beamed, vaulted ceiling displaying an array of whisky water jugs. It offers various seating options including stools at the bar. The quiet family-run bar has helpful staff and good food (booking is advisable at weekends). There is a secure south-facing garden to the side with plenty of seating, and a gravel car park at the front. The bar is within walking distance from the beach at Seafield. Q❀❁✦☺◑Ⓛ&P☷(9) 🛜

Glen Park Hotel Ⓛ

5 Racecourse Road, KA7 2DG

☎ (01292) 263891 ⊕ theglenparkhotel.co.uk

4 changing beers (sourced locally; often Ayr) Ⓗ

This comfortable lounge bar, in an attractive 1860s B-listed Victorian building, is the tap for Ayr Brewing Company, who operate at the back of the building. The guest ales often include a seasonal from the brewery. Beers are usually also available to take away from a shop/bar at the rear of the dining room. Bar and restaurant meals are served daily except Monday and Tuesday. Local CAMRA Pub of the Year 2021. ❀❁✦☺◑Ⓛ&≠P☷(9) 🐾🛜

Smoking Goat

2A Academy Street, KA7 1HS

☎ (01292) 857137 ⊕ thesmokinggoatayr.com

Fyne Jarl; 1 changing beer (often Fyne) Ⓗ

A basement bar at the entrance to a lane opposite Ayr Town Hall, identified by a sandwich board and a small sign on the wall next to the door. Tuesday is quiz night, comedy the first Thursday of the month, live music on Friday evening and DJ night on a Saturday. Wheelchair access is via a ramp to the upgraded outside drinking area. ❀◑≠&🐾🛜

Wellingtons Bar

17 Wellington Square, KA7 1EZ

☎ (01292) 262794 ⊕ welliesbar.weebly.com

3 changing beers (often Born, Kelburn, Loch Lomond) Ⓗ

A large Wellington boot advertises the location of this basement bar. Close to the seafront, bus station and local government offices, it attracts tourists and office workers alike. The Wednesday evening quiz is popular. Three ever-changing ales vary between brewers. Bar food is served, with daily specials on the menu – check for serving times. ♿ ◑ ≉ 🚱 🐾 🛜

West Kirk ✅

58A Sandgate, KA7 1BX (close to bus station)
☎ (01292) 880416

Belhaven 80/-; Greene King Abbot; 5 changing beers Ⓗ

Spacious Wetherspoon pub serving breakfast and meals all day. A former church, it retains many original features – the toilets are reached via the pulpit (there is an accessible toilet downstairs). The vaulted ceiling is bathed in light, featuring a huge chandelier, and there is a balcony. Various seating options include stools, tables and chairs, and booths. Small TV screens usually show news with subtitles. The paved seating area outside on a busy road gets some sun. The pub can be busy over the weekend and when the races are on at Ayr.
Q ♿ 🏠 ◑ ᪶ 🚱 🛜

Blackwaterfoot: Isle of Arran

Kinloch Hotel

KA27 8ET
☎ (01770) 860444 ⊕ kinloch-arran.com

Ayr Uisge Dubh; 1 changing beer (often Ayr, Belhaven, Greene King) Ⓗ

A hidden gem in a quiet rural village on the west coast of Arran, offering coastal comfort and spectacular scenery. The family hotel has 37 bedrooms, a restaurant and three refurbished bars, and facilities including a heated indoor swimming pool, squash court and a fitness room and sauna. Fabulous local produce is served including fish and seafood. A beer festival is held in August. Coffee is available in the lounge from 11.30am.
♿ 🛏 ◑ ᪶ 🅰 🅿 🚱 🐾 🛜

Brodick: Isle of Arran

Ormidale Hotel

Knowe Road, KA27 8BY (off A841 at W end of village)
☎ (01770) 302293 ⊕ ormidale-hotel.co.uk

3 changing beers (often Arran, Belhaven, Kelburn) Ⓗ

This large red sandstone hotel with a small bar and spacious conservatory is set in seven acres of grounds. Beers are served from handpumps rather than founts on the boat-shaped bar, although one original fount remains. Three ales are available in summer, often including Arran Blonde. Home-cooked meals are recommended. Entertainment includes discos and folk nights, and the attractive beer garden has views across Brodick Bay. ♿ 🏠 🛏 ◑ 🅿 🚌 (322,324) 🐾 🛜

Darvel

Black Bull Inn

24 West Main Street, KA17 0AQ
☎ (01560) 321630

1 changing beer (often Five Kingdoms, Fyne) Ⓗ

Dating from 1840, this former coaching inn retains much of its original character. The bar features a dark wood gantry offering a wide selection of spirits. Many photographs adorning the interior reflect the rich history of the former lace town. An open mic session is held on Wednesday and live bands play on Friday and Saturday

evenings. Although there is no permanent kitchen, a variety of food trucks visit on a regular basis.
🏠 🐾 🅿 🚌 (1) 🐾 🛜

Irvine

Auld Brig ✅

15 Fullarton Square, KA12 8EJ (opp Irvine station)
☎ (01294) 277818

Greene King Abbot; Sharp's Doom Bar; 4 changing beers Ⓗ

Wetherspoon outlet next to the west entrance to Rivergate shopping centre. The large, modern pub has a sloping glass roof providing natural light to the mezzanine area, which features the Ropey Installation artwork, inspired by Irvine's coastal and maritime links and made from cotton rope. Also note the wooden doors on the wall and the various old photographs. The back downstairs area has a long wooden bar, tiled floor and subdued lighting. Six of the 12 handpumps dispense a variety of real ales. Quiz night is the first Wednesday of the month. Q ♿ 🏠 ◑ ᪶ 🚱 🛜

Kilmarnock

First Edition ✅

50-54 Bank Street, KA1 1ER
☎ (01563) 528833

2 changing beers (often Fyne, Loch Leven) Ⓗ

Large town-centre pub in a former furniture shop in the historic core of Kilmarnock. Two ales are usually available from Scottish regional brewers. The large, recently renovated, modern pub serves food all day in bright surroundings. The revamped beer garden has table tennis and pool tables under cover. Numerous TV screens inside and three outside show sports, and a DJ plays Friday to Sunday evenings. ♿ 🏠 ◑ ᪶ 🚱 🛜

Wheatsheaf Inn ✅

70 Portland Street, KA1 1JG
☎ (01563) 572483

Belhaven 80/-; Greene King Abbot; 6 changing beers Ⓗ

This sizeable town-centre Wetherspoon's bar, originally the historic Wheatsheaf Hotel, is famous for its links to Robert Burns, whose first poems were printed in Kilmarnock in 1786. The bar is divided into various seating areas, with booths, sofas and a raised dining space. Six handpumps dispense a range of real ales. Food is standard Wetherspoon fare. Licensed from 11am.
♿ 🏠 ◑ ᪶ 🚱 🛜

Kilmaurs

Weston Tavern 🍺

27 Main Street, KA3 2RQ
☎ (01563) 538805 ⊕ westontavern.co.uk

2 changing beers (often Broughton, Cairngorm, Theakston) Ⓗ

Housed in the former manse of reformist minister David Smeaton, a contemporary of Robert Burns, this fully refurbished country pub and restaurant has a tiled floor, stone walls and a wood-burning fire. It sits beside the Jougs, a former jailhouse and tollbooth. The bar is popular with locals for home-cooked meals. Two handpumps serve ales from a rotating list of local breweries. Entertainment includes regular live music and quiz nights. Local CAMRA Pub of the Year 2022.
♿ 🏠 ◑ ᪶ 🅰 🅿 🚱 🐾 🛜

Lamlash: Isle of Arran

Pierhead Tavern
Shore Road, KA27 8JN
☎ (01770) 600418 ● thepht.co.uk
3 changing beers (often Ayr, Fyne, Kelburn) ⊞
This famous village local was saved by new owners from conversion into flats. Three handpumps serve a choice of rotating ales from breweries such as Kelburn, Ayr and Fyne Ales in summer, with two in winter. The pub grub is all home made and chef's specials change weekly. Live music features on Saturday and Sunday afternoons, and a quiz on Wednesday. The views from the roof terrace across to Holy Isle are spectacular.
怱❀◑&♣☐(323) ❀ ☞

Largs

Paddle Steamer ◎
Gallowgate Street, KA30 8LX (on promenade near Calmac ferry terminal)
☎ (01475) 686441
Greene King Abbot; Sharp's Doom Bar; 4 changing beers (often Kelburn, Redcastle) ⊞
This seafront Wetherspoon outlet has a nautical theme, with a feature fire in the centre of the bar and a viewing window into the cellar. A balcony borders the promenade, overlooked by wide windows with views to the Isles of Bute and Cumbrae, the ferry to the latter being only a minute away. Models of the world-famous paddle steamer Waverley decorate the outside, while the real ship visits Largs in the summer. Licensed from 11am. 怱❀◑&☐(585,901)☞

Maybole

Maybole Arms
37 Whitehall, KA19 7DS
☎ (01655) 883173
1 changing beer (often Ayr) ⊞
A welcome watering hole for those visiting an area that has few real ale pubs. This small, established local inn has a friendly clientele and offers good food from a family-friendly menu. Dogs are permitted, with water and biscuits supplied. A handy stop-off for nearby Culzean Castle & Country Park.
怱◑Å⇌♣☐(58,60)❀☞

Millport: Isle of Cumbrae

Fraser's Bar ᴸ
9 Cardiff Street, KA28 0AS
☎ (01475) 530518
2 changing beers (often Jaw, Kelburn, Redcastle) ⊞
Well maintained and tidy, this bar caters for visitors to the island as well as locals. Buses meet every ferry from Largs and terminate just across the road. Two handpumps serve mostly light-coloured ales, usually including one from a local brewery. Good-value pub food is available lunchtime and early evening. The main bar has an open fire and a fine display of old Clyde steamer photographs. Children are welcome in the rear lounge until 8pm. Q怱❀◑&♣☐(320)☞

Prestwick

Prestwick Pioneer ◎
87 Main Street, KA9 1JS
☎ (01292) 473210
Belhaven 80/-; Greene King Abbot; 6 changing beers ⊞

Modern Wetherspoon outlet in a former Woolworths store, named after the first Scottish Aviation Pioneer light aircraft, built in 1947 at the nearby international airport. The pub has an airy feel with a light-wood decor, and features photographs of early Open Championship golf at Prestwick, and of Elvis at the airport – the only place in the UK he set foot on. Ten handpumps serve local and national ales, and food is available. Licensed from 10am.
怱◑&⇌(Town)☐☞

Stewarton

Mill House
4 Dean Street, KA3 5EQ (from Stewarton Cross follow B769 towards Glasgow)
☎ (01560) 482255 ● themillhouse-stewarton.co.uk
3 changing beers (often Arran, Fyne, Kelburn) ⊞
The Mill House is located in a 400-year-old former mill building in the East Ayrshire town of Stewarton, known locally as the Bonnet Toun due to its bonnet-making heritage. At the bar, two or three cask ales are usually available. Real ales can be also be bought through from the bar to the large restaurant, which opens from 10am. Reasonably priced meals are available throughout.
怱❀◑&⇌♣P☐(9,113)❀☞

Troon

McKay's
69 Portland Street, KA10 6QU
☎ (01292) 737372
3 changing beers (often Fyne, Greene King, Timothy Taylor) ⊞
A friendly single-room town-centre bar, popular with locals for its pub grub. The bar hosts local dominoes competitions and shows live sports on TV. The large CAMRA award-winning beer garden is another attraction on sunny days. Dogs are permitted in the garden only. A longstanding stalwart of the area's real ale scene and former local CAMRA Regional Pub of the Year.
怱❀◑&⇌☐(10,14)❀☞

Number Forty Seven
47 Templehill, KA10 6BQ
☎ (01292) 312814
Cairngorm Wildcat; Morland Old Speckled Hen; 3 changing beers (often Ayr, Five Kingdoms) ⊞
A long single-room bar which has been attractively refurbished. Five handpulls dispense real ales from Scottish and English breweries, with a discount for over-60s. Quiz night is Thursday. There is a pool table, jukebox and many TVs showing live sport. The gantry is stocked with a wide selection of spirits. On Friday and Saturday nights a DJ plays from 10.30pm and the bar moves into nightclub mode. &⇌♣☐(10,14)❀☞

West Kilbride

Twa Dugs
71 Main Street, KA23 9AW
☎ (01294) 822524
2 changing beers (often Ayr, Five Kingdoms) ⊞
A popular, well cared for and comfortable pub in Scotland's Craft Town. There is a pool table, live music at the weekend and a regular quiz night. Two handpulls dispense ales mostly from local breweries, but sometimes from further afield. The bus stop is opposite and the railway station five minutes away. Local CAMRA Pub of the Year 2021. ◑⇌♣☐(585,585A)❀☞

Breweries

Arran SIBA

Cladach, Brodick, Isle of Arran, KA27 8DE
☎ (01770) 302353

Office: Isle of Arran Brewery Guesthouse, Shore Road, Whiting Bay, Isle of Arran, KA27 8PZ
⊕ arranbrewery.com

⊛The brewery opened in Brodick in 2000 using a 20-barrel plant with water sourced from the nearby mountains. It has its own in-house bottling plant, shop and taproom. Around 400 outlets around the UK are supplied direct, and via distributors. The brewery owns the rights to the former Devil's Dyke Brewery beers.
‼ ⯇ ♦ LIVE ⯈

Guid Ale (ABV 3.8%) GOLD
A golden, refreshing session ale with a delicate balance of malt and fruit.
Dark (ABV 4.3%) BROWN
A well-balanced, malty beer, roast and hop in the taste and a dry, bitter finish. A traditional 'Scottish Heavy'.
Sunset (ABV 4.4%) GOLD
A mid-amber summer ale. Light perfumed aroma, good balance of malt, fruit and hops with a pleasant, dry finish.
Blonde (ABV 5%) SPECIALITY
A hoppy beer with substantial fruit balance. An aromatic, strong golden ale that drinks below its weight.
Brewery Dug (ABV 5.5%) IPA
An American-style IPA with a refreshing citrus body and a dry, lemon-zest bitter finish.

Arran Botanical Drinks (NEW)

Cladach Beach House, Brodick, KA27 8DE
☎ (01770) 302513 ⊕ arranbotanicaldrinks.com

Formerly known as Arran Gin, Arran Botanical Drinks is located beside the beach at Cladach, Brodick. It has a small brewkit producing a couple of in-house bottle-conditioned beers using locally foraged ingredients. It has a shop and tastings are available for all its products.
⯇ LIVE

Ayr

5 Racecourse Road, Ayr, KA7 2DG ☎ 07834 922142
⊕ ayrbrewingcompany.com

⊛Established in 2009, Ayr has a five-barrel plant. Typically, two brew runs are carried out each week with casks supplied to more than 50 outlets throughout Scotland and England. The beers are also available in bottles, cans and mini casks from the brewery shop, conveniently located in the neighbouring Glen Park Hotel. ⯇ ♦

Leezie Lundie (ABV 3.8%) GOLD
A pale golden, session ale with hints of grapefruit and a dry, lingering finish.
Uisge Dubh (ABV 3.8%) BITTER
Boing! (ABV 4.1%) BITTER
Jolly Beggars (ABV 4.2%) BITTER
A complex best bitter with plenty of character and lingering malty aftertaste.
Complicated Maisie (ABV 4.3%) BITTER
Rabbie's Porter (ABV 4.3%) PORTER
Award-winning, robust, full-bodied porter with well-balanced toffee, fruity maltiness and a slightly smoky finish.
Siren Song (ABV 5%) PALE
Summer Knitting (ABV 5.3%) BLOND

Ethical (NEW)

Roddenloft Brewery, Roddenloft, Mauchline, KA5 5HH ⊕ ethicalales.com

Ethical Ales is a Scottish craft brewery producing keg beers.

Seagate

Seagate, Lamlash, Isle of Arran, KA27 8JN
☎ (01770) 600110 ☎ 07798 854295
⊕ seagatebrewery.co.uk

In 2020 Stephen Sparshott progressed from homebrewing in his kitchen into commercial brewing in a purpose-built shed on the shores of Lamlash Bay. Concentrating on Belgian and Scottish ales, nine core beers are brewed on his 30-litre and 50-litre kits, with a further two ales produced on a separate installation at Arran Botanical Drinks, Cladach, Brodick. ‼ ♦ LIVE

Rise Above 80/- (ABV 4.2%) BITTER
Moulin D'Or Houblon (ABV 5%) SPECIALITY
RYIPA (ABV 5%) SPECIALITY
Saorsa Blond Ale (ABV 5%) SPECIALITY
Scottie Stout (ABV 5%) STOUT

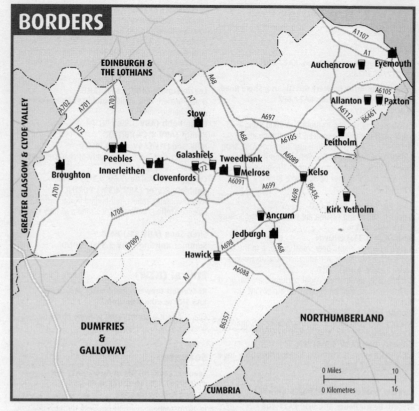

BORDERS

EDINBURGH & THE LOTHIANS

GREATER GLASGOW & CLYDE VALLEY

Auchencrow • Eyemouth

Allanton • Paxton

Leitholm

Stow

Peebles
Innerleithen
Broughton
Clovenfords

Galashiels
Tweedbank
Melrose
Kelso

Kirk Yetholm

Ancrum

Jedburgh

Hawick

DUMFRIES & GALLOWAY

NORTHUMBERLAND

CUMBRIA

| 0 Miles | 10 |
| 0 Kilometres | 16 |

Allanton

Allanton Inn
Main Street, TD11 3JZ (on B6437)
☎ (01890) 818260 ⊕ allantoninn.co.uk
2 changing beers (sourced nationally; often Born, Fyne, Timothy Taylor) Ⓗ
An old coaching inn dating back to the 18th century with a bright, airy feel. Quality food is served in the dining rooms. The small bar area, which overlooks the superb beer garden with views of the countryside beyond, may also be used for dining. The pub has an attractive decor with artworks and comfortable cushioned benches. Families are welcome – a children's menu and games are provided. Booking in advance is strongly recommended, even for a drink. Usually closed Tuesday and Wednesday lunchtimes. Q ☞ ❀ ⇔ ◑ ♣ P ⌶ (260) ☜

Ancrum

Ancrum Cross Keys
The Green, TD8 6XH (on B6400, off A68)
☎ (01835) 830242 ⊕ ancrumcrosskeys.com
Born Amber, Blonde; 1 changing beer (sourced locally; often Born) Ⓗ
Perched on the Ale Water (yes really!), parts of this 200-year-old inn have been upgraded, but the front bar (beware the sliding door), with a real fire and pine panelling, has remained virtually untouched since 1906. There is also a comfortable drinking and dining area and a snug. Owned by Born Brewery, the pub serves traditional food featuring local produce that is sometimes foraged (no food Mon & Tue). Families are welcome, with a children's menu, play area and games available.

The outdoor area has now been extended. Likely to be closed weekday afternoons.
☞ ❀ ◑ ⅃ ❻ ♣ P ⌶ (68,51) ☜ ☜

Auchencrow

Craw Inn
TD14 5LS (signed from A1)
☎ (01890) 761253 ⊕ thecrawinn.co.uk
Timothy Taylor Landlord; 1 changing beer (sourced nationally; often Fyne, Loch Lomond, Orkney) Ⓗ
A friendly and revitalised 18th-century, listed country inn. The real ales are usually from smaller breweries, as can be seen from the numerous pumpclips on show. The cosy front bar has a wood-burning stove and tables for dining and drinking. Excellent home-cooked food is served in both the bar and well-appointed restaurant. There is also an attractive rear area with comfy furniture. Likely to be closed Monday and afternoons Tuesday to Friday, and other hours may vary, so check ahead.
Q ☞ ❀ ◑ ⅃ ♣ P ⌶ (34) ☜ ☜

Clovenfords

Clovenfords Hotel
1 Vine Street, TD1 3LU
☎ (01896) 850203 ⊕ theclovenfordshotel.co.uk
2 changing beers (sourced nationally; often Purity, Sharp's, Stewart) Ⓗ
Set in the heart of an old vineyard village with a striking white statue of Sir Walter Scott outside, this comfortable family-run hotel offers quality food and drink. Old photos adorn the walls reflecting the hotel's literary history. Alongside the main bar area is a conservatory restaurant,

and there is an outdoor seating area at the front. Meals are served all day, every day, and a children's menu and games are available. Opening times may vary in winter.

Q ⛅ 🏨 🍴 ◐ & ♣ P 🚋 (X62) ☻ 🛜

Galashiels

Hunters Hall ✓
56 High Street, TD1 1SE (N end of centre)
☎ (01896) 759795
Greene King Abbot; Ruddles Best Bitter; 3 changing beers (sourced nationally; often Broughton, Sharp's, Stewart) Ⓗ

This former Presbyterian church and school has been sympathetically restored to expose much of the original stonework, high ceilings and skylight roof panels. Historical photographs of Galashiels decorate the walls. The pub offers typical Wetherspoon fare, and caters for families, locals, visitors and students. Meals are available all day, including children's options. Real cider is generally only available during festivals. Likely to open at 8am, with alcoholic drinks served from 11am.

Q ⛅ 🏨 ◐ & Å 🚋 🛜

Hawick

Bourtree ✓
22 Bourtree Place, TD9 9HL (NE edge of town centre)
☎ (01450) 360450
Belhaven 80/-; Greene King Abbot; 3 changing beers (sourced nationally; often Sharp's, Stewart, Wychwood) Ⓗ

Built as the Hawick Conservative Club in 1897, this listed building has been stunningly transformed into a Wetherspoon pub. The original badminton and snooker halls form the main area and there are three other quieter sections. Photographs depict a history of Hawick life. Food is served all day and includes breakfast and children's options. Either bingo or a quiz is held on Wednesday evenings. Real cider is generally only available during festivals. Likely to open at 8am with alcoholic drinks served from 11am.

Q ⛅ 🏨 ◐ & ♣ ⊕ P 🚋 (20,X95) 🛜

Exchange Bar (Dalton's)
1 Silver Street, TD9 0AD (off SW end of High St)
☎ (01450) 376067
2 changing beers (sourced regionally; often Belhaven, Orkney, Born) Ⓗ

Tucked away near St Mary's Kirk, the pub used to overlook the Corn Exchange. However, a previous owner was called Dalton and that name has stuck ever since. Popular with locals, this Victorian gem has a bar featuring original dark-wood panelling and ornate cornice work, and a comfy back lounge used for parties, occasional karaoke and Sunday folk sessions. Children are not admitted. CAMRA Borders Pub of the Year runner-up 2022. 🏨 Å ♣ 🚋 ☻ 🛜

Innerleithen

St Ronan's Hotel
High Street, EH44 6HF
☎ (01896) 831487 ⊕ stronanshotel.co.uk
1 changing beer (sourced regionally; often Born, Orkney, Traquair House) Ⓗ

A village hotel with a prominent blue and white exterior, taking its name from a local saint. The bar is long and narrow with a wood-burning stove. A pool room leads off, and two alcoves provide extra seating and a darts area. There is a restaurant serving evening meals. A pick-up service and packed lunches are available for Southern Upland Way walkers. For children, there is a garden play area and indoor games. Usually open from 3pm Monday to Thursday and 1pm Friday to Sunday.

⛅ 🏨 🍴 Å ♣ P 🚋 (X62) ☻ 🛜

Traquair Arms Hotel
Traquair Road, EH44 6PD (B709, off A72)
☎ (01896) 830229 ⊕ traquairarmshotel.co.uk
3 changing beers (sourced nationally; often Stewart, Tempest) Ⓗ

Elegant 18th-century hotel in the scenic Tweed Valley offering accommodation in 16 en-suite rooms and two self-catering cottages. The comfortable lounge bar features a welcoming real fire, and a flagstoned sports bar with log-burner provides an ideal thawing-out space for mountain bikers, walkers and anglers. A bistro area and separate restaurant offer plenty of room for diners. Meals are served all day at weekends and there is a menu for children. The bar may close earlier if quiet.
⛅ 🏨 ◐ & Å ♣ P 🚋 (X62) ☻ 🛜

Kelso

1905
Crawford Street, TD5 7DP (off N corner of town square)
☎ (01573) 225556
3 changing beers (sourced regionally; often Firebrick, Loch Lomond, Stewart) Ⓗ

This pub, formerly the Red Lion, has a lively atmosphere when events are held, but at other times it has a pleasant peaceful ambience. The main room has a fine wood and plastered vaulted ceiling, wooden panelling and mosaic flooring. Brewery mirrors adorn the walls and are also inlaid into the bar gantry. Other areas with different styling lead off from the bar. Children are not admitted, except for some functions. The pub may start serving food during 2022. Likely to be closed Monday in winter. Q 🏨 ♣ 🚋 ☻ 🛜

Cobbles Freehouse & Dining
7 Bowmont Street, TD5 7JH (off N corner of town square)
☎ (01573) 223548 ⊕ cobbleskelso.co.uk
Tempest Armadillo; 1 changing beer (often Tempest) Ⓗ

This gastro-pub is often busy with diners but drinkers are also welcome. The décor is bright and welcoming, with a bar on the right warmed by a real fire, and a dining area on the left. Food is served throughout, available all day Thursday to Sunday. The food menu has something for everyone, including children. The handpumps are dedicated to Tempest beers, with some lined glasses available. Usually closed Monday and Tuesday, and Wednesday early afternoon. Closing times may vary.
⛅ 🏨 ◐ & 🚋 🛜

Rutherfords
38 The Square, TD5 7HL
☎ 07917 824183
4 changing beers (sourced regionally; often Cheviot, Firebrick, Stewart) Ⓗ

REAL ALE BREWERIES

Aye Been ✦ Eyemouth
Born Jedburgh
Broughton Broughton
Freewheelin' Peebles
Stow Stow (NEW)
Tempest ✦ Tweedbank
Traquair House Innerleithen

This tiny shop conversion was the first micropub in Scotland and has been under new ownership since 2021. With no TV or music to distract, it is ideal for a friendly chat or playing board games. The drinking area extends onto the pavement under canopies. Real ales are generally from smaller breweries and are now served by handpump, with third-pint tasting paddles available. Children are welcome until 3pm and games are provided. Usually closed all day Monday and afternoons expect Saturday. Q✿☞⊛♣♣♠

Kirk Yetholm

Border

The Green, TD5 8PQ
☎ (01573) 420237 ⊕ borderhotel.co.uk
House beer (by Hadrian Border); 2 changing beers (sourced nationally; often Born, Cheviot, Hadrian Border) Ⓗ

An attractive 270-year-old coaching inn with a flagstone floored bar, side room and conservatory restaurant. Photographs and pictures feature items of local interest. Set at the confluence of several long-distance footpaths, the pub is popular with walkers. In a tradition from Wainwright's time, those completing the Pennine Way are awarded a free half of Pennine Pint. Hearty food, served all day on Sunday, is home cooked and includes locally sourced ingredients. A children's menu and games are provided. ☞✿⊨◑♣♣▱♠(81,81A)♠♠

Leitholm

Plough Inn

Main Street, TD12 4JN (on B6461)
☎ (01890) 840408 ⊕ theploughinnleitholm.co.uk
House beer (by Born); 1 changing beer (sourced nationally; often Cheviot, Greene King, Hetton Law) Ⓗ

A charming and friendly family-run inn set in the main street of a quiet village. The wooden-floored bar, featuring a large clock, is decorated and furnished to create a bright, modern and welcoming ambience. Children are welcome until 9pm, with a menu and games provided. The large beer garden overlooks fields. Real cider is generally only available during the summer. Usually closed all day Monday and Tuesday, and afternoons Wednesday to Saturday, but hours may be extended in summer. ☞✿⊨◑♣♠P♠♠

Melrose

Burt's Hotel

Market Square, TD6 9PL
☎ (01896) 822285 ⊕ burtshotel.co.uk
Born Amber; Timothy Taylor Landlord; 1 changing beer Ⓗ

An elegant, family-run hotel with colourful window boxes providing a striking appearance in summer. The comfortable lounge bar décor reflects the country sporting interests of many of its clientele. The focus is unashamedly on food, which is excellent in both the bar and restaurant. Those visiting solely for a drink may find space limited at busy times. Children are permitted and a menu provided. The Townhouse opposite has the same owners. Q☞✿⊛◑Ⅾ♣♠P▱♠♠

George & Abbotsford Hotel

High Street, TD6 9PD (NW of Market Square)
☎ (01896) 822308 ⊕ georgeandabbotsfordmelrose.co.uk
Greene King Abbot; Tempest Armadillo; 2 changing beers (sourced regionally; often Orkney) Ⓗ

A spacious family-run hotel with a comfortable bar and lounges, offering a warm welcome to locals and visitors alike. The real ales come from both sides of the border. Food features prominently and is served all day, and includes various specials and children's options. The partially covered, enclosed suntrap beer garden has plenty of seating. The bar is popular with walkers, cyclists and, naturally, Melrose rugby supporters. It is a pleasant walk from the rail terminus at Tweedbank. Q☞✿⊨◑Ⅾ♣♠P▱♠♠

Paxton

Cross Inn

TD15 1TE (off B6461)
☎ (01289) 384877 ⊕ thecrossinn.co.uk
Timothy Taylor Landlord; 2 changing beers (sourced nationally; often Firebrick, Hadrian Border, Tempest) Ⓗ

A rejuvenated 19th-century village local with friendly staff. Its small, welcoming bar is stone-floored; the larger dining and function area has floorboards and carpeting. Outside at the front is a raised decking area for drinking and eating. Food is very much part of the offering and served all day Saturday and Sunday. The menu, along with daily specials, children's options and Sunday roasts, appeals to most tastes. Usually closed Monday and Tuesday, and mid-afternoons Wednesday to Friday. CAMRA Borders Pub of the Year 2022.
☞✿◑Ⅾ♦♠P▱(32)♠♠

Peebles

Bridge Inn (Trust)

Portbrae, EH45 8AW
☎ (01721) 720589 ⊕ thebridgeinnpeebles.co.uk
3 changing beers (sourced nationally; often Born, Orkney, Stewart) Ⓗ

Cheerful, welcoming pub also known as the Trust and once called the Tweedside Inn. The bright, comfortable bar is decorated with jugs, bottles, pictures of old Peebles and displays relating to outdoor pursuits. There is a cosy corner with a log-burner, and a small room to the rear with a dartboard. The Gents has superb old fittings. The suntrap patio overlooks the river and hills beyond. Children are not admitted. ✿♣♠▱♠♠

Breweries

Aye Been SIBA

Unit 2, Gunsgreenhill Industrial Estate, Eyemouth, TD14 5SF ☎ 07498 356548
✉ hello@ayebeenbrewing.com

⊗ Aye Been is a four-barrel brewery established in Eyemouth in 2020. It moved to new premises in 2021. Tap days are held monthly. ♦

Aye PA (ABV 3.8%) PALE
Blonde (ABV 4%) PALE
Red (ABV 5%) RED
Fort Point Porter (ABV 5.1%) PORTER

Born SIBA

Lanton Mill, Jedburgh, TD8 6ST
☎ (01835) 830495 ☎ 07802 416494
⊕ bornintheborders.com

Scotland's original plough-to-pint brewery, it started brewing as Scottish Borders Brewery in 2011, using its own barley, before changing name to Born in the

Borders Brewery, and then Born Brewery in 2020. Beyond its core range of ales, projects have included the 'Wild Harvest' initiative, which sources locally-foraged ingredients. The brewery has a visitor centre, offering brewery tours, a café/restaurant, gin distillery and shop. Several retail units elsewhere feature the beer, produce and food. !! ☕ ♦

Lager BLOND
Blonde (ABV 3.8%) GOLD
Well-balanced hop and malt flavour, with bitterness coming through.
Amber (ABV 4%) BITTER
An amber ale with a balance of malty sweetness and hop bitterness, fruity and easy to drink.
Holy Cow (ABV 4.2%) GOLD
Gold Dust (ABV 4.3%) PALE
Dark (ABV 4.5%) BITTER

Broughton SIBA

Main Street, Broughton, ML12 6HQ
☎ (01899) 830345 ⊕ broughtonales.co.uk

⊕Founded in 1979, Broughton Ales was one of the first microbreweries. Broughton has developed since then, and though more than 60% of production goes into bottle for sale in Britain and abroad, it retains a sizeable range of cask ales. It merged with Consolidated Craft Breweries Group in 2022. All beers are suitable for vegetarians and Hopo Lager is certified gluten-free.
!! ☕ ♦ GF

Hopo Session IPA (ABV 3.8%) PALE
Dry-hopped pale ale with slightly tart, fruit taste and distinctive tang.
Merlin's Ale (ABV 4.2%) GOLD
A well-hopped, fruity flavour is balanced by malt in the taste. The finish is bittersweet, light but dry.
Wee Jock (ABV 4.6%) BITTER
Pleasant 80/- style. Light fruit and a malty sweetness.

Freewheelin'

Peebles Hydro, Innerleithen Road, Peebles, EH45 8LX
☎ 07802 175826 ⊕ freewheelinbrewery.co.uk

Freewheelin' began brewing in 2013 and is based in Peebles. It is located in a former joiners shed in the grounds of the Peebles Hydro Hotel. Local spring water is used in the brewing process. !! ♦

Blonde (ABV 3.8%) BLOND
IPA (ABV 4.2%) PALE

Ruby (ABV 4.4%) MILD
Stout (ABV 4.4%)

Stow (NEW)

Plenploth House, Old Stage Road, Stow, TD1 2SU
☎ 07834 396991 ⊕ dhubrew.com

Stow is a small-batch nanobrewery in the Scottish Borders that produces two core cask beers available in the Borders and increasingly the central belt, sold under the name Dhu Brew. Beers are also available in can and keg.

Under the Dhu Brew brand name:
IPA (ABV 3.8%) PALE
Pils (ABV 4%) SPECIALITY
Red (ABV 4%) BITTER

Tempest SIBA

Block 11, Units 1 & 2 Tweedbank Industrial Estate, Tweedbank, TD1 3RS
☎ (01896) 759500 ⊕ tempestbrewingco.com

Now well established in its premises at Tweedbank, Gavin Meiklejohn's brewery continues to evolve with specialised brews, many using lesser known hop varieties. Cask beers were restricted during Covid (with Armadillo the only ever-present), but many other beers were available in KeyKeg while the brewery remained open throughout, and expanded its bottle and can portfolio. Within the brewery is the shop where regular tap sessions and beer festivals are held. !! ☕ ♦ LIVE ♪

Armadillo (ABV 3.8%) GOLD
Modern Helles (ABV 4.1%) PALE
Elemental Porter (ABV 5.1%) PORTER

Traquair House SIBA

Traquair House, Innerleithen, EH44 6PW
☎ (01896) 830323 ⊕ traquair.co.uk/traquair-house-brewery

The 18th century brewhouse is based in one of the wings of the 1,000-year-old Traquair House, Scotland's oldest inhabited house. All the beers are oak-fermented and 60% of production is exported. !! ☕ ♦

Bear Ale (ABV 5%) BITTER
Malty aroma and a complex taste of malts, citrus fruit, sweetness and bitterness, all lasting into the aftertaste.

What is real ale?

Real ale is also known as cask-conditioned beer or simply cask beer. In the brewery, the beer is neither filtered nor pasteurised. It still contains sufficient yeast and sugar for it to continue to ferment and mature in the cask. Once it has reached the pub cellar, it has to be laid down for maturation to continue, and for yeast and protein to settle at the bottom of the cask. Some real ale also has extra hops added as the cask is filled, a process known as 'dry hopping' for increased flavour and aroma. Cask beer is best served at a cellar temperature of 11-12 degrees C, although some stronger ales can benefit from being served a little warmer. Each cask has two holes, in one of which a tap is inserted and is connected to tubes or 'lines' that enable the beer to be drawn to the bar. The other hole, on top of the cask, enables some carbon dioxide produced during secondary fermentation to escape. It is vital that some gas, which gives the beer its natural sparkle or condition, is kept within the cask: the escape of gas is controlled by inserting porous wooden pegs called spiles into the spile hole. Real ale is a living product and must be consumed within three or four days of a cask being tapped as oxidation develops.

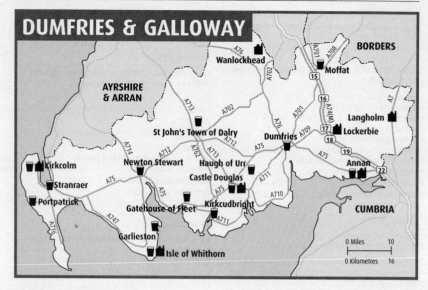

DUMFRIES & GALLOWAY

Annan

Blue Bell Inn

10 High Street, DG12 6AG
☎ (01461) 202385
Caledonian Deuchars IPA; 4 changing beers (sourced nationally; often Carlisle, Kelburn) Ⓗ
Former coaching inn dating from 1770 where Hans Christian Andersen is said to have stayed. It was part of the Gretna State Management Scheme from 1917 to 1972. The red sandstone building retains some traditional features, notably the panelled interior and rear stables. The Gents has a panelled ante-room, tiled inner room and original Shanks urinals. The inn is home to many community activities along with annual beer and cider festivals. Motte & Bailey beers, brewed on-site, are only available here. CAMRA Dumfriesshire Pub of the Year 2020. ⏣☆✿↣♣♠P🚃 (79,383)♣🐾🛜

Castle Douglas

Sulwath Brewery Tap Room Ⓛ

209 King Street, DG7 1DT
☎ (01556) 504525 ⊕ sulwathbrewers.co.uk
Sulwath Black Galloway; 5 changing beers (sourced locally; often Sulwath) Ⓗ
The visitor centre for Sulwath Brewery is a showcase for the brewery's beers, with four in cask conditioned form, alongside other guest beers on occasion. One draught cider, usually from Westons, is also available. Dried hop bines decorate the walls and old wooden casks of various sizes provide some of the furniture. Brewery tours are available Monday and Friday, and annual beer festivals are held at the end of May and August. Open on some Sundays for special events – check Facebook for details. Q⏣♠P🚃 (500)🐾🛜

Dumfries

Cavens Arms 🍸

20 Buccleuch Street, DG1 2AH
☎ (01387) 252896 ⊕ cavensarms.com
Fyne Ales Jarl; Morland Old Speckled Hen; Swannay Orkney IPA; Timothy Taylor Landlord; 4 changing beers (sourced nationally) Ⓗ
Busy food-oriented pub, popular with diners for its range of good-value meals. A separate restaurant area provides more space at peak times. Drinkers are welcome in the bar but seating can be limited during food service times. Guest ales are from a wide range of breweries, including some rarely seen in this locality. There are regular charity quizzes and other theme nights. Local CAMRA Pub of the Year 2022. ⏣◖♿🚃🛜

Coach & Horses

66 Whitesands, DG1 2RS
☎ 07746 675349
Draught Bass Ⓗ
A small, lively former coaching inn overlooking the River Nith. Situated next to the tourist information centre, the pub is handy for local attractions. The bar is small but service is always quick. The room features a flagstone floor with a warming open fire during the colder months. There is a great atmosphere in this gem of a pub, enhanced by regular live music sessions. Winter opening times may vary. ☆↣♣♠P🚃🐾

Douglas Arms

75 Friars Vennel, DG1 2RQ
☎ (01387) 256002
2 changing beers Ⓗ
There has been a pub on this site since 1800, and the cosy, traditional, town-centre bar is always a popular venue. Known as the Dougie to locals, it has a warming fire in winter and a quiet snug. The choice of ales reflects the care taken by the licensee to respond to customers' preferences – see Facebook for updates on beers available and information on hosted events. Q⏣↣♣🚃🛜

REAL ALE BREWERIES

Borderlands ✎ Langholm (NEW)
Five Kingdoms Isle of Whithorn
Lola Rose 🗄 Wanlockhead
Lowland Lockerbie
Mote & Bailey 🗄 Annan
Portpatrick Kirkcolm
Sulwath ✎ Castle Douglas

New Bazaar

39 Whitesands, DG1 2RS

☎ (01387) 268776

Theakston XB; 3 changing beers (sourced nationally; often Fuller's, Greene King, Timothy Taylor) Ⓗ

Former coaching inn beside the River Nith with an attractive airy bar featuring a splendid Victorian gantry displaying an impressive malt whisky collection. The cosy lounge provides a quiet retreat and has a warming coal fire in winter. A small room is available for meetings. The pub is a favourite with football supporters attending the nearby Palmerston Park and is ideally situated for car parking, local buses and tourist attractions. Winter opening times may vary. ❀♣P➹❀🛜

Riverside Bar

Dock Park, DG1 2RY

☎ (01387) 254477

3 changing beers (sourced nationally; often Tempest) Ⓗ

The Riverside Bar is an established venue on the Dumfries real ale scene. Comfortable and friendly, it has seating on two levels and a large conservatory. Two outside seating areas include a terrace with open views over Dock Park and down to the River Nith. The pub is accessible from the St Michaels area near the Robert Burns Mausoleum or from Dock Park. Guest beers can be from local brewers as well as from further afield. ➷❀♣➹❀🛜

Tam o' Shanter

113-117 Queensberry Street, DG1 1BH

☎ (01387) 256696

3 changing beers (sourced locally; often Five Kingdoms, Sulwath) Ⓗ

Established in 1630, this 17th-century coaching inn with a connection to Robert Burns has been a mainstay of the Dumfries beer scene for many years. Situated just off the High Street the pub is under new ownership (Nov 2021) and has been refurbished to an aesthetically pleasing standard. Brand new toilets for all genders are on the ground floor. The twin booth snug is lovely, with a stove made into a glass-fronted feature. The McCubbin family have done a great job of refurbishing the pub without ruining the traditional bar. There is also an updated outdoor smoking/vaping area. ➷≠❀➹❀🛜

Garlieston

Harbour Inn

18 South Crescent, DG8 8BQ

☎ (01988) 600685 ⊕ the-harbour-inn.co.uk

House beer (by Greene King); 1 changing beer (often Belhaven, Greene King) Ⓗ

This is a well-established and well-known pub in the Garlieston area, dating back to 1700. It sits in the village centre with scenic sea views over the bay, and is busy all year round with locals and holidaymakers. A second handpump has recently been installed. The comfortable bar area is friendly and cosy, and pub meals are available lunchtimes and evenings. There is a separate restaurant area adjacent to the bar. This is a great area for coastal walking and fishing. Dogs are very welcome. Q➷❀⏱🔥Å♣➹(415,416)❀🛜

Gatehouse of Fleet

Masonic Arms

10 Ann Street, DG7 2HU

☎ (01557) 814335 ⊕ masonicarms.co.uk

Caledonian Deuchars IPA; 1 changing beer (sourced locally; often Sulwath) Ⓗ

Built by local Masons in 1785, the pub is situated just off the east end of the main street in Gatehouse of Fleet, a lovely traditional village in the heart of the Stewartry. Exposed beams are a feature in the comfortable bar area, along with a real fire. Good locally sourced food is served in the bar, conservatory and restaurant, including daily specials, plus a weekly curry night and a popular Sunday carvery. Winter opening times may vary. ➷❀⏱AP➹(431,500)❀🛜

Haugh of Urr

Laurie Arms Hotel

11-13 Main Street, DG7 3YA

☎ (01556) 660246

4 changing beers (sourced nationally; often Caledonian, Fyne Ales) Ⓗ

Welcoming family-run establishment in a charming, quiet village, popular for its range of beers and freshly cooked food featuring local produce. It has a good village pub atmosphere, enhanced on winter nights by a warming log fire in the bar. Up to four beers are available depending on the season, mainly from independent breweries. National Cycle Route 7 passes nearby. The pub is on the bus route between Dumfries, Dalbeattie and Castle Douglas. Winter opening times may vary, so check before visiting. CAMRA Stewartry Area Pub of the Year 2022. ➷❀⏱♣P➹(501)❀🛜

Isle of Whithorn

Steam Packet Inn Ⓛ ✓

Harbour Row, DG8 8LL (on B7004 from Whithorn)

☎ (01988) 500334 ⊕ thesteampacketinn.co.uk

8 changing beers (often Five Kingdoms, Fyne, Kelburn) Ⓗ

Traditional and historic family-run hotel overlooking the harbour, welcoming to all including families and pets. The public bar has stone walls and a multi-fuel stove, and there are pictures of the village and maritime events throughout. Four guest ales from a wide variety of breweries, along with up to four beers from in-house brewery Five Kingdoms, are available in both bars. Bottle-conditioned ales are also stocked. The extensive food menu features local produce. Local CAMRA Cider Pub of the Year 2022. Q➷❀⏱Å❀P➹(415,416)❀🛜

Kirkcolm

Blue Peter Hotel

23 Main Street, DG9 0NL (on A718 5 miles N of Stranraer)

☎ (01776) 853221

2 changing beers (often Ayr, Born) Ⓗ

A small family-run hotel with two bars packed with memorabilia. Two handpumps dispense a constantly changing range of ales. Home-cooked food is served using fresh local produce, with takeaways available. Outside, the decked patio has views of abundant wildlife including red squirrels. The hotel is popular with real ale enthusiasts as well as walkers and wildlife watchers. Usually open Tuesday evening and Friday to Sunday, it may also open on Wednesday and Thursday evenings if darts or dominoes matches are on. Good-value B&B accommodation is available. Q➷❀⏱Å♣➹(408)❀🛜

Kirkcudbright

Masonic Arms

19 Castle Street, DG6 4JA

☎ (01557) 330517 ⊕ masonic-arms.co.uk

2 changing beers (sourced nationally) Ⓗ
This well-situated, friendly pub in the town has been a firm favourite with real ale enthusiasts for many years. There is a smaller back bar, and a garden with a smoking area. One real ale is available all year round, two in the summer months. A good range of world beers is also available, as well as a choice of more than 50 malt whiskies and over 230 gins. Q✿&ΑΡ♞❀♠

Selkirk Arms Hotel ✓

High Street, DG6 4JG
☎ (01557) 330402 ● selkirkarmshotel.co.uk
2 changing beers (sourced nationally; often Sulwath) Ⓗ
Refurbished 18th-century hotel with a restaurant, bistro and lounge bar, renowned for locally sourced food, with photographs of suppliers featuring on the walls. The large garden area with tables is popular in summer. Two real ales are available, sometimes three in summer. The bar offers a good selection of malt whiskies and gins. Robert Burns wrote his famous Selkirk Grace at the hotel in 1794. Kirkcudbright is notable for its artistic heritage and houses a number of interesting galleries and museums. Q➥✿🗠🌓&ΑΡ♞❀♠

Moffat

Famous Star Hotel

44 High Street, DG10 9EF
☎ (01683) 220156 ⊕ famousstarhotel.co.uk
Sulwath Criffel; 1 changing beer (sourced regionally; often Lowland) Ⓗ
The Famous Star Hotel is recognised in the Guinness Book of Records as the narrowest detached hotel in the world. The building is 20 feet wide and 162 feet long but feels much bigger due to the clever use of internal space. There is a large public bar at the rear and a smaller lounge accessed from the front. The hotel has been run by the same family for over 30 years and offers excellent service. At least one beer is available all year round. Moffat is a good base for exploring the Southern Uplands. ➥✿🗠🌓&ΑΡ♞(X74,101A)❀♠

Newton Stewart

Creebridge House Hotel

Minnigaff, DG8 6NP (on B7079, E of river)
☎ (01671) 402121 ⊕ creebridge.co.uk
2 changing beers (often Five Kingdoms) Ⓗ
This traditional country house hotel is set in three acres of gardens and woodland next to the River Cree and close to the town centre. There is usually one real ale available. Food choices are excellent, with locally sourced meat, game and fish on the menu. The bar and lounge areas have real fires. There is also an outdoor bar when weather permits. Dominoes league games are played here on a Tuesday and some charity events are held. Q➥✿🗠🌓&ΑΡ♞(500)❀♠

Portpatrick

Crown Hotel

9 North Crescent, DG9 8SX (facing harbour)
☎ (01776) 810261 ⊕ crownhotelportpatrick.com
2 changing beers (often Ayr, Five Kingdoms, Sulwath) Ⓗ
Hotel overlooking the picturesque harbour with views on a clear day across to Ireland. The large, comfortable bar area at the front is adorned with fine pictures and ornaments, and warmed by an open fire. Two regularly changing ales are sourced from breweries across the UK, including the nearby Five Kingdoms. Live music plays on

Friday and Saturday nights, featuring both local and visiting musicians and groups. ➥✿🗠🌓&Α♣♞(367,411)❀♠

St John's Town of Dalry

Clachan Inn

8-10 Main Street, DG7 3UW
☎ (01644) 430241 ⊕ theclachaninn.co.uk
3 changing beers (sourced regionally; often Ayr, Five Kingdoms, Fyne) Ⓗ
The Clachan has a reputation for excellent food, cosy, well-equipped bedrooms and a welcoming atmosphere. It has an attractive traditional main bar, a relaxing lounge bar and a separate restaurant – both bars have wonderfully warming open log fires in winter. The menu is varied, with excellent daily specials, and the kitchen makes good use of local produce. The inn is a handy stop-off for walkers on the Southern Upland Way. Winter opening hours may vary. CAMRA Stewartry Area Pub of the Year 2020. Q➥✿🗠🌓&Α♣♞(520,521)❀♠

Stranraer

Grapes

4-6 Bridge Street, DG9 7HY
☎ (01776) 703386
2 changing beers (often Ayr) Ⓗ
Popular, historic public bar with an impressive mirror and gantry, little altered in over 50 years. It has a comfortable, refurbished snug bar downstairs, an Art Deco lounge/function room upstairs, and a bright and sunny seated courtyard. Local musicians play in the public bar most Friday evenings, and touring American-style bands often perform in the public bar or upstairs. There is a strong commitment to real ales, sourced both locally and from around the UK. Mini beer festivals are usually held annually. Local CAMRA Pub of the Year 2021. ➥✿&≠♣♞❀♠

Breweries

Borderlands (NEW)

Townfoot Industrial Estate, Langholm, DG13 0ET
☎ 07843 896644 ⊕ borderlandsbrewery.co.uk
Brewing in the heart of Langholm, also known as 'The Muckle Toon', Borderlands was founded by Stuart Campbell restoring brewing to the town, yards away from the historic brewery, after a break of over a century. Proudly nestled in the Esk Valley, the brewery is a 2.5-barrel plant brewing in small batches. Three core beers are supplemented by limited editions (all cask, bottle and can). Expanded into a new premises incorporating a taproom in 2022. ◆

Esk Blonde (ABV 4.5%) PALE
Reiver Red (ABV 5%) RED
Tarras IPA (ABV 6%) IPA

Five Kingdoms SIBA

22 Main Street, Isle of Whithorn, DG8 8LF
☎ (01988) 500334 ⊕ fivekingdomsbrewery.com
☺Five Kingdoms was established in 2015 by Alastair Scoular, owner of the Steam Packet Inn, using a 2.5-barrel plant. It is situated in the harbourside village of Isle of Whithorn, the most southerly point of the Wigtownshire peninsular in Galloway and a tourist and sailing hotspot. It supplies numerous local and Scottish outlets, selected national beer festivals, and the Steam

Packet Inn. Brewery tours and expansion are planned. !! ♦ LIVE

Bright Idea (ABV 3.8%) BITTER
McGregors Mild (ABV 3.8%) MILD
Bitter X Blonde (ABV 4%) GOLD
Rebus (ABV 4%) PALE
Summerisle (ABV 4%) GOLD
Renton (ABV 4.5%)
Wee McAsh Bitter (ABV 4.5%) BROWN
Captain Morrison's IPA (ABV 6.5%) STRONG
Dark Storm Stout (ABV 6.9%) STOUT
Such Is Life NEIPA (ABV 6.9%) IPA

Lola Rose

🍺 Wanlockhead Inn, Wanlockhead, ML12 6UZ
☎ (01659) 74535 ☎ 07500 663405
⊕ lola-rose-brewery.co.uk

Lola Rose is based in the family-run Wanlockhead Inn, situated in the scenic Lowther Hills of the Scottish Lowlands. Local outlets only are supplied at present. LIVE

Lowland

8 Well Street, Lockerbie, DG11 2EY
☎ (01576) 203999 ☎ 07493 716521
⊕ lowlandbrewery.co.uk

⊠ Brewing began in 2018 using a five-barrel plant. Three regular beers are produced with plans to expand the range as the brewery develops. The brewery is located in converted premises in the town centre and supplies direct to pubs in Dumfries & Galloway, Scottish Borders and north Cumbria. !! 🛒 ♦

Rabbie's Drouth (ABV 3.8%) PALE
Twa Dugs (ABV 4%) PALE
Golden Eagle (ABV 4.5%) GOLD
Dryfe Blonde (ABV 5%) BLOND

Mote & Bailey

🍺 Blue Bell Inn, 10 High Street, Annan, DG12 6AG
☎ (01461) 202385

⊠ Brewing began in 2018 in the cellar of the Blue Bell Inn, Annan, using equipment from Andrews Ales.

Brewing capacity is one barrel. The range varies and is only available at the pub. 🛒 ♦

Portpatrick

24 Main Street, Kirkcolm, DG9 0NN
✉ holmesphil91@gmail.com

⊛The brewery restarted production in 2022 with new owners. New recipes are being trialled to establish a core range. ♦ LIVE

Sulwath SIBA

The Brewery, 209 King Street, Castle Douglas, DG7 1DT
☎ (01556) 504525 ⊕ sulwathbrewers.co.uk

⊛Sulwath started brewing in 1995. Its award-winning beers are supplied to around 100 outlets and four wholesalers as far away as Devon and Aberdeen. The brewery has a popular, fully-licensed tap. !! 🛒 ♦ LIVE ⚡

Cuil Hill (ABV 3.6%) BLOND
Distinctively fruity session ale with malt and hop undertones. The taste is bittersweet with a long-lasting dry finish.
Tri-ball (ABV 3.9%) GOLD
Brewed with three hops, it is fresh, crisp and blond. The ideal session ale.
The Grace (ABV 4.3%) MILD
A refreshing, rich ale with a full-bodied flavour that balances the caramel undertones.
Black Galloway (ABV 4.4%) PORTER
A robust porter that derives its colour from the abundance of chocolate malts.
Criffel (ABV 4.6%) BITTER
Full-bodied beer with a distinctive bitterness. Fruit is to the fore with hops becoming increasingly dominant in the finish.
Galloway Gold (ABV 5%) GOLD
A cask-conditioned lager that will be too sweet for many despite being heavily-hopped.
Knockendoch (ABV 5%) BITTER
Dark, copper-coloured, reflecting a roast malt content, with bitterness from Challenger hops.
Solway Mist (ABV 5.5%) SPECIALITY
A naturally cloudy wheat beer. Sweetish and fruity.

Definitions

bivvy – beer
bumclink – inferior beer
bunker – beer
cooper – half stout, half porter
gatters – beer
shant of gatter – glass of beer
half and half – mixture of ale and porter, much favoured by medical students
humming – strong (as applied to drink)
ponge or pongelow – beer, half and half
purl – mixture of hot ale and sugar, with wormwood infused
rot-gut – bad
small beer shandy – gaffs ale and gingerbeer
shant – pot or quart (shant of bivvy – quart of beer)
swipes – soup or small beer
wobble-shop – shop where beer sold without a licence

J C Hotten, The Slang Dictionary, 1887

EDINBURGH & THE LOTHIANS

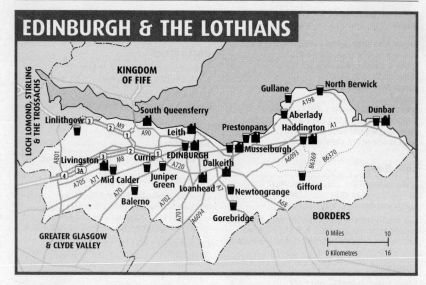

Aberlady

Duck's Inn

Main Street, EH32 0RE
☎ (01875) 870682 ⊕ ducks.co.uk
Sharp's Doom Bar; 2 changing beers (sourced nationally; often Timothy Taylor) Ⓗ
A well-appointed village hotel with a comfortable, compact and intimate bar, restaurant and numerous overspill areas. Three real ales are available in summer. The interior is decorated with sporting and brewing memorabilia. Bar games include the Duck's Challenge putting game. Meals are served all day and families are welcome until 8pm, with children's games and menu provided. Usually open all day in summer but from 4pm Monday to Thursday at other times of the year. May close earlier if quiet. Q☂❀🛇❤🕪ᵹ♣▲P☲❀ᚱ

Balerno

Grey Horse

20 Main Street, EH14 7EH (off A70, in pedestrian area)
☎ (0131) 449 2888 ⊕ greyhorsebalerno.com
4 changing beers (sourced regionally; often Fyne, Orkney, Stewart) Ⓗ
Traditional stone-built village pub dating from the 18th century. The cosy public bar retains original features including wood panelling and a fine Bernard's mirror. The pleasant lounge has a more modern feel, and there is also a small restaurant. A varied food menu is offered, with lighter options at lunchtime, a children's menu and Chinese specials (no food Mon and lunchtimes Tue-Thu). Dogs are allowed in the bar, with biscuits and water provided. Live music is played on some Sunday afternoons. Q☂❀🕪ᵹ☲(44)❀

Currie

Riccarton Inn

198 Lanark Road West, EH14 5NX
☎ (0131) 449 2230 ⊕ riccartoninn.co.uk
4 changing beers (sourced nationally; often Fyne, Loch Leven, Stewart) Ⓗ
Originally a coaching inn, the comfortable pub has a long central bar with half-timbered walls and contemporary exposed stonework. There are attractive seating areas

including booths next to the bar and a separate restaurant space. Meals are served all day including children's options. The decking at the front has southerly views to the Pentland Hills and there is a large covered beer garden at the rear. The inn is handy for the Water of Leith Walkway. ☂❀🛇🕪P☲(44,45)❀ᚱ

Dunbar

Volunteer Arms

17 Victoria Street, EH42 1HP (near swimming pool)
☎ (01368) 862278 ⊕ volunteerarmsdunbar.co.uk
2 changing beers (sourced nationally; often Cairngorm, Harviestoun, Stewart) Ⓗ
Close to Dunbar's harbour and swimming pool, this is a friendly, traditional locals' pub. The cosy wood-panelled bar is decorated with lots of fishing and lifeboat-oriented memorabilia, interesting photos and a good selection of old pumpclip badges on the ceiling. Upstairs is a restaurant serving an excellent good-value menu (all day in summer), with an emphasis on seafood. Food is also served downstairs. A menu and games are provided for children. ☂❀🕪▲⇌♣🖵☲❀ᚱ↺

Edinburgh: Central

Abbotsford Bar & Restaurant ★

3-5 Rose Street, EH2 2PR
☎ (0131) 225 5276 ⊕ theabbotsford.com
7 changing beers (sourced regionally; often Cromarty, Fyne Ales, Swannay) Ⓗ/Ⓐ
This traditional Scottish bar features a magnificent island bar and gantry in dark mahogany – both fixtures since 1902. The ornate plasterwork and corniced ceiling are outstanding. The room is predominantly furnished with large tables and wooden bench seating. An extensive food menu is available all day in the bar. The separate restaurant is upstairs – real ale can be ordered from downstairs – and children over five are permitted here. Return trays are not used on the handpumps.
Q☂❀🕪⇌(Waverley)🚇(St Andrew Sq)🖵❀ᚱ↺

Black Cat

168 Rose Street, EH2 4BA
☎ (0131) 225 3349

2 changing beers (sourced regionally; often Black Isle, Harviestoun, Williams Bros) ⊞

A small, single-room bar, selectively lit and with pleasant, modern styling. An eclectic range of tables, chairs and stools includes half-barrels on the rear wall above an upholstered banquette. The two real ales, usually from smaller Scottish breweries, and an extensive range of malt whiskies may be sampled in taster flights. This friendly howff is open until 3am during the festival in August. It is a lively place to visit, especially when folk musicians perform. Children are permitted until 8pm. ⛴❀◑▶☖(West End-Princes St) ▣❀☂

Blue Blazer

2 Spittal Street, EH3 9DX (SW side of centre)
☎ (0131) 229 5030

Fyne Ales Jarl ⊞; **6 changing beers (sourced regionally; often Cross Borders, Kelburn, Stewart)** ⊞/Ⓐ

Two-roomed pub with wooden floors, high ceilings and old brewery window panels giving an old-fashioned feel, complemented by candles in the evening. Named after a local school uniform, it features a tiled blue blazer inlaid on the floor. The pub specialises in real ales from smaller Scottish breweries. The cider varies and may not always be real. Situated close to theatres and cinemas, it stays open later during August and December. Children are not admitted. ●▣❀☂Ů

Caley Picture House ✅

31 Lothian Road, EH1 2DJ (W edge of centre)
☎ (0131) 656 0752

Greene King Abbot; Sharp's Doom Bar; 9 changing beers (sourced nationally) ⊞

A stunning Wetherspoon renovation of a Grade B-listed former cinema, originally opened in 1923. The main bar has a superb screen-style backdrop and is complemented by a smaller bar 35ft higher in the 'gods', complete with plush cinema-style seating. Meals are served all day and there is a children's menu. Highly commended in the CAMRA Pub Design Awards. Alcoholic drinks are served from 9am (11am Sun). ⛴◑▶☖(West End-Princes St) ▣☂

Guildford Arms

1 West Register Street, EH2 2AA (off E end of Princes St)
☎ (0131) 556 4312 ⊕ guildfordarms.com

Fyne Ales Jarl; Orkney Dark Island; Stewart Pentland IPA; Swannay Orkney IPA; 5 changing beers (sourced nationally; often Black Sheep, Loch Lomond, Timothy Taylor) ⊞

A large establishment built in the golden age of Victorian pub design. The high ceiling, cornices, friezes, window arches and screens are spectacular. There is a large standing area around the canopied bar plus extensive seating areas. The diverse range of real ales includes many from Scottish micros. Meals and simple bar snacks are available all day, both downstairs and in the noteworthy upstairs gallery restaurant where children over five are permitted. ⛴◑▶≈(Waverley) ☖(St Andrew Square) ▣❀☂Ů

Haymarket ✅

11-14A West Maitland Street, EH12 5DS (W edge of centre)
☎ (0131) 228 2537

St Austell Nicholson's Pale Ale; Timothy Taylor Landlord; 5 changing beers (sourced nationally; often Sharp's, St Austell, Stewart) ⊞

This large, busy establishment has a comfortable interior decorated with historic prints of the pub, the locality and local sports teams. The bar overlooks the large central area, with a raised mezzanine floor to one side and arches leading through to a restaurant. Sports events are shown on several TV screens. Food is served all day from the Nicholson's and Pie House menus. Children are permitted until 9pm if dining. May close early if quiet. ⛴❀◑▶♿≈(Haymarket) ☖(Haymarket) ▣❀☂

Jolly Judge

7 James Court, 493 Lawnmarket, EH1 2PB (Old Town)
☎ (0131) 225 2669 ⊕ jollyjudge.co.uk

4 changing beers (sourced nationally; often Cromarty, Fyne Ales, Tempest) ⊞

Small, comfortable bar with an attractive painted ceiling just off the Royal Mile down an Old Town close. Outdoor tables in the close provide extra seating. The real ales are usually from smaller breweries UK-wide. A varying selection of six real ciders is also available. This is a welcome spot for refreshment after visiting the castle and other Old Town attractions. Dogs are permitted after 3pm, but no children inside. Scotland and Northern Ireland Cider Pub of the Year. Q❀◑≈(Waverley) ☖(Princes St) ●▣❀☂

Sandy Bell's

25 Forrest Road, EH1 2QH (½ mile S of centre)
☎ (0131) 225 2751 ⊕ sandybellsedinburgh.co.uk

Caledonian Deuchars IPA; Harviestoun Bitter & Twisted; Inveralmond Ossian; Orkney Dark Island; 1 changing beer (sourced regionally; often Ferry, Orkney, Stewart) ⊞

Sandy Bell's is the premier place for free live folk music in Edinburgh, every evening and on Saturday and Sunday afternoons (daily in August). Bring along an instrument and join in! An arch, the gantry, bar counter and wall panelling are all in dark wood, in marked contrast to the atmosphere which is far from gloomy. In addition to five real ales, there is an impressive range of malt whiskies and gins. Lunchtime pies are excellent. Children are not admitted. ♿≈(Waverley)♣▣❀☂

Teuchters Bar & Bunker

26 William Street, EH3 7NH (W edge of centre)
☎ (0131) 225 2973 ⊕ teuchtersbar.co.uk

Fyne Ales Jarl; Stewart Pentland IPA; Timothy Taylor Landlord; 1 changing beer (sourced regionally; often Fyne, Inveralmond, Swannay) ⊞

A cosy but deceptively roomy bar with a rustic feel, wooden beams and original stone walls. Seating includes chunky sofas and chairs around wooden tables. Small place name plates from Teuchterland create a frieze along the walls. Real ales are usually from smaller Scottish breweries. The gantry has an impressive range of single malt whiskies and an explanation of the pub's

REAL ALE BREWERIES

Alechemy Livingston
Barney's Edinburgh
Belhaven Dunbar
Bellfield ✦ Edinburgh
Black Metal Loanhead
Campervan ✦ Edinburgh
Cross Borders ✦ Dalkeith
Faking Bad ▤ Prestonpans
Ferry ✦ South Queensferry
Hanging Bat ▤ Edinburgh
Newbarns Leith
Newt Musselburgh (NEW)
Pilot Edinburgh
Stewart ✦ Loanhead
Tartan Shark Edinburgh
Top Out Loanhead
Winton ✦ Haddington

name. Meals are served all day from a good varied menu with a Scottish emphasis. Children are permitted until 10pm. ♿🍴🚲♿≈(Haymarket)🚇(West End-Princes St) 🚌🏠🛜

Edinburgh: East

Artisan

35 London Road, EH7 5BQ (1 mile E of centre)
☎ (0131) 661 1603 ⊕ theartisanbar.co.uk
3 changing beers (often Fyne, Orkney, Tryst) Ⓗ

A traditional bar with an ornate exterior which features an eye-catching clock for a hanging sign. Perched at the gable end of a terraced block of colony flats, two entrances lead into a spacious, wood-panelled room dominated by a large island bar and some fine mirrors. Very much a locals' pub, it can be busy when Hibs are at home but normally is more relaxed. Several large screens show football and the jukebox gets regular use. A separate function room is available for bookings. Children are not admitted. 🌐🚌🏠🛜🔄

Bellfield Brewery Tap Room

46 Stanley Place, EH7 5TB (1 mile E of centre)
☎ (0131) 656 9390 ⊕ bellfieldbrewery.com/pages/taproom
2 changing beers (often Bellfield)

The taproom is on the brewery site and tours and tastings are available. It has an excellent beer garden with covered booths. The single cask ale is usually from the standard Bellfield range but some new pilot brews appear at times. Bellfield was the UK's first craft brewery dedicated to gluten-free beers, and all are certified gluten-free. Food is available on a pop-up basis, with the choice changing every few days (see website for schedule). Children are welcome until 9pm. ♿🌐🍴♿🚌🏠🛜

Edinburgh: North

Clark's Bar

142 Dundas Street, EH3 5DQ (N edge of New Town)
☎ (0131) 556 6677
2 changing beers (sourced locally; often Stewart) Ⓗ

This tenement bar is popular with locals and office workers. The internal layout is interesting, with two private rooms at the rear. A number of historical brewery mirrors and old photos of the pub adorn the main room. Look for the interesting mural on the steep stairs down to the toilets, which shows some former worthies. Food is available from Brioche restaurant next door. Likely to be open from 3pm Monday to Thursday, all day Friday to Sunday. 🍴🚌🏠🛜

Dreadnought 🍺

72 North Fort Street, Leith, EH6 4HL (2 miles N of centre)
☎ 07876 351535 ⊕ dreadnoughtpub.com
4 changing beers (sourced nationally; often Brass Castle, Cromarty, Dark Revolution) Ⓗ

A welcoming one-room pub with big picture windows, a high ceiling with plaster cornicing, an attractive old-fashioned bar gantry and sports TV screens. A large photograph of HMS Dreadnought hangs on the wall along with other nautical items. The Brass Castle beers are all vegan. No food is served, but pizza and burgers can be ordered from local outlets. Children are not admitted. Open Monday to Thursday from 4pm, Friday to Sunday from 2pm. Local CAMRA Pub of the Year 2022. 🌐🍴♣🚌🏠🛜

Henry Hall's Carriers Quarters

42 Bernard Street, Leith, EH6 6PR (2 miles N of centre)
☎ (0131) 554 4122
2 changing beers (sourced regionally; often Fyne Ales, Stewart, Tryst) Ⓗ

Popular with locals, this small, cosy bar is said to be the oldest pub in the area. The front room has the bar counter and an alcove displaying a series of historical prints depicting life in Leith. The rear room has exposed stone walls and a large fireplace with a welcoming gas fire in winter. The real ales are from Scottish breweries and there is a good selection of malt whiskies. Home-made pizzas are served all day. Children are not admitted. 🍴♣🚌🏠🛜

Kay's Bar

39 Jamaica Street West, EH3 6HF (New Town, off India St)
☎ (0131) 225 1858 ⊕ kaysbar.co.uk
Fyne Ales Jarl; Theakston Best Bitter; Timothy Taylor Landlord; 3 changing beers (sourced nationally; often Oakham, Stewart) Ⓗ

A cosy and convivial pub that retains many features from its days as a Victorian wine merchant and is decorated with whisky barrels. Considering its size, it offers an impressive range of real ales. It also specialises in malt whisky, with a large selection behind the bar. If the front bar is busy, try the small room at the back. Filled rolls are available at lunchtime. Children are not admitted. Edinburgh winner of the CAMRA Real Ale Quality Award in 2021. Q♣🚌🏠🛜🔄

Malt & Hops

45 The Shore, Leith, EH6 6QU (1½ miles N of centre)
☎ (0131) 555 0083
Hadrian Border Tyneside Blonde; 7 changing beers (sourced nationally; often Fyne Ales, Swannay) Ⓗ

Single-roomed, old-fashioned bar by the Water of Leith dating from 1747. It has a real fire and the walls are bedecked with mirrors, prints and beer-related artefacts. A large selection of pumpclips, many from long-lost breweries, hangs from the ceiling along with hop bines renewed every harvest. The wide variety of real ales has an emphasis towards smaller breweries – beers are listed on the mirror behind the bar. Children are permitted until 6pm. ♿🌐🚌🏠🛜🔄

Mather's

25 Broughton Street, EH1 3JU (½ mile N of centre)
☎ (0131) 557 4377 ⊕ mathersbroughtonstreet.co.uk
3 changing beers (sourced regionally; often Inveralmond, Orkney, Stewart) Ⓗ

A traditionally styled bar that reopened in 2021 following a major refurbishment to recapture its former heritage, with a new bar counter and fittings giving a definite feel of the original Mather's. The decor provides an interesting history of the premises. Three handpumps offer real ales from local independent breweries, and locally sourced steak pies are available at weekends. Live sport is often shown on TV. Children are not admitted. ≈(Waverley) 🚇(York Place) 🚌🏠🛜

Stockbridge Tap

2-4 Raeburn Place, Stockbridge, EH4 1HN (¾ mile N of centre)
☎ (0131) 343 3000
Swannay Island Hopping; 5 changing beers (sourced nationally; often Alechemy, Cross Borders, Cromarty) Ⓗ

A specialist real ale house offering unusual and interesting ales from all over the UK and holding occasional beer festivals. The bright front area offers plenty of seating and space for vertical drinking, while

the rear area has low tables and sofas. Both feature mirrors from lost breweries, including Murray's and Campbell's. A handy stop for those walking the Water of Leith path. Children are not admitted. ♿♣🚌😺🛜

Teuchters Landing

1C Dock Place, Leith, EH6 6LU (2 miles N of centre)
☎ (0131) 554 7427 🌐 teuchtersbar.co.uk
Fyne Ales Jarl; Inveralmond Ossian; Timothy Taylor Landlord; 2 changing beers (sourced regionally; often Black Isle, Orkney, Stewart) Ⓗ
Once the waiting room for the Leith to Aberdeen ferry, the attractive front bar has a wood-panelled ceiling edged with tiles featuring Scottish place names from Teuchterland. There are two smaller rooms and a large conservatory opening out onto a pontoon floating on the Water of Leith. The varied food menu is available all day. An excellent selection of malt whiskies is available. Children are allowed in the back rooms, no dogs after 6pm. Likely to be open at 9.15am, with alcoholic drinks served from 11am. 🛏️😺🍴🌶️♣🚌😺🛜

Edinburgh: South

Bennets Bar ★

8 Leven Street, EH3 9LG (¾ mile SW of centre)
☎ (0131) 229 5143
3 changing beers (sourced regionally; often Fyne Ales, Orkney, Stewart) Ⓗ
One of the city's top pub interiors in a Grade B-listed building, this is quintessential late-Victorian Edinburgh pub architecture – from the Jeffrey's Brewery etched door panels and window screens to the snug and a wonderful Bernard's mirror. The magnificent gantry houses a top-class range of malts and spirit barrels. Sadly the Aitken founts are no longer working for the foreseeable future. A range of food is available all day in the bar and adjoining lounge. Children are permitted until 8pm.
Q🛏️😺🍴🚌😺🛜

Cloisters Bar

26 Brougham Street, EH3 9JH (¾ mile SW of centre)
☎ (0131) 221 9997 🌐 cloistersbar.com
8 changing beers (sourced nationally; often Black Isle, Stewart, Swannay) Ⓗ
Established in 1995 in the former All Saints Parsonage, many traditional features have been maintained in this warm and friendly bar. The real ales are generally from interesting breweries UK-wide. Frequent tap takeovers and Meet the Brewer events are held. The wide range of single malt whiskies, gins and rums does justice to the outstanding gantry. Sourdough pizzas can be ordered from Peanut Press next door. Children under 16 are not admitted. Q🍴♣🚌😺🛜🔁

Dagda Bar

93-95 Buccleuch Street, EH8 9NG (¾ mile S of centre)
☎ (0131) 667 9773
Oakham Citra; 3 changing beers (sourced regionally; often Cromarty, Ferry, Stewart) Ⓗ
Small ground-floor bar in an 18th-century tenement terrace, in the heart of a university area. A stone-flagged floor surrounds the large rectangular counter which takes up at least a third of the room. The colourful, mirrored gantry blends with the cornice, the joins blurred by an extensive collection of pumpclips. The bar is often busy, especially on Tuesday evening when a quiz is held. Children are not admitted. Q♣🚌😺🛜

John Leslie ★

45-47 Ratcliffe Terrace, EH9 1SU (1½ miles S of centre)
☎ (0131) 667 7205

Timothy Taylor Landlord; house beer (by Allendale); 4 changing beers (sourced nationally; often Alechemy, Kelburn, Windswept)** Ⓗ
Located on the ground floor of a four-storey tenement, this superb pub is divided in two by a fine mahogany counter, gantry with clock and a mirrored snob screen with small 'ticket window' hatches. The bar has an alcove with banquettes, while the lounge has three areas – a small snug by the door, an area around the fire and a quieter corner with more banquette seating. The elaborate late 19th-century decorative plaster work includes a Lincrusta frieze. Children are permitted until 9pm. 🛏️♣🐾😺🛜🔁

Edinburgh: West

Athletic Arms (Diggers) ✓

1-3 Angle Park Terrace, EH11 2JX (1½ miles SW of centre)
☎ (0131) 337 3822
House beer (by Stewart) Ⓐ**; 5 changing beers (sourced nationally; often Fyne Ales, Stewart, Timothy Taylor)** Ⓗ/Ⓐ
Dating from 1897, this legendary Edinburgh pub is known as Diggers due to its location between two graveyards. Banquette seating lines the walls, and the wooden floor features a compass drawing. Children over five are allowed in the two smaller back rooms if dining. There is more seating here, and the larger room has a dartboard. The pub gets busy when Hearts are playing at home. Outstanding pies are available. Autovacs are only used with the tall founts. 🛏️♣🚌😺🛜🔁

Roseburn Bar ★

1 Roseburn Terrace, EH12 5NG (1½ miles W of centre)
☎ (0131) 337 1067 🌐 roseburnbar.co.uk
Fyne Ales Jarl; Stewart Pentland IPA; 2 changing beers (sourced nationally; often Cromarty) Ⓗ
A traditional pub, popular with locals and close to Murrayfield for rugby and Tynecastle for football. It boasts high ceilings and a largely wooden interior, with interesting mirrors and period photos on the walls. There are numerous comfortable booths along the walls and two separate lounge areas. Three TVs show sporting events, though the volume is typically kept low. Live music plays on Friday and Saturday evenings. Children are not admitted. ♿🚇(Murrayfield Stadium)🚌😺🛜

Gifford

Tweeddale Arms Hotel

High Street, EH41 4QU
☎ (01620) 810240 🌐 tweeddalearmshotel.com
Hop Back Summer Lightning; 1 changing beer (sourced regionally; often Broughton, Stewart, Winton) Ⓗ
Clad in traditional black and white and sitting opposite the village green, this hotel can be identified by its coat of arms suspended on wooden posts. The cosy locals' bar, with a wood-burning stove, is where you will find the handpumps. The larger lounge bar is set up for dining, and there is also an elegant lounge area across the corridor. Food is served all day at weekends, with a children's menu available. May close early if quiet. 🛏️😺🛌🍴♣🚌(123) 😺🛜

Gorebridge

Stobsmill Inn (Bruntons)

25 Powdermill Brae, EH23 4HX (⅓ mile S of centre)
☎ (01875) 820202 🌐 stobsmill.com

1 changing beer (often Born, Cross Borders, Stewart) ⊞
This small inn, built in 1866, is now the only pub in Gorebridge. The single-room bar has a long L-shaped counter with a row of bar stools, and an area with tables and chairs, benches and a large clock. The décor and skylight help to create a bright and welcoming interior. Downstairs is an attractive dining area where meals are served Thursday evening and all day Friday to Sunday. Over-21s only, unless dining. It is likely to be closed Tuesday and Wednesday. ⭾✿❶≁♣P☐(29,48)✿❖

Gullane

Old Clubhouse
East Links Road, EH31 2AF (W end of village, off A198)
☎ (01620) 842008 ⊕ oldclubhouse.com
Orkney Island Life; Timothy Taylor Landlord; 2 changing beers (sourced regionally; often Alechemy, Stewart) Ⓟ
There is a colonial feel to this pub, with views over the golf links to the Lammermuir Hills. The half-panelled walls are adorned with historic memorabilia and stuffed animals. Caricature figures of the Marx Brothers and Laurel and Hardy look down from the gantry. Food features highly and is served all day. The extensive, varied menu, including simple snacks and vegetarian choices, is supplemented with daily specials and children's options. Q⭾✿❶♣☐✿❖

Haddington

Waterside Bistro
1-5 Waterside, EH41 4AT (by Nungate Bridge)
☎ (01620) 825674 ⊕ thewatersidebistro.co.uk
3 changing beers (sourced regionally; often Loch Lomond, Stewart, Winton) ⊞
Occupying a picture-postcard setting by the old Nungate Bridge, this bistro enjoys views across the River Tyne to St Mary's Collegiate Church. The bar features a long, light oak counter with bar stools, and offers real ale from Winton, who brew in the town. While the emphasis is on dining, drinkers are warmly welcomed. Food is served all day at weekends and there is a children's menu. A great spot for outdoor drinking by the river. Q⭾✿❶P☐✿❖

Juniper Green

Kinleith Mill
604 Lanark Road, EH14 5EN
☎ (0131) 453 3214 ⊕ kinleithmill.com
3 changing beers (sourced regionally; often Fyne Ales, Stewart, Timothy Taylor) ⊞
This well-maintained pub has a friendly atmosphere, welcoming locals and visitors alike. The large room is decorated with old village pictures and has an island bar separating the public bar and the lounge/dining areas. Meals are served all day and the menu includes children's options. A full range of sports is shown on TVs. Dogs are allowed in the non-carpeted areas. The rear beer garden has an Astroturf surface and a part-covered decked area. ⭾✿❶♣P☐(44,45)✿❖

Linlithgow

Four Marys ✓
65-67 High Street, EH49 7ED
☎ (01506) 842171 ⊕ fourmarys-linlithgow.co.uk
Belhaven 80/-; 6 changing beers (sourced nationally; often Cromarty, Fyne Ales, Swannay) ⊞
Close to Linlithgow Palace, birthplace of Mary Queen of Scots, the building dates back to around 1500 and is

named after Mary's four ladies-in-waiting. Initially a dwelling house, the building has had several changes of use over the centuries - it was once a chemists' run by the Waldie family whose most famous member, David, helped establish the anaesthetic properties of chloroform in 1847. The pub serves good-quality food and at least six real ales from breweries across Scotland and the UK. Q⭾✿❶♿≁☐✿❖

Platform 3 ✓
1A High Street, EH49 7AB
☎ (01506) 847405 ⊕ platform3.co.uk
Stewart Pentland IPA; 2 changing beers (sourced regionally; often Cairngorm, Fyne Ales, Tryst) ⊞
Small, friendly hostelry on the railway station approach. Originally the public bar of the hotel next door, it was renovated in 1998 as a pub in its own right. Look out for the miniature goods train that travels from the station above the bar, with ducks waiting for a train that never arrives. Two Scottish beers are served in addition to the regular ale. Dogs are welcomed with biscuits and water. A live train departures board keeps travellers informed. ≁♣☐✿❖

Mid Calder

Black Bull ✓
Market Street, EH53 0AA
☎ (01506) 882170 ⊕ blackbullmidcalder.co.uk
3 changing beers ⊞
Established in 1747 and at the heart of the community, the pub has a fine old L-shaped public bar with wooden decor and a coal fire. There is also a comfortable open-plan lounge where families are welcome, popular for food served all day. Both are decorated with country photos and prints. The changing real ales are chosen by customers. Closed Monday and Tuesday and the public bar is only open evenings and weekends. ⭾✿❶♣≁☐✿❖

Musselburgh

David Macbeth Moir ✓
Bridge Street, EH21 6AG (opp the Brunton)
☎ (0131) 653 1060
Greene King Abbot; Ruddles Best Bitter; Sharp's Doom Bar; 2 changing beers (sourced nationally) ⊞
This Wetherspoon pub, named after a local physician and writer, is a conversion of a cinema dating back to 1935. Many original features have been beautifully restored and it is filled with Art Deco artefacts relating to the cinema. The vast single room has a long bar counter offering a good mix of real ales. Food is served all day and families are welcome until 8pm, with a children's menu and games provided. Likely to open at 8am with alcoholic drinks served from 11am (12.30pm Sun). Q⭾✿❶♿☐✿❖

Levenhall Arms
10 Ravensheugh Road, EH21 7PP (B1348, 1 mile E of centre)
☎ (0131) 665 3220
2 changing beers (sourced regionally) ⊞/Ⓐ
A friendly three-roomed hostelry dating from 1830 and close to the racecourse. The lively, cheerfully decorated public bar is half timber-panelled and carpeted. Expect to find some interesting real ales here from smaller, mainly Scottish breweries. Dominoes is popular and there is a TV for sporting events. A smaller area leads off, with a dartboard and pictures of old local industries. The pleasant lounge, where families are welcome until 8pm, has comfortable seating. Q⭾✿🅰♣P☐✿❖

Volunteer Arms (Staggs)

81 North High Street, EH21 6JE (behind the Brunton)
☎ (0131) 665 9654
Oakham Bishops Farewell, Citra, JHB; 4 changing beers (sourced nationally; often Fyne Ales, Nene Valley, Two by Two) ⊞
Superb pub run by the same family since 1858. Its bar and snug are traditional, with wooden floors, wood panelling, mirrors from defunct local breweries, and an attractive gantry topped with old casks. The more modern lounge opens at the weekend. A partially covered beer garden is to the rear. Real ales are mostly pale and hoppy, but there is always a dark beer. Children are permitted until 7.30pm in the lounge and snug. Local CAMRA Lothian Pub of the Year 2022, and winner of many previous awards. ⏰🞭♿♣P🖩♿☕🛇

Newtongrange

Dean Tavern

80 Main Street, EH22 4NA
☎ (0131) 663 2419 ∰ deantavern.co.uk
1 changing beer (sourced regionally; often Born, Cross Borders, Stewart) ⊞
Superb pub run by trustees on Gothenburg principles, with profits returned to the local community. The spacious bar was designed to help miners recover from their day in darkness, with roof lights in a high ceiling supported by arched iron beams. There is also the Lamp Room restaurant and function room with a large mural depicting the town's mining past. Meals are available all day Thursday to Sunday; children are permitted until 8pm if dining. ⏰🞭🍽♿🅰🚆♣🖩♿☕

North Berwick

Auld Hoose

19 Forth Street, EH39 4HX (N edge of centre)
☎ (01620) 892692 ∰ auldhoosenorthberwick.co.uk
Greene King Abbot; Timothy Taylor Landlord; 1 changing beer (sourced regionally; often Williams Bros) ⊞
Interesting, high-ceilinged, traditional Scottish drinking shop, tastefully updated with bare floorboards around a mahogany bar, carpeted areas and a welcoming atmosphere enhanced by a real fire in winter. The gantry has four carved pillars and supports six old numbered whisky casks. The through lounge has varied seating, a pool table and pictures of sporting heroes. Built in 1896 and said to be the oldest licensed premises in town, it is certainly the closest to the Firth of Forth, and supports the RNLI. ⏰🚆♣🖩♿☕

Nether Abbey Hotel

20 Dirleton Avenue, EH39 4BQ (A198, ¾ mile W of centre)
☎ (01620) 892802 ∰ netherabbey.co.uk
Fyne Ales Jarl; 3 changing beers (sourced nationally; often Stewart, Timothy Taylor, Williams Bros) ⊞
Family-run main road hotel in a stone-built villa with a bright, contemporary, open-plan interior. The Fly Half Bar is in a split-level glass extension; large folding doors open out onto an attractive patio. Real ales can be served without sparklers on request. The award-winning restaurant is famed for its freshly cooked and locally sourced food, available seven days a week and served all day Friday to Sunday. Children are welcome until 8pm (7pm in the bar). Likely to be open from 4pm Monday to Friday, and all day Saturday and Sunday.
⏰🞭🛏🍽♿🅰🚆P🖩(124,X5)♿☕

Ship Inn

7-9 Quality Street, EH39 4HJ (E edge of centre)
☎ (01620) 890699 ∰ theshipinnnorthberwick.com
Fyne Jarl; 3 changing beers (sourced nationally; often Greene King, Timothy Taylor) ⊞
Spacious, open-plan, often lively venue with a wide variety of seating and tables. The bar area has pine floorboards and a tastefully modernised bar and gantry. To the side and rear is a quieter carpeted area and there is maritime artwork throughout. The pub is popular for food, served all day until 8pm, with good children's, vegetarian, vegan and gluten-free choices. Sparklers are happily removed on request. Try the suntrap rear patio garden in the summer. ⏰🞭🍽🖩♿☕

Prestonpans

Prestoungrange Gothenburg ★

227 High Street, EH32 9BE (W edge of town)
☎ (01875) 898200 ∰ prestoungrange.org/gothenburg
3 changing beers (sourced locally) ⊞
Superb Gothenburg pub built in 1908 with a magnificent painted ceiling in the bar. The walls throughout are covered in murals and paintings depicting past local life. The on-site microbrewery, which can be viewed from the bar, is now used by Faking Bad Brewery to produce the in-house real ales. There is also a bistro, and a lounge and function room upstairs with superb views over the Forth. Meals are served all day and include children's and gluten free options. ⏰🞭🍽♿P🖩♿☕

Breweries

Alechemy

5 Rennie Square, Brucefield Industrial Park, Livingston, EH54 9DF
☎ (01506) 413634 ∰ alechemy.beer
Dr James Davies, a keen traditional brewer and chemist, started brewing in 2012. A 12-barrel plant is used. New beers are being produced regularly. Beers can be found in shops and pubs across the UK. Alechemy is now part of the Consolidated Craft Breweries group, which opened its first bar in 2019, the Froth & Flame in Edinburgh. Brewing may be undertaken for other breweries in the group. ♦LIVE

Charisma (ABV 3.7%) PALE
Seventy/- (ABV 3.8%) BITTER
Ritual (ABV 4.1%) PALE
Well-balanced, golden ale. A strong hop character, balanced by malt and fruit with a long and dry finish.
10 Storey Malt Bomb (ABV 4.5%) BITTER
Bad Day at the Office (ABV 4.5%) GOLD
Arcana (ABV 5%) BITTER

Barney's SIBA

Summerhall Brewery, 1 Summerhall, Edinburgh, EH9 1PL ☎ 07512 253660 ∰ barneysbeer.com
The only microbrewery in Edinburgh's city centre, Barney's Beer was founded in 2010 and now brews on the site of the original 1800s Summerhall Brewery. Summerhall is Edinburgh's centre for the arts and science.

Extra Pale (ABV 4%) PALE
Red Rye (ABV 4.5%) RED
Warming spicy notes from the rye malt create an interesting twist.

Belhaven

Brewery Lane, Dunbar, EH42 1PE
☎ (01368) 862734 ⊕ belhaven.co.uk

☺Belhaven is Scotland's oldest working brewery, established 1719. Nestling between the rolling hills of East Lothian and a beautiful bay (the meaning of Belhaven), it brews beers using 100% Scottish malted barley, fresh water from a local source and its own Belhaven yeast. Part of Greene King PLC. ‼️🍺

80/- (ABV 4.2%) BITTER
St Andrew's Amber Ale (ABV 4.9%) BITTER
A bittersweet beer with lots of body. The malt, fruit and roast mingle throughout with hints of hop and caramel.

Contract brewed for Heineken:
Deuchars IPA (ABV 3.8%) GOLD
Golden session ale with hop aroma and dry bitter finish. Balanced, with malt adding body and fruit a balancing sweetness.
Edinburgh Castle 80/- (ABV 4.1%) BITTER
A predominantly malty, brown beer with soft roast and caramel throughout. Fruit gives sweetness, typical of a Scottish 80/-.

Bellfield SIBA

46 Stanley Place, Edinburgh, EH7 5TB
☎ (0131) 656 9390 ⊕ bellfieldbrewery.com

☺Bellfield was established in 2014 and was the UK's first certified gluten-free brewery. It is accredited by Coeliac UK and registered with the Vegan Society. A site with taproom and beer garden opened in 2019.
‼️♦GF V♦

Lucky Spence Ale (ABV 3.5%) BITTER
Session Ale (ABV 3.8%) BLOND
Light citrus tones flavour this balanced bitter.
Osprey Platform IPA (ABV 4.2%) IPA
Lawless Village IPA (ABV 4.5%) PALE
Eighty Shilling (ABV 4.8%) BROWN
Jex-Blake Mosaic IPA (ABV 5.6%) IPA

Black Metal

Unit 3, 6b Dryden Road, Loanhead, EH20 9LZ
☎ (0131) 623 3411 ☎ 07711 295385
⊕ blackmetalbrewery.com

Black Metal Brewery was established in 2012 by two old friends – metalheads and inspired brewers. Equipment was shared with Top Out (qv) but it has now moved next door to its own site. ♦LIVE

Will-o'-the-Wisp (ABV 6%) SPECIALITY
Blood Revenge (ABV 6.6%) SPECIALITY
Yggdrasil (ABV 6.6%) GOLD

Campervan SIBA

Unit 4, Bonnington Business Centre, 112 Jane Street, Edinburgh, EH6 5HG
☎ (0131) 553 3373 ☎ 07786 566000
⊕ campervanbrewery.com

Campervan began brewing in 2016 in a private garage and a 1973 VW campervan (hence the name). The van is used as a mobile sales outlet at beer festivals and other outdoor events. It expanded to a new 10-barrel facility in Edinburgh in 2017. In 2020, Lost in Leith Bar and Fermentaria was opened, which houses an onsite, barrel-ageing project. Some barrel-aged beers are bottle-conditioned. After a two-year haitus Campervan recommenced production of cask ale in 2022. LIVE ♦

Hoppy Camper (ABV 4.5%) PALE

Cold Town SIBA

8-10 Dunedin Street, Edinburgh, EH7 4JB
☎ (0131) 221 9978

Second Site: 4 Grassmarket, Edinburgh, EH1 2JU
⊕ coldtownbeer.com

Launched as a microbrewery in an old disused church on Grassmarket in 2018, Cold Town evolved quickly and expanded to a larger site in 2019. The original brewery metamorphised into a bar and restaurant, Cold Town House, was upgraded and continues to produce some beers on site. Beers available in keg and can. ‼️♦

Cross Borders SIBA

28-1, Hardengreen Industrial Estate, Dalkeith, EH22 3NX
☎ (0131) 629 3990 ⊕ crossborders.beer

⊗ Established in 2016 by childhood friends Jonathan Wilson and Gary Munckton. Cross Borders brews traditional Scottish ales without pretension. The brewery has an onsite taproom open Fridays and Saturdays.
‼️🍺♦

Hop Series Pale (ABV 3.8%) PALE
Notes of citrus on the nose with a balanced bitter finish.
Wee Braw (ABV 4%) PALE
A fresh, fruity beer with lots of hops creating a great aroma and a lightly bitter aftertaste.
Heavy (ABV 4.1%) BITTER
A malt-forward 'heavy', fruity with a slight bitterness not found in a traditional 80/-.
Bill's Beer (ABV 4.2%) PALE
Session IPA, a pale, full-flavoured ale with zesty fruits and a clean finish.
Porter (ABV 4.2%) PORTER
Flavours of coffee and chocolate come through in the finish of this easily drinkable porter.
Stout (ABV 5%) STOUT
Braw (ABV 5.2%) PALE
Enticing citrus and tropical notes in the aroma of this juicy, refreshing golden ale.
IPA (ABV 6%) IPA

Edinburgh Beer Factory

The Works, Implement Road, West Barns, EH42 1UN
☎ (0131) 442 4562 ⊕ edinburghbeerfactory.co.uk

Family run brewery that was established in 2015. With packaging inspired by Leith born artist Eduardo Paolozzi the beers are available in bottle, keg and can. Brewing ceased in Edinburgh in 2022, before moving to West Barns, East Lothian. ‼️♦

Faking Bad

🍺 **Prestoungrange Gothenburg, 227-229 High Street, Prestonpans, EH32 9BE**

Faking Bad was established in 2018 by chemistry teachers and avid homebrewers Gareth Evans and Gordon Kidd. All beers are unfined and unfiltered and are available in the Prestoungrange Gothenburg.

Ferry SIBA

Bankhead Farm Steading, Bankhead Road, South Queensferry, EH30 9TF
☎ (0131) 331 1851 ⊕ ferrybrewery.co.uk

The first brewery in South Queensferry since 1851, Ferry Brewery was established in 2016 by Mark Moran and has an on-site taproom and shop. In late 2021, the brewery opened additional licenced premises including a shop

along the main High Street, South Queensferry. Its beers combine traditional and historic beer recipes with a contemporary twist as well as modern-style beers. Tasting tours are available for group bookings. ‖ ⬔ ♦ LIVE ✦

Fair (ABV 4%) PALE
Light and fruity with some bitterness. A complex, golden session ale.

40/- Fine (ABV 4.2%) BITTER
A light take on a traditional 80/- style. Malty with a balance of sweetness and bitterness.

Three Bridges (ABV 4.5%) PALE

Witches Brew (ABV 4.5%) BITTER
Full-bodied, brown bitter with distinctive malt flavour and bittersweet finish.

Alt (ABV 4.9%) SPECIALITY

Stout (ABV 4.9%) STOUT
Well-balanced stout with hints of chocolate and subtle roast coffee flavours.

Thomas Miller 1785 (ABV 5.5%) PORTER

Oatmeal Stout (ABV 6.5%) STOUT

Hanging Bat

🍺 c/o Hanging Bat Beer Café, 133 Lothian Road, Edinburgh, EH3 9AB
☎ (0131) 229 0759
🌐 hangingbatbrewco.tumblr.com

⊗ Brewing began in 2012 from within the Hanging Bat bar using a 50-litre brew kit from the United States.

Keller

🍺 23-27 Broughton Street Lane, Edinburgh, EH1 3LY
☎ (0131) 556 7360 🌐 kellertaproom.com

This in-house brewery operates from a space next to, and visible from, the Keller Taproom. There is also a distillery. The first unfiltered craft lager appeared in mid 2021. No real ale. ✦

Moonwake SIBA

6a Tower Street, Leith, Edinburgh, EH6 7BY
☎ (0131) 553 6995 🌐 moonwakebeer.com

Brewing commenced in 2021 from a site close to the Water of Leith using a 35hl three-vessel brew kit. The range of core beers together with seasonal beers, one-

offs and collaborations are produced. Beers are also available in can. No real ale. ⬔ ♦

Newbarns

13 Jane Street, Leith, EH6 5HE
☎ (0131) 554 4363 🌐 newbarnsbrewery.com

The four founders moved north from London having worked at Kernel and Siren breweries in the past decade, and opened Newbarns in 2020. Real ale production commenced at the end of 2021.

Table Beer (ABV 3%) PALE

Pale Ale (ABV 4.8%) PALE

Stout (ABV 5%) STOUT

Newt (NEW) SIBA

Unit 1, Block 4, Inveresk Industrial Estate, Musselburgh, EH21 7UL ☎ 07979 905055
🌐 newtbrew.com

Originally set up at the ecological organic farm, East Coast Organics in Pencaitland, Newt Brew has moved to new premises at Eskbank, Musselburgh, just outside Edinburgh. Beers are produced in small 100-1,000 litre batches on a 190-litre pilot kit. Available in bottles and cask with expansion into cans and kegs planned. LIVE V

Bavarian Pale (ABV 4.2%) BLOND

Organic Pale Ale (ABV 5%) PALE

Otherworld (NEW)

27/ 1 Hardengreen Estate, Eskbank, EH22 3NX
🌐 otherworldbrewing.com

Otherworld Brewing Ltd was established in 2022 and specialises in producing modern sour and mixed fermentation beers. Available mostly in cans.

Pilot Beer SIBA

4B Stewartfield, Edinburgh, EH6 5RQ
☎ (0131) 561 4267 🌐 pilotbeer.co.uk

Pilot began brewing in 2013 in an industrial unit in Leith using a five-barrel plant. A move to larger premises has allowed for expansion. Beers are unfined and unfiltered. Almost all output is keg or can but cask-conditioned ale is occasionally available. There is a brewery shop. LIVE

Stenroth

Kenmure Avenue, Edinburgh, EH8 7HD
🌐 stenrothbrewing.co.uk

Founded by partners Kat Drinnan and Jimmy Mehtala in 2019, this home-based, 60-litre nanobrewery produces four core beers.

Stewart SIBA

26a Dryden Road, Bilston Glen Industrial Estate, Loanhead, EH20 9LZ
☎ (0131) 440 2442 🌐 stewartbrewing.co.uk

☺Established in 2004 by Steve and Jo Stewart, the brewery now operates from a custom-built brewhouse just outside of Edinburgh. It produces a wide range of award-winning beers and hosts a varied retail offering, including the onsite Brew It Yourself Experience, a well stocked brewery shop with growler fill station, and a Bar & Pizza Kitchen, that was added in 2021, with cask conditioned, tank and kegged beers. ‖ ⬔ ♦ LIVE ✦

Jack Back (ABV 3.7%) PALE

Return trays

Also known as an Autovac or beer economiser, a return tray is a device that collects beer spilled in the pouring process, recycles it by mixing it with fresh beer, and returns it to the glass. It can be identified by a stainless steel drip tray below the nozzle on a handpump, with a pipe connected from the bottom of the tray to the draw line of the cask. They are commonly found in use in Yorkshire and parts of south-east Scotland and have been seen in north-east Scotland and north-west England. A symbol will appear next to entries in the Guide where a return tray is in use on some or all of the beers (see inside cover key).

A pale hoppy beer with strong citrus and tropical fruit aromas. The taste is light, crisp and refreshing.

Pentland IPA (ABV 3.9%) PALE
A delicately-hopped, deep golden-coloured session ale. The dry bitter taste is well-balanced by sweetness from the malt, and fruit flavours.

Citra Blond (ABV 4%) BLOND

80/- (ABV 4.4%) MILD
Superb traditional Scottish heavy. The complex profile is dominated by malt with fruit flavours giving the sweetish character typical of this beer style. Hops provide a gentle balancing bitterness that intensifies in the dry finish.

Radical Road Reverse (ABV 4.6%) PALE
Well-hopped gold/amber ale with hints of biscuit and oodles of tropical fruit (mango) flavour continuing into the aftertaste.

Edinburgh Gold (ABV 4.8%) GOLD
A full-bodied, easy-drinking, continental-style golden ale. Bitterness from the hop character is strong in the finish and complemented in the taste by a little sweetness from malt, and fruit flavours.

Suspect

34 Jane Street, Leith, Edinburgh, EH6 5HD ☎ 07468 436652 ⊕ suspectbrewing.co.uk

A gluten-free brewery set up in the former Liquid Brewing premises. No real ale. GF

Tartan Shark

5 Bangholm Park, Edinburgh, EH5 3BA ☎ 07746 432512 ⊕ tartanshark.co.uk

This self-styled 'smallest brewery in Edinburgh' began production in early 2020, brewing bottle-conditioned, can-conditioned and keg beers (often delivered by pushbike).

Top Out SIBA

Unit 3, 6b Dryden Road, Loanhead, EH20 9LZ ☎ (0131) 440 0270 ☎ 07742 234970 ⊕ topoutbrewery.com

Brewing began in 2013 using a six-barrel plant. Branding has a topographical theme. A core range of eight beers is available, plus a changing 'First Ascents' range with an adventurous new style each time. ♦LIVE

Copperheid (ABV 3.4%) SPECIALITY

Refreshing, lightly-gingery beer. Works really well!

Pale Ale (ABV 3.6%) PALE
Single-hop pale ale. Same recipe but different hop each time.

Staple (ABV 4%) BITTER
Gold-coloured bitter. Intense hops but with malt coming through. Aroma has a hint of fruit. A lasting, dry finish.

Altbier (ABV 4.5%) BITTER
Based on a traditional German style ale. Malty and fruity but with a certain amount of hop bitterness.

Schmankerl (ABV 4.9%) SPECIALITY

Simon Says-on (ABV 5.1%) SPECIALITY

Smoked Porter (ABV 5.6%) SPECIALITY

The Cone (ABV 6.8%) GOLD

Vault City SIBA

Unit 2, A1 Industrial Park, Sir Harry Lauder Road, Edinburgh, EH15 2QA ⊕ vaultcity.co.uk

Launched as a kitchen brewery in Edinburgh in 2018, Vault City Brewing relocated to share facilities at 71 Brewing in Dundee in 2019 before moving back to Edinburgh. Making fruit-forward, modern sour beers, the monthly Farm to Fermenter series utilises local fruits. Available in bottles and kegs.

Walkie Talky (NEW)

10 Whitecraig Road, Whitecraig, EH21 8PG ⊕ walkietalkybrewing.com

A craft brewery set up in 2021 by Michael Johnstone and Joel Saunderson amplifying classic beer styles with a post-punk mindset.

Winton

10 Station Yard Industrial Estate, Hospital Road, Haddington, EH41 3PP ☎ (01620) 826854 ⊕ wintonbrewery.com

After a spell brewing at Top Out (qv), and a site adjacent to Thistly Cross Cider in West Barns, Winton relocated to Haddington in 2021. It produces a range of distinctive beers in keg, cask and can. It took over the Station Yard micropub, Dunbar, in 2020 before opening a brewery tap room in 2022. ◆

Peelywally (ABV 5%) BITTER

Dowie's ale

Johnnie Dowie was the sleekest and kindest of landlords. Nothing could equal the benignity of his smile when he brought in a bottle of 'the ale' to a company of well-known and friendly customers. It was a perfect treat to see his formality in drawing the cork, his precision in filling the glasses, his regularity in drinking the healths of all present in the first glass (which he always did, and at every successive bottle), and then his douce civility in withdrawing. Johnnie lived till within the last few years (he died in 1817), and, with laudable attachment to the old costume, always wore a cocked hat, and buckles at the knees and shoes, as well as a cane with a cross top, somewhat like an implement called by Scottish gardeners 'a dibble'
William Hone, The Year Book, 1839

Dowie's Tavern in Edinburgh was famously frequented by Robert Burns. Other habitues included Henry Raeburn, Adam Smith and the ballad collector, David Herd. The ale served was invariably Younger's, whose reputation the inn helped to make. After Dowie's death it became Burns Tavern but was demolished in 1831.

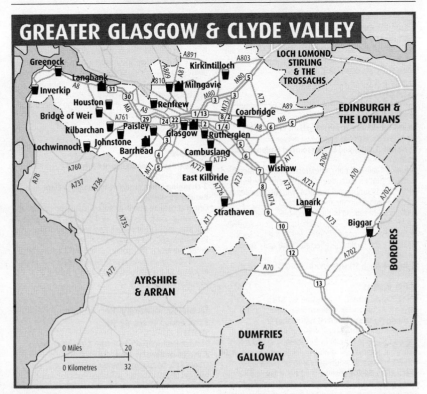

GREATER GLASGOW & CLYDE VALLEY

Biggar

Crown Inn 🅛

109-111 High Street, ML12 6DL

☎ (01899) 220116 ⊕ thecrownbiggar.co.uk

6 changing beers (sourced nationally; often Broughton, Stewart) Ⓗ

A pleasant and friendly inn in the centre of this market town, the Crown has hundreds of years of tradition behind it, officially dating from the mid-17th century. The bar area is directly accessed from the street and there is a small, quiet room, conservatory and beer garden to the rear. The real ales are mainly from Scottish breweries and can be served in flights of three third-pints.

🕭❀◑➐🖵(91,191) ✿ 📶

Elphinstone Hotel ⊘

145 High Street, ML12 6DL

☎ (01899) 220044 ⊕ elphinstonehotel.co.uk

2 changing beers (sourced regionally; often Broughton, Fyne) Ⓗ

An old coaching inn dating from the 18th century which has a bright, modern public bar, a lounge bar, guest rooms and a large outdoor drinking area. There are two handpumps but in winter only one is in use to ensure that quality is maintained. The beers come in rotation from a selection of Scottish breweries. The bar has a pool table and dartboard, and a warming cast-iron fire. The hotel has 11 en-suite bedrooms.

🕭❀⇋◑➐🖵(91,191) ✿ 📶

Bridge of Weir

Coach House

Main Street, PA11 3NR

☎ (01505) 800999 ⊕ thecoachhouse-bow.co.uk

1 changing beer (often Fyne Ales, Inveralmond, Kelburn) Ⓗ

Situated in Bridge of Weir, this stylish, modernised bar and restaurant offers all day eating and drinking in a relaxed, comfortable environment. The glamorous restaurant seats over 100 diners, and there is also an intimate private dining room for up to 20 – perfect for all types of gatherings and celebrations. Food is also available in the bar. One changing beer is currently served, with scope for expansion depending on demand. A quiz night is hosted monthly. 🕭◑➐🖵(19,X7)📶

Cambuslang

John Fairweather ⊘

52-58 Main Street, G72 7EP

☎ (0141) 646 2411

Belhaven 80/-; Greene King Abbot; 3 changing beers (sourced nationally) Ⓗ

An impressive Wetherspoon conversion of the former Savoy cinema, named after the man who designed it. Many original features have been retained and restored, including some of the seats that fold up when you stand. The former ticket office leads to the bar, and there is an area upstairs where the screen used to be. The pub is watched over by old movie-goers sitting in the balcony. Outside is a small beer garden. ❀◑➐🖵📶

East Kilbride

Hudsons ⊘

14-16 Cornwall Way, G74 1JR

☎ (01355) 581040

2 changing beers (often Black Sheep, Wychwood) Ⓗ

Busy town-centre pub just outside the bus station, near the entrance to the Princes Mall shopping centre and

handy for the cinema complex. There is a central elliptical-shaped bar, with comfortable seating around both sides. The real ales are prominently displayed on the curve of the bar as you enter. Several strategically placed TVs show sport. The main toilets are accessed by a spiral staircase. ♿❄🚱🐾🛜

Glasgow

Babbity Bowster

16-18 Blackfriars Street, Merchant City, G1 1PE
☎ (0141) 552 5055 ⊕ babbitybowster.com
Fyne Jarl; 2 changing beers (sourced nationally; often Kelburn) Ⓗ

A long established pub/hotel/restaurant that reopened in 2020 after an extensive refurbishment. The furniture in the bar is simple and practical, with plain tables and free-standing chairs augmented by wall seating. Outside, there is more seating in the beer garden including bench tables. Three pumps serve beers mainly from Scottish breweries. Fine meals are provided in the restaurant upstairs – the quality is reflected in the daily specials available in the bar.
🏮🍴🌑⏺❄(High St) ⋈(St Enoch) �ℙ🚌(CB4) 🛜

Ben Nevis

1147 Argyle Street, Finnieston, G3 8TB
☎ (0141) 576 5204 ⊕ thebennevisbar.com
2 changing beers (sourced nationally) Ⓗ

A corner tenement pub established around 1880 but closed for a long time before reopening in 1999. Now a small but popular bar, it offers a large selection of malt whiskies, some of which appear to be precariously perched on sloping shelves. A range of unusual canned and bottled beers is also kept. The back wall features some unusual stone, wood and straw artwork, which complements the rustic wood panelling at the bar. Traditional live music sessions are hosted throughout the week. 🏮❄(Exhibition Centre)🚌(2,3)🐾🛜

Bon Accord Ⓛ

153 North Street, Charing Cross, G3 7DA
☎ (0141) 248 4427 ⊕ bonaccordpub.com
Caledonian Deuchars IPA; 7 changing beers (sourced nationally) Ⓗ

One of the pioneers of the real ale scene in Glasgow, the Bon has been serving quality ales for over 50 years. The wall opposite the bar is adorned with an impressive array of award certificates, including some from CAMRA. The pub's owner is passionate about malt whisky and there are 400 varieties behind the bar to complement the wide choice of real ales. A raised dining area at the rear also hosts quiz and live music nights.
🌑🏮🌑♿❄(Charing Cross) ⋈(St George's Cross) 🐾🚌🛜

Clockwork Ⓛ

1153-1155 Cathcart Road, Mount Florida, G42 9HB
☎ (0141) 649 0184 ⊕ clockworkglasgow.com
3 changing beers (sourced nationally; often Loch Lomond, Stewart, Tryst) Ⓗ

Reopened in 2020 after an extensive refurbishment, this bar is ideally located for events at nearby Hampden Park, and has great public transport links and a car park. It gets busy when there are football matches or other events at Hampden, and is also popular for watching live sport on the screens dotted about the interior. As well as a range of house beers brewed by Tryst, there is a selection of guest ales mainly from Scottish breweries. Food is served throughout the day. 🌑🏮🌑♿❄(Mount Florida)ℙ🚌🛜

Counting House ✅

2 St Vincent Place, G1 2DH
☎ (0141) 225 0160

Belhaven 80/-; Sharp's Doom Bar; 8 changing beers (sourced nationally) Ⓗ

A busy Wetherspoon conversion of a bank provincial head office, in the centre of the city overlooking George Square. It has many fine features including a central dome and surrounding sculptures. As well as the regular cask beers, there is a wide selection of guest ales, sourced UK-wide. A bottle store in one of the old strong rooms holds a large range of bottled and canned beers. Meet the Brewer events are held regularly.
🌑🏮🌑♿❄(Queen St) ⋈(Buchanan St) 🚌🛜

Doublet

74 Park Road, Woodlands, G4 9JF
☎ (0141) 334 1982
2 changing beers (sourced nationally; often Broughton, Kelburn) Ⓗ

Corner tenement pub in a mock-Tudor style that opened its doors in 1961. The small, friendly locals' bar offers two real ales, mostly from Broughton and Kelburn breweries. In addition there is a range of bottled beers and a distinctive lager. The lounge up the stairs to the rear is usually closed at quiet times but is available for large functions and is often used as a music venue.
🏮⋈(Kelvinbridge) 🚌🐾🛜

Drum & Monkey ✅

91 St Vincent Street, G2 5TF
☎ (0141) 221 6636
St Austell Nicholson's Pale Ale; 5 changing beers (sourced nationally; often Stewart) Ⓗ

Corner pub, housed in a former American-style bank, with an opulent marble and wood-panelled interior and ornate ceilings. Convenient both for main railway stations and numerous bus routes, it is usually busy with a varied clientele. Family groups are welcome until 8pm when dining. The large P-shaped central bar features six handpulls offering a wide variety of styles, from the familiar local and national favourites to ales from new emerging breweries.
🌑🌑♿❄(Central) ⋈(Buchanan St) 🚌🐾🛜

Horse Shoe ★ ✅

17-19 Drury Street, G2 5AE
☎ (0141) 248 6368 ⊕ thehorseshoebarglasgow.co.uk
4 changing beers (sourced nationally; often Northern Monk, Stewart) Ⓗ

Close to Central Station, and very busy in the evenings and at weekends, the downstairs bar has four handpumps, with beers from Stewart often featuring. Dating from 1870, this Victorian pub is recognised by CAMRA as having a nationally important interior, which includes Scotland's longest bar. Above the bar is a lounge/diner where children are welcome until the evening, when karaoke takes over.
🌑🌑♿❄(Central) ⋈(Buchanan St) 🚌🛜

REAL ALE BREWERIES

Dargavel Langbank (NEW)
Dookit Glasgow (NEW)
Drygate 🍴 Glasgow
Epochal Glasgow (NEW)
Glasgow Beer Works Glasgow
Jaw Milngavie
Kelburn Barrhead
Overtone Glasgow
Ride Glasgow
Simple Things Fermentations Glasgow
Veterans Coatbridge
WEST 🍴 Glasgow

Laurieston Bar ★

58 Bridge Street, Tradeston, G5 9HU
☎ (0141) 429 4528
Fyne Jarl; 2 changing beers (sourced locally; often Broughton, Fyne) Ⓗ
A warm welcome is guaranteed at this characterful but unpretentious corner pub. Unchanged over decades, it is owned and run by two brothers. A horseshoe bar is surrounded by formica-top tables, with walls covered in vintage photographs, mirrors and memorabilia. The roomier lounge has a much smaller bar and some unusual artwork on the walls. Pies are served from a 1970s counter-top display unit. Close to Bridge Street subway station and Glasgow Central. The pub can be busy at weekends. ₹(Central)☝(Bridge St)⬛❀❖🛜

Pot Still

154 Hope Street, G2 2TH
☎ (0141) 333 0980 ⊕ thepotstill.co.uk
4 changing beers (sourced regionally; often Loch Lomond, Orkney) Ⓐ
Near both main rail stations and major bus routes, this classic city centre bar is one of Scotland's leading whisky pubs, with a collection of around 750 malts. Four traditional Scottish air founts offer beers, usually from Scotland, but some rarely seen in Glasgow. Food of the 'pie and beans' school is available during the day. The main bar area is small but there is a mezzanine level providing additional seating. Tutored whisky tastings can be arranged. ₹◑₹(Central)☝(Buchanan St)⬛❀❖🛜

Scotia Bar

112-114 Stockwell Street, G1 4LW
☎ (0141) 552 8681
4 changing beers (often Broughton, Orkney) Ⓗ
One of several pubs that claim to be the oldest in Glasgow. It certainly looks the part with its half-timbered frontage, wood panelling, dark wooden benches and low ceilings. It has been a firm fixture on the folk music scene for decades – the likes of Hamish Imlach and Billy Connolly performed here, and there are still regular sessions and live bands. There are three distinct areas: one closer to the band, one round the corner, and a cosy snug. ₹(Argyle St)☝(St Enoch)♣⬛❀🛜

Sir John Moore ✓

260-292 Argyle Street, G2 8QW
☎ (0141) 222 1780
Belhaven 80/-; Greene King Abbot; Sharp's Doom Bar; 8 changing beers (sourced nationally; often Orkney, Stewart) Ⓗ
A Wetherspoon pub across the road from Glasgow Central Station's (lower level) Hope Street exit. With live departure screens inside, this is an ideal place to wait for a train. It is also handy for breakfast after a night on the sleeper. Converted from several shops into one very large room, it has several distinct areas marked with screens, and a licensed pavement area. It takes its name from a 19th-century Glasgow-born general. ₹❀◑₹(Central)☝(St Enoch)⬛🛜

Sir John Stirling Maxwell ✓

136-140 Kilmarnock Road, Shawlands, G41 3NN
☎ (0141) 636 9024
Belhaven 80/-; Greene King Abbot; Sharp's Doom Bar; 4 changing beers (sourced nationally; often Broughton, Oakham, Orkney) Ⓗ
A popular Wetherspoon pub named after a local benefactor and landowner. It is situated at the end of the Shawlands Arcade in a converted supermarket. Photographs of former local cinemas adorn the walls – at one time the Embassy used to occupy this site. To the rear, there is a raised TV-free family area. A good

selection of dark and light beers, from both traditional and newer breweries, is often available. The pub hosts regular quiz nights and darts evenings throughout the year. ₹◑₹❀(Pollokshaws East)⬛🛜

Society Room ✓

151 West George Street, G2 2JJ
☎ (0141) 229 7560
Belhaven 80/-; Greene King Abbot; Sharp's Doom Bar; 3 changing beers (sourced nationally) Ⓗ
Large Lloyd's No.1 bar in the city centre, attracting a diverse clientele. The room's low ceiling and lack of windows at the back give it a cavernous feel. The ale choice often includes several high-strength beers. In the evening the pub is frequented by a younger crowd, accompanied by loudish background music. At weekends there is music from 5pm, with a DJ from 8pm. ₹❀◑₹(Central)☝(Buchanan St)⬛❀🛜

State Bar

148 Holland Street, Charing Cross, G2 4NG
☎ (0141) 332 2159
House beer (by Stewart); 5 changing beers (sourced nationally; often Oakham) Ⓗ
A regular local CAMRA Pub of the Year, this popular town centre pub just off Sauchiehall Street is handy for restaurants and entertainment venues. It has a traditional island bar and gets very busy at lunchtimes and weekends. Some of the changing ales are rarely seen in Glasgow – usually at least one, often two, beers are from Oakham. Old pictures and show bills displayed around the walls reflect the pub's proximity to the King's Theatre. There are blues sessions on Tuesdays. ₹(Charing Cross)☝(Cowcaddens)⬛❀🛜↻

Tennent's ✓

191 Byres Road, Hillhead, G12 8TN
☎ (0141) 339 7203 ⊕ thetennentsbarglasgow.co.uk
St Austell Tribute; Sharp's Doom Bar; Timothy Taylor Landlord; 4 changing beers (sourced nationally; often Dark Star, Northern Monk, Stewart) Ⓗ
One of Glasgow's oldest pubs, dating from 1884, listed in the Guide for more than 20 years. It retains some of its Victorian finery, with tall columns supporting the high ceilings. The pub is situated on the West End's main street near Glasgow University and is often very busy. A wide selection of ales is available and food is served all day. Sports are shown on several large TVs. ❀◑₹❀(Hillhead)⬛❀🛜

Three Judges Ⓛ ✓

141 Dumbarton Road, Partick, G11 6PR
☎ (0141) 337 3055
9 changing beers (sourced nationally; often Fyne, Kelburn) Ⓗ
For over 30 years this traditional corner pub has brought the best new real ales to Glasgow from all over Britain. Beers are available on nine handpumps, with a 10th pump reserved for cider. Two more ciders are served from a bag in a box. The range of cider varies but may not always be real. Numerous local CAMRA awards adorn the walls. There is a monthly jazz session on a Sunday afternoon. ₹(Partick)☝(Kelvinhall)♣⬛❀🛜

Greenock

James Watt ✓

80-92 Cathcart Street, PA15 1DD
☎ (01475) 722640
Greene King Abbot; Sharp's Doom Bar; 4 changing beers Ⓗ
Situated across the road from Greenock Central Station and 200 yards from the bus station, this large open-plan

Wetherspoon, in a former post office, is named after one of Greenock's famous sons who improved steam engine technology and has the SI unit of power named after him. The chain's standard value-for-money food is available all day and beer festivals are hosted at various times throughout the year. This pub is an oasis in a beer desert. ◑&≢(Central)☂

Houston

Fox & Hounds ♈ ⅃

South Street, PA6 7EN
☎ (01505) 808604 ⊕ foxandhoundshouston.co.uk
Kelburn Goldihops; 4 changing beers (sourced nationally; often Fuller's, Fyne, Kelburn) Ⓗ
Excellent traditional village pub established in 1779. The bar, lounge and restaurant are downstairs, and a cocktail bar upstairs. The bar offers a range of beers on five handpumps alongside a selection of canned and bottled craft beers and a wide choice of spirits including 130 whiskies. Gastro-pub food made wholly on the premises is served throughout. There is a pool table upstairs and a board games night held every Wednesday. An annual beer festival is held on the late May bank holiday weekend. Local CAMRA Pub of the Year for the last two years. Q❀❀◑&♣P☷❁☂

Inverkip

Inverkip Hotel

Main Street, PA16 0AS
☎ (01475) 521478 ⊕ inverkip.co.uk
Fyne Ales Jarl; 1 changing beer (sourced regionally; often Fyne Ales) Ⓗ
Small, family-run hotel set in the heart of a conservation village. Just a short walk from the large Inverkip Marina, it makes an ideal staging post for those just messing about on the river or passing through on the way to Largs and the Ayrshire coast. Food options range from snacks through to special-occasion dining. All-ticket Battle of the Brewer nights are extremely popular.
❀⇄◑≢P☷(578,580) ☂

Johnstone

Callum's ⅃

26 High Street, PA5 8AH
☎ (01505) 322925
Harviestoun Bitter & Twisted; Kelburn Pivo Estivo; 4 changing beers (often Orkney) Ⓗ
Popular town-centre pub in an area short of real ale outlets, offering a friendly welcome and a comfortable atmosphere. A large but unobtrusive TV screen features major sporting events. The lounge has an area set out for formal dining, with an extensive menu on offer. There is a wide range of events throughout the year including live music most Saturdays, quiz nights, tribute acts and karaoke. ❀◑&≢(Strathclyde)☷(36,38)☂

Kilbarchan

Habbies Bar & Grill

25 New Street, PA10 2LN
☎ (01505) 706606
2 changing beers (sourced locally) Ⓗ
Busy local pub within a conservation village and close to the famous Weaver's Cottage owned by the National Trust for Scotland. Live music plays most Saturday nights, with an emphasis on supporting local musicians. Live sport, including Six Nations rugby, is shown on large screens in a separate area. A wide range of food is available, with steak and curry nights, weekend specials

and afternoon teas. The beer garden is popular in summer. The pub is family friendly and offers children's menus and drinks. ❀❀&P☷(38)

Kirkintilloch

Kirky Puffer ✅

1-11 Townhead, G66 1NG (by canal)
☎ (0141) 775 4140
Belhaven 80/-; Sharp's Doom Bar; 4 changing beers (sourced nationally; often Oakham, Stewart) Ⓗ
Large, community friendly Wetherspoon pub standing alongside the Forth & Clyde Canal. It features a modern interior with Mackintosh-style wood panelling, and has an extensive beer garden at the rear. Off the main room is a sizeable family-friendly corner and more secluded alcoves. There are two regular and four guest beers, usually from Scottish breweries, sometimes also from further afield. The pub is popular with locals, travellers on the canal and the Roman Antonine Way. There are frequent buses to Glasgow. ❀❀◑☷&☷☂

Lanark

Clydesdale Inn ✅

15 Bloomgate, ML11 9ET
☎ (01555) 678740 ⊕ clydesdaleinn-lanark.co.uk
Morland Old Speckled Hen; 2 changing beers (sourced nationally) Ⓗ
Old coaching inn built in the late 18th century by local worthies in the centre of the historic old county town. A former Wetherspoon conversion, it was sold to a new chain which has retained many previous features, including the commitment to cask ale. The bar area is quite small but there are several rooms nearby. Live music plays on most Mondays and bingo and karaoke often feature on other evenings. Q❀◑&≢P☷❁☂

Lochwinnoch

Brown Bull

32 Main Street, PA12 4AH
☎ (01505) 843250
Harviestoun Bitter & Twisted; 3 changing beers (sourced nationally; often Cromarty, Fyne Ales, Kelburn) Ⓗ
More than 200 years old, this family-run pub attracts locals and visitors throughout the year. An ever-changing range of national ales is offered, with an emphasis on regional breweries. The upstairs restaurant uses local produce, and bar meals are also available. The pub hosts a quiz night on Tuesday and live music monthly. At the rear is a quirky outdoor seating area and garden with cooperage tools. Located close to Lochwinnoch RSPB nature reserve and Castle Semple Visitor Centre and Country Park. Q❀❀◑☷(4,307)❁

Milngavie

Talbot Arms

30 Main Street, G62 6BU
☎ (0141) 955 0981
2 changing beers (sourced regionally; often Kelburn) Ⓗ
Named after the Talbot hunting dog, once bred on a nearby estate. The pub is situated in a suburban town a short train ride from Glasgow and a long walk from Fort William on the West Highland Way. The single-room bar is popular with locals, with board and cards games played. Big matches are shown on large-screen TVs. The beers are constantly changing and can be from Scottish or English breweries. ❀❀&≢☷(15,X10)❁☂

Paisley

Bull Inn ★ ✔

7 New Street, PA1 1XU

☎ (0141) 849 0472

4 changing beers (sourced regionally; often Kelburn, Loch Lomond, Orkney) ⊞

Established in 1901 and identified by CAMRA as having a nationally important historic interior, this is the oldest inn in Paisley. The building retains many original features including stained-glass windows, three small snugs and a spirit cask gantry, and boasts the only original set of spirit cocks left in Scotland. Live sport is shown on large screens in the main bar and the snugs. The four guest ales are usually sourced from Kelburn, Jaw, Loch Lomond, Orkney and Stewart breweries. ௯≈(Gilmour St)🚌🐾🛜

Last Post Ⓛ ✔

2 County Square, PA1 1BN

☎ (0141) 849 6911

Caledonian Deuchars IPA; Greene King Abbot; Sharp's Doom Bar; 6 changing beers ⊞

This large Wetherspoon pub was previously the town's main post office. Open plan in design on two levels, it has plenty of seating and good wheelchair access. The standard Wetherspoon food menu is served. Next to Gilmour Street railway station and close to the bus station, it is handy for a pint between trains or buses. Six guest ales are usually available. ◐௯≈(Gilmour St) 🚌(9,36) 🛜

Wee Howff ✔

53 High Street, PA1 2AN

☎ (0141) 887 8299

2 changing beers (sourced nationally; often Kelburn) ⊞

The Wee Howff has appeared in 30 editions of this Guide and is a little piece of heaven in an otherwise crowded area of cheap drinking establishments. A small, traditional pub with a loyal regular clientele, the Howff offers up to three guest ales from all four corners of Britain, from a quarterly rotating list. It has an open mic night on the first Monday of each month and a pub quiz every Thursday. The jukebox caters for even the most eclectic of tastes. ௯≈(Gilmour St)🚌(9,36)🐾🛜

Renfrew

Lord of the Isles ✔

Unit 21 Xscape, Kings Inch Road, PA4 8XQ

☎ (0141) 886 8930

Caledonian Deuchars IPA; Greene King Abbot; Sharp's Doom Bar; 3 changing beers (sourced nationally; often Adnams, Kelham Island) ⊞

Large, purpose-built Wetherspoon pub at the XSite leisure complex, with its cinema, ski slope, rock climbing and more at the Braehead Shopping Centre. The outside seating area is south-facing and a suntrap on warm summer days. The typical JDW menu is available all day, and three ever-changing guest ales are on handpump. Cider is usually served from a box on the fridge and on one tap. Throughout the pub, the walls display photographs depicting the industrial history of the River Clyde. A short stroll takes you to the shipyard opposite, where you can view the ships in dock. 🚃🕮◐௯🚌🛜

Rutherglen

Ruadh-Ghleann ✔

40-44 Main Street, G73 2HY

☎ (0141) 613 2370

Belhaven 80/-; Greene King Abbot; Sharp's Doom Bar; 5 changing beers (sourced nationally) ⊞

Busy Wetherspoon pub taking its name from the Gaelic name of the town. It has a long, narrow bar decorated in a contemporary style, and a family area at the far end leading to the beer garden. There is a window into the cellar. The beer garden is on two levels and affords a view of the Cathkin Braes. Six of the handpumps are usually in use. Q🚃🕮◐௯🚌🛜

Strathaven

Weavers 🍴 Ⓛ ✔

1-3 Green Street, ML10 6LT

4 changing beers (sourced nationally) ⊞

Situated in the centre of the town, the pub has links to the 19th-century weaving industry. The single room has modern and comfortable furnishings, and is decorated with an assortment of black and white pictures of film stars. Four handpumps offer ales from an ever-changing range featuring a mix of beers from breweries in the region, and some that are rarely seen in Scotland. A range of imported bottled beers is also available. Local CAMRA Pub of the Year 2022. ௯🚌(254,256)🛜

Wishaw

Wishaw Malt ✔

62-66 Kirk Road, ML2 7BL

☎ (01698) 358806

Belhaven 80/-; Greene King Abbot; Sharp's Doom Bar; 5 changing beers (often Kelburn, Theakston) ⊞

A town-centre bar converted from a furniture store at the beginning of the century. The Wishaw Malt has eight handpumps, with guest beers from all over the UK supplementing the three regulars. Around the walls are information panels and photographs of old Wishaw. The pub takes its name from a 19th century distillery and bonded warehouse. Ironically, a church to the rear of the pub once hosted the Wishaw Templar Lodge of Temperance. 🚃🕮◐௯≈🚌🛜

Breweries

Boden

Unit 3, 95 Boden Street, Glasgow, G40 3QF ☎ 07511 022231 ⊕ bodenbrewing.co.uk

Launched in 2019, Boden Brewing is a one-man operation based in the east end of Glasgow. Six core beers are available in bottle and keg.

Bungo (NEW)

50 Moray Place, Glasgow, G41 2DF
⊕ bungobrew.co.uk

A homebrew collective of four members, Ewen, Fin, Michael and Will, turned commercial in 2021. Small-batch production available, mostly in cans, with a range from milk stouts through to lager.

Dargavel (NEW) SIBA

Mid Glen Farm, West Glen Road, Langbank, PA14 6YL ☎ 07493 854537 ✉ dargavelbrewery@hotmail.com

☺Established in 2021 this is a traditional real ale brewery. Using its own spring water from the initial source of Dargavel Burn located between Kilmacolm and Langbank, its beers are available in cask and various small pack formats. LIVE

Blonde Belter (ABV 3.6%) BLOND
Peter's Wellies (ABV 4.2%) PALE

Moo-Lin Rouge (ABV 5%) RED
Haud Yer Wheasht (ABV 5.1%) SPECIALITY

Dead End Brew Machine

Office: Flat 1-2, 10 Lawrence Street, Glasgow, G11 5HQ ✉ chris@deadendbrewmachine.com

Dead End Brew Machine produce small batch, artisinal beers specialising in brettanomyces and saccharomycetes blends, augmented with fruit and spices. Beers are available in bottle and can. ♦LIVE

Dookit (NEW)

Block 3, Unit 1, Tollcross Industrial Estate, Causewayside Crescent, Glasgow, G32 8LJ ☎ 07792 889210 ⊕ dookitbrewing.co.uk

Established in 2020, Dookit originally brewed at Ride Brewing before moving to its own premises in 2022. Beers are available in bottle and keg. LIVE

Drygate

▤ 85 Drygate, Glasgow, G4 0UT
☎ (0141) 212 8810 ⊕ drygate.com

Restaurant, bar and microbrewery, Drygate is a joint venture of Tennent's and Williams Bros, though operationally independent. The on-site brewery began production in 2014. A core range of keg and bottle beers is available. The brewery is also committed to cask ale, with at least one ale on at all times. ‼♦LIVE

Epochal (NEW)

Payne Street, Glasgow, G4 0LE ⊕ epochal.co.uk

Gareth Young founded Epochal in 2021. A former winner of the UK National Homebrewing Awards, Gareth spent time with local craft breweries to learn about brewing on a small commercial scale. The brewery specialises in barrel fermentation, with beers available in keg and bottle. LIVE

Glasgow Beer Works SIBA

Block 23, Unit 2, Queenslie Industrial Estate, Glasgow, G33 4JJ
☎ (0141) 258 1661

Office: Pavillion 1, Finnieston Business Park, Minerva Way, Glasgow, G3 8AU ⊕ merchantcitybrewing.com

Established in 2017 as Merchant City Brewing using a 12-barrel plant, Glasgow Beer Works moved and rebranded in 2020. In addition to the core range, small pilot batches and barrel-aged beers are produced. 25 outlets are supplied direct, plus specialist off-licences across central Scotland. A pop-up bar in Osborne Street, beneath the John Byrne mural of Billy Connolly, opened in 2020.

Session Ale (ABV 3.9%) GOLD
Unit 1 Red Ale (ABV 4%) RED
American Pale Ale (ABV 4.7%) PALE
Vienna Lager (ABV 5%) SPECIALITY
IPA (ABV 5.8%) IPA

Hidden Lane

Argyle Street, Finnieston, G3 8ND
☎ (0141) 258 2520 ⊕ hiddenlanebrewery.com

Organic brewery launched in Glasgow in 2019.

Jaw SIBA

26 Crossveggate, Milngavie, G62 6RA

☎ (0141) 237 5840 ⊕ jawbrew.co.uk

An independent, family-run, craft microbrewery from Glasgow. Committed to producing the absolute pinnacle of high quality beer. LIVE

Fathom (ABV 4%) MILD
Drop (ABV 4.2%) BITTER
Surf (ABV 4.3%) PALE
Drift (ABV 4.6%) GOLD
Wave (ABV 4.7%) SPECIALITY

Kelburn SIBA

10 Muriel Lane, Barrhead, G78 1QB
☎ (0141) 881 2138 ⊕ kelburnbrewery.com

⊠ Kelburn is an award-winning family business established in 2002. ‼♦

Goldihops (ABV 3.8%) GOLD
Well-hopped session ale with a fruity taste and a bitter finish.
Pivo Estivo (ABV 3.9%) GOLD
A pale, dry, citrus, hoppy session ale.
Misty Law (ABV 4%) BITTER
Red Smiddy (ABV 4.1%) BITTER
This bittersweet ale predominantly features an intense citrus hop character balanced perfectly with fruity malt.
Dark Moor (ABV 4.5%) MILD
A dark, fruity ale with undertones of liquorice and blackcurrant.
Jaguar (ABV 4.5%) GOLD
A golden, full-bodied ale with undertones of grapefruit and a long lasting citrus, hoppy aftertaste.
Cart Noir (ABV 4.8%) STOUT
Cart Blanche (ABV 5%) GOLD
A golden, full-bodied ale. The assault of fruit and hop camouflages the strength of this easy-drinking ale.

Mains

Office: 45a Alderman Road, Glasgow, G13 3YG
✉ mainsbrewco@gmail.com

Mains is a small-batch brewery, producing farmhouse-inspired beers.

Out of Town

84 Telford Road, Lenziemill Industrial Estate, Cumbernauld, G67 2NJ ⊕ outoftown.co

Originally set up in 2016 by three homebrewers, the brewery was sold and is now part of Consolidated Craft Breweries. Beers may be brewed by Alechemy (qv).

Outlandish (NEW)

Woodend Hayloft, Birkenshaw Road, Glenboig, ML5 2QH ✉ info@outlandishbrewco.com

Established in 2020, brewing traditional and contemporary craft beers with names inspired by local lingo.

Overtone

Unit 19, New Albion Industrial Estate, Halley Street, Glasgow, G13 4DJ
☎ (0141) 952 7772 ⊕ overtonebrewing.com

Established in 2018, Overtone produce hop-forward craft beers with an emphasis on quality and flavour. It specialises in New England-style IPAS but also brews a number of other styles such as fruit sours and stouts.

Ride SIBA

Unit 1, Bridge Court, 12 Cook Street, Glasgow, G5 8JN
☎ 07463 667097 ⊕ ridebrewingco.uk

Ride Brew Co is a social enterprise brewery established in 2017.

Charon (ABV 4.5%) PORTER

Shilling

92 West George Street, Glasgow, G2 1PJ
☎ (0141) 353 1654 ⊕ shillingbrewingcompany.co.uk

Brewing began in 2016.

Simple Things Fermentations SIBA

The Bakehouse, 6 Hazel Avenue Lane, Glasgow, G44 3LJ
☎ (0141) 237 2202
⊕ simplethingsfermentations.com

Opened in 2019 the brewery has a 600-litre capacity. Beer is produced in bottle and keg, with one core cask-conditioned ale available. !!LIVE

Spectra (NEW)

Office: 33 Highfield Drive, Clarkston, G76 7SW
⊕ spectrabrewing.com

Former science teacher Alex Cavers launched Spectra Brewing in early 2022. Being a gypsy brewery Alex uses other breweries equipment to produce his American East Coast style beers. Beers are available in cask and can.

Visible Light (ABV 3.9%) PALE

Fundamental DDH IPA (ABV 5.5%) IPA

Up Front

Office: 1 / 1, 27 Skirving Street, Glasgow, G41 3AB
☎ 07526 088973 ⊕ upfrontbrewing.com

Founded in 2015 by former homebrewer Jake Griffin, Up Front is a gypsy brewery primarily using spare capacity at Overtone Brewing Co (qv), plus that at other local breweries. Predominantly producing canned beers and speciality bottles, cask-conditioned beers are available on rare occasions.

Veterans

Unit 0, Dundyvan Enterprise Park, Dundyvan Way, Coatbridge, ML5 4AQ
☎ (01236) 425281

South East: 35 Carden Hill, Brighton, East Sussex, BN1 8AA ☎ 07487 791444 ⊕ veteransbrewing.uk

Established on Armistice Day 2014, Veterans Brewing is owned, run by and supports veterans. Initially based only in Scotland, a second depot opened in Brighton in 2018, with beers contract brewed at Franklins.

WEST

🏠 Binnie Place, Glasgow Green, Glasgow, G40 1AW
☎ (0141) 550 0135 ⊕ westbeer.com

Brewery producing artisan lagers and ales in strict accordance with the German Purity Law of 1516, which also has an on-site beer hall, restaurant and events venue. All beers are unpasteurised. !!◆

Food for thought

Ale is an enemy to idlenesse, it will worke and bee working in the braine as well as in the Barrel; if it be abused by any man, it will trip up his heeles, and give him either a faire or fowle fall, if hee bee the strongest, stowtest, and skilfullest Wrastler either in Cornwall or Christendome. But if Ale bee moderately, mildly, and friendly dealt withall it will appease, qualifie, mitigate, and quench all striffe and contention, it wil lay anger asleepe, and give a furious man or woman a gentle Nap, and therefore it was rightly called Nappy ALE, by our Learned and Reverend Fore-fathers.

Besides it is very medicinable, (as the best Physitians doe affirme) for Beere is seldom used or applyed to any inward or outward maladies, except sometimes it bee warmed with a little Butter to wash the galled feete, or toes of a weary Traveller; but you shall never knowe or heare of a usuall drinker of ALE, to bee troubled with the Hippocondra, with Hiopocondragacall obstructions or convulsions, nor are they vexed (as others are) with severall paines of sundry sorts of Gowts, such as are the Gonogra, Podegra, Chirocgra, and the lame Hop-halting Sciatica, or with the intollerable griefe of the Stone in the Reines, Kidneys, or Bladder.

Beere is a dutch Boorish Liquor, a thing not knowne in England, till of late dayes an Alien to our Nation, till such time as Hops and Heresies came amongst us, it is a sawcy intruder into this Land, and it's sold by usurpation; for the houses that doe sell Beere onely, are nickname Ale-houses; marke beloved, an Ale-house is never called a Beere-house, but a Beere-House would have but small custom, if it did not falsely carry the name of an Ale-house; also it is common to say a Stand of Ale, it is not onely a Stand, but it will make a man understand, or stand under; but Beere is often called a Hogshead, which all rational men doe knowe is but a swinish expression.

John Taylor (1580-1653), Ale ale-vated into the Ale-titude, 1651

HIGHLANDS & WESTERN ISLES

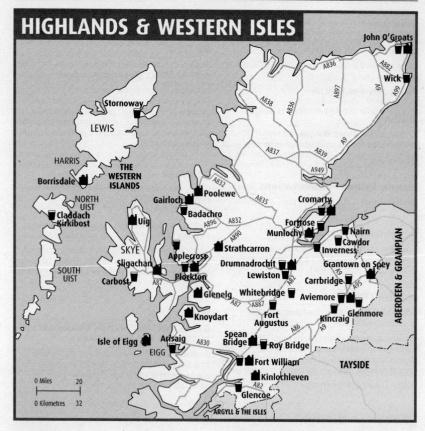

Applecross

Applecross Inn

Shore Street, IV54 8LR NG70974444
☎ (01520) 744262 ● applecrossinn.co.uk
3 changing beers (sourced locally; often Applecross) Ⓗ

This iconic, multi award-winning inn is in a remote location reached by a hair-raising road over one of the highest vehicular ascents in Britain or by a longer scenic coastal route. Renowned for its local seafood and venison, with a massive chalkboard menu, the pub is a must for foodies. Beers come from local microbrewery Applecross Ales. There are additional tables outside, with the Inn-Side-Out Airstream caravan offering light refreshments and takeaways. The pub is a popular stop-off on the North Coast 500. A former local CAMRA Pub of the Year runner-up. ☕️❄️🍴🍽️♿🅿🚃🐾🛍️🕱

Arisaig

Arisaig Hotel (Crofters Rest)

Main Road, PH39 4NH (A830 to Mallaig from Fort William) NM65808650
☎ (01687) 450210 ● arisaighotel.co.uk
2 changing beers (often Cromarty) Ⓗ

An old coaching inn built around 1720, this hotel is just off the main road to Mallaig and looks out over the turquoise waters of the bay towards Eigg, Rum and Skye. The Crofters Bar offers up to two Cromarty beers. Locally caught seafood dominates lunch and dinner menus, with a menu for vegetarians. Music plays on Friday nights and Sunday afternoons, and music festivals feature twice a

year. For train spotters, the Jacobite steam special chugs through the local station during the season. There are many scenic coastal walks nearby.
Ⓠ☕️❄️🍴🍽️♿🅿🚃🐾🛍️🕱

Aviemore

Cairngorm Hotel Ⓛ

77 Grampian Road, PH22 1PE (opp railway station)
☎ (01479) 810233 ● cairngorm.com
Cairngorm Gold, Stag Ⓗ

Just over the road from the train station and bus stop, this is often the first watering hole for many after a long journey. The privately owned Cairngorm Hotel has a warm and familiar feel about it, with comfy seats in the lobby to the bar and seating under cover outside. Although not tied, Cairngorm beers feature on the two handpumps. Large-screen TVs show popular sporting events and there is Scottish entertainment for the many visitors most evenings. Food with a Scottish twist is available much of the day. ☕️❄️🍴🍽️♿🅰🚃🅿🛍️🕱

Old Bridge Inn Ⓛ

23 Dalfaber Road, PH22 1PU
☎ (01479) 811137 ● oldbridgeinn.co.uk
4 changing beers (sourced regionally; often Cairngorm, Caledonian, Windswept) Ⓗ

Close to the gently flowing River Spey, this gem of a pub off the main drag is worth seeking out. The cosy, intimate inn, converted from a cottage in 1982, is an ideal place to relax after a busy day on the hills, or even just touring in the area. Booking is recommended for the restaurant, with a menu using produce with low food

miles. Entertainment is hosted most nights. There is a bunkhouse adjacent and self-catering accommodation available. Handy for the Strathspey Steam Railway. ⬥❄🏠🍴◐♿🅰�"🅿🚆❀🛜

Winking Owl 🅛 ✅

123 Grampian Road, PH22 1RH (N end of village)
☎ (01479) 812368 ⊕ thewinkingowl.co
6 changing beers (sourced regionally; often Cairngorm, Caledonian) 🅷
The Winky has been the brewery tap for the award-winning Cairngorm Brewery since 2014, with the addition of the Bothy Bar downstairs in 2018 massively increasing its popularity. Both bars offer four Cairngorm and two Caledonian beers. A menu of hearty pub grub, international and Scottish dishes – including children's, vegetarian, gluten- and dairy-free – is served throughout. Live music plays in the Bothy. The rustic courtyard has a covered seating area made from upcycled materials and logs. Once a farmhouse, this is probably one of the oldest hostelries in Aviemore, and Robert Burns is reported to have breakfasted here in 1787. ⬥❄🏠🍴◐♿🅰🚆🅿🚆❀🛜

Badachro

Badachro Inn

IV21 2AA (B8056 to Red Point and Badachro) **NG781736**
☎ (01445) 741255 ⊕ badachroinn.com
2 changing beers (sourced regionally; often Cairngorm, Cromarty) 🅷
Badachro Inn is on the south side of Loch Gairloch, with a single bar that remains essentially unchanged. Specialising in seafood, it is a foodies' delight. The decking outside offers an idyllic location to watch the tide ebb and flow in the safe and secure anchorage that the inlet provides. The inn is slightly more than a three-mile drive from the road itself, but worth it. You may miss the small sign on the road out of Gairloch, but you can't miss the big one! Q⬥❄🏠🍴◐♿🛜

Carbost: Isle of Skye

Old Inn

IV47 8SR NG379318
☎ (01478) 640205 ⊕ theoldinnskye.co.uk
3 changing beers (sourced locally; often Cuillin, Isle of Skye) 🅷
On the shores of Loch Harport, the Old Inn nestles on the tideline. Outside, trestle tables take advantage of the views that Skye is famous for – there can be no better place to enjoy a pint. The pub is busy all year round with an eclectic mix of outdoor folk, and those touring Skye or visiting the Talisker Distillery close by. Seafood is top of the menu, most of it coming from the loch. Q⬥❄🏠🍴◐♦🅿🚆❀

Carrbridge

Cairn Hotel 🅛

Main Road, PH23 3AS (just off A9 on B9153)
☎ (01479) 841212 ⊕ cairnhotel.co.uk
3 changing beers (sourced regionally; often Cairngorm, Cromarty, Orkney) 🅷
The Cairn Hotel is the hub of this small village, with the lure of a warming open fire and excellent gastro-pub style menus. The licensee selects the best cask ales from the Highlands and Islands for his three handpumps and deservedly the pub is popular with loyal locals and the many visitors to the area. The 1717 Packhorse Bridge and Landmark Forest Adventure Park are in the village. There are 14 rooms for overnight stays. ⬥❄🏠🍴◐♦🅿🚆❀🛜

Cawdor

Cawdor Tavern

The Lane, IV12 5XP NH845500
☎ (01667) 404777 ⊕ cawdortavern.co.uk
Orkney Dark Island, Northern Light, Red MacGregor; 1 changing beer (sourced regionally; often Orkney) 🅷
The Cawdor Tavern's owners took over in 1994 and they also run the Orkney Brewery at Quoyloo. Accordingly, up to five handpumps feature the brewery's beers. Oak panelling covers the walls of the public areas, including the spacious cosy bar room with its water taps for whisky on the bar. The lounge is mainly for dining and includes a separate baronial-style dining hall. A tempting food menu caters for all tastes and ages – leave room for pudding! Q⬥❄🏠🍴◐♿♣🅿🚆(2,20)🛜

Claddach Kirkibost: North Uist

Westford Inn

HS6 5EP (2½ miles NW of Clachan on A865)
NF7751066195
☎ (01876) 580653 ⊕ westfordinn.com
3 changing beers (sourced regionally; often Fyne, Isle of Skye) 🅷
The owners took on the Westford Inn in 2015 and have turned around its fortunes. The pub is very much the hub of the community, with live music and an annual beer festival. A second Skye ale is on rotation in winter, with three ales in summer, as well as a range of bottled beers. Good-quality pub food is served and also available to take away. Probably one of the most remote bars in the Guide, it is well worth making the effort to visit. Accommodation is in The Bothy, a former byre. Q⬥❄🏠🍴◐🅰♣🅿🚆❀🛜

Cromarty

Fishertown Inn 🅛

Church Street, IV11 8XA
☎ (01381) 600230 ⊕ cromartyarms.com
Cromarty Happy Chappy; 1 changing beer (sourced locally; often Cromarty) 🅷
A family-run pub providing B&B accommodation and delicious home-made bar meals. Formerly the Cromarty Arms, the pub underwent a major refurbishment during 2022. The beers are from Cromarty Brewery less than three miles away. A traditional music session is held on the second Friday of every month as well as other local

REAL ALE BREWERIES

Applecross Craft Strathcarron
Ardgour Fort William
Black Isle Munlochy
Cairngorm Aviemore
Cromarty Cromarty
Cuillin 🍺 Sligachan: Isle of Skye
Dun ♦ Glenelg
Ewebrew Poolewe (NEW)
Glen Spean Spean Bridge
Hanging Tree 🍺 Drumnadrochit
Isle of Eigg Galmisdale: Isle of Eigg (NEW)
Isle of Harris Borrisdale
Isle of Skye Uig: Isle of Skye
John O'Groats ♦ John O'Groats
Knoydart Knoydart
Old Inn 🍺 Gairloch (brewing suspended)
Plockton Plockton
River Leven Kinlochleven
Strathcarron Strathcarron
Two Thirsty Men Grantown on Spey

interest events. Just opposite is the National Trust for Scotland's Hugh Miller's Cottage and Cromarty Courthouse, or take a dolphin-spotting tour from the harbour where you can also see the oil rigs in for maintenance. A two-car ferry operates during the summer to Nigg. Q♿🍽️◗⏸️🚃♿🅿️🚌(26,26A)🐕🗠

Drumnadrochit

Benleva Hotel Ⓛ

Kilmore Road, IV63 6UH (signed off A82) NH513295
☎ (01456) 450080 🌐 benleva.co.uk
Hanging Tree After Dark, Eighty Shillings, Hangmans IPA; 1 changing beer (sourced regionally; often Hanging Tree) Ⓗ
The 400-year-old sweet chestnut outside the Benleva was once a hanging tree, hence the name of the brewery in the bothy just outside. The bar in this 300-year-old former manse offers four Hanging Tree beers and a guest ale. The food menu features classic home-made dishes with a Scottish twist. Regular music and themed nights are held throughout the year, and an annual beer festival in September.
♿⏸️🍽️◗🅰️♿🅿️🚃🐕🗠

Fort Augustus

Bothy Bar Ⓛ ✅

Canalside, PH32 4AU (off A82, next to road swing bridge)
☎ (01320) 366710
Isle of Skye Skye Red; 1 changing beer (often Isle of Skye) Ⓗ
In a picturesque location next to a flight of locks, with canalside seating outdoors, the pub is something of a tourist trap and can get very busy in the summer months. Two ales are usually served but sometimes only one during the quieter months. A good selection of food is available, but the pub does not take bookings, so chance your arm if you want to eat. Parking close by is limited, and vehicular access is via a narrow one-way system.
♿⏸️◗♿🅰️🅿️🚃🐕

Fort William

Ben Nevis Bar

103 High Street, PH33 6DG
☎ (01397) 702295 🌐 bennevisbarfortwilliam.com
Hanging Tree After Dark, Hangmans IPA; 1 changing beer (often Hanging Tree) Ⓗ
Built in 1806 and under new ownership since 2019, this pleasant two-roomed traditional locals' pub on the pedestrianised High Street is said to have a resident ghost in the loft. A decked area at the rear gives splendid views of Loch Linnhe. As well as the three ales, over 50 malt whiskies are stocked. A food menu of good honest pub favourites is available all day. Live music plays at weekends. ♿⏸️◗♿🍽️🅰️♣🚃🐕🗠

Ben Nevis Inn Ⓛ

Achintee Road, Claggan, PH33 6TE NN12477293
☎ (01397) 701227 🌐 ben-nevis-inn.co.uk
3 changing beers (sourced locally; often Cairngorm, Isle of Skye, River Leven) Ⓗ
Traditional 200-year-old stone-built barn at the start of the Ben Nevis mountain path, popular with outdoor enthusiasts. The small bar counter has three handpumps offering beers from local breweries. The barn, with long beer hall-style tables and a beckoning stove, decorated with mountaineering and skiing paraphernalia, is a warm, informal and friendly setting – an ideal venue for live music. A hearty food menu is available until 9pm,

changing daily. There is an adjacent bunkhouse. Check ahead for seasonal opening hours (closed Nov and Mon-Wed Dec-Feb). Q♿🍽️◗⏸️♿🅰️🅿️

Grog & Gruel Ⓛ

66 High Street, PH33 6AE (in pedestrianised area)
☎ (01397) 705078 🌐 grogandgruel.co.uk
6 changing beers (sourced regionally) Ⓗ
The Grog & Gruel alehouse is busy all day, every day with a mix of locals and tourists. A regular in the Guide since 1997, the pub has up to six handpumps dispensing often local and sometimes regional beers, making it a draw for the real ale connoisseur. The bar menu offers imaginative and interesting food at affordable prices all day. The restaurant upstairs opens from 5pm, providing a wider selection for hungry hill walkers. Open mic features on most Friday evenings. ♿◗🅰️🚆♣🚃🐕🗠

Fortrose

Anderson

Union Street, IV10 8TD (corner of High St)
☎ (01381) 620236 🌐 theanderson.co.uk
2 changing beers (sourced nationally; often Cromarty, Inveralmond) Ⓗ
A regular in the Guide since 2005, the Anderson offers well-chosen ales – mostly local or regional – drawn from the 200-year-old cellar. The whisky lounge has a single cider handpump and more than 250 single malts. The restaurant also has a reputation for excellence and is a popular destination for foodies. Regular music, quiz and special food nights feature throughout the year. Nine bedrooms are available, with local attractions including the golf course and dolphin-watching at Chanonry Point. Closed Monday and Tuesday.
Q♿⏸️🍽️◗♿🅰️♣🚃(26,26A)🐕🗠

Glencoe

Clachaig Inn Ⓛ

PH49 4HX (3 miles SE of village, off A82) NN12705668
☎ (01855) 811252 🌐 clachaig.com
10 changing beers (sourced regionally; often Cairngorm, Orkney, River Leven) Ⓗ
The Clachaig is a must for outdoor enthusiasts and beer lovers alike, set in a remote location among the spectacular hills and scenery of Glencoe. Having worked up a hunger on the hills, a huge choice of well-kept beers and hearty grub will replenish your energy. There are also more than 400 whiskies and 130 gins to distract you. On cooler days, wood-burning stoves keep the three bars and snugs warm. Beer festivals are held during the year and music hosted most weekend evenings.
♿⏸️🍽️◗♿♣🅿️🐕🗠

Glenmore

Pine Marten Bar & Scran

PH22 1QU (on ski road by Loch Morlich) NH974098
☎ (01479) 861253 🌐 aviemoreski.co.uk
Cairngorm Black Gold, Trade Winds, Wildcat Ⓗ
Unassuming from the outside, this 'wee snug of a bar' has a welcoming wood-burning stove and a bar topped with three handpumps. The minimalist building is designed to emulate mountain refuges in Austria, Switzerland and Bavaria, and ice axes and skis decorate the walls, along with quirky artefacts from across Europe. The kitchen serves some great food, and there is also a shop, ski hire, and accommodation including glamping pods and a treehouse. Live music plays most Friday and Saturday nights. ♿⏸️◗♿🅰️♣🅿️🚃🐕🗠

Inverness

Black Isle Bar Ⓛ

68 Church Street, IV1 1EN
☎ (01463) 229920 ⊕ blackislebar.com
Black Isle Red Kite, Yellowhammer; 4 changing beers (sourced locally; often Black Isle) Ⓟ
Immediately popular when it opened in 2016, this bar has up to three real ales and 23 craft beers on offer, mostly from Black Isle but including some guests, with prices for pints, halves and thirds. The open-plan bar area has a mix of seating. Upstairs, a secret garden utilises upcycled pallet tables and stools under a cover of reclaimed corrugated iron. Organic ingredients from the brewery farm are used in the interesting food menu, with pizzas the speciality. Q🛏️🕙👶♿🚆Pᗺ🐕✦🔊

Castle Tavern Ⓛ

1 View Place, IV2 4SA (top of Castle St)
☎ (01463) 718178 ⊕ castletavern.pub
5 changing beers (sourced regionally; often Cromarty, Isle of Skye, Windswept) Ⓗ
Just a short walk from town, the Castle Tavern is popular with tourists visiting the castle opposite and with locals who know their beer. Six handpumps offer an interesting rolling selection of beers, mostly from Scottish independents, and a changing cider. There is plenty of seating inside, but the covered canopy area outside is always busy, even in winter, with panoramic views along the River Ness. Bar meals are available all day; the restaurant upstairs opens in the evening.
👶🐕🕙👶♿🍴🚆♣Pᗺ🐕✦🔊

Clachnaharry Inn

17-19 High Street, Clachnaharry, IV3 8RB (on A862 Beauly road)
☎ (01463) 239806 ⊕ clachnaharryinn.co.uk
Fyne Jarl; Harviestoun Bitter & Twisted; Inveralmond Ossian; 2 changing beers (sourced nationally; often Cairngorm) Ⓗ
The Clach has featured in the Guide for more than 35 years. The 17th-century coaching inn offers a warm welcome to all, with an open fire most days. Locally sourced food is available in both the bar and the quieter restaurant. Quiz and music nights feature regularly. Outside, the occasional train rumbles by or boat using the Caledonian Canal. Beyond are stunning views of the Beauly Firth and Ben Wyvis, often snowcapped. Q👶🐕🕙👶🅰♣Pᗺ(28,28A)🐕🔊

Corriegarth Ⓛ

5-7 Heathmount Road, IV2 3JU
☎ (01463) 224411 ⊕ corriegarth.com
Cromarty Happy Chappy; 3 changing beers (sourced nationally) Ⓗ
The Corrie is in the quiet Crown area of Inverness, just five minutes from the town centre. The imposing red sandstone building was once a hotel and did a stint as a club for Navy and RAF officers. Guest ales, including Caledonian Deuchars IPA and two others from the Punch list, are almost always available. In the summer, there is a large area to sit outside. This busy and popular local has nine boutique en-suite rooms, making it a great place to stay. Q👶🛏️🕙👶♿🚆Pᗺ🐕✦🔊

MacGregor's

109-113 Academy Street, IV1 1LX (corner of Friars Lane)
☎ (01463) 719629 ⊕ macgregorsbars.com
2 changing beers (sourced regionally; often Cromarty, Spey Valley, Swannay) Ⓗ

Crowdfunding allowed Blazin' Fiddles musician Bruce MacGregor's pub to become an instant hit on opening in 2017, offering an insight into Scottish history, culture, food and drink. Two handpumps and a font gantry feature beers from local breweries, alongside an extensive menu of bottled beers, gins and whiskies. A simple but elegant Scottish-themed food menu is served all day. Wood-burning stoves warm both the main bar and side whisky room. There is a patio area outside. Bruce is often in the bar playing his fiddle on a Sunday afternoon. 👶🐕🕙👶♿🚆Pᗺ

Phoenix Ale House Ⓛ

106-110 Academy Street, IV1 1LX (near bus station)
☎ (01463) 240300 ⊕ phoenixalehouse.co.uk
10 changing beers (sourced nationally; often Cairngorm, Cromarty, Windswept) Ⓗ
Walk into the Phoenix and you are greeted by a choice selection of Scottish real ales on up to 10 handpumps, making it a popular destination for tourists and those who know their ales. Built in 1894 and identified by CAMRA as having a regionally important historic pub interior, the public bar has a classic Scottish island bar surrounded by a spittoon – there is even talk of sawdust returning! The bar area is mostly standing only. The pub's restaurant next door, with its own lounge bar, has plenty of seating for hearty meals all day. Q🕙♿🚆Pᗺ

John O'Groats

John O'Groats Brewery & Tap Room

The Last House, KW1 4YR
☎ 07842 401571 ⊕ johnogroatsbrewery.co.uk
4 changing beers (sourced locally; often John O'Groats) Ⓗ
The Last House is the tap room for the adjoining John O'Groats Brewery. Situated just yards from the Pentland Firth, it is the most northerly pub and brewery in mainland Britain. Drinkers can sit in the small bar or in the shop window overlooking the sea and Orkney Isles, or outside on warmer days. Four handpumps serve ales brewed in the next room, and often a real cider from the Highlands. 👶🅰♣Pᗺ(77,80)

Seaview Hotel Ⓛ

County Road, KW1 4YR (A99/A863 jct) ND380727
☎ (01955) 611220 ⊕ seaviewjohnogroats.co.uk
John O'Groats Swelkie; 1 changing beer (sourced locally; often John O'Groats) Ⓗ
The Seaview Hotel is one of the most northerly pubs on the UK mainland. It has two handpumps on the bar offering at least one local beer from John O'Groats Brewery. Meals are served throughout the day. Accommodation is available in the hotel itself, the annexe over the road, and in camping pods. The pub is a popular stop-off for 'End to Enders' and the many visitors with John O'Groats on their bucket list. The surrounding area, including Duncansby Head, offers great views and walking. 👶🛏️🕙👶♣Pᗺ🐕✦🔊

Kincraig

Suie Bar Ⓛ

PH21 1NA (on B9152, just off A9) NH829057
☎ (01540) 651788 ⊕ thesuiebar.com
Cairngorm Trade Winds; 2 changing beers (sourced regionally; often Orkney) Ⓗ
It is worth pulling off the busy A9 and following the old road to seek out this wee gem of a country pub. From the outside it doesn't look much, but inside a warm Highland welcome is accompanied by four handpumps offering Cairngorm and some local Highland beers. The much-

loved old stove has been replaced with a more modern, efficient model. The Suie holds a beer festival in late February and hosts music most weekends. Handy for the Kincraig Wildlife Park. ✿🚃🍴♣️P🍽️🐾🛜

Lewiston

Loch Ness Inn

Lewiston, near Drumnadrochit, IV63 6UW (W of A82)
☎ (01456) 450991 ⊕ staylochness.co.uk
3 changing beers (sourced locally; often Cairngorm, Cromarty, Windswept) 🅷

Dating from 1838, this traditional inn has rooms and a new bunkhouse. The comfy bar with its warming stove has up to three handpumps offering beers from mainly local breweries, occasionally Applecross. The restaurant is fiercely proud of the local provenance of its ingredients. Located centrally, the inn is ideal for visiting Loch Ness, local Nessie tourist haunts, nearby Urquhart Castle or even walking the Great Glen Way. A free eight-seater courtesy bus is available for pick-ups within five miles. 🚃✿🍴🕐🦽♣️P🍽️🐾🛜

Nairn

Bandstand 🏆 🅛 ✅

Crescent Road, IV12 4NB (E end of town towards beach)
☎ (01667) 452341 ⊕ thebandstandnairn.co.uk
5 changing beers (sourced nationally; often Cairngorm, Cromarty, Orkney) 🅷

Overlooking the green, with its bandstand and the Moray Firth beyond, the bar has five handpumps offering a great selection of local and regional Scottish beers, and an occasional English ale. Popular spring and autumn beer festivals are said to be among the biggest independent events in the UK, accompanied by themed food and music acts over three days. The restaurant offers good-value, quality food. Live music features at the weekend. Local CAMRA Pub of the Year 2022.
Q🚃✿🍴🕐🦽♣️🍴👫P🍽️🐾🛜

Plockton

Plockton Hotel ✅

41 Harbour Street, IV52 8TN (signed from Kyle of Lochalsh) NG80293343
☎ (01599) 544274 ⊕ plocktonhotel.co.uk
4 changing beers (sourced regionally; often Cromarty, Fyne, Swannay) 🅷

Plockton was the setting for TV's Hamish Macbeth, which is a draw for visitors to this pretty village, many of whom arrive by train on the picturesque Kyle Line. This popular and award-winning family-run hotel is sheltered by mountains at the edge of Loch Carron. The bar proudly offers four handpumps dispensing both local and regional beers, which can be enjoyed on the terrace with views of the sea. The food menu features locally sourced seafood, beef and venison. A real ale and gin festival is held in May. Closed in January. Q🚃✿🍴🕐🦽♣️P🍽️🛜

Roy Bridge

Stronlossit Inn 🅛

Main Street, PH31 4AG NN27228117
☎ (01397) 712253 ⊕ stronlossit.co.uk
3 changing beers (sourced regionally; often Cairngorm, Isle of Skye, Orkney) 🅷

The location of the Stronlossit makes it attractive to those keen on the outdoors and, with the railway station just over the road, you can abandon the car and arrive by train from Fort William or London. The train can also take you for a day trip to Corrour, to walk around Loch Ossian.

Up to four handpumps spoil real ale fans, with beers from varying Scottish breweries including the local Glen Spean. Great food is served all day, and there are rooms for all budgets. Q🚃✿🍴🕐🦽🅰️♣️🚭P🍽️🛜

Stornoway: Isle of Lewis

Crown Inn (Harbour Bar) ✅

Castle Street, HS1 2BD (close to ferry terminal)
☎ (01851) 703734 ⊕ crownhotelstornoway.com
2 changing beers (sourced nationally; often Caledonian, Inveralmond, Isle of Skye) 🅷

The lounge bar and Harbour View restaurant are accessed via the hotel entrance, while the large public Harbour Bar has a separate entrance. Although both hospitality areas sport two handpumps offering Scottish and English beers, the offering is the same upstairs and downstairs, with only one beer in winter. However, a testament to the popularity of the ales is that they do run out very quickly. 🚃🍴🕐♣️P🍽️

Whitebridge

Whitebridge Hotel 🅛

IV2 6UN (on B862 towards SE side of Loch Ness) NH487152
☎ (01456) 486226 ⊕ whitebridgehotel.co.uk
3 changing beers (sourced regionally; often Cairngorm, Cromarty, Orkney) 🅷

Built in 1899 and located on the quiet east side of Loch Ness, this two-star hotel has fishing rights on three local lochs. Inside is an attractive pitch-pine panelled bar, with a welcoming wood-burning stove. An adjacent room has a pool table and also a separate area for dining. Three ales are usually available, reducing to one or two in winter. The traditional pub food is all home-cooked. The hotel has a green tourism policy. Q✿🚃🕐🦽♣️P🍽️🐾🛜

Wick

Alexander Bain ✅

Market Place, KW1 4LP (in pedestrianised area just off High St)
☎ (01955) 609920
Caledonian Deuchars IPA; 2 changing beers 🅷

This most northerly Wetherspoon in the UK opened in 2003, taking over the old post office. Offering the chain's usual reasonably priced drinks and meals, it is popular with locals. The large single-room bar has many side areas and quiet corners, and there is decking outside. The bar sports six handpumps, although only three are in operation, two in winter. Music groups play regularly. Alcoholic drinks are served from 11am.
Q🚃✿🕐🦽🅰️🚭P🍽️🛜

Breweries

Applecross Craft

Russel Yard, Kishorn, Strathcarron, IV54 8XF
⊕ applecrossbrewingcompany.co.uk

Applecross Brewing Co was established in 2016 in the remote wilderness of the Applecross Estate in the Highlands of Scotland. All the beers are available in bottle and cask. The main cask outlet is the famous Applecross Inn.

Applecross (ABV 3.7%) PALE
Sanctuary (ABV 4%) RED
Inner Sound (ABV 4.7%) PORTER

Ardgour SIBA

The Manse, Ardgour, Fort William, PH33 7AH
☎ (01855) 632321 ☎ 07785 763659
🌐 ardgourales.scot

Opening in 2020, eight years after Fergus and Lizzy Stokes bought the crumbling Manse with a view to bringing great beer to Scotland's west coast, this new-build, five-barrel brewery is situated in the village of Ardgour on the edge of the remote Morvern and Ardnamurchan peninsulas. An on-site bakery is also in operation. 🕯🍴

Boc Beag (ABV 3.6%) GOLD
Gobhar Shamhna (ABV 4.1%) RED
Gobhar Odhar (ABV 4.3%) BITTER
Bainne nan Gobhar (ABV 4.5%) STOUT
Boc Ban (ABV 5.1%) BITTER
Boc na Braiche (ABV 6.4%) PALE
Gobhar Reamhar (ABV 6.5%) STOUT

Black Isle

Old Allengrange, Munlochy, IV8 8NZ
☎ (01463) 811871 🌐 blackislebrewery.com

☺Black Isle Brewery was set up in 1998 in the heart of the Scottish Highlands. It expanded substantially in 2011 with a new brewhouse and bottling line. All beers are organic with Soil Association certification. 🕯🍴♦

Yellowhammer (ABV 3.9%) GOLD
A refreshing, hoppy golden ale with light hop and peach flavour throughout. A short bitter finish.
Red Kite (ABV 4.2%) BITTER
Tawny ale with light malt on the nose and some red fruit on the palate and a hoppy background. Slight sweetness in the taste.
Heather Honey (ABV 4.6%) SPECIALITY
Sweet, amber beer brewed with a background mix of organic malt, hops and Highland heather honey.
Porter (ABV 4.6%) PORTER
A hint of liquorice and burnt chocolate on the nose and a creamy mix of malt and fruit in the taste.
Blonde (ABV 5%) BLOND

Cairngorm SIBA

Unit 12, Dalfaber Industrial Estate, Aviemore, PH22 1ST
☎ (01479) 812222 🌐 cairngormbrewery.com

☺Cairngorm brews using a 20-barrel plant. Now with its own bottling line, it supplies the free trade as far south as the central belt, and nationally via wholesalers. In 2016, in partnership with the Cobbs Group, it bought the brands of the Loch Ness Brewing Co and now brews selected beers under the Loch Ness brand name. 🕯🍴♦

Nessies Monster Mash (ABV 4.1%) BITTER
A fine best bitter with plenty of bitterness, a malt flavour, and a fruity background. Lingering bitterness in the aftertaste with diminishing sweetness.
Stag (ABV 4.1%) BITTER
A good mix of roasted malt, red fruits and hops throughout. This tawny brew also has plenty of malt in the lingering bitter-sweet aftertaste.
Trade Winds (ABV 4.3%) SPECIALITY
Award-winning brew with a strong elderflower and citrus fruity hop nose, following on through to the bittersweet finish.
Black Gold (ABV 4.4%) STOUT
Roast malt dominates throughout, slight smokiness in aroma leading to a liquorice and blackcurrant background taste giving it a background sweetness. Very long, dry, bitter finish. Worthy Championship winner.

Cairngorm Gold/ Sheepshaggers Gold (ABV 4.5%) GOLD
Fruit and hops to the fore with a hint of caramel in this sweetish brew. Also known as Sheepshaggers Gold.
Highland IPA (ABV 5%) PALE
Refreshing, light-coloured, citrus American and South Pacific-hopped IPA. Some background biscuit and caramel.
Wildcat (ABV 5.1%) BITTER
A full-bodied, warming, strong bitter. Malt predominates but there is an underlying hop character through to the well-balanced aftertaste. Drinks dangerously less than its 5.1%.

Cromarty SIBA

Davidston, Cromarty, IV11 8XD
☎ (01381) 600440 🌐 cromartybrewing.co.uk

Family-owned, Cromarty began brewing in 2011 in a purpose-built brewhouse. Many awards have been garnered. Fermenting capacity was increased during 2014 and again in 2015, while developing a varied portfolio of regularly brewed ales, and around eight occasional brews. A bottling line was commissioned in 2017, a warehouse in 2018, and a canning line in 2019. The brewer is constantly trialling new recipes and collaboration brews. 🕯🍴♦

Whiteout (ABV 3.8%) SPECIALITY
Happy Chappy (ABV 4.1%) GOLD
An excellent golden ale with plenty of hop character. Floral citric hop aroma with a good bitter taste which increases in aftertaste and balanced with malt.
Red Rocker (ABV 5%) SPECIALITY
Red-coloured, rye hop monster with a malty background leading to a bitter finish.
Raptor IPA (ABV 5.5%) IPA
Rogue Wave (ABV 5.7%) IPA
Easy-drinking, strong, peachy, hoppy bitter.
Ghost Town (ABV 5.8%) PORTER
Classic, dark-roasted, malty porter with blackcurrant and liquorice background.
AKA IPA (ABV 6.7%) IPA
Strong IPA with a smooth, citrus hoppy taste.

Cuillin SIBA

🍴 **Sligachan Hotel, Sligachan, Carbost, Isle of Skye, IV47 8SW** ☎ 07795 250808 🌐 cuillinbrewery.com

☺The five-barrel brewery opened in 2004 and is situated in central Skye at the foot of the Cuillin mountains. The water from the Cuillins provides a distinctive colour and taste to the ales. Beers are available on-site at the Sligachan Hotel and at several other pubs and hotels on the Isle of Skye. The brewery is open by appointment only in winter (November-March). 🕯♦

Dog Falls SIBA

Scaniport, IV2 6DL 🌐 dogfallsbrewing.com

Microbrewery founded by Bob Masson in 2019, Dog Falls brew modern interpretations of international beer styles. Beers are unfined and unfiltered, available mainly in can.

Dun

Corrary Farm, Glen Beag, Glenelg, Kyle, IV40 8JX
☎ (01599) 522333 🌐 dunbrewing.co.uk

☺Established in 2018, this four-barrel brewery is named after the two neighbouring Iron Age brochs (forts) – Dun Telve and Dun Trodden. Using its own spring water, Soil Association-certified, 100% organic ingredients, and

100% renewable energy, the environmentally-sustainable ales are unfiltered and naturally carbonated. Beers are only available locally at present. ☛ LIVE ✦

Ewebrew (NEW) SIBA

2 Naast Achnasheen, Poolewe, IV22 2LL ☎ 07494 310317 ⊕ ewebrew.beer

☺ Commissioned in early 2022, Ewebrew is the creation of James and Jo Struthers. Initially two core beers are brewed with an ever evolving range coming on stream. A self catering holiday cottage is operated adjacent to the brewery. LIVE

Arctic Convoy (ABV 4.5%) BLOND
Firemore (ABV 5%) BITTER

Glen Spean SIBA

Tirindrish, Spean Bridge, PH34 4EU ☎ 07511 869958 ⊕ glenspeanbrewing.com

Based in a converted steading, brewing began in 2018. ☛

Pale Blonde (ABV 3.6%) BLOND
Highbridge IPA (ABV 4%) BITTER
Red Revival (ABV 4.5%) BITTER

Hanging Tree

🛏 Benleva Hotel, Kilmore Road, Drumnadrochit, IV63 6UH

☺ Hanging Tree began brewing in 2017 using a two-barrel brew plant in an old bothy in the grounds of the Benleva Hotel. Named after the 400-year-old chestnut tree growing in the garden, which was used as the hanging tree for the local area. Beers are available in the pub and a few other local outlets.

Isle of Eigg (NEW)

Galmisdale, Isle of Eigg, PH42 4RL
⊕ eiggbrewery.com

Crowdfunded during 2020, Isle of Eigg is Scotland's first cooperative brewery. Having built the brewery and installed the kit in 2021, production began in 2022. The brewery uses 100% renewable energy with its water coming from a natural source, and supports the local crofting community by reusing its raw materials.

Isle of Harris

Croft No. 6, Borrisdale, Outer Hebrides, HS5 3UE
☎ 07584 354144 ⊕ isleofharrisbrewery.com

Established in 2020, small batch, limited edition beers are produced in a tiny brewshed overlooking the Sound of Harris. Beers are bottled and labelled by hand. LIVE

Isle of Skye SIBA

The Pier, Uig, Isle of Skye, IV51 9XP
☎ (01470) 542477 ⊕ skyeale.com

☺ The Isle of Skye Brewery was established in 1995. Originally a 10-barrel plant, it was upgraded to 20 barrels in 2004. ‼☛✦

Skyelight (ABV 3.8%) GOLD
Tarasgeir (ABV 4%) SPECIALITY
YP (Young Pretender) (ABV 4%) BITTER
A refreshing, amber, hoppy grapefruit bitter. Some sweetness in the taste but continuing into a lingering, bitter finish.
Skye Red (ABV 4.2%) BITTER

A light, fruity nose with a hint of caramel leads to a hoppy, malty, fruity flavour and a dry, bittersweet finish.
Skye Gold (ABV 4.3%) SPECIALITY
Porridge oats are used to produce this delicious speciality beer. Nicely balanced. it has a refreshingly soft lemon, bitter flavour with an oaty background.
Skye Black (ABV 4.5%) OLD
Full-bodied with a malty richness. Malt holds sway but there are plenty of hops and fruit to be discovered in its varied character. A delicious Scottish old ale.
Skye IPA (ABV 4.5%) PALE
Blaven (ABV 5%) BITTER
A well-balanced, strong, amber bitter with kiwi fruit and caramel in the nose and a lingering sharp bitterness.
Skye Blonde (ABV 5.5%) BLOND
Cuillin Beast (ABV 7%) BARLEY
A winter warmer; sweet and fruity, and much more drinkable than the strength would suggest. Plenty of caramel throughout with a variety of fruit on the nose.

John O'Groats

County Road, John O'Groats, KW1 4YR
☎ (01955) 611220 ☎ 07842 401571
⊕ johnogroatsbrewery.co.uk

☺ Brewing began in 2015 with a four-barrel plant. It is housed in the old John O'Groats Fire Station almost opposite its tap, the Seaview Hotel. A second three-barrel plant is installed in the Last House by the harbour, which is now a visitor centre complete with shop, bar and brewery tours. A bottling facility has been added next to the Fire Station plant. ‼☛✦

Swelkie (ABV 4%) BITTER
Slight honey taste in this citrus hoppy brew
Duncansby (ABV 4.2%) BITTER
Deep Groat (ABV 4.8%) STOUT
Nearly black brew full of chocolate and coffee with some background roast.

Knoydart

St. Agatha's Chapel & Manse, Inverie, Knoydart, PH41 4PL ⊕ knoydartbrewery.co.uk

Knoydart is one of the most remote breweries on mainland Britain. There are no road links so access is by ferry, or on foot over mountain passes. Beers are brewed in part of an old chapel using a 60-litre electric brewery and a five-barrel plant with four fermenters.

Nessie

Westoaks, Fort William Road, Fort Augustus, PH32 4BH

Set up in 2017 Nessie Brew is a nanobrewery that markets a range of bottled beers to the tourist trade around Fort Augustus.

Old Inn

🛏 Old Inn & Brewpub, Flowerdale Glen, Gairloch, IV21 2BD
☎ (01445) 712006 ⊕ theoldinn.net

Brewing began in 2010 using a 150-litre plant. Brewing is currently suspended. ✦

Plockton

5 Bank Street, Plockton, IV52 8TP
☎ (01599) 544276 ☎ 07823 322043
⊕ theplocktonbrewery.com

The brewery started trading in 2007 and expanded to a 2.5-barrel plant in 2009. Bottle-conditioned beers are available and are suitable for vegetarians. ‼ ♦ LIVE

Yarrowale (ABV 4.2%)
Plockton Bay (ABV 4.6%) BITTER
A well-balanced, tawny-coloured, premium bitter with plenty of hops and malt which give a bittersweet, fruity flavour.
Starboard! (ABV 5.1%) GOLD
A fine, fruity, golden ale with a light citrus bitterness. Hop and spicy fruit feature in the nose with a smack of grapefruit in the taste. The bitterness holds well into the aftertaste.
Ring Tong (ABV 5.6%) IPA

River Leven SIBA

Lab Road, Kinlochleven, PH50 4SG
☎ (01855) 831519 ☎ 07901 873273
⊕ riverlevenales.co.uk

Established in 2011, River Leven Ales is situated among stunning scenery on the West Highland Way in Kinlochleven. Beers are produced using the pure Kinlochleven water with no added sugars or unmalted grain.

Blonde (ABV 4%) GOLD
Traditional IPA (ABV 4%) PALE

Strathcarron

Arinackaig, Strathcarron, IV54 8YN
☎ (01599) 577236 ⊕ strathcarronbrewery.com

⊠ Brewing since 2016 with a 2.5-barrel plant using its own on-site water supply. All beer is cask and bottle-conditioned, and is usually available on draught at seven or eight local pubs, and in bottles at a dozen or so local shops and restaurants (see website). Bottles available from the website. Labels are available in Gaelic or English. LIVE

Golden Cow (ABV 3.8%) GOLD
Black Cow (ABV 4.2%) STOUT
Red Cow (ABV 4.2%) BITTER
Highland Cow (ABV 5.4%) BITTER

Two Thirsty Men

76 High Street, Grantown on Spey, PH26 3EL
☎ 07779 227795 ⊕ twothirstymen.com

Brewing began in 2016 in a garage at the back of a café bar.

Spey IPA (ABV 3.5%) PALE
No74 (ABV 4.5%) BITTER

Wild Barn

Unit 1, Caol Industrial Estate, Kilmallie Road, Caol, PH33 7PH ☎ 07367 888431
✉ hello@wildbarnbeer.com

Purchased in late 2021, this nanobrewery moved to new premises by the end of 2021. Building from the recipes inherited from the previous Belgian owner, production is currently focused on cans and bottles. No real ale at present. 🍺

Bandstand, Nairn (Photo: Stuart McMahon)

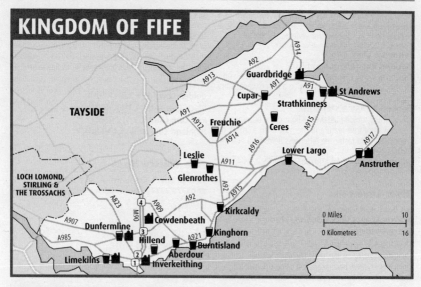

KINGDOM OF FIFE

Aberdour

Foresters Arms

35 High Street, KY3 0SJ
☎ (01383) 861245 ⊕ theforestersarms.pub
1 changing beer (sourced nationally) ⊞
This corner pub is only a few hundred yards from the railway station and Aberdour Castle. It sits in the middle of the village and is an ideal stop-off point for tourists and ramblers using the Fife coastal path. As you would expect from a pub right at the heart of the community, several weekly events are held, ranging from bingo to raffles. You will also find a jukebox, pool table and live sporting events on a big screen. ❀ ⅋ ⇌ ♣ ♫ (7) ● ⚲

Anstruther

Dreel Tavern

16 High Street, KY10 3DL
☎ (01333) 279238 ⊕ dreeltavern.co.uk
3 changing beers (sourced nationally; often Adnams, Redcastle, Stewart) ⊞
One of Anstruther's most historic buildings, the Dreel Tavern is traditional family-run pub that is popular with locals, walkers and visitors to the area. It is renowned for the quality of its food, much of which is locally sourced. An open fire creates a cosy atmosphere in winter. At the rear is a sunny beer garden overlooking the Dreel Burn, from which the pub takes its name. Closed Mondays and Tuesdays. Q ⅋ ❀ ⅃ ♣ ♫ (95,X60) ● ⚲

Burntisland

Sands Hotel ✅

Kinghorn Road, KY3 9JX
☎ (01592) 872230 ⊕ burntislandsands.co.uk
2 changing beers (sourced regionally) ⊞
A warm welcome awaits at this family-run hotel by the seafront in this picturesque coastal town. Burntisland is home to the second oldest Highland Games in the world, held at the end of July, traditionally the start of the Fife/Glasgow Fair fortnight. The hotel has a choice of restaurants and is renowned for its excellent high teas – book ahead to avoid disappointment. ❀ ⚮ ◑ ♫ ⚲

Ceres

Ceres Inn

The Cross, KY15 5NA
☎ (01334) 828305 ⊕ ceresinn.co.uk
1 changing beer (sourced regionally) ⊞
A family-friendly pub with a warm atmosphere, in the centre of the village and a 15-minute drive from St Andrews. The Inn has established a reputation for friendly service, as well as for the quality and value of its food and drink. Its dining room is ideal for smaller functions. A takeaway menu is available. ❀ ◑ ♫ (41,X61) ●

Cupar

Boudingait

43 Bonnygate, KY15 4BU
☎ (01334) 208310 ⊕ theboudingaitcupar.co.uk
2 changing beers (sourced nationally) ⊞
An award-winning, family- and dog-friendly pub at the centre of this old market town. Its extensive menu of good home-made pub grub includes a wide range of specials. The bar can be busy at the weekend, especially when the local farmers' market comes to town. Weekly activities ranging from live music to quizzes are enjoyed by all. Q ⅋ ◑ ♫ (42) ● ⚲

Dunfermline

Commercial Inn ▼

13 Douglas Street, KY12 7EB
☎ (01383) 696994
6 changing beers (sourced nationally; often Inveralmond, Spey Valley, Stewart) ⊞

Located at the heart of the town centre, close to the main retail area, the pub attracts an eclectic clientele and gets busy on match days. Formerly a hotel, this 19th-century listed building is full of character and retains the high ceilings and decorative cornices of that period. A spiral staircase leads down to the lower levels. Local CAMRA Pub of the Year 2022. ◖▶︎⬤≉(Town)🛏🐱🛜

Guildhall & Linen Exchange ✅

79-83 High Street, KY12 7DR
☎ (01383) 625960
8 changing beers (sourced nationally; often Caledonian, Redcastle, Sharp's) Ⓗ

This Wetherspoon outlet was indeed originally a guildhall and linen exchange, when Dunfermline was synonymous with fine-quality table linen. The category A-listed building is now a split-level pub and hotel. The interior is decorated with a mix of modern and Art Deco features, and displays numerous pictures highlighting the historic past of the town. In the middle of the busy retail area, this is a great place to stop for a pint and a bite to eat. 🛏🐱🛌◖▶︎&≉(Town)🛏🛜

Freuchie

Albert Tavern

2 High Street, KY15 7EX
☎ 07876 178863 ⊕ alberttavern.wixsite.com/albert
5 changing beers (sourced nationally; often Harviestoun, Stewart) Ⓗ

This welcoming 18th-century coach house is the heart and soul of the village, and has the feel of an old English inn with its low-beamed ceiling and cosy atmosphere. The two-roomed interior includes a lounge with a TV and the bar with five handpumps. Ales come from throughout the UK, and three real ciders are also on the bar. The pub hosts a number of community events, from the famous pie night to the quarterly meeting of the malt whisky society. Q🐱🌳🛏🛜

Glenrothes

Golden Acorn ✅

1 North Street, KY7 5NA
☎ (01592) 755252
Caledonian Deuchars IPA; Greene King Abbot; Sharp's Doom Bar; 4 changing beers (sourced nationally) Ⓗ

This pub is located at the heart of Glenrothes, only a few minutes' walk from the bus station, the Kingdom shopping centre and the local Rothes Halls theatre. A typical Wetherspoon outlet, it has a large open-plan bar area and a smaller family section. Seven handpumps serve real ale. Many large TV screens show sporting events and rolling news. There is a hotel attached. 🛏🐱🛌◖▶︎&🌳🛏🛜

Hillend

Hillend Tavern ✅

37 Main Street, KY11 9ND
☎ (01383) 415391 ⊕ hillendtavern.co.uk
3 changing beers (sourced nationally; often Greene King, Stewart, Timothy Taylor) Ⓗ

A community-focused village pub near Dalgety Bay, with cosy coal fires, a beer garden and real ales all adding to the friendly and welcoming atmosphere. The Tav, as it is known, has a traditional bar and a spacious area at the rear that is ideal for larger groups or functions. The pub hosts many village events, and its live music nights and two quiz nights each month are well attended. 🛏🐱≉(Dalgety Bay)🌳🛏(7,87)🐱🛜

Kinghorn

Auld Hoose

6-8 Nethergate, KY3 9SY
☎ (01592) 891074
Fuller's London Pride; 1 changing beer (often Caledonian) Ⓗ

A traditional multi-roomed pub just off the main street of this busy seaside village. It has a large bar area as you enter, and a generously sized lounge at the side. The family-run pub is popular with both locals and visitors. Its excellent selection of beers makes it an ideal venue for real ale enthusiasts. ≉🌳🛏🐱🛜

Crown Tavern Ⓛ ✅

55-57 High Street, KY3 9UW
☎ (01592) 891363
2 changing beers (sourced nationally; often Beath, Sharp's) Ⓐ

Affectionately known as the Middle Bar by locals, this two-roomed venue is right at the centre of a pleasant coastal village, a short walk from the train station. Very much a community pub, it is a sports bar at heart, with a large screen and a number of smaller screens showing sports. Two ales are served from traditional Scottish tall founts, as well as three or four ciders. The pub is a keen LocAle supporter, often with beers from Beath Brewing. Local CAMRA Cider Pub of the Year 2022. ≉🛏(7)🐱🛜

Kirkcaldy

Betty Nicols Ⓛ

297 High Street, KY1 1JL
☎ (01592) 591408
Fyne Jarl; 1 changing beer (sourced regionally) Ⓗ

Betty Nicols has long been one of Kirkcaldy's most popular places to enjoy a drink in a relaxed and comfortable atmosphere. This traditional bar attracts a varied clientele due to its location on the High Street. Live music nights are popular, as is the quiz which is held twice a month on a Thursday night. The modern bistro serves lunchtime meals and afternoon teas (booking essential). Closed on Monday. 🛏◖&≉🛏🐱🛜

Robert Nairn ✅

2-6 Kirk Wynd, KY1 1EH
☎ (01592) 205049
Caledonian Deuchars IPA; Greene King Abbot; 4 changing beers (sourced nationally) Ⓗ

A Wetherspoon pub on Kirk Wynd, just off the town's main pedestrianised area. It has a split-level lounge with pictures of old Kirkcaldy on the walls. The pub's central location allows it to attract a mixed clientele, who enjoy the wide varietyy of real ales dispensed by six handpulls. Meet the Brewer evenings are hosted regularly. 🛏◖&≉🛏🛜

Leslie

Burns Tavern

184 High Street, KY6 3DB
☎ (01592) 741345
Timothy Taylor Landlord; 1 changing beer (sourced nationally; often Stewart) Ⓗ

A traditional tavern that is the hub of the community in this former paper-making town. It consists of a public bar and a lounge. The main bar is divided into two sections – the lower level with the main bar and the higher area with a pool table. This is a pub where you can sit back, relax and enjoy your pint of Landlord or a guest ale while watching a sporting event on one of the numerous TVs. Q🐱🛌&🌳🛏(39A)🐱

Limekilns

Bruce Arms 🅛

2 Main Street, KY11 3HL

☎ (01383) 872259 ● brucearmslimekilns.co.uk

2 changing beers (sourced nationally; often Inner Bay) Ⓗ

A warm and welcoming pub in this scenic and historic village on the Fife Coastal Path; the original settlement here dates back to the 14th century. There are stunning views across the Firth of Forth to admire while you enjoy a relaxed pint or a bite to eat. The pub supports LocAle and usually offers a beer or two from local brewery Inner Bay. Closed on Monday. ➤❀◑♣️P🖨🐾🎵🛜

Ship Inn 🅛

Halketts Hall, KY11 3HJ

☎ (01383) 872247 ● the-ship-inn-limekilns.co.uk

3 changing beers (sourced nationally; often Brewshed, Greene King) Ⓗ

A wee gem on the way out of Limekilns, which in its early days was a fishing village. The Ship sits on the River Forth, with views of the three bridges spanning the water. The Ship is a family-run venue and prides itself on a warm, relaxed atmosphere. The pub features in Robert Louis Stevenson's novel Kidnapped, in which two characters are carried across the Forth after an alleged tipple here. Q➤❀◑P🖨(6)🐾

Lower Largo

Railway Inn 🅛

1 Station Wynd, KY8 6BU

☎ (01333) 320239 ● railwayinnlargo.co.uk

5 changing beers (sourced regionally; often Born, Coul, Stewart) Ⓗ

A friendly and traditional public house that dates back to 1749. It rests in the shadow of the old railway viaduct in this picturesque village, with views of Largo harbour. The two-roomed pub is a little gem, warmed by a cosy real fire, with numerous items of railway memorabilia adorning the walls, fireplace and even the bar counter. It is a champion of LocAle and usually serves a beer from a Fife brewery. Outside is a secluded beer garden. Q➤❀🖨(95)🐾🛜

St Andrews

Criterion 🅛 ✅

99 South Street, KY16 9QW

☎ (01334) 474543 ● criterionstandrews.co.uk

5 changing beers (sourced nationally; often Caledonian, Coul, Stewart) Ⓗ

This small establishment dates from 1874, and is one of the few remaining family-run pubs in the area. On one of the town's main shopping streets, it is popular with locals, tourists, students and golfers. Five cask ales are served alongside a large selection of whiskies and gins. A locally sourced menu is offered, with the famous Cri Pies available all day. ➤❀◑🍴🐾🛜

Whey Pat Tavern ✅

1 Bridge Street, KY16 9EX

☎ (01334) 477740

Greene King IPA; 3 changing beers (often Inveralmond, Timothy Taylor) Ⓗ

The birthplace of the Kingdom of Fife Branch of CAMRA, this is a busy corner pub adjacent to the historic West Port and handy for the bus station. It is popular with the usual mix of locals, tourists, students and golfers found in the town. The building is on two levels, with a lively public bar at the front and a spacious lounge to the rear. ❀◑♿♣️🐾🛜

Strathkinness

Tavern

4 High road, KY16 9RS

☎ (01334) 850085 ● strathkinnesstavern.co.uk

2 changing beers (sourced nationally; often Cromarty, Stewart) Ⓗ

The Tavern is at the heart of the village, with an outdoor seating area giving wonderful views over the Eden estuary and north to the Grampian Mountains. Owned and run by the Wilkie family, it is renowned for its friendly hosts, excellent food and varying beer selection. Lunches and evening meals are served in the bar and restaurant, and traditional pub games played in the cosy lounge. Q➤❀◑♿♣️🖨(64,64A)🛜

Breweries

Beath SIBA

54 Foulford Road, Cowdenbeath, KY4 9AS ☎ 07792 369678 ● beathbrewing.com

⊛Beath began brewing in 2016, originally with a 20-litre capacity upgraded to 100-litre within a few months. There are plans for a further expansion. The beer range varies from week to week. LIVE

Mad World (ABV 4%) PORTER
Are You With Me (ABV 4.5%) BITTER
Ella Ella Ella (ABV 4.5%) SPECIALITY
Funky Town (ABV 5%) BITTER

Brew Shed

Wellheads House, Sandilands, Limekilns, KY11 3JD

☎ 07484 727672 ● brewshedbeers.wordpress.com

Brewing began in 2016 in a tiny brewery behind the owner's house, the first brewery in Limekilns since 1849. Brew Shed Beers revives a tradition of local breweries serving the neighbourhood.

Eden Mill

Main Street, Guardbridge, KY16 0UU ☎ 07786 060013 ● edenmill.com

⊛The brewery was established in 2012 using a five-barrel plant in part of the former Guardbridge paper mills. In 2014 a new 20-barrel plant and distillery was installed. Brewing is currently suspended. ♦️🛒LIVE

Futtle

Unit 2 The Bowhouse, St Monans, KY10 2FB ● futtle.com

Organic farmhouse brewery producing European-style beers. A 1,000-litre 'coolship' (a shallow, open fermentation vessel), has been installed in the rafters of the brewery.

Inner Bay SIBA

Seacliffe Villa, Hill Street, Inverkeithing, KY11 1AB ● innerbay.co.uk

Brewing began in 2016. Inner Bay is a family-run brewery using traditional ingredients and methods producing bottle-conditioned beers in small batches.

North Sea

15 Primrose Court, Rosyth, KY11 2TE

✉ info@northseabrewery.co.uk

A microbrewery based in Rosyth, supplying craft beer locally to Fife, Scotland.

Ovenstone 109 SIBA

Ovenstone Works, Ovenstone, Anstruther, KY10 2RR
☎ (01333) 311394 ⊕ ovenstone109.com

Established in 2018, Ovenstone 109 is a microbrewery in the East Neuk of Fife. The brewer aims to use renewable and sustainable technology in the brewing process.

St Andrews Brewing

Unit 7 Bassaguard Business Park, St Andrews, KY16 8AL
☎ (01334) 208586
⊕ standrewsbrewingcompany.com

Established in 2012, the brewery is a four-barrel plant producing bottle-conditioned, cask and eco keg beers. In addition to its own three outlets (two in St Andrews, and one in Dundee), beers are supplied to a number of supermarket chains, local retailers and outlets. ❸LIVE

Oatmeal Stout (ABV 4.5%) STOUT
Mocha Porter (ABV 6%) SPECIALITY
Notorious BIPA (ABV 6%) SPECIALITY
Yippie IPA (ABV 6%) IPA

SaltRock SIBA

Lochend Farm, Dunfermline, KY12 0RY
⊕ saltrockbrewing.co.uk

SaltRock Brewing began brewing in 2021. Born of a desire to re-awaken a celebration of malt over the hop, it produces malt-forward beers.

Commercial Inn, Dunfermline (Photo: Stuart McMahon)

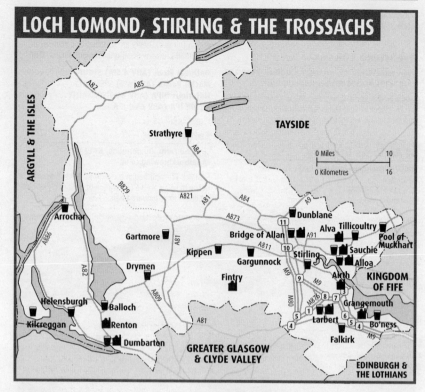

LOCH LOMOND, STIRLING & THE TROSSACHS

Alloa

Bobbing John ✔

46 Drysdale Street, FK10 1JL
☎ (01259) 222590
Belhaven 80/-; Greene King Abbot; Sharp's Doom
Bar; 2 changing beers (sourced regionally; often
Harviestoun, Hybrid, Williams Bros) Ⓗ
A Wetherspoon pub in a traditional three-storey
sandstone building, purpose-built in 1895 for the Alloa
Co-operative Society. It commemorates locally born John
Erskine, who developed the town as a coal-mining
centre in the early 18th century, and was nicknamed
Bobbing John due to his frequent changes of political
allegiance. Much of the building's original stonework has
been retained and a Victorian shopfront reintroduced.
There is a warming firepit in the centre.
Q ➤ ✿ ◑ ⅃ ♿ ♣ ♞ ♟ 🖶 ☂ 🛜

Arrochar

Village Inn ✔

Shore Road, G83 7AX (down A814 from A83 jct)
☎ (01301) 702279
5 changing beers (sourced nationally; often Fyne) Ⓗ
Picturesque inn that was built in 1827 as the local
manse, and offers views over Loch Long to the Arrochar
Alps. Its bar and restaurant are decorated in a traditional
Scottish country style. Five handpumps offer ales from a
variety of Scottish breweries. The large front lawn is a
pleasant spot to enjoy a beer overlooking the loch.
Accommodation is in 14 rooms. The pub is popular with
locals, day trippers, hill walkers and weekending tourists
staying at the inn due to its proximity to the Arrochar
Alps, and the Loch Lomond & the Trossachs National Park.
➤ ✿ ⅃ ◑ ⅃ ♿ ♠ ♟ 🖶 (926,976) ❀ 🛜

Balloch

Tullie Inn ✔

Balloch Road, G83 8SW
☎ (01389) 752052
3 changing beers (often Fyne, Loch Lomond) Ⓗ
Large establishment by Balloch Station and close to the
shores of Loch Lomond, offering food and up to
three real ales. Its modern decor and comfortable sofas
give it a bright and airy feel. In good weather you can
enjoy a drink in the patio alongside the pub or in the
large raised rear garden (alcoholic drinks are served after
11am). There is a separate dining area. Live music
features regularly. ➤ ✿ ⅃ ◑ ⅃ ♿ ♞ 🖶 🛜

Bo'ness

Corbie Inn

84 Corbiehall, EH51 0AS
☎ (01506) 825307 ⊕ corbieinn.co.uk
3 changing beers (sourced regionally; often Hybrid,
Kelburn, Tryst) Ⓗ

REAL ALE BREWERIES

Allanwater 🏠 Bridge of Allan
Devon 🏠 Sauchie
Harviestoun Alva
Hybrid Grangemouth
Lennox Dumbarton
Loch Lomond Renton
Mosaik 🏠 Fintry (NEW)
SLOPEmeisteR Airth
Tryst Larbert
Williams Bros Alloa

Community pub serving up to three ales, mainly from Scottish breweries plus a few from England. It has a large lounge area offering bar lunches and meals. Outside is a large covered beer garden with a pizza oven. The Corbie is involved with local charities and supports the Bo'ness Real Ale Society festival. it is handy for the Bo'ness & Kinneil Railway, Bo'ness Motor Museum and the Hippodrome, Scotland's oldest purpose-built picture house. Q☆☆●&P☷❀◆

Bridge of Allan

Allanwater Brewhouse
Queens Lane, FK9 4NY
☎ (01786) 834555 ⊕ allanwaterbrewhouse.co.uk
Allanwater Choc Pot 80/-, Gold Pot 70/-, Pot Black, Procrastination; 5 changing beers (sourced locally; often Allanwater) Ⓗ
The tap for Allanwater is a small working brewery and pub in one, tucked away behind the main street in the lovely Bridge of Allan. The barn-like L-shaped room has a low-lit interior with real fire and candles on the tables, providing a warm welcome to a mix of walkers, tourists, cyclists, locals and students. The decor includes hop pockets, breweriana, barrel seating and a collection of bottles. Brewery tours can be booked in advance.
Q☆▶☷◆☷❀◆

Drymen

Clachan Inn
2 The Square, G63 0BL
☎ (01360) 660824 ⊕ clachaninndrymen.co.uk
2 changing beers (sourced regionally; often Belhaven, Loch Lomond) Ⓗ
Popular free house that was established in 1734, making it Scotland's oldest licensed premises. It has recently been refreshed with many original features preserved. Two handpumps (one in winter) dispense an ever-changing selection of excellent local and Scottish beers. Quality food is served all day in the bar and restaurant. The pub welcomes dog owners, walkers on the West Highland Way and visitors to Loch Lomond & The Trossachs National Park. ☆☷●&▲☷(309)❀◆

Dumbarton

Captain James Lang Ⓛ ◆
97-99 High Street, G82 1LF
☎ (01389) 742112
Belhaven 80/-; Greene King Abbot; 3 changing beers (sourced nationally) Ⓗ
A former Woolworths store, this Wetherspoon pub has a light and open layout with a variety of seating options. It is named after the renowned captain of the paddle steamer Leven, which was built in the town. Pictures on the wall commemorate Woolworths, the locally built Cutty Sark and racing driver Sir Jackie Stewart, who was born nearby. A large beer garden at the rear overlooks the River Leven. Frequent trains and buses serve the area. Q☆☆●&⇌(Central)☷◆

Dunblane

Tappit Hen ♉ ◆
Kirk Street, FK15 0AL
☎ (01786) 825226 ⊕ thetappithen-dunblane.co.uk
Greene King IPA; 4 changing beers (sourced regionally; often Cromarty, Fyne, Stewart) Ⓗ
Taking its name from a type of Scottish pewter drinking vessel, this is a traditional one-room pub with a friendly atmosphere and knowledgeable staff. Refurbished in

2019 to an excellent standard, it is opposite one of Scotland's oldest cathedrals. The four guest beer pumps serve a regularly changing choice of ales. The pub hosts charity and community events plus an annual real ale festival. The railway station and car parking are both close by. ⇌☷❀◆

Falkirk

Wheatsheaf Inn ◆
16 Baxters Wynd, FK1 1PF
☎ (01324) 638282 ⊕ wheatsheaffalkirk.co.uk
2 changing beers (sourced nationally; often Cromarty, Hybrid, Tryst) Ⓗ
The town's oldest pub, dating from the late 18th century, is a must-visit venue off the High Street near the famous Falkirk Steeple. The wood-panelled bar is furnished in traditional style with plenty of interesting historical features, retaining much of its original character. Two guest beers come from breweries in Scotland and England. Outside at the rear is a secluded suntrap beer garden. ☆⇌(Grahamston)☷❀◆

Gargunnock

Gargunnock Inn
8 Main Street, FK8 3BW
☎ (01786) 860333 ⊕ gargunnockinn.co.uk
2 changing beers (sourced regionally; often Cromarty, Harviestoun, Redcastle) Ⓗ
An 18th-century building that has been extensively modernised to create a roomy yet cosy pub/restaurant. The bar room has original features, comfortable seating and two wood-burning stoves in winter. There is just one bar, with two handpumps serving at least one Scottish ale. Several separate dining areas offer an extensive menu of quality food. The pub hosts an annual beer festival on the second Sunday in August. Popular local walks abound. ☆☆●&P☷(X10)❀◆

Gartmore

Black Bull Hub & Pub
Main Street, FK8 3RW
☎ (01877) 382054 ⊕ blackbullgartmore.com
Harviestoun Schiehallion Ⓗ
A community-owned pub and hotel that is a hub of the area. The fine old building is largely unspoilt and comprises a warren of small rooms, including a cosy bar with a real fire, two dining rooms and a games room. It is mainly staffed by enthusiastic volunteers, supported by a chef and cellarman. A free shuttle bus service to and from two local campsites and Aberfoyle and Buchlyvie is available on request. Q☆☆☷●▲P☷(X10A)❀◆

Helensburgh

Ashton
74 West Princes Street, G84 8UG
☎ (01436) 675900
Stewart Pentland IPA; 2 changing beers (sourced nationally; often Fyne, Timothy Taylor) Ⓗ
A warm welcome awaits at this genuine local. The bar has been tastefully modernised and decorated with a nautical theme while retaining its original charm. There is a small room for playing darts. A changing selection of ales from Scottish microbreweries is complemented by quality English beers. Live music is a regular Saturday night feature. ⇌(Central)♣☷(1B,316)❀◆

Kilcreggan

Creggans

Princes Terrace, Shore Road, G84 0JJ
☎ (01436) 842700
2 changing beers (sourced nationally; often Fyne, Harviestoun) ⊞

Single-room pub that is ideally placed opposite the traditional wooden pier – a calling point for the paddle steamer Waverley and the small passenger ferry to Gourock. The bar has a wooden floor and a mix of tables and chairs, with a pool table and sports TV. Two beers are generally served. Pub food is available every day. Live music is hosted from time to time. The front patio offers fine views of the Firth of Clyde. ❀◑&🖶(316)🐾🎵

Kippen

Cross Keys

Main Street, FK8 3DN
☎ (01786) 870293 ⊕ kippencrosskeys.com
2 changing beers (sourced regionally; often Cromarty) ⊞

Attractive old coaching inn with a rustic feel – one of the oldest of its kind in Stirlingshire. A locals' pub with a traditional feel, it has low ceilings, wood-panelled walls and a wooden floor. Log fires warm the bar in winter and the beer garden has great views in summer. It is popular with walkers, cyclists, golfers and anglers. Ideal as a stopover whether travelling north or south, it is near Loch Lomond & the Trossachs National Park, with Stirling close by. Q❄❀🖾◑♣🖶(X10)🐾🎵

Larbert

Station Hotel ⊘

2 Foundry Loan, FK5 4AW
☎ (01324) 557186 ⊕ stationhotellarbert.com
3 changing beers (sourced nationally; often Brampton, Loch Lomond, Redcastle) ⊞

A popular local next to the railway station and on regular bus routes. It has a cosy lounge area and a large enclosed beer garden. Three cask ales are usually on offer and efforts are made to provide a variety of local, regional and national ales. Food is served daily. Large-screen TVs show sporting events. The pub is a supporter of CAMRA's Larbert Real Ale Festival in nearby Dobbie Hall in the spring. It prides itself on the help it gives to a number of community groups. ❄❀🖾◑&≢🖶🐾🎵

Pool of Muckhart

Inn at Muckhart ⊘

Pool of Muckhart, FK14 7JN
☎ (01259) 781324 ⊕ theinnatmuckhart.com
Devon Original (70/-), 24K IPA, Pride ⊞

Single-storey former coaching inn in a picturesque rural village on the south-east edge of the Ochil Hills. It has a friendly atmosphere with low ceilings, exposed timbers and a welcoming open fire. The Devon ales served are brewed at the inn's sister pub, the Mansfield Arms in Sauchie. The restaurant produces good food, attracting locals on winter weekends and tourists throughout the summer. There is a beer garden to the rear. Q❄❀🖾◑Å🖶(202)🐾🎵

Sauchie

Mansfield Arms ⊘

7 Main Street, FK10 3JR (in centre of village, 100yds from main road)
☎ (01259) 722020 ⊕ devonales.com

Devon Original (70/-) ⊞, **24K IPA** ⊞/🅖, **Pride** ⊞
A traditional two-bar pub and the oldest operating microbrewery in the county. It brews four Devon ales which are dispensed from three changing handpumps. Owned and run by the family, the pub is situated within an ex-mining community. The bar is popular with the locals, who enjoy lively banter. Families come to enjoy the food served in the comfortable lounge. Both beer and meals are excellent value for money. The pub is on the Stirling via Alloa circular bus route. Q❄❀◑&♣🖶🐾🎵

Stirling

Birds & Bees

Easter Cornton Road, FK9 5PB (off Causewayhead Rd)
☎ (01786) 473663 ⊕ thebirdsandthebees-stirling.com
3 changing beers (sourced locally; often Harviestoun, Stow, Williams Bros) ⊞

A welcoming converted rustic farmstead, located between the historic Wallace Monument and Stirling Castle, in a residential area on the northern outskirts. An award-winning gastro-pub, it serves locally sourced food. Three handpumps offer a variety of quality Scottish real ales. Outside, there are two large, well-maintained beer gardens, with a barbecue area in the courtyard and a pétanque pitch. This popular pub attracts a good mix of regulars and tourists. Q❄❀◑&♣🖶(C30)🐾🎵

Settle Inn

91 St Marys Wynd, FK8 1BU
3 changing beers (sourced regionally; often Alechemy, Hybrid, Stewart) ⊞

Warm, friendly and atmospheric inn frequented by a mix of locals, students and tourists. Situated on a hill descending from Stirling Castle, it was built in 1733 and is the oldest pub in the city. It lives up to its name: settle down in front of the cosy fire and you may not want to leave – ghosts or no ghosts. There is music on Monday, Wednesday, Friday and Saturday evenings, and a quiz on Sunday. The pub hosts an annual beer festival. Q❄≢♣🖶🐾🎵

Strathyre

White Stag Inn

Main Street, FK18 8NA
☎ (01877) 384333 ⊕ thewhitestag.co.uk
3 changing beers (sourced regionally; often Ardgour, Fyne, Loch Lomond) ⊞

A cosy pub that serves meals in its bar and bistro, all made with local produce. The beers are mainly from small independent Scottish brewers. Dogs and children are welcome in the bar. Hill walking, fishing, golf and watersports opportunities are all close at hand, and Stirling, Callander and the Trossachs are within easy travelling distance. Accommodation is available on-site. Opening hours are reduced in winter – check before setting out. Q❄❀🖾Å♣🖶🐾🎵

Tillicoultry

Royal Arms

2 High Street, FK13 6AE
☎ (01259) 753037
3 changing beers (sourced nationally; often Greene King, Theakston, Timothy Taylor) ⊞

Popular drinks-only pub with an enthusiastic owner, catering mainly for locals but welcoming to visitors. It has a dartboard, large sports TVs and a fruit machine. It is furnished with bar stools and comfortable seating, and warmed by a log-burner in the Victorian fireplace. The

three handpumps dispense changing beers. A quieter side room with service via a small counter is ideal for families. The pub is well served by regular bus routes to Stirling and Alloa. ♿♣🚌(52,C2)👜🅿️🛜

Breweries

Allanwater

🏠 Queens Lane, Bridge of Allan, FK9 4NY
☎ (01786) 834555 ☎ 07831 224242
⊕ allanwaterbrewhouse.co.uk

☺Originally named Tinpot and then Wash House, the brewery was established in 2009 using a one-barrel plant designed to brew speciality beer. From 2018 all beers and branding are under the Allanwater Brewhouse name. The beer range varies depending on season and demand, which is increasing every year. ‼🍽♦LIVE

Black Wolf

Unit 7c, Bandeath Industrial Estate, Throsk, Stirling, FK7 7NP
☎ (01786) 437187 ⊕ blackwolfbrewery.com

☺Established in 2005, the brewery is located in a former torpedo factory on the shores of the River Forth. In 2014 the brewery changed its name from Traditional Scottish Ales to Black Wolf Brewery and rebranded its range of beers. All Black Wolf beers are brewed on demand all year round at Throsk. The brewery also bottles beers for other breweries. Currently no cask ales are being produced but this may change in the future. ♦

Devon

🏠 Mansfield Arms, 7 Main Street, Sauchie, FK10 3JR
☎ (01259) 722020 ⊕ devonales.com

☺Named after the nearby River Devon and the former Devon colliery, the brewery was established in 1992 and run by the Gibson family to supply their two pubs, the Mansfield Arms, and the Inn at Muckhart. Beer is also available to the free trade. ‼

Harviestoun SIBA

Alva Industrial Estate, Alva, FK12 5DQ
☎ (01259) 769100 ⊕ harviestoun.com

Harviestoun has grown from one-man brewing in a bucket in the back of a barn in 1983, to a 60-barrel, multi award-winning brewery today. Now based in Alva, Scotland. Two cask ales produced all year round and monthly rotational ales. ‼🍽♦LIVE

Bitter & Twisted (ABV 3.8%) GOLD
Refreshingly hoppy beer with fruit throughout. A bittersweet taste with a long, bitter finish. A golden session beer.

Schiehallion (ABV 4.8%) SPECIALITY
A Scottish cask lager, brewed using a lager yeast and Hersbrucker hops. A hoppy aroma, with fruit and malt, leads to a malty, bitter taste with floral hoppiness and a bitter finish.

> Give my people plenty of beer, good beer and cheap beer, and you will have no revolution among them.
> **Queen Victoria**

Hybrid SIBA

Unit 14C, Abbotsinch Industrial Estate, Abbotsinch Road, Grangemouth, FK3 9UX ☎ 07854 288685
⊕ hybridbrewing.com

Hybrid began brewing in 2016 using a 10.5-barrel dual train brewplant, allowing for two different beers to be brewed at a time. Up to 40 outlets are supplied direct, mostly in the Forth Valley. A number of core beers are brewed, with seasonal and special beers throughout the year. The pandemic has driven Hybrid to not only produce bottle-conditioned beers but also an effective local delivery service for bottles and mini kegs. All beers are now vegan-friendly. ♦V

Sesh (ABV 3.6%) BITTER
Groat (ABV 3.8%) GOLD
GTF (ABV 4%) PALE
Apex (ABV 4.1%) BITTER
Hindsight (ABV 4.4%) BITTER
Citra Storm (ABV 4.5%) BITTER
Lost Angel (ABV 4.6%) BLOND
Magic Porridge (ABV 4.7%) STOUT
Street Legal (ABV 4.7%) BITTER

Lennox

25 Lime Road, Dumbarton, G82 2RP
☎ (01389) 298642 ☎ 07709 192168

Office: 62 Glencairn Road, Dumbarton, G82 4DW
⊕ lennoxbrewery.com

Established in 2018 and brewed on the banks of the River Leven, inspired by the rich local history of the area and the raw ingredients that the local countryside provides. All the beers use as many locally-sourced ingredients as possible. Expansion took place in 2020.

Sons Pale Ale (ABV 4%) PALE
Golden Ale (ABV 4.6%) GOLD

Loch Lomond SIBA

Vale of Leven Industrial Estate, Unit 11, Block 2, Renton, G82 3PD
☎ (01389) 755698 ☎ 07891 920213
⊕ lochlomondbrewery.com

☺Established in 2011 by Fiona and Euan MacEachern, Loch Lomond was the first brewery to be established in the area. Having reached brewing capacity at its original site, it moved to a new purpose-built 35-hectolitre brewery, which also houses a canning line. 🍽♦LIVE

West Highland Way (ABV 3.7%) BITTER
A light ale with fruity flavours.
Bonnie & Blonde (ABV 4%) BITTER
Maris Otter and Caragold malts give a light, refreshing ale and a blend of hops produces a well-rounded citrus flavour.
Southern Summit (ABV 4%) BLOND
The palate is fresh and fruity, with hints of grapefruit and lemon which lead on to a crisp, light bitter finish.
The Ale of Leven (ABV 4.5%) BITTER
An amber ale with spicy citrus aroma and a well-rounded bitterness, it seems to please most palates.
Bonnie 'n' Clyde (ABV 4.6%) BITTER
A wonderful amber ale with a big citrus hit on the nose that follows through to the rich, bitter finish.
Silkie Stout (ABV 5%) STOUT
Award-winning black stout with chocolate-orange spicy notes.
Kessog Dark Ale (ABV 5.2%) BITTER
Dark with warm spicy flavours.
Bravehop Amber IPA (ABV 6%) IPA
Up-front hop bite and lots of sweetness to give balance.

SCOTLAND

Bravehop Dark IPA (ABV 6%) IPA
A black IPA with upfront hop bite balanced with roasted malt and a long, dry, bitter finish.

Mosaik (NEW)

🏠 Fintry Inn, 23 Main Street, Fintry, G63 0XA
☎ 07970 473601 ⊕ fintryinn.co.uk/mosaik-brewing

Mosaik Brewing is a microbrewery based at the Fintry Inn.

SLOPEmeisteR

Oak House, Airth Castle Estate, Airth, FK2 8JF
☎ 07895 734867 ⊕ slopemeister.com

SLOPEmeisteR started brewing in 2018, initially at Hybrid Brewery in Grangemouth, then setting up a nanobrewery in a garage in Airth. Cask-conditioned beer is supplied to festivals. SLOPEmeisteR purchased brewing equipment from the now closed Kinneil Brewery.

Strangers (NEW)

Narrowboat Farm, Linlithgow, EH49 6QY
⊕ strangersbrewing.co.uk

Commencing brewing in 2022, Strangers Brewing Co brew hand-crafted beer in small batches from quality local ingredients. Three core beers are available in cans, as well as seasonal specials that take their flavours from what's growing on the farm and the surrounding Scottish countryside.

Tryst

Lorne Road, Larbert, FK5 4AT

☎ (01324) 554000 ⊕ trystbrewery.co.uk

The brewery started production in 2003. A large range of beers is available, in cask and bottle. Beers for Clockwork Beer Co are also produced. ‼️ 🍴 ♦ LIVE

Brockville Pale (ABV 3.9%) PALE
Hop Trial (ABV 3.9%) BITTER
Carronade Pale Ale (ABV 4.2%) PALE
Drovers 80/- (ABV 4.3%) OLD
Chocolate and Coconut Porter (ABV 4.4%) PORTER
Double Chocolate Porter (ABV 4.4%) SPECIALITY
Sherpa Porter (ABV 4.4%) PORTER
German Hops Pils (ABV 4.5%) SPECIALITY
V.I.P (ABV 4.5%) BITTER
RAJ IPA (ABV 5.5%) IPA

Williams Bros SIBA

New Alloa Brewery, Kelliebank, Alloa, FK10 1NT
☎ (01259) 725511 ⊕ williamsbrosbrew.com

☺A brotherhood of brewers, creating unique beers. Bruce and Scott Williams started brewing Heather Ale in 1988. A range of indigenous, historic ales have been added since. Three cask ales are produced all year round. The ales are regularly found in pubs in Central Scotland. ‼️ 🍴 ♦

Fraoch Heather Ale (ABV 4.1%) SPECIALITY
The unique taste of heather flowers is noticeable in this beer. A fine floral aroma and spicy taste give character to this drinkable speciality beer.

Birds & Bees (ABV 4.3%) GOLD
Joker IPA (ABV 5%) PALE

Tutankhamun's ale

In July 1996 one of London's most famous department stores, Harrods of Knightsbridge, was the unlikely setting for the launch of a new beer. But this was no ordinary beer. Brewers and scientists had combined their skills to create an ale from Ancient Egypt, and Harrods, owned by the Egyptian al-Fayed brothers, was the ideal setting in which to present this remarkable link with the Old World.

Against a backdrop of Egyptian artefacts and with Mr Mohammed al-Fayed dressed in a fetching Pharoah's head-dress, the world's media converged on Dr Delwen Samuel as she presented them with bottles of Tutankhamun's Ale. It is not often that someone engaged in the rare field of archaeo-botany appears on the main television news or the pages of the tabloid press, but Dr Samuel, a Canadian from Montreal carrying out research at Cambridge University, was talking about a topic dear to journalists' hearts: beer.

Tutankhamun's Ale was the result of years of painstaking research by archaeologists, archaeo-botanists, Egyptologists and brewers. The end result not only gave us a glimpse of what beer from the Old World may have tasted like but it also deepened our knowledge of life in those days, the importance of beer to those societies and its role in turning nomadic people into settled communities. Until Dr Samuel and her colleagues from the Egypt Exploration Society at Cambridge University presented their recreation of Egyptian ale, the received wisdom of historians was that beer had been a bi-product of bread making in the Old World. Now history was turned on its head. It was beer, not bread, that came first, and it was alcohol that had convinced the ancients to stop wandering the fertile valleys of the Nile and the Euphrates, and settle down to grow grain.

Roger Protz, The Taste of Beer, Weiden feld, 1998.

NORTHERN ISLES

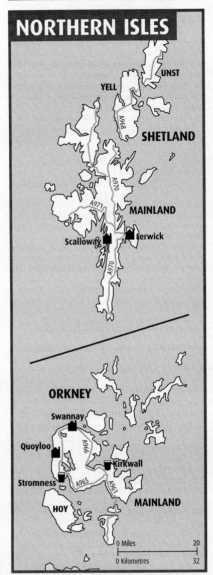

UNST

YELL

A968

SHETLAND

A970

A971

MAINLAND

A970

Scalloway · Lerwick

ORKNEY

Swannay

Quoyloo

A966

Kirkwall

Stromness

A965

A961

MAINLAND

HOY

0 Miles 20
0 Kilometres 32

Kirkwall: Orkney

Auld Motor Hoose

26 Junction Road, KW15 1AB
☎ (01856) 871422
Swannay Scapa Special Ⓗ

A friendly motor-themed pub with a single bar room, featuring lots of motoring memorabilia and with car parts scattered throughout. The jukebox tends to blast out rock classics. There is regular live music, mainly at weekends, and the pub is one of the venues for the Orkney Rock Festival. Outside, the patio has a smoking area. The pub is the sister bar to the Torvhaug in Bridge Street, and is convenient for the bus station. Two-time local CAMRA Pub of the Year. ⊛&♠♣🚽(X1)🐾🅿🛜

Ayre Hotel

Ayre Road, KW15 1QX
☎ (01856) 873001 ⊕ ayrehotel.co.uk

Swannay Scapa Special Ⓗ

The recently refurbished restaurant and bar is now renamed the Orcadian Restaurant & Bar and has a smart, modern look. Overlooking Kirkwall harbour, the oldest part of the hotel dates back to 1791 and it was a Temperance Hotel between 1885 and 1938. The dinning area has a conservatory and booking is strongly advised. Lunches and evening meals use Orkney beef, fish and other produce. The hotel is close to bus station and the ferries to the outer isles of Orkney. 🛏🍴◑&♠♣🅿🚽🛜

Bothy Bar (Albert Hotel)

Mounthoolie Lane, KW15 1HW (lane connecting Junction Lane and Bridge St)
☎ 0800 050 9037 ⊕ hotelorkney.co.uk
Orkney Corncrake; Swannay Scapa Special; 2 changing beers (sourced locally; often Orkney, Swannay) Ⓗ

Popular town-centre local that was damaged by fire a few years ago and has been rebuilt using many of the original materials. It now has more space than before, and features intimate alcoves plus a roaring fire for winter. It is frequented by locals and after-work drinkers, and is a fixture of the weekend circuit. A premium is charged for half pints. The pub is handy for buses, North Isles ferries and the shops. The historic St Magnus Cathedral is close by. May close Monday and Tuesday. 🛏◑♠🚽🛜

Helgi's Bar

14 Harbour Street, KW15 1LE (right by harbour)
☎ (01856) 879293 ⊕ helgis.co.uk
Swannay Scapa Special; 2 changing beers (sourced locally; often Swannay) Ⓗ

Converted from a former shipping office, this small, smart bar has the look of a modern café with wood panelling and a floor of local stone. Special nights where food is matched with ales are a highlight. Regular music sessions and a weekly Thursday quiz night are also hosted. Set on the harbour front where seafood is landed daily, this is a handy place to fill in time before island hopping on the many ferries to outlying parts. Local CAMRA Pub of the Year 2022. May close Monday and Tuesday. ◑&♠🚽🛜

St Ola Hotel

Harbour Street, KW15 1LE
☎ (01856) 875090 ⊕ stolahotel.co.uk
Swannay Scapa Special; 1 changing beer (sourced locally; often Swannay) Ⓗ

Built overlooking the harbour on the site of the Inns of Sinclair dating back to the 14th century, the Ola is a short walk from all of Kirkwall's attractions. It has a traditional public bar complete with a roaring fire in winter and a larger lounge to the rear where food is served. Ales are available in both bars along with an extensive range of whiskies. There are frequent Sunday music sessions. ⊛🛏◑&♠♣🚽🐾🛜

Stromness: Orkney

Ferry Inn

10 John Street, KW16 3AD (directly across from ferry terminal)
☎ (01856) 850280 ⊕ ferryinn.com

SCOTLAND

REAL ALE BREWERIES

Lerwick ✐ Lerwick: Shetland
Orkney ✐ Quoyloo: Orkney
Swannay Orkney: Swannay
Wreck Creation Shetland: Scalloway (NEW)

Swannay Scapa Special; 2 changing beers (sourced locally; often Orkney, Swannay) ⊞
An easy walk from the harbour front, the Ferry reopened in spring 2022 following refurbishment of rooms including the kitchens. It is popular with locals and visitors, notably divers who come to Orkney to explore the sunken German fleet at Scapa Flow. Annual folk and blues festivals are held, featuring a marquee that houses an ale pump. The pub is handy for buses to Kirkwall and the mainland ferry from Scrabster. Nearby attractions include the Ring of Brodgar stone circle and Skara Brae prehistoric village. A previous local CAMRA Pub of the Year winner. May not open till 4pm – best phone to confirm. ⊛✍◑Å♣♇⌨♨♀

Breweries

Lerwick SIBA

Staneyhill, North Road, Lerwick, Shetland, ZE1 0NA
☎ (01595) 694552 ☎ 07738 948336
⊕ lerwickbrewery.co.uk

Lerwick Brewery was established in 2011 using a 12-barrel plant and sits at the very edge of the North Atlantic. Originally only brewing keg beer, a cask-conditioned range was launched in 2015. ✉♦⟐

Skipper's Ticket (ABV 4%) BITTER
Azure (ABV 4.3%) GOLD
Refreshing, grapefruity/peachy, hoppy, golden bitter.
Lerwick IPA (ABV 5%) PALE
Grapefruity hoppy bitter with a slight biscuit background.
Tushkar (ABV 5.5%) STOUT
Very good, dark brown, roasted malty stout with chocolate, coffee and liquorice.

Orkney SIBA

Orkney Brewery, Quoyloo, Orkney, KW16 3LT
☎ (01667) 404555 ☎ 07721 013227

Office: Sinclair Breweries Ltd, Cawdor, IV12 5XP
⊕ orkneybrewery.co.uk

⊛Orkney was established in 1988 in an old village school building. Having incorporated sister brewery Atlas, it moved next door in 2010 to enable an increase in capacity and the completion of an award-winning visitor centre in 2012. ⊪✉♦⟐

Raven (ABV 3.8%) BITTER
A well-balanced, quaffable bitter. Malty fruitiness and bitter hops last through to the long, dry aftertaste.
Dragonhead (ABV 4%) STOUT
A strong, dark, roasted malt aroma flows into the taste. The roast malt continues to dominate the aftertaste, and blends with chocolate to develop a strong, dry finish.
Northern Light (ABV 4%) BITTER
A well-balanced clean and crisp amber ale with a good mix of malt, citrus and hops in the taste and an increasing bitter aftertaste.
Red MacGregor (ABV 4%) BITTER
This tawny red ale has a well-balanced mix of red fruit, malt and hops. Slight sweetness throughout.
Corncrake (ABV 4.1%) GOLD
A straw-coloured beer with soft citrus fruits and a floral aroma.
Puffin Ale (ABV 4.5%) BITTER
Dark Island (ABV 4.6%) MILD
A sweetish roast chocolate malt taste leads to a long-lasting roasted, slightly bitter, dry finish. Winning many awards.
Skull Splitter (ABV 8.5%) BARLEY

Intense, velvet malt nose with hints of apple, prune and plum. Hoppy taste is balanced by satiny smooth malt with sweet, fruity, spicy edges. Long, dry finish, with a hint of nut.

Brewed under the Atlas Brewery name:
Lattitude (ABV 3.6%) SPECIALITY
This straw-coloured lager has a light citrus taste with a smack of hops and grapefruit in the light bitter finish.
Three Sisters (ABV 4.2%) BROWN
Malt, summer fruits and caramel in the nose and blackcurrant in the taste, followed by a short, hoppy, bitter finish.
Wayfarer (ABV 4.4%) SPECIALITY
Full of citrus fruits and hops with a bitter finish.
Golden Amber (ABV 4.5%) SPECIALITY
Refreshing hops, honey, marmalade and grapefruit to the fore with a dry, hoppy finish.
Blizzard (ABV 4.7%) SPECIALITY
Light on malts and hops with ginger and spices coming through.
Nimbus (ABV 5%) BITTER
A full-bodied golden beer using some wheat malt and three types of hops. Sweet and fruity at the front, it becomes slightly astringent with lasting fruit and a pleasant, dry finish.

Swannay SIBA

Birsay, Swannay by Evie, Orkney, KW17 2NP
☎ (01856) 721700 ⊕ swannaybrewery.com

⊛Brewing began in 2006 at the redundant Swannay dairy on Orkney mainland's exposed North-Western tip. Two brewing plants are utilised, a five and a twenty barrel. Founder Rob is assisted by son Lewis plus a further small team of passionate beer lovers. ⊪✉♦

Orkney Best (ABV 3.6%) GOLD
A refreshing, light-bodied, low-gravity golden beer bursting with hop, peach and sweet malt flavours. The long, hoppy finish leaves a dry bitterness.
Island Hopping (ABV 3.9%) GOLD
Passionfruit hoppiness with some caramel with a lasting bitter aftertaste.
Dark Munro (ABV 4%) MILD
The nose presents an intense roast hit which is followed by plums and blackcurrant in the mouth. The strong roast malt continues into the aftertaste.
Scapa Special (ABV 4.2%) BITTER
A good copy of a typical Lancashire bitter, full of bitterness and background hops, leaving your mouth tingling in the lingering aftertaste.
Sneaky Wee Orkney Stout (ABV 4.2%) STOUT
Bags of malt and roast with a mixed fruit berry background. Dry, bitter finish.
Pale Ale (ABV 4.7%) PALE
Orkney IPA (ABV 4.8%) PALE
A traditional bitter, with light hop and fruit flavour throughout.
Duke IPA (ABV 5.2%) PALE
Good, refreshing, citrus-fruited IPA with background malt.
Orkney Blast (ABV 6%) BITTER
Plenty of alcohol in this warming strong bitter/barley wine. A mushroom and woody aroma blossoms into a well-balanced smack of malt and hop in the taste.

Wreck Creation (NEW)

Scalloway Public Hall, Berry Road, Scalloway, Shetland, ZE1 0UJ
☎ (01595) 880884 ✉ wreckcreation@outlook.com

Small batch microbrewery established in 2021 in Shetland producing two bottled beers. LIVE

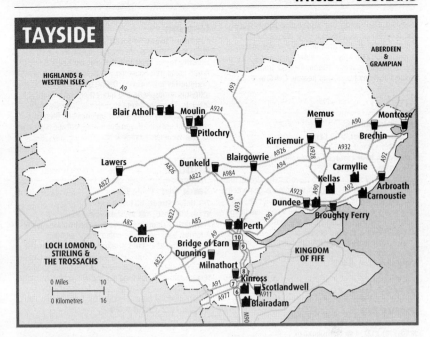

SCOTLAND

Arbroath

Corn Exchange L ✔
14 Olympic Centre, Market Place, DD11 1HR
☎ (01241) 432430
**Belhaven 80/-; Greene King Abbot; Sharp's Doom
Bar; 4 changing beers (sourced nationally; often
Redcastle, Stewart)** ⊞
A Wetherspoon pub in the former 19th-century corn
exchange just off the High Street. It is largely open plan
but has a number of booths that give some privacy. A
varied selection of real ales is always on offer, with
alcoholic drinks served from 11am. Boat trips offering
fishing or a visit to the 200-year-old Bell Rock lighthouse
are available from the nearby harbour. ⏱✿❶❺⚲☂

Blair Atholl

Atholl Arms Hotel L
PH18 5SG
☎ (01796) 481205 ⊕ athollarmshotel.co.uk
**Moulin Light, Braveheart, Ale of Atholl, Old
Remedial** ⊞
The Atholl Arms has a grand and imposing façade in the
Victorian Highland style. Its characterful Highland Bothy
Bar serves four ales produced by the local Moulin
Brewery, and offers freshly cooked food throughout the
day. Blair Atholl and the surrounding area is a popular
destination for walking, climbing, biking and sightseeing.
The Bothy Bar's opening hours may be reduced in the off
season but ales can be brought through to the lounge
bar. Q⏱✿❶◐❺▲⇌➁(M91,87)♣☂

Blairgowrie

Ericht Alehouse
13 Wellmeadow, PH10 6ND
☎ (01250) 872469
6 changing beers (sourced nationally) ⊞
Classic town-centre pub with a friendly atmosphere,
close to the River Ericht. There are two seating areas
separated by a well-stocked bar offering a wide range of

ever-changing ales and ciders, plus a number of Scottish
gins, malts and rums. No food is available but customers
are welcome to bring their own. A winner of local CAMRA
Pub of the Year several times during the current
landlord's tenure of more than two decades.
Q✿♣❶◐❺✿☂

Fair O'Blair L ✔
25-29 Allan Street, PH10 6AB
☎ (01250) 871890
**Belhaven 80/-; Greene King Abbot; 4 changing beers
(sourced regionally; often Redcastle, Stewart)** ⊞
Town-centre Wetherspoon run by a real ale enthusiast. It
has a small beer garden to the rear on two levels, the
lower of which is accessible by wheelchair. The pub is
near the Wellmeadow, a grassy triangular plot that has
been a venue for markets and outdoor entertainment
since 1824. Alcoholic drinks are served from 11am.
⏱✿❶◐❺♣⇌(57)☂

Stormont Arms L
101 Perth Street, PH10 6DT
☎ (01250) 873142
**1 changing beer (sourced regionally; often Kelburn,
MòR)** ⊞
Real ale is served from two handpulls in this traditional
Scottish two-roomed pub, with local and Scottish brews

REAL ALE BREWERIES

71 Brewing ✒ Dundee
Blunt Chisel Blairadam
Cullach ✒ Perth
Inveralmond Perth
Law Dundee
Loch Leven Kinross
MòR Kellas
Moulin ▤ Moulin
Nat 20 Comrie (NEW)
Redcastle Carmyllie
Shed 35 Carnoustie
Wasted Degrees ✒ Blair Atholl

featuring. The friendly bar has wooden bench seating and a dartboard, and hosts a darts league during the week. A small seating area outside includes space for smokers. The pub may close early if quiet so check before travelling. It is a 10-minute walk from the town centre but many buses stop nearby. Q♣☐🚃❀🕏

Brechin

Brechin Arms

44 St David Street, DD9 6EQ
☎ (01356) 625405
1 changing beer (sourced regionally; often Orkney, Stewart) Ⓗ

A small, family-run pub in the town's main street. The clientele is mixed, and a warm welcome is guaranteed. The cosy interior features a lounge and quiet alcoves within easy access from the bar. The single handpump serves a regularly changing real ale, most often from Stewart Brewing. Brechin has historically been described as a city due to its impressive cathedral, and is also the home of the private Caledonian Railway.
&≠(Caledonian) ♣❀🕏

Bridge of Earn

Cyprus Inn Ⓛ

Back Street, PH2 9AB
☎ (01738) 812313 ⊕ cyprusinn.co.uk
1 changing beer (sourced locally; often Loch Leven, MòR) Ⓗ

A friendly wee pub with a great community atmosphere. It has a cosy bar area with fixed bench seating and a low ceiling, a separate lounge/function room and a large beer garden. The inn dates back to around 1790 and is a category C-listed building. Original rings on external walls for tying up horses are now used by cyclists. There is only one handpull but the next cask is always tapped ready for a quick changeover. Q☎❀P☐❀🕏

Broughty Ferry

Fisherman's Tavern Ⓛ

12-16 Fort Street, DD5 2AD
☎ (01382) 775941 ⊕ fishermanstavern-broughtyferry.co.uk
Greene King IPA; 5 changing beers (sourced nationally; often Belhaven) Ⓗ

Licensed since 1857, this famous hostelry was originally three fishermen's cottages, later converted into a small hotel. The bar is to the right of the entrance, and a snug is to the left, leading to the dining room/lounge, warmed by a real fire. The lounge to the rear has wheelchair access from Bell's Lane. This Belhaven managed house serves ales from breweries all around the UK. It hosts an annual beer festival in July.
☎❀🏠◑&≠❀🕏

Jolly's Hotel Ⓛ ✔

43a Gray Street, DD5 2BJ
☎ (01382) 734910
Belhaven 80/-; Greene King Abbot; Sharp's Doom Bar; 3 changing beers (sourced nationally; often Redcastle) Ⓗ

Named after John Jolly, its proprietor for two decades in the late 19th century, this Wetherspoon hotel has expanded considerably over the years. It features two large areas, one for drinking and dining, the other principally for dining. The numerous handpulls dispense a wide selection of ales to a mixed clientele; alcohol is served from 11am. The TV screens are usually muted. An outdoor patio area has a number of tables.
☎❀🏠◑&≠☐(73) 🕏

Ship Inn

121 Fisher Street, DD5 2BR
☎ (01382) 779176 ⊕ theshipinn-broughtyferry.co.uk
Timothy Taylor Landlord; 2 changing beers Ⓗ

A traditional free house on the waterfront, with views over the Tay towards Fife. Dating back to 1847, this cosy retreat is atmospheric and interesting, with nautical features. Three well-kept real ales are usually available. A range of tasty bar meals is on offer and there is a restaurant upstairs. Pavement seating outside is pleasant for fine weather. 🏠◑❀❀🕏

Dundee

Bank Bar Ⓨ Ⓛ ✔

7-9 Union Street, DD1 4BN
☎ (01382) 205037 ⊕ thebankbardundee.com
Fyne Jarl; 3 changing beers (sourced nationally) Ⓗ

A former bank with bare-board floors, wooden furnishings and a series of alcoves with tables, in the tradition of older Scottish city pubs. Three or four ales are usually available, and excellent home-cooked food is served until early evening every day. Quality live music features on most Friday and Saturday nights. The rail station and local buses are close by. Local CAMRA Pub of the Year 2022. ☎❀◑≠☐❀🕏

Counting House Ⓛ ✔

67-71 Reform Street, DD1 1SP
☎ (01382) 225251
Belhaven 80/-; Greene King Abbot; Sharp's Doom Bar; 4 changing beers (sourced nationally; often Redcastle, Stewart) Ⓗ

City-centre pub that was once a branch of the Royal Bank of Scotland, having first opened as a bank in 1856. It is smaller than most Wetherspoon outlets, and gets busy at peak times, but still offers a good selection of ales. Its location on the scenic Albert Square make it an ideal place to stop off for a few beers. Alcoholic drinks are served from 11am. ❀◑&≠☐❀🕏

Phoenix

103 Nethergate, DD1 4DH
☎ (01382) 200014
Caledonian Deuchars IPA; Timothy Taylor Landlord; 3 changing beers (sourced nationally; often Greene King, Morland, Orkney) Ⓗ

One of Dundee's oldest pubs, this traditional inn has a great atmosphere. It is warm and cosy, like pubs used to be, with subdued lighting, sturdy wooden tables and chairs, green leather benches and a rare Ballingall Brewery mirror contributing to its character. Five ales are on offer, along with excellent pub food at sensible prices. The location is handy for the Rep Theatre, Dundee Contemporary Arts and Bonar Hall. ◑≠☐(73)❀🕏

Speedwell Bar (Mennies) ★ Ⓛ ✔

165-167 Perth Road, DD2 1AS
☎ (01382) 667783
3 changing beers (sourced nationally) Ⓗ

Built in 1903 for James Speed, this pub is known as Mennies after the family who ran it for more than 50 years. The L-shaped bar is divided by a part-glazed screen and has a magnificent mahogany gantry and counter, dado-panelled walls and an anaglypta Jacobean-style ceiling. There are usually three ales to choose from, alongside a selection of Belgian bottled beers and around 150 malt whiskies. ☐❀🕏

Dunkeld

Perth Arms

High Street, PH8 0AJ

☎ (01350) 727270

Moulin range; 2 changing beers (sourced regionally; often Loch Lomond, Stewart, Wasted Degrees) 🖫

Cosy one-room establishment serving a mix of locals and tourists. This friendly inn has been in the same family for almost 50 years and is the area's oldest trading pub, dating back to 1795. Its two handpulls dispense ales mostly from Scottish breweries. The beer garden at the back has an area for smokers. ☎⊛◖▯➤❀☂

Dunning

Kirkstyle Inn ✔

Kirkstyle Square, PH2 0RR

☎ (01764) 684248 ⊕ thekirkstyleinn.co.uk

House beer (by Marston's); 2 changing beers (sourced nationally) 🖫

A traditional village inn dating from 1760, overshadowed by the Norman steeple of St Serf's Church, home to the ancient Dupplin Cross and other Pictish relics. One or two ales in the cosy public bar come from a variety of Scottish independents, as well as English and Welsh regional breweries. The pub also serves a house beer, Risky Kelt. There is a separate restaurant. ☎⊛⌂◖▯➤(17)❀☂

Kirriemuir

Airlie Arms 𝕃

St Malcolm's Wynd, DD8 4HB

☎ (01575) 218080 ⊕ airliearms.net

2 changing beers (often Burnside, MòR, Redcastle) 🖫

A large 18th-century establishment that has gone from strength to strength since 2015, when it was reopened by a local family following substantial renovation. Real ale made a welcome appearance, and the bar's two handpulls offer a good selection of beers. Food is served in the bar at most times of day, and also in the restaurant at weekends. Accommodation is available.
☎⊛⌂◖♣P▯❀☂

Lawers

Ben Lawers Hotel

Loch Tay, PH15 2PA

☎ (01567) 820436 ⊕ benlawershotel.co.uk

2 changing beers (sourced regionally; often Tempest) 🖫

In the heart of one of Scotland's most beautiful and accessible unspoilt areas, this small hotel provides fantastic views over Loch Tay. It is popular with walkers, having the Ben Lawers mountain range, including numerous Munros, on its doorstep. Its handpulls serve Tempest ales, alongside a selection of the brewery's bottled and canned beers, plus Helles lager. Good food and accommodation are offered. Closed in January, and on Tuesdays and Wednesdays in winter.
☎⊛⌂◖P❀☂

Memus

Drovers Inn 𝕃

DD8 3TY

☎ (01307) 860322 ⊕ the-drovers.com

Timothy Taylor Landlord; 1 changing beer (often Harviestoun, MòR) 🖫

In a rural setting just north of Forfar and handily placed for the Angus Glens, the Drovers is a traditional Scottish inn with a contemporary look. An old range fire in the bar adds to the atmosphere, especially on chilly days. Two ales are usually served, and excellent food is available daily, featuring locally sourced seasonal produce. There is a large outdoor dining area under the trees, with an adjoining play area for children. Q☎⌂⊛◖P❀☂

Milnathort

Village Inn

36 Wester Loan, KY13 9YH

☎ (01577) 863293

2 changing beers (sourced regionally) 🖫

Friendly local with a semi open-plan interior featuring classic brewery mirrors and local historical photographs. The comfortable lounge has low ceilings, exposed joists and stone walls, and the bar is warmed by a log fire. The pub has been family owned since 1985 and usually serves three beers, mostly locally sourced. Milnathort links some great cycling routes through the Ochils, via Burleigh Castle, to the more leisurely Loch Leven Heritage Trail. ⊛&♣▯❀☂

Montrose

Market Arms 𝕃

95 High Street, DD10 8QY

☎ (01674) 673384

2 changing beers (sourced regionally; often Harviestoun, MòR, Orkney) 🖫

Busy town-centre pub that provides a comfortable retreat for its wide mix of customers. Two handpulls are sited on a long bar near the entrance in the main open area. Several TVs show live sport, and there is a snug at the front for those wishing to enjoy a quiet pint. Beers are mostly from Scottish brewers. Convenient for visitors to the nearby Montrose Air Station Heritage Centre.
⊛◖&▲⇌▯(x7) ❀☂

Moulin

Moulin Inn 𝕃

11-13 Kirkmichael Road, PH16 5EH

☎ (01796) 472196 ⊕ moulininn.co.uk

Moulin Light, Braveheart, Ale of Atholl, Old Remedial 🖫

First opened in 1695, the inn is the oldest part of the Moulin Hotel, situated within the village square at an ancient crossroads just east of Pitlochry. Full of character and charm, it is traditionally furnished and has two log fires. A good choice of home-prepared local fare is available, along with four Moulin beers, brewed in the old coach house behind the hotel. There is an area outside for dining and drinking in good weather. An ideal base for outdoor pursuits, with several marked walks nearby. Q☎⌂⊛◖♣P▯❀☂

Perth

Capital Asset 𝕃 ✔

26 Tay Street, PH1 5LQ

☎ (01738) 580457

Greene King Abbot; 5 changing beers (sourced nationally; often Redcastle, Stewart) 🖫

A Wetherspoon pub in a former savings bank, now managed by a real ale enthusiast. High ceilings and ornate cornices have been retained; pictures of old Perth adorn the walls of the open-plan lounge which overlooks the River Tay. A large safe from the building's banking days can be seen in the family area. Six ales are dispensed, with alcoholic drinks served from 11am. Food is available all day. Local ale drinkers enjoy the twice-yearly beer festivals. Q☎⊛◖&▯(7)☂

Cherrybank Inn

210 Glasgow Road, PH2 0NA
☎ (01738) 624349 ⊕ cherrybankinn.co.uk
Harviestoun Bitter & Twisted; 2 changing beers (sourced nationally; often Belhaven, Fyne) ℍ
This 250-year-old former drovers' inn with seven en-suite rooms is a popular watering hole and stopover for travellers. Three ales are dispensed in the public bar or the larger L-shaped lounge. Good bar lunches and evening meals are served. There is a large elevated and covered wooden deck to the rear. Golf can be arranged for residents. ☜❀❦❀❀P🖳(7,19)❀🛜

Cullach Tap Room ⓛ

50 Princes Street, PH2 8LJ
⊕ cullachbrewing.co.uk
House beer (by Cullach); 6 changing beers (sourced locally) ℙ
Central Perth's first microbrewery and taproom is located in a quiet side street, not too far from the city's busier areas. It features a comfortable and well-appointed seating area. The pub serves Cullach beers – typically Tayside IPA, Red IPA and Cabin Porter – plus guests. It opens Wednesday to Sunday; from 3pm in the week and from noon at the weekend. Q☜🍴❀❀🛜

Old Ship Inn ✔

31 High Street (Skinnergate), PH1 5TJ
☎ 07956 924767 ⊕ oldshipinnperth.co.uk
3 changing beers (sourced regionally; often Fyne, Harviestoun, Belhaven) ℍ
Said to be the oldest pub in Perth, having traded under the same name since 1665. This was the city's oasis for real ale in the 1980s, and now serves one regular beer and two changing ales. A large oil painting of a sailing ship adds interest in the timber-lined bar, which is lightened by a frieze and a white-painted ceiling. The upstairs lounge was closed for 20 years before reopening a few years ago. ❀❀🖳(7)❀🛜

Silvery Tay

189 South Street, PH2 8NY
☎ (01738) 321119
1 changing beer (often Stewart) ℍ
This pub, formerly known as Dickens, at the historic South Street Port is the first you encounter when walking from the train station to the city centre. Real ale was reintroduced in 2019. The high-ceilinged single-room establishment features dark wood panelling and a fine staircase up to its closed first floor. A number of alcoved seating areas offer privacy if desired. ❀❦🖳❀🛜

Twa Tams

79-81 Scott Street, PH2 8JR
☎ (01738) 580948 ⊕ thetwatamsperth.com
2 changing beers (often Cross Borders, Cromarty) ℍ
Perth's premier music pub began its rise in 2019 when it was taken over by the Mad Ferret Band folk duo, whose enthusiasm for real ale is matched only by their passion for music. The atmospheric bar has a low beamed ceiling. Its three handpulls serve at least one real ale and a cider. There is a large outdoor drinking area. ☜❀❀❦❀❀🖳(X56) ❀

Pitlochry

Old Mill Inn

Mill Lane, PH16 5BH
☎ (01796) 474020 ⊕ theoldmillpitlochry.co.uk
4 changing beers (sourced regionally; often Cromarty, Orkney, Wasted Degrees) ℍ

A well-run, family-owned establishment in the town centre. Built in the 19th century as a mill, it still has a mill wheel driven by the stream, which customers can sit beside when the weather allows for outdoor drinking. The large bar serves a varied selection of guest ales, and usually has three or four to choose from. Their website and Facebook page are mostly kept up-to-date, however it is recommended to telephone to check opening time prior to your visit. ☜❀❦❀❦❀❀P🖳❀🛜

Scotlandwell

Well Country Inn

Main Street, KY13 9JA
☎ (01592) 840444 ⊕ thewellcountryinn.co.uk
2 changing beers (sourced regionally; often Alechemy, Stewart) ℍ
Pleasant country inn that sits below the imposing Bishop Hill on the road between Kinross and Glenrothes. Both the village and pub take their name from the impressive canopied well. The bar is warmed by an open fire in winter. Its real ale often comes from Stewart Brewing. Accommodation is available in chalets or en-suite rooms. The pub is close to the Loch Leven Heritage Trail, popular with walkers and cyclists. ❦❀❦P❀🛜

Breweries

71 Brewing

36-40 Bellfield Street, Dundee, DD1 5HZ
☎ (01382) 203133 ⊕ 71brewing.com

Brewing began in 2016, principally brewery-conditioned lagers. A taproom and bottle shop is open daily. ⦙🍺♦⚘

Aurora Burst (ABV 4.1%) PALE
Breakfast Toast (ABV 4.5%) SPECIALITY
Cloud Fall (ABV 4.5%) PALE
Mandarina Sky (ABV 5%) PALE

Abernyte

South Latch Farm, Abernyte, Perthshire, PH14 9SU
☎ 07827 715915 ⊕ abernytebrewery.com

Established in 2016, the brewery overlooks the Carse of Gowrie. Brewing features a step mashing process in small batch, producing a range of unfiltered and naturally carbonated craft beers, packaged mainly in bottles.

Blunt Chisel

Phoenix Mill, Sawmill Road, Blairadam, KY4 0JG
⊕ thebluntchisel.co.uk

A nanobrewery set up in a former sawmill on the north bank of the Kelty Burn. A range of bottle-conditioned beers is on sale at the monthly Kinross Farmers' Market and at Leith Market. LIVE

Cullach

50 Princes Street, Perth, PH2 8LJ
⊕ cullachbrewing.co.uk

⊠ The brewery opened in 2019 in an industrial unit on the outskirts of Perth. It moved into a retail outlet closer to the town centre allowing a welcoming taproom to be set up for direct onsite sales. All draught beers are real ale in KeyKeg. Some cans are also produced. 🍺LIVE ⚘

Holy Goat (NEW) SIBA

Unit 5, Mid Wynd, Dundee, DD1 4JG ⊕ holygoat.beer

Holy Goat is a Dundee based brewery specialising in the production of mixed fermentation and wood-aged beers. All beers are bottled with some available in can.

Inveralmond SIBA

22 Inveralmond Place, Inveralmond Industrial Estate, Perth, PH1 3TS
☎ **(01738) 449448** ⊕ **inveralmond-brewery.co.uk**

☺Established in 1997, Inveralmond was the first brewery in Perth for more than 30 years. In 2016, it became part of the Innis & Gunn family, an independent Scottish brewer based in Edinburgh. I&G makes no real ale but the Inveralmond range continues. ‼ ☛ ♦

Ossian (ABV 4.1%) GOLD
Well-balanced best bitter with a dry finish. This full-bodied amber ale is dominated by fruit and hops with a bittersweet character, although excessive caramel can distract from this.
Lia Fail (ABV 4.7%) BITTER
Gaelic name meaning Stone of Destiny. A dark, robust, full-bodied beer with a deep malty taste. Smooth texture and balanced finish.

Law

Unit 17, Mid Wynd, Dundee, DD1 4JG ☎ **07893 538277** ⊕ **lawbrewing.co**

Law was established in 2016 and is named after Dundee's most distinctive landmark; the volcano-like slopes of the Law.

Loch Leven SIBA

The Muirs, Kinross, KY13 8AS
☎ **(01577) 864881**

Office: Wymet House, 87 New Row, Dunfermline, KY12 7DZ ⊕ **lochleven.beer**

Based opposite the Green Hotel in Kinross, the brewery started production in 2017. ‼ ☛

Warrior Queen (ABV 3.8%) PALE
Shining Knight (ABV 4%) SPECIALITY
Outlaw King (ABV 5%) MILD
King Slayer (ABV 5.2%) OLD

Manual

c/o 36-40 Bellfield Street, Dundee, DD1 5HZ
⊕ **manualbrewing.co.uk**

Launched in 2018, Manual Brewing Co uses spare capacity at 71 Brewing in Dundee.

MòR SIBA

Old Mill, Kellas, DD5 3PD ☎ **07402 900755**
⊕ **morbeers.co.uk**

Established in 2012 and now trading as MòR Beers. Dominic Hughes, an experienced brewer, moved to Scotland from London to take ownership of the brewery in 2018. ‼ ♦ LIVE

MòR Tea Vicar? (ABV 3.8%) BITTER
MòR Ish! (ABV 4.2%) BITTER
MòR Please! (ABV 4.5%) GOLD

Moulin

⊜ 2 Baledmund Road, Moulin, Pitlochry, PH16 5EL
☎ **(01796) 472196**

Office: Moulin Hotel, 11-13 Kirkmicheal Road, Moulin, Pitlochry, PH16 5EH ⊕ **moulinhotel.co.uk**

⊜The brewery opened in 1995 to celebrate the Moulin Hotel's 300th anniversary. Two pubs are owned and four outlets are supplied. ‼LIVE

Munro (NEW)

Devonian Lodge, Logie, Kirriemuir, DD8 5PG
☎ **(01575) 572232** ⊕ **munrobrewingco.com**

A family-owned business founded in 2020 in Kirriemuir, the final resting place of the Scottish mounaineer, Sir Hugh Munro. Beer is available in cans.

Nat 20 (NEW)

Hut 53, Cultybraggan Camp, Comrie, PH6 2AB
☎ **07754 093561**

A microbrewery producing traditional ales plus mead, brewed using old family and historic recipes.

Redcastle SIBA

Drummygar Mains, Carmyllie, Arbroath, DD11 2RA
☎ **(01241) 860516** ☎ **07967 226357**
⊕ **redcastlebrewery.co.uk**

⊠ Established by local farmer John Anderson, brewing began in 2016 in a purpose-built brewery on the family farm. The brewery takes its name from the nearby, ruined red castle at Lunan Bay. The beers are named accordingly with a historic theme. In addition to the 10-barrel plant, the brewery also includes a bottling line.

Headstock (ABV 3.8%) PALE
Crusader (ABV 4%) BITTER
Red Lady (ABV 4%) MILD
Norseman (ABV 4.2%)
Cannonball (ABV 4.5%) PALE
Tower IPA (ABV 4.8%) PALE
Courthill (ABV 5%) PALE
Dark Knight (ABV 5.6%) STOUT
Laird (ABV 5.6%) SPECIALITY
Monster Hop (ABV 6%) BITTER

Shed 35

Chapman Drive, Carnoustie, DD7 6DX ☎ **07530 430579** ⊕ **shed35brewery.co.uk**

Set up by friends Gary Mellon and John Wilson, brewing began in 2016. Although mainly producing bottle-conditioned beers for sale locally at farmers' markets and other outlets in Angus and the surrounding area, the brewery occasionally produces cask beer. LIVE

Two Towns Down

c/o 36-40 Bellfield Street, Dundee, DD1 5HZ
⊕ **twotownsdown.com**

Two Towns Down is a brewing project founded in 2019 by Sandy McKelvie, formerly of Hanging Bat, Fallen and Black Isle breweries. Spare capacity is used at 71 Brewing.

Wasted Degrees

Unit 11, Sawmill Yard, Blair Atholl, PH18 5TL
⊕ **wasteddegrees.com**

Small-batch brewing began commercially in 2017 before expanding to a 1000-litre brewhouse in Blair Atholl in 2019. A barrel-ageing programme was established in 2018. A taproom is open in the summer. ‼ ☛ ♦

Drookit Session (ABV 3.9%) PALE

A Year in Beer

Jonny Garrett

The Fortnum & Mason Food and Drink awards 2022 – **Best drinks book**
British Guild of Food Writers 2022 – **Best drinks book**

A Year in Beer is an exploration of how our ingredients and tastes change with the seasons, and how Britain's rich brewing history still influences us today. Going beyond lager when it's hot and stouts when it's cold, this book dives into why IPAs might taste best in April and Pilsners best in September, why smoked beer is so nostalgic and why lambic is only made in winter.

Discover the best UK beer experiences, from summer festivals to the autumn hop and apple harvests, taking in the glory of the seasons that make them all possible.

'This book is a sheer joy. It will endure and continue to delight people for years to come.'
OLLY SMITH, wine expert, TV personality, author and columnist.

RRP: £15.99 **ISBN**: 978-1-85249-372-1

For this and other books on beer and pubs, visit CAMRA's online bookshop at **shop1.camra.org.uk** or call 01727 867201.

Discounts are available for CAMRA members.

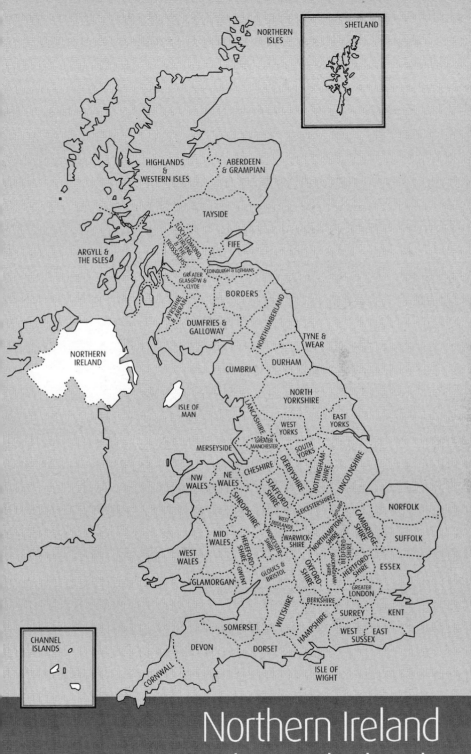

SHETLAND

NORTHERN
ISLES

HIGHLANDS
&
WESTERN ISLES

ABERDEEN
& GRAMPIAN

TAYSIDE

FIFE

ARGYLL &
THE ISLES

LOCH LOMOND, STIRLING & THE TROSSACHS

EDINBURGH & LOTHIANS

GREATER
GLASGOW &
CLYDE

BORDERS

AYRSHIRE
& ARRAN

DUMFRIES &
GALLOWAY

NORTHUMBERLAND

TYNE &
WEAR

NORTHERN
IRELAND

CUMBRIA

DURHAM

ISLE OF
MAN

NORTH
YORKSHIRE

LANCASHIRE

EAST
YORKS

WEST
YORKS

MERSEYSIDE

GREATER
MANCHESTER

SOUTH
YORKS

LINCOLNSHIRE

NW
WALES

NE
WALES

CHESHIRE

DERBYSHIRE

NOTTINGHAM-
SHIRE

STAFFORD-
SHIRE

SHROPSHIRE

LEICESTERSHIRE

RUTLAND

NORFOLK

WEST
MIDLANDS

CAMBRIDGE-
SHIRE

MID
WALES

HEREFORD-
SHIRE

WORCESTER-
SHIRE

WARWICK
SHIRE

NORTHAMPTON-
SHIRE

SUFFOLK

WEST
WALES

BEDFORD-
SHIRE

BUCKINGHAM-
SHIRE

HERTFORD-
SHIRE

ESSEX

GLAMORGAN

GLOUCS &
BRISTOL

GWENT

OXFORD-
SHIRE

GREATER
LONDON

BERKSHIRE

WILTSHIRE

SURREY

KENT

SOMERSET

HAMPSHIRE

WEST
SUSSEX

EAST
SUSSEX

CHANNEL
ISLANDS

DEVON

DORSET

CORNWALL

ISLE OF
WIGHT

Northern Ireland
Channel Islands
Isle of Man

Northern Ireland

Any visitor to Northern Ireland will be eager to sample world-class attractions like the Titanic exhibition and the Game of Thrones tour. Northern Ireland is a verdant country full of beautiful, breathtaking scenery. Natural wonders like the Giant's Causeway and the cliffs of Sliabh Liag are unmissable items on your agenda.

The region is enjoying a renaissance in beer as it is now much easier to access small-scale producers. Changes to licensing laws in 2021 have allowed the sale and consumption of alcohol at breweries, leading to an emerging taproom scene. Breweries like Hilden, the oldest brewery in the country, Lacada and Boundary now host regular taprooms. You can also enjoy a tour at Whitewater, the largest brewery in the province.

Armagh is known as the Orchard County, so it is no surprise that some wonderful cider makers can be found there; seek out MacIvors Cider, Armagh Cider Company, Tempted Cider and Long Meadow Cider for some of the very best examples. Or taste a wide range by visiting the annual Food & Cider Festival, held in the county in September.

The Northern Ireland CAMRA branch is on the hunt for a new venue for their annual beer festival, but meanwhile, there are smaller events being held around the country and throughout the year to take its place. This includes the wonderful Belfast Beer Week held in the spring that offers events around the city and gives a great opportunity to immerse yourself in the local beer culture.

There are many pubs in Northern Ireland worth adding to your itinerary. The Dirty Duck Ale House in Holywood offers fantastic views, particularly on a fine day. Northern Lights, the taproom of the Galway Bay Brewery, is noted for its wide range of Irish beers. The Crown Liquor Saloon and the Errigle Inn, both in Belfast, have beautifully preserved historic features and serve well-kept real ale.

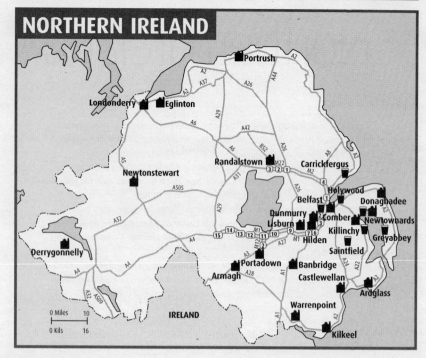

NORTHERN IRELAND

Portrush

Londonderry Eglinton

Newtonstewart

Randalstown Carrickfergus

Holywood

Belfast Donaghadee

Dunmurry Comber Newtownards

Lisburn Killinchy Greyabbey

Hilden Saintfield

Derrygonnelly

Portadown Banbridge

Armagh Castlewellan

Ardglass

Warrenpoint

IRELAND

0 Miles 10
0 Kils 16

Kilkeel

Belfast

Bridge House ✔

37-43 Bedford Street, BT2 7EJ
☎ (028) 9072 7890
Greene King Abbot; Sharp's Doom Bar; changing beers (sourced nationally) Ⓗ
Busy city-centre Wetherspoon bar that has twice been local CAMRA Pub of the Year. It has a large ground floor and a smaller, more family oriented bar upstairs. The main bar has eight handpumps serving beers sourced nationally, and occcasionally locally from Whitewater. The pub opens early for breakfast, with alcohol available from lunchtime. Seating is via a mixture of tables and booths, including in the beer garden outside.
Q ☷ ✿ ◖ ᴴ ᵹ ⇌ (Great Victoria St) 🚌 🛜

Crown Liquor Saloon ★ ✔

46 Great Victoria Street, BT2 7BA (opp Europa Hotel and Great Victoria St station)
☎ (028) 9024 3187
St Austell Nicholson's Pale Ale; 5 changing beers (sourced regionally) Ⓗ
Renowned for its historic architecture, the Crown Liquor Saloon also has one of Belfast's most varied and frequently changing ranges of real ale. Six handpumps regularly dispense Nicholson's Pale Ale alongside a mixture of local and national beers. Handpulled cider is reguarly available. Good food is served in the main bar and upstairs in the Crown Dining Rooms. This former local CAMRA Pub of the Year is a must-see.
Q ◖ ᵹ ⇌ (Great Victoria St) 🚌

Errigle Inn ♥

312-320 Ormeau Road, BT7 2GE
☎ (028) 9064 1410 ⊕ errigle.com
4 changing beers (sourced locally; often Whitewater) Ⓗ
The Errigle Inn serves craft beers in its main bar but its real treasures are in the quiet back bar, the Oak Lounge,

where enthusiasts congregate to enjoy ale in peace. The four handpumps dispense beers sourced mostly from local breweries, with occasional national brands. Handpulled cider is a permanent feature. Attractions include tap takeovers. Opening hours are limited. Current local CAMRA Pub of the Year. Q ◖ ᵹ 🚌 🛜 .

McHughs

29-31 Queens Square, BT1 3FG (near Albert Clock)
☎ (028) 9050 9999 ⊕ mchughsbar.com
Whitewater Maggie's Leap IPA Ⓗ
A well-established traditional pub to the north-east of the city centre, with several drinking and eating areas. Its main public bar has a handpump exclusively dispensing

REAL ALE BREWERIES

Ards Newtownards
Armagh Armagh (NEW)
Baronscourt Newtonstewart
Beer Hut Kilkeel
Black Mountain ≣ Lisburn
Boundary ⚓ Belfast
Bullhouse Belfast
Farmageddon Comber
Fermanagh Derrygonnelly
Hercules Belfast
Hilden Hilden
Knockout Belfast
Lacada Portrush
Lecale Ardglass
Mashdown Banbridge
McCracken's Portadown
Mourne Mountains Warrenpoint
Norn Iron Dunmurry
Northbound Eglinton
Our Randalstown (NEW)
Rough Brothers Londonderry
Twisted Kettle Donaghadee
Whitewater Castlewellan

ales from Whitewater Brewery. The restored old bar alongside features wall paintings depicting Belfast's history. An upstairs restaurant serves good food. The pub is popular for sport on TV, and for traditional and folk music performed both in the bar and basement.
Q❀◑&≼(Central)🖵🛜

Northern Lights
451 Ormeau Road, BT7 3GQ
☎ (028) 9029 0291 ⊕ galwaybaybrewery.com/northernlights
1 changing beer (sourced regionally) Ⓗ
A modern craft beer bar on a corner of the Ormeau Road, owned by Galway Bay Brewery. It has long tables and rows of taps, which serve around 10 of the brewery's beers alongside a similar number from other craft outlets. A handpump dispenses cask ales from a variety of Irish breweries. The pub also stocks an impressive selection of beer and cider in bottles and cans. Good food is available. Local CAMRA Pub of the Year 2020.
Q❀◑&♣🖵❀🛜

Sunflower
65 Union Street, BT1 2JG
☎ (028) 9023 2474 ⊕ sunflowerbelfast.com
1 changing beer (sourced locally; often Hilden)
Now in its 10th year as a real ale pub, the Sunflower has one handpump serving beers from Hilden Brewery, and also offers a selection of craft ales. It is one of the few pubs that does not sell Ireland's most famous beverage. Tap takeovers are hosted, and music is performed in both the bar and the upstairs lounge. Outside is a large beer garden where pizza is available on Thursday, Friday and Saturday evenings. ❀◑🖵❀🛜

Carrickfergus

Central Bar ⊘
13-15 High Street, BT38 7AN (opp castle)
☎ (028) 9335 7840
Greene King Abbot; Ruddles Best Bitter; Sharp's Doom Bar; 2 changing beers (sourced regionally) Ⓗ
Lively market-town community local with a loyal clientele. This Wetherspoon pub has a ground-floor public bar of robust character. On the first floor is a quieter, family-friendly loggia-style sitting room with exposed timber trusses, giving fine views from its many windows over Belfast Lough and the adjacent 12th-century castle. Handpumps on both levels dispense two house beers and three guests, often from Whitewater Brewery. Alcoholic drinks are served from 11.30am (12.30pm Sun). Q❀❀◑&≼🖵(563)

Greyabbey

Wildfowler Inn
1 Main Street, BT22 2NE (7 miles S of Newtownards on A20)
☎ (028) 4278 8234 ⊕ wildfowlerinn.co.uk
1 changing beer (sourced locally; often Ards)
Stained-glass windows, exposed wooden beams and a tiled and stone floor are features of this pub and restaurant in a village on the Ards Peninsula. Good food is served alongside ale from the nearby Ards Brewing Co. Drinks can be enjoyed in the restaurant without purchasing a meal. There is also a lounge and function room, and a beer garden outside. Q❀❀◑&P🖵

Holywood

Dirty Duck Ale House
3 Kinnegar Road, BT18 9JN

☎ (028) 9059 6666 ⊕ thedirtyduckalehouse.co.uk
3 changing beers (sourced nationally) Ⓗ
Set in the pleasant surroundings of Belfast's Lough shore, the Dirty Duck offers great views, particularly from its upstairs restaurant. The downstairs bar serves three regularly changing ales, mostly from national brands rarely found in the province. Attractions include an outside bar and a beer garden with retractable roof. The pub hosts regular live music and a summer beer festival. Twice winner of local CAMRA Pub of the Year.
Q❀❀◑&≼🛜

Killinchy

Daft Eddy's ⌁
Sketrick Island, BT23 6QH (2 miles N of Killinchey at Whiterock Bay)
☎ (028) 9754 1615
1 changing beer (sourced locally; often Farmageddon)
A family-run bar, restaurant and coffee house in a picturesque setting beside Strangford Lough. Slightly hard to find, it is one of the province's hidden gems. The bar's single handpump dispenses ales from the nearby Farmageddon Brewery. High-quality, locally sourced food can be consumed in the restaurant, in Little Eddy's coffee shop or outside on the veranda. Q❀❀◑&P❀🛜

Newtownards

Spirit Merchant ⊘
54-56 Regent Street, BT23 4LP (opp bus station)
☎ (028) 9182 4270
Greene King Abbot; 4 changing beers (sourced nationally) Ⓗ
A medium-sized Wetherspoon pub noted for its large beer garden, which is heated and partly covered. Inside is a mixture of seating, with booths on the right and a raised area to the rear. Five handpumps serve regularly changing ales of high quality. Like other pubs in the chain, it opens at 8am (12.30pm Sun). Q❀❀◑&A🖵(7)🛜

Saintfield

White Horse
49-53 Main Street, BT24 7AB
☎ (028) 9751 1143 ⊕ whitehorsesaintfield.com
Whitewater Copperhead, Maggie's Leap IPA Ⓗ
Modern pub that is a main attraction of this village between Belfast and Downpatrick. It consists of a bar, bistro and pizza restaurant, plus a beer garden at the rear. There are usually two ales on handpump, often Copperhead and Maggie's Leap from Whitewater Brewery, the former owners. Pizza is served from early evening on Thursday, Friday, and Saturday. A former local CAMRA Pub of the Year. Q❀❀◑&🖵(15,215)

Breweries

Ards

34B Carrowdore Road, Greyabbey, Newtownards, Co Down, BT22 2LX ☎ 07515 558406
✉ ardsbrewing@blackwood34.plus.com

Ards began brewing in 2011 using a 100-litre plant. A five-barrel plant is now in operation, allowing cask production in addition to the increasing range of bottle-conditioned and KeyKeg beers. Very much a local brewery with beers generally only supplied within a 15-mile radius. LIVE

ISLANDS

Citra (ABV 4.8%) GOLD
Scrabo Gold (ABV 4.8%) GOLD
Hip Hop (ABV 5%) BITTER
Pig Island (ABV 5.2%) BITTER

Armagh (NEW)

28 Drumgaw Road, Armagh, BT60 2AD ☎ 07828
473199 ⊕ armagh-brewing-co.business.site

A microbrewery based on the outskirts of Armagh,
established in 2016.

Baronscourt

38 Baronscourt Road, Newtonstewart, Omagh,
BT78 4EY ☎ 07788 839907
⊕ baronscourtbrewery.com

A family-run, farm-based brewery founded in 2018
nestled at the foot of the picturesque Bessie Bell
mountain, close to Harry Avery's Castle, producing high
end hand-crafted artisan beer. Brewery waste is directly
fed back to livestock or sent to the local anaerobic
digester thereby neutralising the carbon footprint.

Beer Hut

6 Riverside Park, Kilkeel, BT34 4NA ☎ 07885 566599
✉ andrew@beerhutbrewing.co.uk

Microbrewery situated near Kilkeel harbour. Established
in a flat pack hut using a 100-litre kit, it has since
upscaled twice and now operates using a 1,000-litre
plant. Further expansion is planned.

Citra Ella (ABV 4.5%) GOLD
Fluffy Bunny (ABV 5%) SPECIALITY
Wahey IPA (ABV 5.6%) IPA
There's Something in the Water (ABV 6%) IPA
Simcoe Simon (ABV 6.5%) IPA
Ahoy Captain (ABV 7.4%) IPA

Bell's (NEW)

⬭ Deer's Head, 2 Lower Garfield Street, Belfast,
BT1 1FP
☎ (028) 9043 4655 ⊕ bellsbrewerybelfast.com

Brewery within the Deer's Head pub, Belfast.

Black Mountain

⬭ Speckled Hen Pub & Restaurant, 47 Derriaghy
Road, Lisburn, BT28 3SH
☎ (028) 9061 1113 ⊕ speckledhenlisburn.com/
black-mountain-brewery

Small brewery attached to the Speckled Hen pub,
established in 2016. The beer is only available in the pub,
with a new ale every week.

Boundary SIBA

Unit A5, 310 Portview Trade Centre, Newtownards
Road, Belfast, BT4 1HE ⊕ boundarybrewing.coop

Boundary is a cooperative brewery based in Belfast,
established in 2014. A taproom is open to the public. ◆ ⬭

APA (ABV 3.5%) PALE
Export Stout (ABV 7%) STOUT
IPA (ABV 7%) IPA

Bullhouse SIBA

22 Balmoral Road, Belfast, BT12 6QA ☎ 07749
877841 ⊕ bullhousebrewco.com

Bullhouse was set up in 2016 by beer enthusiast and
homebrewer William Mayne at his family farm. The
brewery has since relocated to Belfast and a new
permanent taproom/pub has opened at 442-446
Newtownards Road, Belfast.

Road Trip (ABV 4%) GOLD
Small Axe (ABV 4.3%)
Frank the Tank (ABV 5%) SPECIALITY
The Dankness (ABV 5.5%)
Merc Bro (ABV 6.5%) SPECIALITY

Dopey Dick

Skeoge Industrial Estate, Derry, BT48 8SE
☎ (028) 7141 8920

Office: 4 Custom House Street, Derry, BT48 6AA
⊕ dopeydick.co.uk

A microbrewery founded by the proprietors of the Grand
Central Bar in Derry. Beers are contract brewed.

Farmageddon

25 Ballykeigle Road, Comber, BT23 5SD ☎ 07966
809481 ⊕ farmageddonbrewing.com

Co-operative brewery, formed in 2014. All beers are
unfiltered with no preservatives. ◆LIVE

Gold (ABV 4.2%) PALE
Session (ABV 4.8%) BITTER
India Export Porter (ABV 5.2%) PORTER
IPA (ABV 5.5%) IPA
Mosaic IPA (ABV 6.3%) IPA

Fermanagh

75 Main Street, Derrygonnelly, BT93 6HW
☎ (028) 6864 1254

Under the Inishmacsaint brand, Fermanagh Beer
Company is a small-scale brewery producing a range of
bottle-conditioned beers since 2009. LIVE

Heaney Farmhouse

c/o Boundary Brewing, Portview Trade Centre,
Newtownards Road, Belfast, BT4 1HE
⊕ heaneyfarmhousebrewing.com

Founded in 2014. Bottled beers are currently brewed at
Boundary (qv) in Belfast while its brewhouse project is
underway at a farm in Bellaghy, Co Londonderry. No real
ale.

Hercules

Unit 5b, Harbour Court, Heron Road, Sydenham,
Holywood, Belfast, BT3 9HB
☎ (028) 9036 4516 ✉ niall@herculesbrewery.com

The original Hercules Brewing Company, founded in the
19th century, was one of 13 breweries in Belfast at the
time. The company has been re-established to produce
small batch brews using old brewing traditions. Its output
is all under the Yardsman brand name.

Brewed under the Yardsman brand name:
IPA (ABV 4.3%) PALE
Lager (ABV 4.8%) SPECIALITY
Belfast Pale Ale (ABV 5.6%) GOLD

Hilden

Hilden House, Grand Street, Hilden, Lisburn, Co
Antrim, BT27 4TY
☎ (028) 9266 0800 ⊕ hildenbrewery.co.uk

⊕Established 1981, Hilden is Ireland's oldest independent brewery. Now in the second generation of family ownership, the beers are widely distributed across the UK. The beers are regularly available in JD Wetherspoon outlets in Northern Ireland. ⏸🍺◆

Nut Brown (ABV 3.8%) BITTER
Hilden Ale (ABV 4%) BITTER
An amber-coloured beer with an aroma of malt, hops and fruit. The balanced taste is slightly slanted towards hops, and hops are also prominent in the full, malty finish.
Barney's Brew (ABV 4.2%) SPECIALITY
Irish Stout (ABV 4.3%) STOUT
Scullion's Irish Ale (ABV 4.6%) BITTER
Twisted Hop (ABV 4.7%) BITTER
Halt (ABV 6.1%) RED

Brewed under the College Brewery brand name:
Headless Dog (ABV 4.3%) GOLD

Knockout

Unit 10, Alanbrooke Park, Alexander Road, Belfast, BT6 9HB

Founded in 2009 by Joseph McMullan, Knockout produces a range of bottle-conditioned beers. Each brew is usually in small 900-litre batches. LIVE

Lacada SIBA

7a Victoria Street, Portrush, BT56 8DL
☎ (028) 7082 5684 ⊕ lacadabrewery.com

Lacada is a co-operative brewery founded in 2015. It produces a wide variety of styles. It is situated on the scenic north coast of Northern Ireland, and each beer is named after a feature of the coast line (along with a picture of the feature on the cans and bottles).

Lecale

5 High Street, Ardglass, County Down, BT30 7TU
☎ 07763 142100 ⊕ lecalebrewery.com

Based in the historic fishing village of Ardglass on the east coast of County Down, Lecale uses local malts and hops with water from the Mourne Mountains.

McCracken's

Derryall Road, Portadown, BT62 1PL
⊕ mccrackensrealale.com

Currently Co Armagh's only real ale brewery, established in 2018. Producing a range of bottle-conditioned beers.

Mashdown

58 Castlewellan Road, Banbridge, BT32 4JF ☎ 07866 580077 ⊕ mashdownbrewery.com

Formerly brewing took place in collaboration with other breweries, Mashdown now has its own nanobrewery. Most of production is bottled.

Modest

86 Clonkeen Road, Randalstown, Co Antrim, BT41 3JJ
⊕ modestbeer.co.uk

Small, independent brewery, originally brewing in a private garage but has now moved to a much larger brewery in Randalstown.

Mourne Mountains SIBA

Milltown East Industrial Estate, Upper Dromore Road, Warrenpoint, BT34 3PN
☎ (028) 4175 2299
⊕ mournemountainsbrewery.com

Brewing since 2015 with an extensive and varying range of seasonal, special and one-off brews produced throughout the year – some may appear in cask format. Isinglass finings are used in all cask products, except stouts, and so they are not suitable for vegans. Keg, can and bottled beers (not bottle-conditioned) are suitable for vegans. ◆V

Mourne Gold (ABV 4%) GOLD

Norn Iron

Unit 30, The Cutts, Dunmurry, Belfast, BT17 9HN
⊕ nornironbrewco.com

Brewing began in 2018.

Northbound

Campsie Industrial Estate, McLean Road, Eglinton, BT47 3XX ☎ 07512 198686
⊕ northboundbrewery.com

Established in 2015, Northbound produce a range of bottle-conditioned beers named after their measurement of bitterness (IBUs). ◆LIVE

O'Connor

12 Lime Road, Faughanvale, Greysteel, BT47 3EH
☎ 07748 004065 ⊕ oconnorbrewing.com

Brewing began in 2013. No real ale.

Our (NEW)

Get Er Brewed Home Brew & Microbrewery Supply Store, 86 Clonkeen Road, Randalstown, BT41 3JJ
☎ 0800 2289 433 ⊕ ourbrewerygeb.com

Energy efficient brewery launched in 2022, which is a passion project from the team at Get Er Brewed, overlooking Lough Neagh.

Out of Office (NEW)

96-98 High Street, Belfast, BT1 2BG
⊕ outofofficebrewing.co.uk

Brewery with taproom established in 2019. ◆

Rough Brothers

Unit 2d, Altnagelvin Industrial Estate, Trench Road, Londonderry, BT47 2ED

A family-run microbrewery producing handmade beer in Derry/Londonderry.

Twisted Kettle

Deadman's Island, Donaghadee, County Down

An independent nanobrewery producing small-batch beers.

Walled City

▤ Ebrington Square & Parade Ground, 70 Ebrington Square, Derry, BT47 6FA
☎ (028) 7134 3336 ⊕ walledcitybrewery.com

Restaurant-based brewery established in Derry in 2015.

ISLANDS

Whitewater

Lakeside Brae, Clarkhill Road, Castlewellan, Northern Ireland, BT31 9RH
☎ **(028) 4377 8900** ⊕ **whitewaterbrewery.com**

Established in 1996, Whitewater is now the biggest brewery in Northern Ireland. ‼♦

Copperhead (ABV 3.7%) BITTER
Belfast Black (ABV 4.2%) STOUT
Belfast Ale (ABV 4.5%) BITTER
Maggie's Leap IPA (ABV 4.7%) PALE
Clotworthy Dobbin (ABV 5%) PORTER

McHughs, Belfast (Photo: Mircea Sarbu / Flickr CC BY-SA 2.0)

Channel Islands

Composed of the islands of Jersey, Guernsey, Alderney, Sark, and Herm, along with many smaller islands, this region is located 14 miles off the coast of France. Each island has its own character. Reach them by air or ferry and take in the striking scenery on foot with many trails available across the islands. La Hougue Bie Museum on Jersey is a must-see, one of the world's oldest buildings with Norman and 16th-century chapels built on top of a 2000 BC burial mound.

Stinky Bay Brewing Co on the northwest tip of Jersey is well worth seeking out. Not only does it make a small range of choice beers, including a well-regarded session IPA, but it also donates 1% of its income to good causes, including Mind Jersey and Durrell Wildlife Conservation. You can take a brewery tour at the historic Randalls in St Peter Port, Guernsey, or the Liberation Brewery at St Saviour on Jersey. They are both in the region of 150 years old, meaning they brewed their way through German occupation during WWII.

Another great place for a brewery tour is the Little Big Brew Co at St Peter Port. It holds open brewery tours one evening a month and also operates a taproom. Also in the town, the Slaughterhouse pub won a CAMRA Design Award in 2019 for its conversion from an abattoir, giving it quite a unique character.

In the summer, the annual Beer Island Festival is a great way to discover the range of live ales and craft beers from the Channel Islands and beyond. Held at the Lido in Jersey, it also celebrates local food and spirits from the region.

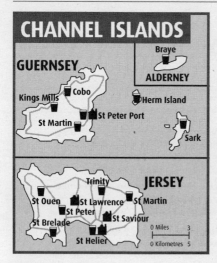

☎ (01481) 257996 ⊕ fleurdujardin.com
3 changing beers (sourced regionally; often Little Big Brew) Ⓗ
A building of unique charm with two bars – one traditional, small and cosy, attached to the restaurant, the other renovated in a more contemporary style. A door leads to a large covered patio and out to the garden. Menus in both the bar and restaurant feature fresh local produce. Q⛲☺🚲🍴◖🅿🅿🐾❀

St Martin

Les Douvres Hotel
La Fosse, GY4 6ER
☎ (01481) 238731 ⊕ lesdouvreshotel.co.uk
3 changing beers (often Little Big Brew) Ⓗ
Former 18th-century manor house, set in private gardens in St Martin near the south coast, two and a half miles from St Peter Port, with cliff walks and a tiny fishing harbour. A well-maintained, changing range of beers is offered on three handpumps, and real cider during the season. Excellent meals, including pizzas, are served in the bar and separate restaurant. Live music features on Friday night and occasional Wednesdays. ☺🚲◖◗🐾🅿🏴

St Peter Port

Cock & Bull
2 Lower Hauteville, GY1 1LL
☎ (01481) 722660 ⊕ cockandbullguernsey.com/home
5 changing beers (often Marston's, Randalls) Ⓗ
The pub is just up the hill from the town church. It serves a good mix of local and national ales, with Marston's beers a regular feature, plus real cider in summer. Seating is on three levels, with a pool table on the lower level. Live music features throughout the week, with blues, jazz or baroque on Monday, open mic on Tuesday and Irish folk on Thursday. A meat draw is held on Friday. Open on Sundays when rugby is on. ●🖵🛜

Golden Lion
7 Market Street, GY1 1HF
☎ (01481) 726634 ⊕ thegoldenlion.gg
4 changing beers (sourced nationally) Ⓗ
Town-centre pub opposite the former market. The single room has the feel of a modern craft beer bar, with a long bar serving up to six real ales (the beer range is reduced in winter) and four real ciders. Gluten-free ales are available in bottles. Live music is performed at weekends. The first-floor Lions Den is open in the evenings and available for private hire. ●🖵🛜

Red Lion
Les Banques, GY1 2RX (on seafront to N of St Peter Port)
☎ (01481) 724042
4 changing beers (often Randalls) Ⓗ
Friendly pub on the outskirts of St Peter Port with two bar areas – a lounge overlooking Belle Greve Bay to the front and a public area at the rear. Gluten-free beer is available in bottles, and real cider is served in summer. Numerous TVs show sport. Meat draws are held on Friday and Saturday evenings. The pub is on several bus routes and on the cycle route between St Peter Port and St Sampson. 🚲☺◖●🖵🛜

ALDERNEY
Braye

Divers Inn
Braye Street, GY9 3XT
☎ (01481) 822632 ⊕ brayebeach.com
2 changing beers (sourced nationally; often Butcombe) Ⓗ
Traditional pub with a great atmosphere, attached to the Braye Beach Hotel. It serves two real ales and has a good bar menu. The interior is warmed by real fires. Walking through the bar area reveals sea views and an outdoor seating space overlooking the beach. Themed and musical events attract locals and visitors alike. 🛏◖◗🌂🐾♣

GUERNSEY
Cobo

Rockmount Restaurant & Bar
Cobo Coast Road, GY5 7HB
☎ (01481) 252778 ⊕ therocky.gg
4 changing beers (often Randalls) Ⓗ
The pub comprises a large lounge bar and a taproom that shows sport on TV. The lounge has an emphasis on food, served lunchtimes and evenings, but there are comfy chairs near the fire for drinkers. Five handpumps offer a changing range of beers and you can also try a tasting paddle of different ales. Q⛲☺☀◖◗🐾●🅿🖵(41,42)🐾🛜

Herm Island

Mermaid Tavern ✓
GY1 3HR
☎ (01481) 750050 ⊕ herm.com/mermaid
House beer (by Liberation); 2 changing beers Ⓗ
A welcoming inn, the large courtyard is a popular spot in summer; an open fire adds to the charm in winter. The house beer is from Liberation, brewed specially for the island. The pub holds regular themed music and food events, and hosts real ale and cider festivals in June and September. 🚲☺◖●🏕♣🐾🐾🛜

Kings Mills

Fleur du Jardin ✓
GY5 7JT

REAL ALE BREWERIES
Bliss Brew Co 🍴 St Helier, Jersey
Liberation St Saviour: Jersey
Little Big ✦ St Peter Port: Guernsey
Randalls St Peter Port: Guernsey
Stinky Bay St Lawrence: Jersey

Ship & Crown ✓
North Esplanade, GY1 2NB
☎ (01481) 721368
3 changing beers Ⓗ
Traditional venue in the heart of the town with fantastic views of the harbour, neighbouring islands and Castle Cornet. It is decorated with photos of local shipwrecks, Guernsey and the pub under German occupation. Popular with regulars, yachtsmen and tourists alike, this is the perfect place to enjoy a pint and a good meal. All major sports events are shown in a friendly and lively atmosphere. Liberation and Butcombe beers are served, and real cider is also on handpump. ◑❀🖼🎵

Slaughterhouse
Castle Pier, GY1 1AN
☎ (01481) 712123 ⊕ slaughterhouse.gg
6 changing beers (often Randalls) Ⓗ
Busy harbourside bar and eatery offering fine views over Havelet Bay from its mezzanine restaurant and large outdoor terrace. The Randalls-managed pub serves a changing range of up to six real ales, some from small breweries. Winner of a CAMRA design award in 2019 for its conversion from an abbatoir. ❀◑❀&

JERSEY
St Brelade

Old Smugglers Inn ✓
Le Mont du Ouaisne, Ouaisne, JE3 8AW
☎ (01534) 741510 ⊕ oldsmugglersinn.com
Draught Bass; house beer (by Liberation); 2 changing beers (often Marston's, Ringwood, Skinner's) Ⓗ
Perched on the edge of Ouaisne Bay, the Smugglers has been the crown jewel of the Jersey real ale scene for many years. Steeped in history, dating back to when pirates came to enjoy an ale or two here, it is set within granite-built fishermen's cottages with foundations reputedly from the 13th century. Up to four ales are available including one from Skinner's, and mini beer festivals are regularly held. Renowned for its good food and fresh daily specials. Q🌳◑❀P❀

Trafalgar Inn ✓
Charing Cross, St Aubin, JE3 8AA
☎ (01534) 741334 ⊕ trafalgarinn.com
5 changing beers (often Butcombe, Liberation, St Austell) Ⓗ
Traditional community pub with a nautical theme. There are two bars – the saloon bar at the front and a sports bar with pool, darts and sports TV behind. The handpumps are in the sports bar – beers are regularly rotated but usually include one from Liberation Brewery. See the website for what's in the cellar. Popular with local rugby fans, the Jersey Reds usually come here after Saturday home matches. &♣🖼❀

St Helier

Biere Atelier
Bath Street, JE2 4ST
☎ (01534) 874059 ⊕ labastille.bar
Purity Pure Gold, Mad Goose, Pure UBU; 1 changing beer (sourced nationally) Ⓗ
Possibly Jersey's first micropub, this single-room bar has a few tables and stools around the walls. The small counter has real ales on handpump and a craft beer wall behind. Popular with office workers, it is fast becoming a destination bar for real ale lovers. On the corner of Bath Street and Hilgrove Street, it is interconnected with the nearby Bastille restaurant and bar, where the beers are

also available. Food from the Bastille can also be enjoyed at tables outside on the pedestrian street. &

Lamplighter Ⓛ ✓
9 Mulcaster Street, JE2 3NJ
☎ (01534) 723119
8 changing beers (sourced nationally) Ⓗ
A traditional pub with a modern feel. The gas lamps that gave the pub its name remain, as does the original antique pewter bar top. An excellent range of up to eight real ales is available – the largest selection on the island – including one from Skinner's. All real ales are served direct from the cellar. A real cider is sometimes also on offer. A repeat winner of local CAMRA Pub of the Year. ❀🖼❀🎵

Post Horn Ⓛ ✓
Hue Street, JE2 3RE
☎ (01534) 872853
Butcombe Original; Draught Bass; Liberation Ale, IPA; 1 changing beer (often Liberation) Ⓗ
Busy, friendly pub adjacent to the precinct and five minutes' walk from the Royal Square. Popular at lunchtimes with its own nucleus of regulars, it offers up to four draught ales. The large L-shaped public bar extends into the lounge area where there is an open fire and TV showing sport. A good selection of freshly cooked food is served. There is a large function room on the first floor, a drinking area outside and a public car park nearby. ❀◑❀🎵

Prince of Wales Tavern
8 Hilgrove Street, JE2 4SL
☎ (01534) 737378
Courage Best Bitter; Fuller's London Pride; Ringwood Boondoggle; Sharp's Doom Bar; Wychwood Hobgoblin Gold; 5 changing beers (sourced nationally; often Shepherd Neame) Ⓗ
A traditional pub, next to the historic central market, offering a large selection of up to eight cask ales advertised on blackboards. The Victorian-style interior has a bright and sparkling bar-back which features a large selection of whiskies. No food is served but there are a number of eateries nearby. The beer garden at the rear is a pleasant spot for a relaxing drink. ❀❀❀

St Martin

Royal
La Grande Route de Faldouet, JE3 6UG
☎ (01534) 856289
Courage Directors; Skinner's Lushingtons Ⓗ**; 1 changing beer (often Bombardier)** Ⓗ/ⓖ
Originally a coaching inn, this large country-style hostelry is located at the centre of St Martin with sizeable public and lounge bars, a restaurant area, and a spacious alfresco area. The interior features traditional furnishings, cosy corners and a real fire in colder months. Owned by Randalls Brewery, it serves guest ales from the Marston's, Sharp's and Skinner's stables. Quality food is popular with locals and visitors alike, with a good menu available lunchtimes and evenings (no food Sun eve). 🌳❀◑&🏕♣P🖼(3)❀

St Ouen

Farmers Inn ✓
La Grande Route de St Ouen, JE3 2HY
☎ (01534) 485311
Butcombe Original; Liberation Pale Ale, Herm Island Gold; 2 changing beers (often Liberation) Ⓗ

Situated in the hub of St Ouen, near the war memorial and parish hall, the rustic Farmers Inn is a typical country inn offering up to three ales as well as a locally-made cider when available (usually April to July). Traditional pub food is served in generous portions. Best described as a friendly community local, there is a good chance of hearing Jersey French (Jerriais) spoken at the bar. There is an outside seating area at the front. ♿◗♣♠♟🚫

Moulin de Lecq ✔

Le Mont De La Greve De Lecq, Greve de Lecq, JE3 2DT
☎ (01534) 482818 ⊕ moulindelecq.com
Shepherd Neame Spitfire; house beer (by Liberation); 2 changing beers (often Marston's, Skinner's) 🅷
A free house offering a range of real ales, the Moulin is a converted 12th-century watermill situated in the valley above the beach at Greve de Lecq. The waterwheel is still in place and the turning mechanism can be seen behind the bar. A restaurant adjoins the mill. The children's play space and a barbecue area are used extensively in the summer. The 120-seat restaurant can be hired for functions. Pool can be played in the second-floor games room. Q♿♨◑🕭♿♣♠🚫😺🐾🛜

St Peter

Tipsy

La Route de Beaumont, JE3 7BQ
☎ (01534) 485556 ⊕ thetipsy.co.uk
6 changing beers (sourced nationally; often Castle Rock, Elland, Liberation) 🅷
The Tipsy, formerly The Tipsy Toad, was the site of the original Skinner's Brewery before it moved to Cornwall. The friendly pub has been refurbished to provide a main bar with comfortable seating. Six handpumps dispense a rotating selection of ales, including a house beer from Liberation, Tipsy Toad Ale, a 3.8% ABV bitter. The separate restaurant area offers an extensive menu. Outside is a patio with heating. ♿♨◑🕭🚫(9)😺🛜

Trinity

Trinity Arms Ⓛ ✔

La Rue es Picots, JE3 5JX
☎ (01534) 864691
Liberation Ale; 1 changing beer (often Butcombe, Liberation) 🅷
Sporting the parish's ancient symbol of the Trinity, this place, built in 1976, is modern by Jersey country pub standards but has plenty of character. Owned by Liberation Group, it is central to and popular within village community life. It has recently undergone a full refurbishment and both bars have been merged into one, with a central island bar. Food is served at breakfast, lunchtime and evenings. There is seating outside and a children's play area. ♿♨◑🕭🚫(4)😺🛜

SARK
Sark

Bel Air

Harbour Hill, GY10 1SB
☎ (01481) 832052
2 changing beers (often Randalls) 🅷
Popular, family-friendly pub at the top of Harbour Hill but worth the walk or tractor ride. It serves two real ales and real cider, and offers food all day. There is a cosy fire for cold weather, and a large beer garden and courtyard where food and drink can be enjoyed on warm days. Barbecues and live music feature at the weekend in summer. ♿♨◑🕭♣♠🐾😺

Mermaid Tavern

Main Street, GY10 1SG
☎ (01481) 832022
1 changing beer (sourced nationally) 🅷
A pub established before WWII, the Mermaid harks back to an earlier time and the decor has remained unchanged since the 1960s. A no-frills local with a warm welcome for island visitors, it is child-friendly and serves snacks such as pizza and sandwiches. Darts, pool and shove-ha'penny can be played, and there is a jukebox and a piano available for spontaneous singsongs or a dance. After exploring Sark, the seating area outside is a pleasant place to end the day. ♿♣🛜

Breweries

Bliss

🏭 4 Wharf Street, St Helier, Jersey, JE2 3NR
⊕ blissbrewco.com

Bliss Brew Co was formed during 2019, the first new commercial brewery in Jersey for over a century. A partnership between a talented former homebrewer and a local craft beer brewer, it focuses on craft beers mainly served from KeyKeg, tentative steps have been taken in cask. Some beers have been made available in can.

Liberation

Tregar House, Longueville Road, St Saviour, Jersey, JE2 7WF
☎ (01534) 764089 ☎ 07911 744568
⊕ liberationgroup.com

⊠ The Liberation Brewery (owned by the Liberation Group, which also owns Butcombe Brewery) is located at Longueville, just outside St Helier. Its multi-award-winning flagship beer Liberation Ale can be found in many of the Group's freehold and partner pubs in the Channel Islands (39 in Jersey, 17 in Guernsey and three in Alderney) and 60 in the UK. ‼🍺♦

Ale (ABV 4%) GOLD
Herm Island Gold (ABV 4.2%) GOLD
IPA (ABV 4.8%) PALE

Little Big

23 St George's Esplanade, St Peter Port, Guernsey, GY1 2BG
☎ (01481) 728149 ⊕ littlebigbrewco.com

⊛Little Big Brew Co was founded in 2020. ‼🍺♦♠

Alan (ABV 4%) PALE
Betty (ABV 4%) RED

Randalls

La Piette Brewery, St Georges Esplanade, St Peter Port, Guernsey, GY1 3JG
☎ (01481) 720134 ⊕ randallsbrewery.com

Randalls has been brewing in Guernsey since 1868. The company was bought out in 2006 and moved into a modern, purpose-built brewery in 2008. 19 pubs are owned and a further 70 outlets are supplied. ‼♦

Stinky Bay

La Grand Route, St Lawrence, Jersey, JE3 1NH
☎ 07797 781703 ⊕ stinkybay.com

Named after a rugged bay on the North-Western tip of Jersey, Stinky Bay Brewing Co was established in 2017.

Isle of Man

Nestled in the Irish Sea, the Isle of Man is composed of picturesque coastal towns and rural villages dotted across the island. It has a unique place within the British Isles as a Crown Dependency, complete with its own laws, parliament, and currency. The island is famous worldwide for its annual TT motorbike road races which hurtle around an almost 38-mile course through towns and villages at up to 200mph. The region is also known for Manx Kippers, the tailless Manx cat and the Laxey Waterwheel - the largest in the world.

Despite having a population of just 85,000, the Isle of Man is well served by pubs and bottle shops - more than a hundred in fact. Visitors often remark on the unspoilt charm that many of them retain. The first micropub opened in Peel in 2018, the Miller's T'Ale, and offers a great selection of local and imported beers. There are also five breweries to explore; Okell's, Bushy's, Odin, Keenans and Radical.

Okell's is the oldest and largest brewery, and many of the local pubs are managed houses. You can see them in action with a brewery tour, held weekly on Wednesday evenings. Dr Okell famously persuaded the Manx parliament to institute the Brewers' Act in 1874, a Manx Pure Beer law stating that only water, malt, hops and yeast can be used in beer production. Unlike its German equivalent, the Reinheitsgebot, the Isle of Man law also permits the use of sugar alongside malt. This law was amended in the late 90s to allow specific additives so that lagers and fruit beers, for example, could also be produced.

Bushy's is the next largest brewery, with a quirky style and a strong association with the TT races. It puts on a 10-day festival during practice and race week with live music and a strong beer tent offering. If you want to sample the range of beers made by Odin, your best bet is to head to the Trafalgar Hotel in Ramsey, owned by the brewery and local CAMRA Pub of the Year 2022.

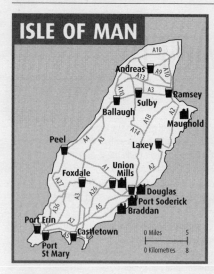

ISLE OF MAN

Andreas A10 A9
A13
Ballaugh A3 Ramsey
Sulby A2
Maughold
Peel A4 A3
Laxey
A1 Union
Foxdale Mills A2
A27 Douglas
A3 A26 Port Soderick
Braddan
Port Erin A7 A5 Castletown
Port St Mary A5

0 Miles 5
0 Kilometres 8

Andreas

Grosvenor Country Inn L

Andreas Road, IM7 4HE
☎ (01624) 888007
2 changing beers (sourced nationally; often Odin) Ⓗ
The island's most northerly pub is a free house that is popular for both drinking and dining, and is a meeting place for many local groups. Its informal public bar hosts pub games and displays many darts trophies. Quiz nights and musical events are hosted. Food is offered both to eat in (booking advised) and to take away.
🛋🏠🕩🔥♿🅿🖪🐾🌐

Ballaugh

Raven L ✓

The Main Road, IM7 5EG
☎ (01624) 896128
Okell's Bitter; house beer (by Okell's); 2 changing beers (sourced nationally) Ⓗ
Village-centre pub next to Ballaugh Bridge on the TT course. Popular with diners, it has tables on both sides of a central bar. The former darts and pool playing area has been removed to make way for an extended kitchen. Seating space outside is heavily used in summer especially during race periods, when motorbikes leap over the bridge. The house beer is Raven's Claw from Okell's. Q🛋🕩🔥♿🅿🖪(5,6)🐾🌐

Castletown

Castle Arms L ✓

The Quay, IM9 1LD
☎ (01624) 824673
3 changing beers (sourced locally; often Okell's) Ⓗ
Known locally as the Glue Pot, this small and characterful two-roomed bar is wedged in between the castle and harbour. It is featured on the Manx £5 note – the only pub in the British Isles to appear on a banknote. One room houses nautical memorabilia, the other displays photos and paintings of the TT races. The patio overlooking the picturesque harbour is popular in summer. Q🛋🕏🔥♿🅿🖪(1,2)🐾🌐

George Hotel L ✓

The Parade, IM9 1LG
☎ (01624) 822533

Okell's Manx Pale Ale, Bitter; 1 changing beer (often Okell's) Ⓗ
An imposing historic building in the ancient capital of Mann, dating back to 1833. Steeped in history, some a little dark, the George has a well-earned place on the Castletown ghost walk. A rare Okell's pub with accommodation, it has recently been refurbished to a high standard. The front rooms provide superb views of the castle across the market square. Numerous photos on the walls depict scenes from around the island.
🛋🏠🕩🔥♿🚶♿🅿🖪(1)🐾🌐

Sidings L

Victoria Road, IM9 1EF (next to railway station)
☎ (01624) 823282
Bushy's Castletown Bitter, Bitter; Castle Rock Harvest Pale; Okell's Bitter; 8 changing beers (sourced nationally; often Bowness Bay, Coach House, Copper Dragon) Ⓗ
This former ticket office for the Isle of Man Steam Railway is now an unashamedly beer-orientated traditional pub, serving four local real ales and up to eight more from all over. Its main bar is warmed by a real fire in winter. There is also a TV and games room. The recently revamped kitchen serves food daily; the dining area also hosts quizzes and live music. To the rear is a beer garden. Q🛋🏠🕩🔥♿🚶🅿🖪🐾🌐

Douglas

Albert Hotel ✓

3 Chapel Row, IM1 2BJ (close to bus stands and indoor market)
☎ (01624) 673632 🌐 albertiom.com
Bushy's Castletown Bitter, Bitter; Odin Manx Mild; Okell's Bitter; 1 changing beer (sourced locally) Ⓗ
Traditional, immaculately maintained pub near Douglas Harbour and the sea terminal. A central bar area serves two rooms – the one to the right features pool, darts and sports TV; to the left is a quieter bar adorned with photographs of Steam Packet boats on the walls. The long-time owner was a stalwart supporter of the hospitality industry during Covid. The cellar areas are reputedly among the oldest structures in Douglas.
Q🚶♿🖪🐾🌐

Bottle Monkey

22 Nelson Street, IM1 2AL
☎ (01624) 626495 🌐 bottlemonkey.im
6 changing beers (sourced nationally; often Cloudwater, Tiny Rebel, Wild Beer)
The island's first bottle shop is a welcome addition. It opened in 2020 in central Douglas and is a recent winner of a SIBA independent craft beer retailer award. The pub serves six rotating keg lines of which four are always KeyKeg, plus a range of approximately 250 cans and bottles that can be consumed on or off the premises.
Q🚶♿🍴🖪🐾

Brendan O'Donnells L ✓

16-18 Castle Street, IM1 2EU (on main shopping street)
☎ (01624) 621566
Okell's Bitter Ⓗ

This rare surviving pub on the town's main street is an old favourite of the island's large Irish community. Recently refurbished, it retains an intimate front snug separate from the main areas. The main bar to the rear has plenty of comfortable seating. There is also a TV sport and games room where live music is hosted. ⅁≠♣🖫👻🗢

Old Market Inn 🗓
Chapel Row, IM1 2BJ
☎ 07624 381076
2 changing beers (sourced locally; often Bushy's) 🅗
A bustling and lively traditional local with a loyal following, the Market is renowned for offering a warm welcome to visitors. Its two rooms are served by the island's smallest bar. The landlord is a keen TT supporter and the pub's walls are adorned with photos of the races, and records of generous fund-raising activities. The jukebox is well priced and popular. ≠🖫🗢

Prospect Hotel 🗓 ✅
Prospect Hill, IM1 1ET
☎ (01624) 616773
Okell's Manx Pale Ale, Bitter, Dr Okell's IPA; 5 changing beers (often Okell's) 🅗
Single-room pub that opened in 1857 in the finance sector of the island's capital. Its walls feature pictures of famous figures from the legal profession, reflecting its proximity to the law courts. There are eight handpumps in two banks of four on separate sides of the bar. They serve regularly changing guest ales, with real cider and perry occasionally also available. Wednesday is quiz night. Weekday night closing times vary significantly. ◖≠♦🖫(3,11)👻🗢

Rovers Return 🗓
11 Church Street, IM1 2AG (pedestrianised area behind the town hall)
☎ (01624) 676459
Bushy's Bitter; 5 changing beers (sourced nationally; often Bushy's) 🅗
An intriguing pub with a warren-like series of rooms, one dedicated to Blackburn Rovers. Popular with locals and visitors alike, it has an eclectic style that matches its clientele. One of only two Bushy's pubs on the island, it serves a choice of cask ales plus real cider. The lunchtime meals come in large portions. Attractions include TV sport and music, a pool room and a cosy real fine in winter. ❀◖≠♣♦🖫🗢

Thirsty Pigeon 🗓
38/40 Victoria Street, IM1 2LW
☎ (01624) 675584 ⊕ thirstypigeon.com
4 changing beers (sourced locally) 🅗
A welcoming open-plan pub in a former bank, popular with frequenters of wine bars and traditional drinkers alike. The interior features unfussy decor and dark wood, complemented by button-back seating and matching bar stools. Casks are taken down to the vault cellars via a box lift. Live music is performed regularly at weekends. ◖⅁≠🖫👻🗢

Woodbourne Hotel 🗓 ✅
Alexander Drive, IM2 3QF (in Woodbourne area of Douglas)
☎ (01624) 676754
Okell's Manx Pale Ale, Bitter; 5 changing beers (sourced nationally) 🅗
Large and attractive Victorian local in a residential area within walking distance of the town centre. This friendly, wet-led pub is known as the Woodie by its varied clientele. It has three bars plus a separate pool room. A former male-only bar now promotes real ale, serving a

range of Okell's beers plus multiple guests that change weekly. The pub hosts a Sunday quiz night and much charitable fundraising. Q❀⅁♣🖫👻🗢

Foxdale

Baltic Inn 🗓
1 Glentramman Terrace, IM4 3EE
☎ (01624) 801305 ⊕ balticinn.pub
Okell's Manx Pale Ale, Bitter; 1 changing beer (sourced nationally) 🅗
The only pub in a former mining village, featuring one main room divided into separate seating areas. A roaring real fire in winter adds to the atmosphere. There are some fascinating historical photos on the walls of Foxdale during the mining boom. This friendly pub is the essential hub of the village. Accommodation is available all year round. Q🐾❀≠⅁⅁🛆♣🖫(4)👻🗢

Laxey

Queen's Hotel 🗓
New Road, IM4 7BP (600yds S of village centre)
☎ (01624) 861195
Bushy's Castletown Bitter, Bitter; Odin Manx Mild, Laksaa Pale, Asgard Bitter 🅗
The Queen's has undergone much incremental improvement this past year but retains its traditional character. It is very much at the heart of the community, hosting pool, darts and monthly live music, and showing sport on TV. The walls display photos of local views and the TT motorcycle races. The Sunday afternoon meat raffle is popular. There is an idyllic beer garden hidden away at the rear, overlooking the historic Manx Electric Railway that runs between Douglas and Ramsey. 🐾❀🛆≠(Manx Electric) ♣♦🖫(3,3A)👻🗢

Shore Hotel 🗓 ✅
Old Laxey Hill, IM4 7DA (follow signs to Old Laxey from Laxey Main Rd)
☎ (01624) 861509 ⊕ shorehotellaxey.im
House beer (by Bushy's) 🅗
Built in 1837, the pub is in a picturesque location in Old Laxey, beside the Laxey River and harbour. It was refurbished in 2021 and now combines Victorian design with contemporary styling. A boutique hotel and restaurant will be the next phase of the renovation. Tables and chairs outside beside the river make for the perfect location to enjoy a beer on a summer evening. ❀🛆≠(South Cape Halt Manx Electric) ♣P🖫🗢

Peel

The Miller's T'Ale
33 Michael Street, IM5 1HD
☎ 07624 307356
5 changing beers (sourced nationally) 🅗
The Isle of Man's first micropub opened in 2018. It offers numerous styles of cask ale, focusing on lesser-known breweries and beers that are rarely seen on the island. It also serves two continental and craft ales plus an extensive choice of real ciders. An absence of music and gaming machines makes this popular, dog-friendly pub a venue for conversation and good company. It offers an excellent free cheeseboard on Sunday afternoons. Recent local CAMRA Cider Pub of the Year. Q♦🖫(5,6)👻🗢

White House Hotel 🗓 ✅
2 Tynwald Road, IM5 1LA (200yds from bus station)
☎ (01624) 842252

ISLANDS

Bushy's Bitter; Odin Manx Mild, Laksaa Pale, Asgard Bitter; Okell's Bitter; Timothy Taylor Landlord; 2 changing beers (sourced nationally) ⓗ
Traditional community pub with numerous rooms warmed by real fires. It has a cosy Captain's Cabin with a rare sliding door, a games room with darts and pool table, and another room for TV sport and live music. Alongside an extensive range of cask ales, available in two bars, real cider is regularly stocked. The White House has been identified by CAMRA as having a regionally important historic pub interior. Local CAMRA Pub of the Year 2020. Q❀♣♠P₽(5,6)❀ 🖤 🛜

Port Erin

Bay Hotel ⓛ
Shore Road, IM9 6HL
☎ (01624) 832084 ⊕ bushys.com/the-bay
Bushy's Bitter, Old Bushy Tail; house beer (by Bushy's); 2 changing beers (sourced locally) ⓗ
Bushy's flagship pub is on one of the island's best beaches. It has several traditional rooms including a public bar, a quiet room and a dining area. A good range of Bushy's beers is usually available alongside occasional and seasonal ales from the brewery, and the pub has recently started to serve two guest beers sourced nationally. Beach concerts featuring local bands and a promenade patio help make the Bay a great venue.
Q🏮🛏😀◑&🗽♣🖨🛜

Port St Mary

Albert Hotel ⓛ
Athol Street, IM9 5DS (opp harbour)
☎ (01624) 832118
Bushy's Bitter; Greene King Abbot; Okell's Bitter; 2 changing beers (sourced nationally; often Kaneen's, Marston's) ⓗ
A hidden gem in the heart of this coastal village, the Albert boasts impressive views over the harbour. It has a cosy lounge bar and a public bar with games area, both heated by wood-burning stoves. The pub is immaculately furnished and decorated, its walls displaying paintings by local artists. Toasties are available at most times. An overflow area provides extra tables and seating when needed. Q❀&♠🖨🛜

Ramsey

Mitre ⓛ
16 Parliament Street, IM8 1AP
☎ (01624) 813045
Okell's Bitter; house beer (by Okell's); 2 changing beers (sourced locally) ⓗ
Welcoming quayside pub with a friendly clientele. It has been refurbished to good effect in recent years, most recently the downstairs bar. The first floor Harbour Bar gives a fine view of the quay and illuminated swing bridge, and serves Okell's Jough, the house beer. Food includes a popular Sunday lunchtime carvery (booking advised). The pub can be accessed from the quay, which has ample parking, or the main street.
◑🖤≢(Plaza Manx Electric) ♠🖨(3,3A) 🖤 🛜

Trafalgar Hotel 🍺 ⓛ ✔
West Quay, IM8 1DW
☎ (01624) 609247
Odin Manx Mild, Rhumsaa Bitter, Laksaa Pale, Asgard Bitter; 2 changing beers (sourced nationally) ⓗ
A long-standing real ale pub on the harbour, now owned by Odin and usually serving four of the brewery's beers plus two guests. There are unobtrusive TVs showing

sport. Outside is a small area of wooden bench seating that overlooks the harbour. Well-behaved dogs are welcome. Local CAMRA Pub of the Year 2022.
🛏≢(Plaza Manx Electric) ♠🖨🖤🛜

Sulby

Ginger Hall ⓛ
Ballamanagh Road, IM7 2HB
☎ (01624) 897231
Odin Rhumsaa Bitter; 3 changing beers (sourced locally) ⓗ
Welcoming traditional pub that is an iconic landmark on the TT course. Its interior features a real fire and an impressive beer engine that dispenses two local real ales plus regularly changing guests. Attractions include a large TT circuit map on the ceiling – do not spill your beer while admiring it – and a mirror commemorating Castletown Brewery behind the bar. The pub has a pool room and a separate Thai restaurant, and offers en-suite accommodation. 🛏❀🍴◑🛏▲♠P🖨🖤🛜

Union Mills

Railway Inn ⓛ
Main Road, IM4 4NE
☎ (01624) 853006
Okell's Bitter; 4 changing beers (sourced nationally; often Bushy's, Odin) ⓗ
The only pub in the village, this free house has three connecting rooms and occupies a popular spot on the TT course. Its garden overlooks the famous circuit and provides superb views when racing takes place. The local Okell's Bitter is served alongside four changing beers from elsewhere, almost always from both Manx and national breweries. Q❀◑▲♠P🖨🖤🛜

Breweries

Bushy's SIBA
Mount Murray Brewery, Mount Murray, Braddan, Isle of Man, IM4 1JE
☎ (01624) 661244 ⊕ bushys.com

☺Launched in 1986 as a brewpub, Bushys relocated in 1990 when demand outgrew capacity. Bushys goes one step further than the Manx Pure Beer Law preferring the German Reinheitsgebot (Pure Beer Law). The brewery hosts a successful festival during the TT period at Villa Marina Gardens, Douglas. Bushys distributes to many pubs and clubs throughout the Isle of Man. 🍺♦

Castletown Bitter (ABV 3.5%) BITTER
Bitter (ABV 3.8%) BITTER
A traditional malty and hoppy beer with good balance. The fruit lasts through to the bitter finish.
Bosun Bitter (ABV 3.8%) BITTER
Darkside (ABV 4%) MILD
Mannannan's Cloak (ABV 4%) BITTER
Triskellion (ABV 4%) GOLD
Classic (ABV 4.3%) BITTER
Bramble (ABV 4.4%) SPECIALITY
Buggane (ABV 4.4%) BITTER
Old Bushy Tail (ABV 4.5%) BITTER
Red (ABV 4.7%) RED
Star of India (ABV 5%) PALE

Brewed for Old Laxey Brewery:
Bosun Bitter (ABV 3.8%) BITTER

Kaneen's

Kaneens Garage, Main Road, Union Mills, Isle of Man, IM4 4AE ☎ 07624 302245 ⊕ kaneensbrewery.com

⊠ Launched in 2021, head brewer Peter Kaneen converted a vehicle repair garage into Kaneen's Microbrewery.

Lhune Airh (ABV 4.8%) GOLD

Odin SIBA

Glen Mona Loop Road, Maughold, Isle of Man, IM7 1HJ ☎ 07624 266664

Established in 2019 using the 2.5-barrel brewery from Betteridge's of Hampshire. Founder and brewer Rob Storey brews six core beers in cask. LIVE

Manx Mild (ABV 3.4%) MILD
Well-balanced mild, malt and caramel sweetness along with roast bitterness in the taste is followed by a sweeter, malty finish.
Rhumsaa Bitter (ABV 3.7%) BITTER
Laksaa Pale (ABV 3.8%) PALE
Asgard Bitter (ABV 4.2%) BITTER
Black Claw (ABV 4.5%) STOUT
Oyster Stout (ABV 4.8%) STOUT

Okell's

Kewaigue, Douglas, Isle of Man, IM2 1QG ☎ (01624) 699400 ⊕ okells.co.uk

⊛ Founded in 1874 by Dr Okell, this is the main brewery on the island and moved in 1994 to a new, purpose-built plant at Kewaigue. All the beers are produced under the Manx Brewers' Act. ‼♦

MPA – Manx Pale Ale (ABV 3.6%) PALE
A golden, fruity, session beer with background sweetness and a rising hoppy finish.
Bitter (ABV 3.7%) BITTER
Classic traditional bitter with sweet malt and hops in balance. Some fruit and caramel throughout and an even bitter finish.
Dr Okell's IPA (ABV 4.5%) BLOND
A clean, fruity, sweetish bitter with an alcoholic bite.

Radical

Lough Ned, Oak Hill, Port Soderick, IM4 1AN ☎ 07624 493304 ⊕ radicalbrewing.im

Dr Mike Cowbourne, who was in charge of brewing at Okell's Brewery, has set up this small brewery in his garage. The beers are available to the free trade and the most likely venue to have them is the Falcon Hotel, Port Erin. This brewery only produces pins so no firkins are used and usually there's one brew a week (could be one of four beers).

Ironic Rye (ABV 3.8%) PALE
Radical Bitter (ABV 3.8%) BITTER
Amarillo Dreamin (ABV 4.4%) PALE
SuperNova Sunshine (ABV 4.6%) PALE

George Hotel, Castletown (Photo: Rick Pickup)

London's Best Beer, Pubs & Bars

Des De Moor

The essential guide to beer drinking in London, completely revised for 2022. Laid out by area, the book makes it simple to find the best London pubs and bars – serving the best British and world beers – and to explore the growing number of London breweries offering tours, taprooms and direct sales. Features tell you more about London's rich history of brewing and the city's vibrant modern brewing scene. The venue listings are fully illustrated, with detailed information on opening hours, local landmarks, and public transport links to make planning any excursion quick and easy. The book also includes a comprehensive listing of London breweries.

RRP: £16.99 **ISBN:** 978-1-85249-360-8

For this and other books on beer and pubs, visit CAMRA's online bookshop at **shop1.camra.org.uk** or call 01727 867201.

Discounts are available for CAMRA members.

Indexes & Further Information

Places index

Blakedown *439*
Blaxhall *92*
Bledington *327*
Bledlow *169*
Blisland *276*
Bloomsbury *111*
Blyth *713*
Bo'ness *840*
Bodfari *760*
Bodmin *276*
Bognor Regis *263*
Boldmere *423*
Bollington *605*
Bolney *263*
Bolton *658*
Boot *619*
Boothstown *659*
Boreham *41*
Boreham Street *250*
Borough *124*
Borough Market *125*
Bosbury *378*
Bostock Green *605*
Boston *482*
Botley *179*
Bottesford *470*
Boundstone *238*
Bourne *483*
Bourne End *169*
Bournemouth *315*
Bourton *316*
Bourton-on-the-Water *327*
Bovingdon *59*
Bow *114*
Box *365*
Bracknell *158*
Bradford *576*
Bradford on Tone *350*
Bradford-on-Avon *366*
Bradiford *294*
Bradley *535*
Bradshaw *577*
Braemar *792*
Brailes (Lower) *410*
Braintree *42*
Bramhall *659*
Bramley *238*
Bramling *203*
Brampton *620*
Brancaster Staithe *71*
Brandon *92*
Branscombe *295*
Bransgore *179*
Bratton Clovelly *295*
Braye *862*
Brechfa *776*
Brechin *848*
Brecon *755*
Bredbury *659*
Brenchley *203*
Brent Eleigh *92*
Brentford *140*
Brentwood *42*
Bretforton *439*
Bridford *295*
Bridge of Allan *841*
Bridge of Earn *848*
Bridge of Orchy *797*
Bridge of Weir *821*
Bridgend *734*
Bridgnorth *383*
Bridgwater *351*
Bridlington *526*
Bridport *316*

Brierley Hill *423*
Brigg *483*
Brighouse *577*
Brightlingsea *42*
Brighton *251*
Brightwell-cum-Sotwell *228*
Brill *169*
Brimscombe *328*
Bristol *330*
Brithdir *768*
Brixham *295*
Brixton
 Devon *295*
 Greater London *133*
Broad Campden *332*
Broad Oak *203*
Broadbottom *659*
Broadhembury *295*
Broads Green *42*
Broadstairs *204*
Broadway *439*
Brockdish *71*
Brockley *126*
Bromborough *685*
Bromham *21*
Bromley *129*
Brompton *204*
Bromsgrove *440*
Bromyard *378*
Broom
 Bedfordshire *21*
 Warwickshire *410*
Brough *527*
Broughton *28*
Broughton-in-Furness *620*
Broughty Ferry *848*
Brownhills *423*
Broxted *42*
Brynnau Gwynion *734*
Bubbenhall *410*
Buckfastleigh *296*
Buckingham *169*
Bude *277*
Builth Wells *755*
Bulkington *410*
Bungay *92*
Buntingford *59*
Burbage *471*
Bures Hamlet *42*
Burford *228*
Burgess Hill *263*
Burn *535*
Burnage *659*
Burnham Thorpe *71*
Burnham-on-Crouch *42*
Burnley *639*
Burntisland *836*
Burrough on the Hill *471*
Burrowbridge *351*
Burscough *639*
Burston *72*
Burton Bradstock *316*
Burton Latimer *498*
Burton upon Trent *393*
Burton-upon-Stather *483*
Bury *660*
Bury St Edmunds *92*
Burythorpe *536*
Bushey *59*
Butterleigh *296*
Butterton *394*
Buxton *452*

Bwlch *755*
Bwlchgwyn *760*

C

Cadgwith *277*
Cadishead *660*
Cadole *760*
Caerleon *749*
Caernarfon *769*
Caerphilly *734*
Cairndow *797*
Calderbridge *620*
Caldicot *749*
Caldwell *536*
California *72*
Callington *277*
Callow End *440*
Camberley *238*
Camberwell *126*
Cambridge *28*
Cambuslang *821*
Camden Town *122*
Cannock *394*
Cannon Street *110*
Canonbury *119*
Canterbury *204*
Capel Curig *769*
Capel Hendre *776*
Car Colston *508*
Cardiff *736*
Cardigan *776*
Cardington *384*
Carisbrooke *197*
Cark-in-Cartmel *620*
Carleton *640*
Carlisle *620*
Carlton *21*
Carlton in Lindrick *509*
Carmarthen *776*
Carnforth *640*
Carrbridge *829*
Carrickfergus *857*
Carrog *760*
Carshalton *135*
Cartmel *621*
Castle Bytham *483*
Castle Donington *471*
Castle Douglas *808*
Castleford *577*
Castleton
 Derbyshire *452*
 Greater Manchester *660*
Castletown *866*
Castor *30*
Caterham *239*
Catfield *72*
Catthorpe *471*
Caulcott *228*
Caunsall *440*
Caversham *159*
Caverswall *394*
Cawdor *829*
Cemmaes Road *756*
Ceres *836*
Cerne Abbas *317*
Chadderton *660*
Chaddesley Corbett *440*
Chadlington *228*
Chadwell Heath *117*
Chagford *296*
Chaldon Herring *317*
Chance's Pitch *379*
Chandler's Ford *179*

Chapel St Leonards *483*
Chappel *43*
Charcott *205*
Charfield *332*
Charing Cross *111*
Charlbury *228*
Chatteris *30*
Cheadle
 Greater Manchester *661*
 Staffordshire *394*
Cheadle Hulme *661*
Cheam *136*
Chearsley *170*
Cheddar *351*
Cheddleton *394*
Chedworth *332*
Chelford *606*
Chelmsford *43*
Cheltenham *333*
Chepstow *749*
Cheriton *179*
Cheriton Fitzpaine *296*
Chertsey *239*
Chesham *170*
Chester *606*
Chester-le-Street *699*
Chesterfield *452*
Chew Magna *351*
Chichester *263*
Chickerell *317*
Chilbolton *179*
Child Okeford *317*
Childer Thornton *607*
Chilsworthy *277*
Chilton Foliat *366*
Chingford *114*
Chinnor *229*
Chippenham *366*
Chipping Campden *333*
Chipping Norton *229*
Chipping Sodbury *333*
Chipstead *205*
Chislehurst *129*
Chiswick *138*
Chittlehamholt *296*
Chittlehampton *296*
Chobham *239*
Chop Gate *536*
Chorley *640*
Chorlton-cum-Hardy *661*
Chrishall *43*
Christchurch *317*
Christow *296*
Chulmleigh *296*
Church Crookham *179*
Church Fenton *536*
Church Laneham *509*
Church Minshull *607*
Churchdown *334*
Churchill *351*
Churchinford *351*
Churchstoke *756*
Churt *239*
Cilgerran *777*
Cippenham *159*
Cirencester *334*
Clachan Seil *798*
Clacton-on-Sea *44*
Clapham *132*
Clapham Junction *133*
Clapton *114*
Clare *93*
Clayton le Moors *641*
Clearbrook *296*

PLACES INDEX

London index

*shown on Inner London map

Brewery index

Beers index

These beers refer to those in bold type in the brewery listings (beers in regular production) and so therefore do not include seasonal, special or occasional beers that may be mentioned elsewhere in the text.

Clotworthy Dobbin Whitewater *860*
Cloud Fall 71 Brewing *850*
Cloud Piercer Bone Machine *532*
Clout Stout Nailmaker *571*
Clout Beowulf *403*
Club Hammer Stout Pope's Yard *67*
Clwyd Gold Facer's *765*
Coachman Clavell & Hind *341* Old Vicarage *633*
The Coachman Posh Boys *56*
Coachman's Best Bitter Coach House *614*
Coal Aston Porter Drone Valley *465*
Coal Face Stout Industrial Ales (Silver) *467*
Coal Porter Brightwater *247* Great British Breworks *554*
Coalface Firebrick *725*
The Coaster Platform 5 *312*
Coastline Kettlesmith *374*
Cobbler's Ale Phipps NBC *505*
Cobblers Revival Downham Isle *37*
Cobnut Kent *222*
Cock & Hoop Nottingham *520*
Cock 'n' Bull Story Concrete Cow *175*
Cockle Row Spit Leigh on Sea *55*
Cockleboats George's *55*
Cocky Piddle *325*
Coco Loco Grafton *517*
Coco Nutter Little Critters *571*
Cocoa Wonderland Thornbridge *468*
Cocow Ampersand *83*
Coffee Switch Hops & Dots *709*
Coffin Lane Stout Ashover *462*
Cofton Common Weatheroak Hill *446*
Coggeshall Gold Red Fox *56*
Cold Bath Gold Harrogate *555*
Cold Brew North Pier *709*
Coldharbour Hell Yeah Lager Clarkshaws *145*
Colley's Dog Tring *68*
Collusion Surrey Hills *248*
Colonial Pale Ale Milestone *519*
Columbus Pale Cat Asylum *516*
Columbus Bottle Brook *463*
Come As You Are Nightjar *597*
Comet Crankshaft *652* Newby Wyke *496*
Common Grounds Magic Rock *596*
Common Pale Ale Wimbledon *156*
Communion Blueball *613*
The Company Consett *708*
Complete Muppetry Two Towers *437*
Complicated Maisie Ayr *803*
The Cone Top Out *820*
Coniston K7 Coniston *630*
Conkerwood Lord Conrad's *37*
Conqueror Windsor & Eton *167*
Conquest Battle *258*
Consols Mine *288*
Converted Front Row *404*
Cooking Grainstore *523*
Cool Bay Chelmsford *54*
Cool Citra Ainsty *552*
Copper Ale Palmers *325* Rother Valley *260*
Copper Beacons Brecon (Cold Black Label) *744*
Copper Best Taw Valley *314*
Copper Hop Long Man *260*

Copper Hoppa Wriggle Valley *326*
Copper Jack Grafton *517*
Copper Leaf Ale Wimbledon *156*
Copper Penny Flipside *517*
Copper Plate Irwell Works *678*
Copper Top Old Dairy *223*
Copper 3 Brewers of St Albans *66* Wrytree *717*
Copperhead Whitewater *860*
Copperheid Top Out *820*
Coppernob Tonbridge *225*
Copy Cat Snowhill *655*
Corbel Eight Arch *324*
Corby Ale Great Corby *631*
Corinium Gold I Corinium *341*
Cormorant Stout Thames Side *249*
Corn Du Brecon (Cold Black Label) *744*
Corncrake Orkney *846*
Cornish Arvor Penpont (Firebrand) *286*
Cornish Best Bitter Castle *285* St Austell *289*
Cornish Bitter Harbour *287*
Cornish Coaster Sharp's *289*
Cornish Knocker Skinner's *290*
Cornwall's Pride Tintagel *290*
Corsair American Pale Ale Three Engineers *345*
Corvus Squawk *681*
Cosmati Hophurst *678*
Cosmic Pop Beat *433*
Cosmic Black Hole *463*
Cosmonaut Nightjar *597*
Costa Del Salford Irwell Works *678*
Cote De Reiver Crankshaft *652*
Cotswold Best North Cotswold *415*
Cotswold Gold Donnington *342*
Cotswold Way Wickwar *346*
Cotton Clouds Craft Ale Donkeystone *677*
Country Bitter McMullen *67*
Country Bumpkin Country Life *309*
Country Wobbler Dartford Wobbler *221*
Countryman Tonbridge *225*
County Best Exeter *310*
Courthill Redcastle *851*
Courthouse Porter New Buildings *479*
Cousin Jack Mine *288*
Coventry Bitter Byatt's *434*
Covert Stealth *375*
COW Brolly *270*
Cowcatcher American Pale Ale East London *146*
Cowgirl Gold Fallen Angel *55*
Cowjuice Milk Stout Breakwater *220*
Crack Gold Twisted Oak *364*
Crack Hops Twisted Oak *364*
Crackatoa IPA CrackleRock *192*
Cracker Barngates *629* Quartz *406*
Crackerjack CrackleRock *192*
Crafty Flanker Front Row *404*
Crafty Fox Wily Fox *683*
Crafty Mild Kirkby Lonsdale *632*
Crafty Shag CrackleRock *192*
Crafty Stoat Wibblers *57*
Cragg Bitter Little Valley *596*
Craven Bitter Dark Horse *554*
Crazy Daze Potbelly *505*
Crazy Like A Fox Totally Brewed *521*

Creation Pale Ale Penpont (Firebrand) *286*
Cregennan Cader *773*
Creme Bearlee Beartown *613*
Crex Squawk *681*
Crib Goch Cold Black Label *744*
Cribyn Brecon (Cold Black Label) *744*
Criffel Sulwath *811*
Crimson Rye'd GT *310*
Crispin Ale Mad Cat *223*
Crispin's Ommer Fownes *435*
Crispy Pig Hunters *311*
Critical Temperature Atom *531*
Crofters FILO *259*
Cromwell Best Bitter Coach House *614*
Cromwell Best Milestone *519*
Crooked Hooker Towcester Mill *506*
Crop Circle Hop Back *374*
Cross Collar Marble *679*
Cross Pacific Pale Ale Firebrand *286*
Crouch Front Row *404*
Crow Black Hattie Brown's *324*
Crow Potton *26* Wobbly *382*
Crowlas Bitter Penzance *288*
Crown Ale Drink Valley *373*
Crown Best Bitter Stockport *682*
Crown And Glory Cheddar *362*
Crown Imperial Stout Goacher's *221*
Crows-an-Wra Penzance *288*
Crowstone Leigh on Sea *55*
Cruckhouse New Buildings *479*
Crusader Gold Unsworth's Yard *634*
Crusader Milestone *519* Redcastle *851*
Cryo Triple Point *572*
Crystal Ship Papworth *38*
Crystal Quartz *406*
Cub Moody Fox *466*
Cubbio Damage Marble *679*
Cuil Hill Sulwath *811*
Cuillin Beast Isle of Skye *834*
Cult Leader Anarchy *724*
Cumberland Jennings (Marston's) *406*
Cumbria Way Robinsons *681*
Cumbrian Bitter Carlisle *629*
Cunning Stunt Fuzzy Duck *652*
The Cure Shortts *104*
Curiously Dark Dartford Wobbler *221*
Cushie Butterfield Firebrick *725*
Cuthbert's Fee Bakers Dozen *523*
Cutting Edge Stockport *682*
Cwrw Caradog Ogwen *774*
Cwrw Eryri/Snowdonia Ale Purple Moose *774*
Cwrw Glaslyn/Glaslyn Ale Purple Moose *774*
Cwrw Glyndwr Llŷn *773*
Cwrw Gorslas/ Bluestone Bitter Glamorgan *745*
Cwrw Grav Tinworks *785*
Cwrw Gwyn Gwaun Valley *784*
Cwrw Madog/Madog's Ale Purple Moose *774*
Cwrw Melyn Gwaun Valley *784*
Cwrw Teifi Mantle *785*
Cwrw Ysgawen/Elderflower Ale Purple Moose *774*

Flack's Double Drop Flack
 Manor 193
Flamme Rouge Chapeau 271
Flange Noir Toolmakers 572
Flash IPA Barefaced 322
Flat Cap Bank Top 675
Flatland Bitter Welland 497
Flaxen Carlisle 629
 Hophurst 678
Fleek Wylam 727
Fletcher's Ale Milestone 519
Flight of the Falcon Peregrine 654
Flint's Gold Burnside 795
Flintlock Pale Ale Coach
 House 614
Flintlock Musket 223
Flintshire Bitter Facer's 765
Flippin Eck Yorkshire
 Brewhouse 533
Flipping Best Flipside 517
Flipside Flipping Best Magpie 519
Flipside Sterling Pale Magpie 519
Flodden Thirst Cheviot 716
The Flookburgh Cockler
 Unsworth's Yard 634
Flora Daze Blue Anchor 285
Flotilla Emsworth 192
Flower Power Mithril 555
 Whim 469
Flowerdew Townhouse 634
Fluffy Bunny Beer Hut 858
Flummoxed Farmer Ainsty 552
Fluthered Anstey (MonsteX) 479
Flux Wishbone 601
Flying Elephants Ulverston 634
Flying Herbert North Yorkshire 556
Fog of War Spartan 154
Foggy Gold Crankshaft 652
Fogline Kettlesmith 374
Folded Cross Beowulf 403
Folkestone Best McCanns (Angels
 & Demons) 220
Font Ashover 462
Fools Gold 3P's 461
 Brinkburn Street 725
 Lord Conrad's 37
Fools Nook Digfield 504
Forager's Gold Indigenous 165
Foreman's IPA Consett 708
Forest Gold Bespoke 341
 Rockingham 505
Foresters Black Dawkins 342
Forever Godstone 248
Format Beermats 515
Fort Point Porter Aye Been 806
Fortitude Bristol Beer Factory 341
 Wantsum 225
Fortune Teller Origami 680
Fortyniner Ringwood 195
Fosse Ale Dow Bridge 478
Fossil Dinner Chapter 614
Fossil Fuel Isle of Purbeck 325
Fossil Madrigal 311
Foundation Bitter East London 146
Foundation Stone Lymestone 405
Founders Best Bitter Hurst 272
Founder's JW Lees 678
Foundry Mild Nottingham 520
Fountain Dale Lincoln Green 518
Four Acre Arcadia Star Wing 104
Four Freedoms Clarkshaws 145
Four Hopmen of the Apocalypse
 Totally Brewed 521
Four Sons Creaton Grange 504
Four Stones Radnorshire 759

Four XT 176
The Fourth Spire Twisted
 Barrel 437
Fox Brown Ale Great Corby 631
Fox Dark Keswick 632
The Fox Hat Wily Fox 683
Fox Pale Keswick 632
Fox Exmoor 362
Foxtrot Pale Two by Two 727
Foxtrot Premium Ale Great North
 Eastern 726
FPA Pale Ale Fat Belly 310
Fra Diavolo Ulverston 634
Franc in Stein Flipside 517
Franconia Torrside 468
Frank the Tank Bullhouse 858
Frank Revolutions 598
Frankenstein Aldwark Artisan 461
Fraoch Heather Ale Williams
 Bros 844
Free Style Fine Tuned 362
Freebird Deeply Vale 676
 Sandbanks 326
Freedom Hiker Gyle 59 324
Freehand Big Hand 765
Fresh Start Farr Brew 66
Friday Gold Friday Beer 445
Friday Street IPA Framework 478
Friday Street Humber Doucy 102
Frigate Irving 193
Friggin' in the Riggin' Nelson 223
Frisky Mare Indigenous 165
Frizzle British IPA Hop Shed 446
Frog Hill Cornish IPA Dynamite
 Valley 286
Froglet 8 Sail 494
Front Runner Ascot 246
Frost Hammer Fownes 435
Frothingham Best Great
 Newsome 532
Fruits of the Forest
 Rockingham 505
FSB (Forest Strong Bitter) Forest,
 The 342
FSB – Fishguard Special Bitter
 Gwaun Valley 784
Fudge Unit Three Fiends 600
Fuggle Stone Hop Back 374
Fuggle-Dee-Dum Goddards 200
Fuggles Eden River 630
Full Chat Apex 361
Full Gallop Uttoxeter 408
Full Measure Porter
 Aitcheson's 531
Full Moon Porter Canopy 145
Full Moon Chantry 569
 Hattie Brown's 324
Full Nelson Hartshorns 465
 Kelchner 26
Full Steam Ahead Isle of
 Purbeck 325
Full Tilt Wriggly Monkey 237
Full Whack Peerless 694
Fundamental DDH IPA Spectra 827
Funk Beat 433
Funky Monkey Frome 363
Funky Town Beath 838
Funny Farm Blindmans 361
Fursty Ferret Hall & Woodhouse
 (Badger) 324
Fusee Chain Drop The Anchor 192
Fusion Hartshorns 465
Fusioneer Mr Winter's 86
Fuster Cluck Bang-On 743
Fyrds Gold Battle 258

G

Gadds' Black Pearl Ramsgate
 (Gadds') 224
Gadds' Faithful Dogbolter Porter
 Ramsgate (Gadds') 224
Gadds' Hoppy Pale Ramsgate
 (Gadds') 224
Gadds' No. 3 Kent Pale Ale
 Ramsgate (Gadds') 224
Gadds' No. 5 Best Bitter Ale
 Ramsgate (Gadds') 224
Gadds' No. 7 Bitter Ale Ramsgate
 (Gadds') 224
Gadds' Seasider Ramsgate
 (Gadds') 224
Gadds' She Sells Sea Shells
 Ramsgate (Gadds') 224
Galapagos Darwin 725
Galaxy Australian Pale Ale
 Frome 363
Galaxy Hopping Basement
 Beer 340
GalaXy IPA Xtreme 39
Galaxy Bridge 676
Galene Neptune 694
Gallia Twice Brewed 717
Galloway Gold Sulwath 811
Gallows Gold Park 152
Galvy Stout Weldon 506
Game changer Facer's 765
Game Over Leatherbritches 466
Gamekeeper Wensleydale 558
Gannet Mild Earl Soham 101
Garden Shed Outhouse 571
Garland Madrigal 311
Garsdale Smokebox Yorkshire
 Dales 558
Garside Gold Grafton 517
Gate Hopper Maypole 519
Gatekeeper Buxton 463
Gates Burton Ale (GBA) Gates
 Burton 405
Gaucho / Fly Half Twisted 375
Gem Bath Ales 340
General Picton Rhymney 753
Genesis Goody 221
George Shaw Premium Tipsy
 Angel (4Ts) 613
George's Best George's 55
German Ale Altbier Fuddy
 Duck 496
German Hops Pils Tryst 844
GFB Hop Back 374
Ghost Porter Yorkshire Heart 558
Ghost Ship Adnams 100
Ghost Ships Whitley Bay 727
Ghost Town Cromarty 833
Ghoul Brew Monster 744
Ghyll Fell 631
Giggle & Titter Parkway 363
Gigglemug Bang The Elephant 462
Gilt Complex Surrey Hills 248
Gilt Trip Surrey Hills 248
Gin & Beer It Lincoln Green 518
Ginger Beer Enville 404
 Fallen Angel 55
Ginger Brew Bollington 613
Ginger Ninja Dancing Duck 464
Ginger Panther Panther 87
Ginger Stout Angel Ales 432
Ginger Weal Weal 408
Ginger Blackedge 675
GL12 Lucifer 344
Glacier Beartown 613

Levelly Gold Shalford 56
Leveret Twisted Oak 364
Leveson Buck Titsey 249
Leviathan IPA Brew Monster 744
Leviathan Hopdaemon 222
Leyland Badger Crankshaft 652
Leyland Tiger Cub Crankshaft 652
LFB (Lunns First Brew) Golden Duck 478
LGM1 Green Jack 101
Lhune Airh Kaneen's 869
Lia Fail Inveralmond 851
Liberation Suthwyk (Bowman) 192
Liberator Tindall 88
Lickety Split Lord Conrad's 37
Life & Death Vocation 600
Life on Mars Hammerton 149
Life Of Riley Wincle 617
Lifeboat Titanic 407
Lifeline Brolly 270
Lifesaver Strong Bitter Mumbles 746
Lifesaver Salcombe 313
Lift & Shift Burnside 795
The Light Brigade Ben's 651
Light But Dark Old Spot 598
Light no2 Harbour 287
Light Oak Weatheroak 416
Light Railway Kinver 405
Light Rale Ashover 462
Light Harbour 287
Lighterman Exeter 309
Lightfoot Theakston 557
Lightheaded Great British Breworks 554
Lighthouse IPA Red Rock 312
Lighthouse Pale Ale New Buildings 479
Lightning Pale Ale Axholme (Docks) 495
Lights Out Apex 361
Lightweights & Gentlemen Irwell Works 678
Lignum Vitae Grain 85
Likely More Bar Tat Red Rose 680
Limehouse Porter Lister's 273
Limestone Cowboy Iâl 766
Lincoln Best Poachers 497
Lincoln Gold Lincolnshire Craft 496
Lincoln Imperial Ale Small Beer (Black Hole) 463
Lincoln Lager Ferry Ales 495
Lincoln Tank Ale Pheasantry 520
Lincolnshire Country Bitter Firehouse 496
Line of Sight Broadtown 373
Linebacker Leadmill 465
Lion's Pride Milestone 519
Lip Smacker Brightwater 247
Liquid Bread Bakehouse (Warwickshire) 416
Opa Hay's 87
Liquid Gold Goldmark 271
Liquorice Lads Stout Great Newsome 532
Lit Beartown 613
Litehouse Forge 287
Little Belgium Firebrick 725
Little Bitter That Brew Foundation 613
Little & Black S Big Hand 765
Little Bollington Bitter Dunham Massey 677
Little Fox Newbridge 436
Little Hopper Little Critters 570

Little IPA Liverpool Brewing 694
Little John Lincoln Green 518
Milestone 519
Little Nipper Brightwater 247
Little Pearl Brolly 270
Little Rock IPA Harbour 287
Little Sharpie Humpty Dumpty 85
Little Tor Buxton 463
Little Weed Maypole 519
Littlemoor Citra Ashover 462
Liverpool Light Rock the Boat 694
Liverpool Pale Ale Liverpool Brewing 694
Liverpool Stout Liverpool Brewing 694
Llandogo Trow Kingstone 753
Lleu Lleu 773
Lobster Licker Lord Conrad's 37
Local is Lekker Kelchner 26
Lock N Load BOA (Brothers of Ale) 445
Lockdown IPA Fat Cat 85
Lockdown Joe No Frills Joe 223
Locomotion No 1 George Samuel 709
Lode Star Hop Kettle 374
Lodestar Festival Ale Calvors 101
Lodona 1862 Bricknell 532
LOHAG (Land of Hops and Glory) Front Row 404
Lol! Twt Lol 747
Lomas Loxley 571
London Glory Greene King 102
London Lush London Brewing 150
London Original Young's (Eagle) 26
London Pale Ale Southwark 154
London Porter Mad Squirrel 67
Moonface 479
London Pride Fuller's 148
London Special Young's (Eagle) 26
London Tap New River 67
London Thunder Rooster's 556
Lone Rider Tombstone 88
Lonely Snake Three Blind Mice 39
Lonely Souls Twisted Barrel 437
Lonesome Pine Ulverston 634
Long Blonde Long Man 260
Long Hop Bollington 613
Long Lane Austendyke 494
Long Moor Pale Small World 599
Long White Cloud Escape 677
Longbow Empire 594
Lincoln Green 518
Longdendale Lights Distant Hills 464
Longdog IPA Longdog 194
Loop Extra Pale Ale Little 466
Looper Full Circle 726
Loophole Clun 389
Lord Cullens Ruby Elmesthorpe 478
Lord Have Mercy Draycott 465
Lord Kitchener Mr Grundy's (Black Hole) 463
Lord Marples Thornbridge 468
Lost & Found Madrigal 311
Lost Angel Hybrid 843
Lost in Ikea Nightjar 597
Lost in the Woods Devon Earth 309
Lost Shadow Burnside 795
Lotus IPA Ilkley 595
Lou's Brew Driftwood Spars 286
Loud Mouth BOA (Brothers of Ale) 445

Love Monkey Glastonbury (Parkway) 363
Lovelight Melwood 694
Lovely Nancy Longdog 194
Lovely Nelly Cullercoats 725
Low 5 Hand 259
Low Force Barnard Castle 707
Low Tide Southsea 195
Low Tor Buxton 463
Loweswater Gold Cumbrian 630
Lowry Hydes 678
Loxhill Biscuit Crafty 247
Loxley Ale Milestone 519
LSD (Langham Special Draught) Langham 272
Lucid Dream Turning Point 558
Lucky Dip South Lakes 633
Lucky Spence Ale Bellfield 818
Lucy Strawberry Fields (Big Bog) 693
Luda Stout Firehouse 496
Luddite Ale Mill Valley 596
Ludlow Best Ludlow 390
Ludlow Blonde Ludlow 390
Lumberjack Brentwood 54
Lumina Siren 166
Luminaire Pope's Yard 67
Lunnys No8 Golden Duck 478
Lupa Flagship 693
Lupus Lupus Wolf 89
Lurcher Stout Green Jack 101
Lush Hopstar 652
Lushingtons Skinner's 290
Luvly Little London 194
Lux Folly 652
Lyme Regis Ammonite Gyle 59 324
Lynch Pin Toolmakers 572

M

M V Enterprise Harbwr Tenby 784
M&B Brew XI Molson Coors (Brains) 744
MòR Ish! MòR 851
MòR Please! MòR 851
MòR Tea Vicar? MòR 851
Machlyd Mawddach Cader 773
Mad Dogs & Englishmen Irwell Works 678
Mad Gaz Amwell Springs 235
Mad Goose Purity 416
Mad Hatter Weetwood 617
Mad Jack Papworth 38
Mad Max Weldon 506
Mad Monk Digfield 504
Mad O'Rourke's Lump Hammer Gold Dig 434
Mad O'Rourkes Lump Hammer Bitter Dig 434
Mad O'Rourke's Sledge Hammer IPA Dig 434
Mad Ruby Leatherbritches 466
Mad Trappiste Dominion 54
Mad Van Mild Urban Chicken 469
Mad Wolf Wolf 89
Mad World Beath 838
Madagaska Donkeystone 677
Madchester Cream Mighty Medicine 653
Madre Brolly 270
Maggie's Angel IPA Whitewater 860
Maggs' Mild Renegade 166
Magic Malt Mighty Medicine 653
Magic Number Carlisle 629

S

BEERS INDEX

There's Something in the Water Beer Hut *858*
Thieves & Fakirs Dartford Wobbler *221*
Thieving Rogue Magpie *519*
Thirst Aid Kit Rock & Roll *437*
Thirst Aid Bang-On *743*
Thirst Celebration Keswick *632*
Thirst for Knowledge BritHop *258*
Thirst of Many GT *310*
Thirst Quencher Keswick *632*
Thirst Rescue Keswick *632*
Thirst Run Keswick *632*
Thirstquencher Spitting Feathers *616*
Thirsty Blonde Teignworthy *314*
Thirsty Moon Phoenix *680*
Thirsty Walker Dove Street *101*
Thirteen Blimey! *84*
Thirty Three Brighton Bier *258*
This is the Modern Weal *408*
This Splendid Ale Facer's *765*
This Teme Valley *446*
Thomas Lift Langton *479*
Thomas Miller 1785 Ferry *819*
Thomas Sykes Burton Bridge *404*
Thomcat Burton Town *404*
Thoroughbred IPA Hambleton *554*
Thousand Yard Stare Rooster's *556*
Three & Sixpence Twisted *375*
Three Amigos Snaggletooth *655*
Three Bridges Ferry *819*
Three Erics St Annes *390*
Three Lions Porter Ben's *651*
Three Sisters Atlas (Orkney) *846*
Three Swords Kirkstall *595*
Three Tails Boudicca (S&P) *88*
Three XT *176*
ThreeOneSix Grain *85*
Thriller Cappuccino Porter Glastonbury (Parkway) *363*
Through and Off Fixed Wheel *434*
Thunderbird Glamorgan *745*
Thunderbridge Stout Small World *599*
Thurlton Gold People's *87*
Thurstein Pilsner Coniston *630*
Tick Tock Boom Muirhouse *466*
Ticket to Ride Escape *677*
Tickety-Boo Indigenous *165*
Tickle Muckle *717*
Tidal Pool Northdown *223*
Tidy Bang-On *743*
Tiffield Thunderbolt Great Oakley *504*
Tiffin Gold Kirkby Lonsdale *632*
Tiger Rut Millstone *679*
Tiger Tom Ruby Mild Cerne Abbas *323*
Tiger Everards *478*
Tigers Tail Milltown *597*
Tight Bar Steward Elmesthorpe *478*
Tiller Pin Wishbone *601*
Tilt S&P *87*
Time Lapse Good Chemistry *343*
Timeline Kettlesmith *374*
Tin Plate Irwell Works *678*
Tinder Box Inferno *343*
Tinderbox IPA Fell *631*
Tip Top Citra London Beer Lab *150*
Tipsy Fisherman Steamin' Billy *480*
Tiptoe Stealth *375*
Tiramisu Horbury *594*
Titanium Quantock *363*

Titus Saltaire *599*
TNT IPA Dynamite Valley *286*
Tod's Blonde Little Valley *596*
Tolly Roger Cliff Quay *101*
Tom Cat Fat Cat *85*
Tom, Dick & Harry Escape *677*
Tom Long Stroud *345*
Tomahawk Exeter *309*
Tonkoko Brew York *553*
Too Wet To Woo Red Rose *680*
Toon Broon Firebrick *725*
Top Dog Oscars *654*
Top House Mild Aitcheson's *531*
Top Knot Handsome *631*
Top Notch Brightwater *247*
Top of the Hops Draycott *464*
Topaz Blonde S&P *87*
Topsail Bays *307*
Totty Pot Cheddar *362*
Touch Front Row *404*
Touchpoint Paradigm *67*
Toujours Gyle 59 *324*
Tournament Goff's *343*
Tower IPA Redcastle *851*
Town Crier Hobsons *390*
Towy Tiger Zoo *785*
TPL Brightwater *247*
TPP (The People's Poet) Marlix *150*
Trade Star Firebrick *725*
Trade Winds Cairngorm *833*
Traditional Ale Larkins *223*
Tonbridge *225*
Traditional Bitter Old Mill *532*
Traditional IPA River Leven *835*
Strands *634*
Traditional Porter Gwaun Valley *784*
Traditional Sussex Bitter Hepworth *272*
Traditional Butts *165*
Trafalgar Bitter Nelson *223*
Tranquility Mr Winter's *86*
Transmitter Potton *26*
Trapper's Hat Bitter Brimstage *693*
Travelling Light George Samuel *709*
Trawlerboys Best Bitter Green Jack *101*
Treacle Miner's Tipple Red Rose *680*
Trembling Rabbit Mild Poachers *497*
Trenchman's Hop Godstone *248*
Trent Bridge Inn Ale Nottingham *520*
Trespasser Torrside *468*
Tri State Bingley *591*
Tri-ball Sulwath *811*
Tribune Roman Way *506*
Tribute St Austell *289*
Trident Scarborough *557*
Trig Point Cheviot *716*
Trigger Musket *223*
Trilogy Three Brothers *710*
Trinity Oxford *236*
Redemption *153*
Trink Penzance *289*
Triple B Grainstore *523*
Triple Blond Peerless *694*
Triple Champion 1648 *257*
Triple Choc Saltaire *599*
Triple Chocolate Stout Nailmaker *571*
Triple Hop Xtra-IPA Xtreme *39*

Triple Hop Blue Bee *569*
Brunswick *463*
Triple S Untapped *754*
Triple XXX Langham *272*
Triskellion Bushy's *868*
Trooper Robinsons *681*
Tropic Ale Kent *222*
Tropical Pale Liverpool Brewing *694*
Navigation *519*
TropicAle Avid *651*
Trout Tickler Poachers *497*
True Grit Millstone *679*
Trumpington Tipple Moonshine *38*
Trunk Koomor *222*
Trusty Steed Bowler's *36*
Try Front Row *404*
Tryfan Ogwen *774*
Tub Thumper 3P's *461*
Tubbers' Tipple Riverside *273*
Tuck Lincoln Green *518*
Tucktonia Drop The Anchor *192*
Tudor Rose Brampton *463*
Tumble Home Cliff Quay *101*
Tumbledown Dick St Annes *390*
Tune In, Hop Out Nightjar *597*
Tunnel Vision Box Steam *373*
Godstone *248*
Tupping Grainstore *523*
Turbine Porter Lakeland *633*
Turbulent Priest Wantsum *225*
Turning Tides Brewis *716*
Tushkar Lerwick *846*
TVO 54 Farm Yard *652*
TW8 Ealing *146*
Twa Dugs Lowland *811*
TwentyFourSeven Rooster's *556*
Twilighter IPA Ember (Black Sheep) *553*
Twin Falls Small World *599*
Twin Parallel Mr Winter's *86*
Twin Spring New River *67*
Twist & Stout Lenton Lane *518*
Twist and Stout Fine Tuned *362*
Twisted Dragon Sandstone *766*
Twisted Hop Hilden *859*
Twisted Ladder Mr Winter's *86*
Twisted Oak IPA Stow Fen *104*
Twisted Spire Hobsons *389*
Twisted Vine Hophurst *678*
Twisted Wheel Bull of the Woods *84*
Twisterella Hemlock *478*
Twitchell Buntingford *66*
Two Hoots Joseph Holt *678*
Two Horses Firebird *271*
Two Islands Quirky *598*
Two Tone Shortts *104*
Two Tree Island Red Leigh on Sea *55*
Tŵti Ffrŵti Twt Lol *747*
Tyne 9 Firebrick *725*
Tyneside Blonde Hadrian Border *726*
Type 42 Irving *193*
Typo Beer Ink *591*

U

Uber Brew Old Dairy *223*
Ubiquitous Engine Shed Project (Brunswick) *463*
Uisge Dubh Ayr *803*
Ullswater Blonde Tirril *634*
Ultimate Beermats *515*

Readers' recommendations

Suggestions for pubs to be included or excluded

All pubs are regularly surveyed by local branches of the Campaign for Real Ale to ensure they meet the standards required by the *Good Beer Guide*. If you would like to comment on a pub already featured, or on any you think should be featured, please fill in the form below (or a copy of it), and send it to the address indicated. Alternatively, email **gbgeditor@camra.org.uk**. Your views will be passed on to the branch concerned. Please mark your envelope/email with the county where the pub is, which will help us to direct your comments efficiently.

Pub name:

Address:

Reason for recommendation/criticism:

Pub name:

Address:

Reason for recommendation/criticism:

Pub name:

Address:

Reason for recommendation/criticism:

Your name and address:

Please send to: [Name of county] Section, Good Beer Guide, 230 Hatfield Road, St Albans, Hertfordshire AL1 4LW

HOW BEER IS BREWED

The brewer's art sees raw ingredients transformed into a wide variety of styles of beer. Follow their journey from field to glass with this general look at how beer is brewed.

THE KEY INGREDIENTS OF BEER

While brewers will experiment and make use of the cornucopia of ingredients available to them, there are four key elements most beers have in common: water, yeast, malt and hops, although, increasingly brewers are playing with extra ingredients that impart unusual and exciting flavours, aromas or consistency into a beer. Lactose, and heather, for example, have historically been used as additions, but more and more brewers are now employing honey, flowers, spices, fruits, and even meat in specialty ales.

Differing preparation methods, and varietals can create a spectrum of beer – from the very pale, to the near black; from clean, simple aromas, to deep coffee notes, or a fruity punch on the nose; and gentle, sessionable flavours that comfort the palate, to those that assault and challenge your taste buds.

Some breweries will have their own specific way of doing things, and each brewery set-up is individual, but the process is broadly the same. Use the flow chart overleaf to discover how brewers take the four key ingredients below and use them to create one of the most diverse drinks on the planet.

MALT

The mix of malts used in making a beer contribute to the colour, flavour and strength of the beer. Malted barley is most common, but other grains, such as wheat, oats or rye can be used. Once harvested, maltsters steep barley in water to absorb moisture, then spread it on heated floors or inside rotating drums where it will start to germinate. It is then kilned to dry. The temperature determines the type of malt produced – from pale, through to black. Common flavours and aromas derived include Ovaltine, oatmeal biscuits, Ryvita, almonds/nuts, honey, butterscotch, caramel, tobacco and vanilla.

HOPS

Hops can be used either as dried whole flowers or ground and compressed into pellets. Hops – via their oils and resins – impart aroma and flavour (including bitterness) into a beer, and are added into the copper/kettle, but can also be added later in the process. 'Dry-hopping', for example, is the process of adding a small amount of hops to a cask before it leaves the brewery en route to the pub, for additional aroma. Delicate aromas that can be destroyed during the boil can be retained in this way. While New World hops have become increasingly popular for their tropical fruit explosion in recent decades, UK hops provide the basis of more traditional beers.

◊ WATER

Water used for the brewing process is called liquor. Pure water can come from springs, bore holes or from the public supply. And while some breweries will treat their water to achieve a certain profile (adding sulphates such as gypsum and magnesium), or to remove potential off-flavour-causing compounds, others have embraced the natural, distinct quality of the local water – such as world-renowned Burton water. This water trickles through bands of gypsum and gives the resulting beer the world-famous, sought-after 'Burton snatch'.

⚗ YEAST

Every brewery will have its own yeast culture and often this will be a closely guarded asset. Yeast are living organisms that consume sugars, turning them in to alcohol and carbon dioxide. Traditionally most yeast used in UK beer production would have been 'ale yeast' which rises to the surface during fermentation and is therefore known as 'top-fermenting'. Other commonly-used yeasts are lager yeast, known as 'bottom-fermenting', and wild yeasts which create 'spontaneous fermentation', when beer in open vats is exposed to wild yeast in the air. Yeast produces natural chemical compounds called esters that give off aromas reminiscent of apples, oranges, pear drops, banana, liquorice, molasses and, in especially strong beers, fresh leather.

START

When malted barley reaches the brewery, it's ground in a mill into a powder called grist.

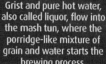

Grist and pure hot water, also called liquor, flow into the mash tun, where the porridge-like mixture of grain and water starts the brewing process.
The mixture is left to stand in the mash tun for around two hours, and during that time enzymes in the malt convert the remaining starch into fermentable sugar.

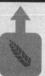

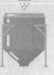

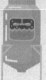

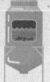

Malt mill Mash tun Liquor tank

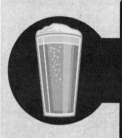

When the publican is satisfied that the beer has 'dropped bright', plastic tubes or 'lines' are attached to the tap and the beer is drawn by a suction pump activated by a handpump on the bar. Some pubs and beer festivals may serve the beer straight from the cask.

FINISH

Casks have to be vented to allow some of the natural gas to escape. A cask has two openings: a bung at the flat end where a tap is inserted to serve the beer; and a shive hole on top. A soft porous peg of wood, known as a spile or peg, is knocked into the shive, enabling some of the CO_2 to escape. As fermentation dies down, the soft spile is replaced after 24 hours by a hard one that leaves some gas in the cask: this gives the beer its natural sparkle, known as 'condition'.
Inside the cask, finings sink to the bottom, attracting the yeast in suspension.

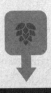

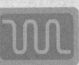
Cooler

When starch conversion is complete, the brewer and their team will run the sweet extract (called wort) to a second vessel – the copper/kettle – where it's vigorously boiled with hops.

The copper boil lasts between 1½ and 2 hours. The hopped wort is passed through a cooler to lower the temperature and is then pumped to fermenting vessels. These can be open or closed, upright or horizontal, but it's here that the liquid starts the conversion of malt sugars to alcohol thanks to the addition of yeast.

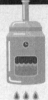
Copper

Cask

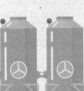
Fermenting vessels

Ale fermentation lasts for about a week and it's a method known as 'warm fermentation', which distinguishes it from the 'cold fermentation' method used to make genuine lager. Yeast converts malt sugar into alcohol and carbon dioxide (CO_2), and also creates a dense, rocky blanket on top of the liquid. Eventually the yeast will be overcome by the alcohol it has created and the yeast blanket is skimmed from the vessel. The beer will rest for several days in conditioning tanks to mature and to purge unwanted rough alcohols and esters.

From the conditioning tanks, beer is racked into casks. Finings may be added to clear the beer and additional hops may be placed in the casks for extra aroma and flavour. Brewing sugar can be added to encourage a strong secondary fermentation. The beer that reaches the pub cellar is said to be 'still working' as remaining yeast turns the final sugars into alcohol and CO_2.

Then comes the major divide in the world of brewing. One route leads to brewery-conditioned beer that is filtered, pasteurised and carbonated. The other creates Britain's great contribution to the world of beer: cask-conditioned ale. Cask ale is unique as it's not finished in the brewery but in the pub cellar.

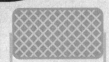
Filter

BREWERIES OVERVIEW

The Covid pandemic has left deep scars on British breweries and pubs. They are remarkably resilient and have returned to making and selling beer with gritty determination but there have been losses along the way. Roger Protz looks at what's been happening over the past year.

Four hundred pubs closed for good in 2021 and a further 200 had shut by the middle of 2022. CAMRA, along with UK Hospitality and the British Beer & Pub Association, have urged the government to come to the aid of pubs with cuts in VAT and Business Rates.

Pubs need the kind of support seen in France where President Macron launched a €150 million rescue plan for what he described as 'cherished and endangered cafés, the beating heart of neighbourhoods, important to France for community, culture and comfort.'

They are impressive words that could equally sum up the role of pubs in Britain, with their deep roots in our heritage and history.

BREWERY CLOSURES

While the Guide lists some 100 new breweries, there have been some sad and even shocking losses. The saddest was the closure in 2022 of the Kelham Island Brewery in Sheffield that was opened in 1990 by Dave Wickett next to the famous Fat Cat pub.

Many other brewers were inspired to set up shop as a result of Kelham Island's success that included winning the Champion Beer of Britain trophy in 2004 for Pale Rider, one of the first golden ales.

But Ed Wickett, who took over the brewery when his father died in 2012, says he was forced to close as a result of 'a whirlwind of problems – Covid, lockdowns and increased prices for gas, malt, hops and delivery charges.'

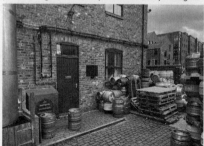

Kelham Island Brewery in Sheffield was forced to close in 2022 as a result of the pandemic and increasing operational costs

Fears that the merger of Marston's with Carlsberg could lead to brewery closures bore fruit in September 2022 when the group announced it was closing Jennings Brewery in Cockermouth. The brewery dates from 1828 and brewed such popular Lakeland ales as Sneck Lifter.

Other breweries that have closed include Fallen Brewery in Stirling, Beatnikz Republic in Manchester and London Fields in East London that was owned by Carlsberg. Shane Swindells closed his Cheshire Brewhouse in Congleton, saying it was impossible to make a living when bigger breweries were discounting beer so heavily to free trade pubs.

TAPPING INTO A TREND

To meet this challenge, several breweries have adopted the American taproom model that enables them to sell beer direct to the public. They include Beavertown and Five Points in London, Cloudwater in Manchester and Beartown in Cheshire. Brew York has taprooms in York, Leeds, Pocklington and Osbaldwick.

Even big brewers have joined the rush. Everards has moved from central Leicester to a greenfield site with the Beer Hall while Wells & Co sold its brewery to Marston's and has moved to a new site in Bedford with Brewpoint. Both brew and retail under one roof along with restaurants and bars.

More positive news on the brewery front comes from Guinness, which is building a new brewery in the Covent Garden area of London at a cost of £73 million. Guinness currently produces neither cask nor bottle-conditioned beers, but it says it will make beers for the local market and it may be open to persuasion to produce live stouts and porters.

CALEDONIAN CALAMITY

The most shocking loss came with Heineken UK's decision to close the Caledonian Brewery in Edinburgh that has been brewing since 1860. It achieved national status when its Deuchar's IPA won the Champion Beer of Britain award in 2002.

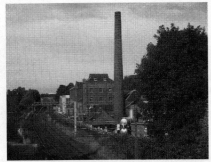

The Caledonian Brewery in Edinburgh has been in operation since 1860

Heineken claims the equipment is old and the brewery is 'economically unviable'. In other words, Caledonian needs investment but the global giant isn't prepared to put its hands in its pocket. It says it has spent 'millions' developing a new lager, Heineken Silver, but it's not prepared to devote a fraction of that to update the Edinburgh plant. Deuchar's IPA and a few other Caledonian beers will be brewed for Heineken at Greene King's Belhaven Brewery in Dunbar.

CAMPAIGNING NEWS

Appeals to the government by CAMRA and SIBA, the Society of Independent Breweries, for a cut in excise duty on draught beer sold in pubs was met in the Autumn Budget of 2021 by a 5 per cent cut that applies to containers of 40 litres or more. But 34 per cent of licensees stock containers of less than 40 litres and one in 10 venues don't have the cellar space for large containers. The Treasury said it would address the anomaly, but nothing had been heard by the time the Guide went to press.

There was further disappointment when a planned review of alcohol duties, with the aim of reducing the number of main duties from 15 to six, was delayed until the autumn of 2022.

A meeting of parliament's Business, Energy and Industrial Strategy Committee in July 2022 into the workings of the Pubs Code that regulates relations between large pub companies and their tenants produced another shock. The proceedings showed that only a tiny proportion of tied tenants who applied for MRO – Market Rent Only – agreements went ahead with their applications. MRO means that a tenant can go free of tie in order to buy a better range of beers in return for a rent review.

The committee heard that Punch Taverns, with 1,200 pubs, had granted MRO to just 14 tenants; Star Pubs & Bars, with 2,400 pubs, part of Heineken UK, had agreed MRO with 56 tenants; and Stonegate, the biggest pubco with an estate of 4,500 pubs, had agreed MRO with 17 tenants. All the tenants had seen their rents increase.

It seemed clear that the pubcos had put considerable pressure on their tenants not to go down the MRO route. As a result, CAMRA launched a survey for tied tenants to enable them to give feedback to the government on how they see the Pubs Code working.

SELLING UP

The implosion of Brains of Cardiff continues. The company moved in 2019 to a new site in Cardiff Docks costing £10 million but chalked up such massive debts that it has hived off a large number of its pubs.

In 2021 it signed a deal that allows Marston's to run 140 of its pubs with an annual rent to Brains worth £5.5 million. It followed in 2022 with a deal worth £100 million that sold the freehold and leasehold of a further 100 pubs to a European investment group Song Capital. Brains is now seeking a buyer for the brewery.

Magic Rock and Fourpure breweries had been bought by Lion of Australia, part of the global Kirin group based in Japan. Lion sold both breweries, saying trading was exceptionally difficult but they continue in business.

ORIGINAL CRAFT

On a positive note, Black Sheep Brewery in Yorkshire has launched a major campaign to boost the fortunes of cask beer. Chief executive Charlene Lyons promotes the campaign with the slogan 'Real ale – the original craft beer'.

They are fine words that should be inscribed above the entrance to every pub in the country.

Former editor of The *Good Beer Guide*, Roger Protz is considered one of the leading beer writers in the world, with a long career in journalism and publishing, and having won multiple awards. Roger has authored many books on beer and pubs including *300 Beers to Try Before You Die*. Follow him on Twitter **@RogerProtzBeer** and **protzonbeer.co.uk**

Closed Breweries

The following breweries have closed or gone out of business since the 2022 Guide was published:

81 Artisan, West Dean, West Sussex
Acid Brewing Cartel, Glasgow, Greater Glasgow & Clyde Valley
Alpha State, Horsmonden, Kent
Antoine's, Westcott, Surrey
Argyll, Oban, Argyll & the Isles
Art Brew, Sutcome, Devon
Atomic, Rugby, Warwickshire
BAD, Dishforth, North Yorkshire
Barnet, Barnet, Hertfordshire
Bartlebys, Belper, Derbyshire
Beatnikz Republic, Manchester, Greater Manchester
Beckstones, Millom, Cumbria
Belvoir, Old Dalby, Leicestershire
Benchmark, Eridge Green, East Sussex
Big River, Stroud, Gloucestershire
Binghams, Woodley, Berkshire
Bishop's Crook, Penwortham, Lancashire
Blackpit, Stowe, Buckinghamshire
Brew Buddies, Swanley Village, Kent
Brewery58, Wallingford, Oxfordshire
Brewhouse & Kitchen, Wilmslow, Cheshire
BrightBeer, Bournemouth, Dorset
Brown Cow, Barlow, North Yorkshire
Brumaison, Marden, Kent
Caledonian, Edinburgh, Edinburgh & the Lothians
Chapel, Criftins, Shropshire
Chapel Street, Poulton-le-Fylde, Lancashire
Cheshire Brewhouse, Congleton, Cheshire
Chickenfoot, Bonsall, Derbyshire
Chorlton, Manchester, Greater Manchester
Clanconnel, Gibson's Hill, Northern Ireland
Clouded Minds, Lower Brailes, Warwickshire
Colne Valley, Colchester, Essex
Concept, Leeds, West Yorkshire
Connoisseur, St Helens, Merseyside

Cotleigh, Wiveliscombe, Somerset
Cotton End, Northampton, Northamptonshire
Coul, Glenrothes, Kingdom of Fife
Crafty Beers, Stetchworth, Cambridgeshire
Crafty Little, Hull, East Yorkshire
Crosspool Ale Makers Society, Sheffield, South Yorkshire
CTZN, SW14: East Sheen, Greater London
Cwm Rhondda, Treorchy, Glamorgan
Dalrannoch, Meikleour, Tayside
De Vossen, Stanningfield, Suffolk
Deeside, Banchory, Aberdeen & Grampian
Derwent, Silloth, Cumbria
Devilstone, Langley Park, Durham
Double Top, Worksop, Nottinghamshire
Druid, Penysarn, North West Wales
Eastcote, Eastcote, Northamptonshire
Enfield, N18: Upper Edmonton, Greater London
Exe Valley, Silverton, Devon
Fallen, Kippen, Loch Lomond, Stirling & the Trossachs
Fat Pig, Exeter, Devon
Fellows, Cottenham, Cambridgeshire
Fishponds, Bristol, Gloucestershire & Bristol
Five Towns, Wakefield, West Yorkshire
Fool Hardy, Heaton Norris, Greater Manchester
Fowey, St Breock, Cornwall
Franklins, Ringmer, East Sussex
Gallus, Glasgow, Greater Glasgow & Clyde Valley
Geeves, Barnsley, South Yorkshire
Gibberish, Liverpool, Merseyside
Goodall's, Alsager, Staffordshire
Grasshopper, Langley Mill, Nottinghamshire
Grey Friars, Wheaton Aston, Staffordshire
Handley's, Barnby in the Willows, Nottinghamshire

Haywood Bad Ram, Ashbourne, Derbyshire
Headcorn Hop, Headcorn, Kent
Heathton, Heathton, Shropshire
High House Farm, Matfen, Tyne & Wear
High Weald, East Grinstead, East Sussex
Hillstown, Randalstown, Northern Ireland
Hitchin, Hitchin, Hertfordshire
Holcot Hop-Craft, Holcot, Northamptonshire
Hop & Stagger, Norton, Shropshire
Hop Studio, Elvington, North Yorkshire
Hoppy Family, Kettering, Northamptonshire
Hurly Burly, Musselburgh, Edinburgh & the Lothians
Isle of Avalon, Ashcott, Somerset
Isle of Sark, Sark: La Seigneurie, Channel Islands
Itchen Valley, Alresford, Hampshire
Jennings, Cockermouth, Cumbria
Kelham Island, Sheffield, South Yorkshire
Kings Head, Bildeston, Suffolk
Laine, E9: Victoria Park, Greater London
Late Night Hype, Clydebank, Greater Glasgow & Clyde Valley
Laverstoke Park, Overton, Hampshire
Lazy Bay, Nottingham, Nottinghamshire
Leila Cottage, Ingoldmells, Lincolnshire
Little Dewcurch, Little Dewchurch, Herefordshire
Little Giant, Bristol, Gloucestershire & Bristol
London Fields, E8: London Fields, Greater London
Loomshed, Tarbet: Isle of Harris, Highlands & Western Isles
Mallard, Maythorne, Nottinghamshire
Market Bosworth, Stoke Golding, Leicestershire
Marko Paulo, W13: Northfields, Greater London

Martland Mill, Wigan, Greater Manchester

Masquerade, Bristol, Gloucestershire & Bristol

Modern Day Monks (MDM), Warrington, Cheshire

Moncada, NW2: Dollis Hill, Greater London

Mouselow Farm, Dinting, Derbyshire

Mr Majolica, Grays, Essex

NauticAles, Ramsgate, Kent

Neath, Port Talbot, Glamorgan

North Coast (Wooha), Kinloss, Aberdeen & Grampian

Oakwood, Wells-next-the-Sea, Norfolk

Offa's Dyke, Trefonen, Shropshire

Old Kent Road, SE15: Peckham, Greater London

Outstanding, Manchester, Greater Manchester

Oxted, Oxted, Surrey

Park, Brechin, Tayside

Penlon, New Quay, West Wales

Penton Park, Penton Mewsey, Hampshire

Polarity, Worthing, West Sussex

Prospect, Wigan, Greater Manchester

Rectory, Streat, East Sussex

Rival, Cardiff, Glamorgan

Rothes, Rothes, Aberdeen & Grampian

Saints Row, Darlington, Durham

Seven Kings, Dunfermline, Kingdom of Fife

Severn, Tortworth, Gloucestershire

Sheffield, Sheffield, South Yorkshire

Silver Street, Bury, Greater Manchester

SlyBeast, SW18: Wandsworth, Greater London

Springhead, Laneham, Nottinghamshire

Stag, Walton, Cheshire

Stanway, Stanway, Gloucestershire

Strathaven, Strathaven, Greater Glasgow & Clyde Valley

Strathbraan, Amulree, Tayside

Stratton Lane, East Stratton, Hampshire

Swan, Leominster, Herefordshire

TAP, Rendcomb, Gloucestershire

Three Castles, Pewsey, Wiltshire

Three Sods, E8: London Fields, Greater London

Twisted Magnolia, Keswick, Cumbria

Vendetta, Aveley, Essex

Violet Cottage, Gwaelod y Garth, Glamorgan

Wayoh, Horwich, Greater Manchester

Weird Bear, W7: Hanwell, London

Whitacre, Nether Whitacre, Warwickshire

White Rabbit, Honeybourne, Worcestershire

Wintrip, Worcester, Worcestershire

Withnell's, Chorley, Lancashire

Wood, Winstanstow, Shropshire

Working Hand, Leamside, Durham

Worsthorne, Briercliffe, Lancashire

Yeovil, Yeovil, Somerset

Yetman's, Bayfield, Norfolk

Zymurgorium, Irlam, Greater Manchester

Future Breweries

The following new breweries have been notified to the Guide and will start to produce beer during 2022/2023. In a few cases they were in production during the summer of 2022 but were too late for a full listing:

Bishy, Bishopthorpe, North Yorkshire

Boojum & Snark, Sandown, Isle of Wight

Bredy, Burton Bradstock, Dorset

Clovelly, Bideford, Devon

Coastline, Barrow in Furness, Cumbria

Common Rioters, SE3: Blackheath, Greater London

Drum & Monkey, Stamford, Lincolnshire

Durty, Innerleithen, Edinburgh & the Lothians

Hammersmith, W6: Hammersmith, Greater London

Jimbrew, Preston, Lancashire

Maverick, Farnham, Surrey

Mill Hill Cask & Coffee, Enderby, Leicestershire

Monkey House, Berwick on Tweed, Northumberland

On Point, Bristol, Gloucestershire & Bristol

Reluctant Hero, Leeds, West Yorkshire

Soar, Mountsorrel, Leicestershire

SpadeTown, Lurgan, Northern Ireland

Three Hounds, Beckenham, Greater London

Two Flints, Windsor, Berkshire

Yaptown, Arundel, West Sussex

Breweries for Sale

The following breweries are reported as being for sale:

Church Aston, Church Aston, Shropshire

Crafty Cats, St Nicholas Hurst, Berkshire

Keystone, Berwick St Leonard, Wiltshire

Shropshire Brewer, Longden Common, Shropshire

Trinity Ales, Gisleham, Suffolk

AWARD-WINNING PUBS

The Pub of the Year competition is judged by CAMRA members. Each of the CAMRA branches votes for its favourite pub: criteria include the quality and choice of real ale, atmosphere, customer service, community offering, and value. The pubs listed below are the current winners of the title, look out for the ♟ next to the entries in the Guide.

ENGLAND

Bedfordshire
Fox, Carlton
March Hare, Dunton
Black Lion, Leighton Buzzard

Berkshire
Victoria Arms, Binfield
Lion, Newbury
Bell, Waltham St Lawrence
A Hoppy Place, Windsor

A Hoppy Place, Windsor, Berkshire

Buckinghamshire
Hop Pole Inn, Aylesbury

Cambridgeshire
Queen Edith, Cambridge
Drayman's Son, Ely
Ostrich Inn, Peterborough
Ale Taster, St Neots

Cheshire
Olde Cottage, Chester
Borough Arms, Crewe
Wharf, Macclesfield
Chapter Brewing Tap, Sutton Weaver
Little Manor, Thelwall

Cornwall
St John Inn, St John

Cumbria
Punch Bowl Inn, Great Broughton
New Union, Kendal
Fell Bar, Penrith
Old Friends, Ulverston

Fell Bar, Penrith, Cumbria

Derbyshire
Smith's Tavern, Ashbourne
Smithfield, Derby
Miners Arms, Hundall
Colvile Arms, Lullington
Twenty Ten, Matlock
Talbot, Ripley

Devon
Axminster Inn, Axminster
Globe Inn, Beaford
Tally Ho, Littlehempston

Dorset
Ropemakers, Bridport
Horse & Groom, Wareham

Durham
Grey Horse, Consett
Quakerhouse, Darlington
Station House, Durham

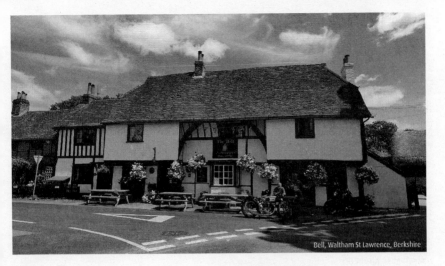

Bell, Waltham St Lawrence, Berkshire

Essex
Queen's Head, Boreham
Theobald Arms, Grays
Maybush Inn, Great Oakley
Olde Albion, Rowhedge
Railway Arms, Saffron Walden
Station Arms, Southminster
Woodbine Inn, Waltham Abbey
Mile & a Third, Westcliff-on-Sea

Gloucestershire & Bristol
Mousetrap Inn, Bourton-on-the-Water
Shakespeare, Bristol
Jolly Brewmaster, Cheltenham
Pelican Inn, Gloucester
Berkeley Arms, Tewkesbury

Hampshire
Ten Tun Tap House, Alton
Olaf's Tun, Southampton
Wonston Arms, Wonston

Herefordshire
Black Swan, Much Dewchurch

Hertfordshire
Full House, Hemel Hempstead
Land of Liberty, Peace & Plenty, Heronsgate
Half Moon, Hitchin
Woodman, Wild Hill

Isle of Wight
Travellers Joy, Northwood

Kent
New Inn, Canterbury
Larkins' Alehouse, Cranbrook
Compass Alehouse, Gravesend
Bowl Inn, Hastingleigh
Three Tuns, Lower Halstow

Two Halves, Margate
10:50 from Victoria, Strood
Nelson Arms, Tonbridge
Berry, Walmer

Lancashire
Bankers Draft, Barrowford
Bookmakers, Heysham
Tap Room No. 12, Ormskirk
Fifteens at St Annes, St Annes
Red Lion, Wheelton

Leicestershire
New Plough Inn, Hinckley
Anchor, Plungar
Stilton Cheese, Somerby

Fifteens at St Annes, St Annes, Lancashire

Lincolnshire
No. 2 Refreshment Room, Cleethorpes
Goat, Frognall
Lord Harrowby, Grantham
Strugglers Inn, Lincoln
Consortium, Micropub, Louth

Greater London
Olde Rose & Crown, E17: Walthamstow
Little Green Dragon, N21: Winchmore Hill
Carlton Tavern, NW6: Kilburn Park
River Ale House, SE10: East Greenwich
Eagle Ale House, SW11: Clapham Junction
Queen's Head, WC1: St Pancras
Owl & the Pussycat, W13: West Ealing
Long Haul, Bexleyheath
Hope, Carshalton
Jolly Coopers, Hampton
Hop Inn, Hornchurch
Wych Elm, Kingston
One Inn the Wood, Petts Wood

Greater Manchester
Grocers, Cadishead
Chiverton Tap, Cheadle Hulme
Beer House, Chorlton-cum-Hardy
Silly Country Bar & Bottle Shop, Droylsden
Smithfield Market Tavern, Manchester
Fox & Pine, Oldham
Union Arms, Tyldesley
Beer School, Westhoughton
Real Crafty, Wigan

Merseyside
Bridewell, Liverpool: City Centre
Magazine Hotel, New Brighton
Guest House, Southport
Beer EnGin, Whiston

Norfolk
White Hart Free House, Ashill
Tombstone Saloon Bar, Great Yarmouth
Kings Head, Norwich

Northumberland
Office, Morpeth

Nottinghamshire
Marquis of Granby, Granby
Organ Grinder, Newark
Beer Under the Clock, Retford
Horse & Jockey, Stapleford

Oxfordshire
Red Lion, Horley
Greyhound Inn, Letcombe Regis
Crown, South Moreton

Shropshire
Golden Lion, Bridgnorth
Red Lion, Market Drayton
Prince of Wales, Shrewsbury
Pheasant Inn, Telford: Wellington

Somerset
Star Inn, Bath
Crossways Inn, West Huntspill

Real Crafty, Wigan, Greater Manchester

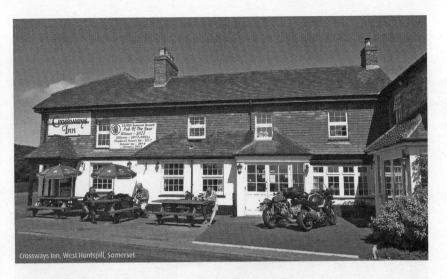
Crossways Inn, West Huntspill, Somerset

Staffordshire
Old Royal Oak, Burton upon Trent
Love & Liquor, Codsall
Bridge Inn, Hednesford
Holy Inadequate, Stoke-on-Trent: Etruria
Swan Inn, Stone
Tamworth Tap, Tamworth
Night Inn, Uttoxeter

Suffolk
Butchers Arms, Beccles
Dove, Bury St Edmunds
White Horse, Sweffling

Surrey
Olde Swan Hotel, Chertsey
Crown, Horsel
Running Horse, Leatherhead
Surrey Oaks, Newdigate

East Sussex
Brickmaker's Alehouse, Bexhill on Sea
Hole in the Wall, Brighton
Hare & Hounds, Framfield

West Sussex
Hornet Alehouse, Chichester
Brewery Shades, Crawley
Selden Arms, Worthing

Tyne & Wear
Marine, South Shields

Warwickshire
Turks Head, Alcester
Malt Shovel, Bubbenhall
Three Tuns, Henley-in-Arden
Lord Hop, Nuneaton
Merchants Inn, Rugby

West Midlands
Bull, Birmingham: City Centre
Hops d'Amour, Coventry
Hail to the Ale, Wolverhampton
Bird in Hand, Wordsley

Wiltshire
Three Crowns, Chippenham
Duke of York, Salisbury
Hop Inn, Swindon

Worcestershire
Fleece Inn, Bretforton
Cross Inn, Finstall
Bear & Wolf, Kidderminster
Bull Baiters Inn, Worcester

East Yorkshire
Old Ship Inn, Bridlington
Butcher's Dog, Driffield

North Yorkshire
Little Ale House, Harrogate
George & Dragon, Hudswell
Sun Inn, Pickering
Blue Bell, York

South Yorkshire
Heaven & Ale, Barnsley
Steptoes Café Bar, Kimberworth
Rising Sun, Sheffield: West

West Yorkshire
West Riding Refreshment Rooms, Dewsbury
Fox & Goose, Hebden Bridge
Rat & Ratchet, Huddersfield
Brown Cow, Keighley
Salt Cellar, Saltaire
Black Rock, Wakefield

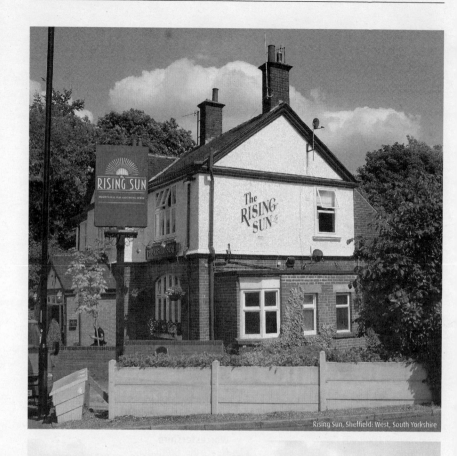

Rising Sun, Sheffield: West, South Yorkshire

Salt Cellar, Saltaire, West Yorkshire

WALES

Glamorgan
Gwaelod Y Garth Inn, Cardiff: Gwaelod Y Garth
Cross Inn Hotel, Cross Inn

Gwent
Queen's Head, Chepstow

Mid Wales
Royal Oak, Pencelli

North East Wales
Mold Alehouse, Mold
Bridge End Inn, Ruabon

North West Wales
Black Cloak Taproom, Colwyn Bay
Torrent Walk Hotel, Dolgellau

West Wales
Ship & Castle, Aberystwyth
Royal Oak Inn, Fishguard
Mansel Arms, Porthyrhyd

SCOTLAND

Aberdeen & Grampian
Queen Vic, Aberdeen

Ayrshire & Arran
Weston Tavern, Kilmaurs

Dumfries & Galloway
Cavens Arms, Dumfries

Edinburgh & the Lothians
Dreadnought, Edinburgh: North

Greater Glasgow & Clyde Valley
Fox & Hounds, Houston
Weavers, Strathaven

Highlands & Western Isles
Bandstand, Nairn

Kingdom of Fife
Commercial Inn, Dunfermline

Loch Lomond, Stirling & the Trossachs
Tappit Hen, Dunblane

Tayside
Bank Bar, Dundee

NORTHERN IRELAND

Errigle Inn, Belfast

ISLE OF MAN

Trafalgar Hotel, Ramsey

Commercial Inn, Dunfermline, Kingdom of Fife

ADDITIONAL RESOURCES

The Good Beer Guide is also available in digital formats, including a mobile app and a sat-nav Points of Interest (POI) download. Together, these offer the perfect solution to pub-finding on the move. See **shop1.camra.org.uk** for further information.

GOOD BEER GUIDE APP

The Good Beer Guide mobile app provides detailed information on the latest Good Beer Guide pubs, breweries and beers wherever you are or wherever you are going. It also provides information for more than 31,000 other real ale pubs all over the UK, collated by CAMRA. Social media integration lets you share your beer experiences with other users and you can record your pub visits, tasted beers and personal reviews. For more information visit **camra.org.uk/gbgapp**

CAMRA'S NATIONAL BEER SCORING SYSTEM

CAMRA's National Beer Scoring System (NBSS) is used by members across the country to help them identify outlets that serve consistently good beer. The system uses a 0–5 scale that can be submitted online. Any member can submit a beer score by visiting **whatpub.com**, logging in as a member and selecting 'Submit Beer Scores' or by using the beer scoring function on the Good Beer Guide app.

The NBSS is also used to select beers for the annual Champion Beer of Britain competition.

See **camra.org.uk/NBSS** for details.

JOIN CAMRA'S GOOD BEER GUIDE PRIVILEGE CLUB

CAMRA members can take advantage of an even bigger discount on the *Good Beer Guide*, and get further benefits, by joining the Good Beer Guide Privilege Club.

- Pay just £11 (RRP £16.99) for your copy, with free p&p
- Receive your copy hot off the press and in advance of other purchasers
- Receive occasional special Club offers and discounts on other CAMRA books and merchandise
- Stay up-to-date every year with The Good Beer Guide as everything is taken care of with one simple Direct Debit
- Help to fund CAMRA directly, allowing us to continue to campaign for real ale and community pubs

For further details and to sign up visit **camra.org.uk/gbg-privilege-club** and follow the online instructions.

BOOKS AND MERCHANDISE

CAMRA's online shop is the ideal place to visit for anyone looking for beer-and pub-related books, clothing or merchandise for themselves or fellow beer lovers.

Books on beer, brewing, pubs, and breweries have been exploding onto our bookshelves in more numbers than ever before in recent years. Alongside a rise in the 'craft' beer movement the books on beer have taken on a much more eclectic and varied approach to the subject. Beer and cooking, brewing your own with a myriad of ingredients and the most exotic places to drink beer, have all been covered in one form or another. CAMRA books are keen to embrace this new-found desire to explore the quirky and exciting aspects of beer but with 50 years of publishing and a combined membership life experience of over 9 million years, we are much more inclined to approach these subjects with the long term in mind. As an authority on beer, we are very much concerned with preserving it in its purest form and celebrating the changes and innovations for their benefits.

- Browse the full range of CAMRA Books titles within categories including beer knowledge; beer travel; history & culture, heritage, home brewing and pub walks & travel
- Discover our growing selection of beer-related titles from other publishers
- Shop our expanding range of clothing and merchandise
- Get upcoming CAMRA titles in advance of publication at special pre-order prices
- As a CAMRA member, log in to receive further discounts

Visit us at: **shop1.camra.org.uk**

JOIN THE CAMPAIGN

CAMRA, the Campaign for Real Ale, is an independent, not-for-profit, volunteer-led consumer group. We promote good-quality real ale and pubs, as well as lobbying government to champion drinkers' rights and protect local pubs as centres of community life.

CAMRA has over 155,000 members from all ages and backgrounds, brought together by a common belief in the issues that CAMRA deals with, and their love of good-quality British beer.

From just £28.50† a year, you can join CAMRA and enjoy the following benefits:

- A **welcome pack**, including membership card, to help you make the most of your membership

- Access to award-winning, quarterly **BEER magazine** and **What's Brewing** online news

- £30* worth of **CAMRA real ale** vouchers

- Access to the **Real Ale Discount Scheme**, where you receive discounts on pints at over 3,500 participating pubs nationwide

- **Learn & Discover** online resources to help you discover more about beer and brewing

- **Free or reduced entry** to CAMRA beer festivals

- The opportunity to **campaign for great real ale, cider and perry**, and to save pubs under threat from closure

- **Discounts on CAMRA books** including our best-selling *Good Beer Guide*

- Social activities in your local area and **exclusive member discounts online**

Whether you're a dedicated campaigner, a beer enthusiast looking to learn more about beer, or you just love beer and pubs, CAMRA membership is for you. Join us today!

Join the campaign at
camra.org.uk/join

CAMRA, 230 Hatfield Road, St Albans, Herts AL1 4LW.
Tel: 01727 798440 Email: camra@camra.org.uk

Rates and benefits are subject to change.
† Concessionary rates may be lower.
* Joint members receive £40 worth of vouchers.
** real ale, cider and perry, subject to terms and conditions.

Campaign
for
Real Ale

ACKNOWLEDGEMENTS

Thank you to all of the following who pledged support for this publication:

Alasdair Dobbing

Alex Sanchez: Advocate abroad for good beer and country pubs via Walla Walla, WA

Alexander Wright

Andrew Revans: into beer and pubs for many years. His first GBG was 1977's

Anthony Morgan: Real ale since I was teenager, CAMRA since 1983

Ash Mather: Romsey, Hampshire. Joined CAMRA 1974

Barry Phillips

Bert Kerks

Bob Stukins: In celebration of amazing friends and experiences I enjoy through CAMRA

Carolyn "Cazza" Simms

Charles Miller: Founder and owner of The Miller's T'Ale Micropub, Peel, Isle of Man

Charles Tucker: brewing for over 50 years, with the motto Vires Cervisiam!

Chris Lee: lifelong lover of real ale and traditional locals

Clive Stonebridge: Celebrating 50th edition of *The Good Beer Guide*, Cheers

Dave & Karen Breed: Pearl Wedding Anniversary Year 2023

David Neil: drinker of real ales, stouts and porters

Dominic Shaw: Passionate about protecting pubs, quality ale and promoting UK heritage

Elaine Fairless: Lover of real ale and life member of CAMRA since the Covent Garden Beer Festival in 1975!

Eliot Shelley

Ellie Blumenthal: Colin Blumenthal, real ale connoisseur, Reading FC fanatic & loving daddy

Emma Haines: In memory of Martin Price and Nigel Bevan

Frank McGowan: Frank, Ian & Roger too. They love smoke beer, they have had a few. Prost to Bamberg.

Gary Elflett: CAMRA life member and real ale drinker and advocate since the 1980s

Gary Timmins: proud to support the campaign for the last 15 years

Geoff Austin: Hon. Alderman of the Royal Borough of Kingston upon Thames

Gillian Hough: David Hough and Martin Hough – both life members & firm supporters of CAMRA

Gillian Hough: Jeanette Williams – passionate life member, amazing volunteer & my daughter!

Gillian Hough: Remembering Julian R Hough – who was passionate about beer, pubs and CAMRA

Graham Clements: "He thanked Heaven that in a world of much evil there was still so good a thing as ale"

Graham Larn: In memory of friend and colleague, Dennis Lister

Gunter Nembach: beer lover – craft beer brewer and farmer

Ian and Catherine Lee

Ian Anderson: 40 years of enjoyment and friendship from discovering real ale

Jan Halvor Fjeld: Skein, Telemark, Norway

Joe & Sarah Crawford: brought together by a passion for real ale – 01/04/18

John Bodnar: Bodders thanks CAMRA for 50 years of keeping Real Ale in my glass. Cheers

John Gillis: Brian Carpenter – his personal consumption a major factor in CAMRA's success!

John Leader

John Taylor

Jonathan Mayor: Jonny & Mozzer, together for 20 years supporting British beer and pubs

Keith N. A. Alexander: lifelong enthusiast for real ales and pubs

Ken Owst: with thanks for your work as CAMRA's Deputy Chief Executive

Kevin Horsewood: beer expert and loved dearly by Sharon, Matthew & Thomas!

Lee Cooper: supporter of the Great British pub and CAMRA member since 2018